Publications in [Southern] California Art, vol. 13 (Part VI)

SANTA BARBARA COUNTY, NORTH
(including SANTA MARIA, SOLVANG, and LOMPOC)

ART AND PHOTOGRAPHY BEFORE 1960

by

Nancy Dustin Wall Moure

*For Library
Sonoma State
Nancy Moure*

Cambria
Dustin Publications
2021

PUBLICATIONS IN [SOUTHERN]
CALIFORNIA ART 13 (Part VI)

Cambria: Dustin Publications, 2021

Dustin Publications
5524 Sunbury Ave.
Cambria, Ca. 93428
(805) 924-1540

ISBN 0-9790645-7-0
ISBN13 978-0-9790645-7-9
Publications in [Southern] California Art, vol. 13 (Part VI)

First Edition
100 copies printed and distributed to American research institutions.

PUBLICATIONS IN [SOUTHERN] CALIFORNIA ART

Vol. 1 *The California Water Color Society: Prize Winners 1931-1954; Index to Exhibitions 1921-1954*, by Nancy Dustin Wall Moure, Los Angeles: Privately Printed, 1973 and 1975. 80 pps. (re-printed with Vols. 2 and 3 in one volume in 1984)

Vol. 2 *Artists' Clubs and Exhibitions in Los Angeles before 1930*, by Nancy Dustin Wall Moure and Phyllis Moure, Los Angeles: Privately Printed, 1974. 160 pps. (re-printed with Vols. 1 and 3 in one volume in 1984)

Vol. 3 *Dictionary of Art and Artists in Southern California before 1930*, by Nancy Dustin Wall Moure with research assistance by Lyn Wall Smith, Los Angeles: Privately Printed, 1975. 340 pps. (re-printed with Vols. 1 and 2 in one volume in 1984)

Vol. 4 *A History of the Laguna Beach Art Association to 1955*, and *Art in Orange County California* and *So What's So Great About Santa Barbara Art After 1930?*, by Nancy Dustin Wall Moure (published in one volume with Vols. 5 and 6) Los Angeles: Dustin Publications, 1999. 599 pps. total

Vol. 5 *Historical Collections Council Newsletters, November 1985-December 1998*, edited by Janet Blake Dominik and Nancy Dustin Wall Moure (published in one volume with Vols. 4 and 6) Los Angeles: Dustin Publications, 1999. 599 pps. total

Vol. 6 *Index to [Exhibition] Catalogues on California Art and Artists Published before 1955 and Found on the Microfilm of the Archives of American Art*, by Phil Kovinick and Marian Yoshiki Kovinick, and *Index to Notices on California Artists Found in the Los Angeles Times Sunday Art Review Column, 1930-1945*, by Nancy Dustin Wall Moure (published in one volume with Vols. 4 and 5) Los Angeles: Dustin Publications, 1999. 599 pps. total

Vol. 7 *Exhibition Record of the San Francisco Art Association 1872-1915, Mechanics' Institute 1857-1899 and California State Agricultural Society 1856-1902*, by Ellen Halteman, Los Angeles: Dustin Publications, 2000. 708 pps.

Vol. 8 *Index to Articles on California Art and Artists found in Newspapers published in Laguna Beach (c. 1920-1945), Hollywood (c. 1911-1936) and Pasadena (c. 1900-1940)*, by Nancy Dustin Wall Moure, Los Angeles: Dustin Publications, 2006. 736 pps.

Vol. 9 *Historical Collections Council Newsletters, January 1999-May 2006*, edited by Nancy Dustin Wall Moure, and *Miscellaneous Articles* by Nancy Dustin Wall Moure, Los Angeles: Dustin Publications, 2006. 740 pps.

Vol. 10 *A Dictionary of Art and Artists of Nineteenth Century Fresno*, by Ralph J. Gorny, (originally Privately Published, 1998) and **Master Index** to vols. 1-10 by Nancy Dustin Wall Moure, Los Angeles: Dustin Publications, 2006. 579 pps.

Vol. 11 *Index to California Art Exhibited at the Laguna Beach Art Association, 1918-1972*, by Nancy Dustin Wall Moure, Los Angeles: Dustin Publications, 2015. 757 pps.

Vol. 12 *Historical Collections Council Newsletters, September 2006 – September 2010*, by Nancy Dustin Wall Moure; *Westways /Touring Topics 1909-1981, Index to Art*, by Nancy Dustin Wall Moure; *William Wendt Letters; Lawrence Murphy: An Undiscovered Master Painter* by Kirk McDonald; *Santa Cruz Art League Statewide Art Exhibition Index, First through Twenty-seventh, 1928-1957*, by Nancy Dustin Wall Moure; *Index to PSCA, vols. 11 and 12*, by Nancy Dustin Wall Moure, Los Angeles: Dustin Publications, 2015. 541 pps.

PUBLICATIONS IN CALIFORNIA ART, VOL. 13, NOS. I-VII
(Art and Photography of the Central Coast before 1960)

TABLE OF CONTENTS

INTRODUCTION TO CENTRAL COAST ART

The coastal area north of Santa Barbara and south of Carmel, which is the subject of the seven numbers of *Publications in California Art*, Vol. 13, has remained primarily agricultural to the present, a haven of quiet outside the metropoli of San Francisco and Los Angeles, and prior to 1960 rarely acknowledged for its culture.

This is the first in-depth treatment of the art of this section of California, and the ending date of 1960 was intentionally chosen. Traditional American art histories break their discussions of art at 1945 (when abstract art challenged representational art). However with the Central Coast's small number of early full-time artists and the fact that art really only "took off" after World War II, this history extends to 1960.

Because most of the artists herein are not known in the national art scene nor are most included in any art dictionary or art history, the core information in this book necessarily comes from primary sources such as local newspapers (found on microfilm at local libraries and/or digitized on the Internet). (See Bibliography.) These newspapers were first browsed to uncover the names of local artists and photographers. Then, those names were searched digitally for additional information (on such sites as newspapers.com, genealogybank.com, ancestry.com, and California Digital Newspaper Collection). (The digitization of newspapers is ongoing and future researchers will obviously be provided with additional sources.)

Because this is a Dictionary and not a History, <u>every</u> person mentioned as having been associated with some kind of art (painting, sculpture, printmaking, arts and crafts, teaching, drafting, even photography and some architecture) was admitted. No judgment was made as to whether that person was artistically "good enough" to be discussed. Included in *PSCA* vol. 13, no. 6, are artists who lived in Northern Santa Barbara County, i.e., that portion of the county lying north of the Santa Ynez mountains. This volume differs from earlier volumes in that because so many artists were active in the area and because the book grew to have too many pages – it became physically unwieldy – individual biographical entries for artists of high school or lower ages were not made.

Difficulties. Newspaper misspellings of artists' names and the fashion of the time to use only initials for a person's first and middle names slowed down digital searching until the correct spelling or full name of the individual could be determined. Also posing difficulties was the custom of the time, when reporting on a married woman, of referring to her by her husband's name, or his initials. In Santa Barbara area newspapers, a woman was often listed under her married name when a newspaper reported her activities with clubs, but then under her own name, if exhibiting art. Also, digital searches are dependent on the ability of the optical character reader to identify text. This editor found it often failed when the original text was too blurry to read, when names were hyphenated and split between one column and the next, and when typeface was too large (as in headings) for the optical character reader to "see" it.

Format. The goal of this compiler was <u>not</u> to compose "fresh" biographies for each artist/photographer, since composing anew opens up the chance of misinterpretations and errors. Preferentially this editor tried to find some pre-written biography that was not already published in an art book or available on a free Internet site. No reason to duplicate information that is easily available from other sources. When a biography could not be found, this editor created one by "pasting together" individual facts chronologically. These facts were gleaned from genealogical sources – primarily ancestry.com (with its census reports, city directories, military records, and its birth, marriage, divorce, and death records), as well as from newspapers on newspapers.com and genealogybank.com.

Acknowledgements – Other than the indexing done by this editor directly from microfilm (housed in various libraries), most of the work on this book was accomplished in the author's home via the Internet using the paid sites of ancestry.com, genealogybank.com and newspapers.com. This editor is exceedingly grateful to ancestry.com for its diligent work in making thousands of biographical facts instantly available, and to the two newspaper sites for the on-going digitization of newspapers, one of the most overlooked of historical sources.

This volume contains hundreds of thousands of facts gathered together for the first time, necessitating just as many judgment calls. The author apologizes in advance for any incorrect information, hopefully to be corrected by later art historians with greater resources.

It is hoped that this series of books on Central Coast art, the first to treat the subject, will make Central Coast residents aware of their art history and bring recognition to many previously unheralded artists.

Nancy Moure

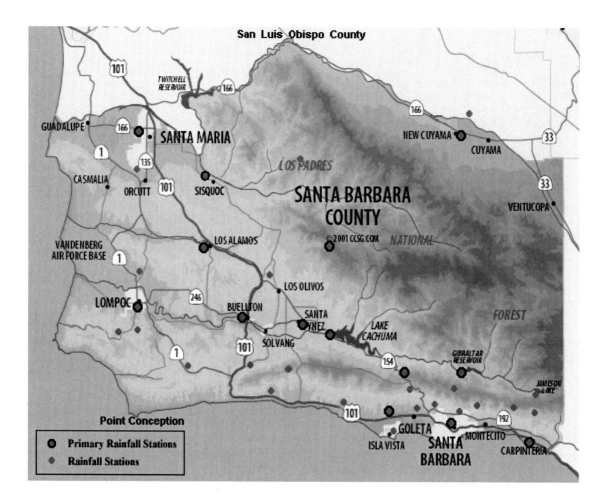

San Luis Obispo County

101 · TWITCHELL RESERVOIR · 166

GUADALUPE · 166 · SANTA MARIA

1

CASMALIA · ORCUTT · 135 · SISQUOC · 101

LOS PADRES

SANTA BARBARA COUNTY

NEW CUYAMA · 166 · CUYAMA · 33

33

VENTUCOPA

©2001 CCSG.COM · NATIONAL

VANDENBERG AIR FORCE BASE · 1

LOS ALAMOS

LOS OLIVOS

LOMPOC · 246 · BUELLTON · SANTA YNEZ · LAKE CACHUMA · FOREST

SOLVANG · 101 · 154 · GIBRALTAR RESERVOIR

1 · JAMESON LAKE

101

GOLETA · 192

Point Conception

ISLA VISTA · SANTA BARBARA · MONTECITO · CARPINTERIA

Primary Rainfall Stations
Rainfall Stations

ART AND PHOTOGRAPHY IN SANTA BARBARA COUNTY

I
ART IN THE TOWN OF SANTA BARBARA

Santa Barbara, the well-known cultural resort, is sandwiched on a thin strip of land between the Pacific Coast to its south and the Santa Ynez Mountains to its north. It has been a center of culture on California's Central coast since the arrival of the Chumash, c. 13,000 years ago, and escalating since the foundation of the Santa Barbara Mission, 1786. Art, photography, architecture, interior decoration, etc., is a town-wide focus. Thus, the town's art has been studied and described by many historians. This volume does NOT contain information on artists resident in the town of Santa Barbara except for those few who the newspapers noted were active in Northern Santa Barbara county.

For those readers who wish to supplement the data in this book on north county artists with knowledge about the town artists, the list below gives some publications on the subject.

Bibliography for Santa Barbara Art, Photography, Etc..
1. "Adobes of Montecito," *Noticias*, v. 53, no. 2, 2009.
2. "Adobes of Santa Barbara, From the Earth," *Noticias*, v. 48, no. 1, Spring, 2002.
3. Baer, Kurt, *Painting and Sculpture at Mission Santa Barbara*, Washington, D. C.: Academy of American Franciscan History, 1955, 244 pp.
4. Bell, Margaret, David Zumaya… "Sacred Art in the Age of Contact: **Chumash and Latin American Traditions** in Santa Barbara," *Noticias*, v. 55, no. 3, 2017.
5. Bradley, Fred, "The Expansive Years: **Santa Barbara Art and Artists 1940-1960**," *Noticias*, v. XLIII, no. 1, Spring 1997, pp. 1-23.
6. Burd, Brian, "Santa Barbara **Postcard Photography**," *Noticias* (Quarterly Magazine of the Santa Barbara Historical Society) v. XLIX, no. 2, Summer 2003.
7. Carlisle, Lynn, "The **Santa Cruz Island Collection**," *Art of California*, v. 3, no. 1, January 1990, pp. 35-41.
8. Cleek, Patricia Gardner, "**Arts and Crafts** in Santa Barbara: The Tale of Two Studios [**Charles Frederick Eaton / Elizabeth Eaton Burton**]," *Noticias*, v. XXXVIII, no. 4, Winter 1992, pp. 61-77.
9. Cleek, Patricia Gardner, "Santa Barbara **Muralists** in the **New Deal Era**," *Noticias*, v. XLI, no. 3, Autumn 1995, pp. 45-67.
10. Cleek, Patricia Gardner, "Santa Barbara's Riviera and the **Eucalyptus Artists**," *Noticias* (publication of the Santa Barbara Historical Society), vol. XLVIII, no. 2, Summer 2002, pp. 29-43.
11. Conrad, Barnaby, "Open Studio," *Santa Barbara Magazine*, June/July 2009. The early days of **Santa Barbara's artist colony** including discussion of Thomas Moran and others.
12. Crain, Mary Beth, "Beauty in the Background,' [**painters of the dioramas in the Santa Barbara Natural History Museum**], *Santa Barbara Magazine*, January/February 1993, pp. 20+.
13. Curtis, Christine Turner, "The Community Arts Association of Santa Barbara," *The American Magazine of Art*, v. 17, August 1926, pp. 415-19.
14. Davis, Sally Ogle, "Counting Their Blessings: The **Velozes** contribute…," *Santa Barbara Magazine*, Spring 2001, pp. 65-67. [The couple collect historic California art and substantially funded several shows at the Santa Barbara Museum of Art devoted to the subject.]
15. Deans, Laurie, "A Passionate Pair: **Robert and Christine Emmons**," *Santa Barbara Magazine*, Fall 2000, pp. 65-66. [Collectors of California art and donors of the Emmons Gallery at the Santa Barbara Museum of Art devoted to displaying California art.]
16. Dominik, Janet Blake, "The **Arts in Santa Barbara**," in Westphal, Ruth Lilly, *Plein Air Painters of California: The North*, Irvine, Ca.: Westphal Publishing, 1986, p. 20.
17. *Early Santa Barbara Pictorially*, an exhibit commemorating the sixtieth anniversary of County National Bank and Trust Company of Santa Barbara, 1935.
18. *The Final Eden: Early Images of the Santa Barbara Region*, Wildling Museum, Los Olivos, Ca. [Oil paintings, watercolors and prints depicting the Central Coast of California between 1836 and 1960 and celebrating its rural pristine and fertile nature selected by guest curator, Frank Goss.] April 7 - June 23, 2002.
19. Gebhard, Patricia and Frank Goss, "**George Washington Smith**, Painter," [famous architect who was also a painter] *Santa Barbara Magazine*, Summer 2000, pp. 91-94+.
20. Goss, Frank D., "**Colin Campbell Cooper**: A Prolific Artist," *Santa Barbara Magazine*, Fall 2000, pp. 61-62.
21. Graffy, Neal, "Wish You Were Here: Arlington Echoes," [historic **postcards** depicting the Arlington Hotel] *Santa Barbara Magazine*, Summer 2000, p. 156.
22. Graffy, Neal, "Wish You Were Here: Celebrating Oil," [historic **postcards** of oil wells] *Santa Barbara Magazine*, Spring 2000, p. 116.
23. Graffy, Neal, "Wish You Were Here: The Mountain Drive," [historic **postcards** depicting Santa Barbara's Mountain Drive] *Santa Barbara Magazine*, Spring 1999, p. 116.
24. Grant, Campbell, *The Rock Paintings of the **Chumash***, Berkeley: University of California Press, 1965.
25. Hansen, James, Gallery, exhibition catalogues / monographs on **Colin Campbell Cooper, Ejnar Hansen**, and **Alexander Harmer**, Santa Barbara, various dates
26. "Heritage of **Tile** on the South Coast: Tile at the Casa del Herrero," *Noticias*, v. 42, no. 3, Autumn 1996.
27. "**Italian Renaissance** in Santa Barbara," *Noticias*, v. 41, no. 4, Winter 1995.
28. Lapidus, Roxanne Grant, "Brothers in Art: **Campbell Grant** (1909-1992) and **Gordon Kenneth Grant** (1908-1940)," *Noticias* (Quarterly Magazine of the Santa Barbara Historical Society), v. XLIX, no. 3, Autumn 2003.
29. *A Legacy Set in Stone: **Santa Barbara Stone Architecture**, 1870-1940*, Casa de la Guerra, 15 East De La Guerra Street, Santa Barbara, January 29 – July 26, 2009. [A display of research and photos used by the Santa Barbara Conservancy in its forthcoming book *Stone Architecture in Santa Barbara*. Building with river boulders was fashionable around the turn of the twentieth century.]

30. Martin, Gloria Rexford and Michael Redmon, "The **Santa Barbara School of the Arts**: 1920-1938," *Noticias*, v. XL, nos. 3, 4, Autumn & Winter, 1994, pp. 45-80.
31. Martin, Gloria Rexford and Michael Redmon, "**Santa Barbara School of the Arts**, 1920-1938," *American Art Review*, v. XXII, no. 1, January-February 2010, pp. 66-73.
32. Martin, Gloria Rexford, "Then and Now: Two Generations of **Santa Barbara Landscape Painters**," *Antiques and Fine Art*, v. IX, no. 1, November/December, 1991, pp. 85-93.
33. McFadden, Hamilton, "**Community Arts Association**, Santa Barbara, Calif.," *The American Magazine of Art*, v. 15, June 1924, pp. 300-303.
34. Marquis, Neeta, "From the **De La Guerra Home**," *Los Angeles-Saturday Night*, June 30, 1928, p. 17.
35. "Murals by **D. S. Groesbeck** in Santa Barbara Court House," *Writer's Program*, Santa Barbara, 1941, p. 96.
36. Moure, Nancy Dustin Wall, "One Hundred-Eighty Years of **Santa Barbara Art**," *Noticias* (Quarterly Magazine of the Santa Barbara Historical Society), v. XLV, no. 4, winter 1999.
37. Moure, Nancy Dustin Wall, "History of **Art in Santa Barbara to c. 1918**," *Publications in Southern California Art*, vols. 4, 5, 6, Los Angeles: Dustin Publishing, 1998.
38. Moure, Nancy Dustin Wall, "So What's so Great About **Santa Barbara Art after 1930**?," in *Publications in Southern California Art*, vols. 4, 5, 6, Los Angeles: Privately Published, 1998.
39. Moure, Nancy Dustin Wall, "Art, general (Santa Barbara)," in *Publications in California Art*, v. 13, no. 6 (2021).
40. Neuerburg, Norman, "**Painting Mission Santa Barbara**," *Noticias*, v. XLII, no. 4, Winter 1996, pp. 69-87.
41. *Pacific Coast Biennial, an Exhibition of Sculpture and Drawings by Artists of California, Oregon and Washington*, Santa Barbara Museum of Art, 1955-59.
42. Palladino, D. J., "The 1% Solution," [**1% for art**] *Santa Barbara Magazine*, Fall 1999, pp. 75-77.
43. Palmer, Christine, "The **Old Adobe Buildings of Santa Barbara**," *Noticias* (Quarterly Magazine of the Santa Barbara Historical Society), v. XLVIII, no. 1, Spring 2002, entire issue.
44. Palmer, Kevin (Lex), "Santa Barbara **Craftsman Style**," [discusses homes, the craftsman F. H. Rhead, other craftsworkers, and Nathan Bentz] *Noticias* (Quarterly magazine of the Santa Barbara Historical Society), v. XLV, no. 1, Spring 1999.
45. "Public Art in Public Places," *Noticias*, v. 41, no. 3, Autumn 1995.
46. "Rocks of Ages, Santa Barbara **Stonemasonry**," *Noticias*, v. 40, no. 1, Spring 1994.
47. "Santa Barbara Art Club," "**Santa Barbara Art Association**," and "**Santa Barbara Craftworkers Association**," in Nancy Moure, *Artists Clubs and Exhibitions*, PSCA vol. 2, Los Angeles: Privately Printed, 1974.
48. Seldis, Henry J., "Artists of the West Coast: A Family of Painters [**Lebrun, Warshaw, Brice, Peake**]," *Art in America*, v. 44, Fall 1956, pp. 37-40+.
49. *Southern California Assemblage: Past and Present* [contains a large number of Santa Barbara artists], exh. cat., Santa Barbara Contemporary Arts Forum and College of Creative Studies, Gallery, University of California, Santa Barbara, September 20 – October 25, 1986.
50. Spencer, Russ, "Discoveries: Soulful Radiance," [**St. Francis statue** above the altar at the Old Mission] *Santa Barbara Magazine*, Winter 2000, pp. 41-42.
51. Spencer, Russ, "A Generous Spirit: The Life and Legacy of **Margaret Mallory**," [museum supporter] *Santa Barbara Magazine*, fall 1999, pp. 84+.
52. Sullivan Goss Gallery, *Women Artists of the Central Coast: 1875-1950*, Montecito, Ca., 2003. [Included in the exhibit are Ellen Cooper Baxley, Jessie Arms Botke, Rosemary Carton, Emma Lampert Cooper, Henrietta Latham Dwight, Lydia Cooley Freeman, Mary Steven Fish, Lyla Marshall Harcoff, Adele Herter, Eunice MacLennan, Lilia Tuckerman, Grace Libby Vollmer, Marian Wachtel, Ludmilla Welch, and others.]
53. Sullivan Goss Gallery, Santa Barbara, numerous exhibit catalogues and full-scale monographs on various Santa Barbara artists (both historic and contemporary), over the last 40 years. [Listing available on sullivangoss.com under "Publications".]
54. Thompson, Willard, "**Montecito's Nineteenth Century Adobes** and the Settlers Who Built Them," *Noticias*, v. LIII, no. 2, 2009, pp. 33-76.
55. Van Horsen, Lloyd, "Visions of Spain," [**Groesbeck**'s mural in the Santa Barbara courthouse], *Santa Barbara Magazine*, Winter 1995, pp. 20-21.
56. Webb, Michael, "Savoring the Art of Design," [**UC Santa Barbara's Architectural drawings collection**], *Santa Barbara Magazine*, Winter 2000, pp. 78-83.
57. Welsh, Nick, "**Conway's Collection**," [historic photographs] *Santa Barbara Magazine*, Summer 2001, pp. 98+.
58. Wilson, L. W., "**Santa Barbara's Artist Colony**," *American Magazine of Art*, v. 12, December 1921, pp. 411-14.

[Ed. my special thanks to Michael Redmon, editor of the Santa Barbara Historical Society's, *Noticias*, for his long-time devotion to articles on art, photography and architecture. *Santa Barbara Magazine* and *Montecito Magazine* have also run articles on Santa Barbara's artists / photographers / architects / interior decorators, but they focus on more contemporary artists. Exhibits of historic Santa Barbara art (some with published catalogues) have been mounted in galleries, including commercial galleries, the Santa Barbara Museum of Art, and the University of California, Santa Barbara. The *Santa Barbara News Press* gave good coverage to art (exhibits, etc.) as it was happening, but as of the compilation of this book the *Press* had not been digitized.]

NORTHERN SANTA BARBARA COUNTY TOWNS

About 90% of Santa Barbara County lies north of the Santa Ynez Mountains. The area is rural and largely devoted to agriculture and military purposes. To date it has largely been ignored by historians of art. Yet, as this treatise will show, an interest in culture existed well before 1960. Northern Santa Barbara County is included in the series of books on art of the Central Coast because its lifestyle has more in common with San Luis Obispo county, both physically and psychologically, than it does with the town of Santa Barbara.

> Bibliography: Justin M. Ruhge, *The Western Front: The War Years in Santa Barbara County 1937 to 1946*, Goleta, Ca.: Quantum Imaging Associates, 1988.

Northern Santa Barbara County has three main population areas centered around the towns of Lompoc, Solvang and Santa Maria.

LOMPOC
(La Purisima Mission, Celite Plant, Flower Industry, Camp Cooke / Vandenberg Air Force Base, Surf)

Lompoc. Subdivided 1875. Incorporated 1888. Arthur Millier (etcher, water color painter, and art critic for the *LA Times* who often traveled to California's Central Coast in search of picturesque and "untouched" natural beauty to depict) wrote of Lompoc,

> "… I, too … have my Shangri-La. If you have lived in Los Angeles as I have since horses were parked outside department stores and open fields began at Melrose avenue, you, too, may long for some stretch of country that is (1) beautiful, (2) unpolluted by man and his 'improvements' and (3) empty of tourist resorts, hikers, portable radios, hot-dog stands and litter. We have found it. The White Hills region between Lompoc and Point Concepcion in Santa Barbara county. As an artist I learned long ago that the hilly promontories which jut into the ocean contain the most beautiful country in California. This area of Stock range and valley farms is the loveliest of them all. The minute we turn off 101 at Las Cruces in Gaviota Pass all our cares melt away. … Grassy hills that rise up in long slow curves. Red steers munching under great oaks. Black soil, massed willows and blue water in the bottoms. Roads that wind pleasantly with the land contours. If you meet seven cars or trucks in the 21 miles to Lompoc it's a busy day. Lompoc itself is unbelievable to people who live in our metropolitan mad-house. Whether you approach it from Las Cruces or by two equally beautiful roads from Buellton, one minute you are in open country, the next in town. It has no 'ribbon strips' such as disfigure our suburbs. Its Chamber of Commerce gives the place 6500 souls. They live in a clean, compact little city surrounded in season with the world famed fields of seed flowers. It has a better than average hotel with a good café. We sleep there, relaxed and rise soon after dawn, breakfast on buttermilk pancakes and thick ham at the Owl Café and take the road to Point Concepcion. On the way out of town we pass Lompoc's one conspicuous plant. It processes the diatomaceous earth of the White Hills for chemical filters and insulating brick. This winding road is the loveliest in the State. Oak forests crowd up the bare hills. In the paddocks of the vast Jalama Ranch cattle and deer feed peacefully together. At Jalama Beach we find surf fishers frying their catch for breakfast. The lighthouse keeper is as wild about his surroundings as we are. He spends his spare time exploring the hills on his motorbike. And the ocean climate is so healthy that the light's first keeper lived to be 104! Well, that's the essence of it. Oh, I forgot La Purisima Mission three miles from town, a complete restoration of what was once a hive of faith and industry. This is our idea of a place to week-end and, perhaps, to retire in. It suits us down to the last larkspur and live oak. It's our Shangri-La," *LR*, Dec. 26, 1957, p. 1.

The town of Lompoc began as a subdivision – cut out of raw land near the middle of the Lompoc Valley by the Lompoc Valley Land Company. It was promoted to attract farmers. The town's newspaper, *The Record*, first issued April 10, 1875, served as its promotional organ (and is the main source for information on Lompoc's art and photography for this Dictionary). Through the ensuing years, Lompoc valley's rich soil supported various vegetable crops, cattle grazing, flower seed growing (from c. 1922) and today, vineyards.

Notable within Lompoc's sphere are: 1) Mission La Purisima, 2) a large outcrop of diatomaceous earth that is still being mined, 3) flower farms followed by vineyards, and 4) a large military base.

Mission La Purisima Concepción. 1787. The eleventh mission in the chain of Catholic missions eventually established the length of California. It was first located near the current town of Lompoc but after an earthquake destroyed it, it was rebuilt in the foothills on the valley's north rim. By the time the town of Lompoc was laid out, the mission had fallen into disrepair. In 1935 it was made a state park and in the second half of the 1930s was renovated and restored by Civilian Conservation Corps' artists, architects, artisans, and landscape architects.

> Bibliography: "Mission Tract Becomes State Park This Week… 507 Acres," *LR*, Jan. 11, 1935, p. 1; Michael R. Hardwick, *La Purisima Concepcion: The Enduring History of a California Mission*, The History Press, 2015.

Mining. 1894. The commercial value of the outcropping of diatomaceous earth on the homestead of Mr. Balaam was recognized by 1894 when Balaam's sons became the pioneer shippers of the material. Their Magna-Silica company was bought out in 1912 by Kieselguhr, which, in 1917 – because of WWI and the negative connotation of the German-sounding name – was renamed to Celite Products Co. In 1928 Celite sold out to Johns-Manville. Each new owner expanded operations with updated equipment and facilities.

Bibliography: "Passing of … Francis S. Balaam… In 1878 he came to Lompoc … Most of the land now owned by the Celite Products Company where the great quarries are now in operation, was the original homestead of Mr. Balaam…," *LR*, Jan. 30, 1920, p. 8; "New Chalk Rock People File Deeds… Kieselguhr company… The new company has taken over the holdings of the Magna-Silica company of Lompoc … for nearly twenty years there has been constantly shipped to all parts of the United States from this deposit, the material being used in the manufacture of steam and pipe coverings and other non-conductors … Kieselguhr is the German word for diatomaceous earth. … Its value first came out in 1894 when A. G. and John B. Balaam, the sons of F. S. Balaam, became the pioneer shippers of the material …," *LR*, July 5, 1912, p. 1; "Operations Start April 1. Kieselguhr Company Will Put on Large Force of Men at Mill and Quarries," *LR*, March 24, 1916, p. 10; "Name Has Been Changed. Kieselguhr Company of America Will Hereafter be Known as Celite Products Co," *LR*, March 23, 1917, p. 1; "Fitger Sale to Johns-Manville… sale of the Celite Company to the Johns-Manville Corporation… of New York … The Celite Company was originally incorporated in 1912 and its business has been developed from a small company employing a few men to a nationally known industry…," per "Fitger Sale to Johns-Manville Confirmed Here," *LR*, Nov. 23, 1928, pp. 1, 3.

Flower Seed Industry. 1922. In the early 1920s, farmers noted the soil and climate in the Lompoc Valley was particularly adapted to flower growing. Soon national companies bought and leased acreage to grow flower seeds. The local woman's club started an annual Flower Festival to draw in tourists. Among the arrivals were artists who painted the colorful fields and photographers who took photos of them.

Bibliography: "Dahlia Bulb Culture is New Industry Here. Lloyd Callis is branching out as a florist and is now devoting all of his time to … dahlia culture. … dahlia show that the Alpha club will sponsor… It is reported that a seed man has contracted with at least one resident for petunia seed," *LR*, June 30, 1922, p. 6; "Ship Carload Flower Seed to the East… The W. Atlee Burpee Seed company have just shipped a carload of seed from their Floradale farm… sweetpeas and garden seeds… they have irrigated 80 acres of ground …," *LR*, Dec. 12, 1924, p. 4; "Magazine Emphasizes Flower Industry in Lompoc Valley… *Pacific Rural Press* in the issue of August 8… total acreage for the county of about 2,000 acres. Some 800 varieties of flowers are grown … The flower seed business in America started shortly after the war. Up until that time most flower seeds had been imported from Europe… Now California produces more flower seeds than any other place in the world…," *LR*, Aug. 14, 1936, p. 8.

Military Bases. 1941. In preparation for possible entry into World War II, the Federal Government bought up hugh acreages across the nation to be used as military training centers. In March 1941 it acquired approximate 86,000 acres in the Lompoc-Guadalupe-Santa Maria triangle. This consisted of both flat valley land as well as rolling hills. During WWII this was known as Camp Cooke and trained thousands of soldiers. Near the end of the war German and Italian prisoners of war were quartered there. Camp Cooke closed in June 1946. For the Korean War (1950-53), Camp Cooke was reactivated. In the mid-1950s about 2/3 of camp land was transferred to the Air Force to use as a missile launch and training base. On October 4, 1958 the Air Force base was renamed Vandenberg Air Force Base. The base has since been used to coordinate with Strategic Air Command and more recently to launch missiles and space flights. In August 1959 the United States Disciplinary Barracks (started 1946) was transferred to the U.S. Bureau of Prisons to house civilian offenders and today it is known as the United States Penitentiary at Lompoc.

Bibliography: "Buildings Take Shape at Camp Cooke Project" and "Signal Company Arrives… Officers and men of the 255th Signal Construction company, known as the 'Fighting 255th,' arrived at Camp Cooke Tuesday, forming the vanguard of a larger group of men to arrive soon to start installation of permanent telephone facilities…," *LR*, Oct. 17, 1941, p. 1; "Ranchers Prepare to Leave Coast Area As Army Acquires [More] Land. Options Taken on All but Four Ranches," *LR*, Oct. 31, 1941, p. 1; "The Vandenberg AFB Dedication Edition," *SMT*, Oct. 4, 1958, section B contains such headlines as "Building Missile Base Enormous Undertaking," "Atlas Missile Key to Four-man Space Station," "Thor Major Weapon in NATO Defense," "Operational Capability is Missile's Mission," Air Force "Crews Trained" by General Electric in guidance equipment, "Construction Opportunities in Vandenberg," "Bombers to Missiles Gradual Transition," "Space Age Lessons Learned" [as Russia excels USA], "SAC's Story is One of Dedication," and "U.S. Defense Keeps Ahead of Russia"; "6 ½ Million Vandenberg Air Field to Begin Operations Next Week," *SMT*, Feb. 7, 1959, p. 2; Joseph T. Page II, *Vandenberg Air Force Base*, Charleston, S. C.: Arcadia Publishing, 2014.

Surf, Ca. (south of the historic Lompoc Landing)
Surf is located where Ocean Avenue (Highway 246) ends at the Pacific Ocean. Since 1896 it has been the site of a Southern Pacific Railroad station, and during WWII of a United Service Organization.

Bibliography: "Surveyors Now Laying Out New Town at Surf… Myers and McDonald of Los Angeles who made a deal with the Huyck family… fronts on the ocean for a considerable distance and is adjacent to the Southern Pacific Company's right-of-way…, *SYVN*, Jan. 15, 1926, p. 1

SANTA MARIA
(including Casmalia, Guadalupe, Los Alamos, Orcutt, Sisquoc etc.)

Santa Maria. 1875. The largest town of northern Santa Barbara County, is situated just a few miles from the county's northern border with San Luis Obispo. It is centered in a broad, river valley, with fertile soil. The townsite was recorded in 1875. Although agriculture remains an important industry even today, exploration for oil as early as 1888 led to discoveries of major pockets, particularly to the south east in current-day, Orcutt. Over the next 80 years, thousands of oil wells were drilled and put into production. During WWII the two airports (Hancock Field and Santa Maria Army Airbase) brought some income to the town.

Bibliography: "In Santa Maria. The Valley Continues to Come to the Front. The Drouth has its ill effects. But the Many Industries Keep Up the Town," and article details business activity of the town, *SMT*, June 4, 1898, p. 1; "Santa Maria, a Progressive City. Pictorial Review of Santa Maria's Progress...," *SMT*, Dec. 30, 1911; "Recalling Early Santa Maria in Photograph and Anecdote," *SMT*, May 9, 1932, p. 8; "Writer [for LA Examiner] Extolls Beauty of Santa Maria Valley and Point Sal" ... written by John H. C. Stingle... with three striking photographs...," *SMT*, March 4, 1935, p. 1; many historical articles, *SMT*, April 30, 1937, Second Section "Pioneer Edition"; historical articles, *SMT*, April 29, 1938, "Pioneer Edition," Second Section; historical articles, *SMT*, May 3, 1940, section B, i.e., "Pioneer Edition"; "50 Years of Progress," *SMT*, Sept. 9, 1955, pp. 1-A to 14-A and 1-B to 27-B; additional historical articles in *SMT*, Sept. 10, 1955, scattered pages; Vada F. Carlson, *This is Our Valley* (compiled by the Santa Maria Valley Historical Society), Santa Maria, 1959, Chapt. XVI "Cultural Development" p. 176; Filipino American National Historical Society (California Central Coast Chapter), *Stories, Legends, and Memories*, Santa Maria, Ca., 2008; Santa Maria Valley Genealogical Society and Library *Quarterly*; Carina Monica Montoya and the Santa Maria Valley Historical Society, *Images of America: Santa Maria Valley*, Charleston, S.C.: Arcadia Publishing, 2011; Bob Nelson, *Sagas of the Central Coast, History from the Pages of Central Coast Magazine*, Santa Maria, Ca.: R. J. Nelson enterprises, 1994; Brian Fagan, *Snap Shots of the Past*, Walnut Creek, Ca.: Altamira Press, 1995; Winifred Weathers Swanson, *From Tennessee and New York State to California: A History of my Weathers, Orr, Cunningham, Fine, Joslin/Joslyn, Passmore, Shapland and Dee Families*, Santa Rosa, Ca.; 2003.

Airfields. Allan Hancock Field was established in 1927 between Jones Street to the north, Stowell Road to the south just west of present-day Highway 1. In Spring 1929 Hancock Foundation College of Aeronautics, a nonprofit educational institution, was established there to train pilots. From c. 1938-44 Hancock College of Aeronautics was home to the Santa Maria Junior College ground school that taught drafting, among other subjects. From Sept. 1945 to 1953 Hancock College was leased to University of Southern California College of Aeronautics with its first class graduating in 1949. In fall 1954, Santa Maria Junior College (classes held since 1918 at the High School), moved into the buildings. In 1958 a bond was passed allowing Santa Maria Junior College to purchase the land. At a totally different site, southwest of Santa Maria, during WWII, an airport with a much longer runway was built by the United States Army and that was known as **Santa Maria Army Air Field**. After the war the land was sold back to local entities and began its life as a public airport. Since 1964 it has been known as Santa Maria Public Airport.

Bibliography: "Hancock College [of aviation] Enlarged with New Field Added" and now has 125 aviation cadets beginning flight school, *SMT*, Oct. 6, 1941, p. 1; Santa Maria Army Airfield closing Dec. 31, *SMT*, Oct. 25, 1945, p. 1; "USC Aviation Classes Open Today on Hancock Field," *SMT*, Nov. 1, 1945, p. 1.

Los Alamos. 1876. Located off Highway 1, half way between Buellton to the south and Santa Maria to the north. One of northern Santa Barbara county's first towns it is yet, today, one of its smallest. During Mexican times, the hills above Rancho Los Alamos served as a hideout for bandito, Salomon Pico, whose escapades were popularized by the character, Zorro. The town was an important stage coach stop 1861–1901 and this led to the construction of the Union Hotel in 1880 that is currently repurposed as a bed & breakfast. The narrow-gauge Pacific Coast Railway that ran down from Port Harford (near Pismo Beach) ended in Los Alamos by 1882, and the town currently boasts the last standing Pacific Coast Railroad Station. In spite of "progress" in the towns around it, Los Alamos' single street retains many of its late-nineteenth century commercial buildings, and this historic ambiance attracts tourists visiting local vineyards and wine tasting rooms.

Bibliography: R. Lawson Gamble, *Los Alamos Valley*, S. C.: Arcadia Publishing, 2015.

Orcutt. 1904. Orcutt, a few miles south of Santa Maria, is named after geologist William Warren Orcutt who discovered the underlying oil field in 1901 for Union Oil. It was the first giant field (over 100 million barrels in ultimate recovery) to be found in Santa Barbara County. There, in 1904, the famous "Maud" a 12,000-barrel-a-day oil well came in. Orcutt grew up to house oil workers, but following the oil boom has turned into a bedroom community for Santa Maria.

Bibliography: Sally L. Simon, *From Boom Town to Bedroom Community: A History of Orcutt, California, 1904-1982*, Orcutt Historical Committee: Santa Barbara, Ca., 1990.

Guadalupe. Guadalupe, west of Santa Maria near the coast, became a station for the Southern Pacific when tracks arrived from the Bay Area in 1895. The mostly flat landscape (a river delta) is still a highly productive agricultural area. Between town and the sea lies the second largest stretch of dunes in California, the part in Santa Barbara County being known as the Guadalupe-Nipomo Dunes. It, along with many acres of wetlands, all owned by various government and private agencies, is currently set aside as nature preserves and for recreation. In 1923 Cecil B. DeMille filmed the *Ten Commandments* on the dunes. A spur railroad line from Guadalupe to Santa Maria was constructed in 1911.

Bibliography: Doug Jenzen (of the Guadalupe-Nipomo Dunes Center), *Images of America: Guadalupe*, Charleston, S.C.: Arcadia Publishing, 2014.

SANTA YNEZ VALLEY
(including Solvang, Mission Santa Ines, Ballard, Buellton, Los Olivos, and Santa Ynez)

The picturesque Santa Ynez Valley is sandwiched between the north-south Highway 1/101 and the Los Padres National Forest (which takes up nearly all of the east half of the county). In horse-and-buggy days its several small towns provided services to large cattle ranches. Today, still relatively small and retaining architectural styles reminiscent of the late 1800s, the boutique townlets attract tourists seeking escape from large cities.

Bibliography: "Santa Ynez Valley, with its Wealth of Beauty, Always Beckons to Vacationists and Motorists…," *SYVN*, June 24, 1932, p. 2; "New Road Across Valley Receives Publicity in State Magazine with Photographs… [*California Highways Magazine*, and map]," *SYVN*, April 3, 1936, p. 4; "Alisal Guest Ranch Nearing Completion," *SYVN*, July 5, 1946, p. 1; "Valley Featured in '*Fortnight*' Magazine Story. A three-page spread, complete with pictures… in the March 12 issue …," *SYVN*, March 26, 1948, p. 1; "Proposed County Water Plan, Celebrations, Took News Spotlight in Valley During 1947," and summary of 1947 events, *SYVN*, Jan. 2, 1948, pp. 1+; "Prescott Says…" he has the first TV set in the Santa Ynez valley and it works, *SYVN*, Feb. 11, 1949, p. 4; "Final Plans Now Underway for Horseshow in March… to be held at the Alisal Guest Ranch March 17 and 18…," *SYVN*, Feb. 2, 1951, p. 1; "Pea Soup Andersen Reveals Revolutionary Canning Method," *SYVN*, April 6, 1951, p. 1; "Norquist Milling Co. in SY Scheduled to Open Sept. 25," *SYVN*, Sept. 14, 1951, p. 1; "Year 1951 Passes By" and list of area's major events, *SYVN*, Dec. 28, 1951, p. 1; "Valley Recovering After Violent Earthquake Monday Morning… worst to hit California since 1906… center of the quake … 10 miles southwest of Tehachapi…," *SYVN*, July 25, 1952, p. 1; "Chronology [for 1952] Reveals Big, Little Bits of News Here During Year," *SYVN*, Jan. 2, 1953, p. 1; "Pasadena Paper Features Valley in weekend Motorlog… *Pasadena Star News* entitled 'Santa Ynez Valley Goal of Weekend Motorlog'," *SYVN*, Feb. 13, 1953, p. 3; "Green Bulk Packing of Tomatoes Underway… at the T. M. Parks Packing Shed on Highway 101 in Buellton..," *SYVN*, Sept. 25, 1953, p. 9; "Home of the Week," series on local ranches is run, *SYVN*, Sept. 25, 1953, p. 10; "Novelist Arthur Meeker Pens Lyrical Picture of Santa Ynez Valley in Chicago Papers Article," *SYVN*, Dec. 25, 1953, p. 5; "53 Years of Progress" and summary of events in 1953, *SYVN*, Jan. 1, 1954, p. 1+; series of articles on local ranches (poultry, swine, horse, crops, cattle grazing, dairy, parakeets, chinchillas) and local homes in *SYVN*, various issues, 1954; 58 pages of historical articles celebrate the 150th birthday of Santa Ines Mission, *SYVN*, Sept. 17, 1954; "The Valley in 1954: Steady Growth," and review of year's events, *SYVN*, Dec. 31, 1954, p. 1+; "Alisal Guest Ranch Begins 9th Straight Season. New Feature this Year is Golf Course Opening," and ranch holds annual horse shows, *SYVN*, April 1, 1955, p. 4; "Memo Pad" discusses how Santa Ynez Valley is developing into a hot tourist attraction, *SYVN*, May 6, 1955, p. 2; "'55 Pictorial Review," *SYVN*, Dec. 30, 1955, pp. 1-32; "Post Office in Santa Ynez Marks 75th Anniversary…," and history and early photo, *SYVN*, June 27, 1958, p. 2; "Valley Tour is Featured… *Westways*… 'Let's Explore a Byway' with a tour through Santa Ynez Valley…," *SYVN*, June 5, 1959, p. 8; "Tempo of Rapid Growth Highlights Year [1959] in Valley," *SYVN*, Jan. 1, 1960, p. 1; "Report Sets Valley Population at 5,700," i.e., 1960 population count, *SYVN*, Nov. 4, 1960, p. 1; "Year of Change. Unprecedented Growth Highlights '60 in Valley…," *SYVN*, Dec. 30, 1960, p. 1.

Sanja Cota Reservation. 11,000 BCE (dates vary). Ancestors of the Chumash (whose activity can be traced to c. 13,000 years ago), settled in small bands throughout Santa Barbara and San Luis Obispo counties. A few descendants currently reside on the Santa Ynez Reservation, a strip of land along the Zanja de Cota Creek first established 1901 and expanded greatly in 2010. It currently contains the Chumash Indian Resort and casino adjacent to the small town of Santa Ynez.

Mission Santa Ines. 1804. The first European permanent presence in the Santa Ynez Valley, it linked Mission Santa Barbara to Mission La Purisima. After falling into disrepair in the 19th century, the buildings were renovated and expanded under the direction of several priests through the twentieth century. Still owned by the Catholic Church, it holds regular services.

Ballard. 1862. The oldest community in the Santa Ynez Valley began as a stage station in 1862. Historically it retains the rebuilt "Little Red Schoolhouse" and the Oak Hill Cemetery.

Bibliography: "Quaint town of Ballard First in Santa Ynez Valley" and history and illus., *SYVN*, Sept. 17, 1954, p. A-4.

Buell's Flat / Buell Flats / Buellton. 1875. The site now occupied by the town of Buellton, was originally part of the Rancho San Carlos de Jonata Mexican land grant. In 1867 the land was acquired by Rufus T. Buell who developed a successful cattle ranch. The specific area occupied by his general store / post office / bunkhouse / blacksmith shop and family homes was known until c. 1921 as Buell's Flat / Buell Flats. The area grew in significance after 1913, when State Highway 1 began construction through it (north/south) and later when the east-west route between Lompoc and Solvang (currently State Route 246) turned Buellton into a crossroads. Today the town is best known for Pea Soup Andersen's restaurant.

Bibliography: "Booster Stories of Santa Ynez Valley… in the *Santa Barbara Morning Press*… 'Youngest Town in the Valley of Santa Ynez… pictures of the new Buellton school, the Buell Tavern, the bridge across the Santa Ynez river, and the Budd & Bodine general store and post office… Five years ago the inhabitants applied for a post office and changed the name of Buell Flats to Buellton…Three garages also are supported by trade of the inhabitants and transient motorists. So are the three service stations …," *SYVN*, June 25, 1926, p. 2; "Andersen's Café… Andy Andersen's Electrical Café of Buellton received considerable space in the June issue of the San Joaquin Light and Power monthly magazine…," because of all the uses to which he put electricity, *SYVN*, July 23, 1926, p. 1; "Bueltmore Hotel for Buellton Soon," hostelry for travelers, prop. Anton Andersen, *SYVN*, March 2, 1928, p. 1; Curt Cragg and the Buellton Historical Society, *Images of America: Buellton*, Charleston, S. C.: Arcadia Publishing, 2006.

Santa Ynez. 1882. The town of Santa Ynez (just east of Solvang and Mission Santa Ines), sprang into existence in the fall of 1882. "A daily stage runs to Santa Barbara passing through Santa Ynez. There are two blacksmith shops, two stores and other store buildings, a school house, twenty-nine buildings, and several other dwellings in progress. Two large water tanks will supply

the town with water from the head of Santa Cota creek by means of rams. There are about 12,000 acres of good farming land…These lands are selling from $6 to $14 per acre, one-fourth down, and the balance at 7 per cent…" (per *SYVN*, Jan. 22, 1926, p. 1). Still relatively small, the town retains a post-Civil War "western" style and houses the Santa Ynez Valley Historical Society.

Bibliography: "Town of Santa Ynez… Known in Beginning as 'New Town'," photos and history, *SYVN*, Sept. 17, 1954, p. C-4.

Los Olivos. 1885. One hundred fifty-seven acres purchased in 1885 by a New Yorker and planted with five thousand olive trees was named Rancho de los Olivos. By the end of 1887 the Pacific Coast Railway had been extended southward to Los Olivos. The small town was, for many years, best known for Mattei's Tavern. Its rolling country formed the backdrop for several Hollywood movies. Currently the town, greatly expanded, continues its late nineteenth century "western" architecture and is visited by tourists attracted by the growing wine industry.

Bibliography: "Town of Los Olivos Saw Its Beginning in 1886-87," and photos and history, *SYVN*, Sept. 17, 1954, p. B-11; photo and "History of Education in Los Olivos Dates Back to 1888," and history of school, *SYVN*, Sept. 17, 1954, p. B-5; Jim Norris, *Images of America: Los Olivos*, Charleston, S.C.: Arcadia Publishing, 2008.

Solvang. 1911. In 1911 three Danes from Iowa purchased 9000 acres of the former San Carlos de Jonata rancho. Dreaming of an all-Danish community where they could recreate the customs and arts of the homeland and establish a Danish folk school, they sent out prospectuses to attract persons of Danish background living in Midwestern states as well as to individuals still residing in Denmark. Although Solvang is the most recent of the five Santa Ynez Valley towns to be founded, it is currently the largest. Its success is in large part due to tourists. Recognizing tourism as a "clean" industry, beginning c. 1947 the town made itself over in the Danish provincial style of architecture. Today tourists flock in to enjoy "Little Denmark's" atmosphere, to eat Danish food, to buy Danish souvenirs, and, at occasional special celebrations, to view Danish dancing and other programs.

Bibliography: – "Danish Village Proposed for Solvang [and] Inn to Cost $25,000 to be First Building … Danish architecture, sculpture, painting, metal craft, woodwork, ceramics, textiles, fine silver and other arts and crafts…," *SYVN*, Oct. 13, 1939, pp. 1, 8; "'Little Denmark' Publicized in Jan. 18th 'Post' Article," *SYVN*, Jan. 17, 1947, p. 1; "Tentative Plans Point to Gala Celebration for 'Danish Days'… will start on Friday evening, May 30… Danish games… banquet and dance… gym group… program in the College Bowl…," *SYVN*, April 18, 1947, p. 1; "Atterdag [College] Featured in [*Christian Science] Monitor* Article," *SYVN*, June 13, 1947, p. 5; "Solvang Receives Big Puff… Last Sunday's edition of the *San Francisco Chronicle*…," *SYVN*, July 11, 1947, p. 10; "Solvang Given Publicity in *NY Journal-American*," *SYVN*, Nov. 10, 1950, p. 1; "*Ford Times* Gives Story on Solvang," and photo of] Ferdinand Sorensen's windmill, with four youngsters in Danish costumes appearing in the foreground, *SYVN*, Jan. 5, 1951, p. 4; "Danish Magazine [*Familie Blad*] Features Solvang," *SYVN*, May 11, 1951, p. 3; "More Solvang Publicity… *Berkeley Gazette* entitled 'Vale of Sun and Danes' which described Solvang's Danish Days…," *SYVN*, Nov. 30, 1951, p. 8; "Charm of Scandinavia Retained in Solvang… Oct. 19 issue of the *New York Herald Tribune*…," *SYVN*, Oct. 31, 1952, p. 11; "Danish Influence Prominent in Street Renaming Plan," *SYVN*, July 31, 1953, p. 3; "Residents of Solvang Given House Numbers," *SYVN*, Feb. 26, 1954, p. 1; "Ceremony to Herald Natural Gas Arrival" in Buellton and Solvang, *SYVN*, Sept. 13, 1957, p. 1; "1957 Passes in Review," *SYVN*, Jan. 3, 1958, p. 1; "Danish Quarter," gives history of bakers in Solvang, *SYVN*, July 10, 1959, p. 2; "Looking Backward… 20 Years Ago [i.e., to 1939]… Street signs for the town of Solvang are being put up this week by Soren Petersen. …," *SYVN*, Oct. 16, 1959, p. 2; "Princess Here Sunday," i.e., visit to Solvang of Crown Princess Margrethe of Denmark, on Sunday, June 5, *SYVN*, May 13, 1960, p. 1, and June 3, 1960, p. 1, and report, June 10, 1960, p. 1; history of town summarized in a special edition of the *Santa Ynez Valley News* celebrating the 150th birthday of Old Mission Santa Ines – "A majority of the photographs in both the news and ad columns were taken during the past six weeks. Close to 550 pictures… ," per "Memo Pad," *SYVN*, Sept. 17, 1954, p. 3; "Solvang … Began as Colony in '11," and photos and history, *SYVN*, Sept. 17, 1954, p. C-2; "This year's Solvang and Valley Booklet and Souvenir Program is presented to you free of charge through the Solvang Businessmen's Association… 42 pages… 100 photographs," *SYVN*, Aug. 10, 1956, p. 5; "Track-Side Village Magazine Feature… October issue of *Westways*… With simple line drawings [G. F.] Brommer has captured the charm and spirit of this small, track-side village …," *SYVN*, Oct. 3, 1958, p. 6; Curt Cragg, *Postcard History Series: Solvang*, Charleston, S.C.: Arcadia Publishing, 2008.

CHRONOLOGY OF ART / PHOTOGRAPHY IN NORTHERN SANTA BARBARA COUNTY

** B = Buellton; L = Lompoc; SB = Santa Barbara; SM = Santa Maria; SY = Santa Ynez

10,000-8,000 B.C.E.? PREHISTORIC
Earliest artifacts of Homo Sapiens discovered on California's Central Coast. Chumash tribes lead a semi-nomadic, hunting/gathering existence, their artwork consisting of carved stone, wood and shell, of pottery and baskets, as well as of paintings on the walls of caves.
(For "Native American" art see *Central Coast Artist Visitors before 1960.*)

1542 Oct. 18 – ERA OF EXPLORATION
Juan Rodriguez Cabrillo reached Point Conception on the Santa Barbara coast and within the next few months explored the neighboring coast and islands. Over the next 250 years, the California coast was mapped and explored by several European oceangoing expeditions.
(For art during the "Era of Exploration" see *Central Coast Artist Visitors before 1960.*)

1769-1822 SPANISH ERA
Spaniards explored their new possession of California and cemented their ownership with the establishment of military presidios and towns. Franciscan missionaries ultimately established a chain of 21 missions between San Diego, in the South, and Sonoma, in the north. The mission fathers imported art (paintings, sculpture, reliquaries, vestments) both from Spain and Mexico and taught Native American neophytes' skills such as embroidery, silverwork, weaving, carving wood and stone, leatherwork, mural painting, etc.
(For "Spanish Era" art see *Central Coast Artist Visitors before 1960.*)
1769 – **Gaspar de Portola** land expedition, on its way north from Baja California to Monterey and San Francisco Bay, traveled through Lompoc Valley in late August and on Sept. 1 arrived at Guadalupe. By Sept. 3 the expedition had progressed on to current San Luis Obispo County.
1771 – L – **Miguel Cabrera** painted "La Virgin Purisima" in Mexico (now coll. Mission La Purisima).
1787 – L – **Mission La Purisima** was founded. First built in the Lompoc valley, after several earthquakes it was rebuilt in 1813 at the base of the chain of hills to the north of the present town. (The mission was restored by CCC workers in the second half of the 1930s and is currently a State Historic Park. It contains wall paintings, some easel paintings, wooden sculptures, etc.)
1804 – SY – **Mission Santa Ines** was founded. Owned by the Catholic Church, it was restored and expanded by art-oriented priests (Kerwick, Cyprian, and O'Sullivan) at various times in the twentieth century, funded by private donations. (It currently contains wall paintings, and its museum owns a large collection of religious easel paintings, carvings, vestments, etc.)

1822-1846 MEXICAN ERA
When Mexico overthrew Spain's rule, California came into Mexican hands. Church lands were re-distributed to Native Americans and to privileged Mexicans. "Art" was produced on the ranchos in the form of decorative personal trappings such as embroidery, silver work, tooled leather, etc.
(For "Mexican Era" art see *Central Coast Artist Visitors before 1960.*)
1821 – Mexico won the war with Spain Sept. 1821 and **Alta California became Mexican Territory**.
1827-46 – Disegnos were made of Mexican ranchos to identify ownership.
1833-36 – Secularization of Mission lands.
1837-48 (1833-46) – Rancho days of California. A lifestyle of large cattle ranches owned by private citizens and the impoverishment of Native Americans.

1846/8+ AMERICAN ERA
The second half of the nineteenth in California was marked by the Mexican-American War (1846-47/48), the gold discovery of 1848, the Gold Rush of 1849, and the rapid influx of immigrants into towns such as San Francisco and Sacramento. The Civil War (1861-65) had been won, and California's great drought of 1862-65 had ended. The Transcontinental Railroad that linked the East and West Coasts (Oakland) was completed in 1869.
1846-Spring – 1847, Fall (or Feb. 1848) – **Mexican-American War**.
1846-65 – Itinerant artists of all kinds traversed California's central region and made images of it. Federal government topographical artists and military engineers produced surveys and maps, cross section drawings of mineral resources on land, and also mapped and drew California's shoreline.
1848 – Treaty of Hidalgo – **Mexico ceded California to the United States**.
1849 – **Gold Rush**.
1850-Sept. 9 – California became America's 31st state.
1860s – U. S. courts established ownership of Mexican ranchos with the help of 1) freehand landscape drawings of ranchos (disenos) originally created c. 1827-46, 2) privately funded surveys, and 3) official U. S. Government surveys of ranchos (plats). (See: "Land Case Art.")
1865 – America's **Civil War** ended and Americans turned their focus to westward settlement.
1881 – The Atcheson, Topeka and Santa Fe connected with the Southern Pacific RR at Deming, N.M., forming the second transcontinental rail route.

1865-1898 FIRST TOWNS
By about 1885, events across America and within California resulted in northern Santa Barbara county's first communities. These were on former Mexican ranchos that had been acquired by Americans, some of whom subdivided or sold off portions. Farmers, ranchers and tradesmen came. The earliest of Northern Santa Barbara County's towns came into being: Ballard (1862, founded 1880), Lompoc (laid out in 1874/75 and incorporated 1888), Central City, i.e., Santa Maria (townsite formally recorded 1875), Buell's Flats (ranch buildings erected by 1875), Los Alamos (townsite allocated 1876), Santa Ynez (1881/2), and Los Olivos (1885). Late nineteenth century access to California's sparsely populated central coast was primarily via oceangoing steamboats (until the mid-1890s), although horses, mules, wagons and stage coaches traversed the general route of the King's Highway.
1865c. – c. 1880 – **R. R. Harris**, C.E., surveyed many properties in Santa Barbara County.
1876 – Lompoc wharf opened.

1880 – Chute Landing for ships, built by a group of Santa Maria men, opened.

1882 – The Pacific Coast Steamship Co., with a dock at Port Harford (near Pismo Beach), constructed railroad tracks in the 1870s to San Luis Obispo to enhance its services to travelers and freight. Reorganized in 1882, the narrow-gauge **Pacific Coast Railway** was extended south to Los Alamos (1882) and then to Los Olivos (1887).

1895-1901 – The **Southern Pacific**, which was building its own tracks south from the Bay Area, reached Guadalupe (west of Santa Maria) on July 1, 1895, and Surf (west of Lompoc) by 1896. Five more years would elapse before the 56 miles of difficult terrain between Surf and Elwood (about 15 miles west of Santa Barbara) (necessitating a major trestle and several tunnels) was finally crossed with rails. The tracks were finished December 30, 1900. After refinements were made, service was finally opened between the Bay Area and the Los Angeles area on March 31, 1901. A spur line from Surf/Lompoc Landing to the town of Lompoc was completed in 1899. A spur line from Guadalupe to Santa Maria, the **Santa Maria Valley Railroad**, was built in 1911.

1893-98 – The Panic of 1893 set off a nation-wide Depression.

Artists and Photographers

Itinerant artists – Itinerant artists of all kinds crossed California's central coast on foot, by mule, by horse, by wagon, by stagecoach, and by train. They included Bay Area artists intent on capturing images of California's missions and adobes before rampant settlement destroyed them, illustrators for East Coast and California magazines whose readers were curious to see images of the mysterious "West," illustrators for real estate developers who produced pamphlets about their subdivisions, makers of bird's-eye views of newly developing towns, East Coast tourist artists who took advantage of Transcontinental and California railroads for easy travel to picturesque sites within the state. Some important artists active in northern Santa Barbara county include: **Henry Chapman Ford**, artist of Santa Barbara, who sketched Mission La Purisima and Mission Santa Ines. **William Kistenmacher** of San Francisco who was in Santa Maria in 1882 making initial sketches for illustrations in Thompson & West's *History of Santa Barbara County* in 1883, and **Henry Sandham**, illustrator of NY, who made an etching of Mission Santa Ines.
(For "Itinerant" art see *Central Coast Artist Visitors before 1960*.)

Resident artists and photographers – In early Northern Santa Barbara County, Santa Maria and Lompoc formed the two main population centers. As they grew, the towns were able to support specialty occupations such as doctors, lawyers, grocers, newspapermen, etc., and to develop social strata. The first schools were constructed. A few individuals expressed themselves through needlework, crafts, and paintings.

Artists – The area's earliest resident commercial "artists" were often house painters who were also "decorators" or "ornamental painters." Some could fake wood and marble graining, apply stencils, and create other decorative effects with paint. Others became carriage painters who showed their adeptness with the brush in pin striping and pictorial decorative embellishments, often on doors and around windows. Painters also created signs. Totally separate was the group of artists formed by talented women (young ladies, matrons, and educated women, often school teachers) who practiced drawing or water color or oil painting as a hobby. Women also excelled in handwork (needlework). Such women, often the wives of well-to-do citizens, were the same persons who formed women's clubs (a post-Civil War movement, that helped emancipate women by providing them with a social and educational milieu outside the home). In Santa Maria such women formed the Ladies Literary Society, 1894 and in Lompoc the Alpha Literary and Improvement Club, 1898. "Art" (both handicraft and fine art) was exhibited at the annual agricultural fairs (pre-cursors to the Santa Barbara County Fair), 1886-94. During this "art renaissance" centering around 1890, a few ladies and men taught art privately. Occasionally someone put together an Art Loan exhibit, as did the ladies of the Episcopal Guild in Lompoc in 1892 and the Ladies Literary Society in Santa Maria 1895. Other women expended their artistic talents on hat making. Freehand drawing and sloyd were sometimes taught in schools. Annual Teachers' Institutes held in Santa Barbara often had lectures and demonstrations on art, sloyd or manual training so that their teachers could spread the knowledge to their students. One artistically talented teacher was Frank Miller of Lompoc. In Lompoc the best-known artist was probably Mrs. A. J. Nichols, wife of the jeweler. In Santa Maria the most professional artist was probably the briefly resident J. F. Renoult, although Oliver Jones, Sallie Lucas, Frank Stewart and his sister, as well as Minnie Stearns deserve mention.

Infrastructure - Some local businesses found it profitable to include artists' materials among their stock and to frame pictures.

Photographers – Photography was the first artistic medium in north county that promised sufficient income to support the practitioner. North county towns had both itinerant and resident photographers. They captured residents' likenesses as well as the growth of the towns. Career photographers usually did their own developing and printing and sometimes did that of local amateurs. Their galleries were fitted in an elegant manner and could provide elegant props for portrait customers. In Lompoc top, long-term photographer was Henry McGee. In Santa Maria it was John McMillan.

1875-1898 Lompoc

1875-77 – L – **Dewitt Henning** acted as sign painter, grainer, and ornamental house painter.

1880 – L – **William H. Austin** carried on a sign, house and carriage painting business to c. 1894.

1880 – L – Gravestones were supplied by **Los Angeles Marble Works** through a representative in the area.

1883-1910 – L – **Egbert T. Briggs**, itinerant photographer, worked in Lompoc, and throughout Northern Santa Barbara and SLO Counties.

1888/92 – L – **Holton Webb**, teacher at Lompoc High School, had students who excelled at pen drawing.

1889 – L – **Lompoc School of Art Embroidery** was run by **Henrietta Hendrickson**, also a painter.

1890 – L – **Mr. McKenzie** was active as a sign painter, grainer, marbler.

1890-92 – L – **Collegiate Institute**, a private school that offered freehand drawing, was conducted by Rev. B. F. Whittemore.

1890-1904 – L - **Henry Fabing** was active as a sign painter. In 1903 he painted the drop curtain in McMillan's hall that consisted of a number of ads for local businesses.

1891+ – L – **Frank Miller**, an artistically talented student at Lompoc High School, exhibited artworks at the annual Fair (1891-94), went on to teach in Los Olivos (1897) and the artistically talented **Clarence Mattei**. Later he ran **Miller's** (1911-17+) that sold, among other things, artists' materials.

1892 – L – **Clara Black**, milliner, took painting lessons from **Mrs. A. J. Nichols** and exh. a flower painting at the annual Fair.

1892-Apr. – L – An **Art Loan Exhibit** was sponsored by the Ladies of the Episcopal Guild, Lompoc.

1892, 1894 – L - **A. J. Nichols**, jeweler, and **Mrs. A. J. Nichols** (artist) exh. at the annual Fair. Mrs. Nichols (Alice) also superintended the Fair art department (1892), and taught art. After Mr. Nichols' death, Alice married Eugene Barton and lived in Manila, although her very last years were spent in Los Gatos.

1893-1909 – L – **Henry McGee** was active as a photographer in several northern Santa Barbara County towns as well as Los Angeles.

1894 – L – **Lucy Colvin**, prop. of a ladies' millinery shop, exhibited paintings of fruit and flowers at the annual Fair. In 1897 the shop moved to Santa Maria, and she exhibited again at the Fair in 1900.

1898 – L – **Alpha Club** was founded as the Alpha Literary and Improvement Club. In the years to come it had Art and Handicraft sections, sponsored art lectures, and among its members were several easel painters.

1875-1898 – Santa Maria

1876/78-1918 – SM – **T. A. Jones & Son** manufactured furniture. In their retail store they sold household items including picture frames (1882+) and artists' paints and tools (1894+). The store boasted artistic window displays.

1883 – SM – **J. F. Renoult**, house painter and decorator, also produced fine art and taught it.

1883 – SM – **Leslie's** in Los Alamos sold picture frames.

1885 – SM – **Niels Lunge** taught photo painting.

1884+ – SM – **Lawrence Jeter** painted signs, did graining, and painted houses.

1885-88+ – SM – **John and Charles McMillan** conducted McMillan Brothers photograph gallery. In 1888 Charles relocated to Vallejo in northern California. John carried on in Santa Maria until at least 1901 and then segued into running a music hall.

1885-90 – SM – **Oliver Lee Jones**, druggist, painted portraits and landscapes, exhibited at the annual agricultural Fair, and designed stage sets, before resettling in Healdsburgh.

1886-89+ – SM – **Anna** and **Carrie Strube** taught Kensington painting and ran a millinery shop.

1886-93 – SM – **Anna Strube Lutnesky** exhibited art at the annual agricultural Fair.

1886-94 – SM – Annual Agricultural Fair (precursor to the **Santa Barbara County Fair**) was held sometimes in Santa Maria and at other times in Lompoc. The woman's section had categories for needlework and for fine arts. Student artwork was also shown.

1889 – SM – **Samuel Jefferson Jones** exh. drawings and was Gen. Supt. of Fine Arts for the annual Fair. He collected Native American materials. His family store (T. A. Jones and Son) sold artists' materials.

1889-90 – SM – **George Mayers** painted signs, houses and carriages and acted as a decorator.

1890-93 – SM – **Sallie Lucas** of Woodland, residing with her brother, exhibited and taught art.

1891 – SM – **Santa Maria Union High School** was organized. A school was constructed, 1894, and in 1899 photography was taught by **George Russell**.

1891-95 – SM – **Lillie Morris** created, taught, and exhibited her art.

1892-93 – SM – **Frank Stewart** and his sister (name never mentioned) from Chicago, taught crayon art and drawing.

1892-96+ – SM – **Eugene Revetagat** painted homes, executed graining and decorating.

1892+ – SM – **Minnie Stearns** painted landscapes and taught art privately.

1893-96 – SM – **Fred Koerner** ran a photography studio.

1894-96 – SM – **William H. Elliott**, photographer, was active.

1894+ – SM – **Ladies Literary Society** formed, 1894. The name was changed to the **Minerva Club** in 1906. Its early efforts were directed to obtaining a library for the town.

1895-Mar. – SM – **Art Loan Exhibit** was held by the Ladies Literary Society at McMillan's Hall.

1897-c. 1908+ – SM - **John Hart** painted signs, among other things.

1899 – SM – **George Russell** taught photography at Santa Maria High School.

1875-1898 Santa Ynez Valley

1896 – SY – **Santa Ynez Valley Union High School** opened in the Old Grammar School.

1897 – SY – **Frank Miller** from Lompoc taught art to artistically talented **Clarence Mattei** at the Los Olivos School.

1898-end of WWI – TURN OF THE CENTURY

By 1900 America had established itself as a world power. In the West, the Indian wars were over, the buffalo had been decimated, people of European background had settled, barbed wire fences cut up the vast prairies, and the McCormick reaper had made large-scale farming profitable and the U.S. into the world's largest agricultural producer. The Spanish-American war, partially fought with metal-hulled ships, left the U. S. a world naval power. Henry Ford built his first automobile in 1892, and the rush was on to locate oil to make fuel. By 1900 telephones were in wide use, cities were being electrified. Moving pictures were a curiosity and, in Hollywood, Nestor established the first studio, 1911. In larger cities the "city beautiful" idea led to the creation of parks and public statues as well as "beaux arts" style architecture. Skyscrapers (first constructed 1884) changed the look of large cities.

1901 – Oil was discovered south of Santa Maria in an area now known as Orcutt, named after the field's discoverer. Santa Maria escalated in population.

1901 – The **Southern Pacific Railroad** provided through travel from the Bay Area to Los Angeles with stops at Guadalupe and Surf.

1905 – Santa Maria Light and Power Company (of Los Angeles, est. 1904) turned on electricity for the town.

1912 – Automobile ownership was rapidly supplanting the horse and wagon. Surveying and engineering began for an automobile **state highway** up the California coast generally following El Camino Real.

1913-1915+ circa – **Highway 1**, California's first north-south automobile road was constructed in bits and pieces through northern Santa Barbara County followed by the construction of satellite roads to peripheral towns in the Lompoc and Santa Ynez Valleys.

1914-July – 1918, Nov. – **World War I** raged in Europe.

1915 – **Panama Pacific Exposition**, SF, included large exhibits of American and European art, and the grounds included sculpture and murals. The art exhibits, statuary, and architecture influenced California artists. Panama California Exposition was held in San Diego.

1917-April – U. S. Joined the allies fighting in **World War I**.

1918-19 – The deadly Spanish flu epidemic killed millions.

1918-Nov. 11 – World War I ended.

Artists and Photographers

Nationally, at the turn of the twentieth century, artists in larger American cities were adopting the latest European artistic innovations. The most widely practiced "styles" included "Hudson River," "Academic" (as practiced in the academies), "Barbizon," Impressionism and Post-Impressionism. In Northern Santa Barbara County, the towns of Lompoc and Santa Maria were still too sparsely populated to support viable art communities. However, a few persons of artistic talent did occasionally produce "art". Without local professional art schools, aspiring artists would have had to rely on self-education – viewing art displayed in exhibits in larger metropolitan areas (including at the Panama Pacific Exposition in San Francisco and the Panama California Exposition in San Diego, both 1915), viewing reproductions of art in national and international art magazines, studying "how-to" type books, taking correspondence courses (such as those from the University of California, Berkeley), and studying art on the East Coast or in Europe, even in California at San Francisco or Los Angeles. Easel painters were still primarily women with enough leisure to pursue the hobby, and most are assumed to have painted realistically. (Few examples of such art are currently available for study and thus it is impossible to state exactly in what styles local artists painted.) Some women practiced China painting.

Schools – In Lompoc and Santa Maria, northern Santa Barbara County's largest towns, the main proselytizer for "art" were the schools. In the early years of the twentieth century "Sloyd" (an educational concept developed in Sweden that taught handicrafts and drawing to develop hand-eye coordination, to make its users think, and to allow children to express cultural and aesthetic values), was taught. In elementary schools (which were often one-room school houses) early "art" teaching, which might include drawing, primarily depended on the proclivities of individual teachers rather than school system dictum. The Sloyd movement in the public schools ultimately led to the development of programs in manual training / manual arts where carpentry and metal work were taught. These, in turn, evolved into "industrial arts" vocational programs, still a permanent part of most junior high and high schools. Also considered worthy of teaching was mechanical drawing since it could lead toward various careers such as drafting and surveying. Lompoc High School enjoyed an almost unbroken line of teachers who imparted the elements of freehand and mechanical drawing. Santa Maria High School benefitted from the long-standing art teacher Minnie Stearns followed by other short-termers. Schools also were the sites for exhibits, primarily consisting of art objects produced by the pupils to demonstrate their abilities to their parents. Several times after 1912 various schools hosted the traveling exhibits of the Elson Art Publication Company of Boston, Mass. It marketed its reproductions of art masterpieces through exhibits held in public schools, charging admission, then allowing the schools to use the net proceeds to purchase prints for their school rooms. High school graduates who hoped to earn a living from their art abilities were forced to move on to larger metropolitan centers. Several became quite successful, including the Mattei brothers (Clarence and Charles) portraitists from Los Olivos. Neil McGuire (of Santa Maria) became an artist and producer in Hollywood.

Infrastructure. Exhibitions of art outside the schools were almost nil. Agricultural fairs, which had provided venues in the nineteenth century, were not held, except for one in 1900 in Santa Maria. At this 37th District Agricultural Fair there was an exhibit of handwork and fine arts. In 1917 the Santa Maria Inn opened, and its proprietor Frank J. McCoy, over the ensuing years, provided free rooms to artists, commissioned artworks of some, decorated the main Inn rooms with antiques, and provided a venue for a few art exhibits.

Santa Ynez Valley. The inland Santa Ynez Valley entered the art picture. Since 1804, the area had been able to claim as "art" Mission Santa Ines with its adobe architecture and artistic embellishments and furnishings. By 1900, thanks to car ownership and easier access between the valley and the "outside world," at least one artist of Santa Barbara, Alexander Harmer, had a second home in the valley, a ranch named Oak Dene, whose terrain he captured in paintings (1900-13). In Los Olivos, both sons of the owner of Mattei's tavern showed superior artistic talent and went on to study and work at art outside California before returning to paint portraits. In 1911 the town of Solvang was founded as a Danish community. Unfortunately details of early Solvang including any "art" activities are minimal since the local newspaper, the *Santa Ynez Valley News,* did not begin publication until the mid-1920s.

Photographers – The main pictorial output of this period was photography. Both Lompoc and Santa Maria had a number of commercial photographers (both long-term and short-lived). Generally, such men (and sometimes women) worked in black-and-white, restricted their subject matter to paying subjects such as portraits, wedding pictures, and documentary photos of events, landscapes and architecture. And, they strove for realism. (In larger American towns some photographers worked in "styles" such as Pictorialism.) Amateur photographers photographed family, landscapes, etc. In Lompoc Charles Baechler invented a simple and less expensive method for making photo engravings, 1910. In Santa Maria one of the best-known photographic families was the Judkins. Many photographs of this period survive in archives and historical collections (Lompoc Valley Historical Society, Santa Maria Valley Historical Society, Santa Ynez Valley Historical Society), but have yet to be analyzed for styles and techniques (if any).

1898-WWI Lompoc

1898-1919 – **Alpha Club** – founded 1898, enjoyed a few programs on "art."

1903-05 – **Florence Sollman** taught drawing at Lompoc High School.

1906 or 07 – L – **Frank Barker**, Lompoc High School grad. who studied drawing with **Florence Sollman**, went on to use his talents in the construction industry but most importantly for this publication employed them after 1960 making drawings of Lompoc, as he once knew it, which were used to illustrate his father's *To California and Lompoc* (1979) (coll. Lompoc Valley Historical Society).

1908/11 – L – **Olivia McCabe** taught sloyd to Lompoc elementary and high school students.

1909-13 – L – **Lillian Dodge** taught freehand drawing in Lompoc Grammar school.

1910 – L – **Charles Baechler**, photographer active in Lompoc c. 1907-1940, invented a simple and less expensive method of making photo engravings.

1910 – L – **Ed Beard**, sign painter, had some drawings reproduced in the *Lompoc Record*.

1910/11 – L – **Marie Simon** taught drawing at Lompoc high school.

1911/12 – L – **Miss Cooper** taught sloyd and domestic science at Lompoc High School.

1911/14 – L - **Juanita Nicholson** taught drawing at Lompoc High School.

1912-14 – L – **Rachel Broughton**, daughter-in-law to the founder of the *Lompoc Record,* was active as an artist although she later practiced in Los Angeles.

1912/14 – L – **Loua Gorham** taught sloyd at Lompoc High School but spent most of her life teaching sloyd in Oxnard.

1914-16 – L – **Robert Chesnut** taught manual training and manual drawing at Lompoc Union High School. **Addie Vadney** taught freehand drawing and Domestic Arts.

1914-18 – L – **Birdie Coffin** served as art teacher at the Artesia Grammar School.
1916/17 – L – **Otis Hyde** taught drawing at Lompoc High School. Most of his career was spent in Los Angeles.
1916-55 – L – **Lettie Risor** resided in Lompoc where, at some time, she pursued the painting of easel pictures.

1898-WWI Santa Maria

1898-1900 – SM – **B. L. Brigham**, sign and house painter, was active.
1898-WWI – SM – **Ladies Literary Club / Minerva club** – Held study groups on the works of various authors and on various countries, public lectures of a general appeal, entertainments, concerts and dances.
1900 – SM – **37th District Agricultural Fair** included, in the Women's Department, handwork and "fine arts."
1903/04 – SM – **H. Lee Jellum** was prop. of a photography studio. Sold out to Fitzhugh, 1904.
1903+ – SM – **Santa Maria High School** – Art was first taught by local artist, **Minnie Stearns** (1903/09). She was followed by others, usually for circa two-year intervals, which appears to have been the duration for a beginner's contract.
1904 – SM – **Fitzhugh Photograph Gallery**, prop. L. M. Fitzhugh. Sold out to **Roebuck**.
1904-07 – SM – **E. D. Shull** was active as a photographer, working c. 1906-07 with Judkins.
1905 – SM – **Maria Avila** advertised to give art lessons, Nov.-Dec.
1905 – SM – **California Portrait Co.**, prop. **Charles Alexander Smith** of Chicago, was in Santa Maria making crayon/water color portraits from photographs.
1907+ – SM – **David Roby Judkins**, photographer, bought out Shull and opened **Judkins Studio**. He died in 1909. In 1910 the studio was taken over by his nephew **Edgar George Judkins** (1910-12), after which it was run by Edgar's widow, **Hila** (c. 1913-1917?) and then sold to **Cambridge Graham Willett** (1917).
1907+ – SM – **Obart "Mac" Langlois** grad. from Santa Maria High School, went on to study art in Berkeley, and worked briefly as an apprentice in the art room of the *Oakland Tribune* before returning to Santa Maria and to ranching.
1909/10 – SM – **Marie Pioda** taught drawing and manual training at Santa Maria High School.
1909-c. 1912 – SM – **John Dahlgren** ran Louise Studio of photography.
1909+ – SM – **Neil McGuire**, who grad. Santa Maria High School, 1909, went on to become an artist and producer in Hollywood.
1910/12 – SM – **Frances Heil** taught drawing and manual training at Santa Maria High School.
1910-22 – SM – **Charles Turek** ran a monument business.
1910-1940 – SM – **John Nicholson** was active as a photographer, a painter of carriages, etc., and a businessman.
1912/16 – SM – **George Young** taught drawing and manual training at Santa Maria High School. In retirement he turned to painting landscapes.
1912-1922 or 23 – SM – **George Borst**, photographer, was prop. of **Louise Studio**.
1916+ – SM – **Helen Otis**, grad. of Santa Maria High School, went on to attend the California School of Arts and Crafts.
1916/19 – SM – **Clarence Rogers** taught manual arts and drawing at Santa Maria High School.
1917 – SM – **Santa Maria Inn** opened. Through the years proprietor **Frank J. McCoy** provided free rooms to artists, commissioned artworks of some, decorated the main Inn rooms with antiques, and provided a venue for a few art exhibits.

1898-WWI – Santa Ynez Valley

1900-13 – SY – **Alexander Harmer** of Santa Barbara painted landscapes of his ranch, Oak Dene, in the Santa Ynez valley.
1903+ – SY – **Clarence Mattei** of Los Olivos, after studying art in SF, NY, and Paris, established a portrait painting studio in NY (1909). After ten years he began working bi-coastal, i.e., Santa Barbara / New York.
1911 – SY - The town of **Solvang** was founded as a Danish community.
1916 – SY – **Charles Mattei** of Los Olivos attended the Chicago Art Institute. Later he became a portrait painter in Santa Barbara.
1918-19 – SY – **Kate Donahue** taught manual training at Santa Ynez Valley High School.
1918-27 – SY – **Rev. Lorentz Henningsen** retired to Solvang and produced art.

1919-1932 – ROARING TWENTIES

The end of WWI was met with relief and initiated in a decade of optimism and great economic growth that we now call "The Roaring Twenties." All aspects of society boomed. Business and the stock market surged. Living conditions were made easier and women liberated from household drudgery thanks to electrical appliances such as irons, washing machines, and vacuum cleaners. Invented earlier but widely utilized in the 1920s were the telephone, the phonograph, and automobiles. Urbanites at eight-to-five jobs found themselves with more leisure time. With their greater affluence many turned to "culture." Entertainment had already been expanded with the invention of the phonograph and motion pictures (although still mostly silent) but the 1920s ushered in radio broadcasts. ("KSMR Opening Soon," radio station in new Santa Maria RR building, *SMT*, March 10, 1926, p. 1.) People also entertained themselves with automobile travel, sports and hobbies. With the revolution in **Mexico** over (1924), Americans began to travel to Mexico, and Mexican influences began showing up in American art.
Rural Central California benefitted doubly from the invention of the automobile. 1) The large oil field discovered just south of Santa Maria provided jobs for hundreds of workers, which increased the town's population and income and allowed for a greater variety of businesses as well as luxuries such as culture. 2) The bucolic rural lands of the Central California Coast became a magnet for tourists hoping for a temporary escape from the growing metropolises of Los Angeles and San Francisco. Automobile touring was aggressively promoted by entities such as the Southern California Automobile Club through its publications *Touring Topics* (1909+) and its successor *Westways*. And, even the smallest towns of northern Santa Barbara County were reachable by auto as, through the 1920s, side-roads from Highway 1 to peripheral towns were improved or constructed.

1918-Nov. 11 – **World War I** ended. American troops returned home.
1920-Aug. – **19th Amendment** to the U. S. Constitution guaranteed American women the right to vote.
1920-1933 – **Prohibition** spawned bootlegging. California's isolated central coast beaches were prime areas for landing illegal liquor.
1920s – Booming economy in America.
1920s – Automobile ownership encouraged touring, and the industry grew exponentially.
1920s – **Motion picture industry** in Hollywood (first studio established 1911) resulted in film "fans" and the construction of motion picture theaters, many with artistic décor.
1922 – Flower seed industry began in the Lompoc Valley.

1923-Sept. – The solar eclipse, viewable from the Lompoc area, attracted photographers (such as **James Worthington**), artists (such as **Howard Russell Butler**) and scientists.

1924 – B – **Andersen's Pea Soup Restaurant** opened in a small way in Buellton.

1925-June 29 – A major earthquake in the town of Santa Barbara destroyed many buildings, but north of the Santa Ynez mountains only minor damage was suffered.

1925 Dec. – SY – *Santa Ynez Valley News* was first published.

1926 – KSMR (first named KFXC), Santa Barbara County's first radio station owned by Capt. Alan Hancock, broadcast.

1927 – **Hancock Field** was established on 210 acres within the city limits of Santa Maria by Captain Allan Hancock.

1928 – The airplane, *The Southern Cross*, owned by Alan Hancock but piloted by Charles Kingford-Smith and Charles Ulm, flew from Oakland, Ca., to Brisbane, Australia, making the first trans-Pacific flight.

1928 – First Santa Barbara County Fair was organized as the Santa Maria Valley Fair and held in Santa Maria.

1928-Oct. 21 – SM – **Santa Maria Airport** was dedicated at Hancock Field. (The current Santa Maria Airport is the former Santa Maria Army Airfield, SW of the town.)

1929-Spring – **Hancock Foundation College of Aeronautics**, a nonprofit educational institution, was established and opened at Hancock Field, Santa Maria.

1929 – **California Highway Patrol** was created by state legislature.

1929-Oct. – **Stock Market Crash** ushered in the Depression.

1932 – Bottom of the **Depression**.

Artists and Photographers

Nationally in the 1920s, America was still looking toward Europe for its art ideas. The most avant garde artists, located on the East Coast, attempted their versions of the newer European styles – Art Deco, Dada, and Surrealism. Most California landscapists utilized earlier European conceived styles such as Impressionism and post-Impressionism although a few experimented with the more modern styles.

Northern Santa Barbara County was still dominated by cattle ranches, farms (some devoted to growing flower seeds), the oil industry in Santa Maria and the celite industry in Lompoc, but automobiles were now giving its resident artists more mobility and easing the exchange of artistic ideas with the "outside world".

Public Schools. Public schools remained the main bastions for arts dissemination. Elementary schools, many of them one-room, exposed children to "art" through drawing. Girls learned various kinds of needlework and boys learned various kinds of manual art. The amount of art teaching depended on the personal proclivities of each teacher. In 1919 Santa Maria elementary schools introduced an official program of handicraft. The system also had an art specialist that traveled from class to class and school to school to teach art. Population increase in each of the area's three main towns allowed for greater specialization than before and in 1926 Lompoc built a separate "Junior High." In 1931 El Camino School (ultimately a stand-alone Junior High) was constructed in Santa Maria. Junior highs prepared 6, 7th, and 8th grade students for the more specialized classes of high school, by offering discrete classes in introductory Domestic Arts, Industrial Arts, and Fine Arts. High schools in Santa Maria and Lompoc, by the 1920s, had developed separate departments for Domestic Arts, Industrial Arts, and Fine Arts, and each of those contained several classes varying in subject and difficulty. Domestic arts, taught primarily to girls, imparted sewing and handwork (including clothing design and embroidery, etc.) as well as table setting, some household crafts, and interior decoration. Manual training (sometimes referred to as industrial arts), attended primarily by boys, usually included mechanical drawing, carpentry and metal work. Fine Arts was most advanced at Santa Maria High School, particularly after the arrival in 1922 of Stanley Breneiser. He was north county's first major art "mover and shaker." He not only taught art in High School and Junior College (Santa Maria's Junior College, started c. 1920/21, and consisted of advanced classes taught by high school teachers in high school buildings) but, for a few years, adult school. He also started clubs (Blue Mask Club and College Art Club) to provide extra cultural opportunities for aesthetically minded Santa Marians. He also wrote articles for national magazines about Santa Maria High School's art program. Lompoc High School, whose student body was much smaller, still offered the basics. In 1924 "applied arts" was added, and in 1926 "beginning and advanced design" as well as "commercial art" were added. Mechanical drawing enjoyed several levels of difficulty including architectural drawing. Santa Ynez High School was handicapped by its relatively small student body and yet by 1921 offered both freehand and mechanical drawing. In all high schools, art assignments were of a practical nature – designing posters for events, designing school publications, such as yearbooks, and designing costumes and painting stage sets for school and other plays. Santa Maria High School art students were unique in producing an award-winning hand-made, small edition magazine titled *Splash*, full of student-written articles and student-created art. Adult schools were another new trend in education. Local adult schools primarily utilized high school facilities and teachers. Lompoc attempted an adult school in 1923 at which it intended to offer both freehand and mechanical drawing but it may not have materialized. It was not until 1940 that a sustained crafts program was offered. Santa Maria's adult school, started in 1918, survived through the decade with popular classes being mechanical drawing and industrial arts. In mid-decade it blossomed with art programs taught by Stanley Breneiser. All schools put on exhibits of their students' products, usually open houses for parents, with varying titles including Public Schools Week. At least twice in the 1920s the Elson Art Publication Co. circulated exhibits of its reproductions of art masterpieces to local schools where some were bought and placed on display at the schools. Several local high school grads went on to become career artists including from Lompoc: Forest Hibbits, from Santa Maria: Gaylord Jones, Marshall Lakey, Margaret Fortune, Virginia McBride, Clarence Norris, and Mabel Glazier Burwick, and from Santa Ynez: Ruberna Downs.

Supplementary "art" study was available at Santa Maria School of Art, a summer private art school held in 1927 by Stanley Breneiser. Attendance was small and another attempt at it was not made until 1933. Solvang had the private Atterdag College that, by 1926, taught Danish crafts. A significant educator for wives of farmers or ranchers were the several branches of the Home Department of the State Farm Bureau, the first of which may have been organized in Northern Santa Barbara County in 1920. Traveling demonstrators appeared at meetings of various branches where they taught housewives practical subjects such as health and nutrition but also "artistic" things like interior decoration, crafts, clothing and hat design. In 1931 Kiddie Kartune Club members learned drawing by viewing films shown at the Lompoc Theater. Crafts were taught in Four-H Clubs and at Girl and Boy Scout meetings and summer camps. In Santa Maria, between 1925 and 1927, Annie White taught painting and crafts privately.

Women's clubs flourished in the 1920s benefitting from a higher standard of living as well as new labor-saving devices. New clubs formed: in 1920 the Guadalupe Welfare Club, in 1922 the Community Club in Santa Maria, before 1919 the Orcutt Woman's Club, and in 1927 the Solvang Woman's Club. Local women's clubs affiliated with the state and national Federation of Women's Clubs, benefitting from their programs and from lectures and demonstrations by their circulating department chairs. United, they made a formidable force and, among other things, were strongly influential in getting laws passed to prohibit billboards along California's scenic highways. Women's clubs met monthly (or more often) and hosted occasional lecturers on various art topics. The two largest women's clubs – Alpha Club in Lompoc and Minerva Club in Santa Maria – both started subsections for art and handicraft. Sub-sections, usually self-organized by a group of women who had an interest in a specific subject, allowed those members to meet separately on a regular basis and to go into depth on that subject. Art subsections, primarily studied the history of art and antiques whereas handicraft sections taught members various kinds of handwork (embroidery, etc.) how to make small items for home décor or entertaining, and also new craft techniques. The Alpha Club's art section, started by high school English teacher, Gertrude Bowen, was first mentioned by the local newspapers in 1928. Women's Clubs were often sponsors of city-wide events. In 1920 in Santa Maria, an Art Loan exhibit was mounted by the Minerva Club. In Lompoc in 1922, the Alpha Club, started the Flower Festival, to celebrate the infant flower industry in the Valley, at which floral displays were judged for artistry. In 1928 the Minerva Club opened its new home designed in Spanish style by architect Julia Morgan.

The increased leisure of the 1920s also gave people the time to reflect on their own beginnings and to collect a variety of objects. Art Loan exhibits, country fairs, and hobby shows displayed antiques brought in by local settlers from former homes on the East Coast or in the Midwest as well as artifacts from the Spanish and Mexican-era owned by the missions or by descendants of rancho owners. Some locals scoured the hills for Native American artifacts and built collections. In 1923 Santa Marians formed the Santa Maria Valley Pioneer Association and in 1926 people in Lompoc formed the Lompoc Valley Pioneer Society. Both preserved photos and artifacts of their towns' histories. At Mission Santa Ines, through the 1920s, various improvements and restorations were made, and historical artifacts were gathered into a museum collection.

Automobiles brought greater mobility, and local artists began to interact with the greater art world particularly the town of Santa Barbara. Stanley Breneiser and his family produced art of enough sophistication to be exhibited in the Faulkner Memorial Art Gallery, opened 1930 in the Santa Barbara City Library. And Breneiser's students were included in the annual exhibit of art from county schools. In reverse, artists from outside the area motored to the Central Coast to paint the bucolic farms, ranches and seashore. The missions remained popular as subject, and a new visual draw was Lompoc's flower fields as well as the gardens and buildings of the Santa Maria Inn. A one-time attraction was the solar eclipse of 1923, viewable from Lompoc Valley. The picturesque Santa Ynez Valley attracted several artists including Elmer House.

Infrastructure. Places to display locally made art were minimal. In 1920 in Santa Maria an Art Loan exhibit was mounted by the Minerva Club. Orcutt Woman's Club held a picture exhibit (primarily of Santa Barbara town artists) at the Orcutt Grammar School, 1927. The Elson Art Publication company again circulated its exhibition of art prints through schools, and the Colonial Art Company, which had a similar program, circulated its exhibit through 1928 and 1937. Santa Barbara County held no annual fair from 1901 through 1927. The town of Santa Barbara, being the most populous would have seemed the natural organizer but it failed year after year to get support. In 1927 Lompoc, possibly with the idea of taking the fair into its own hands, put on a Lompoc Valley Fair, and the following year, 1928, Santa Maria put on a 37th District Agricultural Valley Fair. Santa Ynez also put on a Valley Fair. Santa Maria now looks back at their 1928 fair as being the "first" Santa Barbara County Fair. In it, by 1929 there was a "Woman's Department" where needlework and antiques were exhibited, a display of school children's art and a special exhibit of miniature western paintings displayed by Bank of Italy. The 1931 Fair had, among other things, a booth of landscape painting – by Frances Meade Jensen. Art stores – 1921-23 in Santa Maria Leone Haslam opened Haslam's Art Shop that sold paintings consigned from LA. Possibly from lack of patronage, it soon morphed into a children's clothing store. Making a living from art was Ryan Stuart of Stuart Sign Service (1925-28), and Tobe Holcomb (1926-35+).

Photography – All three major towns had resident commercial photographers. In Santa Maria, the best known was the long-lasting Les Stonehart. Aerial photographic surveys were possible thanks to Hancock Field, est. 1927. In 1928 George Stone took many documentary photos of Santa Maria Valley for Capt. Allan Hancock. Placed in an album they were presented to the Chamber of Commerce. Other aerial photographers included Harold Rycher of Fairchild Aerial Surveys who took photos of the Santa Maria valley. Many amateurs took photos. High School students talented at photography took group photos for the yearbooks, although head shots were usually only trusted to commercial photographers. Hollywood, as a center of filmmaking, began to impact California. In 1923 Cecil B. DeMille filmed the silent movie, "The Ten Commandments" on the Guadalupe sand dunes. Films demanded theaters (which in larger towns contained lavish interior decoration) and in Lompoc resulted in the Lompoc Theatre (1927) that had some artistic décor. In Santa Maria the Little Theatre was constructed by Capt. Hancock in 1929. Over the years some artistically talented high school grads ended up working in the studios.

Architecture – In 1927 the Lompoc Theater was constructed and its interior painted with decoration. In 1928 in Solvang, Bethania Lutheran church was built in Danish provincial style. Neighboring architectural styles in town were mixed (Spanish revival, wood frame, etc.) until 1947, when the town, suddenly made aware of the tourist draw of a "Little Denmark," began constructing and remodeling its buildings in the Danish provincial style.

1919-1932 Lompoc
1919/21 – L – **Florence Van Sant** taught drawing at Lompoc High School.
1919/22 – L – **Otho Gilliland** taught manual training at Lompoc High School.
1919/21 and Spring 1923 – L – **Hazel Katzenstein (Dinsdale)** taught Domestic Science and Art at Lompoc High School.
1920-21 – L – **Forbes' Photo Studio** was briefly active.
1920+ – L – **Virgil Hodges**, employee of the Lompoc Street Department, privately took many photos of Lompoc over the years.
1920s – L – **Lompoc Elementary Schools**. A new grammar school was constructed 1922. In 1925 it was a special demonstration school for Industrial Arts. At school exhibits, children showed drawing, sewing and sloyd work.
1920s – L – **Lompoc High School**. A new building was constructed in 1922. Through the decade – in the domestic arts department it offered some handwork and sewing. For fine arts it offered drawing (both freehand and mechanical). In 1924 "applied arts" was added, and in 1926 "beginning and advanced design" as well as "commercial art" were added. Mechanical drawing expanded to several levels of difficulty and to architectural drawing. And, it offered Manual Training to which was added auto shop.

1921/23 – L – **Violet Beck** was teacher of drawing at Lompoc High School.

1921-41 – L – **Gertrude Bowen** taught Domestic Arts at Lompoc High School, where she also oversaw stage design and costumes for school plays. She headed the Alpha Club Art Section, c. 1928-32 and remained a member to 1941.

1922+ – L –The **Flower Festival** sponsored by the Alpha Club was started to celebrate the flower industry in Lompoc. The show held competitions for live flower specimens as well as floral arrangements. In later years the festival was held in late spring/early summer and included a parade with home-designed and made floats as well as, in the 1950s, an Open-Air Art Exhibit. Easel painters, many coming from outside the area, captured Lompoc's flower fields in landscapes and floral arrangements in still lifes.

1922/23 – L – **Lyman Kidman** taught manual training at Lompoc High School and Lompoc Adult School.

1923 – L – **Howard Russell Butler** traveled to Lompoc to paint the solar eclipse in September.

1923 – L – A **Lompoc Adult School** was attempted and some of the classes it intended to take up were manual training and drawing (both mechanical and freehand) but it may not have materialized.

1923-25 – L – **Ethel Colledge** taught drawing at Lompoc High School.

1924/26 – L – **Joseph Lenfest** taught manual training at Lompoc High School.

1924+ – L – **Forrest Hibbits** grad. Lompoc High School c. 1924. Studied art in San Francisco, graduating in 1927, worked as a commercial artist in San Francisco, 1930s, served in WWII, then returned with wife, **Marie Jaans** to the Lompoc / Buellton / Solvang area c. 1947 where he turned to teaching art, painting, and to running La Petite Galerie.

1925/27 – L – **Frances Jones** taught drawing at Lompoc Jr. High and High School.

1925/29 – L – **Lee Sims** taught mechanical drawing at Lompoc High School.

1926 – L – **Lompoc Junior High School** was constructed – 4-room frame stucco building.

1926 – L – **Lompoc Valley Pioneer Society** formed. It collected early photos and historic items. It held picnic social events and had booths at fairs and other events. It morphed into the Lompoc Valley Historical Society, 1964.

1926-46 – L – **Harry Nelson** taught mechanical drawing and industrial arts (woodshop) at Lompoc High School.

1927 – L – **Lompoc Theater** was constructed by the Knights of Pythias. Its interior was decorated by **Vern Laney** of Hollywood. He returned in 1935 to redo the foyer and lobby.

1927, 1930 – L – The **Lompoc Valley Fair** was sponsored by the Farm Bureau.

1927/31 – L – **Vina Queisser (West)** taught art and drawing at Lompoc High School.

1928-30 – L – **Art Section** of the **Alpha Club** was started (?) and headed by **Gertrude Bowen**, local English teacher who had a strong interest in art.

1929-30 – L – **Mortimer Oakes**, photographer of Atascadero, purchased and ran **Van's Studio** in Lompoc.

1931 – L – **Kiddie Kartune Club** members learned drawing by viewing films shown at Lompoc Theater.

1919-32 – Santa Maria

1918+ – SM – **Santa Maria Adult/Night school** was initiated by the Santa Maria High School Board. First "art" class was mechanical drawing, which proved useful during WWI. Art classes briefly blossomed with the arrival of **Stanley Breneiser** (1922-25) who taught subjects such as art history as well as the principles of art accompanied by actual practice periods.

1919 – SM – **Louis Crawford** taught manual training at Santa Maria High School. Architect of several school buildings.

1919-22 – SM – **Ida Kriegel** taught drawing and art at Santa Maria High School, and went on to teach other subjects for many years.

1919/21 – SM - **Margaret Reid** taught manual training to Santa Maria Elementary School students.

1919+ – SM - **Gaylord Jones**, grad. Santa Maria High School. Became an architect, occasionally taught artistic subjects such as mechanical drawing and interior design, and pursued his "hobbies" of photography, wood carving, and archaeology.

1920-Apr. – SM – **Art Loan Exhibit** held by Minerva Club at a commercial store front.

1920 – SM – **Theodore Stewart** opened a photograph studio.

1920s – SM - Artwork in **Elementary School** classes varied depending on the talents of individual teachers and whether the school system had a circulating manual training (sloyd) specialist or art specialist on its payroll. Special art teachers included Margaret Reid, 1919/21, Holland Spurgin, 1921/26, Hal Caywood, 1926/28. In 1919 a program of handicraft was introduced in the primary grades: basketry, raffia work, weaving, folding, cutting and clay modeling. In the higher grades 6, 7, 8 (in larger school systems termed "Junior High School") separate classes were held for domestic art, fine arts, and industrial arts classes to prepare students for those in high school. Products were exhibited for parents annually. In 1931 El Camino School (ultimately a stand-alone Junior High) was constructed.

1920-54 – **Santa Maria High School** added a Junior College curriculum 1920/21. A new high school building was completed in 1923. In 1922 Stanley Breneiser began teaching art and remained to 1945. Art projects were practical such as the production of posters for real events, the production of the high school yearbook.

1920+ – SM – Santa Maria-born **Marshall Lakey**, studied sculpture in San Francisco, taught in Santa Barbara (1920s), became a professor of sculpture in Oklahoma City (1929-31+), resided in Los Angeles (post WWII), and was active as a sculptor and operator of a ceramics shop in Ventura (c. 1949-52).

1921 – SM – **Ray Conner**, itinerant artist from Indiana, made oil paintings from photos.

1921/22 – SM – **Burt Cannon** taught mechanical drawing at Santa Maria High School and Adult School.

1921-23 – SM – **Leone Haslam** (Mrs. Fred Haslam) opened Haslam's Art Shop that sold paintings consigned from LA.

1921/26 – SM – **Holland Spurgin** taught manual training in the Santa Maria elementary schools.

1922-March – SM – **Community Club** formed.

1922 – SM – **Breneiser family** (Stanley, Elizabeth "Babs", Margaret, Marrie, S. Eliot, Valentine), arrived in Santa Maria. Stanley taught art at Santa Maria High School 1922-1945 and Elizabeth taught arts and crafts at Santa Maria High School, c. 1928 (?)-43. Top art figure of the town, he wrote articles on art education that appeared in national magazines. At the high school he started the Blue Mask Club and the College Art Club, for students interested in aesthetics. He started the school magazine, _Splash_, to display student art talents. Besides day teaching, he taught briefly in adult/night school, and started a private Santa Maria School of art during the summers of 1927 and 1933. He lectured widely to civic clubs on art. Many of his children (Margaret, Marrie, Valentine) and his "adopted" children (John Day, Louis Ewing, and Yukio Tashiro) either produced some form of art or music or ended up pursuing careers in art or music.

1922-34 – SM – **Harry Snell** taught mechanical drawing at Santa Maria High School and at Adult School.

1922-38 – SM – **Blue Mask Club**, Santa Maria Union High School, started by teacher Stanley Breneiser, sponsored art, music, dance, and drama lectures, as well as art exhibits and involved itself in other art events.

1923 – SM – The new **Santa Maria Union High School** was completed.

1923 – SM – **Margaret Fortune**, art major at Santa Maria High School, went on to attend Otis Art Institute in LA.

1923 – G – **Cecil B. DeMille** filmed the silent move, "The Ten Commandments" on the Guadalupe sand dunes.

1923+ – SM – **Wilbur Harkness** began his 30-year career as teacher of manual arts (including wood and metal shops) at Santa Maria High School.

1923+ – SM – **Santa Maria Valley Pioneer Association** was formed, held annual get-togethers, and collected historic photos and other items. It is currently active. ("Relics Recall Early Days in Santa Maria Valley" shown at Pioneer Days, *SMT,* May 4, 1925, p. 5.)

1923+ – SM – First issue of *Splash*, hand-made art magazine consisting of stories and original art, was produced by students of the Santa Maria High School. Limited copies were made. Over the years, the publication was erratically issued, to c. 1940.

1924/26 – SM – **Winifred Crawford** taught Domestic Art at Santa Maria High School, but her main subject was English.

1925 – SM – **Virginia McBride**, grad. Santa Maria High School. Studied art in college and, after teaching in elementary school became art teacher at Los Banos, 1933-37. Later, in the Bay Area, she was active as an artist, particularly with ceramics.

1925 – SM – **Clarence Norris** grad. Santa Maria High School where he excelled in art and for 45 years (beginning c. 1931) was a sign painter in the Santa Maria area including prop. **Norris Sign Shop** (that advertised 1932-39)

1925-27 – SM – **Annie White** taught painting and crafts privately. In 1958, she founded **White's Doll Hospital**.

1925-28 – SM – **Stuart Sign Service** was active until the illness of Ryan Stuart.

1925+ – SM – **Mabel Glazier Burwick** grad. Santa Maria High School. Went on to marry Coulton Waugh and to draw a nationally syndicated comic strip, "Dickie Dare" in the 1940s.

1926/28 – SM - **Hal Caywood** taught manual training in the Santa Maria elementary schools.

1926-35+ – SM - **Tobe Holcomb** painted signs in Santa Maria.

1926+ – SM – **Myrton Likes** began a 30-year career teaching science at Santa Maria High School and Junior College and on the side was an avid "photo bug" (movies, color slides) and a painter in oils.

1926+ – SM – **Sara Peck** from the "talented" Schwartz family of San Francisco, settled in Santa Maria with her musician husband, but only by 1932 do the newspapers mention her woodcarving.

1927 – SM – **Colin Campbell Cooper** of Santa Barbara painted at Santa Maria Inn.

1927 – SM – **Orcutt Woman's Club** held a picture exhibit (primarily of Santa Barbara town artists) at the Orcutt Grammar School and at its meetings discussed art.

1927 – SM – **Father Lorenzo Capitani,** formerly of Our Lady of Guadalupe, began exhibiting his paintings in Santa Maria, including landscapes of the Santa Maria valley. Capitani eventually moved to Los Angeles to pursue art full time.

1927 – SM – **Santa Maria School of Art**, held during the summer by the Breneisers, proved not to be a moneymaker. One of the teachers was **Harold Stadtmiller** from Exeter.

1927-35 – **Nancy Folsom** served as Demonstration Agent for the Home Department of the State Farm Bureau in Santa Barbara Co. Supplanted by Irene Fagin.

1928 – SM – **Harold Foster** taught architectural and mechanical drawing in Santa Maria Adult School.

1928 – SM – **Minerva club house**, designed by Julia Morgan, opened for use. A Handicraft Section was started 1934. Over the years the Club held many art programs and exhibitions (including Art Loan exhibits in 1895 and 1920, a National Art Week exhibit of Santa Barbara artists, 1940, and an Art and Hobby Show, 1957, 1958, 1959.

1928 – G – A traveling exhibit of fine art reproductions of famous paintings circulated by the **Colonial Art Co.**, was booked by the Guadalupe Welfare Club.

1928 – SM – **George Stone** took many documentary photos of Santa Maria Valley for Capt. Allan Hancock. Placed in an album they were presented to the Chamber of Commerce.

1928-Aug.+ – Both a **Santa Maria Valley Fair** and a **Santa Ynez Valley Fair** were held. The Santa Maria fair in 1928 may not have contained "art" except for that of school children. However, in 1929 there was a "Women's Department" which contained needlework and art craft as well as a Floral Booth, school children's work, a miniature art gallery in the Bank of Italy booth, models, antiques, and photos. The 1930 fair included education displays ranging from crafts created in grammar schools to mechanical drawing and items created in high school shop classes as well as art created by S. Breneiser's students, Clarence Ruth's collection of Indian relics, items by Leon Vaughn, a sign painting booth, and photographs. The 1931 fair had a large flower display, artistic touches by Leon Vaughn, historic photographs, a sign-painting booth, and a booth of paintings by Frances Meade Jensen.

1928-Sept. – SM – **Harold Rycher** of Fairchild Aerial Surveys took aerial photos of the Santa Maria valley.

1929 – SM – **Little Theatre** was constructed by Capt. Hancock.

1919-1932 – Santa Ynez Valley

1921 – SY - By 1921 both freehand and mechanical drawing were offered at **Santa Ynez High School.**

1926 – SY – At **Atterdag College**, traditional Danish craft making was taught at least by this date. By 1933 weaving was taught. By 1940 there was a kindergarten where students painted and modeled in clay. Between c. 1939 and 1949, intermittently, Mr. and Mrs. Viggo Tarnow headed **Atterdag Folk School**, a "summer school" which taught crafts.

1926 – SY – **Peter Petersen**, amateur landscape painter, received notice for his "Gaviota Pass" picture.

1926 – SY – Edward Salisbury Field purchased Zaca Lake and surrounding territory (300 acres) near Los Olivos. There, he and his wife **Isobel Osbourne** (step daughter of Robert Louis Stevenson) entertained many actors and writers.

1926/27 – **John William Bentley** of NY painted views of California, including the Santa Ynez mountains.

1927+ – SY – **Ruberna Downs** grad. Santa Ynez Valley High School. Studied art at Stevens College, Missouri, grad. UCLA (1932), taught art for the EEP in the Santa Ynez Valley (1934, 1935), and made drawings for "Snow White" for Disney (1937).

1927+ – SY – **Solvang Woman's Club** was organized. Over the years it supported and hosted various cultural programs and functions. It was renamed Santa Ynez Valley Woman's Club, 1959.

1926 – SY – **John Frame**, ex. salesman for Chicago Portrait Co., photographer, retired to Los Olivos.

1928 – SY – **Bethania Lutheran church** was built in Danish provincial style. After 1947, Solvang, suddenly made aware of the tourist draw of a "Little Denmark," adopted the style for all its buildings.

1928, 1931 – SY – **Elmer House**, painter, of Chicago and Brazil, settled briefly in the Santa Ynez Valley and painted landscapes

1928-33 – SY – **Better Homes Week** (a national movement focusing on better architecture and interior decoration) was celebrated in the Santa Ynez Valley.

1929-31 – SY – **Rev. Vincent Kerwick** oversaw the art and museum collection at Mission Santa Ines.

1932-1941 – DEPRESSION

In spite of debilitating financial conditions, cars continued to be purchased and owners, in their turn, demanded roads. A large portion of the several Federal and State "work project" funds of the 1930s were spent to build new highways. Dirt wagon roads were improved by grading, then by graveling, then by oiling, and the best were made of concrete to accommodate the faster moving autos. (Examples of spectacular government road projects of the 1930s are the Bay Bridge, opened in 1936, and the Golden Gate Bridge, opened 1937.) Tourism and its dollars became increasingly important to the rural Central California coast. Auto tourism, especially with travel trailers, was touted as an inexpensive vacation alternative to European travel. In 1930, hotel owners along California's Camino Real joined to promote their hotels under the umbrella banner of Mission Trail Hotels. The following year Mission Trails Association was organized to boost travel along Highway 1 and c. 1935 published a 28-page booklet, *California's Mission Trails, the Scenic Ocean Route between Los Angeles and San Francisco* (followed by other booklets through c. 1970).

1932 – Bottom of America's **Depression**.
1933 – **St. Peter's Episcopal Church**, Santa Maria, was consecrated.
1933-Dec. – **Prohibition ended**.
1933-42 – Several **State and Federal financial "relief" programs** supported, among other things, the arts in a variety of ways.
1934 – Santa Maria's new City Hall, designed by Louis N. Crawford and Francis Parsons, and decorated by Gaylord Jones, was dedicated.
1935 – **California Pacific International Exposition,** held in San Diego, contained art exhibits.
1936 – Franklin D. Roosevelt won the presidency by a landslide. California state population passed 6 million. Motor busses became air conditioned.
1936 – **Oakland Bay Bridge** opened.
1937 – **Golden Gate Bridge** was opened.
1939 – **Golden Gate International Exposition** was held in San Francisco. The Exposition contained an exhibit of Californian and other art that influenced California's artists.
1940 – Regular **Social Security** payments began.
1941 – Looming entry into **World War II** led the military to acquire land for bases and to construct buildings thereon.

Artists and Photographers

Nationally, Depression-era artists struggled to earn their livings. Those who did not turn to other occupations attempted to get on relief projects, tried bartering their art for goods or services, or turned to creating in media that could be produced cheaply and in multiples. This was primarily various forms of printmaking – that could be marketed for modest prices and to multiple buyers. Artists turned to less expensive art materials such as leather, soap (carved or sculpted), common forms of stone (as opposed to marble), clay and wood (in place of gold and bronze), printmaking on paper (as opposed to oil paintings on canvas), and new-to-America art forms such as batik (tie-dying). The interest in handicrafts that had risen through the 1920s, blossomed in the 1930s. The movement was spurred by 1920s Americans' resentment of and backlash to the new machine technology as well as the infiltration of European modernistic art styles. In the 1930s handicrafts received further encouragement from – 1) leisured Americans' need for recreation, and 2) Americans' need for reassurance of America's goodness during hurting economic times. Americans retreated into happier, earlier times: espousing back-to-nature, non-mechanized farming and hand-made objects. Federal government programs of the 1930s responded to this need. Recreation programs taught crafts like weaving, wood carving, and art metal work, techniques / skills that some had believed to be dead.

Schools – In Northern Santa Barbara County, schools continued to be the main generators of "art." In the 1930s school curricula followed the same general formats in place in the 1920s but, because of higher enrollment, schools could offer a greater variety of art classes, domestic art classes, and industrial arts classes. Specialist art teachers were hired. Some notable trends of the 1930s included an increased interest in poster making at all grade levels. Posters were sometimes made to advertise local events and at other times to compete in the national Latham Foundation contest (first held 1926). Also, newly popular, was the making of puppets and the presentation of puppet plays. Handicraft grew in popularity with leather work and tooling being one of the most attended. Some Domestic Art programs obtained looms and offered weaving. Students' products continued to be exhibited annually at Public Schools Week. In Santa Maria, elementary schools benefitted from a special circulating art teacher, such as Edna Davidson. Students began to exhibit outside the area. Junior High schools now separate from elementary schools were able to provide more specialized classes in preparation for high school, including separate classes in art and shop. High Schools continued to assign practical projects, such as the making of posters for town and school events, the designing of costumes and stage sets for plays and other programs, and the designing of yearbooks and other publications. In Santa Maria High School/Junior College, through the 1930s, Stanley Breneiser and his extended family continued to provide many levels of art instruction. Mrs. Breneiser focused on arts and crafts. Breneiser also brought in traveling art exhibits to enhance students' experiences. Art, crafts, and shop projects by students were displayed at annual Public Schools Week exhibits. From 1938, the aeronautical classes of Santa Maria Junior College were moved to buildings at Hancock Field where drafting was taught. Santa Ynez Valley High School student body was too small for the school to afford specialized teachers or provide specialized "appreciation subjects" like music and art. By 1931 it did offer mechanical drawing, and the home economics teacher taught free hand drawing and some crafts as well as poster making. In 1936 the school opened its new, modern building that contained murals painted by a Santa Barbara artist (a WPA project). It also ran a satellite school for the CCC boys at Los Prietos. Adult School – At Lompoc High School, some graduates returned to high school for further training. Lompoc's "adult school" appears to have started in earnest c. 1939 when it offered typing and lettering. In 1940, Viola Dykes began her more than 10-year stint teaching crafts. Santa Maria adult school -- resumed in 1934 after a brief hiatus -- offered many "art" courses, the most popular and long running being woodshop and metal shop. Sporadic arts and crafts classes were taught by various members of the Breneiser family. Interior Decorating was taught for a couple years by Gaylord Jones and art metal work was taught by H. O. Schorling (1939/41). Other "schools." In the summer of 1933 Stanley Breneiser attempted for a second time to run a **Santa Maria School of Art**. Attendance remained disappointing. Through 1935, monthly, Rev. Horace Campbell planned to lecture on "Great Masterpieces of Art" at the Christian Church. Most art he discussed was religious in subject. Local high school grads who went on to become career artists include, from Lompoc: Pauline Cronholm, Ernest Brooks (in photography), Margaret Fratis, Ruby Parker; in Santa Maria: Rex Hall, Robert Mason, Archie Case, Louie Ewing, John Day Breneiser, Leonard Fisher, Ada Okamoto, Nicholas Firfires, Byron Openshaw, Joffre Bragg, and Yukio Tashiro; and from Santa Ynez Valley: Clifford Powers.

Women's Clubs – Women's clubs continued to support the arts through occasional lectures to the entire membership and also through special sections for art and handicraft. In Lompoc a very active Alpha Club Art Section studied art history of America and California, American antiques, printmaking, "modern" art, and "Old Masters" under such leaders as Mrs. Charles E. Maimann, Mary Elizabeth Bucher, and Mrs. J. P. Truax. In 1932 the Club formed a Junior Alpha Club for younger women. The following year in September 1933 the Alpha Club moved into its own home designed in Spanish style. That same year the Club started a "handcraft section." This taught various skills such as weaving, embroidery, etc. In Santa Maria the Minerva Club, beginning 1934, had a Handicraft Section and from 1935 sponsored art lectures at some of its monthly meetings. In 1940 its clubhouse was the site for a National Art Week show curated by S. Breneiser that was comprised primarily of Santa Barbara (town) artists. The Community Club of Santa Maria and its junior group, the Junior Community Club (founded 1935) held an "art" lecture at least once a year. Toward the later 1930s the parent club started a Handicraft department in which craftswoman Hazel Lidbom was involved. In January 1935 at Santa Maria City Hall it co-sponsored an Art Festival consisting of exhibits and lectures. In the late 1930s the club could count several easel artists among its members. Another club that had a significant art program was the Delphian Society of Santa Maria that spent 1934 studying American and European art of the previous 200 years. In Santa Ynez Valley the Solvang Woman's Club, formed 1927, presented its members several lectures on various art media.

Government Work Projects – The most visible art proselytizers of the 1930s were several government art projects meant to employ out-of-work individuals, including artists. Each project made its own and separate contribution to north county. Generally, Northern Santa Barbara County benefitted not from the spectacular, publicity-generating mural and sculpture competitions of the state's larger cities, where offices for the projects were located and where the state's more accomplished artists resided. Few of northern Santa Barbara County's small-town artists were of a caliber to attract the attention of funding agencies. Primarily, northern Santa Barbara County benefitted by receiving artworks either specially created by outside artists for certain of its public buildings or distributed to them. All programs wound down as America came out of the Depression, c. 1940, its unemployed now working for defense plants or joining the military to fight in WWII. Funding for all programs was curtailed by Dec. 1942.

1933 – **State Emergency Relief Administration (SERA)** paid painters to re-paint Main Street school in Santa Maria.

1933/34 – **Civil Works Administration (CWA)** was a short-lived job creation program established by the New Deal to rapidly create mostly manual-labor jobs for millions of unemployed workers during the hard winter of 1933-34 (Wikipedia). It funded Ed Beard's mural on the rear wall of the little stage at the Lompoc Elementary School, 1934, and paintings by Santa Barbara (town) artists distributed as decorations to Lompoc public schools.

1933-Dec. – June 1934 – **Public Works of Art Project (PWA)**, a short-lived relief project for artists. Administered out of Santa Barbara, some of the artworks it commissioned were distributed to Northern Santa Barbara County schools and institutions.

1933-42 – **Civilian Conservation Corps (CCC)** was a voluntary public work relief program for unemployed, unmarried men ages 18–25 (later extended to ages 17–28). In northern Santa Barbara county, the men did most of the restoration on Mission La Purisima. This project necessitated architects, designers, and experts on historical recreation as well as a landscape architect. The school, meant to further the education of the workers, employed art and drafting teachers. A separate CCC school was located at Los Prietos in the Santa Ynez Valley.

1934 – **Emergency Educational Program (EEP)** part of the Federal Emergency Relief Administration, paid for some "art" teachers outside public school programs. In Lompoc, adult-level art was taught by Edna Davidson. In Santa Maria, Louie Ewing taught arts and crafts, and in Santa Ynez Margaret Teall taught interior decorating and landscape design while Ruberna Downs taught arts and crafts.

1934+ – **Treasury Department, Section of Painting and Sculpture**. The "Rolls Royce" of art projects, commonly known as "Section," considered an application to have a mural painted in the new Santa Maria Post Office, but the project never was realized. Carl Vinton Young of the CCC was funded by the Treasury Department to paint watercolors of La Purisima.

1935/6-Dec. 1942 – **Works Progress Administration / Work Projects Administration (WPA)**. The WPA was established in Washington, D.C., May 6, 1935. In Sept. – California WPA Funding was approved in Washington. The WPA's most famous project was Federal Project Number One, with its subsection **Federal Art Project (FAP)**. Most of its funds were spent 1936-38. In northern Santa Barbara County, the WPA paid for artwork for the Veterans Memorial in Lompoc, a mural at Santa Ynez Valley Union High School, and a carving and some easel paintings for Lompoc High School. It also proved a fountain at La Purisima Mission. In 1941, Henry Helmle of the **Index of American Design** (a subsection of the Federal Art Project) was commissioned to decorate the chapel walls at Mission La Purisima. The majority of WPA funds in north county were spent for recreation classes.

Infrastructure – The 1930s witnessed the emergence of some significant venues for the exhibition of art. The Santa Barbara County Fair, temporarily suspended (except for the horse show) at the depths of the Depression (1932, 1933), was revived in 1934 and ran to 1940, held at various rented sites. At it, displays and competitions were held for handiwork (needlecraft), antiques, some crafts (leather and wood carving) and schoolchildren's exhibits. At the High School, special traveling exhibits of art were displayed through the 1930s. In 1935, a stand-alone Art Festival consisting of an art exhibit and art lectures was held at Santa Maria City Hall co-sponsored by three clubs. In 1940 a National Art Week exhibit of Santa Barbara artists was held at the Minerva Club. In Solvang an Art Loan Exhibit was held by the Woman's Missionary Society at Legion Hall (March 1935). Also, in Solvang, beginning 1936 and lasting to 1959, the town held the annual Danish Days, meant to celebrate Solvang's Danish heritage. This consisted of food, music, dancing, and a parade, and also, in the 1930s, exhibits of heirlooms lent by local families.

Increased interaction with the wider art world. Thanks to increased ease of communication with outside communities, artworks by north county artists began to appear in exhibits in Santa Barbara and beyond. Scholastic Art Exhibit – a national art contest for students, was first entered by Santa Maria High School students in 1930 and then annually at least through 1960. Lompoc High School does not seem to have participated in the contest, but Santa Ynez Valley Union High School students, once the school acquired a discreet art teacher, Leo Ziegler, in 1944, first placed in the exhibit in 1947. A few teachers and students from Lompoc and Santa Maria had their art exhibited at educational shows in Santa Barbara, particularly at the newly formed Faulkner Memorial Art Gallery. Further afield, north county students had artworks on view in the education building at the California Pacific International Exposition in San Diego, 1935. In 1940 three freshmen from Lompoc High school had their art works exhibited in the "Young America Paints" exhibition at the American Museum of Natural History in New York. Outside art also traveled into north county in the form of exhibits presented through the decade at Santa Maria High School. Some artists whose main residence was outside north county, acquired second homes there (particularly Santa Ynez Valley) and interacted with locals and ostensibly painted the local landscape. Several artists from Southern California and the Bay Area motored to north county in search of bucolic landscape which they depicted in watercolors and oil paintings.

Artists. Notable in Lompoc were Mary Elizabeth Bucher, Carl Vinton Young and Loiz Lord Rhead Huyck, ceramist. In Santa Maria: several members of the Breneiser family (including Louis Ewing) taught and exhibited art. Elizabeth Mason Collison illustrated *Gin Chow's Farm*, 1932. Kazuo Matsubara, protégé of Setsuo Aratani, a leader in the Japanese community who patronized art, held several exhibits. Chandler Weston photographer was active 1931-33. Wayman Parsons, architect also painted water colors, 1932-36. Nicholas Firfires, painted Western scenes. Joffre Bragg, talented artist, died 1940. Eugene Hoback, carved wood.

Photographers – Commercial photographers continued to make livings taking portraits and wedding photos as well as some landscapes. One of the best known of the decade from Lompoc was Ernest Brooks who started his Camera Shop in Lompoc about 1934. (He rose to wider fame after WWII when he started Brooks Institute of Photography in Santa Barbara.) In Santa Maria the two photographer sons (Brett and Chandler) of nationally famous photographer Edward Weston, briefly resided, 1931. Stonehart continued as one of the town's better-known photographers. Bernard Karleskint ran the Santa Maria Camera Shop, 1939+. A novelty of the 1930s were baby contests. In 1932, at Lompoc Theater, photos for one were taken by Wathey Studio and in 1934 by Ernest Brooks. Newspaper photographers, sometimes also serving as journalists, snapped current events for newspapers that included an increasing number of illustrations. As for "amateurs," by the middle of the 1930s additional technological improvements had been made to both cameras and film to make photography more user-friendly. Kodak put 35 mm motion picture film on the market (1922) and 16 mm amateur motion picture film in 1923. Leica introduced the 35 mm format to still photography (1925). Kodak introduced the first 8 mm amateur motion picture film, cameras and projectors (1932). The 135-film cartridge was introduced in 1934, making 35 mm easy to use for still photography. Agfacolor color reversal film was introduced for home movies and slides (1936). Amateur photographers formed clubs for mutual education – La Purisima Camera Club, in Lompoc in 1938, and the Santa Maria Camera Club, in Santa Maria in 1938. Fans usually focused on one of three media: traditional black and white prints, the new 35 mm color slides or motion pictures. There was irregular official teaching of photography in the public schools (Junior High, Senior High, Junior College). Although portrait photos for the various school annuals were usually taken by professional commercial photographers, some group shots in the senior high yearbooks were actually taken by student photographers.

1932-1941 – Lompoc
1930s – L – **Lompoc Elementary School and Junior High** – Received a privately painted mural in the cafeteria painted by Fred Berger (the principal's future brother-in-law) (1934) and one on the back wall of the stage by Ed Beard (1935). Puppetry was popular medium. Students had art displayed at the San Diego Exposition (1935). A popular art theme was missions. Students exhibited work at Public Schools Week openings. The Junior High began teaching separate classes for art and music in the 7th grade.

1930s – L – **Lompoc Union High School** – Shop classes grew in popularity since they imparted vocational skills usable by ranchers and others as well as by people who just wished to save money by doing things themselves. The school also initiated two mechanical drawing classes. Graduates were returning for additional training. Hence, the number of Industrial arts teachers grew including Mr. Garrison in addition to Mr. Nelson, with some help from others. Shop classes made practical items, such as tables, desks and chairs for the drawing classes. In 1939 they designed the pergola in Ryon park. Art under Pauline Cronholm followed by Muriel Moran, then Mary Elizabeth Bucher and Margaret Morton, was taught in a series of ever more difficult classes from basic drawing to oil and watercolor painting as well as crafts, batik, carving, printmaking and leather work. High School teachers also taught some classes in Junior High. Classes produced items such as posters for school events (plays, the Jamboree) and helped on the yearbook. In 1934 the art and mechanical drawing rooms were remodeled. In 1935 Domestic Arts added a loom for weaving. Finished products were exhibited at annual Public Schools Week programs. In 1940 three freshmen had their art works exhibited in the "Young America Paints" exhibition at the American Museum of Natural History in New York.

1930s – L – **Lompoc Adult School** – In 1935 a class in vocational carpentry was offered but it may not have been part of an "official" adult school. In 1939 the Lompoc Adult School offered a class in lettering. 1940 marked the first of a ten-year run of crafts classes taught by Viola Dykes.

1930s – L – **Alpha Club** had a very active Art Section that studied art history of America and California, American antiques, printmaking, "modern" art, and "Old Masters" under such energetic leaders as **Mrs. Charles E. Maimann**, **Mary Elizabeth Bucher**, and **Mrs. J. P. Truax**.

1931-35 – L – **John Cummins** taught history, manual training and mechanical drawing at Lompoc High School.

1932 – L – Baby contest photos were taken by **Wathey Studio** at Lompoc Theater.

1932/34 – L – **Muriel Moran** taught art at Lompoc High School.

1932+ – L – **Leila Maimann**, once a photo tinter, was active with the Alpha Club Art Section 1932-52. Her sister, **Oma Perry** of Carmel, a full-time painter, often visited in Lompoc.

1932 – L – **Alpha Club** formed a **Junior Alpha Club** for younger women.

1933-Sept. – L – **Alpha Club** moved into its own home designed in Spanish style.

1933 – L – **Alpha Club** started a "handcraft section." It taught various handicraft such as weaving, embroidery, etc.

1933+ – L – **Lompoc High School** held a yearly **Jamboree** that utilized posters made by art students and stage settings and costumes made by other school departments.

1934 – L – **Edna Davidson** taught art under the EEP.

1934 – L – **Pauline Cronholm** grad. Lompoc High School. Majored in art at Santa Barbara college, 1935.

1934 – L – **Civil Works Administration**, funded **Ed Beard**'s mural on the rear wall of the little stage at the Lompoc Elementary School and distributed paintings by Santa Barbara (town) artists to Lompoc public schools for decoration.

1934 – L – Baby photos were taken by **Ernest Brooks** for a contest at Lompoc Theater.

1934 – L – **Fred Berger** painted a mural in the Lompoc elementary school cafeteria.

1934-Aug.-1938 – L – **Fred Hageman** served as architect and superintendent of reconstruction of Mission La Purisima

1934-38 – L – **Mary Elizabeth Bucher** taught art at Lompoc High School and was active with the Alpha Club Art Section.

1934-38+ – L – **Harvey Harwood** assisted then became architect (1938) of the restoration of Mission La Purisima. He painted many watercolors of the mission.

1934-WWII – L – **Ernest Brooks**, Lompoc High School and LA art school grad., opened the **Camera Shop** by 1934. Helped organize **La Purisima Camera Club**, 1938.

1934-42 – L – Two **Civilian Conservation Corps** camps at La Purisima (aka "Twin Camps") worked primarily on the restoration of **Mission La Purisima** (a property of California State Parks). Workers made adobe bricks, carved wooden architectural embellishments, re-painted murals, and in "school" studied art, crafts, mechanical drawing and photography, among other artistic endeavors.

1935 – L – Mickey Mouse Club met at Lompoc Theater and manager **Earl Calvert** filmed the members.

1935 – L – **Margaret Fratis**, grad. Lompoc High School. Went on to study art in Los Angeles and to work as a designer.

1935, 1936 – L – **Carl Vinton Young**, Treasury Department employee at the CCC, taught art and painted easel works and murals at Mission La Purisima before going on to a career as an art teacher in San Bernardino.

1935-38 – L – **Ruby Parker**, Lompoc High School grad. 1931, returned to teach Domestic Arts, specializing in handwork.

1937+ – L - **Loiz Lord** (Rhead / Huyck), ceramist, formerly of Santa Barbara but later resident of the Midwest and East Coast, came to Lompoc to care for her aged mother and lectured to local clubs on her art. She later settled and married.

1938 – L – **Camera Shop** moved to 106 East Ocean avenue.

1938-40 – L – **Margaret Morton** taught art at Lompoc High School.

1938+ – L – **La Purisima Camera Club,** was organized at **Ernest Brooks' Camera Shop**. It held monthly meetings with photo competitions on specific themes and an annual meeting with a yearly competition. Members created in all media: Black and white prints, color slides, motion pictures. Its meetings included speakers and demonstrators.

1939-40 – L – **Hazel Ferne Ruth (Berger)** taught art in Lompoc elementary schools.

1940 – Three **Lompoc High School** freshmen exhibited art in the fifth annual "Young America Paints" at the American Museum of Natural History, NY.

1940-Nov. – L – **Mrs. Viola Dykes**, art teacher from Santa Barbara, began teaching arts and crafts in Lompoc via the adult education program, first at the Alpha Club, then on the grounds of the high school, and finally in fall 1947 at the new Community Center. In 1953 she retired to Encino.

1941-April – L - **Henry Helmle** of the Index of American Design was commissioned to decorate the chapel walls at Mission La Purisima.

1941-Dec. 7 – L – The newly restored **Mission La Purisima** was dedicated as a state historic monument.

1932-1941 – Santa Maria

1930s – SM – **Santa Maria Elementary and Junior High Schools**. Main Street school was repainted in 1934 with SERA labor. Elementary school projects included puppets and posters. Circulating art teachers were Dorothy Green followed by Edna Davidson. Children exhibited their works at Public Schools Week. By 1936 Blochman School was receiving national publicity for its teach-by-doing method. In 1931 El Camino School was constructed as a grammar school but also took in all the city's "Junior High" pupils where woodshop and specialized classes in art were taught in preparation for high school. "Jr. High" art classes taught several subjects and media in a second story room. In 1931 woodshop students renovated toys for Christmas donation to needy children. In 1936 the **WPA** paid for handicraft recreation classes.

1930s – SM – **Santa Maria Union High School and Junior College**. Main art teacher continued to be **Stanley Breneiser** who also led the Blue Mask and the College Art Club. He contracted to bring several traveling art exhibits onto campus, initiated the *Splash* art magazine, and wrote articles on art education, using Santa Maria High School as an example, that were published in national magazines. His art students designed sets and costumes for high school plays, designed and provided illustrations for school publications (the newspaper, *Breeze*, the yearbooks, *Review* and *Mascot*, and the special art publication, *Splash*), and competed in the annual national Scholastic Art Exhibit, from 1930+. In 1935 students began creating puppets and putting on shows. That same year students were invited to exhibit at the Palace of Education at the California Pacific International Exposition in San Diego. The school added to its developing art collection (1937). In 1937 at Christmas, students transformed the two big windows over the stairway into a "stained glass" window. Top art students were Nicholas Firfires and Joffre C. Bragg. **Elizabeth Breneiser** taught arts and crafts c. spring 1928-1943. Domestic arts teachers taught other handcraft. Teaching woodworking through the decade was A. L. Merrill and metalwork, W. D. Harkness. In 1934 shop students built a Swedish loom for weaving. Art metal work at the end of the decade was taught by **Horace Schorling**. Mechanical drawing was taught on a regular basis. Student creations were displayed at the annual Public Schools Week. In 1936 there was a special Continuation School on campus that provided housing and taught girls domestic arts and boys primarily shop. Beginning 1938 and through WWII, the JC increased vocational classes in shop and offered aeronautics ground courses at Hancock Air Field.

1930s – SM – **Santa Maria Adult School**. In 1932 night school was temporarily abandoned for lack of funds. Resumed in 1934, the regular and long-running classes appear to have been woodshop under A. L. Merrill and metal shop under W. D. Harkness. In 1934/35 Louie Ewing taught an arts and crafts class followed by John Day Breneiser (1935/38) who introduced Mexican tin work. Leatherwork was popular. Classes in interior decorating, taught by Gaylord Jones, ran for several years. Starting 1939 H. O. Schorling taught a couple years of art metal work.

1930s – SM – **Setsuo Aratani** of Guadalupe fostered Japanese art and artists.

1930s – SM – **Minerva Club**. In 1934 it started a Handcraft Section to create interest and knowledge of what can be done in the home by means of handcraft at very little expense. 1935+ the Club sponsored several lectures on art at its monthly meetings. In 1940 it provided the site for a National Art Week show curated by S. Breneiser and comprised primarily of Santa Barbara (town) artists.

1930s – SM – **Community Club and Junior Community Clubs**. Sponsored at least one lecture on art each year. In 1937 it began an American Home Section. The same year, it consolidated the departments of art, drama and literature into one group called the "Fine Arts" department. In 1935 it co-sponsored an Art Festival in Santa Maria. In the late 1930s it could count several artists among its members including Hazel Lidbom who was handicraft chairman. In 1935 it organized a Junior Community Club for younger matrons with which it held many joint meetings. The Junior Club also sponsored occasional "art" lectures.

1930 – SM – **Elizabeth Mason Collison** sketched people in Santa Maria. She illustrated *Gin Chow's Farm* written by her husband (published 1932), and advanced to illustrating for the *Santa Barbara News*, 1933.

1930 – SM – **Kazuo Matsubara**, protégé of Setsuo Aratani, exhibited in Guadalupe and Santa Maria.

1930-34 – SM – **Dorothy Merritt Green** acted as art instructor for the Santa Maria Elementary schools.

1931 – SM – **Rex Hall**, Santa Maria High School grad. JC student (1932, 1933) who won art awards and went on to a career as an illustrator.

1931 – SM – **Brett Weston**, photographer, resided briefly in Santa Maria before moving to Santa Barbara.

1931 – SM – A traveling exhibit of work by students of the New York School of Fine and Applied Art was shown at Santa Maria High School.

1931 – SM – Santa Maria High School students exhibited in a county-wide student art exhibit at the **Faulkner Gallery** in Santa Barbara.

1931-33 – SM – **Chandler Weston**, photographer was active.

1931+ – SM – **Blochman City** was constructed and run by students.

1931-69 – SM – **Euland Payne** taught industrial arts at El Camino Jr. High School.

1932 – SM – **Art Kaiser**, photographer, took a giant (30 inches high and 18 feet long) color photo of the Santa Maria Valley with a special motor-driven 'circuit' camera. It was hung in the Santa Maria Valley Chamber of Commerce.

1932 – SM – **Robert Mason** (aka **Dwight Fred Stewart**), grad. Santa Maria High School. Became an artist in Los Angeles.

1932-36 – SM – **Wayman Parsons**, local architect, returned from a European tour with many watercolors, which he exhibited. In 1934 he designed the Santa Maria City and Town Halls.

1933+ – SM – **Archie Case**, Santa Maria High School art student, went on to major in art at San Jose State College and then to become an interior decorator in Ventura.

1933 – SM – Stanley Breneiser attempted for a second time the **Santa Maria School of Art**, a summer school run and taught by the Breneisers. Attendance remained disappointing.

1933-34 – SM – **Louie Ewing** studied art at Santa Maria Junior College. Taught arts and crafts at Santa Maria adult school (1934), married **Marrie Breneiser**, and the two soon moved to Santa Fe to pursue their art.

1933-34 – SM – **Leonard Fisher**, student at Santa Maria JC. Became an art instructor and coach in the Compton school system, 1937-73. In retirement he turned to painting landscapes.

1934 – SM – **Delphian Society** spent most of the year studying American and European art of the preceding 200 years.

1934 – G – **Ada Okamoto**, Santa Maria High School grad. Became an art major at University of California, Berkeley.

1934 – SM – **Nicholas Firfires**, Santa Maria High School grad. Went on to become a well-known painter of Western scenes.

1934 – SM – **Fritz Poock**, engineer working in Mexico, exhibited his work in Santa Maria.

1934-46 – SM – **John Stout** taught mechanical drawing at Santa Maria High School.

1934-60+ – SM – **Edna Davidson** of Lompoc who first taught art under the **Emergency Educational Program** in 1934 and was a member of the Alpha Club Art Section, 1933-36, also served as art supervisor of Santa Maria Elementary schools, c. 1937-57, and was active in art matters in both communities.

1935 – SM – **Rev. Horace Campbell** lectured on "Great Masterpieces of Art" at the Christian Church. Lectures occurred once a month over the year.

1935-Jan. – SM – **Art Festival** at Santa Maria City Hall, consisting of exhibits and lectures was sponsored by the Alpha Club, the College Art Club, and the Community Club.

1935+ – SM – **Byron Openshaw** excelled in art at Santa Maria High School, grad. 1935, and possibly studied art in Los Angeles. By 1938 he was listed in the *Santa Maria CD* as an artist. By 1940 he had transferred his activities to Santa Barbara, but by 1947 was back in Santa Maria and at one period used his artistic abilities with G&O Production Services. He exh. his paintings in Santa Maria by 1959.

1935 – SM – Artworks made by WPA artists **Ettore Cadorin** and **Marian Brackenridge** were installed in the Veterans' Memorial building.

1935 – SM – **Junior Community Club** for young women leaders of the community was formed. Worked in conjunction with the Community Club. From the beginning the juniors had a handcraft section.

1935-40 – SM – **Joffre Bragg**, exceptional art student at Santa Maria High School and friend of fellow art student Nick Firfires, went on to attend Otis Art Institute in Los Angeles, but his career was cut short when he died in an auto accident in 1940.

1935-64 – SM – **Elizabeth Taff Dennison** taught home economics (with an emphasis on art) at Santa Maria High School, was a weaver, and had two daughters: **Elizabeth A. Dennison** and **Maryrose Dennison**, both of whom majored in art in college.

1936, 1938 – SM – **Grumbacher Traveling Exhibit** was shown in Santa Maria. It contained work by the Breneisers.

1936+ – SM – **George Utsunomiya** returned from schooling in Japan. After WWII he attended art school in LA but spent his career as a vocational instructor at the Federal Correctional Institute. While there he produced artwork, such as designs for theater sets, signs, and parade floats

1936+ – SM – **Hazel Lidbom**, a county employee, spent her life making and teaching arts and crafts.

1938-39 – SM – **Edna Baker** received mention in the newspaper for interior decoration and her artwork (painting).

1938-40 – SM – **Roy Jones** taught drawing at Hancock College of Aeronautics.

1938-44 – SM - **Hancock College of Aeronautics** was home to the Santa Maria Junior College "ground school" that taught drafting, among other things.

1938-60+ – SM – **Ted Bianchi** was founding member and later president of the Santa Maria Camera Club; his medium was motion picture film. For 37 years he was official photographer for the Elks rodeo and parade.

1938+ – SM – **Santa Maria Camera Club** formed.

1938+ – SM - **Harry Bell**, amateur photographer, began a nearly 20-year association with the Santa Maria Camera Club.

1938+ – SM – **Kenneth Moore**, amateur color photographer, helped found the Santa Maria Camera Club (1938), organized photography classes at Santa Maria High School (1947/48) and taught crafts and photography at Arroyo Grande High School (1947/48).

1938+ – SM – **Ernest Edwards**, amateur photographer, was active with the Santa Maria Camera Club.

1939-42 – SM – **John Feeley**, Santa Maria High School teacher. Sponsored the school Camera Club, 1941.

1939-55 – SM – **Bert Dinnes** was active with the Santa Maria Camera Club.

1939-58 – SM – **Joseph Sousa**, amateur photographer, was active with the Santa Maria Camera Club.

1939-60 – SM – **Bernard Karleskint** and sister **Mary Roemer** operated the **Santa Maria Camera Shop**. He was a founding member and active with the Santa Maria Camera Club, 1938+.

1939+ – SM – **Santa Maria Camera Shop**, prop. Bernard Karleskint and Mary Roemer, opened.

1939+ – SM – **Eugene Hoback**, woodcarver, raised in Orcutt, traveled to Hollywood to seek work related to his art.

1939+ – SM – **Yukio Tashiro**, Santa Maria High School grad. went on to become an artist in New Mexico and then a career artist with the U.S. Army and concurrently an independent book illustrator.

1940 – SM – **National Art Week** exhibit at Minerva Club library showed work by Santa Barbara artists.

1932-41 – Santa Ynez Valley

1930s – SY- **Santa Ynez Valley Elementary Schools** – students created "art" in conjunction with academic subjects; they also made posters and puppets.

1930s – SY – **Santa Ynez Valley High School** student body was too "small" for the school to afford specialized teachers or provide specialized "appreciation subjects" like music and art. By 1931 it did offer mechanical drawing, and the home economics teacher taught free hand drawing and some crafts as well as poster making. In 1936 the school opened in new, modern building that contained murals painted by a Santa Barbara artist paid by the WPA. It also ran a satellite school for the CCC boys at Los Prietos. In 1937 it hosted the traveling exhibit of the Colonial Art Co. producers of fine art reproductions.

1930s – SY – **Solvang Woman's Club** had at least one lecture a year on various media (square knotting, landscape gardening, flower arranging, finger painting, handcraft) and contributed Danish weaving and yarn pictures to a woman's club convention in Santa Barbara in 1934.

1931+ – SY – **George Erwin** taught mechanical drawing at Santa Ynez Valley High School, 1931, 1934.

1932-35 – SY – **Mary / Mae Gladys Johnson** taught freehand drawing at Santa Ynez High School

1932+ – SY – **Joseph Forsyth**, painter, photographer, retired to a ranch in the Santa Ynez Valley where he raised walnuts and contributed artistically to the valley until his death in 1957.

1933 – SY – **Soren Sorensen** purchased the property on which he built, over the years, a folk art environment (house and retaining walls) of rocks.

1934 – SY – **Louise Chrimes** moved to the Santa Ynez Valley and, over the years until her death, created needlework and crafts, ran the **Tank House Studio** in Ballard that sold hand-made items, many by her (c. 1947-49), designed various items for various local organizations including the **Midland School**, and ran the **Crafts Shop** in Ballard (1954).

1935-Mar. – SY – **Art Loan Exhibit** was held by Woman's Missionary Society at Legion Hall, Solvang.

1935-38 – SY – **Margaret Conneau** taught homemaking and fine arts at Santa Ynez Valley Union High School.

1935-42 – **Irene Fagin**, as agent for the Home Department of the State Farm Bureau, taught some "artistic" subjects, such as needlework and interior decoration.

1935+ – SY – **Ellen Hanchette Taft Gleason** moved to the Santa Ynez Valley and participated in photography exhibits there and in Santa Barbara for many years.

1936 – SY – **Lyla Harcoff** of Santa Barbara painted a mural in the newly constructed Santa Ynez High School under WPA.

1936+ – SY – **William Bowen**, a resident of Santa Barbara in the mid-1930s, sketched in the Santa Ynez valley (Jan. 1936). He taught lettering at Lompoc Adult School, 1939 and later pursued his art in San Francisco and the Los Angeles area.

1936-42 – SY – The school at the **Civilian Conservation Corps** in **Los Prietos** taught, among other things, mechanical drawing and metal work.

1936-59 – SY – **Danish Days** celebrated Solvang's Danish heritage with food, music, dancing, and a parade; it also had an exhibit of heirlooms lent by local families.

1937 – SY - A traveling exhibit of fine art reproductions of famous paintings circulated by the **Colonial Art Co.**, was exhibited at the Santa Ynez Valley Union High School.

1937 – SY – **Lenora Anderson** was active first as a grammar school teacher. From 1950-c. 1954 she taught crafts at Santa Ynez Valley Adult/Night School. From 1950-1956 she taught English as well as Arts and Crafts at Santa Ynez Union High School.

1940 – SY – **Clifford Powers**, Santa Ynez High School grad. Served in WWII, studied at Santa Barbara College, then taught drafting and general shop at Lompoc High School 1954/57.

WWII

Looming entry into World War II led to America strengthening its military forces. The country was already retooling manufacturing plants and producing planes and bombs to support France and Britain on the European front. But, by c. 1941 in California it began purchasing large acreages for military bases. The California National Guard was strengthened. The sudden demand for workers in aircraft plants, including draftsmen, prompted schools across the nation to ramp up their classes in skills that would be useful in wartime such as mechanical drawing, drafting and photography. Many artists in larger cities who had been supported by government aid projects were weaned off. Some became draftsmen at airplane factories, or teachers of drafting. Some made war posters. Some others, who were drafted, found artistic employment in one of the several areas of the military, such as Special Services (that produced training aids and handled publicity) and the Signal Corps (that took photographs). A privileged few artists were hired by the military to document the war in paintings. Artists who remained on the home front and who continued to produce found it difficult to obtain raw materials, since the war got priority. "Fine Art" productions and exhibitions, considered a luxury and non-essential to the war, were reduced or eliminated altogether.

1939-44 – **Hancock College of Aeronautics** at Santa Maria trained pilots under contract with the U. S. Army Air Force, and the Santa Maria junior college "ground school" there taught tasks including drafting.

1941 – **Santa Barbara Museum of Art** was opened in the repurposed Post Office. Over the years, a few northern Santa Barbara County artists exhibited in its shows, particularly in the post-WWII Tri-County Art Exhibit.

1941 March – U. S. Army acquired approximately 86,000 acres of land in the Lompoc-Guadalupe-Santa Maria triangle and later named it **Camp Cooke**. Construction of buildings commenced in September. The incomplete camp was dedicated on 5 Oct 1941, administration put in place, and armored divisions began arriving for training early in 1942.

1941-Dec. 7 – Japanese bombed **Pearl Harbor**, Hawaii.

1941-Dec. 8 – US declared war.

1941-46—The national **USO** was founded Feb. 4, 1941 to service the on-leave recreation needs of members of the armed forces. In northern Santa Barbara County, there were centers in Lompoc, Surf, and Santa Maria.

1942 – **Santa Maria Army Air Base** was activated as a field SSW of Santa Maria, but it was not highly used during WWII because its runway was on unfirm soil. [Do not confuse with Hancock Airfield that was located closer to downtown Santa Maria and taught pilots.]

1942 – The many Japanese who farmed in northern Santa Barbara County, including some artists, were relocated away from the coast. The lack of hands to work northern Santa Barbara County's many farms was solved by using women and children, alien soldiers in local prisoner-of-war camps, and imported Mexican farm hands.

1942-Dec. – **WPA** projects closed, and some of its recreation programs (such as those for soldiers) were absorbed into military budgets.

1942-47 – **Florence Spaulding** served as Santa Barbara County Home Demonstration agent for the State Farm Bureau.
1944-April – Camp Cooke was designated a camp for German Prisoners of War. First group arrived June 16.
1945-May 8 – V-E Day in Europe – **WWII** ended in Europe.
1945-Aug. 15 – V-J Day in Japan – **WWII** ended in the Pacific.
1946 June – Camp Cooke was closed.

WWII
Artists and Photographers
Across America, art was considered a luxury and thus "non-essential" to war interests. Civilian art production decreased while, ironically, the military found many uses for art both in running stateside bases and for producing propaganda. It even hired some artists to go to war fronts and depict scenes they viewed.

Schools. All schools had to adjust their art projects to materials available in wartime. Themes about the war became relevant. The American Legion Poppy poster contest for school children, in which northern Santa Barbara county students began competing in the very late 1920s, continued during WWII and after. Elementary schools continued utilizing various forms of "art" to supplement their teaching of selected academic subjects. Upper-level schools in northern Santa Barbara County (High Schools, Junior Colleges, Adult Schools) maintained their established curriculum but ramped up classes that could help the war effort. These included mechanical drawing and drafting as well as vocational classes, such as woodworking, metal shop, and welding. Most of this higher-level teaching appears to have been in Santa Maria. At Santa Maria High School, art students continued with their usual practical projects of aiding theater productions with set and costume design, producing the school yearbook, working on crafts (leather, batik), and exhibiting their products during Public Schools Week. But, the school had a teacher of photography, J. Miles Booth (1945+). Its Junior College arm set up a special "aeronautics" program whose classes were taught in buildings at Hancock College of Aeronautics at Hancock Field. Offered were a full slate of aeronautical ground skills, including drafting. At Santa Maria's adult school, woodwork remained a favorite class, but to support the war effort new classes were offered in airplane drafting taught by a series of short-term teachers. Photography was added in 1943, taught by J. Miles Boothe, who continued to teach for many years. Crafts, also, were added in 1943. In 1944, blue print reading and mechanical drawing tailored to oil field workers became a new course. Local high school grads who went on to art careers included: in Lompoc: Richard Harris and Evelyn Costa; in Santa Maria there was Ruth Dowty, Leslie Stonehart, Jr., Howard Plumm, and Mary Marshall.

Recreation Programs. While the recreation programs funded by the Federal projects of the 1930s were phased out, their legacy remained. Certain towns, such as Lompoc, voted civilian budgets to continue recreation – including summer classes for children that taught both sports and crafts (1940+). In 1940 Viola Dykes was hired under the adult school to teach handicrafts, a task she continued for more than ten years. During the war years some of her students were wives of servicemen. Along with lampshade making she also taught pottery, hinting at the popular movement to come. Santa Maria, in 1941, turned its old city library (Carnegie) into a recreation center, and organized a Recreation Commission in 1942, but during WWII the building became a USO for servicemen from Santa Maria Army Airfield. In 1943, the city began a "Day Extension" program of handcrafts for children at Main Street School.

Women's Clubs. In Lompoc the Alpha Club continued some art programs but it seems to have had dwindling attendance in its Art Section because that was combined at various times with other sections. The Alpha Club also co-sponsored and held a tea in conjunction with an exhibit of artwork circulated to USOs by the Museum of Modern Art, N. Y. (1945). In Santa Maria, the Minerva Club still held occasional lectures on art as well as demonstrations of handicraft at its monthly meetings, but they were greatly reduced. Clubwomen, during the war years, turned their efforts to war. Some taught handicraft to recuperating soldiers at the Santa Maria Hospital. Other clubwomen knitted or sewed clothing for soldiers at the front or for refugees. Solvang Woman's Club held an occasional lecture on art or handicraft.

Military – Camp Cooke (including USO's) – In the fall of 1941 on the newly purchased Camp Cooke property, buildings were constructed and management put in place. In early 1942 the first soldiers arrived for training. Many inductees proved to have artistic talents, and the army employed them for several useful military needs. (In this study, data on artists and photographers at Camp Cooke is limited because the Camp newspaper, the *Clarion*, focused more on military subjects than human interest.) Generally, persons with artistic talents were assigned to units like Special Services that included Public Information or, if they were photographers, to the Signal Corps. Military artists made maps, and designed signs, posters, and training aids plus other publications. Official camp photographers on the home front took portrait and identification photos, documented camp life, and took photos for camp publicity. On the war front photographers took still photos and films for both aerial reconnaissance and historical documentation. Some military personnel who were not employed as military artists but who had been artists in civilian life gave themselves the self-appointed tasks of creating cartoons for military publications, decorating post recreation halls with murals or taught art to other servicemen at service clubs or USOs. Some amused their fellow soldiers by sketching portraits. Soldiers who created art or handicraft competed in the several camp, or military, or private sector contests for cartoons, posters, art, or photography. Maintaining soldier morale during off duty hours was important and thus the military had an extensive recreation program both at base Service Clubs as well as the USOs in Lompoc and Surf that included classes in handicrafts and photography and occasionally "fine art." At the Lompoc USO a kiln to fire ceramics was acquired by 1945. As for photography, the military had many uses for it and utilized both those inductees who had experience by working in photography as well as others who showed an aptitude for it and could be taught. Backgrounds of military photographers ranged from individuals who had worked for Hollywood studios, or those who had been commercial photographers in their home towns, or even free-lance newspaper and magazine photographers. Inducted recent high school graduates who had the raw talent were sometimes trained by the military to be photographers. Many servicemen enjoyed photography as a hobby. Personal cameras and equipment were allowed on bases, as long as they were registered and as long as soldiers did not photograph militarily sensitive subjects. The Lompoc USO had a photography Club. As for the Santa Maria Army Air Base, information is minimal, and the small, local USO may have only provided a reading room, etc. Local soldiers were bussed to Lompoc USO for dances and may have used the Lompoc USO for aesthetic needs as well. **Milford Zornes** (who is strongly identified with Santa Maria although his parents lived in Nipomo) stands out as a major war-artist, one of a selected few watercolor painters hired by the military to paint images of activities on various war fronts.

<u>Infrastructure</u>. Art was generally considered "non-essential" during the war, although some people argued that art exhibits were important for morale since they raised the spirits of those who viewed them. Art exhibits almost completely disappeared. The Santa Barbara County Fair went "dark" for the war years. Women's clubs did not mount or sponsor art exhibits (except for the Alpha Club that co-sponsored a traveling exhibit at the USO in 1945). Schools also seem to have reduced or curtailed Public Schools Week and its related exhibits. The USOs occasionally held exhibits of soldier-created handicrafts or photography.

<u>Photography</u>. Civilian photographers in all of northern Santa Barbara County's towns continued to run businesses. As for photography clubs – La Purisima in Lompoc appears to have lapsed, but notices on the activities of Santa Maria Camera Club continue strong through the war. The latter "taught" its own members the subtleties of black and white photography, 35 mm color slide photography, and films. Several graduating high school seniors who entered the military took up photography, either to become aerial reconnaissance photographers or to work in ground-based laboratories. After the war, some became commercial photographers. At Lompoc's USO there was a photography club that interacted with local photographers. The Lompoc Police installed a photo plant to process photos of finger prints as well as crime and accident scenes. In Santa Maria, John Feeley, High School teacher and amateur photographer, sponsored a school Camera Club, 1939-42. following sporadic teaching of photography, J. Miles Boothe, a long-time member of the Santa Maria Camera Club, taught photography in Adult school at least by spring 1943 running to c. 1955.

WWII – Lompoc / Camp Cooke
WWII – L – **Lompoc High School**. Main art teacher was **Crystal Lund**. Posters had war themes.
WWII – **Alpha Club** – many of the members of Viola Dykes' adult school class on crafts were also Alpha Club members. Although war was on, the Art Section continued a full slate of meetings. Possibly reduced membership in the Art Section led to combining it with the Literature Section (1943) and decreased programs for art. By 1945 the Art Section had joined with the Music Section, and for a couple of years art topics were European. The Alpha Club co-sponsored and held a tea in conjunction with an exhibit of artwork circulated to USOs by the Museum of Modern Art, NY (1945).
WWII – L – **Margaret Heiges**, amateur filmmaker, showed her films of Mexico and Alaska to local groups.
1940-53 – L – **Viola Dykes** taught crafts to civilians and to officer's wives under the auspices of the **Lompoc Adult School** (first at the Alpha Club, then at the High School, and finally at the Community Center). By 1941 she had added pottery work. Her specialties were lampshades, upholstery, ceramics, general crafts.
1940+ – L – **Summer School** for children (including crafts) was first held, then continued with various sponsors and at various sites to the present.
1940s, 1950s+ – **Al Taylor**, amateur photographer, was active with the Santa Maria Camera Club.
1941-46 – L – **Camp Cooke** housed many artistically talented soldier artists – some only briefly during military training and others stationed for longer terms – and utilized their artistic and photographic skills in both Special Services (handling public relations, designing camp posters and brochures, etc.) and the Signal Corps (photography). (Information on these artists is minimal since the camp newspaper rarely featured "art" news.)
1941-47 – L – **Harry Buckman**, flower grower and camera buff, took many films of Lompoc events which he projected for various clubs.
1941+ – L – **Leonard Reed**, Lompoc High School grad. learned photography in the Navy in WWII, during which stint he photographed the atom bomb blast on Bikini atoll, and later pursued the career concurrent with his avocations of rocketry and aeronautics.
1942 – L – **(Charles) Richard Harris**, born in Lompoc but raised primarily in Whittier, painted portraits of the presidents of Whittier College on commission.
1942 – L – About this date **Lompoc Police** installed a photography plant, using the medium to help solve crimes. **Richard Smith** was in charge.
1942-46 – L – Foresters Hall was dedicated as a **United Service Organization** center for soldier recreation. Sporadically it had classes in arts and crafts and a photography club. By 1945 it had acquired a kiln to fire ceramics. Occasionally, when soldiers with art backgrounds were stationed at Camp Cooke and took the time to organize them, the USO was the site of sketching classes or art exhibits.
1943 – L – **Evelyn Costa** won a scholarship to California College of Arts and Crafts, Oakland.
1943 – L – **Wilfred Hardy**, photographer with the Camp Cooke photo section, exhibited (at the Lompoc Library) his photos of western Indian tribal chiefs, hand colored by his wife, **Eva Drankow Hardy**.
1945 – L – **David Carman, Pfc.**, painted a mural at Camp Cooke. And his fellow soldier-artists were **Addison Walker, Jeff Lewis**, and **Ralph Winter**.

WWII – Santa Maria
WWII – SM – **Santa Maria Elementary School** – circulating art instructor was **Edna Davidson** whose students enjoyed drawing landscapes, stenciling, and making maps. In **Junior High** (El Camino School) students created dioramas as well as complex designs and modernistic drawings. In 1943 a **Child Care Center** that included handcrafts was added at Main Street School taught by **Louise Whitteker**.
WWII – SM – **Santa Maria High School and Junior College** – by 1938 the JC added aircraft design and drafting and some aeronautics and shop courses were moved to classrooms at Allan Hancock Air Field. Art students under **Stanley Breneiser** continued with their usual projects of aiding theater productions with set and costume design, producing the school yearbook, working on crafts (leather, batik), learning "fine art" and exhibiting products during Public Schools Week. A photography unit was under **J. Miles Boothe** (1945+).
WWII – SM – **Santa Maria Adult School** – Woodwork remained a favorite class, but to support the war effort, by 1941 new classes were offered in airplane drafting taught by a series of short-term teachers. Photography was added in 1943, taught by **J. Miles Boothe**, who continued to teach for many years. Also added that year was crafts which was largely attended by housewives. In 1944, blue print reading and sketching tailored to oil field workers was added.
WWII – SM – **Santa Maria Hospital** – Hazel Lidbom taught handicrafts to recuperating soldiers.
WWII – SM – **Minerva Club** – continued to hold an occasional lecture on art.
1938-44 –SM – The **Santa Maria Junior College** ran an aeronautical "ground school" next to Hancock College of Aeronautics where it taught "art," such as drafting.
1940s – SM – **Rolla Houston**, amateur photographer, was active with the Santa Maria Camera Club.
1940s – SM – **Dave Kaukonen** was active with the Santa Maria Camera Club.
1940s-late, 1950s – SM - **Vernon Houghton**, photographer, was active with the Santa Maria Camera Club.

1940 – SM – **National Art Week** exhibit of Santa Barbara artists was held by the Minerva Club.

1940+ – SM – **Adams Studio of Photography** was run by **Ralph Adams**, also a magician.

1940-41 – SM – "**Santa Maria Sketches,**" a series of single-frame cartoons by **Will Danch** (not a local resident) featuring people and events in Santa Maria, were run in the *Santa Maria Times*.

1941 – SM – **Ruth Dowty**, grad. Santa Maria High School. Studied art at San Jose State.

1941 – SM – **Leslie Stonehart, Jr.**, studied art at Woodbury college. Later he attended Chouinard Art Institute and Hollywood Art Center, both in Los Angeles, served in WWII, worked briefly for Warner Brothers Studios, then, in 1947 returned to Santa Maria to join his parents in their photography business, Stonehart Studios. He opened his own photography studio in Solvang, 1947, briefly, then returned to work with his parents.

1941-44 – SM – **George Heath**, amateur photographer, was active with the Santa Maria Camera Club.

1941-45 – SM – **Community Club** – its attention focused primarily on war support.

1941-55 – SM - **Jimmie Johnson**, amateur photographer, was active with the Santa Maria Camera Club.

1941+ – SM – **Owen Lightfoot**, house painter, painted easel pictures of Western scenes by 1950.

1941+ – SM – Santa Maria converted its former City Library into a **Recreation Center,** the interest in government sponsored recreation being an outgrowth of recreation classes offered by the EEP and WPA in the 1930s. In 1942, a Recreation Commission was organized and a Recreation Director named. During WWII the Center became a USO.

1942-46 – SM – **United Service Organization** – club rooms in the former Carnegie Library were used primarily for relaxation and unlike other USOs did not emphasize arts, crafts or photography. Soldier/students were bussed to Lompoc for dances.

1942+ – SM – **Howard Plumm**, grad. of Santa Maria High School, served in WWII, became an art major at San Jose State College and went on to teach art and to privately produce paintings.

1943 – SM – **Mary Marshall** grad. from Santa Maria High School. Became a commercial art major at Vassar.

1943 – SM – An exhibit of the paintings by **Esther Wood Schneider** was put on by her widower, Gustavus Schneider.

1943/45 – SM – **Myrtle Lange** taught arts and crafts at Santa Maria High School and crafts at Santa Maria Adult School.

1944+ – SM – **Elk's Club** sponsored a charity **Rodeo**. This evolved into an annual event and grew elaborate with posters, window decorating and a parade that both utilized and inspired artists and photographers.

1945-Sept. to 1953-Sept. – SM –**University of Southern California College of Aeronautics** leased (?) Hancock College buildings, and had its first class graduating in 1949.

1943-circa-55 – SM – **J. Miles Boothe** was a member of the Santa Maria Camera Club from its start in 1938, and he also taught photography at Santa Maria Adult/Night School, 1943+.

WWII – Santa Ynez Valley

WWII – SY – **Santa Ynez Valley Elementary School** – students continued to make various forms of art in relation to academic subjects like history, etc. In 1942, Joseph Knowles "of the Santa Barbara Museum" provided art advice.

WWII– SY – **Santa Ynez Valley High School** – In 1942 art and mechanical drawing classes were added. Art was taught by **Theodora Corey** of the Domestic Arts class, and students made posters and various crafts. In 1944, **Leo Ziegler** began teaching "fine art" on a part-time basis.

WWII – SY – **Solvang Woman's Club** – held an occasional lecture on art or handicraft

1940s-1950s – SY – **Vern Parker** painted murals and carved signs in the Santa Ynez Valley.

1941+ – SY – **Leo Ziegler** taught art to various entities privately (1941+), part time at Santa Ynez Valley High School (1944+), at Adult School (1946-57), at Santa Ynez Valley Elementary (1947+) and at Valley Farm School (c. 1951+), lectured to local clubs, and exhibited in local art shows.

1941-60+ – SY - **Channing Peake**, residing on Rancho Jabali, a 1300-acre ranch near Buellton where he raised quarter horses, painted semi-abstracts and exhibited nationally.

1942/43 – SY – **Theodora Corey** taught Home Economics and Art at Santa Ynez Valley Union High School.

1942/43 – SY – **Lora Jones** taught mechanical drawing at Santa Ynez High School.

1943 – SY – **Ervin Rubey**, Santa Ynez Valley Union High School grad. Went on to a career in photography with the U. S. Navy.

Post-WWII ATOMIC AGE

GI's returned home. Just as in the aftermath of WWI, America burst from the constraints of WWII into frenetic activity to make up for the years of domestic deprivation. The immediate post-war years were marked by economic conflict – a baby boom, shortages of food and housing, worker strikes, but they also witnessed the first autos to come off the assembly plants since before the war. Fear of Communism arose along with the Cold War with Russia; UFO's were sighted.

1945-May 8 – V-E Day in Europe – **WWII** ended in Europe. ("German Surrender," *SMT,* May 7, 1945, p. 1.)

1945 – In the Pacific, through May, June, and July, American forces captured Okinawa and shelled Japan, and on Aug. 6 dropped a bomb on Hiroshima. Along the Chinese border, Russia took advantage of the chaos to expand its borders. ("Million Red Soldiers Invade Manchuria," *SMT,* Aug. 9, 1945, p. 1.)

1945 Aug. 15 – V-J Day in Japan – **WWII** ended in the Pacific. (Japanese Surrender signed, *SMT,* Sept. 1, 1945, p. 1.)

1946 June – Camp Cooke closed. On Cooke grounds, the United States Disciplinary Barracks was activated Dec. 1946. USOs were closed and the buildings repurposed by Lompoc and Santa Maria to be city recreation centers.

1949 – In celebration of California's Centennial the California Historical Caravan consisting of two busloads of historical artifacts stopped in Santa Maria, Guadalupe and Arroyo Grande.

Artists and Photographers

Art activity increased in the post-WWII environment. Residents of rural areas such as northern Santa Barbara County were less insular (thanks to increased ease of transportation and communication as well as war experiences), American artists returned to their "fine art" with a vengeance. Art materials, even those imported, soon became available. Ceramics, plastics, jewelry making and textile painting became popular. Artists in both San Francisco and New York broke with realism and came up with their own brands of non-objective Abstract Expressionism. (The modern trends became a popular subject for lectures as laic people struggled to understand them.) Many other artists updated themselves by compromise

– by keeping recognizable images but reducing them to flat designs. The most conservative formed clubs, intent on preserving academic painting and three-dimensionality. Post-war prosperity and new mechanical devices increased leisure time. To fill the hours, individuals sometimes took up art (either working as an amateur or as a professional) and/or were able to appreciate and patronize art, as museum goers and collectors. In northern Santa Barbara County, a number of persons took up painting as an avocation, but their painting styles (as of the writing of this book) are not known. It is logical they painted representationally with their own stylistic twist. To satisfy the public demand, art teaching in local schools expanded, particularly in the field of "fine arts." In handicrafts leatherwork prove popular in the ranch environment, but there also arose a fad for studio ceramics. Adult schools added "art" courses including "fine arts," crafts (including ceramics), and photography classes. In Santa Maria Jeanne DeNejer, active between c. 1945 and 1953 served as an art proselytizer. Venues for the exhibition of art and photography resumed or came into being, and a sufficient number of practitioners were interested in the various media to form art clubs.

Schools. The post-war baby boom soon necessitated the construction of new schools and allowed the separation of 6th, 7th, and 8th grade into Junior Highs where entry-level art and shop classes could prepare students for the more advanced work in high school. Elementary schools now had the benefit of a circulating art supervisor. Joseph Knowles, earlier employed as art supervisor for children by the Santa Barbara Museum of Art, started serving as County Supervisor for Art in Santa Barbara Schools (by 1948). He made many visits to northern Santa Barbara county towns to lecture to parents and to give art demonstrations to children. Noteworthy for Lompoc was the exhibit in 1948 of classroom artworks by Elementary School students at the Santa Barbara Museum of Art where their artwork was recognized as outstanding. In Santa Maria Edna Davidson served as floating art teacher. Notable was fifth grade teacher, Marie Sluchak, who taught her students movie making (her hobby). The class produced an 8-minute, 8 mm color film on American history. At El Camino (the Junior High) ceramics were popular. High Schools with their larger student load could now afford more teachers and to offer more specialized and a greater number of art and shop classes. At Santa Maria high school, long-time teacher Stanley Breneiser was replaced by local Jeanne DeNejer for one year and then Lompoc-based Delia Davis (Sudbury), supplemented with a second teacher for arts and crafts. The JC added to its curriculum a class on elementary photography (1948) and one on interior decoration (1949). In Santa Ynez, in spite of Santa Ynez Valley High School's relatively modest-sized student body, part-time Leo Ziegler taught "fine art," and the shop teacher and the domestic science teacher covered classes in mechanical drawing and arts and crafts. Harold Venske, teacher of mathematics and science, took photos and oversaw production of the school annual. Adult school. Americans' greater leisure time and desire for learning led them in larger numbers than ever to adult school. In Lompoc, Viola Dykes continued to teach a variety of crafts classes. Notable also was Forrest Hibbits' class in oil and water color painting held under the recreation department in 1948. Santa Maria had the largest adult school and its "art" classes varied from woodshop and welding to crafts, jewelry making, painting and photography. In Santa Ynez, Leo Ziegler, under the adult school banner, continued classes in landscape and still life painting. High School teachers of Domestic Arts taught arts and crafts. Popular subjects were leather craft, textile painting, copper tooling. In 1949 the Santa Ynez school board voted to buy a kiln for the firing ceramics. At USC College of Aeronautics at Hancock Field in Santa Maria, Robert Greene served as photographer (1946-48). North county high school grads who went on to art careers included: from Lompoc: Bob Scolari; and from Santa Maria: Elizabeth Dennison, Russell Manning, JoAnn Smith Wilson, and Margaret Giorgi.

Women's Clubs continued their interest in art both through special sections for art-oriented members as well as through lectures for the general membership. Those in Lompoc and Santa Maria opted into the national program of Penny Art Fund. In Lompoc the Alpha Club still had a special Art Section but it may have suffered low attendance because its meetings were merged with the club's other "artistic" sections. The club had frequent programs by local artist Forrest Hibbits and by itinerant educator Joseph Knowles. In 1946 the Alpha Club garden group started a fall Flower Show, where, in 1948, 1949 and 1958, art shows were held. Lompoc also formed a new woman's club – the Lompoc Community Woman's Club – and it stood out for its great interest in art. In its first year, winter 1947/48, it sponsored an exhibit of work by Forrest Hibbits as well as a hobby show and also invited top "art" speakers including photographer Ernest Brooks. In Santa Maria the Minerva Club, the Community Club and the Junior Community Club reduced their "art" interests to occasional lectures, and those were less on the "fine arts" than about antiques, interior decorating, flower arranging, landscape designing, and art education in the schools. In 1949 the Community Club held the first of three Art and Hobby shows. The Solvang Woman's Club held a flower show and art exhibit in 1945, and a flower show possibly accompanied by a hobby show in 1946. In 1947 it sponsored a home tour. And in 1948 and 1949 it held programs on arts and crafts and Danish antiques.

Recreation. Lompoc organized a Recreation Commission, 1946. While Santa Maria formed a Recreation Commission in 1942, newspapers only begin to use the term "Recreation Department" about 1947. Both towns repurposed former USO buildings as city recreation centers. Nationally city recreation departments usually provided a year-round center as well as summer schools that offered sports as well as arts and crafts – to children as well as adults. Classes and programs taught at Community/Recreation centers were sponsored sometimes by the Recreation Department, sometimes by the school systems, and sometimes by private entities such as women's clubs and youth clubs. Class products were shown at art and hobby shows, etc.

Ceramics had grown in popularity from the 1930s. In California, especially, there naturally occurred excellent clays of many types as well as minerals to create interesting glazes. In the 1930s the state witnessed the proliferation of manufactories (both commercial and home industries) most located in the greater metropolitan centers of Los Angeles and the Bay Area, that designed and made dinnerware as well as slip cast figurines in molds for the popular market. By the 1940s, studio ceramics, i.e., one-of-a-kind wheel-thrown pottery made by artisans in private studios became the new trend. Particularly after WWII Northern Santa Barbara county espoused the medium. For years, school children had been forming and baking figurines and other items. In Lompoc in 1940 Viola Dykes began teaching ceramics in adult school, and the town had several practitioners some of whom ran shops that sold ceramic products and taught the medium (both wheel-thrown and slip cast). In Santa Maria ceramist Jeanne DeNejer taught privately at her home, DeNejer Studio, where she had a pottery kiln. After studying at Pond Farm with the famous potter Marguerite Wildenhain (summer 1949) DeNejer brought the Wildenhains to Santa Maria to give demonstrations (Nov. 1949). Her exceptional talent led her to move to New York c. 1953. Ceramics were also taught at all levels of Santa Maria schools, and the Junior High even owned a kiln. Darling Ceramics run by Herbert and Ivy Nickson exhibited its products at the Santa Barbara County Fair (1946) as did Audrey Chappell (1949). In the Santa Ynez Valley, in 1949, the school board voted to purchase a kiln.

Infrastructure. Before the post-WWII period, organizations for the "arts" had been few and far between. Standouts were the College Art Club of Santa Maria High School, active from c. 1922, the various Art Sections of women's clubs, as well as the Camera Clubs both in Lompoc and Santa Maria, founded c. 1938. After WWII in Lompoc, in 1948, both a Civic Theatre (for stage performances) and a Film Council, were

formed. In Santa Maria, in 1945, Jeanne DeNejer, along with some of her private art students, started the Santa Maria Art Association. Art exhibitions resumed or were newly instituted. Throughout the county public schools mounted displays of student products at various times and during Public Schools Week. Often an art exhibit was held in conjunction with another celebration. For example, in Lompoc an art exhibit was held in 1948, 1949 and 1958 along with the Alpha Club fall Flower Show. The Lompoc Community Woman's Club sponsored a one-man show of Forrest Hibbits (1947). Santa Maria resurrected the Santa Barbara County Fair in 1946. At first, Fair "artistic" offerings were the pre-war mainstays – flower displays and Domestic Arts (cooking, table arrangements, and needlework). In 1946 the fair included a small ceramic display by the Nicksons set up in the floral booth. "Fine arts" first appeared in 1948 with a small display of paintings arranged by Jeanne DeNejer and her pupils, again in a corner of the floral booth in the main tent. There was no official "Fine Arts" category until the mid-1950s but each year up to that time a variety of one-time displays of art and photography organized by interested parties appeared. In Solvang the Woman's Club held a flower show and art exhibit in 1945 and a flower show and hobby show in 1946. Antique collecting had always existed on a low level from the time of the first European arrivals into the area, the first areas of interest being the preservation of items handed down from ancestors. Others scoured the local hills to build collections of Indian relics. It was the higher standard of living in post-WWII times that gave the average person the money and leisure to start their own collections of items other than the standard coins, stamps, etc. Hobby shows (composed of either collected items or created items) after WWII became larger and the displays more historically significant. In 1949 in Santa Maria, the Community Club held the first of its three hobby and art shows (1949, 1950, 1952). Collectors increased sufficiently to support stand-alone Antique shops, such as the Americana Shop (1948-50) in Santa Maria.

Santa Ynez Valley. Whereas both Lompoc and Santa Maria were relatively large towns and tended to be "commercial" in their dependence on income from the military or oil or farming, the inland Santa Ynez Valley remained picturesque and rural, an area of large and small ranches. Even before the end of WWII, the Valley had provided a popular second home for artists from larger California towns (particularly Santa Barbara and Los Angeles). After WWII this trend only escalated. The Valley's main town was Solvang whose Danish heritage led it to foster Danish arts and crafts. Circa 1947 the town discovered its potential for tourist dollars, adopted the Danish provincial style of architecture, and many of its shops began retailing arts and crafts. Solvang also could boast nearby Mission Santa Ines, restored over the years by the Catholic church, which also owned a collection of historic church artifacts and artwork. In Buellton in 1949 there was serious talk of starting a Displaced Persons Colony for European refugees having handicraft skills, although it failed because local Veterans feared job competition.

Resident, full-time artists. From the time of the first settlers in north county, people of artistic talent, particularly women who had higher education or who enjoyed a comfortable economic bracket, expended their "sensibilities" by producing art. Men with art talent practiced it outside their main professions. Occasionally there happened to be a high school graduate with superior artistic talent. He/she usually moved to a large town to further his/her art education or pursue a career. Before 1950, the best-known artists who pursued art full time locally were the extended Breneiser family of Santa Maria that was active 1922-1950. After WWII northern Santa Barbara county began to develop and keep its own "art stars." In Lompoc, and later in the Santa Ynez Valley, Forrest Hibbits, retiree from a career as a commercial artist in the Bay Area, supported himself running an art shop/gallery while he exhibited his artwork throughout California. In Santa Maria ceramist Jeanne DeNejer was active (c. 1945-52) although she eventually moved to NY, and Alice Linsenmayer produced and taught art wherever her minister-husband was assigned. Santa Maria had even become large enough to support a full-time commercial artist, not just the house painter/sign painter combinations of earlier years. He was Roy Potter. In the Santa Ynez Valley Channing Peake, a rancher, painted in the modern vein and exhibited both in the town of Santa Barbara and beyond. Also to be mentioned is western painter Nicholas Firfires. Several professional artists from outside the area, including some from Santa Barbara as well as Hollywood, acquired small ranches in the picturesque Santa Ynez Valley, and produced art locally.

Photography. Photography blossomed as a medium after WWII. Commercial photographers continued to take "important" photos such as portraits for school yearbooks, official family portraits, and wedding photos. Each town could boast one or two full time commercial photographers. In Lompoc The Camera Shop (now run by Tommy Yager) as well as B&B Studio were probably the two largest. In Santa Maria Stonehart continued, along with others. And Solvang had Solvang Photo Shop. At most of the area's high schools as well as at Santa Maria Junior College classes in photography were taught. Its importance as a career (commercial photography, news and sports photography, military spy photography, Hollywood photography, aerial surveys, etc.) was recognized. Many military personnel who had been active with photography units during WWII, turned to a civilian career in photography. As for private individuals using photography as an artistic medium, there were many, and they continued to hone their skills in camera clubs, in adult school courses, and from syndicated "how-to" columns for photography printed by the local newspapers. A newly popular medium was color film (both 16 and 8 mm). Aficionados of filmmaking started the Lompoc Film Council (1948). Photographers exhibited at the Santa Barbara County Fair as well as at several of the smaller, one-time art or hobby exhibits held either by civic organizations or camera clubs (some out-of-county). Amateur photographers who took travel photos sometimes showed them to local clubs. Located in Santa Barbara but frequently active in north county was Ernest Brooks, formerly of Lompoc, but now of Brooks Institute of Photography in Santa Barbara. He and his teachers often traveled to the northern part of the county to teach, advise, and judge work produced by local amateur cameramen. Several northern Santa Barbara county photographers boasted of having studied at "Brooks."

Post-WWII – Lompoc
1945+ – L – **Lompoc Elementary School and Junior High** – Joseph Knowles out of Santa Barbara acted as art consultant. The post-war baby boom demanded additional school buildings, but the Junior High (designed 1949) lacked funding and was not constructed until 1953.
1945+ – L – **Lompoc High School** – Several short- term art teachers, including Margaret Hodgdon, oversaw the long-established curriculum of students attending a series of increasingly sophisticated art classes, to make posters, to design sets and costumes for school plays, and to design the yearbook.
1945+ – L – **Lompoc Adult School** (a program of the High School) – **Viola Dykes** continued her classes in arts and crafts increasing emphasis on ceramics, only ending them when she retired c. 1953.
1945 Fall – L – **Virginia Murray** taught art at Lompoc High School.
1945-49 – L – **Alpha Club** – An Art Section continued to meet but possibly, because of attendance, merged with other of the club's sections including music. Mrs. Charles Maimann was leader and the group discussed European arts of various kinds but, by fall 1946, had returned to American themes. There is first mention of the Penny Art Fund. In 1947 Forrest Hibbits was commissioned to paint a landscape for the clubhouse. In 1947 the Art Section joined with the Junior Alphas to study finger painting and handicrafts and hear

Joseph Knowles. In 1948 the Art Section studied the work of north county artist, Channing Peake, as well as modern art, and held some joint meetings with the Lompoc Community Woman's Club. In 1949 Mrs. Arnold Brughelli spoke on contemporary art. Handicrafts were covered by Mrs. Viola Dykes and Mrs. Loiz Lord Huyck.

1946-Spring – L – **Margharite Colby** taught art at Lompoc High School.

1946 – L – An attempt was made to start a **Camera Club at Johns Manville**.

1946 – L – **Alpha Club** garden group started a <u>fall</u> **Flower Show**, focusing on chrysanthemums, and in 1948, 1949 and 1958, art shows were held in conjunction with it.

1946 – L – **Bob Scolari** grad. Lompoc High School. Went on to become a commercial artist, first in the Bay Area and then, after 1958, in Lompoc.

1946-51 – L – **Margaret Hodgdon** taught art at Lompoc High School.

1946-60+ – L – **Fred Keller**, photographer, was prop. of **B&B** Studio.

1946+ – L – **Ernest Brooks** opened **Brooks Institute of Photography** in Santa Barbara. Returned frequently to northern Santa Barbara County to advise and judge work of local camera club members.

1946+ – L – **United States Disciplinary Barracks** was activated Dec. 1946, became the **Federal Correctional Institution**, a medium-security prison run by the Federal Bureau of Prisons, Aug. 1959. It contained murals and c. 1960 had an educational program for inmates that offered mechanical drawing and vocational crafts such as painting and woodwork.

1946+ – L – **Lompoc Recreation Department**. The Recreation Commission was formed in 1946. The former USO, purchased by the City in Aug. 1947, was converted to civilian use. The Department sponsored summer classes for children and evening classes for adults (both of which included arts and crafts), at various venues, including its own Community Center. Notable for art was Forrest Hibbits' class in oil and water color painting in 1948.

1947-48 – L – **Ken Pollard** was president of the revived La Purisima Camera Club during its short run.

1947-54 – L – **Tommy Yager** worked for The Camera Shop then became owner.

1947+ – L – **Lompoc Community Woman's Club** was formed. It evinced a great interest in art. In its first year, winter 1947/48, it sponsored an exhibit of work by Forrest Hibbits as well as a hobby show and brought in top speakers including photographer Ernest Brooks.

1948 – L – **Elementary School** students made a field trip to the Santa Barbara Museum of Art where their artwork, voted outstanding in an exhibit of classroom art, was on view.

1948 – L – An art exhibit of paintings by **Forrest Hibbits** was co-sponsored by the Community Woman's Club and held in the Community center.

1948 – L – **Lompoc Civic Theatre** was organized and utilized artists to design and paint sets and sew costumes for productions, etc.

1948 – L – **Lompoc Film Council** members made their own films.

1948-50 – L - "**Camera Topics**," a syndicated "how-to" column on photography written by T. T. Holden was printed in the *LR*.

1948+ – L – **Elsa Schuyler** was active as an artist.

1949-50 – L – **Helen and Ina's** ceramic supply shop was in business briefly in a private home, one of several private ceramic businesses.

1949+ – L - **Lompoc Hospital Women's Auxiliary** enlivened the hospital atmosphere with paintings and short-term exhibits.

Post-WWII – Santa Maria

1945-49 – SM – **Santa Maria Elementary School and Junior High** – **Edna Davidson**, art supervisor, had the goal of teaching a number of different media, such as crayon, paints and clay, expended on practical projects, such as posters and murals. Notable was **Marie Sluchak**, fifth grade teacher, who taught her students movie making (her hobby). The class produced an 8-minute 8 mm color film on American history. Students' projects were exhibited at Public Schools Week.

1945-49 – SM – **Santa Maria High School and Junior College** – Stanley Breneiser, art teacher since 1922, retired and moved to New Mexico. His place was taken for one year by **Jeanne DeNejer** followed by **Verla Leonard** and then by **Delia Davis (Sudbury)** from Lompoc, supplemented with a second teacher for arts and crafts. The JC added to its curriculum a class on elementary photography (1948) and one on interior decoration (1949).

1945-49 – SM – **Santa Maria Adult School** – Adult school attendance increased, and in 1945 the school offered classes in woodshop (the most popular) and welding plus crafts, jewelry making, and painting. Crafts teacher, beginning fall 1948 was **Attilio de Gasparis** who taught leathercraft, metal crafts, plastics, and textile painting, among other media. In 1947 photography was taught by **J. Miles Boothe**.

1945-49 – SM – **Minerva Club** held occasional lectures on topics like interior decoration, landscape architecture, bird pictures, new trends in furniture, flower arranging, and American antiques. **Community Club** held occasional "art" lectures on such topics as glass collecting, and in 1949, 1950 and 1952 sponsored an Art and Hobby Show. The **Junior Community Club** heard lectures on art education and the artistic wrapping of Christmas gifts.

1945-49 – SM – **Santa Maria Recreation Department** – At the close of WWII it took back control of its recreation building (the former Carnegie Library) from the USO and began to offer typical civilian recreation classes (primarily sports and arts and crafts).

1945-52 – SM – **Arrow Photo** was run by Robert Stratton. After 1952 it was run by Henry A. Datter to c. 1955.

1945-46 – SM – **Wynn Bullock**, photographer of national repute, briefly co-owned a photography business in Santa Maria.

1945-47 – SM – **Kes Ovington** took color slides of vacation trips and projected them with narration for local clubs.

1945-48 – SM – **Darling Ceramics** was run by **Herbert and Ivy Nickson**.

1945-53 – SM – **Jeanne DeNejer** graduated from San Jose State College with a major in art (June 1945). Almost immediately she became a force for art in the community. In December 1945 she and her private art students formed the <u>Santa Maria Art Association</u>, and this group continued after DeNejer moved east in 1953. She taught art at Santa Maria High School, 1946/47, and privately at her home, DeNejer Studio, where she had a pottery kiln. After studying at Pond Farm with the potter Marguerite Wildenhain (summer 1949) she brought the Wildenhains to Santa Maria to give demonstrations (Nov. 1949).

1945-55 – SM - **Santa Maria Art Association** was active.

1946 – SM – **Elizabeth Dennison** grad. Santa Maria High School. Went on to major in dress design at U of C, Berkeley.

1946 – SM – **Russell Manning** grad. from Santa Maria High School. Served as a topographic artist with the military during the Korean War, and became a nationally known comic book artist.

1946/48 – SM – **Verla Leonard** taught arts and crafts at Santa Maria High School.

1946-48 – SM – **Robert Greene** served as photographer for USC College of Aeronautics at Hancock Field.

1946-48 – SM – **Roland Youtz** was active with the Santa Maria Camera Club, then became a student at the Brooks School of Photography, 1950. After service in the Korean War, he became an elementary school teacher in Camarillo and later principal of the Robinayre Acad.

1946-c. 1950 – SM – **Earl Stubblefield**, a photographer in the Navy in WWII, was active with the Santa Maria Camera Club and briefly operated Stubby's Sporting Goods and Camera Supply store.

1946-50 – Guadalupe - **Dave Carlin**, amateur photographer, was active with the Santa Maria Camera Club.

1946+ – SM & L – **Roy Potter** was active as a commercial artist.

1946+ – SM – **Santa Barbara County Fair**. Revived in 1946, Fair "artistic" mainstays remained flower displays and Domestic Arts (cooking, table arrangements, and needlework). 1946 also witnessed a small ceramic display by the Nicksons set up in the floral booth. 1947 boasted mural backgrounds by Nicholas Firfires in two booths as well as exhibits of Boy Scout and school art. Post WWII "fine art" seems to have received its first presence in 1948 with a small group display arranged by Jeanne DeNejer (who included some of her pupils as well as others from the newly formed Santa Maria Art Association) in a corner of the floral booth in the main tent. Art in Action demonstrations were given. School art was also shown, plus glass blowing. The Americana Shop showed antiques. The first permanent exhibition building went up. In 1949, in addition to the standard flower show and Domestic Art exhibit (needlework, etc.), there was an exhibit of the Santa Maria Art Association including art in action demonstrations, furniture created by students of Dunham Cabinet Shop, and an exhibit of ceramics by Audrey Chappell. Artists from the Artists Barn of Fillmore as well as the Brooks School of Photography had applied for booths. In 1950 the fair included the standard flower and Domestic Art exhibits. The Santa Maria Art Association planned a group exhibit, but it may not have come to fruition. DeNejer pottery showed work in the booth of Nelson Fuchsia Gardens. Joseph Knowles exhibited leather work in the Home Economics department.

1947 – SM – **Richard Scalf** invented a process that allowed photos to be printed on ceramic tile.

1947 – SM – **Emma Brians**, photographer, journalist, began working for the *Santa Maria Times*.

1947 – SM – **John Costello** and **Robert Herda** briefly ran **Aerial Photography Service** to earn money while students at USC College of Aeronautics.

1947-50 – SM – **Delia Davis** (later **Sudbury**) taught arts and crafts at Santa Maria High School and Junior College.

1947-51 – SM – **Alice Linsenmayer**, during the pastorship of her husband at the Orcutt Community Church, and at other churches where he served, produced paintings and murals and was active in the art community. At Orcutt Community she conducted a **Junior Art Class** (1947-49?). She also painted windows at the Los Alamos Community Church (1948-49)

1947+ – SM – **Don Johnson**, Santa Maria Union High School English instructor, painted and exhibited water color landscapes.

1947+ – SM – **JoAnn Smith Wilson**, grad. Santa Maria High School, became an art major at Whittier College, and after marriage practiced her art.

1948-50 – SM – **Americana Shop** for antiques was run by Albert and Nina Maguire.

1948-50 – SM – **Norma Martin**, grad. of Lompoc High School, taught art at Santa Maria High School.

1948-57 – SM – **Attilio DeGasparis** taught crafts at Santa Maria Adult School (c. 1948-50) and crafts and mechanical drawing at Santa Maria High School (c. 1950-57) after which he was head of the Industrial Arts Department.

1948+ – SM – **Kenneth Prindle** was active with the Santa Maria Camera Club.

1949 – SM – **William Hyland**, of the City Engineer's office, taught drafting at Santa Maria Adult School.

1949 – SM – **Joe Wilson** invented a device to synchronize home films with sound, i.e., the Wilson-Garlock Synchro-Meter.

1949 – SM – **Audrey Chappell** exhibited her ceramic figurines at the Santa Barbara County Fair.

1949 – SM – **Margaret Giorgi**, grad. Santa Maria High School. Became an art education major at San Jose State College.

1949-50 – SM – **Katherine West**, interior decorator of SLO, ran **House of Charm**.

1949, 1950, 1952 – SM - A **Hobby and Art Show**, sponsored by the Community Club, was held at Veteran Hall the first two times and then at the Minerva clubhouse.

1949-55 – SM – **Maye Nichols** created and exhibited paintings.

Post – WWII – Santa Ynez Valley

1940s, 1950s – SY – **Channing Peake** produced modernist paintings at his ranch.

1945-49 – SY – **Santa Ynez Valley Elementary School and Junior High** – **Joseph Knowles**, art supervisor for Santa Barbara County schools, gave frequent art lessons to students and lectures on art to parents. As before, children created "art" (including paintings, murals, maps, totem poles when studying Alaska, models of missions when studying California history, carvings of animals when studying ecology, and made pottery bowls when studying Native Americans), to enforce knowledge learned in academic subjects. Posters and puppetry were also popular. **Leo Ziegler** began teaching art, 1948.

1945-49 – SY – **Santa Ynez Valley High School** – main art teacher until the end of the 1950s was part-timer **Leo Ziegler** who provided a number of field trips to Santa Barbara to enhance his students' artistic experience. In spite of the school's relatively small student body and teaching staff the shop teacher and the domestic science teacher were able to provide classes in mechanical drawing and arts and crafts. **Harold Venske**, teacher of mathematics and science, took photos and oversaw production of the school annual.

1945-49 – SY – The **Solvang Woman's Club** held a flower show and art exhibit in 1945 and 1946, the second potentially accompanied by a hobby show. In 1947 it sponsored a home tour. And in 1948 and 1949 it held programs for club members on arts and crafts and Danish antiques. In 1950 it moved into its new club house, a private home donated to the organization.

1945-75 – SY – **Karl Jorgensen** owned and published the *Santa Ynez Valley News*. For a few years he authored the column, "Jus' Lookin'" and in several described his personal experiences as a news photographer (early 1950s). Cartoonist, 1953.

1946-51 – SY – **Mission Santa Ines** restoration continued under Father Cyprian.

1946+ – SY – **Amory Hare Hutchinson**, painter, poet, author, horsewoman, produced and exhibited her paintings.

1946+ – SY – **Santa Ynez Valley Adult/Night School** offered Art (still life and landscape painting) taught by **Leo Ziegler** (1946-c. 1957). Arts and crafts were taught by various short-term teachers (usually the High School teacher of Domestic Arts). Popular subjects were leather craft, textile painting, copper tooling. In 1949 the school board voted to buy a kiln for the firing of ceramics.

1946+ – SY – **Roy Hosier** carved many signs in the Santa Ynez Valley.

1947 – SY – **Forrest Hibbits** returned to Santa Barbara County from San Francisco with wife, **Marie Jaans,** and he turned to teaching art, to painting, and to running La Petite Galerie.

1947 – SY – **Lena Boradori**, a student under Leo Ziegler, exhibited her paintings at several venues through at least 1955.

1947 – SY – **Milt Neil**, former Disney artist, briefly acted as advertising manager for Anderson's Pea Soup, and re-drew the cartoon pea-splitters Hap-pea and Pea-wee to give them more "personality." Created a series of pictures of little Danish girls in bright costumes.

1947+ – SY – **Amber Broadus Dunkerley**, cartoonist of "Snooper the Colt" and resident of Santa Barbara, purchased a 20-acre ranch in the Santa Ynez Valley with her husband, Steve.

1947 – SY – **Ray Paaske** completed the building of Copenhagen Square in **Danish provincial style**, the first step in the dream of his father to see the whole of Solvang in Danish provincial style.

1947+ – SY – **Solvang Photo Shop** was opened by **Robert Nelson** and c. 1952 became the property of J. Griesbauer.

1947/49 – SY – **Isabelle MacPherson Simerly** taught arts and crafts at Santa Ynez Valley Adult School and at Santa Ynez Valley Union High School.

1947+ – SY – **Catherine MacKenzie**, early Cuyama teacher (1930s) but later of Portland, Oregon, showed her work in Solvang (intermittently 1947-51) and at the Santa Ynez Valley Art Exhibit (1955, 1957, 1958).

1947+ – SY – **King Merrill** served as photographer and journalist for the *Santa Ynez Valley News*.

1948-50 – SY – **Vern and Bonnie Dove** moved to Santa Ynez Valley. She designed maternity clothing (Bonnie Dove Originals) and he worked in glass.

1949 – Nov. – SY – **Hal Homrig** exhibited art by Veterans in Solvang.

1949 – B – **Displaced Persons Colony** for European refugees with handicraft skills, was conceived for Buellton but failed because local Veterans feared job competition.

1949-50 – SY – **Iron Art**, a shop making forged iron products, was active under Ernest Pedersen and Walter Kristensen, and afterwards under only Pedersen.

1949 – SY – **Terry Hubbard** entered artwork in the Scholastic Art Exhibit. Went on to become an engineer/designer with Douglas Aircraft.

1949/50 – SY – **Mary La Vaut** taught homemaking, arts and crafts at Santa Ynez High School and Adult School.

1949-55 – SY – **Creative Arts and Woman's Exchange** (aka **Red Cottage**) in Solvang sold hand-made items by locals.

1950-1960 THE 1950S

Cold War adversaries, Russia and the U. S., with their opposing economic systems of Communism and Democracy, competed for world supremacy. Key words were atom and hydrogen bombs, marijuana, juvenile delinquency, Beatniks, blood bank donations, square dancing, and polio. America took in refugees from Hungary as well as Korean orphans. The 1950s continued the post-war upward swing to greater personal incomes along with conspicuous consumption and inflation. Rampant construction to deal with the post-war baby boom included the building of extensive housing projects, the laying of freeway systems ("Despite Engineer Shortage, California Going Ahead with Unprecedented Highway Program," *SYVN*, March 30, 1956, p. 2), and the expansion of schools, notably higher education facilities. A higher standard of living allowed most families to own cars. People moved to the suburbs. Jobs, with their enforced weekends and annual vacations, encouraged family tourism by car. Jet planes enabled easy long-distance travel to Europe and the East. Television spread, unifying Americans through its values. At the end of the decade Alaska and Hawaii officially became states of the union (1959). Russia and the U. S. jockeyed to be the first in space and on the moon. Mainframe computers began relieving humans of mathematical calculations and the organization of data. In northern Santa Barbara County – the area's three major towns intensified their personalities. Lompoc became strongly identified with Vandenberg AFB, and Santa Maria with general "big city" qualities. Santa Ynez Valley, on the other hand, was recognized for its picturesqueness. It became a tourist destination. It also became a "weekend escape" to second homes/ranches and to guest ranches like Alisal with its horse show and golf tourney, and it witnessed such elite events as the trek of Rancheros Visitadores. It also offered recreationists the new Lake Cachuma, opened 1954.

1950s – **Douglass Parshall** of Santa Barbara was a frequent visitor to northern Santa Barbara county on art matters.

1950-1953 – **Korean War – June 25, 1950-July 27, 1953.** Camp Cooke was reactivated.

1950s mid – **Highway 101** was constructed through Santa Barbara County generally following much of the route of the earlier Highway 1.

1951+ – Neon became popular as the "new" medium for signage.

1953 – KVEC-**TV** (as opposed to KVEC **radio**) started broadcasting out of SLO to the Arroyo Grande and Santa Maria valleys.

1954 – **Cachuma** recreation area opened. ("Cachuma Recreation Area Open to Public," with 200,000 acre-feet of water when filled and 42 miles of shore line. The dam is more than 300 feet high, *SMT*, April 26, 1954, p. 1.)

1954 – Five families of the Chumash Tribe were living on the **Sanja Cota Reservation**. ("Five Families of Chumash Tribe Settled … [1878] Five Families There Today," *SYVN*, Sept. 17, 1954, p. 50.)

1955 – Pacific Telephone laid a coaxial cable through the Santa Ynez Valley. ("Last Link of Coaxial Telephone Cable Being Laid Through Valley," *SYVN*, Dec. 2, 1955, p. 1.)

1957 – Racial integration at Little Rock, Ark. Sputnik was launched by Russia giving that country the lead in the space race.

1959 – Fidel Castro, revolutionary, made his triumphal entry into Havana, initiating a Communist sympathetic regime. Alaska and Hawaii officially became states of the union. The Soviet flag was planted on the moon (i.e., the flag was inside a module that crash-landed on the moon). Soviet leader, Khrushchev visited America in September and his train stopped in SLO. TV quiz shows proved to be rehearsed.

1959 – Discoverer, the world's first polar orbiting satellite, was rocketed into space from Vandenberg AFB.

Artists and Photographers

Art – Nationally, the interest in art continued the upswing started in the immediate post-WWII era. America's most forward-thinking artists expressed themselves in various forms of modernism (including abstract and hard-edge abstraction). "Art for Arts Sake," rather than to serve a practical purpose, arose, many of its practitioners supported by teaching jobs in high schools and colleges. Non-representational art, for the first time, placed American artists in artistic advance of their European peers and turned America into a world art leader. Most Americans didn't "understand" such art, and this prompted lectures by individuals who "explained" it. Most American artists (including practical commercial artists) produced representational or semi-representational imagery. Americans' increased affluence (with no war-torn infrastructure to repair) and increased leisure, led many to "the finer things in life" – travel, theater, music, dance, television and art -- including hobbies and crafts. In northern Santa Barbara County, in the post WWII era, nascent art communities began to form.

Schools continued to be the main purveyors of art. Elementary schools continued to teach the basics of design and mechanics via simple media such as finger painting, coloring with crayons, papier mâché, clay modeling, puppetry, etc. Separate Junior High schools were built and provided specialized classes in fine art and domestic art along with shop and mechanical drawing to prepare students for advanced classes in high school. In 1953 the Hapgood School, a junior high, was constructed in Lompoc. In Santa Maria, El Camino School offered classes in shop and art taught respectively by Euland Payne and Edna Davidson. High Schools in Lompoc and Santa Maria took on additional teachers

(who sometimes also taught in the Junior Highs) so that many different media in both the "fine arts" and in arts/crafts could be offered. Mechanical drawing was taught but often as a part of the Shop/Industrial Arts program. At Santa Maria High School (that included the junior college up to 1954) advanced art classes in subjects such as interior decoration, costume design, lettering, commercial art, and advertising art as well as "fine art" painting and sculpture were offered. Art teachers were, George Muro followed by Nathaniel Fast and Robert Gronendyke. They also produced personal art sophisticated enough to be exhibited outside the county. Photography became a regular school course (after 1948), and after 1952 it was taught by J. Miles Boothe. In 1954, when the Junior College moved into buildings at Hancock airfield previously used for USC College of Aeronautics and took the name Allan Hancock College, George Muro transferred over as art teacher. Available there were an even greater variety of art courses and, in addition, the school had its own dedicated art gallery where students could learn from a changing round of art exhibits. Adult schools attracted even greater attendance. As the 1950s progressed, handicraft classes became more specialized. Ceramics was a mainstay. Always popular leather craft was supplemented with metalcraft including jewelry design. Wood-fiber flower making was a flash in the pan. Photography was taught. Lompoc enjoyed the handicraft teaching of Viola Dikes through the early 1950s followed by teachers from the high school. In Santa Maria in mid-decade, the adult school was moved from the high school to Allan Hancock College and art classes were taught by George Muro. New and specialized schools came into being and also included crafts in their curriculum. Nursery schools had been in existence in America since the early 19th century to accommodate women who left home to work in factories. They were especially needed in the 1950s as women took up careers. Their mission was to not just keep an eye on tots but to prepare them for kindergarten. Private art teachers included – in Lompoc/Buellton/Solvang Forrest Hibbits, and in Solvang Martha Brandt-Erichsen, who started Studio Workshop in 1956, first to teach art to children and then to adults. A special winter 1952/53 course for adults was the "Winter Arts Program" of Santa Maria – a series of classes on the arts under the University of California Extension program. High school graduates who went on to careers in the arts were: from Lompoc: Judith Collier and Eddie Fumasi; from Santa Maria: Kenneth Brown, Marilyn Smith, Henry Fujioka, Betty Eya, Earle Leitner, Roy Imamura, Trinidad Amador, and Richard York; and from the Santa Ynez Valley: Evelyn Joughin, Vernal Gillum, Annette Negus, Robert Jensen, and Philip Leighton.

Women's Clubs continued to be strong proselytizers for art. But art and/or handicraft only existed in women's clubs if there was a sufficient number of members interested in it and if a natural leader arose who would plan meetings and arrange programs. Several women's clubs in the area interested themselves in the Penny Art Fund which collected money to buy artworks by American artists and sometimes "paid back" through the gift of a painting to decorate club walls. In Lompoc, The Alpha Club that had enjoyed such a strong art program in the 1930s, now ran a greatly diminished slate. It did employ the expertise of local artist Forrest Hibbits several times – for lectures and, in 1950, for an exhibit of his art students. But, in 1956 the Fine Arts Group announced its meetings were "indefinitely postponed," and art efforts seem to have swung to the Penny Art Section. In 1959 Mrs. Ernest Wiedmann taught a series of classes, "Arts and Crafts Made Simple," to Alpha members and their children. The Junior Alpha Club shared in many of these events. The Lompoc Community Woman's Club, of which art activator Mary Brughelli was a member, initiated an annual Children's art contest and, in 1957, started the Open-Air Art Exhibit (for adults and later for children) held in Ryon Park in conjunction with the Alpha Club's Flower Festival in late spring. In Santa Maria the Minerva Club hosted the traveling Tri-County art exhibit (1950), held various lectures on art related to the home, and in 1957, 1958 and 1959 put on an Art and Hobby Show. The Community Club held a Hobby and Art Show, 1949, 1950, 1952. The Junior Community Club proved the most art active of all with early 1950s art chairmen Mrs. James Hosn followed by Mrs. Thurman Fairey. Their display of art in the "art corner" at every meeting qualified them to win several paintings from state headquarters to decorate the clubhouse. The club was particularly strong in teaching and showing handicraft. In the second half of the decade, it coordinated a couple of times with the American Association of University Women to aid in the organization of art exhibits at the new Allan Hancock College Art Gallery. In Solvang, the Solvang Woman's Club moved into the home donated for its quarters in 1950 and redecorated it. Through the 1950s it offered an occasional art lecture at its meetings although its interest in "the arts" was reflected in its many theater and music programs as well as travel lectures.

Recreation programs – By the 1950s both Lompoc and Santa Maria had seasoned city recreation departments with physical quarters that provided a venue both for year-round sports and crafts programs as well as special Summer Schools, that also taught sports and arts/crafts. Some of its classes were also held at local sites – sports at school playgrounds and crafts, ceramics and photography at school shops and labs. Teachers were often public-school teachers adding to their income during the summer, but also talented "civilians" as well as college students looking for summer employment. Both Lompoc and Santa Maria, during the Korean War of the early 1950s, provided space and activities for soldier recreation. Santa Maria recreation department employed a full-time woman's recreation supervisor, and 1959+ Nat Fast offered an actual class in oil and watercolor painting. The Department acquired a specially constructed building in 1964.

Camp Cooke (Korean War) – Art" was present on the base in the same variety of forms as during WWII only on a smaller scale. In addition, many servicemen returned from Asian duty with collections of Japanese or Korean art or having studied Asian art disciplines such as ikebana (Japanese Flower arranging) while abroad. Wives of servicemen practiced various forms of Western art including painting and ceramics.

Movers and shakers – Lompoc and Santa Maria both benefitted from individuals who first conceived of and then developed some of north county's most important art activities of the 1950s. In Lompoc the standout was Mary Brughelli, an artist who had re-settled in 1949 and was active through the 1950s. She taught arts and crafts at summer school (under the Lompoc Recreation Department), 1952-59. In her association with the Lompoc Community Women's Club, she initiated the Children's Art show, mid 1950s+, and the Open-Air Art Show held in conjunction with the Alpha Club Flower Show, 1957+. In Santa Maria, replacing the Breneisers, who had been "movers and shakers" between 1922 and 1945, came unaffiliated ceramicist Jeanne DeNejer. She had a private art school on her property, was involved in the formation of the Santa Maria Art Association, showed art by herself and students several times at the Santa Barbara County Fair in the early post-WWII period, advised at the Santa Maria Art Festival of 1952, and organized the Winter Arts Program of 1952/53. Taking her place as a "mover and shaker" in the mid-1950s was George Muro, art teacher at both the high school/JC and after 1954 at the new Allan Hancock Junior College. He taught art, oversaw the exhibits as the Allan Hancock Art Gallery, and c. 1957+ ran the art program at the Santa Barbara County Fair. In Santa Ynez Valley the efforts of the early 1950s "art shaker," Viggo Brandt-Erichsen, were cut short by his death in 1955. Through the 1940s and 1950s, also active with many organizations, was the less visible art teacher Leo Ziegler. The area's major art venues, such as Danish Days and the St. Marks-in-the-Valley Art Exhibit that morphed into the Santa Ynez Valley Art Exhibit, were organized by committees.

Infrastructure: With the increase in practicing artists – most still in the amateur category – an art infrastructure began to solidify. Art Clubs. The Santa Maria Art Association that had formed in 1945 lasted to 1955 and later. In Solvang the Santa Ynez Valley Art Association (formed 1953) was less for practicing artists than for several churches who came together to foster the arts. Art exhibitions increased in number. The main repeating venue for "fine art" was the Santa Barbara County Fair at Santa Maria. In the first half of the 1950s it hosted sporadic, privately arranged art/ceramics/photography exhibits, many tucked into the floral booth and other places. In 1957, an official division of "Arts and Crafts" was established, and the first full-scale art show was held. In 1958 George Muro (whose official title was "fair art director") enhanced the aesthetic look of the fair buildings with the help of some of his top students and oversaw the fair art show. The area's first permanent as well as most sophisticated art exhibition site was the Gallery at Allan Hancock College, where exhibits were first held 1954. There, with help from certain local women's clubs, George Muro was able to present a steady offering of one-man shows by artists who lived outside the local area, but also, for several years (1955, 1956, 1957) a non-juried group show of work by local artists. The shows provided local artists with a "college" setting, allowed isolated locals to meet each other and to have their art viewed and certified by a sophisticated venue. Throughout the county, other art exhibits began popping up. In Lompoc there was the Open-Air art Exhibit (1957-60+) associated with the Alpha Club's Flower Festival. In Santa Maria there was the Santa Maria Valley Art Festival (1952-53). In Solvang, arts/crafts/antiques were displayed at the annual Danish Days. The St. Marks-in-the-Valley Art Exhibit (1953) morphed into the Santa Ynez Valley Art Exhibit (1954-1958). Privately, in Buellton, in 1954, Pea Soup Andersen's began holding revolving one-man art exhibits on its premises. Additionally, the Solvang Library allotted space to changing one-man shows by local artists, 1959+. Most of its exhibitors were based in Santa Barbara county. Shops. La Petite Galerie, a permanent commercial gallery run by Mr. and Mrs. Forrest Hibbits, held periodic exhibits from 1950 in Buellton/Solvang. Ultimately the Equinox Gallery was formed by a group of artists in Lompoc, 1961. In Solvang, where there was significant tourist traffic, boutiques sold local hand-made crafts as well as imported items.

Art jobs. In the 1950s, a few artists were able to support themselves with their art. Some interior decorators opened studios, although most shops were short lived. Decorators in Santa Maria included: Blum's Interiors, Le Decor, and Blue Lantern. In Santa Ynez Valley, where moneyed people took second homes, there was Holt Lindsley and Dee McLaughlin. Proprietors, in order to generate business, often lectured to women's clubs on interior decoration principles. In some schools, interior decoration became a stand-alone class. A few people set up as commercial artists applying their talents to a variety of projects including architectural design and the creation of posters and signs. In Lompoc there was Charles Sookikian (1957+), and Forrest Hibbits, and in Santa Maria, Earle Leitner and Paul Winslow. Draftsmen found full-time employment with the military, with certain city departments, and in architectural offices that were responsible for a wave of tract and single-design homes. In Solvang, people who didn't go to Santa Barbara for their architects could rely on Ortega & Sammons or on Earl Petersen.

Handcraft making and exhibiting continued to be popular at all age levels. Various skill levels were taught in schools from nursery school through Junior College and Adult School. Handcrafts were also taught by city recreation departments, by 4-H Clubs, by Boy and Girl Scouts as well as by Camp Fire Girls organizations and the Farm Home Departments. City recreation departments sponsored both year-round and "summer schools" that taught both sports and handicrafts. The popularity of handicrafts made it financially feasible for hobby shops that sold materials to open and survive financially. Exhibitions of hand-made items occurred during Public Schools Week, at the end of summer schools, and at special hobby shows as well as at the County Fair and some other special events. In Lompoc: Lompoc Gem and Mineral Club, some of whose members designed and manufactured jewelry and other items from rocks and gems, held two hobby shows (1959, 1960). In Santa Maria the Community Club put on Hobby Shows in 1949, 1950, and 1952. The Minerva Club hosted one in 1957, 1958 and 1959. Solvang was a center for sophisticated craftsmen, possibly a legacy of the town's heritage of Danish handcraft. Able to support themselves through their craft were Walter Kristensen who created hand-wrought iron items at his Old World Metal Craft (1950-75) and Ernest Pedersen who forged items at Iron Art (1949-69). The Viggo Brandt-Erichsen house, finished in 1953, contained handwork, and that can be viewed today in the home's current role as the Elverholj Museum. Solvang, being a tourist town, also maintained several shops for the retailing of both locally hand-made goods as well as imported items. In Buellton in 1949 there was serious consideration given to starting a Displaced Persons Colony for European refugees having handicraft skills, although it failed because local Veterans feared job competition.

Ceramics was one of the most popular of the hand industries, and each town could boast its own ceramists, some of whom taught the skill of throwing on a wheel. Others taught painting of pre-cast ceramics. Ceramics were taught at all levels in school. Kilns for firing ceramics were owned both publicly and privately. The most sophisticated ceramics may have been produced in Santa Maria where, in the early 1950s, private ceramist Jeanne DeNejer was active for several years before moving to New York. Ceramics were also taught at the Santa Maria High School / Junior College by Ward Youry (1950-52) and by Nat Fast (by at least 1955) and at Adult School (by 1957), and by Paul Winslow at several schools (1959+). At Allan Hancock College, Paul Winslow's teaching was followed by William Shinn (1962-88). Santa Ynez Valley High School obtained a ceramic kiln in 1957 for its new shop/photography/ceramic building. The great interest in the medium supported several shops that sold raw materials. Lompoc had Smiley's Ceramic Supplies, King's Ceramics, Ocean Avenue Ceramics, and Mildred I. White Ceramics (renamed to Betti's Ceramics). Santa Maria had Stotts Potts, Edwina's Ceramic Studios and El-Ma-Ro Studio. In the Santa Ynez Valley, there was Helen Barbera with her Valley Ceramic Shop as well as the Mud Mill Pottery Studio.

Photography – In the wake of WWII and with additional technical photographic advances made in the 1940s (more sensitive film emulsions, automatic exposure meters, simpler printing systems, the commercialization of the Polaroid camera, and the excellently manufactured 35 mm and other cameras made in post-war Japan), amateurs' interest in photography continued to grow. Classes in photography appeared in many north county schools. In Santa Maria, photography was taught in adult school, high school and Allan Hancock College night school by J. Miles Boothe (various years in the 1940s-1950s). Mervin Slawson taught photography at Santa Maria High School (1958-78) and held an OMS of his work at Allan Hancock College Art Gallery (1956). At the Santa Ynez Valley High School, in 1954 Ted Muradian, music teacher, sponsored a photography club, and in 1957 the school obtained a new building for shop and photography. As for clubs – Lompoc's camera club appears not to have survived renewal attempts in the late 1940s, but in Santa Maria the Camera Club continued strong through the 1950s and beyond and, at the end of the decade, arranged photography shows at the County Fair. In 1956, five teens ran their own Camera Club and had their own developing lab. In Solvang, in 1950, Raymond Paaske formed a Camera Club. Camera knowledge was also disseminated in north county through "how to" columns in the newspapers – "Camera Tips" in Lompoc 1954-55, written by Tommy Yager of The Camera Shop, that appeared in the *Lompoc Record*, and "Snapshot Guild," a nationally syndicated column run in the *SMT*, 1952-58. Commercial photographers continued to thrive and included in Lompoc Tommy Yager. In Santa Maria, Stonehart Studios continued active alongside Bob Hendrick at the Santa Maria Studio of Photography (1955-c. 1976), Weaver's Camera Shop (1957-88), and Bob Dupuis of

Professional Photographers (c. 1958+). In Solvang there was Jack Griesbauer, Hans Sorensen and Loris Gardner. Each of the larger towns had newspapers that either employed a specialized photographer or journalists who also took photographs, and the papers also bought photos from talented locals. Exhibits of photography were held monthly and yearly by camera clubs for their members, primarily to provide learning challenges and for self-education through peer criticism. Photography exhibits at the annual Santa Barbara County Fair began 1952 with a small display of photos by the Santa Maria Camera Club in the floral booth. In 1958, the medium was sanctioned with its own division under the Arts and Crafts Department and was given a full show with prizes and awards. Photographs were also displayed in most other special exhibits of art / antiques / hobbies held in all three towns. For example, in Solvang photos were shown at the Santa Ynez Valley Art Exhibit.

1950s – Lompoc

1950s – L – **Lompoc Elementary School** – various forms of art were practiced in conjunction with academic studies and art was also deemed an important outlet for feelings and ideas. Media were drawing, painting, clay modeling, building, dramatizing, etc. **Joseph Knowles,** art coordinator for Santa Barbara county schools, visited many elementary schools in north county, particularly in Lompoc and Santa Ynez Valley to give demonstrations, etc.

1950s – L - **Lompoc Junior High.** The Hapgood School was constructed, 1953. Junior High offered elective classes in specialty subjects like art, music and/or science, woodworking and mechanical drawing. Art teachers were **Mary Cardoza** followed by **Kenneth Carr.** Vandenberg Junior High was constructed in 1959.

1950s – L – **Lompoc High School** – Instruction in arts and crafts was by **Conley McLaughlin** (1952/56) followed by **Alex Rule** (1956/58) (who taught ceramics, copper enameling, lapidary work) followed by **Mrs. Woods** [Sic. ? Mildred Wood?] (1960). Art was also taught by **Louise Hunt**, homemaking teacher, 1955. Mechanical drawing seems to have been taught, and woodshop was given by **Lester Sabin**. In the new high school building planned 1960, there was a shop building for woodworking, drafting, photography and arts and crafts.

1950s – L – **Lompoc Adult School** –**Viola Dykes'** arts and crafts class eventually succumbed in 1953. By 1954 high school teachers **Conley McLaughlin** and later **Alex Rule** had resumed teaching ceramics as well as other arts and crafts. Other classes were the ever-popular woodworking, and a class in welding (1956). During the Korean War, attendance at Adult School was bolstered by the military presence. In 1960 a class in "art" (teacher not mentioned) had an enrollment of 9 (not the 15 needed), and it is not known if it survived.

1950s – L – **Alpha Club** – In 1950, at its Chrysanthemum tea, there was an exhibit of paintings by students of **Forrest Hibbits**. The Penny Art Fund program built awareness of art among members. Art was shown in an "art corner" during each monthly meeting. In 1951, the Club along with the Lompoc Community Woman's club commissioned Forrest Hibbits to paint figures representing the Christmas story for Ryon Park. Several members of the Club, who were also students of Hibbits in 1952, held an exhibit. Joseph Knowles and Forrest Hibbits were both occasional lecturers through the decade. At the end of 1956 the Fine Arts Group announced their meetings were "indefinitely postponed," while the Penny Art Section became more active. Sporadic art lectures continued to the end of the decade. In 1959, Mrs. Ernest Wiedmann taught a series of classes – Arts and Crafts Made Simple – to Alpha members and their children. The Junior Alpha Club shared in many of these events.

1950s – L – **Lompoc Community Woman's Club** sponsored art events (exhibits, lectures, demonstrations at its meetings). Its Arts and Crafts section, active through the decade, met at the Community Center. In the mid-1950s the Arts and Crafts Section was headed by Mary Brughelli. It sponsored a Children's Art Contest that became an annual event. In 1957, Brughelli started the Open-Air Art Exhibit held in Ryon Park in conjunction with the Alpha Club Flower Festival in late spring. The art section was taken over by Mrs. Erick Anderson in 1958 and she continued the Children's Art Contest and the Open-Art Art Exhibit. Several members painted easel works.

1950s – L – **Recreation Department** – during the Korean War the recreation center building was reopened by AWVS, and it provided many of the services to soldiers that the USO had in WWII, although on a greatly reduced level. Although civilians could still use the building, boys up to age 16 were not allowed in at night, and girls of any age were banned at any hour unless chaperoned. Apart from the war years, throughout the school year, various activities were available at the recreation building / community center. However, only the annual summer program was announced in detail by the newspapers. The summer program always contained sessions for arts and crafts.

1950s – L – **Mary Brughelli**, taught arts and crafts at Lompoc recreation department's summer school, 1952-59. In the mid-1950s she served as Art Section chairman for the Lompoc Community Women's Club in which position she initiated the Children's Art show, c. 1955, and the Open-Air Art Show held in conjunction with the Alpha Club Flower Show, 1957+.

1950 – L – **Smiley's Ceramic Supplies** was opened by Francis W. Smiley.

1951+ – L – **Ethel Bailey** painted landscapes.

1951-52 – L – **Burton Blanchard** served as staff artist of the *Cooke Clarion*.

1951-56 – L – **Conley McLaughlin** taught art at Lompoc High School and ceramics at Lompoc adult school and other places. He moved on to teach art at John Burroughs High School in Burbank.

1952 – L – **Robert James**, cartoonist, worked as graphic illustrator in the Training Aids Section, Camp Cooke.

1952 – L – **Angie King** opened North H. Ceramics Shop / King's Ceramics.

1952-57 – L – **Mildred Fairey**, painter, served as art chairman of the Junior Community Club and aided in putting on the group shows for local artists at Allan Hancock Art Gallery (1956, 1957). After moving to Cambria in 1964, she ran antique shops.

1952/58 – L – **Ellis Price** taught chemistry, but was also in charge of Audio Visual, at Lompoc High School. His background included making photos and travelogues for steamship companies and a 10-year stint as a commercial photographer.

1952+ – L – **Lester Sabin** taught woodwork and drafting at Lompoc High School.

1952+ – L – **Johanna "Juka" Carlson / Beattie** arrived as a war bride from Estonia, became active as an easel painter, and remained until her death.

1953-54 – L – **Virginia Erickson**, writer for the *Lompoc Record*, wrote about her experiences with art.

1954-Fall – L – **Richard Storey** taught arts and crafts at Hapgood School.

1954-55 – L – **Camera Tips** a "how-to" column on photograph, written by **Tommy Yager** of The Camera Shop, appeared in the *Lompoc Record*.

1954-89 – L – **Tommy Yager** prop. of The Camera Shop.

1954+ – L – **Marion Herta Lewis**, art-trained Austrian, arrived in Lompoc with her husband who worked at the USDB, and she taught and produced art through c. 1972.

1955 – L – **June Blakely** created a mural at the USDB.

1955+ – L - **Moselle Forward** served as writer and photographer for the *Lompoc Record* (1955-58) and, in 1960, became prop. of Moselle's Gifts at the Inn.

1955/56 – L - **Louise Hunt** taught art and homemaking at Lompoc High School.

1956 – L – **Judith Collier**, grad. Lompoc High School. Advanced to Woodbury College, L.A., to study fashion illustration.

1956+ – L – **Lothelle Grossini** worked with ceramics in the mid-1950s but by the early 1960s was exhibiting paintings with Equinox Gallery.

1956-57 – L – **Ocean Avenue Ceramics** was run by Elva Beattie and Bernice Woodall and later Nina Hitchen.

1956/58 – L – **Alex Rule** taught arts and crafts at Lompoc High School and in Adult school.

1957-61 – L - **T-Sgt Robert Parker** won a Camp Cooke photo contest and developed a novel technique for modern painting.

1957-63 – L – **Mike Guerrero** served as photographer for the Air Force and in 1960 was official photographer for the SAC MISSILEER.

1957+ – L – **Open-Air Art Exhibit**, the inspiration of **Mary Brughelli** and sponsored by the Lompoc Community Woman's Club, was held in conjunction with the Alpha Club's annual, late spring Flower Festival. Originally for adults, in 1959 it was opened also to children.

1957+ – L – **Charles Sookikian** was in business as a commercial artist.

1958 – L – **Linda Harrod**, a Los Angeles art student, painted murals in The Lompoc Lady beauty parlor.

1958 – L – **Bea Pate** served as Woman's Page Editor of the *Lompoc Record* and also took photos.

1958/59 – L – **Ellen Sanders**, wife of a Cooke AFB officer, expressed herself in multiple artistic media.

1958-60 – L – **Betti Tognetti**, managed Mildred I. White Ceramics Shop (1957), bought it (1958) and renamed it to **Betti's Ceramics.** There she gave ceramic lessons and sold raw materials. At other dates she taught crafts under the Lompoc Recreation Department.

1958+ – L – **Lompoc Gem and Mineral Club** formed. It held two hobby shows (1959, 1960) and participated in hobby shows held by other organizations. Some members designed and manufactured jewelry as well as other items from rocks and gems.

1959 – L – **Marie DeBolt** and **Ruth de Buda**, Lompoc school teachers, painted in their spare time.

1959 – L – **Nora Wiedmann**, art education consultant, taught "Arts and Crafts Made Simple" to Alpha Club mothers and their children.

1959-61 – L - **Moselle's Gifts at the Inn**, prop. Moselle Forward, sold work by local artists.

1960-61 – L – **Photo-Craft Studios** was run by John Charles Wallace and Richard A. Bodwin.

1960-64 – L – **Alan Haemer**, a career air force man with artistic talents exh. at the Santa Barbara County Fair, taught art to Barbara Kern, 1960, and in 1963 painted a mural in the Pediatric ward at Vandenberg Hospital.

1960+ - L – **Leslie Mayer**, a commercial artist from c. 1949, became active in Lompoc as an easel artist (c. 1960-83) before moving to Arkansas.

1961 – L – **Eddie Fumasi** grad. Lompoc High School. Majored in art at college and went on to a career in the art field as an art museum registrar and, in retirement, an easel painter.

1961 – L – Several artists joined and started **Equinox Gallery** in a space in Evans Jewelry Shop.

1964+ – L – **Lompoc Valley Historical Society** developed out of the Lompoc Pioneer Society. It serves as a repository for historic items including art and photography.

1950s – Santa Maria

1949-53 – SM – **Jeanne DeNejer** exhibited ceramics at the Santa Barbara County Fair (1950). She advised at the Santa Maria Valley Art Festival (1952). She gave lectures on art to local clubs and organized the "Winter Arts Program" (1952/53). After exhibiting some of her pottery in NY in late 1952, she studied at the NY State College of Ceramics at Alfred University. By 1954 she was teaching there and by 1955 she copyrighted the "DeNejer System of Design."

1950s – SM – **Santa Maria Elementary School and Junior High (i. e. El Camino School) – Edna Davidson** circulated through schools teaching art. Children created art in conjunction with learning academic subjects and exh. at Public Schools Week. At <u>El Camino School,</u> **Euland Payne** was in charge of shop classes while art student made ceramics. In the second half of the 1950s **Joseph Knowles** out of Santa Barbara spoke several times to parents' groups on art in the schools.

1950s – SM – **Santa Maria High School (and Santa Maria Junior College up to 1954)** – The decade's art teachers were **Ward Youry** (1950-52), **George Muro** (1951-54), **Gordon Dipple** (1953-), **Attilio DeGasparis** (drawing / industrial arts, c. 1948-57), **Nathaniel Fast** (arts & crafts, ceramics, 1955+), and **Robert Gronendyke** (art, drawing, painting, 1956+). Manual training was taught by **Perino Merlo** (1946+). Photography was added as a JC course in 1948+ and later taught by **J. Miles Boothe** (1952-) who also took photos for the school yearbook. Students continued to make posters, design window decorations for the Elk's Rodeo, exhibit art at annual Public Schools Week and to win Scholastic Art exhibits. In 1954 the Junior College split off and moved to buildings at Hancock Field.

1950s – SM – **Santa Maria Adult School** – Classes were taught by high school teachers, including woodworking by **Perino Merlo** (c. 1954-60+), drawing and crafts by **Atillio De Gasparis** (1950) followed by **Ward Youry** (c. 1951), and **George Muro** (1950s), and photography by **J. Miles Boothe**. Mechanical drawing was also offered along with specialized sporadic art classes such as interior decoration and ceramics (by **Paul Winslow**, 1959). About 1955 <u>most classes were moved to Allan Hancock College</u>, although some that needed special equipment, like woodwork and ceramics were still held at high school labs.

1950s – SM – **Minerva Club** – 1950 hosted the traveling Tri-County art exhibit. 1951+ – Occasional art lectures included home décor, antique collecting, history of pottery (by Jeanne DeNejer), Richard Gump of SF speaking of antique collecting, flower gardens of the world illustrated by color films, interior decoration, and landscape design. Handicrafts included the making of Christmas decorations. In 1954 the club was gifted a watercolor by local artist Alfred Ybarra. The club also enjoyed a puppet show (1957) and learned about George Stuart's miniature historical figures (1960). In 1957, 1958 and 1959 the club put on an Art and Hobby Show.

1950s – SM – **Community Club** sponsored a Hobby Show, that included art, in 1949, 1950, 1952. The club arranged for occasional lectures on various art subjects to be given at meetings, sometimes in conjunction with the Junior Club, and it showed art at an "art corner" and participated in the Penny Art Program.

1950s – SM - **Junior Community Club.** The most art active of the several north-county women's clubs in the 1950s. Its early 1950s art chairman was Mrs. James Hosn followed by Mildred Fairey to at least mid-decade. In 1950 Mrs. Hosn displayed ceramics, the club sponsored a competition among elementary school students for Christmas decorations, and members decorated the Santa Maria hospital at Christmas. In 1951 the club sponsored art classes for servicemen at DeNejer Studios and coordinated with DeNejer on other activities. Through the 1950s the Club displayed various forms of art in the "art corner" and was active with the Penny Art Fund with the result it won several paintings from state headquarters to decorate its clubhouse. The club also held numerous lectures on a creative variety of subjects including textile painting, wood carving, painting from Mexico, stoneware, dolls, and notably paintings by local artists and artisans, as well as finger painting, needlework, lace, interior decorating wood fiber flowers, and comic hats. Several club members took up painting, including Mrs. Thurman Fairey. In the latter part of the decade Hazel Lidbom was in charge of handicrafts. The club built a float for the Elks Rodeo parade. The club also worked with Allan Hancock College Art Gallery on presenting exhibits.

1950s – SM – **Recreation Department** – The department held Summer Schools each year and the sessions always contained arts and crafts. The department held its classes at various school playgrounds and other facilities, such as the plunge. 1959+ Nat Fast taught an actual art class. The Department rapidly outgrew its facilities at the old Carnegie Library/USO but did not gain new quarters until 1964. Peripheral recreation centers arose in Orcutt and Guadalupe.

1950s – SM – **Santa Barbara County Fair** – "Art" exhibits were: 1950 – Domestic Arts/needlework, DeNejer pottery, and leatherwork by Joseph Knowles. 1951 – Flower paintings by the Santa Maria Art Association, a room display by Maurice Blum interior decorator, as well as high school art. 1952 – Santa Maria Art Association exhibit with Art-in-Action, as well as floral paintings by the Art Association and floral photographic prints by Santa Maria Camera Club hung in a corner of the floral booth, hand-carved miniatures by Moise Potvin, a Canadian. 1953 – a display of miniature missions, photographs in the floral booth, and Domestic Art/Handicraft. The Santa Maria Art Association planned two exhibits but they may not have come to fruition. In 1954 and 1955, there were competitions for "Clothing and Textiles," for table settings, and for floral displays. In 1956 – a ceramics exhibit was added. In 1957 – a new division called "Arts and Crafts" offered cash prizes for ceramics and crafts; the first full-scale art show, possibly curated by George Muro was held, the County Fair had a Camera Day. 1958 – trade mark of "Casey Jr" was adopted, an art show was curated by George Muro (whose title was "fair art director") complete with cash prizes, ceramics were shown, certain fair buildings were re-designed for "a new look," and in the new Photo Division there was a photo exhibit. 1959 – was marked by an enlarged arts and crafts display, addition of leather and metalwork divisions, an art exhibit, a photography exhibit, and a ceramics and China exhibit. Following years saw increased and higher quality entries in all these areas and further décor changes to the Fair grounds to spice them up. In 1960 two art purchase awards were instituted, to acquire works for a permanent collection.

1950s – SM – **Santa Barbara County Library** (Santa Maria) held art exhibits through the decade.

1950s – SM – **Betty Hosn** was active as art chairman for the Junior Community Club. An amateur painter, she exh. at Allan Hancock Art Gallery and elsewhere.

1950s – SM – **Barney Miller**, amateur photographer, was active with the Santa Maria Camera Club (president in 1954 and color chairman 1956). He was supervisor of the photography division at the Santa Barbara County Fair, 1957+. His wife, Lillian, was also a photographer of some talent.

1950s – SM – **Rudy Hawkins** and wife traveled, took color slides, and gave presentations to local organizations.

1950s – SM – **Bud Quick** was active with the Santa Maria Camera Club and exhibited his photos at the County Fair.

1950-Sept. – SM – Second annual **Hobby Show** sponsored by Community Club.

1950 – SM – **Elinor Chambers**, an artist from Seattle, was active in Santa Maria for a few years.

1950-51 – SM - **Blum's Interiors** was run by **Maurice Blum** with the help of **Louise Corollo**.

1950-52 – SM – **Ward Youry** taught art and ceramics at Santa Maria High School/JC before taking a job at Long Beach State College.

1950-53 – SM – **Melba Bryant** was active as a painter.

1950-57 – SM – **Stotts Potts** ceramic studio was run by Lucy and Bert Stotts.

1950+ – SM - **Louise Corollo** acted as an interior decorator with Blum Interiors, 1950, and was prop. of Blue Lantern Art studio, 1956.

1950, 1958, 1959 – Selected artworks (many by north county artists) from the **Tri-County Art Exhibit** at the Santa Barbara Museum of Art were exhibited in north county.

1951-67+ – SM – **Edwina's Ceramic Studios,** run by **Edwina Freitas,** was conducted at her home for a year and then opened at 227 E. Chapel.

1951+ – SM – **American Association of University Women** co-sponsored art events such as the Santa Maria Valley Art Festival (1952, 1953), the Winter Arts Program (1952/53), a Junior Art Course under the City Recreation Department (1959) and aided exhibits at Alan Hancock Art Gallery and at the Santa Barbara County Fair, among other happenings. At its meetings lecturers spoke on various art topics, and artists gave instruction in various crafts.

1951+ – SM – **Fun Club**, a Saturday morning program of the YMCA for children in the 4th, 5th and 6th grades, included crafts.

1951+ – SM – **George Muro** taught art and crafts and Santa Maria High School and Adult School and, in 1954, became art teacher and head of the art gallery at Allan Hancock Junior College. He served as Art Division Chairman, Santa Barbara County Fair, 1958+.

1952-March – SM – Third annual **Hobby & Art Show** was held by the Community Club.

1952, 1953 – SM – **Santa Maria Valley Art Festival** contained exhibits and art in action and lectures, probably the idea of Jeanne DeNejer, art chairman of the American Association of University Women, who sponsored the Festival.

1952/53 – SM – **Winter Arts Program**, under the University of California Extension program, consisted of a series of "arts" lectures held at Santa Maria Junior College and other places, organized by **Jeanne DeNejer**.

1952/56 – SM – **Gordon Dipple** taught art and crafts at Santa Maria High School.

1952-58 – SM – **Snapshot Guild**, a nationally syndicated "how to" column on photography was run in the *SMT*.

1952-62 – SM – **Barbara Bixby**, amateur photographer, was active with the Santa Maria Camera Club.

1953-Feb. – SM – **Elizabeth Borquist** taught china painting at Edwina's Ceramic Studio.

1953-March – SM – **Le Décor**, interior decorating shop, was opened by **Jules Jeannotte**.

1953 – SM – **Hazel Heller** held a OMS at the Santa Maria Library.

1953-56 – SM – **Luther Thurman**, journalism instructor at Santa Maria High School, had many of his photos reproduced in the *SMT*.

1953-57 – SM - **Fred Gibbs** was active with the Santa Maria Camera Club.

1954-Aug.+ – SM – **Allan Hancock College.** Santa Maria Junior College was moved from the high school into buildings on Hancock airfield recently vacated by USC College of Aeronautics. **George Muro**, art teacher, was first borrowed from the high school but by 1956 was fully employed by the college. The JC's art mission was college prep courses for the college bound as well as basic design courses for non-college bound students. Muro also put on a full slate of art exhibits at the college's Art Gallery. JC art students helped design college theater stage settings, and were active in the Rembrandt Club. Art and photography students helped produce the yearbook. **J. Miles Boothe** followed by **Mervin Slawson** taught photography. **Adult School** was also moved from the high school to Allan Hancock College c. 1955, although for a number of years some classes continued to be held in high school buildings. Art/crafts was taught by **George Muro**. Art metals was taught by Edgar Eimon and Milo Holenda.

1954-Dec.+ – SM – **Allan Hancock College Art Gallery** was overseen by **George Muro** aided by various local women's groups. This was the first year-round, non-commercial art gallery in Northern Santa Barbara County. Between 1954 and 1960 most shows were borrowed from top contemporary California artists or entities although there were several one-man shows of local artists. In support of "home" talent, the gallery held group shows of northern Santa Barbara County artists in 1955 (March), 1956 (March), 1957 (May), and for area art teachers, 1958 (May). Lectures and docent tours of Gallery shows helped educate college art students as well as the laic public.

1954-Dec. – SM – **Gardner Boyd**, having studied at Brooks School of Photography and having had experience with newspapers, became the photographer for the *Santa Maria Times*. Member Santa Maria Camera Club c. 1957.

1954/56 – SM – **Jim Taylor**, journalism student at Santa Maria Junior College, had many of his photos reproduced in the *SMT*.

1954-58 – SM – **Dave Colgrave** was active with Santa Maria Camera Club.

1954+ – SM – **Marilyn Smith**, Santa Maria High School grad., went on to major in art at Mills College.

1954+ – SM – **Henry Fujioka**, grad of Santa Maria High School, went on to study art at the California College of Arts and Crafts in Oakland and to follow an art career in the Bay Area.

1954+ – SM – **Betty Eya**, grad. of Santa Maria High School, won a scholarship to the College of Arts and Crafts, Oakland. In 1959, in LA, she was a student at Chouinard Art Institute.

1955 Aug. – SM – **Santa Maria Valley Historical Society** was formed.

1955-Sept. – SM – **Allan Hancock College** provided classrooms for certain **Night School** classes including welding and woodshop. Ceramics and Crafts were added in 1957.

1955 – SM – **Rembrandt Club** was active at Allan Hancock College.

1955 – SM - **Earle Leitner** grad. Santa Maria High School. After attending Santa Maria JC and various art schools (in Mexico City and San Francisco), he returned to Santa Maria in 1966 to pursue various careers in art (Interior Decorator, graphic designer).

1955-c. 1976 – SM – **Bob Hendricks** ran Santa Maria Studio of Photography.

1955+ – SM – **Edgar Eimon** was welding and art metals teacher at Allan Hancock college adult school.

1955+-- SM – **Nat Fast** taught art at Santa Maria and Righetti high schools, and at Allan Hancock College, 1955-82. Exh. Allan Hancock [College] Art Gallery, 1957, 1958.

1955+ – SM – **Guido Signorelli** who had showed art promise at Santa Maria High School, 1933, discovered and produced Chinese brush art.

1956 – SM – Five teens started their own Camera Club and ran their own developing lab.

1956 – SM – **Kay Patton** of Los Angeles painted murals at Santa Maria Inn.

1956 – SM – **Blue Lantern** interior decorating studio was started by **Louise Corollo**.

1956+ – SM – **Robert Gronendyke**, sculptor, taught art at Santa Maria High School. He exhibited his sculpture throughout California.

1957, 1958, 1959 – SM – **Art and Hobby Show** sponsored by the Minerva Club was held at its clubhouse.

1957-88 – SM – **Freddie** and **Dave Weaver** ran **Weaver's Camera Shop**. She was also active with the Santa Maria Camera Club.

1958-59 – SM – **Ken Park**, student at Santa Maria JC, had many of his photos repro. in the *Santa Maria Times*.

1958/78 – SM – **Mervin Slawson** taught photography at Santa Maria High School and held a OMS at Allan Hancock College Art Gallery, 1956.

1958+ – SM – **Phyllis Ingram** moved to Santa Maria where she practiced various forms of art: painting, photography, table settings.

1958+ – SM – **Richard York**, Santa Maria High School grad., was a student at the California School of Fine Arts, San Francisco

1958+ – SM – **Roy Imamura** won prizes as a Santa Maria High School student. Grad. 1958 and then majored in landscape architecture at Cal Poly, grad. 1964.

1958+ – SM – **Trinidad Amador** grad. Santa Maria High School, then helped update the look of the Santa Barbara County Fair, and later practiced his art as a sideline in the broader community.

1958+ – SM – **Bob Dupuis** became active with the Santa Maria Camera Club, served as photo chairman at the Santa Barbara County Fair (1960), and opened **Professional Photographers**, a free-lance photo business at 705 West Hermosa Street (1960).

1959 – SM – **Katherine Goodenough** made a mosaic of the Madonna and Child for the First Methodist Church.

1959 – SM – **Taro Makimoto** taught flower arranging.

1959 – c. 1963 – SM – **Richard Holman** served as photographer for the *Santa Maria Times*.

1959+ – SM – **Paul Winslow** taught ceramics at Santa Maria Adult School, taught art at Santa Maria High School and Allan Hancock College, and later (1981) ran his own design studio.

1960 – SM & L – Traveling **Air Force Art Exhibit**.

1960-64 – SM – **Camera and Hobby Center** was in business.

1962-88 – SM – **William Shinn** taught ceramics at Hancock College.

1950s – Santa Ynez Valley

1949-Oct. – **Brandt-Ericksens** move from Jaffrey, N.H., to Solvang.

1949-50 – SY – **Iron Art**, a shop where forged iron products were made, was active under **Ernest Pedersen** and Walter Kristensen. From 1950-69+ the prop. was run solely by Ernest Pedersen.

1950s – SY – **Santa Ynez Valley Elementary Schools**. **Joseph Knowles** out of Santa Barbara made frequent trips to teach art in various classes in various schools. Typical art projects made in conjunction with academic classes were: totem poles, puppets, murals, landscape paintings, and clay modeling. Leo Ziegler taught art in some schools from 1948.

1950 s– SY – **Santa Ynez Valley High School** – The small faculty often necessitated teachers taking on a variety of subjects, and each teacher's slate changed from year to year. Continuing part time as teacher of art was **Leo Ziegler** to c. 1959. Arts and crafts was taught by **Mrs. Jack Anderson** (1950-56) and mechanical drawing by **Harold Venske** (1952-53) followed by **Earl Petersen** (to 1959). Industrial arts was taught by **Phil Condit** (1956-63), and in 1957 a new building for shop and photography, that included a ceramic kiln, was constructed. **Wilfred Stensland** (1959+) took over Industrial Arts. In 1959 the school offered its first summer classes. In 1960 an arts building was designed to be added to the Industrial Arts building. From c. 1944 graduating art students donated artwork to the school which was hung in classrooms.

1950s – SY – **Santa Ynez Valley Adult School**. **Leo Ziegler** continued teaching art, sometimes in rooms at Santa Ynez High School and at other times at scenic spots until c. 1957. Crafts teachers of the 1950s include **Mrs. Jack Anderson** (c. 1950-54) and **Fillmore Condit** (1958).

1950s – SY – **Solvang Woman's Club** moved into the home donated for its quarters and redecorated it (1950). Through the 1950s it offered only the occasional art lecture at its meetings.

1950s – SY – **Helen Eloise Joughin** painted, exhibited, and was active in art circles. She headed the Santa Ynez Valley Art Exhibit (1955, 1956) at which time it was opened to artists living outside the Santa Ynez Valley.

1950s, 1960s – SY – **(Gertrude) Evelyn Joughin** studied art in SLO and exh. in northern Santa Barbara County late 1950s and thru 1960s.

1950s-Mid – SY – **Mary Stine** made and taught the making of wood fiber flowers.

1950-52 – SY - **Michael Barnes**, artistically talented Santa Ynez Valley High School student, produced art for only a short while before he shot himself in the head.

1950-53 – SY – **La Petite Galerie**, gift shop, retailer of artists' materials and picture frames, conservation studio, site of art exhibits and art classes, and puppet factory, was run by **Forrest and Marie Hibbits** in Buellton and then moved to Solvang (1953) where it was open at least through 1960.

1950-60+ – SY – **Raymond Paaske** formed a Camera Club in Solvang that was active at least through 1960.

1950+ – SY – **Jack Griesbauer**, photographer, was first active in the valley when he drove up from Santa Barbara to take photos for another photographer (1950), but in 1951 he opened his own studio in Solvang, and in 1953 expanded his entrepreneurial abilities to other projects.

1950-75 – SY – **Walter Kristensen** created hand-wrought iron items at his **Old World Metal Craft** in Solvang.

1951 – SY – **Herbert Emerson**, top advertising photographer, took a home in the Santa Ynez Valley.

1951 – SY – **Mildred Wood**, former teacher at the Midland School, held a OMS at the Santa Barbara Museum of Art.

1952-60+ – SY - **Charles Glasgow** was active as a landscape painter.

1952+ – SY – **Paul Kuelgen**, artist in Hollywood for 17 years, retired to the Santa Ynez Valley to raise poultry and to engage in some art projects, such as creating signs.

1952+ – SY – **Helen Barbera** purchased a house in Solvang (Oct.) where she started **Valley Ceramic Shop**.

1953 Feb. – SY – **St. Mark's-in-the-Valley** held an **Art Exhibit** and auction to raise funds, and this led to the formation of the Santa Ynez Valley Art Association and the annual Santa Ynez Valley Art Exhibit, 1954-58.

1953-Dec. - 1959 – S – **Atterdag Studio** for photography was run by Hans Sorensen. Continued with other owners.

1953 – SY – The **Brandt-Erichsens** held a house-warming for their newly built **Elverhoj** to whose construction both contributed artistically. After Viggo's death in 1955, Martha taught private art classes there. In 1988, according to her will, it was made into a museum of Danish heritage and culture.

1953 – SY – **Vernal Gillum**, Santa Ynez Valley High School grad. Went on to study at the California School of Fine Arts, then into advertising in LA, and finally used his artistic abilities to produce commercials in Hollywood and New York.

1953 – SY – **Rev. D. K. Schmidt** hand carved the pulpit and altar at Bethania Lutheran Church, Solvang.

1953 – SY – **Santa Ynez Valley Art Association** – an association of four churches, formed as an outgrowth of the successful **St. Mark's-in-the-Valley Art Exhibit,** put on the annual **Santa Ynez Valley Art Exhibit**, 1954-58.

1954-July – SY – **Andersen's Pea Soup Restaurant** began holding changing art exhibits on its premises, at first under the direction of **Paul Kuelgen**, the restaurant's decorator. Over the years, artists who showed included Santa Barbara County artists: Helen Motzko, Forrest Hibbits, Nell Brooker Mayhew, Charles Glasgow, Joseph Knowles, Amory Hare Hutchinson, and Paul Kuelgen.

1954-Dec. – Ballard – **Louise Chrimes** opened the **Crafts Shop**.

1954-58 – SY – **Grace Davison**, writer, historian, painter, exhibited at the Santa Ynez Valley Art Exhibit.

1954-58 – SY – **Santa Ynez Valley Art Exhibit**, continuation of the St. Marks in the Valley Art Exhibit (1953), was held, the last two years (1957, 1958) in conjunction with Danish Days.

1954-58 – SY – Self-taught landscape artist **Ernest Walford** exh. at Santa Ynez Valley Art Exhibit.

1954+ – SY – **Ted Muradian**, music teacher at Santa Ynez Valley Union High School, sponsored a photography club.

1955 – SY – **Annette Negus**, grad. from Santa Ynez High School. Went on to study art and education. When married to her first husband, Svend Lindegaard, she maintained an art studio on the Lompoc-Buellton road.

1955 – SY – **Santa Ynez Valley Child Workshop Project** combined a nursery school with teaching of parents.

1955-58 – SY – **Charles Sloane**, rancher and amateur artist, exhibited at the Santa Ynez Valley Art Exhibit and other venues.

1956-63 – SY – **Fillmore Condit** taught industrial arts at Santa Ynez Valley Union High School and was crafts teacher in adult school, c. 1958-59.

1956 – SY – **Scandinavian Arts and Crafts** in Solvang sold metalcraft made by Walter Kristensen and also imported objects.

1956 – SY – *The Treasures of Mission Santa Ines* by Kurt Baer was published.

1956+ – SY – **Studio Workshop**, art classes for children and later for adults, was run by **Martha Brandt-Erichsen**.

1957 – SY – **Robert Jensen**, grad. from Santa Ynez High School. Attended art schools in San Francisco (1960) and Los Angeles (1962-64), then took a job in advertising in Chicago.

1957+ – SY – **Charles Carroll**, interior decorator and custom jeweler of Arizona, was active in the Santa Ynez Valley as a rancher and with his business, **Cadra Jewelry,** to at least 1960.

1957-58 – SY – **Ortega & Sammons** performed art and drafting in Solvang.

1957+ – SY – **Oscar Lindberg** exhibited his paintings and also served as curator for art exhibits at the Solvang Library, 1959-64.

1958 – SY – **Gerald Brommer**, watercolorist from southern California, painted views of Solvang for an article in *Westways* magazine.

1958 – SY – **Rita Kaslow**, costume designer from Hollywood, settled in the Santa Ynez Valley.

1958-59 – SY – **Holger Petersen** from Long Island painted "Danish" paintings in Solvang before settling in Carmel.

1959 – SY - **Laura Davidsen** of the Solvang Lutheran Home painted.

1959-62 – SY – **Solvang Studio of Photography** was run by **Loris Gardner** (1959-62) then by George Ives (1963+?).

1959-68 – SY – **Mud Mill Pottery Studio** was run by **Kirsten and Frank Pedersen**. Sold in 1968 to Dwight and Claire Watts.

1959-76 – SY – **Dee McLaughlin** acted as interior decorator and muralist and dealt in antiques.

1959+ – SY – **Earl Petersen** opened a drafting/design studio and went on to design and build many homes.

1959+ – SY – The **Solvang Library** held a revolving slate of art exhibits of local artists.

1960 – SY – **Astrid Blystad**, **Walter A. Swanson**, and **Peter Jacobsen**, residents of the Solvang Lutheran Home, all self-trained in art, received newspaper recognition for their painting.

1960 – SY – **Lawrence Hauben**, student at UC, Santa Barbara, exh. in SLO (1959), made illustrations for the Beaudette Foundation and later was credited as actor and screenwriter of the Hollywood film, "One Flew Over the Cuckoo's Nest."

1960 – SY – **Santa Ynez Valley Historical Society** was founded by the Santa Ynez Valley Woman's Club. **Santa Ynez Valley Museum of Natural History**, a public service unit of the Beaudette Foundation, was started.

FORMAT OF ENTRIES

The format of this Dictionary is the author's own. There are two types of entry – 1) an "Artist" entry for an individual artist, and 2) an "Entity" entry (for organizations or businesses or "groupings," such as "Art, general (Lompoc)").

Artist Entries:
Heading: **Morrison (Taylor), Amelia (Helene) (Mrs. Lawrence David Taylor) (1915-2008/9) (Santa Maria)**.
The heading above breaks down into: Last Name, (married name or several married names), first name, (middle names, maiden names, and/or married names held before being active in Santa Barbara County), (married name), (birth - death dates), (main town of residence).
Artists are listed under the name they were know by while working in Santa Barbara County. For women this was often their maiden name. (Maiden names and married names are cross referenced.)
What artists were included in this Dictionary.
The artists chosen for this volume (no. 6, on Northern Santa Barbara County artists and photographers before 1960) varies slightly from those included in the earlier nos. 3 and 4 (on Atascadero and San Luis Obispo artists). This volume contains primarily adults who received artistic mention in the local newspapers multiple times. It also contains a few high school and junior college students who, after high school, advanced to specialized art schools or pursued actual careers in art or photography. Although this volume purports to be only for artists residing north of the Santa Ynez mountains, it contains a few entries for artists who resided in the town of Santa Barbara but who were active in the northern part of the county. (Entries are brief if that "Santa Barbara" artist already enjoyed substantial published information. However, entries are long if the artist is still relatively unknown to the California art community.) This inconsistency in treatment comes from this editor's desire not to duplicate information already easily available in books and on the Internet, and conversely, to make easily accessible as much new information on a California artist as possible.
Biography: Artist entries begin with one or several pre-written biographies (if any were found).
Newspaper Bibliography: Additional information found on the artist in newspapers either on microfilm or digitally on the
 Internet.** Articles were organized chronologically so that, if no written biography could be located, the bibliography itself
 could provide a kind of "biography." Within this section, **bolded words** point to other entries in this Dictionary where
 additional information for this artist / entity can be found. Underlined entries highlight 1) significant themes or, 2) names of
 individuals who showed some artistic talent but not enough to be given a separate entry in this Dictionary.
Misc. Bibliography: Contains genealogical references to the artist found on ancestry.com. These millions of public records
 include Census records, City Directories, and birth, marriage, divorce and death records, etc., and were arranged
 chronologically.
See books: Lists published books that mention the "artist".
See: Includes pointers to other entries in this book where additional information on the artist can be found.

Entity Entries:
Definition of entity: A "history" of the entity was included if a pre-written one was found.
Newspaper Bibliography: This section includes information found in newspapers, either on microfilm or digitally on the
 Internet.** Articles were organized chronologically so that, if no written history of the Entity could be located, the
 newspaper notices themselves could provide a kind of "history." Within this section, **Bolded words** (usually artist names)
 makes them easier to find when searching the sometimes dense paragraphs. Underlined entries highlight 1) significant
 themes or, 2) names of individuals who showed some artistic talent but not enough to be given a separate entry in this
 Dictionary.
See books: Points to published books that mention the entity.
See: Includes pointers to other entries in this book where additional information on the entity can be found

This compiler, acutely aware that re-writing original material often results in misinterpretation and errors, made the decision to transcribe source material *verbatim*. **Warning!!** Grammar – When transcribing, this author often corrected newspaper grammar and spelling but NOT the mis-spelling of artist names. Mis-spelled artist names are identified with (Sic.) followed by the correct spelling. In an age of digital searching this seemed wise. Capitalization – The author followed the capitalization used by the newspaper – although in the mid twentieth century it was the fashion to leave the capital letter off the last word in a proper title, as in "Alvarado st."

** Format of newspaper entries =
- "Title of Article" (if any)
- Text of the article or a summary of the contents of the article.
- *Title of newspaper* (often in acronym form, always in italics)
- Date = Jan. 24, 1923

- Page = p. 4 OR p. ? (**<u>Alert</u>!!** Page numbers are tricky. Those obtained from microfilm reflect the actual number at the top of the printed page. (Sometimes these were blurry but the indexer tried her best to translate them into a correct number.) Page numbers obtained from digitized versions of the newspapers on the Internet reflect the numbers assigned by the Internet source and may not match the numbers on the printed page. They appear to have been assigned sequentially as the newspaper was scanned. Sometimes this editor added the correct number in parentheses, such as (i.e., pt. III, p. 2).

** **Warning !!** – Sometimes persons wanting to look up an original article in the newspaper cannot find it by digitally searching. There can be several reasons for this:

1. Differing editions – the edition microfilmed is not the same as the edition digitized on the Internet.
2. Missing pages – digitized versions of the newspaper may be missing pages or whole days or weeks or months.
3. Failure of optical character reader – in certain cases the optical character reading machine could not "read" the text. This occured because, 1) the original from which the scan was made was too blurry, 2) a proper name was hyphenated and split between lines in a column, 3) typeface was too large (as in the case of headings) or too small (as in the case of legal statistics) for the machine to read.
4. Proper names and other words were misspelled.

(In most cases, a person can search for a nearby name or string of characters. If that fails then it will be necessary to BROWSE by state, then town, then newspaper, then date, then page.)

ABBREVIATIONS

AA – Art Association

AAA Scrapbook – Atascadero Art Association Scrapbook (owned by the Association)

AAUW – American Association of University Women

AG or AGH – Arroyo Grande *Herald Recorder*

AHS – Atascadero Historical Society

Allan – L. W. Allan, *Atascadero: The Vision of One – The Work of Many*, Mike Lucas, 2008

Achievers – *The Achievers: Central California's Engineering Pioneers*, SLO: Central Coast History Foundation, 2004

ancestry.com = Internet site where information such as City Directories and Public Records can be found

Angel – Myron Angel, *Reproduction of Thompson and West's History of SLO County, California* c. 1883 [reprint c. 1966]

ann. - announcement

AN – *Atascadero News* (newspaper of Atascadero)

APS – Atascadero Photographic Society

APSA – Associate, Photographic Society of America?

ASL – Art Students' League, New York

Assn. – Association

AWCA – American Water Color Society

AWVA – American Women's Voluntary Services

b. – born

B – Bonham's auction gallery

B.A. – Bachelor of Arts

B&B – Bonham's and Butterfield, auctioneers

b. c. – born circa

Baker – Gayle Baker. *Cambria: A Harbor Town History.* 2003

Beacon (yearbook of SLO Junior College)

Bearcat – (newspaper of the Paso Robles Union High School)

bio. – biography

BMAI – Businessman's Art Institute

BPWC – Business and Professional Women's Club

Bristow – Allen P. Bristow, *History of the California State Guard in SLO County, 1942-1945*, n.p., 1992

C – Cambrian (newspaper of Cambria)

C – Christie's auction house

CAI – Chicago Art Institute

Camp Roberts Parade – (newspaper for Camp Roberts during the Korean conflict, 1951-52)

Carotenuti – Joseph A. Carotenuti, *SLO 1850-1876*, SLO: Central Coast Press, 2006

CCAC – California College of Arts & Crafts, Oakland

CD – City Directory

CHP – California Highway Patrol

CDNC – California Digital Newspaper Collection (on line)

CofC – Chamber of Commerce

Crimson & White – (newspaper of Paso Robles Union High School)

CSFA – California School of Fine Arts, San Francisco

CUHS – Coast Union High School, Cambria

CWCS – California Watercolor Society

DAR – Daughters of the American Revolution

d. – died

D – Dunite (Norm Hammond, *The Dunites*, South County Historical Society, 1992)

Dispatch – (newspaper of Camp Roberts during WWII)

dob – date of birth

dod – date of death

DT – SLO *Daily Telegram* (newspaper for SLO to c. 1939)

Dune Forum (publication of residents of the Dunes in Oceano)

E - etching

Eagle – Templeton High School yearbook

exh. – exhibited

EEP – Emergency Educational Program

El Camino – yearbook of Mission High School, SLO (NOT browsed for this Dictionary)

El Roble Murmullo – yearbook of Paso Robles High School

El Rodeo – (yearbook for Cal Poly) (Copies on the Internet)

ERS – *Eagle Rock Sentinel* (newspaper of Eagle Rock, Ca.)

F&J – Franklin and James, index to auction records (i.e., *Decade Review: American Artists at Auction 1/83-1/93*, and *Decade Review: American Artists at Auction 2001*)

Gates – Dorothy L. Gates, *Morro Bay's Yesterdays*, El Morro Publications, c. 1982

GB – genealogybank.com

GGIE – Golden Gate International Exposition, San Francisco, 1939-1940

Guinn – Coast Counties – James Miller Guinn, *History of the State of California and Biographical Record of Coast Counties, California*, 1904 (republished several times and available from print-on-demand)

Guinn – Central Coast – J. M. Guinn. *History of the State of California and Biographical Record of Santa Cruz, San Benito, Monterey and SLO Counties*, 1903

Hamilton – Geneva Hamilton, *Where the Highway Ends*, Cambria: Williams Printing Co., 1974

Hi-C – Hi-Chatter (newspaper of Arroyo Grande High School)

HN – Hilltop News (newspaper of the Atascadero Union High School)

Hoving – Gary L. Hoving, *SLO County Sheriff's Department*, Arcadia, 2011

HS – High School

h&w – husband and wife

Hughes – Edan Hughes, *Artists of California, 1786-1940* (three different editions plus information placed on ancestry.com).

Independent – (Newspaper of Paso Robles) (Copies at Paso Robles Public Library)

info. – information

IR – Illustrated Review/ California Illustrated Review/ Atascadero Illustrated Review

Jespersen – Chris Jespersen. *History of SLO County, State of California, Its People and Resources*, 1939

JM – John Moran auction house, Pasadena, Ca.

Junior Journal – (publication of Paso Robles Union High School) (copies from 1903-1912 are owned by the Paso Robles Historical Society)

KOV – Phil Kovinick and Marian Yoshiki-Kovinick, *An Encyclopedia of Women Artists of the American West*

Krieger – Daniel E. Krieger, *SLO County: Looking Backward into the Middle Kingdom*, SLO: Ez Nature Books, c. 1988

LA – Los Angeles

LACMA – Los Angeles County Museum of Art

LAT– Los Angeles Times (newspaper) (some entries from ProQuest)

La Vista – La Vista (magazine of the SLO County Historical Society), 1958-1975

LBAA – Laguna Beach Art Association

LBL – Laguna Beach Life (newspaper)

LCD – Lompoc, Ca., City Directory

LL – Laguna Life (newspaper)

Loomis – John Loomis, *John and Gordon, the Old Days: 1932-1944 in Arroyo Grande, California: Memories of Our Growing Up Years*, Arroyo Grande: Boocoocks of America Press, 2002

LR – *Lompoc Record* (digitized on newspapers.com)

MacGillivray – J. Fraser MacGillivray, *The Story of Adelaida*, 1993

MacLean – *Curse* – Angus MacLean, *The Curse of the Feathered Snake and Other Stories*, Pioneer Publ., c. 1981

MB – Morro Bay

MBAA – Morro Bay Art Association

MBHS – Morro Bay Historical Society

MFA – Master of Fine Arts (degree)

misc. – miscellaneous

Moon – (Early newspaper of Paso Robles) (Copies at Paso Robles Public Library

Morrison – Annie L. Morrison, *History of SLO County and Environs*, LA: Historic Record Co., 1917

NAD – National Academy of Design, New York

nfs – not for sale

Nicholson – Loren Nicholson, *Glimpses of Childhood in the Old West, 1840-1940*, SLO: California Heritage, 1995

Obit. – obituary

o/c – oil on canvas

Ohles – Wallace V. Ohles, *The Lands of Mission San Miguel*, Fresno, Ca.: Word Dancer Press, 1997. (This history covers the later towns of San Miguel, Paso de Robles, Atascadero, and Cholame/Parkfield as well as Camp Roberts)

OES – Order of Eastern Star

OMS – one-man show

Pioneer – *Pioneer Pages* (publication of the Pioneer Museum, Paso Robles)

pod – place of death

Polytechnic Journal (Monthly publication, Cal Poly, 1906-12) (On the Internet)

port. – portrait (usually a photographic portrait)

PRHS – Paso Robles Historical Society

PRP – Paso Robles *Press* (newspaper)

PRR – Paso Robles *Record* (newspaper)

PSA – Photographic Society of America

PSCA – *Publications in [Southern] California Art* (Dustin Publications), 12 vols.

PT – Pismo Times (newspaper)

PTA – Parent Teachers' Association

Raycraft – Susan Raycraft and Ann Keenan Beckett, *San Antonio Valley*, Arcadia, 2006

refs – references

repro – reproduced

rev. – review

San Miguel Messenger – (newspaper of San Miguel, Ca.)

Santa Lucia – yearbook of the Atascadero High School

SBCS – *San Bernardino County Sun* (newspaper)

SCD – *Solvang City Directory*

SCN – *South Coast News* (newspaper of Laguna Beach)

SERA – State Emergency Relief Administration

Seventy – Patti Taylor and Suzette Lees, *75 SLO City Sites*, SLO: Graphic Comm. Inst., Cal. Poly., 2010

SF – San Francisco

SFMA – San Francisco Museum of Art

SLO – SLO [in order to reduce the size of the text, the phrase "San Luis Obispo" even within transcribed newspaper articles, was shortened to "SLO"]

SLOCD – *San Luis Obispo City (and County) Directory*

SLO DT – SLO *Daily Telegram* (newspaper) [Some of the articles from this newspaper were located by browsing microfilm and others by searching digitally on genealogybank.com. The newspaper dates cited in this text were taken from the top of the actual page (when using microfilm) and from the citation provided by genealogybank.com, when using the website. Some of the genealogybank.com citations were off by a page or two from the actual.]

SLO Fire Dept. – *Souvenir, SLO Fire Department*, J. H. Tigner, [1904]

SLO History Index – PDF spreadsheet compiled by Lynn Wiech, SLOHS – History Center of SLO County

SLO T-T – SLO *Telegram-Tribune* (newspaper) [Some of the articles from this newspaper were located by browsing microfilm and others by searching digitally on genealogybank.com. The newspaper dates cited in this text were taken from the top of the actual page (when using microfilm) and from the citation provided by genealogybank.com, when using that service. Some of the genealogybank.com citations were off by a page or two from the actual. At the time this book was researched, most of the newspaper from the mid 19th century to 1960 (excepting a span around 1890) had been digitized.]

SMagHS – Santa Margarita Historical Society

SMCD – *Santa Maria, Ca., City Directory*

SMFA – *Santa Maria Free Advertiser* (newspaper of Santa Maria)

SMHS or SMVHS – Santa Maria Valley Historical Society

SMM – *San Miguel Messenger* (newspaper) (quotes transcribed from Ohles)

SMT – Santa Maria *Times* (newspaper on microfilm and digitized on newspapers.com)

SNS (or *Shot*) – *Shot and Shell* (newspaper of Camp SLO. This newspaper had several different names over time = *40th Division Camp News*, *Sunburst Sentinel*, and *Shot n' Shell*)

SYVN – *Santa Ynez Valley News* (newspaper of Solvang, Ca.) (digitized on newspapers.com)

Spectacular – *Spectacular Wineries of California's Central Coast*, Panache Partners, 2010

SS – *Sunburst Sentinel* (originally named *40th Division Camp News* until contest for renaming it c. May 1941)

Storke – Yda Addis Storke. *Memorial and Biographical History of the Counties of Santa Barbara, SLO and Ventura, California*. 1891

Sun – Morro Bay *Sun* (newspaper)

SW – *Salinas Weekly* (newspaper)

TA – *Temple Artisan* (bi-monthly published by Temple of the People, Halcyon)

Templeton Advance – (newspaper of the town of Templeton)

Templeton Times – (newspaper of the town of Templeton)

T-T – SLO *Telegram-Tribune* (newspaper)

Today – *Today, Tomorrow & Yesterday* (magazine of the South County Historical Society), 1976-1981

Travis – Marguerite Travis, *The Birth of Atascadero*, Atascadero: Atascadero Historical Society, 1960, 1976, 1989

Tribune (newspaper of SLO, 19th century on genealogybank.com)

Twisselman-Changing – Henry A. Twisselman, *Changing Times*, Los Olivos: Olive Press Publications, 1998

Twisselman-Don't – Henry A. Twisselman, *Don't Get Me Started!*, Los Olivos, Ca.: Olive Press Publications, 1995

UC – University of California

USO – United Service Organization

Vol. – volume

wc – watercolor

WPA – Works Progress Administration

WWC – *Who's Who in California*

WWI – World War I

WWII – World War II

? – used when the author is uncertain of a fact

DICTIONARY OF ARTISTS, PHOTOGRAPHERS AND ORGANIZATIONS

A

Abbott, Joaquina / Juaquina / Juanquina / Juanita Arbelaitz (Mrs. Ronald A. Abbott) (1915-1968) (La Verne / Santa Ynez)
Artist. Exh. annual Santa Ynez Valley Art Exhibit, 1952-54, 1957-58. Mother of Ronnie Jean Abbott, below.

■ "Mrs. Abbott Rites Conducted… for Mrs. Ronald A. Abbott… of Santa Ynez, talented artist and longtime resident of the Santa Ynez Valley… She was born March 2, 1915 in Goleta. Mrs. Abbott was known for many years in the Santa Ynez Valley for many artistic contributions. She was educated in the valley elementary and high schools… the former Miss Joaquina J. Arbelaitz…," *SYVN*, Dec. 12, 1968, p. 2.
A few notices regarding her work as an event decorator appear in the *SYVN* but were not itemized here.
See: "Abbott, Ronnie Jean," "Danish Days," 1957, "Santa Ynez Valley Art Exhibit," 1952-54, 1957-58, "Tri-County Art Exhibit," 1952

Abbott, Mary (Santa Barbara)
Photographer on the staff of Brooks Institute who attended a meeting of the Santa Maria Camera Club, 1946.
See: "Santa Maria Camera Club," 1946

Abbott, Mary (Midwest)
Mid-western artist and teacher of c. 1920 whose work was shown at the Community Club, Santa Maria, 1950.
Possibly – Mary Beth Abbott (1887-1981) born in Nebraska but settled in Glendale, Ca., listed in Edan Hughes, *Artists in California 1786-1940*.
See: "Community Club," 1950

Abbott (Dellar), Ronnie Jean "Jean" (Mrs. Ronald D. Dellar) (1939-?) (Santa Ynez Valley)
Watercolorist. Exh. annual Santa Ynez Valley Art Exhibit, 1953, 1956. High School student who won a Bank of America Achievement Award in art, 1956. Art major at UC, SB, 1956. Daughter of Joaquina Abbott, above.

■ Port with husband-to-be and "Miss Abbott, R. D. Dellar are Engaged. Mr. and Mrs. R. A. Abbott of Santa Ynez announced this week the engagement of their daughter …. Miss Abbott attended Valley schools. She was graduated from Santa Ynez Valley Union High School with the class of 1956 and was a scholarship student in both art and music. In her senior year she was president of the Girls' Athletic Association, art editor of the *Pirate Log*, editor of the school annual, and winner of the Babe Ruth Foundation Award, which was for general school sportsmanship. She attended the University of California at Santa Barbara

College and is now employed in the Sansum Clinic in Santa Barbara…," *SYVN*, Feb. 22, 1957, p. 3; "Ronnie Jean Abbott, Ronald D. Dellar United in Marriage in Las Vegas Rite… now at home at 1823 Bath Street in Santa Barbara," *SYVN*, April 5, 1957, p. 3.
Abbott, Ronnie Jean (notices in Northern Santa Barbara County newspapers on microfilm and on newspapers.com)
1953 – "Youth… Art Exhibit… St. Mark's-in-the-Valley… Youthful Jean Abbott will show her work in water colors. She was taught to paint by her mother, **Jouquina** [Sic.] …," *SYVN*, Jan. 30, 1953, p. 3.
1956 – "Four HS Students Winners in Bank of America Program… 1956 Achievement Awards program… Ronnie Jean Abbott, fine arts…," *SYVN*, March 23, 1956, p. 7; port. receiving BofA award, *SYVN*, March 30, 1956, p. 10; "Jean Abbott Wins Art Scholarship… the 1956 St. Mark's-in-the-Valley Art Scholarship… daughter of Mr. and Mrs. Ronald Abbott, plans to use the scholarship in furthering her education. Her mother, **Joaquina Abbott**, is an accomplished artist and a regular contributor to St. Mark's Art Shows," *SYVN*, May 25, 1956, p. 1; photo of Jean Abbott receiving the scholarship from Rev. Karl Mark Graf, while **Mrs. Andrew Joughin** looks on, and in background is a water color of Old Mission Santa Ines by Miss Abbott. "She will be an art major next Fall at Santa Barbara College," *SYVN*, June 1, 1956, p. 8; "Scholarship Awards Given HS Students… Ronnie Jean Abbott…," *SYVN*, June 15, 1956, p. 1.
1957 – Wedding port., *SYVN*, Feb. 22, 1957, p. 3.
Abbott, Ronnie Jean (misc. bibliography)
Ronnie Jean Abbott, mother's maiden name Arbelaitz, was b. Jan. 19, 1939, in Los Angeles per Calif. Birth Index; Ronnie Jean Abbott is listed in the 1940 U. S. Census as residing in San Jose with her parents, Arthur Donald and Joaquina Abbott; Ronnie J. Dellar is listed with husband Ronald in the *Santa Barbara, Ca., CD*, 1959, 1960; R. Jean Dellar is listed with husband, Ronald, in the *Santa Barbara Ca., CD*, 1960-72; Ronnie J. Abbott divorced Ronald D. Dellar in Oct. 1972 in Santa Barbara County per Calif. Divorce Index; Ronnie J. Abbott, b. Jan. 19, 1939, was residing in Bartow, Florida, at an unspecified date per *U. S. Public Records Index, 1950-1993*, vol. 2 (refs. ancestry.com).
See: "Abbott, Joaquina," "Christmas Decorations (Santa Ynez Valley)," 1953, "Four-H," 1954, "Santa Ynez Valley Art Exhibit," 1953, 1956

Abel, L. E. (Vandenberg AFB)
Photographer. Active with Santa Maria Camera Club, 1960.
See: "Santa Maria Camera Club," 1960

Ables, Emma Jones (Mrs. John William Ables) (1865-1928) (Santa Maria)
Exh. still life paintings at Santa Barbara County Fair, 1889.

Ables, Emma (notices in Northern Santa Barbara County newspapers on microfilm and on newspapers.com)
1884 – "Married. Ables-Jones – At the Cosmopolitan Hotel San Luis Obispo, Oct. 23, 1884… both of Santa Maria," *SMT*, Oct. 25, 1884, p. 5; "Fifty Years Ago. Mr. J. W. Ables and Miss Emma Jones took passage for San Luis Obispo and were united in the holy bonds of matrimony at the Cosmopolitan hotel by Justice Barnes … Both… have passed the majority of their days in the valley… They left by the steamer *Santa Rosa* for a tour of the northern part of the state," *SMT*, Nov. 1, 1934, p. 4.
1918 – MOTHER – "Mrs. Jones' Life… Mrs. Sophia B. Jones… surrounded by her children, Mrs. Emma Abels [Sic. Ables?] …," *SMT*, Nov. 18, 1918, p. 3.
Two references to Emma Jones' schoolwork in the early 1880s was not itemized here.

Ables, Emma (misc. bibliography)
Emma T. Ables is listed in the 1910 U. S. Census as residing in Santa Maria with her husband John W. Ables; Emma T. Ables is listed in the 1920 U. S. Census as age 55, b. c. 1865 in Iowa, residing in Santa Maria with husband William J. Ables (age 59); Emma Ables b. Dec. 5, 1865 in Redfield, Iowa, d. March 19, 1928 in Santa Maria, spouse John William Ables, and is buried in Santa Maria Cemetery District per findagrave.com (refs. ancestry.com).
See: "Santa Barbara County Fair," 1889

Adair, Lee (Mrs. Dabney) (Mrs. James W. Hastings) (c. 1933-after 2020) (Santa Barbara / Bay Area)
Exh. under the name Lee Dabney in the Santa Ynez Valley Art Exhibit, 1954.

■ "Adair Exhibit Shows Interest in Bodies Floating in Space. Opening in the Santa Barbara Museum of Art Thursday, December 19, will be a one-man exhibition of paintings by Lee Adair. The Bay Area artist attended school in Santa Barbara and graduated with a master of arts degree from the University of California at Berkeley. Since then her work has been seen in group shows in the San Francisco Museum of Art, the Dilexi Gallery and the Bolles Gallery in San Francisco and in one-man exhibits in the Eric Locke Gallery, the Berkeley Gallery in San Francisco and in the Richmond Art Museum. In Santa Barbara her work has been exhibited in the Esther Bear Gallery. Miss Adair's paintings illustrate her interest in the launching of figures in outer space...," *SMT*, Dec. 16, 1968, p. 10; and similar article in *LR*, Dec. 19, 1968, p. 4.

Adair, Lee (notices in California newspapers on microfilm and on newspapers.com)
1957 – "Art Student Prizes. Seven art students at the University of California, Berkeley, have been named prize winners for their works in a campus exhibit… held by Delta Epsilon, national student art honorary society, all this month at the Stephens' Union. Winners are Mrs. Lee Dabney Adair [Sic. Lee Adair Dabney?] …," *SF Examiner*, April 21, 1957, p. 26.
1959 – "Art … Lee Dabney oils and graphic arts – at Eric Locke Galleries," *SF Examiner*, Jan. 25, 1959, p. 126 (i. e.

continued from p. 13); "Bolles Stable. For the summer, Bolles Gallery is showing most of its stable of artists… Other painters… Lee Dabney…," *Oakland Tribune*, Aug. 23, 1959, p. 103 (i. e. S-11).
1964 – "Art. Eastbay… Berkeley Gallery… Oils by Lee Adair ... to May 17…," *Oakland Tribune*, May 3, 1964, p. 178 (i. e. p. 8EL); repro: painting of a child... Lee Adair... Holding a B. A. from U. C., Lee Adair traveled in Europe and the Middle East in '60 and '61 and the following year lived and worked in London," *Oakland Tribune*, May 10, 1964, p. 149 (i. e. 5EL).
1972 – "New Series of Classes... San Francisco Jewish Community Center... Lee Hastings will give personalized instruction in life drawing starting July 11 at 9 a.m.," *SF Examiner*, July 7, 1972, p. 29.
1977 – "Art ... Lee Adair Hastings – ink drawings of trees and shrubs of Golden Gate Park, Helen Crocker Russell Library, Strybing Arboretum, 9th avenue at Lincoln way, through March," *SF Examiner*, March 13, 1977, p. 142 (i.e., magazine?, p. 10).
And, many additional notices on her art in California newspapers were not itemized here.
Lee Adair Hastings of Sonoma, Ca., has a facebook page.
Adair, Lee (misc. bibliography)
Lee A. Dabney, student, residing at 607 Mira Monte Dr., is listed in the *Santa Barbara CD*, 1955; Mrs. Lee A. Dabney, student at 607 Mira Monte is listed in the *SBCD*, 1957; Lee A. Dabney is listed in Berkeley in the *Oakland, Ca., CD* [i.e., Telephone Directory], 1955, 1957; Lee A. Dabney, b. c. 1934, married James W. Hastings on Dec. 4, 1959 in San Francisco per Calif. Marriage Index; James Hastings with spouse Lee is listed in the *Sonoma, Ca., U. S. Phone and Address Directory*, 1995-1996 and in the *El Verano, Ca., U. S. Phone and Address Directory*, 1997-2002 (refs. ancestry.com).
See: "Dabney, Lee," "Santa Ynez Valley Art Exhibit," 1954

Adam, Kenneth Laird (1916-1966) (Lompoc)
Amateur photographer, 1950. Columnist of "Something About Nothing." Editor and publisher, Lompoc Record, 1952-66.

■ "Kenneth L. Adam, *Lompoc Record* Editor, Publisher, Dies at 49… Mr. Adam was born in Santa Maria, Oct. 10, 1916, attended Lompoc schools and was a graduate of the University of Southern California. He served as an officer in the U. S. Navy during World War II. After the war he was a publicist for MGM studios in Hollywood. He left that post in 1946 to become managing editor of the *Lompoc Record*…. Became publisher… in 1952 upon the retirement of his late father, Ronald Adam…," *SYVN*, July 28, 1966, p. 2.

Adam, Ken (notices in Northern Santa Barbara County newspapers on microfilm and on newspapers.com)
1950 – "Something About Nothing by Ken Adam… hobbies… newest of hobbies, which is one we follow when our town's commercial photographers are otherwise engaged and one which we find is almost as befuddling as all the others combined… After many years of trial and error, we finally decided in our advanced youth, that the only answer in the photography problem was the box

Brownie. We tried many types of cameras having varying numbers of dials, levers, handles, settings, slides, and related paraphernalia, all calculated to produce better pictures and confuse the people. But finally concluded that for all-purpose picture taking, the Brownie as perfected in the year '06 was the best. Furthermore, it could be purchased at any drug store for $1.69 or less. But the Brownie, for all its good points, has its limitations. When it became apparent that a photographer would soon have to be added to the staff of the weekly blast and volunteers were less than numerous, it was obvious that the pocket-size job we acquired in a Carmel grocery on our honeymoon would not be adequate. It was at that point that we were introduced to an impressive looking piece of gear known in the trade as the Speed Graphic. The Speed Graphic is a machine reminiscent of sonar, radar, and despair packaged in the convenient family size. Advertised as a simplified version of all the best that has gone before, it is to the Brownie what Mr. Einstein is to a slow student in freshman arithmetic. In order to reach that crucial point where a 'click' is heard, it is necessary to remember to perform 22 different prior operations, all of them mechanical and any of them fatal if forgotten. Mere performance of the mechanics is not enough, moreover for half of the steps are variables, meaning that the possibility for error is astronomical and the probability of success is too far removed from reality to be worth considering," *LR*, Oct. 19, 1950, pp. 1, 8.
1956 – Port. wearing printer's apron, *LR*, Jan. 12, 1956, p. 13.
And, hundreds of additional notices in the *LR* not itemized here.

Adam, Linda J. (Mrs. Ronald M. Adam) (Lompoc)
Member of Art Section of Alpha Club, mid 1930s and of the club itself, 1933-56.
See: "Alpha Club," 1933-35, 1938-39, 1954-56

Adams, Olive H. Crosby (Mrs. John Adams) (1865-1945) (Santa Maria / Alameda)
Artist. As "Mrs. Johny Adams" exh. best flower painting at "Santa Barbara County Fair,"1891. As "Mrs.? John Adams" exh., 1893. And she is possibly the Mrs. Jno Adams who exh. a marine painting at "Santa Barbara County Fair,"1900.
Adams, John, Mrs. (notices in Northern Santa Barbara County newspapers on microfilm and on newspapers.com)
1902 – HUSBAND – "Mr. John Adams is now the Southern Pacific Milling Co's resident agent and grain buyer," *SMT*, July 5, 1902, p. 3.
1903 – MOTHER – "Old Pioneer Dies. Elizabeth H. Crosby, mother of Mrs. John Adams and one of the very first settlers of the Santa Maria valley…," *SMT*, March 20, 1903, p. 2.
Additionally – Olive H. Adams was a donor to the Red Cross (1917), bought Liberty Loan bonds (1918), resided in Alameda (from 1918+) and bore a daughter named, Edith. There were 94 "hits" for Mrs. John Adams in *SMT* and several for Mrs. Adams and daughter Edith in the *SLO DT* but they were not itemized here.

Adams, John, Mrs. (misc. bibliography)
Mrs. Olive H. Adams is listed in the 1910 U. S. Census as age 40, b. c. 1870 in Calif., residing in Santa Maria with husband John (age 60) and daughter Edith (age 22); Olive H. Adams is listed in the 1920 and 1930 U. S. Census as residing in Alameda, Ca.; Olive H. Adams, mother's maiden name Blaney, father's Crosby, was b. Oct. 26, 1865 in Calif. and d. Jan. 12, 1945 in Alameda County per Calif. Death Index (refs. ancestry.com).
See: "Santa Barbara County Fair," 1891, 1893, 1900, and *San Luis Obispo Art and Photography before 1960*

Adams, Ralph Harry (1910-1998) (Santa Maria)
Drawing repro. in Splash, 1927. Photographer / magician. Owner of Adams Studio of Photography, Santa Maria, for 35 years.

■ "Ralph Adams, the youngest of 12 children, was born April 18, 1910 in Ross Fork, Mont. … and came to Santa Maria by way of Oregon in 1922. Always being somewhat interested in the illusion of magic, after buying a little pocket trick from a street vendor, he sent away for $2.65 worth of tricks. He volunteered as a magician at the Main Street School, and although he didn't know any tricks, he bought a book, gave the show and, as he said, 'I was a big shot around the school for a few days.' … It took years for Adams to develop his sleight-of-hand shakes. But he didn't stop there. Adams was an accomplished lapidary artist (making polished tables that remain pieces of art), and operated the Ralph Adams Photography Studio for 35 years, first on West Main Street in Santa Maria, and later at 617 S. Broadway. During the 1930s, while running his photography studio, he was also busy performing magic at local lodges. Eventually, his hobby became his profession. For many years he took school pictures and years later took these same children's wedding pictures. People have often told of how he mesmerized the children, as they were lined up to have their pictures taken, with his magic tricks. … After retiring from his photography business, he was able to devote more time to his magic acts, and it wasn't long before he received recognition from illusionists throughout the world as 'the man who put entertainment into magic.' Adams worked hundreds of stages throughout the country … After he retired for good, he and Hilda put on magic shows for 65 people at a time in the garage of their home in Orcutt. Admission for the children was a note from their parents saying that they were "good kids," while parents needed similar notes from their children. … Ralph Adams was a patient in Marian Medical Center and passed away on July 8, 1998. Both he and Hilda, who passed away in October of 2009, are buried in the Santa Maria Cemetery. …" by Shirley Contreras, in *SMT*, Feb. 28, 2010, on the Internet.

■ "World renowned illusionist Ralph H. Adams… died as a result of pneumonia July 8, 1998… His career as a photographer spanned 35 years. Some of his photos can be seen throughout local historical displays," *SMT*, July 10, 1998, p. 4.

Adams, Ralph (notices in Northern Santa Barbara County newspapers on microfilm and on newspapers.com)
1946 – HS annual "Review Pictures Being Taken," *SMT,* Feb. 1, 1946, p. 3; repro: "Young Pianists," *SMT,* May 23, 1946, p. 2; "Ralph Adams Now at Chicago Meet… attending sessions of a national convention of commercial photographers… staying at Lake Shore Club…," *SMT,* Aug. 27, 1946, p. 3.
1947 – "Now at Chicago Meet" for commercial photographers, *SMT,* Aug. 27, 1946, p. 3; "Camera Pictures Opening of KRJM," *SMT,* April 2, 1947, p. 11; "Four Beehive Girls… Latter Day Saints… photographs to be sent to the church news were taken by Branch President Ralph Adams," *SMT,* April 10, 1947, p. 3; "Adams Protests Solicitations of Outside [photograph] Peddlers…," *SMT,* Dec. 2, 1947, p. 1.
1948 – "Cub Scouts… A picture was taken by Ralph Adams of the Cub Scouts when they repeated the human Christmas tree stunt…," *SMT,* Jan. 19, 1948, p. 3.
1950 – "Druids… Ralph Adams made the official photographs for the Grand Grove and the Grand Circle," *SMT,* June 22, 1950, p. 3, col. 3.
1953 – "Photographers Hear Plans for West Coast Meet… [of] California Photographers' Assn. … Long Beach … Santa Maria was represented by Ralph Adams and … **Mr.** and **Mrs. L. J. Stonehart**," *SMT,* Jan. 9, 1953, p. 4.
1959 – "Large size pictures, 4 x 5 just like a regular press camera, now can be made by advanced amateur and professional photographers – right out of the air. A Santa Maria photographer-mechanic-businessman, came across 100 aerial cameras sold through war surplus outlets. He converted their complicated film roll arrangements into holders for the conventional 4 x 5 film. The special back Ralph Adams put on these sturdy army cameras will take film holders, six-sheet magazines, polaroid backs and film packs. 'With my adaptation,' Adams said, 'You don't have to shoot a 20-foot roll of film for 50 pictures. You now can take one shot at a time, the same as any other large camera.' The cameras originally cost $800 each. Adams is advertising them for sale at about one-tenth of that figure. Adams has his son, Ralph Jr., help him convert the complicated cameras to the simpler type. Young Adams has been learning camera repair for several years. The senior Adams said he has been tinkering with mechanical things since he was a boy, some 40 years ago. He started by dismantling and reassembling clocks. As a camera technician, Adams has synchronized two cameras for rapid pictures of many individuals, such as in a school class. By a special hookup, he can take black and white and color pictures simultaneously. His talents lie not only in the field of photographic reproduction…," and port. with army serial camera which he uses to make negatives, per "Photographer Works Magic with Cameras – Ropes Also," *SMT,* Sept. 2, 1959, p. 9;
1995 – "Abracadabra," *SMT,* Sept. 3, 1995, "Life" C-1.
And, 706 "hits" for "Ralph Adams" in the *SMT* between 1940 and 1970, primarily regarding his magic shows, were not itemized here.
Adams, Ralph (misc. bibliography)
Ralph Harry Adams was b. April 18, 1910 in Moore, Mont., to William Jay Isaac Adams and Nancy Jane Wilson, married Hilda Cora Howard and d. July 8, 1998 in

Santa Maria, Ca., per Diamond Family Tree (refs. ancestry.com).
See: "Adams Studio of Photography," "Lompoc Community Woman's Club," 1957, "Splash," 1927

Adams Studio of Photography (Santa Maria)
Photography studio active c. 1940+. Prop. Ralph Adams, above.
Adams Studio (notices in Northern Santa Barbara County newspapers on microfilm and on newspapers.com)
1940 – "Portraits, Kodak Finishing, commercial work. Special introductory offer, one doz. 3 x 5 portraits, $3.50. Adams Studio, 215 S. McClelland," *SMT,* Feb. 8, 1940, p. 5;
1945 – "Elks Present… The photograph of Sgt. Sutti and his bride, published in *The Times* last Friday, was furnished by the Adams studio, 117 West Main street," *SMT,* March 19, 1945, p. 3, col. 2.
1951 – "Get a Free Portrait of Your Baby. No obligations, just go to the Economy Drug Co. 114 South Broadway and register your baby's name to receive a coupon which will entitle you to a Free 8 x 10" photograph of your baby. Photos by Adam's Studio… This Sensational Offer Ends December 15, 1951," *SMT,* Nov. 26, 1951, p. 7.
1959 – "Adams Studio of Photography. Commercial – Aerial – Photostats – Copies – Portraits – Line Copy. Adams Studio of Photography, 617 So. Broadway, Santa Maria. Phone WAlnut 5-3620," *LR,* Feb. 19, 1959, p. 23; "**Modern Neon Co.** to erect and install a neon sign for Adams Studio of Photography, 617 S. Broadway…," *SMT,* March 19, 1959, p. 1, col. 6.
And, 366 additional "hits" for "Adams Studio" (usually credits for photographs reproduced in the *Santa Maria Times*) in the *SMT* between 1940 and 1980 were not itemized here.
See: "Adams, Ralph"

Adobe
See: "Architecture (Northern Santa Barbara County)"

Adult/Night Schools
See: "Allan Hancock College Adult/Night School," "Buellton, Ca., Adult/Night School," "Home Department of the State Farm Bureau," "Lompoc, Ca., Adult/Night School," "Los Alamos, Ca., Adult/Night School," "Santa Maria, Ca., Adult/Night School," "Santa Ynez Valley, Ca., Adult/Night School," "University of California, Extension"

Aerial Photography Service (Santa Maria)
Photography service, prop. John Costello and Robert Herda, 1947.
■ "Announcing the Opening of The Aerial Photography Service. All Types of Aerial Photography. Oblique, Vertical Map Surveys. **John Costello. Robert Herda**. Route 2, Box 272B2. Santa Maria," *SMT,* Oct. 23, 1947, p. 7.
See: "Costello, John L.," "Herda, Robert C."

Affleck, Roy (Santa Maria)
Photographer. Prop. Central Studio, 1909.

■ "Roy Affleck, late of the Central studio, has disappeared and with him has gone his wife… this precious pair have bought everything that their faces were good for, amounting to hundreds of dollars and never paid a soul, excepting those who could bring criminal action against them. Affleck afflicted the community with his presence about a year ago and then tried to get someone with a small amount of capital to go into the photograph business with him. But money was tight … so instead he took a job tending bar. Finally, when he got sufficiently acquainted to be able to run debts, he started in business and like all professional swindlers, at first paid his bills … after awhile he got to running hundred dollar accounts at some of the stores and when he had bought everything that he could possibly get on credit, even to having gold filled crowns made for his mouth, he and his wife silently shook the Santa Maria dust… and skipped… Affleck is a man of small features and is about 5 feet 9 inches tall and has dark eyes and black hair. His index finger on the right hand is amputated up to the first joint. He has an English accent… One of his favorite grafts is to solicit orders for photographs with a medallion," *LR*, June 4, 1909, p. 1.

Air Force Art Exhibit / Show
See: "Art, general (Lompoc)," 1960, "Art, general (Santa Maria)," 1960

Alba Studio of Photography (Santa Maria)
Photography studio active 1957.
1957 – "502 South Broadway. WA. 5-7315," *SMT*, Dec. 10, 1957, p. 12.

Albro, Maxine (1893-1966) (San Francisco / Los Angeles)
Printmaker, one of whose works was owned by John Breneiser and exhibited a couple of times in the mid-1930s.
■ "American painter, muralist, lithographer, mosaic artist, and sculptor. She was one of America's leading female artists, and one of the few women commissioned under the New Deal's Federal Art Project," Wikipedia.
See: "National Art Week," 1935

Alexander (Coughlin), Elizabeth Louise "Betty Lou"/ "Betti Lou" Thompson (Mrs. John Marcus Coughlin, Jr.) (1934-2002) (Lompoc)
Art student, California College of Arts and Crafts, Oakland, late 1950s.
■ Port. and "Betty Lou Alexander Becomes Bride of John Marcus Coughlin… [daughter of] Leland William Thompson… The bride attended Delano schools, Bakersfield Junior College, and an Arts and Crafts school in Oakland. … Point Arguello, where the couple met when she was employed there by the Ralph M. Parsons Co.," *LR*, Feb. 11, 1960, p. 6.

Alexander, Betty (misc. bibliography)
Elizabeth Louise Thompson, mother's maiden name Schlitz, was b. March 24, 1934 in Kern County, Ca., per Calif. Birth Index; Elizabeth Louise Thompson is listed in the 1940 U. S. Census as age 6, b. c. 1934 in Calif., residing in Alila, Tulare County, Ca., (1935, 1940) with her parents Leland Thompson (age 33) and Lucile F. Thompson (age 20); Betti Lou Thompson was b. March 24, 1934 in Delano, Ca., to Leland William Thompson and Lucille Frances Cash, and d. Dec. 28, 2002 in Houston, Tx., per Thompson/Fontaine Family Tree (refs. ancestry.com).

Alexander, Margaret Rowena
See: Lowell (Alexander), (Margaret) Rowena (Mrs. Whitney Alexander)

Allan, Chara
See: Broughton (Allan), C. (Chara C.) , (Mrs. George B. Allan?)

Allan Hancock College (aka Santa Maria Junior College) (Santa Maria)
Junior College. Santa Maria JC was first held at the Santa Maria High School (until c. 1953) after which time it was centered at Hancock Air Field and renamed.
■ "Allan Hancock College, founded in 1920 as Santa Maria Junior College, is one of the 112 California public community colleges. As the only college in the Allan Hancock Joint Community College District, it serves all of northern Santa Barbara County … The college district includes Santa Maria, Orcutt, Lompoc, Vandenberg Air Force Base, Guadalupe, New Cuyama, Cuyama, Solvang, Santa Ynez, Buellton, Los Alamos, Los Olivos, Casmalia and parts of San Luis Obispo and Ventura counties. The college's main campus is located … in Santa Maria …." from www.hancockcollege.edu.
■ "The chronicle of the Allan Hancock college campus … In 1927, Hancock field was established on 210 acres within the city limits of Santa Maria by Captain Allan Hancock … on October 21, 1928, [the following spring] some of the older buildings and grounds that now comprise the Allan Hancock college were dedicated as the Hancock Foundation College of Aeronautics. This organization was set up as a non-profit, private military school and graduated its first class in May 1930. The Hancock Foundation College of Aeronautics continued until 1934, when, due to the depression, its operation was curtailed to a standby basis until 1938 when it was revived as the Santa Maria School of Flying. On September 3, 1939, England declared war on Germany and war threatened the United States. … Hancock field was rededicated to the aviation cadet training program on September 17, 1939 and named the Hancock College of Aeronautics. …. From July 1, 1939 to June 30, 1944, 8,414 aviation cadets were enrolled in this cadet training program. … Following the end of the war, plans were made to offer a course in aeronautical engineering on this campus and in September 1944 all facilities were leased to the University of Southern California for $1 a

year. The name was changed to the University of Southern California College of Aeronautics with the Hancock Foundation assuming all expenses. ... after graduating its first class in 1949, the University of Southern California transferred most of the engineering and flight courses to its main campus in Los Angeles. In May 1950, the Air Force again called on private aviation schools, this time to train airplane mechanics. During the next two years approximately 1000 airplane and engine mechanics for the Air Force were trained in addition to civilian pilot and mechanic trainees. September 1953 saw the termination of the Southern California College of Aeronautics on this campus and [in 1954] the major portion of the facilities were leased to the Santa Maria Union High School and Junior College districts for three years with the option to renew the lease. ... [In expectation of expansion, since then] trustees have purchased 40 acres, extending from Miller Street to the south extension of Airport Avenue and from Park Avenue to Camino College, as a future college site," per "Hancock College Campus Historic," *SMT*, Jan. 14, 1955, p. 7.

Allan Hancock College (notices in Northern Santa Barbara County newspapers on microfilm and the Internet)
[For all information on Santa Maria junior college prior to 1954, see "Santa Maria, Ca., Union High School."]
1954 – "New Junior College District is Planned... authorizing the District Attorney to draw up necessary lease and purchase papers moving the Junior College to a new campus on Hancock field...," *SMT*, May 12, 1954, p. 1; "Allan Hancock College Launched" moving out of old Santa Maria Jr College and into buildings at Hancock Field leased for 3 years by Santa Maria Union High School district from former USC College of Aeronautics that offers 37 classrooms and 22 dormitory rooms and room to expand from 300 students to 700, *SMT*, Aug. 7, 1954, p. 3; "New College is to Open Soon," *SMT*, Aug. 25, 1954, p. 1, 3; "Our City's College. Opportunity Knocks (This is the seventh in a series of articles on Santa Maria's newest educational institution...) [port of Merlo] **Peirino C. Merlo**, head of carpentry, furniture construction, cabinet and millwork, an instructor who encourages his students to 'learn by doing.'... [port of **Holenda**] **Milo F. Holenda**, new to the faculty of Allan Hancock College and the Santa Maria union high school this year, will head up the automotive department...," *SMT*, Sept. 1, 1954, p. 1.
1955 – "College '*Mascot*'... first annual to be compiled on the new Allan Hancock college campus... **Jim Taylor** and **Barbara Hutchinson** are responsible for group and activity pictures and **Bill Currens** supplied the cartoons spotted throughout the pages... **George Muro**, college art instructor, assisted Mrs. Dixon, the faculty advisor, by advising on art work and layouts," *SMT*, May 28, 1955, p. 7.
1956 – "Railroad Divides Hancock Campus ... cut into two sections by the Santa Maria Valley Railroad. The heart of the campus is the Student Union building... In the science building are and the photography laboratory... All the laboratories are equipped with the latest equipment... The art and music departments, the drama departments and the nursery school are each located in separate barracks. ... Unfortunately, the buildings are of a temporary nature and are constantly being repaired... it is hoped that in the very

near future a permanent campus will be built...," *SMT*, Aug. 7, 1956, p. 6; "Allan Hancock College Gets Face Lifting... increased faculty staff... Three faculty members who taught also in the high school last year are now full-time teachers on the college campus. **George Muro**, in addition to his regular art assignments, will have a class for the college yearbook and will have more time for special students and the direction of the art gallery... **Milo Holenda**, a former teacher here, will return as a full-time instructor in machine shop, auto mechanics, math and engineering drawing...," *SMT*, Sept. 6, 1956, p. 8.
1957 – "Hancock Helps to Develop Cultural Vocational Arts... Junior College ... mechanical drawing, machine shop...," *SMT*, April 4, 1957, p. 12.
1958 – "Photography Courses Offered at Hancock... being offered for college credit for the first time ... with **Mervan [Sic. Mervin] Slawson** as the instructor. Students enrolled in the course may choose the technical, professional training, or they may use the course as a means of learning an interesting and enjoyable hobby. Slawson is known in the community for his activities with the La Brea Securities and [for the] Photographic work for Capt. A. G. Hancock. Courses in photography are being offered also in the night school on Thursdays from 7 to 10 p.m. in room 129 at the high school," *SMT*, Sept. 26, 1958, p. 10.
1959 – Group photo of class and caption reads "Tract Home Beautification – Art appreciation students at Allan Hancock college... Beana Hinkle, Charles Reeves, Martin Schell, William Tomasini, **George Muro**, art instructor, Jim Wilson, **Melba Boroff**, Janet Knott [Sic. Knotts] and Ruth Ware" Stonehart Photo, *SMT*, Oct. 30, 1959, p. 7.
1960 – Photo of students at Hancock College who produce "*The Mascot*" yearbook... Janet Knotts and **Melba Boroff**, artists, **Earle Leitner**, design supervisor, *SMT*, May 5, 1960, p. 10.
See: "Allan Hancock College Adult/Night School," "Allan Hancock College, Art Department," "Allan Hancock College, Art Gallery," "Allan Hancock College Nursery School"

Allan Hancock College, Adult/Night School (Santa Maria)
Adult school appears to have been transferred from the administration at Santa Maria High School to Allan Hancock College c. 1955, although afterwards, some classes that necessitated special equipment, such as ceramics, were still held at the high school labs. Photography was taught by J. Miles Booth followed in 1959 by Mervin Slawson. Woodwork and art metals work continued. Arts and crafts were taught by George Muro, 1956+.
Allan Hancock College Adult/Night School (notices in Northern Santa Barbara County newspapers on microfilm and on newspapers.com)

1955 – "Adult Education Classes Open Tomorrow. Adult education... in Santa Maria High school and Allan Hancock college will open at 7 p. m. tomorrow evening... Art classes will be held in the old cafeteria building, with **George Muro** as instructor... The welding class is to meet in room 30 at Hancock college with **Edgar Eimon** to give the course, woodshop will also be at the college in room 31

with **Peirino Merlo** in charge… Photography will be a subject in the science building at the high school, **J. Miles Boothe** to teach both on Mondays and Thursdays," *SMT*, Sept. 14, 1955, p. 1.

1956 – "Extended Day Enrollment… Welding which has been discontinued in the day classes will be taught by **Edgar Eimon** on Monday and Thursday evenings in the college shops," *SMT*, Jan. 27, 1956, p. 9; "Night Life that Pays. Your Community College. Allan Hancock College Presents Adult Education and Extended Day Program, Fall Semester 1956. … Functional Home Furnishings. Tues., Sept. 18 and Thurs. (7-9 p.m.), Woodshop, HS, **Kunch**, Crafts. Mon. Sept. 17 & Thurs. (7-9 p.m.), No. 36, College, **Muro**… Nursery School. Starts Sept. 11, Daily from 8:30-11:30 a.m. Thurs. 7-9 p.m., No. 35, College, Matson. Photography, Thurs., Sept. 20 (7-10 p.m.), No. 129, High School, **Boothe**. Woodshop, Mon. Sept. 17, Thurs. 6:30-9:30 p.m., No. 31, College, **Merlo**. Welding and Ornamental Iron, Mon., Sept. 17, Thurs. 6:00-9:00 p.m., No. 30, College, **Eimon**. Machine Shop and Art Metals, Mon., Sept. 17, Thurs. 6:00-9:00 p.m., No. 27, College, **Holenda** …," *SMT*, Sept. 8, 1956, p. 3.

1957 – "New Courses Offered for Adult Classes… Newly added adult education courses… include ceramics, 7 to 9 on Monday and Thursday in room 201 at the high school…," *SMT*, Jan. 25, 1957, p. 1; "Allan Hancock College presents Adult Education and Extended Day Program. Fall Semester – 1957… Photography, Thurs., Sept. 19 (7-10 p.m.) Rm. 129 High School, **Boothe**… Welding and Ornamental Iron, Mon., Thurs., Sept. 16 (6:30-9:30), No. 30 College, **Eimon**… Machine Shop and Art Metals, Mon, Thurs., Sept. 16 (6:30-9:30), No. 27 College, **Holenda** … Woodshop, Mon., Thurs., Sept. 16 (6:30-9:30 p.m.), No. 31 College, **Kunch**… Crafts, Mon., Thurs., Sept. 16 (7-9:00 p.m., No. 36, College, **Muro**… Nursery School, Thurs., Sept. 19 (7-9 p.m.) Daily (8:30-11:30 a.m.) No. 35, College, Wilson…," *SMT*, Sept. 11, 1957, p. 10; "Home Furnishing … Tuesday and Thursday from 7 to 9 p.m. in the high school woodshop. Purpose of the course is to make available materials needed for the creation of varied small home furnishings. Items such as wall barometers, period clocks (or modern), lamps, occasional furniture or swinging doors may be built by students," *SMT*, Sept. 24, 1956, p. 3.

1958 – Adult education "Art Group Fetes Matron" – i.e., **Mrs. H. S. Van Stone** who is relocating to Idaho with her husband – "The party … was attended by three of the original members of the Santa Maria Art Association, **Mrs. John Foster, Mrs. Joseph McCullough** and **Mrs. Herb Nichols** and by **George Muro**, art teacher, and other members of the class," *SMT,* Jan. 13, 1958, p. 3; "Allan Hancock College Adult Education Classes Spring 1958. **Boothe**, Photography, Thursday (7-10 p. m.) Rm. 129 – High School… **Eimon**, Welding and Ornamental Iron, Mon.-Thurs. (6:30-9:30), Rm. 30 – College… **Holenda**, Machine Shop & Art Metals, Mon.-Thurs. (6:30-9:30), Rm. 27 – College… **Muro**, Crafts, Mon.-Thurs. (7-9 p.m.), Rm. 36 – College… **Wilson**, Parent Nursery, Monday (8-10 p.m.), Daily (8:30-11:30 a.m.), Rm. 35 – College," *SMT*, Jan. 22, 1958, p. 2; "Allan Hancock College Presents Adult

Education and Extended Day Program Fall Semester 1958," and list of classes, *SMT*, Sept. 10, 1958, p. 4; "Photography Class. Change of date… for the opening… new date is Wednesday, Sept. 17, room 129 at the high school. **Mervin Slawson** is the instructor. The class convenes from 7 to 10 p.m.," *SMT*, Sept. 12, 1958, p. 2.

1959 – "Enrollment for Hancock Night School Scheduled… 51 courses… Welding and Ornamental Iron – Course includes the fundamentals of oxy-acetylene-arc welding and cutting, a series of welding exercises and welded projects. Iron casting and shaping… Machine and Metal Shop – Basic principles of bench and machine work. Broad opportunities for metal work… Woodshop – Theory and practice: hand tool skills and processes, operation of wood-work machinery, wood finishing, and construction of personal projects… Crafts – This is an exploratory course in such craft mediums as leather work, textile design, ceramics, copper enameling, and jewelry. Stress is placed on the function and form of the object… Photography – Optical principles as applied in cameras and enlargers, exposure meters, artificial lighting and laboratory technique. For those interested in photography as an avocation and for the occasional user of photography… Extended Day… Welding… Machine Shop… Woodwork… Crafts 7A, 7B – 2 units… Photography…," *SMT*, Jan. 17, 1959, p. 2; "Night Courses Available at Your Community College. Allan Hancock College Presents Adult Education and Extended Day Program… Starting Date Week of September 14, 1959. … Arts and Crafts, **Muro**, Monday and Thursday, 7-10 p.m., Room 36A, College… Parent Nursery, Wilson, Monday, 7-9 p.m. room 35, College… Photography, **Slawson**, Monday and Thursday, Starts Thurs., Sept. 17, 7-10 p. m., Rm. 129, High School … Welding, **Eimon**, Monday and Thursday, 7-10 p. m., Room 30, College. Woodshop, **Merlo**, Monday and Thursday, 7-10 p. m., Room 28, College…," *SMT*, Sept. 10, 1959, p. 9**;** "Additional Adult Classes are Available," including "Ceramics will be offered Tuesday and Thursday, starting Sept. 22, in the high school art department from 7 to 10 p.m. **Paul Winslow** will be instructor. … woodshop, Monday and Thursday at Hancock, arts and crafts, Monday and Thursday at Hancock," *SMT,* Sept. 17, 1959, p. 3.

1960 – "Shop Instruction Popular Course… **Peirino Merlo**, head of the industrial arts department of the college will be the instructor in woodshop, which will meet on Mondays and Thursdays … **Edgar Eimon**, regular instructor in the college aeronautics department during the day will be the welding class instructor. This class will meet Mondays and Thursdays…," *SMT*, Aug. 27, 1960, p. 12; "Academic Courses Help Adults Brush Up… classes in the academic field for adults not wishing credit or permanent grades will be given by the Allan Hancock College adult division this fall. … The classes were instituted last year and the enrollment indicated the popularity and necessity for classes of this type… Arts and Crafts. Three classes in the crafts field will start the week of Sept. 6. Arts and crafts will meet Monday and Thursday nights in room 36-C, Hancock College, starting Sept. 8. **George Muro**, head of the college art department will be the instructor. … Instruction in wood carving, painting and leather work will

also be given. Ceramics class will again be attempted this year, meeting at the high school art department on Monday and Wednesday nights. Starting date will be Sept. 8. All phases of ceramics will be considered, including molding and pottery work as a hobby and pleasure. Lapidary class has been one of the most successful classes in the adult education program. The making of brooches and rings are some of the items made from rocks. **Aldo Orin**, a specialist in the field of lapidary work, will be the instructor. Articles completed last year by individuals were displayed at the County Fair. Classes will begin Tuesday night, Sept. 6, and will meet every Tuesday and Thursday at the high school in room 201. The fee for this class is 50 cent per meeting to help defray the cost of the expensive machinery required," *SMT*, Sept. 1, 1960, p. 14.
See: "Santa Maria, Ca., Adult/Night School"

Allan Hancock College, Art Department (Santa Maria)
Began c. 1954.
■ "Junior College Education … Art. The Art department has become a very important part of the Allan Hancock college. Three years ago, the program consisted of combination art classes with the high school students, but because of the tireless efforts of **Mr. George Muro**, the program has grown to the point where we now have Mr. Muro full-time in the junior college and teaching all college classes. Part of his duty is also to direct the **Allan Hancock College Art Gallery**… on the campus, [which] is visited by hundreds of people. The art program is geared to meet the needs of two types of students. Those students intending to transfer as art majors to a college university or art school. The art department offers courses which will satisfy lower division requirements for most four-year colleges and universities. Those students who will terminate their formal education at Allan Hancock… The courses that are offered in art – depending on the number of people desiring to take the courses – are: color and design, drawing and composition, watercolor, oil painting, Lettering, Advertising, general crafts, jewelry, enameling and metal work, art appreciation, individual work, and figure drawing. Some of these courses are offered every semester and some on alternate semesters. One of the most popular classes last year was made up of approximately 15-20 women in the community who were interested in developing a hobby as well as to express their feelings in one of the mediums of art. This class will be offered again this year … Through the adult education and extended day program, classes in art are also offered at night," *SMT*, Aug. 29, 1956, p. 8.
Allan Hancock College Art Department (notices in Northern Santa Barbara County newspapers on microfilm and the Internet)
1955 – "Art Appreciation Class Visits Homes as Study Project," to see how homes were designed to fit the personality of the owners, taught by **G. Muro**, *SMT*, March 10, 1955, p. 9.
1962 – "Girls Do Well in Hancock Play… settings of the play were excellent, so credit must go to **Carol Schilder**… for work with the props and the college's art department for the set design," *SMT*, Dec. 10, 1962, p. 7.

Allan Hancock [College] Art Gallery (aka "Art Gallery," "Hancock Art Gallery," "Santa Maria Art Gallery")
Art gallery at Allan Hancock College that held its first show, Dec. 1954. Some exhibits were co-sponsored by the American Association of University Women. Director was George Muro. Muro often took his high school and junior college art students to the gallery for lectures by invited specialists and to study techniques in the art.
■ "The **American Assn. University Women** Santa Maria branch is mainly responsible for the exhibits, being brought to the gallery. Various members give much time after work hours at teaching and in other occupations, while attending the desk at the gallery on Thursday evenings and Sunday afternoons. Visitors are welcome, and the number attending will no doubt have a bearing on the future of the gallery as a Santa Maria cultural center. The AAUW is having success creating new interest through other women's groups …. Exhibits in the gallery are of value also to art classes both in Santa Maria High school and in the Junior college. They meet in the gallery and are given talks on the paintings by their instructor, **George Muro**, who has given much of his time after hours to the project," per "Knowles Paintings Are at Gallery," *SMT*, Dec. 8, 1955, p. 4.
Allan Hancock [College] Art Gallery (notices in Northern Santa Barbara County newspapers on microfilm and on newspapers.com)
1954 – "Art Gallery is AAUW Objective," *SMT*, Oct. 23, 1954, p. 4, hopefully to be housed at Hancock College, and they will be helped by **Geo. Muro** with funds coming from two art festivals held in 1952 and 1953; "Art Gallery to Open on Sunday," with **George Muro** of Santa Maria High school and Allan Hancock college art department as curator and headed by AAUW, and first show is group exhibit sent by Santa Barbara Art Association, and gallery will be open certain mornings 9 a.m. to noon and Wed, Fri. and Sun. 2-4 p.m., and "The art chairman said it is planned to use the art gallery for lectures. It is hoped that the building will become a center of community interest and that many groups will visit the art exhibits," per *SMT*, Dec. 1, 1954, p. 4; photo of backs of **Mrs. Taylor** and **Mrs. Foster** at easels in art class and "Formal Opening of Art Gallery Set Tomorrow," and article adds, "Santa Maria Art Gallery to open formally tomorrow 2 to 5 p.m. at Allan Hancock college campus will offer a fine collection of oil, water colors, sculpture and bronzes, the first art show being contributed by **Santa Barbara Art Assn**. The public is invited to see the exhibit and to hear **Henry Seldis**, Santa Barbara art critic, who will speak at 2:30 p.m. on 'The Value of an Art Institute in the Community.' **George Muro**, curator, who is instructor in art at Allan Hancock college and in Santa Maria High school, has received a list of the first exhibit, to feature paintings of **Douglass Parshall** and **Forrest Hibbits**, a sculpture, by **Joseph Knowles** and a pair of bronzes by **Frances Rich**, entitled 'The Tritons.' Oils to be shown are 'Anacets,' by **Marilyn Griffith**, 'Sunflowers,' **C. M. Glasgow**, 'Charlsetta and Her Embroidery,' **M. E. Webb**, 'Hungry Birds,' **Wallace Curlee**, 'Cucumbers,' **Clarence Hinkle**, 'In the Well, the Garden,' **Ruth R. Liecty**, 'In Philadelphia,' **Sarah Kolb Danner**, 'Half Loaf,' **Gladys Castagnola**, 'The Lesson,'

Helen S. Motzko, and a still life study, **Grace Vollmer**. **Olga Higgins** is sending a water-oil [sic.?], 'Old Town.' **John A. Gorham** and **William Dole** will send ink drawings, the latter artist's to be 'Bandit in a Landscape.' Artists sending water colors for the gallery opening are **Janet Ketro [Sic. Ketron], Joseph Knowles** (Nojoqui Trail), **Douglass Parshall** (Beach Park), **Dr. Neville T. Ussher** (Weary Wetback), and **Standish Backus, Jr.**, "Nojoqui Falls.' **Forrest Hibbits**' 'Bijoy' is a casein and ink drawing. **Merrill Remick**'s crayon 'Imaginary Construction' will be shown. ...," *SMT,* Dec. 4, 1954, p. 4; "**Henry Seldis** is Speaker at Art Gallery Opening" on topic of "The Value of an Art Institute in Our Community" and description of "gallery" as a former army barracks and seating as army cots covered with block-printed cloth and rooms warmed by nursery plants, *SMT,* Dec. 6, 1954, p. 4; "**George Muro** is Speaker on 'Art Gallery Values'," and announces that since the gallery opened a class in painting for housewives has been started three mornings a week, "The present All-Santa Barbara artists' exhibit to remain until the end of December, contains work of **Douglass Parshall**...," *SMT,* Dec. 8, 1954, p. 4; Associated Women Students "Christmas Tea to be Held in Art Gallery" with **G. Muro** as speaker and repro. of wc 'Beach Park' by **Douglass Parshall** in current exh., *SMT,* Dec. 9, 1954, p. 7; "Holiday Tea Attended at Gallery by 100 Guests," *SMT,* Dec. 18, 1954, p. 4; "New Art Exhibit. ... open to the public 2 to 4 p.m. Wednesday... one-man show... 24 items... **Rico Lebrun** of Los Angeles," *SMT,* Dec. 31, 1954, p. 1.

1955 – "Paintings by **Lebrun** to Show at [Allan Hancock] Art Gallery," *SMT,* Jan. 3, 1955, p. 4; "**Rico Lebrun** Paintings are Viewed at [Santa Maria] Gallery," in January and bio., *SMT,* Jan. 6, 1955, p. 6; "Rent with Option to Buy Painting is Discussed" by **Geo Muro** to **Santa Maria Art Assn.** with display space to be in Art Gallery, *SMT,* Jan. 10, 1955, p. 4; "**Lebrun** Exhibit Viewed by Art Gallery Visitors," *SMT,* Jan. 10, 1955, p. 4; "Lithograph Talk Given by Artist... **William Hesthal**, Santa Barbara artist ... before an audience in Santa Maria Art Gallery...," *SMT,* Jan. 14, 1955, p. 4; "Exhibit to Open in [Allan Hancock] Art Gallery," i.e., **Edmondson**, *SMT,* Feb. 4, 1955, p. 4; "Water Colors are Gallery Exhibit," and includes water colors and lithographs by **Leonard Edmondson** of Pasadena, and was show arranged by George Muro, "...born in California in 1916. He studied at the University of California, Berkeley. Since 1947 he has been a member of the faculty at Pasadena City college teaching drawing and design. His water colors have won many awards... Art students at the college have collected weathered wood and plants or foliage to make a background. Mr. and Mrs. Dan Chern have loaned the modern period furniture," *SMT,* Feb. 5, 1955, p. 4; "Local Artists to Have Show at Hancock Gallery," and showing concurrently will be teacher-artists at **California College of Arts and Crafts**, *SMT,* Feb. 25, 1955, p. 6; "Los Angeles Artist to Show Paintings Here [**Phil Dike**]," *SMT,* March 4, 1955, p. 4; "Students Hear Art Talk on [**Phil**] **Dike** Water Colors" and photo of Patricia McFall and **Joyce Fleming** looking at Dike painting, and article says, "to remain another week... On opening day several out-of-town visitors came to see the paintings among them **Mr. and Mrs. Forrest Hibbits** and

party from Solvang, **Mario Veglia**, Casmalia artist, and **Mr. and Mrs. Andrew Joughin** of Santa Ynez valley... Wednesday afternoon an art class from **Santa Maria High school** viewed the water colors and heard comment on them by **George Muro**... scenes at Southern California beaches in summer... Students were shown steps in making a water color in the traveling exhibit by students of **California College of Arts and Crafts** showing concurrently with the Dike pictures. They were told that at least two Santa Maria art students are working hard to enroll in the same school... Art Gallery... improvements... installation of a reading table filled with art magazines and a new screen-type display rack for exhibit material... The show following **Phil Dike** will be entirely by local artists ...," *SMT,* March 11, 1955, p. 4; photo of Dorothy Branker and **Betty Scott** at easels with pictures and "Santa Maria Painters to Exhibit Works in Art Gallery March 23," *SMT,* March 15, 1955, p. 1; photo of Mrs. **Valerie Rand** and Mrs. Sue Darnell [?] at easels preparing work for exhibit in the Santa Maria artists show, *SMT,* March 17, 1955, p. 11; photo of Mrs. **Edna Myers** and **Marian Wise** at easels preparing work for exhibit in the Santa Maria Artists show, *SMT,* March 22, 1955, p. 7; photo of Mrs. **Veglia** viewing a painting by her husband and "Home Talent Art Show is Drawing Large Number," and article states, "Places to go in Santa Maria Sunday afternoon should include Allan Hancock Art Gallery where over 40 canvases, ceramics and fabric are to be seen in a local talent show by Santa Maria and Santa Ynez valley artists... On entering the gallery visitors may see 'The Forest' painting of an imaginary and mysterious place in tall trees, by the Casmalia artist, **Mario Veglia**. Another of his studies is a pastel crayon, 'Erosion,' of a canyon in Casmalia. The artist has placed on canvas a section of an eroded canyon of miniature formations remindful of the Grand Canyon country. The colors and forms are true to nature, a visitor said on choosing this for one of the outstanding entries. The present exhibit is indebted to **George Muro** ... for the loan of two of his finest and most recent water colors, one of feeding deer in Waller park. Soft greys and fawns of the animals merge into a background that is their home. Dated 1955 is **Muro**'s 'Old Barn.' Both paintings are evidence that this artist should by all means continue his painting as well as his teaching career. Earlier work of **Forrest Hibbits** that was shown here some seasons ago cannot be recognized in either of the entries he has placed. His two abstract type paintings are 'Euroasian,' a portrait, and 'Army with Banners.' Sharp detail, color and a feeling of motion and rhythm is to be seen and felt in the oil painting of a Highland bag piper by **Thomas Tinsley** of Santa Maria. Visitors to the gallery have praised the water color design by **Elizabeth Scott** for precision of line and color harmony in pleasing effect. 'Chickens' is the title of a gay tempera study in which **Elva Van Stone** has enjoyed applying bright color in the plumage of three strutting barnyard fowls. **Elsa Schuyler**, Lompoc artist, is to be congratulated for the mood and atmosphere of ancient weathered frame houses in 'Back Yard,' and in the pictures of 'Boys' Clubhouse' a ramshackle frame building typical of a place in which boys might spend hours of play. The 'Mountain Cabin' water color by **Valerie Rand**, blends shades of green in a restful forest setting. Another Lompoc artist,

Ethel H. Bailey, has entered one of her marine water colors that shows good perspective, depth and color. In the favorite subject of Elizabeth Taylor, landscapes, are certain to be green leafy trees, and the one shown here, 'Waller Park,' is no exception. It is a pleasant study of cottonwoods in early summer. A surprise to many friends who had known of his talent for directing dramatics is the water color titled, 'Ducks,' by Don Johnson. Line, composition and color of the marsh and dune country are good, as are ducks in flight. Another member of the high school faculty, Gordon Dipple of the art department, has used vivid color in his entry, not titled, and evidently an example of painting for pleasure. Gallery visitors will find interest in the oil painting 'Sunflowers,' by C. M. Glasgow of Los Olivos. The artist has achieved a living effect in yellows and golds of this massive flower that tempts many who like to paint in bright colors. Mrs. Mae Nichols' love of flowers is well expressed in her oil painting of flowers. Iris, snapdragons and calendulas are the garden-fresh spring bouquet. 'Zinnias' and 'Magnolias' are fine examples of painting by another who loves flowers, Helen E. Joughin, of Solvang. Edna Myers of Santa Maria is exhibiting her still life of fruit that is praised for good line, color and atmosphere. Florence Foster's 'Bird of Paradise' is a casein painting in which the artist has captured in fine detail the contrasts of blues, orange and shaded greens of a dramatic tropic flower found in Santa Maria gardens. Dean William Houpt has tried his brush on a seascape in azures and 'shapes' study in oils. Three art students, Sue Darnell, Marion Wise and Dorothy Branker, have entered their work on the same study of violin, mandolin and music sheets. These are an interesting comparison of the same subject as seen by three students who are making progress. Good landscapes are those entered by Myrton Likes and Erhardt Hoffman, the latter including one of his studies of Indians in Montana in battle regalia. Betty Corbett of Solvang has entered her new painting 'Barn and Corral,' and 'Wharf at Huntington Beach' is a fine effort by Amory Ware [Sic. Amory Hare Hutchinson] of Solvang. One of the exhibit's surprises is the portrait, 'Margo' by Jo Ann Wilson. This artist is now working on a portrait of her grandmother, Mrs. Myrtle Smith," SMT, April 2, 1955, p. 4; "Rex Brandt Paintings on Exhibit at Art Gallery" this month. "Critics have said of Rex Brandt as an artist that his work is difficult to type. The moderns say that he is of the conservative school, and the conservatives class him as a modern... the art gallery, is showing a few of his paintings with the present exhibit," SMT, May 21, 1955, p. 4; "Allan Hancock Art to Open Season Tomorrow" with show lent by IBM titled Indians of the Long House, SMT, Oct. 1, 1955, p. 4 and next show will be wc by Daniel Mendelowitz of Stanford; photo of Mendelowitz's painting of Notre Dame in Paris and "Art Gallery has New Exhibit of Mendelowitz Water Colors," SMT, Oct. 8, 1955, p. 4; Joseph "Knowles Paintings are at Gallery ... transparent water colors... fondness for scenes in Refugio Canyon and Santa Barbara boat harbor... 26 [in number]... He studied in France and England and has many paintings in private collections. Knowles has just finished a large mural for the Beckman Instrument Corp., Fullerton, an assignment that occupied most of the summer. He has worked and studied with Standish Backus...," SMT, Dec. 8, 1955, p. 4; "Dean

is Host at Gallery Tea," and photo of people standing around a tea table, SMT, Dec. 16, 1955, p. 4.

1956 – Port. with paintings and "Mario Veglia's Paintings on Exhibit," SMT, Jan. 9, 1956, p. 4; "Series of Art Shows Planned for Gallery" announced by Mrs. John McCabe, AAUW Chairman of Art – in February: Forrest Hibbits, in March another local artist, in April: artists from Santa Barbara?, during Public Schools Week a show of copies of Old Masters, in May or June: commercial art, SMT, Jan. 12, 1956, p. 4; "Junior Community [Club] Will Sponsor Art Exhibit" in March, SMT, Jan. 18, 1956, p. 4; "Muro Water Colors to be Exhibited" in February sponsored by Beta Sigma Phi sorority, SMT, Feb. 1, 1956, p. 4; "Local Artists to Exhibit at Gallery" in group show in March and entries solicited, SMT, Feb. 17, 1956, p. 4; port. of Earl Leitner, George Muro and Marilyn Hoback and "SM and Solvang Artists to Exhibit" and artwork now being collected from all [even amateur] artists, and article says, "Two oil portraits are being entered by Mrs. Thurman Fairey, art chairman of the Junior Community Club, which group will sponsor the gallery in March. One of these paintings is a self-portrait made while she was a student in the Santa Maria junior college several years ago. The other is a recent portrait of her young son. Landscape and nature studies in water colors are being entered by Don Johnson, Santa Maria union high school English instructor, who entered paintings in last year's exhibit. He claims he is definitely an amateur although he did take a summer course in painting at Stanford university. Bob Bruchs, now business education instructor in the high school and college is also planning on entering some of his oil paintings. Students in Muro's classes who will enter works are Earle Laitner [Sic. Leitner?] who expects to enroll at Art Center, Los Angeles, to become an industrial illustrator, and Marilyn Hoback, who is taking a basic course in art at the college in preparation for her teaching major in elementary education. High school art students of Muro's who will enter art works are Ben Amido, Richard York, and Robert Pasillas. ... Last March approximately 30 exhibits were displayed with many local citizens putting their art work on exhibit for the first time. Also Solvang's Forrest Hibbits entered painting as well as Casmalia's Mario Veglia, Hancock college dean William S. Hount [sic. Houpt] and art teachers Gordon Dipple and Muro. Members of Muro's adult art class held Monday, Wednesday and Friday mornings at Hancock college, made their exhibit debuts as others of his students plan on doing this year. Muro will receive work for exhibit in the mornings at the art gallery on the college campus or the office staff will accept exhibits any time during the school day where they will be stored in the large fire proof office safe," SMT, Feb. 26, 1956, p. 10; Santa Maria Valley Amateur "Art Show Opens Today" and article adds, "A response that taxes capacity of Allan Hancock Art Gallery has come to an appeal for art to make up a Santa Maria Valley Amateur Art show that is to open today. George Muro... has supervised hanging the paintings ...The Junior Community club is sponsoring the exhibit this month and is furnishing hostesses and attendants for opening hours. A few of the artists and entries are Helen Joughin, oil paintings, 'Red Roses' and 'Iris,' C. M. Glasgow, oils, 'Old Stage Coach House,' and 'Dahlias,' Mildred Fairey, two portraits in oils, Evelyn Joughin, two

oils, 'In the Park,' and 'Across the Tracks.' Kay Cajas, water color, 'Carnival,' Susan Chadband, oil paintings, 'Mountain Scene,' Barbara Chrisman, oil painting, 'Sail Boats,' **Lilia Tuckerman**, oil, 'In the Park,' **Florence Foster**, oils, 'Bouquet,' and 'White Bowl,' **Forrest Hibbits** … is sending two oils, 'Cat,' and 'Mexicana.' A group of oil paintings by an artist signing only as 'Grupa,' [Audrey?] have titles 'Fleeting Moment,' 'Happy Pair,' 'Abundance,' and 'Panther.' **Ida Kriegel** will be represented with water colors of country scenes and **Fred Beerbohm** has oil studies of mountains, seashore and lakeside. **Jo Ann Wilson**'s pastel, 'Joey,' one of her finest, is given a prominent place. **Don Johnson, Elsa Schuyler** and Nancy Larsen have one or more entries. **Earl Leitner** is showing car design drawings. 'Football' is the subject of a watercolor by Bill Massey. Ed Pickard [realtor] has titled his drawing 'Monique,' and Marty [aka Martha?] Mougeotte has a study in oils of 'Coast Highway.' **Marian Schuyler**'s 'La Casa' is one of her best in oils. New are **Jane Merlo**'s two oil paintings, 'Union Sugar Plant,' and still life of fruit. Not to be missed in the art show are F. Benson's paintings of Santa Ynez [Sic. Ines] Mission, 'Shell Beach,' and 'Sand Dunes.' **Marian Wise** will have two entries, one in oils, still life, and a water color study entitled 'Squash.' There is no charge to see the exhibits, but anyone wishing to help defray packing and shipping expense and maintenance cost of hanging the paintings may place money in a collection box near the entrance," *SMT,* March 11, 1956, p. 5; "Santa Barbara [Museum of Art] Sends Art Exhibit" of unnamed private collection that includes a **Douglass Parshall**, a lithograph "Watermelons" by Rufino, **Millard Sheets**' wc "Manhattan Waterfront" and Max Weber's "Winter Twilight," and **George Muro** is in charge, *SMT,* April 9, 1956, p. 4; famous paintings "Reproductions Shown at Art Gallery," and the show consists of artists from the Renaissance to the modern period.... from the Santa Barbara County Education center…," *SMT,* May 7, 1956, p. 4; "Prints of Old Masters to Go, Student Art Next," *SMT,* May 29, 1956, p. 4; repro of **George Muro**'s "Magnolias" won by visitor, Lorraine Gularte 12, and announcement of some upcoming shows – works from **Immaculate Heart College** in LA, a show of prints and wc by Hancock College students, and a show by **Milford Zornes**, *SMT,* Aug. 5, 1956, p. 5; "**Slawson** Photography Shown at Art Gallery," and article adds, "Art gallery exhibits for the year have been scheduled with a new exhibit each month. Various activities have also been planned by **Muro** and **Mrs. Joe McCullough**, art chairman of the **American Association of University Women**, Santa Maria chapter, who are again helping to sponsor the exhibits. The first of these programs is a film on 'How to Hang Pictures in Your Home,' being shown through the courtesy of the **Santa Maria Studio of Photography**… October 10 at 8 p.m., *SMT,* Oct. 6, 1956, p. 5; "**Muro** Paintings New Exhibit at Gallery," *SMT,* Nov. 2, 1956, p. 4; port. of Charles Chenoweth [English instructor] and **George Muro** and "Art Collections for SM" which lists upcoming exhibits at Hancock Gallery with some further information about art from **Immaculate Heart** College, children's art from around the world, **Milford Zornes** (January), **Edward Reep** (February), **Douglass Parshall** (March), and a competitive exhibit to acquire a permanent

collection for the college (April?), *SMT,* Nov. 3, 1956, p. 5; **Immaculate Heart** College, LA "Christmas Art Hung at Gallery," *SMT,* Nov. 24, 1956, p. 4; photo of students with 3 items in **Immaculate Heart** exhibit and "Art Students Visit Gallery," *SMT,* Dec. 8, 1956, p. 4; "Children's Art Worth Trip to Gallery," *SMT,* Dec. 29, 1956, p. 4.

1957 – "**Milford Zornes** to Speak, Tea at Gallery...," *SMT,* Jan. 10, 1957, p. 4; port. and **"Milford Zornes** Will Speak at Gallery," and bio., *SMT,* Jan. 12, 1957, p. 4; "Future of Art is Topic at Gallery… **Milford Zornes**… spoke yesterday at a tea and exhibit of his own work that was a homecoming occasion at Allan Hancock Art Gallery. An audience of over 200… speak on his painting representing different periods of his career of over 20 years as a water colorist… 'Unsold paintings are of less concern than … to continue and progress… brought much of the beauty and color of Mexico home with him… fine studies of the Mexico City cathedral and of the public parks and playgrounds. 'One of the beautiful and striking things about Mexico City is the amount of space given to parks. The colorful crowds…' … a painting may become a historical record…," *SMT,* Jan. 14, 1957, p. 4; "**Edward Reep** Water Colors at Gallery" and bio., *SMT,* Feb. 11, 1957, p. 3; "Santa Barbaran Exhibits at Art Gallery… **Douglass Parshall**… is loaning 17 of his paintings for the March exhibition… most of Parshall's much-talked-of paintings are now in **Cowie Galleries** … where he exhibits permanently, he reserved some of his paintings of people and of trees to show in Santa Maria. One, 'The Lesson' … Experimenting lately in abstracts, Parshall has sent one…," *SMT,* March 11, 1957, p. 2; "What Are They? ... Paintings, all of them abstractions by the Southern California artist, **Igor Mead**, now exhibited in Allan Hancock Art Gallery, are causing many questions to be asked. … 'What do they represent?' Some of the paintings are pleasing from the standpoint of color and composition. And, certainly they are interesting. … Artist Explains. What the artist has to say about his own paintings [is] found in a pamphlet left at the gallery for students to read… 'It takes long intervals of time for a layman to listen to a symphony and decide whether or not he likes it. Unfortunately, it takes only a split second for him to decide whether or not he likes a painting. … 'We cannot stop progress. Interests and ideas gradually are changing. Consequently, the criteria and process of judgment should have changed too. Unfortunately, the general public does not realize this and continues to judge modern abstract and semi-abstract art with the same criteria of judgment that was used for realistic art. Then why not try to form your opinion, not in a split second, but slowly, as in music. Absorb the painting gradually. It is not the one who creates and advances who is the loser, but the one who rejects for lack of absorption and understanding.' For the benefit of students, the artist defines abstract art as abstraction from a subject, which may be an idea, a feeling, an emotion, or a material object. The abstract painter, says Mead, is interested primarily in his personal message and the method of its expression, employing the principles of good painting. These, as he points out, as abstract or realist, are color, composition, and movement. **George Muro**, local art instructor, said of Mead's paintings, 'They are full of movement,' and in answer to a question, 'The artist does not want the viewer

to see but to feel the message in his art.' To show that he is capable of turning out realistic paintings, Igor Mead has hung one study, almost photographic in its realism, of two elderly women. This painting speaks for itself as work of one whose gifts are beyond 'meaningless patterns' as the abstracts are sometimes dubbed by those who have not tried to paint. When a question was asked – 'Have you seen the Gainsborough paintings in the Huntington Gallery?' Muro, who has an open mind on the subject, said they are fine and splendid expressions of life in the 18th century. Many artists today are turning out abstract paintings that express this age of rapid advances in machines, jet air travel, atomic energy and other new sciences, said Muro. Asked if such paintings as Mead's would look well on the wall in any home, the answer was: 'That is not the sole object of painting.' And to another question, 'Will future generations have to go to museums and galleries if they wish to see examples of 20th century abstract painting, the answer was that many individuals recognizing merit of this art, are buying it up for private collections. And there still are others who say '—give me Norman Rockwell',” *SMT,* April 13, 1957, p. 3; port. of Reseda artist with paintings, *SMT,* April 16, 1957, p. 5; “Art Talent Show to Open in Gallery” with prizes going to adult and junior entrants, and article names judges: **George Muro, Nat Fast, Robert Gronendyke, Mrs. Mildred Fairey, Mrs. Marie McCullough**, and entries are invited, *SMT,* May 4, 1957, p. 3; “Art Show Opens” with submissions from students and teachers at Hancock College and Santa Maria HS, and article adds, “**Richard York** is one of the younger art students who has entered some of his oil paintings of flowers, and **Mrs. Betty Hosn** is entering her paintings. There are others by Santa Maria members of an adult painting class, and new to Santa Maria will be paintings exhibited in South America, loaned for this exhibit by **Mrs. Adelyne Feulner**,” *SMT,* May 9, 1957, p. 5; ports. of **Mrs. Margaretta [Sic. Margarette] Jagla, Dr. Carl Johnson, Trinidad Amador** and Dan Chern, and “Local Artists Win Cash Prizes,” donated by Exchange Club, and article adds, “**Ray Amador**, Allan Hancock college sophomore and **Roy Imamura**, Santa Maria high school student, won first prizes in the local talent art contest which is now being exhibited at the Hancock Art gallery. … Amador received $10 for his pen and ink drawing. An equal sum went to Imamura for his water color. **Mrs. Louise Corolla [Sic. Corollo]** and **Mrs. Mae Nichols** won $5 each as second place winners in the senior division. Mrs. Corolla entered a water color while an oil painting was exhibited by Mrs. Nichols. A water color won $2.50 for **Mrs. Margarette Jagla**. Another $2.50 went to **Mrs. [Sic. Miss] Marian Mehlschau** for her casein painting. Second places in the junior division went to **Barbara Prater** and Tom Anthony who each received $5. Barbara did a pen and ink drawing while Anthony entered a wooden bowl he had carved. Prizes of $2.50 each went to **Trinidad Amador** for his wood sculpture and to Betty Sue Sherrill who also did a wood sculpture. Judges for the contest **George Muro**, gallery curator, **Robert Gronendyke** and **Nat Fast**, high school art instructors, and **Mrs. Mildred Fairey**, incoming president [Sic.] of the Junior Community Club. The **Junior Community club** is sponsoring the local exhibit,” *SMT,* May 27, 1957, p. 5; “New Exhibit at Gallery” and article

adds, “An art exhibit of work by inmates of **California State Mental Hospital** [Camarillo] is open to the public at Allan Hancock Art Gallery… The unusual collection has been secured by **George Muro**. … Painting, said Muro, is important as therapy to these people, and it is also of help in analyzing their illness, for it may express what they will not talk about to the doctor. Muro said he became interested on exhibiting his own work at the hospital, some months ago, and at that time learned that some of the patients liked to paint. …,” *SMT,* Oct. 5, 1957, p. 3; “Art Gallery Exhibit… 30 paintings by **Stanton** and **Gladys Gray**,” and extended article, and port. of **Stanton Gray** painting a barn, *SMT,* Oct. 19, 1957, p. 3; “**Rex Brandt,** Artist is Subject of Film” titled Water Colors showing him painting in the area of Morro Bay, and another film on automobile design, and “This month's exhibit is a collection of water colors and oil paintings by **Gladys** and **Stanton Gray**, San Luis Obispo county artists, [that] will be taken out at the end of the month to be replaced on Nov. 27 by an exhibit named 'Integrated Design.' This is to be a collection of drawings, silk screen work, fabric and textile prints, and other items to show materials and techniques that apply in making of various designs. It is loaned by a crayon manufacturing company,” per *SMT,* Nov. 14, 1957, p. 2.

1958 – “Paintings by **Oback** at Hancock Gallery … instructor in San Jose State College Art department … Some of the paintings are done by rather interesting techniques such as the still-life done with an eye-dropper and three others done with a piece of cardboard in substitution of a brush...,” *SMT,* Jan. 10, 1958, p. 2; two photos of gallery interior showing St. Mary's Parochial School 8th grade students who are touring **Erick Oback** show and extended info. on lecture by **George Muro**, *SMT,* Jan. 17, 1958, p. 3; “**John Gill** Shows Art at [Hancock] Gallery,” *SMT,* Feb. 8, 1958, p. 3; “Fabric Designs at Art Gallery” lent by American Crayon Co., *SMT,* March 11, 1958, p. 3; “Art Teachers Have Gallery Exhibit” and article reads, “Allan Hancock Art Gallery is currently exhibiting a collection of drawings, sculptures, paintings and crafts through the courtesy of art educators from San Luis Obispo, Allan Hancock College, Santa Maria and Santa Barbara High Schools. This exhibit is of keen interest since the work is keyed to specific abilities of the individual exhibitors… Among noteworthy objects are metal sculptures by **Robert Gronendyke**, Santa Maria High School, done in sensitive contemporary technique. One of particular interest is 'The Greeters.' Also, his wooden bowl forms are worthy of individual mention. Of equal interest is a water color of horses by **Margaret Maxwell**, San Luis Obispo Junior College, a completely non-objective painting 'Arabian Knights,' by **Margaret Straight**, Santa Barbara High School. The subtle and sensitive drawings and figures of **Nat Fast**, Santa Maria High School, and **Alice Doud**'s fine oil painting titled 'A Prayer.' Also to enhance the exhibit are water colors of **Harold Forgostein**, San Luis Obispo Junior college, and **George Muro**'s usual interpretation of typical California subject matter,” *SMT,* May 9, 1958, p. 3; “Area Artists Will Exhibit Paintings Here,” i.e., artists of Northern Santa Barbara County and Southern San Luis Obispo County who exhibited in the **Tri-County** exhibit will show their paintings in a 2-day

show at Hancock Gallery, i.e., 48 paintings by 23 artists, and article adds "'Wild Geese,' a painting by **Ethel H. Bailey** of Lompoc, was selected from the Santa Barbara show for a purchase award. It will be on tour with other paintings after which it will be permanently on display in Santa Barbara," *SMT,* May 15, 1958, p. 2; "Art Show, Tea at Gallery Sunday," i.e., opening for two-day **Tri-County** presentation, *SMT,* May 23, 1958, p. 3; "...oils and watercolors by **Ann Snider** of Santa Barbara. The exhibition's highlights are the portraits by this artist and specifically the painting 'Backwash' which caused much comment during its display here at the County Fair. The present collection consists of 20 paintings in oils and water colors... Those who like studies of flowers should not miss ... paintings of calla lilies, geraniums, magnolias, hibiscus and others," and port of **George Muro** with painting "Backwash" per "Snider Paintings at Hancock Gallery," *SMT,* Sept. 30, 1958, p. 3 [i.e., 9]; "**Woody Yost** Collection Now at AHC Art Gallery," *SMT,* Oct. 27, 1958, p. 3; **Jack Gage "Stark** Oil Paintings in Gallery Exhibit ...nineteen paintings... Some of the still life titles are 'Library Table,' 'Table with Decanter,' 'Hot Country,' and 'Bathers.' There are other interesting still life studies and a few nudes ...," and repro. of one painting, *SMT,* Dec. 11, 1958, p. 5.

1959 – "The present exhibit by **Margaret Singer** displays talent in various media such as water color and pencil, pen and ink, and mixed media. The subject matter ranges from nude figures to intricate landscapes, each with a modern flavor. ... The paintings being shown here have been exhibited in a one-man show at Santa Barbara Museum of Art and at other noteworthy art centers of the west coast, such as Carmel," and port. of Singer with two of her paintings, per "Singer Paintings at Hancock Art Gallery," *SMT,* Jan. 16, 1959, p. 7; repro. of painting 'Cathedral' by **John V. DeVincenzi** and "San Jose Artist Shows Paintings at Gallery," *SMT,* March 3, 1959, p. 3; "Student Art Sale" and "interest in painting, its history and study has grown at the college this semester. ... One or more paintings are shown by **Mrs. Emma MacMillan,** who studied in Long Beach State College before attending AHC. Her work rates as professional, the instructor said, and another talented student is **Mrs. Lena [Sic. Rena] Towle,** living here while her husband is stationed at Point Aguello. Three of the most successful students in the class are planning to major in art as they continue their education in the fall," *SMT,* May 1, 1959, p. 5 [This entry cannot be found with a digital search and must be browsed]; photo of 3 students with work in student art sale – Roxanne Lane, Helen Pudwill and Evalee Victorino [the latter is listed in the *Santa Maria, Ca., CD,* 1958-70], *SMT,* May 2, 1959, p. 3 [This entry cannot be found with a digital search and must be browsed]; "**Tri-County** Artists Show in Santa Maria," i.e., Art for All travels from Santa Barbara Museum of Art, *SMT,* June 20, 1959, p. 3; **Dr. Marques E. Reitzel,** "Artist-in-Residence Plans Demonstration at College," *SMT,* Nov. 11, 1959, p. 5.
See: "Gill, John W.," "Junior Community Club," 1955

Allan Hancock College, Nursery School / Allan Hancock Nursery School
Nursery school that included "art" in its curriculum.
Port of tot, Michael Wilson, at easel and "Nursery School Serves Purpose for Children" i.e., Allan Hancock Nursery School, *SMT,* Feb. 21, 1959, p. 3.
See: "Allan Hancock College Adult/Night School," various years, "Knowles, Joseph," 1957, "Wilson, JoAnn"

Allen, Annette Irene
See: Negus (Lindegaard) (Johns) (Allen), Annette Irene

Allen (Bumb), Elva (Mrs. Frank Edward Bumb) (1921-2014) (Santa Maria)
Santa Maria High School student who won several poster prizes in the late 1930s. Active in high school theater.
1940 – "I Spied... '*Youth Today*' a magazine, asking permission to reproduce one of Elva Allen's drawings for the magazine cover," *SMT,* April 5, 1940, p. 1.
1942 – "Elva Allen returned to San Jose State after a visit here to her parents, Mr. and Mrs. Henry Allen," *SMT,* April 21, 1942, p. 2, col. 6.
Allen, Elva (notices in Northern Santa Barbara County newspapers on microfilm and on newspapers.com)
Elva Mae Allen was b. Jan. 19, 1921 in Santa Maria [Sic. Placer County?] to Henry Loid Allen and Nellie Agnes Cook, married Frank Edward Bumb and d. April 19, 2014 in San Jose, Ca. per Bumb Family Tree (refs. ancestry.com).
See: "Minerva Club Flower Show," 1936, "Posters, general (Santa Maria)," 1939, "Posters, Latham Foundation (Santa Maria)," 1937, "Santa Maria, Ca., Union High School," 1935, 1937, "Splash," 1938

Allen, Mitchell (San Luis Obispo / Morro Bay)
Photographer who demonstrated motion picture taking to Santa Maria Camera Club, 1940.
See: "Santa Maria Camera Club," 1940, and *San Luis Obispo Art and Photography before 1960* and *Morro Bay Art and Photography before 1960*

Almanzo, Robert "Bob" (1929-1993) (Lompoc)
Photographer for the Army who later used the talent to illustrate various publications.
■ "Bob Almanzo to be Sent Overseas... Robert Almanzo, son of Mr. and Mrs. A. E. DeAlmanzo, left last week for Fort Lewis, Wash. ... Almanzo graduated from Lompoc High school in 1949 and attended the University of California at Berkeley. He graduated from there in 1953 and after a semester of student teaching, entered the Army. Following basic training at Fort Ord, he was sent to Fort Monmouth Signal School of Photography where he graduated with honors. He has been assigned to an Air Force unit at Fort Lewis and expects orders for overseas. When his tour of duty ends, Almanzo expects to resume his studies toward a Masters' degree," *LR,* Oct. 14, 1954, p. 3.

Almanzo, Robert (notices in Northern Santa Barbara
County newspapers on microfilm and on newspapers.com)
1956 – "Lompoc Student Learns Ways of Old Mexico,"
LR, Feb. 2, 1956, p. 15; "Bob Almanzo Named to College
Post… recently elected to the Student Council of Mexico
City College as president of the Graduate Class… studying
toward an M. A. degree in Latin American History. … A
veteran, Almanzo served twenty-one months in the U. S.
Army as a Signal Corp. photographer. He was attached to
the Korea Civil Assistance Command and Engineer Aerial
Photo Detachment," *LR*, Dec. 13, 1956, p. 15.
1957 – "Rodriguez-Almanzo Engagement Announced in
Mexico City … The couple met at Mexico City college …
Almanzo entered Mexico City college in January 1956.
Active in student government, he has been … photographer
and circulation manager for the newspaper the 'Mexico
City Collegian,' and editor of the 'Alumni Bulletin.' …,"
LR, Dec. 12, 1957, p. 14.
1993 – "Robert Almanzo… Mr. Almanzo was born Aug.
24, 1929 in Lompoc and was raised and attended schools
here, graduating from Lompoc High in 1949. He served in
the U. S. Army as a photographer for the Korean Civil
Assistance Command and as an English instructor at Seoul
National University for the United Nations Korea
Reconstruction agency. He received his B.A. degree from
UC-Berkeley and received his M.A. degree from Mexico
City College. He was a junior high school teacher for the
Los Angles Unified School District for many years and was
also a teacher of numerous special bilingual and cultural
programs. He died Saturday, Oct. 16, 1993 at his home,"
LR, Oct. 20, 1993, p. 5.

Alpha Club (including Junior Alpha Club) (Lompoc)
*Women's Club founded 1898 as the Alpha Literary and
Improvement Club, that held cultural programs in music,
theater, literature, gardening (including flower arranging
and landscape design), crafts (including needlework) and
art (including art history). First mention of an "Art
Section" occurred in 1928, when it was headed by
Gertrude Bowen, and lasted to possibly late 1930. In 1932
it was referred to as "newly organized" and headed by
Mrs. Charles E. Maimann, 1932-36. The art section took
up themes, one of which was American and California
artists (1932-33), followed by American antiques (1933-
34), tapestry, dishes, ceramics, tile, silverware (1934-35),
jewelry, printmaking (1935-36) interspersed with
paintings. Headed 1936-37 by Mary Elizabeth Bucher at
which time the group studied modern art, murals,
Surrealism. Headed by Mrs. J. P. Truax, 1937-41 at
which time the group studied Old Masters for two years
and then American historical and modern art for two
years then European modern art. Headed by Mrs. James
Kenney, 1941-42 the group studied miscellaneous topics
including ceramics. Back under the chairmanship of Mrs.
J. P. Truax, 1942-44. In spring 1943 the Art and
Literature sections began holding joint meetings. It was
headed by Mrs. Harry Hobbs, 1944-? In fall 1945 the Art
section first met jointly with the Music section. In spring
1947 the Art section was again holding joint meetings
with the Literature section and by fall studying principles
of color and design and Santa Barbara artists. By spring*

*1948 Mrs. Ed Negus was art chairman and the Alpha art
section was meeting jointly with the Lompoc Community
Woman's Club art section and learning about local artists
such as Forrest Hibbits and Channing Peake and then
Abstract painting. By c. 1950 the art section appears to
have combined into the Music, Art and Literature Section
(aka Fine Arts Section), lasting to Spring 1956, and art
programs were sporadic and also presented to the club as
a whole. Starting c. 1946, the Club also participated in the
Federation of Women's Clubs Penny Art Program, which
netted it a few paintings to decorate its clubroom walls.
The handcraft section was started 1933 at which Lucy
Benson taught various crafts (weaving, embroidery, etc.)
to members. The handcraft section was combined with the
Garden section, 1936. In fall 1940 handcrafts were first
taught by Viola Dykes through the high school's Adult
School and held at the Alpha clubhouse (but later at the
Recreation Department). In 1959 Mrs. Wiedmann taught
her "Arts and Crafts Made Simple" to Alpha members
and their children. Among Alpha Club members were
many who painted or made other forms of art, including
Elsa Schuyler, Ethel Bailey, and Mrs. Ernest Weidmann.*

■ "Alpha Club celebrates 100 years of service... The
Harmony club was formed by 10 ladies in 1898. It was
immediately evident that members were assigned literary
topics to discuss, including geographical references, current
literature, music and history. In 1900, the decision was
made to join the California Federation of Women's Clubs.
The club's name was then changed to The Alpha Literary
and Improvement Club. The constitution and by-laws state
their objective 'shall be the mutual improvement of its
members in literature and the vital interests of the day'... In
1903 the ladies were heavy into Temperance. They were
busy building a library... In 1906, California Federation of
Women's Clubs reported that the Alpha Club was the only
one with a scholarship fund. Lompoc Museum, now located
on the corner of east Cypress Avenue and South H Street,
was at one time the municipal library, started by the Alpha
Club. ... In 1922 ... they held a Dahlia Show that expanded
to the present ... Flower Show. The music section was
formed in 1927... That year, the property where the
clubhouse now stands was purchased, and the building was
completed in 1934 [sic. 1933]...," *LR*, Oct. 11, 1998, p. A9.
Alpha Club (notices in Northern Santa Barbara County
newspapers on microfilm and the Internet)
1914 – "Alpha Year Book Issued… Miss Helen Bradley [of
Palo Alto] … contributed to the artistic cover design by
painting thereon in watercolors, pansies, the club
flower…," *LR*, Aug. 7, 1914, p. 8.

1918 – "Famous California Men… regular meeting in the
basement of the Library… then different members of the
club told of California's artists and their paintings…," *LR*,
April 12, 1918, p. 3.

1919 – "Alpha Club Tomorrow. … **Mrs. Smith**, teacher of
Purisima school, will entertain the Club tomorrow with
cartoon work," *LR*, March 14, 1919, p. 5.

1921 – "'American Sculpture' will be the subject at the
Alpha club meeting tomorrow …," *LR*, March 4, 1921, p.
5, col. 3; "Club Plans… The program for the day consisted
of the extinct missions of California… The San Diego

Mission was given by **Miss Gertrude Bowen…**," *LR*, Nov. 11, 1921, p. 3.

1923 – "California Birds Prove Interesting Study… Miss Scroggy … explained which of our California birds were an aid to the agriculturist… Her ideas were demonstrated by some very clever <u>illustrations</u> by **Miss Beck…**," *LR*, Feb. 23, 1923, p. 1; "Regular Meeting … Saturday, March 17 will be International Day …. The committee in charge… will have a display of the <u>handicraft</u> of the foreign countries… [in] Library basement. Anyone having any articles of foreign handiwork will be welcome. Come and put them on display," *LR*, March 9, 1923, p. 3; "Rehearsals Commence for Alpha Pageant… Some especially fine poster work by Miss <u>Kathryn Brendel</u> depicting scenes from the 'Valley of Gold' will appear in the local store windows next week…," *LR*, Aug. 24, 1923, p. 1.

1925 – "The meeting of the Alpha Club… at 2:30 in the club rooms of the library… Miss **Gertrude Bowen** of the High school faculty will read a paper on 'Art in Connection with Literature'," *LR*, Nov. 6, 1925, p. 10.

1927 – "Alpha club… Miss **Jeannette Lyons**, teacher of one of the county's model schools at Buellton… gave an interesting talk at the Parent Teachers' association … on creative education. … At the Alpha Club … Miss Lyons will relate some of her experiences while abroad two years ago. Miss Lyons has a witty style…," *LR*, Jan. 21, 1927, p. 5.

1928 – "Alpha Club Meeting. **Miss Gertrude Bowen**, chairman of the <u>art section</u>… is in charge of the program to be given at the club tomorrow afternoon… **Mrs. Mockford** will give a talk on Raphael. <u>Mrs. Oettinger</u> and others in the Art department will speak on subjects of interest," *LR*, Feb. 17, 1928, p. 5.

1929 – "Alpha Club Women to Honor President … The program will consist of a Christmas story by the literature section, a display of Christmas art by the <u>art section</u>. A demonstration of decorating a small tree, making a wreath and arranging a bowl of fruit for the holiday board will be given by <u>Mrs. Robert Casson</u>, **Mrs. J. P. Truax** and **Mrs. Ralph Davidson** for the homes and gardens section…," Dec. 6, 1929, p. 6; "Alpha Club Begins Seasons Activities… talk by chairman of <u>art section</u>, **Miss Gertrude Bowen**…," *LR*, Sept. 6, 1929, p. 8; "Entertain Club – The <u>Art Section</u>… will have charge of the program… when **Mrs. Julian Mockford** will give a talk on art of the Huntington gallery in Pasadena and **Miss Bowen** will give her impressions of the sculpture exhibit at the Palace of the Legion of Honor in San Francisco….," *LR*, Oct. 18, 1929, p. 8.

1932 – "<u>Art Section</u> of Alpha Club Hold First Meet. The newly organized art section… met with the chairman, **Mrs. Charles E. Maimann**, Monday night. As a preliminary study before taking up the 'History of Art in California and California artists' Mrs. Maimann gave a review of '*The History and Ideals of American Art*' … At the next meeting there will be a short summary of this period … The book will then be continued up to the painters of the west [chapters]," *LR*, Sept. 9, 1932, p. 10; "<u>Junior Group</u> [**Junior Alpha Club**] is Planned here… Junior clubs, which are composed of young women, under the sponsorship of federated club groups, are growing in favor throughout southern California. Their purpose is organized study and recreation… Interest… has been expressed by many local young women… activities of junior clubs in other communities include drama study, arts and crafts, and social events… All local young women interested are welcome to the informal meeting…," *LR*, Sept. 23, 1932, p. 2; "History of American Art… <u>Art Section</u>… at the home of the chairman **Mrs. C. E. Maimann**, who reviewed the history of American art from the Colonial primitives through the time of George Inness… Mrs. Fred Carlson took up the history from 'The Followers of Inness' to 'The Cosmopolitans,' which included 'The Independent Romanticists,' 'The Dusseldorf Influence,' and 'The Munich School'…," *LR*, Oct. 7, 1932, p. 6; "<u>Art Section</u> Meets – An illustrated lecture on the life of the Danish sculptor <u>Bertel Thorvaldsen</u>, was given by the Rev. Charles E. Maimann … in the home of the chairman, **Mrs. C. E. Maimann**," *LR*, Nov. 4, 1932, p. 4; "Club's Art Section … under the leadership of **Mrs. C. E. Maimann**, chairman… will present **Stanley Breneiser**… will speak on <u>modern art</u> and will illustrate his talk with a number of prints of modern paintings. He will be accompanied by **Mrs. Breneiser**, who may also speak briefly … The Breneisers… are preparing an exhibit for an eastern gallery…," *LR*, Nov. 18, 1932, p. 12; "Santa Maria Artist Addresses Alpha Club, Exhibits Paintings… **Stanley Breneiser**… Breneiser spoke on the 'Approach to the study of modern art' and illustrated his talk with a number of prints of modern paintings…," *LR*, Nov. 25, 1932, p. 7; "Art Group Meets at **Lilley** Home… **Mrs. J. P. Truax** read a magazine article… Miss Helen Riggs reviewed two chapters of 'The History of American Art' by Alfred [Sic. Eugen] Neuhaus … Mrs. Fred Carlson reviewed the life of <u>Jean Mannheim</u>, a California artist whose study of Morro Rock appeared on the front page of '*Touring Topics*' for November…," *LR*, Dec. 9, 1932, p. 5.

1933 – "<u>Art Section</u>… **Mrs. J. P. Truax** was hostess… at her home on north K street. The life of <u>Whistler</u> was reviewed by **Miss Gertrude Bowen**," *LR*, Jan. 13, 1933, p. 6; "Personals. Section to Meet… <u>art section</u>… Monday evening at the home of **Mrs. O. B. Westmont**… Mrs. Jack Hudson will discuss <u>Sargent</u>… and Mrs. Westmont will have as her subject 'Other Figure Painters.' There also will be a discussion on some of the modern painters of California," *LR*, March 3, 1933, p. 12; "<u>Art Section</u> Studies Painters… home of **Mrs. O. B. Westmont**… a paper on 'The Figure Painters' who were contemporary … with <u>Whistler</u>, given by Mrs. Westmont. … **Mrs. C. E. Maimann** had as her subject <u>Donna Schuster</u>, a modern painter noted for her California landscapes, who has a studio at La Crescenta and one at Laguna Beach…," *LR*, March 10, 1933, p. 5; "<u>Art Section</u> Will Study Native Painters… home of **Miss Gertrude Bowen**… **Mrs. J. P. Truax** will continue the discussion of American artists including the work of California's great landscape painter, **William Wendt**. A new feature of the program has been arranged by the chairman **Mrs. C. E. Maimann**, consisting of 'Brush Strokes' (current events in the world of art)," *LR*, March 31, 1933, p. 3; "<u>Art Section</u> Studies American Painters… Miss **Gertrude Bowen** … American artists

including a number of well-known California artists and was led by **Mrs. J. P. Truax**, who had a number of reproductions of their work… Some of the best-known artists in this group who have made California famous are **William Wendt**, who has given to his landscapes a spirit of profound reverence, Oscar Borg, whose painting are bound up with the Southwest, its deserts and mountains and who has also specialized in Indian paintings and their pueblos, and **Armin Hansen**, whose work is associated entirely with the sea," *LR*, April 7, 1933, p. 5; "Plans Approved by Lompoc Alpha Club. Spanish-Type Structure [for clubhouse building] … program, presented **Stanley Breneiser** … who talked on art in relation to music, illustrating his talk with paintings and explaining how one trained along those lines could visualize pictures as described by notes and tones of music," *LR*, April 21, 1933, p. 7; "Alpha Club Art Section Meets. **Mrs. Ronald Adam** conducted a study of 'Paintings of the Sea' and 'Paintings of American Indians'… on Monday evening. Mrs. Adam illustrated her talk with a number of reproductions of the paintings… **Mrs. O. B. Westmont** presented as her subject an article entitled, 'Why not start collecting fine prints?'. The article brought out the fact that really good prints cost little more than ordinary reproductions and have the advantage of increasing in value with the years…," *LR*, May 5, 1933, p. 7; "Art Section to Meet… final meeting of the year… home of **Mrs. Charles E. Maimann**. The book, '*History and Ideals of American Art*' will be finished, the chapters including modern and ultra-modern paintings, murals and etchings," *LR*, June 2, 1933, p. 5.

FALL – Photo of new clubhouse and "Goal Realized as Alpha Club Opens Year in New Home," but no architect mentioned, *LR*, Sept. 1, 1933, p. 1; "Alpha Club Meets in Own Home After 35 Years Activity in Community… Many gifts were presented to the club including an oil painting presented by **Mrs. Leila Maimann** from the art section, the work of Mrs. Maimann's sister [**Oma Perry**] …," *LR*, Sept. 8, 1933, p. 4; "Art Group Plans Study of Antiques… Preliminary… **Mrs. Leila Maimann**… will speak Monday night of 'Old New England Houses.' … **Mrs. O. B. Westmont** will describe the art exhibit she visited at the Century of Progress Exposition…," *LR*, Sept. 15, 1933, p. 10; "Period Furniture Studied… art section… Monday night at the clubhouse. Chippendale furniture… **Mrs. Linda Adam**… **Miss Gertrude Bowen** had as her subject 'The Concord Antiquarian Collection and its Setting,' an interesting account of the museum at Concord, Mass. William and Mary and Queen Anne furniture will be the subject of discussion at the November meeting with **Mrs. Francis Truax**…," *LR*, Oct. 6, 1933, p. 5; "**Miss Muriel Moran** to Discuss Art… art section … Miss Muriel Morgan [sic. Moran] art teacher of the Lompoc Union High School, will speak on … art as taught in the high school at the next meeting of the club, October 21… An interesting exhibit of art work done in the high school will be on display," *LR*, Oct. 13, 1933, p. 4 and *LR*, Oct. 20, 1933, p. 4; "Alpha Club Topic by **Miss Moran**… Different phases of preliminary art study as taught to students of the seventh and eighth grades in preparation for more difficult problems of art presented to students of the higher grades were explained… Examples of the work of many pupils proved interesting…," *LR*, Oct. 27, 1933, p. 4; "France is

Subject of Junior Alpha Club Meeting. Illustrating her talk on the art of France preceding and after the French Revolution with reprints of masterpieces of the old French artists, **Miss Edna Davison** … program was given in the manner of a round table discussion…," *LR*, Nov. 3, 1933, p. 7; "Equal Right for Women… Alpha Club… During the business meeting announcement was made that a section of handicraft would be organized with **Mrs. Perry H. Benson** as chairman …. All sorts of handwork including the making of lampshades, tables and favors would be taught. Mrs. Benson is chairman of handicraft for the county federation of women's clubs…," *LR*, Nov. 10, 1933, p. 3; "Clubhouse… 'Gay Nineties'… Junior Alpha… Needlework, hand-blocked Christmas cards, tally cards, score pads and table decorations, hand-decorated pottery articles and hand-made clay articles will be disposed of in booths attractively arranged by **Miss Edna Davidson**…," *LR*, Dec. 1, 1933, p. 3; "Handcraft Section… a group of members met Monday afternoon in the clubhouse to take up the story of handwork under the direction of **Mrs. Perry H. Benson**, chairman of handcrafts for the Santa Barbara County Federation of Women's Clubs. Instructions were given… for crystallizing orange peel and other fruit peel and demonstrations given for making table decorations for the holidays. The section will meet again next Monday afternoon …," *LR*, Dec. 1, 1933, p. 5; "Period Furniture Study Subject… William and Mary and Queen Anne furniture by **Mrs. J. P. Truax** at her home Monday… **Mrs. Ronald M. Adam**, who recently gave a talk before the members on the subject of 'Chippendale' furniture gave an account of her visit to the Huntington Library and told of the many fine pieces of Chippendale on display there. **Mrs. Maimann** told of the museum established at Sudbury, Mass, by Henry Ford in the old 'Wayside Tavern'…," *LR*, Dec. 15, 1933, p. 14; "Club Handicraft Section Meeting Date Changed… announced by **Mrs. Perry Benson**, chairman. At that time weaving on hand looms, stitching and other hand work desired by members will be taken up. Mrs. Benson … spoke over radio station KDB Tuesday afternoon in Santa Barbara on the Federation broadcast. Her subject was arts and crafts, and she gave instructions in making last minute Christmas gifts," *LR*, Dec. 22, 1933, p. 6; "Art Section Holds 'Radio Tea' … [at home of **Leila Maimann**] Members listened to the program broadcast over station KNX by **Mrs. Keith Harkness** … Mrs. Harkness spoke of the Madonnas painted by the great artists of the world," *LR*, Dec. 29, 1933, p. 6.

1934 – "Art Section… at the home of chairman **Mrs. Leila Maimann**… program… Hepplewhite furniture with Mrs. Maimann giving a talk on the subject," *LR*, Jan. 5, 1934, p. 10; "Art Group Topic. Meeting Monday night at the home of … **Mrs. Leila Maimann**… study of Hepplewhite furniture with Mrs. Maimann leading the discussion… **Miss Gertrude Bowen** will have charge of the program for the next meeting, having as her subject Sheraton furniture," *LR*, Jan. 12, 1934, p. 8; "Demonstrates Handcraft – Egyptian weaving on hand looms, stitchery and the making of screens arrangements were demonstrated by **Mrs. Lucy Benson**, chairman, at the meeting of the handcraft section of the Alpha club Monday afternoon at the clubhouse. This work will be carried out at future meetings scheduled for the third Monday of each month," *LR*, Jan. 26, 1934, p. 4;

"Literature Group Hears Book Review… Lives of artists prominent in England during the Victorian period… **Mrs. Leila Maimann** reviewed the book '*Poor Splendid Wings*' by Frances Winwar. Artists included in the book were the Rossettis, Swinburne and Ruskin," *LR*, Feb. 9, 1934, p. 7; "Handicraft Group to Meet Monday. Under the supervision of **Mrs. Lucy Benson** … in the clubhouse for an afternoon of handwork. Many of the women have taken up weaving, some are weaving purses and some are working on footstool covers. Mirror screens displayed at the last meeting will be made… and exhibited at the Spring **Flower Show**. Many of the women are interested in stitchery and plan on making coats of linen crash [Sic.?] to be decorated with designs in stitchery. Mrs. Benson will conduct a forum on 'handicrafts' at the convention of the federated women's clubs of the county March 20 at 'Rockwood,' home of the Santa Barbara Woman's Club. An exhibit of handwork will be on display at the meeting," *LR*, March 2, 1934, p. 7; "Art Section to Meet… Monday night at the home of **Mrs. J. P. Truax**… with early American furniture as the subject…," *LR*, March 9, 1934, p. 7; "Study Furniture – Meeting Tuesday night at the home of **Mrs. J. P. Truax**… art section… heard a talk on early American furniture given by the hostess. Illustrations of the different types were shown including the Duncan Phyfe…," *LR*, March 16, 1934, p. 9; "Handicraft Group Has Study Meet," *LR*, April 6, 1934, p. 3; "Study Handcraft – Meeting at the home of Mrs. Anne Calvert Wednesday night… spending the evening in handwork under the direction of **Miss Kay Batkin**. Several of the juniors are starting to weave purses to match their costumes and a number have begun work on coats of osanberg [Sic.?] material to be trimmed with hand stitchery of colored yarn," *LR*, April 13, 1934, p. 10; "Art Group to Present Alpha Club Program… **Mrs. Leila Maimann**, chairman… arranged the program… Period furniture and antiques will be the subject… with Mrs. Ernest Klein speaking on the subject of antiques and exhibiting some antiques in her possession. Norman Betaque will talk on various woods and finishes," *LR*, April 20, 1934, p. 7; "Alpha Club Holds Art Program… sponsored by the art section… Mrs. Ernest Klein gave an interesting treatise on the experiences of an art collector, speaking especially of the noted collector, Paul Byck, with whom she is well acquainted, who collected objects of art for William Randolph Hearst and others, searching Europe for the articles. … Articles of antiquity, including a spinning wheel, a tea set, silver articles and old books were on display. Norman Betaque of the high school spoke of the various kinds of wood and their uses and finishes, showing samples of the best-known varieties…," *LR*, April 27, 1934, p. 11; "Section Meets. Members of the handicraft section of the Alpha Club met Monday afternoon in the clubhouse to continue their handwork under the direction of **Mrs. Lucy Benson**, chairman," *LR*, May 25, 1934, p. 4; "**Mrs. Leila Maimann** Heads Art Section… met at the home of **Mrs. Ronald M. Adam**. Modern furniture was the subject… with the hostess giving an illustrated talk on the lines of styles of modern designers. ... Next year the women will take up the study of China, silverware and fabrics," *LR*, May 25, 1934, p. 4; "Handcraft Section will continue to Meet in Summer… [per] Mrs. Betty Dickey, who has served as chairman of the handcraft section… during the last year and will continue in office during the coming club year… The meeting will be held Monday afternoon at the clubhouse at 2 o'clock and will be held the first and third Monday afternoons hereafter. Organized as a new department of the club, the section has created among the members a new interest in handwork with **Mrs. Lucy Benson** as instructor. Making of party and table decorations and favors, weaving, stitchery and embroidery were taken up and articles made during the year's work. Exhibits of their work have been on display at meetings of the county federation of women's clubs," *LR*, June 1, 1934, p. 5.

FALL – "Luncheon Opens Alpha Club Activities … **Mrs. Leila Maimann**, art section, chairman, reported that the section last year had made a study of period furniture and this year would continue study along the same lines with a study of tapestry, dishes and silverware. A large membership in this group was anticipated as many new members had already signified their intentions of attending," *LR*, Sept. 7, 1934, p. 4; "Alpha Club Art Section… home of **Mrs. Leila Maimann**… number of new members in attendance. Mrs. **Linda Adam** was elected secretary… Continuing along the same line of study followed last year when period and antique furniture was studied, the program will be extended to take in the subjects of tapestries, dishes and silverware. A new idea to be inaugurated this year… will be the devoting of a certain part of each program to the study of a certain famous painting. A member will be appointed to choose the picture to be studied and to lead in discussion. **Mrs. Frances Truax** had charge of the first program and had as her subject, 'Tapestries,' giving an interesting account of the early history of tapestry weaving… Colored illustrations of the different types were shown. **Mrs. Maimann** presented the painting to be studied… 'The Man with the Hoe,' Millet's famed picture, the original of which Mrs. Maimann and other section members had seen in the French exhibit in the Legion of Honor Building, San Francisco, during the summer. Next month the group will meet at the home of Miss **Gertrude Bowen**. … study of rugs with **Mrs. Violet Lilley**… **Mrs. Bradford Kelley** will present the… painting to be studied," *LR*, Sept. 14, 1934, p. 11; "Handcraft Section of Alpha Club to Meet Twice Monthly … not only on the first Monday afternoon of each month but also on the fourth Wednesday evening of each month in the clubhouse in conjunction with the handcraft section of the Alpha Club Juniors, each to operate under their own chairman. **Mrs. Hattie Smith** was elected chairman of the senior section and Mrs. Beatrice Cakebread of the junior section. At Monday night's section meeting, **Miss Bucher** of the high school faculty gave a handcraft talk on the various kinds of craft work including stitchery, woodwork of all kinds, including inlay work and wood carving, metal work, block printing, leather work and Batik work. On Monday afternoon the senior group will meet in the clubhouse when block threading and stitchery and Batik work will be taken up. **Miss Edna Davidson** will assist with the instructions…," *LR*, Sept. 28, 1934, p. 5; "Art Section… Monday night… will meet with **Miss Gertrude Bowen** for an evening … program will feature floor coverings. **Mrs. Robert C. Lilley** will talk … **Mrs. Bradford Kelley** will present the topic of well-known

paintings…," *LR*, Oct. 5, 1934, p. 3; "Art Section Hears Talk on Oriental Rugs Monday Evening … home of Miss **Gertrude Bowen**… by **Mrs. Violet Lilley**. Illustrations of many of the most beautiful rugs were shown, including Ghiordes Prayer rugs. …," *LR*, Oct. 12, 1934, p. 6; "Art Section Studies Modern Rugs… home of Mrs. **Leila Maimann**, chairman… Mrs. **Ethel Kelley** who led the discussion … of famous 'Mona Lisa' painting by Da Vinci… In December the art section is to supply the program for the general meeting and it was decided to present **Mrs. E. Keith Harkness** of Los Angeles…," *LR*, Nov. 16, 1934, p. 7; "Handcraft Section… the handcraft section of the club and the handcraft section of the Junior Club will have an assortment of their work on display in the clubroom…," *LR*, Nov. 16, 1934, p. 7; "Art Section…present **Mrs. E. Keith Harkness**, who is devoting her time to giving lectures on art, in an illustrated talk on the Madonnas. Mrs. Harkness, before her marriage, taught art in the University of Kansas, is quite an artist herself, and has served the Los Angeles District Federation of Women's Clubs as art chairman. …," *LR*, Nov. 23, 1934, p. 4; "**Solvang Women's Club** Provides Program… An exhibit of lovely hand work including hand woven articles from the **Atterdag College** at Solvang, was displayed… A display of handwork, which combined the efforts of both the Alpha Club and the Alpha Club Juniors handcraft sections was attractively arranged for inspection. The work incuded articles decorated with stitchery, woven articles including 8 different varieties worked up into handbags and stools with woven tops, carved and dyed woodwork, Christmas cards and many other specimens… **Mrs. Hattie Smith** is chairman of the senior group…," *LR*, Nov. 23, 1934, p. 5; "Handicraft Section Holds Monday Meeting… in the clubhouse for an afternoon of handwork under the supervision of **Mrs. Hattie Smith**, chairman. Instruction was given in the different crafts, including the making of tea tiles, the blocking of Christmas cards and making wall hangings. The women also learned attractive new ways of wrapping gifts for Christmas," *LR*, Nov. 23, 1934, p. 7; "Art Section Will Offer Program… Christmas music and a talk on the 'Madonnas,' … art section… under the direction of **Mrs. Leila Maimann**…," *LR*, Nov. 30, 1934, p. 1. "Talk on Madonnas is Well Received… **Mrs. E. Keith Harkness**, lecturer for the Los Angeles Art Institute [Otis?] and former District Art Chairman for the Los Angeles District of the California Federation of Women's Clubs… Bringing with her prints from the Los Angeles Museum of the most famous of the Madonna paintings… Dividing the paintings into five groups, Mrs. Harkenss first mentioned the Primitive Madonnas…," etc., *LR*, Dec. 7, 1934, p. 3; "Art Section Studies Chinaware… home of Mrs. **Violet Lilley** under the leadership of Mrs. **Leila Maimann**, chairman… study of chinaware with Mrs. **Harry Johnston** having charge… chinaware originated in the orient… English makers… Presented by Mrs. **Frances Truax** a study was made of the famous painting 'The Sleeping Girl' by Vermeer…," *LR*, Dec. 14, 1934, p. 4; "Handcraft Section Studies Tables. Christmas dinner table arrangements… In January the regular course of handwork will be resumed working up toward the spring **flower show** and a craft exhibit to be given later. The members also will take up the making of flower screens to make flower arrangements more effective," *LR*, Dec. 14, 1934, p. 11; "Art Section Will Aid SM Group in Festival January 7-14… meeting… at the home of **Mrs. Leila Maimann**… co-operate with the **Community Club of Santa Maria** in presenting an **art festival** in Santa Maria… under the direction of **Mrs. Stanley Breneiser** … that will include a display of … **Rockwell Kent**… amateur exhibit…," *LR*, Dec. 21, 1934, p. 10.

1935 – "Alpha Club Presents [program in Solvang] … following women who took part in the program representing the various study sections of the club… **Mrs. Maimann** as chairman of the art section, spoke on the subject of art and told of the art exhibit being held in Santa Maria last week sponsored by the women's club…," *LR*, Jan. 18, 1935, p. 4; "Art Section Studies Old and Modern Glassware Monday… presents the subject of a famous painting for study and discussion. Miss **Mary Elizabeth Bucker** [Sic. Bucher] led the discussion choosing Van Gogh's 'Pere Tanguy,' a picture in the French exhibit in San Francisco last summer… **Mrs. Frances Truax** will entertain the members next month at her home. Pottery and pottery making will be studied with Miss **Gertrude Bowen** furnishing the program. Mrs. **Violet Lilley** will speak about some famous painting which she chooses…," *LR*, Jan. 18, 1935, p. 9; "Art Section will Study Pottery… Continuing the study of subjects of interest to the home-maker and yet allied to the subject of art… meet Monday evening at the home of **Mrs. Frances Truax** and devote the evening to a study of pottery… **Miss Gertrude Bowen** has charge of the program and will read an article giving the history of pottery making… **Mrs. Violet Lilley** will present… her favorite famous painting…," *LR*, Feb. 8, 1935, p. 5; "Art Section Meets to Study Pottery making… home of **Mrs. Frances Truax** … with Miss **Gertrude Bowen** taking charge of the program. According to Miss Bowen the making of pottery was one of the first arts and began about 400 B.C. [sic?] and she traced the development of the art … The making of Indian and Mexican pottery also was explained… showed illustrations of the different kinds of pottery. The Rookwood pottery made in New Jersey … The subject of a favorite famous painting was covered by **Mrs. Leila Maimann**, chairman, who chose Corot's painting, 'The Goatherd of Terni'…," *LR*, Feb. 15, 1935, p. 6; "Garden Section will Hear Landscape Architect … **Edwin Rowe**… for the National Park Service…," *LR*, Feb. 22, 1935, p. 4; "Art Section to Meet… at the home of **Mrs. Ronald M. Adam**. The topic to be discussed is 'Tile Making, Ancient and Modern.' **Mrs. Robert Lilley** will discuss the picture of her choice," *LR*, March 8, 1935, p. 7; "Art Section Hears Talk on Tile at Monday Meeting… Devoting the evening to a study of tile and tile-making, the members of the art section of the Alpha Club met Monday evening at the home of **Mrs. Linda Adam**, who also had charge of the program. Speaking on the subject of tile with special emphasis given to the decorative type of tile used for interior decoration, Mrs. Adams told of the tile of Mexico and described an old house made of tile which she had seen while touring Mexico… Mrs. Marietta Johnston, who was to present a famous painting for discussion… chose as her favorite artist, William Keith, whom she was personally acquainted with…," *LR*, March 15, 1935, p. 9; "Garden Section to Study Flower Arrangements," *LR*,

March 22, 1935, p. 6; "Old Silver, Painting to be Discussed," *LR*, April 5, 1935, p. 9; "Art Section Studies Old Silver… Old silver was discussed by **Mrs. W. B. Kelley**, who told of the various patterns and religious vessels made by early silversmiths. A reproduction of 'The Song of the Lark,' by Jules Breton, was exhibited by Mrs. **R. M. Adams** [Sic. Adam], who gave a brief biography of the artist…," *LR*, April 12, 1935, p. 9; "Landscape Architect Designs New Alpha Club House Gardens… **E. D. Rowe**…," *LR*, May 3, 1935, p. 10; "Art Section will Hear Talk on Antique Jewelry. **Mrs. Charles E. Maimann** will be hostess… The supper is planned by Mrs. Maimann to close the art section's activities until fall. **Miss Mary Elizabeth Bucher**, high school art teacher, will talk on 'Antique Jewelry.' Illustrating her subject with a miniature reproduction of one of his best-known paintings, **Miss Gertrude Bowen** will tell of the life and works of Corot, French artist," *LR*, May 10, 1935, p. 7; "Art Section Elects **Mrs. Maimann** Next Year's President… Speaking on 'Antique Jewelry,' Miss **Mary Elizabeth Bucher** told the part played by personal ornaments in lives of humans from the most primitive beings to modern times. Early types of jewelry were described … also told something of the origin and treatment of various precious stones … Miss **Gertrude Bowen** exhibited a reproduction of 'Saint Francis,' by Giotto, Italian pre-Renaissance painter, and briefly related the biography and achievements…," *LR*, May 17, 1935, p. 7.

FALL – "Cosmetics, Styles to be Discussed. … Junior Alpha… Miss **Mary Elizabeth Bucher** … is to discuss fall fashions and the importance of artistry in clothing and color trends…," *LR*, Sept. 13, 1935, p. 7; "Art Collections in Various Parts of Nation Described… exhibits viewed during the summer by members of the Art section of Alpha club were described… at the home of **Mrs. Charles E. Maimann**… **Mrs. J. P. Truax** told of art works she saw at San Diego, New Orleans and Nashville, Tenn. … **Miss Gertrude Bowen** described early American type paintings and Soviet art displayed in San Francisco, and **Mrs. Maimann** told of viewing the private exhibit of work by the late William Keith… and of visiting the Stanford art gallery. 'Lithographs' will be discussed by **Miss Bowen** at the next meeting … at the home of **Mrs. Truax**. **Mrs. W. B. Kelley** will talk on some well-known painting," *LR*, Sept. 13, 1935, p. 9; "Handcraft Section to Study Knitting…," *LR*, Sept. 20, 1935, p. 6; "Alpha Clubwomen to Hear of Prints. 'Prints and Printmaking' will be explained… by **Stanley Breneiser**… Examples of various types of prints and the blocks used in their production are to be exhibited by the speaker …," *LR*, Oct. 18, 1935, p. 1; [Art Section] "Pre-Raphaelite Works, Lithographing Told… Jean Millet and Gabriel Rossetti… **Miss Gertrude Bowen** explained the process of lithographing, illustrating her talk with lithographs by Bolton Brown, Joseph Pennell and other noted contemporary artists," *LR*, Oct. 18, 1935, p. 9; "Printmaking Told Alpha Club… Explaining in detail the three types of prints and the processes… The comparatively low cost of prints, enabling more persons to possess good examples, makes prints the most democratic form of art, **Mr. Breneiser** stated. From his personal collection of prints, the speaker showed examples of relief work, including wood carvings and wood blocks,

planographic or lithographic works, and intaglio prints, including the various types of etching. 'Morro Bay,' a print by **John Day Breneiser**, to be reproduced in an early issue of '*The Western Artist*,' was shown with several of his other works and prints of **Mrs. Stanley Breneiser**. Among examples of the various types of prints shown accompanied by description of processes by which they were made, were: an original wood carving print by **Frank Morley Fletcher**, the first white man to make prints by the ancient Japanese method; one of Timothy Cole; linoleum block prints by Noland Zane; lithographs by **Gerald Cassidy**, old French magazine cover prints, and lithographs by **Jean Charlot**, … etchings by **Mildred Bryant Brooks** and **Arthur Millier** and an 'aqua tint' by **Marian Hebert** of Santa Barbara," *LR*, Oct. 25, 1935, p. 10; Handcraft Section Will Give Program… Products of the loom and needles operated by members of the Handcraft section … will be exhibited with examples of handwork from various foreign countries tomorrow afternoon… 'The Click of the Knitting Needles,' a reading will be given by Mrs. S. B. Dimock. **Mrs. J. D. Callis** is to read a paper dealing with American embroideries. Weaving will be discussed by **Mrs. J. M. Smith**, section president, who has arranged the program," *LR*, Nov. 1, 1935, p. 14; "Art Section to Meet… Monday evening in the clubhouse. **Miss Edna Davidson** will talk on etchings. **Mrs. W. B. Kelley** is to tell the life of some painter and exhibit a reproduction of his most prominent work," *LR*, Nov. 8, 1935, p. 11; "Art Section – Etchings were discussed by **Miss Edna Davidson**… Monday… **Mrs. W. B. Kelley** discussed the life and work of Whistler…," *LR*, Nov. 15, 1935, p. 8; antique "Needle, Craftwork For Country Fair is Requested…," *LR*, Nov. 22, 1935, p. 11; "Woodblocks, Artists to be Art Section Topic Monday at the home of **Mrs. J. P. Truax**, who will give a brief autobiography [sic.] of some noted artist, illustrating with reproductions of his work the 'school' to which he belonged. Reproductions of woodblocks by the old masters, an original copy of *Harper's Bazaar* with woodblock illustrations, and contemporary woodblock work will be displayed by **Mrs. R. M. Adam** who will give the history and development of woodblock prints and explain the way in which the blocks are made," *LR*, Dec. 6, 1935, p. 2; "Alpha Club to Stage Country Fair Saturday … members in costumes of pioneer days…," plus an antique display, handcraft products, and novel window decorations, *LR*, Dec. 13, 1935, pp. 1, 8.

1936 – "Japanese Prints are Art Section Topic… discussed Monday evening by **Miss Mary Elizabeth Bucher**, high school art teacher," *LR*, Jan. 10, 1936, p. 11; "French, Japanese Art Studied. Japanese prints were discussed by **Miss Mary Elizabeth Bucher**… Monday eening in the clubhouse. Miss Bucher illustrated her talk with examples of the various types of Japanese prints. 'A Cup of Chocolate,' by Pierre Auguste Renoir was exhibited in reproduction by **Mrs. Charles E. Maimann**, who told of the French painter's life and achievements…," *LR*, Jan. 17, 1936, p. 6; "Shown Art Section Local Loom Work. Articles woven by **Mrs. James M. Smith** and by high school students were displayed Monday evening at meeting of Art section… **Mrs. Lilley** gave a short history of development of weaving using the local work to illustrate contemporary weaving. 'Green-Eyed Girl' and a still life painting by

Henri Matisse, French artist, were exhibited in reproductions by Miss **Mary Elizabeth Bucher** who briefly told of Matisse's life and importance of his works," *LR*, Feb. 14, 1936, p. 6; "Loom Demonstration Given… Operation of looms used in domestic science classes at the high school was observed… **Miss Mary Elizabeth Bucher** gave the demonstration… explaining construction of the looms. Later in the evening the group adjourned to the home of Miss **Gertrude Bowen** where Miss **Edna Davidson** exhibited a reproduction of a mural by Diego Rivera, noted Mexican artist [and]… briefly told of Rivera's work to date…," *LR*, March 13, 1936, p. 5; Handcraft Section… knitting as the main project of the day…," *LR*, April 3, 1936, p. 5; "Alpha Observes Conservation Week… Lockwood Forsythe, in charge of planting on the Soil Erosion project and **Carl Young**, artist under whose direction the La Purisima Mission details are being worked out, will speak of their work in restoring the mission," *LR*, April 3, 1936, p. 5; "Art Group Discusses Modern Art… at the home of **Mrs. J. P. Truax**. An exhibition of sculpture which was displayed in Santa Barbara in November was discussed by Mrs. Truax. **Miss Gertrude Bowen** read an article on 'German Modern Art,' which characterized art as the 'spiritual emptiness of post war minds'," *LR*, April 17, 1936, p. 5; "Japanese Art Topic… 'Japanese Prints' was the subject of a talk by Miss **Mary Elizabeth Bucher** at Wednesday's meeting of Junior Alpha. Illustrated with pictures from the Santa Barbara County library… meaning, symbolism and development of Japanese art, particularly of wood blocks…," *LR*, April 17, 1936, p. 5; "Art Section to Hold Final Meeting… 'Modern Art' will be the theme… at the home of **Mrs. C. E. Maimann**… **Miss Mary Elizabeth Bucher** and **Mrs. R. C. Lilley** will have charge of the program featuring current day art," *LR*, May 8, 1936, p. 4; "Miss M. E. Bucher New Chairman of Art Section. Miss **Mary Elizabeth Bucher** elected… **Mrs. C. E. Maimann**, retiring… Talks were given by **Mrs. Lilley** and Miss Bucher in connection with… Adolph Dehn, modern American painter … Advocate of non-objective paintings, Rudolph Bauer was described in detail by Miss Bucher… **Mrs. J. P. Truax** won a contest… and was awarded a miniature oil painting. Members cut pictures from ads which represented or suggested some of the paintings studied by the group," *LR*, May 15, 1936, p. 5; "Two Alpha Sections to Unite for Next Year. Garden and Handcraft sections will meet together next Wednesday… for a potluck. This is the final meeting of the year for the Garden section, with craft members as special guests, preliminary to combining the two sections into one under a single chairman," *LR*, May 22, 1936, p. 4.

FALL – "Art Section to Meet Monday Evening… the home of **Miss Gertrude Bowen**… **Miss Mary Elizabeth Bucher**… newly elected chairman… 'Modern American Art'… will be studied from several angles… Monday's meeting will be an Introductory Art meeting," *LR*, Sept. 11, 1936, p. 7; "Crowd of Junior Alpha Members Take 'Trip Through Mexico'… Mexican blankets and serapes were draped over chairs and divans in the clubhouse, and baskets, pictures and articles of handcraft were on display… and Miss **Edna Davidson** talked on the life and murals of Diego Rivera, well-known modern artist," *LR*, Sept. 18, 1936, p. 8; "Art Section Discusses Murals

Monday … home of the chairman, **Miss Mary Elisabeth Bucher**. Problems of composition and coloring and the peculiar difficulties to be met by the decorator were discussed by **Miss Gertrude Bowen**… **Mrs. W. B. Kelley** will deliver a talk on Murals at the next meeting…," *LR*, Oct. 16, 1936, p. 5; "Art Section – **Mrs. W. B. Kelley** will be hostess… She will lead the discussion on Murals and will present excerpts from current studies on the subject," *LR*, Nov. 6, 1936, p. 3; "Water Color Artist to Speak … **John Warren** of Santa Barbara… will discuss the Federal Art projects planned for this district and current results," *LR*, Nov. 6, 1936, p. 7; "Meeting Postponed by Garden Section… to Thursday, December 3… Christmas theme… A demonstration will be given by **Mrs. John Callis** and **Mrs. J. M. Smith** will contribute ideas of handcraft which might be used for Christmas gifts from the Arts and Crafts division," *LR*, Nov. 27, 1936, p. 5.

1937 – "Art Alpha Will Meet… with **Miss Mary Elisabeth Bucher**… at her home on Monday. Miss Bucher will be… discussing a contemporary American artist …," *LR*, Jan. 8, 1937, p. 5; "**Millard Sheets** Discussed by Art Section… One of Sheets paintings, which is to be hung in a local school building, was displayed and discussed…," *LR*, Jan. 15, 1937, p. 4; "Surrealist Art Discussed by Art Section… and the works of Franklyn Watkins… Monday evening… at the R. C. Lilley home. Leading the discussion on art, **Mrs. J. P. Truax** read a criticism of an exhibit of surrealist art now being shown in New York to be seen in San Francisco this summer," *LR*, Feb. 12, 1937, p. 4; "Art Alpha members were entertained Monday night by **Miss Mary Elisaeth Bucher**. While she talked, Miss Bucher gave a drawing lesson in which all the members participated. A better idea of how to look at drawings and illustrations was gleaned from the lesson," *LR*, March 12, 1937, p. 7; "Art Alpha Group to Discuss Sculptor. Paul Manship… discussed by **Mrs. C. E. Maimann**… at her home Monday night for the monthly meeting…," *LR*, April 9, 1937, p. 7; "Art, Music Sections Prepare Program for Alpha Meeting… Chinese curios collected during her residence there as a missionary will be displayed and discussed by Mrs. Helen Gammon. She will also give a short talk on conditions in that country," *LR*, May 14, 1937, p. 4; "**Mrs. Truax** will Head Art Section… dinner meeting… held Wednesday night at the home of **Miss Gertrude Bowen**. Arrangements for the tea to be served by Art section tomorrow at Alpha club…," *LR*, May 14, 1937, p. 8.

FALL – "Alpha Club Art Section to Study Old Masters… at the home of **Mrs. J. P. Truax**… opened their 1937-38 year with a study discussion from the Charles H. Caffin book 'How to Study Pictures'…," *LR*, Oct. 1, 1937, p. 3; "Art Section to Conduct Alpha Meet Tomorrow… **Mrs. Arthur Baker**, county Chairman of art, will be the speaker… Monday evening members of the Art Section met at the home of **Miss Mary Elisabeth Bucher**. Discussion of the works of Raphael, Botticelli and Bellini was … [led by] Miss Bucher…," *LR*, Oct. 15, 1937, p. 4; "Home Decorating is Topic at Alpha Club. **Mrs. Arthur Baker** of Santa Maria, chairman of arts for the County Federation of Women's clubs, was the guest speaker at the Alpha club meeting Saturday afternoon. **Mrs. J. P. Truax** as chairman of the local art section was in charge of the

program... 'Color in the Home' was Mrs. Baker's topic... With her she brought several of her flower pastels. Each of the blossoms she had painted were from her own garden...," *LR*, Oct. 22, 1937, p. 5; "**Mrs. Lord** Tells Art Group of Pottery Making. Mrs. **Lois [Sic. Loiz] Lord** of Pittsburgh ... With her, Mrs. Lord brought several of her pottery pieces and also several plaques done in bronze," *LR*, Nov. 12, 1937, p. 4; "**Mrs. Lord** Tells Alpha Club Juniors of Ceramics Work," *LR*, Dec. 3, 1937, p. 5; "Alpha Club to Hold Christmas Party... **Mrs. J. P. Truax** as Art section chairman, will show a series of the madonna paintings and give a discussion on the artists who created them," *LR*, Dec. 17, 1937, p. 5; "Alpha Women Enjoy Yule... Each of the Alpha club sections, the literature, art, music and home and garden groups had a part in the annual Christmas program... A talk on the madonnas was given by **Mrs. J. P. Truax** together with short sketches about the various artists who created them. Mrs. Truax also displayed a number of reprints of some of these famous paintings," *LR*, Dec. 24, 1937, p. 2.

1938 – "Alpha Club Art Section Meets at **Lilley** Home... comparative discussion of the works of Tintoretto and Veronese, Rubens and Valasques and Frans Hals and Van Dyke. **Mrs. Lilley** led the discussion. Members attending were...," *LR*, Jan. 14, 1938, p. 3; "Handcraft Talk... Knit work, weaving, embroidery, rugs, potteries, wood and linoleum carvings and many other types of handcraft were displayed at the recent Alpha club meeting when **Mrs. Ralph T. Henderson**, district chairman of handcrafts was guest speaker...," *LR*, Jan. 21, 1938, p. 7; "Art Alpha Studies Work of Famous Old World Artists... at the home of **Miss Gertrude Bowen**. From the text book 'How to Study Pictures,' the work of Murillo (Spanish) and Rembrandt (Dutch), Rousseau (French) and Ruisdale (Dutch), Hobbema (Dutch) and Claude Lorraine (French) were studied by the women. Prints of the artists' famous pictures were displayed. Miss Bowen directed the program," *LR*, Feb. 18, 1938, p. 7; "Art Section Meets with **Mrs. R. Adam**... to continue their study series comparing the works of the world's outstanding artists. Those discussed at the session this week included Watteau and Hogarth, Reynolds and Gainsborough, Constable and Turner," *LR*, March 18, 1938, p. 3; "Handcraft is Program Topic at Junior Club... A talk on hand crafts by **Miss Mary Elizabeth Bucher** was the feature of the Junior Alpha club meeting Wednesday evening at the Alpha clubhouse. Members brought their own fancywork or sewing for the informal occasion. Explaining some of the leather, wood-carving and jewelry work done in her high school art classes ...," *LR*, May 6, 1938, p. 3; "Mrs. Smith to be Art Group Hostess... **Mrs. James Smith**... Wednesday afternoon... pot luck... election of officers. Flower arrangements will be discussed as a part of the program," *LR*, May 20, 1938, p. 5.

FALL – " 'How to Study Pictures' Subject at Art Section... met Monday evening at the home of **Mrs. J. P. Truax**... Mrs. Truax discussed the work of Puvis de Chavannes and Gerome, Sargent and Whistler and Monet and she showed copies of their work. Present at the meeting were...," *LR*, Sept. 16, 1938, p. 7; "Art Section to Give Program... Venetian paintings will be the topic at the regular Alpha club meeting to be held Saturday afternoon in the clubhouse ... Miss **Gertrude Bowen** will present... and will tell of the exhibits of Venetian art in San Francisco this summer...," *LR*, Sept. 30, 1938, p. 7; "Venetian Art Topic at Sat. Alpha Meet. Twenty-five Alpha club members gathered at the clubhouse Saturday afternoon to hear **Miss Gertrude Bowen** give a talk on Venetian Art and of her visit to a Venetian art exhibit in San Francisco during the summer. The program was sponsored by the Art section... with **Mrs. J. P. Truax** in charge. Coloring was the outstanding feature of the Venetian masters...," *LR*, Oct. 7, 1938, p. 3; "Art Chairman in Talk to Junior Alphas," Mrs. George Henry Hotz on paintings of George Washington, *LR*, Oct. 7, 1938, p. 6; "Art Group Meets ... continued its study from the book 'How to Study Pictures.' **Mrs. C. E. Maimann** led the discussion... comparing the works of Claude Monet with a Japanese artist, Hashimoto Gaho. Present at the meeting were the **Mmes. R. M. Adams** [Sic. Adam], **R. C. Lilley, J. P. Truax, Kenneth Rudolph, C. E. Maimann** and **Miss Gertrude Bowen**," *LR*, Oct. 14, 1938, p. 3; 'Handcraft Chairman to Address Alpha Group... Mrs. **W. G. Ross**, Los Angeles district chairman of handcraft...," *LR*, Oct. 14, 1938, p. 4; "Handcraft Leader Delights Alpha Club Audience. Alpha club women started work on individual handcraft activities under the direction of State Handcraft Chairman **Mrs. J. W. [Sic. W. G.?] Ross** of Bell, Calif.... Mrs. Ross was assisted by Mrs. Brightman who accompanied her here. Individual activities of the members included work with leather, brass, aluminum, copper and linoleum," *LR*, Oct. 21, 1938, p. 3; "Handcraft Group Enjoys Work Meet. Garden and Handcraft Section members met Wednesday evening to continue work on the projects started recently under the direction of **Mrs. J. W. [Sic. W. G.?] Ross**, state handcraft chairman... **Mrs. Begg**, chairman of the group, reported on the Federation handcraft session held recently in Los Angeles," *LR*, Oct. 28, 1938, p. 5; "Picture Study Topic of Art Section... met Monday evening at the home of **Miss Gertrude Bowen** to continue their discussion on 'How to Study Pictures.' Miss Bowen led the study. Attending were ...," *LR*, Dec. 16, 1938, p. 3.

1939 – "Color is Topic at Art Section Meet.... **Mrs. James Sloan**. To illustrate her talk on color, Mrs. Sloan displayed a group of picture prints which she had obtained from the Santa Barbara library... Attending were **Mrs. J. P. Truax**, section chairman, **Mrs. R. C. Lilley, Mrs. R. M. White, Mrs. Sloan** and **Miss Gertrude Bowen**," *LR*, Jan. 13, 1939, p. 3; "Crafts, Gardens are Club Topics Wed. Handcraft and Gardens section members... all day session. During the morning craft work and hobbies were discussed and in the afternoon garden problems were taken up. Papers were read by ... Mrs. William Hall on 'Craft Work for a Hobby,'..., *LR*, Jan. 27, 1939, p. 6; "Art Section Group Meets with **Mrs. ... R. M. Adam**. Study topic of the evening was 'Drawing as Developed by Artists of the 16th Century' and was discussed from Barnes 'Outline of Art.'" and names of those attending, *LR*, Feb. 17, 1939, p. 3; "Alpha Art Section. **Mrs. J. P. Truax**, chairman ... will entertain the group at her home Monday evening. She will present a program on 'composition'," *LR*, March 10, 1939, p. 8; "Artists to Give Talks at Alpha Club Saturday... two guests. Miss **Oma Perry** of Los Gatos will tell of artists

she has known and will display some of her work. … **Mrs. Lois [Sic. Loiz] Whitcomb Lord** who will talk of sculpturing and will also exhibit some of her work…," *LR*, March 31, 1939, p. 5; "**Mrs. Lord** Tells of Sculptoring Work at Club… Paintings by **Miss Oma Perry** of Los Gatos were displayed… originally planned to be present but was unable to attend. Miss Perry is a sister of **Mrs. C. E. Maimann** of this community…," *LR*, April 7, 1939, p. 7; "Art Group Meets with **Mrs. Maimann**… Art section… and a talk was given by **Miss Oma Perry**… telling of her work as an artist. She also displayed a number of her paintings. Attending were the **Mmes. J. P. Truax, Harry Sloan, R. M. Adam, Miss Gertrude Bowen**…," *LR*, April 14, 1939, p. 3; "Talk on Flower Arrangement is Topic for Club… Mrs. J. S. Livengood of the Little Garden Club in Santa Barbara will be guest speaker…," *LR*, April 14, 1939, p. 5.

FALL – "Alpha Club to Hear State Art Chairman. **Madame Bertha Amet**…," *LR*, Sept. 22, 1939, p. 5; "**Mme. Bertha Amet** Addresses Alpha Club… 'Look for beauty in the world and you'll find it everywhere,'…" *LR*, Oct. 6, 1939, p. 8; "Members of Art Section Meet. '*History and Ideals of American Art*' by Neuhaus will be the study book of the year… First two chapters of the book on primitive art were discussed. Thomas Craven's latest editions of '*Modern American Prints*' and '*Masters of Art*' were also discussed. Present were **Mrs. O. B. Westmont, Mrs. R. M. Adam, Mrs. R. C. Lilley, Mrs. J. M. Smith, Mrs. C. E. Maimann, Miss Gertrude Bowen**, and hostess **Mrs. Truax**," *LR*, Oct. 13, 1939, p. 3; "Handcraft Group Holds Meeting… All day meeting… **Mrs. Kenneth Rudolph** acted as instructor with the group working on leather work. Present were…," *LR*, Oct. 13, 1939, p. 5; "Alpha Club Holds All Day Meeting… when **Mrs. Ralph Henderson**, District chairman of handcraft of Los Angeles, attended for the day. She was accompanied by Mrs. L. E. Bailey of Westwood Hills Women's club. Group worked on beadwork and leatherwork during the day… Announcement was made that the handcraft division of Home Garden and Craft section will meet on the second Thursdays," *LR*, Oct. 20, 1939, p. 3; "Art Section to Meet Monday at **Mrs. R. C. Lilley**'s…Two chapters of the study book of American art will be discussed…," *LR*, Nov. 10, 1939, p. 7; "Art Section Meets at Mrs. Lilley's," *LR*, Nov. 17, 1939, p. 5; "**Mrs. R. Henderson**, Angeleno at Alpha Club this Week… district chairman of Handcraft of Los Angeles met with club members… Instruction in leatherwork and craft work of all kinds was given…," *LR*, Dec. 1, 1939, p. 3; "Tri-Y Members … met at the Alpha club house Tuesday evening to hear **Mrs. Ralph Henderson**, district handcraft chairman of Los Angeles. Group worked on handcraft during the evening…," *LR*, Dec. 1, 1939, p. 5; "Art Section Meets at … home of Mrs. **O. B. Westmont**… Program was a continuation of Neuhaus' book, 'History and Ideals of American Art.' Brief sketches of the lives and works of early American artists including Ingram, Neagle, Francis Alexander, Thomas Sully, Daniel Huntington and the Hudson river artists were given by **Mrs. James Smith**. Short biographical talk on Peter Hurd was given by **Mrs. Ronald Adam** and reproductions of his work displayed…," *LR*, Dec. 15, 1939, p. 8.

1940 – "Art Section Members Meet at Home of **Miss G. Bowen**… American artists of the 1860s were discussed by Miss Bowen and a comprehensive review of the life of George Inness was also given. **Mrs. James Kenney** also gave a review on the life of John Sloan," *LR*, Jan. 12, 1940, p. 3; "Handcraft Section to Meet at **Mrs. John Callis**… all day meeting…," *LR*, Feb. 2, 1940, p. 2; "Art Section Meets Monday… at the home of **Mrs. R. C. Lilley**… Study book on American Art was studied and the works of John Steuart Curry discussed. … In attendance … were…," *LR*, Feb. 16, 1940, p. 7; "Alpha Club has Achievement Day Wednesday… Exhibits were placed on tables which included rugs, afghans, crochet work, gloves, beads, metalwork, weaving, flowers, quilt and other articles… Mrs. O. B. Chamberlain gave a brief talk on her collection of Haviland china saucers and **Mrs. James Kenney** touched on her block print work. William Wright's woodwork was exhibited as was **Mrs. Hall**'s collection of vases…," *LR*, March 8, 1940, p. 4; "Mrs. Sloan to be Hostess to Art Alpha… Continuing their study on American Artists, Mrs. Sloan and **Mrs. J. M. Smith** will present reviews on several chapters," *LR*, March 8, 1940, p. 7; "Art Section… **Mrs. James Kenney** will review several chapters of the section's study book on American artists. **Mrs. J. P. Truax** will give an address on the Japanese artist, Yasuo Kuniyoshi," *LR*, April 5, 1940, p. 5; "Art Section… **Mrs. James Kenney** was in charge of the program with American artists discussed. **Mrs. Truax** gave a review on the Japanese artist, Yasuo Kuniyoshi," *LR*, April 12, 1940, p. 3; "Art Section to Meet Monday… **Mrs. C. E. Maimann** will be hostess… May 13… **Mrs. J. P. Truax** will preside. Meeting will be the last one prior to summer vacation. **Mrs. O. B. Westmont** in charge. A review will be given on early American art by **Mrs. J. M. Smith**," *LR*, May 10, 1940, p. 3; "Mrs. Truax is Re-elected to Head Art Section… when they met on Monday evening at the home of **Mrs. C. E. Maimann**. Pictures of the world trip were shown by **Mrs. J. M. Smith**… This is the last meeting prior to summer vacation," *LR*, May 17, 1940, p. 7.

FALL – "Art Section to Hold First Meeting, Mon.," *LR*, Sept. 6, 1940, p. 7; "Art Section Holds Meeting… Decision was reached that the group continue to study Eugene Neuhaus' book on 'American Art'. Present day artists will also be discussed by the group at a later date," *LR*, Sept. 13, 1940, p. 7; "Alpha Club Opens New Year with Talk on Artists. **Mrs. S. J. Stanwood**, Santa Barbara county chairman of Art, spoke on 'Art and Artists of Santa Barbara County'… Exhibiting her large collection of the works of Santa Barbara artists, Mrs. Stanwood told of the progress being made on the new museum in Santa Barbara," *LR*, Sept. 20, 1940, p. 2; "Artists Discussed at Art Section … Artists on Indian life and artists of the realistic school were discussed by **Mrs. J. M. Smith**… **Miss Gertrude Bowen** gave a review on the works of Thomas Benton…," *LR*, Oct. 18, 1940, p. 3; "Art Section Hears Talk on Lines in Art. The significance of lines in art and post impressionism were ably discussed by **Mrs. James Kenney**… at her home Monday evening. … **Mrs. R. C. Lilley** will talk on murals when members meet at her home December 9. In attendance…," *LR*, Nov. 15, 1940, p. 2; "First Arts and Craft Class Slated Tuesday… December 3 at the Alpha

clubhouse, **Mrs. Kenneth Rudolph** announced. The class is sponsored by the **Adult Education** class of the high school. Meeting will be held from 9:30 to 11:30 and from 1 to 3:30 in the afternoon. No definite plans have yet been made for the evening class, but if enough members are interested a class will be held Tuesday evening… **Mrs. Viola Dykes** of Santa Barbara has been secured as the instructor…," *LR*, Nov. 29, 1940, p. 1; "To Meet. Murals will be the topic of discussion Monday evening, December 9, at meeting of the Art Section… **Mrs. J. P. Truax** will preside," *LR*, Dec. 6, 1940, p. 2; "Art Section Discusses Murals… The discussion was led by **Mrs. Sloan** with a collection of pictures from Santa Barbara exhibited during the evening…," *LR*, Dec. 13, 1940, p. 3; "Arts and Crafts Classes held Weekly Here. The second of a series … was held at the Alpha clubhouse Tuesday, with **Mrs. Viola Dykes** of Santa Barbara as the instructor. The classes are being sponsored by the adult classes at the high school. Classes are being held in the morning, afternoon and evening, with a large number of townspeople enrolled… Classes are held every Tuesday at the clubhouse. **Mrs. Kenneth Rudolph** is in charge… Enrolled in the course are…," and names of the many enrollees are given, *LR*, Dec. 13, 1940, p. 7.

1941 – "Pottery Work Added to Craft Classes… craft class held every Tuesday at the Alpha clubhouse. Hours are from 9 to 4 and evening classes are from 7 to 9. The classes, which were started early in December, are under the sponsorship of the Board of Education **[adult school]** and are open to the public. … **Mrs. Viola Dykes** of Santa Barbara is the instructor… all types of handcraft taught…," *LR*, Jan. 10, 1941, p. 3; "Art Section Discusses Prints, Etchings… at the home of **Mrs. R. C. Lilley**… The discussion was led by Mrs. Lilley," *LR*, Jan. 17, 1941, p. 5; "Exhibition of Art Needle Work and Craft Held… Alpha clubhouse Tuesday under the supervision of **Mrs. Viola Dykes**, instructor of the arts and crafts classes which are being held here weekly. The exhibit attracted a large number of townspeople. The classes which are sponsored by the **Adult Education** class at high school are open to the public. The classes are being held all day on Tuesdays and also a class during the evening. They will continue until June… Materials… are purchased from the instructor. Among the articles displayed were scrapbooks and trays, scrapbooks decorated with tooled copper and etched copper, pottery, felt pictures, Mexican crackle and many other useful and decorative articles," *LR*, Jan. 31, 1941, p. 2; "Pan America is Theme of Alpha Club Meeting… The three periods including the early native, colonial and modern art periods of South America were discussed by **Mrs. James Kenney** of the art section…," *LR*, Feb. 7, 1941, p. 5; "Meeting Held by Art Section… home of **Miss Gertrude Bowen**… Early illustrators up to the present-day ones were discussed…," *LR*, Feb. 14, 1941, p. 2; "Art Section to Study French Artists… '*The Significant Moderns*' is the title of the new study book…," *LR*, March 7, 1941, p. 3; "Art Section… at the home of **Mrs. H. U. Gaggs**. Works of Cezanne, Seurat, Gauguin and Van Gogh were discussed. Taking part were **Mrs. C. E. Maimann, Mrs. James Sloan, Mrs. J. M. Smith, Mrs. J. P. Truax, Mrs. James Kenney** …," *LR*, March 14, 1941, p. 3; "Adults Urged to Attend Craft Classes… there is room for

more adults in the handcraft classes being held at the Alpha clubhouse three times daily every Tuesday – in the morning from 9:30 until 12:00, in the afternoon from 1 until 4:30, and in the evening from 7 until 9. Since the work is all of an individual nature, it is possible for persons to enter the classes at any time and do any type of handcraft work they wish to according to Mrs. Richard Pannell, handcraft section leader," *LR*, March 14, 1941, p. 7; "Art Section to Meet Monday. '*The Significant Moderns*' will be the topic… at the home of **Miss Gertrude Bowen** …," *LR*, April 11, 1941, p. 5; "Plans for Annual Spring Dance to be Given by Junior Alpha… May 10… Veterans Memorial Building… Other committees… **Miss Crystal Lund** is in charge of the posters assisted by Mrs. Ernest Brooks and Miss Thora Lindstrom…," *LR*, April 25, 1941, p. 5.

FALL – "Reviews Given at Art Section… home of **Mrs. James T. Kenney** Monday evening for the first fall meeting of the year. **Mrs. J. P. Truax** gave a report on the exhibitions at the Santa Barbara Museum of Arts and a brief review of *American Art Then and Now*. A report on the national museum at Washington, D. C. was presented by **Mrs. O. B. Westmont**. The program for the ensuing year was outlined… **Miss Gertrude Bowen** will be hostess to the group at the October meeting," *LR*, Sept. 12, 1941, p. 3; "Curator to Talk Before Alpha Club… **Donald J. Bear**," *LR*, Sept. 19, 1941, p. 5; "Santa Barbara Curator to Talk … **Donald J. Bear**," *LR*, Sept. 26, 1941, p. 2; "Curator Gives Talk… Discussing 'Painting, Yesterday and Today,' **Donald Bear** … Supplementing his talk with colored slides, Mr. Bear touched on various artists including Winslow Homer for his seascapes, Inness for his landscapes, Henri of the ash can school, Mary Cassatt of the mother and child school of painting and numerous other artists. … Art Section members will meet October 13 at the home of Miss **Gertrude Bowen** with Miss **Crystal Lund** to talk on phases of art…," *LR*, Oct. 3, 1941, p. 9; Northern "European Madonnas Subject at Art Section Meeting… at home of **Mrs. O. B. Westmont**… Each member contributed to the discussion… **Mrs. J. P. Truax** will be hostess… in December at her new home. Italian Madonnas will be the topic," *LR*, Nov. 14, 1941, p. 3.

1942 – "Art Section to Meet Monday… at home of **Mrs. Harold U. Gaggs**… Porcelain china will be the topic," *LR*, Jan. 9, 1942, p. 2; "Art Section to Hold Meeting. English porcelain will be the subject of a discussion at a meeting… held next Monday evening at the home of **Mrs. C. E. Maimann**…," *LR*, Feb. 6, 1942, p. 5; "Santa Barbaran to Speak at Alpha Club. **LeRoy Hunt**… next Wednesday… on fine porcelains. Members of the Art section under the chairmanship of **Mrs. James Kenney**, will be in charge of the afternoon's program," *LR*, Feb. 27, 1942, p. 8; "Alpha Club and Guests Hear Talk on Ceramics…. Given by **LeRoy Hunt** of Hunt's China Shop in Santa Barbara …," i.e., history of ceramics, *LR*, March 6, 1942, p. 8; "Art Section to Discuss China. French and American China… next Monday evening at the home of **Mrs. James Smith**… Appointment of the chairman for next year will be made…," *LR*, April 10, 1942, p. 5; "Art Section to Hold Meeting Next Monday… at the home of **Mrs. O. B. Westmont**… Each member is to bring some item of interest to the section and be able to discuss it for 15

minutes," *LR*, May 8, 1942, p. 2; "Art Section Members Hold Final Meeting… previous to summer vacation… at the home of **Mrs. O. B. Westmont**… **Mrs. J. P. Truax** discussed the labor situation while **Mrs. James Kenney** spoke on porcelain. The hostess exhibited a notebook which she had made during the year," *LR*, May 15, 1942, p. 9.

FALL – "Literature Section to Meet with **Mrs. R. Lilley**… **Mrs. J. P. Truax**, chairman of the Art section will be in charge of part of the evening's program…," *LR*, Dec. 4, 1942, p. 2; "**Mrs. Robert Lilley** Hostess… **Mrs. J. P. Truax** chairman of the Art section, read several chapters from H. V. Morton's '*Middle East*.' She also displayed various … relating to Mexican art…," *LR*, Dec. 11, 1942, p. 3.

1943 – "Early American Subjects Topic at Alpha Club. Garden section. An interesting review on the early American furniture was given by **Mrs. John Callis** and included the various names of furniture makers down through the Federal, American, Empire and Victorian periods. Articles on the pantry shelf in the 1840s was the subject discussed by **Mrs. C. E. Maimann** … American homes and furniture was the topic discussed by Mrs. Edward Marquart…," *LR*, Jan. 8, 1943, p. 7; "Art, Literature Section Meets… A combined meeting of Art and Literature sections was held Monday evening at the home of **Mrs. J. P. Truax**. An interesting talk on the Widener gift to the National Art Gallery was given by **Mrs. O. B. Westmont**. Illustrations were shown…," *LR*, Feb. 5, 1943, p. 3.

1944 – "Rummage Sale to be Given by Jr. Alpha. Posters are being made… Working on the poster committee are Miss Stella Kilmer, Mrs. Al Lazarus, Miss Genevieve Murphy, Miss Mary Louise Yount, and **Miss Crystal Lund**," *LR*, Jan. 14, 1944, p. 5; "Reviews Given at Section Meeting… Art and Literature section held at the home of **Mrs. J. P. Truax**… **Mrs. Harry Hobbs** as chairman of the Art Section [for the coming year]," *LR*, June 9, 1944, p. 3.

FALL – "Art, Lit. Section to Meet Monday. Fall activities… will be launched next Monday evening…," *LR*, Sept. 29, 1944, p. 2; "Program is Planned at Lit. Section… combined Literature and Art Section… Monday evening at the home of Mrs. Max Wilson, chairman of the Literature section… The next meeting will be under the supervision of Mrs. Harry Hobbs, chairman of the Art section," *LR*, Oct. 6, 1944, p. 8.

1945 – "Music and Art Club… Music and Art Section of the Alpha Club… **Mrs. C. A. Maimann** brought some pictures of paintings by Polish artists and gave brief sketches of their works and their lives," *LR*, Oct. 26, 1945, p. 2; "Music Section of Alpha … The program will be in two parts, with the Art Chairman, **Mrs. Charles Maimann** taking over the first part. She will have an exhibit of the paintings of the Madonna on hand for the members to view and discuss…," *LR*, Nov. 23, 1945, p. 2; "Alpha Club Tea Opens Art Exhibit… A tea served in the **USO** auditorium … This traveling exhibit was prepared for the USO Division National board, YWCA, by the Museum of Modern Art, New York City, and comes to Lompoc

through the courtesy of the local **USO** and the Lompoc Alpha Club…," *LR*, Dec. 7, 1945, p. 3.

1946 – "**Mrs. Chas. Maimann** Presented Program… The Music Section … met at the Preston Plumb home Monday evening… Mrs. Charles E. Maimann gave an interesting report on Scandinavian Art in keeping with the program topic, 'Norwegian Art and Music.' Pictures of Scandinavian art were borrowed from the library…" *LR*, Jan. 31, 1946, p. 3; "American Music is Section Topic… and American art will be the topic for discussion," *LR*, Feb. 21, 1946, p. 5; "Alpha Club Takes Mythical Journey… Music and Art Section… last Monday evening at 8 o'clock at the home of **Mrs. O. B. Westmont**… The second part of the program dealt with Russian Art with a talk on Peasant Handcraft by **Mrs. C. E. Maimann**. … illustrated… with some pictures from the County library…," *LR*, March 28, 1946, p. 3; "Alpha Club in Final Meeting… heard **Leo Ziegler**, artist and art teacher in the Santa Ynez Valley high school, speak on the subject, 'Art Brightens Life and We Can Learn Art.' The speaker demonstrated his talk with examples of his students' art, and also showed some of his own work. … A highlight of the afternoon was the unveiling of a painting which was won by the Alpha club art section in competition with other women's clubs in California. The painting was awarded for outstanding achievement during the year as part of the **Penny Art Fund** work. The picture is a floral composition which the artist, **Isabelle Scheidt** has named 'Red, White and Blue'," *LR*, June 20, 1946, p. 10; "Ziegler Speaks … **Leo Ziegler** of Santa Ynez was a speaker at the final meeting of the Alpha Club in Lompoc Wednesday afternoon. His topic was 'Art Brightens Life and We Can Learn Art," *SYVN*, June 28, 1946, p. 7, col. 1.

FALL – "Art Section to Study Early American Painting. 'American Art for American Homes,' theme chosen by the state art chairman of the Federated Women's club, will be the subject for discussion Monday evening… The group will review the work of early American artists and display prints of their work … **Mrs. R. M. White**, who has obtained prints of paintings by Stuart, Keith, Inness and other painters…," *LR*, Oct. 31, 1946, p. 5.

1947 – "Art, Literature Sections of Alpha Club to Meet… at the home of Mrs. R. E. Sudden… The Art section will be in charge of the program with Mrs. Joseph Kirchmaier as chairman for the evening," *LR*, Jan. 2, 1947, p. 8; "Art, Literature Section Meeting is Postponed," *LR*, Feb. 27, 1947, p. 11; "Club Commissions Hibbits… At its meeting last night, the Lompoc Alpha club agreed to commission **Forrest Hibbits**, local artist, to paint a picture for the clubhouse as the initial step in the redecoration of the interior…," *LR*, March 20, 1947, p. 5; "Exhibit of Local Artist's Work on Display… **Forrest Hibbitts** [sic. Hibbits] Lompoc artist… in the Alpha clubhouse … The exhibit will be of particular interest to residents of Lompoc valley because the artist introduces a strong flavor of the valley in many of his works – particularly water colors. Some of the titles given… are 'Toward Tranquillon,' 'Santa Ynez River in Summer,' and 'Miguelito Park.' The painting, which was commissioned by the Alpha club for its clubhouse, is a typical view of the valley, looking across rich green and

mustard yellow fields to the blue hills beyond. The exhibit demonstrates the artist's versatility in various mediums, including lithographs, oil, egg tempera, tempera and ink and water colors. One of the most interesting groups in the exhibit is that devoted to the war. … **Hibbits** spent considerable time making illustrations for the Army Air Force. Two … are the artist's humorous conception of a war fought entirely with machines. Other works exhibited include abstract arrangements of figures and color planes and a number of water colors which have as their subject parts of San Francisco, where the artist has studied for several years. A portrait, 'Portrait of L. Ospina,' done in egg tempera, displays Hibbits' skill in catching the interesting and revealing aspects of the human face. The artist and his wife leave today for Europe where he will study until fall, when they will return to Lompoc and make their home," *LR*, May 22, 1947, p. 11.

FALL – "Art Sections… to Meet Monday. A joint meeting of art sections from both the Junior and Senior Alpha clubs… On the agenda will be a discussion of the year's program which will have as its theme, Practical Application of the Principles of Color and Design. This month the art sections will feature the making of personal Christmas cards and decorative Christmas wrappings. **Mr. and Mrs. C. S. Shelly** will lead the discussion and present a demonstration," *LR*, Oct. 9, 1947, p. 6; "California Art to be Studied … Contemporary Santa Barbara and California artists will be studied by the Art section… November 17. The artists, **Knowles, Harcoss [Sic. Harcoff], Bachus, Parshall** and **Hinkle** are now being given a show at Slynn's [Sic. Flynn?] Gallery in Santa Barbara and the five will be the first studied by the section. The exhibit in Santa Barbara will be open for the next two weeks," *LR*, Oct. 23, 1947, p. 20; "Art Section… Members of the section will bring examples of finger painting. **Mrs. C. S. Shelly** will demonstrate uses of decorative paper in making Christmas gifts. The art appreciation topic to be discussed will be 'Santa Barbara Artists'," *LR*, Nov. 6, 1947, p. 13; "Artist to Speak… **Joseph Knowles**… at the Alpha clubhouse at 2:00 p.m. and the Santa Barbara artist will speak on modern aspects of teaching art," *LR*, Nov. 13, 1947, p. 11; "Art Section has Meeting Monday… at the Community Center with home Christmas decorations as the subject. Mrs. James Smith gave a talk and demonstration on making Christmas wreaths; Mrs. Richard Byington explained and demonstrated Christmas tree decorations; and **Mrs. C. S. Shelly** demonstrated Christmas card making," *LR*, Dec. 11, 1947, p. 15.

1948 – "Joint Meeting … At the meeting last night, **Mr. and Mrs. C. S. Shelly** demonstrated block printing…," *LR*, Feb. 19, 1948, p. 5; "**Channing Peake**'s Art to be Studied… The application of color and design in painting will be studied by the Art section at their next meeting to be held April 12… Drawings by Channing Peake… will be used as illustrations. The following month the group will visit the Peake Studios at his ranch in Santa Rosa. The two future meetings will be joint meetings of Art sections of the Alpha club and the **Lompoc Community Woman's** club. Arrangements will be made by **Mrs. Ed Negus**, art chairman of the Alpha club and **Mrs. Julian Rogers**, art chairman of the **Community club**. The last meeting of the

Alpha club art section was held Friday, March 19. **Lois [Sic. Loiz Lord] Huyck**, local artist known for her talent in sculpturing, gave an illustrated talk on modeling and casting of miniature heads…," *LR*, April 1, 1948, p. 11; "Art Section to Meet… at the home of **Mrs. J. M. Smith**… The group will discuss the application and principles of design in painting as well as an introduction to moden art. The works of **Channing Peake**… will be discussed and examples of his work exhibited," *LR*, April 8, 1948, p. 3; "Art Sections … A joint meeting of the Art Sections of the Alpha club and **Lompoc Community Woman's club** was held Monday evening at the home of **Mrs. James Smith**. The book '*Discovering Design*' by Marion Downer was discussed and an introduction to Modern Art was undertaken by the group. The works of **Channing Peake** were studied and various prints were displayed through the courtesy of **Forrest Hibbits**. A visit to the **Peake Studio** was planned by the group for May 23, and it was announced that a tour of the Santa Barbara Art Museum and art studios will be made in June. Members of the two groups attending were …," *LR*, April 15, 1948, p. 6; "Gay Nineties Show May 7, 8… Junior Alphas… melodrama… Jane Henning and Harriet Adam are working on the posters, programs and decorations…," *LR*, April 29, 1948, p. 9; "Art Sections to Visit Studio of **Channing Peake** … of the Alpha club and the **Community Woman's club**… meet at 3:15 p.m. at the **Community Center**…art chairman of the Alpha club, **Mrs. Ed Negus** … or art chairman of the **Community Club**, **Mrs. Julian Rogers**," *LR*, May 13, 1948, p. 18; "Lompocans Exhibit… The art sections of the Alpha club and **Lompoc Community Woman's club** attended the **Tri-county Art Exhibit** held Tuesday at the Santa Barbara Museum of Art. The exhibit was the second annual event… In the afternoon following the exhibit, the group visited the **Joseph Knowles** Studio in Santa Barbara. Those attending from Lompoc…," *LR*, June 17, 1948, p. 2.

1949 – "Junior Alpha … Country Store Project… [selling] white elephants… cookies and candy… handicrafts…," *LR*, April 28, 1949, p. 7.

FALL – "Alpha Club Opens Fall Session with Luncheon … Reports were also made at the meeting by section chairmen… and **Mrs. William Bailey**, arts and crafts," *LR*, Sept. 22, 1949, p. 8; "Junior Alpha… Music, art and literature committee members of the Junior Alpha club met Tuesday evening… Purpose of the committee is to note and discuss musical and dramatic productions, art exhibits and related subjects currently being shown in southern California…," *LR*, Sept. 29, 1949, p. 3; "Mus, Art, Lit. Section of Junior Alpha Club Meets… second fall meeting… **Mrs. Arnold Brughelli**, guest speaker… gave a review on the different phases of contemporary art. She listed the phases as abstract, surrealistic, free-fantasy, fauvism, impressionism, dadism, and modern landscape. Along with the review she had a number of her own paintings to identify each form of art she was describing. The guest speaker has shown her paintings in the annual San Francisco Museum of Art show and has had several exhibits in and around San Francisco, including the Oakland Art Gallery, Western Women's World, William D. McCann, interior decorator showing and at Baldwin's in Berkeley," *LR*, Oct. 20, 1949, p. 4; "Alpha Club Hears

Mrs. Brughelli Speak on Art. Abstract and free phantasy paintings, both phases of contemporary art, were the subject of an address given before the Alpha club yesterday by **Mrs. Arnold Brughelli**. She illustrated her talk with some of her own work … A member of the Art Association in San Francisco, Mrs. Brughelli studied at the California Art school in that city and at the Art Institute in Chicago. … An exhibit of arts and crafts done by **Mrs. Viola Dykes'** pupils was on display at the meeting. Processes for making ceramics were discussed by **Mrs. Lloyd Huyck**, a student of Mrs. Dyke, who used some of her own ceramics in illustrating her talk…," *LR*, Nov. 17, 1949, p. 6.

1950 – "Junior Alphas… 'Photography and its Effect Upon Our Economy' was the subject on which **Ernest H. Brooks**, photographer, addressed the Junior Alpha club last night. … illustrated his talk with photography work done by his students and a number of magazine pictures…," *LR*, March 2, 1950, p. 5; "**Forrest Hibbits** Tells Lit Section of Trends in Modern Painting … members of the music, art and literature section of the Junior Alpha club… Beginning with the impressionists … Hibbits traced the various lead-offs of modern painting … impressionism, … post-impressionist Cezanne, futurism and primitivism. Particular emphasis was placed on surrealism and abstraction, the important trends in modern painting today. The guest speaker illustrated his talk with a number of magazine reproductions of famous works of art and also with some of his own paintings in landscape and the abstract done through various mediums…," and bio of Hibbits, *LR*, March 2, 1950, p. 3; "75 View Exhibits at Chrysanthemum Tea… annual Chrysanthemum tea given by the Alpha club Home and garden section yesterday… 75 persons were present… wide variety of fall flower arrangements and an exhibit of oil and water color paintings by students in **Forrest Hibbits'** art class… Exhibiting paintings in the Heiges home were **Mmes. Walter Anderson, W. H. Bailey, Claire Callis, J. T. Kenney** and **Milton Schuyler**," *LR*, Oct. 26, 1950, p. 4;

1951 – ■ "Alpha President… Art Speaker. Mrs. **W. J. Huebner**, fine arts chairman for the California Federation of Women's clubs, was guest speaker… she discussed 'Living with American Art.' The speaker also told members of the **Penny Art fund** project, which was officially adopted by the general federation in 1930 as a permanent and major feature… In each state, Mrs. Huebner said, a fine arts chairman is appointed… Her duties include administering the substantial fund accumulated for the purchase of paintings by outstanding artists to be given as awards to clubs ranking highest in support of the project in the **Penny Art fund** contest held annually in each state. 'In this way,' Mrs. Huebner added, 'it is intended not only to encourage an active interest in art on the part of clubs and club members but likewise to afford recognition and encouragement to artists throughout California. She added that California federated clubs' Penny Art fund was second in the nation having a total of $1,542. Explains Points. In explaining the three types of design, **Mrs. Huebner** pointed out that objective art is accomplished when a painter tries to paint an object as real as possible. Non-objective art, she said, is done by changing an object into a design such as the American Indians do with the patterns in

their weaving work. Abstract design is apparent when an artist looks at an object and then distorts it to represent the way he feels about it. Have Paintings. Mrs. Huebner stressed educating people to want to have original paintings in their homes and also stressed the idea of selecting the paintings for one's own home rather than having an artist do the choosing. Active in art work herself for many years, the fine arts chairman showed several of her own paintings as well as those of another artist in illustrating her talk. She is the third vice president of the San Francisco district federation, chairman of the Flood Control and River Beautification commission and chairman of the Santa Cruz City Beautification commission …. A resident of Santa Cruz, Mrs. Huebner is also president of the Santa Cruz Art league," and port., *LR*, March 22, 1951, p. 3; ■ "Crafts Subject for Alpha Club… At an open meeting of the Alpha club Wednesday afternoon, all types of craftwork will be discussed by **Mrs. L. L. Williams**, state federation chairman for crafts. In conjunction … there will be a table display of ceramic work done by various Alpha club members. Interest of the Alpha club in crafts dates back nearly 12 years ago, when the club started a section devoted to crafts. The section proved so popular that the group had to move from one place to another to provide enough room for interested members. Start Classes. Through this enthusiasm shown for crafts, adult education classes in the subject were started and **Mrs. Viola Dykes** was engaged as the teacher….," *LR*, April 12, 1951, p. 3.

■ "Alpha Club Hears Talk by State Crafts Chairman… **Mrs. L. L. Williams**… talk on all the various phases of craft work illustrating her discussion with a number of ceramics, weaving, stenciling and knitting items, most of which she had made herself. … A letter of withdrawal was read from **Mrs. Claire Callis**, who will be leaving Lompoc in the near future… Discussion was held concerning the federated clubs' project for which artist **Forrest Hibbits** has been engaged to make the master plan and paint figures representing the Christmas story to be placed in the city park across from the public library… subject to approval by the **Lompoc Community Women's club**, the project will be co-sponsored by both the Alpha and Community clubs as a federated project…," *LR*, April 19, 1951, p. 5.

FALL – "Jr. Alpha Plans for DDD Sale… 'Dolls, Delicacies and Do-Dads'… [baked goods] Also part of the event will be a sale of originally designed hand-made favors…nut cups, place cards, and other table decorations, bridge talleys, name tags for Christmas packages, birthday and baby shower decorations… A boy and a girl doll… Posters were made by Mmes Ames and Robert Fowler…," *LR*, Nov. 1, 1951, p. 5; "Lompoc Will Have … Outdoor Art Gift… Planned as the first component in what will be in course of three years a fully integrated effort toward beautification of Lompoc, the city's two Federated clubs… are announcing that a Nativity Scene will be set up in the city park … on Friday, December 14. … an installation for the Christmas season… intend to expand into a valuable artistic effort toward city beautification. Framework for the screen has been made in the woodworking class at the High school and has been painted by **Forrest Hibbits**… Built of sturdy materials… the panel will be to all intents weatherproof. At close of the holiday season, it will be

stored and next year, an additional panel will be added. In three years, the entire scene will be complete...," *LR*, Nov. 29, 1951, p. 4.

1952 – "Alphans Arrange Own Impromptu Exhibit of Member Artists... **Mrs. Schuyler**, after speaking briefly of the Santa Barbara County Art Section, introduced **Mrs. Ethel Bailey**, who exhibited a canvas of her own ... 'Orchard in Spring,' and related that she had become so familiar with the orchards in San Joaquin Valley that she could almost have painted it from memory. **Mrs. C. E. Maimann** displayed one of the desert scenes she does so well... Mrs. Breitwieser [Sic. Breitwieser of Berkeley] showed a shivery 'Winter Scene' reminiscent of the snowy landscapes of North and East. **Mrs. Milton Schuyler** showed 'Box Cars at the Ice Plant,' which proved that art is where you find it. She explained that she had looked at the scene for a long time one gloomy day and out of that came the original canvas. **Mrs. Lloyd Huyck** exhibited a portrait and **Mrs. James Kenny** [Sic. **Kenney**] harked back to the days before automobiles with her 'Old Livery Stable,' which, she said, still stands on the Zvolanek ranch. The small gallery was concluded with a marine scene by **Mrs. Walter Anderson**...," *LR*, Jan. 17, 1952, p. 7.

FALL – "Jr. Alphas Have Annual Potluck Wednesday Eve... On display at the meeting were hand-painted Christmas cards made by members of the Music, Art and Literature section under the chairmanship of **Mrs. Don Kelliher**. The cards are being sold as the section's money-raising project for the year," *LR*, Nov. 6, 1952, p. 3; "Section Meeting of Alpha Club November 10. 'Pioneering in Art' will be the program theme at the next meeting of the Music, Literature and Art Section of Senior Alpha Club to be held Monday, November 10 at 8 p.m. at the home of Mrs. J. V. DeGroot ... Samuel F. B. Morse, famous artist, will be the theme of Mrs. Will Hall, and **Mrs. Harry Betaque** will give a sketch of Charles Willson Peale," *LR*, Nov. 6, 1952, p. 4; "Nativity Scene to be Displayed in City Park. Permission to erect a Nativity scene in the city park ... was given by the city council this week. Sponsor of the project is the Alpha club. The scene is being painted by **Forrest Hibbits**... and is arranged in panels. The first of the panels was displayed in the park during the Christmas season a year ago and a new panel has been added this year," *LR*, Dec. 4, 1952, p. 11.

1953 – "Junior Alphas... On the program, chairmaned by the Music, Art and Literature section, **Mr. and Mrs. Forrest Hibbits** presented their delightful puppets in 'Hansel and Gretel'," *LR*, Jan. 15, 1953, p. 2; "Early Americans of Three Arts... Mrs. James Mulholland reviewed Nineteenth Century art and artists [saying 50% followed European ideas and the other looked to American scenes and themes] ...," *LR*, Jan. 15, 1953, p. 3; "Great Names in Music, Art... For the Art Section **Mrs. Charles Laubly**, for primitives, reviewed the work of Grandma Moses and her own story told in her own expressive language and intriguing spelling. This volume issued several years ago with an introduction by Louis Bromfield, was one of the best sellers for several seasons. ... **Mrs. Schuyler** exhibited a canvas done in somewhat the same manner of the primitive, painted by **Mrs. Ruth LaRue**,

former resident of Lompoc, now residing in Florida... **Mrs. Milton Schuyler**, chairman for Art, presented... Mrs. Will Hall, who told of the school of early American painters as pointed up by Albert Ryder, Winslow Homer, James McNeill Whistler and Thomas Eakins. Influence of Europe on the work of Whistler, John Singer Sargent and Mary Cassatt, all American artists, was described by Mrs. Ruth Breitwieser," *LR*, Feb. 12, 1953, p. 2; "Jr. Alpha Hears Art Consultant... Designs for dinner ware and Early American Art were discussed by **Joseph Knowles**, as speaker at last week's meeting...," *LR*, Feb. 26, 1953, p. 5; "Sr. Alpha Music, Art, Lit. Section Meeting March 9," *LR*, March 5, 1953, p. 3; "Three Arts Section Senior Alpha. Twentieth Century Art ... was contrasted with Eighteenth Century placid philosophy and modern romance at the monthly meeting of the Art, Music and Literature Section of Senior Alpha Monday. **Mrs. Milton Schuyler**, Art chairman, introduced **Mrs. William Bailey**, who limited her discussion to two artists who pioneered an entirely new school ... Hobert [Sic. Robert] Henri ... frequently dubbed the 'ash can' artist... and George Bellows... devotee of realism ...," *LR*, March 12, 1953, p. 4; "Junior Alpha Members... **Mrs. Don Kelliher**, chairman of the Music, Art and Literature Section, reported on the meeting held in her home on March 11, at which **Forrest Hibbits** was the speaker on art subjects. Mr. Hibbits demonstrated casein painting by doing two pictures...," *LR*, March 26, 1953, p. 5; "Final Meeting Planned by Art Section... Monday evening at the home of **Mrs. William Bailey**... Mrs. J. V. DeGroot, section chairman, announced a varied program which will feature special music, a discussion of art development under the WPA by **Mrs. James Smith**, and a round-table discussion of flower arrangements to be led by Mrs. DeGroot...," *LR*, May 7, 1953, p. 10.

FALL – "Pumpkins to be Peddled by JA's... The Fine Arts section of the club, chairmanned by **Mrs. Don Kelliher**, will design posters for advertising the sale...," *LR*, Oct. 15, 1953, p. 5; "Unique Program Set for Alpha Club... illustrated talk on gardening – Mrs. [D. R.] Tolman specializes in research and commentary, Mrs. [H. E.] Adams in photography... Their program will consist of three sections: plant material, with accompanying photographic slides of specimen plants, color slides of Santa Barbara gardens... and color slides of vistas in the Colorado Rockies. Mrs. Adams, who is a member of the Santa Barbara city park commission...," *LR*, Nov. 12, 1953, p. 4; "Junior Alpha Club Renews Old Toys... Members of the music-art-literature section of the club are making Christmas corsages and wreathes which they will sell later. They are doing the work during Monday night conclaves at the home of **Mrs. Don Kelliher**," *LR*, Dec. 3, 1953, p. 4; "Christmas History is Studied by Fine Arts Group... Fine Arts Section... at the home of **Mrs. J. M. Smith**. The Christmas motif inspired the program which spanned music, painting and metal craft. **Mrs. Milton Schuyler** talked on 'The Madonna' and outlined the interpretation of the subject by painters of many lands over several centuries... she exhibited reproductions of classic Madonna paintings...," *LR*, Dec. 10, 1953, p. 8; photo of Jr. Alpha Music-Art-Literature section women making corsages, *LR*, Dec. 24, 1953, p. 3.

1954 – "**Mrs. J. M. Smith** is Hostess to Fine Arts Section… opera diva…," and program all about music, *LR*, Feb. 4, 1954, p. 4; "Virginia City Paintings to be Shown by **F. Hibbits** at Jr. Alpha Meeting… The picturesque old mining town in Nevada is world famous and a center of attraction for thousands of tourists every year. It is located some 25 miles from Reno…," *LR*, Feb. 25, 1954, p. 4; "Junior Alpha Club Hears Hibbits on 'Modern Art.' A fascinating talk on water color painting plus an exhibit of his own work in that medium was given last night by **Forrest Hibbits**… Most of the paintings shown… were created during his recent stay in the reconstructed frontier town of Virginia City, Nevada… explaining the techniques of the water colorist, Hibbits set up his easel and demonstrated the first steps … [He] explained that the academic or realistic is a depiction of the subject exactly as it appears to the human eye whereas the abstraction is the artist's own interpretation… as a study of color, line or mass…," *LR*, March 4, 1954, p. 6; "**Forrest Hibbits** Heard in Lompoc… informal talk on art techniques at the Junior Alpha Club Wednesday in Lompoc… He also gave a demonstration of water color technique," *SYVN*, March 12, 1954, p. 4; "Art and Literature Claim Attention of Fine Arts Group… at the home of Mrs. Vivian Shanklin… Also claiming the interest of the company were three pieces of original art done by charter members of the Alpha club. Included were two oil paintings 'El Capitan' by **Mrs. James Sloan** and 'Red Cactus' by **Mrs. Frank Moore**. Also exhibited was an unusual Victorian type dimensional artwork made entirely of human hair, by Mrs. Mary Saunders…," *LR*, April 8, 1954, p. 5; "Nominate Officers at Alpha Club Luncheon… Fine Arts section… will convene May 3 at the home of **Mrs. Howard Moore**," *LR*, April 22, 1954, p. 4; "Fine Arts Section Will Meet Monday… at the home of **Mrs. William Bailey**… June 7… Mrs. Bailey will show colored slides of European scenes which she made during her most recent trip abroad. **Mrs. Charles Laubly** will present a report on the adult pottery-making class conducted by **Conley McLaughlin**, high school art director," *LR*, June 3, 1954, p. 5.

FALL – "Junior Alpha Fetes… **Mrs. Hazel Martin**, Home Advisor of the University of California Agricultural Extension Service in Santa Barbara County, who gave an interesting talk on the use of pictures in the home. She displayed various types of pictures suitable for use in the different rooms of a home and also discussed appropriate mattings and frames. Mrs. Martin also demonstrated how to pick up the colors used in a picture to redecorate a room," *LR*, Sept. 23, 1954, p. 5; "Fine Arts Section of Sr. Alpha… will meet at the home of **Mrs. Ronald Adam** this coming Monday evening October 11…Since this is the first meeting of the current club year an informal 'fun' program is being planned by the hostess for the evening," *LR*, Oct. 7, 1954, p. 3; "Senior Alpha Club Hosted at Dinner by Junior Alphas… pot luck… The **Penny Art** Section of the Junior Alphas made the flags used in the table decoration and invitations for the party were made by Mrs. Loyce Weaver…," *LR*, Nov. 11, 1954, p. 5; "Senior Alpha Club… regular monthly meeting… 103 Alpha club members… **Mrs. William Bailey** called attention to the adult education class for beginners in art, drawing and water colors, which will start at the high school in January… It was also

announced that there would be no meeting of the Fine Arts section … until January…," *LR*, Nov. 18, 1954, p. 5; "Nativity Scene … in the park… joint project of the **Lompoc Community Woman's Club** and the Alpha Club, the scene has grown through the years with the addition of various figures. The artist who has painted the figures is Mr. **Forrest Hibbits**," *LR*, Dec. 16, 1954, p. 3.

1955 – "Fine Arts Section of Alpha to Meet… Monday… at the home of **Mrs. Ronald Adam**. The … program will feature thumbnail sketches of Pulitzer Prize winning novels and an art discussion presented by Mrs. W. H. Pixley (?)," *LR*, Feb. 10, 1955, p. 5; ■ "Alpha Club to Hear Travel Lecture on South America… Feb. 16 at 1 p. m… trip taken in January 1952 by 28 North American women to nine countries of South America… experiment of developing international understanding by means of personal contact. The General Federation of Women's Club… visiting their member clubs in these overseas spots… Mrs. Butler served as official photographer on the trip… slides… The itinerary included Panama, Colombia, Peru, Chile, Argentina, Uruguay, Brazil, Venezuela, and the Dutch West Indies… Mrs. Butler began her club work as President of the Ojai Valley Women's Club, of which she is still a member," *LR*, Feb. 10, 1955, p. 5; "Junior Alphas Present Comedy for Senior club… regular monthly luncheon meeting… **Mrs. Ronald Adam** as chairman of the Fine Arts Section… was responsible for arranging the afternoon's entertainment… A most amusing comedy entitled, 'Husbands Are Human'…," *LR*, March 17, 1955, p. 12.

FALL – "Alpha Club Addition Christened… [tea room] … **Mrs. Arthur Batty** announced that the Fine Arts Section meeting will be held tonight at 8 o'clock at the home of Mrs. Jack DeGroot… 'We are all taking part in the **Penny Art Program**,' stated Mrs. Batty, 'and hope to earn an award for our club room.' The September exhibit was a painting by Grandma Moses … 'The Checkered House.' The October exhibit is an original Kassimer [Sic. Luigi Kasimir] etching in the wood shades …," *LR*, Oct. 20, 1955, p. 4; "Fine Arts Section to Feature Series. Highlights of United States art, music and literature from the earliest settlements to the present will be featured in a series of programs scheduled… The first program of the series was presented when the group met last Thursday evening at the home of Mrs. J. V. DeGroot… **Mrs. Arthur Batty**, chairman… with a brief resume of the early Colonial period from 1620 to 1765, identifying writers of that time … Mrs. Howard Sperber gave interesting descriptions of the approximately 80 colored slides … Interiors and exteriors of early Colonial homes, public buildings, and many authentic costumes… In the pictures, which covered the art of the time, and revealed that the necessities of life rather than formal expression predominated the period…. The next meeting… has been set for November 1 at the Alpha clubhouse…," *LR*, Oct. 27, 1955, p. 5; "Local Florist Guest Speaker… **Mrs. Arthur Batty**, speaking for the Fine Arts Section, reported that their next meeting will be held on December 6 at 8 p.m. in the home of Mrs. Richard Henning … displayed to club members was an original oil painting by **Mrs. Milton Schuyler**, Alpha Club member,' *LR*, Nov. 17, 1955, p. 7; "Xmas in Tyrol Presented by **Mrs. Arthur Batty**… Fine Arts Section… met at the home of

Mrs. Richard Henning last Tuesday for a delightful program presented by **Mrs. Arthur Batty** who titled her speech 'Christmas Traditions and Customs as I Saw Them in the Tyrolean Alps.' Dressed in a Salsburger Dirndl… Mrs. Batty described the garment's detailed craft and symbolism and displayed other interesting souvenirs of her residences in the Tyrol. … description of a typical Christmas night scene when the townspeople light small Christmas trees in the cemetery… the 'Stille Nacht' chapel at Oberndorf… and the Christmas eve service…," *LR*, Dec. 15, 1955, p. 4.

1956 – "Alpha Club Hears Address… Mrs. C. H. Reynolds, Music Chairman, reported on behalf of the Fine Arts section and announced that the next regular meeting… will be held on February 7 at the home of **Mrs. Arthur Batty** …," *LR*, Jan. 19, 1956, p. 7; "Alpha Club Members… Chairmen of the various sections made reports… it was announced that the Fine Arts Section under the chairmanship of **Mrs. Arthur Batty**, would be in charge of the program for the May 16 meeting. The speaker scheduled … is **Mr. Joseph Knowles** …," *LR*, April 19, 1956, p. 4; "Artist is Speaker at Alpha Meeting … **Joseph Knowles**… 'Recent Trends in Art Education'… It was also reported that the Fine Arts Section would discontinue scheduled meetings during the summer months," *LR*, May 24, 1956, p. 4.

FALL – "Fine Arts Section … of the Alpha Literary and Improvement Club will meet tonight… in the home of **Mrs. Ronald Adam**… The Literary division… will present the program…," *LR*, Nov. 8, 1956, p. 4; "Fine Arts Group Postpone Meeting. 'Indefinitely postponed' was the reported status of the Fine Arts Section meeting scheduled by the Alpha Literary and Improvement Club for tonight at 8:00 p.m. in the home of Mrs. **Walter Anderson**," *LR*, Dec. 6, 1956, p. 6.

1957 – "Jr. Alphas to Present Fashion Show in **Schuyler** Home Flower Garden… **Penny Art Section** members are in charge of decorations…," *LR*, May 16, 1957, p. 5.

FALL – "Jr. Alphas Plan Rush Luncheon… The **Penny Art** section under the chairmanship of Mrs. George McCann will be in charge of decorating the clubrooms … The … first regular club meeting of the season will be held on Wednesday evening, September 18… at the clubhouse… **Mrs. James Lewis** of Lompoc will address the gathering on the subject of art," *LR*, Sept. 12, 1957, p. 6; "Jr. Alphas … regular club meeting held in the Alpha clubhouse last Wednesday… **Mrs. Jack Lash** of Ventura, District Fine Arts Chairman… each spoke on specific topics of interest to clubwomen. **Mrs. Paul Highfill** concluded the program discussion with a brief talk on main objectives of the **Penny Arts** Section and called attention to the **Penny Arts** corner which featured a copy of the Currier and Ives etching of 'By the Mississippi'," *LR*, Oct. 10, 1957, p. 5; "Candy Cane Kids. Carol Ann Starcher and Glen Scott, both second graders, were named this week as winners of the art contest sponsored by the **Penny Arts** division of the Junior Alpha club, as a means of selecting the 'Candy Cane Kids' to head up the Children's Christmas Parade here on Saturday. Drawings submitted by first, second and third graders were judged by **Mrs. Ernest**

Wiedmann and **Mrs. Robert Lilley, Jr.,** and prize-winning entries have been placed in the show window of Penney's Department store on East Ocean avenue," *LR*, Nov. 28, 1957, p. 4.

1958 – "Jr. Alphas… The **Penny Art** corner was represented by a painting done by one of the coordinators, **Mrs. Robert Chilson, Sr**….," *LR*, Jan. 23, 1958, p. 5; "Local Artist, Guest Speaker. Junior Alpha club members of the Penny Art section enjoyed a program presentation by **Mrs. William Bailey**… Mrs. Bailey spoke on water color techniques, outlining advantages and disadvantages … and giving pointers for beginner artists… she also demonstrated … by painting a transparent water-color picture and by exhibiting other finished paintings. Those attending were…," *LR*, Feb. 6, 1958, p. 5; "Alpha Gardeners … gathered in the home of **Mrs. Arthur Batty** to hear Mrs. F. A. Ruder discuss various Hawaiian handcrafts and to examine samples of the unique art brought to the meeting by Mrs. Ruder…," *LR*, Feb. 6, 1958, p. 8, and photo of the meeting on p. 5; "Junior Alphas Hold Meeting… The **Penny Art Corner** for the evening was a painting labeled 'Sycamores' done by **Mrs. Ethel Bailey**. It was also announced that Mrs. Bailey had demonstrated water color technique and addressed members of the **Penny Art** Section at their meeting last week," *LR*, Feb. 13, 1958, p. 4; "Junior Alpha Club Members Plan Events for Spring and Summer… The **Penny Art** chairman, **Mrs. Robert Cox**, displayed an interesting pencil sketch portrait by Mr. **Leonard Horowitz** … and it was decided by the membership to sponsor a **Tri-County** Art Exhibit in Lompoc later in the spring….," *LR*, Feb. 27, 1958, p. 5; "Junior Alphas Hear Tableware Talk and View China… Miss Lois Copley and Mrs. Penny Cole from Ott's China Shop in Santa Barbara… Miss Copley showed tableware in pottery, earthenware and china and explained difference in firing and durability… **Penny Art** report was given by District Art Chairman, **Mrs. Paul Highfill** who displayed five different examples of portraits and gave a brief discussion of each type and of the artist who painted it…," *LR*, March 13, 1958, p. 5; "Chaffey College Professor… **Mrs. Robert Cox** announced that **Mrs. Arnold Brughelli**, local artist, would speak at the April 10 meeting of the **Penny Arts section**…," *LR*, April 10, 1958, p. 13; "Public Invited to [**Tri-County**] Art Exhibit at Alpha Club on Tues. and Wed… 3:00 and 9:00 p. m…. paintings on exhibit under the auspices of the Lompoc Junior Alpha club in cooperation with the *Santa Barbara News-Press*…," and more, *LR*, May 22, 1958, p. 4; "Jr. Alpha Club … Committee reports… **Mrs. Robert Cox, Penny Arts** chairman, discussed a painting of Refugio Beach painted by **Vance Locke**, a commercial artist, and reminded the group of the Art Exhibit to be held in the clubrooms on May 27 and 28. Forty paintings will be on exhibit and a silver tea will enhance the occasion. **Mrs. Ethel Bailey** was congratulated on her recent honor at the Tri-Counties Art Exhibit, and a **Penny Arts** section meeting was announced for the following week," *LR*, May 22, 1958, p. 4; "Alphas Score at Fashion Event… The Jr. Alpha **Penny Art Section** decorated…," *LR*, May 29, 1958, p. 15; "Jr. Alphas Launch New Officers… **Mrs. Paul Highfill** reported that the Junior Alpha Art Exhibit was also quite successful," *LR*, June 26, 1958, p. 13.

FALL – "Junior Alphas Host Rushees at Lunch… The clubhouse was artistically decorated by the **Penny Art** section under the chairmanship of **Mrs. Bob Cox**…," *LR*, Sept. 18, 1958, p.17; "Club Year Started by Junior Alphas … **Mrs. Robert Cox**, Junior California Federation of Club Women president of Tierra Adorada district … Crafts Display. Mrs. Robert Cox announced opportunities for members interested in and working with crafts to display their work at each meeting. She also suggested having speakers to demonstrate some techniques at various times. This program will replace monthly meetings of the special Crafts section. Mrs. Cox also explained the **Penny Arts** section was so named because each Junior in California donates a penny to stage an exhibit for young artists to get a start. This group also furthers art appreciation at club meetings with exhibits…," *LR*, Oct. 2, 1958, p. 4.

1959 – "Crowds Visit Six Lompoc Residences… Junior Alpha Home Tour… Robert Sudden residence… The **Arthur Batty** home …Cecil Moses Home in Miguelito Canyon… Bob Wilkinson residence… LeRoy Begg home," *LR*, April 9, 1959, p. 21; port. and caption reads, "First Grade Painter … Steven Burns… children's art contest sponsored by the Junior Alpha club…," *LR*, April 9, 1959, p. 21; "Duncan Home Hosts Alpha Club… **Mrs. Ernest Weidmann [Sic. Wiedmann]**, art consultant for American Crayola Company, outlined her plans for the new art section and told her theme which will be '**Arts and Crafts Made Simple**.' She plans evening programs covering all easily available known art and waste materials designed to help mothers, grandmothers and teachers working with children of all ages. The course will also seek to solve some problems with regard to seasonal decorating, gifts and greeting cards," *LR* July 30, 1959, p. 4.

FALL – "Alphas, Junior Alphas to Click Scissors in Crafts Class… when **Mrs. Ernest Wiedmann** begins her first class in '**Arts and Crafts Made Simple**' … Mrs. Wiedmann, art chairman of the Alpha Club, is using her background as Art Consultant for the American Crayon Company, to show members how to develop the creative ability and thinking of children. … Arts and crafts and with its skills and knowledge of simple materials used for a creative purpose lend many educational advantages to children's development. With double sessions in Lompoc schools, parents will have more of a problem finding ways to occupy their children's time in a constructive manner to supplement their learning. … learning to make objects of seasonal and holiday interest… For instance, the first class per folding and paper sculpture will comprise a lesson in … relation to Halloween and Thanksgiving. Members will bring a shoebox with their name on it to store their materials at the club and have been asked to bring an apron, scissors, note paper and pencil, two yards of aluminum kitchen foil paper, a stapler, one newspaper and one small roll of scotch tape. They will also bring 5 or 6-inch diameter pot lid (to draw a circle) and a small ruler. … 'This course will not require talent,' said Mrs. Wiedmann, 'only enthusiasm. It will be relaxing and free on one hand and decidedly practical on the other.' She plans to hold class sessions one evening a month with an optional second evening to complete special projects… Mrs. Wiedmann has suggested that those attending bring a child of ten or over

'to help you'," *LR*, Sept. 17, 1959, p. 4; Junior Alphas… "Craft Chairman. … Mrs. Richard Johnson, district craft chairman… Mrs. Robert Wilkinson… presented the following chairmen… **Mrs. Paul Highfill**, arts and crafts," *LR*, Oct. 12, 1959, p. 5; "Alpha Club Art Students… Three dimensional effects were achieved with paper at the last Alpha Club art class taught by **Mrs. Ernest Weidmann [Sic. Wiedmann]**, art chairman for the Alpha Club. Mrs. Weidmann demonstrated how to fold paper to get an appearance of depth, to achieve a fish net effect and to construct Christmas ball holders, May baskets and fiesta articles… The response to the regular monthly meeting has been so enthusiastic that extra voluntary follow-up meetings are being held. Parents have brought their children to the meeting… Emphasis was placed on Hallowe'en, Thanksgiving and Christmas decorations as those attending the class were taught a simple drawing technique with crayon and water color…," *LR*, Oct. 15, 1959, p. 5; "Alpha Club Board Meets … Mrs. Duncan announced that the next meeting of the art section will be conducted by **Mrs. Ernest Wiedmann** in the Alpha Club house Monday Nov. 23. Silk screening for Christmas cards, gifts and wrapping paper will be the evening project," *LR*, Nov. 12, 1959, p. 4; "Christmas Cards May be Child's Drawing. Children or grandchildren of Junior and Senior Alphas may be the cause of an original silk screen Christmas card … **Mrs. Ernest Wiedmann** who teaches the Alpha-Junior Alpha Club art class has told her students to ask the young ones in their families for versions of Santa Claus, Christmas trees, gift stockings and other festive holiday trappings. The November session takes place Monday night at 8 in the Alpha Club house. Monthly Meetings. Mrs. Wiedmann will then show her class how to reproduce these drawings and ideas of children in the next two or three monthly meetings of '**Arts and Crafts Made Simple**,' when she explains simplified silk screen printing methods. … 'The same design could then be used on pockets of gift aprons, fingertip towels, napkin and handkerchief corners, nursery curtains, scarves and any number of articles.' Members who plan to use a child's imagination will bring the result in the form of a 5 ½ x 6 ½ inch drawing in bold crayon to the class tonight… It is not restricted to children's talents. … she is so convinced of a child's importance in art she has recommended that those in the class should 'bring along a child to help you.' As a result, children from the age of eight and over have been attending class with their mothers…. Anyone who is a member or prospective member of the Alpha or Junior Alpha Clubs may attend… Classes are free and designed specifically for the fun … class Monday night. ... bring scissors, a box of gummed labels, notebook reinforcements, note book paper, a pencil, an apron, a small roll of masking tape, an old newspaper and several Christmas ideas," *LR*, Nov. 19, 1959, p. 9; "Arts, Crafts Class Set for Monday," *LR*, Nov. 19, 1959, p. 11.

1960 – "Alpha Art Section Work Shop, 7:30 p.m., Alpha Clubhouse. Open to public.," *LR*, April 25, 1960, p. 5.

FALL – "Alpha Members Hear Talk on Club Founding… 1898… **Mrs. Milton Schuyler**, history and landmarks chairman, displayed a painting of a local valley scene by **Elizabeth Kenney**, former Lompoc resident whose

husband was an executive at Johns Manville for many years," *LR*, Sept. 26, 1960, p. 4; "Grossman Speaks to Alpha Club… **Mrs. Elsa Schuyler**, history and landmarks chairman, showed an original painting by **Mary King Brughelli**," *LR*, Oct. 24, 1960, p. 4; "Lompoc Junior Alpha… Mrs. Frank Giovanocci, arts and crafts chairman. Told of … decision to make dry arrangements for their November meeting in the home of Mrs. Richard Ostlie… She displayed a lovely mosaic made by Mrs. William Mosby," *LR*, Oct. 24, 1960, p. 4; "Chas. White… Alpha Club… Two paintings by **Mrs. J. R. Sudbury** were exhibited by **Mrs. Milton Schuyler**, history and landmarks chairman, and a brief history of the artist was given. **Mrs. Robert Chilson** announced that those who wished to display craft at the Junior-Senior Alpha meeting Dec. 3 should contact her … Those who expect to model their original fashions during the style show …," *LR*, Nov. 21, 1960, p. 12; "Junior Alphas Entertain Seniors at Wednesday Dinner-Fashion Show… Members of the Club's craft department and **Mrs. Arthur Batty, Mrs. J. Edward Beattie** and Mrs. Kenneth Rule of the senior club displayed handicraft on a table at the rear of the assembly room. Featured was a lovely pink afghan, a crocheted table cloth, dry flower arrangements, ceramic model of Santa's sleigh and reindeer, Christmas stockings and a red dress for a child," *LR*, Dec. 12, 1960, p. 4.

1961 – "Alpha Club Paintings Win… at the recent district convention in San Luis Obispo. In addition, Lompoc won all three prizes in the art division… From the 25 paintings entered from the Tri-Counties… three local women came out victorious… **Mrs. William Bailey's** 'Spring Blossoms' won first, **Mrs. Elsa Schuyler's** runner up first was titled, 'Battles.' **Mrs. Ernest Wiedmann's** abstract, 'Excavation of United Nations Secretariat Building' won the second prize ribbon. The paintings will be entered in state competition…," and photo of **Elsa Schuyler, Mrs. William Bailey**, and **Mrs. Ernest Weidmann** and their paintings," *LR*, May 8, 1961, p. 4.

1962 – "Convention Awards to Alpha Club … at sixth annual convention of the California Federated Women's clubs … at the Miramar Hotel, Santa Barbara… **Mrs. Elsa Schuyler** placed second with her oil painting entry and **Mrs. Ethel Bailey** third with a water color…," *LR*, April 30, 1962, p. 4; "Garden Tearoom Popular… [at Alpha Club **Flower Show**] … Rock gardens planted with flowers and trees… marble statue… striped window awnings… potted greenery formed a colorful background for painter's easels displaying original paintings of Alpha club members, **Elsa Schuyler, Ethel Bailey**, Hazel Burris, **Marion Lewis**, Jeannie Christensen, **Ellen Martin** and Terry Genest…," *LR*, June 28, 1962, p. 7.

1964 – "Alpha Club Receives Awards at CFWC District Convention… In the art contest, the oil painting, 'Autumn in the Woods,' by **Mrs. William (Ethel) Bailey** won first place and blue-ribbon award for Lompoc Alpha Club. … Honorable mention went to Alpha Club for **Mrs. Milton (Elsa) Schuyler's** oil painting, 'Autumn Landscape." … Mrs. Schuyler also painted the winning entry for the History and Landmarks Art. Her subject was 'La Rinconada School.' Alpha club artists, **Mmes. Bailey,**

Milton and **Vernon (Marian) Schuyler, James (Marian) Lewis**, and C. D. (Wilma) Jack entered ten of the 28 pictures exhibited…," *LR*, April 17, 1964, p. 4.
See: "Community Club (Santa Maria)," 1935, "Federation of Women's Clubs," 1960, "Junior Alpha Club," "Lompoc, Ca., Adult/Night School," 1940, 1941, "Summer School (Lompoc), 1946, "Tri-County Art Exhibit" 1958, "United Service Organization (Lompoc)," 1945

Alvarez, Amelia (Lompoc)
Twelve-year old winner of Poppy poster contest, who painted in her spare time and hoped to become a fashion designer, 1954.
1959 – Port. and "Couple Announce Marriage Plans… to Larry Clarence Carlson…," *LR*, Jan. 29, 1959, p. 5.
See: "Halloween Window Decorating Contest (Lompoc)," 1953, "Posters, American Legion (Poppy) (Lompoc)," 1954

Amador, Jose Trinidad (1940-?) (Santa Maria)
Artist. Exh. Allan Hancock [College] Art Gallery, 1957. Grad. Santa Maria High School, 1958. Assistant Art Director, Santa Barbara County Fair, 1958. Prop. Amador's Fine Furniture, 1984+
■ "SANTA MARIA … A group of distraught, weeping victims of molestation received a bit of justice Monday in a Santa Maria courtroom at the start of National Crime Victims/ Rights Week. Matching the theme of 'Bringing Honor to Victims,' Santa Maria Superior Court Judge Eugene Huseman unexpectedly placed their 'Pappa Trini' in county jail for the next three weeks until his sentencing. His action came after Jose Trinidad 'Trini' Amador, 62, pleaded no contest to one felony charge of continuous sexual assault with a female under the age of 14 and five counts of misdemeanor child molestation. The incidents allegedly occurred from January of 1996 to November of 2000. … He will receive about six months in county jail, five years of probation and will be required to register as a sex offender. The former Santa Maria furniture dealer now living in Southern California…," Senior staff writer Karen White" from *Santa Maria Times*, April 23, 2002, on the Internet.
Amador, Trinidad (notices in Northern Santa Barbara County newspapers on microfilm and the Internet)
1956 – Port. with **George Muro** working on the last of a five-panel painting of the Vaquero Dam… which will serve as the backdrop for the annual dinner meeting of the Santa Maria Chamber of Commerce, *SMT*, Jan. 20, 1956, p. 1; "Wins Golden Key Art Award," in 10th Annual **Scholastic Art** Awards in LA, *SMT*, Feb. 24, 1956, p. 4.
1957 – Port. with his art that won National Arts Scholarship award, *SMT*, Feb. 11, 1957, p. 1; repro. of his winning entry in contest sponsored by Rosicrucian Art Gallery in San Jose and port. of Thomas C. Leighton, a judge, *SMT*, May 15, 1957, p. 5; "Suzie Sez… Trinidad Amador is leading the student body into what, we hope, will be the best year SMUHS has seen. (Trinidad is also Editor-in-Chief of the *Review* and art editor of the school annual)," *SMT*, Oct. 3, 1957, p. 5.

1958 – Port. as SMUHS senior who won a scholarship of $250 to California College of Arts and Crafts, *SMT*, May 7, 1958, p. 1; port erecting 'Dancing Flowers' display (designed by George Muro) at Santa Barbara County Fair, *SMT*, June 19, 1958, p. 1.

1960 – "FM Car Radio… Three colorful sections of the 26-foot exhibit will be highlighted by large framed paintings by Trinidad Amador, who designed the setting… Amador's work is spread also to enlargements of record covers…," *SMT*, July 20, 1960, p. 6.

1984 – Port. receiving keys to Amador's Fine Furniture at 620 N. Broadway… Trinidad Amador who has worked for McMahon's Furniture for the past 20 years, is finally striking out on his own… The store… has undergone an extensive remodeling by Amador… eight rooms or 'vignettes' … which he will wallpaper and decorate with furniture…," *SMT*, July 22, 1984, p. 22.

1990 – Port. with **George Muro** as donor of $10,000 worth of furniture from Amador Furniture to Santa Maria Museum and Art Center, *SMT*, Aug. 26, 1990, p. 28.

2002 – "Molester sentenced… no-contest…," *SMT*, May 15, 2002, p. A-2.

And, numerous additional non-art notices not itemized here.

Amador, Trinidad (misc. bibliography)
Jose Trinidad Amador, mother's maiden name Siordia, was b. March 18, 1940 in Santa Barbara County per Calif. Birth Index (refs. ancestry.com).
See: "Allan Hancock [College] Art Gallery," 1957, "Amido, Ben," 1957, "Elk's Club – Rodeo and Race Meet," 1956, 1957, 1958, "Santa Barbara County Fair," 1958, 1960, "Santa Maria, Ca., Union High School," 1956, 1958, "Scholastic Art Exhibit,"1958

Amador, Ray (Santa Maria)
Hancock College sophomore and track star who won first prize for his pen-and-ink drawing in the local talent art contest exh. at Hancock College Art Gallery, 1957. Won a scholarship to pursue art studies.
Amador, Ray (notices in Northern Santa Barbara County newspapers on microfilm and on newspapers.com)
1955 – "Janet Brown… Scholarships … Ray Amador was presented with the Rotary club scholarship to Allan Hancock college will use it to advance his art studie [sic.]. He also received a plaque …," *SMT*, June 10, 1955, p. 1.
Amador, Ray (misc. bibliography)
Ray Amador is pictured in the Santa Maria High School yearbook, 1953; *Santa Maria, Ca., CD*s indicate that after high school he worked as a "dockman" and at miscellaneous other jobs (refs. ancestry.com).
See: "Allan Hancock [College] Art Gallery," 1957

Amateur Art Show (aka "Local Art," aka "Art Talent")
Exhibit of local artists at Hancock College, 1955, 1956, 1957.
See: "Allan Hancock [College] Art Gallery" 1955, 1956, 1957

American Art Week
See: "National Art Week"

American Artists Group (NY)
See: "Santa Maria, Ca., Union High School" 1937

American Association of University Women (AAUW), (Santa Maria chapter)
Santa Maria chapter began 1951 with 16 Charter Members. One of its subdivisions was the Creative Arts section for handicraft. The group sponsored the Santa Maria Valley Art Festival, 1952, 1953. Co-sponsored the Winter Art Program, 1952/53. Sponsored exhibits at the Allan Hancock College Art Gallery, 1954+. Sponsored the Junior Art Course with the Santa Maria city Recreation Department, 1959.
AAUW (notices in Northern Santa Barbara County newspapers on microfilm and the Internet)
1951 – "University Women to Meet… organizational meeting… Home Economics building at the high school," *SMT*, April 9, 1951, p. 4.
1952 – "The largest number to date attended the creative arts group meeting, and spent part of the evening at a class on 'Color,' taught by **Mrs. DeNejer** with the aid of a lighted screen. This was followed with work in individual examples of paintings in water color on one of the chosen designs," *SMT*, Jan. 17, 1952, p. 4; "**Mrs. Ray De Nejer**, art chairman of Santa Maria Branch of the American Association of University Women who are sponsoring the Art Festival…," per "Zornes Paintings to be in … **Santa Maria Valley Art Festival**, May 24 and 25 in Veterans' Memorial building," *SMT*, May 20, 1952, p. 4.
1953 – See: "Santa Maria Valley Art Festival"
1955 – **Daniel Marcus Mendelowitz** port. and "Stanford Artist AAUW Speaker" and he uses 30 of his wcs as examples in his talk, *SMT*, Feb. 14, 1955, p. 4; "Talk on Greece with Slides… Miss Nance O'Neall…. A former librarian in Santa Maria High school. ... The speaker, who is at present on the faculty of Manual Arts High school in Los Angeles, will show slides taken in Greece of classic arts, architecture and sculptures. In 1952-53, Miss O'Neall taught at Pierce college, Athens, on a Fullbright exchange. At the end of that year, she became a student in the American college in Greece…," *SMT*, April 19, 1955, p. 4; "Art Section … To Meet … The Creative Arts section of AAUW… will meet at 8 p.m. tomorrow in the home of the chairman, **Mrs. John McCabe**, 530 W. McElhaney. **Mrs. Paul Dal Porto** will give instruction in the making of hammered copper pictures," *SMT*, Nov. 29, 1955, p. 4.
1956 – General news about studying art and serving as hostesses at Hancock Gallery, *SMT*, April 9, 1956, p. 4, col. 5; "Mrs. Condon is AAUW Leader… fifth anniversary of AAUW, Santa Maria branch was observed… Saturday's speaker was **Henry Seldis**, writer and lecturer on art at Santa Barbara college, University of California… [and gist of his lecture was] art should not be entangled with politics… **Mrs. John McCabe**, art chairman for the past term, introduced the speaker…," *SMT*, June 11, 1956, p. 4.
1957 – "AAUW Hears [Gerome] De Rollin on 'History of Art'," and he is head of Santa Monica City College, "De

Rollin's subject was 'Background for <u>Modern Art</u>,' and in an interesting and informative way he traced the development of art forms in painting from the day of the French revolution, at the end of the 18th century, to the present. … De Rollin studied in Paris with Matisse followers such as Utrillo and Dufy. He said theirs was sometimes called the 'School of the Wildstan'(?) Also flourishing at this time was the surrealist school, which was Freudian in art, and was world-wide. Mexican art, DeRollin characterized as unique, both in the past and present, a school of its own. Twentieth century painting reflects time of chaos and transition when artists everywhere seem to be trying to understand themselves and what they are doing. An art collector and critic of international note, De Rollin had the misfortune to lose three valuable originals, including a Cezanne, and about 250 of his own paintings in the recent Malibu fire. Following his talk, he showed a group of excellent reproductions of noted works from the old masters to those of today," per "AAUW Hears De Rollin on 'History of Art'," *SMT,* Feb. 12, 1957, p. 4.
 "Artist, Writer Speak to AAUW… 'How to Relax in a Busy World' … Dr. Floyd Corbin… at the AAUW <u>workshop meeting</u>… Among other exceptional talent on the speakers' rostrum… is **Gladys Gray**… Mrs. Gray, a member of a panel to discuss 'The Therapeutic Value of Art' … ," and port. of **Mrs. Gray** sketching flowers, *SMT,* Oct. 26, 1957, p. 3.
1958 – "Women Will Aid Fair Art Exhibit," *SMT,* June 17, 1958, p. 3, and article says, "**Mrs. Nadean Bissiri**, art chairman for AAUW local branch, is signing up volunteers in the membership who will help serve at the art exhibit at the County Fair July 23-27. The possibility of summer art classes for children, to be under the direction of **George Muro**, local director of Art at Allan Hancock College, was presented to the AAUW for discussion"; port. of **Mrs. J. S. Ingram**, teacher Santa Maria elementary school, painting a scene on Waller Franklin flower seed farms to be sold to raise funds for the AAUW scholarships… AAUW extends financial aid and grants [to] women of many lands where the International Federation of University Women is established," per "AAUW to Aid Scholarships," *SMT,* Dec. 10, 1958, p. 6.
<u>See</u>: "Allan Hancock College Art Gallery," 1954+, "San Luis Obispo County Art Show," "Santa Maria Valley Art Festival," 1952+, "Summer School (Santa Maria)," 1959, "Winter Arts Program"

American Federation of Arts, Washington, D. C.
Creator of programs and exhibitions on art that it circulated to its member organizations, including the College Art Club in Santa Maria.
<u>See</u>: "College Art Club," "Santa Maria, Ca., Union High School," 1931

American Legion / Auxiliary (Northern Santa Barbara County)
Group that sponsored an annual national Poppy Poster contest and locally was an outlet for handicrafts made by disabled American veterans, who were not necessarily resident in Northern Santa Barbara County.
1931 – Cooley's Store is Scene of <u>Veterans' Handwork</u> Disposal. Representing many hours of tedious, painstaking work, articles made by disabled war veterans are being sold by members of the local branch of the American Legion Auxiliary at Cooley's Store today and tomorrow… articles … consist of basket work, woven woolens, wooden novelties and tooled leather work … Each year the Auxiliary sponsors the co-operative sale … make fine Christmas gifts…," *LR,* Nov. 20, 1931, p. 7.
And additional notices on handicraft sales not itemized here.
<u>See</u>: "Floats (Northern Santa Barbara County)," 1948, 1949, 1951, 1957, "Homrig, Hal," "Posters, American Legion," "Quilts," 1936, "Santa Ynez Valley Fair," 1941, "Veterans Memorial"

American Women's Voluntary Services (AWVS) (Lompoc)
Largest American women's service organization in the US during WWII. Helped sponsor Vets Art Exhibit brought to Lompoc by Hal Homrig.
<u>AWVS (notices in Northern Santa Barbara County newspapers on microfilm and on newspapers.com)</u>
1949 – "AWVS Opens Fall Activities with Group Meeting… at the home of Mrs. Clarence Ruth… A water color painting by **Forrest Hibbits** of Lompoc was exhibited… and will be given by him to raise money for the service group's overseas relief fund…," *LR,* Oct. 20, 1949, p. 4.
<u>See</u>: "Brandt-Erichsen, Martha," 1953, "Hibbits, Forrest," 1948, 1953, "Homrig, Hal," "Lompoc, Ca., Recreation," Korean War, 1950, "Peake, Channing, Mrs.," 1942, "Quilts," "Santa Ynez Valley Union High School," 1942, "Solvang Woman's Club," "Summer School (Lompoc)," 1946

Americana Shop (Santa Maria)
Prop. Albert L. and Nina Maguire. Open 1948-50.
■ "One of the new shops in Santa Maria that tourists are finding of interest, even tho it is not on the main highway, is the gift and antique shop opened by Mr. and Mrs. Albert L. Maguire, at 208 West Church. The Maguires became interested in collecting glassware, china and early American furniture while they traveled about the eastern and New England states. They paid a visit to the Smoky Mountains section of Tennessee, and there found a great many places where arts and crafts, such as loom weaving, pottery, and making of decorative hearth brushes was in progress. In their shop they display many rare pieces of glass, chinaware, porcelain, and copper pieces against a background of genuinely fine mahogany chests and tables. Several of the pieces are marble topped and are constructed by hand. Mrs. Maguire is the former Miss Nina Cornwall, a Santa Marian. In the collection, which helped with the idea

to open a shop, is a set of pattern glass, a Gridley pitcher, and several coronation mugs, to mention one small group. Meanwhile the new shop owners are making further excursions into the old and new field and are finding the venture an educational and interesting one," per "Collectors Open Shop" for antiques, *SMT*, Aug. 4, 1948, p. 5.

Americana Shop (notices in Northern Santa Barbara County newspapers on microfilm and on newspapers.com)
1948 – "Handicrafts, Antique Furniture, Gifts, Bric-a-Brac, 208 W. Church St., Santa Maria (Next to Telephone Bldg.) Nina and **Albert Maguire**," *SMT*, July 14, 1948, p. 5.
1950 – Ad "Going Out of Business. Americana Shop. … Many Fine Bargains in Antiques and Modern Gifts," *SMT*, Aug. 24, 1950, p. 13.
See: "Santa Barbara County Fair," 1948

Ames, Joseph "Joe" Warren (1926-?) (Lompoc)
Photographer who exh. at Santa Ynez Valley Art Exhibit, 1954, 1955. Photographer for Johns-Manville. Many of his photos were reproduced in the Lompoc Record, 1952-57.

■ "The 'Play's the Thing' Tonight .. with The Lompoc Players' Presentation of 'Harvey'… working on the production of 'Harvey'… Joe Ames, technical director and photographer is a native of Long Beach, being particularly interested in lighting. He spent 2 ½ years in the Navy and then attended Long Beach City College and the **Brooks Institute of Photography**. He has done some beautiful photographic work as a free-lancer and is at present employed in the Industrial Engineering department of J.M. He does all the photographic work for the local plant. He is married and has two children," *LR*, March 31, 1955, p. 5.

Ames, Joe (notices in Northern Santa Barbara County newspapers on microfilm and on newspapers.com)
1952 – Repro: "City Champions… Johns-Manville basketball team," *LR*, Feb. 21, 1952, p. 16; "Fun & Fellowship… Methodist Church…The program to be presented by Joe Ames will consist of a showing of colored slides of Mexico," *LR*, July 24, 1952, p. 5.
1953 – Repro: "A Wish Came True… Santa Claus," *LR*, Jan. 1, 1953, p. 8: repro: "Guest of Honor," *LR*, May 7, 1953, pp. 1, 4; "Joe Ames Produces Photos for 60th Anniversary Edition [of Johns-Manville in the *Lompoc Record*]. Plant photographer Joe Ames is the nice guy responsible for the pictures… He learned to take pictures at the **Brooks School of Photography** in Santa Barbara which he attended for two years… Joe and his wife, Dorothy, who is loved by ever so many school children… came here 2 ½ years ago and live in one of the Johns-Manville homes on North D Street," *LR*, May 14, 1953, p. 31 (i.e., pt. IV, p. 7) and other photos in this issue; repro: "Something New… at the Johns-Manville plant," *LR*, Aug. 20, 1953, p. 8; repro: "Mrs. James Haven," *LR*, Sept. 17, 1953, p. 3; repro: "MMMMM! Also, Yum-Yum," *LR*, Nov. 12, 1953, p. 2; "For the Children… Junior Alpha," *LR*, Dec. 24, 1953, p. 3.
1954 – Repro: "Charming Quartet," *LR*, Jan. 28, 1954, p. 2; repro: "White Elephants," *LR*, March 4, 1954, p. 6; repro: "No Interference," play, *LR*, May 6, 1954, p. 5; repro: "It's Good for You," a play, *LR*, May 20, 1954, p. 5; repro: "Ready to Go," *LR*, June 3, 1954, p. 2; repro: "Flower

Festival Princesses," *LR*, June 24, 1954, p. 1 and another p. 2; repro: "Paris in the Spring," *LR*, June 24, 1954, p. 5; repro: "La Reina De Los Flores… Donna Grossi," *LR*, July 8, 1954, p. 7; repro: "A Whale of a Lot of Whale," *LR*, July 15, 1954, p. 2; repro: "Mr. and Mrs. Robert Merritt," *LR*, Aug. 19, 1954, p. 5; repro: "Pioneers at Reunion," *LR*, Sept. 9, 1954, p. 1; repro: "A Flower," *LR*, Sept. 16, 1954, p. 5; repro: "James A. King," *LR*, Oct. 7, 1954, p. 5; repro: "Drill Team… Companions of the Forest," *LR*, Oct. 21, 1954, p. 4; repro: "Installed… Junior Catholic Daughters of America," *LR*, Oct. 28, 1954, p. 5; repro: "The 55th Installation… Order of Eastern Star," *LR*, Dec. 2, 1954, p. 5; repro: "Construction Started… Johns-Manville's new synthetic silicate plant," *LR*, Dec. 16, 1954, p. 9; repro: "Not Jack Frost," *LR*, Dec. 23, 1954, p. 4.
1955 – Repro: "Admiring a Poster… Junior Alpha club Rummage Sale," *LR*, Jan. 27, 1955, p. 5; repro: "Congratulations were in Order… Johns-Manville," *LR*, Feb. 3, 1955, p. 4; repro: "Given the Reins…. Johns-Manville," *LR*, Feb. 24, 1955, p. 1.
1956 – Repro: "School Board Candidates," *LR*, May 17, 1956, p. 1.
1957 – Repro: "Storybook Splendor," wedding cake, *LR*, March 14, 1957, p. 16; "Safety First Brings Award," *LR*, July 4, 1957, p. 16; repro: "Sign Pact… Johns-Manville," *LR*, Oct. 31, 1957, p. 1; repro: "Modelairs Explore the Sky," *LR*, Nov. 14, 1957, p. 13.
And, numerous notices on his bridge playing not itemized here.

Ames, Joe (misc. bibliography)
Joseph Warren Ames provided the following information on his WWII Draft Card, b. Feb. 16, 1926 in Los Angeles, residing in Long Beach, employed by Harbour Steam Plant, Wilmington; Joe Ames port. with camera and caption "Photographic Editor" SAGA Staff, and port. with BLIXT (camera club), and one additional photo, appear in the Long Beach City College yearbook, 1947; Jos W. Ames is listed as photostat operator, Board of Education, in the *Long Beach, Ca., CD*, 1948; Joseph W. Ames, engineer, Lockheed, is listed with wife, Dorothy, in Lompoc, in the *Santa Maria, Ca., CD*, 1958, 1959 (refs. ancestry.com).
See: "Santa Ynez Valley Art Exhibit," 1954, 1955

Amet, Bertha (Los Angeles)
State Art Chairman, California Federation of Women's Clubs, who spoke to the Alpha Club in Lompoc, 1939.
See: "Alpha Club," 1939, and *Atascadero Art and Photography before 1960*

Amido, Benjamin "Ben" Lim (1939-?) (Guadalupe)
High school art student of George Muro, 1955. Won a Gold Key in the Scholastic Art Exhibit, 1955. Exh. Allan Hancock [College] Art Gallery, 1956. Won the Bank of America award for art.
Amido, Ben (notices in Northern Santa Barbara County newspapers on microfilm and on newspapers.com)
1956 – "Teen Topics… class jackets… The emblems, designed this year by Ben Amido, have a silhouetted senior on them and a two-tone 1957. Very striking!" *SMT*, Feb. 19, 1956, p. 6.

1957 – "… Scholarships … Certificates … are given annually by the Bank of America to recognize high school graduates who excel in various fields… Certificate winners are: … Ben Amido, art," *SMT*, April 6, 1957, p. 8; photo and caption reads, "Local Boys Win – **Trinidad Amador** … contest sponsored by the Rosicrucian Art Gallery in San Jose… Ben Amido of Guadalupe… won honorable mention in the humorous division. **Robert H. Gronendyke** was instructor …," *SMT*, May 15, 1957, p. 5; "diplomas for 222… Bank of America awards were presented to … Benjamin Amido in art …," *SMT*, June 14, 1957, p. 1.

1958 – Port. and "completes Training – Airman Third Class, Benjamin L. Amido, son of Mrs. Rosita Amido… has completed his initial course of Air Force basic military training at Lackland AFB, Tex. He has been selected to attend the technical training course for Aircraft and Engine Mechanics at Amarillo AFB, Tex. A graduate of the Santa Maria Union High School, he also attended Allan Hancock Junior College. He played with the John Perry Dance Band in Guadalupe before entering the Air Force," *SMT*, Aug. 14, 1958, p. 5.

And additional notices on his baseball playing were not itemized here.

Amido, Ben (misc. bibliography)
Benjamin Lim Amido, mother's maiden name Lim, was b. Sept. 20, 1939 in Santa Barbara County per Calif. Birth Index (refs. ancestry.com).

See: "Allan Hancock [College] Art Gallery," 1956, "Halloween Window Decorating Contest (Santa Maria)," 1953, "Santa Maria, Ca., Union High School," 1955

Andersen, Ruth Burnor (Mrs. Erick / Eric T. Andersen) (1905-1989) (Lompoc)
Chairman of children's art contest and exhibit at the Lompoc Community Woman's Club, Flower Festival Art Show, as well as its annual School Art Contest, c. 1958+, and of the club's Handcraft section. Exhibited embroidered pictures at Lompoc Gem and Mineral Club Hobby Show, 1960+.

Andersen, Ruth (notices in Northern Santa Barbara County newspapers on microfilm and on newspapers.com)
1961 – Port. with winning child artists in School Art Contest, *LR*, March 23, 1961, p. 6.

And, many additional entries in the *LR* not itemized here.

Andersen, Ruth (misc. bibliography)
[Often this name was erroneously spelled "Anderson".]
Ruth Andersen is listed in the 1940 U. S. Census as age 34, b. c. 1906 in Calif., finished high school 4th year, residing in Lompoc (1935, 1940) with husband Erick Anderson (age 49); Ruth Burnor Andersen, mother's maiden name McLachun and father's Wilson, was b. Sept. 27, 1905 and d. May 18, 1989 in Santa Barbara County per Calif. Death Index (refs. ancestry.com).

See: "Lompoc Community Woman's Club," 1948, 1958, 1959, "Lompoc Gem and Mineral Club," 1960, "Open-Air Art Exhibit," 1957, 1958, 1960, "Posters, American Legion (Poppy) (Lompoc)," 1933, 1935

Andersen's Pea Soup Restaurant (Buellton)
Restaurant, opened 1924, that gave space for art exhibits, 1954+.

■ "On Friday the 13th, 1924, Andersen's 'Pea Soup' Restaurant came into being when Anton Andersen, born in Denmark and associated with exclusive restaurants both in Europe and New York, hung up his tuxedo and donned a bib apron… It was in the early thirties that a cartoon appeared in the old '*Judge*' magazine… one of a series by the famous cartoonist Forbell, under the heading 'Little Known Occupations.' The cartoon showed the little known 'occupation' of splitting peas for split pea soup, with two comic chefs standing at a chopping table, one wielding the mallet and the other holding a huge chisel splitting peas singly. Andersen obtained permission to use the idea for his trade mark and the two chefs, Hap-Pea and Pea-Wee were started on their now famous career… Names were chosen in a special contest… Robert [son of the original owner] had **Milt Neil**, **Disney**-trained artist re-draw the two characters… giving them each a distinctive personality. The big fellow was shown getting the glory and the easy side of the work and the little fellow looked sad and a bit frightened, always in danger of getting in the way of the mallet. Thousands of entries poured in during the contest to name the two… 1947 the new high 101 was constructed through Buellton…," *SYVN*, Sept. 17, 1954, p. 42 (i.e., 16).

Andersen's (notices in Northern Santa Barbara County newspapers on microfilm and on newspapers.com)
1954 – ■ "Andersen's shows Motzko Paintings. Over a dozen colorful oil paintings done by Santa Barbara artist **Helen Motzko**, went on display… in a move by the restaurant ownership to encourage and promote the work of California artists… Mrs. Motzko is the first artist to exhibit though the plan calls for exhibits to be placed regularly by artists throughout the state. The exhibit will remain at Andersen's for the balance of this month, under the super vision of **Paul Kuelgen**, decorator for the restaurant," *SYVN*, July 16, 1954, p. 6; ■ "**Hibbits** Work Exhibited … entire month of August … second in a series of showings featuring California artists… to encourage and promote the work of artists in this area… [and bio. of Hibbits] The 12 paintings which are on display in the halls and entrance to Andersen's are … landscape, still life and figures … Favorable comments on last month's exhibition… have encouraged the management… to continue to offer various Western artists the opportunity of displaying before the thousands of visitors who come to Andersen's each month," *LR*, Aug. 12, 1954, p. 13; "**Hibbits** Work on Exhibition at Andersen's," *SYVN*, Aug. 13, 1954, p. 3; ■ "Art exhibit… Eighteen original color etchings by **Nell Brooker Mayhew** featuring California Missions are now being exhibited at Andersen's… the third in a series of exhibitions… The etchings were created by an unusual process perfected by the artist herself. Working with a hand operated etching press, she painted each color separately on the etching plate, running a limited number of prints each time, repeating the process for each additional color. This series… are among the last available prints and are the property of Mrs. Mayhew's daughter, Mrs. E. K. Kemble, of Santa Barbara," *LR*, Sept. 23, 1954, p. 11; "Mission Etchings Go on Display. Eighteen original color etchings…

[Nell Brooker Mayhew] featuring California missions are now being exhibited at Anderson's [Sic. Andersen's] 'Pea Soup' Restaurant in Buellton, the third in a series of exhibitions by famous California artists," *SYVN*, Sept. 24, 1954, p. 6; ■ "Buellton Restaurant has New Art Exhibit... 18 oils and water colors by **Ann Louise Snider** ...," *LR*, Nov. 18, 1954, p. 9; ■ "Havens' Art Work... The largest art display to date is now being installed at Andersen's Pea Soup Restaurant... joint showing of paintings by **Kay** and **William B. Havens** of La Crescenta ... and features two dozen of their works, mostly colorful landscapes of western scenes. The Havens received their art training at Chouinard School of Art in Los Angeles, in addition to the Copley Society of Boston, and each took private instruction in the east. Their professional experience has included designing and originating greeting cards for a large eastern manufacturer and also free-lance work in advertising, ceramic design, and conducting special art classes. They have exhibited recently in Oregon, California, New York and Boston. The exhibit of the Havens will remain ... until the middle of January," *SYVN*, Dec. 24, 1954, p. 5.

1955 – "**Havens**' Paintings Now on Display. The man and wife artist team of Bill and Kay Havens is exhibiting a selection of oil paintings at Andersen's in Buellton. The La Crescenta artists have shown previously... Mrs. Havens is a sister of Helen Barbera of Solvang," *SYVN*, Oct. 21, 1955, p. 2.

1956 – ■ "Glasgow Paintings on Display Here. Oil paintings by **Charles Glasgow** of Los Olivos are being displayed this month in the lobby of Andersen's Pea Soup Restaurant in Buellton. This is a service of Andersen's to bring before the public works of art from Valley and County artists. Each month they display a different artist," *SYVN*, Sept. 21, 1956, p. 6.

1957 – ■ "**Glady Gray**'s Water Colors Now on Display at Andersen's... 22 full-sheet and half sheet size water colors, including landscapes, seascapes, horses, cattle, and flowers, will continue through March 26," *SYVN*, Feb. 22, 1957, p. 4.

1958 – ■ "Buellton Briefs... Paintings by **Joseph Knowles**, prominent Santa Barbara artist and designer, are on exhibition at Andersen's Restaurant. Knowles, who is a teacher and instructor in fine arts, is the past president of the Art Association in Santa Barbara," *LR*, July 3, 1958, p. 10; ■ Amory Hare "Hutchinson Art Work on display.... In the lobby of Andersen's Pea Soup restaurant in Buellton. The exhibit, which includes portraits of well-known horses presently running, including her famous *Night Command*, will continue through Sunday," *SYVN*, July 25, 1958, p. 1; ■ "Buellton Briefs. Andersen's Pea Soup restaurant is exhibiting paintings in the lobby by the well-known artist, **Amory Hare Hutchinson**. On display are portraits of race horses, *Round Table*, United National handicap winner; Vicar, a descendant of the famous *Man of War*, and many other well-known race horses including *Porterhouse* from the Liangallen Stables, Pueblo and *Black Turquin*. Paintings of *The White Foal* and the famous *Night Command* are also included... A portrait entitled 'Mr. Fitz' is most expressive of that well-known trainer James Fitzsimmons," *LR*, July 31, 1958, p. 6.

1959 – "Andersen's to Expand... Concurrent with the 35th anniversary... Among the innovations already completed is the 'Hans Christian Andersen Room,' a luxurious cocktail lounge featuring a unique fairy tale mural by ... **Paul Kuelgen**. The lounge is situated at the southwest corner of the restaurant's main floor," *SMT*, June 19, 1959, p. 17 (i.e., p. 5); "'Pea Soup' Restaurant Marks 35th Anniversary ... Spurred by Valley expansion and its accompanying traffic boom, the restaurant remodeling from top floor to wine cellar is halfway completed. Fall of this year will see the second stages begun, following designs by Santa Barbara architect Robert Ingle Hoyt. Among the innovations already completed is the 'Hans Christian Andersen Room,' a luxurious cocktail lounge featuring a unique fairy tale mural by ... **Paul Kuelgen**...," *SYVN*, June 19, 1959, p. 6;

■ "Memo Pad... An interesting display of colorful glass mosaics, the work of **J. Eloise Hansen** (Mrs. Karl Hansen), is now being exhibited in the dining room of Pea Soup Andersen's Restaurant in Buellton...," *SYVN*, Nov. 20, 1959, p. 2.

See: "Havens, Kay and William," "Neil, Milt," "Valles, Alex"

Anderson, Frederick Adolph (1893-1973) (Vermont / Santa Maria)
Stone Carver. Purchased a marble works in SLO from A. Turek, 1922. Returned the business to Turek by 1924.

■ "Turek Sells Marble Works. Frederick A. Anderson of Vermont today purchased the marble and granite works from **Chas. A. Turek**... Mr. Anderson comes from the monumental state of Vermont... far famed for its great granite and marble works. He has been in this business for 18 years... Mr. Anderson plans to carry out his motto of 'first class and up-to-date work'. He is now associated in the business with Mr. Turek but will take sole possession on the first of November. His family is now visiting at Atascadero and will move to Santa Maria in the near future," *SMT*, Oct. 18, 1922, p. 5.

Anderson, F. A. (notices in Northern Santa Barbara County newspapers on microfilm and on newspapers.com)
1923 – Ad. "Monuments of Granite and Marble. F. A. Anderson, next to Massey Hotel," *SMT*, March 7, 1923, p. 7.

Anderson, Frederick (misc. bibliography)
Frederick A. Anderson is listed in the 1940 U. S. Census as age 45, b. c. 1895 in New York, completed elementary school 8th grade, a stone carver, residing in Santa Maria (1935, 1940) with wife Agnes E.; Frederick A. Anderson b. Sept. 12, 1893 in New York to John Alfred Anderson and Alma Maria Johannesdotter Segergren, was residing in New York in 1900 and d. May 20, 1973 in Santa Barbara County per Johansson Family Tree; Frederick Adolph Anderson (1893-1973) is buried in Santa Maria Cemetery District per findagrave.com (refs. ancestry.com).
See: "Turek, Charles A.," and "Marble Works (SLO County)" in *San Luis Obispo Art and Photography before 1960*

Anderson, Grace Burke (Mrs. Dr. Walter M. Anderson) (1904-1979) (Lompoc)
Member of Hibbits' art class who exh. paintings at Heiges home, 1950. Exh. marine painting at Alpha Club, 1952. Exh. art at Open-Air Art Exhibit, 1957. Piano / organ player, music teacher.

■ Port. at organ and "The Musician and You…," i.e., feature article on her music. She played as a child by ear, then took instruction, played in churches, etc. in the greater Los Angeles area, and taught piano. After marriage, she came to Lompoc and entertained soldiers during war years, and gave performances in various places, fashion shows, flower shows, charities, etc., *LR*, June 21, 1956, p. 18. And, over 300 notices on her (as either Grace or as Mrs. Walter Anderson) in *LR*, were not itemized here.
Anderson, Grace (misc. bibliography)
Grace Anderson is listed in the 1940 U. S. Census as b. c. 1905 and residing in Lompoc with her husband Walter; Grace Anderson b. Dec. 27, 1904, d. Oct. 18, 1979 in Lompoc per Social Security Death Index and Calif. Death Index, and is buried in Lompoc Evergreen Cemetery per findagrave.com (refs. ancestry.com).
See: "Alpha Club," 1950, 1952, 1956, "Flower Show," FALL, 1949, "Open-Air Art Exhibit," 1957, "Tri-County Art Exhibit," 1958

Anderson, John Richard "Dick" (1933-1981) (Lompoc)
Photographer, and author of "About Town" column in the Lompoc Record, 1960.

■ "Dick Anderson… John Richard (Dick) Anderson, 48… Mr. Anderson was born in Santa Barbara May 9, 1933 and died at his home on Monday. He was a graduate of Lompoc High School and Loma Linda University where he earned a B.A. degree in history. He had been a journalist for 22 years and joined the *Lompoc Record* editorial staff in 1959. In 1961 he moved to the staff of the *Santa Barbara News-Press* where he was currently employed as a reporter for the Lompoc Bureau… Korean War Army veteran…," *LR*, Nov. 3, 1981, p. 2.
Anderson, Dick (notices in Northern Santa Barbara County newspapers on microfilm and on newspapers.com)
1960 – "About Town… Fond Memories – We had occasion last week to set foot on the property of Vandenberg Air Force base adjacent to the Ocean Park lagoon. We crossed the salt water barrier and drove northward about two or three miles to photograph a train wreck. During the course of the drive, we passed some scenic spots long closed to the eye of the public. We refer to the rugged rocks and pounding surf in that area. When we were a young tot, back in the 'good old days,' we frequently were invited with the parents for an outing to the rugged coastline…," and further childhood memories, *LR*, May 23, 1960, p. 8; "About Town with Dick Anderson. Have you ever wondered what it's like to be on the shooting end of a press camera? … We have operated in that capacity for some two years now and have viewed through the probing eye of a speed-graphic everything from tragedy to comedy. [and article relates some anecdotes about being a news photographer] … But all in all, news photography is exciting, challenging and full of fun. To see the results of a picture, when good, come

out in print, is ample reward to a bonified photo-journalist," *LR*, Nov. 28, 1960, p. 6.
1961 – Port. and caption reads "John R. 'Dick' Anderson reporter-photographer for the *Lompoc Record*, loaded down with three cameras, *LR*, Jan. 19, 1961, p. 1; repros.: several photos of the Lompoc High School band when it participated in the inaugural parade for President Kennedy, *LR*, Jan. 26, 1961, p. 1.
And numerous additional notices not itemized here.

Anderson, Lenora Katherine Adams (Mrs. Jack Anderson) (1910-1958) (Santa Ynez)
Teacher at College Grammar School who also taught crafts at Santa Ynez Valley Union High School, 1950-56, and in Santa Ynez Valley Adult/Night School, 1950-54. Exh. annual Santa Ynez Valley Art Exhibit, 1953, 1956.

■ "Mrs. Jack Anderson, 47, laid to Rest in Ballard… Mrs. Anderson was born May 20, 1910 at Capitola, Calif., the only child of the late Mr. and Mrs. Bert Adams. As Lenora K. Adams, she attended grammar and high school at Taft. She was a graduate of the University of California at Santa Barbara and received her general secondary and master's degree from the University of Southern California. She was married to Jack Anderson of Santa Ynez at Las Vegas on April 21, 1937. They lived all of their wedded life in Santa Ynez. Mrs. Anderson taught at College Grammar School for many years. She was a member of the faculty at Santa Ynez Valley Union High School since 1950 where she taught sophomore English and arts and crafts. … The school's 1957 year book was dedicated to her…," *SYVN*, Jan. 17, 1958, p. 5.
And additional notices on her teaching not itemized here.
Anderson, Lenora (misc. bibliography)
Lenora Katherine Anderson, mother's maiden name Knotts, father's Adams, was b. April 21, 1910 in Calif. and d. Jan. 14, 1958 in Santa Barbara County per Calif. Death Index; Lenora Katherine Anderson is buried in Oak Hill Cemetery, Ballard, Ca. per findagrave.com (refs. ancestry.com).
See: "Girl Scouts," 1948, "Posters, American Legion (Poppy) (Santa Ynez Valley)," 1954, 1955, "Santa Ynez Valley Art Exhibit," 1953, 1956, "Santa Ynez Valley, Ca., Adult/ Night School," 1950, 1951, 1952, 1953, 1954, "Santa Ynez Valley, Ca., Elementary / Grammar Schools," 1948, 1949, "Santa Ynez Valley Union High School," 1950, 1952, 1956

Anderson, Marilyn Gayle
See: Smith (Anderson), Marilyn Gayle (Mrs. John E. Anderson)

Andresen, Laura (1902-1999) (Los Angeles)
Ceramist. Teacher at UCLA, whose work was shown by Jeanne DeNejer during a lecture to the Minerva Club, Santa Maria, 1952.
See: "Minerva Club," 1952

Anna S. C. Blake Manual Training School (Santa Barbara)
The school trained some northern Santa Barbara County teachers. Prop. Edna Rich.
1908 – "Teachers' Reception to Normal Class. The Anna S. C. Blake manual training school presented a brilliant scene last evening when Miss Rich and the teachers of that institution … [description of interior of building] … The personnel of the class is as follows … Miss **Olivia McCabe**, Lompoc … All these are experienced teachers, normal and university graduates who have given this year to this manual training and are now qualified to take positions as sloyd teachers anywhere on this coast. Their diplomas being recognized, since the school is accredited by the state board of education…," *Independent* (Santa Barbara), June 2, 1908, p. 3.
See: "Rich, Edna," "Teacher Training," 1897

Annabelle, G., Dr. (Stanford University)
Lecturer on photography at Solvang school, 1938.
See: "Photography, general (Santa Ynez Valley)," 1938

Anonymous Artists (Northern Santa Barbara County)
See: "Art, general …," "Labels, Fruit Crate," "Land Case Art," "Thompson & West"

Antiques Collectors
See: "Collectors"

Apalategui, Mary Alice Hibard (Mrs. Frank Apalategui) (Santa Maria)
Handcraft chairman, Jr. Community Club, 1950s.
See: "Junior Community Club (Santa Maria)," 1952, 1953, 1954, 1955, 1958

Aratani, Setsuo (Guadalupe)
Art patron. Owner of the Guadalupe Produce company and president of the Japanese association. Friend of Bay Area artist Chiura Obata. Sponsor of artist Kazuo Matsubara.
Aratani, Setsuo (notices in Northern Santa Barbara County newspapers on microfilm and on newspapers.com)
1932 – Repro of Matsubara's port. of **Setsuo Aratani**, Guadalupe Japanese leader, and biography of Aratani, *SMT*, April 9, 1932, p. 3.
1940 – Repro of Matsubara's port. of **Setsuo Aratani**, *SMT*, April 17, 1940, p. 6.
See: "College Art Club," 1931, "Japanese Art," "Matsubara, Kazuo," "Obata, Chiura"

Archer, Fred (1889-1963) (Los Angeles)
Photographer. Prop. Archer School of Photography, LA. Judge at Santa Maria Camera Club, 1950.
■ "Fred Robert Archer (December 3, 1889 – April 27, 1963), was an American photographer who collaborated with Ansel Adams to create the Zone System. He was a

portrait photographer, specializing early in his career in portraits of Hollywood movie stars. He was associated with the artistic trend in photography known as pictorialism. He later became a photography teacher and ran his own photography school for many years," per Wikipedia.
See: "Hendricks, Robert L.," "Santa Maria Camera Club," 1950

Architecture (Northern Santa Barbara County)
Scattered articles on architecture. Not intended to be thorough.
Architecture (notices in Northern Santa Barbara County newspapers on microfilm and on newspapers.com)
1935 – F. W. Jones, "City Hall, Santa Maria, Calif.," *Architect and Engineer*, v. 120, March 1935, pp. 23-29.
1937 – "Adobe List to be Compiled in County History. An authentic list of all the old adobes in Santa Barbara county is to be incorporated by Miss Marion Parks in the History of Santa Barbara County, now in process of compilation with county Engineer Owen H. O'Neil as editor…," *SYVN*, Nov. 5, 1937, p. 1.
1947 – "Old Street Cars Used to Build New Restaurant. 'Mullens Dining Cars,' … now open to business on Highway 101 just north of Buellton. The café, a dream of Edward Mullens, is probably the only one of its type in the nation. Several months ago Mullens acquired two yellow street cars from the Los Angeles Railway Co…," *SYVN*, March 7, 1947, p. 12; ["Copenhagen Square" built by Ray Paaske, the first in Danish provincial style].
1948 – "Just where did the old Benjamin Foxen home stand?' This question, asked hundreds of times a year, came up in a gathering of Santa Maria business men. … It was pointed out by some of those in the group that there are still three important old houses in this area that could be preserved – the old Dana home on the mesa near Nipomo, and the two old adobes in Guadalupe. … The two Guadalupe adobes are still standing, and occupied, though in a very poor state of repair. The county has agreed, through supervisor T. A. Twitchell, to buy them … the present owner has given an option on the property to Matt Zanetti, who would turn it to commercial use. Guadalupeans had envisioned the front of the property as a park for the memorial building city hall and had hoped to see the old adobes preserved as a tourist attraction. The Foxen home. The group discussing the historic spots wanted to know just where to find the former location of the Foxen home … . pile of earth almost in the center of a small field on the south side of Foxen canyon road … Today it is nothing but a heap of earth … 'English sailor who had married the daughter of a Spanish California family, dispensed the only hospitality between Santa Barbara and San Luis Obispo. The present owners of the land have constructed a low fence of barbed wire about the mound. … Foxen Memorial Chapel, one of the very few historic monuments in this area that has been preserved. Through the efforts of R. E. Easton, the Security First National Bank donated the old church to the county. Old Graciosa. Other historic spots in the vicinity of Santa Maria suggested for marking by the group… include the site of the old town of La Graciosa that once stood south of Orcutt and antedated both Orcutt and Santa Maria. … Then there

was a <u>notable saloon</u> that once stood near the present Olive school, beyond Sisquoc, that served first as a tavern to accommodate stage passengers," per "Historic Landmarks Disappearing," *SMT,* Jan. 15, 1948, p. 9.

1950 – State's Attention Focused on <u>Grist Mill</u> Dedication," east of old Mission Santa Ines, *SYVN,* Aug. 18, 1950, p. 1; photo. and "<u>Grist Mill</u> Dedication Tomorrow," *SYVN,* Sept. 8, 1950, p. 1; "Impressive Admission Day Ceremony Marks Dedication of Plaque at Old <u>Grist Mill</u>," *SYVN,* Sept. 15, 1950, p. 1.

1953 – Photo of historic <u>adobe</u> on Old College Ranch of Archie and Bess Hunt…," *SYVN,* Sept. 25, 1953, p. 1; "Paul Nielsens… Built Home Dirt cheap… <u>adobe</u>…," and photos, *SYVN,* Oct. 16, 1953, p. 10.

1954 – "Early California Era Reflected in <u>Rancho Cerro Alto Adobe</u>… adobe home of **Mrs. Virginia de la Cuesta** and her daughter, **Miss Tulita de la Cuesta**… built 52 years ago by Mrs. de la Cuesta and her late husband Gerardo… The location of the home, filled with treasures of the day of Early California… The home was constructed by Antonio Camargo, who built many of the old adobes in the Valley… The living room drapes of plaid are hand woven… Family pictures and paintings, some the work of **Mrs. de la Cuesta**, hang on the walls… A painting of the Old Mission, including the store edifice, an original by Mrs. de la Cuesta, hangs from the wall. It reveals that the store building was located to the right of the bell tower and it was a frame structure… Part of the dining area is alcove. Hanging from the walls of the alcove are branding irons, riatas… One corner of the dining area is taken up with cupboard which had been made by **Tulita de la Cuesta**….," *SYVN,* April 16, 1954, pp. 10, 12 and several photos of interior; The "<u>Home of the Week</u>" series started in late 1953 and was only itemized here if the homes were owned by artists or were historic or contained antiques, and sometimes they are cited under the name of the owner; "The Old <u>Grist Mill</u>," *SYVN,* June 25, 1954, p. 1; "James Ferguson Ranch-Style Solvang Residence Built of <u>Adobe</u>," *SYVN,* July 23, 1954, p. 5; "Various Settlers in Valley Have Left Mark on Type of Architecture used in Homes Here," *SYVN,* Sept. 17, 1954, p. C-8.

1957 – Port. of <u>Miss Gerry Anderson</u>, student at Hancock College, who spoke to Episcopal Guild, "Why <u>Modern Design</u> Should Apply to Church is Topic," *SMT,* Jan. 26, 1957, p. 4.

1959 – Drawing of proposed <u>Valley Bowl</u> to be built about a half mile east of Buellton along Highway 150, *SYVN,* March 27, 1959, p. 8.

1960 – "<u>Santa Ynez Rancho Estates</u> Stages Opening Ceremonies," *SYVN,* March 11, 1960, p. 6; "Now Under Construction … Santa Ynez Valley's <u>Valley Industrial Center</u>" and map, *SYVN,* March 18, 1960, p. 5.

1972 – "Groups fighting to save historic adobe buildings… Latest adobe to bite the dust is the Ortega Adobe on the Santa Ynez Indian Reservation near the town of Santa Ynez… Meanwhile, efforts are continuing to save La Barranca, one-time adobe home and studio of the late famed western artist, **Edward Borein**, in the Mesa area of Santa Barbara…," *LR,* July 31, 1972, p. 3.

See: "Architecture (Solvang)," "Better Homes," "Crawford, Louis," "Daniel, Mann, Johnson and Mendenhall," "Harwood, Harvey," "Jones, Gaylord," "Leighton, Philip,"

"Lindsay, John," "Lockard, E. Keith," "Mission La Purisima," "Mission Santa Ines," "Morgan, Julia," "Murayama, Frank," "Ortega & Sammons," "Paaske, Ray," "Parsons, Wayman," "Sorensen, Soren," "Spangler, Lafayette," "Taylor, Cameron," "Viole, Laurence"

Architecture (Solvang)
Danish style architecture was constructed in Solvang as early as 1928 with the Bethania Lutheran church. Other buildings followed from the mid-1930s. "Alfred Baker Petersen was the first to incorporate Danish bindingsværk into his home (1931). Einer Johnsen's jewelry and radio shop (1936) became the first Main Street business to adopt a simple bindingsværk [half-timber] design." Following a Saturday Evening Post article on Solvang in 1947 and the consequent rush of tourist business, astute businessmen began focusing on the Danish provincial style. In 1956 shopfronts in other styles were remodeled to Danish. Today, 2020, the entire town is in Danish style.

1926 – "Three [Solvang] Buildings to Have <u>Mission Arcade</u>," i.e., 3 new commercial buildings will take their design inspiration from Santa Ynez mission, *SYVN,* Feb. 26, 1926, p. 1.

1928 – Photo of <u>Danish Lutheran church</u>, erected in 1928, Danish architecture of the 15th century, *SYVN,* June 5, 1936, p. 14.

1939 – Repro: drawing of <u>Danish Village Inn</u> to soon be constructed, *SYVN,* Nov. 3, 1939, p. 1; "Two More Business Houses to be Constructed… cabinet and repair shop… constructed in Danish architecture …," *SYVN,* Dec. 1, 1939, p. 1.

1940 – "<u>New Solvang School</u> Completed… New Building in Danish Architecture Blends in Beautifully with Danish Village… The school architects, Soule and Murphy of Santa Barbara, made the plans to conform with Danish architecture, following the style of the nearby <u>Danish Lutheran church</u>, which is copied after the early centuries' architecture in Denmark…," *SYVN,* Jan. 12, 1940, p. 7; photo of building and "Café Opens Sunday in New <u>Knudsen Building</u> … of Danish architecture," *SYVN,* Jan. 19, 1940, p. 4.

1947 – "'Little Denmark' Publicized in Jan. 18th '*Post*' Article," *SYVN,* Jan. 17, 1947, p. 1; "Article on Solvang, or 'Little Denmark'… *Saturday Evening Post*," *SMT,* Jan. 15, 1947, p. 2; "Visitors Flock to Valley Following Magazine Article… a greater majority of the visitors had their eyes bent for natives parading around in 'old country' costumes. Danish pastry shops going full swing," and gift shops with Danish goods, but most shop owners were not prepared for the sudden tourism and in many cases had no "real" Danish products (milk, cheese, butter, Continental breakfasts) available to sell, etc., *SYVN,* Jan. 24, 1947, p. 1; "Business Men Suggest New Building [a body and fender works] be Constructed Along Danish Lines" to match neighbors, *SYVN,* Feb. 28, 1947, p. 12; "'<u>Copenhagen Square</u>' Project Being Developed… Plans are now underway for the development of a tract of land on Alisal Road in the center of town to be known as 'Copenhagen Square' and the first of a series of buildings constructed along provincial lines is expected to be ready within two weeks. The plan,

conceived many years ago by the late Termann Paaske, is being carried out on the land lying behind the Old Mission Santa Ines and Alisal Road. … the property is being developed by **Ray and Erwin Paaske**, sons of the late Mr. Paaske… a series of buildings all constructed along Danish provincial lines…," *SYVN*, March 7, 1947, p. 1; "Newspaper Columnist Hurls Verbal Barrage at Solvang," for daring to accept the name of 'Little Denmark' and article appeared in the Danish American newspaper '*Dansk Ugeblad*,' which is published weekly in Minneapolis. The editor's objections were more to the facts cited in the Danish historical culture film 'Cavalcade' and his visit to the town showed no Danish architecture or people speaking Danish and to her the celebration "Denmark's Day" is only propaganda, *SYVN*, March 14, 1947, p. 1; "Two Ex-GI's Will Establish Danish Inn, Motor Court Here. Ever since the *Saturday Evening Post* wrote a descriptive article on Solvang entitled 'Little Denmark,' the town has played host to a great number of visitors. … Asselstine and Dukek … plan to start construction immediately on a Danish Inn… proposed development will be of Danish or provincial architecture…," *SYVN*, April 18, 1947, p. 1.
1948 – "Doors Open Tomorrow at Copenhagen Square…," *SYVN*, March 12, 1948, p. 1.
1950 – Illus. and "Danish Village Theatre Remodeling Scheduled Soon," *SYVN*, July 21, 1950, p. 1;
1951 – Site plan of proposed Lutheran Home designed by Riner C. Nielsen of Los Angeles, *SYVN*, Dec. 7, 1951, p. 1.
1952 – "Nearly 1000 Attend Opening of Solvang Inn…," *SYVN*, July 4, 1952, p. 5.
1953 – "**Ferdinand Sorensens**' Quaint Windmill, Danish-Style Architecture Proves to be Popular Tourist Attraction," and photos of house and windmill, and interior, and stone cottage, *SYVN*, June 19, 1953, pp. 1, 2, 6; "$200,000 Motel, shopping Center Planned for Solvang… 40-unit motel and a nine-store shopping area … on Mission Drive bounded by Spring street," *SYVN*, Sept. 4, 1953, p. 1; "Solvang Gaard Converted from Apartment House to Motel … 'First Motel' for Solvang Now Operating," *SYVN*, Nov. 6, 1953, p. 1.
1956 – "Solvang Retailers Endorse New Store Fronts, Parking Plans, Store fronts along Danish provincial architectural lines…," *SYVN*, Sept. 21, 1956, p. 1; photo of construction and caption reads "Business people along the west side of Solvang are going ahead with plans to re-model their establishments to Danish style architecture…," *SYVN*, Nov. 9, 1956, p. 7.
1957 – "Solvang Rest Rooms Construction Slated," *SYVN*, April 26, 1957, p. 1; "Danish Architecture" to be used in new Post Office, *SYVN*, July 12, 1957, p. 1.
1958 – Photo of "windmill" and "Solvang Provincial Style Building Trend Continues. A post World War II trend toward developing a Danish style type of architecture in Solvang, reflecting the community's Old-World heritage, moves with full force today as work continues on converting the fronts of two of the largest buildings along Copenhagen Drive…," *SYVN*, May 2, 1958, p. 5.
1959 – "Danish Quarter… architecture…," *SYVN*, June 26, 1959, p. 2; "Thumbelina Village Hosts Opening Tomorrow… a planned community of ranch style, custom designed, three-bedroom, two bath homes along Highway 150 east of Buellton… carried out in stages," Nick Paola, artist-designer-builder, resides in Bakersfield," *SYVN*, Nov.

27, 1959, p. 1; "New Solvang Shopping Center to Feature Danish Styled Shops, Motel, Restaurant…," developer Raymond M. Paaske, *SYVN*, Dec. 25, 1959, p. 1.
1960 – "New Solvang Recreation Club" and photo of model, *SYVN*, Aug. 19, 1960, p. 1; "'Denmark City' Amusement Park Proposal Unfolded … slated for 145 acres on three levels of a parcel of land lying north of the Santa Ynez river and roughly between Highway 150 and Alisal Rd., adjacent to the town of Solvang… Danish architect Svend V. Peschardt, of Beverly Hills, had presented the sketches… replica of a Danish city… application for rezoning of the land from agricultural to planned residential and planned commercial…," *SYVN*, July 29, 1960, p. 1; "Architect for 'Denmark City' Describes Plans… a castle… windmill… bell carillon…Old Town… various trades and shops… Country Town with its farms and stables… Revolving exhibitions of all trades are shown inside the old farm houses… windmill grinds the flour… H. C. Andersen Garden [complete with characters from his folk tales],… Hamlet bowl [open air theater]… Viking City [as it was 1000 years previous] … great Hall of Odin [restaurant] … a show is performed every night… Saga Land where inside hills and grottos the tales and legends will live forever… train… Frederick IX Inn where next morning a wonderful Danish breakfast…," *SYVN*, Aug. 12, 1960, pp. 1, 10; "Denmark City Hearing Off… [project] temporarily abandoned…," *SYVN*, Sept. 23, 1960, p. 5.
See: "Architecture (Northern Santa Barbara County)," "Elverhoj Museum"

Arellanes, A., Miss (Santa Maria)
Exh. "Santa Barbara County Fair,"1886.
Is this "Artemisa" from Graciosa who married Enrico Bonetti? or Miss "Amelia" from Graciosa who d. 1888?
See: "Santa Barbara County Fair," 1886

Argus **(Santa Ynez)**
Santa Ynez Valley's first newspaper, 1887. NOT indexed in this publication.
Photo of front page, *SYVN*, Sept. 17, 1954, p. A-1.

Ark, The (Santa Maria)
Name of the Stanley Breneiser home. Meeting place for the College Art Club and various cultural events, c. 1927-35.
See: "Breneiser, Stanley," "College Art Club"

Arklin, Haig (1881-1965) (Los Angeles)
Painter / entertainer who lectured on Old Masters throughout the U. S. and who presented a symposium at Santa Maria High School, 1924.
■ "Haig Arklin ... For many years [beginning c. 1910] he gave critical expositions on the famous masterpieces of painting. He made copies of these masterpieces and the copies were used in stereopticon views illustrating his talks. He lectured at the Ebell Club in 1912," per Nancy Moure, *Publications in California Art*, vol. 3 and further bibliography in vol. 8.

Arklin, Haig (notices in California Newspapers on newspapers.com)
1910 – "Haig S. Arklin, until recently of Fowler, has taken up a new line of work in which he is immediately gaining recognition... He is now Prof. Haig Arklin of Pasadena and is ready to fill lecture engagements, his outfit being a fine stereopticon with sets of beautiful slides... Mr. Arklin has already made contracts with the Shakespearian Club of Pasadena... 'Biblical scenes through the Prophetic Vision of the Old Masters' is the title of another lecture which he is prepared to give and illustrate...," *Fowler Ensign* (Fowler, Ca.), July 16, 1910, p. 4; "Art Symposium at High School... 'World's Famous Paintings'... Stereopticon reproductions ... are exquisite miniatures painted by himself in transparent oil and the sumptuous 12-foot image cast upon the screen... Mr. Arklin is ... also a critic of deep insight... Moreover, Arklin is a remarkably fine reader. Rarely do we find a platformist possessing such dramatic powers as he shows while depicting 'the tragic in art,' or 'the sublime in nature'," *Hanford Sentinel*, Dec. 9, 1910, p. 3.
1919 – "M. L. Weigle Sold 80 Acre Ranch... Haig Arklin, an Armenian, formerly a resident of Kingsburg, has purchased the 80-acre ranch of M. L. Weigle, located four miles northwest of Tulare. The ranch comprises a big vineyard and orchard and is one of the best irrigated tracts in this locality," *Tulare Advance-Register*, May 1, 1919, p. 5; [This property was foreclosed upon in 1924.]
1927 – "Southland is Widely Known as Art Center... Haig Arklin was born in New York but was taken during early childhood to Italy where he studied in Rome under Andrea Allinari. He completed his studies in Paris and London. ... He spoke of modern art and said the impressionistic, cubistic, futuristic, so-called modernistic movement is a crazy fad...," *Santa Ana Register*, Feb. 8, 1927, p. 6; "Is Exhibiting Paintings by Old Masters... talented actor and painter... Mr. Arklin spent some time in Europe recently, visiting the art galleries and the churches where the originals of these old masterpieces are placed. The reproductions which Mr. Arklin has in his collection were painted by his own hands from the originals," *Napa Valley Register*, Oct. 21, 1927, p. 5.
1965 – "Arklin, Haig, of Granada Hills, passed away June 5, beloved husband of Queenie Takoohie Arklin, beloved father of Florindo, Henry and the late Virgil P. Arklin...," *LA Times*, June 7, 1965, p. 51 (i.e., pt. III, p. 9).
And, more than 170 hits for "Haig Arklin" in California newspapers, and another 160 in U. S. newspapers outside California, 1900-1965, primarily regarding his lectures, digitized on newspapers.com, were not all itemized here.
See: "Santa Maria, Ca., Union High School," 1924

Armitage, Merle (1893-1975) (Los Angeles)
Empresario, collector of prints exhibited at College Art Club, 1935.
■ "Merle Armitage (1893 - March 15, 1975) was an American set designer, tour manager, theater and opera producer, author, and book designer," per Wikipedia.
See: "Art Festival," 1935, "Breneiser, John," "College Art Club," 1935, "Community Club (Santa Maria?)," 1935, "McGehee, Ramiel," "Weston, Brett," 1931

Armitage, Roblan Frank (1924-2016) (Australia / Santa Ynez Valley / Hollywood)
Exh. first annual Santa Ynez Valley Art Exhibit, 1953.
■ Port. and "Roblan Frank Armitage (5 September 1924 – 4 January 2016) was an Australian-born American painter and muralist, known for painting the backgrounds of several classic animated **Disney** films, designing areas of and painting murals for Walt Disney World and Tokyo Disney Sea, and his biomedical visualization artwork," per Wikipedia; port. at his easel and "Frank Armitage, Famed Disney Artist and 'Fantastic Voyage' Illustrator, Dies at 91," *Hollywood Reporter*, 1/7/2016 (on the Internet).
Armitage, Frank (notices in Northern Santa Barbara County newspapers on microfilm and on newspapers.com)
1953 – "An Australian whose specialty is murals. Married to the former Joan Drake of the Valley, Armitage recently returned from Jamaica where he had a one-man show...," *SYVN*, Jan. 23, 1953, p. 6.
See: "Santa Ynez Valley Art Exhibit," 1953

Arrow Blueprinting (Lompoc / Santa Maria)
Blueprinting office. Prop. Mrs. Gertrude Brown 1947+.
Props. John and Betty Borquist, 1955+.
■ "Blueprinting Office Opened … headquarters in Santa Maria… 214 ½ East Ocean avenue. The firm is operated by John and **Betty Borquist**. The latter will be in charge of the Lompoc office. Services being offered include various blueprinting and design reproduction processes and drafting supplies. The firm has been in existence for the past 11 years," *LR*, Oct. 30, 1958, p. 15.
Arrow Blueprinting (notices in Northern Santa Barbara County newspapers on microfilm and on newspapers.com)
1953 – Strictly Business. Mrs. Gertrude Brown, owner-operator… formally re-open… at 311 N. Lincoln, following a removal of the business from 103 E. Bunny. Mrs. Brown established Santa Maria's only blueprinting business six years ago last August… In her new quarters she has expanded work facilities appreciably," *SMT*, Oct. 21, 1953, p. 6.
1954 – "Mrs. Brown… Mrs. Gertrude Brown, owner-manager of Arrow Blueprinting…," *SMT*, Aug. 26, 1954, p. 9.
1955 – "Certificate of Individual Transacting Business Under Fictitious Name… John W. Borquist…. Arrow Blueprinting…," *SMT*, July 19, 1955, p. 9.

Arrow Portrait Studio / Arrow Photo / Arrow Photo Finishers / Arrow Photo Club? (Santa Maria)
Photography studio, 120 East Church St., SM, 1945+.
Prop. Robert V. Stratton, and after 1952, Henry A. Datter.
Arrow (notices in Northern Santa Barbara County newspapers on microfilm and on newspapers.com)
1945 – "Special Sale 122 Roll Film. Arrow Photo…," *SMT*, Aug. 24, 1945, p. 2.
1946 – "Order Your Xmas Portraits Now. See Us for Personalized Photographic Xmas Cards. Prices Have Not Advanced. Arrow Photo…," *SMT*, Nov. 19, 1946, p. 5.
1948 – "Photography. Arrow Photo. 120 E. Church. PH. 115-W. Portraits – Commercials – Finishing," *SMT*, Sept. 24, 1948, p. 2.

1949 – Repro: "Health Spigot," *SMT*, April 23, 1949, p. 8; repro: "Commendable Cop," *SMT*, May 3, 1949, p. 1; repro: "Queen of the May," *SMT*, May 3, 1949, p. 5; "Arrow Photo Studio. Santa Maria's Most complete Photographic Studio. Child Photography a Specialty. 120 E. Church. Phone 2079," *SMT*, Sept. 13, 1949, p. 8; repro: "Comfort and Charm," *SMT*, Sept. 30, 1949, p. 9.

1950 – Repro: "Say It with Flowers," *SMT*, Jan. 23, 1950, p. 1; "No Damage in Blaze at Photo Concern… workmen had been using a torch to cut a pipe… Fire got into the wall…," *SMT*, April 8, 1950, p. 1.

1952 – "Notice of Intended Sale… **Robert V. Stratton** will sell at private sale the personal property hereinafter described to **Henry A. Datter**… All of the fixtures, equipment, supplies and stock in trade of that certain photo finishing business… at 120 East Church Street… known as 'Arrow Photo Finishers'…," *SMT*, Nov. 13, 1952, p. 10.

1954 – "**Harry Lane. Troy Compton**. Lane-Compton Air Photos. Commercial and aerial photography. Associated with Arrow Photo Finishers. 120 E. Church St.," *SMT*, March 13, 1954, p. 5.

1955 – "TV Program Log… Friday – KSMA, Arrow Photo Club," *SMT*, Sept. 22, 1955, p. 10.

1957 – "TV Program Log. Radio… 7:45 – Arrow Photo Club…," *SMT*, Oct. 16, 1957, p. 7.

Art, general (Ballard)

Site of the progressive Ballard School.

1947 – "The Readers Corner… Something different in Ballard? Every day a group of young artists line up behind George's barn to paint on their canvases the beautiful historical and monumental buildings on the other side of Main Street, and hardly a week passes without a feature writer or a well-known lecturer having something to say about our beloved home…," *SYVN*, Oct. 31, 1947, p. 4.

See: "Ballard School," "Chrimes, Louise," "Davison, Grace," "Fields, Iva," "Forsyth, Joseph," "Forsyth, Sarah," "Lyons, Jeannette," "Sandvik, Uno"

Art, general (Buellton / Buell Flats / Buell's Flat)

Located at the crossroads of Highway 101 (constructed 1914), a major north-south state highway, and State Route 246, that led westward to Lompoc and eastward to Solvang. Home of Andersen's Pea Soup Restaurant. After WWII a potential site for a colony of handicrafters displaced from Europe by the war.

Art, general (Buellton) (notices in Northern Santa Barbara County newspapers on microfilm and on newspapers.com)

1926 – "Among the handiwork being done by the Buellton ladies are some very attractive baskets. Those exhibit [Sic.?] works of the weaver's art are: Mrs. O. R. Skinner, Mrs. Wm. Budd, Mrs. Andersen, **Mrs. Odine Buell** and Mrs. Mercer," *SYVN*, June 4, 1926, p. 4, col. 2.

1949 – "Reveal Plans for DP Colony… A plan conceived more than a year ago by Odin Buell of La Rancheria for the establishment of a colony for displaced persons in Buellton was apparently beginning to take form this week as an announcement was made by the William Zimden Foundation of promised support for the project… [as long as others also contribute] The colony in the Valley would

consist of 25 families of skilled workers from the Baltic states who would be settled on land in the Buellton area owned by Odin Buell or other members of the Buell family. The fund being raised would be used for providing housing and working capital to enable craftsmen to purchase tools and equipment… 'This committee has lists of people, investigated and screened, of Baltic origin, who are handicraftsmen in many fields, both men and women who, in their home countries, before having had to flee into the DP camps, were skilled workers being artisans of leather craft, metal work, wood work, weaving, embroidery, shoemaking, etc. … 'The main problem probably is housing, which must be guaranteed in the application for the entry into this country for any such people and also for working capital for at least the first year'…," *SYVN*, April 29, 1949, p. 8; "Legion Post Opposes DP Colony in Valley. Claiming the importation of displaced persons… might endanger the employment status of local veterans…," *SYVN*, May 13, 1949, p. 1; letter-to-the editor for DP colony from F. W. Nordhoff, *SYVN*, May 20, 1949, p. 2; "LA Paper Features DP Colony Plan…," *SYVN*, May 27, 1949, p. 5.

1960 – "Delay Seen in Opening New School," *SYVN*, Aug. 12, 1960, p. 2.

See: "Andersen's Pea Soup Restaurant," "Architecture (Northern Santa Barbara County)," 1947, 1959, "Buell, Josephine," "Buellton, Ca., Adult/Night School," "Displaced Persons Colony," "Ferslew, Irna," "Gardner, Margaret," "Handcrafts," 1926, "Hauben, Lawrence," "Hibbitts, Forrest," "Hibbits, Marie," "Knowles, Joseph," 1938, "Kuelgen, Mary," "Kuelgen, Paul," "La Petite Galerie," "Lompoc Valley Fair," 1933, "Negus, Annette," "Neil, Milt," "Peake, Channing," "Rubey, Ervin," "Santa Barbara County Library," "Santa Ynez Valley, Ca., Elementary Schools"

Art, general (Camp Cooke/ Vandenberg AFB)

Military base near Lompoc. Named Camp Cooke 1941-58 and afterwards Vandenberg Air Force Base.

Art (whittled wood) was produced by German prisoners of war during WWII. Photography was produced by American military personnel employed in the Signal Corps Office (responsible for Public Relations) and some art by those in the Training Aids section. Handicrafts were produced by soldiers recuperating from injuries at the hospital. Photography and art were produced privately by artistically inclined American military personnel. Some military personnel owned collections of art and objects d'art acquired on various assignments, particularly from Japan. During WWII, USOs taught both crafts and photography. During the Korean War the Lompoc, Ca., Recreation Department started some recreation programs for servicemen at the former USO building, converted in 1947 to a city Community Center. At the U. S. Disciplinary Barracks vocational arts were taught. Art was supported by the Officer's Wives Club.

Art, general (Camp Cooke), (notices in Northern Santa Barbara County newspapers on microfilm)

WWII – ■ "Thanks to a deal swapping some cigarettes for wood carvings 50 years ago, two sisters received items from the Central Coast's all but forgotten role in World War II. The wood carvings, shared by **Herman Menezes'** daughters, are part of the legacy left from German soldiers imprisoned at Camp Cooke – now Vandenberg Air Force Base – during World War II. Camp Cooke, which opened as an armored and infantry training site in 1941, also housed a POW camp from 1944 to 1946, when up to 2,000 prisoners were incarcerated. … Oceans away from combat, Menezes' carvings by the POW's themselves paint a pacific picture of the captivity. A Santa Maria native who died in 1992, Menezes was an avid collector, according to his daughters, Santa Marian Ileen Barberena and Marjorie Tucker of Ventura. Their mother's brother, also named Herman, worked at Camp Cooke and acquired the carvings in a trade involving cigarettes. He then passed them to Menezes. … The carvings range from useful desk tools to decorative designs. A letter holder. An ink holder with an animal's head carved at one end. Two elephants sitting on half-circles featuring the words Camp Cooke. A six-inch wooden Indian Head Penny sports Camp Cooke and 'Amerika.' Included in the collection is a black-and-white photo of a German prisoner posing with his multipiece wood carving of a temple, featuring intricate designs. 'My dad called this an African Buddha temple,' said Tucker. 'I'm sure it had another name. He (the POW) won first prize for it.' While the crafts show the artists' talents, a recently published book tells about life at Camp Cooke for the POW's. Woodcarving was just one of the recreational activities by German prisoners of war held at Camp Cooke, according to '*German Prisoners of War at Camp Cooke, California*,' a book by Orcutt resident and Vandenberg historian Jeffrey E. Geiger. 'Painting and sculpture were less rollicking diversions among the POWs,' Geiger wrote. 'Talented prisoners fashioned ornate chess sets, figurines, and other articles from wood scrapings… Contests were held, and prizes were awarded by a panel of judges for the best paintings and handicrafts.' Conducting letter interviews over three years, Geiger includes recollections of 14 former POW's, compiling a sometimes poignant, sometimes amusing, sometimes dry look at life as a Camp Cooke prisoner of war. The POW camp was located near Ocean View Boulevard where Vandenberg AFB family housing is today. Ex-POW **Hans-Joachim Bottchar** arrived at Camp Cooke Nov. 4, 1944. 'My first impression of Camp Cooke was that this could be a place where one could breathe freely,' he told Geiger. 'The whole camp was generous in size and style.' Camp Cooke prisoners were contracted out to Santa Maria and Lompoc farmers, according to Geiger. Others worked at the Lompoc Johns-Mansville diatomaceous earth mining and processing plant. … For the most part, friendships flourished between captives and captors, 'transcending nationality and army prohibitions against fraternization,' … Escapes occurred from Camp Cooke, but others said they had no interest in leaving the POW camp before the war's end. … Secretly we were glad to be in captivity and in safe hands.' From theater to movies to orchestra to sports, inmates had a variety of very un-POW activities," per "Camp Cooke Remembered," *SMT*, Nov. 18, 1996, p. B-1.

1942 – "Santa Barbara Junior Chamber of Commerce has given two murals to Camp Cooke, one of the Santa Barbara coastline, the other showing the channel islands. Each mural is 20 feet long," *SMT*, May 9, 1942, p. 6, far right column; "I spied… A lifelike painting of a soldier on a poster in Camp Cooke gift headquarters on Main street, drawn by **Jo Ann Smith**, young daughter of the Leland Smiths," *SMT*, Dec. 14, 1942, p. 1.

1943 – "Army Old-Timer Views Facilities… Paying a brief visit to Service Club No. 1, the group inspected the different facilities of the building, the cafeteria, soda fountain, library, lounge and office. The art display, mural painting, various pianos… recreation equipment were introduced to the amazed veteran …," and the group saw the motor pool, sports arena, PX, etc., *SMT*, April 3, 1943, p. 2; "Handcraft by Soldiers on Display… soldiers of Camp Cooke Station Hospital… in the display window of the **public library**, arranged by **Mrs. Paul Nelson** … The work, done under the direction of **Mrs. Fred Hau**, is under the auspices of the Adult Education Department of the Red Cross in conjunction with Santa Maria high school. Featuring the use of scrap materials, the display includes leather work, such as belts, wallets, tags, and desk sets, tin ashtrays and a candelabra, jewelry and stencil work," *SMT*, Nov. 8, 1943, p. 3.

1944 – "**Janet Alexander** Takes Position at Station Hospital…as a craft worker and assistant in recreational therapy on the station hospital's Red Cross staff. A native of Watsonville, Miss Alexander was graduated in 1941 from San Jose State College, where she majored in education. She taught school for two years in Petaluma. **Miss Alexander** will assist in the arts and crafts program through which hospitalized GIs may fashion useful articles of wood, leather, plastic and pottery. Other projects available to ambulatory patients are clay modeling, charcoal sketching, painting with oil and water colors, airplane model making, rug and belt weaving, glass etching and linoleum block printing," *LR*, Dec. 15, 1944, p. 3.

1945 – "Murals from Camp Cooke Shown. Ten murals on the Christmas holiday theme painted by four men of the 386th Infantry Regiment, a unit of the 97th Infantry Division now stationed in Camp Cooke, went on exhibition this week in an Ojai art gallery. Displayed during the holiday season in the regiment's recreation hall… **Pfc. Addison Walker**'s 'Snowbird' portrays a ski jumper, while his 'Postman' is a life-sized caricature of a mail carrier. **Pfc. Dave Carman** painted tobogganers on 'Blackhawk Hill,' the hunter and deer in 'Archer's Prize' and the 'Skaters' in the mural of that name. Murals by **Pfc. Jeff Lewis** include 'Silent Night' and 'Cider and Doughnuts,' while **Pfc. Ralph Winters'** [Sic. **Winter**] contributions to the exhibit are entitled 'The Snowman' and 'Yule Log'," *SMT*, Jan. 15, 1945, p. 3; "Army Men's Paintings on Display … Ojai Art Center… One of the men had gained some useful technical knowledge and skill working as a sign painter. One or two others had worked a little at painting but none had specialized. The enterprise was carried out under the supervision of the officer in charge of recreation… himself a musician. The sketches approved by him were painted full size on large sheets of carton [sic.?] paper. The men

worked on the sheets laid on the floor, borrowing and sharing limited equipment of brushes and color.... The titles of the paintings and the names of the artists are as follows: 'Yule Log' by **Ralph Winter**, Sacramento; 'The Archer's Prize,' by **Dave Carmen [Sic. Carman]**, Madison, Wis.; 'Black Hawk Hill,' by **Dave Carmen [Sic. Carman]**; 'Snow Man' by **Ralph Winter**; 'The Postman' by **Addison Morton Walker**, Kansas City, Mo.; 'Silent Night by **Jeff Lewis**, Florence, N. C.; 'The Snow Man' by **Addison Morton Walker**; 'Cider and Donuts' by **Jeff Lewis**; 'The Skaters' by **Dave Carmen [Sic. Carman]**, and 'Dinner is Served' by **Jeff Lewis**," *Ventura County Star-Free Press*, Jan. 20, 1945, p. 7.

KOREAN WAR

Art, general (Camp Cooke) (Notices in *Cooke Clarion*, Feb. 23, 1951-Dec. 3, 1952, scattered copies, Cpl. **Burton C. Blanchard**, Staff Artist.)

"Camp Cooke 'Clarion' Makes First Appearance Since '46. … The Clarion was published weekly from 1942 to 1946… Pfc. Burton C. Blanchard is staff artist… The Clarion is to be published every Friday and is printed by The Times," SMT, Sept. 29, 1950, p. 1;
1951 – Clarion – "Service Club Activities… Service Club No. 1… Monday, 26 February, 19:30 hours, Light Crafts… Service Club No. 2. … Sunday, 25 February, 19:30 hours, Colored Slides, Monday, 26 February, 19:30 hours, Crafts – Copper Tooling…," *Clarion*, Feb. 23, 1951, p. (2); "Service Club Activities … Sunday, 29 April, 13:00 hours, Camera Tour… Wednesday, 2 May, 20:00 hours, Crafts, … Thursday, 3 May, 20:00 hours, Crafts. … Service Club No. 2… Monday, 30 April, 18:00 hours, Crafts, Tuesday, 1 May, 18:00 hours, Crafts, 19:30 hours, Sketching," *Clarion*, April 27, 1951, p. (2); "Service Club Activities. Service Club No. 1… Monday, 11 June, 19:30 hours, Crafts … Tuesday, 12 June, 19:30 hours, Crafts… Wednesday, 13 June, 19:30 hours… Crafts, Camera Club… Service Club No. 2… Tuesday, 12 June, 18:30 hours, Sketch Artist…," *Clarion*, June 8, 1951, p. (2); "Service Club Activities … Monday, 18 June, 19:30 hours … Crafts… Tuesday, 19 June, 19:30 hours… Crafts… Wednesday, 20 June, 19:30 hours, Crafts, Camera Club… Service Club No. 2… Tuesday, 19 June, 19:00 hours, Sketch Artist…," *Clarion*, June 15, 1951, p. (2); photo of parade float and caption reads "Independence Day – Units from Camp Cooke … participated in the Fourth of July parade held in Lompoc… The 747th Amph T. & T. Sn. Marched… [and photo of] 'Dixie Doll' an amphibious tractor of the 747th …," *Clarion*, July 13, 1951, p. 1; "Service Club Activities. Service Club No. 1… Saturday, 14th July, 2000 hours… Crafts, Sunday, 15th July, 10:30 hours… Crafts… Monday, 16 July, 2000 hours… Crafts, Tuesday, 17 July, 19:30 hours… Crafts… Wednesday, 18 July, 19:30 hours… Camera Club – Crafts… Service Club No. 2, Friday, 13 July, 2000 hours… Crafts… Monday, 16 July, 19:30 hours, Light Crafts," *Clarion*, July 13, 1951, p. 2; "Service Club Activities. Service Club No. 1… Monday, 30 July, 2000 hours … Crafts… Tuesday, 31 July, 19:30 hours… Workshop – Crafts, Wednesday, 1 August, 19:30 hours … Crafts, Camera Club…," *Clarion*, July 27, 1951, p. (2); "Service Club Activities. Service Club No. 1… Monday, 6 August, 19:30 hours – Crafts… Tuesday, 7 August, 19:30 hours – Crafts… Wednesday, 8 August,

19:30 hours – Crafts… Camera Club… Service Club No. 2… Monday, 6 August, 19:30 hours – Crafts…," *Clarion*, Aug. 3, 1951, p. 2; "Service Club Activities. Service Club No. 1… Monday, 13 August, 19:30 hours … Crafts… Tuesday, 14 August, 19:30 hours… Crafts … Wednesday, 15 August, 19:30 hours – Crafts… Camera Club… Service Club No. 2… Monday, 13 August, 19:30 hours, Crafts…," *Clarion*, August 10, 1951, p. 2; "**Camera Club** Meets… at 1930 hours each Wednesday at Service Club No. 1 now has acquired the facilities of a complete darkroom for the use of members. A model has also been obtained for one evening session. All active camera fans, whether amateur or professional, are encouraged to take part in the Club's regularly scheduled programs," *Clarion*, Aug. 10, 1951, p. 4; "Service Club Activities. Service Club No. 1. … Monday, 20 August, 19:30 hours … Crafts… Wednesday, 22 August, 19:30 hours… Crafts… 2000 hours … Camera Club… Service Club No. 2… Monday, 20 August 1800 – Crafts…," *Clarion*, Aug. 17, 1951, p. 2; "Service Club Activities. Service Club No. 1… Monday, 27 August, 2000 hours … Crafts… Tuesday, 28 August, 19:30 hours… Crafts… Wednesday, 29 August, 19:30 hours … Camera Club… Thursday, 30 August, 19:30 hours… Crafts… Service Club No. 2… Monday, 27 August, 19:00 hours, Crafts …," *Clarion*, August 24, 1951, p. 2; "Service Club Activities… Monday, 17 September, 19:30 hours – Crafts… Tuesday, 18 September, 19:30 hours, Crafts… Wednesday, 19 September, 19:30 hours … Crafts… Thursday, 20 September, 19:30 hours – Crafts…," *Clarion*, Sept., 14, 1951, p. 2; "Service Club Activities… Monday, 24 September, 19:30 hours – Crafts… Tuesday, 25 September, 19:30 hours – Crafts… Wednesday, 26 September, 19:30 hours – Crafts… Thursday, 27 September, 20:00 hours… Camera Club, Crafts… Service Club No. 2… Tuesday, 25 September, 17:30 hours – Sketch Artist," *Clarion*, Sept. 21, 1951, p. 2; "Service Club Activities. Service Club No. 1 …Monday, 1 October, 19:30 hours … Crafts…Tuesday, 2 October, 19:30 hours – Crafts… Wednesday, 3 October, 19:30 hours – Crafts… 20:00 hours… Camera Club, Thursday, 4 October, 19:30 hours – Crafts… Service Club No. 2… Monday, 1 October, 19:30 hours – Light Crafts…," *Clarion*, Sept. 28, 1951, p. 2; "Service Club Activities. Service Club No. 1… Monday, 22 October, 19:30 hours… Crafts… Tuesday, 23 October, 19:30 hours … Crafts… Wednesday, 24 October, 2000 hours, Camera Club… Service Club No. 2… Monday, 22 October, 2000 hours… Christmas Crafts…," *Clarion*, Oct. 19, 1951, p. 2; "Service Club Activities. Service Club No. 1… Monday, 29 October, 19:30 hours… Crafts… Tuesday, 30 October, 19:30 hours – Crafts… Wednesday, 31 October, 19:30 hours – Crafts, Camera Club… Thursday, 1 November, 19:30 hours – Crafts… Service Club No. 2… Monday, 29 October, 2000 hours – Christmas Crafts Party…," *Clarion*, Oct. 26, 1951, p. 2; "Service Club Activities. Service Club No. 1… Monday, 5 November, 2000 hours… Christmas Crafts. Tuesday, 6 November, 2000 hours… Christmas Crafts. Wednesday, 7 November, 2000 hours … Christmas Crafts. Thursday, 8 November, 2000 hours … Christmas Crafts. Service Club No. 2… Monday, 5 November, 2000 hours – Christmas Crafts…," *Clarion*, Nov. 2, 1951, p. 2.

1952 – Clarion – "Service Club Activities… Service Club No. One… Monday – Crafts…," *Clarion*, March 21, 1952, p. 4; "Former S&S Artist Contributes Cartoon on 44th's Departure. Contributor of the 'change of address' cartoon on page 4 is **Cpl. Robert C. James**, former feature illustrator for *Stars and Stripes*' Pacific Edition and currently assigned to Camp Cooke as a graphic illustrator in the Training Aids Section…," *Clarion*, Dec. 3, 1952, p. 1, 4.

Art, general (Camp Cooke) (notices in Northern Santa Barbara County newspapers on newspapers.com)
1952 – Photo and caption reads, 'Official Thanks… persons for their volunteer services provided soldiers hospitalized at Camp Cooke… assisted with the arts and crafts program in the hospital," *LR*, Jan. 24, 1952, p. 5.

VANDENBERG AIR FORCE BASE

1958 – "Recreational Facilities Become Available…under the control of the Personnel Services Section… All three clubs – NCO, Officers and Airmen's Clubs – come under the jurisdiction … a number of other activities in operation for the off duty use of Cooke AFB men and their families including the theatre, library, education center, gymnasium, automotive hobby shop, and two recreational areas, one at Lake Canyon and the Surf Beach Recreational area… A multi-purpose hobby shop, to include photography, ceramics, leathercraft and other arts and crafts should open shortly thereafter…," *SMT*, July 14, 1958, p. 6;

■ "Vandenberg Air Force Base personnel will have another outlet for their leisure off-duty time when the multi-purpose Hobby Shops building opens soon. The building will contain woodworking, ceramics, photo and electronics shops. The woodworking shop will be a 'Carpenter's dream' with a large variety of equipment. Hand tools of all types, a drill press, band saws, lathes, table saws and joiners, etc. have been installed in the shop. Over 200 different molds, two baking kilns, paints, clays and other tools needed will be contained in the ceramics shop. The line of molds contains every item from a small ash tray to a huge flower pot. The photo shop section of the building consists of a film developing room, a projection room and a finishing room. These rooms contain all types of photo equipment and are well ventilated. The projection room has a 33 mm, a 4 x 5 and a 2 ¼ inch enlarger. And added attraction for motion picture enthusiasts is the 16 mm projector and editor. Three print dryers and two washers along with finishing tables have been placed in the finishing room. …" per "Vandenberg Plans Base Hobby Shop," *SMT,* Nov. 20, 1958, p. 12; ■ "Hobby Shop Now Open at VAFB. …," and repeat of information in *SMT*, Nov. 20, 1958, per *LR*, Dec. 4, 1958, p. 24.
1959 – "Popsicle Purse … and planter log were seen at the NCO Wives Club in a display by Mrs. Paul H. Bryant at their last meeting. The display was to indicate what people can do in their own home with ceramics and everyday articles…," *LR*, Aug. 13, 1959, p. 4; "Convair Wives Get Pointers… Oriental flower arrangements were created by **Mrs. R. E. Clapper** of Santa Maria recently when she gave a demonstration for Convair Wives in the Vandenberg AFB Officers Club. Mrs. Clapper attended a school of flower arranging in Japan while her husband was stationed there and offered pointers to the 70 members present…

Centerpieces for the tables were arranged by Mrs. Clapper in vases made by the Convair Wives ceramics class in Lompoc," *LR*, Oct. 8, 1959, p. 5; "Vandenberg Boasts Big Youth Recreation Plan. The Youth Recreation and Sports Program at Vandenberg… is one of the biggest in the Air Force. … Besides the sports, the Youth Center is of most modern design, fully equipped and located right in the Capehart area where presently 1405 families reside… and in the Main Youth building… classes are planned for arts and crafts," *LR*, Oct. 26, 1959, p. 8.
1960 – "NCO Wives… Celebrating their second anniversary as a club… Members approved a motion that ceramic cups especially made by **Mrs. Ross Mangona/e** and her newcomers committee be awarded to all members in good standing being transferred to Vandenberg, as a memento of their membership in Vandenberg NCO Wives Club," *LR*, June 20, 1960, p. 4; "NCO Wives Plan Big County Fair… on October 18 at 1:30 p.m. in the NCO Club. The program will feature exhibits, a cake contest and games. On display will be collections of Wedgewood, Hummels, wood carvings, oil paintings and antiques plus hand painted china and assorted works in ceramics," *LR*, Oct. 10, 1960, p. 10; ■ "Unique County Fair – Visiting Vandenberg. The NCO Wives Club of Vandenberg turned the Club dining room into a fantastic County Fair, Tuesday. The displays varied from collections of Wedgewood china to a table full of dried flowers. In between these two extremes one found hand carved wooden pieces from the South Pacific, antiques collected from all over the world, paintings done or owned by members, and an exquisite collection of Hummel figures, including the seldom seen Nativity scene. … Mrs. Vee Sadler, in charge of the needlework table, had everything from tatting to quilting. There were prized pieces made by loving grandmothers and modern works by members of the club. Christmas decorations were shown by Mildred Tyler … Tricks with Styrofoam, pipe-cleaners and ingenuity made the Decorations booth a popular place. One Christmas tree was made entirely of painted spools. An unusual display of guns, ancient and modern, was flanked by ceramics and wood carvings. … the ceramics by **Fran Levingston** and the wood carvings by **Bobby Jones**. The Art Exhibit, handled by Peggy Jones, displayed some talented artists from the club. One, an oil, was painted by Janice Skinner, 13-year-old daughter of member Liz Skinner. In the same room with the art exhibit, James Bedore, aged 12, son of member Roberta Bedore, displayed his fine collection of sea shells picked up at Bikini after the atomic explosion. There was a cake baking contest for members…," *SMT*, Oct. 22, 1960, p. 3.
See: "Baird, Bobbie J.," "Camp Cooke," "Carey, E. T., Lt.," "Conover, Roy, Pfc.," "Haemer, Alan," "Hansen, Lorrayne," "Kern, Barbara," "Kern, Agnes," "Leslie, John," "Lompoc, Ca., Recreation Department," Korean War, "Marion, Harue," "Naval Missile Facility (Point Arguello)," "Photography, general (Camp Cooke/ Vandenberg AFB)," "Rogers, Alma," "Santa Barbara County Library (Santa Maria)," 1943, "Sculpture (Camp Cooke)," "Sicard, Pierre," "Spindler, Cliff," "United Service Organization," "United States Disciplinary Barracks," "Vandenberg AFB," "Waldron, Ralph," "Zachman, Harold"

Art, general (Casmalia)
See: "Casmalia, Ca., schools," "Veglia, Mario"

Art, general (Cuyama)
Several artists painted landscapes of Cuyama.
See: "Ballenger, E.," "Ballenger, Margaret," "Posters, American Legion (Poppy) (Cuyama)"

Art, general (Gaviota)
Although located south of the Santa Ynez Mountains, this area was rural and often clumped with the ranching area north of the mountains. Gaviota Pass was the subject of landscape paintings. Santa Ynez Valley High School art students made painting excursions to Gaviota Beach.
See: "Boyer, Mary," "House, Elmer," 1932, "May, Dick," "Petersen, P.," "Quilts," 1930, "Santa Barbara County Fair," 1931, "Santa Ynez Valley, Ca., Adult/Night School," 1947, "Santa Ynez Valley, Ca., Elementary," 1927, "Sculpture, general," 1937, "Sheets, Millard," "Vista del Mar school," "Wright, Stanton," "Wygal, Elsa,"

Art, general (Guadalupe)
Small town on the coast SW of Santa Maria. Its high school age students attended Santa Maria High School. This heading contains articles that do not fit under other, more specific headings, in this Dictionary.
Art, general (Guadalupe) (notices in Northern Santa Barbara County newspapers on microfilm and on newspapers.com)
1935 – "Guadalupe to Honor its Saint… Ancient Painting to be Presented to Church at Christmas time… Fr. Canseco discovered in the Guadalupe church a painting of Our Lady of Guadalupe which had been presented to the diocese of California by the church in Mexico in 1841. Later it was presented by the bishop of California to Mission Santa Ines, and when a church was erected in Guadalupe, the painting was presented to the Guadalupe parish. Fr. Canseco has sent the painting to Los Angeles for renovation…," *SMT*, Oct. 9, 1935, p. 2.
See: "Amido, Ben," "Aratani, Setsuo," "Ayres, Angie," "Bixby, Barbara," "Carlin, David," "DeGasparis, Lucy," "Fukuto, S.," "Guadalupe, Ca., Elementary School," "Guadalupe Welfare Club," "Ikeda, Victor," "Lauritzen, Dillon," "Minetti, Italo," "Motion Pictures (Guadalupe)," "Oishi, Yoshisuke," "Okamoto, Ada," "Pezzoni, Lily," "Photography, general (Guadalupe)," "Posters, American Legion (Poppy) (Guadalupe)," "Signorelli, Guido," "Smith, Pearl," "Ueki, Masuo,"

Art, general (Lompoc)
Town in the center of a valley of flower fields, and within its sphere is Mission La Purisima, the Johns-Manville plant, and Camp Cooke / Vandenberg AFB.
This heading contains articles that do not fit under other, more specific headings, in this Dictionary.
Art, general (Lompoc) (notices in Northern Santa Barbara County newspapers on microfilm and on newspapers.com)
1877 – "Beautiful Pictures. We have received from the Fine Art Publishing House of Geo Stinson & Co., Portland, Maine, several pictures recently published by them…. Works of high art… They publish every description of fine works of Art from a chromo to a photograph – from a fine crayon drawing to the elegant Steel Engraving… are at present in want of a large number of new agents…," *LR*, March 10, 1877, p. 2.
1895 – Ad: "*Sarony's Living Pictures*, a High-Class Monthly Magazine of Reproductive Art. Every number is a portfolio of fascinating beautiful pictures, every picture represents the work of some famous painter or an original composition by the great Sarony: in all, the figures are from living models after photographs by Sarony, reproduced with wonderful fidelity and effectiveness. For sale by all newsdealers at 25 cents a copy. $3.00 a year. A copy of Bouguereau's masterpiece, 'Cupid on the Watch,' will for the present be sent as a premium to every yearly subscriber," *LR*, Feb. 9, 1895, p. 3.
1899 – See 1930, below.
1914 – "More Sidewalks Ordered Down by Trustees … The proposition of the **Civic Club** to improve the municipality's appearance by having shade and ornamental trees planted on the streets was considered… The **Civic Club** are also contemplating the building of an appropriate gate or entrance to the Ryan [Sic. Ryon] Memorial park and have offered a prize to high school students who submit the best drawing for such an entrance…," *LR*, Oct. 23, 1914, p. 8; "Drawings for Park Entrance are Submitted," *LR*, Nov. 20, 1914, p. 1; "The prize offered by the **Civic Club** for the best drawing for an entrance way to Ryan Memorial park and which was competed for by the students of the high school, was awarded to Walter Lewis… The **Civic Club** will submit the drawing to a contractor for an estimate," *LR*, Dec. 18, 1914, p. 1, col. 3.
1915 – "**Civic Club** Submit Plans for Park Entrance… The drawings for the entrance way to Ryan Memorial Park were received from the Civic Club… made by Mr. John Smithers… The entrance way will cost in the neighborhood of $350 and the Civic Club will need some assistance from the city to complete it," *LR*, June 4, 1915, p. 1.
1936 – Repro. of antique bird's-eye view of Lompoc and caption identifies subjects of insets surrounding overview of town, *LR*, Sept. 4, 1936, p. 7.
1938 – "Curios and Art Exhibit… from many foreign countries will be displayed at the Methodist church today. Work of the Goodwill Industries will also be represented… The exhibit will be open from 4 to 5 o'clock in the afternoon and from 7 to 7:30 o'clock in the evening. The public is cordially invited. No admission is asked …," *LR*, Oct. 7, 1938, p. 6.
1940 – "Palaver [discusses naming Lompoc streets after flowers] … The Lompoc artist colony suggests that when the streets are flora-named the street signs might carry a

painting of the flower in natural colors as well as the spelling of the name….," *LR*, June 21, 1940, p. 5.

1949 – "Something about Nothing… Have you ever considered the pictures that hang on the walls of other people's houses? … indices of the character… landscapes [signify]… wide-open hearts and a yearning for unfettered living… photographs [signify]… feeling for family… etching of the cathedral at Nantes or perhaps a water color of a street in London [signify]… interest in distant places… flowers and masks … chosen for their decorative values … past president of the United States [signify]… veneration for the past … calendar art [signify]… their wants are unsullied and unimpaired by snobbish preconceptions…," *LR*, July 14, 1949, p. 1.

1956 – "Who Wants to Know About Lompoc… [letters received by the Chamber of Commerce] … What would you tell this inquiring artist? A man from La Canada writes that he is interested in bringing his wife and stopping at some nearby hotel or the like… 'Are there motel facilities at Surf? I would like to be within driving distance of the coast. Preferably the bold, rocky coast formations so that I can paint the rocks and surf. Does Point Arguello lend itself to such uses?' Would you send the man the word that Surf is nothing more than a railroad station with no commercial housing accommodations available and that Point Arguello meets the painting specifications but only persons specifically authorized by the Sudden Estate Co. are permitted free access. Or would you speak of the magnificent views available from open beach areas off our coast, list the hotels and motels in Lompoc, and stress that the city is located only ten miles from the ocean? From Los Angeles a professional photographer sends questions about the annual Flower festival. 'Is there street dancing… Do you have camp grounds or a park or school yard where one can sleep in a station wagon?... I am in the mood to shoot 100 or so colored slides…" *LR*, Sept. 13, 1956, p. 14.

1960 – "About Town [art on cars] Local Art – We have seen products of people's aesthetic abilities in almost every conceivable location. In restrooms, on billboards, subway station walls, caves (Indian drawings), sidewalks, children's bedrooms and highway tunnels… But as of late we have perceived a new candid easel – automobile fenders… messages…," etc., *LR*, Feb. 1, 1960, p. 6; Lompoc Toastmistress "Club Members… Theme for the March meeting will be 'Painters or Other Artists'," *LR*, Feb. 25, 1960, p. 4; "Air Force Art Exhibit on Display Tomorrow in Memorial building… **National Society of Illustrators**… 75 illustrations of Air Force activities around the world… Among the illustrated episodes of Air Force operations depicted… fighter planes stabbing through the night sky… Desolate, wind-swept outposts of the radar warning line across the arctic. Jet bombers far above the highest cloud layers… People of foreign lands watching in awe the take-offs and landings of the Air Force's mightiest fighters and bombers. Vandenberg is represented in the collection by a painting of the first Atlas launch by **Pierre Sicard**. Sicard stopped over at the Base in January of this year *en route* to a showing in Switzerland of his paintings of 'American Cities at Night.' The Air Force paintings presently are being seen … Los Angeles County Fair at Pomona," *LR*, Oct. 3, 1960, p. 11; port. of "**Mrs. James Lewis**, local art instructor… [and notables] seen as

they visited the Air Force Art Exhibit currently being shown at the Veteran's Memorial Building in Lompoc…," *LR*, Oct. 6, 1960, p. 29; "… we highly recommend the exhibit presently on display at the Veterans Memorial building in our town. The paintings were done by many of the nation's top artists on commission from the Air Force and tell the many-sided story of service life in the far corners of the earth. The variety of techniques and approaches represented in the show is startling. It is unquestionably the finest collection of illustrative art ever assembled in these parts…," *LR*, Oct. 6, 1960, p. 1; "H and Ocean" by HJC reveals the writer's personal opinions on art, *LR*, Oct. 20, 1960, p. 6.

1961 – "Six Artists Will Open Gallery [**Equinox**]… at the Evans Jewelry Shop, 117 south H Street. Participating will be **Forrest Hibbits, Marie Jaans, Mary Bondietti, Ethel Bailey, Elsa Schuyler** and **Dee Sudbury**… guest space… Occupying this space this week will be the work of **Elva Beattie**, wife of J. Edward Beattie, who has worked with ceramics, copper and other crafts for many years and has been studying painting with **Dee Sudbury** for approximately a year," *LR*, Nov. 20, 1961, p. 4.

1962 – "**Equinox Gallery** Adds to Lompoc Art Achievement. Lompoc is developing a veritable art colony with any number of groups meeting with instructors to learn more about painting, excellent programs for children in the summer and regular school sessions, group shows at the Flower Festival, a monthly exhibit at the library, occasional group shows at the Officers Wives Club and Service Club at Vandenberg, art department shows in the various women's clubs. One of the more recent innovations is the Equinox Gallery. Under the leadership of **Dee Sudbury**, well-known local resident who was born on what is now Camp Cooke, seven area painters display their work at 117 B South H, Evans Jewelry. They are nationally known **Forrest Hibbits** and his wife, **Marie Jaans** of Buellton, **Ethel Bailey, Elsa Schuyler, Mary Bondietti, Elva Beattie, Lathell [Sic. Lothell] Grossini** and **Dee Sudbury**. The collections are changed every three months, hence the name Equinox Gallery. Each month a guest artist is invited to display a group of paintings. During August Madelyn Ferrell, wife of Lt. Col. Frank Ferrell, is the guest artist. **Dee Sudbury**, who teaches a class in art to a group of friends without charge, and to children in the summer school program, is a graduate of Lompoc High School and earned a Bachelor of Arts degree at the University of California, Santa Barbara. **Ethel Bailey**, a former school teacher, was a prize-winner [at] the Tri Counties art exhibit four years ago and first in the Federation of Women's clubs last year. **Elva Beattie** had a ceramics studio in Lompoc for many years. **Forrest Hibbits** has achieved national recognition for his outstanding work, and his wife, **Marie Jaans**, from France, is well-known, too. **Elsa Schuyler**, another former school teacher, was a prize winner for two years in the Federation of Women's Clubs shows. Since the gallery opened last November, 120 paintings have been hung. Most are oils with some water colors and gouache. Subjects are varied to include still life, seascapes, landscapes and nudes. The paintings may be seen any weekday from 9 a.m. to 5 p.m.," *LR*, Aug. 6, 1962, p. 4.

1964 – "Lompoc Music and Art… Lompoc's Music Association invites the community to the Music and Art

Program to be held Sunday at 3:30 p.m. in the El Camino School auditorium… Artists showing their works Sunday will include … **Col. Allen Haemer**…," *LR*, May 1, 1964, p. 6.
See: "Art Loan"

Art, general (Los Alamos)
Small town south of Santa Maria.
See: "Bartholomew, Lucille," "Boradori, Lena," "Curtis, Eliza," "Hopkins, Lesli," "Laughlin, Dora," "Leslie's," "Los Alamos, Ca., Adult/Night School," "Los Alamos Ceramic Club," "Los Alamos Community Church," "Santa Ynez Valley, Ca., Elementary Schools," "Tognazzi, Olga"

Art, general (Los Olivos)
Small town NE of Solvang.
See: "Campbell, Linda June," "Chrimes, Louise," "Frame, John," "Girl Scouts," "Glasgow, Charles," "Hutchinson, Amory," "Mattei, Charles," "Mattei, Clarence," "Mattei's Tavern," "Midland School," "Miller, Frank," "Motion Pictures (Santa Ynez Valley)," 1928, 1940, "Mud Mill Pottery," 1969, "Needlecraft Club," "Osbourne, Isobel," "Parker, Vernon," "Pedersen, Kirsten," "Posters, American Legion (Poppy) (Santa Ynez Valley)," 1941, 1956, 1957, "Posters, general (Santa Ynez Valley)," 1958, 1960, "Santa Ynez Valley, Ca., Elementary Schools," "Santa Ynez Valley Fair," "Sedgwick, Francis," "Scholastic Art Exhibit," 1948, "Tallant, George," "Valley Farm School," "Walford, Ernest," "Wood, Mildred"

Art, general (Orcutt)
Small town, unincorporated, south east of Santa Maria.
Art, general (Orcutt) (notices in Northern Santa Barbara County newspapers on microfilm and the Internet)
1951 – "Road to Rhythm Show… song and dance show… presented by Amby Soule's pupils… Robert Todd and Patty Pabst of the seventh grade and Lenna Clark and Carol Autner of the eighth grade won prizes in a poster contest held in connection with the show," *SMT*, Jan. 31, 1951, p. 4.
1957 – Photo of Linda Shaw and youngsters participating in a six-week Orcutt recreation program. Youths… worked on leather, copper and painting projects," *SMT*, Aug. 14, 1957, p. 5.
See: "Gill, John," "Hoback, Joseph," "Hobby Show," "Linsenmayer, Alice," "Openshaw, Byron," "Orcutt, Ca., Elementary School," "Orcutt Community Church," "Orcutt Women's Club," "Quick, Jonah"

Art, general (Santa Barbara)
Santa Barbara, the principal town of the County, is located on the southernmost edge of the county sandwiched between the Pacific shore on the south and the Santa Ynez mountains on the north. Occasionally artists and photographers from the town crossed into the northern part of the county to exhibit at the Santa Barbara County Fair (held in Santa Maria), to exhibit in special shows of "Santa Barbara" artists, to lecture, to

sketch, or to judge local art shows. A few owned ranches as second homes.
[Contrary to the title of this book, there are entries in this Dictionary for some artists from the town of Santa Barbara, i.e., artists who newspapers show were active in the northern part of the county. If these "Santa Barbara" artists were well-known and enjoyed a lot of published information, this Dictionary cites only a brief biographical reference, usually Wikipedia. If they were little known, this Dictionary tries to create as full a biographical entry as possible from newspapers.]
Art, general (Santa Barbara) (notices in California newspapers on microfilm and the Internet)
1884 – "Art and Artists. Santa Barbara's Devotees of the Palette and Brush… [author regales the natural beauty of the Santa Ynez mountains and streams and waterfalls as subjects for the artist's brush] **Mrs. Dimmick**… [and her students] Miss Jennie Hollister, Miss Lillie Calkins, Miss Alice Huse, Mrs. Shives and Grace L. Prescott… Leonora Stearns … Miss Flora Hoyt …Miss [Mary] Fish is at the head of a coterie of crayon students… Among Miss Fish's pupils who are doing good work are Mrs. Sander, Walter Sawyer, Miss Lona Noble… Miss Louise Hart, Mrs. M. L. P. Hill, Mrs. G. M. Williams and Miss Daisy Cameron… Mrs. Lunt is a professional artist of local note… Besides the many pupils of the teachers in the city are a large number of artists and amateurs who are doing a little work now and then as some special object strikes their fancy… Miss Barnard … Mrs. Kellogg… Mrs. De Long… China Painting has been practiced by Mrs. Shaddock… Mrs. Austin… Miss Cooper … Miss Beatrice Fernald … Miss Jennie Weldon … Art Exhibition … present would be a proper time for the display… **Prof. H. C. Ford** …," *Independent*, Jan. 9, 1884, p. 4.
1889 – "Artistic Photography … We have in our city many who draw and paint excellently. We are happy in also having an exponent of photography… Mr. W. J. Rea…," *Independent*, July 30, 1889, p. 1; "Art and Artists Beautiful Sights in Santa Barbara. A Series of Articles Upon the Paintings and Sketches of Resident Artists.… III. Mrs. Clara Lunt…," *Independent* (Santa Barbara, Ca.), Aug. 6, 1889, p. 4; "Art and Artists… IV. Mr. H. A. Loop … [and] V. Mrs. H. A. Loop…," *Independent*, Aug. 12, 1889, p. 4; "Art and Artists… VI. **Henry Chapman Ford**," *Independent*, Aug. 14, 1889, p. 4; "Art and Artists. …VII. Mrs. Lola B. Sleeth … [and] VIII. **Capt. Frank W. Thompson**…," *Independent*, Aug. 22, 1889, p. 4; "Art and Artists … IX. Mrs. Josie Ingham… [and] X. George E. Hall…," *Independent*, Aug. 27, 1889, p. 4; "Art and Artists…XI. Mrs. N. P. Austin…," *Independent*, Aug. 30, 1889, p. 4; "Art and Artists… XII. Miss Hattie B. Manning…," *Independent*, Sept. 14, 1889, p. 4; "Stamped Leather. … Mr. J. M. Forbes…," *Independent*, Oct. 16, 1889, p. 4; And, many additional notices on "town" artists in the *Independent* not itemized here.
1890 – "Art and Artists … XIII … Miss Ella Vail Thorn…," *Independent*, Jan. 14, 1890, p. 4.
1908 – "The Artist Colony of Santa Barbara" – mentions **Fernand Lungren**, J. N. Marble, **Lockwood de Forest**, **Howard Russell Butler**, Oscar R. Coast, H. J. Breuer, Willis E. Davis, **John Gamble, Alexander Harmer**," *SF Call*, June 28, 1908, p. 4.
See: "Abbott, Mary," "Adair, Lee," "Avila, Maria Olympia," "Backus, Standish," "Baer, Kurt," "Baxley,

Ellen," "Bear, Donald," "Berend, Charlotte," "Bigler, Alice," "Billet, James," "Bitterly, Lilly," "Bodrero, James," "Bonn, Trin," "Borg, Carl," "Bowen, William," "Brackenridge, Marian," "Bradford Studio," "Brians, Emma," "Broadus, Amber," "Bromfield, Dora," "Brooks, Ernest," "Brooks, Mildred," "Brooks Institute," "Browne, Belmore," "Burbank, Robert," "Burtch, Emma," "Butler, Howard," "Campbell, Catherine," "Carey, Rockwell," "Carpenter, Dudley," "Cary, Robert," "Castagnola, Gladys," "Channel City Camera Club," "Cherry, Herman," "Colby, Margharite," "Collin, Hedvig," "Cooper, Colin," "Coulter, Mary," "Cram, Allan," "Croswell, Mary," "Crow, Augusta," "Curlee, Wallace," "'D'Andrea, Martino," "Daniels, Charles," "Danner, Sarah Kolb," "Davis, Cecil," "Deaderick, Moreland," "DeForest, Lockwood," "De la Cuesta, Tulita," "Dimmick, Walter," "Dimmick, Sarah," "Dobro, Boris," "Dole, William," "Donahue, Katherine," "Donoho, David," "Edwards, Stanley," "Evans, Elliot," "Faulkner Memorial Art Gallery," "Fenton, Howard," "Fenci, Renzo," "Fletcher, Frank," "Folsom, Nancy," "Ford, Henry," "Fredrickson, Mr.," "Friedman, Jerrold," "Gamble, John," "Garnsey, Elmer," "Gilbert, Rudolph," "Gilbert, Wendell," "Girvetz, Berta," "Gorham, John A.," "Griesbauer, John," "Griffith, Marilyn," "Hamilton, John," "Hansen, Jacob," "Harcoff, Lyla," "Harmer, Alexander," "Harrah, Donald," "Hart, David," "Hart, Margaret," "Hart, Merrill," "Hebert, Marian," "Herter, Albert," "Hesthal, William," "Higgins, Olga," "Hill, Rose Ann," "Holmes, Katharine," "Hopkins, J. Barton," "Howard, Doris," "Hunt, Leroy," "Jensen, Chris," "Johnson, James," "Jones, Frances," "Kaplan, Harry," "Keen, George," "Kelsey, Richmond," "Ketron, Janet," "Kincaid, Edward," "Knowles, Joseph," "Koonce, Ruth," "Krell, Walter," "Lakey, Andrew," "Langlois, Obart," "Lawhorne, Roy," "Lebrun, Rico," "Liecty, Ruth R.," "Lockard, E. Keith," "Lockard, Grace," "Lungren, Fernand," "Lutz, Dan," "Mattei, Charles," "Mattei, Clarence," "May, Theodore," "Mayer, Edna," "MacLennan, Eunice," "May, Theodore," "McAllister Studio," "Midtby, Mary," "Mills, Jody," "Modern Neon Sign Co.," "Moore, Brett," "Motzko, Helen," "Muench, Adam," "Nadeau, Evelyn," "Newhall, Elbridge," "Norcross, Lorin," "Novelty Studio," "Ollis, Donald," "Orendorff, Martha," "Otte, William," "Owen, Elizabeth," "Parker, Mary Lucile," "Parshall, DeWitt," "Parshall, Douglass," "Peake, Channing," "Perry, Charles," "Podchernikoff, Alexis," "Ravenscroft, Virgil," "Remick, Merrill," "Rich, Edna," "Rich, Frances," "Richmond, Evelyn," "Roberts, Stanley," "Rohrbach, William," "Rolle, Frederick," "Ross, Gene," "Santa Barbara Art Association," "Santa Barbara County Fair," "Santa Barbara Museum of Art," "Scofield, Ronald," "Seegert, Helen," "Seldis, Henry," "Singer Margaret," "Smith, Dick," "Snider, Ann," "Stark, Jack," "Stewart, Al," "Story, Ala," "Straight, Margaret," "Streeter, Josefa," "Struthers, Irene," "Stuart, Charlotte," "Swanson, David," "Sykes, John," "Szeptycki, Jerzy," "Thompson, Frank," "Tinsley, Thomas," "Tri-County Art Exhibit," "Tuckerman, Lilia," "Turner, Ava," "Ussher, Neville T.," "Vaughan, Edson," "Verhelle, George," "Vollmer, Grace," "Warren, John," "Waterman, Richard," "Warshaw, Howard," "Webb, Margaret," "Weigman, Marjorie," "Wesselhoeft, Mary," "Weston, Brett," "Whittenberg, Alice," "Woggon,

William," "Wolf, Peter," "Wood, Louise," "Wright, James Couper"

Art, general (Santa Maria)
Largest metropolitan center of Northern Santa Barbara County. First named Central City. Allied communities are Guadalupe, Los Alamos, Orcutt, Casmalia.
This heading contains articles that do not fit under other, more specific headings, in this Dictionary.
Art, general (Santa Maria) (notices in Northern Santa Barbara County newspapers on microfilm and the Internet)
General background --"Amateur Artists. Fair Hands Finding Employment for Idle Moments at the East. 'The craze just now among the young ladies is for painting,' said a society man to a reporter. 'All the art schools are full to overflowing with pupils, and young ladies who are unable to attend them are either taking private lessons or endeavoring to become accomplished in this line of work through the medium of books of instruction and patient, industrious practice at home. The art department of the Cooper Institute never was so crowded as now ... In a large number of the schools, so great has become the interest in the art, professional artists are taking part as instructors. ... The craze is particularly noticeable for painting in oil on brass, silk, velvet, plush, china, tapestry, etc. A set of artist's materials in oil costs from six to ten dollars, and while the work is so decidedly the fashion a great many young ladies earn considerable pin-money by what they paint, selling their work to dealers in fancy articles. Lustra painting is just now quite the thing. ... The designs chiefly painted are flowers, fruit and birds, and they are especially satisfactory on velvet or plush. These Lustra colors are not regular paints, but are metallic colors, and on velvet or satin they give a very brilliant effect... A set costs three dollars and fifty cents... The rage is especially for decorating room ornaments, such as placques, vases and Limoges ware... A new thing in this line are reliefs of models. They are made in France, of white cardboard, and include heads, figures, flowers ... [quote from *NY Mail and Express*]," *SMT*, Jan. 23, 1886, p. 7.

1884 – "Auction House! I have had consigned to me ... also a large variety of oil paintings, pictures, albums and fancy articles, which will be sold at Public Auction, Every Saturday until the entire stock is disposed of, J. A. Crosby, Auctioneer," *SMT*, Aug. 30, 1884, p. 4.
1886 – "While we are reminiscing, an article by Grace Clark Strong in yesterday's *Santa Maria Times* on the two 'petrified bodies' unearthed near Point Sal in 1886... At this late day **Grace Strong** of the Clark family, pioneers of Point Sal, sets us clear ... Mrs. Strong writes... 'Two men and a boy, posing as father, son, and grandson, came and rented a home in an obscure spot. They said they were artists and as the coast scenery there is unsurpassed, their story was given credence. One day mother and I strolled by that way and stopped to make a friendly call. My attention was attracted to a long, low object, covered by a sheet, which I saw through an open door. Soon thereafter, these men 'discovered' indications in the soil of a certain mineral and in digging to confirm their convictions, behold, they uncovered two 'petrified bodies,' a man and a woman.

They were complete and perfect specimens, except the woman had six toes on one foot and the man had a bump on his head. Excitement ran high as the bodies were brought to Santa Maria and put on display at so much per look. Later, these enterprising gentlemen conceived the idea of taking their findings across the ocean where they were exposed and apprehended. My father, the late C. H. Clark, had charge of the gypsum mines at that time. One of the miners confessed that he had been hired to get out these two large pieces of gypsum by Messrs. Hall and Hall. Gypsum being a large percentage water, is extremely heavy and must have entailed great effort on their part," *LR*, April 17, 1947, p. 7.

1892 – "Chas. Russell called at this office on Tuesday last. He reports the sale of 100 lots in Grover to Paso Robles people. He also exhibited a bird's eye view map of the coast country extending from Santa Margarita to Los Alamos and including a splendid view of the Santa Maria Valley and San Luis Bay. The map was recently sketched by a San Luis boy and reflects much credit upon him as an artist," *SMT*, July 9, 1892, p. 3.

1907 – Prize Winners at Catholic Fair. Japanese tea set, **Mrs. Abram Ontiveros**. Burnt leather pillow cover, **Mrs. A. Ontiveros**… Oil painting of Father Ternes, Mrs. E. A. Abadie… The following is a list of the donations contributed to the Catholic fair… E. A. Abadie, Japanese tea set … **E. D. Shull**, dozen photos …," *SMT*, Nov. 30, 1907, p. 3.

1926 – "Painting of Cuyama Valley Scene Attractive" – painted on outside wall of Shell service station by unnamed artist, *SMT*, March 12, 1926, p. 5.

1929 – "Santa Maria will be represented in four divisions at the 'Made in Santa Barbara' show which opens tomorrow at the Recreation Center in Santa Barbara. **Gaylord Jones** has entered examples of his cabinet work and carving, **Darrell Froom** is showing a massive copper chest, and **Frank W. Crakes** has contributed a tile-top table and lamp of wrought-iron. …," *SMT*, April 30, 1929, p. 5; "Students Show Craft Work at Santa Barbara … 'Made in Santa Barbara'…. Santa Maria union high school art department students. A special table has been provided for their displays and includes fine embroidery, needlework, batik handkerchiefs, stenciled table runners and pillows to match by Mrs. Mary Itria. Tooled leather coin purses, hand bags, bill folds, book markers and similar craftsmanship is exhibited by Velma Kennedy, Florence Grafft, **Marie [Sic. Marrie] F. Breneiser**, Thelma Dutra, Hazel Williams, Frieda Goedinghaus, and Nona Vaughn. Beautiful batik wall hangings, scarves and handkerchiefs are shown by **Margaret Sutter, Lucy de Gasparis**, and Barbara Careaga," *SMT*, May 2, 1929, p. 1.

1932 – ■ "Something which individual citizens have thought of for a long time, and which Santa Maria eventually will be forced to consider, is the establishment of a museum to preserve the natural history of this locality. Judging from the amount of interesting exhibits at county fairs held here in the past and the much larger number of relics and historical pieces which cannot be trusted by their owners under the canvas tent at a fair, Santa Maria would have a good start toward a museum, if a building could be found to house the exhibits safely, and people could be found who would undertake the leadership of such a

movement. Many residents here are engaged in hunting for Indian relics, old Spanish articles and other relics peculiar to this locality, and for the most part these people would probably be glad to place them in a museum where the public, including visitors to the city, could see them. The **College Art Club** has already started a small collection of painting, and it might be possible that they would use their growing collection as a nucleus for the museum's art gallery. Almost every city of importance has a museum, large or small, and if the various collectors would get together and talk it up, a real plan might be evolved," per "Wanted a Museum," *SMFA*, Oct. 21, 1932, n. p.

1949 – "Ruth St. Denis Asks Help for Young Art Students" at lecture at Fair Oaks theater – wants to raise money for an art colony, *SMT*, July 11, 1949, p. 5.

1958 – "Man or Woman. Artist Wanted. Experienced in layout, design, in either agency or newspaper. Work entailed will be newspaper layout, artwork in pen & ink, scratchboard, lettering, etc. A good future with many fringe benefits, paid vacation, insurance, etc. Please bring portfolio for interview to Mr. MacMorris, *Santa Maria Times*. Please phone for appointement, WA5-2693," *SMT*, Nov. 11, 1958, p. 12, col. 1.

1960 – "Air Force Art Show Set Here. Part of the 2,000-piece collection of art showing Air Force activities during the past 45 years will be on free exhibition at the National Guard Armory at the Santa Maria Fairgrounds from Monday through Saturday Oct. 29. … 73 paintings by major American artists …," *SMT*, Oct. 22, 1960, p. 2.
See: "Art Festival," "Art Loan Exhibit," "Elson Art Co."

Art, general (Santa Ynez Valley)
The Valley's main town is currently Solvang, while others include Ballard, Buellton, Los Olivos, and Santa Ynez. This heading contains articles that do not fit under other, more specific headings, in this Dictionary.
Art, general (Santa Ynez Valley) (notices in Northern Santa Barbara County newspapers on microfilm and the Internet)
1915 – "From the Santa Ynez *Argus*. In this day of the automobile and motorcycle, distance between towns is almost obliterated, and a long trip into the country is considered but a very small affair… We have here in the Santa Ynez valley a veritable artist's paradise. The scenery is not surpassed by that of any section on this continent. But all of this scenery is not observable from the state highway, and one must take to the byways…," *LR*, Oct. 8, 1915, p. 8.

1952 – "Young Artists Bicycle Here. Two young men, students at a school of art in Los Angeles, made a trip to the Valley on Monday on their bicycles from Santa Barbara and stayed here two days to paint scenes in Santa Ynez and Solvang. In Santa Ynez they painted the little chapel, built in 1897, the blacksmith shop and a home. In Solvang they did scenes of Ferd Sorensen's windmill," *SYVN*, Sept. 26, 1952, p. 6; "Charla Hill Wins Coloring Prize… nine-year-old daughter of Dr. and Mrs. Earl M. Hill has been awarded first prize in the recent Santa Barbara County Milk Producers association coloring contest. Charla won a $10 first prize and 10 quarts of ice cream," *SYVN*, Dec. 26, 1952, p. 8.

1959 – Photo of a painting of a Danish farm by unnamed artist, given as gift to retiring elementary school custodian, *SYVN*, June 5, 1959, p. 1.
See: "Art, general (Ballard)," "Art, general (Buellton)," "Art, general (Los Olivos)," "Art, general (Solvang)," "Ballard …," "Buellton…," "Danish Days," "Los Olivos…," "Mission Santa Ines," "Officer's Wives Club," "Santa Ynez Ca….," "Santa Ynez Valley…,"

Art, general (schools)
See: "Schools (Northern Santa Barbara County)," "Teacher Training"

Art, general (Solvang)
Largest town of the Santa Ynez Valley.
This heading contains articles that do not fit under other, more specific headings, in this Dictionary.
Art, general (Solvang) (notices in Northern Santa Barbara County newspapers on microfilm and on newspapers.com)
1928 – "Solvang Furniture… Imported Danish Paintings and Pictures. These are of exceptional values and include many wonderful scenes in Denmark," *SYVN*, July 27, 1928, p. 12.
1935 – "State Convention of Danish YPS Held in Solvang… On Wednesday evening, **Chas. Danillo** [Sic. Charles Daniels?], an artist from Santa Barbara, gave an interesting talk on art and explained the paintings on exhibit in the lecture…," *SYVN*, July 19, 1935, p. 1. [This entry does not come up with a digital search and must be found by browsing.]
1936 – "Model Ship Arrives in Solvang. To be Placed in Danish Church… schooner with full riggings… five feet long and four and one half feet high … ship *Marmora* of Copenhagen… made by Chris Kjeldsen, a retired seaman, and has been donated to the Danish Lutheran church by the Rasmus Jensen family of Santa Cruz…," *SYVN*, Jan. 31, 1936, p. 1; "Work is Really Underway… The emblem and motto contest is creating interest, and some drawings have already been submitted. The publicity committee wants everyone handy with pencil or pen to send in drawings of an emblem and motto working in the word Solvang and signifying the 25th Anniversary…. The history committee has collected a number of old pictures and have several writing articles on the history of the colony and Solvang…," *SYVN*, March 6, 1936, p. 1.
1946 – "Spring Festival to Include Art Exhibition… Sixth Annual Spring Music Festival next Friday evening will be an exhibition of paintings by the students of art instructor **Leo Ziegler**. Dr. Ziegler teaches art at several of the Valley schools and will present the work of many of his young pupils … After the musical portion of the program has ended the doors of the small meeting room at the Memorial Hall will be opened to those who would like to see the paintings," *SYVN*, April 5, 1946, p. 1; "Hancock Players to Appear… Music Festival… Public School Week… April 12 in the Memorial Hall… Arrangements have been made to exhibit the paintings of some of the students of Mr. **Leo Ziegler**… work in leather craft and flower arrangements by high school students will be shown at the flower show," *SYVN*, April 5, 1946, p. 1.

1954 – "Art Students to Tour Solvang. A group of 75 adult art students from the Los Angeles area will arrive today for a tour of points of interest in Solvang. They will come to Solvang by bus and will lunch at the Danish Inn," *SYVN*, May 7, 1954, p. 1.
1960 – Photo of Yuletide Calendars – hand made by Mrs. Oda Markussen of Copenhagen for the Leo Mathiasen family of Solvang, *SYVN*, Dec. 16, 1960, p. 1.
See: "Architecture (Solvang)," "Art Loan Exhibit," "St. Mark's in the Valley Episcopal Church," "Danish Days," "Handcraft," "Lauritzen, Dillon Theodore," "Presbyterian Church / Ladies Aid," "Santa Ynez Valley Art Exhibit"

Art, general (Vandenberg AFB)
See: "Art, general (Camp Cooke / Vandenberg AFB)," "Photography, general (Camp Cooke/ Vandenberg AFB)"

Art Alpha
See: "Alpha Club," 1937

Art and Hobby Show (Santa Maria)
See: "Community Club (Santa Maria)," 1949, 1950, 1952, "Minerva Club, Art and Hobby Show," 1957, 1958, 1959, "Hobby Show…," "Hobby Shows"

Art / Antiques Collectors
See: "Collectors"

Art Club (Santa Maria)
See: "College Art Club"

Art Corner
Corner of the Community Club (Santa Maria) clubhouse in the 1950s where temporary art and handicraft exhibits were set up. Sometimes (?) also used as the "Penny Art Corner." At each meeting of either the Community Club or the Junior Community Club there was included a brief presentation by various chairmen, including the "art" and "handicraft" chairmen, who showed items ranging from fiber flowers, to shell jewelry, to paintings, etc. (These regularly occurring art presentations qualified the group for women's club state-wide awards in art, which were sometimes actual paintings to decorate the clubhouse.)
See: "Community Club," "Junior Community Club (Santa Maria)

Art Festival (Santa Maria)
Sponsored by the Alpha Club of Lompoc in conjunction with the College Art Club and the Community Club of Santa Maria, Jan. 7-11, 1935.
[Do not confuse with the Santa Maria Valley Art Festival of the 1950s, see "Santa Maria Valley Art Festival."]
■ "Art Exhibit is slated in Santa Maria January 7-14 … featuring exhibits of paintings, both professional and

amateur and art talks… before high school classes and art groups. The main exhibit will be in the new Santa Maria City Hall and will be the art exhibit of **Merle Armitage** of Redondo Beach, the largest privately-owned one-man exhibit. **Ramiel McGehee**… will accompany the exhibit and give several art lectures including a talk on Oriental literature. **Stanley Breneiser**… will give art talks… exhibits of paintings of local artists in the store windows … **Mrs. George Secour** of Santa Maria is serving as the chairman… **Mrs. Leila Maimann** heads the Lompoc art group," *LR*, Jan. 4, 1935, p. 5.

Art Festival (notices in Northern Santa Barbara County newspapers on microfilm and on newspapers.com)
1935 – "Art Festival to Be Featured All Next Week in Santa Maria… first Art Festival… wealth of exhibits… under the auspices of the **College Art club** and the Community Club… original works by **Rockwell Kent**… hung in the city hall … obtained through the courtesy of **Merle Armitage**… Original works of Winifred Balch of Glendale will be hung in the library… The high school will contain an exhibit of examples of Chinese and **Japanese art** of the drama and monodrama, exhibitions of lithographs by **Jean Charlot**, **Richard Day** and Peter Krasnow besides the permanent exhibit of the **College Art club**. Lectures will be held in the high school… Block print souvenirs of the festival will be sold by students. Local artists will have exhibits in store windows," *SMT*, Jan. 4, 1935, p. 6; "Mexico and Orient Depicted in Art Works on Display Here. Among exhibits featured in Santa Maria's first annual Art Festival are collections of the works of **Jean Charlot, Richard Day** and Winifred Balch on display in the high school and public library this week… Lithographic Display. Another collection of lithographs on display in the high school is that of the work of **Richard Day**, Los Angeles artist formerly associated with the Metro-Goldwyn-Mayer studios… Other compositions on display here include several abstractions by Elise, a Los Angeles painter…one by **Henrietta Shore** of Carmel and a Biblical print by Paul Landeau [Sic. Landacre?]. **Ramiel McGehee** has also placed on exhibit here a collection of prints, drawings and photographs on Oriental art… Fantastic pencil and charcoal portraits done by Winifred Balch of Glendale, an artist who has never exhibited before, are being shown in the public library… Lithographs and block prints by Peter Krasnow, a Jewish artist from Los Angeles, depict symbolical racial ideas… Another portrait exhibited in connection with the Art Festival this week is one of **Rowena Lowell**, local junior college student, done by **Marrie Breneiser**, which is on display in the **Santa Maria Inn**," *SMT*, Jan. 8, 1935, p. 3.
See: "Alpha Club," 1934, "College Art Club," 1935, "Community Club (Santa Maria)," 1935

Art Festival (Santa Maria)
Sponsored by American Association of University Women, 1952, 1953.
See: "Santa Maria Valley Art Festival"

Art Festival (Santa Ynez Valley)
See: "Santa Ynez Valley Art Exhibit"

Art Loan Exhibit (Lompoc)
Exhibit sponsored by the Ladies of the Episcopal Guild, held in conjunction with the Grand Promenade, 1892.
■ "Grand Promenade Concert and Entertainment. Given by the Ladies of the Episcopal Guild at the New Opera House on Friday Evening, April 29, at 8 o'clock. Programme for the Evening will consist of Vocal and Instrumental Music, New England Kitchen, Japanese Booth, Art Loan Gallery, Ice Cream, Etc….," *LR*, April 23, 1892, p. 3.

Art Loan Exhibit (Santa Maria)
Exhibit organized by the ladies of the Literary Society (Minerva Club) and held at McMillan's Hall, Mar., 1895.
■ "Art Loan Exhibit. A Rich Display of Curios on Exhibition at … McMillan's Hall… On entering the hall one is astonished at the magnificent display. In the background the stage with its artistic draping and lovely display of flowers. To the right the picture gallery with its 125 paintings, consisting of oils, watercolors, crayons, pastels, etc., and all from the Santa Maria valley. … One hardly knows where to begin. So many of the paintings are deserving of special notice. Of the few that space will permit us to mention are: A portrait, by **Mrs. Stearns**; horses by **Mrs. Mau**; Pharoles horses by **Mrs. E. Morris**; deer by **Minnie Miller**; portrait, **Mrs. Weaver**; carnations by **Mrs. A. W. Streeter**; deer by **Deacon Stanley**; cathedral of Strasbourg, also life size portraits from Alsace and Loraine, **Mrs. Coblentz**; sketch, San Fernando Valley, **Mrs. Stearns**; pencil sketch by an Indian girl; sketch by **Mrs. Curtis** of Los Alamos done at the age of 76. The Nipomo display is valued at $2,000 consisting chiefly of Mrs. John Dana's articles. Opera cloak, fancy needle work, dresses, etc. Wandering through the hall we noticed silver spoons 100 years old, an old stirrup formerly belonging to the noted bandit Vasquez, old Spanish and Mexican sword belonging to Abram Ontiveros, also a magnificent piano cover of **Mrs. Ontiveros**, fine art in painted china, beautiful cut glass, an old newspaper – *Mariposa Gazette* – containing an account of the assassination of Abraham Lincoln, artificial flowers used to decorate the streets of London during the wedding of the Duke of York and Princess May, Bohemian glass ware from **Midwinter Fair**, Hungarian ware from World's Fair. In Mrs. Schwabacher's display were dishes from Japan, ware from Dresden, embroidery and lace from Paris. The stamped leather work is deserving of special mention, also the fact that 20 per cent of the proceeds of sale of same is donated to the library fund. At the close of the exhibition the goods will continue to be sold at Mrs. Newman's. The display of art needle work by **Mrs. A. W. Streeter** of Santa Barbara is something in which all the ladies of Santa Maria are very much interested. The display consists of the Kensington Queen-Anne darning, Mexican drawn work, decorative painting, the designs being specially California flowers. After hurriedly going through the main hall we were invited to visit the annex which was simply grand beyond description," *SMT*, March 9, 1895, p. 3.

Art Loan (notices in Northern Santa Barbara County newspapers on microfilm and on newspapers.com)
1895 – "The Literary Society… The following lady members of the society constitute the Art Loan committee. **Mrs. Stearns, Mrs. McMillan, Mrs. Hart, Mrs. Watson, Mrs. George Smith, Mrs. Marsh, Mrs. Weaver, Mrs. Dickes** and **Mrs. Farington**. It is earnestly desired that anyone having anything in the line of paintings, water colors, etchings, portraits, painted plaques, Spanish lace work, old lace, painted china, embroidery or fancy work, handsome table linen, or anything artistic…," *SMT*, Feb. 23, 1895, p. 2; "Art Loan Exhibit. A Rich Display of Curios…," and many items are described, *SMT*, March 9, 1895, p. 3; "The ladies who conducted the Art Loan are deserving of a great deal of praise. The exhibition was not only a success financially but was the bringing together of a great many paintings, curios, etc., and was a revelation, not only to the people in general, but even to those who have made art a study. In fact, no one imagined that Santa Maria possessed such a collection of fine paintings. It encourages amateurs, opens up a broader field for those making art a study, and is a general educator, one whose influences will be felt in the near future. The Ladies' Literary Society is doing a good work. The various lectures, entertainments, etc., are not only interesting and instructive, but the fund thus derived is to be used in the founding of a free public library…," *SMT*, March 16, 1895, p. 3, col. 1.
See: "Minerva Club"

Art Loan Exhibit (Santa Maria)
Sponsored by Minerva Club, 1920.

■ "Art Loan Exhibit… A newspaper with the original printing of Washington's 'Farewell to His Troops' will be one of the many historical old exhibits ... of the Minerva Club… held in the store building next door to Northman's, Thursday afternoon and evening, April 8 …," *SMT*, April 6, 1920, p. 2.
Art Loan (notices in Northern Santa Barbara County newspapers on microfilm and on newspapers.com)
1920 – "Famous Old Relics to be Shown at Minerva Exhibit" and some listed, *SMT*, March 20, 1920, p. 1.
See: "Minerva Club," 1920

Art Loan Exhibit (Solvang)
Sponsored by Woman's Missionary Society and held at Legion Hall, 1935.

■ "Many Attend the Art Loan Exhibit on Sat. About fifty people from the Valley towns attended the Art Loan exhibit at Legion hall last Saturday afternoon which was sponsored by the Woman's Missionary Society. Due to the splendid cooperation of those in the valley who owned interesting pictures and brought them in for display, Legion hall was transformed into a gallery of most beautiful and interesting works of art. This is the first time such an exhibit has been attempted ... During the afternoon Mrs. Chester Hollister entertained with several piano and vocal numbers, and readings were given … Mr. and Mrs. E. M. Howard from Santa Barbara were present. Mrs. Howard (**Doris Overman Howard**) artist and art reporter for the *Morning Press*, brought with her several lovely studies of her own

loaned by the Chamber of Commerce of Santa Barbara. Mr. and Mrs. Howard, who own the Alamo Pintado ranch, feel an interest in the valley and in the valley's progress. Among the pictures loaned, one which attracted much interest was 'Indian Dance' by **Narjot**, a French artist, loaned by **Mrs. Earl Jensen** whose grandfather and the artist had been friends. While at the University of California Mrs. Jensen, then **Miss de la Cuesta**, discovered that one of her instructors was a relative of her grandfather. At the time of her marriage to Mr. Jensen, the instructor presented them with this picture as a wedding gift. Another fine oil study loaned by Mrs. Jensen was the grape arbor at the old de la Cuesta place, painted by **Fritz Poock**. **Edgar Davison** loaned two paintings by **John Gamble** – 'The Uncle Davy Brown Cabin' and 'Sunset Valley,' besides an interesting collection of photographs. **J. H. Forsyth** had on exhibition a most beautiful collection of photographic art studies, a pencil drawing, which he had done at the age of eleven, which was quite remarkable and a wild flower study, the work of a friend whose style closely resembled that of **John Gamble** and who was a friend of the latter artist. **John Frame** entered several lovely studies by **Elmer House** … One was the Old Mission Santa Ines. **Micaela de la Cuesta** loaned a sketch by **Ed Borein** and several tinted photographs. Mrs. Samuel Lyons, Sr., loaned a picture painted by **Philip Matzinger**, a former resident, which was a present to her and Judge Lyons on the occasion of their golden wedding anniversary in 1921. Mrs. Gardner loaned a study of Zaca Lake by **Grace Lockard**, mother of the Santa Barbara architect, E. Keith Lockard, and flower studies by **Mrs. St. John** and her daughter. Mrs. St. John resided here many years ago, her husband having been supervisor from this district at one time. **Mrs. Howard**'s picture of Eucalypti was exhibited at the State Fair. She also donated a view of the Santa Barbara Mission taken at the time of the pageant, which was sold … as a benefit to the Missionary society. A picture of the ranch house on Santa Cruz island was also shown by Mrs. Howard. Other pictures and studies were displayed by courtesy of **Mrs. H. Stark**, who loaned photographic work done by Rev. Kenneth Brown, former pastor here; a painting on organdie [Sic.] and a lovely aquatint owned by Mrs. J. C. Hansen; animal studies in free hand by Miss Leatha Riley; and a copy of La Purisima Mission. A group of water colors by **Anna Larsen**, who had no professional instruction, showed quite considerable talent. **Irna [Sic. Erna] Ferslew** loaned a group of landscape studies, and flower studies were loaned by **Nellie McMurray, Clara Skytt, Mrs. Weston** and **Mrs. Maloney**," *SYVN*, March 15, 1935, p. 1; "Buellton Notes… Numerous paintings in oil and water color, sketches in pencil and crayon and scenic photography were among the collection at the art exhibit which was held at the Legion hall in Solvang last Saturday by the ladies of the Missionary Society, and among those entering were **Mrs. E. M. Howard** of Santa Barbara, **Miss Micaela de la Cuesta, Mrs. William Maloney, Miss Irna Ferslew**, Miss Leatha Riley, **Mrs. C. C. Gardner, Mrs. S. K. McMurray, Mrs. Clyde Weston, Miss Clara Skytt**, Mrs. Robert J. Batty, **Miss Anna Larsen, Mrs. J. C. Hansen, J. H. Forsyth, Edgar Davidson** and Dick Weston. A beautiful hooked rug brought by Mrs. R. R. McGregory was also on display…," *LR*, March 15, 1935, p. 5.

Art Review
Column authored by Moselle Forward in Lompoc Record,
Jan. 17, 1957, p. 5.
See: "Forward, Moselle"

Art Week
See: "National Art Week"

Arts and Crafts (aka Handcrafts / Handicrafts)
Crafts were ubiquitous, a part of public school domestic
arts programs as well as fine arts programs. In the mid-
1930s they became part of women's club programs and of
public recreational programs. With the advent of
adult/night schools, classes were offered in media such as
basket making, leather tooling and ceramics. Church
schools and youth groups also offered programs in crafts.
See: "Adult/Night Schools," "Boy Scouts," "Camp Fire
Girls," "Four-H," "Handicrafts," "Handiwork," "Lompoc
Valley Fair," "Santa Barbara County Fair," "Schools,"
"Summer Schools," "Women's Clubs"

Arts and Crafts Club of Aloha Park (Lompoc)
Club at WWII trailer park for soldier's wives, 1942.
"Federal Trailer Project News Notes… Arts and Crafts
Club of Aloha Park will hold its next meeting July 27th at
10:00 a.m. in the garage building. All the ladies interested
in this work are cordially invited to attend. The work is
supervised by **Mrs. Craw**…," *LR*, July 24, 1942, p. 4.

Arts and Crafts Guild, St. Peter's Episcopal Church
(Santa Maria)
Members sewed toys, household linens and gift items for
the annual Christmas Fair and other events.
■ "This group is responsible largely for success of the
annual Christmas Fairs, and members undertake sewing of
a quantity of toys and household linens and gift items for
the sale. All members are asked to bring with them ideas
for the annual fund raising activity," per "Arts & Crafts to
Meet Tonight," *SMT,* Jan. 7, 1957, p. 4.
Arts and Crafts Guild (notices in Northern Santa Barbara
County newspapers on microfilm and the Internet)
1951 – "Sadie Hawkins Dance Opens Dogpatch Days
Friday" for church fundraiser and there will be hand-made
crafts for sale, and crafts include: "dolls, aprons, and
fancywork are to be featured. … Hand painted place mat
sets, wooden salad sets and dish towels will be offered by
the Crafts Guild… Original posters have been made by the
Rev. A. Leonard Wood and Mrs. Burford Sheen," *SMT,*
Oct. 18, 1951, p. 4.
1954 – "Arts and Crafts" to meet tomorrow evening, *SMT,*
Aug. 16, 1954, p. 4; "Come to the [Episcopal Church
Christmas] Fair, Public Invited" to enchilada luncheon,
puppet show by Girl's Friendly Society, and gift items
made by Arts and Crafts Guild, *SMT,* Dec. 1, 1954, p. 4.
1955 – Brief ann. meeting "Arts and Crafts Guild," *SMT,*
Jan. 17, 1955, p. 4.
1957 – "Work on Hobby Horses," and article adds, "two of
the most popular at former church fairs, hobby horses and

aprons, now being turned out in quantity. Last year, only
one dozen of the hobby horses were offered, and all were
sold in minutes after the door opened to a crowd waiting on
the sidewalk. Hobby-horse work headquarters will be the
new home on Ranch Drive of the Arts & Crafts Guild
president, **Mrs. Lee Carlson**. Headquarters to make both
fancy and kitchen aprons, and the popular upside-down
dolls will be the home on East Church of **Mrs. Harry
Wood**," *SMT,* Oct. 2, 1957, p. 3.
1958 – "Sews for Bazaar," and article reads, "The home of
Mrs. Joe S. Daly… was the meeting place last night… The
members worked on sewing for the annual Christmas Fair
to be held early in December. There is a need now for
broom handles to make hobby horses, one of the items that
sell out minutes after the Bazaar door opens," *SMT,* Oct. 7,
1958, p. 2.
1959 – Photo of Mrs. Phillip Baciu and **Mrs. Joe Daly** with
crafts and large caption about holding Annual Christmas
Fair, *SMT,* Dec. 4, 1959, p. 3.
Numerous announcements of upcoming meetings and other
notices for the Guild were not itemized here.

Arts and Crafts Guild (Santa Maria)
Of the Episcopal Church, 1957.
"Christmas Fair at Parish Hall… annual … Last year all
toys were sold out ten minutes after the doors opened and
all articles were sold out before closing time. The Arts &
Crafts Guild, sponsoring the Fair, have held weekly sewing
meetings since September to complete a much larger quota
of dolls, stuffed animals, stick harnessed horses, sachets,
house linen items, aprons and others, nothing to be over
$1.50. There will be many inexpensive gifts to select
from…," and photo of women standing behind a table of
their products, *SMT*, Dec. 5, 1957, p. 2.

Arts and Crafts Made Simple
Class taught by Mrs. Ernest Wiedmann to members of
Alpha Club or Junior Alpha Club, 1959.
See: "Alpha Club," 1959

Arts and Crafts Section of the Red Cross (Vandenberg)
"Vandenberg Red Cross Plans Activities During Holiday…
The workshop and open house will be held December 16 at
9:30 a.m. in the patient's recreation hall, Pase Hospital…
The Arts and Crafts section of Red Cross is sponsoring
many projects among the patients to assist them in making
Christmas gifts as well as by way of occupational
therapy…," *SMT*, Nov. 16, 1959, p. 2.

Askenazy, Mischa (Maurice) (1888-1961) (Los Angeles)
Artist. Painted at least two landscapes of the Santa Ynez
Valley in the 1940s.
■ Born in Russia and trained in New York and Europe, he
became a high-priced portrait painter in New York by the
1920s. A commission brought him to Montecito in 1925
and, delighted with the climate, he settled in Los Angeles.
There he painted landscapes and still lifes as well as
portraits. (Roughly from askart.com.)

Askenazy Bibliography
The Final Eden: Early Images of the Santa Barbara Region, Wildling Museum, Los Olivos, Ca., April 7 - June 23, 2002. Contained artwork depicting the Central Coast of California between 1836 and 1960 including two large oil paintings of the Santa Ynez Valley from the 1940s by the Russian-born Mischa Askenazy.

Atterdag College (Solvang)
School that taught Danish culture including art, needlework, crafts, dancing, gymnastics, 1911-c. 1936. Site of numerous conventions and special events. Became a cultural center c. 1938? Between 1939 and 1949 Mr. and Mrs. Viggo Tarnow headed Atterdag Folk School, a summer school, on its premises.

■ "Atterdag College Reminiscences… first conducted in a two-story building next to the Solvang Hotel… three years … In the fall of 1914 Rev. Nordentoft was able to build Atterdag with funds solicited from friends throughout U. S. and Denmark… During the war the number of students diminished considerably… Rev. Nordentoft… back to Denmark… May 1921. Before leaving he sold the College and its furnishings to the congregation… Rev. E. Kristensen… was president of the school for the next 10 years. It was during these years that the Gym Hall and the church were built … In 1931… Rev. Krog took his place. The number of students the last years has, for various reasons, been smaller…," *SYVN*, June 5, 1936, p. 16; photo of fish pond and back yard at Atterdag, *SYVN*, June 5, 1936, p. 14.
Atterdag College (notices in Northern Santa Barbara County newspapers on microfilm and the Internet)
1926 – "Gymnastics and Folk Dances at College… After the dancing the audience were invited to the art room of the college where a display of handwork and needle work had been arranged by the students…," *SYVN*, March 12, 1926, p. 1.
1931 – "Many Recreation Leaders Meet in Solvang College… A school for the training of recreational leaders opened in Solvang Tuesday at Atterdag College… under the direction of John Bradford, field secretary of the National Recreation association of America who arrived here from Arizona to hold four study periods in what is proposed to be a means of selecting leaders to carry out a five years' course in cultural training in their respective communities… a view of building for the children a cultural background … The course includes music, drawing, painting, singing, field sports, indoor games, cabinet work… Study periods were continued Thursday night and tonight after which, with the material furnished the student leaders, they will have a year's study ahead of them which they can carry on independent of instructors," *SYVN*, Dec. 4, 1931, p. 1.
1933 – "Atterdag College Opens December First with Four Instructors … but on account of the depression, a very small number of students are expected…The Folk High School association … cover the deficit … The faculty will consist of Rev. and **Mrs. Marius Krog**… and Miss Susanne Sorensen, formerly connected with the Hull House in Chicago for 26 years, and who instructed in weaving at Atterdag College last year. Miss Sorensen is offering a

complete course in art weaving to anyone…," *SYVN*, Nov. 10, 1933, p. 1;
1935 – "Atterdag College… **Miss A. Harkowf** [Sic. **Lyla Harcoff**?] of Santa Barbara, an artist, and **R. Robinson**, also of Santa Barbara, were visitors at the college Tuesday. There is a possibility that Miss Harkowf will have an exhibition of her paintings at the Summer convention," *SYVN*, July 5, 1935, p. 1; "Atterdag College Notes… closing meeting of the Young People's convention… The art exhibited last week was returned to the respective artists at Santa Barbara Monday by **Rev. and Mrs. M. Krog**," *SYVN*, July 26, 1935, p. 4.
1939 – "Danish Folk Schools… at present Atterdag College has no director, and it is doubtful that it will have one, at least as long as Danish is maintained as the official… language in classroom… It is the wish of the colony to have Atterdag College as a community center … a Danish cultural center. 'Atterdag College enjoyed success for a quarter of a century under fine leadership, but … Immigration stopped and the children of Danish-American parents were sent to state high schools and colleges'…," *SYVN*, Dec. 15, 1939, p. 10;
1940 – "Kindergarten Class at Atterdag… conducted last year by Mrs. Benedict Rich at Atterdag College will be continued this year as play school for children four and five years old. Classes are held three times a week, on Mondays, Wednesdays and Fridays, from nine to eleven-thirty o'clock in the morning… The children learn to play together in such activities as songs, dances, games and stories and such handwork as painting, carpentering modeling in clay, cutting and pasting, and similar kindergarten activities," *SYVN*, Aug. 30, 1940, p. 1.
See: "Alpha Club," 1934, "Atterdag Folk School," "Elverhoj Museum"

Atterdag Folk School (aka "summer school" "Danish summer school") (Solvang)
Five-week summer course held on Atterdag College grounds, c. 1938-49 by Rev. Aage Moller, pastor of the Danish Lutheran church and Mr. and Mrs. Viggo Tarnow.
Atterdag Folk School (notices in Northern Santa Barbara County newspapers on newspapers.com)
1939 – "50 Attend Atterdag Summer School. … Rev. Aage Moller and **Mr. and Mrs. Viggo Tarnow** are in charge… Bible study in the morning… Following lunch, there is folk dancing, gymnasium, hiking and swimming, etc. and in the evening, story telling and reading…. Four weeks," *SYVN*, June 30, 1939, p. 1.
1940 – "Fifty Children in Attendance … summer school… up at seven with breakfast at 7:30… at 9 o'clock… Bible lesson. The rest of the forenoon is given to handwork and gymnasium…," *SYVN*, June 28, 1940, p. 1.
1941 – "Summer School… starts on Monday, June 23, with an expected enrollment of over 50 pupils… The instructors Rev. Aage Moller, Mr. and Mrs. **Viggo Tarnow**, will teach Danish, folk singing, group singing, physical training, gymnastics, folk dancing and religion. There will also be lessons in hand-work and craft taught…," *SYVN*, June 20, 1941, p. 1.

1944 – "Open Summer School at Atterdag Wed. … its sixth year… with Mr. and Mrs. **Viggo Tarnow** in charge… The instruction will include bible study, Danish language, U. S. History, craft, physical training, hiking, swimming, story telling and folk dancing," *SYVN*, June 23, 1944, p. 1.
1946 – "Summer School Closes… On Saturday, the 3rd of August, summer school at Atterdag will be over for 80 children from all parts of the state. They have been busy the past six weeks with classes of art, sewing, hand craft, literature, gymnasium and folk dancing… swimming…," *SYVN*, July 26, 1946, p. 1.
1948 – Atterdag Folk School … "Opens this Sunday. Under the direction of Mr. and Mrs. **Viggo Tarnow**… five week summer course for youngsters between the ages of nine and 15… at [Atterdag] College… tenth year Mr. and Mrs. Tarnow have conducted a folk school in Solvang… First coming to Solvang in 1924, Mr. Tarnow was here for three years and then went to Hutchinson, Minn., where he was supervisor of physical education in the Hutchinson public schools… The Tarnows returned to Solvang in 1938 and have conducted school at Atterdag every year since with the exception of last year when they made a trip to Denmark…[morning] devotional period… instruction of the Danish language… At 10 a.m. grades one to four will participate in gymnastics while the upper grades of five to eight will have an hour of crafts. The crafts class is taught by Mrs. Tarnow. At 11 a.m. the program is reversed with the older children taking gymnastics and the younger ones joining for the crafts class…" and in the afternoon hike and swim, *SYVN*, July 2, 1948, p. 10.
1948 – "Atterdag Folk School Classes Starting July 4. Following a lapse of one year… under the direction of Mr. and Mrs. **Viggo Tarnow**, will open its doors July 4th this year for a five week Summer course for youngsters between the ages of nine and 15… The congregation of the Bethania Church, owner of the building, has taken over the project of readying the College for the convention and the Summer's school work…," *SYVN*, April 9, 1948, p. 1.
1949 – "Folk School Opens Monday. Tarnow Begins 11th Year," and includes crafts, *SYVN*, June 17, 1949, p. 1.
See: "Atterdag College"

Atterdag Studio (Solvang)
Photography studio, run by Hans Sorensen, 1953-59. Loris Gardner purchased Atterdag Studio from Hans Sorensen, 1959, and renamed it Solvang Studio. Sold Solvang Studio to George Ives, c. 1963.
■ "**Hans Sorensen** Opening New Studio Dec. 1… Atterdag Studio on Spring Street… will specialize in photography and offset printing… Mr. and Mrs. Sorensen purchased their Atterdag studio property a few months ago from Mr. and Mrs. Robert Knudsen. Since that time, they have been busily engaged in a remodeling program… which included the conversion of a former workshop to an offset printing room while a new addition to the building houses the photo studio for portrait and other photo work… In the beginning, Mr. Sorensen plans to try out various ideas in specialized offset printing including… greeting cards… the work of local artists… Mr. Sorensen was formerly a compositor for the *Santa Ynez Valley News*. He gave up his position… last January to devote full time to

his photography and to make plans for his offset printing business," *SYVN*, Nov. 27, 1953, p. 6.
Atterdag Studio (notices in Northern Santa Barbara County newspapers on microfilm and on newspapers.com)
1954 – Ad: "Distinctive Portraits. Time Stands Still… in a Portrait… Phone 4425," *SYVN*, June 18, 1954, p. 3; ad: "Greetings and Best Wishes to Old Mission Santa Ines on its 150th Birthday Celebration, Atterdag Studio, printing and photography, Hans, Alice, Kim Sorensen," *SYVN*, Sept. 17, 1954, p. B-14.
And many ads in the *SYVN* through 1956 not itemized here.
See: "Gardner, Loris"

Auman, Patricia (Santa Maria)
Modeled for Santa Maria Camera Club, 1939.
■ "Daughter … of Mr. and Mrs. E. E. (Ted) Auman, former Lompoc residents, was elected Queen of the Pasadena Tournament of Roses…," *LR*, Dec. 21, 1945, p. 1.
See: "Santa Maria Camera Club," 1939

Austin, William Horatio (or H. W.) (1830-1900) (Lompoc)
Sign, house and carriage painter, 1880+.
Austin, W. H. (notices in Northern Santa Barbara County newspapers on microfilm and on newspapers.com)
1880 – "We wanted to see artist Austin the other day and found him busy in his studio painting wagons and buggies…," *LR*, July 3, 1880, p. 3; "Business in Lompoc is steadily advancing. We see numerous new business signs that have lately been painted by W. H. Austin," *LR*, Aug. 21, 1880, p. 3, col. 1.
1882 – "W. H. Austin, House, Sign and Carriage Painter. (Up Stairs) Next door to butcher shop….," *LR*, Aug. 5, 1882, p. 1.
1883 – "We see our local artist W. H. Austin has moved his shop to the premises just vacated by J. C. Murray on H. street…," *LR*, Jan. 13, 1883, p. 3.
1889 – "Certificate of Co-partnership… paint shop and painting business in the town of Lompoc… firm name… Austin & Co….," *LR*, March 30, 1889, p. 2.
1893 – "Mr. Austin, the painter, was taken suddenly ill Thursday afternoon and is still confined to his bed," *LR*, Sept. 30, 1893, p. 5.
1894 – "H. W. Austin, House, Carriage and Sign Painter … Mixed Paints for Farm Wagons for sale by the quart or gallon…," *LR*, Sept. 8, 1894, p. 1.
Austin, W. H. (misc. bibliography)
William H. Austin is listed in the 1880 U. S. Census as age 50, b. c. 1830 in Connecticut, a painter, married to Fanny A. Austin, and residing in Lompoc, Ca.; William Horatio Austin, Printer [sic. painter?], age 66, 5 9 ½ in. fair complected, grey eyes, grey hair, b. Connecticut, registered to vote on June 17, 1896 per *Santa Barbara County – Lompoc Precinct, No. 2*; William Horatio Austin, spouse Fanny A., was b. Feb. 5, 1830 in Connecticut and d. Jan. 27, 1900 in Watsonville, Ca., per My Bohannon Family Tree (refs. ancestry.com).

Avila, Maria Olympia Estrada (Mrs. Juan Alfredo "John" Avila) (1871-after 1917) (Santa Barbara / Los Angeles)
Painting teacher, November, December, 1905.
Avila, O. Mrs. (notices in Northern Santa Barbara County newspapers on microfilm and on newspapers.com)
1905 – "Painting Lessons – I am prepared to give painting lessons in either oil or water colors. Rates reasonable. Apply to Mrs. O. Avila. Near P. C. depot," *SMT*, Dec. 2, 1905, p. 4, col. 4.
Avila, O., Mrs. (misc. bibliography)
Olympia Estrada married Jonas Avila in 1898 in Santa Barbara, Ca. [OR at Santa Ines Mission?], per Western States Marriage Index; Olympia Estrada is listed in the 1880 U. S. Census as age 8, b. c. 1872 in Calif., residing in Los Alamos with her parents and 6 siblings; Olympia E. Avila is listed in the 1900 U. S. Census as age 28, b. June 1871 in California, residing in township 5 (Lompoc), Santa Barbara County, Ca. with husband John, a farmer, who she married in 1898, and a son, Ricardo (age 1); is she Olympia Avila listed in the 1910 U. S. Census in Los Angeles, age 34, b. c. 1876 (?) in Calif., working as a chambermaid in a Hotel, married for 13 years, two children; Mrs. Olympia Avila is listed under "Artists" at 535 W. 1st St., in the *LA City Directory*, 1917; Olympia Estrada y Avila was b. June 24, 1871 in Santa Barbara, Ca., [to Jose Antonio Estrada and Maria de los Dolores de la Guerra] married Juan Alfredo (John) Avila, and was last listed in Los Angeles in 1917 per Shoden Tree Connections (refs. ancestry.com).

AWVS
See: "American Women's Voluntary Services"

Ayres, Angie Morse (Mrs. William "Billie" W. Ayres) (1857-1946) (Guadalupe)
Exh. panel paintings at "Santa Barbara County Fair," 1888. Daughter of James Morse, below.
Ayres, Angie (notices in newspapers)
1883 – "Proceedings of the District Lodge… Mrs. Angie Ayres read an excellent selection, which received the most hearty applause," *SMT*, Sept. 22, 1883, p. 5.
Ayres, Angie (misc. bibliography)
Angie Ayres is listed in the 1880 U. S. Census as age 27, b. c. 1853 in Vermont, residing in Guadalupe with husband William W. Ayres and three children, Eugene (age 4), Wallace (age 2) and Edwin (age 5 mos.); Angie M. Morse Ayres is listed in the 1910 U. S. Census as age 53, b. c. 1857 in Vermont, residing in San Francisco at the home of her parents James Morse (age 75) and Angeline Morse (age 75) with her husband William W. Ayres and two of her sons, Eugene and Edwin, and a daughter Beatrice (age 28); Angie M. Ayres is listed in the 1940 U. S. Census as age 83, b. c. 1857 in Vermont, widowed, residing alone in Los Angeles in a rented house; Angie Ayres, mother's maiden name Perry, father's Morse, b. Dec. 22, 1857 in Vermont, d. March 20, 1946 in Los Angeles County per Calif. Death Index (refs. ancestry.com).
See: "Santa Barbara County Fair," 1888

Azevedo, Jose? R. (Santa Maria?)
Prop. of a photo shop in his own home, c. 1938-48.
Azevedo, J. R. (notices in Northern Santa Barbara County newspapers on microfilm and on newspapers.com)
1943 – "I Spied. J. R. Azevedo, West Main street, harvesting his second crop of corn from his garden back of his photography shop," *SMT*, Nov. 1, 1943, p. 1.
Azevedo, J. R. (misc. bibliography)
J. R. Azevedo, photo shop, is listed with wife Refugio in the *Santa Maria, Ca., CD*, 1938, 1945; J. R. Azevedo, 215 W. Main, is listed under Photo Finishing in the *Santa Maria, Ca., CD*, 1948; J. R. Azevedo is listed with wife Concepcion, occupation Photo Shop, in the *Santa Maria, Ca., CD*, 1948; Jose R. Azevedo, wife Concepcion C., retired, listed in the *Santa Maria, Ca., CD*, 1977 (refs. ancestry.com).

B

B&B Studio (Lompoc)
Photography studio. Prop. Fred C. Keller, 1946-60+. Some years the studio took photos for the high school yearbook.
■ "B&B Studio Moves Location. … local photographers, moved this week into new and larger quarters at 111 South H, next door to their old location. … the studio has a remodeled, redecorated facility which is considerably greater in floor space than their former site. **F. C. Keller** is owner-proprietor…," *LR*, Nov. 4, 1948, p. 9.
B&B Studio (notices in Northern Santa Barbara County newspapers on microfilm and on newspapers.com)
1946 – Ad "B&B Studio. Portraits and Commercial Work. 109 So. H.," *LR*, May 23, 1946, p. 4.
1950 – Ad: "'Small-Fry' Picture Party. … Here is the first of our series of children's pictures which will appear in *The Lompoc Record*. When your child's card arrives in the mail, be sure to phone us for an appointment. These pictures are taken and published free of charge…," and photos of 4 children, *LR*, July 27, 1950, p. 5; ad: "B and B Studio 'Baby Parade'," and repros of baby photos, LR, Oct. 19, 1950, p. 5.
1956 – "Your Photograph – a Precious Gift. Make an Appointment Now…," *LR*, Nov. 29, 1956, p. 17.
More than 118 reproductions of B&B-taken photos appear in the *LR* between 1946 and 1960 but were not itemized here.
See: "Flower Festival (Lompoc)," 1953, 1955, "Keller, Fred," "Lompoc, Ca., Union High School," 1951, 1959

Baby contest / Baby Motion Picture Stars contest (Lompoc)
Annual contest in which photographs taken by local photographers (Wathey Studio (1932), Ernest Brooks (1934)) of local babies were projected on the Lompoc Theater Screen, and voted on by the audience, 1930s. Other photographers who claimed to specialize in baby photos were Louise Studio, Esther Mathewson, Santa

Maria Studio of Photography, Elsie and Leslie Stonehart, and Stonehart Studio.
See: "Brooks, Ernest," "Wathey Studio"

Backus, Standish, Jr. (1910-1989) (Montecito)
Watercolor artist. Member Santa Barbara Art Association who was frequently active in Northern Santa Barbara county.

■ "Born in Detroit, Michigan to a wealthy family, Standish Backus studied watercolor while an architecture student at Princeton and at the University of Munich. His formal art training was limited to a brief period of study with Eliot O'Hara. In 1935, he moved to Santa Barbara, California and became active with the California Water Color Society," per askart.com. Also listed in Wikipedia.

Backus, Standish (notices in Northern Santa Barbara County newspapers on microfilm and on newspapers.com)
1956 – "Artist to Tell Experiences of Expedition to Antarctic… participated in the latest Byrd Expedition… six-month… at the Veterans Memorial Building… Backus, who covered the Polar expedition with brush and camera is a Commander in the US Naval Reserve. He went along as the official artist… During World War II he gained fame as a combat artist… Backus will describe the trip… and will show sketches and photographs made of the expedition," *SYVN*, Nov. 9, 1956, p. 1; "Large Crowd Hears Backus… [on] Byrd Expedition to the Antarctic. … highlighted his talk with the showing of many colored slides which told the story of the trip from the time it left the Panama Canal to the Antarctic and the return six months later to the Canal Zone," *SYVN*, Nov. 23, 1956, p. 8.
See: "Allan Hancock [College] Art Gallery," 1954, 1955, "Bowen, William," 1941, "California State Fair, Sacramento," 1949, "Castagnola, Gladys," 1955, "Knowles, Joseph," intro., "Liecty, Ruth," intro., "National Art Week," 1940, "Santa Barbara County Fair," 1961, "Santa Ynez Valley Art Exhibit," 1954, "Santa Ynez Valley, Ca., Elementary / Grammar Schools," 1949

Badgley, Elaine Stranahan (Mrs. John Badgley) (San Luis Obispo)
Painter. Exh. Santa Ynez Valley Art Exhibit, 1955, 1956. Wife of John Badgley, below.
Badgley, Elaine (notices in Northern Santa Barbara County newspapers on microfilm and on newspapers.com)
1960 – "SLO Art Assn. To Hear Talk…. Monday at 8 p.m. in the Colonial Room in the Anderson Hotel… Mrs. Elaine Badgley will speak … Mrs. Badgley… gradually left realism to work with abstract and non-objective subjects. She will show how and tell why this evolution … took place," *SMT*, Nov. 16, 1960, p. 6.
See: "Badgley, John," "Santa Ynez Valley Art Exhibit," 1955, 1956, "Stranahan, Elaine," and *San Luis Obispo Art and Photography before 1960*

Badgley, John (San Luis Obispo)
Painter. Exh. Santa Ynez Valley Art Exhibit, 1955. Architect of the Buellton School, 1958. Husband of Elaine Badgley, above.
Badgley, John (notices in Northern Santa Barbara County newspapers on microfilm and on newspapers.com)
1958 – "Enrollment of Over 400 Seen at Buellton School," per Badgley who spoke to Buellton PTA, *SYVN*, Nov. 7, 1958, p. 4; And, approx. 10 additional notices on his Buellton school project not itemized here.
See: "Badgley, Elaine," "Santa Ynez Valley Art Exhibit," 1955, "Santa Ynez Valley, Ca., Elementary / Grammar Schools," 1958, and *San Luis Obispo Art and Photography before 1960*

Baechler, Charles (1853-1940) (Lompoc)
Photographer who settled in Lompoc c. 1907. Inventor of a photo-engraving process, 1910.

■ "Charles Baechler is Buried Here… 87-year-old native of Germany who has been a resident of Lompoc for 33 years. … The deceased came to the United States at the age of 16. He operated a photo-engraving business in Portland, the first on the Pacific coast, prior to taking up residence in Lompoc. During his 33 years here, he served the community as photographer and about 20 years ago he invented an inexpensive substitute for photo-engraving which he called photo-stereotyping. One of the big 'scoops' of Mr. Baechler's career … came when he obtained exclusive photographs of the seven U. S. Navy destroyers that ran aground at Pt. Arguello in 1928. An estimated 300 pictures were sold by Baechler from these negatives," *LR*, Sept. 20, 1940, p. 5.

Baechler, Charles (notices in Northern Santa Barbara County newspapers on microfilm and on newspapers.com)
1909 – "Well-known Couple Wed… our genial photographer, was present and secured a negative of the bridal couple and also one of the guests," *LR*, March 5, 1909, p. 1.
1910 – Repro: "Happy Jack's Slate" – Cut Illustrating Line Work Made by Process Invented by C. Baechler," more simple and less expensive, from Tuesday's Daily, *LR*, March 11, 1910, p. 1; repro: drawings by **Ed Beard** of "Chalk Rock Man" and "King Jackson," with cuts "prepared by the new process recently developed by Chas Baechler, Lompoc's well-known and enterprising photographer," *LR*, March 25, 1910, p. 1; ad: "Baechler's Studio, Lompoc, Calif. Can supply you with Photo Stamps, Buttons, Post-Cards, Photo Engravings for the Printing Press as well as the Genuine High Grade Photos of the Photo-Artist," *LR*, June 17, 1910, p. 3; "Chas. Baechler… has gotten up a souvenir post card of various buildings and places for the Fourth of July," *LR*, June 24, 1910, p. 5; repro: fac simile of one of the medals given at the Columbian Fair to the Lompoc Valley Exhibit of Agricultural products…, *LR*, Aug. 5, 1910, p. 1.

■ "Lompoc Man Invents a New Paper Picture Process. … Charles Baechler, a Lompoc photographer, today demonstrated at N. H. Reed's studio, a new process invented by himself by which half-tone plates, suitable for use in newspapers, can be made in 30 minutes after the picture is taken and with equipment costing only a few

dollars. ... Mr. Baechler has been at work on his invention for years, but only within the past few weeks has he succeeded in producing half-tone plates that are equal to those made of zinc in the very expensive plants used by the large city newspapers. ... Mr. Reed today declared that portraits can be printed from the plates which Mr. Baechler makes so that the result will be even better than photogravure. ... At present, plates for making newspaper half tones cost from $5,000 to $10,000 and require the service of from two to ten highly paid workmen. ... normally two to three hours' work, although half-tone plates have been made in half an hour by rushing work on them. Mr. Baechler is a man of middle age who was born in Germany, but for many years has lived on the Pacific coast. In the '80s he made the first half-tone plates on the coast, at Portland, Ore. Before going to Lompoc, he lived for five years at Santa Paula, always working on his invention.... Baechler's method consists of taking an ordinary negative and impressing it in a mold. Into this mold he pours a fluid composition of his own discovery, which hardens and retains the impress of the negative. When placed in a newspaper press and inked, it will strike off thousands of copies, even on the cheapest paper. On glazed paper, resulting pictures are, of course, much better. ..." *SLO Daily Telegram*, Aug. 20, 1910, p. 7.

"Mr. Baechler... returned from Santa Barbara Saturday evening. He was there for the purpose of demonstrating the value of his new photo engraving process to parties who hold a '60 days' option for its purchase... The new process bids fair to supercede the old one and to be a profitable investment...," *LR*, Aug. 19, 1910, p. 3, col. 2; "New Process Invented by Lompoc Man," and article is taken from the *Santa Barbara Independent, LR*, Aug. 26, 1910, p. 1.

1911 – "Monday, Photographer Chas. Baechler returned from Los Angeles where he met parties interested in his new photo casting process...," *LR*, Jan. 27, 1911, p. 5; "Photographer Baechler has a large series of fine post card pictures and others portraying our crowded streets on 'circus day.' We know of nothing more appropriate for sending abroad to friends or intending settlers, ... For sale at the rate of three cards, each containing two views for 25 cents, at the Baechler' studio," *LR*, April 14, 1911, p. 5; "Baechler... is sporting a Texas pan handle straw hat punched full of holes. Whether the holes are for ventilation or irrigation is unknown to us but judging from the thinness of the crop on his cranium it must be the latter," *LR*, April 21, 1911, p. 5; "Business Goes On While He Sleeps. Photographer Baechler thinking that as it was Sunday, he might have an opportunity for a good nap... went through the motions of locking his studio door and stepped over home. Here he slept the sleep of a good conscience... and returning found the door unlocked. Entering, he found on the counter a brief note weighted down with a coin ... while the paper bore this brief inscription without a signature, 'Received one half dozen postal cards'," *LR*, Aug. 11, 1911, p. 1; "All persons wishing photographs of children during the months of December and January will please come for their sittings before 2 p.m.," *LR*, Nov. 27, 1911, p. 5, col. 4.

1914 – "Chas. Baechler... left Monday for Los Angeles where he will attend the photographers' convention ...,"

LR, June 12, 1914, p. 4; "Chas. Baechler, the photographer, has purchased a Metz roadster and is enjoying motoring immensely...," *LR*, Nov. 13, 1914, p. 5, col. 1.

1916 – "Chas. Baechler... arrived home Monday evening from a two weeks vacation ... in the southern part of the state. Mr. Baechler studied for a few days at the Eastman Professional School in Los Angeles," *LR*, June 23, 1916, p. 5, col. 3.

1923 – "From Here to New York. Pictures that were made of the wrecked destroyers at Honda on the day following the tragedy... have been widely published in the east. The pictures were sent to San Francisco through the local post office and from there sent to Underwood & Underwood in New York by the airplane mail service. Mr. Baechler also made one of the most unusual pictures of the eclipse that anyone obtained here and this was exhibited by **Professor James Worthington** at the scientists' convention recently in Los Angeles. Baechler's eclipse picture showed the cloud effect on September 10, just before the totality. ... It was presented to Prof. Worthington by Mr. Baechler who prized it highly. Mr. Baechler developed all of the negatives that were made here of the eclipse by the **Worthington expedition**. The eager scientists were so anxious to see the results of their work that they kept on his heels for two nights and several days while he was doing the developing in his studio and were like exuberant children whenever a good negative was brought out. The most valuable picture of the eclipse that Prof. Worthington made was one which showed Venus, as it is claimed that this was the first time that a star had been photographed during an eclipse. This photo was made by aid of a mirror device invented by Worthington. Mr. Baechler made some of Worthington's pictures into slides and these were exhibited on the screen in Los Angeles at the scientists' convention," *LR*, Oct. 5, 1923, p. 8.

1924 – "Photographer Tells His Side of the Story... celebration at Los Olivos ... The only untoward incident of the day was the ejecting of a cameraman from the grounds who had persisted in taking pictures, despite Crawford's earnest protest to desist. It was reported that in the skirmish the camera was broken... The cameraman... was Mr. Charles Baechler, veteran photographer of Lompoc. Mr. Baechler states that he was engaged by a newspaper to go to the celebration and make some pictures. They wanted pictures of the principals, all of whom were strangers to him and he did not know them by sight. After he arrived at Los Olivos, Taylor Downs was pointed out to him and he approached him and asked permission to take his picture. Taylor Downs readily agreed... At the same time Mr. Baechler states that another man spoke up and said: 'You can take my picture too, if you don't take too long doing it,' or words to that effect. Mr. Baechler says that he thought that the last man who had spoken was Crawford... After he had taken Taylor Downs' picture, Mr. Baechler says he went to where the man who was pointed out to him as Crawford was standing and prepared to train his camera upon him. Without a word Crawford kicked the camera out of his hands... Mr. Baechler states that he had no intention of making the pictures without permission and that it was a case of mistaken identity on his part ... Had Crawford or anyone else requested him not to make the picture, he would not have attempted to do so... Fortunately it was a

good strong camera and the rough treatment did not hurt it. Mr. Baechler wrote Crawford a letter of apology after he arrived home but says that so far he has not received an acknowledgment…," *LR*, Aug. 8, 1924, p. 6.

1926 – "Every Snap Shot Could be Good One… commonest mistakes [for ruining film] … out of focus because the indicator is not set right. The shutters are not set right for the amount of light and the speed is too slow for a [hand held] snap shot … one should hold the camera close against oneself… 'Close' pictures at about eight feet or so, need to have the shutters wide open… Harshness in effect comes from faulty placing of persons in snap shots of people or children. Never place anyone close to an object, such as a wall … but have them stand six or seven feet out… To place them close to an object gives the effect of a poster on the wall … Never touch the lens in your camera… for you can never polish it as it was polished in the factory," *LR*, Aug. 20, 1926, p. 7.

1932 – "Shorts and Overs… Charles Baechler, pioneer photographer, exhibiting some photographs of pioneer residents, the prints having been discovered in an attic while the photographer was presumably undergoing an attack of spring-cleaning fever," *LR*, March 4, 1932, p. 1; "Impressions: Photographer Charles Baechlor [sic.] bringing in a print of the Pitcairn autogiro within half an hour of the time the novel craft landed at the Lompoc Airport. The picture shows 'Morg' Rudolph climbing aboard for his first autogiro flight…," *LR*, May 6, 1932, p. 1.

1933 – "Ocean Park News… [speed boat race?] Although the event was staged impromptu, there were plenty of spectators and the only painful incident was Photographer Baechler, on the breezy railroad bridge, trying to perform the impossible feat of getting all the speed-burners lined up in one irresistible moving picture…," *LR*, May 5, 1933, p. 10.

1937 – "Business Firms Will Remodel… The property on south H street until recently occupied by the Batchelor [sic.] photograph studio, recently purchased by Mrs. Eunice Talbott, will be remodeled and will be used as offices by the Lompoc Seed company…," *LR*, March 12, 1937, p. 1; and additional notices not itemized here.

Baechler, Charles (misc. bibliography)
Charles Beechler [sic.] is listed in the 1930 U. S. Census in Lompoc; Charles Baechler married to Anna Hoffmann was b. May 6, 1853 in Germany and d. Sept. 12, 1940 in Santa Barbara County and is buried in Lompoc Evergreen Cemetery (refs. ancestry.com).
See: "Beard, Ed," 1910, "Lompoc Valley Historical Society, House," "Oakes, Mortimer Leon," "Worthington, James"

Baechler's Studio (Lompoc)
See: "Baechler, Charles"

Baer, Kurt, Dr. (1903-1979) (Santa Barbara)
Art teacher, University of California, Santa Barbara, 1947+. Restorer of some artwork at Mission Santa Ines, 1954. Author of "The Treasures of Mission Santa Ines," 1956.
A full biography "Kurt E. Baer, Art: Santa Barbara" appears on calisphere on the Internet.
See: "Mission Santa Ines," 1954, 1957

Bailey, Ethel H. (Mrs. William Bailey) (1896-1976) (Lompoc)
Painter, watercolors, c. 1951+. Exh. painting at Santa Barbara County Fair, 1952, 1958. Exh. Allan Hancock [College] Art Gallery, 1955, 1958. Active with Alpha Club.
■ "Artist Started Painting Career Eight Years Ago. 'I'm not Van Gogh, I'm Ethel Bailey.' Thus does one of Lompoc's artists, although the recipient of several awards and a member of The Santa Barbara Art Association, maintain that she considers herself still an amateur with much to learn… Having never touched painting material for 20 years while raising her children, Earl and Eleanor Bailey Moore, Mrs. Bailey decided to take lessons from **Forrest Hibbits**, Buellton artist, when he opened an adult education class in the USO Building approximately eight years ago. Since then, she has been smearing palettes, brushing canvases and squeezing paint tubes, enjoying it to the hilt in her 'studio,' which was originally intended to be a sewing room. The 'studio' is a sunny open room which one can view Olive and South H Street at a northeast vantage point … Day's Gone. 'I can sit down before my easel on an afternoon when there is nothing to do, and before I know it the day has gone,' Mrs. Bailey said. A quick-minded individual, Mrs. Bailey finds it hard to sit still for any length of time except while she is at her favorite pastime for this is the one medium giving her mind free rein. When a person is enthused about and loves something, they want to share it with others and such is the case with Mrs. Bailey who recommends that more people paint and become interested in art. … Having had a painting on exhibit at the recent **Tri-County** traveling art show in Lompoc, Mrs. Bailey is planning to enter two canvases in the Santa Maria Fair this month. She won second prize in the amateur watercolor division at the fair last year. Watercolor is her preferred medium because, for one reason, it is fast – 'one can dash it off while it's really hot,' she states. In answer to a question concerning the idea that in watercolor painting one cannot add highlights after once painting an area, she explained that this was true only with transparent water color, they may repaint after a period of one hour when the original paint dries. Mrs. Bailey who signs her paintings 'Ethel Bailey' rather than 'Mrs. William Bailey,' never received formal art training before her lessons with Forrest Hibbits. 'While in high school I took courses in drawing because I like to study that better than anything else, but I never owned a set of oils or did a picture at home.' She worked for a while in Cambria, Calif., in classes taught by **Phil Paradise** where she felt as though she were in the Garden of Eden for 'one had to paint every day.' Imparting a modern style to her paintings little by little and becoming more interested in cubism, Mrs. Bailey related that at first she was afraid to use bold

colors and turned out light pictures, but she grew to use more vivid colors and is now leaning toward interlocking 'planes and lines to get away from reality.' An admirer of Paul Cezanne, Mrs. Bailey likes impressionistic paintings more than the old masters – 'all angles [sic.? angels?] and cows with huge gold frames'," and port with some of her paintings and a second port. showing her at her easel, *LR*, July 6, 1959, p. 4.

Bailey, Ethel (notices in Northern Santa Barbara County newspapers on microfilm and on newspapers.com)
1953 – "Mrs. William H. and [daughter] Eleanor Bailey Describe Three-Month European Tour… of 335 North H street… Southampton… London… Newcastle… Scandinavian countries… The Baileys also were enthused over Swedish modern design in furniture, objects of art, ceramics and glassware… From Denmark they traveled to the Netherlands… Germany … Rhine river by steamer… Switzerland… Rome … Venice… Paris… Le Havre… New York… San Francisco by train…," *LR*, Nov. 5, 1953, p. 5.
1957 – "Happy Notes. Mrs. Ethel Bailey of 335 South H street, has been notified that her watercolor painting of sycamore trees has been selected for showing at the Long Beach Art Museum next month. The delightful picture is now on exhibit in the Santa Barbara Art Museum. It was one of 20 watercolors chosen for the Long Beach showing," *LR*, May 23, 1957, p. 5.
1958 – Port of Ethel Bailey and caption reads "Just off the Easel… 'City Cats,' a watercolor in the same semi-abstraction technique as Mrs. Ethel Bailey's prize winning 'Wild Geese' painting is displayed here by the artist who was asked this week to comment on her change of style from contemporary to semi-abstract. 'I've been painting landscapes for the past several years,' she said, 'and just decided to try something different'," *LR*, May 8, 1958, p. 4.
1959 – "Lompocans Join SB Art Assoc…. Ethel Bailey and **Elsa Schuyler**… Membership was granted as a result of the paintings which they submitted… The Art Association holds its exhibitions in the **Faulkner Gallery** in the Santa Barbara Library," *LR*, July 13, 1959, p. 4.
1963 – "Ethel Bailey Wins Art Award of Santa Barbara Association," *LR*, Sept. 17, 1963, p. 4.
Nearly 100 notices appear on "Ethel Bailey" in *LR* between 1940 and 1960 but most were not itemized here.

Bailey, Ethel (misc. bibliography)
Ethel H. Bailey is listed in the 1930 U. S. Census as age 34, b. in Calif. c. 1896, residing in Lompoc with her husband William H. Bailey (age 47) and child Carl W. Bailey (age 3); listed in 1940 U. S. Census; Ethel H. Bailey b. Feb. 6, 1896 in Calif., and d. June 20, 1976 in Santa Barbara County per Calif. Death Index, is buried in Lompoc Evergreen Cemetery per findagrave.com (refs. ancestry.com).
See: "Allan Hancock [College] Art Gallery," 1955, 1958, "Alpha Club," 1948-50, 1952-54, 1958, 1961, 1962, 1964, "Art, general (Lompoc)," 1961, 1962, "Federation of Women's Clubs," 1960, "Flower Show (Lompoc)," 1948, 1949, 1958, "Hibbits, Forrest," 1964, "Lompoc Community Woman's Club," 1952, 1957, "Lompoc Hospital, Women's Auxiliary," 1949, 1952, 1956, "Open-Air Art Exhibit," 1957, 1960, "Posters, general (Lompoc)," 1952, "Santa Barbara County Fair," 1952, 1958, "Schuyler, Elsa," 1959,

"Tri-County Art Exhibit," 1950, 1958, 1959, "Winter Arts Program," intro

Bailey, Vic (Victor N.) (Santa Maria)
Photographer. Member Santa Maria Camera Club, 1945, 1946. Sgt. of the local California Highway Patrol office to 1956. Judge in Safety Poster Contest, 1950.
Bailey, Vic (notices in Northern Santa Barbara County newspapers on microfilm and on newspapers.com)
1945 – "**Ken Moore**, Vic Bailey Back from High Sierras" fishing trip, *SMT*, Aug. 30, 1945, p. 3.
1956 – "Vic Bailey to Receive Promotion. Victor Bailey, currently sergeant at the local barracks of the California Highway patrol, has been promoted to State traffic lieutenant and will be transferred to the San Bernardino area effective July 16. Bailey, 40-year-old father of four children, has been stationed at the Santa Maria substation since November, 1953 [Sic.?]. He was appointed a State traffic officer in January 1942 and was assigned to the Oakland area. He was promoted to sergeant in May 1952 and was transferred to the Santa Barbara area at that time [Sic.?]," *SMT*, May 29, 1956, p. 1.
Bailey, Vic (misc. bibliography)
Victor N. Bailey, traffic officer, is listed in the *Alameda, Ca., C D*, 1942, 1944; Victor N. Bailey, patrolman, and wife Marguerite are listed in the *SMCD*, 1948 (refs. ancestry.com).
See: "Santa Maria Camera Club," 1945, 1946

Baird, Bobbie J. Toon (Mrs. Eldon Baird) (Vandenberg AFB)
Painter. Exh. at Santa Barbara County Fair, 1960.
■ "Local Artists Place at S.B. County Fair… prize winning oil paintings of … Mrs. Eldon Baird, 508 North Poppy Street. … Mrs. Baird, whose painting, 'Only a Few Treasured Years' won third prize in the amateur oil painting division, was inspired by thoughts of her son, Billy, who died in 1957. The picture was a form of recording his interests as a memorial to the boy. Pictured are the autographed baseball which Mrs. Duke Snyder presented to Billy when he and his father attended a World Series game; his saxophone, his Bible, a model airplane, Boy Scout symbols, and a copy of the newspaper for which he was a carrier boy. Mrs. Baird has been interested in painting for some years. From the age of 10 until her high school graduation, she took lessons in pastels and pencil sketches. After that she took up oil painting on her own. She has painted many pictures for her home and as gifts to friends. In her home she presently displays one called 'Stormy Day,' a snow scene and one of a mountain and lake. Her own favorite, besides the memorial picture, is the snow scene. This is her first entry in competition, although she displayed a number of pictures in Ryon Park this June at the Flower Festival Art Show… Other hobbies of Mrs. Baird include ceramics, artificial flower making, gardening and sewing," and port of Mrs. Eldon Baird with several of her paintings, *LR*, July 25, 1960, p. 6.

Baird, (notices in Northern Santa Barbara County newspapers on microfilm and on newspapers.com)
1966 – "Vandenberg Village News… Enjoying coffee and doughnuts as well as the demonstration were Mesdames … Eldon (Bobbie) Baird…," *LR*, Aug. 5, 1966, p. 7.
Baird, (misc. bibliography)
Eldon L. Baird and Bobbie J. Toon divorced in Santa Maria in Dec. 1973 per Calif. Divorce Index (refs. ancestry.com).
See: "Santa Barbara County Fair," 1960

Baker, ? (Santa Maria)
Commercial artist, 1959.
Classified ad: "Sign Painting. Show Card. Lettering. Wall Mural Designs. Ph. 5-9064 – Between 6-7 p. m. for appointment. Ask for Baker," *SMT*, March 18, 1959, p. 16.

Baker, Edna Angelina Reed (Mrs. Arthur F. Baker) (1890-1980) (Santa Maria)
Interior decorator / artist who lectured to Episcopal Guild, 1938. County Chairman of Art, Federation of Women's clubs, 1937, 1938. Art Chairman, Community Club for whose meetings she often made decorations. Member of Forensic Club (her husband being a mortician), and of Business and Professional Women's Club. Active Santa Maria 1936-39.
Baker, Arthur, Mrs. (notices in Northern Santa Barbara County newspapers on microfilm and on newspapers.com)
1938 – Episcopal "Guild Hears Talk on Color in the Home" given by Mrs. Arthur Baker who also exhibited several water colors, pastels and oil paintings done by herself, *SMT*, June 9, 1938, p. 3; "I Spied … Mrs. Arthur Baker returning from her vacation with oil paintings she made of Rainbow Falls in San Joaquin river and Crystal Crag," *SMT*, Aug. 6, 1938, p. 1; "Arthur and Edna Baker elated over arrival of their first grandson, born to the Charles [Hastings] Bakers [Charles was age 21 in Dec. 1937]," *SMT*, Dec. 17, 1938, p. 1, col. 1.
1939 – "Businesswomen… Party… The picture painted by Mrs. Edna Baker club artist, went to Mrs. Brown…," *SMT*, Jan. 14, 1939, p. 3; "I spied… **Mrs. Ralph Lidbom** showing new paintings by Edna Baker, former Santa Marian," *SMT*, Oct. 18, 1939, p. 1; "Christmas Party Scheduled by B and PW… A painting by Edna Baker, former member… will be disposed of and proceeds added to the fund for $25 gift to the high school welfare department at Christmas time… and **Hilda Van**, chairman of music and arts, are in charge of the party…," *SMT*, Nov. 30, 1939, p. 3; "Caroling, Christmas… A picture painted by Edna Baker, formerly the [Community] club's artist, was awarded to Miss Freeman…," *SMT*, Dec. 6, 1939, p. 3.
1940 – "Arthur Bakers Here for Visit… former Santa Marians are visiting their son and daughter-in-law, Mr. and Mrs. Charles Baker of Orcutt. The Bakers left Santa Maria last year to take charge of an undertaking establishment in Eureka and more recently moved from Eureka to San Francisco where they are in charge of a similar business," *SMT*, June 26, 1940, p. 3.
Many social notices for "Mrs. Arthur Baker" and "Edna Baker" in the *SMT* 1937-1939 were not itemized here.

Baker, Arthur, Mrs. (misc. bibliography)
Edna Angelina Reed was b. Nov. 6, 1890 in Clinton, Ill., to Thomas "Harry" Reed and Eliza Ann Campbell, married Arthur F. Baker, was residing in Skagit, Wash., in 1910 and d. March 15, 1980 in Los Alamitos, Ca. per Byerly-Dietz Family Tree (refs. ancestry.com).
See: "Alpha Club," 1937, "Community Club (Santa Maria)," 1938, 1939

Balaam, Arthur G. (George) (1870-1946) (Lompoc)
Educator in Lompoc schools, 1890-1915. Donated a painting of Yosemite to the Lompoc School, 1891.
See: "Lompoc, Ca., Union High School," 1891, "Schools (Northern Santa Barbara County)," 1910

Ball, Adelaide Benjamina Weaver (Mrs. Walter Colton Ball) (1855-1933) (Lompoc / Berkeley)
Exh. crayon drawing, "Santa Barbara County Fair,"1894.
■ "Daughter of Fanny (Tooley) Weaver. … in the 1880 Census living in the home of Lewis Moody who is her future grandfather-in-law. … At this time Addie was working as a school teacher. Addie married Walter on December 25, 1883 in Paris, Michigan. … By 1900 [Sic. 1888] the family was in Lompoc, California and then by the 1920's had moved north to Berkeley, California. Ran a boarding house in the 1920's and 30's," per findagrave.com. "George Ball's Mother Expires in Berkeley," *Napa Valley Register*, Jan. 24, 1933, p. 8.
Ball, W. C., Mrs. (notices in Northern Santa Barbara County newspapers on microfilm and on newspapers.com)
1888 – "Mr. W. C. Ball, wife, son and mother… from Grandville, Michigan, arrived in Lompoc Thursday evening… Mrs. Ball has been engaged as teacher to succeed Miss Skinner in the Lompoc School…," *LR*, Aug. 4, 1888, p. 4.
1889 – "The town school opened on Monday with the following teachers… Intermediate Department, Mrs. W. C. Ball…," *LR*, Aug. 3, 1889, p. 3, col. 1.
1909 – SON – "Will Be United … Miss Zena McDonald [daughter of **Minnie McDonald**, below] and Mr. George Nelson Ball… The prospective groom is a son of Mr. and Mrs. W. C. Ball who now reside in Berkeley…," *LR*, June 25, 1909, p. 1.
Ball, Addie (misc. bibliography)
Addie B. Ball b. March 1855 in New York and d. 1933, wife of Walter Colton Ball, is buried in Sunset View Cemetery, El Cerrito, Contra Costa County, Ca. per findagrave.com (ref. ancestry.com).
See: "Lompoc, Ca., Elementary," 1889, "Santa Barbara County Fair," 1894

Ballard, Ca.
See: "Art, general (Ballard)"

Ballard School (Santa Ynez Valley)
Elementary school that frequently utilized art in its programs.

■ "Ballard School History … first to be established in the valley. The present school house was built in 1883. In the early days it served many purposes. It was the civic center… On Sundays, church was held here, and during the week evening many were the social affairs … weddings, funerals, lectures, debates, dances, banquets… According to those who know, Mrs. Marshall was the first teacher followed by Miss Miner and in 1885 Miss Nellie Galagher…," *SYVN*, Dec. 18, 1925.
Ballard school (notices in Northern Santa Barbara County newspapers on microfilm and on newspapers.com)

1925 – "Ballard School has Unique Publication. '*The Eagle*' which is the name of the paper gotten out by the Ballard school, consists of eight pages neatly typed by the teacher, Mrs. Maud C. Fox, and illustrated with original drawings by the pupils…," *SYVN*, Dec. 11, 1925, p. 1.

1928 – "Ballard Children… The Ballard school closed Thursday of last week with an exhibition of handcraft and pressed wild flowers display, the work of the pupils…," *LR*, June 15, 1928, p. 4.

1937 – "Ballard School… Last week the main study was about conservation… Friday we all made conservation posters…," *SYVN*, March 19, 1937, p. 5; "Ballard School… Last Friday we made posters for Columbus Day and Halloween," *SYVN*, Oct. 15, 1937, p. 4.

1938 – "Ballard School Notes… We are painting our maps this week. We are painting different colors for different altitudes…," *SYVN*, Jan. 28, 1938, p. 4; "Ballard School… Friday, November 18, we made some Thanksgiving posters for the room. Monday we each made a picture about a Thanksgiving song…," *SYVN*, Nov. 25, 1938, p. 4.

1940 – "Ballard School Notes. For Conservation Week we are making posters, pictures and scrapbooks…," *SYVN*, March 15, 1940, p. 8; "Ballard… Monday we began our study of the missions of California. Some of us are going to make scrapbooks… Others are drawing pictures of the missions. Some are making models. Olga has begun a picture map of California to show where the twenty-one missions are," *SYVN*, April 5, 1940, p. 5; "Ballard… Three of the children are painting our garden doll… Arleigh brought her woodburning set to school. Holger is woodburning pictures of some of the Mission towers," *SYVN*, April 26, 1940, p. 5; "Ballard School… In our unit we have completed drawing pictures of foods… a large map of California showing where the foods grow…," *SYVN*, Nov. 22, 1940, p. 4; "Ballard School Notes. Last Monday we started our new unit on Arts. Our unit includes living artists in Santa Barbara county, old masters in art, music, poetry, story writing, modeling and sculpturing. We have all decided what we want to do. We are going to make an art gallery of our own which will include designs on cloth, models out of soap, pencil sketches and paintings. Later on we are going to sketch pictures of the trees and mountains that we can see from our school yard. We are saving artistic pictures of all sorts. We have been mounting pictures of famous paintings for our bulletin board," *SYVN*,

Nov. 29, 1940, p. 4; "The upper grades have all finished their reports on their favorite animal picture and favorite landscape paintings. They have also given reports on engravings, lithography and etchings and murals. We have all finished some of our activities, which include a dog carved out of soap by Dorisa, a rabbit modeled of clay by Anna, a chalk picture drawn on the easel by Arleigh, and two pencil sketches, one of a squirrel and one of a deer, by Olga. We are now drawing landscapes that we can see from our school grounds," *SYVN*, Dec. 13, 1940, p. 10.

1947 – "Elementary Schools Notes. Ballard. The Ballard School was paid a visit last Thursday by **Joe Knowles**… The upper grade children painted pictures of South America, the middle grade children painted scenes of early California, and the primary grades did water colors of home and community life under Mr. Knowles' direction…," *SYVN*, Nov. 21, 1947, p. 5.

1948 – Photo of historic Ballard school … and history of school, and "**Miss Phoebe Lee Hosmer**, the third teacher, came from Orange, Mass., and began her work as teacher in 1886. She taught for three years and then resigned to accept a position at Los Alamos. Miss Hosmer influenced her pupils… developing in them a love for art, music and good reading… Miss Hosmer resides in her old ancestral home in Orange and is still keenly interested in the good things life affords…," *SYVN*, Oct. 8, 1948, pp. 1, 10; "Ballard School… Much appreciation was expressed for the gift of a large water color painting of the school before it was painted red. The artist, **Merrill Gage** of Santa Monica, is noted for his paintings and sculpture work. … The gift was made to the school by Mr. and Mrs. William Slaughter, former residents…," *SYVN*, Oct. 15, 1948, p. 4.

1951 – "Children of Ballard School Present Christmas Program… The scenery, which was most effective, showed an adobe ranch house and patio. This was painted … under the direction of **Leo Ziegler**, art instructor…," *SYVN*, Dec. 28, 1951, p. 4.

1953 – Photo and "Ballard School to Celebrate 70th Birthday… One of Three One-room School Houses in County" and history, *SYVN*, Dec. 18, 1953, p. 1.

1954 – Photo and "Ballard's 'Little Red Schoolhouse,' Built in 1883" and history, *SYVN*, Sept. 17, 1954, p. B-9.

1958 – Photo and "Ballard School… to Celebrate 75th Birthday…" and history, *SYVN*, June 27, 1958, p. 5.
See: "Art, general (Ballard)," "Posters, American Legion (Poppy)," "Santa Ynez Valley, Ca., Elementary Schools"

Ballenger, E., Miss (Cuyama?)
Exh. pencil drawings and water colors at "Santa Barbara County Fair," 1888. Sister to Margaret Ballenger, below?
FATHER? – "Mr. Ballenger has sold his cattle. He says the country is too uncivilized for him and he wants to go back into civilization where nobody lives," *SMT*, Aug. 25, 1888, p. 3.
This individual could not be further identified.
See: "Santa Barbara County Fair," 1888

Ballenger, Margaret, Miss (Cuyama?)
Exh. best pencil drawing of a dapple horse and saddle at "Santa Barbara County Fair," 1886. Sister to E. Ballenger, above?
1890 – "S. Ballenger is preparing to start for Arizona, as soon as his daughter Margaret, who has been very sick, recovers," *SMT*, May 24, 1890, p. 2.
This individual could not be more fully identified.
See: "Santa Barbara County Fair," 1886

Barbera, Helen Fitts (1892-1971) (Solvang)
Artist / ceramist, 1952+. Exh. Santa Ynez Valley Art Exhibit, 1954, 1955, 1956. Prop. of Valley Ceramic Shop.

■ Port with bowl and "Helen Barbera, Artist and Ceramist, New Resident Here.... A New Englander by birth, comes to the Valley from La Crescenta. In October of 1952, she purchased the little house under the oak between First and Second Streets from Mrs. Jane Hentze who lives in Alaska. The home, designated in Danish as Braeddehytten – the little wooden house—is one of Solvang's landmarks and through the years has been noted for its quaintness and attractive garden dominated by a giant old oak tree. The garden, planned originally by **Karl Kuhl**, a landscape gardener now living in Altadena, will be brought back to life by Helen Barbera who says she just 'loves to garden.' 'I have long been interested in gardens and garden sculpture,' she said. It is her plan to adorn her garden with pieces of her sculpture When she started taking lessons in sculpturing, her instructor asked her what she would like to do for her initial work. She replied she liked to create a statue just 'sitting, looking and thinking.' She said she'd call it 'Dreaming of Solvang.' Helen Barbera completed her 'Dreaming of Solvang' statue, and this piece of work will be donated by her to the **St. Mark's** show, as well as a tile plaque of a Danish stork, 'Peter,' which she had made several years ago.... Helen Barbera will also display three clay models in the show. They are 'Polka,' 'Goose Girl,' and 'What Did You Do to my Cabbage?' The artist was busy unpacking this week as she prepared to move into her new home. The little house has been redecorated and one of the smaller bedrooms will be used as her studio. A former utility room, off this bedroom, will house her kiln, while part of the garage will serve as casting and modeling area...," *SYVN*, March 19, 1954, pp. 1, 4.
Barbera, Helen (misc. bibliography)
Mrs. Helen F. Barbera, artist, 2712 Sanborn Ave. (La Crescenta) is listed in the *La Crescenta CD*, 1946; Helen F. Barbera b. Sept. 24, 1892 in Arkansas, d. June 6, 1971 in Los Angeles County per Calif. Death Index; Helen Fitts Barbera, 1892-1971, is buried in Forest Lawn Memorial Park, Glendale, Ca. (refs. ancestry.com).
See: "Danish Days," 1954, "Santa Ynez Valley Art Exhibit," 1954-56, "Valley Ceramic Shop"

Barbour, E. L., Dr.
Itinerant puppeteer who performed at Santa Maria high school, 1938.
See: "Puppets (Santa Maria)," 1938

Barker, Francis "Frank" Joshua (1886-1980) (Lompoc / San Pedro)
Lompoc High School grad. '07, who studied art in his junior year with Florence Sollman. Retrospectively, in the 1960s, made pencil (?) drawings of historic Lompoc, now Coll. Lompoc Valley Historical Society.

■ Frank Barker "... Lived many years in [the] Wise District in Cebada Canyon." He married Grace Campbell (1893-1965) on Jan. 14, 1912 in Lompoc. He appears to have spent the years 1914-17 in Santa Barbara as a carpenter. "Frank and Grace Barker moved from Lompoc to San Pedro in 1918. He was building repairman for L. A. Recreation and Parks Dept. in the Harbor area 22 years. Frank remained active, attending dances 2 or 3 times a week until Jan. 1979 when he was hit by a car when on his way to a dance. His hip was broken ... so sold [his] home in San Pedro and went to Sun City with daughter Margaret Faust... [He] was a faithful contributor of history to Lompoc Valley Historical Society..." to whom he donated his many pencil sketches and diaries.

■ In his book *To California and Lompoc; A Memory Garden*, [by Presley Bascom Barker, Lompoc, Ca.: Lompoc Valley Historical Society, 1979, illus. by his son, Frank Barker] Frank writes on p. 58, "The turning point in my High school work happened in my Junior Year. **Miss Soleman** [Sic. **Sollman**] was teaching free hand drawing. I saw no particular point, except to make a credit, but what changed my course was an old friend and employee of my Dad's. He came to me and said 'I have books that you can use in school.' I accepted his books more out of curiosity, thinking that would be all. With the books was a drafting board, a T square, a case of drawing instruments, triangles, irregular curves and instruction books of all kinds. This was a course in Architecture from the International School of Correspondence. This looked like a new world that I had never seen. I took the whole set to school for Miss Soleman [Sic.] to look over. She was intensely interested, and called me to her desk and said 'Frank this is something you can use in your life work. I will see **Mrs. McCabe** [Sloyd teacher at both Lompoc Elementary and High Schools, 1908/11?] and I think she will approve teaching a course in Geometrical Drawing, so you can use these books. ... I worked thru the Geometrical drawing and then started the architecture course' ... He goes on to describe working on a large job in Montecito setting everything square, in school studying estimating, costs, bookkeeping, commercial law and typing. He worked for John Henning who had built some of the schools, churches and residences of Lompoc. In 1912, he was hired to work on an extensive remodeling job at San Julian Ranch under the supervision of Francis T. Underhill, a Santa Barbara Architect and son in law of Thomas Dibblee, ranch owner. He designed a truss for the hay loft, rustic fence, seats and furniture. His largest job was to make plans for a two-story annex to the East wing which would conform to the old building, and a bridge.
He was hired by Mr. Underhill to go to Santa Barbara and take up some of the work in Montecito ... which he did in 1913. He lived there with his wife and children. Frank does not say why he made the [historical] drawings... except that

some are in the book" (information courtesy Myra Manfrina, Lompoc Valley Historical Society).

Barker, Frank (notices in Lompoc newspapers on newspapers.com).

1910 – "New Dwelling on Ocean Avenue. P. B. Barker is having built a neat dwelling on Ocean avenue between F and G streets. Frank Barker is supervising the construction," *LR*, March 4, 1910, p. 8.

1956 – Port. as 1907 grad of Lompoc High School, *LR*, Aug. 30, 1956, p. 7.

1967 – Port. admiring a painting of a historic house in Lompoc, *LR*, Sept. 2, 1967, p. 1; "Class Reunions… presence of the last remaining members of the Lompoc High School, class of 1907 … Frank Barker of San Pedro…," *LR*, Sept. 6, 1967, p. 6.

1968 – "Wise school… began in a barn on the old Wise place in Cebada Canyon in 1886… Frank Barker, the last pupil to attend the school … The Barkers moved onto the ranch in November 1897… Frank, now 82, walked down the country road two miles to school. He has lately done some sketches of local scenes that are excellent… When the school closed, as Frank was the only young person left – he trudged over the hill west to Purisima School, which he attended for two years before entering high school…," *LR*, Aug. 30, 1968, p. 4.

1969 – "Two Life Memberships Given by Lompoc Historical Society … Frank Barker… has written many memoirs of Lompoc and drawn pictures of early day scenes for the Historical Society. At age 83, he is still writing and drawing early Lompoc vignettes…," *LR*, Sept. 2, 1969, p. 4; "Historical Society Files Genealogies… Frank Barker, an honorary member of the society and [current] resident of San Pedro, as a boy lived at the corner of N. St. and Cypress Avenue," *LR*, Dec. 10, 1969, p. 8.

Barker, Frank (misc. bibliography)

Frank J. Barker is listed in the 1910 U. S. Census as age 23, b. c. 1887 in Calif., a carpenter, residing in Lompoc with his parents Resler [Sic. Presley] B. Barker (age 59) and Allie A. Barker (age 43); Frank J. Barker, carpenter is listed in the *Santa Barbara, Ca., CD*, 1914-17; photos and archival material for Francis Barker (Dec. 17, 1886-June 6, 1980) are contained in *Public Member Photos & Scanned Documents* (refs. ancestry.com).

Barmack, Manasseh Morris, M-Sgt. (1915-2013) (Vandenberg AFB)

Photographer. Associated with the 1352d Motion Picture Squadron at Vandenberg. Judge of a post photography contest, 1959. Member of Organ Society. Son named Peter Barmack.

1960 – "Lehmans Host Organ Society… Manasser Barmack family who will leave for Hawaii shortly…," *LR*, June 23, 1960, p. 8.

1963 – "Lehman's Host Welcome Party… to … the Barmack family, Sgt. Mannie, Natalie, Peter and Virginia. They have been on a three-year duty tour in Hawaii," *LR*, Sept. 30, 1963, p. 6.

1964 – Port. presenting official Air Force photo portrait of the late Gen. Hoyt S. Vandenberg, which he took in 1951 in Washington, D. C., to Brig. Gen Jewell C. Maxwell, *LR*, Dec. 21, 1964, p. 15.

Barmack, Manasseh (misc. bibliography)

Manasseh M. Barmack b. Oct. 19, 1915 and d. Nov. 20, 2013 is buried in Riverside National Cemetery, Ca., per findagrave.com (ref. ancestry.com).

See: "Photography, general (Camp Cooke)," 1959

Barnes, (John) Michael Medd (1933-1952) (Santa Ynez Valley)

Artist, 1950-52. Memorial exh. held at first annual Santa Ynez Valley Art Exhibit, 1953. Shot himself in the head.

■ "Graveside Rites Tomorrow for Michael Barnes… Oak Hill Cemetery in Ballard… 19-year-old son of Mr. and Mrs. Landon Barnes of Little Patch Ranch, Ballard… Young Barnes, a senior student at the Santa Ynez Valley Union High School died shortly after noon on Wednesday… took his own life… Michael Barnes was born on March 2, 1933 in Santa Barbara. he attended elementary schools here and was destined to graduate in June… He was athletically inclined and had played first string end on the high school football team the past season. He was also a talented artist. Late in February he was honored for the third consecutive year when he won a 'Certificate of Merit' for his painting in the Southern California **Scholastic Art Contest**… Young Barnes had previously won two gold keys for his exhibits … The young man took an active part in other programs at the high school, including the band. For a period of five months last year he served in the US Navy but was released on a medical discharge…," *SYVN*, April 11, 1952, p. 1.

Barnes, Michael (notices in Northern Santa Barbara County newspapers on microfilm and on newspapers.com)

1951 – "Navy Enlistee…," *SYVN*, April 6, 1951, p. 4.

1952 – "Baccalaureate Rite Dedicated to Memory of … John Michael Medd Barnes, who passed away in early April… Santa Ynez Valley Union High School," *SYVN*, June 6, 1952, p. 3; And approx. 50 additional notices for sports not itemized here.

Barnes, Michael (misc. bibliography)

John Michael Barnes, son of Landon Leaford Barnes and Elizabeth "Betty" Medd, was b. March 2, 1933 in Santa Barbara County and d. April 9, 1952 in Santa Barbara County per KFamilyTree 6.003 (ref. ancestry.com).

See: "Santa Ynez Valley Art Exhibit," 1953, "Santa Ynez Valley Union High School," 1949, 1951, "Scholastic Art Exhibit," 1949, 1950, 1951, 1952

Barr, Tom (?)

Printmaker, one of whose works was owned by John Breneiser and exhibited at National Art Week, 1935.

Is this Tom Barr listed in the 1900 U. S. Census as age 17, b. c. 1893 in Pennsylvania, working as an advertising artist, residing in Bellevue, Pa., with his parents John B. Barr (age 60) and Flora Barr (age 57) and siblings: is this Thomas C. Barr listed as an artist in the *Pittsburgh, Pa., CD*, 1912-16? (ref. ancestry.com).

See: "National Art Week," 1935

Barraza, (Mary) Olga (1934-?) (SLO / Lompoc)
Art Student, SLO Junior College, 1950. After her move to Lompoc, she became a member of Lompoc Valley Camera Club and exh. photos at Santa Barbara County Fair c. 1985+.
Barraza, Olga (notices in Northern Santa Barbara County newspapers on microfilm and the Internet)
1949 – "Judges will Select Queen... Club Alegria... Participating in the contest this year... Olga Barraza, SLO," *Santa Maria Times*, Sept. 29, 1949, p. 5.
1950 – "Films, Dances, Music... Business and Professional Women's club... Don Carlos and Olga Barraza will perform Spanish dances...," *SLO T-T*, April 14, 1950, p. 3.
1985 – "First in the 'non-living closeup' photo slides was Olga Barraza of Lompoc...," *Santa Maria Times*, July 30, 1985, p. 8; "Medical Laboratory Opens... Medical Diagnostic Systems ... staff medical technologist, Olga Barraza...," *SYVN*, Sept. 12, 1985, p. 12.
1987 – "Fair Results... Color Prints Landscapes, Amateur: ... Olga Barraza, Lom., 3rd...," *SMT*, July 26, 1987, p. 10.
1992 – "Santa Barbara County Fair... Photography... Color Prints... Children the Center of Interest. ... 3rd Place – Olga Barraza, Lompoc, 'Jay',", *SMT*, July 10, 1992, p. 17.
2011 – "Margaret Geralyn Adriansen... Margie began to photograph as a hobby in 1990... Thank you to ... Olga Barraza... and all the others in the Lompoc Valley Camera Club who taught, shared with, and encouraged Margie...," *SYVN*, March 17, 2011, p. A6.
Barraza, Olga (misc. bibliography)
Mary Olga Barraza b. May 19, 1934, mother's maiden name Soto, was born in Imperial County per Calif. Birth Index; Olga Barraza is listed in the 1940 U. S. Census as age 6, b. c. 1934 in California, residing in El Centro (1935) and SLO (1940) with her parents Jeverino Barraza (age 44) and Ysaura Barraza (age 52) and siblings (refs. ancestry.com).
See: *San Luis Obispo Art and Photography before 1960*

Barrett, Minna "Minnie"
See: Miller (Barrett), Minna "Minnie"

Bartholomew, Lucille L. (1910-1999) (Los Alamos)
Painter. Exh. "Hibiscus" at Tri-County Art Exhibit, 1947. Exh. at Santa Maria Valley Art Festival, 1953.
A few social notices in the *SMT* were not itemized here.
Bartholomew, Lucille (misc. bibliography)
Lucille L. Bartholomew, age 20, is listed in the 1930 U. S. Census as b. c. 1910, residing in La Paters, Santa Barbara County, Ca., with her husband Ralph W. Bartholomew (age 29) and children Myrtle M. (age 1) and John H. (less than 1 year); listed in 1940 U. S. Census as finished elementary school, 8th grade, residing in Santa Barbara city with husband Ralph and children Myrtle, John and Nancy; is she Lucille L. Bartholomew b. Jan. 24, 1910 in Calif. and d. June 6, 1999 in Grosse Pointe, Mich., per Social Security Death Index (refs. ancestry.com).
See: "Santa Maria [Valley] Art Festival," 1953, "Tri-County Art Exhibit," 1947

Basse, Lynn (Los Angeles)
Public relations representative for furniture store, Cannell & Chaffin, Los Angeles, who spoke to Minerva Club, 1955.
See: "Interior Decoration" "Minerva Club," 1955

Batkin, Kay, Miss (Lompoc)
Member of Handiwork Section of Alpha Club, 1934. Professional seamstress. Competed frequently with handicrafts at the Santa Barbara County Fair, 1930s.
See: "Alpha Club," 1934

Battles, (Ulysses) Grant (1863-1935) (Santa Maria)
Dairyman who exh. colored (?) photos at "Santa Barbara County Fair,"1890.
■ Port. and "Death Calls U. G. Battles Here 67 Yrs. ... One of the valley's most prominent ranchers for forty years ...," *SMT*, Nov. 1, 1935, pp. 1, 6.
See: "Santa Barbara County Fair," 1890

Batty, Anita H. Hoag (Mrs. Arthur Burgess Batty) (1907-2005) (Lompoc)
Collector, 1959. Member of Fine Arts Section, Alpha Club, late 1950s.
■ "Crowds Visit Six Lompoc Residences... Junior Alpha Home Tour... "Objects d'Art. The Arthur Batty home across the street was filled with interesting objects d'art from paintings to dainty statuettes and was enhanced by a giant picture of the countryside from floor to ceiling glass panels. ... The gun collection belonging to Mr. Batty with pieces dating far back into time was something few people could resist asking questions about. Swords and halberds together with 200 guns are lined along the workshop wall ... Residing in the Batty home are Dr. and Mrs. Hoag, parents of Mrs. Batty, and of special note was the spread on Mrs. Hoag's bed. She made it herself years ago of colorful material from dresses ...," *LR*, April 9, 1959, p. 21.
Batty, Anita (notices in Northern Santa Barbara County newspapers on microfilm and on newspapers.com)
More than 110 social (bridge playing) matches (including a couple of ports.) for "Anita Batty" in *LR* between 1950-1965 and 230 matches (primarily Alpha Club related, flower show) for "Mrs. Arthur Batty" in *LR* between 1950 and 1965 were not itemized here.
Batty, Anita (misc. bibliography)
Anita H. Batty was b. Sept. 29, 1907 in Milwaukee, Wisc. and d. Jan. 4, 2005 in Milpitas, Santa Clara County, Calif., per findagrave.com (ref. ancestry.com).
See: "Alpha Club," 1955, 1956, 1958-60

Baxley, Ellen Cooper (1860-1949) (Montecito)
Montecito artist who visited her cousin in Lompoc, mid 1930s.
■ "Funeral Today for Mrs. Baxley. ... last surviving child of the late Ellwood Cooper, the man who brought the eucalyptus trees to California... Mrs. Baxley died at the age of 89, all of it spent in Santa Barbara except her first 12

years. Her father brought her to Santa Barbara in 1872 when he purchased a ranch where the present Ellwood oil field is located. He came from Haiti, where he had been U. S. consul," *SMT*, Nov. 25, 1949, p. 7.

Baxley, Ellen (notices in Northern Santa Barbara County newspapers on microfilm and on newspapers.com)
1928 – "Mrs. **Muriel Edwards** spent the week end with Mrs. Ellen Baxley in Montecito. Mrs. Baxley had a preview of her paintings Saturday evening at her studio," *SYVN*, March 23, 1928, p. 8.
1934 – "Is Guest – Miss Ellen Cooper Baxley… is a house guest of her cousin, Mrs. W. A. Meyers and family," *LR*, Aug. 24, 1934, p. 3.
1935 – "Montecito Artist Here – Guest at the home of Mrs. William A. Meyers is her cousin, Mrs. Ellen Cooper Baxley, well-known artist from Montecito," *LR*, June 28, 1935, p. 7.

Beach, Clyde P. Delmar, Sgt. (1897-1979) (Lompoc)
Dark room expert with Highway Patrol, 1942.
■ Port. with Chief of Police examining a "negative" turned out in the new **police** photography laboratory, *LR*, April 17, 1942, p. 1.
Beach, Clyde (misc. bibliography)
Clyde Delmar Beach was b. Feb. 6, 1897 in Gainesville, Missouri, married Ruby Ellen Johnson and d. Aug. 28, 1979 in San Bernardino, Ca. per #1Sellers, Campbell, Hesterlee2 Family Tree (refs. ancestry.com).
See: "Lompoc, Ca., Police Department"

Beane, Frank Orval (1910-1998) (Lompoc)
Photographer, amateur. Member La Purisima Camera Club, 1938.
Beane, Frank (notices in Northern Santa Barbara County newspapers on microfilm and on newspapers.com)
1941 – "Laura O'Dale, Franke Beane Are Wed… Frank Orval Beane… Mrs. Beane is the manager of **The Camera Shop**…," *LR*, Feb. 28, 1941, p. 3.
1942 – "Frank Beane is New Kiwanis Club President… The new president has operated the Lompoc Western Auto supply here for the past six years …," *LR*, Sept. 25, 1942, p. 1.
1948 – Port. with others mapping Dollar Day plans, *LR*, April 15, 1948, p. 1.
Beane, Frank (misc. bibliography)
Frank Orval Beane b. March 18, 1910 in Nipissing, Ontario, Canada, married Laura Bell Brooks, and d. Nov. 21, 1998 in Studio City, Ca., per The Whole Forest Family Tree (refs. ancestry.com).
See: "Hobby Show – Kiwanis," 1948, "La Purisima Camera Club," 1938, "Santa Maria Camera Club," 1939

Bear, Donald Jeffries (1905-1952) (Santa Barbara)
Curator and later Director of the Santa Barbara Museum of Art and lecturer on art to various clubs in Northern Santa Barbara County, 1940s.
■ "Bear Services… Funeral rites for Donald J. Bear, 47, director of the Santa Barbara Museum of Art, who died of a heart attack Sunday… at the home of a friend in La Jolla…

survived by his wife, Mrs. Esther Fish Bear, two daughters…," *SYVN*, March 28, 1952, p. 4.
Bear, Donald (misc. bibliography)
Donald Jeffries Bear, married to Esther F. Bear, was b. Feb. 5, 1905 and d. March 16, 1952 per findagrave.com (ref. ancestry.com).
See: "Alpha Club," 1941, "Berend, Charlotte," 1944, "Santa Ynez Valley Union High School," 1946, 1952, "Stark, Jack," 1944, "Solvang Woman's Club," 1952

Bear, Marcelle Levy (Mrs. M/Sgt Jack I. Bear) (1917-1995) (Camp Cooke / Jacksonville, Fla.)
Painter who held and exh. at the high school, 1945. By 1949 Marcelle and Jack had settled in Jacksonville, Fla. where they ran Reddi Rents and she pursued her art.
■ "Artist Bear's Work Exhibited in School… Marcella [Sic. Marcelle] Bear… Miss [Sic. Mrs.] Bear has studied art in France. She has traveled extensively, taking an interest in the people of the different countries … Eventually she hopes to combine landscapes with portraits," *SMT,* Oct. 4, 1945, p. 3.
Bear, Marcelle (notices in Northern Santa Barbara County newspapers on microfilm and the Internet)
1945 – "Painting Exhibition" by Mrs. Marcelle Bear of landscapes and still life in wc will be displayed in HS, *SMT,* Sept. 21, 1945, p. 3.
1962 – Is she Marcelle Bear, a Jacksonville artist who exhibited in a group show at the University of South Florida Gallery, *Tampa Tribune* (Tampa, Fla), May 27, 1962, p. 89 (i.e., 3-E).
And, additional notices on her art in Florida newspapers after 1949, were not itemized here.
Bear, Marcelle (misc. bibliography)
Jack I. Bear (age 29, US citizen) and Marcelle L. Bear (age 27, US citizen) flew from El Paso, Texas, to Monterrey, N. L. in Mexico on December 15, 1944 per Clearance Declaration of Aircraft Commander; Marcelle Bear is listed with spouse M/Sgt Jack Bear in the *SMCD*, 1945; Marcelle Bear, b. Jan. 13, 1917 and d. Dec. 22, 1995 per Social Security Death Index (refs. ancestry.com).
See: "DeNejer, Jeanne," "Santa Maria Art Association," 1945, "United Service Organization (Santa Maria)," 1945, 1946

Beard, Ed/ Edwin S. (1886-1957) (Lompoc)
Special sketch artist for Lompoc Record, 1910. Sign painter.
■ "Funeral Rites Held for Ed Beard… He was born in Lompoc August 20, 1886 and spent most of his life as a resident of the valley where he was engaged in sign painting until his retirement a few years ago. …," *LR*, Jan. 31, 1957, p. 1.
Beard, Ed S. (notices in Northern Santa Barbara County newspapers on microfilm and on newspapers.com)
1910 – "The *Daily News*, following the trend of progressive journalism, has added a sketch department and with today's issue begins the publication of life sketches of well-known Lompoc people. Ed. S. Beard, who has developed decided talent as an artist along these lines has been engaged for the service, and the half-tone work will be executed by **Mr.**

Baechler by a new process entirely his own," and drawing of Ed Beard and "Uncle Joe" Harris, *LR*, March 11, 1910, p. 7; repro: drawing of "John Mullinery, the Fire Chief," *LR*, March 18, 1910, p. 1; repro: drawings of "Chalk Rock Man" and "King Jackson," with cuts "prepared by the new process recently developed by **Chas Baecheler**," *LR*, March 25, 1910, p. 1; repro: "Fernando Libraza," 100 years old, *LR*, April 1, 1910, p. 4; repro: sketch of blacksmith, *LR*, April 22, 1910, p. 2.
1939 – "Shine Shop. Ed Beard, who has operated a shoe shine stand here for many years, has opened a shine parlor at 121 South H. street, which he will operate in conjunction with his sign painting business," *LR*, June 30, 1939, p. 8.
See: "Civil Works Administration," "Lompoc, Ca., Elementary Schools," 1935

Beard, Matte Willis (SLO / Morro Bay)
Artist who exh. at Santa Ynez Valley Art Exhibit, 1954.
See: "Santa Ynez Valley Art Exhibit," 1954, and *Morro Bay Art and Photography before 1960*, and *San Luis Obispo Art and Photography before 1960*

Beattie, Elva Elizabeth Davis (Mrs. John Edward Beattie) (1915-1999) (Lompoc)
Ceramist. Exh. Santa Ynez Valley Art Exhibit, 1956. Prop. Ocean Avenue Ceramics, 1957.
■ "Elva Davis Beattie... was born Sept. 28, 1915 in Los Olivos to Bernard and Martha Cox Davis, a pioneer family in Santa Ynez Valley... married Ed Beattie in 1935. ... She graduated from Santa Ynez Valley High School in 1935," *SYVN*, Jan. 28, 1999, p. 5.
Beattie, Elva (notices in Northern Santa Barbara County newspapers on microfilm and on newspapers.com)
1960 – "Mr. and Mrs. J. E. Beattie Celebrate Silver Anniversary," *LR*, July 21, 1960, p. 22.
Beattie, Elva (misc. bibliography)
Elva E. Beattie is listed in the 1940 U. S. Census as age 24, b. c. 1916, finished high school 4th year, residing in rural Santa Barbara County (1935, 1940), married to John E. Beattie (age 25); Elva E. Beattie b. Sept. 28, 1915, d. Jan. 23, 1999 in Santa Ynez, Ca., per Social Security Death Index (refs. ancestry.com).
See: "Alpha Club," 1960, "Art, general (Lompoc)," 1961, 1962, "Ocean Avenue Ceramics," 1957, "Santa Ynez Valley Art Exhibit," 1956

Beattie, Johanna "Juka" Mesikep Carlson (Mrs. Francis Beattie) (1919-2015) (Estonia / Lompoc)
Painter, collector of ceramic figurines, 1952+
■ Port. of Juka Beattie in her home and port. at easel, and "New Beattie Home has Beauty Plus. On a clear day they can see Vandenberg from an upper window… In the making for two years… the contemporary home on East Fir Avenue… and pictures within, painted by Mrs. Beattie both here and in Europe… Because she is an artist of high talent and at one time also took an architectural course, drawing the plans for the 'dream house' was a pleasure to Mrs. Beattie… [on] the December 17 Christmas Home Tour of the Lumen Vitae League of the Children's Home Society…

[and description of interior and furnishings] … The dining room … highlight a built-in wall cabinet of birch where many objets d'art are displayed. Here is the Hummel collection brought from Europe by Mrs. Beattie, the dozen pastel Meisen figurines, the graceful Rosenthals and statuettes by famous foreign craftsmen. Here too, is the rich cobalt tea set of porcelain, heavy with 24 karat gold trim. … A retreat for Mrs. Beattie's painting sessions is the studio room which stores easel, palettes, paints and brushes. White walls and blue drapes lessen distraction from her work. …," *LR*, Dec. 5, 1960, p. 4.

■ Port. and "Johanna Beattie... Born September 18, 1919 in Narva-Joesuu, Estonia, she entered the United States on May 21st, 1951 at Fort Hamilton, Brooklyn, N. Y. and became an American citizen on December 15th, 1954 at the Superior Court in Santa Barbara... She was a loving, elegant wife to Frances H. Beattie Sr. for 28 years, who preceded her in death. Johanna who was fondly referred to as 'Juka' was an incredible mother, grandmother, great grandmother, and friend. Her only son Mati Mesikep, of Lompoc, California preceded her in death," *SMT*, Sept. 6, 2015, p. E7.
Beattie, Juka (notices in Northern Santa Barbara County newspapers on microfilm and on newspapers.com)
1960 – Port. and repro of painting, *LR*, Dec. 15, 1960, p. 30; port. with husband and mother-in-law at retirement of Supervisor Francis Beattie after 12 years in the position, *LR*, Dec. 13, 1976, p. 1.
Beattie, Juka (misc. bibliography)
Juka Beattie is listed with Francis H. (Beattie Mtrs) in the *Lompoc CD*, 1976; HUSBAND – Francis H. Beattie (1912-1985) per findagrave.com (refs. ancestry.com).
See: "Carlson, Juka"

Beaudette, Cobina Carolyn Wright (Mrs. Palmer Thayer Beaudette) (1921-2011) (Los Angeles / Santa Ynez Valley)
Founding member and publicist Santa Ynez Valley Art Association, 1953. Collector. Associated with Beaudette Foundation.
■ "Cobina Wright Beaudette," obituary and port., *SYVN*, Sept. 22, 2011, p. A6.
See: "Hutchinson, Amory," "Santa Ynez Valley Art Association," 1953, "Santa Ynez Valley Art Exhibit," 1953, "Santa Ynez Valley Museum of Natural History," 1957

Beck, Violet Miriam, Miss (1886-1989) (Lompoc)
Teacher of art / drawing at Lompoc High School, 1921-23. Illustrator for a lecture on birds to the Alpha Club, 1923. In 1923 she was a post-graduate student at San Diego state college and spent the remainder of her career as a teacher in San Diego County.
Beck, Violet (misc. bibliography)
Violet Beck is listed in the 1920 U. S. Census as age 30, b. c. 1890, a teacher, residing in Round Valley, Ca.; Violet Miriam Beck, teacher, is listed in *California Voter Registrations, Lompoc Precinct, No. 3* (sometime between 1920 and 1928); Violet M. Beck is listed in various *San Diego CD*, 1921-1933; Violet M. Beck is listed in the 1930

U. S. Census as b. c. 1888 in Illinois, a teacher, lodging in El Cajon, Ca.; Violet Miriam Beck b. Dec. 15, 1886 in Chicago, Ill., to Augustus Beck and Louise Edith Myers, d. July 3, 1989 in Alpine, Ca., per Cleaning-up Myers/Trask Tree (refs. ancestry.com).
See: "Alpha Club," 1923, "Lompoc, Ca., Union High School," 1921-23

Beerbohm, Emilie / Emile Seery (Mrs. Fred Beerbohm) (1894-1975) (Santa Maria)
Painter, 1961. Wife of Fred Beerbohm, below.
Beerbohm, Fred, Mrs. (misc. bibliography)
Emilie Seery Beerbohm married to Fred W. Beerbohm was b. July 2, 1894 in Topeka, Kansas and d. May 24, 1975 in Concord, California and is buried in Topeka Cemetery, Kansas (refs. ancestry.com).
See: "Beerbohm, Fred," "Hobby Night," "Minerva Club," 1957

Beerbohm, Frederich W. "Fred" (1893-1977) (Santa Maria)
Carver of canes and pipes. Landscape painter. Exh. Allan Hancock [College] Art Gallery, 1956. Husband of Emilie Beerbohm, above.
■ "Anyone inclined to twist their ankles easily ought to take their talents to the home of Fred Beerbohm, 213 Capital Drive. He has approximately 50 canes … He just whittles them… This very skillful hobby began with a collection of pipes, the smoking kind, that is. Beerbohm figures he now has some 200 pipes. …. He is deeply interested in wood. In fact, he used to refinish antique furniture as a hobby. Because both Beerbohm and his wife like wood, they picked up various interesting pieces as they traveled around the United States… All of the canes tell a story… On each one is carved the name of the wood, where it was picked up and the date of acquisition. … Being a perfectionist, Beerbohm studies the pieces of wood and carefully plans his whittling project. The finished cane must have the same character as the rough piece… and the grains of the wood must be shown to their fullest. [One cane is two pieces wound around each other, another one piece with a 'snake' of wood wound around it, another has a large hole on the top so it appears to be a needle.] Designs of other canes run from the very simple to the complex… Beerbohm's oldest possession… is a pipe he was given when he first entered high school. While in college he carved the Greek letters of his fraternity on it. … [The bowls on] some of the pipes … are heads of men and horses. One appears to be a part of a masthead on an old time ship. One pipe … survived the Napoleonic wars. It even made the trip to Moscow and back. Beerbohm's interest in wood is shared by his wife who has helped him collect much of it. A few pieces have been picked up by friends who knew of his hobbies. They have run into no trouble with property owners for trespassing or stealing wood, but they have their fingers crossed whenever they start roaming. ... Being immune to poison ivy [he picked up one piece that was in a patch of it] … Later when he began working on the piece… he discovered it was infested with ants… And, from the lowly little ant Beerbohm got his first case of poison ivy," per port. with carved canes and "Wood Collector Carves Many Fancy Canes, Pipes," and port., *SMT,* March 9, 1957, p. 8.
Beerbohm, Fred (notices in Northern Santa Barbara County newspapers on microfilm and on newspapers.com)
1956 – Port. as vice president of Fuchsia Society, *SMT,* July 18, 1956, p. 4.
1957 – "No Quick Solution to Knotty Problem…," for carving a cane with "fake" knots, *SMT,* April 2, 1957, p. 1.
1961 – "Fred Beerbohm Relates Carving Story to Minerva," *SMT,* Nov. 16, 1961, p. 3.
Beerbohm, Fred (misc. bibliography)
Fred W. Beerbohm, wife Emilie, is listed in *Santa Maria, Ca. CD* between 1958 and 1963; Frederich W. Beerbohm was b. Nov. 18, 1893 in Topeka, Kansas, married Emile Seery, and d. Dec. 16, 1977 in Palo Alto, Ca., per Morton and Palmer Extended Family Tree August 3, 2015 (refs. ancestry.com).
See: "Allan Hancock [College] Art Gallery," 1956, "Hobby Night," "Hobby Show," "Minerva Club, Art and Hobby Show," 1957, 1958

Bell, Dorothy Elizabeth Martin (Mrs. Harry Hudson Bell, Jr.) (1913-2002) (Santa Maria)
Photographer, amateur. Member Santa Maria Camera Club, 1939, 1941. Wife of Harry Bell, below.
■ "Dorothy Elizabeth Bell … raised her family in Santa Maria, Ca., and wrote for the *Santa Barbara News-Press* and the *Santa Maria Times* papers…," *SMT,* Oct. 12, 2002, p. 7.
Bell, Harry (notices in Northern Santa Barbara County newspapers on microfilm and on newspapers.com)
1936 –"Dorothy Martin is Bride of Harry Bell … daughter of Mr. and Mrs. Frank Martin of San Luis Obispo … The bride attended high school in San Luis Obispo, junior college in Santa Maria, and San Jose State college…," *SMT,* May 25, 1936, p. 3.
1977 – "Dorothy Bell… moved to San Antonio after lifetime residence in this area, to be near her son and his family … address is 10418 Annapolis, San Antonio, Tex.," *SMT,* Oct. 17, 1977, p. 9, col. 1.
Possibly 200 social notices for "Mrs. Harry Bell" were not itemized here.
Bell, Harry, Mrs. (misc. bibliography)
Dorothy M. Bell is listed in the 1940 U. S. Census as age 26, b. c. 1914, finished college 3rd year, working as a waitress, residing in Santa Maria with her husband, Harry H. Bell (age 25) and parents-in-law; Dorothy M. Bell is listed with husband Harry H. Bell in the *SMCD,* 1970; Dorothy E. Bell b. Aug. 10, 1913 and d. Oct. 6, 2002 per Social Security Death Index (refs. ancestry.com).
See: "Bell, Harry," "Santa Maria Camera Club," 1939, 1940, 1941,

Bell, Anthony "Tony" (1935-2019) (Solvang)
SYVUHS art student under Leo Ziegler, 1951, 1952,
1953. Exh. annual Santa Ynez Valley Art Exhibit, 1953,
1954.

■ Port. and "Obituary. Tony Bell. 9/12/1935-5/19/2019.
Tony Bell died… at age 83 from pneumonia and other
health issues. He resided in Solvang from 1951-63. Tony
was a Professor of Sociology at Cal State, Fullerton for
over 50 years. He is survived by wife Karen…," *SYVN*,
June 4, 2019, p. A5.
Bell, Tony (misc. bibliography)
Tony Bell appears in the UC, Santa Barbara yearbook, c.
1958; Tony A. Bell b. Sept. 12, 1935 was residing in
Anaheim, Ca., in 1970 per *U. S. Public Records Index,*
1950-1993, vol. 1 (refs. ancestry.com).
See: "Santa Ynez Valley Art Exhibit," 1953, 1954, "Santa
Ynez Valley Union High School," 1951, 1952, 1953

Bell, Harry Hudson, Jr. (1914-1975) (Santa Maria)
Photographer, amateur. Founder and long-time member,
Santa Maria Camera Club, 1938+. Fire Chief. Wife is
Dorothy Bell, above.

■ "Harry Bell, Jr. Heads Camera Club," *SMT*, Nov. 8,
1940, p. 3.
■ Obituary, retired fire chief, *SMT*, Sept. 27, 1975, p. 2.
Bell, Harry (misc. bibliography)
Harry H. Bell, b. Aug. 31, 1914 and d. Sept. 25, 1975 in
Santa Barbara County per Calif. Death Index (refs.
ancestry.com).
See: "Bell, Dorothy," "Santa Maria Camera Club," 1938,
1939, 1940, 1941, 1942, 1955

Benhart, Frederick Dawn (1937-1971) (Lompoc)
Photography apprentice at Camera Shop, 1956. Son of
Helen Benhart, above.

■ "Home Town Opportunity… Fred Benhart, senior
student, has a daily 45-minute period in the **Camera Shop**,
with opportunities to learn from a professional
photographer, **Mr. Tommy Yager**, the many complicated
details of that profession. … 'I've learned more than I
knew I didn't know already, and Fred, in discussing the
matter, his use of professional terms was noticeable. 'If the
lighting's off, the edges must be burned,' he said … Mr.
Yager provides the necessary equipment … Condensed bits
of technical know-how are passed onto him … He has
recently accomplished a difficult assignment in that he
processed a picture from the initial step through the final
printing process… progress… is exceptionally noteworthy
because of the fact that Fred is handicapped by the lack of
use of his right hand as a result of polio. With the use of
only one hand then, Fred arranged the lighting effects for
his proposed picture, loaded the film in the camera,
adjusted the focal apparatus, took the picture, processed the
film and finally printed from the negative a finished
picture. Mr. Yager instructs by demonstrating, illustrating
and by providing Fred the opportunity to experiment with
various photographic chemicals and timing procedures. …
Work Educational Program…," *LR*, Feb. 9, 1956, p. 12.

Benhart, Fred (notices in Northern Santa Barbara County
newspapers on microfilm and on newspapers.com)
1956 – Port. as graduating senior, *LR*, May 31, 1956, p. 12;
Attended Santa Maria Junior College, *LR*, Nov. 1, 1956, p.
15; and more than 15 additional notices in the *LR*,
including his activities with DeMolay, were not itemized
here.
Benhart, Fred (misc. bibliography)
Fred Dawn Benhart appears in the Lompoc High School
yearbook, 1956 with port. and "Choir 4, Junior Play
Production Staff 3, Senior Play Production Staff 4"; Fred
Benhart, salesman, Sprouse Reitz, is listed in the *Lompoc*
CD, 1963, 1965; Frederick Dawn Benhart b. April 7, 1937,
d. June 25, 1971 and is buried in Lompoc Evergreen
Cemetery per findagrave.com (refs. ancestry.com).

Benhart, Helen G. Lawrence (Mrs. Russell Benhart)
(1918-2010) (Lompoc)
Teacher of ceramics at Community Center, 1949. Prop.
Helen and Ina's, 1950. County Chairman of Crafts for
Federation of Women's Clubs, 1952. Judge in Halloween
Window Decorating contest, 1954. Mother of Fred
Benhart, below.

■ HUSBAND – "Russell Benhart… came to Venice [Ca.]
in 1935… where he met his wife Helen Lawrence Benhart.
He moved to Lompoc in 1942 from Santa Monica. Mr.
Benhart… was manager of Sprouse Reitz in Lompoc for 20
years…," *SMT*, Jan. 10, 1996, p. 5.
Benhart, Helen (misc. bibliography)
Helen G. Benhart was b. Aug. 23, 1918 and d. March 18,
2010 and is buried in Lompoc Evergreen Cemetery per
findagrave.com (ref. ancestry.com).
See: "Benhart, Fred," "Community Center," 1949,
"Federation of Women's Clubs," 1952, "Halloween
Window Decorating Contest (Lompoc)," 1954, "Helen and
Ina's"

Bennett, Mary Leonette, Sister (Sacramento)
See: "Leonette, Mary"

Benson, Esther
Is this mother or daughter –
1. Benson, (Pollorena), Esther Louise (Mrs. Mark
Francis Pollorena) (1936-2010) (Santa Maria)
Student at Los Alamos school who submitted art to
Scholastic Art Exhibit, 1950.
Benson, Esther (misc. bibliography)
Esther Louise Benson was b. March 2, 1936 to Newton
Benson, married Mark Francis Pollorena, and d. Jan. 12,
2010 in Santa Barbara, Ca., per Gilbert Family Copy 3
Family Tree (refs. ancestry.com).
2. Benson, Esther S.
Her mother, Esther S. Benson (b. 1912) wife of Newton
H. Benson, was a Ceramic student in the adult class in
Los Alamos, 1954.
See: "Los Alamos, Ca., Adult/Night School," 1954,
"Scholastic Art Exhibit," 1950

Benson, Lucie / Lucy Sunier (Mrs. Perry Hazard Benson) (1887-1968) (Lompoc)
Chairman of Handicraft, County Federation of Women's Clubs. Member Alpha Club Art section and Handcraft Section, 1933, 1934.
Benson, Lucy (notices in Northern Santa Barbara County newspapers on microfilm and on newspapers.com)
1934 – "Attends Meeting – Mrs. Lucy Benson, county chairman of handicraft for the federated women's clubs, attended the meeting of the division of handicrafts at the Los Angeles District Federation of Women's Clubs headquarters in Los Angeles, Monday. Instructions in leather work, weaving on hand looms and other hand work were given…," *LR*, Jan. 19, 1934, p. 6.
Benson, Lucy (misc. bibliography)
Lucie Sunier Benson is listed in the 1930 U. S. Census as age 42, b. c. 1888 in Iowa, residing in Lompoc, Ca., with her husband Perry (age 43); Lucie Benson, teacher and Republican is listed in *Voter Register, Lompoc Precinct No. 2*, 1930-1932; and most of the other references show her as residing in Santa Barbara; Lucie S. Benson, mother Brunnen, b. July 10, 1887, d. July 31, 1968 in Santa Barbara County per Calif. Death Index (refs. ancestry.com).
See: "Alpha Club," 1933, 1934, "Minerva Club," 1934, "Solvang Woman's Club," 1934

Benthograph
"Submarine" invented before 1950 by Dr. Maurice Nelles, research engineer at the Allan Hancock Foundation, to carry cameras into ocean depths.
Photo. and "Robot Deep-Sea Diving Sphere… withstand water pressures of more than 5,000 pounds per square inch at depths of 12,000 feet… Present equipment is capable of taking 800 single-frame photographs at a rate of 12 per minute using stroboscopic lights…," *SMT*, May 26, 1950, p. 1; "Benthograph Opens New Fields of Sea Research," *SMT*, Nov. 17, 1950, p. 1.

Bentley, John William (1880-1951) (Woodstock, N.Y.)
Painted views of the Santa Ynez mountains, c. 1927.
■ "Born in Paterson, NJ on Jan. 3, 1880, Bentley was a pupil of George Bridgman, Frank V. DuMond, and Robert Henri. While based in Woodstock, NY, he made trips to California where he painted on the Monterey Peninsula, the Santa Barbara area and at Mission Capistrano" (from askart.com). Auctioned: *La Cumbra [sic] Peak, Santa Ynes, Santa Barbara, Ca.* o/c, Christies, 5/26/94, lot 76 (per F&J 2001).
Bentley, John William (notices in California newspapers on microfilm and on newspapers.com)
1923 – "Colorful Pictures by John W. Bentley… of Woodstock, N. Y. who is showing twenty eastern landscapes at the Stendahl galleries, Ambassador Hotel, through the month of August…," *LA Times*, Aug. 19, 1923, p. 62 (i.e., pt. III, p. 30).
1927 – "Bentley Shows Art at Woodstock. Fifty Paintings … at Old Woodstock Inn… traveler-poet and artist… Bentley, who has lived at Woodstock between his trips abroad in search of material… recently returned from an

eight-months' trip up and down the California coast … Bentley has also visited the South Sea Islands… From his eight months' wandering up and down the Pacific coast … almost a poet with his titles… 'Spanish Cloisters,' 'Sunny Santa Ynez,' 'La Cumbra Peak,' 'Toward Carmelito,' 'Point Castillo at Santa Barbara,' and 'Eucalyptus Grove.' … The paintings also reflect… the artist's viewpoint… gorgeous colors of sunsets… mission bells hanging in Spanish buildings, courtyards that speak of a drowsy southern heat, relentless rocks … ocean waters… As an artist, Bentley is modest; he wants no historical record of his work… prefers to have his pictures tell their own story," *Kingston Daily Freeman* (Kingston, New York), July 21, 1927, p. 3.
1940 – "Works of Noted Painters Shown at S.A. Library… Painting-on-a-palette display arranged by Hazel N. Bemus, artist and teacher of Laguna Beach. In each instance the artist painted a scene on a wood palette and signed his or her name… included … moderns, John W. Bentley… landscapes…," *Santa Ana Register*, Jan. 23, 1940, p. 5.

Berend (Corinth), Charlotte (Mrs. Lovis Corinth) (1880-1967) (Europe / Santa Barbara / NY)
Artist active in Santa Barbara during WWII years who exh. in National Art Week show at Minerva Club, 1940.
■ "European Woman Artist … A group of water colors by Madame Charlotte Berend, European artist now living in Santa Barbara, make up a new exhibit which will open Monday in the E. B. Crocker Art Gallery. The artist, who was born in Germany, studied in Paris and has spent much time in Italy, living and painting in small and picturesque coastal villages. Exhibitions of her work were held in Rome, Florence and Naples. On coming to the United States, she settled in Santa Barbara in 1940 and a one man show of her water colors was held at the **Faulkner Gallery** there. She has also exhibited at the Carnegie Institute, in New York, Denver, Palm Springs, Los Angeles, San Francisco and Washington. Madame Berend paints in oil as well as in water color. In the latter medium she is said to have found a very personal style and developed an interesting technique somewhat different from that used by most other contemporary water colorists," *Sacramento Bee*, Nov. 29, 1941, p. 17.
Berend, Charlotte (notices in newspapers on newspapers.com)
1942 – "College … [Sacramento Junior College] … An exhibit of water colors by Charlotte Berend also will open Monday in the Little Gallery. Most of the scenes are taken from the neighborhood of Santa Barbara.… will continue to January 31st," *Sacramento Bee*, Jan. 17, 1942, p. 11.
1943 – "Santa Barbara Artist Exhibits in New York … Charlotte Berend… landscapes and portraits in watercolor and oil in the Schaeffer Galleries in New York City until Dec. 19…," *LA Times*, Dec. 5, 1943, p. 74 (i.e., pt. IV, p. 3).
1944 – Repro: "The Harbor" water color and "Charlotte Berend's Paintings at de Young… portraits and landscapes in oil, most of the latter having been painted during her residence in Italy. Many of the watercolors have been done since the artist has made her home in Santa Barbara and in gay impressionistic manner … 50 works … one of the notable portraits … is that of the Santa Barbara director

[Donald Bear] and his wife; there is also a self-portrait of the artist and a drawing of the renowned scientist Albert Einstein. ... through January," *Oakland Tribune*, Dec. 31, 1944, p. 16 (i.e., 2C).

1945 – "New Berend Art Offered. Charlotte Berend, whose oils and watercolors are at the DeYoung Museum, is the widow of the famous European painter, Lovis Corinth. Santa Barbara, where she now lives, is the scene of many of her landscape impressions. In a radiant palette, she offers a capable group of serious portraits. Especially pleasing are a number of her still lifes," *SF Examiner*, Jan. 7, 1945, p. 105 (i.e., Magazine?); repro: self-portrait with palette, *SF Examiner*, Jan. 14, 1945, p. 109.

1967 – "Charlotte Corinth. New York. Funeral services... for Charlotte Berend Corinth, 86, one of Germany's outstanding women painters and widow of the noted German painter Lovis Corinth. Mrs. Corinth came to the United States in 1939, 14 years after her husband's death, and later became a citizen... she married Corinth, her art teacher, in 1903, when he was the leader of the German impressionist school," *SF Examiner*, Jan. 12, 1967, p. 43.
<u>See</u>: "Bowen, William," "National Art Week," 1940

Berger, Fred (1898-1971) (Panama / Lompoc / Salt Lake City)
Artist of murals in the Lompoc elementary school cafeteria, 1934. Husband of Hazel Berger, below.

■ "Church News ... Artist Berger Paints Another Mural at School... We have another beautiful picture painted by Mr. Berger in our cafeteria. The latest one is a jungle scene. A lion and lioness on a rocky cliff are looking down at three elephants that are nearing the water hole. In a tree nearby is a leopard. The leopard looks like he is ready to jump right at you. The other picture, showing a group of flamingoes, is very beautiful. ...," *LR*, March 30, 1934, p. 11.

<u>Berger, Mr. (notices in Northern Santa Barbara County newspapers on microfilm and on newspapers.com)</u>
1930 – "Sartorial Splendor... [Clarence Ruth] The hat and stick were brought from Panama by Fred Berger, a friend of the Ruth's, who has been in the Republic of Panama for the last two years in the employ of the United Fruit company. He is here on a three weeks' visit and will return to the Central American country...," *LR*, Aug. 29, 1930, p. 1.
1934 – "To Los Angeles – Fred Berger of San Francisco who spent the holidays here as a guest of the Clarence Ruth family, left Sunday night for Los Angeles," *LR*, Jan. 12, 1934, p. 8.

<u>Berger, Mr. (misc. bibliography)</u>
Fred Berger, wife Hazel R, is listed as designer, Kennecott, in the *Salt Lake City CD*, 1949, and with no wife is listed in the *Salt Lake City, Ut., CD* through the 1950s, and in 1965 and 1970 was listed as retired; is he Fred Berger, b. Jan. 13, 1898 and d. March 1971 per Social Security Death Index (refs. ancestry.com).
<u>See</u>: "Berger, Hazel," "Lompoc, Ca., Elementary School," 1934

Berger, Hazel Ferne Ruth (Mrs. Fred Berger) (1898-1945) (Lompoc / Martinez / Salt Lake City, Ut.)
Teacher in Lompoc elementary schools, c. 1926-44, and of art 1939, 1940. Wife of Fred Berger, above. Sister to Clarence Ruth, below.

■ "Miss Ruth Marries. Miss Hazel Ruth, sister of the local elementary school principal, **Clarence Ruth**, and a teacher in the sixth grade, disclosed... she was married this summer to Fred Berger of Martinez. Mrs. Berger will continue to teach this year," *LR*, Sept. 10, 1937, p. 6.

■ "Mrs. Berger's Death ... in Salt Lake City. ... Mrs. Berger went to Salt Lake City last summer to join her husband, Fred Berger, who is in the engineering department of the Utah Copper company. At that time, she resigned as a member of the teaching staff of the Lompoc elementary School, a position she had held for 18 years. ... Mrs. Berger came to Lompoc soon after her brother, Clarence Ruth, was elected principal of the Lompoc school and became a member of the teaching staff. She was 47 years of age ...," *LR*, Feb. 23, 1945, p. 1.
And more than 75 additional social and school notices for "Hazel Ruth" in the *LR* between 1925-1937 and 75 for "Hazel Berger" in the *LR* between 1937 and 1945 were not itemized here.
<u>Berger, Hazel (misc. bibliography)</u>
Hazel Ferne Ruth Berger daughter of Louella Reed and Edmund Ruth was b. May 9, 1898 in Portsmouth, Ohio, married Fred Berger, and d. Feb. 16, 1945, in Salt Lake City, Utah per Salt Lake County, Utah, Death Records (ref. ancestry.com).
<u>See</u>: "Berger, Fred," "Lompoc, Ca., Elementary Schools," 1939, 1940, "Ruth, Clarence"

Beta Sigma Phi Sorority (Santa Maria)
Sorority. Had some art programs.

■ "In 1931, during the Great Depression, there was a need for an organization that could bring women together and expose them to a social, cultural and educational climate that was not available in those difficult times," per BSPinternational.org
<u>Beta Sigma Phi (notices in Northern Santa Barbara County newspapers on microfilm and on newspapers.com)</u>
1951 – **Blum** "Speaks on Color in Home" to Beta Sigma Phi, *SMT*, Feb. 26, 1951, p. 4.
1954 – "Beta Sigma Phi Hears Art Talk. **Gordon Dipple** of Santa Maria High school art department... on 'Painting and Sculpture' with art objects and paintings...," *SMT*, May 15, 1954, p. 4.
1958 – "Beta Sigma Phi... After dinner... Mrs. Dolan then presented the cultural program entitled, 'Sculpture and Painting'," *SMT*, April 17, 1958, p. 3.
<u>See</u>: "Allan Hancock College Art Gallery," 1956, "Blum, Maurice," "Floats," 1952, 1953, "Muro, George," 1956, "Reiner, D. E.," 1957, "Youry, Ward," 1952

Better Homes Exhibit / Better Homes Week (Solvang)
Exhibit, tour / program held in the Santa Ynez Valley during Roosevelt's Better Homes Week, 1928-33.

■ "Better Homes Week. The week of April 24 to May 1 is being observed throughout the United States as Better Homes Week, and Secretary of Commerce, Herbert Hoover, who is president… [says] More than 3500 local committees invite the American people to join in observing…. These voluntary groups are doing much to advance improved housing, home ownership and the art of home-making … The local committees throughout the nation have a record of five years of sound, practical achievement …. The homes exhibited each year have represented striking advances in conveniences, attractiveness and artistic quality with a steady lowering in average cost…," *SYVN*, April 29, 1927, p. 1.
Better Homes Exhibit (notices in Northern Santa Barbara County newspapers on microfilm and on newspapers.com)
1928 – "Better Homes Issue," *SYVN*, April 27, 1928, p. 1.
1929 – "Better Homes Week Observed in Valley," *SYVN*, April 26, 1929, p. 1.
1930 – "Elaborate Plans Outlined for Valley Better Homes Week," *SYVN*, April 11, 1930, p. 1.
1931 – "Exhibits for B. H. Week to be Seen Saturday… Anyone having flower or fine needle work to display are asked to please notify Mrs. Walter Buell of Buellton. Exhibits will include paintings by **Elmer House**, cut flowers, remodeled furniture, slip covers and hand work, small house plans… samples of materials for home decorating shown by **Miss Nancy Folsom**, home demonstration agent, and a school exhibit with Miss **Grace Garey** in charge," *SYVN*, May 1, 1931, p. 1; "Better Homes Week Success… **Elmer House** exhibited a large number of his paintings done in South America, Florida, Monterey and this valley," *SMT*, May 9, 1931, p. 6.
1932 – "Better Homes Committee Meet… In connection with this, Mrs. Barbara Phelps is arranging a plant exchange bureau for the **Los Olivos Needle Craft**. The schools of the valley will be represented and are making posters and will also have some form of exhibit," *SYVN*, April 15, 1932, p. 1; "Patchwork **Quilt and Rug** Exhibit to be held Apr. 29… An exhibit of hooked and braided rugs and patchwork quilts will be held at **Mattei's Tavern** on Friday, April 29 as a part of … Better Homes week…," *SYVN*, April 15, 1932, p. 1; "B. H. Tour… 40 person… homes in the valley which were thrown open for inspection… Los Olivos was the next point visited, where a display of hand-made rugs and quilts were shown in one of the cottages adjoining **Mattei's Tavern**. A marvelous collection of quilts assembled from all over the valley… Many and varied were the patterns, from the old fashioned design to the most modern…," *SYVN*, May 6, 1932, p. 1.
1933 – "Program Better Homes Week is Outlined… A tour of the valley… to Santa Ines Mission, where the committee plans an exhibit of the sewing work of the Costereras club… The Danish Lutheran church will be visited, one country garden is listed for the tour, and a **quilt** and handcraft exhibit at **Mattei's tavern** is planned…," *SYVN*, April 7, 1933, p. 1; "Lompoc Women Join Better Homes Tour… The tour was arranged locally by Mrs. Ernest Klein, local chairman…," *LR*, April 28, 1933, p. 2.

Bettersworth (Mussell), Ruth Agnes (Mrs. Loren H. Mussell) (1908-1967) (Santa Maria)
Santa Maria High School student winner of an art scholarship to Santa Maria School of Art, 1927. Santa Maria J. C. student who made a poster for a quartette performance, 1927. Creator of illustrations for Splash, 1927, 1928. Her sister, Kathleen, also showed artistic talent in high school.
See: "Santa Maria, Ca., Union High School," 1927, "Santa Maria School of Art," 1927, "Splash," 1927, 1928

Betti's Ceramic Shop (Lompoc)
See: "Mildred I. White Ceramics Shop"

Betty's Little Knitwits club (Lompoc)
Club for child knitters, 1949.

■ "Girls' Group Works on Knitting… met at the Yarncraft for their weekly meeting Friday night. … The girls who make up this club are doing both knitting and crocheting, particularly on sweaters. This form of handwork seems to have replaced the older 'embroidery' clubs which their mothers kept…," *LR*, April 14, 1949, p. 5.

Bianchi, A. (Aurelio Michele?) (1864-1940) (Santa Maria)
Exh. transfer pictures at "Santa Barbara County Fair," 1890.

■ Various notices in the *SMT* between 1888 and 1896 show that Aurelio Bianchi was a shoemaker, a leather merchant, in business for a while with his brother B. T. Bianchi as Bianchi Brothers, that he worked c. 1893 as an insurance salesman, that his business was liquidated at auction, and that he worked briefly in Arroyo Grande and in Salinas but returned to Santa Maria c. 1896.
Bianchi, A. (misc. bibliography)
Aurelio M. Bianchi, b. Switzerland, arrived in the US c. 1887, was listed in the 1910 U. S. Census in Morro Bay, in the 1920 U. S. Census in Sisquoc, Santa Barbara County, and in the 1930 and 1940 U. S. Census as residing in SLO; Aurelio Michele Bianchi b. Nov. 13, 1864 d. May 10, 1940 and appears in Public Member Photos & Scanned Documents (refs. ancestry.com). OR,
Is this "**Mrs. A. M. Bianchi**" – "Mrs. A. M. Bianchi received first premium on a very fine knitted bedspread for which she has been offered $50," *SMT*, Oct. 15, 1892, p. 3, col. 4.
See: "Santa Barbara County Fair," 1890

Bianchi, John Joseph (1913-2001) (Santa Maria)
Photographer, filmmaker active with (c. 1939-44) and president of (1943) the Santa Maria Camera Club. Manager of a service station who became district service station superintendent of Union Oil Co, 1944 and plant manager, 1945. Possibly his extra duties caused him to drop his participation in the Camera Club.
See: "Santa Maria Camera Club," 1939, 1940, 1942, 1943, 1944

Bianchi, Theodore "Ted" (1903-1997) (Santa Maria)
Photographer, filmmaker, amateur, post WWII.
Founding member Santa Maria Camera Club, 1938.
Official photographer for Elks rodeo and parade for 37 years.

■ Port. and "Theodore Bianchi Businessman / Photographer... lifetime resident of Santa Maria and former owner and operator of Bianchi's Market... Mr. Bianchi was official photographer for the Elks rodeo and parade for 37 years...," *SMT*, Dec. 19, 1997, p. 6.
Bianchi, Ted (notices in Northern Santa Barbara County newspapers on microfilm and on newspapers.com)
1949 – "Chapter Members Hear Talk on Home Movies... members of **Phi Epsilon Phi** sorority heard a talk and demonstration of photography with Theodore Bianchi, local motion picture photographer as speaker... Bianchi showed the group examples of pictures taken for home movies and how to write titles for continuity... He told of the relatively low cost... Bianchi's movies of the 1949 Elks Rodeo, titled, edited and narrated for showing as a sound film, were shown ...," *SMT*, Dec. 2, 1949, p. 5.
1953 – "Rodeo Parade Film ... last year's fourth of July parade will be offered tomorrow evening at Lind's restaurant... The film was made for the Chamber of Commerce by Ted Bianchi, Santa Maria photographer, and is devoted entirely to the Lompoc celebration. It is aimed at catching the color and action of the floral parade... the film will be available for showing to the various local organizations," *LR*, April 23, 1953, p. 8; "4th Parade Film Wins Praise... beautiful color film... with well synchronized sound and narration... Lompoc parade and rodeo of July 4th, 1952...," *LR*, April 30, 1953, p. 1.
1955 – "R. C. Lilley Honored by Vaqueros... showing after dinner of the pictures of the '54 ride by Ted Bianchi, official photographer for the organization...," *LR*, Feb. 24, 1955, p. 2.
1956 – "Color Films Shown" created by local photographer Ted Bianchi of city's 50th anniversary celebration, *SMT*, Feb. 28, 1956, p. 4; "Elks Rodeo Film Ready for Showing... color film...," *SMT*, May 1, 1956, p. 8.
And, more than 600 "hits" for "Ted Bianchi" in the *SMT* between 1945 and 1965, including more on his filmmaking, were not itemized here.
Bianchi, Ted (misc. bibliography)
Is he Theodore Alfred Bianchi b. Nov. 17, 1903 in California to Battista Theodore Bianchi and Viviana Bibiana Valenzuela, who married Mary Eunice Aranjo, was residing in Santa Maria in 1910, and d. Dec. 18, 1997 in Santa Barbara County, Ca. per heidi vanhonsebrouck family tree (refs. ancestry.com).
See: "Elk's Club – Rodeo and Race Meet," 1959, "Santa Barbara County Fair," 1944, "Santa Maria Camera Club," intro., 1941

Bienieck / Biebieck, Joan W. (Mrs. Capt. Stephen Bienieck) (1907-1994) (New York / Florida)
Art student of Forrest Hibbits. Exh. Tri-County Art Exhibit, 1948.
Joan W. Bienieck (1907-1994) is buried in Lee Memorial Park, Fort Myers, Fla., per findagrave.com (ref. ancestry.com).

See: "Community Center (Lompoc)," 1948, "Tri-County Art Exhibit," 1948

Bigler, Alice Mary Heckendorf (Mrs. Judge Alexander Bowman Bigler) (1899-1952) (San Jose / Santa Barbara)
Artist in National Art Week show at Minerva Club, 1940.
Second wife of Judge Bigler. (The judge had practiced law for many years in Santa Maria before being appointed judge and moving to Santa Barbara, c. 1931.)
1932 – Port. and "Ex-Rose Queen to Wed Judge... Miss Alice Heckendorf, who was queen of the first San Jose Fiesta de las Rosas six years ago... Miss Heckendorf has lived in Santa Barbara for several years. She was born in Santa Rosa... Miss Heckendorf gave her age as 31 on the application for a marriage license and Judge Bigler as 61," *SF Examiner*, Feb. 24, 1932, p. 6; "Miss Alice Heckendorf Married... The bride is the daughter of Mrs. Jean Heckendorf of Santa Barbara and A. J. Heckendorf of San Jose... she is also a member of the pioneer Heckendorf family of Ukiah...," *Ukiah Dispatch Democrat*, March 4, 1932, p. 4.
1934 – "Died ... Heckendorf – in San Jose, Sept. 29. August J. Heckendorf, husband of Lillian Heckendorf, father of Alice Bigler and Percy Heckendorf, a native of Iowa," *Oakland Tribune*, Oct. 1, 1934, p. 27.
1939 – "Bigler Property is Left to Sons... No provision is made for ... the former Alice Heckendorf, the will explaining 'for the reason that she has received a just share of my property'," *SMT*, Nov. 28, 1939, p. 2.
1943 – "Local Folk. Mrs. Jeanne Heckendorf and Mrs. Alice Bigler of Santa Barbara, mother and sister of Percy C. Heckendorf, state director of professional and vocational standards, are visitors here," *Sacramento Bee*, Nov. 5, 1943, p. 13.
Bigler, Alice (misc. bibliography)
Alice Mary Bigler, mother's maiden name Airard and father's Heckendorf, was b. Dec. 22, 1899 and d. June 25, 1952 in Santa Barbara per Calif. Death Index (ref. ancestry.com).
See: "National Art Week," 1940

Billet, J. (James) R. (Santa Barbara)
President of House of Mosaics in Santa Barbara; demonstrated mosaic work to College School Community Club, 1960.

■ "Cocoa Beach [Florida] … The greatest success town fathers here can point to in attracting industry involves a concern called House of Mosaics that moved six months ago from Santa Barbara, Calif., and employs about 50 persons. It brought 11 of its staff from California. James R. Billet, the owner, said he had wanted to move east because of a poor economic outlook in Santa Barbara, because he did most of his business in the East anyway, and because of high freight rates. He responded first to a newspaper ad placed by the state of Florida... realtor Jack Korenblit... called around to the banks and got the concern a loan... He arranged for it to move into a vacant 24,000 square foot building ...," *LA Times*, June 13, 1971, p. 22 (i.e., Sec. A, p. 20).

Billet, J. R. (misc. bibliography)
James R. Billet was residing in Florida c. 1950-55; James R. Billet, wife Ezell A., is listed with House of Mosaics in the *Santa Barbara CD*, 1960-1970; James R. Billet is listed on Merritt Island, Florida, 1990, per *U. S. Public Records Index, 1950-1993*, vol. 1 (refs. ancestry.com).
See: "Santa Ynez Valley, Ca., Elementary / Grammar Schools," 1960

Bissiri, Nadean / Nadine Ellen (i.e., Ellen N. Hart) (Mrs. Paul G. Bissiri) (1926-?) (Santa Maria)
Art chairman, AAUW, 1958. Teacher. Thespian.
Fourteen social notices for Nadean Bissiri appear in the *SMT* between 1958-67 but were not itemized here.
Bissiri, Nadean (misc. bibliography)
Paul G. Bissiri married Ellen N. Hart, age 23, in Tulare County, California, on June 16, 1950 per Calif. Marriage Index; Nadean E. Bissiri is listed in *Index to Register of Voters, Lakewood Precinct No. 40, Los Angeles County*, 1950 and in *Bonner Precinct No. 13, Los Angeles County*, 1954; Nadean Bissiri is listed on Flower St. in *Santa Maria CD*, 1962-68; Ellen N. Bissiri b. Nov. 30, 1926, was residing in Napa, Ca., 1993, per *U. S. Public Records Index, 1950-1993*, vol. 1 (refs. ancestry.com).
See: "American Association of University Women," 1958

Bitterly, Lilly Peterson (Mrs. Arthur B. Bitterly) (1883/5/6-1967) (Santa Barbara)
Commercial artist in Denver c. 1906-20+, who moved to Santa Barbara c. 1935 and who exh. in National Art Week show at Minerva Club, 1940.
1945 – "St. Louis Woman Wins Proetz Advertising Award... For commercial art, honorable mention was awarded to Miss [Sic.] Lilly Bitterly of Santa Barbara, Cal., for an 80th anniversary campaign for the Daniels & Fisher Stores of Denver, Colo...," *St. Louis Star and Times* (St. Louis, Mo.), May 22, 1945, p. 12.
Bitterly, Lilly P. (misc. bibliography)
Lilly Peterson is listed as "artist" in the *Denver, Colo., CD*, 1906, 1909; Lilly Peterson is listed in the 1910 U. S. Census as age 23, a sketch artist in the illustrating industry, residing in Denver with her parents Axel W. Peterson (age 50) and Christine Peterson (age 52) and siblings Roy and Aegeria; Lilly Bitterly is listed in the 1920 U. S. Census as a commercial artist, residing in Denver with her husband A. G. Bitterly (a watch maker); Lilly Bitterly is listed in the 1930 U. S. Census as b. Colorado, no occupation, residing in Los Angeles with husband Arthur G. Bitterly (age 45) and son Jack G. Bitterly (age 11); Lilly Bitterly, age 48, b. Dec. 3, 1886 in Denver, residing at 1021 State St., Santa Barbara, sailed from Gothenburg, Sweden, on July 31, 1935 on the *S. S. TMS Kungsholm* and arrived at NY, Aug. 9, 1935, per *NY Passenger and Crew Lists*; Lilly P. Bitterly is listed in the 1940 U. S. Census as age 53, b. c. 1887 in Colo., finished high school first year, an artist, residing in Santa Barbara (1935, 1940) with husband Arthur B. Bitterly (age 55) and son Jack G. (age 20); in 1942 husband Arthur George Bitterly filled out a WWII Draft Registration Card stating he was residing in Glendale, Ca.; husband Arthur George Bitterly d. 1948 in Santa Barbara

per findagrave.com; Lilly Peterson Bitterly b. Dec. 3, 1885, d. Aug. 7, 1967 and is buried in Santa Barbara Cemetery per findagrave.com (ref. ancestry.com).
See: "National Art Week," 1940

Bixby, Barbara N. (Mrs. Dwight F. Bixby) (1915-1982) (Guadalupe)
Photographer, amateur. Member Santa Maria Camera Club, 1950s. Wife of Dwight Bixby, below.
■ "Barbara N. Bixby, 67, died Saturday... Mrs. Bixby was born July 4, 1915 in Brawley. She had been a resident of Santa Maria since 1917 and attended local schools. She was a member of the Santa Maria Valley Pioneers Association and the Santa Maria Camera Club. Survivors include her husband, Dwight F. Bixby, Santa Maria...," *SMT*, Dec. 7, 1982, p. 20.
Bixby, Barbara (notices in Northern Santa Barbara County newspapers on microfilm and on newspapers.com)
1956 – 'Round Town – Mrs. Barbara Bixby has been named first prize winner in *Desert* magazine's photography contest. Her photo, a bleached steer skull in a sand dune near Hanksville, Utah, appears in the September issue of the magazine. The cut is entitled 'Sand Patterson'," *SMT*, Aug. 20, 1956, p. 4, col. 1.
Nearly 70 notices on "Barbara Bixby" photo awards, primarily with the Santa Maria Camera Club, appear in the *SMT* between 1950 and 1970 but were not itemized here.
Bixby, Barbara (misc. bibliography)
Barbara Bixby b. July 4, 1915, d. Dec. 1982 per Social Security Death Index (refs. ancestry.com).
See: "Bixby, Dwight," "Santa Barbara County Fair," 1952, 1958, 1959, 1960, "Santa Maria Camera Club," 1952, 1954, 1955, 1962

Bixby, Dwight Fuller "Bud" (1909-1991) (Santa Maria)
Photographer, amateur. Active with Santa Maria Camera Club, 1952-60+. Husband of Barbara Bixby, above.
■ "Dwight F. Bixby... born in Corning, N.Y. He moved to Templeton as a youth and was reared there, moving to Santa Maria in 1928. He worked for Rosemary Farms for 35 years in egg production and then as a sales clerk in the sporting goods department of Afco department store for five years. He was... a member of the Santa Maria Camera Club...," *SMT*, Dec. 6, 1991, p. 7.
See: "Bixby, Barbara," "Santa Maria Camera Club," 1954, 1955

Black, Anna Adele (Santa Maria)
Santa Maria JC art student who exh. at Faulkner Memorial Art Gallery, 1933. Weaver.
Anna A. Black is listed in the 1930 U. S. Census as age 15, b. c. 1915 in Calif. residing in Santa Maria with her parents Robert E. Black (age 37) and Anna L. Black (age 35) and younger sister, Virginia (ref. ancestry.com).
See: "Breneiser, Marrie," 1932, "Faulkner Memorial Art Gallery," 1933, "Santa Maria, Ca., Union High School," 1934, "Santa Maria School of Art," 1933

Black, Clara E. Wilkin (Mrs. John D. Black) (1859-1940) (Lompoc)
Milliner. In 1892 exhibited Best flowers in oil at "Santa Barbara County Fair," Lompoc. Took painting lessons from Mrs. A. J. Nichols.

■ "Firm Retires After 45 Years. Mrs. J. D. Black Closes Millinery Store. Failing Health… The store was started in 1882 by Mrs. Black who was Clara Wilkin, daughter of Mr. and Mrs. Charles Williams [Sic.?] at that time. With the proprietor was her sister, Miss Lulu Wilkin, who was in the business a year and then was married to Albert H. Dyer. The Wilkins and their six children, three boys and three girls, came to Lompoc in 1881 from Santa Ana. Miss Wilkin opened her millinery store in 1882 on the corner of H street and Ocean avenue… Failing health in recent years has led to a gradual relinquishment of leadership in ladies' furnishings until last week the offer of another firm for the lease on the store building was accepted… Mrs. Black had been in the millinery business two years when J. D. Black, a young harness maker came to town and opened a pioneer saddler business. About a year later, in 1885… were married. Mrs. Black continued to conduct her millinery business and Mr. Black managed his harness shop… [and article provides information on Mr. Black's harness shop] … Every spring and fall Mrs. Black would go to San Francisco to buy hat goods, making the trip each way in three days. The route of travel before the days of the railroad… was to take the stage to Los Alamos, stay there overnight, go to San Luis on the narrow-gauge railroad, stop there … next morning and take the train into San Francisco. The goods purchased… were sent to Lompoc Landing … and were hauled to the city by team. … Every spring and fall the *Lompoc Record* heralded Mrs. Black's spring millinery style opening… millinery creations… wide-brimmed hats trimmed with ostrich plumes… Later on the sailor hat came into vogue… A month or so before Easter every woman in Lompoc valley began to worry about her Easter bonnet… Hats were made in Lompoc in the early days, instead of coming to local hat shops ready to wear, as is the case today. Mrs. Black's spring and fall purchases included the fashion plates which showed how the creations … were intended to look, the wire shapes for the hats, and the material which was later to be built on the frames. Hat trimmers came for a few months each year to finish the hats to the taste of the individual wearers. One of these hat trimmers was Miss Anna Sodewall, who came from San Francisco for two seasons. Miss Sodewall then married Ed Wilkins… she continued to assist Mrs. Black in finishing hats. Mr. and Mrs. Wilkins now live at San Jose. Some Early Employees. Mrs. Blanche Compton… Miss May Dyer… married to William J. Oates… Miss Lottie Barnes … now Mrs. Harvey McDonald and lives at Santa Ynez… failing health 12 years ago forced her to relinquish her leadership…," *LR*, Jan. 23, 1931, p. 2.

Black, Mrs. J. D. (notices in Northern Santa Barbara County newspapers on microfilm and on newspapers.com)
1931 – "Morton Nichols Revisits Boyhood Home… One couple upon whom the Nichols called were Mr. and Mrs. J. D. Black. Mrs. Black recalled that she took painting lessons from **Mrs. Jack [A. J.] Nichols** many years ago …," *LR*, July 31, 1931, p. 4.

Black, Mrs. J. D. (misc. bibliography)
Clara E. Black is listed in the 1900, 1910, 1920, and 1930 U. S. Census with husband John D.; listed in various voter registration indexes in the 1930s not itemized here; Clara Black is listed in the 1940 U. S. Census as age 70, b. c. 1870 in Iowa, finished elementary school, 8th grade, residing in Lompoc (1935, 1940) with husband John D. Black (age 79) and a servant; Clara E. Black, mother's maiden name Young, father's name Wilkin was b. March 16, 1859 in Iowa and d. Dec. 16, 1940 in Santa Barbara County per Calif. Death Index; Clara E. Black (1859-1940) is buried in Lompoc Evergreen Cemetery per findagrave.com (refs. ancestry.com).
See: "Santa Barbara County Fair," 1892, and *San Luis Obispo Art and Photography before 1960*

Black, John P. (1862-1933) (Huasna / Santa Margarita)
Mapmaker, surveyor, active in Northern Santa Barbara County, 1887-1932. In 1925 he was SLO county surveyor.

■ "John Black Dies in San Luis Today… San Luis Obispo county surveyor and a member of the prominent pioneer family of Santa Maria valley, died of pneumonia… Black, a resident of Santa Margarita, is well-known in this city," *SMT*, Dec. 16, 1933, p. 1.
Black, John P. notices in Northern Santa Barbara County newspapers on microfilm and on newspapers.com)
1894 – "J. P. Black showed us a very neat map of the H. Dutard ranch – up the river – which he has just completed. This map is done in colors and proves John an artist as well as surveyor," *SMT*, Feb. 3, 1894, p. 3.
1895 – "Surveyor J. P. Black of Huasna was in town Wednesday. He has been doing considerable drafting and some surveying of late," *SMT*, June 1, 1895, p. 3, col. 1.
1933 – "Funeral for John Black Held Today … in the Elks Lodge room in San Luis Obispo… 71, pioneer… Interment was in the IOOF cemetery…," *SMT*, Dec. 18, 1933, p. 1. And more than 100 additional social and land notices in the *SMT* between 1880 and 1900 were not itemized here.
Black, John (misc. bibliography)
John P. Black b. March 17, 1862, d. Dec. 16, 1933 and is buried in San Luis Cemetery per findagrave.com (refs. ancestry.com).

Blakely, June Gillingham (Mrs. Capt. Hugh J. Blakely) (Lompoc)
Painter. Created a mural at the USDB, 1955. Exh. Open-Air Art Exhibit, 1957. Swimming instructor.

■ Port. as lifeguard and "June Blakely Ends Close Tie With City Pool" – she was born in England, was raised to be an actress and appeared in plays, but married, came to the U. S., was in Lompoc because her husband was stationed here, was active with the Community Players and as a lifeguard and was now going to Fort Ord in Monterey, *LR*, Aug. 3, 1959, p. 5.
See: "Open-Air Art Exhibit," 1957, "United States Disciplinary Barracks," 1955

Blanchard, Burton C., Pfc./Cpl. (1912-1970) (Camp Cooke)
Staff artist of Cooke Clarion, Korean War, 1951-52.
1950 – "Windsor Serviceman… Camp Cooke, Calif. The promotion of Pfc. Burton C. Blanchard, a member of the Headquarters Detachment at Camp Cooke, to the grade of corporal has been announced today. He is the son of Mrs. Florence E. Blanchard of Windsor, Vt." *Rutland Daily Herald* (Rutland, Vermont), Nov. 10, 1950, p. 10.
Blanchard, Burton (misc. bibliography)
[Do not confuse with Burton L. Blanchard of Lompoc.]
Burton C. Blanchard's WWII Army Enlistment Record states he was b. 1912 in Massachusetts, was single, was then living in New Hampshire, had one year of college, was working in the art field, was single, and enlisted Jan. 27, 1943 in Manchester, N.H., as a Private; Burton C. Blanchard was b. April 5, 1912 in Mass. to Winthrop Shirly Blanchard and Florence C. Blanchard, who was residing in Windsor, Vt. in 1930, and d. April 27, 1970 in Hillsborough, Fla. per The Leach/Riley Family Tree (refs. ancestry.com).
See: "Art, general (Camp Cooke)," Korean War

Blanchard, Ruth (1903-1998) (Santa Maria)
Teacher of sewing at Santa Maria high school, whose classes put on fashion shows and made costumes for school plays, c. 1933. President Business and Professional Woman's Club.
■ "Six Teachers at High Resign, Four Replaced… Miss Ruth Blanchard has been engaged for the Domestic Art section. She is a graduate of the Santa Barbara State Teachers' college and has had graduate work at Columbia university. During this year's summer session she will teach in the textile and clothing department at Columbia. Miss Blanchard was a member of the teaching staff at Rio Vista, year before last, under H. S. Benton, former principal of the local high school," *SMT*, June 8, 1927, p. 1.
Blanchard, Ruth (notices in Northern Santa Barbara County newspapers on microfilm and on newspapers.com)
More than 200 notices for "Ruth Blanchard" regarding sewing classes and fashion shows, her activities with the BPWC, and vacations in Carmel, in the *SMT* 1931-34 were not itemized here.
Blanchard, Ruth (misc. bibliography)
Ruth Blanchard is listed in the 1930 U. S. Census as age 27, b. c. 1903 in California, single, residing in Santa Maria, working as a teacher in public school; Ruth Blanchard b. May 5, 1903 is listed in Carmel, Ca., per *U. S. Public Records Index, 1950-1993*, vol. 2; Ruth Blanchard b. May 5, 1903, d. Dec. 31, 1998 per Social Security Death Index (refs. ancestry.com).
See: "Boy Scouts," 1933, "Camp Fire Girls," 1933, "College Art Club," 1928, 1932, "Minerva Club," 1929, 1934, "Santa Maria, Ca., Union High School," 1927, 1934

Blauer (Whitaker), (Sara) Joyce (Mrs. Leslie Arthur Whitaker) (1928-2009) (Santa Maria / Denver)
Muralist for dining room of Rick's, 1947. Santa Maria High School student of Mrs. DeNejer who exh. in an art show, 1946.
■ "Art Student Given Assignment" – former SM resident and now Denver U art student is visiting with **DeNejers** and is assigned murals and decoration of dining room at Rick's, and article adds, "Miss Joyce Blauer, daughter of Col. and Mrs. Blauer who formerly lived in Santa Maria is here on a visit with Mr. and Mrs. Ray DeNejer, and while in Santa Maria has been assigned work to do murals and decorating of the dining room at Ricks. Miss Blauer is majoring in art while attending Denver University, in which she will enroll for the fall term on completing her work here. The young art student began her studies under Mrs. DeNejer while attending the Santa Maria Junior College," *SMT*, Sept. 9, 1947, p. 3.
Blauer, Joyce (misc. bibliography)
Sara Joyce Blauer, b. c. 1927, port. appears in the University of Denver yearbook, 1947; Joyce Blauer appears in the University of Denver yearbook, 1948 with the statement for seniors "B. A. Fine Arts, Denver, Kappa Delta; Delta Phi Delta; Kappa Delta Psi" and her port. in cap and gown appears on another page; Sara Joyce Blauer b. July 16, 1928 in Brush, Colo., to Clinton E. Blauer and Sally M. Westbrook, married Leslie Arthur Whitaker and d. May 5, 2009 in Tucson, Ariz., per Gill Family Tree (refs. ancestry.com).
See: "Santa Maria, Ca., Union High School," 1946, "United Service Organization (Santa Maria)," 1945

Blochman City / Blochman Village (Sisquoc)
Miniature village created by students, the brainchild of Bina Fuller, principal of Benjamin Foxen Elementary School, Sisquoc.
■ Blochman City – "Today, this is the site of Greka Oil & Gas Co. facilities which have had a number of well-publicized oil spills, … Once Palmer Road was renowned for something far different – a Depression-era social experiment called Blochman City, devised by Blochman School principal Bina Fuller. On donated oil company land and with building materials supplied by area merchants, a junior-size town was surveyed and built by schoolchildren. With 8-foot high buildings including a bank, post office, Chamber of Commerce and store, neatly laid out streets complete with concrete curbs, police department and mayor, the student-run model city received extensive national publicity. Today, nothing remains of Blochman City but a grassy hillside south of Dominion Road. Fuller is memorialized on a plaque outside the Bina Fuller Memorial Hall at the present Blochman School (officially known as Benjamin Foxen Elementary) in Sisquoc. The pretty 1950s-era school at the edge of the Santa Maria Valley, where Palmer Road ends, houses 92 students from Sisquoc, Garey, Tepusquet and Santa Maria," per lompocrecord.com/lifestyles, Jan. 27, 2009, on Internet.
See: "Blochman School," "Fuller, Bina," "Santa Maria, Ca., Elementary Schools," 1936, 1940, 1946

Blochman School (aka Benjamin Foxen Elementary School) (Santa Maria)
See: "Santa Maria, Ca., Elementary Schools"

Bloom, Arvid Seth (1893-1953) (Lompoc)
Painter, furniture dealer, 1930. Painted the background for the Lompoc booth at the County Fair, 1930.

■ "Local Booklet Nears Completion. C of C Eloquence Fails to Impress Artist. Proud Parent Paints Picture of Valley. At last! After a southern California artist had listened to verbal descriptions of the floral and other beauties of the Lompoc valley told him by an eloquent resident… he reached avidly for his palette and bush … The picture was required for the outside cover of a Lompoc valley publicity booklet now in preparation… [C of C did not like the painting] … Ronald M. Adam went to A. S. Bloom, local furniture dealer, whose canvases have occasioned favorable comment here… Mr. Bloom had studied art for many years and not vainly. Enthused by the opportunity to make the Chamber of Commerce publicity booklet an 'all-Lompoc' publication. Mr. Bloom seized his materials and sallied forth. When the committee saw the result of his work, they broke out in smiles of satisfaction…. Mr. Bloom's picture shows the fields of flowers stretching across the wide valley floor, their blues, reds, yellows and purples as vivid as the rainbow and with the protecting mountains showing blue through the afternoon haze. Not only does the picture impress the beholder with its fidelity to the actual appearance of the valley, but Mr. Bloom has exhibited skill in adaption of the scene to the purposes to which it will be put…," *LR*, July 4, 1930, p. 7.
Bloom, A. S. (notices in Northern Santa Barbara County newspapers on microfilm and on newspapers.com)
1931 – "Get the Fish, Forget the Beauty, is Axel Nielsen's Viewpoint… On Sunday Arvid Bloom, proprietor of the Lompoc Furniture store, was fishing from a motorboat off Gaviota and hooked a rock cod so big that when he tried to describe it his hands would hardly spread far enough apart to indicate its length… [he landed him but said] 'Aw, no; isn't he a beauty!' when the hook came out of the cod's gaping mouth, its fins flashed into action and it was gone," *SYVN*, Oct. 16, 1931, p. 1.
1939 – "Sworn Affidavit of Facts … Mr. A. S. Bloom, being duly sworn, deposes and says that he is the owner of the store known as the Lompoc Furniture company, located in the city of Lompoc … That he has decided to close out his entire stock of merchandise and fixtures at retail public sale… in the shortest possible time. Sale to commence on Friday, September 8, 1939…," *LR*, Sept. 8, 1939, p. 4.
Bloom, A. S. (misc. bibliography)
Arvid S. Bloom, b. Norway, arrived in U. S. in 1913, is listed in the 1930 and the 1940 U. S. Census as residing in Lompoc; Arvid Seth Bloom gave the following information on his WWII Draft Registration Card: age 49, b. Nov. 2, 1893 and residing in Los Angeles (1942); Arvid Seth Bloom, mother's maiden name Anderson, was b. Nov. 2, 1893 in Other Country, and d. Aug. 23, 1953 in San Francisco County per Calif. Death Index (refs. ancestry.com).
See: "Santa Barbara County Fair," 1930

Blue Birds
See: "Camp Fire Girls"

Blue Lantern (Santa Maria)
Interior decorating studio at 500 S. Broadway. Prop. Louise Corollo, 1956.
See: "Corollo, Louise"

Blue Mask Club (Santa Maria)
Club at Santa Maria Union High School organized Jan. 1922. Devoted to art, drama, music, 1922-38. Succeeded by the Theatre Arts class.
[Only notices about the club's Art activities were itemized here.]
■ "The purpose of the Blue Mask Club is to promote interest in music, art and drama. During the first semester the members helped to obtain the art exhibition of the New York and Paris School of Fine and Applied Arts. …During the second semester a permanent program committee was appointed. Before, it had been the custom to have a committee of two or three for each meeting to plan the entertainment. Some good programs were given for the members. Mr. Peck's Symphony Orchestra ensemble played several numbers. A picture cantata, with the girls' glee chorus and some dancing scenes, was also enjoyed," and group photo of members: "First Row: Philip Madruga, **Byron Openshaw,** Leo Kieran, Harold Shoup, Tilden Barr, **Mr. Breneiser,** Albert Dexter, Tommy Burlan, Guido Signorelli, Jim Baker, David Tognazzini, Alvin Cox. Second Row: Lillian Righetti, Annadele Black, Lillian Holmes, Hilda Caligari, Lillian Freitas, Doris Goble, Anna Gardner, Ruth Roemer. Third Row: Katherine Scaroni, Dorothy Bettersworth, Dorothy Wharff, Virginia Johnson, Blythe Baird, Florence Case, Hazel Dutra, Gertrude France, Margaret Fesler, Lois Stewart. Fourth Row: Faye Mendenhall, Iola Houghton, Verna Dutcher, Clementine Allen, Irene Hudson, Marie Cossa, Pauline Quick, Lenore Ray, Alma Drexler, Eleanor Fesler. Fifth Row: Dorothy Rivers, **Marrie Breneiser,** Frances Snell, Harriet Thornburg, Leota Pollard, Ardith Lowe, Emiko Fukuto, Stella Sudduth, Ruby Marston, Ervina Guidotti," from Santa Maria, Ca., Union High School, yearbook, 19??.
Blue Mask Club (notices in Northern Santa Barbara County newspapers on microfilm and on newspapers.com)
1922 – "H. S. Breeze… 'Blue Mask' Missed Last Regular Meeting. Due to the rush for Senior Frolic… **Mr. Breneiser** made an announcement about the Art Exhibit at the Senior Frolic…," *SMT*, Dec. 16, 1922, p. 6.
1924 – "Club Hears Lecture on Correlation of Arts. That a correlation, a likeness, a bond of sympathy is to be found between music and painting, was the theme of **Mr. Breneiser**'s talk to the Blue Mask club, Thursday, April 24. With **Mrs. Breneiser**'s accompaniment on the piano, he interpreted paintings of different types, successfully proving that there are pieces of music that give the same impression as some painting you look at. Some of the examples used were 'The Land of Make Believe' by Parrish, was used with 'The Spring Dance with the Elfin Dance' by Greig; a 'Group of Indians' by Hoffer with 'From An Indian Lodge' by McDowell; a weird Norwegian snow scene with 'O! Beware' by Grieg; a coast scene of

Maine by Winslow Homer with 'A. D. 1920' by McDowell…," *SMT*, May 2, 1924, p. 3.

1925 – "Work of Art … The Blue Mask club, which is the art and drama club of the school, has been under the direction of **Mr. Breneiser** for three years and a half, but has now been turned over to Miss Edith Mohney, the capable drama teacher in the high school. Mr. Breneiser continues an interest, however, as he is instructing the drama class in the principles of art as related to the stage …," *SMT*, Sept. 26, 1925, p. 1.

1928 – "Eight Dolls… dressed in costumes ranging from the 13th century to the early 19th, are to be the gift of the Blue Mask club to Santa Maria Union high school this year. They are the work of **Mrs. Elizabeth Ellis Scantlebury**, who, besides her fame for her dolls and her research work in early manners of dress, is well-known as an authoress and poet," and some bio. of Scantlebury, *SMT*, Oct. 30, 1928, p. 1.

1929 – "High School and Junior College Students Given Acclaim for Dance Review… through an article published in the *Christian Science Monitor* for May 28 written by **Stanley G. Breneiser**… It describes the Dance Revue given here recently by the Blue Mask club…," to raise funds to purchase costumed dolls donated to the school," *SMT*, June 7, 1929, p. 7.

And possibly 100 additional notices between 1922 and 1941 (?) in the *SMT*, primarily about theater presentations were not itemized here.

See: "College Art Club," 1931, "Santa Maria, Ca., Adult/Night School," 1924, "Santa Maria, Ca., Union High School," 1922-33, 1937, 1938, 1941

Blum, Maurice (Santa Maria)
Interior decorator. Prop. Blum's Interiors, 1950-51.
Taught interior decorating in adult school, 1951.
Lectured to Beta Sigma Phi, 1951. Mounted a room display at the County Fair, 1951.

■ "Maurice Blum, a native of San Francisco, has opened an interior decorating business in Santa Maria. Blum and **Miss Louise Markevich [Corollo]** are operating Blum's Interiors, 417 South Broadway. Both Blum and Miss Markevich attended Rudolph Schaeffer School of Design in San Francisco. Blum also holds an engineering degree from UCLA. The pair chose Santa Maria as the 'best spot in California' after a thorough search up and down the coast, Blum said. 'We felt there was a need here for decorating, design and architectural service," per "Opens Interior Decorating Shop" in Santa Maria, *SMT*, Aug. 12, 1950, p. 3.

Maurice Blum is pictured in the UCLA yearbook, 1945 (ref. ancestry.com).

See: "Beta Sigma Phi," "Corollo, Louise," "Santa Barbara County Fair," 1951, "Santa Maria, Ca., Adult/Night School," 1951

Blum's Interiors (Santa Maria)
Interior decorating studio, 417 So. Broadway, 1950-51.
See: "Blum, Maurice," "Corollo, Louise"

Blystad, Astrid Marie (1886-1988) (Solvang)
Artist residing at Solvang Lutheran Home, 1960.

■ Port. with paintings and "Trio of Residents Enjoy Painting … A trio of Solvang Lutheran Home residents, two men and a woman … are providing daily pleasure for themselves as well as for fellow home inhabitants by the creation of oil and water paintings covering a variety of subjects. The elderly artists are Miss Astrid Blystad, 74, a retired masseuse, who received art training in her native Norway as a girl and later when she lived in Los Angeles, **Walter A. Swanson**, 76, and **Peter Jacobsen, Sr.**, 86, both of whom taught themselves to wield an artist's brush. Miss Blystad, who came to the home last March after living in Los Angeles for 35 years, received her first instruction in art in Norway. 'I gave it up however,' she disclosed, 'upon coming to America and did not return to art work until a few years ago when I resumed study in Los Angeles.' Miss Blystad has no set schedule of working at her easel 'I paint when I have the urge,' she added. She works in both oils and water colors. … B.P. Christensen, home manager, said plans are now under way to show the work of the three artists at an outdoor exhibit which will be staged at the home during Solvang's golden jubilee celebration next August," *SYVN*, Dec. 9, 1960, p. 6.

Blystad, Astrid (notices in Northern Santa Barbara County newspapers on microfilm and on newspapers.com)

1968 – "Home Starts Festivities of Yuletide… Solvang Lutheran Home… dining room windows of the home have been painted with decorations by Miss Astrid Blystad. Miss Blystad, one of the long-time residents of SLH who has remained unusually alert and active, has contributed freely of her artistic abilities for many years," *SYVN*, Dec. 19, 1968, p. 14.

1986 – "Solvang Home to Inaugurate Century Club… One of the current members… is Miss Astrid Blystad, who has lived at the Home since March, 1960. She celebrates her 100th today…," *SYVN*, March 6, 1986, p. 24; and more than 100 additional notices in the *SYVN* not itemized here.

Blystad, Astrid (misc. bibliography)

Astrid Marie Blystad, mother's maiden name Dorthea, was b. March 6, 1886 in Other Country and d. Dec. 31, 1988 in Santa Barbara County per Calif. Death Index (refs. ancestry.com).

Bodie, Perham Mason (1892-1949) (Lompoc)
Filmmaker, amateur, who showed his films of vacation lands at the Lompoc Film Council meeting, 1948. Co-prop. Camera Shop, 1946-48.

■ "P. M. Bodie Passes… He came to Lompoc during the war from the Los Angeles area and managed the Post Exchange at Camp Cooke. After the war he and **Tom Coker** bought and reorganized the Camera Shop. About a year ago, because of ill health, he sold his interest to his partner and left here," *LR*, Aug. 11, 1949, p. 1.

See: "Camera Shop," 1946, 1948, "Lompoc Film Council," 1948

Bodrero, James Spalding (1900-1980) (Santa Barbara / Pasadena)
Artist who exh. in National Art Week show at Minerva Club, 1940.

■ "James Spalding Bodrero was born in Belgium on July 6, 1900. ... He began drawing and painting as a child and remained self-taught. As a teenager he was working as a freelance artist in NYC, submitting work to national magazines and illustrating for authors. In 1925 he settled in Pasadena and in 1938 went to work in the art department at **Disney** Studios as a story director and character designer. There he created Dumbo the elephant, the ostrich who danced in 'Fantasia' and José Carioca, the parrot. After leaving Disney in 1946, he painted several murals in local restaurants. In 1949 he moved to San Francisco where he remained, except for sojourns to Spain, until his death on Feb. 6," per Edan Hughes, *Artists in California, 1786-1940*, on askart.com, who cites an interview with the artist or his family.

■ "James S. Bodrero, Sr. ... socially prominent artist who for many years divided his time between homes in San Francisco and Spain... In 1963 he received widespread attention for a book which he illustrated recounting his adventures on a ride through Spanish mountains that duplicated the journey described by Washington Irving in 'Tales of the Alhambra'," *San Francisco Examiner*, Feb. 8, 1980, p. 40

Bodrero, James (misc. bibliography)
James S. Bodrero is listed without occupation in the *Santa Barbara, Ca., CD*, 1932-43; James Spalding Bodrero b. July 6, 1900 in Liege, Belgium to Catharine Lucretia Spalding Clearwater, married Eleanor Cole, d. Feb. 6, 1980 in San Francisco and is buried in Los Angeles National Cemetery per findagrave.com (ref. ancestry.com).
See: "National Art Week," 1940

Bodwin, Richard A. (Lompoc)
Prop. of Photo-Craft Studios, 1960.

■ "New Photo Studio Set Up in Lompoc… at 117 North G Street, called the **Photo-Craft Studios**. The new business is owned by **John Charles Wallace** and Richard A. Bodwin. The photo studio will specialize in portraiture, wedding coverage and general commercial photography," *LR*, Nov. 17, 1960, p. 29.

Bodwin, Richard A. (misc. bibliography)
Richard A. Bodwin (Photo-Craft) (Lom) is listed in the *SMCD*, 1961 (refs. ancestry.com).
No additional information on this individual could be found.

Bond (Wilkie) (Vasile), Doree Nan (Mrs. Herbert Marston Wilkie) (Mrs. Alfred Vasile) (1932-2015) (Santa Maria)
Painter. Exh. oil paintings at Community Club hobby show, 1950, 1952.

■ Port. and "Doree Bond, Kiwanis Club Queen Entry… high school senior… queen contest for the Santa Maria Elks Rodeo… Miss Bond, 17 years of age, is a Santa Maria girl, born in the old Grigsby hospital and is one of the outstanding music and art pupils in Santa Maria high school… In her second year in high school, she had made such progress in art that she was transferred into the junior college art classes, where she is still working. She plans to become an interior decorator, but intends to finish college first. She will spend two years in Santa Maria junior college and finish her work for a degree in Fresno State college…. The daughter of Mr. and Mrs. G. B. Bond, 215 North Vine, the young queen candidate is an enthusiastic horseback rider and in school is a member of the California Scholarship Federation," *SMT*, May 16, 1950, p. 1.

Bond, Doree (notices in Northern Santa Barbara County newspapers on microfilm and on newspapers.com)
1952 – "Couple Say Vows… Miss Doree Nan Bond yesterday became the bride of Herbert Marston Wilkie, Jr…. St. Peter's Episcopal church…. Honeymoon by way of the Redwoods to San Francisco and into Nevada… Their new home address is to be 609 South Thornburg…," *SMT*, Sept. 8, 1952, p. 4.

Bond, Doree (misc. bibliography)
Doree Nan Bond was b. Oct. 12, 1932 in Santa Barbara, Ca., married Alfred Vasile, was living in Sacramento in 1993 and d. 2015 per Antoinette Crosby Family Tree (refs. ancestry.com).
See: "Community Club (Santa Maria)," 1950, 1952, "Santa Barbara County Library (Santa Maria)," 1951

Bondietti, Mary Elizabeth (Mrs. Ernest Bondietti) (1922-2008) (Lompoc)
Art student of Forrest Hibbits. Exh. Open-Air Art Exhibit, 1960. One of the group of artists who exh. at the Equinox Gallery, 1961+.

■ "Mary E. Bondietti, 1922-2008. ... Mary was born in Lompoc ... to Everisto and Maria Sousa. She attended Lompoc High School and graduated from Tracy High School. She was a lifelong homemaker, enjoyed gardening, sewing, and art, especially painting china, oil and water painting...," *LR*, April 30, 2008, p. 3.
See: "Art, general (Lompoc)," 1961, 1962, "Open-Air Art Exhibit," 1960

Bonn, Trin Francis (1914-1973) (Santa Barbara)
Draftsman who was active in Santa Barbara 1938-72. Artist who exh. in National Art Week show at Minerva Club, 1940.

Bonn, Trin (misc. bibliography)
Trin F. Bonn is listed as artist in the *Santa Barbara , Ca., CD*, 1937, and as draftsman, 1938; Trin Francis Bonn gave the following information on his WWII Draft Card – age 26, b. Aug. 2, 1914 in Los Angeles, mother's name: Mrs. Maria Bonn, not employed; Trin Bonn is listed in the 1940 U. S. Census as finished high school 4th year, working as a sales clerk in a retail grocery, residing in Santa Barbara with his parents John and Marie Bonn; Trin F. Bonn is listed as draftsman in the *Santa Barbara, Ca., CD*, 1954-72; Trin F. Bonn b. Aug. 2, 1914 in Calif., d. April 17, 1973 in Santa Barbara per Calif. Death Index (ref. ancestry.com).
See: "National Art Week," 1940

Booth, Stanley Lewis (1932-?) (Goleta)
Naval photographer, 1949?

■ "Stanley Booth, graduate of the Santa Ynez Valley Union High School in 1949 is attending the U. S. Naval Academy Prep School at the Naval Training Station, Newport, R. I. … Booth joined the Navy in June, 1949, immediately after graduating from high school. For the past year he has been attending the Navy's Aerial Photography School in Pensacola, Fla. It was there that he took and passed the competitive examination for the Newport school…," *SYVN*, Oct. 6, 1950, p. 3.

Booth, Stanley (notices in Northern Santa Barbara County newspapers on microfilm and on newspapers.com)
1951 – "Booth Named to Annapolis… appointed as a midshipman to the U. S. Naval Academy… Mr. Booth, a graduate of the Santa Ynez Valley Union High School, class of 1949, is the second appointee to the academy from the Valley… Booth recently completed a course at the Naval Preparatory School at Newport, R. I. He is now on a 20 day leave and will begin his training at Annapolis July 1," *SYVN*, June 8, 1951, p. 1.
1959 – "Valley High Alumni Plan Reunion… Members of the class and their present place of residence are … Lieut. Stanley Booth, Laguna Beach…," *SYVN*, May 29, 1959, p. 3; and additional notices in the *SYVN* on his interest in music in high school were not itemized here.

Booth, Stanley (misc. bibliography)
Stanley Lewis Booth, mother's maiden name House, was b. Jan. 26, 1932, in Ventura County per Calif. Birth Index; Stanley Booth is listed in the 1940 U. S. Census as age 8, b. c. 1932, a student in elementary school, residing in Goleta (in 1935 in Santa Paula) with his parents Stephen Booth (age 44), Jane Booth (age 45) and brother Stephen Booth, Jr. (age 16); is he Stanley L. Booth who married Susan L. Scharnikow on Feb. 5, 1959 in San Diego per Calif. Marriage Index; Stanley L. Booth was residing in various coastal communities in northern San Diego County in the 1990s per *U. S. Public Records Index, 1950-1993*, vol. 1 (refs. ancestry.com).

Boothe, J. (Joseph) Miles (1891-1981) (Santa Maria)
Photography teacher at Santa Maria High School, c. 1944-55, at Santa Maria Adult/Night School, 1943+, and at Allan Hancock College night school, c. 1955-58. Member of Santa Maria Camera Club from 1938.

■ "Obituaries…. Joe Miles Boothe, 89, died Tuesday in a local hospital… Mr. Boothe was born in La Grande, Ore. on Sept. 21, 1891. He moved to Santa Maria in 1926 and taught agriculture at Santa Maria High School for 12 years. He established the Future Farmers of America at Santa Maria High School and also instituted the first class in photography at the school. In 1939 he coached the champion C basketball team at Santa Maria High School and retired from teaching in 1958. He was a member of the Masonic Lodge No. 14, F&AM in Oregon for over 50 years, member of the Santa Maria Camera Club, Toastmasters, Farm Bureau Association, Good Timers Club, California State Teachers Association, the Retired Teachers Association and the Santa Maria Valley Senior Citizens," *SMT*, June 20, 1981, p. 16.

Boothe, J. Miles (notices in Northern Santa Barbara County newspapers on microfilm and on newspapers.com)
1942 – "I Spied… Miles Boothe taking photographs in the junior college library for the '*Mascot*,' jaysee annual," *SMT*, April 22, 1942, p. 1.
1948 – "J. Miles Boothe … is attending summer school at University of California, Santa Barbara, taking an advanced special course in photography, among other things. He has, for a number of years, taught photography in the high school," *SMT*, July 23, 1948, p. 5.
And nearly 400 hits for "Miles Boothe" (primarily for his wife, clubwoman and organist Mrs. J. Miles Boothe) in the *SMT* between 1930 and 1960 were not itemized here.

Boothe, J. Miles (misc. bibliography)
Joe Miles Boothe b. Sept. 21, 1891 in Oregon, married Litta Christine Welch, was residing in Union, Oregon, in 1910, and d. June 16, 1981 in Santa Barbara, Ca., per Walker Family Tree (ref. ancestry.com).
See: "Allan Hancock College Adult/Night School," 1955, 1956, 1957, 1958, "Miller, Lillian," 1953, "Santa Maria, Ca., Adult/Night School," 1943, 1946-1955, "Santa Maria, Ca., Union High School," 1945, 1952-55, 1958, "Santa Maria Camera Club," 1938, 1948, 1952

Boradori, Lena (Mrs. Samuel Boradori) (1885-1982) (Los Alamos)
Painter. Student under Leo Ziegler at Los Alamos Adult School, 1947+. Exhibited her art at several venues, c. 1947-55.

■ "Life-long Los Alamos resident dies. Lena Boradori, 96… died Monday in a Santa Maria hospital… Mrs. Boradori was born Oct. 29, 1885 in Santa Maria. She had been a life-long resident of Los Alamos, moving there in 1888 at the age of three… She lived with her family on a ranch in Los Alamos and attended elementary school there. Her high school years were spent in San Luis Obispo. She married Samuel Boradori and helped him run his father's general merchandise store, The Swiss-American Store, for more than 15 years. The store was located on what is now Arthur Ferrini Park in Los Alamos. In 1917 they moved from the house behind the store to a home of their own. They had two daughters, Aida and Jean… In 1929 they bought a grocery store and moved the business to the building now known as the Los Alamos General Store. Samuel Boradori was killed in a car accident in 1933, while walking home from work. Lena Boradori operated the store until her retirement in 1942," *SMT*, April 28, 1982, p. 2.

Boradori, Lena (notices in Northern Santa Barbara County newspapers on microfilm and on newspapers.com)
1949 – "Los Alamos News. Mrs. Lena Boradori and daughter Jean have returned home from a three-week vacation … and two weeks in Salinas. While there Mrs. Boradori took an advanced course in color painting in oils, from a New York artist, Frederic Taubes, in Carmel," *SMT*, Sept. 15, 1949, p. 7.

Boradori, Lena (misc. bibliography)
Lena Boradini is listed in several *Los Alamos CD* (1938, 1945, 1947) as "Merchant"; Lena Boradori was b. Oct. 29, 1885 and d. April 1982 per Social Security Death Index; Lena Boradori b. 1885, d. April 26, 1982 and is buried in

Santa Maria Cemetery District per findagrave.com (refs. ancestry.com).
See: "Santa Barbara County Fair," 1952, "Santa Barbara County Library (Santa Maria)," 1948, "Santa Maria Art Association," 1953, "Santa Maria [Valley] Art Festival," 1952, "Santa Ynez Valley Art Exhibit," 1953, 1958, "Santa Ynez Valley, Ca., Adult/Night School," 1947, 1949, 1953, 1955, "Tri-County Art Exhibit," 1947, 1950

Borein, Edward (1872-1945) (Jesus Maria Rancho / Santa Barbara)
Cowboy artist who spent his first years as a vaquero at Jesus Maria Rancho (now Vandenberg AFB), early 1890s. Leased a ranch near Solvang, 1938. Exh. first annual Santa Ynez Valley Art Exhibit, 1953.
■ "Edward Borein, 72, Famous Etcher, Dies in Santa Barbara… next to the last of famous artists to have made Santa Barbara county notable … Borein, a native of California, began to develop his art abilities when a vaquero on the old Jesus Maria Rancho, now Camp Cooke, and finished his art education in New York and Paris. He specialized in etchings of the Old West and the old Spanish period of California…," *SYVN*, May 25, 1945, p. 1.
See also: Wikipedia, that lists several of the articles and complete books written on this famous artist.
Borein, Ed (notices in Northern Santa Barbara County newspapers on microfilm and on newspapers.com)
1927 – "Improvements Being Made at Old Mission… noteworthy gift… Mrs. R. Herrick of Boston… a complete set of etchings of all the chain of Missions from San Diego to San Francisco is being prepared by the Santa Barbara artist, Mr. Edward Borein, and will be hung as a fresco around the walls of the enlarged entrance hall," *SYVN*, Nov. 4, 1927, p. 1; "Mr. Edward Borein, the well-known artist of Santa Barbara, and Mr. Will Rogers, mayor of Beverly Hills, a writer and entertainer of national fame, were guests of **Mattei's** tavern one day this past week," *SYVN*, Nov. 4, 1927, p. 4.
1935 – Raising Local Funds for [Will] Rogers Memorial … Ed Borein, county chairman… An etching of **La Purisima** mission, the work of Ed Borein, noted artist and personal friend of the late Will Rogers has been given to the committee…," *LR*, Nov. 8, 1935, p. 1.
1938 – "Famous Artist Leases Janin Ranch Home… on Marcelino rancho near Solvang and took possession this week," *SYVN*, Aug. 5, 1938, p. 1.
1940 – Repro: "Don Jose de Castro" printed in *Overland Monthly*, August 1908, *SMT,* May 3, 1940, p. 2-B.
1945 –- "Edward Borein, 72, Famous Etcher, Dies in Santa Barbara," *SMT,* May 21, 1945, p. 6.
1950 – "Ramblings … *'Etchings of the West'* is probably the most beautiful book ever produced in Santa Barbara county. Its collected etchings, drawings and water colors of western life produced by the late Edward Borein… Dwight Murphy, T. Wilson Dibblee and a dozen other friends of the late artist sponsored the edition… Borein started out as a cowboy, and one of his first jobs was on the Jesus Maria Rancho (now Camp Cooke). There he plastered the bunk house walls with his drawings – news of his skill reached the outside world – and in a few years he was famous…," *LR*, Dec. 28, 1950, p. 16.

Bibliography
Coloring the West: Watercolors and Oils by Edward Borein, Santa Barbara Historical Museum, 2007. 72 pp. 56 illus.
See: "Architecture (Northern Santa Barbara County)," 1972, "Art Loan Exhibit (Solvang)," 1935, "Hebert, Marian," "Mission Santa Ines," 1927, and Bibliography, "Orcutt Women's Club," 1927, "Peake, Channing," "Santa Ynez Valley Art Exhibit," 1953

Borg, Carl Oscar (1879-1947) (Santa Barbara)
Painter of several scenes in the Santa Ynez Valley and at least one of Hearst Castle.
■ "Carl Oscar Borg was a Swedish-born painter who settled in the United States and became known for views of California and the South West," and list of books discussing Borg in Wikipedia.
Borg, Carl Oscar (notices in Northern Santa Barbara County newspapers on microfilm and on newspapers.com)
1930 – "Historic Danish Film, '*The Viking*' will be Offered Here Saturday… detailing the early history of the Danes… It has been produced on a lavish scale with settings designed by the famous artist, Carl Oscar Borg. … photographed entirely in natural colors by the improved methods of Technicolor…," *SYVN*, Aug. 8, 1930, p. 1.
Over 400 hits occur for "Carl Oscar Borg" on newspapers.com in papers published in California and Arizona, etc. but were not itemized here.
Borg, C. O. (auctioned works that depict the Central Coast)
"Hearst Castle," 20 x 16 in., o/c, auctioned Clars, Oakland, 9/8/2007, lot 6467; "In the Santa Inez Range," o/c, auctioned JM, 2/16/99, lot 92 and again B, 2/9/99, lot 5446a (F&J 2001); "Mission at Santa Ynez, California," 16 x 20 in., wc, c. 1915, auctioned Swann Galleries, 6/4/2009, lot 21; "Santa Yenez [sic] Mts., Santa Barbara, Cal," 16 x 20 in., o/c, auctioned John Moran, 2/19/08, lot 149; "Landscape, Santa Susanna Park [sic. Peak?]," 9 x 12 in., o/board, auctioned B&B, SF, 1/28/2007, lot 7053.
Borg, C. O. (exhibited works depicting Santa Ynez)
"Mission Garden (Santa Inez)'" wc, in 1931 (*PSCA* #1, p. A-10); "Santa Ynez Mountains," 1924, (coll. John D. Relfe Family) repro. in William H. Gerdts and Will South, *California Impressionism*, NY: Abbeville, 1998, p. 130.
Borg, C. O. (books and articles)
Many references to Borg appear in *Publications in California Art* vols 1-13.

Borg, Olive Jane
See: McClure (Borg), Olive Jane (Mrs. Sven Hugo Borg)

Bork, Enid Marie "Bobbi" Shrader (Mrs. Rudolph John Bork) (Lompoc)
Painter. Exh. three oil paintings at Open-Air Art Exhibit, 1960.
See: "Open-Air Art Exhibit," 1960

Borland, Charles Wesley, Dr. (1875-1952) (Santa Ynez Valley)
Art student under Leo Ziegler at adult school, 1949.

■ "Dr. Borland Rites Held... a retired dentist, had been a resident of Solvang the past eight years.... In 1920 Dr. and Mrs. Borland moved to California where he practiced dentistry in Los Angeles and Long Beach...," *SYVN*, June 20, 1952, p. 3.
See: "Santa Ynez Valley, Ca., Adult/Night School," 1949

Boroff, Melba Arlene (1941-?) (Orcutt / Santa Maria)
Art student at Santa Maria High School who submitted art to Scholastic Art Exhibit, 1959. Art student at Hancock College, 1959, 1960. Employee at Consultant Designers, 1960s.
Boroff, Melba (notices in Northern Santa Barbara County newspapers on microfilm and on newspapers.com)
1956 – "Sunday School Dedication... First Baptist church... Assisting as teachers... Myrtle and Melba Boroff," *SMT*, Aug. 17, 1956, p. 7.
1959 – "Honor Students Feted at Meet... Allan Hancock College... Minerva Club ... Seniors: Melba Boroff...," *SMT*, March 19, 1959, p. 2.
And a few notices in the *SMT* 1955-1970 not itemized here.
Boroff, Melba (misc. bibliography)
Melba Arlene Boroff, mother's maiden name Pollard, was b. April 2, 1941 in Kern County per Calif. Birth Index; Melba Boroff port. appears in Santa Maria High School yearbook, 1957, 1959; Melba A. Boroff, student, is listed in the *Santa Maria, Ca., CD*, 1961 at 350 E. Clark Ave., the same address as Mildred I. and Paul R. Boroff, oil worker; Melba Boroff, blue line operator, Consultant Designers, is listed at 350 E. Clark Ave., Orcutt, the same address as Paul R. and Mildred I. Boroff, *Santa Maria, Ca., CD*, 1962, 1963, 1970; Melba A. Boroff, b. April 2, 1941 was residing in Clovis, Ca., in 1980 per *U. S. Public Records Index, 1950-1993*, vol. 1 and in Yuba City, Ca., per *U. S. Public Records Index, 1950-1993*, vol. 2 (refs. ancestry.com).
See: "Allan Hancock College," 1959, 1960, "Elk's Club – Rodeo and Race Meet," 1959, "Santa Barbara County Fair," 1960, "Santa Maria, Ca., Union High School," 1959

Borquist, Elizabeth C. (1915-1996) (Mrs. John W. Borquist) (Santa Maria)
Teacher of china painting at Edwina's Ceramic Studio, 1953. Prop. Arrow Blueprinting.
Borquist, Elizabeth (misc. bibliography)
Elizabeth C. Borquist b. Sept. 4, 1915, d. Feb. 1996 per Social Security Death Index (refs. ancestry.com).
See: "Arrow Blueprinting," "Edwina's Ceramic Studio," 1953

Borst, George Albert (1869-1939) (Santa Maria)
Photographer of Louise Studio, c. 1912-23.

■ "War Veteran, Photographer, dies, Aged 70. ... George Albert Borst, 70, resident of Santa Maria for the past 29 years, died last night... Borst, who was born in Detroit, Feb. 11, 1869, came to California in 1879. ... Coming to Santa Maria in 1910, Borst opened a photograph gallery

[Louise Studio], which he continued until 1923. After ... he worked for several years as a painter. ...," *SMT*, Jan. 12, 1939, p. 1.
Borst, Mr. (notices in Northern Santa Barbara County newspapers on microfilm and on newspapers.com)
1913 – "Mesquit-Borst. Mr. George A. Borst and Miss Bessie Mesquite, both of this city, were married in San Luis Obispo Monday morning by Judge Mallagh... Mr. Borst is the well-known proprietor of the Louise photo studio," *SMT*, Aug. 2, 1913, p. 1.
More than 50 hits (mostly social) for "George Borst" in *SMT* between 1908 and 1939 were not itemized here.
Borst, Mr. (misc. bibliography)
George A. Borst was listed in the 1920 U. S. Census as age 46, b. c. 1874 in New York, working as a photographer, residing in Santa Maria with wife Bessie (age 36) and son George (age 5); George Albert Borst was b. 1869 and d. 1939 and is buried in Santa Maria Cemetery per findagrave.com (refs. ancestry.com).

Bostwick, Phil / Phillip (b. c. 1932-?) (Santa Maria)
Santa Maria High School student who progressed on to study art at University of California, Santa Barbara, 1949.

■ "... Smith Essay Contest... Second place winner was Phil Bostwick, 16, 412 West Tunnell... Bostwick ... is destined to 'go places in commercial art,' according to his instructors and family. He displays remarkable talent in drawing and illustrating posters, remembrance cards and nature subjects. He came to Santa Maria four years ago and has been an outstanding student in the public schools," *SMT*, June 3, 1949, p. 5.
Bostwick, Phil (notices in Northern Santa Barbara County newspapers on microfilm and on newspapers.com)
1950 – "'round the town. Phil Bostwick will leave early in September to enroll as a freshman at University of California, Santa Barbara college... He will major in art and will attend with the help of UC Alumni Assn. scholarship awarded to him as a graduating senior of SM high school. He is the son of Mr. and Mrs. L. C. Dailey of Santa Maria," *SMT*, Sept. 1, 1950, p. 4.
1951 – "Triple Honors. Phillip Bostwick ... received triple honors in an ROTC ceremony held last week at the Santa Barbara College of the University of California. Bostwick, a freshman art major...," *SMT*, June 11, 1951, p. 6.
Many non-art notices on "Phil Bostwick" appeared in the *SMT* but were not itemized here.
Bostwick, Phil (misc. bibliography)
Is he Phil Bostwick whose port. appears with "Village 214" in the Stanford University yearbook, 1953 (refs. ancestry.com).
See: "Santa Maria, Ca., Elementary School," 1948, "Santa Maria, Ca., Union High School," 1948

Botke, Cornelis and Jessie Arms (Santa Paula)
Exh. Santa Maria Art Festival, 1953.
See: "Richmond, Evelyn," 1941, "Santa Maria Valley Art Festival," 1953, and *Morro Bay Art and Photography before 1960*

Bowen, Gertrude Neelands (1880-1950) (Lompoc)
Member of Art Section of Alpha Club, 1928-29, 1933-41. Teacher of English at Lompoc High School, c. 1921-1941. Directed many of the school plays and oversaw stage design and costumes.

■ "Leaves – Miss Gertrude Bowen left Tuesday night to make her home in Berkeley. Miss Bowen, who has taught at the high school for the past 22 years is retiring from the teaching profession," *LR*, June 12, 1942, p. 2.
And hundreds of additional notices on "Gertrude Bowen" in the *LR* between 1920 and 1945 were not itemized here.
Bowen, Gertrude (misc. bibliography)
Gertrude Bowen port. appears in the Lompoc High School yearbook, 1924, 1926, 1939; Gertrude Neelands Bowen was b. Aug. 30, 1880 in Buffalo Creek, Colo., to Ezra Bowen and Maria Cecilia Neelands, was residing in Berkeley in 1910 and d. Jan.19, 1950 in Berkeley per Young Family Tree (refs. ancestry.com).
See: "Alpha Club," 1921, 1925, 1928-29, 1933-41, "Flower Festival/ Show," 1932, 1934

Bowen, William (1913-1966) (Santa Barbara)
Painted landscapes of Santa Ynez, 1935/36. Taught lettering at Lompoc Adult School, 1939.

■ "William Bowen… 53, who apparently took his own life Sunday at his Santa Rosa home. Mr. Bowen had lived in California all his life, and in Sonoma County five years. He was a veteran of World War II. He was employed in San Francisco as a sign painter and commercial artist. He lived at 317 Bucks road. …," *Press Democrat* (Santa Rosa, Ca.) June 30, 1966, p. 10.
Bowen, William (notices in California newspapers on microfilm and on newspapers.com)
1935 – "**Atterdag College** Notes… An artist, Mr. R. [sic. W?] Bowen of Santa Barbara, who has become very enthusiastic over the beautiful scenery around the valley, expects to be here about the first of the year and will conduct a class in drawing and painting. Mr. Bowen will live at the college and will do considerable drawing while here," *SYVN*, Dec. 6, 1935, p. 4.
1936 – "Wm. Bowen of Santa Barbara, artist of renown, is to spend a month in the Santa Ynez valley painting," *SYVN*, Jan. 3, 1936, p. 8; "William Bowen, Santa Barbara artist, is staying at the school [**Atterdag College**] and is painting various scenes of the Santa Ynez Valley," *SYVN*, Jan. 10, 1936, p. 5; "Atterdag College Notes… the group from the school were out in the Ballard hills Wednesday afternoon sketching under the able guidance of artist William Bowen," *SYVN*, Jan. 24, 1936, p. 5.
1941 – "Santa Barbara and SF Artists in Exhibit… City of Paris galleries, San Francisco. Watercolors by **Douglass Parshall**, William Bowen, **Standish Backus, Joseph Knowles, Charlotte Berend**…," *Oakland Tribune*, may 4, 1941, p. 23 (i.e., B-7).
1952 – Verdugo Hills Art Assn… Board members this year are … William Bowen, treasurer…," *Valley Times* (North Hollywood), Sept. 23, 1952, p. 11.
Bowen, William (misc. bibliography)
William Bowen was listed in the 1930 U. S. Census as b. c. 1913, a sign painter, residing in Santa Barbara with his

parents Charles and Theresa Bowan [Sic.], and siblings; William Bowen, artist, residing at 1123 Walnut, the same address as Martha, waiter, was listed in the *Santa Barbara, Ca., CD*, 1937; William Bowen is listed in the 1940 U. S. Census as age 27 b. c. 1913, in Calif., finished high school 2nd year, show card writer for a retail store, lodging in Lompoc; William Bowen, painter, residing at 1113 Walnut, the same address as Teresa (wid. C), per *Santa Barbara, Ca., CD*, 1946 (and listed without occupation, 1941, 1943); William Bowen gave the following information on his WWII Draft Card dated Oct. 16, 1940 = b. Feb. 4, 1913 in Santa Barbara, residing in Santa Barbara, unemployed, next of kin = Charles Bowen; William Bowen gave the following information on his WWII Army Enlistment Record dated April 15, 1943 = b. 1913, residing in Santa Barbara, finished college 2nd year, enlisted in Fresno, skilled painters, construction… single… no branch assignment; William Bowen b. Calif. on Feb. 6, 1913, mother's maiden name Gueavarr, d. June 26, 1966 in Sonoma county per Calif. Death Index; William Bowen is buried in Golden Gate National Cemetery per findagrave.com (refs. ancestry.com).
See: "Lompoc, Ca., Adult/Night School," 1939

Bowersox, (Alvin) Lee, Sgt. (1930-1988) (Solvang)
Photographer. Exh. photos of Japan at first annual Santa Ynez Valley Art Exhibit, 1953.

■ "Lee Bowersox… Alvin Lee Bowersox, 57, of Buellton, a longtime resident of the Santa Ynez Valley… He was born April 20, 1930 in Los Angeles and moved to the Santa Ynez Valley from Lockport. Ill., in 1968 [Sic.?]. Mr. Bowersox leaves his wife, Carolyn E. Bowersox of Buellton…," *SYVN*, Feb. 4, 1988, p. 7.
1954 – "Lee Bowersox Home on Leave… after 28 months service in Japan… He will be stationed at Williams Air Force Base until December, when his tour of duty will be completed," *SYVN*, March 26, 1954, p. 8; port. with new wife and "Carolyn Mackey, Lee Bowersox, Married in Doublering Ceremony… the newlyweds left on a wedding trip to Santa Barbara and Los Angeles. After July 10 they will be at home in Phoenix, Ariz., where the bridegroom will be stationed at Williams Air Force Base," *SYVN*, July 2, 1954, p. 3.
And more than 30 additional family notices for "Lee Bowersox" in the *SYVN* before 1960 not itemized here.
Bowersox, Lee (misc. bibliography)
Alvin Lee Bowersox was b. April 20, 1930 in Los Angeles to Joseph Wallace Bowersox and Charlotte Leona Hardwick, married Carolyn Edith Mackey and d. Jan. 31, 1988 in Santa Barbara County per Donie's Family Tree (ref. ancestry.com).
See: "Santa Ynez Valley Art Exhibit," 1953

Boy Scouts (including Cub Scouts) (Northern Santa Barbara County)
Handicrafts were taught at the organization's various dens and at its summer camp, Camp Drake. Crafts included wood carving, leather, etc. Products were publicly displayed during Boy Scout Week.

Boy Scouts (notices in Northern Santa Barbara County newspapers on microfilm and on newspapers.com)
1926 – "Boy Scouts of 3 Counties Gather at Camp Drake… two weeks… This year more time will be devoted to hand work, which includes leather work and making of totem poles. The boys in patrols will make plaques to leave as trade marks in the camp…," SYVN, June 25, 1926, p. 3.
1931 – "Scoutcraft Displayed at … four downtown store windows… in observance of 21st anniversary of scouting in the United States. Camp scenes, knot boards … flags, posters, totem poles…," SMT, Feb. 12, 1931, p. 1.
1933 – "Examiners in Subjects for Scouts Named … merit badge… examiners… Art – S. R. [Sic. G.] Breneiser, Dorothy Green; architecture – L. N. Crawford; … basketry – H. M. Snell, Ruth Blanchard, Mrs. McClure; … handicraft – Jesse Chambers, Euland Payne; … leathercraft – J. W. Morehouse, Mrs. S. G. Breneiser, Marian Svensrud; … metal work – W. D. Harkness, Euland Payne; … painting – Euland Payne; pottery – Mrs. S. G. Breneiser; photography – L. J. Stonehart; … sculpture – S. G. Breneiser; … textiles – Ruth Blanchard, Miss Feeley; woodcarving – Mrs. Sidney Peck, Euland Payne, Alvin Rhodes; …," SMT, Dec. 5, 1933, p. 6.
1934 – "Activities of Boy Scouts in Window Display… a vacant store building at 217 South Broadway. In celebration of annual Boy Scout week… interesting array of craft work, photographs and items indicating what boys learn … One of the features of the exhibit is a collection of photographs taken by local Scouts together with a camera exhibit and the equipment used in developing and printing photographs," SMT, Feb. 14, 1934, p. 4.
1939 – "Boy Scouts… Basil Hanson… who is assistant Scoutmaster of troop 1, showed color films he made of last year's camporee in Santa Barbara, of the summer camp in Camp Drake and of shots taken on the recent trip of Scouts to San Francisco and Treasure Island," SMT, Feb. 24, 1939, p. 3.
1941 – "Examiners for Scouts Named. Local Men who Will Give Tests… Merit Badge examiners… Non-required Badges for Life and Eagle… basketry, Mrs. S. Breneiser… bookbinding, Miss Kriegel or Ernest Hamlin [a Boy Scout]… handicraft, John Amaral [carpenter?] or Ernest Hamlin… leathercraft, Harold Takken, leather work, Harold Takken, mechanical drawing, John Stout, metal work, Dale Harkness, painting, Gaylord Jones, photography, B. Karlskint…woodcarving, woodturning or woodwork, Gaylord Jones or Ernest Hamlin," SMT, Aug. 14, 1941, p. 7.
1943 – "Air Scouts to Organize Here… a branch of the Boy Scouts specializing in aeronautics … the work will cover all of the ground school phases of flying… will include studies and projects in airplane structure, aerodynamics, airplane design … mechanical drawing… photography…," SMT, July 6, 1943, p. 2.
1946 – Photo of Cub Scout Pack 99 displaying their individual handicraft exhibits and "Pets and Handicraft on Display at Cub Scout Show Last Friday" at the Lompoc Scout house, LR, Aug. 1, 1946, p. 1.
1947 – "Many Cub Scouts Receive Their Badges and Pins… Handicraft was on display… including a miniature battleship, knot board, a freak zoo made of vegetables and pine cones, a shell exhibit, scrap books and stamp albums.

The next handicraft theme… will be on kites," SMT, Feb. 3, 1947, p. 3; "Pack Two Cubs Win Awards, Show Handicraft," SMT, Feb. 15, 1947, p. 5; "Cub Scouts Work on Handcraft," i.e., copper pictures at Orcutt Community Church Hall, SMT, Sept. 25, 1947, p. 3; [activity tied in to pastorship of Ross Linsenmayer and wife?]
1948 – "Orcutt Cubs Adopt Varied Study Projects… handicraft… Qimbly [Sic. Joseph Quimby] Hoback gave a demonstration of leather work which was attended by all three dens… Cubs of den Two, under the leadership of Mrs. Margaret Cole, divided into two groups – one to work with copper and one with woodburning…," SMT, Jan. 19, 1948, p. 3.
1949 – "Cub Scouts Enter Window Displays… Pack Five… handicraft and hobby collections on exhibit at the Prindle store thru courtesy of Kenneth Prindle. Work in metal, wood, paper and leather makes up the … display," SMT, Feb. 11, 1949, p. 5; "Cub Scouts Work on Crafts," SMT, Nov. 5, 1949, p. 5.
1950 – "Kiwanis Club to Host Cub Scout Pack… A display of handcraft prepared by the Cubs was the center of interest for the evening," LR, Feb. 2, 1950, p. 10; "Photo Exhibit Highlights Cub Pack Meeting… Pack 99… at the Veterans Memorial building… The theme for the month being photography, a display of pictures of various activities was exhibited. Cubs of Den 2 displayed pin-point cameras constructed as a den project…," LR, March 30 1950, p. 2.
1951 – "Good Camper … at Camp Drake… Santa Maria leaders at the camp were Leander Gatewood, handicraft director, Terry Hayes, assistant handicraft director …," SMT, July 5, 1951, p. 4; "Awards Presented at Cub Meeting… Dens 1, 2, and 3 participating in the presentation of puppet shows. The puppets had been made previously by the boys in their weekly den meetings," LR, Nov. 22, 1951, p. 2.
1952 – "Camp Drake… Other leaders from Santa Maria area were: Leander Gatewood, handcraft instructor…," SMT, July 1, 1952, p. 6.
1953 – "Carnival Tomorrow… Santa Ynez Valley Cub Scouts will stage their parade and carnival in Solvang… there will also be an exhibition in the smaller Memorial building room of various handcraft work accomplished by the Cubs. The exhibit is being arranged by Arthur McArthur," SYVN, April 24, 1953, p. 1.
1954 – "Valley Scouts to Attend Camp Drake … The program will include swimming in the camp pool, boating on Lake Cachuma, nature study, handicraft on an implemented basis, Scoutcraft skills, rifle shooting, campfires and dozens of other attractions," SYVN, June 18, 1954, p. 5.
1955 – "Cub Scouts Have Exhibit… in the Times window on West Main… such items as scrap books with hand carved decorated wood covers, small ceramics pieces, model trains, a puppet doll, a hand-woven basket and holder for canapé snacks," SMT, Feb. 11, 1955, p. 3.
1956 – "The Scouting Trail… Scouting News. In an effort to get more publicity for the individual troops and packs, a Scouting Press Club is being formed in the Santa Maria area. This club is especially for scouts who are interested in obtaining their journalism and photography merit badges. Scoutmasters should select at least one scout from each troop to belong to this club in order that their unit may

receive publicity and recognition…," *SMT*, April 19, 1956, p. 8; "Scouting Trail… Camp Drake… A new handicraft and nature lodge…," and other buildings completed, *SMT*, June 7, 1956, p. 8.

1958 – "Cub Scout Pack 63 Entertains Parents… with a puppet show called, 'A Thanksgiving Nightmare,' by Jannette Woolsey given by the older boys of Den 3…," *LR*, Nov. 20, 1958, p. 3.

1960 – "Solvang Scouts Exhibit Crafts. Members of Solvang Boy Scout Troop No. 40 joined for a demonstration night Monday at Atterdag College and gave exhibitions of various crafts for their parents and friends. …," *SYVN*, May 13, 1960, p. 1; photo of boys and caption reads, "Handicraft Lodge – Among the more popular spots at Camp Drake is the handicraft lodge where Boy Scouts learn art, basketry, leatherwork and woodcarving…" and photo includes Roger Boggs, blind handicraft instructor, and there is an accompanying article on the Boy Scout Camp, *SYVN*, July 1, 1960, pp. 1, 8; feature with several photos showing boys at Camp Drake, *SMT*, July 2, 1960, p. 4.

And, additional notices, some regarding displays of handcraft in the windows of local business establishments, were not itemized here.

Boyd, Gardner (1916-2002) (Santa Maria)
Photographer with Santa Maria Times, Dec. 1954+.

■ "Gardner Boyd came to work last week [at *The Times*] and some Santa Marians and many Guadalupeans will remember him as the former editor of the *Guadalupe Chronicle* before it folded. Gardner has been down in Oxnard, has worked on the paper there and at Ventura and has safely tucked under his belt a two-year graduate course from the **Brooks School** of Photography in Santa Barbara. Perhaps you have noted some improvement here and there in the pictorial coverage of *The Times*. That's Boyd's work…," *SMT*, Dec. 17, 1954, p. 10.

Boyd, Gardner (notices in Northern Santa Barbara County newspapers on microfilm and on newspapers.com)
1955 – "Hunter, Boyd, Join Times…," *SMT*, Jan. 4, 1955, p. 1; "Heart O' the Times… 'news room' … Gardner Boyd ranks all others in the news room in-so-far as photography is concerned. Although every news room staffer regularly uses a camera in their work, Boyd uses the photographic equipment more than any one. He also is the chief of the darkroom and does the greater part of developing negatives, printing them to correct size and putting them on the Scan-A-Graver. In addition, as a working reporter, Boyd 'covers' Guadalupe and other outlying districts, as well as the City Board of Education…," *SMT*, Oct. 4, 1955, p. 9.
1957 – Santa Maria "Times Photographer Wins Third in Region Contest" for photography and repro. of "Opening of Lenten Season" against regional National Press Photographers Association, *SMT*, March 29, 1956, p. 1; repro. of photo, *SMT*, Dec. 29, 1956, p. 7; repro: "Sign of the Cross" that won third place in Episcopal Church photo contest, *SMT*, Dec. 18, 1957, p. 7.

And more than 300 additional notices for "Gardner Boyd" in the *SMT* between 1940 and 1960 were not itemized here.

Boyd, Gardner (misc. bibliography)
Gardner Boyd is listed in the *Oxnard, Ca., CD* 1952 as a "student" with wife Suzanne S, and in 1953 as asst. mgr. Standard Station, with wife Suzanne; listed in the *Santa Maria, Ca., CD* 1958 and 1959 as clerk, Santa Maria Valley RR, with wife Suzanne, and listed as employee of P. O. in 1970; Gardner Boyd was b. Sept. 25, 1916 in Greenfield, Mass., to Gardner Boyd and Lucile Murray Blanchard, married Suzanne Seymour, was residing in Santa Maria, Ca., in 1970, and d. Nov. 1, 2002 in Boise, Id., per Boyds of Dedham and related families Family Tree (refs. ancestry.com).
See: "Hutchinson, Barbara," "Santa Maria Camera Club," 1957, 1958

Boyer, Mary Ann (1875-1953) (Santa Ynez Valley)
Sloyd instructor, Edna Rich Sloyd School, Santa Barbara.

■ "Boyer Rites… Miss Mary Ann Boyer, 78, long-time resident of the Santa Ynez Valley… Miss Boyer, who had lived in the Valley since 1883, died last Friday morning in a Santa Barbara Hospital… Miss Boyer was a retiree school teacher and lived alone in her Refugio road home. Born in Alleghany County, Pa., she came to California and the Valley with her parents in 1883. The family lived for a number of years on a ranch near the Alamo Pintado. She taught at one time at the old Gaviota School on the coast and for a number of years was a home economics instructor at the Edna Rich Sloyd School, a private institution in Santa Barbara," *SYVN*, July 10, 1953, p. 8.
Boyer, Mary Ann (misc. bibliography)
Mary Ann Boyer was b. Oct. 14, 1875 in Pennsylvania to George W. Boyer and Rhoda Jane Wicks, was residing in Jefferson Hills, Pa., in 1880, and d. July 3, 1953 in Santa Barbara, per FLWW DNA Master Family Tree; Mary Ann Boyer was buried in Oak Hill Cemetery, Ballard, Ca., per findagrave.com (refs. ancestry.com).

Brackenridge, Marian (1903-1999) (Santa Barbara)
Sculptor / painter. Pupil and associate in Ettore Cadorin's Santa Barbara studio, 1925/26+, who came to Santa Maria with him to help install artwork for the Veterans Memorial Building, 1935. She later worked in San Francisco and in Santa Rosa, Ca., where she died.

■ "Marian Brackenridge (16 April 1903, Buffalo, New York – 17 March 1999, Sonoma, California) was an American sculptor known for her portrait busts, bas-reliefs, and religious works," per Wikipedia.
Brackenridge, Marian (notices in California newspapers on newspapers.com).
1929 – "Well-known Family … Summer Months to be Spent Near Miramar… Their daughter, Miss Marian Brackenridge, who prefers art in place of a round of social pleasures … has had one of her recent sculptures accepted for exhibition, now being held in the California Palace of Legion of Honor at San Francisco. Miss Brackenridge is now visiting in the northern city with Mr. and Mrs. Cadorin…," *Pasadena Post*, May 13, 1929, p. 6.
1943 – "Brackenridge Will Filed… Mrs. Margaret Brackenridge… South Pasadena… The children include

Marian Brackenridge of Sonoma...," *Pasadena Post*, June 24, 1943, p. 7.

1951 – "Successful Exhibit... Petaluma Woman's Club... Arts and Crafts Show... Exhibitors of paintings... Marian Brackenridge...," *Petaluma Argus-Courier*, Feb. 22, 1951, p. 10.

1956 – Port. in her studio in Santa Rosa which is part of a "home tour," *Press Democrat* (Santa Rosa, Ca.), May 20, 1956, p. 13.

1957 – "Washington Cathedral to Display New Joan of Arc Statue ... by sculptor Marian Brackenridge of Sonoma, Calif... 30 inch statue will be placed in a niche on the south outer aisle of the nave. It is one of the first works of art obtained for the huge Gothic cathedral through a $500,000 endowment provided by the late Mr. and Mrs. John Ewell of Washington for embellishment of the cathedral... Miss Brackenridge depicted St. Joan at the age of 17, dressed in the leather jacket of a peasant girl. Joan's right hand is raised and her head turned slightly to the right in the attitude of one listening intently. ... the cathedral already has a stained-glass window of Joan in the traditional suit of armor... The plaster model, executed by Miss Brackenridge at her La Brenta studio at Sonoma arrived here by train late in April... Roger Morigi, a master stone carver on the cathedral's permanent staff, was assigned to the month-long job of reproducing the design in Indiana limestone... Two figures by Miss Brackenridge already are in the cathedral... carvings of St. Andrew and of John Calvin in the Woodrow Wilson memorial chapel. She also carved the corbel, or base, on which the St. Joan statue will rest. The design of the corbel depicts the facade of the Cathedral of Rheims...," *Eureka Humboldt Standard* (Eureka, Ca.), June 11, 1957, p. 23 (i.e., B5).

1959 – Port. working on annunciation panel for Maryland church and "Sonoma Sculptress... A pupil of Ettore Cadorin ... in 1925, she worked with him first as an apprentice and later shared in his commissions. In 1931 she assisted him in work done in the Washington Cathedral... Miss Brackenridge's first contract on her own, was let by the Washington Cathedral for the head of Dr. Albert Schweitzer, as a part of the architectural decoration of the vault of the ceiling. Other statues include those of St. Andrew and St. Calvin, which she did for the beautiful sarcophagus – tomb of Woodrow Wilson – in the cathedral's Memorial Bay... Miss Brackenridge's latest and perhaps most beautiful work, is the memorial in form of a reredos … installed in the Cathedral Church of the Incarnation of Baltimore, just before Christmas, 1958. Consisting of three panels eight feet high, it is surrounded by gothic tracery and carving, all of lindenwood. The subjects of the three panels are the Annunciation, the Nativity and the Visitation. Six weeks were spent in Washington and Boston last fall by the sculptress while the carving of the reredos was being done... Coloring was applied in an unusual manner – almost transparent, so the technique of wood carving was visible. The polychrome effect... with pure gold leaf was very striking... A final feature was the new stained-glass window over the entrance, casting a beautiful light over the statue. Miss Brackenridge lives at La Brenta, a beautiful old home surrounded by trees, shrubbery and spacious lawns, located on East Napa St. Her studio is only a short distance from

the main house," *Press Democrat*, Feb. 8, 1959, p. 42 (i.e., 4E); port. planning the 13th annual Valley of the Moon Vintage Festival, *Press Democrat*, Sept. 20, 1959, p. 25.

1960 – "Art Lecture... An added feature at the art work shop [by **Dr. Reitzel**] during the month of April, will be the Saturday afternoon classes in elementary pastel painting taught by Marian Brackenridge. ... Webster 8-3308," *Press Democrat*, March 25, 1960, p. 8; "Art Works on Display at Library... Outstanding examples of sculpturing, pastel portrait work and oil paintings by Sonoma artist, Marian Brackenridge are on display... Busts and portraits of local residents as well as models, intricate in detail and design and done to perfect scale, which served as models for carvings in the Washington Cathedral, Washington, D. C. Miss Brackenridge, who studied under the late Ettore Cadorin, ... is also proficient in other art media, including oils and pastels. She is an active member of the Sonoma Valley Art Center and at present is instructing classes in pastels on Saturday afternoons at the Sonoma Community Center. Also on display... is a statue of the Madonna and Child done in plaster which Miss Brackenridge is doing in wood at her studio...," *Press Democrat*, April 5, 1960, p. 5; port. arranging her exhibit at the Sonoma library, *Press Democrat*, April 10, 1960, p. 46 (i.e., 7E).

1992 – Port. and caption reads "Entering the home of Marian Brackenridge... it is a shrine to the life and work of **Ettore Cadorin**, a Venetian sculptor who created 'Evening Star,' probably the most popular sculpture at the GGIE. Marian became his apprentice in the 1920s... then traveled north with him to find work at the fair, aiding with 'Evening Star.' Brackenridge... is still active at 89 ...," *SF Examiner*, April 19, 1992, p. 240 (i.e., Magazine, p. ?). And, more than 100 additional notices in California newspapers 1961-1999 on newspapers.com not itemized here.

See: "Cadorin, Ettore"

Bradford Studio (Santa Barbara)
Photographer. Visited Solvang weekly from Santa Barbara to take photographs, 1931.
See: "Photography, general (Santa Ynez Valley)," 1931

Bradley, Dora Davenport
See: Bromfield (Bradley), Dora Davenport

Braflaadt, Chester "Chet," and Helen (Santa Maria)
Photographer, amateur. Member Santa Maria Camera Club, 1941, 1942. Employed by the Highway Patrol.
See: "Santa Maria Camera Club," 1941, 1942

Bragg, Joffre Claxton (1917-1940) (Texas / Santa Maria)
Otis Art Institute student who died in a car crash, 1940. Active in Little Theater. His sister LeNora Bragg was also talented in art.

■ "Young Bragg was born in Fort Stockton, Texas, August 10, 1917, and had resided in California for the last nine years...." and article states his parents were Mr. and

Mrs. Dan E. Bragg of Santa Maria and that he and Firfires [who was driving the car when Bragg died] had been roommates at art school in LA, that Bragg was currently working with his father in the Broadway café on North Broadway, that the walls of the restaurant were filled with Bragg's oils and watercolors, and that he spent his vacations at the Firfires ranch near Santa Margarita making sketches, driving home from Arroyo Grande when their car plunged off the highway … into Los Berros creek, about two miles north of Nipomo. Young Firfires, driver of the family Studebaker sedan, was thrown clear of the car… Bragg, who was killed instantly by the impact…," per "Joffre Bragg Dies in Car Crash. Pal, Nicholas Firfires, Hurt but Will Live, Local Art Students Hurtle Off Road in Foggy Night," *SMT*, March 23, 1940, pp. 1, 4.

Bragg, Joffre (notices in Northern Santa Barbara County newspapers on microfilm and on newspapers.com)
1935 – "Bragg Does Painting for Exhibit. Joffre Bragg, high school art student … is painting a thumbnail sketch in oils which he will enter in the traveling exhibit sponsored by the Los Angeles Art association. **Mr. and Mrs. Breneiser** and **John Day Breneiser**… have also sent in small canvases for the exhibit," *SMT*, Oct. 28, 1935, p. 2.
1936 – "Santa Maria Boy Wins Art Honor" when his block print is given third place in *Western Artist* contest, *SMT*, Feb. 29, 1936, p. 2; "Picture of Local Boy" with his Otis Art Institute fellow students in LA Herald, *SMT*, April 24, 1939, p. 3.
1938 – "Back to Art Work – **Nicholas Firfires**… and Joffre Bragg… returned last night to the Los Angeles art school they are attending after spending the Easter vacation with their parents. Mr. Bragg drove them down. The two lads spent a part of their vacation sketching on the **Firfires** ranch near Santa Margarita," *SMT*, April 18, 1938, p. 3.
1940 – "LeNora and Joffre Bragg at Home… Joffre, who has been taking a course in Chouinard Art School in Los Angeles, completed his work with the close of the mid-winter semester and is at home awhile before going East to continue his studies. He will do some sketching in this vicinity in the next few months and may stage a one-man show of his work," *SMT*, Jan. 23, 1940, p. 3.
And approx. 60 additional notices in *SMT* between 1930 and 1942 including his activities with little theater and his high school scholarship not itemized here.
His sister, LeNora Bragg, won several poster design contests.

Bragg, Joffre (misc. bibliography)
Joffre Claxton Bragg was b. Aug. 10, 1917 in Texas to Daniel Elmo Bragg and Edith Leona Best, was residing in Lockney, Tx., in 1920, and d. March 22, 1940 in SLO, Ca., per SRBragg Tree (refs. ancestry.com).
See: "Christmas Decorations (Santa Maria)," 1935, "Firfires, Nicholas," 1938, 1940, "Minerva Club, Flower Show," 1933, "National Art Week," 1940, "Posters, Latham Foundation (Santa Maria)," 1934, 1935, 1937, "Santa Maria, Ca., Union High School," 1934, 1935, 1937, "Splash," 1934, 1935

Brandt, Rex (Rexford Elson) (1914-2000) (Corona del Mar, Ca. / Cambria)
Watercolor painter. Artwork shown at first Santa Maria Valley Art Festival, 1952, courtesy Cowie or Dalzell Hatfield Gallery in LA. Exh. at Hancock College, 1955.
Brandt, Rex (notices in Northern Santa Barbara County newspapers on microfilm and on newspapers.com)
1957 – "Artist is Subject of Film" titled Water Colors showing him painting in area of Morro Bay, etc. shown at Hancock College, *SMT*, Nov. 14, 1957, p. 2.
See: "Allan Hancock [College] Art Gallery," 1955, 1957, "Santa Maria [Valley] Art Festival," 1952, 1953, and *Cambria Art and Photography before 1960* and *San Luis Obispo Art and Photography before 1960*

Brandt-Erichsen, Martha Mott ("Patt") (aka Martha Mott) (Mrs. Viggo Brandt-Erichsen) (1905-1983) (Solvang)
Painter. Art teacher to children and, later, adults. Exhibited under the name Martha Mott. Exh. Santa Ynez Valley Art Exhibit, 1953, 1954, 1955, 1956, 1957. Wife of artist Viggo Brandt-Erichsen, below.

■ Port, with a painting of her son David. "… an accomplished painter and art teacher shown here doing a portrait of her son David, donated Elverhoj to be used as a museum to promote the arts and the Danish heritage of Solvang," per www.elverhoj.org. Website also contains her biography and reproductions of some artworks.
Brandt-Erichsen, Martha (notices in Northern Santa Barbara County newspapers on microfilm and on newspapers.com)
1951 – "Solvangites Gather to Mark 40th Anniversary of Town… at **Atterdag College**… original skit… was presented… 'En Kaffetaar'… The painting of the scenery used for the tableaux was done by Mrs. Viggo Brandt-Erichsen," *SYVN*, June 22, 1951, p. 1.
1953 – Photo of her **AWVS** holiday display entry with theme of Thanksgiving, *SYVN*, Nov. 13, 1953, p. 3; "The front doors to each apartment are the same. Each are green and each contains eight panels. Each panel contains a hand-painted floral figure, the work of Mrs. Viggo Brandt-Erichsen … The Danish flavor is seen in the living room by the hanging of many beautiful oil paintings depicting various scenes of Denmark…," per "American-Danish Architecture Feature of Andresen Residence," *SYVN*, Dec. 18, 1953, p. 12.
1956 – "Children's Studio Workshop Classes to Start Here. Mrs. Patt Brandt-Erichsen has announced the opening of studio workshop classes for children in painting, drawing, modeling and decorative crafts… her studio at Elverhoy tomorrow from 4 to 6 p.m. The work of her late husband Viggo Brandt-Erichsen will be on display, and information about the class may be obtained," *SYVN*, Feb. 3, 1956, p. 1; ad in the shape of an artist's palette, "Studio Workshop at the Brandt-Erichsen studio. Classes for children. Drawing, Painting, Modeling, Decorative Crafts. For information call Patt Brandt-Erichsen 6831," *SYVN*, Feb. 3, 1956, p. 2; "Art Students Exhibit Set… An exhibition of drawings, paintings, pastels and sculpture by the pupils of Mrs. Viggo Brandt-Erichsen's Studio workshop will be held next Wednesday from 3 to 6 pm at the studio, Elverhoy Way in

Solvang… Everyone is welcome… Registration for summer classes will be taken next Wednesday," *SYVN*, May 11, 1956, p. 4; "Studio Exhibit Due Tomorrow… [exhibit of] the work of her students who took part in summer classes… 3 to 6 p. m.," *SYVN*, Aug. 17, 1956, p. 4; photo of artwork and child and Mrs. Brandt-Erichsen, *SYVN*, Aug. 24, 1956, p. 3; ad "Announcing Schedule of Art Classes—Beginning Monday, September 17th. Studio Workshop. Classes for ages 6-7: Monday & Thursday – 2:30-3:30 p. m., Classes for ages 8-11: Monday & Thursday – 4-5 p. m., Classes for Ages 11-15: Tuesday & Friday – 4-5 p. m., Adult Class from 16 Years Up: Wednesday Evening – 7-9. All classes $10.00 per month (Supplies included, except for adult class.) Telephone Mrs. Viggo Brandt-Erichsen S.Y. 6831," *SYVN*, Sept. 7, 1956, p. 3.

1957 – "Studio Workshop at the Brandt-Erichsen Studio. Drawing, Painting, Modeling, Decorative Crafts, Classes for Children. An exhibition of Student's Work will be held on Saturday, March 2, 4-5 p.m. Studio Workshop Classes to Reopen on March 4. Schedule of Classes (As Before) Monday & Thursday – from 2:30 to 3:30 p.m., Pupils of 1st and 2nd Grades, Monday & Thursday, from 4:00 to 5:00 p.m. Pupils of 3rd, 4th and 5th Grades. Tuesday & Friday – from 4:00 to 5:00 p.m. Pupils of 6th, 7th and 8th Grades. Wednesday Evening – from 7:00 to 9:00 p.m. Adults and High School," *SYVN*, Feb. 22, 1957, p. 2; Ad: "An Invitation to All. An Exhibition of Students' Work will be held at The Studio Workshop, Brandt-Erichsen Studio, Elverhoy Way – Solvang on Monday – June 3, from 4 to 7 p.m. There will be no Summer Session this year. Classes will be resumed in the fall," *SYVN*, May 31, 1957, p. 2; ad: "Opening Fall Classes Sept. 9… Studio Workshop… Schedule of Classes. Monday & Thursday Grades I, II… 2:30 to 3:30, Grades III, IV, V… 4:00 to 5:00, Tuesday & Friday Grades VI, VII, VIII… 4:00 to 5:00, Wednesday evening High School & Adults… 7:30 to 9:30," *SYVN*, Sept. 6, 1957, p. 4; "Memo Pad… Mrs. Viggo Brandt-Erichsen has extended an invitation to all to attend an exhibition of children's art at her studio, Elverhoy, in Solvang, tomorrow from 4 to 7 p. m… All of the youngsters whose work will be shown are art students of Mrs. Brandt-Erichsen…," *SYVN*, Dec. 20, 1957, p. 2; ad for invitation to view children's art, *SYVN*, Dec. 20, 1957, p. 4.

1958 – "Children's Art Exhibit Tomorrow. A Spring exhibition of children's art will be held tomorrow from 4 to 7 p.m. at the studio workshop of Mrs. Viggo Brandt-Erichsen on Elverhoy Way in Solvang. The public has been invited…," *SYVN*, May 16, 1958, p. 1; "Art Classes Slated Here… start of her Studio workshop classes… The first session will be held Monday afternoon, Sept. 15 from 2:30 to 3:30 for first and second graders. This group will meet each Monday and Thursday afternoon at this time. The remainder of the schedule includes: Grades 3-5, Monday and Thursday, 3:30 to 4:30, and grades 6-8, Tuesday and Friday 3:30 to 4:30. There will also be a class for adults and high school students in portrait and still life each Wednesday evening from 7:30 to 9:30," *SYVN*, Sept. 5, 1958, p. 5, and ad on p. 6; "Children's Art Exhibit Tomorrow… at the Studio Workshop of Mrs. Viggo Brandt-Erichsen, Elverhoy Way, Solvang, tomorrow from 4 to 7 p.m.," *SYVN*, Dec. 19, 1958, p. 6.

1959 – "Children's Art Exhibit Tomorrow… pupils of Mrs. Viggo Brandt-Erichsen at her Elverhoy Studio… from 4 to 7 p.m. The public is invited…," *SYVN*, May 8, 1959, p. 2; ad: "Studio Workshop Art Classes Opening Monday, Oct. 5. Schedule of classes. First & Second Grades: Mon. & Thurs., from 2 to 3. Third Grade: Tues. & Fri. from 2:30 to 3:30. Fourth & Fifth Grades: Mon. & Thurs. from 3:30 to 4:30. Sixth, Seventh & Eighth Grades: Tues. & Fri. from 3:30 to 4:30. Adult Class in Portrait and Still Life: Wed. evening from 7:30 to 9:30. High School Students: A class will be given on Friday evening or Saturday morning for two hours, if enough students register. Phone: Mrs. Brandt-Erichsen, SY 6831 for registration & information," *SYVN*, Sept. 11, 1959, p. 8.

1960 – Ad: "Exhibition of Children's Art. Pupils of Mrs. Brandt-Erichsen. Saturday, Jan. 9 – 4 to 7 p.m. At the Studio Workshop, Elverhoy Way, Solvang," *SYVN*, Jan. 8, 1960, p. 2; "Mrs. Viggo Brandt-Erichsen has a very colorful exhibition of her paintings on display at the **Solvang Library** in the Veterans Memorial Building," *LR*, May 12, 1960, p. 20; ad: "Art Classes Opening Monday September 12. Studio Workshop… Tentative Schedule… Mon. & Thurs: 2:00-3:00 p.m. 1st & 2nd Grades, 3:45-4:45 p.m. 5th & 6th Grades, Tues. & Fri: 2:30-3:30 p.m. 3rd & 4th Grades, 3:45-4:45 p.m. 7th & 8th Grades. Wed. Eve: 7:30-9:30 p.m. Adults. Saturday: 10 a.m. – Noon High School. Art Exhibition. Adult Student work will be shown Saturday, September 10 from 4 to 7 p.m. at the Studio Workshop," *SYVN*, Aug. 26, 1960, p. 3; "Studio Workshop Art Exhibition Set Tomorrow. Adult art students of Patt Brandt-Erichsen will display their work… tomorrow from 4 to 7 p.m. at the Studio Workshop … The Valley artist will launch a new series of Fall-through-Spring art classes for children … next Monday…," *SYVN*, Sept. 9, 1960, p. 3.

Brandt-Erichsen, Martha (misc. bibliography)
Martha Mott Brandt, mother's maiden name Bigelow and father's Davis, was b. Nov. 28, 1905 in New York and d. Oct. 2, 1983 in Santa Barbara County per Calif. Death Index; Martha Mott Brandt-Erichsen is buried in Oak Hill Cemetery, Ballard, Ca., per findagrave.com (refs. ancestry.com).

See: "Brandt-Erichsen, Viggo," "Danish Days," 1957, 1958, "Elverhoj Museum," "Joughin, Helen," 1986, "Kramer, Monica," "Nelson, Robert," 1950, "Santa Barbara County Library (Solvang)," 1959, 1960, 1962, "Santa Ynez Valley Art Association," 1953, "Santa Ynez Valley Art Exhibit," 1952-58, "Scholastic Art Exhibit," 1954, "Solvang Woman's Club," 1955, "Studio Workshop," "Valley Farm School," 1953, 1954

Brandt-Erichsen, Viggo Axel (1896-1955) (Solvang)
Danish-American artist and sculptor who moved to Solvang fall 1949, and built Elverhoj (now a museum) as his dream home and studio. Head of Danish Days. Husband of artist Martha Mott Brandt-Erichsen. Exh. annual Santa Ynez Valley Art Exhibit, 1953, 1954, 1955.

■ "Danish Born Sculptor, Family, 'Find' Valley, Plan to Work and Live Here. Viggo Brandt-Erichsen … has moved to the Santa Ynez Valley with his wife and three children to make their home. The Brandt-Eriksens [sic.] arrived in the Valley on Monday after a motor trek from the Eastern part

of the United States. They had never been to the Valley before and didn't know Solvang was a Danish-American community until they arrived here. Plan to Build. They first became familiar with the name of the Valley after viewing a friend's motion pictures of one of the recent Rancheros Visitadores treks. They said they knew the Valley was a beautiful place, judging from its film appearance, but said they were positive after spending a day here that 'this is where we want to live.' The Brandt-Erichsens have leased the home of Mrs. Jessie Boyd O'Shea on the Solvang-Los Olivos Road… The Brandt-Erichsens plan to purchase land in Solvang area and start building soon what they described 'a Danish type home.' The new Valley residents formerly lived in Jaffrey, N. H., a town of about 2800 population… Mr. Brandt-Erichsen is the possessor of a wide and interesting background in the field of art. He began to study art at the age of 14 when he was given a scholarship to attend school under the direction of the renowned Danish artist, Gustav Vermheren. … At the age of 14 he was asked by his father to make his choice of future schooling. Brandt-Erichsen, to the dismay of his father, chose art. His father consented but said he would have to 'be on his own.' Brandt-Erichsen got his personal belongings together and made a tent for a home. He said, incidentally, that he lived in this tent for 10 years, traveling through all parts of Denmark, Norway, and Finland. Shortly after leaving his home, he was at work one day sketching two kid goats at play. A man looked over his shoulder and asked where he had received his training. Brandt-Erichsen said he had had no training but wished to attend school in Copenhagen. The on-looker suggested he leave for Copenhagen at once because the Vermheren art school was soon to resume classes. The young man said he was short of funds and therefore could not enroll. The gentleman introduced himself as Vermheren, the artist and head of the school. He said Brandt-Erichsen had better plan on enrolling. Being impressed with his work the great artist was offering him a two year scholarship. A native of Faxe, Denmark, Brandt-Erichsen studied art under Vermheren for some time and later spent the next 10 years traveling and painting through the Scandinavian countries. He later went to Paris and four years studied sculpture under Bourdelle. While in Paris he met many Americans and some from Jaffrey. It was these people who helped influence him to come to America. He arrived in Jaffrey in 1926 and had lived there the past 23 years. 'I was the only Dane there,' he added humorously. Mrs. Brandt-Erichsen is also an artist, but said her talents developed more along the lines of teaching. A native of New York City, she is a member of a family of Cape Codders. Mr. Brandt-Erichsen has done much work in ceramics. He says coming to California will enable him to work along these lines and also to work the year round. While in Jaffrey, he did the work on two war memorials. The memorial for World War I was entitled 'Buddies,' and depicted an American soldier carrying his wounded comrade. This memorial was cut from a 56-ton glacier stone. His World War II memorial is a nine-foot ceramic monument showing a Gold Star mother and sister of a fallen American hero. The ceramic memorial is the only one of its kind in the world and the biggest piece of ceramic work 'fired' or kiln baked since 800 years before Christ. The Brandt-Erichsens have three children, Jean, 14, who

will attend the Santa Ynez Valley High School, Thor, who is 10 and who will attend Ballard School, and David, who is two and a half," *SYVN*, Oct. 7, 1949, p. 5.

■ "Viggo Brandt-Erichsen Paid Final Tribute… Although a resident of the Santa Ynez Valley a comparatively short period of time, Mr. Brandt-Erichsen was one of the community's most colorful residents… Since his arrival in the community in the fall of 1949, Brandt-Erichsen and his family have taken a most active part in civic affairs… A man of vision and imagination, Brandt-Erichsen in the fall of 1953 announced plans for a $200,000 motel and shopping area which was to be of Danish architectural design and which was to be constructed on property he had purchased from Mrs. Henry G. Hanze along Mission Drive… Illness forced him to lay aside plans…," and short bio., *SYVN*, Jan. 14, 1955, pp. 1, 8.

Brandt-Erichsen, Viggo (notices in central California coast newspapers on microfilm and Internet sites)
1949– "Sculptor Buys Madsen Property… six acres of land from Chris Madsen… plans to start construction on a large home and studio… The dwelling will be of Danish type architecture," *SYVN*, Oct. 21, 1949, p. 5.
1950 – "'Elverhoy Way' Suggested as Name for Street Known as '20 Foot Alley.' Viggo Brandt-Erichsen, sculptor and artist, who recently bought a large tract of land on what was known as the '20-foot alley' between Alisal Road and third Street… thought the street should have a 'better name.' Mr. Brandt-Erichsen, who is building a 3,300 square foot home and studio on a portion of his property… The artist donated 40 feet of his land for road purposes and also deeded to the county an 80-foot strip on First and Third Streets for the continuation of these streets. It was his suggestion the street be given the official title of 'Elverhoy Way,' in honor of the famous Danish play 'Elverhoj'…," *SYVN*, Sept. 1, 1951 [Sic. 1950], p. 1; "Be Sure to See Nativity Scene… at the bus shelter on Mission Drive… showing the babe in the manger and the three wise men is a striking work of art… figures and background were designed and painted by Mr. and Mrs. Viggo Brandt-Erichsen…," *SYVN*, Dec. 15, 1950, p. 1; repro: "Valley Nativity Scene" and photo by **Robert C. Nelson**, *SYVN*, Dec. 22, 1950, p. 1.
1951 – "Solvang Gaard, New Apartment Building… The building is constructed along Danish provincial architectural lines with Viggo Brandt-Erichsen … responsible for the architectural planning," *SYVN*, May 11, 1951, p. 1.
1952 – "Tickets… 'Whole Town's Talking'… presented … at the Veterans' Memorial Building under the auspices of the Solvang Woman's Club… and posters made by Mr. and Mrs. Viggo Brandt-Erichsen have made their appearance in various parts of the Valley…," *SYVN*, Feb. 22, 1952, p. 3; designer of house – Carl Hansen "Regains Health, Helps Build Own House," *SYVN*, Sept. 12, 1952, p. 1; repro: of nativity scene "For the third successive year… on display at the bus shelter on Mission Drive in Solvang," *SYVN*, Dec. 26, 1952, p. 9.
1953 – 3 photos of Brandt-Erichson home and "Brandt-Erichsens Move into Unique, Expansive, Old Country Style residence, 'Elverhoj,' in Solvang… hand-made **stained glass** … hand wrought iron hinges the work of **Walter Kristensen**…," *SYVN*, May 8, 1953, pp. 1, 3, 5; "Brandt-

Erichsens Given Housewarming," *SYVN*, June 19, 1953, p. 5.

1954 – "Away from Elverhoy Way and Homesick" – taking cancer treatment in LA, *SYVN*, June 4, 1954, p. 2; repro of Nativity scene in Solvang park bus shelter, *SYVN*, Dec. 24, 1954, p. 1.

1955 – Port. of **Marie Brandt-Erichsen** viewing Los Rancheros Visitadores sculpture made by her husband, Viggo, that will be cast in bronze by Federico Quinterno of Santa Barbara, and "Last Brandt-Erichsen Work Slated for Intended Role… destined to appear in ceramic form as part of a fountain in the garden of Los Adobes, headquarters of the Rancheros in Santa Barbara … Scheduled to be added to the statue, which will be set upon a base of cast stone, will be a bit and rein which will be designed by **Walter Kristensen**, Solvang metalcraft artist…" *SYVN*, Aug. 19, 1955, p. 1.

Brandt-Erichsen, Viggo (misc. bibliography)
Viggo Brandt-Erichsen, 1896-1955, is buried in Oak Hill Cemetery, Ballard, Ca., per findagrave.com (ref. ancestry.com).

See: "Brandt-Erichsen, Martha," "Christmas Decorations (Santa Ynez Valley)," 1950, "Danish Days," 1951, 1952, 1953, "Elverhoj Museum," "Nelson, Robert," 1950, "Santa Barbara County Library (Solvang)," 1967, "Santa Ynez Valley Art Association," 1953, "Santa Ynez Valley Art Exhibit," 1952-55, "Solvang Woman's Club," 1951

Brandt-Erichsen, (Viggo) Thor (1939-2008) (Solvang)
Author of 'From the Danish Quarter of Solvang,' with artistic perspective, 1960. Son of Martha and Viggo Brandt-Erichsen.

■ "A service celebrating the life of Anchorage artist Viggo Thor Brandt-Erichsen (Thor) was held May 31 at Amazing Grace Lutheran Church in Anchorage. Brandt-Erichsen died of a heart attack May 22 in Homer while clearing trees for a new home he planned to build overlooking Kachemak Bay. Brandt-Erichsen was born June 3, 1939, in Peterborough, N.H., to Joan (Crowley) Brandt-Erichsen and Viggo Axel Brandt-Erichsen. His father, a Danish immigrant and sculptor, and stepmother, Patt, an artist, moved the family to Solvang, Calif. ... Active in Boy Scouts, he developed his love for the outdoors camping in the Santa Ynez Valley, where he completed high school and studied geology at the University of California, Santa Barbara. He moved to Alaska in 1962 with his wife, Nancy, and infant son, Svend. Their second son, Scott, was born days after the 1964 earthquake. In the mid-1960s, Brandt-Erichsen homesteaded in Nabesna, located in the Wrangell-St. Elias area, and built cabins and scenic outhouses in Talkeetna and Homer. He also enjoyed prospecting for gold and antimony in several locations around the state. Brandt-Erichsen worked as a journeyman printer for 30 years, starting in California and then at the *Anchorage Daily News*. In 1974, he moved to Color Art Printing where he worked for another 10 years. From 1976 to 1979, he published the *Susitna Sentinel*, a weekly newspaper based in Talkeetna. He continued to do specialty printing out of his home print shop. In 1984, he retired from printing and went to the University of Alaska, Anchorage, completing a

degree in fine arts in 1990. He served a term as president of the Alaska Artists Guild, and as a member of the Alaska Plein Air Painters particularly enjoyed 'extreme plein air painting' in challenging outdoor locations such as the Ruth Glacier on Mt. McKinley. …," on "Public Member Stories" on ancestry.com.

Brandt-Erichsen, Thor (notices in Northern Santa Barbara County newspapers on microfilm and on newspapers.com)
1960 – Thor "Brandt-Erichsen Authors 'Solvang Quarter' Book… [i.e., titled] *From the Danish Quarter of Solvang*. Published by the Santa Ynez Valley News, the 64-page volume, containing more than 40 illustrations… compilation for the most part of columns 'From the Danish Quarter,' written by Brandt-Erichsen for the *Valley News* under pseudonym **Klods-Hans (Clumsy Hans)**. The volume is dedicated to his late father, Viggo Brandt-Erichsen, sculptor and artist," and bio., *SYVN*, Dec. 16, 1960, p. 1; "Solvang Library Corner" and review of Brandt-Erichsen's book on Solvang, and "Outstanding in this book are the photographs. The art-photographer **Boris Dobro** has contributed three outstanding photographs of costumed residents. [Other photos are by] **King Merrill, Karl Jorgensen** and Thor Brandt-Erichsen]… **Martha Mott (Mrs. Viggo Brandt-Erichsen)** has added some of her original pen and ink line drawings…," *SYVN*, Dec. 23, 1960, p. 9 (i.e., p. 5).

Brandt-Erichsen, Thor (misc. bibliography)
Viggo Thor Brandt-Erichsen was b. June 3, 1939 in Jaffrey, N. H., to Viggo Axel Brandt-Erichsen and Joan Miriam Crowley and d. May 21, 2008 in Anchorage, Alaska, per Scott Brandt-Erichsen Family Tree (refs. ancestry.com).

See: "Santa Ynez Valley Union High School," 1953

Breeze
Newspaper of Santa Maria Union High School.

■ *Breeze*, created by the English III class to inform the students, as well as the communities composing the district, of student happenings and to bring our high school before the people, published weekly, on Saturday, in the *Santa Maria Daily Times*, beginning Feb. 12, 1921.

Breneiser, David (Santa Maria)
Son of Stanley Breneiser, who played the cello and was active in little theater.
See: "Breneiser, Stanley," 1934, 1938, 1939, "Splash," 1935

Breneiser, Elizabeth "Babs" C. Day (Mrs. Stanley Breneiser) (1890-1983) (Santa Maria)
Artist / teacher at Santa Maria high school, Spring 1928?-43. Wife of Stanley Breneiser, below.

■ Port. and "Elizabeth Day Breneiser is a Washingtonian. She studied in the New York School of Fine and Applied Arts and also in Italy, France and England. Also a teacher, she has taught in Detroit and Erie, and in Santa Maria was head of the department of crafts for 18 years. She is presently teaching crafts, design and color at the Hill and Canyon School of the Arts [Santa Fe, N.M.]. Mrs. Breneiser has also contributed to the *Christian Science*

Monitor and has exhibited her work in Santa Maria, at the Faulkner Gallery of Santa Barbara, and in the Museums of Santa Fe and New Mexico. She is also listed in *Who's Who in the West*," per *Albuquerque Journal*, Jan. 25, 1953, p. 18.

Breneiser, Elizabeth (notices in Northern Santa Barbara County newspapers on microfilm and on newspapers.com)
1915 – "Mrs. Breneiser has taken courses at the Arts and Crafts School in Washington, D. C., the Clark Ellis Studios and the School of Fine and Applied Arts in New York and the Thatcher School of Metalwork in Woodstock, N.Y. She also accompanied Mr. Breneiser in his European studies," *Reading Eagle*, June 19, 1915, p. 5 (on the Internet).
1922 – "Interpretive Dancing, class for Children from 4 to 10 years old. Elizabeth Breneiser. 431 South Broadway. 10 o'clock, Saturday Mornings," *SMT*, March 3, 1922, p. 6.
1928 – Repro: new airport, *SMT*, Oct. 20, 1928, p. 9.
1939 – "Diploma Awards – ... and Mrs. Elizabeth Day Breneiser, instructors in the Santa Maria schools, were awarded life diplomas by the county board of education at a meeting in Santa Barbara," *SMT*, March 13, 1939, p. 3; "I Spied – Mrs. Elizabeth Breneiser admitting that she could only laugh at surrealistic art," *SMT*, April 22, 1939, p. 1.
1943 – "School Plans... Teacher Resigns. ... Mrs. Elizabeth D. Breneiser as a member of the teaching staff... board members expressed their regret at the termination of her services after so many years ...," *SMT*, Sept. 16, 1943, p. 1.
1948 – "Former Resident Pictured in Current National Magazine. Latest issue of the *Saturday Evening Post* contains a picture of Mrs. Stanley G. Breneiser, known to her intimates as 'Babs,' ... in front of one of Santa Fe, New Mexico's ancient buildings, illustrating a story on that ancient city... The Breneisers left here two years ago for Santa Fe and are now operating the Hill and Canyon School of the Arts in Santa Fe. ... they are living on Canyon road... in a home 250 years old, with apple trees 150 years old in the garden. **John Breneiser**, eldest son... now living in Alhambra, is building a new home on South Miller street and plans soon to return to Santa Maria to live. **Eliot Breneiser**, another son, is now professor of music in Wooster College in Ohio; **Mrs. Louis [Sic. Louie] Ewing** ... is also living in Santa Fe at present and she and her husband are both artists; Cathryn, the other daughter, is in school," *SMT*, Sept. 21, 1948, p. 8.
Eighty-one "hits" for "Elizabeth Breneiser" appear in *SMT* between 1922 and 1947, many for the "living pictures" she helped stage, and for costumes and stage sets for high school plays, but were not itemized here.

Breneiser, Elizabeth (notices in New Mexico newspapers on newspapers.com)
1971 – Port. and "Babs—Canyon Road's Answer to Perle Mesta... ," and feature article on her in *Santa Fe New Mexican*, Sept. 3, 1971, p. 6.
1975 – "Friendly New Mexicans... One is never too young to score a first. Elizabeth 'Babs' Breneiser, at a mere 84, smiles happily from the back cover of the first collected edition of her poetry, *'from the quiet pools'*," per *Santa Fe New Mexican*, Feb. 2, 1975, p. 26 (i.e., C-2).
Twenty notices appear for "Elizabeth Breneiser" between 1946 and 1983, but were not itemized here.

Breneiser, Elizabeth (misc. bibliography)
Elizabeth Breneiser and Stanley G. are listed in the *Erie, Pa., CD*, 1917, 1919; various passenger lists for ships show that Elisabeth, Marrie, David and John sailed from Baltimore, Md. to Los Angeles in Dec. 1921, that she sailed from the Virgin Islands to NY in 1924, that with her in-laws she sailed from Honolulu to San Francisco in April 1925, from NY to Puerto Rico and the Virgin Islands in Jan. 1927, and with her in-laws from New York to Puerto Rico in Feb. 1931; Elizabeth D. Breneiser is listed in the 1940 U. S. Census as age 50, b. c. 1890 in Washington, D. C., finished college 3rd year, residing in Santa Barbara? (1935, 1940) with husband Stanley G. Breneiser (age 50), and children David D. (age 22) and Stanley Eliot (age 17) and Cathryn C. (age 6) and lodgers Satoko Murakami (age 23) and Warren Tashiro (age 17) and servant Helen Chester (age 27); port. in Santa Maria High School yearbook, 1930; Elizabeth C. Day was b. April 20, 1890 in Washington, D. C., to David Talbot Day and Elizabeth Elliott Keeler, was residing in Washington, D. C. in 1900, married Stanley G. Breneiser, and d. Oct. 1983 in Santa Fe, N. M., per Breneiser Family Tree (refs. ancestry.com).
See: "Alpha Club," 1932, 1934, 1935, "Ark," "Blue Mask Club," 1924, "Boy Scouts," 1933, 1941, "Bragg, Joffre," 1935, "Breneiser ...," "Business and Professional Women's Club," 1937, 1941, "Citadel," "Cleaver, Walter," 1926, "College Art Club," "Eidolon," "Faulkner Memorial Art Gallery," 1932, 1933, "Fortune, Margaret," 1924, "Lange, Myrtle," "Marshall, Mary," "Minerva Club," 1939, "Minerva Club Flower Show," 1933, 1936, "National Art Week," 1935, "Radford, Dorothy," "Rushforth, Carol," "Santa Barbara County Fair," 1930, 1937, "Santa Maria, Ca., Adult/Night School," 1936, "Santa Maria, Ca., Union High School," 1926, 1929, 1930, 1934, 1935, 1936, 1937, 1938, 1939, 1940, 1943, "Santa Maria Camera Club," 1944, "Santa Maria School of Art," 1927, 1933, "Scholastic Art Exhibit," 1931, 1933, 1935, "Splash," 1928, 1934, 1935

Breneiser, John Arthur "Day" Zaehnle (1905-1981) (Santa Maria / Santa Fe, N. M.)
Artist, teacher. Adopted son of Stanley and Elizabeth Breneiser. Exhibited art in the Los Angeles area in the 1930s. Artist at North American [Aviation?] 1953. Husband to Margaret Breneiser, below.

■ "John Day Breneiser is a native of Youngstown, Ohio, where he was born May 2, 1905. He is a graduate of Santa Maria union high school and attended junior college here, winning a scholarship at Otis Art Institute in Los Angeles. He chose to attend the University of Oregon instead, from which he graduated with a bachelor's degree from the School of Architecture. He later taught art in the elementary schools of Santa Maria, 1929-30. Since that time, he has devoted his entire time to his profession, exhibiting at Santa Cruz, Santa Barbara and elsewhere. He won commendation for an illustration of an article written by his father ... for the *Christian Science Monitor* following their return as delegates from the Sixth International Congress of Art held in Prague in 1928. He is listed in the directory of Southern California artists recently

issued and in the *American Art Annual…*," *SMT*, Feb. 8, 1933, p. 6.

"John left his birth father and was raised by the Breneisers, whose name he adopted," per Public Member Stories (ancestry.com).

Breneiser, John Day (notices in Northern Santa Barbara County newspapers on microfilm and on newspapers.com)

1923 – "**Blue Mask Club** Play will be Staged Friday" with John Breneiser playing Yung Loh, *SMT*, Nov. 1, 1923, p. 5; "Breneiser, H. S. S. President Will Speak at Los Angeles" i.e., at Honor Scholarship Society about his local chapter, *SMT*, Dec. 21, 1923, p 2.

1924 – "Heard in the Halls" – drove to Santa Barbara with his mother to hear Madame Butterfly, *SMT*, Feb. 23, 1924, p. 2; "Gets High Reward," i.e., editor of *Breeze* wins top prize at Stanford Journalism convention, and many details, *SMT*, May 12, 1924, p. 2; "Wins Scholarship in LA School," i.e., Otis Art Institute, *SMT*, June 5, 1924, p. 5.

1926 – "Chosen J. C. Students Leader," *SMT*, Feb. 5, 1926, p. 5.

1932 – "Art Salon Honors Breneiser… state-wide exhibit sponsored by the Santa Cruz Art league… Breneiser's painting 'Symphony Point Sal,' was exhibited and catalogued in the gallery and 16-page book. The work is a gem of soft and translucent color forms revealing the great beauty of the valley's coastwise scenic pride. Cliffs and ocean are in shimmering colors partly enveloped in fog and contrasted with a group of giant eucalyptus trees in the foreground. … Although he never before had a painting hung in an exhibition of the Santa Cruz type, he has been recognized as a professional craftsman with an exhibit in the Los Angeles public library under the auspices of the Southern California Art Teachers association. He also is accorded national recognition … in a 'Who's Who' published by the American Federation of Artists…," *SMT*, Feb. 3, 1932, pp. 1, 4; "Local Artists Reflect Saner Form Attitude. Proof that the real artist is found not only in a Paris garret starving to death… but also works in the gorgeous rolling hills of California… Right here in Santa Maria we have several young artists… viewing … private exhibition of the water colours of John Day Breneiser. The latter… is primarily an observationist … Breneiser paints not only what he sees in a landscape but what you see. … his work… is as alive and vibrant as you could desire. Breneiser's brush is not merely facile, it is articulate… His most successful medium is that of still life, though his landscapes are thoughtfully formed. For instance, he has one he called 'Pinochio,' portraying the legendary child's hero … Simple in form but striking in conception, it makes one wish he had continued with a series… JBS," *SMT*, Sept. 10, 1932, p. 6.

1933 – Repro: "Down by the Gas Works," *SMT*, Feb. 8, 1933, p. 1; "Local Artist's Work on Display in East. Washington D. C…. a complete exhibition of water color paintings by a Santa Maria artist, John Day Breneiser… Fifty paintings, including scenes from Cuyama, Betteravia, Oceano, Casmalia, Morro Bay, Santa Maria, Los Alamos, Guadalupe, Santa Barbara and the Santa Maria oil fields are in the exhibit at 1106 Connecticut avenue in the national capitol. The gallery is operated by Sears, Roebuck and company to 'promote, stimulate and guide toward practical expression the artistic sense of the American people.' …

Besides landscapes, young Breneiser's subjects embrace a great variety of material including still life, groups of flowers, fruits, vegetables and objects of art, birds, horses, street scenes and industrial subjects. The exhibit will remain in Washington during the month of February and afterward may be sent to Richmond, Va., before it is returned west where it may be placed in San Francisco….," *SMT*, Feb. 8, 1933, p. 6; "Local Paintings Win Commendation. Fifty water color paintings by John Day Breneiser… in the Sears, Roebuck art galleries at Washington, D. C. … Among Breneiser's titles are 'Morning in Cuyama,' 'Harvesting Flower Seeds at Betteravia,' 'Hill Forms at Casmalia,' 'Fog at Point Sal,' 'Morro Rock,' 'An Adobe at Guadalupe,' 'Santa Barbara Mission,' and 'Palomino Stallion'. In the *Washington Post*, Vylla Poe Wilson speaks of the local man's work as 'sprightly bright landscapes and still lifes'," *SMT*, Feb. 28, 1933, p. 6; "Breneiser Exhibit on Display in L. A. John Day Breneiser… has a one-man exhibit of lithographs on display at the Biltmore gallery in Los Angeles this week in connection with an exhibit of rare books from the collection of **Merle Armitage**… he is on a trip into the Sierra Nevadas in search of material for his brush and easel," *SMT*, Sept. 7, 1933, p. 1.

1934 – "Breneiser Works Shown in South. At the Stendahl galleries on Wilshire boulevard in Los Angeles is hanging a one-man exhibition of water colors by John Day Breneiser. The exhibit consists of over 20 scenes painted by Mr. Breneiser in this vicinity. Some of these pictures were exhibited in the local high school last fall. Mr. Breneiser is at present teaching the design and craft classes in the high school, substituting for his mother, **Mrs. Elizabeth Day Breneiser**, who is on a leave of absence this semester," *SMT*, March 19, 1934, p. 2.

1937 – "Breneiser Will Exhibit Art Collection" at High School, month of March, "lithographs, etchings and wood-cuts collected by John Day Breneiser, night school art instructor, will be displayed in the upper corridor of the high school during the first week of March… exhibit… is being arranged by **Stanley G. Breneiser**… both modern artists and old masters… Breneiser will also show some of his own work which has been exhibited … in the Biltmore and Stendahls' galleries in Los Angeles, Paul Elder's in San Francisco, and several galleries in New York City," *SMT*, Feb. 26, 1937, p. 3, and high school plans two more exhibits, one of wc and one of oils; "Breneiser Painting to be in Exhibit,"– his 'Ruins of a 17th Century Church' will be in traveling exhibit of American Federation of Arts, *SMT*, Nov. 20, 1937, p. 2.

1939 – "Local Artist's Painting Hung for Fair," i.e., **Golden Gate Expo** in SF, "In addition… two prints by local artists were also hung, lithograph of an old ranch near Point Sal by young Breneiser…," *SMT*, March 10, 1939, p. 3.

1940 – "Works of Noted Painters Shown at S. A. Library. Art work and signatures of more than two dozen noted painters from all parts of the country were put on display … in the form of a painting-on-a-palette display arranged by Hazel N. Bemus, artist and teacher of Laguna Beach. In each instance the artist painted a scene on a wood palette and signed his or her name… Among those artists… **Stanley G. Breneiser**, landscapes... John Day Breneiser

and **Margaret Breneiser**, moderns…," *Santa Ana Register*, Jan. 23, 1940, p. 5.

Breneiser, John Day (misc. bibliography)
Port. and "John Breneiser Transferred from Academy High, Erie, Penn. (3), H.S.S. (1, 2), Off. (3, 4), Delegate to H.S.S. Convention, Long Beach (4), Blue Mask Officer (3), Lighweight Basketball (3), 'Suppressed Desires' (3), Review Vaudeville (3), *Breeze* Staff (3), *Splash* Staff (4), *Review* Editor (4), 'Singing Soul' (4), Senior Play (4), 'Smiles – and More Smiles'," in Santa Maria High School yearbook per Public Member Photos & Scanned Documents, n.d.; port. in University of Oregon yearbook, 1929; John Arthur Breneiser gave the following information on his WWII Draft Card, age 35, b. May 2, 1905 in Youngstown, Ohio, residing in Santa Maria with wife Margaret Eleanor Breneiser; John A. Breneiser (Margt) artist, North Am., is listed in the *Temple City, Ca., CD*, 1953; John A. Breneiser and wife Margaret E. are listed in *Index to Register of Voters, Los Angeles County, Temple City Precinct, 37*, 1956; John A. Breneiser and wife Margaret E. are listed in *Index to Register of Voters, Los Angeles County, Rio Hondo Precinct 121*, 1962; John Breneiser, emp. Pac Tel, is listed in the *Alhambra, Ca., CD*, 1964; John Breneiser b. May 2, 1905 in Ohio, d. Oct. 2, 1981 in Los Angeles County per Calif. Death Index (refs. ancestry.com).
See: "Alpha Club," 1935, "Bragg, Joffre," 1935, "Breneiser, …," "Business and Professional Women's Club," 1936, "Cleaver, Walter," 1926, "College Art Club," introd., 1928, 1930, 1934, 1935, "Community Club," 1934, "Eidolon," "Faulkner Memorial Art Gallery," 1932-36, "Minerva Club," 1937, "National Art Week" 1935, 1940, "Rahbar, Ethel," "Santa Maria, Ca., Adult/Night School," 1929, 1935, 1936, "Santa Maria, Ca., Union High School," 1923, 1924, 1925, 1926, 1938, "Santa Maria School of Art," 1927, 1933

Breneiser, (John) Valentine "Val" (Santa Maria)
Exh. weaving at Santa Barbara County Fair, 1937. Primarily active on the stage crew of theater performances.
Valentine, "Son of Stanley Breneisers is Wed in North," *SMT*, March 23, 1939, p. 3; "Santa Feans Wed Today. The wedding rites of Mary Ruby Romero and John Valentine Breneiser were performed this afternoon…," *Santa Fe New Mexican*, Jan. 24, 1948, p. 3.
Breneiser, John Valentine (misc. bibliography)
"John Valetin [sic.] Breneiser was b. Feb. 7, 1919 in Erie, Pa., to Stanley G. Breneiser and Elizabeth C. Day, married Jean Shneyeroff Shneyeroger, was residing in Santa Fe., NM in 1947, and d. Oct. 16, 2000 per Fox Family Tree; John V. Breneiser, Sr., was b. Feb. 7, 1919 and d. Oct. 16, 2000 and is buried in Father Kauper Cemetery, Embudo, New Mexico, per findagrave.com (refs. ancestry.com).
See: "Breneiser, Stanley," 1935, "Santa Barbara County Fair," 1937, "Santa Maria School of Art," 1933

Breneiser, Margaret E. Chester (Mrs. John Day Breneiser) (1916-1981) (Santa Maria)
Artist. Exh. painting in Grumbacher exh., 1937. Poster prize winner for Minerva Club Flower Show, 1936. Wife of John Day Breneiser, above.
Breneiser, Margaret (notices in California newspapers on newspapers.com)
1936 – "Santa Marians Marry in Ventura. A surprise greeted the friends of Mr. and Mrs. Stanley G. Breneiser at an informal gathering Saturday evening in 'The Ark'… when the marriage of their son, **John Day Breneiser** to Miss Margaret E. Chester in Ventura on Friday was announced. The announcement was made by the exhibit of a snapshot of the two taken at their wedding. Mrs. Breneiser is the daughter of George Chester, member of the faculty of the Santa Maria high school, and graduated from that school last June," *SMT*, Aug. 3, 1936, p. 2.
1940 – "Young Breneisers Parents – Mr. and Mrs. John Breneiser… parents of a daughter born yesterday…," *SMT*, Dec. 27, 1940, p. 3.
Breneiser, Margaret (misc. bibliography)
Margaret E. Breneiser is listed in the 1940 U. S. Census as age 23, b. c. 1917 in Calif., finished high school 4th year, residing in Santa Barbara (1935, 1940) with husband John A. Breneiser (age 35) and child Diana (age 11 months); Mrs. Margaret E. Breneiser is listed in Voter Registers in Santa Barbara between 1938 and 1944; Mrs. Margaret E. Breneiser is listed in Voter Register in Los Angeles, 1956; Margaret E. Breneiser, mother's maiden name Whitcher, father's Chester, b. Nov. 8, 1916 in Calif. and d. May 15, 1981 in Los Angeles County per Calif. Death Index (refs. ancestry.com).
See: "Breneiser, John Arthur Day," "Breneiser, Stanley," 1937, 1940, "Minerva Club Flower Show," 1936, "National Art Week," 1940, "Santa Maria, Ca., Union High School," 1938

Breneiser (Ewing), Marrie Friedericka (Mrs. Louie Henry Ewing) (1915-2004) (Santa Maria / Santa Fe, N.M.)
Painter, musician, thespian. Daughter of Stanley and Elizabeth Breneiser, 1934. Wife of Louie Ewing, below.
■ "Miss Breneiser, **Louis [Sic. Louie] Ewing** Married. Miss Marrie Breneiser, daughter of Mr. and Mrs. Stanley G. Breneiser… and Louis Ewing, also of Santa Maria, were married last evening at 7 o'clock in Santa Fe, N. Mex. The wedding rites were held in the patio of **Eidolon** art school where both Mr. Ewing and his bride have been instructors this vacation. Mr. and Mrs. Ewing will make their new home in Santa Fe where Mr. Ewing has secured a federal government position as art instructor. Mrs. Ewing's parents, **Mr. and Mrs. Breneiser**, who taught at Eidolon this summer also, will return this week from Santa Fe … **John Day Breneiser** expects to remain in Santa Fe during the coming year," *SMT*, Aug. 19, 1935, p. 3.
Breneiser, Marrie (notices in Northern Santa Barbara County newspapers on microfilm and on newspapers.com)
1932 – "Marrie Breneiser Wins Scholarship… winner of the year's scholarship offered at the Santa Barbara School of the Arts… full year's tuition. She competed with **Rowena Lowell** and **Anna Adele Black** for the prize as

majors in art at the high school and eligible for the contest. The work of all three students was sent to the Santa Barbara school marked only by numbers… **Miss Lowell** and Miss Black will enter another scholarship contest with a few other students at the Art Center school in Los Angeles…," *SMT*, May 10, 1932, p. 1; "Santa Maria Sends Many Students to Universities… **Lucy DeGasparis** is studying art at the **California School of Arts and Crafts** in Oakland while Marrie Breneiser will study art also at the Santa Barbara School of Fine Arts which begins October 3…," *SMT*, Aug. 17, 1932, p. 6.

1934 – "Painting by Local Artist is Removed from S.B. Show… Community Art Salon opened in the chamber of commerce auditorium … a nude exhibited by Marrie Breneiser, 19-year-old Santa Maria artist was removed and placed in an inconspicuous part of the auditorium… 'hung near the floor, 'behind a desk where you can see it if you know where to look – and can move the desk' … 'the rather startling but splendidly executed nude study, which was taken down after reigning all through one night as one of the most prominent features of the exhibition… represents a near life-sized female figure done with extreme realism,' [Franklin] Howatt said in his review of the exhibition. Miss Breneiser, who is also an accomplished pianist …," *SMT*, July 13, 1934, p. 1; "Portrait Draws Attention. … [at] Santa Maria union high school… a likeness of **Rowena Lowell**, high school graduate, painted by Marrie Breneiser… The painting was on exhibition throughout the day in the school library… The painting is particularly notable for the good lighting of the face and for the excellent proportioning of the body lines," *SMT*, Nov. 27, 1934, p. 3.

1939 – "Secours Return from Tour. **Mr. and Mrs. George Secour** have returned from a trip to New Mexico… the Secours visited Louie and Marrie Breneiser Ewing, formerly of Santa Maria …," *SMT*, Jan. 11, 1939, p. 3.

1944 – "Marrie [Breneiser] Ewing a painter, is featured article in Oct. issue of *New Mexico* magazine, *SMT,* Oct. 20, 1944, p. 3.

And 42 "hits" for "Marrie Breneiser" in the *SMT*, 1925-36, most of which were for her music and theater work were not itemized here.

Breneiser, Marrie (misc. bibliography)
Marrie Breneiser is pictured in the Santa Maria High School yearbook, 1930; Marrie Breneiser is pictured in the Santa Maria High School yearbook 1931 with the Blue Mask club, the French Club, the Point and Letter Club and the Junior A Girls; Marrie Friedericka Breneiser was b. April 13, 1915 in Detroit, Mi., to Stanley Grotevent Breneiser and Elizabeth Cathcart Day, married Louie Henry Ewing, and d. July 2, 2004 in Arizona per West Family Tree (ref. ancestry.com).
See: "Art, general (Santa Maria)," 1929, "Art Festival," 1939, "Blue Mask Club," intro., "Breneiser, Stanley,' 1933, 1934, 1935, 1939, 1950, "College Art Club," 1934, "Community Club," 1934, "Ewing, Louie," "Faulkner Memorial Art Gallery," 1933, "Lowell, Rowena," "Posters, Latham Foundation (Santa Maria)," 1934, "Santa Maria, Ca., Union High School," 1937, "Santa Maria School of Art," 1933

Breneiser, (Stanley) Eliot (Santa Maria)
Musician. Son of Stanley and Elizabeth Breneiser.

■ "S. Eliot Breneiser, known as Eliot Breneiser, was born in Santa Maria, California to Stanley G. and Elizabeth Day Breneiser. He was married to Violet Kathryn Breneiser. After serving in the U.S. Army Medical Corps during World War II, Breneiser graduated from Pomona College in Claremont, California. He then obtained his Master of Arts degree with a concentration in Piano" (per finding aid for his papers in Old Dominion University, Norfolk, Va. On Internet).
See: "Breneiser, Elizabeth," intro., "Breneiser, Stanley," 1935, 1939, 1945, "Santa Maria, Ca., Union High School," 1941, "Santa Maria School of Art," 1933

Breneiser, Stanley Grotevent (1890-1953) (Ohio / Pennsylvania / Santa Maria / Santa Fe, N.M.)
Art Teacher, Santa Maria high school, c. 1922-45. Director of the Hill and Canyon School of the Arts, 1946-50. Director of the Citadel School, Santa Fe, N. M., 1951-53.

■ "A native of Reading, he studied at the Museum School of Industrial Art, the Pennsylvania Academy of Fine Arts, the Art Students League in New York and was graduated from the Parsons School of Design. He also studied in Italy, France and England. Now director of the Hill and Canyon School of the Arts in Santa Fe, he started teaching in 1914 at the Detroit Museum School of Design. For three years he was director of art education at All Schools, Erie, Pa., and served as head of languages and arts at the Santa Maria Union High School and Junior College in California. At Santa Maria he also lectured and was dramatic coach. He has written on art and allied topics for such magazines and newspapers as *American Art Student* magazine, *Columbia University Press* magazine, *Christian Science Monitor* and many others. He is listed in the *Who's Who in the West* and is a member of Artists Equity Assn.," *Albuquerque Journal*, Jan. 25, 1953, p. 18.
Breneiser, Stanley G. (notices in American newspapers on newspapers.com).
1910 – "Mr. and Mrs. William Breneiser of Reading, Pa., arrived Friday to join their two daughters and son at their very pretty bungalow on Spruce Point," *Lewiston Saturday Journal*, July 20, 1910, p. 2, col. 2 (digitized on Internet).

1915 – "Art Studio at Mt. Penn. A new studio, 'The Sign of the Lucky Bird,' has been opened at 24th and Cumberland streets, Mt. Penn, by Mr. and Mrs. Stanley G. Breneiser, who returned from Detroit after a winter teaching art. Mr. Breneiser taught Costume Design, Illustration, and Interior Decoration at the Detroit School of Design while Mrs. Breneiser held private classes in jewelry making and design. The studio will be the scene of varied activities. Mr. and Mrs. Breneiser will conduct classes in design. Mr. Breneiser will teach drawing and painting and interior decoration. Mrs. Breneiser will hold classes in jewelry, tooled leather, and stenciling," *Reading Eagle*, June 19, 1915, p. 5 (on the Internet); "Stanley Breneiser moved to Reading," *Reading Eagle*, Feb. 7, 1916, p. 10 (digitized on Internet).

Breneiser, S. (notices in Northern Santa Barbara County newspapers on microfilm and on newspapers.com)
1921 – "Dr. and Mrs. David Day… have as their eastern visitors, Mr. and Mrs. Stanley Breneiser of Erie, Pa. Mrs. Breneiser is a daughter of the Days. Mr. and Mrs. Breneiser are artists. Mr. Breneiser was director of art in the schools of Erie, Pa. They motored to California and are planning to make their home in this state," *SMT*, Oct. 7, 1921, p. 5.

1922 – "Breneisers Will Open Art Studio" at 819 South Lincoln St. with a tea, where they will hold special exhibits including their coll. of **Liotra** color prints, *SMT*, Nov. 16, 1922, p. 5; "**Liotra Color Prints**" i.e., photos taken in various parts of the world and tinted in oil by the Breneisers priced from $2 to $75, *SMT*, Nov. 24, 1922, p. 6; "**Liotra**" Santa Maria, Color Prints, California, oil painted photographs taken in this country and abroad, *SMT*, Dec. 9, 1922, pp, 4, 6.

1924 – Anecdote of teaching art history class, *SMT*, Jan. 19, 1924, p. 2, col. 4-5; "Birthday Party Held by Mr. and Mrs. Breneiser" for friend, *SMT*, Feb. 13, 1924, p. 5; "Breneiser Has Article in '*Signs of the Times*' official organ of display advertising community, and illus. by student, first of series of several articles, *SMT*, March 1, 1924, p. 5; "Local High Art Instructor Gains Fame" – is considered for position of director of Art for all Boston schools, and elected to Editorial Staff of '*Signs of the Times*', *SMT*, March 13, 1924, p. 5; "Breneiser Will Address Woman's Club at Riverside" discussing Historic Dress, *SMT*, April 12, 1924, p. 5; "Breneiser Will Speak" and departs with wife and 3 students, *SMT*, April 14, 1924, p. 5; "Club Hears Lecture on Correction of Arts" i.e., Breneiser speaks on sympathy between music and painting, *SMT*, May 2, 1924, p. 3; "Art Instructor at High Gives Practical Training … Breneiser… His articles appear in the art and commercial magazines and papers throughout the United States … In the '*American Art Students*' magazine for the month of September is a lengthy article on 'High School Art that Functions' … using our local school's art department as an example … illustrated with two full page reproductions from 'The *Splash*' … and several smaller cuts from the '*Breeze*'…," *SMT*, Sept. 13, 1924, p. 5.

1925 – "Art Instructor speaks to Local Kiwanians,' on art and its use in automobiles and motion pictures, *SMT*, Jan. 8, 1925, p. 1.

1926 – "Mr. and Mrs. Stanley G. Breneiser are having as their house guest, over the week-end, Miss Emily Grace Hanks of New York City. Miss Hanks is a prominent portrait painter and mural decorator. Some of her work can be seen in the St. Francis Hotel in San Francisco. She has been spending the summer in Oregon and Carmel and is now on her way home. She teaches several days a week at Pratt Institute in Brooklyn," *SMT*, Sept. 17, 1926, p. 5; "High School Art Department Again Honored… Mr. Stanley G. Breneiser has had a call extended to him to give a series of lectures at a state conference of Vocational Home Economics teachers at El Paso, Texas. The general theme of the three talks will be 'Art in Life.' On Monday, November 22, the subject of the first lecture will be 'Art in the Home,' on Tuesday, November 23, the subject will be 'Art on the Street' and on Wednesday the talk will be

entitled 'Art at Our Leisure.' Mr. Breneiser has also been requested to give an illustrated talk to the art teachers of the State during the sessions of the Texas State Teachers' association on Friday, November 26. This lecture will be entitled, 'An Expression of Oneself.' On Saturday, November 27, Mr. Breneiser will give an informal talk called, 'A Feast of Ideas' at a luncheon of the Fine Arts Section. Mr. Breneiser will take with him a series of photographs of our school building and examples of the students' work from all his classes in the high school and junior college. Mr. Breneiser expects to return Sunday, November 28,' *SMT*, Nov. 15, 1926, p. 1.

1928 – "Breneiser and Son Back from European Trip … **John A. Breneiser**, senior in the School of Architecture, University of Oregon… itinerary included England, Belgium, France, Italy, Switzerland, Austria, Germany, Holland, and attendance at the sixth International Congress of Art in Prague, Czechoslovakia. The Breneisers came back thrilled with the wonderful sights and experiences… 'We strongly feel that the United States is by far the most progressive and beautiful of all countries and that California is certainly the best place to live' … Aside from the extensive study of Painting, Architecture and Minor Arts of the various Art periods in the different countries, the Breneisers took many hundreds of feet of moving pictures which, after they have arranged them logically … will be used to illustrate a series of lectures … given… under the auspices of the evening high school and another series through the **College Art Club**. Breneiser and his son also collected a great quantity of valuable reference material to be used in teaching in the local high school and college…," *SMT*, Aug. 27, 1928, p. 1; "Breneiser Takes European Lecture Course Position… for summer of 1929 as a member of the faculty of the American Institute of Educational Travel of New York City. He will act as an European lecturer on the history of Art in various European countries. … conduct lecture classes on drawing, painting and sculpture in the art galleries and museums…. Breneiser is hoping to be able to include some Santa Marians in this tour… The session will be about 12 or 14 weeks in length including the time for crossing the Atlantic…," *SMT*, Dec. 1, 1928, p. 5.

1931 – "Decorative Painting by Breneiser Exhibited… California Artists' Fiesta which is coincident with La Fiesta de Los Angeles… The Breneiser painting is an individual interpretation of Chopin's Prelude No. 8 and is a modernistic painting made in tempera. The picture is typical of his style of distinctively original, interpretative compositions from music. These have become well-known in the last year over the entire country. Just last February, in an issue of … '*Everyday Art*,' two of Breneiser's paintings … were reproduced in full color… The painting to be exhibited in Los Angeles is a dynamic composition of stimulating forms and contrasting, vital colors in harmonious and dissonant tones. The whole effect expresses the emotional and mental reactions of the artist … The last work of Breneiser exhibited in Los Angeles was a large batik wall hanging interpreting another of Chopin's preludes… [in the] gallery of the Los Angeles public library several years ago… by the Southern California Art Teachers' association… He is also a member of the Laguna

Beach Art association, The <u>American Federation of Arts</u>, Washington, D. C., and is president of the **College Art club** of Santa Maria, which is a chapter of The <u>American Federation of Arts</u>," *SMT*, Aug. 31, 1931, p. 3.

1933 – "Musicale at Breneiser Home… interesting social features of the annual convention of the State Federation of Music clubs in session in Santa Maria… An address on 'The Harmonious Relations in Music and Painting' given by Mr. Breneiser… was the program feature … Mr. Breneiser presented a subject that has been his personal hobby for about 20 years, the emotional expression of music in painting. Coming from a family of musicians he has a deep inherent love of music that gropes for expression. He would have liked to have been a composer, he declared, but since his education specialized in the graphic arts rather than in music, he relieves his intense desire to play and create musical compositions by translating in form and color his inspirations derived from the various tones, harmonies and rhythms of a musical composition. He exhibited some of his musically inspired works based on two Chopin preludes and the 'Adagio' from Grieg's 'Concerto in E Minor' which presented highly colorful and original flights of fancy and were viewed with profound interest. Mr. Breneiser has found the correlation of music and art of general and specific benefit. The first includes the personal comfort and satisfaction derived from this form of musical expression. The second helps him to develop in his students' creative art ability and an appreciation of good music. The new idea conceived by Mr. Breneiser of the relationship that can be effected between music and painting is attracting attention of artists in both spheres, and several magazines have already given him recognition with published articles and colored reproductions of some of his works… The clever little programs were in the form of teacups…," *SMT*, April 18, 1933, p. 3; "Laguna Vacation Ends – Two weeks vacationing at their beach cottage in Laguna have been concluded by the Stanley Breneiser family and **Louis [sic. Louie] Ewing**, who came back to Santa Maria yesterday. On their trip home, they stopped in Santa Barbara where **Miss Marrie Breneiser** will visit with her friend, Miss Rosalind Cooper, for 10 days," *SMT*, Aug. 23, 1933, p. 3; "Local Artists' Work Displayed in LA Salon. Included in 35 lithographs… at the <u>Stendahl galleries</u> on Wilshire boulevard in Los Angeles this week are five from the studio of two Santa Maria artists, **Stanley G. Breneiser** and his son, **John D. Breneiser**. Four are the work of the younger Breneiser and the other is his father's… The lithographs, made by the artists on stone, were printed by Lynton Kistler… **Stanley Breneiser**'s 'Banana Leaves' is listed for exhibition while those of **John Day Breneiser** are 'Ranch at Point Sal,' 'Circus Roustabouts,' 'Water Lily,' and 'Cereus,' the latter from the **Santa Maria Inn** gardens. The exhibit will be open… from today to October 21…," *SMT*, Oct. 9, 1933, p. 6.

1934 – "Art Teacher Honored…," listed in *Who's Who in Art* for 1933, "A separate volume listing teachers of art was issued several years ago which included … **Mrs. Breneiser** and **John Day Breneiser**," *SMT*, March 1, 1934, p. 1; "Program Given by Breneisers," and article says, "'Adaption of art to everyday life and everyday people was

the general theme of Stanley Breneiser's talk to members of the **Community club** when they met at 'The Ark' Tuesday evening…. The evening's program consisted of a cello solo by **David Breneiser** accompanied by Mrs. Breneiser, two German songs by David, two piano solos by **Eliott Breneiser**, a talk on **Rockwell Kent**, America's foremost all-round painter, by **John Breneiser**, two vocal solos by Mr. Breneiser, accompanied by **Mrs. Breneiser**, a duet by the host and hostess of the evening, and a piano solo by **Marrie Breneiser**. Following the program an exhibit of paintings by the Breneiser family was given and refreshments were served," *SMFA*, Nov. 2, 1934, n. p.

1935 – "Breneisers Will Go To Santa Fe. Summer vacations of the **Stanley G. Breneiser** family and of **Louie Ewing**, Santa Maria artists, will be spent in Santa Fe, New Mexico, where they plan to teach a 10-week summer course in <u>Eidolon</u>, new art school and center… **Mr. Breneiser**… will have charge of painting courses. **John Day Breneiser** is to instruct in painting, drawing and various types of print-making. **Mrs. Breneiser** is scheduled to teach courses in design and hand-craft. **Louie Ewing** will have charge of wood carving and related courses," *SMT*, May 3, 1935, p. 3; "Santa Marians Will Go to <u>Santa Fe</u>. **John Breneiser** and **Louie Ewing** depart this week-end for Santa Fe, N. Mex. Where they will teach art courses … Ewing will assist **Mrs. Stanley Breneiser** in her craft classes as well as supervise courses in mask making, wood carving and block printing," *SMT*, May 31, 1935, p. 2; "Go to New Mexico – **Mr. and Mrs. Stanley Breneiser** and **Marrie, David, Valentine** and **Katherine Breneiser** are in Santa Fe, N. Mex. Where Mr. and Mrs. Breneiser will instruct courses in **Eidolon** school. **John Breneiser**, accompanied by **Louie Ewing** and **Eliot Breneiser**, left earlier in the month for Santa Fe…," *SMT*, June 18, 1935, p. 2; "Valley Artists Enter Works… traveling exhibit of thumbnail oil paintings which the Los Angeles Art association is sending out this year … Mr. Breneiser's painting is a scene near Pt. Sal. **Mrs. Breneiser's** subject is decorative gourds, while **John Breneiser's** work shows the Pecos ruins of New Mexico. Each canvas measures about eight inches by five inches. The younger Breneiser has also been honored with the selection of a woodblock print of his by 'The Western Artist' for reproduction in an early issue of the magazine. The print, which depicts a scene near Morro Bay, will be in the form of a single-leaf insert, suitable for framing," *SMT*, Oct. 23, 1935, p. 3.

1936 – "Breneiser Writes for Magazine," *Western Artist*, that also contains account of **National Art Week** exhibit in Santa Maria, *SMT*, Jan. 14, 1936, p. 3; "Local Artist's Sketches are Featured," in lecture before Eastern Arts convention in NYC, on techniques, and has works in traveling <u>Grumbacher</u> exhibit that will be shown in Santa Maria in June, *SMT*, April 8, 1936, p. 3; "Faculty Plans Vacation Trips… **Mr. and Mrs. Stanley Breneiser** and family have planned a trip to the eastern states. They will first stop in New Mexico where they will pick up their son-in-law and daughter, **Mr. and Mrs. Louie Ewing**. From there they will travel by car to Pennsylvania to visit Breneiser's parents. The remainder of the summer will be spent in Maine where Mr. and Mrs. Breneiser will attend the summer session of the Summer Art school in Boothbay

Harbor," *SMT*, June 6, 1936, p. 2; "Called East – Stanley G. Breneiser… has gone to Pennsylvania where his mother is reported to be seriously ill. He was accompanied by his son, **Eliot**. **John Day Breneiser** will take his father's classes until his return," *SMT*, Oct. 16, 1936, p. 5; "Breneiser's Mother Passes in East," *SMT*, Oct. 26, 1936, p. 3.

1937 – "Breneisers Enter Work in Exhibit" – Stanley, **John**, **Margaret** send work on national tour sponsored by Grumbacher – "Stanley Breneiser's entry is a study of Morro Bay. His son, **John Day Breneiser**, has entered an oil painting depicting men at work driving tent stakes on a circus lot. The design is taken from his own lithograph, 'Men at Work,' which has been shown in other exhibits. **Margret Breneiser** has entered her picture showing a corner of **Frank McCoy**'s cactus garden at the **Santa Maria Inn**," *SMT*, Oct. 1, 1937, p. 3.

1938 – "To Go to Yosemite" and then to Shasta City where **John** will attend summer school, *SMT*, June 16, 1938, p. 3; "**David Breneiser** is Party Guest," *SMT*, Sept. 22, 1938, p. 3.

1939 – "New Oil Well for Breneiser is Spudded In," *SMT*, Feb. 18, 1939, p. 2;"Breneiser Well Goes on Test," *SMT*, March 30, 1939, p. 1; "Breneiser Well is Brought in Flowing," *SMT*, March 31, 1939, p. 6; son **David** "In Pasadena Plays" at Pasadena Playhouse School of the Theatre, *SMT*, May 16, 1939, p. 3; "Instructors End Tour of East. **Mr.** and **Mrs. Stanley G. Breneiser** are home from an extended tour of the East, returning by way of Canada. En route east they visited their son-in-law, **Louie Ewing**, in Santa Fe artists' colony. Mrs. Ewing, the former **Marrie Breneiser**, is spending the summer here. While in the east the Breneisers visited Washington, D. C., birthplace of Mrs. Breneiser. They also visited Mr. Breneiser's father in Reading, Pa. After a visit to the World's Fair, the family continued north, spending ten days in Vermont and visiting the coast of Maine. Monhegan island, where Mr. and Mrs. Breneiser became acquainted as children, was also visited. On the return trip, Yellowstone National park was visited. **Eliot** and **Cathryn** accompanied their parents," *SMT*, Aug. 12, 1939, p. 2.

1940 – Play "Graustark Will be Presented Tomorrow" directed by S. Breneiser, *SMT*, Jan. 3, 1940, p. 3; "Works of Noted Painters Shown at S.A. Library… Painting-on-a-palette display arranged by Hazel N. Bemus, artist and teacher of Laguna Beach. In each instance the artist painted a scene on a wood palette and signed his or her name… included … Stanley G. Breneiser, landscapes… **John Day Breneiser** and **Margaret Breneiser** …," *Santa Ana Register*, Jan. 23, 1940, p. 5; "Breneisers Hosts at Dinner Tonight" for drama society, *SMT*, March 13, 1940, p. 2; "Breneiser Home to be Setting for Supper" for theatre fraternity, *SMT*, May 16, 1940, p. 3; "Breneisers Return from Southwest," via Pasadena and in Santa Fe they stayed with their daughter and son-in-law, *SMT*, July 12, 1940, p. 3; takes two students on trip to Pasadena, *SMT*, Nov. 7, 1940, p. 3; "Final Pinocchio Performance Given" directed by Breneiser, *SMT*, Dec. 6, 1940, p. 3; "Breneisers Hosts to Delta Psi Omega," HS dramatic society, *SMT*, Dec. 18, 1940, p. 3.

1941 – "Breneiser's Play in State Contest" titled 'The Master's Touch', *SMT*, March 28, 1941, p. 3; Maskers, "Amateur Players Make Initial Appearance," with plays directed by Breneiser, *SMT*, April 10, 1941, p. 3; "Sorority Program Set" – radio skit directed by Breneiser, *SMT*, April 22, 1941, p. 3; "Breneisers Hosts to Sorority Members," *SMT*, April 24, 1941, p. 3; Theater Arts Presentation Tomorrow," includes actors who were members of original Theater Arts class begun by Breneiser in 1938, an outgrowth of the old **Blue Mask** club organized in 1922, *SMT*, April 29, 1941, p. 3; "Theatre Arts Class Play Amuses," *SMT*, May 1, 1941, p. 3.

1943 – "Free Exhibit. Paintings by Stanley G. Breneiser. High School. 9-4 Daily – On School Days. 7-9 P.M. – Mon.-Thurs," *SMT*, Nov. 8, 1943, p. 1.

1944 – "Breneiser Shows Water Colors" he painted this last summer at Santa Fe, N.M., at HS where he teaches. "Some of the titles are 'Nambe Pueblo,' 'Ranch Near Lamy,' 'Penitante,' 'Chinaga,' 'Talaya Hill,' 'New Mexican Twilight,' and 'Golden Rain.' Ten of the group were painted in the twilight evening hours between 7:30 and 9 o'clock. Several were painted on a mountain 9,000 feet high in the dusk preceding storms," *SMT*, Oct. 16, 1944, p. 3.

1945 – "Breneisers Hosts to Faculty at Dinner Party," an annual custom except for last year," *SMT*, April 16, 1945, p. 3; after 23 ½ years of teaching at Santa Maria HS and Jr. College, "Painting, Research, Study for Breneisers in Santa Fe." Breneiser "came to Santa Maria in January 1922 from Erie, Pa., where he was director of art education in all the schools of that city. Since coming here, he has been head of the Language Arts Department and has taught Fine and Applied Art, Art History and Art Appreciation. He directed 25 3-act plays" and he and wife will spend year in Santa Fe. "The family will not be separated by the move, because the Breneiser's daughter, **Mrs. Louie Ewing** lives in Santa Fe with her husband and son Carl. **John Breneiser**, the eldest son, and his family, are also going to Santa Fe at the same time. A daughter, Cassie, 11, will also accompany her parents … Two other sons are in service. One, S/Sgt. **David D. Breneiser**, has just returned from 30 months of overseas service in the Persian Gulf Command. He has reported back to Camp Beale after spending a 30-day furlough here. **Sgt. Stanley Eliot Breneiser** is stationed in the 40th General Hospital in France. During their absence, Mr. and Mrs. Charles Beldon Taylor will occupy their home, 'The Ark,' on lower Orcutt Road," *SMT*, May 31, 1945, p. 3; "Scotts Buy Breneiser Home" which son has been temporarily occupying and will turn it into a restaurant, *SMT*, Sept. 5, 1945, p. 4.

1946 – ad: "Bopst Galleries … Current Showing. Recent Paintings by Stanley Breneiser," *Santa Fe New Mexican*, Feb. 7, 1946, p. 2; "New Exhibit at Art Museum… Stanley G. Breneiser… holding one-man shows… Mr. Breneiser has come to Santa Fe recently from California and he and his wife are starting the Hill and Canyon School of the Arts, at 1005 Canyon road….," *Santa Fe New Mexican*, March 18, 1946, p. 3. **1946?** – "Stanley G. Breneiser, director of the Hill and Canyon School of Arts, has a painting hanging in the fifth annual art exhibition of the

State Teacher's College, Indiana, Pa." (undated clipping from historic files of *Santa Fe New Mexican* on Internet).

1947 – "Art Exhibit Opens Today at Studio… student exhibit of the summer session work [of the Hill & Canyon School of the Arts] at the studio of Miss Elizabeth Waters at 233 Canyon road…," *Santa Fe New Mexican*, Aug. 8, 1947, p. 6; "Exhibition of Tempera Paintings at Library. A dozen artists… at the High School Library Gallery … Stanley G. Breneiser, founder and director of the Hill and Canyon School of Art, Santa Fe. Besides tempera, he paints in water color and oil. He also produces lithography and wood engraving," *Clovis News-Journal* (Clovis, New Mexico), Nov. 9, 1947, p. 9.

1948 – "Social Calendar … Tuesday … 8:00 'The Significance of the Arts, Today.' A lecture by Stanley G. Breneiser at the new St. Michael's college little theater. Admission free," *Santa Fe New Mexican*, Jan. 10, 1948, p. 3; "Art in the News… Museum of New Mexico … Work by Stanley G. Breneiser in the same alcove shows a fine command of composition and a thorough understanding of basic pictorial rhythms. His drawing is excellent and his color can be classed as being on the lyric side," *Espanola Valley News* (Espanola, NM), May 6, 1948, p. 2.

1949 – "New Shows next week at the art gallery, Museum of New Mexico will include paintings by … and **Elizabeth W. Breneiser**, Stanley D. Breneiser, and Hill and Canyon school… in the alcove section …," *Santa Fe New Mexican*, March 27, 1949, p. 20; repro: "San Jose Buildings," now on exh. at the Museum of New Mexico, *Santa Fe New Mexican*, April 3, 1949, p. 13; ad: "Montecito School… Fall Term… Teaching Staff will include: Stanley G. Breneiser and **Mrs. Stanley G. Breneiser**," *Santa Fe New Mexican*, Aug. 31, 1949, p. 2; "Breneiser Show Hangs … San Miguel gallery, 221 East De Vargas… one-man show of water colors by Stanley G. Breneiser, director of Hill and Canyon School of the Arts…," *Santa Fe New Mexican*, Dec. 11, 1949, p. 12.

1950 – "Well-Known Water Colorists Showing Work at City Library… Albuquerque Public Library…," *Albuquerque Journal*, Jan. 22, 1950, p. 9; "The Hill and Canyon School of the Arts has announced the faculty for its summer session, June 25 to Aug. 19, is: Stanley G. Breneiser, director and instructor… **Elizabeth D. Breneiser, Louis [Sic.] H. Ewing… Harold C. Stadtmiller**… and the following visiting instructors … **Marrie B. Ewing** and **John A. Breneiser**," *Santa Fe New Mexican*, May 28, 1950, p. 12; "Hill and Canyon Courses to Start… fifth summer session…," *Santa Fe New Mexican*, June 25, 1950, p. 16; "Showing Work of Two Artists… New Mexico Alliance for the Arts…," *Santa Fe New Mexican*, July 31, 1950, p. 6; "Artist Doings in New Mexico… Stanley Breneiser's painting, 'Cold Houses,' will be seen in an exhibition called 'In the Modern Medium' at the Grand Central Art galleries, N. Y….," *Santa Fe New Mexican*, Oct. 15, 1950, p. 8.

1951 – ■ " 'Citadel,' a resident and day school for sons and daughters of Christian Scientists, located at Alcalde, N. M. is now operated by Mr. and Mrs. Stanley G. Breneiser, former Santa Marians. … under their tutelage, several

artists, who have since become nationally known received primary instruction… **Milford Zornes**… **Nick Firfires**… The Breneisers left Santa Maria after selling their home on Orcutt road, where drilling companies discovered oil some years ago. The school in New Mexico is located near Santa Fe, and is housed in rambling white-walled pueblo style buildings typical of the area. The courses, from fifth grade thru high school, offer all required subjects, and in the upper grades, a college preparatory curriculum. Art, crafts, drama and music are offered, as well as a choice of electives. The school has attractively furnished dormitory rooms and a large comfortable lounge room, known as the Kit Carson room. All of the furnishings are in keeping with the pueblo theme of the building. Breneiser is president of the school …A block print, designed by Breneiser … appears on the cover of the school's hand book," per "Breneisers Open 'Citadel' School in New Mexico," *SMT,* July 20, 1951, p. 4.

1953 – "Breneisers Exhibit Art Work at Botts With Reception Today… from the Hill and Canyon School of Arts in Santa Fe… at the invitation of the New Mexico Art League… showing of their work at Botts Memorial hall of the Public Library… The artists are Stanley G. Breneiser, well-known in the representational school and widely shown, and **Elizabeth Day Breneiser** who works in jewelry," and port., *Albuquerque Journal*, Jan. 25, 1953, p. 18 [Sic? on the internet?].

■ "Word was received here today of the death in Santa Fe, N. M., on August 25, of Stanley Breneiser, former head of Santa Maria High school art department. He was a member of the local school faculty for 25 years. A native of Redding, Pa., his life work as a teacher, and his hobbies also were in the field of painting and other cultural arts… Mr. and Mrs. Breneiser left Santa Maria some 12 years ago to locate at Santa Fe, N.M. and established a private school there, in which both were instructors. Their home in Santa Maria, 'The Ark' on Lower Orcutt road, was the center of many social gatherings for students of the local high school, and for adults interested in theater arts, music, and painting. During the depression they opened their home to children without homes, and helped many young people gain a foothold in higher education. **Milford Zornes** and **Nicholas Firfires** are two of the several students who advanced to the top of their profession in illustrating …in classes taught by Stanley Breneiser…. He was a member of the Christian Science church and was a reader in the local church, which he helped to build," per "Former Head of High School Art Department Dies" in Santa Fe, *SMT,* Aug. 28, 1953, p. 4.

And, more than 630 "hits" for "Stanley Breneiser," were not all itemized here.
Breneiser, S. (Books and articles he authored)
Author of "The Place of Art in Vocational Schools," *Proceedings of the Education Congress*, by Pennsylvania Dept. of Public Instruction, 1920, p. 609+ (Google book on Internet).
Author of "Design Helps for Supervisors," *School Arts Magazine*, v. 21, 1922 (digitized on Internet).

Author of "Art in High School Periodicals" (p. 34+) and "Art Possibilities in Stage Craft" (p. 103+), in *School Arts*, v. 25 (Google book on Internet).
Author of "Continuation Schools," in *The School Arts Magazine,* Vol. 24, Sept. 1924-June 1925 (table of contents on Internet).

Breneiser, S. (misc.)
His and his son's prints were printed by Lynton Kistler according to *The Fine Arts and Lithography in Los Angeles*, oral interview of Lynton Kistler at UCLA Special collections.
Exh.: Los Angeles Art Association, *First Annual All-California Art Exhibition*, Biltmore Salon, May 15 – June 15, 1934.
Biographical note appears in 38th annual *Exhibition for New Mexico Artists*, Museum of New Mexico, Art Gallery, Santa Fe, August 19 to September 16, 1951 (on the Internet),

Breneiser, S. (misc. bibliography)
Port. In Santa Maria high school yearbook, 1930; Stanley G. Breneiser was b. Jan. 10, 1890 in Reading, Pa., to Thomas Breneiser and Mary F. Grotevent, was residing in Reading, Pa., in 1910, married Elizabeth C. Day, and d. 1956 [Sic. 53] in Santa Fe, N.M., per Breneiser Family Tree (refs. ancestry.com).
See: "Alpha club," 1932, 1933, 1935, "Ark," "Art Festival," 1935, "Blue Mask Club," "Boy Scouts," 1933, "Bragg, Joffre," 1935, "Breneiser, Elizabeth," "Breneiser, John Day," "Breneiser, S. Eliot," "Breneiser, Marrie," "Business and Professional Women," 1934, 1938, "Citadel," "Cleaver, Walter," "College Art Club," intro, 1927-35, "Community Club (Santa Maria)," 1930, 1932, 1934, 1935, 1941, 1942, "Eidolon," "Faulkner Memorial Art Gallery," 1932, 1933, 1934, "Fortune, Margaret," "Guadalupe Welfare Club," 1925, "Marshall, Mary," intro., "Minerva Club," 1922, 1923, 1924, 1937, "National Art Week" 1935, 1940, "Posters, American Legion (Poppy) (Santa Maria)," 1933, 1940, "Posters, general (Santa Maria)," 1939, "Posters, Latham Foundation (Santa Maria)," 1934, 1943, "Santa Barbara County Fair," 1930, "Santa Maria, Ca., Adult/Night School," 1922, 1925, "Santa Maria, Ca., Elementary Schools," 1925, "Santa Maria, Ca., Union High School," 1922-45, "Santa Maria Camera Club," 1940, 1941, 1944, "Santa Maria School of Art," "Scholastic Art Exhibit," 1930, 1931, 1932, 1937, "Signorelli, Guido," 1964, "Splash," 1923, 1927, 1928, 1938, "Sutter (Ryan), Margaret," "Tashiro, Yukio," 1937, 1941, 1950, "Veglia, Mario," 1954, 1956, "Waugh, Mabel," intro., "Wilson, JoAnn Smith"

Brenneis, Mary Elizabeth
See: Bucher (Brenneis), Mary Elizabeth / Elisabeth (Mrs. Andrew Brenneis)

Brezee, F. (Frank) S. (c. 1887-1962) (Lompoc)
Sign maker, 1916.
Brezee, F. S. (notices in Northern Santa Barbara County newspapers on microfilm and on newspapers.com)
1916 – "F. S. Brezee, the sign painter, prepared a fine electric sign this week for the Moore Mercantile

Company's new store. Mr. Brezee informs us that he is prepared to furnish all kinds of electric signs," *LR*, March 10, 1916, p. 3, col. 3; "The Chamber of Commerce have their new bulletin board in place at the post office. Mr. Brezee finished the board Wednesday…," *LR*, May 19, 1916, p. 5.
And a handful of additional notices in *LR* regarding his painting of autos through 1918 were not itemized here.

Brezee, F. S. (misc. bibliography)
Frank S. Brezee is listed in the 1910 U. S. Census in San Francisco; listed in the 1920 U. S. Census as age 34, b. c. 1886 in Virginia, working as a painter, residing in Santa Margarita with wife May and four children; listed in 1930 U. S. Census as active in Stockton; listed in city directories as active in Modesto, San Francisco; Frank S. Brezee, b. c. 1888, d. March 20, 1962 in Alameda County per Calif. Death Index (refs. ancestry.com).

Brians (Davis), Emma (Mrs. Brians) (Mrs. John Dorian Davis) (1893-1991) (Santa Maria / Santa Barbara)
Photographer, journalist for SM Times, 1947+.

■ "Society Editor Recalls Career Highlights… retired after more than 25 years of newspaper experiences… Began working for *The Times* in May 1947… She had previously worked 15 years as Santa Maria correspondent for the *Santa Barbara News Press* and from 1943 to 1947 also was news editor of *The Courier*… As a correspondent she saw much of Santa Maria's earlier development… The 'soc' editor attempted photography and carried her own press camera for several years. Her first published picture was of an oil well on fire. Her 14-year-old son, Richard Brians, took pictures which were published of the collapse of Garey bridge during a winter flood. The work, she says, besides keeping the wolf from the door, has been an exciting adventure… [in retirement] she has accepted an invitation from her husband to travel to her former home in England and see some of the European countries…," *SMT*, Oct. 8, 1959, p. 1.

Brians, Emma (notices in Northern Santa Barbara County newspapers on microfilm and on newspapers.com)
Almost 3000 "hits" for "Emma Brians" in the *SMT* between 1945 and 1980 were not itemized here.

Brians, Emma (misc. bibliography)
Emma Brians is listed in the 1940 U. S. Census as age 46, b. c. 1894 in England, finished high school second year, naturalized, a reporter, divorced, residing in Santa Maria with her son James and a lodger; Emma Brians, b. c. 1894, married John D. Davis in Monterey on June 29, 1957 per Calif. Marriage Index; Emma Brians Davis b. March 5, 1893 in Norfolk, England, d. June 17, 1991 in Santa Barbara County and is buried in Santa Maria Cemetery per findagrave.com (refs. ancestry.com).

Briggs (Brazier?), Dorothy J. (1894?-1968?) (Santa Ynez Valley)
Maker of materials for displays and decorations, 1949.
Associated with Needlecraft Club, Los Olivos, 1929.

■ "Mrs. Briggs Begins New Industry Here… Mrs. Dorothy J. Briggs, one-time teacher at the Los Olivos School… opening of a studio at Feather Hollow Ranch

where she will manufacture materials for displays and decorations. Two years ago, Mrs. Briggs developed a chemical formula to process dried materials, especially flowers, for store and window displays. About a year ago, after the process was thoroughly tested, her products were accepted by some of the leading stores in San Francisco for use in window displays. Coming to the Valley and to Feather Hollow from San Carlos where she developed the formula, Mrs. Briggs has opened her manufacturing 'plant'… She said she also hoped to do local Christmas display work and expects to start soon on the processing of leaves and branches. Mrs. Briggs taught school in Los Olivos from 1928 to 1934 and then moved to San Carlos where she resided for six years. …," *SYVN*, April 15, 1949, p. 8.

Briggs, Dorothy (misc. bibliography)
Dorothy J. Briggs is listed in the 1930 U. S. Census as age 35, b. c. 1895 in Canada, naturalized, a teacher, divorced, residing in Ballard, Ca., with daughter Dorothy Briggs (age 9); is she Dorothy J. Briggs, b. c. 1894, who married James W. Brazier on Dec. 27, 1954 in Alameda County per Calif. Marriage Index; is she Dorothy J. Brazier, mother's maiden name Rowell, b. March 17, 1894 in California (?) and d. Sept. 4, 1968 in Alameda County, Ca. per Calif. Death Index (refs. ancestry.com).

Briggs, Egbert Thomas (aka? Thomas E. Briggs) (Sept. 1851-1910) (Lompoc / Santa Rosa)
Photographer, active from at least 1883. In 1892 exhibited Best exhibit of photos at "Santa Barbara County Fair".

■ "Valvular Diseases of the Heart. Coroner Palmer went to Cambria this morning to hold an inquest on the remains of E. T. Briggs, a traveling photographer, who was found dead kneeling at his bed. Briggs recently opened a studio in Cambria and roomed in the rear of the studio. For several days past the man had been drinking heavily and is said to have gone home in an intoxicated condition Tuesday night. He was discovered at noon yesterday by friends. The coroner's jury said he died of 'Valvular disease of the heart," *SLO DT,* Dec. 28, 1910, p. 4.

Briggs, E. T. (notices in Northern Santa Barbara County newspapers on microfilm and on newspapers.com)
1883 – The Briggs Bros., who are said to be excellent artists, will shortly visit Santa Maria with their photograph gallery. At present they are stationed at Lompoc," *SMT*, Nov. 24, 1883, p. 4; "The Brigg [Sic.] Bros are excellent artists as may be seen by their work and crowded gallery every day," *SMT*, Dec. 15, 1883, p. 5.
1885 – "E. T. Briggs of San Luis Obispo made arrangements to open a permanent photograph gallery in Santa Maria. He was prepared to do good work," per "Fifty Years Ago," *SMT*, Jan. 9, 1935, p. 4.
1887 – "Mr. Briggs, the photographer, is back with his family with the intention of locating," *LR*, July 9, 1887, p. 3.
1888 – "Mr. Briggs, our local artist, is taking some very fine pictures with his new apparatus. A group of twelve young men recently taken is a fine sample of superior work," *LR*, May 5, 1888, p. 3.
1889 – "Have our people considered that on May 1st our photographer, Mr. E. T. Briggs will close up and leave the town. All who require his valuable services should not fail to call…," *LR*, April 20, 1889, p. 3; "Mr. E. T. Briggs, who for so long was our local photographer, will soon be among us as a permanent resident … open his gallery at the old place on H street," *LR*, Aug. 24, 1889, p. 3; "We are glad to announce that Mr. E. T. Briggs, our pioneer photographer, is with us again, this time to stay. He is at the old stand as ready and accommodating as ever," *LR*, Sept. 21, 1889, p. 3.
1890 – "E. T. Briggs the Photographer is now ready for business. Pictures and views of every style known to the art taken and satisfaction guaranteed," *LR*, Jan. 4, 1890, p. 1.
1892 – "Photographer Briggs has some very fine views of the interior arrangement of the Pavilion which can be had at a fair price," *LR*, Oct. 1, 1892, p. 3.
1893 – "E. T. Briggs, the photographer, has just received a new style of paper for making cabinet photos with. This paper is exceptionally fine, giving a smooth and glossy finish to the pictures that are even superior to any enameled photos made anywhere, and the paper never fades…," *LR*, Jan. 7, 1893, p. 3; "In another column will be found the advertisement of photographer Briggs, announcing the closing of his gallery on July 15th," and "The Briggs Photograph Gallery will be closed on July 15th… For about six months. Those desiring any work in my line of business must call and have the same finished before July 15th. E. T. Briggs: Photographer," *LR*, June 10, 1893, p. 3; "Photographer Briggs left town Thursday morning for Santa Ynez and from there will commence making a tour of the county making photographs. He will be assisted by **Henry McGee**. When they return the new gallery in the Sherman Building will be finished and Briggs will move in and to celebrate the event will make a specialty of cabinet photos and crayon work…," *LR*, July 22, 1893, p. 3; "E. T. Briggs, the photographer, is expected home some time next week, with materials for his gallery in the Sherman Block," *LR*, Dec. 2, 1893, p. 3; "Photographer Briggs has received his new supplies for his gallery in the Sherman Block and is now ready for business," *LR*, Dec. 9, 1893, p. 3; "On account of a delay in some of the materials arriving Photographer Briggs was unable to open his gallery as advertised last week. Since then, the goods have been received… The new gallery is a model one and is built with proper skylights, etc., so that the Artist will have a perfect light, which is so essential in photography. Mr. Briggs invites the public to give him a call," *LR*, Dec. 16, 1893, p. 3.
1910 – "From Tuesday's Daily. Leaves Lompoc. E. T. Briggs… left today for several week's stay at Los Alamos. **A. M. Rudolph** will be associated with him and they propose to visit various towns during the coming summer, where short stands will be made," *LR*, April 29, 1910, p. 8.
Briggs, E. T. (misc. bibliography)
Egbert Thomas Briggs, age 34, b. Kentucky, photographer, registered to vote June 6, 1882, residing in Wilmington [a suburb of Los Angeles], is listed in *Country Electors*, p. 47; Egbert T. Briggs, age 33, b. Kentucky, a photographer, who registered to vote on April 4, 1884 is listed in an untitled California Register of Voters, p. 5; Egbert Tom Briggs, age 35, b. Kentucky, a photographer, residing in Bakersfield (transferred from SLO County), registered to vote Sept. 18, 1886, per *Great Register Kern County*, 1886; Egbert

Thomas Briggs, age 39, b. Kentucky, a photographer residing in Lompoc, registered to vote Aug. 4, 1890 per *The Great Register, Santa Barbara County, California, 1890*; listed in Lompoc in *Great Register, Santa Barbara County, Ca., 1892*; Egbert Thomas Briggs, photographer, age 44, described as 5' 6", light complexion, blue eyes, brown hair, no distinguishing marks, b. Kentucky, residing in Lompoc, registered to vote June 19, 1896 per voter register *Santa Barbara County – Lompoc Precinct, No. 1*; Egbert T. Briggs is listed in the 1900 U. S. Census as age 48, b. Sept. 1851 in Kentucky, a photographer, residing in Santa Rosa with wife Margaret M. Briggs (age 36) and children Harry J. Briggs (age 14) and Ivan C. Briggs (age 13); Egbert Thomas Briggs, age 50, is listed in *Index to Registrations, Santa Rosa Precinct No. 4* (unspecified date) AND as age 55 in *Santa Rosa Precinct No. 4*, AND as age 56, a photographer, in voter register *Santa Rosa Precinct No. 11* (at various times between 1900 and 1912); Egbert T. Briggs, photographer, is listed in the *Santa Rosa, Ca., City Directory*, 1903, 1905, 1908, 1909; Egbert T. Briggs is listed in the 1910 U. S. Census as age 50 [Sic.], b. c. 1860 in Kentucky, a photographer, residing in Santa Rosa, Ca., with wife Margaret Briggs (age 45) and children Harry J. Briggs (age 24) and Ivan C. Briggs (age 23), AND Egbert T. Briggs is listed in the 1910 U. S. Census as age 58, b. c. 1852 in Kentucky, a photographer, residing in township 6, Santa Barbara County, with wife Marietta Briggs (age 46) and children Clay Briggs (age 24, also a photographer) and Henry J. Briggs (age 22); Egbert Thomas Briggs, age 58, photographer, Rep., H St. bet. Ocean and Walnut Aves., is listed in voter register *Lompoc Precinct No. 3* [ed. c. 1910?]; Elbert [Sic.] Thomas Briggs b. 1851 and d. 1910 is buried in Cambria Cemetery per findagrave.com (refs. ancestry.com).

See: "McGee, J. H.," 1893, 1945, "Olson, Idell," 1945, "Santa Barbara County Fair," 1892, "Tucker, Charles," 1889, and *San Luis Obispo Art and Photography before 1960*

Brigham, B. L. (LeGrand Bliss?) (1838-1915?) (Santa Maria)
Painter of houses, signs, 1899-1900.

■

Brigham, (notices in Northern Santa Barbara County newspapers on microfilm and on newspapers.com)
1899 – "B. L. Brigham has been in Guadalupe for the past few weeks coloring and papering, and his signs show up on all sides. His reputation as a painter has followed him from here and he is just crowded with work, but Santa Maria will get him again as soon as a job or two he is now on is completed. The F & A. M. hall has been retouched by his artistic brush. The front, where Ben Slack dispenses liquid refreshment, is also showing his skill, but the job of all others is that on the Bank Exchange, Bontadelli's place. It has been papered and painted all the way through and the walls tinted. The signs in the two front windows are as neat as any ever made, and the blending colors in the stained glass throws them well to the front. All around Guadalupe has cause to be proud that Brig, the painter, has painted her," *SMT*, Nov. 4, 1899, p. 3, col. 4.

1900 – "Brigham, the painter, is doing some of his artistic sign work and decorating for our new confectioner, C. M. Tabler. By the way, did you notice Jessee's new sign? That is from Brig's brush," *SMT*, March 3, 1900, p. 3, col. 4.
Brigham, B. L. (misc. bibliography)
Is this Legrand B. Brigham listed in the *National Guard Register* (v. 50-51, 1st Artillery, 4th Brigade, Enlisted Men) a painter, age 33, b. c. 1849, enlisted March 28, 1882; LeGrand B. Brigham, painter, age 74 who registered to vote in Santa Margarita, SLO County in 1906; LeGrand B. Brigham is listed in *Veterans General Registers*, 1910, as residing in San Diego, a painter, years in state 4 (?), age 71, b. New York, widower, cause of disability = Rheumatism/ Piles, rate of pension $15.00, nearest relative: Brother: Joseph L. Brigham, New York City, General Delivery, N.Y.; is he LeGrand Bliss Brigham b. Aug. 31, 1838 in New York City to Erastus Forbes Brigham and Sophia Home, married Mary Eda Daugherty, and d. Feb. 18, 1915 in San Francisco per Cottam Ancestors Family Tree (refs. ancestry.com).

Bright, Jack (Santa Maria)
Photographer, amateur. Active with Santa Maria Camera Club, 1941-43. Prop. gas station.
See: "Santa Maria Camera Club," 1941, 1942, 1943

Brinn, Donald "Don" Arthur (1901-1974) (Los Angeles)
Photographer. Head of the Los Angeles bureau of Wide World Photos, national feature and picture syndicate, who photographed in Lompoc, 1947.
See: *Central Coast Artist Visitors before 1960*

Broadus, Amber G. Dunkerley (Mrs. Verle C. Dunkerley) (Mrs. Steve Broadus) (1893-1973) (Santa Ynez Valley / Santa Barbara)
Painter, primarily of animals, 1947+. Artist of the comic strip, Snooper the Colt. Cartoonist.

■ "Horses, Art and Music Form Broadus' Pattern of Living… The newcomers are Steve and Amber Dunkerly [Sic. Dunkerley] Broadus who recently purchased 20 acres of land from Robert E. Herdman… Raise Arabian Horses. Contained in the sale was a small home… The 20 acres is composed principally of alfalfa under irrigation… Mr. Broadus will occupy his time with the raising of purebred Arabian horses and will also continue his research with plastic reed musical instruments and accessories. Mrs. Broadus, an artist, who has had several pieces of her work on exhibition in Santa Barbara on many occasions, paints in oil and most of her work is devoted to the painting of animals. Writes Colt Cartoon. For the past seven years her comic strip, 'Snooper the Colt,' has been appearing regularly in the *Western Livestock Journal*. She has also done commercial cartooning for ranch organizations, and much of her work appears regularly in livestock magazines and papers throughout the country. … The Broadus, who were married last April in Santa Barbara, were given a Hammond organ as a wedding gift…," *SYVN*, June 20, 1947, pp. 8, 3 (or 10?).

Broadus, Amber (misc. bibliography)
Amber G. Dunkerley is listed in the 1940 U. S. Census as age 47, b. c. 1893 in Pennsylvania, finished elementary school, 7th grade, a self-employed artist, residing in Inglewood, Ca. (1935, 1940) with husband Verle C. Dunkerley (age 47); Mrs. Amber Dunkerley without occupation or husband is listed in the *Santa Barbara, Ca., CD*, 1944; Amber D. Broadus b. Oct. 13, 1893 in Pa., d. Dec. 20, 1973 in Riverside County per Calif. Death Index (refs. ancestry.com).

Bromfield (Bradley), Dora Davenport (Mrs. Joseph Clark Bradley) (1917-2014) (Santa Barbara)
Daughter of D. Gordon Bromfield who exh. in National Art Week show at Minerva Club, 1940. Member Junior League, Spinsters. Married Joseph Clark Bradley in 1945 and settled in San Francisco.
Bromfield, Dora (notices in California newspapers)
1939 – Port. with her dachshund, *LA Times*, July 23, 1939, p. 58 (i.e., pt. IV, p. 4).
1941 – "Channel City [Junior] League has New Officers... Miss Dora Bromfield, arts-and-interests chairman...," *LA Times*, April 6, 1941, p. 67 (i.e., pt. IV, p. 5).
1942 – "Santa Rita Clinic Guild... Duty Calls. Another who has abandoned private life for public service is Dora Bromfield. Her paints and easel have been relegated to a far corner of the house while she performs Red Cross duties away from home," *LA Times*, March 11, 1942, p. 31 (i.e., pt. II, p. 5).
1945 – "Dora Bromfield Goes to Altar... A graduate of the Ethel Walker School at Simsbury, Conn., and a former Finch College student, the new Mrs. Bradley has been working here with OWI [Office of War Information]," *SF Examiner*, Sept. 16, 1945, p. 27.
1953 – "Hosts, Hostesses ... Santa Barbara ... Concert Planned. ... Everyone turned out for the informal showing and reception given recently by Barbara and **Douglass Parshall**... Particularly delightful ... the stunning portrait of Mrs. Joseph Bradley (Dora Bromfield)," *LA Times*, Sept. 20, 1953, p. 92 (i.e., pt. III, p. 8).
More than 100 hits occur for "Dora Bromfield" in California newspapers, 1930-1960, on newspapers.com but most don't refer to her art and so were not itemized here.
Bromfield, Dora (misc. bibliography)
Dora B. Bromfield b. Dec. 11, 1917 in San Francisco to Davenport Gordon Bromfield and Dorothy Innis, was residing in Santa Barbara in 1940, and d. Oct. 7, 2014 per Dickinson/Litwack Family Tree (ref. ancestry.com).
See: "National Art Week," 1940

Bromley, Bob
See: "Puppets (Santa Ynez Valley)," 1960

Brommer, Gerald F. (b. 1927) (California)
Illustrator of an article on Solvang in Westways, 1958.
■ "Gerald Brommer is a watercolor and acrylic painter, collagist, teacher, author and juror. He has written 23 books for high school and college art classes, on a wide range of subjects. He has also edited many high school and college texts and teacher resource books. His books are published by Davis Publications Inc. of Worcester, Massachusetts, and by Watson-Guptill Publishers of New York City. He has exhibited in many national competitive watercolor shows and has had over 160 one-man shows from Alaska to Florida and from Bermuda to Hong Kong and Taiwan. Each year, he juries several national watercolor shows and regional exhibits," from askart.com

Brooks, Barbara (Mrs. Capt. Lawrence E. Brooks, Jr.) (Lompoc)
Craftswoman whose materials were sea shells, driftwood and other materials. An Army wife, 1953-55.
■ Port. with some of the items she fabricated – **Tom Yager** photo – and "A Designer of Seacraft Souvenirs. 'There is so much basic beauty at the ocean,' said vivacious, attractive Barbara Brooks as she emptied a container of tiny seashells upon her work table for me to admire. 'At first the seashore seems such a monotone, that is until you learn to see things...' I had dropped by to spend the evening with Barbara and learn more about her 'seacraft' work. ... wife of Capt. Lawrence Brooks, Jr., of the USDB Dental Detachment ... 'Seacraft' with Barbara is far more than just a hobby, it is an artistic dream which she hopes to develop into a practical and paying profession... most of her previous life has been spent inland. At the shore she has found a whole new world... Barbara was born in Minneapolis, Minn. She moved to Des Moines, Iowa, as a small child and received her early education in that city at the elementary school, the high school and Drake University. She also attended Cottey Junior College in Nevada, Missouri. On May 3, 1948, she married Lawrence Brooks who had just graduated from the University of Iowa Dental College. That August the couple left Des Moines for Guam where Lawrence was first a company dentist and then opened up his own practice. From 1948 to '49 Barbara was the Advertising Manager for 'The Navy News,' which has since become the 'Guam Daily News,' then she opened up her own advertising agency, the first full-time such agency ever to operate on the island. The Brooks Advertising Agency, which Barbara ran from '49 to '53, employed a full and part time staff of one to six members during the last two years under Barbara's management. All manner of accounts were handled: retail stores, grocery stores, specialty shops, theatres, restaurants, airlines, services political and civic organizations, churches and public ... by professional people. Barbara drew on her previous experience as a copy writer with Blakemore Co., the Ad Agency in Des Moines, and four years in the advertising departments of the Meredith Publishing Co. of Des Moines, publishers of 'Better Homes and Gardens' and 'Successful Farming Magazine.' Despite the fact that a second full-time advertising agency opened up on Guam and offered her stiff competition, her own business grew in size and success, and she was able to sell it profitably when she and her husband left the island in '53 to return to the United States when Lawrence entered the Service. Capt. Brooks received his Army indoctrination at Ft. Sam Houston and then was transferred to the USDB here. Barbara said that her shell hunting talents, long latent as an Iowan, began in

Guam in the rare hours she had free to spend at the beach away from the agency, and there too was born her idea of turning the shells into saleable items. She used to wake up in the middle of the night and make sketches of jewelry designs… When she and Lawrence came to Lompoc, week-end fishing at Surf and along the Camp Cooke coast was inaugurated into their routine, and that led to the beginning of her now enormous collection of shells of all the local varieties… limpets, chiton, mussels, abalone, etc. … sea urchins, sand dollars, star fish, and drift wood. Not a casual collector content to gather shells which happened to be lying loose upon the beach, Barbara 'works' at her gathering, pulling the small limpets and mussels from the rocks and digging them out of crevices and crannies. She has purchased several dozen small wooden Army lockers, painted them and fitted them with slide-out trays to store her collection. Even these cannot hold all of her sea 'booty.' Kitchen shelves are stacked with jars and cans of shells and her workroom has boxes of them waiting to be properly sorted and matched. In the garage a ceiling-to-floor rack holding her driftwood collection covers one whole wall. Strings of dry material for floral arrangements hang from the ceiling. Telling of the rapid growth of her collection and her goal of turning it into a profitable enterprise. Barbara says: 'When I first started going to the beach, I saw no shells except perhaps the occasional abalone washed ashore. Gradually I got my 'sea eyes'… acres of wonders opened… and the probing adventure began … [to] accomplish, that is, souvenirs that are good art, well executed, useful, authentic and inexpensive. 'Take just one point, authenticity. California has a natural gem not found except on the Pacific Coast in the lustrous abalone shell. Its many pastels form an almost endless variety of patterns and are always beautiful in costume pieces with pinks, sea blues and lavenders for the ladies… and now for men with this year's stressed use of colors in men's shirts. The whole shell with its holes filled with porcelain sets a beautiful and interesting table for serving chowder. The abalone is a colorful catch-all for dresser or end table. It can be decorated in endless ways. (Some of the most attractive I saw at Barbara's she had ornamented with small jewels, sequins and glitter dust.) 'Except for the abalone, California shells are mostly brown, grey, blue and white. Florida shells are considerably more colorful but unless we are going to compromise authenticity Florida shells are not a souvenir of California. Advice on producing shell jewelry has been varied and in quantity. 'Produce a gross a day and you'll be in business,' says one. That's one item every five minutes, 12 hours a day. 'Produce to retail at one dollar,' says another, and you sit down to analyze your wholesale price against what goes into each piece … gathering time, cleaning, polishing, matching, designing, assembling, packaging, selling, keeping detailed business records, tax reporting … not to mention time and money needed to locate and buy all the necessary supplies. And I'm lucky. I have a set of dental tools from my husband to use for the necessary grinding, polishing and boring. 'You keep working, experimenting, showing, asking, learning and one day, maybe on a wholly unexpected twist, if you are lucky, you'll hit a winning combination. In the meantime, most of our house is devoted to the enterprise … though I hope attractive and orderly enough for a home.' …

Barbara's home at 224-D South H is attractive, imaginatively furnished in modern décor with 'conversation pieces' like the king-sized coffee table, occasional chair, driftwood lamps and knick knacks, clever wall ornaments fashioned from the simple medium of wire coat hangers, plastic clay cigarette boxes and ash trays, decorated tissue boxes, match books, book markers, towels… all made by Barbara. 'I am searching,' says Barbara, 'for the practical craft medium for me and California…',*" LR*, April 14, 1955, p. 3.

Brooks, Barbara (notices in Northern Santa Barbara County newspapers on microfilm and on newspapers.com)
Author of "Memories of Lompoc Valley," *LR*, June 30, 1955, p. 27 (i.e., B-1 3).

Brooks, Barbara (misc. bibliography)
HUSBAND – Lawrence E. Brooks, Jr. is listed as student at the same address as his parents Lawrence E. and Hazel Brooks, per *Des Moines, Iowa, CD*, 1943; and he is pictured in the State University of Iowa yearbook, 1948; Barbara Brooks is listed with husband Larry Brooks, engineer with Okonite, in the *Santa Maria, Ca., CD*, 1968, 1969 (refs. ancestry.com).

Brooks, Ernest Hiram (1909-1990) (Lompoc / Santa Barbara)
Photographer. Prop. of Camera Shop, Lompoc, c. 1934-1941? Prop. Brooks Institute, Santa Barbara, 1946+
■ "Ernest Brooks, Founder of Photo Institute. Ernest H. Brooks, who began by photographing flowers for seed companies, saw a need for training in color photography and started what evolved into an internationally recognized institute, has died at age 80… in Laguna Niguel…. Brooks was raised in Lompoc, where he earned his first pennies by taking pictures of his friends. After studying at Los Angeles Trade Tech and USC, he went to work for Fox West Coast Theatres in their art layout department, then worked in a sign business. He opened his own studio and camera store in Lompoc in the late 1930s and it was there he was commissioned by the Burpee Seed Co. to put out its first color catalogue. He taught classes through the Depression-era federal **Civilian Conservation Corps** and went into the Air Force during World War II. Back in Lompoc after his discharge… In 1945 he sold his business, moved to Santa Barbara, and started his institute where his first 30 students were housed on the second floor of a downtown building. … Today [the school employs] about 30 faculty members, all professional photographers with a specialty in one area… In addition to standard commercial photography, classes and training are offered in undersea technology, nature photography, photojournalism and audiovisual studies. Brooks retired in 1971…," *LA Times*, June 28, 1990 (on the Internet).

Brooks, Ernest (notices in Northern Santa Barbara County newspapers on microfilm and on newspapers.com)
1928 – "*La Purisima* Out [High School yearbook] … The book is profusely illustrated both in half tone and line drawing. The art work has been in charge of Ernest Brooks …," *LR*, June 1, 1928, p. 7.
1929 – The Casual Observer … Christmassy spirit becoming very much in evidence, Ernest Brooks decorating the windows in Lind's," *LR*, Dec. 13, 1929, p. 1.

1931 – "New Ready-to-Wear… Betty's … one door south of Walter Ziesche's Jewelry Store… Ernest Brooks who has taken a lease on the building formerly occupied by the Candy Kitchen," *LR*, June 19, 1931, p. 4; "Local Newlyweds to Open Ladies' Dress Shop Here… United in marriage at San Luis Obispo on Tuesday, Ernest Brooks and the former Miss Betty Novo… The bride-groom is a graduate of Lompoc High School and was a student in commercial art and lettering under Harold H. Day in Los Angeles…," *LR*, June 26, 1931, p. 2.

1934 – "Mary Lou Shoemaker Wins Theater **Baby Star Contest**… "Photographs of the babies entered in the contest, ranging from tiny infants to youngsters of five years of age, were taken by Ernest Brooks, young photographer, <u>who has recently opened a studio</u>. The baby contest is staged annually by the Lompoc Theater management, who announced that the 1935 contest will feature motion pictures of the youngsters. This year and in past contests, enlarged photographs of the babies are thrown upon the screen… Local merchants donated the prizes…," *LR*, Sept. 28, 1934, p. 3.

1936 – "Old-Time Portraits Recall Early Scenes … a large collection of old-time scenes and portraits is on display in the window of Ernest Brooks, photographer. … pioneer pictures will remain over the weekend for benefit of 'home-comers.' Grouped around the plaque which will be placed on the monument in special dedication ceremonies Sunday afternoon, the pictures… were brought in by members of pioneer families … Charter members of Foresters… several views of early school houses… the 'saloon busters'… etc.… threshing machine… portraits…," *LR*, Sept. 4, 1936, p. 7.

1938 – "Tots Finish Motion Picture 'Sleeping Beauty.' Despite floods, rains and illnesses that upset production schedules on the motion picture 'Sleeping Beauty,' adapted from the famous fairy tale and enacted by Miss Aaney [Sic.?] Olson's third grade class, the picture has been completed and sent in for finishing. The colorful picture, all taken on Kodachrome film by Ernest Brooks, local photographer, will soon be ready for presentation at the school. … Ryan [Sic. Ryon] park is the setting… and characters are pupils of Miss Olson's class… adapted into a musical playlet by Miss Olson…," and article names children in the film, *LR*, May 13, 1938, p. 5; "Theater, Brooks Seek **Baby Star**. Lompoc's most popular baby is being selected in a contest staged by the Lompoc Theater and Ernest Brooks' Camera shop…," *LR*, Dec. 23, 1938, p. 12.

1939 – "**3 –F Club** Meets at Brooks'… ," *LR*, May 26, 1939, p. 2; "Ernest Brooks <u>Photographer for Seed Catalog</u>… Burpee seed catalog of 1940 which will all be done in Kodachrome…," *LR*, July 7, 1939, p. 7; "Palaver. The *Country Gentleman* magazine given Lompoc's Floradale farm an unusually good picture and story in its January issue … Entitled the 'Wizard of Floradale,' the article is devoted to the accomplishments of William T. Hoag manager of the W. Atlee Burpee Seed company here. … Illustrating the article is the finest picture of local flower fields we have seen. Taken by Ernest Brooks, local photographer, who has done a great amount of work for the Burpee company, the photograph was taken with a small camera and color film, yielding a finished magazine color

plate of exceptional detail and exactness of color," *LR*, Dec. 22, 1939, p. 1; "Local Photographer Leaves on 3-Month <u>South American Trip</u>… Brooks is first going to New York for a short but intensive study of color photography. While in the east he will also visit the Philadelphia headquarters of the W. Atlee Burpee Seed company for which he did a large amount of work this year. Leaving New York on January 8, the local photographer will visit Rio, Santos, and Montevideo, and he plans to fly from Buenos Aires to the west coast. From Valparaiso he will come on the long journey homeward, visiting Antofagasta, Mollendo, Callo, Cristobal, Balboa, Mansanillo and then arrive in Los Angeles on March 18. During Brooks' absence, Mrs. Nelson Collar will care for his photography business, and his store will be operated by his sister, Mrs. Laura O'Dale. Brooks, who is a graduate of the local schools, has operated the **Camera Shop** here for several years. He has recently been devoting much of his time to color photography and has obtained excellent results," *LR*, Dec. 29, 1939, p. 1.

1940 – "Ernest Brooks of Lompoc… left this week for New York where he will embark for a three-months trip to <u>South America</u> …," *SYVN*, Jan. 5, 1940, p. 1, col. 2; "Article on E. Brooks Appears… in this month's issue of '*The Focus*,' monthly magazine of professional photographers published by Hirsch and Kaye of San Francisco. … Photographs of his work are also appearing in the *Country Gentleman*, *Saturday Evening Post* and other magazines. Brooks at present is in South America on a special assignment," *LR*, Feb. 2, 1940, p. 2; "Ernest Brooks Returns from So. American Trip. Three months of boat, plane and railroad travel came to an end Monday morning… picture-taking tour… Lone passenger on a Scandinavian freight boat out from New York, Brooks tells of the shock he had when word was received that sister ship of the one he was on had been sunk, and his vessel was ordered to proceed without wireless communication and with lights out. Battling a gulf storm added to the 'pleasure' of journeying 'in the dark.' Arriving in South America, Brooks had difficulty on numerous occasions with his camera equipment. Officials in some of the southern countries wished to seal up his instruments and ship them to some other country. Apparent reason for this attitude toward cameras was the recent prevalence of immigrants bringing such equipment with them from Europe for sale (not being able to take money out of some European countries). Plane trip across the tip of the southern continent – three hours over the Andes – was described by Brooks as 'plenty rough.' The large plane made an uneventful trip, but photography was difficult because of the constant bouncing of the ship. Brooks entertained scores of groups with series of slides he took with him on his trip showing Lompoc's flower fields, old mission and the beautiful blossoms cultivated here. He found large plots of flowers, grown from Lompoc seed, in various countries. The many photographs taken by the visitor have not yet arrived, but Brooks hopes to have several programs of slides prepared in the near future. He anticipates commercial connection with publicity departments as the result of the trip. … Buenos Aires was described by Brooks as being particularly English, whereas German and Italian influence is prominent in many of the bigger cities of the southern continent. War has had a definite effect on South American business and commerce,

and expectation of Allied success was questionable, Brooks declared," *LR*, March 22, 1940, p. 4; "Colored Pictures. Two natural-colored photographs taken by Ernest Brooks… appear in this month's edition of a popular Science magazine. The photos show David Burpee inspecting flowers at Floradale farm," *LR*, March 29, 1940, p. 4.

1941 – "In this month's edition of the '*American*' magazine, Lompoc's W. Atlee Burpee Seed company and Ernest Brooks … come in for some nice puffs in an article on new flowers. Among the full color photographs that reveal the flowers in all their beauty are five pictures taken by Brooks for the Burpee company," *LR*, March 7, 1941, p. 8.

1942 – "Large Crowd at Church Supper… Methodist church… Following the supper moving pictures and a talk on South America were given by Ernest Brooks," *LR*, Oct. 9, 1942, p. 2; "Junior Alphas… By way of entertainment pictures on South America were shown by Ernest Brooks. Mr. Brooks gave a talk accompanying the pictures," *LR*, Oct. 23, 1942, p. 2; ad: "Have your portrait made now for xmas… The **Camera Shop**. Ernest H. Brooks, photographer," *LR*, Nov. 20, 1942, p. 8.

1943 – Port. and caption reads, "Ernest Brooks… left Wednesday for Dayton, Ohio, where he will work in the allocation of photographic equipment for the Army," *LR*, May 14, 1943, p. 8; "Photographic Artist Takes U. S. Position…. left Wednesday for Dayton, Ohio to become junior administrator of the Air Service Command as a civilian employee at Patterson Field," *AGH*, May 14, 1943, p. 2; "Mrs. Ernest Brooks and children left today for Springfield, Ohio, where they will join Mr. Brooks and make their home," *LR*, July 16, 1943, p. 5.

1945 – "Ernest Brooks Returns from Big Army Job. Ernest H. Brooks who established and operated the **Camera Shop** in Lompoc for 12 years prior to the war and has been in a responsible civilian position with the Army for the past two and a half years, is back in Lompoc. Following a recent appendectomy… he asked for and received his release from the post of supervisor of picture epuipment requirements for the Army Air Forces. His headquarters were on Wright Field, but his work required flights to various parts of the United States and many visits to Washington. Wright [Sic. Brooks] was accompanied home by his wife and two children Joyce and Ernest Junior… He plans to reenter the commercial photography field somewhere in this area, probably in Santa Barbara. When he was in business in Lompoc, Wright [sic. Brooks] photographs of the outdoors ranked among the best that were made. He was a member of the Lompoc Rotary Club when he entered the service," *LR*, Sept. 28, 1945, p. 2.

1946 – "Lompoc Resident Opens Photo School in S.B. Ernest Brooks of Lompoc, founder and operator of the **Camera Shop** here until he entered the Army three years ago to serve in WWII, has established the Brooks Institute of Photography in Santa Barbara. Catalogs of the school have reached friends in Lompoc where his mother, Mrs. Claude Wakefield and his sister, Mrs. Laura Beane, reside. [and brief bio. of Brooks] … The catalog… sets out that night courses will be operated as well as full daytime courses… arrangements have been made with a Santa Barbara hotel to house the students from out of town. The spring session will run from March 4 to May 24, the summer session from June 10 to Aug. 30, the fall semester from Sept. 3 to Dec. 20. Next year the spring session will begin earlier and run for 16 weeks," *LR*, Feb. 7, 1946, p. 2.

1950 – "Burpee, Brooks Address Lompoc Rotary Club… Brooks analyzed some of the basic principles of artistic photograph taking. He said that photography is one of the most important phases of national advertising, especially in magazines, through its ability to illustrate products being offered to the public…," *LR*, March 2, 1950, p. 3.

1951 – "Ernest Brooks is 20-30 Speaker… Thursday night … discussed various aspects of photography …," *LR*, Oct. 18, 1951, p. 8; "Ernest Brooks Photography School to Move… purchase of a big Montecito estate 'Graholm' as the new site for his school… The palatial 'Graholm' estate was built by Mr. and Mrs. David Gray, Sr., early stockholder in the Ford Motor company in 1920. It was purchased by Mr. and Mrs. Herschel McGraw and was opened to the public as a museum," *LR*, Oct. 25, 1951, p. 14.

1952 – "Lompoc Glimpses… Ernest Brooks returning to Lompoc to show a motion picture of his nationally known school for photographers," *LR*, June 19, 1952, p. 1; "Film Show… A new color sound film entitled, 'Your Future in Photography' produced by the Brooks Institute of Photography… provided the program… Lompoc Rotary Club. The picture lavishly depicted many of the scenic attractions of Santa Barbara city and county, including Lompoc Valley flower fields. Present at the meeting as a guest was Ernest Brooks… who spoke briefly regarding the production of the film. He is starting on a speaking tour which will take him into the Midwest for three months," *LR*, Sept. 25, 1952, p. 4.

Bibliography
Lanz-Mateo, Barbara, "A Son Remembers **Ernest H. Brooks Sr.**: Snapshot of a Man," *Montecito Magazine*, Fall 1999, pp. 30-34+.

Brooks, Ernest (misc. bibliography)
Ernest Hiram Brooks b. Oct. 17, 1909 in Arroyo Grande, Ca., to Floyd Raymond Brooks and Elizabeth Lee "Bessie" McLaughlin, married Mary Elizabeth Novo-Holt, and d. June 21, 1990 in Laguna Niguel, Ca., per Vicki Jones Family Tree (refs. ancestry.com).

See: "Alpha Club," "Baby contest," "Camera Shop," "Civilian Conservation Corps," 1936, "La Purisima Camera Club," 1938, 1947, 1948, "Lompoc, Ca., Elementary Schools," 1939, "Lompoc, Ca., Union High School," 1928, 1936, 1939, "Lompoc Community Woman's Club," 1948, "Mission La Purisima," 1940, "Photography, general (Lompoc)," 1936, "Santa Maria Camera Club," 1938, 1939, 1940, 1946, 1947, 1948, 1949, 1950, 1952, "Santa Maria Camera Shop," intro., "United Service Organization," 1943, 1945

Brooks, Mildred Bryant (Mrs. Donald Joseph Brooks) (1901-1995) (Pasadena / Santa Barbara)
Printmaker. One of her artworks was distributed to a public building in northern Santa Barbara County by the PWAP, 1934. One of her works was owned by John Breneiser and exhibited at National Art Week, 1935. Her art was shown at the Alpha Club, 1935.

■ Printmaker, teacher and lecturer, active in the Los Angeles area but who died in Santa Barbara, per Kovinick.
Brooks, Mildred (misc. bibliography)
Mildred Bryant was b. July 21, 1901 in Burlington, Mo. to Josiah Jay Bryant and Millie Mame Davis, married Donald Joseph Brooks and d. July 4, 1995 in Santa Barbara per Sharon Luttrell Salazar Family Tree (ref. ancestry.com).
See: "Alpha Club," 1935, "National Art Week," 1935, "Public Works of Art Project," 1934

Brooks Institute of Photography / Brooks School of Photography (Santa Barbara)
Institute founded 1946, prop. Ernest Brooks. Brooks and his Institute's teachers often traveled to northern Santa Barbara County to teach, advise and judge for local camera clubs. Several northern Santa Barbara county photographers boasted of studying there.
"Brooks Institute Teachers to Speak for Local Artists. The Santa Maria Valley Art Association… two guest speakers **Joseph Knowles** and James D. Armstrong…," *SMT*, March 7, 1970, p. 19 (i.e., 3-B).
See: "Abbott, Mary," "Ames, Joe," "Brooks, Ernest," "Deaderick, Moreland," "Dobro, Boris," "Donoho, David," "Griesbauer, Jack," "La Purisima Camera Club," 1947, 1948, "Lawhorne, Roy," "Moore, Kenneth," 1949, "Perry, Charles," "Roberts, Stanley," "Santa Maria Camera Club," 1947, 1948, 1949, 1950, "Slawson, Mervin," "Yager, Thomas," "Youtz, Roland"

Brosnan, Margaret Angela
See: "Giorgi (Brosnan), Margaret Angela (Mrs. Thomas Joseph Brosnan)"

Brotzman, Marian
See: "Mehlschau (Brotzman), Marian (Mrs. James Brotzman)"

Broughton (Allan), Chara C. (Mrs. George B. Allan) (1870-1955) (Lompoc / Sacramento / San Francisco)
Exh. Kensington plaque at "Santa Barbara County Fair,"1894. Active in Lompoc in 1894. Sister of Mrs. Mae McLean, below. Sister-in-law to Rachel Broughton, below.
■ "Mrs. Chara B. Allan, 84, Dies… She was born in Santa Cruz, the daughter of William Wallace Broughton who established a newspaper, the *Lompoc Record*, in San Francisco in 1875. [Sic.] …," *Sacramento Bee*, Feb. 25, 1955, p. 8.
Nine social notices on her appear in the *LR* in 1894 but were not itemized here.
Broughton, C. (misc. bibliography)
Chara C. Broughton is listed in the 1900 U. S. Census as age 29, b. Aug. 1870 in Calif., residing in Lompoc with her parents and several siblings; Chara Broughton was b. Aug. 14, 1870 in Santa Cruz, Ca., to William Wallace Broughton and Amanda Elizabeth Anthony, was residing in Santa Barbara, Ca., in 1880, married George B. Allan, and d. Feb.

24, 1955 in Sacramento, Ca., per Parker Family Tree (refs. ancestry.com).
See: "Broughton, Rachel," "McLean, Mae," "Santa Barbara County Fair," 1894

Broughton, Rachel Hannah Brundige (Mrs. Ralph Broughton) (1880-1957) (Lompoc / Los Angeles)
Artist active c. 1912-1914. Her father-in-law was founder of the Lompoc Record. Sister-in-law to Chara Broughton, above, and to Mae Broughton McLean, below.
■ "Rachel H. Broughton was born in Iowa on Aug. 13, 1880. Broughton settled in Los Angeles in 1922. She died there on April 11, 1957," from Edan Hughes, *Artists in California, 1786-1940*, on askart.com.
Broughton, Ralph, Mrs. (notices in Northern Santa Barbara County newspapers on microfilm and on newspapers.com)
1912 – "Christmas Gift…. Year's Subscription to *The Lompoc Record*… Special Offer – The Record, $2.00 and an Artistic, Hand Painted Christmas Souvenir… receipts, which are suitable inscribed with the season's greetings and adorned with an artistic Hand Painting, made especially for us by Mrs. Ralph Broughton," *LR*, Dec. 20, 1912, p. 3.
1913 – "Born to Mr. and Mrs. Ralph Broughton, Wednesday, November 5, a ten and one half pound daughter," *LR*, Nov. 7, 1913, p. 4.
1914 – "Ralph Broughton left last week for Glendale where he joined his wife and baby who have been residing there for the past month. Mrs. Broughton and her niece, who are both artists, are filling orders for paintings for the Christmas trade," *LR*, Nov. 27, 1914, p. 5, col. 3.
1920 – HUSBAND: "Lompoc relatives were notified last week of the death of Ralph Broughton, son of the founder of the *Record*. He was 37 years of age and leaves a wife and little daughter …," *LR*, Feb. 7, 1930 [repeating a 1920 notice], p. 2.
1953 – "Lompoc Pioneer Returns for Valley Visit. Mrs. Ralph Broughton, pioneer Lompocan, and her daughter Rachel [Sic? Ellen?], were visitors in Lompoc early this week. Mrs. Broughton was the daughter-in-law of the late W. W. Broughton, founder of the *Lompoc Record* in 1875. She is now a resident of the Los Angeles area," *LR*, June 11, 1953, p. 15 (i.e., pt. II, p. 7).
1954 – "Stopover en Route to San Luis Obispo was made by Mrs. Ralph Broughton and her daughter, Ellen, who ... now live in Los Angeles," *LR*, June 17, 1954, p. 5.
Broughton, Ralph, Mrs. (misc. bibliography)
Rachel H. Brundige was listed in the 1900 U. S. Census as age 19, b. Aug. 1880 in Iowa, working as an Orange paster (?) (one brother was an orange box maker) residing in Riverside, Ca., with her mother and two brothers; Rachel Brundige is listed in the *LACD* in 1907, 1908; Rachel H. Brundige is listed in the 1910 U. S. Census as age 29, b. c. 1881 in Iowa, a self-employed artist, residing in Los Angeles with her mother, Ellen (age 59); Rachel H. Brundige married on Oct. 24, 1910 in Los Angeles per Calif. County Birth, Marriage and Death Records; Rachel Hannah Brundige was b. Aug. 13, 1880 in West Branch, Iowa, to Judson D. Brundige and Ellen Margaret Langstaff, married Ralph Hodson Broughton, had a child, Ellen R., and d. April 11, 1957 in Los Angeles, Ca., per Langstaff/Daniels Family Tree; photos of her appear in

Private Member Photos; Rachel H. Broughton, mother's maiden name Langstaff, was b. Aug. 13, 1880 in Iowa and d. April 11, 1957 in Los Angeles per Calif. Death Index (refs. ancestry.com).
See: "Broughton (Allan), Chara," "McLean, Mae"

Brouhard, Jess / Jesse (1920-2008) (Buellton)
Photographer, amateur, who took photos on a European trip, 1955.

■ "Mr. and Mrs. Jess Brouhard Depart for Picture Tour of Europe... of Buellton loaded their cameras and departed last Friday for an extended trip through European countries which will consume seven months... The couple plan to drive first to Canada, then to Washington, D. C. where they will secure permission to photograph class rooms of foreign elementary schools before making connections with their ship the *Mauretania*, which sails from New York on August 30. The ship will dock at Cobh, Ireland, on approximately September 5. The Brouhard's itinerary begins with a tour of Ireland, visiting Dublin, Killarney and then Glasgow and Edinburgh and into the Lady of the Lake country in England and on to London and Stratford-on-the-Avon. They will cross the channel from Dover to Calais, France, and journey to Paris and to Versailles and on to Tours before circling back through Fontainebleau enroute to Belgium. From Brussels they will visit the Hook of Holland, Amsterdam, and then go to Cologne and by river boat to Mainz, Germany. From Frankfurt they will make a flying trip to Berlin, return to visit Heidelberg and other German cities before going to Salzburg, Austria and to Vienna and Innsbruck on the way to Zurich in Switzerland. Cortina D'Ampezzo in Italy is the next stop and then Venice and Trieste and on to Yugoslavia and to Istanbul, Turkey, and to Beiruit and Baghdad and on to Greece. They will fly to Cairo and to the Holy Land and return to Greece before visiting Naples and Rome. From the Italian Riviera they will sail to Barcelona, Spain and journey down to Gibraltar to Casablanca and to Fez in Morocco and return to Spain for an eight-day stay, visiting Madrid and other cities as time allows before going to Lisbon, Portugal and then back to Gibraltar to embark on the *Constitution* for the return voyage, approximately the latter part of next January. Home again, the couple will tour eastern United States before journeying westward. They hope to photograph scenes and sites of more than postcard interest and plan to make notes which will illustrate foreign customs and the human interest aspects of their colored slides. Mrs. Brouhard has been a Lompoc kindergarten teacher for the past six years and Mr. Brouhard has been connected with Lindon Electric company for several years. The Brouhards have indicated that they will send pictures from time to time which might prove of specific interest to the community," *LR*, Aug. 11, 1955, p. 4.
Brouhard, (misc. bibliography)
Jesse Brouhard was b. Oct. 1, 1920 and d. Feb. 22, 2008 in Santa Barbara, Ca., per Social Security Death Index (ref. ancestry.com).

Brown, Kenneth A. (Santa Maria)
Santa Maria JC student who won poster contests, 1947, 1949. His wife, Joy Alice Pittman Brown, was an art major at Santa Barbara College, 1951.

■ Port. and "Kenneth A. Brown. Seaman Kenneth A. Brown, son of Mr. and Mrs. D. D. Brown of Los Alamos, will be transferred to sea plane tender *U. S. S. Salisbury Sound* for overseas duty at the conclusion of his present leave. Brown was graduated from Treasure Island school of electronics November 20... Mr. Brown, and his bride of July, the former Joy Alice Pittman, after spending the Thanksgiving holidays with his parents and sister here, have returned to San Francisco to await his orders. Mrs. Brown, who is a daughter of Mr. and Mrs. Earl Pittman of Miami, Fla. and a graduate of Ventura Junior College, is an art major and will return to Santa Barbara College to continue her studies February 1...," *SMT*, Dec. 13, 1951, p. 13.
See: "Posters, general (Santa Maria)," 1947, "Posters, Latham Foundation (Santa Maria)," 1949

Brown, Marian (Camp Cooke)
Filmmaker, amateur. A showing of her Alaska films was sponsored by the Santa Maria Camera Club, 1942.
See: "Santa Maria Camera Club," 1942

Brown, Norman (Arroyo Grande)
Photographer. Active with and advisor to the Santa Maria Camera Club, post WWII.
Ninety-five "hits" for "Norman Brown" in the *SMT* between 1945 and 1960 were not itemized here.
See: "Carlin, David," 1948, "Phi Epsilon Phi," 1960, "Prindle, Kenneth," 1956, "Santa Maria Camera Club," 1946-50, 1955, and *Arroyo Grande (and Environs) Art and Photography before 1960*

Browne, Belmore (1880-1954) (Santa Barbara)
Painter, writer, big game hunter, head of Santa Barbara School of the Arts 1930-34. Sketched in the Santa Ynez area.

■ "He was born at New Brighton, Staten Island, New York, in 1880 and died in 1954. He was head of the Santa Barbara School of the Arts, 1930-34. He had written a book on the conquest of Mt. McKinley... Because of his interest in big game, he volunteered on several occasions to paint backgrounds for Museum animals... After a field trip to Oso (Bear) Canyon near the Santa Ynez Ranger Station in 1932, he painted a wild gorge for the Grizzly Bear Group," per "Santa Barbara Museum of Natural History: First Twenty-five Years," *Noticias,* Volume XI, No. 2, Spring 1965, pp. 69-70.
Monograph:
Robert H. Bates, *Mountain Man: The Story of Belmore Browne*, Clinton, N. J.: Amwell Press, 1988.

Brownies
See: "Girl Scouts"

Bruchs, Robert "Bob" J. (1922-1983) (Santa Maria / Palos Verdes)
Painter in oils / business education instructor at Santa Maria Union High School. Exh. with "local artists" at Allan Hancock [College] Art Gallery, 1956.

■ "Hires Three New Teachers ... Robert Brucks [Sic. Bruchs] commercial; from Los Angeles, degrees from Bloomsburg (Pa.) State Teachers College, UCSBC, Los Angeles State College," *SMT*, June 22, 1955, p. 1; port. at Junior Chamber barbecue, *SMT*, Sept. 7, 1955, p. 1.

■ "Bruchs... Robert J. Bruchs, 60, of Palm Desert... A native of Pennsylvania, he was a resident of the Coachella Valley for six years. Mr. Bruchs is survived by his wife, Jane...," *Desert Sun* (Palm Springs, Ca.), Jan. 13, 1983, p. 3.

Bruchs, Robert (misc. bibliography)
Port. of Robert Bruchs, teacher of "Commercial" appears in El Segundo High School yearbook, 1958; "Robert Bruchs" M. S., Work Experience Coordinator, port. appears in Palos Verdes High School yearbook, 1963, 1966, 1970, 1975 (refs. ancestry.com).
See: "Allan Hancock [College] Art Gallery," 1956, "Santa Maria, Ca., Union High School," 1955

Bruckner, Pete (Vandenberg AFB)
Active with Santa Maria Camera Club, 1960-62.
See: "Santa Maria Camera Club," 1960, 1962

Brughelli, Mary King (Mrs. Arnold Brughelli) (1911-1978) (Berkeley / Lompoc)
Teacher of arts and crafts at summer school, administered by Lompoc Recreation Department, 1952-59. Active with the Lompoc Community Women's Club and initiator of the Children's Art show, mid 1950s+ and the Open-Air Art Show held in conjunction with the Alpha Club Flower Show, 1957+.

■ "Mrs. Brughelli has conducted Arts and Crafts classes for the Community Women's club, assisted many of the local clubs with their floral floats, painted many signs for the childrens' parades and assisted the grange with their many prize winning displays at the Santa Maria County Fair. She has had a wide experience in Arts and Crafts both locally and out of town. An established artist, she spent part of her career in and around San Francisco. She attended the Art Institute of Chicago and the California Art School of San Francisco through which she became a member of the San Francisco Art Association. While living in the bay area she was a designer, creating new designs for some of the leading interior designers. Prior to coming to Lompoc, she had several one-man shows of her art work at the Western Women's building and the William McCann Galleries in San Francisco," per "Well-known Artist Instructs at Park. With the opening of the two playgrounds this week, the summer Arts & Crafts classes under the direction of **Mrs. Arnold Brughelli** were conducted by the City Recreation Department at Ryon and Floresta Parks ...," *LR*, June 28, 1956, p. 5.

Brughelli, Mary (notices in Northern Santa Barbara County newspapers on microfilm and on newspapers.com)
1949 – "Brughelli's Return to Lompoc. Mr. and Mrs. Arnold Brughelli, former Lompoc residents, have returned here after living in Berkeley for seven years...," *LR*, June 23, 1949, p. 15 (pt. II, p. 5).
And 13 notices for "Mary Brughelli" regarding children's art classes in the *LR* 1952-58, and 28 hits for "Mrs. Arnold Brughelli" in the *LR*, 1949-58, some of which are noted elsewhere in this publication.
Brughelli, Mary (misc. bibliography)
Mary Brughelli is listed in the 1940 U. S. Census as age 29, b. c. 1911 in England, finished elementary school 8th grade, naturalized, residing in San Francisco (1935) and Santa Barbara (1940) with husband Arnold (age 29) and children Tilden (age 8) and Nancy King Boe (age 6); Mary Brughelli is listed in Lompoc in *Santa Maria CD* 1962, 1965, 1974; Mary Brughelli b. 1911, d. 1978 and is buried in Lompoc Evergreen Cemetery per findagrave.com (refs. ancestry.com).
See: "Alpha Club," 1949, 1958, 1960, "Federation of Women's Clubs," 1960, "Flower Festival," 1957, "Halloween Window Decorating Contest," 1954, "Lompoc, Ca., Union High School," 1952, "Lompoc Community Women's Club," 1954-58, "Lompoc Gem and Mineral Club," 1960, 1962, "Lompoc Hospital Women's Auxiliary," 1950, 1952, "Open-air Art Exhibit," 1957, 1959, 1960, "Posters, American Legion (Poppy) (Lompoc)," 1954, 1958, 1959, "Posters, general (Lompoc)," 1959, 1960, "Summer School (Lompoc)," 1952-59, "Tri-County Art Exhibit," 1950, 1958

Bryant, Everett Lloyd (1864-1945) (Los Angeles)
One of his paintings was distributed to a public building in northern Santa Barbara County by the PWAP, 1934.

■ "Bryant was an artist at an early age but he didn't start formal study until he was 28 years old. At that time, he moved to London and later Paris studying under Herbert Herkomer and Monat Loudan and Thomas Couture. He later moved back to the US and aside from engaging in several business pursuits, he mined for gold in the Klondike. By 1900 he had turned back to art and studied at the Pennsylvania Academy of Fine Art in Philadelphia. He married Maude Drein, a fellow student, in June of 1904 and they honeymooned in England and France visiting art galleries. In 1930 Bryant moved to Los Angeles and there adopted the medium of tempera, which he found best suited for western landscapes. He made numerous sketching trips throughout the western states [and] continued to paint until three weeks before his death on September 7, 1945," per findagrave.com.
Bryant, Everett (misc. bibliography)
Everett Lloyd Bryant was b. Nov. 13, 1864 in Galion, Ohio, d. Sept. 7, 1945 and is buried in Angelus Rosedale Cemetery, Los Angeles, per findagrave.com (ref. ancestry.com).
See: "Public Works of Art Project," 1934

Bryant, Melba Adelaide (Mrs. Arthur Sylvester Bryant) (1905-1964) (Santa Maria)
Painter active c. 1950-53.

■ "Obituaries. Melba Bryant… born Aug. 3, 1905 in Los Angeles and had lived in the local area since 1935…," *SMT*, May 6, 1964, p. 14.

Bryant, Melba (notices in Northern Santa Barbara County newspapers on microfilm and on newspapers.com)
Forty-one notices for "Melba Bryant" in the *SMT* between 1935 and 1965 concerned her prowess at art, bowling and bridge, but most were not itemized here.

Bryant, Melba (misc. bibliography)
Melba Bryant is listed in the *Santa Maria CD* 1948-65; Melba Adelaide Bryant was b. Aug. 3, 1905 in Calif., married Arthur Sylvester Bryant, and d. May 4, 1964 in Santa Barbara County, Ca., per Reilly-Medlock Family Tree (refs. ancestry.com).
See: "Community Club (Santa Maria)," 1950, "Halloween Window Decorating Contest (Santa Maria)," 1951, "Junior Community Club," 1953, "Santa Barbara County Fair," 1949, 1951, 1952, 1953, "Santa Maria Art Association," 1952, 1953, "Santa Maria Valley Art Festival," 1952

Bryant & Trott (Santa Maria)
Purveyors of Averill and Painter's Pure Paints, 1901.

■ "Chas Huff, the efficient representative of Pure Paints, was in town this week, placing an unusual large order for the Cal Paint Co. with Bryant & Trott. Painters Pure Paint has been used upon the residence of the *Times'* editors and we cannot speak any too highly of its merits. Many of our best residences will need paint soon and the owners in placing their order should not hesitate to use Painter's Pure for sale at Bryant & Trott's," *SMT*, March 30, 1901, p. 3; ad: "Use Averill and Painter's Pure Paints. Bryant & Trott, Agts.," *SMT*, Oct. 19, 1901, p. 4.

Bucher (Brenneis), Mary Elizabeth / Elisabeth (Mrs. Andrew Brenneis) (1910-1998) (Lompoc)
Art teacher at Lompoc High School, 1934-38. Member Alpha Club Art Section, 1934-38.

■ "Miss Bucher Weds in North… Miss Mary Elisabeth Bucher of Susanville to Andrew Brenneis, Saturday, March 16, at Napa. Miss Bucher is a former resident in Lompoc and was art instructor at the local high school. The couple spent their honeymoon at Mono Lake. They will make their home at Weaverville following June 1. The bridegroom is employed with the Lassen National forestry," *LR*, March 29, 1940, p. 4.

Bucher, Mary (notices in Northern Santa Barbara County newspapers on microfilm and on newspapers.com)
1936 – "In the February issue of the *Sierra Educational News* is a picture and story which honors Miss Mary Elizabeth Bucher, art instructor…," *LR*, Feb. 14, 1936, p. 7.
1938 – Port., *LR*, June 3, 1938, p. 7.
And more than 160 notices on Bucher (both social and art) in the *LR*, 1930-1940, some of which were itemized under other entries.

Bucher, Mary (misc. bibliography)
Port. of Mary Elisabeth Bucher in the Lompoc High School yearbook, 1938; Mrs. Mary Elizabeth Brenneis is listed in *Voter Registration in Trinity, Ca.*, at various dates; Mary E. Brenneis is listed with husband Andrew in *Santa Barbara CD* 1948, 1949; Mary Elisabeth Brenneis d. Dec. 1, 1998 in Menlo Park, Ca., per *Obituary Daily Times Index, 1995-2016*; "Mary E. Brenneis, b. July 11, 1910 and d. Nov. 26, 1998, was residing in Pennsylvania 1953-55, last residence was Pomona, Ca., per Social Security Death Index (refs. ancestry.com).
See: "Alpha Club," 1934-38, "Cakebread, A. Sidney," "Flower Festival / Show," 1938, "Fratis, Margaret," 1935, "Lompoc, Ca., Union High School," 1934-38, "Posters, American Legion (Poppy) (Lompoc)," 1938, "Works Progress Administration," 1938

Buckman, Harry Fell (1879-1947) (Lompoc)
Filmmaker, amateur, 1941-47.

■ Port. and "H. F. Buckman, Beloved Civic Leader Passes… the man chiefly responsible for the development of Lompoc's flower seed industry… Mr. Buckman came to Lompoc Valley 33 years ago from his native Bucks County, Penn. He was associated with the Burpee Seed company and was the manager of the Floradale Farm until starting his own seed business. That business later became the Buckman, Denholm and Holden Seed Co. As a seedsman, Mr. Buckman developed many new varieties of flowers, specializing in sweet peas …," *LR*, Nov. 20, 1947, p. 1.

Buckman, Harry F. (notices in Northern Santa Barbara County newspapers on microfilm and on newspapers.com)
1941 – "Rotarians See Flower Films. Moving pictures in color showing flower fields of Buckman, Denholm & Holden, as well as other commercial growers in Lompoc valley, together with community events including the parade and Fourth of July Rodeo, were screened Wednesday evening for the entertainment of the Lompoc Rotary club. Rotarian Harry F. Buckman presented the pictures and was assisted by Ted Holden. The photography is excellent and Buckman plans to take the films with him when he goes East in August and show them before Rotary clubs and other groups," *LR*, March 21, 1941, p. 5.
1942 – "Companions Buy Defense Bond … Following the business meeting moving pictures of Florida and the East coast were shown by Harry Buckman," *LR*, April 17, 1942, p. 4.
1943 – "Program Given at Camp Cooke Hospital. Pictures of the beauty spots of California… Other programs which have been presented included… pictures of Lompoc scenery by Harry Buckman…," *LR*, June 4, 1943, p. 5.
1944 – "Pictures of Lompoc groups and individuals as well as local scenes accompanied by a talk by Harry Buckman will constitute the program to be offered when the Junior Alpha club holds its next meeting…," *LR*, Jan. 21, 1944, p. 4.
1946 – "Lompoc Glimpses – Harry Buckman gandering at a field of Iceland poppies and adjusting his light meter," *LR*, May 2, 1946, p. 1; "Eastern Star… next meeting… November 12. Also on the program… will be the exhibit of

motion pictures taken by Harry Buckman on his recent vacation trip," *LR*, Oct. 31, 1946, p. 2.
1947 – "Lompoc Glimpses… Harry Buckman, a camera fan, happily 'snapping' a bridal party," *LR*, Sept. 4, 1947, p. 1.
Buckman, Harry F. (misc. bibliography)
Harry Fell Buckman was b. Sept. 19, 1879 in Bucks, Pa., to Pierson W. Buckman and Mary J. Rufe, married Martha Garfield Gross, was residing in Lompoc, Ca., in 1940, and d. Nov. 16, 1947 in Lompoc, Ca., per Haas Reunion… Family Tree (refs. ancestry.com).
See: "Heiges, Margaret"

Buell, Josephine Macon Thomas (Mrs. Odin Buell) (1897-1989) (Buellton)
Collector of art / antiques.
■ "Josephine Buell. Longtime Buellton resident… 91 years old. A former school teacher who graduated from St. Mary's College in North Carolina, Mrs. Buell married into the Buell family, founders of the town of Buellton. She was a homemaker and lived on North Highway 101…," *SYVN*, March 23, 1989, p. 14.
Buell, Odin, Mrs. (notices in Northern Santa Barbara County newspapers on microfilm and on newspapers.com)
1953 – "Odin Buell Home… many of the furnishings are antiques which Mrs. Buell brought with her from her native North Carolina… A grandfather's clock is on one side of the fireplace, while hanging above the fireplace is an oil painting of R. T. Buell, Mr. Buell's father… [by] **Charles Mattei** and was taken from a photograph of R. T. Buell on the latter's 21st birthday…," and photo of living room showing portrait, *SYVN*, Nov. 13, 1953, p. 10.
More than 700 notices for either "Josephine Buell" or "Mrs. Odin Buell" in the *SYVN* between 1947 and 1960 were not even browsed for possible inclusion here.
Buell, Odin (misc. bibliography)
Josephine Thomas Buell, mother's maiden name Macon, was b. May 27, 1897 in North Carolina and d. March 19, 1989 in Santa Barbara County per Calif. Death Index (refs. ancestry.com).
See: "Santa Ynez Valley Art Exhibit," 1954, 1956, "Santa Ynez Valley, Ca., Adult/Night School," 1953

Buellton, Ca., Adult/Night School
■ "Ceramics Class to Start. The Parent-Teachers-Friends of Buellton are organizing a group of adults for a ceramic class. The first meeting will be this evening at 8 at the Buellton School. **Joseph E. Knowles**, art consultant from the Educational Service Center in Santa Barbara County, will attend the first three or four meetings in order to give help to the group. He will also give assistance in many other arts using paints, crayons, etc. Future meetings of the class will be scheduled on Friday evening. Everyone is invited to attend," *SYVN*, Feb. 18, 1955, p. 5.

Buellton, Ca., Art
See: "Art, general (Buellton)"

Buellton School
See: "Santa Ynez Valley, Ca., Elementary Schools"

Bullock, Percy Wingfield "Wynn" (1902-1975) (Santa Maria)
Photographer of national repute. Briefly, a co-owner of a photographic business in Santa Maria. Active in northern Santa Barbara County 1945, 1946.
■ "Wynn Bullock (April 18, 1902 – November, 16, 1975) was born in Chicago, Illinois, and raised in South Pasadena, California. As a boy, his passions were singing and athletics (football, baseball, swimming, and tennis). After high school graduation, he moved to New York to pursue a musical career and was hired as a chorus member in Irving Berlin's *Music Box Revue*. … Road Company. During the mid-1920s, he furthered his career in Europe, studying voice and giving concerts in France, Germany, and Italy. While living in Paris, he became fascinated with the work of the Impressionists and post-Impressionists. He then discovered the work of Man Ray and Lazlo Moholy-Nagy and experienced an immediate affinity with photography, not only as an art form uniquely based on light, but also as a vehicle through which he could more creatively engage with the world. He bought his first camera and began taking pictures. During the Great Depression of the early 1930s, Wynn stopped his European travels and settled in West Virginia to manage his first wife's family business interests. He stopped singing professionally, completed some pre-law courses at the state university, and continued to take photographs as a hobby. In 1938, Wynn moved his family back to Los Angeles and enrolled in law school at the University of Southern California …. Completely dissatisfied after a few weeks, he left USC and became a student of photography at the nearby Art Center School. From 1938 to 1940, Wynn became deeply involved in exploring alternative processes such as solarization and bas relief. After graduation from Art Center, his experimental work was exhibited in one of L.A. County Museum's early solo photographic exhibitions. During the early 40s, he worked as a commercial photographer and then enlisted in the Army. Released from the military to photograph for the aircraft industry, he was first employed at Lockheed and then headed the photographic department of Connors-Joyce until the end of the war. Remarried, and with a new daughter, Wynn traveled throughout California from 1945 to 1946, producing and selling postcard pictures while co-owning a commercial photographic business in Santa Maria. He also worked on developing a way to control the line effect of solarization for which he later was awarded two patents. In 1946, he settled with his family in Monterey where he had obtained the photographic concession at the Fort Ord military base. He left the concession in 1959, but continued commercial free-lance work until 1968."
See website wynnbullockphotography.com.
Bullock, Wynn (notices in Central Coast newspapers on microfilm and on newspapers.com)
1944 – "Nipomo Club Hears Talk on Raid Photos… Nipomo Men's Club … Lynn [Sic. Wynn] Bullock, from Santa Maria Army Air Base and a world-traveled photographer, described the method of obtaining pictures of areas bombed during raids…," *AGH*, April 28, 1944, p. 1.

1946 – "Prints Winning Photo – Wynne Bullock, 120 East Church street… has been awarded first prize … for his picture entitled 'High and Dry.' The informal reflections of a mass of pilings sustaining a rickey wooden bridge…" in July issue of *Popular Photography, SMT,* June 6, 1946, p. 3.

Bullock, Wynn (misc. bibliography)
Percy Wingfield "Wynn" Bullock was b. April 18, 1902 in Chicago, Ill., to William Wingfield Bullock and Georgiana Philipps Morgan, and d. Nov. 16, 1975 in Monterey, Ca., per Davenport Bodley Bullock Jarvis Family Tree (refs. ancestry.com).
See: "Photography, general (Camp Cooke / Vandenberg AFB), 1946, "Santa Maria Camera Club," 1945

Bumb, Elva
See: "Allen (Bumb), Elva (Mrs. Frank Edward Bumb)"

Buntz, Florence V.
See: "Van Sant (Buntz), Florence V. (Mrs. Lloyd Buntz)"

Burbank, Robert (Santa Barbara)
Interior decorator from Michael Levy store in Santa Barbara who spoke to Lompoc Community Woman's Club, 1950.
See: "Lompoc Community Woman's Club," 1950

Burck, Nadine Alma (Mrs. Jack M. Burck) (Santa Maria)
Handcraft chairman, Community Club, 1953-54 and also active with Needlework Guild.
Port. modeling hat she designed, *SMT,* April 24, 1954, p. 4.
See: "Community Club (Santa Maria)," 1953, 1954, "Pierce, Ruth"

Burke, Ed (Lompoc)
Photographer. Industrial engineer who attempted to start a Camera Club at Johns-Manville plant, 1946. Active with Lompoc Players.
See: "Photography, general (Lompoc)," 1946

Burke, Georgina S. (Saratoga)
Exh. "Guadalupe Bridge" at Santa Cruz SWE 1952.
See: *Central Coast Artist Visitors before 1960*

Burtch, Emma (Mrs. Ellery Linus Burtch) (1851-1939) (Santa Barbara in 1894 / Los Angeles County)
Exh. water colors of flowers at "Santa Barbara County Fair,"1894. Wife of a barber.
Burtch, E. (notices in Northern Santa Barbara County newspapers on microfilm and on newspapers.com)
1894 – "The Masquerade… ball given at the Opera house New Year's night… The costumes of Mrs. E. Burtch… are deserving of mention," *LR,* Jan. 6, 1894, p. 3; Many ads for

The Electric Barber Shop, prop. Burtch & Rios, *LR,* 1893-95, were not itemized here.
Burtch, E. (misc. bibliography)
Emma Burtch is listed in the 1900 U. S. Census as age 43, b. Dec. 1856 in England, immigrated 1873, married in 1892, residing in Los Angeles with husband Ellery Burtch; Emma Burtch is listed in the 1930 U. S. Census as residing in Downey, Ca., with her husband Ellery; Emma Burtch b. Dec. 15, 1851, d. Nov. 3, 1939 and is buried in Downey District Cemetery per findagrave.com; HUSBAND – Ellery Burtch, b. c. 1860, was listed in the *Voter Registers of Santa Barbara, Ca.,* in 1894 as b. Illinois and residing in Lompoc (refs. ancestry.com).
See: "Santa Barbara County Fair," 1894

Burvik, Odin
Pseudonym of Mabel Glazier "Grace" Burwick.
See: "Waugh, Mabel Odin Burwick"

Burwick, Mabel Glazier "Grace"
See: "Waugh, Mabel Odin Burwick"

Bury, Helen (Santa Maria)
Crafts teacher at Santa Maria High School, 1946/47.
See: "Santa Maria, Ca., Union High School," 1946.

Bush, William E. (Shell Beach)
Photographer. Active with Santa Maria Camera Club, 1950-51.
1950 – "Rotary to View Photos. Guadalupe Rotarians will tonight view photographs shown in the most recent exhibit of Camera clubs in the Central coast area... will be commented upon ... by William Bush, professor of chemistry and physics in California Polytechnic college, an avid amateur photographer...," *SMT,* Aug. 25, 1950, p. 3.
See: "Santa Maria Camera Club," 1950, 1951, and *San Luis Obispo Art and Photography before 1960*

Business and Professional Women's Club (BPW) (Santa Maria)
Woman's club that held some art programs, 1936+.
Business and Professional Women (notices in Northern Santa Barbara County newspapers on microfilm and on newspapers.com)
1931 – "Art Contest Sponsored by Club… National Federation of Business and Professional Women's club… poster symbolizing the progress of business and professional women… the prize-winning poster in each state will be sent to New York to be judged in a national competition … contest is open to students in art schools and art departments of high schools… The poster contest in this city will close October 25," *SMT,* Sept. 26, 1931, p. 3.
1934 – **Stanley "Breneiser** Speaks Before B and PW Club … Monday night in the auditorium of the Main Street school … In his talk, Mr. Breneiser explained that art raises one above the cares of life and that it also was an interesting and useful occupation. He also believes that the

minor arts, such as etching, block printing, stenciling, weaving and pottery will be taken up to a great extent by the public," *SMFA*, Feb. 23, 1934, n. p..

1936 – "B. P. W's Arrange Program on Art," but no speaker is mentioned, *SMT*, March 26, 1936, p. 3.

1937 – "Business Club Entertained at Dinner" with talk by **E. Breneiser** on making of jewelry, batik, block printing and leather crafts, exhibiting work done by herself and her son, **John [Breneiser]**, and several of her students including **Yukio Tashiro**, *SMT*, May 6, 1937, p. 2.

1938 – "Music and Art Evening Enjoyed" with talk on modern art by **Stanley G. Breneiser**, *SMT*, May 4, 1938, p. 3, and article adds, "Modern art was taken up … He explained that the reason persons do not like the modern pictures is because they cannot connect them up with anything with which they are familiar. Modern art tries to express ideas of the artist. He spoke of four ways of viewing art, through mechanical, curious, imaginative and pure vision. He passed around examples of modern work, pointing out its value as the expression of ideas of the authors, instead of reproductions of concrete objects."

1941 – "Club Sets Hobby Show and Art Program," *SMT*, Feb. 1, 1941, p. 3; "Business Women See Hobby Show, Hear Talk on Crafts," i.e., one-night show held at assembly hall of Santa Maria Gas Co. and talk by Mrs. **Elizabeth Breneiser**, and among hobbies is hammered silver by **Margaret Rodriguez**, collection of old etchings by Gladys Forbes, handcrafts by **Hazel Lidbom** and also by her class in the tubercular ward of the county hospital, *SMT*, Feb. 5, 1941, p. 3.

1942 – "BPW… Music and Arts committee under the chairmanship of **Edna Davidson**…," *SMT*, Dec. 14, 1942, p. 3.

1945 – "Talk on Spain… During the evening BPW year books were distributed. They were hand made with the cover design – a block print – made by **Edna Davidson**, art teacher…," *SMT*, Jan. 24, 1945, p. 3.

1948 – "Business and Professional Women's Club. BPW Club is Told Inside Story of Hobbies" – **Miss Edna Davidson**, supervisor of art in Santa Maria Elementary Schools demonstrated flower arranging, and Miss Elizabeth Campbell talked about doll collecting, and Mrs. Gladys Forbes spoke on antique glass collecting, *SMT*, Sept. 8, 1948, p. 5.

Butler, Howard Russell (1856-1934) (New York / Pasadena / Santa Barbara)
Landscape painter of New York who was in California 1905-1907 and in Pasadena / Santa Barbara, 1921-1926. Painted an eclipse of the sun at Lompoc, Sept. 1923.

■ "Eclipse Seen Here is Now on Canvas. … A [re]production of the painting may be seen in the *American Weekly* of the *Los Angeles Examiner*, in the June 6 edition. The article with the picture says: 'Science and Art have combined to give the world the first accurately colored picture of the gorgeous corona of the sun as it appears during a total eclipse – the three paintings of recent eclipses now on exhibition in the American Museum of Natural History, New York. These interesting and educational paintings were made by Howard Russell Butler, N. A., a physicist by early training and an artist by life training…

As the eclipse lasts only a few minutes, Mr. Butler drew on his canvas an outline of the corona as he expected it to appear. Then, during the eclipse, he corrected the outline – later verifying his drawing by photographs —and with the aid of special binoculars and his own shorthand system, noted the various colors and shades on the canvas. The first such painting he made at Baker, Oregon, in 1918, when he had only 112 seconds to work in – less than two minutes. He painted the second picture at Lompoc, California, during the eclipse of September, 1923, which lasted for 140 seconds, and was able to portray in that time the rare 'diamond ring' effect. It was in Middletown, Conn., during the January eclipse of last year, that the third opportunity offered and on this occasion the eclipse lasted only 110 seconds. At this time there was a maximum of sun-spots and not only was the outline of the corona a surprise to astronomers, but some of the streamers were much longer than had been expected. Photographs of eclipses have, of course, been made in great numbers. Attempts have also been made to color these photographs from memory. But this is the first time the world has had before it accurate color productions of the sun's corona made by an artist from actual observation during total eclipse'," *LR*, July 2, 1926, p. 6.

Butler, Howard R. (notices in newspapers on microfilm and on newspapers.com)

1910 – Repro: "Summer and Seventeen," *LA Herald*, Jan. 2, 1910, p. 60 (i.e., rotogravure?).

1918 – "Chickens Seek Their Roosts in Northwest … [eclipse of sun] Special study of the corona lights was made by … Howard Russell Butler as an oil painter of Reno, who came from Princeton, N. J. and made a study of the colors of the corona, listing several hundred varying shades by shorthand system of numbering…," *SF Chronicle*, June 9, 1918, p. 2.

1923 – "Noted Artist to Paint Eclipse … from Point Concepcion in September…," *SF Chronicle*, Aug. 20, 1923, p. 5.

1925 – "U. S. Party to Watch Eclipse in Sumatra… report of the results of the observation… contained in the '*Publications of the U. S. Naval Observatory*,' second series, volume X, part II, appendix… There are some remarkably fine plates in this volume, photographs… and drawings… The frontispiece is a reproduction in color of the painting of the corona of the eclipse of June 8, 1918 by the artist, Howard Russell Butler, who was a member of the Naval observatory eclipse expedition to Baker, Ore. There is also a reproduction in color of a painting by the same artist of the approach of the moon's shadow and of details in the structure of the prominences," *Petaluma Daily Morning Courier*, April 10, 1925, p. 6; "Art, Millions to Build Beautiful Santa Barbara… yesterday's devastating temblor… Artists See Chance. When… Howard Russell Butler… and a galaxy of other famous brush wielders, all of them members of the National Academy, were rudely rolled out of bed by the vicious quake early yesterday morning, they all gravitated toward State street… for years the artists and the financially opulent have been fighting to reform Santa Barbara's 'main street' into something more artistic…," *Oakland Tribune*, June 30, 1925, p. 8.

1926 – "The Sun's Gorgeous Corona. Colored Paintings Made From Telescopic Observations During Recent Solar

Eclipse… made by Howard Russell Butler, N. A., a physicist by early training and an artist by life training…," and several repros, *SF Examiner*, June 6, 1926, p. 11; "The *American Magazine of Art*, November issue, contains a tribute to the late Thomas Moran, Santa Barbara painter, from the pen of Howard Russell Butler of Santa Barbara and New York. An excellent portrait of the late Mr. Moran by Mr. Butler illustrates the article," *Press-Courier* (Oxnard, Ca.), Nov. 12, 1926, p. 5.

Bibliography:
Cleek, Patricia Gardner, "Friends in Art: Discovering Howard Russell Butler," *Santa Barbara Magazine*, Winter 1999, pp. 48-50.
And many articles in the *LA Times* not itemized here (listed in Nancy Moure, *Dictionary of Art and Artists in Southern California before 1930*).

Byrd, Stan (Pismo Beach)
Photographer, amateur, who exh. at Santa Barbara County Fair, 1960. Sales Manager of Oceano Packing Co., 1963.
See: "Santa Barbara County Fair," 1960, and *Arroyo Grande Art and Photography before 1960*

C

Cabrera, Miguel (Mexico)
Painter of "La Virgin Purisima." AKA the "Mexican Murillo."
See: "Mission La Purisima," 1940, 1941

Cadorin, Ettore (1876-1952) (Italy / Santa Barbara / San Francisco / Sonoma)
Sculptor who visited "Valley Beautiful," 1935. Sculpted artworks for the Veterans' Memorial building, Santa Maria, 1935.
■ "Sculptor Cadorin is Dead. Sonoma ... A native of Venice, Italy, Mr. Cadorin studied in his father's studio and at the Royal Academy of Fine Arts in Venice. In 1912 he married Lovie Mueller of Australia [Sic. Austria?] and 3 years later came to New York to teach at Columbia University and later at Santa Barbara State College. His principal works in Italy are statues for the Civic Library on St. Mark's Square in Venice. In this country his major works include a bronze statue of Father Junipero Serra in the National Statuary Hall, Washington, D. C.; statues of Sts. Peter, Paul and John in Washington Cathedral, and statuary at the Santa Barbara courthouse, the Edgewood (N.J.) War Memorial and Christian Brothers monastery at Napa. Mr. Cadorin's distinctive ivory sculptures were his specialty. He carved portraits on sheets of ivory so thin they appeared blue. ... Mr. Cadorin had lived in Sonoma for about 11 years. Living at the Cadorin home on East Napa St. at the time of Mr. Cadorin's death were 2 of his students, Luceba Jouett and **Marian Brackenridge** ... A good share of Mr. Cadorin's most important work is in San Francisco where he had a studio for many years. These include 4 statues in stone of the Sts. Peter and Paul. He carved 'Evening Star,' a fountain, and 'The Moon and the Dawn,' a group of figures, for the **Golden Gate Exposition** in 1939," *Press Democrat* (Santa Rosa, Ca.), June 19, 1952, p. 10.

Cadorin, Ettore (notices in Northern Santa Barbara County newspapers on microfilm and on newspapers.com)
1931 – Photo of Junipero Serra and caption reads "This statue, seven and a half feet high, will soon be occupying a spot in the California section of National Statuary hall in Washington, D. C. It honors Father Junipera [Sic.] Serra, Fanciscan founder of the California missions and was executed in Santa Barbara by Ettore Cadorin," *SMT*, Feb. 27, 1931, p. 2.
1935 – "Statuary to be Unveiled … for the fountain in the patio of the new Veterans' Memorial building… The statue, along with seven plaster plaques, arrived last week from Santa Barbara and has been erected in the center of the patio fountain, which has an octagon-shaped pool measuring eight feet across. Red, green, blue and flame-colored electric globes, placed under water, will throw a variety of colors upon the statue, which was designed and made by Ettore Cadorin of Santa Barbara. …. The four tablets, on which eagles are depicted, will be placed above the arches and doorways in the entry hall. Over the main arch, facing the entrance, will go the largest plaster ornament, that showing a soldier, sailor and marine. Two round plaques, with figures of the Goddess of Liberty, go above the entrances to the Legion clubrooms and the balcony …," *SMT*, July 3, 1935, p. 2; "Sculptors Here – Ettore Cadorin and **Miss Marian Brackenridge**, Santa Barbara sculptors, who have been making plaques and a statue for the fountain in the Veterans' Memorial building for Santa Maria, are guests of **Santa Maria Inn** while supervising installation of some of their work on the building…," *SMT*, July 31, 1935, p. 3; "Famous Sculptor. This week Mr. E. Cadorin… was a visitor in The Valley Beautiful… Mr. Cadorin's reputation as a sculptor led the Italian government to decorate him a few years ago… Mr. Cadorin was accompanied by…," *LR*, Aug. 2, 1935, pp. 1, 10; "Cadorin, the noted sculptor, looked us over Wednesday and approved our plans for a veterans' memorial and community center. He liked the design of the building and was impressed with the beautiful site," *LR*, Aug. 2, 1935, p. 2.
1949 – "I Spied… Kenneth Trefts ... using a fig leaf where they thought it would do the most good on Cadorin's statue of a nymph in Veterans' Memorial building patio while decorating for the Flower Show," *SMT*, May 14, 1949, p. 1.

Cadra Manufacturing Jewelers
See: "Carroll, Charles C."

Cakebread, A. Sidney (Lompoc)
Teacher of industrial arts at Lompoc High School, 1931/35.
"Cakebread will be Principal at Plumas… several teachers in the Lompoc high school have been offered positions at Plumas by Mr. Cakebread… **Miss Mary Elizabeth Bucher**…," *LR*, June 21, 1935, p. 7.

See: "Lompoc, Ca., Union High School," 1931, 1933, 1934

Calandri, Xandra "Sanny"
See: "Orton (Calandri), Xandra "Sanny" (Mrs. Raymond E. Calandri)"

California College of Arts and Crafts (Oakland)
"In 1907, Frederick Meyer, known as one of the fathers of the early 20th Century Arts and Crafts Movement, established the School of the California Guild of Arts and Crafts just a block away from UC Berkeley. He wanted to create a space for artists in the East Bay after his workshop was destroyed by fire in the powerful 1906 San Francisco earthquake. The college moved around Berkeley a few times during its early years, settling on the Oakland campus in 1922 (per "Campus Goodbye," by Michelle Pitcher on Oaklandnorth.net, Dec. 12, 2019). The name California College of Arts and Crafts was set in 1936. The school remained in Oakland until 2019 at which time it began its move to a San Francisco campus. Many Northern Santa Barbara County artists and art teachers studied there, and many local high school students advanced to the school to hone their art skills.
See: "Alexander, Elizabeth," "Allan Hancock Art Gallery," 1955, "Amador, Trinidad," "College Art Club," 1935, "Costa, Evelyn," "Davidson, Edna," "Dipple, Gordon," "Eya, Setsuko," "Fujioka, Henry," "Gill, John," "Grant, Campbell," "Hibbits, Forrest," "Lange, Myrtle," "Langlois, Mac," "Leitner, Earle," "Negus, Annette," "Oback, N. Eric," "Otis, Helen," "Peake, Channing," "Tashiro, Yukio," "Scolari, Bob," "Wiedmann, Nora"

California Historical Caravan
Two bus-loads of historical artifacts that circulated through California towns to celebrate California's Centennial, 1949.
■ "… it is a project of the State Centennials commission… The caravan, made up of two specially-constructed buses, contains historical objects and documents dating from Drake's plate, nailed up in Marin county in 1579, to the gold spike that joined the first transcontinental railroad. Admission is free. The rolling museum features exhibits from all periods in the state's early history, including sections on exploration, Spanish and Russian colonization, the Bear Flag republic and the gold rush. Designed to form a single display unit, the two white, blue and gold buses will be joined during stops so visitors can move thru without going outside. A detail of state police will guard the exhibits…" and it will stop in Santa Maria, Guadalupe and Arroyo Grande, *SMT*, Jan. 31, 1949, p. 1; "Historical Caravan to Visit Here," *SMT*, June 16, 1949, p. 1.

California Pacific International Exposition (San Diego)
Exposition held 1935. In its education building, art from northern Santa Barbara county schools was included.
See: "Lompoc, Ca., Elementary," 1935, "Santa Maria, Ca., Union High School," 1935, "Young, Carl," 1936

California Portrait Co. (Santa Maria)
Prop. C. A. Smith, who painted portraits from photographs, 1905.
■ "The California Portrait Co. **Chas. Alexander Smith** of Chicago, Artist. A. P. King, Manager. Portraits of all kinds enlarged in Crayon and Water Colors – from photographs only. We Make Our Own Frames. Prices reasonable … Beware of traveling agents. We are here permanently and do our own work. California Portrait Co., Santa Maria, Cal.," *SMT*, July 22, 1905, p. 3, col. 1.
[ed. Is this the same as "California Portrait Co." active in LA in 1906 that the *LA Times* identifies as a "new graft" outfit (see *LA Times*, May 17, 1906, pt. II, p. 5), a photography studio that made enlargements of customer's photos. Is Chas. Alexander Smith the same as Charles L. A. Smith, also from Chicago, who ultimately settled in LA where he became a landscape painter?]

California School of Fine Arts aka San Francisco Art Institute (aka Berkeley School of Fine Arts)
One of several California art schools where Santa Barbara County high school grads took advanced training. Offered scholarships. Several teachers in the county had attended it.
See: "Fratis, Margaret," "Gillum, Vernal," "Hibbits, Forrest," "Lompoc, Ca., Union High School," 1931, 1935, "Matsubara, Kazuo," "Taylor, Elizabeth," "York, Richard"

California State Fair (Sacramento)
Annual. Held at State Fairgrounds, Sacramento. Artists from Santa Barbara County (particularly from the town of Santa Barbara) submitted artworks to the show.
[Do not confuse with the "Santa Barbara County Fair," held in various towns in Santa Barbara County erratically from the mid 1880s.]
California State Fair, Sacramento (notices in Northern Santa Barbara County newspapers on microfilm and on newspapers.com)
1949 – "County Artists … twenty-two artists and craftsmen from Santa Barbara County have submitted 32 entries for competition in the art show at the California State Fair in Sacramento Sept. 1 through 11… oils: **Douglas Parshall**, Charles A. Schallis, Edith Catlin Phelps, Phillip Nunn, Joseph C. Bradley, Lloyd Petersen, Goode P. Davis and Don Freeman of Santa Barbara and **Forrest Hibbits** of Lompoc… water colors: William T. Colville, Jr., Liam O'Sullivan, **Standish Backus**, Jr., and **Joseph E. Knowles**, Santa Barbara, **Forrest Hibbits**, Lompoc and Mrs. Stanley Hollister, Goleta… prints: **Marian Hebert, S. Backus, Jr.** and Don Freeman of Santa Barbara," *SYVN*, July 29, 1949, p. 1.
1951 – "**Jeanne De Nejer** to Show at State Fair… Betteravia Lateral road potter… will exhibit in ceramics at the California state fair in Sacramento, Aug. 30 thru Sept. 9. Also exhibiting… will be eight other county exhibitors. All from Santa Barbara, they are: **Sara Kolb Danner, Clarence Hinkle, Grace L. Vollmer** and Mae D. Holmes, conservative oils; **William Dale [Sic. Dole]**, modern oils; **Douglass Parshall**, watercolors; Ruth D. Schurz and **Renzo Fenci**, sculpture. **Mrs. De Nejer** said that she would exhibit a stoneware sherry wine set… She had a ceramics demonstration booth at the Santa Barbara county fair in

Santa Maria for the past three years but, being out of instruction now, did not take a booth space this year. She said she will have a demonstration booth and exhibit at the Lake county fair in Lakeport, Sept. 1, 2, and 3 and then go to the giant Los Angeles county fair at Pomona, for two weeks starting Sept. 14…," *SMT*, July 31, 1951, p. 5.
1956 –"Five Artists of this County Exhibitors" in California State Fair art show and include **Clarence Hinkle, Douglass Parshall**, and **Olga Higgins** (of SB?), **Mary Parker** (of Goleta) and **Forrest Hibbits** (Buellton) and from SLO Co are **Dorothy Bowman** and **Howard Bradford** (of Pismo Beach), *SMT*, July 31, 1956, p. 4.
1957 – "Three County Artists Exhibit at State Fair… **Forrest Hibbits** of Santa Ynez, 'Submarine Ballet,' print, **Douglass Parshall** of Santa Barbara, 'Dancers,' oil, and 'Bathers,' watercolor, and <u>Robert C. Thomas</u> of Santa Barbara, 'Maenads III' sculpture," *SMT*, Aug. 6, 1957, p. 3.
<u>See</u>: Ellen Halteman, "Exhibition Record of the San Francisco Art Association 1872-1915, Mechanics' Institute 1857-1899, and California State Agricultural Society 1856-1902," (*Publications in California Art*, v. 7), Los Angeles: Dustin Publications, 2000. 708 pp.

California State Mental Hospital (Camarillo)
Art exhibit by patients was held at Allan Hancock [College] Art Gallery, 1957.
<u>See</u>: "Allan Hancock [College] Art Gallery" 1957

California State Relief Administration (SRA)
Successor to the State Emergency Relief Administration (SERA), 1935. A Depression-era relief project.
<u>See</u>: "Santa Maria, Ca., Recreation Department," 1935

Callis, Claire Alys Hatlestad (Mrs. John D. Callis) (1889-1975) (Lompoc)
Painter. Student of Forrest Hibbits. Exh. locally and donated some of her paintings to decorate the Lompoc Hospital. Active with Handicraft Section of Alpha Club.
Twenty-five notices on "Claire Callis" and 60 on "Mrs. John Callis" appear in *LR* between 1945 and 1950 but were not itemized here.
<u>Callis, Claire (misc. bibliography)</u>
Claire Callio [sic. Callis] is listed in the 1940 U. S. Census as age 50, b. c. 1890 in Mississippi, finished college 2nd year, residing in Lompoc (1935, 1940) with husband John Callio [Callis] age 71; Claire H. Callis is listed with husband John D., a farmer, in the *Santa Maria CD*, 1948; Claire H. Callis is listed with husband John in the *Santa Barbara CD*, 1951+; Claire H. Callis, retd., widow of John D. Callis, is listed in the *Santa Barbara CD*, 1962-72; Claire H. Callis b. Aug. 6, 1889 in Mississippi, d. July 23, 1975 in Santa Barbara per Calif. Death Index (refs. ancestry.com).
<u>See</u>: "Alpha Club," 1935, 1936, 1943, 1948, 1951, "Art general (Lompoc)" 1948, "Flower Show," 1948, 1949, "La Petite Galerie (Buellton / Solvang)," 1950, "Lompoc Hospital, Women's Auxiliary," 1949, 1956, "Tri-County Art Exhibit," 1950

Callis, Martha Benn (Mrs. Thomas Canada Callis) (1848-1929) (Lompoc)
Quilt maker.
■ "The Casual Observer… Mrs. Martha Callis, 80, passed away on Tuesday… To those who were fortunate enough to have heard her relate her experiences crossing the western plains in a prairie schooner, Mrs. Callis used to tell exciting tales of the marauding Indians … From Salt Lake City the party started west when Mrs. Callis was a little seven-year-old girl… The late Mrs. Callis had one particular hobby… quilt making…. Mrs. Callis must had [sic] completed fully four hundred quilts. Every Presbyterian minister and family who occupied the church residence here since 1907, when Mrs. Callis joined the church, received one of her hand-made quilts…," *LR*, Aug. 23, 1929, p. 1.
<u>Callis, Martha (misc. bibliography)</u>
Martha Callis b. Dec. 23, 1848 in Saint Louis, Mo., d. Aug. 20, 1929 in Lompoc, Ca., and is buried in Lompoc Evergreen Cemetery per findagrave.com (refs. ancestry.com).

Calvert, Earl Walter (1905-1997) (Lompoc)
Amateur filmmaker, theater manager, 1935, 1939.
■ "Earl Calvert… born… in San Jose … The family moved to Lompoc when he was six months old and he was a lifelong resident of the valley… graduated from Lompoc High School in 1925… Student Body President during his senior year. He attended the University of California at Berkeley from 1925 to 1927… He managed the newly-built Lompoc Theater from 1927 to 1952 and continued working with the Metropolitan Theaters until 1960…," *LR*, Dec. 28, 1997, p. 12.
<u>Calvert, Earl (notices in Northern Santa Barbara County newspapers on microfilm and on newspapers.com)</u>
1935 – "Miniature Movies. Beginning Saturday, members of the **Mickey Mouse club** will see "Mickey Mouse Miniature Movies" every other week, of themselves. Earl Calvert of the local theater, will take a 100-foot reel of … film one Saturday… and will show it on… the following week. … five-minute showing, and all of the club members will have an opportunity to have their pictures taken. ... The theater recently purchased the special camera and projection machine for … [miniature film] … Calvert… believes this feature is unique among **Mickey Mouse club**s in the state," *LR*, May 31, 1935, p. 6.
1937 – "Over 150 Attend Reception… [for William Olivers at the Odd Fellows hall] After supper the group continued to the lodge room where a program of motion pictures was shown. **Mr. Hutton** showed three reels of pictures, some of which were taken in the Lompoc vicinity and others taken as the Huttons vacationed at Boulder dam and Bryce canyon. Earl Calvert presented several reels of color film taken of the Lompoc flower fields and of the mission dedication on Labor day. <u>Dr. L. E. Heiges, Jr.</u>, showed pictures of the recent Sea Scout trip," *LR*, Oct. 15, 1937, p. 4.
1939 – "Kiwanians See Industrial Film. Moving pictures were shown at … club meeting by Earl Calvert showing the development and manufacture of moving picture and camera equipment," *LR*, April 28, 1939, p. 8; "Looking Backward… 20 Years Ago. The Mission Theatre is

presenting a special program Tuesday night when it shows pictures in Technicolor of the recent visit of the Crown Prince and Princess of Denmark to Solvang. These pictures were taken by Earl Calvert of Lompoc…," *SYVN*, May 22, 1959, p. 2; "Ramblings… Los Vaqueros de los Ranchos … Motion pictures of the first ride – done in Technicolor – show some striking scenes … that is we are living in one of the most beautiful areas on earth. Even the dust stirred up by the horses' hoofs is pretty … Next year's ride in Honda valley will enable Earl Calvert, the official photographer – to obtain some marvelous 'shots,'" *LR*, July 28, 1939, p. 1. And additional social and film notices in the *LR*, 1930-1940 not itemized here.

Calvert, Earl (misc. bibliography)
Earl Calvert is listed in the 1910, 1920 and 1930 U. S. Census in Lompoc; Earl W. Calvert b. Sept. 25, 1905, d. Dec. 24, 1997 per findagrave.com (refs. ancestry.com).
See: "Kiddie Kartune Club," "La Purisima Camera Club," 1938, "Lompoc Theater"

Camera and Hobby Shop / Center (Santa Maria)
Shop in Stowell center, 1960-64. Props. Maurice Shook and John LeSuer.
■ "Camera, Hobby Shop Winners are Announced. Winners in the drawing held at the grand opening of the Camera and Hobby Shop new store in Stowell center have been announced. [and names of winners given] The store is owned by **Maurice Shook** and **John LeSuer**," *SMT*, Dec. 1, 1960, p. 7.
1961 – Ad: "Camera & Hobby Center. Everything for the Model Builder. New '61' Cars in Stock Now. The Perfect Spot for all your camera needs and film developing. Open this Friday 'till 9 p.m. Always good parking. Maurice Shook & John LeSuer, Owners. 1525 S. Broadway, Stowell Shopping Center," *SMT*, Feb. 10, 1961, p. 6.

Camera Club (Camp Cooke)
See: "Art, general (Camp Cooke)," Korean War

Camera Club (Johns Manville)
1946 – "Among J-M Men… the Camera Club held a meeting in the clubhouse on Tuesday evening of this week. **Ed Burke** is a leader in the formation of the new group," *LR*, May 23, 1946, p. 8.

Camera Club (La Purisima)
See: "La Purisima Camera Club"

Camera Club (Lompoc)
See: "Camera Club (Johns Manville)," "La Purisima Camera Club," "United Service Organization," WWII

Camera Club (Santa Maria)
Camera Club formed by five youngsters, 1956.
■ Photos of teens at work in a darkroom and "The club presently consists of five members, spokesman Jeff Fitz-Gerald, vice president…pres. [ident Gary Lindberg, 13, trea] surer Terry Fitz-Gerald, 10, and Kim Froom, 11, the club's top developer and printer. Rounding out the quintet is 11-year-old Johnny Mortenson, owner of a flash camera. Qualifications for entry into the club include being at least 10 years of age or in the sixth grade, own a camera and have an interest in photography. The club's assets include four cameras, two of them Brownie Hawkeye flash cameras, two developing sets, a printer, and a darkroom located in the basement of the Fitz-Gerald residence at 223 East Morrison. Expansion plans are already underway to put a dark room in the basement of the **Froom** residence, 905 Haslam Drive – possibly because Kim owns the printer. The club is the outgrowth of an effort by President Gary to save some money on developing of films. Gary tells it this way: 'I had about three rolls of films to get developed and thought it would be cheaper to do it myself. I asked my uncle … who does his own developing, … and he suggested I get a book… After reading… Gary set out to purchase the needed equipment and wound up 56 cents short. Kim, buying his equipment, picked up the 56 cent deficit and the corporation began working. [monies were earned in jobs such as watering lawns and delivering newspapers]. The junior darkroom technicians have been handicapped by lack of working space and some modern facilities – namely a print box timer and enlarger. To make up for the lack of a timer, the boys have devised their own developing system. One member of the club is stationed near the 'safe' light with a watch. Another inserts printing paper and negative in the print box. At a given signal… the lid of the print box is closed setting into action the methods of producing a picture… Another problem to overcome is the lack of running water in which to wash negatives and prints. 'We use a large bucket,' Gary explained… Present financial investments in the club total about $25… A charge of 10 cents a picture is made if the club develops the negatives and prints the pictures. [Printing only] cost only five cents… The club will also contract to shoot pictures…," *SMT*, Sept. 15, 1956, p. 7.

Camera Club (Santa Maria)
Club of amateur adults, 1938+.
See: "Santa Maria Camera Club"

Camera Club (Solvang)
Club active 1950-60.
"Camera Club Meets Tonight. The second meeting of the recently formed camera club will be held at the home of **Raymond Paaske** in Solvang tonight. The meeting will begin at 8 p.m. and anyone interested in joining the club is welcome," *SYVN*, Dec. 15, 1950, p. 1.
Camera Club (Solvang) (notices in Northern Santa Barbara County newspapers on microfilm and on newspapers.com)
1951 – "Camera Club. A meeting and election of officers … will be held at 8 o'clock tonight at the home of **Ray Paaske**…," *SYVN*, Jan. 19, 1951, p. 1; "Top-Flight

Photographer, Resident Here, Offers to Direct Camera Club… **Lyman Emerson**, one of the nation's top-flight advertising photographers," *SYVN*, Sept. 14, 1951, p. 1. And more than 200 additional meeting notices in the *SYVN* between 1950 and 1960 were not itemized here.
See: "Santa Ynez Valley Art Exhibit," 1953

Camera Club (USO)
See: "United Service Organization (Lompoc)"

Camera Clubs
See: "Camera Club …" above, "Central California Camera Club Council," "Channel City Camera Club (Santa Barbara)," "La Purisima Camera Club," "Santa Maria Camera Club," "United Service Organization," and for the camera club of the Los Angeles Bureau of Power and Light see "Photography, general (Santa Ynez Valley)," 1958

Camera Council
See: "Central California Camera Club Council"

Camera Day
One-day special event at Alisal Ranch, April 8, 1954.
"Alisal Guest Ranch Booked Solid for Opening… will open April 8 for the beginning of the Easter vacation period…," *SYVN*, April 2, 1954, p. 8; "Monday's issue of the *Los Angeles Herald and Express* contained a large photo of a bevy of attractive women with their cameras preparing for 'Camera Day' at the beautiful Alisal Ranch. Amateur photographers will have a field day … held on April 8," *SYVN*, March 26, 1954, p. 2.

Camera Shop (Lompoc)
Founded at least by 1934, although earliest use of the name appears in the SMT in 1935. Prop. Ernest Brooks to c. 1941, and later prop. of others. Prop. Tommy Yager 1954+.
Camera Shop (notices in Northern Santa Barbara County newspapers on microfilm and on newspapers.com)
1938 – "Camera Shop to Open in New Location…. Monday, May 2, the Camera Shop, operated by **Ernest H. Brooks**, will open … at 106 East Ocean avenue. The building, now housing the Mercer Plumbing shop, will be arranged to offer an enlarged photographic studio and the usual complete line of camera equipment," *LR*, April 22, 1938, p. 2.
1940 – "Sale… Stationery Items… Gifts, Artists Supplies, Albums, Cameras & Supplies, Leather Goods," *LR*, June 28, 1940, p. 7.
1941 – "Announcing the Reorganization and Expansion of The Camera Shop. Under the Proprietorship of H. Weston, owner of the Santa Barbara Camera Shop. Portraits, Commercial Photography, Photo Finishing, Cameras, Films and Supplies, Magazines, Greeting Cards, Gifts, Stationery, Office Supplies. **Ernest Brooks**, Photographer. 106 E. Ocean Ave.," *LR*, Sept. 19, 1941, p. 5.

1943 – "Send Your Photo. You have hers. … It's not early to have your Christmas photograph made for her… 106 E. Ocean Avenue. Phone 4032," *LR*, Nov. 5, 1943, p. 2.
1944 – "Finds Case" for a camera stolen from Lompoc Camera Shop, *LR*, March 31, 1944, p. 1;
1946 – "Camera Shop to Have New Owners… **T. M. Coker** and **P. M. Bodie**… The property is being purchased from Weston Camera Shop. The business was originally begun here by Ernest Brooks, … During the war it was acquired by Weston and has been managed by **Mrs. Elsie Weston**. The new owners were formerly at Camp Cooke connected with post exchanges. Mrs. Weston plans to move to Santa Barbara next week," *LR*, Aug. 22, 1946, p. 1; "Help Wanted… Photographer to operate studio and do commercial photography. Salary and bonus. Apply Camera Shop, 106 E. Ocean, Lompoc, Calif. Phone 4032," *SMT*, Sept. 13, 1946, p. 7; "Legal Notices. Certificate of Partnership Fictitious Name… We here certify that we are partners transacting a photographic and general novelty business at 106 East Ocean Avenue in the City of Lompoc … Camera Shop… **Thomas M. Coker** … **Perham M. Bodie**…," *LR*, Oct. 17, 1946, p. 4.
1948 – "**P. M. Bodie** Sells Interest in the Camera Shop. **Tommy Coker**, co-owner of the Camera Shop, announced this week that his former partner **P. M. Bodie** has sold his interest in the business to Jack D. Koser, a major in the United States Air Force stationed at Bergstrom Field, Austin, Texas. Koser, it was stated, does not plan to have an active part in the business, and the firm will continue to be operated by Coker. At the same time, it was also announced that the Camera Shop had purchased the complete stocks of Hobby Land, a Lompoc business formerly operated by Curtis Kendal on North H street. The hobby line of merchandise … will include model airplanes and motors, midget racers, engines, trains, ships and other items in the model field, also balsa wood and accessories. Continuing on the staff of the Camera Shop are **Tommy Yager**, photographer and **Ken Pollard** who assists in the photographic department. Coker and Bodie began business at the Camera Shop in August 1946. They were engaged in the post exchange service at Camp Cooke during the war. Major Koser's home is in St. Joseph, Mo., and he is a brother-in-law of **Tommy Yager** of the Camera Shop staff. **Mr. and Mrs. Bodie** planned to leave Lompoc this week for an extended vacation … The Bodies have not decided as yet where they will make their future home," *LR*, July 22, 1948, p. 9.
1949 – "Camera Shop… Bob and Miriam Pope owners. **Tommy Yager** continues in charge of our Photography Department and Studio. Introducing two new lines to Lompoc: Special! Ceramics. Sets of Four Ceramic Flower Place Cards 2.00.," *LR*, Nov. 3, 1949, p. 11; "New Owner Takes Over Operation of Camera Shop. Sale of the Camera Shop in Lompoc to Mrs. Miriam Pope was announced this week and at the same time the new owner issued an invitation to Lompocans to attend a 'Get Acquainted Open House' at the East Ocean avenue store tomorrow and Saturday. … Mrs. Pope is the wife of Robert Pope, Boy Scouts of America executive for the Lompoc and Santa Maria area. The Popes plan to move their residence to Lompoc within the next few weeks… Mrs. Pope stated that there will be no changes in the Camera Shop for the

immediate future, but that an expansion into additional lines of merchandise is planned before the year is out. The store was closed Monday for an inventory and was reopened for business on Tuesday. Every tenth visitor to the Camera Shop Saturday will receive a gift certificate for a free portrait… Two new lines are being introduced at the store, ceramics and philatelic supplies… **Tommy Yager** will continue in charge of the Camera Shop's studio and photography department. The department will be operated as in the past except that service charges on outside picture-taking calls will be eliminated. **Mr. and Mrs. Tommy Coker** have not settled their future plans and will continue residing in Lompoc. Coker … thank his many friends and customers for their patronage… Coker purchased the business with **P. M. Bodie** shortly after the end of World War II," *LR*, Nov. 3, 1949, p. 15.

1952 – "Many Valley Firms Participate in Great Lakes Construction Project… of the new Dicalite Division plant…in Lompoc… The Camera Shop, Lompoc, have served as the official photographers…," *LR*, April 24, 1952, p. 8.

1953 – "Camera Shop and Sporting Goods, 106 E. Ocean Ave.… All Out Stock Disposal Sale… We must reduce stock… 35 MM Cameras new and used [and list of items with prices] … Camera and Photograph Accessories [and list of items with prices] … Cameras [and list of cameras and prices] … Movie Cameras… Photograph Frames… ½ price…," *LR*, April 30, 1953, p. 11.

1954 – "**Yager** Buys Camera Shop," *LR*, Aug. 26, 1954, p. 9.

1956 – "Everything for a Photographer…Film – Cameras. Complete line of Photograph, Hobby and Sports Equipment. Camera Shop and Sporting Goods. **Tommy Yager**. 106 East Ocean Ave., Tel. 4032," *LR*, June 21, 1956, p. 28.

1989 – Classified ad: "Business Close-Out Sale. **Tommy Yager**'s Camera Shop, 113 W. Ocean Ave., Owner retiring after 42 years. Everything goes, antique to modern cameras. Amateur & professional equipment. Hard to find items, dark room equipment, all types projection lamps. Sale starts Mon, May 1st. 20% off Everything except Film," *LR*, May 1, 1989, p. 11.

Camera Shop (Santa Maria)
See: "Santa Maria Camera Shop"

Camera Tips
"How-to" column in Lompoc Record authored by Tommy Yager, of the Camera Shop, Lompoc, 1954-55.
■ "Camera Tips by Tommy Yager. Hello friends and camera bugs! Starting today and every Thursday hereafter we're going to visit with you in this column and pass on some valuable tips that will help you take better pictures. … If you have any problems about taking better pictures, drop in to our store and let's talk them over. If they are of interest to our other friends and customers, we'll gladly pass on the correct answers… In the meantime, drop in our store for a little visit and free advice… **Camera Shop**. 106 E. Ocean. Phone 4032," *LR*, Oct. 7, 1954, p. 16.

Camera Tips (notices in Northern Santa Barbara County newspapers on microfilm and on newspapers.com)
1954 – "Composing Your Pictures," *LR*, Oct. 21, 1954, p. 13; "ABC of Good Photography," *LR*, Nov. 4, 1954, p. 16; "Birthday Pictures," *LR*, Nov. 11, 1954, p. 16; "Baby Pictures," *LR*, Nov. 18, 1954, p. 14.
1955 – "Color Likes More Light," *LR*, March 3, 1955, p. 14; "Shooting in the Sun," *LR*, April 7, 1955, p. 15; "Lighting Know-How," *LR*, May 12, 1955, p. 12; "Less Finery, More Expression," *LR*, June 9, 1955, p. 13. And possibly additional columns not itemized here.
See: "Yager, Tommy"

Camera Topics
Syndicated "How-to" column in Lompoc Record, 1948-50, authored by T. T. Holden.
Camera Topics (notices in Northern Santa Barbara County newspapers on microfilm and on newspapers.com)
1948 – "Plan Scenic Pictures with Care," *LR*, June 3, 1948, p. 5; "Angles Put Drama in Pictures," *LR*, June 24, 1948, p. 5; "Natural Lighting is Best for Pictures," *LR*, July 8, 1948, p. 15; "Flowers are Good Picture Subjects," *LR*, July 15, 1948, p. 2; "How to Make Interesting Action Photos," *LR*, July 22, 1948, p. 16; "Show Subjects at Their Best," *LR*, July 29, 1948, p. 5; "What Makes a Prize-Winning Picture," *LR*, Aug. 26, 1948, p. 10; "Press Type Camera Ideal for Serious Amateurs," *LR*, Sept. 9, 1948, p. 8; "Framing Your Pictures Adds Interest," *LR*, Sept. 30, 1948, p. 15; "Cropping Often Makes the Picture," *LR*, Nov. 11, 1948, p. 11; "More About Prize-Winning Photography," *LR*, Dec. 16, 1948, p. 16.
1949 – "Flash Doubles Fun of Photography," *LR*, Jan. 20, 1949, p. 16; "Portraits Require Psychology," *LR*, Feb. 24, 1949, p. 13; "What About Speedlights?," *LR*, March 3, 1949, p. 8; "Snow Scenes Make Interesting Pattern Pictures," *LR*, March 3, 1949, p. 20; "Single Lens vs. Twin Lens Reflex Cameras," *LR*, March 10, 1949, p. 7; "Good Pictures Take Planning" Thanksgiving, *LR*, March 17, 1949, p. 10; "Learn to See Pictures," *LR*, June 2, 1949, p. 6; "Fall Clean Your Camera for Better Pictures," *LR*, July 14, 1949, p. 9; "Plan Your Vacation Pictures Beforehand," *LR*, Aug. 4, 1949, p. 15; "Camera Care Means Better Pictures," *LR*, Aug. 11, 1949, p. 7; "Some Tips on Wedding Photography," *LR*, Aug. 18, 1949, p. 8; "Ideas for Better Action Photographs IV," *LR*, Sept. 29, 1949, p. 18.
1950 – "Choosing a Camera," *LR*, July 6, 1950, p. 12.

Camp Cooke (aka Vandenberg AFB) (Lompoc)
Military Base that had some "art" in the form of photography and in crafts taught in recreation centers, etc. Known as Camp Cooke, 1941-1958 and afterwards as Vandenberg AFB.
See: "Art, general (Camp Cooke)," "Photography, general (Camp Cooke)," "United Service Organization"

Camp Cooke Welfare Carnival
See: "Kolding, Merritt"

Camp Fire Cottage / Camp Fire Cabin (Santa Maria)
Built on the Santa Maria high school campus, 1935.
Some meetings of the College Art Association were held there.

■ "**Joann Wilson** was a 6-year-old growing up in the heart of the Great Depression when the Camp Fire Cabin was built in 1935 on the Santa Maria High School campus. Over the next dozen years, the cabin almost became a second home for Wilson, who would become a member, counselor and eventually branch president of the organization. Now an active and energetic 82, Wilson was just one of thousands of young girls, and later boys, who learned many of life's valuable lessons in that cabin. Today, she will be one of the Camp Fire alumni on hand as the Santa Maria Landmark Committee designates the cabin an 'Object of Historical Merit.' The ceremony is especially notable for Wilson, who is not only a former Camp Fire girl but a current member of the Landmark Committee. The event is scheduled for 11 a.m. at Buena Vista Park, at the corner of Morrison Avenue and Pine Street, where the cabin now rests and serves a new generation of Camp Fire kids. 'We learned to cook. We learned to sew on a button. We learned how to make a camp fire. We learned how to make a bed with hospital corners. It was pretty much an all-around education,' Wilson said. 'Lots of friendships there.' Recalling her times at the cabin, Wilson's smile is as warm as the fires where she and her friends roasted marshmallows, drank hot chocolate and sang songs. 'We'd all meet there and work on our beads,' Wilson said, remembering the Camp Fire awards they received for mastering skills or completing projects. 'There was a loft and we'd sleep up there. It was great fun.'" from santamariatimes.com/news/local/ posted May 14, 2011.
See: "Camp Fire Girls," 1937, 1940, 1950, "College Art Club," 1935

Camp Fire Girls (including Blue Birds) (Northern Santa Barbara County)
Girls' organization that held some handicraft classes.
Adult leaders were labeled "Guardians."
Campfire Girls (notices in Northern Santa Barbara County newspapers on microfilm and on newspapers.com)
1923 – "Camp Fire Girls … week's camping … Paradise Camp on the Santa Ynez river… camp schedule… 9:30 a.m. – Handcraft… Special Programs – … handcraft exhibit… ["orders"] … (2) make a basket (3) make a headband … Special honors will be given (made of leather appropriately decorated and intended as ornaments for the ceremonial gown) for the following… (8) for the best piece of hand work with original design (9) for the best piece of hand work with adapted design…," *SMT*, June 11, 1923, p. 2.
1930 – "Benefit Bridge Party to be Given… to Furnish Camp Fund… At the camp to which the girls will be sent there will be lessons in swimming, diving, first aid, nature study, handcraft, sports, citizenship, business and the various other Campfire crafts," *LR*, May 30, 1930, p. 6.
1931 – "State Institute Campfire Leaders… banquet… Santa Maria club… An exhibit of handcraft, photographs, campfire supplies and publications will be shown," *SMT*, Feb. 6, 1931, p. 5.

1932 – "Guardians of Campfire in… monthly meeting … the evening was given over to a study of craft work. A high light of the program was a demonstration in knotting twine for belt making by Mr. [Otto E.] Kramer [assistant Boy Scout executive] … Another interesting feature… was a display of…handcraft by Mrs. Glenna Germain, guardian of the Nissaki group at Orcutt, who is working for the Torch Bearer's rank, the highest degree in Campfire, which requires this exhibit for obtaining the honor," *SMT*, March 3, 1932, p. 3.
1933 – "Campfire Girls School… of instruction in … handcraft will be held in this city on October 21… [by] Miss Lilly Stevens…," *SMT*, Oct. 5, 1933, p. 3; "Guardians Gain Pointers from Miss … Lillian Stevens of Long Beach on Saturday … new ideas and suggestions for carrying out handcraft projects in their respective groups… weaving on homemade looms… book binding and making marbleized paper… Assistance during the afternoon was lent by **Miss Ruth Blanchard**, sewing instructor, and by **Arthur Merrill**, instructor in the boys' manual training department…," *SMT*, Oct. 23, 1933, p. 2.
1934 – "Hobbies Theme of Grand Council…," *SMT*, May 7, 1934, p. 2; "Many Girls Plan Week at Camp Talaki … Among the directors who will oversee the girls will be … **Laura Penny** of San Luis Obispo, who will have charge of the handcraft classes…," *SMT*, July 28, 1934, p. 2; "Campfire Girls at Home after Week's Sojourn at Camp… During the week the girls had lessons in handcraft, campcraft, nature study and citizenship. They learned how to make their headbands, how to mount books, to decorate Christmas boxes, to make Christmas cards and to make plaster-of-paris book-ends and decorate them…," *LR*, July 31, 1934, p. 8.
1935 – "More than 50 to Enter Camp… Drake in the Santa Ynez mountains… teaching of Indian handcraft will be one of the features… just as it was last year when girls learned to make pottery, do basket work, tool leather and make beaded articles," *SMT*, June 29, 1935, p. 2; "Sixty-Two Girls… Summer Camp… **Theda Ferini**, **Elaine Dudy**, and Alice Graham are to have charge of handcraft…," *SMT*, July 9, 1935, p. 3; "Girls Return from Camp Drake… All of the handcraft work and supervision of camp activities was done this summer by local Campfire girls… **Elaine Dudy**, Veda [Sic. **Theda**] Ferini and Alice Graham were in charge of the handcraft classes, which made baskets, tea towels, reed hats and other articles. These will be exhibited at the fair next week…," *SMT*, July 18, 1935, p. 2.
1936 – "Woodcarving Diverts," i.e., making buttons and jewelry, *SMT*, Jan. 10, 1936, p. 3; "How Honors in Campfire Work Inspire Girls… Handcraft covers all kinds of handiwork, such as sewing, art work, and wood and metal work, and it enables the Campfire girl to become skilled in making objects with her own hands and to express her thoughts and ideas in actual things," *SMT*, Jan. 23, 1936, p. 8.
1937 – "Jubilee Week… Silver Jubilee… An exhibit in the window of Bryant and Trott's store on West Main street… depicting the seven crafts of Camp Fire. Outstanding work is shown in nature craft, hand craft and household craft… Koshuta group will meet tomorrow night in **Camp Fire cottage**… The group also will report on the series of nature studies and paintings worked on during recent meetings,"

SMT, March 18, 1937, p. 2; "Seventy-Five Girls to Go to Camp... Drake... **Mrs. Hazel Lidbom, Miss Alberta Ow** and Miss Esther Kashner of Los Angeles will direct the handcraft sections... Miss Mary Ellen Germain will direct the camp craft workers...," *SMT*, June 11, 1937, p. 3.
1938 – "Councilors Selected for Camping Trip... Camp Drake, June 12 to 19... Handcraft will be directed by Miss Barbara Crow of UCLA and Miss Myrna Jullien of Santa Barbara State...," *SMT*, April 18, 1938, p. 3; "Camp Fire Girls Return from Camp... Drake... **Mrs. Lidbom** also received a national honor, the 'keda' given for fine work in handcraft and design. ... awarded for the workmanship in the book Mrs. Lidbom made for the rank of Torch Bearer. During the week campers were kept busy with handcraft ...returned with articles made by them such as wooden book covers, Chinese-knotted belts, plaques, prints and plaster of Paris casts," *SMT*, June 20, 1938, p. 3; "**Mrs. Lidbom** Wins Honor" from Camp Fire Girls, i.e., Shuta honor of written thought. The honor was won when the literary critic of the national honor committee recommended it for an article, 'Inspiration Giver and Receiver,' by Mrs. Lidbom, which was published in the magazine, *Western Woman*," *SMT,* June 30, 1938, p. 3; "To Attend Camp – **Mrs. Hazel Lidbom** of the county health department" will attend training for Camp Fire guardians in the San Bernardino mountains, *SMT,* July 1, 1938, p. 3; "Camp Fire Girls Do Handcraft," *SMT,* Sept. 24, 1938, p. 2; "Birthday Dinner," *SMT,* Oct. 10, 1938, p. 3; "Camp Fire Girls Make Cards," *SMT,* Dec. 10, 1938, p. 2; "Holds Open House," *SMT,* Dec. 24, 1938, p. 3.
1939 – "Girls Photograph Old Landmarks... girls of the Tanpa group will take pictures of many of Santa Maria's old landmarks and buildings," *SMT,* Jan. 26, 1939, p. 3; "Camp Fire Handcraft," *SMT,* Feb. 4, 1939, p. 3; "Handcraft Show Arranged by Camp Fire," *SMT,* March 21, 1939, p. 3; "Camp Directors are Selected... at Camp Drake, June 12-19... Miss Marguerite Kohler, Guadalupe school teacher and guardian of the Guadalupe Camp Fire group, is to be one of the handcraft counselors. She will be assisted by another young woman from Santa Barbara State college, Miss Dorothy Horner...," *SMT,* May 19, 1939, p. 3.
1940 – "Camp Fire Crafts Shown for Leaders... Leaders... saw a display of handcraft by **Mrs. Ralph Lidbom** last night in **Camp Fire cottage** and heard Mrs. Lidbom outline possibilities for teaching handcraft to girls. Among the articles displayed were simple notebooks, plaques and 'spatter prints' through an array of more difficult projects up to gloves and bags of crochet...," *SMT,* Feb. 16, 1940, p. 3; "Summer Camp Open... Camp Drake... Rose Cicero Cravey [teacher] of Betteravia will be handcraft counselor," *SMT,* May 29, 1940, p. 2; "Camp Visitor's Day Friday... [day changed to] allow the girls more time for handcraft ... in preparation for the handcraft exhibit...," *SMT,* June 11, 1940, p. 3.
1941 – "Summer Camp's Counselors... Lois Funk, **Vivian Patterson** and Rose Cicero Cravey, handcraft...," *SMT,* June 17, 1941, p. 3.
1942 – "Camp Registration... Another counselor has been added... Norma Deising who will assist Lois Funk and **Vivian Patterson** with handcrafts...," *SMT,* May 19, 1942, p. 3.

1943 – "Camp Fire Girls... Camp Drake... June 13 to 20 ... Those in charge... will be: Handcraft. Norma Deising, Mary McGraw and Elaine LaFranchi...," *SMT*, June 8, 1943, p. 3.
1945 – "United Nations Meeting for Camp Fire Sessions... Counselors ... **Mrs. John M. Sluchak** and **Miss Davidson** will be handcraft counselors... The camp schedule starts at 6:45 a. m. with reveille ... 7:10, parade grounds, flag raising, 7:20, breakfast, 7:50, clean camp and make beds, 8:40, meet for sing and orders of the day, 9:10, first period of handcraft and swimming, 10:10, second period of handcraft and swimming, 11:10, free time, 12:00 lunch. 1:00 p.m., rest hour, 2:00, handcraft, swimming and nature craft, 4:00 free time, 5:00 dress in uniform for dinner, 5:30 dinner, 6:30, on parade ground for flag lowering, 6:45 games on parade ground, 7:30, evening campfire, stunts and songs, 9:00 taps," *SMT*, July 3, 1945, p. 3; "Water Carnival Presented for Parents... in Camp Drake... In the hand-craft room, Marcia Ann Hancock and Sharon Truesdale constructed raffia dolls and there was considerable tooling of leather ...," *SMT*, Aug. 6, 1945, p. 3.
1946 – "Camp Fire Group... weekly meeting of the Wiconcantwaste Camp fire group was held yesterday with the main feature of the meeting a demonstration of textile painting presented by Mrs. Gilbert Martin. Following the demonstration, the members practiced the technique on scraps of cloth," *LR*, Oct. 31, 1946, p. 6.
1948 – "Parents Spend Day at Camp Talaki... The handcraft classes are doing work in leather wallets, coin purses and belts, copper pictures, and stenciling on cloth. Jo Ann Hudson and Patricia Palmer are the instructors," *SMT*, June 14, 1948, p. 5.
1949 – "The Cheskchamay [Sic.?] Horizon club met at Mrs. Quinton McCabe's home recently. Mrs. Charles Bodger helped the girls with their work in ceramics. Those attending the meeting were ...," *LR*, March 3, 1949, p. 3.
1950 – "Camp Fire Girls... Camp Talaki... All girls have two periods of crafts, working with clay at the first session. Figurines, containers and costume jewelry are favorite subjects... **Mrs. Gladys Celander** and **Miss Edna Davidson** are teachers of the classes in clay, Joyce Fessler and **Marilyn Smith**, assisting...," *SMT*, June 23, 1950, p. 6; "Camp Fire Guardians... Meeting... at **Camp Fire Cottage**... An exhibition of handicraft was shown by **Mrs. Vivian Williams**...," *SMT*, Oct. 10, 1950, p. 4; "C. F. Guardians... **Mrs. Vivian Williams** gave a handicraft demonstration for Blue Bird leaders," *SMT*, Nov. 7, 1950, p. 5.
1951 – "Nora Jenks New Prexy. Tanda Camp Fire girls... At Christmas time Tanda girls made ceramic snowmen favors which were used on trays at the Lompoc Community hospital. Each snowman was carrying an armload of holly berries. The favors not used were given to the girls...," *LR*, Jan. 11, 1951, p. 5; "Camp Fire Girls... Dolls made by the girls while at Camp Talaki for the purpose of fostering friendships with children in foreign countries are to be sent overseas for Christmas... December meeting... An art collection of masks made by children in El Camino school taught by **Miss Edna Davidson** was on display arranged by **Mrs. Vivian Williams**, who has been active in promoting

interest in art for the Junior Community club," *SMT*, Nov. 6, 1951, p. 4.

1952 – "Program Dates… Representation in the Elks Rodeo parade was discussed… a demonstration of handicraft by Mrs. Leota Clark…," *SMT*, Feb. 6, 1952, p. 4; "Blue Birds Leaders Training Offered. … four classes … Tissue tikes will be made and special crafts for the holiday season shown. All leaders are urged to attend… Attending the first class were Mesdames… **Gertrude Dal Porto**…," *SMT*, Nov. 10, 1952, p. 4.

1955 – "Camp Fire Girls Model Skirts… Several of the girls had other crafts, such as hand-made lapel ornaments … One girl showed a hand-puppet she had made of scraps of cloth and buttons. Another demonstrated making a decorative snow man for a party table," *SMT*, Nov. 8, 1955, p. 4.

1956 – Photo of handicraft teacher Marline [Sic. Marlene] Edwards helping two campers, *SMT*, July 8, 1956, p. 11; "Campfire Girls… Next week on Monday at their meeting, the I-Yo-Pta girls will resume work… making Hansel and Gretel puppets to be used in the staging of a show later in the season," *LR*, Sept. 27, 1956, p. 5.

1958 – "Tendalohe Girls … Campfire group… regular meeting last Thursday in the **Community Center** Annex room… A review of recent activities… include … working with and painting ceramics…," *LR*, March 6, 1958, p. 4; "Tonapa … One of their present activities is making puppet dolls for a puppet theater," *SMT*, July 24, 1958, p. 2; "Camp Fire Leaders Meet… **Mrs. Nora Wiedmann** will speak Wednesday night, October 15, at the meeting of Camp Fire Guardians to be held at eight o'clock at the Camp Fire Room of the **Community center**. Her topic will be 'leadership training'… She will also demonstrate textile painting. Those attending are asked to bring with them scissors, an apron, a sponge, a small container such as a milk carton for water, a stapler and extra staples," *LR*, Oct. 9, 1958, p. 2.

1959 – "Girls Enjoy Week at Camp Talaki… Miss Barbara LaRosa is counseling in handcraft…," *SMT*, June 24, 1959, p. 5.

1960 – "Young Society. Da Kon Ya Camp Fire Girls made red and green yarn dolls recently under the instruction of Kathy Burton. … In the offing is work on textile paintings and fashioning of pin-cushion ladies," *LR*, Nov. 24, 1960, p. 23.

And, numerous additional notices not itemized here.

See: "Camp Fire Cottage," "Community Center (Lompoc)," "Community Club," 1941, "Floats," 1951, "Handcrafts," "Handwork," "Horizon Club (Lompoc)," "Hutchinson, Barbara," "Lidbom, Hazel," "Santa Barbara County Fair," 1930, 1935, "Stotts Potts"

Campbell, Catherine C. (Santa Barbara)
Assistant professor of art at Santa Barbara College, 1953, who spoke at Winter Arts Program.
See: "Winter Arts Program," 1953

Campbell, Horace, Rev. (Santa Maria)
Lecturer on Great Masterpieces of Art at Christian Church, 1935. Pastor.

■ "A new venture in Santa Maria will be initiated Sunday evening, January 20, at the Christian church when Rev. Horace Campbell begins the first of his lectures on Great Masterpieces of Art. The subjects of his lectures will be taken from the works of painters such as Raphael and others. Rev. Campbell has purchased several copies of each painting on which he will lecture, and plans to present each family present at the lecture with a copy. A brief resume of the life of the artist, his background and inspirations will be given in addition to facts about the pictures that will lend to those attending some idea of art appreciation. There will also be given a short summary of the part the church has played in the production and preservation of arts during the ages. The lectures will be given at the rate of one per month for the next year," per "Art to be Discussed," *SMFA*, Jan. 4, 1935, n. p.

Campbell, Linda June (1941-?) (Los Olivos)
Photographer, WAVEs, 1960. Active in high school with Little Theater.

■ Port and "Linda Campbell Completes Basic WAVE Training. Linda June Campbell, daughter of Mrs. Robert J. Campbell of Los Olivos, completed nine weeks of basic training at Recruit Training-Women, US Naval Training Center, Bainbridge, M. D., and was graduated during a military review… a former student at Santa Barbara City College and a graduate of Santa Ynez Valley Union High School will spend a 14-day leave with her mother before reporting to Pensacola, Fla., for photographer's school…," *SYVN*, Sept. 23, 1960, p. 3.

Campbell, Linda (notices in Northern Santa Barbara County newspapers on microfilm and on newspapers.com)
Port. as graduate of Santa Ynez Valley Union High School, *SYVN*, June 5, 1959, p. 6.

Campbell, Linda (misc. bibliography)
Linda June Campbell, mother's maiden name Harmon, was b. Aug. 29, 1941 in Santa Barbara County per Calif. Birth Index; Linda June Campbell b. Aug. 29, 1941, was residing in Empire, Nv., in 1992 per *U. S. Public Records Index, 1950-1993*, vol. 1 (refs. ancestry.com).

Campbell, Sarah Kolb Danner
See: "Danner (Campbell), Sarah Kolb (Mrs. William M. Danner) (Mrs. Edward L. Campbell)"

Canfield, Elizabeth "Betty" J. Sherwood (Mrs. Boyd W. Canfield) (1906-2000) (Lompoc)
Home economics at Lompoc Junior and Senior High School, 1953+.

■ "Elizabeth 'Betty' Canfield… born March 14, 1906 in Karo, Texas to Rueben and Della Jennings Sherwood. … She earned her bachelor's degree in home economics from the University of New Mexico at Albuquerque and her masters of science degree from Colorado A & M in 1939. A teaching career spanning 60 years included teaching

elementary school through high school and junior college throughout New Mexico, Arizona and California. She came to Lompoc in 1945 and retired from the Lompoc Unified School District in 1971 … She married Boyd W. Canfield… in 1946 …," *LR*, Aug. 22, 2000, p. 2.
See: "Lompoc, Ca., Junior High School," 1953

Canfield, Sena Marie Mathiesen (Mrs. Lloyd Everett Canfield) (c. 1920-2013) (Lompoc / Santa Maria)
Cake decorator, 1957.
■ Port. with cake decorating props, and "Masterpieces Designed by Lompocan … asked to prepare some sort of festive cake for the high school Football Lettermen's annual dinner… gaily decorated goal posts marked off the field ends. Pipe-cleaner men hunched in formation, each pinned with an enlarged facial picture… Colors were red and white, and blue and white – Lompoc and their arch rivals, Santa Maria… The largest [cake] Mrs. Canfield has created … for her daughter's senior prom… Sharon Canfield… 1955 class… 55 inch by 41 inch sheet cake… The cake had carrousel frostings of multi-colored splendor. Story-book dolls, representing a pretty young thing and her escort in top hat and tails danced in the center of the fluffy-duff topping. Last year, at the senior prom … was Mrs. Canfield's 'Three Coins in the Fountain' cake. A candle-holder turned upside down formed the fountain. Piano wire covered with silver sparkle gave the illusion of spray, and small golden coins glistened in the fountain… When popular young Kay Hume exchanged vows with handsome Charles Williams recently, a wedding cake… was prepared for them. Bells, hearts, arches and glistening love birds… The wedding cake for the Burroughs-Miller bridal reception … was another masterpiece… How did it start … Mrs. Canfield is the youngest daughter of Mr. Pete Mathiesen of Fresno. At an early age she began 'taking care' of her father. The family lost the mother, so kitchen chores became routine for the youngest daughter. At first it was fried potatoes, bacon, eggs and the like. Gradually she began to fuss about with food, prettying it up. As a bride she came to Lompoc …," *LR*, March 14, 1957, p. 16.
Canfield, Sena (notices in Northern Santa Barbara County newspapers on microfilm and on newspapers.com)
2013 – "Death Notices. Sena Marie Canfield, age 93, resident of Paso Robles, former resident of Santa Maria and Lompoc, passed away January 11th, 2013. Arrangements and services are pending," *LR*, Jan. 13, 2013, p. A3.
And, more than 20 notices for "Mrs. Lloyd Canfield" in the *LR* between 1940 and 1960, including some references to cakes she had decorated, were not itemized here.

Cannon, Burt E. (Santa Maria)
Teacher of mechanical drawing at Santa Maria High School / Junior College, and Adult School, 1921/22. Cannon became a real estate developer.
■ "Faculty Additions… Mr. B. C. [Sic.? E.] Cannon, who taught mechanical drawing and coaching at Montebello last year, has charge of the mechanical drawing and part of the wood work," *SMT*, Sept. 24, 1921, p. 4.

Cannon, B. E. (notices in Northern Santa Barbara County newspapers on microfilm and on newspapers.com)
1921 – "This year the girls are being taught a course in bungalow planning. … by B. E. Cannon," *SMT*, Aug. 31, 1921, p. 4, col. 2.
1922 – "Commencement Week… following teachers have signified their intention of remaining… B. E. Cannon, mechanical drawing, manual training," *SMT*, May 24, 1922, p. 1; "Local Men Open Tract in Ventura," *SMT*, July 12, 1922, p. 1; "B. E. Cannon, who recently resigned his position as mechanical drawing and manual training teacher in the local school …," *SMT*, Oct. 3, 1922, p. 5, col. 2.
1924 – "Former Member of High Faculty Weds in Santa Paula… B. E. Cannon… *Santa Paula Chronicle*… to Miss Myrtle Helmer of Glendale. Mrs. Cannon is a director of dramatics, a professional reader and an organizer of Little Theatres … Mr. Cannon is associated with the firm of Purkiss and Cannon," *SMT*, Jan. 4, 1924, p. 5.
And additional notices for "B. E. Cannon" in *SMT* not itemized here.
Cannon, B. E. (misc. bibliography)
Burt E. Cannon, teacher at 910 S. Broadway, is listed in *California Voter Registrations, Santa Maria Precinct, No. 5* (c. 1920?) (refs. ancestry.com).
See: "Santa Maria, Ca., Adult/Night School," 1921, "Santa Maria, Ca., Union High School," 1921

Capitani, Lorenzo, Rev. Father (1875-1963) (Guadalupe / Los Angeles / Italy)
Priest of Our Lady of Guadalupe, poet, artist, 1927.
■ "Painting Exhibit is Held Here… Father Lorenzo Capitani, at one time in charge of Our Lady of Guadalupe Catholic church… but now devoted principally to oil painting, today had a number of his works on exhibit at **Santa Maria Inn**. Father Capitani will leave tonight for Los Angeles, his present home. … His paintings depict scenes made throughout California and Italy. Of special interest to local citizens are his canvases showing Santa Maria valley flower fields and beach landscapes near Guadalupe. He also has a number of works done in Marin county and garden spots of the state, both in northern and southern California. Some of his paintings made in Italy are titled 'Lake Lugano,' "Monte Carlo," 'Scene Near Florence' and 'Lake Maggiore.' Father Capitani is planning to do all missions of California in oils. He decorated the new Santa Clara Catholic church recently completed in New York City. He has held exhibits in New York, Atlantic City, Los Angeles, Long Beach and Beverly Hills and has sold paintings to Amelita Galli-Curei, Beniamino Gigli, Mary Pickford, Harold Lloyd and other celebrities," *SMT*, Aug. 23, 1932, p. 6.
Capitani, Lorenzo (notices in Northern Santa Barbara County newspapers on microfilm and on newspapers.com)
1927 – "Guadalupe has as the pastor of the Roman Catholic church a poet as well as an artist of note. An exhibition of paintings by Rev. Lorenzo Capitani… was opened at studio No. 11, 3275 Wilshire boulevard, Los Angeles on April 1. Father Capitani is an Italian by birth and has spent many years studying art in Florence, Italy. Later he came to New York city where he painted murals in Santa Clara Catholic

church … His first exhibition was held in the Ambassador hotel, Atlantic City. Among the paintings which Father Capitani will exhibit in Los Angeles are many California scenes painted in the Santa Maria valley, mostly around Guadalupe and also in Lompoc. There are also several Italian scenes among the group, which numbers over thirty or more. The villa of the late Rudolph Valentino, nestling at the foot of Beverly Hills, is also among Father Capitani's collection," *SLO DT*, April 1, 1927, p. 5; "Rev. Father Lorenzo Capitani arrived Saturday from Los Angeles where he has been spending the past few months recuperating from injuries which he received when some hit-and-run driver struck him several months ago. Rev. Capitani returned to the southern city Monday afternoon," *SMT*, Aug. 11, 1927, p. 8; "Priest Honored. Father Lorenzo Capitani of Florence, Italy, but formerly pastor of the Church of Our Lady of Guadalupe here, was honored Thursday evening, Sept. 22, at the Alexandria hotel in Los Angeles by a musical and reception … by the art committee of the Los Angeles Opera and Fine Art clubs. … During his stay in Guadalupe, Father Capitani painted some remarkable scenes of the flower fields in bloom in the valley and also some wonderful sunset scenes on the Pacific. At the close of the reception that evening, 12 of his best paintings were sold to the highest bidders, the proceeds to be given to charities," *SLO DT*, Sept. 24, 1927, p. 7; "Former Pastor is Honored in LA. (Special from Guadalupe)," *SMT*, Sept. 26, 1927, p. 4.

1929 – "At Beverly Hotel. An exhibition of paintings by Father Lorenzo Capitani now at the Beverly Hills Hotel, includes paintings of the houses and gardens of several famous motion picture stars including those of Mary Pickford and Charles Chaplin," *LA Times*, March 17, 1929, p. 48 (i.e., pt. III, p. 16); "Painting All Missions. Father Lorenzo Capitani of the Brayton Apartments is engaged in painting all the California missions. He has exhibited his California and Italian landscapes here and in New York and is returning to Italy to paint in August. Among his best-known subjects are the gardens of Charles Chaplin and the grounds of Pickfair," *LATimes*, July 14, 1929, p. 44 (i.e., pt. III, p. 18); port. with caption "Artist-Priest. Father Lorenzo Capitani of Florence, Italy, will paint California's missions and exhibit the work in Rome—*Tribune* photo," and longer article, "Priest Paints Old Missions… Father Capitani, whose paintings of California's rural and seacoast scenes have won national and international attention made this announcement in Oakland today on the eve of his departure for Italy, where he will paint the Vatican gardens. He will return to San Francisco and Oakland soon, he said, and will be ready to place on exhibition here a number of Italian landscapes. During the last two years Father Capitani, who has been residing at the Francis hotel, San Francisco, has held a number of exhibitions. While in Long Beach, California, his paintings were viewed and praised by many art connoisseurs as well as dozens of motion picture celebrities. Mary Pickford purchased the priest's painting of her home, 'Pickfair,' and Harold Lloyd bought a landscape of the Lloyd gardens of the comedian's Hollywood residence. … Since being in California, Father Captiani has painted sixty landscapes…," *Oakland Tribune*, Nov. 24, 1929, p. 18 (i.e., 18A).

1930 – "Was Recent Guest at Brookdale Lodge. Professor Lorenzo Capitani of Florence, Italy, was a recent guest at Brookdale lodge. Capitani is an artist and is in the United States to paint the Missions of California. He is also one of the leading art critics of Italy and was much impressed with the artistic beauty of the lodge dining room," *Santa Cruz Evening News*, Aug. 13, 1930, p. 6.

1931 – "New Suits, Filings, Etc. … Attachments… Filed June 23, 1931… 17635 – Eula Wright v Lorenzo Capitani, money $300 – P.S. Ehrlich…," *The Recorder* (San Francisco), July 1, 1931, p. 8.

Capitani, Lorenzo (misc. bibliography)
Lorenzo Capitani, provided the following information on his WWI Draft Registration Card – b. March 10, 1875, residing in Manhattan, NY; Lorenzo Capitani, Catholic Priest, Republican, Guadalupe, registered to vote in *Guadalupe Precinct* (c. 1926); Rev. Lorenzo Capitani, 2424 Wilshire Blvd., priest, D, is listed in *Index to Register of Voters, Los Angeles City Precinct No. 602*, 1928; Lorenzo Capitani is listed in several *Passenger and Crew lists* to and from Italy not itemized here; Rev. Lorenzo Capitani, b. March 10, 1875 in Porto Santo Stefano, Toscana, Italy, d. Sept. 4, 1963 with residence at Murray Hill, NY, and is buried in Calvary Cemetery, Woodside, Queens County New York per findagrave.com (refs. ancestry.com).

Capp, Al (aka Alfred Gerald Caplin) (1909-1979)
Nationally syndicated cartoonist of "Li'l Abner" strip, who ran a national competition.

■ "Alfred Gerald Caplin (September 28, 1909 – November 5, 1979), better known as Al Capp, was an American cartoonist and humorist best known for the satirical comic strip Li'l Abner, which he created in 1934 and continued writing and (with help from assistants) drawing until 1977," Wikipedia.
1951 – "Sends Telegram and Sketches to Aid [publicity of] Dogpatch Days in Santa Maria," i.e., St. Peters Episcopal church building fundraiser, and posters supplied by Gil Silva, Junior college art student, *SMT,* Oct. 12, 1951, p. 4.

Carey, E. T., Lieut (Camp Cooke)
Photographer, teacher of photography at Camp Cooke, 1945.
Carey, E. T. (notices in Northern Santa Barbara County newspapers on microfilm and on newspapers.com)
1945 – "Cameraman Talks to Rotary Club. Lieut. E. T. Carey, Camp Cooke, a camera instructor in the Army intelligence division during the war, was the speaker before the Lompoc Rotary Club Wednesday evening. He explained the fundamentals taught cameramen by the services and gave pointers to the Rotarians on how to get best results in photography," *LR*, Oct. 12, 1945, p. 12; "Wanted to Rent: Small apartment or house for Army officer and wife, on or after December 15. Lieut. E. T. Carey, Spec. Service Hdq., 20th a. D.," *LR*, Dec. 7, 1945, p. 8.
This individual could not be more fully identified.

Carey, Rockwell Wolfard (1881/4-1951/4) (Oregon / Santa Barbara)
Exh. lithographs at Santa Ynez Valley Art Exhibit, 1954.

■ "Largely self-taught, fifteen-year-old Rockwell Carey won a prize for drawing at the Oregon State Fair in 1897. He continued to enjoy success with his watercolors at the Society of Oregon Artists in 1912 and 1913. Carey attended the Museum Art School and was a member of its first graduating class. As a participant in the U.S. Treasury's Public Works of Art program, which preceded the WPA by several months, he produced several works. A mural, Early Mail Carriers of the West, for the Newberg Post Office was produced under the Section of Fine Arts. Carey also won a prize in the American Artists Professional League show of 1937, where his painting was voted the most popular. The next year he won the grand prize for The White House. Although his early work was impressionistic, he was later known for his expressionist-style marines and landscapes. He was also a lithographer. Carey was living in Santa Barbara by 1949, but died in Portland while on a visit in 1954," Artist biography in Ginny Allen and Jody Klevit, *Oregon Painters: The First Hundred Years (1859-1959),* Oregon Historical Society, from portlandartmuseum.us
Carey, Rockwell (misc. bibliography)
Rockwell W. Carey is listed in the 1910, 1920, 1930 U. S. Census in Portland, Ore.; Rockwell W. Carey, artist, is listed with wife Maybelle at 303 Santa Anita rd. in the *Santa Barbara, Ca., CD,* 1951, 1953, 1954; Rockwell Wolfard Carey was b. Nov. 20, 1881 in Salem, Ore., to Richard W. Carey and Amelia Wolfard, married Mae Carey, was residing in Salem, Ore. in 1900, and d. March 30, 1951 [sic.] in Portland, Ore., per Wolfard Family Tree; Rockwell W. Carey b. 1884, d. 1954 and is buried in Lincoln Memorial Park, Portland, per findagrave.com (refs. ancestry.com).
See: "Santa Ynez Valley Art Exhibit," 1954

Carle, Cecil Eugene "Teet" (1899-1992) (Hollywood)
Photographer who spoke on trick photography in motion pictures to the SYVUHS, 1935.

■ Teet Carle, author, "Backward Look at Glamour," *Hollywood Studio Magazine,* 5, no. 9 (January 1971), pp. 8-10; co-author of *The Laugh's on Hollywood,* Roundtable Pub., 1985, 190 pps.; Carle is described in various places on the Internet as "Paramount Studio publicist" 1927-1936; Carle is buried at Forest Lawn Memorial Park (Hollywood Hills) per findagrave.com.
See: "Santa Ynez Valley Union High School," 1935

Carlin, David "Dave" Paul (1919-2001) (Guadalupe)
Photographer, amateur, post WWII. Active with Santa Maria Camera Club, c. 1946-50.
Carlin, David (notices in Northern Santa Barbara County newspapers on microfilm and on newspapers.com)
1946 – "Money Received... First official photograph of the new body [Guadalupe City Council] was made by David Carlin, son of Mayor Paul Carlin, who presided over the session...," *SMT,* Dec. 17, 1946, p. 5.
1948 – "Photographer Explains Art to Rotarians... **Norman Brown,** Arroyo Grande... introduced by David Carlin,

himself an amateur photographer," *SMT,* Aug. 7, 1948, p. 4; repro: "It was Dinner," *LR,* Nov. 25, 1948, p. 11; photo of a small, nameless valley in the Point Sal hills, which his father, Mayor Paul D. Carlin of Guadalupe, is viewing, won a prize in the Santa Maria Camera Club's competition, *LR,* Dec. 9, 1948, p. 13.
1949 – "Guadalupe Glimpses ... David Carlin, cashier of Guadalupe bank, is one of the best photographers in these parts and has a dark room at home that's a honey...," *SMT,* Jan. 25, 1949, p. 4.
See: "Santa Maria Camera Club," 1949, 1950

Carlson (Beattie), Johana / Johanna "Juka" / Euka / Uka (Mrs. Robert Carlson) (Mrs. Francis Beattie) (Lompoc)
Artist in Lompoc by 1952. Exh. at Santa Ynez Valley Art Exhibit, 1954, and at Open-Air art exhibit, 1957.

■ Port. and caption reads "Talented Lompocan. Juka Carlson, born in Estonia, married Sgt. Robert Carlson in Mannheim, Germany, and they now make their home in Lompoc. Mrs. Carlson studied painting under Professor Peter Haick. ... She has exhibited in Mannheim and also in Santa Barbara's art museum. Three of her oils will be shown in the Santa Ynez Art Festival... **Hans Sorensen** Photo," *LR,* April 1, 1954, p. 5.
Carlson, Johanna (notices in local newspapers)
1952 – "Estonian Refugee Finds Safe Harbor, America ... Johanna Carlson... husband, Sgt. Robert Carlson, stationed at the USDB. They returned to America last May...," and article on her art and her life in Europe, *LR,* Jan. 17, 1952, p. 4.
1957 – "The Park Wedding Chapel in Reno, Nevada, was the setting for the ceremony which united Mrs. Johanna Carlson and Mr. Francis H. Beattie, both of Lompoc, in holy matrimony on Nov. 20," *LR,* Dec. 26, 1957, p. 4, col. 6.
Carlson, Johanna (misc. bibliography)
Johana Carlson is listed with husband Robert Carlson in Lompoc in the *Santa Maria, Ca., CD,* 1958, 1959 (ref. ancestry.com).
See: "Beattie, Johanna 'Juka' Mesikep," "Santa Ynez Valley Art Exhibit," 1954, "Lompoc Community Woman's Club," 1956, 1957, "Open Air Art Exhibit," 1957, "Posters, American Legion (Poppy) (Lompoc)," 1954

Carman, David "Dave" G., Pfc. (1922-2005) (Wisconsin / Camp Cooke)
Painted a mural at Camp Cooke, 1945.

■ "Carman Gives Art Lessons in Army. Any art-inclined GI stationed at Camp Cooke, Calif. now may have that talent furthered under the apt tutorship of a Madison serviceman... Pfc. Dave Carman, son of Mr. and Mrs. Charles W. Carman, 332 N. Baldwin st., who formerly studied at the Chicago Art Institute. Stationed at Camp Cooke with the U. S. army infantry, Pfc. Carman, 22, is giving the art instruction 'on the side,' and his class, according to the camp paper, 'is expected to exhibit some real masterpieces when they have their official showing.' Pfc. Carmon, who gives instruction every Wednesday night, is working on sketches of soldiers and army life in

general, and hopes to exhibit his work after the war when the Chicago Art Institute holds a planned exhibition of the work of former Institute students now in the armed forces. He hopes eventually to complete his plan of portraying all of his company buddies. The GI artist, in service about a year and a half, attended East high school and the University of Wisconsin before going to Chicago. While attending the institute, Carman worked for Larry Stults Associates, a Chicago layout studio. Just before his induction, he had been granted a year's scholarship in the institute for his first year's efforts. He also was staff artist for the Lawson YMCA in Chicago," *Wisconsin State Journal* (Madison, Wisc.), Nov. 16, 1944, p. 3.

Carman, David (misc. bibliography)
David G. Carman, commercial artist, is listed with wife, Patricia E., in the *Madison, Wisc., CD*, 1954, 1956, 1958; David G. Carman b. July 17, 1922, d. Nov. 7, 2005 per Social Security Death Index (ref. ancestry.com).
See: "Art, general (Camp Cooke)," 1945

Carnegie Library
See: "Santa Barbara County Library, Santa Maria"

Carnival
See: "Mission Santa Ines," "Camp Cooke Welfare Carnival"

Carpenter, Dudley Saltonstall (1870-1955) (Santa Barbara)
Sculptor who occasionally was active in Northern Santa Barbara County.

■ "From Tennessee, Dudley Carpenter was a painter, illustrator and teacher who lived in New York City; Denver, Colorado; La Jolla and Santa Barbara, California. He studied at the Art Students League in New York and in Paris at the Académie Julian with Jean Paul Laurens, Aman-Jean and Benjamin Constant. He exhibited with the Paris Salon and won an honorable mention in 1911. Carpenter lived in the East until 1909, then moved to Denver, and in 1921, settled in Southern California. He first lived in La Jolla and by the 1930s was living in Santa Barbara where he remained until his death on May 15, 1955," Edan Hughes, *Artists in California, 1786-1940*, from askart.com.

Carpenter, Dudley (notices in Northern Santa Barbara County newspapers on microfilm and on newspapers.com)
1928 – "County Wins Fair Honors … State Fair… At the rear of the booth is a picture of the mountains back of the city of Santa Barbara …[that forms]… a background for the fruits and vegetables grown in the county. The painting is the work of Dudley carpenter…," *SMT*, Sept. 6, 1928, p. 6.
1929 – "County Exhibit at State Fair… The exhibit, which occupies a prominent place on the main floor of the horticultural building, is a replica of a Spanish garden. The background is a beautiful painting of the Santa Ynez range by Dudley Carpenter…," *SMT*, Aug. 24, 1929, p. 6.
1930 – "State Fair Crowds … Sacramento… Santa Barbara county will occupy one of the most prominent spaces on

the west wall of the horticultural pavilion… A beautiful panoramic oil painting of the Santa Inez [Sic. Ynez] range and the surrounding country, showing the fertile valleys and points of interest, occupies the main background. The painting is the work of Dudley Carpenter, landscape artist. In the foreground is a garden scene, interspersed with tiled walks and leading from the gate in the front wall of Tunisian tile to a splashing fountain and pool across the garden. By the clever use of flowering plants and tropical shrubbery the produce display of walnuts, beans and sub-tropical fruits are worked in as an integral part of the garden scene…," *SMT*, Sept. 2, 1930, p. 6.
1939 – "Painter Dudley Carpenter will form a new School of the Arts in Santa Barbara," *SMT*, Oct. 11, 1939, p. 2.
1945 – "Dudley S. Carpenter, Santa Barbara sculptor and artist, spent a month at the **Channing Peake** ranch, 'Jabala,' on Santa Rosa road, making a cast of the head of 2-year-old Jacqueline Peake," *LR*, Feb. 9, 1945, p. 4.

Carpenter, Dudley (misc. bibliography)
Dudley Saltonstall Carpenter was b. Feb. 26, 1870 in Nashville, Tenn., to Gilbert Saltonstall Carpenter and Elizabeth Thacher Balch, was residing in San Diego, Ca., in 1920, married Margaret Stafford Van Wagenen, and d. May 18, 1955 in Santa Barbara, Ca., per Harold Thomas Wyman Tree (refs. ancestry.com).

Carr, Kenneth L. (Lompoc)
Art teacher, Lompoc Jr. High, 1956+.
See: "Lompoc, Ca., Junior High School," 1956, 1957

Carrick, Margaret (Los Angeles)
Teacher of flower arranging who demonstrated techniques to Minerva Club, 1949.
See: "Minerva Club," 1949

Carroll, Carrie aka Will Danch?
See: "Santa Maria Sketches"

Carroll, Charles C. (Santa Ynez Valley)
Interior decorator, custom jeweler, 1957-60+.

■ Port. of Charles C. Carroll and daughter, Lee, and caption reads, "Moving to the Santa Ynez Valley recently from Scottsdale, Ariz., is the Charles C. Carroll family…," and article on p. 4 says, "Carroll, who first became acquainted with the Santa Ynez Valley 20 years ago when he was interior decorator, has returned… to carry out a dual operation of handmade jewelry manufacture coupled with walnut ranching. The jewelry making enterprise is something new for the Santa Ynez Valley… The Carroll family, consisting of Mr. Carroll, his wife, Emily, their daughter, Lee, 12, a pinto pony named Patsy and two dogs… are now in the process of settling… [from] Scottsdale, Ariz., near Phoenix, where Carroll conducted his jewelry manufacturing business the past two years… known as **Cadra Jewelry**, featuring hand-made originals, entered the jewelry making business two years ago. Until that time he had been an interior decorator and designer and had created jewelry only as a past time… devoted to the

manufacture of rings, bracelets, tie tacks, tie slides, ear rings, cuff links … now has retail outlets in Colorado, Arizona, New Mexico, California and Honolulu… Carroll, who is assisted in the jewelry making process by his wife, spends a great deal of time designing and creating his products, and three or four times a year he makes a sales circuit through the various states serving his accounts. He says he is especially busy at this time of the year making the jewelry in anticipation for the Christmas buying season… Most of his pieces are made of gold with black star sapphire stones, which come from Australia…. The black star sapphire were discovered as recently as 1948… The Cadra firm's shop is neat and compact, and many of the tools used… are similar to those employed in a dentist's office… These dental tools are handled in delicate fashion as Carroll carefully conceives a wax replica of a piece of jewelry-to-be. Later, a plaster-like material is applied over the wax model, and still later this hollow plaster mold is baked in a small oven for a half hour at a temperature of 2,000 degrees. The cast is then filled with melted gold through the use of a centrifugal casting machine. Next step is the polishing … and setting of the gems… he designs and builds his jewelry pieces around each stone… Carroll first came to know the Valley about 20 years ago when he was engaged as an interior decorator of a number of new ranch homes here, including those on the Juan y Lolita, the L. B. Manning (now Rancho Piocha) and Hutton Ranches. It was at this time he developed a desire to return … At that time Carroll was residing in Montecito. Recently he and his wife purchased the 30-acre Wagon Tongue Ranch on Refugio Road… The new owners have renamed the property Carroll Ranch… The Carrolls also have a son, Teddy, 17, who is stationed in Texas with the Air Force," *SYVN*, July 26, 1957, pp. 1, 4,
Carroll, Charles (notices in Northern Santa Barbara County newspapers on microfilm and on newspapers.com)
1960 – "Jewelry Firm Reveals Plans for Expansion. As an adjunct to his **Cadra Manufacturing Jewelers** firm and aiming for a nationwide market, Charles C. Carroll announced today the formation of a partnership with William Rudnick, executive of Kasanjian Brothers, one of the largest wholesale jewelry firms in the West. Carroll, who brought his Cadra operation to his ranch on Refugio Road three years ago from Prescott, Ariz., said the association with Rudnick will mean that the firm is now direct importers of precious gems. With a combined experience of 33 years in the fine jewelry business, Carroll said the firm's shop 'is the most complete between Los Angeles and San Francisco.' He noted that the most recent addition to the shop's facilities was the installation of diamond laps for cutting precious stones. The firm contemplates developing a mail order and sales program through the medium of national advertising, Carroll added," *SYVN*, May 27, 1960, p. 10.
Carroll, Charles (misc. bibliography)
Chas. C. Carroll, int. dec., with no wife, is listed at 6122 N. Scottsdale Rd. in the *Scottsdale, Ariz., CD*, 1956 (refs. ancestry.com).

Carroll, Glenn Franklin (1935-) (Santa Maria)
Santa Maria high school student who exh. a painting at Santa Barbara County Fair, 1951 and at the library, 1952. He became a Highway Patrol officer.
See: "Community Club (Santa Maria)," 1951, "Halloween Window Decorating Contest," 1951, "Santa Barbara County Fair," 1951, "Santa Barbara County Library (Santa Maria)," 1952, "Santa Maria, Ca., Union High School," 1951, 1953

Carroll, Ralph Leroy / Leroy R.?, Captain (Bakersfield?)
Chalk talk artist, religious, 1914.
See: "Chalk Talks," 1914

Cartoons / Comic Strip (Northern Santa Barbara County)
Three types exist: 1. Animated – made in Hollywood but shown in local theaters, 2. Drawings created at Chalk talks, usually by itinerant entertainers, 3. Single-frame and strip cartoons printed in publications.
Between 1911 and 1925 and later, animated cartoons were projected in conjunction with the main feature film at the local movie theater (as noted in various issues of the *Lompoc Record*) providing an example to budding cartoonists. Many chalk-talk artists (some pure entertainers / some with messages) performed in northern Santa Barbara County. Single-frame and strip cartoons appear in newspapers, sometimes made by local artists but more often syndicated from nationally known artists. Single frame cartoons by high school students also appeared in yearbooks and, during WWII, some made by military men appeared in military publications.
Cartoons (notices in Northern Santa Barbara County newspapers on microfilm and on newspapers.com)
Repro: Several cartoons by an unknown hand depicting local individuals appear in *SYVN*, July 2, 1926 [ed. each has a vertical "squiggle" in the l. r. side, but this appears not to be a monogram.]
See: "Andersen's Pea Soup," "Broadus, Amber Dunkerly," "Capp, Al," "Carroll, Carrie," "Chalk Talks," "Comic Strip (Santa Ynez Valley News)," "Currens, William," "Curryer, Charles," "De la Torre, William," "Ferg," "Haemer, Alan," "James, Robert," "Jekel, August," "Jones, Fred," "Jorgensen, Karl," "Kiddie Kartune Club," "Langlois, Obart," "Manning, Russell," "Martin, Ben," "Mason, Robert," "McGuire, Neil," "Mickey Mouse Club," "Neil, Milt," "Patin, Ray," "Santa Maria Sketches," "Shaw, Richard," "Sloane, Charles," "Smith, Mary," "Smith, Zet," "Stonehart, Leslie, Jr.," "Swinnerton, James," "Waugh, Mabel Odin," "Woggon, William"

Cary, Robert (Santa Barbara)
Artist of a 12 x 8 foot colored map of the Spanish Colonial Empire from 1492 to 1898 owned by Mission Santa Ines.
This individual could not be identified.
See: "Mission Santa Ines," 1955

Case, Archie Royce (1918-2004) (Santa Maria)
Santa Maria high school student who won a Poppy poster contest, 1933. Designer of stage sets for Santa Maria High School plays, 1939. Exh. at Faulkner Memorial Art Gallery, Santa Barbara, 1933. Art major at San Jose State College, 1940. Interior decorator in Ventura County, post WWII.

Case, Archie (notices in California newspapers)
1940 – "In College Role – Archie Case, junior art major from Santa Maria in San Jose State college, will appear in the forthcoming college production of the Kaufman-Hart comedy, 'Once in a Lifetime'," *SMT*, Jan. 20, 1940, p. 2; "Student Honored – Archie Case … was this week elected vice president of Artisans, men's art society. He is a graduate of Santa Maria high school where he was a member of the Year Book staff and active in dramatics and of Santa Maria junior college. He is majoring in art and working toward a teaching credential. Mr. and Mrs. Royce Case of 621 East Mill street are his parents," *SMT*, Oct. 4, 1940, p. 3.
1945 – "Archie R. Case, hospital apprentice first-class of Santa Maria, has been assigned to the U. S. Naval Hospital, Astoria, Ore... Case... previously had duty in the hospital corps school in Farragut, Ida. Before joining the Navy in 1944 he was an employee of the Army Quartermaster Corps, serving in Aden, Arabia," *SMT*, June 13, 1945, p. 4.
1948 – Classified ad, "Archie R. Case, Interior Designer and Decorator will be in town for limited time representing Edward Biester, Decorator of Los Angeles. For consultation appointments, please call 814-W," *SMT*, Feb. 25, 1948, p. 5.
1949 – "Buena Center BPWC ... New decorating materials were displayed ... by Archie Case, Ventura decorator, who addressed them in a talk titled 'Save Aunt Phoebe's Chair'...," *Ventura County Star-Free Press*, Oct. 10, 1949, p. 7.
1950 – "Case to Address Ojai Juniors... Archie Case, Ventura decorator, will be the speaker tomorrow evening ...," *Ventura County Star-Free Press*, Feb. 1, 1950, p. 5.
Case, Archie (misc. bibliography)
Archie Royce Case was b. July 7, 1918 in Alpaugh, Ca., and d. Jan. 17, 2004 in Las Vegas, Nev., per Varney Family Tree (ref. ancestry.com).
See: "Faulkner Memorial Art Gallery," 1933, "Posters, American Legion (Poppy) (Santa Maria)," 1933, "Santa Maria, Ca., Union High School," 1939

Case, Clifford Edmond, Dr. (1901-1986) (Santa Maria)
Obstretrician. Sculptor. Donated prize money for sculpture at the Santa Maria Valley Art Festival, 1952, 1953. President of Santa Maria Community Concert Assn., 1949. Collector of glass with sister Ruth. Brother to Harold Case, below.

■ "Dr. Clifford E. Case … Dr. Case was born in Little R.., Kan., and came to Santa Maria in 1931. He graduated from Kansas University in 1926. He was a pre Med graduate from Western Reserve Medical School in Cleveland, Ohio in 1929. He had a practice in Santa Maria from1931 until 1982. He was former Chief of Staff at Marion Hospital, and for many years was president of the Santa Maria Community Concert association. Dr. Case is

also listed in *Who's Who in the West*," *SMT*, June 17, 1986, p. 17; "Dr. Case Dead at 85 Years… Santa Maria obstetrician who delivered more than 10,000 babies… He moved to Santa Maria in 1931 after serving as an intern at the Clara Barton Memorial Hospital in Los Angeles. … 52-year practice … developed a heart condition in the mid-1970s… According to his brother, Dr. Harold T. Case, the physician was a great lover of music, who played the piano… He was also a member of the Physicians' Art Association… Survived by his sister, Ruth Case, his brother, Dr. Harold T. Case…," *SMT*, June 16, 1986, p. 2.
Case, Clifford (notices in Northern Santa Barbara County newspapers on microfilm and on newspapers.com)
1938 – "Case is Sculptor" of three plaques which will be sent for approval to the American Physicians' art association, formed last fall. If accepted, the articles will be exhibited in San Francisco in June, *SMT*, April 1, 1938, p. 3.
Case, Clifford (misc. bibliography)
Clifford Edmund [Sic.? Edmond] Case provided the following information on his WWII Draft Card – age 40, b. March 3, 1901 in Little River, Kansas, Physician and Surgeon, residing in Santa Maria, Ca., with next of kin Ruth Case; Clifford Edmond Case b. 1901 and d. 1986 is buried in Santa Maria Cemetery District per findagrave.com (refs. ancestry.com).
See: "Case, Harold," "Santa Barbara County Library (Santa Maria)," 1949, "Santa Maria Valley Art Festival," 1952, "Taylor, Al"

Case, Harold Tivus, Dr. (Santa Maria)
Dentist. Lectured on x-rays to Santa Maria Camera Club, 1940. Brother to Clifford Case, above.
His son, Harold C. Case, "Casey" was named instructor in photography and cinema courses at Allan Hancock College, 1972 per "Case Named to Hancock Faculty," *SMT*, Sept. 13, 1972, p. 8.
See: "Case, Clifford," "Santa Maria Camera Club," 1940

Casey, Jr.
Official "fairmark" for the Santa Barbara County Fair, 1958.
See: "Santa Barbara County Fair," 1958

Casmalia, Ca., schools
See: "Santa Barbara County Fair," 1891, "Santa Maria, Ca., Elementary Schools," 1954

Cassidy, Ira D. Gerald (1869-1934) (Pasadena / Santa Fe, N. M.)
Printmaker, one of whose works was owned by John Breneiser and exhibited at National Art Week, 1935, as well as during a lecture at the Alpha Club, 1935.

■ "Gerald Cassidy (November 10, 1869 – February 12, 1934) was an early 20th-century artist, muralist and designer who lived in Santa Fe, New Mexico," per Wikipedia.
See: "Alpha Club," 1935, "National Art Week," 1935

Castagnola, Gladys Irene Swain Headley (Mrs. Edward Watson Headley) (Mrs. Mario Milo Castagnola) (1899-1983) (Santa Barbara)
Member Santa Barbara Art Association, who exh. at opening exh. of Allan Hancock College Art Gallery, 1954. Exh. Santa Barbara County Fair, 1952 and Santa Ynez Valley Art Exhibit, 1954, 1955, 1956.

■ "Gladys Castagnola, born in San Francisco and now living in Santa Barbara, started painting in 1953. She studied with **Douglass Parshall**. She has won awards at Sacramento State Fair, 1954; in Santa Paula 1950; Society of Western Artists, 1960; Pomona State Fair, 1960; and also several smaller prizes in Santa Barbara. She is a member of the Santa Barbara Art Association, Society of Western Artists, Women Painters of the West, and Laguna Beach Art Association" (*PSCA*, vol. 11).
Castagnola, Gladys (notices in Northern Santa Barbara County newspapers on microfilm and on newspapers.com)
1948 – Port. volunteering with San Pedro's Veterans of Foreign Wars fundraiser, *News-Pilot* (San Pedro, Ca.), May 21, 1948, p. 12.
1954 – ad: "A Showing of Water Color and Oil Paintings by Well-known Members of the Santa Barbara Art Association, Including ... Gladys Castagnola... on Display Throughout the Month of September, County Stationers, Ventura," *Ventura County Star-Free Press*, Aug. 31, 1954, p. 2.
1955 – "Art Gallery Offers Paintings for Rent in Home. The women's board of the Santa Barbara Museum of Art will reopen the Museum's art rental gallery... Among the contributing artists... **Leonard Edmondson... Standish Backus, Forrest Hibbits, Joseph Knowles, William Dole... Douglass Parshall ... Channing Peake**, Gladys Castagnola...," *SMT*, April 2, 1955, p. 4.
1961 – "Lobster Still Life Selected. 'Lobster Catch' by Gladys Castagnola, still-life painted in traditional style, was purchased by the Santa Paula Chamber of Commerce in the oil division of the 25th Annual Art Exhibit ... in the Santa Paula High School cafeteria...," *Ventura County Star-Free Press*, Aug. 21, 1961, p. 2.
1962 – "Las Vecinas... Peninsula Gallery, 1714 S. Catalina, in the Hollywood Riviera section of Redondo Beach... Featured are ... Gladys Castagnola...," *News-Pilot* (San Pedro, Ca.), Aug. 3, 1962, p. 6; repro: "Kitchen Corner," shown in the annual exhibit of the Society of Western Artists at the de Young Museum, *The Times* (San Mateo, Ca.), Nov. 24, 1962, p. 33 (i.e., Weekend, p. 12A).
1967 – "Roundabout. The Lobster House, just opened on the Marina del Rey, is the largest yet for American dreamers Mario Castagnola and stepsons, Thomas and Richard Headley... Worthy of note are the paintings on the walls, done by Gladys Castagnola, wife of Mario. Happily, she is entranced by still-lifes of lobsters, fish, vegetables, copper pots and such. These have a feeling of the Flemish and become the restaurant very well," *LA Times*, July 12, 1967, p. 78 (i.e., pt. V, p. 10).
1977 – "Seafood Restaurant Chain. Nautical decor featured at Castagnola... Mario Castagnola, the son of an immigrant Italian fisherman, began in his father's fishing business in Santa Barbara over 50 years ago... Each Castagnola restaurant features extensive nautical regalia inside and out... Gladys Castagnola, Mario's wife and a painter, has

graced the dining rooms with an impressive collection of original still-life oil paintings. Castagnola's Lobster House Restaurants are located in Santa Barbara, Pasadena, Marina del Rey, King Harbor Marina, Redondo Beach and Canoga Park," *LA Times*, Aug. 11, 1977, p. 233 (i.e., 4 F?). And, additional notices on her art in her husband's various restaurants and on awards she won in group shows were not itemized here.
Castagnola, Gladys (misc. bibliography)
Gladys I. Swain is listed in the 1900 U. S. Census as age 5 months, b. Dec. 1899 in Calif., residing in Los Angeles with her parents George and Lona Swain; Gladys I. Headley is listed in the 1930 U. S. Census as residing in Santa Barbara with husband Edward and children Richard and Thomas; Gladys Headley is listed with husband Edward in the *Ventura, Ca., CD*, 1931; Gladys I. Headley is listed in the *Glendale, Ca. CD*, 1932-36 and in the *Los Angeles, Ca., CD*, 1938 usually as a saleswoman; Gladys I. Headley is listed in the 1940 U. S. Census as age 39, finished high school 4th year, widowed, a saleslady, residing in Glendale, Ca., with her children Richard S. Headley (age 12) and Thomas M. Headley (age 11); Marie [sic.] W. Castagnola married Gladys Headley on Sept. 28, 1940 in Yuma, Arizona per Arizona County Marriage Records; Gladys Castagnola registered to vote in Santa Barbara 1942-44 per *Calif. Voter Registrations*; Gladys Castagnola at 1035 Alma St., Dem. is listed in *Index to Register of Voters, Los Angeles City Precinct No. 2436*, 1948; Gladys Castagnola is listed with husband Mario M. (Milo) in the *Santa Barbara, Ca., CD*, 1942-85; Gladys Irene Swain, father's name George Mortimer Swain and mother's Lona Alfretta Williams, was b. Dec. 25, 1899, married Edward Watson Headley [of Springfield, Mo. who d. May 1, 1937 and is buried in Forest Lawn Memorial Park, Glendale, Ca.], had a child Thomas Massey [Sic.?] per Douillard Family Tree; Gladys Irene Castagnola, d. May 15, 1983 in Santa Barbara per Calif. Death Index; Gladys Irene Castagnola is buried in Santa Barbara cemetery per findagrave.com (refs. ancestry.com).
See: "Allan Hancock [College] Art Gallery," 1954, "Hibbitts, Forrest," 1959, "Santa Barbara County Fair," 1952, "Santa Ynez Valley Art Exhibit," 1954, 1955, 1956

Castle, ... Mr.
Itinerant entertainer artist, 1893.
See: "Chalk Talks"

Cavalier [Cavallier?], J. D. [Sic. G. C.?], Prof. (Santa Maria)
Artist. Exh. pencil drawings of Zaca lake, etc. at "Santa Barbara County Fair,"1886, and exh. a photo, 1889. Teacher. Bookseller? Phrenologist?
Cavallier, Prof. (notices in Northern Santa Barbara County newspapers on microfilm and on newspapers.com)
1886 – "Prof. Cavallier exhibited to us yesterday the shoulder blade of a bear that he found on Solomon's Peak... Mr. Cavallier has utilized the fossil by drawing on one side a very good landscape view of the Martin district school house and the road leading thereto. On the reverse side he has illustrated the inside of the school house,

showing his Spanish class at their studies. Some of the faces bear strong family resemblances to the originals. Altogether it is a curio worthy of preserving," *SMT*, Jan. 2, 1886, p. 5.

1888 – "Mr. Cavalier has returned from his trip northward. He showed us on his return some of his landscape sketching and among the number a drawing of the Cruikshank mine, which he intends to have painted or lithographed," *SMT*, Oct. 24, 1888, p. 3, col. 1.

1889 – "A Sketching Trip. G. C. Cavalier returned a few days since from a trip to the Sisquoc Falls. In this vicinity he explored the mountains and visited Vulture Falls … and also discovered another fall… on the south fork of the Sisquoc river… He made many sketches on the trip. Among the number we noticed the following: Vulture Falls, newly discovered falls, Mr. Wheat's place, Uncle Davy Brown's log cabin and the camping party," *SMT*, Aug. 3. 1889, p. 3.

1891 – "Some time since it was reported that Mr. Cavalier was drowned in his attempt to ford the San Joaquin river last winter. We are pleased to learn… as Mr. J. R. Weeks informs us, that he received a letter from Mr. C. stating that he is selling books in Los Angeles county," *SMT*, July 4, 1891, p. 3.
This individual could not be traced further.
See: "Santa Barbara County Fair," 1886, 1889

Caywood, Hal (Santa Maria)
Manual training teacher for Santa Maria Elementary schools, 1926/28? Became principal of Goleta school, 1928.
See: "Santa Maria, Ca., Elementary Schools," 1926, 1927

Central California Council of Camera Clubs /
Central California Camera Club Council
Council created to weld together 13 separate camera clubs in Central California, 1950.
Central California … (notices in Northern Santa Barbara County newspapers on microfilm and on newspapers.com)
1950 – "Camera Fans to Attend Meeting..,. Santa Maria next week… quarterly photographic competition being staged by the Central California Council of Camera clubs. Santa Maria's Camera club will act as host… with the show beginning at 8 p.m. Saturday, Nov. 4, at the IDES hall, 625 West Chapel street. Three experts from leading California camera and photographic concerns will be on hand to judge…," *LR*, Oct. 26, 1950, p. 19.
1953 – "Camera Council Staging Big Show in Santa Maria" for both prints and color slides, *SLO T-T*, April 23, 1953, p. 16; "Camera Print Exhibits Attended by Over 200," at exhibit held in 100F hall, Santa Maria, *SMT*, April 27, 1953, p. 4.
See: "Muench, (Adam) Emil," "Santa Maria Camera Club," 1953, and *San Luis Obispo Art and Photography before 1960*

Central Studio
See: "Affleck, Roy"

Ceramic Club (Los Alamos)
See: "Los Alamos, Ca., Adult/Night School," 1954

Ceramics (Northern Santa Barbara County)
Ceramics became a popular "hobby"/ "craft" in the immediate post WWII era. It was taught primarily in adult schools, in high school / JC, by commercial shops that retailed ceramic materials, and by ceramist, Jeanne DeNejer. Ceramics were exhibited at hobby shows, at the Santa Barbara County Fair, that had its own special section for ceramics starting 1957, and at various special fairs and festivals.
1955 – "Letters – Re: Ceramics… we do want to… encourage someone to open a ceramic shop here in Lompoc. … It not only would and could be supported by the Lompoc hobbyists and schools, but also by the outlying communities. Many of the women are driving to Santa Maria and many to Santa Barbara for instructions in china painting, decorating techniques and much of their supplies. This could all be kept here in Lompoc… Here in Lompoc several homes have kilns in them. Many of these women make their own hand made molds from their finished greenware. … In the same establishment they could reserve a section for the disposal of the finished ware, as an outlet for the hobbyist… The accommodations that we have had here since the close of our Adult Education system will no longer be available. The little shop is closing as of Dec. 20. … One can always learn something new in ceramics… Sincerely, One of Lompoc's Ceramists," *LR*, Nov. 3, 1955, p. 2.
1956 – Photo and caption reads, "Ceramic Workers' Round Table. Becomes cluttered with art objects, plates, planters, ash trays, figurines, and other useful and/or decorative items when Lompoc ceramic enthusiasts gather in first one home then the other to experiment with the ancient art. Shown here in the 313 South I street home of **Mrs. Richard Rudolph** are only a few of the many ceramic enthusiasts of this city. Left to right, **Mrs. Robert Hendy**, Mrs. Bud Hennessy, **Mrs. Eddie Houk**, Mrs. C. W. Durham, **Mrs. Jasper Wygal, Mrs. Rudolph, Mrs. Joe Grossini** and Mrs. Jack Newsham [LaDora]," *LR*, Aug. 2, 1956, p. 16.
1958 – "Martha's Helpers… Mrs. John Larcom demonstrated ceramics to members of Martha's Helpers of the Girls Friendly society of St. Mary's Episcopal church, Saturday morning…," *LR*, Oct. 2, 1958, p. 4; Officers Elected by Little Saints… of the Girls' Friendly Society… After refreshments one part of the group worked on ceramics while the other studied the life of Moses…," *LR*, Oct. 30, 1958, p. 2; "'Learn by Doing' Meeting Held by Beta Theta Chapter … of Delta Kappa Gamma… on the subject of 'Ceramics.' The meeting was held at the Maple School in Lompoc with Mrs. William Proud, a Lompoc teacher and **Miss Alice Doud**, art teacher in the San Luis Obispo High school, demonstrating some techniques in the use of clay, clay modeling and molds. The group then began their own 'projects' with some very interesting and satisfying results…," *LR*, Oct. 30, 1958, p. 7.
1960 – "Welcome Wagon Club Entertains… organized to welcome newcomers to the community… Members are encouraged to join groups within the club to pursue their

individual interests such as bowling, bridge, ceramics, flower making… When enough interest is shown in any such area, meetings are arranged as 'extras' during the month…," *LR*, Sept. 19, 1960, p. 4; "Women Plan… FCI. A discussion was held on the possibility of starting a hobby shop for ceramics, if equipment can be obtained," *LR*, Oct. 20, 1960, p. 23.

See: "Allan Hancock College Adult/Night School," 1959, "Alpha Club," "Anderson, Lenora," "Art, general (Camp Cooke)," 1958, 1959, 1960, "Baird, Bobbie," "Barbera, Helen," "Brandt-Erichsen, Viggo," "Buellton, Ca., Adult/Night School," "China Painting," "Community Center (Lompoc)," 1947, 1949, "Community Club Hobby Show," "Conrad, Mary," "Danish Days," "Danish Village Gifts," "Darling Ceramics," "DeNejer, Jeanne," "Dill, Edwin," "Dixon, Vern," "Dove, Vern," "Edwina's Ceramic Studio," "El-Ma-Ro Studio Ceramics," "Fast, Nat," "Freitas (Hamilton), Edwina," "Friedman, Jerrold," "Girl Scouts," "Gleason, Ellen," "Grady, Elmer," "Grossini, Lothelle," "Guadalupe, Ca., Elementary School," 1953, "Hart, Margaret," "Helen Barbera Ceramics," "Helen and Ina's," "Hendy, Mary," "Hitchen, Nina," "Hobby Show…," "Houk, LaVerne," "Huntington, Harold," "Huyck, Marie," "Junior Community Club," 1950s, "King, Angie," "King's Ceramics," "La Fontaine, Eleanor," "Lainhart, Grace," "Laughlin, Grace," "Lompoc, Ca., Adult/Night School," "Lompoc, Ca., Recreation Dept.," "Lompoc, Ca., Union High School," "Lompoc Community Woman's Club," 1950s, "Lompoc Gem and Mineral Club," "Lord (Huyck), Loiz," "Los Alamos, Ca., Adult/Night School," "Los Alamos Ceramic Club," "Martin, Virginia," "McBride, Virginia," "McCullough, Bertha," "McLaughlin, Conley," "Mildred I. White Ceramics Shop," "Minerva Club," "Nickson, Herbert," "Nirodi, Hira," "North H Ceramics Shop," "Ocean Avenue Ceramics," "Ocean Avenue Shoe Repair and Upholstery Shop," "Palmer, David," "Preston, Ralph," "Purkiss, Myrton," "Puttering Micks Ceramics group," "Red Cottage," "Rudolph, Dorothy," "Sample, Alice," "Santa Barbara County Fair," 1949+, "Santa Maria Art Association," "Santa Maria, Ca., Adult/Night School," "Santa Maria, Ca., Elementary…," "Santa Maria, Ca., Union High School," 1952+, "Santa Maria Valley Art Festival," "Santa Ynez Valley Art Exhibit," "Santa Ynez Valley, Ca., Adult/Night School," 1950s, "Santa Ynez Valley, Ca., Elementary…," "Scalf, Richard," "Shinn, William," "Skeate, Gladys," "Smiley's Ceramic Supplies," "Stotts, Lucy," "Stotts Potts," "Szeptycki, Jerzy," "Thornburgh, Mary Jane," "Tognetti, Betti," "United Service Organization," 1945, "Valley Ceramic Shop," "Waldron, Ralph," "Ward, Ruth," "West, Charles," "White (Houghton), Mildred," "Wildenhain, Marguerite," "Winslow, Paul," "Winter Arts Program," "Woodall, Bernice," "Works Progress Administration," "Wright, Cora," "Wygal, Elsa," "Young, Carl," "Youry, Leon"

Chalk Talks (Northern Santa Barbara County)
Itinerant entertainers on the Vaudeville, Chautauqua, or church circuit, plus local entertainers.
Chalk Talks (notices in Northern Santa Barbara County newspapers on microfilm and on newspapers.com)

1893 – "To-Night … **Castle** Paints by Magic at the M. E. Church ... Rival of Thos. Nast. His entertainment is original, humorous, instructive. He paints pictures with chalk, with lightning rapidity and explains them as he goes along. He portrays tragedies, such as the capture of Sontag and Evans. He gives glimpses of the old world, such as the Sea of Galilee with its several cities in the background. He takes his audience to Naples to view the Eruption of Vesuvius and the destruction of Herculaneum and Pompeii. … The doors will be open at 7:30 p.m. and the performance will begin at 8. Admission 25 cents, children 10 cents. Proceeds to be divided with the Church…," *SMT*, July 8, 1893, p. 2.

1911 – "Were There with the Real Goods. **Kingsten and Musser**, exceptionally clever sketch artist… vaudeville attractions at Dale's theatre last week," *SMT*, April 22, 1911, p. 1; "The two Medoras, late from Australia, are at Dale's for the week-end vaudeville feature, playing Thursday, Friday and Saturday nights. The **Medoras** do some great work and their clever turns are well worth seeing. Original shadowgraph and the execution of Lightning oil painting are their great features. Mr. Medora uses both hands at once finishing two pictures at the same time. Pictures are given away at each performance," *SMT*, May 13, 1911, p. 1; "The **Miller**s, two clever vaudeville artists, will be the special attraction at the Orpheum this evening. A feature of their act is a display of lightning freehand painting intermixed with genteel comedy," *SMT*, Sept. 23, 1911, p. 5, col. 1.

1912 – "The second in our [high school] season of events **Ross Crane** the cartoonist will be at the Opera House on October 30. It would be worth your while to see the splendid work of this man and hear him sing old familiar songs while accompanying himself on the piano," *LR*, Oct. 25, 1912, p. 8; port. of **Ross Crane** and "Cartoonist Crane in Lyceum Work… A tabloid account of this man's life, so far, is given by the *Atlanta Constitution*… His college training lends the pleasing literary quality to his speech; his theological training fitted him for platform work; his art studies gave strength and vigor to his drawing and painting and sculpturing work, while the remarkable bigness and swiftness of his cartoons was gained in the hurly-burly of metropolitan newspaper life. His years of travel in many lands… He has seen life at first hand and behind the scenes from mining camps as a mine engineer to the cotton fields of Alabama where he taught school in a cotton warehouse, from straw-hut life of the Kanakas in the Hawaiian Islands. He has traveled in ocean palaces, Mississippi river steamboats and the catamarans of the South Sea islands, on a special train with a presidential candidate and in a boxcar crowded with negro refugees from the yellow fever districts of Louisiana. For twelve months in the year he travels from coast to coast and from Canada to the gulf – eight months of the time living in hotels and railway trains, but during the summer months traveling and living in his own floating

home, the studio houseboat, 'Crane's Next' [sic. Nest?]" *LR*, Oct. 25, 1912, p. 2.

1914 – "Long Distance Hikers Here. After journeying on foot for close to 4200 miles, Sergeant Louis A. Mohr and Charles F. Saunders, L. L. B., who are walking from Newport, R. I., to San Francisco, arrived here Monday, accompanied by Sergeant **T. R. Walker** of Los Angeles, who will finish the trip with them in place of their third member, Karl Rittman… They appeared at the **Gaiety** Theatre Tuesday night and told of their travels. Mr. Walker, who is an artist, illustrated the amusing incidents of the trip in black and white cartoons…. They are the only men who ever made the journey across the continent with the complete army pack of 42 pounds. They left Rhode Island June 15th last, coming through Texas and Arizona," *SMT*, May 9, 1914, p. 8; "The revival at the Methodist church is still in progress … A special feature of the street meeting Saturday evening will be a chalk talk. **Captain Carroll** is a sign painter by trade and will illustrate his subject, 'The Prodigal Son' with drawings…," *LR*, Aug. 28, 1914, p. 4.

1919 – "Baptist Church News … Several local musicians have greatly assisted with the meetings, and the blackboard cartoon and illustrations by **Mr. Colyar** are attracting considerable attention," *LR*, Feb. 21, 1919, p. 6; "Choral Recital … **C. W. Affelds** in 'Something in Crayon' proved to be a clever cartoonist and artist of the vaudeville lightning sketch variety. With his crayon work and monologue, he drew many a laugh as well," *SMT*, Oct. 22, 1919, p. 5.

1921 – Vaudeville… "The **Pictorial Lytells** offer their original painting and singing scenes, a unique and clever novelty of an artistic nature," *SMT*, Sept. 16, 1921, p. 4, col. 1; "High School Lyceum Course. The Midland Lyceum Bureau will present a series of entertainments… The attractions and dates follow: **Clayton Staples** (artists with crayon and musicians) Oct. 3…," *LR*, Sept. 16, 1921, p. 8.

1922 – "White Hills Minstrels… Following the minstrel scene, **L. B. Copeland** performed some clever cartoon work and his caricatures on local celebrities brought a big laugh. …," *LR*, Sept. 1, 1922, p. 6.

1923 – "Jubilee Singers Coming Next Friday Evening… The California All-Star Quartet, a company of colored jubilee singers… Odd Fellows hall under the auspices of the Epworth League… There is not a dull moment anywhere. **Mr. Morris**, the first tenor, is a cartoonist of rare ability. Always sees the funny side of everything and puts it in his original rapid drawings…," *LR*, Nov. 23, 1923, p. 8.

1925 – Port and "**Alton Packard** to Entertain … Audiences with Famous Cartoons," *SMT*, April 24, 1925, p. 3; "**Alton Packard**, Comedy Cartoonist, Here Tuesday," *SMT*, April 25, 1925, p. 5; "Chautauqua Opens Six-day Session Tuesday," *SMT*, April 27, 1925, p. 1.

1926 – "Gaiety Show… A bright, snappy line-up of acts are promised on the vaudeville bill at the **Gaiety** this Saturday. **Jean & Jeanette**, in an artistic novelty act featuring painting on china…," *SMT*, Dec. 17, 1926, p. 5.

1928 – "Saturday's Vaudeville at the **Gaiety**. **Fred Howard**, known as the singing artist, introduces something unique and new to vaudeville. His painting novelties are alone a novel bit of entertainment but his song hits mark him decidedly an artist of the first class," *SMT*, March 23, 1928, p. 5.

1937 – "Cartoonist in Talk… **Bob Wood**, cartoonist and noted caricaturist of presidents, entertained the students and teachers of **Lompoc High school** with a chalk talk in the school auditorium Tuesday afternoon. His ability to sketch one type of figure and then with a very few deft strokes he would create something entirely different. Wood is a graduate of the Chicago Art Institute and came to this city under the auspices of the National Assembly association," *LR*, Dec. 3, 1937, p. 7.

1938 – "Tom an' Jerry Creator Here. **H. E. Ryan**, cartoonist and originator of the newspaper comic strip 'Tom an' Jerry' spent Monday, Tuesday and Wednesday in Lompoc gathering ideas for his work. Travel gives Ryan ideas… Ryan showed how his cartoons were made on the stage of the Lompoc theatre and also presented his chalk talk at the Kiwanis on Tuesday and at the Rotary club on Wednesday," *LR*, Jan. 14, 1938, p. 7.

1939– Port. and "Cartoonist to speak at … Christian and Missionary Alliance church… **Dr. Pace** whose cartoon illustrations rank with the craftsmanship of this country's finest cartoonists, confines all his work to spiritual themes and for 23 years has been furnishing the weekly cartoon illustration for that outstanding religious periodical, *The Sunday School Times*. His illustrations are also published in tract and poster form and hundreds of them have been grouped around various religious themes as film-slide lectures for projection upon the screen. This man has had wide experience, having traveled extensively for 15 years, visiting many parts of the United States, Canada, the British Isles, Europe and Africa. For about 10 years he was a missionary in the Philippine Islands. He has also been a member of the faculty of The Moody Bible Institute of Chicago, and the author of several books, '*Life Begins at ?*,' and '*Christian Cartoons*,' and others. For the service… Monday night… Dr. Pace will use the theme, 'Cartoons of the Christian Life,' and will show from 40 to 60 stereopticon slide pictures of his cartoons …," *LR*, June 9, 1939, p. 6.

1942 – "Pictures to be Unveiled Friday…. Assembly of God church at 111 North C street… The baptistry has the river Jordan scene painted on the wall and above the baptistry drapes will be unveiled showing the picture of the Ascension of the Lord Jesus Christ. **Rev. H. R. Love** of Yucaipa, California, who is the artist, will paint a picture of the City of Jericho and name it 'The Doomed City,' as he preaches a message on the fall of Jericho," *LR*, June 5, 1942, p. 7.

1943 – "Victory Talent Show is Success… Other acts… A clever chalk talk by **Miss Lois Nielsen**, the Solvang Mother's Club offering…," *SYVN*, Feb. 19, 1943, p. 1.

1951 – "Youth for Christ. Guest speaker … **Rev. Charles Ziall** [Sic. **Viall**?] … a 'Mid-night Evangelist' … a black

light chalk artist and has a puppet which he uses in his work," *SMT*, Sept. 1, 1951, p. 3.

1952 – "'Black Light' to Illustrate Topic of Evangelist. **Chuck Viall** [Sic. **Ziall**?] of Van Nuys... illuminated chalk board to illustrate his sermons... Ordinary drawings change as if by magic when placed under transforming rays of black light... In addition, ... Nosey the puppet who sings and talks in a comic way...," *SMT*, June 6, 1952, p. 4.

1953 – "Special Services are Slated at Guadalupe... Guadalupe Community Church. Speaker will be the **Rev. O. G. Lewis**, known as the 'gospel artist.' Formerly a commercial artist, Mr. Lewis paints pictures while singing appropriate hymns. His work and paintings have been assembled into a feature film," *SMT*, April 7, 1953, p. 5; port of **O. G. Lewis**, *SMT*, April 10, 1953, p. 4.

1955 – "Artist-Evangelist at Alliance Church. **Rev. Jack Foster,** who is a chalk-artist evangelist, will be at the Christian and Missionary Alliance church, 222 North I street, October 2-7. Rev. Foster has traveled the entire eastern seaboard during the past five years with his unique ministry. Last year he was the assistant pastor to one of the Los Angeles Alliance churches. Rev. Foster portrays the Bible by beautiful use of the sermon and the use of illustrated drawings made before the congregation. Upon completion of each drawing, he changes the entire color schemes of the picture by use of various colored lights and black light worked with rheostats. Rev. Foster is a graduate of Art College, Bible College and has attended the University of Southern California... services begin Sunday morning at 9:45 and 11:00. Evening services begin at 7:30 p.m.," *LR*, Sept. 29, 1955, p. 7.

1957 – "Evangelistic Meets Slated. A series of special evangelistic meetings will start Sunday, March 24 and will continue through Sunday, March 31 at the Calvary Bible Church in Buellton. ... appearance of **Jerry Zwall**, blacklight chalk artist, musician and evangelist. The Rev. Zwall confines his work for the most part to youth activities. ...," *SYVN*, March 1, 1957, p. 2; "Evangelistic Campaign with artist **Jerry Zwall** evangelist... blacklight chalk artist, March 24 through March 31, 7:30 p.m. nightly, Calvary Bible Church... Buellton...," *SYVN*, March 29, 1957, p. 2; "Evangelist at Assembly Church ...**Donald Landers** of Arizona would preach, sing and give chalk drawings at the 7:00 p.m. Evangelistic services to be held nightly in the church for the next two weeks...," at Assembly of God church, 213 North J. street, *LR*, April 18, 1957, p. 12.

1959 – "Evangelistic Crusade continues with Rev. Bill Raber, Gospel Preacher, Gifted Singer, Chalk Artist... nightly... El Camino Park Church...," *SMT*, Jan. 24, 1959, p. 12; "Zwall to Lead Church... After an absence of two years, blacklight artist **Jerry Zwall** will return to the Calvary Bible Church in Buellton to lead a series of special meetings which will begin Tuesday evening, March 31, at 7:30 and which will continue through April 5....," *SYVN*, March 20, 1959, p. 8; "Buellton Briefs ... Calvary Bible Church... Due to a series of meetings scheduled at the church under the chalk artist **Jerry Zwall**, there will be no Bible classes on Tuesday evenings for the next two weeks,"

LR, April 2, 1959, p. 18; "Rev. Nygren Berean Baptist Speaker Sunday. **Rev. Holmes Nygren** of the Goleta Baptist Church will be the guest speaker at all of the services of the Berean Baptist Church in Los Olivos this Sunday... Rev. Nygren will speak again in the evening at the Gospel Hour at 7:30 using black light and the artist's easel ...," *SYVN*, Sept. 11, 1959, p. 5.
See: "Chautauqua," "Euwer, Anthony," "Lompoc Community Woman's Club," 1956, "Matzinger, Philip," "Neff, Adele"

Chambers, Elinor M. DeVan (Mrs. V. Palmer Chambers) (1912-1985) (Seattle / Santa Maria)
President of Santa Maria Art Association, 1950 and active in northern Santa Barbara County early 1950s.
Chambers, Elinor (misc. bibliography)
Elinor M. Devan is listed as student in the *Seattle, Wa., CD*, 1931, 1932, as artist, 1934, as student, 1935, as assistant, 1936, and as dental asst., 1940; Elinor Devan was married to V. Palmer Chambers on Jan. 30, 1942 in Seattle per Washington Marriage Records; Mrs. Elinor M. Chambers is listed in the *Seattle, Wa., CD* as clerk, 1943, as stenographer, 1954, 1956, as secretary, 1959-60; Elinor M. Chambers b. Aug. 16, 1912, d. July 27, 1985, and is buried in Lakeview Cemetery in Seattle per findagrave.com (refs. ancestry.com).
See: "Santa Barbara County Fair," 1949, "Santa Maria Art Association," 1950, "Santa Maria Valley Art Festival," 1952

Channel City Camera Club (Santa Barbara)
Camera Club composed primarily of photographers active in the town of Santa Barbara.
See: "Gleason, Ellen," "Stewart, Al"

Chappell, (Susie) Audrey (Mrs. Lemell C. Chappell) (1892/3-1975) (Santa Maria)
Ceramist, with a studio on the Orcutt road, who exh. figurines at Santa Barbara County Fair, 1949.
■ "Audrey Chappell... 82, of 295 N. Broadway, Space 114, Orcutt... Mrs. Chappell died Sunday in a local hospital. She was born June 3, 1893 in Montrose, Colo. She had been a resident of the area since 1946. She was a member of the Clark Avenue Southern Baptist Church...," *SMT*, Nov. 17, 1975, p. 15.
Chappell, Audrey (misc. bibliography)
Susie Audrey Chappell, b. 1892 and d. Nov. 16, 1975 is listed in finadagrave.com (refs. ancestry.com).
See: "Santa Barbara County Fair," 1949

"Charley the Painter" (Santa Maria)
See: "Howell, Charley E."

Charlot, Jean (1898-1979) (Los Angeles / Hawaii)
Printmaker. One of his prints was owned by Stanley Breneiser who displayed it on several occasions in Santa Maria, 1935.

■ "French born, naturalized American painter, illustrator, and printmaker active in Mexico and the U. S.," per Wikipedia.
See: "Alpha Club," 1935, "Art Festival (Santa Maria)," 1935

Chautauqua (Santa Maria)

■ "... adult education movement in the United States, highly popular in the late nineteenth and early twentieth centuries. Named after Chautauqua Lake where the first was held. ... A [itinerant] Chautauqua Assembly brought entertainment and culture for the whole community, with speakers, teachers, musicians, entertainers, preachers and specialists of the day. ..." per Wikipedia.
Many smaller California towns contracted for appearances, thus acquiring for their area a kind of "culture."
Chautauqua (notices in Northern Santa Barbara County newspapers on microfilm and on newspapers.com)
1923 – Traveling troupe of lecturers, musicians, dramatists was scheduled in Santa Maria in spring of 1921, 1922, 1923, but no "fine art" was listed on the slate of offerings, *SMT*, March 15, 1923, p. 5.
See: "Chalk Talks," 1925, and see "Chautauqua" in *Atascadero Art and Photography before 1960*

Cherry, Herman (1909-1992) (Santa Barbara / Los Angeles / New York)
Artist. Sketched in the Santa Ynez Valley to obtain material for a mural in the Ventura post office, 1936.

■ "Mr. Cherry was born in Atlantic City on April 10, 1909, and grew up in Philadelphia, where he studied art in a local settlement house. At the age of 15 he moved with his family to Los Angeles and dropped out of high school to work for 20th Century-Fox, designing blueprints for sets. Later, he studied with the noted painter Stanton MacDonald-Wright in Los Angeles. In 1930, after working his way to Europe and back, he hitchhiked to New York City and studied at the Art Students League with Thomas Hart Benton. Back in Los Angeles by 1931, he set up a gallery at the Stanley Rose Bookstore, where he gave shows to Philip Guston, Reuben Kadish and Lorser Feitelson, among others. He had his own first solo show at the gallery in 1934," *NY Times*, April 14, 1992, Sect. B, p. 8 (on the Internet).
Cherry, Herman (notices in Northern Santa Barbara County newspapers on microfilm and on newspapers.com)
1936 – "**Atterdag College** Notes… Herman Cherry, artist from Santa Barbara, is staying at the college for a couple of weeks. Mr. Cherry is employed by the **PWA** and is painting sketches of the Santa Ynez valley," *SYVN*, April 3, 1936, p. 8; "Herman Cherry, an artist from Santa Barbara who has been living at the college [Atterdag] for several weeks, left for Santa Barbara Tuesday after having finished sketches of the Santa Ynez valley to be used as a mural for the Ventura post office," *SYVN*, April 17, 1936, p. 4.

1938 – "Congress Group in New Exhibit… American Artists' Congress Gallery, 6731 ¾ Hollywood Boulevard until June 26, are … Herman Cherry paints flowers with mellow rich color…," *LA Times*, June 19, 1938, p. 51 (i.e., pt. III, p. 7); "Exhibits to Open Here This Week… The Needham's Books, Santa Monica: Watercolors by Denny Winters and Herman J. Cherry…," *LA Times*, Nov. 13, 1938, p. 60 (i.e., pt. III, p. 8).
1939 – "In the Galleries… Two young artists, Herman J. Cherry and Denny E. Winters, make a brave show at the Stanley Rose Gallery until Feb. 15. … Cherry is more the studio painter, concerned with design and pigment. His most successful pieces here are, in my view, not the large, swollen figure compositions nor the tree designs, but the small, compact, solid portraits of himself, 'Mother' and 'Marie.' He knows how to intensify form with deeply glowing color," *LA Times*, Feb. 5, 1939, p. 52 (i.e., pt. III, p. 6); "Learning to Walk… Denny Winters and Herman J. Cherry will stage an outdoor exhibit of their paintings July 9 at 2640 N. Commonwealth Ave., 1 p.m. to dusk…," *LA Times*, July 2, 1939, p. 49 (i.e., pt. III, p. 7); "Two Schools of Art in Rival Exhibitions… Borden Gallery's 'California Moderns'… Herman Cherry has a remarkable abstract piece in which he makes color sing beautifully and originally," *LA Times*, Aug. 27, 1939, p. 52 (i.e., pt. III, p. 8).
1940 – "Paste 'Em In." Cherry was author of *Scrapbook of Art, No. 1 – French Modern Art*, LA: Ward Ritchie Press, 1940, per *LA Times*, March 31, 1940, p. 50 (i.e., pt. III, p. 8); "Briefly Noted. … Herman Cherry won the Flax cash and artist's materials prize in the current American Artists Congress exhibit for his painting, 'Odalisque.'…," *LA Times*, April 7, 1940, p. 54 (i.e., pt. III, p. 8); and later notices not itemized here.
Cherry, Herman (misc. bibliography)
Oral History interview with Herman Cherry, Sept. 1965 is located in www.aaa.si.edu/collections/interviews/oral-history.
See: "Works Progress Administration," 1936

Chester (Huffman) (Purcella?), Ida Mae (Mrs. Fred Huffman) (Mrs. Purcella?) (1938-1978) (Solvang)
Clothing design student, UCLA, 1957.

■ Port. and Miss Chester Weds Monday in Hawaii… forthcoming marriage of Miss Ida Mae Chester, daughter of Mr. and Mrs. Jack Chester of Solvang to Fred Huffman ... The bride-to-be was graduated from Santa Ynez Valley Union High School in 1956 and has completed her freshman year at the University of California at Los Angeles where she is majoring in apparel design. …," *SYVN*, July 19, 1957, p. 3.
Chester, Ida (notices in Northern Santa Barbara County newspapers on microfilm and on newspapers.com)
Several ports. of her and notices on her clothing design in high school appear among the more than 60 hits for "Ida Mae Chester" in the *SYVN* between 1950 and 1957 but were not itemized here.
Chester, Ida (misc. bibliography)
Ida Mae Chester was b. June 25, 1938 in Santa Maria to George H. Chester and Margaret Mae Smith, was residing in Long Beach, Ca., in 1960 and d. Feb. 14, 1978 per

HUFFMANB Family Tree; Ida Mae Purcella b. June 25, 1938 in California, d. Feb. 14, 1978 in Los Angeles County per Calif. Death Index (refs. ancestry.com).

Chester, Margaret (Santa Maria)
See: "Breneiser, Margaret Chester"

Chesnut, Robert Asa (1891-1985) (Lompoc)
Teacher of Freehand Drawing, Lompoc Union High School, 1914-16.
■ "New Teachers Chosen… Robert A. Chestnut [Sic. Chesnut] will handle the manual training and teach some classes in mechanical and freehand drawing. Mr. Chestnut [Sic. Chesnut] is a graduate of the University of Colorado. He has had charge of manual training in the schools of Needles, California, for the past three years. There the boys in his department constructed a seven-room manual training building. Mr. Chestnut [Sic. Chesnut] is capable of teaching the students practical carpentering and cabinet making…," *LR*, June 12, 1914, p. 1.
Chesnut, Robert (misc. bibliography)
Robert A. Chesnut is listed as a teacher in Needles and Dem. in *Voter Registration, Needles Precinct, No. 1*, 1914; Robert Asa Chesnut was b. July 28, 1891 in Weld, Colo., to Robert Samuel Chesnut and Minnie Jane Elliott, married Elisabeth Agnes McDonald, was residing in El Centro, Ca., in 1942, and d. Dec. 25, 1985 in El Centro, Ca., per Jennifer Ann's Family Tree (refs. ancestry.com).
See: "Lompoc, Ca., Union High School," 1914, 1915, 1916

Children's Art Contest / Young Artists (Lompoc)
Contest sponsored annually by Lompoc Community Woman's Club, 1955+.
See: "Lompoc Community Woman's Club," 1955-59

Chilson, Dorothy O. (Mrs. Charles K. Chilson) (Lompoc)
Member Lompoc Community Woman's Club who helped with Children's Art Exhibit, 1955, 1956, 1957.
See: "Lompoc Community Woman's Club," 1955, 1956, 1957, 1958

Chilson, Velma Carlena Schnurstein (Mrs. Robert Wentworth Chilson, Sr.) (Lompoc)
Clubwoman. Coordinator of Penny Art corner for Junior Alpha Club, 1958. Collector. Painter. Competed in needlework and textiles at Santa Barbara County Fair, 1960s.
See: "Alpha Club," 1958, 1960, "Hobby Show – Kiwanis," 1948, "Lompoc Hospital, Women's Auxiliary," 1949, "Tri-County Art Exhibit," 1958

China painting / painters (Northern Santa Barbara County)
Painting on pre-cast, bisque fired china bric-a-brac. Hobby for women, especially at the turn of the twentieth century. Practiced in Lompoc and in Santa Maria.
China painting (notices in Northern Santa Barbara County newspapers on microfilm and on newspapers.com)
1890 – "About Ceramic Colors… In Chinese ceramics the colors are divided into families and many are curiously symbolical, owing their origin often to some peculiar or remarkable occurrence of a past age. It is well-known by every one that blue has always been a favorite color with the Chinese potter or decorator, but that each shade of blue has its own particular use and significance… The same is true, in a less degree, however of the greens and other colors. The brilliancy of the blues invented during the Tsin dynasty, about 265 A.D. is remarkable… One of these blues, called 'blue of the sky after rain,' became very popular… The greens produced by the Chinese about the year 600 were particularly noted… green was the exclusive imperial color for over 200 years… Owing to the unreliability of gold colors in firing they have been a subject of continual study and experiment… remaining the most charming and fascinating of all the mineral colors. (The colors designated as the rose family come under the head of gold colors and include all the rich rose, crimson and violet shades). The date of the discovery of these colors is not known. Amateurs of the present day are disappointed with failures in the gold colors; they are either dull and lusterless or quite purple after firing and, indeed, they never seem to be twice alike. This is probably why carmine is considered a test color and the amateur who can successfully use it is said to have conquered the mysteries of mineral colors. … Our rose Pompadour and rose Du Barry prove the estimation in which they were held at Sevres in the time of these two women from which they derive their names… The royal color of China at one time was a brilliant yellow known as egg yellow… The composition of many of the enamel colors by which is understood all overglaze colors except the matt colors, is a secret carefully guarded and transmitted as an inheritance from father to son…," from the Philadelphia Record, *LR*, Sept. 13, 1890, p. 4.
1915 – "Xmas Suggestions. … embroidery linens, towels, hand bags, purses, post card albums, dolls, hand painted china. The Misses Bailey's," *LR*, Dec. 10, 1915, p. 7.
1917 – "Misses Bailey. Lompoc Shoe Store," *LR*, Dec. 14, 1917, p. 2.
And, more than 200 hits for "hand-painted" in Santa Barbara county newspapers on newspapers.com show that hand-painted china (either imported or by local artists and sold by jewelry or china stores or by local artists) was a status symbol to own in the early 20th century but the articles were not itemized here.
See: "Ceramic," "Edwina's Ceramic Studio (Santa Maria)," "Santa Barbara County Fair"

Chitolis, Hila Catherine Stuart
See: "Judkins (Chitolis), Hila Catherine Stuart"

Chrimes, Louise Amelia (1898-1995) (Ballard)
Caligrapher, 1954. Prop. of Tank House Studio, Ballard, 1947-49. Prop. of Crafts Shop, Ballard, 1954.

■ "Louise Chrimes… 97, died Nov. 11, 1995 at Santa Ynez Valley Recovery Residence in Solvang. She was born Feb. 18, 1898 in Brookline, Mass. … In 1934 she came to the valley to visit friends Louise and Paul Squibb who had just finished one year organizing **Midland School** in Los Olivos. The two Louises had gone to grammar school together in Massachusetts. She stayed to help them until 1952 and never lived in Boston again. She worked as a companion for different women, with her home being in Ballard. She attended art school in Boston in early years and was a needlework artist (learned from her mother who was a master craftsman). She did printing and artwork for certificates and awards as well as metal work and wood work…," *SYVN*, Nov. 16, 1995, p. 6.

Chrimes, Louise (notices in Northern Santa Barbara County newspapers on microfilm and on newspapers.com)

1938 – "Unique Cachets … in connection with the National Airmail week observance… A drawing by Miss Louise Chrimes of Midland, of mountains surrounding [Sic.?] with Zaca peak in the background and oak trees, forms the design for the Los Olivos cachet…," *SYVN*, May 20, 1938, p. 1.

1945 – "Exhibition. You are cordially invited to an exhibition of Decorative Ornament in tin and wood by Louise Chrimes. Also examples of fine stitchery by Mrs. Louise A. Chrimes of Boston. At Veteran Memorial building, Saturday, September 8th, 11-6 o'clock. No admission charge," *SYVN*, Aug. 31, 1945, p. 1.

1947 – "Tank House Studio – Ballard. (Opposite Store). Furniture, lamp shades and trays painted and decorated. Lessons. Louise A. Chrimes," *SYVN*, Nov. 7, 1947, p. 7.

1948 – "Tank House Studio. Ballard, opposite store. Furniture, lamp shades and trays painted and decorated. Lessons. Louise A. Chrimes," *SYVN*, Sept. 3, 1948, p. 7.

1949 – "Tank House Studio. Ballard, opposite store. Furniture, lamp shades and trays painted and decorated. Lessons. Louise A. Chrimes," *SYVN*, Sept. 16, 1949, p. 7.

1952 – "13 Graduated from Midland… Twenty-year medals designed by Miss Louise Chrimes, commercial artist and designer who has been in charge of the commissary at Midland the past 20 years, were awarded to… and Miss Chrimes. Miss Chrimes designed the attractive gold medal in 1933. In addition to her work at the commissary, Miss Chrimes has done much other designing and painting at the school," *SYVN*, June 13, 1952, p. 1; "Living in Ballard. Miss Louise Chrimes, formerly of **Midland School**, is now living at her home in Ballard. Her cousin, Mrs. Louise King and son, Edward, formerly of Alabama, are occupying their recently completed home which is located on the property adjoining that owned by Miss Chrimes," *SYVN*, July 4, 1952, p. 6.

1953 – "Health Memorial Report… Children's Health Memorial of the Valley Presbyterian Church… The first year six names were recorded in the 'Book of Memories.' This second year 21 more names have been inscribed… Miss Louise Chrimes has done the beautiful work of inscribing the names and illuminating the capitals beginning the names of those in whose memory

contributions have been received," *SYVN*, July 17, 1953, p. 5.

1954 – "Children's Health Memorial Fund," *Book of Memories* in which is inscribed the names of all donors in painstakingly applied Old English lettering with colored capitals in various shades of ink, *SYVN*, Oct. 8, 1954, p. 8; "**Crafts Shop** Opens in Ballard… Miss Louise Chrimes announces the opening of her Crafts Shop… located next to the Ballard Bridge, will feature hand painted and decorated furniture, lamp shades and screens," *SYVN*, Dec. 3, 1954, p. 1.

1957 – Port. with other churchwomen, *SYVN*, March 1, 1957, p. 3.

1958 – "Miss Louise Chrimes of **Midland School** is spending the summer at her studio in Ballard," *SYVN*, July 25, 1958, p. 2, col. 2.

1960 – "Church Tea… A hand-painted tray, donated by Miss Louise Chrimes, will be awarded as a door prize at 5 p.m.," *SYVN*, Sept. 9, 1960, p. 3.

And more than 200 additional social and travel notices for "Louise Ballard" in the *SYVN* 1930-1960 were not itemized here.

Chrimes, Louise (misc. bibliography)
Louise Amelia Chrimes was b. Feb. 18, 1898 in Mass. to Walter Albert Samuel Chrimes and Louise A. Austin, was residing in Hingham, Mass. in 1910 and d. Nov. 11, 1995 in Santa Barbara, Ca., per All Crymes, Chrymes, Crimes and Chrimes Family Tree; Louise Amelia Chrimes is buried in Oak Hill Cemetery, Ballard, per findagrave.com (refs. ancestry.com).

See: "Crafts Shop," "Solvang Woman's Club," 1952

Christian Church (Santa Maria)
See: "Campbell, Horace," "Collectors, Art / Antiques (Santa Maria)," 1945, "Kelsey, Olive," "Ladies Aid Society of the Christian Church," "Rick, Maxine," 1952

Christmas in art
In various towns there were competitions for the best decorated home at Christmas. Christmas crafts (cards, toys, package wrapping, etc.) were taught at the various women's clubs, and wherever crafts were normally taught (adult school, city recreation department, etc.). Religious themes were seen in stained glass windows of churches and in the missions. Many artists depicted the Madonna in easel paintings, and there were some special exhibits of Madonna paintings held. The Lompoc High School woodworking students repaired toys to give away at Christmas. Puppet shows were presented at Christmas parties. Photographers urged people to give portrait photos for Christmas, and they made Christmas cards from photographs. Grade school children gave Christmas presentations that necessitated painting of stage sets, the making of costumes and use of makeup.
See: "Allan Hancock [College] Art Gallery," 1956, Immaculate Heart College," "Alpha Club," 1929, 1933, 1934, 1936, 1937, 1947, 1951, 1952, "Art, general (Camp Cooke), Korean War, "Arts and Crafts Guild," 1951, "Christmas …," "Civilian Conservation Corps," 1935, "College Art Club," 1931, "Community Center (Lompoc),"

1949, "Community Club (Santa Maria)," 1938, "DeGasparis, Lucy," "DeWitt, Zena," "Emergency Educational Program," 1934, "Fast, Nat," 1996, "Feeley, Lola," "Gamble, John," 1940, "Goodenough, Katherine," "Gray, Gladys," "Hibbits, Forrest," 1948, 1951, "Home Dept.," 1930, 1931, 1932, 1934, "Hosn, Betty," "Ingram, Phyllis," 1964, "Iron Art," 1952, "Jacobsen, Peter," "Junior Community Club," 1949+, "Kuelgen, Paul," 1956, "Leonette, M., Sister," "Lewis, Marion," "Lompoc, Ca., Recreation," 1947, "Lompoc, Ca., Union High School," 1924, 1928, 1932, "Lompoc Community Woman's Club," 1955, 1956, 1959, "Martin, Ben," "McFadden, Ann," "Melton, Edward," "Mildred White Ceramics," 1961, "Minerva Club," 1929, 1953, 1957, "Olivera, James," "Orcutt Community Church," 1947, 1949, "Puppets (Lompoc)," 1947, "Puppets (Santa Maria)," 1935, 1938, 1954, "Rome, Richardson," "Rowe, Barbara," "Sabin, Charles," "Santa Maria, Ca., Adult/Night School," 1936, 1938, "Santa Maria, Ca., Elementary School," 1931, 1955, 1957, "Santa Maria, Ca., Recreation," 1949, 1959, "Santa Maria, Ca., Union High School," "Santa Maria Camera Shop," 1942, "Santa Ynez Valley, Ca., Elementary School," "Snapshot Guild," "Stonehart Studio," "Sudbury, Delia," "United Service Organization (Lompoc)," 1942, 1945, "Ward, Margery," "Winter, Ralph," "Wygal, Elsa"

Christmas Decorations (Lompoc / Vandenberg AFB)

Contest sponsored by the retail division of the Chamber of Commerce 1955. Forrest Hibbits created a Nativity scene for Ryon Park, 1951, 1952 for the Alpha Club.

Christmas Decorations (notices in Northern Santa Barbara County newspapers on microfilm and on newspapers.com)

1955 – "Winners of Xmas Home Decoration Contest Told… E. J. Godden residence at 439 South J street… The display is a silhouette of the Three Wise Men against a background of a manger. Second place went to the Art Wilson residence at 120 South O street for a reproduction of a church window showing the Madonna and Child with the Star of Bethlehem above. The painting was done by **Miss Barbara Rowe**….," *LR*, Dec. 22, 1955, p. 1.

1960 – "Vandenberg Village Invites Christmas home Decorations," *LR*, Dec. 1, 1960, p. 13; "Visiting Vandenberg… The home of Major Nelson Oman on the corner of Dogwood and Ocean View. The sleigh, reindeer and jovial Santa… it's the handiwork of 17-year-old **Barry Oman**. He started last year and made the Santa Claus. In November of this year, he began on the rest of the fantasy. He used his mechanical drawing skill to enlarge the bigger-than-life pieces from small pictures…," *SMT*, Dec. 21, 1960, p. 13.

See: "Alpha Club," 1951, 1952

Christmas Decorations (Santa Maria)

Some competitions were sponsored by the Lions Club, c. 1949+

Christmas Decorations (notices in Northern Santa Barbara County newspapers on microfilm and on newspapers.com)

1934 --"City Takes on Holiday Air… The decorations extend along the entire business section of Broadway… An extra large tree adorns each of the four corners at the junction of the two principal business corners. Four large Christmas bells draped in green are suspended from the four corners of the 'Santa Maria' sign; about the flagpole and beneath are four scenes connected with the birth of Christ, painted by students of the Art department of the high school …," *SMT*, Dec. 8, 1934, p. 1.

1935 – "Yule Trees to be Lighted… A huge mural depicting Santa Claus in a sleigh drawn by reindeer traveling over the tops of houses and trees is being painted in the **high school** to surround the base of the flagpole. Designed by **Joffre Bragg** and **Nicholas Firfires**, the work is being done on seven veneer panels, four by eight feet, which will be put together in the form of a circle, 28 feet in circumference and eight feet high," *SMT*, Dec. 4, 1935, p. 1.

1947 – "Santa and Reindeer Galloping Over Tree Tops at City Hall… sponsored by … the Santa Maria **Police** Department… An assist for the colorful exhibit goes to the high school classes of **Perino Merlo** and **Miss Verla Leonard**. Merlo's woodworking classes cut out the huge playboard figures and Miss Leonard's art classes painted them…," *SMT*, Dec. 5, 1947, p. 1.

1949 – "Winners are Announced in Outdoor Lighting" and Decoration contest, *SMT*, Dec. 23, 1949, p. 6.

1951 – "Lions Home Decorating Contest Set" Christmas, *SMT*, Dec. 13, 1951, p. 1; repro of nativity scene set up between two different churches, *SMT*, Dec. 21, 1951, p. 1; photos of Lions Christmas home decoration contest winners, *SMT*, Dec. 24, 1951, p. 6.

1952 – "Home Decoration Judging Sunday" for Lions Club second annual Christmas home decorating contest, *SMT*, Dec. 17, 1952, p. 1.

1953 – Photo of winners in Lion's Club home Christmas decoration contest, *SMT*, Dec. 24, 1953, p. 1.

1954 – "Christmas Home Decorators to Compete in Annual Lions Event" – fourth, *SMT*, Dec. 14, 1954, p. 1; "Home Decoration Contest: Zierman Wins Again," *SMT*, Dec. 24, 1954, p. 1 and photo and other photos of winners, p. 7; photo of Christmas home decoration winners, *SMT*, Dec. 31, 1954, p. 1.

1955 – Photo of a decoration in the Lion's Club Christmas decoration contest, *SMT*, Dec. 17, 1955, p. 1; photo of Zierman decoration in competition for Lion's Club Christmas decoration contest, *SMT*, Dec. 21, 1955, p. 1; "Russell Zierman Captures Lion's Home Decoration Sweepstakes," *SMT*, Dec. 23, 1955, p. 1.

1956 – Photo of winners and "Tops in Home Decoration" for Christmas, *SMT*, Jan. 18, 1956, p. 1; repro of display and "Zierman Cops Sweepstakes Trophy Again" in Christmas decoration contest, *SMT*, Dec. 22, 1956, p. 1.

1957 – Photo of reindeer in Christmas display in front of City Hall, *SMT*, Nov. 8, 1957, p. 7.

1959 – "Lions Sponsor Home Christmas Displays," and article adds, "The Santa Maria Lions Club will once again sponsor its annual contest for the best decorated homes showing a Christmas theme… Six trophies will be awarded. Four of these will go to the best decorated homes in each of the city's four geographical areas. One will go to the owners of the best decorated home in outlying areas immediately adjacent to the city. These five homes will then compete for the judge's selection of the home best mirroring the Christmas spirit through its decorations.

Owners of this home will receive the club's grand trophy," *SMT,* Nov. 25, 1959, p. 1; photo of Schmidt family preparing their home decorations for Lion's Christmas competition, *SMT,* Dec. 12, 1959, p. 1; four photos of winning Christmas home decorations and "Homes Decorate City," and "Schmidt Home Lions Winner," *SMT,* Dec. 22, 1959, p. 1.

1960 – "City's Hospitals Get Yule Look from Volunteers. A forest of nylon net and spangled Christmas trees… gold foil door angels had lovely hand painted faces by Mrs. James F. Kelly, a professional artist, who co-chairmaned the Sisters' Hospital committee… The green wreaths with picture centers were designed by Mrs. James L. Tobin… 'It all began with a box of tongue depressors… toothpicks, Green poster paint, fringed aluminum pie tins…artificial snow and glitter… Christmas bells… covered egg carton cups with gold foil, then strung them on ribbons…," *SMT,* Dec. 14, 1960, p. 17.

Christmas Decorations (Santa Ynez Valley)
Christmas Decorations (notices in Northern Santa Barbara County newspapers on microfilm and on newspapers.com)
1939 – "Ten Dollar Xmas Decoration Contest… sponsored by a group of persons interested in more Christmas decorations for the valley… A prize of $5 is offered for the best outside decorations for any residence… Another $5 cash prize is offered to the home having the best inside tree or decoration that can be seen from the outside… This is the first time such a contest has been held in the valley…," *SYVN,* Dec. 22, 1939, p. 1.
1948 – "Businessmen to Sponsor Yule Contest … home Christmas decoration contest… cash awards… decorating of the town…," *SYVN,* Nov. 26, 1948, p. 1; "Christmas Decoration Contest Open … home decoration contest, sponsored by the Solvang Businessmen's Association… prizes totaling $100 will be awarded… deadline for entries is 6 p.m. Dec. 23… Judging in the contest will be based on originality and aptness… not necessarily be based on the most expensively decorated entry… entry must be plainly visible from outside… open to every resident of the Valley… both urban and rural areas…," *SYVN,* Dec. 17, 1948, p. 1; "Mrs. [Arden T.] Jensen's Entry Wins top Prize… revolving colored lights, silver colored trees… Second prize of $15 went to Mrs. Todd Brouhard of Buellton. A hand painted scene of the Madonna and the Christ Child on a large window of the Brouhard home with a Christmas tree in the background…," *SYVN,* Dec. 31, 1948, p. 1.
1949 – "Christmas Home Decoration Contest Planned… Solvang Businessmen's Association will sponsor…" and extended plans, *SYVN,* Dec. 2, 1949, p. 2; "Yuletide Contest Underway," *SYVN,* Dec. 9, 1949, p. 1; "Yule Contest Deadline Set," *SYVN,* Dec. 16, 1949, p. 1; "Yule Contest Judging Set for Tonight," *SYVN,* Dec. 23, 1949, p. 1; "Mrs. [Todd] Brouhard's Entry Wins Xmas Contest," *SYVN,* Dec. 30, 1949, p. 1.
1950 – Christmas Home Decoration Contest Planned…," *SYVN,* Dec. 1, 1950, p. 1; "Pohls Youngsters Win Top Prize in Decoration Contest… Erling and Betty Pohls, children of Mr. and Mrs. Holger Pohls… second prize of

$15 went to **Viggo Brandt-Erichsen** of 'Elverhoy,' …," *SYVN,* Dec. 29, 1950, p. 1.
1951 – "Fourth Annual Christmas Decoration Contest slated…," *SYVN,* Nov. 30, 1951, p. 1; "Pohls Youngsters Again Win Top Decoration Prize… Erling and Betty Pohls, children of Mr. and Mrs. Holger Pohls… Santa Claus riding atop the Pohls home in his sleigh being pulled by reindeer…Second prize… Katrinka Heinrich and Mary Davison… Babe in the Manger scene… Third prize… Dr. Earl Hill… gaily lit front portion of his house and Christmas tree…," *SYVN,* Dec. 28, 1951, p. 8.
1952 – "Businesses to Again Stage Christmas Decoration Contest," *SYVN,* Nov. 28, 1952, p. 2; "Solvang School Top Winner in Yule Contest," *SYVN,* Jan. 2, 1953, p. 3.
1953 – "Christmas Home Decoration Contest Underway," *SYVN,* Dec. 4, 1953, p. 14; "Large Picture Windows Feature of Holger Pohls' Residence," and description of rooms and photos, *SYVN,* Dec. 4, 1953, p. 10; "**[Paul] Kuelgen, [Betty] Corbett** Entries Win Top Decoration Prizes… second… Miss Thora Mae Nielsen. Third prize… **Jean Abbott…**," *SYVN,* Dec. 25, 1953, p. 1.
1956 – "Valley Christmas Home, School Decoration Contest Launched Today… under the joint sponsorship of the Solvang and Buellton Businessmen's Assn. and the Santa Ynez Valley News…," *SYVN,* Dec. 7, 1956, p. 1; "Winners in Decoration Contest Told… Eskild and Edna Skytt and Mr. and Mrs. Marston Daugherty…," *SYVN,* Dec. 28, 1956, p. 2.

Christmas Fair
See: "Arts and Crafts Guild, St. Peter's Episcopal Church"

Chumash
See: "Native American"

Churchman, Reece Edward (c. 1882-1915) (Lompoc)
Sign painter, 1911, 1912.
Churchman, R. E. (notices in Northern Santa Barbara County newspapers on microfilm and on newspapers.com)
1911 – "The Lompoc Garage is having sign posts, directing the wayfarer to Lompoc, painted at Churchman's. The signs are to be placed on the Lompoc-Santa Maria road," *LR,* June 2, 1911, p. 4; "Painter Leaves for Parts Unknown… Is Arrested in Santa Barbara… R. E. Churchman, who had a paint shop on Ocean avenue, left for parts unknown last week… Churchman seemed to be a quiet sort of fellow at first, but lately has been drinking heavily going so far as to dilute alcohol, which he used for cutting his shellac, and drinking it. Last Friday he was seen hiking to Surf and the next heard of him was that he had been arrested in Santa Barbara…," *LR,* June 23, 1911, p. 1.
1912 – "R. A. [Sic.] Churchman returned to Lompoc this week after an absence of several months. Mr. Churchman is an expert sign painter and is already busy at his trade," *LR,* March 8, 1912, p. 2, col. 1; "Railroad Time Schedule… R. E. Churchman, the sign painter on H street, imbibed not wisely but too well… and as a result went through the same performance as he did about this time last year. Churchman, who is a clever sign painter, is a man who can

not stand too much prosperity and as soon as business reaches the point where it begins to pay more than wages, he starts celebrating. And, when he starts, well, the end is not seen in the town in which he begins. ... 'his feet begin to itch' and he 'hits the road'," *LR*, June 14, 1912, p. 1.

Churchman, R. E. (misc. bibliography)
Reece Edw Churchman is listed in *Voter Registration, San Francisco*, 1907; Reece Chuchman is listed in the 1910 U. S. Census as a sign painter, residing in Township 1, San Mateo, Ca.; R. E. Churchman, is listed in the *Tulare County, Ca., Sheriff's Office and Jail Records*, 1910, Oct. 28, drunk; Reece E. Churchman, painter, is listed in the *Bakersfield CD*, 1911; Reece E. Churchman was b. 1882 in Roseburg, Ore., to William Churchman and Alice Lovinia Howard, was residing in San Francisco in 1900 and d. Jan. 4, 1915 in San Francisco per Taylor/Dallmann Family Tree (refs. ancestry.com).

Citadel (New Mexico)
A resident and day school for sons and daughters of Christian Scientists, operated by Mr. and Mrs. Stanley Breneiser, at Alcalde, N.M., 1951-53.
See: "Breneiser, Stanley," 1951

City Recreation Department
See: "Lompoc, Ca., Recreation Department," "Santa Maria, Ca., Recreation Department"

Civic Club (Lompoc)
Woman's club – responsible for city beautification, 1914, 1915.
See: "Art, general (Lompoc)," 1914, 1915

Civil Works Administration (CWA) Project (Northern Santa Barbara County)
Short-lived job-creation program (winter 1933/34) under the Federal Emergency Relief Administration (FERA), 1933. Much of the work was construction of public buildings or roads. CWA workers painted many schools inside and out and were involved with Santa Maria City Hall and the recreation bungalow on the Santa Maria high school grounds. SERA superseded the CWA, which ended March 30, 1934.
CWA Project (notices in Northern Santa Barbara County newspapers on microfilm and on newspapers.com)
1934 – "Mural of Mission La Purisima Draws Admiring Comment. Wielding a brush with skill no one, even himself knew, he possessed, **Ed Beard**, local sign writer and painter, demonstrated his prowess as a painter of murals when he created a scene of Mission La Purisima Concepcion on the rear wall of the little stage in the music room at the Lompoc Union Elementary School. Using merely a postcard view of the mission as it appeared a generation ago, Mr. Beard painted a scene 12 feet long and eight feet high, depicting the ancient edifice in its pleasant setting in Mission canyon with the spring house and other supplementary structures in approximately the places they occupied before their dissolution by time and the elements.

Mr. Beard completed the assignment in four days, as a CWA project... The mural was unveiled Friday afternoon at the meeting of the Parent Teacher Association... Since that time many other residents have visited the music room to inspect the painting...," *LR*, Jan. 19, 1934, p. 2; "Schools Receive Painting Made by Noted Artists. Pictures Made as CWA Projects ... Paintings of excellent quality now adorn Lompoc schools... Mrs. Muriel Edwards, county superintendent of schools, arranged for and distributed Santa Barbara county's allotment of paintings. Mrs. Edwards was here Tuesday, accompanied by **Douglass Parshall**, Santa Barbara artist, to present the paintings to the local schools. Oil paintings were given to the Lompoc high school and water colors to the Lompoc Union Elementary School. Pictures for the high school included 'Rocks,' by **Stanley Edwards**, which was hung in the new auditorium, 'March Winds,' by **John Coolidge**, which was placed in one of the class rooms, and 'Santa Barbara Channel,' by **Alan [Sic. Allan] Cram**, which now adorns the school's library. The outstanding work of art presented to the elementary school was 'The Good Shepherd,' by **Everett L. Bryant**, which was placed in the corridor," *LR*, June 8, 1934, p. 9.
See: "Federal Art Projects," "Hageman, Fred"

Civilian Conservation Corps (CCC) (Lompoc)
The Civilian Conservation Corps was a voluntary public work relief program that operated from 1933 to 1942 in the United States for unemployed, unmarried men ages 18–25 and eventually expanded to ages 17–28 (Wikipedia). The Lompoc area had two – Twin Camps – whose primary project was the restoration of Mission La Purisima, 1934-42. There was also a CCC group at Los Prietos in the Santa Ynez Valley.
Civilian Conservation Corps (notices in Northern Santa Barbara County newspapers on microfilm and on newspapers.com)
1934 – "Improvement Projects for CCC Outlined. Construction of Camp Begun Opposite Old Mission Ruins. 'Skeleton' Crew at Work...," *LR*, July 27, 1934, p. 1.
1935 – "Crafts Building is Nearing Completion... members of the photographic practice class built a partition in the building. It will make a photographic dark room, nine feet square, of the north portion of the building. When the room is complete, **Frank Cooper**, who has had two years practical experience in photography, will instruct...," *LR*, Nov. 22, 1935, p. 7; "Voice of the Twin Camps. Company 1951, Purisima, Company 2519, Lompoc. Civilian Conservation Corps... **Carl Vinton Young**, treasury artist assigned to Co. 2519, commenced instructing a class in commercial art last Friday. Those enrolled were Ed. Conti, J. Groves, Horace Kunkle, Thomas Murphy, August Quintille, Ed Rogers, William Seidowsky and John Woodward," *LR*, Dec. 6, 1935, p. 5; "Happy New Year. Under the expert supervision of **Carl Vinton Young**, the art class of the Twin Camps painted and erected beautiful Christmas banners in the recreation halls of both camps and in town...," *LR*, Dec. 27, 1935, p. 7, col. 4.
1936 – "**Carl Vinton Young**, official treasury department artist, has planned a new art schedule in which he will teach clay modeling, wood block printing, commercial art,

designing, interior decorating, carving, pottery and tile work, drawing and painting. Mr. Young has co-operated greatly in the educational program of the Twin Camps," *LR*, Jan. 31, 1936, p. 7; "Old Furniture Being Repaired… Purisima Recreation Hall is going to be the envy of the whole corps area… With the aid of **Carl Vinton Young**'s murals, the dream is bound to become a reality," *LR*, March 6, 1936, p. 8; "CCC Exhibits in Pasadena. The Twin camps were represented at the Secondary School Superintendents of Southern California meeting at the Maryland Hotel in Pasadena April 3rd with an exhibit of arts and crafts projects made in camp. Chief among the articles shown were wood-carving, diatomaceous earth (Celite) blocks carved into various useful articles, and paintings depicting the surrounding scenery of the Twin Camps. **Carl Young**, treasury department artist who instructs in the art classes accompanied Mr. Quin to the exhibit…," *LR*, April 10, 1936, p. 8; ■ "Voice of the Twin Camps… New News from the EA. There has just come to our office a series of pamphlets on craftwork prepared and distributed by Headquarters office of the educational adviser of the Ninth corps. They are: *How to make handmade lantern slides; The handiman club; Horncraft; Copper craft; The cutting, grinding and polishing of semi-precious stones; Square knot work; Amateur pottery.* The EA personally has also pamphlets on leathercraft, silvercraft and archery and beadwork. These and other handicraft subjects will be taught in the new craft building now being made available by Lieutenant Tornell, skipper of the Lompoc camp. All enrollees interested in using their hands to create beautiful and useful handmade articles are asked to make their wishes known to the educational staff in order that new classes may be arranged…" *LR*, May 15, 1936, p. 9.

■ "2950 Workshop Nearing Completion. The Lompoc camp now boasts of an ideal workshop … remodeled from the old Barracks One and is divided into sections. In the south sector … is a well-equipped craft shop, consisting of four woodworking benches, two metal benches and one cast iron table for leather-craft. The latter can also be utilized for silver and copper craft. In addition, there is a power table equipped with a seven-inch power saw, a woodworking lathe, and a power grinder is to be added. A complete stock of woodworking and other shop tools are also available for class use. A great deal of credit is due Mr. Day, the educational adviser, who has gone to the trouble and expense of installing this equipment, practically all of which is his personal property. Also included in the south sector of the building is storage space for camp plumbing, electrical and paint supplies. In the other section a dark room is under construction for the Lompoc photography class. The dark room is furnished for portrait and enlarging as well as regular finishing work. Coloring and tinting will be done in both water and oil. Film tanks, a projection enlarger, a foot operated printing machine and a print drying rack are among other furnishings to be installed. This room is power ventilated and lighted with various photographic lights. Also in this section… is to be a small drafting and general classroom. … Mr. Hollister, SCS foreman, holds class in this building on Wednesday evenings in architecture. This class is laying plans for a model bungalow to be constructed on a scale of 1 inch to 1 foot. This will be an exact replica of a modern home.

Photos will be made and the plans studied in order for the class members to familiarize themselves with construction of homes. This model will be kept on display at the Lompoc camp for the interest of inspecting officers and visitors," *LR*, June 12, 1936, p. 7.

■ "Twin Camps' Shooting. In the greatest shooting scrape since the Mission Indian uprising in the 'forties, 300 men were shot at Twin Camps [CCC camp] last week. None were injured, however, as the shooting was done by **Ernest Brooks**, Lompoc photographer who came to camp to make negatives of the two companies separately and one also of a joint retreat. Lompoc Camp 2950th Co., was the first to meet the camera's gaze. Both camera and company came through unscathed, and the two companies were lined up on opposite sides of the flagpole and the retreat ceremony was photographed. Due to the absence of 20 men from the Purisima company, the company picture of 1951 was postponed until Tuesday. Orders for these pictures are being taken through the canteens at a nominal sum, and the prints are being made by the photography class in the newly completed darkroom," *LR*, June 19, 1936, p. 9; heading circled with black line – "'51-50' 'In the Land of Mustard and Sweet Peas' Co. 1951 CCC, Purisima… Co. 2950 CCC, Lompoc… Staff Artist **Alan Soul**," *LR*, Aug. 21, 1936, p. 6.

1937 – "Construction of School …building formerly used for a mess hall into an educational activity building with the formulation of plans for high school classes for enrollees scheduled to start in September… The classes conducted at the Twin Camps will be independent of the local high school … One of the best equipped and largest among the CCC camps… Over one thousand volumes … comprise the school library… The art department studio… instruction and practice in various types of commercial art. The ceiling of the room is being equipped with skylights, and ideal working conditions are being afforded the art students. Murals and panelings by an outstanding WPA artist decorate the room, which will be devoted to academic study … academic and avocational classes will be conducted in the evenings after the boys return from work. Vocational instruction will be given them each morning before work and will be continued during the day in conjunction with the particular job in which they are engaged on the camp project…," *LR*, July 2, 1937, p. 8.

1938 – "Increased Activity at Twin Camps … necessary to enlarge the quarters for the different branches of the work. The National Park service has erected a mill and shop on the site of the mission. This shop and mill will contain machinery and equipment for making the mission furniture for the restoration… The church is about ready for the furniture installation. Work has already started on the third building, and furniture will be made for that. This shop will also provide for making the hardware for the buildings as well as other fixtures to be installed… The work of the Soil Conservation service has so enlarged … necessary to enlarge the office to make room for a map and chart room and also for a drafting room….," *LR*, April 29, 1938, p. 3.

1939 – "Purisima CCC Camp Holds Open House," and extensive article and photos on the two CCC camps and on each new group of enrollees that come in every three months, *LR*, April 7, 1939, p. 6.

1940 – "Trades for CCC Enrollees to be Featured… to prepare future CCC enrollees for employment in civilian life…," *SMT*, Dec. 16, 1940, p. 2; "CCC to Stress Specialized Training in Several Fields. In preparing for the regular January CCC enrollment… specialized training will be given to an even greater degree… Extra funds have been made available and facilities have been set up for intensive training in the following subjects: cooking and baking, short wave radio, telephone-line construction, clerical and accounting work, operation and repair of heavy equipment, carpentry, photography – including making mosaics from aerial photographs, blueprint reading, etc.," *LR*, Dec. 27, 1940, p. 2.

1942 – "Purisima **CCC Camp** Observes Anniversary with Open House [ninth anniversary of the CCC, and the restoration of the mission was the local group's major project, the enrollees making thousands of adobe bricks] … The interior of the mission has been decorated by **Joseph Helmle**… with the assistance of CCC members. The original design was developed from the collection of plaster fragments which were gathered during the excavation… On the north wall of the church hangs the famous painting La Virgen Purisima, signed by **Michel Cabrera** in 1771, a gift of John R. Southworth of Santa Barbara. Since August 1941, approximately half the enrollment of the [CCC] company has been working on war projects [construction of an army recreational area at Pismo Beach and landscaping of Camp Cooke] … Each enrollee is paid $30 a month besides his board and room, clothing and medical care… there are assistant leaders and leaders being paid $36 and $45 respectively …," *LR*, April 10, 1942, p. 5; "Discontinue CCC Camp after 8-Year Service," *LR*, July 17, 1942, p. 1.

1944 – "CCC Buildings at Purisima are Dismantled," *LR*, Aug. 25, 1944, p. 1.

Books:
"Mission La Purisima; The Civilian Conservation Corps Story," *Noticias*, v. 50, no. 2, Summer 2004.
See: "Brooks, Ernest," "Curie, Paul," "Day, Willard," "Flower Festival / Show," 1939, "Helmle, Henry," "La Purisima Camera Club," 1938, "Lompoc, Ca., Union High School," 1938, "Mission La Purisima," "Olivera, Bob," "Oxx, William," "Rowe, Edwin," "Soul, Alan," "Young, Carl"

Civilian Conservation Corps (CCC) (Los Prietos)
The CCC school at Los Prietos taught mechanical drawing and metal work, among other vocations – it was a "branch" of Santa Ynez Valley Union High School, 1936+. See also the CCC in Lompoc, above.

■ "How CCC School Was Handled by Local High School District. Local High School Closes CCC Educational Program at Los Prietos … eight years… has been transferred to the La Purisima camp near Lompoc… At their new location these boys will assist in the maintenance of Camp Cooke… Since 1936 the Santa Ynez Valley Union High School has maintained a branch school at Los Prietos for the benefit of the CCC enrollees… Approximately 200 have received diplomas… Vocational subjects were given particular emphasis… Such subjects as Carpentry, Auto Mechanics, Mechanical Drawing, Metal

Work, Agriculture, etc. were taught as a part of each boy's daily work assignment… Courses in History, English… were offered in evening classes to round out the educational program… The buildings were especially constructed by the Federal Government…," *SYVN*, June 5, 1942, p. 1.
See: "Civilian Conservation Corps (Lompoc)," "Romer, Christian," "Santa Ynez Valley Union High School," 1937, "Waterman, Richard"

Clark, Mary Jenks
See: "Coulter (Clark), Mary Jenks / Jencques"

Cleaver, Walter Sipler (1905/6-1968) (Oregon / Santa Maria / LA County)
Santa Maria J. C. art student 1926/27. Charter member, College Art Club, 1926. Scholarship winner to Santa Maria School of Art, 1927. Attended Chouinard School of Art, Los Angeles, spring 1928. Active in little theater in Santa Maria, and with Inglewood Community Players in the 1930s.
Cleaver, Walter (notices in Northern Santa Barbara County newspapers on microfilm and on newspapers.com)
1926 – "Walter Cleaver of Portland, who was **John Breneiser**'s room-mate at the University of Oregon, has arrived here and will make his home with **Mr. and Mrs. Stanley G. Breneiser**," *SMT*, Sept. 8, 1926, p. 5.
Cleaver, Walter (misc. bibliography)
Walter S. Cleaver is listed in the 1910 U. S. Census as age 3, b. c. 1907 in Iowa, residing in La Grande, Ore. with his parents George L. and Helen H. Cleaver; Walter L. Cleaver is listed in the 1920 U. S. Census, residing in Portland, Ore. with his parents; Walter S. Cleaver is listed in the 1930 U. S. Census as residing in Inglewood, Ca., with his parents George and Helen Cleaver; Walter Sipler Cleaver provided the following information on his WWII Draft Card = b. April 23, 1906 in Red Oak, Iowa, employed by his father, George, relative is Barbara Helen Cleaver, residing in Inglewood, Ca.; Walter Cleaver b. April 23, 1905, d. June 12, 1968 in Hawthorne, Ca., per Social Security Death Index and Calif. Death Index (refs. ancestry.com).
See: "College Art Club," intro, 1927, "Santa Maria School of Art," 1927

Clemens, Paul, Mr. and Mrs. (New York)
Itinerant performers (marionettes, music, acting) booked by Redpath into Santa Maria high school, 1925.
See: "Santa Maria, Ca., Union High School," 1925

Clendenon Studio (Santa Maria)
Photography studio. Branch of Los Angeles studio, operating in Santa Maria, 1909.
■ "New Photo Studio. **C. S. Stubbs** and **A. G. Reynolds** have taken up the studio in the Jones building and will from now on conduct the same as first class photo gallery. Both Mr. Stubbs and Mr. Reynolds are expert photographers and come most highly recommended. Mr. Stubbs is a member of the Knights of Pythias while Mr. Reynolds is a Mason

and Woodmen of the World. Their studio will be known as the Glendenon [Sic. Clendenon] Studio and is a branch of the well-known photo establishment in Los Angeles under the same name," *SMT*, June 5, 1909, p. 1
Clendenon Studio (notices in Northern Santa Barbara County newspapers on microfilm and on newspapers.com)
1906 – Repro: "Miss Evlyn Erwin," *LA Times*, Oct. 10, 1906, p. 21 (pt. II, p. 7);
1909 – "Clendenen Studio Got Fine Pictures of Parade ... Fourth of July celebration. At 20 minutes to 11 they photographed the parade and by noon had a dozen different views of the procession ready for distribution… fine collection presented to this office. The pictures are printed on postal cards ready for mailing … Special credit is due to **Mr. Reynolds**…," *SMT*, July 10, 1909, p. 8.

■ "Special Offer… We have demonstrated to the people of Santa Maria and vicinity our ability to make high grade artistic photographs. Our prices have been very reasonable, in fact much lower than you would be compelled to pay in the city for the same excellent quality of work. Our force is large and is composed entirely of competent men and women, skilled in their respective line of work: Special operators, retouchers, printers and finishers. Having such a force of skilled artists … we must do a large business in order to keep things moving. Now, in order to stimulate business during this quiet season, when the people are busy with their crops or enjoying a vacation at the sea shore or elsewhere, we have decided to give all an opportunity of securing some of our fine down-to-date photos at a great reduction in price. For the next ten days we are going to make you one dozen of Cabinets, mounted on cards, which we have heretofore sold at $4.50 per dozen, for only $2.50. … We also make views of all kinds, exteriors and interiors, flashlights, postals and stamps. Our studio is upstairs over Jones furniture store, where you will find a lady in attendance…," *SMT*, July 17, 1909, p. 8.
1912 – Active in Bakersfield per *Bakersfield Californian*, Jan. 26, 1912, p. 7 and March 25, 1912, p. 9 and June 10, 1912, p. 7.
1913 – Active in Fresno per *Fresno Morning Republican*, Oct. 3, 1913, p. 9.
See: "Stubbs, C. S." "Reynolds, A. G."

Clifton, Pauline Atkins
See: "Price (Clifton), Pauline Atkins"

Coblentz, Henrietta Kraemer? (Mrs. Samuel? Coblentz) (1857-1921) (Santa Maria)
Flower arranger. Exh. "Santa Barbara County Fair," 1891. Collector who lent a picture of the cathedral of Strasbourg, also life-size portraits from Alsace and Loraine, to Art Loan Exhibit, 1895. O. L. Jones painted portraits of her sons, 1886.
Coblentz, Henrietta (misc. bibliography)
Henrietta/e Coblentz is listed in the 1920 U. S. Census as age 63, b. c. 1857 in France, naturalized, residing in Santa Maria with husband, Samuel (age 67); Henrietta Coblentz, b. 1857 in Alais France, d. March 1, 1921 per Halsted & Co. Funeral Records, in *San Francisco Area, California, Funeral Home Records, 1850-1931* (refs. ancestry.com).

See: "Art Loan Exhibit (Santa Maria)," 1895, "Conner, Ray," "Jones, O. L.," "Santa Barbara County Fair," 1891

Coffin (Easterday), Birdie S. (Mrs. Robert Oscar Easterday) (1893-1972) (Lompoc)
Art teacher, Artesia Grammar School, Lompoc, 1914-18.
Coffin, Miss (notices in Northern Santa Barbara County newspapers on microfilm and on newspapers.com)
1915 – "Miss Olive Baker of Los Angeles is visiting in Lompoc with Miss Birdie Coffin. The young ladies are former school mates," *LR*, May 7, 1915, p. 5; "Miss Birdie Coffin returned Sunday noon from her vacation which was spent with her mother at Los Angeles and assumed the duties at her school Monday," *LR*, Sept. 3, 1915, p. 5.
1917 – "Miss Birdie Coffin, teacher in our schools the past two years, left Monday for a visit to her former home at Kenard, Indiana," *LR*, June 15, 1917, p. 5.
1918 – "School Opens for Spring Term… Miss Coffin, art and overflow class," *LR*, Jan. 18, 1918, p. 6; "Miss Vivian Saunders went to Los Angeles last Friday to attend the wedding of Miss Berdie [Birdie] Coffin," *LR*, Oct. 11, 1918, p. 5; "Bridegroom of Ten Days Succumbs… Robert Easterday… died… at his home in Palo Alto after a brief illness from Spanish influenza. Only last week *The Record* recorded his marriage on October 5 to Miss Birdie Coffin… The wedding was a social event at Pasadena…," *LR*, Oct. 18, 1918, p. 1.
Coffin, Birdie (misc. bibliography)
Birdie S. Coffin was b. Feb. 1, 1893 in Indiana to Claudius C. Coffin and Cora A. Wood, was residing in Greensboro, Ind., in 1900, married Robert Oscar Easterday, and d. Sept. 27, 1972 in Artesia, Ca., per Hallman Family Tree; ports. under Private Member Photos (ref. ancestry.com).
See: "Lompoc, Ca., Elementary Schools," 1916, 1917

Coker, Thomas Monroe (1905-1990) (Lompoc)
Prop. of Camera Shop, 1946-51?
1949 – "Speaker Discusses… **Thomas Coker** demonstrated one of the new polarized cameras which produces a finished print one minute after the picture has been snapped. Using a flash attachment, Coker took pictures of the Kiwanis officers and a minute later passed them around for the membership to examine. The quick developing system is operated through the use of film which has a developing roll of paper along with it. The rolls are slipped into the camera and after the picture is taken, the film comes in contact with the paper which provides a thin film which develops, prints and fixes the photograph," *LR*, April 28, 1949, p. 5.
1953 – "Tom Coker... has been appointed to the position of storekeeper and assistant purchasing agent for the City of Santa Maria. Coker sold his interest in the local store [Camera Shop] to take a position in the purchasing department of the PX's at Camp Cooke when the camp was reactivated two years ago," *LR*, March 26, 1953, p. 4.
See: "Camera Shop"

Colby, Margharite (Mrs. Colby) (Santa Barbara)
Instructor in art, Lompoc High School, spring 1946.
Replaced Virginia Murray (McArthur).
■ "Item. Mrs. Margharite Colby, who has served in the high school as a substitute teacher in the art department during the spring term, will leave shortly after the close of school for New York where she will attend Columbia University and do work on an advanced degree. ... Mrs. Colby resides with her husband in Santa Barbara and commutes to Lompoc for her teaching duties by car," *LR*, June 6, 1946, p. 9.
Colby, Margharite (misc. bibliography)
Port. in Lompoc High School yearbook, 1946 (ref. ancestry.com).
See: "Lompoc, Ca., Union High School," 1946

Cole, Natalie Robinson (1901-1984) (Los Angeles)
Teacher / writer / artist who participated in the Santa Maria Valley Art Festival, 1952.
■ "Parents and teachers who desire help in guiding children to express themselves thru art have a rare opportunity in the appearance of Natalie Robinson Cole during **Santa Maria Valley Art Festival**... Mrs. Cole is a Los Angeles elementary classroom teacher who surprised herself, family and friends by writing a book, '*Arts in the Classroom*.' The biggest educators in the country took it up. *Time Magazine* reviewed it with her picture. It is now in its ninth edition and in use in universities and teachers' colleges over the nation. Mrs. Cole's philosophy and techniques are based on a psychological approach to children's art. She feels the role of the teacher and parent is not to 'teach' in the old acceptance of the word, but to free the individual of fear and lack of faith and build confidence in his own honest way of doing. Mrs. Cole has had remarkable success with this approach to children's art. A huge exhibit of children's primitive block prints traveled under the American Federation of Arts of Washington, D.C. to museums and universities throughout the country. Some of these prints will be shown during her demonstration here. In her lecture, 'The Arts in the Classroom,' Mrs. Cole gets across her philosophy and approach during the showing of a wealth of exciting children's work. At intervals she steps out of her role and seems to speak directly to the children. The audience hears the little sentences and paragraphs she uses as she builds confidence and faith in 'their own way of doing.' Natalie Cole will open the Art Festival with a three-hour workshop on Saturday morning, May 24, for all interested parents and teachers. There is no charge other than the 50 cents admission fee. In the afternoon those who have been instructed by Mrs. Cole in the morning will be given a group of children with whom to work under Mrs. Cole's supervision. In the evening Mrs. Cole will present a lecture to which all are invited..." per "Natalie Cole, Art Teacher to Hold Children's Class," *SMT*, May 16, 1952, p. 4.
Cole, Natalie (notices in Northern Santa Barbara County newspapers on microfilm and on newspapers.com)
■ "Art Teachers Hear Mrs. Natalie Cole," and article adds, "Mrs. Natalie Cole, noted teacher of art, spoke on 'Personality Development Thru Creative Arts,' at

Saturday's program at the art festival. Mrs. Cole was in charge of a morning session of creative arts at which teaching techniques for parents and teachers were demonstrated. ... 'Then the art comes – amazingly, from deep within the child as we go over and over such simple sentences as: Pretty things, children, you can buy five cents a dozen. But to make your picture beautiful you have to feel it way down deep inside and let it come out your own honest way.' Before every painting lesson, a teacher will say, 'How many different kinds of painting will we have today children? – and the children will shout, as many as there are of us, painting right next to one another, but each as different as we are ourselves.' 'As the children absorb such simple directions, unconsciously the child's own primitive patterns and rhythms come spontaneously to the surface. His creative effort then shows work of his own, different from that of everyone else in the entire world, and in doing he will become a happier individual.' Mrs. Cole said that with the simple approach of working with the real child that exists beneath the exterior, block prints made by seriously handicapped children have been viewed by the public on an exhibit tour of the United States," *SMT*, May 26, 1952, p. 4.
See: "DeNejer, Jeanne," "Santa Maria Valley Art Festival," 1952, 1953

Colgrave, David "Dave" (Canada? / Santa Maria)
Photographer, amateur. Active with Santa Maria Camera Club, 1954-58.
See: "Santa Maria Camera Club," 1954, 1955, 1957, 1958

Collectors, Art / Antiques (Lompoc)
A feature of the collectors in the Lompoc area were servicemen and their families who collected art items from various countries to which they were assigned, often Japan.
Collectors (notices in Northern Santa Barbara County newspapers on microfilm and on newspapers.com)
1960 – ■ "The Orient Comes Alive Here in Local Couple's Residence. Life in the Orient for five and a half years, has permanently affected the lives of **Mr. and Mrs. Harold S. Ferrel**l, 129 South G Street. The Lompoc home contains more Japanese, Chinese and Korean articles than possibly any other in the area. Ferrell, as a civilian engineer, was stationed at Misawa Air Force Base near Hokkaido, Japan, and at Chitose Air Force Base, following two years in Okinawa. The couple lived in government housing and had the usual maids and houseboy to take care of the household duties. Pictures from their thick scrapbook show a particularly interesting Quonset hut quarters transformed by colorful wall hangings and paintings, comfortable bamboo furniture and a part of the fan collection of Mrs. Ferrell. The collection started when the couple first went overseas, grew rapidly as the maids adopted the habit of bringing new fans to add to the lot. It now numbers 83 fans of varied size, materials and decoration. There is a special wedding fan; fans used by geisha girls and samples of the small fans carried by children.... The Farrells thoroughly enjoyed their life in the Orient ... They adopted many of the customs... In their

Lompoc bedroom is a huge clothes chest of camphor wood. It contains kimonos, obis, tabis, coats, purses, lengths of gorgeous silks, and at least one sample of each type of Oriental costume. There are complete outfits for both and they occasionally don the comfortable kimonos for the warm padded housecoats. Their authentic Japanese costumes however have the added touch of American fastenings. Oriental clothes are tied…. In their rooms are custom made chairs and davenport, intricately carved tables, statues, temple style lamps and shades, chests and screens, dolls, wall hangings and Japanese prints. Lacquer Art. Two thickly lacquered tables are the work of special artisans who achieve a uniquely beautiful effect through 'floating' vari-colored paints on the surface. Each table has 21 coats of lacquer. There is a silken wall screen created by a Japanese artist rated tenth high in his country. Interesting items are the wood animal figures carved by the Ainu Indian girls with chisel and hammer. Sets of Japanese tableware and individual pieces of china… Pre-War Cups. Especially favored by the couple is the set of eight pre-war Okinawan lacquer cups and saucers, the gift of a friend. The set is estimated at over 100 years old. Colors are bright and flawless. The lacquer is applied over thin wood. … With their definite interest in the Oriental people, there is also a plan to help in the organization of a club for Japanese wives of servicemen stationed in the area …," and photos of Mrs. Farrell, fans, artifacts, *LR*, May 30, 1960, p. 4.

■ "Public Is Invited to Attend Exhibit of Doll Collections at Fitzgerald Home… Mrs. L. J. Fitzgerald…," and other Vandenberg doll collectors, *LR*, July 11, 1960, p. 3; "'Rec' Room Equipped for Tea Time – Plus. … It started out to be a car port although **Carmen McIntosh** has no car. It grew from drawings she made on the back of an old envelope until it became a complete fun unit of living room, kitchenette and bath, swimming pool and patio – and the car port. All this was constructed by her brother, Ed Negus… Decorative Feature. A striking decorative feature of the room is the display of a part of Carmen's colorful tea pot collection of more than 300. A half wall which divides the living room from a short hall entrance to the cloak and bath rooms, is built with shelves that reach from floor to ceiling. Here and on glass shelves at the opposite side of the room, are tea pots of every size, shape and description. … and, of course, there are musical tea pots which play – what else – 'Tea for Two'," *LR*, Aug. 29, 1960, p. 4.

See: "Alpha Club" 1934, "Art, general (Camp Cooke)," WWII, "Art Loan Exhibit," "Batty, Anita," "Beattie, Johanna," "Chilson, Velma," "Erickson, Virginia," "Grady, Elmer," "Highfill, Patricia," "Hobby Show," "Japanese Art," "Lompoc Gem and Mineral Club," "Lompoc Community Woman's Club," 1948, "Lompoc Gem and Mineral Club," "Menezes, Herman," "Organ, William," "Padrick, Walter," "Ruth, Clarence"

Collectors, Art / Antiques (Santa Maria)
Collectors located in Northern Santa Barbara County owned 1. Native American artifacts which they scavenged, 2. Mexican American era heirlooms which they inherited from ancestors, 3. East Coast and Midwest heirlooms which they inherited, 4. Gems and minerals, 5. Miscellaneous items always found in hobby shows (dolls,

stamps, coins, glass, chinaware), and 6. a rare few owned some form of art. Items were exhibited at Art Loan exhibits, at Hobby Shows and at the Santa Barbara County Fair. A few antique stores were able to survive.
Collectors (notices in Northern Santa Barbara County newspapers on microfilm and on newspapers.com)
1926 – "Well-known Picture Added to Local Collection," titled 'The Quiet Smoke' [by **Ralph Davidson Miller**] hung in home of M/M Harry Nuss [banker, Legionnaire] a gift of the Nuss' parents, M/M U. S. Royar of LA, *SMT*, April 19, 1926, p. 5.
1935 – "Chinese Handwork Seen in Fair…," collection of Mrs. Hugh Toy Jr. and Mrs. Louise Wylie, *SMT*, July 26, 1935, p. 3;
1945 – Collector "Gladys Forbes Speaks on Collection of Old Glass," to Women's Aid of Christian Church, *SMT*, Aug. 17, 1945, p. 3; "Heirlooms in Santa Maria Families on Display" at Christian Church, and many items and collectors named but there was only one painting. "One of the outstanding heirloom exhibits was an oil portrait of her sister Sylvia Eager, painted by **Mrs. Minnie Stearns**, 53 years ago. The colors in this work had remained as true as the day they were placed on the canvas, it was said," *SMT*, Oct. 27, 1945, p. 3.
1947 – "Antique Glass Speaker's Topic" at Soroptimist Club by Mrs. Gladys Forbes, *SMT*, Jan. 10, 1947, p. 5;
1948 – Ceramic and glass – "Ornamental Shoes Make Up Hobby Collection" of Mrs. Louis Bowles, *SMT*, July 21, 1948, p. 5.
1950 – "Delegates are Named… Mrs. Clyde Plumm … the hostess, Mrs. Plumm, gave a talk on woodcarving illustrated with finished work from her hobby collection…," *SMT*, July 22, 1950, p. 5.
1952 – **Herman Menezes** gun museum "Backyard Museum Pride of Tepesquet Dad, Boys," *SMT*, Feb. 22, 1952, p. 5; "Perlman Collection Campaign Buttons Traces Presidential Political History… items such as buttons, badges, banners, cartoons, posters, music, letters, photographs, any and all of the curious reminders of political campaign slogans… auto plates, newspapers, brochures, ties, photographs, plates, placques and bric-a-brac…," *LR*, Aug. 7, 1952, p. 2.
1955 – McCullers, Carl, Retired dairy farmer. Port. with painting of one of his Holstein herd painted in 1922 that once hung in the old Pacific South West Bank (now the Security First National), artist unnamed, per "Carl McCuller's Farm was Once Dairying Center," *SMT*, Dec. 6, 1955, p. 6.
1956 – "Political Campaign Relics Fascinate Alfred Perlmans," *SMT*, Oct. 6, 1956, p. 4.
1957 – Port of Elizabeth Campbell and "Santa Maria Women [sic] Has Rare Collection" of dolls, *SMT*, Dec. 17, 1957, p. 9.
1958 – "Antiques, Food Listed… Los Alamos Valley Men's Club will stage its annual 'Old Days in Los Alamos' … Antique collectors and others interested in old items will have a field day at the General Store… Included in the display is …," *SMT*, Sept. 20, 1958, p. 11.
See: "American Association of University Women," 1957, "Americana Shop," "Armitage, Merle," "Art, general (Santa Maria)," 1932, "Art Loan Exhibit," "Beerbohm, Frederick," "Case, Clifford," "Coblentz, Henrietta,"

"Community Club (Santa Maria)," 1949, 1950, 1952, "Denman, John," "Duncan, Raymond," "Hobby Shows," "Huff, Elizabeth," "Jones, S. J.," "Lidbom, Hazel," "Maguire, Albert," "McCoy, Frank," "Menezes, Herman," "Miller, Lillian," "Minerva Club," 1941, 1949, "Minerva Club, Art and Hobby Show," "O'Neal, Merilyn," "Patterson, Vivian," "Price, Vincent," "Rahbar, Ethel," "Rick, Maxine," "Santa Barbara County Library (Santa Maria)," 1947, "Santa Barbara County Fair," almost annually, "Santa Maria, Ca., Union High School," 1935, "Santa Maria Inn," "Weldon, John," "White, Annie"

Collectors, Art / Antiques (Santa Ynez Valley)

Collectors of the Santa Ynez Valley owned similar items to those collected by Santa Marians except for the emphasis on items of Danish heritage.

Collectors, Art / Antiques (notices in Northern Santa Barbara County newspapers on microfilm and on newspapers.com)

1935 – **Umberto Minetti**, Owner of a "huge" painting of Santa Ines Mission lent to the center booth where it was used as a backdrop at the Santa Maria fair, *SYVN*, June 21, 1935, p. 1, col. 6.

1953 – "Unusual Collection of Early-Day Pistols, Other Items Shown ere… in the window of the Nielsen and Rasmussen Store…," owned by Link Wilson, *SYVN*, July 3, 1953, p. 10.

1954 – "Story of Dolls… Dolls are big business, Mrs. Lillian Spain, a collector now residing in Santa Maria told an audience at the Soroptimist club yesterday…," *SMT*, Feb. 24, 1954, p. 4; "Friendly, Hospitable Atmosphere at Martin Jacobsen Residence… Danish oil paintings are placed throughout the room. An especially beautiful painting depicting the Danish hillsides hangs above the divan…," *SYVN*, April 30, 1954, p. 8; "Large Combination Living-Dining Room Farstrup Home… Danish Paintings, China on Walls Adds to Attractiveness of Parsonage… The home of Rev. and Mrs. A. E. Farstrup… The fireplace screen, designed by **Ernst Pedersen**, opens at the center and is unique in design. … coffee table imported from Denmark. The top of the table is designed with Danish tile…The kitchen… The mahogany cabinets have Swedish copper hardware…," *SYVN*, May 7, 1954, p. 8.

1955 – "Mr. and Mrs. J. M. Conner Celebrate 60ᵗʰ Anniversary" and port. with some of the 500-600 salt and pepper sets she collected, *SYVN*, April 1, 1955, p. 3; "C. T. Nichols, [Las Cruces] Inn Founder, Dies at 82… **Charles T. Nichols**, 82… He was a collector of antiques of early California and it was his wish that his collection be presented La Purisima Mission following his death," *SYVN*, July 1, 1955, p. 4; port. looking at poster of runaway slaves in his collection, and "Z. F. Hamilton's Pastime is Collecting Memorabilia… pharmacist in Solvang…," *SYVN*, Aug. 26, 1955, p. 4.

1956 – "Valleyites to Take Part in S. B. Collectors' Exhibit… sponsored by the Women's Board of the Santa Barbara Museum of Art scheduled to open next Thursday evening at the Cabrillo Pavilion opposite the Mar Monte Hotel in Santa Barbara… Among the 62 collections to be shown will be the unique firearm array of Samuel Dabney, a collection of more than 500 soldiers of the Charles

Perkins children, Peter and Tim, a doll house of Mrs. Perkins which has been shown in the east along with one belonging to Queen Mary, ivories of Mrs. **Katherine Peake**, a collection of Swiss bells of Mrs. Max Schott, **Elaine Mattei**'s collection of Lake County Indian baskets, Mrs. Jane Alt's porcelain miniatures and Eduardo de Koch's famous spurs and bit once owned by Hernandez Cortez," *SYVN*, Oct. 12, 1956, p. 3; photo "In Collector's Exhibit" 700 piece collection of imported toy soldiers owned by Kim Perkins and Peter Wilder, *SYVN*, Oct. 12, 1956, p. 8.

1957 – Photo of Dick Lawton of Los Olivos with some of his collection of antique firearms and "Collector of Muzzle-Loading Type of Firearms…," *SYVN*, July 19, 1957, p. 6.

1959 – "Woman's Club to View Display of Chinese Coats… **Miss Jeannette Lyons** of Ballard of hand-crafted materials and coats from pre-communist China… They were obtained in China by Miss Tirzah Bullington during her stay there. Miss Bullington, recently of Afghanistan, is a former resident of the Valley…," *SYVN*, May 1, 1959, p. 3; "Displays Rare Array of Chinese Coats…," *SYVN*, May 29, 1959, p. 8; port. of Mrs. Edwin E. Vetter and caption reads "Display of Dolls… which will be shown at an annual Missionary Medical Tea Sunday afternoon from 3 to 5 o'clock at the Santa Ynez Valley Presbyterian Church…," *SYVN*, Sept. 25, 1959, p. 1 and history of her collecting, p. 3.

1960 – "Bank to Exhibit Display of Coins. In commemoration of National Coin Week, which begins next Monday, the Santa Ynez Valley Bank is featuring a display of coins from the collection of Everett Fitzgerald of Los Alamos. The exhibit contains a portion of the array of coins collected by Fitzgerald during the past 20 years," *SYVN*, April 22, 1960, p. 1; "Coin Collectors Elect, Choose Name for Group… Valley Coin Club…," *SYVN*, Oct. 21, 1960, p. 5.

See: ""Art Loan Exhibit (Solvang)," "Buell, Josephine," "Danish Days," "De La Cuesta, Micaela," "De la Cuesta, Virginia," "De Lindholm, Adolf," "Hobby Show," "Mission Santa Ines," "Santa Ynez Valley Art Exhibit," "Santa Ynez Country Fair," "Santa Ynez Valley Rock Club," "Sedgwick, Francis," "Skytt, Clara," "Sloane, Charles," "Stelzer, Glenn," "Wulff, Jeppe," "Ziegler, Leo"

Colledge (Kelley), Ethel Elder (Mrs. W. Bradford Kelley) (1901-1937) (Lompoc)

Teacher of drawing at Lompoc High School, 1923/25. After her marriage and her return to Lompoc as Mrs. W. Bradford Kelley, she was active with the Alpha Club, 1934-36.

■ "Final Rites Held for Mrs. Kelley… Mrs. W. Bradford Kelley… lingering illness. She was a native of California aged 35 years. The wife of the local Johns-Manville company manager …The former Miss Ethel Colledge, Mrs. Kelley had been a teacher at the local high school following her graduation from the University of California. She lived in Redwood City for several years following her marriage, returning here when Mr. Kelley became manager of the local Johns-Manville plant. The deceased had been an active member of the local Alpha club, acting as an advisor for the Junior Alpha club and taking an active part in the

annual flower show ... Mrs. Kelley was born in Galt on July 31, 1901...," *LR*, March 26, 1937, p. 6.

Colledge, Ethel E. (notices in Northern Santa Barbara County newspapers on microfilm and on newspapers.com)
1923 – "Many New Members in This Year's H. S. Faculty... Miss Edith [Sic. Ethel] Colledge... is a recent U. C. graduate and will be in charge of the classes in drawing. She received very high marks at the art school...," *LR*, Aug. 10, 1923, p. 1.
1925 – "Marriages ... Kelley-Colledge – W. Bradford Kelley, 25, Riverside, and Ethel E. Colledge, 23, Galt," *Oakland Tribune*, July 11, 1925, p. 21.
1934 – "Kelley is New Johns-Manville Head... manager of the Redwood City plant of the Johns-Manville group...He was married to Miss Ethel Colledge, former art teacher in the local high school, before going to Redwood City...," *LR*, March 16, 1934, p. 1.

Colledge, Ethel E. (misc. bibliography)
Ethel E. Colledge is listed in the Lompoc, Ca., High School yearbook, 1924, 1925; Miss Ethel Elder Colledge, teacher and Rep. is listed in *Voter Registrations, Lompoc Precinct, No.3*, one unidentified year between 1920 and 1928; Ethel Elder Colledge was b. July 31, 1901 in Galt, Ca., to Jacob H. Calledge [sic.?] and Aurelia Colby Relia Moore, married W. Bradford Kelley, was residing in Redwood City, Ca., in 1930, and d. March 19, 1937 in Santa Barbara, Ca., per Kelley-Rymus-Hughes-Loomis Family Tree (refs. ancestry.com).
See: "Alpha Club," 1934-36, "Kelley, Ethel," "Lompoc, Ca., Union High School," 1923, 1924, "Posters, general (Lompoc)," 1928

College Art Club / College Arts Club (Santa Maria)
*Club at Santa Maria High School devoted to the various arts, organized and headed by the Breneisers, 1923+. First **regular** meeting held Oct. 12, 1926+. Meetings were usually held at the "Ark," the Breneiser home on Lower Orcutt road.*

■ "The Breneiser 'Ark' is 'home' to many young folks in Santa Maria who through their connection with an interest in the arts have found inspiration and understanding in a group much like themselves. The Breneiser home and family has a personality all its own, and they instill in the minds and lives of those who come in contact with them a sense of freedom of mind and thought and expression that one does not get in the routine of school education. And the College Art Club, which has sprung from the association of this group, also has a personality of its own. The term 'Club' could hardly be given to the college art group, however, as it was in the beginning. During the first three years, from 1925 [sic? 3] to 1926, it met, had programs and definite plans for the future, but there was no constitution or regular council of officers to govern its activities. It was not organized in a businesslike manner with the election of officers on the first meeting date and the usual committee appointed to draw up a set of laws, but rather it just grew out of the belief on the part of **Mr. and Mrs. Stanley Breneiser** that a group of college people interested in cultural works should have a place where they felt free to gather in a social way and glean information along artistic lines from others similarly inclined. Hence 'Babs' and

'Stanley,' as they are known, declared open house on certain nights of the month when students and ex-students assembled and enjoyed some talent programs, featuring speakers on subjects that would benefit them in their work. Since the first gathering at West Morrison street, the Breneiser home has always been the meeting place for the club, and their reward is a host of friends. The first regular meeting of the organization was held on October 12, 1926, and **Stanley Breneiser** was chosen president with Margaret Graham [viola player] as secretary. It was decided that meetings would be held every third Thursday night and that the president would have power to take charge of the next meeting. This was its definite beginning, although by that time it was popularized and had attracted a large enrollment. The principles of the club, as put forth by the president at that first meeting, were that it would function as an art club and that each member should gain some principle at each meeting and would have a good time socially. Twenty-one charter members signed their names on the permanent roll, as follows: **Stanley G. Breneiser, Elizabeth D. Breneiser,** Margaret Graham, Pitts Elmore, **Elwin Mussell,** Robert Y. Higgins [his main interest was music], **Walter Cleaver,** Dorothea Hoover [her main interest was music], Mary Angell [pianist], **Sidney Peck, Virginia Peck, Mabel Anne Baird** [English teacher], Helen G. Gaynor [interested in music], May S. Gaynor [mother of Helen], Harriet Raab, ... E. White [?], **John A. Breneiser,** Eva Baldwin [her interest was music and dance], **Florence [Bland Sandvik?]...k,** Barbara Higgins [Mrs. Mussell], Walter J. ...mley [?] and Mrs. Cecilia Elmore. During that first year a series of talks was given by members of the faculty on the art of other countries, and occasionally outside speakers would add variety to the program. During the remainder of the evening after the business meeting and lecture, the group would be royally entertained with a diversified program of music and readings or novelty numbers, either representing local club talent or featuring a special entertainer secured through the efforts of the hosts. On January 23, 1928, it was unanimously decided that the Art Club become a member of the American Federation of Arts and Progressive Education Association, with the privilege of obtaining three lecture courses each year and a magazine, which was placed for use in the J. C. library. The benefits derived from this venture are many, and this is the club's fourth year as a chapter of the association. Each meeting presented some new idea in lectures, games, and even the refreshments were at times novelties in themselves. At one meeting the club celebrated the wedding anniversary of **Mr. and Mrs. Breneiser.** At another the members were given an opportunity to demonstrate their artistic skill when the program committee handed out different articles to be used as they saw fit, and a prize was offered to the winner, Barbara Lamb, who modeled a ship from a bit of clay. At one of the Halloween meetings the program was given over entirely to **Robert Higgins,** who read a play of his own, entitled, 'The Yellow Sign.' It would be difficult to relate all the clever programs that have been the life of the club since the first. In fact, programs representing all the arts are its purpose, and so much local talent ... has appeared before the group that it would be impossible to name them all. However, some of those who have given of their talent repeatedly are **Sidney**

Peck, Mrs. Chas. Schenck [her interest was music], Vina Freeman, **Robert Higgins, Harry Johnston [Sic. Johnson?]**, Mrs. Arthur Reum, [Virginia, of Guadalupe] and Virginia Reum [daughter] **Mrs. Ferguson, Mary Angell** and Mrs. Dorothea Hoover, but more than any others **Mr.** and **Mrs. Breneiser**, both competent in so many kinds of entertainment. In January of 1929, the club had an exhibit of **William P. Silva**'s paintings, which was held in the Art room at the High school, with great success, and in 1929, also, the club had a page in *The Mascot*, Junior college yearbook. One of the most remembered events in the life of the club will perhaps be that meeting of May 27, 1930, when it met for the first time in the new Breneiser home on the lower Orcutt road. It was in the nature of a house-warming for the Breneisers, and the inauguration of a new era for the club in the large but cozy Breneiser 'Ark.' This residence, realizing the Breneiser dream of a home expressing themselves, has become the final and real home of the College Art club, and it was wonderful to see the pride felt by the Breneisers in inviting the club to its first meeting there. During the last year the club has had the privilege of hearing an illustrated lecture by **Mr. McGehee** of the photographic masterpieces of Mr. **Edward Weston**, followed by a talk by Weston's son, **Chandler Weston** of Santa Maria. Another outside speaker was Mrs. Appleton, a modern composer who sketched the theme of one of her works, 'The Witch's Well.' This year the club is seriously considering the sponsoring of an art exhibit for Santa Maria for the benefit of those who do not have time to attend exhibits outside the city, but are interested. … As summer approaches the club begins to plan its annual outdoor event, which is one of the most enjoyed in the entire year. On one of these occasions, Mrs. Dorothea Hoover, a member who had moved away, invited the organization to be guests at a picnic at the Atascadero Lake. One outdoor party was held at Shell Beach and another on the Wickenden ranch. This is the ninth year of the Art club's existence. **Mr.** and **Mrs. Breneiser** have become a part of the lives of the constantly changing membership of the club they instigated when they first saw the need for social art in the classes they were instructing in the High school. They have seen their students reach college age, join the club, become imbued with the spirit it has, and finally move away or marry – but they always come back for another taste of the life the **Breneisers** exemplify. The great fireplace at the end of the long reception room is always burning a cherry welcome … and the group continues to grow as new students interested in the arts come to Junior college…," by Virginia Tognazzini, "Organization is formed Around Art Instructors," *SMFA* (article printed sometime between March and Oct. 1932, n. p., Coll. Santa Maria Valley Historical Society).
College Art Club (notices in Northern Santa Barbara County newspapers on microfilm and on newspapers.com)
1927 – "College Art Club Ends School Year… two splendid talks by College Art students. One on American art was given by Miss Harriet Raab … **Walter Cleaver**, also of the Junior college Art department gave an intensely interesting talk on… 'A Primer of Modern Art,' by Sheldon Cheney…," *SMT*, May 27, 1927, p. 5; "Art Club Holds Meeting Monday… at the home of Mr. and Mrs. Breneiser… Barbara Lamb and Maggie Downs… had

arranged a very entertaining and educational program. **Mr. Breneiser**… started a series of talks on the techniques of various artists. He gave an educational talk on fresco painting… Barbara Lamb read an interesting paper on Spanish architecture written by Maggie Downs…," *SMT*, Nov. 15, 1927, p. 5; "College Art Section Meets… regular meeting at the Breneiser home… **Breneiser** gave an interesting talk on oil painting. … **Elwyn [sic. Elwin] Mussell** gave a very entertaining and educational talk on printing… Three papers on 'An Esthetic Experience' which had been written for the Art Principles course, were then read by **Miss Florence Cook**…," *SMT*, Nov. 29, 1927, p. 5.
1928 – "Art Club Holds Meeting, Monday… at the Breneiser home… The formal program consisted of an interesting talk by **Stanley Breneiser** on oil painting, a very instructive talk on two modern Spanish painters by Mrs. Ida Davis Hall… In his talk, Instructor Breneiser told of the process of combining paints with linseed oil and of the various methods of applying that paint …," and discusses the brown underlay of the Italians, and various color underlays of later Europeans, and Sorolla, *SMT*, Feb. 21, 1928, p. 5; "Santa Maria Art Club Has Session. An illustrated lecture of more than 50 slides of famous American paintings was the principal feature of the program… entitled 'American Paintings' was sent from American Federation of Arts at Washington, D. C. and was read by Breneiser … Breneiser's son, **John**… visiting here from Oregon university…," *SMT*, March 20, 1928, p. 5; "College Club has Last Meet of Year… at the home of **Mr.** and **Mrs. Stanley G. Breneiser**… the program was opened with a talk on the process of enameling by **Mrs. Breneiser**, who is an artist in the making of hand wrought jewelry… **S. G. Breneiser** gave an informal resume of the trip and study tour that he and his son, John, are to take this summer, in England and the continent… One of the very best lectures of the club year was that given by **Miss Ruth Blanchard**. The subject, 'Embroideries,' was effectively illustrated by actual examples of many types of historic and modern subjects including French needlepoint, German tapestry, and Swedish stitchery. Harry Johnson [singer/thespian] of the junior college faculty gave a dramatic, forceful and picturesque interpretation of the much-discussed play 'Lazarus Laughed' which he witnessed recently in Pasadena…," *SMT*, May 15, 1928, p. 5.
1929 – "Mayan Relics Are Shown… by Mrs. Atwater… Many bits of pottery and other treasures were found by the Atwaters in Honduras while others were given them by the natives. Modern decorative arts, as applied to the home, were shown with a series of slides sent out by the American Federation of Art … **Mr. Breneiser** reported on the recent exhibition of the painting of **William Silva**, which was held at the high school. He deplored the lack of enthusiasm and appreciation shown by Santa Maria for exhibitions of this kind… The next meeting will be held on March 11…," *SMT*, March 1, 1929, p. 5; "Miss Smith Gives Talk on Fiji Isles… **Miss Elizabeth Smith**… of the Domestic Science department of the high school spent last summer at these islands… Miss Smith brought back with her some wall hangings made by the natives from the pounded bark of the mulberry tree, also some photographs of the islands and the natives…," *SMT*, May 15, 1929, p. 5; "Enjoys Illustrated

Mural Painting Lecture. Through its membership in the American Federation of Art… privileged to enjoy a … illustrated lecture on 'American Mural Painting.' This was the first of four lectures… this season… The typed lecture was sent, with a series of lantern slides, from the headquarters of the Federation in Washington, D. C. and was read by **Stanley Breneiser**…," *SMT*, Oct. 9, 1929, p. 5.

1930 – "College Club has First Meeting After Holidays… The program arranged by **Miss Ethel Pope** and Miss Vina Freeman… short talk contrasting the ideals and paintings of the Renaissance painter Da Vinci and Jougin, the modernist, discussed by **John Breneiser**…," *SMT*, Jan. 29, 1930, p. 5; "Address on Education… College Art club members were entertained with a program arranged by Barbara Lamb…," *SMT*, March 26, 1930, p. 5.

1931 – "School Exhibits are Interesting," says "original student work from the New York School of Fine and Applied Art is on display in the art room of the high school. The College Art Club, co-operating with the **Blue Mask Club** of the high school, secured the exhibit through" the American Federation of Arts in Washington, D. C., *SMFA*, Jan. 16, 1931, n. p.; "Strobridge Talks About Authors at Art Club Meeting," i.e., W. E. Strobridge, manager of Radio Station KSMR, gave a talk on three English authors to the College Art Club, *SMFA*, hand dated 3/27/31, n.p.; "**Stanley Breneiser** Elected President College Art Club. An illustrated lecture, 'Swedish Sculpture,' from American Federation of Art, Washington, D. C.," *SMT*, May 13, 1931, p. 5; "Last Chance to See Famous Artist. … The coming of **Chiura Obata** to Santa Maria to exhibit his paintings at the **Little Theatre** for the College Art Club who have invited the public to view them… Mr. Obata displayed his paintings and block prints yesterday and today (Thursday)… He has won great fame in all arts of the United States and Japan for his painting. It is perhaps only through his good friend, **Setsuo Aratani**, of Guadalupe that he comes to Santa Maria at all," *SMFA*, 7/31/1931, p. 1; "Art of Camera Told at Meet … College Art club members last evening listened … **Ramiel McGehee** authority on Oriental subjects and a close friend of **Edward Weston**… sketched briefly the development of Weston's art and displayed numerous prints illustrating the change from the merely pictorial to the charming simplicity and trueness to life which has gained him international fame. **Chandler Weston**, his son, who has established a studio here with his brother, Brett, told of the objective of a photographer and the effort to bring out character rather than to produce simply a pretty picture," *SMT*, Oct. 28, 1931, p. 3; "Art Club Entertained by Dramatics Society" of Santa Maria junior college, at regular meeting of Club at "Ark," *SMFA*, Nov. 13, 1931, n. p.; "Art Club Hears Operatic Program," *SMFA*, (clipping hand dated Dec. 11, 1931, n. p.) and article explains – by Gilbert and Sullivan, conveyed through lecture and selected skits. "During the business meeting, **Stanley Breneiser**, president… announced that they had been able to secure a series of three lectures from the American Federation of Art with slides illustrating the subjects. The first of the group, entitled 'Spanish Painting,' will be given with the regular program on January 16. 'American Sculpture' will be given on February 9 and 'Porcelain' on March 8. These lectures, compiled by

famous authorities and sent out to be read to the group by one of the members, promises to be worthwhile and entertaining"; CAC enjoys a Christmas party complete with songs and exchange of gifts, *SMFA* (clipping hand dated Dec. 25, 1931, n. p.).

1932 – "The Art Club Program Features Fashions," and article says, "Fashion art as presented by Miss **Ruth Blanchard** of the High School was the crowning interest of the **Junior College Art Club** meeting at the home of **Mr. and Mrs. Stanley Breneiser**… Miss Blanchard traced the history of fashion and fads and the reasons for their existence from the days of the early Egyptians … to the present day of fur trimmed gowns and Eugenie hats. Beautiful little dolls in complete attire illustrated the fashions…," *SMFA*, Jan. 15, 1932, n. p.; "'Spain' Theme at College Art Club. Spanish music and painting… The greater part of the evening was devoted to an illustrated lecture on Spanish painting … sent by the American Federation of Art at Washington, D. C…. and was read by President Breneiser… who was assisted in showing the slides by **Robert Mason** of the junior college… During the business session the group decided to sponsor another lecture on 'American Sculpture' within the near future… ," *SMT*, Jan 28, 1932, p. 3; "Fine Program for College Arts Group," *SMT*, Feb. 10, 1932, p. 3; "Art Club Observes Feb. with Varied Program," and article says, "Members … listened to the second of a series of stereopticon lectures from the American Federation of Art, entitled, 'American Sculptors'" and listened to music, viewed a short but clever play, and dispensed with the next club meeting in view of the presentation of "Carmen" at the high school auditorium, *SMFA*, Feb. 12, 1932, n. p.; "Art Club May Start Collection," *SMFA*, March 11, 1932, n. p.; "Art Work of Kansan to be Seen. An exhibition of original etchings, wood block prints and lithographs by **C. A. Seword** [Sic. **Seward**] of Wichita, Kans., will be held for one week in the art room of the Santa Maria Union high school beginning next Monday… brought here by the College Art club for the benefit of its members and is open to the public free of charge… about 50 prints… and subject matter includes the southwest Indian country, landscapes and even a portrait or two…," *SMT*, May 7, 1932, p. 3; "College Arts Meeting… On the program… **W. Francis Parsons**, architect and artist, will speak on water color technique and exhibit his group of paintings which were recently on display at the **Little Theatre**," *SMT*, Sept. 12, 1932, p. 3; "First Meeting College Arts Club… Music, literature, dramatics … members were informed of the progress of the club's permanent picture exhibition and of the latest gift to the society, 'Coast of Brittany.' This oil painting is by the Japanese artist, **K. Matsubara**, and was presented by Mr. and **Mrs. J. Boyd Stephens**…," *SMT*, Sept. 14, 1932, p. 3; "Water Colors Discussed… by **W. Francis Parsons**…," *SMT*, Sept. 27, 1932, p. 3; "Stained Glass Lecture to be Given Club. A lecture on 'Stained Glass' by **James Couper Wright**, illustrated with examples of his own work, will be given …," and bio., *SMT*, Oct. 1, 1932, p. 6; "The College Art Club is considering the sponsorship of a permanent art collection for Santa Maria. Elementary plans were made… when President **Stanley G. Breneiser** appointed a committee and empowered it to bring exhibits of paintings to Santa Maria. The club is considering the

purchase of a good painting to start the collection, and has hopes that by donations from artists of note and by funds voluntarily raised by any organization or individual in the community, the project may be furthered. ... the collection, increased occasionally by exhibits, be displayed at the high school, in city club houses, the library or any place that it was welcome until a permanent location might be decided upon at some distant time" [source lost]; "Wanted – A Museum – Something which individual citizens have thought of for a long time and which Santa Maria eventually will be forced to consider, is the establishment of a museum to preserve the natural history of this locality. Judging from the amount of interesting exhibits at county fairs... Many residents here are engaged in hunting for Indian relics, old Spanish articles and other relics peculiar to this locality... The College Art Club has already started a small collection of paintings, and it might be possible that they would use their growing collection as a nucleus for the museum's art gallery. Almost every city of importance has a museum, large or small, and if the various collectors would get together and talk it up, a real plan might be evolved," *SMFA*, Oct. 21, 1932, n. p.; "College Art Hears Craft Lecture... **James Cooper [Sic.] Wright**... talk on 'Stained Glass' ... [and article gives some history of the medium] ... He interpolated his talk with interesting coincidences from the time he spent studying famous windows in the cathedrals of France and Germany," *SMT*, Oct. 26, 1932, p. 3.

1933 – "Illustrated Lecture at Art Club... The club's standing as a chapter of the American Federation of Art entitles it to three lectures each year on subjects chosen by the members from a list sent out by the federation. This particular lecture on 'Contemporary Art' ... While the slides lost something of the beauty of the original paintings by their lack of color, they ... gave a clear perspective of the work of the best artists of the period from 1910 up to the present day... The text of the lecture by Leila Mechlin was thought-provoking and fair...," *SMT*, Jan. 11, 1933, p. 3; "Mystic East Interpreted... Theatrics of the Orient, legends of the mystic east, myths of ancient Japan's strolling players... by **Ramiel McGehee**, Oriental authority from Redondo Beach," *SMT*, May 8, 1933, p. 2; "Art Club has Picnic at Grove... Washington Grove park...," *SMT*, Oct. 9, 1933, p. 3; "Danish Group Entertain... [i.e.] Danish residents of Solvang... program of Danish songs and folk dances, brought an exhibit of ... Danish handicraft...," *SMT*, Nov. 16, 1933, p. 2; "Paintings of Noted Artist on Display. Thirty paintings by **G. Thompson Pritchard**, a noted Australian artist, grace the halls of the art gallery of the local high school ... invitation of the **Junior Art Club**... until November 25... Mr. Pritchard and his son, on a tour of this country, were here on Wednesday, continuing northward to display the remainder of the artist's works," *SMT*, Nov. 18, 1933, p. 1.

1934 – "Art Club Holds Play Practice... at the home of **President and Mrs. Stanley Breneiser**... the play, 'The Gods of the Mountain' by Lord Dunsany, which will be presented by College Art club and the Blue Mask club of the high school on February 16. Each member of the cast will wear a grotesque mask depicting his character. The art department of the junior college and high school completed the masks for last night's rehearsal. Mrs. Ray Rogers has

charge of costumes while **Marrie Breneiser**, Ruth Whittlesey and Maurine Bakeman are designing scenery," *SMT*, Jan. 6, 1934, p. 2; "Piano Solos Enjoyed... College Art Club... The program followed a business meeting and announcement of the Santa Maria Artist society's exhibition which is now on view in the upper hall of the high school and open to the public. It consists of oil paintings, water colors and block prints by the members...," *SMT*, March 29, 1934, p. 3; "Mexican Adventures Related... as **Mrs. A. H. Nichols**, local floral authority and **Fritz Poock**, artist and construction engineer, related their experiences... Mr. Poock, who lived in Mexico three different times while on engineering jobs, amused his audience with the description of his first trip to Durango, when he knew no Spanish and had to give his orders by drawing pictures of the things he wanted done. His experiences in the 1910 earthquake, trouble with bandits, difficulties in obtaining proper drinking water and similar episodes rounded out his talk. The artist-engineer also spoke of the attitude of Indians towards the Christian religion and the old rites of sun-worship. 'One finds that as he goes higher in the mountains and further away from civilization, the Indians tend more towards their early primitive religion than towards Christianity,' Mr. Poock declared...," *SMT*, Sept. 26, 1934, p. 2; "Art Club Hears Talk on Mexican Culture" and article states, "**Fritz Poock**, artist and construction engineer, and **Mrs. A. H. Nichols** spoke on various phases of Mexican culture and life. Mr. Pooch [sic. Poock] was in Santa Maria for the week to paint a water color of **Santa Maria Inn** for **Frank J. McCoy**. During the evening he showed some of his drawings and spoke on construction work supervised by him in Mexico," *SMFA*, Sept. 28, 1934, n. p.; "Art Club Hears Talk by **Fritz Poock**," *SMFA*, Oct. 12, 1934, n. p.; "Art Club Will Hear Talk... An illustrated lecture with material sent by the American Federation of Art, is planned for the next meeting, Tuesday, Oct. 16, of the College Art club in the home of **Mr. and Mrs. Stanley Breneiser**. At the same time, displays of block prints by **Louie Ewing**, Santa Maria, and by members of the **Breneiser family** will be shown. The art club is purchasing one of **Fritz Poock**'s pictures to add to its permanent collection. Mr. Poock is a Huntington Park artist," *SMT*, Oct. 12, 1934, p. 3; "Art Club Hears Talk by **Fritz Poock**," and article adds, "'The technique of water -color painting is the utilization of free light,' said Fritz Pooch [Sic.], well-known water color artist in his talk for the College Art Club Tuesday night. Mr. Pooch [Sic.] went on to say that the frequent usage of the white of the paper brings out the natural brilliancy and light of the color. 'However,' he said, 'do not try to copy the work of others. One's pictures, just like all other arts, must reveal the personality of the artist.' ... During the business discussion it was voted that the club would buy Mr. Pooch's [Sic.] painting of Manzanilla Bay for their permanent collection, now on display in the study hall of the high school. After the meeting refreshments were served and informal discussion of water colors was held with Mr. Pooch [Sic.] showing some of his works as examples of his lecture," *SMFA*, Oct. 12, 1934, n. p.; "Art Club Hears Illustrated Lecture... from the American Federation of Arts, 'The Artist Sees Differently.' ... forty slides reproducing paintings by ancient and modern

masters… During the business meeting… many possibilities were suggested for the Art Club [theater] production this year… An informal exhibit and sale of water colors, prints and other works of art by the **Breneiser family** preceded the serving of refreshments," *SMT*, Oct. 24, 1934, p. 2; "Illustrated Lecture Given College Art Club," and article adds, "'It is not the personality that the artist puts into his work which makes it great, but the personality he leaves out,' said **Stanley Breneiser** at the meeting of the College Art Club Tuesday evening. The feature of the evening was an illustrated lecture on the graphic arts from the American Federation of Arts in Washington… During the serving of refreshments an informal exhibit of paintings by the Breneiser family was held," *SMFA*, Oct. 26, 1934, n. p.

1935 – "Art Club to Hear **McGehee**, i.e., **Ramiel McGehee**, dancer and artist, who will talk on 'Chinese and Japanese Poetry.' … "At this meeting [of the College Art Club] announcements will be made concerning the Art Festival Week to be held January 7 to January 11 inclusive. An exhibition of **Rockwell Kent**'s paintings will be given at the new City hall during the week through the courtesy of **Merle Armitage** and Mr. McGehee. There will also be a series of exhibitions at the high school and library. The week will close with a public address by **Mr. McGehee** at the high school auditorium on Friday night. His talk at this time will be on 'Japanese and Chinese Art.' As souvenirs of the week, block prints will be offered for sale at 10 cents each at lectures and exhibitions," per *SMFA*, Jan. 4, 1935, n. p.; "Arts Ball Will be Given Here" – at club meeting there were songs to commemorate the 250th anniversary of Bach and Handel, German composers and also at club meeting **Stanley Breneiser** read short sketches from "Zarathustra Jr. Speaks of Art," and club plans a masked arts ball to be given on March 8 in the high school gymnasium, which will be the first event of its kind in Santa Maria, *SMFA*, Feb. 15, 1935, n. p.; "Masked Arts Ball is Scheduled Tonight," and article reads, "… fantastic, modernistic and elaborate decorations … palm leaves, huge masks …transparent columns of light… add to the uniqueness of Santa Maria's first masked arts ball tonight in the high school gymnasium. The affair will open with a grand march led perhaps by Robin Hood and Elaine or any other person or creature of myth or fact. … Prizes will also be given for the best costume. Judges for this will be the students who are in charge of the bi-monthly appearance of '*Trend*,' the high school and junior college fashion magazine. They are Misses **Henrietta …eros, Theda Ferini** and **Eleanor Kelsey**. … If it is impossible to attend in costume, persons in attendance will be asked to wear a mask and … dress. Proceeds from the dance will be used toward completing the permanent art works of the club," *SMFA*, March 8, 1935, n. p.; "Art Club Plans Exhibit and Viola Concert," and article says the show will open Saturday evening, March 23, when ■ "Club members …will formally open an exhibit of the finest works of graphic art in Santa Barbara county. The … are being brought to Santa Maria through the kindness of Mr. **William Otte** … After the exhibition, a reception will be held in the … The exhibition will be open to the public for one week beginning Sunday afternoon, the 24th of March," and after the viola concert, "club members will adjourn to

the **Ark** where a reception will be held… After the [club] program and business session, an exhibit of work done by students in the Oakland School of Arts and Crafts was viewed," *SMFA*, March 15, 1935, n. p.; ■ "Art Exhibit to be Opened Here Sat. Night," i.e., "oil painting exhibit by the leading artists of Santa Barbara will be opened in the city hall tomorrow evening at 8 o'clock by the College Art Club members and guests. The art club is sponsoring the exhibit through the kindness of Mr. **William S. Otte**…who is bringing the paintings from the southern city. After viewing… members and guests will journey to the **Stanley Breneiser** home on the Lower Orcutt road for a reception… On Sunday afternoon at 2:30 o'clock a public opening will be held with club members acting as hosts," *SMFA*, March 22, 1935, n. p.; "Club Will View Art Display Tonight… selected by **William Otte**…," *SMT*, March 23, 1935, p. 2; ■ "Art Exhibit Opened to Public… **John Gamble, Marian Hebert, William Louis Otte, Colin Campbell Cooper** and **Eunice MacLennan** are represented in the collection of representative Santa Barbara artists opening in the city hall this week for public exhibit. Sponsored by the College Art club, the group includes 11 large oil paintings, six small [ed. - The left margin of the following article was cut off by the digitizer and was unreadable.] oils, two etchings, … aquatints, four water colors and … colored block prints. Wins Prizes. One of the most popular works is … portrait by **C. Daniels** 'Dwight … ard, American Buddhist.' Daniels has been painting only three … oners of several national prizes… decorative paintings. **Eunice MacLennan** is exhibiting '… in Rock Garden' and 'Hi…'. **Colin Campbell Cooper** has '…rs' on display. **Antonio J.** … 'Study of Child'; **Marjorie [Murphy**?] … 'Alan'; **Edson Vaughan** '…rt' and 'Portrait'; **Walter** … yer, 'Just Jean.' **Doris Overman Howard**, 'Old Ranch House – Santa Cruz Island'; **Mrs. S. E. Crow** [i.e., second wife, **Augusta**], wife of Judge Crow, 'A Cactus Blossom'; **Lilia Tuckerman**, '… Morning' and **Mrs. Sam J. (Carolyn) Stanwood**, 'Storm…' Particularly interesting study is … of **Cecil Clark Davis** 'Mme [??]' … exhibits a large oil called 'Sentinels of the Coast – Carmel.' … **John Gamble** … has contributed … 'The Yellow Canon.' Water Colors Displayed. … four water colors have been … **E. E. Karnsey [Elmer E. Garnsey]**, who depicted Hawaiian scenes; **Evelyn K. Richmond**, who selected a bowl of persimmons for her subject, and **L.** … tterly, who has done 'Zebra.' **Marian Hebert**, recent speaker at College Art club, is represented by two aquatints. **Campbell Grant**… two colored block prints and **Mary J. Coulter** by two etchings…," *SMT*, March 25, 1935, p. 2; "Art Frolic Held by College Art Club Members" and frolic consisted of reading of humorous plays, clever games, and refreshments, and newspaper lists attendees, *SMFA*, April 26, 1935, n. p.; "Art Club will Meet for Last Time on 28th," and evening will include nomination and election of officers, the high school-junior college string quartet, a Japanese student in a dance, dramatic readings and refreshments, *SMFA*, May 24, 1935, n. p.; "Club Re-Elects Breneiser as President… Miss Vina Freeman was selected as treasurer," *SMT*, May 29, 1935, p. 3; "**Stanley Breneiser** is Reelected President College Art Club at Last Meeting of Term" and article adds, "The local club has been in existence for 12 years…. Following the program and the

business meeting a personal remembrance from the Breneisers to members of the club were presented in the form of little booklets with block-printed covers. Inside was a little poem by **Babs Breneiser**. Napkins for the refreshments were very unique in that each one had an individual design upon it. [list of attendees] ... A fine oil painting has been presented to the **Camp Fire cabin** at the school grounds and was seen for the first time at a tea given to honor senior high school girls, who are members of the Zontalee **Camp Fire Group**," *SMFA*, May 31, 1935, n. p.; "Art Club Will Convene Tuesday Evening" and article adds, "A night with the ancient lore of Indians predominating throughout decorations and main speech will be enjoyed next Tuesday evening, September 10... The speaker of the evening will be **Stanley Breneiser** who is president of the club. He spent the summer in Santa Fe, New Mexico and is well-versed in the historical background and present-day customs of the red man ... The meeting will start at 8 o'clock in the Camp Fire bungalow in the local high school grounds," *SMFA*, Sept. 6, 1935, n. p.; "Art Club Plans Varied Fall Program. Miss **Alberta Ow** is new vice president of the College Art club for the coming year... The club is planning to supervise the celebration of **National Art Festival Week** as it did last year. At that time, work of the **Breneisers – Stanley, Elizabeth** and **John Day** – done this summer in Santa Fe, N. Mex., will be exhibited. Other fall activities include the sponsoring of a recital by two San Francisco artists and an exhibit of lithographs," *SMT*, Sept. 12, 1935, p. 2;

■ "College Art Club Reconvenes" and article adds, "First meeting of College Art club was held Tuesday night in **Camp Fire Cabin** on the high school ground... the business meeting was mainly concerned with discussion of the club's activities in the artistic field during the coming year. Plans are tentatively scheduled for the appearance of two musicians from San Francisco and also for an exhibit of lithographs by a state renowned artist. Discussion was held regarding the sponsoring of a local Art Festival week in November when the President of the United States declares a **National Art week**... During art week, in addition to numerous programs in which examples of all the arts, music, dance and drama will be given, a joint exhibition of work completed this summer by **Stanley, Elizabeth** and **John Day Breneiser** will be in progress. These examples of pictorial art will exemplify the country and inhabitants of New Mexico where the Breneisers spent the summer teaching in Santa Fe... Decorations in the cabin consisted of Indian rugs and lumenarus [sic]. The latter is a much used form of lighting and decoration in New Mexico and are placed all about the cities and house yards and terraces every evening. Entertainment features of the evening were the painting? of an ... and descriptions of the Indian country by Mr. Breneiser and son, **David**. They described New Mexico as a country devoid of sophistication to the point of crudeness. They also commented on the blanket costumes of the natives and their elaborate headdresses. Ceremonial dance forms, held in the public squares and churches were described by David. These dances are in the nature of festivals and last from sun-up to sun-down. ... [list of attendees] Meetings are now held only once a month in the **Camp Fire cabin** unless otherwise specified," *SMFA*, Sept. 13, 1935, n. p.

See: "Art Festival," 1935, "Breneiser, Stanley," 1928, 1931, "Santa Maria, Ca., Union High School," 1931, 1933, 1934, "Stone, George E."

College of Arts and Crafts (Oakland)
See: "California College of Arts and Crafts"

College school / College Community Club
See: "Santa Ynez Valley, Ca., Elementary Schools"

Collegiate Institute (Lompoc)
School. Prop. Rev. B. F. Whittemore, 1890-92.
"Stanford's University... I have arranged my course of study so as to prepare my students for entrance to the Freshman class... following subjects... freehand drawing... **B. F. Whittemore**," *LR*, July 4, 1891, p. 2.
In June 1892 Whittemore was chosen principal of the Lompoc High School.
And additional notices and ads in the *LR* in 1890-92 not itemized here.

Collier (Wisser), Judith "Judy" Amelia (Mrs. Robert Chester Wisser) (1939-?) (Lompoc)
Lompoc high school winner of Bank of America achievement award in fine arts, 1956. Exh. Open-Air Art Exhibit, 1957. Designer/sewer of clothing. Studied fashion illustration at Woodbury College, LA, 1957.

■ "Double Ring Ceremony Unites ... Judith Amelia Collier and Mr. Robert Chester Wisser ... the bride was dressed in a ballerina length gown which she designed ... She is a graduate of the Lompoc Union High School and for the past year has been attending Woodbury College in Los Angeles ... will ... resume her studies in fashion illustration....," *LR*, Sept. 5, 1957, p. 7.
1956 – "Judith A. Collier, daughter of Mr. and Mrs. Harry Collier of 239 South D street, enrolled in a Commercial Art Course at Woodbury College of Los Angeles this week...," *LR*, Sept. 6, 1956, p. 6.
Collier, Judith (misc. bibliography)
Judith Amelia Collier, mother's maiden name Jensen, was b. Jan. 26, 1939 in Santa Barbara County per Calif. Birth Index (ref. ancestry.com).
See: "Lompoc, Ca., Union High School," 1956, "Open-Air Art Exhibit," 1957

Collin, Hedvig (1880-1964) (Denmark / Santa Barbara)
Danish artist and illustrator who was in America during WWII and who spoke on Denmark and her art to various clubs.

■ "Illustrated Talk on Denmark Sunday Eve. Miss Hedvig Collin, Danish artist and illustrator of Santa Barbara, will give an illustrated lecture at **Atterdag College** on Sunday, July 15, starting at 7:30 o'clock. She will tell of Denmark using colored slides and she will also show some of her drawings and paintings made in Santa Barbara. Miss Collin has operated a studio in Santa Barbara and will soon leave

for New York where she will try and secure passage back to Denmark," *SYVN*, July 13, 1945, p. 1.

Collin, Hedvig (notices in Northern Santa Barbara County newspapers on microfilm and on newspapers.com)
1940 – "Danish Artist Guest at Newcombe Studio... [and lectured on Denmark to] ... the Fine Arts guild of Riverside...," *San Bernardino County Sun*, April 30, 1940, p. 8; "Danish Writer is Seeking Material at ... Rio Vista elementary school... The visitor has been in America since November collecting material for a book on friendship between American and Danish children...," *San Fernando Valley Times*, April 30, 1940, p. 7.
1941 – Review of her book "Two Viking Boys," *LA Times*, Dec. 7, 1941, p. 76 (i.e. pt. III-A, p. 6).
1943 – "Danish Portrait Painter Guest Speaker ... Tamalpais Center Women's Club... presented an interesting lecture on life in Denmark and later displayed some of her own works – several portraits and some books she had illustrated. She showed some colored slides which very successfully portrayed the beauty, spaciousness and immaculateness of Denmark today...," *San Anselmo Herald*, Dec. 2, 1943, p. 4.
1946 – "Library at Solvang Acquires New Books... The book presented by Hedvig Collin, Danish illustrator, well known in Solvang, is a copy of her latest book, 'Wind Island'," *SYVN*, Jan. 25, 1946, p. 1.

Collins, Gertrude Finley (1872-1947) (Santa Maria)
Teacher to handicapped of both academic work and handicrafts, 1935. Member Santa Maria Camera Club, 1940.

■ "Former Ballard School Teacher in New Type of Work in S.M.... appointed instructor in a branch of education new to Santa Maria, that of instructing children unable to attend school because of physical handicaps. Although this work has been carried on in parts of California for several years, it .. was inaugurated in Santa Barbara county just this year... Under the supervision of Mrs. Muriel Edwards, county superintendent of schools, Mrs. Collins works directly with the County Health department... Mrs. Collins visits eight homes in Casmalia, Guadalupe and Santa Maria. Most of her pupils are American ranging in age from 6 to 15 years. Each child receives approximately an hour's instruction daily. Since Mrs. Collins carries all of her teaching supplies, her automobile resembles a traveling schoolhouse, whose arrival is eagerly awaited by each child. As there is very little literature available concerning this particular type of work, Mrs. Collins develops her own means of instruction. Various kinds of handcraft are used to interest and train the child in overcoming weaknesses due to paralysis or extreme nervous condition... Mrs. Collins has been a resident of Santa Maria for three years, during two of which she was instructor in the Mexican camp located near here at that time. Last year she taught all of the non-English-speaking children in classes held in main street school. She received her training in specialized or visiting teacher work in the University of Oregon where she had extensive work in psychology. Although she has had many years of experience in various types of teaching, she states that this new work is the most absorbing she has known. She feels that there are few things more satisfying

than helping these unfortunate children ... find their places in life... While they are overcoming physical handicaps, they receive the regular academic work thus enabling them to enter their own age group in school when normalcy is reached," *SYVN*, Nov. 1, 1935, p. 8.
Collins, Gertrude (misc. bibliography)
Gertrude F. Collins is listed in the 1930 U. S. Census as b. c. 1878 in Kansas, widowed, working as a teacher in grade school and boarding in Ballard, Ca.; Gertrude Finley Collins, b. Feb. 8, 1872 in Kansas, d. Dec. 28, 1947 in Santa Barbara county per Calif. Death Index (refs. ancestry.com).
See: "Santa Maria Camera Club," 1940

Collison, Elizabeth E. Mason (Mrs. Thomas F. Collison) (1908-1995) (Santa Maria / New York)
Book illustrator, 1930s.

■ "Mrs. Collison as Book Illustrator" for *Scat, Scat* by Sally Francis, and she now lives in NY, *SMT*, Oct. 14, 1940, p. 3.
Collison, Elizabeth (notices in Northern Santa Barbara County newspapers on microfilm and on newspapers.com)
1930 – "Artist-Mother Draws Sketches of Local Faces. Santa Marians who find themselves the subject of a young woman artist's sketching pencil while taking their afternoon siesta or snatching an afternoon bite need not be alarmed. Not only is she harmless but really adept with her pencil and already has put down in black and white a number of prominent local people. Her name is Elizabeth Mason and from oils to ink she ranges in her spare time, sketching, painting and drawing whatever takes her fancy – human or still. An excellent pen and ink likeness of Justice of the Peace L. J. Morris is one of her latest products. Incidentally she is the wife of Thomas F. Collison, *Daily Times* editorial staff man and the mother of Jimmy Collison, eight months' old young fellow who is fast learning to pound a typewriter like his dad and wield a brush like mother," *SMT*, June 20, 1930, p. 4.
1932 – "*Gin Chow's Farm*... written by Thomas F. Collison, editor and manager of the *Santa Maria Valley Vidette* and illustrated by his wife, Elizabeth Mason Collison," *SMT*, Feb. 16, 1932, p. 1; "Gin Chow's Book Selling Fast in Places on Coast... Gin Chow, Chinese weather prophet and philosopher of Lompoc valley ... First Annual Almanac... Oriental rancher who has definitely demonstrated his prowess to forecast weather... 62-page book which is profusely and adeptly illustrated by Elizabeth E. Mason Collison, young artist who lives in Santa Maria...," *SYVN*, Feb. 19, 1932, p. 1.
1933 – "Closer to Home, we note that Tom Storke has ... improved the appearance of his *Santa Barbara News and Morning Press*... We note with some pride that Santa Maria and the *Daily Times* have contributed four members to the staff... They include... Elizabeth Mason Collison, artist and illustrator," *SMT*, Dec. 27, 1933, p. 6.
Collison, Elizabeth (misc. bibliography)
Elizabeth Collison is listed in the 1930 U. S. Census as age 21, b. c. 1909 in Illinois, residing in Santa Maria with her husband Thomas F. Collison (age 24) and baby James W. (less than 1 year); listed in *Santa Barbara CDs* in the mid 1930s; Elizabeth E. Collison b. May 25, 1908 and d. March

21, 1995 is buried in Santa Barbara Cemetery per findagrave.com (refs. ancestry.com).

Colonial Art Company (East Coast)
Publisher of reproductions of art masterpieces. The company circulated exhibits to public schools, charged admission, and the net proceeds were used by the schools to purchase prints of their choice.
See: "Elson Art," "Guadalupe Welfare Club," 1928, "Santa Ynez Valley Union High School," 1937

Colvin, Lucy S. Patterson (Mrs. Lewis L. Colvin) (1862-1936) (Lompoc / Santa Maria)
Painter, milliner. Exh. paintings of fruit and flowers at "Santa Barbara County Fair," 1894, 1900. Prop. of ladies fancy goods and millinery shop.
Colvin, L. L. (notices in Northern Santa Barbara County newspapers on microfilm and on newspapers.com)
1897 – "Mr. and Mrs. L. L. Colvin will move to Santa Maria next week where they will carry on the millinery business, the same as they have done here…, *Lompoc Journal*…," *SMT*, Aug. 7, 1897, p. 3; "**Jeter**, the artist, painted an attractive sign on the Broadway side of the Hart house this week, informing the public that L. L. Colvin carries on a ladies furnishing goods business within," *SMT*, Sept. 4, 1897, p. 3.
1904 – "Mrs. L. L. Colvin… will shortly move into the new Ables building where her splendid display of millinery, ladies' furnishing goods, tailor suits and novelties can be displayed to advantage… one of the most complete and carefully selected stock… Her millinery shows the true artistic touch… A full line of embroidery silks and stamped goods for working is carried and a specialty is made of novelty collars… ," *SMT*, Dec. 17, 1904, p. 11.
1910 – SON – "Sadness Prevails over Death of Lewis Earl Colvin," *SMT*, Oct. 1, 1910, p. 1.
More than 40 notices for "Mrs. L. L. Colvin" appear in the *SMT* between 1890 and 1910, some pertaining to her trips to San Francisco to purchase goods for her hat shop, and to vacation trips, but were not itemized here.
Colvin, L. L. (misc. bibliography)
Lucy S. Colvin [Lucy S. Patterson] is listed in the 1910 U. S. Census as age 47, b. c. 1863 in Ohio, prop. of a ladies furnishing shop, residing in Santa Maria with her husband Lewis L. Colvin (age 56) and her mother Lydia J. Patterson (age 70); Lucy S. Colvin b. June 26, 1862, d. Oct. 14, 1936 and is buried in Santa Maria Cemetery District per findagrave.com (refs. ancestry.com).
See: "Santa Barbara County Fair," 1894, 1900

Colyar, J. C., Mr. (Lompoc)
Cartoonist, itinerant, evangelist, Baptist, 1919.
See: "Chalk Talks (Northern Santa Barbara County)," 1919

Comic Strip (*Santa Ynez Valley News*)
■ "Coming Friday, Aug. 5. Completely New Comic section featuring 'Pepe' [by] de la Torre. **Bill de la Torre** was born in Juarez, Mexico. He received a scholarship

from the Otis Art Institute in Los Angeles. After his art training he went to work at the Walt **Disney Studio** as an animator and story man. His own cartoons have appeared in *The New Yorker* and *Script* Magazines for the past 3 years. His hobby is collecting Jazz records. 'Hollywood' [by] **Fred Jones** started his cartooning career in 1932 at the 'Krazy Kat' Cartoon studio in Hollywood. Since then, he has worked on 'Oswald the Rabbit,' 'Porky Pig,' 'Bugs Bunny' and up to the present, Walt **Disney**'s Mickey Mouse in 'Fun and Fancy Free.' During the war, Fred worked at Douglas Aircraft Corp. making illustrations for the Navy parts catalog… 'Sidetrack' [by] Shaw. **Dick Shaw** started magazine cartooning in 1935 when he sold his first cartoon to *Collier's* magazine. Attended the Art Institute of Chicago for four years and drew cartoons for *Post, Collier*'s and *Aviation* magazines until 1939. Started working for **Walt Disney**'s Studio in 1940 and worked as Story and Gag man until 1946. At Walt Disney's studio he worked on the famous story of Casey Jones, which was an inspiration for the series of cartoons called 'Sidetrack.' Dick's hobby is trying to pay off the phone bill. 'Milford Muddle' [by] Ray Patin. **Ray Patin** began his cartoon career on a Los Angeles High school paper. He went to Otis Art Institute in Los Angeles and worked for **Walt Disney**'s Studio for 6 ½ years. Ray has done a considerable amount of story work both for the studio and cartoon books. During the war he headed the poster group at Douglas Aircraft Corp. 'Pam' [by] Gus Jekel. **Gus Jekel** is 21 years old. He has a twin brother, a wife and a little girl that looks very much like 'Pam' the little girl in his strip. In fact, many of the situations that Gus illustrates so cleverly have actually happened to his own daughter. Gus has worked for **Walt Disney** as an assistant animator for five years with time out for the Navy," *SYVN*, July 29, 1949, p. 4.
See: "Cartoons"

Commercial Art Service (Santa Maria)
Club at Santa Maria High School, 1935.
See: "Santa Maria, Ca., Union High School," 1935

Community Center (Lompoc)
Former Walnut Street USO building purchased by the city of Lompoc August 1947. Site of adult education classes sponsored by the Rec. Dept., as well as some "summer school" classes sponsored by the Lompoc, Ca., Recreation Department, 1947+. At times the Center was a meeting place for 4-H, Camp Fire Girls, Boy Scouts, La Purisima Camera Club and other clubs.
■ "Opening of Community Center Featured Exhibits… Focus of attention was a mantle arrangement which displayed a Santa Barbara landscape by … **Joseph Knowles**… Exhibits of leisure time activities placed throughout the building … In the room to be occupied by adult education classes under the direction of **Mrs. Viola Dykes**, an extensive display of upholstery work, ceramics, pictures, copper work, leather craft, lamp shades and other hand work attracted unusual interest. Classes are offered Monday through Thursday 9:30 a.m. to 3:30 p.m. and Monday and Tuesday 7:00 to 9:30 p.m. Also on exhibit

were examples of block printing the work of **Mr.** and **Mrs. C. S. Shelley [Sic. Shelly]**, who will direct the activity. Yarn craft was displayed by **Mrs. Betty Webber**, who will offer instructions on Tuesday evening, 7:00 to 9:00, sponsored by the Recreation department. The collection of historical photographs exhibited through the courtesy of Mr. Art Sills of the State Park Department and Mr. **Ed Rowe**, president of the Mission Association, showed the ruins and restoration of **La Purisima** Mission. Also on exhibit were a mission painting, work of **Forrest Hibbits**, local artist, and an arrangement of fruit and plant material from Mission Gardens by **Mrs. Ed Negus**. Included in the work shown by the **La Purisima Camera club**, headed by **Ken Pollard**, were many interesting studies of the Mission. The club, which plans to sponsor a junior division, will use the facilities of Community Center. Lompoc youth demonstrated by their exhibits the fine work done in the various organized youth groups. **4-H** girls exhibited in the pent house room, which they will occupy, the work done in various phases starting with simple sewing by nine-year-olds to the advanced phase where expert tailoring is taught. … **Cub Scouts** displayed their abilities at model plane building, craft work, hobby collecting and group activity. These boys meet in neighborhood den groups but will meet in Community Center on special occasions. Showing their appreciation for Community donations, the **Camp Fire** Girls displayed articles for which the money is spent. Examples were shown of work of textile painting, wood craft … Of special interest was the 'Round the World Friendship Knits' project sponsored by local A.W.V.S. Warm articles made… are sent… with a friendship message to children in need throughout the world … **C. S. Shelley [Sic. Shelly]**, Superintendent of Recreation who planned the activities of the opening," *LR*, Sept. 18, 1947, p. 14.

Community Center (notices in Northern Santa Barbara County newspapers on microfilm and on newspapers.com)
1946 – "Recreation Building Needed! Most Lompocans seem to think that the Walnut Avenue USO building would be a first-rate community recreation center when no longer needed for the military," *LR*, March 21, 1946, p. 7; "City Authorizes Negotiation on USO Building," *LR*, March 21, 1946, p. 10; "Latest… The 'off again, on again' history of the local USO building appeared at an end this week with the announcement that the building will be inventoried and sold," *LR*, Dec. 19, 1946, p. 1;
1947 – "Closes Argument on USO Building. Federal Agreement Approved. City to Pay $20,300," *LR*, Aug. 7, 1947, p. 1; "Artist on Display at Community Center… The painting now hanging over the mantle… is on loan from the Santa Barbara Museum of Art through the courtesy of the artist, **Joseph Knowles**… The artist made a special trip to Lompoc in order to bring the painting… in time for its opening. The painting itself is a water color landscape done in greens and browns. The scene was painted near Montecito. Incidentally Knowles will speak before the Alpha club sometime in November," *LR*, Sept. 18, 1947, p. 3.
1948 – "Students Exhibit Water Colors at City Center. Scenes well-known and well-loved by Lompocans … at the Community Center … The exhibitors were members of a class conducted here last year by **Forrest Hibbits**. The

exhibit was held in conjunction with the opening meeting of the Community Woman's club. Exhibiting their works were **Joan Biebieck [Sic. Bienieck]**, Maxine Alspach, **Ruth L. LaRue, Mrs. James T. Kenny [Sic. Kenney], Mrs. Milton Schuyler** and **Mrs. Claire Callis**," *LR*, Sept. 9, 1948, p. 2; "Variety Features Events Presented at Lompoc's Community Center. (The following is the second in a series of articles on Lompoc recreation prepared by the City Recreation Commission.) Many things 'have been doing' at the Community Center during the past year… Junior Alpha Club Fashion Show… Friday night 'Country Square Dances' … Outstanding programs of a cultural and educational nature held during the year were: … Film Forum presenting Miss Mabel Head, representative of National Council of Church Women and observer at United Nations presented by **Community Women's Club**. Other bi-monthly forums were co-sponsored by **Lompoc Film Council**, Alumni Association of U. C., **Camera Club** … A series of Art Exhibits under auspices of **Community Women's Club** included works of local artists **Forrest Hibbits** and **Channing Peake**, and children of Maple School. The Kiwanis Club sponsored Hobby Show was an interesting event… Adult organizations regularly meeting in the Community Center were … Farm Bureau, **Community Women's Club**… **Adult Education** Craft classes …," *LR*, Sept. 16, 1948, p. 16.
1949 – "Ceramics Class Planned for City Center,' *LR*, Nov. 24, 1949, p. 2; "Ceramic Classes to be Offered. The class in Ceramics for high school and junior high girls and boys starts tomorrow in the Penthouse of the Community center, from 3:30 to 5:30 p.m. … primarily a Christmas gift-making class… and will be conducted every Friday afternoon until Christmas… will feature green-ware ceramics. **Mrs. Russell Benhart** and **Mrs. C. L. Epperly** will be the instructors," *LR*, Dec. 1, 1949, p. 6.
See: "Dykes, Viola," "Hibbits, Forrest," 1948, "Knowles, Joseph," 1947, "La Purisima Camera Club," 1948, 1949, "Lompoc, Ca., Adult/Night School," "Lompoc, Ca., Recreation Department," "Lompoc Community Woman's Club," 1948, 1950, 1956, 1957, "Lompoc Film Council," "Summer School (Lompoc)," "United Service Organization (Lompoc)," "United States Disciplinary Barracks," intro.

Community Club (Lompoc)
Community Club, a project beginning 1915 to build a city recreation center.
[Do not confuse with the Lompoc Community Club, a woman's club organized 1947.]

Community Club (Lompoc)
Woman's Club organized 1947.
See: "Lompoc Community Woman's Club," 1947+

Community Club / Senior Community Club (including a few notices on Junior Community Club) (Santa Maria)

Woman's club, organized March 1922, that held some art lectures and sponsored some art activities. The club had special sections for "American Home," "Fine Arts" and "Handicrafts," at various times, depending on member interest. In 1935 it started the Junior Community Club for younger members. Held a Hobby Show, 1949, 1950, 1952.

Community Club (notices in *Santa Maria Times* and Santa Maria *Free Advertiser*)

1922 – "Stores of Santa Maria Close… Community Club of Santa Maria has just recently been taken into the Federation of Womens' Clubs…," *SLO DT*, Sept. 14, 1922, p. 3.

1923 – "Community Club Celebrates First Anniversary," *SMT*, March 26, 1923, p. 3.

1924 – "Community Club… February meeting at the Red Cross rooms… Clean-Up committee… Mrs. Max Miller was appointed chairman of the poster committee… Mrs. Miller is an artist whose especial work has been the designing of posters…," *SMT*, Feb. 5, 1924, p. 5; "Community Club… yearly clean-up campaign … a $1 prize will be given to the grammar school student who makes the best poster… A $2 prize will be given to the best poster submitted by students of the high school, and a household or garden implement for the best poster submitted by anyone not included in the schools," *SMT*, May 6, 1924, p. 5; "Offers Prize for Poster" advertising Clean Up Campaign designed by student in either local grammar or high school, *SMT*, May 15, 1924, p. 5.

1930 – "Community Club Hears Interesting Speakers… Stanley Breneiser… gave a talk on the large and increasingly important place art is occupying in the schools today. Art does not merely mean the painting of pictures or the modeling of figures but is that quality which brings out the beauty and symmetry in every effort of mankind…," *SMT*, April 12, 1930, p. 3.

1932 – "Community Club has Mr. **Stanley Breneiser** as Guest Speaker," and article adds his topic was 'The Valuation of Art.' i.e. "Mr. Breneiser spoke on art, not only from the artist point of view, but brought out the practical side of art. He also made mention of a number of Santa Marians who were former students in his classes here, who have made a success of their work," *SMFA*, Feb. 17, 1932, n. p.

1934 – "**Breneiser Family** Presents Program to Community… in the **Ark**… In the living room of the house, illuminated only by candles and the glowing fireplace, lighted pumpkins with artistic faces, a shock of corn and green boughs evidenced the Halloween spirit. [music played by David and Eliot and Marrie]… **John Day Breneiser**, introduced by his father, spoke on the life of **Rockwell Kent**, American artist… **Stanley Breneiser** then spoke of his work in the art department of the local high school and junior college… 'Our aim,' he declared, 'is not to try to make real artists of all who register, since many do not have any creative sense, but … to teach them of art, to develop appreciation. The aim of art in schools is the same as that in the study of literature, mathematics, poetry and

history – to find Self,' [Valentine and Cathryn Cathcart were introduced] … While refreshments were being prepared… a display of pictures by members of the family was shown…Among the paintings was an almost life-size portrait of **Rowena Lowell**, posed at the Breneiser pool and painted by **Marrie Breneiser**. The other large picture on the wall was by **John Day**. Both of these created much interest while hung in the Santa Barbara gallery. Other art works on display were a leaf lithography by **Stanley Breneiser**, wood blocks by **John Day** and **Louis [Sic. Louie] Ewing**, block printings on silk and water colors by each member of the family. There was also a woodblock print of Santa Maria by **Louis [Sic. Louie] Ewing** which was used for the philatelic clubs' distribution Oct. 12. Many of the subjects were found at Point Sal, Morro Bay and ranches in the valley…," *SMT*, Nov. 1, 1934, p. 3.

1935 – ■ "Art Exhibit is Slated in Santa Maria January 7-14. With the co-operation of the art section of the **Alpha Club**, the Community Club of Santa Maria is staging an **art festival**… featuring exhibits of paintings, both professional and amateur, and art talks on the subject before high school classes and art groups. The main exhibit will be in the new Santa Maria City Hall and will be the art exhibit of **Merle Armitage** of Redondo Beach, the largest privately-owned one-man exhibit. **Ramiel McGehee**, impresario of the events held in the Philharmonic Auditorium, Los Angeles, will accompany the exhibit and give several art lectures including a talk on Oriental literature. **Stanley Breneiser**, art teacher at the Santa Maria High School and Santa Maria artist, also will give art talks. Music and oriental dancing will form part of the program. Arrangements are being made for displaying exhibits of paintings of local artists in the store windows. **Mrs. George Secour** of Santa Maria is serving as the chairman… **Mrs. Leila Maimann** heads the Lompoc art group," *LR*, Jan. 4, 1935, p. 5.

1937 – "New Section Planned by Club… The 'American Homes' department was added, and the departments of art, drama and literature were combined into one group to be called the 'Fine Arts' department…," *SMT*, May 26, 1937, p. 7; "Community Club Hears Talk… Reports were also heard from various club chairmen… **Mrs. George Secour**, art chairman, showed a painting of the eucalyptus trees at Point Sal, painted by **Mary [Sic. Marrie] Breneiser Ewing**, and gave a short talk on it…," *SMT*, Oct. 27, 1937, p. 3.

1938 – "Community Club… In observation of Education week… arranged a program for… January 25… held in the junior college social hall… There will also be an art display by students in the school… Art in the Home…. **Mrs. Arthur Baker** would give a talk on 'Art and Color in the Home' at the meeting of the club's American Homes department on February 2… **Mrs. George Secour**, chairman of art, gave a short talk on the Madonna and displayed copies of paintings from different countries showing the different types of the Madonna," *SMT*, Jan. 12, 1938, p. 3; "Community Club Members Display Talent as Musicians and Artists" as seen in last night's talent meeting, and exhibits on display, **Mrs. Secour**, art chairman, included paintings by Mesdames **Lidbom, Effie**

Lawrence, C. W. Rahbar and Arthur Baker with handcraft by Mesdames Lidbom, Baker, Doris Young and B. E. Marvin, and quilts, painted china and needlework, *SMT*, April 13, 1938, p. 3; Community Club Plans Tea… Mrs. Hazel Lidbom exhibited articles which she has made, as chairman of the handcraft section, including hand-made Christmas cards, belts and scarfs of crochet, etched glass and early American prints," *SMT*, Nov. 23, 1938, p. 3.

1939 – "Antiques to be Shown … An amateur talent program… with singing, painting, poetry… Mrs. Arthur Baker, county chairman of Art for the Federated clubs, is program chairman," *SMT*, April 10, 1939, p. 3; "Antique Show Staged," *SMT*, April 12, 1939, p. 3; "Friday Dinner Scheduled … for Community club and Junior Community club members… On display during the evening were hammered metal articles and other bits of handcraft produced by members…," *SMT*, Dec. 6, 1939, p. 3.

1941 – "Art Talk for Club," i.e., Art in the Home for Community Club, *SMT*, Feb. 24, 1941, p. 3; "Breneisers Give Art Program for Club," and M/M. B. speak on art hung in the home, art decorating walls, and Mrs. B. on carved wood, tooled leather work and batik, *SMT*, Feb. 26, 1941, p. 3; "Federation Leader to Show Handcraft" from Bakersfield, metal work, *SMT*, April 5, 1941, p. 3; "Handcraft Program Set by Club," under Mrs. Ralph Lidbom, chairman "will give a demonstration of the making of necklaces and other simple articles. Mrs. Lidbom teaches handcraft classes in Santa Maria hospital and has had several years of experience as a handcraft counselor for Camp Fire Girls," *SMT*, Oct. 15, 1941, p. 3; "Novelty Jewelry Designing Shown" by Mrs. Lidbom, *SMT*, Oct. 29, 1941, p. 3.

1942 – "Federated Clubs Plan District Meet Here… The Community club meeting … At the next club meeting, Mrs. Corbett, Art chairman, will present the work of student artists under the direction of Edna Davidson of the elementary schools, and Stanley G. Breneiser of the high school. The meeting will take place in the junior college social hall…," *SMT*, Feb. 11, 1942, p. 3.

1943 – "Jewelry Collection Goes Badly… look up their old costume jewelry and colored buttons … importance of these articles for trading purposes with natives in the South Pacific…," *SMT*, June 15, 1943, p. 3;

1945 – Miss Ruth Chase antique "Glass Collector Addresses Club Women" of Community Club, *SMT*, Jan. 24, 1945, p. 3.

1947 – "Community Club to Meet" and hear lecture by Mrs. Jean Harman, state chairman of art, *SMT*, Jan. 14, 1947, p. 3; Jr. Community Club, "Sr. Community Club to See Exhibits" and hear lecture by Mrs. Ralph Lidbom who has exhibit of colored glass at public library, *SMT*, Feb 11, 1947, p. 3; "Sr. Community Club Meets in Mason Home… Mrs. Ralph Lidbom identified and described pieces of glassware and told the age and place each piece was made. The group then viewed an exhibit on antiques arranged by members of the club, including photographs, quilts, bed spreads, clothing, Chinaware, glassware, and two mercury vases," *SMT*, Feb. 13, 1947, p. 3.

1949 – ■ "Hobby Show Date Set for November 19, 20" at Veterans Hall and will include crafts as well as an exhibit of paintings by Santa Maria artists, *SMT*, Aug. 23, 1949, p. 5; "Hobby Show Management Reports Many Entries … Both high school and elementary school students are making posters for which prizes will be awarded… Early entries include collections of glass and china by Mrs. Hazel Lidbom… Stamp collections… miniature mechanical toys… Atascadero Gem and Mineral club… Hand-made hooked rugs from Solvang… Woodwork will be entered by Kenneth Castro and Mrs. Bertha Steele. … Santa Maria Camera club will have a collection of prints… DeNejer Studios will be represented by a large number of students and teachers with a section of ceramics, crafts and paintings. It is expected one or more of the paintings by Forrest Hibbits and others by Mrs. Ross Linsenmayer will be shown. Plastic work by Robert Blackley and copper work and tooling by Mrs. John Jenkins, Mrs. Paul Dal Porto and Miss Patricia Boyd have been promised," *SMT*, Nov. 4, 1949, p. 6; "Hobbyists List Collections for Community Show… [and list of some lenders and subjects] including … ceramics by Mrs. C. B. White…," and high school winners in poster contest named, *SMT*, Nov. 9, 1949, p. 6; "Community Clubs List 75 Entries for Hobby Show," with Santa Maria Art Association commanding an entire side wall, *SMT*, Nov. 17, 1949, p. 6; "Fine Arts and Collections Displayed at Hobby Show … Mrs. Ynez Lukeman is one of the surprise exhibitors with many lovely floral paintings and metal work. Original ideas are carried out in framing… Miss Margret Castro and her brother, Kenneth Castro, have a table with polished rock from Casmalia beach fashioned into candle holders and knife and fork handles. Textile painting, polished driftwood, crochet and decorated wooden ware are featured in unique patterns. Gaylord Jones has entered an elaborately hand-carved chest… Milton Shriner has two paintings of ferry boats…" *SMT*, Nov. 19, 1949, p. 6; "700 Attendance at Community Hobby Show" and exhibitors interviewed on tape, *SMT*, Nov. 21, 1949, p. 5; photo of interior of Hobby Show, *SMT*, Nov. 25, 1949, p. 5.

1950 – "Community Club … A program on art was arranged by Mrs. Oliver Hudson, chairman, with showing of two canvases by a local artist, Mario Veglia. With these were displayed other paintings furnished by Mrs. Corbett. Following the talk on art, a penny march was held, proceeds to go to the Federation's fund to sponsor and further the work of individual artists, selected as outstanding of the 48 states. Final reports on the hobby show indicated a total of $241 raised for the club treasury," *SMT*, Jan. 25, 1950, p. 6; "Community Club Elects… Mrs. Ross Linsenmayer of Orcutt, artist and teacher, was speaker of the evening. She spoke on painting as a hobby, and recommended a study of painting flowers as an enjoyable pastime for beginners. Her talk on various mediums of painting was illustrated with a collection of 50 canvases, her own work in portraits, principally in charcoal drawings and also landscapes in oils and water colors. The club had arranged an art corner in which was also displayed two valuable landscapes painted over 30 years ago by Mary Abbott, mid-western artist and teacher. The

paintings were loaned by **Mrs. Arthur Olsen**," *SMT*, April 26, 1950, p. 6; "Mrs. Saunders Names… Chairmen… Art and hobby show, **Mrs. James Hosn**… Mrs. William Harkness, fine arts… Mrs. Claude Buss, handcraft…," *SMT*, June 9, 1950, p. 5; "Hobby Show Posters Made…," *SMT*, Aug. 31, 1950, p. 2.

■ "**Second Annual Art and Hobby Show** Due Saturday. Responses are coming in apace … Mrs. Essie Turnage, in charge of a new department to display 'History of Santa Maria Valley' items reports a gratifying number of entries. Mrs. Alfa Mason will display a quilt, hand-made by her mother, with event dates embroidered in the pattern. The quilt was started in 1887. Also a gold-framed picture with hair wreath made into floral patterns by the late Mrs. S. J. Jones, Alfa's mother, will be shown, and a doll wearing a wig made of hair that was clipped from a relative's locks in early days. There will be a collection of antique silver entered by Edgar S. Leedy, and glassware by Mrs. C. B. Ferguson, and Mrs. Edith Gregory. … 'The Hobby Huddle, also an innovation, is to be a place where visitors to the show may see hobbyists at work. Mrs. Ruth Brown will be at work on flour pictures, **Mrs. Gertrude Dal Porto,** leather tooling, and **Mrs. Martha Friday**, ceramics. The latter, who has turned out exceptional pieces, will exhibit her best finished work in the way of decorative tiles, figurines and jewel boxes. A few of the late entries are those of Miss Marjorie Hall, who collects fans and handkerchiefs, and Mrs. John Jenkins, who is expert in leather tooling. Miss Patty Boyd will enter metal work pieces. … The Bossell doll collection, greatly admired when shown at the Arroyo Grande festival, will be a part of the local show. On the list of early entries are names of Mrs. William Hoey, rare spoons, E. E. Crofut, retired local jeweler, semi-precious stones, collected locally, polished and cut, **Doree Bond**, an oil painting, 'The Good Shepherd,' Mrs. Hans Mehlschau, salt and pepper shakers, and Dr. Phillip Reiner, stamp collection and miniature … Many amateur artists and hobbyists as well as collectors will enter one or more items. **Santa Maria Art Assn.** will fill the main stage with their entries and, judging from the last, virtually all space in the large auditorium will be filled," *SMT*, Sept. 21, 1950, p. 4.

■ "**Hobby Show** Opens at 12 Noon Today in Veteran Hall. Wonders of the world in small or greater degree may be found in displays at the second annual Hobby and Art show being sponsored in Veterans Memorial building today and tomorrow by the Community club and Junior Community club… Glass cases fill the center of the main auditorium, the one facing the main entrance displaying on its gilded shelves a valuable and rare coin collection owned by William Sexton of Santa Maria. Tables along either side of the long room are filled with objects of art, curios, collections and craft work. The stage is filled with a ceramics display and paintings, entered by the **Santa Maria Art Assn.**, while at the main entrance to the left is a space occupied with a Santa Maria pioneer collection with data on valley history. … Elsie Hicks is displaying a walnut burl chair, in the family many years, and also a fine hand-made wool shawl, property of her relative, Mrs. Sarah Lewis. Estelle Hicks' contributions are outmoded kitchen

gadgets in use in the last century, a few items being premiums on which appear names of early-day local firms. Edith Gregory is owner of a lace centerpiece and linens handed down in her family. A cradle used in the Enos family since 1900 is a fine piece of woodwork entered by Mr. and Mrs. Joe Enos. Mrs. Turnage is owner of a family album and old-time pictures, one an 1896 photo of the *Times* staff of Frank Winters, Lott A Harriman and Fred Lewis. Pretty clothing worn for dress-up occasions in an earlier decade complete with fan, gloves and beaded bag are Mrs. Phyllis Levey's property in the pioneer section. The collections are displayed more effectively with the help of a large braided rug, entered by Mrs. Tom Feland. Among hobby displays is the work by Miss Patricia Boyd of the form of batik wall hangings and a pongee butterfly cloth. Etched copper bowl and tooled copper pictures of Javanese dancers also are Miss Boyd's work. To illustrate a girl's pastime before radio and television, Sheila Bell has entered a quilt made of cigar box ribbons by the godmother of Bertram Bell, the exhibitor's father. Excellent western paintings are those shown by **G. E. Lightfoot**. The titles might well be 'The Get-away,' and 'Rim of the Canyon.' Mrs. Bea Sutton's large collection of salt and pepper shakers representing figurines, animals, birds, fish and other novelties are worth a visit to the show. Patrick Craig, 15-year-old Boy Scout who attended the 1950 National Jamboree in Washington has an exceptionally fine collection of rocks, minerals and semi-precious stones … His stamp book, with several complete sets of issues, is of interest to collectors of stamps. **Mrs. Irene Ferini** and **Mrs. Vern Dixon** show ceramics for **Santa Maria Art Assn.**, while oil paintings and water colors are the work of **Mrs. Florence Foster, Mrs. Mae Nichols** and **Mrs. Melba Bryant**. Marjorie Hall's collection of fans and lace handkerchiefs are shown for the first time. Miss Ada Bennett of Santa Barbara presented Miss Hall with several of the feathered fans. Unusually beautiful Italian cut work and hand-embroidered house linens are shown by Mrs. A. W. Pearson. Baby clothing made by Mrs. Leona Coughlin's mother fills one case. Mrs. R. J. Mason's books of verse, illustrated by Harrison Fisher and set of posters are treasured by the owner. One of the largest collections that demand time to fully appreciate are the international dolls owned by Mrs. C. E. Boswell of Arroyo Grande. These fill a case on the east wall of the building. Mrs. Nona Hoey's Burma Indian table near the main entrance had fine examples of metal, leather, ivory, ebony and embroidered textiles from that section of the world. Antiques as well as cut glass and frosted bon-ware comprises Miss Ruth Case's table. Philip Reiner is the owner of ship models and a stamp album, and Mrs. **Hazel Lidbom** is showing perfume bottles and book markers. A press clipping book of Frank Dailey, father of Mrs. Ennis Ackerman, and one of his dancing shoes, is in the display by the Ackerman family. Many other items and collections were in process of being set up in readiness for the doors to open at 12 today– EB," *SMT,* Sept. 23, 1950, p. 4; "UN is Theme… Community Club. … It was announced **Mrs. Oliver Hudson** will arrange an art display in observance of **national art week** in November as a club project. An art corner display, arranged by **Mrs. Corbett**, consisted of two paintings by

Mrs. Florence Foster, local artist," *SMT*, Oct. 25, 1950, p. 4.

1951 – Mrs. Lillian Huebner "Art Chairman [of California Federation of Women's Clubs] Will Address Community Club," *SMT,* March 12, 1951, p. 4; "Mothers are Honor Guests... **Mrs. James Hosn**, art chairman of the junior club, arranged for a display of exceptionally fine oil paintings of local landscapes by **Mario Veglia** of Casmalia," *SMT*, May 14, 1951, p. 4; "**Penny Art** Fund is Explained by **Mrs. Huebner**"– started in 1917 to purchase canvases by American artists and announces that Junior Community Club of Santa Maria stands in first place in state for its art programs, *SMT*, March 15, 1951, p. 4; "Community Club Seniors... To begin the term with a feature on art appreciation, three paintings, the work of **Glenn Carroll**, son of Mr. and Mrs. William Carroll, were displayed," *SMT*, June 14, 1951, p. 4; "Junior Club... **Mrs. Betty Hosn**, art chairman, displayed a picture, her own work, made of felt flowers and offered to give the club instruction at some future meeting on making similar pictures....," *SMT*, Sept. 5, 1951, p. 4; "Mrs. Beckman is Speaker... An art display arranged by Mrs. L. L. Richardson, consisted of leather and metal work by **Mrs. Blossom Davis**, instructor, and including book ends, wall plaques, trays, purses and other items," *SMT*, Sept. 12, 1951, p. 4; "Community Club is Hostess to Conference" and displays paintings of **Mrs. John Foster** of Santa Maria, *SMT,* Sept. 19, 1951, p. 4.

1952 – Calif. Federation of Women's Clubs "Art Chairman Speaks at Community Club Program" on art as a necessity and **Mrs. Betty Hosn** arranges display of art by school children and Mrs. **Mary Jane Thornburgh** brought paintings by American artists and some of her own art, "She spoke on the Federated clubs' 'Penny Art Fund' in which clubwomen have raised $100,000.00 to promote and further the cause of fine art in America. **Mrs. Betty Hosn, Junior community** art chairman was introduced and had arranged an exhibit of block printing and textiles for her 'art corner.' Miss Case announced dates of the **Hobby and Art show** to be held on March 28, 29, and 30 in the Minerva club house," *SMT*, Feb. 13, 1952, p. 4.

■ Third Annual: "Hobby & Art Show Dates Set by Club," for March 29 and 30 in the Minerva Clubhouse, *SMT,* Feb. 23, 1952, p. 5; "**Hobby & Art Show** Creates Interest," and news of progress, and "One of the unusual collections is to be Danish hand-made lace, owned by Miss Elinor [Sic. **Elna**] Larsen of Solvang, who will be on hand to give a demonstration of lace-making. **Mrs. John Foster**, local artist, will have several of her paintings to display and there will be work on exhibit by members of her art class of handicapped children. The sponsoring club has contacted makers of hand-tooled leather, metal work, and woodwork, among the latter being **Elwin Mussell**, who hand-carves gun stocks. ... Mrs. Richardson is contacting a retired rancher, who is noted for his work in making leather riatas, hatbands, watch fobs and western belts and harness that is almost a forgotten art...," *SMT*, March 13, 1952, p. 4; "Entries Arrive for Hobby & Art Show," and article adds, "Danish lace-making by Miss **Elna** Larsen of Solvang will be demonstrated at the show on Sunday as a special feature.

Miss Larsen turns out cobwebby hand-spun lace using thread as fine as No. 400. This hobbyist has her own theories about how to be happy with your hobby, one of them being, 'never go commercial.' ... It is hoped she will wear one of her picturesque Danish costumes... hand-tooled leather and work demonstration, **Mrs. Blossom Davis**, painting, **Mrs. John Foster**, student paintings, students of Mrs. Foster ... Others are paintings, **Doree Bond**... hand-carved gun stocks, **E. E. Mussell**. ... Winning posters in a conservation poster contest...," *SMT,* March 25, 1952, p. 4; "**Hobby**ists Will Give Demonstrations at Show" including **Mrs. Inez Lukeman** at work on copper pictures and plaques and Mrs. Ruth Brown will display her 'baked' flower pictures, and the names of some collectors of collectibles are given, *SMT,* March 28, 1952, p. 4; "Visitors Praise 1952 **Hobby Show** as Best" but article contains only general reference to "art" entries, *SMT,* March 31, 1952, p. 4; "Tribute is Paid Mrs. Stubbs... last night. ... Mrs. E. R. Trebon was hostess to the club in her home... **Mrs. Florence Foster**, who exhibited two paintings, one a portrait of Herb Nichols, the other a still life study. Mrs. Foster spoke on activities of **Santa Maria Art Assn.** ...," *SMT,* Sept. 25, 1952, p. 4; "Club Members See Demonstration on Cake Frosting... **Mrs. James Hosn**, art chairman, showed different types of work in illustrating such as is taught locally in the Santa Maria High school art department," *SMT*, Nov. 14, 1952, p. 4.

1953 – "Jr. Community... Sewing Meeting... in the home of the Needlework Guild chairman, **Mrs. Jack Burck**. Yardage purchased for the undertaking... Guest speaker was **Mrs. Ira Pattishall** [Sic. **Patishall**] who showed the group how to make wood fibre flowers ...," *SMT*, Nov. 5, 1953, p. 6.

1954 – "Junior Club Hears About Dolls... Dolls from the collection owned by Mrs. Lillian Spain of 'The Doll Heaven' were shown Tuesday evening... The speaker displayed one of the dolls to show restoration work, another that was a replica of the china-headed dolls of an earlier age. One of the dolls most highly prized the royal Kaisri has been in the owner's possession since 1912. Mrs. Spain told the club that much of her restoration work is done for museums in different parts of the United States... **Mrs. Joe Epperson** arranged an art display of drawings by **Brian Connelly**. ... The club needs a total 118 articles to be sent in to Los Angeles by March 22 to fulfill its Needlework Guild quota, **Mrs. Jack Burck**, chairman, announced, *SMT*, Feb. 4, 1954, p. 4; "Community Club Installs... **Mrs. Ruth Case**, a past president... presented each new officer with an artist's palette, explaining colors as they symbolize various qualities of leadership... The theme of the artist and palette was carried out with ... place cards and in other decorations made by **Mrs. Hosn**... [chairmen] handcraft, **Mrs. Jack Burck**...," *SMT*, June 8, 1954, p. 4.

1956 – "Community Club... Burt Trick, local nurseryman and landscape artist, will be speaker at the next meeting, Jan. 24, on 'What's New in the Garden'," *SMT*, Jan. 11, 1956, p. 4.

1957 – "Community Club... home of Mrs. Lily Corbett... was the meeting place for the ... Club Tuesday... Mrs. Pierre Arreguy directed a game called 'You Are a Part of

Penny Art,' which was also a means of raising funds to be sent to the California Federation of Women's Clubs art program. The money is used to encourage students and artists by purchasing their paintings, and the group also sponsors art appreciation literature and talks for the club memberships," *SMT*, Feb. 14, 1957, p. 4.

1960 – "Pictures Judged for Club. Amateur photography in color slides and black and white prints were judged in a competition for the Community Club at its recent meeting in the Security First Bank building. Winning places… were Miss Mildred Marlatt, Mrs. Henry Aldrich, Mrs. Alfa Mason and Mrs. James I. Tobin. **Mrs. Barney Miller** and **Bud Quick** of Santa Maria Camera Club judged the contest in which all members participated," *SMT*, June 17, 1960, p. 3.
See: "Allan Hancock [College] Art Gallery," 1956, 1957, "Art Festival," 1935, "Breneiser, Stanley," 1934, "Floats," 1949, "Junior Community Club," "O'Neal, Merilyn," "Penny Art Fund," "Rick, Maxine," "Santa Barbara County Fair," 1935, 1941, 1944, "Santa Barbara County Library (Santa Maria)," 1951, 1955

Community Club (Santa Ynez Valley)
Renamed College Community Club Feb. 10, 1950.

Community Club – Junior (Santa Maria)
See: "Community Club (Santa Maria)," "Junior Community Club (Santa Maria)"

Condit, Fillmore (1927-2005) (Solvang)
Industrial arts instructor at Santa Ynez Valley Union High School, 1956-63, and crafts teacher in summer school, c. 1958-59.
■ "Return to School … Seven new teachers … Fillmore Condit will head the new program which is being established in industrial arts … Condit is a graduate of the University of California at Santa Barbara and has done graduate work at Los Angeles State College. He taught last year at Morningside High School in Inglewood…," *SYVN*, Aug. 31, 1956, p. 5.
Condit, Fillmore (notices in Northern Santa Barbara County newspapers on microfilm and on newspapers.com)
1956 – "School Faculties… Fillmore Condit, a graduate of Santa Barbara College … will teach classes in industrial arts. Condit at present is teaching at Inglewood High School…," *SYVN*, June 8, 1956, p. 4.
1960 – Port. of family, *SYVN*, Aug. 12, 1960, p. 1.
1964 – Letter re: Communist infiltration addressed to Regents at the University of California, Berkeley signed Fillmore Condit, Class of '55," *SYVN*, Dec. 24, 1964, p. 16.
1965 – "Meet Your Area School Board… Fillmore Condit. Newcomer… served as a teacher at the Valley High School for 7 years and was in the Navy Air Corps for 2 ½ years. He lives on Roblar Ave., with his wife and three children… He is engaged in building and real estate in the Valley… His local activities include the office of first vice commander of the American Legion and he is secretary of

the Santa Ynez Improvement Assoc.," *SYVN*, April 15, 1965, p. 9.
Condit, Fillmore (misc. bibliography)
Fillmore Condit was b. Feb. 27, 1927 in Los Angeles to Donald Paul Condit and Jean W. Condit, was residing in Long Beach in 1930, married Germaine C. Behnke, and d. 2005 in Solvang, Ca., per New Improved Behnke Family Tree; Fillmore Condit d. March 23, 2005 per Social Security Death Index (refs. ancestry.com).
See: "Girl Scouts," 1960, "Santa Ynez Valley, Ca., Adult/Night School," 1958, "Santa Ynez Valley Union High School," 1957, 1958, "Summer School (Santa Ynez Valley)," 1958

Confer, Barbara
See: "Kern (Confer), Barbara (Mrs. Donald D. Confer)"

Conn, Jesse C. (Orcutt / Santa Maria)
Photographer, amateur. Member Santa Maria Camera Club, 1940, 1942.
[It is not known if this is J. C. Conn, Sr., oil worker, b. c. 1895 and married to Oma Lee Conn, or J. C. Conn, Jr., b. 1921 married to Mary Aileen Lewis.]
See: "Santa Maria Camera Club," 1940, 1942

Conneau, Margaret C. (1911-1988) (Oakland / Solvang)
Teacher of homemaking and fine arts at Santa Ynez Valley Union High School, 1935-38.
■ "High School Faculty … Miss Margaret Conneau of Berkeley, a graduate of the University of California and the State college at San Jose, will be the instructor in homemaking … Home making course under the Federal vocational act will be introduced when school opens…," *SYVN*, June 14, 1935, p. 1.
Conneau, Margaret (notices in Northern Santa Barbara County newspapers on microfilm and on newspapers.com)
1938 – "Miss Margaret Conneau resumed teaching duties at the high school Monday after being absent for several months in Berkeley where she took post-graduate work…," *SYVN*, May 6, 1938, p. 5; "New Teacher Here… position made vacant by the resignation of Miss Margaret Conneau…," *SYVN*, Aug. 26, 1938, p. 1.
Conneau, Margaret (misc. bibliography)
Margaret C. Conneau was b. May 26, 1911 in San Francisco to William Albert Conneau and Margaret A. Noon, was residing in San Rafael, Ca., in 1920, and d. Sept. 28, 1988 in Alameda County, Ca., per Kleeman Family Tree2; Margaret Conneau, d. Sept. 30, 1988, is buried in Holy Cross Catholic Cemetery, Colma, Ca., per findagrave.com (refs. ancestry.com).
See: "Santa Ynez Valley Union High School," 1935, 1936

Conner, Ray Cora (1895-1974) (Indiana / Hanford / Santa Maria / greater Los Angeles)
Itinerant artist who was active in Santa Maria making oil paintings from photos, 1921.
■ "Ray Conner was born in Muncie, Indiana June 27, 1895. His family moved to Porterville, California in about

1911. Ray dropped out of high-school and entered the U.S. Navy in 1915. He married Mary Root, a native of Paso Robles, California 22, June 1917. They had four children. … Ray found his passion for painting quite by accident in about the 1920s. He sketched in the open air, and developed his own formula for mixing paint…," askart.com.

Conner, Ray (notices in American newspapers on microfilm and on newspapers.com)

1921 – "Artists Open Classes… **Renn Griffith** and Ray Conner, artists who have been demonstrating in the window of the S. S. Lovelace clothing store, where a fine exhibit is now installed, have arranged with L. M. Powell and remain here indefinitely teaching classes in landscape painting, portrait work and all branches of the art," *Hanford Morning Journal* (Hanford, Ca.), Feb. 6, 1921, p. 4; "Announcement. Ray Conner the artist is now permanently located in Hanford – teaching landscape painting – and will paint pictures to order – any size, from any copy. Room 26, Emporium building," *Hanford Morning Journal*, March 12, 1921, p. 8; "Ray Conner of Indiana, noted artist, arrived in Santa Maria Monday. His work and exhibits on display are bringing much attention to the window at Coblentz & Schwabacher's store. Nature studies of interpretative talent of hand are considered quite incomparable, especially when done in such short time. Mr. Conner gives drawing lessons; however, none will be given in Santa Maria on account of his brief stay. He plans to leave Wednesday," *SMT*, June 7, 1921, p. 5, col. 2; "Artist Copies Kodak Pictures in Oil Colors. Beautiful Landscape Paintings will be made Tuesday and Wednesday in the window of the Coblentz & Schwabacher establishment by Ray Conner and will be sold at very reasonable prices. Mr. Conner comes from Indiana, where he received his training, although he is a natural artist. He copies in oil colors and [sic.] Kodak pictures or photo and will do so while you wait. Prices are reasonable," *SMT*, June 7, 1921, p. 8 and June 8, 1921, p. 7.

1923 – "Artist Conner Here Till Saturday… and will accept a few more orders for copy work. Mr. Conner uses the very best artists' oil colors… See the exhibit just inside the main entrance…. Prices for Mr. Conner's paintings are $1.75, $1.95 and $3.89," *Bakersfield Morning Echo*, May 17, 1923, p. 3.

1937 – "Fine Miniatures… Ray Conner, exhibiting until November 13 at the Frances Webb Galleries, gets some very nice color into his desert and mountain scenes and catches the outdoor feeling," *LA Times*, Nov. 7, 1937, p. 60 (i.e., pt. III, p. 10).

1939 – "Bad Time. Students of Ray Conner, Glendale artist and art instructor, had planned for a long time to go to the desert on a sketching trip. They finally went last week-end to glory in the sunshine and paint the cactus and sagebrush at Palm Springs… And it snowed for the first time since De Anza came through…," *LA Times*, Feb. 8, 1939, p. 9.

Conner, Ray (misc. bibliography)

Ray Cora Conner b. June 27, 1895 in Indiana and d. Nov. 28, 1974 in Honolulu is buried in National Memorial Cemetery of the Pacific (Punchbowl) per findagrave.com (refs. ancestry.com).

Conover, Roy, Pfc (Camp Cooke)
Photographer. Took color photos of USO art exhibit, 1945.
See: "United Service Organization," 1945

Conrad, Mary Ellen (Mrs. Benjamin Dixon Conrad) (Arroyo Grande)
Exh. ceramics at Santa Barbara County Fair, 1949.
See: "Santa Barbara County Fair," 1949, and *Arroyo Grande (and Environs) Art and Photography before 1960*

Constans, Emma H. Backus (Mrs. Alfred Constans) (1908-1985) (Santa Ynez)
Painter who studied with Forrest Hibbits. Exh. Santa Ynez Valley Art Exhibit, 1957. Head of art at Santa Ynez Valley Woman's Club, 1960.
Constans, Al, Mrs. (misc. bibliography)
Emma Nell Backus-Braddy-Constans was b. March 19, 1908 in Seattle, Wa., to Le Roy Manson Backus, Sr. and Edith Helen Fredericka Boekztes-Backus, was residing in Seattle, Wa., in 1910, married Robert Edgar Braddy (end) and d. April 20, 1985 in Santa Barbara, Ca., per Backus Family Tree (refs. ancestry.com).
See: "Danish Days," 1957, "Hibbits, Forrest," 1964, "Santa Ynez Valley Art Exhibit," 1957, "Santa Ynez Valley Woman's Club," 1960

Continuation School (Santa Maria)
See: "Santa Maria, Ca., Union High School," 1936

Convair Wives
See: "Art, general (Camp Cooke…)"

Cook, Florence (Santa Maria)
Member College Art Club, 1927. Active in art at Santa Maria JC, grad., 1928. Attended San Jose State Teacher's College, 1928.
Approx. 20 social/school notices for "Florence Cook" appear in the *SMT* between 1925-1930 but were not itemized here.
See: "College Art Club," 1927, "Santa Maria, Ca., Union High School," 1927

Cook, Zelia Anna
See: "Toy (Cook), Zelia Anna (Mrs. George Crist Cook)"

Cooke, Camp (aka Vandenberg AFB)
See: "Art, general (Camp Cooke)," "Camp Cooke"

***Cooke Clarion* (Camp Cooke)**
Newspaper for Camp Cooke.
See: "Art, general (Camp Cooke...)," Korean War

Coolidge, John Earle (1882-1947) (Los Angeles)
Commercial artist of Los Angeles. One of his paintings was distributed to a public building in northern Santa Barbara County by the PWAP, 1934.

■ "Coolidge graduated from La Fayette College, Easton, Pa., in 1904 and became a student in the art department of Stanford University in 1905. Returning to the Pennsylvania Academy of Fine Arts he studied from 1906-9 and then moved to Los Angeles where he opened a studio for commercial art," per Nancy Moure, "Dictionary of Art and Artists in Southern California before 1930," *Publications in California Art*, vol. 3, and other bibliography in vols. 1-13.
See: "Civil Works Administration," 1934, "Public Works of Art Project," 1934

Cooper, Miss (Los Angeles / Lompoc)
Teacher of sloyd and domestic science in Lompoc high school, 1911/12.
1911 – "Schools Open… Miss Cooper, a graduate in domestic science, has been appointed to take her place," *LR*, July 7, 1911, p. 8; "Schools Close… Mr. Terre and Miss Cooper will both spend the greater part of their vacations at their homes in Los Angeles," *LR*, Dec. 18, 1911, p. 1.
1912 – "Mitchell Retained … Miss Cooper who had charge of the manual training and sloyd department will seek a position elsewhere…," *LR*, June 14, 1912, p. 4.
This individual could not be further identified.
See: "Lompoc, Ca., Union High School," 1911

Cooper, Augustus S. (1851-1923) (Los Olivos / Bay Area)
Illustrator of geological books, surveyor?, 1909.

■ "Cooper Writes Book on Oil Formations… A. S. Cooper, author of several works on geology and mineralogy, whose home is at Los Olivos… The book will be liberally illustrated with drawings made by Mr. Cooper, showing in color plates what science has discovered for the earth's formations… *Santa Barbara Independent*," *SMT*, April 3, 1909, p. 7.
Cooper, A. S. (misc. bibliography)
Augustus S. Cooper is listed in the 1910 U. S. Census as age 59, b. c. 1851 in Maryland, a mining engineer, residing in Township 4, Santa Barbara County, with his wife, Mary F. Cooper (age 58); Agustus [Sic?]/ Agustin S. Cooper is listed in the 1920 U. S. Census as age 74, b. c. 1846 in Maryland, civil engineer, residing in Santa Barbara, Ca., with wife Mary F.; Augustus S. Cooper, b. c. 1846, d. Nov. 11, 1923 in Santa Barbara County per Calif. Death Index (refs. ancestry.com).

Cooper, Colin Campbell (1856-1937) (Santa Barbara)
Artist of national repute who painted views of Santa Maria Inn, 1927. Exh. under auspices of College Art Club, 1935.

■ "Colin Campbell Cooper, Jr. (March 8, 1856 – November 6, 1937) was an American Impressionist painter, perhaps most renowned for his architectural paintings, especially of skyscrapers in New York City, Philadelphia, and Chicago. An avid traveler, he was also known for his paintings of European and Asian landmarks, as well as natural landscapes, portraits, florals, and interiors. In addition to being a painter, he was also a teacher and writer," per Wikipedia.
Cooper, Colin (notices in Northern Santa Barbara County newspapers on microfilm and on newspapers.com)
1928 – "Manta Maria Inn… in the current issue of 'California Southland'… cover design… painting by Colin Campbell Cooper of a basket of dahlias sitting in the sunlight on the table near a window at the Inn… The painting was done here before Christmas by Cooper who made a short stay in Santa Maria… made especially for the *California Southland*… though the courtesy of **Frank McCoy**, proprietor of the Inn…," *SMT*, Feb. 8, 1928, p. 4.
1929 – "**Santa Maria Inn** and Entire Valley Given National Recognition… in the *Ladies Home Journal*… 'It's always blossom time at **Santa Maria Inn**,' is the title of … a painting of flowers on a table near a window, while a 5 x 6 painting of the entire hostelry is presented. Relics of Indian and Spanish days found in numerous niches about the Inn are subjects of another small picture while the old ox cart, familiar to all Santa Marians, is also portrayed…," and text of advertisement accompanying photos, *SMT*, July 31, 1929, p. 10.
1937 – Obit., *SMT*, Nov. 8, 1937, p. 6, col. 2.
Bibliography: *An Exhibition of Paintings by Colin Campbell Cooper*, James M. Hansen Galleries, Santa Barbara, Ca., 1981, contains a detailed biography and many reproductions of his paintings.
See: "College Art Club," 1935, "Orcutt Women's Club," 1927

Cooper, Frank (Lompoc)
Photographer at Civilian Conservation Corps, 1935.
See: "Civilian Conservation Corps," 1935

Copeland, L. B.
Itinerant cartoonist entertainer in Lompoc, 1922.
See: "Chalk Talks," 1922

Corbett, Betty Virginia (Mrs. Donald F. Corbett) (1923-1997) (Solvang)
Painter who exh. at Santa Ynez Valley Art Exhibit, 1954, 1955, 1958 and at other art venues. Bookkeeper.

■ Port… April 27, 1923 – Jan. 5, 1997, and "Betty Virginia Corbett, 73, of Solvang, died at home… after a logn battle with cancer. She was born april 27, 1923 in Seal Beach. She worked as a bookkeeper for Jonata Elementary School in Buellton and also at Santa Ynez Valley Hardware Store," *SYVN*, Jan. 9, 1997, p. 6.
See: "Allan Hancock [College] Art Gallery," 1955, "Christmas Decorations (Santa Ynez Valley)," 1953, "Santa Ynez Valley Art Exhibit," 1954, 1955, 1958

Corbett, Mario (San Francisco / Pismo Beach)
Exh. "Guadalupe Church" at SCSWE, 1931.
See: *Central Coast Artist Visitors before 1960*

Cordoza, Isabel (Lompoc)
Sloyd teacher at Lompoc Elementary School, 1919.
See: "Lompoc, Ca., Elementary / Grammar School," 1919.

Corey, Theodora Opal (1909-1977) (Solvang / Los Angeles)
Santa Ynez Valley Union High School teacher of Home Economics and Art, 1939/43.
■ "Theodora Corey ... was a member of the faculty at the valley high school in the early 40s. At that time she lived at the one-time **Atterdag College**... After leaving the valley high school, Miss Corey taught for 19 years at the University of California at Los Angeles and later at the University of Texas," *LR*, Nov. 14, 1977, p. 2.
1942 – "Miss Theodora Corey and Mrs. Daveda Park, high school instructors, held open house in their home in Solvang Sunday night...," *SYVN*, Oct. 2, 1942, p. 5.
Corey, Theodora (misc. bibliography)
Port. of Theodora Corey appears in Theodore Roosevelt High School, LA, yearbook, 1928; port. of Theodora Corey with cap and gown appears in Santa Barbara State College yearbook, 1932; Theodora Corey port. as "associate in home economics" appears in the UCLA yearbook, 1950; Theodora Opal Corey was b. Oct. 28, 1909 [in Los Angeles] to Richard Nelson Corey and Opal Heath [Stewart] Corey, d. on Oct. 2, 1977 in Los Altos, Ca., and is buried in Rose Hills Memorial Park, Whittier, Ca., per findagrave.com (ref. ancestry.com).
See: "Santa Ynez Valley High School," 1942, 1943

Corinth, Charlotte
See: "Berend (Corinth), Charlotte (Mrs. Lovis Corinth)"

Corollo, Louise H. Markevich (Mrs. Mario F. Corollo) (1913-2001) (Santa Maria)
Interior decorator with Blum Interiors, 1950. Prop. Blue Lantern Art Studio, 1956. Art prize winner in exh. of local talent, senior division, Allan Hancock [College] Art Gallery, 1957.
■ "Interior Decorating Studio Opens Here. Mrs. Louise Corollo, a graduate of Rudolph Shaeffer's School of Interior Decorating in San Francisco has opened the **Blue Lantern** art studio at 500 south Broadway. Enrollment has begun in color, texture and design classes. Help is given with home interior problems, and consultations are arranged, Mrs. Corollo said," *SMT*, Sept. 19, 1956, p. 10.
Corollo, Louise (notices in Northern Santa Barbara County newspapers on microfilm and on newspapers.com)
1956 – Port. at opening of Marjorie Hall dance studio, *SMT*, Jan. 3, 1956, p. 4; "Classes in Color, Texture and Design to qualify you to do your own decorating in a professional way. Louise Corollo (Formerly of Maurice **Blum Interiors**). A graduate of Rudolph Schaeffer's

School of Interior Design. **Blue Lantern Art Studio**. Phone 5-3763," *SMT*, Nov. 30, 1956, p. 4.
Corollo, Louise (misc. bibliography)
Louise H. Markevich, b. c. 1913, married Mario F. Corollo on Oct. 9, 1950 in Santa Barbara County per Calif. Marriage Index; Louise H. Corollo b. Aug. 11, 1913 was residing in Cambria, Ca., in 1993 per *U. S. Public Records Index, 1950-1993*, vol. 1; Louise H. Corollo b. Aug. 11, 1913, d. Aug. 9, 2001 per Social Security Death Index (refs. ancestry.com).
See: "Allan Hancock [College] Art Gallery," 1957, "Dipple, Gordon," 1957, "Junior Community Club (Santa Maria)," 1953, 1956, "Markevich, Louise"

Costa, Evelyn Marie (1925-1954) (Lompoc)
Scholarship winner to California College of Arts and Crafts, Oakland, 1943.
■ "Local Girl Wins Scholarship… statewide contest… California College of Arts and Crafts in Oakland… Miss Costa submitted eight examples of work ranging from pencil technique, pastels, water color, poster and landscape drawings all under the supervision of Miss **Crystal Lund**, high school art instructor. The scholarship … will be from August 16 to December 18 of this year…," *LR*, June 4, 1943, p. 2; ■ "Rites Held Monday for Evelyn Costa … Evelyn Marie Costa, 28-year-old Lompoc native who passed away Friday in the Lompoc hospital following a prolonged illness. Miss Costa was born the daughter of Mr. and Mrs. Manuel V. Costa. Mrs. Costa passed away when her daughter was a small child. The family home is in Drum Canyon. Following graduation from Lompoc High school, Miss Costa was employed for a while as a clerk in Lompoc stores. She was secretary of the SPRSI Portuguese women's society, a member of the Catholic Daughters and the Blue Jacket Drill Team. She is survived by her father, Manuel V. Costa and three brothers…," *LR*, Feb. 11, 1954, p. 3
Costa, Evelyn (notices in Northern Santa Barbara County newspapers on microfilm and on newspapers.com)
1946 – "Original Lompoc Rancho Haciendo … A drawing of the original hacienda of Lompoc rancho is being sketched by Evalyn [Sic.] Costa … The Haciendo has long been out of existence and the sketch is to be drawn on the basis of old records and [Emmett] O'Neill's memory. The building was originally located near the intersection of K street and Locust avenue, according to O'Neill. It was originally built by the Carillo family, who owned the Lompoc and Santa Rosa ranchos …. When completed, the drawing will be included in the O'Neill collection of letters, books and records related to the Lompoc area," *LR*, Aug. 29, 1946, p. 12.
Seventy-five social and school notices for "Evelyn Costa" in the *LR* between 1935 and 1954 were not itemized here.
Costa, Evelyn (misc. bibliography)
Evelyn Marie Costa was b. July 27, 1925 in Lompoc, Ca., to Manuel Vieira Costa and Maria Delphina Mello, was residing in Santa Barbara in 1935, and d. Feb. 5, 1954 in Lompoc, Ca., per Cordoza Family Tree (refs. ancestry.com).

Costantini, Agosto (Santa Maria)
Portrait artist, 1901.

■ "Agosto Costantini, the Austrian who was lodged in the county jail some time ago for defrauding the dear people of Santa Maria and elsewhere by his picture scheme, is a most useful member of the chain gang. He is an artist of much skill and can turn out portraits or landscapes while you wait. He now finds employment painting the railing, desks, etc., in the Superior Court room, which is being remodeled," *SMT*, July 27, 1901, p. 3, col. 5.
This individual could not be further identified.

Costello, John Lawler (Santa Maria)
Prop. Aerial Photography Service, while an engineering student at USC College of Aeronautics, 1948.

■ "John L. Costello and Bride… Mr. and Mrs. John Lawler Costello are making their home in Santa Maria … husband is the son of Mr. and Mrs. James W. Costello of Los Angeles. He attended Black Foxe Military Academy and Van Nuys High School. He served with the Army Air Corps on a B-29 and is now an aeronautical engineering student, also enrolled at USC College of Aeronautics," *SMT*, Jan. 3. 1948, p. 3; "USC Students Get Army Medals… decorated with World War II … American Defense campaign medal … **John L. Costello**…," *SMT*, April 6, 1948, p. 1.
See: "Aerial Photography Service"

Costume Design
See: "Fashion Design"

Coughlin, Elizabeth
See: "Alexander (Coughlin), Elizabeth Louise "Betty Lou"/ "Betti Lou" Thompson (Mrs. John Marcus Coughlin, Jr.)"

Coulter (Clark), Mary Jenks / Jencques (Mrs. Fred Coulter) (Mrs. Orton Loring Clark) (1880-1966) (Santa Barbara / Massachusetts)
Museum administrator, painter, craftswoman who exh. at Mattei's in Los Olivos, 1945.

■ "Pre-Xmas Exhibition Coming to Los Olivos. Mary J. Coulter will present an exhibition of her work this coming week-end at Mattei's Tavern in Los Olivos. Mrs. Coulter, Kentucky-born artist of English ancestry, was for a time 'Curator of Prints' at the Art Institute of Chicago and later the Assistant Director of the Fine Arts Gallery in San Diego. An artist with extraordinary versatility, Mrs. Coulter turns with ease and skill from painting or etching, to various handicrafts-textiles, jewelry, book-binding, pottery. Mrs. Coulter's former exhibits include showings in the Los Angeles Museum of Art, the California Palace of the Legion of Honor and at the M. H. de Young Memorial Museum, the Uffizzi Gallery in Florence, Italy, the Bibliotheque National in Paris and the Victoria and Albert Museum in London. Her work has a wide representation in the public and private collections in the United States as

well as in the British Museum and the Chaleographie du Louvre," *SYVN*, Dec. 7, 1945, p. 1.
Coulter, Mary (notices in Northern Santa Barbara County newspapers on microfilm and on newspapers.com)
1936 – "Mrs. Mary Coulter … is recovering in a hospital in Auburn, northern California, from injuries sustained when her car skidded off a grade during a rain," *SMT*, Sept. 19, 1936, p. 1.
1940 – "Destruction by Forest Fire is Great… Cabins Saved… Mrs. Mary Coulter…," *SMT*, Aug. 13, 1940, p. 6.
1946 – Coulter ran numerous ads in the *SYVN*, 1946, 1947, for her art gallery in Santa Barbara, not itemized here.
Coulter, Mary. (misc. bibliography)
Mary J. Coulter is listed in the 1930 U. S. Census as age 43, b. c. 1887 in Kentucky, divorced, self employed as an artist-painter in the Arts and Crafts industry, residing in Santa Barbara by herself; Mary J. Coulter is listed in the 1940 U. S. Census as age 59, b. c. 1881 in Kentucky, finished college 4th year, widowed, owned her own home and was residing in Santa Barbara (1935, 1940) by herself; Mary Jenks/Coulter married Orton L. Clark on Dec. 28, 1953 in Los Angeles per Calif. Marriage Index; Mary Coulter Clark was b. Aug. 30, 1880 in Newport, Kentucky, and d. Oct. 18, 1966 in Amherst, Mass., and is buried in Spring Grove Cemetery, Cincinnati, Ohio, per findagrave.com that includes a biography (refs. ancestry.com).
See: "College Art Club," 1935, "Solvang Woman's Club" 1951

Country Fair (Los Olivos)
See: "Santa Ynez Valley Fair," 1928+

Cowie Galleries, Biltmore Hotel (Los Angeles)
Gallery that lent works by some of its stable of artists to the Santa Maria Valley Art Festival, 1952, 1953.
See: "Allan Hancock College Art Gallery," 1957, "Parshall, Douglass," 1957, "Santa Maria [Valley] Art Festival," 1952, 1953

Cox, Rose / Rosie M. (Mrs. Robert Cox) (Lompoc)
Artist? Exh. at Open Air Art Exhibit, 1957. Penny Art Chairman, Junior Alpha Club, 1958.
1950s – Port. of Mrs. Rose Marie Cox with Eastern Star dignitaries, *LR*, Dec. 10, 1953, p. 2; port. of Rose Marie Cox installed as officer of Miguelito Chapter OES, *LR*, Dec. 1, 1955, p. 4.
And 30 club notices for "Rose Marie Cox" and nearly 200 for "Mrs. Robert Cox" in the *LR* between 1950 and 1965 were not itemized here.
Rose M. Cox, wife of Robert L. Cox, electrician, is listed in Lompoc in the *SMCD* 1958, 1959, 1961 (refs. ancestry.com).
See: "Alpha Club," 1958, "Open Air Art Exhibit," 1957

Cox, Sybil Mason (Mrs. Henry Elliot Cox) (1872-1969) (Santa Maria / Arroyo Grande)
Exh. landscape painting at "Santa Barbara County Fair," 1900.
Cox, H. E., Mrs. (misc. bibliography)
Sybil [Lydie] Cox is listed in the 1900 U. S. Census as age 23, b. Aug. 1872 in England, immigrated to U. S., 1896, married to H. Elliot Cox (age 33) in 1898 and residing in Township 7, Santa Barbara County, with him and no children; Sybil Mason (Cox) was b. Aug. 27, 1872 in India to Charles Crawford Mason and Lucy Ella Holmes, married Henry Elliot Cox, and d. Dec. 2, 1969 in Arroyo Grande, Ca., per Michael Burdick Family Tree (refs. ancestry.com).
See: "Santa Barbara County Fair," 1900

Crafts
See: "Arts and Crafts," "Handcrafts," "Handwork"

Crafts Shop (Ballard)
■ "Crafts Shop Opens in Ballard... **Miss Louise Chrimes** announces the opening of her Crafts Shop... located next to the Ballard Bridge, will feature hand painted and decorated furniture, lamp shades and screens," *SYVN*, Dec. 3, 1954, p. 1.
See: "Chrimes, Louise"

Cram, Allan / Allen Gilbert (1886-1947) (Santa Barbara)
Artist in exh. at Orcutt Women's Club," 1927 and at National Art Week show at Minerva Club, 1940. One of his artworks was distributed to the Lompoc High School library by the CWA, 1934.
■ "Allan G. Cram... Seattle... Allan Gilbert Cram, 61, nationally known artist who exhibited marine paintings in many galleries and who moved here five years ago, died today...," *LA Times*, May 23, 1947, p. 8.
Bibliography: Kovinick
See: "Civil Works Administration," 1934, "National Art Week," 1940, "Orcutt Women's Club," 1927

Crawford, Louis Noire (1890-1946) (Santa Maria)
Manual training teacher at Santa Maria Union High School, 1919. Architect of several school buildings, 1919-46. Husband to Winifred Crawford / Dixon, below.
■ "Death Summons L. N. Crawford, Noted Architect ...Louis N. Crawford, 56, one of the most brilliant architects of the state and noted for his ability as a designer of school buildings until his career was cut short by a 'stroke' in January 1939, last Friday passed away in a local hospital... He is survived by his wife, the former **Winifred Kittredge** of Berkeley, a member of the local high school faculty and instructor in journalism... He was born in Louisville, Ky., on May 31, 1890, reared on a farm and educated in the public schools there and in Charleston, Ind. He studied civil engineering for two years in Purdue university, taught four years and then graduated in architecture from the University of Illinois. He took special

work in the universities of Michigan and California and was certified to practice architecture in the states of Illinois and California. After office experience in Indiana and Illinois, he came to California in 1915 as an instructor in the University of California summer school. He became a member of the Santa Maria Union High school faculty in 1919, remaining one year during which time he introduced the game of football into the school as coach. He also coached the local American Legion football team. Designs Schools. In 1920 he opened his own offices of architecture and rapidly gained a widespread reputation for ability. Many Santa Maria buildings and schools along the coast remain as a testimonial to this ability. The Santa Maria city hall is perhaps the finest and most famous of these, but he also planned the annex to the Southern Counties Gas Co., building, the Knights of Pythias building, additions to the Santa Maria Union High school, the Fairlawn and El Camino schools, and improvements to the Main street school. Among the other schools designed by Crawford were the elementary grade buildings in Orcutt, Goleta, Vista del Mar, Arroyo Grande and Pismo Beach, the San Luis Obispo High school and Junior High school, the Cambria and Morro bay schools, and others. The year that Crawford first took ill he was serving as vice president of Association of California Architects for which he also was a district adviser. He also was a member of the American Institute of Architects and of the Santa Barbara chapter of Alpha Rho Chi, architectural fraternity. [first exalted ruler of the Santa Maria Elks lodge, and in 1939 was scheduled to become worthy master of Hesperian lodge cancelled by his illness] ... he was a past president of the Santa Maria Rotary club," per (undated) (1946) clipping with port. in SM Historical Society Scrapbook); "Louis N. Crawford, Noted Santa Maria Architect, Dies," and port., *SMT*, July 12, 1946, p. 1; "Architect Passes in Santa Maria," designed many local schools, *AG*, July 19, 1946, p. 4;
See: "Boy Scouts," 1933, "Dixon, Winifred Kittredge," "Parsons, W. Francis," 1932, "Santa Barbara County Fair," 1930, "Santa Maria, Ca., Elementary," 1931, "Santa Maria, Ca., Union High School," 1919

Crawford (Dixon), Winifred K. (Mrs. Louis N. Crawford) (Mrs. Dixon) (1893-1968) (Santa Maria)
Teacher of Domestic Art at Santa Maria High School, 1924-26, but primarily an English teacher for many years.
See: "Dixon, Winifred," "Santa Maria, Ca., Union High School," 1924, 1926

Creative Arts and Woman's Exchange (aka Red Cottage) (Solvang)
Sales venue for Valley-made handicrafts, 1949. Existed as Red Cottage, c. 1950-55.
■ "Three Sisters to Launch Valley Woman's Exchange... in Miss Penney's home on Mission Drive.... outlet for Valley women to market their handicrafts of all descriptions. She said many women in the Valley are fast becoming expert at making things by hand... These will include ceramics, lamps, lampshades, needlework, copper crafts, leather goods, rugs and woodcarving... Another

feature will be the offering of a few choice antiques for the collector…," *SYVN*, Oct. 7, 1949, p. 3.

Creative Arts and Woman's Exchange (notices in Northern Santa Barbara County newspapers on microfilm and on newspapers.com)
1949 – "Creative Arts Open House Set for Tomorrow… from 2 to 5 p.m. at its studio on Mission Drive in Solvang. The Woman's Exchange will be operated by three sisters, **Miss Mae Penney** and **Mrs. J. H. Watson**, formerly of Chicago, and **Mrs. J. H. Forsyth**, a resident of the Valley for many years. Miss Penney, spokesman for the group… The studio will be open every day with the exception of Sunday and Monday," *SYVN*, Oct. 14, 1949, p. 1.
See: "Red Cottage"

Creator's Club
Club for Homemaking students of Lompoc High School, 1934+.
See: "Lompoc, Ca., Union High School," 1934, 1935

Cronholm (Harding), Pauline (Mrs. LeRoy Clarkson Harding) (1917-1995) (Lompoc)
Lompoc high school senior with artistic talent, 1934. Majored in art at Santa Barbara college, 1935.
■ "Newlyweds… Pauline Cronholm and LeRoy Harding … Palo Alto will be the future home… The bride, whose parents have made their home in Salinas for some time, graduated from high school in Lompoc and she later attended Salinas junior college…," *Salinas Morning Post,* July 1, 1939, p. 5.
Cronholm, Pauline (notices in Northern Santa Barbara County newspapers on microfilm and on newspapers.com)
1934 – "A Creditable Sketch. Although probably the *U. S. S. Constitution*'s sailing days are over … 'Old Ironsides' goes sailing the bounding main under a snow cloud of canvas – in a pencil sketch now on exhibition in Lundberg's Store window. The picture is the work of Miss Pauline Cronholm, Lompoc Union High School senior … Miss Cronholm displays great promise in … the pencil sketch…," *LR*, April 13, 1934, p. 1.
1935 – "Wins Poster Contest – Winner of the peace poster contest sponsored by the central coast alliance of Methodist churches. Miss Pauline Cronholm plans to enter her poster in the regional contest. First prize in the alliance contest is a paid registration fee for Epworth League institute, July 20 to 27…," *LR*, May 24, 1935, p. 6; "To Santa Barbara – Miss Pauline Cronholm plans to leave Thursday for Santa Barbara where she will enroll in the state college, with art studies as her major," *LR*, Sept. 6, 1935, p. 5.
1936 – "Mrs. E. S. Cronholm returned Tuesday from a short visit… and to her daughter, Miss Pauline Cronholm, now a junior college student in Bakersfield," *LR*, Feb. 21, 1936, p. 5; and approx. 30 additional school and social notices for "Pauline Cronholm" in *LR* between 1930 and 1940 were not itemized here. And several notices on her choral work and activities with Epworth League appear in Salinas newspapers.
Cronholm, Pauline (misc. bibliography)
Sophia Pauline Cronholm was b. Feb. 17, 1917 in Woodrow, Utah, to Bror Nils Otto Thure Cronholm and

Esther Sophia Christensen, was residing in Lompoc, Ca., in 1930, married LeRoy Clarkson Harding, and d. Sept. 15, 1995 in Sunnyvale, Ca., per Feilke/Steigner/Gil Family Tree (refs. ancestry.com).
See: "Lompoc, Ca., Union High School," 1932, "Posters, general (Lompoc)," 1935

Crosby, Edward "Ed" B. (1868-1925) (Santa Maria)
Set painter, manager of a theater troupe, 1889. Later a house painter in the Bay Area.
1889 – "House, Sign and Carriage Painting, Kalsomining and decorating, E. B. Crosby, Painter & Decorator… Call at my office in Jones & Lucas' Block, Santa Maria, Cal.," *SMT*, July 20, 1889, p. 4.
1925 – "Funeral for Edward Crosby… Mr. Crosby moved from Santa Maria 32 years ago and has made his home in the north since that time….," *SMT*, March 27, 1925, p. 5.
Crosby, Ed (misc. bibliography)
Edward B. Crosby, house painter, is listed in the Bay Area according to various city directories c. 1900-25; Edward Crosby, 1868-1925, is buried in Santa Maria Cemetery District per findagrave.com (ref. ancestry.com).
See: "Jones, O. L.," 1889

Croswell, Mary Ella Tanner (Mrs. Dr. Thomas R. Croswell) (1870-1953) (Santa Barbara / Glendale)
Head of art department at Santa Barbara Teacher's College (c. 1918-1941) and County Art Chairman of women's clubs, who spoke several times on art to northern Santa Barbara county groups.
■ "Funeral Services for Mrs. Mary Croswell, 82, head of the art department at Santa Barbara State College for 25 years prior to her retirement in 1941… Mrs. Croswell was the widow of Dr. Thomas R. Croswell, a UCLA professor who died in 1951. She was born in Berlin, Wis., graduated from Brooklyn's Pratt Institute, and had lived in Glendale 50 [Sic.?] years," per findagrave.com
Croswell, Mary T. (notices in Northern Santa Barbara County newspapers on microfilm and on newspapers.com)
1927 – "Club Women of Northern Part of County Meet… Art Chairman Speaker. Mrs. M. Croswell, head of the Art department at the Teachers' College in Santa Barbara and county chairman of Art was the main speaker of the afternoon. The main requirement of an art chairman for any club is a love of beauty and not necessarily an art education, Mrs. Croswell said. The importance of the teaching of drawing and art work in schools that children may gain an appreciation of beauty, the necessity of children being taught to do things well, and the field in commercial art as a means of making a living….
'Education should be the means of teaching children to be better citizens,' was the gist … Mrs. Croswell had an interesting display of art work done by the students of the Teachers' College, which included posters, Batik work on shawls and scarfs, pottery and elementary book binding. Mrs. Croswell urged the forming of clubs in the small communities where women could learn to make beautiful things for themselves. 'There are not enough well-trained students to fill the demand in commercial art work,' the speaker stated in her point on application of art in industry.

'Advertising is becoming more and more important in selling goods, and art work is in great demand'," *LR*, April 22, 1927, p. 6.

1935 – "New Art Courses in State College… In addition to securing a degree and a certificate to teach art in elementary or secondary schools, students may now prepare to teach handicrafts to handicapped individuals in special schools and recreational art activities on playgrounds. The Santa Barbara college is the only school offering these two types of training Mrs. Croswell states," *SMT*, Aug. 30, 1935, p. 3.

Croswell, Mary T. (misc. bibliography)
Portraits of her appear in many Santa Barbara State Teacher's College yearbooks, 1932-42; Mary Ella Tanner Croswell b. Dec. 5, 1870 in Berlin, Wisc., d. June 28, 1953 in Glendale, Ca., and is buried in Forest Lawn Memorial Park (Glendale) per findagrave.com (refs. ancestry.com).
See: "Four-H," 1934, "Guadalupe Welfare Club," 1927, "Home Department," 1933,"Lompoc, Ca., Elementary Schools," 1937, "Orcutt Women's Club," 1927, "Santa Ynez Valley, Ca., Elementary School," 1926

Crow, Augusta Zabel (second wife of Judge Samuel Eugene Crow) (1870-1963) (Santa Barbara)
Santa Barbara artist who exh. in a show sponsored by the College Art Club at city hall, Santa Maria, 1935.

■ "Augusta L. Zabel. Painter. Born in California on June 10, 1870. … She died in Ojai, Ca., on April 15, 1963. Her work includes landscapes of the San Francisco Bay area," Edan Hughes, *Artists in California 1786-1940*;
And she is listed in Ellen Halteman (*PSCA*, vol. 7).
Crow, Augusta (notices in Northern Santa Barbara County newspapers on microfilm and on newspapers.com)
1890 – "High School Commencement… at First Congregational Church… The graduates were as follows: … Augusta L. Zabel," *SF Chronicle*, May 24, 1890, p. 3.
1902 – "Authorized to Teach. Oakland. The County Board of Education granted teachers certificates to-day as follows… Primary… Augusta L. Zabel," *SF Chronicle*, April 20, 1902, p. 11; "Certificates Granted to Many New Teachers. Alameda County Board of Education… Life diplomas – … Augusta L. Zabel…," *SF Call*, April 20, 1902, p. 31.
1904 – "Starr King [Fraternity] Art Exhibit… Wendte Hall … Many canvases by non-professionals are being shown. Among the contributors are … Miss Augusta Zabel…," *Oakland Tribune*, Feb. 22, 1904, p. 2 and the *SF Call*, Feb. 21, 1904, p. 36; "Clever Young Artists Enjoy Commencement … California School of Design… The awards of the examining board… Night class (honorable mention life class) –… Augusta L. Zabel…," *SF Call*, May 14, 1904, p. 14; "Changes Made Among Teachers… Leaves of absence were granted to … Miss Augusta Zabel, a substitute…," *SF Chronicle*, Dec. 30, 1904, p. 13.
1906 – "Nine Couples Will Take Marriage Vows… Samuel E. Crow, 45, of Santa Barbara, and Augusta L. Zabel, 35, of Oakland," *Oakland Tribune*, July 9, 1906, p. 12; "Oaklander… Miss Augusta Zabel, daughter of J. J. Zabel, Monday became the bride of S. E. Crow, an attorney of Santa Barbara… The honeymoon is to be spent in Alaska. On their return the couple will reside in Berkeley…," *SF*

Examiner, July 12, 1906, p. 9; "On Monday evening last Miss Augusta Zabel became the bride of S. E. Crow, an attorney of Santa Barbara. The bride… in Oakland where she has lived all her life. She is an artist of more than passing merit, several really good exhibits of her work having been hung in the last Art Association exhibit at Oakland…," *SF Call*, July 12, 1906, p. 8; "Teachers Are Granted Leaves of Absence…by Board of Education… The resignation of Augusta Zabel Crow as a teacher in the department was accepted," *SF Call*, July 20, 1906, p. 13.
1920 – "Women Called to the 1920 Grand Jury. For the first time in Santa Barbara county…," *LR*, Dec. 12, 1919, p. 6.
1941 – "Judge S. E. Crow Passes at 80… Samuel Eugene Crow… admitted to the bar in 1883… He removed to Santa Barbara about 1891 … He is survived by his widow, Augusta Z. Crow, a son, Carl Crow of San Francisco…," *SMT*, April 24, 1941, p. 7; and several articles on her pre-marriage social activities (Unity Club) in the Bay Area were not itemized here.
See: "College Art Club," 1935

Crow (Watson), Kate Alisa Sedgwick "Miss Allie"? (first wife of Samuel E. Crow) (Mrs. John [Marion, Nathaniel] Watson) (1866-1967) (Santa Maria)
Milliner. In 1888 won "best exhibit" in the Santa Barbara County Fair. In 1891 exhibited Best marine painting and Best fruit painting at Santa Barbara County Fair.

■ "Kate Watson. A Christian Science funeral… Mrs. Watson died Tuesday in a Bakersfield Hospital. She was born April 17, 1866 in Stockton and had lived in Arvin for the past seven years. She had formerly lived in Santa Maria for many years and was a member of the Eastern Star… Mrs. Watson was preceded in death by her husband, John Watson, in 1928," *SMT*, March 15, 1967, p. 4.
Crow, K. A., Mrs. (notices in Northern Santa Barbara County newspapers on microfilm and on newspapers.com)
1883 – "Surprise Party…," attendees include Allie Sedgwick and S. E. Crow, *SMT*, Sept. 29, 1883, p. 5.
1884 – "Judge Crow, our popular young attorney, has found a mate in the sprightly daughter of Mr. Chas. Sedgwick…," *SMT*, Nov. 29, 1884, p. 5, col. 2.
1889 – DAUGHTER – "Died in Santa Maria, Feb. 9th, 1889, after an illness of 16 days, Lois, only daughter of S. E. and K. A. Crow, aged two years lacking 13 days… Lois had spent the greater part of her short life with grandfather and grandmother…," *SMT*, Feb. 13, 1889, p. 3.
1891 – "Miss Francis Fulton's entertainment at McMillan's Hall… excellent programme… [music]… Graceful and artistic posing by the following ladies… Mrs. K. A. Crow…," *SMT*, Oct. 17, 1891, p. 3.
1892 – "Married. Watson-Crow – At the Ramona, San Luis Obispo, Tuesday, Dec. 13th, 1892, John Watson and Mrs. K. A. Crow, both of Santa Maria…," *SMT*, Dec. 17, 1892, p. 3.
1928 – "Mrs. K. A. Watson, wife of John Watson of Santa Maria… has filed certificate and oath of office as deputy sealer under C. A. Page, appointed to succeed her husband. Mrs. Watson was Mr. Watson's deputy, he resigning because of ill health," *SMT*, July 6, 1928, p. 1.

And, 45 notices in the *SMT* between 1890-1892 about her millinery shop, located next door to the post office, were not itemized here.

Crow, K. A., Mrs. (misc. bibliography)
Kate E. Sedgwick, age 14, b. c. 1866 in California, was residing in Stockton, Ca., with her parents: Charles Sedgwick (age 50) and Mary A. Sedgwick (age 39) and younger brother Thomas C. (age 7); Kate Alisa Sedgwick married S. (Samuel) E. Crow on Nov. 24, 1884 in Santa Maria per *California County Birth, Marriage and Death Records*; [Divorced him.] Kate A. Crow married John N. Watson on Dec. 13, 1892 in Los Berros, SLO County, per Calif. Select Marriages; Kate Alida Sedgwick was b. April 17, 1866 in California to Charles Sedgwick and Mary Ann Clements, married John N. Watson, was residing in Santa Maria, Ca., in 1920, and d. March 15, 1967 in Kern County per Iron Mike's Family Tree (refs. ancestry.com).
See: "Santa Barbara County Fair," 1888, 1891, "Watson, Mrs.," and *San Luis Obispo Art and Photography before 1960*

Cub Scouts
See: "Boy Scouts"

Cucchetti, Janice "Jan" Marie
See: "Westrope (Cucchetti), Janice "Jan" Marie (Mrs. 1st Lt. Robert P. Cucchetti)"

Culp, Cora (Santa Maria)
Winner of an art scholarship to Santa Maria School of Art, 1927. Drawing repro. in Splash, 1927, and she designed the Splash cover, 1928.
See: "Santa Maria School of Art," 1927, "Splash," 1927, 1928

Cummins, John Ferdinand (Lompoc)
Teacher of history and manual training at Lompoc High School, 1931-35.
Cummins, John F. (notices in Northern Santa Barbara County newspapers on microfilm and on newspapers.com)
1935 – "Two More Local Teachers Leave… Formal resignations of … Ferdinand Cummins…," *LR*, July 12, 1935, p. 1.
1936 – "Teacher Here. J. F. Cummins, former teacher in the junior high school here, visited… Cummins is teaching at Greenville high school in Plumas county," *LR*, Dec. 25, 1936, p. 4; and more than 50 additional social and school notices not itemized here.
See: "Lompoc, Ca., Union High School," 1931, 1933, 1934

Curie, Paul S. (La Purisima)
Photographer of a view of Mission La Purisima reproduced on cover of Chamber of Commerce folder, 1940. Senior clerk in the NPS office at the CCC camp.
See: "Mission La Purisima," 1940

Curlee, Wallace Charles, Jr. (1914-1997) (Fillmore / Santa Barbara)
Fillmore artist and member Santa Barbara Art Association, who exh. "Hungry Birds" at opening exh. of Allan Hancock College Art Gallery, 1954. Frequent exhibitor at the Santa Paula Art Show, post WWII.
Curlee, Wallace (notices in California newspapers on microfilm and on newspapers.com)
1949 – Repro: "Green Bottle," *Ventura County Star-Free Press*, Aug. 22, 1949, p. 8.
1952 – Repro: scene of the big top, selected as one of the best six pictures exhibited in the 16th annual Santa Paula Art Show…," *LA Times*, Aug. 7, 1952, p. 44 (i.e., Pt. II, p. 10); ad: "An Exhibition of Oil Color Paintings by Wallace Curlee, Fillmore, California (Winner of the Purchase Award for Best in Show at last year's Santa Paula Annual Exhibition.), County Stationers, Ventura," *Ventura County Star-Free Press*, Oct. 31, 1952, p. 3.
1996 – Exh. at Santa Paula Union Oil Museum "…Wallace Curlee's 'Circus Elephants' … deliver on the promise of their titles, but with rough charm to spare," *LA Times*, Feb. 8, 1996, p. 265 (i.e., "Ventura County Weekend," "Sights," p. F 13).
And, additional notices on his art in the *Ventura County Star-Free Press*, 1949-54 were not itemized here.
Curlee, Wallace (misc. bibliography)
Is he Wallace C. Curlee listed in the 1940 U. S. Census as age 26, b. c. 1914, finished college, 3rd year, bookkeeper, single, residing in Newton, N.C., with his sister Virginia C. Huss (age 28) and her husband John B. Huss (age 30); Wallace C. Curlee is listed as Dem. in *Index to Register of Voters, Los Angeles*, 1948; Wallace C. Curlee, artist with no wife, is listed at 608 Saratoga in the *Oxnard, Ca., CD*, 1949, 1952; Wallace Charles Curlee was b. Feb. 9, 1914 in Catawba, N. C., to Wallace Charles Curlee and Minnie Dora Sigmon, and d. Dec. 17, 1997 in Long Beach, Ca., per Daniel/Bailey/White/Romine Family Tree (refs. ancestry.com).
See: "Allan Hancock [College] Art Gallery," 1954

Currens, William "Bill" Ahlin (1932-2014) (Santa Maria / Nipomo)
Commercial art student at Allan Hancock College who created the cartoons in the Mascot, 1955. Son of artist Maja Lisa Currens of Morro Bay.
■ Port. and "Betrothal Announced. Miss Emma Dora Longest... to William Ahlin Currens... Currens is now training to be a commercial artist. He attended Allan Hancock College here and graduated from Gresham Union High School, Gresham, Ore. ... also served with the U. S. Navy," *SMT*, Oct. 2, 1957, p. 3.
Currens, William (misc. bibliography)
William Currens is listed in the *Santa Maria, Ca., CD*, 1958, 1959, 1961; William A. Currens is listed in the *Pasadena, Ca., CD*, 1968; William A. Currens, b. June 1932, was residing in Nipomo in 1977 per *U. S. Public Records Index, 1950-1993*, vol. 1; William A. Currens b. June 25, 1932, d. July 13, 2014 per Kieffer Family Tree (refs. ancestry.com).
See: "Allan Hancock College," 1955, "Taylor, James," 1955

Curryer, Chas (Charles A. or E. or V.) (1864/5-1925) (Santa Maria)
Exh. pencil cartoon at "Santa Barbara County Fair," 1890.

■ Thirty-seven notices in the *SMT* between 1880 and 1920 for "C. V. Curryer" and another 36 for "Chas Curryer" and 23 for "Charles Curryer" reveal he was raising Belgian hares, sold pumps, was involved in a number of building projects, ran the Pioneer Harness Shop (1888-89), had a son named "Charles A. Curryer" who served in WWI, and had a socially active wife, but they were not itemized here.

Curryer, Chas (misc. bibliography)
Charles V. Curryer, age 25, b. c. 1865 in Ohio, a carpenter, left eye blind, residing in Santa Maria, registered to vote Aug. 4, 1890 per *Great Register, Santa Barbara County, California*, 1890 [and on the lines below him appear his brothers (?) George Willard (age 31) a truckman, and John Squire (age 34) a teacher; is he Charles A. [Sic. V.?] Curryer who married Sallie Sharp Allott in Santa Barbara County in 1891 per Western States Marriage Index; Charles V. Curryer had a patent on three homesteads, 1892, per *U. S. General Land Office Records*; Charles V. Curryer, age 41, a carpenter of Orcutt, Ca., is listed in *California Voter Register, La Graciosa Precinct*, c. 1906?; Chas V. Curryer, carp., with no wife, is listed in Orcutt in the *Santa Barbara CD*, 1909; Chas V. Curryer, carp. with no wife, is listed in the *San Pedro and Wilmington, Ca., CD*, 1914; Charles V. Curryer, b. c. 1864, d. Oct. 16, 1925 in Los Angeles County per Calif. Death Index ((refs. ancestry.com).
See: "Santa Barbara County Fair," 1890

Curryer, Dora Adelaide Baker (Mrs. George Willard Curryer) (1867-1962) (Santa Maria / San Francisco)
Exh. landscape, flowers at "Santa Barbara County Fair," 1891.
1900 – "Mrs. G. W. Curryer expects to return to her San Francisco home next Tuesday. Grandpa Baker will accompany her," *SMT*, April 14, 1900, p. 3, col. 2.
1909 – "Dora Curryer who was married to William [Sic.] Curryer on November 2, 1886 at Santa Maria charges that on October 5, 1901 she was deserted," *SF Chronicle*, Dec. 19, 1909, p. 58, col. 1.
Curryer, G. W., Mrs. (misc. bibliography)
Dora A. Baker married George W. Curryer in Santa Maria, Nov. 24, 1886 per *Calif. County Birth, Marriage and Death Records*; Dora Adelaide Baker was b. May 2, 1867 in Potter Valley, Ca., to Henry Womack Baker and Elizabeth Wilkerson, married George William Curryer, was residing in San Francisco in 1930, had a child, Carl Willard, and d. April 23, 1962 in Santa Rosa, Ca., per Calvin Family Tree (refs. ancestry.com).
See: "Santa Barbara County Fair," 1891

Curtis, Eliza (S/P?) (Mrs. W. W. (?) Curtis) (1836-after 1909) (Los Alamos)
Seventy-six-year old woman who exh. a sketch at Art Loan Exhibit, 1895.
1908 – "County Recorder's Office. ... land ... commencing at the northeast corner of the land owned by Eliza S. Curtis...," *Independent*, April 4, 1908, p. 5;
1909 – "Deed – Eliza S. Curtis to C. H. Pearson, 7:27 acres in block 1 of town of Los Alamos and lot 2 of block 3," *Independent* (Santa Barbara), Oct. 18, 1909, p. 4, col. 2;
Curtis, Eliza (misc. bibliography)
Is she Eliza S. Curtis listed in the 1880 U. S. Census as age 46, b. c. 1834 in Ohio, residing in Los Alamos, Ca., with W. W. Curtis (age 55); is she Eliza P. Curtis listed in the 1900 U. S. Census as age 64, b. June 1836 in Ohio, divorced, a farmer, residing in Los Alamos with a female boarder, a teacher (ref. ancestry.com).
See: "Art Loan Exhibit (Santa Maria)," 1895

Cuyama, Ca., art
Tiny town in the extreme NE corner of Santa Barbara County.
See: "Art, general (Cuyama)"

CWA Project
See: "Civil Works Administration," "Federal Art Projects"

Cyprian, Father (Solvang)
Oversaw restoration of Mission Santa Ines c. 1946-51.

■ "Father Cyprian Ends Work, Leaving Mission... After successfully directing a program of restoration at Old Mission Santa Ines the past five years... Father Cyprian came to the Mission in October of 1946. His assignment was for a three-year period and it was during this time that the first stages of the restoration program began... The restoration project grew in magnitude and Father Cyprian's stay at the Old Mission was extended another two years to enable him to 'see the project through.' Among the work completed... was the re-creation of a second story and living accommodations, rebuilding of a portion of the Mission building in the rear, the extension of archways in the same area, repairing of the plastered walls, the building of a parapet along the second story, and the replacing of the bell tower with one which conformed more closely to the one which fell in 1911...," *SYVN*, Nov. 9, 1951, p. 1.
See: "Mission Santa Ines"

D

Dabney (Hastings), Lee Adair (Mrs. James W. Hastings) (Santa Barbara / Bay Area)
Artist who exh. mobiles at Santa Ynez Valley Art Exhibit, 1954.
See: "Adair, Lee"

Dahlgren, John A. (Santa Maria)
Photographer. Prop. of Louise Studio, 1909-c. 1912.
John A. Dahlgren is listed in the 1910 U. S. Census as age
48, b. c. 1862 in Pennsylvania, a portrait photographer,
residing in Santa Maria with wife Louise Dahlgren (age 24)
(refs. ancestry.com).
See: "Louise Studio"

**Dal Porto, Gertrude B. Francis (?) (Mrs. Paul Samuel
Dal Porto) (1920-2001) (Santa Maria)**
*Demonstrator of leather tooling at Hobby Show, 1949,
1950. Interested in needlecraft, made copper pictures, and
fabricated puppet stages.*
Dal Porto, Gertrude (notices in Northern Santa Barbara
County newspapers on microfilm and on newspapers.com)
Over 30 matches for "Gertrude Dal Porto," and over 100
matches for "Mrs. Paul Dal Porto" (primarily regarding her
varied activities with the Junior Community Club) appear
in *SMT,* 1945-1960, but most were not itemized here.
Dal Porto, Gertrude (misc. bibliography)
Gertrude Francis Dal Porto was b. May 18, 1920 in Santa
Maria to Walter Raymond Bonilla and Augusta Victoria
Kehrer, married Paul Samuel Dal Porto, and d. Jan. 8, 2001
in Santa Maria, Ca., per Brickey Family Tree (refs.
ancestry.com).
See: "American Association of University Women," 1955,
"Camp Fire Girls," 1952, "Community Club (Santa
Maria)," 1949, 1950, "Junior Community Club," 1952,
1953, 1955

**Dalzell Hatfield Galleries, Ambassador Hotel (Los
Angeles)**
*Commercial art gallery that lent works by its stable of
artists to the Santa Maria Valley Art Festival, 1952.*
See: "Santa Maria Valley Art Festival," 1952

**Danch, William "Will" Gabriel aka "Carrie Carroll"
(1910-2004) (Indiana / California)**
Artist of "Santa Maria Sketches," 1940-41.
■ Port. and "Hard work and constant study have won for
Will Danch, 6034 Wallace road, Hammond, son of Mr. and
Mrs. Gabriel [E.] Danch, [Sr.] rapid promotions as a
cartoon humor writer and illustrator. Danch was the first
artist to sell comic drawings to *Delineator* magazine. He
has also sold drawing to *The New Yorker, The Saturday
Evening Post* and *The American Magazine.* During 1934 he
illustrated a World war news feature that appeared in Latin-
American newspapers. The Walt Disney Enterprises of
Hollywood are also interested in his work and out of
several thousand artists in New York city, he was selected
to receive special training in animation," *The Times*
(Munster, Indiana), Feb. 17, 1937, p. 49.
And, more than 1500 "hits" for "Will Danch" in Indiana
newspapers on newspapers.com, 1930-1960.
Danch, Will (misc. bibliography)
William Danch/Donch is listed in the 1940 U. S. Census as
age 29, b. c. 1911 in Indiana, finished high school 4th year,
a cartoonist, residing in Hammond with his parents Gabriel
Danch/Donch (age 52) and Pauline Danch/Donch (age 47)

and younger brother John (age 23); Will Danch married
Margene Meyn on Nov. 16, 1940 per Indiana, U. S.
Marriages; William G. Danch provided the following
information on his WWII Draft Card dated Oct. 16, 1940,
employed by Esquire Features, Inc., and residing in West
Los Angeles, Ca.; William Gabriel Danch was b. May 14,
1910 in Hammond, Ind., to Gabriel Danch and Pauline
Ridzi, married Margene Reiter Meyn, and d. Oct. 6, 2004
in Ventura, Ca. per Melichar-Wilke Comprehensive Tree
(refs. ancestry.com).
See: "Santa Maria Sketches"

**D'Andrea, Martino Angelo "Martin" (1887-1950)
(Santa Barbara)**
*Artist who exh. in National Art Week show at Minerva
Club, 1940.*
D'Andrea, Martin (misc. bibliography)
Martin D'Andrea is listed without occupation or wife in the
Santa Barbara, Ca., CD, 1937, 1940, and as "artist," 1944;
Martino Angelo "Martin" D'Andrea was b. July 22, 1887
in San Martino Annita, Italy to Angelo D'Andrea, was
residing in Phoenix, Ariz. in 1932, and d. Feb. 16, 1950 in
Los Angeles per Dana Perdau Family Tree Master (ref.
ancestry.com).
See: "National Art Week," 1940

Daniel, Mann, Johnson and Mendenhall (Los Angeles)
Architects of several buildings on the Central Coast.
■ "Architectural Firm Honored... known in the Santa
Ynez vicinity for design of the Santa Ynez Valley High
School... also designed schools in nearby school districts
such as Lompoc, Blockman, Orcutt, and Guadalupe. The
firm also designed schools in Santa Maria, including the
high school and several elementary schools," *SYVN,* May
13, 1955, p. 14.

Daniels, Charles Cabot (1889-1953) (Santa Barbara)
*Santa Barbara painter of portraits and landscapes who
exh. in a show sponsored by the College Art Club at city
hall, Santa Maria, 1935.*
Daniels exhibited at the *Allied Arts Festival,* Los Angeles
Museum, 1936 where he won a silver medal, at the
Corcoran Gallery of Art, Washington, D. C., 1937, and at
the San Francisco Art Association, 1938 per rogallery.com.
And, he exhibited at the **Golden Gate International
Exposition,** 1939, and at Montecito County Club, 1940, per
Edan Hughes, *Artists in California, 1786-1940.*
Daniels, Charles Cabot (notices in California newspapers
on newspapers.com).
1913 – "Cabot Daniels of Grafton and a friend, Paul Pier,
expect to sail from New York today for Italy. They will
remain a year or more in Rome," *Rutland Daily Herald,*
Feb. 22, 1913, p. 9, col. 6.
1915 – "Grafton. ... Cabot Daniels returned to Grafton
Saturday after being abroad two years and two months,
seeing the countries of Italy, Germany, Austria,
Switzerland and Greece and studying the different
languages. Mr. Daniels was in Italy a year and a half. Mr.
Piel of New York, with whom he went, is still at Naples.

Mr. Daniels did not return on account of the war and expects to go to Italy again in the fall ... [and newspaper editorial comments on upcoming war] ... Mr. Daniels says that Greece was the most impressive country in which he traveled, Italy the most fascinating, Germany the most comfortable. He also calls Vermont scenery unequalled by any other that he has seen," *Brattleboro Reformer* (Brattleboro, Vt.), May 27, 1915, p. 7.

1918 – "Cabot Daniels has enlisted in the U. S. army hospital No. 12, which is located at Biltmore, N. C. and left Grafton Monday morning to take the required course in training before starting for the front," *Brattleboro Daily Reformer* (Brattleboro, Vt.), June 13, 1918, p. 8, col. 4; "Brattleboro Local... Cabot C. Daniels of Grafton, who has been in Chicago, has gone from Brattleboro to Biltmore, N. C. having been inducted into the service as a scenic painter on special order," *Brattleboro Reformer*, June 14, 1918, p. 5.

1922 – "Summons. In the Third Judicial District Court in and for Salt Lake County, State of Utah. Charles Cabot Daniels, plaintiff, vs. Utah Sulphur Corporation... request for approval of its sale of the real and personal property of the defendant...," *Deseret News* (Salt Lake City, Ut.), Sept. 26, 1922, p. 14.

1924 – "Married Here. Weddings of out-of-town people continue. Grace G. Lange of San Francisco and Charles Cabot Daniels of Los Gatos were married yesterday noon at the home of the officiating justice, C. C. Houck," *Santa Cruz Evening News*, Aug. 28, 1924, p. 6.

1926 – "Mr. and Mrs. Cabot Charles Daniels of Los Gatos are sailing on June 26 for New York via the Canal to spend four months with Mr. and Mrs. Charles Daniels at their country home in Grafton, Vermont," *SF Examiner*, June 20, 1926, p. 64, col. 2 (i.e., p. 2S).

1932 – "Sewage System Causes $3000 Suit. Charles Cabot Daniels and his wife, Grace Daniels... purchased from Mrs. Patterson two lots... in the Mission Canyon district outside the city limits," that needed a septic tank but didn't have the required space for 400 feet of legal leaching...," *Ventura County Star and the Ventura Daily Post*, June 9, 1932, p. 12.

1935 – "Grafton... Friends of Cabot Daniels may be interested to know that he has attained quite some reputation in California as a portrait painter. He is doing some etchings also. His exhibits in the cities of California have received most favorable comments with first prizes...," *Springfield Reporter* (Springfield, Vt.), June 27, 1935, p. 21.

1937 – "Cabot Daniels, who has had a portrait on exhibition at Corcoran Galleries, Washington, D. C. has been asked by the Art Institute of Chicago to exhibit this portrait there," *Springfield Reporter* (Springfield, Vt.), June 10, 1937, p. 18, col. (4).

1938 – "Exhibition and Program Reviews... San Francisco Art Association's annual at the San Francisco Museum of Art... They are Still Good. Mentioning oils ... Other workers in oil: ... Cabot Daniels, Santa Barbara – 'Portrait of a Young Man' a good work...," *Oakland Tribune*, April 3, 1938, p. 47 (i.e., S9).

1940 – "Exposition Luncheon Honors State Artists... [whose works are on view at the **Golden Gate International Exposition**] ... Poll of Visitors... superior items as ... and Charles Cabot Daniels...," *SF Examiner*, July 16, 1940, p. 10; "For British refugee children and British Red Cross war relief, artists of Southern California have placed on exhibit 50 outstanding oils, water colors and etchings at the Montecito Country Club... Artists participating include ... Charles Cabot Daniels...," *LA Times*, Aug. 26, 1940, p. 9 (i.e., pt. I, p. 7).

1941 – "Arms Sought by Home Guard... Santa Barbara... Cabot Daniels, acting commander," *LA Times*, July 12, 1941, p. 21.

And, more than 120 hits for "Cabot Daniels" in United States newspapers on newspapers.com between 1913 and 1958 were not even browsed for itemization here.

<u>Daniels, C. (misc. bibliography)</u>
Cabot Daniels is listed in the 1900 U. S. Census as age 1 [Sic. 10 ?] b. March 1899 in Nebraska, residing in Chicago, Ill. with Charles and Gertrude Daniels; Cabot Daniels appears in the yearbook of Phillips Academy, Andover, Mass., 1908, stating his home is Chicago, Ill.; Cabot Daniels is listed in the *Harvard University Alumni Directory*, 1913; Cabot Daniels applied for a passport, issued Feb. 18, 1913, stating he resided at Grafton, Vermont, he was a student, he was about to go abroad temporarily and he intended to return to the United States in about two years, and he wanted the passport to be sent to 245 West 72nd St., NYC, per *U. S. Passport Applications*; "Certificate of Registration of American Citizen... Naples, Italy... Charles Cabot Daniels is registered as an American citizen. He was born March 7th, 1889 at York, Nebraska... He left his residence in the United States on February 1913 and arrived in Naples, Italy on March 1913 where he is now residing for the purpose of embarking for America... The person to be informed in case of death or accident is Charles Daniels, 945 Marquette Building, Chicago, Illinois. ...," *U. S. Consular Registration Certificates, 1907-1918*; Cabot C. Daniels provided the following information on his *WWI Draft Registration Card, Chicago, Ill.*, b. March 7, 1889, "present trade = general law office. By whom employed = Charles Daniells..."; "*Roster of Vermont Men and Women in the World War, 1917-1919*, ... Daniels, Cabot, 2,593,968. Res: Grafton. Born at York, Neb., Ind: June 6, 1918, Chicago, Ill., Org: 12th Gen. Hosp., Biltmore, N. C. to Feb. 1, 1919; QMC Det., 12th Gen. Hosp., to disch. Grades: 1/c Pvt. July 24, 1918. Disch: Apr. 29, 1919, Biltmore, N.C."; Charles C. Daniels is listed in the 1930 U. S. Census as age 41, b. c. 1889 in Nebraska, a writer in the magazine industry, residing in Redwood, Santa Clara County, Ca., with wife Grace and a servant; Charles C. Daniels is listed in the 1940 U. S. Census as age 51, finished high school 4th year, a portrait painter, residing in Santa Barbara with wife, Grace G. Daniels (age 51); Charles Cabot Daniels provided the following information on his *WWII Draft Registration Card, 1942*, age 53, b. York, Nebraska, on March 7, 1889, employed by self, at home, and name of person who will always know his address as Grace G. Daniels, Montrose Road, Santa Barbara; Charles C. Daniels, artist, is listed with wife, Grace, in *Santa Barbara CD*, c. 1934-53; Charles Cabot Daniels, mother's maiden name Grippen, was b. Nebraska March 7, 1889 and d. Aug. 19, 1953 in Santa Barbara per Calif. Death Index; Cabot Daniels is buried in Santa Clara Mission Cemetery per findagrave.com (refs. ancestry.com).

See: "College Art Club," 1935

Daniels, Elizabeth "Betty"
See: "Hosn (Daniels), Elizabeth "Betty" Baclu (Mrs. James Hosn) (Mrs. Walter Daniels)"

Danish Days (Solvang)
Annual celebration, held June, then August, starting in 1936, to celebrate Solvang's Danish heritage through food, music, dancing, parades, and an exhibit of heirlooms lent by local families. In 1951-53 Viggo Brandt-Erichsen oversaw a play and painted its scenery. A film was made of Danish Days, 1956. In 1957 and 1958 Danish Days incorporated the Santa Ynez Valley Art Exhibit. The celebration was cancelled, 1959.

■ "Growth of Danish Days... Danish Days is strictly a voluntary affair... Beginning as a small community event, it was originally a one-day affair and was usually held on the fifth day of June. This date commemorated the adoption of the Danish constitution and is known in the native language as 'GrundlovsDag.' [originally] a day set aside each year for a community get-together... Simplicity was the keynote... The festival, if it could be called that, remained on the more simple plane until 1936 when the Solvang community celebrated its Silver Anniversary... The festival in 1936 began on a Friday evening with a torchlight parade and procession to Atterdag Bowl... [organ recital, Scandinavian folk dancing, fairy dancing, games, stunts, horseshoe contests... dedication of Solvang's park ... banquet, street dancing, Mass, parade, Viking Pageant, concert.] ... a halt was called due to World War II... revived after World War II with a most interesting two and a half day program in 1947... More and more out-of-towners began to learn of Danish Days. And 1947 also marked the year the town received publicity in the *Saturday Evening Post*... last year... The small community of Solvang, population probably less than 1,000, played host to more than 5,000 visitors... [and article lists admission charges to various events]," *SYVN*, June 9, 1950, p. 2.
"Memo Pad" and history of Danish Days, *SYVN*, Aug. 6, 1954, p. 1; "Danish Days," history, *SYVN*, Sept. 17, 1954, p. C-6.
Danish Days (notices in Northern Santa Barbara County newspapers on microfilm and on newspapers.com)
1947 – "Solvang Preparing... Craft Exhibit. A Danish craft exhibit will be held at the Veterans Building on Saturday afternoon under the direction of Mrs. Alice Tvede... Persons wishing to place articles on exhibition at the Veterans' Memorial building are asked to contact Mrs. Vett...," *SYVN*, May 23, 1947, p. 1.
1948 – "Danish Days Starts Tomorrow," but only costumes, dances, food, gymnastics, horses, i.e., NO displays of any kind, *SYVN*, Aug. 6, 1948, p. 1.
1949 – "Solvang Relives Danish Customs" and celebration includes display of Danish iron, brassware and woodwork at the Veterans Memorial Bldg., *SMT*, July 25, 1949, p. 1; "Danish Days Festival... In the afternoon attention will focus on the Danish display and bazaar scheduled to start at 1:30 p.m. at the Veterans' Memorial Building. The smaller

meeting room of the Memorial Building will contain an exhibit of Danish art work, brass, copper and needlework, while the large auditorium will be the scene of the bazaar...," *SYVN*, July 8, 1949, p. 1; "Danish Days Coming...," *SYVN*, July 15, 1949, p. 1; "Old-Fashioned Bazaar... Veterans Memorial Building... 13 Valley organizations have entered booths... **Danish ladies aid**, which will feature the sale of homemade dolls... the Bethania guild which will offer for sale hand-made aprons ... [and many booths for food]... The exhibit, which will be open to the public tomorrow and Sunday afternoon, will feature the display of many heirlooms and art pieces of rare value. Included will be a display of chinaware, copper work, pipes, needlework, silverware, porcelain and pictures," *SYVN*, July 22, 1949, p. 1.
1950 – "Big Attendance Expected Next Weekend for Annual Danish Days ... Beginning at 12:30 P.M. Saturday, the doors to the authentic Danish display and exhibit will open at the Veterans' Memorial building. The exhibit will feature priceless heirlooms from the old country, including lacework, art, copper pieces, porcelain, china and silver," *SYVN*, June 2, 1950, p. 1; "Expect Record Crowd for Two-Day Festival," *SYVN*, June 9, 1950, p. 1; "Bazaar, Exhibit Planned for Memorial Hall... 12 noon ... til 5 p. m.... Danish exhibit of heirloom and priceless pieces of art from the native country... booths at the Bazaar are... **Forrest Hibbits** who will exhibit his work and art crafts he has on display at his shop in Buellton...," *SYVN*, June 9, 1950, p. 1; "Free Portraits Offered Tomorrow. **Forrest Hibbits**, one of California's outstanding artists and now a resident of Buellton, will... [do] eight to 10 pastel or ink sketches of that number of lucky visitors. Hibbits will do the sketches free of charge with the Danish Days Committee footing the bill. Numbered tickets, entitling the holder to a free portrait will be passed out to the fortunate individuals at the Aebleskiver breakfast and afternoon luncheon at the Memorial Building," *SYVN*, June 9, 1950, p. 1; "Community 'Recovering' After Big Danish Days Celebration," *SYVN*, June 16, 1950, p. 8.
1951 – "**Brandt-Erichsen** Appointed 1951 Danish Days Chairman...," *SYVN*, March 2, 1951, p. 5; "Completed Plans for Solvang's Annual Danish Days Unfolded... **Brandt-Erichsen**... several innovations... a Hans C. Andersen fairy tale parade through Solvang to Atterdag bowl and a Hans C. Andersen pageant following the parade at the bowl... [and then as in earlier years] display of Danish heirlooms...," *SYVN*, June 1, 1951, p. 1; "Danish Days Celebration Set... Fairy Tale Tableaux... Atterdag Bowl in the afternoon when a series of Hans Christian Andersen fairy tale tableaux will be presented beginning at 3 p.m. ... The bowl and its stage will assume the aspects of Dyrehaven (Deer Garden) the beautiful forest a few miles from Copenhagen... chairman **Brandt-Erichsen**, an artist and sculptor of note, is now completing a huge oil painted backdrop for the stage, providing the setting of the house and beautiful forest...," *SYVN*, July 27, 1951, p. 1; "Solvang's 'Danish Days' Celebration to Draw Big Crowd on Weekend...," and lengthy article," *LR*, Aug. 2, 1951, p. 9; "Exhibit Tomorrow, Sunday... authentic display and exhibit staged at the Veterans' Memorial Building. This year the exhibit is being managed by the Solvang Woman's Club... On exhibition will be ... chinaware, copper, brass

and iron art, clay pipes, needlework, silverware, porcelain and art work. Many of the items… have been part of Solvang families for many years. Most of the articles were made in Denmark…," *SYVN*, Aug. 3, 1951, p. 5; "Solvang Recuperates After Big Danish Days Festival," *SYVN*, Aug. 10, 1951, p. 1.

1952 – "Rehearsals for Danish Days Comedy are Now in Full Swing … 'Jeppe on the Mountain'… The play was translated from Danish by **Viggo Brandt-Erichsen**, who is director and who also has been working during the past few weeks in painting and constructing the scenery…," *SYVN*, July 18, 1952, p. 3; "Danish Art Needed for Exhibit… **Danish Ladies Aid** which is in charge of the exhibit… silver, copper, brass, iron and porcelain handwork, needlecraft, paintings …," *SYVN*, July 25, 1952, p. 1; "Solvang's Danish Days Scheduled for Week End," *LR*, July 31, 1952, p. 16; photo of women in Danish costume serving breakfast and "They're Here. Solvang's Danish Days…," [and] "Old Country Art, Family Heirloom Show… Veterans Memorial Building…," [and] Danish Comedy…," directed by **Viggo Brandt-Erichsen**, all in *SYVN*, Aug. 1, 1952, p. 1; "Publicity from Far and Wide Precedes Danish Days, '52," *SYVN*, Aug. 1, 1952, p. 2; port. of **Viggo Brandt-Erichsen** hanging a painting for the 'Jeppe' play scenery, *SYVN*, Aug. 8, 1952, p. 3.

1953 – "Danish Days Program Announced…," *SYVN*, May 29, 1953, p. 1; "Danish Days Play Cast… Mr. Brandt-Erichsen is also in the process of completing stage setting," and costumes, *SYVN*, July 10, 1953, p. 4; "Danish Days Here in Week," and schedule of events, *SYVN*, July 24, 1953, pp. 1, 8; "Danish Days Are Here," and photos, *SYVN*, July 31, 1953, p. 1; port. of **Viggo Brandt-Erichsen**, director of the play at Danish Days," *SYVN*, July 31, 1953, p. 1; "Danish Exhibit at Memorial Hall," *SYVN*, July 31, 1953, p. 7; "Danish Days Celebration Attracts Record Crowd," *SYVN*, Aug. 7, 1953, p. 1; photo of table with displays, *SYVN*, Aug. 7, 1953, p. 4.

1954 – "Innovation This Year: Farmers Market… There will be a maximum of 50 booths… Booths already reserved… Danish silver, D. E. Nielsen, jeweler … handmade Danish ceramics, **Helen Barbera** paintings featuring Valley scenes, **Forrest Hibbits** of La Petite Galerie…," *SYVN*, May 21, 1954, p. 2; "Torchlight Parade to Signal Start of Danish Days Aug. 6," and additional details, *SYVN*, July 16, 1954, p. 1; "Danish Days Arrive… **Ray Paaske** Festival Chairman… Also scheduled for tomorrow afternoon is the exhibit of Danish arts and crafts and folk dancing at the Veterans' Memorial Building…," *SYVN*, Aug. 6, 1954, p. 1; "Exhibit Tomorrow, Sunday. … exhibit of Danish arts and crafts… family heirlooms… Veterans' Memorial Building… silver, copper, brass, porcelain, needlecraft, paintings, literature, handicrafts, and handmade articles of wood," *SYVN*, Aug. 6, 1954, p. 1; Solvang Hosts thousands Over Danish Days Weekend…," *SYVN*, Aug. 13, 1954, pp. 1, 8.

1955 – "**Ray Paaske** Again Heads Danish Days," *SYVN*, April 1, 1955, p. 4; "Danish Days… Set for Solvang Aug. 5-7… and added features will be a flight breakfast to be prepared and served by the Valley Flying Club at the County airport in Santa Ynez… [and] a soccer game…," *SYVN*, July 15, 1955, p. 1; ■ "Solvang and the Santa Ynez Valley as a whole are in the midst of preparing for one of

the most colorful summer festivals on the Pacific Coast – Danish Days, scheduled in the Danish American community Friday evening through Sunday Aug. 5-7. … Townspeople will don native attire, revive old world customs and serve Danish food in an atmosphere typical of Denmark itself. The Danish and American flags will fly side by side. Danish music will fill the air and the sound of folk dancers' feet on the pavement in front of Danish style Copenhagen Square will be heard by the thousands of visitors expected to swell Solvang's normal population count of 1350 to over 6000. …Scheduled for both Saturday and Sunday afternoons starting at 1:30 o'clock at the Veterans Memorial building are programs of folk dancing by groups from Santa Barbara and Ojai, as well as the annual display of Danish Arts and crafts. The arts exhibit features the showing of priceless heirlooms and treasured works of art coming from the homes of Danish-Americans in Solvang," per "Danish Days Set for Solvang, Santa Ynez Valley, Aug. 5-7," *SMT*, July 28, 1955, p. 17; "It's Danish Days… general chairman **Ray Paaske**…," *SYVN*, Aug. 5, 1955, pp. 1, 10; "Arts, Crafts Exhibit Due at Vets Hall … an added feature this year will be a commercial display of Danish and Danish-American art, gift items and other products from Solvang's gift shops, artisans and artists," *SYVN*, Aug. 5, 1955, p. 5; "Danish Days Fest Attracts Biggest Crowd in History," *SYVN*, Aug. 12, 1955, p. 1.

1956 – "Danske Dage" and port. of chairman **Ray Paaske**, and "Art, Crafts Display Set for Two Days … The exhibit is regarded as one of the most unique and interesting displays of its kind. Coming from Danish-American homes throughout the Solvang area, heirlooms and treasured works of art are placed on display… Another feature will be a commercial display of Danish and Danish-American art, gift items and other products from Solvang's gift shops, artisans and artists," *SYVN*, Aug. 10, 1956, p. 1; "Estimated Crowd of 11,000 Jams Solvang's Danish Days," *SYVN*, Aug. 17, 1956, p. 1.

1957 – "Danish Days Color Film Here Sunday. A 15-minute film in color, 'Festival in Solvang,' … will be shown at the Mission Theatre in Solvang this Sunday at 4:30 p.m. According to Robert Neubacher, who produced the film … made during last Summer's Danish Days…'it has been made principally as an educational film to be used in intermediate and junior high grades'… The film shows Danish Days in all its color … and exhibits of Danish arts and crafts. Featured, too, are local craftsmen at work including a metal worker fashioning a skillet of copper and iron, a weaver operating her loom, a demonstration of lace making and bakers making Danish pastries," *SYVN*, Jan. 4, 1957, p. 3; "Danish Days Color Film Wins Applause… filmed and produced by Robert B. Neubacher of Neubacher Productions of Los Angeles…," *SYVN*, Jan. 11, 1957, p. 6; "Solvang's Danish Days to Open Saturday … St. Mark's-in-the-Valley Art Exhibit and lengthy article, *LR*, Aug. 15, 1957, p. 3; "New Feature to D-Days… Mrs. Sigvard Hansen is general chairman of the art festival. **Dr.** and **Mrs. Walter B. Swackhamer** are in charge of checking in entries and **Mr.** and **Mrs. Charles Glasgow** will direct the hanging of pictures. The exhibit will be planned around a worship center at one end of the parish house. The paintings and works of art are being loaned for the worship center by a number of Valley residents, including **Father**

Tim O'Sullivan, OFM, … and **Mrs. Amory Hare Hutchinson**… Among the Valley artists who will exhibit are **Francis Sedgwick, Mrs. Albert Weisbrod, Paul Kuelgen, Oscar Lindberg, Forrest** and **Marie Hibbits, Martha Brandt-Erichsen, Leo Ziegler, Amory Hare Hutchinson, Charles Glasgow, Walter Swackhamer, Charles Sloane, Marie Venske, Grace L. Davison, Jeannette Davison, Joaquina Abbott, Eloise Joughin, Natalie Elliott, Thorvald Rasmussen,** Harold M. Young, **Ellen Gleason, Ida Belle Tallant,** Lee Taft [Mrs. Mervin Elroy Johnson], Venetia Gleason and **Mrs. Al Constans**," *SYVN*, Aug. 16, 1957, p. 5.
1958 – "Danish Days Honorary Membership Drive Set. … a means of raising funds for the staging of the colorful festival in Solvang on the weekend of Aug. 8-10…," *SYVN*, June 27, 1958, p. 1; photo of a painting of a man and a woman without heads that is popular comic photo prop for visitors, painted by **Mrs. Brandt-Erichsen**, *SYVN*, July 11, 1958, p. 1; "Fund Campaign Over Top… [and] One of the highlights … this year will be the festival of the California Folk Dance Federation. Hundreds of dancers… Old World Exhibit at Dania Hall… third annual Santa Ynez Valley Horse Show… at the Alisal Guest Ranch Arena… sixth annual St. Mark's-in-the-Valley Art Exhibit…," *SYVN*, July 25, 1958, pp. 1, 8; "Valley Artists Given Invitation to Enter Coming **St. Mark's Show**… sixth annual… limited again this year to artists of the Valley…," and entry information, *SYVN*, July 25, 1958, p. 1; "Memo Pad" discusses income and expenses of recent Danish Days, *SYVN*, Aug. 15, 1958, p. 2; "Readers' Corner. Danish Days Wins Praise…," *SYVN*, Aug. 15, 1958, p. 2.
1959 – "Danish Days Celebration Cancelled by Businessmen," *SYVN*, April 3, 1959, p. 1.
See: "Brandt-Erichsen, Viggo," "Davison, Jeannette," 1954, "Knudsen, Robert," "Kristensen, Walter," 1969, "Kuelgen, Paul," 1958, "Lindberg, Oscar," 1961, "Motion Pictures (Santa Ynez Valley)," 1955, 1957, "Museums," "Paaske, Raymond," "Santa Ynez Valley Art Exhibit," 1957, 1958, "Trudeau, Harold,"

Danish Ladies Aid
Group in charge of Danish art exhibit at Danish Days.
See: "Danish Days," 1949, 1952, "Handwork," 1929, "Jus Lookin'," 1954

Danish Village Gifts / Royal Copenhagen Gifts (Solvang)
Shop that sold ceramics (probably imported), 1946+.
Prop. Lyla and Larry Solum.

■ Photo of façade and, "Ms. Solum, who came to Solvang from San Diego, began on a small scale by opening a pottery shop in the present location of **Forrest Hibbits'** La Petite Galerie. Leaving the Southland and personnel work, Mrs. Solum launched her business in Solvang on a 'semi-retired' basis. The demand for pottery and later Royal Copenhagen porcelain and Danish imported gift items has resulted in the Danish Village Gift store of today. In 1947 Mrs. Solum moved 'up the street,' occupying a quarter of the building of her present location. When Ray and Erwin Paaske moved their furniture store

from the building to their new Copenhagen Square location, Mrs. Solum took over the entire building for her gift wares. Two years ago, further expansion was noted when the shop assumed space in the building to the rear of the shop for storage and packing purposes. Danish Village Gifts, a mecca for tourists the year 'round, specializes in handmade silver, Royal Copenhagen dinnerware and figurines, hand-made pewter and antique copper. Since its start, too, the gift shop has developed a large mail order business through the distribution of a catalogue … An innovation this year is the wholesale distribution of greeting cards throughout all of the states west of the Mississippi… Seen in the photo below are, from the left, Mrs. Bloom, Mrs. Solum, Miss Madsen and Mrs. Bjornson," *SYVN*, Sept. 17, 1954, p. 18 (i.e., 8).
Danish Village Gifts (notices in Northern Santa Barbara County newspapers on microfilm and on newspapers.com)
1948 – "Book Exhibition at Solvang Shop… Danish Village Gifts. Books on art, selected to further activities of the art workshop held recently in Solvang for teachers of the Valley … are also on exhibition," *SYVN*, Nov. 19, 1948, p. 8.
1950 – "Certificate for Transaction of Business under Fictitious Name. The undersigned hereby certifies that she is conducting a business …. at Main Street, in the town of Solvang… Danish Village Gifts and that the firm is composed of **Lyla G. Maxwell**, the sole owner…," *SYVN*, May 12, 1950, p. 7.
1959 – "Memo Pad… Announcement was made this week of the retirement of Mr. and Mrs. O. L. (Larry) Solum from their Danish Village Gifts business in Solvang… The firm, which was the first gift shop in Solvang, was started by Mrs. Solum (then Lyla G. Maxwell) in 1945 in a part of what was formerly called the Sunny Corner building at the intersection of First Street and Copenhagen Drive… later she moved the shop to its present location on the north side of Copenhagen Drive between Alisal Road and First Street… In 1951, Mrs. Maxwell and Larry Solum were married … recently the O. L. Solums retired from active business and sold their interest in the firm to the Pat Solums… the retired couple, who reside at 545 Alisal Road, are now looking forward to a life of comparative leisure and fun by camping and fishing…," *SYVN*, July 17, 1959, p. 2.
See: "Maxwell (Solum), Lyla G."

Danner, Sarah Kolb (Mrs. William M. Danner) (Mrs. Edward L. Campbell) (1894-1969) (Santa Barbara)
Member Santa Barbara Art Association, who exh. at opening exh. of Allan Hancock College Art Gallery, 1954. Active with Women Painters of the West.

■ Port with her painting "Reading" that won a prize at the Women Painters of the West exhibit at the Los Angeles Museum, and feature article, "Artist Uses Own Family for Models. Sarah Kolb Danner of Santa Barbara uses members of her own family for models… The canvas of her son's second-grade class in Santa Barbara School took sweepstakes and one other prize. The pastel portrait of her mother, Mrs. Emanuel G. Kolb of Philadelphia, won honorable mention. It is called 'Reading.' Mrs. Danner has been taking prizes rather steadily since she won the cash

prize offered by the *Terre Haute (Ind.) Star* in the Hoosier Art Salon in 1928. Last year she won the Julia Ellsworth Ford Prize in the annual show of the Women Painters. Mrs. Danner teaches in Santa Barbara Art Museum. She is a member of the California Art Club, of the National Association of Women Artists and the Chicago Society of Artists," *LA Times*, Aug. 25, 1943, p. 23 (i.e., pt. II, p. 5). Bio. and bibliography in Nancy Moure, "Dictionary of Art and Artists in Southern California before 1930" (*PSCA*, vol. 3).

Examples of her art are reproduced on askart.com.
Danner, Sarah (notices in newspapers on newspapers.com)
1922 – "Paintings by Sarah Kolb Danner of South Bend will be displayed at the Woman's Department Club during January... Indianapolis art lovers have had but little opportunity to see the work of Sarah Kolb Danner. A few times it has been included in the annual show of Indiana artists at the art institute and at the state fair," *Indianapolis Star* (Indianapolis, Ind.), Dec. 31, 1922, p. 35, col. 1.
1923 – Port. and "Indianapolis Art Lovers are Given Chance to View Work of Mrs. Danner... Exhibit of Paintings of South Bend woman at Department Club. 'Copper and Brass,' a still life, shown in the annual exhibition of work by Indiana artists at the art institute in the spring of 1921 aroused interest in the work of Sarah Kolb Danner of South Bend... The exhibit contains three or four large still-life pictures and a number of landscapes, street scenes and coast views. The addition of one example of portraiture, brings the number up to nearly thirty pictures... One of the paintings most admired is the large still life, 'Yellow Tulips'... 'Little Red Teapot'... "Pussy Willows'... artist makes a generous use of purple tones in her color schemes... A nocturne, entitled 'Moonlight' pictures old ruins... 'Through the Trees' ... Sarah Kolb Danner has not long been counted among Hoosier artists... She came from Philadelphia about three years ago with her husband, W. M. Danner, Jr. who is the secretary of the Young Men's Christian Association in South Bend... Both by exhibitions of her pictures and by talks that would tend to bring about a better understanding of the work of a painter, she is helping to a greater appreciation of art... At one of her exhibitions at the Progress club as many as six pictures were sold... During the summer she paints in the Eastern art colonies in Gloucester and at Malden, Mass. and at Chester Springs, Pa. There are several pictures from the Gloucester series, also from work done in Boston, Plymouth and elsewhere in the East. 'West on the Fenway, Boston' is beautiful in composition... 'A Plymouth Doorway'... 'Plymouth Homes' ... 'Spring Street, Plymouth' ... 'Gloucester Pier'... 'Gloucester, Boats'... As a rule, she paints boldly and expresses solidity and bulk in an agreeable way... 'A Sunny Corner,' 'A Duxbury Garden,' 'Sun on the Moors,' 'Polish Barns,' 'A Friend's Garden,' 'Autumn Hills,' 'Morning Clouds,' 'Evening Sky,' 'A Road in Summer,' 'Boats and Clouds,' 'Opal Sky,' 'A Melrose Path' and 'An Old Barn.' The greater part of the canvases are small in size as exhibiting artists are requested to send small pictures to the Department Club exhibits," *Indianapolis Star*, Jan. 21, 1923, p. 9.
"South Bend Women Contribute to Art Exhibit... annual spring exhibit of oils and water colors... South Bend Woman's club... The paintings of Sarah Kolb Danner have

been shown in many exhibits. She studied at the Philadelphia School of Design for Women under Henry Snell and also in the summer school of the Pennsylvania Academy of Fine Arts. She was a student in the Massachusetts Normal Art school and has painted in the classes of George L. Noyes, of Boston. Mrs. Danner paints mostly in oils but she also works in water colors and pastels. In a review of a recent 'one-man' show of Mrs. Danner's work at Indianapolis, the *Indianapolis Star* says: '... As a rule she paints boldly and expresses solidity and bulk in an agreeable way. She likes to flood her pictures with sunlight... Sunny landscapes and gardens, glimpses of streets and wide sky spaces are interpreted in her canvases'," *South Bend Tribune*, March 4, 1923, p. 21.
1924 – "The joint exhibit of the works of Mrs. Sarah Kolb Danner and Carl Kraft of Chicago sponsored by the art department of the Progress club, will open Wednesday afternoon with a studio tea...," *South Bend Tribune* (South Bend, Ind.), April 22, 1924, p. 5.
Possibly one hundred notices for "Sarah Kolb," the painter, can be found in US newspapers but they were not browsed for itemization here.
See: "Allan Hancock [College] Art Gallery," 1954

Darling Ceramics (Santa Maria)
See: "Nickson, Herbert William"

Davidsen, Laura (Mrs. Carl J. Davidsen) (1878-1959) (Solvang)
Retiree, landscape painter, 1959.

■ Solvang Lutheran "Home Resident, 80, enjoys working with Art, Reading… Mrs. Laura Davidsen, 80… first became attracted to art as a little girl in her native Denmark and has been enjoying working with oils and paints ever since… Mrs. Davidsen, who was born Oct. 20, 1878 in Varde, Denmark, on the family farm, was a daughter of a Danish sea captain. His name was B. K. Eskesen. One of seven girls and five boys in the family, Mrs. Davidsen came to the United States with her parents and four sisters when she was 13. They made their home for a time in Perth Amboy, N. J., and later moved to Mattawan along the South Jersey coast. In 1900, Mrs. Davidsen became the wife of Carl J. Davidsen in Trenton. They first came to California and to San Francisco in 1905, failed to like the Bay Area climate, and returned to New York the following year. Ten years later they responded to the call of the west again. This time they moved to Los Angeles and stayed. During their many years' residence in Los Angeles, both Mr. and Mrs. Davidsen were active in the Emmanuel Danish Lutheran Church. It was during this period that the Davidsens visited Solvang frequently for various church meetings. Mrs. Davidsen received her first instruction in art while attending a country school in Denmark. Later, as a young woman she studied for a time in New York. Through the years she has continued her hobby. The walls of the room at the home are decorated with many examples of her work, including pieces of painted china, sketches copied from photographs of her mother and husband, an oil painting of the family farm house in Denmark, and some of her latest creations –

landscapes of the range of mountains south of Solvang with the Danish-styled Solvang Grammar School and Bethania Lutheran Church in the foreground. Later, she plans to do an oil painting study of the Bethania Church. Mrs. Davidsen also spends many hours a week hand painting pieces of china. At one time she completed work on a 107-piece dinner set and for many years specialized in adorning coffee sets with attractive decorations. Several years ago she was awarded a bronze medal for her painted china entry in a Long Beach exhibition. After completing her various works of art, Mrs. Davidsen takes delight in giving them away as presents to her 'many friends.' She also offers her creations to church-sponsored bazaars as aid in raising funds…," *SYVN*, Jan. 2, 1959, p. 4.

Davidson, Laura (notices in Northern Santa Barbara County newspapers on microfilm and on newspapers.com)
Port with one of her paintings and caption reads "Long Time Artist – Mrs. Laura Davidsen, 80, a resident of Solvang Lutheran Home, spends a great deal of her time creating landscapes in oil and painting delicate designs on china. Mrs. Davidsen, who first became attracted to art as a girl in Denmark, is pictured with an oil painting of her farm home in the old country, while some of her painted china hangs on the wall," *SYVN*, Jan. 2, 1959, p. 1 and "Lutheran Home Boasts Artist 80 Years Old," *LR*, Jan. 8, 1959, p. 5.

Davidsen, Laura (misc. bibliography)
Laura Davidsen was b. Oct. 21, 1878 in Other Country and d. June 5, 1959 in Santa Barbara County per Calif. Death Index (refs. ancestry.com).

Davidson, Edna (1910-1996) (Lompoc / Santa Maria)
Art teacher, EEP, 1934. Member of Alpha Club Art Section, mid 1930s. Art supervisor of Santa Maria elementary schools, c. 1937-57. Active in many art activities in Lompoc and Santa Maria.

■ "Community Art Festival to Open Second Annual Showing May 29," and article adds, "Miss Edna Davidson, art supervisor of the local elementary schools and chairman of this section of the [Santa Maria Art] festival program, stated today…. Miss Davidson, who has been art supervisor in the local elementary schools for some years, received her bachelor of arts degree from the California College of Arts and Crafts and has added to that graduate work at the University of California, Los Angeles, at Claremont and San Jose State college," *SMT*, May 14, 1953, p. 1, 6.

Davidson, Edna (notices in Northern Santa Barbara County newspapers on microfilm and on newspapers.com)
1930 – "From Oakland. Miss Edna Davidson who has been a student at the Oakland School of Arts and Crafts, arrived here a few days ago to spend her vacation with her parents, Mr. and Mrs. Ralph H. Davidson," *LR*, May 30, 1930, p. 8.
1931 – "Home from Art School. Miss Edna Davidson, a student at the **California School of Arts and Crafts** in Oakland, has returned home to spend the Christmas holidays with her parents, Mr. and Mrs. R. H. Davidson," *LR*, Dec. 18, 1931, p. 2.
1933 – "Returns Home—Miss Edna Davidson returned to her home in Lompoc Saturday evening from Oakland. She recently graduated from the **California School of Arts and Crafts**, receiving her degree of Bachelor of Arts," *LR*, June 16, 1933, p. 6.

1940 – "Attends School. Edna Davidson is attending the Caroline Swope school for teachers in Santa Cruz," *LR*, Aug. 16, 1940, p. 7.
1953 – Port. of art teacher at El Camino school," *SMT*, March 19, 1953, p. 1.
There were more than 230 "hits" for "Edna Davidson" in the *SMT* between c. 1935 and 1960, some of which were entered under other headings and some of which were not itemized here. And more than 100 "hits" for "Edna Davidson" in the *LR* were not itemized here.
Davidson, Edna (misc. bibliography)
Edna Elizabeth Davidson was b. March 8, 1910 in Lompoc, Ca., to Ralph Hall Davidson and Elizabeth Horn, was residing in Santa Barbara in 1935, and d. Dec. 28, 1996 in Santa Maria, Ca., per Farley-Weed Family Tree (refs. ancestry.com).
See: "Alpha Club," 1933-36, "Business and Professional Women," 1942, 1948, "Camp Fire Girls," 1945, 1951, "Community Club (Santa Maria)," 1942, "Emergency Educational Program," intro., 1934, 1935, "Four-H," 1937, "Four-H Camp," 1937, "Fujioka, Henry," "Guadalupe, Ca., Elementary School," 1947, "Halloween Window Decorating (Santa Maria)," 1952, 1953, "Junior Community Club (Santa Maria)," 1950, 1951, "Lompoc, Ca., Elementary," 1934, "Minerva Club, Flower Show," 1950, "Posters, American Legion (Poppy) (Santa Maria)," 1940, 1953, 1956, "Posters, general (Santa Maria)," 1953, "Santa Maria, Ca., Elementary school," 1938, 1939, 1941, 1942, 1947, 1950, 1952, 1953, 1957, 1958, "Santa Maria, Ca., Union High School," 1937, "Santa Maria [Valley] Art Festival," 1953, "Set Decoration," 1934, "Teacher Training," 1940, "Wilson, JoAnn Smith"

Davies, John (Arthur) (1899-1985) (Monterey)
Painter of missions – displayed art in Lompoc, 1960.
See: *Central Coast Artist Visitors before 1960*

Davis, (June?) Blossom Johnson (Mrs. Braswell E. Davis) (Santa Maria)
Teacher of leather and metal work who spoke to Community Club, 1951. Exh. hand-tooled leather at Community Club Hobby Show, 1952.
See: "Community Club (Santa Maria)," 1951, 1952

Davis, Cecil Clark (1877-1955) (Santa Barbara)
Santa Barbara artist who exh. in a show sponsored by the College Art Club at city hall, Santa Maria, 1935.

■ Female. "Portrait painter. Born in Chicago in 1877 to wealthy Chicago industrialist John Marshall Clark and his wife Louise, a concert pianist…. Attended the Art Institute of Chicago… also attended the progressive Miss Porter's School for Girls in Farmington, Connecticut… class of 1893… In 1899 … married [Richard Harding Davis, a handsome writer] … platonic… divorced 1908… [active in Santa Barbara] … last several years… paralysis and debilitating pain… in Marion… died on September 12, 1955…," from Wendy Todd Bidstrup, *Cecil Clark Davis: A Self Portrait (1877-1955)*, Wendy Todd Bidstrup, 2013.

Davis, Cecil (misc. bibliography)
Mrs. Cecil C. Davis living at 780 Mission Canyon Road, is listed in the *Santa Barbara CD*, 1938, 1939 (refs. ancestry.com).
See: "College Art Club," 1935

Davis (Sudbury), Delia Lord (Mrs. Jay Royal Sudbury)
Teacher of arts and crafts at Santa Maria High School and Jr. College, 1947/48. Continued teaching under the name "Sudbury" 1948/50.
See: "Sudbury, Delia"

Davis, Emma
See: "Brians (Davis), Emma (Mrs. Brians) (Mrs. John Dorian Davis)"

Davis, Kansas Ed (Lompoc)
Puppeteer, 1957.
See: "Lompoc, Ca., Elementary Schools," 1957

Davison, (Esther) Jeannette Bumbaugh (Mrs. Norman M. Davison) (1910-1998) (Solvang)
Painter, amateur. "Doll Lady." Water color painter, 1955. Exh. first annual Santa Ynez Valley Art Exhibit, 1953, 1957. Sister-in-law is Regina Davison, below.
Davison, Jeannette (notices in Northern Santa Barbara County newspapers on microfilm and on newspapers.com)
1940 – Author of "Garden Corner" and her experiences with a lath house, *SYVN*, March 15, 1940, p. 8 and other columns in other issues not itemized here.
1951 – "Valley Views… Scene along the Solvang-Los Olivos Road Friday evening: Jeannette Davison and **Mrs. Don Davison** parked along side the road, seated in deck chairs, painting a scene on the Tom Petersen Ranch…," *SYVN*, Sept. 21, 1951, p. 2.
1953 – Classified ad – "Dolls repaired, made to or dressed to order. Jeannette Davison, Ph. 4031," *SYVN*, Jan. 30, 1953, p. 7; "Valley Views… Jeannette Davison is busily engaged these days between sales, hand-painting those model cars of yesteryear vintage. Jeannette's real handy with the paint brush and does a neat job on the models…," *SYVN*, Feb. 6, 1953, p. 2.
1954 – Port. with dolls and caption reads "Solvang's 'Doll Lady' is seen with her group of handmade dolls which she displayed at" Danish Days, *SYVN*, Aug. 13, 1954, p. 8.
1955 – Community "Woman's Club… During the second half of the program Mrs. Norman Davison of Solvang was introduced and showed her personally hand-made Danish doll collection. Mrs. Davison is also an enthusiastic gardner as well as something of an artist in water color paintings. She has had exhibits in Santa Barbara as well as in Solvang," *LR*, May 12, 1955, p. 4.
And 100 additional "hits" for "Jeannette Davison" in the *SYVN*, including her work in a record shop (i.e., Davison's, below, that had a "craft department" c. 1952-53) were not itemized here.

Davison, Jeannette (misc. bibliography)
Jeannette B. Davison is listed in the 1940 U. S. Census as age 29, b. c. 1911 in Calif., finished high school 3rd year, residing in Solvang (1935, 1940) with husband Norman M. Davison (age 34) and children Hanette M. (age 9) and Donald R. (age 7); Jeannette B. Davison was b. May 9, 1910 and d. Oct. 9, 1998 and is buried in Oak Hill Cemetery, Ballard, per findagrave.com (refs. ancestry.com).
See: "Danish Days," 1957, "Davison, Regina," "Santa Ynez Valley Art Exhibit," 1953, 1957, "Santa Ynez Valley, Ca., Adult/Night School," 1947

Davison, Grace Wilson Lyons (Mrs. Edgar Davison) (1875-1967) (Ballard)
Student of Leo Ziegler in Adult School. Artist who exh. at Santa Ynez Valley Art Exhibit, 1954, 1955, 1957, 1958. Sister to Jeannette Lyons, below.
■ "Grace Lyons Davison… 92… came to the Santa Ynez Valley as a girl of seven with her parents and a sister and two brothers from Pennsylvania. That was in the year 1882. … She attended the famed one-room little Red School House in Ballard as a child and returned there later to become its teacher… Among her chief interests, too, was her church… Santa Ynez Valley Presbyterian Church edifice which was built in 1898 under the guiding hand of her father, the late Judge Samuel Lyons… Grace Davison knew the Valley and its history intimately. She recorded that … in a pair of books, '*The Gates of Memory*' which she authored at the age of 80 and her second volume, '*Beans for Breakfast*.' For more than 30 years, too, Grace Davison reported the activities of the area as a correspondent for the *Santa Barbara News-Press*…," *SYVN*, June 1, 1967, p. 12.
Davison, Grace L. (notices in Northern Santa Barbara County newspapers on microfilm and on newspapers.com)
1954 – "Grace L. Davison Recollects with Nostalgia Her Arrival Here, the Mission 72 Years Ago," *SYVN*, Sept. 17, 1954, p. A-5; port., *SYVN*, Sept. 17, 1954, p. C-9.
1955 – Port. and caption reads 'Book Published… '*The Gates of Memory… Recollections of Early Santa Ynez Valley*'," *SYVN*, March 11, 1955, p. 3.
1956 – Port. at stove and caption reads '*Beans for Breakfast*' That's the title of Grace L. Davison's latest book," is autobiographical, *SYVN*, Nov. 30, 1956, pp. 1, 2. And more than 500 "hits" for "Grace Davison" in the *SYVN* between 1940 and 1967 were not itemized here.
Davison, Grace L. (misc. bibliography)
Grace Davison was b. Feb. 9, 1875 in Pennsylvania and d. May 23, 1967 in Santa Barbara County, and is buried at Oak Hill Cemetery per findagrave.com (refs. ancestry.com).
See: "Danish Days," 1957, "Lyons, Jeannette," "Presbyterian Church," 1945, "Santa Ynez Valley Art Exhibit," 1954, 1955, 1957, 1958, "Santa Ynez Valley, Ca., Adult/Night School," 1947, 1949, 1953, 1955, "Tri-County Art Exhibit," 1952, "Ziegler, Leo," 1947

Davison, Regina May Bonner (Mrs. Donald "Don" McNeil Davison) (1916-1981) (Santa Ynez Valley)
Painter, amateur. Moved to Chico in 1953. Sister-in-law to Jeannette Davison, above.
See: "Davison, Jeannette," "Knudsen, Robert F.," "Tri-County Art Exhibit," 1952

Davison's Craft Department (Solvang)
"Davison's. Home of everything in Music. Retailers of craft supplies, 1952+. Prop. Norman Davison, husband of Jeannette B. Davison, above.
Davison's Craft Department (notices in Northern Santa Barbara County newspapers on microfilm and on newspapers.com)
1947 – "Announcement. Davison's Radio Sales and Service Store. Open for Business Tuesday – April 15. Our new sales room which is located in the H. B. Foss Electric Shop… It will be necessary for us to postpone the formal opening of our new business pending the arrival of our stock of new radios… Norman N. Davison. Jeannette B. Davison," *SYVN*, April 11, 1947, p. 10.
1952 – "What Fun. They're Sensational. Craftmaster Oil Painting Sets. 2 Sizes. 2.50 and 5.00. Includes Canvas, Paints and Brushes from our new Handcraft Dep't. Davison's. Home of Everything in Music… Main St., Solvang…," *SYVN*, Sept. 26, 1952, p. 3; "Gifts. From our hand craft dep't. Oil painting sets, Craftmaster – 2.75-5.00. Model Kits… Hand Tool Copper… Doll Kits… Davison's," *SYVN*, Nov. 28, 1952, p. 4; "Visit Our Handcraft Department. See Our Selection of Handmade Candles… Davison's," *SYVN*, Dec. 12, 1952, p. 3.
1953 – Ad "Lots! of New Things in our Craft Department… Draw and Paint with Water Color Crayons, Crayoffs, the Washable Crayons, Know 'Em and Draw 'Em Animal Books, All Kinds of Model Kits (airplane Dope, too!), Copper and Leather Crafts, Doll Kits, Craftmaster Paint Sets [at] Davison's Home of Everything in Music, Radios, Phonographs, Records, Main St., Solvang," *SYVN*, Jan. 8, 1953, p. 5.

Day, Richard (1896-1972) (Hollywood)
Printmaker, one of whose works was owned by John Breneiser and exhibited at National Art Week, and at the Art Festival, 1935.
■ "Richard Day (9 May 1896 – 23 May 1972) was a Canadian art director in the film industry. He won seven Academy Awards and was nominated for a further 13 in the category of Best Art Direction," and outside of the studios he created art on his own, per Wikipedia.
See: "Art Festival (Santa Maria)," 1935, "National Art Week," 1935

Day, Willard T. (1897-1960?) (Lompoc)
Photographer. Taught La Purisima Camera Club, 1938. Educational director, CCC, 1936+. A couple of his photos were reproduced in the Lompoc Record, 1937-38.
■ "Voice of the Twin Camps… Co. 2950 Gets Educational Adviser. Last week Willard T. Day reported to this company… Mr. Day comes from Long Beach, where

he was formerly North Branch Executive Secretary of the YMCA. In addition to his experience in boy's work, he has practiced as an engineer, a salesman and a mechanic. His hobbies are shooting, fishing, all sports such as tennis, archery, swimming, golf and badminton. He also enjoys handicraft in its many forms, such as model building, woodworking, leathercraft, silver smithing, beadwork and photography…," *LR*, May 8, 1936, p. 8.
Day, Willard T. (notices in Northern Santa Barbara County newspapers on microfilm and on newspapers.com)
1937-38 – Repro: "Keepers of the Bees," *LR*, Nov. 5, 1937, p. 7; repro: photos of CCC camp, *LR*, Feb. 4, 1938, p. 5.
Day, Willard T. (misc. bibliography)
Willard T. Day, exec. sec. North Long Beach YMCA, appears in the *Long Beach, Ca., CD*, 1932; Willard T. Day with no occupation is listed with spouse Ethel M. Day in the *Long Beach, Ca., CD*, 1936; is he Willard T. Day b. April 4, 1897 in North Dakota, who married Ethel M. Birchall, and d. July 17, 1960 in Los Angeles County per Stone Family Tree (refs. ancestry.com).
See: "La Purisima Camera Club (Lompoc)," 1938

Deaderick, Moreland M. "Max" (1902-1991?) (Santa Barbara / Oxnard)
Photographer. Brooks Institute. FPSCA. Judged photo shows in Santa Maria. Active with Santa Maria Camera Club, c. 1946-64.
[Caution. Father (1902-1991) and son (1923-1996) have the same name.]
1955 – Port. – as a man with graying temples pictured with **Ken Prindle** and Gibbs – suggests, of the two Deadericks – father and son – the "father," 1902-1991, was the photographer, *SMT*, Jan. 17, 1955, p. 1.
One or more of his photographs are in the collection of the Seattle Art Museum (per Internet).
Deaderick, Moreland M. (misc. bibliography)
He is probably Moreland McAdory Deaderick b. Feb. 18, 1902 and d. Nov. 26, 1991, buried in Carpinteria Cemetery per findagrave.com; various entries in Census and city directories show that his "main" business was trucking (refs. ancestry.com).
See: "Santa Maria Camera Club," 1946, 1948, 1950, 1954, 1955, 1961, 1962, 1964

Deakin, Ida (Santa Ana)
Artist of "Blue Seas," a watercolor won by the Junior Community Club, and exh. at Santa Maria Library, 1955. This individual could not be positively identified.
See: "Santa Barbara County Library (Santa Maria)," 1955

Dean, James Burroughs (Lompoc)
Retailer of artists materials, druggist, apothecary, bookseller, 1887-93.
Druggist and Apothecary… Patent Medicines, Artists' Materials, and all varieties of Druggists' Sundries, and stationery," *LR*, April 27, 1889, p. 1, col. 1.

de Angeles, Augusta J.
See: "Stone (Maggini) (de Angeles), Augusta J. (Mrs. Charles Maggini) (Mrs. de Angeles)"

De Araujo, Dorothy (SLO)
Artist who exh. at Santa Ynez Valley Art Exhibit, 1954, 1955.
See: "Santa Ynez Valley Art Exhibit," 1954, 1955, and *San Luis Obispo Art and Photography before 1960*

De Bernardi, Mario Antonio (1907-1974) (Santa Maria)
Photographer. Projected his slides of Switzerland to several local clubs, 1946. Santa Maria Valley builder.

■ "Around Town ... His eyes lighted as he spoke: 'This time I'm going by way of the boat up the Rhine River... Every year Mario De Bernardi made a pilgrimage to Switzerland, the land of his birth and the home of his mother and his brothers and sisters ... Mario savored his Swiss ancestry. He built the Swiss Chalet in the style of his homeland...," *SMT*, Dec. 13, 1974, p. 21;
1946 – "De Bernardi Slides Picture Swiss Birthplaces of Valley Folk" and shown to Guadalupe Rotary Club, *SMT*, Nov. 9, 1946, p. 1.
DeBernardi, Mario (misc. bibliography)
Mario Antonio DeBernardi was b. Jan. 17, 1907 in Lodano, Switzerland, to Elevita Pacifico DeBernardi and Sabina Sartori, married Adelaide (Ida) Romilda Rotta, and d. Dec. 8, 1974 in Santa Maria, Ca. per Brass Family Tree Nov 2010... (ref. ancestry.com).
See: "Phi Epsilon Phi," 1946, "Santa Maria Camera Club," 1946

deBolt, Marie (1904-1967) (Lompoc)
Teacher at elementary school. Artist, 1959.

■ "Art Exhibit by Teachers at Lindens. Two Lompoc school teachers have developed a paying hobby with their artistic talents. An original exhibition of water colors painted by the two educators is currently on display at Linden's Complete Home Furnishing Store on North H Street. ... **Ruth de Buda** and Marie de Bolt have painted scenes portraying Latin America and local scenes of the Lompoc Valley area. Miss de Buda has painted abroad and is teaching in the Westwings School. Miss de Bolt developed her techniques with water colors over the past 12 years, giving instructions to students in the classroom," and port. of two teachers with some of their paintings, *LR*, Dec. 17, 1959, p. 25.

■ "Arvin Elementary School Names Teaching Staff... Marie DeBolt, Santa Paula, holds a B. S. degree from Goshen College [Indiana] and has taught in Santa Paula, San Jose and Maricopa schools. She will have a fifth grade assignment," *Bakersfield Californian*, Aug. 29, 1950, p. 7.
deBolt, Marie (notices in Northern Santa Barbara County newspapers on microfilm and on newspapers.com)
1959 – "Welcome New Teachers" and port., but no bio., *LR*, Aug. 24, 1959, p. 11 (i.e., 3b).

deBolt, Marie (misc. bibliography)
Marie E. Debolt listed in the 1930 U. S. Census as age 25, b. c. 1905 in Indiana, a teacher, residing in Perry, Indiana, with her father Edward E. Debolt (age 62) and siblings; Marie Debolt, b. June 24, 1904 in Huntertown, Indiana, departed Le Havre, France on the *S. S. France* and arrived at NY, Sept. 8, 1950 per *NY Passenger and Crew Lists*; Marie Debolt, teacher Pub Sch, is listed in the *San Jose, Ca., CD*, 1947; Miss Marie E. DeBolt, Box 168 Lebec, Rep., is listed in *California Voter Register, Lebec*, November 1956, and 1958; Marie De Bolt, teacher, Lompoc Elementary School, is listed at the same apartment complex but different unit as Mrs. Ruth deBuda, teacher PS, in Lompoc in the *Santa Maria, Ca., CD*, 1959; Marie Debolt, teacher PS, is listed in the *Bakersfield, Ca., CD*, 1961; a port. of Marie E. Debolt, b. June 24, 1904, who d. 1967 is contained in *Public Member Photos & Scanned Documents* (refs. ancestry.com).

deBuda, Ruth Dorfman (Mrs. Francis deBuda) (1910-1979?) (Lompoc)
Teacher, artist, 1959.

■ "New Studio in Taos. Francis and Ruth DeBuda have recently opened their new art studio and gallery on Placitas Road in Taos, and are showing their own water colors and oils... Their works include landscapes, mostly, as well as figure painting and contemporary semi-abstract works. Both women [Sic. husband and wife] have won ribbons in juried art shows and examples of their art are included in the collections of Sir James Rothschild in London and Edward J. Reilly of Philadelphia. The sisters are also members of the Taos Art Association. Formerly they lived in Los Angeles, California, and were members of Laguna Gloria and the Texas Art Association. Francis and Ruth DeBuda have been in the area for about three weeks," *Santa Fe New Mexican*, Sept. 28, 1975, p. 71 (i.e., 17).
DeBuda, Ruth (notices in California newspapers on microfilm and on newspapers.com)
1961 – "Corcoran Students Prepare for First Annual Art Fair... High School... Serving on the directors committee.... Mrs. Ruth deBuda...," *Hanford Sentinel* (Hanford, Ca.), April 12, 1961, p. 9.
1975 – "Gallery of Francis and Ruth DeBuda, Placitas Road. Hours: 9-5 Monday thru Friday, 9-noon Saturday & by appointment. 758-8469. Featuring works of owner artists in watercolors & oils (landscapes in semi-abstract contemporary figures)," *Santa Fe New Mexican*, Nov. 16, 1975, p. 67.
1977 – "Exhibition Opens at Library... paintings by Wide Ruin artists Francis and Ruth de Buda ... Community Room of the Gallup Library.... Francis de Buda was born in Switzerland but spent most of his childhood in Milan, Italy... Ruth de Buda was born in New York where she received a B. A. degree in Art from Hunter college. She earned a Master's degree from California state University in Los Angeles. She has studied with Charles La Monk and has belonged to the Taos Art Association, Laguna Gloria of Austin, the Los Angeles County Employees Art Association, the Laguna Beach Art Association, and the Harvey Ballew Art Club. Her work is represented in private collections in Los Angeles, New York, Texas, London and

Rome... For exhibition in Gallup, she has chosen 11 watercolors (using wet-on-wet and dry-brush techniques) and several acrylics, acrylic collages and block prints. The deBudas have travelled extensively in Europe, the Middle East and throughout the U.S. They lived and worked in Taos, where they had their own studio and gallery before moving to the Navajo Reservation in 1976...," *Gallup Independent* (Gallup, NM), Sept. 3, 1977, p. 14.
deBuda, Ruth (misc. bibliography)
Ruth D. DeBuda, no occupation or husband, listed at P. O. Box 123 (Corcoran) in the *Hanford, Ca., CD*, 1961 and a couple of lines above is B. F. Debolt in (Lem)(?); Ruth Dorfman Debuda was b. July 5, 1910 and d. Nov. 19, 1979 per Jewish Gen Online Worldwide Burial Registry; buried in Congregation Albert Cemetery, Albuquerque, N.M. per findagrave.com (refs. ancestry.com).
See: "deBolt, Marie"

Decker, Jessie (Berkeley?)
House furnishing specialist from University of California at Berkeley who spoke to Home Department, 1934.
See: "Home Department," 1934

De Erdely, Francis (1904-1959) (Los Angeles)
Painter. Artwork by him was sent by his LA gallery to the first Santa Maria Valley Art Festival, 1952.
■ "Francis de Erdely (Hungarian: Erdélyi Ferenc) (1904–1959) was a Hungarian-American artist who was renowned in Europe and the United States for his powerful figure paintings and drawings as well as for his teaching abilities," per Wikipedia.com.
See: "Santa Maria [Valley] Art Festival," 1952

De Forest, Lockwood, Jr. (1896-1949) (Santa Barbara)
Landscape artist who spoke to Garden Club, 1924.
■ "Born in New York City as Lockwood de Forest III, he was known professionally as Lockwood de Forest, Jr. He developed a deep love and knowledge of the California landscape while at the Thacher School in Ojai. ... de Forest practiced as a landscape architect in Santa Barbara for almost 30 years.... De Forest, along with his wife and business partner, Elizabeth Kellam de Forest ... founded and subsequently edited *The Santa Barbara Gardener* from 1925-1942, combining Elizabeth's plant knowledge and elegant prose with Lockwood's knowledgeable commentary on design," tclf.org/pioneer/lockwood-deforest-iii
De Forest, Lockwood (notices in Northern Santa Barbara County newspapers on microfilm and on newspapers.com)
1924 – "Landscape Artist will Speak at Garden Club Meeting," *SMT,* March 31, 1924, p. 5; "Garden Club Members Enjoy Address," *SMT,* April 2, 1924, p. 3.
1931 – "Small Gardens Discussed by Architect... Lockwood DeForrest [Sic.] ... Minerva Club, Garden Section...," *SMT,* Nov. 17, 1931, p. 3.
1932 – "Mrs. DeForest Speaker Here... at the Garden section of the Minerva club," *SMT,* May 3, 1932, p. 3; "Prominent People at [California] Garden Club Convene...," *SMT,* Oct. 10, 1932, p. 5.

1946 – "Personal Notes ... Lockwood DeForrest [Sic. DeForest], Jr., of Montecito is spending his vacation at the home of Agnes Brons. He is attending summer school at **Atterdag**," *SYVN*, July 5, 1946, p. 4.
Bibliography:
Some information on him may be contained in the book on his father (Lockwood Deforest, 1850-1932) i.e., Roberta A. Mayer, *Lockwood de Forest: Furnishing the Gilded Age with a Passion for India*, Newark: University of Delaware Press, 2008. 240 pp. 182 illus.
See: "Mission Santa Ines," 1949, "Santa Barbara, Ca.," 1908, "Solvang Woman's Club," 1936

DeGasparis, Attilio Maurice (1914-1994) (Santa Maria)
Teacher of crafts at Santa Maria Adult School, 1948-50, and of crafts and mechanical drawing at Santa Maria High School, c. 1948-57 and head of Industrial Arts Dept. 1957. Brother to Lucy DeGasparis, below.
De Gasparis, Attilio (notices in Northern Santa Barbara County newspapers on microfilm and on newspapers.com)
1947 – "H.S. Teachers Dissatisfied with Pay... Probationary teachers offered contracts for next year were ... Attilio DeGasparis...," *SMT*, April 16, 1947, p. 1.
1961 – "... did the lettering of the titles on the 46 Madonna prints loaned by Rev. and Mrs. Roy O. Youtz...," to the Madonna Art Exhibit, *SMT*, May 22, 1961, p. 12.
1994 – "Nixon was on coast during his run for governor in '62... visited Guadalupe ... I asked if he would be kind enough to pose for a picture for me. And, he did...," *SMT*, April 25, 1994, p. 6; "D-Day: Vets remember... Another teacher who has memories of that 'Longest Day' is Attilio ('Dee') DeGasparis, 80, of Santa Maria. He saw action as a warrant motor officer ...We came in on an LST (Landing Ship, Tank) ...," *SMT*, June 5, 1994, p. 9.
And more than 50 additional notices not itemized here.
De Gasparis, Attilio (misc. bibliography)
Attilo M. Degasparis is listed in the *Santa Maria, Ca., CD*, 1959, 1962; Attilo M. Degasparis b. Feb. 4, 1914 in Calif. to Ernesto Severino Degasparis and Rina Alliata, married Mary Helen "Judy" Sanders, and d. Dec. 31, 1994 in Santa Maria per Tomasini (Bill) Tree (refs. ancestry.com).
See: "DeGasparis, Lucy," "Santa Maria, Ca., Adult/Night School," 1948, 1949, 1950, "Santa Maria, Ca., Union High School," 1950, 1954, 1955, 1957

DeGasparis (Nelson), Lucy Elaine (Mrs. Dr. Harold Olaf Nelson) (1910-1998) (Guadalupe)
Artist, 1939. Studied art at California School of Arts and Crafts in Oakland, 1932. Sister to Attilio DeGasparis, above.
■ "Dr. Nelson and Bride on Trip to Yosemite. ... Lucy Elaine DeGasparis of Guadalupe... The bride is a graduate of Santa Maria high school. She attended Santa Barbara School of Art and the Chouinard Art school in Los Angeles. She has been connected with a handcraft shop at El Paseo in Santa Barbara. Dr. Nelson is a graduate of Rush medical college... On their return the couple will live on Olivera street in San Luis Obispo where Dr. Nelson recently opened offices," *SMT*, May 29, 1939, p. 3.

DeGasparis, Lucy (notices in Northern Santa Barbara County newspapers on microfilm and on newspapers.com)
1928 – "Miss Lucy de Gasparis, daughter of Mr. and Mrs. Ernest De Gaspari, and a student at Santa Maria Junior college, was awarded first prize of $5.00 in the poster contest recently held by the Players' Club of Santa Maria. Miss de Gasparis has been very prominent in art work during her four-year high school course, having many examples of her work in the '*Splash*'... The theme used by Miss Lucy was the play, 'Icebound,' which the players will present Friday, November 2nd," *SLO DT,* Nov. 2, 1928, p. 12.
1942 – FATHER – Ernest DeGasparis of Guadalupe dies at 61... business man... native of Italy... came to America 40 years ago and to Guadalupe some 35 years ago... Guadalupe Meat Co... Besides the widow... The daughter, Mrs. Lucy Nelson, is the wife of Capt. H. O. Nelson, Army Medical Corps, now in Australia. The son, **Attilio De Gasparis**, a former high school teacher in Bishop, is a warrant officer in the Army somewhere in the East," *SMT,* Oct. 27, 1942, p. 1.
1963 – "Mrs. Lucy Nelson receives Life Member Award from Guadalupe PTA... She has lived in Guadalupe all of her life, coming from Italy with her parents soon after she was born. She graduated from grammar school, high school and junior college here and attended the Santa Barbara School of Arts and the Chouinard School of Art in Los Angeles. Later she married Dr. Harold O. Nelson ... Mrs. Nelson lends her artistic talents to beautify many community functions such as parties, luncheons, weddings and dinners. At Halloween, Easter, Christmas, Communion breakfasts, etc., she is always first to step forward and offer her assistance... She has made many tray favors and party decorations for the Sisters Hospital Guild ... She assists all Catholic Church functions with food, decorations and gift articles, always with the interest of raising money or doing something for children who are first in her heart," *SMT,* March 2, 1963, p. 3.
1998 – "Lucy E. Nelson, Guadalupe Resident...," *SMT,* July 6, 1998, p. 5.
And, more than 140 "hits" for "Lucy Nelson" in *SMT* between 1930-1998, reported social and club activities, as well as activities with her children, but were not itemized here.
DeGasparis, Lucy (misc. bibliography)
Lucy E. Degasparis was b. March 25, 1910 in Italy to Earnest [Sic.] Degaspiry and Rena Degaspiry, was residing in Guadalupe, Ca., in 1920, married Harold Olaf Nelson, and d. July 4, 1998 in Guadalupe, Ca. per Jensen-Collins-Haugtvedt-Svare Family Tree (refs. ancestry.com).
See: "Art, general (Santa Maria)," 1929, "Breneiser, Marrie," 1932, "DeGasparis, Attilio," "Guadalupe, Ca., Elementary School," 1930, "Santa Maria, Ca., Union High School," 1928, 1931, "Santa Maria School of Art," 1933, "Splash," 1927

De La Cuesta, Micaela, Miss (Santa Ynez?)
Collector and lender to Art Loan Exhibit, 1935, and to the Historical Society. Member of pioneer Valley family.
See: "Art Loan Exhibit (Solvang)," 1935, "Santa Ynez Valley Historical Society"

De la Cuesta, Tulita (1888-1981) (Santa Barbara)
North valley ranch owner who taught arts and crafts at Santa Barbara High School, retiring 1949. Daughter of Virginia de la Cuesta, below.
■ "Mrs. Gerard de la Cuesta and Miss Tulita de la Cuesta have returned to their ranch home El Cerro Alto Nojoqui where they will be glad to see their Valley friends. Miss de la Cuesta retired in June as a member of the faculty of the Santa Barbara High School where she was a counselor and teacher of arts and crafts," *SYVN,* July 29, 1949, p. 4.
■ "Tulita de la Cuesta dies at 92... had taught for 60 years beginning at the old Nojoqui School and later at the Santa Barbara High School... class of 1907 at Santa Ynez Valley High School, attended the one time Santa Barbara State College, now UCSB, completed extension courses through the University of California at Berkeley and held bachelor of education and bachelor of arts degrees... member of the Santa Barbara Historical Society... descendant of Pablo Antonio Cota and Raimundo Carrillo both of whom came to California in 1769 with Padre Junipero Serra... Cota, an agent of the King of Spain, became grantee of Rancho Santa Rosa... 15,000 acres... great granddaughter of Capt. William Goodwin Dana of Boston ... Miss de la Cuesta's parents built the Rancho Cerro Alto adobe in 1901.... historian...," *SYVN,* Jan. 15, 1981, p. 13.
De la Cuesta, Tulita (notices in Northern Santa Barbara County newspapers on microfilm and on newspapers.com)
1964 – Author of "History of Santa Ynez... Editor's Note: ... Lived at one time on Rancho Cerro Alto south of Buellton...," *SYVN,* June 11, 1964, p. 9;
And, more than 150 "hits" for "Tulita" in the *SYVN* between 1910 and 1981 cover her travels, social events, and articles on local history but were not itemized here.
De la Cuesta, Tulita (misc. bibliography)
Tulita de la Cuesta is listed in the 1940 U. S. Census as age 45, b. c. 1895, finished college 4th year, a teacher, residing in Santa Barbara (1935, 1940) with her widowed mother **Virginia de la Cuesta** (age 70); Tulita de la Cuesta was b. Oct. 6, 1888 in California to Gerardo Delacuesta and **Virginia Pollard de la Cuesta**, was residing in Santa Barbara, Ca., in 1935, and d. Jan. 7, 1981 in Santa Barbara County per Cota Family Tree; buried in Calvary Cemetery, Santa Barbara per findagrave.com (refs. ancestry.com).
See: "Architecture (Northern Santa Barbara County)," 1954, "Home Department of the State Farm Bureau," 1950

De la Cuesta, Virginia Pollard (Mrs. Gerardo de la Cuesta) (Buellton)
Antique collector. From a pioneer local family. Mother of Tulita De la Cuesta, above.
See: "Architecture (Northern Santa Barbara County)," 1954

De Laret (de Toreto?), Lollis (Santa Barbara)
Member of Santa Maria Art Association who exh. a painting at Santa Barbara County Fair, 1952.
No information can be found for this individual whose name was spelled both "DeLaret" and "de Toreto" by the newspaper.
See: "Santa Barbara County Fair," 1952

De la Torre, William "Bill" (1915-1955) (Los Angeles)
Cartoonist of "Pepe" that appeared in Santa Ynez Valley News, 1949.

■ 'Pepe' [by] de la Torre. **Bill de la Torre** was born in Juarez, Mexico. He received a scholarship from the Otis Art Institute in Los Angeles. After his art training he went to work at the Walt **Disney Studio** as an animator and story man. His own cartoons have appeared in *The New Yorker* and *Script* Magazines for the past 3 years. His hobby is collecting Jazz records...," *SYVN*, July 29, 1949, p. 4.

■ "William de la Torre was the author of the Mexican comic strip 'Pedrito' ('Little Pedro'), which ran from 1948 to 1955. ... the strip did appear in the USA and Canada. De la Torre's work appeared in the *New Yorker* between 1948 and 1953. The artist died in early 1955 at the age of 39," www.lambiek.net

De Lindholm, Adolf (1901-1977) (Solvang)
Restorer of antiques and furniture, 1960+.

■ Port and "Adolf De Lindholm Joins Group of Solvang Artisans... Specializing in antiques, De Lindholm carries on his work... in his neat, well-equipped shop located behind his home at 1616 Maple Avenue where he resides with his wife, Margaret... A native of Rockford, Ill., De Lindholm grew up in Davenport, Ia. He first became exposed to woodworking as a boy and gained much of the basis of his present-day knowledge from his late father, Niels De Lindholm, who had learned the trade of a cooper and cabinet maker as a lad in Flensburg, Schleswig-Holstein, where he was born. De Lindholm said he practically 'grew up' in his father's shop and added to his skill by taking industrial arts courses in high school and by working after school and on Saturdays in cabinet, finishing and pattern shops in Davenport. In the meantime, due to his mother's insistence, young De Lindholm also had to find time each day to practice diligently at the piano. Shortly after World War I, De Lindholm and his work with wood... became separated. He enlisted in the Navy and during a three-year hitch was given an assignment as a musician in a Navy band. After leaving the service, De Lindholm played the piano professionally and was a member of several name bands which toured various parts of the country. He left the musical field in 1925 when he enrolled at the University of Iowa to study pre-medicine. A year later, he was again attracted to his interest of working with his wood tools and finishes. De Lindholm left the university to work in a piano factory and other shops in Rockford. He and his wife came to Los Angeles in 1930. These were the depression years, and work was not easily found. He took odd jobs at auto and furniture refinishing shops. Obtaining what he describes as his 'best training in antique work,' De Lindholm spent the next four and a half years working at a Bekins Van and Storage custom shop which specialized in restoring furniture and pianos. He was later employed by the Los Angeles board of education and traveled daily from school to school refinishing pianos and desks. With the advent of World War II, De Lindholm went to work at the El Segundo plant of Douglas Aircraft. He spent two years there in the wind tunnel model design department. After operating his own shop in Los Angeles for a year and a half, he returned to Douglas. Assigned to the Santa Monica plant, his creative ability with wood was utilized in contriving mock up components of individual working parts of aircraft. Following seven years at Douglas, De Lindholm retired in May 1957. The next month he and his wife and father moved to Solvang after purchasing a home from Lawrence McDonald on Maple Avenue. Two months later his father died at the age of 84. De Lindholm started work immediately after coming here on building his 18 by 30-foot shop. With the exception of the stuccoing, he did all of the building himself, including the installation of an intricate heavy duty wiring system which carried electricity to his power tools. The immaculate shop contains jig, power, and band saws, wood lathe, jointer, drill press, metal lathe, grinder and compressors to operate his spray guns. Hung above his woodworking bench are neat rows of various wood chisels and carving tools, many of which were designed and made by De Lindholm in his shop. These include, too, a variety of planes, hammers, and metal plug cutters. Another area of the shop contains an assortment of dry stains which are mixed with water, alcohol or lacquer. The shop also provides space for a laboratory where De Lindholm creates bleaches and formulates the various finishes. De Lindholm, who is 59, spends about five hours a day in his shop. He arrives punctually from the back door of his house at 8 a.m. and works through the noon hour until 1 p.m. Periodically he spends time in his laboratory, too, preparing his own furniture polish formula which carries the trade name of Anadel. De Lindholm explained, 'every finisher has his own and I have been bottling mine since 1935," *SYVN*, Feb. 12, 1960, p. 8.

De Lindholm, Adolf (misc. bibliography)
Adolf de Lindholm, married to Margaret... b. 1901 and d. 1977 is buried in Oak Hill Cemetery, Ballard per findagrave.com (refs. ancestry.com).

Dellar, Ronnie Jean
See: "Abbott (Dellar), Ronnie Jean (Mrs. Ronald D. Dellar)"

Delphian Society (Santa Maria)
Club that sponsored a year of art lectures, 1934.

■ "New Woman's Club Formed in Santa Maria ... National Delphian Woman's Club... One general meeting will be held each month... Among the subjects to be studied ... will be the Liberal Arts course, consisting of the study of history, literature, music and the drama. Modern work includes book review and reviews of drama as well as a resume of coming events. The club is organized solely for higher education and social advancement...," *SMT*, Feb. 3, 1925, p. 1.

Delphian Society (notices in Northern Santa Barbara County newspapers on microfilm and on newspapers.com)
1934 – "Delphians Discuss and Study Modern Art," Monday afternoon in the Santa Maria club...," *SMFA*, Jan. 12, 1934, n.p.; "Pictures Used in Studies of France. In connection with their study, 'Romanticism in France,' members of Alpha Tau chapter, Delphian society, at their regular meeting in the Santa Maria club yesterday

afternoon, made a study of an exhibit of about 70 pictures obtained from the **Faulkner Memorial** gallery in Santa Barbara. Some of the pictures also covered periods in art history previously studied by the club…," *SMT*, March 13, 1934, p. 5; "Artists Discussed by the Delphian Club," *SMFA*, March 30, 1934, n. p., and article says, "'The Barbizon School' was the subject of discussion… Those who reported on the subject were **Mrs. T. A. Twitchell**, who spoke on 'The Rise of the Barbizon School,' Mrs. Wagner, who spoke on 'Rousseau,' Mrs. Craig, who spoke on 'Corot, the Poet Painter,' Mrs. W. J. Wilson, on 'Lesser Barbizon Artists,' and Mrs. Denzil Glines, on 'Millet and L'Hermite'"; "Delphians Study Romanticists. 'Romantic Schools of English Painting' will be the topic for study at the next meeting… The subject will be studied under the separate topics of 'The Real Father of the Barbizon School,' 'Turner, Nature's Great Showman,' 'Academic Romanticists,' 'Scotch Painters,' 'Romantic Realists' and 'Blake the Mystic'," *SMT*, April 7, 1934, p. 2; "Delphians Study English Artists. … 'Romantic Schools of English Painting,' … The program included a discussion of 'The Real Father of the Barbizon School' by **Mrs. T. A. Twitchell**, 'Turner, Nature's Great Showman,' **Mrs. G. E. Secour**, 'Academic Romanticists,' **Mrs. Denzil Glines**, and 'Romantic Realists,' Mrs. Kai Hansen," *SMT*, April 10, 1934, p. 2; "Modern Artists Discussed by Club… meeting of Delphian Society… at the Minerva club… Gauguin was the subject of Mrs. W. J. Wilson's talk, while Mrs. Franklin chose Van Gogh. The American painter and etcher, James McNeil whistler, was the topic of an address by **Mrs. George Secour**. The ever-interesting Rodin… made a talk by Mrs. E. Wagner illuminating…," *SMT*, Aug. 28, 1934, p. 2; "Modern Art Studied by Delphians," *SMFA*, Aug. 31, 1934, n.p., states members spoke on Gauguin, Van Gogh, Whistler, and Rodin; "Delphian Club Discusses Painting. Realism and post-impressionism, cubism and futurism in painting were discussed … yesterday afternoon in the Minerva clubhouse. Sub-topics under Realism were: 'Three Italians,' discussed by Mrs. C. B. Ferguson, 'Zubiarre, Typical Spaniard,' by Mrs. J. H. Franklin, "American Portraitists,' Mrs. Karl Hansen, 'American Landscapists,' Mrs. Holmes Tabb, 'Realists of Northern Europe,' Mrs. W. J. Wilson, 'Women Painters,' Mrs. Ethel Cleaver. Under Post-Impressionism, Cubism and Futurism, topics discussed were: 'Rousseau,' Mrs. Scott Pyle, 'The Significance of Post-Impressionism,' Mrs. Carl McCullers," *SMT*, Oct. 11, 1934, p. 2; "Delphian Club Studies Art. 'Realism' 'German Slavic Expressionism' and 'Sculpture' were discussed at the Delphian meeting in Minerva clubhouse yesterday…," and details, *SMT*, Nov. 8, 1934, p. 2; "Club Discusses Sculpture… and 'New Internationalism in Art' …," and details, *SMT*, Dec. 6, 1934, p. 3.

DeMille, Cecil B. (Hollywood)
Motion picture director who shot a film in Guadalupe, 1923.
See: "Hoback, Eugene," "Motion Pictures (Guadalupe)," 1923

DeNejer, Jeanne (aka Deana Hill) (Mrs. Ray De Nejer) (c. 1909-after 1955) (Santa Maria / New York)
Ceramist. Art teacher Santa Maria High School, 1945/46. Founded the Santa Maria Art Association, 1945. Taught ceramics and art privately, 1946-52. Exh. at Santa Barbara County Fair, 1949-52. Chairman Santa Maria Art Festival, 1952. Organized the Winter Arts Program, 1952/53. Exh. first Santa Ynez Valley Art Exhibit, 1953.

■ "Lake George Board Lists Faculty Members for 1954-5… Lake George Central School… Mrs. Jeanne DeNejer is from New York and is a graduate of San Jose College and has done graduate work at New York State College of Ceramics. She has studied painting with Frederick Taubes and **Douglass Parshall** and pottery with **Marguerite Wildenhain**. Mrs. DeNejer has taught at Santa Maria High School and Junior College, the University of California Extension at Santa Barbara and Wilber Lynch High School in Amsterdam. In addition, she has had her own studio for pottery, painting, jewelry and sculpture," *Post-Star* (Glens Falls, N.Y.), Aug. 16, 1954, p. 9.
De Nejer, Jeanne (notices in Northern Santa Barbara County newspapers on microfilm and on newspapers.com)
1945 – "Art Honors for Jeanne DeNejer" upon graduation from San Jose State College with AB degree and major in art, *SMT*, June 18, 1945, p. 3; "Art Exhibition Scheduled to Open Jan. 1" organized by J. DeNejer at **USO** Building with talk by HS student and pastel demonstration by **Marcelle Bear** and finger painting demonstration by Mrs. DeNejer and display of puppets by DeNejer students, *SMT*, Dec. 28, 1945, p. 3.
1946 – Took over teaching art class at HS formerly taught by Breneiser – (see: "**Santa Maria, Ca., Union High School**"); "Program, Elections Scheduled" for Main Street PTA and **De Nejer** to talk on "Adjustment to Art," *SMT*, March 19, 1946, p. 3 and "Parent-Teacher Group of Main Street," *SMT*, March 21, 1946, p. 3; "De Nejer Painting in Art Show" at Oakland, *SMT*, March 21, 1946, p. 3; photo of students of DeNejer's art classes who journeyed to Santa Barbara on a field trip: **Eddie Melton**, Don Black, Mrs. DeNejer, Lois Mankins, Leslie Leal, Bill Lentz, Ken Brown, **Billy Morton**, Leon Permasse … Charles Miller, **Elizabeth Dennison**, Janice Glaister, Judy Dilbeck, Earlene Willey, Marjorie Gish, Virginia Owens and Shirley McAree, *SMT*, May 17, 1946, p. 8.
1947 – [ed. Almost no publicity on DeNejer appears through the year of 1946-47 nor about the SM Art Assn nor about numerous exhibits of work by other shows she intended to mount. President of Santa Maria Art Association whose meetings are often held in her studio.]
1949 – "'Round the Town… Mrs. Ray DeNejer is leaving for Guerneville to take a course in ceramics design with **Marguerite F. Wildenhain**…," *SMT*, Aug. 1, 1949, p. 5; "Spends Summer at Art School" – Pond Farm Workshop run by **Marguerite Wildenhain**, and "At Carmel she sat in classes on oil painting taught by Frederick Taubes, who spent the summer in California and who has now returned to New York," *SMT*, Sept. 20, 1949, p. 6; "Schedule of Art Classes Starting Monday, Oct. 3, De Nejer Studio," *SMT*, Sept. 21, 1949, p. 3; "De Nejer Studio Resumes Schedule" … operate six days a week. **Mrs. Alice Linsenmayer** will give instruction Mondays in drawings and the same day, ceramics classes will be taught by **Mrs. Alice Sample**. The

remainder of the week students will be offered instruction in various types of painting by **Forrest Hibbits** of Lompoc. Ceramics, sculpture, painting and furniture decorating are subjects to be taught by Mrs. DeNejer," *SMT,* Sept. 24, 1949, p. 6; "**Wildenhains**, Pottery Makers, Will Demonstrate" at De Nejer studio, Nov. 30, *SMT,* Nov. 8, 1949, p. 6; Main St. school PTA – "Parents Hear Talk on Art by Jean De Nejer," *SMT,* Nov. 17, 1949, p. 6; "Demonstration Due by **Wildenhains**, Potters," and bio and details, *SMT,* Nov. 22, 1949, p. 6.

1950 – "Talk on Painting Heard by Sorority" **Phi Epsilon Phi**, i.e., "Painting as a Hobby," *SMT,* Feb. 25, 1950, p. 6; "Mrs. DeNejer to Have Novel [Santa Barbara County] Fair Attraction. ... has completed a two-week course of study at Pond Farm, Guerneville, with **Marguerite Wildenhain**... is now preparing for a special exhibit in the county fair ... She will operate a pottery wheel at the county fair flower mart... Mrs. DeNejer will take orders for individual designs while at the fair. Pottery made by Mrs. DeNejer is being sold by the Bouquet Flower shop in Santa Maria and the **Red Cottage** Gift shop in Solvang...," *SMT,* July 15, 1950, p. 5.

1952 – "Pottery Making to be Demonstrated" to **Minerva Club**, *SMT,* Feb. 6, 1952, p. 4; "Creative Art Group AAUW Makes Study of Modeling" and "class is being introduced to all types of material in preparation for teaching children of Santa Maria in free classes, to be sponsored by the AAUW... All classes have been built around **Natalie Cole**'s book on creative arts, '*Art in the Classroom.*' Miss Cole will lecture and hold workshops at **Santa Maria Art Festival** May 24 and 25," per *SMT,* March 18, 1952, p. 4; "De Nejer Pottery to Show in Art Gallery," i.e., City of Paris, SF, 11th Annual Ceramics Show, *SMT,* May 8, 1952, p. 4; "Periods of Art Are Defined for Chapter" of AAUW in Santa Maria in lecture on 'Appreciation of Art,'" and details. "Mrs. DeNejer emphasized in her talk that art is an important part of life of the average human being. 'We must have a willingness to be susceptible to art – intolerance in art as well as in all other fields is a lack of understanding,' she said. Further, it was pointed out, in order to understand art, one must project oneself into the times of the artist, since an artist is the medium to convey a view of his life and time in history. Mrs. DeNejer reviewed the different schools of art. [Renaissance, Gothic cathedrals, Dutch painting, French school, Industrial revolution] The audience learned further that abstract art conveys the abstract idea rather than the subject by line, color and perspective. Some persons have sympathy, while in others, a lack of understanding results in anger. ... Continuing, Mrs. DeNejer spoke of the surrealist school as a 'result of psychology and acceptance of the sub-conscious.'... The non-objective needs no subject matter, but combines beautiful color, line and form. It is difficult to differentiate between the non-objective and abstract schools...," *SMT,* May 12, 1952, p. 4; "Painting Class. Portrait and Still-Life instructed by **Douglass Parshall**, A.N.A. Oils and Watercolors $5.00 per Lesson. Mondays – From 1 p.m. till 4 p.m. De Nejer Studio," *SMT,* June 27, 1952, p. 4; "Mrs. DeNejer Will Go to Washington" to serve as consultant to national AAUW art committee in establishing national guidelines, *SMT,* Sept. 27, 1952, p. 4; "To Leave Wednesday for Washington" and

while in East plans to visit many museums and is accompanied by art patron Mrs. L. A. Ramey, *SMT,* Oct. 11, 1952, p. 4; port. boarding airplane, *SMT,* Oct. 17, 1952, p. 1; "New York Critic Praises Jeanne De Nejer Pottery" in exhibit at Pottery Barn, 10th Ave., NY, *SMT,* Nov. 6, 1952, p. 4.

1953 – "Mrs. DeNejer to Study in New York... New York State College of Ceramics, Alfred University, Alfred, N. Y. where she will begin work on her M. A. degree in industrial ceramic design. Before enrolling, Mrs. DeNejer will go to New York City to attend opening of the 'Five California Potters' exhibition to show her own work ...," *SMT,* Jan. 23, 1953, p. 4; "Mrs. DeNejer Writes 'Hello' From New York... where she is taking advanced work in the study of pottery-making ... at Alfred, N. Y. Two students who share an apartment with Mrs. DeNejer are **Hira Nirodi** of Bangladore, India...," *SMT,* May 6, 1953, p. 4.

1954 – "Lake George Board Lists Faculty members for 1954-5... Mrs. Jeanne DeNejer ...," *Post-Star* (Glens Falls, NY), Aug. 16, 1954, p. 9; "Art Teachers Hold Meeting... at Glens Falls Senior High school ... first in a series of monthly meetings in which the new group plans to exchange information ... On Jan. 14, the group will have dinner at the home of Mrs. Jeanne DeNejer, Lake George. Mrs. DeNejer will present her own system of teaching design in the public schools," *Post-Star* (Glens Falls, NY), Dec. 6, 1954, p. 10.

1955 – "Teachers Hold Dinner Meeting... Mrs. Jeanne DeNejer... of Lake George... Mrs. DeNejer presented her own method of teaching design in the junior and senior high schools. Protected by copyright, the 'DeNejer System of Design' has met with considerable success in the public schools and is beginning to influence art education on the collegiate level as well. Mrs. DeNejer employs her design procedure not only in the fine arts but also in the commercial fields of ceramics, jewelry design, wallpaper and textile design," *Post-Star* (Glens Falls, NY), Jan. 17, 1955, p. 14.

1966 – FORMER HUSBAND – "Raymond DeNejer... 80... self-inflicted, gun-shot wound... retired superintendent of the Kovar Oil Co... Survivors include his wife, Mrs. Jewell DeNejer, [who he married May 15, 1958 in Nevada], two stepdaughters...," *SMT,* June 22, 1966, p. 4.

De Nejer, Jeanne (misc. bibliography)
Deana [Sic. Jeanne?] Hill is listed in the 1910 U. S. Census as age 9 months, residing in Bellflower, Ill., with her parents W. D. Hill (age 43) and Pauline H. Hill (age 36) and siblings: Paul (age 9), Lucy (age 8) and Kent (age 5); Dina [Jeanne?] Hill is listed in the 1920 U. S. Census as age 10, b. c. 1910 in Ill., residing in Miami, Ariz., with her parents, Walter D. and Pauline, and her siblings: Paul, Lucy, and Kent; Jeanne De Nejer is listed in the 1940 U. S. Census as age 31, b. c. 1909 in Illinois, finished high school 1st year, residing in Muroc, Kern County, California (1935) and Santa Barbara County (1940) with husband Ray De Nejer (age 54) and her mother Pauline H. Hill (age 66); in the mid-1940s she registered to vote in the Betteravia Precinct of Santa Barbara County; MOTHER – Pauline Hill d. July 1967 in Santa Ana, Ca., per Social Security Death Index (refs. ancestry.com).

See: "American Association of University Women," 1952, "Blauer, Joyce," "Ceramics," "Community Club (Santa Maria)," 1949, "Edwina's Ceramic Studio," "Hibbits, Forrest," "Foster, Florence," "Junior Community Club," 1950, 1951, "Minerva Club," 1952, "Nirodi, Hira," "Parshall, Douglass," 1952, "Plumm, Howard," "Red Cottage," 1950, "Sample, Alice," "Santa Barbara County Fair," 1949, 1950, 1951, 1952, "Santa Maria Art Association," 1945, 1949, 1950, 1952, "Santa Maria, Ca., Union High School," 1945, 1946, 1951, "Santa Maria [Valley] Art Festival " 1952, 1953, "Santa Ynez Valley Art Exhibit," 1953, "Tri-County Art Exhibit," 1947, 1949, 1950, "United Service Organization (Santa Maria)," 1945, 1946, "Wildenhain, Marguerite," "Winter Arts Program," intro, 1953, "Youry, Ward," 1952

DeNejer Studios (Santa Maria)
Prop. Jeanne De Nejer, c. 1946-52.
See: "DeNejer, Jeanne"

Denman, John Otto (1874-1946) (San Francisco / Santa Maria / Santa Monica)
Painter (sign), 1918. Collector of art, 1916. Promoter.

■ "The Shadow of the Cross. The Genuine Picture. Shown at the **Panama-Pacific** Exposition. A mysterious and unexplainable picture, seen by thousands, admired by all. An unknown light, illuminating it, inspiring devotion and reverence. Even the artist who painted it cannot explain its effulgence. Mr. J. O. Denman, a resident of Santa Maria, purchased this wonderful masterpiece, and will exhibit the same on the afternoon and evening of Saturday, Sunday, Monday, Nov. 18, 19, 20, at the Novelty Theatre before leaving with it, for exhibition purposes throughout the United States…," *SLO DT*, Nov. 17, 1916, p. 8.
Denman, J. O. (notices in Northern Santa Barbara County newspapers on microfilm and on newspapers.com)
1912 – "Unions Concerned… J. O. Denman… have been elected delegates to the Building Trades Council by local No. 510 of the Sign and Pictorial Painters' union…," *SF Call*, March 31, 1912, p. 35.
1913 – "Labor Will Look … Local No. 510 of the Sign and Pictorial Painters' union at its last meeting elected … treasurer, J. O. Denman…," *SF Call*, Jan. 4, 1913, p. 5.
1918 – "Denman the painter has fixed up a nice sign on Judge Morris' window," per "From Saturday's Daily," *SMT*, May 18, 1918, p. 6.
Denman, J. O. (misc. bibliography)
John O. Denman, painter / sign painter, is listed in the *San Francisco, Ca., CD*, 1908, 1910, 1911, 1915, *Santa Monica, Ca., CD*, 1913, 1914, 1917, 1918, 1925; J. O. Denman, painter, is listed in *California, Railroad Employment Records*, 1918; is he John O. Denman, b. Florida c. 1874, enlisted in WWI Aug. 8, 1919 and discharged Jan. 9, 1922, residing Sawtelle, Ca., 1924 per *U. S. National Homes for Disabled Volunteer Soldiers, 1866-1938*; John O. Denman, no occupation, is listed with wife Josephine, in *SF, Ca., CD*, 1920; John O. Denman, retd., Dem. is listed on Hope St. in *Index to Register of Voters, Los Angeles City Precinct No. 323*, 1928; John O. Denman is listed in the 1930 and 1940 U. S. Census as age 65,

finished elementary school 4th grade, divorced, no occupation, residing in Los Angeles; [ed. Do not confuse with his son John O. Denman, Jr., b. 1917 in Calif.]; John O. Denman b. Sept. 5, 1874 and d. Dec. 19, 1946 is listed in *U. S. Headstone Applications for Military Veterans, 1925-1963*; John O. Denman is buried in Los Angeles National Cemetery per findagrave.com (refs. ancestry.com).

Denning, Robert (Pasadena)
Artist, who died at Mattei's Tavern, 1946.

■ "Mr. Robert Denning [sp?] of Pasadena passed away suddenly at Mattei's Tavern Sunday morning. Mr. and Mrs. Denning who were guests at Mattei's Tavern in Los Olivos and at Atterdag in Solvang, spent several weeks in the valley. Mr. and Mrs. Denning were both artists. Mr. Denning's death came as a complete shock to his wife from whom he had never been separated even for a short time during their married life of twenty-six years," *SYVN*, Sept. 20, 1946, p. 3.
This individual could not be identified.

Dennison (Harper), Elizabeth A. (Mrs. Oscar C. Harper, Jr.) (c. 1930-) (Santa Maria / Altadena)
Santa Maria High School student of Mrs. DeNejer who exh. in an art show, 1946. Student of dress design at U of C, 1948. Daughter of Elizabeth T. Dennison, below. Sister of Maryrose Dennison, below.

■ "Early Summer Wedding for Miss Dennison… daughter of Mrs. Elizabeth T. Dennison of Santa Maria … [to] Oscar C. Harper, Jr., son of Mr. and Mrs. Oscar C. Harper of Pasadena… The bride-to-be attended Santa Maria public schools and is a graduate of the University of California at Berkeley with the class of 1950. She is employed as assistant buyer at the Emporium in San Francisco. Her prospective husband, a power engineer, is employed by Combustion Engineering Super-heater Co., Inc.… Miss Dennison was active in campus social life… and was chosen 'homecoming queen' … in her junior year. Miss Dennison majored in decorative art and served as secretary-treasurer of her class as a university senior…," *SMT*, Feb. 16, 1951, p. 4.
Dennison, Miss (notices in Northern Santa Barbara County newspapers on microfilm and on newspapers.com)
1948 – "Miss Dennison Wins Award in Dress Design … a sophomore at the University of California majoring in decorative art…," wins American Wool Growers Assn. competition with two-piece wool dress, *SMT*, Jan. 31, 1948, p. 3.
And possibly 70 social and school notices in the *SMT* between 1944 and 1952 were not itemized here.
Dennison, Miss (misc. bibliography)
Elizabeth A. Dennison is listed in the 1940 U. S. Census as age 10, b. c. 1930 in California, residing in Palo Alto (1935) and Santa Maria (1940) with her mother Elizabeth T. Dennison (age 48) and siblings: Henry, Joseph, and Mary R.; Elizabeth D. Harper is listed in *California Voter Registrations, LA County, Monterey Park, Precinct 50*, 1956 and Precinct 58, 1958; Oscar C. and Elizabeth D. Harper are listed in the *Pasadena, Ca., CD*, 1970; Oscar C.

Harper, Jr. and wife Liz, are listed in the *La Jolla, Ca., Phone and Address Directory*, 2000-2002; (refs. ancestry.com).
See: "DeNejer, Jeanne," 1946, "Dennison, Elizabeth Taff," "Dennison, Maryrose," "Santa Maria, Ca., Union High School," 1944, 1946

Dennison, Elizabeth Taff (c. 1893-1982) (Mrs. Henry C. Dennison) (Santa Maria)
Teacher in home economics at Santa Maria Union High School, 1935-1964, weaver, 1953. Mother of Elizabeth A. Dennison, above and Maryrose Dennison, below.

■ "Although Mrs. Dennison is of the home economics department of SMUHS, she believes that art should be woven like a thread through all the fields of home making. Art has been so interwoven into her own training and experience. A graduate of Stanford, she spent her first two years at that institution concentrating on art before she decided to major in [home?] economics. It was after her fifth year at Stanford, from which she also received her General Secondary credential, that she spent two years at Santa Barbara College specializing in home economics. For her part in 'Art in Action,' Mrs. Dennison will demonstrate weaving on a loom belonging to the art department of SMUHS. She plans to weave place mats of a soft apricot hue intermingled with bright metallic thread. Weaving is a skill in which she has received a great deal of training and experience, having spent two years at the Swedish School of Applied Arts, a weaving center in San Francisco. She also teaches it to her home making students at the high school," per "'Art in Action' to Feature Annual SM Art Festival," *SMT*, May 18, 1953, p. 3.

■ "Elizabeth T. Dennison. San Jose... former resident of Santa Maria died Saturday in a Los Gatos retirement home... Mrs. Dennison had been a resident of Los Gatos for the past 10 years. She had been a teacher in the home economics department at Santa Maria High School from 1935 until her retirement in 1964. She was a graduate of Stanford University. Survivors include ... Elizabeth Harper, Altadena...," *SMT*, May 18, 1982, p. 14.
Dennison, Elizabeth T. Mrs. (notices in Northern Santa Barbara County newspapers on microfilm and on newspapers.com)
Port. with daughters Elizabeth and Mary, *SMT*, Dec. 18, 1944, p. 3; And possibly 150 school and social notices in the *SMT* between 1944 and 1960 were not itemized here.
Dennison, Elizabeth, Mrs. (misc. bibliography)
Elizabeth J. [Sic. T.] Dennison is listed in the 1930 U. S. Census as residing in Woodland, Ca., with her husband and children; Elizabeth T. Dennison is listed in the 1940 U. S. Census as age 48, b. c. 1892 in Texas, finished College, 5th or subsequent year, a teacher, residing in Palo Alto (1935) and Santa Maria (1940) with her children Henry C. (age 16), Joseph G. (age 14), Mary R. (age 12) and Elizabeth A. (age 10); listed in *Santa Maria, Ca., CD*, 1938-70; port. in Santa Maria High School yearbooks, 1942, 1947, 1954 (refs. ancestry.com).
See: "Dennison, Elizabeth A.," "Dennison, Maryrose," "Santa Maria, Ca., Union High School," 1935, 1937, 1939, 1957, "Santa Maria [Valley] Art Festival," 1953

Dennison, Maryrose (Santa Maria)
Art major at San Jose State College, 1947. Sister of Elizabeth A. Dennison, above. Daughter of Elizabeth Taff Dennison, above.

■ "Engagement of Miss Dennison is Announced. Mrs. Elizabeth Dennison has announced the engagement of her daughter, Maryrose, to Thomas Gregory Dusek... of Monterey... Both the bride-elect and her fiancé are junior students at San Jose State College... Miss Dennison graduated from the Santa Maria high school in June 1945 and she is majoring in commercial art," *SMT*, Oct. 30, 1947, p. 13.
See: "Dennison, Elizabeth ..."

Denton, Dora / Doro Way (Mrs. Joseph S. Denton?) (1862-1955) (Santa Maria / Lompoc / Ventura)
Exh. paintings at "Santa Barbara County Fair," 1890. Wife of J. S. Denton, below.

■ "Mrs. Dora Way Denton. Mrs. Doro Way Denton of Ventura, a former resident of Oxnard, died yesterday at her home after a short illness. She was 93. Mrs. Denton, born April 21, 1862 in Redfield, Iowa, moved to Ventura from Oxnard 13 years ago. She was a member of the First Methodist Church of Ventura. She leaves a son, James, of New York, two daughters, Mrs. Faye Edy of Glendale and Mrs. Laura Cooper of Ventura...," *Press-Courier* (Oxnard, Ca.), Nov. 2, 1955, p. 3.
Denton, J., Mrs. (notices in Northern Santa Barbara County newspapers on microfilm and on newspapers.com)
1902 – "Mrs. J. S. Denton of Gilroy is visiting relatives in Santa Maria this week," *SMT*, March 22, 1902, p. 3.
1904 – "Mrs. J. S. Denton of Oxnard is visiting here," *SMT*, Aug. 26, 1904, p. 3, col. 1, and *SMT*, Feb. 27, 1909, p. 5, col. 2.
1939 – "Mrs. Dora Denton returned to Oxnard today after a visit...," *SMT*, Feb. 16, 1939, p. 3.
1954 – "Grace Burden Rites... 77, a resident of Santa Cruz... A native of Iowa, she is survived by a sister, Dora Denton of Ventura...," *Santa Cruz Sentinel*, Jan. 18, 1954, p. 10.
Denton, J., Mrs. (misc. bibliography)
Dora Denton is listed in the 1910 U. S. Census as age 47, b. c. 1863 in Iowa, residing in Oxnard, Ca., with husband Joseph S. Denton and children Lora, Gertrude and Marjorie; Doro Way Denton, mother's maiden name Marshall, father's Way, was b. April 21, 1862 in Iowa and d. Nov. 1, 1955 in Ventura County per Calif. Death Index (refs. ancestry.com).
See: "Denton, Joseph," "Santa Barbara County Fair," 1890

Denton, Joseph Sumner (1861-1938) (Santa Maria / Lompoc)
Exh. wood work at "Santa Barbara County Fair," 1891. Husband to Dora Denton, above.

■ "Former Educator Taken by Death. Joseph S. Denton... He was a member in 1881 of the first graduating class of Drake University, the first principal of the high school at Santa Maria and in succeeding years was principal of Lompoc and Oxnard high schools. His last teaching

position was at Rio Vista, near Sacramento. He retired in 1935…," *LA Times*, Feb. 15, 1938, p. 8.

Denton, J. S. (notices in Northern Santa Barbara County newspapers on microfilm and on newspapers.com)
1890 – New principal, *SMT*, Aug. 2, 1890, p. 3, col. 3.
1892 – "The High School… Prof. Denton as Principal…," and detailed report on previous year's study and pupils, *SMT*, July 16, 1892, p. 3.
1893 – "J. S. Denton, resigned the principal ship of the [Santa Maria] High School here and accepted that of the Lompoc High School. Mr. Denton has been principal of the Santa Maria High School since its organization two years ago…," *LR*, July 29, 1893, p. 3.
1898 – "Mrs. J. S. Denton of Lompoc and two little daughters… on her way north where Prof. Denton has a position at Oak Vale [Sic. Oakdale, San Joaquin County] in the High School," *SMT*, Aug. 27, 1898, p. 3.
And more than 150 additional social and school notices for "Denton" in the *SMT* and 4 for "J. S. Denton" in the *LR*, 1885-1910, were not itemized here.

Denton, J. S. (misc. bibliography)
Joseph S. Denton, no occupation listed, age 30, b. Iowa, residence Santa Maria, is listed in *The Great Register, Santa Barbara County, California*, 1892; Joseph Sumner Denton, teacher, age 36, b. Iowa, is listed in *California Voter Register, Santa Barbara County, Lompoc Precinct No. 3*, 1898; Joseph S. Denton is listed in the 1900 U. S. Census as b. Dec. 1861 in Iowa, residing in Oakdale, Stanislaus County, Ca.; Joseph S. Denton is listed in the 1910 U. S. Census as age 48, b. c. 1862 in Iowa, principal of a high school, residing in Oxnard, Ca., with wife Dora Denton (age 47) and children: Lora, Gertrude and Marjorie; Joseph Denton is listed in the 1920 U. S. Census as a teacher in high school in Napa, Ca. with wife Dora and daughter Marjorie (refs. ancestry.com).
See: "Denton, Dora," "Santa Barbara County Fair," 1891

Denton's (Lompoc)
Jeweler (1909-11) that sold hand-painted china, 1910. Prop. H. E. Denton. Later moved to Santa Maria.
"Our hand painted China is a California product and is second to none, at Denton's the Jeweler," *LR*, Dec. 23, 1910, p. 5.

De Santiago, Miguel (Spanish)
Artist of a painting donated to Mission Santa Ines, 1930.
See: "Mission Santa Ines," 1930

De Toreto, Lollis (Santa Maria)
Member Santa Maria Art Association who exh. at Santa Barbara County Fair, 1952.
No information can be found for this individual whose name was spelled both "DeLaret" and "deToreto" by the newspaper.
See: "Santa Barbara County Fair," 1952

DeVincenzi, John D. (1921-2006) (San Jose)
Artist. Exh. at Hancock College, 1959. Judge at Santa Barbara County Fair, 1959.

■ "Work being exhibited currently at Allan Hancock College Art Gallery consists of fourteen canvases by the California artist John V. DeVincenzi. His exhibit shows that this artist likes to paint street scenes in watercolor with interesting buildings against the sky, and there are one or two oils, drawings, and mixed media studies … A variety of subject matter here is matched by diversity in treatment. The range is from quite representational work to complete abstraction. Born and educated in San Jose, John DeVincenzi was graduated from San Jose State College and received his Master of Arts degree at Stanford University. He is an assistant professor in San Jose College Art department, has done summer teaching in Hartnell College, Salinas, and evening teaching in water color and drawing at San Jose Adult Center. Other teaching experience has included special water color classes for the Montalvo Association and extension teaching in art throughout Central California. His activities have included numerous lectures and demonstrations in the Central California area. DeVincenzi has exhibited in the San Jose Art League annual shows since 1948 and at the annual Santa Clara County Fair since 1946, where he has won numerous awards. Paintings by this artist have been exhibited annually at the California State Fair, the Jack London Square exhibition in Oakland, the Santa Cruz Watercolor exhibitions, and Crocker Gallery exhibition in Sacramento where he was an award winner in 1958. One of DeVincenzi's specialties is portrait painting. Numerous commission portraits of leading citizens in the Central Coast area have been painted by him," and repro of painting 'Cathedral' per "San Jose Artist Shows Paintings at [Allan Hancock College] Gallery," *SMT*, March 3, 1959, p. 3.

DeVincenzi, John (misc. bibliography)
The John De Vincenzi papers are at San Jose State University, Special Collections; exh. Kingsley Art Club, per *Fifty Years of Crocker Kingsley* cited in *PSCA* no. 12.
See: "Allan Hancock [College] Art Gallery," 1959, "Santa Barbara County Fair," 1959

Devine, Patrick Bernard (1875/76-1951) (Santa Maria / Hollywood)
Painter / pastelist of portraits of service men, WWII. Retired customs office inspector from San Francisco.

■ California resident – "Irish Artist Exhibits … opened in the High School Art Department. Most of the paintings in the show are landscapes, although this Irish artist specialized in portraits. He has made more than 800 free pastel portraits for service men and women. Four years ago, Devine resigned after thirty years from his position in the customs office in San Francisco, and since, has devoted his time entirely to art, living in Santa Maria and in Hollywood," *SMT*, March 13, 1946, p. 4.

Devine, Pat (notices in Northern Santa Barbara County newspapers on microfilm and on newspapers.com)
1910 – Her portrait [Lena Edith Thornburg/h Devine] was painted by her second husband P. B. Devine – "Amateur's Art Interests Us. An item appearing in the *San*

Francisco Examiner relating to an art exhibit at the St. Francis Hotel speaks of a painting by P. B. Devine of a pretty woman and as the woman referred to is Mrs. Devine (formerly Miss Thornburg of this city…) … 'A life size portrait of a pretty woman by P. B. Devine, carries a tinge of romance. Devine is a student and the portrait is his first real serious work. He was recently married and during his honeymoon painted the charming picture of his bride. She stands in white street gown which is admirably painted. The color and modeling of the flesh show much promised skill'," *SMT*, Dec. 31, 1910, p. 5.
1942 – "Ida Davis Hall Marriage… to Patrick Bernard Devine which took place in Reno, Dec. 29, 1939. In July of this year Mr. Devine retired from the United States Custom Service, having been employed in the San Francisco office for 36 years. For the past 10 years he served there as examiner and appraiser of works of art, textiles and jewelry imported from Europe. He began his study of art in Tralee, Ireland, where he attended school until 19 years of age. Coming to California, he then studied for several years at the Hopkins Art Institute in San Francisco. He also studied accountancy in San Francisco. He expects to spend his entire time now in art activities. For the present, Mrs. Devine will continue teaching Spanish in Santa Maria high school and junior college where she has been employed for the past 22 years," *SMT*, Sept. 12, 1942, p. 3.
1950 – "Devines will Visit British Isles on Trip… left New York City Monday by plane for Paris, going by way of Luxembourg. After a five-weeks stay in France, the couple planned to visit England, Scotland and Ireland. Mrs. Devine will study French and her husband will study art while in France. It will be Devine's first visit to Ireland, his native land, since leaving many years ago at the age of 19. While in Ireland, they will visit relatives in Tralee, including Devine's cousin, Tom Nolan who is owner and publisher of a newspaper, 'The Kerryman.' The couple expect to return to Santa Maria the last of August…," *SMT*, June 28, 1950, p. 5.
Devine, Pat (misc. bibliography)
Patrick Bernard Devine gave the following information on his *WWI Draft Registration Card* = b. March 1, 1876, working as a Customs Examiner, at US Appraiser's Office, SF; Patrick B. Devine is listed in the 1940 U. S. Census as age 64, b. c. 1876 in Ireland, finished college 1st year, naturalized, divorced, examiner of merchandise, U. S. Customs, residing in Oakland (1935, 1940) with his son, Patrick E. Devine (age 24); Patrick Bernard Devine was b. 1875 in Ireland, married Lena Edith Thornburg [of Santa Maria], and d. 1951 in Santa Barbara County per Gillis/Horton Family Tree; Patrick Bernard Devine was married to Ida Ellen Devine [second wife] and is buried in Santa Maria Cemetery District per findagrave.com (refs. ancestry.com).

DeWitt (Kinkade), Ozena "Zena" B. (Mrs. James Alexander Kinkade) (1878-1961) (Santa Maria)
High School student who earned high marks in art, 1896.
DeWitt, Zena (notices in Northern Santa Barbara County newspapers on microfilm and on newspapers.com)
1894 – "The Grammar Grade. Successful Applicants at the Teacher's Examination. The following is a list of pupils of the Santa Barbara County Public Schools who passed the Grammar School Examination of the County Board of Education, ending June 19, 1894… Santa Maria District – Zena DeWitt…," *SMT*, June 30, 1894, p. 2.
1895 – "Miss Zena DeWitt is spending her vacation at her home, deeply occupied in making dainty Christmas presents for her friends," *SMT*, Dec. 21, 1895, p. 3.
1896 – "High School Notes… Zena DeWitt finished a beautiful painting the first of this week at her studio in her parents' home. She has much natural artistic talent and her paintings have received many flattering compliments,' *SMT*, April 11, 1896, p. 2.
1897 – "Miss Zora DeWitt is in Santa Barbara visiting her sister, Zena, who is a graduate of the High School at that place [1897] and who is taking the teachers' examination," *SMT*, June 19, 1897, p. 3.
DeWitt, Zena (misc. bibliography)
Ozena "Zena" B. DeWitt was b. Sept. 1878 in Santa Barbara to Christopher Columbus DeWitt and Melinda Angeline Gard, married James Alexander Kinkade, was residing in San Francisco in 1916 and d. Sept 23, 1961 in San Francisco per DeWitt Family Tree (refs. ancestry.com).

Dike, Phil (Claremont / Cambria / Palm Springs)
Artist whose work was shown at the first Santa Maria Valley Art Festival, 1952, courtesy Cowie or Dalzell Hatfield Gallery in LA. Held an exh. at Hancock College Art Gallery, 1955.
See: "Allan Hancock [College] Art Gallery," 1955, "Santa Maria [Valley] Art Festival," 1952, 1953, "Santa Ynez Valley Union High School," 1946, and *Cambria Art and Photography before 1960*

Dill, Edwin Marian / Marion (1876-1949) (Chicago)
Chicago potter who demonstrated at the Century of Progress Exhibition in Chicago and at the San Diego Fair. Lectured at SYVUHS, 1939.

■ More than 130 "hits" for Edwin M. Dill in newspapers across America between 1935 and 1945 suggest he toured the country giving ceramic demonstrations, often at high schools and civic clubs. "As a part of the program, Mr. Dill describes the circumstances under which he first learned the potter's trade. He was bound out as an apprentice at an early age, served some seven years apprenticeship, and then became a journeyman potter. He compared this with the present industrial system, and shows how pottery-making was one of the last of the trades to bow before the onslaught of the machine," *Evening Times* (Sayre, Pennsylvania), May 8, 1937, p. 2; port. of Edwin M. Dill, *Wilkes-Barre Times Leader* (Pa.), Dec. 9, 1936, p. 20.
Dill, Edwin (misc. bibliography)
Edwin Dill is listed in the 1920 U. S. Census as age 42, b. c. 1878 in Ill., a potter, residing in Macomb Ward 2, McDonough, Ill., with wife Mary and four children; listed 1930 U. S. Census in Macomb; Edwin Marion Dill b. April 25, 1876 in Macomb, Ill., per Social Security Applications and Claims Index; Edwin Marian Dill d. May 7, 1949 in Macomb, Ill., per Horton Cornish Family Tree (refs. ancestry.com).
See: "Santa Ynez Valley Union High School," 1939

Dimmick, "Sarah" Martha Elizabeth Stewart (Mrs. Phillip J. Dimmick) (1834-1915) (Santa Barbara)
Flower painter, c. 1880-1886. Widowed mother of Walter Dimmick, below.

■ "Mrs. S. M. Dimmick's Studies. We cannot, by anything we may say, add to the enviable reputation enjoyed by the artist Mrs. Sarah M. Dimmick of Santa Barbara, among those who know her pictures. But we cannot refrain from expressing our acknowledgment for the pleasure of a visit to her studio. While Mrs. Dimmock [Sic.]'s brush is not inept at general painting, her admirable taste and exquisite skill is particularly shown in the direction of panel painting. Of wild flowers, foliage, flower and berries of the pepper tree, a branch of almond buds and blossoms, she has some perfect gems. But for truthfulness to nature, delicacy of touch, and minuteness of detail without appearance of labored effort, commend us to the charming morceaus of native grasses. At first, they seemed just transferred to the wood, until, as you gaze at them, fascinated by the grace and beauty of the fragile stems and seeds, you almost expect them to wave and nod in the gentle air," *LR*, Aug. 14, 1880, p. 3.

Dimmick, Sarah (misc. bibliography)
M. S. Dimmick is listed in the 1880 U. S. Census as age 43, b. c. 1837 in Ill., keeping house in Santa Barbara for her son, Walter Dimmick (age 22) and daughter Clara (age 24, at home); Mrs. M. S. Dimmick, studio Hotel Elwood, is listed under "artists" in the *Santa Barbara, Ca., CD*, 1886; Martha Elizabeth Stewart Dimmick is listed in the 1910 U. S. Census as age 75, b. c. 1835 in Ill., widowed, residing in Los Angeles with her niece Sada E. Stewart (age 40); Martha S. Dimmick, b. c. 1834, d. June 27, 1915 in Los Angeles County per Calif. Death Index (refs. ancestry.com).
See: "Art, general (Santa Barbara," "Dimmick, Walter"

Dimmick, Walter Norton (1857-1930) (Santa Barbara)
Prop. of the cannery, "Dimmick & Sheffield," started 1880, for which he drew some of the crate labels. Son of Sarah M. Dimmick, above.
Dimmick, Walter (misc. bibliography)
Walter Dimmick is listed in the 1880 U. S. Census as age 22, b. c. 1858 in Illinois, an agent for a steamship line, residing in Santa Barbara with his widowed mother, M. S. Dimmick (age 43) and sister; Walter N./W. Dimmick married Fannie Wright on March 10, 1887 in Santa Barbara per Calif. County Birth, Marriage and Death Records; Walter Norton Dimmick was b. Jan. 1857 in Ill., to Phillip J. Dimmick and Martha Sarah Stewart, married Fanny Wright, was residing in Alameda, Ca., in 1890 and d. Dec. 11, 1930 in Berkeley per Ebert_Egan_Dimmick_Ward Family Tree (refs. ancestry.com).
See: "Dimmick, Sarah M.," "Labels, Fruit Crate," 1880

Dinnes, Bert T. (1891-1973) (Santa Maria / Orcutt)
Photographer, amateur. Member and secretary of the Santa Maria Camera Club, c. 1939-55. Husband to Gladys Dinnes, below?
Dinnes, Bert (notices in Northern Santa Barbara County newspapers on microfilm and on newspapers.com)
One hundred fourteen "hits" appear for "Bert Dinnes" and his activities with the Camera Club in the *SMT* between 1935 and 1973 but most were not itemized here. He was an employee of the Union Oil Co.
Dinnes, Bert (misc. bibliography)
Bert Dinnes is listed with wife, Gladys, in various Northern Santa Barbara County CDs, 1938+ as employee of Union Oil Co.; Bert Dinnes is listed in the 1940 U. S. Census as age 48, b. c. 1892 in Calif., finished high school 4th year, working as a gas inspector, residing in Santa Barbara (1935, 1940) with wife Gladys (age 47); Bert Dinnes b. Oct. 2, 1891, d. Nov. 1973 per Social Security Death Index (refs. ancestry.com).
See: "Dinnes, Gladys," "Santa Maria Camera Club," 1935-55

Dinnes, Gladys (Mrs. Bert Dinnes) (Santa Maria / Orcutt)
Photographer, amateur. Member Santa Maria Camera Club, 1955. Wife of Bert Dinnes, above.
See: "Dinnes, Bert," "Santa Maria Camera Club," 1955

Dinsdale, Hazel Ardella
See: "Katzenstein (Dinsdale), Hazel Ardella (Mrs. Lawrence Weges Dinsdale)"

Dipple, Gordon Cyril (1928-?) (Santa Maria / Santa Barbara / Deming, N.M.)
Sculptor. Painter. Teacher in the art department at Santa Maria Union High School, 1952-56. Exh. Allan Hancock [College] Art Gallery, 1955, 1956. By 1957 was teaching art in Sacramento.

■ "Dipple will show the production of metal crafts in three classifications: jewelry, hammer work in copper and silver, and enamelware. There will be a keen interest in his work because of the public comment caused by the outstanding exhibit of enamelware shown in a local store window during **Public Schools Week**, all the work of his high school students. He is a graduate of the **California College of Arts and Crafts**, where he also was a member of Delta Phi Delta. His work has been shown in national magazines," per "'Art in Action' to Feature Annual SM Art Festival," *SMT*, May 18, 1953, p. 3.
Dipple, Gordon (notices in Northern Santa Barbara County newspapers on microfilm and on newspapers.com)
1953 – "Retirement Party… Joe Ramalho… [gardener and general handyman at Santa Maria High School] … Art teacher Gordon Dipple created a huge and colorful greeting card bearing the names of all Joe's co-workers through the years. … The hand-tooled wallet was the creation of art director **George Muro** and members of his classes….," *SMT*, Nov. 19, 1953, p. 1.

1957 – "An interest in the history and study of art will be further developed for **Mrs. Louise Corollo** on a visit to San Jose, Vallejo and Sacramento this week-end… and will also pay a visit to the art department at American University, North Sacramento. Gordon Dipple, who taught in Santa Maria High School art department and who specializes in wood carving is in charge of the art department at the North Sacramento school…," *SMT*, Feb. 2, 1957, p. 4.

1992 – Port. with dog and "Gordon Dipple exhibits eclectic pieces in DCA [Deming, New Mexico, Center for the Arts] show… paintings, drawing and wood sculptures … 'I'm not a 'theme' person' he said. From the enormous, brightly colored paintings of oriental poppies in his Deming yard to the stark charcoal studies of glorioso daisies, Dipple's works cover a broad range of styles, techniques and mediums… pastels of local landscapes, a set of pine carved figures based on Picasso lithographs… A native Coloradan, Dipple spent most of his career in California where he received a Master of Fine Arts degree from the California College of Arts and Crafts in Oakland. He has shown works in several prestigious Californian galleries including the Santa Barbara Museum of Art, the San Francisco Museum of Modern Art and the Oakland Museum … He has also taught arts and crafts at both the high school and junior college levels. Moving to Deming seven years ago, Dipple rebuilt a northside home and added a studio for art work. Though he was an early arts council promoter and organizer, and has shown selected works in the area, this is his first one-man show in Deming… Dipple believes that Deming's location on I-10 and other factors give it the potential to make a strong little industry of arts and crafts…," *Deming Headlight* (Deming, NM), Oct. 21, 1992, p. 1.

1995 – MOTHER – "Ida Mae Dipple, 86, Deming resident, died… Ida married Cyril Dipple on May 23, 1925 … She is survived by her husband Cyril… a son, Gordon Dipple…," *Deming Headlight*, Jan. 3, 1995, p. 3.
And more than 70 additional "hits" for "Gordon Dipple" in New Mexico newspapers up to 2005 on newspapers.com were not itemized here.

Dipple, Gordon (misc. bibliography)
Gordon Cyril Dipple was b. Feb. 8, 1928 in Toole, Mont. per Montana Birth Index; Gordon Dipple is listed in the 1930 and 1940 U. S. Census in Montana; Gordon Dipple whose port. appears with juniors in the Oilmont High School (Oilmont, Mont.), yearbook, 1945? and with seniors, 1946; Gordon Dipple is listed in the Oakland, Ca., telephone book, 1953; Gordon Dipple port. appears in the Santa Maria High School yearbook, 1953, 1954; Gordon Dipple, artist, is listed on Chapala in *Santa Barbara, Ca., CD*, 1959; is he Gordon C. Dipple, cook, Unicorn, listed in the *San Jose, Ca., CD*, 1962; Gordon Dipple, artist, is listed in the *San Jose, Ca., CD*, 1964 and in the same CD is a Cyril Dipple; Gordon Dipple, teacher PS is listed in the *Santa Barbara, Ca., CD*, 1966; Gordon Dipple, teacher, Happy Valley School, is listed in the *Ojai, Ca., CD*, 1966; Gordon Dipple Custom Jewelry is listed in the *Santa Barbara, Ca., CD*, 1969; "Gordon D. Dipple Jewelry & Design, appears in *Santa Barbara, Ca., CD*, 1972; "Gordon Dipple Gallery, on Coast Village Circle in Montecito is listed in the *Santa Barbara, Ca., CD*, 1976; Gordon Dipple

is listed in Deming, N. M. per *U. S. Public Records Index, 1950-1993*, vol. 3 and *U. S. Phone and Address Directories, 1993-2002* (refs. ancestry.com).
See: "Allan Hancock [College] Art Gallery," 1955, 1956, "Beta Sigma Phi," 1954, "Halloween Window Decorating Contest (Santa Maria)," 1953, "Santa Maria, Ca., Union High School," 1953, 1954, 1955, "Santa Maria [Valley] Art Festival," 1953, "Scholastic Art Exhibit," 1954, "Winter Arts Program," intro

Disney Studios (Hollywood)
One-time employer of several artists who were active in Northern Santa Barbara County. A Disney film was made on the Peake Ranch.
1938 – Repro: "Snow White," *SYVN*, March 18, 1938.
See: "Andersen's," 1954, "Armitage, Frank," "Bodrero, James," "Comic Strip," "De La Torre, Bill," "Downs, Ruberna," "Grant, Campbell," "Jekel, Gus," "Jones, Fred," "Kuelgen, Paul," "Leslie, John M.," "McGuire, Neil," "Motion Pictures (Santa Ynez Valley)," 1954, 1956, "Neil, Milt," "Patin, Ray," 'Peake, Channing," 1954, 1957, "Santa Ynez Valley High School," 1954, "Shaw, Dick," "Stonehart, Leslie, Jr."

Displaced Persons Colony (Buellton)
Proposed colony in Buellton for European handicrafters displaced by WWII, 1949.
See: "Art, general (Buellton)"

Dixon, Vern Dillman / Dellman (Mrs. Charles Parlin Dixon) (1889-1966) (Santa Maria)
Female. Manager of a restaurant. Exh. decorated chest, bowls, tinware and ceramics at Santa Barbara County Fair, 1949. Exh. ceramics at hobby show, 1950. President of Santa Maria Art Association, 1949.
Dixon, Vern, Mrs. (notices in Northern Santa Barbara County newspapers on microfilm and on newspapers.com)
1937 – HUSBAND – "Coffee Shop owner in S.M. Passes in L.A. Charles Parlin Dixon, 49, proprietor of Harvey's Coffee Shop… He was a native of Kansas and had lived in Santa Maria for seven years. Deceased is survived by his wife, Vern Dixon…," *SMT*, Oct. 18, 1937, p. 6.
1950 – "Hats Cause Fun… parade of original 'creations' in millinery held at last night's meeting of Women of the Moose, Mrs. Vern Dixon won first prize, wearing a 'bathroom special.' Her hat was made out of a hot water bag. 'Horses under the pepper tree' was the name of the second prize winner, worn by Mrs. **Matilda Sorenson**. **Mary Simas**, whose hat was fashioned from an old style toaster, was judged third. … **Emily Roderick**, devised her hat of 'the things you do not find in an auto court kitchen'…," *SMT*, Sept. 2, 1950, p. 4.
And, more than 100 "hits" for club, business and family matters for "Vern Dixon" in *SMT* between 1935-66 were not itemized here.
Dixon, Vern, Mrs. (misc. bibliography)
Vern Dixon is listed in the 1940 U. S. Census as age 57, b. c. 1883 in Kansas, finished high school 4th year, widowed, manager of a restaurant, residing in Santa Maria (1935,

1940) with her mother Ellen Dellman (age 73) and five roomers; Vern Dixon is listed in the *Santa Maria, Ca., CD,* 1948-65; Vern Dixon, mother's maiden name Raines, was b. July 4, 1889 and d. May 7, 1966 in Santa Barbara County per Calif. Death Index; Vern Dixon (1889-1966) is buried in Santa Maria Cemetery District per findagrave.com (refs. ancestry.com).
See: "Community Club (Santa Maria)," 1950, "Hobby Night," 1961, "Santa Barbara County Fair," 1949, 1952, "Santa Maria Art Association," 1949, 1950

Dixon, Winifred Kittredge Crawford (Mrs. Louis N. Crawford) (Mrs. Henry W. Dixon) (1892-1968) (Santa Maria)
As Winifred Crawford taught Domestic Art at Santa Maria High School, 1924-26 but taught English for c. 28 years. Exh. paintings and pastels at Minerva Club, Art and Hobby Show, 1959. Widow of Louis Crawford, above.
■ "Winifred Dixon, Well Known Teacher [of journalism] Dies… She was born July 4, 1893 [Sic?] in Portland, Ore., and came to Santa Maria in 1919… Mrs. Dixon was a graduate of the University of California at Berkeley with the class of 1915. She taught for 28 years in the Santa Maria High School district and then served as a teacher at Allan Hancock College for three years. She was Hancock's dean of women in 1956-57. She retired from teaching in June of 1957. She also was active in many local organizations. [organizations named] … She was a long time member of Minerva Club and headed that group as president in 1960-61. She served as a member of the city recreation committee from 1942 to 1949. Her first husband, **Lewis [Sic. Louis] N. Crawford**, prominent architect in Santa Barbara and San Luis Obispo counties, preceded her in death in 1946. Survivors include her husband, Henry W. Dixon of Santa Maria…," *SMT*, Nov. 20, 1968, p. 2.
Dixon, Winifred (notices in Northern Santa Barbara County newspapers on microfilm and on newspapers.com)
1955 – Port. with Hancock college students, *SMT*, Jan. 13, 1955, p. 1.
1957 – Port., *SMT*, Jan. 9, 1957, p. 1 and Jan. 16, 1957, p. 7; port. as retiring dean of women at Hancock College, *SMT*, June 17, 1957, p. 3.
And more than 80 social and school notices for "Winifred Dixon" between 1950 and 1968 were not itemized here.
Dixon, Winifred (misc. bibliography)
Winifred K. Dixon appears in the *Santa Maria, Ca., CD,* 1958-68; Winifred Kittredge Dixon b. 1892 and d. Nov. 19, 1968 is buried in Santa Maria Cemetery District per findagrave.com (refs. ancestry.com).
See: "Crawford, Louis," "Crawford, Winifred," "Minerva Club, Art and Hobby Show," 1959

Doane, Warren H. (Los Angeles / Santa Maria)
Filmmaker (Hollywood and Italy), 1937-38. His son, Warren P. Doane, was active with the Santa Maria High School theater arts department where he acted and made set sketches, 1939. Oil was discovered on the Doane property.
Doane, Warren (notices in newspapers on newspapers.com).
1937 – "Warren Doane Joins Film Firm of Young Mussolini. Warren Doane, Santa Maria motor court and oil well owner, has left for Europe to return to his former work in the making of motion pictures. He left today for Rome, Italy, to join the film company of young Mussolini, son of the premier-dictator of that country. His contract is for six months, with the privilege of renewal... Mrs. Doane and their son and daughter remained here. They will go to Italy at the end of six months for a visit. If Mr. Doane decides to remain after that time, the family will also probably remain in Europe. Before coming to Santa Maria, the Beacon Motel owner was connected with the picture industry in Hollywood for several years in the production department of the Hal Roach studio...," *SMT*, Dec. 2, 1937, p. 1.
1938 – "Mrs. Doane Leaves by Plane for East ... to meet her husband, who is arriving in New York on a two months' leave of absence from his motion picture work in Italy," *SMT*, Aug. 3, 1938, p. 3; "Pickups and Comments. People in Italy are not as fat as the people in America according to Warren Doane... back from a six-month stay...," and other observations, *SMT*, Sept. 8, 1938, p. 1.
1943 – SON – "A notice to *The Times* from McCloskey General Hospital, Temple, Tex., names Warren P. Doane of Santa Maria... as among men 'recently returned from active duty in the South Pacific as patients in this hospital'," *SMT*, Oct. 11, 1943, p. 3.
Doane, Warren (misc. bibliography)
Warren Doan is listed in the 1930 U. S. Census as age 38, b. c. 1892 in North Dakota, general manager of a Movie Studio, residing in Los Angeles with wife, Aileen and children Elmer (age 15), Frances (age 13) and Warren (age 10); Warren Doane is listed with spouse Aileen in the *Santa Maria, Ca., CD,* 1938; SON, Warren P. Doane, provides the following information on his WWII Army Enlistment Record = b. Oct. 28, 1919, finished 2 years of college, civil occupation = Actors and actresses, residing in Los Angeles, enlisted March 3, 1941, branch infantry, component National Guard; FATHER – Warren Howard Doane b. Oct. 30, 1890 in Valley City, ND, to Erastus Blinn Doane and Sarah Lottie Lynn, married Aileen Elizabeth Duncan, and d. May 12, 1964 in Los Angeles per Wylie Family Tree (ref. ancestry.com).
See: "Santa Maria, Ca., Union High School," 1939

Dobro, Boris (1890-1975) (Santa Barbara)
Photographer with Brooks Institute of Photography in Santa Barbara who often judged photo competitions on the Central Coast, including that of the Santa Maria Camera Club.
See: "Santa Maria Camera Club," 1948, 1949, 1950, 1954, "Brandt-Erichsen, Thor," 1960, and *San Luis Obispo Art and Photography before 1960*

Dodge, John (Lompoc / Atascadero / SLO)
Lompoc high school coach who turned to teaching mechanical drawing in San Luis Obispo, 1955.
Dodge, John (notices in Northern Santa Barbara County newspapers on microfilm and on newspapers.com)
1957 – "Dodge Replaces Tuttle as Coach…," *SMT*, Jan. 24, 1957, p. 2; "Dodge to Coach Bengal Baseball. John Dodge, former football coach at Lompoc High school, has been named head baseball coach at San Luis Obispo High school. Dodge left Lompoc in 1955 to take over the coaching reins at Atascadero. He moved to San Luis Obispo the following year as a mechanical drawing instructor, dropping out of the sports scene…," *LR*, Feb. 7, 1957, p. 16.
See: *Atascadero Art and Photography before 1960* and *San Luis Obispo Art and Photography before 1960*

Dodge (Schmitt), Lillian (Lillie Jennie Dodge) (Mrs. George Herman Schmitt) (1886-1988) (Lompoc / Los Angeles)
Teacher of free hand drawing, 5th grade, Lompoc Grammar School, 1909-13.
1909 – "Miss Lillian Dodge, teacher of the La Salle school, and her aunt, Miss [Margaret A.] Coolidge [age 64] of Los Angeles, have taken rooms for the present with Mrs. Q. R. McAdam. When the rainy season sets in Miss Dodge will move nearer to her work," *LR*, Aug. 6, 1909, p. 8.
1910 – "Miss Mary E. Cooley… Lompoc Grammar School … Miss Cooley has been succeeded by Miss Dodge, who taught the La Salle school last year," *LR*, Feb. 4, 1910, p. 8.
1911 – "5th. Miss Lilian Dodge. She has 32 enrolled, from 10 to 11. Miss Dodge has Drawing in addition to the regular course and is meeting with fine success in the progress and management of her department," *LR*, May 19, 1911, p. 1, col. 1.
1913 – "21st Annual C. E. Union Convenes… The following leave Lompoc … to attend the session… Lillian Dodge…," *LR*, May 23, 1913, p. 1; "Friends Here… Announcements … wedding of Miss Lillie Jennie Dodge to George Herman Schmitt which was solemnized in Salt Lake City last Friday, Sept. 5. … Mr. Schmitt was a resident of Lompoc for several months and for a while was connected with the Lompoc Cyclery … They will be at home after October 31 at Glendale, Cal.," *LR*, Sept. 12, 1913, p. 1;
Dodge, Lillian (misc. bibliography)
Is she Lillie Jennie Dodge, age 25, school teacher, Rep. listed in *Voter Registrations, Lompoc Precinct No. 3*, c. 1911, 1912 or 1913?; Lillie J. Dodge was b. July 26, 1886 in Mountain Home, Id., to David Dodge and Jennie Steers, married George H. Schmitt, and d. July 9, 1988 in Los Angeles per Cole Family Tree (refs. ancestry.com).
See: "Lompoc, Ca., Elementary Schools," 1910, "Schools (Northern Santa Barbara County)," 1910

Dole, William (1917-1983) (Santa Barbara)
Artist, art professor at UC, Santa Barbara, who exh. at Allan Hancock College Art Gallery, 1954.
■ "William Dole was born in 1917 in Angola, Indiana to his postmaster father, W. Earl Dole and his mother, Edna

Cowen Dole. … Dole chose to further his education at Olivet …. He also apprenticed under George Rickey, receiving a degree in Art History and went on to receive his teaching credentials in art. It was during the 1940s that Dole enrolled in art classes at Mills College in Oakland, California … [After service in WWII] … Dole attempted a job as a commercial artist for Virgil A. Advertising. He quickly changed his mind when he entered graduate school at the University of California, Berkeley, in the summer of 1946. It was here that he continued on for two years as a lecturer in the Arts Department. During these years Dole began professionally exhibiting his work. In 1949, he took on a position as an Assistant Professor at the University of California, Santa Barbara. … and went on to become a full time professor in 1962. Collage quickly became his medium … Dole was appointed Department Chairman in 1971 until 1974. The *William Dole Retrospective 1960-1975* exhibition traveled from 1976 from the Los Angeles Municipal Art Gallery to the Santa Barbara Museum of Art," from www.sullivangoss.com
See: "Allan Hancock [College] Art Gallery," 1954, "Castagnola, Gladys," 1955, "Santa Barbara County Fair," 1958, 1961, "Winter Arts Program," 1953

Domingos, Albert "Bert" (Santa Maria)
Photographer, amateur. Active with Santa Maria Camera Club, 1946-48. Empl. Valley Ice Co.
See: "Santa Maria Camera Club," 1947

Dominques/z, Margaret Zella
See: "Hodgdon (Dominguez / Dominques), Margaret Zella (Mrs. George Richard Dominguez / Dominques)"

Donahue, Katherine Teresa (Kate / Katie) (1872-1944) (Solvang / Santa Barbara)
Painter of water color of old mission, c. 1890. Teacher of manual training, SF, and Santa Ynez Valley Union High School, 1918-19.
■ "Kate Donahue Buried Tuesday… passed away at the family home… She was born in Gilroy in 1872 and came to the Santa Ynez valley with her parents, the late Mr. and Mrs. Thomas J. Donahue, and eight brothers and sisters, by steamer from Santa Cruz to Gaviota and thence by wagon to Old Mission Santa Ines in 1882. For 16 years the family lived in the Mission living quarters and cared for the church which, at that period, held occasional services. … From early childhood, Miss Kate was devoted to her church. The children of the family walked twice daily to attend the Ballard school, a distance of more than three miles. In the early 90s she taught in the public schools, her first school being the Ines district in a small building not far from the Mission. She also taught in San Luis Obispo and Ventura counties. After teaching for several years, she attended the manual training school in Santa Barbara and was a member of its first graduating class. Following graduation, she taught manual training in a San Francisco high school for several years and later taught the same course in the Santa Ynez Valley Union High school. She taught for 29 years before she retired to make her home with her sister, Miss

Nellie Donahue, last remaining member of the family…," *SYVN*, Aug. 4, 1944, p. 1.

■ Photo of her water color of Old Mission Santa Ines (held by her sister, Miss Nellie Donahue) … Katy and Annie … were twins…," *SYVN*, Sept. 17, 1954, p. 51 (i.e., C-9).

Donahue, Katie (misc. bibliography)
Miss Katie [Kate, Katherine] Donahue, teacher, residing at Solvang, Ca., is listed several times in the *California Voter Registrations, Santa Barbara County, Solvang Precinct*, between 1920-1928; Catheran [Sic.] Donahue is listed in the 1920 U. S. Census as age 48, b. c. 1872 in Calif., a teacher, residing in Solvang with her mother Mary Donahue (age 80), sister Nellie and two nieces; Katherine Teresa "Kate" Donahue was b. March 23, 1872 in Calif. to Thomas James Donahue and Mary Agnes Condron, and d. July 29, 1944 in Santa Barbara County per Aslak Paulson Strand Family Tree; Katherine T. Donahue is buried in Calvary Cemetery, Santa Barbara per findagrave.com (refs. ancestry.com).

Donoho / Donahoe / Donohue, David / Dave (Santa Barbara)
Artist and photographer, teacher, Brooks Institute of Photography, who judged a photo show at La Purisima Camera Club, 1947 and at Santa Maria Camera Club, 1946, 1947.
Is he Dave Donoho whose poster appeared in *19 South Bay Photographers*, Fresno State College Art Gallery, 1972. *This individual could not be further identified.*
See: "La Purisima Camera Club," 1947, "Santa Maria Camera Club," 1946, 1947

Dorsey, Harry C. (1877-1961) (Santa Maria)
Filmmaker, theater owner.

■ "Harry C. Dorsey, owner and operator of theaters in Santa Maria for 40 years, died this morning at Broadview Sanatorium in Pasadena. Mr. Dorsey was 83. Born in Benton County, Iowa, on May 12, 1877, Mr. Dorsey spent more than 60 years in show business, operating theaters, producing motion pictures, and working in theater management. He came to Santa Maria in 1919, purchasing the **Gaiety** Theater. He later built the Santa Maria Theater, opening it in 1928, and then purchased the Studio Theater. … He began his career in show business when he was 14, following in the footsteps of an aunt and uncle. His first job in the theater was backstage, and filling in in front of the footlights, but his main interest was production, and that was the career he eventually followed. In San Francisco in the 1890s, he joined forces with Frank Montgomery and the two were in the motion picture business in various cities throughout the country, including Memphis, Tenn., Jacksonville, Fla., Savannah, Ga., Columbia, S.C., Dayton, Ohio, and New York City. After selling out his New York interests in the early 1900s, he returned to the west coast and eventually to Santa Maria," and port. and "H C. Dorsey, Theaterman, Dies at 83," *SMT*, Feb. 22, 1961, p. 1.

■ "Harry Dorsey brought true showmanship to Santa Maria," *SMT*, July 8, 2001, p. 25 (i.e., C-5).

And, almost 100 additional "hits" on the "showman" after his death in 1961 were not itemized here.
Dorsey, Harry C. (misc. bibliography)
Harry Custer Dorsey was b. May 12, 1878 and d. Feb. 22, 1961 in Pasadena, Ca., and is buried in Santa Maria Cemetery District per findagrave.com (refs. ancestry.com).

Dorsey, Harry Custer, Jr. (1928-after 2018) (Santa Maria)
Photographer.

■ "Harry Dorsey, Jr. Photo Appears in National Magazine… snapped by Dorsey aboard the *S. S. Volendam* when a fellow student, Dick Shafer, slipped and fell into the ocean… The photographer, a sophomore at Occidental college, is the son of Mr. and Mrs. Harry C. Dorsey… After being graduated from Santa Maria high school, he served two years with the U. S Marine Corps and entered Occidental college a year ago. Dorsey was one of a group of students who toured Europe the summer of 1948. He traveled thru Holland, France and Italy, his trip being arranged thru the Institute of International Education of New York city… Mrs. Dorsey said her son's interest in photography began when, as a 10-year-old, he went to the World's Fair in New York City with his father, snapping pictures en route with his first camera. His pictures of flower arrangements have appeared in the *Christian Science Monitor* and *Los Angeles Times* as well as local newspapers," *SMT*, Feb. 18, 1949, p. 6.
Dorsey, Harry C., Jr. (notices in Northern Santa Barbara County newspapers on microfilm and on newspapers.com)
1946 – "Harry Dorsey Enlists in Marine Corps. … aviation branch and is in San Diego for 'boot' training for eight to 14 weeks. He was graduated in the June class from Santa Maria High School with honors and was one of the four student commencement speakers. He was photograph editor of the '*Review*,' high school annual. Young Dorsey's enlistment is for a two-year period," *SMT*, July 29, 1946, p. 3.
1949 – "The photograph taken… last summer of a fellow traveler falling off the deck of a passenger liner scored in this week's *Satevpost*. Harry's one-in-a-million shot was taken when a youth climbed into a lifeboat No. 13 (a swell movie title, that) to have his picture taken. Just as he slipped over the side, Harry let him have it with a 1/400th-of-a-second shot. The near-disaster proved good fortune for Harry who received a $100 award from the *Post* …," *SMT*, Feb. 21, 1949, p. 4.
1952 – "Dorseys are Guests at Surf Rider on Hawaii… Hawaii abounds in camera enthusiasts but none more interested in photography than Harry Dorsey, Jr.… who plans to become a professional after majoring in the subject at USC…," *SMT*, Sept. 5, 1952, p. 4.
1984 – "Three Architects Win Five Awards in Design Contest… Harry Dorsey Residence, Playa del Rey, Buff & Hensman Architects…," *LA Times*, Dec. 2, 1984, p. 184 (i.e., pt. VIII, p. 2).
2018 – SISTER – "Anne Dorsey Gill … Anne is survived by … Harry Dorsey, Jr. and his wife Beverly of Montecito …," *SMT*, July 19, 2018, p. A4.

Dorsey, Harry C., Jr. (misc. bibliography)
Listed 1940 U. S. Census as age 11, b. c. 1929, living in
Santa Maria with his parents Harry C. and Ethel May
Dorsey; Harry Dorsey appears in the Santa Maria High
School yearbook, 1946; ship passenger lists show he sailed
from Rotterdam to New York, arriving Sept. 12, 1948 and
from San Francisco to Honolulu arriving Aug. 18, 1952;
Harry Custer Dorsey was b. Oct. 12, 1928 in Los Angeles
to Harry C. Dorsey and Ethel May Dorsey, was residing in
Santa Maria, Ca., in 1935, per Fricker Family Tree Canada;
Harry C. Dorsey b. Oct. 12, 1928 was residing in Playa del
Rey, Ca., in 1996 per *U. S. Public Records Index, 1950-
1993*, vol. 1 (refs. ancestry.com).
See: "Minerva Club Flower Show," 1948

Doud, Alice (San Luis Obispo)
*Art teacher in SLO who exh. Allan Hancock [College] Art
Gallery, 1958.*
See: "Allan Hancock [College] Art Gallery," 1958,
"Ceramics," 1958, and *San Luis Obispo Art and
Photography before 1960*

Dougan, Kathleen, Miss (Berkeley)
*Photographer who took still shots of condors at Cuyama,
1934.*
See: "Photography, general (Santa Maria)," 1934

Dougherty, Joan (SLO)
*Artist who exh. at Santa Ynez Valley Art Exhibit, 1954,
1955.*
See: "Santa Ynez Valley Art Exhibit," 1954, 1955, and *San
Luis Obispo Art and Photography before 1960*

**Douglass, William Harlan "W. H." (1856-1941)
(Lompoc)**
*Prop. of store that sold picture frames. Morehead &
Douglass became W. H. Douglass, c. March 1892.*
See: "Morehead & Douglass," "Variety Store"

**Dove, Bonnie Dortha Reid (Mrs. Vern William Dove)
(1924-1981) (Solvang)**
*Clothing designer of Bonnie Dove Originals, 1948. Wife
of V. William Dove, below.*
■ "Mr. and Mrs. V. William Dove, Jr., are the new
residents and they are both in business. ... here for about a
month, the Doves purchased the small redwood home of
the Misses Sampson and Linkfelder of Santa Barbara on
Grand Avenue... Mr. Dove is head of the Dove Roofing
Company and his wife is designer of custom clothes for
women.... Bonnie Dove is the creator of the 'Bonnie Dove
Originals,' and was for a time the leading designer on the
west coast of maternity clothing. She expects to continue
her designing work on a limited basis and will cater to local
trade...," per "Roofing Firm Opens Here," *SYVN*, Nov. 19,
1948, p. 4.

**Dove, Bonnie (notices in Northern Santa Barbara County
newspapers on microfilm and on newspapers.com)**
1949 – "Girls Preparing for S.B. Parade... costumes for the
Santa Barbara Fiesta parade... The girls are making their
costumes at the high school under the direction of Mrs. V.
William Dove...," *SYVN*, July 29, 1949, p. 1.
1950 – "Notice of Trustee's Sale. T. O. No. 28611... Deed
of Trust dated October 15, 1948, executed by **Vern W.
Dove, Jr.**, and Bonnie D. Dove, his wife...," *SYVN*, Jan.
20, 1950, p. 7.
Dove, Bonnie (misc. bibliography)
Bonnie Dove, wife of V. William Dove, is listed at 123
Miramar Ave., per *Santa Barbara, Ca., CD*, 1948; Bonnie
Dortha Reid (to 1946)/ Bonnie Dove (1960)/ Bonnie Rowe
(1977)/ Bonnie MacDougall (1998), was b. March 28, 1924
in Grady, Okla. to Robert Reid and Elsie Tudor, and d.
May 1981 per Social Security Applications and Claims
Index (refs. ancestry.com).

Dove, Vern William, Jr. (1918/19/20-1992) (Solvang)
Glass designer, 1948. Husband to Bonnie Dove, above.
■ "Mr. and Mrs. V. William Dove, Jr., are the new
residents and they are both in business. ... Mr. Dove has
been in the roofing business for nearly 14 years and before
coming to the Valley operated firms in Santa Barbara,
Ventura and the San Fernando Valley. He was also in the
roofing and general construction business in Honolulu for
six years... Mr. Dove is also somewhat of an artist. He has
had considerable experience in tile and ceramic work and
specializes in unique designs for glass shower doors," per
"Roofing Firm Opens Here," *SYVN*, Nov. 19, 1948, p. 4.
Dove, V. William (misc. bibliography)
Vern William Dove gave the following information on his
U. S. WWII Draft Card (dated Oct. 21, 1940), b. July 24,
1918 in Bristol, Okla., working for Dixon Co., residing in
Pismo Beach, Ca., relative John Bechtold; Vern W. Dove,
Jr. was residing in South Pasadena, Ca., in 1981 and in
Huntington Beach, Ca., in 1988 per *U. S. Public Records
Index, 1950-1993*; Vern William Dove was b. July 24, 1920
in Bristow, Okla., to Verne W. Dove and Grace Ellen
Borders, married Bonnie Dortha Reid, was residing in
Pismo Beach in 1940, and d. July 16, 1992, in Los Angeles
per McCall Family Tree; Vern William Dove, mother's
maiden name Borders, was b. July 24, 1919 in Okla. per
Calif. Death Index (refs. ancestry.com).

Dowe, Oscar Smith (1855-1932) (California)
*Itinerant photographer. Prop. of Oriental Photographic
Gallery who visited Northern Santa Barbara County,
1887.*
■ "Mr. Dowe of photographic fame of SLO gave us a call
to-day. He intends to locate here for a few weeks. Mr.
Dowe's ability as a photographic artist cannot be too highly
praised. His work shows for itself...," *SMT*, Aug. 27, 1887,
p. 3.
**Dowe, Mr. (notices in California newspapers on microfilm
and on newspapers.com)**
1887 – "O. S. Dowe of the Oriental Photographic Parlors of
San Luis Obispo has established branch parlors at Los
Alamos and advertises a stay at that point of but three

weeks. All work is done by the instantaneous process. Prices same as in San Luis Obispo," *LR*, July 30, 1887, p. 3, col. 2.

1889 – "Rafenburg [Sic. Rifenburg?] & Dowe, the photographers on F street, just south of The Hughes, have certainly done some of the finest work in their line ever seen on the coast. … For some time past, they have had a branch at Selma and last night Mr. Dowe went to Porterville to open a branch there. Their work is second to none…," *Fresno Weekly Republican* (Fresno, Ca.), March 22, 1889, p. 6, col. 1; "Mr. O. S. Dowe of the Oriental gallery, lately of San Francisco, and who has been located at Bakersfield for the last few months, is now with us for a few weeks only…. Best on the coast. His samples of work show for themselves and his prices being so reasonable (only \$3 per doz.) for fine cabinet photos … brings them within the reach of all… thirty days will be the limit of his stay… Opposite Cosmopolitan hotel …," *Tulare Advance Register*, May 2, 1889, p. 3; "A Card. Through the interference of a couple of third-rate photographers, I have been compelled to move my place of business outside of the fire limit and will be found from this date on H street between Tulare and King streets where I propose to remain for the next thirty days… O. S. Dowe. Prop. Oriental Gallery," *Tulare Advance-Register* (Tulare, Ca.), May 13, 1889, p. 3; "Mr. Dowe's frame of photographs at the Grand hotel of some of the citizens of Tulare show that he is a photographer of merit and deserving of the liberal patronage of the people. Good photos are what we all want… Mr. Dowe's stay here is limited to the 8th of June. He cordially invites all to call… Gallery on H street between Tulare and King streets," *Tulare Advance Register* (Tulare, Ca.), May 30, 1889, p. 2.

1895 – "For once Auburn can claim to possess a photographer. Mr. Dowe who has located here for the next thirty days is, without question, as fine a workman as the State can boast of… His prices, \$2 per dozen for cabinet photos, is very reasonable… He will be here until December 10th. Gallery next to Odd Fellows' Hall," *Placer Herald*, Nov. 23, 1895, p. 5, col. 1; "Photographer Dowe's photos of the platino process are grand – something entirely new in Auburn," *Placer Herald* (Rocklin, Ca.), Nov. 30, 1895, p. 5.

Dowe, Mr. (misc. bibliography)
O. S. Dowe is listed in the 1900 U. S. Census as a photographer residing in Inyo, Ca.; Oscar Smith Dowe, b. Dec. 1855 in Ill., to Perkins S. Dowe and Lucy E. Rifenburg, was residing in Humboldt, Ca., in 1888, and d. June 26, 1932 in Fort Bragg, Ca., per Photographer Search Dowe D. W. Family Tree (refs. ancestry.com).

Downs (Pursel), Ruberna Ruth (Mrs. Harry Wellman Pursel) (1909-1997) (Los Olivos / Los Angeles)
Studied to be an art teacher. Taught art classes for the EEP, 1934-35. Worked as an artist for Disney, 1937.

■ "Los Olivos Girl Weds Architect in L.A. Miss Ruberna Ruth Downs, eldest daughter of Mr. and Mrs. W. H. Downs of Los Olivos, and Harry Wellington [Sic. Wellman] Pursel, son of Mr. and Mrs. Louis Pursel of Hollywood … The bride was born in Los Olivos, attended grammar school, graduated from the Santa Ynez Valley Union high

school with the class of '27. After two years at Stevens college, Missouri, she attended the University of California from which she graduated … will make their home in Hollywood…," *SYVN*, April 9, 1937, p. 1.

Downs, Ruberna (notices in Northern Santa Barbara County newspapers on microfilm and on newspapers.com)
1927 – "Ruberna Downs to Attend Art School … leaves Sept. 5 for Columbia, Missouri, where she will enter art school. Miss Downs was a graduate of the local high school in last June's class," *SYVN*, Sept. 2, 1927, p. 1.
1929 – "Miss Ruberna Downs left on Saturday for Missouri where she is attending the Art School at Columbia University," *SYVN*, Jan. 11, 1929, p. 8.
1932 – "Miss Ruberna Downs was one of the 1760 who graduated from the University of Calif. last week…," *SYVN*, May 20, 1932, p. 8.
1933 – "Miss Ruberna Downs has returned to Los Angeles where she is taking a post-graduate course at the University of Southern California," *SYVN*, April 21, 1933, p. 4.
1935 – "Ladies' Aid of Santa Maria and Los Olivos Needlecraft… all day meeting… Talk on the work of **EEP** art classes with exhibits, Ruberna Downs," *SYVN*, June 7, 1935, p. 1; "Miss Ruberna Downs left Wednesday for Los Angeles where she expects to take up research work," *SYVN*, Oct. 4, 1935, p. 8.
1937 – "Los Olivos Girl Aids in **Disney Film**. Walter Disney's 'Snow White and the Seven Dwarfs' … **Mrs. Harry Pursel**, better known as Miss Ruberna Downs, has been working in the Disney studios in Hollywood, where she has been making drawings for the 'seventh dwarf.' … [She grew up locally.] Her art work showed such decided talent that she was encouraged to continue in this line of study. She attended Stephens school in Missouri, later taking special art courses in the University of California and University of Southern California," *SYVN*, Dec. 24, 1937, p. 1.
And more than 60 additional social and travel notices in the *SYVN* 1925-40 not itemized here.

Downs, Ruberna (misc. bibliography)
Ruberna Ruth Downs was b. Feb. 6, 1909 in Ballard to William Henry Downs and Etelka 'Aunt Telk' Davis, married Harry Wellman Pursel and d. Jan. 3, 1997 in Monrovia, Ca., per Davis Family Tree by Kitty (refs. ancestry.com).
See: "Emergency Educational Program," 1934, 1935, "Santa Ynez Valley Union High School," 1927

Dowty, Ruth Ida (Santa Maria)
Santa Maria J. C. student. Painted designs on various theater sets for JC play, 1940. Active on Splash magazine, 1938, 1939. Studied art at San Jose State College, 1941.
See: "Posters, general (Santa Maria)," 1941, "Santa Maria, Ca., Union High School," 1940, "Splash," 1938, 1939

Drafting

Akin to mechanical drawing. Taught in ALL higher schools: i.e., high schools, adult schools, JCs. Utilized in many Central California industries, including architecture, engineering, general design, etc.

Drafting (notices in Northern Santa Barbara County newspapers on microfilm and on newspapers.com)

1913 – "Coloring Drawings. A Tip to Draftsmen that May Save Time and Trouble. Every draftsman has had occasion at one time or another to color a drawing or a white print. The use of colored inks is unsatisfactory; crosshatching in colors obscures the details and is slow, while water colors have the disadvantage of slowness, besides being difficult to apply evenly. A quick and satisfactory method of coloring involves the use of ordinary wax crayons and gasoline. Crayon of the color desired is applied and then rubbed with a piece of cloth wet with gasoline until the color is even and extended to the limits desired. If it overruns the lines, it can be erased with a pencil eraser. Some colors, particularly the yellows, purples, greens and light blues, produce much better results than others. … The method is applicable with equal success to eggshell and smooth drawing papers and to white prints on both paper and cloth – *Engineering and Mining Journal*," *SMT*, July 12, 1913, p. 6.

1959 – "Federal Electric Corp. A service company of the World Wide International Telephone & Telegraph Corp. Operator and Maintenance Contractor of the **Naval Missile Facility**… Pt. Arguello, has immediate openings for: … Junior Draftsman. Young man or lady to perform drafting duties in Engr. Dept. Duties include detailed drawings and sketches, retouching work, preparation of calibration curves, layout and some art work. Applicant should be High School Graduate with one year exper. in drafting capacity," *LR*, Oct. 26, 1959, p. 12.

See: "Arrow Blueprinting," "Barker, Francis," "Black, John," "Civilian Conservation Corps," 1936, "Hyland, William," "Lompoc, Ca., Union High School," 1939, 1948, 1959, 1960, "Marriott, O.C. & Co.," "Mayer, Edna," "Murayama, Frank," "Nadeau, Evelyn," "Naval Missile Facility," "Nelson, Milton," "Ortega (R. M.) & Sammons (Wm)," "Oxx, William," "Petersen, Earl," "Powers, Clifford," "Sabin, Charles," "Sanders, Ellen," "Santa Maria, Ca., Adult/Night School," 1921, 1926, 1931, 1949, "Santa Maria, Ca., Union High School," 1925, 1937, 1938, 1941, 1956, 1957, 1958, 1959, 1960, "Spangler, Lafayette," "Stout, John," "Van Zandt, Warren," "Wood, A. L."

Dudy, Elaine (Santa Maria)

Teacher of handcraft at Camp Drake, 1935. Winner in Scholastic Art Exhibit, 1935. Made posters for Minerva Club Flower Show, 1933.

See: "Camp Fire Girls," 1935, "Junior Community Club," 1936, "Minerva Club, Flower Show," 1933, "Scholastic Art Exhibit," 1933, 1935

Duffy, Marynett (Mrs. Duffy) (Los Angeles / Lompoc)

Ceramics teacher at Smiley's, 1950.

See: "Smiley's Ceramic Supplies"

Duggan, Ann L. (Mrs. Duggan) (Santa Maria)

Taught arts and crafts at Santa Maria High School, 1945/46. Serviceman's wife.

Port. in Santa Maria High School yearbook, 1946 (ref. ancestry.com).

No additional information could be found for this individual.

See: "Santa Maria, Ca., Union High School," 1945, 1946

Duncan, Raymond Thomas (1881-1982) (Santa Maria)

Carver who worked with a pen knife on wood and sandstone, 1934. Collector. Prop. of an auto court.

■ "Knife Carves Sandstone. Patience and a pen-knife produce for a Santa Maria man excellent small pieces of statuary. Chalky, hard-surface standstone from Santa Maria hills furnish him with a free medium for expression. R. T. Duncan, 305 Bunny avenue, found leisure time on his hands and so from caving links of chain from a block of wood to the point where he now has more than 30 finished pieces of sandstone sculpture was a natural step. Purchase of a small marble statuette some time ago from a Santa Maria dealer gave him the idea of copying its intricate lines and curves. A month later he finished it. It is smaller but sharply accurate. He has made copies of many small objects 'd'art, and other work he has completed just 'grew.' Most of them are given away to friends. His most ambitious exhibit is nearly a foot wide by four inches high and four inches thick. It is a copy of a marble piece embracing vines clinging to and covering a wall and large vases. He changed its design slightly in places but used to complete the piece only the pen-knife, a drill and sandpaper. Feet and claws of a tiny lizard are reproduced faithfully and flower buds, vines, etc. are sharp and accurate as the original. In his home-made art exhibit, he has small, odd-appearing ash trays, a bowl with a pipe resting beside it, the large statuette described above and many others. They fit in well with many queer curios he has collected from South American spots. He has a fan carved from one small piece of wood. It has a spread of eight inches. Its blades lock and are evenly spread. But it is in his new love – sandstone working – that he finds greatest enjoyment, and it is to this he devotes most of his time. Excursions to nearby hills are made regularly for raw material. Sometimes he finds a bad piece of sandstone which chips or breaks in two when he works on it. An amazing amount of work and time go into completion of the larger projects," *SMT*, March 13, 1934, p. 1.

Duncan, R. T. (notices in Northern Santa Barbara County newspapers on microfilm and on newspapers.com)

1930 – "City Building Permits Skyrocket … R. T. Duncan, four-unit court, three rooms each, 305, A. B. C. and D," *SMT*, March 31, 1930, pp. 1, 4.

1934 – WIFE – "Dora Bell Duncan… native of Draston, Texas, aged 49 years, passed away at the family home, 305 Bunny Avenue," *SMT*, May 24, 1934, p. 3;

1937 – MOTHER – 'Mrs. Lizzie Duncan is Called by Death… in the home of her son, Raymond T. Duncan, 305 East Bunny Ave.," *SMT*, July 22, 1937, p. 5;

1943 – "I Spied… R. T. Duncan showing friends examples of his intricate stone and wood carving," *SMT*, July 1, 1943, p. 1.

Duncan, R. T. (misc. bibliography)
Raymond Thomas Duncan, b. April 1, 1881 in Corsicana, Tx., married Dora Belle Stewart, and d. Nov. 8, 1982 in Ventura, Ca., per Kirby-Dunn & Barker-Johnson Family Tree (ref. ancestry.com).

Dunham Cabinet (Santa Maria)
Prop. Kenneth F. and Rose Dunham. Exh. Santa Barbara County Fair, 1949. In 1959 it was located at 224 N. Smith. Rose Dunham was active with the Santa Maria Art Association, 1949.
Almost 700 "hits" for "Dunham Cabinet" in *SMT*, 1945-1960, primarily ads, were not itemized here.
See: "Santa Maria Art Association," 1949, "Santa Barbara County Fair," 1949

Dunkerley, Amber
See: "Broadus, Amber G."

Dunlap, Joe (?) (Joseph Byron?) (c. 1851-after 1906?) (Point Sal)
Carver. Gypsum (Diatomaceous earth / Celite?). As "J. Dunlap" exh. best stone work at "Santa Barbara County Fair," 1891. Prop. of White Laundry, 1883?
Dunlap, J. (notices in Northern Santa Barbara County newspapers on microfilm and on newspapers.com)
1888 – "Mr. Joe Dunlap of Pt. Sal, when last in town, presented the *Times* with an open book, made out of a fine sample of Point Sal gypsum," *SMT*, Dec. 5, 1888, p. 3.
1891 – "Married… Dunlap – Million – Point Sal, Oct. 28, 1891 by Rev. G. T. Weaver, Mr. J. B. Dunlap and Mrs. Mary Million," *SMT*, Oct. 31, 1891, p. 3.
And, a few notices in the *SMT* 1880-1900 not itemized here.
Dunlap, J. (misc. bibliography)
[This individual could not be positively identified.]
Is he Joseph Byron Dunlap, age 21, b. Indiana, laborer, residing in Pescadero, who registered to vote Oct. 2, 1875 per *Great Register, San Mateo County*; Joseph B. Dunlap, age 28, b. Indiana, a farmer in Lompoc, registered to vote June 23, 1879 per *Great Register of Santa Barbara County*, 1879; Joseph Byron Dunlap, age 39, b. Indiana, laborer, residing in Guadalupe, who registered to vote Aug. 25, 1890 per *The Great Register Santa Barbara County*; Joseph F. Dunlap married Mrs. Mary J. Milliom [Sic?] in 1891 per Western States Marriage Index; is he Joseph Byron Dunlap, Engineer, age 47, b. Indiana, residing in Soquel, registered to vote April 4, 1897 per *Great Register of Santa Cruz County, Soquel Precinct No. 2*, p. 69; is he Joseph Byron Dunlap, age 55, painter, residing in Santa Rosa RFD, No. 5, listed in *California Voter Registrations, Sonoma County, Matanzas Precinct*, c. 1906 (refs. ancestry.com).
See: "Santa Barbara County Fair," 1888, 1891

Dunlap, (James) Reldon
Secretary-manager of Santa Barbara County Fair, mid 1950s.
See: "Santa Barbara County Fair," 1954, 1957, and see "Helen Dunlap (Mrs. James Reldon Dunlap)" in *Cambria Art and Photography before 1960*

Dunlap, William A., Rev. (Lompoc)
Photographer, amateur. Minister of Presbyterian church, 1946.
■ "First Pastor to Be Guest Speaker. Rev. William Dunlap, whose first pastorate was in Lompoc First Presbyterian Church during World War II, will be one of the guest speakers at a Presbyterian meeting January 27 in the Santa Ynez Valley Church in Ballard. Dunlap (retired) and Mrs. Dunlap now live in Santa Barbara," *LR*, Jan. 25, 1960, p. 2.
Dunlap, William (notices in Northern Santa Barbara County newspapers on microfilm and on newspapers.com)
1944 – "Rev. Case to Close Pastorate… The following two Sundays in June, the church will be supplied by William Dunlap, a graduate of this year's class in Princeton Theological Seminary. Mr. Dunlap is a graduate of Wheaton College, Wheaton, Illinois, and a resident of Hollywood, Calif.," *LR*, May 26, 1944, p. 5.
1945 – "Preacher Almost Shoots Big Bear – With His Camera. Reverend and Mrs. William Dunlap are home after spending an enjoyable vacation at Yosemite…," *LR*, July 6, 1945, p. 1.
1946 – "Dunlaps to Show Colored Films. Colored slides of their motor trip through 30 states and two Canadian provinces will be shown Sunday evening by Rev. and Mrs. William Dunlap at the Presbyterian church. The minister and his wife recently returned from an extended tour of the east during which they took more than 600 colored photographs," *LR*, June 27, 1946, p. 4; "Rev. Dunlap to Speak at 20-30 Meeting Tonight… will show Kodachrome slides of his recent trip which took him over 9,000 miles, thirty states and two provinces," *LR*, July 25, 1946, p. 9.
Dunlap, William (misc. bibliography)
William A. Dunlap, pastor, is listed with wife Lillian R. in the *Lompoc, Ca., CD*, 1945; Rev. William A. Dunlap is listed with wife Lillian in the *Westwood / Brentwood / Bel-Air, Ca., CD*, 1955, 1956, Rev. William A. Dunlap, retired minister, is listed with wife Lillian R. in the *Santa Barbara, Ca., CD*, 1964 (refs. ancestry.com).

Dupuis, Robert Charles "Bob" (1924-1982) (Santa Maria)
Member Santa Maria Camera Club, 1958, president 1959, active beyond 1965. Handled or exh. photos at Santa Barbara County Fair, 1958, 1959, 1960. Photo chairman of Santa Barbara County Fair, 1960. Prop. Professional Photographers, 1960. Husband of Shirley DuPuis, below.
■ "Robert Charles Dupuis, 58 … Mr. Dupuis was born May 14, 1924 in Lowell, Mass. He retired from the Army-Air Force Base Exchange Services in 1976 and was former general manager of Professional Surveillance, Inc. He had been a sergeant with the Guadalupe Police Department Reserves and formerly a reserve officer with the Arroyo

Grande Police Department. He was a veteran of the U. S. Navy during World War II. He was a member of the Santa Maria Elks Lodge… Survivors include his widow, Shirley J. Dupuis …," *SMT*, Sept. 1, 1982, p. 24.

Dupuis, Bob (notices in Northern Santa Barbara County newspapers on microfilm and on newspapers.com)
1960 – Port. as Photo Chairman of SB Co. Fair, *SMT*, July 20, 1960, p. 37 (i.e., 21-B); "Certificate of Transacting Business Under Fictitious name… I, the undersigned, certify that I am transacting a commercial free-lance photography business at 705 West Hermosa Street in the city of Santa Maria… under the fictitious name to wit: **Professional Photographers**. My name in full and residence address is: Robert C. Dupuis, residing at 403 West Burny, Santa Maria," *SMT*, Oct. 4, 1960, p. 6.

Dupuis, Bob (misc. bibliography)
Robert C. Dupuis, employee of General Telephone, and wife Shirley are listed in the *Santa Barbara, Ca., CD*, 1956, 1957, 1958; Robert C. Dupuis, cable splicer, Gustav Hersch, with wife Shirley, is listed in the *Santa Maria, Ca., CD*, 1959; Robert C. Dupuis, electrician, Kellogg, and wife Shirley J. are listed in the *Santa Maria, Ca., CD*, 1965; Robert C. Dupuis, salesman Tire Outlet, and wife Shirley J. are listed in the *Santa Maria, Ca., CD*, 1968; Robert C. Dupuis, employee, Vandenberg AFB and wife Shirley J. are listed in the *Santa Maria, Ca., CD*, 1970; Robert Charles Dupuis was b. May 14, 1924 in Lowell, Mass., to Charles Joseph Dupuis and Irene Robert, married Shirley Jean Everhart, and d. Aug. 28, 1982 in San Luis Obispo per Spreng / May Family Tree (refs. ancestry.com).
See: "Santa Barbara County Fair," 1958, 1959, 1960, "Santa Maria Camera Club," 1958, 1959

Dupuis, Shirley Jean Everhart (Mrs. Robert C. Dupuis) (1930-2016) (Santa Maria)
Photographer, amateur. Wife of Robert C. Dupuis, above. Member Santa Maria Camera Club c. 1958+.

■ "Shirley was born on January 11, 1930 to John L and Eva Viola Adams Everhart in Grand Island Nebraska. She had a head full of lovely red curls, and green eyes. …The family of six moved … to California in 1937, finally settling in Santa Maria California in 1938….
Shirley met Robert Charles Dupuis one Saturday night while dancing at the Rose Garden Ballroom in Pismo Beach, CA. She loved to jitterbug and swing dance, and was usually found there on the weekends. Robert (Bobby) and Shirley were married in Santa Maria on May 14th, 1950…. They had three children together, Teresa Michelle, Maryjo Ann, and Richard Charles. … Shirley had a few long-term jobs that she enjoyed. …," Stevenson & Sons Funeral Home Notice 09/230/2016 on findagrave.com.

Dupuis, Shirley (misc. bibliography)
Shirley Jean Everhart Dupuis was b. Jan. 11, 1930 in Grand Island, Neb., to John L. Everhart and Eva Viola Adams, was married on May 14, 1950 in Santa Maria, and d. Sept. 29, 2016 per U. S. Obituary Collection; Shirley Jean Dupuis died in Miles City, Montana but is buried in Santa Maria Cemetery District per findagrave.com (refs. ancestry.com).
See: "Dupuis, Robert," "Santa Maria Camera Club," 1959

Duquette, Anthony "Tony" (1914-1999) (Hollywood)
Hollywood designer who exh. at Santa Ynez Valley Art Exhibit along with "Hollywood Notables," 1954.

■ "Anthony Duquette (June 11, 1914 – September 9, 1999) was an American artist who specialized in designs for stage and film," Wikipedia.org.
See: "Santa Ynez Valley Art Exhibit," 1954

Durenceau, Andre Maurice (1904-1985) (Hollywood/ New York)
Illustrator of animals (painted for National Geographic) exh. at Santa Maria Library and in Arroyo Grande, 1950. The artwork, owned by Travelers Insurance, toured the country in 1950.
See: "Santa Barbara County Library (Santa Maria)," 1950, and *Central Coast Artist Visitors before 1960*

Dyer, Ernest I. (1872-1939) (Piedmont)
Photographer. Member of Ornithological Society of California, who filmed condors in Cuyama, 1934.
See: "Photography, general (Santa Maria)," 1934

Dykes, Viola Mildred (1895-1955) (Lompoc)
Teacher of craft classes in Lompoc adult school, 1940-53. She also taught art in Santa Barbara, second half of 1930s, and briefly in Solvang.

■ "Mrs. Viola Dykes Honoree at Park Bon Voyage. … here Since 1939. Mrs. Dykes came to Lompoc as head of Adult Education at the Community Center [Sic.], in 1939 [Sic. 1940?] and is now planning to reside with her son-in-law and daughter, Major and Mrs. Frank Howard, in Encino… Students in Mrs. Dykes' classes have gone all over the world, some are now in Guam, some in Germany and many of them keep in touch with her by card and letter. …," *LR*, June 11, 1953, p. 16.

Dykes, Viola (misc. bibliography)
Viola M. Dykes is listed in the 1930 U. S. Census as divorced, an "art teacher," lodging in Sacramento; Mrs. Viola M. Dykes is listed in *Voter Registrations, Los Angeles*, 1932; Viola M. Dykes is listed as "teacher" in *Voter Registrations, Santa Barbara*, 1934-40; Viola Dykes is listed in the 1940 U. S. Census as age 44, b. c. 1896 in Calif., finished high school 4th year, divorced, working as a teacher in government work, residing in Santa Barbara with Jack Dykes, her son, and a lodger; Mrs. Viola M. Dykes is listed as "teacher" in *Voter Registrations, Santa Barbara County, Lompoc Precinct No. 4*, 1942-44; Viola M. Dykes is listed as "teacher" in the *Lompoc, Ca., CD*, 1945, 1947; Viola M. Dykes is listed as "teacher" in the *Santa Maria, Ca., CD*, 1948; Mrs. Viola M. Dykes is listed in *Voter Registration Index, Los Angeles*, 1954; Viola Mildred Dykes b. May 10, 1895 in California, d. Feb. 4, 1955 in Reno, Nev., per Nevada Death Certificates (refs. ancestry.com).
See: "Alpha Club," 1940-41, 1949, "Community Center (Lompoc)," 1951, "Huyck, Marie," "King, Angie," "Lompoc, Ca., Adult/Night School," 1940-53, "Lompoc, Ca., Recreation Department," 1948, "Lompoc, Ca., Union High School," 1946, "Lompoc Community Woman's

Club," 1948, 1950, "Santa Ynez Valley, Ca., Adult/Night School," 1948, 1949, "Wygal, Elsa"

E

Early, Mr. (?) (Hollywood)
Photographer who visited Lompoc, 1955.
"Delightful Buffet Supper… flower-fringed patio of Mr. and Mrs. Walter Manfrina's Floradale Avenue home… following the white marigold contest judging… guests… **Mr. Bob Landry** and Mr. Early, Los Angeles photographers… two-day activities… Mr. Early and Mr. Bob Landry who were on hand to capture the first shot of a white marigold, should one have been found. …," *LR*, Aug. 25, 1955, p. 5.

Easterday, Birdie
See: "Coffin (Easterday), Birdie S. (Mrs. Robert Oscar Easterday)"

Ebbert's Interiors (Lompoc)
Interior Decorator, 1961-62.
■ "Ebbert's Interiors Offers Complete Décor Service… in the V. Village Shopping Center carries a choice selection of furnishings, along with floor coverings and draperies,and interior decorating service," *LR*, Nov. 30, 1961, p. 29.
See: "Kern, Barbara"

Edmondson, Leonard (1916-2002) (Los Angeles)
Printmaker / teacher who held a one-man show at the Hancock Art Gallery, 1955.
See: "Allan Hancock College Art Gallery," 1955, "Castagnola, Gladys," 1955, and *Central Coast Artist Visitors before 1960*

Education Week
See: "Public Schools Week"

Edwards, Ernest Freeland (1882-1978) (Santa Maria)
Photographer, amateur. Charter member Santa Maria Camera Club, and lecturer, 1939. Member Rock and Mineral Club, 1941. Principal of Main Street School, 1939.
■ "Ernest F. Edwards… Mr. Edwards was born Feb. 10, 1882 in Marshall, Minn., and had been a resident of Santa Maria since 1918. He was a retired schoolteacher having taught in the Santa Maria Valley for more than 30 years and had been a member of Hesperian Masonic Lodge 264…," *SMT*, Nov. 24, 1978, p. 11.
Edwards, E. F. (notices in Northern Santa Barbara County newspapers on microfilm and on newspapers.com)
1939 – "Popularity of Camera Hobby Continues. Thousands of camera fans were the most noticeable thing seen at the New York World's Fair by E. F. Edwards, he

told other members of the local Camera club last night. He also described Gloucester, Maine, where he found 5000 artists living in various stages of privation, for the sake of their art. Edwards and his wife spent a ten-week vacation touring the United States and Canada. Other points of interest described for the club were the slave market of New Orleans, the oldest cathedral in the [new?] world which is located in St. Augustine, Fla, and Callander, Ontario, where they saw the Dionne quintuplets…," *SMT*, Sept. 22, 1939, p. 3.
See: "Santa Maria Camera Club," intro, 1939, "Teacher Training," 1940

Edwards, Stanley Murray (1899-1981) (Santa Barbara)
Painter / decorator / teacher. His artwork, "Rocks" was distributed to Lompoc High School, 1934.
Edwards, Stanley (notices in California newspapers on newspapers.com).
1925 – "Will Address Art Club… Oxnard Art club … Decoration and Color … Mr. Edwards was a judge at the first Ventura County Eisteddfod. Decoration of the Samarkand hotel in Santa Barbara was under his direction and he will supervise this year the decoration of the Ark of the Covenant at the new Jewish synagogue in San Francisco," *Press-Courier*, Sept. 23, 1925, p. 6; "Society… Friday, October 16. Design and Color class, Community Center. 10 a.m. Stanley Edwards, teacher. Auspices Oxnard Art club…," *Press-Courier* (Oxnard, ca.), Oct. 14, 1925, p. 4, col. 1.
1926 – "Art Teacher Goes Abroad. Stanley Edwards of Santa Barbara who has been in Oxnard each week, conducting the color and design class held by the Oxnard Art club at Community Center, has given up his work here and in Santa Barbara and will go abroad. Says the *Santa Barbara News*: Stanley Edwards is en route to New York, having left Wednesday for the Atlantic coast to sail from there on February 13 on the *S. S. Pittsburgh* for Liverpool, from where he will go at once to London to join his former teachers, Frank Ingerson and George Dennison, who have a studio there. He will assist in some work which Mr. Dennison and Mr. Ingerson are doing and engage in study, after which he will tour Europe. He will not return to this country until October and may remain on the other side for a longer time. For several years Mr. Edwards has been a member of the faculty of the State Teachers' college, where he taught applied and decorative arts. He was associated with Mr. Ingerson and Mr. Dennison in doing the furnishing and interior decorating of Samarkand. Mr. Dennison and Mr. Ingerson have been living abroad for several years. Mr. and Mrs. E. F. Edwards accompanied their son to Pasadena and are remaining there for a week's visit with another son, Edward Edwards," *Press-Courier*, Feb. 6, 1926, p. 4.
1937 – Brief rev. of paintings at Woman's Club of Hollywood, *LAT*, Feb. 21, 1937, pt. III, p. 4, col. 2.
Bibliography
Exh. California Art Club (1934, 1935), Painters and Sculptors Club (1935, 1936) and Public Works of Art Project (1934) per Nancy Moure, "Artists' Clubs and Exhibitions in Los Angeles Before 1930," *PSCA*, vol. 2; Exh. Statewide Art Exhibit, 1936, per Nancy Moure,

"Index to the State-Wide Art Exhibits (First through Twenty-Seventh) sponsored by the Santa Cruz Art League," *PSCA*, vol. 12.

Edwards, Stanley (misc. bibliography)
Stanley M. Edwards is listed in the 1900, 1910, 1920, 1930, 1940 U. S. Census, completed high school 4th year, working as a decorative artist, residing with his parents in Santa Barbara, Ca.; Stanley Edwards port. appears in Santa Barbara High School yearbook, 1918; Stanley M. Edwards is listed in many *Santa Barbara, Ca., CD*; Stanley Murray Edwards was b. Nov. 9, 1899 in Montecito, Ca. to Edward Franklin Edwards and Anna May Murray, and d. April 27, 1981 in Santa Barbara per Isaac and Isabel (Anderson) Davisson Family Tree; Stanley Murray Edwards is buried in Santa Barbara Cemetery per findagrave.com (refs. Ancestry.com).
See: "Civil Works Administration," 1934

Edwina's Ceramic Studio (Santa Maria)
Ceramic studio. Prop. Edwina Freitas [Hamilton]. Open 1951-67+.

■ "Mrs. Freitas Will Open Ceramic Studio. Mrs. Edwina Freitas who has been a student of **Mrs. Ray DeNejer** in ceramics and pottery making for two years and who has taught this art in the past year in home classes, is opening a studio tomorrow at 227 East Chapel. Daily hours six days a week will be 9:30 a.m. to 6:30 p.m. Classes for children and adults, and also evening classes, if desired, will be offered by Mrs. Freitas in hand pottery and also in decorating un-fired ware. The studio is fully equipped to do firing and glazing. There will be many finished pieces on exhibition and for sale, including items suitable for gifts and for all occasion use in the home. Door prizes will be offered on opening day to the public," *SMT*, June 25, 1952, p. 4.

Edwina's Ceramic Studio (notices in Northern Santa Barbara County newspapers on microfilm and on newspapers.com)
1951 – "Enroll Now in Ceramic Classes at Edwina's Ceramic Studio – also – Commercial Firing," *SMT*, Oct. 3, 1951, p. 4.
1952 – Classified ad: "Ceramics for Gifts & Personal Pleasure. Be amazed at your own artistic ability. Free instructions! Complete stock of Greenware and Supplies – commercial firing. Visit My Studio Now or call for information. Edwina's Ceramic Studio, 227 E. Chapel," *SMT*, Aug. 14, 1952, p. 13.
1953 – "Announcing Larger Ceramic Studio. Instructions in China Painting. Monday evenings – Wednesday Afternoons, by **Elizabeth Borquist**. Ceramic Classes Daily and Thursday Evenings. We have enlarged our studio and have added a classroom for students' convenience. Visit our studio and arrange to enjoy the charm and relaxation that Ceramic Study can give. Edwina's Ceramic Studio, 227 E. Chapel St.," *SMT*, Feb. 4, 1953, p. 4; "Ceramics. Just Received: Zebras, Giraffes, Fauns and Poodle Dogs. Slip per gal. 75c. Paints, Glazes and Brushes. Edwina's Ceramic Studio, 227 E. Chapel St. Phone 5-6282. Santa Maria," *LR*, Dec. 24, 1953, p. 6.
1954 – "Ceramics, Supplies, Glazes, Greenware. Wholesale, Retail. Free Instructions. China Painting.

Custom Firing… 227 E. Chapel St., Santa Maria," ads run in *SLO T-T*, 1953, 1954.
1955 – "Ceramics: Green Ware and supplies, custom firing, china painting. Free ceramic lessons. Summer classes for school aged children. Custom made gifts. Edwina's…," *SMT*, Aug. 9, 1955, p. 7.
1959 – "Mothers, Enroll Your Child in Free Summer Classes. Edwina's Ceramic Studio…," *SMT*, June 13, 1959, p. 3.
1960 – "Ladies Attention. We have the largest stock of Greenware between LA and SF. Slip, Modeling clay, Supplies, Custom firing, China painting classes. Edwina's Ceramic Studio, 227 E. Chapel St., Santa Maria. Dial 5-6282," *LR*, April 21, 1960, p. 23.
1970 – "Notice of Sale… to be held at the Redevelopment Agency of the City of Santa Maria … Ceramic Spray Booth, Pouring Table, 12 Padded Stools… Clay Mixer, 2 Kilns…," *SMT*, July 23, 1970, p. 22.
And, many additional ads through 1967 not itemized here.

EEP
See: "Emergency Educational Program"

Eidolon (Santa Fe, N.M.)
Art school at which Louie Ewing and some of the Breneisers taught, later 1930s.
See: "Breneiser, Marrie," "Breneiser, Stanley," 1935

Eimon, (Sigvald) Edgar (1920-2012) (Santa Maria)
Instructor in aeronautics at Allan Hancock College during the day and welding and art metals teacher at Santa Maria Adult school, 1955+.

■ Port. and "Actively in charge of the aeronautics program at AHC is Edgar Eimon, long time aeronautics and engine mechanics instructor at the recently closed out USCCA. He received his certificate from Cal Poly in San Luis Obispo and was an instructor at USCCA from January, 1946, until the close recently," *SMT*, Aug. 31, 1954, p. 1.
Port. with students, *SMT*, May 20, 1959, p. 3.
Eimon, Edgar (misc. bibliography)
Edgar Eimon is listed in the 1940 U. S. Census as age 19, residing in Paso Robles, Ca. (1935, 1940) with his father Sigvald Eimon (age 51); Sigvald Edgar Eimon gave the following information on his WWII Draft Card, dated Feb. 14, 1942 = b. Nov. 17, 1920 in Paso Robles, Ca., residing in Santa Maria, employed by Hancock College Aeronautics; Edgar and Fern Eimon were listed in the *Santa Maria, Ca., CD*, 1958-83; Edgar Eimon was listed in Paso Robles, Ca., in the *U. S. Phone and Address Directories, 1993-2002*; Sigvald Edgar Eimon was b. Nov. 17, 1920 in Paso Robles, Ca., married Fern Mabel Dargeloh, and d. July 24, 2012 in SLO, per Koch-Starke-Ahlschwede…. Family Tree (refs. ancestry.com).
See: "Allan Hancock College Adult/Night School," 1955, 1956, 1957, 1958, 1960

El Camino Junior High School
See: El Camino School in "Santa Maria, Ca., Elementary Schools"

Electric Art Studio (Santa Maria)
Photography studio run by Leslie Stonehart, Sr., 1919-24. Ads refer to it as "Stonehart Studio" by June 1924.

■ "Electric Art Studio Will Open Here Soon… an entirely new system of photography is to open here about May 15. Electricity is to be used in the production of all photographic work, instead of depending on the alternating daylight. **L. J. Stonehart** is the proprietor… and at the present time he has taken a lease on a part of the room occupied by the Star Cleaners on West Main street. He expects to have his paraphernalia here for the opening of business by the middle of this month," *SMT*, May 5, 1919, p. 3.
Electric Art Studio (notices in Northern Santa Barbara County newspapers on microfilm and on newspapers.com)
1920 – "Notice. The Electric Art Studio will move into the Grand theatre building, just one door west of present location, and will be open for business Wednesday, August 4th…," *SMT*, July 30, 1920, p. 4; "Fire Destroys Old Landmark… A short circuit in the electric wire connection of the picture machine at the Grand Theatre, Main and Lincoln streets started a fire… The Electric Art Studio, operated by **A. J. Stoneheart**, adjoining the theatre on the east, was entirely destroyed. A portion of the studio's fixtures were saved," *SMT*, Dec. 1, 1920, p. 1.
1921 – "Electric Art Studio Moves into New Rossi Building. Entirely new and modern equipment as well as furnishings are being added… Rossi building, 121 ½ West Main street… When the arrangements now being made are completed, the Electric Art Studio will be one of the most modern equipped establishments of its kind in this section of the state. As the result of the fire, which destroyed the Grand theatre some months ago and the studio, it was necessary for Mr. Stonehart to purchase new equipment. The establishment will not be prepared to handle the regular studio work for a few days, but will accommodate all customers with their Kodak work at present," *SMT*, April 7, 1921, p. 2; "Lest You Forget. Photographs are gifts you can easily afford, and family and friends will cherish them always. Appointments are best arranged for now, free from the bustle and confusion of Xmas week. Electric Art Studio. Phone 334-W," *SMT*, Nov. 3, 1921, p. 5.
1922 – "A Trip to the Photographer. Yes, she promised to stop, At our photograph shop, And we'll certainly welcome our beauty, for her photo she chose, A place that she knows, Makes fine photo portraits a duty. Electric Art Studio, 121 ½ West Main," *SMT*, June 8, 1922, p. 3; "Seven Brothers Belong to Local Order of Eagles… Knotts brothers… **L. J. Stonehart** of the Electric Art Studio was invited to come in and make a photograph of the seven brothers. This, officers of the local aerie believe, will be a great news feature for members of the Eagles throughout the world," *SMT*, Sept. 23, 1922, p. 1.
1923 – "Matthews Wins Prize… The Electric Art Studio announced today the decision of the judges in their recent contest for the best picture of the best catch of fish at the opening of the season… W. C. Matthews… prize of an

enlarged picture of the winning snapshot… on exhibition in the window of the studio," *SMT*, May 12, 1923, p. 6; "**Mr. and Mrs. L. J. Stonehart** leave tomorrow for Los Angeles to purchase new supplies for the Electric Art Studio…," *SMT*, Nov. 3, 1923, p. 5; "Give Portraits. The Gift that is always Appropriate, that has personality, that is your portrait. Phone 334-W Today for an Appointment. Electric Art Studio. 'The Photographer in Your Town'," *SMT*, Nov. 9, 1923, p. 6; "Nearly Here. Imperative – the quality that makes our portrait so desirable is the product of time and care – appointments must be made at once to insure delivery for Christmas. A Dozen 8 x 10 Photographs from $18 up, are Christmas Gifts that you can easily afford to give – and that your friends will always treasure. Electric Art Studio. 121 ½ West Main St., Santa Maria," *SMT*, Nov. 22, 1923, p. 5.
1924 – "Mother – if you wish to keep the cunning baby face you love so well, take me to Electric Art Studio at once… To the boy or girl who will bring in the greatest number of the above pictures to Electric Art Studio between now and Feb. 1st, will be given a professional photograph of the winner encased in a beautiful mount," *SMT*, Jan. 28, 1924, p. 2; "Stonehart Will Take Pictures for Lompoc High" annual – his business called Electric Art Studio, and will photo actors in HS play, *SMT*, April 10, 1924, p. 5.
And, more than 150 additional references (primarily ads) to the studio in the *SMT* between 1919 and 1924, were not itemized here.
See: "Stonehart, Leslie, Sr.," "Stonehart Studio"

Elks Club – Rodeo and Race Meet (Santa Maria)
Event that inspired a window decorating competition, posters, the designing of parade floats, and the taking of moving pictures, 1944+.

■ Itinerant rodeos following a circuit set up by a promoter were popular in rural California towns in the first half of the twentieth century, including in Santa Maria, where they often took place in early summer. Buellton sponsored its own c. 1932. In Santa Maria the Elks Club sponsored its first annual rodeo in 1944 to raise funds for charity. As the years went by the event became more elaborate and incorporated "art" with window decorating contests, poster competitions, and filmings.
Elk's Rodeo (notices in Northern Santa Barbara County newspapers on microfilm and on newspapers.com)
1953 – "Movies of '52 Parade. Moving pictures of the 1952 **Elks rodeo** and parade, now available for showing to Santa Maria service clubs and organizations, may soon be shown in local theaters… Arrangements are also being made to have the pictures shown to patients at **Santa Maria hospital**. Plans are now being made to photograph the 1953 parade and rodeo with the accent placed on local floats and entries… there is a possibility that this year's parade may be televised," *SMT*, April 30, 1953, p. 5.
1956 – **Trinidad Amador** - port. painting sign for Elk's rodeo, *SMT*, May 28, 1956, p. 1; "Trinidad Amador Wins Rodeo Window Decorating Contest… oversized cowboy painted on McMahan's window…," *SMT*, June 1, 1956, p. 1.

1957 – Photo of HS student winners in window decoration contest, and article cites Don Brandon, Dorene Stowell, **Joyce Fleming, Trinidad Amador,** Don Fretwell, Susan Chadband, Ralph Ybarra and Anne Sorensen. "The art class was given $100 by the Elks to be used for prize money and materials. **Robert Gronendyke,** art instructor," *SMT,* May 31, 1957, p. 1; "Final Plans Mapped… The other committee members are … and **JoAnn Gibford,** who will make the Rodeo Headquarters and parking signs," *SMT,* July 19, 1957, p. 2.
1958 – Photo of students at work on annual window design for Elk's rodeo, *SMT,* May 23, 1958, p. 1; port. of **Trinidad Amador** with "Sputnik Cowboy" best window painting in Elks rodeo, *SMT,* May 29, 1958, p. 1.
1959 – Photo of HS students – Janice Vear of Orcutt, Barbara Wheeler, Pat Machado, Barbara Nunes –working on window painting, *SMT,* May 21, 1959, p. 1; "Carolyn Milton and Joanne Shipman 1st in Rodeo Painting… Holser and Bailey window… student artists for their Rodeo paintings on the windows of downtown business establishments… Rosie Furuya… Pat Machado and Barbara Wheeler … Linda Fletcher … Deborah Daymore and Sherry Curnutt [Mrs. Jerry Brummel]… Fifth place will be shared by three sets of winners: Leslie Groves and Marcia Choice… **Melba Boroff** and Myrtle Boroff were named winners for their decoration at the U. S. Army Reserve Center… Ricky Boher and Ralph Ybarra…," *SMT,* June 4, 1959, p. 1.
1960 – "Elks Rodeo Movies Available. Colored movies of the 1959 Elks Rodeo and Parade … photographed and edited by **T. A. Bianchi** assisted by Larry Viegas… Scenes include crowning of the 1959 queen, highlights of the parade…," *SMT,* April 22, 1960, p. 12; "Student Artists Begin Painting Rodeo Windows… Each of the paintings must have a rodeo theme but otherwise the artists are allowed to use their imagination. … $35 for first place down to $5 awards for others," *SMT,* May 25, 1960, p. 1; "Window Painting Contest Winners are Announced. A stogie-smokin' Western sheriff with his arm around an Eskimo and a South Sea island girl took first place in the Elks Rodeo window painting contest… Creator of the painting was Carolyn Milton who also took first place in last year's contest. She was assisted by Judy Blankenship. Both girls are juniors… Mesquit's… Other winners and the location of their paintings are … Johnny Mortonsen, Van Wyk Auto agency, Barbara Mass, Rick's Rancho, Janice Vear, Mae Moore's, June McMurray, location unspecified, Rose Furuya, Ferguson Drugs, and Dot Miyare, Pacific Finance… Judges were **Margaret [Sic. Margarette] Jagla, George Muro**… and **Paul Rosendahl,** head counselor at the high school," *SMT,* June 1, 1960, p. 1.
1961 – "Carolyn Milton Wins Elks Paint Prize for 3rd Time… 'wheel of fortune' painting on the window of Bob Nolan's auto agency… Honorable mention winners were Rosie Furuya…," *SMT,* May 26, 1961, p. 1.
1962 – "Window Painting Winners Listed. **Carol Schilder** and Esther Wolaver won top honors in the window decoration contest…," *SMT,* May 25, 1962, p. 1.
See: "Bianchi, Ted," "Bond, Doree," "Burke, Glenda," "Fleming, Joyce," "Floats," "Hoback, Gene," 1953, "Junior Community Club (Santa Maria)," 1954, "May, Dick," "Motion Pictures (Santa Barbara County)," 1952,

"Photography, general (Santa Maria)," "Ragland, Peggy," "Sander, Ursula," "Santa Maria, Ca., Union High School" 1958, "Turner, Charmian," "United Service Organization (Santa Maria)," 1952, "Vaughn, Leon"

Elliott, ? (Mrs. Robert R. Elliott) (Happy Valley)
Painter who exhibited at the Solvang Library early 1960s. Is she the same as Natalie Elliott, above?
Elliott, Robert, Mrs. (misc. bibliography)
HUSBAND? – Robert Roscoe Elliott, 1908-2003 who is buried in Oak Hill Cemetery, Ballard, per findagrave.com (refs. ancestry.com).
This individual could not be further identified.
See: "Santa Barbara County Library (Solvang)," 1960, 1961, 1963, 1966, "Santa Ynez Valley Art Exhibit," 1958

Elliott, Natalie (Santa Ynez Valley)
"Valley" artist who exh. at Santa Ynez Valley Art Exhibit, 1957. Is she the same at Mrs. Robert R. Elliott, below?
No information on this individual could be found.
See: "Danish Days," 1957, "Santa Ynez Valley Art Exhibit," 1957

Elliott, William H. (Henry?) (1838-1916?) (Sisquoc)
Photographer who was active in Santa Maria, 1894-1896.
Elliott, W. H. (notices in Northern Santa Barbara County newspapers on microfilm and on newspapers.com)
1894 – "W. H. Elliott, the photographer, is stopping at **F. K. Koerner**'s ranch for his health, which is considerably improved," *SMT,* Sept. 15, 1894, p. 3, col. 6.
1895 – "E. E. Forrester and W. H. Elliott have gone to Santa Barbara on business. On their return Mr. Elliott intends opening a photograph gallery in Santa Maria. We wish him much success," *SMT,* May 4, 1895, p. 3, col. 7.
1896 – "Your photographer, W. S. [Sic. H.] Elliott, spent a couple of days in Garey this week, on the way to his ranch on the upper Sisquoc," *SMT,* Feb. 15, 1896, p. 3.
Elliott, W. H. (misc. bibliography)
William H. Elliott, is listed in the 1880 U. S. Census as age 43, b. c. 1837 in Ohio, working as a photographer, residing in Saint Joseph, Mo.; is he William Henry Elliott who registered to vote in Ventura, Ca., 1886; is he William Henry Elliott registered to vote in Santa Clara, Ca., 1889; William Henry Elliott, age 57, ht. 5' 9 ½ in., light complexion, brown eyes, brown hair, b. Ohio, residing in Anaheim, registered to vote March 14, 1894 per *Orange County Electors,* p. 19; William H. Elliott, photographer, age 59, ht. 5 9 ½ in., light complexion, hazel eyes, brown hair, b. Ohio, registered to vote Aug. 5, 1896, with a Santa Maria post office address, is listed in *Santa Barbara County – Sisquoc Precinct;* William H. Elliott is listed in the 1910 U. S. Census as age 73, b. c. 1837 in Ohio, widowed, a farm laborer, residing in Lankershim, LA County, Ca., with Bert and Elsie Holloway; is he William Henry Elliott b. May 21, 1838 in Randolph, Ohio, d. Oct. 10, 1916 in Peninsula, Ohio, and buried in Cedar Grove Cemetery, Peninsula, Ohio, per findagrave.com (refs. ancestry.com).

Ellis, Clara J. (1883?-1925) (Lompoc)
Exh. water color in Children's Department at "Santa Barbara County Fair," 1891.

■ "Miss Clara Ellis has passed her examination before the County School Board and received a primary certificate. Mr. Thurmond says in many of the studies Miss Clara passed a very superior examination and highly recommends her as amply qualified to take any school within her grade. Miss Ellis achieved quite a victory in spelling while at Santa Barbara. The teachers together with all the high school faculty in the county, including Supt. Knepper, had a spelling match and Miss Clara spelled them all down. For the past two or more years Miss Ellis has been under special preparation by Prof. Whittemore. If there is a vacant school in this section Miss Ellis would like the situation. Her knowledge of music renders her specially desirably in the primary schools," *LR*, Dec. 24, 1892, p. 3.
Ellis, Clara (notices in Northern Santa Barbara County newspapers on microfilm and on newspapers.com)
1893 – "Miss Clara Ellis has been engaged to teach the school in the Santa Lucia district," *LR*, Jan. 7, 1893, p. 3; And, an additional 10 "hits" for "Clara Ellis" regarding her piano playing for events appear in the *LR*, 1890-1893, but were not itemized here.
Ellis, Clara (misc. bibliography)
Clara J. Ellis b. 1883?, d. July 28, 1925 in Santa Barbara County per Calif. Death Index; Clara J. Ellis is buried in Goleta Cemetery, Goleta, Ca., per findagrave.com (refs. ancestry.com).
See: "Santa Barbara County Fair," 1891

El-Ma-Ra / El-Ma-Ro Studio Ceramics (Santa Maria)
Ad: "El-Ma-Ro Studio. Ceramics. Greenware and Ceramic Supplies. Free Instructions. Ceramics and Lace Draping. Studio Hours. Monday thru Friday. 10:00 a.m. to 4:00 p.m., 1331 E. Donovan Road (1 mile east of Rick's)," *SMT*, May 31, 1955, p. 4.
Classified ads for 25% discount appear Sept. 1955.

Elsasser, M. (Santa Maria)
Photographer, 1889.
Elsasser, Mr. (notices in Northern Santa Barbara County newspapers on microfilm and on newspapers.com)
1889 – "We were shown a few days since some fine photographs of the Kaiser Bros. ranch and surrounding country, taken by Mr. Elsasser who resides on the place. They represented a fine large orchard, a nicely improved place and beautiful scenery surrounding, and also reflected much credit upon the skill of the artist," *SMT*, July 27, 1889, p. 3.
1891 – "Mr. Elsasser of the Kaiser Orchard, has just returned from Mexico where he has been engaged in mining for a number of years," *SMT*, Oct. 10, 1891, p. 3.
1892 – "Mr. M. Elsasser who has been spending a few days at the Kaiser orchard returned to San Luis Wednesday where he is engaged in surveying, assaying, etc.," *SMT*, Jan. 30, 1892, p. 3.
1894 – "Mr. M. Elsasser, a relative of the Kaisers and a former resident of this valley, now engaged in mining at Catorce, State of San Luis Potosi, Mexico, is here on a

visit. He spent the latter part of the week at the Kaiser orchard and will take this morning's train for San Luis Obispo, thence to Frisco and will soon return again to Mexico," *SMT*, Feb. 24, 1894, p. 3.

Elson Art Publication Co. (Boston, Massachusetts)
Publisher of reproductions of art masterpieces who marketed them by holding exhibits in public schools, charging admission to the public, and allowing the schools to use the <u>net</u> profits to purchase prints for their schools. Often the exhibit was accompanied by lectures by local experts on various art topics.
1912 – "Fine Art Exhibit will be Here Shortly… carbon photographs and engravings loaned by A. W. Elson & Co., of Boston, Mass… two hundred subjects representing all the principal schools of art… catalog has been prepared…," *SMT*, March 23, 1912, p. 1.
See: "Art, general (Santa Maria)," "Colonial Art Company," "Gaviota, Ca., elementary school," 1927, "Lompoc, Ca., Elementary Schools," 1914, "Lompoc, Ca., Union High School," 1913, "Santa Maria, Ca., Elementary Schools," 1920 (?), 1925, "Santa Maria, Ca., Union High School," 1912, "Santa Ynez Valley, Ca., Elementary Schools, 1927

Elverhoj [Elverhoy] Museum of History and Art (Solvang)
Home built by Martha and Viggo Brandt-Erichsen and on their deaths donated to the Historical Society for a Museum of Danish culture. Built 1953. Dedicated as a museum, 1988.

■ "Just two short blocks off Copenhagen, sheltered from the bustle and quaint shops, is a unique house built in the style of the 18th century farmhouses of Jutland, Denmark. The soul of this house is The Elverhøj Museum, which nurtures a warm depiction of Solvang history and Danish culture. The house was built by **Viggo Brandt-Erichsen**, a self-taught Danish sculptor. In his twenties, he received some formal training as a member of Les Amis de Montparnasse in Paris, where he developed a close friendship with Pablo Picasso. In 1926, he emigrated to Jaffrey, New Hampshire where he met and married his wife **Martha Mott**, also an artist. In 1946, they headed west with their three children where they fell in love with the welcoming town of Solvang. In 1949, Viggo began to build their house in the Danish style he loved, and because of his artistic talent, the entire house was constructed in three years without blueprints, using only a scale model and sketches. Viggo built the artists' studio with an eight-inch thick architecturally patterned floor and poured the fireplace in a single slab with relief panels showing Adam and Eve with Adam petting a Great Dane. Even the beautifully carved front door was crafted by Viggo. It depicts an elf spirit with her forest friends from a Danish folk play called Elverhoj (translated as "elves on a hill"), telling of a King's visit to the night world of dancing female wood spirits. "Elverhøj House quickly became a center for art and cultural events. Unfortunately, gentle, well-loved Viggo died in 1955, just three years after Elverhøj House was completed, but Martha lived in the

house, painting and giving art classes until her death in the eighties. According to Martha's wishes, in 1988 the home was dedicated as a museum of Danish heritage and culture and Solvang history. The Elverhøj retains its integrity as a home while presenting each of the original rooms as a small museum. … The cozy Kitchen is decorated with soft green panels of typical Danish farmhouse folk florals, hand-painted by **Martha Brandt-Erichsen**. In the corner is a peat-burning stove for cooking. In the Children's Room are wonderful creations constructed by **Viggo Brandt-Erichsen**—a charming dollhouse with real working lights and a gorgeous crib that he painted with scenes from the tales of Hans Christian Andersen. … [Other rooms contain hand crafted items made in Denmark.] In the Old Solvang Room, many artifacts and pictures from the town's early days tell its history … The Archival Video Project begins with a documentary of **Atterdag College**. The former Art Studio is now a spacious gallery, where a magnificent bull sculpture by **Viggo Brandt-Erichsen** is on permanent display. [Also in the back yard] … a Cottage contains a huge diorama that shows the early days of the Solvang village from 1911 to 1936. The tiny shops and houses are spread far apart as they were then, but you can see that the Danish look in the commercial area was not developed until 1946. … For Internet information, go to www.elverhoj.org" per **"Come Visit the Elverhøj Museum,"** by Joanie Perciballi, on www.syvguest.com/pastIssues/2004...
Many articles on the museum appear in the *SYVN* 1985-1990+ but were not itemized here.
See: "Brandt-Erichson…"

Embroidery Club (Lompoc)
Needlework club, active 1931-55+?
1939 – "Meets at Lundberg's," *LR*, May 12, 1939, p. 3. And 140 additional notices in the *LR,* 1931-1955, not itemized here.

Emergency Educational Program (EEP) (Lompoc / Santa Ynez Valley / Santa Maria)
One of several government programs of the 1930s that funded, among other things, education and recreation (including classes in arts and crafts), 1934. In Lompoc art was taught by Edna Davidson. In Santa Maria, Louie Ewing taught arts and crafts and in Santa Ynez Margaret Teall taught interior decorating and landscape design while Ruberna Downs taught arts and crafts.
■ "Arts and Crafts Classes to Open Here Mon. Night. For fulfilling a need which has been felt by many here, a meeting will be held Monday night for the purpose of organizing adult classes in the arts and crafts. These classes are to be in charge of **Edna Davidson**…. The courses of study are as yet tentative, depending upon the number of students and upon their interests. However, the work will probably be divided into two main divisions: one, work in the applied arts with textiles, leather, metal, wood and some clay, and the other, in commercial and fine arts with still life composition, figure sketch and design. … The only expenses will be those of materials and equipment. … Monday evening Oct. 15th at 8 o'clock in the Methodist

Church. There the time of meeting will be arranged and courses of study discussed…," *LR*, Oct. 12, 1934, p. 9.
<u>EEP (notices in Northern Santa Barbara County newspapers on microfilm and on newspapers.com)</u>
1934 – "Special Classes for Unemployed Considered Here. Federal Government Would Pay Costs of Day or Night Adult Education … Intended primarily to furnish employment for jobless teachers… one hour per day, five days per week for four weeks… Subjects… A – Home-making… B – Health… C – Music… D—Current Events… E—Art: appreciation, drawing, dye, basketry, leather work… F—Commercial… G – Fundamentals… H – Agriculture… I – Recreation…," *LR*, Jan. 12, 1934, p. 9; "Looking Backward. 20 Years Ago [to 1934] … The class in interior decorating and landscape gardening, organized under the E.E.P. with **Miss Margaret Teall** as instructor, met Monday at the home of Mrs. G. L. Erwin and last Thursday at the home of Mrs. Henry G. Hanze. Flowers were studied at the Thursday meeting …," *SYVN*, Feb. 26, 1954, p. 2; 'Landscape [design] Classes Open Sessions in Solvang. The class in interior decorating and landscape gardening, organized under the EEP with **Miss Margaret Teall** as instructor, met Monday at the home of Mrs. G. L. Erwin and last Thursday at the home of Mrs. H. G. Hanze. Flowers were studied…," *SYVN*, March 2, 1934, p. 1; "Four More EEP Classes Opening in City Tonight… in Santa Maria high school… **Louis [Sic. Louie] Ewing** … arts and crafts…," *SMT*, April 10, 1934, p. 1; "Welcome EEP Program Here… Art and Crafts: Course offers practical work in treatment and decorative application to leather and other substances, imparts appreciation of the harmony of color, of balance, of design, will give students ability to initiate own designs on various articles and a better understanding of color and its component parts, **Louis [Sic. Louie] Ewing**. T-Th.," *SMT*, April 12, 1934, p. 4; "Miss **Ruberna Downs** who is a University of California graduate and who also took an art course at an Eastern college and post graduate work at the University of Southern California, will conduct EEP classes in arts and crafts at <u>Los Olivos</u>, as soon as the group is organized. She will also hold preliminary meetings at Santa Ynez and Solvang," *SYVN*, Nov. 16, 1934, p. 1; "EEP Adult Classes Met at <u>College School</u> on Monday Evening… with Miss **Ruberna Downs** as instructor. … about twenty-five adults present. It was shown by Miss Downs how cheaply beautiful articles can be made from most any kind of material one has on hand, even an old tire… After this week, the class will be held on Friday evenings from seven to ten o'clock at the grammar school," *SYVN*, Nov. 23, 1934, p. 1; "Arts, Crafts Classes Being Held by EEP at Grammar School. Under the direction of **Miss Edna Davidson**… Monday and Thursday evenings in the music and sloyd rooms of the <u>Lompoc Elementary School</u> from 7-9. … Members are now … making … placques, … clay models and casting them in plaster of Paris. Some … are making Christmas cards, others are interested in leather work; wall hangings are being made by some of materials being colored with crayonex instead of oil paints. …," *LR*, Dec. 7, 1934, p. 8.
1935 – "EEP Art Classes are Resumed Here. Art classes under the EEP conducted by **Miss Edna Davidson**, art school graduate, have resumed active work since the

Christmas holidays. On Wednesday afternoon from 2:30 to 4:30 a class meets in the cafeteria of the Lompoc Elementary School to study costume designing, pattern drafting and sewing under Miss Davidson's guidance. The craft classes meet in the music room of the school on Monday and Thursday mornings from 7 to 9. Members are beginning the study of pottery making, designing and free hand drawing. …," *LR*, Jan. 11, 1935, p. 8; "EEP Class Meeting at L. O. on Thursday… **Ruberna Downs**… The making of rugs, pattern construction, dress making, etc., are other lines of work engaged in. Those present at the meeting were [and attendees named]," *SYVN*, March 1, 1935, p. 1; "Valley EEP Classes to Have Display of Work in L. O. Today… under the tutelage of Miss **Ruberna Downs**… Los Olivos school house from 2 until 5 and 7 until 9 p. m. … The art classes will continue until June. At Santa Ynez they are held Thursday afternoons and Friday evenings and at Los Olivos Thursday afternoons," *SYVN*, May 3, 1935, p. 1; "EEP Display at Los Olivos Was Success… Most of those who considered an empty corn can an utterly useless thing … had a decided surprise awaiting them when they visited the exhibit given by the valley EEP classes and their instructress, Miss **Ruberna Downs**. The homely corn can was transformed into a most artistic candle stick and others of its kind became, with a snip of tin shears, a bit of solder and a twist of crepe paper, a lovely basket. Many other materials usually overlooked were made into beautiful and useful articles …wood-etching and crayonex batik work adorned the walls, while toys constructed of inner tubes, lovely lamp shades and many examples of crepe paper art, such as bags, hats, baskets, etc. book covers of paper and cleverly sawed animals … Many very handsome rugs, crocheted and hooked, and other kinds of needlework were also on display…," *SYVN*, May 10, 1935, p. 6; "Miss **Ruberna Downs**, who has charge of the EEP classes in the valley, has organized a new night class for children. This is due to the interest shown by the youngsters in the work. The children worked on articles made from phonograph records and leather articles, etc. Those who signed up for the instruction were [and children named]," *SYVN*, May 24, 1935, p. 5.
See: "Needlecraft Club (Los Olivos)," "Santa Maria, Ca., Recreation Department," 1935

Emerson, Herbert Lyman (1908-1983) (Los Angeles / Santa Ynez Valley)
Commercial photographer, 1951.

■ "Top-Flight Photographer… Lyman Emerson, one of the nation's top-flight advertising photographers and now a resident of the Santa Ynez Valley, has offered to give of his time to teach and direct [a camera club] … if enough interest is shown… Mr. Emerson and his wife and family live at the Pressley Lancaster home on Refugio road. Mr. Emerson spends each weekend here, and during the rest of the week he is engaged in his work in Los Angeles. If such a club were formed here, the group would meet regularly on some weekend day. Mr. Emerson does color photographic work for some of the major business firms in the country, including the Sunkist orange concern, Kellogg's and others. If such a club were formed, it would be strictly a hobby group, with Mr. Emerson lending his knowledge of photography to the members. It would also be possible through Mr. Emerson's contact with other photographers, artists and models in the Los Angeles area, to provide the club members with even additional professional advice… Valley camera fans interested in taking up Mr. Emerson's offer are asked to contact him at his home or call or drop a card to the *Valley News*…," *SYVN*, Sept. 14, 1951, p. 1.
Emerson, Lyman (misc. bibliography)
Herbert Lyman Emerson gave the following information on his WWII Draft Card dated Oct. 16, 1940 = b. Aug. 2, 1908 in San Diego County, residing in Los Angeles, next of kin = wife, Elizabeth Mary Emerson; Herbert Lyman Emerson was b. Aug. 2, 1908 in California to Herbert Lyman Emerson and Lillian Andrea Lindenfeld, was residing in Los Angeles in 1940 and d. Sept. 14, 1983 in Mardin, Turkey, per Christina Running Family Tree (refs. ancestry.com).
See: "Camera Club (Solvang)," "Tri-County Art Exhibit," 1952

Engleman, Edwin E. Jr. (Atascadero)
Artist who exh. at Santa Ynez Valley Art Exhibit, 1954, 1955.
See: "Santa Ynez Valley Art Exhibit," 1954, 1955, and *Atascadero Art and Photography before 1960*

Epperly, Ida Mae "Ina" Scott (Mrs. Clarence Lee Epperly) (1894-1976) (Santa Maria / Lompoc)
Ceramist / teacher. Exh. at Santa Barbara County Fair, 1949. Judge at a Halloween window decorating contest.

■ "Ina M. Epperly… 81… Mrs. Epperly was born in 1894 in San Luis Obispo county and died Thursday at the Lompoc Convalescent and Residential Care Center. She had been a Lompoc resident for 29 years, last residing at 511 W. Locust Ave.," *LR*, Jan. 16, 1976, p. 2.
And, more than 60 notices in the *LR* primarily concerning her club work, were not itemized here.
Epperly, Ina (misc. bibliography)
Ina M. and Clarence L. Epperly are listed in the *Santa Maria, Ca., CD*, 1959-76; Ina M. Epperly was b. May 15, 1894 in Calif. and d. Jan. 15, 1976 in Santa Barbara County per Calif. Death Index (refs. ancestry.com).
See: "Community Center," 1949, "Halloween Window Decorating Contest (Lompoc)," 1954, "Santa Barbara County Fair," 1949

Epperson, Nina (Mrs. Rev. Joseph "Joe" Epperson) (Santa Maria)
Painter. Art chairman, Jr. Community Club, 1953, 1954.
See: "Community Club," 1954, "Junior Community Club (Santa Maria)," 1953, 1954

Equinox Gallery (Lompoc)
See: "Art, general (Lompoc)," 1961, 1962

Erickson (Hill), Virginia Teale (Mrs. John Erickson) (Mrs. Eugene "Gene" Hill) (1914-1994) (Lompoc)
Collector of various kinds of art works. Women's Page editor for Lompoc Record, 1953-54.

■ Port. of Virginia T. Erickson. "Newest member of the *Record*'s editorial staff is Mrs. Virginia T. Erickson who last week took over the duties of Women's Editor. Mrs. Erickson recently resigned from her position as associate editor of the Camp San Luis Obispo '*Transmitter*,' an eight page troop newspaper, which has been published at the camp since a few months after its reactivation in 1951. She began work there in December, 1951, as assistant public information officer, transferring later to the staff of the post newspaper. Prior … Mrs. Erickson was employed as Women's Editor of radio station KIBE, Palo Alto, Calif. During the past eight years she has been a staff feature writer and reporter on *The Californian Magazine*, Los Angeles, *Boxoffice* magazine, Hollywood, and the *Telegram-Tribune*, San Luis Obispo, Calif. She also has been an active free-lance writer for the *Palo Alto Times*, *Los Angeles Times, Santa Barbara Star* and *Western Family* magazine. Much of her writing, including a detective novel, has appeared under the by-line 'Virginia Teale,' which is her family name. Mrs. Erickson, a third-generation Californian, was born in Willits. She attended schools in Oakland, Alameda, San Francisco and Healdsburg. At Stanford University she studied short-story writing under Wallace Stegner, playwriting under Hubert Hefner, and radio and television technique under Dr. Stanley Donner…," *LR*, Aug. 27, 1953, p. 3.

■ "Virginia T. Hill… Virginia Teale Hill, a longtime journalist and a former editor at *The Sacramento Bee*… Born Virginia Teale Erickson [Sic.] in Willits, Mendocino County, she was a descendant of a pre-Revolutionary Virginia family and worked as church editor at *The Bee* in the late 1950s. Her late husband, Eugene 'Gene' Hill, retired from *The Bee* after a career that included service as city editor, managing editor and associate editor. During her 30-year career in journalism, Mrs. Hill worked for *Box Office* magazine, the *Los Angeles Times* and the *Woodland Democrat* as well as for newspapers in New Orleans, Lompoc and San Luis Obispo…," *Sacramento Bee*, Jan. 11, 1994, p. 15.

Erickson, Virginia (notices in Northern Santa Barbara County newspapers on microfilm and on newspapers.com)
1953 – "Solo Slant… However, We also own an abstract. We found one we liked that was painted in pleasing colors and seemed to be a house with a couple of bare, black trees in the foreground… developed a craze for mobiles… [and possibly own a ceramic by] Otto Natzler…," *LR*, Aug. 27, 1953, p. 12; ■ "Solo Slant… Throughout our lifetime, at infrequent intervals, we've encountered the so-called Bohemian Life. We say 'so-called' because most of the Bohemians we've known on the west coast have been pseudo… We have been in and out of Bohemian circles in San Francisco, Carmel, Los Angeles, Hollywood and Laguna Beach… California type bohemia… seems to be based primarily on the old student-artist life of Europe—particularly that of the Montmartre section of Paris… to be a chic Bohemian you mustn't give a tinker's dam how you look. You (if female) wear your hair in a Sylvana Magnini

mop or you cut it off down to the skull. You never wear a girdle and seldom a bra. No stockings, of course. And sandals. … Skirts and blouses are the accepted outer garb. Though some wear slacks, And, in warm climates, shorts. For the men it is of prime importance that they show complete disregard for the tonsorial refinements. A beard is good. Five o'clock shadow is accepted. Hair, of course, must be untidy. And always too long. The object being to convey the impression that one is far too absorbed in 'creating' even to think about such things as haircut and shaves. As with the women sandals are chic – the shabbier, the better. Trousers are wrinkled as though their owner had worked far, far into the night on his latest masterpiece and then had simply FLUNG himself on his pallet to sleep the sleep of exhausted genius. Bohemian Beachhead. In California, the greatest concentrations of Bohemians are in the warmer coastal areas. … Those Bohemians whom we encountered in San Francisco were, most always, rather blue looking and goose-pimply [because of the cold]. It was not until we lived in Laguna Beach that we really saw La Vie des Artistes. In Laguna Beach, it is almost a requirement that one be either an artist or a patron of the arts. (We'd like to add that many excellent, hard-working artists live in Laguna Beach. They are seldom seen, however, at the bistros and at bohemian gatherings, being much too hard at work to spare the time.) The sandalled, shaggy characters who stroll along the beach boardwalks in Laguna are, mostly, remittance men, scroungers, opportunists, poseurs and / or pensioners – with a sprinkling of wealthy eccentrics and dilettantes. It's these wealthy eccentrics who are the angels for the rest of the crew. Usually they live in 'studio' apartments at the beach (for which they pay staggering rents) or in the beautiful little canyons; and always they have a full wine cellar and a well-stocked cupboard. Also, they have book shelves overflowing with Gide, Joyce, Capote, Proust and Faulkner and an impressive collection of recordings. There is usually a fireplace at which to warm bare legs and candlelight… in which everyone appears elusively charming… There is always a big, low couch of some kind and many, many cushions. (Although some impresarios go madly austere and incline toward bare floors and Eames chairs with everything else constructed of stark sticks of black iron.) Generally, there is much abstract painting hung about and most always, a piece or two of 'primitive' sculpture, the gift of grateful guests. Dust is a must. A chic studio never, but never, looks tidy. Food served at these gatherings invariably includes one or more of the following items: anchovies, French bread, cheese, onions, and wine. If the host can afford it, and if the company is not too numerous, he may offer gin…. [and author describes "two rich ladies" of Laguna who played at being Bohemian] … Very occasionally one will stumble upon a scrap of true Bohemia … where the old clothing, the bread and cheese and the candles evolve from one thing: poverty. A self-inflicted poverty brought on by the artist's belief in himself and his work. He could get 18 bucks a day, maybe, working… But he has a true desire to create. And he believes that what he has to say – in his music, painting, sculpture or writing – is of sufficient value to world culture that any sacrifice is worthwhile… and to these we humbly take off our beany!," *LR*, Oct. 8, 1953, p. 8; discusses Aunt Zimmie's penchant

for auction sales "… Her apartment was packed…" with objects d'art including 15 large oil paintings," *LR*, Oct. 22, 1953, p. 12.

1954 – "Solo Slant… Lares and Penates. Most everybody has a household god of some sort… In our own house we have a whimsical kind of household god. A silly looking ceramic horse created by the talented 'Bianca.' This horse, about nine inches long and four inches high, is lying down and has her head propped lazily on one upturned hoof. Around her neck is a lei of pastel blossoms and between her ears is a bow with a cluster of blossoms. Her tail, mane, eyelids (half-closed) and nostrils are turquoise blue. Bianca has cleverly created this horse of terra-cotta colored unglazed clay and has made only the tail, mane, flowers, eyelids and nostrils of colored glaze. The effect is, to me, fascinating. I have come to regard this horse as my most prized possession…," *LR*, July 15, 1954, p. 10; "Myra Manfrina Pinch Hits… Mrs. Erickson is in Woodland where she is soon to become women's editor of the *Woodland Democrat* …," *LR*, Aug. 26, 1954, p. 5.

Erickson, Virginia (misc. bibliography)
Mrs. Virginia T. Erickson, reporter with no husband, is listed in the *Palo Alto, Ca., CD*, 1950; Mrs. Virginia Erickson with no occupation or husband is listed in the *SLO, Ca., CD*, 1953; Virginia T. Erickson, wid. John, women's editor *Woodland Daily Democrat*, is listed in the *Woodland, Ca., CD*, 1955 (refs. ancestry.com).

Erwin, George Lewis (1900-1967) (Solvang)
Teacher of mechanical drawing at Santa Ynez Valley Union High School, 1931, 1934.

■ "Funeral Services… for George Lewis Erwin, 67, of Solvang, Valley educator and cattle rancher… Mr. Erwin retired in 1951 after 21 years of teaching at the Santa Ynez Valley High School to go into full time cattle ranching. He was appointed in 1931 to conduct the first Smith-Hughes Program in Vocational Agriculture for the school, and headed the agricultural program there for the next 21 years. … Mr. Erwin was born in Bozeman, Mont. Sept. 16, 1900, the son of William and Masie Erwin. He was a graduate of Montana State University and was a member of Beta Rho chapter of Sigma Chi. He began his teaching career in 1924 at Custer County High School in Montana. He married the former Miss Ella Clark in 1926 in Bozeman, and the young couple spent two years teaching in Hawaii. They moved to California in 1929 and came to Santa Barbara County two years later…," *SYVN*, Nov. 2, 1967, p. 11.

Erwin, G. L. (notices in Northern Santa Barbara County newspapers on microfilm and on newspapers.com)
Hundreds of notices appear in the *SYVN* for "G. E. Erwin" but were not even browsed for itemization here.

Erwin, G. L. (misc. bibliography)
George Lewis Erwin provided the following information on his WWII Draft Card = b. Sept. 16, 1900 in Boseman, Mont., married to Ella Erwin, residing in Solvang, Ca., 1942; George Lewis Erwin was b. Sept. 16, 1900 in Bozeman, Mont., to William Schrader Erwin and Maisy Mae Kent, married Ella Louise Clark, and d. Oct. 25, 1967 in Solvang, Ca., per Liening Family Tree (refs. ancestry.com).
See: "Santa Ynez Valley Union High School," 1931, 1934

ESYHI Section
See: "Santa Ynez Valley Union High School," 1927, 1929, 1931

Euwer, Anthony
Chalk Talk artist at Minerva Club, 1937.
See: "Minerva Club," 1937

Evans, Elliot A. P., Dr. (Santa Barbara)
Chairman of the Department of Art, Santa Barbara College. Spoke at Winter Arts Program, 1952, 1953. Judge at Santa Ynez Valley Art Exhibit, 1954.
See: "Santa Ynez Valley Art Exhibit," 1954, "Winter Arts Program," 1952, 1953

Evans, James (San Simeon)
Exh. Santa Ynez Valley Art Exhibit, 1956.
See: "Santa Ynez Valley Art Exhibit," 1956, and *Cambria Art and Photography before 1960*

Evans, Lowell Duane "John" (1934-2015) (Santa Maria)
Student at Santa Maria JC who exh. in Library, 1951.

■ "One of the earliest members of the ex-gay movement in the United States to leave it and campaign against it has died this week, aged 80. Lowell 'John' Evans co-founded what has been called the earliest ex-gay ministry, Love In Action, in 1973 with a heterosexual Christian preacher named Kent Philpott, and another gay man, Frank Worthen, in San Raphael, California. Two years later Philpott released the book '*The Third Sex?*' in which he claimed his ministry had successfully converted people from being gay to straight. That book inspired the founding of the group Exodus International in 1976 which would go on to become the most prominent 'ex-gay' organization in the world. [Evans saw both his lover and a friend go insane trying to "go straight."] …Evans went on to come to terms with his own sexual orientation and became a vocal critic of the movement, denouncing its practices.… Evans passed away on 18 January … 'Evans was the first 'ex-ex-gay,' meaning a person who touted the message of sexual conversion – before later renouncing it as a damaging fraud. He created a template for so many others who came after him and followed in his footsteps," ~ source: *gay star news* quoted on findagrave.com.

Evans, Lowell (notices in Northern Santa Barbara County newspapers on microfilm and on newspapers.com)
1952 – "Miss Ina… Sunday night services at the Foursquare Church… One of the features of this service will be the painting of a picture by Lowell Evans illustrating a song that is to be sung by Miss Vancil. Evans is a Santa Maria young man who has shown exceptional artistic talent and has been painting these illustrative pictures in various places throughout the state during the summer. The picture will be given to some person chosen from the congregation present Sunday night. Miss Vancil and Mr. Evans will continue these meetings each night, Tuesday thru Friday and will conduct the daily vacation Bible school each morning," *SMT*, Aug. 16, 1952, p. 6;

And several additional notices regarding his piano playing were not itemized here.

Evans, Lowell (misc. bibliography)
Lowell Evans is listed in the 1940 U. S. Census as age 5, b. c. 1935 in Calif., residing in Bakersfield (1935) and Santa Maria (1940) with his parents Berle Evans (age 34) and Josephine Evans (age 29) and older sister Betty Mae (age 10); Lowell Evans port. appears in the Santa Maria High School yearbook, 1951, 1953; Lowell D. Evans is listed in *Santa Maria, Ca., CD* variously as "carpenter helper," "worker, General Dynamics, VAFB," "psychiatric tech," 1961-67; Lowell Duane "John" Evans was b. Dec. 23, 1934 in Morgan Hill, Ca., to Burl Polk Evans and Josephine Esther Northrup (Evans) (Smith), and d. Jan. 18, 2015, in Marin County, Ca., per Weichert_2015-08-05 Family Tree; Lowell Evans (1934-2015) is buried in Mount Tamalpais Cemetery, San Rafael, Ca. per findagrave.com (refs. ancestry.com).
See: "Halloween Window Decorating Contest (Santa Maria)," 1952, "Santa Barbara County Library (Santa Maria)," 1951

Eve's Enterprise (Lompoc)
Handcraft and gift shop, 1958, 1959.
Ad: "Handcraft Items – Belts, Custom-made Jewelry, Novelties – Toys – Cards and Stationery, Ph. 8-0523, 305 South G," *LR*, June 26, 1958, p. 14; " 'Handcraft Gifts for all, from infancy through the golden years.' Also personalized cards, napkins and stationery at Eve's Enterprises…," *LR*, Nov. 19, 1959, p. 24 (i.e., 4c).

Ewing, Louie Henry (1908-1983) (Santa Maria / New Mexico)
Santa Maria JC art student, 1933-34. Taught crafts at Santa Maria adult school, 1934. He and wife, Marrie Breneiser, below, moved to New Mexico, 1935, where they pursued their art.
■ Port. and "Pioneer Artist Louie Ewing Dead at 75. Santa Fe painter and silkscreen pioneer Louie H. Ewing, died in his home Monday afternoon. Born in Pocatello, Idaho, in 1908, Ewing attended Idaho State University and studied and taught at the Santa Maria School of Art in California before moving to Santa Fe in 1935. He was a teacher at the Idolan [Sic. Eidolon] Art School – the Hill and Canyon School of Art. He also taught privately. During nearly 50 years [in Santa Fe], he was an acquaintance of most Santa Fe artists. He is considered a link between the early Santa Fe art colony … and the on-going artistic community. He produced extensive work and actively supported younger painters, taking them to his favorite painting spots, discussing their work and exhibiting with them… Ewing painted in oil, watercolor, gouache and acrylic and is widely known for his contribution in silk screening. He received numerous commissions for books and was the first to make color book plates by silkscreen process for illustrations. He is recognized especially for the book *Kiva Mural Decorations at Awatovi and Kawaika*, published by the Peabody Museum at Harvard University and for the '*Masterpiece*' series of silkscreen prints commissioned by the Laboratory of Anthropology in Santa Fe. His illustrations for books are many: *15 New Mexico Santos*, 1941; *In the Garden of the Home God*, 1943; *Hail Chant and Water Chant*, 1943 (included in Fifty Books of the Year, American Institute of Graphic Arts, 1946); *Beautiful on the Earth*, 1947; *Codex Hall*, 1947; *Southwestern Textiles*, 1949; *Emergence Myth*, 1949; *The Myth and Prayers of the Great Star Chant;* and the *Myth of the Coyote Chant*, 1956. Ewing designed and executed commissions for the Santa Fe Studios of Church Art, including sculpture, murals, mosaic and painted, **stained glass** windows, paintings and wood carvings. From 1967 to 1971 he was in charge of the sculpture-casting division at Nambe Mills. His work has been exhibited at the Santa Barbara Museum, the Dallas Museum of Fine Arts, the Philadelphia Art Alliance, in several one-man Alcove Shows and Biennials, at the Museum of Fine Arts in Santa Fe, the Serigraph Society in Tokyo, the U. S. Army Air Base in the Philippines, the Santa Fe Festival of the Arts, the Armory Shows, the Blue Door Gallery, Taos, Ernesto Mayans Gallery, Graphics House, Nambe Mills and Field Contemporary. He received Purchase Awards from the Santa Barbara Museum and the Museum of Fine Arts in Santa Fe, and numerous awards from the New Mexico State Fair," *Santa Fe New Mexican*, Dec. 21, 1983, p. 9.

Ewing, Louie (notices in New Mexico newspapers on newspapers.com)
More than 170 "hits" for "Louie Ewing" and his art, including several ports., appear in *The New Mexican* (Santa Fe), 1936-1960, but were too numerous to itemize here.

Ewing, Louie (misc. bibliography)
Louie H. Ewing is listed in the *Santa Fe, N.M. CD*, 1938-60; Louie Henry Ewing was b. Dec. 22, 1908 in Pocatello, Ida., to Clyde Osborn Ewing and Golda P. Mayer, married Marrie Friedericka Breneiser, was residing in Santa Fe, N. M., in 1940, and d. Dec. 19, 1983 in Santa Fe, per Coats Family Tree; photos of Ewing appear in *Public Member Photos & Scanned Documents* (refs. ancestry.com).
See: "Breneiser, Elizabeth," intro, "Breneiser, Marrie," intro., 1939, "Breneiser, Stanley," 1933, 1935, 1936, 1939, 1945, 1950, "College Art Club," 1934, "Community Club," 1934, "Eidolon," "Emergency Educational Program" 1934, "Faulkner Memorial Art Gallery," 1933, 1934, "National Art Week," 1940, "Posters, Latham Foundation (Santa Maria)," 1934, "Santa Maria, Ca., Adult/Night School," 1934, "Santa Maria, Ca., Union High School," 1937, "Santa Maria School of Art," 1933

Ewing, Marrie Breneiser (Santa Maria)
See: "Breneiser, Marrie

Eya, Setsuko Elizabeth "Betty" (1936-?) (Santa Maria)
Santa Maria high school art student, 1951, 1954. Won a scholarship from the local Japanese-American Association to study art California College of Arts and Crafts, 1954. Student at Chouinard Art Institute, LA, 1959.
■ Port. with another student artist and instructor Bernard Garbutt at Griffith Park Zoo, and "Paintings of Birds in Zoo Given to City. A group of 21 paintings of birds in one of the flight cages at Griffith Park Zoo were presented to

the zoo yesterday by Chouinard Art Institute. The paintings were done by student artists…," *LA Times*, Feb. 1, 1959, p. 25 (i.e., pt. I, p. 23).

Eya, Betty (misc. bibliography)
Setsuko Elizabeth Eya, mother's maiden name Kihara, was b. May 23, 1936 in Santa Barbara County per Calif. Birth Index; Setauko [Sic. Setsuko] Eya is listed in the 1940 U.S. Census as age 3, b. c. 1937, residing in Township 9, Santa Barbara county, with her grandfather, Takeshi Kihara (age 55) and her grandmother Naka Kihara (age 48) and five uncles and aunts, and her mother Agnes Kihara Eya, and her brother Enizuko [Sic. Chizuko?]; Elizabeth Setsuko Eya b. May 23, 1926 [Sic. 1936], arrived at Gila River Relocation Center on Sept. 2, 1942 and departed Oct. 29, 1945 per *Final Accountability Rosters of Evacuees at Relocation Center, 1942-1946*; Betty Eya is pictured in the Santa Maria High School yearbook, 1951, 1952, 1953, 1954; Betty S. Eya is listed by herself at 1957 Prell Rd., in the *Santa Maria, Ca., CD*, 1958 (refs. ancestry.com).
See: "Santa Barbara County Library (Santa Maria)," 1952; "Santa Maria, Ca., Union High School," 1954, "Santa Maria Valley Art Festival," 1953, "Scholastic Art Exhibit," 1953

F

Faast, Rose F., Miss (1876-after 1976) (Hawaii)
Photographer who visited Lompoc and took photos of the flower fields, 1949.

■ "Hawaii Visitor – Miss Rose F. Faast, a visitor from the Hawaiian Islands, arrived in Lompoc today to take colored photographs of the Valley's famed flower fields. Miss Faast is an instructor at a girls' private school on the island of Maui, Hawaii, and resides at Paia on the Valley Island. Miss Faast will be accompanied here by her brother and sister-in-law, Mr. and Mrs. Victor Faast of Santa Paula, with whom she has been visiting for the past several weeks. In Lompoc they will be guests of Karl Wray," *LR*, Aug. 18, 1949, p. 3.

Faast, Rose (notices in American newspapers on microfilm and on newspapers.com)
1940 – "Miss Rose Faast Writes Book after Thirty Years in Islands … '*The Hawaiian Melting Pot*' … came off the press only recently…Miss Faast, the sister of Mrs. G. A. Dubois and Ben Faast, both of this city [Eau Claire, Wisc.], was born in Eau Claire, was a member of the First Presbyterian church, and received her education here, graduating from Eau Claire High school. She was a teacher in several of the city schools before leaving for the islands in January 1910, being a member of the Third Ward faculty at the time immediately preceding her departure. She spent some time in Honolulu, where she was associated with Kawaiahao Seminary, but in 1920 she took up her work at Maunaolu seminary on Maui, where she is now principal of the school… Miss Faast has visited in Eau Claire several times since 1910…," *Leader-Telegram* (Eau Claire, Wisc.), Jan. 28, 1940, p. 6; "Eau Claire Woman is Ill in Hawaii… infection following a tooth abstraction [sic.?]…," *Leader-Telegram*, Jan. 17, 1940, p. 5; "Margaret Faast Becomes

Bride" and Rose Faast of Hawaii sends a present, *Leader-Telegram*, June 3, 1949, p. 5; "100th Birthday. Rose Faast…," *Leader-Telegram*, Sept. 2, 1976, p. 21 (3-C).

Faast, Rose (misc. bibliography)
Rose Faast was residing in Eau Claire, Wisc., per *CD* in 1897, 1899, 1908, 1914; Rose Faast is listed in the 1910 Hawaii Census; Rose Faast is listed in the 1940 U. S. Census as age 63, b. c. 1877 in Wisc., finished college 5th or subsequent year, single, Principal of Maunaobe [Sic. Mauna'olu] Seminary, residing in Makawao, Maui, Hawaii with 6 teachers and 3 staff (refs. ancestry.com).

Fabing, Henry George (1868-1904) (Lompoc)
Painter of signs c. 1890 – 1904, and of a drop curtain in McMillan's Hall, 1903.

■ "Well Known Painter Dies. Henry Fabing of Lompoc, died at an early hour Sunday evening after a long illness. Mr. Fabing was been a sufferer with Bright's disease for several years and for the past year had been confined to his bed most of the time. … young son, he having married Miss Laura Covarrubus of this city about fifteen years ago. Mr. Fabing was a painter by trade," *SMT*, Oct. 8, 1904, p. 4.

Fabing, H. G. (notices in Northern Santa Barbara County newspapers on microfilm and on newspapers.com)
1890 -- "Messrs. Hopkins & Fabing, painters, have formed a co-partnership … and have established themselves in Lompoc…," *LR*, Feb. 8, 1890, p. 3.
1891 -- "H. G. Fabing, Painter. Ocean Avenue… General house, Sign and Carriage Painting…," *LR*, May 9, 1891, p. 1.
1892 -- "Signs of great men oft remind us, We can make our names to shine, That all rivals stay behind us, While they envy our new sign. We are ever ready, waiting, Brush in hand to work for you, Order all your signs of Fabing, You'll be happy if you do. We can't write first-class poetry, but we can and do beat all others in painting signs. McKee & Fabing, Painters," *LR*, June 25, 1892, p. 3.
1903 -- "H. C. [Sic. G] Fabing, the leading artist of Lompoc, was in town this week finishing up the new drop curtain in McMillan's hall. Among the attractive advertisements placed on the same is one for the *Times*…," *SMT*, Feb. 28, 1903, p. 3, col. 4.

Fabing, H. G. (misc. bibliography)
Henry George Fabing was b. May 1868 in Wisc., to Peter Milton Fabing and Margaret Craner, married Laura C. Covarrubias, and d. Sept. 30, 1904 in Lompoc, Ca., per Thompson Family Tree (refs. ancestry.com).

Fagin, Irene (Santa Barbara County)
Agent for the Home Department of the State Farm Bureau for Santa Barbara County, 1935-42.

■ "Miss Irene Fagin Assigned Co. Home Demonstration Ag't… She will arrive on June 13th … successor to Miss **Nancy Folsom**. Miss Fagin is a graduate of the University of Chicago, having received the Bachelor of Science Degree in home economics. She has served as a home demonstration agent for the agricultural extension service and for the past eight years has been stationed in Butte county. Miss Folsom [who Fagin is replacing] has served as

home demonstration agent in this county for the past eight years," *SYVN*, May 24, 1935, p. 4.

1942 – Irene Fagin Gets State Position… Santa Barbara county home demonstration agent for the past seven years is leaving the post… to become assistant state home demonstration leader … Her place will be taken by **Miss Florence Spaulding**, who as home demonstration agent-at-large was assigned to the county during her predecessor's leave of absence in June," *SMT*, July 8, 1942, p. 3.

See: "Home Department of the State Farm Bureau," 1935, 1942

Fairchild Aerial Surveys
Photographer, Harold C. Rycher (empl. Fairchild Aerial Surveys), mapped the Santa Maria valley with aerial photos, Sept. 1928.
See: "Photography, general (Santa Maria)," 1928

Fairey, Mildred I. Silvera (Mrs. Thurman Fairey) (1926-?) (Santa Maria / Cambria)
Artist. Art chairman of the Junior Community Club, 1950s. Exh. Allan Hancock [College] Art Gallery, 1956, 1957. Opened Millie's Antiques in Cambria in West Village, 1964, relocated to the historic Eubank's house in "East Village," and finally, c. 1986?, to the former Woodland garage in "West Village." Curtis Woodland was Mildred's step-father.

■ "Thurman Faireys … The bride, daughter of Mr. and Mrs. Frank M. Silvera, 612 West Cypress, is the former Mildred … Silvera. Her husband is the son of Mr. and Mrs. Emanuel Fairey of Pismo Beach. … Mrs. Fairey has been employed at the Santa Maria branch of the Associated Telephone Company since graduating from the Santa Maria High school. Her husband, a graduate of the Arroyo Grande High School, is employed with the Holser and Bailey Hardware store. He served in the U. S. Navy during the war. On returning from their wedding trip, the couple will make their home on East Cook…," *SMT*, Sept. 2, 1947, p. 3.

■ Fairey, in a telephone interview 9/11/2020, stated that she took art classes for several years running in the 1950s from **George Muro**, who she greatly admired. (She and her husband lived directly across the street from Hancock College.) She describes her painting style as "primitive," i.e., like Grandma Moses, but that she also had a second style, realism / representationalism. Over the years the artworks have all sold. She is particularly proud, as member of the **Junior Community Club** in 1957, of helping Muro put on the local artists show at Hancock College, a time when, in her opinion, art was not widely evident. After the Faireys moved to Cambria in the early 1960s, she ran an antique store, moving, over the years, to three different locations. While in Cambria Fairey produced several portraits. She also served as art chairman of the Quota Club at which time she put on a fashion show in San Simeon. The artist currently resides in Rapid City, SD (location courtesy Melody Coe, Cambria Historical Society).

And, additional notices in *SMT* between 1930 and 1960 for both "Mildred Silvera" and "Mildred Fairey," primarily reporting childhood and social events, and notices for "Fairey Antiques," in the *Cambrian* after 1964, were not itemized here.

Fairey, Mildred (notices in California newspapers on newspapers.com).
1945 – "Junior College… High school prospective graduates include … Mildred Silvera …," *SMT*, May 22, 1945, p. 3.
1964 – "Come to Fairey's Antiques. Opening July 3. Main St., Cambria, Calif. Mildred Fairey, Prop.," *SMT*, June 29, 1964, p. 13.

Fairey, Mildred (misc. bibliography)
Mildred I. Silvera, Opr, AT Co., is listed in the *Santa Maria, Ca., CD*, 1945; emp. Assoc. Tel Co., Ltd., is listed in the *Santa Maria, Ca., CD*, 1947/48; Mildred Fairey is listed in the *Santa Maria, Ca., CD*, 1958-63; "Mildred Fairey b. 1926, was residing in Cambria, Ca., in 1993 per *U. S. Public Records Index, 1950-1993*, vol. 1 (refs. ancestry.com).

See: "Allan Hancock [College] Art Gallery," 1956, 1957, "Junior Community Club," 1952-55, 1957, "National Art Week," 1954

Famous Players-Lasky
Hollywood motion picture studio that filmed in Northern Santa Barbara County, 1923.
See: "Motion Pictures, Santa Maria, Ca.," 1923

Farm Home Department
See: "Home Department of the State Farm Bureau"

Farm School (Los Olivos)
See: "Valley Farm School"

Farrington, Addie Norton? (Mrs. Wendell Mark Farrington or Mark Wendell Farrington, divorced by c. 1900?) (c. 1862-1936?) (Santa Maria / SLO)
An "A. Farrington" exh. handwork and an animal painting at "Santa Barbara County Fair," 1893, and embroidery, 1900. After separation and divorce from W. M. Farrington, c. 1900?, she became a teacher?
Farrington, Mrs. (notices in California newspapers on microfilm and on newspapers.com)
1891 – HUSBAND? – "W. M. Farrington of San Maguil [Sic. Miguel?] who bought the Santa Maria Market a short time ago, is now running in full blast," *SMT*, Oct. 3, 1891, p. 3.
1895 – "The ladies of the Literary Society closed their year's work by giving an open meeting in Masonic hall… The report of the year's work was read by Mrs. Farrington, the secretary…," *SMT*, Oct. 5, 1895, p. 3, col. 3.
1896 – "The ladies' literary society elected the following officers for the ensuing term… Mrs. W. M. Farrington, sec.," *SMT*, Jan. 11, 1896, p. 3; "The program for this week's meeting of the Santa Maria Ladies' Literary society

… The Society Journal, edited by Mrs. Addie M. Farrington…," *LA Herald*, Sept. 6, 1896, p. 11, col. 4.
1898 – "Mr. and Mrs. J. E. Farrington of Paso Robles were in town last week visiting their daughter-in-law Mrs. W. M. Farrington," *SMT*, April 23, 1898, p. 3; "The following is the programme of the Ladies' Literary Society for August 19th: … 'The Landing of Columbus,' Mrs. Farrington…," *SMT*, Aug. 13, 1898, p. 3.
1900 – "The Tepesquet school opens Monday next with Mrs. Farrington as teacher," *SMT*, July 14, 1900, p. 3.
See: "Santa Barbara County Fair," 1893, 1900

Fashion Design / Costume Design (Northern Santa Barbara County)

All domestic arts departments of schools taught dress design and costume design (for theaters) as well as dressmaking but they were not generally itemized in this book.
See: "Alvarez, Amelia," "Art/Artists, California (non Central Coast)," "Breneiser, Stanley," 1915, "Dennison, Elizabeth," "Emergency Educational Program," 1935, "Fleming, Joyce," "Fratis, Margaret," "Hill, K. Ethel," "Hollywood, Ca.," "Kaslow, Rita," "Kern, Barbara," "Lompoc, Ca., Union High School," 1933, "Milburn, Eddy," "Santa Maria, Ca., Union High School," 1923, 1929, 1931, "Santa Maria School of Art," 1933, "Steele, Gile," "Sutphen, Helen"

Fast, Nathaniel Durgin "Nat" (1924-2013) (Santa Maria)

Art teacher at Santa Maria and Righetti high schools, and at Allan Hancock College, 1955-82. Exh. Allan Hancock [College] Art Gallery, 1957, 1958.

■ Port. and "Artist, Teacher, Nat Fast Dies," by Niki Cervantes. "… Fast is nationally known for his watercolors that feature the look of a fast brushstroke which admirers say imbues his paintings with a feeling of action. 'I drew all my life, but didn't start formal art studies until I was 25,' he told the *Santa Maria Times* in 2005. 'My mother studied art and I used to draw with her as long as I can remember.' But Fast almost didn't become an artist. In 1948, after serving in the Navy, he went to San Jose State to become a CPA, with a minor in art. Within a semester, he became an art major with a minor in accounting. 'I never turned back,' Fast told an audience last March attending a session of FAST ART, a monthly session he had started three years prior to discuss various aspects of the world of art. From 1955 to 1982, he taught at Santa Maria and Righetti high schools before joining Hancock College as a sabbatical replacement for **George Muro**. Fast claimed he didn't start selling his work until 1975, when he had shows at the Rosicrucian Museum in San Jose and at Hancock. 'Then I started to sell, mostly watercolors, but life drawing, too, in conté crayon,' he said. Today, his art can be found in many locations. … Hancock College, where Fast taught full time for 18 years and then part time after retiring in 1982. Fast was in his late 80s. …Alarcio said Fast's daughter, Marti [Fast], the college's longtime gallery director and fine arts faculty member, is planning a 'public celebration of his

life,'…" per *Santa Maria Times*, Oct. 30, 2013 (p. A-1)on santamariatimes.com

■ "MAY 5, 2014 – The late Nat Fast's artistic vision and legacy will be celebrated in a special exhibit opening today at Betteravia Gallery South in Santa Maria. A reception for the public will be held Wednesday, May 7, from 4 to 6 p.m. at the gallery. The exhibit continues through Aug. 15, 2014. … watercolors and conté crayon pieces from family and collectors," per www.hancockcollege.edu.

■ "Parade of Lights: A Celebration of Community," re Nat Fast who donated his services to the Christmas Parade of Lights… "Santa Maria's Rotary Clubs donated $300 for Fast's brightly colored water color of marchers in the traditional parade, passing under the Broadway bridge joining Santa Maria's two downtown shopping centers… Five hundred copies of the poster have been distributed. … Arriving in 1955 he taught art, and coached football, at Santa Maria High School… 'You don't have to separate the two,' he said, calling himself more complete because of such a pairing… Later Fast taught at Righetti High School and finally completed his teaching career at Hancock College. Posters are nothing new for Fast, who considered a career in graphic arts at one point. He remembers the 'good old' days in high school, when the superintendent would drop into his lettering class and order up 50 posters for the Kiwanis, the Elks, or another local event. 'That was part of Santa Maria.' … Fast also painted a series of five yearly posters for the Autumn Arts Festival. Long active in local art promotional committees, Fast also has donated his services to demonstrate art, draw characterization portraits and even 'deal' at Monte Carlo benefits. The Christmas parade poster is 'basically a realistic work,' in the original Fast style with details and colors in a sharp, overlayering watercolor style… fast works from his own memory and experience, but in the case of the parade also looked at photographs of the event two years ago. He opted for bright colors… He first sketched out the general ideas, gave it a 'little thought' and completed the drawing the actual size of the poster… Fast also created a painted view of the yet-to-be-developed Santa Maria Elks Unocal Events Center, as a MAC benefit. As a former public school art teacher, Fast is vitally concerned with the decreasing funding for art education and the need for such facilities as MAC, where many local students have their first opportunity to see quality art work. 'We have lost a lot of ground in art education,' he believes. The youth of today see a lot of 'popular art' in the form of games, advertisements, television and the like, but have limited exposure to the fine arts. As a teacher and parent and grandparent, Fast feels that some of the problems of today's youth could be solved with further exposure to the arts… Fast's art can be seen at First Impressions in Santa Maria, Stinn's Jewelry in Pismo Beach and in a San Francisco gallery operated by Larry Abramson. 'I do very little showing,' he admitted, and seems 'always to be behind on my work,'" and port. per *SMT*, Nov. 22, 1996, p. 3 (i.e., A-3).

■ "Local Artist Nat Fast. As a young man, Fast majored first in engineering and then accounting at San Jose State. As an undergraduate, he was a 'reader' in Dr. Tansey's Art History class. Fast graded papers, operated the slide projector for presentations and generally assisted the

professor who he said was 'awesome!' It was through this class Fast developed his love of art history. He had a flare for drawing, but says, 'It was difficult for a guy to major in art during those days, but when I realized I could make a living by painting and drawing, I changed my major anyway.' Along with Dr. Tansey, who profoundly influenced him, Fast also drew inspiration from Ted Johnson who taught life drawing, John Mottram who taught drawing & lithography and Waren Faus who taught watercolor. After graduation from San Jose, Fast became an army officer and served during the Korean war. 'I had good places to serve, first in Camp Gordon, Georgia, and then in Berlin, Germany, which was hundreds of miles from the fighting. I instructed during that time and found that I really loved teaching.' When he returned home, Fast used that love and began teaching at Santa Maria High School as an assistant football coach and art instructor. He laughs when he recalls 'People thought that was so odd: Art people would say, 'you're an art teacher but you coach football?' and of course football people would say, 'You're the football coach, but you teach art?' It was funny to watch people's reactions, but I always figured that we have a mind, a body and a spirit, and each needs to be developed. It wasn't so odd that I could teach drawing while teaching sports.' Fast also taught art at Righetti High School and then at Hancock College. During those years, Fast and his wife raised six children in Santa Maria. It was also during those years that Fast refined his distinctive style of art. Though Fast does draw and paint on canvas, his 'signature' is his mastery of three-dimensional art. 'This kind of art works especially well with European architecture.' When asked if the mixed-media on two or three surfaces had a particular name, Fast laughed and said, 'No, just mixed-media on two or three surfaces. I didn't seek a distinct style, it just sort of worked out that way. I realized that if I cut the matte to incorporate the drawing with the watercolor that the two styles appeared more distinctive and therefore created a unique image. Plus, I had never seen anyone else do it!' He's been retired from teaching almost 20 years now, but hasn't slowed down on the drawings. Fast does commission paintings and especially enjoys that. 'I get to travel a lot with commission work. I've been to Peru twice, Mexico and Europe. I really enjoy that.' Fast says of portraits, 'I do portraits on a limited basis. If I do paint a portrait, I like to have my lighting and my angle, and sometimes that isn't possible. I love to draw people though…' That's apparent in these paintings (shown) of plays at the Pacific Conservatory for the Performing Arts (PCPA). Fast sits in the control booth to get a view, he sits at the stage right vom and for a third view, at the stage left vom for yet another view of the subjects at hand. Is there a specific title for that job? Fast says, 'Well, resident artist or 'Phantom of the Vom' or something. Mostly, they just let me 'cause I'm an old man and letting me draw keeps me out of mischief.' He laughs. Fast's most important business duties these days include sitting as the co-chairman of the Individual Arts Program for the Santa Maria Arts Council. This arts program awards thousands of dollars each year in grants to youth for the artistic and cultural enrichment of the Santa Maria Valley. Fast encourages all, who are eligible, to apply next year for one of the four categories: dance, drama, music and visual artists. ... Nat feels strongly about encouraging all artistically inclined kids to go forward with beloved skills," and caption, "Exhibit Information. Nat Fast's paintings are on display and for sale at Stinn's Handwrought Jewelry, 561 Five Cities Drive in Pismo Beach. If you're interested in commission work, call him at home at 937-0776 and visit Stinn's Web site to view more of Fast's work at www.stinnjewelry.com," per *Times-Press-Recorder* (Arroyo Grande, Ca.), April 20, 2001, and repros of art, p. 32 (i.e., "Local Artists").

■ "Nathaniel Durgin Fast touched the lives of countless others through his teaching, art, and love of people. Nat died quickly and gracefully in Halcyon, California on October 27, 2013, surrounded by his large and loving family… He mentored countless artists over the years and was an amazing father, friend, and teacher…Fast is survived by his older brother, Dr. Thomas N. Fast, ex-wife and mother of their children, Marcia M. Fast… Nat asked that in lieu of flowers, donations be made to the Santa Maria Arts Council Trust Fund, PCPA Foundation, Orcutt Children's Art Fund (OCAF), or St. Peters Episcopal Church," per "Nathaniel D. Fast" (clipping, probably the *Santa Maria Times*, hand dated 11-14-13, in the SMHS Scrapbook).

Fast, Nat (notices in Northern Santa Barbara County newspapers on microfilm and on newspapers.com)
1957 – "Faculty Wives Meet at School… in the art building of Santa Maria High School… Nat Fast, art and crafts instructor, demonstrated exhibits of ceramics and clay modeling…," *SMT*, April 26, 1957, p. 3.
1959 – "Registration for Art Classes Set. The Saturday Art Classes with Nat Fast… will be open to 30 children ages 6 through 9 only. Classes will be conducted in the kindergarten room of the Robert Bruce school starting 10:30 a.m. Saturday, Dec. 5. Sculpturing collage and poster painting will be featured…," *SMT*, Dec. 2, 1959, p. 3; "AAUW to Have Art Instructor as Speaker" on "Looking to the Future in Art", and article says, "Fast is currently conducting art classes on Saturday mornings for children from the ages of six through nine at the Robert Bruce School. The program is being sponsored by the city recreation department and assisted by the AAUW chapter." **Mrs. James S. Ingram**, art committee chairman of the chapter, *SMT*, Dec. 9, 1959, p. 7.
And, hundreds of additional articles on "Nat Fast" after 1960 and particularly at his death in 2013 in the *Santa Maria Times* and other California newspapers were too many to be browsed for inclusion here.

Fast, Nat (misc. bibliography)
Port. of Nathaniel Fast, art teacher, Santa Maria High School yearbook, 1957; nearly 50 entries for "Nat Fast" on ancestry.com were not itemized here; Nat D. Fast b. Aug. 10, 1924, d. Oct. 27, 2013 per Social Security Death Index (refs. ancestry.com).
See: "Allan Hancock [College] Art Gallery," 1957, 1958, "Muro, George," 1957, "Santa Maria, Ca., Recreation Department," 1959, "Santa Maria, Ca., Union High School," 1955, 1957-58, 1960, "Scholastic Art Exhibit," 1958, 1960, "Summer School," 1959, 1960

Faulkner Memorial Art Gallery (aka "Faulkner Memorial Gallery," aka "Faulkner Gallery") (Santa Barbara)
Gallery opened in the Santa Barbara City Library, 1930, at which some northern Santa Barbara County artists occasionally exhibited. Site of annual exhibits of artwork by students of Santa Barbara County schools, 1931-33.
Faulkner Memorial Art Gallery (notices in Northern Santa Barbara County newspapers on microfilm and on newspapers.com)
1931 – "Santa Marians Book-Minded… Work of the Santa Maria Junior college and the high school now on display at the Faulkner Memorial gallery at the Santa Barbara City library is receiving much commendation. …," *SMT*, May 26, 1931, p. 1.
1932 – "Art Display of Students Wins Praise… second annual exhibition of the county's schools is on display in the Faulkner Memorial gallery. … opened on April 1… Verne Linderman, writing in the *Santa Barbara Morning Press*, says… 'One always finds exuberance, abundance of life and imagination in the displays of Santa Maria junior college and union high school. The pupils of these schools have filled up half of one of the long walls with an amazing variety of good art work and have plenty more to say, one is confident. Instructor **Stanley G. Breneiser** and **Mrs. Breneiser** will take a group of Santa Maria students to the exhibition next Saturday," *SMT*, April 11, 1932, p. 6; "Breneisers Have Display of Work in S.B. Exhibit… summer exhibition of the Faulkner Memorial Art gallery in Santa Barbara. … **Stanley Breneiser**'s works are 'Interpretation: Adagio,' a musical theme in colors and 'Point Sal Beach.' His son, **John**, has on display 'After the Rain' and 'Point Sal.' [Charles C.] **Mattei**'s painting is a portrait of P. Montanaro. At Santa Barbara on July 23, an 'artist's fair' sponsored by the artist's colony of that city, will find the Breneisers again represented," *SMT*, July 12, 1932, p. 6; "Two Santa Marians, **Stanley G. Breneiser**… and **John Breneiser**, his son, have paintings exhibited at the Faulkner memorial Art gallery in Santa Barbara … The high school instructor has… two tempera paintings, one an interpretation of a concerto by Grieg and another entitled 'Point Sal Beach.' Two works done in oil were accepted from **John Breneiser** to be hung … They are 'After the Rain' and 'Point Sal'," *SMT*, Aug. 25, 1932, p. 6.
1933 – "Local Artists in Exhibition at S.B., Four Santa Maria artists are represented in the annual winter exhibition… They are **John Day Breneiser, Stanley G. Breneiser, Elizabeth Day Breneiser** and **Louie Ewing**… Among the work exhibited by the Santa Marians is a large oil painting by **John Breneiser** showing workers in local oil fields, 'Cannas,' an oil painting by **Mrs. Breneiser**, a decorative tempera painting of 'Casmalia Hills,' and a large three-panel screen, in oils, of an interpretation of Chopin's Prelude No. 2, both by **Stanley Breneiser**, a striking wood carving called 'Beaching the Boat' by **Ewing**. Ewing came here from Idaho last summer to make his home with the Breneisers. He has been doing remarkably fine work in sculptured wood carving…," *SMT*, Feb. 4, 1933, p. 3; "Work of Local Artists Lauded in S.B. Exhibit…,"
Elizabeth Day Breneiser, Stanley G. Breneiser, John Day Breneiser, Louie Ewing, by reviewer Verne Linderman in the Santa Barbara paper… *SMT*, Feb. 17,

1933, p. 2; "Students of Art Exhibit in S.B. Santa Maria high school and junior college are well represented at the third annual art exhibition of Santa Barbara county schools now on display at the Faulkner Memorial gallery in Santa Barbara. Sixteen high school students and 11 junior college pupils… High school students represented are Jack Golden, **Francis Gregory,** Geneva Grimsley, Elinor LaFranchi, Nubuo [Sic? Nobuo and Nabuo] Nishiyama, **Yoshisuke Oishi,** Pauline Quick, **Byron Openshaw,** Maxine Saladin, **Archie Case,** Henry Evans, Frances Milhorn, **Ada Okamoto,** Ina Van Noy, Ruby Marston, and **Guido Signorelli**. From the junior college, students entering work are Elma Cook, Louise Marlett, Fay Clevenger, [Miss] Shizue [Shizuye Minami] Hamada, Dorothy Ashbaugh [from Colorado], **Anna Adele Black, Louie Ewing, Leonard Fisher, Rex Hall, Rowena Lowell** and Rose Wagner," *SMT*, May 15, 1933, p. 1; "Five Artists Have Work Exhibited… Faulkner… summer exhibition…**John Day Breneiser** presents a portrait done in oils as well as an original lithograph… A delicate but strong pencil drawing of an old cypress tree at Point Sal is the contribution of **Elizabeth D. Breneiser**, while **Stanley G. Breneiser** has on display two pencil drawings of figures in composition, 'Contemplation' and 'The Flowering.' **Louis [Sic. Louie] H. Ewing** shows an original wood block-print and **Marrie F. Breneiser** displays a portrait done in water colors," *SMT*, Aug. 1, 1933, p. 3.
1934 – "Local Artists in S. B. Exhibit. **Stanley Breneiser, John Day Breneiser** and **Louis [Sic. Louie] Ewing,** all of Santa Maria, have submitted pictures of northern Santa Barbara county scenes to the summer exhibit … **John Breneiser** submitted a water color of a band of horses in Cuyama valley and another showing a corner of his studio. He also sent in two oil paintings, 'Dry Canyon Ranch,' and 'Point Sal.' A water color study of hills near Nipomo was **Stanley Breneiser**'s contribution and a portrait done in water colors was submitted by **Ewing**," *SMT*, Aug. 4, 1934, p. 2.
1935 – "John Breneiser Shows Prints in Exhibit. **John Day Breneiser**… has on exhibit in the print room of Faulkner art galleries, three lithographs and one block print. They are part of a display of works by the Santa Barbara Printmakers. The lithographs are 'Circus Roustabouts,' 'A Study in Line' and "Ranch Near Casmalia.' The block print is entitled 'Depression' …," *SMT*, Dec. 5, 1935, p. 2.
1936 – **John Breneiser**, "Has Work Exhibited" in print show at Santa Barbara's Faulkner Galleries, *SMT,* June 12, 1936, p. 3.
1959 – **Forrest "Hibbits** Invited to Exhibit Art. The board of directors of the Santa Barbara Art Assn. has invited Forrest Hibbits… to be one of four exhibitors from Dec. 1 to Dec. 31 in the Faulkner Memorial Gallery…," *SYVN,* Dec. 4, 1959, p. 7; "Buellton Briefs… **Forrest Hibbits** has several paintings on exhibition at Faulkner Memorial Gallery… included… are watercolors, oils and collages …," *LR*, Dec. 10, 1959, p. 18 (i.e., 2C).
1960 – "Valley Artists Exhibit at Show. The Spring Art Exhibition under the sponsorship of the Santa Barbara Art Association at the Faulkner Gallery in Santa Barbara … a few from Valley artists. Both **Marie** and **Forrest Hibbits** are exhibiting their work, and **Charles Glasgow,** of Los Olivos has a beautiful evening landscape on display. The

show, which will continue through April, is open to the public," *LR*, April 7, 1960, p. 19.

1964 – "Art Style Controversy Resolved. A controversy of abstract art versus traditional art ended in the agreement that high quality art may represent all styles when officials of the Santa Barbara Art Association, trustees of the Santa Barbara Public Library representing the users of the Faulkner Gallery, and members of the library staff, met with a group of artists calling themselves traditional artists. The traditionalists at the meeting last week in the library made a plea for better representation by the traditional group stating that the juries selecting the works to be hung ignore the traditionalists. 'We want a two-party system,' they said. … **Joseph Knowles**, president of the Art Association (which includes several valley residents) said that the membership numbers 114 and about 50 percent have been able to exhibit. The juries, composed of artists with good reputations and integrity, select the paintings on the basis of quality of the work. All styles are represented. He added, several years ago a group of avant garde artists broke away from the association stating it was too conservative …," *SYVN*, Jan. 24, 1964, p. 9.

See: "Bailey, Ethel," 1959, "Berend, Charlotte," 1941, "Breneiser …," "Delphian Society," 1934, "Gamble, John," 1936, "Gilbert, Rudolph," "Glasgow, Charles," "Hibbits, Forrest," 1959, "Hibbits, Marie Jaans," 1959, 1984, "Lompoc, Ca., Union High School," 1934, "Moore, Brett," "Muro, George," 1957, "Richmond, Evelyn," 1939, "Santa Barbara Art Association," "Santa Maria, Ca., Union High School," 1931, "Stark, Jack," 1937, "Stetson, Thomas," "Swanson, David," "Vaughan, S. Edson," 1933, 1936, "Weston, Brett," 1933, "Wright, James," intro.

Federal and State Relief Projects c. 1934-1942
Several federal and state-funded programs during America's Depression of the 1930s supported educational and recreational programs that included arts and crafts.
See: "Alpha Club," 1936, "California State Relief Administration," "Civil Works Administration (CWA) Project," "Civilian Conservation Corps (CCC)," "Emergency Educational Program," "Helmle, Henry," "Hesthal, William," "Lompoc, Ca., Adult/Night School," 1934, "Lompoc Nursery School," "Mackenzie, Catherine," "Mission La Purisima," "Nadeau, Evelyn," "National Art Week," "New Deal," "Parshall, Douglass," "Public Works of Art Project," "Rivol, Lala Eve," "Santa Maria, Ca., Elementary School," 1936, "Santa Ynez Valley Union High School," intro., "State Emergency Relief Administration (SERA)," "Treasury Department, Section of Painting and Sculpture," "Warren, John," "Works Progress Administration"

Federal Correctional Institution (aka "United States Disciplinary Barracks") (Lompoc)
Federal penal institution that took over the buildings belonging to the closed United States Disciplinary Barracks, August, 1959. It offered its prisoners educational courses that included manual drawing and cabinetry, 1960. Best known artist was vocational instructor George Utsunomiya.

Federal Correctional Institution (notices in Northern Santa Barbara County newspapers on microfilm and on newspapers.com)
1959 – "Confinement Facilities of DB Shift… Official acceptance of the confinement facility of the Branch United States Disciplinary Barracks by the Federal Bureau of Prisons was announced…," *LR*, Aug. 3, 1959, p. 1.

1960 – "721 Enroll in FCI Education Courses… actual classroom work or vocational training… Only a small percentage of the inmates are high school graduates and many have unsatisfactory outside school records… Lack of motivation and not lack of ability can be attributed to most of the inmates… School and classroom enrollments are voluntary in the majority of cases; however, the institutional treatment philosophy is that those who have the ability (I.Q.) should be in school, and a mandatory school assignment… classroom instruction is offered in: remedial reading and language arts… mechanical drawing… English… science, physics… Classes that are most popular with the FCI's all-male population are mathematics, mechanical drawing and physics… If the individual desires to enroll in college courses, he may do so at his own expense… correspondence courses… The vocational program presently provides training in the following trades… machine shop… painting, landscaping… Other activities under the direction of the Educational Department are the … recreation programs supervised by James E. Starr, and instrumental music groups… 18 instructors… 12 of whom were … regularly employed in the Lompoc Unified School District …," *LR*, July 28, 1960, p. 11 (i.e., C-1).
See: "Blakely, June," "Brooks, Barbara," "Grady, Elmer," "Horowitz, Leonard," "Lewis, Marion," "Miller, Barney," "Padrick, Walter," "Potter, Roy," "United States Disciplinary Barracks / USDB (Lompoc / Surf)," "Utsunomiya, George"

Federal Electric Corporation
See: "Drafting," "Naval Missile Facility (Point Arguello)"

Federation of Women's Clubs
Umbrella title for Women's Clubs – i.e., local city women's clubs, the Santa Barbara County Federation of Women's Clubs, the California Federation of Women's Clubs and the national or General Federation of Women's Clubs. Most individual clubs plus the Federation itself had various "art" programs. Chairmen of art and handicrafts from the various levels traveled to northern Santa Barbara County to teach their subjects. Conferences of the various levels allowed attendees to hear lectures and share ideas with sister women's clubs.

■ "The General Federation of Women's Clubs (GFWC), founded in 1890 during the Progressive Movement, is a federation of over 3,000 local women's clubs which promote civic improvements through volunteer service," per Wikipedia.

Federation of Women's Clubs (notices in Northern Santa Barbara County newspapers on microfilm and on newspapers.com)
1941 – "Co. Conference of Women's Clubs to Meet Jan. 21…. in Orcutt at the Union Grammar school… Brief outlines will be given by various club presidents on the goal for the year's activities. Exhibition of handcraft work will be given…," *LR*, Jan. 17, 1941, p. 3.
1942 – "Federated Clubs Plan District Meet Here… luncheon speaker will be **Thais Plaisted**, a member of the district Art committee, who will discuss Lincoln statuary in California… will take place in the Methodist church…," *SMT*, Feb. 11, 1942, p. 3.
1949 – "County Federation of Women's Clubs Convene" and one lecture is by **Mary Jane Thornburgh** on 'Don't Let Modern Art Throw You,' *SMT*, Nov. 16, 1949, p. 6.
1952 – "Finer Arts… Santa Barbara County Federation of Women's Clubs here Tuesday… Hostessing… will be members of the Lompoc Community Women's club… Highlight of the afternoon session, which will be held at the Lompoc Grange hall, will be a talk by **Mrs. Mary Jane Thornburgh**, state art chairman, who will bring three of her own paintings to illustrate her talk. Also, a special part of the program will be exhibits of oil and water color paintings done by members of the various county federated clubs. **Mrs. Russell Benhart**, county chairman of crafts, will have charge of an exhibit of ceramic work being done by club women. Club members are being urged to take their paintings and ceramic work, one exhibit per person…," *LR*, Jan. 10, 1952, p. 4.
1960 – "**Alpha Club** Publicizes Lompoc Flower Show-Festival at Convention… Tierra Adorada District California Federation of Women's Clubs fourth annual convention at the Miramar Hotel, Santa Barbara… Featured in the convention art display were paintings by **Mrs. Ethel Bailey, Mrs. Elsa Schuyler, Mrs. Arnold Brughelli** and **Mrs. V. J. Williams**," *LR*, April 28, 1960, p. 6.
And, many other notices not itemized here.
See: "Alpha Club," "Community Club," "Junior Community Club," "Guadalupe Welfare Club," "Lompoc Community Women's Club," "Minerva Club," "Solvang Woman's Club," "Santa Ynez Valley Woman's Club"

Feeley, John Joseph (1913/14-1997) (Santa Maria)
Santa Maria High School teacher, 1939-42. Amateur photographer and sponsor of the school Camera Club, 1941.

■ "Local Teachers Marry in Carmel…. John Joseph Feeley and Miss Betty Roscine Robinson … Both the former Miss Robinson and her husband are teachers in the local high school… He teaches core course and sponsors the Camera club, being a skilled amateur photographer. They joined the faculty at the same time two years ago, before which they had been at Stanford university, where they met. They will be at home in Santa Maria after Aug. 15, at 216 ½ West Church street," *SMT*, Aug. 14, 1941, p. 3.
Feeley, John (notices in Northern Santa Barbara County newspapers on microfilm and on newspapers.com)
1939 – "New Instructor … In a last-minute change, John Feeley of San Francisco was selected as attendance

officer… Feeley was graduated this summer from Stanford university with his A. B. degree and secondary credentials…," *SMT*, Sept. 5, 1939, p. 4.
1943 – "A Year Ago. Four high school teachers joined the U. S. Air Corps as instructors. They were John Feeley…," *SMT*, May 7, 1943, p. 4.
Feeley, John (misc. bibliography)
John Joseph Feeley gave the following information on his WWII Draft Card dated Oct. 16, 1940 = b. Jan. 22, 1914 in Butte, Mont., employed by Santa Maria High School, residing in Santa Maria, next of kin is mother, Josephine Feeley; John Joseph Feeley, mother's maiden name Sullivan, b. Montana Jan. 22, 1913 [Sic.?], d. Dec. 19, 1997 in Orange County per Calif. Death Index (refs. ancestry.com).
See: "Santa Maria Camera Club," 1940

Feeley (McDuffie), Lola (Mrs. Murl McDuffie) (Santa Maria)
Domestic Arts teacher at El Camino School (i.e., Santa Maria's "Junior High"). Examiner in textiles for Boy Scouts, 1933.

■ "Engagement of Miss Feeley… Miss Lola Feeley… to Murl McDuffie of Santa Barbara… Miss Feeley is the daughter of M. G. Feeley of Los Angeles. She is an instructor in El Camino grammar school. She attended the University of California at Los Angeles. Her fiancé is employed by the County National bank of Santa Barbara…," *SMT*, May 15, 1935, p. 3.
About 20 "hits" occur for "Miss Feeley" in the *SMT*, 1930-1935, most for her helping renovate toys for Christmas, but were not itemized here.
See: "Boy Scouts," 1933, "Santa Maria, Ca., Elementary Schools," 1931

Feitelson, Lorser (1898-1978) (Los Angeles)
Modernist painter of Los Angeles. One of his paintings was distributed to a public building in northern Santa Barbara County by the PWAP, 1934.

■ "Lorser Feitelson (1898–1978) was an artist known as one of the founding fathers of Southern California-based hard-edge painting. Born in Savannah, Georgia, Feitelson was raised in New York City, where his family relocated shortly after his birth. His rise to prominence occurred after he moved to California in 1927," per Wikipedia.
Bibliography:
Multiple references occur in Nancy Moure, *Publications in California Art*, vols. 1-13.
See: "Public Works of Art Project," 1934

Fenci, Renzo G. (1914-1999) (Santa Barbara)
Sculptor who participated in Santa Maria Art Festival, 1952, and Winter Arts program, 1953.

■ "Fenci was born in Florence, Italy on 18 November 1914. At a young age he went to study art at the Royal Institute of Art. He received a master's degree in 1932 from Instituto d'Arte Firenze (Art Institute of Florence) and studied with sculptors Libero Andriotti and Bruno

Innocenti. He emigrated to New York City, New York around 1937 or 1938, due to the change in politics in Europe and the rise in Fascism. Fenci lived in New York City, New York and Madison, Wisconsin before settling down in Pullman, Washington in order to teach fine art at Washington State College. … By 1944, Fenci moved to Santa Barbara, California. Between 1947 until 1954, he taught at Santa Barbara College (now called University of California, Santa Barbara). From 1955 until 1977, Fenci was the head of the sculpture department at Otis Art Institute (now named Otis College of Art and Design)," per Wikipedia.

Fenci, Renzo (notices in California newspapers on microfilm and on newspapers.com)
1956 – Port. of Renzo Fenci with two statues he created for Home Savings & Loan Building and short article, *LA Times*, Feb. 24, 1956, p. 28; and 30 additional notices in various California newspapers 1945-60 not itemized here.

Fenci, Renzo (misc. bibliography)
Renzo G. Fenci married Jeanne Lyons / Foster on June 9, 1955 in Santa Barbara, Ca., per Calif. Marriage Index; Renzo Fenci was b. Nov. 18, 1914 in Florence, Italy, d. Dec. 31, 1999 and is buried in Santa Barbara Cemetery per findagrave.com (refs. ancestry.com).
See: "California State Fair," "Santa Maria [Valley] Art Festival," 1952, "Winter Arts Program," 1953

Fenton, Howard C. (1910-2006) (Santa Barbara)
Prof. at Univ. of Calif., Santa Barbara, and director of Santa Barbara museum, 1952. Exh. Santa Maria Valley Art Festival, 1952 and Santa Barbara County Fair, 1960.
Fenton, Howard (books)
Howard Fenton: A Retrospective Exhibition 1948-1968, Art Galleries, University of California, Santa Barbara, Oct. 8 to Nov. 10, 1968.
Phyllis Plous, *Howard Fenton Recent Paintings*, Santa Barbara: University Art Museum, 1990.
Fenton, Howard (misc. bibliography)
Port. and caption reads, "Mr. Howard Fenton has been able to teach Art well and is known for his History of Oriental Art in particular," in Santa Barbara College of the University of California, yearbook, 1950 (and he appears in other yearbooks, 1945-61); Howard C. Fenton, professor, is listed in the *Santa Barbara, Ca., CD*, 1954; Howard Fenton, professor UC-SB, is listed in the *Santa Barbara, Ca., CD*, 1956; Howard C. Fenton was b. July 2, 1910 and d. Aug. 16, 2006 per Social Security Death Index (refs. ancestry.com).
See: "Santa Barbara County Fair," 1961, "Santa Maria [Valley] Art Festival," 1952

Ferg (W. A. Ferguson)
Itinerant cartoonist – "Famous Sperry Flour Co. Left Handed Cartoonist," was in Lompoc, 1938.
1938 – Port. and appeared at Moore's grocery," *LR*, Sept. 9, 1938, p. 3.
See: *Atascadero Art and Photography before 1960*

Ferini, Irene Maria Coppi (Mrs. Peter / Pietro Ferini) (1882-1978) (Santa Maria)
Ceramist. Exh. at Santa Barbara County Fair, 1949, 1952, and at Community Club hobby show, 1950. Member Santa Maria Art Association.
Ferini, Irene (misc. bibliography)
[Do not confuse with her daughter-in-law, Irene W., Mrs. Guido Ferini.]
She is probably Irene Ferini b. June 9, 1882 in Switzerland and d. April 1978 per Social Security Death Index (refs. ancestry.com).
See: "Community Club (Santa Maria)," 1950, "Minerva Club," 1948, "Santa Barbara County Fair," 1949, 1952, "Santa Maria Art Association," 1949, 1950, 1952

Ferini (Plaskett), Theda (Mrs. Archibald Lealand Plaskett) (1917-1978) (Santa Maria)
Santa Maria high school student, associated with the school fashion magazine, Trend, 1935. Teacher of handcraft to Camp Fire Girls at Camp Drake, 1935.
Theda Geraldine Ferini was b. June 2, 1917 in Fresno, Ca., to Adolph Louis Ferini and Frances Charman Sims, married Archibald Lealand Plaskett, and d. Aug. 8, 1978 in Santa Maria, Ca., per Charm Perry Family Tree (ref. ancestry.com)
See: "Camp Fire Girls," 1935, "College Art Club," 1935, "Santa Maria, Ca., Union High School," 1933, 1935

Fernandez, R. (Santa Maria)
See: "Rayo Auto Paint Shop"

Ferrell, Harold S., Mr. and Mrs. (Lompoc)
Collectors of Oriental artifacts, 1960.
See: "Collectors, Art / Antiques (Lompoc)"

Ferslew (Kaperonis), Irna / Erna Louise (Mrs. Paul N. Kaperonis) (1905-1983) (Buellton)
Student at Otis Art Institute, 1926. Prop. beauty salon. Exh. landscape and flower studies at Art Loan Exhibit, Solvang, 1935.

■
Ferslew, Erna (notices in Northern Santa Barbara County newspapers on microfilm and on newspapers.com)
1925 – "Miss Erna Ferslew, a University of California student, is spending her Christmas vacation with her parents in Buellton," *SMT*, Dec. 29, 1925, p. 4, col. 5.
1926 – "Leaves to Attend School in Los Angeles… Miss Erna Ferslew, daughter of Mr. and Mrs. Harald C. Ferslew of Buellton, left Wednesday for West Lake Park, Los Angeles, to attend the Otis Art school. Miss Ferslew attended art school in Oakland last year, but made arrangements to finish her remaining two years in the school at Los Angeles," *SYVN*, Sept. 10, 1926; "Miss Erna Ferslew… visiting her parents…," *SYVN*, Sept. 24, 1926, p. 1.
1939 – "Erna Ferslew Opens Beauty Salon in Oakland… in Hotel Claremont… Miss Ferslew was formerly in business in Solvang and Buellton…," *SYVN*, Oct. 27, 1939, p. 1.

1956 – "Valley Views … A note from Irna Kaperonis in the Philippines saying her husband, Paul, is being transferred by the Navy to duty in San Francisco and they are heading state-side…," *SYVN*, March 16, 1956, p. 2. And more than 20 notices in the *SYVN* between 1920 and 1940 describe her travels but were not itemized here.

Ferslew, Erna (misc. bibliography)
Irna Ferslew was b. Dec. 1905 per Cook County, Ill., Birth Index; Irna L. C. Ferslew is listed in the 1930 U. S. Census as age 24, b. c. 1906 in Illinois, residing in Buellton with her parents Harald C. Ferslew (age 55) and Anna L. Ferslew (age 47) and uncle Max Ferslew; Erna Louise Ferslew is listed in the *Alameda, Ca., CD*, 1940; Erna Ferslew is listed in the *Oakland, Ca., CD*, 1943; Irna L. Kaperonis is listed in the *San Francisco, Ca., CD*, 1948; Irna L. Kaperonis is listed in the *Palo Alto, Ca., CD*, 1958; Irna L. Kaperonis is listed in the *San Jose, Ca., CD*, 1961, 1965; Irna L. Kaperonis is listed in the *Santa Clara, Ca., CD*, 1968, 1970; Irna Louise Kaperonis, mother's maiden name Poulsen, father's Ferslew, was b. Dec. 15, 1905 in Illinois and d. Oct. 30, 1983 in Santa Clara County per Calif. Death Index (refs. ancestry.com).
See: "Art Loan Exhibit (Solvang)," 1935

Festival Art Exhibit / Flower Festival / Floral Festival Art Exhibit (Lompoc)
Open-air art exhibit held at Ryon Park in conjunction with the Alpha Club's annual Floral Festival.
See: "Open-Air Art Exhibit"

Feulner, Adelyne Silva (Mrs. Louis H. Feulner) (1919-1987) (Santa Maria)
Exh. "paintings exhibited in South America," at Allan Hancock [College] Art Gallery, 1957.
Feulner, Adelyne (notices in Northern Santa Barbara County newspapers on microfilm and on newspapers.com)
1952 – "SM Friends May Write to Fuelners. Mrs. Adelyne Silva Fuelner writes from Puerto Rico where her husband Lieutenant Fuelner has been stationed the past two years… the Fuelners and their son, Dennis Paul, miss the good fresh vegetables grown in this valley… Mrs. Fuelner is the daughter of Mrs. Maria R. Silva, 527 East Orange… Santa Maria friends may address letters to Lt. or Mrs. Louis H. Fuelner, Fort Buchanan, P.R., APO 851-A, Postmaster, N.Y.," *SMT*, Oct. 25, 1952, p. 4.
Feulner, Adelyne (misc. bibliography)
Adelyne Kathleen Fuelner, mother's maiden name Lima, father's Silva, was b. Jan. 19, 1919 in Calif., and d. Oct. 25, 1987 in Santa Barbara County per Calif. Death Index (refs. ancestry.com).
See: "Allan Hancock [College] Art Gallery," 1957

Field, Isobel "Belle"
See: "Osbourne (Strong) (Field), Isobel "Belle" (Mrs. Joseph Dwight Strong) (Mrs. Edward Salisbury Field)"

Fields, Iva McKay (Mrs. Edward Fields) (1893-1972) (Ballard)
Home Making teacher at Santa Ynez Valley High School, who also taught some art and crafts, 1926+.
Fields, Iva (notices in Northern Santa Barbara County newspapers on microfilm and on newspapers.com)
1927 – "High School Teachers Sign Contracts for New Term… Mrs. Iva Fields…," *SYVN*, June 17, 1927, p. 1. And, possibly 60 additional entries for "Mrs. Fields" in the *SYVN* between 1926-1940 were not itemized here.
Fields, Iva (misc. bibliography)
Iva M. Fields is listed in the 1930 U. S. Census as age 33, b. c. 1897 in Calif., no occupation, residing in Ballard with husband Edward Fields (age 32) and a son age 8 months; Iva McKay Fields, b. July 9, 1893 in Calif. and d. Feb. 2, 1972 in Santa Barbara County was buried in Oak Hill Cemetery in Ballard per findagrave.com (refs. ancestry.com).
See: "Santa Ynez Valley Union High School," 1926

Firfires, Nicholas Samuel (1917-1990) (SLO and Santa Barbara counties)
Painter of western scenes, 1934+. Half-brother of Violet Stenner, below.

■ "Portraying western scenes in oil painting and watercolor comes to Nicholas Firfires, directly from experiences of having lived the western life of a cowboy, riding the range and breaking horses. He was a descendant of California vaqueros. He was born in Santa Barbara, California, and worked on his family ranch near Santa Margarita and on other ranches in Santa Barbara county. As a child, he showed great interest and skill in drawing animals, especially horses, and after graduating from Santa Maria high school, he attended the Art Center School and the Otis Art Institute in Los Angeles. In 1941, he enlisted in the Army and was with the Combat Engineers in Europe, where he did many illustrations for military publications and also portraits of Army personnel. After the war, he opened a studio in Santa Barbara and illustrated for Western magazines while working on easel paintings. His illustrations included 'Buck Jones,' a popular comic strip and 'Gene Autry'. He had his first one-man show in 1960, and was so successful that he turned exclusively to fine art painting, depicting both historic and contemporary Western scenes. A particular focus has been the Spanish influence on California culture in a style that is Realist and Impressionist. … He was a founding member of the Cowboy Artists of America," per *Contemporary Western Artists* by Harold and Peggy Samuels from askart.com.
Firfires, Nick (notices in Northern Santa Barbara County newspapers on microfilm and on newspapers.com)
1936 – "S. M. Boy Gives Portraits to Klemperer," i.e., caricature given to Hollywood musician Otto Klemperer, *SMT*, March 11, 1936, p. 3.
1938 – "Back to Art Work," i.e., Firfires and **Joffre Bragg** both returned to art school in LA as both had been sketching during vacation on Firfires' ranch near Santa Margarita, *SMT*, April 18, 1938, p. 3.
1940 – "I Spied… M. N. Firfires proudly displaying in his place of business a painting by his son, Nicholas. (Dan **Bragg** is the same way about his son, **Joffrey [Sic.**

Joffre])," *SMT*, Jan. 27, 1940, p. 1; ■ "Pal, Nicholas Firfires, Hurt, But Will Live, Local Art Students Hurtle Off Road in Foggy Night. Heavy fog that obliterated vision and made the highway slippery for motor traffic last night brought instant death to **Joffre Claxton Bragg**, 22-year-old son of Mr. and Mrs. Dan E. Bragg of Santa Maria, and serious injury to Nicholas Firfires, son of Mr. and Mrs. M. N. Firfires of East Cypress. The tragic accident occurred as the two young men were driving home from Arroyo Grande when their car plunged off the highway through a guardrail into Los Berros creek about two miles north of Nipomo. Young Firfires, driver of the family Studebaker sedan, was thrown clear of the car… Bragg, who was killed instantly by the impact… Both young men had been inseparable companions and both were art students. They were room-mates in a commercial art school in Los Angeles for over two years… Firfires had his own studio in Santa Maria and had been doing commercial art work here since leaving school. During vacation periods, the two young men often spent much time on the Firfires ranch near Santa Margarita making sketches. Both boys had turned out much work in oils and watercolors, and the walls of the Bragg restaurant are filled with Joffre's work," *SMT*, March 23, 1940, pp. 1, 4; "Firfires Improves" but other person in car crash, **Joffre Bragg**, lost his life, *SMT*, March 26, 1940, p. 3; "Private Showing Scheduled by Local Artist" at his parents' home, "but for some time he has been confined to the family home recovering from injuries sustained in an automobile accident," *SMT*, April 26, 1940, p. 3; long article "Nicholas Firfires' Art Exhibit is Appealing; His Horses are All Alive, Authentic," *SMT*, May 1, 1940, p. 3; "Santa Maria Artist has Exhibit Here" at office building in SLO, *Telegram-Tribune*, May 28, 1940, p. 7; "Santa Marian Shows Paintings in SLO," *T-T*, May 29, 1940, p. 1-A; "I Spied… An oil painting of Mayor Marion Rice's barn, done by Nicholas Firfires," *SMT*, Aug. 27, 1940, p. 1; "I Spied… Mrs. Michael Firfires at the **National Art Week** exhibit, admitting she never tires of her son's paintings, which 'he keeps hanging all over the house'," *SMT*, Nov. 26, 1940, p. 1.

1941 – "Western Scenes Background for Fair Dance," i.e., panels painted last year will be installed in Moose hall, *SMT*, July 23, 1941, p. 3.

1942 – "Presbyterian Church… Mrs. M. N. Firfires has loaned the church the painting of the Nativity by her son, corporal Nicholas Firfires of the 144th Field Artillery. It will be used as a 'worship center' for the Christmas services," *SMT*, Dec. 19, 1942, p. 5.

1944 – "Art Exhibited … Fourteen water colors of English street scenes, rural landscapes and harbor scenes painted by a former Camp Breckenridge soldier while stationed in the British Isles are now on display in the library of Service Club 1 in Camp Breckenridge, Ky. The paintings have been loaned by Cpl. Nicholas Firfires, Santa Maria, who was with the 83rd Division in Camp Breckenridge… his portrait of Leopold Stokowski has been acclaimed an outstanding work. The group of water colors will be sent to New York City for exhibit…," *SMT*, Sept. 18, 1944, p. 1.

1946 – "Nick Firfires Prepares Local Showing of Works. Nicholas Firfires, young Santa Barbara artist, was in Santa Maria briefly yesterday, appearing in his wide hat, boots and neck scarf, very much like the horsemen he specializes in painting. Young Firfires came to visit his family – he is the son of Mr. and Mrs. M. N. Firfires of Santa Maria – and also to confer with George Fuller on establishing a permanent showing of his work in Fuller's Book Store on South McClelland street. The pictures are for sale, and Firfires will replace them from time to time…. Firfires, who served in the Army for five years, two of them overseas, returned to civilian life toward the end of 1945 and last January went to Santa Barbara, establishing his studio there in L'Arcade Building. …Firfires is now well enough known and established, so that most of his work is done by commission … Firfires has just completed 17 panels for Dwight Murphy's new ranch in Santa Ynez. He has also completed a portrait for Fred Bols of the prize Palomino in California. One of the pictures here, which is called 'Early California Vaquero,' shows a cowboy rounding up cattle toward the twilight of day. …Several more pictures deal with the handling of stock… Most of these employ an unusual technique as far as watercolor as a medium is concerned. A departure from this type, is a picture called 'Sierras,' purely a landscape in which unusual color is the appealing note. Returning to warmer scenes is a picture called 'Yucca in Bloom'… and another called 'Desert Cactus'. 'Flowers by the Sea' shows yellow and blue verbena along the sand. The young artist does not depend on color alone, … but also maintains a high drawing standard," *SMT*, Aug. 23, 1946, p. 3.

1948 – "Nick Firfires Horse Paintings Gain Interest," and article reveals he is recuperating from an illness and making illus. for a Zane Grey novel, and horse pictures, i.e., 17 different types of saddle horses – made for Dwight Murphy at San Fernando Rey Ranch displayed in the tack room. "Mary Abbot has photographed the complete set of paintings and these appeared in an edition of the magazine, *Equestrian*. On a double page, the paintings are titled as Arab lancer, 'Man o'War' and jockey, Mongolian Tartar, Pony Express, English knight, Crow Indian, Irish hunter, Mexican vaquero, Bengal lancer, American cowboy, Canadian mounted police, five-gaited horse, Russian Cossack, California Don, Argentine gaucho, crusader, and cavalry horse," *SMT*, April 23, 1948, p. 5.

1949 – "Nick Firfires to Open Studio in Santa Barbara… in El Paseo… Throughout the summer Firfires has turned out illustrations for reprints of Zane Grey stories and other western tales for Dell Publishing Co… a number of book cover designs… Firfires has lately been notified that the Hymes Lithograph Co. of Silver Springs, Md., is putting out a group of seven of his typical western paintings suitable for framing…," *SMT*, Aug. 9, 1949, p. 5.

1959 – ■ "Nicholas L. Firfires, Santa Barbara artist whose work is attracting attention of many enthusiasts each year, has just finished a portrait in oils of Mrs. George L. Fuller, Jr. of Santa Maria. … Concluding this work last August, he has returned to painting, which he likes best, and has been dividing time between his studio and the Firfires ranch near Santa Margarita, working on some large oils. Firfires has also made progress on a number of landscapes and seascapes near Santa Maria, and has made time also to work on paintings of horses, that were his first subjects …. Some of his finest were made for Dwight Murphy of his fine stable of Palominos, and another set of paintings illustrated a book on horses and their riders in various parts

of the world. The local artist is now making arrangements for a one-man show in Los Angeles as soon as he has completed more paintings. The Maxwell Gallery in San Francisco has invited him to show a collection there also. In the past few months, Firfires has sold several of his paintings in Beverly Hills and recently finished a portrait for Mrs. Noah Beery, Jr.," per "Nick Firfires to Exhibit Paintings" in LA and at Maxwell Galleries in SF, *SMT,* Feb. 18, 1959, p. 7.

And, more than 90 hits for "Nicholas Firfires" in the *SMT,* 1934-1990, some of which were itemized here but most were not.

Firfires, Nicholas (notices in Calif. newspapers)

1973 – "… Nicholas S. Firfires, whose oils, watercolors and sketches of the 'Living West' sell regularly for an average of $2500. Working in his studio in his Santa Barbara home, Firfires spends every possible daylight hour recording on canvas the cowboy scenes he's lived and witnessed all his life. A rancher with a spread in San Luis Obispo county, Firfires says, 'I've always thought being a cowboy was the greatest thing in the world…' As a youth, Firfires hired out for round-ups… [But] 'I found I could make more money selling a painting of someone breaking a horse than I could get for breaking the horse myself,' he says. World War II … he found himself in the European Theater of Operations with the combat engineers. However, even in the Army, Firfires managed to ply his canvas. 'Everything had quieted down,' he recalls, 'and I was walking down a little road when I spotted a woman milking a cow. Here she was, in the middle of a war-torn area, doing what she was accustomed to doing – I had to paint her!' … Quickly sketching the shapes, making action and color notes, Firfires later translated the scene to watercolor. 'I've used that method often,' he relates. 'A quick sketch will capture the action and some penciled notes can help, then I blend the colors at the first opportunity, while they're still fresh in my mind. Shunning what he calls 'recipe painting,' Firfires says he has a knowledge of his materials which compares to that of a chef. Even though he doesn't use a recipe, he knows what effect he will obtain by adding this or that … Watercolors, he says, are more limiting than oil. 'To make a statement in watercolor is to set something permanently. Oil is uniquely changeable, more versatile. You can cover it completely and start again if you like. I like to use oil, but have mastered both media, and there are some things better said in watercolor.' Before he took up the brush full time, Firfires says, he 'painted not to make money, but earned money so I could paint.'… Firfires has no schedule for finishing a painting… 'Enthusiasm never fades,' he adds. 'I put it away, take it out later, feel as enthusiastic as ever – and my enthusiasm for art is infinite. To me it is the most sublime of callings.' High flown idealism notwithstanding, Firfires considers his years in commercial art a valuable business lesson. 'You have to learn to work,' he says, 'and meeting the constant deadlines of commercial illustration requires real effort along with dedication.' Firfires made fine art his sole occupation in 1958… 'It's a jolt to the inexperienced painter who sits terrified before his blank canvas, afraid to make the first mark. You have to have the courage to say, 'This is what I am going to do,' and then do it,' he said. 'It isn't the subject that's important, but what you say about it.' Each of his

paintings is an original and, 'the next always is going to be my best' … 'They're my children.'… More loyal to realism than to artistry, Firfires says he places things in his paintings 'as they are. Maybe I wish something could be placed differently, for the sake of art – but I'm still a cowboy at heart and I know it couldn't be that way under those circumstances. My statement would be a lie if I painted it differently.' Going to work immediately after breakfast, Firfires is left to his art while his wife of three years, Maxine, does his leg work, arranges his shows, takes care of details. 'I never bother him,' she says emphatically. 'Anyone who calls is told he cannot be disturbed. But when he wants a holiday, I can drop everything for him.' The couple recently built their 'early California contemporary' home, hidden in a densely foliaged area of Montecito… Firfires' studio is equipped with a mirror, positioned to his back as he stands at the easel. 'I check my work in the mirror because it's the quickest way to determine any defect.' … 'The whole house is based on the studio,' Mrs. Firfires relates. 'We turned the entire structure around to face magnetic north because that was the best light for Nick.'… When the Firfireses do go on holiday, frequently it's because the artist wants to work 'on location.' … Firfires, however, insists on finding the right site… 'Art,' he continues, 'is an attempt to understand what's about you. An artist doesn't just record the subject, but says something about it… I read extensively, because an artist should understand everything. Then he will know what he has to say on canvas.' … Firfires paints western scenes, because, 'that's where I am, where I've always been. It's what I know best.'… 'Someone asked me once why my cowboys always are moving toward the right of my paintings. I had to laugh to myself. It's because I'm a cowboy and I know a cowboy has his rope on the right side of his horse.'… When the artist is not painting, he's either strumming a 100-year-old guitar, playing a violin (which he studied intensely for eight years as a youth) or cooking…. 'I have quite a reputation for my son-of-a-gun stew. It's made from all the internal portions of the freshly butchered steer – heart, kidneys, liver, brains, sweetbreads – slow-cooked to perfection, served with pan cornbread, chunks of tomatoes and apple pie.' Asked if he has secret recipes, Firfires chuckles, saying: 'No, it's just like my painting! I have no secrets. I tell everything!'" by Jan Allyson Meier, "The West That Never Dies," California Living (*Los Angeles Herald-Examiner*), June 24, 1973, pp. 16-19.

1976 – Verne Linderman, "Nicholas Firfires, Artist With a Western Flair … The design for the cover on the *Santa Barbara News-Press* Fiesta edition will be the work of the Santa Barbara artist, Nicholas Firfires… His subject is Juan Baptista De Anza, who came through Santa Barbara in 1776 as leader of a Spanish expedition… 'I could find only one portrait of De Anza… I had to do a lot of digging – at the public library… Nicholas Firfires, of Greek ancestry, is a native Santa Barbaran. He was born in a small house on De la Vina Street in 1917, but much of his youth was spent in Santa Maria, where his parents later lived. In World War II he served with the combat engineers who were among the first to reach the Rhine, in a 'thunderbolt' dash across Europe. Sketching and illustrating his work in the division's public relations and information offices, he won

the Bronze Star medal, as well as five battle stars. He had studied painting at the Art Center in Los Angeles and the Otis Art Institute in Los Angeles, and with William Spencer Bagdatopoulos in Santa Barbara. He specializes in ranch life as it was in the 1920s and 1930s. He owns a ranch in Santa Margarita and divides his time between there and Santa Barbara. He portrayed the bridegroom in the Fiesta parade two years, and for 30 years had ridden on the Rancheros Visitadores' annual trek. 'I'm still a cowboy at heart,' said Firfires. It was on the 1947 Rancheros ride that he met his wife, Maxine, at the Old Mission ceremonies. Picturesque, vivacious Mrs. Firfires is the daughter of the silent film star, Buck Jones… Firfires, who has exhibited in the Huntington-Sheraton Hotel Gallery in Pasadena and in a one man show in the Charles M. Russell Gallery in Helena, Mont., said he 'goes on location in the artist's way of life.' That is, he and his wife visit friends in Santa Ynez Valley… Last year Monty Montana's 50th anniversary in show business drew him to Wolf Point, Mont…. 'I'm an eternal optimist. Everything is just the way it is supposed to be. Happiness is in your own mind…. The artist is faced with an eternal fight in trying to portray what he sees, but the only challenge is with himself',"
Santa Barbara News Press (clipping in the Santa Barbara Museum of Art ephemera file, hand dated July 4, 1976), and port.
2009 – Josef Woodard, "Art, the cowboy way … Nicholas S. Firfires is celebrated with the first museum exhibition of his art… 'No matter how clever the painting may be, it must possess the spirit of the thing, which is essential in art.' So said the late, no-nonsense Western artist Nicholas Firfires (1917-1990) … first museum exhibition, 'Views From His Saddle,' in the Santa Barbara Historical Museum…" And the article reproduces four paintings: "Cautious Friendship," "No Cow Horse Yet," "Gathering for Fiesta," and "In Old Santa Barbara." The article goes on to say, "A display case sports examples of his varied handiwork as an artist, who worked in Western magazines, book illustrations and created posters for Fiesta and the famous / infamous Rancho Visitadores…," per *Santa Barbara News Press*, Arts Scene, June 26-July 2, 2009, p. 11.
Firfires, N. (Books)
Announcement of an exhibit and cocktail party – *Nicholas S. Firfires*, Gallery de Silva, Montecito Village, Santa Barbara, Sept. 7 – Oct. 3, 1980.
Nicholas S. Firfires, Gallery de Silva, Montecito Village, Santa Barbara, Sept. 9 – Oct. 5, 1984.
Firfires, N. (misc. bibliography)
Some ephemera, including photos of artworks, is in Public Member Photos & Scanned Documents; Nicholas Samuel Firfires was b. Nov. 10, 1917 in Santa Barbara to Michael Nicholau Firfires and Ethel M. Kimes, married Maxine Evelyn Jones, and d. Sept. 21, 1990 per Nicole (Robb, Wiley) Shiffrar Family Tree (refs. ancestry.com).
See: "Bragg, Joffre," intro., 1938, "Breneiser, Stanley," 1951, 1953; "Christmas Decorations (Santa Maria)," 1935, "National Art Week," 1940, "Phi Epsilon Phi," 1940, "Posters, Latham Foundation (Santa Maria)," 1937, "Santa Barbara County Fair," 1940, 1947, "Santa Maria, Ca., Union High School," 1934, 1935, 1937, "Splash," 1934, 1935, "Stenner, Muriel"

First National Pictures (Hollywood)
<u>See</u>: "Motion Pictures (Guadalupe)"

Fisher, Leonard Francis (1912-1999) (SLO / Santa Maria / Compton)
Santa Maria JC winner in Latham poster contest, 1933, 1934. Exh. Faulkner Memorial Art Gallery, 1933. Art instructor and coach, Compton schools, 1937-73. In retirement an easel painter.

■ "Leonard Fisher Marries in South… to Miss Marie Van Boven of Los Angeles… The bridegroom is the son of Mrs. E. Fisher of San Luis Obispo and is a graduate of Santa Maria junior college…The couple is spending a honeymoon in Yosemite… after which they will make their home in Compton where Mr. Fisher has a position as art instructor in the Compton schools," *SMT*, Aug. 17, 1937, p. 3.
Fisher, Leonard (notices in California newspapers on microfilm and on newspapers.com)
1934 – Port. in football uniform and "Former Bulldog Rates High as Gaucho Tackle… transferred from Santa Maria Junior college to Santa Barbara State this fall… Fisher, 185 pounds and 21 years of age is a San Luis Obispoan…," *SMT*, Oct. 11, 1934, p. 8.
1960 – "Fast-Stepping… Citrus Belt League… Compton… Coach Ben Hammerschmidt of Poly and Leonard Fisher of Compton have their charges primed…," *Riverside Daily Press*, Sept. 23, 1960, p. 10 on genealogybank.com.
1976 – Port. at easel and "Teacher retires to life of art after 36 years in Compton schools… Leonard Fisher had etched out a 36-year academic career teaching both art and athletics in the Compton Unified School District before retiring three years ago. 'Now it's my turn to find time to do some art for myself,' he said, hunched over a paint-splattered palette in his Cerritos home. He dabbed a few pin feathers on the likeness of the duck decoy he was painting. Next to the easel, which stood in a corner of the dining room of his home, was the wooden decoy. ... 'I began painting pictures of decoys about a year and a half ago,' Fisher said. 'I guess you would call my style realism. I've been through all the different schools of art.' … 'I can't paint something I haven't experienced,' he declared. 'I can't paint a landscape I've never walked over or a tree I've never sat beneath. I don't only see with my eyes. I see with every fiber of my being.' … 'When I was a kid in San Luis Obispo, my mother used to tell me that I'd rather paint than eat. I guess I still would. My uncle, **Clarence Mattei**, was a widely successful painter… I always looked up to him … I went to college in Santa Barbara and majored in art and played football… I wound up in Compton.' … He still teaches at Compton Community College during the evening. A 17-foot trailer sits in front of Fisher's home. It's ready for the next sojourn into the mountains behind San Luis Obispo. 'I've always loved those mountains,' he said. 'Each time I go climbing or hiking, I find new wonders. I take along my sketch book and my dog, Chopper. That's a nice way to live.' Fisher's paintings are on exhibit at the art gallery at Compton Community College, 1111 E. Artesia Blvd., Compton," *Independent* (Long Beach, Ca.), Oct. 7, 1976, p. 33 (i.e., B-1).

More than 20 hits for 'Leonard Fisher" in *SMT*, 1930-1937, including his acting in little theater, and other hits in Southern California papers for both his art and sports, were not itemized here.

Fisher, Leonard (misc. bibliography)
Leonard Francis Fisher b. Dec. 12, 1912 and d. Nov. 2, 1999 per Private Member Photos (refs. ancestry.com).
See: "Faulkner Memorial Art Gallery," 1933, "Posters, Latham Foundation (Santa Maria)," 1933, 1934

Fitzgerald (Karleskint), Mary Aylward (Mrs. John Peter Karleskint) (Santa Maria)
Photographer, amateur. Member Santa Maria Camera Club, 1940. Later, wife of John Karleskint, below. Sister-in-law to Peter Karleskint and Mary Karleskint Roemer, below.
[Do not confuse with Mary Karleskint Roemer.]
See: "Karleskint …," "Santa Maria Camera Club," 1940

Fitzhugh Photograph Gallery (Santa Maria / SLO)
Photography studio, 1904. Prop. L. M. Fitzhugh. Purchased from Jellum, 1904. Sold to Roebuck, 1904.
■ "Change of the Local Photo Studio… lately operated by **H. Lee Jellum** in the Jones building, has been purchased by L. M. Fitzhugh, the San Luis photographer and will in the future be conducted by Mr. Fitzhugh personally. For the present, Mr. Fitzhugh will devote two days of each week (Friday and Saturday) to the Santa Maria business. Sittings will be made here on these days and all the work will be finished in the San Luis Studio, where the facilities for turning out fine work are far superior to any which could be installed here. Mr. Fitzhugh will at once fit up the local gallery with all apparatus and accessories necessary to making the finest of portraits … Mr. Fitzhugh will make his opening visit here on Friday, April 1st," *SMT*, March 25, 1904, p. 3.
Fitzhugh (notices in Northern Santa Barbara County newspapers on microfilm and on newspapers.com)
1904 –"Fitzhugh, the photographer, will be here Friday, Saturday and Sunday until noon," *SMT*, Sept. 2, 1904, p. 3, col. 1; "The Fitzhugh Photograph Gallery having changed owners, the new photographer will be pleased to receive you at the studio any day in the week," *SMT*, Dec. 17, 1904, p. 3.
See: "Jellum, H. Lee," "Roebuck, Miss," and *San Luis Obispo Art and Photography before 1960*

Five-C (5-C) Camera Club Council
Council that included Santa Maria and Arroyo Grande valley camera club members.
1954 – "Santa Maria Photographers Win at Arroyo… week-end 5C competitions and town meeting of photography held in Arroyo Grande elementary school," *SMT*, April 26, 1954, p. 1.
See: "Santa Maria Camera Club," 1955

Fleischauer, Albert (Santa Maria)
Woodshop teacher, Santa Maria Adult School, 1950, 1951. General shop teacher Santa Maria High School. Northern Santa Barbara county coordinator of the high school work experience program, 1954. Principal of Cuyama High, 1957.
See: "Santa Maria, Ca., Adult/Night School," 1950, 1951

Fleisher, Rachael Barnet (Mrs. Marks Fleisher) (1863-1943) (Santa Maria)
Exh. plaque painting, life-size portraits, "Santa Barbara County Fair," and won Best Exhibit, Ladies' Department, 1886.
■ "Oldtimer in Santa Cruz Dies Aged 80 in San Francisco… death May 20 of Mrs. Rachael Fleisher … Mrs. Fleisher was the last of a family of seven children, all but one born in Santa Cruz. The father, S. Barnet, was a leading clothing merchant many years ago. … She was one of the early graduates of the Santa Cruz high school and was a member of Idlewild Chapter O.E.S. Following her marriage, she resided many years in Santa Maria…," *Santa Cruz Sentinel*, June 11, 1943, p. 2.
Fleisher, M., Mrs. (notices in Northern Santa Barbara County newspapers on microfilm and on newspapers.com)
1892 – "A new line of embroideries and embroidery dress patterns at M. Fleisher & Co's," *SMT*, May 28, 1892, p. 3, col. 2.
Fleisher, M., Mrs. (misc. bibliography)
Rachael Fleisher is listed in the 1900 U. S. Census as age 36, b. Dec. 1863 in Calif., residing in 7th Township, Santa Barbara County, with husband Marks Fleisher (age 47) and children Lillian G. (age 17), Elare F. (age 11) and Wilford R. (age 9) and her brother in law, Samuel (age 33); Rachael Fleisher is listed in the *San Francisco CD*, 1920, 1927; Rachel [Sic. Rachael] Barnet Fleisher b. Dec. 24, 1863 in Calif., mother's maiden name Pliser, father's Barnet, d. May 20, 1943 in San Francisco County per Calif. Death Index (refs. ancestry.com).
See: "Santa Barbara County Fair," 1886

Fleming (Miller), Joyce Arlene (Mrs. Ronnie D. Miller) (Santa Maria)
Santa Maria JC art student, 1955.
■ Port. and "Rodeo Queen Candidate Likes Fashion Designing… Joyce… would like to be a dress designer. She is following up this interest by designing and sewing her own clothes. Joyce, a senior at Santa Maria high school, admits that her interest lies primarily in the designing of the clothes, not the sewing… Joyce is a member of the Art Club at the high school and last year won a certificate of merit in a contest … by Scholastic Magazine… Most of her work is pencil sketches. She also is a member of the Youth for Christ club … The dark haired 18-year-old daughter of Mr. and Mrs. Johnny Fleming of Santa Maria enjoys dancing. She also is taking lessons on the accordion…," *SMT*, April 30, 1957, p. 1.
See: "Allan Hancock [College] Art Gallery," 1955, "Elk's Club – Rodeo and Race Meet," 1957, "Halloween Window Decorating Contest (Lompoc)," 1953

Fletcher, Frank Morley (Santa Barbara)
Printmaker whose prints were shown at the Alpha Club, 1935.

■ "Frank Morley Fletcher, often referred to as F. Morley Fletcher, was a British painter and printmaker known primarily for his role in introducing Japanese colored woodcut printing as an important genre in Western art," Wikipedia.
See: "Alpha Club," 1935, and *Cambria Art and Photography before 1960*

Floats (Northern Santa Barbara County)
Northern Santa Barbara county towns and / or organizations made floats for parades celebrating July 4th, Santa Barbara Fiesta, Elk's Rodeo in Santa Maria, Lompoc's Flower Festival, Santa Barbara County Fair, etc., and even for the Rose Parade in Pasadena.
Early floats were constructed on horse drawn wagons and slowly morphed into decorated automobiles and finally into elaborate motorized floats where the vehicle was totally hidden under construction. The flower fields around Lompoc supplied many of the blooms, especially for floats participating in the **Tournament of Roses** parade in Pasadena. Floats were created by schools and by various fraternal and civic clubs.
Floats (notices in Northern Santa Barbara County newspapers on microfilm and on newspapers.com)
1909 – "Independence Day… parade…," and floats described, *SMT*, July 10, 1909, p. 1.
1920 – "Thousands Attend Big Independence Day Celebration…," and description of floats and winners, *SMT*, July 6, 1920, p. 1.
1923 – "Armistice …," parade described, *SMT*, Nov. 13, 1923, p. 1.
1925 – "Parade Evidence of Much Work" – Lompoc's Golden Jubilee on Armistice Day, and description of floats including some with painted designs, *LR*, Nov. 13, 1925, pp. 1, 8 and 'Prize Winners in Big Parade".
1928 – "Floats Striking and Many Call for Admiration… 4th of July…," *LR*, July 6, 1928, p. 1.
1929 – "Valley Celebration Opened with a Big Parade…," July 4 and floats briefly described, *SYVN*, July 5, 1929, p. 1; "Independence Day Fete at Solvang…," *SMT*, July 10, 1929, p. 3.
1930 – "Redmen's Lodge Winner Cup for Float… Armistice Day…," *SMT*, Nov. 12, 1930, p. 1.
1931 – "Hundreds Attend Celebration Here, Glorious Parade," July 4th, some floats briefly described, *SYVN*, July 10, 1931, p. 1.
1932 – "Armistice Here is Celebrated… and parade floats described," *SMT*, Nov. 12, 1932, pp. 1, 6.
1933 – "Rose Tournament Float Entry Plan Being Submitted… Architect's Drawings of Proposed Local Display… Lompoc's projected float to be entered in the world famous **Tournament of Roses** parade … theme of which will be 'Tales of the Seven Seas.' **Kenneth Weston**, local architect, made the preliminary drawings…," *LR*, Dec. 1, 1933, p. 1.
1934 – "15,000 Blossoms will Beautify Parade Entry. **Tournament of Roses** Float will Picture 'Valley Beautiful'. … Most of the flowers for the float will be

gathered from local gardens… The float will depict an artist, with palette and brushes, painting a picture of flowers…," *LR*, Dec. 28, 1934, p. 1; "Lompoc Float to Be a Mass of Flowers," in **Tournament of Roses** parade, *SMT*, Dec. 29, 1934, p. 2.
1935 – "Local Parade Entry Wins Praise in South… Pasadena **Tournament of Roses**… Lompoc's entry was a float labeled 'The Legend of Flowers,' and represented an artist painting a natural scene of the flower fields of the valley, the painter being **Miss Irene Kirkpatrick**. Her brushes consisted of foliage, and the field was composed of a mass of honeysuckle, sweet peas, pink roses, delphinium, stevia, marigolds, violets, red salvias, nasturtiums and golden gleam, the colors fading into each other delicately and artistically," *LR*, Jan. 4, 1935, p. 1; "Alpha Club Hears Talks on … Pasadena Float… Mrs. W. R. Hull told of the building and decorating of the float… difficulties encountered…," *LR*, Jan. 25, 1935, p. 4; "Float Will Depict **Purisima Mission**. Restoration of old La Purisima mission … Pasadena New Year's Day parade…," *LR*, Nov. 8, 1935, p. 1; "Fiesta is Held in Guadalupe. Parade of Floats," *SMT*, Dec. 16, 1935, p. 2; "Float and Band are Ready for Pasadena," Tournament of Roses parade, *LR*, Dec. 27, 1935, p. 1.
1936 – "Float Wins Second at Pasadena… in its division … **Fred Hageman** of Purisima camp designed the entry… This was the second year that the Lompoc entry has been awarded a prize, The Valley Beautiful winning first prize in its class two years ago…," *LR*, Jan. 3, 1936, p. 1.
1939 – "Prizes Offered for Float Entries… July 4…," *LR*, June 2, 1939, p. 7; "Float Plans for July 4 Parade are Revealed," *LR*, June 23, 1939, p. 7.
1941 – "Moose Float in Parade Wins 'Sweeps'," and "Mammoth Street Pageant Heralds Opening of Santa Maria's Fair," *SMT*, July 23, 1941, p. 6.
1946 – "Entry as Usual of 'Santa Maria' Float in Parade" of Santa Barbara Fiesta, *SMT*, Aug. 7, 1946, p. 3.
1947 – "Colorful Parade Highlights Big July Fourth Celebration…," and some floats described, *SYVN*, July 11, 1947, p. 1.
1948 – "Float Committee of Grange Meets…," for Valley July 4th parade, *SYVN*, July 2, 1948, p. 1; "Valley Marks Holiday, **American Legion** Wins… and queen and three floats described, *SYVN*, July 9, 1948, p. 1.
1949 – "**American Legion** Wins Top Prize in July 4th Parade [at Solvang?]," *SYVN*, July 8, 1949, p. 1; "Invite Valley Float Showing… Three Valley organizations… have been invited to show the floats displayed in the Valley July 4th parade at the Santa Maria County Fair Parade next Wednesday in Santa Maria. The three floats all won prizes…," *SYVN*, July 15, 1949, p. 7; "Santa Maria to Appear in Two Parades," *SMT*, July 12, 1949, p. 1; "A – Z Float Depicts Early Day," *SMT*, July 20, 1949, p. 5; "**Minerva Club** Wins Parade Sweepstakes" for County Fair, *SMT*, July 21, 1949, p. 1; "Heirlooms Worn in **Community Club**'s Float," *SMT*, July 21, 1949, p. 5.
1950 – "Druids Offering Awards for Prize-Winning Parade Floats" in United Ancient Order of Druids parade, *SMT*, May 19, 1950, p. 1; "July 4 Celebration" describes floats, and "Something About Nothing," i.e., rues lack of a specific flower on local floats, *LR*, July 6, 1950, p. 1; "VFW Float Wins Top Prize in July 4th Parade… 'America,

the Melting Pot of the World'…," and other floats mentioned, *SYVN*, July 7, 1950, p. 1.

1951 – Photo of **Camp Fire Girls** float in Elks Rodeo parade, *SMT*, June 4, 1951, p. 5; "July 4th Parade to Stress Freedom and Democracy… In the float division, judging will be based on adherence to theme, possible 30 points, overall beauty, possible 25 points, effort expended, possible 15 points, originality, possible 20 points, and conduct in parade, possible 10 points…," *SYVN*, June 15, 1951, p. 7; photo of floats in July 4th parade, *LR*, July 5, 1951, p. 1; "Valley Joins to Celebrate Nation's 175th Birthday… parade… [floats described]," and photos of Sweepstake float entered by the Dania Lodge and Second Place entered by **American Legion**, *SYVN*, July 6, 1951, p. 1; photo of float and "**Minerva Club** Wins Parade Sweepstakes," *SMT*, July 26, 1951, p. 1.

1952 – "Napkins Make Winning Float. **Beta Sigma Phi**…," Elk's Rodeo, *SMT*, June 2, 1952, p. 1; photo of "Choo-Choo" – Orcutt's community float in Elk's rodeo parade, *SMT*, June 3, 1952, p. 5; photo of award winners in Independence Day Parade, and "History Making Throng Observes Floral Parade" and some floats described, *LR*, July 10, 1952, p. 1; "Dania Lodges Float Entry again Top [July 4] Parade Winner… depicted the Goddess of Justice," and other float winners named and described, *SYVN*, July 11, 1952, p. 1; repro: float entered by Dania Lodges, *SYVN*, July 18, 1952, p. 1; repros of floats entered by Presbyterian Youth and by Valley Grange, *SYVN*, July 18, 1952, p. 3; "City Float Gets Finishing Work for [Santa Barbara] Fiesta Day…," *SMT*, Aug. 4, 1952, p. 1.

1953 – Repro of Elk Queen float, *SMT*, June 8, 1953, p. 1; repro of **Beta Sigma Phi** float in Elk's Rodeo parade, *SMT*, June 9, 1953, p. 3; repro of float for Santa Maria Druids in their annual parade, *SMT*, June 15, 1953, p. 1; "Baptists to Enter First Religious Float in Parade" 4th of July, *LR*, July 2, 1953, p. 9; photo of floral sail boat float in July 4th parade, *LR*, July 9, 1953, p. 1 and of several more floats, p. 4; repro: floats in 4th of July parade, *SYVN*, July 10, 1953, p. 1.

1954 – Repro. and "Lions' Club Float Wins Sweepstakes… 11th annual Elks Rodeo parade…," *SMT*, June 7, 1954, p. 1; "July 4th Celebration … Postponed Until September," *SYVN*, June 25, 1954, p. 1; photo of sweepstakes winner in Lion's Club parade, *SMT*, June 7, 1954, p. 1 and of **Minerva Club** float p. 4 and of others p. 5; photo of winning float in Elk's parade, *SMT*, June 8, 1954, p. 1; "Flowers For Floats to be Available at Park Saturday… Flower Festival parade," *LR*, July 1, 1954, p. 1; photo of Lompoc Odd Fellows sweepstakes winner in July 4th parade and "Flowers Grown Especially for Parade Floats," and "Float Construction Offers Fun, Headaches," *LR*, July 1, 1954, p. 29 (i.e., pt. III, p. 5); photo of Odd Fellows and Rebekas float sweepstakes winner in Lompoc Flower Festival parade, and photo of Children's Parade Winner, and "Odd Fellows, Rebekas Float is Tops," *LR*, July 8, 1954, p. 1 and photo of another float on p. 3; photo of float under construction, *SMT*, Aug. 11, 1954, p. 1.

1955 – Photo of Hansel and Gretel float in Elk's parade, *SMT*, June 4, 1955, p. 1 and of others June 6, pp. 3, 5, 6; photo of Lompoc's "Fairyland in Flowers" winning float in 12th annual Elks rodeo parade, *SMT*, June 6, 1955, p. 1; "Santa Maria Float Prepped" for Santa Barbara Fiesta

parade, *SMT*, Aug. 9, 1955, p. 1; repro of Cal Poly queen's homecoming float, *SMT*, Oct. 24, 1955, p. 1; drawing of California Exchange Club float for Rose Parade, *SMT*, Dec. 12, 1955, p. 10; four photos of floats and "Millions to See Famed Rose Parade on January 2," *SMT*, Dec. 28, 1955, p. 5; "Cowbelles Float Wins Prize… in Elk's Rodeo parade on June 4… The float depicted a barbecue scene with grill and table set for Father's Day…," *SYVN*, June 10, 1955, p. 2; "Floral Floats to be Featured in Lompoc Festival July 2-4," *SYVN*, June 24, 1955, p. 6; photo of some floats in Flower Festival parade, *LR*, July 7, 1955, p. 7; photo of part of Santa Ynez Valley 4th of July parade and description of floats in "Valley Marks Safe, Enjoyable July 4th," *SYVN*, July 8, 1955, p. 1.

1956 – Repro of Elks Lodge float, *SMT*, June 3, 1956, p. 2; and photos of several floats in Rodeo parade, *SMT*, June 3, 1956, p. 11; photo of Lompoc C of C entry in Elk's parade, *LR*, June 7, 1956, p. 1; photo of some floats in the Floral Festival parade, *LR*, June 28, 1956, p. 7; description of floats in "July 4th Fete: … Colorful Parade," *SYVN*, July 6, 1956, p. 1; photos of floats in July 4th parade, *SYVN*, July 13, 1956, pp. 7, 8; photo of Homecoming Parade float, *SYVN*, Nov. 2, 1956, p. 9.

1957 – Photo of float in Elks Rodeo parade, *SMT*, May 29, 1957, p. 9-B; winning float in Elks parade, *SMT*, June 3, 1957, p. 1; 4th place winner in Elks parade, *SMT*, June 4, 1957, p. 4; repro of float in Lompoc Flower Show, *SMT*, June 24, 1957, p. 3; photo of the "Cinderella" float entry of the men's and women's Dania Lodges of Solvang in the July 4th parade, *SYVN*, July 12, 1957, p. 1; photo of Danish Brotherhood Society's float and **American Legion** floats in July 4th Parade, *SYVN*, July 19, 1957, p. 8; photo of Santa Ynez high school homecoming float, *SYVN*, Nov. 15, 1957, p. 8.

1958 – Repro of "From Failure Comes Success" the Orcutt entry in the Elk's rodeo parade, *SMT*, May 2, 1958, p. 10; repro of first place float in Elks rodeo parade, *SMT*, June 2, 1958, p. 1 and others p. 4 and others p. 10; photo of Odd Fellows float in Flower Festival, *LR*, June 26, 1958, p. 2; Solvang July 4th parade floats listed, *SYVN*, July 11, 1958, p. 4 and photos, pp. 5, 6, 8; "Santa Maria Float Set for [SB] Fiesta," *SMT*, Aug. 12, 1958, p. 8; photos of 2 floats in the Santa Ynez Valley Union High School homecoming parade, *SYVN*, Nov. 21, 1958, p. 4.

1959 – "Floral Floats Highlight Old Spanish Days Parade [in Santa Barbara] … David Burpee, head of the W. Atlee Burpee company, world's largest seed firm, has acres of the flowers growing in Santa Paula and Lompoc especially for the Fiesta parade… His firm also will have a float in the Fiesta parade… a grand new marigold. His company pioneered in establishing Lompoc's 'Valley of Flowers' some 50 years ago…," *SYVN*, June 5, 1959, p. 10; "Years See Hundreds of Children March for Flower Festival. Since 1954… marching… as Mother Goose characters, Circus performers…," and history of children's parade, *LR*, June 15, 1959, p. 4; photo of Mayor's Trophy winner, Flower Festival parade, Kiwanis, *LR*, June 25, 1959, p. 8; photos of floats in July 4th parade, *SYVN*, July 10, 1959, pp. 5, 8, 10, 12 and accompanying article.

1960 – Photo of Orcutt float winner in Elks rodeo parade, *SMT*, June 6, 1960, p. 7; photo of first place winner in children's floral parade in Flower Festival, *LR*, June 13,

1960, p. 4; photo of 1959 winner "Pismo Beach" in Flower Festival parade, *LR*, June 23, 1960, p. 30 (i.e., 6aa); several photos of floats in "Parade Pictorial Highlights," in Lompoc Flower Festival, *LR*, June 27, 1960, p. 2; photos of several floats in Flower Festival parade, *LR*, June 30, 1960, pp. 6, 9 (i.e., Section B. p. 1); photo of sweepstakes winner and another float in Santa Ynez Valley's July 4th parade, *SYVN*, July 8, 1960, pp. 1, 6, 8.
And, many additional notices and reproductions of floats not itemized here.
See: "Art, general (Camp Cooke)," 1951, "Flower Arranging," "Junior Community Club," 1952, 1954, "Norris, Clarence," 1953, "Solvang Woman's Club," intro., "United Service Organization (Santa Maria)," 1952, "Utsunomiya, George," 1970, 1971, 1974, "Vaughn, Leon," 1934

Floral Design / Flower Arranging / Flower Arrangement
Flower growing was a major industry in the Lompoc valley. Flower growing and arranging competitions were held annually by various local women's clubs (particularly the Alpha Club), at the Santa Barbara County Fair, and at miscellaneous other events. Flower arranging classes were sponsored by various local clubs. Flowers were used to cover parade floats. Flowers or flower fields were the subject of several artist's paintings.
Flower arranging (notices in Northern Santa Barbara County newspapers on microfilm and on newspapers.com)
1955 – Photo of dried flower arrangements and "Artists Make Dry Arrangements" to sell to raise money for Methodist Woman's Bazaar, *SMT,* Nov. 30, 1955, p. 4.
1959 – "Ikebana Taught by **[Taro] Makimoto** – Stresses Simplicity, Delicacy," *SMT*, July 20, 1959, p. 3.
[Although flower arranging is considered an "art" there were too many articles on the Flower Show to be itemized here.]
See: "Business and Professional Women's Club," 1948, "Carrick, Margaret," "Clapper, Mrs. R. E.," "Floats," "Flower Festival (Lompoc)," "Flower Show (Santa Maria)," "Flower Show (Solvang)," "Four-H," 1937, "Gaynos, Loris," "Hall, Lucille," "Hosn, Betty," "Japanese Art," "Joughin, Helen Eloise," "Makimoto, Taro," "Minerva Club," 1949, "Moran, Muriel," "O'Neal, Merilyn," "Rohlfsen, Margaret," "Romano, Lucille," "Santa Barbara County Fair," 1957, "Wesselhoeft, Mary"

Flower Festival / Flower Show (Lompoc)
Annual SPRING event sponsored by Alpha Club. Began in 1922 as a dahlia show. Posters to advertise it were hand-made. Competitions were held for best flower specimens and for floral design. Beginning 1957, held in conjunction, was an Open-Air Art Exhibit in Ryon Park, overseen by the Lompoc Community Women's Club.
[Do not confuse with the Alpha Club's FALL flower show started in 1946.]
■ "28th Annual Flower Show … History of City's Outstanding Event… Lompocans first began thinking about a flower show back in 1915, when a number of local citizens visited the dahlia exhibits at the San Francisco

World's fair. The garden enthusiasts came home to plant the tuberous colorful flower in their own gardens… With the advent of 1921, Lompocans classed as their leading dahlia growers [and article names private individuals]. … In October of the same year, Mrs. Sloan suggested in an Alpha club meeting that a Dahlia Show be staged the following year with the result that the first Alpha club flower show was held August 26, 1922 in Lompoc's first American Legion hall… In its second year, the dahlia show … was moved to the elementary school where there was more room… Dahlias continued to be the center of the show until 1925 when a table of other garden flowers made into arrangements were added. Thereafter, the size of the show grew and new places to exhibit were selected… The Alpha club garden section had charge of the … event from 1926 until 1930, the former year marking the change from an August to a late spring show. Since that time the show has been gauged to coincide with the peak blooming period in the local flower fields. The year 1930 was the first time the event was staged for two days… During the early war years, the show was held in the elementary school auditorium… [and simplified to] … Flower teas… In 1943 … the Flower show was combined with a victory garden display… The first post-war show was held in 1946 in the Veterans Memorial building…," *LR*, June 1, 1950, p. 27 (i.e., p. 3).
"Milk Bottles to Cloisonne is History of Flower Show," *LR*, June 30, 1955, p. 17 (i.e., B-3?); "Flower Show Started as Dahlia Exhibition," *LR*, June 18, 1959, p. 5.
Flower Festival (notices in Northern Santa Barbara County newspapers on microfilm and on newspapers.com)
1932 – "Lompoc Flower Show Preparations… **Miss Gertrude Bowen** and **Mrs. Truax** will make arrangements for posters advertising the flower show…," *LR*, April 22, 1932, p. 2.
1934 – "Official List of Flower Show Committees… Alpha clubwomen… Posters – **Mrs. Margaret Heiges, Miss Gertrude Bowen**, Mrs. Mary Sanor…," *LR*, May 11, 1934, p. 6; "Handicraft Group to Meet Monday. Under the supervision of **Mrs. Lucy Benson** … Mirror screens displayed at the last meeting will be made… and exhibited at the Spring Flower Show," *LR*, March 2, 1934, p. 7.
1935—"Committees for Flower Display… Alpha Club… **Mrs. Laurence E. Heiges, Sr.**, has been chosen chairman of the poster committee," *LR*, March 1, 1935, p. 1.
1938 – "Townspeople are Urged… **Miss Mary Elisabeth Bucher**, posters…," *LR*, June 3, 1938, p. 3.
1939 – "La Purisima Show of Flowers Set," *T-T*, May 25, 1939, p. 3; "Alpha Club Presents… Attractive posters made through the courtesy of the art department of the **CCC** camps, were placed in Buellton and in Gaviota this week…," *LR*, May 26, 1939, p. 1.
1944 – "Alpha Club to Present Public Flower Show… Posters in downtown business houses were made by members of the Art class at the high school under the supervision of **Miss Crystal Lund**…," *LR*, May 12, 1944, p. 1.
1948 – "To Hold 26th Annual Flower Show," *T-T*, May 18, 1948, p. 2; "Flowers Draw Many Visitors," *T-T*, May 24, 1948, p. 1.

1950 – "Lompoc to Offer Floral Displays," *AG*, June 2, 1950, p. 6; "Large Number of Committees... **Mrs. James Kenney**, posters...," *LR*, June 8, 1950, p. 3.

1951 – "29th Annual Spring Flower Show... more than 1,500 acres of commercial fields... Alpha club, sponsor... two-day event... The date for the flower show was selected after conference with the valley's leading seedsmen. The aim was to have the show scheduled for the weekend which the largest number of fields will be in bloom... June 2 and 3... Veterans Memorial building... Major divisions in the show will be the arrangements and specimen... a junior division for Lompoc children and the displays of the four seed companies active in the valley – Bodgers, Burpee, Desholm and Zvolanek ... In the staging of the show, a high point will be the duplication with flowers of an artist's painting of what is probably the most beautiful photograph ever taken of Lompoc flower fields. The scene will be framed by the proscenium arch of the auditorium's stage and will form a background for the tables of floral entries... sweet peas, calendulas, stock and poppies ...," *LR*, May 31, 1951, p. 1.

1953 – Repro. Flower Show, by **B&B Studio**, *LR*, May 21, 1953, p. 7; "Alpha Club's 31st Annual Flower Show...," and description of many of the floral arrangements, *LR*, June 11, 1953, p. 16.

1955 – "The *Lompoc Record*'s annual Flower Festival edition is now being prepared. Our staff and our photographers **Tom Yager** and **B&B Studio**, took many fine pictures last year which appeared in the *Record*. But we want more pictures... If you took some good pictures of the Alpha Club Flower Show, the Floral Parade, the Gymkhana or have other pictures of Lompoc's flower fields... please call us," *LR*, June 2, 1955, p. 13.

1957 – "Alpha Flower Show Decorations Forecast by Chairman as 'Exciting'. 'Under the Big Top,' the Alpha Club's 35th Annual Flower Show to be staged in the Memorial Building on June 22 and 23... **Mrs. Schuyler** with the aid of artist **Mrs. Arnold Brughelli**...," *LR*, June 13, 1957, p. 5; "What the Flower Show Means to Me. By Irma Henderson... The great desire for self-expression can be enjoyed in many ways ... The art of flower arranging is as creative as if one were painting a picture in oils. The same rules of color and design are used ...," *LR*, June 20, 1957, p. 18.

1959 – Full program of events, *LR*, June 15, 1959, p. 11.

1961 – Photo of outdoor display, *LR*, June 12, 1961, p. 4.

1962 – "**Gem, Mineral Club** Slate Flower Fete Hobby Show... A partial list of displays and their exhibitors include: mosaics... **Mary Hendy**...," *LR*, June 21, 1962, p. 63 (i.e., 27-E).

[Although flower arranging is considered an "art" there were too many articles on the Flower Show to be itemized here.]

See: "Alpha Club," "Flower Show," "Floats," "Sudbury, Delia," "Open-Air Art Exhibit"

Flower Show (Lompoc)
Annual FALL event sponsored by the Alpha Club Garden section beginning 1946. Featured chrysanthemums. Often combined with a Tea and a plant sale. In 1948, 1949 and 1958, it had, as an added feature, an art exhibit.
[Do not confuse –the Alpha Club SPRING flower show was initially held in the fall, but in 1926, was moved to the spring. An entirely separate FALL show was created in 1946.]
Flower Show (notices in Northern Santa Barbara County newspapers on microfilm and on newspapers.com)

1948 – "Garden Group's Fall Flower Show... gorgeous array of chrysanthemums ... Also attracting much attention and favorable comment was an exhibit presented in observance of **National Art Week**, of water color landscapes by the pupils of **Forrest Hibbits**. The work was done by **Mrs. Ethel Bailey, Mrs. James Kenny [Sic. Kenney], Mrs. Claire Callis, Mrs. Milton Schuyler** and **Mrs. Ruth LaRue**...," *LR*, Nov. 11, 1948, p. 13.

1949 – "Chrysanthemums Displayed in Annual Alpha Club Fall Flower Show ... An added touch to the afternoon was an exhibit of paintings by members of an art class conducted by **Forrest Hibbits**. Works shown were done by **Mrs. W. M. Anderson, Mrs. W. H. Bailey, Mrs. Clara Callis, Mrs. E. Kenney, Mrs. William LaRue** and **Mrs. E. H. Schuyler**...," *LR*, Nov. 3, 1949, p. 4.

1956 – "Alpha Fall Flower Show ... Prior to three years ago the annual Fall Flower Show was held in the homes of Alpha Club members, but in 1954 the popularity of the event necessitated the use of the clubrooms...," *LR*, Nov. 1, 1956, p. 5.

1958 – "Garden Section Sets Floral Show... November 15 from 2 to 9 p.m. ... In conjunction ... an art exhibit will be held under the chairmanship of **Mrs. William Bailey** and **Mrs. Elsa Schuyler**. Paintings of local people will be on display...," *LR*, Nov. 13, 1958, p. 19.

Flower Festival Art Show
See: "Open-Air Art Exhibit"

Flower Show (Santa Maria)
See: "Minerva Club"

Flower Show (Solvang)
See: "Solvang Woman's Club"

Folsom (Lebrun), Nancy (Mrs. Harvey Lebrun) (b. c. 1905-?) (Santa Barbara County)
Home Department demonstration agent for Santa Barbara county, 1927-35.

■ "Farm Bureau... Miss Nancy Folsom, new Home Demonstration Agent for Santa Barbara County, has arrived from Ohio...," *SYVN*, Nov. 4, 1927, p. 1.
Folsom, Nancy (notices in Northern Santa Barbara County newspapers on microfilm and on newspapers.com)

1934 – "Household Arts Judges Chosen... [for Santa Barbara County Fair] to judge exhibits of needlecraft and household arts...," *SMT*, Aug. 10, 1934, p. 3.

1935 – Farewell luncheon given in honor of Mrs. Nancy Folsom-LeBrun, who has tendered her resignation as home demonstration agent of the county after… eight years," *SYVN*, June 7, 1935, p. 5.

Folsom, Nancy (misc. bibliography)
Nancy F. Lebrun is listed in the 1940 U. S. Census as age 35, b. c. 1905 in Ohio, finished college, 5th or subsequent year, residing in Berkeley (1935) and Chapel Hill, NC (1940) with her husband Harvey Lebrun (age 50); Nancy F. Lebrun divorced Harvey Lebrun on Jan. 15, 1979 in Alameda County, Ca., per Calif. Divorce Index (ref. ancestry.com).

See: "Better Homes," 1931, "Fagin, Irene," "Home Department of the State Farm Bureau," 1928, 1930, 1932, 1933, 1934, 1935

Fonk's (Lompoc)
Five & dime. Retailer of some art supplies, 1929-38.
"Special up-to Date School Supplies at Fonk's. Carter's inks… pencils… Drawing Pencils 10c. Eversharp Mechanical Pencils 10c, 25c… fountain pens… pencil tablets 5c each… crayolas 10c, 15c box, art gum erasers 5c …," *LR*, Sept. 2, 1938, p. 8.

Forbes, Andrew Alexander (April 21, 1862-March 21, 1921) (Lompoc / Owens Valley)
Photographer. Prop. Forbes' Photo Studio in Stillman building, 1920-21.
■ "Local Photographer Claimed by Death. Andrew A. Forbes passed away at his home in this city on last Monday, March 21. His remains were taken to Santa Ana by his widow for interment. Mr. Forbes was aged 58 years, 11 months and 4 days. He had been ill with heart trouble for some time and his death was not unexpected. The deceased had been conducting a photo studio in this city for several months," *LR*, March 25, 1921, p. 4.

Forbes, Andrew (notices in Northern Santa Barbara County newspapers on microfilm and on newspapers.com)
1920 – "When you think of Xmas, think of **Forbes' Photo Studio** in Stillman building on Ocean Avenue," *LR*, Nov. 26, 1920, p. 5.
1921 – "The **Forbes Photo studio** was moved this week from the Stillman building to Sresovich building on H street," *LR*, Feb. 18, 1921, p. 5; "Beautiful picture given away as prize for best water color, oil painting or crayon or charcoal drawing submitted to us by March 5th. Pictures will be judged according to experience by the artist and returned to them. Children especially urged to enter contest," *LR*, Feb. 25, 1921, p. 5, col. 3.

Forbes, Andrew A. (misc. bibliography)
"… northern Arizona… Cheyenne, Apache, Navajo, 'Moqui' (Hopi), 'Pueblo,' and Supai … For a few years, Forbes made his headquarters with his parents and sisters in Santa Ana, California. During this time he took pictures throughout southern California and north at least to Hollister and the San Joaquin Valley. His subjects included communities and landscapes, Death Valley, the New Idria mercury mine, and fur trappers, among others. About 1902… Forbes established a studio in Bishop, California… married Mary Rosette Prutzman… During the 14 years in

which Forbes operated the studio, the Indians of the area regularly came to him to have their pictures taken … studio portraits, but also photographs of the Indians in their encampments in the Owens Valley, Yosemite and elsewhere…. Paiute… Petrara… Luiseno… Yosemite (Western Mono, Miwok and/or Yokuts) … Occasional side trips from Bishop took Forbes to southern California where he photographed the development of orange-growing communities, the missions and the early industrial growth… including the building of the Los Angeles Aqueduct. The financial mainstay of the studio, however, was the sale to tourists of Forbes' scenic views of the Owens Valley and the country around it, the Sierras, Mt. Whitney, Yosemite, and the San Joaquin Valley. Landscape photography was his 'first love'… Forbes closed the studio in 1916 for family health reasons and moved to southern California… but he never found another place suitable… Anthropological significance of the Forbes photographs… 1200 negatives … in the Forbes collection of the Los Angeles County Museum of Natural History… high technical quality… sharpness and richness of tonality…," *Journal of California Anthropology*, p. 40, and port. and "Biography of Andrew Forbes," in "Photographs of Owens Valley Paiute," p. 39, and repro: of some photos, in *Public Member Photos and Scanned Documents* (ref. ancestry.com).

Forbes Photo Studio (Lompoc)
See: "Forbes, Andrew"

Ford, Henry Chapman (1828-1894) (Santa Barbara)
Nineteenth century landscape painter of Santa Barbara best known for his depictions of the missions including those in northern Santa Barbara county, La Purisima near Lompoc, 1880, and Santa Ines near Solvang.
■ "Henry Chapman Ford (1828–1894) was an American illustrator. His depictions of California's missions were partially responsible for the revival of interest in the state's Spanish heritage," from Wikipedia.

Ford, Henry Chapman (notices in Northern Santa Barbara County newspapers on microfilm and on newspapers.com)
1880 – "Mr. H. C. Ford, the well known artist, is coming to paint some scenery, hereabouts, particularly the Purisima Mission," *LR*, Aug. 21, 1880, p. 3; ■ "We recently had the pleasure of a visit to the Studio of Mr. **H. C. Ford**, the well known artist of Santa Barbara. Though he lost a large part of the labor of years in the great fire of Chicago and has sold many pictures in this State and East, he has still a great number of fine sketches, studies and finished productions in his rooms. We were very much interested in the pictures of the various old Missions of the State. Mr. Ford intends making a trip to Lompoc and north, as far as Sonoma Co., to sketch the few he needs to complete the series. We watched intently the artist mixing his colors 'with brains,' as Opie said long ago, transfer them to canvas and produce a gem of seaside scenery. Mr. Ford is very practical as well as artistic. His beautiful residence and grounds at Carpinteria and his active work in the Horticultural and other societies and the forthcoming Fair, at Santa Barbara, are proofs of this," *LR*, Oct. 23, 1880, p.

2; "Mr. H. C. Ford, the well known artist, is coming to paint some scenery, hereabouts, particularly the **Purisima Mission**," *LR*, Aug. 28, 1880, p. 3, col. 1; "Artist H. C. Ford and wife are also here, the former completing his pictures of the Missions of the State….," *LR*, Nov. 6, 1880, p. 3, col. 1.

1887 – "Artist Ford of Santa Barbara passed through this section in the interest of his profession Tuesday last," *LR*, July 2, 1887, p. 3, col. 1.

1894 – "Prof. H. C. Ford, an old citizen of Santa Barbara, died on Tuesday morning last," *SMT*, March 3, 1894, p. 3, col. 2; "**Mid-Winter** Fair [SF] … [description of art gallery] To the right of the main room is a smaller one devoted to the display of the famous collection of etchings of California Missions drawn by H. C. Ford twenty years ago and the only complete collection in existence…," *LR*, April 14, 1894, p. 3.

1898 – "County Seat News… Anna A. Hitchcock has purchased from the Henry C. Ford estate fifty-six acres in Mission canon. The consideration was $2600," *SMT*, April 30, 1898, p. 4.

Norman Neuerburg, "**Henry Chapman Ford,**" *Occasional Paper of the Santa Barbara Historical Society* (reprint of *Noticias*, v. XLIII, no. 2, Summer 1997), 2007.

Ford, Henry Chapman (misc. bibliography)
Henry Chapman Ford was b. Aug. 6, 1828 at Livonia, NY to Thomas G. and Mary Ford, married Helen Louise Ford, was residing in Santa Barbara, Ca. in 1892 and d. Feb. 27, 1894 in Santa Barbara per Moon Family Tree FSL (refs. ancestry.com).

See: "Art, general (Santa Barbara)," 1884, 1889, "Midwinter Fair," "Mission Santa Ines," "Missions in …,"

Forden Gallery (SLO)
Art display space in Forden's Store, SLO, 1952-59, at which several Santa Barbara county artists exhibited.
See: *San Luis Obispo Art and Photography before 1960*

Forgostein, Harold (Halcyon)
Artist who exh. at Santa Ynez Valley Art Exhibit, 1953, 1954, 1955, 1956. Exh. Santa Barbara County Fair, 1960. Exh. Allan Hancock [College] Art Gallery, 1958.
See: "Allan Hancock [College] Art Gallery," 1958, "Glasgow, Charles," 1955, 'Gray, Gladys," intro., "Knowles, Joseph," 1955, "Santa Barbara County Fair," 1960, 1961, "Santa Maria [Valley] Art Festival," 1952, 1953, "Santa Ynez Valley Art Exhibit," 1953-56, "Tri-County Art Exhibit," 1959, and *Arroyo Grande (and Environs) Art and Photography before 1960*

Forsyth, Joseph Henry (1870-1957) (Ballard)
Portrait artist, commercial artist, photographer, walnut grower. Exh. Art Loan Exhibit, Solvang, 1935. Husband to Sadie Forsyth, below.

■ "Walnut Pioneer: J. H. Forsyth, 88, Dies… Joseph Henry Forsyth, 87, of Ballard who spent his younger years as an artist and who was regarded as the father of the walnut industry in the Santa Ynez Valley… Of Scotch descent, Mr. Forsyth was born in Chicago on April 4, 1870.

He was a member of a family of six boys and a girl. … On Nov. 3, 1910, Mr. Forsyth and his wife, the former Miss Sadie Penney, also of Chicago, were united in marriage. They spent the first year of their wedded life hunting and fishing in the unpopulated wooded area of Wisconsin. Later, the Forsyths spent three years in Brazil and the Argentines, where Mr. Forsyth completed many oil portraits of prominent South Americans. This was from 1928 to 1931. Mr. Forsyth was also regarded as an accomplished photographer. At one time, the Eastman Kodak firm sponsored a one-man showing of his photographic work in Kansas City, Mo. The Forsyths came to California in 1920. During his years in the Los Angeles-Glendale area, Mr. Forsyth operated a studio where he specialized in miniature portraits on ivory. He also painted oil portraits of many movie people and was also engaged in some commercial art work. Three years after arriving in California, the Forsyths discovered the Santa Ynez Valley. They purchased a 20-acre ranch on Refugio Road, then known as Grand Avenue. It was not until 1932, however, that Mr. Forsyth decided to give up his art work and he and his wife moved to the Valley… Soon after moving to their ranch here, Mr. Forsyth developed his idea that the Valley area would be conducive for the raising of walnuts. He consulted with George C. Payne, pioneer walnut man who developed the Payne variety, and acting against the advice of other experts, purchased 750 budded trees from Payne to set out on 10 acres of the ranch… Others in the Valley soon followed Forsyth… Examples of Mr. Forsyth's artistic ability are in evidence in the Valley. At the age of 80, he completed a painting on a four by eight foot piece of plywood of a Valley scene which he gave to the Valley Grange and which is hanging in the Grange Hall in Los Olivos. About 18 years ago he completed an unusual drawing of Los Padres National Forest. It was in the nature of a contour map and is regarded as highly detailed and accurate. The map is now located in the Santa Maria office of the U. S. Forest Service. R. Forsyth was also responsible for creating and hanging the carved sign at the entrance to Oak Hill Cemetery. He also made the first bulletin board for the Santa Ynez Valley Presbyterian Church. ... He also won many awards for his photographic work. …," *SYVN*, Dec. 6, 1957, p. 5.

Forsyth, Joseph Henry (notices in Northern Santa Barbara County newspapers on microfilm and on newspapers.com)
1930 – "Mr. and Mrs. Joseph Forsyth who have been spending several years in Australia, are now living on their property on Refugio drive…," *SYVN*, Aug. 8, 1930, p. 4.

1934 – "Joseph Forsyth is on a business trip to Chicago. While there he will visit the Century of Progress Exposition," *SYVN*, Sept. 21, 1934, p. 5.

1952 – "At Yosemite. Mr. and Mrs. Joseph Forsyth, Miss **Mae Penny** [Sic. Penney] and Mrs. Elizabeth Thomas have returned after vacationing in northern California at Yosemite and Carmel," *SYVN*, May 30, 1952, p. 7.

Forsyth, Joseph Henry (misc. bibliography)
Joseph Henry Forsyth was b. April 4, 1870 in Ill., to Joseph Henry Forsyth and Sarah Elizabeth Bernum Lee, was residing in Chicago in 1900, married Alice C. Sittig, and d. Nov. 30, 1957 in Santa Barbara County per Becker Family Tree (refs. ancestry.com).

See: "Art Loan Exhibit (Solvang)," 1935, "Graham, John," "House, Elmer," 1928

Forsyth, Sarah "Sadie" Elizabeth Penney (Mrs. J. H. Forsyth) (1885-1978) (Ballard)
Won awards in various fairs for her needlework, late 1930s. Prop. with her sisters of Creative Arts & Woman's Exchange. Wife to Joseph Henry Forsyth, above. Sister to Mae Penney, below.
■ "Sadie E. Forsyth… Born in Chicago, Ill., on Feb. 13, 1885, Sadie Elizabeth Forsyth died May 22 at the Santa Ynez Valley Recovery Residence. … 93-year-old retired artist who had lived in Solvang since 1936 …," *SYVN*, May 25, 1978, p. 11.
Forsyth, Sarah (notices in Northern Santa Barbara County newspapers on microfilm and on newspapers.com)
More than 500 entries (mostly social) for "Mrs. J. H. Forsyth" appear in *SYVN* 1927-1960, and 184 for "Sadie Forsyth" but were not itemized here.
Forsyth, Sarah (misc. bibliography)
Sarah Elizabeth Forsyth was b. Feb. 13, 1885 in Ill., and d. May 22, 1978 in Santa Barbara County per Calif. Death Index; Sarah Elizabeth Forsyth is buried in Oak Hill Cemetery in Ballard, Ca., per findagrave.com (refs. ancestry.com).
See: "Art Loan Exhibit (Solvang)," 1935, "Creative Arts & Woman's Exchange," 1949, "Forsyth, Joseph Henry," "Graham, John," 1931, "House, Howard Elmer," 1928, "Penney, Mae," "Presbyterian Church," 1944, Santa Ynez Valley Fair," 1936

Fortune (Smith), Margaret Edith (Mrs. Herman A. Smith) (b. c. 1906-?) (Santa Maria / Los Angeles)
Santa Maria High School student who was Art editor of the Review, 1923. Student at Otis Art Institute, LA, 1924.
1924 – "**Mr. and Mrs. Stanley G. Breneiser** and family are expected home this evening from the southern part of the state. They will be accompanied by the Misses Margaret Smith and Margaret Fortune," *SMT*, April 18, 1924, p. 5; "Miss Margaret Fortune, talented daughter of Mr. and Mrs. C. [Charles] W. Fortune, leaves this week for Los Angeles to enter the Otis Art Institute to further her studies in art," *SMT*, Sept. 26, 1924, p. 5, col. 2.
1926 – "Mr. and Mrs. Herman A. Smith of Los Angeles announce the arrival of a daughter, born June 3. Mrs. Smith was formerly Miss Margaret Fortune," *SMT*, June 7, 1926, p. 3.
Fortune, Margaret (misc. bibliography)
Margaret Fortune is listed in the 1920 U. S. Census as age 13, b. c. 1907 in Canada, residing in Los Angeles with her parents, Charles W. Fortune (age 44, a mechanical engineer) and Florence Fortune (age 42); Margaret Fortune is pictured in the Santa Maria High School yearbook, 1924; Margaret Smith is listed in the 1930 U. S. Census as b. c. 1906 in Canada, residing in Beverly Hills with husband Herman Smith (age 42) and two children Margaret and Jacquelin (ref. ancestry.com).
See: "Santa Maria, Ca., Union High School," 1923

Forward, Moselle (Mrs. Lt. Col. Fletcher C. Forward) (1915-2002) (Lompoc)
Photographer for Lompoc Record, 1955. Editor of Women's Page in Lompoc Record, 1955-58. Author of a one-time "Art Review" in Lompoc Record, 1957. Prop. of Moselle's Gifts at the Inn, 1960.
■ Port. "Mrs. Moselle Forward is a native of Waco, Texas, and received her early education at Fort Worth and Dallas. She later attended Southern Methodist University and University of California at Los Angeles. She has been active in banking, secretarial work, radio and newspaper work. In addition, she taught creative writing in Hawaii. Prior to becoming the co-owner of 'Gifts at the Inn,' Mrs. Forward was Woman's Editor of the *Lompoc Record*. She is a home owner at 319 South H. Street and is married to Fletcher C. Forward, who is serving his final tour of Army duty in France. He will retire as Lt. Col. following the tour. Mrs. Forward has stated the following platform with her candidacy for election to the office of city councilman. 'Lompoc, as the nearest city to the nation's priority endeavor in the Space Age, promises to become one of the most important and best known across the country. Times are changing … As a civic-minded woman, a mother of school children and as a resident actively engaged in business, I seek this office with the firm belief that my positive approach to local programs is a vital and important issue in this election. I believe in treating people courteously, in encouraging the exchange of fresh ideas, listening to different viewpoints and in trying to further the growth, prosperity and orderly development of the city…," *LR*, April 4, 1960, p. 9.
Forward, Moselle (notices in Northern Santa Barbara County newspapers on microfilm and on newspapers.com)
1955 – "Arty Talk… Perhaps there is a gallery somewhere in town that displays paintings, drawings or sketches done by Lompocans, but if so, I haven't found it. If Mr. William Smiley's south L street garden were transplanted in another land, say Japan, artists of all ages and stages of skill could be found from early morning thru the late afternoon sun swishing colors on their easels. And the flower fields! Are there no local artists? Or am I too new to have discovered them?," *LR*, Aug. 4, 1955, p. 5; "Gal Photog Gets Close-Up View of Forest Fire," and extensive description of her plane ride and that she took her Speed Graphic camera into **Tommy Yager** beforehand for settings, and her repros. Are credited as "Record Photos," *LR*, Sept. 8, 1955, pp. 1, 3.
1956 – "Garden Features… Looking ahead … As one new feature planned for next year's special Flower Festival edition of the *Lompoc Record*, ye olde novice photographer is even now scouting a year-round representation of Lompoc's flower grandeur. First picture – one taken during the month of July was of a charming place on East Cypress, house number 602, I think. It has a name, 'The Caywoods' neatly hung at the front. That's to be the picture of July. Now, I'm busy looking for an August picture," *LR*, Aug. 9, 1956, p. 7.
1957 – "For Sale – Polaroid Camera. …Flash attachment, supply of film and bulbs plus close-up lens for portraits… bought as experiment for newspaper work, found not practical. Phone Moselle Forward, 2825 or after 5 p.m. at 8-1294," *LR*, March 7, 1957, p. 7.

1958 – "Missile Age Press Briefing Intrigues … I held firmly to my camera, scribbled hasty notes…," *LR*, Jan. 9, 1958, p. 14; "Buzzin' with Bea. **Bea Pate**… Replacing Moselle Forward as Woman's Editor and photographer, plus many other miscellaneous jobs, leads me to believe these will be footsteps hard to follow," *LR*, Sept. 4, 1958, p. 6.

1960 – Port. and caption reads, "**George Muro**, left, art instructor at Hancock College… is shown explaining his illustrated points on city planning to Mrs. Moselle Forward, president of the Women's Division of the Lompoc Chamber of Commerce…," *LR*, March 3, 1960, p. 7.

Forward, Moselle (misc. bibliography)
Mozelle [Sic.] Forward is listed with Fletcher Forward, USA, in Lompoc in the *Santa Maria, Ca., CD*, 1958, 1959; Moselle Forward is listed in the *San Diego, Ca., CD*, 1961, 1973, 1974; Moselle Forward was b. Dec. 7, 1915 and d. Feb. 22, 2002 per Social Security Death Index (refs. ancestry.com).

See: "Art Review," "Lompoc, Ca., Elementary Schools," 1957, "Moselle's Gifts at the Inn (Lompoc)," "Pate, Bea"

Foster, Florence Irene Sampson (Mrs. John Foster) (1880-1964) (Santa Maria)
Painter. Exh. in Tri-County Art Exhibit, 1949. Exh. Santa Barbara County Fair, 1951, 1952. Exh. Allan Hancock [College] Art Gallery, 1955, 1956. Charter (?) member Santa Maria Art Association.

■ "Obituaries. Florence Foster. … Mrs. Foster was born April 20, 1880 in Nebraska and has been a resident of the local area for the past 24 years….," *SMT*, Nov. 5, 1964, p. 8.

Foster, Florence (notices in Northern Santa Barbara County newspapers on microfilm and on newspapers.com)
1949 – "Watercolor Exhibit Remains Week Longer" at **De Nejer** studios, *SMT*, May 31, 1949, p. 5.

1951 – "Mrs. Foster Visits Son in New York City… Enjoyable experience of Mrs. Foster, whose hobby is painting, was viewing the exhibit of modern art in New York City. … Mrs. Foster… noted there were many fine art collections other than painting, in the building," *SMT*, Oct. 16, 1951, p. 4.

And some notices in the *SMT* between 1940 and 1964 under "Florence Foster" and more than 50 under "Mrs. John Foster" were not itemized here.

Foster, Florence (misc. bibliography)
Is she Florence I. Foster listed in the 1940 U. S. Census as age 59, b. c. 1881 in Nebraska, finished high school 3rd year, residing in Warren, Ariz. (1935) and Santa Barbara, Ca. (1940) with husband John (age 67); is she Florence Irene Foster b. April 20, 1880 in Table Rock, Neb. who d. Nov. 4, 1964 in Santa Maria, Ca., and is buried in Santa Maria Cemetery District per findagrave.com (refs. ancestry.com).

See: "Allan Hancock College, Adult/Night School," 1958, "Allan Hancock [College] Art Gallery," 1954, 1955, 1956, "Community Club (Santa Maria)," 1950, 1951, 1952, "Halloween Window Decorating Contest (Santa Maria)," 1951, "Posters, American Legion (Poppy) (Santa Maria)," 1947, "Rembrandt Club," 1955, "Santa Barbara County Fair," 1949, 1951, 1952, 1953, "Santa Maria Art Association," 1945, 1949, 1950, 1951, 1953, "Santa Maria [Valley] Art Festival," 1952, "Tri-County Art Exhibit," 1947, 1949, 1950

Foster, Harold (Santa Maria)
Teacher of architectural and mechanical drawing in adult school, 1928 and of electricity at Santa Maria high school, 1928+.
See: "Santa Maria, Ca., Adult/Night School," 1928, "Santa Maria, Ca., Union High School," 1928

Foster, Jack, Rev. (Lompoc)
Chalk-Artist Evangelist, who appeared in Lompoc, 1955.
See: "Chalk Talks (Northern Santa Barbara County)," 1955

Four-H (Northern Santa Barbara County)
Club that, among other activities, held Handcraft classes, 1930s. Edna Davidson taught handcraft, 1937.
Four-H (notices in Northern Santa Barbara County newspapers on microfilm and on newspapers.com)
1933 – "4-H Club Heads Will Gather. … seven counties between Los Angeles and San Luis Obispo will meet at Morro Bay…to discuss 4-H Club work and to receive instructions in various lines of handicraft work…," *SYVN*, Nov. 3, 1933, p. 1.

1934 – "25 4-H Leaders… [discuss 1934 year program. typical] activities… Picnics… Exhibits and fairs. Tours… collecting insects, plants, minerals, Indian relics… specimens… overnight hikes… camp craft and wood craft; Nature study, bird life, animal life… Hobbies and Handicraft; Archery, rope work, airplane or boat models, leather work, collections, scrap books…," *SYVN*, Feb. 2, 1934, p. 4; "4-H Club Notes… girls attending the class in handwork by **Mrs. Mary E. T. Croswell** at the State Teachers College in Santa Barbara Saturday …," *LR*, March 16, 1934, p. 6.

1936 – "Community 4H Group to Hold Special Meeting May 18. Handcraft work of all types will be main subject of the meeting… Leaders of the sections will be in charge with **Mrs. Charles Davis** as chairman… Legion hall," *LR*, May 8, 1936, p. 7.

1937 – "4H Leaders Council… Use of the old Legion hall for every Friday night was assured to the 4H groups. … while a 4H handicraft class will be held the fourth Friday of each month led by Mrs. O. B. Chamberlain. Copper, leather and other handicraft work will be studied …," *LR*, March 26, 1937, p. 7; "Handicraft Classes Begun for 4th [Sic. H] Girls… with **Miss Edna Davidson** as teacher at her home… Miss Davidson started out Wednesday with bead work but will teach the girls whatever they would enjoy learning about, such as book-binding, flower arranging and dressing paper dolls for fashion. Miss Davidson will hold the class again on Wednesday, beginning at 2 p.m.," *LR*, July 30, 1937, p. 7; "Handcraft Class is Continued on Wed. **Miss Edna Davidson** conducted the second of her handcraft classes for 4H girls Wednesday afternoon at her home. Several preliminary studies were made of flower arrangements, drawing, and the making of cornstarch designs for book frontispieces," *LR*, Aug. 6, 1937, p. 4;

"Handcraft Class is to Decorate Church. Westminster hall was the scene of the third handcraft class conducted by **Miss Edna Davidson** on Wednesday afternoon for 4H girls who wish to take up various forms of art work instruction. They continue with their book binding, figure drawing and crayon work. Plans were made for the girls who are interested in flower arranging to meet at the Presbyterian church tomorrow to learn that art and to make arrangements of flowers with which to decorate the church for the Sunday service … Attending the lesson were," and girls' names listed, *LR*, Aug. 13, 1937, p. 7; "Color is Studied by Handcraft Class. **Miss Edna Davidson's** 4H handcraft class met Wednesday in Westminster hall to study color wheels. …," *LR*, Aug. 20, 1937, p. 3; "Handcraft Class. Work was continued on their projects by the 4H girls who are attending the Handcraft Class taught by **Miss Edna Davidson** at Westminster hall each Wednesday afternoon," *LR*, Aug. 27, 1937, p. 7; "4-H club… active participation in such community affairs as beautification projects, welfare work… Nearly all the members took part in **Miss Edna Davidson's** handicraft classes," *LR*, Oct. 1, 1937, p. 5.
1952 – "4-H Arts-Crafts Group Formed… meeting every Wednesday afternoon after school in the High School art room. The project will include tours of art studios, shops and museums and will feature the making of craft objects in ceramics and leather. Mr. **Conley McLaughlin**, High School art teacher, is the adult leader with **Annette Negus** as Junior leader. Membership is open to anyone 12 to 17…," *LR*, Dec. 4, 1952, p. 12.
1954 – "4-H'ers Win Region Awards… The local girls' posters were made by **Jean Abbott**," *SYVN*, June 11, 1954, p. 7.
See: "Community Center (Lompoc)," "Four-H Camp," "Griesbauer, Jack," 1954, "Home Department," 1947, 1949, "Lompoc, Ca., Union High School," 1934, "Lompoc Valley Fair," 1928, "Santa Barbara County Fair," 1931, 1934

Four-H Camp (White Oak Flats)
Summer camp where crafts were taught.
Four-H Camp (notices in Northern Santa Barbara County newspapers on microfilm and on newspapers.com)
1931 – "Eighteen Lompoc… 4H Camp… Many prominent men will be at the camp this year… David Davis, vocational agricultural teacher at Ojai and E. L. Merryweather, assistant farm advisor in Ventura county…," *LR*, June 1931, p. 3; "Boys and Girls at 4H Club Camp… White Oak flats … instructing… David Davis and Ted Merryweather, handicraft…," *SYVN*, June 26, 1931, p. 1.
1934 – "Sunday Set Aside for Visiting at 4-H Camp… Annual Visitors Day…Paradise Park on the San Marcos… Basketry, clay modeling, carving, bead work, rope work, leather work, and other handcraft projects… will be on display…," *SMT*, June 22, 1934, p. 6; "4-H Club Camp was Most Successful… 4-H clubs in three counties of Ventura, Santa Barbara and San Luis Obispo completed one of the most successful annual outing camps… [teachers] Crafts: Rope, Sam Edwards; Leather, Merle Remsberg; Basketry, Annie James; Carving, June Wheeler; Pottery, Margaret Freitas; Modeling (airplane, etc.), Edwina Elliott;

Photography, Mr. [Curtis?] Berryman… Another outstanding feature … was the great interest shown in handcraft projects. Hardly a boy left camp without taking with him either a braided or tooled leather belt which he made himself …," *SYVN*, July 6, 1934, p. 1.
1936 – "4-H Club Summer Camp was Attended by 130 Members… Other popular activities were braiding and knotting work with stripcraft and leather lacing in which lanyards, bracelets, watch and knife chains, etc. were made. Leathercraft contributed to the stock of new belts, purses, watch fobs, hat bands, and other articles which will be worn by the club members during the coming year …," *SYVN*, July 24, 1936, p. 8.
1937 – "White Oaks Flat is Scene of 4H Camp… During the camp period **Miss Edna Davidson** acted as handcraft instructress…," *LR*, July 2, 1937, p. 8.
1940 – "4-H Club Camp… swimming… Another outstanding activity… was the handicraft work in leather and copper under … Miss Wilma Kisner, a Santa Barbara girl trained in local schools and now teaching in San Joaquin Valley…," *SYVN*, June 28, 1940, p. 1.
1941 – "Annual 4H Camp Held… Various camp activities are under the leadership of counselors and other leaders. Miss Wilma Kisner is in charge of leather work and other hand craft assisted by **Mrs. Alice McBride**…," *LR*, June 27, 1941, p. 2.
1946 – "Mrs. Svend Hansen [Solvang librarian, clubwoman] Instructs… spent the week of July 1-6th at the 4-H Camp, White Oaks Flats… instructed a class in bead-craft, in which more than thirty boys and girls completed articles such as bead rings, bracelets, necklaces, headbands, and in the advanced group, belts, coin purses and other useful articles…," *SYVN*, July 12, 1946, p. (4?).
1955 – "170 4-H'ers at Annual Camp Session … In addition to a routine program of crafts, swimming and campfires…," *SYVN*, July 1, 1955, p. 4.

Fourth of July Parade
See: "Floats"

Frame, John (1882-1946) (Los Olivos)
Photographer. Salesman for Chicago Portrait Co. prior to settling in Santa Ynez Valley in 1926.
■ "John Frame Passes Suddenly in Los Olivos … John Frame was born June 10, 1882 in Mendon, Missouri. He received his education at Moberly, Mo., and for some time thereafter traveled in Canada, Australia and throughout the Mid-west in the United States as an agent for the Chicago Portrait Company. ... Mr. and Mrs. Frame came to this valley in 1926 where he entered in the Real Estate and Insurance business…," *SYVN*, Jan. 18, 1946, p. 1.
Frame, John (notices in Northern Santa Barbara County newspapers on microfilm and on newspapers.com)
1930 – "Next Sunday John Frame will be at the Sunday school to photograph the different groups and it is hoped that attendance will reach over the hundred mark…," *SYVN*, Oct. 31, 1930, p. 1, col. 1.
And, almost 1800 "hits" for "John Frame" in the *SYVN*, 1928-51, primarily for his real estate and civic work, were not itemized here.

Frame, John (misc. bibliography)
John Frame was b. June 10, 1882 in Missouri, married
Frances 'Fannie' Willis Quisenberry, was residing in Los
Olivos in 1945, and d. Jan. 16, 1946 in Ballard, Ca., per
Jeffries Family Tree #1; buried in Oak Hill Cemetery,
Ballard, per findagrave.com (refs. ancestry.com).
See: "Art Loan Exhibit (Solvang)," 1935, "Graham, John,"
"House, Elmer," 1928, 1931, 1944, "Signs, general," 1929

**Fratis (Marsalisi) (Minnick) (Burgess) (Lundbergh?),
(Mary) Margaret "Marge" "Marga" (Mrs. Joseph
Marsalisi) (Mrs. James Minnick) (Mrs. Burgess) (Mrs.
Ted Lundbergh?) (1917-2013/14) (Lompoc / Los
Angeles)**
*Lompoc high school student. Sculptor in wood and celite,
1935. Designer in Los Angeles. Dancer. Sister to Frank
Fratis, an architect.*
Fratis, Margaret (notices in Northern Santa Barbara County
newspapers on microfilm and on newspapers.com)
1935 – "Margaret Fratis Wins Art Award… daughter of
Mr. and Mrs. Frank Fratis… award of merit from the
California School of Fine Arts for art work she had
submitted in a contest sponsored by the school. An oil
painting and a wood carving executed in an art class at high
school under… **Miss Mary Elizabeth Bucher**…," *LR*,
June 7, 1935, p. 4.
1936 – "Return to Studies … Los Angeles, where Miss
Margaret Fratis has gone to resume study at Woodbury's
business college," *LR*, Jan. 3, 1936, p. 7.
1940 – "Miss Mary Margaret Fratis Becomes Bride of
Joseph Marsalisi… Mrs. Marsalisi attended the local school
and is a graduate of the Immaculate Heart college in
Hollywood, a graduate of Woodberry [Sic. Woodbury]
college in Los Angeles and also the Wolfe school of
costume designing in Los Angeles. She has been engaged
in designing in the southern city …," *LR*, Oct. 18, 1940, p.
2.
1945 – PARENTS – "Observe Golden Wedding… Mr. and
Mrs. Fratis… Mrs. Margaret Marsalisi, daughter, came
from Los Angeles," *LR*, June 15, 1945, p. 1.
1980 – BROTHER – "Fratis, Kenneth E…. Loving brother
of Marga Burgess… A native of Lompoc… For over 50
year… ranching …," *Sacramento Bee*, July 12, 1980, p. 44
(on ancestry.com).
Fratis, Margaret (misc. bibliography)
Mary M. Fratis is listed in the 1930 U. S. Census as
residing in Township 5, Santa Barbara County, with her
parents Frank J. and Maude M. [Maud King] Fratis; Mary
M. Fratis is listed in the 1940 U. S. Census as age 21, b. c.
1919 in Calif, lodging in Los Angeles; Mrs. Margaret
Marsalisi is listed in voter registers in Los Angeles City,
1944-48; Mary M. Marsalisi married James I. Minnick,
July 7, 1947 at an unknown place in California per Calif.
County Birth, Marriage and Death Records; Mary M.
Minnick of Los Angeles (b. Lompoc), sailed from NY on
July 16, 1949, on the *USAT George W. Goethals* for
Southampton, England, intending to be away from the U. S.
for 3 years; Mary M. Minnick of Los Angeles (b. Lompoc)
sailed from Southampton, England on May 7, 1951 on the
USNS Gen. Alex M. Patch (T-AP122) arriving at NY May
15, 1951 per NY Passenger and Crew Lists; Mary M.

Minnick of Los Angeles (b. Lompoc), sailed from NY on
Sept. 14 (?), 1951 on the *USNS Gen. Wm. O. Darby (T
AP127)* for Southampton, England, intending to be away
for 1 year; Marga Burgess (in 1980); Mary Fratis, at some
time, married Theodore "Ted" Albin Lundbergh per
Cary/Lundbergh Family Tree; Mary Margaret Fratis
(Minnick) was b. Sept. 12, 1917 in Lompoc, Ca., to Frank
Joseph Fratis and Mary Maud King, married Theodore
"Ted" Albin Lundbergh, and d. May 2, 2014 [Sic.?] in
Foster City, Ca., per Cary / Lundbergh Family Tree; some
photos of Mary Margaret Fratis b. Sept. 12, 1917, d. Dec.
18, 2013 [Sic.?] per *Private Member Photos* (refs.
ancestry.com).
See: "Lompoc, Ca., Union High School," 1935

**Frazer / Frazier, Amanda Julia? (Mrs. John? H. Frazer
/ Frazier)**
*Mrs. Frazer / Mrs. J. H. Frazier exh. best plaque painting
at "Santa Barbara County Fair," 1886.*
Is this person Amanda? – "John H. Frazer vs. Amanda Julia
Frazer ... [divorce] ... awarding him the custody of the
minor child," *Independent* (Santa Barbara, Ca.), Aug. 21,
1888 p. 4; "Married. Orr-Frazer – In this city, at the M. E.
Church by the Rev. Mr. Robinson, August 20, 1888, J. W.
Orr to Amanda Frazer," *Independent*, Aug. 23, 1888, p. 1.
See: "Santa Barbara County Fair," 1886

Fredrickson, Mr. (Santa Barbara)
*Interior decorator with Fredrickson and Tower who spoke
to the Solvang Woman's Club, 1952.*
Fredrickson & Tower are listed in the *Santa Barbara, Ca.,
CD*, 1953, p. 47 according to the book's Index [ed. – but
not found on the page cited] (ref. ancestry.com).
See: "Solvang Woman's Club," 1952

**Freitas (Hamilton), Edwina Mary Alvernaz (Mrs. Cecil
S. Freitas) (Mrs. Jess Hamilton) (1909-1971) (Santa
Maria)**
*Ceramist. Exh. ceramics at Santa Barbara County Fair,
1949. President Pocahontas Club, 1948. Prop. Edwina's
Ceramic Studio, 1951+.*
■ "Edwina A. Hamilton… died Sunday in a Santa
Barbara hospital… Mrs. Hamilton was born on Oct. 27,
1909 in Providence, R. I., had lived in the Santa Maria area
since 1939 and last resided at 512 E. Fesler St. For 18
years, Mrs. Hamilton had owned the Edwina Ceramic
Studio and Plastics stop [sic.] at 227 E. Chapel St. She was
a member of the Degree of Pocahontas Improved Order of
Redmen Neepawa Council No. 100. Survivors include her
widower, Jess Hamilton…," *SMT*, Jan. 5, 1971, p. 2.
Freitas, Edwina (notices in Northern Santa Barbara County
newspapers on microfilm and on newspapers.com)
1953 – "Annual Camellia Show… Mrs. Edwina Freitas will
have a display from her ceramics studio," *SMT*, March 6,
1953, p. 6; "Nurseries… Mrs. Edwina Freitas had a table
exhibit of ceramics made in her Santa Maria studio, many
of them suitable and designed especially for containers
featuring camellias," *SMT*, March 10, 1953, p. 4.

1954 – "Neepawa Council… Mrs. Eulita Miller was announced winner of a ceramic Santa Claus Tom & Jerry set, designed and made by Mrs. Edwina Freitas…," *SMT*, Dec. 16, 1954, p. 7.

1955 – "Edwina Freitas Wins Certificate… certificate of merit awarded by *Popular Ceramics*, national trade magazine for her participation in ceramics as a hobby. At her studio in Santa Maria, Mrs. Freitas is teaching the art of ceramics to classes in several age groups. At one time, she taught a group of four-year-old tots the making of figures. The certificate… cites 'untiring effort and co-operation to the advancement of knowledge in behalf of hobby ceramics'," *SMT*, Oct. 26, 1955, p. 4.

1960 – Port. with Pocahontas group, *SMT*, Aug. 26, 1960, p. 3.

1971 – "Legal Advertising… Estate of Edwina A. Hamilton, also known as Edwina Alvernaz Hamilton and Edwina A. Freitas, deceased …," *SMT*, Jan. 13, 1971, p. 26 (i.e., 30).

Freitas, Edwina (misc. bibliography)
Edwina A. Freitas is listed in the *Santa Barbara, Ca., CD*, 1939; Edwina A. Freitas is listed in the *Santa Maria, Ca., CD*, 1945-61; Edwina Mary Alvernaz was b. 1910 [sic.] in Rhode Island, to Francisco Silveira Alvernaz and Maria da Gloria Figunes, married Cecil Stanley Freitas, and d. 1971 in Pacific Grove, Ca., per Moore and Plamondon Family Tree; Edwina A. Hamilton was b. Oct. 27, 1909 in Rhode Island and d. Jan. 3, 1971 in Santa Barbara County per Calif. Death Index; Edwina A. Hamilton is buried in Santa Maria Cemetery District per findagrave.com (refs. ancestry.com).
See: "Edwina's Ceramic Studio," "Santa Barbara County Fair," 1949

Friday, Martha Adeline McDaniel (Mrs. Insco A. Friday) (1895-1973) (Santa Maria)
Ceramist who demonstrated her trade at Community Club Hobby Show, 1950.

■ "Martha A. Friday…. Mrs. Friday was born Dec. 21, 1895 in Eldorado, Kan., and died Nov. 9 in a Santa Barbara hospital. She had been a Santa Maria resident since 1928 and was a member of the American Legion Auxiliary and the Eight and 40 of the American Legion…," *SMT*, Nov. 12, 1973, p. 2.

Friday, Martha (notices in Northern Santa Barbara County newspapers on microfilm and on newspapers.com)
1950 – "… has turned out exceptional pieces, will exhibit her best finished work in the way of decorative tiles, figurines and jewel boxes…," *SMT,* Sept. 21, 1950, p. 4. And more than 150 social notices and notices on Girls State in *SMT* between 1945-70 for "Martha Friday" were not itemized here.

Friday, Martha (misc. bibliography)
Martha A. Friday is listed in the 1940 U. S. Census as age 44, b. c. 1896 in Kansas, finished high school 4th year, residing in Santa Maria with husband Insco A. Friday (age 46) and children Betty Ruth (age 18) and Nora Jane (age 14) and her mother Sarah C. McDaniel (age 79); Martha Adeline Friday b. 1895, and d. Nov. 9, 1973, is buried in Santa Maria Cemetery District per findagrave.com (refs. ancestry.com).

See: "Community Club (Santa Maria)," 1950

Friedman, Jerrold Burwell (1926-1997) (Santa Barbara / Los Angeles / Santa Fe)
Ceramist who exh. at Santa Ynez Valley Art Exhibit, 1956.

■ "HCAF Slates April Workshop… Hill Country Arts Foundation… Friedman will be teaching 'Abstraction / Realities.' Abstracting from nature or still life… open media class… Friedman received his MFA degree from Otis Art Institute in Los Angeles and an A. A. in photography from John Muir college in Pasadena, California. He has had a varied career as a painter and sculptor. His works have been exhibited widely in museums throughout the U. S. including New Jersey State Museum, Trenton, N. J., Los Angeles County Art Museum, Gallery of Contemporary Art, Winston Salem, N. C. Friedman taught college level classes in painting and sculpture on both coasts before moving to Santa Fe. Currently he and his artist-wife, Virginia Cobb, teach painting workshops in their Santa Fe studio…," *Kerrville Times* (Kerrville, Texas), March 10, 1993, p. 12 (i.e., 2B).

Friedman, Jerrold (notices in newspapers on newspapers.com)
1955 – Repro: bird shaped ceramic decanter, *LA Times*, Aug. 21, 1955, p. 259 (i.e., Home Magazine, p. 19).

1959 – "26 Noted Artists to Show Wide Variety of Best Works. Valley College's Little Gallery… works of art from the Los Angeles Institute… In the field of ceramics, the following artists will be represented… Jerrold Friedman…," *San Bernardino County Sun*, Jan. 4, 1959, p. 40 (i.e., C-12).

1962 – "Jerrold Friedman, paintings, prints, Aura Gallery, Pasadena, to Oct. 20," *LA Times*, Sept. 23, 1962, p. 425 (i.e., Calendar, p. 13).

1974 – "Princeton – Artisan Gallery: Jerrold Friedman, one-man exhibition of chimeras and other clay objects, closes Saturday," *Central New Jersey Home News* (New Brunswick, N. J.), March 24, 1974, p. 61 (i.e., C-17).

Friedman, Jerrold (misc. bibliography)
Jerrold Burwell Friedman gave the following information on his WWII Draft Card dated Jan. 3, 1946 = age 19, b. July 27, 1926 in Cincinnati, Ohio, unemployed, currently residing in Los Angeles, next of kin is Gladys Hatcher; port. in John Muir College yearbook, Pasadena, 1948; Jerrold B. Friedman married Lavonne E. Miller / Alpaugh on Aug. 10, 1952 in Los Angeles County per Calif. Marriage Index; Jerrold Friedman, with wife LaVonne, is listed in the *Santa Barbara, Ca., CD*, 1954; Jerrold Friedman, ceramic product, and wife Bonnie, are listed at 244 E. Mountain Dr., Montecito, in the *Santa Barbara, Ca., CD*, 1955-58; is he Jerrold B. Friedman who married Patricia M. Clark / Nora P. Martin on July 22, 1961 in Santa Barbara County per Calif. Marriage Index; Jerrold B. Friedman b. July 27, 1926, last residence Houston, Tx., d. Nov. 14, 1997 per Social Security Death Index (refs. ancestry.com).
See: "Santa Ynez Valley Art Exhibit," 1956

Froom, Darrell (1900-1971) (Santa Maria)
Cabinet maker, painter, maker of wrought copper, 1928, 1944.

■ "Darrell A. Froom... 71, 905 Haslam Drive, died this morning in Santa Maria. He was the owner of the Froom Hotel, 215 N. Broadway...," *SMT*, Dec. 27, 1971, p. 4.
Froom, Darrell (notices in Northern Santa Barbara County newspapers on microfilm and on newspapers.com)
1927 – "Frooms Have a Novel Camp Car, Which They Made. Parlor, bedroom and sink. Also a bathtub, refrigerator and plenty of standing room. ... traveling automobile camp. Ten months of labor... Darrell Froom designed the moving house which is built on the chassis of a light truck... [and detailed description] ... Mr. and Mrs. [Asa] Froom plan to take trips throughout the county...," *SMT*, Sept. 22, 1927, p. 2.
1928 – "Unique Chest... Illustrating what can be accomplished in spare time, Darrell Froom, son of Mr. and Mrs. A. H. Froom of this city, has recently completed a remarkable reproduction of an old Spanish chest, made entirely of hand-hammered copper. The chest, copied from a photograph in the Santa Barbara library, is approximately two feet high, four long and two wide. It is bound together and studded with hand made nails, and the whole thing 'antiqued' ... on exhibition at the **Stonehart Studio** on church street," *SMT*, July 20, 1928, p. 4.
1935 – "Casino Night to Attract Elks... The club has been redecorated with new drapes, furniture and rugs under the supervision of Darrell Froom...," *SMT*, May 18, 1935, p. 2.
1938 – "Miss Meyers to Wed Darrell Froom... in Santa Barbara ... eldest son of Mr. and Mrs. A. H. Froom... The prospective bridegroom was born and reared in Santa Maria and received his education in the public schools here. After a brief honeymoon in southern California, the young couple will be at home... at 402 East avenue," *SMT*, Oct. 15, 1938, p. 2.
1944 – "I Spied... Darrell Froom receiving plaudits of friends on the oil paintings and wrought copper works of art he has done with never a lesson," *SMT*, Oct. 16, 1944, p. 1.
And, possibly 150 additional notices for "Darrell Froom" in the *SMT* between 1925 and 1960, some noting he was on decorating committees, participated in little theater, enjoyed boating, and served as master of ceremonies, but they were not itemized here.
Froom, Darrell (misc. bibliography)
"Darrell Acel Froom was b. Jan. 29, 1900 in Santa Barbara County to Acel Harvey Froom and Anna A. Saulsbury, married Lillian Odel Myers, was residing in Santa Maria, Ca., in 1945, and d. Dec. 27, 1971 in Santa Maria per Orr Family Tree (refs. ancestry.com).
See: "Art, general (Santa Maria)," 1929, "Camera Club (Santa Maria)," "Santa Maria, Ca., Elementary School," 1951

Fugler, Bell / Belle, (Mabel Anito Fugler 1871-1892?) Miss (Santa Maria)
Exh. a quantity of paintings at "Santa Barbara County Fair," 1890.
Fugler, Belle (notices in Northern Santa Barbara County newspapers on microfilm and on newspapers.com)
1890 – "Miss Bell [Sic.?] Fugler" exhibited a baby afghan, hand-painted cup and saucer, hand painted vase, crochet box, paper flowers, point lace handkerchief," in the Santa Barbara County Fair, *SMT*, Sept. 13, 1890, p. 3.
1891 – "Miss Belle Fugler, for several months bookkeeper for the firm of **W. A. Haslam & Co.** [a firm in which her relation, Arthur Francis Fugler was financially involved], is now taking a much-needed rest – passing her vacation at home near Garey [10 miles SE of Santa Maria, near Fugler's Point]," *SMT*, Feb. 7, 1891, p. 3, col. 1; "Mr. F. [Francis?] Fugler, accompanied by his daughter (?), Miss Bell [Sic. Belle?], went to Santa Barbara on Tuesday to attend the fair," *SMT*, Aug. 22, 1891, p. 3, col. 1.
1892 – "Mr. and Mrs. F. Fugler and their daughter, Miss Bell, returned home on Monday last from an extended visit to various parts of the State. Miss Bell was formerly book keeper for **W. A. Haslam & Co**. but her health failed and she went with her parents last fall to Napa where her health was very much improved. She spent the winter at San Diego where she had a severe attack of the grippe from which she has not yet fully recovered. They have taken rooms for the present at the Travers residence," *SMT*, March 5, 1892, p. 3.
Fugler, Belle (misc. bibliography)
Is she Mabel Anito Fugler b. 1871 and d. 1892 and buried in Santa Maria Cemetery District per findagrave.com (refs. ancestry.com).
See: "Santa Barbara County Fair," 1890

Fujioka, Henry Tetsuo (1935-2009) (Santa Maria / San Francisco / Oakland)
Santa Maria High School grad. 1954. Studied at California College of Arts and Crafts, Oakland. Career artist in the San Francisco / Oakland area c. 1962+.

■ Port. of **Henry Fujioka** who designed parts of fair and "Artist Expresses Fair's Magnitude... He was born in Santa Ana 25 years ago and came with his family to live here when he was in the fourth grade. ... Fujioka's art stems from his early work in elementary school and at Santa Maria high school. After graduation in 1954, he went to the California College of Arts and Crafts in Oakland. There he completed a four-years course in three and one-half years, receiving a degree as bachelor of fine arts. As a specialist in oils, with landscapes as his major interest, Henry studied the works of a 19th century expressionist, Emil Nolde of Germany. He wrote a thesis on the German painter, thereby gaining a master's degree. Studies in New York. Last year Fujioka was granted a $2,500 'opportunity fellowship' grant from the John Hayes Whitney foundation. He went to New York and studied there for ten months, returning to Santa Maria in June. With the fair work finished, Henry is helping his father Karl harvest strawberries at their Orcutt farm...," *SMT*, July 20, 1960, p. 40 (i.e., 24-B).

Fujioka, Henry (notices in Northern Santa Barbara County newspapers on microfilm and on newspapers.com)
1954 – "High School Students Training as Teachers… Henry Fujioka, a high school senior who is observing the teaching of **Miss Edna Davidson** twice a week in her El Camino art class, confided that he intended to go to the California College of Arts and Crafts at Oakland with a teaching career in mind…," *SMT*, Feb. 16, 1954, p. 1; port., *SMT*, Feb. 27, 1954, p. 5; port. picking strawberries, *SMT*, June 26, 1954, p. 5.
1957 – "Wins School Award" i.e., scholarship to California College of Arts and Crafts, Oakland, "While in high school he received several awards for his artistic talents including a Bank of America Achievement Award and a National Scholastic Art Award. At the California College of Arts and Crafts he is majoring in Painting and Sculpture and is working towards the degree of Bachelor of Fine Arts," *SMT*, Jan. 12, 1957, p. 4.
1959 – "Henry Fujioka, a 1954 graduate of Santa Maria High School, has been awarded the John Whitney Fellowship Award from the College of Arts and Crafts of Oakland… While studying under **[George] Muro** at the high school, Fujioka won in the Scholastic Arts Award program conducted at Bullocks in Los Angeles. He has received tuition scholarships for each of his four college years. The Whitney grant will allow Fujioka to continue his art studies in New York," per "Local Man Wins Art Fellowship," *SMT,* June 16, 1959, p. 2.
1961 – "Local Soldiers Participate in Exercises. Fort Lewis, Wash. … Pvt. Henry T. Fujioka… participating with other personnel from the 2nd Engineer Amphibious Support Command in Exercise Seahorse, a joint Army-Marine amphibious training exercise at Camp Pendleton… Fujioka, son of Mr. and Mrs. Kaku Fujioka, 809 Manda Ct., is assigned to the command's 793d Engineer Amphibious Company at Fort Lewis. He entered the Army last September and completed basic training at Fort Ord …," *SMT*, Feb. 18, 1961, p. 4.
1963 – "Gump's Gallery, 250 Post: Paintings by Taisuke Hamada, Henry Fujioka (January)," *Oakland Tribune*, Jan. 27, 1963, p. 82 (i.e., EL-8).
1965 – Repro: "Rooftops and Yellow Grass" – "impulsive landscape impression… in his one-man show at the Van Maanen Gallery, 1931 Union. Once influenced by Van Gogh, Fujioka's sensitive, lively talent also has produced quieter romantic oils and drawings and others that have Orientally delicate brush-writing," *SF Examiner*, March 28, 1965, p. 235 (i.e., *Show Time*, p. 19).
1972 – "Works by Artist Henry Fujioka," i.e., OMS at **Allan Hancock College Art Gallery**. "He has exhibited at the Bakersfield Art Museum, Oakland Art Museum, San Francisco Museum of Art, **Gumps** Gallery in San Francisco and many others. He has had one-man shows at **Gumps** Gallery and Van Maanen Gallery, both in San Francisco. His collections have also been presented at the California State Fair…," *SMT*, Feb. 7, 1972, p. 5.
1980 – "Art Show – four painters. 'Fujioka, Herman, Rivera and Rodrigues' … exploring the realism of Abstract Expressionism… Fujioka… has worked in California all his life and shown both in galleries and museums throughout the Bay Area. Inspired by forms in nature, he incorporates these images into his drawings and paintings

alluding to the original subjects only in spirit … Center for the Visual Arts … Oakland," *Berkeley Gazette*, June 17, 1980, p. 18.
2009 – Port. and "Henry Tetsuo Fujioka … was born on May 15, 1935 in Santa Ana, Ca. and passed away on August 23, 2009. He resided in San Francisco and Oakland… My glass was always half full and my life was beautiful. Now, the sky is my canvas!," *SMT*, Sept. 6, 2009, p. B3.
Fujioka, Henry (bibliography)
In exh.: *Color and scale: eight contemporary California painters* : [Exhibition] March 9 through April 4, 1971, the Oakland Museum, Oakland, California; several refs on Internet to OMS but no extended bio.
Fujioka, Henry (misc. bibliography)
Port. of Henry Fujioka in the Santa Maria High School yearbook, 1953, 1954 (refs. ancestry.com).
See: "Halloween Window Decorating Contest (Santa Maria)," 1953, "Santa Barbara County Fair," 1960, "Santa Barbara County Library (Santa Maria)," 1952, "Santa Maria, Ca., Union High School," 1952, 1954, "Scholastic Art Exhibit," 1954

Fukuda, Keichi (Japan)
Japanese artist who exh. paintings in Guadalupe, 1934.
■ "Fukuda Exhibition of Valuable Paintings… 50 paintings under auspices of the Japanese Association of Santa Maria Valley. Historical figures, including warriors of many centuries ago, priests, princes and princesses… intricate, delicate coloring, finely patterned figured clothing, landscape scenes and an intensely faithful representation of facial characteristic… almost photographically… Native birds… love for flowers… Tiny children… Painstaking work of more than a year was lavished on each of three large pictures. Ornate costumes of the eras depicted… Three times Fukuda's paintings have been awarded signal distinction in his country… Fukuda is a young man, in his thirties. Gracious, self-effacing but with deep, piercing eyes and delicate artistic hands…," *SMT*, June 28, 1934, p. 2.
Fukuda, Keichi (notices in Northern Santa Barbara County newspapers on microfilm and on newspapers.com)
1934 – "Fukuda Will Speak at Exhibit. The Japan Society will present the paintings of Keichi Fukuda… at the Fairmont Hotel on Tuesday and Wednesday… and evenings beginning at 8 o'clock when a talk will be given by the artist himself. … The artist's works have won the distinction of being awarded three times the 'Special Choice' prize at the exhibitions of the Imperial Academy of Art. The Academy Exhibitions, or the 'Telten,' are the only art exhibitions in Japan held under the management of the Government. … Fukuda's works have been accepted by the Academy annually since 1923…," *San Francisco Examiner*, May 6, 1934, p. 29 (i.e., E-9).

Fukuto, S. (Guadalupe)
Farmer. Exh. sculpted vegetables at Santa Barbara County Fair, 1929.
This individual could not be more fully identified.
See: "Santa Barbara County Fair," 1929

Fuller, Bina Louise (Mrs. George L. Fuller) (1878-1957) (Santa Maria)
Principal of Blochman School. Conceived the idea of "Blochman City," 1931.

■ " 'Blochman City' Originator Bina L. Fuller Resigns," and article reads, "Mrs. Fuller, who started her teaching in the east, came to California in 1912, from Frewsburg, N.Y. In her earliest teaching days, Mrs. Fuller was an advocate of learning by doing. … So, in 1931, 'Blochman City' grew, where only Blochman rural school had been before. The children leveled off the property, laid out six streets, which they named, and built ten buildings. These buildings are the model home, bank, florist shop, health center, information bureau, general store, museum, post office, primary grades building and library. Each building is ten by 12 feet. The streets are 16 feet wide. … Paint concerns, seed companies, oil companies, contributed in some way, if not at first, then at later times, in various projects. A mayor and various other officials, chamber of commerce, fire and police departments, were elected, and ran the 'city' through the school year. In the museum are fine pictures, contributed by interested persons, and there are souvenir museum pieces from all over the world. … Soon an illustrated article on Blochman School and its originator will appear in the *Saturday Evening Post* as told by Mrs. Fuller to Dean Jennings, prominent magazine writer," *SMT,* July 1, 1946, p. 4.

■ "Government of the children, by the children and for the children. That was the educational philosophy supported by Mrs. Bina Fuller, former Santa Maria high school trustee, who died in front of her home here Wednesday. … pupil-built town of Blochman City which was inspired by Mrs. Fuller back in 1931. … The student city, which covered an area of 20,000 square feet, was torn down nearly five years ago, almost two years after the Blochman school was unionized and a new school constructed in Sisquoc. An oil gusher in Cat Canyon on land owned by Leo Blochman led to a sudden influx of population and establishment of the small school district with a two-room schoolhouse in the early 1900s. Mrs. Fuller spent more than 25 years of her life teaching in that tiny schoolhouse. But it was Blochman City itself which was to bring her world-wide recognition as an educator. … On land donated by John Williamson, president of the Palmer Stendel Oil Co., the students laid out a city plan …" *SMT,* Nov. 2, 1957, p. 4.

Fuller, Bina (notices in Northern Santa Barbara County newspapers on microfilm and on newspapers.com)
1946 – Photo of Blochman school, *SMT,* July 9, 1946, p. 3.
1951 – Port of Mrs. Fuller and photo of city and "School-Ma'am's Original Miniature City Subject of World-Wide Publicity," *SMT,* Sept. 21, 1951, p. 8; "Blochman Days Recalled, Tea Honors Mrs. Fuller," by Soroptimists, *SMT,* Sept. 24, 1951, p. 4; port. receiving honorary life membership in Soroptimist Club, *SMT,* Sept. 28, 1951, p. 4.
1957 – Port. of teacher with model home in Blochman City, *SMT,* Nov. 2, 1957, p. 4.
Fuller, Bina (misc. bibliography)
Bina Louise Fuller b. Nov. 9, 1878 in Maryland, d. Oct. 30, 1957 in Santa Barbara County and is buried in Santa Maria Cemetery District per findagrave.com (refs. ancestry.com).

See: "Blochman City," "Blochman School," "Santa Maria, Ca., Elementary Schools," 1936, 1940

Fuller's (Santa Maria)
Retailer of unfinished picture frames, 1954.
1954 – "Now… you can select from a wide variety of Unfinished Picture Frames. Come in today and select any kind and any size unfinished picture frame for your home or office… Easy to finish in your choice of color, to match the interior. They're so inexpensive, you'll be amazed. Fuller's. 'Your Complete Office Supplier,' 123 East Church St.," *SMT,* March 12, 1954, p. 6.

Fumasi, Eddie Lee (1942-?) (Lompoc)
Artist. Lompoc High School grad '61 who majored in art at Foothill College near SF, 1961. Registrar of the Weisman art collection in LA, c. 1987-94. Easel painter in retirement.
[Do not confuse with Edward Pearson Fumasi, his father?]
Fumasi, Eddie (notices in California newspapers on microfilm and on newspapers.com)
1953 – Port. with his winning poster in contest sponsored by Lompoc Community Concert Association, *LR,* Nov. 12, 1953, p. 4.
1961 – Port. with women modeling antique dresses, *LR,* April 27, 1961, p. 24 (i.e., 8c); port. as member of high school Art Club, *LR,* May 4, 1961, p. 20 (i.e., 4c); "College Life Rough … An art major at the new Foothill College near San Francisco [i.e., Los Altos] is Eddie Fumasi – who really likes the new campus…," *LR,* Dec. 21, 1961, p. 31 (i.e., 3-D?).
1987 – Eddie Fumasi is registrar of the Weisman Collection per *LA Times Magazine,* Dec. 20, 1987, p. 15, col. 2.
1994 – "Weisman: Noted Art Connoisseur… Eddie Fumasi, curator of the Frederick R. Weisman Art Foundation…," *LA Times,* Sept. 13, 1994, p. 28 (i.e., A-28).
2007 – "Eddie Fumasi Art Exhibit… 300 pieces of his work at the College of the Canyons Art Gallery through Dec. 15…," *The Signal* (Santa Clarita, Ca.), Dec. 11, 2007, p. 8, col. 2.
Fumasi, Eddie (misc. bibliography)
Eddie Lee Fumasi, mother's maiden name Rizzoli, was b. June 25, 1942 in Santa Barbara County per Calif. Birth Index; Eddie Fumasi appears in the Lompoc High School yearbook, 1958, 1959; Eddie L. Fumasi, student, is listed in the *Santa Barbara, Ca., CD,* 1965; Eddie Lee Fumasi b. June 25, 1942, was residing in Los Angeles in 1993 per *U. S. Public Records Index, 1950-1993,* vol. 1 (refs. ancestry.com).

Fun Club (of the YMCA) (Santa Maria)
Crafts workshop and sports program of the Young Men's Christian Association, held Saturday mornings, for boys of the 4th, 5th and 6th grades, 1951+.

■ "The Fun club of the YMCA in Santa Maria was started in October of 1951 to give the boys of the 4th, 5th and 6th grade a varied activity program on Saturday mornings at the YMCA clubhouse at 701 N. Broadway. The clubhouse was fixed up and arranged so that the kitchen became a craft shop as did the hallway; the main room was turned into a large game room on Saturday mornings as well as a movie theater for the last hour of the morning program. The yard outside of the clubhouse was cleaned up and a lawn planted in front and the sides and the back leveled for playing areas. After all of this was accomplished, the fun club was opened to registration from eligible boys at a minimum cost of $1 per quarter as an activity fee to cover all costs except that of materials used in crafts. Club leaders who have been with the club from the start are William Pike and Carl Nielsen. While the club was started on an experimental basis for one quarter, the response to a questionnaire at the end of the first quarter was so good that it was decided to continue the fun club as long as funds are available. Funds to support the fun club come from the Santa Maria YMCA Board of Governors and the Y's Men's club. The Santa Maria YMCA is a member agency of the Santa Maria Valley Youth Fund. … The craft shop provides equipment and materials for many different types of crafts for the boys according to their level of skill. Some of the various things that the boys have been working on include plaster casting, gimp lacing, bead work, wood burning, model making, plastic rings and assorted wood work. All of the projects are as inexpensive as possible but still provide real work and skill to complete them…," and ports. of children as well as leaders, per "Popular with 4th, 5th, and 6th Graders," *SMT*, March 4, 1952, p. 8.

Fun Club (notices in Northern Santa Barbara County newspapers on microfilm and on newspapers.com)
1951 – "Y Fun Club Set to Start Saturday… with a program of games, crafts and movies…," *SMT*, Oct. 3, 1951, p. 4.
1952 – "Fun Club Opens Saturday," *SMT*, Jan. 8, 1952, p. 3; "Fun Club to be Held by YMCA Again," *SMT*, Sept. 24, 1952, p. 1.
1954 – Photo of boys making crafts at Fun Club, *SMT*, Jan. 7, 1954, p. 1; "Y Boys to See Film… Saturday morning… outdoor games, craft and wood-carving will occupy the first half of the period," *SMT*, Feb. 5, 1954, p. 1.
1957 – "YMCA Fund Drive On… The program now includes … Fun club…," *SMT*, Nov. 12, 1957, p. 6.
And, many additional notices on the "Fun Club" were not itemized here.
See: "Young Men's Christian Association"

G

Gaddis, Marilyn Jean
See: "Tyler (Gaddis), Marilyn Jean (Mrs. Lucius Wesley Gaddis)"

Gage, Merrell (1892-1981) (Los Angeles)
Sculptor who spoke to the Minerva Club in 1941. Exhibited a painting he made in the "Valley," 1949. Gave a lecture / demonstration on the modeling of the head of Lincoln, 1950.

■ "Robert Merrell Gage (December 26, 1892 – October 30, 1981) was an American sculptor frequently credited or referred to as Merrell Gage." from Wikipedia, that cites several references including the Gage papers at the Archives of American Art, Washington, D.C.
Gage, Merrell (notices in Northern Santa Barbara County newspapers on microfilm and on newspapers.com)
1949 – "Valley Scenes Part of Display of Art Work at Feather Hollow. …a water color exhibit by Merrell Gage and Marian Morro … at Orchard House on Feather Hollow Ranch is of seven water colors of which two, one by each of the artists, was painted in the Valley. The two Valley pictures are 'View of Ballard,' by Marian Morrow Gage, and 'Misty Santa Ynez Mornings,' by Merrell Gage. Other pictures in the exhibit include 'Coast Line,' 'La Jolla,' and 'Taos Rancho' by Merrell Gage, and 'Spring Morning,' 'After the Shower,' and 'Byways in Taos,' by Marian Morrow Gage. Merrell Gage is perhaps best known as a sculptor and teacher of sculpture at the University of California… His monumental sculptures include 'Seated Lincoln' and 'Pioneer Mother,' both on the State Capitol Grounds, Topeka, Kan., 'Police Monument' and 'American Legion Fountain,' Kansas City, 'Electric Fountain,' Beverly Hills. He has ornamented many west coast office buildings, schools, and churches with his architectural sculpture. For many years he has been a student of Lincoln. His lecture on Lincoln in which he molds the martyred president's features from youth to age as the audience watches has been given throughout the country. **Mrs. Gage**, besides working with her husband at painting, has studied water color with Millard Sheets," *SYVN*, Nov. 11, 1949, p. 5.
1950 – "Merrell Gage, Sculptor, to Give Lecture Demonstration Here Jan. 27. Under the sponsorship of all of the mother's clubs of all the grammar schools of the Valley, a lecture demonstration on Lincoln… Friday afternoon, Jan. 27, at 2 o'clock at the Veterans' Memorial building in Solvang… he models from a mass of clay the features of young Lincoln" and discusses Lincoln's life, *SYVN*, Jan. 20, 1950, p. 5.
1965 – "Face of Jesus Film Showing Slated Sept. 30… black and white… the film made by the sculptor Merrell Gage who is professor emeritus of sculpture at USC. The sculptured head undergoes maturing changes as the artist tells the story as his fingers work. The artist appeared in person in the Valley about 15 years ago when he talked at Veterans Memorial Building while modeling the head of Lincoln," *SYVN*, Sept. 9, 1965, p. 10.
And for additional bibliography, see: *Publications in California Art*, several volumes.
See: "Minerva Club," 1941, "Santa Ynez Valley, Ca., Elementary / Grammar Schools," 1950

Gaggs, Margerite / Margaret (Mrs. Harold Urquart Gaggs) (Lompoc)
Judge of Poppy posters, 1938. Member of Art Section of Alpha Club, 1941-42.
See: "Alpha Club," 1941, 1942, "Posters, American Legion (Poppy) (Lompoc)," 1938

Gaiety Theater / Theatre (Santa Maria)
Theater that showed films (both made in Hollywood as well as by local amateurs). Venue for Vaudeville chalk talk artists. Its live theatre employed set designers, etc.

■ Photo of 30-year-old painted asbestos curtain in Gaiety theater and "Final Curtain for Famed Gaiety ... Opening June 4, 1910 as Dale's theatre, the Gaiety began its heyday as queen of vaudeville in 1919 when **Harry Dorsey** took over as manager. 'We were one of five theatres on the circuit which played to vaudeville and road shows... The others were Santa Barbara, San Luis Obispo (Elmo theatre), San Jose and Salinas' ... played to the movie crowd daily and had vaudeville performances each Saturday night... 'But talkies killed vaudeville and left us with just another movie theatre,' Dorsey said... Until construction of the high school auditorium in 1922, Santa Maria high graduating classes received their diplomas in the Gaiety. Majority of the senior plays in the early 1900s were also presented on the Gaiety's stage... The asbestos curtain which hung from the Gaiety stage when remodeling began, is estimated to be nearly 30 years old... The Gaiety closed out its screen career in 1948...," *SMT,* April 28, 1954, p. 3.
Gaiety (notices in Northern Santa Barbara County newspapers on microfilm and on newspapers.com)
1916 – "Gaiety Theatre Re-Opens... the interior has been completely transformed by Contractor **McBride**... The ceiling has been sized and tinted with calcimine, the walls papered, and all the woodwork painted to harmonize. The lobby has been finished in ivory enamel and neat easels [sic.] and frames will display the lobby advertising ... a handsome electric sign...," *SMT,* Oct. 21, 1916, p. 8.
And, hundreds of notices in the *SMT,* 1910-1954, concerning live plays (necessitating artist-created sets) that were presented there, were not itemized here.
See: "Chalk Talks," 1914, 1926, 1928, "Louise Studio," 1921, "McGuire, Neil," "Photography, general (Santa Maria)," 1923

Galbraith (Mintz), Joanne Elaine (Mrs. Jon S. Mintz) (1929-?) (Lompoc)
Lompoc High School student who was a winner in the National Scholastic Art Competition, 1947. Art editor for Lompoc High School yearbook, 1947. Taught crafts at summer school, 1949.
■ "Lompoc Girl's Art chosen... The scholarship portfolio submitted by Joanne Galbraith, daughter of Mr. and Mrs. D. D. Galbraith, has been chosen one of the 13 entries to represent Southern California in the National Scholastic Art Awards competition at the Carnegie Institute in Pittsburgh, Pa. Miss Galbraith's art work was the only entry from the tri-county area to survive the Southern California regional [**Scholastic Art Exhibit**] ...," *LR,* March 27, 1947, p. 8.

Galbraith, Joanne (misc. bibliography)
Port and "Assistant Art Editor" in Lompoc High School yearbook, 1946; port. in Lompoc High School yearbook, 1947; Joanne E. Galbraith married Jon S. Mintz on June 27, 1952 in Santa Barbara County per Calif. Marriage Index; Joanne E. Mintz b. Dec. 19, 1929, was residing in Anderson, Ca., in 1981 per *U. S. Public Records Index, 1950-1993,* vol. 1 and at a later date, vol. 2 [ed. Anderson is 10 miles S of Redding in Shasta County] (refs. ancestry.com).
See: "Lompoc, Ca., Union High School," 1947, "Summer School (Lompoc)," 1949

Gamble, John M. (1863-1957) (Santa Barbara)
Painted landscapes of northern Santa Barbara county at various times. Exh. first annual Santa Ynez Valley Art Exhibit, 1953.

■ "Landscape painter specializing in fields of flowers. Gamble came to California in 1883. He studied at the San Francisco School of Design and in Paris at the Academie Julian and the ateliers of Jean Paul Laurens and Benjamin Constant. Although he maintained a studio in San Francisco which was burned with its contents in the fire of 1906, most of his career was spent in Santa Barbara," and extensive bibliography in Nancy Moure, "Dictionary of Art and Artists in Southern California Before 1930," *PSCA,* vol. 3.
Gamble, John M. (notices in Northern Santa Barbara County newspapers on microfilm and on newspapers.com)
1914 – "John W. Gamble of Santa Barbara was a guest this week at the Hotel Arthur.... Mr. Gamble expressed delight with the scenery hereabouts and declared his intention of returning to Lompoc someday for the purpose of making sketches," *LR,* May 15, 1914, p. 5, col. 1.
1932 – "John Gamble, the artist, and two of his friends from Santa Barbara, are enjoying the hospitality of **E. B. Davison** on the reserve this week," *SYVN,* July 8, 1932, p. 2.
1934 – "John Gamble, artist of Santa Barbara, visited Ballard friends on Saturday," *SYVN,* Nov. 9, 1934, p. 1.
1936 – "Pickups... Easter... All hotels were crowded Saturday night with persons bound for the native flower fields... John M. Gamble, noted painter of California wild flowers, was here yesterday afternoon inspecting the flower fields for good spots to paint but found few where there were sufficient quantities of flowers. Mr. Gamble is being honored by the directors of the **Faulkner** gallery in Santa Barbara with a showing of some 35 of his paintings... for the first time Mr. Gamble is exhibiting some of his small pieces of sculpture," *SMT,* April 13, 1936, p. 1.
1940 – "Comments... Only the trees in Santa Maria valley prevent sandstorms such as used to prevail here when old timers assert the grit blown against new paint often damaged it severely... story told by artist John M. Gamble... Coming up from Imperial valley, he encountered a high wind near Palm Springs that blew pebbles so hard against his car that they cut all the paint off the hood and 'ground' the glass of the windshield to the extent that he had to replace it...," *SMT,* Jan. 15, 1940, p. 1; "Comments ... G. A. Martin... [California poppies] ... not exclusively a California flower ... I have a painting of a fine field of

them made within ten miles of El Paso by John M. Gamble… a Christmas present he remembered me with some year ago after a tour of my native state painting the blue bonnets and prairie verbenas …," *SMT*, Feb. 28, 1940, p. 1.

See: "Art, general (Santa Barbara)," 1908, "Art Loan Exhibit (Solvang)," 1935, "College Art Club," 1935, "Santa Ynez Valley Art Exhibit," 1953, "Vaughan, Edson," 1936

Gardner, Loris Mansfield (1904-1984) (Solvang)
Photographer. Purchased Atterdag Studio from Hans Sorensen, 1959, and renamed it Solvang Studio. Sold Solvang Studio to George Ives, c. 1963.

■ "Loris Gardner… professional photographer, who died July 9 at his home in Los Osos after a long illness. Born Sept. 29, 1904 in Lucas, Kan., Mr. Gardner attended San Jose State University and worked for the *San Jose Mercury-Herald* for 10 years. After 12 years as head of a documentary photography research project in Los Alamos, N. M., he operated a photo studio in Solvang for 14 years. His wife, Virginia, who survives, was a teacher at Ballard and Jonata Elementary Schools, while they lived in the Valley. Mr. Gardner was a member of the Santa Ynez Valley Rotary and moved to Los Osos from the Valley upon his retirement…," *SYVN*, July 19, 1984, p. 8.

Gardner, Loris (notices in Northern Santa Barbara County newspapers on microfilm and on newspapers.com)
1959 – "Gardner Opens Photographic Studio here. Loris M. Gardner, who has had 35 years experience as a photographer, announced today the opening of his **Solvang Studio** at 513 Atterdag Road in Solvang. Gardner has purchased the photographic studio of **Hans Sorensen**. During his years as a photographer, he has had experience in various photographic fields, including newspaper, industrial, scientific and portrait. At his Solvang Studio, Gardner will specialize in commercial and portrait work and will also offer a picture framing and mounting service. Gardner comes to the Valley from Oxnard where his wife, Virginia, is an elementary school teacher, and his daughter, Katherine, 16, is a junior in high school. At the end of the school year, Gardner's wife and daughter will join him in Solvang," *SYVN*, Oct. 9, 1959, p. 1.
1960 – Ad: "Photographic Copying. Reproduction of Old Pictures, Documents, etc. Loris Gardner's Solvang Studio. 513 Atterdag Road – Phone SY 8-3861," *SYVN*, Feb. 19, 1960, p. 7.
And, more than 536 wedding photos taken by him appear in the *SYVN*, 1955-1984, but were not itemized here.
Gardner, Loris (misc. bibliography)
Loris Mansfield Gardner was b. Sept. 29, 1904 in Lucas, Kan., to Edgar Nathaniel Gardner and Rosalie Mansfield, married Virginia W. Vickers, was residing in San Jose, Ca., in 1940, and d. July 9, 1984 in Los Osos, Ca., per Stendal Family Tree; Loris Mansfield Gardner is buried in Los Osos Valley Memorial Park per findagrave.com (refs. ancestry.com).

Gardner, Margaret K. "Peggy" / "Peggie" Orton (Mrs. Mark de Forrest Orton) (Mrs. John B. Gardner) (1904-2002) (G-K Ranch, Buellton)
Photographer (amateur). Exh. Santa Ynez Valley Art Exhibit, 1954, 1955. Owner of colored films of rodeos, 1949. Mother of Xandra Orton, below.

■ Port. and "Peggy Gardner… Born in St. Paul, Minn. on Aug. 22, 1904, she died at her Buellton ranch on Thursday, Feb. 21. She married Mark de Forrest Orton in the late 1920s, with whom she had two children, Mark, Jr. and Xandra. She was widowed in 1938. After moving to Beverly Hills, she married John Gardner and gave birth to son Slick Gardner. In 1948, the family bought the Pillsbury Ranch in Buellton, renaming it the GK Gardner Ranch. Activities at the ranch included raising cattle and quarter horses, with branding parties and public racing on their horse track. Following a separation, Mrs. Gardner began raising and breeding thoroughbreds, … She was also active in preserving the Santa Ynez Valley until the 1990s…," *SYVN*, Feb. 28, 2002, p. 6.
Gardner, Peggy (notices in Northern Santa Barbara County newspapers on microfilm and on newspapers.com)
2002 – "Peggie Gardner… A memorial Mass will be held… at the Old Mission, Santa Ines… She died Thursday, Feb. 21, 2002, at her ranch in Buellton. She is survived by her three children, Mark Orton, **Xandra Calandri**, and Slick Gardner…," *LR*, Feb. 24, 2002, p. 2.
And, more than 100 hits for "Peggy Gardner" in the *SYVN* relating to land conservation, to her ranch (located between Buellton and Solvang), to raising race horses, to politics and to ballroom dancing, not itemized here. And 25 matches for "Peggy Gardner" in the *LR* 1948-2002, not itemized here.
Gardner, Peggy (misc. bibliography)
Margaret V. Gardner was b. Aug. 22, 1904 and d. Feb. 21, 2002 per Social Security Death Index (refs. ancestry.com).
See: "Orton, Xandra," "Santa Ynez Valley Art Exhibit," 1954, 1955, "Santa Ynez Valley, Ca., Elementary / grammar schools," 1949

Garey, Grace S. (1884-1983) (Solvang)
Teacher of home economics and freehand drawing at Santa Ynez Valley Union High School, 1929-32.

■ "High School Opens… domestic and commercial… Miss Garey is a graduate of the University of Nebraska and has had seven years of experience in teaching in Nebraska and Wyoming and was home demonstration agent in Carbon county, Montana," *SYVN*, Aug. 9, 1929, p. 1.
Garey, Grace (notices in Northern Santa Barbara County newspapers on microfilm and on newspapers.com)
1929 – "Miss Mabel Bay and Miss Grace Garey, teachers of the high school who attended teacher's institute in Santa Barbara this week, have left for the south where… Miss Garey will spend the holidays at the home of her brother [Myron] in Los Angeles," *SYVN*, Dec. 20, 1929, p. 5.
1930 – "Miss Grace Garey, walking the three miles from Solvang to the High School every school morning in the week," *SYVN*, Sept. 19, 1930, p. 5, col. 4.
1932 – "Miss Grace Garey Resigns… plans to leave at the close of the school term for her old home in Nebraska. Her brother, who is a teacher in the University of Minnesota,

and his family, will meet her there and they plan to spend the summer traveling," *SYVN*, April 22, 1932, p. 1; "Miss Grace Garey... now in charge of the home economics department in a training school in San Francisco...," *SYVN*, Dec. 16, 1932, p. 2.

And more than 60 "hits" for "Grace Garey" in the *SYVN* between 1929 and 1932 most of which were not itemized here.

Garey, Grace (misc. bibliography)

Miss Grace S. Garey, teacher, Rep., is listed in *Calif. Voter Registrations, Santa Barbara County, Solvang Precinct*, 1930-32; Grace S. Garey was b. Nov. 12, 1884 in Furnas, Neb., to Robert Shoemaker Garey and Cathron Sally Farr, was residing in Furnas, Neb., in 1910, and d. Dec. 13, 1983 in Beaver City, Neb., on Dec. 13, 1983 per Murphy Family Tree (refs. ancestry.com).

See: "Better Homes Exhibit," 1931, "Santa Ynez Valley Fair," 1930, "Santa Ynez Valley Union High School," 1931, 1932

Garnsey, Elmer Ellsworth (1862-1946) (Santa Barbara / New York)

East Coast muralist who resided in Santa Barbara c. 1930-1945. Exh. Hawaiian paintings in a show of Santa Barbara artists sponsored by the College Art Club at city hall, Santa Maria, 1935.

■ "Elmer Ellsworth Garnsey, decorative painter, whose work is to be found in many important public buildings and private residences, died Saturday, October 26, in Atlantic City, at the age of 84. Born at Holmdel, a son of John C. Garnsey and the former Louisa J. Fenton, Mr. Garnsey studied art at the Cooper Institute and the Art Students League, New York, his principal masters having been George W. Maynard and Francis Lathrop. In 1893 Mr. Garnsey received a bronze medal as one of the designers of the Chicago Exposition of that year. He won a silver medal and honorable mention for his decoration of the United States Pavilion at the Paris Exposition of 1900. Mr. Garnsey carried out the general decoration of the Library of Congress, Boston Public Library, Rhode Island State House, Carnegie Institute in Pittsburgh, New York Stock Exchange, University and Union clubs, New York; Columbia University Library, Minnesota, [the] Iowa and Wisconsin State Capitols, [the] St. Louis Public Library, [the] United States Custom House and the Andrew Carnegie residence, New York. An honorary member of the American Institute of Architects and a charter member of the American Academy in Rome, Mr. Garnsey also belonged to the National Society of Mural Painters and the Century Association, New York. He leaves a widow, who was Laurada Davis at their marriage ... and a son, Julian E. Garnsey of Princeton," *Daily Register* (Red Bank, N. J.), Nov. 7, 1946, p. 32 (i.e., Six).

Garnsey, E. E. (notices in American newspapers on newspapers.com)

1904 – "Famous Artist Sought... Des Moines... An effort will be made by the Capitol improvement commission to secure the services of Elmer E. Garnsey of New York to decorate the capitol. Mr. Garnsey is now engaged in decorating the new capital of Minnesota at St. Paul...,"

Evening Times-Republican (Marshalltown, Iowa), Aug. 15, 1904, p. 2.

1927 – Port. with artist son, Julian E. Garnsey, aboard the *City of Los Angeles*, as they arrive in Honolulu. Son, "Julian Garnsey did the mural decorations in the new Bank of Hawaii building and is back to decorate the new Hawaiian Electric Co. structure. His father, Elmer E. Garnsey, is a well-known landscape and marine artist," *Honolulu Star-Bulletin*, April 4, 1927, p. 27 (i.e., 13); "An Artist Goes Visiting in South America" and repro of two sketches and review of his show at Honolulu Academy of Arts, and description of his journey, *Honolulu Advertiser*, May 6, 1927, p. 5; "Farewell showing of Garnsey paintings. Paintings by Elmer E. Garnsey, landscape painter who has been visiting Honolulu for some weeks, are being shown for 10 days only, closing Friday, May 27, at the Art Shop in Union St. Garnsey is leaving for New York on June 1. Garnsey's paintings have been reviewed at some length in previous issues of *The Star-Bulletin*, during their showing at the Academy of Arts. They are mainly tropical scenes – India, Indo-China, Central and South America, and Hawaiian subjects, in a treatment characterized by a glow or 'bloom' of color, a misty atmosphere, a feeling of the locality, and impressiveness of height and depth in mountain and sea scenes...," *Honolulu Star-Bulletin*, May 21, 1927, p. 54 (i.e., TEN).

More than 870 notices for "E. Garnsey" appear in American newspapers between 1900 and 1935 but were not itemized here.

Repro: several murals on the ceiling of the Library of Congress, Washington, D. C. and in the Federal Complex, Erie, Pa., appear on commons.wikimedia.org; "1899 Erie Library Murals Conservation," appears on mckaylodge.com/1899-erie-library-murals-paintings-sculpture-preserved-new-u-s-courthouse/.

Garnsey, E. E. (misc. bibliography)

Elmer E. Garnsey is listed in the 1930 U. S. Census as age 68, b. c. 1862 in New Jersey, an artist in the printing (?) industry, residing in Santa Barbara with wife Laurada D. Garnsey (age 65); Elmer E. Garnsey, artist, is listed with wife Lurada in the *Santa Barbara, Ca., CD*, 1935, 1936 and with no occupation 1940-43; Elmer E. Garnsey is listed in the 1940 U. S. Census as age 78, finished high school 2nd year, no occupation, residing in Santa Barbara with wife Caurada [Sic.] (refs. ancestry.com).

See: "College Art Club," 1935

Garrison, Elmer (Lompoc)

Teacher of shop classes (carpentry) at Lompoc High School, 1931-40+. Among other things, his students constructed stage sets.

See: "Lompoc, Ca., Union High School," 1931-36

Garsee, Willie Franklin (1916-1988) (Santa Maria)
Barber. Creator of pencil drawings, 1959.

■ "Barbers are noted for their adroit use of a comb and pair of clippers on a customer's head … [and Willie Garsee] at Dan Gerlick's shop at 123 W. Chapel St. is no exception. But Garcee is one barber who applies those dexterous hands in still another way. … in his hobby of pencil drawing. As an artist he's pretty good, too, at least he has a couple of first prizes to show for his work. His tools are a sheaf of cold pressed paper, a drawing board and a couple of exceptionally soft lead pencils. He usually spends his evenings before his drawing board. His specialty: children and animals. When drawing a child, he prefers to copy a photograph rather than to use a live model. 'Children are constantly changing expressions,' he explained. 'It's hard to capture them and besides they don't sit still for very long at a time.' When drawing animals, Garsee prefers a live subject. He can and has drawn almost every kind of animal but specializes in dogs and horses. Sometimes he draws from a mental image. Garsee, a stout, middle aged man, with intense eyes and a friendly voice, enjoys talking about his pencil drawings to anyone who is interested. He remarked that he draws 'just for relaxation' although he does occasionally sell some of his pictures. His hobby is not an expensive one, and he never rushes to get through. He might draw for an hour and, if he feels tired, he'll stop and resume later. 'I've been asked many times why I don't switch to oils, and I've thought about it. It would be a little more expensive, and a lot messier, so I just continue with my pencils' he said. Those pictures he does not sell, he keeps in his trailer home, and a few of the 'better' ones he takes to the barber shop for 'added decoration.' Started in Navy. His favorite drawing is of a little girl brushing the teeth of her bull terrier. He sold this picture to a dentist in Solvang. 'I sure wish I'd kept it,' he said, 'It was the cutest one.' Exactly how does a barber become an artist? Why is it he switches from combs, clippers, and razors to artist's pencils? He explained it all started when he was in the Navy in 1942. 'I'd always been interested in drawing, but never had the time to do any until I got into the Navy,' he said. He found out he was good. So did the other sailors, and suddenly they were swamping him with requests to draw pictures of their wives, sweethearts, or babies. He said that before the war was over, about 50 U. S. ships had drawings on their towers that he 'donated' to them. Garsee took first prize in the drawing division in Kings County Fair in 1955 and the Sacramento County Fair in 1958 for his drawing of a little smiling six year old girl with a huge bow in her hair. He keeps this picture at the barber shop, feeling that he isn't ready to sell it just yet. For several years he entered his pictures in the Businessmen's Art Exhibit in Visalia, he said. Garsee, a native of Visalia, has been in Santa Maria for four months. He lives with his wife Kathryn in a trailer on the Ames Ranch just south of here," and port. with portrait drawing and "Barber's Free Time Devoted to Drawing,' *SMT,* May 19, 1959, p. 12.

Garsee, Willie (misc. bibliography)
Several references to him in Tulare County; Willie F. Garsee, barber, Collegiate Barber Shop, no wife listed, appears in the *Santa Maria, Ca., CD,* 1961, 1965, 1969, 1970; Willie Franklin Garsee was b. March 21, 1916 in Tulare, Ca., to William J. Garsee and Bertha Mae Evans, and d. Feb. 14, 1988 in Eatonville, Washington, per Watkins Family Tree (refs. ancestry.com).

Gatewood, Leander (Santa Maria)
Boy Scout. Handicraft director at Camp Drake for Boy Scouts, 1951, 1952, while attending Santa Maria JC.
See: "Boy Scouts," 1951, 1952

Gaviota, Ca., elementary school
Vista del Mar Grammar School held an Elson exhibit to raise funds, 1927. Part of the Santa Ynez Valley Union High School District (2020).
See: "Santa Ynez Valley, Ca., Elementary / grammar schools"

Gaynos, Loris "Tex" (Mrs. Col. Nick Gaynos) (1922-?) (Santa Maria / Vandenberg)
Flower arranger in the Japanese style.

■ "Loris (Tex) Gaynos, a Santa Maria woman who herself is a talented flower arranger, plans to start attending [**Taro Makimoto**'s] classes. Mrs. Gaynos, wife of a Vandenberg AFB colonel, has the equivalent of nine years of training under Mr. Safu of Tokyo, number one Japanese Ikebana teacher. Along with her certificate to teach Japanese flower arranging she was given the flower name of 'Surian,' or black orchid. After finishing her schooling, while in Japan with her husband, she wrote a correspondence course in Japanese flower arranging. According to the Library of Congress it was the first such work written in English. She has sent graduate certificates all over the world to students who have taken her course and also taught in Washington, D. C. According to her, flower arrangements are often the center of Japanese rooms. Friends arrive and for hours discuss the merits of an arrangement with their host. More advanced students often use nature-sculptured wood, figures, and even candles in their arrangements she said. Many of the Japanese schools even teach flower arranging during students' early years. … soft muted colors are the most popular with more powerful varieties being grown for accent in their arrangements. Both Mrs. Gaynos and **Makimoto** were offered the opportunity to judge certain arrangements at the **Santa Barbara County Fair** here this month. She accepted, but he turned it down for fear he might be prejudiced in favor of those closely approaching Japanese styles," per "Ikebana Taught by Makimoto – Stresses Simplicity, Delicacy," *SMT,* July 20, 1959, p. 3.

Gaynos, Loris (misc. bibliography)
Loris G. Gaynos, b. Arkansas, with address of Bowie, Texas, traveling with children, Scott and Nikki D., sailed from Yokohama, Japan on March 13, 1950 on the *USNS General Simon B. Buckner* and arrived at San Francisco, March 22, 1950 per Calif. Passenger and Crew Lists; Loris Gaynos is listed with husband, Nick, in the *Santa Maria, Ca., CD,* 1958-70; Loris S. Gaynos b. June 14, 1922 was residing in Santa Rosa, Ca., in 1996 per *U. S. Public Records Index, 1950-1993,* vol. 1 (refs. ancestry.com).

Geddis and Martin Puppet Theater (Santa Barbara)
See: "Puppets (Lompoc)"

Gem and Mineral Club (Lompoc)
See: "Lompoc Gem and Mineral Club"

German prisoners of war (Camp Cooke)
See: "Art, general (Camp Cooke/Vandenberg)," "Menezes, Herman"

Gibbs, Frederick "Fred" Richardson (1896-1959) (Santa Maria)
Photographer (amateur). President of and active with the Santa Maria Camera Club, 1953-57+. Husband to Kittye Gibbs, below.

■ "Frederick Gibbs. Funeral services… Mr. Gibbs was a native of Illinois, born on Oct. 1, 1896, at Oak Park, and had resided here the past 14 years, making his home at 671 E. Donovan Road. Surviving is his wife, Mrs. **Kittye Gibbs**… Mr. Gibbs was a member and past president of Santa Maria Camera Club and a member of the Rotary Club at Chula Vista," *SMT*, June 12, 1959, p. 2.
Gibbs, Fred (notices in Northern Santa Barbara County newspapers on microfilm and on newspapers.com)
1955 – Port. with **Ken Prindle** and **Max Deadrick [Sic. Deaderick]**, *SMT*, Jan. 17, 1955, p. 1.
Thirty notices for "Fred Gibbs" in the *SMT*, 1935-59 primarily concern his activities with the Santa Maria Camera Club but were not all itemized here.
Gibbs, Fred (misc. bibliography)
Frederick Richardson Gibbs b. 1896 and d. June 10, 1959 is buried in Santa Maria Cemetery District per findagrave.com (refs. ancestry.com).
See: "Deaderick, Moreland," 1955, "Gibbs, Kittye," "Santa Barbara County Fair," 1958, "Santa Maria Camera Club," 1953-57

Gibbs, Kittye (Mrs. Frederick Richardson Gibbs) (1900-1968) (Santa Maria)
Photographer (amateur). Member Santa Maria Camera Club, c. 1954+. Wife to Fred Gibbs, above.

■ "'Anyone with an interest in photography can find a great deal of information by attending the Santa Maria Camera club according to Mrs. Kittye Gibbs, who was winner of several awards at the club's recent annual meeting. Mrs. Gibbs was high point winner for the year. Comparatively new to color photography, Mrs. Gibbs won first in advanced pictorial class for the year. 'I was most surprised, and almost embarrassed as my name was called for more than one mention, and of course it was gratifying,' Mrs. Gibbs said. She has been active in photography two-and-a-half years, using a Leica camera. She has chosen color rather than black and white, the latter being more difficult in her opinion, especially in the finish processes in which all of the contestants must become proficient. Mrs. Gibbs finds the Camera club a friendly group – enjoyable because of the assignment field trips and social nights.

There is opportunity to learn something at every meeting in associating with those having the same hobby, and there is much to learn on hearing outstanding judges who give helpful criticism out of their experience when the prints and slides are shown at the annual meetings, she said," and port. with **Gaylord Jones**, "Photography is Fun Award Winner Says," *SMT,* Jan. 24, 1956, p. 4.
Gibbs, Kittye (notices in Northern Santa Barbara County newspapers on microfilm and on newspapers.com)
1956 – Port. with **Gaylord Jones** and **George [Sic. Fred] Gibbs**, *SMT*, Jan. 16, 1956, p. 4.
1968 – Obituary, *San Antonio Express* (Tx.), June 12, 1968, p. 21 (i.e., 4-B).
Five hits for "Kittye Gibbs" in the *SMT* between 1935-1960 are probably already cited under the heading "Santa Maria Camera Club."
Gibbs, Kittye (misc. bibliography)
Kittye W. Gibbs is listed in *Delaware Land Records, 1677-1947* as residing in New Castle, 1943; Mrs. Kittye W. Gibbs, secretary at Gibbs Supplies, Inc., and wife of Frederick R. Gibbs, president of Gibbs Supplies, is listed in the *San Diego, Ca., CD*, 1945, 1948; Kittye Gibbs is listed with Frederick R. Gibbs, office worker [at] Floyd V. Wells, in the *Santa Maria, Ca., CD*, 1958; Kittye Gibbs was b. Feb. 16, 1900 in Texas to Thomas Willis and Louella Langtry, and d. on June 10, 1968 in San Antonio, Tx., per Texas Death Certificates (refs. ancestry.com).
See: "Gibbs, Frederick," "Santa Maria Camera Club," 1955, 1956

Gibford, Joanne / JoAnn (San Luis Obispo)
Won "Best Amateur Watercolor" at Santa Barbara County Fair, 1959.
See: "Elks Club – Rodeo," 1957, "Santa Barbara County Fair," 1959, and *San Luis Obispo Art and Photography before 1960*

Gifts at the Inn (Lompoc)
See: "Moselle's Gifts at the Inn"

Gilbert, Richard (Solvang?)
Landscape designer, 1957-58.

■ "Presbyterians Approve Landscape, Building Plan… Santa Ynez Valley Presbyterian Church… Many of the suggestions included in the program and presented the congregation came from Richard Gilbert, landscape artist and a new resident of the valley who is contributing his services to the church…," *SYVN*, Nov. 1, 1957, p. 5.
Gilbert, Richard (notices in Northern Santa Barbara County newspapers on microfilm and on newspapers.com)
1958 – "Notice of Public Sale … will be held at the residence of Mrs. Ruth Parslow Cobb… property hereinafter described owned by Richard Gilbert… to satisfy a debt owned … for rent… books, pictures, architect's tools, folding chairs, drawings and miscellaneous personal items," *SYVN*, Oct. 31, 1958, p. 11.

Gilbert, Rudolph (Santa Barbara)
Curator of the Faulkner Gallery, Santa Barbara, who helped hang the Santa Ynez Valley Art Exhibit, 1956.
See: "Santa Ynez Valley Art Exhibit," 1956

Gilbert, Wendell (Santa Barbara)
Landscape architect who spoke to Minerva Club, 1947.
See: "Minerva Club," 1947

Gill, John W. (1921-1965) (Santa Maria)
Maker of serigraphs. Exh. Allan Hancock [College] Art Gallery, 1958.
■ "Allan Hancock [College] Art Gallery has now on exhibit a collection of colored serigraphs by John W. Gill, member of a Santa Maria valley family. He is the son of Frank Guy Gill, who moved to Orcutt in 1906, establishing the Orcutt Mercantile Company store. Gill's brothers, all of whom were graduated from Santa Maria High School and the University of California are Capt. Frank F. Gill, U. S. Navy, Menlo Park, Harry M. Gill business man and Samuel S. Gill, attorney, Los Angeles, and Carol G. Gill, Lieutenant Commander in the United States Navy... The artist attended Orcutt Grammar school for five years, Berkeley junior and senior high schools, San Francisco State College, where he won his Bachelor of Arts degree, and <u>California College of Arts and Crafts</u>, where he received the Master of Fine Arts Degree. John Gill will teach at College of the Pacific this summer. He has taught in Placer High School and Junior College, in San Francisco City schools and State College and at San Jose. Exhibits of his work have been hung in New York, at the Baltimore Museum of Art, Pittsburgh, Museum at Princeton University, Miami Art Gallery, San Francisco Museum of Art, DeYoung Museum and in Oakland, Richmond and San Jose. The artist is married and is the father of two daughters, Pamela and Katharine. Principal mediums in which he works are watercolor, serigraph, oil and sculpture. The serigraphs shown at Hancock Art Gallery include nine in bright color that range from stylized interpretation of Victorian architecture to complete abstractions. On viewing the silk screen paintings for the first time, George Muro, Santa Maria artist, said the work reveals a high sense of control," per "John Gill Shows Art at [Hancock] Gallery," *SMT*, Feb. 8, 1958, p. 3.
■ "Victim Dies from Smoke Inhalation. Los Gatos. John W. Gill, 44, well-known local artist, died Wednesday of smoke inhalation in his studio at Los Gatos. Gill's body was found in his smoke-filled studio after neighbors smelled smoke and called the fire department. Firemen said Gill may have fallen asleep with a cigarette in his hand. Gill, who ran the Vault, a local art gallery, specialized in water colors, mosaics and silk screens," *The Californian* (Salinas, Ca.), Dec. 30, 1965, p. 2.
<u>Gill, John (misc. bibliography)</u>
John W. Gill is listed in the 1930 U. S. Census as age 9, b. c. 1921 in Calif., residing in Township 10 (Orcutt), with his parents Frank G. Gill (age 51) and Lena L. Gill (age 50) and five older brothers; John William Gill was b. March 10, 1921 in Orcutt to Frank Guy Gill and Lenora Lucretia Fulgham, was residing in Berkeley, Ca., in 1942, married

Aimee Matilda Rauh, and d. Dec. 25, 1965 in San Bruno, Ca., per Shanahan-Gill Family Tree (refs. ancestry.com).
See: "Allan Hancock [College] Art Gallery," 1958

Gilliland, Otho James (1891/2-1948) (Lompoc)
Teacher of manual training at Lompoc high school, 1919-22.
■ "Gilliland to be Athletic Coach at Santa Barbara State Teachers' College... Mr. Gilliland was a student at University of Pennsylvania, a graduate of Stanford University. He played on the U. P. football team and was selected by Walter Camp to play on the All-American team. He was in Germany at the outbreak of the war, having a scholarship to one of the German universities from Stanford. Unable to continue his studies, he crossed to England and serving with the English, received his captain's commission. He was invalided home shortly before the United States entered the war and served in the hospital corps, directing the work of hospital and camp sanitation in several of the receiving camps in this country, and later in the ship yards in a responsible position. At the close of the war he came to Lompoc as manual training and science teacher, and has made remarkable showings as physical director of the boys here ...," *LR*, June 16, 1922, p. 1.
<u>Gilliland, Otho (misc. bibliography)</u>
Otho James Gilliland b. June 19, 1892 in Pennsylvania and d. April 23, 1948 in California is buried in Golden Gate National Cemetery per findagrave.com; Otho James Gilliland b. June 19, 1891 in Orbisonia, Pa., to James Getys Doras Gilliland and Helen Josephine Corbin, was residing in Palo Alto, Ca., in 1914, married Cora Snyder, and d. April 23, 1948 in Calif. per Diggins and Gilliland Family Tree (refs. ancestry.com).
See: "Lompoc, Ca., Union High School," 1919, 1920, 1921

Gillum, Vernal "Vern" Nathan, Jr. (1935-?) (Paradise Camp / Los Angeles)
Santa Ynez Valley High School grad. '53. Commercial artist, 1959. Hollywood TV Producer, c. 1970+.
■ "Vern Gillum is an American television director. After attending <u>California School of Fine Arts</u> and graduating from <u>Art Center School in Los Angeles</u>, He went into advertising at McCann Erickson, LA / NY. Assc. Creative Director, Director of West Coast Production, and was on the special projects creative team for Interpublic's Professional Advisory Board, New York. He later became Creative Director at Carson Roberts / Ogilvy Mather. Following his stint in advertising and prior to 1990 he established Vern Gillum & Friends Inc., where he produced and directed hundreds of commercials (among others, for McDonald's, General Foods, American Express, General Motors, Mattel) and short subjects throughout the US and around the globe, through his offices in Hollywood and New York," and more on Wikipedia.
<u>Gillum, Vernal (notices in Northern Santa Barbara County newspapers on microfilm and on newspapers.com)</u>
1951 – "Election Time at High School... posters and signs... Other posters read 'let's kill 'em' vote for Vernal Gillum for yell leader...," *SYVN*, Sept. 14, 1951, p. 3.

1953 – Port. as HS grad., *SYVN*, June 12, 1953, p. 1.

1959 – "SY High Schoolers Hold Prom Dance... Tropical Paradise... [at the] Veterans Memorial Building... [decorated] under the direction of Vernal Gillum, commercial artist and interior decorator ...," *LR*, May 28, 1959, p. 24, and *SYVN*, May 22, 1959, p. 1.

1961 – "Mogensen-Gillum Vows Said... The bride and groom are both graduates of Santa Ynez Valley Union High School. He also attended art school in San Francisco. ... the couple are making their home at Cachuma Trailer Park. Mr. Gillum is a ranger at Lake Cachuma," *SYVN*, Oct. 20, 1961, p. 6.

1965 – "Vernal Gillum Given Degree... former Valley resident, was graduated from the Art Center in Los Angeles with a Bachelor of Arts degree in advertising art... Gillum is the son of Mr. and Mrs. Vernal Gillum, Sr., of Paradise Camp, and expects to be employed in making film to be shown as television advertising," *SYVN*, Feb. 4, 1965, p. 15 (i.e., 7B).

1974 – Port. with 1953 class reunion, *SYVN*, Nov. 21, 1974, p. 6.

2011 – "Where Films are made ... Vern Gillum, a New Mexico-based TV director whose resume includes work on *Law and Order, Firefly, Miami Vice* and *Angel*, said the geographical disparity is not about disliking the rest of New Mexico. It's about Albuquerque's proximity to a major airport and the fact that the film crews live in that area. It all adds up to cost savings...," *Santa Fe New Mexican*, Feb. 15, 2011, p. A008; and more on filming, *Santa Fe New Mexican*, July 8, 2012, p. A006.

And, more than 50 additional school notices in the *SYVN* not itemized here.

Gillum, Vernal (misc. bibliography)
Vernal Nathan Gillum, mother's maiden name Bebout, was b. Oct. 4, 1935 per Calif. Birth Index; listed in 1940 U. S. Census with parents and sister, Joy Irene; Vern Gillum was residing in Los Angeles in 1986, 1991 and in Van Nuys in 1993 per *U. S. Public Records Index, 1950-1993*, vol. 1; Vernal N. Gillum b. June 15, 1935, was residing in Ribera, N. M., in 1996 per *U. S. Public Records Index, 1950-1993*, vol. 1 (refs. ancestry.com).

See: "Santa Ynez Valley, Ca., Elementary/Grammar Schools," 1948

Gilmore Puppets
See: "Puppets (Santa Maria)," 1954

Giorgi (Brosnan), Margaret Angela (Mrs. Thomas Joseph Brosnan) (1932-1994) (Foxen Canyon)
Santa Maria High School grad., 1949. Art education major at San Jose State College, 1954.

■ Port. and "Single Red Rose Tells Engagement... of Margaret Giorgi to Tom Brosnan. The bride-elect is the daughter of Mr. and Mrs. Natale Giorgi, Jr., of Santa Maria. She attended Santa Maria High School and is now a senior majoring in art education at San Jose State college. She is a member of Alpha Omicron Pi sorority and Delta Phi Delta honorary art fraternity...," *SMT*, March 23, 1954, p. 4; "Angela Giorgi Wedding... The bride ... was graduated with this year's class majoring in education at San Jose State

college... She will teach in Los Gatos University Avenue school after marriage, when the couple will have established residence in the north," *SMT*, Aug. 7, 1954, p. 4.

See: "Santa Maria, Ca., Union High School," 1949

Girl Scouts (including Brownies) (Northern Santa Barbara County)
National organization for girls that included crafts in its program.

Girl Scouts (notices in Northern Santa Barbara County newspapers on microfilm and on newspapers.com)

1946 – "Los Olivos School Notes... The Girl Scouts of the Santa Ynez Valley went to leathercraft class on Thursday, February 28, 1946, at 7:30 p.m. at Santa Ynez High School in the science room. The class is meant for adults, but the leaders said that we could come and get some leather and information since we were going back to Los Olivos school to work. Anna Mahler, the Scout leader, has already made a wallet out of leather and has tools for carving designs. When the Scouts have finished cutting out their designs, they will go back to the class for more material and instruction," *SYVN*, March 8, 1946, p. 10.

1948 – "Scout News... **Ruth Lindegaard** and **Frances Downey** made posters reminding people to register to vote...," *SYVN*, April 23, 1948, p. 6; "Girl Scouts... Troop 5. We are trying to raise money to go to camp... At camp we plan on earning our second class badge, drawing and painting, design and dramatics...," *SYVN*, April 30, 1948, p. 3; "51 From Valley at Girl Scout Camp... craft instructors are: Delores Chapman, Dinia Acquistapace and Vicentacion Abenido, all of Guadalupe and Mrs. **Lenora Anderson** of Santa Ynez," *SYVN*, June 18, 1948, p. 3.

1952 – "Mrs. Hazel Olson, Scout leader and her assistant, Mrs. Ann Jensen, took charge of the two younger groups who made 'Fall Leaf' pictures. These were made by mounting autumn colored leaves on different shades of art paper and covering them with clear cellophane...," per "Brownies Work on Autumn Leaf Prints," *SMT*, Nov. 8, 1952, p. 4; "Puppet Show Part of Program at Yule Party," i.e., presentation by Los Olivos Girl Scouts at Knights of Pythias and Pythian Sisters annual Christmas party at Dania Hall," *SYVN*, Dec. 19, 1952, p. 4.

1954 – "Girl Scout Organizational Tea... **Mr.** and **Mrs. Forrest Hibbits** will present a puppet show for the Brownies...," *SYVN*, April 2, 1954, p. 1.

1956 – "Solvang Girl Scouts ... Philanthropy projects taken on by [Troop No. 1] ... in the past have been making dolls for Korean children... Their handcraft project now, which they work on during troop meetings, is the making of hand puppets, scenery and writing a play which they hope to produce this Spring...," *SYVN*, March 16, 1956, p. 1; photo of girls making spool dolls for children in Korea, *SYVN*, May 4, 1956, p. 3.

1957 – "Ginger Bumann... Brownie Scouts ... Mrs. Hazel Olson and Mrs. Irma Silva supervised the children in the painting of ceramic dishes modelled at the previous meeting...," *SMT*, March 8, 1957, p. 8.

1959 – "Puppets, Pillows Made by Brownies," *SMT*, May 26, 1959, p. 11.

1960 – "Girl Scouts Prepare Activity for … Girl Scout Week … March 11 is Arts and Crafts Day. Girls of the various troops will work on decorated shoe boxes to be used Saturday to carry lunches to the Saturday 'birthday' party at Elementary School cafeteria," *LR*, March 3, 1960, p. 10; "Brownies Complete Work in Ceramics. Brownie Troops 159 and 163 recently completed their ceramic work under the instruction of **Fillmore Condit** at the Santa Ynez Valley High School…," *SYVN*, April 1, 1960, p. 2; "Girl Scouts Set Courses, Sales. An Arts and Crafts Course in early November was planned … The Arts and Crafts course will be held at Vandenberg Air Force Base for the benefit of both Lompoc and Vandenberg neighborhoods. The first session will be on November 3 and will be taught by **Mmes. J. L. Boling, L. J. Fitzgerald** and **J. Watson**. The second will be instructed November 10 by **Mrs. E. J. Wiedmann**," *LR*, Oct. 20, 1960, p. 23.
See: "Ziegler, Leo," 1952

Girvetz, Berta / Bertha Wise (Mrs. Harry Kenneth Girvetz) (1909-1997) (Santa Barbara)
Exh. oil painting in professional category at Santa Barbara County Fair, 1959, and won honorable mention.
Bertha Wise Girvetz received an A. B. in art from Stanford University, 1931 (per books.google.com).
Girvetz, Berta (notices in Northern Santa Barbara County newspapers on microfilm and on newspapers.com)
Several notices appear in the *SMT* and *LR* and *SYVN* between 1955 and 1970 for Harry Girvetz, Professor of Philosophy at UCSB, but nothing for wife, Bertha.
Girvetz, Berta (misc. bibliography)
Bertha Wise was b. Nov. 21, 1909 in California to William Wise and Hattie Silberstein, was residing in Chico, Ca., in 1920, married Harry Kenneth Girvetz, and d. April 1, 1997 per Susan Miller Roy Family Tree; Bertha Girvetz is buried in Santa Barbara Cemetery per findagrave.com (refs. ancestry.com).
See: "Santa Barbara County Fair," 1958, 1959

Glasgow, Charles Miller (1885-1967) (Los Olivos)
Painter. Exh. annual Santa Ynez Valley Art Exhibit, 1953, 1954, 1955, 1956, 1957. Exh. Allan Hancock [College] Art Gallery, 1954, 1955, 1956.
■ "Last Rites… Charles Miller Glasgow, 81 … a retired mining engineer who had become well known… for his oil painting. Following his retirement in 1939 he took up painting and was honored with a one-man show at the Santa Barbara Museum of Art. He also exhibited regularly at the **Faulkner** Gallery and was a member of the Santa Barbara Art Association. Mr. Glasgow was born May 25, 1885, the son of prominent St. Louis, Mo., parents, Mr. and Mrs. Allan C. Glasgow. His great-grandfather, William Carr Lane, was the first mayor of St. Louis and later territorial governor of New Mexico. He attended Washington University in St. Louis and was graduated from the Colorado School of Mines at Golden in 1910. He was a member of Phi Delta Theta fraternity and Theta Tau mining fraternity. He was employed as a mining engineer by the Empire Zinc Co. and later was a consulting engineer

in Colorado and New Mexico…," *SYVN*, Jan. 26, 1967, p. 6.
Glasgow, Charles (notices in Northern Santa Barbara County newspapers on microfilm and on newspapers.com)
1953 – Port at easel, *SYVN*, Feb. 20, 1953, p. 1; "Charles Glasgow of L.O. Invited to Art Museum Dedication in N. M. … Museum of International Folk Art…," *SYVN*, Aug. 28, 1953, p. 2.
1954 – "Glasgow Paintings… Still lifes and landscapes in oil… will be on exhibition through August at the Art and Frame Shop, 135 East Carrillo in Santa Barbara," *SYVN*, July 30, 1954, p. 8.
1955 – "Los Olivos Man Displays Art at **Forden Gallery**" sponsored by SLO Art Assn, review by **H. Forgostein**, *T-T*, Feb. 11, 1955, p. 8.
1956 – "Glasgow to Stage One-Man Showing… in the Thayer Gallery of the Santa Barbara Museum of Art from next Tuesday through April 8," *SYVN*, March 23, 1956, p. 6; "Glasgow Art Wins Praise … [one-man showing at the Santa Barbara Museum of Art] … **Henry J. Seldis**, art critic of the *Santa Barbara News-Press* was warm in praise… 'It has been evident for some time that Charles Glasgow's paintings shown in Art Association exhibits were approaching a stage where the Art Museum could feel justified in offering him a one-man show. It is a pleasure to report that among three one-man exhibits which opened in Santa Barbara during the week, it is Glasgow's Art Museum show which is the most lively. Glasgow pictures and interprets this area's landscapes with an exuberant palette and with increasing painting know-how. He is equally adept at bringing vitality to the more static subject matter of still lifes. For several years this painter has worked consistently and enthusiastically with local artist-teachers to improve his post-impressionist approach and to increase his familiarity with various painting techniques. Within an inherent conservatism he has not been afraid to experiment, to make mistakes and to revise his views. There is no doubt that stimulation of Art Association exhibitions played an important role in his development. The two largest canvases in the exhibit titled 'Cambria Seascape' and 'Almonds in Bloom' are among the most successful ones while 'Los Olivos Barn' and 'Barley Field' are also competent landscapes. Other top paintings in the show include 'Still Life with Sunflowers,' 'Helbore, Blue Vase and Chair' and 'Avocados in Pewter Plate.' In a few paintings like 'Bottles, Lemons and Mirror' and 'Poppies in Bottle' Glasgow tackles plastic problems he is not yet quite able to master," *SYVN*, April 6, 1956, p. 4; port. with one of his latest oils, *SYVN*, May 11, 1956, p. 3; "Glasgow Paintings … Oil paintings by Charles Glasgow of Los Olivos are being displayed this month in the lobby of **Andersen's Pea Soup** restaurant in Buellton…," *SYVN*, Sept. 21, 1956, p. 6.
1958 – "Glasgow Art on Exhibition… 12 oil paintings, including landscapes and several still lifes, at **Andersen's** in Buellton. They will be shown there until April 1," *SYVN*, Feb. 28, 1958, p. 8; "Memo Pad … Los Olivos artist Charles M. Glasgow won an honorable mention in the art competition this week at the county fair in Santa Maria …," *SYVN*, July 25, 1958, p. 2; "Buellton Briefs… Charles Glassgow [Sic.], well known Los Olivos artist, has been experimenting with a flattening of form and color and is

exhibiting some of his latest efforts at the Art and Frame Shop, 135 E. Carillo, Santa Barbara. Art students may find this adventurous artist's attempt interesting in both color and expression. There are several still life paintings in his usual style also included…," *LR*, Oct. 23, 1958, p. 17.
1959 – "Glasgow Paintings in Library Exhibit. … for the next six weeks at the **Solvang Branch** of the **Santa Barbara Public Library**," *SYVN*, March 13, 1959, p. 1, and similar notice in *LR*, March 19, 1959, p. 15; "Ballard Barometer… We were sorry to hear that on his trip to Europe, Charles Glasgow of Los Olivos, was hospitalized on his arrival at Southampton, England… [Copenhagen snuff was sent to him from Solvang]," *SYVN*, Aug. 7, 1959, p. 2.
Seventy-five matches for "Charles Glasgow" (some for "Mrs.") in the *SYVN*, 1940-1960, were not itemized here.
Glasgow, Charles (misc. bibliography)
Charles Miller Glasgow was b. May 25, 1885 in St. Louis, Mo., to Allan Cuthbert Glasgow and Ellen (Nellie) Griffith Miller, was residing in Kelly, N. M., at some time and d. Jan. 24, 1967 in Los Olivos, Ca., per Lane Family Tree (refs. ancestry.com).
See: "Allan Hancock [College] Art Gallery," 1954, 1955, 1956, "Andersen's Pea Soup," 1956, "Danish Days," 1957, "Faulkner Memorial Art Gallery," 1960, "Hibbits, Forrest," 1954, "Joughin, Helen," 1956, "Lompoc Hospital," 1952, "Santa Barbara Art Association," 1960, "Santa Barbara County Fair," 1958, "Santa Barbara County Library (Solvang)," 1959, 1960, "Santa Ynez Valley Art Exhibit," 1952-58, "Sorensen, Hans," 1953, "Tri-County Art Exhibit," 1952

Gleason, Ellen Hanchette Taft (Mrs. Oren Byron Taft) (Mrs. Robert P. Gleason) (1907-1969) (La Querencia, Ballard)
Photographer (amateur). Member of Channel City Camera Club. Exh. ceramics and photos and paintings at the annual Santa Ynez Valley Art Exhibit, 1953, 1954, 1955, 1957. President of Santa Ynez Valley Historical Society, 1967. Her daughters, Venetia Gleason and Lee Taft, not listed here, painted.

■ "Mrs. Robert P. Gleason Dies… of La Querencia Ranch, Ballard… Mrs. Gleason, a resident of the Valley since 1935, was born Ellen Hanchette in New York City to Emma Cargill Hanchette and Fred M. Hanchette. The family moved to the Pasadena area when she was young. She attended Miss Hall's School in Massachusetts, Mills College and studied at the Sorbonne in Paris. She married Oren Taft III in 1932 in Santa Barbara and moved to the Valley in 1935 where they established La Querencia Ranch. He died in September 1949. They had three children. Mrs. Gleason married Robert P. Gleason, who survives her, in Honolulu, Ha., Nov. 17, 1950. Active in the Santa Ynez Valley and California Historical Societies, Mrs. Gleason was at one time a trustee of the Ballard School District, an officer and charter member of the Ballard Improvement Assn., and active in the Republican Party. She was an enthusiastic amateur photographer, did her own darkroom work, and entered many contests as a member of the **Channel City Camera Club**," *SYVN*, June 12, 1969, p. 2.

Gleason, Ellen (notices in Northern Santa Barbara County newspapers on microfilm and on newspapers.com)
1941 – "Mrs. Oren Taft III … attended the quarterly meeting of the Junior League held at the Santa Barbara Museum of Natural History Tuesday. The Scribblers, a literary section of the league of which Mrs. Taft is a member, was in charge of the fourth annual photographic contest and exhibition, which was held in the Hale Memorial wing of the museum. She was awarded second prize on her photograph of portrait and figure," *SYVN*, Oct. 10, 1941, p. 8.
1953 – "Mrs. Ellen Gleason, a 1952 award winner from the **Channel City Camera Club**, will show a group of her Hawaiian prints" at the Santa Ynez Valley Art Exhibit, *SYVN*, Feb. 13, 1953, p. 1.
1954 – "Robert P. Gleason Home at La Querencia Large and Spacious," and photos, *SYVN*, June 25, 1954, p. 4.
1955 – "Mrs. Gleason's Photos Win Prizes. Entries of Mrs. Ellen Gleason of La Querencia in **Channel City Camera Club** competition, won two prizes recently. Her entry in B class color called 'Siesta' won the top prize in that class. It was taken on the dock at Mazatlán, Mexico, and showed the colorful hulls of two boats on dry dock with a sleeping workman, a tiny figure, at the base of one of them. In class B monochrome print division her print entry of a cat titled 'Negrita' placed third," *SYVN*, March 18, 1955, p. 8.
1970 – "Ellen Gleason Memorial. New Valley Historical Society Library Open… located in the rear of the society's building along Sagunto Street. Originally it served as a pair of store rooms and was separated by a partition. … named after Mrs. Robert P. Gleason of La Querencia who died June 12, 1969. Mrs. Gleason led the move to found the Valley Historical Society in 1961…," *SYVN*, April 23, 1970, p. 1.
Gleason, Ellen (misc. bibliography)
Ellen H. Gleason, mother's maiden name Cargill, was b. Dec. 16, 1907 and d. June 11, 1969 in Santa Barbara County per Calif. Death Index; Ellen Gleason (1907-1969) married twice: Mrs. Oren Byron Taft, and Mrs. Robert P. Gleason, is buried in Oak Hill Cemetery, Ballard, Ca., per findagrave.com (refs. ancestry.com).
See: "Danish Days," 1957, "Hibbits, Forrest," 1964, "Santa Ynez Valley Art Exhibit," 1953-55, 1957-58

Gleason (Smith), Pearl / Pearle "Pearlie" E. (Mrs. ? Smith) (1876-1972) (Guadalupe / Los Angeles)
Artist, 1885. Sister to the artist / illustrator Joe Duncan Gleason of NY and LA.

■ "A Guadalupe Daughter. Pearle Gleason, but nine years old, takes the First Premium at Los Angeles for Oil Painting… [from *Los Angeles Express*] …. To an artistically critical eye the striking characteristics of the painting ('Christmas Roses' – a flower piece) are its wonderful fidelity to nature as well as life-like appearance … the judicious use of delicate colors, the graceful repose of leaves and petals, the absence of everything suggestive of mechanism, and above all, the presence of that subtle spirit of which the word 'genius' approaches nearest a description. … her mother told the writer that the work in question had not been painted for the Fair, that the child had put no extra touches on it nor exerted herself more than

usual and that she had sent her best pieces to her grandmother… Little Pearlie, a petite, amiable, sweet and intelligent creature, is in form, feature, manner and disposition the living embodiment of an artist. Though very small for even her youthful years, she has a dainty little figure, exquisitely refined and intelligent features, dark auburn hair, and beautiful, limpid, expressive eyes, blue in color. Pearlie is the daughter of Henry Gleason, book-keeper of the New Home Sewing Machine Company, residing on Temple street, near Hill. Mr. Gleason is a native Californian, having been born in San Jose. Mrs. Gleason, of Iowa, though California bred. Pearlie was born in Guadalupe… Her mother told the writer that Pearlie has been taking lessons of **Mrs. Jaynes Putnam** [ed. who later married the famous sculptor John Gutzon Borglum and was also known as Elizabeth Borglum] about three months only; that about a year ago she (Mrs. Gleason) began teaching her what she herself knows of drawing but was able to give her only about six months' instruction altogether. 'Her natural inclination,' said Mrs. Gleason, 'tends to art and music. I have noticed ever since she could sit alone, she always had a liking for pictures and even before she could talk, if I gave her paper and pencil to scribble away with, she was happy. Some of her pencil sketches are really fine, but I did not want to exhibit them because I had taught her. She has more inclination for painting than music, for while I have sometimes to drive her to the piano, I often have to drive her from the easel. When I first took her to Mrs. Putnam, she thought that it would be useless to attempt to instruct her on account of her extreme youth, but when I again met the lady, she said Pearlie did better than any grown pupil she ever had. She is of a very sensitive and impressible nature.' The Gleasons have two younger children, boys, who reflect, in part, their sister's precocity," *SMT*, Nov. 14, 1885, p. 1.

Gleason, Pearl (notices in Northern Santa Barbara County newspapers on microfilm and on newspapers.com)
1911 – Port. as individual who opposed the building of a first street tunnel, *LA Times*, March 9, 1911, p. 17 (i.e., pt. II, p. 1).
1925 – MOTHER – "Pioneer's Life Story Closed. Mrs. Nellie Duncan Gleason… She is survived by a daughter, Mrs. Pearl Gleason Smith and by two sons, James Hal Gleason and **Joe Duncan Gleason**," *LA Times*, July 15, 1925, p. 21 (pt. II, p. 1).
Almost 250 notices appear in Los Angeles newspapers between 1880 and 1910 for her recitations and singing and work on the library board but were not itemized here.

Gleason, Pearl (misc. bibliography)
Pearl E. Gleason is listed in the 1900 U. S. Census as age 24, b. Feb. 1876 in Calif. residing in Los Angeles, with her mother Nellie H. Gleason (age 47) and younger brothers J. Hal (age 22) and Joe D. (age 18); Pearl E. Smith b. Feb. 22, 1876 in Calif., d. March 19, 1972 in Los Angeles County per Calif. Death Index (refs. ancestry.com).

Glenn, Bayonne (Mrs. Glenn) (Paso Robles, Lompoc)
Director of activities at the Walnut Street USO Penthouse, Lompoc, 1942.
1943 – "Bayonne Glenn Transferred to Ashland, Oregon. … For the past 17 months Mrs. Glenn has directed activities

for the USO-YWCA branch and has had her office in the Penthouse of the Walnut street club…," *LR*, May 14, 1943, p. 4.
See: "United Service Organization," 1942, and *Atascadero Art and Photography before 1960*

Glenn-Al Shop (Solvang)
Retailer of music / hobby materials, 1946-48.
■ "Glenn-Al Shop Opens Saturday. Mr. and Mrs. Glenn Wiest, formerly of Burbank … natives of N. Dakota and prior to coming here were employed by the Lockheed Corporation at Burbank since 1939. Mr. Wiest is a pianist of ability, having traveled with dance orchestras for several years before the war. … Mr. and Mrs. Wiest have spent several weeks renovating the building formerly occupied by the Paaske Funeral Home… Their business… a complete line of music accessories, sheet music and records, hobbycraft, model airplanes, ships and boats and a good supply of toys…," *SYVN*, Oct. 18, 1946, p. 1.

Golden Gate Exposition (GGIE) 1939/40 (San Francisco)
World's Fair held at San Francisco's Treasure Island to celebrate the city's two newly constructed bridges. It had important art exhibits that acknowledged / celebrated the work of California artists as well as provided other art to inspire and influence them. (Wikipedia)

Goodenough, Katherine Louise Zacker (Mrs. Carl Herbert Goodenough) (1889-1978) (Santa Maria)
Maker of a mosaic Madonna at the First Methodist Church, 1959.
■ "Focal point of interest at Christmas Eve workshop at the First Methodist Church, Broadway and Cook Street, will be a rendering of the Madonna and Child in rock, sand and shells. The art work, about two by three feet, was done in a month by Mrs. Katherine Goodenough, 623 W. Church St., a longtime member of the church and a hobbyist rock collector. Mrs. Goodenough, 70, gathered materials for the Madonna during her travels in the past two years. Jasper and jade rocks and shells were picked up at Shell Beach. These are used in the background. Sand was taken from the Great Salt Lake area in Utah. Halos are made of rock from Yellowstone National Park. Garments gleam brightly with crude silver in sparkling sand taken from Colorado mine areas. The various sands and rocks were glued onto a plywood back, Mrs. Goodenough said. Her next project is to be a large cross," and photo of pastor of First Methodist Church posing with artwork and "Builds Madonna of Rock, Shells," *SMT,* Dec. 24, 1959, p. 6.

Goodenough, Katherine (misc. bibliography)
Listed 1940 U. S. Census as Katherine L. Goodenough, age 50, born c. 1890 in North Dakota, living with husband Carl Goodenough and children Herbert, Katherine, Ernest and Florence; Katherine L. Goodenough b. 1889 and d. March 22, 1978 is buried in Santa Maria Cemetery District, per findagrave.com (refs. ancestry.com).

Gordon, Ruth M. (Solvang)
Artist? Organizer and first president of Santa Ynez Valley Art Association, 1953. Beautician. Owner of Los Olivos Beauty Shop and of Village Beauty Shoppe in Solvang.
Almost 400 "hits" for "Ruth Gordon" in the *SYVN* 1940-1970 reveal her numerous business enterprises, etc., but were not itemized here.
See: "Santa Ynez Valley Art Association," 1953

Gorham, John Anderson (1910-1985) (Santa Barbara)
Member Santa Barbara Art Association, who exh. at opening of Allan Hancock College Art Gallery, 1954. Frequent exhibitor at Art Rental Gallery at Santa Barbara Museum of Art. Exh. Santa Barbara County Fair, 1958.
■ "Born in Los Angeles, CA on Aug. 11, 1910. Gorham grew up on a ranch in Ojai, CA. He received his degree in art at UC Berkeley where he was a pupil of **Chiura Obata**. He moved to Santa Barbara in the 1930s to establish an advertising agency with his wife, Marie. His art career was interrupted by WWII when he served in the Navy. After the war he returned to Santa Barbara where he served two terms as president of the local art association and was a founding member of the Santa Barbara Art Institute. He illustrated several books, one of which, On Santa Cruz Island, received the Western Book Award of 1968. Gorham was an active member of the Santa Barbara art community until his demise at his home in Goleta on Dec. 19, 1985," Source: Edan Hughes, *"Artists in California, 1786-1940"* Interview with the artist or his/her family; Death record; *Santa Barbara News-Press*, 12-22-1985 (obituary) from askart.com.
Gorham, John A. (notices in Northern Santa Barbara County newspapers on microfilm and on newspapers.com)
1952 – "New Watercolors... Other Rotunda exhibits comprise ... drawings by John Gorham...," *SF Examiner*, Jan. 13, 1952, p. 140 (i.e., Pictorial Review, p. 21).
1968 – "Santa Maria Fine Arts Council... May 4... first annual spring arts festival... Allan Hancock College... 17 area artists... John A. Gorham...," *SMT*, April 27, 1968, p. 22 (i.e., 4-B).
See: "Allan Hancock [College] Art Gallery," 1954, "Santa Barbara County Fair," 1958

Gorham (Wilkinson), Lona / Loua L. (Mrs. Robert C. Wilkinson) (1880-1959) (Lompoc / Santa Barbara)
Sloyd teacher at Lompoc High School, 1912-13.
■ "High School Force Chosen ... Miss Lona L. Gorham, who is to have the Sloyd department is a new member of the faculty... from the Santa Barbara Normal School of Home Economics and Manual Arts...," *LR*, July 5, 1912, p. 1.
Gorham, Miss (notices in Northern Santa Barbara County newspapers on microfilm and on newspapers.com)
1912 – "High School Events... tennis... backstop... The construction work is being done by the sloyd pupils under the able direction of Miss Gorham," *LR*, Oct. 11, 1912, p. 8.
1913 – "High School Teachers on Summer Vacations... Miss Gorham... is remaining for a few days to assist in

making the plans for the new building...," *LR*, June 13, 1913, p. 1.
1926 – "High School, Grammar Schools Ready for Opening... Special Teachers. Loua G. Wilkinson, sloyd...," *Press-Courier* (Oxnard, Ca.), Aug. 21, 1926, p. 1.
1959 – "Loua G. Wilkinson... Mrs. Wilkinson, who taught school in the Oxnard area for 30 years, died Thursday at Cottage Hospital in Santa Barbara... She was born Sept. 25, 1880 in Santa Barbara and was the widow of the late Robert C. Wilkinson...," and she leaves siblings Nora, Nellie, Charles and Frank, *Press-Courier* (Oxnard, Ca.), Jan. 5, 1959, p. 3;
And several additional notices in the *LR* for "Miss Gorham" were not itemized here.
Gorham, Miss (misc. bibliography)
Lona Gorham is listed in the 1900 U. S. Census as age 19, b. Sept. 1880 in Calif., residing in Santa Barbara, Ward 7 with her parents Charles Gorham (age 56) and Emma Gorham (age 53) and five siblings; Lona Gorham is listed as president of YWCA, 1903-04 in the Occidental College yearbook, 1908; Lona Gorham is listed in the 1910 U. S. Census as age 29, b. c. 1881 in Calif., teacher in a public school, boarding in Township 1, Santa Barbara County; Lona L. Gorham, teacher and Rep. is listed in Calif. Voter Registers, *Lompoc Precinct no. 3*, some time between 1900 and 1918 (refs. ancestry.com).
See: "Lompoc, Ca., Elementary Schools," 1914

Gracia, Ida Mildred Brass (Mrs. Alfred "Fred" E. Gracia) (1905/6-1954) (Santa Maria)
Artist c. 1949-52. Wife of Santa Maria's mayor.
■ "Mrs. Ida Gracia Dies After Long Illness... Mrs. Gracia was born on February 23, 1905 in Santa Maria... Active in Two Portuguese societies, Mrs. Gracia was a member of SPRSI Council No. 92 and of APPB Council No. 31...," *SMT*, Jan. 4, 1954, p. 1.
Gracia, Ida (misc. bibliography)
Ida M. Gracia is listed in the 1940 U. S. Census as age 35, b. c. 1905, finished elementary school, 8th grade, residing in Santa Maria with husband Alfred E. Gracia (age 38); Ida M. Gracia is listed as wife of Fred A. E. Gracia in the *Santa Maria, Ca., CD*, 1948; Ida Mildred Gracia, mother's maiden name Silveira and father's Brass, was b. Feb. 23, 1905 in Calif. and d. Jan. 3, 1954 in Santa Barbara County per Calif. Death Index; Ida Mildred Gracia b. 1906 and d. 1954 is buried in Santa Maria Cemetery District per findagrave.com (refs. ancestry.com).
See: "Rossini, Hazel," "Santa Barbara County Fair," 1949, 1952, "Santa Maria Valley Art Festival," 1952, "Tri-County Art Exhibit (Santa Barbara)," 1949

Grady, Elmer and Becky (Lompoc)
Craftspersons, collectors, 1954. She judged several children's' art exhibits at the Community Club, 195-57.
■ Port. with metal crafts, ceramics, leather tooling, wood-carving and upholstering made by them (**Tom Yager** photo), and "Meet Your Neighbor...Mr. and Mrs. E. H. Grady... Elmer and 'Becky'... are one married couple who can truthfully say they never find a quiet evening at home

boring… A visit with Elmer and Becky offers the combined attractions of a craft shop, an art studio, an intriguing private museum and a charming home enriched by warm informal hospitality. It will also net the visitor a wealth of information on a wide variety of handcrafts, some fascinating tales concerning the history of certain furnishings of the Grady home… and perhaps a cup of fragrant coffee and some of Becky's delicious home-baked Swedish cookies. … Set well back from the street at 211 South K amid attractive gardens, the Grady's house is a small white ranch-style rambler. The interior is paneled throughout in polished knotty pine and features numerous built-in conveniences of bookcases, cabinets, dressing table, drawers and closets. ... much of the paneling was done by Elmer himself. Most of the furniture is antique maple and each cushioned piece has been reupholstered by Becky and Elmer. Enchanting old metal kerosene-burning lamps have been converted by Elmer into modern floor, table and hanging lamps, and several beautiful ceramic lamps have been made by Becky, who also made all the shades. Wall ornaments, planters, knick knacks, magazine racks, waste baskets – almost all are the original creations of the couple, done in their favorite mediums of metal and ceramics. Elmer is the metal craftsman… turning out lovely original pieces in copper, brass, silver and gold, or converting some old article into a novel and useful item. Metal work has been a hobby with him since he was a youngster and most of his skill has been self-taught or acquired through practice as he has had no particular training in the craft. He has even mined gold and worked it from that raw state into jewelry. Though he does most of his metal work with hand tools, Elmer has converted one end of his garage into a very modern work-shop complete with the latest power equipment and built-in cabinets and work bench. Becky's earliest craft hobby was wood carving, then after coming to Lompoc she took up ceramics, leather tooling, upholstering and lamp-shade making. All of these arts she learned in the Adult Education classes given some years ago by Mrs. **Viola Dykes**. Her latest hobby is gardening… Grady's home… numerous old antique pieces from the far corners of the world… There's a picturesque little spinning wheel from Luckna, Canada, that came down the Red River and then by ox team to Elmer's grandfather's homestead in Quincy, North Dakota… an ancient brass tea-brewer from Kuwait … a planter lamp made from an old brass basin from Russia… colorful porridge bowls from Holland… steins and Dresden china from Germany and Austria… and lustrous old pewter spoon holder and cruet set from England. Elmer Grady, who was born in northern North Dakota but claims Colorado as his native state, is of hearty Irish stock. He says somewhere along the way his ancestors dropped the O' from the family name. He attended the Colorado School of Mines and has done considerable work in mining equipment and locating mines. He is a disabled veteran of the first World War, during the second war was a civilian employee of the Air Force, and is currently an electrician for the Post Engineer at the USDB. Becky, who was born in northern Minnesota, is of Swedish descent and enjoys joking about her ancestry in a delightful Swedish accent. She and Elmer met when they were both working at Hill Air Base in Utah. Looking anything but a grandmother,

Becky proudly talks about her son Elwin Fogelberg and his wife and little boy who live in Kuwait where Elwin is employed by the Kuwait Oil Company, an American British concern. Elmer has three lovely daughters, Ruth, Alice and Mary… all married, all musicians and all blondes. He also has nine grandchildren … Stiner is a large, sleek pussycat, the color of rich Guernsey cream …," *LR*, Dec. 30, 1954, p. 5.

Grady, Elmer and 'Becky' (notices in Northern Santa Barbara County newspapers on microfilm and on newspapers.com)
1955 – Letter to the editor inviting the couple to show their artwork in the International Hobby Show which will be held in conjunction with the Pacific National Exhibition from August 24 to September 5. … Vancouver…," *LR*, June 2, 1955, p. 5.

Grady, Elmer and 'Becky' (misc. bibliography)
Elmer H. Grady, electrician / foreman, VAFB, and wife Agnes B. are listed in the *Santa Maria, Ca., CD*, 1958, 1965, and in the *Lompoc, Ca., CD*, 1974; is he Elmer H. Grady b. Nov. 2, 1899 in Hendrum, Minn., d. Oct. 26, 1981 and buried in Resthaven Memorial Park, Shawnee, Okla. per findagrave.com (refs. ancestry.com).
See: "Lompoc Community Woman's Club," 1955, 1956, 1957

Graham, Charmian Anne
See: "Turner (Graham), Charmian Anne (Mrs. Dwain W. Graham)"

Graham, John J. (1899-1948 or 1969) (Brazil / Santa Ynez Valley)
Artist of Chicago / Sao Paulo, who visited the Santa Ynez Valley and bought land to raise walnuts, 1928.
1928 – "Solvang and Vicinity. A number of real estate transfers have been made during the last few weeks. John Graham of Sao Paulo, Brazil, who was a visitor at the John France [Sic. Frame] home last week, has made a first payment on the 40 acres owned by P. B. Montanaro about one and one-half miles north of Ballard. Graham expects a friend to take 20 acres of the tract. They plan to improve the land and will probably plant walnut trees," *SMT*, June 27, 1928, p. 6; "More Walnut Trees for Valley of Sun. Mr. and Mrs. **John Frame** … returned Tuesday from San Jose where they purchased 8000 Black Walnut trees to be planted on the various ranches in the valley as follows: … John Graham, 1500 trees…," *SYVN*, Dec. 14, 1928, p. 1.
1931 – "Mr. and Mrs. John Graham who recently returned from a six year's stay in Brazil, arrived here this week by motor from Chicago. They are visiting in the home of Mr. and Mrs. **J. H. Forsyth** on Refugio road," *SYVN*, Oct. 30, 1931, p. 5, col. 2.
1934 – "Notice of Trustee's Sale … John J. Graham and Hazel J. Graham, his wife … will sell at public auction," *SYVN*, Nov. 30, 1934, p. 5.
Graham, John (misc. bibliography)
John Graham is listed in the 1940 U. S. Census as age 40, b. c. 1900 in Illinois, finished elementary school, 8th grade, an artist, residing in New York (1935) and Portland, Oregon (1940) with wife, Hazel (age 40) and children

Richard and Patrick; John J. Graham b. Aug. 5, 1899 and d. Oct. 1969 [Sic.?] is buried in Saint Bede Catholic Cemetery, Ingleside, Ill., per findagrave.com; John J. Graham b. Aug. 5, 1899 in Illinois to John Graham and Ellen Walsh married Hazel Josephine and d. Nov. 6, 1948, per Hughes-Mordini Family Tree (refs. ancestry.com).
See: "House, H. Elmer"

Graham Drug Co. (Lompoc)
Retailer of photographic supplies, 1912.
"Agents for Eastman Kodaks and supplies … Stationery and School Books," *LR*, June 7, 1912, p. 4.

Grainger, Kathryn / Catherine (Mrs. Grainger) (Santa Maria)
Artist. Exh. Santa Barbara County Fair, 1952. Won a graphic arts award in the Art Festival, 1952.
This individual could not be further identified.
See: "Santa Barbara County Fair," 1952, "Santa Maria [Valley] Art Festival," 1952

Grant, Campbell (1909-1992) (Carpinteria)
Artist. Exh. in Santa Maria, 1935, 1940. Illustrator for his wife's books and for Walt Disney stories. Author / illustrator for books on Chumash rock art.
■ "Artist's First glimpse of Indian Rock Art Hooked Him for Life… From that decisive moment came a lifelong passion for American Indian rock art and six books, including the 1965 classic, '*Rock Paintings of the Chumash*'… [that] records pictographs from 62 coastal mountain sites between San Luis Obispo and Malibu… He grew up in Berkeley, inspired to a life of art by an uncle who painted pictures of sailing ships and an older brother who painted pictures of Southwest Indians. After high school, Grant studied painting at the **California School of Arts and Crafts** in Oakland and the Santa Barbara School of the Arts. In the 1930s he worked on a federal WPA project painting murals, including one at Santa Barbara high School. From 1934 to 1946, Grant worked as an illustrator for **Walt Disney** Studios in Burbank on the movies '*Fantasia*,' '*Pinocchio*,' and '*Snow White*.' By 1946 he had begun a career illustrating books – mostly about Indians, archeology and anthropology… On the fateful 1959 fishing trip, a Sierra Club member told him offhandedly about a nearby cave that contained some Indian drawings – and thereby sparked his abiding passion for rock art…," *LA Times*, Feb. 11, 1989, on internet.
See: "College Art Club," 1935, "National Art Week," 1940, "Tuckerman, Lilia," 1940

Gray, Gladys (Mrs. Stanton Gray) (San Luis Obispo)
Artist who exh. at Santa Ynez Valley Art Exhibit, 1953, 1955, 1956. OMS at Allan Hancock [College] Art Gallery, 1957. Wife of Stanton Gray, below.
■ "Glady Gray's Water Colors Now on Display at **Andersen**'s… 22 full-sheet and half sheet size water colors, including landscapes, seascapes, horses, cattle, and flowers, will continue through March 26. Mrs. Gray, who

exhibits each Spring at the St. Mark's-in-the-Valley Art Show in Solvang, is a native Californian, reared on a cattle ranch where winters were spent in the Sacramento Valley and summers in the Truckee-Tahoe area. She is a member of a family which lists many artists among its ancestors. She is the wife of **Stanton Gray**, crops instructor at Cal Poly, and also an oil painter. Her daughter, Gaylia Gray, is a student of music, voice and piano at the Los Angeles Conservatory of Music and Los Angeles State College. Mrs. Gray, who holds an AB degree from Fresno State College, did graduate work in art at the University of California at Berkeley, graduate work in design at Claremont College with **Millard Sheets** and Jean Ames. She has taken special art courses from Eliot O'Hara at Laguna Beach and with **Harold Forgostein** in San Luis Obispo. Her paintings have been sold and exhibited at Laguna Beach Art Gallery and Laguna Studio Gallery and gift shops and art stores throughout California. She has taken part in many water color shows, including Del Art, Santa Cruz, Santa Barbara, Santa Ynez Valley and San Luis Obispo. Mrs. Gray, who helped organize the San Luis Obispo Art Assn., also works with **stained glass** windows and figure designs of a religious nature. During the past five years she has helped make the decoration on Orange Drive, the 'Christmas Street' of San Luis Obispo," *SYVN*, Feb. 22, 1957, p. 4.
See: "Allan Hancock [College] Art Gallery," 1957, "American Association of University Women," 1957, "Gray, Stanton," "Santa Barbara County Fair," 1961, "Santa Maria [Valley] Art Festival," 1952, 1953, "Santa Ynez Valley Art Exhibit," 1953, 1955, 1956, "Tri-County Art Exhibit," 1959, and *San Luis Obispo Art and Photography before 1960*

Gray, Stanton (SLO)
Artist who exh. at Santa Ynez Valley Art Exhibit, 1954, 1955. OMS at Allan Hancock [College] Art Gallery, 1957. Husband to Gladys Gray, above.
See: "Allan Hancock [College] Art Gallery," 1957, "Gray, Gladys," "Santa Ynez Valley Art Exhibit," 1954, 1955, and *San Luis Obispo Art and Photography before 1960*

Green, Dorothy Katherine Merritt (Mrs. Paul Jones Green) (1908-2001) (Santa Maria)
Elementary school <u>art</u> instructor, Santa Maria, c. 1930-34. Examiner in art for Boy Scouts, 1933.
■ Port. and "Dorothy Green. Dorothy Katherine Merritt Green, 92, a former resident of Thermal, died June 25, 2001 in Tacoma, Wash. She was born Aug. 23, 1908 in Santa Maria. She was an elementary educator and taught at John Kelley and Westside schools in Thermal, retiring from the Coachella Valley Unified School District after 33 years of service. A resident of the Coachella Valley from 1946 to 1995 …," *Desert Sun* (Palm Springs, Ca.), July 21, 2001, p. 20.
Green, Dorothy (notices in Northern Santa Barbara County newspapers on microfilm and on newspapers.com)
1930 – FATHER – "George Phoenix Merritt… He was a native of San Luis Obispo county but lived most of his life in the Santa Maria valley… Surviving are his widow… two

daughters, Misses **Dorothy Katherine Merritt**… Dorothy Merritt is an instructor in the art department of the Santa Maria elementary schools," *SMT*, Nov. 18, 1930, p. 5.

Green, Dorothy (misc. bibliography)
Dorothy Merritt Green is listed as next of kin on the WWII Draft Card of Paul Jones Green; Dorothy Katherine Green b. Aug. 23, 1908 in Santa Barbara county, d. June 25, 2001 in Tacoma, Wash., and is buried in Coachella Valley Public Cemetery per findagrave.com (refs. ancestry.com).
See: "Boy Scouts," 1933, "Merritt, Dorothy," "Minerva Club, Flower Show," 1933, "Posters, general (Santa Maria)," 1933, 1934, "Santa Maria, Ca., Elementary Schools," 1930, 1931, 1932 (as Dorothy Merritt) and 1933, 1934 (as Green)

Greene, Robert Howard (1893-1956) (Santa Maria)
Photographer for University of Southern California College of Aeronautics at Hancock Field, Santa Maria, 1946.

Greene, R. Howard (notices in Northern Santa Barbara County newspapers on microfilm and on newspapers.com)
1946 – "I Spied … R. Howard Greene, USC College of Aeronautics photographer, out getting pictures of the machine-harvesting of sugar beets in the valley," *SMT*, Sept. 26, 1946, p. 1; "Rotarians See Colored Movies of Flower Fields… Lompoc Rotary… Greene showed films of flowers in striking symphonies of color from both the flower-growing valleys. Some of the scenes of the Lompoc valley were taken from an airplane … resemblance to a brightly colored carpet. Many of the pictures were close-ups of the flowers. Other pictures showed the recent Air Show at Hancock College," *LR*, Nov. 14, 1946, p. 9; "Green [sic. Greene] Shows Films of USC Air Show… Lompoc Rotary Club… recent Air Show on Hancock Field. … Greene recently exhibited the flower pictures to the Guadalupe Rotary Club," *SMT*, Nov. 14, 1946, p. 2.
1953 – "DEED: Robert H. Greene and Elsie Tipton Greene, his wife, and Bertha O. Tipton, to Ivor E. Stubbs and Rose V. Stubbs, his wife in J.T., April 24, 1953, Lot 4, Blk 2, Tract 186, Santa Lucia village," *Californian* (Salinas, Ca.), June 22, 1953, p. 13.
1956 – "Legal Notice… Estate of Robert Howard Greene…," *Californian* (Salinas, Ca.), Dec. 13, 1956, p. 20.
Greene, R. Howard (misc. bibliography)
Robert H. Greene with no occupation is listed with wife Elsie in the *Riverside, Ca., CD*, 1927; Robert H. Greene, staff photog USCCA with wife Elsie is listed in the *Santa Maria, Ca., CD*, 1947, 1948; Robert H. Green with no occupation is listed with wife Elsie T. in the *Salinas, Ca., CD*, 1952, 1955; is he Robert Howard Greene b. c. 1893, who d. Nov. 15, 1956 in Wenatchee, Washington, per Washington Death Records (refs. ancestry.com).

Greenelsh, E. Vernon "Vern" (SLO)
Artist who exh. at Santa Ynez Valley Art Exhibit, 1954.
See: "Santa Ynez Valley Art Exhibit," 1954, and *San Luis Obispo Art and Photography before 1960*

Gregory, Francis (Santa Maria)
Art student at Santa Maria High School. Exh. at Faulkner Memorial Art Gallery, Santa Barbara, 1933.
See: "Faulkner Memorial Art Gallery," 1933, "Posters, American Legion, Poppy (Santa Maria)," 1932, "Santa Maria, Ca., Union High School," 1935, "Splash," 1935

Grider, Wallace Ira "Tyke" (Lompoc)
Art editor of Lompoc High School newspaper and yearbook, 1950. Became a mechanical engineering major at Cal Poly, 1955.
1955 – "Ten Enroll as Frosh at Cal Poly… Wallace Grider, mechanical engineering…," *LR*, Sept. 22, 1955, p. 1; and at least two ports. in the *LR* not itemized here.
See: "Lompoc, Ca., Union High School," 1948, 1950, "Posters, American Legion (Poppy) (Lompoc)," 1948

Griesbauer, John "Jack" C. (1918-1989) (Santa Barbara / Solvang)
Photographer, 1950+. Exh. first annual Santa Ynez Valley Art Exhibit, 1953. Head of photo section of Santa Ynez Valley Art Exhibit, 1954.

■ "Griesbauer, Johnson Plan Open House… opening of their shops in the new Danish-styled Walton building… Griesbauer's office and photo supply store… Jack Griesbauer first came to the Valley from Santa Barbara in September 1950 when he was associated with **Robert C. Nelson** in photography. In April 1951, Griesbauer opened his own photo studio in Copenhagen Square and in January 1953 took over the office supply business formerly operated by the *Valley News*. In November 1953 he moved from Copenhagen Square to the *News* building. His new shop in the Walton Building will feature a complete line of office supplies and stationery, studio greeting cards and photo supplies. Griesbauer, is assisted in the operation of the business by his wife, Jill. The Griesbauers reside on Laurel Avenue in Solvang. They have five children, Carol, 14, Pat, 12, Kathy Ann, 8, Mary, 5, and John, 20 months," *SYVN*, July 11, 1958, p. 1.

■ "Memo Pad. The Passing of Jack Griesbauer… who moved to Ojai some six months ago with his wife, Jill, from Solvang where they had resided since the summer of 1951. We first met the Griesbauers that summer… Jack, a Navy veteran of World War II – he served aboard the heavy cruiser *USS Princeton*—was a recent graduate of **Brooks Institute of Photography**… Jack opened his commercial photography studio in what is now a shop-filled center second story of Copenhagen Square. Later, at our behest and with the cooperation of the late Dick Kintzel and Karl Jorgensen, then owners of the *Valley News*, Jack took over the relatively small office supply operation of the newspaper. This was in the early 1950s when the newspaper was located on Copenhagen Drive (then Main Street). … Room was made for Jack in the newspaper building, but he soon outgrew the space and after Jack Nedegaard built his structure now housing the Mollekroen restaurant and Moore's One Hour Photo and Hobby, Jack moved to the new and larger store on Alisal Road. Because of his knowledge of photography, Jack Griesbauer was a big help to this writer as he learned the business of

newspaper photography. We bought our first Rolleiflex, a used model, for $125 from Jack. He taught us how to use the Rollei, taught us film processing and darkroom techniques… We hadn't seen much of Jack since his retirement in 1977 and after he sold his office supply business to his old friend of Anderson's of Santa Barbara photo store years, Kevin Moore…. Once in a while he would talk about the war – the war in the Pacific that is. He didn't speak in great detail about his days on the *Princeton* except to say that it was sunk by a Japanese torpedo and that he had lost many of his buddies…," *SYVN*, Jan. 12, 1989, p. 4.

■ "Jack Griesbauer dies at 71… Mr. Griesbauer and his wife, Magdalena (Jill) who survives, moved to Ojai six months ago from Solvang where they had lived for 37 years…," *SYVN*, Jan. 12, 1989, p. 9.

Griesbauer, Jack (notices in central coast newspapers on microfilm and the Internet)

1950 – "Portrait Work Offered Here… **Robert C. Nelson** of the Solvang Photo Shop announced today that Jack Griesbauer, portrait photographer and commercial illustrator will now be affiliated with the shop. Mr. Griesbauer, a graduate of **Brooks Institute** and a resident photographer in Santa Barbara, will be available at the Solvang Photo Shop several days a week for portrait work. He was graduated from Brooks Institute last August and is living in Santa Barbara at the present time with his wife and three children. Prior to coming to Santa Barbara, Mr. Griesbauer resided in Arlington, Va., and Washington, D.C., where he was engaged in commercial photography. He served in the Navy for four and a half years in World War II and saw service in the South Pacific aboard the carrier *U.S.S. Princeton*," *SYVN*, Sept. 15, 1950, p. 1.

1951 – "Griesbauers Feted… recently moved to Solvang…," *SYVN*, June 29, 1951, p. 5; ad: "Have your best prints enlarged. 24 hour service. J. Griesbauer. Copenhagen Square. Solvang – Ph. 222 (Use Paaske's Entrance)," *SYVN*, Sept. 28, 1951, p. 3.

1953 – "Valley Office Supply Opened by Griesbauer…," and formerly owned by the *Santa Ynez Valley News*, *SYVN*, Jan. 9, 1953, p. 1; ad: "Announcing the Opening of The Valley Office Supply by Jack Griesbauer…," *SYVN*, Jan. 9, 1953, p. 10; FATHER – "Father Succumbs. Charles L. Griesbauer of Washington, D.C…. a patent draftsman," *SYVN*, Nov. 13, 1953, p. 8; "Griesbauer's Valley Office Supply Opens in New Main Street Location…," *SYVN*, Nov. 20 [sic. 27], 1953, p. 8.

1954 – "Jack Griesbauer, Valley photographer, will speak on photography tonight at a meeting of the Solvang-Buellton 4-H Club…," *SYVN*, April 9, 1954, p. 12. And more than 200 matches for "Jack Griesbauer" in the *SYVN*, 1945-1960, including some for his photos that were reproduced, were not itemized here.

Griesbauer, Jack (misc. bibliography)

John C. Griesbauer, photographer, is listed with wife Magdalena S., in the *Santa Barbara, Ca., CD*, 1949, 1951; John Griesbauer b. Jan. 2, 1918 was residing in Solvang at an unidentified date per *U. S. Public Records Index, 1950-1993*, vol. 2; John Carroll Griesbauer b. Jan. 2, 1918, married to Gladys [?], d. Jan. 4, 1989 and is buried in Oak Hill Cemetery, Ballard, per findagrave.com (refs. ancestry.com).

See: "Jorgensen, Karl," 1951, "Mission Santa Ines," 1953, "Nelson, Robert," 1950, "Santa Ynez Valley Art Exhibit," 1953, 1954, "Solvang Photo Shop," 1950, 1952

Griffith, Marilyn (Santa Barbara?)
Member of Santa Maria Art Association who exh. in opening exhibit at Allan Hancock [College] Art Gallery, 1954. She lived and exhibited in various locations in California.
Griffith, Marilyn (notices in California newspapers on microfilm and on newspapers.com)
1958 – "Old-Style, Futuristic Art in Exhibit… in the 'Discovery Show'… Macy's, San Francisco. … [from] twenty-two Bay area art groups… If there were to be a blue ribbon for consistently good group participation, my candidate for it would be the Diablo Art Association in painting… The exhibit as a whole is at the top of its quality in examples of free impressionism (blending visual subject and free personal imagination) by … Marilyn Griffith…," *SF Examiner*, May 26, 1958, p. 9.
1962 – "Glendale Artists to Show Works. Five Glendale Art Assn. members will enter paintings in the All-California Art Exhibition at the 47th annual Show in San Bernardino, March 15-23. They are … Marilyn Griffith of Sunland…," *LA Times*, March 4, 1962, p. 155 (i.e., Sect. M, Glendale-Burbank, p. 1).
1965 – "Marilyn Griffith, paintings, Paideia Gallery, 765 N. La Cienega, to Aug. 21," *LA Times*, Aug. 1, 1965, p. 518 (i.e., Calendar, p. 18, col. 1); "Giffith's Illusionary Effects Undecided. Sheet metal, burlap and similar materials have become common artistic media in our generation. Marilyn Griffith's paintings, current at Paidea Gallery, suggest these substantial concerns but are entirely flat and painted. Yet they are painted in such a way as to create the illusion of relieved stuffs. Griffith works in two united manners. One is semi-geometric, employing shapes that roughly equate cut rectangles of cloth. The other suggests the landscape of dried, volcanic seas. Both manners use middle sized formats and dominant earth coloring. Her illusionary effects fall between stools. One wishes her pictures were either definitely contrived to fool the eye or that she forget it altogether and concentrate on stained reduced images. As it stands, her work offers the comforts and irritations of conventional things," *LA Times*, Aug. 9, 1965, p. 62 (i.e., pt. IV, p. 10); "… second annual Downtown Palo Alto Festival of Fine Arts… Local artists in the show are… Marilyn Griffith, 1492-J Ebener Street, Redwood City, 'Arch'…," *The Times* (San Mateo, Ca.), Dec. 4, 1965, p. 35 (i.e., The Times – Weekend, p. 3A, col. 2).
1969 – Sixteen small abstractions by Marilyn Griffith mix hard-edge, collage and marble-fudge stain in works looking for a solid direction (Paidea Gallery, 765 N. La Cienega, through March 29)," *LA Times*, March 14, 1969, p. 17.
1970 – "Gallery House – Opening today, works of Marilyn Griffith and Bea Wax, 538 Ramona st., Palo Alto, through November 28," *SF Examiner*, Nov. 8, 1970, p. 214 (i.e., Date Book, p. 24.
1977 – "New Shows Open at Museum. Four shows… Museum staff artist, Marilyn Griffith, who is the artist of the large dioramas of the Coachella Valley and The Desert

Night and Day in the Firestone and Hoover Galleries," *Desert Sun*, March 11, 1977, California Digital Newspaper Collection.

Griffith, Marilyn (misc. bibliography)
Is she Marilyn Griffith wife of Roland K. Griffith, empl. Resin Industries, listed in the *Santa Barbara, Ca., CD*, 1953?; is she Marilyn T. Griffith, wife of Roland K., listed in *Index to Register of Voters, Los Angeles County, Precinct 3155*, 1962; Roland K. Griffith is listed without wife in the *Whittier, Ca., CD*, 1973; is she Marilyn T. Griffith who divorced Roland K. on Jan. 25, 1979 in San Bernardino County per Calif. Divorce Index (refs. ancestry.com).
See: "Allan Hancock [College] Art Gallery," 1954

Gronendyke, Anne E. Timon (Mrs. Robert K. Gronendyke) (Santa Maria)
Artist. Exh. Santa Barbara County Fair, 1959. Teacher of first grade. Second wife of Robert K. Gronendyke, below.
Gronendyke, Anne (misc. bibliography)
Ann Gronendyke is listed with husband, Robert K. [who she married June 21, 1958 in LA] in the *Santa Maria, Ca., CD*, 1958, 1968 [and divorced him June 1975] (refs. ancestry.com).
See: "Gronendyke, Robert K.," "Santa Barbara County Fair," 1959, "Santa Maria, Ca., Elementary school," 1957

Gronendyke, Robert Keith (1930-?) (Santa Maria)
Sculptor. Taught art at Santa Maria high school, 1956+. Exh. Allan Hancock [College] Art Gallery, 1957, 1958. Exh. Santa Barbara County Fair, 1959. Husband of Ann Gronendyke, above.
■ Port. of artist welding and "Artist Here Readies 7 ft. Metal Sculpture… 'mother and child' will ride from Santa Maria to Los Angeles in May on top of a small European car… to the Los Angeles and Vicinity annual Artists' Exhibit… Gronendyke, who slightly resembles the hero of a Saturday night television show… has slam banged the sheet metal figure together by bending and twisting it over an anvil and patching it together by tack welding. His welding torch literally dances as he moves around the figure enclosing seams and rearranging the outline and form… His work is constantly interrupted as classmates at the Allan Hancock College adult education class in welding stop to kitbitz [sic. kibitz] … Gronendyke's imagination is as quick as his ready smile. Leavings from the welding shop scrapbox, patched together and splashed with rivulets of paint, have been transformed into a striking sculpture titled, 'Warrior's Four.' The metal warriors, leaning at a jaunty angle, are armed with spears made of welding rod… This effort will be shipped to the 78th annual San Francisco Art Association's Painting and Sculpturing Exhibition… Gronendyke, who has just completed his master's degree thesis on welding in steel, has been sculpturing in wood and metal for about four years. He has been teaching art at the high school for three years. He has exhibited all over the country in the steel medium, and at present has a piece at a show in Muncie, Ind. And another at a Seattle show. His current creation was inspired by the expected arrival of a baby to him and his wife, **Anne [Gronendyke]**, in April.

His wife, being an art major herself, is 'very tolerant' of his efforts. Gronendyke laughed. Their home at 213 W. Morrison is sprinkled with many of his ideas transformed into metal and wood. He explained that many contemporary sculptors are converting their techniques from wood and casting to metal and welding. It is cheaper than casting and faster than wood. It also allows the more creative person a greater freedom for expression … Gronendyke plans to use pieces from the high school senior bench – smashed when a tree blew over – to create a symbolic piece of wood sculpturing. … He also plans to obtain chunks from the many other trees that blew over at the high school and turn them over to his students to see what they can come up with in wood sculpturing," *SMT*, Feb. 21, 1959, p. 5; "Art Instructor Wins Award" for metal owl sculpture in state-wide competition sponsored by Creative Arts League, *SMT*, April 16, 1959, p. 1.
Gronendyke, Robert (notices in Northern Santa Barbara County newspapers on microfilm and on newspapers.com)
1956 – "New Faculty Faces," port. and new instructor of art at Santa Maria HS who has bachelor's degree from Long Beach State College, *SMT*, Oct. 3, 1956, p. 7; "Gronendyke Wins Woodcraft Award… in the American Craftsmen's Council's seventh annual competition for young American crafts artists… Gronendyke's entry of a tray of walnut with silver will be displayed in an exhibition… at the new Museum of Contemporary Crafts" in NY, *SMT*, Oct. 27, 1956, p. 1.
1957 – "Robert K. Gronendyke… has had his iron and brass sculpture, 'The Devotion Machine,' selected among 218 works of 156 artists… to be shown in the Ball State College Drawing and Small Sculpture Show… Muncie, Ind….," *SMT*, March 16, 1957, p. 3.
1959 – Santa Maria sculptor Robert K. Grenedyke [Sic.] will be included in the collection of 358 art objects to be exhibited at the 1959 California State Fair and Exposition…," *AG*, Aug. 14, 1959, p. 8.
Gronendyke, Robert (misc. bibliography)
Robert Gronendyke appears as a senior in the Compton College yearbook, 1950; Robert K. Gronendyke married Frances A. Beck on July 25, 1950 in Los Angeles per Calif. Marriage Index [cited as Aline F. Gronendyke (?) when listed with Robert in city directories, 1950-1955]; Robert R. [Sic.] Gronendyke is pictured in the Long Beach State College yearbook, 1955; Robert K. Gronendyke married Anne E. Timon on June 21, 1958 in Los Angeles per Calif. Marriage Index; Robert K. Gronendyke, teacher, Cubberley High School, with no wife cited, is listed in the *Palo Alto, Ca., CD*, 1959, 1961; Robert Gronendyke, teacher, San Jose State, is listed with wife Anne in the *Mountain View, Ca., CD*, 1968; Robert K. Gronendyke divorced Anne E. Gronendyke in June 1975 in Sonoma County per Calif. Divorce Index; Robert K. Gronendyke, assoc. prof. Calif. State College, with no wife, is listed in the *Petaluma, Ca., CD*, 1974; Robert K. Gronendyke, b. May 15, 1930 was residing in Cotati, Ca., in 1980 and Santa Barbara, Ca., at a later date, per *U. S. Public Records Index, 1950-1993*, vol. 1, 2; Emeritus professor Sonoma State University **"Robert Gronendyke (1968, 1992)** *Professor, Art and Art History,* B.A. 1955, M.A. 1960, California State College, Long Beach" from www.sonoma.edu. Numerous notices for him appear on the Internet (refs. ancestry.com).

See: "Allan Hancock [College] Art Gallery," 1957, 1958, "Amido, Benjamin," 1957, "Elk's Club – Rodeo and Race Meet," 1957, "Santa Barbara County Fair," 1958, 1959, "Santa Maria, Ca., Union High School," 1958, 1959, "Scholastic Art Exhibit," 1958, 1959

Grossini, Lothelle Moore Hall (1921-1995) (Mrs. Joseph T. Grossini) (Lompoc)
Ceramic enthusiast, 1956. As a painter she was associated with Equinox Gallery, 1962. Granddaughter of Anna Moore, above?

■ "Engagement… Mr. and Mrs. Ernest Moore are announcing the engagement of their daughter, Lothelle, to Joseph T. Grossini, son of Mr. and Mrs. Vincente Grossini… The bride-elect was a student of local schools and attended Sawyers Business college in Los Angeles. Upon completing her studies, Miss Moore became associated in the family business, the Moore Mercantile company…," *LR*, June 6, 1946, p. 5.
Grossini, Joe, Mrs. (misc. bibliography)
Lothelle Moore, mother's maiden name Hugeh, was b. Dec. 20, 1921, in Santa Barbara County per Calif. Birth Index; Lothelle is listed as wife of Joe T. Grossini, of the Richfield Service Station, Lompoc, in the *Santa Maria, Ca., CD*, 1958; Lothelle Grossini b. Dec. 20, 1921 and d. Dec. 12, 1995 per findagrave.com (refs. ancestry.com).
See: "Art, general (Lompoc)," 1962, "Ceramics," 1956, "Puttering Micks Ceramics," "Tri-County Art Exhibit," 1958

Grossini (Watkins), Suzanne / Suzann / Suzzann (Mrs. Frank O. Watkins) (Lompoc)
Lompoc High School grad who aspired to become a great artist, 1960.
Grossini, Suzanne (notices in Northern Santa Barbara County newspapers on microfilm and on newspapers.com)
1960 – "Students Tell Ambition," *LR*, April 21, 1960, p. 17.
1970 – Port. with Lompoc HS class of '60 reunion, *LR*, Sept. 1, 1970, p. 4.
1976 – Port. and caption reads "In the eyes of an artist there is beauty everywhere … Dianna Boehm, foreground, and Suzann Watkins, rear, students of Mike Henderson's Allan Hancock College art class, attempt to capture the beauty of construction [of the I Street downtown revitalization construction project] in sketches yesterday afternoon," *LR*, March 24, 1976, p. 1.
Grossini, Suzanne (misc. bibliography)
Suzzann Grossini appears in the Lompoc, Ca., High School yearbook, 1958; Suzann R. Grossini married Frank O. Watkins on Aug. 19, 1960, in Santa Barbara County per Calif. Marriage Index (refs. ancestry.com).

Grumbacher Traveling Exhibits
Traveling exhibit of art sponsored by Grumbacher, a manufacturer of artists materials. Shown in Santa Maria, 1936, 1938. On several occasions (1936, 1937, 1938) the exhibit contained works by various Breneisers.

See: "Breneiser, Margaret," "Breneiser, Stanley," 1936, "Santa Maria, Ca., Union High School," 1938

Guadalupe, Ca., art
See: "Art, general (Guadalupe)"

Guadalupe, Ca., Elementary School
Guadalupe Elementary School District - Part of the Santa Maria School District? Graduates advanced to the Santa Maria Union High School.

■ "School Bond at Guadalupe… [the new building] will be used by pupils of Guadalupe, Oso Flaco and Laguna districts," *SMT*, May 7, 1929, p. 5; "New Guadalupe School Lauded at Dedication… Joint Union grammar school… ," *SMT*, May 16, 1931, p. 6.
Guadalupe, Ca., Elementary School (notices in Northern Santa Barbara County newspapers on microfilm and on newspapers.com)
1921 – "Guadalupe… Mr. Browning expects to start teaching manual training soon," *SMT*, Aug. 24, 1921, p. 8.
1927 – "Elementary School… Among the schools which received special commendation… is the Guadalupe grammar school… outstanding work in the development of music, art and penmanship…," *SMT*, Oct. 21, 1927, p. 1; "Art Posters by Students Admired… Pupils in the sixth and seventh grades… have drawn posters advertising the Halloween Frolic… Monday night… Two deserving special notice are those drawn by **Francis Rojas** and Genevieve Brazil and are on exhibition in downtown store windows," *SMT*, Oct. 27, 1927, p. 6.
1929 – "Pupils Win Honors with Poster Work… Seven pupils… posters… for the California Valencia Orange show…," *SMT*, June 3, 1929, p. 2.
1930 – "Kiddies Play… operetta 'Santa in Mother Gooseland'… The stage sets… are the work of **Lucy Degasparis**, talented Guadalupe girl who has made a reputation for art work of this character throughout the valley," *SMT*, Dec. 26, 1930, p. 3.
1934 – "Guadalupe School Students Display… for **Public Schools week**. Tables of advanced art work done by sixth, seventh and eighth grade students draw attention to posters depicting the romance of transportation and the historic importance of various California areas. Indian beads and pottery… A products map of Santa Barbara county… Toys, sewing exhibits, salt and flour paste animals …," *SMT*, April 26, 1934, p. 1.
1939 – "Guadalupe Gives School Opera… [**Public Schools Week**] …and present an exhibit of school work… Art classes under guidance of Neil Whitehead and Mary Beatrice made posters advertising the production. Charles Ilenstein and a group of children have been comprising [sic.?] school programs. Decorative covers… featuring a gaily-attired Gypsy maiden, were drawn by Sugako Hamamoto, a pupil," *SMT*, April 27, 1939, p. 7.
1947 – "Newly-Formed Guadalupe PTA… [goals]… increase in handicraft and simple art work and the backing of a school library…," *SMT*, May 24, 1947, p. 1; "Open Six New Class Rooms in Guadalupe… **Miss Edna Davidson**, art instructor in Santa Maria elementary school, showed examples of the work of Santa Maria students in all classes.

She said, 'Copying is not creating. It takes away your creative feeling. Art is creative. Everyone who is normal can lean to draw'," *SMT*, Nov. 21, 1947, p. 2.
1949 – "Artist Exhibits – **Mrs. Alice Linsenmayer**… has recently completed an oil painting of a group of five children in Mrs. Bruner's second grade in the Guadalupe elementary school. The painting was exhibited at the Guadalupe school on Tuesday and has since been entered in the Santa Barbara Museum-sponsored **Tri-County** annual show," *SMT*, June 11, 1949, p. 8.
1953 – Photo of children and fifth-grade teacher <u>Mrs. Claudia Payne</u> and "Guadalupe School Offers <u>Ceramics</u> to Five Grades … The school has two kilns … One… is new this year. All the classes, from the second through the sixth grades, participate. Their progress in each room is staggered so that the kilns are always available when glazing time arrives. The teachers said the children show their best attention in learning how to wedge the clay, shape and paint it. 'After dusting their article of workmanship with the white glazing powder, they can hardly wait to see the beautiful colors emerge to the surface in the kiln,' Mrs. Payne said…," *SMT*, April 13, 1953, p. 1; "<u>Puppet</u> Show is Given at School," created by <u>Mrs. Tunnell's</u> fourth grade class, *SMT*, June 2, 1953, p. 4; "Guadalupe Carpentry. Teachers Go to School… Tuesday and yesterday, **Joseph E. Knowles** … busy conducting a construction workshop for the teachers…," easy for men but challenging for women, *SMT*, Nov. 19, 1953, p. 1.
1957 – Photo of two children from Guadalupe Elementary showing <u>puppets</u> they made, and article titled "Teacher Changes Grades" concerns <u>Mrs. Agnes Tunnell</u> and how she gave her students the project of a <u>puppet</u> show for **Public Schools Week**, *SMT*, May 2, 1957, p. 1.
<u>See</u>: "Posters, American Legion (Poppy) (Guadalupe)"

Guadalupe Welfare Club (Guadalupe)
Woman's club, 1920-c. 1935. Smallest (?) woman's club of Northern Santa Barbara County.
<u>Guadalupe Welfare Club (notices in Northern Santa Barbara County newspapers on microfilm and on newspapers.com)</u>
1921 – "Guadalupe. The Guadalupe Welfare Club celebrated its first birthday anniversary Monday evening with a banquet at the Commercial hotel…," *SMT*, April 1, 1921, p. 5; "Guadalupe… Club held its annual election of officers … the president appointed the chairmen for the different sections: <u>Mrs. Peter Grishingher [Sic. Grisingher],</u> <u>arts and crafts</u>… one business meeting a month, the evening of the first Wednesday. In place of the second meeting a social affair will be held on the Saturday evening after the third Wednesday of each month …," *SMT*, June 3, 1921, p. 8.
1923 – "The needlework section of the Guadalupe Welfare club met at the home of <u>Mrs. A. W. Reum</u>… eight table covers are well started …," *SMT*, May 28, 1923, p. 2.
1925 – "Guadalupe News… The Guadalupe Welfare club… **Stanley Breneiser**… who will give a lecture on his favorite … topic, 'Art,' at the library, Friday evening at 8 o'clock," *SMT*, Jan. 23, 1925, p. 3.
1927 – "Reciprocity Day Program… sessions were held in the Masonic hall… guest of honor, **Mrs. S. B. [Sic. M. T.?]**

Croswell of Santa Barbara, head of the art department of the State Teachers' college. Mrs. Croswell displayed a wonderful exhibit of the art work done by the pupils of the state school… pottery … weaving… designing… posters…," *SMT*, April 21, 1927, p. 5; "Guadalupe has Fine Program… at the Masonic hall, under the auspices of the Guadalupe Welfare Club… Mrs. Tognazzini then introduced the guest of honor and main speaker of the day, **Mrs. Mary T. Croswell** of Santa Barbara … county art chairman. Mrs. Croswell had brought with her a wonderful collection of works of art done by the students in the college, in the line of designing posters, landscape scenery, pottery and weaving in many beautiful colors and designs," *SLO DT*, April 22, 1927, p. 4.
1928 – "Preliminary plans were made for Better Education week and the president [of the Guadalupe Welfare Club] … reported that she had booked an art exhibit of the **Colonial Art company**, 'The House of Art,' for that week. … The exhibition will be held at the club rooms and a very small sum will be charged for admission in order to defray expenses…," per "Welfare Club Plans Month," *SLO DT*, March 3, 1928, p. 5.

Guerrero, Mike, SSgt. (1924-2019) (Guadalupe / Vandenberg AFB)
Photographer for Air Force, c. 1947-63.
■ Port. and "Assigned to Vandenberg. Ex-Guadalupean… Strobe lights will glow and shutters will click because S. Sgt. Mike Guerrero is back at Vandenberg. Mike is official photographer for the SAC MISSILEER, and has just returned from a two months tour at the U. S. Army Information School at Fort Slocum, N. Y. Mike was one of eight airmen attending the huge Army school … The class of over 200 studied applied journalism… Guerrero is one of the best known men at Vandenberg. If a deed is newsworthy you can bet Mike will be there… Guerrero was born in nearby Guadalupe. He attended Guadalupe and Bonita Grammar Schools and Santa Maria Union High school. In high school, Mike played basketball and ran the 440 during the track season. He also got acquainted with the art of photography as a motion picture projectionist in Santa Maria theaters. He reversed the usual procedure by joining the Air Corps and switching over to the Infantry. He served in France and subsequently at the front lines in Gotha, Germany, under Gen. George Patton. At the conclusion of the war, Mike returned to Guadalupe for a month and a half. Then he returned to the military service, to the Air Force, this time to stay. As a projectionist he served at Greensboro, N. C. and Mitchell Field, N. Y. When he was assigned to Ellsworth AFB, S.D., his photography hobby, which he had pursued since high school days, paid off. He was sent to the photographer's school at Lowry AFB, Colorado, and returned to Ellsworth as a photographer in the Photo-Lab. His work was noticed favorably by the Information Office at Ellsworth and he transferred to duty with that office. He married Ethel Jane Garr at the Presbyterian Church in Sturgis, S. D., and Jimmy and Linda Guerrero were born in South Dakota. The family of four traveled to Morocco and returned to Ellsworth at the end of Mike's tour of duty overseas. Top AF Photographer. While at Ellsworth, Guerrero became

noted as one of the leading Air Force photographers, and his news photos of Air Force personnel appeared in Air Force publications throughout the world. SAC's most coveted photo award, 'SAC Photo of the Month,' was awarded Guerrero in 1956 for his picture depicting a maintenance man loading ammunition in the tail gun of a B-36. In 1958 the Guerreros returned home. The assignment to Vandenberg AFB gave Mike the opportunity to record on film the beginning of the missile, practically in his old home town. His pictures of the Atlas being towed on its special trailer became a SAC news release. Many of his other pictures have been published by local papers and Air Force publications. ... Family Pictures.... Mike does take pictures of his family. The Guerrero home on Maple Street in Capehart is filled with prints and negatives of the family and events that have taken place at Vandenberg," *SMT*, March 30, 1960, p. 6.

■ "A full life of 95 years, Mike passed peacefully in his sleep on Patriots Day. He was born in California in 1924. As the oldest of 7 children, he assumed responsibility for his mother and siblings when his father died during the depression. He joined the military and served for 31 years starting in WWII and ending a couple of years after returning from Vietnam where he retired from the USAF. He returned to the Central Coast and worked for the county at Guadalupe and Bonita schools," per findagrave.com.
Guerrero, Mike (notices in Northern Santa Barbara County newspapers on microfilm and on newspapers.com)
1945 – "Guadalupe News... Mike Guerrero, who is in the Army Air Forces, is on furlough visiting friends and relatives here," *SMT*, March 7, 1945, p. 3.
1947 – "Two Enlist... The reenlistment of Mike R. Guerrero... Guadalupe, for Army Air Forces. Mike was discharged from the service in March of this year at Mitchell Field, New York, after serving 4 years of service," *SMT*, June 14, 1947, p. 3.
1948 – "I Spied ... Cpl. Mike Guerrero home on leave from his Air Corps station in South Dakota," *SMT*, Jan. 3, 1948, p. 1.
1956 – Port. and caption reads "S/Sgt. Mike Guerrero (center) former resident of Guadalupe now stationed at Ellsworth AFB, S.D.," *SMT*, Nov. 29, 1956, p. 10.
1957 – "Sgt. Mike Guerrero Assigned to Capital. Ellsworth AFB, S.D.... S-Sgt. Mike R. Guerrero to attend special training at the department of defense news photo shop and will be assigned to the pictorial branch Pentagon, Washington, D. C. S-Sgt Guerrero is stationed at Ellsworth Air Force Base and is assigned to the Information Service Office as a photographer; he takes care of all the news releases for the base. ... 14 years air force service," *SMT*, April 29, 1957, p. 4.
1958 – "An 'Honorary-Honorary' member of a Wives Club is the title recently bestowed on one of the husbands of a member of Vandenberg NCO Wives Club. Noting one time at a meeting that SSgt. Mike Guerrero was always on hand to take pictures and could always be depended upon and had taken pictures of all their events since their organization, one of the members said jokingly that he should be given an honorary membership in the club. ... Sgt. Mike Guerrero has become one of the busiest men at Vandenberg because of his fine photos of any and all events, official or social. ... Mike knows the location of

everything at Vandenberg as he has but a few minutes between assignments, and incoming calls to the ISO office are constant for Mike to come take a picture. He usually arrives as soon as the call is completed, with a big grin, shoots the picture and rushes off to his next assignment. As of last week he has become responsible for the Family News section of the base paper, too, because of his 'in' with the ladies," and port. in "Photographer is Given Honor...," *SMT*, Dec. 4, 1958, p. 5.
1960 – "Assigned to Vandenberg. Ex-Guadalupean Top... S. Sgt. Mike Guerrero is back at Vandenberg. Mike is official photographer for the *SAC Missileer* and has just returned from a two months tour at the U. S. Army Information School at Fort Slocum, N. Y....," and extended article transcribed above, *SMT*, March 30, 1960, p. 6; port. of SSgt. Mike R. Guerrero, *Missileer* reporter and photographer, posed with newly installed Associated Press and United Press International teletype machines at the Vandenberg Press Center, *LR*, June 13, 1960, p. 9.
Guerrero, Mike (misc. bibliography)
Mike R. Guerrero b. Feb. 18, 1924 [in Guadalupe] to Jesus and Adelaida R. Guerrero and d. Sept. 9, 2019 in Santa Maria, is buried in Guadalupe Cemetery per findagrave.com (refs. ancestry.com).
See: "Kern, Mrs. Russell"

Gulley, Carroll E. (Arroyo Grande / San Luis Obispo / Atascadero)
Artist who exh. at Santa Maria Valley Art Festival, 1953, and at Santa Ynez Valley Art Exhibit, 1954.
See: "Santa Maria Valley Art Festival," 1953, "Santa Ynez Valley Art Exhibit," 1954, and *Atascadero Art and Photography before 1960* and *San Luis Obispo Art and Photography before 1960* and *Arroyo Grande (and Environs) Art and Photography before 1960*

Gump, Richard / Gumps (San Francisco)
Prop. of Gump's store in San Francisco. Lecturer to Minerva Club, 1953
See: "Fujioka, Henry," 1963, 1972, "Minerva Club," 1952, 1953

H

Haemer, Alan [often misspelled as Allen and Allan] Gentry, Col. (1909-1982) (Vandenberg)
Career military man with artistic talents. In Lompoc c. 1960-64. Art teacher of Barbara Kern at Vandenberg AFB, 1960. Painted a mural of cartoon characters in the base Hospital, 1963. Prof. of Fine Arts at the University of Oregon.
■ "Alan G. Haemer. Colonel USAF – Retired. Haynesville, La., ... He died Sat. Jan. 16, 1982 at the North Claiborne Hospital in Haynesville. Mr. Haemer retired as Colonel from the U. S. Air Force Nov. 1, 1969, after serving 28 years, and was a veteran of World War II, Korea and Viet Nam. He was also a retired professor of Fine Arts

at the University of Oregon," *Times* (Shreveport, La.), Jan. 17, 1982, p. 7 (i.e., 7-A).

<u>Haemer, Alan (notices in United States newspapers on microfilm and on newspapers.com)</u>

1931 – Port. and "Alan Gentry Haemer… will sail for Europe soon to continue his art studies …," *Brooklyn Daily Eagle*, June 7, 1931, p. 42 (i.e., 10C); "Take Ice Breaker to Arctic, Graf Back… Childhood Neighbors… Alan Haemer…," and article includes information on his canoe trip up the Rhine and through a 10-mile tunnel, *Brooklyn Daily Eagle*, Sept. 8, 1931, p. 7; port. paddling a kayak, and "Flatbush Boy Paddles Thru Holland to Paris. Alan Gentry Haemer of 1801 Dorchester Road Tried 41-Day Canoe Trip before Settling down in Paris to Study Art… Of course, the Augusta Hazard fellowship of a year's tuition in a Paris art school, which the 21-year-old Syracuse University graduate won, had furnished a thrill of its own. But young Haemer had an extra hundred dollars or so, earned in his spare time. And when he sailed June 19 on the scholarship trip, Alan turned his way toward England and then Holland. He bought a canoe. 'This canoe,' he wrote his parents, Mr. and Mrs. William L. Haemer, 'is a second cousin of a sea-going tug. Flat bottomed and with a rudder, it goes well with the wind...' He paddled out of Amsterdam where the boat was purchased, through canals to the River Vecht…. In 41 days Haemer paddled to Paris… There were more than 200 canal locks to pass through… After dark he pitched camp on the river bank… It rained much of the time. That made it impossible for Haemer to paint, as he went… Was Honor Student. Haemer was on the honor roll at Syracuse. In his sophomore year he won a $100 prize for excellence and in his junior year another $50. He was art editor of the college paper, the *Orange Peel*, and a member of Phi Kappa Phi fraternity, the equivalent in the Fine Arts College at Syracuse of Phi Beta Kappa. He was a member of Delta Kappa Epsilon and played on the varsity lacrosse team. While in France Haemer will pursue the classic in his studies, specializing in portrait painting and sculpture. His choice of a school has not been made as yet. At his Flatbush home yesterday, Mrs. Haemer showed the letters from which this material was gathered. … Mrs. Haemer's eager display of various wood-cuts and carvings adorning her home by Alan gave sufficient evidence of her pride in her boy," *Brooklyn Daily Eagle*, Sept. 17, 1931, p. 31.

1941 – "215 Draftees Enter Army… Stratford Group… Board 26A. South Norwalk… Alan G. Haemer…," *Hartford Courant* (Hartford, Connecticut), March 22, 1941, p. 18.

1947 – Repro: three charcoal portraits, *Hartford Courant*, May 4, 1947, p. 76 (i.e., Magazine, p. 12).

1948 – Repro: charcoal portrait of hero in novel by Forrester Blake, *Hartford Courant*, Feb. 22, 1948, p. 82 (i.e., Magazine, p. 12); repro: illus. for book, *The Washbournes of Otterley*, *Hartford Courant*, Aug. 1, 1948, p. 68 (i.e., Magazine, p. 12).

1957 – FATHER – "William L. Haemer," obituary, "survived by … Col. Alan Haemer, with the U. S. Air Force in Omaha, Neb.," *Bridgeport Post* (Bridgeport, Ct.), Sept. 22, 1957, p. 31 (i.e., A-15).

1961 – MOTHER – "Pearl Gentry Haemer's Poetry… Her sons are … Col. Alan Gentry Haemer, a commercial artist, who is currently in the service at Vandenberg Air Force base near Santa Maria, Calif.," *Bridgeport Post*, Nov. 5, 1961, p. 30 (i.e., B-10).

1963 – Photo and "Colonel Makes 'Dream World' with Paints for Little Patients," i.e., Alan Haemer, comptroller, 1st Strategic Aerospace division, painted the walls of the pediatric ward at the Vandenberg Hospital with colorful cartoon figures, and "small pictures painted by **Mrs. Russell Kern**… in the hallway and smaller rooms," *LR*, Feb. 14, 1963, p. 6.

And, additional notices in Chicago, Cincinnati, and other American newspapers for "Alan Haemer" were not itemized here.

<u>Haemer, Alan (misc. bibliography)</u>

Allen [Sic.] G. Haemer is listed in the 1910 New York Census (Brooklyn Ward 26) as age 6 months, b. New York, residing with William L. and Pearle Haemer and older brother Kenneth A. (age 5); Allan [Sic.] G. Haemer b. Oct. 1909 in New York, was residing in First District, Westwood, per New Jersey State Census, 1915; Allan [Sic.] G. Haemer, artist, NH (Noroton Heights), is listed at the same address as Kenneth W. Haemer, statistician, NY, and William L. (wife Pearl G.) statistician, N. Y., in the *Stamford, Ct., CD*, and in the *Darien, Ct., CD*, 1938; Alan Gentry Haemer b. Oct. 1, 1909 in New York City to William L. Haemer and Olive Pearl Gentry, was residing in Norwalk, Ct., in 1948, married Martile Elizabeth Sherman,, and d. Jan. 16, 1982 in Haynesville, La., per Maurer-Klein Family Tree (refs. ancestry.com).

<u>See</u>: "Art, general (Lompoc)," 1964, "Kern, Barbara," "Kern, Mrs. Russell," "Santa Barbara County Fair," 1960

Hageman, Frederick "Fred" Charles (1905-1948) (Lompoc)

Architect and superintendent of reconstruction of Mission La Purisima, Aug. 1934-1938.

■ "Fred Hageman Becomes New Superintendent… of Purisima Mission restoration, was born in Los Angeles and attended the Los Angeles High school. Upon graduation he attended the University of Southern California where he was graduated in 1928 with a B. S. degree in architectural engineering. He attended the University of California at Los Angeles for one year, studying advanced architectural design. He is a member of Alpha Rho Chi professional fraternity and of Phi Kappa Kappa scholarship fraternity. After leaving college he entered an architects office in Los Angeles where he remained for some time. He left… to become an orchard and ranch supervisor and later did considerable work in real estate management. In 1929 he came to Santa Barbara where he became affiliated with Edwards and Plunkett, architects. It was here that he secured some valuable working experience as an architect, designer, specification writer, and draftsman. He later became a private architect and remained in this position until he took a position in the administration office of the CWA and the SERA. In August of 1934 he came to the Santa Rosa CCC camp (now Purisima) and became senior foreman in which capacity he made all the necessary drawings with the exception of a few survey drawings. He carefully planned the work for the Santa Rosa park… He also worked in co-operation with the county in planning the Nojoqui park project… he next concentrated his attention

upon the restoration of the Purisima mission. Not only as an architect and a designer is he important… but his knowledge of archaeology… he is able to piece together the remains of the old mission as it stood before its deterioration…," *LR*, Dec. 6, 1935, p. 5.

Hageman, Fred (notices in Northern Santa Barbara County newspapers on microfilm and on newspapers.com)
1947 – "… a two-page spread in the *LA Times* magazine section displays the architectural handiwork of a former Lompocan – Fred Hageman. He … was the architect for a couple of our town's homes…," *LR*, Sept. 4, 1947, p. 1, col. 1.
1948 – "Hageman, Frederick Charles, April 15, late of 1718 Foothill Boulevard, La Canada, beloved husband of Evelyn Hageman, father of Frederick Hageman, son of Frank C. Hageman of La Canada …," *LA Times*, April 16, 1948, p. 21.

Hageman, Fred (misc. bibliography)
Frederick Charles Hageman was b. July 31, 1905 in Calif., to Frank Charles Hageman and Gertrude Amelia Raynor, married Evelyn Barbara Raymond and d. April 15, 1948 per Newell Family Tree (refs. ancestry.com).
See: "Floats," 1936, "Harwood, Harvey," "Mission La Purisima," 1935, "Santa Barbara County Library (Lompoc)," 1935

Haines, Richard (1906-1984) (Los Angeles)
Artist who exh. at first Santa Maria Valley Art Festival, 1952, courtesy Cowie or Dalzell Hatfield Gallery in LA.

■ "Richard Haines (born Marion, Iowa, December 29, 1906, died, Los Angeles, California October 9, 1984) was an American New Deal muralist from Marion, Iowa," who spent most of his career in Southern California, from Wikipedia.
See: "Santa Maria [Valley] Art Festival," 1952, 1953

Hall, Lucille L. (Mrs. Morris V. Hall) (Santa Maria)
Flower arranger. Manager of Ivy Gift Shop, 1937-39.
More than 220 notices for "M. V. Hall" in the *SMT* between 1935 and 1945 show that Mrs. Hall was interested in flower arranging, was a member of the Minerva Club, was active with St. Peter's Episcopal church, and was frequently put in charge of decorating for special events, but they were not itemized here.
See: "Ivy Gift Shop," "Murals," 1945

Hall, Rex William (1914-2006) (Santa Maria)
Artist. Santa Maria high school grad. '31 and JC student (1932, 1933) whose pencil sketches won at the Scholastic Art Exhibit in Pittsburgh, 1932. Winner of Latham poster contest, 1933. Exh. art at Faulkner Memorial Gallery, 1933. Became a professional artist.

■ "Rex Hall, Bride on Wedding Tour. …The groom is the son of Mr. and Mrs. George E. Hall of Santa Maria… The bride is the former Doris Louise Humphry … The groom … graduated from local schools and then attended Art Center, Los Angeles, and Santa Barbara State College. Both he and Mrs. Hall are associated with Butler

Production Artists in Los Angeles…," *SMT*, Sept. 6, 1946, p. 3.

Hall, Rex (notices in Northern Santa Barbara County newspapers on microfilm and on newspapers.com)
1943 – "I Spied… Twenty-three illustrations in a new Douglas Aircraft Co. catalog from drawings by Rex Hall, son of Mr. and Mrs. George Hall of Santa Maria," *SMT*, July 10, 1943, p. 1.
1959 – Port. and "Aerojet-General Corporation artists Jim Foreman, left, and Rex Hall, examine some of the sketches for the first Space Age Illustrated art show to be held at the Sacramento County Fair, June 18 through 21st… The two will direct the show…," *Sacramento Bee*, May 7, 1959, p. 57 (i.e., D-1).
Approx. 50 notices on "Rex Hall" in the *SMT* between 1928 and 1940 primarily concern his sports in high school and JC and were not itemized here.

Hall, Rex (misc. bibliography)
Port. and caption – "Rex Hall. Transferred from Kendallville, Ind., 4, Basketball, 4, 'Anything for a quiet life'," appear in Santa Maria High School yearbook, 1931; Rex William Hall filled out a WWII Draft Card in 1940 while residing in Santa Maria and enlisted 1941; Rex William Hall was b. Feb. 18, 1914 in Angola, Ind., to George Eagleton Hall and Bessie Smith, was residing in Manhattan Beach, Ca., in 1971, and d. Aug. 23, 2006 in El Dorado Hills, Ca., per Douglass Rodriguez Family Tree (ref. ancestry.com).
See: "Faulkner Memorial Art Gallery," 1933, "Posters, Latham Foundation (Santa Maria)," 1933, "Scholastic Art Exhibit," 1932

Halliday, Mary Hughitt (1866-1957) (Berlin / Santa Monica / Santa Barbara)
Artist who exh. in National Art Week show at Minerva Club, 1940.

■ "Painter. [b. Cairo, Ill., Oct. 31, 1866 and d. Santa Barbara, Ca., June 26, 1957] Mary Halliday studied under William M. Chase and Charles Lasar in the United States and at the Academie Carmen and Academie Colarossi in Paris," per Nancy Moure, "Dictionary of Art and Artists in Southern California before 1960," *PSCA*, vol. 3;
A list of the titles of her artworks exhibited in various group shows at the LA Museum in the 1920s, appears in *PSCA*, vol. 2, p. B-58.
She resided in Santa Barbara the last 20 years of her life (c. 1938-57), per *Santa Barbara, Ca., City Directories*.

Halliday, Mary (notices in American newspapers on newspapers.com)
1889 – "How Packer Girls Paint. An Exhibition in the Gymnasium of the Institute... The drawings from life, heads and shoulders, were not numerous, but all of them were excellently executed... Miss Mary Halliday [had] two... Miss Halliday also gave proof of uncommon ability with the crayon...," *Brooklyn Daily Eagle*, June 1, 1889, p. 5.
1893 – "Mary Hughitt Halliday, a Cairo, Ill., girl educated at Vassar and Packer, has been elected president of the Woman's Art Club of Sculptors and Painters in Paris. She was for two years the pupil of William M. Chase of New York, and since she went to Paris, she has been thrice honored by the art authorities there... She has been in Paris

only a year...," *Buffalo Evening News* (Buffalo, NY), Dec. 11, 1893, p. 9; "American Girl in Paris Art... 'Miss Mary Hughitt Halliday, who has recently achieved such distinction in Parisian art circles, is an Illinois girl. She is the second daughter of Capt. William P. Halliday, President of the City National Bank of Cairo... The foundations of her education were laid in the Cairo public schools. When a mere child she evinced a love of art and literature, which was fostered and encouraged by her father... Before entering upon her collegiate course, she had traveled extensively in Europe and learned French so thoroughly during a prolonged stay in Paris that she speaks and writes the language with as much fluency as she does her mother tongue. Returning to America she was a student at Vassar for several years, but graduated from Packer Institute, Brooklyn, with high honors. Her essay, 'Ophelia,' attracted favorable mention from the New York press, and one of the leading papers published it entire. After graduating she determined to gratify her natural inclinations and entered upon the study of art ... and for several years was a pupil of William M. Chase in New York... In September 1892 she returned to Paris to prosecute her art studies under famous teachers. ... she speedily took front rank among the cultured artists of Europe. Within a year she was thrice honored by the art authorities there, twice by special mention and once with a bronze medal for work done. Quite recently she was elected President of the Woman's Art Club of Sculptors and Paintings....," and port. drawing of Miss Halliday, *Chicago Tribune*, Dec. 17, 1893, p. 25.
1896 – "The *Packer Alumnae*, published semi-annually by the Associate alumnae, is out this week. The long articles are on 'Student Life in Paris,' by Miss Mary H. Halliday...," *Brooklyn Daily Eagle*, June 7, 1896, p. 22, col. 2.
1899 – Obituary of her father, Capt. Halliday, states "family consists of ... and Miss Mary H. Halliday, who is a New York artist," *Olney Times* (Olney, Ill.), Oct. 4, 1899, p. 2.
1909 – "U. S. Invasion of Berlin ... Berlin ... annual picture exhibition... Miss Hughitt Halliday shows three remarkable pictures, 'Urania,' 'Calliope' and 'Thalia'...," *Sun* (New York), May 9, 1909, p. 5.
1913 – "American Artists to Front... Paris ... Forty American artists are represented by pictures at the National Salon... Hughitt Halliday...," *Baltimore Sun*, April 13, 1913, p. 7.
1920 – "Various Artists at the Friday Club... Hughitt Halliday – who, I understand, is a woman – has six attractive pictures, two in water color...," *LA Times*, May 24, 1925, p. 74 (i.e., pt. III, p. 30).
Halliday, Mary (misc. bibliography)
Mary H. Halliday is listed in the 1880 U. S. Census as age 13, b. c. 1867 in Ill., residing in Cairo, Ill., with her parents Wm. P. Halliday (age 52), Eliza W. Halliday (age 37) and siblings: Charlotte (age 16), Wm. P. (age 14), Florence (age 10), Ada G. (age 7) and John (age 5).
NY PASSENGER AND CREW LISTS: **1895** – Mrs. P. Halliday, age 53 and Mary Halliday, age 28, artist, citizen, sailed from Cherbourg on the *Furst Bismarck* and arrived at NY on July 19, 1895; **1914** – Mary Halliday, age 47, residing in Cairo, Ill., sailed from Bremen on Jan. 6, 1914 on the *S. S. Kronprinzessin Cecilie* and arrived at NY Jan.

17, 1914; **1920** – Mary Halliday, age 53, residing at 2146 W. Adams St., Los Angeles, Ca., sailed from Hamburg, Germany on Nov. 11, 1920 on the *S. S. Manchuria* and arrived at NY Nov. 24, 1920; **1921** – Mary Halliday, age 54, b. Dec. 1867 in Cairo, Ill., residing at 316 Adelaide Drive, Santa Monica, Calif., sailed from Bremen, Germany on Oct. 18, 1921 on the *S. S. George Washington*, and arrived at NY, Oct. 28, 1921; **1924** – Mary H. Halliday, age 57, b. Cairo, Ill., Oct. 31, 1866, Passport 274839 issued Wash., April 25, 1923, residing at 316 Adelaide Drive, Santa Monica, Cal., sailed from Hamburg, Germany on Oct. 2, 1924, on the *S. S. Deutschland*, and arrived at NY Oct. 14, 1924; **1926** – Mary Hughitt Halliday, age 59, residing at 316 Adelaide Dr., Santa Monica, sailed from Hamburg, Germany on Sept. 21, 1926 on the *S. S. Andania* and arrived at NY on Oct. 3, 1926; **1928** – Mary Halliday, age 61, residing at 326 [Sic.] Adelaide Drive, Sta. Monica, Ca., sailed from Bremen, Germany on Oct. 15, 1928 on the *S. S. America*, and arrived at NY Oct. 25, 1928; **1930** – Mary Halliday, age 63, residing at 59 Pine St., Santa Monica, Cal., sailed from Bremen, Germany, Feb. 12, 1930 on the *S. S. Bremen* and arrived at NY on Feb. 18, 1930; **1933** – Mary H. Halliday, age 66, residing at Santa Monica, Ca., sailed from Hamburg, Germany on Oct. 4, 1933 on the *S. S. President Roosevelt*, and arrived at NY on Oct. 13, 1933; **1936** – Mary H. Halliday, age 70, US Passport 753 NICE 3/31/33, residing at 316 Adelaide Drive, Santa Monica, Ca., sailed from Hamburg, Germany on Oct. 14, 1936 on the *S. S. President Roosevelt*, and arrived at NY on Oct. 24, 1936; **1938** – Mary H. Halliday, age 71, passport 3769II, issued Wash. March 22nd '37, residing at 316 Adelaide Drive, Santa Monica, Ca., sailed from Hamburg, Germany on July 27, 1938 on the *S. S. Manhattan*, and arrived at NY, Aug. 4, 1938; [and there are several Hamburg and Bremen Passenger lists duplicating the information on the above.] PASSPORT APPLICATIONS: several state that her father was named William P. Halliday, that she resided in Paris from 1891 to 1901 and in Germany from 1901 to 1919, that her permanent address was Los Angeles, that she followed the occupation of Painter, that she was about to go abroad temporarily and intended to return to the United States within 6 months... [In 1920 she was] visiting Holland, France and Switzerland and that she intended to depart the US at New York [In 1920 it was on an as yet unknown ship in June, 1920]; and other passport applications for 1914, 1915, 1917, 1919, 1920, 1923; CONSULAR REGISTRATION CERTIFICATES: "Mary Hughitt Halliday... arrival in foreign country where now residing – June 21st 1907, place of residence, Berlin, reasons... study of art ... Passport issued by the American Embassy at Berlin Oct. 23, 1902, No. 4068.
Halliday, Mary H. (misc. bibliography)
Mary H. Halliday is listed in the *Santa Barbara, Ca., CD*, 1939-55, Mary Hughitt Halliday b. Oct. 31, 1866 in Cairo, Ill., to William Parker Halliday and Eliza Halliday, d. June 26, 1957 in Santa Barbara and is buried in Beech Grove Cemetery, Mounds, Ill., per findagrave.com; her port. and a repro of one of her paintings are contained in Public Member Photos & Scanned Documents (refs. ancestry.com).
See: "National Art Week," 1940

257

Halloween Window Decorating Contest (Lompoc)
Window display contest for school students, 1952+.

■ "Merchants Lay Plans for Halloween… will sponsor a downtown 'Store Window Painting' contest for Halloween… All local students from grammar, junior high and high school will be invited to participate and prizes will be awarded for the most 'artistically' decorated windows. The 'window painting' custom has arisen in the past few years in many cities… helps to offset the pranksters… the students to start their water color operations … by Wednesday, October 29th – two days prior to Halloween…," *LR*, Oct. 16, 1952, p. 1.
Halloween contest (notices in *Lompoc Record* on newspapers.com)
1952 – "Pottering Around… But the budding artists who have hitherto delighted in decorating windows in a surrealist métier, are being forestalled this year by merchants who are offering prizes for the best window drawings," *LR*, Oct. 30, 1952, p. 10; "Window Pix Prize Award… The prize winners were as follows: High School: (1) Roxanne Canfield and Pat Lower, Lerrain's Dress Shop window…," *LR*, Nov. 6, 1952, p. 9; "Lompoc Views… Halloween Windows. The Hallowe'en widow painting contest sponsored by the Retail Merchants Division, Lompoc Valley Chamber of Commerce had two aims. One was to give local youths with artistic inclinations an extra outlet for their talents. It served as an art project for many of the students. The other aim was to eliminate, partly at least, some of the window soaping and kids' pranks… The contest helped a lot… for the soaping ebbed to its lowest in years. The kids respected the drawings… Next year it is planned to elaborate on this competition which was tried here for the first time last week… the students showed an amazing talent in producing their miniature art works on the show windows…," *LR*, Nov. 6, 1952, p. 12; repro: artwork in window of Brooks Plumbing painted by Linda De Lira that won first place in the Elementary School Division, *LR*, Nov. 6, 1952, p. 16.
1953 – "Godden New Chairman of Merch. Div. Christmas, Halloween Decorations Set for Business District. A comprehensive decorating plan was adopted for the Christmas season and a repetition of last year's successful [Halloween] window painting competition was approved," *LR*, Sept. 10, 1953, p. 1; "Winners of Prizes are Announced… second annual Halloween Window Decorating Contest, co-sponsored by the Lompoc schools and the Retail Merchants division, Lompoc Valley Chamber of Commerce… Elementary School [and winners named including **Amelia Alvarez**] … Junior High School [and winners named]… Senior High School. (1st) Roxanne Canfield for her painting at Holser and Bailey's. (2nd) Dixie Macias for her painting at Schroeder Brothers 5 and 10. (3rd) Phil Landis for his painting at Perozzi Hardware…," and repro of painting by Mayette Swonger, *LR*, Nov. 5, 1953, p. 5.
1954 – "Windows to be Decorated Halloween… Lompoc's Retail Merchants' association and Chamber of Commerce will again sponsor… Beginning tomorrow, students will decorate the windows of stores and other business firms with posters being made by them at school…," *LR*, Oct. 28, 1954, p. 2; "Halloween Art Winners Announced… Goblins, ghosts and sundry other Halloween characters and scenes decorated the windows of Lompoc stores last weekend. Lompoc High and Hapgood School students competed for prizes… 34 local merchants contributed to a prize fund and the students made their posters at school. … Dorothy Wheeler won the first prize of $10 in the High School division for her design, which was displayed at Stillman's Cleaners. Judith Phelps won the second prize in the High School division for her poster which was in the window of Brown's Drugs. In the Hapgood School Division, first prize was $5, second prize was $3, and third prize was $2… Hapgood school students, for the most part, worked in groups rather than as individuals … Mr. Hardin's Room 10 group prepared the Men's Corner poster… Mr. Storey's room 3 group prepared the other Moore posters… Third prize went to **Mr. Storey**'s Room 4 group, which decorated the J. C. Penney Co. window … **Mrs. Russell Benhart** was chairman of the judging committee. **Mrs. Arnold Brughelli** and **Mrs. Clarence Epperly** were the other judges… **Frank McCall** was in charge of preparation of the posters at the Hapgood School. **Conley McLaughlin** supervised the art work at the high school. Participating Lompoc High school artists were … [and names listed]," *LR*, Nov. 4, 1954, p. 8.

Halloween Window Decorating Contest (Santa Maria)
Window display for Santa Maria students, 1951+?
Halloween contest (notices in Northern Santa Barbara County newspapers on microfilm and on newspapers.com)
1951 – "Contest Arranged for Jr. High Art Students" by Retail Merchants Assn to decorate store windows for Halloween, *SMT*, Oct. 24, 1951, p. 1; "Students to Win Awards for Art Aid," i.e., decoration of windows for Halloween, *SMT*, Oct. 27, 1951, p. 1; Richard "Pinheiro Wins Halloween Art Contest Honors… painting of skeleton riding on a skeleton horse on Rowan & Green's window…," and other children winners named (Dale Aldridge, Carmen Manning, Henry Oda, Ann Konshi, Betty Eva, Glenn Carroll, Lena Clark) and "Twenty-seven pictures adorned the windows of 22 stores" and 4-woman judging committee included **Mrs. James Hosn, Mrs. John Foster, Mrs. Maye Nichols**, and **Mrs. Melba Bryant**, *SMT*, Nov. 1, 1951, p. 1.
1952 – "Art Students Set Halloween Contest" for decorating windows of downtown retail stores, *SMT*, Oct. 28, 1952, p. 1; "Halloween in Air Downtown, Windows Glow … spectacular display of Halloween paintings as 34 high school students started competing for prizes to be awarded by the Retail merchants division of Santa Maria Chamber of Commerce. A committee of merchant judges will determine winners… Competing for similar awards tomorrow under direction of **Mrs. Edna Davidson**… will be 22 grammar school artists…," and list of high school artists, *SMT*, Oct. 29, 1952, p. 1; "Hallowe'en Artists Awaiting Rewards," i.e., finals of judging, *SMT*, Oct. 30, 1952, p. 4; "Lowell Evans, Patty McFall Win Art Prizes… First prize awards of $10 for Halloween painting on downtown store windows went to high school art student Lowell Evans and El Camino art student Patty Ann McFall…," and lesser prizes listed, "Robert Pasillas received second prize among the El Camino art students for

his Halloween painting at Fletchers," *SMT*, Oct. 31, 1952, pp. 1, 3.

1953 – Retail Merchants Halloween window painting contest "Holiday Art Contestants Eye Prizes" – high school student artists will be supervised by **Miss Edna Davidson** and H.S. art instructors **George Muro** and **Gordon Dipple**, *SMT*, Oct. 29, 1953, p. 1; "Two Boys Grab Honors in Halloween Artistry. Robert Passilas [Sic. Pasillas] and Alfred Rosso, high school and elementary art students… Second in the high school division was Bill Lee's painting at Hopkins'. Third was Lenna Clark, whose entry can be seen at the Holser & Bailey store… These high school pupils received honorable mentions: **Joyce Fleming** (Economy Drug); Rudy Abenido (Santa Maria Furniture), Jerry Edgar (Felmlee grocery), … **Henry Fujioka** (Associated Drug), Myron Battles (Gallison's), Virginia Van Wyk (Penney's) and Ben Amido (Gill and Cross) … Elementary honorable mention winners: … **Barbara Prater** (Goodchild's)," *SMT*, Oct. 31, 1953, p. 1.

1954 – "Allan Dart is named 1st in Decorating… decorated the window of Ida Mae's … Second prize… Edwina Forrester… on the Associated Drug Window… Third prize… went to Robert Pasillas … on a window at Sears Roebuck…," *SMT*, Oct. 30, 1954, p. 1.

Hamilton, John "Jack" Borden (1905-1961) (Montecito)
Artist in National Art Week show at Minerva Club, 1940. Society.
Hamilton, John (notices in California newspapers on microfilm and on newspapers.com)
1938 – Married Polly Forsyth, *LA Times*, Sept. 25, 1938, p. 65 (i.e., pt. IV, p. 9).
1950 – "Polly and Jack Hamilton (the John Borden Hamiltons) confused Santa Claus by moving into a brand new abode on Hot Springs Road just before Christmas. Nevertheless, old St. Nick did find the new address for David and John, the stocking hanging generation of the family," *LA Times*, Dec. 24, 1950, p. 53 (i.e., pt. III, p. 13, col. 2).
Hamilton, John B. (misc. bibliography)
John B. Hamilton is listed as "artist" with wife, Mary F., in the *Santa Barbara, Ca., CD*, 1938, 1941, 1942, 1951; John B. Hamilton is listed as "artist" in Voter Registrations in Santa Barbara, 1938-1944; John Borden Hamilton provided the following information on his WWII Draft Card dated Oct. 16, 1940 = b. July 25, 1905 in NYC, unemployed, residing in Santa Barbara with wife, Mrs. Mary Forsyth Hamilton; John Borden Hamilton was b. July 25, 1905 in NYC to Louis Alford Hamilton and Penelope Adaline Borden, married Mary Elizabeth Forsyth, and d. Nov. 3, 1961 in Santa Barbara per Selby-Hamilton Family Tree (refs. ancestry.com).
See: "National Art Week," 1940

Hampton (Mullane), Tommy (Mrs. First Lt. Paul N. Mullane) (Lompoc)
Art teacher, Vandenberg AFB Junior High, 1960.
■ "Couple Makes Plans for Saturday Wedding. Miss Tommy Hampton, 617 North Fourth Street will become the bride of First Lieutenant Paul N. Mullane of the Naval

Missile Facility, Pt. Arguello… The bride's parents are Mr. and Mrs. Winfred Fulton Hampton of Conway, Arkansas… The bride, an art teacher at Vandenberg AFB Junior High School is a graduate of Hendriz College at Conway… The new home will be at 329 North Sixth Street, Lompoc," *LR*, April 28, 1960, p. 6.

Hancock, G. Allan (1875-1965) (Los Angeles / Santa Maria)
Wealthy capitalist, after whom Allan Hancock College was named. Filmmaker.
■ "Capt. G. Allan Hancock (port.) died Monday night at his ranch home a mile east of Santa Maria… Captain Hancock was born in San Francisco July 26, 1875, a son of Maj. Henry Hancock and Ida Haraszthy Hancock. His parents were '49ers … Los Angeles was his lifelong residence, but he spent much of his time at this ranch home east of Santa Maria. He had extensive interests in the Santa Maria Valley and northern Santa Barbara County. These included the Santa Maria Valley Railroad, La Brea Securities Co., Rosemary Farms and Rosemary Packing Co. He established a school of aeronautics at which is now Hancock College and during World War II hundreds of pilots received their training there. When the Santa Maria Junior College was moved from the high school campus to the aeronautical school, it was renamed Hancock College… He was a farmer, dairyman, horseman, beef cattle and poultry raiser, an oil and gas prospector, producer and distributor, a banker, subdivider of large tracts, manufacturer and industrialist, merchant mariner, ship owner, railroader, packer, trucker, aviator, scientist, explorer, educator, musician and philanthropist…. Though he began his career at hard labor… The foundation of the Hancock wealth was historic Rancho La Brea… which has since become most of Hollywood and the Wilshire district of Los Angeles including the famed 'Miracle Mile' of Wilshire boulevard. On it he grew hay, barley and oats, dug brea from the Pleistocene tar pits, produced oil and subdivided hundreds of acres in the 'roaring twenties.' Later he gave large parcels of it away to the University of Southern California, the City and County of Los Angeles…," *SMT*, June 1, 1965, pp. 1, 7.
Hancock, Allan G. (notices in Northern Santa Barbara County newspapers on microfilm and on newspapers.com)
1933 – "Thrilling Story of Island Life … Captain G. Allan Hancock's films taken on the Galapagos islands… Thursday night's program at the high school auditorium in Santa Maria… Long distance photography as well as microscopic and magnified pictures will be shown … no admission fee…," *SMT*, June 21, 1933, p. 1.
And Hancock paid other professional photographers to fly from his airport and take aerial photos, and others to photograph special "projects" for him, etc.
Hundreds of articles on Hancock's activities appeared in California newspapers but were too numerous to even browse for inclusion here.
Book: Sam T. Clover, *A Pioneer Heritage*, LA: Saturday Night Publishing, 1932, A book about Hancock.
See: "Allan Hancock College"

Hancock Art Gallery (Santa Maria)
See: "Allan Hancock [College] Art Gallery"

Hancock College (Santa Maria)
See: "Allan Hancock College"

Hancock College of Aeronautics (Hancock Field, Santa Maria)
In 1939 Hancock field was rededicated to the aviation cadet training program and named the Hancock College of Aeronautics. In operation July 1, 1939 to June 30, 1944, 8,414 aviation cadets were enrolled. Attached to it or held in its neighboring buildings (?) Santa Maria Junior College offered "ground school" classes including drafting. In 1945, the war effort being over but the age of civilian piloting emerging, University of Southern California started its "air campus." The academic work of flying was taught in classes in Los Angeles with instruction in flying and aircraft engines in Santa Maria. After USC left, the Santa Maria Junior College moved to the campus, 1954.
1940 – "Aeronautics Classes. A class in airplane drafting and lofting has been organized and will begin meetings tomorrow night in the junior college building at Hancock College of Aeronautics from 7 to 9 o'clock… Wm. McConnell teaches…," *SMT*, Sept. 25, 1940, p. 3.
1943 – "Ground School Luncheon … junior college ground school in Hancock College of Aeronautics … The drafting room interested many especially the lofting of a small speed ship for a famous designer by junior college and high school students under the department head, W. L. Bach…," *SMT*, March 12, 1943, p. 3.
And, many additional notices in the *SMT*, not itemized here.
See: "Boy Scouts," "Santa Maria, Ca., High School," 1938

Handcrafts / Handicrafts, general (Northern Santa Barbara County)
Umbrella term for various crafts such as weaving, carving, pottery, leather tooling, basketmaking, etc. In this column appear articles that don't fit under other the more specific headings in this Dictionary.
■ Handcrafts were taught in public schools at all levels, at summer recreation programs, at adult schools, at hospital rehabilitation during WWII, at the USO, at various bible schools, at regular meetings and at summer camps for Girl and Boy Scouts and for Camp Fire Girls. Handicrafts were displayed at the Santa Barbara County Fair and at Public School Week exhibits, at women's clubs, and items were sold at many bazaars, fairs and carnivals. Handcrafts made by disabled American Veterans outside Santa Barbara County were sold within Northern Santa Barbara County by various organizations but were not itemized here.
Handcrafts (notices in newspapers)
1926 – "Among the handiwork being done by the Buellton ladies are some very attractive baskets. Those exhibit works of the weaver's art [sic?]" *SYVN*, June 4, 1926, p. 4, col. 2.

1950 – "Valley Lions to Sponsor Industrial Arts Program… demonstration team from the University of California at Santa Barbara College will appear in a special program at the Veterans' Memorial building in Solvang on Wednesday evening April 12… Taking part in the presentation will be Edward Roberts, leather carving … Chester Troudy, internal carving in plastics… Albert Fine, use of air gun brush, Judge King, crepe paper demonstrations, and Russell Groff, hand weaving. Mr. Groff studied this subject last summer in Denmark…," *SYVN* March 31, 1950, p. 1; "Industrial Arts Program on Wednesday…," *SYVN*, April 7, 1950, p. 1; "Industrial Arts Program Given in Valley Termed 'Outstanding.' A demonstration team from the industrial arts department of Santa Barbara college, U of C, appeared… at the Veterans' Memorial building in Solvang," *SYVN*, April 14, 1950, p. 8.
Various syndicated columns on how-to do specific handcrafts were run in the *SYVN* but were not itemized here.
See: "Alpha Club," "Art, general (Buellton)," "Arts and Crafts …," "Boy Scouts," "Camp Fire Girls," "Ceramics," "Community Club," "Crafts Shop," "Creative Arts and Woman's Exchange," "Danish Days," "Displaced Persons Colony (Buellton)," "Four-H," "Girl Scouts," "Lompoc, Ca., Adult/Night School" "Santa Barbara County Fair," "Santa Maria, Ca., Adult/Night School," "Santa Maria, Ca., Union High School," "Santa Ynez Valley, Ca., Adult/Night School," "Santa Ynez Valley Fair," "Schools (Northern Santa Barbara County," "Solvang Woman's Club," 1940, "Summer School," "United Service Organization"

Handwork / Handiwork
Umbrella term for needlework / fancy-work such as embroidering, cross stitch, needlepoint, crewel, crochet, knitting, hooked rugs, quilts, and other sewing. In this column appear articles that don't fit under other more specific headings in this Dictionary.
■ Handwork was taught in the Domestic Arts department of various public schools, in the Handcraft Section of various women's clubs, and in Girl Scouts, 4-H, and Camp Fire Girls as well as the Home Department of the State Farm Bureau. There were special clubs, often associated with churches, devoted to handwork. Items were displayed at the Santa Barbara County Fair and other smaller, local fairs, at Public Schools Week exhibits, at special exhibits in women's clubs, at Danish Days, etc.
1929 – "The **Danish Ladies Aid** have completed all arrangements for their annual bazaar and dinner… December 6th at Dania hall. A big display of fancy handiwork will be on display as well as a large number of articles donated to be sold," *SYVN*, Nov. 29, 1929, p. 1.
See: "Alpha Club," "Atterdag College," "Danish Days," "Home Department of the State Farm Bureau," "Lompoc Valley Fair," "Maxwell, Lyla G.," "Needlecraft Club (Los Olivos)," "Needlecraft Society," "Pythian Sisters Thimble Bee," "Santa Barbara County Fair," "Santa Ynez Valley Fair," "Solvang Woman's Club"

Hannon, William Huston
See: "Stuart Sign Service"

Hansen, Armin (1886-1957) (Monterey)
Artist who exh. at first Santa Maria Valley Art Festival , 1952.

■ "Armin Hansen (1886–1957), a native of San Francisco, was a prominent American painter … best known for his marine canvases. …," from Wikipedia.
See: "Alpha Club," 1933, "Santa Maria [Valley] Art Festival," 1952, 1953

Hansen, Ejnar (1884-1965) (Pasadena / Los Angeles)
Artists whose work was exh. at first Santa Maria Valley Art Festival courtesy of either Cowie or Dalzell Hatfield gallery, 1952.
See: "Santa Maria [Valley] Art Festival," 1952, and *Morro Bay Art and Photography before 1960*

Hansen, J. Eloise Race Goodwin (Mrs. Richard V. Goodwin) (Mrs. Karl V. Hansen) (1910-1992) (Solvang)
Mosaicist, 1959.

■ "Memo Pad… An interesting display of colorful glass mosaics, the work of J. Eloise Hansen (Mrs. Karl Hansen), is now being exhibited in the dining room of Pea Soup **Andersen's Restaurant** in Buellton… Mrs. Hansen only recently began the hobby of creating the mosaics created through the use of broken pieces of glass of various colors… Many of the mosaics feature famous clowns as subjects…," *SYVN*, Nov. 20, 1959, p. 2.
Several notices both under "Eloise Hansen" and "Mrs. Karl Hansen" in the *SYVN* did not concern art and were not itemized here.
Hansen, J. Eloise (misc. bibliography)
J. E. Race / Goodwin, age 48, married Karl Hansen on Dec. 22, 1958 in Santa Barbara County per Calif. Marriage Index; Eloise Race b. March 24, 1910 in Oklahoma to Lorenzo "Loren" Dow Race and Mollie Leola Dickey, married Richard V. Goodwin, was residing in 1930 in Long Beach, Ca., and d. Nov. 11, 1992 in Riverside, Ca., per Patterson / Newland Family Tree (refs. ancestry.com).

Hansen, Jacob Lindberg (Santa Barbara)
Asst. Prof. Santa Barbara College who spoke at the Winter Arts Program, 1953.
See: "Santa Maria Valley Art Festival," 1952, "Winter Arts Program," 1953

Hansen, Lorrayne Anne Prendergast (Mrs. Major Alton Hansen) (1915-1998) (Camp Cooke)
Craft teacher at Camp Cooke Station Hospital and at USO, 1945.

■ "H St. **USO** Sends Lorrayne Hansen as Craft Worker… Lorrayne Hansen, graduate of Mundelein College in Chicago and wife of Major Alton Hansen of Camp Cooke, has started afternoon Craft classes in the Reconditioning Shop at the Camp Cooke Station Hospital under the sponsorship of the H St. (NCCS) USO. Mrs. Hansen, who majored in arts and crafts and who has taught all manner of hand leather tooling, metal etching, finger painting, free-hand drawing, linoleum blocking and plastic work, works out special designs for each soldier in whatever craft he wishes to work, and then shows him how to use the tools and develop his particular project. Working directly under Captain R. J. McNulty, Chief of Reconditioning at Camp Cooke, Mrs. Hansen is assisted by Patricia Dayton of the H St. Club staff," *LR*, May 11, 1945, p. 2.
Hansen, Lorrayne (misc. bibliography)
Lorrayne Hansen is listed with Alton S. Hansen in the *Lompoc, Ca., CD*, 1945 and in the *Peoria, Ill., CD*, 1952; Lorrayne A. Hansen, b. July 19, 1915, was residing in Sun City, Ariz., at an unspecified date per *U. S. Public Records Index, 1950-1993*, vol. 2; Lorrayne A. Hansen was b. July 19, 1915 and d. Aug. 16, 1998 per Social Security Death Index (refs. ancestry.com).
See: "United Service Organization (Lompoc)," 1945

Hansen, Nanna O. (Mrs. Jens C. Hansen) (Solvang)
Collector / lender to Art Loan Exhibit, Solvang, 1935.
See: "Art Loan Exhibit (Solvang)," 1935

Hanson, Basil (Santa Maria)
Filmmaker, color, amateur. One of three founders of the Santa Maria Camera Club, 1938. Insurance man.
See: "Boy Scouts," 1939, "Santa Maria Camera Club," 1939, 1955

Hapgood school (Lompoc)
Intermediate school (Junior High). Built 1953. Named after Arthur Hapgood whose portrait was painted by Charles Mattei. Its art teacher, Alex Rule, 1955/56 was transferred to Lompoc High School, 1956. Arts and Crafts teacher in 1954 was Richard Storey.
See: "Halloween Window Decorating Contest (Lompoc)," 1954, "Lompoc, Ca., Elementary Schools," "Lompoc Community Woman's Club," 1955, 1957, 1959, "Mattei, Charles," "McFadden, Ann," "Posters, American Legion (Poppy) (Lompoc)," 1954, "Rule, Alex," "Santa Ynez Valley Art Exhibit," 1954, "Storey, Richard," "Wammack, Ritchie," "Ward, Ruth," "Wiedmann, Nora,"

Happytime School (Lompoc)
Nursery school that taught crafts, 1959+.

■ "Happytime School Opens in Lompoc… 521 North D Street. The nursery school opened recently and now has 11 students… Capacity… is 20… The institution is state licensed and enrolls children from ages two to six. Available for the children at the school are the following activities: Picture painting, clay modeling, block building and playground facilities. The school is owned and operated by Mrs. Jane Randall and Mrs. Barbara Liljestrand," *LR*, Sept. 10, 1959, p. 18.
Happytime School (notices in Northern Santa Barbara County newspapers on microfilm and on newspapers.com)
1960 – "Happy Time School. Creative Play – Arts and crafts. Transportation Available. Ages 2-6, 521 No. D St.," *LR*, March 7, 1960, p. 14.

Harcoff, Lyla Marshall (1883-1956) (Santa Barbara)
Artist of a mural in Santa Ynez Valley Union High School, 1936. Exh. in Santa Ynez Valley, 1935, 1951.

■ "Lyla Marshall Harcoff was born near Lafayette, Indiana in 1883. After graduating from Purdue University in 1904, she studied at the Chicago Art Institute and spent a year at the Academe Moderne in Paris…. In 1913 she … traveled alone by train to Winslow, Arizona, eventually ending up at the famous Second Mesa. For two months she studied the arts and customs of the Hopi, becoming the first Anglo woman to live with these Native Americans. Of her six canvases, two sold to the Atchison, Topeka and Santa Fe Railroad…. In 1916 she joined the Chicago based Independent Society of Artists and exhibited at their annual show for eight years. Harcoff was a member and exhibitor at the influential Hoosier Salon of Indiana for nearly a decade. In 1927, she moved to Santa Barbara, remaining there until her death in 1956. She was one of the founders of the Santa Barbara Art Association. In the course of her fifty-year career she exhibited in New York, Chicago, Indianapolis, Los Angeles, San Francisco, San Diego and Santa Barbara. Despite her traditional training, Harcoff's oeuvre is marked by increasing degrees of simplification exploring reductions to her compositions and subjects in an attempt to portray their elemental form." (Roughly from a three-fold brochure with 5 color reproductions. *Lyla Marshall Harcoff 1883-1956*, Sullivan Goss, Ltd., Montecito Gallery. For more information on Harcoff and photos of her artworks, see sullivangoss.com/lyla_harcoff.)
Harcoff, Lyla (notices in Northern Santa Barbara County newspapers on microfilm and on newspapers.com)
1928 – "Santa Barbara Art League… exhibition [at the League galleries] Among those artists whose work appears in the exhibition are: Lyla Marshall Harcoff…," *SMT*, July 3, 1928, p. 4.
1930 – "Lyla Marshall Harcoff… is exhibiting six paintings at Courvoisier's in San Francisco. Most … are portraits," *Oakland Tribune*, April 13, 1930, p. 104 (i.e., 6-M, col. 3).
1932 – "Painters Three at the Ilsley Galleries. **Colin Campbell Cooper**, Lyla Marshall Harcoff and Maurice Braun… Harcoff… seems to me happiest when she tackles gay flowers on gay table cloths…," *LA Times*, Oct. 30, 1932, p. 46 (i.e., pt. III, p. 18, col. 7).
1933 – One of the judges in the **Minerva Club** spring flower show, *SMT*, May 3, 1933, p. 3.
1936 – "Holiday Reception. Mrs. Lyla Marshall Harcoff kept open house on Christmas morning at her studio home in Santa Barbara…," *LA Times*, Dec. 27, 1936, p. 40 (i.e., pt. IV, p. 2).
1937 – "Lyla Harcoff Oils … Artist's Barn will present the paintings of Lyla Marshall Harcoff… in a two weeks exhibition… Fillmore. She will show oil paintings including portraits and flower and fruit studies… Mrs. Harcoff studied art in European centers, at Paris in the Academie Modern and under Simon and Monard. Her early art training was at Purdue university and she studied for a number of years at the Art Institute of Chicago. The artist is well known for her portraits, decorative panels and murals. Oxnard high school owns one of her paintings. Among her western murals are those at the Santa Ynez high school and the Children's hospital in Santa Barbara,' *Ventura County Star-Free Press*, May 13, 1937, p. 6.

1949 – "An exhibition of pictures by Lyla Marshall Harcoff covering her work between 1931 and 1949 is now on view in the McCormick gallery of the Santa Barbara Museum of Art. The exhibit has been arranged chronologically in five groups and a catalogue compiled and written by Mrs. Harcoff explains the goal she was seeking to achieve in each series of paintings," *Ventura County Star-Free Press*, Feb. 10, 1949, p. 20, col. 6; "'30 Paintings' at De Young… Paintings by Lyla Marshall Harcoff who has written of her work: 'Each painting is an organized unit strictly within the picture space. Constant effort is made for more subtle color relations and the elimination of any line, plane or color that does not contribute to the building of an esthetic form conceived as an expression of something universal, not particular. It is the classical point of view in contradistinction to the romantic. The deepest interest lies in human figures. Organizing them into dynamic and significant forms is the highest goal.' The exhibition is arranged in chronological order. Excluding the first painting, 'The Dark Flower,' shown at the Chicago Art Institute in 1917, the work covers the years from 1931 to 1949. The display will close September 25," *Oakland Tribune*, Sept. 11, 1949, p. 76 (i.e., 12-C).
1950 – "In Santa Barbara… Flies to Europe… Arizona for a month is the destination of Mrs. Lyla Marshall Harcoff of Adios Caballos on E. Pueblo St. The Santa Barbara artist motored with Miss Ida Sterchi, a school friend," *LA Times*, Oct. 15, 1950, p. 112 (i.e., pt. III, p. 16).
1951 – "Orchard House Honoring Artist. Lyla Marshall Harcoff… will show a group of her paintings at Orchard House during May. The Misses Louise Merry and Helen Reed will entertain the artist Tuesday afternoon from 3 to 6 p.m. The public is invited," *SYVN*, May 4, 1951, p. 8.
See: "Alpha Club," 1947, "Atterdag College," 1935, "Public Works of Art Project," 1934, "Santa Ynez Valley Union High School," 1936, "Works Progress Administration," 1936

Harding, Pauline
See: "Cronholm (Harding), Pauline (Mrs. LeRoy Harding)"

Hardy (Lopez), Eva Drankow (Mrs. W. S. Hardy) (Mrs. Lopez) (1901-1990) (Santa Maria)
Tinter of photographs. Wife of W. S. Hardy, below.
Hardy, W. S., Mrs. (notices in Northern Santa Barbara County newspapers on microfilm and on newspapers.com)
1943 – "To Des Moines – Mrs. W. S. Hardy, color artist on photography currently being exhibited in the city library, left last evening for Des Moines to visit for a month with her parents," *SMT*, July 28, 1943, p. 3.
And notices in Iowa newspapers for "Mrs. W. S. Hardy" not itemized here.
Hardy, W. S., Mrs. (misc. bibliography)
Eva Drankow is listed in the 1920 U. S. Census as age 18, b. c. 1902 in New York, language Yiddish, residing in Brooklyn, N. Y., with her parents Saul Drankow (age 49) (in the jewelry business) and Sarah Drankow (age 47) and six siblings; Eva Hardy is listed in the 1940 U. S. Census as age 39, b. c. 1901 in New York, finished high school 4th year, residing in Montebello with husband Wilford Hardy

and children William and Betty; Eva Drankow Lopez was b. Jan. 26, 1901 in New York and d. Oct. 29, 1990 in Orange, Ca., per Calif. Death Index (refs. ancestry.com).
See: "Hardy, W. S."

Hardy, W. (Wilfred / Wilfrid / Wilford) (Ivan) S. (Samuel) Sgt (1905-1995) (Santa Maria Air Base)
Photographer, of Camp Cooke photo section, 1943. Husband to Eva Hardy, above.
Hardy, W. S. (notices in Northern Santa Barbara County newspapers on microfilm and on newspapers.com)
1943 – "Photos of Indian Chiefs Shown in Library. Ten enlarged and colored photographs of leading Indian tribal chiefs west of the Mississippi were placed on exhibition today in the **City Library**. The pictures, all 20 x 24 inches… were taken… in 1936-37. They were colored by Mrs. Hardy, now employed in a local studio following ten years of similar work in studios in Hollywood and Middle Western cities. The exhibit first was shown in the Ambassador hotel, Los Angeles and subsequently toured other leading cities. It will be shown in the local library for the next two or three weeks," and includes Chief Thunder Bird (Cheyenne), group photo of Thunder Bird, Princess White Eagle, Chief Many Treaties (Blackfoot), Chief Big Tree (Sioux), etc., *SMT*, July 28, 1943, p. 3; "Service Men Entertained… Sgt. W. S. Hardy of the Base Photo section took several pictures…," *SMT*, Aug. 12, 1943, p. 2.
Hardy, W. S. (misc. bibliography)
Wilfred Ivan Samuel Hardy filled out a *Declaration of Intention* (for Naturalization) in LA in 1928; Wilfred I. S. Hardy married Eva Drankow on Feb. 1, 1932, per *California County Birth, Marriage and Death Records, Los Angeles*; Wilfred S. Hardy, photographer, is listed in *Index to Register of Voters, Los Angeles City Precinct No. 1290*, 1940; Wilford Hardy is listed in the 1940 U. S. Census as age 35, b. c. 1905 in England, finished high school second year, a photographer in the air plane industry, residing in Montebello with wife Eva (age 39) and children William (age 7) and Betty (age 1); Wilfred S. Hardy, b. June 26, 1905 in Warcham, England, serial no. 37430119, living in Des Moines, Iowa on May 16, 1949, provided the following information on his *Application to State of Iowa for World War II Service Compensation* (in *WWII Bonus Case File*) = list of dates he went in and out of the U. S. and that his checks should be sent to Corona del Mar, Ca.; Wilfrid Ivan Samuel Hardy was b. June 26, 1905 in East Stoke, England, to Arthur James Clifford Hardy and Bessie Fox, married Eva Drankow, was residing in Des Moines, Ia., in 1949, and d. May 27, 1995 in Orange, Ca., per Green aka Creber Family Tree (refs. ancestry.com).
See: "Hardy, Eva," "Santa Barbara County Library (Santa Maria)," 1943

Hare, Amory (Santa Maria)
See: "Hutchinson, Amory Hare"

Harkness, Ione B. / J. / S. (Mrs. Edwin Keith Harkness) (1897-1975) (Los Angeles)
Artist. Wife of an artist. Chairman of the district division of art, Women's Clubs, Los Angeles. Lecturer on the 'Madonna in Art'. Lectured on art to Alpha Club, 1933, 1934.
Harkness, Keith, Mrs. (misc. bibliography)
Listed as Ione J. with Edum A. [sic. Edwin Keith] Harkness in the 1930 U. S. Census in Los Angeles; Ione S. Harkness was b. Sept. 11, 1897 in Missouri and d. April 6, 1975 in Los Angeles per Calif. Death Index (refs. ancestry.com).
See: "Alpha Club," 1933, 1934

Harkness, Wilbur D. "Dale"? (1896-1995) (Santa Maria)
Examiner in metal work for Boy Scouts, 1933, 1941. Teacher of wood shop and metal shop at Santa Maria High School, 1923+.
■ "W. Dale Harkness. … Mr. Harkness was born April 22, 1896 in Greencastle, Ind. Following his education in 1916, he began teaching in Glendale from 1918-21. He taught in Calexico, moved to Compton and taught for two more years before coming to Santa Maria. Mr. Harkness taught industrial arts at Santa Maria High School for 30 years. In 1952 he suffered a heart attack and took medical retirement. He built a home in Arroyo Grande where he lived for several years. Mr. Harkness lived in Hemet for several years before moving back to Santa Maria…," *SMT*, Feb. 1, 1995, p. 5.
Harkness, W. D. (notices in Northern Santa Barbara County newspapers on microfilm and on newspapers.com)
1923 – "H. M. [Sic.] Harkness the new manual training instructor at the high school for the coming year, is moving with his family to the house at 408 West Main street. The Harkness' were formerly residents of Compton," *SMT*, Aug. 10, 1923, p. 5; "The six new additions to the faculty… Wilbur Dale Harkness Industrial, formerly in charge of machine shop and auto mechanics, 1921-23, at Compton, California," *SMT*, Aug. 17, 1923, p. 1, col. 2. More than 660 hits for "W. D. Harkness," including "Mrs." (i.e., Hilda), occur in the *SMT* between 1924 and 1960 but were not even browsed for itemization here.
Harkness, W. D. (misc. bibliography)
W. D. Harkness port. appears in Santa Maria High School yearbook, 1930, 1942, 1947, 1951; Wilbur D. Harkness was b. April 22, 1896 and d. Jan. 30, 1995 per Social Security Death Index (refs. ancestry.com).
See: "Boy Scouts," 1933, 1941, "Santa Maria, Ca., Adult/Night School," 1925, 1930, 1935, "Santa Maria, Ca., Union High School," 1924, 1930, 1934, 1935, 1936, 1938, 1939

Harman, Jean C. (Mrs. Egbert P. Harman) (Los Angeles)
State chairman of art, and also Los Angeles District chairman of art, Federation of Women's Clubs. Lectured to Community Club, 1947.
See: "Community Club (Santa Maria)," 1947

Harmer, Alexander (1856-1925) (Santa Barbara)
Santa Barbara painter who painted landscapes of his ranch, Oak Dene, in the Santa Ynez valley, between 1900 and 1913.

■ "HARMER, Alexander Francis (1856-1925), New Jersey-born illustrator and painter who sold his first work at age 11. He sold illustrations to *Harper's Weekly* and later began painting Indian portraits and depicting the American west. Harmer settled in Santa Barbara in 1906 and married into the Abadie family, one of the pioneer California families," islapedia.com, that cites Splitter, Henry Winfred, "Alexander Francis Harmer," *Journal of the West* 2(1):89-90, January 1963.
Harmer, Alexander (info. from *Alexander F. Harmer, 1856-1925*, catalogue of an exhibit at the James M. Hansen Galleries, Santa Barbara, Ca., September 27 – October 16, 1982)
1880s – late – "Upon their return to Santa Barbara, Harmer and his new bride set up quarters in the city's Hawley Block. From 1900-1913, they also owned a ranch in the Santa Ynez valley called 'Oak Dene.' This lush and beautiful spot provided the setting for many of his richest and most textured landscapes…. The Harmers raised seven children … [daughter Inez] wrote nostalgically of the times spent with her father. 'Sketching parties with Papa not only delighted me then, but they still thrill me in memory. Once we went to the Santa Ynez River near The Ranch. In the meadow [sic.] Papa set up his umbrella and sketching paraphernalia while I took my .22 rifle and began shooting squirrels. Then I killed one on a boulder and some cattle suddenly charged me. I screamed. Papa shouted for me to climb a tree, while he waved his umbrella at the stampeding herd and somehow managed to shoo them off." n.p. [Harmer was introduced to Walter Hunt who] "during the early 1900's commissioned him to execute a number of projects. One of these was a California Mission series…on a group of collector plates which were produced by Wedgwood in England." "List of Paintings" includes 54. "Santa Ynez Mountains at Sunset"; 62. "Cabin on the Ranch (Oak Dene)"; 65. "Twilight and Moonlight, Harmer Ranch"; 66. "Old San Marcos Ranch," 1908; 69. "Santa Ynez Mountain Creek, San Marcos"; 70. "Hot Sal Spring Creek, San Marcos Ranch"; 79. "Oak Dene".
Harmer, Alexander (notices in Northern Santa Barbara County newspapers on microfilm and on newspapers.com)
1916 – "'Ramona' A Triumph in Moving Pictures… made by the Clune Film Producing company… Some of the costumes… were loaned under bond and were heirlooms of priceless value. So much importance was attached to this feature… that it was placed in charge of Alexander Harmer… authority on customs of the 'Ramona' period in California," *SMT*, Aug. 19, 1916, p. 5.
1919 – Santa Barbara "Fiesta to Hark Back to Old Spanish Days… will seek to organize the surviving Spanish pioneers of California and their descendents… [named] … Spanish Society… Prime movers in this undertaking are … Alexander T. Harmer…," *SMT*, June 19, 1919, p. 1.
Bibliography:
Exh. "Fire in Santa Ynez Valley," o/c, Coll. Ms. Andree Harmer, in *A Painter's Paradise,* Santa Barbara Museum of Art, 1996.

More bibliography in *Publications in California Art* – vols. 1/2/3-285, 4/5/6-IV-90(1), V-157, V-266, V-300, V-315, 7-III-CSAS-64, I-SFAA-175, 8-226/1 (obit)
See: "Art, general (Santa Barbara, Ca.)," 1908, and *Central Coast Artist Visitors before 1960*

Harper, Elizabeth
See: "Dennison (Harper), Elizabeth A. (Mrs. Oscar C. Harper, Jr.)"

Harrah, Donald William (Santa Barbara / San Francisco / Arroyo Grande)
Art major at UC, Santa Barbara, 1947. Artist who exh. at Santa Ynez Valley Art Exhibit, 1954.
See: "Santa Ynez Valley Art Exhibit," 1954, and *Arroyo Grande Art and Photography before 1960*

Harris, (Charles) Richard (1912-1993) (Lompoc / Whittier)
Portrait painter, Compton JC art teacher, 1942.

■ "Former Lompoc Artist … Native son of Lompoc, Richard Harris has just completed a commission of seven portraits of the presidents of Whittier College… The artist was born at the ranch home of his parents, Mr. and Mrs. Herbert E. Harris, north of Lompoc. He is a graduate of Whittier College and has studied with some of the leading artists of the West. His paintings are mostly portraits in oils, though he has executed some highly regarded murals. He has been teaching art this year at Compton Junior College. One of the portraits shown Sunday and hanging permanently in the administration building is of the artist's father who has been associated with Whittier College for 40 years. During the residence of the family in Lompoc valley, Mr. Harris served a term on the high school board and as president of the Chamber of Commerce," *LR*, Feb. 13, 1942, p. 1.
Harris, Richard (misc. bibliography)
Charles Richard Harris is listed in the 1920 U. S. Census as age 7, residing in Whittier, Ca., with his parents; Charles Richard Harris is listed in the 1930 U. S. Census as age 17, b. c. 1913 in Calif., residing in Whittier, Ca., with his parents Herbert (age 53) and Ruth (age 48); Charles Richard Harris gave the following information on his WWII Draft Card dated Oct. 16, 1940 = age 28, b. Sept. 4, 1912 in Lompoc, a Whittier college student, residing in Whittier, Ca., married to Maxine Massick; Charles Richard Harris b. Sept. 4, 1912 in Santa Barbara County to Dr. Herbert Eugene Harris and Ruth Trueblood, d. July 4, 1993 in Whittier, Ca., per Harris Swearingen Family Tree (refs. ancestry.com).

Harris, Glen L. (1937-2010) (Solvang)
SYVUHS art student, 1951, 1952, 1953. Won a certificate of merit at the Scholastic Art Exhibit, 1953.
See: "Santa Ynez Valley Union High School," 1951, 1952, 1953, "Scholastic Art Exhibit," 1953

Harris, Jaffrey Carl (1890-1967) (Carmel / Santa Barbara)
Artist. Exh. painting at Santa Barbara County Fair, 1952, and at Santa Ynez Valley Art Exhibit, 1955, 1956. Actor with Santa Barbara Repertory Theater, 1953. Orchestra conductor.

■ Harris was a music professor at Ames, Iowa, who married prima donna Rachel Morton and went with her to Europe where she studied singing with European experts. During their last three years in Nice, France, she studied with Reszke. "Jaffrey Harris, meanwhile, was working at training choruses and also trying to paint. … In the summer of 1925 Rachel and her husband went to England" where she was engaged by the British National Opera Company. The couple was poor, "'But I always knew that if the worst came to the worst, Jaff could draw chalk pictures on the sidewalks in London while I accompanied him with my voice'. … She married Jaffrey Harris in 1914 … The coming appearance at Carnegie Hall has only one disappointment … Her husband with whom she has lived amid these contrasts [of poverty and wealth] cannot come with her, as he is chorus master with the British National Opera Company and must remain until the season closes," from *Brooklyn Daily Eagle*, Jan. 29, 1928, p. 82 from "Index to the State-Wide Art Exhibits… sponsored by the Santa Cruz Art League," (*Publications in California Art*, v. 12), LA: Dustin, 2015.
Harris, Jaffrey (misc. bibliography)
Jaffrey Carl Harris, was b. Sept. 21, 1890 in Topeka, Kan., to Theodore Winfield Harris and Margareta E. Schmuck, married Rachel Morton, and d. June 5, 1967 in Santa Barbara per Hauske Family Tree (refs. ancestry.com).
See: "Santa Barbara County Fair," 1952, "Santa Ynez Valley Art Exhibit," 1955, 1956

Harrod, Linda (Los Angeles)
Los Angeles art student who painted murals in The Lompoc Lady beauty parlor, 1958.
"Nine Compete for Sun Valley Queen," *Valley Times* (North Hollywood, Ca.), April 26, 1957, p. 49 (pt. II, p. 1).
Harrod, Linda (misc. bibliography)
Linda Harrod, b. c. 1941, is pictured in the North Hollywood High School yearbook, 1957 (ref. ancestry.com).
See: "Murals (Northern Santa Barbara County)," 1958

Hart, David S. (Santa Barbara)
Photographer. President of the Channel City Camera Club who spoke to Solvang Woman's Club, 1954. Exh. photos at the Santa Barbara County Fair, 1940-80.
1954 – Solvang "Woman's Club Will Hear Photographer. David Hart, president of the **Channel City Camera Club** will be guest speaker… Friday evening, Nov. 12… Mr. Hart is a distinguished prize-winning color photographer. He will speak and show color slides of the southwest…," *SYVN*, Nov. 5, 1954, p. 3.

Hart, David (notices in California newspapers on microfilm and on newspapers.com)
Is he the same as writer / photographer? David Hart, whose revelatory articles appear in the *Times-Advocate* (Escondido, Ca.) in the 1980s but were not itemized here. More than twenty notices for "David Hart" in the *SMT* between 1940 and 1980 refer to his photographs exhibited at the Santa Barbara County Fair, but were not itemized here.

Hart (Jessee), "Hattie" H. (Mrs. Henry Haight Jessee) (Santa Maria)
Exh. hand-painted plate at "Santa Barbara County Fair," 1888, 1889, and six photos, 1900. Sister to John Hart, below.
■ "Funeral Services for Mrs. Jessee… Mrs. Harriet H. [Hart] Jessee, 64, Santa Maria valley pioneer… The deceased was a native of England, coming to Guadalupe in 1881 where she lived until 1900. In that year she moved to Santa Maria… [She married Henry Haight Jessee in 1901.] She is survived by a brother, John Hart of Los Angeles, a former resident of this city for many years, one cousin, Mrs. George Scott [nee Harriet Hart] of Santa Maria…," *SMT*, Oct. 4, 1932, p. 1. Harriet Hart Jessee b. 1867 and d. 1932 is buried in Santa Maria Cemetery District per findagrave.com (refs. ancestry.com).
[Do not confuse with "Harriet Sharp Hart," i.e., Mrs. Reuben Hart, who lived about the same time but who died of cancer in Santa Maria in 1893 [sic. 1896], per *SMT*, Aug. 23, 1976, pp. 1 and 5, and who served on the Art Loan Committee of the Minerva Club, 1895 per "Art Loan Exhibit," 1895.]
See: "Hart, Johnny," "Santa Barbara County Fair," 1889, 1900

Hart, John Hart, Jr., "Johnny" (1867-after 1940) (Santa Maria / Los Angeles)
Painter of houses, signs, carriages, 1897+. Brother to Harriet Hart, above.
Hart, John, Jr. (notices in Northern Santa Barbara County newspapers on microfilm and on newspapers.com)
1897 – "Mr. Keeney is adding to his stock and John Hart, Jr., is painting him a new sign," *SMT*, Nov. 20, 1897, p. 2, col. 3.
1901 – "John Hart informs us this week that he has his hands full at his paint shop on Chapel street. He has just turned out three nicely painted rigs…. Each speak a good word for Johnny as an artist," *SMT*, Jan. 12, 1901, p. 3, col. 4.
1902 – "Marriot & Bond have a new express wagon which has been painted by Johnnie Hart. The wagon looks fine and the lettering shows the master hand of an artist…" *SMT*, Sept. 13, 1902, p. 3, col. 4.
1905 – "Speaks for Itself. Johnnie Hart, the carriage and sign artist, has turned out a number of rigs recently…," *SMT*, Jan. 28, 1905, p. 3, col. 4.
1907 – John Hart… has returned from his trip to the old country and reports a most splendid time. Besides visiting his home in England, he visited the continent and spent a number of weeks in gay Paree. Mr. Hart also stopped off in Washington, New York and other cities, and saw his own

country as well as the big cities across the pond. He was met by his folks in Los Angeles and before coming home, they made a trip to Mexico, San Diego and other points of interest. Mr. Hart looks like a new man and his friends hardly recognized him in his dapper appearance," *SMT*, Sept. 21, 1907, p. 5, col. 2.

1908 – "Johnny Hart… has been doing some pretty nifty gold lettering this week for Arthur Smith," *SMT*, March 7, 1908, p. 5.

And many additional notices in the *SMT* regarding his painting of houses were not itemized here.

Hart, John, Jr. (misc. bibliography)
John Hart, Jr., is listed in the 1900 U. S. Census as b. Sept. 1867 in England, naturalized with the naturalization of his father John Hart, Sr., married in 1886, a carriage painter, residing in Judicial Township 9 (Guadalupe?) with his wife, Lulu and two children; listed in the 1930 U. S. Census as immigrating 1873, and residing in Los Angeles with wife Lulu; John Hart is listed in the 1940 U. S. Census, finished elementary school 8th grade, residing in Los Angeles with wife Lulu (refs. ancestry.com).

See: "Hart (Jessee), Hattie"

Hart, Margaret McGowan (Mrs. Merrill C. Hart) (1896-1980) (Santa Barbara)
Painter. Exh. tempera paintings at Santa Ynez Valley Art Exhibit, 1954 and at Gallery DeSilva, Montecito, 1963. Wife of Merrill C. Hart, below.
[Do not confuse with Margaret Stocking Hart, artist of NY, who was active on the Pacific Coast (Bakersfield / Hanford), c. 1948.]

1940 – "Mothers Awarded Honors as Artists… Two mothers who reared families before they turned to painting won the jury awards Sunday in the annual Kalamazoo artists' exhibit being held at the Kalamazoo Museum of Arts. They are Mrs. Margaret Hart, of 2314 Wilmette, mother of two children of teen age …," *Detroit Free Press* (Detroit, Michigan), March 11, 1940, p. 7.

1945 – Is she – "Coutts Gallery… Many Exhibit Work… invitational exhibit… Margaret Hart…," *Desert Sun* (Palm Springs, Ca.), Nov. 30, 1945, p. 20.

1951 – "Visitors' Votes… Oakland Art Gallery… 19th Annual of Watercolors, Pastels, Drawing and Prints… we also enjoyed works by Margaret M. Hart…," *Oakland Tribune*, Oct. 14, 1951, p. 65 (i.e., C-3).

1960 –Is she – "Surfeit of Ceramic Exhibitions Deplored… Southern California Ceramics Exhibition at the Long Beach Museum of Art… Among the potters and ceramic sculptors… Margaret Hart…," *LA Times*, Feb. 21, 1960, p. 102 (i.e., pt. V, p. 8).

1961 – "Art … Two Artists, Grace Miratti, Margaret Hart, Santa Barbara Artists Workshop, 2779 Foothill Rd., Santa Barbara," *LA Times*, Feb. 26, 1961, p. 379 (i.e., Calendar, p. 21).

Hart, Margaret (misc. bibliography)
Is she Margaret McGowan Hart, b. Feb. 12, 1896 in Wisconsin, father's name, McGowen, and mother's, Sixeby, who married Merrill C. Hart, and d. on July 28, 1980 in Santa Barbara, Ca., per Stone/Yates Family Tree (refs. ancestry.com).

See: "Hart, Merrill C.," "Hibbits, Marie," 1963, "Santa Maria [Valley] Art Festival," 1953, "Santa Ynez Valley Art Exhibit," 1954

Hart, Merrill Curtis (1891-1964) (Santa Barbara)
Photographer who exh. at Santa Ynez Valley Art Exhibit, 1954. Husband to Margaret Hart, above.
Hart, Merrill (notices in U. S. newspapers on microfilm and on newspapers.com)
1964 – "Art Elsewhere: Now showing at the Kalamazoo Art Center is an exhibit of photographs and paintings by Dr. and Mrs. Merrill C. Hart, former longtime Kalamazoo residents. The showing continues through Aug. 15," *Battle Creek Enquirer* (Battle Creek, Michigan), July 19, 1964, p. 27 (Sect. 3, p. 7).
Hart, Merrill (misc. bibliography)
Merrill C. Hart is listed in the 1930 U. S. Census as b. c. 1893 in Indiana, a chemist in a drug factory, residing in Kalamazoo, Mi., with wife Margaret M. Hart (age 34) and children Merrillyn M. (age 7) and Murray C. (age 4); Merrill C. Hart is listed in the *Kalamazoo, Mi., CD*, 1922-50; Merrill C. Hart, retired, is listed with wife Margaret in the *Santa Barbara, Ca., CD*, 1949-64; Merrill C. Hart was b. June 1891 in Indiana to Henry A. Hart and Helen V. Curtis, married Margaret McGowan, was residing in Los Angeles in 1952, and d. Nov. 4, 1964 per Hart Family Tree; Merrill Curtis Hart b. June 6, 1891 and d. Nov. 4, 1964 is buried in Santa Barbara Cemetery under the same headstone as his wife Margaret McGowen (1896-1980) per findagrave.com (refs. ancestry.com).
See: "Hart, Margaret," "Santa Ynez Valley Art Exhibit," 1954

Hartsook Photograph Co.
See: "Myers, T. A."

Harwood, Harvey Rockburn (1905-1996) (Lompoc)
Watercolor painter. National Park service architect at Purisima camp, 1938. Along with Fred Hageman was in charge of restoration of La Purisima Mission.

■ "Drawings of La Purisima are Finished. Two vivid water color drawings of scenes of La Purisima mission have just been completed by Harvey Harwood, National Park service architect at Purisima camp. Harwood has painted many pictures of the colorful mission. One of the two pictures is a striking view of a portico of the administration building seen through the early California gardens. Drawn from the esplanade facing the gleaming white building, the central motif of the picture is the great drinking fountain of the old padres. The other painting depicts the drinking fountain and domestic storage fountain on the mission grounds," *LR*, Dec. 29, 1939, p. 3.
Harwood, Harvey (notices in Northern Santa Barbara County newspapers on microfilm and on newspapers.com)
1937 – "Miss Dorothy White to Become Bride of … Harvey Rockburn Harwood… in Santa Barbara… Mr. Harwood is a draftsman with the National Park service, assisting in the project of restoring the old mission here," *LR*, April 23, 1937, p. 3.

1938 – "**F. C. Hageman**… La Purisima mission restoration project… The local project was started early in 1934 … Architectural work has been practically completed on the … monastery building as well as the church building, which is now being rebuilt… Harvey Harwood will assume Hageman's architectural duties for the NPS on the mission restoration project…," *LR*, Feb. 4, 1938, p. 8.
1939 – "Typical Hacienda to be Built at Purisima Mission… Harvey Harwood, project architect, has completed plans for the custodian and gardeners' quarters…," *LR*, July 7, 1939, p. 1; "Purisima Mission Restoration Proceeds Rapidly…," *LR*, July 21, 1939, p. 1.
1942 – "Joins U. S. Engineers – Harvey Harwood left yesterday for Los Angeles where he has accepted a position as architect with the United States Army Engineers. …," *LR*, Feb. 6, 1942, p. 8.
Harwood, Harvey (misc. bibliography)
Harvey Rockburn Harwood was b. Jan. 13, 1905 in New Mexico to Jesse Ansdill Harwood and Josephine E. "Josie" Myers, married Dorothy Lois White and d. Jan. 10, 1996 in Palm Desert, Ca., per One Big Family Tree (refs. ancestry.com).
See: "Mission La Purisima," 1939

Haslam, Leone Pearl (Mrs. Fred W. Haslam) (1892-1987) (Santa Maria)
Proprietor of Haslam's Art Shop that sold paintings consigned from LA., 1921-23. Morphed into a baby-goods store. Second wife of Frederick W. Haslam who she married c. 1920. Daughter-in-law of Lucy Haslam and of William Haslam, both below.

■ "The new exclusive art store to be opened by Mrs. Fred Haslam in the new Rubel building on December 1ˢᵗ is causing much interest among lovers of beautiful and artistic work. Mrs. Haslam has secured and will carry oil paintings that are really wonderful from an art store of Los Angeles. Some of the paintings range in value up to $100. Among the admired articles will be all kinds of lamp shades, gorgeous fancy work and hand-made work. Arrangements have also been made for a women's exchange, where various ladies will bring their work for display and sale. This department has been in great demand in Santa Maria," per "New Art Store Opens in Rubel Building, Dec. 1," *SMT*, Nov. 16, 1921, p. 5.
■ "Leone P. Haslam… Mrs. Haslam was born in Osakis, Minn., and had been a resident of Santa Maria since the early 1920s. … She was a homemaker and a businesswoman…," *SMT*, Sept. 9, 1987, p. 18.
Haslam, Fred, Mrs. (notices in Northern Santa Barbara County newspapers on microfilm and on newspapers.com)
1920 – "Deeds… Fred W. Haslam and wife, Leone Pearl, to Jasper R. Scott and wife, Maude E. (Jointly) – Lots 22 and 23, block 2, Cook's addition to Santa Maria," *SMT*, Feb. 19, 1920, p. 3.
1921 – "Haslam's Art Shop Opens," *SMT,* Dec. 14, 1921, p. 3.
1922 – "Many Beautiful Pictures Shown at Art Shop," and article adds, "At Mrs. Fred Haslam's excusive Art Shop in the new Rubel building are displayed a number of these beautiful works. …. A 'Marine' by **Edgar Payne**. Mr. Payne is one of the best and well known artists in the

country. He is an American artist, and belongs to the American Academy of Artists. A landscape by **Hanson Puthuff**. Mr. Puthuff is one of the best known artists in the state. He is vice president of the California Art Club. An oil painting by E. Burgman. Mr. Burgman is known as the Dutch painter, in fact he paints very little else but Dutch scenes. This is one of his original paintings in a hand carved frame. A piece of E. Scoville [Sic.?] which picture is the 'Keoweia' of the Philippine Islands. Mr. Scoville has passed out of this sphere. He is known as 'The Fire Painter.' A landscape object 'Poppy Fields and Mountains' by DeTeeville [Sic. Richard De Treville?], who is known as the landscape painter," *SMT,* Jan. 6, 1922, p. 3; "Beautiful Picture Attracts Attention," by DeTeville [Sic?] and article adds, "Batike [sic. batik] is something interesting and new to many. The art shop is showing this hand painted work on cloth. It is done in all colors, and orders are taken in any material," *SMT,* Feb. 8, 1922, p. 3; ad announcing a circulation library, *SMT,* Feb. 20, 1922, p. 3; "Mrs. Haslam's Art Shop. … Rooms 8-9 Rubel Bldg. Everything for the Baby. Hemstitching 10c per yard. Pacific Package Goods. Circulating Library," *SMT,* Aug. 2, 1922, p. 5.
1923 – "Haslam Art and Baby Shoppe, next to Postoffice. Mrs. Fred Haslam, Prop.," *SMT,* June 12, 1923, p. 2.
Haslam, Fred, Mrs. (misc. bibliography)
The 1920 U. S. Census lists Frederick William Haslam, widowed, with four children, living in Santa Maria; Leone P. Haslam is listed in the 1930 U. S. Census as b. c. 1893 in Minnesota, a real estate manager, residing in Santa Maria with her husband Frederick Haslam (age 43), a lodger and a servant; Leone Pearl Haslam, b. 1892 and d. Sept. 5, 1987 per findagrave.com (refs. ancestry.com).
See: "Rinehart, Jack"

Haslam, Lucy Armitage (Mrs. William Haslam) (1868-1942) (Santa Maria)
Exh. painted china and paintings at "Santa Barbara County Fair," 1889. Mother-in-law of Leone Pearl Haslam, above. Wife of William Haslam, below.

■ "Another Pioneer… Mrs. W. A. Haslam is Called at 74… Mrs. Haslam was born in England in 1858 and came with her parents when a small girl to Pennsylvania and later with them to Santa Maria in 1879 when she was 11. She and her late husband, a pioneer merchant, were married in 1885. Mr. Haslam passed away in 1931. Mrs. Haslam was a charter member of the **Minerva** Library club and for many years was its secretary. She was also a very active worker in the **Pythian Sisters** in the early days of their organization in Santa Maria," *SMT,* May 9, 1942, p. 1.
Haslam, Lucy (notices in Northern Santa Barbara County newspapers on microfilm and on newspapers.com)
More than 60 notices for "Lucy Haslam" and 170 for "Mrs. W. A. Haslam" appear in the *SMT* between 1880 and 1942 but refer mainly to her activities with social clubs and were not itemized here.
Haslam, Lucy (misc. bibliography)
Lucy Armitage Haslam b. Jan. 24, 1868 in West Yorkshire, England, d. May 8, 1942 in Santa Barbara County and is buried in Santa Maria Cemetery District per findagrave.com (refs. ancestry.com).

See: "Haslam, William," "Santa Barbara County Fair," 1889

Haslam, William Alexander (1857-1930) (Santa Maria)
Photographer, amateur. Exh. landscape photo at "Santa Barbara County Fair," 1900. Prop. of Haslam & Co. Related to the Haslams, above.
■ "Long Illness Finally Ends Fine Career… He had been in business in the valley since 1872 and established the mercantile firm of W. A. Haslam and company which now is located at West Main and Linden streets," and detailed biography, *SMT*, Oct. 6, 1930, p. 1.
Haslam, W. A. (notices in Northern Santa Barbara County newspapers on microfilm and on newspapers.com)
Possibly 1600 "hits" occur in the *SMT* for "W. A. Haslam" including "W. A. Haslam & Co." but were too many to be even browsed for possible inclusion here.
Haslam, W. A. (misc. bibliography)
William A. Haslam married Lucy A. Sharpe on Feb. 18, 1885 in Santa Barbara County per Western States Marriage Index; William A. Haslam b. c. 1857, d. Oct. 5, 1930 in Santa Barbara County per Calif. Death Index; William Alexander Haslam is buried in Santa Maria Cemetery District per findagrave.com (refs. ancestry.com).
See: "Haslam …," "Santa Barbara County Fair," 1900

Haslam & Company (Santa Maria)
Retailer of photo and art supplies, among other items. Prop. is William A. Haslam, above.
■ "Will Move Shortly. W. A. Haslam's new store promises to be the peer of anything between Santa Barbara city and San Jose. Everything will be of the most up-to-date character … The cash carrier system is installed already and the painters are now putting the finishing touches to the shelves, counters and offices. It will be fully ten days and possibly two weeks before the firm moves," *SMT*, March 16, 1907, p. 1.
Haslam & Co. (notices in northern Santa Barbara County newspapers on newspapers.com)
1910 – "Kodaks, Films, and articles required both by the amateur and the professional artist are carried constantly in stock," *SMT*, March 12, 1910, p. 5.
1919 – "Creator of Artistic Window Displays. … color and arrangement are the things striven for. One does not often look for creation in a grocery window … display window of W. A. Haslam & Co., there would seem a picture. These pictures are painted with fruits and vegetables… now… cranberries, nuts, raisins and apples are arranged into interesting forms… decorated by **Arthur Coy** of the grocery department…," *SMT*, Nov. 18, 1919, p. 5.
See: "Fugler, Belle," 1891, 1892, "Mau, Martha," "Revetagat, Eugene," 1892, "Taylor, Al," "World War I, and art"

Hastings, Lee
See: "Adair, Lee (Mrs. Dabney) (Mrs. James W. Hastings)"

Hathway, Mary, Miss (SLO)
A painted china plate by Mary Hathway was exhibited by Mrs. T. A. Jones at the "Santa Barbara County Fair," 1886.
See: "Santa Barbara County Fair," 1886, and *San Luis Obispo Art and Photography before 1960*

Hau, Charlotte Kathleen Woodward (Mrs. Hans Friedrich Hau) (1906-after 1954?) (Santa Maria)
Handcraft instructor in summer school at Santa Maria high school, and at Camp Cooke hospital, 1943. Wife of Hans Hau, executive for Red Cross in Santa Maria.
Hau, Fred, Mrs. (notices in California newspapers on microfilm and on newspapers.com)
1935 – "Mixed Cargo… The motorship Seattle of the Hamburg-American Line docked yesterday from Europe and central American ports. Among the passengers disembarking at this port were Hans Hau, local importer, Mrs. Hau, and their nine-months old son Jan Christian. The Haus return to the Bay region after a two-year sojourn in Germany," *Oakland Tribune*, June 4, 1935, p. 32; port. and "Women Study Insurance Plan. Under leadership of Mrs. Hans Hau, Stanford graduate, who has just returned from two years in Germany, the Berkeley Soroptimist club [study insurance] … Mrs. Hau, the leader of the group, obtained a bachelor's degree at Stanford and a master's degree at the University of California, later going to the University of London to study for a year. Two years ago she accompanied her husband to Germany, where the latter was called on business, and devoted her sojourn there to a study of the social insurance situation in that country…," *Oakland Tribune*, Nov. 25, 1935, p. 8.
1942 – "Executive named for Red Cross. Fred H. Hau… Mrs. Hau and their seven-year-old son arrived from Berkeley this week-end to join him. … Mrs. Hau, a graduate of Stanford and the School of Economics in London, also holds an M. A. in social services from the University of California and is a former faculty member of Dominican college, San Rafael, and director of Consumers'-Purchasers' survey of Stanislaus and San Joaquin counties. The Haus spent a number of years in Europe, traveling extensively there from 1933 to 1935, until the war curtailed his importing business…," *SMT*, May 4, 1942, p. 3.
1943 – "New Red Cross Secretary Arrives… post of executive secretary of Santa Maria Red Cross chapter, vacated by Fred Hau. Mr. and Mrs. Hau have departed for San Francisco where they will remain until he takes over a Red Cross field directorship in northern California," *SMT*, Dec. 3, 1943, p. 3; "Guadalupe **Red Cross** Needs Material… showing of craft work made by convalescing soldiers in Camp Cooke Station Hospital. Leather and metal work, and stenciled articles were among the many things shown, made under the direction of Mrs. Fred Hau. … At the meeting, the group worked on slippers for use in the hospital…," *SMT*, Dec. 3, 1943, p. 3.
1944 – "Fred H. Hau, general field representative of the area offices of the American Red Cross, feels that the Plumas County Chapter has every right to feel proud…," *Plumas Independent* (Quincy, California), Aug. 31, 1944, p. 1.

And c. 80 additional notices for Mr/Mrs. Hau in the *SMT* between 1942-43, including the fact she was book chairman at the Minerva Club, were not itemized here.
Hau, Fred, Mrs. (misc. bibliography)
[Do not confuse her husband with Frederick H. Hau, clerk, Henry Doscher co., listed in the *San Francisco, Ca., CD*, 1896; or Frederick H. Hau listed under "Artists – Crayon" in the *San Francisco, Ca., CD*, 1898.]
Is she C. Kathleen Woodward listed in the 1920 U. S. Census as age 13, b. c. 1907 in England, residing in San Diego with her father Henry T. Woodward (age 46) and step-mother?, Norah F. Woodward (age 26), and 3 siblings; Kathleen Woodward is listed as member of Delta Sigma Rho honorary debating fraternity per Stanford U, yearbook, 1928; Kathleen W. Hau is listed in the 1940 U. S. Census as age 34, b. c. 1906 in England, finished college 5th or subsequent year, a social worker, residing in Berkeley with her husband Hans F. Hau and her son, John C. [born in Germany]; Mrs. Hans F. Hau (Charlotte K. Woodward) is listed under class of 1928 in the *Stanford Alumni Directory*, 1954 with the information, "Hau, Mrs. Hans F. (Charlotte K. Woodward) Class '28. A. B. Economics, 1057 Keith Ave., Berkeley, Ca. 94708, (415) 524-4891"; her husband is the F. H. Hau listed in Berkeley without wife per the *Oakland, Ca., CD* or *telephone directory*, 1951, 1954, 1957; F. H. Hau is listed in Berkeley in 1993-99 per *U. S. Phone and Address Directories*; Charlotte Kathleen Woodward was b. March 16, 1906 to Henry Thomas Woodward and Marie Eva Schaaf, married Hans Friedrich Hau, per Mary Calwell Family Tree (refs. ancestry.com).
See: "Art, general (Camp Cooke/ Vandenberg)," 1943, "Santa Maria, Ca., Union High School," 1943

Hauben, Lawrence "Larry" Alan (1931-1985) (Buellton)
Painter in group exh. at Tolosa Gallery, SLO, 1959.
Received a degree in art from UC, Santa Barbara, 1960.
Actor in Little Theater in the Santa Ynez Valley, 1958.
■ Lawrence Hauben, the actor and screenwriter of "One Flew Over the Cuckoo's Nest," is documented on Wikipedia.
Hauben, Lawrence (notices in Northern Santa Barbara County newspapers on microfilm and on newspapers.com)
1960 – "Beaudette Research Group on Expedition… in Baja California… on a zoological expedition involving a biological and hydrographic survey of San Quintin Estuary… Lawrence Hauben, foundation illustrator…," *SYVN*, April 22, 1960, p. 1; "Four Valley Students Win UCSB Degrees … Lawrence A. Hauben, Buellton, art…," *SYVN*, June 10, 1960, p. 7.
Hauben, Lawrence (misc. bibliography)
Lawrence Alan Hauben, b. March 3, 1931 in New York, mother's maiden name Weintraub, d. Dec. 22, 1985 in Santa Barbara County per Calif. Death Index (refs. ancestry.com).
See: *San Luis Obispo Art and Photography before 1960*

Havens, Katharine "Kay" Scott (1908-1992) and William Benoni Havens (1907-1993) (La Crescenta / Nevada)
Painters who held a one-man show at Andersen's Restaurant, Buellton, 1954, 1955.
■ "Havens' Art Work Showing at Andersen's. The largest art display to date is now being installed… The exhibit is a joint showing of paintings by Kay and William B. Havens of La Crescenta, cousins of **Helen Barbera** of Solvang, and features two dozen of their works, mostly colorful landscapes of western scenes. The Havens received their art training at Chouinard School of Art in Los Angeles, in addition to the Copley Society of Boston, and each took private instruction in the east. Their professional experience has included designing and originating greeting cards for a large eastern manufacturer and also free-lance work in advertising, ceramic design, and conducting special art classes. They have exhibited recently in Oregon, California, New York and Boston. The exhibit… will remain …until the middle of January," *SYVN*, Dec. 24, 1954, p. 3.
Havens, Kay and William (notices in United States newspapers on microfilm and on newspapers.com)
1976 – "Pizen Palettes. Nevada Artists Association, Pizen Palettes Inc., Yerington chapter… W. D. and Kay Havens donated their prize monies from the recent Spring Art Show to the scholarship fund," *Mason Valley News* (Yerington, Nev.), May 21, 1976, p. 15.
1992 – "Museum Pieces… Frequent visitor to the Museum is William Havens. … (Bill Havens is an artist, a Yerington resident who does outstanding paintings of Arizona Indian pottery)," *Mason Valley News*, Jan. 17, 1992, p. 20 (i.e., Sect. 3, p. 4).
1993 – "William B. Havens. … longtime Yerington resident … He died March 5, 1993 in his home. He was born September 12, 1907 in Rhode Island and was preceded in death by his wife, Katharine," *Mason Valley News* (Yerington, Nevada), March 19, 1993, p. 5.
See: "Andersen's," 1954, 1955

Hawkins, Rudolph "Rudy" Ernest (1898-1979) (Santa Maria)
Photographer, amateur, of colored slides who presented them in shows to various local groups. Prop. of Hawkins Housewares, 1953.
■ Port. and "… Mr. and Mrs. Rudy Hawkins who have just returned to their home on East Church after a three-month trailer tour of Alaska. It was at Point Barrow the Hawkins became acquainted with the Eskimos. They went to Barrow to see and photograph the midnight sun… The plane on which the Santa Marians flew there landed on a link belt field marked out with up-ended empty 50-gallon oil drums… The trip was taken in their trailer, which they said, withstood snow, ice, rain and dust. They traveled comfortably. … Leaving on May 10, they traveled by way of Sacramento and Redding… They crossed into Canada at King's Gate, photographed in their color slide collection… [at Fairbanks] … they stored their car and trailer to fly from Fairbanks to Point Barrow… Scenic spot was Thompson Pass, when, driving through snow banks higher than the car, they could see waterfalls cascading down cliffs either side of the canyon…," and interesting details of their trip

but no further mention of photographs, *SMT*, Aug. 13, 1955, p. 4.

Hawkins, Rudy (notices in Northern Santa Barbara County newspapers on microfilm and on newspapers.com)

1954 – "Round Town. A Geiger counter behind every rock was Mrs. Rudy Hawkins description of sight-seeing on a six-week trip through Nevada, Montana and Colorado. Mr. and Mrs. Hawkins went to Lake Tahoe and then to Nevada, after which they visited all of the western National Parks. …," *SMT*, Oct. 28, 1954, p. 7.

1955 – "Christmas… Native Daughters met Tuesday night… Rudy Hawkins showed colored slide pictures of recent trip through Canada and Alaska," *SMT*, Dec. 22, 1955, p. 4.

1956 – "Soroptimists… The program for the day was provided by Mr. and Mrs. Rudy Hawkins who showed color slides of their trip… three months traveling by automobile and trailer through the southern and eastern states. They visited 21 states, Cuba, and the District of Columbia…," *SMT*, June 6, 1956, p. 4; ■ port. of Mr. and Mrs. Hawkins in front of a slide screen and "Europeans would be coming to the United States to travel and vacation if they were given the opportunity to view excellent color films, taken by Mr. and Mrs. Rudy Hawkins on a three-month tour of 21 states and Washington, D. C. Shown recently for the Soroptimist club… Traveling by the Overland trail through Arizona, the photographers made a point of filming Indian pueblos occupied 1,300 years ago and an Indian cemetery at Tucson, which had every grave decorated with bright paper flowers for a special occasion. Pictures of Boot Hill in another cemetery with close-up of the grave markers; and a drive around Superstition Mountain and the Lost Dutchman mine … Among best shots were sunset on the Mississippi at Baton Rouge; Huey Long's state capitol, Louisiana; lace balconies in iron grille work and the famed cornstalk iron fence, predating the Civil War, in New Orleans. … Recorded on film was sponge diving, Indians fishing for gar, animals training at Ringling Circus winter quarters, alligators in the bayou country, pink flamingoes in flocks at one of the big race courses and drinking from the Ponce de Leon Fountain of Youth. … Biggest tree on the trip was a banyan at Edison Gardens, Fort Myers, and oldest flowering shrub seen and filmed was a camellia, 125 years old, in a Tallahassie garden. Jamestown and Williamsburg's historic buildings were pictured, one house dating back to 1597. Churches and capitol buildings were filmed in each state, and in line with history, the visits to homes of Andrew Jackson and Thomas Jefferson and seeing the grave of Daniel Boone… Oddity was a garden of huge stone modernist carvings near Miami, by a Latvian artist as a memorial to a broken romance. For a whimsical touch, the photographer was at hand while a small bottle of water from Santa Maria was being emptied into the Atlantic. Fort Knox was photographed from a distance. Exceptional scenes are those of the Rockies and Great Smokey mountains. The program ends with a homeward bound picture of the capitol at Sacramento…," *SMT*, June 12, 1956, p. 4.

1957 – "Mr. and Mrs. Rudy Hawkins are home between trips. This time they have spent three weeks traveling with their trailer to Palm Springs, Indio and other points in the desert," *SMT*, March 9, 1957, p. 3.

1958 – "Native Daughters… Confetti angel food cakes… were served to the group while Mr. and Mrs. Rudy Hawkins showed color slides of Mardi Gras festivities taken during one of their many tours. Slides of a recent tour of Canada and the northern United States were also shown, narrated by Mrs. Hawkins…," *SMT*, March 10, 1958, p. 3.

1963 – "Minerva Travel Section… join in the fun of viewing the colored slides… by Mr. and Mrs. Rudy Hawkins…on their recent trip to the United States …," *SMT*, Oct. 22, 1963, p. 4.

1964 – "Phi Chapter Views Alaska Colored Film… Mr. and Mrs. Hawkins traveled up the Alcan Highway, stopping where ever they could to take more pictures and enjoy the fantastically beautiful scenery. Many of the pictures the Hawkins took were of glaciers, ports and communities that were among the many destroyed by the recent earthquake in Alaska," *SMT*, May 9, 1964, p. 3; "Native Daughters … of the Golden West… dinner. … slide pictures of the recent trip taken by Mr. and Mrs. Rudy Hawkins were shown… eight Western States and Western Canada over a three month's period…," *SMT*, Sept. 9, 1964, p. 3; "Native Daughters… Santa Maria parlor… dinner… Rudy Hawkins … will show slides of a recent trip taken over the Western States …," *SMT*, Nov. 24, 1964, p. 4.

And more than 140 hits for "Rudy Hawkins" in the *SMT* between 1940-1965 were not itemized here.

Hawkins, Rudy (misc. bibliography)

Rudolph Ernest Hawkins was b. Feb. 3, 1898 in SLO to Anton Howard Hawkenson and Amanda Christiana Larson, married Ida May Tunnell and d. Dec. 28, 1979 in Santa Maria per Anderson / Jacobson Family Tree (refs. ancestry.com).

Headley, Gladys
See: "Castagnola, Gladys Irene Swain Headley"

Heath, George Calloway (1913-1986) (Santa Maria)
Photographer, amateur. Member Santa Maria Camera Club, 1941-44. Painter.

■ "George C. Heath. … Mr. Heath was born in Santa Maria where he had most of his life. He attended Long Beach schools and graduated from Hancock College… He worked at Saladins Furniture Store in Santa Maria for 22 years and retired to his own laundromat business on South Blosser Road, which he operated for several years… He was an avid rock hound. He was a member of the Santa Maria Valley Arts Association and had paintings displayed in several locations in Santa Maria," *SMT*, Feb. 27, 1986, p. 19.

Heath, George (misc. bibliography)

George Calloway Heath filled out a WWII Draft Card at which time he was residing in Santa Maria; George C. Heath is listed in *Santa Maria, Ca., CD*, 1962-83; George Calloway Heath was b. Jan. 1, 1913 in Santa Maria to Isaac Calloway Heath and Luella May Bobo, married Grace Elizabeth, was residing in Long Beach in 1930, and d. Feb. 26, 1986 in Santa Barbara County, Ca., per Heath Family Tree – adoptive inquiry (ref. ancestry.com).

See: "Santa Maria Camera Club," 1941, 1942, 1943, 1944

Hebert, Marian (1899-1960) (Santa Barbara)
Artist who exh. in a show of Santa Barbara artists sponsored by the College Art Club at city hall, Santa Maria, 1935. One of her works was in the coll. of S. Breneiser and shown at the Alpha Club in Lompoc, 1935.

■ "Born in Spencer, IA on June 5, 1899. Hebert graduated from the University of Montana with a B.A. degree in physics and mathematics. Recovering from tuberculosis, she moved California in 1923 and soon settled in Santa Barbara. There she graduated from the State Teacher's College in 1929 and then studied with **Ed Borein** and **Frank M. Fletcher**. From 1946 to 1957 she was head of the art department at Mary Hardin-Baylor College in Belton, TX. Resigning due to her health, she returned to Santa Barbara and died on July 15, 1960," per Edan Hughes, *Artists in California, 1786-1940*, reprinted on askart.com. Kovinick.
1942 – "New Exhibits This Week... Santa Barbara Museum of Art – Aquatints by Marian Hebert now on...," *LA Times*, March 22, 1942, p. 50 (pt. III, p. 6).
More than 25 additional notices in California newspapers not itemized here.
See: "Alpha Club," 1935, "California State Fair, Sacramento," 1949, "College Art Club," 1935, "National Art Week," 1935

Hedin, Joyce V. (Halcyon)
Artist who exh. at Santa Ynez Valley Art Exhibit, 1954.
See: "Santa Ynez Valley Art Exhibit," 1954, and *San Luis Obispo Art and Photography before 1960* and *Arroyo Grande Art and Photography before 1960*

Heiges, Margaret Lois (Mrs. Dr. Laurence Ephraim Heiges, Sr.) (1877-1964) (Lompoc)
Exh. crafts at Lompoc Valley Fair, 1928, 1930. In charge of posters at Flower Festival, 1934, 1935. Filmmaker, amateur, who showed her films of Mexico and Alaska to local groups (1940s).

■ "Heiges Rites... Margaret Lois Heiges, widow ... Mrs. Heiges, born in Ohio April 3, 1877, died at the Lompoc District Hospital Jan. 11. She lived at 126 North G St. and had been a resident of the city for the past 53 years. She is survived by three sons...," *LR*, Jan. 13, 1964, p. 3.
Heiges, L. E., Mrs. (notices in Northern Santa Barbara County newspapers on microfilm and on newspapers.com)
1936 – "Diary of an Oriental Tour, Part Four... Mrs. L. E. Heiges, Sr., *LR*, Oct. 16, 1936, p. 10.
1940 – "Committees Are Appointed for Companions... Moving pictures of her trip to Mexico accompanied by a short talk were shown by Mrs. L. E. Heiges, Sr.," *LR*, Feb. 9, 1940, p. 5; "Mexico Films are Shown Methodists ... accompanied by amusing incidents of the trip," *Lompoc Shopper?*, Feb. 22, 1940, p. 4.
1941 – "Silver Wedding... Moving pictures of the Columbia highway and old Mexico will be shown by Mrs. L. E. Heiges, Sr.," *LR*, May 2, 1941, p. 2; "Housewarming and Farewell Party is Given... Moving pictures of the recent Alaskan trip... and Mrs. L. E. Heiges, Sr., and also films taken by **Harry Buckman** were shown by the latter," *LR*, Aug. 22, 1941, p. 2; "Alaskan Pictures are Shown at

Heiges. Moving pictures of her recent trip to Alaska were shown by Mrs. L. E. Heiges, Sr., at her residence...," *LR*, Sept. 12, 1941, p. 3; "Curator to Talk Before **Alpha**... Mrs. L. E. Heiges movies on Alaska were shown to the group...," *LR*, Sept. 19, 1941, p. 5; "Methodists to Hold Social Evening. Moving pictures of Alaska will be shown by Mrs. L. E. Heiges tonight...," *LR*, Oct. 10, 1941, p. 2; "Hallowe'en Party Given by Eastern Star... moving pictures of Alaska were shown by Mrs. L. E. Heiges...," *LR*, Oct. 31, 1941, p. 5.
1942 – "**Pythian Sisters**... pot-luck supper... Moving pictures of Alaska were shown by Mrs. L. E. Heiges," *LR*, Feb. 27, 1942, p. 7.
1943 – "Past Chiefs... Moving pictures of Alaska were shown members of the Past Chiefs club... Friday evening at the home of Dr. and Mrs. L. E. Heiges. The pictures were shown by the hostess," *LR*, July 23, 1943, p. 3.
1944 – "Program Staged at Camp Cooke Hospital... Last Sunday evening's program was staged by Mrs. L. E. Heiges who presented her moving pictures on Alaska," *LR*, Jan. 7, 1944, p. 3; "Interesting Programs are Given at Cooke ... Mrs. L. E. Heiges, Sr., presented her colored movies films on pictures taken on an Alaskan trip...," *LR*, Aug. 25, 1944, p. 3.
1963 – Port. congratulating Mrs. L. E. (Margaret) Heiges, Sr., on her 50 years of membership in **Pythian Sisters**," *LR*, March 18, 1963, p. 4.
Nearly 400 social and club notices for "Mrs. L. E. Heiges" (both Sr., and Jr.) appear in the *LR*, 1940-94 but were not itemized here.
Heiges, L. E., Mrs. (misc. bibliography)
Margaret Lois Heiges b. April 3, 1877 in Trumbull Co., Ohio, d. Jan. 11, 1964 in Santa Barbara County and is buried in Lompoc Evergreen Cemetery per findagrave.com (refs. ancestry.com).
See: "Flower Festival / Show," 1934, 1935, "Lompoc Valley Fair," 1928, 1930

Heil, Frances / Francis Joanna, Miss (1876-1967) (Santa Maria / Santa Ana)
Teacher of drawing at Santa Maria High School, 1910-12. Taught at Girls' High School in Riverside, 1912-1920, and then at Orange High School, Orange, Ca., for 43 years.

■ "Our High School... Faculty this year consists of seven members... Francis J. Heil, drawing and manual training: Graduate of State Normal, Los Angeles; special teacher of music and drawing in Santa Ana schools, 1896-08; Student of Pratt Institute, New York City 1908-10; Graduated 1910," *SMT*, Sept. 17, 1910, p. 4.
Heil, Frances (notices in Northern Santa Barbara County newspapers on microfilm and on newspapers.com)
1908 – "Will Go to Pratt Institute. Miss Frances Heil, who has been supervisor of art in the grammar schools of Santa Ana, will leave soon for New York to enter Pratt Institute of Art where she will perfect her work by a year's study...," *Santa Ana Register*, June 18, 1908, p. 5; "Miss Heil Off for the East. Miss Frances J. Heil left today for New York City where she will attend Pratt Art Institute, taking the Normal Art course. She joins a party of high school teachers who are going east to attend Columbia and

Pratt. They have planned a two weeks' pleasure trip, traveling by way of the Canadian Pacific with stopovers at San Francisco, Seattle, Laggan, Banff, Toronto and Montreal…," *Santa Ana Register*, Sept. 5, 1908, p. 5.

1910 – "Personals… Miss Frances J. Heil begins work today in the Santa Maria High School as director in the Art and Manual Training department," *Santa Ana Register*, Aug. 8, 1910, p. 5.

1912 – "Sunday Schools Will Convene… Convention… Programme Committee, Miss Fotheringham, Miss Heil…," *SMT*, March 23, 1912, p. 1; "In the Long Ago. 14 Years Ago Today… Miss Frances Heil left for Riverside where she is to be an instructor in the girls' high school," *Santa Ana Register*, Sept. 20, 1926, p. 22.

1916 – "Real Estate Transfers. October 27… Don H. Porter et ux to Frances J. Heil – Lot 167, Madjeska [Sic. Modjeska] Ranch. $10. Same to Frank L. Heil – Lot 168, same ranch, $10," *Santa Ana Register*, Oct. 30, 1916, p. 7.

1919 – MOTHER – obit. "Mrs. Euretta Ann Heil… lived in Santa Ana since 1885… seven children… survived by … Miss Frances J. Heil of the Riverside Girls' High School…," *Santa Ana Register*, Feb. 12, 1919, p. 7; "To Study Art. Miss Frances J. Heil left last Saturday for Rio Nido, Sonoma county, to attend the summer school of art conducted by Pedro Lemos," *Santa Ana Register*, July 1, 1919, p. 5.

1924 – "Orange Personals… Misses <u>Anna</u> and <u>Mellie Hill</u> [Sic. Hills?] of Laguna Beach were guests of Miss Frances Heil Thursday. The Misses Hill [Sic. Hills] were going to Riverside where they will paint for a few days," *Santa Ana Register*, Nov. 25, 1924, p. 14.

1927 – "Art Appreciation PTA Subject… Art appreciation was the general topic of discussion at the meeting of the Intermediate PTA yesterday afternoon at the intermediate school. Miss Frances Heil, art instructor in the Orange union high school conducted… speaking on the topic of 'Art Appreciation in Home Life'," *Santa Ana Register*, Feb. 10, 1927, p. 4; port. with cast of "The Three Wise Fools," *Santa Ana Register*, March 8, 1927, p. 13.

1936 – "Orange Personals… Miss Frances Heil, 531 North Glassell street, has returned from a summer vacation which she spent at her cabin at Modjeska's…," *Santa Ana Register*, Aug. 27, 1936, p. 27 (i.e., 11).

1941 – "Miss Frances Heil is having her Modjeska cottage painted and re-decorated, *Santa Ana Register*, Aug. 21, 1941, p. 15.

1942 – "Miss Frances Heil Presented Gift at Faculty Picnic … has been art instructor at Orange Union high school for some years was presented with a pen and pencil set… following the announcement that Miss Heil is resigning her position to devote her time to art work…," *Santa Ana Register*, June 9, 1942, p. 8; "Teachers Resign … Orange Union high school… Miss Frances Heil for 21 years art teacher in the school…," *Santa Ana Register*, June 17, 1942, p. 5; "Modjeska. Miss Frances Heil is a new observer at the Modjeska defense station," *Santa Ana Register*, July 22, 1942, p. 4; "Modjeska… Miss Frances Heil is at her home in the canyon and recently was able to sketch a number of deer," *Santa Ana Register*, Sept. 22, 1942, p. 11. [Do not confuse with Miss Frances Heil, daughter of A. J. Heil, who was b. c. 1920.]

And more than 140 notices (mostly social) for "Frances Heil" in the *Santa Ana Register* and other California papers on newspapers.com between 1900 and 1967 were not itemized here.

And, more than 70 notices for "Frances Heil" in the *Riverside Independent*, 1912-20, on genealogybank.com primarily about her teaching at Girls' High School and her students' exhibits, were not all itemized here.

<u>Heil, Frances (misc. bibliography)</u>
Frances J. Heil b. Sept. 15, 1876 in Omro, Wisc. to Frank Heil and Euretta A. Heil, d. Aug. 15, 1967 and is buried in Fairhaven Memorial Park, Santa Ana, per findagrave.com (refs. ancestry.com).

<u>See</u>: "McGuire, Neil," "Santa Maria, Ca., Union High School," 1910, 1911, "Schools (Northern Santa Barbara County)," 1910

Heimann, Elli Julie Mirjam (1891-1966) (Pasadena / Ojai / Santa Barbara)
Artist who exh. at Santa Ynez Valley Art Exhibit, 1954. Won third prize for watercolor in professional class, Santa Barbara County Fair, 1959.

■ Port. and "Pasadena Art Institute… The final chapter in the series of short biographies of Institute art instructors… Miss Heimann has been on the Institute teaching staff since 1941, and since 1943 also on the faculty of the Trailfinders' School for Boys in Altadena. A few months after her arrival in Pasadena in 1941 she took over the Museum's children's classes in the temporary Walnut Street location, then the Union Street Studio, and, when the Art Institute re-opened in the present building, she continued there. Miss Heimann came to Pasadena via Havana and Italy. She graduated as an art teacher from the Royal Art School of Berlin, received her diploma for oil painting from the Weimar Academy and a diploma for graphic arts from the Berlin Academy. Art study trips took her through much of Europe. She exhibited 'solo' and with groups in Germany, Italy, Havana and Pasadena. She teaches the eight to 10-year-olds on Saturday afternoon in the Institute studio," *Metropolitan Pasadena Star-News*, Oct. 6, 1946, pp. 17, 20.

<u>Heimann, Elli (notices in California newspapers on microfilm and on newspapers.com)</u>
1946 – "Art Classes for Young Children … Miss Elli Heimann of Pasadena teaches the eleven-to-fourteen-year-olds on Wednesday and Friday mornings. Her second section, likewise, is still open to new students…," *Metropolitan Pasadena Star-News*, July 7, 1946, p. 17; "Famous Artists to Teach at … Pasadena Art Institute, 46 North Los Robles avenue… The art faculty will include … and Elli Heimann, all of Pasadena…," *Pasadena Independent*, Sept. 18, 1946, p. 24.

1947 – "Elli Heimann art instructor at The Trailfinders, is taking a year's leave to visit Europe. She's going to fix up her family's old home in Italy. Mussolini slept in it during the German occupation," *Metropolitan Pasadena Star-News*, June 18, 1947, p. 11; "Back from Europe. Elli Heimann, Pasadena artist and musician, has returned home from a four-month trip to Europe during which she spent most of the time in Italy," *Metropolitan Pasadena Star-News*, Oct. 27, 1947, p. 13;

1949 – "European Art's Influence Told. Miss Elli Heimann… presented an illustrated lecture on 'European Art and Its Influence Upon America Today,' at the bi-monthly luncheon meeting of the Crespi Study Club…," *Metropolitan Pasadena Star-News*, April 4, 1949, p. 6; "Craft Classes Active in Ojai Art Center… In the Tuesday 10 a.m. sketch class, of which Miss Elli Heimann is teacher, there are [and students named]," *Ventura County Star-Free Press*, Oct. 22, 1949, p. 10.
1950 – Classified ads. "Educational – 25. Art Instruction. Drawing, oil & watercolor painting. Elli Heimann (formerly Pasadena Art Inst.). Creative art for children. Ojai 7713," *Ventura County Star-Free Press*, Jan. 20, 1950, p. 14.
1951 – "Elli Heimann, Ojai painter and educator, has a good show of oils of Europe and America at the Frances Webb Galleries, 3881 W. 6th St. to July 7. 'Rosa,' a finely painted head of a little girl, is among European canvases which exhibit the technical soundness that underlies her freer, later work. In such California scenes as those of street and buildings at Ojai and a typical Pasadena residence street, she captures the character of place and light in a way that artists who live long among such sights rarely succeed in doing. Her watercolors of flowers are very delicate and clear," *LA Times*, June 24, 1951, p. 105 (i.e., Part IV, p. 5); repro: "St. Thomas, Ojai" part of one-woman show by Elli Heimann, Ojai painter, at Frances Webb Galleries to July 7. Artist also paints people and flowers, *LA Times*, June 24, 1951, p. 105 (i.e., Part IV, p. 5).
Heimann, Elli (misc. bibliography)
Elli Julie Mirjam Heimann provided the following information on her US Declaration of Intention for naturalization… present place of residence is 388 Pearl Place, Pasadena, my occupation is painting. I am 49 years old. I was born on November 14, 1891 in Luckenwalde, Germany… Female…White… medium complexion… grey eyes, grey hair, 5' 3" ht., weight 150 pounds… race Hebrew… present nationality German. I am not married…I have no children. My last place of foreign residence was Havana, Cuba… My lawful entry for permanent residence in the United States was at Miami Florida under the name of Elli Julie Heimann on January 3, 1941 on the Airship N.C. 16735 and passport photo and filed in LA on April 7, 1941. Cert. no. 23-101472; Elli Heimann was listed in the *Santa Barbara, Ca., CD*, 1957-65; Elli Heimann was b. Nov. 14, 1891 and d. Feb. 15, 1966 per Social Security Death Index (refs. ancestry.com).
See: "Santa Barbara County Fair," 1959, "Santa Ynez Valley Art Exhibit," 1954

Helen and Ina's (Lompoc)
Ceramic supply shop, 1949, 1950.
■ "Business License in Zone Violation… A business license which was granted for a firm doing business in the R-L zone of the city was ordered revoked… The firm, Helen and Ina's, a ceramics supply establishment located in a residence on North Q street, was given the business license several months ago and a protest was presented to the council Tuesday by **Francis Smiley**, manager of another ceramics supply firm. … the license had been issued in violation of the city zoning laws… the firm might

comply with the 'home business' provisions of the zoning ordinance, which allows certain types of business and professional operations in the residential zones," *LR*, Feb. 9, 1950, p. 1.
Helen and Ina's (notices in Northern Santa Barbara County newspapers on microfilm and on newspapers.com)
1949 – "Too Late to Classify. Ceramics. Greenware, supplies and firing, 127 No. A. Phone 6561 or 6902," *LR*, Nov. 24, 1949, p. 8.
1950 – "Ceramics Firm in Residential Zone," *LR*, Feb. 16, 1950, p. 1; classified ad – "We have ceramics supplies, greenware and paint. We give instructions for painting and decorating greenware. Helen and Ina, 127 North O. Phone 6902," *LR*, Feb. 23, 1950, p. 6; "Council Okay's Home Permit… in the name of **Mrs. Russell Benhart** at 127 North O street…," *LR*, March 9, 1950, p. 3.

Helen Barbera Ceramics (Solvang)
See: "Barbera, Helen"

Heller, Clio (San Jose)
Art demonstrator for Binney and Smith who gave a workshop for teachers in Santa Maria, 1959.

■ Port. and "Fifty teachers from Santa Maria, Guadalupe and Orcutt school districts have signed up for an Art Workshop to be held May 5-7 at the Santa Maria School District administration building. The workshop will be conducted by Miss Clio Heller, a representative of Binney and Smith, Inc., manufacturers of crayons and other art supplies. Techniques will include use of water colors, poster paints, finger paints, colored chalks, crayons and modeling clay. All of the workshop activities will be experiences which the teachers can relate to classroom teaching," per "Art Workshop Planned Here," *SMT*, April 30, 1959, p. 10.
See: *Central Coast Artist Visitors before 1960*

Heller, Hazel Minkin (Mrs. Harry Heller) (1901-1990) (Los Angeles / Santa Maria)
Watercolorist who exh. at Santa Maria Public Library, 1953.

■ "Mrs. Heller was born in Chicago, Ill., and was reared in the Los Angeles area. She worked as a film editor for various movie studios prior to moving to Santa Maria in 1962 [Sic. 1952?]. She and her husband owned and operated Harry H. Heller Produce Packing in Santa Maria for many years, retiring in 1980. She was a member of the Altrusa Club, Minerva Club, Santa Maria Valley Republican Women's Club and Temple Beth El Sisterhood and was a life member of the Hadassah. She was active in many civic and community affairs," per "Hazel M. Heller," *Santa Maria Times*, Nov. 28, 1990, p. 14 (i.e., B-6).
Heller, Hazel (notices in Northern Santa Barbara County newspapers on microfilm and on newspapers.com)
1953 – "Heller Paintings are on Exhibit" at Santa Maria Public Library, and article adds they are water colors and oils and that she is a student of **George Muro** at Santa Maria Junior college. "Mrs. Heller, after one semester of art

training has shown unusual talent and promise. This exhibit is under sponsorship of the Junior community club with **Mrs. James Jarvis** as art chairman," *SMT,* Jan. 23, 1953, p. 4; And c. 14 social notices for "Mrs. Harry Heller" in the *SMT* 1949-54, not itemized here.

Heller, Hazel (misc. bibliography)
Hazel Heller is listed in the *Santa Maria, Ca., CD*, 1967-83; Hazel Minkin Heller, mother's maiden name Brotman and father's Minkin was b. Feb. 15, 1901 in Illinois and d. Nov. 26, 1990 in Santa Barbara County per Calif. Death Index; Hazel Heller is buried in Santa Maria Cemetery District per findagrave.com (refs. ancestry.com).

Helmle, Henry / Heinrich (1882-1966) (Los Angeles)
Artist commissioned by Index of American Design (part of the Federal Art Project) to decorate the chapel of Mission La Purisima near Lompoc, 1941.
■ Born in Germany. He studied there [Art Academy in Karlsruhe] and in 1905 immigrated to NYC, and in 1907 to SF. He decorated fashionable homes there. He married in 1924 and for seven years lived in the Santa Cruz Mountains. "After settling in LA he was commissioned by the Federal Art Project to decorate the chapel of Mission La Purisima near Lompoc." He died in LA. per Edan Hughes, *Artists in California.*

Helmle, Henry (notices in California newspapers on microfilm and on newspapers.com)
1936 – "Winners in Air Race Posters Selected… contest sponsored for the National Air Races by the Women's International Association of Aeronautics and the Women Painters of the West… Three first place awards went to … and Henry Helmle…," *LA Times,* Aug. 19, 1936, p. 30 (i.e., pt. II, p. 10).
1941 – "Mural Artist Begins Decorating Mission Church. Henry Helmle, Los Angeles mural artist, this week began decorating the church at **La Purisima** mission with typical California mission designs. Helmle is a member of the Index of American Design … The artist will be assisted… by CCC enrollees," *LR,* April 18, 1941, p. 1.
Bibliography:
Art Student – *PSCA* - 7-I-SFAA-48
Helmle, Henry (misc. bibliography)
Heinrich Helmle, age 23, a painter, German, sailed on the *S. S. Cretic* from Genoa, Italy, on Oct. 13, 1905 in the company of Theodor Helmle, age 28, also a painter, and arrived at New York on Oct. 30, 1905 per *List of Manifest of Alien Passengers for the U. S. Immigration Officer at Port of Arrival*; Henry Helmle is listed in the 1910 U. S. Census as an artist in the painting industry, residing in San Francisco alone (and gives his year of immigration as 1905); Henry Helmle gave the following information on his WWI Draft Card – age 36, b. March 11, 1882, residing at 2405 Howard St., SF, Cal., working as a lithograph artist with Louis Roesch Co., SF, married to Ida Helmle (who was living in Karlsruhe, Germany), described as medium height, medium build, brown eyes, brown hair; Henry Helmle was listed in the 1920 U. S. Census as an artist in the photography industry, residing in San Francisco with a lodger; Henry Helmle is listed in the 1930 U. S. Census as immigrated 1907 [Sic.], naturalized, a commercial artist residing in Los Angeles with wife Hannah H. Helmle (age

42) and children Gertrude J. Helmle (age 5) and Anita E. Helmle (age less than 1); Henry Helmle provided the following information on his WWII Draft Registration Card = residing in Los Angeles, with wife Hannah and unemployed; Henry Helmle b. March 11, 1882 in Stuttgart, Germany, was residing in San Francisco in 1910, lastly (?) married Johanna Hauser, and d. July 6, 1966 in Los Angeles per Mitchell Family Tree (refs. ancestry.com).

Helms, John (1879-1956?) (Orcutt?)
Artist who exh. at Santa Ynez Valley Art Exhibit, 1954.
Helms, John (misc. bibliography)
Is he John Helms listed as an oil worker in *Voter Registration Index for Orcutt Precinct No. 2*, 1938-40; is he John Helms, listed in the 1940 U. S. Census as age 60, b. Missouri, a house painter, residing in Orcutt with wife Golda and children Chester and Alene; is he John Helms of Orcutt, b. Oct. 9, 1879, married to Golda who said, on his WWII Draft Registration Card, that he worked for the Union Sugar Co., Betteravia, Ca.; is he John Helms b. Oct. 9, 1879 in DeKalb, Mo., to James Madison Helms and Nancy Kerns, married Golda May Thomas, and d. Sept. 13, 1956 in SLO per Wilson-Powers Family Tree (refs. ancestry.com).
See: "Santa Ynez Valley Art Exhibit," 1954

Henderson, Mabel (Mrs. Ralph T. Henderson) (North Hollywood)
Southern District Handcraft Chairman for California Federation of Women's Clubs who spoke to Alpha Club, Lompoc, 1938, 1939, and Junior Community Club, Santa Maria, 1938, 1941.
See: "Alpha Club," 1938, 1939, "Junior Community Club," 1938, 1941

Hendricks, Robert L. "Bob" (1927-2015) and Elizabeth Bonewitz (1924-1994) (Santa Maria)
Photographer. Prop. Santa Maria Studio of Photography, 1955- c. 1976.
■ "… Bob Hendricks, owner, and his wife, Elizabeth, first opened a studio here in 1955. They moved to their South Lincoln location in 1958. During World War II, Hendricks was a photographer for three years in the navy. He has studied photography at the **Fred Archer** School of Photography in Los Angeles. He was later a photographer for Bullock's Portrait Studio in Los Angeles for two years. He was also with Robert's Studio of photography in the Los Angeles area for two years, specializing in graduation portraits and commercial photography. His wife [Elizabeth] has had considerable experience as a color artist and negative retoucher for photographers in the East. She studied art at the Memphis Academy of Arts and the art of airbrushing at the Los Angeles Trade School. She is noted for her exceptionally fine oil coloring work on portraits…," *SMT*, July 25, 1960, p. 4.
Hendricks, Bob (notices in Northern Santa Barbara County newspapers on microfilm and on newspapers.com)
1956 – Ad "Bob Hendricks, Your Photographer. Weddings – Portraits – Commercial. Santa Maria Studio of

Photography…," *SMT*, Sept. 26, 1956, p. 6; port. of local photographer who talked to **Minerva Club** about "How to Hang Family Portraits," and who gave out illustrated booklets on the subject, *SMT*, Oct. 15, 1956, p. 4.

1958 – "Klipper Klub [The Adventurers, club of the Presbyterian Church] Sees Films of Mountains… The program consisted of colored slides of mountain scenery shown by Bob Hendricks," *SMT*, April 11, 1958, p. 3; "'Round Town. Mr. and Mrs. Bob Hendricks are leaving to attend the Western States Professional Photographers convention July 10 to 13 inclusive in Berkeley. They will be staying at the Claremont Hotel," *SMT*, June 11, 1958, p. 9.

1959 – "Tabled until May 6, a use permit request by Robert L. Hendricks to build a two-story professional building (photography shop) with living quarters upstairs, in the 100 block on W. Jones Street," *SMT*, April 16, 1959, p. 2, col. 3; "Photo Convention. Mr. and Mrs. Robert L. Hendricks, 110 S. Lincoln, are attending the 68th Annual Exposition of Professional Photography and 7th National Industrial Photographic Conference of the Professional Photographers of America, Inc., being held this week at the Statler Hilton Hotel, Los Angeles… The professional photographers are attending special sessions designed to keep them abreast of the latest methods, techniques and equipment…," *SMT*, July 30, 1959, p. 9.

1963 – Judge for photography contest at the Santa Barbara County Fair, *SMT*, July 23, 1963, p. 8.

Hendricks, Bob and Elizabeth (misc. bibliography)
"Mrs. Elizabeth B. Hendricks – and separately Robt. L – (Santa Maria Studio of Photography) are listed in the *Santa Maria, Ca., CD*, 1958, 1961, 1967, 1970, 1976; Robert & Elizabeth Hendricks (Santa Maria Studio of Photography) are listed in the *Santa Maria, Ca., CD*, 1976; Robert Hendricks was b. April 21, 1927 in Huntington, Ind., to Jesse L. Hendricks and Mildred Stults, married Elizabeth Bonewitz, was residing in Huntington, Ind. in 1954, and d. July 6, 2015 in Huntington, Ind., per Keri Fields Family Tree; Elizabeth Bonewitz was b. Sept. 28, 1924 in Huntington, Ind., to Alfred Grafton Bonewitz and Catherine G. Moran, married Robert Hendricks, was residing in Huntington, Ind. in 1940 and d. Jan. 22, 1994 in Huntington, Ind., per Keri Fields Family Tree (refs. ancestry.com).
See: "Santa Maria Camera Club," 1957, "Santa Maria Studio of Photography"

Hendrickson, Florence B.
Artist who exh. at Santa Ynez Valley Art Exhibit, 1954.
See: "Santa Ynez Valley Art Exhibit," 1954, and *Morro Bay Art and Photography before 1960* and *San Luis Obispo Art and Photography before 1960*

Hendrickson, Henrietta Alberta Wingard (Mrs. Dr. William Matthew Hendrickson) (1863-1934) (Lompoc)
In 1892 Mrs. Dr. Hendrickson exh. Best flowers, in water colors at "Santa Barbara County Fair," Lompoc. Prop. Lompoc School of Art Embroidery, 1889.
Hendrickson, Henrietta (misc. bibliography)
William Mathew Hendrickson, resident of Lompoc, listed in the *Great Register, Santa Barbara County, Calif.*, 1892; W. M. Hendrickson, is listed as physician or surgeon in Lompoc, Ca., in 1893 per *Calif. Occupational Licenses, Registers and Directories, 1876-1969*; Henrietta Alberta Wingard was b. July 28, 1863 in Flemington, Pa., to Charles Wesley Wingard and Henrietta Elizabeth Shoemaker, married William M. Hendrickson, was residing in Portland, Ore., in 1900, and d. Dec. 8, 1934 per Charles Wesley Wingard Family Tree (ref. ancestry.com).
See: "Lompoc School of Art Embroidery," 1889, "Santa Barbara County Fair," 1892, and *San Luis Obispo Art and Photography before 1960*

Hendy, Mary Emma Fabing (Mrs. Robert G. Hendy) (1921-1980) (Lompoc)
Ceramic enthusiast, 1956, 1958. Maker of mosaics, 1962.
■ "Mary E. Hendy… Mrs. Hendy was born June 14, 1921 in Philomath, Ore., and died Friday at Lompoc District Hospital. A resident of Lompoc for the past 41 years, she last lived at 218 South D St. She was a former laboratory technician at Grefco, Inc. Her great grandfather, Henry W. Fabing, was an early Lompoc settler and builder of the Fabing-McKay-Spanne Historical Home," *LR*, June 2, 1980, p. 2.
Hendy, Robert, Mrs. (misc. bibliography)
Mary E. Hendy, laboratory assistant, Great Lakes Carbon Corp., is listed with Robert G. Hendy, geologist, Johns-Manville, in Lompoc in the *Santa Maria, Ca., CD*, 1965; Mary E. Hendy is listed Lompoc in various area *CD*, 1958-76; Mary Emma Hendy, mother's maiden name Overhulser and father's Fabing, was b. June 14, 1921 in Oregon and d. May 30, 1980 in Santa Barbara county per Calif. Death Index (refs. ancestry.com).
See: "Ceramics (Northern Santa Barbara County)," 1956, "Flower Festival / Flower Show (Lompoc)," 1962, "Puttering Micks," 1958

Henning, Dewitt Clinton (1827-1902) (Lompoc)
Sign, ornamental, house painter and grainer, 1875-77.
Henning, D. C. (notices in Northern Santa Barbara County newspapers on microfilm and on newspapers.com)
1875 – "Fifty-Nine Years Ago. July 10, 1875. The People's Store… on the corner of Cypress and G. streets has come out with a new sign, recently painted by D. C. Henning, our home artist," *LR*, July 13, 1934, p. 2; "Don't forget to try Averill Chemical Paint. It is one third cheaper and goes one-fourth further than any other kind. Mr. Henning, our resident painter, is a capital hand to make the application," *LR*, July 24, 1875, p. 3.
1876 – "Painting! Painting! The undersigned announces that he is prepared to do all kinds of Plain and Ornamental Painting. House and Sign Painting made a specialty. Orders

can be left at J. P. Henning's in Lompoc or by applying to D. C. Henning," *LR*, Feb. 12, 1876, p. 1.

1877 – Ad, *LR*, March 10, 1877, p. 1, col. 1.

1890 – "The safe, counters and all necessary fixtures are now in complete order for the operations of our new bank. The retouching of the counters and fixtures is the work of D. C. Henning, and done most artistically in imitation of black walnut…," *LR*, May 31, 1890, p. 3, col. 3.

1891 – "D. C. Henning & Sons have done a most superior job of graining in the new school house…," *LR*, Feb. 21, 1891, p. 3.

1894 – "The Fourth Annual Fair of the Thirty-Seventh Agricultural Association at Lompoc… In our mention of the manufacturer's booth, we unintentionally omitted to give credit to our townsman, D. C. Henning, for a display of some exceptionally fine specimens of grained panel work of his own creation…," *LR*, Oct. 13, 1894, p. 2. Member of Friends of Sociability, Morality and Intellectuality and of Odd Fellows (1876), and additional notices in the *LR* between 1870 and 1900 were not itemized here.

Henning, D. C. (misc. bibliography)
Dewitt C. Henning, age 48, b. Virginia, a painter, residing in Santa Barbara, registered to vote May 3, 1876, per *Great Register of Santa Barbara County*, 1877; DeWitt Clinton Henning is listed in several voter registers in Santa Barbara in the late 19th century; Dewitt Henning is listed in the 1900 U. S. Census as age 72, b. Dec. 1827 in Virginia, no occupation cited, residing in Lompoc, with wife Adelade (age 68) and sons Hollis (age 34) and Stewart (age 25); several ports of DeWitt Clinton Henning b. Dec. 7, 1827 and d. Dec. 24, 1902 are in *Public Member Photos & Scanned Documents* (refs. ancestry.com).

Henningsen, Lorentz / Lorens (1849/50-1927) (Denmark / Solvang)
Minister / artist. Art teacher at Danish craft school in Michigan (c. 1884-85). Retired to Solvang, 1918.

■ "Rev. Henningsen Dies Suddenly… Lorens Henningsen was born in Denmark in 1849 and came to this country in 1880 and taught in the Danish schools at Racine, Wisconsin; from there he went to Ashland, Michigan, and was a teacher there in the Danish Folk High School for many years. In Danevang, Texas, he followed the ministry and also gave many years of his life in that profession in the Dakotas and Minnesota. He received his education in Denmark, being a graduate of the Copenhagen Academy and was a very good artist in painting of which there are many scattered throughout the United States. He was a very hard consistent worker for his church. Mr. Henningsen was married to Miss Starke in 1880 and is survived by his wife… Rev. Henningsen came to Solvang with his family in 1918 as a retired minister…," *SYVN*, Dec. 16, 1927, p. 1.

Henningsen, Lorentz (various notices)
■ Teacher of – "Jes Petersen Smidt, the Danish-born master wood carver … His mentor was the artist Lorentz Henningsen, who had studied art in Denmark and became an instructor at the Ashland (Grant, Michigan) and Danebod (Tyler, Minnesota) Folk Schools. Henningsen would later write that, during the 1884-85 winter session at

Ashland, Smidt was his finest student," nordicamericanchurches.org/painting-and-painters.

■ Photo of Folk School at Ashland, Michigan and "The Opening was planned for November 1, 1882… [the school had trouble attracting enough students to make it financially viable] … One factor in the slight increase was the addition of Lorentz Henningsen to the faculty. Henningsen had studied art in Denmark. He had come to America in 1882 and had spent some time in Racine. His background made it possible for him to attract some students to the school. Henningsen later became a pastor in the Danish Church. He died at Solvang, California in 1927," www.danishheritage.org.

■ WIFE – "Mrs. Anna Margrethe Barger Henningsen… was married in 1875 to the late Rev. Lorentz Henningsen, who was also born on Aero, an island in Denmark. She and her husband came to the United States in 1882 and settled in Clinton, Iowa. They left for California in 1917, making their home in Solvang. Mrs. Henningsen's husband studied for the ministry abroad and completed that work in this country. He also was an accomplished artist and much of his work was exhibited in Copenhagen. Mr. Henningsen died in 1927 in Solvang. Mr. and Mrs. Henningsen celebrated their silver wedding anniversary in South Dakota and marked their golden anniversary in Solvang. …," per "Funeral Rites for Mrs. Henningsen," *SYVN*, March 21, 1947, p. 1.
And additional notices in American newspapers of Danish language, not cited here.

Henningsen, Lorentz (misc. bibliography)
Lorentz Henningsen was b. April 23, 1850 in Svendborg, Denmark, to Henning Hansen Henningsen and Ane Cathrine Rasmussen, married Anna Margarethe Bager and d. Dec. 10, 1927 in Solvang, Ca., per Danevang Settlers (refs. ancestry.com).

Herda, Robert C. (Santa Maria / Redwood City)
Student and co-prop with John Costello of Aerial Photography Service, 1947-48.
Aerial Photography (notices in Northern Santa Barbara County newspapers on microfilm and on newspapers.com)
1948 – "Robert C. Herda, close friend of the bridegroom, served as his best man," per **John L. Costello and Bride**," *SMT*, Jan. 3, 1948, p. 3; sister-in-law married, i.e., "Bridal Couple… bride's married sister, Mrs. Robert C. Herda of Redwood City and daughters Cathy and Melinda," *SMT*, Oct. 29, 1954, p. 4.
See: "Aerial Photography Service"

Herold, Beatrice C. (Mrs. Arthur "Art" Herold) (Santa Maria)
Handcraft chairman, Jr. Community Club, 1952.
Port. in her own living room, *SMT*, Nov. 18, 1960, p. 6.
See: "Junior Community Club (Santa Maria)," 1952

Herold, Betty M. Dorsey (Mrs. Roland Saunders Herold) (1930-?) (Santa Maria)
Photographer, amateur, who won several prizes at the Santa Barbara County Fair, 1960. Wife of Roland Harold, below
"California Consolidated Plans Improvement to Water System… three employees in the office. Mrs. Betty Herold, a resident of Santa Maria for 30 years, is training to take over the billing job of Mrs. Merle Hill, who is planning to retire," *SMT*, Jan. 16, 1965, p. 20 (i.e., 6-B).
Betty M. and Roland Herold are listed in the *Santa Maria, Ca., CD*, 1958-70 (refs. ancestry.com).
See: "Herold, Roland," "Santa Barbara County Fair," 1960

Herold, Roland Saunders (1927-2002) (Santa Maria)
Photographer, amateur, who won several prizes at the Santa Barbara County Fair, 1960. Husband to Betty Herold, above.
Herold, Roland (misc. bibliography)
Roland S. Herold, b. c. 1927, married Betty M. Dorsey on Dec. 27, 1951, in Santa Barbara county per Calif. Marriage Index; Roland Saunders Herold b. Sept. 23, 1927, d. Dec. 18, 2002 in Santa Barbara County, is buried in Santa Maria Cemetery District and his tombstone includes the inscription "Betty Dorsey Herold March 18, 1930" per findagrave.com (refs. ancestry.com).
See: "Herold, Betty M.," "Santa Barbara County Fair," 1960

Herron, Irma Daisy
See: "Trott (Herron), Irma Daisy (Mrs. James Herron)"

Herter, Albert (1871-1950) (Santa Barbara)
Muralist, painter, nationally known. Stayed at the Santa Maria Inn, 1920.
■ "Albert Herter (March 2, 1871 – February 15, 1950) was an American painter, illustrator, muralist, and interior designer. He was born in New York City, studied at the Art Students League with James Carroll Beckwith, then in Paris with Jean-Paul Laurens and Fernand Cormon. He came from an artistic family; his father, Christian Herter (1839–1883), had co-founded Herter Brothers, a prominent New York interior design and furnishings firm. Herter Brothers closed its doors in 1906, and Albert founded Herter Looms in 1909, a tapestry and textile design-and-manufacturing firm…," per Wikipedia.
Herter, Albert (notices in Northern Santa Barbara County newspapers on newspapers.com).
1920 – "Famous Artist Visits Here. Mr. and Mrs. Albert Herter of New York were among the arrivals at the Inn Saturday. Mr. Herter is a famous artist. Some of his work is in the St. Francis Hotel in San Francisco. Mr. Herter is proprietor of the Strarford [Sic. Stratford?] Hotel in New York City. The Herters are en route to Del Monte,' *SMT*, Nov. 8, 1920, p. 1.
More than 290 "hits" for "Albert Herter" appear in California newspapers (more than 70 in Santa Barbara County newspapers) but were not even browsed for itemization here.

See: "Mattei, Charles," "Orcutt Women's Club," 1927

Hertz, Louis, Major (1858-1930) (Santa Maria / SLO / San Francisco)
Photographer, amateur, designer, c. 1884-89. Exh. "Santa Barbara County Fair," 1886.
■ "The Smiling Countenance of Our Former Townsman. While in San Luis the other day we dropped in upon our friend and former townsman, L. Hertz, who spent some four years in our town as book-keeper for the firm of M. Fleisher & Co. and agent for Wells, Fargo & Co. Mr. H., while here was one among our most active and energetic citizens. There was nothing to be done of a public nature or to the interest of our town or valley but what Mr. H. was always ready to lend a helping hand. He made himself generally useful, acting as secretary for one or more of our lodges, of which he was a member. In most all our public entertainments of a home get up he took part and did much to help entertain our people. In short, Mr. H. was a genial, pleasant and accommodating young man whom we regret to have lost from our midst. He now fills his old position as book-keeper in the firm of Sinsheimer Bros," *SMT*, Dec. 21, 1889, p. 3.
Hertz, L. (notices in Northern Santa Barbara County newspapers on microfilm and on newspapers.com)
1889 – Presented with Two Flags… to Co. A. of the Central School Cadets, the American flag and company colors … The former was presented by the teachers of Central School and the citizens of Santa Maria. The flag of company colors was presented by Major L. Hertz…. The former designing the same…," *SMT*, July 6, 1889, p. 2.
More than 60 notices appear for "L. Hertz" or "Mr. Hertz" in the *SMT* between 1884 and 1889 regarding his activities with club and civic committees, and as owner of "sugar barrel alley" in Santa Maria, that were not itemized here.
Hertz, L. (misc. bibliography)
Is he Louis Hertz listed in the 1880 U. S. Census as residing in San Francisco; is he Louis Hertz, age 33, bookkeeper in SLO, per *California Voter Register, SLO*, 1888/1890; is he Louis Hertz listed in *California Voter Registers* in San Francisco 1892, 1896, 1898; is he Louis Hertz listed in the 1900 U. S. Census as married 1891, a bookkeeper in SF, and listed in the 1920 U. S. Census as age 62, b. c. 1858 in Calif., working as a cashier in the produce industry, residing in San Francisco with wife Laura B. (age 50); is he Louis Hertz b. c. 1858 who d. Nov. 3, 1930 in San Francisco County per Calif. Death Index (refs. ancestry.com).
See: "Charlie the Painter," 1884, "Santa Barbara County Fair," 1886

Hess, J. R. (Los Angeles?)
Aerial photographer who was a guest at the Santa Maria Camera Club meeting, 1940.
He may be John R. Hess, photographer, listed in the 1940 U. S. Census as age 31, b. c. 1909 in NY, residing in LA with wife Audrey and 2 sons (ref. ancestry.com).
See: "Santa Maria Camera Club," 1940

Hesthal, William Jurgen, Jr. (1908-1985) (Santa Barbara)
Artist who spoke at Allan Hancock [College] Art Gallery on lithography, 1955. Judge of Santa Ynez Valley Art Exhibit, 1956.

■ "Painter, muralist, lithographer, etcher. Born in San Francisco, CA on Aug. 24, 1908. At age nine Hesthal began attending the Saturday classes of Alice B. Chittenden at the CSFA and at ten, first exhibited in the San Francisco Art Assn annual. During the 1920s he was a founding member of the Modern Gallery (San Francisco) and in 1929 spent eight months painting in Maupitie in the Society Islands. In 1934 he was one of 26 artists chosen by the federal government under the Public Works of Art Project to paint murals (Railroad and Shipping) in San Francisco's Coit Tower. He used a Senator Phelan Award to study in China and was in Peking when the city was taken by the Japanese. Several painting trips were made to Mexico, the first in 1941 on a Rosenberg Fellowship. Hesthal settled in Santa Barbara in 1942 and joined the staff of the Santa Barbara Museum as a curator in 1954. During the 1960s he taught drawing, art appreciation, and history at Moorpark and Ventura colleges; and, in the 1970s, at the Santa Barbara Art Institute. Hesthal was active as an artist in Santa Barbara until his death on Jan. 5, 1985," from askart.com.

Hesthal, William (notices in California newspapers on microfilm and on newspapers.com)
1941 – Port. of both William Hesthal Sr., and Jr. – "Both Expected to Recover, Divorce Quarrel Cause… William J. Hesthal, Jr., 32, one of San Francisco's noted young artists … was lolling in a crowded bus at the Santa Fe's Fourth Street depot here, waiting for it to take him on the first leg of a gay jaunt to Mexico on a traveling art scholarship, when suddenly his father burst into the bus… climax of a smoldering father and son quarrel. The elder Hesthal, a jewelry store owner, thrust a revolver at the artist's heart and the son was shot in the thigh attempting to wrest it from him" and both went to the hospital, *SF Examiner*, Jan. 19, 1941, p. 3.
1955 – Photo of **Rico Lebrun** painting and "Lithograph Talk Given by Artist" at Allan Hancock [College] Art Gallery and he shows work by Lebrun and others as examples on 'how to read' a painting, *SMT*, Jan. 14, 1955, p. 4.
1957 – Port. with his drawing of a fashion model, *Ventura County Star-Free Press*, July 12, 1957, p. 6.
1961 – "William Hesthal in Overdue Solo Debut… at the Terry DeLapp Gallery. With great versatility and aplomb, Hesthal expresses a very personal fantasy world which is never-the-less communicable. His technical experiments in mixed media paints have added a greater luminosity to his most recent works of which 'Malignant God' is one of the most compelling," *LA Times*, May 12, 1961, p. 34 (i.e., pt. II, p. 4).
1971 – "Destructive Brush Fire Still Unchecked… Summerland, Ca. … William Hesthal's $40,000 home was destroyed. He surveyed the embers as he sat on the charred frame of his son's motorcycle. 'It's funny. Just yesterday my wife's pottery wheel was giving her trouble and I was worried about replacing the electric motor. Now the wheel

is gone along with everything else," *Progress Bulletin* (Pomona, Ca.), Oct. 9, 1971, p. 1.
1985 – "Santa Barbara Museum of Art … Now open is a special exhibition in remembrance of William Hesthal, former SBMA curator, titled 'William Hesthal: A Commemorative' with 12 works on paper drawn from the family's private collection…," *SMT*, Sept. 22, 1985, p. 45, last column (i.e., p. 14-B, "Calendar of Events").
And, more than 210 hits for "William Hesthal" and his art in various California newspapers (*Oakland, Los Angeles,* etc.) between 1930 and 1985 were not itemized here.
Hesthal, William (misc. bibliography)
Ship passenger lists show that he was in Manzanillo, Mexico in 1928 and in Papeete, Tahiti, in 1929; William Jurgen Hesthal, mother's maiden name Schutze, was b. Aug. 24, 1908 in Calif. and d. Jan. 5, 1985 in Santa Barbara County per Calif. Death Index (refs. ancestry.com).
See: "Allan Hancock [College] Art Gallery," 1955, "Santa Barbara County Fair," 1958, 1961, "Santa Ynez Valley Art Exhibit," 1956, "Tri-County Art Exhibit," 1957

Heth, George William "Shorty" (1931-1972) (Camp Cooke / Solvang)
Painter of missions. Exh. first annual Santa Ynez Valley Art Exhibit, 1953. Heth appears to have been in California only during his Korean war service and spent the remainder of his life in Illinois.

■ "Ottawa HS Teacher Passes Away. George W. Heth, 41, Marseilles, died suddenly… in Ottawa hospital. He was a teacher at Ottawa high school … born March 11, 1931 in Peru, he was a son of George and Ruth (Rietgraf) Heth. He married Rita Burke, Feb. 2, 1952. Surviving along with his wife are three sons and one daughter… He was a trustee for the First Baptist church, member of Rutland Township School Board and Veteran of the Korean War…," *The Times* (Streator, Ill.), March 20, 1972, p. 20.
Heth, George (notices in Northern Santa Barbara County newspapers on microfilm and on newspapers.com)
1952 – "Wed in Ottawa… Miss Rita Burke … to Mr. George W. Heth… Mrs. Heth, a graduate of Ottawa high school, is a junior at Northern Illinois State Teachers college, DeKalb. Mr. Heth attended the rural schools, was graduated from Ottawa high school and attended La Salle-Peru Junior College, He is an administrative assistant in the National Guard Medical Unit. After a brief wedding trip the couple will reside in DeKalb," *The Times* (Streator, Ill.), Feb. 5, 1952, p. 5; "Births. Lompoc Hospital line-up… Michael Pat is the new son, born August 9, of Mr. and Mrs. George W. Heth of Solvang," *LR*, Aug. 14, 1952, p. 8.
1966 – Port. as Woodland High School instructor who is touring students through Silica Company quarries and plants, *The Times* (Streator, Ill.), Sept. 30, 1966, p. 16.
1967 – "Three Teachers… Resign… Mrs. Rita Heth, 5th grade teacher, George Heth, biology teacher …," *The Times* (Streator, Ill.), May 10, 1967, p. 2.
And possibly 90 additional notices in Illinois newspapers but none refer to his artwork, were not itemized here.
Heth, George (misc. bibliography)
George William "Shorty" Heth and wife Rita Claire Burke were residing in Lompoc, Ca., at the time of the birth of their son, Michael Patrick Heth, in 1952 per Apte-Burke

Family Tree; George William "Shorty" Heth was b. March 11, 1931 in Ottawa, Ill., to George Linton Heth and Ruth Ella Rietgraf, married Rita Claire Burke, and d. March 19, 1972 in Ottawa, Ill., per Apte/Burke Family Tree (refs. ancestry.com).
See: "Santa Ynez Valley Art Exhibit," 1953

Hibbits, Forrest Silsby (1905-1996) (Lompoc / Buellton)
Grad. (?) Lompoc High School c. 1924, studied art in San Francisco, worked as a commercial artist in San Francisco, 1930s, served in WWII. Returned to the Lompoc / Buellton / Solvang area c. 1947 and turned to teaching art, painting, and running La Petite Galerie. Exh. Santa Ynez Valley Art Exhibit, 1953, 1954, 1955, 1956, 1957. Exh. Santa Barbara County Fair, 1959. Exh. Allan Hancock [College] Art Gallery, 1954, 1955, 1956. Husband to Marie Hibbits, below.
■ "Forrest Hibbits was a mid-century fine artist and watercolorist. He was born in Lompoc, California, on October 9, 1905. He left the Hibbits family ranch to attend the California College of Arts and Crafts and graduated c. 1927. He taught at the San Francisco Art Institute. Hibbits was married to fellow artist **Marie Jaans** (born in Belgium 1895 – died in Solvang, 1984), whom he met in North Beach. … worked as a commercial illustrator … in San Francisco. Marie and Forrest moved from San Francisco back to the Lompoc/Santa Ynez Valley area in the 1940s after Hibbits joined the Army, and lived there for the rest of their lives. … He was a member of the California National Water Color Society from 1948-1953," from Wikipedia.
Hibbits, Forrest (articles from Northern Santa Barbara County newspapers on microfilm and on newspapers.com)

1937 – "Visits Parents – Forrest Hibbits, commercial artist in San Francisco, was a Christmas season visitor with his parents, Mr. and Mrs. Guy Hibbits in Purisima district. He left Wednesday to resume work in the Bay city. Hibbits is planning a three-months' vacation in Europe this spring," *LR*, Jan. 1, 1937, p. 4.

1938 – "Poster Designed by Forrest Hibbits. A poster created by Forrest Hibbits of San Francisco, son of Mr. and Mrs. Guy Hibbits of Lompoc, was selected in a recent contest as the design to be used in publicizing the 1939 **Golden Gate International Exposition** on Treasure Island … Copies of the … poster were sent to young Hibbits' parents here and they picture the two famous bridges over the bay and gate with one of the giant Clipper planes high in the sky. Centering the picture is the tower of the sun, dominant structure on the man-made isle. Young Hibbits attended and graduated from local schools…" *LR*, Feb. 4, 1938, p. 4.

1945 – "Visit with Relatives – Cpl. Forrest Hibbits of Santa Ana and his wife from San Francisco, left on Thursday after a week's visit at the home of his parents... Cpl. Hibbits is on a two weeks furlough. He is on detached service doing art work for the Santa Ana Army Air Base. Cpl. Hibbits makes the drawings that are used by the instructors to show the trainees how to use the various kinds of equipment and how to take care of them," *LR*, Aug. 3, 1945, p. 2.

1947 – "Hibbits Sojourn Here… Mr. and Mrs. Forrest Hibbits of San Francisco have arrived in Lompoc for a two-month visit with Mr. Hibbits' mother…. At the conclusion of their stay here, they will go to Europe … Upon his return… Hibbits is to have a one-man show of his work at the Santa Barbara art gallery. Previously, he has had several one-man shows in San Francisco," *LR*, March 20, 1947, p. 4; "Local Artist's Work to be Shown Here Thursday… Exhibit Sponsored by Alpha Club… Hibbits … is a member of a pioneer Lompoc family and graduated from Lompoc high school in the class of 1924. He received his basic art training at the **California School of Arts and Crafts** in Oakland and studied lithography at the School of Fine Arts in San Francisco. Upon completing commercial art training, Hibbits worked as a commercial artist in the 1930s until he entered the Army. … Hibbits' art, aside from commercial, has received considerable recognition in San Francisco and has been exhibited at the San Francisco Museum of Art and at the Courvoisier Gallery. Just prior to the war, his works were exhibited in the well-known Ferry Building exhibit. During the latter part of his Army service, Hibbits was stationed at Santa Ana Air Base making posters for training aids. He has also made several war illustrations… Since his discharge, he has been working on block prints and other designs for linen and place mats. Mr. and Mrs. Hibbits will leave for Europe following the Alpha Club exhibit. They will visit relatives, and Hibbits plans to study and do considerable sketching … The Santa Barbara Museum of Art is planning an exhibit of Hibbits' work in the Fall," *LR*, May 15, 1947, p. 3; port. with 4 of his paintings and caption reads "Exhibiting his Art Work… recently at the Alpha clubhouse… He is shown above with some of the pictures produced during his career in the Army and used by the Air Force in posters…," *LR*, June 5, 1947, p. 14.

1948 – "Hibbits' Work to be Exhibited at S.B. Museum … commencing next Tuesday. … The one-man show will feature water color work principally and will include paintings done by the artist during his stay in Europe during the past summer. … He is now devoting himself to non-commercial subjects and is residing at the Hibbits ranch on the Buellton road…," *LR*, Jan. 1, 1948, p. 6; "Art Exhibit on Display at City Center… watercolors by Forrest Hibbits … in the penthouse of the Lompoc **Community Center**… Twenty landscapes, executed in bold technique – typical of Mr. Hibbits' work, a female figure and a portrait of a young girl are among paintings shown. Lompcans will recognize some of the landscapes as local subject while others were painted by the artist on his recent European trip. The exhibit, under the sponsorship of the Recreation Department is open to the public free of charge through Sunday, during the regular hours of Center operation," *LR*, Feb. 12, 1948, p. 9; "Artist's Work is Exhibited in Santa Paula. 'Luxembourg City' … at the Twelfth Annual Art Exhibit held in Santa Paula on August 12 through 22 …," *LR*, Aug. 26, 1948, p. 15; "Painting Exhibited – 'Yvonne in Doorway' … has been accepted by the California Water Color Society for exhibition in Pasadena on September 14 through October 31," *LR*, Sept. 16, 1948, p. 14; "Christmas Gifts for French Hospice are Prepared by **AWVS** Members… A committee was also appointed to work with Forrest Hibbits … who has offered to make portrait

sketches with the proceeds to go to **AWVS** philanthropies fund…," *LR*, Nov. 18, 1948, p. 11; "Hibbits Named… has been selected for membership in the California Water Color Society… The honor was accorded him as a result of his picture, 'Yvonne in Door Way.' Hibbits was one of 25 successful artists among the 76 applicants," *LR*, Dec. 2, 1948, p. 13; "A.W.V.S. to Meet… The home of [**Hattie**] **Mrs. J. M. Smith**, 307 South H street… A feature of the gathering will be the award of a personal portrait to be sketched by Forrest Hibbits… The award is being made in connection with the A. W. V. S. overseas program," *LR*, Dec. 9, 1948, p. 2; "**AWVS** Completes Plans… Portrait sketches by … Forrest Hibbits are being presented Mrs. Harry Sloan, Mrs. Robert Sudden, Mrs. Milton Duncan, Mrs. Richard [**Helen**] Byington, **Mrs. J. M. Smith** and Master Brucie Burton…," *LR*, Dec. 16, 1948, p. 3.

1949 – "Local Artist's Work in State Society Exhibit. Mr. and Mrs. Forrest Hibbits attended the annual meeting of the California Water Color Society in the Montecito Country Club at Santa Barbara. The drawing by Forrest Hibbits 'Figure Seated' which had been chosen … for the exhibit, was purchased last week by the Santa Barbara Museum of Art…," *LR*, March 17, 1949, p. 15; "Paintings Hung in Library Exhibit" by Lompoc artist, and article adds, "The group includes canvases made in Belgium and France, and others in Lompoc valley or more familiar scenes. The mediums are water color, pastels, pen and ink, drawings, gouache and oils. …," *SMT,* May 20, 1949, p. 5; "Shows Paintings in Two Exhibits," *SMT,* July 7, 1949, p. 5; "Hibbits' Paintings Accepted by Two Art Exhibitions… Denver Art Museum's 55th annual exhibition and in the statewide exhibit in Fresno. 'Fragment of V-2 Bomb' is the name Hibbits has given the Gouache painting to be exhibited at Denver… first time that the local artist has taken part in an exhibit of national scope. The name of the painting in Gouache accepted for the Fresno exhibit is 'Futile Conflict'," *LR*, July 7, 1949, p. 13; "Artist to Exhibit at California State Fair … Hibbits has entered works in both the oil and water color divisions…," *LR*, Aug. 4, 1949, p. 11; "Lompoc Glimpses… Water color painting of Lompoc's first snowfall adorning the walls of the **Lompoc hospital** – the gift of the artist Forrest Hibbits," *LR*, Sept. 8, 1949, p. 1; "Hibbits Painting to be Exhibited in Two Shows. A gouache painting, 'Figures and Forms,' is to be exhibited at the Associated Artist Galleries in Beverly Hills from September 14 to 28…. also be shown at the Pasadena Art Institute during October as part of the 29th Annual Exhibition of the California Water Color Society," *LR*, Sept. 8, 1949, p. 9; "Artist Displays in Three Exhibits … Lompoc artist who teaches classes in art at the **DeNejer studio** on Black road, has a gouache painting, 'Brussels Street' on exhibition at the State fair in Sacramento… 'Figure and Forms,' is to be on exhibition at the Associated Artists' galleries in Beverly Hills… and will be taken to Pasadena Art Institute for showing October 21… part of the 29th annual exhibition of California Water Color society…," *SMT,* Sept. 9, 1949, p. 6; "Speaks on Art to Junior Club… illustrated his talk on different art mediums with several of his own paintings…," *SMT,* Sept. 21, 1949, p. 6; "Artists' Paintings Chosen for Traveling Exhibit… casein… 'Arachne,' has been selected by the California Water Color society to be shown with the

Virginia Museum of Fine Arts traveling exhibition from October 1949 to October 1950…," *LR*, Sept. 29, 1949, p. 4; "Hibbits' Paintings are Exhibited. Two paintings… are being shown in the 24th Arizona art exhibit at the Arizona state fair in Phoenix this week… Both paintings are water colors and are entitled 'Woman in Bruxelles' and 'The Sculptor.' Another work of the artist was shown in the recently finished Oakland Art gallery's seventh annual exhibit… called 'Last Man'," *LR*, Nov. 10, 1949, p. 5; "**AWVS** Sends Yule Packages… A water color has been given by local artist Forrest Hibbits to provide funds to carry on the shipments…," *LR*, Nov. 10, 1949, p. 13; "Forrest Hibbits, one of three California artists whose work will be exhibited in the American Veterans Society of Artists in the Time-Life building in New York," *LR*, Nov. 24, 1949, p. 1, col. 6; "Hibbits Painting in New York Exhibit," *SMT,* Nov. 25, 1949, p. 5.

1950 – "Three Hibbits Paintings… have been accepted for exhibit in two of California's outstanding art exhibitions. An oil painting, 'City Woman,' is … at the annual Oakland Art Gallery exhibition. … 'Cement Mixer' and 'Monument to a Half Centaur' are … at the 35th Annual National Orange Show Exhibition of Art in San Bernardino from March 9 through March 19," *LR*, March 16, 1950, p. 11; "Hibbits Staging S.B. Art Exhibit… at the Museum of Art… continued until Sept. 1. After that date Mr. Hibbits' paintings will be placed on tour," *SYVN*, Aug. 18, 1950, p. 5; "Utah College Buys Hibbits Drawing. The Utah State Agricultural College has just purchased one of Forrest Hibbits' drawings on exhibition during November at the Salt Lake City Museum of Art… 'White Scarf'…," *SYVN*, Dec. 22, 1950, p. 13.

1951 – "Hibbits Art Work Exhibited at Orange Show… ['Southwind'] one out of 125 accepted for the show. A total of 500 paintings had been entered… Mr. Hibbits is one of five Santa Barbara region artists whose work was accepted…," *SYVN*, March 9, 1951, p. 5; "Memo Pad… Congratulations too to Buellton Artist Forrest Hibbits… Forrest's oil painting 'Southwind' was one of 125 selected for showing at the 36th National Orange Show at San Bernardino this week," *SYVN*, March 16, 1951, p. 2; "Hibbits Painting in Denver Show. A casein painting, 'Ballet Catastrophic,' by Forrest Hibbits… is among the 20 being shown at the 57th Annual Exhibition of Western Art at the Denver Art Museum. The exhibition opened May 14 and will close July 8…," *SYVN*, May 25, 1951, p. 1; "Puppet Show. Mr. and Mrs. Forrest Hibbits gave a puppet show at the home of Mr. and Mrs. John Stout last Sunday evening…," *SYVN*, June 22, 1951, p. 5; "Red Riding Hood to Meet Big Bad Wolf in Puppet Show at St. Mary's Bazaar… which the Hibbits have enlarged by introduction of a scene between a crow and a rabbit… Also, it has the joyful ending of the Grandmother coming to life… All the masculine parts are taken by Mr. Hibbits with Mrs. Hibbits in the women's roles and also as the rabbit… Mr. Hibbits molds the heads from clay after which Mrs. Hibbits takes over and covers them with paper mâché. Then the faces are painted and after that they are in care of Mrs. Hibbits until they are ready to go into their acts for which she makes the costumes, including the hair and hands. Together they make the accessories with Mr. Hibbits designing and

building the stage with the sets and they work together on the curtain and side drops… The new stage folds [up] and can be carried around in their car, which bears the exciting name 'Le Theatre de la Petite Galerie.' At present the Hibbits are working on a 'Hansel and Gretel' show…," *LR*, Nov. 8, 1951, p. 10; "Lompoc Views… That a ready-made juvenile audience for puppet shows exists in Lompoc was proved last Saturday when capacity turnouts greeted the showing of 'Little Red Riding Hood.'… by Forrest and Marie Hibbits at the Grammar School auditorium as part of the St. Mary's church bazaar…," *LR*, Nov. 22, 1951, p. 12; "Woman's Club Yule Party Set Dec. 14… One of the highlights of the program will be the presentation of a puppet show… by Mr. and Mrs. Forrest Hibbits…," *SYVN*, Dec. 7, 1951, p. 3; "Hibbits Paintings on Exhibition… modern watercolors and oil paintings… are on display this month at the Desch Framing Shop, La Arcada Court in Santa Barbara," *SYVN*, Dec. 7, 1951, p. 8; repro. of painting and caption reads, "Making an Effort… **Women's Community Club** and **Senior Alpha** to present… semi-abstraction … painted by Forrest Hibbits… is the first of a series of three similar paintings to be placed in Lompoc Park during Christmas seasons…. at close of the holidays the painting will be stored and Christmas 1952 will witness a companion painting expanding the Nativity scene," *LR*, Dec. 20, 1951, p. 6; "Marie and Forrest Hibbits Find Puppets Fascinating… The Hibbits started making puppets last Spring when **Mrs. Hibbits** decided they would be helpful in teaching her classes in French… Mr. and Mrs. Hibbits later decided to try a fairy story, 'Little Red Riding Hood,' because the little characters seemed so alive and appeared to be 'wanting more action.' 'We put on a show for our friends and neighbors, which was received with enthusiasm,' Mrs. Hibbits said, 'and then we began to receive calls about our puppets. Next thing we knew we were staging shows for clubs and parties and we are now kept busy in giving performances. In January they will donate a performance to the hospitalized GI's at the Camp Cooke Army hospital. … Mr. Hibbits makes the stage while his wife re-writes and translates the plays to adapt them to their two-part cast. Mr. Hibbits plays the male roles, while Mrs. Hibbits takes the feminine parts, although, she added, 'Forrest plays the witch.' She added, 'It is a lot of work, but we find it fascinating and Forrest plans to put on a Punch and Judy show next with the usual action and violence'," *SYVN*, Dec. 28, 1951, p. 6.

1952 – "Hibbits' Stage Puppet Show at Camp Cooke… performance of 'Little Red Riding Hood' last Wednesday for the hospitalized patients at Camp Cooke…," *SYVN*, Feb. 1, 1952, p. 3; "Hibbits Painting Accepted for Show" CWCS 1952 traveling show, *SMT*, Feb. 13, 1952, p. 4; "Accept Painting. The California Water Color Society has accepted a casein painting by Forrest Hibbits, Buellton artist, for their 1952 traveling show. The name… is 'Luneana'," *SYVN*, Feb. 15, 1952, p. 6; "Local Artist Exhibits… A pastel and ink drawing by Forrest Hibbits… was one of the works sold during the **Tri-County Show** held at the Santa Barbara Museum of Art during April. The picture, carrying the title 'Figure,' was purchased by Mrs. A. Perkoff of Santa Barbara," *LR*, April 17, 1952, p. 10; "'Hansel-Gretel' Classic to be Enacted by Puppeteers at Methodist May Fete," *LR*, May 1, 1952, p. 5; "Forrest

Hibbits Has One-Man Show… at the newly opened art gallery at the Santa Monica City College during the month of May… Some of the artist's work is also being exhibited this month at the Santa Barbara Museum of Art as part of the California Water Color Society show of drawings," *LR*, May 15, 1952, p. 15; "Hibbits Work on Exhibition…," *SYVN*, May 16, 1952, p. 6; "Hibbits Puppet Show Tomorrow… Buellton Union Grammar School. The puppets will perform in 'Little Red Riding Hood' and 'Hansel and Gretel'," *SYVN*, May 23, 1952, p. 5; "Hibbits Painting Captures Prize. An oil painting entitled 'Cement Mixer,' by Buellton artist Forrest Hibbits won a first prize this week at the Oxnard Art Festival," *SYVN*, May 23, 1952, p. 4; "Hibbits Paintings are Sold to Oxnard" – "Cement Mixer" and "Bridge at Luxembourg," and are now on display "in the lobby of the *Press Courier* at Oxnard… The first mentioned received first prize at Oxnard open air Art Festival in May and also has been exhibited in the 1950 Tri-county show at the Santa Barbara museum of art. 'Bridge at Luxembourg' was exhibited in 1949 at the Tri-county show… Oxnard Art club was responsible for the purchase which also included 'Tourist,' by **Olga Higgins**…," *SMT*, July 21, 1952, p. 4; "Oxnard Purchases Hibbits Paintings… 'Cement Mixer' … "Bridge at Luxembourg'," *LR*, July 24, 1952, p. 13; "Hibbits Paintings Are on Exhibit" with CWCS at de Young, SF, *SMT*, Nov. 18, 1952, p. 4; photo of St. Mary's Episcopal Church Auxiliary and statement that their annual ham dinner and bazaar will include a show of the Hibbits' puppets presenting Hansel and Gretel, *LR*, Oct. 30, 1952, p. 4; "Hibbits Are Visited… La **Petite Galerie**, Buellton… **Mrs. Ala Story**, who is the Director of the Santa Barbara Museum of Art. … returning to Santa Barbara from a trip up north…," *LR*, Oct. 30, 1952, p. 7; "Puppets Return… 'Hansel and Gretel'… [at] St. Mary's Episcopal Church Bazaar…," *LR*, Nov. 13, 1952, p. 12; "Lompoc Artist's Work on View at CWCS Show SF… gouache painting, 'Violoncello'," *LR*, Nov. 20, 1952, p. 2; repro: J. C. Long, 100 years old, *LR*, Nov. 27, 1952, p. 1.

1953 – Port. with one of the pictures he will exhibit in St. Marks-in-the-Valley exhibit in Solvang, *LR*, Feb. 12, 1953, p. 9; "Picture Frame Special. Natural Finish, Narrow Moulding. Including Glass. 35c per linear foot. For Artists. Panels for oil painting. All sizes. Forrest Hibbits—Buellton – SY 5211," May 7, 1953, p. 9; "Hibbits Named to … executive committee of the Santa Barbara Art Association. The painter… recently was awarded third prize for his 'Woman with Scarf' at the Oxnard Spring Art Festival," *LR*, June 4, 1953, p. 16; "Hibbits to Show at State Fair… Sacramento… a water color 'Violoncello'," *SYVN*, July 17, 1953, p. 6; "Painting Trip. Forrest Hibbits left on Monday for a week's painting trip to the ghost town of Virginia City, Nevada," *SYVN*, Aug. 21, 1953, p. 3; "Hibbits Water Color Showing is Scheduled… entitled 'Unidentified Object' at … California Water Color Society's 33rd National Exhibition… at the Long Beach Municipal Art Center… shown again … Scripps College, Claremont," *SYVN*, Oct. 23, 1953, p. 1; "Cedric Lewis **AWVS** Speaker… A lovely water color painting, generously donated by Mr. and Mrs. Forrest Hibbits, will be awarded in the evening," *SYVN*, Oct. 23, 1953, p. 2; "Hibbits Painting Going on Tour. 'Sisters,' a water color…

California Water Color Society… 'Violincello' … recently been purchased by Dr. L. M. Haroutunian of John Hopkins Hospital, Baltimore, Md.," *SYVN*, Nov. 20 [sic. 27], 1953, p. 8.

1954 – "Lompoc Limelight… Forrest Hibbits has a drawing on exhibit at the Santa Barbara Museum of Art in the California Water Color Society collection…," *LR*, March 25, 1954, p. 3; "Hibbits Painting on Exhibition. 'Potter,' a water color… at the third biennial exhibit of the California Water Color Society at the Santa Barbara Museum…," *SYVN*, March 26, 1954, p. 4; "Valley Artists Show at Oxnard. Forrest Hibbits and **Charles Glasgow**… at Oxnard Art Festival which was held outdoors at City Square. The Oxnard Art Club was sponsor of the festival," *SYVN*, May 21, 1954, p. 5; "Hibbits Paintings on Exhibition… one-man show at **Forden Gallery** in SLO… mixed exhibition of landscapes, figure paintings and abstract paintings," *SYVN*, July 30, 1954, p. 8; "Hibbits Art Now on Display" at **Fordens**, *SLO T-T*, Aug. 13, 1954, p. 2; "Memo Pad… Incidentally, the lobby of **Andersen's** features this month the art work of Valley artist Forrest Hibbits… it's a nice showing and everyone should see it…," *SYVN*, Aug. 13, 1954, p. 2; "Hibbits Exhibition" at **Fordens Gallery** sponsored by SLO Art Assn, *SLO T-T*, Aug. 26, 1954, p. 2; "Hibbits Work on Exhibition at **Andersen's**. The entire month of August… second in a series of showings featuring California artists… His works are well known in the West, having been exhibited in many Western Art museums. The Santa Barbara Museum owns two of his works and has featured Hibbits paintings in several one-man exhibitions. Hibbits is a member of the Santa Barbara Art Association. The 12 paintings which are on display in the halls and entrance to Andersen's are representative of Hibbits' work in landscape, still life and figures and show the broad scope of his ability," *SYVN*, Aug. 13, 1954, p. 3; "Greetings from Solvang to Danish Monarch…," scroll inscribed in Danish letting by Forrest Hibbits of La Petite Galerie, *SYVN*, Nov. 19, 1954, p. 1.

1955 – Port. of Hibbits' puppets and "Show of Puppets Feature of Coming Garden Party… staged by **Santa Ynez Valley Community Art and Music Association**…," *SYVN*, Aug. 12, 1955, p. 3; "Puppets to Appear in Los Olivos… fairy tale scenes…," *LR*, Aug. 18, 1955, p. 4.

1956 – "Hibbits Painting in S.F. Display… a painting called 'Abyss' on display at the Pacific Biennial Exhibition of Contemporary Art at the Palace of the Legion of Honor in San Francisco. It was one of 20 paintings chosen to be shown at the La Jolla Art Gallery later this month. Hibbits is teaching this term at the Adult Education Center in Santa Barbara. He has three classes, portrait, landscape and life and still life," *SYVN*, Jan. 6, 1956, p. 3; "Hibbits Guests… New Year's Eve, *SYVN*, Jan. 6, 1956, p. 8; "Memo Pad… [new book] *Delicious Danish Dishes*… The cover page was designed by Forrest Hibbits," *SYVN*, Jan. 27, 1956, p. 2; "Hibbits Wins Art Awards at Oxnard… Open Air Art Exhibit in Oxnard… He received three awards including a blue ribbon on an oil painting entitled, 'Ukelele with Grapes' and a gold ribbon and cash award on his drawing, 'Unidentified Object.' Oxnard Union High School purchased his abstract oil painting called, 'Cat' for its

permanent collection at the High School," *SYVN*, June 15, 1956, p. 3; "Hibbits Art … An oil painting by Forrest Hibbits called 'Grasshopper' has been accepted by the California State Fair Exhibition at Sacramento… The Laguna Beach Art Association has invited Hibbits to exhibit his oil painting 'Abyss' in Laguna Beach from July 15 to Aug. 1… This painting was part of the Pacific Coast Biennial Exhibition which started in Santa Barbara and was also shown in San Francisco," *SYVN*, July 27, 1956, p. 6; "Hibbits Painting Chosen for Hospital… his painting depicting a scene from the St. Exupery story of 'The Little Prince.' The committee of the Children's Health Foundation of the Santa Ynez Valley commissioned him to paint this picture which is to be hung in the children's ward of the General Hospital," *SYVN*, Sept. 28, 1956, p. 3; photo of painting he made for the Children's hospital, *SYVN*, Oct. 12, 1956, p. 3; "Carousel of Fun, Food & Puppets at St. Mary's Bazaar…," *LR*, Nov. 15, 1956, p. 5; photo of puppet show by the Hibbits shown at St. Mary's Church Bazaar," *LR*, Nov. 22, 1956, p. 3.

1957 – "Forrest Hibbits… received an invitation… to exhibit 20 of his paintings and to give a talk on his work at the 'Meet the Artists Tea' next September. Montalvo is the estate of the late Sen. Phelan …. Hibbits will give a demonstration of water color painting on Saturday, March 9 at the Duncan Vail gallery on Olive Street in downtown Los Angeles where he is exhibiting six of his paintings in March," *SYVN*, March 1, 1957, p. 1; "Memo Pad… *Los Angeles Times* critic **Arthur Millier** applauded artist Forrest Hibbits … 'Forrest Hibbits, a mature, very individual painter who lives in the Santa Ynez Valley, exhibits paintings and drawings at the Jack Carr Gallery, 1128 Fair Oaks Ave., South Pasadena to May 2… figures, still life, Cyclops, a grasshopper and Amazons appear in his well-designed, deep colored, luminous pictures… the Hibbits exhibit began April 5…," *SYVN*, April 19, 1957, p. 2; "Hibbits Art Wins Award. A large oil painting named 'Cello Player'… was one of four paintings to receive awards at the **Tri-County Exhibit** at the Santa Barbara Museum of Art…," *SYVN*, May 24, 1957, p. 7; "Hibbits Print Shown at Fair… A print called 'Submarine Ballet' … at the … **State Fair in Sacramento**. His oil painting, 'Musician,' which received a prize in Santa Barbara in May and which had been selected among 40 paintings from the Tri-county Show in Santa Barbara to be exhibited at the city of Long Beach Museum of Art, has been chosen for the permanent collection of the Long Beach Museum of Art," *SYVN*, Aug. 2, 1957, p. 5; "Hibbits Opens One Man Show … at the Santa Barbara Art Museum… until Aug. 11… Last Saturday, Hibbits displayed his artistic talents during the 'Artists in Action' feature of the **Santa Barbara County Fair** in Santa Maria," and bio., *SYVN*, Aug. 2, 1957, p. 6; "Valley Artist in Demonstration… at the gallery of the Montalvo villa estate at Montalvo near Saratoga last Sunday afternoon… Monday evening, Mr. Hibbits … attended a reception at the Santa Barbara Museum of Art," *SYVN*, Sept. 13, 1957, p. 3; "Valley UVS Party Set… raising funds… prizes include a painting by Valley artist Forrest Hibbits…," *SYVN*, Dec. 6, 1957, p. 7; "UVS Party Termed Success… The gift certificate for the painting donated by Forrest Hibbits was … awarded to Helen Robertson of Buellton…," *SYVN*, Dec. 13, 1957, p. 3.

1958 – "Hibbits Painting ... 'Titanic,' is now on exhibition with the Pacific Coast Biennial Show in Portland, Ore., until March 20. It was shown in San Francisco before… and was purchased there by Richard Lauter of San Francisco," *SYVN*, Feb. 7, 1958, p. 6; "Buellton Artist Exhibits… contributed two pictures to the benefit art show given by the Santa Barbara Chapter of the American Association for the United Nations last week in Santa Barbara. Fifty other artists… viewed daily by a large attendance before they were sold," *LR*, Oct. 30, 1958, p. 17.

1959 – "Hibbits to Judge Art, Crafts Show… has been invited by the Ventura Arts and Crafts Assn., to serve as judge at this year's festival in the adult fine arts and photography classes. He will also show his work, non competitively, in a special section for noted local artists. This will be the fourth annual Arts and Crafts Festival and will be a one-day affair, Saturday May 2, at Ventura Plaza," *SYVN*, April 10, 1959, p. 3; "Hibbits Art on Exhibition … 'The Drawings of Five Centuries' opened Tuesday … at the Santa Barbara Museum of Art… 'Seated Figure,' ink and wash drawing… purchased by the Special Museum Purchase Fund. Mr. and Mrs. Hibbits attended the reception and preview…," *SYVN*, April 24, 1959, p. 6; "Art Showing. Forrest Hibbits… is showing his painting at the Solvang Library [Santa Barbara County Library (Solvang)] during the month of May and until June 15," *SYVN*, May 15, 1959, p. 5; "Buellton Briefs… Sunday May 3 is the date set for the Buellton Union Elementary School carnival and some lucky ticket holder is going to be the winner of a beautiful original oil painting by Forrest Hibbits… sponsored by the PTA," *LR*, April 30, 1959, p. 25 (i.e., 5b); "Buellton Briefs. Forrest Hibbits' gay painting entitled 'Tyrannosaurus Rex' was among the paintings and drawings of almost 400 Tri-County artists at the Art for All exhibition held at the Santa Barbara Museum of Art last Monday and Tuesday," *LR*, June 4, 1959, p. 24; "Hibbits Receives SM Fair Honors… second prize in two categories… In oil… for the painting 'Guitar Player' and… water colors was awarded to 'Seated Figure,' a painting done on rice paper," *SYVN*, July 31, 1959, p. 1; "Buellton Briefs… An ink drawing by Forrest Hibbits has been chosen by the Denver Art Museum for the 65th annual exhibition of western art… July 19 until September 6 … entitled 'Figure with a Bird'…," *LR*, Aug. 6, 1959, p. 16; "Denver Show Honor… Buellton Artist, Forrest Hibbits and sculptor **Robert Thomas** of Goleta are the two artists from Santa Barbara county given the honors of being represented in the current art exhibit in Denver. …," *SYVN*, Aug. 7, 1959, p. 1; "Chairmen Named for Bazaar… United Volunteer Services… **Mrs. Forrest Hibbits** will be in charge of the tickets for the painting donated by her artist husband…," *LR*, Oct. 12, 1959, p. 7; "Hibbits Invited to Exhibit… The board of directors of the Santa Barbara Art Assn. has invited Forrest Hibbits… to be one of four exhibitors from Dec. 1 to Dec. 31 in the **Faulkner Memorial Gallery** in the Santa Barbara Public Library… Hibbits, a member of the association, will show several paintings including oils, collages, and water colors. The three other exhibiting artists, all of Santa Barbara, are Verne Swanson, **Gladys Castagnola** and Aage Pedersen," *SYVN*, Dec. 4, 1959, p. 7; "UVS to Discuss Bazaar Plans… The oil painting by Forrest Hibbits donated for the benefit

of the bazaar, is titled 'Water Tower in Los Olivos' and is on view at **La Petite Galerie** on Copenhagen Drive," *SYVN*, Nov. 6, 1959, p. 3.

1960 – "Bay Area Visit. New Year's Eve and the following day in San Francisco attending several parties was enjoyed by Mr. and Mrs. Forrest Hibbits. Mr. and **Mrs. Mitchell Hoenig** and two children of Solvang drove them to Los Gatos where they were guests until Tuesday at the home of Mr. and Mrs. Luther Ospina. Mr. Ospina and Mr. Hibbits were former classmates in art school. While in San Francisco the four attended an exhibit of contemporary painting by the San Francisco Art Assn. at Golden Gate Park museum. On the way to the city, they stopped in Palo Alto to call on the R. S. Brand daughter and grandson, Mrs. Kirke Comstock and little Billy," *SYVN*, Jan. 8, 1960, p. 5; "Danish Royalty Invited to Solvang. … Forrest Hibbits, Buellton artist, prepared a hand-written invitation for the king and queen of Denmark formally inviting them to visit Solvang during their tour of the United States this fall. The parchment scroll was sent to King Frederick IX and Queen Ingrid by members of the Danish Days and Businessmen's Associations…," *LR*, April 21, 1960, p. 18; "Hibbits Couple Show Paintings… at the Oxnard Art Festival last weekend. This is an open-air affair at which artists set up their work for display in booths. **Mrs. Hibbits'** 'Pink Sails,' a watercolor on rice paper, was sold to the Port Hueneme High School for its permanent exhibit," *SYVN*, June 10, 1960, p. 8; "Solvang Library Corner ... The Friends of the Library… wish to thank Forrest Hibbits, professional artist from Buellton, for designing and contributing the attractive heading which now embellishes the column" in the newspaper, *SYVN*, Sept. 9, 1960, p. 8.

1964 – "Hibbits' Art Pupils Show Work… at their studio Saturday and Sunday during open house and exhibit of paintings by 12 of Hibbits' art students…. The majority in the abstract style for which Hibbits is famous… Three of the outstanding paintings were of boats and the color choices of the artists were stimulating. **Ethel Bailey** of Lompoc, who has been a consistent winner at art shows, had treated the graceful diagonal lines of racing sails in shades of soft purple in contrast to the blending blue lines of sky and sea. Reminiscent of the heat waves in a Mediterranean seaport were the hot colors and burnished sun reflections of the harbor scene by Paul Hutchinson of Vandenberg. Jerry Lu Wright of Santa Ynez chose cool greens and blues for her restful boat haven. Also noted was a sparkling night city scene done by **Ellen Gleason** of Solvang. Among the artists exhibiting were **Annette Lindegaard** of Buellton, **Elsa Schuyler** and **Dee Sudbury** of Lompoc, Mary Kompanek, Mary Costello, Lavon Benedictis and Emma Murphy of Santa Barbara and **Emma Constans** of Santa Ynez," *SYVN*, June 18, 1964, p. 11 (i.e., 3-B).

And, more than 200 notices for "Forrest Hibbits" in the *LR*, and nearly 90 in the *SMT*, and more than 600 in the *SYVN*, between 1945 and 1996 most of which were not itemized here.

Hibbits, Forrest (misc. bibliography)
Forrest Q. Hibbits, mother's maiden name Silsby, was b. Oct. 9, 1905 in Santa Barbara County per Calif. Birth Index; port. of Forrest G. Hibbits appears in the Lompoc

high school yearbook, 1924; Forrest S. Hibbits is listed in voter registers in San Francisco, 1932, 1936, 1948; Forrest Hibbits of Lompoc sailed from Cherbourg, France on June 12, 1937 on the *S. S. Berengaria* and arrived at NY on June 18, 1937 per NY Passenger and Crew Lists; Forrest and Marie Hibbits, residents of Lompoc, Ca., sailed from Rotterdam, Holland, on Oct. 11, 1947 on the *S. S. Y. A. K. A.* Voy 12 W. B., arriving at NY [Oct. 20] per NY Passenger and Crew Lists; Forrest Silsby Hibbits was b. Oct. 9, 1905 in Lompoc, Ca., to Abner Guy Hibbits and Jennie Gregg Silsby, married **Marie Jaans Maris**, and d. July 9, 1996 in Lompoc, Ca., per Kelliher Tree; Forrest Silsby Hibbits is buried in Lompoc Evergreen Cemetery per findagrave.com; several photos appear in Public Member Photos & Scanned Documents (refs. ancestry.com).

See: *Publications in California Art*, vols. - 1/2/3-A-23, 4/5/6-IV-80 (2), v. 11)

See: "Allan Hancock [College] Art Gallery," 1954, 1955, 1956, "Alpha Club," 1947, 1948, 1950-54, "American Women's Voluntary Services," 1949, "Andersen's," 1954, "Art, general (Lompoc)," 1961, 1962, "Bailey, Ethel," "California State Fair (Sacramento)," 1949, 1956, 1957, "Castagnola, Gladys," 1955, "Christmas Decorations (Lompoc)," "Community Center (Lompoc)," intro., 1948, "Community Club (Santa Maria)," 1949, "Danish Days," 1950, 1954, 1957, "Danish Village Gifts," "DeNejer, Jeanne," 1949, "Faulkner Memorial Art Gallery," 1959, 1960, "Flower Show," 1948, 1949, "Girl Scouts," 1954, "Hibbits, Marie," "Homrig, Hal," "La Petite Galerie," "Lindberg, Oscar," 1963, "Lompoc, Ca., Adult/Night School," 1950, "Lompoc, Ca., Recreation Department," intro, 1948, "Lompoc, Ca., Union High School," 1924, 1952, "Lompoc Civic Theatre," 1948, "Lompoc Community Woman's Club," 1948, 1950, "Lompoc Film Council," 1948, "Lompoc Hospital, Women's Auxiliary," 1949, 1952, 1956, "Minerva Club," 1949, "Prater, Barbara," 1959, "Santa Barbara Art Association," 1960, "Santa Barbara County Fair," 1949, 1957, 1959, 1961, "Santa Barbara County Library (Solvang)," 1959, 1960, "Santa Barbara Museum of Art," 1955, "Santa Maria Art Association," 1949, "Santa Maria Valley Art Festival," 1952, 1953, "Santa Ynez Valley Art Exhibit," 1952-58, "Santa Ynez Valley, Ca., Elementary / Grammar Schools," 1959, "Signorelli, Guido," 1964, "Sloane, Charles," intro., "Solvang Woman's Club," 1951, "Sudbury, Delia," "Sutton, Arthur," "Tri-County Art Exhibit (Santa Barbara)," 1948, 1949, 1950, 1952, 1958, 1959, "University of California, Extension," 1949

Hibbits, Marie Jaans Maris (Mrs. Forrest Hibbits) (1895/6-1984) (Buellton / Solvang)
Artist. Puppeteer, 1951+. Co-proprietor of La Petite Galerie. Exh. Santa Ynez Valley Art Exhibit, 1957. Wife of Forrest Hibbits, above.

■ Port. and "Marie Jaans Hibbits… Santa Ynez Valley professional artist and a resident of Buellton for 35 years, died last Thursday in the Santa Ynez Valley Hospital after a long illness. Mrs. Hibbits was born in northern France and spent her early years in Hungary where she taught French and music. Later she lived in Luxemburg, then Belgium, where she and her family were involved with the Resistance … After moving to America and becoming a citizen, she settled in the Valley with her husband, Forrest Hibbits… It was under his instruction that she developed her own unique style of watercolor on rice paper characterized by a diffused technique slightly reminiscent of Oriental art. Mrs. Hibbits taught French at the Santa Barbara Adult Education program and was a member of the Santa Barbara Art Association and the **Santa Ynez Valley Art Association**. Her paintings have been exhibited at the **Faulkner Gallery** and other galleries in Santa Barbara as well as the Country Fair Gallery of Los Olivos. She was also known for her unique paintings of birds and owls, and many of her rice paper watercolors served as illustrations for quotations and poems. In addition to her husband, she leaves a nephew… She is also survived by a brother, sister and other relatives in Luxemburg, New York and Brussels…," *SYVN*, April 19, 1984, p. 10.

Hibbits, Marie (notices in Northern Santa Barbara County newspapers on microfilm and on newspapers.com)
1951 – "French Course Offered… at the Buellton Union Grammar school by Mrs. Marie Hibbits… Mrs. Hibbits uses audio visual folksongs, … as well as puppets for teaching vocabulary…," *SYVN*, June 8, 1951, p. 3.
1957 – "Puppet Show Due Dec. 15. Under the sponsorship of the Santa Ynez Valley Children's Health Memorial, a puppet show will be presented by Mrs. Forrest Hibbits in the social hall of the Santa Ynez Valley Presbyterian Church on Sunday afternoon, Dec. 15 at 4:30 o'clock… The program will feature Hansel and Gretel and Little Red Riding Hood…," *SYVN*, Dec. 6, 1957, p. 1; photo of puppet theater, *SYVN*, Dec. 13, 1957, p. 6.
1959 – "Buellton Briefs… Mrs. Marie Jaans Hibbits is showing an exhibit of her paintings at the North Branch Library in Long Beach along with paintings by Bertha Wise Giertz of Santa Barbara while her husband, **Forrest Hibbits** is exhibiting his work at the Kramer Gallery, 558 North La Cienega, Los Angeles," *LR*, Jan. 22, 1959, p. 8; "Watercolor Sold. The watercolor on rice paper by Marie Jaans Hibbits, entitled 'White Blossoms with Lemons' was sold last week while on exhibit in the **Faulkner Gallery** in the Santa Barbara Public Library building. The exhibition was arranged by the Santa Barbara Art Assn. of which Mrs. Hibbits is a member," *SYVN*, Nov. 20, 1959, p. 7.
1960 – "Buellton Briefs… A watercolor painting by Mrs. Marie Hibbits was sold recently to the Port Hueneme High School. The painting, which is called 'Pink Sails,' was done on rice paper and displays beautiful pastel blending. Mrs. Hibbets [Sic.] and her husband, Forrest Hibbits, exhibited several paintings at the Oxnard Art Festival last week," *LR*, June 16, 1960, p. 15.
1963 – "Marie Hibbits Art Displayed… among the 14 women artists of the area with paintings now on display in the new exhibit opened Monday at Gallery de Silva, 11 Street of Spain, El Paseo, Santa Barbara. The exhibit which will continue through April features a wide variety of work by … **Margaret Hart**…," *SYVN*, April 5, 1963, p. 15.
And, more than 160 hits for "Marie Hibbits" in the *SYVN* and 18 in the *LR*, and 5 in the *SMT*, between 1945 and 1984 were not all itemized here.

Hibbits, Marie (misc. bibliography)
Forrest and Marie Hibbits, naturalized April 4, 1932 in Distr. Court, San Francisco, residents of Lompoc, Ca., departed the U.S. on May 30 and returned from Rotterdam, Holland, on Oct. 11, 1947 on the *S. S. Y. A. K. A.* Voy 12 W. B., arriving at NY [Oct. 20] per NY Passenger and Crew Lists; Marie Jans [Sic. Jaans] Hibbits was b. Jan. 14, 1896 in Other Country and d. April 12, 1984 in Santa Barbara County per Calif. Death Index (refs. ancestry.com).

See: "Art, general (Lompoc)," 1961, 1962, "Danish Days," 1957, "Faulkner Memorial Art Gallery," 1960, "Girl Scouts," 1954, "Hibbits, Forrest," "Joughin, Helen," 1986, "La Petite Galerie," "Lompoc Film Council," 1948, "Minerva Club," 1949, "Santa Barbara Art Association," 1960, "Santa Barbara County Library (Solvang)," 1960, "Santa Ynez Valley Art Exhibit," 1957, 1958, "Solvang Woman's Club," 1951, 1952, "Tri-County Art Exhibit," 1959

Higgins (Mardon), Olga Andrasy (Mrs. Frank Higgins) (Mrs. Austin Mardon) (1906-1991) (Santa Barbara)
Artist of Santa Barbara Art Association, who exh. at opening exh. of Allan Hancock College Art Gallery, 1954. Exh. Santa Barbara County Fair, 1959, 1961, 1962.

■ "Olga Higgins and Alex Gonzales, Gallery de Silva. Miss Higgins' show is comprised of drawings, collages and oils. Collages dominate, many of them of children. She is an ingenious ingratiating artist who has a sure eye and a deft hand, however some of them seem almost too facile and slick. She is clear about the use of paper to build the effect of paint, and many of them achieve rich surfaces and brilliant color. She is a good draftsman and her drawings are clear and sure. 'Children In the Rain' is a lyrical monotype, a new medium in which she is now experimenting using tea-bag paper," *Artforum*, undated, on the Internet. And additional references to her appear on the Internet.

Higgins, Olga (notices in California newspapers on microfilm and on newspapers.com)
1953 – Port. with her painting "Boy with a Horn" which won a prize at the Oxnard Festival, *Ventura County Star-Free Press*, May 18, 1953, p. 8.
1958 – Port. with Oxnard Art Club people, *Press-Courier* (Oxnard, Ca.), Sept. 18, 1958, p. 6.
1965 – "Santa Barbara Museum of Art, Olga Higgins, mixed media, to Nov. 7," *LA Times*, Oct. 10, 1965, p. 539 (i.e., Calendar, p. 14).
And, more than 100 additional notices on her art in Ventura/Oxnard and LA newspapers (that reveal she was honored with several one-man shows, was a member of the Los Angeles Art Association, exhibited in numerous group shows, and won several prizes at the Oxnard Art Club), not itemized here. The executor of her estate in 1991 was Austin Mardon.
Higgins, Olga (misc. bibliography)
Olga Higgins is listed with husband, Frank, in the *Santa Barbara, Ca., CD*, 1953-1985; Olga H. Mardon, b. 1906, is listed in Solvang in *Public Records Index, 1950-1993*, vols. 1, 2, 1993; Olga Higgins, name listed as Olga Mardon on July 27, 1987, d. Jan. 12, 1991 per Social Security Death

Index; Olga Higgins, mother's maiden name Pregartner and father's Andrasy was b. May 9, 1906 in NY and d. Jan. 12, 1991 in Santa Barbara County per Calif. Death Index (refs. ancestry.com).
See: "Allan Hancock [College] Art Gallery," 1954, "California State Fair, Sacramento," 1956, "Hibbits, Forrest," 1952, "Santa Barbara County Fair," 1959, 1961, 1962

Higgins, William Asa, Prof. (1862-1927) (Lompoc)
Teacher at his own school of penmanship, artist, 1882.
Higgins, (notices in Northern Santa Barbara County newspapers on microfilm and on newspapers.com)
1882 – "Grant Jackson… prize… The premium consisted of a beautiful India ink drawing executed with a pen in Professor Higgins' best style," *LR*, April 8, 1882, p. 3.
"Prof. W. A. Higgins left Tuesday on a chirographic [handwriting] cruise through the midland counties of the State," *LR*, April 15, 1882, p. 3, col. 1; "Close of Term. Prof. Higgins' writing school closed the first term last evening… [and prizes given for best penmanship] … The next term commences on Monday evening next," *SMT*, May 6, 1882, p. 4, col. 2; "Prof. Higgins has met with such encouragement with his writing school that he has concluded to teach another term commencing next Monday evening May 8th…This is an excellent opportunity for the young folks to acquire a plain or nice business hand, also the flourish and ornamental branches of the art," *SMT*, May 6, 1882, p. 5, col. 1.
1896 – "At the city election of Santa Barbara held last Monday, the following were elected: … W. A. Higgins, Tax-Collector…," *SMT*, April 11, 1896, p. 3, col. 3.
1898 – "County Seat News … W. A. Higgins, the ex-city assessor, will be the sharpest of the sharp shooters…," *SMT*, May 7, 1898, p. 4, col. 1; "County Ticket… County Recorder, W. A. Higgins of Santa Barbara…," *SMT*, Oct. 29, 1898, p. 2.
And additional notices in the *SMT* not itemized here.
Higgins, (misc. bibliography)
Willie A. Higgins is listed in the 1870 U. S. Census as age 8, b. c. 1862 in Nevada, residing in Santa Barbara with his parents (?) Elijah B. Higgins (age 46) and mother Sarah A. Higgins (age 35) and elder brother Fred (age 14) and younger sister Kate C. (age 3); Will A. Higgins is listed in the 1880 U. S. Census as age 17, b. c. 1863 in Nevada, working in a stationery store, residing in Santa Barbara with his mother Tarah [Sic. Sarah] Higgins (age 47) and younger sister Kate O. (age 13); W. A. Higgins married Carrie L. Hayward on June 21, 1885 in Santa Barbara per *Calif. County Birth, Marriage and Death Records*; William A. Higgins is listed in the *Santa Barbara CD* from c. 1905-26 as bookkeeper, yardman, and other jobs; William A. Higgins is listed in the 1920 U. S. Census as age 56, b. c. 1864 in Nevada, County Assessor, residing in Santa Barbara with wife Caroline L. Higgins (age 58) and two daughters: Winona A. (age 24) and Catherine E. (age 20); William Asa Higgins was b. July 17, 1862 in Nevada to Elisha Breel Higgins and Sarah Evelyn Austin Turner, married Caroline L. Hayard and d. May 17, 1927 in Santa Barbara per Motti Family Tree 9-18-14(1) (refs. ancestry.com).

Highfill, Patricia "Patti" Louise Graham (Mrs. Paul Evans Highfill, Jr.) (1926-2012) (Lompoc)
Active with Alpha Club, and Junior Community Club, late 1950s. Collector and restorer of antique dolls.

■ Port. and "Patricia (Graham) Highfill. March 12, 1926-December 2, 2012… respected doll collector and miniature artisan… 'Patti,' as she preferred, was born … in Santa Barbara, Ca., to Charleton and Christina Graham who built and operated a neighborhood grocery store on San Andreas St…. Patti was the youngest of four children… Early on Patti exhibited special talents in music, theater and art. She graduated from Santa Barbara High School in 1944, performing in the high school acapella choir as well as in USO shows at Camp Cook, Ca. In March of 1944, 18-year-old Patti Graham met Naval electrician Paul Evans Highfill, 21… [they married] … the family moved to Lompoc in 1952 where Patti worked for the City of Lompoc, Sears and International Telephone and Telegraph Corp. at Vandenberg Air Force Base while raising her young family. Her avocations were as a miniature and doll artist, showing and selling her creations throughout the country…[and more on dolls]… In 1979 Patti and Paul moved to Santa Maria where they retired in 1988, immersing themselves in their avocations and collaborating on creative projects… motor home trips…," *SMT*, Dec. 30, 2012, p. B-5.
Highfill, Paul, Mrs. (notices in Northern Santa Barbara County newspapers on microfilm and on newspapers.com)
1971 – Port. with dolls. "Mrs. Paul (Patti) Highfill, 228 S. D St…. hobby of restoring and costuming old damaged dolls… Patti started making dolls when she was 12 years old. She checked a book on doll making out of the library… She made them of wire, old knit underwear wrapping and miscellaneous materials. It was a big thrill for her when she was asked to exhibit them in the Santa Barbara Library. Her collection of dolls runs in three phases. The first covers the ball-jointed china-head and kid dolls that date from about 1885 to the 1920s. The second phase includes dolls of the 30's and a few from the 40's. Dolls that her daughters played with in the 50's belong in the last phase. … Patti says that her sewing career started on a rather dubious note. One day she found some material lying around the house with some scissors nearby. … She started in the center of the cloth and cut a hole in her sister's lace curtain… The beautiful costumes that she now sews for her dolls came out of this experience…," *LR*, Oct. 16, 1971, pp. 2, 9.
Highfill, Paul, Mrs. (misc. bibliography)
Patricia Louise Highfill b. March 12, 1926 in Santa Barbara and d. Dec. 2, 2012 in San Luis Obispo is buried in Santa Barbara Cemetery per findagrave.com (refs. ancestry.com).
See: "Alpha Club," 1957, 1958, 1959, "Lompoc Community Woman's Club," 1959, "Open-Air Art Exhibit," 1957, "Tri-County Art Exhibit," 1958

Hill, Deana
See: "DeNejer, Jeanne (aka Deana Hill)"

Hill, K. Ethel (1883-1967) (Orange County)
Author. Lecturer. Curator. Member of Women Painters of the West and student of costume design who spoke to the Minerva Club, on Blanche Collet Wagner's paintings of historic headdresses, 1936. Author of Evylena Nunn Miller's Travel Tree.
More than 70 notices appear for "K. Ethel Hill" in Los Angeles / Orange County / San Fernando Valley newspapers between 1920-1950 but were not itemized here.
Hill, K. Ethel (misc. bibliography)
K Ethel Hill is listed in the 1930 U. S. Census as age 46, b. in Canada c. 1884, working as a designer in the art industry, residing in Los Angeles with her parents James L. Hill (age 67) and Jessie E. Hill (age 67) and brother John L. Hill (age 33); K. Ethel Hill is listed in various *Voter Registration Indexes* and *LACD*'s between 1920 and 1954; K. Ethel Hill b. 1883 in Canada and d. 1967 is buried in Forest Home Cemetery, Forest Park, Ill., per findagrave.com (ref. ancestry.com).
See: "Minerva Club," 1936

Hill, Rose Ann "Roseanne" (Mrs. Dr. Earl M. Hill) (1922-?) (Santa Barbara)
Student of Leo Ziegler's adult school painting class, 1953. Exh. first annual Santa Ynez Valley Art Exhibit, 1953.
Hill, Roseanne (misc. bibliography)
Is she Rose A. Fullerton / Smith, age 28, who married Dr. Earl M. Hill on Nov. 10, 1950 in Santa Barbara County per Calif. Marriage Index; Rose Ann Hill is listed with husband Earl in the *Santa Barbara, Ca., CD*, 1956-66; Rose A. Hill b. Aug. 12, 1922, was residing in Santa Barbara in 1993 per *Public Records Index, 1950-1993*, vol. 1 (refs. ancestry.com).
See: "Santa Ynez Valley Art Exhibit," 1953, "Santa Ynez Valley, Ca., Adult/Night School," 1953

Hill, Virginia Teale
See: "Erickson (Hill), Virginia Teale (Mrs. John Erickson) (Mrs. Eugene "Gene" Hill)"

Hinkle, Clarence Keiser (1880-1960) (Los Angeles / Laguna Beach / Santa Barbara)
Member Santa Barbara Art Association, who exh. "Cucumbers" at opening exh. of Allan Hancock College Art Gallery, 1954.
■ "Painter, teacher. Hinkle was raised on a ranch outside Sacramento and received his first art instruction at the E. B. Crocker Art Gallery. He continued study at the Mark Hopkins Institute, San Francisco, and attended the Art Students League, New York, and the Pennsylvania Academy of Fine Arts. From 1906 to 1912 he traveled in Europe where he studied at the Beaux Arts and the Academie Colarossi in Paris. On his return to California, he established a studio in San Francisco but moved to Los Angeles in 1917 to teach at the Los Angeles School of Art and Design. Between 1917 and 1935 he had studios in Los Angeles and Laguna Beach, but from 1935 on he worked [and lived] in Santa Barbara. While in Los Angeles he [also] taught at the Chouinard Art Institute," per Nancy

Moure, "Dictionary of Art and Artists in Southern California before 1930" (*Publications in California Art, vol. 3*).

■ "Clarence Keiser Hinkle (June 19, 1880–July 21, 1960) was an American painter and art educator. His art studio was in Laguna Beach, California and later in Santa Barbara, California," per Wikipedia.
Monograph: Janet Blake, *Clarence Hinkle*, Laguna Beach: Laguna Art Museum, 2012.
See: "Allan Hancock [College] Art Gallery," 1954, "Alpha Club," 1947, "California State Fair, Sacramento," 1951, 1956, "National Art Week," 1940, "Santa Barbara County Fair," 1958, 1959, "Tri-County Art Exhibit," 1947, "Wright, James C."

Hitchen, Karen Arlene
See: "Melby (Hitchen), Karen Arlene (Mrs. Douglas Hitchen)"

Hitchen, Nina Belle Lewis (Mrs. Francis Leland Hitchen) (1909-1978) (Lompoc)
Prop. Ocean Avenue Ceramics, 1956.

■ "Nina B. Hitchen... Mrs. Hitchen was born in Nortonville, North Dakota, May 30, 1909 and died Tuesday morning at Lompoc District Hospital. A resident for the past 36 years, she last lived at 321 W. North Ave. She was a member of the first United Methodist Church, the Lompoc Rebekah Lodge and the Miguelito Chapter of the Order of the Eastern Star...," *LR*, Oct. 4, 1978, p. 2.
Hitchen, Nina (misc. bibliography)
Nina Hitchen is listed with F. L. Hitchen in the *Lompoc, Ca., CD*, 1945, 1947; Nina B. is listed as wife of Francis L. Hitchen, whsemn Lom Unified Sch Distr, in Lompoc, in the *Santa Maria, Ca., CD*, 1961; Nina Belle Hitchen b. May 30, 1909 in ND, d. Oct. 3, 1978 in Santa Barbara County per Calif. Death Index; Nina B. Hitchen is buried in Lompoc Evergreen Cemetery per findagrave.com (ref. ancestry.com).
See: "Ocean Avenue Ceramics," 1956

Hoback, Joseph Herrick (1863-1945) (Orcutt)
Watchmaker, carver. Father of Joseph Quimby and Eugene Hoback.

■ "Orcutt Watchmaker Genius with Fingers. Putting a blacksmith shop in a clock! That is the feat that Joseph Hoback of Orcutt has performed. Of course, the blacksmith shop is only a model of a larger one, yet it has the completeness of a full-sized shop. This tiny blacksmith shop, built and fitted into the base of a clock, is enclosed with glass cut from a discarded windshield. It is fully equipped with anvils, hammers, tongs, saws, a branding iron with the initials 'J.H.' and even the standing figure of a vicious looking horse. The little wooden figures are remarkably lifelike ... their arms rising and falling... [motivated] by discarded alarm clock motors and pieces of a steel violin string. Hoback has made two of these 'shops' and a model depicting the noble grand of a Rebekah lodge pounding for order with a speaker's gavel. Beside his skill

with clocks, Hoback is also a musician. He plays the violin and at one time was in an orchestra... He worked for many years in Santa Maria as watch repairer in a shop known as Gardner & Wheatens and also in a shop located in a drug store owned by P. W. Jones, situated on West Main street," *SMT*, March 25, 1936, p. 1.
1945 – "Orcutt Resident, Joseph H. Hoback, Dies in Hospital," *SMT*, Nov.8, 1945, p. 1.
Hoback, Joseph (misc. bibliography)
Joseph Herrick Hoback (1863-1945) son of Bartholomew F. Hoback, married to Rosa, is buried in Santa Maria Cemetery District per findagrave.com (ancestry.com).
See: "Hoback, Eugene," "Hoback, Joseph Quimby," "Santa Barbara County Fair," 1937, 1941

Hoback, Joseph Quimby (1912-1987) (Orcutt)
Woodcarver / musician / clockmaker. Exh. carved wood at Santa Barbara County Fair, 1937. Demonstrator in leatherwork to Boy Scouts, 1948. Brother to Eugene Hoback, above. Son of Joseph Herrick Hoback, jeweler and carver.

■ "Joseph Quindy [Sic. Quimby] Hoback, 75, who died Monday in a local hospital after a lengthy illness... Mr. Hoback was born in Santa Maria, and had been a lifelong resident of the area. He worked as a field operator for Union Oil Co. for over 40 years, retiring in 1973. Survivors include his widow, Dorothy Hoback..." per "Joseph Q. Hoback," *SMT*, April 21, 1987, p. 17.
Hoback, Joseph (notices in Northern Santa Barbara County newspapers on microfilm and on newspapers.com)
1936 – ■ "Hoback Exhibits Hand-carved Clock," at his home in Orcutt with other items he made, and article adds "An elaborately hand-carved clock depicting elements of the Townsend plan is displayed in a downtown store today by Joseph Hoback, Orcutt artisan and musician. He exhibited the clock at last evening's Townsend meeting in Methodist hall. The clock is one of many which Hoback has made. His home in Orcutt is filled with curiously wrought clocks, furniture and other articles which he makes as a hobby," *SMT*, March 20, 1936, p. 3.
Hoback, Joseph (misc. bibliography)
Joseph Q. Hoback, mother's maiden name Mendoreg [Sic. Menderoza], was b. Feb. 2, 1912 in Santa Barbara County per Calif. Birth Index; Joseph O. [Sic. Q] Hoback is listed in the 1940 U. S. Census as age 28, b. c. 1912, finished elementary school, 8th grade, a rig builder, residing in Santa Barbara (1935, 1940) with wife Dorothy (age 23) and children Marilyn (age 3) and Dan (age 8 months); Joseph Quimby Hoback, b. Feb. 2, 1912 in Santa Maria and d. April 20, 1987, in Santa Maria, Ca. per Roy O. Lewis and Bertha L. Hoback Family Tree; Joseph Hoback is buried in Santa Maria Cemetery District per findagrave.com; Hoback and family are pictured in *Public Member Photos & Scanned Documents* (refs. ancestry.com).
See: "Boy Scouts," 1948, "Hoback, Gene," "Phi Epsilon Phi," 1940

Hoback, (Lawrence) Eugene "Gene" (1913-1969)
(Orcutt / Santa Maria / Hollywood)
Woodcarver, born in Santa Maria, who worked for the
Hollywood studios. Brother to Joseph Quimby Hoback,
below. Son of Joseph Herrick Hoback, jeweler and
carver.

■ Port with carving, and "Native of Santa Maria Achieves Wood Carving Fame by Chance… Gene was born in Santa Maria back in 1913. He's the brother of Joe Hoback who lives on Orcutt road. But Gene left the valley area 14 years ago to seek fame and fortune with his woodcarving. That woodcarving business was mostly an accident, according to Gene. He broke his hand here 23 years ago while roping a steer. His horse fell and rolled across Hoback's right hand. Having nothing better to do with the useless mitt, Gene stuck a knife in it and started whittling. The whittlings became cowboys and horses and stage coaches and the first thing Gene knew, he'd carved himself out a career. The career resulted in Hoback assembling over the period of years such a fine collection of western scenes, that he spends most of his time displaying his collection at rodeos and in communities celebrating western days. … Probably the biggest audience Gene's carvings have hit were those who saw Cecil B. DeMille's 'The Greatest Show on Earth.' Remember that sensational train wreck? Well, most of it was done in miniature with the use of Hoback's realistic wood carvings, Gene revealed. Hoback reports most of his work is done for Paramount Studios these days, but he added: 'I hope I can take time off to show my carvings here during the Elks rodeo June 6 and 7," *SMT,* May 11, 1953, pp. 1, 8.

■ "Eugene Hoback, 56, 525 Pala Dr., Ojai, a native of Santa Maria, died Sunday at the Motion Picture Hospital in Woodland Hills where he had been in failing health for several years. Mr. Hoback was born Feb. 4, 1913 in Santa Maria, and grew up in the surrounding area, attending local schools. He became known as a woodcarver and also was employed by Metro-Goldwin-Mayer as a stage coach driver and handler of horses, until his retirement in 1968. He last appeared in the movie 'Camelot.' Survivors include his widow Mrs. Mary Hoback…," per "Eugene Hoback," *SMT,* Sept. 15, 1969, p. 2.

Hoback, Gene (notices in newspapers on microfilm and on newspapers.com and on the Internet)
1939 – "Barbecue Fetes Delegates to … **Phi Epsilon Phi**… The barbecue was served in the main hall at a large U-shaped table with decorations carrying out the early California motif. Individual cactus pots served as favors. Early California figurines made by Eugene Hoback of Orcutt, centered the table," *SMT,* Jan. 23, 1939, p. 3.
1950 – "Wood Carving Habit Develops into Interesting Hobby-Career for whittlin' ex-cowboy from Santa Margarita who is now in LA working for films, and article adds, "Making a habit into a hobby-career, Gene Hoback, 'whittlin' ex-cowboy from Santa Margarita, today is probably the only living exponent in the Los Angeles area of a dwindling art – hand carved reproductions of western life. Hoback dropped in last week for one of his chats with his early friends, Mr. and Mrs. Dave Miller, Santa Margarita. They first met him when he was about four months old and his father, Joseph Hoback, ran a jewelry store from 1913-15 in the Old Miller building in Santa

Margarita. When he grew up, Hoback punched cattle under 'Bun' Hathaway for several years at the Avenales ranch, Pozo. Following that he worked for Bill Stirling on the Canyon ranch, near Shandon, until 1931. He has been carving since 1928 and has whittled out numerous tableaux of diminutive cowboys, horses, stage coaches, and his latest effort – a herd of buffalo and Indians. At first he whittled to strengthen a broken hand, and one day in 1933 he was just 'browsin' under a large oak tree at the Patiaro Seco ranch, Cuyama Valley, when he picked up a chunk of wood and started in with a pocket knife. 'First thing I knew, I got something that looks like a horse,' Hoback recalls. He has played cowboy and Indian parts in Hoot Gibson films and now works as a set carpenter for Motion Picture Center. Some of his work is being pictured in the July issue of *Movie Thrills,*" *AN,* June 8, 1950, n. p., col. 3-4.
1953 – Port. with carving of covered wagon and horsemen and "Rodeo time and window decorations hit the Saladin Furniture Company… Gene Hoback, native of Orcutt, who achieved fame and fortune in Hollywood with his intricate wood carvings, brought several of his larger specimens to Santa Maria for '**Bardy' Saladin**, a long-time friend, to display in the front window of the furniture store," *SMT,* June 5, 1953, p. 1.
1957 – Port. viewing a western scene that he carved, *The Oil City Derrick* (Oil City, Pa.), Jan. 7, 1957, p. 3.
1960 – Port. at his Hawthorne home, whittling, *Santa Cruz Sentinel,* July 14, 1960, p. 10.
And 9 notices for "Eugene Hoback" and more than 25 for "Gene Hoback" in the *SMT,* 1930-1969 were not itemized here.
Hoback, Gene (collections)
A diorama made by him is owned by the Autry Museum, LA.
Speaking of Carl's Billiards in Paso Robles, "Adorning the back bar is a series of carvings of cowboys animals and covered wagons. 'These were carved by a local cowboy named Gene Hoback,' said [current owner Russ] Luke. 'He worked out on the plains on different ranches around here. He made those about 20 years ago,'" per [*SLO] Tribune* "Photos from the Vault" Read more here: http://www.sanluisobispo.com/2014/10/31/3325221_carls-billiards-in-paso-robles.html?sp=/99/177/183/&rh=1#storylink=cpy.
Hoback, Gene (misc. bibliography)
Lawrence Eugene Hoback was b. Feb. 4, 1913 in Calif. to Joseph Herrick Hoback and Rosa Menderoza, married Kathleen Hoback, was residing in Ojai, Ca., in 1940, and d. Sept. 14, 1969 in Ojai, Ca., per Williams Family Tree; Gene Hoback is buried in Nordhoff Cemetery, Ojai, Ca., per www.findagrave.com (refs. ancestry.com).
See: "Hoback, Joseph Herrick," "Hoback, Joseph Quimby," "Phi Epsilon Phi," 1940

Hobbs, Harry Arthur (1902-1955) (Lompoc)
Movie maker, amateur. Member La Purisima Camera
Club, 1938. Portrait painted by Charles Mattei. On one of
his properties exists the original La Purisima Mission,
discovered, 1937.

■ Port. and "Hobbs Brothers Round Out Two Decades in Business. The automotive and sporting goods firm of

Hobbs Brothers… opened for business… April 1, 1933 … born at Champaign, Illinois and received their early education there but were graduated from high school at Denver, Colo… went into the automotive business… Harry Hobbs married Kathleen King of Fargo, North Dakota, in 1924. Their son, George, is also a graduate of the University of California …," *LR*, April 2, 1953, p. 8.
Hobbs, Harry (notices in Northern Santa Barbara County newspapers on microfilm and on newspapers.com)
1955 – "Harry Hobbs Funeral Rites Here Today," *LR*, July 28, 1955, p. 1.
More than 550 hits for "Harry Hobbs" in the *LR* between 1930 and 1955 were too numerous to be browsed for itemization here.
Hobbs, Harry (misc. bibliography)
Harry Arthur Hobbs provided the following information on his WWII Draft Card dated Feb. 14, 1942 = age 40, b. Feb. 6, 1902 in Champaign, Ill., residing in Lompoc with wife Kathleen; Harry A. Hobbs, mother's maiden name Winans and father's Hobbs, was b. Feb. 6, 1902 in Ill. and d. July 25, 1955 in Santa Barbara county per Calif. Death Index; Harry A. Hobbs, 1902-1955, is buried in Lompoc Evergreen Cemetery per findagrave.com (refs. ancestry.com).
See: "La Purisima Camera Club," 1938, "Mattei, Charles," 1932, "Mission La Purisima," 1937

Hobby and Art Show (Santa Maria)
Sponsored by Community Club and Junior Community Club, 1949, 1950, 1952.
See: "Community Club (Santa Maria)," 1949, 1950, 1952

Hobby Night (Santa Maria)
Sponsored by Fuchsia Society, 1961.
"Santa Maria Fuchsia Society Sponsors Hobby Night… Alma Williams, mosaic picture… oil paintings by **Robert H. Wygle**… other paintings **Emile Beerbohm** and Selma Simar…**Fred Beerbohm** displayed his spectacular collection of whittled canes that he has carved … **Vern Dixons** ceramics … Mrs. Howard Triebel added to her ceramics and embroidery, stencil painted towels…," *SMT*, July 3, 1961, p. 3.

Hobby Show – Kiwanis (Lompoc)
Sponsored by Kiwanis Club at Recreation Center, 1948.
■ "Numerous Awards Presented in Kiwanis Club Hobby Show Here… in the Recreation Center… benefit for the club's lighting fund… Special awards … to **Frank Beane** for an exhibit of a complete 'ham' station… In the many different types of collections exhibited… awards presented to the following: **Mrs. Walter Padrick** for an Oriental display, Mrs. Vernon Freiley for a collection of salt and pepper shakers, Mrs. Ernest Cass for a collection of tiny shoes, Mrs. Harms for a collection of pins, Dale Wood for a bird nest collection, Rev. E. Wayne Roberts for a collection of Bibles, Emil Such for a stamp collection, Mrs. E. L. Moumblow, a doll collection, **Mrs. Lloyd Huyck**, a ceramic exhibit, Harold Ruffner, a collection of stones, **Mrs. Robert Chilson**, a needlework exhibit, Chester Cope,

model plane, **Bob Spears**, wood carvings, Al Schuyler, model plane, and Sgt. Bjornsen, model plane," *LR*, May 6, 1948, p. 16.

Hobby Show (Orcutt)
Show sponsored by Friendly Aid at Orcutt Youth cabin, 1948.
"Elizabeth Browning Spoons Items at Hobby Show… Craftwork in wood, copper and leather, several fine collections of dolls, antiques, rock and wood… flowers, photographs, stamp collections… totem pole… glassware and fancywork…," and some collectors named, *SMT*, June 10, 1948, p. 5.

Hobby Show (Santa Maria)
See: "Community Club (Santa Maria)," 1949, 1950, 1952

Hobby Shows
See: "Business and Professional Women's Club," "Community Club (Santa Maria)," 1949, 1950, 1952, "Lompoc Community Woman's Club," 1948, "Lompoc Gem and Mineral Club," "Minerva Club," "Minerva Club, Art and Hobby Show," "Solvang Woman's Club"

Hodgdon (Dominguez / Dominques), Margaret Zella (Mrs. George Richard Dominguez / Dominques) (1923-1962) (Lompoc)
Art teacher at Lompoc High School, 1946-50/51.
Hodgdon, Margaret (notices in Northern Santa Barbara County newspapers on microfilm and on newspapers.com)
1950 – "Lompoc Teachers Plan Vacation…Miss Margaret Hodgdon will take art classes at the University of California, Santa Barbara, during a period from June 19 to August 11. Miss Hodgdon will also take a trip along the Redwood highway to Oregon where she plans to visit the Oregon caves and Crater lake. She will be accompanied on the 10-day trip by Mrs. J. Hodgdon," *LR*, June 8, 1950, p. 4.
Hodgdon, Margaret (misc. bibliography)
Margaret Hodgdon is listed in the 1940 U. S. Census as age 17, b. c. 1923 in Calif., residing in Santa Barbara with parents John Hodgdon (age 53) and Zella Hodgdon (age 38); port. in Santa Barbara College of the University of California, yearbook, 1946; port. in Lompoc High School yearbook, 1947; Margaret Zella Hodgdon married George Richard Dominues on Oct. 9, 1951 in Carson City, per Nevada Marriage Index; Margaret "Domingues" is listed with husband George in the *Santa Barbara, Ca., CD*, 1956-61; Margaret "Dominques" is listed with husband George in the *Santa Barbara, Ca., CD*, 1953-1959; Margaret Zella Hodgdon was b. Jan. 11, 1923 in Siskiyou, Ca., to John Hodgdon and Zella Forrester, and d. Jan 11, 1962 in Calif. per Arnett Family Tree (refs. ancestry.com).
See: "Lompoc, Ca., Union High School," 1946-50

Hodges, Virgil Ulysses (1879-1975) (Lompoc)
Photographer, amateur, 1920s, 1930s. Member La Purisima Camera Club, c. 1947-48.

■ "Early Lompoc photographer dies. Funeral services for Virgil Hodges, 95, whose photographs of Lompoc in the 1920s and 1930s provide some of the clearest records of the town's early years… Born in 1879 on his father's farm south of Arroyo Grande, Mr. Hodges died Monday in Arroyo Grande Community Hospital… Arriving in Lompoc in 1920, Mr. Hodges was employed by the Lompoc Street Department and retired in 1944. He returned to Arroyo Grande in 1959 after the death of his wife to be near his sister… Mr. Hodges is also survived by volumes of photographs that indelibly portray what life was like on the Central Coast in the century's early decades," *LR*, March 4, 1975, p. 2.

Hodges, Virgil (notices in Northern Santa Barbara County newspapers on microfilm and on newspapers.com)
1929 – "Methodist Ladies Picnic… A very pleasant feature of the afternoon was the showing of about one hundred pictures taken by Mr. and Mrs. Virgil Hodges on their recent trip into Canada. Mr. Hodges, who was formerly a professional photographer, did his own developing and printing and secured a really remarkable group of scenic pictures from California, Oregon, Washington, Montana, British Columbia and Alberta," *LR*, Aug. 16, 1929, p. 1.
1933 – FATHER – "In Arroyo Grande. Thomas E. Hodges, 86, Father of Virgil Hodges of Lompoc, Laid to Rest Yesterday," *LR*, Feb. 17, 1933, p. 10.
1935 – "Photograph … is Prize Winner… Reproduced in a late summer issue of *Sunset* magazine is a photograph of Moraine lake in Canada taken by Virgil Hodges when he and Mrs. Hodges were vacationing in the northwest in the summer of 1934. One of eleven winning photographs in a 'Lakes of the Northwest' contest conducted by the magazine… Amateur photography is a hobby indulged by Mr. Hodges whenever he and his wife take a vacation … Mr. Hodges uses a folding Kodak on a tripod. The camera is equipped with a sky filter and anastigmatic lens…," *LR*, Sept. 13, 1935, p. 2.
And hundreds of notices for "Virgil Hodges" in the *LR*, 1920-1975 not itemized here.
Hodges, Virgil (misc. bibliography)
Virgil Ulysses Hodges was b. Sept. 29, 1879 in Calif. to Thomas Exley Hodges and Sarah Elizabeth Wininger, was residing in Arroyo Grande in 1880, married Fae Elnera Winn, and d. March 3, 1975 in Lompoc, Ca., per Geo McClenathan Family Tree; Virgil Ulysses Hodges, 1879-1975, is buried in Lompoc Evergreen Cemetery per findagrave.com (refs. ancestry.com).
See: "La Purisima Camera Club," 1947, 1948

Hoenig, Margaret Neumeyer (Mrs. Mitchell O. Hoenig) (Solvang)
See: "Hibbits, Forrest," 1960, "Puppets (Santa Ynez Valley)," 1960

Hoffman / Hoffmann, Erhardt (1890-1974) (Santa Maria)
Painter of landscapes and Indian scenes. Exh. "Home Talent Art Show," Allan Hancock [College] Art Gallery, 1955.

■ "Erhardt Hoffman… Burial with military graveside rites will be in Santa Maria Cemetery. … He served in the Army for 29 years, retiring in October of 1945 as a master sergeant. Mr. Hoffmann served in World War I and World War II. He had been a Santa Maria area resident since 1945….," *SMT*, Sept. 10, 1974, p. 2.
Hoffman, Erhardt (misc. bibliography)
Erhardt Hoffman is listed in the 1920 U. S. Census as residing in Montabaur, Germany, Military and Naval Forces, single; Erhardt Hoffman is listed in the 1940 U. S. Census as finished elementary school, 8th Grade, working as 1st Sergeant, Co. M, 4th Inf., residing in Fort Lincoln, Burleigh, N. D. (1935) and West Spokane, Wa. (1940), married; Erhardt Hoffman provided the following information on his WWII Draft Registration Card dated 1942 = age 54, b. Dec. 23, 1890, in Buffalo, NY, residing in Santa Maria, unemployed – just retired from the Army (served 30 years); Erhardt Hoffmann [Sic. Hoffman] was b. 1890, d. Sept. 9, 1974 and is buried in Santa Maria Cemetery District per findagrave.com (refs. ancestry.com).
See: "Allan Hancock [College] Art Gallery," 1955

Holcomb, Matthew Winfield "Tobe" (1887-1959) (Betteravia / Santa Maria)
Sign painter, 1926+. Worked for Norris Sign Shop, 1942.
Holcomb, Tobe (notices in Northern Santa Barbara County newspapers on microfilm and on newspapers.com)
1926 – "Holcombe [Sic.] Joins **Stuart Sign Service**. 'Tobe' Holcombe [Sic.], well-known local sign painter, will be associated with the Stuart Sign Service in the future… Mr. Stuart is now devoting a portion of his time to his wall paper and paint store. Mr. Holcombe will do gold sign and lettering work…," *SMT*, March 11, 1926, p. 3; "Sign Painting of all kinds by Tobe. W. S. Edwards Paint Shop. Phone 256 W or 599X2," *SMT*, Oct. 26, 1926, p. 5, col. 6.
1927 – "Auto Show Closes… Special mention is due Tobe Holcomb, popular local sign painter, for all his artistic sign work at the show," *SMT*, April 18, 1927, p. 1; "Sign Painting – Tobe Holcomb, 224 North Smith St…. 256-W," *SMT*, Aug. 2, 1927, p. 5.
1929 – "I Spied… Tobe Holcomb using his hair as an 'oiler' for the gold leaf application on the new *Daily Times* window signs," *SMT*, May 20, 1929, p. 5.
1930 – "Tobe Holcomb. Official Sign Painter for Fair. When Tobe Does it, it is Done Right. Designer, Builder and Letterer of Signs that Speak for Themselves. 112 N. Pine," *SMT*, Aug. 9, 1930, p. 20 (i.e., p. 2); "Here's to You – For your good health, For abundant wealth, For love and friends, And that's happiness. Tobe Holcomb. Designer, Builder and Letterer of Signs," *SMT*, Dec. 24, 1930, p. 8.
1935 – "I Spied… Tobe Holcomb correcting a typographical error in a sign he was painting," *SMT*, Nov. 15, 1935, p. 1.

And more than 200 notices, primarily ads for his sign painting, in the *SMT* from 1926-1959 were not itemzed here.

Holcomb, Tobe (misc. bibliography)
Matthew Winfield Holcomb provided the following information on his WWII Draft Registration Card dated 1942 = age 55, b. Nov. 10, 1887, a painter employed by **Norris Sign Service**, residing in Santa Maria; Matthew Winfield Holcomb b. 1887, d. Dec. 23, 1959 and is buried in Santa Maria Cemetery District per findagrave.com (refs. ancestry.com).

Holenda, Milo Frank (1919-2009) (Guadalupe / Santa Maria)
Teacher of Machine Shop (including art metals and engineering drawing) at Santa Maria Union High School and Allan Hancock College adult school, 1954+.

■ "Milo Holenda. 1919 to 2009. Milo Holenda was born in Webster County, Iowa, on January 1, 1919. He was raised, along with his brothers Vince, Chuck and Roy and sisters Martha, Inez and Alice, on a small farm during the depression years … At the beginning of WWII Milo worked at Le Plant Choate, Cedar Rapids, Ia., which made large earth moving equipment. Milo served in the U. S. Air Force during WWII as a pilot and was stationed at Santa [Maria?] Army air base, which is now Santa Maria Municipal airport. Milo married Margarete Pitz of Amana, Iowa, on March 11, 1942 and raised four children, Forrest, Gregory, Eric and Sheila… After WWII Milo achieved a Master of Science in Industrial Arts from San Jose State University. Milo taught machine shop and welding at Hancock College and, as it was then a small college, was called upon to assist with other courses such as woodshop, aeronautical engineering, drafting … He retired in 1984 after 30 years…," *SMT*, July 15, 2009, p. B2.
Holenda, Milo (notices in Northern Santa Barbara County newspapers on microfilm and on newspapers.com)
1945 – "Returns to Iowa – Mrs. Milow [Sic] Holenda, who has been living in Guadalupe, left for her home in Iowa. Her husband, Lieut. Holenda, has been transferred from Santa Maria Army Air Field," *SMT*, Nov. 27, 1945, p. 3.
1950 – "Guadalupe News. Mr. and Mrs. Milo Holenda and sons, Forrest and Gregory have moved to San Jose where he will take a three-year course at San Jose State college…," *SMT*, Dec. 26, 1950, p. 4.
1954 – Port. and "Milo F. Holenda to teach auto and machine shop at the high school and auto fundamentals and shop at Allan Hancock College, received his doctorate at San Jose State College, served with USAF, taught at Santa Clara High," *SMT*, Sept. 8, 1954, p. 3; "High School Pay Changes Approved… Offered contracts were… Milo Frank Holenda, industrial arts… During five years in the Army Air Force, Holenda served as pilot of a multi-engined aircraft, instructor, equipment officer, and in the Bikini atom bomb tests. He is now a captain in the Air Force Reserves," *SMT*, April 21, 1954, p. 8.
And many additional social notices for him and his wife in the *SMT* not itemized here.
Holenda, Milo (misc. bibliography)
Milo Frank Holenda was b. Jan. 1, 1919 in Webster, Iowa, to John Joseph Holenda and Agnes Jondle, was residing in

Webster, Iowa, in 1930, and d. July 7, 2009 in Santa Maria per Kaplan Family Tree (ref. ancestry.com).
See: "Allan Hancock College," 1954, 1956, "Allan Hancock College Adult/Night School," 1956, 1957, 1958

Hollister, Elizabeth "Blossom"
See: "Owen (Hollister), Elizabeth 'Blossom' (Mrs. Stanley Hollister)"

Hollister, Helen Atkinson (Mrs. William M. Hollister) (SLO)
Member of Santa Maria Art Assoc., who exh. a painting at the Santa Barbara County Fair, 1952 and at the Santa Maria Valley Art Festival, 1952.
See: "Santa Barbara County Fair," 1952, "Santa Maria [Valley] Art Festival," 1952, and see "Atkinson, Helen" in *San Luis Obispo Art and Photography before 1960*

Hollywood, Ca.
Center for photography, filmmaking, set design, animated films, costume design, makeup, etc. Several individuals from northern Santa Barbara county worked at one time or another in a motion picture studio. Motion pictures were made by Hollywood studios in the Guadalupe dunes and other sites in northern Santa Barbara County. A group of "Hollywood notables" exh. their artwork at the Santa Ynez Valley Art Exhibit, 1954.
1930 – Technicolor – "'Sally' Talkie is Technicolor. The coming of Technicolor pictures has brought an era of prosperity to the painting profession in Hollywood. The demand for painters and paint has doubled in the studios… In black-and-white pictures the painting of sets is a minor matter for only neutral shades are needed. In Technicolor pictures every object is photographed in its natural colors. 'Sally,' the First National and Vitaphone picture … tonight and tomorrow at the Santa Maria theatre is entirely in Technicolor, and more than 150 barrels of paint were used on the various sets. Fifty painters were engaged to decorate the various sets, working over a period of six weeks…," *SMT*, March 13, 1930, p. 4.
See: "Adam, Ken," "Archer, Fred," "Armitage, Roblan," "Borg, Carl O.," "Capitani, Lorenzo," 1929, "Carle, Cecil," "Cartoons," "Comic Strip," "Day, Richard," "DeMille, Cecil," "Devine, Pat," "Disney Studios," "Doane, Warren," "Downs, Ruberna," "Duquette, Tony," "Durenceau, Andre," "Early, Mr.," "Erickson, Virginia," "Famous Players-Lasky," "Firfires, Nick," 1936, "First National Pictures," "Gillum, Vernal," "Hardy, Wilfred," "Hoback, Gene," "Huebner, Mentor," "James, Robert," "Jones, Fred," "Kaslow, Rita," "Kosa, Emil," "Kuelgen, Paul," "Laney, Vern," "Leslie, John," "Lester, Gene," "Lindsay, John," "Lindsley, Holt," "Longinotti, Anthony," "Lovet-Lorski, Boris," "Mamoulian, Azadia," "McGuire, Neil," "Monroe Hollywood Marionettes," "Montgomery, George," "Motion Pictures…," "Neil, Milt," "Oberon, Merle," "Osbourne, Isobel," "Parker, Vernon," "Peck, Virginia," "Podchernikoff, Alexis," "Price, Vincent," "Puppets (Santa Maria)," "Ret, Etienne," "Ricca, Theresa," "Rinehart, Jack," "Robinson, Edgar," "Robinson, Gladys,"

"Scheidt, Isabel," "Seawell, Wallace," "Shore, Dinah,"
"Simeone, Adriana," "Skelton, 'Red'," "Smith, Sterling,"
"Sten, Anna," "Stonehard, Leslie, Jr.," "Sutphen, Helen,"
"Travis, N. C.," "Tregor, Nicholas," "Viole, Laurence,"
"Webb, Clifton," "West, Charles," "Willinger, Laszlo"

Hollywood Marionette Theater
See: "Puppets (Lompoc)"

Holman (Petersen), Helen (Mrs. Robert G. Petersen) (1935-1984) (Solvang)
Santa Ynez Valley High School student interested in art, 1953. Exh. first Santa Ynez Valley Art Exhibit, 1953.

■ Port. and "Queen Candidates!"... Entering her senior year next year at Santa Ynez Valley Union High School is 17 year old Helen Holman, daughter of Mr. and Mrs. Max Holman of Solvang. Born in Chico, Helen has lived all but one year of her life in the Santa Ynez Valley. One of her favorite pastimes is horseback riding, and she is interested in all types of outdoor sports, including tennis, swimming and fishing, likes to attend rodeos, and is fond of dancing. During her freshman year at high school, she was a vice-president of her class, is a member of the Girls Athletic Association, sang in the school chorus for two years, was in the band in her freshman year and was a member of the annual staff this year. After graduating from high school, she may go to college. Her most favorite subject in school is art...," *SYVN*, June 19, 1953, p. 1.
Holman, Helen (notices in Northern Santa Barbara County newspapers on microfilm and on newspapers.com)
1953 – Port. and winner of 4th of July queen contest, *SYVN*, July 3, 1953, p. 1.
1954 – Port. and "Plans to Wed ... Robert G. Petersen...," *SYVN*, June 25, 1954, p. 3; port. cutting wedding cake and "Helen Holman, Robert Petersen, Wed," *SYVN*, Aug. 27, 1954, p. 3.
Holman, Helen (misc. bibliography)
Helen Holman is pictured in the Santa Ynez Valley Union High School yearbook, 1954; Helen Louise Holman was b. Nov. 29, 1935 in Chico, Ca., to Max Samuel Holman and Marjorie Jane Ross, and d. June 2, 1984 in Solvang, Ca., per Mood-Howell Families Trees (refs. ancestry.com).
See: "Santa Ynez Valley Art Exhibit," 1953, "Santa Ynez Valley Union High School," 1951, 1952, 1953

Holman, Richard H. (1936-?) (Santa Maria)
Photographer at Santa Maria Times, 1959-c. 1963.

■ "... Today, in his home in Sun City, Holman is a 76-year-old retiree who looks and acts years younger. During an interview with this writer, he repeatedly stood up and pantomimed as he told story after story about his experiences as a news photographer, journalist, and cop. His fascinating life gives new meaning to the term 'great memories.' But that isn't the end of Holman's story, which took a major turn a few years later. 'I freelanced as a news photographer for several papers in Chicago for a few months, and then I got a call from the *Santa Maria Times*, a daily paper on the California coast,' he said. 'I spent four years there, during which I covered President Kennedy's

visit to Vandenberg Air Force Base, and Nikita Khrushchev's visit to San Luis Obispo. On one occasion, a missile flew out of control, and they destroyed it; it exploded near us, and we had to run for cover while huge pieces of debris, some as big as a truck, fell around us. I also did a number of stories about the missile activities at Vandenberg and covered several Atlas missile launches. I also rode along several times with members of the California Highway Patrol and became well acquainted with how they do their jobs. I often gave a set of pictures of incidents to the **police** for their investigations and another set to the cops for their personal use,' he said. 'Since my family was in Chicago, I returned here and worked a year for the *Chicago Tribune*. I talked to a friend who suggested we apply for the Chicago Police Academy. I thought, Why not? and I soon became a cop. For the next 31 years, I was a patrolman, worked traffic on the Kennedy Expressway, processed accident scenes, and patrolled the streets of the northwest side of Chicago,' Holman explained. Like most cops, he has many serious and humorous 'war stories' he loves to tell," per "Former photographer, cop shares historic memories, By Dwight Esau | *Sun Day*, November 29, 2012 | Filed under News & Features, SUN CITY [Huntley, Illinois] - See more at: http://www.mysundaynews.com/2012/11/29/former-photographer-cop-shares-historic-memories/#sthash.BoXtqDv5.dpuf

■ "Employment of Richard Holman, 22, a newspaper photographer since the age of 15, was announced today by William V. Misslin, Managing editor of the *Santa Maria Times*. Holman came to Santa Maria from Chicago where he was photographer for a chain of eight weekly newspapers in that city. He started to work for one of them after school, when only 15. After finishing high school, he started taking portraits while continuing to work for *The Austinite*, now on a full-time basis. Highlight of his career was in covering the Lady of Angels school fire. He was one of the first photographers on the scene. During a week of covering various aspects of the fire and its consequences he hardly slept, and lost 10 pounds. In 1958 one of his pictures took first place in the Illinois Press Photographer's Assn. annual contest. It showed a fireman carrying a small boy out of a burning building. Titled 'Night Rescue' it was carried to papers all over the country by wire services. Working very closely with police officials and firemen, Holman covered, with his camera, a multitude of fires, murders, and accidents. He recalls that his first accident assignment, a particularly gruesome one, made him sick to his stomach. Holman, his wife, Miriam and their six months old daughter live on East Church Street. Both have already become active in The Baptist Church here. Mrs. Holman is a member of the church choir," and port. and "Photographer Employed by SM Times," *SMT,* Oct. 20, 1959, p. 12.
Holman, Richard (misc. bibliography)
Richard H. Holman, Press Photographer, is listed with wife, Miriam, in the *Santa Maria, Ca., CD*, 1959, 1961; Richard H. Holman b. Nov. 14, 1936, was residing in Norridge, Ill. in 1993 per *U. S. Public Records Index, 1950-1993*, vol. 1 (refs. ancestry.com).

Holmes, Katharine / Katherine MacDonald (Mrs. Christian R. Holmes?) (1891-1956?) (Montecito)
Actress / artist? Exh. painting with "Artists of Santa Barbara and Santa Maria" at Santa Barbara County Fair, 1952.

■ Is she – "Silent Star Dies in Santa Barbara… Silent screen star Katherine MacDonald Holmes, once called the 'American Beauty,' died this morning. She had been ill for more than two years. The former actress left Broadway in 1917 for a movie career. She starred with Douglas Fairbanks and Thomas Meighan. She and Christian R. Holmes, heir to the Fleischman Yeast Co. fortune, were married after Miss MacDonald retired from films. The couple was divorced in 1931…," *SMT*, June 4, 1956, p. 1.
Holmes, Katharine (misc. bibliography)
Is she Katherine Holmes b. Dec. 14, 1891, who d. June 4, 1956 and is buried in Santa Barbara Cemetery per findagrave.com (refs. ancestry.com).
See: "Santa Barbara County Fair," 1952

Holmes, Paul M. (Santa Maria)
Aerial Photographer, 1947.
This individual cannot be identified.
1947 – Classified ad: "Aerial Photographs. Paul M. Holmes. Box 88. Santa Maria," *SMT*, Oct. 22, 1947, p. 5.

Home Department of the State Farm Bureau (Northern Santa Barbara County)
Department of the State Farm Bureau organized in Lompoc, 1920, in the Santa Ynez Valley, Dec. 1927. There were Sisquoc and Orcutt branches of the Home Department by 1928. It held meetings in the homes of rural housewives chaired by the Department's representative who taught various subjects of interest to homemakers. Local home demonstration agents for Santa Barbara area were Nancy Folsom (LeBrun) (1928-35), Irene Fagin (1935-42), Florence Spaulding (1942-47), and Hazel Martin (1947-60+). After c. 1949 the service was called the "Women's Department of the Farm Bureau."

■ "Today's Home Builds Tomorrow's World, the theme of home demonstration work, means more today than in any year since the first home demonstration week in 1946… The aim of the home advisor is to improve the quality and the satisfaction of living. What Santa Barbara County has done toward fulfilling those aims will be on display during this week. Home demonstration work has made great strides since the first home demonstration week five years ago. At that time California had 4,888 leaders – local women who carry the teachings of the home advisor to rural communities. At the end of 1950, there were 16,723 leaders in the state. The work of the home advisor, as distributed through the local leaders, reached 55,000 families in California last year. A total of 750 women in 14 centers are cooperators in the home demonstration work in Santa Barbara County. Home demonstration work is a cooperative program carried on in the county by the home advisor, who represents the agricultural extension service of the University of California to the women in the county, also makes known the needs of rural women to the specialists at the university," *SYVN*, May 4, 1951, p. 1.
Home Dept. (notices in Northern Santa Barbara County newspapers on microfilm and on newspapers.com) Soc.)
[Ed. - Only notices about needlework, crafts, interior decorating, flower arrangement, or art, were included here.]
1920 – "Women's' Farm Dept. Will be Organized," *LR*, June 11, 1920, p. 1;
1928 – "The Work and Accomplishments of the Santa Ynez Valley Farm Home Dept. .. organized in his valley last December under… Miss **Nancy Folsom**… dressmaking…," *SYVN*, April 27, 1928, p. 1.
1930 – "**Orcutt Community**… Miss **Nancy Folsom**… will be at the Community Ladies' social hall in Orcutt on Thursday to begin her … demonstrations in hat making…," *SMT*, March 18, 1930, p. 5; "Decoration of Homes will be Orcutt Subject…," *SMT*, April 12, 1930, p. 9; "Furniture Renovation… **Nancy Folsom**… Miss Jessie Lee Decker, house furnishing specialist from the University of California… This month furniture arrangement is the subject of study… Next month color application and Christmas gifts…," *SYVN*, Nov. 14, 1930, p. 1.
1931 – "Sisquoc Home Group Will Meet… Those attending may bring sewing kits and scraps of guaranteed wash prints suitable for making toy cloth animals for the Community Christmas tree…," *SMT*, Oct. 17, 1931, p. 3.
1932 – "Comprehensive Plan for Year… Women of the Santa Barbara County… will study home gardens, cookery, marketing, food service, canning, home accounts, remodeling of clothes and other projects during 1932. … During the spring months the department will carry on projects in food service and canning. Zoned meetings will be held for home accounts, the making of color charts, hooked and braided rugs and summer hats…," *SMT*, Feb. 1, 1932, p. 2; "One-Act Play Enjoyed at Bureau… Sisquoc farm bureau… It was further announced that there will be a zoned rug meeting at the Forester's hall at Lompoc at 10:30 o'clock on May 16. Many from this district will attend including the four leaders. Miss Jessie Lee Decker, specialist from Berkeley university, assisted by Miss **Nancy Folsom** … will instruct in the art of rug making," *SMT*, April 18, 1932, p. 3; "Home Dept. Activities in Santa Ynez Valley… farm women … meet together at some common center… **Nancy Folsom**…. It is amazing to the writer that one person could be so proficient in so many lines of helpfulness whether it be the making of box cushions, refinishing of furniture, making a new hat from an old one… cooking… or making Christmas candles…," *SYVN*, Nov. 18, 1932, p. 4.
1933 – "Spring Hats to be Topic at Meet. 'How to Give 1933 Touches to Our Last Spring Hats' will be the theme of a public demonstration … conducted by Miss **Nancy Folsom**… working with the extension department of the University of California at Main street school tomorrow morning… demonstration which will show how to block straw, felt and fabric crowns, how to make one's own blocks out of muslin and sawdust, how to press and reshape brims and how to make the new style 1933 fabric hats out of a half yard of pique, print, silk and other material…," *SMT*, March 14, 1933, p. 3; "State College Art Chief to Speak Here… suggestions in making practical gifts… **Mrs.**

Mary Croswell. ... Main Street school auditorium...,"
SMT, Dec. 13, 1933, p. 3; "Members of the Farm Woman's
Clubs of the Santa Ynez Valley towns and of Los Alamos
met at the Los Olivos school auditorium on Wednesday
afternoon to hear **Mrs. Mary Croswell**... in a very
interesting talk on hand-work, especially gifts made from
inexpensive materials... After the lecture, the many
beautiful articles made by students of the college were
inspected...," *SYVN*, Dec. 15, 1933, p. 4; "Instructor...
Using for exhibition purposes objects of art made by her
students, **Mrs. Mary Croswell**, head of the art department
of the State Teachers' College, gave an interesting and
instructive talk on arts and crafts before the Home
Department, Friday afternoon at Foresters Hall... Mrs.
Croswell emphasized the fact that art is not only the
painting of pictures but that art is also important
commercially; that all of our rugs, our wallpapers,
linoleums, furniture and many other of the articles of
everyday life are designed by artists. She also spoke of the
use of art in erecting buildings, complimenting the city on
the appearance of the H. S. Rudolph store building nearing
completion, designed by Kenneth Fratis, local architect.
Demonstrating the making of many of the articles, Mrs.
Croswell displayed bowls made of serpentine paper of
different colors and shellacked, used for ash trays, flower
containers, candy dishes and ornaments, according to their
size. Other objects displayed were book-ends made of
galvanized tin ornamented with Chinese medallions,
lacquered in different colors, hand-made pottery articles,
plaster of Paris plaques, dyed and tied work, tooled leather
book covers and book bindings and many embroidered
articles including a white coat, beautifully embroidered
with fine yarns...," *LR*, Dec. 22, 1933, p. 3.
1934 – "Making of Inexpensive Spring Millinery... making
hats and dress accessories...," *SYVN*, March 16, 1934, p. 4;
"Expert on Home Furnishing to Make Tour. **Miss Jessie
Lee Decker**, house furnishing specialist from University of
California at Berkeley will visit each one of the Farm
Home centers in Santa Barbara county this month and bring
a wealth of suggestions for giving homes new touches in
interior decoration...," *SMT*, June 5, 1934, p. 3; "Home
Department will Camp at White Oak Flats July 3-8... the 4-
H Camp in the Santa Ynez mountains... For those who
wish there will be classes in folk dancing, handcrafts and
archery, swimming instruction, books and magazines,
though none of these are obligatory...," *LR*, June 29, 1934,
p. 4; "Treasures – FHD Women Make Them. It has been
said that women of all periods have gone down in history
famous for some kind of handcraft but that women of today
are breaking this record... However, there appears to be an
interest and movement throughout the whole land for a
restoration of needlework ... Home Department women are
wanting to know about 'these old things'... [also] We need
relaxation... Making something beautiful with one's own
hands soothes nerves... The Farm Home Departments of
Santa Barbara County will work on a handcraft program
this summer and have scheduled meetings as follows for
July [and sites listed] ... Hooked Rugs, Early American
Bed Spreads, Bags, Mats, Stool Covers, Chair Seats of
Needlepoint, and Handloom weaving with yarns and raffia,
Block printing... will be among the Arts and Crafts which
the Home Demonstration Agent and Project Leaders will

demonstrate and teach how to make," *SYVN*, July 6, 1934,
p. 1; "Home Department to Study Handcraft... and gift
planning will be demonstrated today... beginning at 10
o'clock ... at Westminster Hall. Included in the day's
demonstration will be hooked rugs, needlepoint tapestry
and early American bed spreads... Members were to bring
their materials for the sort of work they wish to take up...,"
LR, July 20, 1934, p. 3; "Farm Women Hear Handcraft
Talk... demonstrated by **Miss Nancy Folsom**...
needlepoint tapestry, hooked rugs, candlewick bedspreads,
pine needle and serpentine baskets," *SMT*, July 24, 1934, p.
3; "Home Department Studies Handcraft. Meeting Friday at
Westminster Hall for an all-day session, members... and
friends took up the study of handcraft under the direction of
Miss Nancy Folsom, county home demonstration agent.
Instructions were given in the making of the old-fashioned
candlewick bedspreads and hooked rugs and other forms of
hand work...," *LR*, July 27, 1934, p. 3; "Home Department
Meets at Park... Washington Grove Park... Various kinds
of handcraft including hooked rugs and bags, can... cking,
Italian hemstitching, needlepoint tapestry and serpentine ...
etry were studied...," *SMT*, Aug. 18, 1934, p. 2; "Farm
Home Department... met at Los Olivos school
auditorium... **Mrs. Nancy Folsom-Lebrun** gave a very
interesting talk on Christmas decoration in the home ...,"
SYVN, Dec. 14, 1934, p. 1.
1935 – "Farm Centers will Hold a 2-Day Meet. Miss Jessie
Lee Decker, specialist in home furnishings, has been
secured by **Nancy Folsom LeBrun**... from the University
of California Extension bureau to preside at a two-day
session on upholstery and re-upholstery beginning at 10
o'clock tomorrow morning in Main street school
auditorium," *SMT*, Feb. 19, 1935, p. 3; "County Farm
Home Dept. Booth Exhibits Planned ... in the **Santa
Barbara County Fair** to be held July 24-28th... Coast
Center will exhibit some of their lovely work on
needlepointing showing materials to use, designs, stitches,
color schemes, a foot stool, a chair seat, tapestry bag...
Bonita Center will show wrapped rugs... preparation of
materials...," *SYVN*, June 14, 1935, p. 5; "Urge Home
Agent... Santa Barbara County Farm bureau has asked the
county board of supervisors to continue the work of the
county home demonstration agent. Her salary is paid by the
University of California, but it costs the county about $700
a year for her travel and office expenses. **Miss Irene Fagin**
has recently succeeded **Mrs. Nancy Folsom LeBrun** in the
position," *SMT*, July 8, 1935, p. 2.
1938 – Buellton "Studies Home furnishing... under the
direction of **Miss Irene Fagin**...," *SYVN*, Jan. 14, 1938, p.
1; Los Olivos Home Department will discuss home
furnishing, *SYVN*, Jan. 14, 1938, p. 1.
1939 – Buellton "... next Thursday, January 12, at the
home of Mrs. A. G. Bodine. Hand-made rugs and
handcrafts will be demonstrated...," *SYVN*, Jan. 6, 1939, p.
5; "The Farm Home department met Wednesday ... The
project was 'Rug Making' with Mrs. Hugh Irvin, Mrs. N.
B. Oliver and Mrs. Chris Roth as project leaders who
demonstrated a burlap and cotton print rug. Many rugs,
quilts and crochet pieces were on display," *SYVN*, Jan. 13,
1939, p. 5; "Fifty-Six Are Present at Home Dept. ...
members of the Lompoc Center Farm Home department...
at the regular meeting... in the Veterans Memorial

building. Home-made rugs was the popular topic… with an attractive display of braided, burlap, hooked and woven rugs made by the various members. A hobby show of other hand work including bedspreads, fancy work and quilts was also shown the group…," *LR*, Jan. 27, 1939, p. 3; Lompoc "Rugs will be Topic at Home Department. All types of hand made rugs will be discussed at the January 20th meeting… The meeting will be at 10:30 … in the Veterans Memorial building… Project leaders for the day will be Mrs. J. E. Burton, Mrs. John Callis, Mrs. Mike Kolding and Mrs. Ed Marquart… In conjunction with the day's program, it is planned to have a crafts hobby show…," *LR*, Jan. 13, 1939, p. 3.

1942 – Irene Fagin Gets State Position… Santa Barbara county home demonstration agent for the past seven years is leaving the post… to become assistant state home demonstration leader … Her place will be taken by **Miss Florence Spaulding**, who as home demonstration agent-at-large was assigned to the county during her predecessor's leave of absence in June," *SMT*, July 8, 1942, p. 3.

1947 – "Miss Williams as Assistant Home Agent. **Miss Josephine Williams** has been appointed… assistant home demonstration agent in Santa Barbara County… a native of California, is a graduate in home economics from Santa Barbara College. For four years she was research assistant and nutritionist at the California Institute of Technology, Pasadena, where she worked with Dr. Henry Borsook, eminent professor of biochemistry… Miss Williams comes to Santa Barbara from Gentry, Inc., of Los Angeles, where she has been in charge of products development… Daughter of Carl J. Williams, who until his death recently was farm placement manager of the University of California Agricultural Extension Service in Los Angeles… Miss Williams's appointment will make it possible to expand the work in the field of adult home demonstration work and in the **4-H** club program… She will spend two weeks at the University of California in Berkeley before beginning her work in Santa Barbara County on March 1," *SMT*, Feb. 4, 1947, p. 5; "Mrs. Martin… **Mrs. Hazel Brown Martin** of Sinton, Texas, has been assigned to the position of home demonstration agent in Santa Barbara county… Mrs. Martin graduated from West Texas State Teachers college and, after her marriage and the death of her husband, returned to take home economics in Southwest Texas State Teachers college, from which institution she received her degree. Subsequently, Mrs. Martin taught in rural schools, was home economics teacher in Dalhart, Texas, and since 1938, she has served as home demonstration agent in three counties in Texas. Mrs. Martin succeeds **Miss Florence Spaulding**, who will resign June 30 to marry… Mrs. Martin will spend several days at the University of California in Berkeley beginning with her appointment July 16. She will take up her duties in Santa Barbara before Aug. 1," *SMT*, June 17, 1947, p. 3.

1948 – "Farm Home Group Meets… Orcutt… **Mrs. Marjorie Webster** presiding… give a demonstration of room arrangement by **Miss [Sic. Mrs.] Hazel Martin**… Color in the rooms was a point discussed…," *SMT*, March 18, 1948, p. 3.

1949 – "Special Events Planned… **Miss Phyllis Snell**, assistant home demonstration agent, discussed sewing club activities… **4-H**," *SMT*, March 9, 1949, p. 5; photo of

women making slip covers "… at a demonstration in Veterans' Memorial building, one of twelve home-making classes held during the year by the Women's Department of the Farm Bureau…," *SMT*, Aug. 3, 1949, p. 5.

1950 – "'Toy Making' Subject of Meeting Here … with the Misses Ynez and **Tulita de la Cuesta** as project leaders," *SYVN*, Nov. 10, 1950, p. 1.

1953 – "Orcutt Home Dept… **Mrs. Hazel Martin**…," *SMT*, Sept. 16, 1953, p. 4.

1954 – "Home Department to Study Picture-Frame. The Sisquoc Home Department… at the Benamin Foxen school… The next meeting will be held March 17 when the project will be 'Selecting, Framing and Hanging Pictures'," *SMT*, Feb. 27, 1954, p. 4; "Farm Home Dept. … The Santa Ynez Valley Farm Home Department was organized in December of 1927…," *SYVN*, Sept. 17, 1954, p. 15; "Making Lamp Shades…," no agent mentioned, *SYVN*, Feb. 5, 1954, p. 5; "Home Dept. Women Make Lamp Shades," *SYVN*, Feb. 12, 1954, p. 4; and 19 additional notices for the Santa Ynez Valley Home Department in *SYVN*, 1954, not itemized here.

And hundreds of hits for the various agents' names in northern Santa Barbara County newspapers to 1960 not itemized here. And more than 370 hits for "Home Department" in the *SMT* between 1950 and 1960 not itemized here.

Home of the Week (Lompoc)
Weekly feature of Lompoc Record starting Sept. 13, 1951.
See: "Your Home of the Week"

Homecraft Institute
Itinerant institute, run by Jane Barton, who visited Lompoc, 1933.

■ "Jane Barton and Homecraft Institute Coming to Lompoc. Aug. 30, 31, and Sept. 1. … Barton's Homecraft Institutes are widely known throughout California … There is a lot more to Homecraft than merely kitchen craft. There is garden craft, laundry craft and child craft; there is the craft of decoration and above all there is the art of homemaking. … Her three-day session…will be devoted to … practical demonstrations… In kitchen craft she will actually prepare dozens of… recipes… Helpful suggestions galore about home decoration are on the program…," *LR*, Aug. 18, 1933, p. 6.

Homrig, Hal (Newport Harbor)
Curator of an itinerant exh. of work by Veterans held in Solvang, 1949.

■ "Art Exhibit… of veterans art brought to Solvang by Mr. and Mrs. Hal Homig [Sic. Homrig] and sponsored by the Santa Ynez Valley **AWVS** was viewed by a group of Lompoc **AWVS** members Tuesday afternoon. The Homigs [Sic. Homrig] have been touring veterans' hospitals since 1946 and during the past three years have covered 63,000 miles The more than 100 pieces of work exhibited were on loan and not for sale. They included several mediums including paintings, drawings and photography. Those attending the exhibit from Lompoc were Mmes. Ronald

Adam, E. A. Everitt, **Forrest Hibbits**, **Lloyd Huyck** and **Robert Lilley**," *LR*, Nov. 3, 1949, p. 4.

Homrig, Hal (notices in Northern Santa Barbara County newspapers on microfilm and on newspapers.com)
1949 – "Vets Art Exhibit Next Week. Under the auspices of the Santa Ynez Valley Unit, **American Women's Voluntary Services**… Mr. and Mrs. Hal Homrig of Balboa Island, Newport Harbor, are bringing the amazing collection of art work to the Valley. It was in 1946 that the Homrigs made their first tour of hospitals in the southwestern states only. This was followed by a nationwide tour by auto of 20,000 miles reaching every state. In 1947 they made another coast to coast trip and during the past two years have covered more than 43,000 miles. There are some 100 paintings, drawings and photographs in the exhibit to be shown here. One of the most unusual is the picture of Gen. Douglas MacArthur by a Philadelphia veteran, George Floyko, who did it entirely with match flame. Also being shown are original sketches by the late Wally Wellgren, the American Legion cartoonist, whose works Mr. Homrig presented in the 1946 Festival of Arts in Laguna. There are photos by Sgt. Lloyd Patterson, taken during the Pacific fighting; works of Commander Arthur Beaumont of Los Angeles, noted for his seascapes and naval battle scenes that he has done for the Navy; Iwo Jima pictures taken by Marine Corps Photographer Louis Lowrey, and water colors by retired Gen. Pelham Glassford. The evening exhibit next Tuesday is being held especially for the benefit of veterans who may be interested in seeing the collection… Mr. and Mrs. Homrig will give a talk on each showing… not for sale," *SYVN*, Oct. 28, 1949, p. 1.
See: "Homrig, Hal" in *Atascadero Art and Photography before 1960*

Hoopes, A. (Lompoc)
Prop. of Variety Store, 1888-90.
See: "Variety Store"

Hopkins, J. Barton (1905-1981) (Santa Barbara)
Artist who exh. in National Art Week show at Minerva Club, 1940.

■ J. Barton Hopkins, (1905-1981) a salesman for silk stockings, resided in Santa Barbara in 1940 but moved to the Long Beach area by 1948 and died in Seal Beach per William Deniston Family Tree (ref. ancestry.com).
Hopkins, J. Barton (notices in California newspapers on newspapers.com).
1939 – "Revised State Labor Code... California State Federation of Labor's year book... cover is by Barton Hopkins, Santa Barbara artist...," *Sacramento Bee*, Oct. 9, 1939, p. 19.
1948 – "In Art Circles ... "Member of the Spectrum club, local organization of men only whose art is their avocation, have collected their best recent work for the semi-annual fall exhibition at 225 East Third street ... Following are the exhibitors [complete listing] ... Barton Hopkins – 'Palos Verdes'...," *Long Beach Independent*, Oct. 17, 1948, p. 40.
1950 – Repro: "Along the Beach," included in Spectrum Club spring show ...," *Independent Press-Telegram*, April

30, 1950, p. 6 (*Southland Magazine*); "In Art Circles ... Spectrum Club's traveling show... opened yesterday in the Bellflower Conservatory, 16811 S. Ardmore Ave.... where it will remain a month... Exhibiting artists and their work: Barton Hopkins, president, 'Back Country'...," *Independent Press-Telegram* (Long Beach, Ca.), Oct. 8, 1950, p. 4; "Spectrum Club's Show... fall ... Pictures selected... are the best in the club's history... Barton Hopkins, 'Mission Creek, Santa Barbara' ...," and complete listing of show, *Independent Press-Telegram*, Oct. 29, 1950, p. 4.
1951 – "In Art Circles. Spectrum Club in Exhibition... fall show at 225 E. Third St.... Exhibited are: ... 'Palmdale, Calif.,' Barton Hopkins...," and full listing of show, *Independent Press-Telegram*, Nov. 25, 1951, p. 4.
1952 – "Spectrum Club Opens Exhibit at [Municipal] Art Center... 2300 E. Ocean Blvd.... Exhibiting artists... Barton Hopkins, 'Back Country,' 'Still Life' ...," and full listing of show, *Independent Press-Telegram*, Jan. 20, 1952, p. 4.
1955 – "Advertising Art... Opening with a tea... 150 paintings by members of the Spectrum club will be shown in the Home Furniture Co. art department, 210 Locust Ave... Exhibiting artists include... Barton Hopkins...," *Independent Press-Telegram*, March 27, 1955, p. 70.
See: "National Art Week," 1940

Hopkins (Goss), Lesli / Leslie L. Frusetta (Mrs. Hopkin James Hopkins) (Mrs. Calvin W. Goss) (1926-?) (Los Alamos)
Student artist of Santa Maria Art Assoc. who exh. sculpture at Santa Barbara County Fair, 1949. Chairman Santa Maria Art Festival, 1953.

■ "Orcutt to Form New Kindergarten… The School board has authorized the hiring of Mrs. Lesli Hopkins from Los Alamos to be the teacher. Mrs. Hopkins is a graduate of San Jose State Teachers College with an education major," *SMT*, Oct. 3, 1959, p. 2.
Hopkins, Lesli (notices in Northern Santa Barbara County newspapers on microfilm and on newspapers.com)
1970 – DAUGHTER – "Former Los Alamos Resident is Engaged… Mrs. Calvin W. Goss of Bakersfield has announced the engagement of her daughter, Miss Heidi Ann Hopkins, to Alan Dorris. Heidi, also the daughter of H. [Hopkin] James Hopkins of Los Alamos…," *SMT*, March 24, 1970, p. 5 [Heidi Ann Hopkins, mother's maiden name Frusetta, was b. March 25, 1950 in Santa Barbara County per Calif. Birth Index, and Heidi appears in West High School, Bakersfield, yearbooks, 1966, 1967 on ancestry.com].
Hopkins, Lesli (misc. bibliography)
Leslie Frusetta, mother's maiden name Hodges, was b. Sept. 14, 1926 in Santa Clara County per Calif. Birth Index; Leslie Frusetta is listed in the 1940 U. S. Census as age 13, b. c. 1927 in Calif., residing in Tres Pinos, Ca., (1935, 1940) with her parents George J. Frusetta (age 52) and Ruth Frusetta (age 43) and siblings; Leslie Frusetta port, in San Jose State College yearbook, 1946, 1947; [Frusetta gave birth to Heidi Ann Hopkins, 1950]; Leslie L. Frusetta married Calvin W. Goss on July 30, 1961 in San Benito County per Calif. Marriage Index; Leslie L. Frusetta divorced Calvin W. Goss in Nov. 1970 in Kern County per Calif. Divorce Index; is she Leslie L. Goss, architect, listed

in the *Bakersfield, Ca., CD*, 1968: Mrs. Leslie L. Goss, teacher Bakersfield City School Dist., is listed in the *Bakersfield, Ca., CD*, 1972; Leslie L. Goss, b. Sept. 14, 1926, who was living in Bakersfield, Ca., in 1993 per *U. S. Public Records Index, 1950-1993*, vol. 1 (refs. ancestry.com).
See: "Santa Barbara County Fair," 1949, "Santa Maria Art Association," 1949, "Santa Maria (Valley) Art Festival," 1952, 1953, "Taylor, Elizabeth"

Horowitz, Leonard E. (b. c. 1925-?) (Lompoc)
Artist of pencil sketch displayed at Alpha Club Penny Art program, 1958. Civilian employee of the USDB, 1958-63.
1960-63 – Port. with education directors, and "721 Enroll in FCI [Federal Correctional Institute] Education Courses… [where] Leonard E. Horowitz is supervisor of vocational training…," *LR*, July 28, 1960, p. 11; "Civil Service News… Leonard Horowitz, assistant supervisor of education at FCI and president of the local chapter of NFFE," *LR*, May 8, 1963, p. 19 (i.e., 3-C); "Service Notes… Donald Butts…assumed the position formerly held by Leonard Horowitz who was transferred to the FCI, Englewood, Colorado…," *LR*, Sept. 10, 1963, p. 5.
Horowitz, Leonard (misc. bibliography)
Leonard E. Horowitz, b. c. 1925, married Joan A. Gordon (b. c. 1933) on Oct. 6, 1956, in LA per Calif. Marriage Index; Leonard Horowitz, U.S. Army, married to Joan, is listed in Lompoc in the *Santa Maria, Ca., CD*, 1958-62 (refs. ancestry.com).
See: "Alpha Club," 1958, "United States Disciplinary Barracks"

Hosier, Roy Grant (1894-1971) (Orcutt / Ballard)
Sign painter, carver, 1946+.
■ Port and "Hosier Hand-carves Road Marker for La Purisima. Creates Friar in Redwood for Mission. Roy Hosier, Santa Ynez Valley master of hand carved signs and sign painter… Mr. Hosier, who said he has been wood carving 'on and off for many years,' first became interested in art and lettering when he was in the advertising department of Sears Roebuck in Shreveport, La. That was back in 1925. He first came to California in 1914. His first job was with the Union Oil Co., in Orcutt. He followed the oil game in the ensuing years, working for Pan-Am Oil Co., in Old Mexico and South America. Still later, he worked in the oil fields in Texas, Arkansas, and Louisiana. Next came the job with Sears and Roebuck. After that he was in the uniform manufacturing business in Shreveport. In 1936 he returned to California and to Orcutt and back to the oil fields. Hosier has been a resident of the Valley since 1946. Four years ago, he and his wife, Eunice, bought a piece of property in Ballard on the Solvang-Los Olivos Road. Here Mr. Hosier has his shop and engages in his wood carving. Mr. Hosier's hand-carved redwood signs can be seen all over the Santa Ynez Valley… business houses, ranches and homes. … hand carved signs for the State of California. … the big hand carved redwood sign at the Santa Barbara Botanic Gardens. The Ballard resident also engages in wood finishing and is now in the process of converting a former play house into a furniture refinishing shop…," *SYVN*, March 6, 1953, p. 3.
■ "Roy G. Hosier…of Ballard, retired sign painter and creator of hand-carved signs… He was born July 13, 1894 in Wells County, Ind., a son of Mr. and Mrs. Alexander Hosier. He created one of his most memorable wood carvings, a 11 and a half foot, four inch thick redwood road marker, representing the figure of a Franciscan Friar, in 1953 for La Purisima mission. Mr. Hosier was commissioned by the then State Division of Parks and Beaches to make the marker … He and his wife, the former Miss Eunice Smith who survives, purchased a piece of property on Alamo Pintado Road immediately north of Baseline Avenue in Ballard. Here Mr. Hosier operated his shop before retiring. He and his wife were married Dec. 16, 1944," *SYVN*, Jan. 21, 1971, p. 14.
Hosier, Roy (notices in Northern Santa Barbara County newspapers on microfilm and on newspapers.com)
1947 – Ad for "Signs. Hand Carved or Painted. Show Cards. Roy Hosier, Los Olivos – Ph. 3214," *SYVN*, Aug. 22, 1947, p. 7.
1952 – Ad: Roy Hosier, Ballard, mailing add. RFD Solvang. Ph. 6684," *SYVN*, Oct. 17, 1952, p. 8.
1954 – Photo of hand-carved redwood sign by Roy Hosier situated on the Westerly Ranch of **Mrs. Amory Hare Hutchinson** warning motorists, on their way to Ballard, that the road curves sharply…," *SYVN*, April 9, 1954, p. 1; "Benches Give 'New Look… two new benches in front of Danish Village Gifts and the newly decorated 'old green bench' in front of Wally's Barber Shop… 'The old green bench' … complete redecorating job under the artistic hands of Roy Hosier. Outline sketches of folk dancers and red and white 'V's' appear on either side…," *SYVN*, July 30, 1954, p. 2; "Memo Pad… Roy Hosier was in and showed us a sample of the type of hand-carved street signs he is making for some of the streets in Montecito … Roy's 18-foot sign in front of the County Fair administration building was scheduled to be erected this week," *SYVN*, Oct. 22, 1954, p. 2.
And, more than 470 hits for "Roy Hosier" in the *SYVN* between 1945 and 1960, most of which were ads, were too many to be browsed for potential inclusion here.
Hosier, Roy (misc. bibliography)
Roy Grant Hosier is listed as "sign writer" in the *California Voter Registrations, Orcutt Precinct No. 2*, 1942-44; Roy Hosier b. July 13, 1894, d. Jan. 1971 per Social Security Death Index (refs. ancestry.com).

Hosn (Daniels), Elizabeth "Betty" Baciu (Mrs. James Hosn) (Mrs. Walter Daniels) (1916-2006) (Santa Maria)
Painter, amateur. Art chairman for Jr. Community Club, early 1950s. Flower arranger. Chairman, Hobby and Art Show, 1952. Exh. Allan Hancock [College] Art Gallery, 1957.
■ "Betty Hosn Daniels… Romanian emigrants… born on the family's farm in Salmon, Idaho… Betty attended Business College and then worked in Seattle where she met and married James Hosn. In the late 1940's the couple moved to Santa Maria where James owned and operated… the Rex Cafe and Card Room… She was also an active

member and past president of the Minerva club, utilizing her artistic and culinary talents ...," *SMT*, Feb. 8, 2006, p. 9.

<u>Hosn, Betty (notices in Northern Santa Barbara County newspapers on microfilm and on newspapers.com)</u>
1956 – Port. with arrangement of succulents, *SMT*, July 29, 1956, p. 12.
1958 – "Mrs. Hosn to Demonstrate Handcrafts... to... Sisquoc Farm Bureau Women...," *SMT*, Dec. 15, 1958, p. 5.
1969 – Port. and to head Minerva Club, *SMT*, May 29, 1969, p. 5.
Thirty-five hits for "Betty Hosn" and more than 360 for "Mrs. James Hosn" appear in the *SMT* between 1945-1970, to record her portrait, her social and club activities and some art notices (demonstrator of flower arranging, decorator for special events, and maker of Christmas crafts) but were not itemized here.

<u>Hosn, Betty (misc. bibliography)</u>
Elizabeth "Betty" Baciu Hosn was b. Sept. 20, 1916 in Salmon, Id., to George M. Baciu and Maria Milot Vintila, and d. Feb. 5, 2006 in Santa Maria, Ca., per H. Bolton's Lineage Family Tree; Elizabeth Hosn-Daniels b. Sept. 20, 1916 and d. Feb. 5, 2006, is buried in Santa Maria Cemetery District per findagrave.com (refs. ancestry.com).
<u>See</u>: "Allan Hancock [College] Art Gallery," 1957, "Community Club (Santa Maria)," 1950, 1951, 1952, 1954, "Halloween Window Decorating Contest (Santa Maria)," 1951, "Junior Community Club," 1950, 1951, 1952, 1953, 1955, 1957, "Minerva Club," 1957, "Minerva Club, Art and Hobby Show," 1957, 1958, 1959, "Ruth, Clarence," "Santa Barbara County Library (Santa Maria)," 1951

Hospital Women's Auxiliary (Lompoc)
<u>See</u>: "Lompoc Hospital Women's Auxiliary"

Houghton, James Vernon (1912-2004) and Doris Iva Quick (1914-2002) (Santa Maria)
Photographer. Exh. Santa Barbara County Fair, 1959. Active with Santa Maria Camera Club, c. 1941-62+.

■ Ports. and "Picture Perfect... Photographers Doris and Vernon Houghton have Been Partners in Film for 40 Years. ... Vern came in 1941 to Santa Maria to help construct Camp Cook, and joined the fledgling camera group. His wife accompanied him to some photo competition meetings and was soon asked to become club secretary and treasurer. But actually join, take pictures, and enter the contests? A woman wouldn't [in the men's opinion] ... The quiet intellectual proved the boys wrong. First, she attended photography classes taught at night by **Norm Brown** at Arroyo Grande High School, along with working as an accountant and raising her children. ... the Houghtons became a pioneer Camera club couple. Then Vern and Doris ventured into a genre that made many club members turn up their noses. Color photography, others believed, was child's play... 'Real photography is black and white'... Heedless, the Houghtons turned up the heat on their new 35 mm cameras, showing their peers new views of familiar subjects. A brown pelican, wet head haloed with shirring wings against a royal blue ocean. And Doris' answer to Georgia O'Keeffe portraits of single flowers in full sensuous bloom... If anyone can do photographic justice to the Grand Canyon, the Ansel Adams Wilderness east of Yosemite, the blazing petals of a sunflower, it's Doris Houghton. She and Vern have traveled the globe with their black metal boxes at the ready – and they've captured many a glorious moment in the Orange Street backyard they've tended for 50-plus years. Right now, the Houghtons are prowling around Philadelphia, where their daughter lives. From there, the pair will go on to the south of France, where another daughter runs a bed and breakfast inn near the medieval walled city of Carcasonne. Back home in Santa Maria, the Houghtons' place is a vibrant display of international scenes. The Eygptian pyramids, missions in Tucson and Lompoc, pastoral French fields, fiery fall leaves in New Jersey... One hot July day... doubling the size of his darkroom, adding some 70 square feet. ... The Houghtons, well past 70, do anything but cling to old-fashioned photographic gadgetry. Vern produces videos on High 8 tape, adding music and commentary; he also plans to upgrade and incorporate his computer in darkroom exploits...," *SMT*, Aug. 14, 1997, pp. B-1 and B-5.

■ "Vernon Houghton... 92... passed away July 23, 2004... Vernon was born March 11, 1912, in Hollister, Calif. to Jessie Fremont Sharp and James V. Houghton. He moved to Santa Maria in 1941. He was active in the First United Methodist Church, the YMCA, and began the Santa Maria Camera Club, in which he continued as an active member until his death. Vernon worked as a construction engineer and general manager at R. McGray Construction and later formed his own company, McGray Construction. He is survived by his daughters... He was preceded in death by his wife, Doris Iva Quick, in 2002 ...," *SMT*, July 25, 2004, p. 6.

■ "Death Notices... <u>Doris I. Houghton</u>, 88, Santa Maria, Dec. 28, 2002, Dudley Hoffman Mortuary," *SMT*, Dec. 29, 2002, p. 6.

<u>Houghton, Vernon (notices in Northern Santa Barbara County newspapers on microfilm and on newspapers.com)</u>
1960 – Repro: photo of wedding, *SMT*, Oct. 12, 1960, p. 4.
More than 310 notices for "Vernon Houghton" (including "Mrs. Vernon Houghton") and 80 matches for "Doris Houghton" in the *SMT* between 1945-65, most of which related to the Camera Club, but some of which related to other organizations of which he was a member (Y's Men, Quester Club of the Methodist church) were not browsed for inclusion here.

<u>Houghton, Vernon (misc. bibliography)</u>
<u>James Vernon Houghton</u> was b. March 11, 1912 in Hollister, Ca., to James V. Houghton and Jessie Fremont Sharp, married Doris Iva Quick, was residing in Kern, Ca., in 1935, and d. July 23, 2004 in Santa Maria, Ca., per Houghton Family Tree.
<u>Doris Iva Quick</u> was b. July 22, 1914 in Calhan, El Paso, Colorado, to George Martin Quick and Mary Ethel Denison, was residing in San Joaquin, Ca., in 1935, married James Vernon Houghton and d. Dec. 28, 2002 in Santa Maria per Houghton Family Tree; ports. in *Public Member Photos & Scanned Documents* (refs. ancestry.com).
<u>See</u>: "Santa Barbara County Fair," 1958, 1959, 1960, "Santa Maria Camera Club," 1947, 1949, 1952, 1954, 1955, 1957, 1958, 1960, 1962

Houk, LaVerne Alta Stephens (Mrs. George Edward "Eddie" Houk) (Lompoc)
Member Puttering Micks Ceramics group. Ceramic enthusiast, 1956. Her husband appears to have been a race car driver.
See: "Ceramics," 1956, "Puttering Micks," 1958

Houpt, William S. (Santa Maria)
Dean of Hancock College. Painter, amateur, who exh. at Allan Hancock [College] Art Gallery, 1955.
See: "Allan Hancock [College] Art Gallery," 1955, 1956

House, Howard Elmer (1877-1969) (Midwest / Solvang / South America / Oregon)
Landscape painter active in Santa Ynez Valley, 1928, 1931.
■ "H. Elmer House. Portrait artist H. Elmer House, 3809 NE Skidmore St., died Monday at his home … A native of Manhattan, Kan., Mr. House attended art schools in Kansas and Chicago. He worked for the Chicago Portrait Co. in Chicago and Brazil for several years before moving to Portland in the 1930s. He was associated with Midwest Studios here and painted portraits of a number of Portland's prominent people. Many of his landscapes and other paintings also are found in Portland homes. He was a member of the Oregon Society of Artists and the First Church of Divine Science. Survivors include his wife, Augusta W….," *Oregonian*, April 2, 1969, p. 33 (i.e., 4M or 6?)
House, Elmer (notices in Northern Santa Barbara County newspapers on microfilm and on newspapers.com)
1928 – HE House. "Brazilians Visit Valley. Mr. and Mrs. H. E. House and **John J. Graham** of Sao Paula, Brazil, are guests at the **John Frame** home this week. They are on their four months' vacation and plan to return to Brazil in August where they will resume their work of landscape painting and portrait work. They plan to come back next year to locate in our beautiful valley, where they will plant a walnut orchard, with which they have had considerable experience. Mr. House on his return to this state next year will make paintings of all the old Missions in California. He will make several of the Santa Ines Mission at Solvang," *SYVN*, June 15, 1928, p. 1; "Mr. and Mrs. H. E. House and **John J. Graham** of Sao Paulo Brazil, were guests… They were formerly of Chicago but have been in Brazil for several years, being employed in landscape painting and portrait work. They are enjoying a four months' vacation in the United States and will return to South America in August. They are to return next year to make their home," *SMT*, June 20, 1928, p. 5; "News Items from Brazil. **Mrs. J. H. Forsyth** was hostess at a bridge party given at her home in Sao Paulo, Brazil on Saturday September 28th. The guests being ……. Mr. and Mrs. H. Elmer House, and **Mr. and Mrs. John Graham**… Mr. House, **Mr. Forsyth** and **Mr. Graham**, who are artists with the Companhia Artistica Americana, are all California boosters and also land owners in beautiful Santa Ynez Valley. So, it was decided upon to meet regularly as the Santa Ynez Bridge Club…," and information about the **Graham** family, *SYVN*, Nov. 2, 1928, p. 1.

1931 – "Artist Locates in Valley. Will Paint Scenes Here. Mr. and Mrs. Elmer House arrived last week from Sao Paula [Sic.], Brazil, and will make their home in this valley where they own twenty-six acres of land on Refugio road. They have rented the Skyd (?) residence. Mr. House is an artist and plans to open a studio here. He is going to make many paintings of Santa Ynez Valley scenes and also of all the Missions in California," *SYVN*, Jan. 16, 1931, p. 1; "Fine Paintings Shown to Guests at **Frame** Home… Mr. Elmer House who has recently returned from a stay in Brazil, showed the guests a number of beautiful paintings he had made in this state and in Arizona…," *SYVN*, Feb. 27, 1931, p. 10; "Artist's work is Exhibited [at home of] **Mr. and Mrs. John Frame**…," *SMT*, March 7, 1931, p. 3; "Artist Visits Carmel. H. E. House… who has been living here for the past three months painting the beauty spots of the Santa Ynez Valley and over the San Marcos Pass, motored last week to Monterey, Carmel, accompanied by Mrs. House, and returned on Sunday evening. They claim the weather was ideal and Mr. House brought back some beautiful sketches which he made while there and will display some of them at different times in Solvang …," *SYVN*, April 17, 1931, p. 10; "**Better Homes Week**… Saturday, May 2nd, a Better Homes exhibit will be held at the Legion hall from 2 to 4:30 o'clock in the afternoon. Exhibits will include paintings by Elmer House, cut flowers, remodeled furniture, slip covers and hand work…," *SYVN*, April 24, 1931, p. 1; "Noted Artist Will Exhibit Painting at Spring Show. Elmer House, New Established at Solvang, to Paint Many Pretty Scenes in Lompoc Valley. Visitors to the Lompoc Spring Flower Show to be staged at the High School Auditorium next Saturday and Sunday will have the privilege of viewing a canvas painted by an internationally-known master of the brush … it is believed that a scene of the San Marcos Pass, just completed, would be the subject chosen. A painting of the Four Corners district as seen from the hills east of that locality completed three weeks ago, would have been the painting to be exhibited but was sold to a Monterey woman a few days ago. It is possible that Lompoc residents will soon have the opportunity of seeing **Mission La Purisima** Concepcion limned on canvas by Artist House's facile brush… to be one of Mr. House's subjects in the very near future. Elmer House also will paint the Mission as it was … acquiring his conception of the historic pile from a small painting now on display in La Purisima Inn," *LR*, May 15, 1931, p. 8; "About People… Those who have visited the Santa Ynez Valley Bank for the past several weeks have had the privilege of seeing the fine oil painting done by Elmer House, our local artist. Every week a new painting is being displayed of the valley or a scene along the coast," *SYVN*, June 19, 1931, p. 8; "Oil Painting of 'Spring Time on the Alisal' is Displayed at Valley Bank… 24 x 36 of the Alisal rancho…," *SYVN*, July 10, 1931, p. 1; "E. House Completes New Painting of the **Mission Santa Ines**… He has caught the restful feeling of the old mission setting in the peaceful Santa Ynez Valley… Passing by it two or three times daily for the past seven or eight months has put him in a position to know the old Mission Santa Ines as it appears today. The mission has taken on many changes within the past few years… shrubbery… 'The Old Santa Ines Mission of Today' will be exhibited for the first time

to the public at the Country Fair in Los Olivos Saturday, September 12," *SYVN*, Sept. 4, 1931, p. 1; "Dr. Menne to Have New Location here… remodeling the rooms formerly occupied by Elmer House, artist…," *SYVN*, Nov. 13, 1931, p. 1.

1932 – "**Mrs. S. K. McMurray** gave a delightful tea at her home in Buellton on Tuesday afternoon honoring Mrs. Fauerso. A painting of Gaviota Pass, done by Elmer House, was presented Mrs. Fauerso by the guests…," *SYVN*, Jan. 15, 1932, p. 1.

1939 – "Mr. and Mrs. Elmer House of Portland, Oregon, visited friends here this week. Mr. House operated a studio here six years ago, painting many pictures of scenes in the valley. They own a tract of land on Refugio road," *SYVN*, June 23, 1939, p. 10.

1944 – "Elmer House of Portland, Oregon, was a visitor in the valley this week, a guest in the home of Mr. and Mrs. **John Frame**. … Mr. House owns a 30-acre tract on Refugio Road," *SYVN*, July 14, 1944, p. 1.

House, Elmer (misc. bibliography)
Howard E. House is listed in the 1940 U. S. Census as age 63, b. c. 1877 in Kansas, finished elementary school 8th grade, an artist working for Commercial Portrait Co., was residing in Portland, Oregon (1935, 1940), with wife Mabelle E. (age 59); Howard House b. Feb. 5, 1877, d. March 1969 in Portland per Social Security Death Index (refs. ancestry.com).
See: "Art Loan Exhibit (Solvang)," 1935, "Better Homes Exhibit," 1931

House of Charm (Santa Maria)
Interior decorating business, 1949-50 run by Katherine West and her son.
1948 – "Death Takes Resident of San Luis Obispo. Anson West, widely known San Luis Obispo merchant… died… He established West's House of Charm …," *SMT*, June 14, 1948, p. 6.
Many ads for the House of Charm appear in the *SMT*, 1949, 1950, but were not itemized here.
See: "West, Katherine"

Houston, Rolla Francis (1903-1971) (Santa Maria)
Photographer. Active with the Santa Maria Camera Club, c. 1941-47. Gunsmith.
■ "Rolla F. Houston. Redding – A funeral service was conducted today … at Redding for Mr. Rolla F. Houston, 68, former resident of Santa Maria, who died Oct. 9 in a Redding hospital… Mr. Houston was born Aug. 20, 1903 in Madera and had lived in Shasta County 16 years. He was a semi-retired boat repairman … Survivors include his widow, Edna…," *SMT*, Oct. 12, 1971, p. 2.
Houston, Rolla (notices in Northern Santa Barbara County newspapers on microfilm and on newspapers.com)
1947 – "Houston Sells His Gun Shop Interest. Rolla Houston announced today that he has sold his half interest in the Gun Shop, located at the corner of East Church and South Vine …The sale consummates a partnership of about three and a half years for the two men. Allinson originally was whole owner, then sold half interest to Houston. Houston stated that he was leaving late today for the High

Sierras… for some hunting and fishing. He stated he had no plans for the future," *SMT*, Sept. 18, 1947, p. 5.
1948 – R. E. "Werst, Houston Open 'Outdoorsman' Shop… outdoors and sporting goods store at 613 East Main street today… finished on the inside in knotted pine… Houston, a gunsmith, offers service in building guns to order, bluing gun barrels and making repairs and changes in weapons to suit the owner…," *SMT*, May 22, 1948, p. 8.
1953 – "Dick Trefts Proudly announces his ownership of the Texaco Service Station formerly owned and operated by Rolla Houston…," *SMT*, July 31, 1953, p. 3.
And more than 40 hits for "Rolla Houston" and more than 60 for "Rollo Houston" in the *SMT* between 1938 and 1971, relate primarily to his activities with the Santa Maria Camera Club, are reported with the Club activities, and were not itemized here.
Houston, Rolla (misc. bibliography)
Rollo [Sic. Rolla] F. Houston is listed in the *Santa Maria, Ca., CD*, 1938; Rolla F. Houston was b. Aug. 20, 1903 in Madera, Ca., to George Francis Houston and Nettie Fern Renfro, married Edna Dorothy Colby, was residing in Santa Maria, Ca., in 1942, and d. Oct. 9, 1971 in Redding, Ca., per McDonald Family Tree (refs. ancestry.com).
See: "Santa Maria Camera Club," 1941, 1942, 1943, 1945, 1947

Howard, Doris Overman (Mrs. Edward MacLaren Howard) (1892-1973) (Santa Barbara)
Santa Barbara artist who exh. in a show of Santa Barbara artists sponsored by the College Art Club at city hall, Santa Maria, 1935.
■ "Calaveras Conservationist Doris O. Howard, 80. Mokelumne Hill… well-known artist and constructionist [?]… Mrs. Howard died Saturday in a local convalescent hospital. Her painting of the Sequoias in the South Grove of the Calaveras Big Trees State Park was sold throughout the United States to raise funds to save the South Grove. The grove became a state park five years ago. Mrs. Howard, a graduate of Stanford University, was a member of the California Save the Grove Association, Calaveras Garden Club and Calaveras Art Association…," *Sacramento Bee*, Jan. 9, 1973, p. 21 (i.e., C3).
■ "Born in California on Aug. 5, 1892. While a resident of Santa Barbara during 1923-36, Overman was active in the local art scene and employed in the art department of the *Daily News*. In 1926 she wed Ed Howard. She died in Calaveras County, CA on Jan. 6, 1973. Exh: Oakland Art Gallery, 1936," per Edan Hughes, *Artists in California, 1786-1940* from askart.com.
Howard, Doris (misc. bibliography)
Doris Howard is listed with husband Edward in the *Santa Barbara, Ca., CD*, 1927-43; Doris Howard b. Aug. 5, 1892 in Calif. d. Jan. 6, 1973 in Calaveras County was married to Edward MacLaren Howard, and is buried in Gilliam Cemetery, Graton, Sonoma County, Ca., per findagrave.com (ref. ancestry.com)
See: "Art Loan Exhibit (Solvang)," 1935, "College Art Club," 1935

Howard, Fred (Santa Maria)
Chalk talk artist, 1928.
See: "Chalk Talks (Northern Santa Barbara County)," 1928

Howard, Leonard Richard (1891-1987 in England) (Kent, Conn.)
Artist of stained-glass windows in St. Peter's Church, 1935.
See: "Stained Glass," 1935

Howell, Charley E. (Santa Maria)
"Charley the Painter." Painter: sign, decorative, grainer, house, 1884-86.
Howell, Charley (notices in Northern Santa Barbara County newspapers on microfilm and on newspapers.com)
1884 – "Charley the painter has located in Santa Maria and now is the time to secure fine work. Sign painting and artistic work a specialty," *SMT*, June 7, 1884, p. 5; "Charley the painter who swings the artistic brush can be found at Crosby's. In sign writing and graining he can't be beat," *SMT*, July 26, 1884, p. 5; "Charley the painter, has just completed a shop opposite Cook's stable, 18 x 48. He is now ready to take orders for sign, carriage and ornamental painting," *SMT*, Oct. 18, 1884, p. 5; "Knights of Pythias Ball … On entering the hall, a beautiful sight met the eye, the hall having been arranged very tasty. Drawn across the stage and suspended from the ceiling was a finely painted drapery, painted in the colors of the order, blue, yellow and red, bearing the words: 'Friendship, Charity and Benevolence,' two emblems of the order and 'K. of P., No. 90.' This being a masterpiece of workmanship executed by Charlie the Painter and designed by **L. Hertz**," *SMT*, Nov. 22, 1884, p. 5.
1885 – "Charley (the Painter) E. Howell, To the Public. Having connected with me now a first-class house painter, grainer, etc., we will be prepared to do all work in carriage, sign writing, house decorative work in general. Trusting I have pleased in the past we will endeavor to meet your approval in the future. Charley, the Painter," *SMT*, Jan. 24, 1885, p. 8.
1886 – "B. F. Bell has leased the building formerly occupied by Charley the Painter…," *SMT*, April 24, 1886, p. 5.
1951 – Probably distinct from "Charley the Painter" who advertised in the *Pasadena Independent*, 1948-52
This individual could not be further identified.

Hoyer, Fred (1886/87-1956) (Solvang)
Interior decorator. Artist. Contract painter. Decorated Village Inn, 1949.
■ "Fred Hoyer Rites Held… Mr. Hoyer, a resident of Solvang the past 13 years was a native of Denmark. He was born July 10, 1886. He served in World War I and lived in Chicago for many years before moving to Solvang. When in Chicago he was associated with Marshall Field for many years and was head of that large department store's interior decorating department. While a resident of the Valley, he engaged in commercial painting. As a hobby, Hoyer spent much time working with his oil paintings. He was an

accomplished artist. Mr. Hoyer leaves his wife, Mary, who operates Hoyer's Dinner House in Solvang, a daughter, Helen, and a stepson, Ronald Stinar," *SYVN*, May 11, 1956, p. 5.
Hoyer, Fred (notices in Northern Santa Barbara County newspapers on microfilm and on newspapers.com)
1949 – "Fred Hoyers to Open Village Inn … now known as Fredericksen's Village Inn… completely redecorated by Mr. Hoyer, who is known throughout the country as an outstanding decorator and mural painter… Both Mr. and Mrs. Hoyer have had considerable experience in 'meeting the public.' Mr. Hoyer was for 10 years superintendent of the building and decorating department of Marshall Field's department store in Chicago. He was later assistant manager of one of the Goldblatt Bros. large department stores in Chicago," *SYVN*, Nov. 4, 1949, p. 1.
Hoyer, Fred (misc. bibliography)
Fred A. Hoyer, laborer without address, is listed in the *Solvang, Ca., CD*, 1947 and the *Santa Maria, Ca., CD*, 1948; Fred Hoyer b. July 10, 1886 in Other Country, mother's maiden name Hansen, d. May 3, 1956 in Santa Barbara County per Calif. Death Index; Fred Hoyer b. 1887 and d. 1956 is buried in Solvang Cemetery per findagrave.com (refs. ancestry.com).

Hubbard, Terry (Santa Ynez)
Student at Santa Ynez High School who entered art in the Scholastic Art Exhibit, 1949. Active in high school Little Theater. Musically inclined. Engineer / designer with Douglas Aircraft, 1957.
■ "Terry Hubbard Receives Degree… son of Mr. and Mrs. Raymond Hubbard of Santa Ynez, was graduated June 11 from California Polytechnic College in San Luis Obispo with a degree as an aeronautical engineer. Hubbard, a graduate of Santa Ynez Valley Union High School, has accepted a position with Douglas Aircraft in Santa Monica as an engineering designer," *SYVN*, June 21, 1957, p. 2.
See: "Scholastic Art Exhibit," 1949

Hudson, Marie Antoinette (Mrs. Oliver Hudson) (1910-1997) (Santa Maria)
Jewelry maker. Chairman of Community Club art group, 1950.
■ "Making earrings in original flower designs is Mrs. Oliver Hudson's hobby, the sales outlet is several local shops, which has brought in money to pay expense of a three-week vacation trip to the east coast and into Canada. The floral earrings Mrs. Hudson makes are designed with replicas of small type millinery flowers. They are in demand by the dress shops, whose customers are in the market for sets to be worn by brides and their attendants, or for individual sets to match summer dresses. Mrs. Hudson is traveling while on vacation from the Radio Record Center. Her hobby of earrings, occupies her free time at home. Leaving this week, Mrs. Hudson is taking the trip by train. She'll be accompanied by her younger daughter, Teri, and is planning to go direct to Norfolk, Va., where she will visit her son-in-law and daughter, Mr. and Mrs. Ed. Teixeira. A stop-over is arranged in New York City, and the trip into Canada is to take in Lake Louise. The Hudsons

will also see the scenic American northwest, coming home by way of Washington and Oregon," and port. and "Posy Jewel is Hobby," *SMT,* May 25, 1954, p. 4.

■ "Marie A. Hudson... Arroyo Grande... Mrs. Hudson was born Jan. 26, 1910 in Oakland. She was a resident of Arroyo Grande for four years, formerly of Santa Maria from 1946 until 1958, Salinas from 1958 until 1968, and Hawaii for 10 years prior to moving back to Santa Maria. Mrs. Hudson was a former member of the Santa Maria Community Club, and a former hostess at Rick's restaurant, now Central City Broiler, for eight years. Survivors include her sons...," *SMT,* April 24, 1997, p. 7.

Hudson, (misc. bibliography)
Marie Antoinette Hudson b. Jan. 26, 1910, d. April 22, 1997 and is buried in Santa Maria Cemetery District per findagrave.com (refs. ancestry.com).
See: "Community Club (Santa Maria)," 1950

Hudson, Robert "Bert" "Bob" Logan (1871-1969) (Guadalupe / Tepusquet / various Calif. cities)
Exh. two crayon drawings at "Santa Barbara County Fair," 1889, 1890, 1891. Commercial artist in Berkeley, 1907-09, in Santa Barbara, 1910, in Los Angeles, 1913, in San Diego, 1915-16, and possibly other Calif. towns.
Hudson, Bert (misc. bibliography)
Is he Robert L. Hudson listed in the 1880 U. S. Census as age 8, b. c. 1872 in Calif., residing in Guadalupe with his parents William Hudson (age 39) and Eliza J. Hudson (age 34) and 6 siblings; Robert L. Hudson, artist, Sierra Art and Engr. Co., Berkeley, is listed in the *SF, Ca., CD,* 1907, 1908, 1909; Robert L. Hudson is listed in the 1910 U. S. Census as age 38, b. c. 1872 in Calif., a commercial artist, residing in Santa Barbara with his mother Eliza and sister Susan, a teacher; Robert Logan Hudson, 38, Draughtsman and Dem., residing at 1213 Garden St., is listed in *Calif. Voter Registrations, Santa Barbara Precinct No. 9,* 1910; Robert Hudson, artist, is listed in the *Los Angeles, Ca., CD,* 1913; Robert L. Hudson, artist, is listed in San Ysidro in the *San Diego, Ca., CD,* 1915, 1916; Robert L. Hudson b. Oct. 17, 1871 in Morro Bay, d. Feb. 28, 1969 in Newport Beach, Ca. and is buried in Santa Maria cemetery per findagrave.com refs. ancestry.com).
See: "Santa Barbara County Fair," 1889, 1890, 1891, and *San Luis Obispo Art and Photography before 1960*

Hudson, Robert (Lompoc)
Photographer with Navy, 1952.
■ "Home on Leave – Robert Hudson, PHAN, is expected home... prior to beginning a new a new Navy assignment. Hudson has been stationed at the U. S. Naval Station in Pensacola where he attended a photographer school. He is now assigned to the Alameda Naval Air station," *LR,* May 15, 1952, p. 14.
Hudson, Robert (notices in Northern Santa Barbara County newspapers on microfilm and on newspapers.com)
1952 – "Hudson Families Picnic... To speed their son, Robert, on last lap to Alameda where he will be stationed at the Naval Air Base, Mr. and Mrs. Jack Hudson and family gathered Saturday afternoon at Hope Ranch Park for a picnic. Robert, who has been attending the School of

Photography at the Naval Air Base at Pensacola, Florida, since Christmas, has been assigned to the school at the Alameda Base and left Sunday for his station...," *LR,* May 29, 1952, p. 5.
Hudson, Robert (misc. bibliography)
Is he Robert A. Hudson listed in the 1930 U. S. Census as b. c. 1928 in Calif., residing in Lompoc with his parents Jack W. Hudson (age 27) and Louise Hudson (age 25) and older brother Jack (age 3); Robert Arthur Hudson who provided the following information on his WWII Draft Card dated Jan. 27, 1946 = age 17, b. Jan. 29, 1928 in Lompoc, currently in high school or working for high school, residing in Lompoc with his parents; Robert A. Hudson, student, is listed in the *Santa Maria, Ca., CD,* 1948; Robert A. Hudson, no occupation, is listed in the *Santa Barbara, Ca., CD,* 1955 (refs. ancestry.com).

Huebner, Lillian (Mrs. W. H. [or J.] Huebner) (Santa Cruz)
Art chairman, California Federation of Women's Clubs, who lectured to the Alpha Club, 1951.
See: "Alpha Club," 1951, "Community Club (Santa Maria)," 1951, "Penny Art Fund," 1951, and *Atascadero Art and Photography before 1960*

Huebner, Mentor (1917-2001) (Los Angeles)
Artist, one of whose works was sent by his LA gallery for display in the Santa Maria Valley Art Festival, 1953.
■ "Mentor Huebner was a leading Hollywood production illustrator who did storyboards, production art and creative concepts for more than 250 films, including King Kong, Blade Runner and Francis Ford Coppola's Dracula," per Wikipedia.
See: "Santa Maria [Valley] Art Festival," 1953

Huff, Elizabeth H. (Hoag?) (Mrs. Calvin A. Huff, divorced) (c. 1898-after 1965) (Santa Maria)
Collector of antiques who exhibited them at local Hobby shows. Member of Jeanne DeNejer's sketching excursions that led to the formation of the Santa Maria Art Association, 1945. Director of the local Welfare department and county chairman of public health for the California Federation of Women's Clubs, 1939.
See: "Santa Maria Art Association," intro

Huffman, Ida Mae
See: "Chester (Huffman) (Purcella?), Ida Mae (Mrs. Fred Huffman) (Mrs. Purcella?)"

Hughston, C. (Cornelius?) B. (Lompoc / San Luis Obispo)
In 1892 exhibited Best photographs at "Santa Barbara County Fair," Lompoc. Performed in amateur theater, 1892. Associated in various ways with the newspaper industry?
Hughston, C. B. (notices in Northern Santa Barbara County newspapers on microfilm and on newspapers.com)
1894 – "Mr. C. B. Hughston, foreman of the *Record* office, announces himself as a candidate for County Recorder… Mr. Hughston is a young man of superior qualifications and will make a most excellent Recorder or official of any kind requiring fine clerical work. He is a nephew of the Hon. Myron Angel of San Luis Obispo," *LR*, Aug. 4, 1894, p. 3.
See: "Santa Barbara County Fair," 1892, and *San Luis Obispo Art and Photography before 1960*

Hunt, Evelyn Dilly
See: "Nadeau, Evelyn"

Hunt, Leroy (Santa Barbara)
Prop. of Hunt's China Shop in Santa Barbara, who spoke to Alpha Club, 1942.
See: "Alpha Club," 1942, "Solvang Woman's Club," 1951

Hunt, (Mary) Louise Lewis (Mrs. Bob Hunt) (1914-1998) (Lompoc)
Art and Homemaking teacher at Lompoc High School, 1955. President of Lompoc Teacher's Club, 1960.
■ Port. "Louise Hunt… 84, of Solvang died July 4 at Santa Ynez Valley Cottage Hospital after a long illness. She was the wife of Bob Hunt and a resident of the Santa Ynez Valley for 51 years. She was born Mary Louise Lewis in Watsonville on Feb. 11, 1914 to Harry H. and Mary G. Lewis. She was raised in the Spring Valley area near San Diego and graduated from Grossmont High School. She attended Santa Barbara State Teachers' college and married Robert L. (Bob) Hunt Sept. 7, 1935. Following her graduation in 1936, they lived in Davis and in 1937 moved to Riverside. For two years she worked as a social worker with the California State Relief Administration. In 1947 the family moved to the Santa Ynez Valley where they farmed. In 1955 she began a 22-year teaching career with the Lompoc School district, 20 of which she spent as a kindergarten teacher. [The other two at Lompoc High School.] In 1992 the Hunts moved into the Solvang Lutheran Home. Louise Hunt was a member of … [many organizations]. She was well known as a gracious hostess, an excellent cook and seamstress… She is survived by her husband of 62 years, Bob Hunt…," and many children and grandchildren, *SYVN*, July 9, 1998, p. 3.
Hunt, Louise (misc. bibliography)
Port. in Lompoc High School yearbook, 1956 (ref. ancestry.com)
See: "Lompoc, Ca., Union High School," 1955

Huntington, Harold (Santa Maria)
Student photographer for Santa Maria high school who was a guest at Santa Maria Camera Club meeting, 1940. Ceramics demonstrator at Santa Maria Valley Art Festival, 1953.
Port. as deputy district tax assessor, *SMT*, Oct. 29, 1956, p. 1.
More than 80 notices in *SMT* between 1935 and 1960 show he was with the military police (1943), and served as county assessor and District Boy Scout Commissioner (1958) but were not itemized here.
See: "Santa Maria Camera Club," 1940, "Santa Maria [Valley] Art Festival," 1953

Huntoon, Alice Winston Adams
See: "Newcomb (Huntoon), Alice Winston Adams (Mrs. Harry "Hal" Howard Newcomb) (Mrs. John Wesly Huntoon)"

Hutchinson, Amory Hare (Mrs. James Pemberton Hutchinson) (1885-1964) (Los Olivos)
Painter. Westerly ranch. Exh. annual Santa Ynez Valley Art Exhibit, 1952-55, 1957-58. Exh. Allan Hancock [College] Art Gallery, 1955, and other venues.
■ "Amory Hare Hutchinson. … death last Wednesday afternoon of Amory Hare Hutchinson of Westerly Stud, Los Olivos… An Easterner by birth and member of a family whose ancestry could be traced to the earliest Colonial days, Amory Hare Hutchinson came to the Valley a quarter of a century ago… A person of many talents, horsewoman, thoroughbred horse breeder, author, poet and artist … Through the years she was a frequent contributor to the Letters to the Editor column of the *Valley News*…," *SYVN*, July 30, 1964, p. 12.
■ "Funeral Services… Mrs. Hutchinson died last Wednesday afternoon… at her ranch home following an illness since last April. Mrs. Hutchinson, one of the prime movers behind the … California Thoroughbred Breeders Assn., and a one-time officer of the group, came to the Santa Ynez Valley in 1939 from Media, Pa. and built Fairhaven, later owned by **Mr. and Mrs. Palmer T. Beaudette**. In 1942 she purchased the 220-acre ranch which was to become Westerly, determined, as she said in an interview a few years ago 'to get well by restoring this old house and eventually building my own racing stable.' … Her stories have been published in national magazines and her TV plays starring Charles Boyer are now in their 10th rerun. She was a member of the Author's League, Poetry Society of America, Academy of American Poets and the Screen Writer's Guild. … provided *Valley News* with the following biographical sketch… It originally appeared in April 1935 in *Town and Country Review*… [English upper class ancestors. Amory Hare, after whom she is named, was active in Philadelphia at the time of the American Revolution. Her father was a physician…] Love of the out-of-doors… [Her novels and poems are frequently agrarian in theme.] Facile with the brush … she has shown landscapes, hunting scenes and other rural subject paintings at many exhibitions; she also executes murals for trophy rooms and has sold many canvases to appreciative

connoisseurs. ... Amory Hare's home is at Rocky Springs Farm, Media, Pa. Her husband, Dr. James P. Hutchinson, distinguished himself in the world war in charge of those hospitals of which Neuilly was the center," *SYVN*, July 30, 1964, p. 5.

■ "'Tale of 'Westerly' Recounted by '*Thoroughbred*' *Magazine*. Mrs. Amory Hare Hutchinson's Westerly, regarded as one of the outstanding thoroughbred horse ranches in this area ... with two pages of pictures and a descriptive article by John Monte LeNoir in the August issue... LeNoir said, 'Rancho el Bosque del Alamo Pintado probably does not mean a thing to the average person unless he is a student of early California history. [later named Westerly] ... The ranch comprises 240 acres of verdant, rolling land upon which there is an olive orchard of 400 trees. Mrs. Hutchinson acquired the property from the estate of A. S. Boyd, the original owner. The house was built in 1886 and the olive orchard planted in 1891. The owners' quarters had not been occupied for twenty years when Mrs. Hutchinson took over. With the deft touch of the artist and lover of all that is beautiful, she figuratively rolled up her sleeves and began the transformation of the property. ... 61-year-old house. From the living room one looks out over a vista of rolling acres dotted with ancient live oaks ... Mrs. Hutchinson has started in a modest way to build up her Thoroughbred breeding stock. ... The story of Westerly ... is the story of a woman, a talented and gracious lady, painter, author, playwright, who all of her life has loved a horse for himself and not for what his earning on the track may be. ... as soon as I was old enough to hold a bridle... At the age of eight she was winning classes at Devon and Bryn Mawr with her skewbald pony, Mikado ... While still in her 'teens she showed hunters at the Eastern shows...," *SYVN*, Sept. 12, 1947, p. 10.

Hutchinson, Amory Hare (notices in Northern Santa Barbara County newspapers on microfilm and on newspapers.com)
1945 – "Solvang Woman's Club... Mrs. Amory Hutchinson was the guest speaker and told of her interesting experiences in her travels over the Sahara," *SYVN*, Nov. 16, 1945, p. 1.
1946 – "Valley Farm Center Shows Fine Exhibit [at its Fair]... booth... built of brick with an arch formed by a huge horseshoe... in the background is a beautiful painting by Mrs. Amory Hare Hutchinson," *SYVN*, July 26, 1946, p. 1.
1949 – "The Memo Pad... Valley Views... Mrs. Amory Hare Hutchinson gives an artist's conception of last year's Big Snow here in a painting which adorns our office front window... it's kind of refreshing to see after last week's record 115...," *SYVN*, Sept. 30, 1949, p. 2.
1951 – "Valley Views... Thanks to Amory Hare Hutchinson of Westerly, one of her paintings of the Valley now adorns the wall of a Veterans' Administration Hospital in Cheyenne, Wyo.," *SYVN*, Feb. 9, 1951, p. 2.
1955 – "Memo Pad" discusses her recently published book of poems, '*Between Wars*,' Wings Press: Mill Valley, *SYVN*, June 3, 1955, p. 2.
1958 – "Hutchinson Art Work on Display.... In the lobby of **Andersen's Pea Soup** restaurant in Buellton. The exhibit, which includes portraits of well-known horses

presently running, including her famous Night Command, will continue through Sunday," *SYVN*, July 25, 1958, p. 1.
1960 – "**Library** Features Display of Art... oil paintings... for the next five weeks. Among them are several picturesque harbor scenes painted at Martha's Vineyard, Mass.," *SYVN*, Dec. 16, 1960, p. 5.
More than 260 notices for "Amory Hutchinson" in the *SYVN* between 1940-1964 were not all itemized here.
Hutchinson, Amory Hare (misc. bibliography)
Amory Hutchinson was b. Aug. 30, 1885 to Hobart Amory Hare and Rebecca Clifford Hare, married James Pemberton Hutchinson, d. July 22, 1964, and is buried in Oak Hill Cemetery, Ballard, per findagrave.com (refs. ancestry.com).
See: "Allan Hancock [College] Art Gallery," 1955, "Andersen's," 1958, "Danish Days," 1957, "Hosier, Roy," 1954, "La Petite Galerie," 1950, "Lompoc Hospital, Women's Auxiliary," 1952, "Santa Barbara County Library (Solvang)," 1959, 1960, 1962, "Santa Ynez Valley Art Exhibit," 1952-55, 1957-58

Hutchinson (Johnson), Barbara Adele (Mrs. Thomas Malcolm Johnson) (Santa Maria / Texas)
Photographer for Allan Hancock College yearbook, 1955. Darkroom technician for Santa Maria Times.

■ "Troth Told... Mr. and Mrs. Keith Hutchinson have announced the engagement of their daughter, Barbara, to Thomas Malcolm Johnson of Houston, Texas... The engaged couple met through Barbara's uncle and aunt... with whom she had visited in Houston for several months... Miss Hutchinson was born in Fresno and attended elementary school there before moving to Southern California... She is a graduate of Covina Union High school and attended Fresno State college for one year. When her family came to Santa Maria, she enrolled at [Allan Hancock College, where] along with her class room studies she was cheer leader and did photo laboratory work for the college paper and year book. Photography has been one of Barbara's main interests. She was employed by *Santa Maria Times* as [photo] lab assistant and in Houston worked with one of that city's leading portrait studios," *SMT*, June 24, 1956, p. 5.
Hutchinson, Barbara (notices in Northern Santa Barbara County newspapers on microfilm and on newspapers.com)
1955 – "The Tattlin' Tongue... [photos of Camp Talaki taken by *SM Times* photographer, **Gardner Boyd**] ... Once darkroom technician Barbara Hutchinson had developed the negatives more problems arose... [to identify the Camp Fire Girls in the pictures]," *SMT*, July 9, 1955, p. 6; port. planting flower bulbs, *SMT*, Sept. 16, 1955, p. 5.
See: "Allan Hancock College," 1955

Huyck, Loiz (Mrs. Maurice Huyck) (Lompoc)
See: "Lord (Huyck), Loiz Whitcomb Rhead"

Huyck, Marie Edna Pierce (Mrs. Lloyd Dumas Huyck) (1897-1994) (Lompoc)
Craftswoman, 1948; ceramic student of Viola Dykes, 1949. Designer of floral arrangements, late 1940s. Judge of Poppy posters, 1958.
Huyck, Marie (notices in Northern Santa Barbara County newspapers on microfilm and on newspapers.com)
1960 – Port as child, Marie Pierce, with her family fishing in 1905, *LR*, Sept. 1, 1960, p. 22.
And, more than 50 matches for "Marie Huyck" and more than 340 for "Mrs. Lloyd Huyck" in the *LR* between 1930 and 1960, often for working on decorating committees, for her flower arrangements, and for her bridge playing, were not itemized here.
Huyck, Marie (misc. bibliography)
Marie E. Huyck, mother's maiden name Kerr and father's Pierce, was b. March 10, 1897 in Calif. and d. May 27, 1994 in Santa Barbara county per Calif. Death Index; Marie E. Huyck is buried in Lompoc Evergreen Cemetery per findagrave.com (refs. ancestry.com).
See: "Alpha Club," 1949, 1952, "Hobby Show - Kiwanis (Lompoc)," 1948, "Homrig, Hal," "Lompoc Community Woman's Club," 1955, "Lompoc Valley Historical Society," "Open Air Art Exhibit," 1957, "Posters, American Legion (Poppy) (Lompoc)," 1931, 1958

Hyde, Otis Edwin, Prof. (1880-1953) (Lompoc / Long Beach / Campbell)
Teacher of drawing and athletics at Lompoc high school, 1916/17.
■ Hyde graduated Stanford University in 1904 and received a diploma in drawing, 1905. He married in 1909 and resided in Los Angeles from shortly before that date earning his living selling produce-related articles and teaching drawing, etc. in LA city schools. In 1916/17 he taught in Lompoc. In 1929 he was one of the founding members of the Spectrum Club of artists in Long Beach. He appears to have retired back to Campbell, Ca. by the mid-1930s, from which he sent artworks for exhibit to the Statewide exhibit of the Santa Cruz Art League, to the California State Fair in Sacramento and to other venues.
Hyde, O. E. (notices in California newspapers on microfilm and on newspapers.com)
1903 – "Juniors Nominate Officers. Stanford University… candidates … vice-president, Otis E. Hyde of Cupertino…," *SF Chronicle*, Sept. 16, 1903, p. 7.
1904 – World's Fair, St. Louis … "Otis E. Hyde is the only other member of the Stanford team that remained here. He is a son of Santa Clara's Fair Commissioner. He has not entered for the games of the 25th, as he realizes he is not in proper condition. His specialty is the shotput and he has a coast record of 45 feet 6 ½ inches for that event…," *SF Call*, June 23, 1904, p. 9, col. 2.
1905 – "Diplomas Awarded at Stanford… Drawing – Otis Edwin Hyde, Cupertino…," *SF Call*, May 25, 1905, p. 6.
1909 – "To Wed in South. The wedding of Miss Josephine Herron… and Otis Edward [Sic.] Hyde… Hyde graduated from Stanford in 1904 and his fiancée was a member of the class of 1906," *Oakland Tribune*, Dec. 19, 1909, p. 3; "Elsinore Wedding…," *LA Times*, Dec. 24, 1909, p. 25.

1911 – "Board of Education Clings to Purse Strings… Upon recommendation by the Committee on Teachers and Schools, the following substitute teachers were elected: … Otis E. Hyde," *LA Times*, Jan. 24, 1911, p. 7; "Assignment of the Pedagogues… Manual Arts High School … Physical Trigonometry Department … Otis E. Hyde…," *LA Times*, Sept. 2, 1911, p. 22 (pt. II, p. 6).
1913 – Ad: "Florida Sour Orange Seed a specialty – order now. Otis E. Hyde, Monrovia, Cal.," *Visalia Times-Delta*, April 23, 1913, p. 4.
1917 – "Prof. O. E. Hyde, manual training teacher of the local high school, came down from San Jose Tuesday evening where he has been spending the holidays," *LR*, Jan. 5, 1917, p. 5; "High School Board Considers Plan for Gym … Mr. Hyde had made a definite drawing of the proposed building. The board authorized him to submit the plans to the Santa Barbara architect, Mr. Pool, who built the manual training building and to ask for an estimate…," *LR*, March 30, 1917, p. 3.
1918 – "Change of School Heads, Teachers Recommended … for positions in city schools… Polytechnic Evening High school… Josephine Hyde, Otis E. Hyde…," *LA Evening Express*, Aug. 31, 1918, p. 3; "High School Students Studying War Work … Polytechnic Evening High… Otis E. Hyde, who taught charcoal drawing and poster work, is in Chicago training to go abroad as a recreational director. His wife is teaching in his place," *LA Evening Express*, Sept. 15, 1918, p. 10, col. 1.
1930 – "Mrs. Van Zandt … exhibit of the Long Beach Art Club … the work of association members … Otis Hyde …," *News-Pilot* (San Pedro, Ca.), Jan. 25, 1930, p. 6.
1933 – "Maurice Logan… annual water color exhibition… [Oakland Art Gallery?] … Otis E. Hyde – 'Los Gatos Hills' a well painted scene containing many trees and buildings, but they keep in their own planes," *Oakland Tribune*, Nov. 5, 1933, p. 40 (i.e., 8S).
1937 – Santa Cruz "Art League Members Holding Quarterly Exhibit … Otis Hyde of Campbell has an oil painting hanging which shows 'El Capitan' and the Yosemite Valley…," *Santa Cruz Evening News*, Nov. 9, 1937, p. 4.
1938 – State "Fair Has Fine Art Exhibit [complete catalogue listing] … 79. 'The Old Trading Post,' Otis E. Hyde, Campbell…," *Sacramento Bee*, Sept. 3, 1938, p. 15.
1939 – "Miss Cor de Gavere… motored to Stanford art gallery yesterday where they saw two of the Santa Cruz art leaguers exhibits. They belong to F. H. Cutting and Otis Hyde…," *Santa Cruz Evening News*, March 25, 1939, p. 3.
1951 – "Spectrum Club in Exhibition… 22nd anniversary… The club, which has 75 members … was formed Nov. 24, 1929 as a result of an idea which developed when Natt Piper, Robert Unsworth, William J. Wilson and Otis Hyde, friend and artists, were on a week end sketching outing…," *Independent Press-Telegram* (Long Beach, Ca.), Nov. 25, 1951, p. 4.
And approx. 20 additional notices in the *LR*, primarily concerning athletics, and more than 120 hits for "O. E. Hyde" in California newspapers, 1900-1953, were not itemized here.
Hyde, O. E.
A list of artworks exhibited at the Santa Cruz Art League appears in *Publications in California Art*, vol. 12.

Hyde, O. E. (from the Internet)
Otis E. Hyde participated in track events 1903-5 while at Stanford University, per trackfield brinkster online
Hyde, O. E. (from askart.com)
Hyde received a degree in drawing per Degrees Confirmed, May 24, 1905, *Fifteenth Annual Register, Stanford University*, Palo Alto, Ca., p. 228 and also announced in the *S. F. Call*, May 25, 1905, p. 6. Married Josephine Emelia Herron in Riverside on Dec. 22, 1909 per California County Marriages on family search website; listed 1910 U. S. Census as living in Santa Paula, Ventura County, Ca., with Josephine where both he and she were working as English teachers in a high school; register for WWI draft shows his wife was living in Los Angeles but that he was working as a physical director for the YMCA in Chicago…," and more on askart.com.
Hyde, O. E. (misc. bibliography)
Otis E. Hyde was b. May 15, 1880 in Calif. to George Edwin Hyde and Alice L. Hill, married Josephine E. Herron, was residing in Campbell, Ca., in 1935, and d. July 12, 1953 in Santa Clara, Ca. per Nicolas Dowling Family Tree; Otis Edwin Hyde is buried in Madronia Cemetery, Saratoga, Ca., per findagrave.com (refs. ancestry.com).
See: "Lompoc, Ca., Union High School," 1916

Hyland, William (Santa Maria)
Drafting teacher at Santa Maria Adult School, 1949. Employee of the City Engineer's office, 1949-50, City Planning Commissioner, 1951.

■ "Traffic Flow Survey… Doing the actual surveying is William Hyland, new employee in the city engineering department. Hyland is a graduate of the University of California with special training in city planning. He began his duties with the city July 1," *SMT*, July 30, 1949, p. 1.
1952 – "'round the town. Mr. and Mrs. William Hyland, 1015 Avon Place, South Pasadena, are parents of a daughter, Melissa Ann… The baby's father, formerly employed in Santa Maria city hall engineering department, is preparing to leave for England where he is to be employed by the U. S. government," *SMT*, Feb. 29, 1952, p. 4.
See: "Santa Maria, Ca., Adult/Night School," 1949, 1950

I

Ikeda, Victor Masu (1910-?) (Guadalupe)
Photographer, amateur. Member Santa Maria Camera Club, 1940.
Is he Victor Ikeda, interviewed by Richard Potashin, November 6, 2007, Manzanar National Historic site Collection, Densho, cited as footnote 80 in Shelley Sang-Hee Lee, *Claiming the Oriental Gateway: Prewar Seattle and Japanese America*. Is he the Victor Ikeda whose photographs are in the Densho Digital Repository per ddr.densho.org.
Ikeda, Victor (misc. bibliography)
Victor Ikeda is listed in the 1940 U. S. Census as age 30, b. c. 1910 in Washington, finished college 1st year, single,

residing in Seattle (1935) and packing vegetable produce and lodging in Guadalupe (1940); Victor Masu Ikeda provided the following information on his WWII Draft Card in 1940, b. Jan. 2, 1910 in Seattle, Wash., unemployed, residing with a friend, John Toshiyuki, in San Gabriel, Ca. (refs. ancestry.com).
See: "Santa Maria Camera Club," 1940

Imamura, Roy Tatsumi (1940-?) (Santa Maria)
Santa Maria High School student who won a certificate for his poster submitted to the Protect Wildlife contest at Stanford University, 1958. Exh. Allan Hancock [College] Art Gallery, 1957. Landscape architecture major at Cal Poly who grad. 1964.
Imamura, Roy (notices in Northern Santa Barbara County newspapers on microfilm and on newspapers.com)
1960 – "Student Accepted. Roy Imamura, son of Mr. and Mrs. Yasujiro Imamura… has been accepted as a landscape architecture major at the Kellogg campus of California State Polytechnic College," *SMT*, July 4, 1960, p. 2.
1961 – "Roy Imamura Gains Cal Poly Honor Roll … majoring in landscape architecture at Kellogg Campus …," *SMT*, July 27, 1961, p. 5.
1963 – "2 SM Students on Cal-Poly Honor List. Roy Imamura… is a senior majoring in landscape architecture, and the son of Mr. and Mrs. Roy Imamura, 3546 Dakota Dr.," *SMT*, March 6, 1963, p. 8.
1964 – "Imamura is Honor Student… He graduated as a landscape architect, with an overall college record of B plus," *SMT*, June 18, 1964, p. 13.
Imamura, Roy (misc. bibliography)
Is he Roy Tatsumi Imamura, mother's maiden name Arifuku, b. Feb. 8, 1940 in Santa Barbara county per Calif. Birth Index; Roy T. Imamura was relocated to Gila River (Pima, Sacaton) according to *Japanese Americans Relocated During World War II*; port. in Santa Maria High School yearbook, 1957; port. in Cal Poly yearbook, 1961; Roy Imamura is listed with no occupation at the home of his parents in the *Santa Maria, Ca., CD*, 1965; Roy T. Imamura, b. Feb. 8, 1940, was residing in Larkspur, Ca., in 1993 per *U. S. Public Records Index, 1950-1993*, vol. 1 (refs. ancestry.com).
See: "Allan Hancock [College] Art Gallery," 1957, "Santa Maria, Ca., Union High School," 1958

Immaculate Heart College (Los Angeles)
Students exh. Allan Hancock [College] Art Gallery, 1956.
See: "Allan Hancock [College] Art Gallery," 1956

Indian
See: "Native American"

Ingram, Phyllis Rowe (Mrs. James S. Ingram) (1917-?) (Santa Maria)
Artist, 1958. Art committee chairman AAUW, 1959. Photographer. Creator of table settings. Elementary school teacher.

■ "Mrs. J. S. Ingram, who was supervisor of art in Burlingame before teaching in Santa Maria elementary schools, is pictured here at work on the oil painting of a scene on Waller Franklin flower seed farms, to be sold to raise funds for the AAUW scholarships," and port. and statement she is local fellowship chairman of AAUW as well as an artist, *SMT,* Dec. 10, 1958, p. 6.
Ingram, J. S. (notices in Northern Santa Barbara County newspapers on microfilm and on newspapers.com)
1963 – Port. and teacher at Robert Bruce School will be honored for her services to AAUW, *SMT,* April 18, 1963, p. 5; County "Fair Judgings… New Winners Each Day in Table Setting… Phyllis Rowe Ingram… placed second with a 'July fourth' theme table for barbecue…," *SMT,* July 24, 1963, p. 2.
1964 – Port. "Mr. and Mrs. James Ingram. Trip to Europe… sailed June 15 from Long Beach aboard the *M. S. Moldanger* Inter-Ocean Line for Hamburg, Germany… The Ingrams plan to tour Europe and will return in the fall from London aboard the *M. S. Beranger*," *SMT,* June 15, 1964, p. 4; "Craft Show Winners Listed… Christmas Craft Contest and Exhibit staged at the Atkinson Park recreation center. The first annual affair… Division II (adults)… First Prize winners in this division were … Phyllis Ingram (ornaments 51 cents to $1.50 and mantelpieces) …," *SMT,* Dec. 17, 1964, p. 5.
1965 – "Fesler PTA … Panhellenic Meets… Travel pictures will be the entertainment… Wednesday at the home of Mrs. Charles Radaz… Mrs. J. S. Ingram, who made a trip to Europe last summer, will show the pictures on a projector," *SMT,* April 20, 1965, p. 4; County Fair "Photo Awards Announced… Animal life and nature study… second, Phyllis Ingram, Santa Maria," *SMT,* July 20, 1965, p. 10; County Fair "Table Setting Contest… Table-setting using pottery and harmonizing accessories in a 'California Wonderland' theme… Mrs. Phyllis Ingram… was second…," *SMT,* July 21, 1965, p. 8.
Ingram, J. S. (misc. bibliography)
Phyllis R. Ingram is listed in the *Santa Maria, Ca., CD,* 1958-83; Phyllis R. Ingram b. Feb. 18, 1917 was residing in Santa Maria in 1993 per *U. S. Public Records Index, 1950-1993,* vol. 1; Phyllis R. Ingram is listed in Santa Maria 1996-97 per *U. S. Phone and Address Directories* (refs. ancestry.com).
See: "American Association of University Women," 1958, "Fast, Nat," 1959

Interior Decoration (Northern Santa Barbara County)
General articles on interior decoration are listed here. Interior decoration was a frequent theme for lecturers to women's clubs. Most interior decorators came from larger metropolitan areas such as Santa Barbara and Los Angeles where they were employed by furniture stores or shops that sold items to decorate interiors.
Interior decoration was taught in high schools in the Domestic Science/Art programs and in adult schools.

Early "interior decorators" were certain house painters who were talented in painting fake wood and marble, in hanging wallpaper, and in advising on color choices for a room. In the mid twentieth century a few decorators opened shops only to find the local lifestyle did not support professional decorators.
Interior Decoration (notices in Northern Santa Barbara County newspapers on microfilm and on newspapers.com)
1938 – "Use of Color is Subject of Talk" by Mrs. Art Donaldson, to Forensic Club, "…there were more bright colors in homes in California than in homes in any other state, and that it is the fashion now to use bright colors in the home. Red roofs make houses seem lower, green makes them seem higher, she said, and a 'white house especially if surrounded by shrubbery, always seems larger'," *SMT,* June 14, 1938, p. 3.
1952 – "Something New for Amateur Interior Decorators," i.e., decals with Danish designs designed by Peter Hunt, noted artist, are available at Danish Village Gifts, *SYVN,* Jan. 25, 1952, p. 2.
1954 – "Faculty Wives Club… Mrs. Lois Robinson, decorator for a Santa Barbara company, spoke on 'Uses of Color and Wallpaper in the Home'," *SMT,* April 22, 1954, p. 6.
Many notices on "interior decoration" were not itemized here.
See: "Alpha Club," "Baker, Edna," "Basse, Lynn," "Better Homes Week," "Blue Lantern," "Blum, Maurice," "Blum's Interiors," "Burbank, Robert," "Carroll, Charles," "Case, Archie," "Corollo, Louise," "Dykes, Viola," "Edwards, Stanley," "Fredrickson, Mr.," "Herter, Albert," "Home Department of the State Farm Bureau," "House of Charm," "Hoyer, Fred," "Jeanotte," "Jones, Gaylord," "Junior Community Club," "Kern (Confer), Barbara," "Kiler, Leslie," "Lainhart, Grace," "Le Décor," "Leitner, Earle," "Lompoc Community Woman's Club," "Longinotti, Anthony," "McLaughlin, Dee," "Meredith, Margaret," "Minerva Club," 1948, 1954, 1955, "Murals," "Sailors, Patricia," "Scandinavian Arts and Crafts," "Swaney, James," "Teall (Fairley), Margaret," "West, Katherine," "Wileman, Edgar," "Wilson, Marie," "Winter Arts Program," "Wood, Louise"

Iron Art (Solvang)
Hand forged iron products. Shop active 1949-50 under joint prop. of Ernest Pedersen and Walter Kristensen and from 1950-69+ under Ernst / Ernest Pedersen.

■ "Iron Works Development Underway. Mr. and Mrs. **Ernst Pedersen** and **Walther Kristensen**, who came to the Valley a few months ago from Denmark to start an ornamental iron works plant, are going ahead with their plans and expect to have their shop completed within a few months. The plant will be located on the Jacob Roth property south of the high school. The Pedersens and Mr. Kristensen plan to make wrought iron clocks, ranch signs, door knockers, gates, lamps, and lanterns. Models for many of the items they plan to manufacture are original copies brought from Denmark. Several designs are worked out for prospective customers on paper. The customer chooses the design he likes best and then work is started on the manufacture of that item. At the present time the Pedersens

and Kristensen are kept busy making over their building which will house a manufacturing and designing room, a display room and office," *SYVN,* Jan. 28, 1949, p. 4.

Iron Art (notices in Northern Santa Barbara County newspapers on microfilm and on newspapers.com)

1949 – "All Danish Program Given by Solvang Woman's Club… On exhibition were antique copper, oil paintings and wrought iron products. These were shown by **Ernest Pedersen** and **Walther Kristensen** who recently arrived in the Valley from their native land to open a wrought iron works…," *SYVN,* Feb. 4, 1949, p. 4; "Solvang Men Turn Out Fancy Metal Articles" candelabra, weather vanes, clocks, light fixtures, *SMT,* July 7, 1949, p. 5.

1950 – "Iron Art shop Now in Solvang… opened a display shop in Copenhagen Square, Solvang, this week… **Ernst Pedersen** announced Iron Art will continue to maintain its workshop near Santa Ynez and will use the store in Copenhagen Square for display purposes. An open house at the new display store will be held Friday afternoon, Dec. 8 from 2 to 5 p.m.," *SYVN,* Dec. 1, 1950, p. 1.

1952 – Ad: Christmas greeting from "Iron Art" on Copenhagen Square, *SYVN,* Dec. 26, 1952, p. 4.

1954 – Ad: "The introduction of a mail order plan some time ago has proved successful with orders coming from all parts of the country… The shop sells Iron Art made to order for the customer, fire screens, clocks, tools, andirons, weather vanes, Danish imports, and antiques and other gift items," *SYVN,* Sept. 17, 1954, p. 53 (i.e., 11).

1955 – Ad: "Iron Art Gift shop, Ernst, Lili and Steven Pedersen," *SYVN,* Dec. 23, 1955, p. 5.

1961 – Photo of shop and "Sending Our Best Wishes – To Solvang. Ernest and Lili Pedersen and Steven came to Solvang from Copenhagen in 1948. Their business, Iron Art began on a small scale and Mr. Pedersen made to order and sold iron work at his home workshop. In 1950 the iron work and gift items were combined in a retail shop at Copenhagen Square… Since… has tripled in size. The business has grown to such proportions that most all the merchandise is imported with the exception of a few clocks still made by Mr. Pedersen, and some American Lines," *SYVN,* Sept. 22, 1961, p. 49 (i.e., 5?).

And more than 260 "hits" for "Iron Art" in *SYVN,* 1950-1965, and probably many more later, were not itemized here.

Ivy Gift Shop (Santa Maria)
Gift shop open during holiday season, 1937, 1938, 1939. Prop. was Lucille Hall.

■ "Gift Shop Opens Here Tomorrow. Mrs. Lucille Hall will open the Ivy Gift shop tomorrow at 119 East Church. She will carry different types of stationery, vases, platters, pictures, dolls and linens of all kinds. She will feature crystallized fruit, fruit cake, pickles and other spiced foods …," *SMT,* Oct. 28, 1937, p. 3.

Ivy Gift Shop (notices in Northern Santa Barbara County newspapers on microfilm and on newspapers.com)

1938 – "January Sale. Hand Made Washable Suede Dolls and Animals. Mexican Pottery. Many Other Novelties on SALE to Choose From. Save Your Flower with Lu Fluer… Ivy Gift Shop, 119 East Church St.," *SMT,* Jan. 24, 1938, p. 6.

1939 – "New Shop Opens for Holiday Season… Mrs. M. V. Hall… shop on east Church street… Last year **Mrs. Hall** operated the shop in the same location. In the shop this year, Mrs. Hall is showing everything from Mexican jumping beans to a Hawaiian grass cloth painting with novelties for children featured as well as pottery, linens, costume jewelry, perfume, paintings and basketry. The shop also specializes in flower containers," *SMT,* Sept. 30, 1939, p. 6.

J

Jaans, Marie
See: "Hibbits, Marie Jaans"

Jackson, Catherine (1899-1991) (Los Angeles)
Painter, musician who held an exh. at Santa Maria library, 1947. She was the subject of Donna Schuster's painting "Oer Waiting Harpstrings," 1921, that she donated to the Laguna Art Museum.

■ "Eighteen oil paintings, mostly portraits, are now being shown and will be in Santa Maria for a month at least. Miss Jackson lives in Los Angeles and has been playing with the Hancock Ensemble for about 11 years. She began to study painting as a hobby, but it has grown into an actual vocation along with her music. She studied at Syracuse University and also with **Donna Schuster** and Hector Serbaroli. Whenever her busy life permits her to do so, she still studies, attending Lukits Art School in Los Angeles. She is a member of Women Painters of the West, California Art Club and Sanity in Art. Various of her paintings have been exhibited at Ebell Club, Friday Morning Club, Greek Theatre, Los Angeles Library, and one is now on tour in an exhibit in Kern County. The portraits include several members of the Hancock Ensemble – Glen Warmack, the bass violin player, Mary Headrick, violist, George-Ellen Ferguson, singer, as well as a self-portrait of the artist. Four still life paintings add variety to the collection. One is called 'Winter Blossom' and is a eucalyptus branch; another shows jewels against a white brocaded material," per "Ensemble Harpist Shows Paintings in **City Library**," *SMT,* April 15, 1947, p. 3.

Jackson, Catherine (notices in Northern Santa Barbara County newspapers on microfilm and on newspapers.com)

1948 – "Miss Jackson Paints Portrait of Small Girl," i.e., Betty Haeger of San Gabriel, *SMT,* Jan. 12, 1948, p. 3.

1950 –Played the harp at a California Art Club meeting, per *CAC Bulletin,* April 1950, repro. on www.californiaartclub.org/bulletins50s.

Many notices on the Internet regarding her harp concerts were not itemized here.

Jacobsen, Martin
Collector of Danish paintings, 1954.
See: "Collectors, Art/Antiques (Santa Ynez Valley)," 1954

Jacobsen, Peter, Sr. (c. 1874-1960) (Solvang)
Self-taught painter residing at the Solvang Lutheran Home, 1960.

■ Port. with paintings and "Trio of Residents Enjoy Painting … A trio of Solvang Lutheran Home residents, two men and a woman … creation of oil and water paintings covering a variety of subjects. The elderly artists are Miss **Astrid Blystad**, 74, a retired masseuse, who received art training in her native Norway as a girl and later when she lived in Los Angeles, **Walter A. Swanson**, 76, and Peter Jacobsen, Sr., 86, both of whom taught themselves to wield an artist's brush. … Jacobsen, who creates his paintings in oil, water colors, pastels and black crayon, is 86 and the most diligent of the trio… He spends practically all of his time with his art work. Coming to the home last month to live after residing in Torrance for 11 years, Jacobsen is a native of Denmark. A retired machinist, he made his home for many years on the east coast before moving to California. Taking up artistry a half century ago, Jacobsen centers most of his attention on scenes from the Bible, particularly the life of Christ. Many of his paintings have been given to the Salvation Army and churches. He is adept at copying famous paintings as well as creating his own, and his original work is usually devoted to landscapes and marine views. His latest creation is a water color of the Madonna and Christ Child which will be used as part of the Christmas decorations this year at the home. B.P. Christensen, home manager, said plans are now under way to show the work of the three artists at an outdoor exhibit which will be staged at the home during Solvang's golden jubilee celebration next August," *SYVN*, Dec. 9, 1960, p. 6.
This individual could not be further identified.

Jagla, Margarette Leona Rosen Reece/Reese (Mrs. James Hubert Reese) (Mrs. George Frederick Jagla) (1918-1978) (Santa Maria / Northwest)
Exh. Allan Hancock [College] Art Gallery, 1957. Judge of window painting contest, Elk's Club Rodeo, 1960.
Jagla, Margarette (notices in Northern Santa Barbara County newspapers on microfilm and on newspapers.com)
1957 – "Teahouse Benefits Fund… **Minerva Club**'s luncheon and card party… Hand painted tallies with Japanese scenes were made by the party committee and their guest, **Mrs. George Jagla**…," *SMT*, Aug. 16, 1957, p. 3.
Jagla, Margarette (misc. bibliography)
Margarette Rosen is listed in the 1920 and 1930 U.S. Census in Seattle Wa., with parents Gus and Minnie; Margarette L. Rosen is listed in the 1940 U.S. Census as age 21, b. c. 1919 in Washington, finished college 1st year, working as a nurse at the Swedish Hospital and Nurses Home, Seattle, Wa., where she boarded?; Margarette L. Rosen flew from Wake Island to Guam, M.I. on Civil Aeronautics Administration aircraft No.65, on Nov. 15, 1953, per *Agana, Guam, U.S. Passenger and Crew Lists*; Margarette L. Rosen married George Frederick Jagla on June 23, 1954 in Seattle, Wa., per Washington Marriage Records; Margarette L. Jagla is listed with husband George F. Jagla in the *Portland, Ore., CD*, 1956; SON – George L. Jagla, mother's maiden name Rosen, was b. Jan. 29, 1958

in Santa Barbara County per Calif. Birth Index; Margarette Leona Rosen [Reese/Reece?] Jagla b. July 15, 1918 in Seattle, Wa., d. Sept. 1978 per Social Security Death Index; Margarette L. Rosen was b. 1920 [Sic.] in Washington, married James Hubert "Jim" Reece [Sic. Reese?], and d. in Hillsboro, Ore., per Reece Family Tree (refs. ancestry.com).
See: "Allan Hancock [College] Art Gallery," 1957, "Elk's Club – Rodeo," 1960

Jamboree
Event held at Lompoc High School, 1933+. Students in the art classes made posters and designed and painted sets for the stage show. Students in the domestic art classes designed and made costumes for the performance.
See: "Lompoc, Ca., Union High School," 1933-37, 1939, 1941

James, Robert C., Cpl. (c. 1930-?) (Pasadena / Camp Cooke)
Graphic illustrator in Training Aids section, Camp Cooke, 1952.

■ "Former S&S Artist Contributes Cartoon on 44th's Departure. Contributor of the 'change of address' cartoon on page 4 is Cpl. Robert C. James, former feature illustrator for *Stars and Stripes' Pacific Edition* and currently assigned to Camp Cooke as a graphic illustrator in the Training Aids Section. The 22-year old artist has been drawing 'all his life,' he says, and has contributed to all his school papers 'from kindergarten through college.' A resident of Pasadena, California, he studied art at the University of Kansas and Chouinard's in Pasadena, and had held one-man shows of his oil painting in Hollywood before he was drafted into the Army 20 months ago. James' first big assignment in the Army came while he was in Korea with the 2nd Division. He was given the job of illustrating a history of the 2nd Division, then sent to Tokyo on TDY to supervise the publishing of the history in book form. It was this assignment that led to his connection with *Stars and Stripes*. Finding time on his hands while he waited for the book pages to roll off the press, he went down to the newspaper office and offered his services. He was immediately put to work making illustrations for the daily feature pages. After he returned to Tokyo, James continued to send his feature illustrations to *Stars and Stripes*, throwing in an occasional cartoon for good measure. Sent back to the ZI on rotation three months ago, the versatile artist has been 'sweating out his discharge' at Camp Cooke, helping to produce training aids for all outfits on the post. He plans to work as a commercial artist a few weeks hence," *Cooke Clarion*, Dec. 3, 1952, pp. 1, 4 and repro "Nothing Overlooked".
This individual could not be further identified.

Jansen, Helen / Helena May Gould
See: "Seegert (Jansen), Helen / Helena May Gould (Mrs. Frederick Seegert) (Mrs. William Jansen)"

Japanese Art (Northern Santa Barbara County)
Japanese art was of great interest in northern Santa Barbara County. Japanese art was brought back by soldiers returning from WWII, some of whom were stationed in local military bases. This art was exhibited to locals. Japanese print processes were studied by high school and JC art students. Lectures on Japanese art, flower arranging, and the viewing of colored slides taken by travelers in Japan took place at various clubs (photographic, civic and women's clubs). The area had a large Japanese population mostly engaged in farming. Art was fostered by leaders of the Japanese community (such as Setsuo Aratani who championed the artists Chiura Obata and Kazuo Matsubara). Many public school students of Japanese heritage excelled at art. Henry Fujioka, for example, designed a Japanese theme to the County Fair, 1960. Books on Japanese art were available in the library.

Japanese Art (notices in Northern Santa Barbara County newspapers on microfilm and on newspapers.com)
1930 – "Japanese Kids View San Luis Art Exhibit. Scores of Japanese pupils from Guadalupe, Santa Maria and Pismo schools were lured to the Japanese art exhibit held in IDES Hall in San Luis Obispo… The exhibit, which has been shown throughout California… is being sponsored by the San Francisco Japanese association … The thousands of articles were collected by the department of education of the Imperial Japanese government… [and was made by] pupils between the ages of six and 16…," *SMT*, Feb. 28, 1930, p. 11.
1931 – "Orient Trip to be Offered by University…. University of California Extension…," trip led by **Perham Nahl**, *SMT*, Feb. 9, 1931, p. 8.
1936 – "Japan Draws Inspiration from World… Dr. Ken Nakazawa of the University of Southern California told **Minerva** Library clubwomen… professor of Oriental art and literature. After the formal lecture the speaker explained the significance of several Japanese flower arrangements and pieces of art which had been loaned to **Minerva club** for the day by Members of the Guadalupe Japanese association. Arrangements of iris and lilies on the platform had been done by Mr. Seto of Betteravia, Mesdames K. Ito, Saka and N. Ikeda were among those who exhibited other groupings of flowers. **S. Aratani** displayed a large folding screen for the stage. Two long panels, a wall hanging embroidered by the owner and vases belonging to Mrs. Tashima. Mrs. Charles Ishii loaned a small screen and vase, while a piece of Japanese statuary, picture and pottery were among Mrs. Ikeda's exhibits…," *SMT*, March 7, 1936, p. 2.
1953 – "Beta Theta Chapter See Japanese Art… of Delta Kappa Gamma… Maj. and Mrs. Caswell and their family lived in Hiromachi for four years and in Yokohama for two years. Chaplain and Mrs. Dudley Boyd were stationed for 13 months in Osaka, where Mrs. Boyd taught in the university. Both have brought to this country many beautiful Japanese works of art, including silks, kimonos, carved ivory, paintings on silk, Cloisonne vases, jade and jewelry, which they displayed," *SMT*, April 28, 1953, p. 4.
1954 – "Garden section to View Japanese Garden Films…**Mrs. Donald E. Reiner** is selecting the best of her large collection of Japanese garden films… There will be

an accompanying exhibit of Japanese art and ceramics collected by Mrs. Reiner while traveling in Japan with her husband…," *SMT*, Nov. 10, 1954, p. 4.
1957 – "On Japanese Art – discussed with illustrated slides at Santa Barbara College, UC… Dr. Donald H. Shively, associate professor of Oriental languages, UC Berkeley," *SMT*, April 20, 1957, p. 5.
1958 – 'Mrs. Reiner is Speaker at School. Eighth grade art students in St. Mary's Parochial School heard a talk Thursday on Japanese art by **Mrs. Donald E. Reiber [Sic. Reiner]**, who spent a year in Japan while her husband was stationed overseas… block prints, lacquer and ceramics, some antiques and some modern pieces…," *SMT*, March 1, 1958, p. 2.
See: "Alpha Club," 1936, 1940, "Aratani, Setsuo," "Art Festival (Santa Maria)," 1935, "Collectors, Art / Antiques," "College Art Club," 1932, 1935, "Fletcher, Frank Morley," "Floral Design," "Fujioka, Henry," "Fukuda, Keichi," "Gaynos, Loris," "Ikeda, Victor," "Imamura, Roy," "Kincaid, Edward," "Konishi, Ann," "Makimoto, Taro," "Marion, Harue," "Matsubara, Kazuo," "McGehee, Ramiel," "Obata, Chiura," "O'Neal, Merilyn Mason," "Padrick, Walter R., Captain and Mrs.," "Reiner, Donald E., Dr.," "Santa Barbara County Fair," 1928, 1934, 1960, and "Santa Maria, Ca., Union High School," 1921, 1935, "Serisawa, Sueo," "Tashiro, Yukio," "Utsunomiya, George," and *San Luis Obispo Art and Photography before 1960*

Jarvis, Jean (Mrs. James Jarvis) (Santa Maria)
Art chairman, Jr. Community Club, 1952-53.
See: "Heller, Hazel," 1953, "Junior Community Club (Santa Maria)," 1952, 1953, 1954, 1957

Jeanotte / Jeannotte, Jules (Santa Maria)
Interior decorator. Prop. of Le Décor, 1953.

■ Port. and "Nationally Famed Interior Decorator Returns to Santa Maria for Assignment, Wants to Remain… Jules Jeannotte, formerly of New York and Los Angeles and more recently with his studios in Studio City, has recently completed an 'interior re-do' of the Fashion Shop and is currently engaged in working out and doing a brand-new interior for the Beacon Outpost on south Highway 101. Having worked for the larger department stores of New York City and Los Angeles as a commercial artist, Jules subsequently branched out 'on his own.' He took on contracts with Graysons, Ardens, Darling's and other shops, did the interior decorations for them and, on the basis of his performance, achieved fame and was recommended to others. Jeannotte's first working acquaintance with Santa Maria was with Ames and Harris, when he served as consultant and artist in the redecorating … He returned to do the Fashion shop. He returned again to work over the Beacon Outpost (his current enterprise). He says: 'I like Santa Maria. It has a number of opportunities for expression in interior decoration. The people are friendly. The climate is wonderful. The need is here and so am I. What more can one ask for?' Assisting him in his work here is Ted Vamos. Between the two of them, they assert, 'What is formerly an interior of only ordinary

interest can be transformed into an establishment which lends itself to the merchandising of anything from furs to fish – or, if you prefer, from berets to barbecues,'" *SMT*, Feb. 4, 1953, p. 3.
This individual cannot be further identified.
See: "Le Décor"

Jekel, August Allan "Gus" (1927-1994) (Los Angeles)
Los Angeles artist whose cartoon strip ran in the Santa Ynez Valley News, 1949, 1950, 1951. Motion picture producer and vintner. Twin brother named William.

■ "'Pam' [by] Gus Jekel. … Jekel is 21 years old. He has a twin brother, a wife and a little girl that looks very much like 'Pam,' the little girl in his strip. In fact, many of the situations that Gus illustrates so cleverly have actually happened to his own daughter. Gus has worked for **Walt Disney** as an assistant animator for five years with time out for the Navy," *SYVN*, July 29, 1949, p. 4.
Jekel, Gus (notices in California newspapers on newspapers.com)
1969 – "Broadcast Trade Notes … FilmFair, producer of live-action and animated film commercials, will make its entry into feature films with the production of "Alice," it was announced by Gus Jekel, president…," *Valley Times* (North Hollywood, Ca.), May 23, 1969, p. 13.
1978 – "Fictitious Business Name Statement… Jekel Vineyards …," *Californian* (Salinas, Ca.), July 27, 1978, p. 37.
1979 – "Jekel Brothers Premier a Balanced Riesling …," at their "JR" vineyard in Greenfield, Monterey County. "The twins operate a successful motion-picture firm known as Film-Fair. They make TV commercials and soon will release their first major motion picture, feature, 'The Baltimore Bullet,' starring James Coburn and Omar Sharif…," *LA Times*, June 28, 1979, p. 123 (i.e., pt. VI, p. 7).
And, more than 220 notices for "FilmFair" in Calif. newspapers, c. 1960+, were not itemized here.
Jekel, Gus (misc. bibliography)
August Jekel is listed in the 1940 U. S. Census in Los Angeles; August Allan Jekel provided the following information on his WWII Draft Card dated 1946 = age 19, b. Jan. 21, 1927 in Pueblo, Colorado, residing in Burbank and working for Walt Disney Productions; Gus Jekel and wife Bonnie are listed in Los Angeles in 1994 per *U. S. Phone and Address Directories*; August Allen Jekel was b. Jan. 21, 1927 in Calif. to Karl Jekel and Katherine Leone Heller, and d. May 4, 1994 in NY per J. Dues Raffaell 2007 Family Tree (refs. ancestry.com).
See: "Comic Strip (*Santa Ynez Valley News*)"

Jellum, Herbert Lee (1868-1965) (Santa Maria)
Photographer active in Santa Maria, February, 1903-04.
Jellum, H. Lee (notices in Northern Santa Barbara County newspapers on microfilm and on newspapers.com)
1903 – "H. Lee Jellum, a first-class photographer, has taken possession of the office in the Jones Building formerly occupied by the *Times*. The place will be ready for business shortly," *SMT*, Dec. 25, 1903, p. 3.

1904 – "Some low-down sneak-thief broke into one of Photographer Jellum's glass photo cases and took a fine picture," *SMT*, Feb. 26, 1904, p. 2, col. 2; "For first-class work in the photo line call on Jellum, the photographer, in the Jones' building. …," *SMT*, Feb. 19, 1904, p. 3, col. 3; **"Fitzhugh, The San Luis Fotographer**, has opened a branch studio in the quarters recently occupied by Mr. Jellum in the Jones Building, a few doors south of the Post Office. Commencing on Friday, April 1st, the studio will be open…," *SMT*, May 20, 1904, p. 1; and many repeats of the same ad not itemized here.
More than 280 hits for "Jellum" plus "photographer" appear in U. S. newspapers (California, Missouri) on newspapers.com but were not itemized here.
Jellum, H. Lee (misc. bibliography)
Herbert L. Jellum is listed in the 1920 U. S. Census as age 51, b. c. 1869 in Norway, immigrated 1885, naturalization papers submitted, a photographer, residing in Willits, Ca. with wife Anna M. Jellum (age 34) and child Margaret L. Jellum (age 1); Herbert Lee Jellum b. April 18, 1868 in Norway to Lars Jellum, married Anna Mary Hughes, was residing in Ludlow, Mo., in 1929 and d. March 7, 1965 per Williams Family Tree (refs. ancestry.com).

Jensen, Chris A. (Solvang / Santa Barbara)
Photographer, 1939.

■ "Chris. A. Jensen… used to live in Solvang, though he now keeps his home in Santa Barbara from whence he returns to the Santa Ynez valley occasionally for his artistic photographs, four of which have been contributed to the Solvang booklet, pictures which deal especially with the area around the church and Atterdag college. He also supplied splendid portraits of the three early leaders within the colony, Pastor J. M. Gregersen, Pastor B. Nordentoft and Professor P. P. Hornsyld," per "Solvang to Present Danish Royalty with a Unique Souvenir," i.e., a booklet on Solvang, *SYVN*, April 7, 1939, p. 1.
Jensen, Chris (notices in Northern Santa Barbara County newspapers on microfilm and on newspapers.com)
Nearly 450 notices appear on "Chris Jensen" in the *SYVN* from 1925-1960 but were not even browsed for listing here. [There appear to be several Chris Jensens.]
Jensen, Chris (misc. bibliography)
Chris A. Jensen is listed in the 1930 U. S. Census as b. c. 1900 in Denmark, immigrated 1910, naturalized, working on a citrus ranch, residing in Montecito; Chris A. Jensen, gardener, is listed in the *Santa Barbara, Ca., CD*, 1928-42 (refs. ancestry.com).

Jensen, Dulce de la Cuesta (Mrs. Earl T. Jensen) (1893-1983) (Rancho de la Mesita, Solvang)
Collector of paintings, including one by Narjot, 1935.
See: "Art Loan Exhibit (Solvang)," 1935

Jensen, Frances Mead (1915-2004) (Los Berros / Nipomo)
Painter.
1936 – "Woman Shows Paintings Here… in the home of Mr. and **Mrs. George E. Secour**," and long article, *SMT*, March 17, 1936, p. 3.
See: *San Luis Obispo Art and Photography before 1960* and *Arroyo Grande Art and Photography before 1960*

Jensen, Robert Ibsen (1940-?) (Solvang)
Grad. of Santa Ynez High School, 1957. Attended "Fine Arts of California" school, San Francisco, 1960. Attended Art Center, Los Angeles, 1962-64. Advertising artist, 1964+.
■ "Miss [Jeannett] Stromm Weds R. I. Jensen in Bethania Church… The parents of the bride are Mr. and Mrs. Edwin Strom of Solvang. Mr. Jensen is the son of Mrs. Albert Jensen of Solvang and the late Mr. Jensen… Both Mr. Jensen and his bride are graduates of Santa Ynez Valley Union High School. The bride also attended Santa Barbara City College for two years. Mr. Jensen attended Grand View College in Des Moines for two years and this year will be enrolled at Fine Arts of California, San Francisco. Following a wedding trip to Carmel and the San Francisco area, the young couple will reside in San Francisco," *SYVN*, Sept. 9, 1960, p. 3.
Jensen, Robert (notices in Northern Santa Barbara County newspapers on microfilm and on newspapers.com)
1956 – Port. as actor in high school play, *SYVN*, March 30, 1956, p. 8.
1957 – Port as grad of Santa Ynez High School, *SYVN*, June 14, 1957, p. 5.
1962 – "Strom Couple Given Farewell… Mr. and Mrs. Robert I. Jensen who leave this weekend for Los Angeles where he will enroll in Art Center School …," *SYVN*, Jan. 26, 1962, p. 7.
1964 – "Jensen Move to Illinois. Mr. and Mrs. Robert Jensen and their seven-weeks-old son Brad have taken up residence in Evanston, Ill., where Jensen has recently taken a position. He graduated from Art Center in Los Angeles with honors Sept. 18 and accepted a position with McCann and Ericksen, an advertising company in Chicago…," *SYVN*, Oct. 22, 1964, p. 15.
1966 – "Robert Jensens… and son visiting from Park Forest, Ill., *SYVN*, May 12, 1966, p. 14 (i.e., 6B).
And more than 90 additional notices in the *SYVN* from 1950-1970 reporting social and sports activities were not itemized here.
Jensen, Robert (misc. bibliography)
Robert Ibsen Jensen, mother's maiden name Ibsen, was b. Jan. 11, 1940 in Santa Barbara County per Calif. Birth Index; Robert I. Jensen is listed in the 1940 U. S. Census as age 2 months, residing in Santa Barbara with his parents Albert J. Jensen (age 31) and Abeline J. Jensen (age 22); Robert I. Jensen b. Jan. 11, 1940 was residing in Plano, Tx. in 1993 and he cited as "second" addresses one in Franklin, Tn., and a third address as Tampa, Fla., per *U. S. Public Records Index, 1950-1993*, vol. 1 (refs. ancestry.com).

Jenson, Urban Leonard (1901-1980) (Lompoc)
Woodworker. Inventor of woodworking tools, 1971.
■ Port. and "Urban Jenson, 321 W. North Ave., was displeased. Whenever he sought router bits, 'they didn't have the shape I wanted,' he said. So now he makes his own, for use in cabinetwork at home and molding for desks. …An attractive silver ring worn by Jenson is of monel metal, fashioned by a lathe and drill press. And he is especially adept at creating wooden candlestick holders of walnut, oak and hickory. Most are supported by open, intertwining spirals, which require a bit of mathematics. The spiraled column, itself is from one piece of wood. But 15 to 20 lathe attachments are required, along with a specially made machine, to hollow out the wood. After the wood is blocked and measured into squares, it is put in a drill press and punched with up to 108 holes, said Jenson. A fret saw to saw in between the design enables it to come out in one piece. A sanding burr cuts it down until it takes shape. Strips of sanding belt and hand finishing complete the job. With the base and top, four separate pieces of wood form the candlestick holder," and 2 repros of Jensen at work, in "Urban Jenson. Tools and Furniture," *LR*, July 31, 1971, *Vistas*, p. 2.
Jenson, Urban (misc. bibliography)
Urban Leonard Jenson was b. Sept. 28, 1901 in Helvetia, Wisc., to John Peter Jenson and Clara Pauline Olson, married May Cordelia Ice, and d. Sept. 26, 1980 in Santa Barbara per Peterson-Krebsbach Family Tree (refs. ancestry.com).

Jessee, Hattie
See: "Hart (Jessee), "Hattie" H. (Mrs. Henry Haight Jessee)"

Jeter, Lawrence Tinsley (1857-1917) (Santa Maria)
Painter – signs, graining, house, 1884+. Exh. oil and water color paintings at the "Santa Barbara County Fair," 1889.
■ "Lawrence Tinsley Jeter, one of the valley's old-time residents and for many years established in the painting business here, passed away in this city on Tuesday, October 2nd… Mr. Jeter suffered a stroke of paralysis a few years ago and since that time has been practically an invalid… Santa Maria cemetery…," per "Pioneer Resident Passes Away," *SMT*, Oct. 6, 1917, p. 1.
Jeter, L. T. (notices in Northern Santa Barbara County newspapers on microfilm and on newspapers.com)
[Of the many notices and advertisements for Jeter in the newspapers, only those relating to his decorating and to his painting of signs were listed here.]
1884 – "Completion of the Masonic Hall, in the north half of the upper story of Jones & Son's new brick building… The painting in the interior of the hall is a light sky-blue and contrasts nicely with the white walls and was done by J. [Sic.] Jeter…," *SMT*, Jan. 19, 1884, p. 5; "L. T. Jeter, Painter and Sign Writer … House, sign and ornamental painting a specialty. Paper-hanging, kalsomining, etc.," *SMT*, Dec. 13, 1884, p. 10.
1885 – "I. N. Moses returned on Wednesday with his family. … We understand that Mr. Moses will go into

partnership with Mr. Jeter …," *SMT*, March 14, 1885, p. 5, col. 4; "Jeter & Moses, Painters. House and Sign Painting…," *SMT*, May 16, 1885, p. 4; "The interior finishing of Fleisher's building… Mr. Jeter is now finishing the decorative painting on the interior of the room to be occupied by Kallmeyer's Drug Store," *SMT*, Aug. 22, 1885, p. 5, col. 1.

1887 – "L. T. Jeter finished a few days ago the painting and decorating of Mr. John Long's residence on Church Street," *SMT*, June 4, 1887, p. 5, col. 2; "A beautiful and new sign has just been placed in the front of the Palace. … executed by that artistic artist, L. T. Jeter," *SMT*, July 16, 1887, p. 3, col. 2; "Jeter, the artist, painted an attractive sign on the Broadway side of the Hart house this week, informing the public that **L. L. Colvin** carries on a ladies furnishing goods business within," *SMT*, Sept. 4, 1897, p. 3.

1890 – "The Popular Drug Store continues to grow in popularity as can be plainly seen from its neat and new glass front and neatly executed lettering on the same, done by L. T. Jeter the artistic sign painter," *SMT*, Jan. 25, 1890, p. 3.

1891 – "L. T. Jeter the house and sign painter, did a fine job of paper hanging for Dr. Forbes this week," *SMT*, Nov. 14, 1891, p. 3, col. 2.

1892 – "Jas. Lertoria has just had his place of business re-painted and decorated. The style is new and adds much to the attractiveness of the place and does credit to the artist, Mr. Jeter," *SMT*, May 7, 1892, p. 3; "Fleisher Residence… Finest Residence in Town Now Ready for its Occupants… on Broadway two blocks from Main Street… It is very seldom that Mr. Jeter finds a chance to show his full worth as an artist, but he has improved this as he does every other opportunity…," *SMT*, July 9, 1892, p. 2; "The New Church… The new M. E. Church is in the hands of the painter, Mr. Jeter… the plastered walls have been calcimined [sic.] and nearly all the wood work varnished… The fine **stained glass** which was made to order… have not yet arrived from the east," *SMT*, Nov. 12, 1892, p. 3, col. 2.

1893 – "The main hall of the Hart House has just undergone a thorough renovating and has been newly papered and decorated. Jeter was the artist," *SMT*, April 1, 1893, p. 3; "Miss Hourihan has a neat new sign in front of her dressmaking establishment on Broadway. Mr. Jeter is the artist," *SMT*, June 3, 1893, p. 3; "The painting, graining and decorating in the fancy goods department at W. A. H. & Co's is a marvel of blending beauty and marks the artist Jeter as a genius of first rank. The imitation walnut is as perfect as anything can be outside of walnut lumber. His ash and maple grainings would have to be tested to be proven imitations…," *SMT*, June 24, 1893, p. 3; "Mr. Jeter has a very neat sign on the district road tanks, advertising his skill as an artist," *SMT*, Aug. 19, 1893, p. 3; "Mr. and Mrs. L. T. Jeter went to San Luis Wednesday… Mr. Jeter tells us that Mr. Stail, the one-armed painter who worked for him some two or three months during the summer and went from here to San Luis, had very mysteriously disappeared from that city some few weeks ago and has not been seen or heard of since," *SMT*, Nov. 18, 1893, p. 2, col. 2.

1894 – "Dr. Ketcham has a very neat sign at the entrance to the stairway of the Jones Block. Jeter was the painter," *SMT*, Jan. 27, 1894, p. 3, col. 3; "The Painter's Report.

Materials and Labor Required on High School Building… L. T. Jeter, who, in company with Geo. Brown, did all the painting … There were 265 gallons used outside, which is finished in 'light leather, terra cotta and seal brown. The outside doors were finished in antique oak. Fifty-five gallons of finish were used inside, all of which is in natural wood'…," *SMT*, Aug. 11, 1894, p. 1; "A *Times* representative had occasion to visit Jeter's paint and paper store in Lucas' Hall during the week and was surprised at the immense stock of wall paper of all latest shades and designs, just in; also an endless assortment of paints in all colors, dry and in oil; also slating, lamp black, glue, gold leaf, silver bronze and everything else imaginable in the painter's and decorator's line. ..," *SMT*, Aug. 18, 1894, p. 3, col. 2.

1895 – "A Lovely Home… Built by Contractor Orr for Mr. and Mrs. Weilheimer… doors, window casing, base boards, etc., oiled, varnished and grained by L. T. Jeter…," *SMT*, Nov. 16, 1895, p. 3, col. 4.

1902 – "The Grammar school is being overhauled in general. A corps of Santa Maria's best painters and paper hangers are at work… L. T. Jeter has charge …," *SMT*, June 21, 1902, p. 3; "A painter named J. G. Pointer, who had been employed by L. T. Jeter for some time, was arrested this week on a charge of forgery…," *SMT*, Dec. 27, 1902, p. 3, col. 4.

1903 – "One of the neatest little residences in town has just been completed… for John E. Walker… It is a six-room cottage … L. T. Jeter, the painter, has done himself no less credit than the architect and builder… The interior finish is superb, the wood-work being varnished and rubbed until it glistens like mahogany, and the paper-hanging …," *SMT*, June 19, 1903, p. 3.

1904 – "L. T. Jeter … has left for Fresno, where he will establish himself in the future. Mrs. Jeter accompanies her husband…," *SMT*, March 25, 1904, p. 3; "J. T. [Sic.] Jeter… will soon be with us again," *SMT*, Dec. 17, 1904, p. 3, col. 4.

1905 – "Blown from Roof. Ray Hansen, a painter in the employ of L. T. Jeter, while at work on the High school last Thursday during the severe wind, was blown from the roof… Mr. Jeter was also nearly blown from the building but he clung to the rigging and awaited the first opportunity to descend from his perilous position," *SMT*, Nov. 25, 1905, p. 2, col. 2.

1908 – "L. T. Jeter… completed a number of very artistic signs in town prominent among which we mention the dental signs of Bagby & Blosser and Herron & Baker," *SMT*, March 7, 1908, p. 5, col. 2.

1909 – "L. T. Jeter has shown himself an artist of the first order in staining the interior woodwork of the post office as well as finishing William Mead's store," *SMT*, Oct. 30, 1909, p. 5.

1911 – "Painters. L. T. Jeter, Geo. Brown and W. E. Davidson are among the city's old established painters… L. T. Jeter has just built a handsome new building especially for fine sign and carriage work," *SMT*, Dec. 30, 1911, p. 11.

Jeter, L. T. (misc. bibliography)
Lawrence T. Jeter, b. c. 1857, d. Oct. 2, 1917 in Santa Barbara County per Calif. Death Index; Lawrence Tinsley

Jeter (1856-1917) is buried in Santa Maria Cemetery District per findagrave.com (refs. ancestry.com).
See: "Santa Barbara County Fair," 1889

Joaquina/Juanquina
See: "Abbott, Juanquina"

Johansen (Duran) (Carlin), Virginia (Mrs. Lewis G. Duran) (Mrs. Robert Eugene Carlin) (c. 1935-?) (Santa Maria)
Student at Santa Maria High School who exh. in Library, 1951. Exh. painting at Santa Barbara County Fair, 1951. Outstanding high school art student, 1952.
Johansen, Virginia (notices in Northern Santa Barbara County newspapers on microfilm and on newspapers.com)
1952 – "Virginia Johansen Wins Regional Art Contest," i.e., **Scholastic Art Exhibit**, with wc "Village Scene," and she is 17-year-old senior at SMHS, daughter of Mrs. Gerda Johansen and Aage Johansen, *SMT,* Feb. 23, 1952, p. 5; "**Junior Community Club**… check for $25 to Virginia Johansen, Santa Maria high school student, as 'most outstanding in art'," *SMT,* June 4, 1952, p. 6.
1982 – FATHER – "Aage Johansen… died Tuesday in Glendale, Ariz… Mr. Johansen was born… in Denmark. He had been employed in the construction industry and had been a Santa Barbara County building inspector prior to moving to Glendale, Ariz…. 1972 … Survivors include… daughters Virginia Carlin… all of Los Angeles," *SMT,* Aug. 20, 1982, p. 12.
Johansen, Virginia (misc. bibliography)
Virginia Johansen port. and caption, "'My eyes make pictures when they are shut.' 300 club, 2, 3. 600 Club 4, 1000 Club 4. Senior Play 4. Christmas Pageant 4. CSF. Senior Carnival. CSF Auxiliary. Junior Statesmen 3. Girls' Athletic Association 1, 2. Tri-Y 1. National Scholastic Art Award 4. Bank of America Award 4" per Santa Maria High School yearbook, 1952; Virginia Johnson [Sic. Johansen] is listed in the 1940 U. S. Census as age 6, b. c. 1934 in Iowa, residing in Concord, Neb. (1934) and Santa Maria (1940) with her parents Aage Johnson [Sic. Johansen] (age 32) and Gerda Johnson [Sic. Johansen] (age 27) and siblings Wilma, Norma and Lila; Virginia Johansen, b. c. 1935, married Lewis G. Duran on April 26, 1953 in Los Angeles County per Calif. Marriage Index; Virginia Johansen/Duran, b. c. 1934, married Robert E. Carlin on Sept. 23, 1965 in Los Angeles County per Calif. Marriage Index; is she Virginia G. Johansen b. Aug. 1934, residing in Half Moon Bay, Ca., 1981, per *U. S. Public Records Index, 1950-1993*, vol. 1 (refs. ancestry.com).
See: "Posters, general (Santa Maria)," 1951, "Santa Barbara County Fair," 1951, "Santa Barbara County Library (Santa Maria)," 1951, "Santa Maria, Ca., Union High School," 1949, 1951, 1952, "Scholastic Art Exhibit," 1952

Johns, Annette Irene
See: "Negus (Lindegaard) (Johns) (Allen), Annette Irene (Mrs. Svend Lindegaard) (Mrs. Roger M. Johns) (Mrs. James Allen)"

Johnson, Barbara Adele
See: "Hutchinson (Johnson), Barbara Adele (Mrs. Thomas Malcolm Johnson)"

Johnson, Don / Donald O. (1916-1984) (Santa Maria)
Santa Maria Union High School English instructor (1947+) and water color landscape painter. Exh. wc. titled "Barn in Trees" at SLO County Art Show, 1948. Exh. Home Talent Art Show at Allan Hancock [College] Art Gallery, 1955, 1956. Took a summer course in painting at Stanford.
■ "Donald Johnson, long-time SMHS English teacher, dies … taught English, social studies and band at SMHS for 18 years and then served another 10 as a vice-principal before retiring in 1975… Born in McLaughlin, S.D. on April 20, 1916, Johnson graduated from Aberdeen State Teacher's College in 1938 and began his teaching career in Highmore, S.D. and later taught at the Japanese relocation camp at Tule Lake in northern California. Following service in the U. S. Navy during World War II, Johnson moved to Santa Maria in 1947 and continued teaching. He also began the Junior Scandals and Variety Show, which became an annual tradition. … he was a 'very talented, talented man.' He published a book, 'The Star Listeners' about Indians in South Dakota…. He also painted in watercolor and carved wood pipes, wrote poetry and played several musical instruments," *SMT,* May 1, 1984, p. 2.
Johnson, Don (notices in Northern Santa Barbara County newspapers on microfilm and on newspapers.com)
1961 – "Don Johnson Honored. Teacher of Year… Johnson, a member of the high school faculty since 1947 and head of the English department since 1955…," *SMT,* March 14, 1961, p. 1.
1964 – "English Languages Changes Reviewed for Altrusa Club. Donald Johnson, teacher of English at Santa Maria High School… Mr. Johnson formerly headed music departments in High Schools in South Dakota, majored in music receiving his Master's degree at Stanford. …," *SMT,* March 7, 1964, p. 4.
Johnson, Don (misc. bibliography)
Port. in Santa Maria High School yearbook, 1949, 1952, 1953, 1954, 1957, 1962; Donald Johnson, teacher, SM Union High School, and wife Catherine are listed in the *Santa Maria, Ca., CD,* 1959, 1961, 1965; Donald Johnson b. April 28, 1916, was active in South Dakota, and d. April 1984 in Santa Maria, per Social Security Death Index (refs. ancestry.com).
See: "Allan Hancock [College] Art Gallery," 1955, 1956, "Santa Barbara County Fair," 1960, and see "SLO County Art Show," in *San Luis Obispo Art and Photography before 1960*

Johnson, James "Jimmie" T. (Santa Maria / Santa Barbara)
Photographer. Active with Santa Maria Camera Club, 1941-55. Director of portfolios for the Photographic Society of America, 1952.
Johnson, Jimmie (notices in Northern Santa Barbara County newspapers on microfilm and on newspapers.com)
1940 – "I Spied… Officer Jimmie Johnson displaying a photograph of Virgil Alexander holding a large catch of rainbow trout," *SMT*, Sept. 9, 1940, p. 1.
Johnson, Jimmie (misc. bibliography)
James T. Johnson, police officer, is listed in *Voter Registrations for Santa Barbara County*, 1938-44 (refs. ancestry.com).
See: "Santa Maria Camera Club," 1941, 1942, 1943, 1949, 1952, 1955

Johnson, Mary / Mae Gladys (Mrs. ? Johnson) (Mrs. ? Teal / Teele) (?-?) (Berkeley / Solvang)
Teacher of home economics and freehand drawing at Santa Ynez Valley Union High School, 1932-35.
■ "$2500 To Be Saved by The New High School… Mrs. Mary G. Johnson is to teach home economics and freehand drawing and other work. She is a graduate of Santa Barbara State Teachers' College and of U.C., and holds secondary and Smith-Hughes credentials and has had several years' teaching experience. She has been for the last three years on the Berkeley high school teaching staff. She has had broad experience in home economics and was county supervisor in Alameda county a few years ago. Mrs. Johnson has a small 6 year old daughter [Elinar / Elinor / Eleanor] and will move to this district sometime during the summer," *SYVN*, July 8, 1932, p. 1.
Johnson, Mae (notices in California newspapers on microfilm and on newspapers.com)
1935 – "Marriage Announced… tea… in honor of Mrs. Gladys Johnson… whose marriage to Mr. Teele, a girlhood sweetheart, was announced, the wedding having taken place last April…," *SYVN*, June 14, 1935, p. 8.
And many social notices in the *SYVN*, 1932-35 not itemized here.
Johnson, Mae Gladys (misc. bibliography)
Is she Mae Johnson, teacher Oakland Public School, r. 1738 Excelsior Ave., listed without husband in the *Oakland, Ca., CD*, 1934 (refs. ancestry.com).
[With a 6-year-old daughter and an extensive teaching background by 1932, she appears to be too old to be Mae Johnson, artist of Palm Springs in the 1960s or Mae Gladys Johnson 1914-1997 who died in Perris, Ca.]
This individual could not be traced further.
See: "Santa Ynez Valley Union High School," 1932-34

Johnston, P. B. (Santa Maria)
Sign painter Oct. / Nov. 1902 with G. R. Pointer.
See: "Pointer, G. R."

Jones, Esther (Mrs. ? Jones) (Santa Maria)
Teacher of art and crafts in Santa Maria Adult School, 1948. Exh. Santa Maria library, 1948.
■ "Free Course Offered in Arts and Crafts …arts and crafts, leather and copper work, and in oils and water colors… One class is filled but there are openings for all who would like to make up additional classes… Mrs. Esther Jones, member of the Santa Maria High School faculty, whose husband is connected with USC College of Aeronautics administration, is to be the instructor in the new course," per "Free Course Offered in Arts and Crafts," SMT, March 8, 1948, p. 5.
1948 – Mrs. Esther Jones, housewife at 846C East Boone, comments on her shopping problems, *SMT*, May 22, 1948, p. 1, col. 1.
No further information on this individual could be found.
See: "Santa Barbara County Library (Santa Maria)," 1948, "Santa Maria, Ca., Adult/Night School," 1948

Jones (Wayman), Frances / Francis Ellen (Mrs. Virgil Oliver Wayman) (1897-1982) (Lompoc / Santa Barbara)
Teacher of drawing in Lompoc Jr. High and High School, 1925/27. Singer.
■ "High School Notes … Frances E. Jones is a resident of Santa Barbara. She studied at Fort Worth University, Fort Worth, Tex. and is a graduate of Santa Barbara Teachers' college, Music Department and Art Department. She studied Commercial Art at Federal School, Minneapolis, Minn.," *LR*, Sept. 18, 1925, p. 8.
Jones, Frances E. (notices in California Newspapers on newspapers.com and genealogybank.com)
1936 – FATHER – "Veteran 'Y' Man Paid Final Homage .. The Santa Barbara YMCA paid last honors today to Lewis E. Jones, 71 years of age, who had been engaged in 'Y' work for thirty-six years prior to his retirement eleven years ago after serving as secretary of the Santa Barbara organization," *LA Times*, Sept. 4, 1936, p. 30 (i.e., pt. II, p. 10).
Jones, Frances E. (misc. bibliography)
Frances E. Jones, age 2, was residing in Union, per Iowa State Census, 1895; Frances E. Jones is listed in the 1900 U. S. Census as age 5, b. Sept. 1894/5 in Iowa, residing in Olathe Ward 1, Kansas, with her parents Lewis E. Jones, scy YMCA, and Lora M. Jones (b. 1871 Ill.) in the home of his parents; Frances E. Jones, without occupation, is listed at the same address as her father, Lewis E. Jones, sec. YMCA, in the *Santa Barbara, Ca., CD*, 1914; Frances E. Jones, commercial artist, is listed in the *Santa Barbara, Ca., CD*, 1918; Frances Jones is listed as student in the *Santa Barbara, Ca., CD*, 1923; ports of Frances Jones appear in the Santa Barbara State College yearbook, 1923; Frances E. Jones, teacher and Rep., is listed at the same address as her parents Lewis E. Jones, writer, and Lora M. Jones, housewife, at 1921 Bath St., in the *California Voter Registration, Santa Barbara Precinct 21*, 1920-1928; Frances E. Jones is pictured as a teacher in the Lompoc, Ca., high school yearbook, 1926 and 1936; Frances E. Jones is listed in the 1930 U. S. Census as age 29, c. b. 1901 in Iowa, a teacher, residing in San Diego with her parents Louis E. Jones (age 63) and Lara M. Jones (age 56); is she Frances E. Jones, with no occupation, listed at

115 F. Ave., in the *San Diego, Ca., CD*, 1932?; FATHER – Lewis E. Jones, b. c. 1865, d. Sept. 1, 1936 in Santa Barbara County per Calif. Death Index; Frances Ellen Wayman b. Sept. 29, 1897, d. Aug. 21, 1982, married Virgil Oliver Wayman, and is buried in Santa Barbara Cemetery per findagrave.com (refs. ancestry.com).
See: "Lompoc, Ca., Union High School," 1925, 1926, 1927

Jones, Fred (Frederick W.?) (Los Angeles area)
Cartoonist for Santa Ynez Valley News, 1949.

■ "'Hollywood' [by] Fred Jones started his cartooning career in 1932 at the 'Krazy Kat' Cartoon studio in Hollywood. Since then, he has worked on 'Oswald the Rabbit,' 'Porky Pig,' 'Bugs Bunny' and up to the present, Walt Disney's Mickey Mouse in 'Fun and Fancy Free.' During the war, Fred worked at Douglas Aircraft Corp. making illustrations for the Navy parts catalog...," *SYVN*, July 29, 1949, p. 4; and repro. of 4 comic strips in the *SYVN*, 1949, not itemized here.
Jones, Fred (notices on the Internet)
"Fred Jones is known for his work on Straight Shooters (1947), Lighthouse Keeping (1946) and Crazy with the Heat (1947)," imdb.com; repro: "Keep Things Buzzing, Help Produce for Victory" a poster produced for Douglass Aircraft Co., Santa Monica, c. 1942-45, on pinterest.com.
Jones, Fred (misc. bibliography)
Fred W. Jones, artist, with wife Virginia is listed in the *Los Angeles, Ca., CD*, 1940; Frederick W. Jones, artist and Dem., is listed in *Index to Register of Voters, Los Angeles City Precinct No. 1569-A*, 1942; Frederick W. Jones, artist, listed with wife Virginia R. Jones in *Burbank, Ca., CD*, 1949, 1954 (refs. ancestry.com).
See: "Comic Strip (Santa Ynez Valley News)," 1949

Jones, Gaylord Jefferson (1900-1991) (Santa Maria)
Wood carver. Photographer. Architect. Grad. of Santa Maria High School, 1919. Taught mechanical drawing at Santa Maria High School. Taught interior decoration at Santa Maria Adult School, 1935, 1939. Decorated the interior of the Santa Maria City Hall, 1934. Member Santa Maria Camera Club, 1955. Exh. photos at Santa Barbara County Fair, 1958, 1960.

■ "Mr. Jones... was a Santa Maria Valley pioneer. ... born Sept. 14, 1900 in Santa Maria, the youngest son of Samuel Jefferson Jones and Viola Lillian Cook Jones ... The Jones family established one of the community's first stores... He attended Santa Maria schools, serving as vice president of the Santa Maria High School class of 1919. He was a high jumper and pole vaulter on the school track team. He married the president of the class, Ida Wylie, on July 19, 1923 after they had completed studies at the University of California, Berkeley. Mr. Jones graduated from the School of Architecture and was an architect, engineer, carpenter and wood craftsman who dedicated his leisure time to archaeology, Chumash Indian lore and photography. In the 1920s he wandered the sand dunes and hills of the local area with his cameras. He shot more than 20,000 individual portraits of wildflowers in a complete collection of the flora within a 60-mile radius of Santa Maria. ... Mr. Jones was a professional engineer and

designer, at various times operated his own architectural firm, and was superintendent of construction with Daniel, Mann and Johnson from 1940 to 1955. He was the building official for Santa Maria and was a building inspector of schools for the state. He designed and built the Pismo Beach City Hall and the Marre mansion on the hilltop above Port San Luis. As a craftsman he carved the chairs at the historic **Minerva Club** building of Santa Maria as well as the club motto on the proscenium of the state. He was affiliated with the historical societies of Santa Maria, Lompoc, Santa Ynez Valley, Santa Barbara and San Luis Obispo areas... He was also active in the Orcutt Gem and Mineral Society, Santa Maria Camera Club and Santa Maria Valley Pioneers Association, serving as president from 1941 to 1942. He was also active in the California Native Plant Society, the Sierra Club, Audubon Society and archeological societies in San Luis Obispo and Santa Maria ...," *Times-Press-Recorder* (Arroyo Grande, Ca.), Sept. 6, 1991, p. 12.
Jones, Gaylord (notices in Northern Santa Barbara County newspapers on microfilm and on newspapers.com)
1956 – "Gaylord Jones, Camera club president, with camera to photograph Elinor Petersen, exchange student, who was given a welcome party on arrival in Santa Maria yesterday," *SMT*, Aug. 21, 1956, p. 1.
1966 – "Chumash Indians will be Subject of Historical Society Speaker... Slides and a talk on Chumash Indians will be the program presented by Gaylord Jones... His hobby is photography and he has made a photographic study of the Chumash Indians and their culture. ... On display will be some of the early day pictures being printed by **Bud Olson** and placed in picture albums...," *LR*, May 31, 1966, p. 4.
And, more than 1000 hits for "Gaylord Jones" in the *SMT* between 1925 and 1965 were not even browsed for possible inclusion here.
Jones, Gaylord.
Concerning the Santa Maria City Hall built 1934 – "As to the building's interior, the man known as the "Artist of City Hall," Gaylord Jones (son of Samuel Jefferson and Viola (Cook) Jones), provided his personal touch. Doing the artwork and carving out most of the furniture within the structure, he also designed the ceiling painting just inside the front door above the wrought iron chandelier," Shirley Contreras, "The Heart of the Valley," SMT, May 8, 2011, on the Internet.
Jones, Gaylord (misc. bibliography)
Gaylord Jefferson Jones was b. Sept. 14, 1900 in Santa Maria to Samuel Jefferson Jones and Lillian Viola Cook, married Ida Margaret Wylie, and d. Aug. 14, 1991 in Arroyo Grande, Ca. per Cook to Ramos/Soto Tree (refs. ancestry.com).
See: "Boy Scouts," 1941, "Community Club," 1949, "Gibbs, Kittye," "Little Theatre," 1929, "Santa Barbara County Fair," 1958, 1960, "Santa Maria, Ca., Adult/Night School," 1935, 1939, "Santa Maria, Ca., Union High School," 1931, "Santa Maria Camera Club," 1955, 1956, 1958, "Stonehart Studio," 1928

Jones, Lora L. (1903-1977) (Solvang)
Principal of SYVUHS and teacher of mechanical
drawing, 1942, 1943. Moved to Modesto, 1944.
Jones, Lora L. (misc. bibliography)
Lora L. Jones provided the following information on his
WWII Draft Card dated Feb. 15, 1942 = b. April 12, 1903
in Blakesburg, Iowa, residing in Solvang, married to
Georgia B. Jones, working for the Santa Ynez Valley
Union High School District; Lora L. Jones was b. April 12,
1903 in Blakesburg, Iowa, to Selmon Franklin Jones and
Bertha Mae Ross, married Georgia Belle Johnson, and d.
March 8, 1977 in Ventura, Ca., per Jones Family Tree (ref.
ancestry.com)
See: "Santa Ynez Valley Union High School," 1942, 1943

Jones, Oliver Lee (1865-1941) (Santa Maria)
Painter of portraits and landscapes, 1885+. In 1886, 1888,
1889 exhibited art at SLO County Fair Sixteenth District.
Druggist. Musician. Debater. Actor. Giver of recitations.
■ "Mr. James B. Dean left for San Francisco July 23d…
In the absence… Mr. O. L. Jones, an efficient druggist of
Santa Maria, will take charge of the Pioneer Drug Store.
Mr. Jones, besides being a thoroughly competent druggist,
is also a splendid artist. As a portrait painter he has but few
equals on the coast. Many of his pictures adorn the homes
of the people of Santa Barbara and San Luis counties, and
all speak of his work in highest praise. As a scenic painter,
anyone has but to see his paintings to recognize his ability
in that line. We recommend any of our citizens desirous of
having their portraits painted or photographs enlarged, to
call on Mr. Jones,' *LR*, July 28, 1888, p. 3.
Jones, O. L. (notices in Northern Santa Barbara County
newspapers on microfilm and on newspapers.com)
1885 – "Portrait Artist. We had the pleasure this week of
inspecting as fine a portrait painted in India Ink as has ever
been our lot to see. The artist O. L. Jones, although not
engaged in that business at present and therefore working at
a great disadvantage by reason of having to paint the above
mentioned picture by lamp light, has turned out a portrait
that is hard to beat. He has earned a fine reputation as a
scenic artist wherever his work has been on exhibition, but
his ability is best shown in his portraits from life. Who says
Santa Maria is lacking in talent," *SMT*, Dec. 19, 1885, p. 4.
1886 – "The portrait of Mrs. W. T. Lucas painted by Mr. O.
L. Jones which has been on exhibition for a few days past
in Mr. Ayres' Drug Store, is a beautiful specimen of art and
proves him to be a first-class artist," *SMT*, Jan. 16, 1886, p.
5, col. 1; "Mr. O. L. Jones, the artist, finished a few days
ago an exceedingly well executed life-sized portrait of Mr.
Coblentz's two boys. …," *SMT*, March 27, 1886, p. 5, col.
1; "O. L. Jones, the popular clerk with W. W. Ayres, met
with quite an accident while coming down the Santa Maria
river on Thursday. He was driving along leisurely, his
brother and Genie Ayres being in the buggy with him" and
tried to go over some brush in the road and broke his axel,
SMT, June 26, 1886, p. 5, col. 1; "Our local artist, Mr. O. L.
Jones, is constantly turning out beautiful specimens of his
handwork and not a few adorn the parlors of our
townspeople. He is engaged at present enlarging from
photographs the entire family of Abraham Ontiveras. The
children are to be in a group and the whole when finished

promises to be a fine specimen of art," *SMT*, Sept. 4, 1886,
p. 5; "It is always a pleasure to the *Times* to notice any
thing of merit and our young friend Mr. O. L. Jones is
certainly turning out some beautiful work. While in his
studio recently we found him engaged painting the portraits
of the family of John F. Holloway, Jr., also a nearly life
size portrait of Mr. Morrison and several others. His
portraits are giving universal satisfaction owing to their
exactness, smoothness and harmony of contrast," *SMT*,
Oct. 16, 1886, p. 5, col. 1; "The pictures of Mr. and Mrs.
McNeil as shown in the window at the Palace Barber shop
have just been completed by O. L. Jones …," *SMT*, Dec.
18, 1886, p. 5, col. 1.
1887 – "Real Estate Sales … O. L. Jones to Dr. Stacy B.
Collin, 2 lots in Thornburgh's division," *SMT*, March 12,
1887, p. 5, col. 3; "While visiting, recently, the studio of
our local artist, O. L. Jones, we noticed among the many
pictures two beautiful life-size portraits of A. Weilheimer
and his sister, which certainly deserve the highest praise.
Our neighbors are embracing this opportunity to obtain
artistic portraits, Mr. Jones having completed and shipped
to San Luis Obispo an elegant life-size painting of the
children of L. M. Kaiser …," *SMT*, Aug. 6, 1887, p. 3, col.
1; "The public are invited to read the advertisement of O.
L. Jones, the scenic and portrait painter, on page first. As a
portrait painter he has no equal on the Pacific Coast…,"
SMT, Oct. 29, 1887, p. 3; "There has been a beautiful oil
painting on exhibition for the past week in the store of T.
A. Jones & Son which has attracted considerable attention
and reflects great credit on the artist, O. L. Jones. There is
now exhibited in the same place a life-sized portrait of the
late son of Hugh Kelly, which no one should miss seeing,
as it is a perfect likeness of a beautiful child," *SMT*, Nov. 5,
1887, p. 3.
1888 – "The walls of the City Barber shop are decorated
with fine oil paintings, and enough so as to present the
appearance of a fine art gallery. The most of the paintings
were executed by O. L. Jones; the largest one, some three
by five feet, representing Zaca lake, being executed by a
painter who worked for Mr. Jeter a few days, some two
months ago. It is drawn from a photograph taken by
McMillan Bros., and was executed in less than two days,
with common house paint. Those who have visited Zaca
Lake say that it is an excellent representation of the lake
and its surroundings. It is quite a showy picture and was
presented to Chas. Dickes by the executor," *SMT*, Jan. 21,
1888, p. 3; "Mr. O. L. Jones, druggist and artist, from Santa
Maria, who has been in charge of the Pioneer Drug Store
for the past two weeks, left for home on Tuesday on the
arrival of Mr. Dean," *SMT*, Aug. 15, 1888, p. 3; "On the
return of O. W. Maulsby from the Los Angeles Fair we
were shown the silver medal awarded the artist, O. L. Jones
for the best portrait. The medal is a large heavy one made
of solid silver…. Beautiful design and is handsomely
engraved. There were no less than twenty-five competing
artists…," *SMT*, Oct. 1, 1888, p. 3, col. 2.
1889 – "On passing the front of the Hart House the other
day our eye was attracted by the beautifully painted door
sign of R. W. Nuttall, Notary Public and Conveyancer,
executed in several colors by our local artist, O. L. Jones,"
SMT, Feb. 9, 1889, p. 3; "O. L. Jones, the artist, is busily
engaged in painting eight different sets of scenery for

McMillan's Opera House. This beautiful scenery will be used for the first time in the coming play of 'Rip Van Winkle.' **E. B. Crosby**, the manager of the troupe, expects to have all in readiness for this celebrated drama in about four weeks," *SMT*, March 23, 1889, p. 3; "The Scenery to be Seen at the Rip Van Winkle Play. The scenery at McMillan's Hall… was wholly executed by our local artists, O. L. Jones and **Ed Crosby**. The log cabin and its interior and Catskill mountains including other scenes by O. L. Jones and curtain and wooded scene, etc., by **Ed Crosby**. The whole is well and neatly executed and what is more wonderful it is the first work of the kind attempted by Mr. Crosby and yet more astonishing, two large pieces fully executed in a day. His wooded scene in part is painted from a picturesque spot on Suey creek while to the southeast, same as southeast of San Maria in winter, there lies the mountains, tops covered with snow," *SMT*, April 20, 1889, p. 2.

1890 – "Mr. O. L. Jones, who for some months past has been connected with Booth & Latimer's drug store, leaves in a few days for the northern part of the state to investigate certain promising advances which have been made to him…," *SMT*, Jan. 18, 1890, p. 3, col. 3.

1891 – "O. L. J. in Healdsburgh. From the *Healdsburgh Enterprise* we clip the following which will give the many friends of O. L. Jones (brother of P. [Pembrook] W. Jones) formerly of Santa Maria, an idea of his whereabouts: 'G. T. Miller has purchased the interest of Wm. B. Whitney in the Gilt Edge Pharmacy and is now sole proprietor… Oliver Jones, the accomplished pharmacist will have charge of the Gilt Edge henceforth …," *SMT*, Jan. 17, 1891, p. 2.

Jones, O. L. (misc. bibliography)
Oliver Jones is listed in the 1870 U. S. Census as five years old and residing with his parents and siblings in San Rafael, Ca.; Oliver L. Jones is listed in the 1880 U. S. Census as age 14, b. c. 1866 in California, residing in San Rafael, Ca., with his parents James M. Jones (age 52) and Elizabeth Jones (age 43) and siblings: Robert M. (age 21), Pembroke W. (age 19), Hewston (age 17) and sister Ivy P. (age 9); Oliver L. Jones is listed in the *Voter Register in Marin, Ca.*, in 1892; Oliver Lee Jones provided the following information on his *Passport Application* No. 2864 applied for on June 23, 1893 from Jefferson County, Kentucky = b. Siskiyou County, Calif. on or about the 20th day of July 1865, that my father is a native born citizen… my permanent residence being at San Rafael… where I follow the occupation of the practice of medicine … that I intend to return to the United States within two years…," Description of Applicant = 27 years, 5 feet 10 inches… high forehead, blue eyes, prominent nose, full beard, dark hair, dark complexion, square face; Oliver Lee Jones, physician, age 30, is listed in *Great Register, Alameda County, City of Oakland, Second Ward, Precinct No. 7*, 1896; Oliver L. Jones is listed in the 1900 U. S. Census as a physician and surgeon, single, residing in Oakland, Ca.; BROTHER – Pembrook W. [Sic. Pembroke Weller] Jones is listed as Druggist and Rep. in Santa Maria Precinct, 1920-28; Oliver Lee Jones is listed in the 1940 U. S. Census as age 75, b. c. 1865 in Calif. married, residing in Oakland, Ca. (1935) and Santa Clara, Ca. (1940) where he was a patient [Sic? or doctor?] in the Agnews State Hospital for the Insane; Oliver L. Jones was b. July 20,

1865 in Siskiyou, Ca., and his grandparents names are Elisha Weller and Louisa M. Weller, per McLaughlin Family Tree; Oliver Lee Jones, mother's maiden name Weller and father's Jones was b. July 20, 1865 in Calif. and d. July 9, 1941 in Santa Clara, Ca., per Calif. Death Index (refs. ancestry.com).
See: "Santa Barbara County Fair," 1886, 1888, 1889, and *San Luis Obispo Art and Photography before 1960*

Jones, Roy Lee, Capt. / Col. (Santa Maria)
Teacher of drawing at Hancock College of Aeronautics, 1938, 1940. Air Force reservist.
Jones, Roy (notices in Northern Santa Barbara County newspapers on microfilm and on newspapers.com)
1935 – "Reserves Will Meet to Plan for a School… Capt. Roy Jones Air-Reserve and secretary of the Mid-coast chapter, residing at California Polytechnic, San Luis Obispo…," *SMT*, Nov. 26, 1935, p. 4.
1941 – "Capt. Jones' Family Bidden Farewell… Capt. Roy L. Jones, U. S. Air Corps reserve, is in Santa Maria this week to complete arrangements for moving his family to Los Angeles, where he has been since leaving Hancock College of Aeronautics, of which he was manager, to take up active duty with the Air Corps…," *SMT*, Jan. 13, 1941, p. 3.
Jones, Roy L. (misc. bibliography)
Roy Lee Jones is listed in the 1940 U. S. Census as age 45, b. c. 1895 in Missouri, completed 8th grade schooling, teacher of drawing at College of Aeronautics and residing in SLO (1935) and Santa Maria (1940) with his wife Nina E. (age 44) and three children: Roy Lee (age 18), Lincoln (age 16) and Richard (age 12) (refs. ancestry.com).
See: "Santa Maria, Ca., Union High School," 1938

Jones, S. J. [Samuel Jefferson?] (1854-1940) (Santa Maria)
Exh. drawings at "Santa Barbara County Fair," 1889? S. J. Jones, Gen. Supt. of Fine Arts for the Fair, 1889, and of Exhibits at the Pavilion, in 1891 and other years. Collector of Native American materials. Valley historian.

■ "Samuel Jefferson Jones… Longest continuous resident of the city until his death yesterday at the age of 86… year upon year he had tramped over all the country around Santa Maria in furtherance of his hobby, the collection of artifacts of prehistoric man. His researches had been wide and he was an authority on the prehistoric people and their customs as well as on the history of Santa Maria valley. His collection of Indian arrowheads, mortars, pestles and other relics of the first inhabitants of this area was a large and valuable one, and it was he who discovered many of the burial mounds of the aborigines of the Central Coast country. As an authority on the history of Santa Maria and Santa Maria valley, he had no peer… To him … *The Santa Maria Times* owes its thanks for the accuracy and the extensiveness of the early historical sketches of this valley which have been published in these columns from time to time. He was possessed of a valuable collection of early photographs …He had a fund of anecdotes of early days that was amusing, but his stories were always of the character that were not hurtful to anyone… he took part in

all civic activities – even to tooting a horn in the village band and taking an active role in baseball and other athletic events… He was proud of the fact that he had ploughed and cultivated fields where the town now stands and of the part he had in assisting the surveyor to plot the townsite about a crossroads that he lived to see grow into a bustling city….," *SMT*, Jan. 17, 1940, p. 4.

And, many additional notices in the *SMT* between 1885 and 1940 not itemized here.

Jones, S. J. (notices in Northern Santa Barbara County newspapers on microfilm and on newspapers.com)
1887 – "T. A. Jones. S. J. Jones. T. A. Jones & Son. Dealers in Hardware, Glassware, Agricultural Implements, Paints, Oils, Furniture, Etc., Cabinet work to order. Coffins and Caskets on hand," *SMT*, Sept. 17, 1887, p. 4.
1937 – Ports. and "Mr. and Mrs. S. J. Jones Wedded Sixty Years Today," and detailed biography of couple, *SMT*, Oct. 20, 1937, p. 1.
Jones, S. J. (misc. bibliography)
Samuel J. Jones, age 38 [b. c. 1854], 5' 8", light complexion, blue eyes, brown hair, b. Iowa, residing in Santa Maria is listed in *The Great Register, Santa Barbara County, California*, 1892; Samuel Jefferson Jones was b. July 8, 1854 in Redfield, Iowa, to Thomas Allen Jones and Mary W. Huff, married Lillian Viola Cook, and d. Jan. 16, 1940, in Santa Maria per Wilson/Benbow/Jeavons Family Tree (refs. ancestry.com).
See: "Jones, T. A. & Son," "Santa Barbara County Fair," 1889

Jones, T. A. & Son (Santa Maria)
Furniture makers, 1876/78 (?)+. Merchants who sold picture frames, 1882+, and artists' supplies, 1894+. Sometimes had artistic window displays. Exh. Santa Barbara County Fair 1886, 1889.

■ "In Their New Quarters… T. A. Jones & Son established a furniture store in Santa Maria in 1878 [Sic. 1876?]. At that time, they did not carry any stock to speak of but manufactured such furniture as was ordered… they branched out… Their new store rooms on Broadway cover 3900 square feet… Their stock includes everything in the line of furniture… carpet department… Their stock of artist's paints and tools never fail to supply and satisfy the most exacting… crockery, glass…," *SMT*, May 13, 1893, p. 3.
Jones & Son (notices in Northern Santa Barbara County newspapers on microfilm and on newspapers.com)
1882 – Ad: "Go and see Jones & Son in their New Store… picture frames…," *SMT*, Sept. 90, 1882, p. 12.
1883 – Fire in September? Ad: "T. A. Jones. S. J. Jones. Jones & Son. Dealers in Furniture, Hardware, Paints, Oils, Varnishes, Wall Paper… Stoves, Tinware, Window Glass… Picture Frames, Stationery, Cutlery…," *SMT*, Dec. 29, 1883, p. 4;
1894 – "They Always Do Something. While others are talking, Jones & Son are working and are preparing a holiday display … They have a full line of furniture of all kinds, also lamps, shades and fixtures. In paint and artists' supplies they can satisfy the most exacting… silverware… China and crystal… pictures and picture books, games, toys…," *SMT*, Dec. 15, 1894, p. 2.

1895 – "China and glassware, lamps, cutlery, artist's materials, pictures, frames and notions at T. A. Jones & Son's," *SMT*, May 4, 1895, p. 3.
1897 – "To artists – A new line of studies just received. T. A. Jones & Son," *SMT*, Oct. 23, 1897, p. 3.
1902 – "T. A. Jones & Son… The stock consists of … stationery, school books and supplies, artists materials…," *SMT*, April 12, 1902, p. 1, col. 3.
1904 – "Santa Maria Business Enterprises… T. A. Jones & Son…," and history of store, *SMT*, Dec. 17, 1904, p. 13.
1905 – "T. A. Jones & Son's Grand Opening… opening of their fine new establishment on Broadway … The magnificent show windows brought forth constant … admiration… Mr. Bert Jones' conception of artistic window dressing…," *SMT*, Dec. 23, 1905, p. 2.
1914 – "Two splendid paintings of Dr. W. T. Lucas have been on exhibition this week at T. A. Jones & Sons furniture state [sic.?] from the brush of **Clarence R. Mattei**…," per "Twenty-Five Years Ago," *SMT*, May 9, 1939, p. 4.
1918 – A. R. Jones retires – "Announcement. After 40 years of successful merchandising in Santa Maria, the firm of T. A. Jones & Son has decided to retire from business and has disposed of its interests to the Jones Furniture Co., the personnel of which is Mr. Roscoe V. Jones and Mr. Howard S. Helsley who have been associated with the business for a number of years…," *SMT*, July 13, 1918, p. 8.
1919 – "Window Decoration … Jones furniture company … rugs … drapes… Occupying a central part of the display is an oil painting of a California scene the work of **DeTreville**, a rising artist of San Francisco," *SMT*, May 7, 1919, p. 5.
1920 – "T. A. Jones & Son Store Adds Many Improvements... The picture department now occupies a prominent department in the center of the store. … enlarged. The framing department is at the rear of the store… the Kennilworth gift shop will be installed in the main part of the large store. This unusually beautiful art department will be added late in the fall," i.e., the store was totally redecorated, and some description of insides is given, *SMT*, Aug. 5, 1920, p. 8.
1922 – "Merchant's Advertising Ball… T. A. Jones & Son Furniture Store is Awarded First Prize for Exhibit… Wm Bonynge … received the pretty silver cup for the most beautifully decorated booth. The booth displayed a living room in which were rugs, two exquisite lamps, book stand and several pieces of furniture," and other booths described, *SMT*, March 2, 1922, p. 1.
1923 – "Jones Store Wins Prize in Window Display Contest … [held during state Gas Stove and Heater week] …," *SMT*, May 23, 1923, p. 5.
1924 – "Jones Tells of City's Progress in Craft… member of the firm of T. A. Jones & Son… Mr. Jones told the establishing of the furniture firm in Santa Maria, then Central City, in the year 1876 [Sic.? 1878?] and of the growth and expansion of the business here for nearly a half century. An interesting feature… was the description of the town with its 200 inhabitants in 1876 as well as the method of conducting business… many years before factory-made furniture was sold here. Mr. Jones also displayed a number of photographs of interest, showing the store building in the

various stages of advancement until the present day…," *SMT*, Jan. 18, 1924, p. 1.

1938 – Photo and "First Big Fire Here Burned Jones Store… 1883," *SMT*, April 29, 1938, p. 19 (i.e., p. 3). And, nearly 1500 notices in the *SMT* between 1900 and 1940 were not itemized here.

See: "Jones, S. J.," "Santa Barbara County Fair," 1886, 1889

Jones Stationery (Santa Maria)
Retailers of art and photographic items, 1929.
"Cards and Gifts… Oil Painting Set, Framed Etchings… Pen Sets, Leather Writing Cases, Kodak and Memory Books, Jones Stationery and Gifts, 111 W. Church St.," *SMT*, June 4, 1929, p. 5.
Many additional notices in the *SMT* were not itemized here.

Jorgensen, Karl Ross (1920-1994) (Solvang)
Journalist, photographer, and cartoonist [signature "JL" for "Jus' Lookin'"], in Santa Ynez Valley News, erradically from before 1947 through the 1950s. Cartoonist, 1953.
■ Port. and "Karl Jorgensen… 74, died July 3, 1994 in his home in Solvang. He was born April 12, 1920 in Chicago, Ill. He was former owner-publisher of the *Santa Ynez Valley News* for 30 years (1945-'75), having been a 64-year valley resident. He served in US Army during World War II in the South Pacific. He graduated from SYV Union High School in 1937 and attended SB State College. He was a member of SYV Presbyterian Church, having served as a deacon for six years. He served on the board of the Elverhoj Museum and was a member of VFW, American Legion Danish Brotherhood. His proudest achievement was his book, *My West*, which contained photographs of the valley and later led to his murals that captured the essence of the area. … Oak Hill Cemetery, Ballard," *SYVN*, July 14, 1994, p. 5.

Jorgensen (notices in Northern Santa Barbara County newspapers on microfilm and on newspapers.com)
1951 – "Jus Lookin' … One of the best examples I've run onto was the new camera recently acquired by the *News* and upon which we have great hopes for the future .. as far as the *News* becoming more pictorial. Very slyly and without becoming insulting they sent an instruction book about three weeks in advance… Then patiently I waited for the exciting hunk of machinery to arrive. ... with trembling fingers, I lifted the gleaming camera out of the excelsior. But what made the occasion more joyful… was the clever paper tabs of instructions fastened on to everything that could move… Very carefully I lifted each unread tab of instructions, clicked… After a half an hour the machine was in the best disorder in which I have ever placed one…" by Karl, *SYVN*, May 25, 1951, p. 4; "Jus' Lookin'. With pockets bulging with flashbulbs, instruction books tucked under one arm, a thermos bottle (with coffee naturally) and folding chair under the other arm and my hands weighted down with photo equipment… JL strode out very professionally onto the playing field to 'shoot' last Friday's football game. Noting with approval that the east side of the field was covered by two other professionals (**Jack**

Griesbauer and Les Moorman), I wet a finger to test the direction of the wind …," and article continues with Karl's experiences photographing the game," *SYVN*, Oct. 12, 1951, p. 4; repro: of his photo of the game [ed. – the space for the repro. is black] and brief note on camera, *SYVN*, Oct. 19, 1951, p. 4; "Jus' Lookin'," and more about his photographic exploits, *SYVN*, Oct. 26, 1951, p. 4.
1952 – "Jus' Lookin'," discusses his exploits in trying to obtain interesting photographs, *SYVN*, May 2, 1952, p. 4; port. of author of "Jus' Lookin'," *SYVN*, Dec. 26, 1952, p. 2.
1953 – Cartoon drawn by JL, *SYVN*, Jan. 9, 1953, p. 4; and camera exploits, Jan. 16, 1953, p. 4; and Jan. 23, 1953, p. 4; and Jan. 30, 1953, p. 4; and Feb. 6, 1953, p. 4; and he heads his "Jus' Lookin" column with one of his cartoons in place of pure typeface, *SYVN*, Feb. 13, 1953, p. 4; and May 22, 1953, p. 4; and June 12, 1953, p. 4; and Dec. 14, 1956, p. 10; and Aug. 2, 1957, p. 2; not individually itemized here; "The Memo Pad… Karl 'JL' Jorgensen… returned home Sunday after a 4,000 mile trip through the Western desert country… 'JL' sporting a good tan reports the only disappointing aspect of the trip was the fact his camera conked out a few days after they left Solvang," *SYVN*, July 3, 1953, p. 2; port. *SYVN*, Dec. 25, 1953, p. 4.
1954 – "Valley News Camera Goes to Bazaar. The **Danish Ladies Aid**…," and some photos repro., *SYVN*, Nov. 26, 1954, p. 1.
1957 – "Jus' Lookin'," discusses his camera exploits, *SYVN*, May 3, 1957, p. 4.

Joughin, Eloise
See: "Joughin, Helen Eloise?"

Joughin, Evelyn
See: "Joughin, Gertrude Evelyn"

Joughin, (Gertrude) Evelyn (1931-2008) (Arroyo Grande)
Student at SLO JC, 1950, 1951. Painter of still lifes and landscapes. Studied art in Los Angeles, probably second half of 1950s. Exh. under the name "Evelyn." Exh. Allan Hancock [College] Art Gallery, 1956. Held annual OMSs at the Solvang Library, 1960s. Curator of Solvang Library art shows, 1967+. Prop. of Elegant Outhouse. Daughter of Helen Eloise Joughin (Mrs. Andrew Roeder Joughin).
See: "Allan Hancock [College] Art Gallery," 1956, "Joughin, Helen Eloise," "Santa Barbara County Library (Solvang)," 1961, 1962, 1963, 1965, 1966, 1967, "Santa Ynez Valley Art Exhibit," 1958, and *Arroyo Grande (and Environs) Art and Photography before 1960* and *San Luis Obispo Art and Photography before 1960*

Joughin, Helen Eloise Dicken (Mrs. Andrew Roeder Joughin, Sr.) (1897-1977) (Huasna District of SLO County / Santa Ynez Valley)
Artist who exh. under the name "Helen Joughin" or "Eloise Joughin." Exh. at Santa Ynez Valley Art Exhibit, 1953, 1954, and in charge, 1955, 1956, and exh. 1957, 1958. Exh. Allan Hancock [College] Art Gallery, 1955, 1956. Mother to Gertrude Evelyn Joughin, above.

■ "Helen E. Joughin… 80, daughter of a pioneer cattle ranching family, who died in her home Friday. Mrs. Joughin was born April 15, 1897 in Kansas City, Mo. Together with her husband, Andrew R. Joughin, she ran a cattle ranch in the Santa Ynez Valley for 25 years. Before that, the family operated a cattle ranch in San Luis Obispo County. Mrs. Joughin was a member of the Minerva Club in Santa Maria, the Monday Club, Tri-County Artists, past president of the Santa Ynez Valley Woman's Club, and an officer in the Santa Ynez Valley Hospital Auxiliary. Mrs. Joughin, deeply involved in painting and flower arranging, was a judge at the state fair flower show, and many of her paintings were offered in the fund-raising affairs for St. Mark's Episcopal Church, which she helped organize. She is survived by her husband, Andrew R. of Santa Ynez… daughters, Miss Evelyn Joughin …," *SMT*, May 23, 1977, p. 3; "Joughin Services Held in Ballard… Mrs. Helen Eloise Dicken Joughin… A painter of flowers and flower arrangements, she had exhibited her work in the tri counties area…," *SYVN*, May 26, 1977, p. 17.
Joughin, Helen Eloise (notices in Northern Santa Barbara County newspapers on microfilm and on newspapers.com)
[Ed. – Do not confuse with her daughter Gertrude Evelyn Joughin, above, or with her daughter-in-law, Mrs. Andrew Dicken Joughin, who was probably NOT an artist.]

■ "Mrs. Andrew Joughin is one of the first county artists to signify intention to enter the fourth annual [SLO] county art show to be held here this year, Feb. 22 to 26. When Mrs. Joughin visits her ranch forty miles from here in the upper Huasna district, she finds much to inspire her brush. She will enter 'The Sycamore by The Gate,' a strikingly beautiful painting of one of the stately trees on her Rancho Agua Escondido. She is raising many flowers and has decided to do a watercolor of magnolia blossoms, which she will also enter in the art show. Mrs. Joughin manages to keep up with her fascinating hobby as well as raise her five children," per "Paints Scenes from Huasna," *SLO T-T*, Jan. 19, 1950, p. 10.

■ "20 or more oil paintings… They are pictures painted for the home rather than for competitive exhibitions. They are pleasant, agreeable, and livable and rely on the appeal of their subject matter to create this effect. Technically Mrs. Joughin paints with skill in drawing and design that portrays the material she has chosen. Her color work is varied to the nature of the subject and shows the artist's skill in adapting her palette to the needs of her painting problems. Most of the paintings are flower studies. There are a number of landscapes which demonstrate the artist's ability to put into either work the pleasant and kindly charm which she commands for them. Mrs. Joughin's love of art and painting is reflected also in her work in Solvang where she now lives. She has organized and put on very interesting art exhibits and auctions of work by hundreds of artists in the Tri-county area, for the benefit of the Saint

Mark's Church in the Valley at Solvang," per "Forden Gallery has Display," *SLO T-T*, March 28, 1956, p. 18.
1951 – "Andy **Joughin**s Buy Santa Ynez Ranch," *AG*, Nov. 2, 1951, p. 2.
1954 – "Mrs. Joughin Plays Hostess to SLO Club's Garden Section… The Joughin ranch is situated in the foothills that border the San Rafael Mountains consisting of some 2000 acres of rolling hills which provides grazing land for their purebred Herefords… the Joughin home was built of adobe brick and constructed in the early 1840s…," *SYVN*, April 23, 1954, p. 3.
1955, 1956 – Head of **Santa Ynez Valley Art Exhibit**
1956 – "Two from Valley… one-man show of paintings of Mrs. Andrew Joughin in San Luis Obispo. They also attended the SLO County Art Show… Mrs. Joughin and **Charles Glasgow** were exhibitors," *SYVN*, March 16, 1956, p. 6.
1960 – "**Solvang Library** Corner… The colorful flower oil paintings that have been on the Library walls are those of Mrs. Andrew Joughin who is well known in the Valley for her love of flowers and her arrangements," *SYVN*, Nov. 4, 1960, p. 7.
1963 – "Mrs. Joughin Floral Art on Display… one-man show on display at the art gallery at Riley's Department store in San Luis Obispo. The artist, wife of Andrew R. Joughin, has about 15 of her well-known floral paintings in the display which opened this week and will continue for a month…. annual San Luis Obispo flower show… Mrs. Joughin has been asked to act as judge at the flower show and has also been asked to submit a guest flower arrangement. ... Mrs. Joughin is a charter member of the San Luis Obispo Art Association as the family resided in that area for 32 years before coming to the Valley," *SYVN*, March 15, 1963, p. 3.
1973 – Port with other past presidents of the Santa Ynez Valley Woman's Club honored at a tea, *SYVN*, Sept. 27, 1973, p. 4.
1986 – Photo and "Artists of Past show continues… in the Grandstand and Clubhouse rooms of the new Holiday Inn… Buellton… former artists of the Valley who no longer are living. An informative brochure is available giving the background of each artist…. nine artists showing 43 pieces: **Martha Brandt-Erichsen** with several portraits and imaginative paintings… A small bone carving of a bird was made by Richard L. Swensen… **Marie Jaans**, former wife of artist Forrest Hibbits… John St. John who, until his recent death, operated a gallery in Solvang was noted for his abstract landscapes and a weaving. Two large oil paintings by Kenny L. Baker … floral paintings done by Eloise Joughin… **Paul Kuelgen** who had done much decorating in the Valley was represented by a large painting. The colorful and primitive paintings of Andrew 'Old Man' Block, always amusing….," *SYVN*, Oct. 30, 1986, p. 28 (i.e., 6B?).
Joughin, Helen Eloise (misc. bibliography)
Mrs. Helen E. Joughin, housewife and Rep. residing in Arroyo Grande is listed next to Andrew R. Joughin, rancher in *Index to Registration Affidavits, Huasna Precinct, SLO County*, 1930, 1932, 1934; Helen Eloise Joughin is listed in the 1940 U. S. Census as age 43, b. c. 1897 in Missouri, finished high school 4th year, residing in rural SLO County (1935) and Morro Bay (1940) (with husband not on census)

and with several children: Elvise [Sic. Eloise?] Jome (age 14), Helen Emdad (age 11), Joanna Ann (age 10), Gertrude Evelyn (age 9) and Andrew Darika [sic. Dicken] (age 7); Helen E. Joughin and husband Andrew R. are listed in Arroyo Grande in *SLO City/County Directory*, 1953; Helen Eloise Dicken Joughin was b. April 15, 1897, married Andrew Roeder Joughin, and d. May 20, 1977 in Santa Ynez, Santa Barbara County per Provost, Norma (09-05-15) (2) Family Tree; Helen Eloise Joughin is buried in Oak Hill Cemetery, Ballard, Santa Barbara County, Ca., per findagrave.com (refs. ancestry.com).

See: "Abbott, Ronnie," "Allan Hancock [College] Art Gallery," 1955, 1956, "Danish Days," 1957, "Joughin, Gertrude Evelyn," "Santa Barbara County Library (Solvang)," 1959, 1960, 1962, "Santa Ynez Valley Art Association," 1953, "Santa Ynez Valley Art Exhibit," 1952, 1953, 1954, 1955, 1956, 1957, 1958, and *San Luis Obispo Art and Photography before 1960* and *Arroyo Grande (and Environs) Art and Photography before 1960*

Journey's End (Santa Ynez Valley)
Gift shop that sold hand-made gifts, opened 1946.

■ "Unique Gift Shop Opens in Valley… in little white barn down by the Alamo Pintado Creek on the Connecticut Yankee's Ranch by Elizabeth M. Porter and Elizabeth D. Bradley… Here you will be able to buy delicacies from the famed Marker's Preserving Kitchen in Downey… handmade gifts, and a large stock of unusual antiques…," *SYVN*, Nov. 29, 1946, p. 1.

Judkins, David Roby (1836-1909) (Santa Maria)
Photographer, Santa Maria, with Shull, 1906-07. Prop. of Judkins Studio, Santa Maria, 1907-09. Father of Etta Hazle Judkins, below. Uncle of Edgar G. Judkins, below.

■ 'D. R. Judkins Crosses the Divide. David Roby Judkins, the well-known photographer of this city, died on Saturday last after an illness of three weeks. Mr. Judkins was a native of Maine and at the time of his demise was 73 years, 10 months and 28 days of age. He came to Santa Maria about three years ago and opened a photograph gallery, later buying out the interests of the Santa Maria Gallery, which he conducted ever since. About a year ago his gallery was destroyed by fire, but he re-opened a new studio on West Main street and made a success of the business. He was a man of kindly ways and made many friends. As a photographer he was a decided success … He leaves a daughter, Miss **Hazel [Sic. Hazle Judkins]**, who assisted him in the gallery and kept his home… interred in the Santa Maria cemetery," *SMT*, Dec. 18, 1909, p. 1.

■ "David Roby Judkins was born on January 17, 1836, in Chesterville, Maine, the fourth of the ten children of Joseph Judkins (1802-51) and Abigail (Knowles) Judkins (1810-70). Five of these children would grow up to become photographers…." By 1863 David Judkins had moved to San Francisco where he worked as a photographer. He was also in the Gold Field towns in the mid-1860s and then returned east. By 1876 he was back in California in Mendocino but later he was in Port Townsend in Washington Territory and then 1898-99 he followed the

Yukon Gold Rush. "Judkins moved to Santa Maria, California, in 1906, forming a partnership with **E. D. Shull** that operated as the '**Santa Maria Photography Gallery**,' 200 Block of West Main Street. His daughter Hazle worked in the studio as an assistant. Judkins bought out Shull's interest in the business in 1907, and it became known as 'D. R. Judkins, Photographer.' The firm published postcards of Pismo Beach, Casmalia, Santa Maria Valley, and other local attractions. In July 1908 Judkins was temporarily working as a photographer at 521 Alameda in Chihuahua, Mexico, which at that time was a booming mining town frequented by a number of American photographers. The Santa Maria gallery burned in a fire on September 19, 1908. It was insured for only two hundred dollars, and Judkins lost almost all of his negatives. He rebuilt his business on West Main Street and continued photographing there as the **Santa Maria Studio** until his death of 'general senile debility' on December 11, 1909, at the age of seventy-three. He was buried in the Santa Maria Cemetery," per Peter E. Palmquist and Thomas R. Kailbourn, *Pioneer Photographers of the Far West: A Biographical Dictionary 1840-1865*, Stanford, Ca.: Stanford University Press, 2000, pp. 340-42.

Judkins, David (notices in Northern Santa Barbara County newspapers on microfilm and on newspapers.com)
1907 – "D. R. Judkins has opened a photo gallery in the T. A. Jones Building," *SMT*, Sept. 7, 1907, p. 5, col. 2; "D. R. Judkins photographs groups, residences and views anywhere. Post cards of residences $1.00 per dozen. Amateur finishing a specialty. Room 7 over Jones' furniture store," *SMT*, Nov. 23, 1907, p. 5, col. 3.
1908 – "Love's Young Dream Rudely Shattered," i.e., Judkins intercepts his daughter's elopement, *SMT*, July 11, 1908, p. 8; "Exchange Hotel Destroyed by Flames… sufferes [sic.] … D. R. Judkins photograph gallery… Insurance was carried by … Mr. Judkins for $200…," *SMT*, Sept. 19, 1908, p. 1; "Photo Studio Opens Oct. 3. D. R. Judkins will open his new photo studio on or about October 3d in the building adjoining the St. James Livery on Main street. He will be glad to have all those that had sittings prior to the fire call and have their work done over, as the most of his plates were destroyed in the recent fire," *SMT*, Sept. 26, 1908, p. 5, col. 2; "Those wanting photos of children and groups must come in the early part of the day – D. R. Judkins," *SMT*, Nov. 14, 1908, p. 3, col. 5; "We make a specialty of baby's and children's photos. A lady in attendance afternoons. Open all day Sundays. A new lot of folders and card mounts has just arrived. D. R. Judkins, Proprietor," *SMT*, Dec. 26, 1908, p. 5, col. 1.
1909 – "D. E. [sic.] Judkins… has completed the group picture of Hesperian Lodge, No. 264 … The pictures are on sale at his gallery …," *SMT*, Sept. 18, 1909, p. 5; "D. R. Judkins who has been quite ill for the past week or so, is improving and will be at his studio again beginning tomorrow…," *SMT*, Nov. 27, 1909, p. 1.
Judkins, David (misc. bibliography)
David R. Judkins, b. c. 1835 in Chesterville, Maine, married Ellen Gill on Nov. 25, 1868 in Fitchburg, Mass., per Mass. Marriage Records; David R. Judkins is listed in the 1880 U. S. Census as age 40, b. Maine, divorced, a photographer residing in Seattle, Wash.; David R. Judkins, photographer, is listed in the *Seattle, Wa., CD*, 1891. David

Roby Judkins was b. Jan. 13, 1836 in Chesterville, Maine to Joseph Judkins and Abigail G. Knowles, married Ellen Gill, was residing in Lawrence, Mass., in 1855, and d. Dec. 11, 1909 in Santa Maria, Ca., per Fry Family Tree; David Roby Judkins, married to Ellen Lois Judkins, is buried in Santa Maria Cemetery District per findagrave.com; and some photos he took of landscapes are contained in *Public Member Photos & Scanned Documents* (refs. ancestry.com).
See: "Judkins, Edgar G.," "Judkins, Ellen," "Judkins, Etta Hazle," "Judkins Studio," "Santa Maria Photo Gallery," "Shull, E. D."

Judkins, Edgar George (1863-1912) (Santa Maria)
Photographer, 1910-12. Nephew of D. R. Judkins, above, who took over the Judkins Studio at his death. Husband to Hila Catherine Judkins, below.

■ "E. G. Judkins, The Photographer, Passes Away. Edgar G. Judkins, the well-known photographer on West Main Street, died Wednesday, aged 49 years. He had been ill for a number of months and the friends and family realized that his end was drawing near. The deceased leaves, besides a heart-broken widow and three little children, his mother, who has been here since last December. **Mrs. Weaver** [i.e., **Etta Judkins**] wife of the well known oil driller and formerly in charge of the photo gallery, is also related to the deceased... In life Edgar Judkins was a man of quiet and kind disposition. He was a good photographer and made many friends in his business transactions... During the past four months, while he was unable to attend to the business, his wife [**Hila Catherine Judkins**] conducted the photograph gallery with marked success...," *SMT*, May 25, 1912, p. 1.
Judkins, E. G. (notices in Northern Santa Barbara County newspapers on microfilm and on newspapers.com)
1910 – "E. G. Judkins, a nephew of the late D. R. Judkins, arrived here this week and will take charge of the Santa Maria Studio," *SMT*, Feb. 19, 1910, p. 5.
1911 – Photographers. There are two fine studios in Santa Maria... while the Judkins studio is located on West Main St. and is conducted by Mr. Judkins...," *SMT*, Dec. 30, 1911, p. 11.
1912 – "The Judkins photograph studio is having a spacious show window placed in the front by Doane & Sons," *SMT*, July 27, 1912, p. 5, col. 5.
And many ads, not itemized here.
Judkins, Edgar (misc. bibliography)
George Edgar Judkins was b. Nov. 8, 1863 in Lawrence, Mass. to George Henry Judkins and Sophia Bigelow Hodgkins, married Hila Catherine Stuart, was residing in Santa Barbara, Ca., in 1910 and d. May 11, 1912 in Santa Maria, Ca., per Staley Family Tree; Edgar George Judkins (1863-1912) is buried in Santa Maria Cemetery District per findagrave.com (refs. ancestry.com).

Judkins (Weaver), Etta Hazle (Mrs. Miles Franklin Weaver) (1891-1974) (Santa Maria)
Photographer's aid to her father David Roby Judkins, at Santa Maria Photography Gallery, 1906 (when it was co-owned by Shull and Judkins) and then at Judkins Studio, 1907-09. Related to Edgar George Judkins and Hila Catherine Judkins.

■ "Love's Young Dream Rudely Shattered. ... Miss Hazel [Sic. Hazle] Judkins, daughter of **D. R. Judkins** the photographer, was stopped in her flight to join her alleged suitor, **E. D. Shull**, who for some weeks past has been conducting a temporary photograph gallery at Santa Ynez. Mr. Shull was in waiting at Los Olivos. Likewise, was an officer whose prosaic calling was not calculated to lead him into a just appreciation of romantic bliss and upon Miss Judkins alighting from the train he stepped up and claimed her temporarily as his own. Next day he returned with her to her father in Santa Maria. Under the circumstances that personage deemed it wise to send her to her aunt in Los Angeles. In that city love's young dream, though rudely shattered, is fondly cherished while Mr. Shull has returned to his work of developing negatives in the hope that he may at some future time accumulate sufficient of them to make an affirmative which shall bear a speaking likeness to the girl's father. Miss Judkins is in her seventeenth year, while Mr. Shull is considerably her senior," *SMT*, July 11, 1908, p. 8.
Judkins, Etta Hazle (misc. bibliography)
Etta Hazle Judkins was b. Jan. 20, 1891 in Seattle, Wa., to David Roby Judkins and Ida A. Bangs, married Miles Franklin Weaver, was residing in Los Angeles in 1930, and d. Dec. 6, 1974 in Van Nuys, Ca., per Weaver Family Tree; a photo of Etta Hazle Judkins appears in Public Member Photos & Scanned Documents (refs. ancestry.com).
See: "Judkins, ..."

Judkins (Chitolis), Hila Catherine Stuart (Mrs. Edgar George Judkins) (Mrs. George Chitolis) (1882-1962) (Santa Maria)
Photographer, prop.? of Judkins Studio 1913-1917? Widow of Edgar George Judkins.
Judkins, Hila (notices in Northern Santa Barbara County newspapers on microfilm and on newspapers.com)
1916 – "Married. George Chitolis, a native of Greece, age 29, and Hila C. Judkins, a native of North Carolina, age 30, both residents of Santa Maria, were married in San Luis Obispo last Wednesday evening," *SMT*, Sept. 23, 1916, p. 8.
1932 – "Son of Former Resident Dies... Ellis Edgar Judkins...," *SMT*, Aug. 26, 1932, p. 1.
Judkins, Hila (misc. bibliography)
Hila Catherine Judkins, photographer at 214 W. Main St., appears twice in *California Voter Registrations, Santa Maria Precinct, no. 3*, some time between 1900-1918; Hila Catherine Judkins was b. July 9, 1882 in Ashe County, N.C., to Eli C. Stuart and Francis Stuart, married Edgar George Judkins, and d. March 21, 1962 in SLO County but is buried in Santa Maria Cemetery District per findagrave.com (refs. ancestry.com).
See: "Judkins, Edgar George," "Judkins Studio"

Judkins Studio (Santa Maria)
Photography Studio. Proprietors: D. R. Judkins (1907-1909), E. G. Judkins (1910-1912), Mrs. Hila Catherine Judkins (1913-1917?), Cambridge Graham Willett (1917).

■

Judkins Studio (notices in Northern Santa Barbara County newspapers on microfilm and on newspapers.com)
1913 – "Attention is called to the advertisement of Mrs. [**Hila Catherine**] **Judkins**, who is conducting an up-to-date photograph gallery and does excellent work," *SMT*, March 29, 1913, p. 5; ad: "'Mother was a beauty in her younger days.' Mother may smile deprecatingly – but – watch her go to the little top drawer and take out the precious photograph 'taken before I was married.' Chances are she will also tell you of her admirers. … What a priceless record of her younger charms that photograph is to mother and – to you. Modern photography can do infinitely more to preserve the record of yours. There's a photographer in your town – Judkins Studio," *SMT*, April 26, 1913, p. 8; ad: "'Sweet Sixteen' comes but once in a life time. Let the portrait preserve the record of that happy age. A visit to the photographer keeps fresh for all time the budding charms of sixteen or the blooming of twenty. Think what those pictures will mean to you and to her in after years. There's a photographer in your town. Judkins Studio," *SMT*, May 10, 1913, p. 7; ad: "Don't trust to memory to preserve the changing likeness of your growing boy or girl. Memory plays strange tricks some times. A good photograph or so every year will keep an accurate record of the subtle changes in their development… Judkins Studio," *SMT*, Oct. 18, 1913, p. 2; "214 West Main," *SMT*, Dec. 13, 1913, p. 4.
1914 – "Photos. Cabinets $2.00 a dozen. Large folders $2. And $3. A dozen…. Perfect Satisfaction Guaranteed… Judkins Studio," *SMT*, April 4, 1914, p. 3.
And many ads in the *SMT*, 1913-1917 not itemized here.
1917 – "**Cambridge Graham Willett**, aged 69 years, 7 months and 5 days and a native of Pennsylvania, passed away on Friday of last week. The deceased was a photographer and bought the Judkins studio last spring…," *SMT*, Dec. 15, 1917, p. 1.
See: "Judkins, David Roby," "Judkins, Edgar George," "Judkins, Etta Hazle," "Judkins, Hila Catherine," "Santa Maria Photo," "Willett, Cambridge"

Judson Studios (Los Angeles)
Makers of stained-glass windows – for St. Peter's Episcopal Church, Santa Maria, 1959. St. Marks-in-the-Valley church.
1958 – "Rev. Bussingham Memorial Church Window Dedicated… stained-glass window in memory of the late Rev. Alfred Clarence Bussingham… **St. Mark's-in-the-Valley Episcopal Church**… depicts the calling of St. Andrew is given… by the widow… [and bio. of Bussingham] … The memorial window was designed and made by **Judson Studios** of Los Angeles," *SYVN*, Nov. 14, 1958, p. 4.
1959 – "Dedication of a stained-glass window, gift of **Mr. and Mrs. Donald H. Taylor**, and a memorial to his father, Sidney Stockton Taylor, was a special event on Sunday in **St. Peter's Episcopal Church**. The window, designed by a Pasadena Studio [Judson Studios?], pictures St. Matthew, who is wearing light green robes, and is holding a scroll in his hand. Mr. Sidney Stockton Taylor was an attorney, and the subject was chosen as appropriate to his career and life as a church member," per "Stained Glass Window Dedicated," *SMT*, May 12, 1959, p. 5.
See: "Saint Mark's in the Valley," "St. Peter's Episcopal Church," "Stained Glass"

Junior Alpha Club (Lompoc)
Formed 1932.
1932 – "Junior Group is Planned Here by Alpha Club," *LR*, Sept. 23, 1932, p. 2; "Formation of Junior Alpha Club… auxiliary organization of the Alpha Club…," *LR*, Oct. 21, 1932, p. 9; "Juniors to Meet … composed of girls and women between the ages of 18 and 30 years…," *LR*, Oct. 28, 1932, p. 2.
See: "Alpha Club," 1932+

Junior Art Class (Orcutt)
See: "Orcutt Community Church"

Junior Art Club (Santa Maria)
See: "College Art Club," 1933

Junior College (Santa Maria)
See: "Santa Maria, Ca., Union High School," to c. 1954, "Allan Hancock College (aka Santa Maria Junior College)," c. 1954+

Junior College Art Club (Santa Maria)
See: "College Art Club," 1932

Junior Community Club (Santa Maria)
Affiliate of the Community Club – for younger members. Organized fall, 1935. Sponsored some art events. Sponsored Santa Maria Valley Amateur Art Show at Allan Hancock [College] Art Gallery, 1956.
■ "Formation of Junior Community Club… The organization of a junior group will be carried on by Mrs. Essie McMichael. Membership is open to young women leaders of the community interested in learning federated club work," *SMT*, June 12, 1935, p. 3.
Junior Community Club (notices in Northern Santa Barbara County newspapers on microfilm and on newspapers.com)
[Some entries for the Juniors may be under "Community Club."]

1936 – "Club's Work. …Community Club… Last fall it organized a Junior Community club, which now has 18 members," *SMT*, March 20, 1936, p. 3; "Club Juniors Make Plans for Dance… **Miss Elaine Dudy** and Mrs. Leland Prindle will make posters," *SMT*, Oct. 24, 1936, p. 2.

1938 – "Junior Club Hears Handcraft Talk. **Mrs. Ralph Henderson** of North Hollywood, district chairman," *SMT*, Jan. 15, 1938, p. 2.

1941 – "State Leader Here... **Mrs. Mabel Henderson** of Glendale, state chairman of handcraft... discussed the possibilities of handicrafts and displayed examples...," *SMT*, April 29, 1941, p. 3.

1944 – "Antique Glass Subject of Meeting," *SMT,* Sept. 20, 1944, p. 3.

1945 – "Junior Group Committees... **Mrs. William Vaughn**, handcraft...," *SMT*, June 20, 1945, p. 3; "Club Engages in Leather Craft" taught by **William Vaughn**, *SMT,* Oct. 17, 1945, p. 3.

1947 – "Mrs. [Sic. Miss] **V. Leonard**, speaker at Jr. Community Club... Her topic was 'Art Education in the Junior College and High School.' She stressed that a mother should not laugh at the art which her young child has drawn," *SMT*, Feb. 19, 1947, p. 5.

1949 – "**Mrs. Lidbom** Speaks on Crafts" to Junior Community Club, and she demonstrated artistic wrapping of Christmas gifts, *SMT,* Dec. 8, 1949, p. 5.

1950 – "Jr. Community Club... A display of ceramics was arranged as an 'Art Corner' feature by **Mrs. James Hosn** who is to be the club's principal representative for the second annual Hobby show...," *SMT*, Sept. 6, 1950, p. 4; "District Federated Club Leaders Due Tomorrow..." and "A program ... '101 Ways to Make Christmas Gifts.' Members are requested to bring their suggestions, and **Mrs. James Hosn**, art chairman, and Mrs. Claude Buss, handcraft chairman, will bring items of leather and copper work as well as paintings and photography suitable for gifts," *SMT*, Oct. 2, 1950, p. 4; "Jr. Club Asks for College Course... last night's meeting held at the **DeNejer** art studio on Betteravia lateral road... The club was entertained by Mrs. DeNejer who gave a talk on art trends in the past three decades. She illustrated her topic with landscapes, modern paintings and portraits, and after inviting the audience to view her ceramic collection, Mrs. DeNejer gave a demonstration operating the potter's wheel...," *SMT*, Dec. 6, 1950, p. 4; "Community Club Sponsors Contest. The art committee of Junior Community club, composed of **Mrs. James Hosn** and **Mrs. Bill Williams**, is sponsoring a contest in Santa Maria elementary schools with the help of **Miss Edna Davidson**. Students participating are making Christmas decorations... to decorate a tree to be given to a hospital ward at Camp Cooke. The project is one of many being sponsored by the club to further community interest in art," *SMT*, Dec. 14, 1950, p. 4; "Jr. Club to Give Hospital Party... Christmas party in the wards at **Santa Maria hospital**... The club members will take an art exhibit of an oil painting by A. B. Pierce, and also lithographs and floral prints by American artists for the patients to view. **Mrs. George Schmidt** is arranging the art exhibit and also will display a pastel painting by **Mrs. Inez Lukeman** of Santa Maria for the club's business meeting," *SMT*, Dec. 18, 1950, p. 4.

1951 – "Junior Club... Announcement was made of art classes to be sponsored by the club for service men and their wives in DeNejer art studios on Black road. **Mrs. Ray DeNejer** will instruct one night each week in the course ... An art corner display included ceramics loaned by the hostess [Mrs. Simms]. Featured were a Chinese lamp, wall

plaque and other items," *SMT*, Jan. 3, 1951, p. 5; "Youth Welfare Stressed as Junior Clubwomen Vote... [Junior Federated Women's club?] ... In keeping with the hostess club's accent on youth, there were several paintings of children in the art exhibit of **Mrs. Ross Linsenmayer**'s work arranged by **Mrs. James Hosn**, local club art chairman. In the exhibit were also landscapes of Santa Barbara county scenic spots and a pair of charcoal portraits, one a study of the artist's husband," *SMT*, Jan. 29, 1951, p. 4; "Mrs. Nelson... The art corner exhibit, arranged by **Mrs. Bill Williams**, was a hand-stenciled tablecloth, loaned by Mrs. Frank Lee. Mrs. Williams gave a talk on textile paints," *SMT*, Feb. 7, 1951, p. 4; "Maxine Bailey... A South Seas motif will be added with display by **Mrs. Bill Williams** of tapa cloth items. The owner will speak on the making and dyeing of this native material and of its many uses in South Seas homes," *SMT*, Feb. 20, 1951, p. 4; "Fashion Show Due for Jr. Community... **Mrs. James Hosn** will give a talk on 'Wood Carving' and will display for the art corner a bowl of sequoia wood, made and polished by George Sopoff...," *SMT*, March 19, 1951, p. 4; "Mrs. Beckman Elected... The Junior Community club arranged a display and sale of art in an adjoining room. **Mrs. James Hosn**, chairman, was in charge... which included pottery by **Mrs. Ray DeNejer** and prints and paintings by **Mrs. Alice Linsenmayer**," *SMT*, March 21, 1951, p. 4; "Wins District Art Award," i.e., top in American art and third in American citizenship thanks to art chairman **Mrs. James Hosn** who arranged several exhibits of paintings and ceramics for meetings, and article adds, "Accompanying talks on the articles were included. With its outstanding record for study and promotion of American art, in line with the general federation's theme for the year, Santa Maria will now compete for honors at the state convention in May," *SMT,* April 16, 1951, p. 4; "Jr. Community... **Mrs. James Hosn** has arranged an art corner exhibit of pictures imported from Mexico, of parakeets made of feathers. She will also display ash trays from Brazil fashioned with butterfly wings under glass," *SMT*, April 30, 1951, p. 4; port. of **Mrs. Hosn** with **Lillian Heath** painting "Cypress Tree" given as award to club for its interest in art, *SMT,* May 12, 1951, p. 4; "Mothers are Honor... **Mrs. James Hosn**, art chairman of the junior club, arranged for a display of exceptionally fine oil paintings of local landscapes by **Mario Veglia** of Casmalia," *SMT*, May 14, 1951, p. 4; **Mrs. Hosn** re-elected chairman of art, "Club Begins New Annual Term," *SMT,* June 6, 1951, p. 4; **Mrs. Hosn** speaks briefly on art matters, "Club Board to Entertain ... **Mrs. James Hosn**... will have a brief educational program... 'How to Recognize a Good Painting.' **Mrs. Hosn** will ask questions with regard to copies of three famous paintings, 'Polar Expedition,' by **Rockwell Kent**, 'Winter Storage,' by Dale Nichols, and 'March-North Atlantic,' by Frederick Waugh... committees for the new term... Art, **Mrs. Hosn**... handcraft, **Mrs. Dan [Sic. Don] McGray**... needlework guild, Mrs. Bion Campbell... fine arts, Mrs. Donald Burklow [nee Beverly O'Grady] ...," *SMT*, June 28, 1951, p. 4, col. 2; "Mrs. Burklows... Two pictures are being exhibited. Loaned by **Mrs. James Hosn** as an example of different mediums used in paintings, a talk will be given on uses of leather, wool, paper and string in the art of illustration," *SMT*, Aug.

7, 1951, p. 4; "Mrs. Berklow… In a pottery 'art corner' was displayed stoneware made by **Mrs. Ray DeNejer** to be exhibited in Los Angeles county fair at Pomona. Mrs. Berklow [Sic. Burklow] gave the talk on pottery. **Mrs. Don McGray** had an exhibit of handcraft dolls…," *SMT*, Aug. 9, 1951, p. 4; "Junior Community … Nine pictures made in club-sponsored art classes, were displayed by **Mrs. James Hosn**… who announced 21 additional classes have been arranged under club sponsorship. Members are providing materials and patterns for children's use in the classes… Dancing dolls, made of wire, crepe paper and cotton formed the handcraft display by **Mrs. Donald McGray**. The needlework guild displayed knit socks…," *SMT*, Oct. 17, 1951, p. 4; "Junior Club to Meet at **McGrays**… will be given a demonstration of Christmas gift wrapping by Mrs. Opal Fullerton… There will be an exhibit of handcraft felt pictures for children made by Mrs. Frank McCaslin, Jr., and a collection of sketches by **Miss Ruth Pierce** …," *SMT*, Dec. 3, 1951, p. 4; "Junior Community Club… authorized plans to be drawn… for a future clubhouse… Educational features of the evening, in line with **national art week**, was a talk by **Mrs. Ray Stearns** on paintings by the late **Mrs. Minnie Stearns**… Ten of her paintings were shown. The club's art corner display… included a collection of masks made by El Camino eighth grade taught by **Miss Edna Davidson**. **Mrs. Donald McGray**, handcraft chairman, instructed in making of decal plates in the 'handcraft huddle'," *SMT*, Nov. 8, 1951, p. 4; "Gifts Taken… **Mrs. Don McGray**, handcraft chairman arranged a handcraft huddle display of satin covered coat hangers… **Mrs. James Hosn**, art chairman, gave a talk on a Santa Claus and reindeer display as the art corner feature… Button-made earrings, work of Mrs. Dale Saunders, club president, formed another display," *SMT*, Dec. 20, 1951, p. 4.

1952 – "District President … Among local chairmen who gave reports… was **Mrs. James Hosn**… who displayed six paintings by Santa Maria High school and Junior college students and announced an exhibit of leather goods to be held in the school the week of February 11… **Mrs. Bill Williams** displayed a tray, painted with design of the club emblem in colors of green and gold… As handcraft chairman, **Mrs. Donald McGray** showed a pair of wall plaques made by Mrs. Del Sights…," *SMT*, Feb. 7, 1952, p. 4; "Junior Community Club… **Luther Thurman** … will speak on 'Photography as a Hobby'," *SMT*, March 17, 1952, p. 4; "UN Flags are Gift… Guest speaker of the evening, **Luther Thurman** of the Santa Maria high school, gave a talk on photography. He told of many advantages of hobbies and of his own, photography, and of membership in Santa Maria Camera club. His talk was illustrated with photo prints and a description of how they are judged by professionals in the monthly competitions… Appropriate to Lent, **Mrs. James Jarvis** arranged an art corner display of 'The Last Supper,' and other religious pictures. Six dressed dolls with dresses and hats made by Mrs. Nellie Lynn were shown as handcraft by **Mrs. Donald McGray**," *SMT*, March 19, 1952, p. 4; "Jr. Community Wins… at state convention of the California Federation of Junior clubs… in Los Angeles… first place awards for handicraft, art, and veterans' service activities…," *SMT*, April 29, 1952, p. 4; "Women on Board… Drawings by the three-year-old

daughter of **Mrs. Art Herold** were subjects for an art talk," *SMT*, May 9, 1952, p. 4; "Jr. Club Women… The club members are planning to design a float for the Elks parade… **Mrs. James Hosn** arranged a display of three water colors that won in an 'American Way of Life' competition and also a wall plaque by **Mrs. Clara Stearns**. This was the club's 'art corner' display. **Mrs. Don McGray**, handcraft chairman, exhibited place mats of textile painted by **Mrs. Inez [sic. Ynez] Lukeman** of Santa Maria," *SMT*, May 22, 1952, p. 4; "Junior Community Club Installs… Year-end reports gave testimony of progress… Displayed in this connection was the water color, 'Magnolias,' by **Julon Maser [Sic. Moser]** first place state award in art, won for the second year in succession by the Junior Community club. **Mrs. James Hosn**, art chairman, was given the club's thanks, and approval was given to the plan to loan the painting to the public library," *SMT*, June 4, 1952, p. 6; "Junior Community … **Mrs. Art Herold** … arranged for the display of a postage stamp patterned hand-made bed quilt, each piece of cloth being the size of a postage stamp. A hand made rag rug was also exhibited…," *SMT*, June 20, 1952, p. 4; "Jr. Community… The club met Tuesday evening… heard read a letter from Mrs. **Julon Moser**, Ventura artist, who explained that the painting of magnolias won by the club in state competition was done in her garden, which is shaded by a beautiful magnolia tree. In line with the club's interest in art, the local chairman, **Mrs. James Jarvis**, showed prints of tropical flowering trees in the Caribbean and West Indies area. **Mrs. Art Herold**, handcraft chairman, displayed pictures fashioned of dried flowers under glass," *SMT*, July 17, 1952, p. 4; "To See Finger Painting Demonstration" by **Mrs. Bill Williams**, demonstrated at Alvin Avenue school, *SMT*, Aug. 5, 1952, p. 4; "Junior Club…'How to keep your children busy' was the theme on which **Mrs. Bill Williams** spoke. She gave the formula for mixing finger-paint and gave a demonstration of the art suitable as pastime for a child and with possibilities to develop drawing and painting ability. Mrs. Williams displayed the hobby book by Evelyn Glance, '*Scrap Fun for Everyone*'," *SMT*, Aug. 7, 1952, p. 4; "Jr. Club… **Mrs. James Jarvis**, art chairman, showed drawings by Jean Mabe, student in dress design … in Santa Maria High school… **Mrs. Art Herold**, handicraft chairman, illustrated a talk on 'Seashell Artistry' with shell items…," *SMT*, Sept. 3, 1952, p. 4; "Mrs. Nelson… **Mrs. Thurman Fairey**… showed drawings by **Les Stonehart Jr.**, cartoonist…," *SMT*, Oct. 8, 1952, p. 4; "Jr. Community Club Sews on Doll's Wardrobe… Christmas doll fundraising project… **Mrs. Frank Apalategui**, hand craft chairman, displayed a quilt, hand-made by Mrs. Clarence West. The art corner had a display of drawings from Santa Maria High school art department and the Public library, arranged by the chairman, **Mrs. James Jarvis**," *SMT*, Nov. 19, 1952, p. 4; "Thanksgiving Basket… **Mrs. James Hosn**… called attention to chalk drawings of Mrs. Kelley March and her son, Win, and to an embroidered picture shown by Mrs. Howard Corbett," *SMT*, Nov. 26, 1952, p. 4; "Jr. Community… **Mrs. Jean Jarvis**, art chairman, showed copper work done by **Mrs. Paul Dal Porto**… a stole made by Mrs. J. L. Zulberti of hairpin lace…," *SMT*, Dec. 20, 1952, p. 4.

1953 – "Junior Community Club Hears Talk on 'Home'… **Mrs. Mario Corollo** spoke before the Junior community club on 'Interior Decorating – Color in the Home'… The art report was given by **Mrs. Thurman Fairey** who showed reproductions of old masters that hang in the National Gallery, Washington, D. C. **Mrs. Apalategui** displayed household items as handcraft chairman," *SMT*, Jan. 8, 1953, p. 4; "Jr. Community… Social Night… Committee reports were the following: Mrs. Glen Conrad, an exhibit of oil paintings by her cousin, **Mrs. Don Wilson**…," *SMT*, March 19, 1953, p. 4; "Mrs. James Reynolds… As chairman of art, **Mrs. James Jarvis** displayed and spoke on an oil painting print … by Jan Brueghel. A child's dish set was shown in hand-made ceramics. **Mrs. Frank Apalategui**, handcraft chairman … exhibit a luncheon cloth with tatted corners of hand-made lace…," *SMT*, April 8, 1953, p. 4; "Jr. Community Club Meets… 'Path to the Mountain' is the title of a painting by **Mary Etta [Sic. Marietta] Somerville,** won as an award by the Community club. It was displayed at the meeting by **Mrs. Hosn** for the art feature… Hand-made baby shoes were exhibited by **Mrs. Frank Apalategui**, hand craft chairman…," *SMT*, May 7, 1953, p. 4; "Jr. Community Competes for State Awards… The club placed second in art, for which a certificate was awarded. Paintings were exhibited at each meeting. Art tours and art speakers were arranged through the year by chairman, **Mrs. James Jarvis**. Second place was won by **Mrs. Frank Apalategui** in handicraft with an exhibit for each meeting and with articles sent to conferences and conventions," *SMT*, May 12, 1953, p. 4; "Community Juniors… As art chairman, **Mrs. James Jarvis** showed the membership a newspaper story of a local resident, **Mrs. Clara Stearns**, on the making of plaster paints. These were exhibited in the hobby show sponsored in 1952 … A copper picture made by **Mrs. Paul Dal Porto** was shown as the handicraft display…," *SMT*, May 21, 1953, p. 4; "Jr. Community… As art chairman, **Mrs. Frank Ostini** displayed paintings by **Mrs. Art Bryant**… Mrs. Claude Stevens displayed china, hand-painted by her aunt…," *SMT*, June 19, 1953, p. 4; "Jr. Community… last night's meeting… Mrs. Oscar Smith was in charge of the art corner in which was displayed an oil painting by **Margery Ward**, Southern California artist," *SMT*, July 8, 1953, p. 4; "Loyalty Oath Taken… The club met in the home of Mrs. Jack Fleming… **Mrs. Frank Ostini**, art chairman, displayed two paintings by **Mrs. Maye Nichols**, Santa Maria artist, for the art corner," *SMT*, Oct. 8, 1953, p. 4; "Enchilada Dinner … **Mrs. Thurman Fairey** gave an art report on 'Paint is Mud to a Happy Child'," *SMT*, Oct. 8, 1954, p. 4; "Jr. Community… Guest speaker was **Mrs. Ira Pattishall [Sic. Patishall]** who showed… how to make wood fibre flowers… **Mrs. Schmidt** displayed hand painted kitchen utensils for the handcraft feature…," *SMT*, Nov. 5, 1953, p. 6; "Junior Community… **Mrs. Frank Apalategui** … displayed cloth dolls. Pictures made with postage stamps were shown for the art exhibit by **Mrs. Joe Epperson**…," *SMT*, Nov. 19, 1953, p. 4; "Jr. Club… [visited **Santa Maria hospital** and gave wood fibre flower corsages to patients] … meeting… **Mrs. Joe Epperson**, art chairman, displayed a paper sculpture Santa Claus. The painting 'Autumn Bounty,' was displayed at the hospital for the benefit of the patients… A

hand-made Christmas stocking, work of Mrs. E. W. Mathiesen, was the handicraft example…," *SMT*, Dec. 17, 1953, p. 4.

1954 – "Junior Club Knits on Wool Afghan. **Mrs. Don McGray**, handcraft chairman … to be presented to a hospitalized veteran…," *SMT*, Feb. 12, 1952, p. 4; "Community Juniors… meeting… The art feature… consisted of an exhibit of paintings by three of the club members. **Mrs. Bob Sellers'** picture, 'Bowl of Roses,' and **Mrs. Epperson's** 'Riders in the Grove,' were shown… Handicraft exhibit… arranged by **Mrs. Apalategui**, consisted of a mobile made by **Mrs. Bert Weir** and earrings made by **Mrs. Cale Lyman**…," *SMT*, March 5, 1954, p. 4; port. of **Mrs. James Jarvis** and **Mrs. Frank Apalategui**, winners in a hat design competition to represent the wearer's husband's occupation or hobby, *SMT*, April 24, 1954, p. 4; "Junior Community Wins State Awards… won honorable mention in art… **Mrs. Joe Epperson**, whose art programs for the year had given the club honorable mention, arranged for display of a painting of a vase of flowers by **Mrs. Thurman Fairey**, one of the club members," *SMT*, May 20, 1954, p. 6; "Summer Meetings Planned … **Mrs. Thurman Fairey**, art chairman, gave a talk on 'Commercial Art.' She thanked all members who helped build and decorate the float, titled, 'Chinatown My Chinatown,' one of the entries in the Elks Rodeo parade…," *SMT*, June 17, 1954, p. 6; "Jr. Community club… Three landscape pictures, painted by **Burt Weir**, were shown. Mrs. Weir, who is art chairman for the club…," *SMT*, July 9, 1954, p. 4; "Community Juniors Hear Art Report… **Mrs. Joe Epperson** gave an art report of Luigi Lucioni's history and showed copies of his paintings…," *SMT*, Aug. 5, 1954, p. 6; "**Thornton Snyder [Sic. Snider]** Art to be Shown… [SLO] artist will speak and show some of his oil paintings Tuesday evening… The public interested in art may attend the meeting to be held in the home of **Mrs. Frank Ostini**… **Mrs. Thurman Fairey**, art chairman, has arranged the evening's program…," *SMT*, Oct. 29, 1954, p. 4; "Mrs. Frank Ostini… meeting… talk on art by **Thornton Snider**, vice president of the San Luis Obispo Art Assn… As handicraft chairman **Mrs. Robert Sellers** displayed hairpin lace and ceramic earrings," *SMT*, Nov. 5, 1954, p. 4.

1955 – " 'Fine Arts' to be Junior Club Topic" delivered by **Mrs. W. Leland Smith**, *SMT*, Jan. 15, 1955, p. 8; "Handicraft to be Club Topic… **Mrs. Burns Rick**… will speak on 'Handicraft' and will… exhibit… items from South America where she and her husband have traveled…," *SMT*, March 12, 1955, p. 4; "**Mrs. Cale Lyman**… Jr. Community… The evening concluded with a fashion parade of comic hats descriptive of the wearer's favorite son. **Mrs. Paul Dal Porto**, wearing a hat called 'Donkey's Serenade' won first and Mrs. Lloyd Martin second," *SMT*, April 6, 1955, p. 4; "Jr. Community Club Wins State Honors. Second place in state judging for participation in the study of art at each of its programs during the year has been awarded to the Junior Community club. The award is a water color, which will be on display at the club's meetings next month. **Mrs. Thurman Fairey** has served as chairman… Annual reports given… Mrs. Jack Fleming, fine arts, **Mrs. Bob Sellers**, handicraft, **Mrs.**

Paul Dal Porto, needlecraft …," *SMT*, May 18, 1955, p. 4; photo of **Mrs. Fairey** standing next to "Blue Seas," wc by Ida Deakin of Santa Ana, second prize in contest for clubs exhibiting and promoting art, won by Junior Community Club of Santa Maria, and it will be hung in Library until club gets its own home, per "Prize Painting to be Exhibited at Library," *SMT,* May 24, 1955, p. 4; "Juniors Planning… A report by **Mrs. Thurman Fairey**… was given on the uses of oil paints in decorating glassware, china and other objects in the home. She also displayed one of her oil paintings," *SMT*, July 21, 1955, p. 7; "Jr. Community Club Chairmen are Appointed … Art, **Mrs. Thurman Fairey**… fine arts, Mrs. Newton Foster, Handcraft, **Mrs. Frank Apalategui**… needlework guild, Mrs. James E. Reynolds …," *SMT*, Sept. 27, 1955, p. 4; "Jr. Community Club… Under reports by chairmen, **Mrs. Thurman Fairey**, on art, said that every member should engage in some form of art study or practice and showed numbered paintings on which beginners may learn to draw and paint," *SMT*, Oct. 6, 1955, p. 4; "Jr. Community [Club] Hears **George Muro** on Art … in the home of **Mrs. Thurman Fairey**… Muro talked on the **Allan Hancock Art Gallery** and told of the several fine collections exhibited there since opening and of others planned in future. … several oil paintings by **Daniel Mendelowitz** of Stanford… Another interesting feature was an exhibit by Mrs. Fern Shipley of hand-made jewelry set with semi-precious stones and native polished rocks… ," *SMT,* Nov. 3, 1955, p. 4; "**National Art Week** Aims Told by **Mrs. Fairey**" art chairman of Junior Community Club, "the objective is to encourage art consciousness and art appreciation on a club and community level" and to this end the Junior Community Club and the AAUW is co-sponsoring the **Mendelowitz** exhibit and "Consideration is being given to a plan to invite various women's clubs and groups to take the sponsorship for a month's term on the various exhibits being brought here, and thus interest a larger number in the gallery … On Sunday afternoon, members of the Junior Community club will visit the gallery in a group. There is also under consideration a plan to hang paintings won by the Junior Community club in statewide competition for art activity in the gallery where they may be enjoyed by the public…," *SMT,* Nov. 4, 1955, p. 4; "Christmas Decorating is Subject… by **Mrs. James Hosn**… **Mrs. Thurman Fairey**, art chairman, displayed an oil painting and gave a talk. …," *SMT*, Dec. 9, 1955, p. 4.

1956 – "Junior Community [Club] Will Sponsor Art Exhibit" in March, *SMT,* Jan. 18, 1956, p. 4; photo of two paintings the club owns, one a still life of magnolias and leaves [**Moser**?] and the other a landscape of a tree, by unnamed artists, *SMT*, Sept. 29, 1956, p. 5; "Color in Home is Speaker's Topic. 'Interior Decorating-Color in the Home,'… with **Mrs. Louise Corollo** as speaker…," *SMT*, Oct. 4, 1956, p. 4; "Mrs. White… **Mrs. Rosemary Whitaker**, handicraft chairman, displayed turkey tray favors made from pine cones and colored paper… for the County Hospital," *SMT*, Nov. 21, 1956, p. 4; "Jr. Club Holds December Meet… The handicraft chairman displayed yarn Santa Claus tray favors and children's toys to be sent… to **Santa Maria Hospital**…," *SMT*, Dec. 20, 1956, p. 4.

1957 – "Club Endorses… Members were given a lesson in wood fibre flower-making by **Mrs. Ira Pattishall** [Sic. **Patishall**]. The handicraft chairman showed decorations that had been made for the CFWC district Fashion Show being held this weekend at Ojai Valley Inn," *SMT*, Feb. 21, 1957, p. 4; "**Mrs. James Jarvis**… At the club's business meeting, a cash donation was voted to the Needlework Guild… The handicraft chairman had a display of ceramics loaned by **Mrs. James Hosn**…," *SMT*, March 21, 1957, p. 3; "Jr. Community… making Easter tray favors for hospitals as one of their handicraft activities… The members were shown at their recent meetings how to make Easter bunnies with wire and cotton. An oil painting by **Mrs. James Hosn** and handmade frame also was displayed…," *SMT*, April 4, 1957, p. 4; "Jr. Community Club Wins District Honors… won second place in handcraft and second in **penny art**…," *SMT*, April 17, 1957, p. 4; "Chairmen Tell of Activities…As handcraft chairman, **Mrs. Hazel Lidbom** said she has demonstrated various types of hand work at meetings, had one exhibit at the district meeting, and conducted a handcraft meeting in her home for the club … Mrs. Ernita Feland arranged for showing of travel slides and for slides taken in European art galleries by **Myrton Likes** … ," *SMT*, June 13, 1957, p. 4; "Decorating Home is Jr. Club Subject. **Mrs. Thurman Fairey** presented a program on 'Interior Decorating' at last night's meeting… held in the Recreation Building…," *SMT*, Nov. 7, 1957, p. 3.

1958 – "**Mrs. McGray** Elected… president… Members brought handcraft items to the meeting to make a display to be arranged by the local club chairman, **Mrs. [Frank] Apalategui** for the district conference at Lompoc later this month…," *SMT*, March 20, 1958, p. 2.
See: "Allan Hancock College Art Gallery," 1956, "Santa Barbara County Library (Santa Maria)," 1951, 1955

Jus' Lookin' (JL)
SYVN column authored by Karl Jorgensen, that often discussed his photographic experiences, post WWII.
See: "Jorgensen, Karl"

K

Kaiser, Arthur "Art" Erlin (1874-1958) (Santa Maria)
Photographer of a giant panorama of Santa Maria Valley, 1932.

■ "Arthur E. Kaiser, 84, Arcata, died Monday evening in an Arcata hospital. He was born May 26, 1874 in Toronto, Canada. He had been a photographer for 65 years. He retired and moved to Arcata in 1946 from Salinas, where he had owned and operated a photography shop," *Eureka Humboldt Standard*, June 3, 1958, p. 20.
Kaiser, A. (notices in California newspapers on microfilm and on newspapers.com)
1932 – "A colored photograph of Santa Maria valley, one of the largest prints ever made in the state, today was on the wall of the Santa Maria Valley Chamber of Commerce

office in the Knights of Pythias building. Measuring 18 feet long by 30 inches high it shows clearly the breakers in the Pacific ocean west of Guadalupe and the Point Sal hills on the left, while the range of mountains east of Santa Maria, 26 miles from the sea, are seen with equal clarity. The picture was taken from the top of Newlove hill by A. Kaiser, local photographer. In making it he used a special motor-driven 'circuit' camera. Kaiser is said to be one of the few photographers in the state equipped to do such large-scale work. The entire panorama has been gone over with oil paint by Kaiser. The photograph is so accurate in detail that with a glass the Richfield beacon sign can be read on the print," *SMT*, April 30, 1932, p. 1.

1936 – "J. P. Picks List for Trial Jury … The list includes … Arthur E. Kaiser…," *SMT*, Jan. 9, 1936, p. 7; "To Pasadena. **Wm. Vaughn** is leaving tonight to spend New Year's day in Pasadena. On his return he will be accompanied by Arthur Kaiser who has been visiting in Burbank since Christmas," *SMT*, Dec. 31, 1936, p. 5, col. 5. And, more than 15 notices for "Arthur Kaiser" and his photography appear in *Visalia Times Delta* between 1914 and 1925 but were not itemized here.

Kaiser, A. (misc. bibliography)
Arthur E. Kaiser is listed in the 1920 U. S. Census as age 42, b. c. 1878 in Canada, naturalized, a photographer, residing in Dinuba, Tulare County, Ca., with wife Nellie; Art Kaiser, photographer is listed in the *Santa Barbara, Ca., CD*, 1926; Arthur Kaiser is listed in the 1930 U. S. Census as age 52, b. c. 1878 in Canada, naturalized, a photographer with his own shop, residing in Santa Maria with wife, Nellie E. Kaiser (age 42); Arthur Erlin Kaiser, b. May 26, 1874 in Toronto, Canada, married to Nellie, d. June 2, 1958 in Arcata, Ca., and is buried in Greenwood Cemetery, Arcata, Ca., per findagrave.com (refs. ancestry.com).

Kaperonis, Irna
See: "Ferslew (Kaperonis), Irna / Erna (Mrs. Paul N. Kaperonis)"

Kaplan, Harry L. (Santa Barbara)
Antique dealer from Santa Barbara who spoke to Minerva Club, 1951.
See: "Minerva Club," 1951

Karleskint, Alice Francis Souza (Mrs. Bernard Karleskint) (Santa Maria)
Active Santa Maria Camera Club, 1939, 1940. Wife of Bernard Karleskint, below. Sister-in-law to Mary Fitzgerald (Karleskint), to Mary Karleskint Roemer and to John Karleskint.
See: "Karleskint, Bernard," "Santa Maria Camera Club," 1939, 1940

Karleskint, Bernard "Barney" (1908-1960) (Santa Maria)
Photographer. Operated the Santa Maria Camera shop, 1939-60. Founding member Santa Maria Camera Club. Orchid grower. Brother to John Karleskint and Mary Roemer, below. Husband of Alice Karleskint, above. Brother-in-law to Mary Fitzgerald Karleskint.

■ "Bernard (Barney) Karleskint, 51, died Tuesday evening in a local hospital. Born July 16, 1908, in Kansas, he came to this area at the age of seven. He resided at 634 E. Hermosa St., and with his wife, Alice, he owned and operated the **Santa Maria Camera Shop** …Interment will be in the Santa Maria cemetery," per "Barney Karleskint, Camera Shop Owner dies at Age of 51," *SMT*, July 6, 1960, p. 2.

Karleskint, Bernard (notices in Northern Santa Barbara County newspapers on microfilm and on newspapers.com)
1939 – "Amateur Cameraman Discusses Hobby" with Twenty-Thirty Club, *SMT*, March 1, 1939, p. 3.
1941 – "I Spied… Barney Karleskint putting so much light on a subject for photography that he burned out the studio fuse," *SMT*, March 15, 1941, p. 1; "Station Sold. Karleskint's service station, Broadway and Mill, formerly owned by Barney Karleskint, has been purchased by his cousin… Barney is now devoting his time to photography in his Santa Maria Camera shop," *SMT*, March 27, 1940, p. 6.
1947 – "I Spied. The color photograph on this month's *Flower Grower* taken by Barney Karleskint," *SMT*, Jan. 3, 1947, p. 1.
1958 – DAUGHTER – "St. Mary's Setting for Nuptials… Miss Mary Corinne Karleskint became the bride of John Orville Newton. The bride is the daughter of Mr. and Mrs. Bernard Karleskint… the young people are to make their home in Santa Maria… Mrs. Newton attended schools in Santa Maria and has been employed at her father's photography shop," *SMT*, Feb. 8, 1958, p. 3.
More than 190 "hits" for "Bernard Karleskint" and 23 for "Barney Karleskint" including some ports. and some repros. of his photos, appear in the *SMT* between 1940 and 1960 but were not itemized here.

Karleskint, Bernard (misc. bibliography)
Bernard Karleskint is listed in the 1920 U. S. Census as residing in Lompoc with his mother and siblings; Bernard Kaleskint is listed in the 1930 U. S. Census as a plumber's apprentice, residing in Santa Maria with his mother and younger brother; Bernard Karleskint, SM Camera Shop, is listed with wife Alice in the *Santa Maria, Ca., CD*, 1945; Bernard Karleskint was b. July 16, 1908 in Fort Scott, Ks., to John Peter Karleskint and Mary Virginia "Jennie" Lesher, married Alice Francis Souza, and d. July 5, 1960 in Santa Maria, Ca., per Andreas, Butzin, Kline, Lesley, Bodnar Family Tree; Bernard Karleskint is buried in Santa Maria Cemetery District per findagrave.com (refs. ancestry.com).
See: "Fitzgerald (Karleskint), Mary," "Karleskint, John," "Roemer, Mary," "Santa Maria Camera Club," intro., 1938, 1939, 1940, 1941, "Santa Maria Camera Shop"

Karleskint, John Peter (Santa Maria)
Member Santa Maria Camera Club, 1938. Brother to
Bernard Karleskint and Mary Roemer. Husband to Mary
Fitzgerald, above, and brother-in-law to Alice Karleskint,
above.

■ "Nuptial Mass Unites Mary Fitzgerald, John
Karleskint… The husband is employed by Macdonald Seed
Co. here… educated in Los Angeles. Both have been active
in Church and social circles. Young Karleskint is district
deputy of the Knights of Columbus…," *SMT*, June 13,
1940, p. 3.
And more than 300 hits for "John Karleskint" in the *SMT*
between 1935-1965 were not itemized here.
See: "Fitzgerald, Mary," "Karleskint, Alice," "Karleskint,
Bernard," "Roemer, Mary," "Santa Maria Camera Club,"
1938, 1939, 1940

**Kaslow, Rita Bieber Harbinger (Mrs. Dr. Arthur "Art"
Louis Kaslow) (1926-1967) (Los Angeles / Santa Ynez
Valley)**
Costume designer from Hollywood who moved to Santa
Ynez Valley, 1958.

■ "Mrs. Kaslow is a graduate in art from Western Reserve
University in Cleveland which she attended under a four-
year scholarship. An accomplished pianist, she was
awarded a certificate of achievement from Eastman School
of Music in Rochester, N.Y. Prior to her marriage she was a
costume designer for MGM Studio and Western Costume
Co. in Hollywood. Her hobbies are music and sewing," per
port. and "Dr. Kaslow, Family, Moving to Valley from
Southland," and extended biography of her husband,
Arthur, who practiced medicine in LA for 23 years, *SYVN*,
July 18, 1958, p. 5.
Kaslow, Rita (notices in Northern Santa Barbara County
newspapers on microfilm and on newspapers.com)
1962 – "Valleyites Capture… County Fair Awards…
various clothing and textile divisions… coat, any type, Rita
B. Kaslow, Solvang," *SYVN*, Aug. 3, 1962, p. 10.
1967 – "Private Services Conducted for Mrs. Rita B.
Kaslow, 41 … nine-year resident of the Santa Ynez Valley,
was born in Rochester, N. Y. Feb. 17, 1926, the daughter of
the late Jack Bieber and Mrs. Bieber. She was educated in
New York and won a four-year scholarship to Western
Reserve University in Cleveland where she was graduated
in art. An accomplished pianist, she was awarded a
certificate of achievement from Eastman School of Music
in Rochester. Prior to her married to Dr. Kaslow in 1956,
Mrs. Kaslow was a costume designer for MGM Studios and
Western Costume Co. in Hollywood. Dr. and Mrs. Kaslow
lived in Westwood Village before coming to the Valley in
1958. Active in several organizations …," *SYVN*, Oct. 19,
1967, p. 3.
Kaslow, Rita (misc. bibliography)
Rita Beiber Harbinger Kaslow was b. Feb. 19, 1926,
married Arthur Louis Kaslow, and d. Oct. 14, 1967, in LA
per Reshetnik/Heibisch/Daniels Family Tree (refs.
ancestry.com).

**Katzenstein (Dinsdale), Hazel Ardella (Mrs. Lawrence
Weges Dinsdale) (1894-1932) (Lompoc)**
Teacher of Chemistry, Domestic Science and Art at
Lompoc High School, 1919/21, Spring 1923.

■ "Miss Hazel Katzenstein is leaving Thursday for Inyo
County where she will take charge of the Science
Department of the Big Pine Union High School. Miss
Katzenstein is a graduate of the local High School and
recently received a High School teacher's certificate from
the University of California," *Sacramento Bee*, Aug. 28,
1918, p. 3
Katzenstein, Hazel (notices in Calif. newspapers on
newspapers.com).
1922 – Port. as bride, *Sacramento Bee*, April 22, 1922, p.
10.
1932 – "Funeral of Hazel Dinsdale in Yolo… wife of L. W.
Dinsdale, deputy game warden in Yuba and Sutter counties,
died in a local hospital yesterday following an extended
illness. Besides her husband, three children survive…,"
Sacramento Bee, Dec. 17, 1932, p. 10; and another obit in
Sutter County Farmer (Yuba City, Ca.), Dec. 22, 1932, p.
5; and other obits in Calif. newspapers not itemized here.
Katzenstein, Hazel (misc. bibliography)
Hazel Katzenstein, port. in UofC, Berkeley, yearbook,
1917; Hazel Ardella Katzenstein married Laurence [Sic.
Lawrence] Welges Dinsdale on April 17, 1922 in Alameda
County per Calif. Marriage Records from Select Counties;
Hazel Ardella Katzenstein was b. June 28, 1894 in
Sacramento, Ca., to William Harrison Katzenstein and May
Shaplin, married Lawrence Weges Dinsdale, was residing
in Yuba City, Ca., in 1930, and d. Dec. 16, 1932 in Yuba
City, Ca., per Ruth Martin Family Tree (ref. ancestry.com).
See: "Lompoc, Ca., Union High School," 1919, 1920, 1923

**Kaukonen, Dave Ernest Toivo (1913-1982) (Santa
Maria)**
Photographer, amateur. Member Santa Maria Camera
Club, 1940s.

■ "Dave E. Kaukonen… died… Santa Barbara hospital…
Santa Maria Cemetery… He had been a resident of
California since 1938 and was a painting contractor in
Santa Maria for many years. …," *SMT*, July 10, 1982, p.
11.
And, more than 600 notices for "Dave Kaukonen" in the
SMT from 1938-1982 were not even browsed for possible
itemization here.
Kaukonen, Dave (misc. bibliography)
Dave Ernest Toivo Kaukonen was b. March 13, 1913 in
Iron, Minn., to Isaac Oscar Kaukonen and Wilhelmina
Kristina Lofberg, married Margaret Foltan, and d. July 7,
1982 in Goleta, Ca., per Owens Family Tree (ref.
ancestry.com).
See: "Santa Maria Camera Club," 1940, 1945, 1946

Keen, George Hope (1875-1973) (Santa Barbara)
Cabinetmaker who became an artist in retirement. Exh. a painting at Santa Barbara County Fair, 1952.
Keen, George (misc. bibliography)
George Keen, cabinetmaker and Dem. is listed in *California Voter Registrations, Santa Barbara Precinct No. 43*, 1942-44; George H. Keen cabinetmaker, sometimes listed with wife, Helen, appears in the *Santa Barbara, Ca., CD*, 1945; George Hope Keen, artist, with no wife, is listed in the *Santa Barbara, Ca., CD*, 1923-48; George Hope Keen b. Dec. 30, 1875 and d. Sept. 12, 1973 is buried in Santa Barbara Cemetery per findagrave.com (refs. ancestry.com).
See: "Santa Barbara County Fair," 1952

Keller, Fred C. (1878-1963) (Lompoc)
Photographer, prop. of B&B Studio, 111 S. "H" St., 1946-60+.
Keller, Fred (notices in Northern Santa Barbara County newspapers on microfilm and on newspapers.com)
1952 – "Cover Girl… for the *Record*'s Spring Flower edition is Miss Loma Lee Nelson..,. a junior at the Lompoc High school… photograph was taken by Mr. Fred Keller…," *LR*, June 5, 1952, p. 18.
1962 – WIFE – "Services Today for Alice L. Keller … Born… in South Dakota … She has resided in Lompoc for the past 18 years and is survived by her husband, Fred Keller…," *LR*, Feb. 12, 1962, p. 3.
Keller, Fred (misc. bibliography)
Fred C. Keller, B&B Studio, is listed with wife Alice L., at 111 South H, Lompoc, in the *Santa Maria, Ca., CD*, 1959, 1961; Fred C. Keller, mother's maiden name Dykes, was b. Oct. 22, 1878 and d. June 13, 1963 in Santa Barbara county per Calif. Death Index (refs. ancestry.com).
See: "B&B Studio," "Lompoc, Ca., Union High School," 1959, "United Service Organization (Lompoc)," 1945

Kelleway (Shaug), Helen (Mrs. James Jerome Shaug) (1905-after 1938) (Lompoc / Corvallis, Ore.)
Domestic Arts teacher at Lompoc high school, c. 1935/38, who helped with costumes for school plays.
Port. in Lompoc High School yearbook, 1938.
Kelleway, Helen (notices in Northern Santa Barbara County newspapers on microfilm and on newspapers.com)
1938 – James Shaug, and Helen Kelleway Wed…," *LR*, June 17, 1938, p. 4; "In Corvallis, Ore. … George H. Kelleway had died at his home… Mrs. James Shaug (Helen Kelleway) left immediately…," *LR*, Dec. 2, 1938, p. 8.
And, more than 30 additional social notices for "Helen Kelleway" in the *LR* between 1930 and 1940 were not itemized here.
See: "Lompoc, Ca., Union High School," 1935, 1937, 1938

Kelley, Ethel Colledge (Mrs. W. Bradford Kelley)
See: "Colledge, Ethel"

Kelliher, Virginia (Mrs. Donald Artel Kelliher) (Lompoc)
Chairman of the Music, Art, Literature Section of the Junior Alpha Club, 1952/53.
1955 – "Former Lompocans to Holiday Here. Mr. and Mrs. Don Kelliher … now residing in Arizona…," *LR*, Dec. 15, 1955, p. 3.
See: "Alpha Club," 1952, 1953

Kelsey, Eleanor (Los Angeles / Santa Maria)
Santa Maria JC student and art clerk, 1934. Associated with the school fashion magazine, Trend, 1935. Designed sets for school theatrical performances.
Kelsey, Eleanor (notices in Northern Santa Barbara County newspapers on microfilm and on newspapers.com)
1934 – "New Art Clerk Here – Miss Eleanor Kelsey arrived on Saturday from Los Angeles to take a position as clerk in the art department of the high school and junior college. This position was left vacant by Miss **Margaret Sutter**, who has resigned to be married in the near future," *SMT*, March 5, 1934, p. 2; "Junior Red Cross to Meet… Miss Eleanor Kelsey, a junior college student and assistant in the school art department, will also speak…," *SMT*, Sept. 29, 1934, p. 2.
And numerous additional references in the *SMT* 1934-1935 for her set designs were not itemized here.
Kelsey, Eleanor (misc. bibliography)
Miss Eleanor Kelsey, Ass't. Teacher and Dem. is listed in *California Voter Registrations, Santa Maria No. 12*, 1934-36 (refs. ancestry.com).
See: "College Art Club," 1935, "Santa Maria, Ca., Union High School," 1934, 1935

Kelsey (Shepherd), Olive C. (Mrs. Francis A. Shepherd) (1872-1949) (Santa Maria)
"Miss O. Kelsey" exh. landscape in oil and marine in oil at "Santa Barbara County Fair," 1893. Teacher.
Kelsey, O. (notices in Northern Santa Barbara County newspapers on microfilm and on newspapers.com)
1892 – "Miss Kelsey, daughter of Rev. and Mrs. Kelsey of the Christian Church, is here on a visit," *SMT*, Dec. 10, 1892, p. 3.
1893 – "Our Public Schools… The next room visited was the one in which Miss Kelsey, the new teacher, presides… She had a class in drawing at the boards…," *SMT*, March 11, 1893, p. 3; "Our Teachers. Some changes… since last term… Miss Kelsey, daughter of Rev. Mr. Kelsey of the Christian Church of this place has been engaged to preside over the room formerly occupied by Miss Tarr. She is highly educated and comes well recommended as a teacher…," *SMT*, Jan. 7, 1893, p. 3; "Miss Olive Kelsey has been quite ill the past week and was compelled to temporarily abandon her school …," *SMT*, Dec. 9, 1893, p. 3.
1894 – "The Town Schools… Miss Olive Kelsey has 47 enrolled, all of whom are doing work which requires a great deal of time and assistance from the teacher… Miss Kelsey… is putting forth her utmost endeavors in the direction of thorough work," *SMT*, March 24, 1894, p. 2; "Miss Olive Kelsey, one of the intermediate teachers of our

public schools, left on Tuesday last for Vacaville where she expects to spend her vacation," *SMT*, June 16, 1894, p. 3.
1895 – 'Miss Olive C. Kelsey… now teaching in San Luis Obispo county, has been granted a grammar grade certificate by the San Luis Obispo Board of Education," *SMT*, Jan. 26, 1895, p. 3, col. 2; "Miss Olive Kelsey who numbered among our town teachers last year returned from her school work in San Luis Obispo county last week. She has been teaching the Summit school for the past year and has been re-engaged for the next school year… She was accompanied by her sister Miss Eugenia who has been attending the Normal school at Chico. They will spend the summer vacation with their parents at Lompoc," *SMT*, July 6, 1895, p. 3.
1898 – "The Teachers' Institute… present are … Olive Kelsey…," *LA Times*, Oct. 16, 1893, p. 6, col. 4.
Kelsey, O. (misc. bibliography)
Olive Kelsey is listed in the 1880 U. S. Census as age 7, b. c. 1873 in Kansas, residing in Hamlin, Ks., with her parents John W. Kelsey (age 40) and Ellen Kelsey (age 32) and sister Jeannie (age 5); Olive C. Kelsey, father John W. Kelsey and mother Nellie Haegler, b. Kansas c. 1873, married Francis A. Shepherd on July 25, 1899 per Cuyahoga County, Ohio, Marriage Records; Olive Shepherd is listed in the 1940 U. S. Census as age 67, b. c. 1873 in Ks., finished college 3rd year, widowed, residing in Cleveland, Ohio (1935, 1940), with her children and grand children; Olive Shepherd b. Oct. 19, 1872 in Ks., d. Sept. 18, 1949 in Cleveland, Ohio, and is buried in Harlem Springs Cemetery, per findagrave.com (refs. ancestry.com).
See: "Santa Barbara County Fair," 1893

Kelsey, Richmond (Santa Barbara)
Artist of a painting of Mission La Purisima used in a booklet on the museum, 1935.
See: "Mission La Purisima," 1935, and *Morro Bay Art and Photography before 1960*

Kenney, (Lily) Elizabeth "Betty?" Whyte (Mrs. James Theodore Kenney) (1903-1994) (Lompoc)
Artist. Member of Art Section of Alpha Club, c. early 1940s, and later chairman of garden section. Exh. art at Lompoc Hospital, 1949. Exh. painting at Santa Barbara County Fair, 1952 and other venues.
Kenney, James, Mrs. (notices in Northern Santa Barbara County newspapers on microfilm and on newspapers.com)
1942 – "Departs for Kansas – Mrs. James Kenney and children left this week to join Mr. Kenney in Kansas where he is employed as a Johns-Manville official there," *LR*, July 10, 1942, p. 2.
More than 90 club/social notices for "Mrs. James Kenney" in the *LR* between 1935 and 1960 were not itemized here.
Kenney, James, Mrs. (misc. bibliography)
Lily Elizabeth Whyte married James Theodore Kenney on Nov. 6, 1923 in Alameda County per Calif. Marriage Records from Select Counties; Elizabeth Kenney is listed with husband James T. in the *Oakland, Ca., CD*, 1926; Elizabeth Kenney is listed in the 1930 U. S. Census as residing in Antioch, Contra Costa County, Ca., with husband James T. and children James and Malcolm;

Elizabeth Kenney is listed in the 1940 U. S. Census as age 36, b. c. 1904 in Calif., finished college 3rd year, residing in Lompoc (1935, 1940), with husband James Kenney (age 39) and children James (age 15) and Makom [Sic.] (age 11); Lily Elizabeth Whyte was b. Aug. 26, 1903 in Calif. to Malcolm Calvin Whyte and Lucy Webb Dewing, married James Theodore Kenney, and d. Oct. 29, 1994 in Davis, Ca., per Phil O'Neil Family file 2014 (refs. ancestry.com).
See: "Alpha Club," 1940-42, 1950, 1952, 1960, "Community Center (Lompoc)," 1948, "Flower Festival," 1950, "Flower Show," 1948, 1949, "La Petite Galerie (Buellton / Solvang)," 1950, "Lompoc Hospital, Women's Auxiliary," 1949, 1956, "Posters, general (Lompoc)," 1952, "Santa Barbara County Fair," 1952, "Tri-County Art Exhibit," 1948, 1950

Kent, Dexter Hewell, Corporal (1931-2009) (Solvang)
Photographer with the Air Force in Japan, early 1950s. Exh. Santa Ynez Valley Art Exhibit, 1953.
Kent, Dexter (notices in Northern Santa Barbara County newspapers on microfilm and on newspapers.com)
1949 – Port. with SYVHS graduating class, *SYVN*, June 10, 1949, p. 1.
1950 – "Choir to Sing at Presbyterian Church… The Youth Fellowship will be led by Dexter Kent on the subject of 'Camera Craft,' and how it can be used in the work of the church…," *SYVN*, March 17, 1950, p. 3.
1951 – "Dexter Kent Now Corporal. … son of Mr. and Mrs. Hewell Kent, serving with a photographic unit of the Air Force in Japan, has been promoted to the rank of corporal," *SYVN*, Dec. 28, 1951, p. 5.
1952 – Repro: Korean girl photographed by Cpl. Dexter Kent of Solvang, who is with the famed Third Air Rescue Squadron in the Far East. Although stationed in Japan, Cpl. Kent flies over Korea frequently. He is a photographer with his unit recently in The Land of the Morning Calm. The youngster photographed above is typical of thousands of young south Koreans who have become homeless since the start of the war there… and Solvang Air Force Man Dexter Kent Gives Word Picture of Farming Land of Nippon…," *SYVN*, May 30, 1952, p. 7; repro: street scene in south Korea, *SYVN*, June 20, 1952, p. 5.
1953 – "Dexter Kent Ends Leave… Japan where he had been stationed with the U. S. Air Force the past two and a half years… Kent leaves today for Alexandria Air Base …," in Louisiana, *SYVN*, Oct. 23, 1953, p. 8.
1954 – "Dexter Kent Home on Leave… from Alexandria Air Force Base in Alexandria, La.. After his separation from the service early next month, Mr. Kent will enroll as a business administration major at Louisiana State University," *SYVN*, Aug. 6, 1954, p. 1.
1955 – Port. as lifeguard at Cachuma Swimming Pool, *SYVN*, June 24, 1955, p. 4; "Notice of Intended Sale… Town and Country Service…. To Howell M. Kent and Dexter H. Kent of Solvang…," *SYVN*, July 22, 1955, p. 7.
1960 – "Norma Schall Weds Dexter Kent… of Ventura… Mr. Kent is the son of Mr. and Mrs. H. M. Kent of Lake Cachuma… Mr. Kent was graduated from Santa Ynez Valley Union High School and Santa Barbara City College and attended Louisiana State University. He also served

with the Air Force. … The young couple will live in Ventura…," *SYVN*, July 22, 1960, p. 3.

Kent, Dexter (misc. bibliography)
Dexter Hewell Kent, mother's maiden name Jones, was b. Jan. 9, 1931 in Santa Barbara County per Calif. Birth Index; Dexter H. Kent, b. Jan. 9, 1931, d. May 10, 2009 per Social Security Death Index (refs. ancestry.com).
See: "Santa Ynez Valley Art Exhibit," 1953, "Scholastic Art Exhibit," 1949

Kent, Rockwell (1882-1971) (New York)
American East Coast artist. Member of American Artists' Group whose prints were circulated to Santa Maria in 1937 for exhibit. Stanley Breneiser spoke to local groups on Kent's prints. An issue of Splash was dedicated to him. One of his prints was purchased by the Blue Mask Club for Santa Maria High School, 1937.

■ "Rockwell Kent was an American painter, printmaker, illustrator, writer, sailor, adventurer and voyager," per Wikipedia.
See: "Alpha Club," 1934, "Art Festival," 1935, "Breneiser, Stanley," 1934, "College Art Club," 1935, "Community Club," 1934, "Junior Community Club," 1951, "Santa Maria, Ca., Union High School," 1937, "Splash," 1935

Kern, Agnes? (Mrs. Major Russell Kern) (Vandenberg)
Artist. Mother to Barbara Kern, above. Other "artistic" daughters were Lillian, Judith, and Linda, not listed here.

■

Kern, Russell, Mrs. (notices in Northern Santa Barbara County newspapers on microfilm and on newspapers.com)
1960 – Port. at easel making a charcoal sketch of Mrs. Joseph Driscoll at the recent 'Spring in Paris' luncheon of Vandenberg Officers' Wives Club," and photo by **S/Sgt. Mike R. Guerrere [Sic. Guerrero]**, *LR*, April 28, 1960, p. 6.
1964 – "Taking Up Space… In conjunction with the program scheduled for the Vandenberg Officers' Wives' club luncheon on Thursday, October 8, an art exhibit is planned. OWC members who paint either professionally or as a hobby are requested to contact… Mrs. Russell Kern … if they would like to exhibit their work … must be framed…," *LR*, Oct. 3, 1964, p. 5, col. 3.
1966 – "Our Lady of the Stars… Farewells were said to Mrs. Russell Kern who leaves Vandenberg for civilian life in Santa Maria," *LR*, Jan. 24, 1966, p. 4.
Kern, Russell, Mrs. (misc. bibliography)
Is she Agnes Kern listed with husband Russell, Emp. Federal Elec., in the *Santa Maria, Ca., CD*, 1967 (refs. ancestry.com).
See: "Haemer, Alan"

Kern (Confer), Barbara (Mrs. Donald D. Confer) (1942-?) (Vandenberg)
Art student of Col. Allen Haemer. Exh. Santa Barbara County Fair, 1960. Interior decorator with Ebbert's Interiors, 1961. Interior Decoration major at San Jose State College and grad, 1965. Daughter of Mrs. Russell Kern, below.

■ "Local Artists Place at S.B. County Fair… prize winning oil paintings of Miss Barbara Kern, 635 Korina Street, VAFB … Barbara, the 17 year old daughter of Major and Mrs. Russell Kern, won second place with the first still life oil she had ever painted, a picture called 'Rusty Shears.' She has been taking lessons for a few months from **Col. Allen Haemer** at the base. Previous to that she had dabbled in water colors and done some sketching. Barbara is interested in other forms of art, including dancing, singing and piano. She has been an assistant teacher at the Marjorie Hall School of Dancing and this summer is teaching Vandenberg pupils while Mrs. Hall is in Europe. A June graduate of Lompoc High School, she will attend Santa Barbara City College this fall, majoring in art. She will also teach dancing at Gunsett Academy of the Dance. Barbara's mother is also a painting enthusiast and takes lessons at the base. Her sister Lillian took art while attending Allan Hancock College. Another sister, Judy, 13, does pen and ink and pencil sketches of her favorite subject – horses," and port. of Barbara Kern at her easel, *LR*, July 25, 1960, p. 6.
Kern, Barbara (notices in Northern Santa Barbara County newspapers on microfilm and on newspapers.com)
1961 – Port. and "Ebbert's Interiors Offers Complete Décor Service… Barbara Kern, a graduate of Lompoc High School, class of '61 [sic. '60]. She hopes to become a licensed interior decorator with a B. A. degree from San Francisco's College of Fine Arts. With one year of college to her credit, she recently joined the staff of Ebbert's to supplement her scholastic studies with first-hand information. The second eldest of six children in the Kern family, Barbara's interests are artistic and musical. She first became interested in interior decoration while in high school. When she was 15 her designs for the architecture and interior decoration of an entire house won the first award in an interstate art fair held at Lincoln, Nebraska. Since then, Barbara has added to her studies many forms of art, including painting and fashion design…," *LR*, Nov. 30, 1961, p. 29 (i.e., 5-C?).
1965 – Engagement port., "Miss Kern is a graduate of San Jose State College where she majored in interior decoration," *LR*, July 12, 1965, p. 4; "Marriage Licenses… Donald D. Confer, Beeville, Tex., and Barbara Kern, 635 Korina, Vandenberg AFB," *LR*, July 26, 1965, p. 3.
Articles in the *Petaluma Argus-Courier* not itemized here show that she remained active in the arts field (dramatics, dancing, painting) 1970-1994, and in teaching kindergarten age children (Willow Tree School).
Kern, Barbara (misc. bibliography)
Barbara Kern, b. c. 1943, married Donald D. Confer on July 24, 1965, in Santa Barbara County per Calif. Marriage Index; Barbara Confer is listed with husband Don at The Mingei Shop in the *Petaluma, Ca., CD*, 1971; Barbara K. Confer b. Nov. 2, 1942 was residing in Petaluma, Ca., in

1992 per *U. S. Public Records Index, 1950-1993*, vol. 1 (refs. ancestry.com).
See: "Santa Barbara County Fair," 1960

Kershaw, Isabel (SLO / Atascadero)
Artist who exh. at Santa Ynez Valley Art Exhibit, 1954.
See: "Santa Ynez Valley Art Exhibit," 1954, and *Atascadero Art and Photography before 1960* and *San Luis Obispo Art and Photography before 1960*

Kerwick, Vincent, Father / Rev. (1883-1965) (Mission Santa Ines)
Artist, priest, in charge of art at Mission Santa Ines, 1929-31.
■ "Father Kerwick is a young Irishman from county Kilkenny. Having been educated as an artist, he has made the art and museum collection of Santa Ines the finest of any of the missions. He feels reasonably certain that one of the mission pictures is by El Greco… In its heyday Santa Ines was famous for its Indian leather workers. Some very fine pieces have been rescued – especially two ancient confessionals… There is at least one Indian painting – of St. Michael the Archangel – which is a weird affair, also many mural decorations in the church itself were painted by the Indians. 'To me Santa Ines is one of the most interesting landmarks in California'," *SYVN*, Aug. 22, 1930, p. 4.
■ "Rev. Father Vincent Kerwick, O. F. M. Cap., was a Catholic priest and a Capuchin Franciscan friar. Ordained in his native Ireland, he came to America in 1920, and was the pastor of the Mission Santa Ynes [Sic. Ines] near Solvang, California, during the 1930s. He then served as a chaplain at St. Anthony's Hospital in Pendleton, Oregon. He remained in Oregon for some years, and was the assistant pastor of St. Francis of Assisi Catholic Church at Bend. Returning to California, Fr. Vincent died at Los Angeles in 1965, age 81," from findagrave.com.
Kerwick, Father (notices in Northern Santa Barbara County newspapers on microfilm and on newspapers.com)
1931 – "Rev. Vincent Kerwick is Injured in LA," after falling beneath the wheels of a Pacific Electric car, *SYVN*, Aug. 14, 1931, p. 1; "Father Vincent Kerwick, now of Ukiah, former pastor of the Old Mission Santa Ines…," *SYVN*, Dec. 25, 1931, p. 1
Kerwick, Father (misc. bibliography)
Fr. Vincent Kerwick, b. Sept. 22, 1883 in County Kilkenny, Ireland, d. May 4, 1965 in Los Angeles and is buried in Calvary Cemetery, LA, per findagrave.com (refs. ancestry.com).
See: "Mission Santa Ines," 1930

Ketcham, Harriet P. (Mrs. Daniel H. Ketcham?) (1826-1907) (Nipomo / Santa Maria)
Exh. Kensington painted banner and a flower panel at "Santa Barbara County Fair," 1889.
■ "Mrs. Harriet Ketcham, Aged Eighty Years, Dies Suddenly. Mother of Our Postmaster… Mrs. Ketcham has been a resident of the state since 1875 and came to the

Santa Maria valley in 1881. Her husband died in November 1886, since which time she has made her home with her son," *SMT*, March 30, 1907, p. 1.
[She seems to be Harriet P. Ketcham widow of Dr. Daniel K. [Sic. H.?] Ketcham (d. 1886). She is probably Mrs. H. E. [Sic. P?] Ketcham who exhibited embroideries, etc., at the Santa Barbara County fair in 1890. She is probably mother of Ed Ketcham (once with the *SM Times*, and the SLO *Standard*, 1886), who became Edward T. Ketcham, DDS, active in Lompoc by 1892 and later Postmaster in Santa Maria.]
1890 – "Mr. Goland and daughter from Goleta are visiting Mrs. Ketcham and her son Edward," *SMT*, June 21, 1890, p. 3.
1893 – "Not Quite So Pleasant as Santa Maria… Mrs. H. P. Ketcham, formerly of Santa Maria, now at Hudson, Wis., has had an opportunity to contrast Santa Maria climate with that of her present home… Twenty-two inches of snow…," *SMT*, March 4, 1893, p. 3.
Ketcham, Mrs. (misc. bibliography)
Harriet Ketcham is listed in the 1870 U. S. Census as age 43, b. c. 1827 in NY, residing in Oak Grove, Wisc., with husband D. H. Ketcham (age 49) and children Eugene (age 17) and Edward (age 2); P. Harriet Ketcham is listed in the 1880 U. S. Census as age 53, b. c. 1827 in NY, residing in Patera, Ca., with her husband D. H. Ketcham (age 60), physician, and son T. Edward Ketcham (age 12, b. Wisconsin); Harriet P. Ketcham is listed in the 1900 U. S. Census as b. Aug. 1826 in NY, residing in Township 7, Santa Barbara County, with son Edward T. Ketcham, dentist (age 32); Harriet P. Ketcham b. c. 1827 d. March 27, 1907 in Santa Barbara County per Calif. Death Index (ref. ancestry.com).
See: "Santa Barbara County Fair," 1889

Ketchum, Helen, Mrs.
Itinerant demonstrator of furniture decoration who taught in Santa Maria, 1929.
■ "Mrs. Helen Ketchum, representative of the E. F. Dupoit de Nemours' Co., will be at our store all day Friday, Saturday and Monday, April 5th, 6th and 8th and will give a series of lessons and demonstrations in the decorating and painting of ornamental pieces of home furniture and bric-a-brac. You are cordially invited to bring small articles that will be decorated or painted without charge. Taylor Bros. Hardware. Santa Maria," *SMT*, April 5, 1929, p. 5.

Ketron, Janet (Mrs. Wayne Ketron) (Santa Barbara)
Member Santa Barbara Art Association, who exh. at opening exh. of Allan Hancock [College] Art Gallery, 1954. Exh. Santa Barbara County Fair, 1959.
Janet Ketron is listed as wife of Wayne in the *Santa Barbara, Ca., CD*, 1956-61 (refs. ancestry.com).
See: "Allan Hancock [College] Art Gallery," 1954, "Santa Barbara County Fair," 1959

Keys, Wesley Noble (1911-1971) (Lompoc)
Photographer, flower arranger, floraculturalist, judge of flower contests, 1952.

■ "Wesley N. Keys … retired greenhouse manager for Bodger Seed Company…," and informative obituary, *LR*, July 12, 1971, p. 3.
Keys, Wesley N. (notices in Northern Santa Barbara County newspapers on microfilm and on newspapers.com)
1949 – "**Clinton Stillman** to Open New Florist Shop… Associated with him… will be Wesley Keys, former head floral designer for Flower Haven in Denver, Colo. Keys was awarded a lifetime membership in the National Delphinium Society for his outstanding displays in the shows in Chicago," *LR*, Nov. 17, 1949, p. 10.
1951 – "Prominent Lompoc Couple Recite Marriage Vows on Christmas Day… Catherine Helen McCloskey… Wesley Noble Keyes… The bridegroom is the son of the late Mr. and Mrs. Charles Wesley Keys of Fond du Lac, Wis…," *LR*, Dec. 27, 1951, p. 3.
1952 – "Keys Shows Pix to Rotary. … colored slides which he had taken on many trips throughout the United States and Mexico at last week's meeting of Lompoc Rotary in the Valley Club. Photographs of the National Delphinium Show in Boston, rustic landscapes in Wisconsin, the pyramids near Mexico City, and the Hoover dam were included…," *LR*, Sept.11,1952, p. 16.
1955 – Photo of flower arrangement of zinnias and marigolds, *LR*, June 23, 1955, p. 5; port. and caption reads "Wesley Keys has been a member of the Floradale Farms staff for five years supervising the six greenhouses and the hybrid and double petunia and perennial plant production. Born in Fond du Lac, Wis., where for a time he had his own florist business in perennial plants and water lilies, he later taught in the Denver School of Floral Design and worked at Flowerhaven in Denver, Colo., before coming to Lompoc. He and his wife, the former Catherine McCloskey, a native Lompoc daughter, and their little daughter, Mary Margaret, recently moved into their newly purchased home …," *LR*, June 30, 1955, p. 20.
And, approx. 40 additional references for "Wesley Keys" club activities and floral decorations appear in the *LR* between 1945-1960 but were not itemized here.
Keys, Wesley N. (misc. bibliography)
Wesley Keys, b. March 4, 1911, in Wisconsin, d. July 10, 1971 in Santa Barbara County per Calif. Death Index (refs. ancestry.com).

Kiddie Kartune Club (Lompoc)
Children's club that learned drawing by viewing periodically released film instruction shown at Lompoc Theater, 1931.

■ "Attention, Kiddies! Join The Lompoc Theater's Kartune Klub … for children between the ages of five and twelve years… The purpose… is to promote the development of motion picture arts as it pertains to clean screen entertainment and educational features, furthering the production of screen subjects … Special Kiddie Klub events will be planned for every Saturday afternoon …The hour of 1 to 2 p.m. will be set aside… at the Lompoc Theater for the meetings of the club. Special entertainment features will be selected for each Saturday matinee including cartoons, news events, and special educational features in addition to the regular Saturday feature picture attraction….," *LR*, March 20, 1931, p. 9.
Kiddie Kartune Club (notices in Northern Santa Barbara County newspapers on microfilm and on newspapers.com)
1931 – "Kiddie Kartune Club Meets Today… Winning highest honors among 35 juvenile cartoonists who turned in drawings in the first Kiddie Kartune Club contest sponsored by the Lompoc Theater, **Alice Laubly** and Gladys Williams received first and second prize, respectively… There are 150 children enrolled in the club, who study drawing under regular film releases which give instructions. …," *LR*, June 5, 1931, p. 6; "Record 'Funnies' To be Used by Kiddies in Cartoon Lessons. At their meeting to be held tomorrow at the Lompoc Theater, members of the Kiddie Kartune Club will endeavor to draw likenesses of the well-known 'Mr. Ritz' from 'Fritzi Ritz' of the *Lompoc Record* 'funnies,' using copies of the *Record* for models. Last week the competition was in the drawing of hands with Miss Gladys Williams and Miss Ilene Huyck winning prizes…," *LR*, June 26, 1931, p. 1;
"There are to be fire-crackers for all members of the Kiddie Kartune Club at their meeting at the Lompoc Theater tomorrow morning… Drawings will be made of 'Mutt and Jeff' and the winners of the Kodak contest and the bow and arrow contest will be announced. Little Gladys Williams and Don Ray were the winners in the drawing contest last week, submitting the best drawings of 'Mr. Ritz' of the *Lompoc Record* 'funnies'," *LR*, July 3, 1931, p. 8; "Kiddie Kartune Club Holds Outing at Park," *LR*, Aug. 28, 1931, p. 7; "Kiddie Kartune Club will Stage Revue Here Tuesday," *LR*, Oct. 16, 1931, p. 6; "Kiddie Kartune Club to Entertain Young People at Program," *LR*, Oct. 30, 1931, p. 1.

Kidman, Lyman (1892-1969) (Lompoc)
Teacher of manual training at Lompoc High School, 1922, 1923. Also, an athletic coach.

■ Port. and "Lyman Kidman… died April 9, 1969… Born April 3, 1892, Petersboro, Cache County, a son of John and Elizabeth Jane Bird Kidman. Married to Alta Norman… Graduate Utah State University; lettered in football, basketball and baseball. Former teacher, Richmond, Cache County, and in California. Auto mechanic and math teacher at South High School. Retired…," *Salt Lake Tribune* (Salt Lake City, Utah), April 11, 1969, p. 34 (i.e., 10B).
Kidman, Lyman (notices in Northern Santa Barbara County newspapers on microfilm and on newspapers.com)
1924 – "Mr. Kidman and family left this morning for Utah, where he is to attend the Utah Agricultural College and will receive his Master's degree," *LR*, June 13, 1924, p. 8; "High School Notes. Lyman Kidman, former teacher… visited here the last few days. He is now teaching in the Santa Ana High School," *LR*, Sept. 12, 1924, p. 4.
Kidman, Lyman (misc. bibliography)
Lyman Kidman, teacher, is listed in the *Anaheim, Ca., CD*, 1925 and in the *San Diego, Ca., CD*, 1927; Lyman Kidman provided the following information on his WWI Draft Registration Card = b. Utah, April 3, 1892, residing in Cache, Utah (refs. ancestry.com).

See: "Lompoc, Ca., Adult/Night School," 1923, "Lompoc, Ca., Union High School," 1922, 1923

Kiler, Elza Leslie (1896-1992) (Palo Alto / Santa Barbara?)
Set Designer. Landscape architect. Water colorist. Member Santa Barbara Art Association who exh. at Santa Ynez Valley Art Exhibit, 1954, 1955.
Kiler, Leslie (notices in California newspapers on microfilm and on newspapers.com)
1955 – "Water Color Exhibit… An exhibition of watercolors by Leslie Kiler, former Palo Alto landscape architect now living in Santa Barbara is currently being shown at the Stanford art gallery… The 16 Kiler paintings… are landscapes, including some of the Peninsula. He was the architect of Stanford's famous outdoor Frost amphitheater. …," *The Times* (San Mateo, Ca.), Aug. 8, 1955, p. 8.
1956 – Article on the E. Leslie Kiler home in Santa Barbara, *LA Times,* Nov. 18, 1956, *Home Magazine,* cover and p. 16.
And more than 50 additional notices for "Leslie Kiler" reporting gardening lectures, etc., in Calif. newspapers between 1920 and 1960 were not itemized here.
Kiler, Leslie (misc. bibliography)
Port. with wife in Stanford University yearbook, 1927 with comments that the stage settings were created by the team of Chrysella and Leslie Kiler; port. in *Stanford University Yearbook*, 1928 and caption reads, "Enthusiasm for Les Kiler's [stage] sets is a standard thing, but this year praise is tinged with a great deal of regret. This is the last season the campus will have the opportunity of witnessing his interpretations of interior decorations as-it-should-be-done. Both Chrysella Dunker Kiler and Les Kiler will leave at the end of spring for the east…"; Elga [Sic.] Leslie Kiler, b. Santa Barbara, c. 1897, and wife Chrysella, residing in Palo Alto, sailed from Liverpool, England, on the Britannic on April 24, 1931, arriving at Boston on May 2, 1931; Leslie Kiler is listed in Palo Alto area CDs in the 1930s and 1940s; E. Leslie Kiler is listed in the *Santa Barbara, Ca., CD*, 1953-1970; Elza Leslie Kiler was b. April 12, 1896 in Calif. to Edmond Francis Kiler and Annie E. Franklin, was residing in Palo Alto, Ca., in 1932, married Chrysella, and d. Feb. 5, 1992 in San Francisco per Palmer Family Tree; Kiler died in Napa, Ca., per Calif. Death Index (refs. ancestry.com).
See: "Santa Barbara County Fair," 1958, "Santa Ynez Valley Art Exhibit," 1954, 1955

Kilpatrick, Aaron (Morro Bay)
Exh. Santa Maria Art Festival, 1953.
See: "Santa Maria Valley Art Festival" 1953, and *Morro Bay Art and Photography before 1960*

Kincaid, Edward Amos (1923-2015) (Santa Barbara)
Asst. prof. of Industrial Arts, University of California Santa Barbara College, who lectured on art at University Club, Lompoc, 1955. Taught a craft class for UC Extension, 1955.
■ "University Club Speaker Announced. Edward A. Kincaid, assistant professor of industrial arts at the University of California, Santa Barbara College, will speak to the University club of Lompoc, Friday, January 14, 7:00 p.m. at the Alpha clubhouse… Kincaid's subject will be 'Phases of **Japanese Art**' and he will have examples of the many art and craft forms of the Japanese people. He has made many studies in this field and has collected a considerable collection of prints on the West Coast of Noh and Kabuki drama prints. He will discuss lacquer ware, both 17th century and contemporary, porcelains and contemporary ceramics, block prints, textiles in both brocades and embroidery, silk screen prints and other processes. The young professor gained an interest in this subject as an undergraduate at San Jose State College and then went to Japan in the Navy in 1945 and 1946, where he had an opportunity to visit all parts of the country. He collected many of his materials at that time and since has inherited others until now he has a total of 800 prints. He later taught Oriental art at Stanford University. He will discuss each art form in terms of aesthetic values and actual processes and how it has progressed or regressed over centuries. He will show that in the Japanese mind there is no difference between the fine and applied arts as we know it. Kincaid joined the Santa Barbara college faculty in 1952 after earning his MA degree at Stanford," *LR*, Jan. 6, 1955, p. 2.
Kincaid, Edward (misc. bibliography)
Edward A. Kincaid, prof. UC-SB College, is listed with wife Neil R. in the *Santa Barbara, Ca., CD*, 1954; port. in Santa Barbara College of the University of California, yearbook, 1956-59; Edward Amos Kincaid was b. Jan. 3, 1923 in Fort Smith, Ark., to Edward Amos Kincaid and Novel Virginia White, married Virginia Neill Rush, was residing in Livermore, Alameda County, Ca., in 1940, and d. 2015 in San Diego, Ca., per Swenerton Family Tree (refs. ancestry.com).
See: "Teacher Training," 1955, "University of California, Extension," 1955

King, Angie (Mrs. H. L. King) (Lompoc)
Ceramist, teacher, prop. North H Ceramics Shop / King's Ceramics, 1952.
■ "Mrs. Angie King Opens North H Ceramics Shop. Indicated by a shining new sign on North H street, beyond the city limits, Mrs. Angie King has opened an attractive ceramics shop where clever pieces of her own will be found. Several years' work, under **Mrs. Viola Dykes** at the Adult Education school in the Recreation center have developed Mrs. King's special flair for this type of work. Highlighting her equipment is the newest type of kiln for firing green ware, and this is complemented by a line of supplies on sale so that workers may avail themselves of her facilities in making their own ceramic items. Night classes are being planned by Mrs. King who will also take day classes if desired," *LR*, July 17, 1952, p. 14.

King, Angie (notices in Northern Santa Barbara County newspapers on microfilm and on newspapers.com)
1953 – "Superintendent to Conduct LDS… The Relief Society will meet at 7:30, April 8, when Mrs. H. L. King will teach ceramics," *LR*, April 2, 1953, p. 11; "H. L. Kings buy Horne Property on North H Street… have occupied the property for about four years and since last July, Mrs. King has operated a ceramics business there, having her own kiln and conducting classes in work with clay," *LR*, June 4, 1953, p. 13 (i.e., pt. II, p. 5?).
This individual could not be further identified.
See: "King's Ceramics"

King, J. P. (Itinerant?)
Artist who sold pictures in Santa Maria, 1907.
1907 – "J. P. King, the picture artist, has sold out his entire stock at auction sale on Saturday last," *SMT*, Dec. 28, 1907, p. 5, col. 2.
This individual could not be further identified.

King, James W. (Santa Maria)
Exh. oil painting of Pt. Sal at "Santa Barbara County Fair," 1886. Gave recitations at the Lyceum.
1886 – "Personal Mention… J. W. King, recently in the employ of Jones & Son, has gone to Oakland where he thinks of engaging in business," *SMT*, Dec. 4, 1886, p. 5.
This individual could not be further identified.
See: "Santa Barbara County Fair," 1886

King's Ceramics / North H Ceramics Shop (Lompoc)
1952 – "Hand Made, Ready Made. Gifts for Christmas – good selection. Also Greenware. We will make up your presents for you. King's Ceramics. North H at City Limits – Telephone 5852," *LR*, Dec. 18, 1952, p. 6.
See: "King, Angie"

Kinney, Harold Orton (1909-1962) (Santa Maria)
Photographer, amateur. Member Santa Maria Camera Club, 1947-52. Cashier at PG&E and a chinchilla rancher.
Kinney, Harold (notices in Santa Barbara County newspapers on newspapers.com).
1949 – Repro: queen of Black and White ball, *SMT*, Oct. 5, 1949, p. 6.
1950 – "Just Offhand …," anecdote of Kinney passing out fake $2 bills as a joke, *SMT*, Oct. 7, 1950, p. 6.
1951 – Repro: wedding photo of M/M Mario Navarro, *SMT*, Jan. 17, 1951, p. 4; "Just Offhand…," anecdote about Harold's and fellow Pacific Gas & Electric Co. staff's trick on their manager, "Then Harold photographed the desk piled high with valuable gifts in exactly the same manner in which he had taken the previous picture the week before when Everett was behind the desk [and his desk was piled with junk gifts]. Harold succeeded in superimposing the print of the valuable gifts on the picture they had taken previously with such precision that only a professional eye can detect the fake. Harold then supplied Clyde Dyer, Rotary club secretary, with a copy of the 'faked' picture

and suggested that club members would perhaps be interested in seeing just how marvelously Everett's office staff had treated him prior to his departure to the Rotary convention…," and further details of trick, *SMT*, June 14, 1951, p. 14.
1952 – "Just Offhand…," and anecdote about Kinney's TV reception, *SMT*, March 29, 1952, p. 6.
And, many additional notices in the *SMT* 1940-1960 discuss his activities as a marksman, with the PTA, with civic clubs, etc., but were not itemized here.
Kinney, Harold (misc. bibliography)
Harold O. Kinney, collector, PG&E, is listed in the *Santa Maria, Ca., CD*, 1945; Harold Orton Kinney was b. April 25, 1909 in South Dakota to Frederick Sepheres Kinney and Eva Levoy Hollingsworth, married Josephine, and d. Aug. 16, 1962 in Santa Barbara County per Walker-Thompson Family Tree (refs. ancestry.com).
See: "Santa Maria Camera Club," 1947, 1950

Kinze and Martin (San Jose)
Photographers active in Lompoc, Dec. 1926.
■ "Are Successful with Little Tots' Pictures. Messers Kinze and Martin of San Jose, photographers, spent the past week in Lompoc taking pictures in the home. Some excellent work has been done with child studies, in which the photographers specialize. It has been found by them that it is easier to get good, natural poses of children in the home where they are accustomed to the surroundings. … Mr. Martin has an infant son of his own of whom he has secured lovely pictures. Mr. Kinze and Mr. Martin will return to San Jose tomorrow evening but will be back in Lompoc after the Christmas holidays," *LR*, Dec. 17, 1926, p. 3.

Kistenmacher, William (Los Angeles / SF)
Itinerant illustrator for Thompson & West's, Santa Barbara County Illustrated 1883, and History of San Luis Obispo County California with Illustrations, 1882.
See: "Thompson & West," and *Central Coast Artist Visitors before 1960*

Kit-n-Kate (Santa Ynez Valley)
Manufacturer of broomstick horse toys. Props. Mrs. Channing Peake and Mrs. Katherine Franks, 1955.
■ Photo of toys and "Broomtails, Hobby Horse Variation… Basis of the improvement over the old stuffed-sock-on-a-stick type of horse is the frame which provides a skull for the 'animal'… Spring action is added to enable the horse to nod his head… Finishing is in cotton yarn, hair-on steerhide and leather, with socks for skin. Mrs. Peake was inspired to invent and perfect the Broomtail when her little daughter came home from nursery school with demands for a horse like the horses at school. Mrs. Franks had been given a stick horse made by the **Farm Home Department** in a class on home making playthings several years ago and had copied and improved upon it… The frames are made by Hanly Bros., contractors, and stuffing and finishing are in the capable hands of a group of Solvang and Buellton women who are glad to be able to work at home and

finding it's lots of fun to make horses," *SYVN*, April 1, 1955, p. 6.
See: "Peake, Katherine"

Kleine, Agnes Christine (1874-1945) (Santa Maria)
Child who exh. mission painting at "Santa Barbara County Fair," 1891. Sister to Bertha Kleine, below.
Kleine, Agnes (notices in Northern Santa Barbara County newspapers on microfilm and on newspapers.com)
1894 – "Miss Agnes Kleine now boards at home and comes to school on horseback every morning. She is a skillful equestrienne ...," *SMT*, Feb. 24, 1894, p. 3.
1895 – "Misses Agnes and Bertha Kleine are resting from their high school labors at their father's Laguna ranch. They vary the monotony by assisting in the work about the home," *SMT*, Dec. 21, 1895, p. 3.
1900 – "Teachers Certificates... issued to the following to teach in the primary grades... Agnes Kleine...," *SMT*, July 14, 1900, p. 2; "Miss Agnes Kleine will teach the Point Sal school the coming term which opens August 6th," *SMT*, July 28, 1900, p. 3.
And several notices appear in the *SMT* in the late 19th century recording her excellence in scholarship.
Kleine, Agnes (misc. bibliography)
Agnes C. Kleine is listed in the 1900 U. S. Census as b. Dec. 1874 in Calif. and still living in the house of her father John H. Kleine, dairyman (b. May 1840); several ports of Agnes Christine Kleine b. Dec. 24, 1874 and d. Dec. 7, 1945 appear in *Public Member Photos & Scanned Documents* (refs. ancestry.com).
See: "Kleine, Bertha," "Santa Barbara County Fair," 1891

Kleine (Newlove), Bertha Annette (Mrs. Ernest Alford Newlove) (1878-1950) (Santa Maria)
Child who exh. mission painting at "Santa Barbara County Fair," 1891. Sister to Agnes Kleine, above.
Several notices appear in the *SMT* in the late 19th century recording her excellence in scholarship and her local activities, but they were not itemized here.
Kleine, Bertha (misc. bibliography)
Bertha A. Kleine is listed in the 1900 U. S. Census as age 21, b. Nov. 1878 in Calif., a servant/boarder in Township 9, Santa Barbara County living a couple of doors down from her parents; her port. may appear in group photos of Kleine siblings in *Public Member Photos & Scanned Documents*; Bertha Annette Kleine was b. Nov. 7, 1878 in Santa Barbara County to John Henry Kleine and Anna Catharina Margaretha Schilling, married Ernest Alford Newlove, was residing in Berkeley, Ca., in 1940, and d. Feb. 2, 1950 in Santa Barbara County per Wright Family Tree (refs. ancestry.com).
See: "Kleine, Agnes," "Santa Barbara County Fair," 1891

Klods-Hans (Clumsy Hans) (aka Thor Brandt-Erichsen)
See: "Brandt-Erichsen, Martha," "Brandt-Erichsen, Thor"

Knecht, Walter J. (Ventura)
Landscape design artist who spoke to Minerva Club, 1956.
See: "Minerva Club," 1956

Knechtel, Lloyd W., Capt. (Camp Cooke)
Photographer. Captain 153rd Signal Headquarters, 13th Armored Division, stationed at Camp Cooke for two weeks' training, 1950.
1950 – "13th Division Officer Injured... suffered a fractured vertebra when he fell off a M24 tank last week. ... was sitting on the turret of the tank, taking pictures, when the tank made a sudden turn throwing him to the ground. Capt. Knechtel is now confined to the Camp Cooke hospital," *LR*, Aug. 24, 1950, p. 13.

Knight, Lena
See: "Tognini (Knight), Lena (Mrs. Charles Fredrick Knight)"

Knitwits
See: "Betty's Little Knitwits Club"

Knott, A. Harold (Morro Bay)
Artist who exh. in National Art Week show at Minerva Club, 1940.
See: "National Art Week," 1940, and *Morro Bay Art and Photography before 1960*

Knowles, Joseph Edward (1907-1980) (Santa Barbara)
Watercolorist. Art coordinator for Santa Barbara county schools who was often in the Santa Ynez Valley giving talks and demonstrations on art as well as on art education in the elementary schools, c. 1948+. Judge of photo exh. at Santa Ynez Valley Art Exhibit, 1954. Member Santa Barbara Art Association, who exh. at opening exh. of Allan Hancock College Art Gallery, 1954.
■ "Joseph Knowles, art coordinator for Santa Barbara county schools, has shown a fondness for scenes in Refugio Canyon and Santa Barbara boat harbor... The present group of watercolors and a few in mixed media, 26 in all, are nicely framed. The work shows a diversity of style. One that many people like, and new from this artist, is his study in somber colors of the area burned over in the wake of last summer's forest fire in the Santa Barbara mountains. The work is that of one who likes the out-doors, and those of the wooded scenes are exceptional for detail and shading in trees. The collection, to be here ten days or so longer, is well worth seeing and should not be missed... Joseph Knowles is a member of the California Water Color Society. He studied in France and England, and has many paintings in private collections, Knowles has just finished a large mural for the Beckman Instrument Corp., Fullerton, an assignment that occupied most of the summer. He has worked and studied with **Standish Backus**, eminent Santa Barbara artist," per "Knowles Paintings are at [Allan Hancock] Gallery," *SMT*, Dec. 8, 1955, p. 4.

1938 – "Modern Murals Added… A large mural, about twenty-seven feet long, has been placed in La Buvette in Buellton by Joseph Edward Knowles of Santa Barbara. The paintings depict three typically Parisian scenes: a bookseller's stall, a portion of Vieux Quartier, and a railroad station scene, all with various odd characters…," *SYVN*, Sept. 2, 1938, p. 5.

1940 – "Light Opera for Santa Barbara Shortly… Sari, a gay musical with scenes laid in Hungary and Paris… Sets were designed by artist Joseph Knowles…," *SMT*, April 11, 1940, p. 8.

1941 – "Club Hears Art Instructor… Junior Chamber of Commerce… guests…Joseph Knowles, Santa Barbara muralist and recently appointed curator of juvenile art for the Santa Barbara Art Museum," *SMT*, June 4, 1941, p. 2.

1947 – "Santa Barbara Artist Exhibits at Biltmore" in LA, *SMT*, May 15, 1947, p. 1; "Work of Noted Artist on Display at **Community Center**. The painting now hanging over the mantle in the Community Center is on loan from the Santa Barbara Museum of Art, through the courtesy of the artist, Joseph Knowles… Knowles, who is in addition to being a prominent painter, the County Supervisor for Art in Santa Barbara Schools, has exhibited his work all over California and in the East. The artist made a special trip to Lompoc … to bring the painting… a water color landscape done in greens and browns. The scene was painted near Montecito. Incidentally Knowles will speak before the Alpha club sometime in November," *LR*, Sept. 18, 1947, p. 3.

1951 – "PTF Club Hears Speaker on Art," i.e., art consultant "who talked on art in elementary school programs. He illustrated his talk with both movies and still films. The speaker evaluated samples of art on display from all class rooms, showing how each child expressed his personal reaction to things about him," per *SMT*, Oct. 31, 1951, p. 4.

1955 – "25 paintings by Joseph Knowles of Santa Barbara… **Harold Forgostein**, art instructor at the adult school, termed Knowles one of the foremost painters in our country. 'His exhibition demonstrates clearly the professional competence of an artist who matches the mastery of his craft with aesthetic sensitivity,' Forgostein said. Paintings by Knowles are in transparent watercolor, and opaque medium. 'For subject matter, Knowles draws with equal facility from nature and man, whether as an industrial, a boat, or a harbor scene. …," per "Paintings by Joseph Knowles are Exhibited at Gallery," i.e., **Forden's**, per *SLO Telegram-Tribune*, Nov. 16, 1955, p. 15.

1957 – "Hancock [Parent] Nursery to Hear Art Consultant" and "will present a program on children and art for the Hancock Parent-Nursery school… The program will include an audience participation portion for the parent education group," *SMT*, March 27, 1957, p. 12; "Speaks on Art" to Parent Education group at Hancock College, on topic of "Children and Art," *SMT*, April 1, 1957, p. 3; "Joseph Knowles to Speak to Parents… 8 p.m. at a meeting of the parent education class of AHC Nursery School… It is a return engagement for this speaker who will demonstrate art suitable for children's rooms at home and give out materials for class-room work in which the parents may engage," *SMT*, May 7, 1957, p. 5.

1961 – "Paint Class Series Set for University… daytime series of painting classes for elementary teachers to be held on the campus of University of Santa Barbara… 'Painting for the Elementary Grades'," *LR*, March 16, 1961, p. 15 (i.e., 1c).

1966 – "Mosaics to Beautify Greek Amphitheatre… Righetti High School… two colored mosaics will be installed at the Greek amphitheater … The mosaic project was started last year and is being financed by a special study body treasure fund. Joseph Knowles is the artist…," *SMT*, Feb. 4, 1966, p. 7.

1968 – "GOP Women's Art Auction Exhibit Sunday. … second annual… sponsored by the Santa Barbara County Federation of Republican Women's Clubs will be held this Sunday at Casa Dorinda… Montecito… will feature 14 artists from Santa Barbara County… Joseph Knowles…," *SYVN*, May 9, 1968, p. 14 (i.e., 6B).

1970 – "County History Guide Published… by Santa Barbara County Schools Office…. All three of the guides have been designed to provide teachers with historical information about Santa Barbara county… Cover designs for all three books were created by Joseph E. Knowles…," *LR*, April 20, 1970, p. 3.

1972 – "La Casa Sets Conference on Art… weekend conferences at La Casa de Maria in Montecito will be 'Art as an Ecological Means of Survival,' Nov. 3 through 5. … 'Can man remain man without art?'… Experts who will be leading the discussion groups are … Also invited to participate in the discussions are: … Joseph Knowles and James Armstrong, painters and co-directors of the Santa Barbara Art Institute…," *SYVN*, Oct. 19, 1972, p. 19 (i.e.?).

Joseph Edward Knowles was b. June 15, 1907 in Montana to Edward Roy Knowles and Minnie Hayton Blackburn, was residing in San Diego in 1926, married Elizabeth Vail Bakewell, and d. Sept. 8, 1980 in Santa Barbara, Ca., per We've been there… done that Family Tree (refs. ancestry.com).

See: "Allan Hancock [College] Art Gallery," 1954, 1955, "Alpha Club," 1947, 1948, 1953, 1956, "Andersen's," 1958, "Ballard School," 1947, "Bowen, William," 1941, Brooks Institute / School of Photography," 1970, "Buellton, Ca., Adult/Night School," "California State Fair," 1949, "Castagnola, Gladys," 1955, "Community Center (Lompoc)," intro., 1947, "Faulkner Memorial Art Gallery," 1964, "Guadalupe, Ca., Elementary School," 1953, "Liecty, Ruth," 1956, "Lompoc, Ca., Elementary Schools," 1948, "Minerva Club," 1950, "Murals," 1941, "National Art Week," 1940, "Posters, general (Orcutt)," "Orcutt, Ca., Elementary School," 1947, "Santa Barbara County Fair," 1950, 1958, 1961, "Santa Maria, Ca., Elementary Schools," 1954, 1956, "Santa Maria [Valley] Art Festival," 1952, "Santa Ynez Valley Art Exhibit," 1954, "Santa Ynez Valley, Ca., Elementary / Grammar Schools," 1942, 1946, 1947, 1948, 1949, 1950, 1953, 1954, 1955, 1957, "Santa Ynez Valley Child Workshop Project," 1955, "Santa Ynez Valley Union High School," 1951, "Teacher Training," 1953, 1957, "Tri-County Art Exhibit," 1947, 1948, 1950, "University of California Extension," 1952, 1961, 1962,

1963, 1964, and *San Luis Obispo Art and Photography before 1960*

Knudsen, Marguerite (Mrs. Dr. Arnold F. Knudsen) (Santa Maria)
Exh. landscape painting at Minerva Club Art and Hobby Show, 1958, 1959.
Port. pouring tea, *SMT*, May 14, 1956, p. 4.
See: "Minerva Club, Art and Hobby Show," 1958, 1959, "Santa Maria Valley Art Festival," 1952

Knudsen, Robert Fredric (1887-1969) (Solvang)
Cabinetmaker, furniture maker, clock maker, 1954.
■ "Robert F. Knudsen dies at 83, Maker of Grandfather Clocks... A retired cabinet maker and carpenter, Mr. Knudsen was known for his skill in woodworking and during his retirement made grandfather clocks of solid mahogany, 13 in all. Coming to Solvang upon his retirement in 1953, his works included China cabinets, gun cabinets, and furniture, all of his own design," and detailed biography, *SYVN*, Oct. 30, 1969, p. 9.
■ Port. with grandfather clock and "Grandfather's Clock Created by Cabinet Maker R. F. Knudsen... Knudsen, who began his work as a cabinet maker as a boy apprentice in his native Denmark more than 50 years ago, is in the midst of realizing the ambition of conceiving a grandfather's clock... He plans to have it completed in time for Danish Days in order that he may display it at the Exhibit at the Memorial Building. After the exhibit he will present it to his wife, Thelma, as a gift... Knudsen is also working on the second portion of a birds-eye maple and black walnut bedroom set which he began in 1938. That was when he made a cedar lined chest for the set... Incidentally, the cedar lined chest won a blue ribbon in hobby show in Waterloo, Ia., in 1940. Mr. Knudsen began his cabinet furniture making career in 1902 in Denmark. After serving five years as an apprentice and working in Denmark, he came to America and to Dike, Ia., near Cedar Falls, in 1908. He served for a year and a half in the US Army during World War I as a sergeant carpenter and after the war returned to Dike where he helped organize Dike American Legion Post No. 414. Later he moved to Kansas. In 1929 he and Mrs. Knudsen were married and they lived in Moorland, Kan., at the time of the dust bowls. Those were rough years, Mr. Knudsen said, with the dust conditions halting all activity. Schools were closed, stores were open only an hour a day. The dust was so heavy you couldn't see across the street. Still later the Knudsens returned to Dike. After that Mr. Knudsen came to California to take a job at the Mare Island Navy Yard. This was followed by eight months at Culver City where he was employed by Howard Hughes working on the big flying boat *Hercules*. Next came a job at the Long Beach Navy Yard. Mrs. Knudsen joined him and Knudsen was employed at the Navy Yard for 10 years before he retired and moved with Mrs. Knudsen to Solvang. During the war Knudsen was an instructor of a carpenter's helpers' class with most of the students, girls. About five years ago the Knudsens read of Solvang and Danish Days in the *Pioneer*. They attended the celebration and immediately thought they would like to make Solvang their home. They purchased... two lots at School Street and Elm and a small home on Atterdag road, which they rented out until they moved here a year ago last April. Last September they sold the home to **Hans Sorensen** and in turn purchased their Willow Drive property from Capt. Don Davison... The former two-car garage was extended 14 feet by Mr. Knudsen to provide space for his workshop. A Dutch door in the front leads the way to the shop. Above the door, in traditional Danish style, is a hardwood smoothing plane containing the inscription 'Mobelsnedker,' the Danish for cabinet-furniture maker. Another addition in the workshop building is lighted, glass enclosed cupola with a windmill on top...," *SYVN*, July 2, 1954, p. 1.
Knudsen, Robert (notices in Northern Santa Barbara County newspapers on microfilm and on newspapers.com)
1950 – "Long Beach Couple Buys Property. Mr. and Mrs. Robert F. Knudsen of Long Beach have purchased a strip of land adjoining the Skytt subdivision in Solvang... plan to construct an income bearing building...," *SYVN*, Aug. 4, 1950, p. 7.
1954 – "Grange Dance... Saturday night, Dec. 4 at the Grange Hall in Los Olivos and admission will be by purchase of a ticket on the cedar chest event prize. The cedar chest, hand made by Robert Knudsen of Tennessee dry kilned cedar and completely filled, will be awarded Dec. 18," *SYVN*, Nov. 26, 1954, p. 3.
1962 – "Royal Copenhagen Motel Open House Next Monday... The office interior includes... a large Old World clock which was made by Robert Knudsen...," *SYVN*, Nov. 9, 1962, p. 8.
Knudsen, Robert (misc. bibliography)
Robert Fredric Knudsen b. March 2, 1887 in Copenhagen, Denmark, d. Oct. 22, 1969 in Santa Barbara County and is buried in Oak Hill Cemetery, Ballard per findagrave.com (refs. ancestry.com).
See: "Atterdag Studio"

Kodak Club
Photography club at Santa Maria High School, 1935.
See: "Santa Maria, Ca., Union High School," 1935

Koerner, Fred / Frederick J. (c. 1866-after 1932) (Sisquoc / Santa Maria / Auburn / Arizona)
Photographer in Santa Maria, 1893-96. Later a grocer in Auburn, Ca.
Koerner, F. J. (notices in Northern Santa Barbara County newspapers on microfilm and on newspapers.com)
1893 – "Fred Koerner left yesterday for Santa Barbara county where he will look up a good location to open up a photograph gallery," *LA Herald*, Feb. 10, 1893, p. 3, col. 5; "F. J. Koerner, photographer, is looking for a gallery location in Santa Maria," *SMT*, Dec. 9, 1893, p. 3, col. 2.
1894 – "Mr. F. J. Koerner, the photographer has been in the adjacent hills taking views and has temporarily located at Garey," *SMT*, March 10, 1894, p. 3; "F. J. Koerner, photographer of the Sisquoc section, paid us a pleasant social and business visit Monday last," *SMT*, Aug. 18, 1894, p. 3, col. 1.

1895 – "F. J. Koerner, the new photographer, has located on the vacant lot adjoining J. C. May's warerooms on Broadway and will be ready for business next Tuesday. He is fitting up a large tent and will have a very attractive gallery when completed," *SMT*, May 11, 1895, p. 2; ad: "Koerner's Photograph Gallery … Landscape Work a Specialty… One block south of Post Office…," *SMT*, May 18, 1895, p. 3; "The photographer at the Koerner gallery has put in a very busy week. You are invited to call and inspect his work at the new gallery," *SMT*, June 15, 1895, p. 3; "Old Uncle John… Recently he has had his photograph taken at Koerner's gallery. The picture represents the old man seated and holding in his hand a copy of the *Times*. He is quite proud of his picture," *SMT*, Aug. 3, 1895, p. 2; "Koerner's Photograph Gallery. We are here to stay. Is now open and ready for business. Will do strictly first-class work. Satisfaction guaranteed. Landscape Work a Specialty. ... One block south of Post Office, Broadway street…," *SMT*, Aug. 31, 1895, p. 2; "Any person returning private papers, letters and art souvenirs taken from Koerner's photograph gallery will be suitably rewarded by leaving same at gallery and no questions asked," *SMT*, Aug. 31, 1895, p. 3.
1896 – "F. J. Koerner, the photographer, was in from the More ranch Thursday and paid the *Times* a call," *SMT*, Jan. 25, 1896, p. 3, col. 1; "Re-opened – Koerner gallery," *SMT*, March 14, 1896, p. 3, col. 1; "Jones & Son bought the gallery building of Koerner and have moved the same to Olive Hill for ranch and orchard housing, etc.," *SMT*, March 21, 1896, p. 3; "Koerner the Photographer has left his negatives at **McMillan's gallery** where duplicate orders can be given," *SMT*, April 4, 1896, p. 3.
1925 – "Fred Koerner, L.A. Carpenter … spending the week in the neighborhood of Sierraville, on a camping trip. Fred's grocery store is being run by Miss Pauline Watson during Fred's absence," *Auburn Journal*, June 25, 1925, p. 11.
1926 – "Fred Koerner Sells … Fred Koerner has sold his grocery business…," *Auburn Journal*, May 13, 1926, p. 14.
1928 – "Fred Koerner is Operating Local Store… Fred relieved Mr. and Mrs. H. S. McGowan who wished to retire from active business. Fred now owns a ranch in Arizona. Fred claims he can sit on his front porch… and catch all the trout he wants out of a stream that passes through his property," *Auburn Journal*, Feb. 16, 1928, p. 12.
Koerner, F. J. (misc. bibliography)
Fred J. Koerner, age 25, b. Indiana, a photographer, residing in San Luis Rey, registered to vote Oct. 4 per *Great Register of San Diego County for 1890*, p. 100; Frederick Koerner, age 26, b. c. 1865, enlisted in the California National Guard March 26, 1891, 7th Infantry, 1st Brigade; Fred J. Koerner, age 27, residing in West Anaheim, registered to vote on Aug. 1, 1892, per *Orange County Electors*, p. 20; Fred J. Koerner, age 29, ht. 6' ½ in, dark complected, black eyes, black hair, scar on chin, b. Indiana, residing Sisquoc, registered to vote in Santa Maria, Aug. 30, 1894, is listed in *Supplement to the Great Register, Santa Barbara County, California*, 1894; Fred J. Koerner is listed in the 1920 U. S. Census as age 53, b. c. 1867 in Indiana, divorced, a carpenter, boarding in Township 14, Placer County, Ca.; F. J. Koerner is listed in the *Phoenix, Ariz., CD*, 1928; F. J. Koerner, Rep., b.

Indiana, a farmer, registered to vote per *Official Register of Electors for Oak Creek Precinct, Yavapai County, Arizona*, 1928, 1930, 1932 (refs. ancestry.com).

Koker, Hermann, Prof. (Northern California)
Teacher of mechanical drawing at University of California, Extension, 1921.
See: "University of California, Extension," 1921

Konishi (Oyama) (Aihara), Ann Kazue (Mrs. Fred Y. Oyama) (Mrs. Henry K. Aihara) (1935-?) (Santa Maria)
Member of Rembrandt Club, Allan Hancock College, 1955. Art award and art scholarship winner. Athlete
Konishi, Ann (notices in Northern Santa Barbara County newspapers on microfilm and on newspapers.com)
1953 – "Outstanding Seniors are Honored with Scholarships… Bank of America engraved cup… Ann Konishi for work in fine arts…," *SMT*, June 12, 1953, p. 1.
1955 – Port. as art editor for Hancock college yearbook, *SMT*, May 25, 1955, p. 5; "Grads Receive Scholarships. Six scholarships were awarded to Allan Hancock college graduates… Ann Konishi received the Allan Hancock college Nisei scholarship which was originated by the Japanese Women's club of the valley," *SMT*, June 11, 1955, p. 1.
Konishi, Ann (misc. bibliography)
Ann Kazue Konishi, mother's maiden name Saki, was b. Nov. 10, 1935 in Santa Barbara County per Calif. Birth Index; port in Santa Maria High School yearbook, 1952, 1953; Ann K. Konishi married Fred Y. Oyama on Dec. 14, 1957 in Los Angeles County per Calif. Marriage Index; Ann K. Oyama is listed without husband in the *Santa Maria, Ca., CD*, 1958; Ann K. Oyama divorced Fred Y. on June 29, 1982 in Orange County per Calif. Divorce Index; Ann K. Oyama married Henry K. Aihara on July 7, 1982 in Los Angeles County per Calif. Marriage Index; is she Ann K. Konishi who was residing on Palos Verdes Peninsula in 1990 per *U. S. Public Records Index, 1950-1993*, vol. 1 (refs. ancestry.com).
See: "Rembrandt Club, Allan Hancock College," 1955

Koonce, Ruth L. (Mrs. Lawrence L. Koonce) (1895-1983) (Santa Barbara)
Collector, dealer, owner of Seven Gables studio, who spoke to Minerva Club on antiques, 1949.
Ruth L. Koonce is listed with husband Lawrence in the *Santa Barbara, Ca., CD*, 1945-78; Ruth L. Koonce, mother's maiden name Nolan, father's Lucas, was b. Nov. 30, 1895 in Minnesota and d. Nov. 3, 1983 in Santa Barbara County per Calif. Death Index (ref. ancestry.com).
See: "Minerva Club," 1949

Kosa, Emil, Jr. (Los Angeles)
Landscape painter, artist with Hollywood studios, who occasionally sketched on the Central Coast. Moderated a panel during the Santa Maria Art Festival, 1952.
■ "Emil Kosa Jr. … was the art director of 20th Century Pictures's special effects department for more than three

decades, winning an Academy Award for Best Visual Effects along the way," per Wikipedia.
See: "Santa Maria [Valley] Art Festival," 1952, 1953, "Santa Ynez Valley Union High School," 1946, and *Morro Bay Art and Photography before 1960* and *Central Coast Artist Visitors before 1960*

Kramer, Monica (Mrs. Kramer) (Santa Ynez Valley)
Art student of Mrs. Viggo Brandt-Erichsen, 1957. May have exh. Santa Ynez Valley Art Exhibit, 1957, 1958.
Is this Monica Fauerso Kramer (Mrs. Loel Kramer), 1913-2005? (ancestry.com).
See: "Santa Ynez Valley Art Exhibit," 1957, 1958

Krell, Walter (1889-1955) (Santa Barbara)
Exh. first annual Santa Ynez Valley Art Exhibit, 1953.
Krell, Walter (misc. bibliography)
Walter Krell, artist, is listed with wife Elizabeth in the *Santa Barbara, Ca., CD*, 1954; Walter Krell b. June 3, 1889 in Other Country [Wiesbaden, Germany], d. Aug. 8, 1955 in Santa Barbara county per Calif. Death Index; various photos of him are available on *Private Member Photos*; Walter Krell is buried in Santa Barbara Cemetery per findagrave.com (refs. ancestry.com).
See: "Santa Ynez Valley Art Exhibit," 1953

Kriegel, Ida May, Miss (1880/81-1957) (Santa Maria)
Drawing teacher at Santa Maria High School, 1919/22, superseded by Stanley Breneiser and B. E. Cannon. Exh. watercolors of local scenes in group show of local artists at Allan Hancock [College] Art Gallery, 1956.
■ "Miss Ida M. Kriegel… 74, life-long resident of this area … Born in Lompoc, November 30, 1880 [Sic.], she began her teaching at the Careaga school in Los Alamos valley, teaching later in Orcutt and the Belmont School for boys. She was a graduate of the University of California at Berkeley in 1912, also attended the University of Washington and Columbia. She taught in Santa Maria for 28 years until her retirement in 1945. She was a member of the Santa Maria Library board for many years, member of the Minerva club and many other organizations… Burial will be in the family plot in the Los Alamos cemetery," *SMT*, June 6, 1957, p. 7.
Kriegel, Miss (notices in Northern Santa Barbara County newspapers on microfilm and on newspapers.com)
1916 – Administratrix of the estate of Frederick Kriegel, Deceased," *SMT*, Feb. 9, 1916, p. 4.
1957 – "Notice to Creditors… Estate of Ida Kriegel also known as Ida M. Kriegel, Deceased," *SMT*, July 30, 1957, p. 8.
And, more than 500 "hits" for "Ida Kriegel" in the *SMT* from 1915-1957 were mostly social or concerned her club (Retired Teachers) activities and/or travels (local/Alaska/Mexico) and were not all itemized here.
Kriegel, Ida (misc. bibliography)
Ida M. Kriegel is listed in the 1930 and 1940 U. S. Census in Santa Maria, Ca.; port. in Santa Maria High School yearbook, 1930, 1942; Ida M. Kriegel was b. Nov. 30, 1881 in Calif. to Christian Gottfried Fred Kriegel and Louise C.

Kutschke, was residing in Los Alamos, Ca., in 1900 and d. June 6, 1957 in Ventura County, Ca., per One Big Happy Family Tree (refs. ancestry.com).
See: "Allan Hancock [College] Art Gallery," 1956, "Boy Scouts," 1941, "Santa Barbara County Library (Santa Maria)," 1948, "Santa Maria, Ca., Union High School," 1919, 1921, 1923, 1926, 1931, 1937, 1938

Kristensen, F. Walter / Walther (d. between 1985 and 1990) (Solvang / Denmark)
Prop. with Ernest Pedersen of Iron Art, 1949. Sole prop. of Old World Metal Craft, 1950+. Active in Solvang 30 years before returning to Denmark.
■ "Skimmin' Over the ads … Walter Kristensen, formerly of **Iron Art**, is announcing this week the opening of his metal crafts shop in what was 'Bill's Snack Bar.' But like all new businesses, Walter finds that the new firm is without a name. And so, this week a contest is being started…," *SYVN*, Sept. 15, 1950, p. 4.
Kristensen, F. Walter (notices in Northern Santa Barbara County newspapers on microfilm and on newspapers.com)
1950 – "Certificate for Transaction of Business Under Fictitious name… F. Walter Kristensen… Old World Metal Craft…," *SYVN*, Oct. 13, 1950, p. 7.
1952 – Ad: "Christmas greetings, Old World Metal Craft, F. Walter Kristensen," *SYVN*, Dec. 26, 1952, p. 13.
1953 – "Walter Kristensen Buys Property… owner of Old World Metal Craft, has purchased a house and property on Spring Street… It is Mr. Kristensen's plan to build a metal art shop of Danish architectural design in front of the house. …," *SYVN*, March 20, 1953, p. 6.
1955 – Port. working on a wrought iron grill which will soon be part of All Saints Episcopal Church in Beverly Hills, *SYVN*, Nov. 25, 1955, p. 6.
1956 – Photo of Walter Kristensen and grill, and another photo of grill made for All Saints Episcopal Church in Beverly Hills, and article, "Kristensen's Shop Completes Wrought-Iron Church Grilles… took Kristensen and three helpers two and a half months to make the grilles from plans designed by Architect Roland E. Coate of San Marino… the second 'big' job he has turned out… Last July he delivered a bronze communion rail and six bronze candelabra to a Norwegian church in South Pasadena… [designed by] Howard Atwood, one of southern California's leading ecclesiastical designers… [and] will start work on a communion rail-candelabra project for St. Mathias Episcopal Church in Whittier. Kristensen, who is a native of Denmark, started his apprenticeship in the ornamental iron business at the age of 17 and has been going strong at it ever since. He is now rounding out 30 years in the business. Coming to Solvang nearly seven years ago, he specializes in the designing and creation of articles made from iron, copper, brass and silver. Most of his small creations, such as jewelry, lamps, and copper mugs, are turned out during his 'spare' evening hours. Kristensen one time owned and operated an ornamental iron shop in Iceland. At various times during his career he worked in Norway, Sweden, Switzerland, Germany, Austria and, of course, Denmark. He says ornamental ironsmiths are 'few and far between in the United States, but you'll find some of the best in Germany and Italy.'

With more and more orders coming in for his work from various parts of the state, Kristensen has increased his operation from a one-man to a four-man plant. Joining him recently as helpers were Albert Weisbrod who recently moved to the Valley from the Los Angeles area, Jorgen Lebech, who recently returned to Solvang after spending some time in Denmark, and Knud Jacobsen. The fame of the Solvang craftsman is spreading throughout the State and before Christmas Kristensen and his helpers will set about to fill orders for wrought iron screen doors and irons, clocks, lamps, tables and copper hoods. The orders come from customers living as far south as San Diego and as far north as Sonoma," *SYVN*, Nov. 25, 1955, p. 6.

1969 – "Walter Kristensen wins Denmark Trip" offered by Danish Days, *SYVN*, Oct. 2, 1969, p. 1.

1978 – "Note and Scribbles… Word has been received that 'Iron' Walter Kristensen is planning a move back to his Danish homeland in the near future…," *SYVN*, March 2, 1978, p. 4.

1984 – "From the Mail Bag. From Walter Kristensen, longtime former Solvang metal craftsman, now living in Denmark… Solvang, where I spent the best 30 years of my life," *SYVN*, April 19, 1984, p. 4.

And, more than 120 hits for "Walter Kristensen" in the *SYVN* between 1945 and 1984 concerning items he made for various homes and businesses and his activities with various civic organizations, were not itemized here.

See: "Brandt-Erichsen, Viggo," 1953, 1955, "Iron Art," "Old World Metal Craft," "Santa Ynez Valley Industrial Center," "Scandinavian Arts and Crafts," "Signs," 1990, "Solvang Woman's Club," 1949, "Sorensen, Soren," 1951

Krog, Marius [Martinus?], Rev. (1894-1971) (Solvang)
Pastor of the Danish Lutheran Church in Solvang (1932-1937) and superintendent of Atterdag College (1934), who lectured on art to Twenty-Thirty Club, 1937.
See: "Atterdag College," intro., 1933, 1935, "Twenty-Thirty Club," 1937

Kubon, Charlotte "Lottie" Gricel (Mrs. Ralph T. Kubon) (1889-1977) (Alaska / California)
Exh. first annual Santa Ynez Valley Art Exhibit, 1953.
■ "Charlotte G. Kubon… A native of the state of Washington, Mrs. Kubon spent most of her life in Fairbanks, Aka., helping her late husband, Ralph T. Kubon, operate a family drugstore. She painted as a hobby and was known in the Fairbanks area for her oil paintings. She is survived by two sons…," *Daily Independent Journal* (San Rafael, Ca.), June 17, 1977, p. 4.
Kubon, Charlotte (misc. bibliography)
Charlotte "Lottie" Gricel b. 1889 in Washington to Joseph William Gricel and Margaret "Maggie" O'Dell, married Ralph T. Kubon, and d. June 16, 1977 in San Rafael, Ca., per Gerald M. Hoffman Family Tree – 2015 (refs. ancestry.com).
See: "Santa Ynez Valley Art Exhibit," 1953

Kuelgen, Mary Ann (Solvang)
Santa Ynez Valley High School senior who planned to major in art and design at college, 1957. Daughter of Paul Kuelgen, below.
■ Port. and "A resident of the Santa Ynez Valley the past five years, 17-year-old Mary Ann Kuelgen is another of the five Santa Inez Valley misses who are seeking the title of July 4th queen candidate next week. A daughter of Mr. and Mrs. Paul Kuelgen, Mary Ann was born in Los Angeles. She attended schools in Los Angeles and Buellton before entering Santa Ynez Valley Union High School where she will begin her senior year in September. Following graduation, Mary Ann plans to attend college where she will major in art and design. As a student at high school, Mary Ann is a member of the girls Athletic Assn., Future Business Leaders of America, helped with the school yearbook, and her extra-curricular activities have included membership in 4H, the Catholic Youth Organization, and after school and on weekends she is employed at the St. Agnes Gift Shop at Old Mission Santa Ines. For recreation, Mary Ann enjoys horseback riding and swimming and she derives great pleasure from art, crafts, sewing and animals," *SYVN*, June 28, 1957, p. 6; port. and "Mary Ann Kuelgen Reigns Over July 4th," *SYVN*, July 5, 1957, p. 1; port. and "Miss Kuelgen, Steven Lykken Betrothal Told," and she is working for a beauty shop, *SYVN*, Oct. 21, 1960, p. 3; Additional notices not itemized here.
Kuelgen, Mary Ann (misc. bibliography)
Port. of Mary Ann Kuelgen appears in the Santa Ynez high school yearbook, 1958 (refs. ancestry.com).
See: "Kuelgen, Paul"

Kuelgen, Paul Anton (1914/16-1977) (Solvang)
Commercial artist with various motion picture studios in Hollywood up to 1952. Retired and started a poultry ranch. Exh. annual Santa Ynez Valley Art Exhibit, 1953, 1955, 1957. Known for his painted and carved signs in the Valley.
■ Port. and "Paul A. Kuelgen succumbs at 61… Mr. Kuelgen was born June 1, 1916 [Sic.?] in Rochelle, Ill. His parents were Barney and Agnes Kuelgen. A commercial artist and musician, Mr. Kuelgen moved with his family to the Santa Ynez Valley 25 years ago from the Los Angeles area. Active in the community life of the Valley…. As an artist, Mr. Kuelgen was responsible for many of the ornate, carved wooden signs in Buellton, Solvang and the rest of the Valley," *SYVN*, July 28, 1977, p. 13.
■ "Paul Kuelgen, who worked in every phase of production in the art department of RKO Studios in Hollywood for 17 years and who now lives in the [Santa Ynez] Valley with his family, will be among the long list of artists who will display their wares at the forthcoming **St. Mark's-in-the-Valley Art Exhibit** and auction at the Veterans' Memorial Building on Wednesday evening Feb. 25. Mr. Kuelgen, who was born in Illinois, studied at the Art Institute of Chicago and came to California in 1936. He was with RKO for 17 years. In the meantime he was active in his sideline of raising poultry on his San Fernando Valley ranch. Mr. Kuelgen also had a studio there were he did water colors, oils and original carvings on Masonite.

These carvings are a specialty with Mr. Kuelgen and originated with him. He and his wife, Cathie, and three curly-headed daughters, later decided they would like to live in a small town where he could raise poultry on a larger scale and still have time to devote to his art. By chance they heard of the George Burtness place on Ballard Field Road. They bought the Burtness property and are now living here. Mr. Kuelgen is not only lending his knowledge of art to help make the St. Mark's event a success, but is also quite occupied lending his efforts to the forthcoming carnival to be staged by Old Mission Santa Ines on Sunday, Feb. 15 at the Memorial Building…," per "Paul Kuelgen, Former RKO Artist…," *SYVN*, Jan. 23, 1953, p. 6.

■ "Paul Kuelgens Give up Hollywood to 'Return to Farm.' Artist, Wife and Family Settled in Valley to engage in Poultry Ranch Development… Paul and Kathy Kuelgen, who were both raised on farms in the east… settled down with their three young daughters to develop a poultry ranch… program is in full swing at their 10-acre ranch… Coming here a year and a half ago, the Kulgens purchased the ranch property from Mr. and Mrs. George Burtness… Paul Kuelgen was brought up on a farm near Rochelle, Ill. Nearby was located the Poultry Tribune experimental farm… During his high school years, Kuelgen worked on the Tribune Farm… led to further training at the publication's expense at schools in Iowa, where he specialized in poultry husbandry. Kuelgen always enjoyed drawing and art, and his ability in this field was demonstrated when he was called upon to provide sketches and drawings for classwork and even textbooks. One of the professors at the school in Ames, Ia., commented on Kuelgen's art and suggested that he leave the poultry field and go into art on a commercial basis. Kuelgen took the professor's advice and enrolled at the Chicago Institute of Art. After 11 months there he won an art contest and landed a job with the Walt **Disney** Corporation in Hollywood. This developed into a permanent position and finally a job with the scenic art department of RKO Studios. He was with RKO for 16 years before moving here. While at RKO, the Kuelgens lived in North Hollywood where they engaged in a hobby of operating a small poultry ranch… During the time of the movie industry strike in 1945, Kuelgen became even more closely affiliated with the poultry business when he took a job with King's Hatchery in the southland. He was away from the movie industry job for 18 months during the strike and it was during this period that his desire to again return to the poultry business was further strengthened. The Kuelgens made up their minds to leave Hollywood and the search for a ranch location began. The quest took about three years before they found what they call 'the right place.'… their present ranch… Starting from scratch a year and a half ago, the Kuelgens [developed the chicken facility and remodeled their home and article gives details on the chicken operation] …Since taking over the ranch the Kuelgens have also planted 70 fruit trees and about 60 shade trees… Mr. Kuelgen has also been busily engaged in his 'spare time' working for a period at Andersen's Wine Cellars in Buellton, engaging in commercial painting and sign making, both painted and hard carved. In the meantime, he's also had time to create some oil and water colors and also to start work on

constructing a studio for himself," *SYVN*, Nov. 6, 1953, pp. 9, 12.

Kuelgen, Paul (notices in Northern Santa Barbara County newspapers on microfilm and on newspapers.com)
1953 – "Lions to Hear Kuelgen Talk on Movie Industry," *SYVN*, Feb. 6, 1953, p. 1; "Sign Painting and Wood-Carved Signs. Paul Kuelgen. Phone: 3904," *SYVN*, Oct. 9, 1953, p. 3.
1954 – "Church Women Hear Kuelgen… Junior Presbyterian Women's group… Kuelgen, who told of his experiences in Hollywood while an artist with RKO studios," *SYVN*, Feb. 5, 1954, p. 8.
1955 – Photo of sign he designed to advertise Lions Club scholarship dance, *SYVN*, Nov. 25, 1955, p. 1.
1956 – Photo of sign he designed to advertise Old Mission Carnival, *SYVN*, Jan. 20, 1956, p. 1; "Farm Center, Grange Booth… Santa Barbara County Fair in Santa Maria… 30-foot booth… The Santa Ynez Valley Farm Center booth, created by Solvang artist Paul Kuelgen… featured a revolving table… which showed water and wealth on one side and revealing waste and want on the other…," *SYVN*, July 27, 1956, p. 1; port. with a painted Christmas decoration to aid the Solvang Retail Merchant's Assn., and "Merchants Seek Suggestions on Kris Kringle's Arrival… Plans include the placement of cut-out Danish style figures to be created by artist Paul Kuelgen on store fronts in the business area and along the entrance routes to town…," *SYVN*, Nov. 16, 1956, p. 1; photo of nativity scene of cut out figures by Kuelgen, *SYVN*, Dec. 21, 1956, p. 6.
1957 – "New Fashions for Spring… The originals by Maggie Coleman included a number of skirts, blouses, hats and bags. Sketches for the suffed animals on the skirts were created by artist Paul Kuelgen…," *SYVN*, March 22, 1957, p. 3; "Kuelgen's Sign Painting now Located in the Vic Bruhn Building. First Street – Solvang. Phone SY 4641," *SYVN*, March 22, 1957, p. 6.
1958 – Photo of headless figures of a boy and girl in Danish costumes by Kuelgen used as a photo prop at Danish Days, *SYVN*, July 11, 1958, p. 1.
1959 – Photo of sign for Old Mission carnival, *SYVN*, Jan. 23, 1959, p. 4; "Mission Fete Slated… The walls of the large auditorium of the Memorial Building will be lined with gay and colorful booths. Work on the booths and their decorations will be carried out under the direction of … Paul Kuelgen," *SYVN*, Feb. 22, 1957, pp. 1, 10.
1976 – Port. and photos of some signs and "Paul Kuelgen Dresses Up the Art of Sign Painting," *SYVN*, Aug. 12, 1976, p. 21 (i.e., p. 1B).
And, more than 1000 notices for "Paul Kuelgen" in the *SYVN*, 1950-1977 were too numerous to browse for inclusion here.
Kuelgen, Paul (misc. bibliography)
Paul Anton Kuelgen was b. June 1, 1914 [Sic.?] in Rochelle, Ill., to Bernard Kuelgen and Agnes Mary Dee, married Katherine M. Hess, and d. July 24, 1977, in Solvang, Ca., per Margaret Arnold's Family Forest FBK 2 (refs. ancestry.com).
See: "Andersen's," 1954, 1959, "Christmas Decorations," 1953, "Danish Days," 1957, "Joughin, Helen," 1986, "Lindsley, Holt," "Mission Santa Ines," 1953, "Santa Ynez Valley Art Association," intro., 1953, "Santa Ynez Valley Art Exhibit," 1953, 1954, 1955, 1956, 1957, "Santa Ynez

Valley, Ca., Elementary Schools," 1955, "Signs, general," 1954, "Sloane, Charles," intro.

Kunch, Joseph "Joe" (1923-1973) (Santa Maria)
Shop instructor at Santa Maria high school. Constructed sets for school and other plays.

■ "Joe Kunch is a man who believes in doing what he preaches. Joe is a shop instructor at the Santa Maria High School, and has his home filled with samples of the type of fine work he trains his students to produce. Everything but the kitchen sink has been made by Joe in almost any medium you could suggest. Many types of wood, metal, plastic, and ceramics are used, and living room furniture, bed room furniture, lamps, painting boxes, wall ornaments, cowboy designed equipment and yachting instruments and models are among the many items of home designed and construction [sic.?] to come from his very busy shop. Joe and his wife Diane are products of Ohio, and after his college tour at U. S. C. at Los Angeles, Joe returned to Lorain, Ohio, for four years teaching. Prior to his return to California in September 1955 to teach in the S. M. high school, the Kunch's subscribed to the *Times* to keep abreast of things in Santa Maria, and he was able to surprise many of their students by calling them by name and relating some of their many achievements," per port. and several illustrations of his products including painting, "Local High School Shop Instructor Practices What he Preaches," *SMT,* April 22, 1956, p. 11, "Feature Section" and port.
Kunch, Joe (misc. bibliography)
Joe Kunch divorced Diana L. Totter, Aug. 1972 in Santa Barbara County per Calif. Divorce Index; Joseph Kunch was b. June 22, 1923 in Akron, Oh., to Michael (Mihail) Kunch and Mary Haleczko, was residing in Santa Maria, Ca., in 1968 and d. May 12, 1973 in Sarasota, Fla., per Totter, Shedon / Evans Family Tree (refs. ancestry.com).
See: "Allan Hancock College Adult/Night School," 1956, 1957

Kurka, Anton J. (1895-1990) (New York)
New York illustrator. Artist of animal paintings made for National Geographic who exh. at Santa Maria Library and in Arroyo Grande, 1950. The artwork, owned by Travelers Insurance, toured the country in 1950.
See: "Santa Barbara County Library (Santa Maria)," 1950, and *Central Coast Artist Visitors before 1960*

L

La Fontaine, Eleanor (Mrs. Victor Albert La Fontaine) (1917-1981) (Los Alamos)
Ceramic student at Los Alamos Adult School, 1954.
See: "Los Alamos, Ca., Adult/Night School," 1954

La Petite Galerie (Buellton / Solvang)
Art & Gift Shop. Retailer of frames and art supplies. Occasional exhibits held. Paintings restored. Art taught. Prop. Forrest and Marie Hibbits. Located in Buellton 1950-53. Moved to Solvang in summer, 1953.

■ "Hibbits at Solvang. Mr. and Mrs. Forrest Hibbits… have moved their La Petite Galerie art shop to Solvang. They were scheduled to open in their new location last Friday. The Hibbits shop was situated in Buellton for the past several years at the junction of the Lompoc road and U. S. 101. Their new location is in the Bradley building on Mission Drive, Solvang, opposite the Valley Hardware store," *LR,* July 30, 1953, p. 15.
La Petite Galerie (notices in Northern Santa Barbara County newspapers on microfilm and on newspapers.com)
1950 – "Visit La Petite Galerie Art and Gift Shop, Buellton, Opposite Post Office. On Display: Oil, Water Color and Casein Paintings by Artists of Santa Barbara County," *LR,* Aug. 31, 1950, p. 14; "For Individual Framing, Also Cleaning and Renovating of Old Paintings," *SYVN,* Sept. 8, 1950, p. 4; "La Petite Galerie, Buellton. Original paintings by **Claire Callis, Forrest Hibbits, Amory Hare Hutchinson, Elsa Schuyler** and **Leo Ziegler.** Open Sundays," *SYVN,* Sept. 22, 1950, p. 3; "La Petite Galerie Art & Gift Shop, Buellton. Paintings by **Claire Callis, Betty Kenney, Elsa Schuyler, Leo Ziegler, Forrest Hibbits** – Open Sundays," *LR,* Oct. 12, 1950, p. 3.
1951 – "La Petite Galerie… On exhibition through January, Group of 10 paintings by **Forrest Hibbits** just returned from Salt Lake City exhibition," *SYVN,* Jan. 12, 1951, p. 8.
1953 – "Masonite Painting Panels at special prices: 10 x 14 $.29. Larger sizes available. Discount on unfinished frames," *SYVN,* March 20, 1953, p. 7; "Hibbits Move Art Shop to Solvang… their La Petite Galerie Shop from Buellton to the Bradley Building on Mission Drive in Solvang…," *SYVN,* July 24, 1953, p. 1; ad: "Picture Frames, Mats Cut to Order, Masonite Painting Boards," *SYVN,* Aug. 7, 1953, p. 4; ad.: "Art Supplies. Sketch Books, Brushes, Portfolios, Varnish & Turpentine, Tube Colors. Free Instruction on Use of Tri-Tec Color. La Petite Galerie. Mission Drive. SY 5211. Closed Sunday & Monday," *SYVN,* Nov. 13, 1953, p. 8; "La Petite Galerie Changing Location. **Forrest and Marie Hibbits**' La Petite Garerie [Sic.] art and gift shop will be in a new location in Solvang effective Tuesday, Dec. 1…. Moving from its present location on Mission Drive to Main Street in the former Davison Radio and Record Shop," *SYVN,* Nov. 27, 1953, p. 4.
1954 – Ad: "Six Weeks Art Course in Oil Starting June 7, instructor – **Forrest Hibbits**. Information at La Petite Galerie," *SYVN,* June 4, 1954, p. 2; ad: "Frame. Art Supplies. Monogrammed Bath Towels. La Petite Galerie (Opposite Valley Bank). Art lessons by **Forrest Hibbits**," *SYVN,* Oct. 22, 1954, p. 2; "Paint-by-Number Sets, Artists Supplies…," *SYVN,* Nov. 5, 1954, p. 8.
1955 – Ad: "Art Classes – All Media. Starting June 8th – by **Forrest Hibbits**. For information call La Petite Galerie – Phone SY 5211 or 4074," *SYVN,* June 3, 1955, p. 2; "Art Classes by **Forrest Hibbits**. Art Supplies, Easels, etc. La Petite Galerie," *SYVN,* July 29, 1955, p. 5.

1956 – "Exhibition of 15 Landscape Paintings, Water Colors and Oils by a Group of Regional Artists, November 24 to December 8 (incl)…," *SYVN*, Nov. 23, 1956, p. 6.
1958 – "Art materials, Picture Frames, Stationery, Paintings Restored, Genuine Delft China – 30% off, La Petite Galerie, Solvang, Phone 5211 or 4074, Art instruction by **Forrest Hibbits**," *SYVN*, Jan. 31, 1958, p. 6; "Picture Frames, Art Materials. Hand-Made Pottery by Mahaca. La Petite Galerie, S.Y. 5211 or 4074," *SYVN*, Aug. 1, 1958, p. 2.
1959 – "Art Materials & Frames. Brushes – General Art Supplies. Paintings Renovated. La Petite Galerie. Classes in Art by Forrest Hibbits. Phone 5211 or 4074," *SYVN*, Oct. 2, 1959, p. 3.
1960 – "Picture Frames. Artists' Materials – illustration board, velour paper, rice paper, oil and chalk pastels, brushes, etc. La Petite Galerie, Copenhagen Dr., Solvang – SY 5211 or 4074," *SYVN*, Feb. 12, 1960, p. 3.
And more than 110 hits for "Petite Galerie" in the *SYVN*, 1949-1960, primarily ads, were not itemized here.
See: "Danish Village Gifts," "Hibbits, Forrest," "Hibbits, Marie"

La Purisima
Annual / yearbook of the Lompoc High School.
See: "Lompoc, Ca., Union High School," 1928+

La Purisima Camera Club / Lompoc Camera Club (Lompoc)
Photo club. Organized 1938. Held monthly meetings with photo competitions on specific themes and an annual meeting with a yearly competition. Members created in all media: Black and white prints, color slides, motion pictures. Invited speakers and demonstrators, and members competed with other camera clubs and at the Santa Barbara County Fair. Reorganized? 1947 and active to 1949.

■ "Camera Club is Organized. La Purisima Camera club, a new organization… was formed this week. … last night, the first meeting of the club, was held at **Brooks Camera** shop [**Ernest Brooks' Camera Shop**], at which time officers were elected. Devoted to the advancement of photography, the club members will hear a series of classroom discussions on photography led by **Willard T. Day**. Three or four such classes, beginning next Thursday evening, will be held, at which techniques of photography and developing will be taught. Later the club will hold only monthly meetings. Several contests and other features are planned for the members," *LR*, Sept. 23, 1938, p. 3.

■ "Purisima Camera Club Organized …. took place Tuesday evening at a meeting of Lompoc camera fans held at the high school. **Kenneth Pollard** was elected temporary president… Harry Round was named temporary vice president, and **M. J. Lee** was elected the temporary secretary-treasurer. A meeting of the group will be held next Thursday to perfect plans for the group. At that meeting, **Charles Seffens** will give a talk on the use of film and will show a series of slides. Both men and women interested in photography are invited to join the organization… and the activities of the group will be concerned with still photography, slides and motion pictures. Tentatively, the meeting dates for the club have been set as the second and fourth Thursdays of the month. Fifteen persons were in attendance…," *LR*, Jan. 23, 1947, p. 9.

La Purisima Camera Club (notices in Northern Santa Barbara County newspapers on microfilm and on newspapers.com)
1938 – "Camera Club Meets… 50 members … first of a series of classes being conducted by **Willard T. Day**, CCC camp educational advisor and **Ernest Brooks**. Technique of photography is being studied," *LR*, Sept. 30, 1938, p. 6; "Prints are Topic… Photograph printing was demonstrated at last evening's meeting of the Camera club held in the Camera shop. **Willard T. Day** was in charge… while **Frank Beane** presided… At the last gathering the camera itself was the subject of Day's discussion. The various types of lenses and their functions in photography were pointed out. A developing demonstration closed the evening's program," *LR*, Oct. 7, 1938, p. 3; "Picture contest is Planned by Local Camera Club… members gathered Wednesday evening… to … discussing amateur movies and problems which are encountered in [filming]… Reels taken by various club members were shown and criticized. President **Frank Beane** presided. Pictures shown included a color film of the Fiesta in Santa Barbara and other of the Model T races taken by **Harry Hobbs**; another of the T races taken by **Earl Calvert**, and a Sea Scout cruise taken by Dr. L. E. Heiges Jr. Plans for a club contest were made… and men in industry, a human interest shot, was agreed upon as a subject… The winner will receive a prize…," *LR*, Oct. 28, 1938, p. 5; "**Frank Beane** Wins First Camera Contest… The subject was 'men in industry' and Beane's picture portrayed a watchmaker. Another contest on the subject of 'recreation' will be held at the next club meeting. Discussion on a club dark room was held…," *LR*, Nov. 11, 1938, p. 4; "Filters, Prints Are Camera Club Topic… The contest on a print representing recreation was won by **Frank Beane**. …," *LR*, Dec. 2, 1938, p. 10.
1939 – "…members are planning a contest for movie fans during the next few weeks. The contest will be open to everyone interested, may be on 16 or 8 millimeter film, and may be colored or not. The films will be judged on photography, continuity, interest and composition. May 11 was set as the closing date of the contest. Prizes will include a roll of color film and a unipod to be given by the camera shop. During the regular meeting of the club last Thursday evening in the **Camera Shop**, first movie films by several of the members were shown. Picture contest for the March 30 meeting will be a table top subject. The picture may be an interior or outside shot. For April 26, the topic will be an inanimate subject," per "Camera Club to Sponsor Movie Contest Here," *LR*, March 24, 1939, p. 7; "Movie Contest Slated May 11…," *LR*, May 5, 1939, p. 9; "Camera Club Members Meet… this evening (Thursday) at the **Camera shop** for their bi-monthly meeting. … This week end the movie contest… The Camera Shop is giving a prize for the best film shown," *LR*, May 12, 1939, p. 5.
1947 – "Camera Club Set for Tuesday. Organization of a Lompoc Camera club will take place Tuesday evening when local photography fans meet in the library of the high school at eight p. m….," *LR*, Jan. 16, 1947, p. 5; "Camera

Club has Meeting Thursday… in the study hall of the high school with **Ken Pollard** presiding. Mrs. A. Winters and Albert E. Ring were affiliated with the membership… Albert Eller was named as chairman of the program committee. The previous meeting was discussed with Pollard giving a resume of the illustrated lecture which had been given. **Thomas Yeager** [Sic. **Yager**] then offered a critique of several photographs exhibited by the **Santa Maria Camera club** brought here by Eller. At the next meeting… Pollard and Eller will conduct an illustrated lecture with slides on the essentials of photography," *LR*, April 3, 1947, p. 9; "Camera Club to Sponsor Contest for [club] Insignia … an illustrated lecture was presented by **Ken Pollard** and Albert Eller," *LR*, April 17, 1947, p. 5; "Lompoc Views… La Purisima Photo-Taking – At La Purisima Mission Saturday, we saw a number of Lompoc [Sic. La Purisima?] Camera club members taking pictures of the famous old sanctuary for their contest. The photograph chosen as best will be utilized as the club's insignia and will be reproduced in the *Record*…. Yes – we [Karl Wray] took along our own camera too and tried our hand…," *LR*, April 24, 1947, p. 16; "Judges to Pick Prize Photo… Selection of the prize-winning photograph of **mission La Purisima** to be used as the insignia of La Purisima Camera club, will take place tonight when the organization meets in the club rooms of the library. **Ernest Brooks**… will be the judges…," *LR*, June 26, 1947, p. 11; "Picture of Bell Tower Wins for **E. L. LeBlanc**… best print entered in the contest conducted last week… Judging of prints took place Thursday… **Ernest Brooks** and **David Donohue**, president and art director respectively of the **Brooks Institute of Photography** … Second, third and fourth places… were awarded to **Ken Pollard, Virgil Hodges**, and Albert Eller…**LeBlanc**'s winning photo is to be used as the club's insignia," and repro of photo, *LR*, July 3, 1947, p. 1; "Two Sections are Formed in Purisima Camera Club… One section will be devoted to still photography and the other… with motion pictures. The club is meeting on the second and fourth Thursdays of each month in the clubrooms of the Public Library…," *LR*, Oct. 2, 1947, p. 8; "Camera Club has Print Contest," *LR*, Oct. 30, 1947, p. 2.
1948 – "Winners in Camera Club Competition… **Esther Pollard** was the first prize winner … 'Marine Scenes' was the theme… judging on the entries was done by **Ernest Brooks**… Second and third awards went to **Virgil Hodges** and **Bob Murray** respectively, and honorable mention was accorded **E. J. LeBlanc, Ken Pollard** and **Merle Lee**. The theme for the club's January contest will be 'Landscapes'," *LR*, Jan. 15, 1948, p. 17; "Camera Club has Portrait Night," *LR*, March 18, 1948, p. 14; "Photo Classes Are Planned by Camera Club. Classes for beginners… with the first meeting slated for tonight in the **Community Center**. The club is moving its headquarters to the Center and is making plans for a dark room… Depending upon the size of the enrollment… instructors will be brought here from the **Brooks Institute of Photography** in Santa Barbara. The classes will be concerned with all phases of photography according to **Ken Pollard**, who is organizing the instruction," *LR*, Sept. 9, 1948, p. 9; "Purisima Camera… Completion of a dark room available to members of La Purisima Camera club was announced … The dark room,

reported completely equipped for amateur photographers is located in the Community Center. The club, which has its membership rolls open to the public, meets on the second and fourth Thursdays of each month at 8:00 o'clock in the Community Center," *LR*, Dec. 16, 1948, p. 6.
1949 – "Photo Fans to Inaugurate Beginner Course… commenced by the Lompoc Camera club at a meeting set for tonight in the community center. 'Exposure' will be the initial subject discussed by the class. The club now has complete darkroom equipment available at the center and membership in the organization is open to the public. The class will start tonight at 8 p.m.," *LR*, March 10, 1949, p. 10; "Recreation Dept. Reports on Adult Activities… [community center] used by seven organizations, including… Camera Club…," *LR*, June 16, 1949, p. 12.
See: "Camera Club (Lompoc)," "Community Center (Lompoc)," 1947, "Lompoc Film Council," 1948

La Purisima Mission
See: "Mission La Purisima"

Labels, Fruit Crate (Northern Santa Barbara County)
Artist designed pictorial labels stuck to the ends of wooden crates in which vegetables and fruits were shipped. Made for various growers in the fertile valleys of Santa Maria, Guadalupe and Lompoc.
Produce Crate Labels: Crate labels in California reflect the produce grown in the various areas. On the Central coast this was primarily vegetable crops – as opposed to the citrus fruits grown in Southern California. Central Coast labels emphasized graphics over images. Below are listed labels for products grown in northern Santa Barbara County, i.e., primarily Santa Maria, Guadalupe, and Lompoc. All the labels, below, are reproduced on the website www.thelabelman.com.

- CLIFF SIDE Brand Santa Maria Lettuce Crate label, grown and packed by Tomooka Brothers, Santa Maria
- Bear Vegetable crate label, grown and packed by Phelan and Taylor Produce Company, Oceano and Lompoc
- Santa Maria Brand California Vegetables - Grown and Packed By Rosemary Packing Corporation, showing a RR train coming at the viewer
- 52 70 Vintage Oceano Celery Crate label, grown and packed by Phelan & Taylor Produce Co. Inc.,
- BONIPAK Vintage Santa Maria Vegetable Crate label, Finest Vegetables, Bonita Packing Co.
- BOPCO Vintage Guadalupe Vegetable Crate label, Select Guadalupe Vegetables, Bonita Packing.
- BULLDOZER Vintage Guadalupe Vegetable Crate Label, California Vegetables, packed and shipped by Valley Growers and Packers, image of a bulldozer
- BYCO Vintage Guadalupe Vegetable Crate label, Selected Vegetables, grown and shipped by Byrd Produce Co.
- FANCY DAN Vintage Santa Maria Vegetable Crate label, Selected Vegetables, packed and shipped by Richman Produce, Inc.

- GOLDEN TRIANGLE Vintage Oceano Vegetable Crate label, grown and packed exclusively for Consumers Produce Co. by Phelan & Taylor Produce Co., Inc.
- GRUBSTAKE Vintage Guadalupe Vegetable Crate label, California Vegetables, packed and shipped by Bonita Packing Co.
- HEAVY WEIGHT Vintage Guadalupe Vegetable Crate Label, Selected Vegetables, packed and shipped by Byrd Produce Co.
- HEAVY WEIGHT Vintage Guadalupe Vegetable Crate Label, Baby on a scale, John W. Law Co.
- HHH Vintage Santa Maria Vegetable Crate label, Triple H Brand, Selected Vegetables, Packed and shipped by Harry H Heller Co.
- HONEY CHILE Vintage Guadalupe Vegetable Crate Label, packed and shipped by H. E. Tabb Co.
- LUCCCHESI BROS Vintage Purisima Artichoke Crate Label, distributed by American Fruit Co., San Francisco, California, image of an artichoke
- LUPE Vintage Guadalupe Vegetable Crate label, select Guadalupe vegetables, grown and packed by Bonita Packing Co.
- PAY DIRT, Vintage Guadalupe Vegetable Crate Label, grown, packed and shipped by United Farms. Image of a miner pushing a mining cart
- PREMIER Vintage Santa Maria Vegetable Crate label, Selected Vegetables, grown and shipped by Tani Farms
- REVENUE Vintage Guadalupe Vegetable Crate label, blue, grown, packed, shipped by United Farms
- REVENUE Vintage Guadalupe Vegetable Crate label, green, grown, packed, shipped by United Farms
- SECURITY Vintage Santa Maria Vegetable Crate label, Selected Vegetables, packers and shippers H. Y. Minami & sons
- SHOW QUEEN Vintage Santa Maria Vegetable Crate Label, California Vegetables, grown, packed and shipped by Tani Farms
- STARBOARD Vintage Guadalupe Vegetable Crate label, California Vegetables, packed and shipped by H. H. Maulhardt Co.
- STARLET Vintage Santa Maria Vegetable Crate Label (cartoon), California Vegetables, packed by Oceano Packing
- STARLET Vintage Santa Maria Vegetable Crate Label (girl), California Vegetables, packed by Oceano Packing
- STAUNCH Vintage Guadalupe Vegetable Crate Label, California Vegetables, packed and shipped by Valley Growers and Packers
- TANI Vintage Santa Maria Vegetable Crate label, Selected Vegetables, grown and shipped by Tani Farms
- TORNADO Vintage Guadalupe Vegetable Crate label, California Vegetables, packed and shipped by Valley Growers and Packers
- UNIQUE Vintage Guadalupe Vegetable Crate label, California Vegetables, grown, packed and shipped by United Farms Co.
- UNIQUE Vintage Guadalupe Vegetable Crate label, purple, California Vegetables, grown, packed and shipped by United Farms Co.
- UNITED FARMS, Vintage Guadalupe Vegetable Crate Label, California Vegetables, grown, packed and shipped by United Farms Co.

Labels (notices in Santa Barbara County newspapers on newspapers.com).
1880 – "The Santa Barbara Fruit Cannery. We condense the following from the *Santa Barbara Press*… The Fruit Cannery, established last July by Messrs. Dimmick & Sheffield in this city has proven an entire success… [cans are made at the factory] … The cans are neatly varnished and labeled. These labels present a very artistic appearance, the design for the handsome lithograph having been drawn by **Mr. Dimmick**," *LR*, Nov. 27, 1880, p. 2.
1940 – "Lompocans Win at [Santa Barbara County] Fair … Plates and Commercial. In the agricultural tent are also displayed the plate specimens of fruits and vegetables and the commercial packing companies' products. A collection of Santa Maria and Lompoc labels for vegetable crates covers one end of the commercial section and many Santa Marians are learning for the first time how many and varied are the brands sent out to the world from this valley – and the beauty of some of the labels," *LR*, July 26, 1940, p. 1.
Labels (Books):
McClelland, Gordon, *California Orange Box Labels*, Beverly Hills: Hillcrest Press, 1985; and many additional books on crate labels are listed on the Internet.

Ladies Aid (Santa Maria)
And, more than 2,000 notices for "Ladies Aid" in the *SMT* between 1910 and 1960 were not even browsed for inclusion here.
See: "Danish Ladies Aid," "Presbyterian Ladies Aid," "Quilts"

Ladies Literary Society / Literary Society (Santa Maria)
See: "Art Loan Exhibit," "Minerva Club," intro., "Santa Barbara County Library (Santa Maria)," intro.

Lainhart, Grace L., Miss (1881-1966) (Glendale, Ca.)
Ceramicist who exh. at Santa Ynez Valley Art Exhibit, 1954.
Lainhart, Grace (notices in United States newspapers on microfilm and on newspapers.com)
1922 – "Featuring Week… Society of Independent Artists… exhibition… mezzanine floor of the Hillman Hotel… and a series of lectures each afternoon was inaugurated Monday with a talk by Miss Grace Lainhart upon interior decoration …," *Birmingham News*, Dec. 11, 1922, p. 8.
1923 – Is she – "Full List of City School Teachers… South Highland School … manual training, Grace Lainhart…," *Birmingham News* (Birmingham, Ala.), June 3, 1923, p. 32 (?).
1940 – "Helen Ducker… La Canada… Gardens… Among exhibitors will be … and ceramics by Grace Lainhart…," *Pasadena Post*, April 30, 1940, p. 10.

1946 – MOTHER – "West Palm Beach – Funeral services for Mrs. George W. Lainhart, Palm Beach county pioneer… she had been a resident of this city for 40 years… Her husband died 16 years ago. Survivors include… Miss Grace Lainhart, California…," *Miami Herald*, Dec. 21, 1946, p. 4.

1952 – Is she – "Now When I Was a Freshman … Hollins college in Virginia in 1903 … Birmingham girls at Hollins… Miss Hortense Estes and Miss Grace Lainhart were students there at that time. They later came to Birmingham and opened a studio [for crafts?] in Edgewood…," *Birmingham News* (Birmingham, Ala.), Aug. 24, 1952, p. 53 (i.e., D-1).

1958 – "Off the Cuff… In 1908, Grace Lainhart opened a private school on Flagler Dr., where Good Samaritan Hospital now stands…," *Palm Beach Post* (West Palm Beach, Fla.), Dec. 7, 1958, p. 4.

Lainhart, Grace (misc. bibliography)
Grace L. Lainhart, with no occupation, is listed in the *Los Angeles, Ca., CD*, 1894; Grace Lainhart is listed in the 1900 U. S. Census as "at school" and residing in Lake Worth, Fla. with her parents and siblings; Grace L. Lainhart is listed in the 1910 U. S. Census as age 28, b. New York, teacher at a school, and residing in Palm Beach, Fla., with her parents George and Minnie and brothers Spencer and Donald; Grace Lainhart, crafts studio, 458 Hood bldg., is listed in the *Birmingham, Ala, CD*, 1913; Grace A. [Sic.] Lainhart is listed in the 1920 U. S. Census as age 38, b. c. 1882 in New York, residing in Precinct 25, Ala., head of a home she owns, "crafting"? in the Crafts / Arts industry and working on her own account; Grace L. Lainhart is listed in various Los Angeles voter registers and *Glendale, Ca., CD*s from c. 1920-40 as a Designer/Artist; Grace L. Lainhart is listed in the 1930 U. S. Census as a designer in the art industry residing in Glendale, Ca.; Grace L. Lainhart is listed in the 1940 U. S. Census as age 58, b. c. 1882 in NY, finished college 5th or subsequent year, owner of a pottery studio, working on her own account, and residing in Glendale, Ca., in a home she owned; Grace Lainhart was b. Aug. 29, 1881 in NY to George Washington Lainhart and Martha Amelia Toll, was residing in Lake Worth, Fla. in 1900, and d. June 18, 1966 in Los Angeles County per Deborah Thiele Nadjadi Ancestors Family Tree (refs. ancestry.com).
See: "Santa Ynez Valley Art Exhibit," 1954

Lakey, Andrew Marshall (1896/97/98-1952) (Betteravia / Oklahoma)
Sculptor. Student in San Francisco and teacher in Santa Barbara (1920s). Prof. of sculpture, Oklahoma City, 1929-30. Sculptor, Los Angeles, post-WWII. Sculptor and operator of a ceramics shop in Ventura, c. 1949-52.

■ "Son of Betteravia Man Attains Prominence in Field of Sculpturing. Marshall Lakey, son of Thomas M. Lakey of Betteravia ... In an article published by the '*Oklahoman*,' Lakey is described as an artist who 'has reached the height of happiness in joy in his creative work. …' Lakey was born in Garey, schooled there and in Santa Maria and Betteravia. He served in the American army in Mexico and during the world war in which he was disabled. Upon returning to his country, he took up sculpture as a profession and is today recognized as one of the most promising artists in the United States. He was a pupil of Count Henry Von Sabern for four years and spent years in numerous Pacific coast schools of art. For two years he was instructor of sculpture in the School of The Arts in Santa Barbara. At present he is professor of Sculpture in the Oklahoma City university. In speaking of his career, Lakey says, '**Frank J. McCoy**, Miss Frances Coiner [principal of Betteravia school, 1910], and Dr. and Mrs. W. W. Wymore are my outstanding ideals, and it is through their interest in me that I have gained the position that I hold. I am not yet that artist that I want to be, however. I expect some day to return to my home city as it is so beautiful there. Still, I cannot now, for one is never recognized in his home, which, I suppose, is all for the best.' More than 1000 people visited the salon where Lakey's work was shown in Oklahoma City. During his studies under Von Sabern, Lakey won a scholarship to the Belgium Royal Academy in Brussels which as yet he has not taken," *SMT*, June 5, 1929, p. 3.

Lakey, Andrew (notices in newspapers on newspapers.com)
1930 – "Former Valley Student Wins Sculpture Job… Lakey is shown in a double column picture on the first page of the *Oklahoman* constructing a model of the late President Woodrow Wilson in plaster of Paris. It is to be used in a campaign to raise money for a Wilson memorial to cost $250,000 and to be built on the capitol grounds in Oklahoma City. … 'Lakey was commissioned to make the model with the first $1000 raised this year. … He formerly was head of the department of sculpture of the School of Arts, Santa Barbara, Calif….," *SMT*, Dec. 30, 1930, p. 2.

1952 – "Sculptor's Death Listed as Suicide. Andrew M. Lakey, 54, sculptor and operator of a ceramics shop, was found hanged in the garage of his Rincon home last night… [He left a note.] A native of Santa Barbara where he was born June 28, 1898, he had resided in the Rincon area the past three and a half years. He was a veteran of the first World War…," *Ventura County Star-Free Press*, Sept. 26, 1952, p. 1.

Lakey, Marshall (misc. bibliography)
Marshall Lakey is listed in the 1900 U. S. Census as age 2, b. June 1897 in Calif., residing in Township 8, Santa Barbara County with his parents Thomas Lakey (age 28) and Annie L. Lakey (age 20) and sister Laurena (age 1); Andrew Marshall Lakey gave the following information on his WWI Draft Registration Card dated June 5, 1918 = residing in Newcastle, Ca., single, working as a warehouseman for Southern Pacific; Andrew M. Lakey married Sara Shepard in Redwood City, Cal., in March 1922 per Newspapers.com Marriage Index; Andrew M. Lakey, sculptor, and Rep., is listed in *California Voter Registrations, San Francisco*, 1924; Andrew M. Lakey is listed in the 1930 U. S. Census as a teacher at a university in Oklahoma City, Okla.; Andrew M. Lakey married Evangeline Shepard on Oct. 12, 1931, per *Oklahoma County, Marriage Index*; Andrew Marshall Lakey provides the following information on his WWII Draft Card dated Feb. 16, 1942 = b. June 28, 1897 in Santa Maria, Ca., residing in Washington, D. C. and next of kin is Neva B. Lakey; Andrew M. Lakey, sculptor and Rep. is listed in *Calif. Voter Registrations, Santa Barbara Precinct No. 8,*

some time between 1920 and 1928; Andrew M. Lakey, sculptor and Dem., is listed in *Index to Register of Voters, Los Angeles City Precinct No. 1148*, 1944, and at *Precinct No. 1136*, 1946, 1948; Andrew Marshall Lakey b. June 28, 1896 in Santa Maria to Thomas Marshall Lakey and Anna Laura Pack, was residing in Anaheim, Ca., in 1910, married Sara Shepard, and d. Sept. 25, 1952 in Ventura, Ca., per Copp_Sheridan_Hunnewell Family Tree; Andrew Marshall Lakey b. 1898 [Sic.?], d. Sept. 25, 1952 and is buried in Santa Maria Cemetery District per findagrave.com (refs. ancestry.com)

Land Case Art
Landscape drawings, plats and surveys describing Spanish ranchos – served as proof of ownership in American courts.
See: *Central Coast Artist Visitors before 1960*

Landacre, Paul Hambleton (1893-1963) (Los Angeles)
Printmaker. One of his prints was purchased for the Santa Maria High School by the Blue Mask Club, 1937.

■ "Paul Hambleton Landacre (July 9, 1893, Columbus, Ohio - June 3, 1963, Los Angeles, California) participated in the Southern California artistic Renaissance between the world wars and is regarded as one of the outstanding printmakers of the modern era," per Wikipedia.org.
See: "Santa Maria, Ca., Union High School," 1937

Landers, Donald (Lompoc)
Chalk talk artist, 1957.
See: "Chalk Talks (Northern Santa Barbara County)," 1957

Landry, Robert "Bob" (1913-1960) (Hollywood)
Photographer who visited Lompoc, 1955.
See: "Early, Mr.," and *Central Coast Artist Visitors before 1960*

Laney, Vern C. (active LA, c. 1925-62) (Hollywood)
Decorator of the Lompoc Theater sponsored by the Knights of Pythias, 1927. Re-do of lobby, 1935.
Laney, Vern (notices in Northern Santa Barbara County newspapers on microfilm and on newspapers.com)
1927 – "Huseman's New Home… The decorators who have been working on the handsome new Knights of Pythias theatre building have accomplished a charming effect in the beautifully arranged living room of the Huseman house," *LR*, March 18, 1927, p. 1; "Inspector Fisk Proud of Every Building Detail. … new Knights of Pythias building… 'Verne [Sic.] Laney, the artist who did the decorating and spent half a day dabbing colors on pieces of boards to get the right effect for the ceiling … and we made several trips to Santa Barbara to study the decorative work on the Granada,' Mr. Fisk said… 'It is the nicest theatre in miles about,' he proudly and justly boasts…," *LR*, May 27, 1927, p. 2; "Color Harmony is Achievement of Scenic Artist … Just inside, in the foyer… wrought iron light fixtures… soft brown and blue of the jazz finish of the

walls … The curtains are a study in color. Blue predominates, as it does throughout the color scheme of the theatre … The ceiling is a study in color… Many tones are combined to produce a gorgeous effect…," *LR*, May 27, 1927, p. 5; "Community Dedicates New Theater Tonight…," *LR*, May 27, 1927, p. 10.
1935 – "Theater Decorated. Verne Laney, theater decorator of Los Angeles, who was the original decorator of the Lompoc Theater, arrived here Monday to redecorate the foyer and lobby," *LR*, Jan. 18, 1935, p. 9; "To Los Angeles – Verne Laney… who has spent the last three weeks here re-decorating the lobby and the foyer of the Lompoc Theater in modernistic design in harmonizing colors, returned to his home in Los Angeles," *LR*, Feb. 1, 1935, p. 6.
"**Lompoc Theatre**," *Lompoc Valley Historical Society, Inc., Quarterly Bulletin*, Summer 1985, pp. 1-8.
Laney, Vern (misc. bibliography)
Vern C. Laney is listed as decorator and Rep. in the *Index to Register of Voters, Los Angeles County, West Hollywood Precinct No. 6*, 1940-62 (refs. ancestry.com).
See: "Learned, George F.," "Lompoc Theater," "Santa Maria Camera Club" (?)

Lange (Thomas), Myrtle Fredericka (Mrs. Mervin A. Thomas) (1912-2008) (Hanford / Santa Maria / San Francisco)
Teacher of Arts and Crafts at Santa Maria High School, 1943/45, replacing E. Breneiser. Taught crafts at Santa Maria Adult School, 1943, 1944.

■ Port. with "New Faculty Members in Santa Maria High School and Jaysee," *SMT*, Sept. 18, 1943, p. 4.
More than 50 notices for "Myrtle Lange" appear in Calif. newspapers on newspapers.com between 1930 and 1958. Some refer to her as a student at College of Arts and Crafts (1937-39). Many refer to her teaching art at various schools (Hanford High School, 1940-43; Santa Maria High School, 1943-45; and schools in San Rafael, 1949-56), but they were not itemized here.
Lange, Myrtle (misc. bibliography)
Myrtle F. Lange is listed in the 1920 U. S. Census as residing in San Francisco with her parents; Myrtle F. Lange is listed in the 1930 U. S. Census as age 17, b. c. 1913 in Calif., residing in San Francisco with her parents Fred C. Lange (age 42) and Myrtle D. Lange (age 37); Miss Myrtle F. Lange, student and Dem. is listed in *California Voter Registrations, San Francisco County*, 1938, 1940, 1944; port. in Hanford High School yearbook, 1941, 1942, 1943; Myrtle F. Lange, teacher, E. St. Grammar School, SF, is listed in the *San Rafael, Ca., CD*, 1952-53; Myrtle F. Lange, b. c. 1918 [Sic. 1913] in Calif. married Mervin A. Thomas on July 27, 1958 in Monterey County per Calif. Marriage Index; Myrtle F. Thomas b. Sept. 26, 1912 was residing in San Francisco in 1995 per *U. S. Public Records Index, 1950-1993*, vol. 1; Myrtle Fredericka Thomas b. Sept. 26, 1912 and d. Sept. 20, 2008 per Social Security Death Index (refs. ancestry.com).
See: "Santa Barbara County Library (Santa Maria)," 1943, "Santa Maria, Ca., Adult/Night School," 1943, 1944, "Santa Maria, Ca., Union High School," 1943, 1945

Langlois, Obart "Mac" (1886-1977) (Santa Maria / Los Angeles / Santa Barbara)
Santa Maria high school student who illustrated the Review, 1906, and grad., 1907. Advanced to art study in Berkeley, 1908, and a potential career in cartooning in San Francisco. He spent most of his career as a salesman in auto accessories.

■ "Newsboy Remembers When … In 1901, a person could buy a year's subscription to the *Santa Maria Times* for $2.00 – a weekly paper then – and have it delivered to his door every Saturday by one of the *Times'* first paper boys, Mac Langlois. Now a widower in his 80's living in Ventura, Langlois made a visit to Santa Maria recently and recalled what it was like growing up on the Central Coast prior to and after the turn of the century. The son of a local dairyman… A 1907 graduate of Santa Maria High School, Langlois was on the school track team and worked on the school paper… In 1908, Langlois went to Berkeley where he attended the California Guild of Arts and Crafts. He studied cartooning and worked as an apprentice in the art room of the *Oakland Tribune*. After a short time, he gave up the idea of becoming a cartoonist and returned to Santa Maria, then left with his father for Arizona where they tried ranching…," *SMT*, June 4, 1971, p. 4.
Langlois, Mac (notices in Northern Santa Barbara County newspapers on microfilm and on newspapers.com)
1902 – "Mac Langlois is the latest apprentice on the *Times* staff who will learn the art of typesetting," *SMT*, Jan. 11, 1902, p. 3, col. 3.
1906 – "Creditable Work. The [*Santa Barbara*] *Press* is in receipt of 'The Santa Maria High School *Review*,' a booklet edited annually by the Juniors of the high school… An artistic green and gold cover is used, designed by Mac Langlois '06 [Sic. '07], who has also contributed some very humorous and clever illustrations…," and "One of the Best… *Review*… A feature of the edition are the splendidly executed cartoons, which are suggestive of events in school life… genius of Mac Langlois, who, aside from his skill with the pen, is an athlete … It would not be surprising to see Langlois ranking some day with those who have made Happy Hooligan… household favorites ...," *SMT*, June 30, 1906, p. 6.
1907 – "Will Graduate This Year… Mac and Lou Langlois…," *SMT*, May 18, 1907, p. 1.
1908 – "From the Files of the *Santa Maria Times* Twenty Years Ago. Mac Langlois has purchased the right side of Charles Richards' opera house advertising curtain which will be painted with cartoons. It is expected to be different from any theatre curtain in this section," *SMT*, Feb. 3, 1928, p. 5; "Mac Langlois will leave in a few days for San Francisco where he will divide his time by working part of the time on the artist's staff of the *Examiner* and attending the Berkeley Art School," *SMT*, April 4, 1908, p. 5, col. 1; "Mac Langlois arrived home on Monday from Berkeley, where he had been attending the Berkeley school of arts and crafts learning illustrated work and designing," *SMT*, Nov. 21, 1908, p. 5.
1912 – "Santa Marians Gather in Arizona… A surprise party was given to Mac Langlois in Chandler, Arizona… nearly all of the former residents of Santa Maria who have made Arizona their new home…," *SMT*, Oct. 19, 1912, p. 1.

Langlois returned to Santa Maria in 1937, 1947 and 1957 for Santa Maria High School class reunions, as reported in the *SMT*, and is described as a "Los Angeles manufacturer."
Langlois, Mac (misc. bibliography)
Mac O. Langlois is listed in the 1900 U. S. Census as age 13, b. Oct. 1886 in Calif. residing in Township 7, Santa Barbara county with his parents William H. Langlois (age 36) a rancher, and Lizzie L. Langlois (age 41) and 4 siblings; Obart (Mac) Langlois was b. Oct. 12, 1886 in Cambria, Calif. to William Henry Langlois and Elizabeth L. Terry, married Mable Clare Babcock, was residing in Los Angeles in 1942 (WWII Draft Reg), and d. July 14, 1977 in Santa Barbara per Hanger Family Tree (refs. ancestry.com).
See: "Santa Maria, Ca., Union High School," 1906

Lantis, Jack Webber (1937-2019) (Santa Maria)
Photographer, hobbyist who intended to turn professional, 1960. Spent most of his career with Sears? in Santa Maria and Eureka, Ca.

■ "Local Man in Mormon Pageant. Elder Jack W. Lantis, son of Mr. and Mrs. Webber A. Lantis, 539 Newlove Drive… in the Mormon Pageant… NY… Lantis is presently fulfilling a two-year term as a missionary of the Church of Jesus Christ of Latter-day Saints… He is a member of the Santa Maria Ward… During his college career, Lantis belonged to Phi Upsilon Sigma Phalanx. Subsequently he has worked in the field of carpentry with photography as a hobby. Following the completion of his mission this fall, Lantis plans to make a full time occupation of his former hobby, photography…," *SMT*, Aug. 2, 1960, p. 2.
Lantis, Jack (notices in Northern Santa Barbara County newspapers on microfilm and on newspapers.com)
1956 – Repro of a man welding and caption reads "Photo Award. This photo taken by Santa Maria high school senior Jack Lantis won a certificate of merit in the national high school photographic contest. Jack, taking his second year of photography, was one of 250 U. S. winners. His interest in photography started at the age of 12 when his parents owned a photo studio in Oregon," *SMT*, June 5, 1956, p. 5.
1960 – "Sheila Bodley to Wed Jack Lantis… graduated from Santa Maria Union High School and attended Allan Hancock Junior College. He is now employed here by Reserve Life Insurance," *SMT*, Nov. 11, 1960, p. 4.
Lantis, Jack (misc. bibliography)
Jack Lantis, employee of Sears, is listed in the *Eureka, Ca., CD*, 1968, 1973; Jack Webber Lantis was b. 1937 in LA and d. Dec. 31, 2019 in Springfield, Mo. per Running through the Branches – Leptien Family Tree (refs. ancestry.com).

Larsen (Nielsen), Anna (Mrs. Paul Nielsen) (Solvang)
"Untrained" artist who exh. water colors at Art Loan Exhibit, Solvang, 1935.
See: "Art Loan Exhibit (Solvang)," 1935

Larsen, Elna Sleiborg, Miss (1908-2006) (Solvang)
Lace maker who exh. at Community Club Hobby Show,
1952. Gave many lace-making demonstrations over the
years. Owner of Elna's Dress Shop.

■ "Elna Larsen's Hobby feature in *LA Times*. Miss Elna
Larsen's hobby of making bobbin or 'pillow lace'
according to the Danish method… article in last Sunday's
Los Angeles Times Home Magazine. The feature, entitled
'First… Take a Kniple Bret' … describes quite thoroughly
the art of creating the lacework…. 'Miss Larsen learned the
craft on a visit to Denmark. (She was born there and came
to America as a child.) On her return to Solvang, she had a
friend make a kniple bret and has been deftly turning out
lace ever since… Another of her (Miss Larsen's) theories
about how to be happy with your hobby is 'Never go
commercial.' At first, she took orders for lace to sell, but
she says, 'As soon as I sat down to work on someone's
order, it just wasn't fun any longer.' So now she makes lace
only for gifts and for her own home. Some of her Solvang
friends have taken up her hobby, too, and you see charming
evidences of it during the picturesque Danish Days
celebration…," *SYVN*, Oct. 5, 1951, p. 4.

■ "A festive reminder of the old world traditions that
distinguish Solvang … shines in the windows of a
venerable store on Copenhagen Avenue. Elna's Dress
Shop—62 years old and still going strong—offers not only
contemporary fashions and quality accessories, but a fine
line of its original stock-in-trade: handmade Danish
costumes. Elna Larsen, who founded her eponymous dress
shop in 1942, initially designed and stitched all the
costumes and colorful sweaters herself. As her business
grew, she hired seamstresses to help keep up with the
demand for the sturdy jumpers, aprons, hats, and snow
white shirts worn by local Danes whenever they gathered to
celebrate their heritage. Throughout the decades, Elna
Larsen played an active role in community life and could
often be found tatting Danish lace at the Elverhoj Museum.
Now 97 years old, Elna still lives in Solvang and takes
great pride in the enduring success of the business she
created. 'When we bought it,' remembers current owner
Bob Manning, 'Elna said, 'I was afraid you'd change the
name.' I said, 'Why would I want to change it? It has a nice
local trade and it's known all over the Valley'…," *Santa
Ynez Valley Magazine*, 2004.

Larsen, Elna (notices in Northern Santa Barbara County
newspapers on microfilm and on newspapers.com)
1952 – "Entries Arrive for Hobby & Art Show … Danish
lace-making by Miss Elna Larsen of Solvang will be
demonstrated at the show on Sunday as a special feature.
Miss Larsen turns out cobwebby hand-spun lace using
thread as fine as No. 400. … It is hoped she will wear one
of her picturesque Danish costumes," *SMT,* March 25,
1952, p. 4.
Hundreds of notices for "Elna Larsen" have appeared in the
SYVN over the years but were not itemized here.

Larsen, Elna (misc. bibliography)
Elna Larsen is listed in the 1930 U. S. Census as b.
Denmark, single, residing in Solvang, working in a bakery;
Elna S. Larsen is listed in the 1940 U. S. Census as age 32,
b. c. 1908 in Denmark, finished high school 1st year,
naturalized, married [Sic.?], working as a housekeeper in a
home in Santa Barbara; Elna S. Larsen b. Jan. 18, 1908, d.

June 21, 2006, last residence Solvang, per Social Security
Death Index (refs. ancestry.com).
See: "Community Club," 1952, "Santa Ynez Valley Union
High School," 1960

**Larsen, Helen Cecilie Glidden (Mrs. James Perry
Larsen) (1906-1996) (Lompoc)**
Filmmaker, amateur, who showed her film of National
Parks and of Santa Barbara Channel fishing at the
Lompoc Film Council meeting, 1948. President of
Lompoc Women's Club, 1949.
A painting signed "Mrs. James P. Larsen" is owned by the
Lompoc Valley Historical Society.
See: ""Lompoc Film Council," 1948, "Lompoc Valley
Historical Society, House"

**LaRue, Ruth G. (Mrs. William LaRue) (Lompoc /
Florida)**
Art student of Forrest Hibbits who exh. water colors at
Alpha Club Flower Show, 1948, at Tri-County Art
Exhibit, 1948, 1950, and who exh. art at Lompoc
Hospital, 1949. Moved to (or returned from) Florida
before 1953.
LaRue, (misc. bibliography)
Is she Ruth G. LaRue b. May 22, 1915 and d. Aug. 4, 2015
in Laguna Hills, Ca. per U. S. Obituary Collection (refs.
ancestry.com).
This individual could not be fully identified.
See: "Alpha Club," 1953, "Community Center (Lompoc),"
1948, "Flower Show," 1948, 1949, "Lompoc Hospital,
Women's Auxiliary," 1949, 1956, "Tri-County Art
Exhibit," 1948, 1950

Lasalle, Charles Andrews (c. 1871-1947) (Lompoc)
In 1892 exhibited Best landscape in oil at "Santa Barbara
County Fair."
■ "Veteran of Two Wars Passes at Sawtelle Hospital.
Charles A. LaSalle, aged 76… died at the Veterans'
Hospital in Sawtelle… The deceased was a son of the late
Mr. and Mrs. Charles LaSalle who came here in 1877 and
established a home in what is still known as LaSalle
Canyon. He was born in Goleta, Calif. … Mr. LaSalle was
a veteran of the Spanish American War and also of World
War I. He served in the Army a total of over 30 years and
ranked as a sergeant first class. He had never married…,"
LR, Sept. 11, 1947, p. 2.
Lasalle, Charles (notices in Northern Santa Barbara County
newspapers on microfilm and on newspapers.com)
1916 – FATHER – "Charles LaSalle Succumbs… survived
by the widow and three children, they being Charles A.
LaSalle who is in the army…," *LR*, Oct. 27, 1916, p. 1 (and
other children are named Vernon A. LaSalle (Lompoc) and
Mrs. Gaston Dreyfus (Switzerland)).
1932 – MOTHER – "Mrs. Clarinda Rowley LaSalle,
widow of Charles LaSalle for whom LaSalle canyon is
named… surviving relatives are three children… and
Charles A. LaSalle of Spokane…," *LR*, Sept. 23, 1932, p.
11.

[Do not confuse with Charles LaSalle, famous illustrator, 1894-1958.]
Several non-art references to "Chas. LaSalle" in the *LR* between 1880 and 1895 were not itemized here.

Lasalle, Charles (misc. bibliography)
Charles Andrews LaSalle, age 21, 5' 10," fair complexion, blue eyes, dark hair, scar on the forehead, b. California, residing in Lompoc, is listed in the *Great Register, Santa Barbara County, California*, 1892 (refs. ancestry.com).
See: "Santa Barbara County Fair," 1892, and *San Luis Obispo Art and Photography before 1960*

Lash, Martha / Mardi (Mrs. Jack Lash) (Ventura [1945-62] / Santa Maria [1962+])
District Fine Arts Chairman who spoke to Alpha Club, 1957.
See: "Alpha Club," 1957

Lasky [Famous Players – Lasky], (Hollywood)
Motion picture studio that filmed in Northern Santa Barbara county, 1923.
See: "Motion Pictures (Guadalupe)," 1923

Latham Foundation (Oakland)
See: "Posters (Latham Foundation)"

Latter Day Saints church (Lompoc)
See: "Wiedmann, Nora"

Laubly (McBride), Alice (Mrs. James McBride) (1916-2003) (Lompoc)
Lompoc High School student who contributed art to the yearbook, 1931. As Mrs. McBride taught crafts at 4-H camp. Daughter of Dale Laubly, below.
Alice Anna Laubly was b. Dec. 15, 1916 in Washington, D. C. to Charles Sylvester Laubly and Emilie Dale Havenor, married James Albert McBeride and d. March 28, 2003 in Sacramento per Semet Hoag Family Tree (ref. ancestry.com).
See: "Four-H Camp," 1941, "Kiddie Kartune Club," 1931, "Laubly, Emilie Dale," "Lompoc, Ca., Union High School," 1931, 1935, "Lompoc Valley Fair," 1930

Laubly, Emilie Dale Havenor (Mrs. Charles Sylvester Laubly) (1889-1976) (Lompoc)
Member of adult pottery-making class?, 1954. Flower raiser and arranger. Mother of Alice Laubly, above.
■ "Dale Laubly… Mrs. Laubly was born in 1889 in Nevada… A 56-year resident… Known for her prize winning floral arrangements at the annual Alpha Club flower show, she held memberships in the Alpha Club, Robert R. Young Iris Society, Miguelito chapter of the Order of the Eastern Star, AARP… **Pioneer Society** and was a charter member of the Lompoc Historical Society. She leaves two daughters, Mrs. Alice L. McBride of North Highlands…," *LR*, Sept. 9, 1976, p. 2.

Port. with her granddaughter in the Laubly garden, *LR*, June 16, 1966, p. 6; And, more than 110 additional notices for "Dale Laubly" and almost 550 for "Mrs. Charles Laubly" in the *LR* between 1925-70, primarily regarding club activities and flower contests were not itemized here.
Laubly, Dale (misc. bibliography)
Dale Laubly is listed in the 1940 U. S. Census as age 50, b. c. 1890 in Nevada, finished college 4th year, residing in Lompoc with husband Charles Laubly (age 50) and children Jerry, Marilyn and William; "Dale H. Laubly was b. May 9, 1889 in Nevada and d. Sept. 8, 1976 in Santa Barbara County per Calif. Death Index (refs. ancestry.com).
See: "Alpha Club," 1953, 1954, "Laubly, Alice" "Lompoc Gem and Mineral Club," 1959, "Santa Barbara County Fair," 1955, "United Service Organization," 1944

Lauck, Katherine (Paso Robles)
Artist who exh. at Santa Ynez Valley Art Exhibit, 1954.
See: "Santa Ynez Valley Art Exhibit," 1954, and *San Luis Obispo Art and Photography before 1960*

Laughlin, Dora M. Short (Mrs. B. E. / Bert / Burt / Berton / Burton Eugene Laughlin) (1872-1962) (Los Alamos)
Exh. silk or satin painting at "Santa Barbara County Fair," 1893, 1894. Husband was a druggist.
Laughlin, B. E., Mrs. (notices in Northern Santa Barbara County newspapers on microfilm and on newspapers.com)
1891—'Married. Laughlin-Short – In San Luis Obispo, Jan. 6th, 1891 at the residence of G. W. Downings. Esq. by the Rev. Mr. Elliott, B. E. Laughlin of Los Alamos and Miss Dora M. Short of Lompoc," *SMT*, Jan. 10, 1891, p. 3 and *LR*, Jan. 17, 1891, p. 3.
1894 – "Mr. Alex Foxen contemplates buying out Mr. B. E. Laughlin's stock of drugs … If Mr. Laughlin sells his store he intends to go east to his former home," *SMT*, Feb. 24, 1894, p. 2.
Laughlin, B. E., Mrs. (misc. bibliography)
Dora Short was b. Jan. 6, 1872 in Missouri to Oscar Short and Elizabeth J. Elliott, married Berton Eugene Laughlin, was residing in San Jose, Ca., in 1956, and d. Jan. 25, 1962 in Santa Clara County per Steph's Family Tree (refs. ancestry.com).
See: "Santa Barbara County Fair," 1893, 1894

Lauridsen, Niels (1895-1960) (Solvang)
Cabinetmaker, musician, 1950-60.
■ Port and "Cabinet Maker Uses Homemade Saws in Activities at His Shop. … 61-year-old cabinet maker of Solvang… uses a wide variety of these hand-made saws in his daily work at his home shop in Fredensborg Canyon… Lauridsen, a bachelor, came to the United States in 1913. He lived for a time in Iowa and shortly after arriving in this country he enrolled at Grand View college where he took a special three-month course to learn English. Still later, he lived in Chicago and in 1944 came to California and the Bay Area. During World War II he worked for the Navy. After the war, in 1948, he returned to Denmark for the first

visit there since 1929. Lauridsen, who is also an accomplished musician, came to the Sana Ynez Valley six years ago. He lived for a time in Ballard and three years ago purchased an acre and a half from R. K. Kintzel in Fredensborg Canyon. Here he built a new home and workshop… One of the prize examples of his woodworking ability is the cabinet, shaped like a grandfather's clock case, which holds his cello…," *SYVN*, July 6, 1956, p. 8.

Lauridsen, Niels (notices in California newspapers on newspapers.com)

1953—Port. as musician, *SYVN*, July 17, 1953, p. 1.

1960 – "Funeral Rites Conducted for Niels Lauridsen, 65," died of a self-inflicted bullet wound, *SYVN*, June 17, 1960, p. 1; And, more than 40 additional notices for "Niels Lauridsen" in the *SYVN* primarily concerning his activities with the Niels Lauridsen Ensemble were not itemized here.

Lauridsen, Niels (misc. bibliography)

Niels Lauridsen was b. April 13, 1895, d. June 13, 1960 and is buried in Solvang Cemetery per findagrve.com (refs. ancestry.com).

Lauritzen, Dillon Theodore (1904-1952) (Los Angeles)
Watercolor painter and art director of Westways. Visited Solvang, 1948, and his paintings of it were reproduced in Westways. Visited Guadalupe and his images of it were published in Westways, 1949.

■ "Lauritzen, Auto Club Art Chief, Taken by Death. Dillon T. Lauritzen, 48, who had served as art director of the Automobile Club of Southern California since 1933, died yesterday in the California Hospital after a short illness. Mr. Lauritzen's paintings had been widely exhibited, having been shown at the American Water Color Society show in New York, the Chicago International and in San Francisco, Boston, San Diego and Jackson, Miss. Mr. Lauritzen had been chosen by the Los Angeles Art Directors club this year as its candidate for the fifth annual National Art Director Award. He was a member of the California Water Color Society, had won awards at the Santa Cruz water color show and the Santa Paula show and had been given honorable mention at Denver and Oakland. Mr. Lauritzen was born in Salt Lake City and lived at 2344 ½ S. Beverly Glen Blvd. He had been an artist with the Automobile Club since 1924…," *LA Times*, May 28, 1952, p. 12.

Lauritzen, Dillon (notices in Northern Santa Barbara County newspapers on microfilm and on newspapers.com)

1948 – "Artist Pays Solvang Visit… A pleasing art trip through Solvang with watercolors by Dillon Lauritzen, is one of the feature attractions in the November issue of *Westways*, monthly magazine of the Automobile Club of Southern California. The article is entitled, 'An Artist Visits Solvang,' and depicts Mr. Lauritzen's impressions of Ferdinand Sorensen's windmill garage, the Bethania Lutheran Church, Atterdag College, Copenhagen Square and Old Mission Santa Ines…," *SYVN*, Nov. 12, 1948, p. 1.

1949 – "*Westways*…," *SMT*, Feb. 1, 1949, p. 8; "Guadalupe sees itself through the eyes of an artist – the February number of *Westways*… two pages of reproductions of paintings by Dillon Lauritzen. Familiar scenes in the neighboring town – the old adobe, Monte Carlo Hotel that was a stage stop in 1894, the S. P. station,

a street scene with ancient architecture – all set off in contrast by a drawing of the handsome and modern Guadalupe Union School. Artist Lauritzen is art director of *Westways* … His illustrations are very complimentary but the text is not so good. Tells about the 'polyglot population' –- no mention that Guadalupe is an incorporated city – has a bank and newspaper – is located in one of California's most productive areas – and is a progressive little city," *LR*, Feb. 3, 1949, p. 12, col. 6. And, additional notices in the *LA Times* not itemized here.

Lauritzen, Dillon (misc. bibliography)

Dillon Theodore Lauritzen was b. Jan. 14, 1904 in Salt Lake City to Christian "Christie" Leander Lauritzen and Sena Christensen, married Thelma Marie Logan, was residing in Los Angeles in 1938, and d. May 27, 1952 in Los Angeles per Robertson Family Tree (refs. ancestry.com).

La Vaut, Mary March (Mrs. Tom La Vaut) (1924-2001) (Solvang)
SYVUHS teacher of homemaking, arts and crafts, 1949/50. Taught arts and crafts in adult school, 1949.

■ "H.S. Teaching Staff Complete… Mrs. La Vaut will teach homemaking, arts and crafts… a graduate of the University of California at Los Angeles, taught last year at Fallbrook. During the war years she was affiliated with the American Red Cross Hospital Corps and did considerable physio-therapy work in veterans' hospitals. Mrs. La Vaut's husband will attend the University of California at Santa Barbara College next year and will commute to school from the Valley," *SYVN*, July 1, 1949, p. 1.

La Vaut, Mary (misc. bibliography)

Mary M. LaVaut, teacher Kerman High School, is listed with no husband in the *Fresno, Ca., CD*, 1951; Mary Vaut is pictured in the Kerman High School yearbook, 1953; Mrs. Mary M. Lavaut is listed as teacher in the *San Diego, Ca., CD*, 1972, 1979; Mary M. Lavaut, b. March 19, 1924, d. May 26, 2001 per Social Security Death Index (refs. ancestry.com).

See: "Santa Ynez Valley, Ca., Adult/Night School," 1949, "Santa Ynez Valley Union High School," 1949, 1950

Lawhorne, Roy Elliot (1885-1952) (Santa Barbara)
Photographer. Instructor at Brooks Institute, who attended a meeting of the Santa Maria Camera Club, 1946. Commercial artist in Santa Barbara 1920+.

■ "Roy Elliot Lawhorne was born in Summer, Oregon, October 21, 1885. His father, William Griffith Lawhorne, and his mother, Lois Jean Pratt … Following public school, he began his basic drawing courses at the age of eighteen and spent the next three years in landscape and life drawing studies with Jefferson Post. He enjoyed the following four years in exploring the fascination of photography with various teachers, at the same time earning his living doing part-time commercial art work. In 1912 he met Emma Hall Johnson, whom he married on May 2, 1914, at Coquille, Oregon. During these years he continued the study of the art of photography, composition, and photochemistry. A subsequent period was spent in further concentration in this particular field, and simultaneously he was photographer

and cartoonist for the Coos Bay *Times*, the Portland *Evening Telegram*, the Portland *Oregonian*, the *Pacific Motorboat*, and other papers and periodicals. Mr. Lawhorne was always searching, and became profoundly interested in many arts. He not only mastered the technique of those that interested him, but, as a true artist, he believed that he must have a complete and sympathetic understanding of both materials and tools used in each. In this way he acquired knowledge of wood-carving, furniture design, and ceramics. When he moved to Santa Barbara in 1920 and became associated with **Phil Paradise**, a painter and craftsman of importance. The two carried on meticulous experiments in wood block, dry point, etching, lithography, and watercolor-rendering processes. He practiced commercial art professionally in Santa Barbara, having outside accounts with the Ward Baking Company and Johnson-Ayers Advertising Company. During this time, he established a silk screen process plant which aided in the production of many advertising color posters. An ingenious designer, Lawhorne was for ten years Art Director for the Seaside Oil Company, executing their calendars and advertising, and, in addition, designing the famous Fiesta posters for the City of Santa Barbara. Because of his continued study and success in advanced photography, optics, and color printing, *Life*, *The Saturday Evening Post*, *Mademoiselle*, and several other magazines published many of his photographs. On several occasions, his photographs and water colors were exhibited in galleries in Santa Barbara and at the Sacramento State Fair, as well as traveling art exhibits. Always a lover of the out-of-doors, Roy Lawhorne was an archery enthusiast, taking recognized part in state-wide competition. … Another expression of his feeling for nature was his rock mountain house. He was a frequent traveler to the desert, which he loved and which also provided inspiration for his painting. Whether Mr. Lawhorne was painting or photographing the bobbing boats in the harbor, the brilliant coloring of the desert, or the misty violets of the mountain, his work revealed profound sensitivity of composition and understanding of nature. His teaching reflected these qualities as well as his tremendous experience and experimental activity. … Roy Lawhorne began teaching at Santa Barbara College in 1926. He also taught in **Brooks Institute of Photography**. He was interested in the Santa Barbara Museum of Art and other art organizations. The two professional groups in which he most enjoyed participation were the Institute of American Inventors and the Photographic Society of America. … Declining health became apparent soon after his retirement as Lecturer in Art at Santa Barbara College in June, 1950. … His death occurred on May 3, 1952. …," R. M. Ellison, E. A. P. Evans, J. Lindberg-Hansen from texts.cdlib.org/view?docld
See: "Santa Maria Camera Club," 1946

Lawrence, Effie A. (Mrs. William Scott Lawrence) (1872-1947) (Santa Maria)
Painter. Exh. at Community Club, 1938.
■ "Mrs. Lawrence, Teacher, Dies … pioneer retired elementary school teacher… Mrs. Lawrence was born Oct. 25, 1872 in Jamestown, Wis. She had been a resident of Santa Maria since 1927 and during that time taught two

years at Betteravia, two years in the Pleasant Valley school, and the same length of time at Lakeview, until that school was united with the Santa Maria city elementary school system, after which she served as a substitute teacher. Mrs. Lawrence also conducted private summer school classes at her home … member of Mizpah Chapter, Order of Eastern Star… author of magazine and newspaper articles on the subject of education…," *SMT*, June 24, 1947, pp. 1, 2. And, more than 620 hits for "Effie Lawrence" in the *SMT*, 1930-1947 primarily regarding club activities, were not itemized here.
See: "Community Club (Santa Maria)," 1938

Lawrence, Hattie Belle
See: "Shoults (Lawrence), Hattie Belle (Mrs. Howard C. Lawrence)"

Lawson, Glendon (Santa Maria)
Elementary school teacher who included art in his curriculum, 1939. Stanford trained. Married 1941. Became a Navy Petty Officer during WWII. Singer.
See: "Santa Maria, Ca., Elementary Schools," 1939

Learned, George Fred (1861-1939) (Lompoc)
Painter (houses and signs), 1909+.
■ "Last Rites Held for G. F. Learned… born in San Francisco, November 12, 1861, Learned was a resident of Lompoc for over the past 30 years…," *LR*, Aug. 25, 1939, p. 8.
Learned, G. F. (notices in Northern Santa Barbara County newspapers on microfilm and on newspapers.com)
1910 – "Blossoms Out with New Sign. The Lompoc Commercial Company has blossomed out with a new sign which shows up conspicuously on the company's place of business on Ocean avenue. The sign was executed yesterday under the artistic supervision of the wel- known painter, G. F. Learned," *LR*, Jan. 21, 1910, p. 6.
1924 – "Painter Learned is blotting out the old Saladin sign at the Lompoc Music Shop, preparatory to a new one. W. O. Garrett, the new proprietor don't believe in hiding his light under a bushel," *LR*, July 25, 1924, p. 5.
1927 – "Contractors are Justly Proud… G. F. Learned did all of the painting [in the **Lompoc Theater**] except the decorating, which was done by **Verne Laney** of Hollywood. Mr. Learned did the woodwork in the theatre and in all of the rest of the building in the offices upstairs and the stores on the first floor as well as all of the exterior painting. The painting on the marquee and the doors were his most particular jobs," *LR*, May 27, 1927, p. 8.
1928 – "Airport Sign Painted… Work of painting the big letters 'Lompoc' on both sides of the roof of the house at the new airport was finished this week by G. F. Learned. The sign is in white letters on a background of red. It will designate the location of the town from the air," *LR*, Nov. 2, 1928, p. 3.
Learned, G. F. (misc. bibliography)
George F. Learned is listed in the 1930 U. S. Census as age 69, b. c. 1861 in Calif., a painter, residing in Lompoc with wife Mary J. (age 65); George F. Learned was b. 1861 and

d. 1939 and is buried in Lompoc Evergreen Cemetery per findagrave.com (refs. ancestry.com).

Leather Craft Club (Santa Maria)
Club at Santa Maria High School, 1938.
See: "Santa Maria, Ca., Union High School," 1938

LeBlanc, E. L. / E. J. (Lompoc)
Photographer. His photo of La Purisima mission became the insignia for the La Purisima Camera Club, 1947.
This individual could not be further identified.
Is this Ed / Edward LaBlanc, listed in the 1940 U.S. Census as resident of Lompoc with wife Myrtle (ref. ancestry.com).
See: "La Purisima Camera Club," 1947, 1948

Lebrun, Nancy
See: "Folsom (Lebrun), Nancy (Mrs. Harvey Lebrun)"

Lebrun, Rico (1900-1964) (Los Angeles / Santa Barbara)
Modernist artist. Held a OMS at Allan Hancock [College] Art Gallery, 1955.
■ "Rico (Frederico) Lebrun (December 10, 1900 – May 9, 1964) was an Italy-born, Italian-American painter and sculptor. He was educated at the Naples Academy of Fine Arts and received practical training at a stained-glass factory. ... He moved to California in 1936. He exhibited in New York, Boston, Chicago, Los Angeles, and Toronto, and taught at Yale, the Art Students' League of New York, and UCLA," per Wikipedia.
Lebrun, Rico (notices in Northern Santa Barbara County newspapers on microfilm and on newspapers.com)
1959 – "Lebrun Drawings shown at Museum… Santa Barbara Museum of Art… Mr. Lebrun has [been] an artist in residence at the Museum for the year of 1944 and most of the work to be exhibited is from that period. Rico Lebrun received a Guggenheim Fellowship in both 1936 and 1937. He has exhibited and taught widely in the United States and has done such varied things as designing costumes for a ballet, 'The Man Who Married a Dumb Wife,' and illustrated an article for *Fortune* magazine entitled, 'The South At War.' Teaching at the Art Students League for four years, at Tulane University, at Chouinard Art Institute and now currently Visiting Professor of Painting at the Yale School of Art and the Modern Museum of Art in New York and was one of the six artists chosen to represent the U. S. in 1950 at the Venice Biennale…," *SMT*, Feb. 9, 1959, p. 5.
See: "Allan Hancock [College] Art Gallery," 1954, 1955, "Hesthal, William," 1955, "Peake, Channing," "Warshaw, Howard"

Le Décor (Santa Maria)
Interior decorating shop. Prop. Jules Jeannotte, 1953.
■ "Jules Jeannotte, formerly of Studio City where he owned and managed an interior decorating shop has formally opened a new business in Santa Maria, Le Décor, at 111 West Chapel. Jeannotte said he would offer his services as consultant in industrial, commercial and residential painting and decorating. 'We also do specialty displays, signs and fixtures,' he said. His work is not unknown to Santa Maria. Last year he served as consultant and artist in the redecorating of Ames and Harris. More recently he has given 'interior redos' to the Fashion Shop and the Beacon Outpost. Jeannotte is married and is moving his wife and children to Santa Maria where they will make their permanent home, he said, adding: 'I like Santa Maria. It has a number of opportunities for expression in interior decoration." and port. of Jules Jeannotte and "New Interior Décor Firm Opens in City," *SMT*, March 23, 1953, p. 3.
There is a Le Décor listed in Grover Beach, Ca. in 2020 per referlocal.com.
See: "Jeannotte, Jules"

Lee, Merle J. (1909-1999) (Lompoc)
Charter member and temporary secretary-treasurer, La Purisima Camera Club, 1947.
■ "Merle J. Lee… died July 21, 1999 in a local care center of natural causes. He was born May 7, 1909 in Garden Grove, Calif. Mr. Lee has lived in Santa Maria since 1933. He retired in 1975 from Southern California Gas Co. after over 20 years of service…. His hobbies included photography and reading…," *SMT*, July 24, 1999, p. 2.
Lee, Merle (misc. bibliography)
Merle J. Lee, employee, So. Co. Gas Co. of Calif., is listed in the *Lompoc, Ca., CD*, 1945, 1947, and listed as motor mechanic in the *Santa Maria, Ca., CD*, 1948, 1958; Merle J. Lee was b. May 7, 1909 and d. July 21, 1999 per Social Security Death Index (refs. ancestry.com).
See: "La Purisima Camera Club," intro, 1948

Lehmann / Lehman, Werner (1885-1960) (Santa Maria)
Artist father of Mrs. Mabel Bright who exh. his paintings at the Minerva Club, 1957, 1958.
■ "Werner Lehman... died early this morning... born July 10, 1885, in Switzerland, he had resided here for the past 6 ½ years and in California for 48 years. Formerly of Fresno, Mr. Lehman owned and operated an auto painting company in that city for 30 years. He resided at 1507 N. Broadway where he was co-owner of the Valley Motel...," *SMT*, Jan. 25, 1960, p. 2.
Lehman, Werner (misc. bibliography)
Werner Lehman, Valley Motel, is listed with wife Helen A. in the *Santa Maria, Ca., CD*, 1958, 1959; Werner Lehmann was b. July 10, 1885 in Zofingen, Switzerland, to Jakob Friedrich Lehmann and Elise Nothiger, married Helen Agnes Steinke, and d. Jan. 30, 1960 in Santa Maria, Ca., per Don's Complete Family Tree (ref. ancestry.com).
See: "Minerva Club, Art and Hobby Show," 1957, 1958

Leighton, Philip D. (1938-?) (Los Olivos / Palo Alto)
Student at SYVUHS who exh. artwork in several local exhibits in the late 1950s. Became an architect.
Leighton, Philip (notices in Northern Santa Barbara County newspapers on microfilm and on newspapers.com)
1958 – "Holiday Reunion… The Little Creek Ranch home of Dr. and Mrs. Philip Leighton was the setting for a family thanksgiving… their son, Phil of Menlo Park…," *SYVN*, Nov. 28, 1958, p. 4.
1960 – "Philip Leighton Enlists in Army. Philip D. Leighton, son of Dr. and Mrs. Philip A. Leighton of Little Creek Ranch, has enlisted… and has begun basic training at Fort Ord," *SYVN*, July 8, 1960, p. 6.
1965 – "Two Graduated from Stanford… Philip D. Leighton, A. B. architecture, son of Dr. and Mrs. Philip Leighton of Little Creek Ranch, Los Olivos," *SYVN*, June 17, 1965, p. 16 (i.e., 8B).
1968 – "Philip Leighton Awarded Degree… Bachelor of Architecture degree from the University of Pennsylvania…," *SYVN*, May 23, 1968, p. 9.
1969 – "Stanford Library Building Post… appointed to the position of building projects manager at Stanford University libraries. He will work with the planning office, the architect, and the engineers on proposed additions to the main library building. Leighton is a 1965 graduate of Stanford in the pre-architectural program and took his architectural degree from the University of Pennsylvania. He served two years with the U. S. Army and has been employed with a number of firms working in the field of educational specifications and school projects," *SYVN*, Sept. 18, 1969, p. 6.
Leighton, Philip (misc. bibliography)
Philip D. Leighton is listed in the 1940 U. S. Census as age 1, b. c. 1939 in Calif., residing in Palo Alto with his parent Philip A. Leighton (age 42); Philip D. Leighton b. Nov. 4, 1938 was residing in Portola Valley, Ca., in 1995 per *U. S. Public Records Index, 1950-1993*, vol. 1 (refs. ancestry.com).
See: "Santa Ynez Valley Art Exhibit," 1957, "Scholastic Art Exhibit," 1955

Leitner, Earle Franklin (1937-2013) (Santa Maria)
Santa Maria High School grad. '55. Interior decorator. Sign painter. Graphic artist at Vandenberg.
■ "Earle Franklin Leitner… passed away at Twin Cities Community Hospital in Templeton on December 11, 2013. Earle was born and raised in Santa Maria and attended local schools graduating from Santa Maria High School in 1955. He then attended Art Schools in Mexico City, Oakland and San Francisco. He returned to Santa Maria 1966. He formerly worked as an Interior Decorator and owned his own sign painting business. He retired in 2003 as a Graphic Artist for U. S. Civil Service at VAFB and eventually moved to Paso Robles 'Heritage Ranch.' Earle's hobbies included playing guitar, horses, oil painting and listening to the mariachis…," *SMT*, Dec. 15, 2013, p. B5.
Leitner, Earl (notices in Northern Santa Barbara County newspapers on microfilm and on newspapers.com)
1952 – Port. as boxer, *SMT*, April 26, 1952, p. 2.

1958 – "Two Santa Maria area men-in-the-service are Army 'Saints.' Earl F. Leitner son of Mr. and Mrs. Leitner, 171 Cox Lane," *SMT*, March 6, 1958, p. 11.
■ "Linda Fletcher Weds Earle Leitner… both are students at Mexico City College where they plan to continue their studies during the winter quarter. Earle is a transfer student from Oakland College of Arts and Crafts and is a commercial art major. Linda is in her second year at Mexico City College as an Anthropology major," *SMT*, Jan. 8, 1963, p. 3.
More than 60 notices for "Earl Leitner" in the *SMT* between 1950 and 1965 refer to his guitar playing, his ping pong championship, and his bantam weight boxing, but were not itemized here.
Leitner, Earl (misc. bibliography)
Earle Franklin Leitner, mother's maiden name Azcarate, was b. May 6, 1937 in Santa Barbara County per Calif. Birth Index; Earle Leitner port. appears in Santa Maria High School yearbook, 1952, 1954; Earle Leitner, salesman Fletcher's, with wife Linda, is listed in the *Santa Maria, Ca., CD*, 1968; port. of Earle Franklin Leitner in later years appears in *Public Member Photos & Scanned Documents*; Earle Franklin Leitner was b. in Santa Maria [c. 1938] and d. Dec. 11, 2013 in Templeton, Ca., and is buried in Santa Maria Cemetery District per findagrave.com (refs. ancestry.com).
See: "Allan Hancock College," 1960, "Allan Hancock [College] Art Gallery," 1956, "Santa Maria, Ca., Union High School," 1952

Lemere, Bosworth (1909-2002) (Carpinteria)
Photographer. APSA. Active with Santa Maria Camera Club, 1955. Judged some local photographic shows.
See: "Santa Maria Camera Club," 1955

Lenfest, Joseph D. (Lompoc)
Manual training teacher at Lompoc High School, 1924-26.
■ "High School Notes… faculty… Mr. Lenfest's first teaching experience was at Maricopa union high school where he taught auto mechanics, wood working and athletics. The next year he spent at Santa Barbara State Teachers' College and secured a special certificate in shop subjects. The following year was spent at Venice Union Polytechnic high school in the sheet metal shop and Physical Training. Returning to his home town the next year, he followed his former occupation in the automotive. A year ago, Mr. Lenfest was added to the Lompoc high school faculty and since then has been in charge of the shop division," *LR*, Sept. 18, 1925, p. 8.
See: "Lompoc, Ca., Union High School," 1924, 1925

Leonard, Verla Marie (1916-1995) (Santa Maria)
Teacher of crafts and arts at Santa Maria High School, 1946/48. Lectured to Junior Community Club, 1947.

■ "17 New Teachers for High School … New Art Teacher. Miss Verla Leonard comes from Corey, Pa., and will teach art in the high school and junior college. She is a graduate of Pennsylvania State Teachers' College and has a master's degree from Pennsylvania State College. She has been art supervisor in the elementary and high schools of Pennsylvania…," *SMT*, Aug. 28, 1946, p. 4.
Leonard, Verla (misc. bibliography)
Verla Leonard, teacher, is listed at the same address, 825 S. Lincoln, as John H. and Doris Leonard [her parents?], in the *Santa Maria, Ca., CD*, 1947-48; Verla Leonard port. appears in the Santa Maria High School yearbook, 1947, 1948; Verla Marie Leonard was b. Jan. 7, 1916 in Erie, Pa. to John Henry Leonard and Doris Ferber and d. Nov. 13, 1995 in Mill Valley, Ca., per Leonard Family Tree (ref. ancestry.com).
See: "Christmas Decorations (Santa Maria)," 1947, "Junior Community Club," 1947, "Martin, Norma," 1948, "Santa Maria, Ca., Union High School," 1948

Leslie, John M., Jr. (1936?-?) (Vandenberg)
Artist once with Disney Studios, worked in Comptroller shop at Vandenberg, 1959.

■ "Former 'Donald Duck' Creator [Now] at Vandenberg. … A-3C John M. Leslie, Jr. of the Comptroller shop at Vandenberg AFB, Lompoc. For the 22-year-old new addition to the 392nd Combat Support Group's Headquarters Squadron was an illustrator in **Walt Disney** Studio at Burbank before entering the AF seven months ago, and during his two years with Disney drew the celebrated D. Duck hundreds of thousands of times for TV productions. He also drew the TV appearances of Mickey Mouse and Goofy … Leslie says the short-tempered and highly individualistic Donald was his favorite figure to draw, but he admits that a steady diet of duck for a couple of years can get to be pretty filling. … it takes about 18,000 drawings to make one Donald Duck feature which runs for eight minutes at the base theater! A native of Hollywood, Calif., Leslie studied at the famed Chouinard Art School Institute in Los Angeles for two years," *LR*, Oct. 8, 1959, p. 2.
Leslie, John M. (Internet)
Port. slumped in chair at Disney studios, 1957. "The kid slumped in his chair on the right is Disney artist, John Leslie…. Leslie seemed to adopt a James Dean like persona. At times, girls at the studio would mistake him for the troubled Hollywood actor… John Leslie sometimes wore a black leather jacket … Often we would see Leslie, cigarette in hand, slumped against a studio wall. At a glance he could easily pass for the famous actor. It soon became a studio gag to place signs on John's office door stating that 'James Dean is Alive'," floydnormancom.squarespace.com
Leslie, John M. (misc. bibliography)
Is he John M. Leslie, Jr., '50, of Bellevue, Washington, listed in the *Stanford Alumni Directory*, 1954; John M. Leslie, Jr., '63, is listed in the *Stanford Alumni Directory*, p. 1536; Mr. John M. Leslie, Jr., Engineer, is listed in the

Stanford Alumni Directory, 1967, p. 1944; is he John M. Leslie, Jr., b. Oct. 13, 1936, residing in Oxnard, Ca., in 1995 per *U. S. Public Records Index, 1950-1993*, vol. 1 (refs. ancestry.com).

Leslie's, A. (Los Alamos)
Purveyor of picture frames, 1883.
1883 – Ad: "A. Leslie's. Stock of new goods… The Ladies would say that our millinery department is complete… Autograph and photograph albums, writing desks and picture frames….," *LR*, Jan. 13, 1883, p. 2.

Lesselli Marionettes
Itinerant puppeteer active at various towns on California's central coast.
See: "Santa Maria Valley Art Festival," 1953, and *San Luis Obispo Art and Photography before 1960* and *Central Coast Artist Visitors before 1960*

Lester, Gene (Hollywood)
Took photographs of Blochman Village for Saturday Evening Post, 1946.
See: "Santa Maria, Ca., Elementary Schools," 1946

LeSuer, John C. (Santa Maria)
Engineer. Co-prop. Camera and Hobby Shop, 1960.

■ Port. and candidate for Santa Maria Airport District board of directors… "'I have been affiliated with aviation and the supporting industries for more than 20 years during which time my work has included the planning, layout and management of airports and facilities'… came to Santa Maria in August 1959 after he retired from the United States Air Force with the rank of Major. Since that time, he has been employed as an engineer with TRW Space Technology Laboratories and Vandenberg Air Force Base… a pilot… In 1960, with a partner, I started my business career in Santa Maria by opening the **Camera and Hobby Center** … My latest business venture is Micronized Engines, Inc…," *SMT*, March 20, 1964, p. 7.
See: "Camera and Hobby Shop," 1960

Lew, Elmer (Fresno)
Photographer from Fresno Camera Club who attended several meetings of the Santa Maria Camera Club, 1954-55.
See: "Santa Maria Camera Club," 1954, 1955

Lewis, Jeff, Pfc. (Camp Cooke / Florence, N. C., i.e., S. C.?)
Muralist while stationed at Camp Cooke during WWII. Exh. artwork at Ojai Art Center, 1945. After the war he studied dentistry.
1945 – "Safe Arrivals: William Lloyd of Lydia on Luzon. Jeff Lewis, Jr., in Japan," *Florence Morning News* (Florence, S. C.), Oct. 16, 1945, p. 6.
See: "Art, general (Camp Cooke)," 1945

Lewis, Marion Herta / Hertha Marion (Mrs. Sgt. James E. Lewis) (1924-1986) (Austria / Lompoc)
Painter in Lompoc, July 1954+. Art teacher. Active with the Alpha Club in art related ways through the 1960s.

■ Port. with painting, and caption reads "attractive wife of Sfc. James E. Lewis of the USDB. Marion, who is a graduate of the University of Art in Vienna, is a gifted artist in landscape and flower paintings, working in mediums of both water color and oil. She has entered three of her pictures in the Santa Ynez Valley Art Exhibit being held in Solvang this week end. The painting shown is one she did for Mrs. M. S. Hamilton. **Tom Yager** photo," and "Meet Your Neighbor. An Artist from Vienna. … Born in Winzendorf, a small town near Vienna, Marion moved to Wiener-Neustadt, also near Vienna, where she spent her childhood. Her father was station master there, and it was from him that she derived her early interest in art, for his hobby was portrait painting. Her youthful years were happy ones filled with family life, her studies and extensive travel in Austria, Germany, Poland and Czechoslovakia. She recalls a delightful tour of Germany and Poland she and her sister took by themselves when she was fourteen and her sister seventeen. Deciding to make a career of art, Marion entered the University of Art in Vienna, obtaining her Master's Degree from there after six years of intensive study. She had originally thought that she would like to specialize in costume design for the stage but, as she expressed it, when she actually began working on that type of drawing, she 'became lost among the pleats,' putting too much intricate detail into her sketches. Her instructors suggested she try her hand instead at natural subjects and there, in landscapes and flowers she 'found herself.' Training at the Vienna Academy was thorough and arduous. Many days during her six years of study she was in class from 8 a.m. until 10 p.m. And during vacation periods she and other university students were recruited to work on costume and set designs for the local theatres. She also designed many of her own clothes during her school years. World War II broke out in Europe and Marion and her family went through the harrowing experiences of life in a war-ravaged land. Wiener-Neustadt, site of a large Messerschmidt factory, was the first city on the continent bombed by the Americans. Other bombings followed upon the city and upon a train on which she was riding but Marion was fortunate in coming through them all unharmed. When the Russians were closing in on the town Marion and her mother fled on bicycles for six days and nights. They finally reached the comparative safety of the small Alpine town of Jenbach, near Innsbruck, where the family had a summer home. Marion's sister was in Prague, Czechoslovakia at the time but she later managed to get out of the country and join them in the Alps as did Marion's father, who had stayed behind to fight when the Russians came. The family was fortunate because Innsbruck fell into the French zone when the division of Germany and Austria by the Allies occurred, and Marion was able to earn food for her sister's new baby and the family by doing art work, posters, etc., for the Red Cross. She is enthusiastic in her praise of the Red Cross and in her gratitude for their help. In 1947 Marion married Sfc. Lewis, who was stationed in Salzburg. Their first child, little Barbara Jo, who is now six and a half, was born while they were still in Austria. After a four-year tour of duty in Salzburg, Sfc Lewis was transferred home in 1950 and Marion and Barbara accompanied him back on the Army transport. When asked her first impression of the United States Marion said, 'Big!' … like so many Europeans she was immediately astounded by the number or automobiles which she first saw on New York streets and parking lots. She recalls happily the friendliness with which she was received by the American people and that there was never an unkind remark made to her because she was from a country which had recently been at war with the United States. The Lewises were first stationed briefly at Ft. Lawton, Washington, and then later at Ft. Warden, which is located at Port Townsend, Washington. Their second little girl, Donna Elizabeth, was born while they were at Ft. Warden. She is now three years old. Entering wholeheartedly into the community life of Port Townsend and giving generously of her time and talents, Marion taught night classes in art at the city's Recreation Center and also instructed private students, both children and adult. She painted a beautiful life-size nativity scene which is still being used by the city at Christmas time and also did the stage backdrop for the queen's coronation during the Port Townsend annual Rhododendron Festival. When her husband was sent to Korea for 18 months, Marion remained in Port Townsend and continued with her art teaching. After his return the family came to Lompoc last July and the Sergeant was assigned to the USDB here. Last February, a year ago, Marion officially became an American citizen. In her painting, Marion does beautiful flowers, landscapes and still life in water colors and oils. Skilled in both mediums, her first love is water colors. Almost better than painting, Marion loves to teach art and considers herself a better teacher than artist. She particularly likes to work with students who have had little or no experience. 'There are tricks in every trade,' says Marion, 'and skill is a trick in painting. It is something which can be learned. One is born with talent but skill can be acquired. It is remarkable what a person with just a little talent can do when he has learned skill.' 'Also,' explained Marion, 'a person must be taught to 'see' things. Once he has learned to 'see' them he can put them down in paint.' Marion finds painting relaxing and a good morale builder for painting requires concentration and the artist is concentrating on something pleasant. Marion Lewis has had exhibits of her art in Munich, Vienna, and in this country in Port Townsend. This week-end she is among the artists exhibiting in the third annual Santa Ynez Valley Art Exhibit… She has donated one of her water colors for the art auction tomorrow. Runing a home for her husband and two lively young daughters and painting keeps Marion well occupied, but she is still enthusiastic about teaching art and would welcome giving lessons to anyone who would like to learn. Marion lives at 227 South H St.," *LR*, April 28, 1955, p. 5.

Lewis, Marion Herta (notices in Northern Santa Barbara County newspapers on microfilm and on newspapers.com)
1961 – Several photos of her art class and "Lompoc Has Viennese Art Teacher… Mrs. Marion Lewis of 227 S. H. Street teaches small groups of aspiring artists nearly every evening of the week. She also teaches 10 children during afternoon classes…," and bio., *LR*, Oct. 5, 1961, p. 13 (sect. AA).

1970 – Port. with sketch, *LR*, June 23, 1970, p. 4.
And more than 40 notices for "Marion Lewis" in the *LR* between 1959 and 1972 primarily regarding her art activities with the Alpha club and private teaching of art, were not itemized here.
Lewis, Marion Herta (misc. bibliography)
Marion H. Lewis is listed with husband James E. Lewis, USA in Lompoc in the *Santa Maria, Ca., CD*, 1958, 1959, 1961, 1962, and retd, 1965, 1976; Hertha Marion Lewis, mother's maiden name Hinschik and father's Polaschek was b. April 7, 1924 in Other Country and d. June 2, 1986 in Santa Barbara County per Calif. Death Index; Hertha Marion Lewis b. April 7, 1924 and d. June 2, 1986 is buried in Lompoc Evergreen Cemetery per findagrave.com (refs. ancestry.com).
See: "Alpha Club," 1957, 1962, 1964, "Art, general (Lompoc)," 1960, "Lompoc Community Woman's Club," 1959, "Open-Air Art Exhibit," 1957, 1960, "Posters, American Legion (Poppy) (Lompoc)," 1959, "Tri-County Art Exhibit," 1958

Lewis, O. G., Rev. (Santa Maria)
Chalk talk artist, 1953.
See: "Chalk Talks (Northern Santa Barbara County)," 1953

Leyva, Belvin "Bob" (1910-2007) (Santa Maria)
Photographer, amateur. Member Santa Maria Camera Club, c. 1947-50. Brick and concrete block mason / politician.
■ "Council Candidate Leyva… Born and raised in Santa Maria valley. Attended and graduated from our public schools. Attended and completed college courses in the following… Recently completed a real estate course. Held the position as head chemist of Tara Laboratory at the Union Sugar Company for a number of years and also as a chemist for the Bell Oil Company. Presently engaged in the general contracting business … for the past 15 years in the construction business. ... A member of the Santa Maria Camera Club and Santa Maria Country Club. Hobbies: Photography, fishing and dancing. … presently living at 220 W. Orange Street," *SMT*, April 5, 1960, pp. 1, 8.
Leyva, Bob (notices in Northern Santa Barbara County newspapers on microfilm and on newspapers.com)
2007 – Obituary, *SMT*, June 20, 2007, p. 9 (i.e., B3).
More than 220 hits occur for "Bob Leyva" in the *SMT* between 1945-1960, some of which concerned his activities with the Santa Maria Camera Club (1947-1950), but they were not itemized here.
See: "Santa Maria Camera Club," 1950

Library
See: "Santa Barbara County Library (Lompoc)," "Santa Barbara County Library (Santa Maria)," "Santa Barbara County Library (Solvang)"

Lidbom, Hazel Jeanette (Mrs. Ralph Lidbom) (1892-1983) (Santa Maria)
A county employee who spent her life teaching crafts to Camp Fire Girls and other groups, c. 1936+. Collector of glass.
■ "Mrs. Lidbom Marks 25 Years in County Employ… county registrar of vital statistics… her first day on the job was August 6, 1929… Aside from her daytime work, Mrs. Lidbom has occupied spare time with the collection of glass and antiques and with a variety of handwork which has won many ribbons for her at the County Fairs… She is one of the three charter members of the Business and Professional Women's club … 25 years' membership in the Community club…. director of the County Employees Assn., and has served many years as a member of the Santa Maria Valley Council of Camp Fire Girls. ... During a busy life, she has taken time for travel about the United States and Canada and two years ago managed a trip to Hawaii…," *SMT*, Aug. 6, 1954, p. 4.
Lidbom, Hazel (notices in Northern Santa Barbara County newspapers on microfilm and on newspapers.com)
1936 – "Health Department Shows Exhibits… in their window on South Lincoln street. Mrs. Ralph Lidbom will be in charge… and plans to put in new [items] each Monday…," *SMT*, Aug. 20, 1936, p. 3.
1940 – "Child Welfare Workers are Busy… county hospital… handcraft… occupational therapy class taught in the hospital by Mrs. Hazel Lidbom…," *SMT*, Feb. 27, 1940, p. 3.
And, almost 1000 hits for "Hazel Lidbom" in the *SMT* between 1925 and 1960, many of which refer to her exhibiting her crafts at various places (after 1936), including the Santa Barbara County Fair, teaching crafts at various places, and her activities with clubs, but were not even browsed for possible inclusion here.
Lidbom, Hazel (misc. bibliography)
Hazel Jeanette Lidbom, b. Dec. 23, 1892 in Iowa and d. Feb. 27, 1983 in Santa Maria, mother's name Tibbits, father's Rosebrook, per death-records.mooseroots.com.
See: "Baker, Arthur," 1939, "Business and Professional Women's Club," 1941, "Camp Fire Girls," 1937, 1938, 1940, "Community Club (Santa Maria)," 1938, 1941, 1947, 1949, 1950, "Junior Community Club," 1949, 1957, "Santa Barbara County Fair," 1936

Liecty, Ruth Russell (1896-1978) (Santa Barbara)
Painter. Member Santa Barbara Art Association, who exh. at opening exh. of Allan Hancock College Art Gallery, 1954. Exh. at Santa Barbara County Fair, 1952. Exh. Santa Ynez Valley Art Exhibit, 1954, 1955, 1956.
■ "Santa Barbara Artist… Recent paintings of Mrs. Ruth Liecty… are being shown during August and September at County Stationers, 532 E. Main Street, Ventura… Mrs. Liecty is a graduate in fine arts of the school of arts and crafts, Berkeley. She has studied and done advanced work with **Douglass Parshall**, **Standish Backus** and **Joseph Knowles**. A member of the Santa Barbara Art association, she recently held a one-woman show at the Santa Barbara museum and won first prize in oils in the Solvang art show," *Ventura County Star-Free Press* (Ventura, Ca.), Aug. 6, 1956, p. 9.

Liecty, Ruth (notices in California newspapers on microfilm and on newspapers.com)
1956 – "New Exhibits… Ninth annual **Tri-County exhibition**… Ruth Liecty, Clifton Williams, paintings… Santa Barbara Museum of Art, Tuesday through June 3," *LA Times*, May 13, 1956, p. 110 (i.e., pt. IV, p. 12). And, a few additional notices revealing she exh. on other occasions in Ventura and at the Santa Paula Art Show (1965) were not itemized here.
Liecty, Ruth (misc. bibliography)
Mrs. Ruth Liecty, artist, is listed in the *Santa Barbara, Ca., CD*, 1939-72; Ruth Russell Liecty was b. Aug. 18, 1896 in Mass. and d. Jan. 31, 1978 in Santa Barbara County per Calif. Death Index (refs. ancestry.com).
See: "Allan Hancock [College] Art Gallery," 1954, "Santa Barbara County Fair," 1952, "Santa Ynez Valley Art Exhibit," 1954, 1955, 1956

Lightfoot, Owen Emerson (1906-1984) (Santa Maria)
House and easel painter. Wife, Grace, exh. western paintings [probably painted by her husband, Owen] at Community Club hobby show, 1950.
■ "Owen E. Lightfoot… 77… Mr. Lightfoot was born in Michigan and was a lifelong painter. He had resided in Santa Maria since 1941, and was a former resident of Pipestone, Minn. He was last employed at Vandenberg AFB as a painter. He was a veteran of World War II, serving with the Seabees of the U. S. Navy. He was a life member of the Veterans of Foreign Wars. Survivors include his widow, Grace Lightfoot…," *SMT*, Jan. 30, 1984, p. 5; "Owen Lightfoot… former resident of Rapid City, S. D…. moving to Santa Maria in 1941…," *Rapid City Journal* (SD), March 6, 1984, p. 5.
Lightfoot, Owen (notices in California newspapers on microfilm and on newspapers.com)
1942 – "Navy Takes in Six More Men… Owen Emerson Lightfoot, 517-C South Pine, enlisted as a painter, third-class. He has lived in Santa Maria for two years working as a painter for local business firms and in Camp Cooke and the air base. He is married," *SMT*, Dec. 9, 1942, p. 2.
1951 – "Art Exhibits at Hotels" – his one-man show replaces that of Mrs. Joslin at the Carlton, under auspices of the Atascadero Art Club, *AN*, Oct. 11, 1951, p. 1.
1952 – Port. and caption reads "Indian Chief – Owen Lightfoot, a three-eighth Chippewa Indian from Pipestone, Minnesota, will convincingly portray the character, Joseph Whitebear, in Squash Hollow School, Kiwanis-sponsored production opening tonight…," *SMT*, April 15, 1952, p. 1.
1968 – Repro. of one of his paintings hanging on the wall of a home, *SMT*, Aug. 8, 1968, p. 4.
Lightfoot, Owen (misc. bibliography)
Owen E. Lightfoot, painter, and wife, Grace E., are listed in the *Santa Maria, Ca., CD*, 1958-83; Owen Emerson Lightfoot, mother's maiden name Spruce, was b. Nov. 10, 1906 in Michigan and d. Jan. 18, 1984 in Santa Barbara County per Calif. Death Index (refs. ancestry.com).
See: "Community Club (Santa Maria)," 1950, and *Atascadero Art and Photography before 1960*

Likes, Myrton Dellard (1894-1961) (Santa Maria)
Photographer, amateur. Painter in oils. Science teacher at Santa Maria High School and Junior College. Exh. Allan Hancock [College] Art Gallery, 1955.
■ Port. and Myrton Likes, 66, Santa Maria high school and junior college instructor for 30 years died here Wednesday night in a local hospital after a brief illness… Mr. Likes taught general science at the high school and junior college from 1926 to 1956 when he retired. He was acting dean of the JC here from 1943 to 1945. Born in Aurora, Neb., Mr. Likes attended Colorado School of Mines at Golden, Colo., and worked his way through school as an electrical contractor. He received his masters' degree from Washington University and did graduate work at University of California. Prior to coming to Santa Maria, Mr. Likes taught at Astoria, Ore. While in Santa Maria he also instructed University of California extension classes here and in Paso Robles… He was active in Santa Maria Kiwanis club for 11 years and also the Rock and Mineral Club and Camera Club…," *SMT*, March 30, 1961, p. 1.
■ Port. and "Likes Concludes 30 Years of Teaching… originally got into teaching 'for something to do during the winter,' … now beginning his retirement after 30 years of instructing in the local high school and junior college… He started teaching at the age of 18 in a one-room schoolhouse… in Colorado… he's retiring 'early'… so he can 'get to do all the things I've always wanted to do.' This includes, among other things, touring Europe, especially the Scandinavian and Mediterranean countries, doing some photography, and oil painting, and getting around to reading the thousand or so books he's got packed into the shelves of his library… bone-dry sense of humor… Like's father was a Denver lawyer and ran a cattle ranch… Likes first went to work in a one-room rural school in eastern Colorado… He moved on to Erie, Colo. and then Spratton, Colo., serving as village principal… Then he went to Astoria, Ore., as head of the science department… at the end of the 1926 term married Marie Wade, a commercial teacher… When Likes came to Santa Maria he was originally hired as a chemistry teacher in the junior college, but … also put in some time teaching in the high school. In 1932 he was appointed dean of the junior college and held the post for 19 years, until 1951, when he … returned to teaching… In the meantime, he found time during his summer to pick up a degree in mining engineering from the Colorado School of Mines and a master's degree in chemistry from the University of Washington… In 1936, Likes joined an expedition to an unexplored area in the Monument valley country in Arizona and New Mexico sponsored by the New York Museum of Natural History, taking motion pictures of the trip. … for nine years he taught classes in nearly every field of science for the extension department of the University of California… traveled extensively… It was a trip 32 years ago that led to Likes wearing the dark green-shaded glasses he always uses now… eyes that are extremely sensitive to light… Likes is an avid photo-bug and claims to be one of the pioneers in visual education. 'I started using it 33 years ago in Astoria when it was still yet unheard of. I used it for 19 years in the high school and junior college too.' He also took extensive movies and some 5,000 color slides during the last European trip and claims it would take three hours

to view all the slides he took of Paris alone and another three hours for Rome...," *SMT*, June 17, 1956, p. 11.

<u>Likes, Myrton (notices in Northern Santa Barbara County newspapers on microfilm and on newspapers.com)</u>
1936 – "Santa Marian Photographs Ruins ... Members of the office staff of the Santa Maria high school have received a letter from Myrton D. Likes who has joined the Rainbow Bridge Monument valley expedition for scientific exploration and field work in Arizona this summer. The expedition is working in a 3000 square mile section of canyon, mesa and desert, bisected by the Arizona-Utah line, in the extreme north of the Navajo Indian reservation. Mr. Likes' letter was written from the Tsegi camp in Arizona and mailed from the base camp in Kayenta, Ariz. He had just completed a climb up the Tsegi, accompanied by an Indian guide where he took colored motion pictures of ancient cliff dwellings. He was joined on this trip by Milton Wetherill, custodian of the Navajo National monument. The next day, Wetherill took him up the Doyzshi Biko to see Keet Seel, the largest ruin except for the Cliff palace in Colorado. The whole camp, under the direction of Ansel P. Hall, chief of the division of education of the United States National Park service, is moving now to Monument valley to search for archaeological valuables. The party is equipped with new motor equipment constructed to meet desert conditions and mountain climbing. The first pictures taken by Likes are to arrive in Santa Maria sometime this week," *SMT,* July 20, 1936, p. 5; "Men's Club Sees Pictures of Desert Trip" taken by M. D. Likes, *SMT,* Nov. 19, 1936, p. 2.
1937 – "Santa Marian's Films will be Shown in East. Ansel F. Hall, general director of the Rainbow Bridge Monument Valley expedition has asked Myrton D. Likes... for permission to use his color photographs of the northern Navajo country on a eastern tour. Hall is to address the Explorers Club of New York at its annual dinner Jan. 16... Hall also asked the use of other films which would be shown by other lecturers in Fresno the week of Jan. 19," *SMT*, Jan. 12, 1937, p. 4.
1951 – Port. with **Native American** bowl found atop a hill at Pismo Beach, *SMT*, Oct. 23, 1951, p. 1.
And, more than 360 hits for 'Myrton Likes' in the *SMT* between 1940 and 1961, many reporting his science lectures to local groups, were not itemized here.
<u>Likes, Myrton (misc. bibliography)</u>
Listed 1930 and 1940 U. S. Census as b. c. 1898 in Nebraska, married to Marie W. Likes, living in Santa Maria, Ca.; Myrton Dellard Likes was b. June 16, 1894 in Aurora, Neb. to Henry Israel Likes and Olive Florence Libolt, married Marie M. Wade, and d. March 30, 1961 in Santa Barbara per Steven Westberg Family Tree (refs. ancestry.com).
<u>See</u>: "Allan Hancock [College] Art Gallery," 1955, "Junior Community Club," 1957, "Minerva Club, Art and Hobby Show," 1958, "Santa Maria Art Association," 1945, "Santa Maria, Ca., Union High School," 1926, 1937, 1940, 1948, 1953, "Santa Maria Camera Club," 1938, 1939

Lilley, Helen M. Stone (first wife of Mrs. Robert C. Lilley, Jr., 1918-1986, divorced 1970) (1922-1975) (Lompoc)
Painter. Exh. Open-Air Art Exhibit, 1957. Flower arranger.
<u>See</u>: "Alpha Club," 1957, "Homrig, Hal," "Open-Air Art Exhibit," 1957

Lilley, Violet Wolf / Wolfe (Mrs. Robert C. Lilley, Sr., 1895-1961) (1896-1979) (Lompoc)
Active with Art Section of Alpha Club, 1934-42.
<u>See</u>: "Alpha Club," 1932, 1934-42

Lindberg, Oscar Wilhelm (1892-1971) (Santa Ynez Valley)
Artist. Exh. paintings at various places, 1957+. Curator of art exhibits at Santa Barbara County Library (Solvang), 1959-64.
■ "Oscar Wilhelm Lindberg, 79 ... of Solvang... Mr. Lindberg was born on March 11, 1892 in Falskog, Sweden. He was a member of Masonic Lodge No. 615 and was a World War I veteran. Mr. Lindberg, an artist, had lived in Janin Acres and moved to Hemet in 1961...," *SYVN*, Nov. 18, 1971, p. 3.
<u>Lindberg, Oscar (notices in Northern Santa Barbara County newspapers on microfilm and on newspapers.com)</u>
1958 – "Miss Margelli... Never have I appreciated more ... I have enjoyed nature's exhibitions and the beautiful paintings of Oscar Lindberg that will be shown as a one man show at the Fox Arlington Theatre throughout the month of October in Santa Barbara. And now, thank you to Solvang and the Lindbergs for they came to Santa Barbara Saturday afternoon to bring me to their beautiful home... Maria Margelli, KTMS Radio Station," *SYVN*, Sept. 12, 1958, p. 2; "Lindberg Art on Display. An exhibition of 26 paintings by Solvang artist Oscar Lindberg is now being featured in the gallery of the Fox-Arlington Theatre in Santa Barbara. Lindberg has exhibited at the Greek Theatre and the Friday Morning Club in Los Angeles where he won blue ribbons. He is a member of the Los Angeles Painters and Sculptors Club and the San Fernando Valley Artists Guild, of which he is a board member," *SYVN*, Oct. 17, 1958, p. 6.
1959 – "Lindberg Headed Fiesta Art Event. Oscar Lindberg... was chairman of the art section of the third annual <u>Fiesta Open Air Fine Arts and Crafts Exhibit</u> Sunday afternoon on Cabrillo Boulevard in Santa Barbara. Lindberg had 16 of his oil paintings on display...," *SYVN*, Aug. 21, 1959, p. 1; "Lindberg Art on Exhibition. On invitation of Miss Maria Margelli of Santa Barbara, Oscar Lindberg... is having his second Santa Barbara showing during the month of September in the Fox Arlington Theatre. Lindberg has 20 pictures, all oils, on display in the lounge," *SYVN*, Sept. 4, 1959, p. 6 and *LR*, Sept. 10, 1959, p. 13; "Lindberg Paintings in Library Showing. Six oil paintings... on display until Nov. 15 at Solvang Branch Library...," *SYVN*, Oct. 9, 1959, p. 2.
1960 – "Lindbergs Return. Mr. and Mrs. Oscar Lindberg returned last weekend to their home in Janin Acres. They spent New Year's weekend with friends in Palm Springs

and since then the Lindbergs have been in Beaumont while Mr. Lindberg completed his commission to paint <u>murals</u> for the Lamppost restaurant to be opened in March," *SYVN*, Jan. 29, 1960, p. 8; photo of artist and sign he painted for the Santa Ynez Valley Woman's Club, *SYVN*, June 17, 1960, p. 6.

1961 – "Library Shows Lindberg Art… next six weeks … oil paintings … Among them are three still lifes and a colorful painting of folk dancers and Danish-costumed people against the background of buildings on Copenhagen Dr., painted during Solvang's last **Danish Days**. Lindberg belongs to the Painter's and Sculptor's Club and the Valley Artist's Guild," *SYVN*, March 10, 1961, p. 3; "Lindberg Named Art Unit Member. … American Institute of Fine Arts, a comparatively new organization which meets at the Ambassador Cocoanut Grove… Lindberg was in Los Angeles last week to accept an invitation to join the group… extended to recognized realistic painters and sculptors…," *SYVN*, Oct. 6, 1961, p. 1; "Lindberg Gives Painting to Home… painting of the Bethania Lutheran Church. The painting, bordered by a light-colored frame which Mr. Lindberg made in his shop, has been hung in the main foyer directly above the visitor's desk…," *SYVN*, Dec. 15, 1961, p. 12.

1962 – Photo of the model of the proposed $500,000 Santa Ynez Valley Hospital and caption explains that the model was "conceived by Santa Ynez Valley artist Oscar Lindberg. Here Lindberg points to wing which will contain 32 beds…," *SYVN*, June 29, 1962, p. 7; "Lindberg Art on Exhibit. An oil painting, 'Blue Pitcher and Onions' by Valley artist Oscar Lindberg, was among the 200 jury accepted paintings hung at the Santa Paula Chamber of Commerce 26th annual exhibit," *SYVN*, Aug. 24, 1962, p. 9; "Lindberg Paintings Shown in Beaumont… five oil paintings in 'The Lamp Post,' a Beaumont restaurant," *SYVN*, Sept. 14, 1962, p. 6; port. of Lindberg and his oil painting of flowers, "… which captured a first award at the Santa Ynez Valley Art Exhibit in 1957" which he donated to the hospital fund drive, *SYVN*, Nov. 2, 1962, p. 8.

1963 – "Valley Organizations Offer Help to Hospital Carnival … **Forrest Hibbits** has donated an oil painting, 'Santa Ynez Valley' …. will be awarded to lucky winners of the drawing… Oscar Lindberg, local artist, is painting the figures for the photo booth where customers with a sense of humor can have their pictures taken," *SYVN*, May 31, 1963, p. 4; "Library Friends Book Fair… One of the highlights of the day was the display of the scale model in color of the new library building, made by Oscar Lindberg. The model is now on view in the branch library room," *SYVN*, Nov. 22, 1963, p. 5; "Library Shows Lindberg Art. New paintings… seen during December until mid-January include two charcoal portraits and four oils…," *SYVN*, Dec. 13, 1963, p. 11 (i.e., 1B).

1964 – "Larson Oils… Oscar Lindberg, who has represented the Friends of the Library in making arrangements for a new display of Valley art work each six weeks since Feb. 1959, will be moving from the Valley with his wife Ann next week and will take up residence in Hemet. …," *SYVN*, Feb. 7, 1964, p. 3; "Oscar Lindbergs Given Farewells. Residents in Janin Acres since 1957 and active in many events in the Valley … left today for their new home near Hemet…," *SYVN*, Feb. 14, 1964, p. 6.

And, more than 150 hits for "Oscar Lindberg" in the *SYVN* between 1930 and 1971, including exhibiting at the Santa Ynez Valley Art Exhibit (1961), and donation of paintings to charities (1962), were not itemized here.

See: "Danish Days," 1957, "Lompoc Community Woman's Club," 1960, "Santa Barbara County Library (Solvang)," 1959, 1960, 1963, "Santa Ynez Valley Art Exhibit," 1957, "Santa Ynez Valley Woman's Club," 1960

Lindberg-Hansen, Jacob
See: "Hansen, Jacob Lindberg"

Lindegaard, Annette I. Negus (Lompoc / Buellton)
See: "Negus, Annette"

Lindegaard, Ruth Elizabeth (1936-?) (Santa Ynez Valley)
Santa Ynez Valley high school student who won a Bank of America Achievement Award for art, 1955. Winner of Poppy poster contest, 1954. Singer. Competed and won in Flower Show floral arrangements, 1968, 1974.
Lindegaard, Ruth (notices in Northern Santa Barbara County newspapers on microfilm and on newspapers.com)
1955 – "Bank Awards Go to Four HS Students… Santa Ynez Valley Union High School… Bank of America Achievement Awards… Ruth E. Lindegaard, in fine arts…," *SYVN*, March 25, 1955, p. 8.
1960 – "Home from Alaska. Miss Ruth Lindegaard arrived last week from Alaska to spend the summer with her parents, Mr. and Mrs. K. P. Lindegaard of Solvang," *SYVN*, May 6, 1960, p. 8; MOTHER – "Funeral Rites Conducted for Mrs. K. P. Lindegaard," *SYVN*, Aug. 12, 1960, p. 8. And, many additional entries for "Ruth Lindegaard" in the *SYVN* between 1950 and 1980 regarding schoolwork and local travels were not itemized here.
Lindegaard, Ruth. (misc. bibliography)
Ruth Elizabeth Lindegaard, mother's maiden name Jorgensen, was b. Dec. 27, 1936, in Santa Barbara County per Calif. Birth Index; Ruth E. Lindegaard is listed in the 1940 U. S. Census as age 3, b. c. 1937 in Calif., residing in Santa Barbara with her parents Kristen P. Lindegaard (age 43) and Thyra V. Lindegaard (age 34) and siblings: Svend, Ellen L., Marian E., and Otto; Ruth E. Lindegaard was residing in Solvang in 1987 per *U. S. Public Records Index, 1950-1993*, vol. 1 (refs. ancestry.com).
See: "Girl Scouts," 1948, "Posters, American Legion (Poppy) (Santa Ynez Valley)," 1954, 1955, "Santa Ynez Valley, Ca., Elementary Schools," 1948, "Santa Ynez Valley Union High School," 1951, 1952, 1953

Lindekugel, Thomas (or) H. H. (Santa Maria)
Welding teacher at Santa Maria Adult School, 1946.
See: "Santa Maria, Ca., Adult/Night School," 1946

Lindholm, Adolf de (Solvang)
See: "De Lindholm, Adolf"

Lindsay, John Carl (1918-1977) (Hollywood)
Actor / artist / architect who exh. along with other
Hollywood notables at Santa Ynez Valley Art Exhibit,
1954.

■ Port. making jewelry and "This LA Architect Doubles
in Diamonds … Lindsay, who says he has been designing
jewelry as a hobby 'ever since I met my first girl at 14,' has
an engineer's approach to the delicate art. Almost
everything has moving parts …," *LA Times*, Dec. 16, 1965,
p. 70 (i.e., pt. IV, p. 6).
Lindsay, John C. (misc. notices)
Architect, John Lindsay, married to actress Diana Lynn,
Long Beach Independent, Dec. 16, 1948, p. 48 (i.e., ?); and
estranged, *Valley Times* (North Hollywood), Aug. 23, 1952,
p. 8, and divorced, *Pomona Progress Bulletin*, July 9, 1954,
p. 27 (i.e.?); June K. Lockhart married John C. Lindsay,
age 41, on April 5, 1959 in San Francisco per Calif.
Marriage Index; married to actress June Lockhart of the
Lassie series, *Independent Star-News* (Pasadena, Ca.), Sept.
11, 1960, p. 65 (9-Scene)? And is head of John C. Lindsay
and Associates, 1955. The Internet reproduces photos of
several homes he designed in the Santa Monica /
Brentwood area of Los Angeles in the immediate post-
WWII era; John Carl Lindsay was b. March 14, 1918 in
Chicago, Ill., married Diana Lynn (and later June
Lockhart), and d. Nov. 24, 1977 in Los Angeles per
Royalty & Peerage Family Tree (ancestry.com).
See: "Santa Ynez Valley Art Exhibit," 1954

**Lindsley, Holt Deland (1897-1974) (Hollywood /
Solvang)**
Former RKO Scenic Art Dept. Head. Decorator in
Solvang, 1953-54.

■ "Decorator's Touch Vividly Seen in Holt Lindsley
Residence… Mr. Lindsley, a licensed painting contractor,
was head of the scenic art department of RKO studios in
Hollywood for 25 years before moving to the Santa Ynez
Valley. He is now in the decorating business here…
Construction on the California ranch style home began in
August of 1952…," *SYVN*, Dec. 11, 1953, pp. 10, 12.
Lindsley, Holt (notices in Northern Santa Barbara County
newspapers on microfilm and on newspapers.com)
1954 – "George Burtness Home… Finishing of the birch in
the kitchen and family room and decorating in other parts
of the house was done by Holt Lindsley…," *SYVN*, March
5, 1954, p. 11; port. antiquing **Santa Ines Mission** interior,
SYVN, Aug. 27, 1954, p. 5.
1959 – "Memo Pad… Holt Lindsley, now at Desilu
Productions in Hollywood and formerly in the painting-
decorating business in the Valley," *SYVN*, Jan. 2, 1959, p.
2.
And, 28 notices in the *SYVN*, some of which show he
worked together with **Paul Kuelgen** on several projects,
were not itemized here.
Lindsley, Holt (misc. bibliography)
Holt Lindsley is listed in the 1920 U. S. Census as a painter
in the scenic department of a motion picture studio and in
the 1930 U. S. Census as scenic artist, motion picture
studio; Holt Lindsley is listed in the 1940 U. S. Census as
age 41, b. c. 1899 in Michigan, head of scenic department,

motion picture studio, residing in Los Angeles (1935, 1940)
with wife, Winifred (age 39) and child Patricia (age 2);
Holt D. Lindsley was b. July 1, 1897 in Menominee, Mich.,
to Asa Herbert Lindsley and Agnes Deland, married Mabel
A. Ashelford, was residing in Santa Barbara in 1965, and d.
Feb. 7, 1974 in Santa Barbara per Her Side of the Family
Tree (refs. ancestry.com).
See: "Signs, general," 1954

Line, Francis Raymond (1904-1920) (Eagle Rock)
Filmmaker who lectured to Minerva Club, 1943.
See: "Minerva Club," 1943 and *Central Coast Artist*
Visitors before 1960

**Linsenmayer, Alice Doris English (Mrs. Rev. Jacob
Ross Linsenmayer) (1907-1995) (Orcutt)**
Artist of portraits, murals. Active Orcutt, during her
husband's pastorage of Orcutt Community Church, 1947-
51. Held a OMS at Santa Maria Library, 1947.

■ "Works of a noted artist now making her home in
Orcutt, Mrs. Ross Linsenmayer, are being shown in the
Santa Maria Public Library in a group comprising a number
of portraits, several of them of Santa Maria valley
residents, five California landscapes and one still life of
flowers, the subject, yellow daisies. Mrs. Linsenmayer is
the wife of Rev. J. Ross Linsenmayer of the **Orcutt
Community Church**, and she is the former Alice English
of San Francisco. She studied sculpture with Charles Porta,
landscape with the late George Berg, and portrait painting
with Matteo Sandona. Her public works include mural
paintings in the First Christian Church of Klamath Falls,
Ore., and in Jackson School at Medford, Oregon. Others
are the reredos in the children's chapel at Grace United
Church, San Francisco, a bas relief reredos in the First
Presbyterian Church in San Francisco, and a bas relief arch
in the First Methodist Church at Klamath Falls. Mrs.
Linsenmayer has exhibited at Meier and Franks in Portland,
Ore., and also with the Independents in New York City, at
the San Francisco Museum of Art, and the Civic Art
Annual in San Francisco. The artist was at one time vice
president of the Southern Oregon Arts Association and
recently a member of the San Francisco Society of Women
Artists. Of special interest in the local exhibit, which will
remain in the public library for a month, are two recently
completed portraits in oils, one of M. Yonan Malek, lately
of Persia, the other entitled, 'Young Navigator' of Warren
Edwin Stowell of Orcutt. The artist has used the mediums
of charcoal and conte crayons as well as oils and several of
her portraits are of Orcutt children with whom she meets in
connection with her husband's work in the church. The
landscapes are of well-known California resort subjects,
one in particular made by Mrs. Linsenmayer at Lake
Tahoe" per "Exhibit by Local Artist at Library," *SMT*, Oct.
16, 1947, p. 3.
Linsenmayer, Alice (notices in newspapers on microfilm
and Internet)
1947 – "Orcutt Pastor Assumes Duties. The Rev. and Mrs.
J. Ross Linsenmayer… **Orcutt Community Church**…
Mrs. Linsenmayer is a native Californian. She studied at
San Francisco Seminary and has served as director of

religious education at First Presbyterian Church and Grace United Church of the Mission in San Francisco. She is an artist whose religious sculptures and murals are features in the decoration of a number of churches and public buildings in San Francisco, Oregon and Nevada," *SMT*, Feb. 7, 1947, p. 4; "Mrs. Ross Linsenmayer Returns from S.F." funeral, and there she restored a painting, *SMT*, March 27, 1947, p. 3; "Five Receive Awards," *SMT*, May 19, 1947, p. 6; teaches art at Washoe County Vacation Bible School, per *Nevada State Journal* (Reno), July 29, 1947, p. 3.

1948 – "Orcutt Church Rededication… New pews, designed and fabricated by A. L. Pabst… A series of beautiful window paintings depicting scenes in the life of Jesus, have been created by artists Alice Linsenmayer and **Jean De Nejer**," *SMT*, May 20, 1948, p. 5; "Los Alamos Church Slates Children's Day… Mrs. Ross Linsenmayer, who is a talented artist, is painting the church windows, a marked improvement…," *SMT*, June 12, 1948, p. 5.

1949 – "Los Alamos Dedicates New Church Windows. Dedication of the six new art windows and rose window of the **Los Alamos community church** will be held at 4 p.m. Sunday. The artist wife of the pastor, Mrs. Alice Linsenmayer, whose murals, mosaics and sculptures have been installed in Presbyterian and Methodist churches in San Francisco and Reno, Nev., and in other communities in California and Oregon, has recently completed a series of 23 original paintings which appear in the six windows of the Los Alamos church. Each window is illustrative of a series of events in the life of Jesus, following a chronological arrangement. At the top of each window is a symbol, which serves as a pictorial title or summary. In their order, the windows represent the Nativity, the boyhood, beginning ministry, continuing ministry, the passion and Resurrection. … The key color of the decoration of the sanctuary in windows, rugs, upholstery is azure blue…," *SMT*, May 19, 1949, p. 7; "Artist Makes Sketches on Trip" to N. Calif. with her Rev. husband, *SMT*, July 29, 1949, p. 5; "Linsenmayers Go to Conference" on church matters, *SMT*, Sept. 14, 1949, p. 6.

1951 – "Orcutt News… Mrs. Alice Linsenmayer is spending the week at San Diego where she is painting a chancel art window for the Linda Vista Presbyterian church," *SMT*, March 3, 1951, p. 5; "Pastor's Wife Designs Window" for Linda Vista Presbyterian Church near San Diego, and article adds, she painted a rose window, *SMT*, March 8, 1951, p. 4; HUSBAND – "Orcutt Pastor is Called by El Monte Church" and extended bio., "The Linsenmayers have served in their present charge for more than four years. Mrs. Linsenmayer is a director of Christian Education of the Presbyterian church and has been active as a leader in area Christian educational programs and a member of the faculty of Presbyterian Summer Leadership schools…," *SMT*, April 16, 1951, p. 1; "Linsenmayers are Guests at Farewell Party," *SMT*, May 2, 1951, p. 4.

1953 – Los Alamos "Community Church Annex…," and history of church including role played by the Linsenmayers, *SYVN*, Oct. 16, 1953, p. 12.

1959 – "Women to Work on Windows at Los Alamos… Mrs. Alice Linsenmayer, wife of a former pastor of the church, will come… on Feb. 6 to help with finishing of strained glass effect windows being installed in **Los Alamos Community Church**," *SMT*, Feb. 3, 1959, p. 3.

1964 – Letter to editor "Matteo Sandona… It was my privilege to study under him for four years, and although I shall miss the annual visits to him and his studio, he will always be a part of San Francisco to me. Alice Linsenmayer," *SF Examiner*, Nov. 20, 1964, p. 38 (i.e., 5C?).

1966 – Repro: "Christ and the Rich Young Ruler" mural in the narthex of Sebastopol Methodist Church, and articles in *Sonoma West Times and News* (Sebastopol, Ca.), May 26, 1966, p. 11 (i.e., 5) and *Press Democrat* (Santa Rosa, Ca.), May 27, 1966, p. 15.

Linsenmayer, Alice (misc. bibliography)
Mrs. Alice Linsenmayer, exec. sec. United Nations Assn. is listed in Summerland without husband in the *Santa Barbara, Ca., CD*, 1970, 1972; Alice Doris Linsenmayer, mother's maiden name Mason and father's Ducey was b. Dec. 14, 1907 in Calif. and d. March 21, 1995 in Del Norte County, per Calif. Death Index; Alice Doris Linsenmayer is buried in the IOOF Cemetery, Crescent City, Ca., with spouse Jacob Ross Linsenmayer per findagrave.com (refs. ancestry.com).
See: "Boy Scouts," 1947, "Community Club (Santa Maria)," 1949, 1950, "DeNejer, Jeanne," 1949, "Guadalupe, Ca., Elementary School," 1949, "Junior Community Club," 1951, "Los Alamos Community Church," "Orcutt Community Church," 1947, 1949, 1957, "Santa Barbara County Fair," 1949, "Santa Barbara County Library (Santa Maria)," 1947, "Santa Maria Art Association," 1949, 1950, "Stained Glass"

Lions Club Home Decoration Contest
See: "Christmas Decorations"

Liotra Prints
See: "Breneiser, Stanley," 1922

Literary Society (Santa Maria)
See: "Art Loan Exhibit (Santa Maria)," 1895, "Farrington, Addie," "Minerva Club," "Santa Barbara County Library (Santa Maria)," intro.

Little Theatre / Theater (Santa Maria)
Built by Alan Hancock and opened 1929. Site of some art exhibits, 1931. Located at Jones and McClelland streets. Opened 1929.

■ "'Little Theatre' City's New Addition… Promised… Architects are at work and in a few days will have completed plans for the proposed 'little theater' sketch which will be erected in conjunction with the KSMR radio studio in the office building of the Santa Maria Valley railroad," *SMT*, Oct. 12, 1928, p. 1; "Santa Maria Little Theatre, Built by Capt. Hancock, Opens Tonight… at Jones and McClelland street… [and interior physically described] … At the rear of the theatre is a fireproof projection room for showing motion pictures… The stage set … was designed and executed by **Gaylord Jones** and certain of the

properties were planned by a committee of the Players Club of Santa Maria…," *SMT*, April 3, 1929, p. 5.
See: "College Art Club," 1931, 1932, "Obata, Chiura," "Parsons, Wayman," "Weston, Brett," 1931

Llords, Daniel, Puppet Theater (not Californian)
Puppet theater that performed before Minerva Club, 1957.
See: "Minerva Club," 1957

Lockard, E. Keith (Santa Barbara)
Architect. Designed one or more Santa Maria Junior College buildings, 1935-36. Son of Grace Lockard, below.
See: "Santa Maria, Ca., Union High School," 1936

Lockard, Grace (Santa Barbara?)
Painter? Exh. "Study of Zaca Lake," at Art Loan Exhibit, Solvang, 1935. Mother of Santa Barbara architect, E. Keith Lockard, above.
See: "Art Loan Exhibit (Solvang)," 1935

Locke, Vance Thomas (1913-1977) (California)
Penny Arts artist. Commercial artist discussed at Alpha Club, 1958. Amateur thespian. Painted murals in Long Island, NY.

■ "Commercial artist, watercolorist. Born in Santa Monica, Ca. on May 29, 1913, Locke spent his early career in Los Angeles. About 1952 he moved north to Los Altos where he remained until his demise on July 23, 1977," per Edan Hughes, *Artists in California, 1786-1940*.
Numerous notices for Vance Locke in the *San Francisco Examiner* show that he taught at the Academy of Advertising Art, illustrated various books, acted in Little Theater, and was president of the Artists Club of San Francisco, but they were not itemized here.
See: "Alpha Club," 1958

Lockwood, Robert Augustus (1893-1949) (Los Angeles)
One of his paintings was distributed to a public building in northern Santa Barbara County by the PWAP, 1934.

■ "Commercial artist, architectural draughtsman. Lockwood served in the camouflage corps in France during WWI and on his return attended the Chicago Art Institute. he was active in Los Angeles from 1926 where he worked for the firm of Myron Hunt and exhibited locally. By 1931 he had moved to San Francisco where his model, who was in love with him, tried to take his life," and bibliography, in Nancy Moure, "Dictionary of Art and Artists in Southern California before 1930," in *Publications in California Art*, vol. 3, and more information in *PSCA*, vols. 1-13.

■ "Robert A. Lockwood. Robert Augustus Lockwood, 56… Born in San Francisco, he had lived in Los Angeles most of his life, moving to El Monte about 12 years ago. He was a free lance artist and had done special art work for motion picture studios and for prominent architects throughout the Southland," *Pomona Progress Bulletin* (Pomona, Ca.), Jan. 25, 1949, p. 15 (Sec. 2, p. 5).

■ "Artist Robert Lockwood to be Buried Tomorrow. … Mr. Lockwood was killed Monday when an automobile he was driving went out of control near Pomona and crashed into a pepper tree. The accident occurred on his 56th birthday. The artist, a member of the Beaux Arts Institute of Los Angeles, made his home at 1429 San Gabriel River Parkway in El Monte. He had won numerous awards for his art work and had specialized in architectural art. He was also noted for his water color achievements. A veteran of World War I, he was cited for gallantry in action in France. He had resided in Southern California for the past 52 years. He was a native of San Francisco…," *LA Times*, Jan. 26, 1949, p. 22 (pt. II, p. 2).
And, many articles in California newspapers on newspapers.com detailing the attempt by his model to kill him, 1931, were not itemized here.
See: "Public Works of Art Project," 1934

Lockwood, Ruth (Santa Maria)
State art chairman of AAUW, 1952.
See: "Santa Maria [Valley] Art Festival," 1952

Lompoc Agricultural Association
See: "Santa Barbara County Fair," 1888

Lompoc, Ca., Adult/Night School
Lompoc's attempt to start an adult school may have first occurred in 1923 but does not appear to have been sustained. In 1934 the town took advantage of the federal government's Emergency Educational Program to teach some adult classes under Edna Davidson. But an official night school does not appear to have been offered until 1935 (?) or 1939 when the high school offered typewriting and lettering. A <u>sustained</u> adult school class in crafts sponsored by the Lompoc school system, did not start until 1940 when the course was delivered by Viola Dykes who continued for 13 years. Crafts classes were first held at the Alpha Club but within a couple of years on the grounds of the high school, and finally, in fall 1947 at the town's new Community Center (the former USO building).
[Do not confuse with the adult craft classes sponsored by the Lompoc Recreation Department, although some of both, after 1947, were held at the Community Center.]
Lompoc, Ca., Adult/Night School (notices in Northern Santa Barbara County newspapers on microfilm and on newspapers.com)

1923 – "Night School to Open Soon… It is the intention of the High School board to open a night school in the near future. The plan, as outlined at present, is to hold the school three nights a week, probably Monday, Wednesday and Friday night. Four of the high school teachers will conduct the classes and the following subjects may be take up… auto mechanics, <u>manual training, drawing (both mechanical and free hand)</u>, Spanish, French and English for foreigners," *LR*, Sept. 14, 1923, p. 1; "Large Enrollment in Night School … will be given a month's trial… There are

at present … 4 in the manual training class under **Mr. Kidman**. There are several other courses open. The art course offers an especially wide field and now that Christmas is drawing near, this course would prove very valuable to the women. Sewing and millinery are also open to anyone … The classes begin at seven and last 'til nine…," *LR*, Nov. 2, 1923, p. 1.

1935 – "Registration Opens for Adult Class in Carpentry… Vocational Carpentry… class will start November 4. One of the small houses being erected near the school campus will be used as a laboratory project. … J. C. Beswick, director of vocational education …," *LR*, Oct. 18, 1935, p. 1.

1939 – "Night School to have Classes in Lettering… weekly on Friday evenings, will be under the direction of **William Bowen** and are held under the sponsorship of the high school… Other trade extension short unit courses such as carpentry, blueprint reading…. and metal work…," *LR*, Nov. 3, 1939, p. 1.

1940 – "First Arts and Craft Class Slated Tuesday… December 3 at the Alpha clubhouse, **Mrs. Kenneth Rudolph** announced. The class is sponsored by the Adult Education class of the high school. Meeting will be held from 9:30 to 11:30 and from 1 to 3:30 in the afternoon. No definite plans have yet been made for the evening class, but if enough members are interested a class will be held Tuesday evening… **Mrs. Viola Dykes** of Santa Barbara has been secured as the instructor…," *LR*, Nov. 29, 1940, p. 1; "Arts and Craft Class… launched… by **Mrs. Viola Dykes** of Santa Barbara who will act as instructress … An attractive display of pottery, tool copper, Mexican crackle, cut-out felt pictures, wood books and other articles was placed this week in the window at Rudolphs' grocery store. Townspeople wishing to register for the course … Mrs. Dykes conducts arts and crafts classes in Santa Barbara… Classes will be held at the **Alpha club** and will be held all day. Evening classes will also be held. Art and needlework will be taught, rugs, colonial and Italian quilting, knitting, crocheting, silk lampshades and many other types of arts and craft will be taught," *LR*, Oct. 18, 1940, p. 2; "Arts and Crafts Classes held Weekly Here. The second of a series … was held at the Alpha clubhouse Tuesday, with **Mrs. Viola Dykes** of Santa Barbara as the instructor. The classes are being sponsored by the adult classes at the high school. Classes are being held in the morning, afternoon and evening, with a large number of townspeople enrolled… Classes are held every Tuesday at the clubhouse. **Mrs. Kenneth Rudolph** is in charge… Enrolled in the course are…," and long list of names, *LR*, Dec. 13, 1940, p. 7.

1941 – "Pottery Work Added to Craft Classes. Pottery work is one of the new projects launched by the Handcraft class … at the **Alpha club**house… The classes, which were started early in December, are under the sponsorship of the Board of Education and are open to the public… **Mrs. Viola Dykes** of Santa Barbara is the instructor … Classes, which have been postponed during the holidays have been resumed," *LR*, Jan. 10, 1941, p. 3; "Exhibition of Art Needle Work and Craft Held… at **Alpha clubhouse** Tuesday under the supervision of Mrs. **Viola Dykes**…," *LR*, Jan. 31, 1941, p. 2; "New Handcraft Class to Start. In

answer to many requests for an additional night besides Tuesday, a new class in handcraft will start on Monday evening at the high school at 7 p.m. All forms of art work, pottery, metal work, tray-making, etc. will be offered. No charge… only a small fee is levied for the material used…," *LR*, March 14, 1941, p. 2.

1942 – "Night class to be Launched… Another class which has reopened following a brief vacation is the arts and crafts classes under the directorship of **Mrs. Viola Dykes**. These classes are being held daily from 10 to three o'clock and on Tuesday evenings from seven to nine o'clock. Classes have been well attended by officers' wives and other towns women," *LR*, Sept. 25, 1942, p. 3.

1943 – "Craft Classes Reopened at High School… under the adult education program… with **Mrs. Viola Dykes** as instructor. Mrs. Dykes has conducted craft classes for adults at the high school for several years. The new series will be open from 10 to 12 o'clock each morning and from 1 to 3 o'clock in the afternoon," *LR*, Oct. 15, 1943, p. 8.

1944 – "Arts and Craft Classes to Resume Tuesday. With the advent of the re-opening of schools the arts and crafts classes conducted by **Mrs. Viola Dykes** at the high school will be resumed next Tuesday… These classes are being held under the auspices of the Adult Education. Mrs. Dykes, accompanied by her daughter, flew to San Francisco last week to visit relatives," *LR*, Sept. 1, 1944, p. 2.

1945 – "Upholstery Classes. Adult classes in arts and crafts, including upholstery, are again in operation in Lompoc High School under direction of **Mrs. Viola Dykes**. Additional room has been provided, she said, and all persons interested in the work may now be accommodated. Classes are held from 10 a.m. to 3 p.m. daily except Saturday and on Tuesday and Wednesday evenings from 7 to 9:30," *LR*, Sept. 14, 1945, p. 4.

1946 – "Adult Education Classes to Close… conducted at the high school by **Mrs. Viola Dykes**," i.e., no summer school, *LR*, June 13, 1946, p. 8; "Adult Education Class Visits Show in Santa Barbara… exhibit of crafts at the Community Institute… The exhibit featured work done by adult education classes at the city schools in leatherwork, pottery and wood carving. Those attending the exhibit from Lompoc were: **Mrs. Viola Dykes, Betsy Burgess, Bea Potter, Betty Carlson** and **Jo Ruth Rogers**, all of the adult education class in Lompoc," *LR*, June 20, 1946, p. 9; "Mrs. **Dykes** to Re-Open Adult Education Class… at high school…," *LR*, Sept. 19, 1946, p. 3; "High School Expands Adult Education Plan… four subjects… shorthand… Craft classes are conducted daily from 10 to 12 in the morning and from one to three in the afternoon by **Mrs. Viola Dykes**. Craft classes are also held from seven to nine p.m. on Tuesdays and Wednesdays. A class in sewing has also been opened…," *LR*, Oct. 10, 1946, p. 9.

1947 – "Adult Education … A change in class schedules and an expansion in program were announced this morning… by **Mrs. Viola Dykes**, director of adult education… Classes formerly held on Wednesday evenings will be moved up to Monday. This will mean that **Mrs. Dykes** will be giving instruction in home crafts Monday

through Wednesday from 9:30 a.m. to 3:30 p.m. and on Monday and Tuesday evenings from 7 to 9:30 p.m. A variety of crafts are being studied by local housewives. The latest addition will be ceramics. … made possible because clay has become available …. Leather work, home decoration, furniture covering have been favorites in the classes in the past and are being continued… Silk lamp shades are being given particular attention…," *LR*, April 10, 1947, p. 5; "Adult Class Registration Started Monday… classes in upholstering, homemaking and interior decorating, Spanish leather carving, general crafts and ceramics began at the Community Center on Monday morning under **Mrs. Viola Dykes** … Classes will begin on Wednesday. They are to be held from 9:30 to 3:30 Monday through Friday and from 7:00 to 9:30 on Monday and Tuesday evenings," *LR*, Sept. 11, 1947, p. 3; "Lompoc Views… Community Center Opening… Pioneers Reception … Not directly related to the Pioneer reception but also a part of the exhibition at the Community center, was a showing of articles made by the Adult Education class members and Camp Fire Girls and Boy Scout exhibits. Exquisite hand-made dolls, Spanish leather carving, lampshades, cloth handiwork and remodeled chairs made over from dilapidated ones…," *LR*, Sept. 11, 1947, p. 16; "Schools Report High Enrollment… Two adult education classes have been opened… In addition, … classes in crafts and home decoration are drawing a record number of students," *LR*, Oct. 2, 1947, p. 1.

1948 – "New Projects… A new project of combining ceramic bowls and spun copper or brass lamp standards has been taken up by the Adult Education classes at the Recreation Center. **Mrs. Viola Dykes**, instructor of the classes, announced that she will spend the week end purchasing lamp frames and needed materials for the new project. The lamps will feature ceramic bowls made and decorated by the students with spun copper or brass forming the standards. The lamp shades will also be made by the students in colors to match the ceramic designs. … ceramics made in her classes are fired by **Mrs. Nickson** in Santa Maria. …," *LR*, March 18, 1948, p. 6; "Adult Education Classes to Move Mon. into Community Center Annex … classes conducted here by **Mrs. Viola Dykes** will open Monday in new quarters … Mrs. Dykes said that the new premises will make it possible to increase the number of students enrolled by more than 20, with eight more being accommodated in the upholstery classes. The classes have been conducted in the Community Center for the past year, but a shortage of space was limiting the enrollments. The city council approved alterations in the annex buildings in order to make the move possible. Mrs. Dykes said that she has a waiting list of persons desiring to enroll…," *LR*, Aug. 5, 1948, p. 2.

1949 – "Adult Classes Show Gains in Enrollment… operated by the high school with state assistance. … Best attended of the classes is the arts and crafts conducted by **Mrs. Viola Dykes** at the community center. Her classes accounted for 43.32 of the total average daily attendance, with enrollment running as high as 80 during the semester…," *LR*, March 3, 1949, p. 5; "Enrollment Shows Increase… Registration for adult education classes at the Lompoc high school will open Monday… These classes

will be in addition to the adult education classes conducted at the Community Center by **Mrs. Viola Dykes**… At the Center, classes are being offered in upholstery, leatherwork, ceramics and related subjects…," *LR*, Sept. 8, 1949, p. 1.

1950 – "Art Work on Display. An exhibit of handwork and ceramics made by the adult education classes will be displayed along with paintings by **Forrest Hibbits** during both the afternoon and evening meetings of the **Lompoc Community Women's club** Wednesday afternoon. The hand work and ceramics display are being exhibited by **Mrs. Viola Dykes**. The exhibits are open to the public," *LR*, Feb. 2, 1950, p. 2; "Ceramics Movie to be Shown. A motion picture demonstrating methods of making and glazing ceramics will be shown at Community Center twice on Tuesday. … 3 o'clock in the afternoon and … 7:30 o'clock that evening. Information… may be obtained from **Mrs. Viola Dykes** … The showings are open to the public," *LR*, May 4, 1950, p. 7; "Adult Education Classes Wind Up Successful Year… under the direction of **Mrs. Viola Dykes**… Held as a branch of the local high school, the classes have been staged at the Community Center since the opening of the school term. While each person supplies his own material… and pays a two and a half cent fee for each piece fired in the kiln, admittance to the class and use of the tools and equipment is free… **Mrs. Dykes** is leaving here this week for Grass Valley where she will teach advanced ceramists in a class at the Barngrover studio the last week in July and the first two weeks in August. She will also take ceramic work herself in Los Angeles following the northern summer session. The concluding class year yesterday marked **Mrs. Dykes** 11th year teaching adult education classes in Lompoc…An exhibit of work done by students… this year will be on display at the **Rexall Drug** store when Mrs. Dykes returns the latter part of the summer," *LR*, June 29, 1950, p. 9.

■ "Adult Education Program Faces Discontinuance. Unless some method can be devised to make the Lompoc adult education program self-supporting, it will be dropped this fall, according to a decision of the school board … The program is now financed approximately 80 per cent by the state and … the cost to the school district is only about $300 per year. A tuition system similar to that used two years ago may be invoked… Average daily attendance at the day-time adult education classes conducted by **Mrs. Viola Dykes** at the Community Center has been running in excess of 40. Practically all of the enrollment consists of Lompoc women who are studying arts and crafts such as upholstery, ceramics and leather work. Two years ago when the school board decided to discontinue the classes, a strong protest in the form of the petition delivered to the board… was reconsidered with the proviso that tuition of 50 cents per month be charged thereafter… majority of the board were of the opinion that the adult education program should be discontinued 'so long as it cost the high school district a cent.' … The classrooms used for the adult education program at the Center were formerly called the **USO** annex and were used for emergency housing for wives of servicemen stranded in Lompoc during World War II without accommodations," *LR*, Aug. 24, 1950, pp. 1, 8; "Adult Education Classes Due for Airing Tonight…

The school board voted two weeks ago to shelve the program, discontinuing the classes in arts and crafts conducted for the past several years by **Mrs. Viola Dykes**...," *LR*, Sept. 7, 1950, p. 1; "Adult Education Program Okayed by School Board ... board voted unanimously to reopen the classes and seek a renewal of a lease on the annex building at the Community Center. Approximately 50 interested citizens were on hand for the board meeting... practically all of them appearing to support adult education... The board agreed with the proviso that the classes be self-supporting... This will mean that a 50-cent tuition will be charged... The chief bone of contention has been the class in arts and crafts conducted by **Mrs. Viola Dykes**. The classes have been held heretofore in the Community Center annex. Nelson said that as the classes have been considered of recreational value, there is every probability that the space will again be available at the center. ... The schedule calls for classes in typing, shorthand, music appreciation and arts and crafts... **Mrs. Viola Dykes** will teach classes during the days at the Community Center annex in home arts and crafts. Tentatively the classes will cover ceramics, upholstery, leather work and lampshade making...," *LR*, Sept. 21, 1950, pp. 1, 7; "Seventy-Nine in Initial Sign Up... The initial roll showed 43 students in **Mrs. Viola Dykes'** classes in home arts and crafts. The classes meet Monday through Thursday in the Community Center annex beginning at 9:30 a. m. and closing at 3:30 p.m. Evening classes in the subjects are offered Tuesdays and Wednesdays beginning at 7 p.m.," *LR*, Sept. 28, 1950, p. 1; "Adult Education Program Has 133 Enrollments... In addition to the civilian classes, arrangements are being completed for the local schools to conduct classes for military personnel stationed at Camp Cooke," *LR*, Nov. 23, 1950, p. 7.

1951 – "Closing Date of Adult Education May be Extended. Army wives, their husbands, and the public generally are reminded by **Viola Dykes** of the Adult Education department, that if enough interest is shown in upholstery, ceramics, leather carving, silk lampshade making or interior decorating, the department, instead of closing June 30, will be open through July ...," *LR*, May 3, 1951, p. 5; "Adult Education Classes Close for Summer. Mrs. **Viola Dykes'** adult education classes... will be resumed on September 11 with the same schedule as has prevailed during the past year... The classes, conducted in the annex of the Community and Servicemen's Center...," *LR*, June 28, 1951, p. 7; "Enrollment in Adult Education Classes Hits 117.... Despite the record enrollments, there were openings in most classes... Among the classes still open... needlecraft (covering knitting, crocheting and sewing) ... Nearly enough registrations have also been received for woodwork... Mrs. **Viola Dykes'** adult education classes conducted at the Community center annex have openings for Ceramics, leather craft, general crafts and homemaking...," *LR*, Sept. 13, 1951, p. 1.

1952 – "**Public Schools Week** Programs Draw Crowds... [following a concert] ... Exhibits will be opened at 9 p.m. at which time refreshments will be served... The Adult Education program was also being given recognition through exhibits of ceramics, upholstery and kindred

artifacts in the windows of the **Camera Shop**, Rudolph's Store and American Jewelers. Works on display are representative of the production of more than 70 adults who are attending classes conducted by **Mrs. Viola Dykes**," *LR*, May 1, 1952, p. 8; "Adult Education... Many of the classes in charge of **Mrs. Viola Dykes**, are held in the Recreation Center... upholstery... lampshades... draperies... home decoration... ceramics... carving in leather... **Mrs. Dykes** has been conducting such classes in Lompoc for the last 14 years and before that in Santa Barbara. And before that she was designing silk lampshades for one of San Francisco's swankier department stores. One of the nicest things about the Adult Education classes is that those who sign up receive this expert advice for a 50 cents month tuition fee. Those who go in for ceramics may have items fired for five cents per article and this means two firings, regardless of size of the article. However, there are other classes, such as typing, shop work and driver education... Suggestions for classes will be received by **Mrs. Dykes**, such as for all kinds of rug making, and will be formed if a sufficient number of registrations are received," *LR*, Sept. 11, 1952, p. 8; "Adults Eager ... the fee is 50 cents a month. Now registered in the ceramics alone are 52... One of **Mrs. Dykes'** students is a woman 77, and she is in the delightful throes of upholstering a chair... Another, a bride of a little more than a year, although she is 69, has availed herself of the adult classes' advantages of ceramics... crocheted rugs...," *LR*, Oct. 9, 1952, p. 5; ■ "Dresden-Style Ware will Feature New Semester of Adult Education Classes. From far away Guam comes a nostalgic letter to **Mrs. Viola Dykes**, head of the Adult Education school at the Community Center. It is from Miss Dora Wood, formerly with the Red Cross at Camp Cooke. She had asked for foreign service and was sent to the station in Guam. While at Camp Cooke, Miss Wood was a member of the ceramics class conducted by Mrs. Dykes and she writes: 'I have missed the ceramics class awfully. Guam offers very little to do, and I could really have fun here with a hunk of clay.' The ceramics class at the Center is one of the most popular, although all classes have been filled to capacity. An innovation to be introduced with the re-opening of classes on January 5, 1953, will be porcelain work. All the porcelain slip and clay is imported from England and when the pieces are completed have the genuine, delicate appearance that hallmarks Dresden ware. This effect is achieved with actual lace, bought here, and which disappears during the firing, leaving only the lacy detail in the clay. Ceramics promises to be one of the most popular classes at the Center and in the past has accommodated as many as 75 students. There will be two openings ...and also in the class in which lamp shades are originally designed and made. Leatherwork, too, popularly known as 'Spanish carving,' has had many students who make all sorts of articles... such as bags, brief cases, wallets ... Another craft is tooled copper and the refinishing of furniture. More recently the re-caning of chairs has been an interesting activity... The school is conducted four days a week from 9 a.m. until 4 p.m., also Tuesday and Wednesday evenings from 7 until 9:30. Sessions closed today for the holidays to re-open when the high school semester begins, on January 5," *LR*, Dec. 25, 1952, p. 16.

1953 – "School Board Discontinues Adult Class. Adult education classes in ceramics, upholstery and kindred arts have been dropped by the high school district and the lease on classroom space at the Community Center has been cancelled… The classes were taught for several years by **Mrs. Viola Dykes**… classes in other subjects would be organized provided there is enough interest and facilities are available," *LR*, Oct. 8, 1953, p. 1.

1954 – "History of Pottery … Adult students in the pottery making class, which convenes each Monday and Wednesday evening in room 15 at the high school, are learning ancient as well as modern techniques of the potter. **Conley McLaughlin**, high school art director who teaches the class, said: 'Our approach is a little different than in most pottery making courses. We are not making ceramic plates or ashtrays or small animals with flowered topknots. Instead, we're concentrating on the traditional art of the potter – the hand molding, individual design, and the use of the potter's wheel. In addition, we are studying the pottery of ancient civilizations and exploring methods and materials used by the old artisans.' McLaughlin added that he has patterned the course closely along the lines of those offered in universities," *LR*, April 1, 1954, p. 5; "Adult Education in Lompoc… has come in for severe criticism because of the manner in which it has been administered in some school systems. At a time when the schools are crying for more money to finance legitimate educational programs, it does not sit well that public funds should be used to teach grown-ups how to dance or play ping pong. For several years, tax money was used here to teach local matrons how to upholster their furniture, make ceramic ear rings and other arts and crafts. It was finally concluded by the school board, however, that all available local school funds should be used to give boys and girls an education and to teach adults courses which would improve their chances of making a living…," *LR*, Sept. 23, 1954, p. 10.

1955 – "27 Adults Sign Up for Art Classes… at the high school … **Conley McLaughlin**, high school art teacher, is the instructor…," *LR*, Jan. 6, 1955, p. 14; "Ceramics Material Available. All former members of the Adult Education ceramics class who are interested in obtaining a small portion of porcelain slip may do so by phoning 4812 or 8-1112 and leaving their names. Requests for the material must be made before March first," *LR*, Feb. 10, 1955, p. 4; "Letters. Re: Ceramics… we do want to make an attempt to reach, inspire and encourage someone to open a ceramic shop here in Lompoc… The accommodations that we have had here since the close of our Adult Education system will no longer be available. The little shop is closing as of Dec. 20…," *LR*, Nov. 3, 1955, p. 2.

1956 – "Adult Education Class in Welding is Offered…," *LR*, Jan. 5, 1956, p. 3; and other classes offered are for First Aid, Typing, Electronics, and Upholstery.

1957 – "Arts and Crafts Classes Offered by High School. Tuesday evening between the hours of 7:00 and 9:00 p.m. ... The first class will be conducted tonight with **Alex Rule** as instructor. Instruction will be given on ceramics, jewelry and leather work on Tuesday and Thursday evenings. A minimum enrollment of 16 persons will be required to continue the course, and a tuition fee of 50 cents per month

will be charged. Providing there is sufficient interest, painting classes will also be offered,' *LR*, March 14, 1957, p. 9; "Lompocans Take to Arts & Crafts. Lompocans enrolled in the Arts and Crafts class meet each Tuesday and Thursday evening with instructor, **Alex Rule**, in the workshop at the local high school. Now in the second week of instruction, students are proceeding with their initial endeavors which include leather work pieces, ceramics or jewelry making. The instructor plans to include a class in oil painting when and if students require the addition. Presently enrolled are the Mmes. Georgina M. Hough, Flo Price, Lulu Lockwood, Darlene Landon, Wilma Roberts, Arlene Welke, Betty Baum, Ann Wheeler, Esther Nykreim and Mrs. Howard Wang; Art Nykreim, Howard Wang, Robert Valentine and the Misses Aileen Olivera, Emma Guevarra and Betty Roberts," *LR*, March 28, 1957, p. 8.

1958 – "Adult Craft Class Starts… next week at the Lompoc High school… Tuesday and Thursday nights from 7 p.m. until 10 p.m. Instruction will be offered in lapidary … leathercraft, metal enameling and other phases of jewelry making… **Alex Rule**, art and crafts instructor at the high school, will conduct the classes," *LR*, Oct. 9, 1958, p. 15.

1959 – "Night Adult Classes to Start Here October 12… The basic courses… include… arts and crafts (including many kinds of crafts) …," *LR*, Sept. 28, 1959, p. 9.

1960 – "Curriculum Due Board… the board approved adult education classes in… typing, basic English, shorthand, bookkeeping, crafts and Algebra I…," *LR*, Sept. 10, 1959, p. 20; "Adult Education Slated… starting October 10… Classes tentatively planned… Vocational Arts… mechanical drawing, metal shop and woodworking… Art, *LR*, Sept. 22, 1960, p. 1; "Adult Education… It is interesting to note then that last year the district ended up only with classes in typing and shorthand. They attempted to organize English, Spanish and other language classes, science, mathematics and others. However, no interest was shown…," *LR*, Sept. 22, 1960, p. 6; "213 Signups … Breakdown of registrations… art, 9… mechanical drawing, 2…," *LR*, Oct. 3, 1960, p. 1; "Adult School Gets New Courses… Art, Tuesdays and Thursdays, Exercise Room … Mechanical Drawing, Tuesdays and Thursdays, Room 33 …," *LR*, Oct. 13, 1960, p. 25.
See: "Alpha Club," 1940, 1941, "Ceramics," "Community Center," "Emergency Educational Program," "University of California, Extension"

Lompoc, Ca., Community Center
See: "Community Center (Lompoc)"

Lompoc, Ca., Elementary Schools (aka Lompoc Grammar School and others in the system)
From earliest years the Lompoc Elementary School included drawing in its curriculum. At the turn of the 20th century sloyd, the manual arts program that combined art with hand/eye coordination was faddish. Olivia McCabe (1908/11) followed by Isabel Cordoza was sloyd teacher (1919). As time went by "art" gained respect in its own right as a precursor to various careers, and students exhibited their products during the annual Public Schools Week. The 1930s saw a fad for puppetry. In the 1950s art helped students learn history through making maps, drawings and models of people, events and costumes.
History of early elementary schools appears in "Old Records Tell Growth of Pioneer Schools in Valley," *LR*, Sept. 3, 1953, pp. 9, 11.
[Only notices on art in the schools were cited under this heading. Elementary age "artists" were not given individual entries in this Dictionary.]
In the 19th century, emphasis was placed on drawing and at the turn of the twentieth century on sloyd. By the mid-1930s the making of puppets and the carving of soap came into favor.
Lompoc, Ca., Elementary School (notices in Northern Santa Barbara County newspapers on microfilm and on newspapers.com)

1888 – "The school in Miguelito Canyon closed on Friday, Nov. 30th, with a full attendance… The exercises consisted of songs and recitations… We must not omit to mention that the room was tastefully decorated with flowers and toyon berries, the blackboards also covered with drawings showing considerable talent…," *LR*, Dec. 15, 1888, p. 3.

1889 – "Grateful Pupils… As **Mr. I. Weill** has shown the kindness to present our school with three beautiful paintings… we … do vote a resolution of thanks…," *LR*, Feb. 16, 1889, p. 3; "The crazy-work silk banner representing the State of California by counties, gotten up by the pupils of the Principal's room of the Lompoc school, is on exhibition at the store of **I. Weill** & Co.," *LR*, July 13, 1889, p. 3, col. 1.

1890 – "On Friday evening of last week the Maple School gave a literary and musical programme… The drawings on the blackboard were fine…," *LR*, May 3, 1890, p. 3; "Town School Exercises. We had the pleasure of going through the schoolhouse on Saturday and seeing the blackboard drawings of Friday's exercises. The exercises consisted of Entomology and the insects injurious to garden vegetables and fruits. The drawings of the apple, peach, pear, quince and lemon were fine works of crayon art…," *LR*, May 17, 1890, p. 3; "The Superintendent of Schools was present at the local teachers' association on Saturday… The subject of drawing was introduced by **Miss Idella Rudolph**… The various subjects were discussed by the teachers and several pupils from the town school took part," *LR*, May 24, 1890, p. 3, col. 3, and "The school work to be exhibited today will consist of drawings and classwork…," col. 2; "Lompoc at the Institute… Lompoc makes a very extensive exhibit from the primary and intermediate grades… Lynden district is well represented by … well executed drawing… The perspective drawing from Artesia district deserves particular attention… Maple district has several pictures

illustrating poems and stories, one from the 'Lady of the Lake,' which is well executed … Bear Creek offers eight papers with the bear himself guarding them, and some fine drawings…," *LR*, Sept. 27, 1890, p. 3.

1909 – "Pupils Will Exhibit Work. On Friday, June 4, the Lompoc Grammar School is going to have an exhibit of manual training and drawing. The drawing will be on exhibition in the third grade room … there will be a class of boys at work in the sloyd room. There will also be shown work done by the pupils…," *LR*, May 21, 1909, p. 1; "Large Attendance View Wonderful Display of Articles Executed by Pupils… from the second to the eighth grades… Much credit is due to **Miss McCabe**, the Sloyd instructor, for the rapid progress made in manual training… Owing to the increase in the school there is not room to accommodate all the grades and part of the manual training room has been occupied by one of the other grades… There is no reason why manual training should not be taught in the high school…," *LR*, June 4, 1909, p. 1.

1910 – "These will Teach Youth of County … Lompoc … **Olivia McCabe** Sloyd and Sewing – 8th, 7th, 6th, 5th, 4th grades. Paper Sloyd – 3rd and 2nd Grades. Mechanical Drawing, 7th and 8th grades. Marguerite Rennie, 7th grade, freehand drawing – 8th, 7th and 6th grades… **Lillian Dodge**, 5th grade, freehand drawing – 5th, 4th and 3rd grades… Lompoc Union High School … **Marie Simon**, Commercial branches, botany and drawing, **Olivia McCabe**, manual training … Santa Maria Union High School … **Frances J. Heil**, drawing, manual training…," *Independent* (Santa Barbara, Ca.), Sept. 5, 1910, p. 8; "Valley School Appointments… Santa Ynez. Lompoc Grammar School … **Olivia McCabe**: sloyd and sewing… Mechanical drawing… Marguerite Rennie, 7th grade, freehand drawing … **Lillian Dodge**, 5th grade, free hand drawing… ," *LR*, Sept. 9, 1910, p. 1.

1914 – "Shall Lompoc Have a Public Kindergarten?... Some of the parents of children between the ages of 4 ½ and 6 years are considering the establishment of a public kindergarten… The purpose of a kindergarten is not to relieve parents of the care of their children or to prepare them for the regular school work or to make precocious children. The kindergarten is to enrich the lives of the children with songs, stories, and games acted out or played. They learn good manners and to respect the rights of other children. They learn simple sewing, drawing and weaving. It develops them on all sides," *LR*, May 15, 1914, p. 1; "Grammar School Exhibition. Friday, May 29, at 3 p.m. at the grammar school there will be an exhibition of drawing, manual training and domestic science…," *LR*, May 22, 1914, p. 4; "Grammar School Art Department. Art has its place in the school curriculum just as well as reading and arithmetic and tho' its study probably does not directly lead to the making of ones living, it does assist every other subject in that it teaches accurate observation and it cultivates the power of appreciation through which we are enabled to find the beauties in the most lowly and the most commonplace. Different kinds of drawings teach different lessons. For instance, freehand drawing of models and standard art and proportion, landscape and plant life, the idea of composition, power of construction and good color

harmonies. Design is the most practical of all school arts, in that its application to other problems teaches the idea of correlation, which thus opens the field to actual life. Drawing, as a guide to the artistic in all arts, is becoming more and more important as a school study, and from our first grade where the little hands are taught to give expression to imaginative ideas, through the 8th the different phases of the subject are studied and are creditably expressed through the mediums of pencil, charcoal, crayon, India ink and water color. The Grammar school expects to exhibit its school arts, May 29th and a cordial invitation to attend is extended …," *LR*, May 22, 1914, p. 9; "Last November, the **Elson Art Publishing Co.**, of Belmont, Mass., under the auspices of the High and Grammar schools, exhibited carbon prints of the world's most famous master pieces. The collection displayed was of general interest for there were pictures of child life, animal life, court pictures, landscapes, pictures portraying legendary and historical subjects as well as those which were sacred and religious. The pictures were all and more than represented, and were heartily enjoyed by the pupils as well as by the community at large. The Grammar school entertained the public one afternoon during exhibit week, the principal feature of the program being art talks on selected pictures by the pupils of the various grades. The proceeds from the exhibit, which netted $54.65, was invested in selected pictures for the different school rooms. The class which sold the most tickets for the exhibit was to be awarded a prize picture. There was considerable enthusiasm and rivalry displayed among the grades, but the 8th was the most successful and the prize picture was theirs. The pictures purchased were 'Sir Galahad' and 'A Member of the Humane Society' (prize picture) for the 8th grade, 'St. Barbara' for the 7th, 'Dance of the Nymphs' for the 6th, 'Shoeing of the Bay Mare' for the 5th, 'The Lake' for the 4th, 'The Train' for the 2nd, 'I Hear a Voice' for the 1st, 'Cat and Kittens' for the 3rd. Most of the pictures were framed when received; those which were not were framed by the boys of the sloyd department under the supervision of **Miss Gorham**," *LR*, May 22, 1914, p. 9; "San Julian School… [7 pupils, school is surrounded by nature] … For drawing for instance, the children take a delight in finding mushrooms and the different wild flowers as they come out. One day two silk worms were taken to school to be drawn; another day at noon they all went to the creek and caught some polliwogs for the same purpose…," *LR*, May 22, 1914, p. 13.

1916 – "School News… Grammar School Briefs … A new course has been introduced in the 7th grade this year, namely book-making. This course is for the girls and will last one half year. It will be followed by basketry. The object of the course is to give the girls the same training in accuracy and concentration that the boys should get in the sloyd classes. The materials are paper and velum used on clip board as a foundation. The models are note-books, scrap books, a desk set, clipping file, etc. This work is correlated to some extent, with drawing under **Miss Coffin**…," *LR*, Sept. 22, 1916, p. 4; "Grammar School Briefs… **Miss Coffin** has some very interesting art work from the various classes on exhibition in the hall of the new building," *LR*, Oct. 13, 1916, p. 5.

1917 – "Grammar School Exhibit. On Friday evening, May 25, at 7:30 o'clock, there will be an art exhibit after the Parent/Teacher meeting at the grammar school…," *LR*, May 18, 1917, p. 1; "Grammar School has Excellent Exhibit. The sloyd, art and handwork exhibit at the grammar school last Friday was very favorably commented on… The exhibit was held in the afternoon and evening… nicely displayed in the new building… The exhibit in sloyd was especially good and reflects well upon the teacher, **Miss Kerr**. Useful articles such as stands, footstools, cedar chests, tables, medicine chests, hat racks, bread boards, shoe stands, hall racks, taborets, etc., were on display… sewing exhibit… The art work and hand work by the children of the primary grades made a most interesting exhibit in the west part of the building, while in the central corridor the art exhibit by the advanced scholars was worthy of careful consideration. The latter was exhibited by the pupils of the 6th, 7th and 8th grades, **Miss Coffin** being their special art teacher. The exhibit was a charcoal work, plaster of Paris work and mechanical drawing," *LR*, June 1, 1917, p. 4.

1919 – "Four Teachers in Serious Auto Mishap … Miss **Isabel Cordoza**, sloyd teacher in the grammar school…," *LR*, Dec. 26, 1919, p. 1.

1922 – "Work of Finishing School… Lompoc's new grammar school building is now in the finishing stage…," *LR*, March 31, 1922, p. 1.

1924 – "Grammar School Will Have an Exhibit. On next Thursday, December 11… exhibit of hand work at the grammar school… The exhibit will consist of drawing, sewing and sloyd work that has been done this year by the children. Every room will have an exhibit and the school will be open all afternoon to visitors," *LR*, Dec. 9, 1924, p. 4; "Grammar School has Creditable Exhibit," *LR*, Dec. 12, 1924, p. 7.

1925 – "'Creative Education' is Discussed by Principal… Lompoc school as a special demonstration school… six demonstration schools in the county… new things. An industrial program of about one-half hour daily has been put over in nearly all the rooms and this is the busiest and happiest half hour of the day. When possible, this is the last half hour of the day. During this period the children are allowed to choose the thing they wish to create … At present activities prevail along the line of sewing, embroidering, stencil work, original tray making, pillow making, bead making, desk pads, poster making, art of different kinds, rug making and wood work. Each room is doing the thing best suited to the capacity of the children…," *LR*, Oct. 9, 1925, p. 8.

1930 – "Portrayal of Indian Life Given by Pupils of Purisima School… Wednesday morning with an original play portraying early Indian life. All properties and costumes were made by the children…," *LR*, Nov. 28, 1930, p. 1.

1932 – **Public Schools Week** Observed… Grammar School Active… two days devoted to a display of art work prepared by the pupils. The display was opened on Wednesday and was visited by approximately 200 parents and friends… The walls of the corridor were covered with

colored drawings and paintings by the children as well as a map showing the distribution of resources of California and one illustrating the areas inhabited by Indian tribes prior to the occupation of the state by the white race. In the latter map the northwestern part of what is now Santa Barbara county was shown to have been populated by the Chumash Indians, many of whose one-time implements and adornments were to be seen in a display case nearby. They had been picked up by Principal **Clarence Ruth**…," *LR*, April 29, 1932, p. 2.

1934 – "Elementary School Gains **Mural** from San Francisco Man. As a favor to his friend, Principal **Clarence Ruth** of the Lompoc Elementary School, **Fred Berger** of San Francisco donated considerable time and artistry to painting a beautiful mural on the wall of the school cafeteria… done in oils and depicts a water scene, graceful pink flamingoes standing boldly out from a background of tall green bamboo and blue sky with water lilies dotting the water where the birds stand feeding… Mr. Ruth plans to have another mural painted on the west wall of the cafeteria and feels very fortunate in having had the work donated," *LR*, Feb. 23, 1934, p. 6; "Elementary… 5th Graders Plan for Puppet Show…," *LR*, March 2, 1934, p. 11; "Elementary School News… Fourth Grade… pupils are making the missions of California. They are drawing some and making others out of soap and Celite bricks. They are hanging the pictures on the wall and displaying the models," *LR*, March 16, 1934, p. 4; "Elementary… Puppet Show Staged… ," and details, *LR*, March 30, 1934, p. 11; "Visitors Watch Classroom Work… observance of **Educational Week**… Art exhibits on the different grades, including the first efforts of the kindergarten pupils, to those of the more advanced work of the sixth grade pupils, were on display in the corridors of the buildings and in the class rooms. Most of the drawings were creditable to children of the ages represented … and many showed artistic talent…," *LR*, April 27, 1934, p. 7; "Elementary PTA Observes **National Education Week**. [at its regular program] An interesting talk on arts and crafts was given by **Miss Edna Davidson**, art teacher, who has until recently conducted art classes under the **EEP** free of charge to the students. Articles made by the pupils and articles to be made were displayed by Miss Davidson, who explained some of the ideas carried out in modern art," *LR*, Nov. 16, 1934, p. 7.

1935 – "Founder's Day to be Observed… **Clarence Ruth**, principal of the Lompoc Elementary school, related interesting historical facts about **La Purisima Mission**… [and article gives extensive original building details] … pointed out the various points of interest on a painting of the mission, on the back wall of the stage which is the work of **Edwin Beard**…," *LR*, Jan. 18, 1935, p. 4; "Miguelito Pupils Enjoy Picnic… Water colors were used by the children in painting eggs for the [Easter egg] hunt. Place cards and baskets for an Easter entertainment were made by pupils, and first and second grade students colored half-shells and placed small flower plants in the shells to be presented to their mothers," *LR*, April 12, 1935, p. 9; Crayon Panel on transportation is Sent to S. D. Fair… by Charlotte Hager, daughter of Mr. and Mrs. Charles Hager…" by her fourth grade teacher in the Lompoc grammar school…," *LR*, May 17, 1935, p. 10; "Pupils Send

Picture of State Relief Map to **Exposition**" in San Diego "Begun as a fourth grade project in California history…… Miniature adobe bricks… Miniature airplanes and hangar," *LR*, May 17, 1935, p. 10; repro: Architect's drawing of the proposed addition to the local elementary school, *LR*, Oct. 4, 1935, p. 1; "Puppet Show Given by Santa Rita Pupils," *LR*, Dec. 27, 1935, p. 3.

1936 – "Fifth Graders Give Puppet Show for Classmates… under direction of Miss Dorothy Snyder… Famous characters in the history of the United States… class project in connection with **Public Schools week**," *LR*, May 1, 1936, p. 7.

1937 – "Art Exhibit at PTA Meet. Rural schools are bringing art exhibits to show to the public at a meeting of the elementary school Parent-Teacher association Wednesday afternoon in the new auditorium of the local school. Of especial interest… will be the exhibit from La Purisima school, which has been working with clay modeling and baking. Art will be the subject for the afternoon's program and an art teacher will be the guest speaker," *LR*, March 19, 1937, p. 3; "Art Understanding is Discussed by Mrs. Croswell at PTA Meet. 'Art is merely a language of lines and form,' stated **Mrs. Mary T. Croswell**, head of the art department at Santa Barbara State college, before a meeting of the elementary PTA Friday afternoon. Greater understanding of art is necessary among teachers if they are to teach the 'art language' to their pupils… Practical art, the designing of buildings, cloth, furniture and other useful subjects… should be taught… Illustrating this she displayed many art articles made by the students at Santa Barbara State college and at Carpinteria high school. Principles of design and color were the main examples displayed. Photography, freehand cutting, water colors, Batik work and commercial posters were included," *LR*, April 16, 1937, p. 3.

1939 – "5 Local Youths Confess Series of Burglaries… Practically all of the burglaries were undertaken in isolated parts of the district… local elementary school was burglarized and a quantity of tools and drawing instruments were taken…," *LR*, March 17, 1939, p. 8; "Mr. [**Ernest**] **Brooks** had to take the pictures [photos] over of **Mrs. Berger**'s class Thursday, because it was not clear enough to get a good view of the pupils," *LR*, May 12, 1939, p. 6.

1940 – "Every Thursday afternoon we have Art and Hygiene. In art we make things out of wood. Some of these are belts, trays, plant holders, waste paper baskets and many other things. We have it from one to two and our teacher is **Mrs. Berger**…," per "Sixth Grade News," *LR*, March 1, 1940, p. 2; "Miguelito School Gives Program… Marionette show 'Children of Many Lands' was given by upper class students with the puppets made by the pupils themselves…," *LR*, June 14, 1940, p. 3.

1948 – "Work of Artesia, Maple School Children Recognized. A bus load of school children from the Maple and Artesia districts traveled to Santa Barbara, Wednesday, where they visited the Museum of Art, where a special exhibit of classroom art was on display as part of the Southern California Supervisors conference. Highlighting the visit… was the fact that their exhibit at the museum was

given recognition as the outstanding work in the show. … **Joseph Knowles** art consultant… assembled the materials from various schools in the county for the exhibition," *LR*, April 29, 1948, p. 14 (i.e., 6).

1949 – Repro: drawing of the new <u>Lompoc Elementary & Junior High School</u> by Daniel, Mann & Johnson, <u>architects</u> & school planners," *LR*, Nov. 24, 1949, p. 1.

1950 – "School Bond Vote Set. Board Reduces Goal … While all details have not been worked out, the building plan at the high school covers construction of a new gymnasium and shop buildings. The elementary school program will include the acquisition of a site for a new school and the construction of buildings adequate for 10 classrooms," *LR*, Jan. 19, 1950, p. 1.

1954 – Photo of children in school and caption reads "fifth graders (right) who are enjoying their <u>arts and crafts</u> studies under <u>Mrs. Lorene Brummel</u>…," *LR*, Feb. 4, 1954, p. 7; "<u>Maple School</u> Pupil Reports on Santa Barbara Trip… Our first stop was to be the <u>Goleta Educational Center</u>. … When we got to Goleta, we were just in time to see our <u>mural</u> on California go up in the hall…," *LR*, March 18, 1954, p. 9.

1957 – "Art Review by **Moselle Forward**… Artists have never been able to explain their creations… drawings, paintings, sketches – any kind of art work is a medium of expression complete unto itself… The four first prize winning art pieces submitted by promising young artists in classes at the <u>Hapgood school</u> each have something to say to the beholder. 'Sheperds' [sic.] by Bette Withrow, 4th Grade … 'The Christmas Story' by Eileen Negus, 5th grade … 'Sea-scape' by Eddie Escobar of the 6th Grade… 'An Original' by Eddie Casarez, 7th Grade…," and ports of Withrow, Negus and Escobar, *LR*, Jan. 17, 1957, p. 5; "<u>PTA Carnival</u> … in Elementary School auditorium… The <u>puppets</u> will be brought to the show by **Kansas Ed Davis** who has been manipulating the comical characters since his wife put the finishing touches on them in 1952 … The Puppet Show is scheduled to start during the evening's fun at 7:30. **Kansas Ed** and his characters will be on hand the remainder of the evening to present shows, visit with the children, and entertain all comers…," *LR*, Feb. 28, 1957, p. 5; "<u>Lompoc Elementary</u> Curriculum, Kindergarten Thru Grade Four… Kindergarten… Language Skills: Objective is to develop desirable habits in listening and talking, to provide outlets for feelings and ideas in <u>drawing, painting, clay modeling</u>, building, dramatizing and other artistic expression…," *LR*, June 6, 1957, p. 13.

See: "Knowles, Joseph," "Lompoc, Ca., Junior High School," "Posters," "Posters, American Legion (Poppy) (Lompoc)," "Puppets" "Schools (Northern Santa Barbara County)," "Teacher Training"

Lompoc, Ca., Junior High School
A new Junior High School was built in 1926. The Hapgood school was built, 1953. Art teachers were Mary Cardoza followed by Kenneth Carr. In 1960 the Lompoc Junior High was moved to the high school campus. Special, elective, art and mechanical drawing classes were sometimes taught by high school teachers.

■ "Lompoc Building a New Junior High School… four-room frame stucco building…," *SYVN*, July 30, 1926, p. 1. [Only notices on <u>art</u> in the schools were cited under this heading. Jr. high age "artists" were <u>not</u> given individual entries in this Dictionary.]
<u>Lompoc, Ca., Junior High (notices in Northern Santa Barbara County newspapers on microfilm and on newspapers.com)</u>
1933 – "Eight A <u>Art Class</u> (by Stanley Phoenix) During the last semester we have made many <u>colored plates and designs</u>. We studied diamond, fan, and square shaped framework as a background for design. The drawings have been done in water color, paints and crayons. We make our own designs for each plate," *LR*, Feb. 3, 1933, p. 5.
1934 – "Students Drawing <u>Maps</u>… The 7B students under the supervision of <u>Mr. Morris</u>, are drawing maps of the United States. These maps are being made to give us a better idea of the location of the large cities. …," *LR*, Jan. 19, 1934, p. 8.
1935 – "Changes in Class Arrangement… for <u>teaching of home economics, mechanical arts, art and music</u>… In previous years, classes have been scheduled to give each student a little of each of these subjects, boys taking mechanical arts while girls studied domestic science. Present curriculum changes call for instruction in art and music in the seventh grade, with home economics and mechanical arts being taught in the eighth grade. 'In the junior high is the place for the pupils to discover their aptitudes for these subjects… Under previous schedule… the pupil did not get enough of any one subject to determine which suited his talents best," *LR*, Sept. 27, 1935, p. 5; "Seventh Grade Pupils Make Relief Maps," *LR*, Oct. 4, 1935, p. 4.
1949 – Repro: drawing of the new <u>Lompoc Elementary & Junior High School</u> by Daniel, Mann & Johnson, architects & school planners," *LR*, Nov. 24, 1949, p. 1 [this was not built owing to lack of money].
1953 – Hapgood School built.
1954 – "4 Teachers Hand in Resignations … **Miss Mary Cardoza**, junior high art teacher for the past year who is accepting a position in San Luis Obispo," *LR*, May 20, 1954, p. 2; port of **Richard Storey** and "Twenty-One Join School Faculties… Richard Story, previously in the Army, will teach seventh grade reading, spelling, <u>arts and crafts</u>. He has a B. A. degree from the School of Art Institute, Chicago…," *LR*, Aug. 26, 1954, pp. 1, 8.
1956 – Photo of "New Teachers at Hapgood School… Mr. **Kenneth L. Carr** of Ceres, Calif., Art teacher," and "Twenty-Seven Teachers Join Lompoc Faculties … **Kenneth L. Carr**, Fresno State…," *LR*, Sept. 6, 1956, p. 2.
1957 – Photo of Hapgood School teachers including **Kenneth Carr**, 7th grade and art, *LR*, Aug. 22, 1957, p. 16.
1959 – Vandenberg Junior High School constructed, *LR*, Jan. 15, 1959, p. 1.

1960 – "Courses Proposed for Junior High Students for Coming School Year Allow for 'Room at the Top' … Required subjects proposed for seventh graders at Lompoc Junior High are: … an elective of Art, Music or Science for one semester. In addition, they are required to take nine weeks each in woodwork, mechanical drawing…," and continued details of various grades along with their required and elective subjects, *LR*, Feb. 8, 1960, p. 3; "Double Sessions May End in Fall … Lompoc Junior High School now on the high school campus," *LR*, Feb. 25, 1960, p. 1.
See: "Posters," "Schools (Northern Santa Barbara County)," "Teacher Training"

Lompoc, Ca., Police Department
Photography was utilized by the police in the solving of crimes. The Lompoc Police Department had its own photographic plant, 1942.

■ "Modern 'Sherlock Holmes' Method… 'Mugging' criminals and finger-printing suspects may be age-old routine to metropolitan law enforcement agencies, but to Lompoc, the installation of a modern police photography plant and other technical equipment marks one more step in the miniature 'social revolution' which has taken place here during the past eight months. The photography plant, installed by the city council at the recommendation of Chief of Police William Petersen and equipped principally by **Serg. C. P. Beach** of the Highway Patrol, brings the city up to standard in this phase of crime detection and prevention and includes high-powered cameras and a dark room equipped for developing and printing photographs. Already the equipment has come in handy in convicting a hit-and-run driver… The dark room is operated cooperatively by the State Hiway Patrol and the city police department. State patrolmen are equipped with cameras in order to photograph the scenes of accidents where criminal charges result. Because only photographs which remain in the hands of the police are allowed as evidence in court, it became necessary to equip a dark room at the local police office. **Sergeant Beach**, who heads the Highway Patrol locally, does the dark room work for the patrol and **Officer R. O. Smith** is the photography expert for the city police. Since being equipped for photography and finger-printing, the local police have been able to tie in with the state and federal crime detection systems. Criminals arrested locally are 'mugged' and finger-printed. Copies of the prints and the photographs are sent both to the FBI and the state, to discover whether the arrested persons have previous criminal records and whether they are wanted by police in any other city. The effectiveness of the system was demonstrated last week when it was found that a man arrested here on a morals charge had been arrested for similar offenses before," and photo of Beach and Smith in the laboratory, *LR*, April 17, 1942, p. 1.
1958 – "**Police** Dept… The present building occupied by the department is 20 feet by 90 feet containing three offices, a squad room, a photographer's room, dark room for developing pictures, general storage room, and cell blocks…," *LR*, May 8, 1958, p. 22.
See: "Police"

Lompoc, Ca., Recreation Department
The City Recreation Commission was formed 1946. During the school year, Forrest Hibbits taught painting, 1948. Classes were often held at the Community Center (the former USO building converted in 1947) and year-round included crafts. Summer schools (offering sports and crafts and whose specific programs were announced annually in the newspapers) were held at various playgrounds and parks, c. 1946+.
[Adult school classes overseen by the school system should not be confused with Lompoc Recreation Department programs for adults, although both, after 1947, were held at the Community Center.]

■ "Organization of City Recreation Department… (This is the fourth in a series of articles concerning community recreation in Lompoc…) The activities at Community Center are under the direction of the Superintendent of Recreation employed on a full-time, year-round basis. The superintendent also directs all other recreation activities sponsored by the City Recreation Department held in various parts of the city. These included during the past year: Summer playground at Ryon Park, [various sports], … special events sponsored or assisted by the Recreation Department were **float** in 4th of July parade; Children's Costume parade at La Purisima Mission Fiesta… picnics and barbecues at the parks. The Recreation Department office acts as an information center for various recreational activities and facilities… swimming pool in Santa Maria and reference material on various sports and hobbies. … The superintendent is assisted by a part time employee…. When the Community Center was opened in September 1947, **C. S. Shelly** was the superintendent. He set up a comprehensive system of bookkeeping, reports and filings … 'Hardy' Pelham served as assistant and was instrumental in starting the Lompoc Film Council, representing various community organizations… **Mrs. C. S. Shelly** taught adult classes in block printing. **Mrs. Phil Tognetti (nee Betti Weber)**, taught yarncraft… **Forrest Hibbits**… has taught classes in water color and oil painting… **Adult Education** classes sponsored by the High School District, rent quarters in the annex of Community Center. **Mrs. Viola Dykes** is conducting the craft classes which have been commended by authorities as being outstanding in the state. Present staff of the Recreation Department are as follows: Ted Grant, superintendent, has had extensive experience in Army Special Service and in recreation programs in New York State…," *LR*, Sept. 30, 1948, p. 20.
Lompoc, Ca., Recreation (notices in Northern Santa Barbara County newspapers on microfilm and on newspapers.com)
1945 – "City Recreation Commission Act Passed by Board," *LR*, Sept. 7, 1945, p. 1;
1947 – "Christmas Card Making to be Studied… City Recreation department starting on Friday evening, October 24, in the club room of the Community Center. The activity will be handled by **Mrs. C. S. Shelly** an experienced craftswoman," *LR*, Oct. 16, 1947, p. 14; "Adult Classes in Crafts are Commenced. … Christmas card designing and block printing… Several techniques and examples of design were demonstrated by the instructor, **Mrs. Helen Shelly**. There will be no class held on Friday, October 31, it being Hallowe'en night, but the group will meet again on

Friday, November 7. Starting today, craft instruction for youths and teen-agers will be provided by the department. **Mrs. Shelly** will also handle this activity. Block printing, crepe paper work and other crafts are to be included. This group will also meet at 7:30 p.m. in the club room of the Community Center...," *LR*, Oct. 30, 1947, p. 8.
1948 – "Hibbits to Give Art Course at City Center... The course will be offered only if a minimum of 10 persons sign up with the department prior to February 15...," *LR*, Jan. 29, 1948, p. 3; "Art Class proves Popular... under the leadership of **Forrest Hibbits**... 13 students registered for instruction in water color and oil painting... The group is currently working on still life arrangements and the instructor expects to add landscape painting in the near future," *LR*, March 4, 1948, p. 3; "Art Classes are Continued... Classes in landscape watercolor painting are continuing to be held twice weekly in the Community Center with **Forrest Hibbits**... as instructor. The classes are on Tuesday and Friday afternoons from 1:00 p.m. to 3:00 p.m. Instruction in other art media is also being offered and information regarding classes may be obtained from ... the Community Center," *LR*, June 3, 1948, p. 3; "Plans Nearly Complete for Art Classes... City Recreation department ... a plan for classes in still life and landscape painting has created wide interest... **Forrest Hibbits** ... will provide the instruction, Classes will be held at the **Community Center** two afternoons a week from 1:00 p.m. to 3:00 p.m. with Tuesday and Friday afternoons being the probable days for the classes. The course, designed primarily for the beginners, will stress water color techniques but individual instruction in oils and other art media can be provided if requested... A nominal registration fee of $5.00 per student for a four-week course will be charged... registration for the class will close on February 15...," *LR*, Feb. 5, 1948, p. 6.

Korean War
1950 – "Recreation Center Building will be Reopened by **AWVS**... With the outbreak of the Korean crisis... many of the **AWVS** services carried on during World War II will be renewed. The local unit is working closely with the Lompoc AWVS unit where the reopening of Camp Cooke is bringing many of the old war problems to that community. Plans are being made there to open the Recreation Center, the former **USO** building, for the use of the service men...," *SYVN*, Sept. 15, 1950, p. 1; "Lompoc Gets Top Priority from State in G. I. Rec. Aid Request," *LR*, Oct. 26, 1950, p. 1; "Servicemen's Center" – essay on who will fund a local recreation program for servicemen, *LR*, Nov. 9, 1950, p. 14.
1951 – "Annual Report on City's Recreation Program... With the reactivation of Camp Cooke some changes were made regarding the use of the recreation building by children and teenagers... curtailing the use of the City Center at night for boys up to the age of 16 years. Girls were not admitted unless chaperoned... change of policy was to permit the free use of the building for off-post recreation for soldiers and adults only... the Community Center is now known as the Community and Servicemen's Center. The Recreation department staff... is endeavoring to handle the greatly expanded recreation activities... During World War II, the same building was operated by

the USO and had a staff of 4 full-time directors...," *LR*, Feb. 15, 1951, p. 3.
1957 – "'Play' for Lompocans Ready for Use at Recreational Department Anytime... located at the Community Center... dancing, ... arts and crafts and swimming...," *LR*, Jan. 10, 1957, p. 12.
1960 – "Classes in Crafts Set by City. Adult Christmas Crafts Classes that will cover various fields... will be held in the Annex Building of the City Hall, 119 West Walnut Ave.... So that mothers with children on double session at school may attend, there will be a morning class from 10 a.m. to noon on Wednesdays and an afternoon class from 1:30 to 3:30 p.m. on Thursdays... Enrollment will be limited... A few of the Crafts to be covered are Christmas card making, candle making, enameling on copper, glass etching and mosaics," *LR*, Oct. 10, 1960, p. 12.
1961 – "New Ceramics Class Scheduled. Tomorrow morning at 10 a. m. a new class in Ceramics will start under the instruction of **Betti Tognetti**, former owner of **Betti's** Ceramic Shop in the Annex Building beside the City Hall. Anyone who has not already registered is invited to come and see if there are vacancies in the class. The activity is sponsored by the Recreation Dept. of Lompoc," *LR*, May 1, 1961, p. 5; "Ceramic Classes Held Each Tuesday... in the Annex building at City Hall... every Tuesday morning from 10:00 to 12:00 noon... **Mrs. Tognetti** has a large selection of greenware available to her students and she does the firing," *LR*, Oct. 5, 1961, p. 14.
1963 – "Knitting-Crocheting Classes Offered... instruction by **Mrs. Betti Tognetti**... Classes start September 9 and continuing for ten lessons every Monday afternoon at 1:00 p.m. in the Administrative Office meeting room at 105 South 'C' St.... Mrs. Tognetti will teach the making of gifts for coming birthdays and holidays," *LR*, Sept. 5, 1963, p. 8.
See: "Community Center (Lompoc)," "Summer School (Lompoc)"

Lompoc, Ca., Union High School
In the late nineteenth century, freehand drawing was provided – if it happened that the single or small staff had talent in art. In the early twentieth century educators realized that mechanical drawing could lead toward various careers and so it was offered. In the teens sloyd and manual training (in carpentry and metal work) was added to the curriculum per the vogue to add vocational subjects to the academic. Art" such as needlework and arts and crafts to make items for the home as well as costume design and interior decoration were taught to Domestic Arts students. Toward 1930 students focusing on fine arts enjoyed specialized classes in aesthetic subjects, leading either to college work or to careers in commercial art. Their projects often had practical purposes, such as posters, costumes and stage sets for school plays and the Jamboree (1933+). They also designed the school annual, La Purisima, beginning c. 1928. Teachers of freehand drawing or art include Holton Webb (1888-92), Frank Miller (1891), Miss Florence Sollman (1903/06?), Olivia McCabe (1908-11), Marie Simon (1910/11), E. Juanita Nicholson (1911-14), Addie Vadney (1914-16), Otis Hyde (1916/17), Helen Rose (1919/20?), Florence Van Sant (1919-20), Violet Beck

(1921-23), Ethel Colledge (1923-25), Frances Jones (1925-27), Vina Queisser (1927-31), Muriel Moran (1933-34), Mary Bucher (1934-38), (Margaret Morton (1938-40), Crystal Lund (1940-45), Virginia Murray (Fall, 1945), Margharite Colby (Spring, 1946), Margaret Hodgdon (1946-51), Conley McLaughlin (1951-56), Louise Hunt (1955), Alex Rule (1956-58).
Teachers of <u>manual training</u> / sloyd include Olivia McCabe (1908/11), Miss Lona L. Gorham (1912-14), Robert Chesnut (1914-16), Otho Gilliland (1919-), Mr. Kidman (1922-), Joseph Lenfest (1924-26), Harry Nelson (1926-46), Mr. Garrison (1931-), Dean Upton (1946-), and others. Teachers of <u>manual drawing</u> were often the same as teachers of manual training but also include Lee Sims (1925/29), Mr. Cummins (1934), Lester Sabin (1955).
Domestic art (crafts, interior decoration, dress design) was handled by the Domestic art teacher.
<u>Lompoc, Ca., Union High School (notices in Northern Santa Barbara County newspapers on microfilm and on newspapers.com)</u>

1889 – "A Few Way Notes. A Visit to Los Alamos, Lompoc and Other Points… One of the most prominent features of Lompoc… is the school house… **Mr. Webb** has charge of the <u>high school</u> department. He is one of the most able instructors in the State and has had about 14 years experience as a teacher. The room over which he presides is adorned with two very original designs for mottos…. Some of the class work in <u>pen drawing</u> is very fine. It equals anything of the kind exhibited at San Francisco a year ago. Mr. Webb has four grades in his room…," *SMT*, June 29, 1889, p. 2.

1891 – "The exercises at the high school yesterday… The Sistern [sic.? Sistine] Madonna awarded by the State Board of Education to our school was placed on the wall with appropriate exercises… The 'Biography of Raphael' read by Miss Sanor was instructive and well written. An 'Order for a Picture,' by Master George Allen was given in that young man's best manner… The floral decorations and <u>blackboard drawings</u> were very artistic and appropriate. The scene on the Hudson drawn by **Master Frank Miller** was truly a work of art in blending of colors and shading. The Great Seal of California was drawn well… But the most pleasant surprise to all was the beautiful picture of the Yosemite presented to the school by **Arthur Balaam**. We believe our school has one of the most efficient corps of teachers to be found in the State…," *LR*, April 4, 1891, p. 3.

1905 – "'*The Beam*, Lompoc Annual for Year 1905… [according to the text] this year the students have decided to change their school paper's [sic. annual?] name from the '*Mustard Stalk*' to '*The Beam*'… On the school faculty are … **Miss Florence Sollman**, English, History, <u>Drawing</u> and Spanish… Within the last two years Spanish and <u>Drawing</u> have been added to the list of studies …," *LR*, Sept. 1, 1955, p. 14.

1909 – "The Union High School… will open Monday, August 2d… The addition of the new courses will depend considerably upon the interest displayed in them. A course in general elementary science will be given and courses in

<u>freehand and mechanical drawing</u>, natural geography and additional business courses … university accredited…," *LR*, July 23, 1909, p. 1; "Union High School Notes … The study which leads to a greater appreciation of Nature as well as of the works of man, is drawing. <u>Drawing</u> is also practical. Better houses, better barns, more beautiful places and towns, can be produced at no greater expense if drawing is understood. Drawing may develop latent ability and bring to the one who can draw the keenest enjoyment of common things. As Warner has said, 'Art is not a thing to be done but the best way of doing whatever needs to be done.' The two great needs of the Lompoc Union High School are courses in agriculture and drawing…," *LR*, Sept. 3, 1909, p. 1; "Attendance Not Up to Standard. At present there are fifty-seven pupils attending the Lompoc Union High School. The number should be one hundred and ten… The studies, which are attracting the most interest – the only ones which answer the child's demand for activity – are commercial subjects… If agricultural training were introduced, if drawing were added to the curriculum… there would then be other outlets for the natural demand of the pupil – the demand for activity… Miss M. V. Lehner, Superintendent of Schools of Santa Barbara county, has announced in a daily paper, that during the ensuing year <u>manual training</u> and agricultural arts will be taken up by the schools throughout this county. This step was taken to develop the practical mind of the pupil … pupils must know how to CREATE things. Drawing goes hand in hand with the above as well as leading to creation along the line of applied art …," *LR*, Sept. 17, 1909, p. 1.

1910 – "Pleasing Program Rendered… remarks, which Mr. Rowell, the principal, gave… 'The high school, as it stands, if compared with other high schools similarly placed, is a failure… If pupils of high school age wander the streets or loaf at home when they might obtain a free education, then the educational system of the high school is a failure. The responsibility is fourfold: The parents, the children, the teacher and the school board … Our school will continue to be a failure unless there are other studies besides the purely mental… we must teach music, drawing, cooking, manual training and agriculture…'," *LR*, Feb. 11, 1910, p. 6; "Valley School Appointments… Lompoc Union High School… **Marie Simon**, commercial branches, botany and drawing, **Olivia McCabe**, manual training …," *LR*, Sept. 9, 1910, p. 1.

1911 – "Schools Open, July 31st… **E. Juanita Nicholsen [Sic. Nicholson]**, formerly of Ventura, will teach <u>freehand drawing</u> and the commercial branches… to teach cooking and <u>sloyd</u> in both the grammar and high school. …**Miss Cooper**, a graduate in domestic science…," *LR*, July 7, 1911, p. 1, and p. 8, col. 1.

1912 – "High School Will Exhibit… Wednesday, May 29, in the High School Assembly Hall… actual school work. There will be <u>drawings, freehand, mechanical</u> and applied… other oral and written work, articles of cooking and sloyd…," *LR*, May 24, 1912, p. 1; "High School Force Chosen… **Miss Juanita Nicholson** will teach <u>drawing</u> and the commercial branches… **Miss Lona L. Gorham**, who is to have the <u>Sloyd</u> department is a new member of the faculty… Miss Gorham… are from the Santa Barbara

Normal School of Home Economics and Manual Arts…," *LR*, July 5, 1912, p. 1; "High School Notes… The drawing class and advertising committee have been making posters and advertisements for our rally, tennis tournament with Santa Ynez and our season of events to be given at the opera house. These posters are now in several windows of the town…," *LR*, Oct. 25, 1912, p. 8; "Honor List of Students… Seniors… Subject honors… Dimock, Harold, solid geometry and drawing… McDonald, John, solid geometry and drawing… Simpson, Earl, solid geometry and drawing… Sophomores… Moore, Ernest, drawing… Pierce, Marie, drawing…," *LR*, Nov. 15, 1912, p. 8.

1913 – "The High School Exhibition… program of gymnastics, folk dances, music and lantern slides showing some of the Normals and the Universities of the state. All afternoon work of the classes in sloyd, sewing, domestic science and drawing will be on exhibition…," *LR*, May 23, 1913, p. 7; "Boys and Girls. Go to High School… The high school of today is a sample house of the different kinds of knowledge and of the different kinds of occupations… [a student] should take … freehand drawing for self expression, for bringing out any latent talent, or for preparation along mechanical lines …," *LR*, Aug. 8, 1913, p. 2; "H.S. Art Exhibit Well Supported. [loan exhibit] … The community was really interested in looking at the copies of the master-pieces of the world, and the students of both schools were very much interested in picking out the pictures that they liked best. In some classes the students were required to make out a list of the best ten pictures, according to their judgment… The schools cleared $104.90 on the project…. Thus making $54.90 for each school for the investment in pictures from the **Elson Art Publication Company** of Belmont, Massachusetts… six or seven carbon photographs of the masterpieces of the world … They will come unframed, but there is a plan on foot to have the pictures framed by the students in Manual training. The beautiful picture, 'The Song of the Lark,' has been presented to the Senior Class…," *LR*, Nov. 28, 1913, p. 2.

1914 – "Special Exhibition of Applied Arts at the High School Assembly Hall and the New Manual Training Building, 2 to 4 p.m., Friday, May 22, 1914… Works will be exhibited from the departments of Science, Drawing, manual training, domestic science and domestic art. Several masterpieces in art secured by means of our art exhibition in the fall will be shown for the first time. Short program and refreshments…," *LR*, May 15, 1914, p. 4; "Happenings of the Week… A merry company… First Year Cooking Class of the Lompoc Union high school… The place cards were designed and made by the drawing class of **Miss Nicholson** who is a very competent teacher," *LR*, May 22, 1914, p. 16; "The Policy and Plans of the Lompoc Union High School… This year we are expanding our work in manual training and in domestic science and art. … furnishing the rest of the house… We hope to be able to furnish some rooms in the town the coming year … A good foundation has been laid the last few years in both the domestic science and domestic art work and in the manual training work. This next year we shall carry on carpenter work in one form or another. We hope to have the boys of the manual training department construct a gymnasium for

the high school under the direction of their teacher. For the carpentry we have secured the services of **Robert A. Chesnut** of Needles, California. Mr. Chesnut has been in Needles for the past three years doing good work along those lines. Last year the boys under his direction put up a seven-room building for the manual training work… the board of trustees have just erected a manual training building of a foot thick solid concrete reinforced walls, with a roof of red burned clay tile. This building should last a century or two…," *LR*, May 22, 1914, p. 18; "Exhibition. On Friday afternoon May 22nd, the manual training, domestic science, sewing and drawing departments of the Lompoc High School gave their annual exhibition… at the new manual training building… short program … Miss Lottie Whipple, in behalf of the drawing classes, presented the 'Winged Victory' purchased with the money cleared from the pennant sale, to the school… At the conclusion of the program the guests were invited to the new manual training building to inspect the work of the various departments. One feature of this exhibit was a room in the southeast corner of the building fitted up as a bed room … The various pieces of furniture were picture frames, a fumed oak bed stead, a dressing table and a tabourette of the same material, made by Miss Leoti Steele and a dressing table, a chair and rocker with woven cane backs and bottoms and a cedar chest made by Miss Vivian Saunders. In the main room of the building and in another small room, the walls were adorned with beautiful drawings and water color works done by **Miss Nicholson**'s pupils. In the east part of the main room was the furniture made by the other pupils. At the other end of the room the walls were lined with the sewing and fancy work done by the sewing classes…," *LR*, May 22, 1914, p. 19; "Drawing Department. One year of freehand drawing is required of all students in the high school, and for those planning to take up engineering, medicine or any of the scientific courses in college, two years of freehand drawing are required. For any kind of engineering one year of mechanical drawing is required. One period of forty minutes a day, in freehand drawing, counts as a unit and a half toward graduation. While two periods a day of mechanical drawing counts as three units toward graduation. The freehand drawing is divided into two main divisions – representation and design. Under representation comes, first – the study of light and shade and perspective, this is the regular object or model drawing; second – nature drawing, or the careful study of flowers, making drawings of the structure of different parts, joining, and the color; and third – some outdoor sketching when the weather permits. In the beginning the subject of design, attention is first given to simple borders, using abstract forms, then becomes conventionalization of flower and leaf forms using the flower studies made earlier. These units are used in patterns for wall paper, silks, curtains, book-covers, magazine decorations, etc. Freehand lettering is studied, as during the school year we do all the advertising for the high school sports and entertainments. This gives a knowledge of advertisement spacing and wording. Some simple crafts work is done in bookbinding and in each case original designs are applied. In mechanical drawing, facility with the use of mechanical instruments is obtained by beginning with simple geometrical constructions and advancing to

more complicated drawings, all of which require the greatest accuracy. Working drawings are also an essential part of this course," *LR*, June 5, 1914, p. 5; "News of Lompoc… The high school will open next Monday with the following corps of teachers… **Addie M. Vadney**, Domestic Science and Art, Drawing… **Robert A. Chestnut** [Sic. **Chesnut**] Manual Training, Carpentry, Metal Work…," and list of studies and years in which various courses are taken, *LR*, June 26, 1914, p. 3.

1915 – "Honor List at the Lompoc High School… Freshmen… Myrtle Pierce, Drawing… Minnie Rennie, Drawing…," *LR*, April 2, 1915, p. 7; "Attend High School Exhibit… of the manual training and home economics department… work done by the pupils… revelation… proficiency … Furniture that had been constructed by the pupils made the largest display … Clarence Plumm had the largest display of furniture, this consisting of a Morris chair, a rocker, table, pedestal and chair. The boys are constructing two children's' tables and eight chairs for the public library … They have also constructed a complete set of domestic science tables for the school this year and framed the pictures that adorn the interior wall of the new manual arts building. As an incentive the pupils are allowed to dispose of articles manufactured, a display of a cedar chest being on exhibition by Herman Hodges, this being the third one the young man has made and disposed of. Nor was the display confined to the advanced grades for among the freshmen pupils came exhibits that were of real merit. Howard Reed exhibited a serving table and Dottie Steele a dressing table… Metal Work. Although metal work has only been taken up since Christmas, the school made a very good display… Home Economics. This exhibit consisted of a large exhibit with a wide range of plain and fancy sewing, embroidery, crocheting, etc. … Drawing. All admired the display of drawing which was exhibited as taken from the various stages of the course. First came the simple work, then the geometrical models, the light and shade effects, plant forms, the design and water colors. The mechanical drawings with the intricate problems also were admired…. Miss **Addie M. Vadney** is in charge of the sewing and cooking classes and has one class in free hand drawing. Mr. **R. A. Chestnut** [Sic. **Chesnut**] is in charge of the classes in wood work, metal work, mechanical drawing and also has one class in free hand drawing. Their work speaks for itself…," *LR*, May 21, 1915, p. 1; "High School Honor List… Seniors (11 in class) … Subject honors… Edward Bissinger, American History, drawing… Juniors (17 in class) … Clinton Stillman, carpentry, drawing… Sophomores (37 in class) … Vera Balaam… Mech. Drawing… Chester Ruffner, Mechanical Drawing, Drawing. Leslie Smith, Arithmetic, Drawing … Freshmen… Lucile Rudolph, English, Latin, Drawing…," *LR*, Dec. 10, 1915, p. 10.

1916 – "Elect High School Principal… The resignations of Mr. Boudreau, **Chesnut** and Miss Mitchel have been received. Mr. Chesnut has accepted a position with the El Centro high school as manual training teacher with a large increase in salary. The trustees are endeavoring to get a man for the manual training department… who will also teach freehand drawing and mechanical drawing…," *LR*, May 19, 1916, p. 1; "High School Exhibition … will be held in the Assembly Hall and Manual Training Building… June 2…," *LR*, May 26, 1916, p. 1; Exhibit of Manual Arts… Practically all of the work completed this year was shown… This consisted of several dressing tables, dressers, rocking chair, arm chairs, library tables, two dozen straight chairs that were made for the public library, a number of cedar and oak chests and other pieces of furniture too numerous to mention. The display of mechanical drawing attracted much attention. While visiting the high school recently, Prof. Washburn, the examiner sent out by the University of California, stated that the mechanical drawings of our students were among the best he had seen in the state and compared well with the work as given in the University. The carpenters class exhibited two poultry houses… **Prof. R. A. Chesnut** has had charge of this work in our high school for the past two years but he's leaving to head the mechanical arts department of the Central Union High School at El Centro, California," *LR*, June 9, 1916, p. 8; "High School News. The increased enrollment and the consequent larger classes… **Mr. Hyde**'s drawing classes are so large that they need a whole building to themselves. Consequently they have moved from Room ?, one of the large recitation rooms in the main building out into the manual training building… [school] enrollment up to 79," *LR*, Aug. 25, 1916, p. 2; "School News… Mr. Smith made the announcement last week that, after much consideration and after consultation with others, it seems best that all students be treated impartially regarding the materials which they 'use up' in their school work. During the past four months the district has been paying for the paper used by the penmanship and mechanical drawing classes, whereas students in all other classes have been required to pay for the paper they used… seemed better… plan of having each student pay for what he 'uses up.' Two reasons were given … [items cannot be reused and students will not waste materials] …," *LR*, Nov. 24, 1916, p. 3.

1919 – "High School Opens Monday… following faculty… **Otho J. Gilliland**, Vice-Principal, Science, Manual Training… **Hazel Katzenstein**: Chemistry, Domestic Science and Art… **Helen G. Rose** [of Berkeley]: Commercial Subjects and Drawing… ," *LR*, July 25, 1919, p. 1; "**Miss Van Sant**, late of Berkeley, is now in charge of all drawing work at the high school and has part of the intermediate work," *LR*, Oct. 10, 1919, p. 5, col. 1; "Close Basketball… The drawing class have been doing some splendid work in the poster line lately. Several posters were exhibited in the store windows advertising the last Saturday's game…," *LR*, Nov. 14, 1919, p. 3, col. 1.

1920 – "Intermediate Graduate Exercises June 10th… [program, diplomas] There will be an exhibition of drawing and Manual Training articles made by the students… girls will wear dresses made in the sewing class," *LR*, June 4, 1920, p. 1; "Our Grammar and High Schools Open Aug. 16… The high school this year will have nine teachers… **Mr. Otho J. Gilliland**, vice-principal, science, manual training, physical education… **Miss Hazel Katzenstein**, chemistry, domestic science, domestic art… **Miss Florence Van Sant**, drawing… [new state requirements for graduation listed] …," *LR*, July 30, 1920, p. 1.

1921 – "Fall Term Will be Later in Starting… As the new high school building, for which the contract has just been let, cannot be completed in time for the opening, the trustees are forced to erect a temporary building to care for the drawing department before school can open – This will be a frame building with dimensions 24 x 34 feet," LR, July 29, 1921, p. 8, col. 3; "Fall Term of High School Starts August 22… [with eight faculty]… Vice-Principal, **Otho J. Gilliland**: Agriculture, Manual Training, Physical Education… **Violet Beck**: Art, Mechanical Drawing… **Anne Mallinson**: Domestic Science, Art, Science…," LR, Aug. 5, 1921, p. 1.

1922 – "New High School Building Inspected by Parents… The lower floor … contains four sunny, well ventilated class rooms. Upstairs are the physics and chemistry laboratories which are very well equipped… The classes in sewing made a very good display in the millinery line and the various drawing classes had a very fine exhibit in the drawing room…," LR, June 9, 1922, p. 1; "Faculty of High School… **Violet Beck**, drawing… **Anne Mallinson**, domestic science and art …," LR, June 23, 1922, p. 7; "High School Opens… Monday… 230 pupils… **Miss Beck**, drawing… **Mr. Kidman**, manual training …," LR, Sept. 22, 1922, p. 8.

1923 – "High School Has Two New Teachers… Mrs. Dinsdale succeeds Mrs. Hardman as domestic science teacher… Mrs. Dinsdale (nee **Miss Katzenstein**) formerly taught in the local high school)," LR, Jan. 5, 1923, p. 5; "High School Exhibit of Unusual Merit… yesterday afternoon… work done by the drawing, sewing and manual training classes the past year… In manual training the completed products of the class were cedar chests, Morris chairs, stools, benches and tables, all of simple design and excellent workmanship for which **Prof. Kidman** deserves due credit. Marked talent was evident in many of the exhibits of the drawing classes, and the many lines of art studied under the versatile teacher, **Miss Beck**, made an interesting display…," LR, June 15, 1923, p. 1; "Many New Members in This Year's H. S. Faculty… Other new members… are **Miss Edith [Sic. Ethel E.] Colledge**… **Mr. [Lyman] Kidman** will be vice-principal again this year and will teach manual training and physical education… **Miss Colledge** is a recent U. C. graduate and will be in charge of the classes in drawing. She received very high marks at the art school…," LR, Aug. 10, 1923, p. 1.

1924 – "High School Notes … Departments Preparing for Opera 'Pinafore'. The advanced drawing class has been busy this week painting marine settings for 'Pinafore' under **Miss Colledge**'s supervision. …," LR, May 23, 1924, p. 8; "Class Honor Rolls for 1924. Seniors … Lawrence Armstrong – Manual Training… **Forrest Hibbits** – drawing, Gym… Roy McHenry – History, Physics, Mechanical Drawing… Juniors … Katherine Brendel – Drawing… **Charles Hibbits** – Mechanical Drawing, Freehand Drawing… Carmen Oliver – Glee, Gym, Drawing… Arthur Pearce – Mechanical Drawing… Harold Riser – … Mechanical Drawing… Sophomores… Augusta Adams – Drawing… Lynn Berkenkamp – Drawing… Percy Main – Mechanical Drawing… Susie

Murray – Drawing…," LR, June 27, 1924, p. 2; "High School Prepares for the Fall Term… faculty… **Ethele [sic. Ethel E.] Colledge**, drawing and art… **Joseph D. Lenfest** who comes to us from the Venice high school and will take charge of the Manual training, auto mechanics and forging…," LR, Aug. 8, 1924, p. 1; "Exhibit Shows Skill of Pupils… high school gymnasium was the center of attraction yesterday afternoon and evening when the work of the drawing and applied art classes under **Miss College** [Sic. **Colledge**] … was on exhibition… The course in applied art, which is a new one in the school this year, has met with the greatest approval and interest of the students… many of the dainty and useful articles have been made for Christmas gifts… That there is much real artistic talent among the students is quite evident from the display of pen and ink sketches, crayon work and water colors. The work of Eugene Skinner, Katherine Brendel, Lynn Berkenkamp and Carmen Oliver deserves particular mention as each in his own line is doing very good work," LR, Dec. 12, 1924, p. 4; "High School Notes… The exhibit which was put on by the Sewing and Art classes last evening … The gymnasium was a beautiful sight, with its red geraniums and green live oak and holly about the walls, the Christmas tree with its brightly colored decorations and the many-hued garments and dainty art work of the exhibit. The ornaments of the tree were particularly unique, being made of pine cones painted in all the bright Christmas colors. This was done by students in some of the art classes. The exhibits of the drawing classes consisted of mechanical drawing plates, and a great deal of very creditable freehand work. The applied art class displayed tie and dye work, stenciled scarfs, cushions, bedroom sets and daintily decorated coat hangers, salt and pepper shakers and shoe trees…," LR, Dec. 12, 1924, p. 8.

1925 – "Annual Pictures Taken. Those pictures for the high school annual which were spoiled last week because of superfluous activity on the part of the males of the institution were taken today, and it is the hope of the exasperated photographer and the more exasperated students that this time the pictures will be a success…," LR, April 3, 1925, p. 4; "Lompoc High Will Open… **Mr. Leefest [Sic. Lenfest]**, manual training, **Miss Francis Jones**, art, 1921 Bath Street, Santa Barbara…," LR, Aug. 7, 1925, p. 1; "High School Notes… **Lee Thomas Sims**' home town is Woodburn, Oregon. He graduated from the School of Industrial Arts of Oregon Agricultural College, 1923. Since then, he has taught two years in the Union High school of LeGrand. He spent the first part of the summer in Berkeley and later toured Oregon, visiting beaches and the famous Oregon lakes. Mr. Sims held the Pacific coast record for the one-half mile run when he left college. Mr. Sims coached football, basketball and baseball at LeGrand for the past two years. … **Frances E. Jones** is a resident of Santa Barbara. She studied at Fort Worth University, Fort Worth, Tex. and is a graduate of Santa Barbara Teachers' college, Music Department and Art Department. She studied Commercial Art at Federal School, Minneapolis, Minn.," LR, Sept. 18, 1925, p. 8; "High School Notes… The editor in chief and business manager for the Annual were elected… staff… Howard Marsh, art editor… **Miss Jones**, art advisor…," LR, Oct. 9, 1925, p. 7.

1926 – "Rotarians… Clever place cards, the work of **Miss Jones** and the art class of the high school, and dainty nut baskets, further carried out the club's chosen colors [of blue and gold]," *LR*, March 5, 1926, p. 5; "High School… The art department under **Miss Jones** is doing many interesting bits of work. At present classes are learning the intricacies of decorative embroidery – beautiful lamp shades, batique [Sic. batik], tridge [Sic.?] and gesso work have been completed and the finished products show much originality and reflect due credit on the instructor," *LR*, April 23, 1926, p. 3; "High School … Exhibit. The school gymnasium was the scene of a wonderful exhibit yesterday afternoon and evening. The walls were decorated with specimens of free hand drawing, colorful designs and plates of mechanical drawing. On the floor were many articles of handiwork. For the domestic science department there were tables of underwear, hand embroidery, aprons and cotton dresses… The students designed and constructed dresses for a partner… The Art Department tables contained stencil caps, pillows, Jesso boxes, candle sticks, Tie and dye scarfs, handkerchiefs, table cloths. Lamp shades of parchment and silk, dresses, table runners, pillows with designs of decorative needle work, all of which was supervised by **Miss Francis Jones** whose clever craftsmanship was ever manifested. The Mechanical Drawing plates were examples of neatness and splendid workmanship. To **Mr. Sims**, the teacher of mechanical drawing go the honors of this exhibit…," *LR*, June 4, 1926, p. 2; "**Harry J. Nelson**, the new manual training teacher at the high school, has arrived to prepare for the opening of the shop," *LR,* Aug. 20, 1926, p. 8; "High School Notes… The Art Department. … **Miss Jones** has the regular Junior High School free hand drawing besides several classes in the Senior High school. Classes in Applied Design, Beginning and Advanced Design and a class in Commercial Art give the students a wide field for the development of their artistic abilities," *LR*, Sept. 3, 1926, p. 3.

1927 – "Principal Lists Required Courses for High School… Seniors are required to take United States history and physical training. Electives are: Spanish, Commercial subjects, English Literature, Mechanical Drawing, Physics, Geometry, Art, Manual Training, Domestic Science and Trigonometry… Juniors… Sophomores … Freshmen… Eighth Grade… Seventh Grade…," *LR*, Aug. 26, 1927, p. 4; "Teaching Staff Numbers 17 in Local School… **Harry Nelson** has been attending summer school at the State Teachers' College in Santa Barbara and will again handle manual training. New teachers… **Miss Vina Kuiesser [Sic. Queisser]** … Miss Kuiesser [Sic.] is a graduate of the University of California. She takes **Miss Frances Jones'** place in art department, Miss Jones having resigned to attend U. C. and get her degree," *LR*, Aug. 26, 1927, p. 1; "High School Notes… Domestic Science. Mrs. Benson's Eighth Grade sewing classes are now making clever little realistic men and animal door stops and toys. The girls are turning these out in the manual training room and they are painting them in the art room. Some of the toys are to be given to the Annual White Gift booth and will later be distributed by the Associated Charities at Christmas time," *LR*, Nov. 18, 1927, p. 5.

1928 – "*La Purisima* Out… The book is profusely illustrated both in half tone and line drawing. The art work has been in charge of **Ernest Brooks**. …," *LR*, June 1, 1928, p. 7; "New Courses at High School… **Harry Nelson** has charge of woodwork and the auto shop… **Vina Quiesser** [Sic. **Queisser**] will teach art and drawing… **Lee Sims** will teach freshman English, mechanical drawing, building-construction… located… **Mr. and Mrs. Sims** are at 147 East Locust… **Harry Nelson** and Dwight Carmack have taken a bachelor apartment from Mrs. Pollack next to the Court Hotel…," *LR*, Aug. 24, 1928, p. 5; "High School Notes… Art Class Growing – three times as large as that of last year. So far work done has been along the line of practice drawing and colored sketches. At present members of the class are doing poster painting. The class seems to be doing better work this year than the year before. In the manual training department, the Junior High boys are making toys, which the art classes will later paint. These toys are to be given to the Associated Charities for distribution at Christmas time," *LR*, Oct. 5, 1928, p. 7; "News of High School… The mechanical drawing class has started in with a total enrollment of eleven. Six are beginners, three are second year pupils, and two are doing third year work. This year's beginning class has adopted a new system in lettering. The pupils have to complete a plate a week, making a total of thirty plates a year. The pupils of the second-year class… are paying particular attention to the development of angles and structure work. The work of the third-year pupils … along the line of architecture. They are now making plans for foundations of buildings," *LR*, Oct. 19, 1928, p. 4; "High School Notes. Start Semester Work – The second-year mechanical drawing class … At the present time they are having the uses of conventional sections of machine and building material as well as different threads. The common threads they are now studying are the U. S. standard, square thread, acme thread, and various others. Later on, they will make drawings of machine lathes, engine cylinders and structural connections," *LR*, Nov. 16, 1928, p. 6; "News of High School… Annual Staff Appointed – *La Purisima*… art editor, Stanley Horn… Art Class – … has started on theritical [sic.] work, this includes lamp shades, pillow cases and purses. They are also making toys for Christmas. At the present time they are painting boxes, animals and Christmas cards. This will probably be given away by the Associated Charities to the public… Mechanical Drawing – The first-year mechanical drawing pupils are making rapid progress in their drawings. This work is based on supplementary problems, symmetrical objects and Geometric constructions. The second semester drawings are based on domestic and developing objects as they appear," *LR*, Nov. 23, 1928, p. 3.

1929 – "News of High School… Mechanical Drawing Class… The first year… pupils are commencing on second semester work… supplementary problems such as rip saws and sprocket wheels. They also take up practical shop problems which consist of towel racks and electric lamp stands. Some of the pupils are commencing on isometric drawings, which are in the line of geometric problems," *LR*, Jan. 25, 1929, p. 7; "High School Notes… The 3-year Mechanical Drawing pupils … are doing work along the line of architectural construction. Different types of floor

plans and different details of porch, fireplaces, and window problems are taken up. They will also take up residential plans later on. The second year Mechanical Drawing pupils … different methods of representing conventional sections of machines and building material," *LR*, Feb. 8, 1929, p. 8.

1931 – "High School Writers and Artists Prepare Material for Annual. *La Purisima*, 1931 … will be a handsome volume filled with pictures and other material contributed by students… Cartoons and art illustrations have been prepared by a number of the students and are of a high order of merit…. Wilbur [Sic. Wilbert] Fitzpatrick, Minnie Cooley, Edwin Jenks, **Alice Laubly**. Practically all of the photographs of faculty and students have been taken …," *LR*, April 10, 1931, p. 3; "High School Notes. New Teachers for Enlarged Classes… Each year there has been an increase in the numbers in the shop classes. This accounts for the new teachers: **Mr. Garrison** who will teach full time along with **Mr. Nelson**, shop instructor; **Mr. Cakebread** and **Mr. Cummings** [Sic.] who is taking Mr. Whitlock's place, teaching one class each. The extra teachers are also for the new classes – two classes mechanical drawing, two classes auto mechanics, two hours construction work and one hour wood work. The shop subjects for the year are: mechanical drawing, cabinet making, sheet metal, auto mechanics and building construction," *LR*, Sept. 25, 1931, p. 6.

1932 – "Shop Classes are Kept Busy. **Mr. Nelson** and **Mr. Garrison** shop and construction teachers… Drawing tables and benches are under construction in the shop itself…," and list of other construction projects, *LR*, Sept. 16, 1932, p. 6; "Post-Graduate Courses Attract Many Students. This year there has been a greater number of post-graduates coming back for work than ever before. These include [names of students] … The students are enrolled in typing, bookkeeping, shorthand, U. S. history, commercial arithmetic, mechanical drawing, shop and gym," *LR*, Sept. 16, 1932, pp. 6, 7; ■ "Art Department Encourages the Creative Spirit… by **Pauline Cronholm**… The art department is one of the most interesting in the high school… As one enters the art room, he will see an exhibit of students' work. This represents only a minor part of the high school talent. Out of sight, in a cupboard, or maybe in individual lockers, are some fine examples of craftsmanship, such as woodcuts, tiles and decorative bo?es. These are done by upper classes that have had more training … The lower classes participate in the more simple forms of art, such as water color, crayon and poster work. They are taught the main principles of art, some of which are appreciation of color, knowledge of proportion and sense of design. The art department is called upon to make posters for all school activities, including basketball, football and plays. This gives the students training in types of lettering and effective arrangement of lettering on posters. It gives them an understanding of related colors and their uses in making attractive posters. At present a number of students are working hard to finish their Christmas cards. Some very lovely ones are being made from wood cuts and linoleum cuts. Others are making Christmas presents of tiles and decorative boxes. Later on in the year we hope to be able to delve still more deeply into the various divisions in art such as outdoor sketching,

soap carving, batik and leather work….," *LR*, Dec. 9, 1932, p. 11.

1933 – "Art Classes Make Senior Play Cards. The high school classes in art are busy making posters for the Senior Play, coming April 7. Each pupil is assigned a poster problem to be worked out individually. The student selects his or her own background and makes up his or her own design and color scheme best suited for it. The lettering, illustrating and arrangement is individually selected. The merits show that the time spent in working out the posters has been well worth their while. The Seventh Grade class is studying figure drawing. The pupils take turns being models … The studies are being made in brown or black, and a touch of color may be added if desired, representing a bright jacket or dress. In a few cases real talent has been shown," *LR*, March 24, 1933, p. 11; "Shop News… Twenty mechanical drawing tables are being made by the first period shop class …," *LR*, Jan. 13, 1933, p. 8; "School Board Revokes Cuts for Teachers … the faculty will be paid during the school year … 1932-1933… **John F. Cummins**, history, manual training, $1800… **Elmer Garrison**, construction, $1800… **Miss Muriel Moran**, art, $1800… **Harry G. Nelson**, manual training, mechanical drawing, $2000…," *LR*, Sept. 1, 1933, p. 1; ■ "Art in Education Teaches Many Valuable Lessons in Appreciating Surroundings (by Miss **Muriel Moran**). There is rarely a child who does not find pleasure in working with his hands. He enjoys making things. Upon this natural urge for activity, we try to realize certain objectives such as to see the value of a plan, to know how to care for tools and supplies, to be mentally sensitive to beauty and color in nature and other surroundings, to have a means of using leisure time profitably and to have a chance to develop natural talent. The Art Department has 108 students enrolled in the seventh, eighth and senior high school grades. To see the value of a plan … In all our drawings we first make small pencil sketches to arrive at a working plan or arrangement for the final drawing. This is done also for color, small color sketches first being made. Only in this way can needless blunders in drawing and color harmony be avoided. … Each student handles numerous colors, brushes, such as: pencils, paper, water colors, brushes, rulers and paint pans during any one class hour. This distribution, collection and care of these supplies is as important a part of the day's lesson as the drawing and painting. At every opportunity the classroom work is linked with objects outside to develop a sensitiveness to color and form in nature and home surroundings. … Beauty exists in our everyday surroundings… Anyone who has developed some ability to draw can spend hours of leisure time sketching and designing if only for the fun of doing so… The art classes do give a chance to discover and develop natural talent. However, … success in art work is nine-tenth honest effort and one tenth natural ability. Those who do make good may wish to specialize in further study for an artistic profession. The two most common being costume designing and the field of commercial art, which has to do with advertising…. Problems and materials do vary according to the group, but the objectives remain the same. That which differs is the relative achievement which can be expected of any one group," *LR*, Feb. 17, 1933, p. 6.

■ "Industrial Arts Course at High… by **A. S. Cakebread**. Many students do not plan on going to college … The Industrial Arts Course has been designed to take care of the many boys who will remain on the ranches or work at technical jobs in the community or may continue on to some trade school for a period of advanced work… Classes are crowded at the present time… with as high as 20 or 25 students in each class. Eighteen is the number that can be handled most efficiently… there is a need for greater shop space. This course is so designed that each boy takes at least two periods of shop work during the day… Freshman year – … Sheet Metal and Shop Mathematics, Vocations… Woodwork… Sophomore year – Cabinet Making… Woodwork. Junior year – Mechanical Drawing… Auto Mechanic, Carpentry… Senior year – … Mechanical Drawing, Carpentry, Auto Mechanics…," *LR*, May 26, 1933, p. 6; "Hi School Study Courses Outlined…," and article lists options by school year and options include: Woodwork, Art, Cabinet Making, Mechanical Drawing, *LR*, Sept. 1, 1933, p. 7; "Art Pupils Aid **Jamboree** Plans… The art classes under the instruction of **Miss Moran** have co-operated toward the development of the show by making posters and scenery. Forty-two posters already have been made and have been placed in neighboring towns and down-town stores. Clever ideas for lettering and illustration have been used. Special scenery for certain acts are being made by the shop classes and will be painted by students taking art,' *LR*, Nov. 3, 1933, p. 8.

1934 – ■ "Industrial Arts Program at High School Keeps Many Students Busy on Projects. New Semester Marked by Several Changes in Schedules… Some of the classes of eighth grade boys have been changed around; one class had woodwork while the other had mechanical drawing. Now, since the new semester started … The woodwork boys take mechanical drawing …. **Mr. Stewart** is the instructor of woodwork and **Mr. Cummins** is the instructor of mechanical drawing. One of the two Freshman classes has continued with the same work in woodwork. The other class is taking sheet metal work for the second semester. They took shop math for the first semester…. Electricity class… auto mechanical classes… The construction classes have done a great deal around the school. They are building another handball court and are helping with the installment of new gas heaters in the basement…," etc., *LR*, Feb. 2, 1934, p. 9; ■ "Growth of Industrial Subjects at High School… In 1927 **Mr. Nelson**, the only teacher in this course… taught wood shop and one period of mechanical drawing. For the auto mechanic shop there was nothing but an old barn. The following year a sheet-metal class was put in. In 1929 a construction class was added. The boys in these classes built the additional balcony on the gym and laid the tennis court. The following year they built the present excellent auto shop. In 1932 [Sic. 1931] **Mr. Garrison** was added as an instructor. Two hours of construction and auto mechanics were instituted. The eighth grade was also allowed the privilege of taking mechanical drawing. The next year **Mr. Stewart** was taken on as part-time teacher in wood-shop, sheet-metal and related shop math. Two courses of mechanical drawing were also given. In 1933, **Mr. Stewart** was hired as a full-time teacher, and two periods of electricity were added.

From 85 to 90 percent of the boys are taking, or have taken, some course in industrial education," *LR*, March 2, 1934, p. 5; "**Creator's Club** on Tour of S.B. Domestic Science Girls Visit… [from profits of candy sales] … The first place visited was the Museum of Natural History… Indian relics… beautiful baskets and blankets… Max Fleishman wing… stuffed animals. Each seems amazingly real, natural rocks, shrubbery and beautiful oil paintings being used for the background… Botanical Gardens… As the State College was showing an art exhibit that day, nine rooms displaying weaving, clay modeling, painting, needlework, toy-making, book-binding and tooled leather were visited. The Lompoc **4-H** Club was visiting the State College that day and working on projects in the above courses. From here the girls visited the **Faulkner** memorial gallery. Here there was an exceptionally interesting exhibit of textiles and paintings from Guatemala. There was hand-loom work of different tribes of Indian descendants of the Mayans. Thirty-three paintings in oil and water colors representing the leading artists in Guatemala have been contributed…," *LR*, March 16, 1934, p. 5; "Improvements to be Made on High School Buildings… The art and mechanical drawing rooms of the local high school are being remodeled to prevent further damage to the building by water seepage through the window frames. It was necessary to build a porch on the south side or to remove the windows and fill in the opening. The latter course was followed leaving windows on the north, which gives sufficient light and eliminates a lot of strong glare which was very hard on the student's eyes. Further improvements and repairs are being made by Industrial arts classes. …," *LR*, Sept. 14, 1934, p. 9;

■ "Art Department Changes, by **Patsy Oliver**. The art department this year has many new and interesting features. … most of the classes are full. **Miss Bucher** is giving the pupils a choice of working with metal, leather, cloth or any other material that can be obtained. Some of the things being made are bracelets, ash trays and book ends. There is also a Related Arts course in connection with Domestic Science, the girls taking this learn the principles of interior decoration and color harmony," *LR*, Sept. 21, 1934, p. 7;

■ "About Your High School … Craftwork. By **Miss E. Bucher**. New educational theories and principles stress the fact that students learn by doing rather than by merely studying or hearing. A particularly suitable situation for carrying out this principle is in the Art and Craft classes. Much art training has heretofore been given to students who had no particular talent or interest in drawing and yet had a desire to create. Such training necessarily made use of academic ideas of actual reproduction of natural phenomenon and the creation of abstract designs with pen, pencil or paint on paper with few opportunities of carrying them further. In more modern art workrooms, the procedure is reversed. The creative desire is encouraged in every student, regardless of talent, by permitting him to make actual worthwhile and useful articles in a variety of materials. An increased appreciation of good proportions, good design and pleasing colors is fostered. The student himself quickly becomes a severe critic of his own work as well as the work of others. When making such simple articles as a copper ash tray, he comes to an understanding of such aesthetic principles as suitability to use and

environment as well as good workmanship and proportion. He also realizes the added richness a clever design may lend to articles of everyday usage and the limitations certain materials place upon the original sketch of a design. Many students at first try to depict a realistic scene only to discover that their design on the finished article is incoherent and out of keeping with the tone of the piece of work and would have been far better had it been simplified to an abstract harder [sic.?] pattern or all over design. By appreciating the problems set by certain materials the student comes to distinguish between good and poor work of others, whether it be in furniture, automobiles, architecture, clothing or advertising. This will lead him to select the proper material things which play such an important part in any one's life. Color theory is also taught in this way. Every craft besides metal demands the use of dye, stain, ink or paint. Colors rarely come in the exact shade desired so the student himself soon discovers that mixing of various hues will produce interesting and original combinations. Actual experimentation is far more interesting when carried out for a specific purpose as a leather wallet than just aimlessly experimenting. Here again his eyes become open to the use made of color by others. He notices discriminatingly and may even come to realize the part color plays on the emotion and develop originality in combining colors in his home and clothing. Besides passively increasing appreciation, craft work is the most fascinating of all hobbies. It usefully and constructively fills leisure time besides satisfying the creative urge latent in every person. By providing students with the basic processes of a variety of crafts he will be able to progress from there by himself and experiment and produce innumerable useful and beautiful articles. Tooled leather work is one of the simplest of all crafts but possibly does not offer such a wide field in variety of articles to be made. Key-tainers, wallets, desk sets, book ends and book covers are a few which can be made with little equipment, little experience and effort, and yet be of permanent value. Metal work offers limitless possibilities. Copper, brass, pewter, lead, chromium and monel metal are the most satisfactory. Jewelry making is an art in itself. Ash trays, bowls, book ends, desk sets, buckles and boxes may all be made easily. Various techniques may be used with metal, etching, soldering, hammering and riveting all give pleasing effects. Metal is particularly lasting and comparatively inexpensive. The natural colors are quite beautiful in themselves but may be more pronounced by heating, polishing or the use of acids. Block printing and stencil work are different techniques which may be used on the same materials. They are both entirely successful in repeating designs on fabrics, whether silk, cotton or linen and wall papers. Such articles as drapes, luncheon sets, dresser scarfs or wall hangings may all be decorated with colorful designs in this manner. When printers ink and oil paints are used, the colors are permanent and will stand a number of washings. Batik work is particularly beautiful because of the infinite number of colors possible to use. Seldom is a batik ugly due to the process of dying one color over another which necessarily blends them harmoniously. Very beautiful wall hangings and table throws may be made on silk and velvet or even cotton and linen. Wood is a particularly gratifying material with which to work. It may be carved in simple

relief, half round, round or even round pieces. The natural grains and textures of most woods are generally pleasing in themselves, but very interesting effects may be obtained by lacquering. Imitation inlay work is quite simple and gives very beautiful and colorful effect. Book ends, boxes, placques, buttons and buckles are all practical objects which may be made with wood. Cut paper work is often used in decorating boxes, table tops, waste paper baskets and infinitely more commonplace articles. When handled carefully and artistically and shellacked thoroughly the effect is very gay, decorative and beautiful. The most necessary materials for all these crafts are few and very inexpensive compared with the market value of the finished article. It is not hard to realize the value of familiarity and skill in these various techniques when the many advantages are considered," *LR*, Oct. 5, 1934, p. 4; "Art Classes Prepare **Jamboree** Publicity. The art department has taken over the publicity for the Jamboree. Many very attractive posters have been made. There is to be a display window for advertisement … In the new fourth period there is a craft class of nineteen boys who are making belts, bill folds and other useful articles," *LR*, Oct. 19, 1934, p. 8; "250 Students… **Jamboree** of '34… stage sets… Then the stage crew under **Mr. Garrison** must get busy… preparing stage settings … The Art Department under **Miss Baker [Sic.? Bucher]** assists the stage crew on the painting of scenery. This department also helps [sic. words missing] … under the direction of **Mr. Cakebread**… [words missing] um of the poster and window displays…," *LR*, Oct. 26, 1934, p. 11; "Preparations for **Jamboree**…The construction class has done much… They have made all the scenery and changed the settings for the different acts. The art class has also done much to help. They have advertised widely with their posters and have done a great deal of work painting scenery and they have given many color suggestions…," *LR*, Nov. 2, 1934, p. 12; "About Your High School…" discusses classes that high school students should take in order to qualify for college, and these include freehand drawing and geometrical drawing, and Lompoc High offers Mechanical Drawing, *LR*, Nov. 16, 1934, p. 4; "High School PTA Hear Dr. Phelps of S. B. State. Tuesday, November 27… After the talk the meeting adjourned over to the art and domestic science classes to see an exhibit displayed there. The art exhibit consisted of metal, wood and leather articles, some of which were ash trays, bowls, trays, book ends, purses, pocketbooks and cigarette cases. …," *LR*, Dec. 7, 1934, p. 10.

1935 – "Weaving Learned on Two New Looms… This year two large looms were added to the Home Making Department… Each girl is permitted to make what she wishes. Many have brought old rags from home and have woven very nice rag rugs. Pillows, scarfs, pocket books, doilies and wool table runners are also made, copying patterns from old crochet patterns…," and brief history of weaving, *LR*, Jan. 25, 1935, p. 8; "Girls Spend Leisure Time at Needle Work… luncheon sets with elaborate appliques and embroidery designs. Fancy stitching of every kind…," *LR*, Jan. 25, 1935, p. 8; "**Creators' Club** Works at Projects," *LR*, Jan. 25, 1935, p. 8; "High School… to Buy Motion Picture Machine…," Feb. 1, 1935, p. 4; "Needle Craft is Aided by Looms, by Florence Murray. This work was put in especially for the girls who were

interested in this type of needle craft… Mrs. Harris worked very hard to get looms… and have made some very beautiful things such as pillows, table runners, scarfs, wall hangings and some very lovely embroidered pieces … The faculty members… have asked several of the girls to weave something for them," *LR*, Feb. 8, 1935, p. 9; "Classes in Forge Work Being Given… first time in seven or eight years…," and "Boys Study Sheet Metal Work" and are making copper cookie cutters, *LR*, Feb. 15, 1935, p. 4; "The Devil in the Cheese… the art department has been making posters with all sorts of frightful looking pictures on them…," *LR*, March 8, 1935, p. 2; "Re-Take Yearbook Class Pictures. Group photographs of the seventh, eighth, ninth, tenth and eleventh grade classes were re-taken…" because of glare on the first batch, *LR*, April 5, 1935, p. 5; "Local School will Exhibit… weaving… will be shown at the San Diego fair this summer as one of six school exhibits in the state homemaking booth," *LR*, April 12, 1935, p. 3; "Art Classes will Exhibit Projects Here Next Week… [**Public Education Week**] a display of wood carvings, sketches, posters, fabrics, metal and leather craftwork and oil paintings is being shown this week in the window of Rudolph's grocery store, facing on H street. The display is made in observation of **Education week**, April 8 to 12, and contains art work done by junior high school and high school students under the direction of **Miss Mary Elizabeth Bucher**, art teacher. Examples of metal work exhibited are those made by Donald Burton and Clarke Harris. Leather craft work by James [Logan] Beattie, Frank Dyer, Eugene Cook and Senta Tognetti are shown. The wood carvings of Howard Downing, Eldon Gilkeson, Emma Guerra, Florence Murray, Stella Grossi [Mrs. Edward Raff], Mary Harris, **Margaret Fratis** and **Alice Laubly** are part of the display. Oil paintings by **Margaret Fratis** and **Alice Laubly** are also included… A batik blocked by **Catherine Beatie**, a drawing by Patsy Oliver and posters painted by William Fortney are other examples of student art…," *LR*, April 12, 1935, p. 7; "Casting… 'Marriage of Nannette'… **Elmer Garrison**, stagecraft instructor, is directing construction of sets for the production… Decorating of the stage sets is being done by art students under the direction of **Miss Mary Elizabeth Bucher**," *LR*, April 12, 1935, p. 7; "Domestic Science Classes Exhibit at OES Meeting… clothing, weaving, embroidery and other skills…," *LR*, April 12, 1935, p. 8; "Three Seek Fine Arts Scholarships. Art work of three Lompoc high school students is being submitted to the **California School of Fine Arts** in a contest for two scholarship awards by the school for the best work sent in. An oil painting and wood carving executed by **Margaret Fratis**, a Celite carving by **Alice Laubly**, and a wood carving and several book plates by Patsy Oliver are being submitted… Title and selection pages designed by Miss Oliver for use in the high school yearbook, *La Purisima*, are the book plates entered in the contest, which closes May 11. In addition to the two scholarships, the Fine Arts school will make several awards of merit for outstanding work. The three girls are pupils of **Miss Mary Elizabeth Bucher**," *LR*, May 3, 1935, p. 10; "Pupils Exhibit Articles Made for Local Needy Twins" – i.e., two cribs by Industrial arts, quilts, sleeping garments by Home Economics, *LR*, May 17, 1935, p. 3; "City Schools … Ten

changes in the high school faculty … **Miss Ruby Parker**, sister of Bud Parker, and Miss Helen Kelleway will take over the domestic science classes. Miss Parker is a graduate of Santa Barbara state college…," *LR*, Aug. 23, 1935, p. 1; "Jamboree of 1935. Third Annual Performance. High School Auditorium… Costume Committee. Miss **Helen Kelleway**, Miss **Ruby Parker**… Stage Designing Committee: **Miss Bucher**, chairman; Emma Guerra and Will Fortney, chief designers…," *LR*, Nov. 1, 1935, p. 9.

1936 – "Senior Class Meets… It was decided to have **Ernest Brooks**, local photographer, do the photograph work on the senior class pictures for the high school annual," *LR*, Feb. 7, 1936, p. 7, col. 2; "In the February issue of the *Sierra Educational News* is a picture and story which honors **Miss Mary Elizabeth Bucher**, art instructor… The picture shows several students at work painting and arranging the setting on the stage, which was used at the recent **Jamboree**. Pupils shown at work are Annie Dettemanti, Virginia Guerra, Thelma Morehart [Mrs. Manfrina], Emma Guerra, Mary Tashiro and Donald Burton. The set was designed and directed by students…," *LR*, Feb. 14, 1936, p. 7; "Widespread use of Pictures to Feature Annual… *La Purisima*… Circus theme… Miss **Mary Elizabeth Bucher**, art advisor for the publication… Group photographs will occupy a large share of space in the book which is expected to establish a precedent for quality, style and number of innovations," *LR*, April 10, 1936, p. 4; "Needlecraft Display. Needlecraft, weaving and a general handcraft display was placed in the *Record* window on Monday by girls from the local junior and senior high schools under direction of **Miss Ruby Parker**. In connection with **Public Schools Week**…," *LR*, May 1, 1936, p. 8; "Senior Class Play… 'Sky Train' … A modernistic stage setting is being built… ill-fated dirigible… Kalsomined Celotex is … used… to simulate the interior… Properties and furniture for the set at the work of **Miss Mary Elizabeth Bucher**, art teacher, and her committee, Thelma Morehart…," *LR*, May 8, 1936, p. 1; "Class Finishes Stage Settings for Play… supervision of **E. W. Garrison**, are finishing the painting of scenery … the junior play, 'Let's Be Somebody,' to be presented November 18," *LR*, Oct. 30, 1936, p. 14; "Pupils Start Rehearsals on 1936 **Jamboree**… Members of the Publicity Committee are … **Clinton Stillman** in charge of art department…," *LR*, Nov. 27, 1936, p. 1.

1937 – "High School Annual Staff is Chosen… Mary Tashiro, art…," *LR*, March 5, 1937, p. 7; "Operetta is Presented… Spanish Grandee… Responsible for the production… Art – David Hitch, Betty Herdman, Anita Rohlfsen, Jane Adams, Shuizuye Murokami, Ted Higgins, Mary Vail. Costumes – **Helen Kelleway, Mary Elisabeth Bucher, Ruby Parker** … Managing Staff—Posters, **Clinton Stillman**…," *LR*, March 26, 1937, p. 5; "Drafting Classes Study House Plans. Several members from each of the drafting classes under the direction of **Harry Nelson** … are now studying and making house plans. Each is making a floor plan of a home which he hopes to build. This week they were given a chance to visit two houses now under construction ….," *LR*, April 9, 1937, p. 7; "Variety is Offered in Art Department. A large variety of work is offered in the art department of the high school under the

direction of **Miss Mary Elisabeth Bucher**, and some fine examples will be on display Monday, April 26, when the high school holds an exhibit as part of the observation of education week. Jewelry making, art metal, sculpturing in wood, leather tooling, block printing, commercial art, charcoal and pencil drawing and oil painting are being studied," *LR*, April 16, 1937, p. 7; "**Public School Week**… Examples of articles made and projects undertaken during the school year were exhibited Monday night at the high school… Most important display was in the library where science and craft work of all types was exhibited… made both in the junior and senior high school. Some excellent wood carving and cabinet making was on display. Showing in more detail the everyday school work, the shops, domestic science rooms and commercial departments were open for public inspection… Handicraft included hand-made rings, leather tooling, embroidery, dress-making, weaving, drawing and carving…," *LR*, April 30, 1937, p. 2; "Student **Jamboree** of 1937… Costumes… **Miss Kelleway, Miss Parker**, June Tokuyama, Hiroko Shirokawa… Posters … Art Department… Kiyoshi Matoba, Glendora Collier, David Hitch, Virginia Pirtle. Dance Masks … Art Department… Frank McCollum, Bobby Roberts, Jack Alexandroff," *LR*, Dec. 10, 1937, p. 5.

1938 – "April 1 is Set as Date of Operetta… 'Pirates of Penzance'… Assisting in the arrangements… stage crew who have built a typical pirate's lair. **Miss Mary Elisabeth Bucher** has assisted in the painting and decorating of the scenes. **Miss Ruby Parker** is in charge of costumes…," *LR*, March 18, 1938, p. 7; "Art Classes Visit Camp. Monday and Tuesday of this week, art classes at the high school enjoyed a visit to the **CCC camps** at La Purisima mission where they viewed an exhibit of leather crafts. Joseph Winn, educational director, explained some of the methods in making the leather work. **Miss Mary Elisabeth Bucher** accompanied the classes," *LR*, March 25, 1938, p. 8; "Three Teachers Resign at Hi School… **Miss Mary Elizabeth Bucher** has received an offer of a position at Susanville high school and junior college…," *LR*, May 20, 1938, p. 1; "Three teachers Named… **Miss Margaret Morton** of Fresno will replace **Miss Mary Elisabeth Bucher** in the art department. Miss Irene Minkin of Santa Barbara will fill the place left vacant by **Miss Helen Kelleway** in the home economics division…," *LR*, July 22, 1938, p. 5; "Roll Call for Red Cross… Posters telling of the coming Red Cross drive will be made in the local high school art classes under the direction of Miss **Margaret Morton**, instructor," *LR*, Oct. 14, 1938, p. 1.

1939 – "Civic Club Pushes Plans for Pergola at Ryon Park… drawings are being made in the high school carpentry classes…," *LR*, Jan. 13, 1939, p. 5; "Variety Acts in **Jamboree**… Music racks painted and decorated in gay colors have been made by the school art department under the direction of Miss **Margaret Morton**…," *LR*, Feb. 3, 1939, p. 1; "Jamboree… Gay and colorful posters have been distributed to various local business places to publicize the show. These were made by the students under the direction of Miss **Margaret Morton**, art instructor," *LR*, Feb. 10, 1939, p. 8; "Pictures Being Taken This Week for School Annual… Senior pictures were completed last week, and campus groups are in the camera's focus during

school hours. **Ernest Brooks** of the **Camera Shop** is doing the photography. A new innovation this season is the making of annual covers in the local art department, Miss **Margaret Morton**, art instructor, is supervising the work of the book with … **Clinton Stillman**, art editor…," *LR*, March 17, 1939, p. 2; "Civic Club will Use New Pergola… Ryon park… to be erected by E. A. Petersen… following plans by the high school drafting class," *LR*, May 5, 1939, p. 1.

1940 – "Local Youths Exhibit Pictures in New York Museum. According to a bulletin from the American Museum of Natural History, three Lompoc high school freshmen, **Norma Martin**, Hoshiko Hozaki and Kimiko Nagata have pictures done in wax crayon in the Fifth Annual Exhibition 'Young America Paints' at the museum. Work was done under the direction of Mrs. G. Brotherton (**Margaret Morton**) former instructor in art at the high school," *LR*, Sept. 20, 1940, p. 7.

1941 – "Student **Jamboree** of 1941, High School Auditorium… Posters and Backdrop Painting – Art department, **Miss Lund**, director…," *LR*, Feb. 28, 1941, p. 4; "Students Given Awards at High School Assembly … American Legion Auxiliary poppy poster contest, junior high, Grace Bay, senior high, Mary Sousa …," *LR*, May 23, 1941, p. 7.

1942 – "Victory Book Campaign… At the meeting the decision was reached that posters will be made by the Commercial art class at the high school under the direction of **Miss Crystal Lund**…," *LR*, Jan. 23, 1942, p. 2.

1943 – "Posters for V Book Campaign Being made… Victory Book boxes which will be placed in front of various stores as well as in the public library to collect books for the recreation of servicemen are being made by the High School art classes, **Miss Crystal Lund**, Art instructor, is supervising …," *LR*, Feb. 5, 1943, p. 5; "Tri-Y club… Dance… **Miss Crystal Lund** will supervise the posters," *LR*, May 7, 1943, p. 2; "Spring Concert… Scenery painted by **Miss Crystal Lund** and the Commercial Art Class. Posters by **Bob Scolari**…," *LR*, May 21, 1943, p. 8.

1945 – "Public Schools Plan Opening… four new teachers for the high school… **Miss Virginia Murray** will teach art, replacing **Miss Crystal Lund**, who is attending school in San Francisco…," *LR*, Aug. 24, 1945, p. 4.

1946 – "**Virginia Murray** Married. … Miss Virginia Murray was married on January 9 to John McArthur at her parents' home in Wadena, Minnesota. While in Lompoc Mrs. McArthur was art instructor at the Lompoc High School. She is to be replaced by **Mrs. Margharite Colby** of Santa Barbara," *LR*, Jan. 10, 1946, p. 8; "Seniors ready for Annual Play… 'Tomorrow Heaven'… Posters, Gertrude De Bolt, Helen Oursler," *LR*, April 25, 1946, p. 2; "Five Teachers to Leave High School in June … Mr. and Mrs. **Harry Nelson**, who plan to move to Pismo Beach. Mrs. Nelson has taught Latin and social sciences at the school and Mr. Nelson has been in charge of the wood shop and mechanical drawing classes… The fifth teacher to leave will be **Mrs. Colby**, instructor of art, who plans to join her husband in the East …," *LR*, May 30, 1946, p. 8;

"Faculty for High School Fall Term… The new members include … **Miss Margaret Hodgdon**, art instructor from U. C., Santa Barbara; **Dean Upton**, wood shop instructor from U. C. Santa Barbara… **Mrs. Viola Dykes**, who has taught adult education classes in arts and crafts has accepted a post with the Los Angeles city schools. Hull said that she will be replaced … and that the courses would continue…," *LR*, Aug. 22, 1946, p. 1.

1947 – "'47 *La Purisima* Yearbook Out… the students have used a 'ball and chain' theme, with sparkling art work by **Joanne Galbraith**, art editor…, carrying out the motif," *LR*, June 5, 1947, p. 13.

1948 – "Faculties… Carry-over members of the high school faculty will include … **Margaret Hodgdon**…," *LR*, Aug. 12, 1948, p. 4; "Tours of High School Slated… for persons who attend the school's spring concert… Included… will be visits to the following: commercial department, library, drafting room, art room, home economics department, science laboratories, wood shop, auto shop, gymnasium and classrooms," *LR*, April 29, 1948, p. 4; "Dolores… *Smoke Signal*… student newspaper … coming year… **Tyke Grider**, art editor," *LR*, Sept. 23, 1948, p. 4.

1949 – "Elaborate Annual… 'Echoes of '49' … Placing their emphasis on pictures… The book is divided into several sections, each preceded by a double-page photographic treatment indicating the subject of the section. … Advertisers who supported the student effort… are represented by candid camera photographs of their business houses," *LR*, June 16, 1949, p. 7; "Increase at Both Schools… At the high school the faculty roster includes… **Margaret Hodgdon**…," *LR*, Sept. 8, 1949, p. 8.

1950 – "Annual Appears at High School… **Tyke Grider**, art editor…," *LR*, June 8, 1950, p. 11; "H.S. Club Leaders Named… Art club, **Miss Margaret Hodgdon**…," *LR*, Sept. 7, 1950, p. 2; "High School… high school annual, *La Purisima*… staff… **Don Mattias**, photography editor… Betty Nufer, pictorial editor… Redricia Wellemeyer, art editor," *LR*, Sept. 28, 1950, p. 15; "Homecoming Game… Also, any photographs of the early Lompoc high school and some of its classes and students would be welcomed, according to Anne Marie Proud. She plans to have an exhibition of photographs for the public at the dance…," *LR*, Oct. 26, 1950, p. 17.

1951 – "School Yearbook Makes Appearance… 1951 edition… Little pages in the book photographically depicted familiar scenes in the valley… Photography for the book was produced by **B&B Photo Studio** and the **Camera Shop**…," *LR*, May 31, 1951, p. 10; "Eight Members Join High School Staff … **Conley R. McLaughlin** … instructor in arts and crafts. He holds an A. B. degree from Los Angeles State College and taught in the LeConte school in Los Angeles…," *LR*, Aug. 30, 1951, p. 8; "Staff for School Yearbook Told… **Jim Galbraith**, art editor, Jim Tuni, photography editor…," *LR*, Oct. 11, 1951 p. 9.

1952 – "Treble Ensemble Delights Audience at Concert in High School Auditorium… **Mrs. [Arnold] Brughelli** also made the exceptionally fine posters," *LR*, May 1, 1952, p.

4; "Lompoc PTA Hosts 15th Dist. Members at All Day Conferences… at Elementary school… On view in the room were paintings in pastels and water colors, done by High School students under direction of **Conley McLaughlin**, High School Art instructor," *LR*, June 5, 1952, p. 5; "Arsenic… **Mr. Sabin** who teaches woodshop is in charge of the set. Neva Sechrest and Barbara Sprouse … did the decorating for the set. Barbara Sprouse also designed the cover to be used on the programs…. The art director for the play is **Conley McLaughlin**… The photographs were the responsibility of **Forrest Hibbits**…," *LR*, Nov. 20, 1952, p. 8.

1955 – "Schools are Valley's Third Largest Employer… high school… **Louise Hunt (Mrs.)** Art and Homemaking… **Conley McLaughlin**, Art and Crafts… **Clifford Powers**, General Shop, Mechanical Drawing… **C. Lester Sabin**, Mechanical Drawing, Stage, and Woodshop…," *LR*, Sept. 8, 1955, p. 9.

1956 – "Top Students... Bank of America's 1956 Achievement Awards … **Judy Collier**, fine arts …," *LR*, March 22, 1956, p. 1; "Resignations Accepted by School Brd. … Contracts were approved for … The board also approved shifting **Alex Rule** from Hapgood school to the high school where he will teach classes formerly taught by **Conley McLaughlin**," *LR*, May 31, 1956, p. 11; "'57 *La Purisima* Staff Workers Selected… under the direction of … **Mr. Alex Rule**…," *LR*, Nov. 8, 1956, p. 16.

1957 – "Display Cases at Lompoc High School Reveal Student Activity and Interest… There are three display cases, the largest of which is devoted to the athletic glories…. At the south end of the main hall more trophies. This is the Band's showcase… A third case, at the north end of the hall, is the main ring… There, **Mr. Alex Rule**, the school's art and crafts teacher, displays the best art work of LUHS students. Leather pieces, an intricately tooled purse by Jim Escovedo and a belt of roses by Mayetta Swonger … Other craft pieces include pottery … Five pieces by Ray Angel are: A little olive-green jar with a nubby top, a perfectly rounded pink vase, delicately designed with black lines … a dappled green jar, a wide bowl which is a motley blue-green, and a figurine of a horse, done in rich brown and showing a wonderful capture [sic.] of motion. A pert little bird, made by Violetta Arnado, holds a light blue vase atop his tail. Frank Angel's vase, a wine-colored piece, must have been inspired by the land of the Arabian Nights. Another vase, by the same craftsman, is a deep blue one, simple and flawless. A delicately fringed baby blue pitcher by Wilfredo Garife and a richly colored brown maple-leaf bowl by Ken Bettendorf complete the pottery collection. Jewelry is also popular among LUHS artists. Esther Ogden has made a pair of light green triangles … Joe Quinonez has tooled a delicate copper cross and Jim Escovedo has made a tie pin sporting his initials in large fancy letters. Eddie Fumasi's abstractly designed man, a soap carving, is representative of the work being done by LUHS eighth graders. Larry Wills' snorting bull is an example of the copper tooling which some of the students are doing. Leroy Thomas' disk, to be used as either coaster or ash tray, has a modernistic design resembling facial parts on a chartreuse background. Bob

Valentine has created an ash tray-coaster in warm, red and yellow tones, with a well-placed design. All this craftsmanship and more. There's Jeannelle Alexander's painting, a delicate picture of a fairy princess, seated beside a deep blue brook, surrounded by a richly-colored forest of green and reddish brown. The girl's dress, a graceful swan, and fleecy clouds lend a pure white touch to the color scheme, accenting the fullness of the other tones. Bill Downing's paintings, two of them, of underwater scenes done in intense blue, portray the magic romance of the sea. Another excellent picture by Suzanne Grossini shows ducks in flight over a marshy field," *LR*, Feb. 21, 1957, p. 8; "LUHS Notes… Mr. **Alex Rule**'s crafts class has increased to 63 students in four classes. Their latest project is water colors to replace the pictures now in the hall. Some are doing lapidary work or cutting and polishing stones. In the leather department, projects are ranging from comb cases to hand bags and in the plastics projects you can see objects from small jewelry items to large corner shelves. All kinds of ceramics and pottery are being done along with copper enameling with all types of jewelry. Work will soon start on items of silver. As a part of the class work, each student takes his turn in the tool room. While checking out tools, he is also learning the names and uses of various tools. Other work done by the crafts class can be seen in the display case in the main building of the high school," *LR*, Dec. 19, 1957, p. 16.

1958 – "Teen Time… high school newspaper staff… Donna Negus, art and photography…," *LR*, Nov. 6, 1958, p. 8; "Teen Time… Making the beautiful posters advertising the [homecoming] dance and seeing that they are put up in the hall were Fred Aquino, Pat Skaggs and Sidney Rice…" *LR*, Nov. 13, 1958, p. 14.

1959 – "Teen Time… The first part of the week was spent in taking pictures for the Yearbook, though it looked as if the pictures might not get taken when a cloud burst fell on one group of students that stood posed and ready. Taking the pictures is **Mr. Keller** from the **B and B** studio and is aided by Kati Allen. Student photographers Elden Sandy and John Stephens have been busy every seventh period this past week taking pictures of the various club officers," *LR*, Feb. 12, 1959, p. 12; "High School Plant Gets Summer Overhaul… The auto shop is being modified to drafting room…," *LR*, July 9, 1959, p. 1; "English… Elective Program Slated for Discussion… Scheduled for explanation to the board and interested parents will be … and the elective programs… Industrial arts will include Drawing I and II, Wood I and II and Metal Work. He stated that he will briefly describe what is planned for … the new high school currently on the drawing boards…," *LR*, Nov. 23, 1959, p. 1.

1960 – "Trustees Give Tentative Nod to Preliminary Plan… for the new $3,000,000 high school… Other buildings to be situated on the campus will be a shop building containing electrical and automotive rooms, metal, woodworking and drafting, agriculture and home economics, printing and photography, arts and crafts, an oral communication theater…," *LR*, Feb. 4, 1960, p. 1; "Elective Subjects for Students Diversified in Final Three Years of High School Education… Electives… Art I and

II… Crafts I and II… Mechanical Drawing I and Woodwork I, Mechanical Drawing II… ," *LR*, Feb. 11, 1960, p. 20; "Students, Teachers… La Purisima… Highlighting the publication was the theme: Humor…. Carried out in 'Peanuts' cartoons drawn by Sammy Zwanzig [Mrs. Joseph F. Ruwitch]. Special permission was granted by artist Schultz to use the characters. The Annual was dedicated to Mr. **Lester Sabin**, Wood Shop teacher… Annual staff members… photographers, Mr. Stobbe, Dave Johnson, Steve Shidler and Hank DeLespinasse… Art editor, Sammy Zwanzig, Art staff, Ellen Hatcher, Robin Christie, Donna Negus and Jani Perry…," *LR*, June 9, 1960, p. 18 (i.e., 4-C); "Senior Girls Picked as Editors of School Book… The staff will receive the help of the art department and art teacher, **Mrs. Woods [Sic.? Mildred Wood?]**, in their publicity campaign," *LR*, Sept. 15, 1960, p. 8; "54 LUHS Students Enroll in Work Ed… Donald Beheymer is studying drafting under architect Pierre Claeyssens… Linda Haven is studying commercial art at the **Bob Scolari** Art Shop… Marjorie McDermid is learning floral art at the Avenue Flower shop…," *LR*, Sept. 29, 1960, pp. 10, 20 (i.e., 2c, 6c); "Annual Staff Nears Goal… A contest will be held to choose the cover design. The staff has proposed selecting covers from designs submitted by LUHS students. Budding artists are requested to draw designs including the name or symbol of the school and submit them to any member of the annual staff. A prize will be offered for the chosen design," *LR*, Oct. 20, 1960, p. 13; "Annual Staff Selects Chairmen… 1960-61 … La Purisima. Heading the Art section is Sammy Swanzig. Her staff includes Marion Huyck and **Sandy Zimmer**…," *LR*, Nov. 24, 1960, p. 9.
See: "Chalk Talks," 1912, "Lompoc Community Woman's Club," 1954, "Posters …," "Works Progress Administration"

Lompoc Camera Club
See: "La Purisima Camera Club"

Lompoc Civic Theatre (Lompoc)
Little theater organized, 1948. It utilized artists to design and paint its sets, design and sew its costumes, apply makeup, create posters to advertise the plays, etc. Some of this artistic work was done by students from the high school.

■ "Civic Theatre Organized; Miguelito School to Serve as Unique Playhouse … Lompoc Civic Theatre was formally organized here last Wednesday evening. The group is the out-growth of a play-reading group and is already at work on a theatre home for its ambitious program of activities… The site for the Lompoc Civic Theatre is the former schoolhouse building in Miguelito Canyon, approximately three miles from Lompoc… and when conversion of the buildings are completed, Lompoc should have a unique Civic Theatre. … **Forrest Hibbits**… will be the art director. His art experience and ability are expected to bring interesting set designs when production gets under way," *LR*, Aug. 26, 1948, pp. 1, 5.
See: "Lompoc, Ca., Union High School"

Lompoc Community Woman's Club / Lompoc Community Women's Club
Woman's club that occasionally held art events (exhibits, lectures, demonstrations) at its meetings, 1947+. Its Arts and Crafts section, active in the 1950s, met at the Community Center. Beginning c. 1955 it sponsored an annual Children's Art Contest and, in 1957, started an art exhibit [Open-Air Art Exhibit] held in Ryon Park in conjunction with the Alpha Club Flower Show in late spring. All seem initiated by member Mary Brughelli.
[Do not confuse with the Community clubs in Santa Maria.]
■ "Initial Meeting of New Women's Group … Lompoc Community Woman's club… more than 300 women have sent in cards signifying their intention to become members … Formal organization will take place at the first luncheon meeting scheduled for October 8… A complete corps of temporary officers has been organized…," *LR*, Sept. 25, 1947, p. 14.
Lompoc Community Woman's Club (notices in Northern Santa Barbara County newspapers on microfilm and on newspapers.com)
1948 – "Art Exhibition … An exhibit of paintings by **Forrest Hibbits** of Lompoc, jointly sponsored by the Community Woman's club and the City Recreation department, will be held in the **Community Center** February 12 through 15. Included in the exhibit will be many of the watercolors currently shown in the Santa Barbara Museum of Art, among them several paintings made by Mr. Hibbits during his recent European trip. … free of charge … A preview… will be given to the members of the Community Woman's club… at the club's regular meeting on Wednesday, February 11," *LR*, Jan. 29, 1948, p. 2; "Flowers, Hobbies Displayed at Woman's Club Tea… in the Recreation Center… **Mrs. Julian E. Rogers**, art chairman, who was in charge of the **hobby show**… Those who displayed hobbies were as follows: Mesdames Richard Brooks, European crystal; William Harm, Jr., pins and buttons; George Lavenson, spoons; V. L. Freiley, salt and peppers; Ernest Cass, shoes; **W. K. Padrick**, Japanese articles; Lettie Jane Gantner, dog pictures; **Eric Anderson** [Sic. **Andersen**], old china; William Hoag, ceramics; James Kenney, silver, copper and brass work; Robbie Warren, perfume; **Forrest Hibbits**, Belgian lace; R. L. Byington, Indian baskets; Harold Lovelace, Japanese articles; W. K. Harns, vinegar cruets; **Viola Dykes**, ceramics and miniature tea pots; Sam Thompson, horses; A. L. Moumblow, dolls and coins; William Schuyler, racing boats and trophies; Dale Wood, Chinese articles; and Robert Winters, moving pictures of the club's first meeting …," *LR*, March 4, 1948, p. 8; "Brooks Speaker… Lompoc Community Woman's Club … Victor Gallant, guest whistler… Gallant, now a student at Brooks School of Photography, formerly served in the Army Signal Corps, and has appeared on the Major Bowes radio program. He whistled two selections, 'Glow Worm,' and 'Listen to the Mocking Bird' accompanied at the piano… Guest speaker for the afternoon was **Ernest Brooks**, owner and instructor of the Santa Barbara School of Photography. An explanation of the personnel and operation of the school was given by Brooks. He also displayed various pictures and photographs and explained their uses in commercial work," *LR*, March 11, 1948, p. 8; "Mrs. Perozzi… Mrs.

Julian Rogers made available an exhibit which included water colors by students of **Forrest Hibbits**, work of students of Artesia and Maple schools, and a painting by **Channing Peake**," *LR*, April 15, 1948, p. 3; "Woman's Club… **Edgar H. Wileman**, manager of the Home Advisory Bureau at Barker Bros., in Los Angeles, will be the guest speaker at next Wednesday's meeting… Wileman will bring samples of floor coverings and drapery fabrics to illustrate his talk on home furnishings. … Wileman will also speak to the evening group of the club … The evening meeting will start at 8:00 p.m. at the Community Center…The Adult Education class under the direction of **Mrs. Viola Dykes**, will present an exhibition of their upholstery work, ceramics and other crafts studied…," *LR*, May 6, 1948, p. 4.

1950 – "Interior Decorator Slated as Speaker… **Robert Burbank**… In conjunction with the meeting and under the auspices of the club, exhibits by **Mrs. Viola Dykes** of work done by the adult education classes as well as an exhibit of painting by local artist **Forrest Hibbits** will be on display. The former exhibit will include ceramics, silk lamp shades, hand craft pictures, hand tooled leather goods and upholstering. Mrs. Dykes also does professional interior decorating and color harmonizing for homes…," *LR*, Feb. 2, 1950, p. 4; "Decorator Speaks at Night Meeting of Community Club. **Robert Burbank**, a staff member at the Michael Levy store in Santa Barbara … Speaking on the same subject, interior decoration, which he used as his topic before the afternoon club meeting, Burbank discussed and illustrated with samples various types of wall paper, draperies, and upholstering which are being used in home decoration today… Exhibits Shown. For both the afternoon and evening meetings exhibits were on display of ceramics and hand-work done by the adult education classes under the direction of **Mrs. Viola Dykes** and art work done by students of local artist, **Forrest Hibbits** …," *LR*, Feb. 16, 1950, p. 4; "Los Angeles Interior Decorator Set as Community Club Speaker. **Edgar Harrison Wileman**, noted lecturer and consulting decorator… guest speaker for Wednesday afternoon's November meeting… Home furnishings will be the speaker's subject when he addresses the gathering at the Community Center…," *LR*, Nov. 2, 1950, p. 3.

1951 – "Opens Season with Novel Wedding Gown Parade," and "rush" tea, *LR*, Sept. 13, 1951, p. 7.

1952 – "County CFWC Meeting in Alpha Club, February 12. Lompoc Community Women's club will be hostess to the monthly meeting of the Santa Barbara County Conference of CFWC… Highlight of the afternoon will be an exhibit of paintings and ceramics done by members with **Mrs. Mary Jane Thornburgh** of Santa Monica, State Art chairman, as speaker. She will illustrate her talk with a number of her own paintings. **Mrs. Milton Schuyler**, County Art chairman will be in charge of the exhibit which will be followed by a brief discussion of new trends in flower arrangement," *LR*, Feb. 7, 1952, p. 8; "Every Woman an Artist… CFWC Speaker at Feb. All-Day Meeting… at the Alpha Clubhouse… Afternoon Session. Guest speaker of the day was **Mrs. Mary Jane Thornburgh**, State Art chairman, on the topic, 'Every

Woman an Artist,' in which she declared every woman should use her hands in creative work, whether it be painting, ceramics, flower-arranging, rug making, home decoration, or gardening, 'Art,' the speaker declared, 'is anything well done.' Mrs. Thornburgh exhibited several paintings of her own and several that were to be given as prizes in the State **Penny Art Fund**. County Exhibitors. Club women of the County had some of their own paintings and ceramics on exhibit, arranged by **Mrs. Milton Schuyler**, County Art chairman, and **Mrs. William Bailey**, Alpha Club Fine Arts chairman. The Goleta Service Women's club submitted several paintings done by their High School Art students, one of which was selected by the state chairman of Art for 'The World Friendship Through the Arts' school project on the 'American Way of Life' theme," *LR*, Feb. 21, 1952, p. 2.

1954 – "Women's Club to Hear Speaker on Arts, Crafts... Wednesday's meeting... **Mrs. L. L. Williams** of Los Angeles will discuss present trends in painting, ceramics, sculpture and related arts. Her talk will be augmented by an exhibit of local art which will include adult compositions and also a display of work being done by **Lompoc high school** students," *LR*, March 4, 1954, p. 6; "Nominations Read for New Officers... The tables were brightly ornamented with the Shamrock and Harp theme of St. Patrick's Day and reflected the artistry of **Mrs. Arnold Brughelli** and Mrs. Victor Kolding who were in charge of decorations. Featured on the afternoon's program was **Mrs. L. L. Williams**, state club chairman of arts and crafts, who spoke on art trends and traditions while illustrating her talk with interesting hand-crafted objects," *LR*, March 11, 1954, p. 6.

1955 – "**Children's Art Contest** Winners are Announced. Members... enjoyed an exhibit of paintings from the fifth, sixth and seventh grades of the Hapgood school at their meeting and luncheon yesterday. **Mrs. Arnold Brughelli**, art chairman for the club, arranged the exhibit... The youngsters were quite enthusiastic about the contest... Thanks go to **Mrs. Lloyd Huyck** and **Mrs. E. H. Grady** who helped along with Mrs. **Brughelli** in judging the winners...," and winners' names listed, *LR*, Feb. 10, 1955, p. 5; "Arts & Crafts Section Have Sewing Bee. The second meeting... met last night at the home of Mrs. Russel Benhart... for sewing Santa Claus dolls to be used as gay decorations on either packages or the Christmas tree. The dolls were created out of bits of left-over yarn and materials," *LR*, Oct. 27, 1955, p. 3; "Woman's Club Executive Board... Reports were made by the Arts and Crafts Section and an announcement made that a meeting would be held on Wednesday, November 16 at 8 p.m. in the home of **Mrs. C. K. Chilson**...," *LR*, Nov. 3, 1955, p. 3.

1956 – "Woman's Club to Exhibit Prize Drawings... [**Children's**] **Art Contest** sponsored by the club, and that winning drawings were to be on exhibition at the February meeting...," *LR*, Jan. 12, 1956, p. 5; "Arts and Crafts Make Silhouettes... Section... met last night in the home of Mrs. Walter Livingston ... making silhouettes for framing. Those attending were ...," *LR*, Feb. 2, 1956, p. 4; "Community Woman's Club... Also, during the meeting on

Wednesday, winners of first and second and third prizes of the recently judged art contest sponsored by the Woman's Club... **Mrs. Arnold Brughelli**, art chairman... Judges for the contest were **Mmes. C. K. Chilson, E. H. Grady** and **Juka Carlson**. Winning students were announced as follows" and students named, *LR*, Feb. 2, 1956, p. 5; "Space Adventure... February 8th meeting... enjoyed a 'Spaceship Tour' conducted by Mrs. Evelyn Toor, Educational Lecturer, with the aid of colored art slides drawn by an internationally recognized scientific artist, Chesley Bonestell...," *LR*, Feb. 16, 1956, p. 4; "Section Meeting Held in Annex. Copper etchings suitable for framing or for trays were made by members of the Arts and Crafts Sections... at their March 19 meeting held in the annex of the Recreation Center," *LR*, March 22, 1956, p. 5; "Woman's Club Set Rummage Sale... **Mrs. Rohlfsen**, chairman of the Arts and Crafts Section, announced that all club members were invited to attend the meeting to be held Monday evening at 7:30 in the Recreation Center. The Section has adapted a copper work project and on the theory that other than Section members might be interested, those who wish to attend were asked to notify the chairman," *LR*, April 5, 1956, p. 7; "Woman's Club ... **Mrs. Glen Rohlfsen** reported that the Arts and Crafts Section of the Club will hold monthly meetings throughout the summer months with the next meeting scheduled for May 28 with a pot luck planned for 7:30 p.m.," *LR*, May 17, 1956, p. 4; "Woman's Club Program... program events scheduled for the regular monthly meetings which are held on the second Wednesday of each month. The club year opened with the annual fashion show... In January there will be the art display and awards for young artists. **Mrs. Mary Brughelli** will be in charge ... **Adele Neff**, delineator of characters, who has been acclaimed for her unique programs of one-woman theatre, 'A Cavalcade of Ladies, Women and Females,' will be in Lompoc for ... March program ...," *LR*, Sept. 27, 1956, p. 5; "Woman's Club Making Plans... this evening beginning at 7:30 when the Arts and Crafts Section meet at the Community center for their regular get-together. **Mary Brughelli**, chairman of the Section, will act as instructor for an evening of work with ceramics and sculpturing... bring clay with which to work...," *LR*, Nov. 1, 1956, p. 4; "Plates or Pretties for Arts & Craft. The Arts and Craft Section of the Community Woman's Club has scheduled a meeting for tonight, beginning at 7:30 in the Community Center. Members of the group will work with ceramics or, if they prefer, will make and design Christmas decorations," *LR*, Nov. 15, 1956, p. 8.

1957 – "Woman's Club to Award Artists [**Children's Art Contest**]. Prize-winning art pieces will be unveiled when members of the Community Woman's Club hold their first meeting of the new year on Wednesday, January 9... in the Alpha clubhouse. Art work created by students of Hapgood school and selected by a panel of judges will be exhibited by **Mary Brughelli**, art chairman... The yearly event, sponsored by the Woman's Club, is geared to offer encouragement to youngsters interested in art...," *LR*, Jan. 3, 1957, p. 4; "**Young Artists** Rewarded with Prizes... Community Woman's Club hosted scores of youngsters who had entries of art work in the annual Art Contest ... held in the Alpha Clubhouse with **Mrs. Arnold Brughelli**

as arts and craft chairman… and clever magician from Santa Maria, **Mr. Ralph Adams**… In the call-off of first place winners of the Art Contest were Betty Withrow, 4th Grade, Eileen Negus, 5th Grade, Eddie Casarez, 6th Grade, and Eddie Escobar, 7th Grade. Judges… **Mrs. Elsa Schuyler**, **Mrs. E. H. Grady** and **Mrs. C. K. Chilson**… so many fine drawings and paintings… Along with ribbons… finalists… also received art books and art materials for prizes. Other winners…," and students named, *LR*, Jan. 10, 1957, p. 7; "Arts & Crafts Section to Meet Thursday… will continue with ceramic work, sketch or water color when they meet on January 24 beginning at 7:30 p.m. in the Community Center. Section chairman **Mary Brughelli** will lend assistance with art objects and will conduct the meeting. Members were requested to attend with paints and art materials for their own use," *LR*, Jan. 17, 1957, p. 4; "Woman's Club to Honor Past Presidents at 10th Anniversary … It was also announced that Club plans for the summer months ahead include sponsorship of the Art Exhibit to be held in conjunction with Lompoc's Annual Flower Festival on June 22-23. **Mrs. Mary Brughelli** [Sic.] was named chairman," *LR*, May 2, 1957, p. 4; "Call for Artists… The Lompoc Community Woman's Club has extended an invitation to each aspiring artist in the city to join in the first **open-air Art Show** to be held in conjunction with Lompoc's annual Flower Festival in June. Scheduled from 1:00 to 4:00 p.m. on both Festival afternoons, June 22 and 23, art pieces will be shown against the best of backdrops, nature's own setting in Ryon Park. **Mrs. Arnold Brughelli**, chairman of the Woman's Club Festival activity, announced this week that all types of art pieces, in all media, will best represent the artistic interests of local residents and urged all artists, all art teachers and all aspiring artists to exhibit their work. Entry blanks for the convenience of exhibitors are available at the *Lompoc Record* office at 112 East Ocean avenue in the front office. Student artists are requested to fill out an entry blank and label each art piece and leave [it] at the City Library basement on June 15. Exact time will be announced later. Exhibitors with framed pieces will be asked to bring art pieces to the Ryon park showing on either Saturday or Sunday afternoon, or both. A responsible person will be on hand to take charge of the pictures until called for at 4:00 p.m. by each individual artist. The chairman, an artist herself, expressed the hope that all interested persons will join enthusiastically… **Mrs. Brughelli** will exhibit some of her fantasies in water colors… Other artists who have to date volunteered to participate are **Mr. and Mrs. Ernest Weidmann [Sic. Wiedmann], Mrs. Juka Carlson, Mrs. Elsa Schuyler,** and **Mrs. Ethel Bailey**," *LR*, May 16, 1957, p. 5.

1958 – "Arts, Crafts Section to Meet Monday… in the 315 East Locust avenue home of **Mrs. C. K. Chilson**… Jan. 27… Section chairman, **Mrs. Erick Andersen**, requested members to bring ideas and materials… for Easter decorations," *LR*, Jan. 23, 1958, p. 4; "Woman's Club to Salute Young People with Community Program next Wed… Annual Art Contest and Exhibit… Approximately 40 pictures are expected… judges are **Mrs. Elsa Schuyler**, Miss [Virgie] Sanborn and **Mrs. Arnold Brughelli**," *LR*, March 6, 1958, p. 7; "Community Woman's Club Awards **Young Artists** at Annual Event [**Children's Art Show**]…

meeting held in the Alpha Clubrooms. Pictures, paintings and sketches entered in the contest were posted on the walls of the assembly room… **Mrs. Erick Andersen**, chairman of the Woman's club Art Contest and Exhibit, called off the names of ten prize winners. Two from each grade [and children named] … Special awards were given to all pictures exhibited at the Woman's club Annual Art Contest and Exhibit event held Wednesday March 12," *LR*, March 13, 1958, p. 7; "Young, aspiring artists of the community were given the spotlight Wednesday evening at the meeting of the Lompoc Community Women's Club, when they were presented with awards for their outstanding art work," per "Spotlight on [**Young**] Artists, Awards" for elementary school children, *SMT,* March 17, 1958, p. 3.

1959 – "**Young artists awards** were announced by the Lompoc Community Women's club as paintings and sketches posted on the walls of the Alpha clubhouse were judged. **Mrs. Eric Andersen**, chairman of the contest, announced as winners…," and children named, *LR*, Jan. 1, 1959, p. 4; "Hapgood Students to Show Paintings. Students of Hapgood Elementary School will exhibit their art work in a special event sponsored by the Community Women's Club at their monthly luncheon… this Wednesday at 1:30 p.m. in the Alpha Club House… Judges of the art will be **Mrs. Elsa Schuyler, Mrs. James E. Lewis** and **Mrs. Paul Highfill**," *LR*, March 5, 1959, p. 3; "Community Woman's Club Holds Opening Session… **Mrs. E. T. Andersen** thanked the members who worked with her for the Art Display in Ryon Park during the Flower Festival last June. She suggested having an Arts and Crafts group work with the Garden Section during Christmas season to create wreaths and other decorations," *LR*, Sept. 10, 1959, p. 5.

1960 – "Woman's Club… The new hand carved sign which **Oscar Lindberg**… had made for the club, was displayed. Mr. Lindberg was presented with a scroll of appreciation," *LR*, June 30, 1960, p. 7.
See: "Alpha Club," 1948, 1954, "Lompoc, Ca., Adult/Night School," 1950, "Open-Air Art Show," "Tri-County Art Exhibit," 1948

Lompoc Film Council
Club for advocates of filmmaking, 1948.
Lompoc Film Council (notices in Northern Santa Barbara County newspapers on microfilm and on newspapers.com)
1948 – "Film Council Sets Program… final program before recessing for the summer months. 'Film Council for Fun' will be the theme of the meeting in the **Community Center** and a three-ring circus of motion pictures and slide photographs is planned. … provided by local hobbyists and several projects will be in use simultaneously. The event will be co-sponsored by the [La] **Purisima Camera club** of Lompoc and the Lompoc Film Council…," *LR*, May 27, 1948, p. 16; "Camera Fans to Present Work at Meet Tonight. Vacation Spots to be Theme… 'Pacific Coast Vacation Spots' a color slide and film program, will be presented by the Lompoc Film Council tonight in the Community Center at 8:15. Co-sponsored by the **Purisima Camera club**… several projectors operating simultaneously, like a three-ring circus… no admission charged… Camera fans whose films will be shown

include… Mrs. Robert Lind, Death Valley, Kenneth Rudolph, Grand Canyon, **Mrs. James Larsen**, National Parks and Santa Barbara Channel Fishing, **Dr. and Mrs. David Florell** [superintendent of Lompoc schools], Mountains and Valleys East of the Sierras, **P. M. Bodie**, Vacation Lands, and **Gilbert Martin**, Oregon and Washington. A film on Belgium and Luxembourg will also be shown by **Mr. and Mrs. Forrest Hibbits**," *LR*, June 3, 1948, p. 9.

Lompoc "Fine Arts" Club
Short-lived club devoted to music (?), 1923.
1923 – "Fine Arts Club has Musical and Banquet," *LR*, June 15, 1923, p. 1; concert by Prof. Hague Kinsey in high school auditorium, *LR*, Oct. 26, 1923, p. 3.

Lompoc Flower Festival
See: "Alpha Club," 1934+, "Flower Festival (Lompoc)"

Lompoc Gem and Mineral Club
Club that held hobby shows that included art, 1959, 1960. Some members designed and manufactured jewelry and other items.
■ "Gem-Mineral Club Fun for Local Prospectors," and club takes many field trips. "Hartley Glidden called the first meeting together on April 30, 1958 …," *LR*, Jan. 29, 1959, p. 10.
Lompoc Gem and Mineral Club (notices in Northern Santa Barbara County newspapers on microfilm and on newspapers.com)
1959 – "Hobby Show Slated for Sat., Sunday in Lompoc… at the Veterans Memorial Building when the Lompoc Gem and Mineral Club sponsors a Hobby Show. Among some of the things to be seen will be a 20-item weapon collection owned by Arthur Batty…. Another interesting hobby on display will be a penny collection being offered by Mrs. Everett Martell. The coins date back to 1909. Officials for the hobby show have indicated that anyone in the community is welcome to bring their hobbies… Children are especially encouraged … For those who would like further information they should call **Mrs. Charles Laubly** at Lompoc 8-1484 or Hartly Glidden at 8-4361. Other exhibits will include a quarter midget, gem and minerals, model trains, bows and arrows, spoons, Dutch dishes, paintings, needlework, and a crystal collection. Some others will be a fossil collection, ceramics, doll collection and even some Franciscan jasper. The **Camera Shop** of Lompoc will have a display booth. On Saturday, the show will begin at 1 p.m. and will continue until 9 that evening; on Sunday, the doors will open at 10 a.m. and close at 6 p.m.," *LR*, Nov. 5, 1959, p. 18.
1960 – "Gem and Mineral Rock Display… October Hobby Show… [and details of the rock collection of rancher Jim Larsen] … second annual… It is hoped to have displays in many categories," *LR*, Oct. 6, 1960, p. 28 (i.e., 6a); "Gem and Mineral Club Sponsor October Show… October 29-30… in the Veterans Memorial Building… Already listed for displays are: Melba D. Latham [Mrs. Damon Latham], paintings, Andre and Nancy Namenek, [military man,

silverwork] jewelry, **Dee Sudbury**, paintings, Kathryn Davis, enameled copper, Faye Jense, gems, M. L. Geyer, wood turnings, **Mrs. Glen Wegner**, painting and two mosaics, **Ed Tenney**, novelty concreations (gems and feathers), **Mrs. Ethel Oester**, mosaics… Elsa Schuyler, paintings, Sally Henning, dolls, Audrey Bryan, ceramics (group display)… ," *LR*, Oct. 20, 1960, p. 22; "Hobby Show Displays Prove of Wide Interest… Hobbyist displays included… cut glass pieces owned by Mrs. Jim Beattie, glass items colored by the desert sun from the collections of Mrs. William Cornell of Ridgecrest and of Mrs. Shew Gee. … Embroidered Pictures. Other interesting displays included the embroidered pictures by **Mrs. Erick T. Anderson**, the mosaic peacock picture made by **Ethel Olster** [Sic. **Oester**] of Vandenberg, the enamel copper jewelry made by **Mrs. Melvin (Kathryn) Davis**. …Lovely paintings were shown by **Dee Sudbury, Elsa Schuyler** and **Mary Brughelli**, and students of **Betti Tognetti** entered a group display of ceramic items," *LR*, Nov. 7, 1960, p. 12.
1962 – "Gem, Mineral Club Slate Flower Fete Hobby Show… A partial list of displays… mosaics, **Mrs. Ethel Oester**…," *LR*, June 21, 1962, p. 63 (i.e., 27E).

Lompoc Historical Museum
Located in the city's Carnegie Library, 1957.
[The current library on East North Avenue, opened in March 1969, does not own any historic items and is not certain of the disposition of the items described below. The items may have gone to the current Lompoc Museum, established 1969 in Lompoc's repurposed Carnegie Library. Among other items, that Museum currently owns the **Clarence Ruth** Collection of Chumash and other Native American artifacts. Or, the items may have gone to the **Lompoc Valley Historical Society** that runs the historic Fabing McKay Spanne house at 200 South H Street.]
■ "Historical Museum Approved for Library. Establishment of a historical museum in the Lompoc municipal library was approved by members of the library board this week. The museum will serve principally as a repository of documents, photographs and other articles having historical significance for the community. … many local families possess historically significant items which are stuck away in attics and basements and which easily may be lost or discarded as the years pass. Articles for the museum are now being received by the library either on the basis of a gift or loan. As material is received, cupboards in the library clubrooms will be converted to display cases with glass doors so that the material may be kept under lock. Glenn Schuyler, president of the **Pioneer Society…** lauded the library board's decision and promised the assistance of the pioneer group in developing the museum. The society has for several years been working toward the same end and already has an extensive collection of photographs. Mrs. Charles Lockwood, who was responsible for organizing a museum of the same type in San Jacinto a few years ago, has volunteered to assist…," *LR*, Nov. 14, 1957, p. 1
See: "Lompoc Valley Pioneer Society," "Lompoc Valley Historical Society," "Santa Barbara County Library (Lompoc)"

Lompoc Hospital Women's Auxiliary (Lompoc)
Volunteer group responsible for hanging original art to brighten up the Community hospital, 1949+. Held an art exhibit and hung artwork in the hospital, 1949, 1952, 1956.
1949 – "Local Artists Exhibit Works at Hospital … arranged… by the Hospital Women's Auxiliary. Paintings of four Lompoc artists have been placed on display in the patients' rooms… and under present plan will be changed at intervals. Lompocans contributing their watercolors … include **Mrs. James Kenney, Mrs. Claire Callis, Mrs. K. [or E.] H. Schuyler** and **Mrs. R. G. LaRue**. In all, 23 paintings are on display, all of them … Lompoc scenes …," *LR*, March 3, 1949, p. 20; "Hospital Auxiliary Hears Report… The members reviewed the paintings lately presented to the hospital by the artist **Forrest Hibbits** and his students. Those contributing pictures were **Elsa Schuyler, Ruth La Rue, Claire Callis, E. Kenney** and **Mrs. William Bailey**…," *LR*, March 10, 1949, p. 7; "Rebekahs … An art contest was held, each member drawing the picture of his neighbor. Mrs. Frank Fratis and Lettie Jane Gantner being the judges chose the efforts of **Mrs. Robert Chilson, Mrs. Milton Schuyler** and Ray Stalker as the prize winners," *LR*, March 17, 1949, p. 3.
1950 – "Holiday Projects… Hospital Auxiliary members… discussed various Christmas projects which will be undertaken for the Lompoc Community hospital… **Mrs. Arnold Brughelli** had given a painting which she has titled 'United in Faith and Aid' to the hospital. The work depicts the history and development of the local institution…," *LR*, Dec. 14, 1950, p. 5.
1952 – "Valley Artists Loan Paintings to Hospital… Community Hospital …include **Forrest Hibbits, Hare Hutchinson, Frances M. Sedgwick** and **Charles Glasgow** of Santa Ynez Valley; **Mrs. Arnold Brughelli, Mrs. Charles E. Maimann, Mrs. Milton Schuyler** and **Mrs. Ethel Bailey** of Lompoc…," *LR*, Dec. 11, 1952, p. 9.
1956 – "Then, in 1949, as things began to shape up … around the hospital and most of the basic necessities were now off the checklist, the ladies started still another project. Artists in the community and surrounding areas were invited to lend paintings to be hung in the rooms. The response was good. It was agreed that anyone contributing a painting could replace it or remove it whensoever he wanted. Twenty-three paintings were offered and the Auxiliary had good reason to be pleased when patients began saying how much it meant to have the otherwise barren walls brightened with such pretty and interesting paintings. Artists whose pictures have brought pleasure to Lompoc Community hospital patients… include **Mrs. Ethel Bailey, Mrs. Claire Callis, Mrs. James Kenney, Mrs. C. E. Maimann, Mrs. Ruth LaRue, Mrs. Milton Schuyler, Francis Sedgwick** and also **Forrest Hibbits**, whose fine snow scene painting now hanging in the waiting room reminds all who view it of those January snow days in 1949," per "Service to Others Tells History of Lompoc Hospital Women's Auxiliary," *LR*, Nov. 15, 1956, p. 4.

Lompoc Library
The city's first library opened in 1911 in a building constructed with funds provided by Andrew Carnegie. In 1969 a new library was constructed on East North Avenue and the "Carnegie Library" was repurposed as the Lompoc Museum.
See: "Lompoc Historical Museum," "Santa Barbara County Library (Lompoc)"

Lompoc Nursery School
Nursery school that included creative activities, 1942.
■ "More Volunteer Assistance Needed… a community project… Over 40 children of employed mothers are in daily attendance… Federal government, through the Child Protective Program and WPA, has made possible the establishment of a nursery school here, but community support both financial and volunteer time are needed to maintain it… The present staff of 5 paid teachers to care for the children from 7:30 to 5:30 is inadequate… Thirty volunteer workers spending about 2 hours a week each are needed to carry out the program. Definite work hours are from 10-11 a.m. to assist with supervision of creative activities such as painting, music appreciation, clay modeling, coloring and hammering…," *LR*, Dec. 11, 1942, p. 5.

Lompoc School of Art Embroidery (Lompoc)
Embroidery school, 1889.
■ "Embroidery… Owing to the rapid growth of the inclination of ladies in our midst for opportunities to learn the above art, I have determined to give lessons – in Class or Private – In Kensington, satin, Sorrento, Holbein, and all the stitches known to the art. Spanish Lace Work – a Specialty. Original Designing, Drawing, Stamping, and work artistically executed to order on all kinds of fabrics. Etching in wash paints on linen or muslin. Classes – Tuesdays and Saturdays from 1 to 5 p.m. **Henrietta A. Hendrickson**," *LR*, Dec. 21, 1889, p. 2.

Lompoc Theater
Historic building, constructed 1927 by Knights of Pythias to replace the old Lompoc Theater. Manager Earl Calvert, above. Site of the Kiddie Kartune Club, 1931, and the Baby Motion Picture Stars contest, 1932, 1934.
■ "The [New] Lompoc theatre opened Friday, May 27, 1927… one of the finest on the coast as every detail is new and up-to-date. The building was erected by the Knights of Pythias of Lompoc… **G. F. Learned** did all the painting except the decorating done by **Verne Laney** of Hollywood. Mr. Learned did the woodwork in the theatre, offices and stores in the building… The theatre's scenic equipment, consisting of drapes, olios, scene curtains and a 'beautiful' cyclorama were built to the specifications of the **Los Angeles Scenic Studios**. Mr. Norman K. White, manager of the firm's scenery department, was there on opening night…," and photo of interior of theater in "Lompoc Theatre," *Lompoc Legacy* (Lompoc Valley Historical Society Quarterly Bulletin), Summer 1985, pp. 1-8.

■ "Fourteen Years Continuous Show at Old Theatre. The old Lompoc theater will close its doors as a motion picture play house next Monday night after a continuous run of over fifteen years… the new Lompoc theater will be opened on next Friday evening, May 27, and following the show at the old theater on Monday night the projecting machines and other equipment will be moved to the new show house… Baker & Calvert will retain the old theater as a dance hall and later it will be converted into a skating rink…," *LR*, May 20, 1927, p. 6.

Lompoc Theatre Project… is a registered 501 (c) (3) non-profit organization working to restore and re-open the historic Lompoc Theatre as a venue for arts, entertainment, education and culture.

See: "Baby contest / Baby Motion Picture Stars contest," "Calvert, Earl," "Kiddie Kartune Club," "Laney, Verne"

Lompoc Valley Fair / Lompoc Valley Exposition
Sponsored by Farm Bureau, 1927, 1930. [After years of no county fair arranged by the town of Santa Barbara, the various valleys in north county appear to have taken things into their own hands and each put on a fair. The first was the Lompoc Valley Fair in 1927, followed in 1928 by the Santa Ynez Country Fair and a Santa Maria Valley Fair.]

Lompoc Valley Fair (notices in Northern Santa Barbara County newspapers on microfilm and on newspapers.com)

1927 – "Immense Exhibit Pledged for Lompoc Valley Fair… Friday and Saturday, September 9 and 10… An immense tent has been leased and all the exhibits will be housed… continuous entertainment … Pioneers Reunion…," *LR*, Aug. 12, 1927, p. 1; "The Lompoc Fair, Santa Barbara county's only Fair and the first to be held in the county for several years, will take place September 9-10….," *SMT*, Aug. 27, 1927, p. 6, col. 1.

1928 – "Fair Entry List Covers Fully Local Products… Schools… 4-H Club… **Mrs. Alexander McLean** will have charge of the needlework department… Mrs. Jack Alexander has the arts and crafts department, which includes lamp shades, floor pillows, basketry and flower making displays…," *LR*, June 29, 1928, p. 1; "9 Valley Schools Plan Displays of Arts and Crafts. All of the nine schools of the valley in addition to the Lompoc elementary school, the junior high school and the high school will be represented in the educational display … The school display will be next to the main entrance of the tent … It will include complete showing of manual work, machine work, arts and crafts. Cash prizes have been offered… Prizes for the junior high school work will be divided as follows: wood work, applied art, drawing, home economics. For the high school awards will be for sheet metal work, cabinet making, dye arts, lamp shades, textile making, stitchery, designing, sewing and cooking…," *LR*, Aug. 31, 1928, p. 3; "Lompoc Valley Fair will Open with Big Program," *SYVN*, Aug. 31, 1928, p. 1; "600 Compete in Exhibitions Opened in Tent Last Night… The section devoted to fancy work was one of the most attractive to women last night. A large section in the north end of the tent is filled with needlework of the most delicate and beautiful character… Pioneer Display… filled with old pictures, relics, clothing… displayed handmade quilts,

paisley shawls, old laces and linens, and numerous antique articles… Arts and Crafts… **Mrs. L. E. Heiges** showed a floor lamp, a fernery, a floor pillow and a dwarf doll. Ida Isom entered a boudoir lamp. Mildred Daniels showed a table lamp, book ends and plaques. Howard Gale showed a specially fine hammered copper plaque and several book ends. Mrs. Jack Wall is showing inlaid jewel pictures. In addition to these entries there is a display of handiwork of veterans of the Burbank and Palo Alto hospitals… The school exhibits… variety of work. … The booth of the Lompoc elementary school had a centerpiece of a small model of the school building built by **Principal Clarence Ruth**… Grouped about this and on the walls of the booth are samples of work by pupils showing drawings, carpentry, silhouettes and other work. Artesia school shows a model home and grounds… San Julian features… a table of toys, Santa Rita features woodwork toys. Jalama has fancy work, drawing and toys. Miguelito has an elaborate array of art and fancywork. Lynden shows vases, toys and art work. Maple features two large dolls at a table loaded with books. Purisima features dolls and artwork…," *LR*, Sept. 7, 1928, p. 6.

1929 – "Lompoc Valley Fair. Is Lompoc going to have a Lompoc Valley Fair this year? …," *LR*, March 29, 1929, p. 2.

1930 – "Boost the Valley Fair… September 11, 12, 13," *LR*, July 11, 1930, p. 2; "Valley Fair Plans Completed… examples of everything produced within the boundaries of this district… Every school in Lompoc and the district will be represented… the arts and crafts division will be complete with examples of the best handicraft … an exhibit of Indian artifacts and other Indian relics…," and "Pioneers' Pictures on Public Parade…," *LR*, Sept. 5, 1930, p. 1; "Who Was Who Locally 2 Years Ago Revealed by Files of Last Valley Fair Edition of *Review*… By reproducing a number of 'About People You Know' items of the *Lompoc Review* of September 4, 1928… **Miss Vina Queisser**, art teacher at the high school, will have charge of the high school and junior high school booths at the fair. Shop work, applied arts and drawing, cakes and cookies will be shown… (**Miss Queisser** is now **Mrs. Franklin West** and lives in Santa Barbara) …," *LR*, Sept. 5, 1930, p. 2; "High School Executive Committee Will Handle School Booths at Fair… The color scheme is to be … blue and white, the high school colors. Work done by the art classes, domestic science and manual training classes will be on display. Among the exhibits will be water-colored drawings, craft work, fancy embroidery and sewing, nut and fruit bowls, a sewing table, book cases, and magazine racks," *LR*, Sept. 5, 1930, p. 3; "Friendship Quilt is Displayed with Old Time Articles… in the Lompoc **Pioneer society**'s booth at the Lompoc Valley Fair…," *LR*, Sept. 12, 1930, p. 1; "Great Success of Lompoc Valley Exposition… display sign… Fronting the Farm Center's display is a sign which compels the admiration of every visitor. The words, 'Lompoc Valley' and 'The Valley Beautiful' are read emblazoned in large letters formed of [actual] flowers of contrasting colors, the work of Mrs. Harold J. Whitlock, Walter E. Callis and Ed Foster. The idea for the sign was conceived by Walter Callis, the sign was laid out by Ed Foster, and **Mrs. Whitlock** constructed the sign using flowers for her material. … Schools

represented. City and district school displays… high class of art work and manual training being taught… The Maple school exhibit consists of a scale model of the school property… two years in the making… Relief maps of various countries are featured in several of the school exhibits while others have some really creditable pen, paint and crayon drawings… The three Campfire Girl troops of Lompoc are represented by a booth framed in greenery in which products of their needles, pens, pencil and brushes are effectively displayed… **Clarence Ruth**, principal of Lompoc Union school, has an interesting display of Indian artifacts, including mortars and pestles, bowls, pottery dishes, flint arrowheads and beadwork. This collection represents devotion to an avocation during many years and is declared one of the finest in existence outside of museum walls… Lompoc **Pioneer society**'s old time exhibit… Rugs made by pioneers, quilts, pillows and cushions… Pictures of pioneers … and other relics of the past…," *LR*, Sept. 12, 1930, p. 4; "Complete List of Premiums… Educational Division… Junior High. Drawing—1st ribbon, **Patsy Oliver**. Applied Art, special mention, Patsy Oliver, **Alice Laubly**. Group of black-and-white drawings, special mention, **Alice Laubly**. Senior High. Manual Art – Lamp, Mac McCullum, bowl, Mac McCullum. Applied Art – A. no entry, B. lampshade, 2st, Helene Hardesty, C. handkerchief, 1st, Luella Ray, D. pillow, Harriet Batkin. Drawing – 1st, Joe Manfrina [b. 1915] … Home Economics – Hand work … **Ruby Parker**… Theodora Thompson… Group of black-and-white drawings, no classification, special mention… Division Two. Campfire Girls… Needlework… Susie Lundberg… Florence Murray… Women's Clubs… Needlework … Arts and Crafts. Lampshades (boudoir) – 1st, **Miss Annie Heiges**, 2nd, **Mrs. F. J. Fratis**, (Bridge) – 1st, **Mrs. L. E. Heiges**. (Floor) – 1st, Mrs. Lester Douglass. Basketry – 1st, **Mrs. L. E. Heiges**, 2nd, **Mrs. L. E. Heiges**. Floor Pillows – 1st, **Miss Annie Heiges**, 2nd, Mrs. John Forbes, 3rd, **Mrs. L. E. Heiges**. Artificial Flowers – 1st, **Mrs. W. A. Calvert**. Hand Painting (China) Mrs. Elsa Dowse. (Fabric) Mrs. Elsa Dowse. (Pictures) Mrs. Elsa Dowse. Book Ends – 1st, Fred Carlson, 2nd, David Carlson. Door Stoppers – 1st, Mrs. John Forbes, 2nd, **Mrs. C. E. Maimann**. Crepe Paper Novelties – 1st, Irma Henderson, 2nd, Miss Annie Heiges. ... Trays – 1st, Mrs. Berkenkamp, 2nd, Mrs. Herman Thompson. Complimentary – Silk Shawl, Mrs. Joseph Stephenson. Remarks: The [category for] trays and embroidered pictures were added, as there were no stools and no stencil work," *LR*, Sept. 19, 1930, p. 6.
1931 – "No Valley Fair This Year, Say Assn. Directors…. It would be best not to hold a fair this year. Effects of the business depression…," *LR*, March 13, 1931, p. 10.
1932 – "Kiwanis… Resolve Against Fair … opposition ... It was suggested that the Lompoc Valley Fair Association might be wise to use its surplus for the purchase of a permanent fairground rather than to stage an exhibition this year. A resolution embodying these ideas was voted on and adopted," *LR*, April 1, 1932, p. 3.
1933 – "Buellton in Bid for 1934 [Santa Ynez Valley Fair] Valley Fair. Lompoc's Co-Operation in Staging Exhibition Would be Asked" in return for Buellton cooperating in the Lompoc Valley Fair of 1935, *LR*, Sept. 22, 1933, p. 8.

1934 – "Group to Decide Fate of Fair…," *LR*, Oct. 19, 1934, p. 1.
1935 – "Plans for Fair This Year Are Dropped… insufficient time to prepare, *LR*, May 10, 1935, p. 1.
See: "Santa Barbara County Fair," "Santa Ynez Valley Country/County Fair"

Lompoc Valley Historical Society, House
Historical Society first met 1964. It currently operates the Fabing-McKay-Spanne house, 207 North L. Street, purchased in 1968. Repository of historic items including local art and photographs.

■ "The Lompoc Valley Historical Society developed out of the Lompoc Pioneer Society. The first meeting was December 1964 when Earl Calvert was installed as President. Mr. Calvert served for 20 years and was the force behind the Society. The Society was founded as a subsidiary to the Pioneer Society with the objective to build and maintain a building to house a Museum of Historical objects, papers, pictures and other historical items. Eventually the Pioneer Society was disbanded. The 1875 Fabing-McKay-Spanne House was purchased in 1968 to house the Historical Society in Lompoc," per Myra Manfrina communicated by Karen Paaske, Lompoc Valley Historical Society, July 26, 2020.
Lompoc Valley Historical Society (notices in Northern Santa Barbara County newspapers on microfilm and on newspapers.com)
1964 – "Curator to Speak… Charter Night dinner… and qualifications for membership," in the new Historical Society listed, *LR*, Dec. 11, 1964, p. 1.
1968 – "Spanne home tour is scheduled this weekend. … to give members an opportunity to see the home and its condition before the society purchases the property. Lompoc Valley Historical Society plans a restoration of the building to its original Victorian splendor…," *LR*, March 13, 1968, p. 8.
Collections (pre-1960) hanging in the house, 2017.
Photo by "**Van**". A pastel (?) dated 1878 signed Miss **May Richardson**; a painting of a schoolhouse signed "**Marie Huyck.**" A wc of boys on the beach by E. [Estelle] **Nichols**. Signatures on other paintings are **Mrs. James P. Larsen**, and **Leslie Mayer**. As for needlework, there is a quilt by Edna Lair Barr; a cigar ribbon display by George Kimbel family; a needlework picture of wool; a feather wreath by Effie Kelley Huyck; and a needlepoint sampler, "Peace be Unto This House," by Amy Ruffner.
Collections (pre-1960) in archives.
Photographs: The Society owns c. 5000 uncatalogued photographs contained in family albums as well as many by **Idell Olson** and the work of historic photographers he collected, such as **Charles Baechler** (and possibly **Henry McGee** and **Egbert Briggs**).
Artworks: The Society owns some **Leslie Mayer** copies, i.e., 8 x 10 prints and cards that depict c. 10 historic buildings.
See: "Lompoc Historical Museum," "Lompoc Valley Pioneer Society"

Lompoc Valley Pioneer Society
Society of early residents of the Lompoc Valley, organized 1926. It held annual reunions and collected photos and other materials of historic interest. Members helped start the Lompoc Valley Historical Society in 1964. The Pioneer Society no longer exists.
Annual meetings in the early 20th century usually consisted of displays of old photographs and of members discussing or writing about "old times." The Society's collection of historic photos was displayed at Pioneer and other events. [ed. Many articles on the Pioneer Society appeared in the *LR* over the years but were too numerous to all be itemized here.]
Lompoc Valley Pioneer Society (notices in Northern Santa Barbara County newspapers on microfilm and on newspapers.com)
1926 – "Picnic and Re-Union Planned… The formation of a 'Pioneer's Society of Lompoc' is now being undertaken…," *LR*, July 16, 1926, p. 1.
1927 – "Pioneers Set 1901 as Year to be 'Old Timer'," *LR*, Aug. 26, 1927, p. 1.
1930 – "Pioneer Society… Reunion of Lompoc Pioneers… **Henry McGee** was named chairman of the exhibit committee, which will assemble a wealth of old pictures and mementos of pioneer days in Lompoc. Henry McGee was a photographer here for many years and has a large number of old pictures to form the nucleus for the unique collection… The old time exhibit will be on display at the Lompoc auditorium on the Saturday previous to the old timers' reunion…," *LR*, Aug. 29, 1930, p. 5.
1946 – "Pioneer Photos to be Feature of Annual Re-Union. A large exhibit of early day Lompoc photos is planned for the annual Re-Union of the Lompoc Pioneer Society… The photographs will be projected on a screen at the Pioneer reception and tea to be held Saturday afternoon, August 31, at old Dinwiddie Hall…," *LR*, Aug. 22, 1946, p. 10.
1948 – "Collection of Pioneer Photos Being Sought … by a committee of the Pioneer Society… The photos will be on display at the annual Pioneer Tea next week…," *LR*, Aug. 26, 1948, p. 8.
1959 – "Reunion of Pioneers to Begin Sat… Specially written stories and photographs depicting life in the early days of Lompoc will be found in the 'B' section of today's *Lompoc Record*," *LR*, Sept. 3, 1959, p. 1.
See: "Lompoc Historical Museum," 1957, "Lompoc Valley Fair," 1930, "Lompoc Valley Historical Society," "McGee, Henry"

Longinotti, Anthony "Tony" (1906-1964) (Hollywood)
Artist / interior decorator, who exh. with Hollywood notables at Santa Ynez Valley Art Exhibit, 1954.
■ "Longinotti Rites Slated… Longinotti, 58, an interior decorator here for more than 30 years … Forest Lawn Memorial Park, Glendale. Mr. Longinotti, who also was co-owner with his son, Anthony D. Longinotti, Jr. of the San Francisco Restaurant in Santa Monica, died Friday Morning. He resided at 1737 N. Vista Ave.," *LA Times*, Aug. 23, 1964, p. 39 (i.e., C-7).
Longinotti, Tony (misc. bibliography)
Anthony D. Longinotti is listed in the 1930 U. S. Census as age 23, b. c. 1907 in Oregon, a decorator for the studios, residing in Pomona with wife Annie D. (age 21); Anthony

D. Longinotti is listed as Interior Decorator in the *Los Angeles, Ca., CD*, 1937-38; Anthony D. Longinotti was b. April 16, 1906 in Oregon to Antonia Michel Longinotti and Margaret S. [Wetzel] was residing in Los Angeles in 1944, married Annie Duca Longinotti, and d. Aug. 21, 1964 per Saunders Family Tree (refs. ancestry.com).
See: "Santa Ynez Valley Art Exhibit," 1954

Lopez, Jesse Joe (Santa Maria)
Santa Maria High School student who exh. a mobile at Public Schools Week, 1954. Author of an article on arts exh. at Public School Week, 1954. Joined the U. S. Marines.
See: "Minerva Club, Flower Show," 1950, "Santa Maria, Ca., Union High School," 1954

Lord (Huyck), Loiz Whitcomb Rhead (Mrs. Frederick Hurten Rhead) (Mrs. Franklin G. Lord) (Mrs. Maurice "Babe" Huyck) (1892-1994) (Santa Barbara / Pittsburgh / Ohio / Lompoc)
Ceramics sculptor who visited her mother in Lompoc, 1937. Lectured to Alpha Club, 1937. Settled.
■ "In Memoriam. Loiz Whitcomb Rhead [Lord] Huyck, Ceramist, died September 5, 1994 at the age of 102 in Santa Barbara. She was born January 16, 1892 in Chicago, Illinois and adopted Santa Barbara as her home when her mother brought her and her brother, Eugene Whitcomb, a long-time Santa Barbara resident who died in 1985, to California just after the turn of the century. Loiz attended local schools, studied art at the Chicago Art Institute and in Europe, and worked and studied in Paris for several years. She also attended classes at the Chicago Technical Institute from time to time to further her art studies and to learn sculpting. During World War I, while working as a nurse in a local hospital, Loiz took lessons at the Mission Canyon pottery of English artist and renowned potter Frederick Hurten Rhead. She quickly became an indispensable member of the pottery. In 1917, she married Mr. Rhead. Mrs. Rhead-Huyck worked as Rhead's assistant when they moved to Zanesville, Ohio, where he was head designer and art and research director with American Encaustic Tiling Company, then the largest tile and tableware manufacturer in the world. Loiz also undertook design work for the company, including a series of tiles with signs of the zodiac, which were illustrated in the April 1923 issue of '*The Pottery and Glass Record*.' '*The Architectural Record*' of December 1926 featured one of Loiz's sculptures on the cover accompanied by an article describing her important work… She was now working principally in 'pate-sur-pate' (clay upon clay), in which a portrait is sculpted with clay upon a clay surface. She perfected this art form, which she had learned from Rhead, who had learned it from his father. The process involved the building up of a design, then applying successive layers of liquid porcelain to a porcelain body. Each layer had to dry and then be carved before the next layer could be added. The glaze used was Rhead's own formula. … Loiz's life and work in the July 1989 issue of '*The Antique Collector*.' She was always looking for particular qualities in faces and forms and often used dancers as models. She

also created pieces from photographs, one of her favorites being the profile of a soldier with helmet taken from an antique Roman coin... In 1935, after the termination of her marriage to Rhead [and Lord?], Loiz returned to Lompoc to care for her aged mother. There she met and married Maurice 'Babe' Huyck in 1940; they lived on his ranch in Lompoc until his death. The 40-acre ranch was then sold to the Hapood School, which remains on the property today. She described herself as a free spirit with a great desire to know about everything. She was a fiercely independent person who enjoyed a simple straightforward life, preferring to keep occupied with her art. She maintained a very positive attitude about life, and believed that 'Even when you have chit chat, you have truth at the same time, 'cause it's no use talking if it's going to be a fable.' No services will be held," *LR*, Sept. 25, 1994, p. 3.

Lord, Mrs. (notices in Northern Santa Barbara County newspapers on microfilm and on newspapers.com)
1937 – "Best Chinaware Made in America... Rotary dinner, the speaker being Mrs. Franklin G. Lord of Pittsburgh," *LR*, July 16, 1937, p. 1; "Creative Design in Ceramics Sculpture... Mrs. Loiz Whitcomb Lord who is here from Pittsburgh, Penn., to visit her mother, Mrs. W. J. Oates is one of those charming and talented women who really do things. She is a sculptress who creates delicate figures in ceramics. Technically known as pate sur pate, this work is one of the most difficult of artistic mediums – consisting of a cutting process through several layers of white porcelain superimposed on a blue base. The resulting bit of art may be compared to a cameo, except for the material used and also that the bas-relief is not so sharply defined. Mrs. Lord's placques range from thumb-nail sizes up, but each one is completely lovely to the merest gossamer detail. She has studied under Conrad Dressler, Leon V. Salon and Fredrick H. Rhead, pupil of Taxile Doat, famous French maker of ceramics. The artist has exhibited her work at the Architectural League, the Art Institute of Chicago, the San Francisco Museum of Fine Arts, the Philadelphia Academy of Fine Arts, the Associated Artists of Pittsburgh, the Carnegie Institute and the Society of Sculptors in the same city. One series of her lovely pate sur pate placques she called 'The Dance of the Hours.' These are done on a blue base about four by five inches with a white circular center in which dancing figures are carved in bas-relief. The figures on these pieces are exquisitely dainty and represent interesting legendary characters. A favorite with the artist herself, this series, remains as yet, incomplete. 'Apparently this group is not supposed to be completed,' she laughed, 'because each time I finish 12 of them, one or more is sold, I make a gift to a friend, or if not that perhaps one will be broken. But never can I collect and keep 12.' Commercially Mrs. Lord turns her activities to potteries. Previous to making her home in Pittsburgh, she was for 10 years art director of the American Encaustic Tiling Company, Ltd., at Zanesville, O. [founded 1875, closed in 1935, re-opened as Shawnee Pottery per Wikipedia], where she created designs for pottery pieces. In creating her decorative motifs and styles in vases, bowls, dinnerware, ornaments, etc., she likes best to follow the Chinese shapes and designs. Among the interesting things she has done is a set of carved pottery dinnerware for a Persian prince, a series of comic-

grotesque animals in silhouette cut-outs and many beautifully carved vases and bowls. 'Portraits in the round' or sculptured busts is another of her specialties. Working in sculpture, she first makes her model in ordinary plasteline wax, the modeling clay we've all 'had a hand in' at one time or another. Then she makes a plaster cast which she finishes accurately in the finest detail. This finished cast is sent to the bronze caster where it is made up in any shade of bronze, from pale gold to black, that may be desired by the artist. A piece may also be done in non-tarnishable silver, she added. The casting is mounted on marble or any type of base selected. ... Mrs. Lord is not doing commercial work at present, she said, but is competing for various sculpturing and architectural prizes," *LR*, Nov. 26, 1937, p. 4.

Lord, Mrs. (misc. bibliography):
Loiz W. Whitcomb who married [Franklin G. Lord?] on Dec. 5, 1934 in Owego per NY State Marriage Index; Loiz W. [Whitcomb] Rhead / Huyck was, b. Jan. 16, 1892 in Illinois, mother's maiden name Roddin, father's Whitcomb, and d. Sept. 4, 1994 in Santa Barbara per Calif. Death Index (refs. ancestry.com).
See: "Alpha Club," 1937, 1939, 1948

Los Alamos, Ca., Adult/Night School
Los Alamos, Ca., Adult/Night School (notices in Northern Santa Barbara County newspapers on microfilm and on newspapers.com)
1950 – "Los Alamos news. Thirty-one adults enrolled in the art craft classes Monday at Los Alamos school. Classes will be held every Monday start[ing] at 7 p.m. in copper and leather tooling, ceramics, and textile painting," *SMT*, Sept. 30, 1950, p. 4.
1954 – "Ceramics Class formed in L.A. [Los Alamos] A group of persons interested in the making of ceramics met at the school Monday evening with the result that a class was formed which plans to meet there each Monday from 7 to 9. Any adult interested in joining the group is invited to attend and bring his own green ware or clay which may be secured from any ceramic or hobby shop in Santa Maria or Santa Barbara. Each individual is to purchase his own material. First-nighters included Mr. and Mr. Alfonso Monighetti, Mr. and Mrs. Gail Carruthers, and **Mmes, Virginia Martin**, Helen Meadows, Irma Silva, Elsie Bumann [Mrs. William John Bumann], **Esther Benson,** Hazel Olson, Dora Scolari and Olga Reed," *SYVN*, Feb. 19, 1954, p. 6; "Ceramics Group Meets in LA," *SYVN*, March 12, 1954, p. 6; "The Ceramics group met at Los Alamos school Monday evening for its weekly get-together. Those attending were Mr. and Mrs. Alfonso Monighetti, **Mr. and Mrs. Oscar Olson,** and Mmes. Shirley Woods, **Orma [Sic. Irma] Silva**, Elsie Bauman [Sic. Bumann], **Virginia Martin, Esther Benson,** Dora Scolari, Olga Reed, Vivian Erickson, Marguerite Bailey, Shirley English and **Eleanor La Fontaine.** Among articles being made are ash trays, television lamps, egg cups, ornamental chickens, lamp vases, razor blade holders and all sorts of figurines and planters," per "Ceramics Group Meets in School," *SMT,* March 13, 1954, p. 4; "Old Days in Los Alamos... The Los Alamos Ceramics class is opening the Fall session at the School next Monday. The group meets from 7 to 9:00 p.m.

Everyone is welcome… Some green ware is now available at school for beginners…," *SYVN*, Sept. 10, 1954, p. 2.

Los Alamos, Ca., art
See: "Art, general (Los Alamos)"

Los Alamos Ceramic Club (Los Alamos)
Possibly the name adopted by the Adult Education class in ceramics held in Los Alamos, 1954.
See: "Los Alamos, Ca., Adult/Night School," 1954

Los Alamos Community Church
Site of stained glass by Alice Linsenmayer. In 2020 named Cottonwood Community Church.
■ "Alamos Presbyterians Mark Centennial," and history of the church, *SMT*, March 16, 1982, p. 6.
Los Alamos Community Church (notices in Northern Santa Barbara County newspapers on microfilm and on newspapers.com)
1948 – "Art Work of Children on Display" by children's classes at Los Alamos Community Church, *SMT,* May 18, 1948, p. 5.
1953 – "Hand-Painted windows in the Los Alamos Community Church," and photo, "the work of Mrs. **Alice Linsenmayer** [artist wife of the former pastor]… Her love for the little church inspired her to put in many hours of work in creating the 23 original paintings that make up the six large windows of the church. Each window is illustrative of a series of events in the Life of Christ, following a chronological arrangement. At the top of each window is a symbol, which serves as a pictorial title or summary. In their order, the windows represent the Nativity, the Boyhood, Beginning Ministry, Continuing Ministry, the Passion and the Resurrection. The Rose window, above the entrance, has a quatrefoil which symbolizes the four evangelists; the blue signifies truth and constancy; red signifies divine love; the gold signifies divine glory. Together they are emblematic of the Holy Trinity. The last painted was the small one in the belfry which represents The Burning Bush. **Mrs. Linsenmayer** said that the picture 'In Gethsemane' is a copy of the famous painting by Hoffman, but all others are original with her. Following their completion, dedication services for the window were held on May 23, 1949…," *SYVN*, Nov. 20, 1953, p. 6.
1982 – "Presbyterian Church will Mark 100th Birthday… There will be a rededication of the six art windows and the rose window, painted by **Mrs. Alice Linsenmayer** who [whose husband] served as pastor from 1947-1951. Mrs. Linsenmayer will be present. The windows were dedicated on May 23, 1949 at which time the cornerstore of the annex was laid with appropriate ceremonies. The original painting was fading, but they have been restored recently with fresh paint," and history of church, *SYVN*, March 18, 1982, p. 29 (i.e., 10B), and similar article *LR*, March 19, 1982, p. 7.
See: "Linsenmayer, Alice," "Stained Glass"

Los Alamos School
See: "Santa Ynez Valley, Ca., Elementary School"

Los Angeles Bureau of Power and Light Camera Club
See: "Photography, general (Santa Ynez Valley)," 1958

Los Angeles Marble Works
Gravestones, supplied to Lompoc, 1880.
■ "Gravestones and Monuments. Cheaper than at any other works in the state… Fac Simile drawing of various styles on hand showing full size. **James Morse**, agent Guadalupe," *LR*, Oct. 16, 1880, p. 2; "Gravestones – Mr. James Morse of Guadalupe has sent us drawings and designs of the above. They can be seen at our office for the next week and Mr. M will be over on the 20th and 21st and parties can see him and make contracts," *LR*, Oct. 23, 1880, p. 3.

Los Angeles Scenic Studios
See: "Lompoc Theater"

Los Olivos, Ca.
Town north of Solvang. Artistically notable for the painters Charles and Clarence Mattei and, until recently, for the Wildling Museum (now located in Solvang).
See: "Art, general (Los Olivos)"

Los Olivos Needlecraft Club
See: "Needlecraft Club (Los Olivos)"

Louis, Howard Wong (SLO)
Flower arranger. Son of Ah Louis of SLO. He judged some flower shows and lectured to some clubs in Santa Maria c. 1947-53. Brother to Young Louis, below.
1951 – "… and that's '30',": re: Louis' meeting at Elks lodge," *SMT*, June 13, 1951, p. 6; and additional notices not itemized here.
See: *San Luis Obispo Art and Photography before 1960*

Louise Studio (Santa Maria)
Photography studio, prop. J. A. Dahlgren, 1909+. Prop. George A. Borst, c. 1913-22.
■ "Notice. About the 20th of November the Louise Studio will open in the Jones building, second floor. They will offer strictly high-grade photos with latest lightings, styles and mounts. …," *SMT*, Nov. 27, 1909, p. 8.
Louise Studio (notices in Northern Santa Barbara County newspapers on microfilm and on newspapers.com)
1910 – "In another column appears the advertisement of the Louise Studio, owned and conducted by **Mr. J. A. Dahlgren**, a thorough and up-to-date photographer. A cordial invitation is extended to the people of Santa Maria to call and see his studio in the T. A. Jones & Son Building," *SMT*, Feb. 5, 1910, p. 5.

1911 – "A Xmas Offer. Our agent, Mr. Deacon, will call on you and explain how you can obtain a beautiful and elegant toilet, practically free, with a dozen fine photos. … Louise Studio," *SMT*, Dec. 23, 1911, p. 2; "Photographers. There are two fine studios in Santa Maria which do high grade work, many of the cuts in this issue being samples of their work. The Louise Studio is owned by **Mr. Dahlgren** and is located on Broadway, while the **Judkins Studio** is located on West Main St. and is conducted by Mr. Judkins. Both do work equal to the very best found in the cities," *SMT*, Dec. 30, 1911, p. 11.

1912 – "Notice to Coupon Holders. Coupons or tickets for photos and mirrors with photos on the back must be used before March 1st next or arrangements made at the studio to extend the time in order for us to procure the mirrors or sets to fill the orders …," *SMT*, Feb. 24, 1912, p. 9; "Elegant Portraits which are in every way equal or superior to any to be had in the cities, are being made here by the Louise studio. You can see the portrait being made and watch the painting by looking in the windows, as it is all in plain view. … You can have an opportunity to secure this work now… prices most reasonable…," *SMT*, March 2, 1912, p. 1; "The Louise Studio will remove to the building formerly occupied by the *Santa Maria Times* about May 15th, 1912 and to advertise their new location will make it to your interest to see them when you want the best in photography," *SMT*, June 1, 1912, p. 4; "$4.50 for You. Special offer for a short time by Louise studio. We will make you 12 fine large photos, regular value $5.00. 1 large photo framed 11 x 14, value $2.50. Total Value $7.50. Special Offer for a Short Time … Three Dollars for All… You have the choice of two proofs. A small extra charge for groups and sepias. Contracts good 60 days. If extension is wanted, Studio must be notified. We show samples of all work," *SMT*, Aug. 24, 1912, p. 2.

1913 – "All Babies Will be Shot Free. Tuesday, Aug. 12, between the hours of 10 a.m. and 3 p.m. We will make one photo free of every baby not over one year old. The baby weighing the most, one doz. will be given. The baby weighing the least, one doz. will be given free. If you haven't a baby, borrow one and follow the crowd… Louise Studio, 110 N. Church St., Santa Maria, Cal.," *SMT*, Aug. 9, 1913, p. 4; "Masquerade Party… Before unmasking at about ten o'clock **Mr. Borst** of the Louise Studio took a flashlight group picture of the maskers arranged before the music stand. Another picture was taken after unmasking," *SMT*, Nov. 8, 1913, p. 1.

1914 – "**Mr. Borst** of the Louise studio secured many fine views of the work done by the storm. His photographs of the wrecked county and railroad bridges are especially interesting," *SMT*, Jan. 31, 1914, p. 5.

1918 – "A. A. Apperson… is in the city on business with **George A. Borst** of the Louise Studio," *SMT*, May 18, 1918, p. 7.

1919 – "Photographs but for these two specials for 10 days only, you pay Less and Get More. Our $12 Sepias, per doz. $9. Our $4 Panels, per doz. $2. Louise Studio. 'The Recognized Standard'," *SMT*, Aug. 16, 1919, p. 6.

1920 – "Louise Studio is Now Open and ready for business in new quarters in Hart Building. Across street from P. O. Up-to-date equipment and better prepared than ever before. Call and see our new studio and new lighting system. We make sittings Day or Night," *SMT*, March 15, 1920, p. 4; "Friday, Saturday, Monday, Tuesday, Wednesday and Thursday we will give free 12 water color painting upon these days; two each day to first two in on each day – Bring this in with a roll of films and we will develop the films free of charge on these days. Photography Day or Night, Louise Studio, Hart Building, Across from Post Office," *SMT*, April 17, 1920, p. 2.

1921 – "Boys' Band… Arrangement have been made by the management of the Rodeo for **Geo. Borst** of the Louise Studio… to take <u>moving pictures</u> of the various events for the Pathe news service. The pictures will also be shown on the screen of the **Gaiety** theatre as soon as the reels are completed," *SMT*, May 2, 1921, p. 1.

And, more than 170 hits for "Louise Studio" in the *SMT*, 1909-1922, mostly ads, were not itemized here.

<u>See</u>: "Dahlgren, J. A."

Love, H. R., Rev. (Yucaipa/ Lompoc)
Artist of religious pictures in Assembly of God church, Lompoc, 1942. "Chalk Talk" artist.
<u>See</u>: "Chalk Talks," 1942

Lovely, Anna E. (Santa Maria)
Itinerant teacher of furniture painting employed by Bass-Huerter Paint Co. She taught in Santa Maria, 1927.

■ "Free Instruction in Decorating and Painting Furniture. In connection with the opening of C. T. Bates beautiful new paint and wallpaper store, free classes… in decorating, enameling and painting furniture will be conducted for the benefit of local housewives on March 25 and 26 at the new location, 408 North Broadway… conducted by Miss Anna E. Lovely, an expert on furniture decorating and color harmony. She is head of the 'Home Beautiful' department of the Bass-Hueter Paint Co., and her classes are always largely attended. Miss Lovely will give special instruction in painting and decorating bedroom sets, breakfast room sets, and small articles for the home or for gifts… She will also explain how softwood floors may be made to look like hardwood… During the demonstration, all ladies attending will be presented, free of charge, with a set of Lustrelac Decorative Transfers," *SMT*, March 24, 1927, p. 8.

Lovet-Lorski, Boris (1894-1973) (Hollywood)
Sculptor who was among the "Hollywood" artists who exh. at Santa Ynez Valley Art Exhibit, 1954.

■ "Boris Lovet-Lorski studied architecture and sculpture at the Imperial Academy of Art in St. Petersburg. He worked as an architect in Russia until 1920, when he immigrated to the United States and decided to focus on sculpture. He settled in New York, but continued to travel all over the world in search of new and unusual types of stone, describing his collection of marble, lava, and onyx blocks as colored 'jewels.' He carved portrait busts of four American presidents, as well as of members of the royal families in Greece and Italy. He was inspired by the nude human figure and even tried briefly to go without clothes himself, but found he was annoyed and distracted by the clothing of others," americanart.si.edu/artist

See: "Santa Ynez Valley Art Exhibit," 1954

Lowell (Alexander), (Margaret) Rowena (Mrs. Whitney Alexander) (1914-2011) (Santa Maria / Los Angeles)
Santa Maria JC art student who exh. at Faulkner Memorial Art Gallery, 1933. Advertising major at USC, 1936. Her portrait was painted by Marrie Breneiser.
Lowell, Rowena (notices in Northern Santa Barbara County newspapers on microfilm and on newspapers.com)
1933 – "Piano Pupils in Recital Tonight. … Posters used to bring the event to the attention of the public and programs for the performance … designed by Rowena Lowell, art student in junior college," *SMT*, June 1, 1933, p. 5.
1936 – "Another Santa Marian who is completing her education in the University of Southern California, Miss Rowena Lowell has been doing special work …during the summer and will enroll as a senior this fall. She is an advertising major…," *SMT*, Aug. 17, 1936, p. 2.
1937 – "Visits in Los Angeles. Miss Betty Haslam… guest of Miss Rowena Lowell, student in the school of merchandising in University of Southern California," *SMT*, May 18, 1936, p. 3.
More than 140 hits for "Rowena Lowell" appear in the *SMT* c. 1928-37 revealing she was a member of the College Art Club, active in student government, and an amateur thespian, but they were not itemized here.
Lowell, Rowena (misc. bibliography)
Margaret Rowena Lowell, mother's name Gertrude Abby and father's Arthur P. Lowell was b. Sept. 20, 1914 in Okanogan per Washington Birth Records; Rowena Lowell is listed in the 1930 U. S. Census as age 15, b. c. 1915 in Washington, residing in Santa Maria with her parents Arthur Lowell (age 42) and Gertrude Lowell (age 42) and siblings Walter and George; Rowena Lowell is pictured in the Santa Maria High School yearbook, 1930, 1931; Rowena M. Alexander b. Sept. 20, 1914, d. Feb. 9, 2011 in Kings County, Ca., and is buried in Lemoore Cemetery per findagrave.com (refs. ancestry.com).
See: "Art Festival (Santa Maria)," 1935, "Breneiser, Marrie," 1932, 1934, "Community Club," 1934, "Faulkner Memorial Art Gallery," 1933, "Santa Maria, Ca., Union High School," 1935, "Santa Maria School of Art," 1933, "Splash," 1935

Lucas (Stephens), Sallie (Mrs. Joseph Josiah Stephens) (1861/2-1947) (Santa Maria / Woodland)
Woodland, Ca., artist, active in Santa Maria 1890-1893. In 1890 exh. and in 1891 won Best display of paintings at "Santa Barbara County Fair," Santa Maria.
■ "Miss Lucas' Studio. It will Pay You to Call and See Those Pictures. There are paintings and drawings. There are attractive landscapes and striking portraits. The available room was occupied with canvases mounted on easels, about which palettes and brushes were floating and occasionally touching the pictures like butterflies among the flowers. A class of six were at work and their instructress, Miss Sallie Lucas… He was very much surprised at the progress of the pupils … Miss Lucas is a fine artist and an exceptionally good teacher. We are proud to claim her as a local artist and hope she may continue her residence among us. … anyone contemplating a course in painting should see her at once… She will pay a visit to her old home in the near future, and we hope the inducements to return may be so strong that she cannot afford to stay away. There are but few towns that can boast of so good an artist … Miss Lucas' Studio. It is one of the attractions of our town…," *SMT*, Feb. 27, 1892, p. 3.
Lucas, Sallie (notices in Northern Santa Barbara County newspapers on microfilm and on newspapers.com)
1890 – "Miss Sallie Lucas, sister of Dr. W. T. Lucas, arrived from Woodland a day or so ago. She came down to keep house for her brother – George," *SMT*, Sept. 13, 1890, p. 3, col. 2.
1891 – Superintendent of the "Fine Arts" section of the Santa Barbara County Fair, *SMT*, Sept. 5, 1891, p. 3, col. 4; "Fine Paintings. Miss Lucas of Santa Maria, was in town on Wednesday and Thursday arranging for classes in oil painting. The specimens of her handiwork now on exhibition in the windows of Carman's drug store, show her extraordinary talent as an artist. She succeeded in securing a good class and lessons will begin in the north-east room of the Good Samaritan building on Tuesday, Nov. 17th, at 9 a.m. sharp. Pupils should come provided with materials ready for work. We are requested to state that Miss Lucas' terms are $6 per month of twenty-two hour lessons, or fifty cents per lesson for a shorter time. Anyone wishing further information can call at this office," *AGH*, Oct. 31, 1891, p. 4; "Miss Sally Lucas, Santa Maria's artist, is meeting with splendid success as a teacher in painting and drawing. It is rumored that several of our young people will soon pose as artists. Miss L has recently organized a class at Arroyo Grande where her skill is also appreciated and liberally patronized," *SMT*, Nov. 14, 1891, p. 3.
1892 – "Painting and Drawing Studio. Miss Sallie Lucas, painting and drawing studio at the Lucas Hall, where she gives lessons in crayon drawing Mondays and Thursdays and lessons in oil painting Friday and Saturdays. Terms reasonable," *SMT*, Jan. 2, 1892, p. 2 and *SMT*, Jan. 30, 1892, p. 2; "Miss Sallie Lucas and her brother, the dentist, will depart on Tuesday next for Woodland on a two months visit among relatives and friends after which Miss Lucas will return and reorganize her class in painting in Santa Maria," *SMT*, April 2, 1892, p. 3, col. 3; "Fifty Years Ago… Miss Sallie Lucas, a talented artist, returned to her home here after a stay in the north for lessons in oil painting," *SMT*, Sept. 3, 1942, p. 4.
1893 – "Fifty Years Ago… Miss Sallie Lucas, sister of Dr. W. T. Lucas, was to open a studio of drawing and painting instruction in San Luis Obispo…," *SMT*, Jan. 4, 1943, p. 4; "Miss Sallie Lucas, teacher of drawing and painting, has removed her studio to the residence of Mrs. Call," *SMT*, March 11, 1893, p. 3, col. 1.
1894 – "Among the Sick. Miss Sallie Lucas is very ill at the residence of George D. Stephens," *Woodland Daily Democrat* (Woodland, Ca.), March 9, 1894, p. 3; "Sallie Lucas, sister of Dr. W. T. Lucas and well known here, was recently married to Mr. Jos. Stephens, a capitalist of Woodland," *SMT*, May 5, 1894, p. 3.
More than 250 notices in Yolo County newspapers between 1894 and 1947 show that "Sallie Stephens" or "Mrs. J. J. Stephens" did not receive notices on her art, if any.

Lucas, Sallie (misc. bibliography)
Sallie Lucas was b. Sept. 18, 1862 in Andrew, Mo., to George Johnson Lucas and Sallie Thomas, married Joseph Josiah Stephens, was residing in Woodland, Ca., in 1930, and d. April 2, 1947 in Yolo, Ca., per Myers-Broemser Family II Tree (refs. ancestry.com).
See: "Santa Barbara County Fair," 1890, 1891, and *San Luis Obispo Art and Photography before 1960*

Lukeman, Ynez (Melissa) (Mrs. William Oswald Lukeman) (1899/1900-1975) (Santa Maria)
Exh. flower paintings at Community Club Hobby Show, 1949. Member Santa Maria Art Association who exh. at Santa Barbara County Fair, 1952.

■ "Ynez M. Lukeman, 75, 324 W. Chapel St., died Monday while visiting her daughter in New Woodstock, N. Y. Born Jan. 21, 1900 in Gilroy, she was a 68-year resident of the Santa Maria area. She was a member of the First United Presbyterian church and served as a deacon. She also was a member of the Native Daughters of the Golden West," *SMT*, July 23, 1975, p. 2.
Lukeman, Ynez (notices in Northern Santa Barbara County newspapers on microfilm and on newspapers.com)
1975 – Personal anecdotes about Ynez Lukeman appear in "Around Town," *SMT*, March 7, 1975, p. 11.
More than 50 notices on "Ynez Lukeman" appear in the *SMT* between 1945-1960, mostly reporting club activities, so were not itemized here.
Lukeman, Ynez (misc. bibliography)
Ynez Lukeman b. Jan. 21, 1900, d. July 1975 per Social Security Death Index; Ynez Melissa Lukeman b. 1899 and d. July 21, 1975 is buried in Santa Maria Cemetery District per findagrave.com (refs. ancestry.com).
See: "Community Club (Santa Maria)," 1949, 1952, "Junior Community Club," 1950, 1952, "Santa Barbara County Fair," 1952

Lund (Squier), Crystal (Lompoc / Paso Robles)
Art Teacher Lompoc High School, 1940/45.
See: "Alpha Club," 1941, 1944, "Costa, Evelyn," "Flower Festival / Show," 1944, "Lompoc, Ca., Union High School," 1941, 1942, 1943, 1945, "United Service Organization," 1944, and see "Squier, Crystal" in *Atascadero Art and Photography before 1960*

Lundberg's Stationers (Lompoc)
Retailers of some art materials, 1947, 1959.

■ "Party Games… Children's Books… Toys. Woodcraft. Artist's Sets… Lundberg's Stationers, 110 South H St., Phone 4031," *LR*, Aug. 21, 1947, p. 4; "Barometers… Social Stationery, Portable Typewriters… Pens, Pen Sets… Artist's Paint Sets, Lundberg…," *LR*, Dec. 10, 1959, p. 5.

Lunge, Niels Christian Larsen (c. 1855-after 1887) (Santa Maria / Santa Barbara / San Luis Obispo)
Teacher of photo painting, 1885.

■ "Fine Pictures. Mr. N. C. L. Lunge is canvassing this section and teaching the art of painting photographs in the original Italian oil style. He certainly has some very creditable specimens which speak for themselves. Orders can be left at Fleisher & Co's or at Rev. Mr. Holdridge's residence," *SMT*, Aug. 25, 1883, p. 5.
Lunge, N. C. L. (notices in Northern Santa Barbara County newspapers on microfilm and on newspapers.com)
1883 – "N. C. L. Lunge does house painting, paper hanging, kalsomining, white washing, by the job or by the day. Orders left at H. Holdridge's or at Bell's Hardware Store. Give me a Trial," *SMT*, March 17, 1883, p. 1.
1885 – 'Professor N. C. L. Lunge and wife are now in this city and are prepared to give lessons in the original Italian oil paintings, charging only $3 for full instruction, or to clubs of four or five making it but $2 each. The popularity of this style of painting has caused fraudulent persons to imitate it, but this is the genuine art. Mr. and Mrs. Lunge may be found on Santa Barbara street, below Montecito. Call and see samples and learn particulars. Orders may be left at Crane's book store," *Independent* (Santa Barbara, Ca.), June 5, 1885, p. 4, col. 3.
1889 – "On Thursday evening, Mr. Lunge, a pioneer and former resident of Santa Maria, promises our people the most complete selection of Stereopticon views ever witnessed on the coast. From his fine selection, to be exhibited by way of magic lantern, you will learn more in two hours by attending this exhibition than you can by years in reading. Admission 50cts. Children 25cts, under eight years free. Doors open at 7 p.m. Exhibition commences at 8 p.m.," *SMT*, Jan. 9, 1889, p. 3.
Lunge, N. C. L. (misc. bibliography)
Niels Christian Larsen Lunge married Elvira Church in Santa Barbara in 1882 per *Western States Marriage Index, 1809-2011*; is he N. C. Lunge, laborer, listed in the *Santa Barbara, Ca., CD*, 1886; Niels C. L. Lunge applied for homesteads in SLO in 1890s? per *U. S. General Land Office Records, 1776-2015*; Niels Christian L. Lunge, age 32, b. Denmark, Farmer, Cholame, naturalized Oct. 29, 1887 in SLO Superior Court, registered to vote Nov. 1?, 1887 per *California Voter Registers, San Luis Obispo, 1867-1898* (refs. ancestry.com).

Lungren, Fernand (1857-1932) (Santa Barbara)
Santa Barbara painter who lectured to Minerva Club, 1921 and frequently passed through Central Coast cities to and from sketching trips to the desert.

■ "Fernand Lungren (1857-1932) was an American painter and illustrator mostly known for his paintings of American South Western landscapes and scenes (California, New Mexico, Arizona) as well as for New York and European city street scenes," per Wikipedia.
See: "Minerva Club," 1921, "Moore, Brett," "Orcutt Women's Club," 1927, "Santa Barbara, Ca.," 1908, and *Central Coast Artist Visitors before 1960*

Lutnesky, Anna Strube (Mrs. Alfred Emil Lutnesky) (1863-1935) (Santa Maria)
Artist. Under the name "Anna Strube" exh. at "Santa Barbara County Fair," 1886, 1888. Under name Lutnesky exh. a marine view at "Santa Barbara County Fair," 1891 and velvet plush painting, 1893.
Lutnesky, A. E. (notices in Northern Santa Barbara County newspapers on microfilm and on newspapers.com)
1890 – "Wedding Bells. On Wednesday evening last, June 4th 1890, in San Luis Obispo, Mr. A. E. Lutneskey [Sic. Lutnesky] and Miss Anna Strube of Santa Maria were united in holy matrimony...," *SMT*, June 7, 1890, p. 3.
1935 – "Mrs. Anna Lutnesky dies at Age of 72... passed away yesterday in Santa Monica...," *SMT*, Jan. 16, 1935, p. 5.
Lutnesky, A. E. (misc. bibliography)
Anna Lutnesky listed in the 1900 U. S. Census as b. Dec. 1863 in California, married in 1890, residing in Township 7, Santa Barbara with her husband; Anna Gutnesky [Sic.] is listed in the 1920 U. S. Census as age 57, b. c. 1863 in Calif. residing in Santa Maria, Ca., with husband Alfred E. Gutnesky (age 63) and children Esther (age 25) and Leland (age 16) and she is listed in the 1930 U. S. Census; Alfred Emil Lutnesky aka Lutinaska married Johanna 'Anna' Strube per Bitterman Family Tree; Anna Lutnesky, b. c. 1863, d. Jan. 15, 1935 in Los Angeles County per Calif. Death Index (refs. ancestry.com).
See: "Santa Barbara County Fair," 1886, 1888, 1891, 1893

Lutz, Dan (1906-1978) (Los Angeles / Santa Barbara)
Artist. His artwork was shown at the Santa Maria Valley Art Festival courtesy Cowie or Dalzell Hatfield Gallery in LA, 1952, 1953.
■ "Dan Lutz (1906-1978) Born: Decatur, IL; ... Dan Lutz grew up in Illinois. He attended the Chicago Art Institute for four years and in 1931, received the James Nelson Raymond Traveling Fellowship which enabled him to study and paint in Europe. After returning to the United States, he settled in Southern California. Throughout the 1930s and 1940s, he primarily produced watercolors featuring regional subjects. After 1950, he concentrated on abstract works painted with oils on canvas. He taught art at the University of Southern California in the 1930s and at the Chouinard Art Institute in the 1940s. In the 1950s and 1960s, he lectured occasionally, while continuing to paint," Biographical information: Interview with Dorothy Lutz Fleurat, 1983. Biography courtesy of *California Watercolors 1850-1970*, ©2002 Hillcrest Press, Inc.
See: "Santa Maria [Valley] Art Festival," 1952, 1953

Lyman, Dorothy A. (Mrs. Cale Strong Lyman) (Santa Maria)
Jewelry maker. Member, Jr. Community Club, 1954. Handicraft chairman, 1957. City Clerk, Santa Maria.
More than 100 notices in the *SMT* between c. 1950 and 1960, appear for "Mrs. Cale Lyman" and note her activities with the Junior Community Club, where she served as president (c. 1955, 1956) and handicraft chairman (1957) but they were not itemized here. The name "Dorothy

Lyman" appears hundreds of times in the *SMT* in her guise as City Clerk.
See: "Junior Community Club (Santa Maria)," 1954, 1955

Lyons, Jeannette (1885/86-1982) (Ballard)
Elementary school teacher who lectured on creative education, 1926. Member of Leo Ziegler's adult landscape painting class, 1947. Photographer of colored slides made on a world tour, 1960. A portrait of her father, Judge Samuel Lyons painted by Charles Mattei, is in the collection of the Santa Ynez Valley Historical Society. Sister to Grace Lyons Davison, above.
■ Port. and Graveside rites conducted for pioneer Jeannette Lyons, 95... lifelong resident of the Valley, retired teacher and historian... interest in music... story teller... bridge player ... world traveler... ," and extended bio., *SYVN*, May 6, 1982, p. 7.
Lyons, Jeannette (notices in Northern Santa Barbara County newspapers on microfilm and on newspapers.com)
1957 – Port. with members of the Solvang Woman's Club, *SYVN*, June 14, 1957, p. 3.
1960 – "Miss Jeannette Lyons Leaving Monday on Trip Around World... As part of a group under the direction of Commander Scott, tour organizer, Miss Lyons will travel by boat to France where the official tour boat will be boarded. This will carry the group through the Suez Canal to storybook cities in the Orient and a visit of a week in Japan. She will fly home by way of Hawaii...," *SYVN*, Jan. 8, 1960, p. 3; "Miss Lyons Depicts Paris Excitement on First Part of Trip Around World," *SYVN*, Feb. 12, 1960, p. 7; "Excitement of Camel Ride to Pyramids, Sphinx in Egypt Related by Miss Lyons," *SYVN*, Feb. 26, 1960, p. 8; "Poverty of India, Thrill of Elephant Ride in Ceylon Related by Miss Lyons," *SYVN*, March 18, 1960, p. 9; "Valley Traveler Describes Visits to Saigon, Cambodia," *SYVN*, March 25, 1960, p. 10; "Miss Lyons Tells of Trip Around World in Talk Presented Woman's Club Members," illustrated with colored slides she took, *SYVN*, May 20, 1960, p. 3.
More than 600 notices appear in the *SYVN*, 1940-1960 for "Miss Jeannette Lyons" but were too many to browse for inclusion here.
Lyons, Jeannette (misc. bibliography)
Passport application for Jeannette Lyons, b. Nov. 7, 1885 (?), residence Ballard, Ca., father's name "Samuel Lyons" was issued May 12, 1924, cert. no. 412287; Jeannette Lyons b. Nov. 7, 1886 in Calif., mother's maiden name Wilson, and d. April 29, 1982 in Santa Barbara county per Calif. Death Index (refs. ancestry.com).
See: "Alpha Club," 1927, "Collectors, Art/Antiques (Santa Ynez Valley)," 1959, "Davison, Grace Lyons," "Mattei, Charles," 1948, "Presbyterian Church," 1948, "Santa Ynez Valley, Ca., Adult/Night School," 1947, "Santa Ynez Valley, Ca., Elementary / Grammar Schools," 1926, "Santa Ynez Valley Fair," 1931, "Santa Ynez Valley Historical Society,"

M

Mackenzie, Catherine de Witt (1896-1960) (Santa Ynez Valley / Oregon)
Artist. Exh. in Solvang, 1947+. Exh. at Santa Ynez Valley Art Exhibit, 1955, 1957, 1958.

■ "Catherine DeWitt MacKenzie was a graduate of the Portland Art Museum School in Portland, Oregon. She participated in the Public Works of Art Project (1933-34) and Federal Artists Project (part of WPA). She had a studio in Portland. Her noted watercolor, 'Mt. Hood,' is in a staff work area at the Central Library of Multnomah Public Library System and was acquired in 1934 from her participation in PWAP. She also had one-person shows at Reed College in 1949 and at Harvey Welch's Gallery in 1959 as part of the Oregon Centennial celebration. Her works can also be found at the Portland Art Museum and Reed College." Most of this information came from the book *Oregon Painters: The First Hundred Years* by Ginny Allen and Jody Klevit, and is found on findagrave.com.

Mackenzie, Catherine (notices in Northern Santa Barbara County newspapers on microfilm and on newspapers.com)
1930 – "Miss Catherine McKenzie [Sic.] is departing this week-end for Santa Cruz where she will attend teachers' institute. Following the institute sessions, Miss McKenzie will go to her sister's home at Lodi where she will spend the Christmas vacation. Miss McKenzie is the teacher of the Cuyama school in Oso Flaco," *SMT*, Dec. 13, 1930, p. 10.
1936 – "Miss Katherine McKenzie [Sic.] has returned from San Diego where she attended the exposition and visited relatives. She is the teacher of Cuyama school in Oso Flaco valley," *SMT*, April 16, 1936, p. 8.
1947 – Ad: "Drawings … Trees and Landscape by Catherine MacKenzie on the walls of Nielsen and Rasmussen Dry Goods Department," *SYVN*, Dec. 19, 1947, p. 4.
1948 – Ad: "Paaske's Solvang Furniture is happy to welcome its friends at the new location in Copenhagen Square … Be Sure to See The Display of Art Work by Catherine Mackenzie in The Furniture Department," *SYVN*, March 12, 1948, p. 4; "Be sure to see the charcoal drawing by Catherine Mackenzie in the dry goods window of the Nielsen-Rasmussen Store," *SYVN*, March 26, 1948, p. 9, col. 1.
1951 – "Former Valley Artist's Work Now on Exhibit… now has a collection of her drawings and paintings on exhibition at 135 East Carrillo street in Santa Barbara. Miss Mackenzie, who has been sketching much and writing occasionally for a number of years in the Valley, Santa Barbara and Ojai, recently went to Portland, Ore., for the Summer season and there, with her sketches was a successful artist-chamber of commerce representative for this area. Bits of this area's scenery, weathered buildings and characteristic 'residents,' from goats to the field hands are among the artist's favorite subjects. Friends are interesting her in sketches of training camp life around the military installations at Camp Cooke and the naval activities at Hueneme and Point Mugu," *SYVN*, Feb. 2, 1951, p. 2.

And, approx. 15 notices under the name "Katherine McKenzie" in the 1930s relating to her movements as a teacher during school vacations were not itemized here.
Mackenzie, Catherine (misc. bibliography)
Catherine DeWitt MacKenzie b. May 11, 1896 in Portland, Ore., to William MacKenzie and Virginia Hook MacKenzie, d. Nov. 19, 1960 in Ojai, Ca., and is buried in River View Cemetery, Portland, Ore., per findagrave.com (refs. ancestry.com).
See: "Santa Ynez Valley Art Exhibit," 1955, 1957, 1958

MacLennan, Eunice C. (Mrs. John William MacLennan) (1886-1966) (Santa Barbara)
Artist who exh. in a show of Santa Barbara artists sponsored by the College Art Club at city hall, Santa Maria, 1935. Once described as "Montecito socialite artist."

■ "Other Exhibitions. A decorative painter of birds, animals and plants, Eunice C. MacLennan of Santa Barbara is introduced to Los Angeles in her exhibition now at the Ilsley Galleries. Her work has been shown in New York, Chicago and elsewhere. She has a true decorative gift, composes well, keeps her colors quiet enough to blend well with a room, has character and humor in her pelicans, flamingoes and other birds, and makes good use of the decorative possibilities of plants," *LA Times*, May 20, 1934, p. 36 (i.e., pt. II, p. 8).
And more than 35 art notices for "Eunice MacLennan" in California newspapers on newspapers.com were not itemized here.
MacLennan, Eunice (Bibliography)
Nancy Moure, *Publications in California Art*, vols. 1/2/3, 4/5/6, 8, 9 (for exact pages, see index in vol. 10); Edan Hughes, *Artists in California, 1786-1940.*
MacLennan, Eunice (misc. bibliography)
Eunice C. MacLennan is listed in the 1930 U. S. Census as age 40, b. c. 1890 in Missouri, an artist, residing in Santa Barbara with husband, J. William MacLennan (age 49); Eunice C. MacLennan (1886-1966) is buried in Hollywood Forever, Hollywood, Ca., per findagrave.com (refs. ancestry.com).
See: "College Art Club," 1935

MacMillan, Emma E. Nikkel (Mrs. Robert S. MacMillan) (1898-1992) (Santa Maria)
Student Allan Hancock College. Exh. Allan Hancock [College] Art Gallery, 1959. "… studied in Long Beach State College before attending AHC. Her work rates as professional, the instructor said."

■ "Emma K. [Sic.] MacMillan… Mrs. MacMillan was born in Corn, Okla. She moved to California in her early teens and had been a Santa Maria resident for the past 40 years. She was a homemaker, a member of the Santa Maria church, Science of Mind, and an avid gardener," *SMT*, Feb. 28, 1992, p. 8.
MacMillan, Emma (misc. bibliography)
Emma E. MacMillan is listed with husband Robert S., no occupation cited, in the *Santa Maria, Ca., CD*, 1958-65; Emma E. MacMillan b. Oklahoma Oct. 21, 1898, mother's

maiden name Rogalsky and father's Nikkel, d. Feb. 27, 1992 in Santa Barbara County per Calif. Death Index (refs. ancestry.com).
See: "Allan Hancock [College] Art Gallery," 1959

MacPherson (Simerly), Isabelle (Mrs. James Simerly) (Solvang)
Home economics teacher at Santa Ynez Valley high school, 1947/48. Taught crafts in adult school, 1947.
See: "Santa Ynez Valley, Ca., Adult/Night School," 1947, "Simerly, Isabelle"

Magdaleno, (Jose) Guadalupe "Lupe" (1916-2012) (Lompoc)
Photographer, unofficial, for Johns-Manville, 1943.

■ "Magdeleno [Sic. Magdaleno] Family All Out for Allied Victory … Five strong, father Norberto and his two sons and daughters are in war work at Johns-Manville… All are working at C-22, known outside the trade as the brick plant… and Guadalupe a brick setter. The latter, better known as Lupe, was a professional photographer before the war and now serves J-M as their unofficial cameraman…," *LR*, July 30, 1943, p. 3; "Held by FBI. J. Guadalupe Magdaleno, 32, Lompoc, was arrested yesterday in Santa Paula by the FBI for violation of the selective service act…," *Ventura County Star-Free Press* (Ventura, Ca.), Feb. 18, 1949, p. 3.
Magdaleno, Guadalupe (misc. bibliography)
Guadalupe Magdaleno is listed in the 1930 U. S. Census as b. c. 1916 in Mexico, immigrated 1916, an Alien, residing in Los Angeles with his parents Norberto Magdaleno (age 36) and Alejandra Magdaleno (age 36) and 6 siblings; J. Guadalupe Magdaleno filled out a WWII Draft Card in 1940 while residing in Santa Paula, Ca.; Jose Guadalupe Magdaleno was b. April 14, 1916 in Gomez Palacio, Durango, Mexico, and d. Dec. 26, 2012 per Barba Magdaleno Family Tree (ref. ancestry.com).

Maggini, Augusta J.
See: "Stone (Maggini) (de Angeles), Augusta J. (Mrs. Charles Maggini) (Mrs. de Angeles)"

Magnussen, Gustave / Gustav Adolph (1868-1944) (Balboa / Santa Ana)
Landscape painter who exh. in Solvang, 1933.
See: *Central Coast Artist Visitors before 1960*

Maguire, Albert L. (Santa Maria)
Collector. Prop. with wife, Nina, of Americana Shop, 208 W. Church St., Santa Maria, 1948-50. Investment counselor.
1949 – "Antiques is Topic for Soroptimists… by Albert L. Maguire… He spoke of the cultural value and of prestige … Illustrating his talk with glass and porcelain… The speaker told of personalities and collecting…," *SMT*, May 4, 1949, p. 5.

And, more than 90 notices for Albert Maguire in the *SMT* between 1945 and 1960, many of which were for speaking engagements on antiques and youth recreation – but most on financial investment – were not itemized here.
See: "Americana Shop"

Mailliard, Ida Belle Wheaton
See: "Tallant (Mailliard), Ida Belle Wheaton (Mrs. George Payne Tallant) (Mrs. Thomas Page Mailliard)"

Maimann, Leila Morrell Perry (Mrs. Charles E. Maimann) (1882-1960) (Lompoc)
Painter. Photo tinter. Mainstay of Alpha Club Art Section, 1932-43, 1945-46, 1952. Sister to painter Oma Perry, below.

■ "Churchman More than Half Century Rev. Maimann Observes 89th Birthday… Rev. and Mrs. Maimann have resided in Lompoc since 1930 when he came here from two years at Anaheim to open St. Mary's Episcopal church … He remained its active vicar until 1941 when failing health caused him to retire… [after numerous changes of church venue] … then went to Hemet. It was in Hemet he met Mrs. Maimann, then employed on the local newspaper, the *Hemet News*. From Hemet he went to the church in Corona… Meanwhile Miss Perry had planned to visit her family in Kansas, but she and Mr. Maimann were married in Trinity Church, in San Francisco. After four years with the church in Corona, Rev. Maimann was transferred to San Bernardino, where he remained for seven years … Followed two years with the church in Anaheim, then came St. Mary's which opened in 1930. …," *LR*, March 12, 1953, p. 2.
Maimann, C. E., Mrs. (notices in Northern Santa Barbara County newspapers on microfilm and on newspapers.com)
1935 – "Rev. Mrs. Maimann Return from North… vacation trip by automobile through northern California. … While in Berkeley, the Maimanns … also viewed the private collection of paintings by the late William Keith, now at the home of his widow in Berkeley," *LR*, Aug. 23, 1935, p. 8.
1938 – "Photographs Tinted in Oil. 4x6, 50c, 5x7, 60c, larger sizes 75c and $1. Landscapes also tinted. Mrs. C. E. Maimann, 322 W. Walnut," *LR*, July 22, 1938, p. 7.
1960 – "Rites Set for Former Resident. Mrs. Leila Morrell Maimann, 77, passed away at Spotswood Memorial Hospital, Los Gatos… Before moving to Los Gatos nine months ago, Mrs. Maimann had been a resident of Lompoc for 30 years and was the widow of the late Reverend Charles Eiler Maimann, formerly rector of St. Mary's Episcopal Church, who passed away in Lompoc, May 1953," *LR*, June 20, 1960, p. 6.
Maimann, C. E., Mrs. (misc. bibliography)
Leila M. Maimann, mother's maiden name Morrell, was b. Nov. 29, 1882 in Illinois and d. June 18, 1960 in Santa Clara County per Calif. Death Index; Leila Morrell Maimann, 1882-1960 is buried in Lompoc Evergreen Cemetery per findagrave.com (refs. ancestry.com).
See: "Alpha Club," 1932-43, 1945-46, 1952; "Art Festival (Santa Maria)," intro, "Community Club," 1935, "Lompoc Hospital," 1952, 1956, "Lompoc Valley Fair," 1930, "Open

Air Art Exhibit," 1957, "Orcutt Woman's Club," 1934, "Perry, Oma," "Tri-county Art Exhibit," 1948, 1950

Makimoto, Taro (b. c. 1926) (Japan / Santa Maria)
Teacher of flower arranging, 1959.

■ Port. and "Ikebana Taught by Makimoto – Stresses Simplicity, Delicacy… A slight, 33-year-old Japanese flower field worker is teaching the ancient art of Ikebana (flower arranging) to a handful of Japanese-American women each Friday evening at the Japanese Community Building. Taro Makimoto, who came here two years ago on a three-year Japanese season's worker program, doesn't speak English. Most of his students speak and understand some. Generally, he communicates with them through his expressive hands as he delicately adds to or subtracts from their beginning creations. Makimoto studied under Houn Oharo, generally considered the number two teacher of Ikebana in Japan… The theory behind all Japanese flower arranging is called Sho Fuku or, in English, 'Heaven, Man and Earth.' All arrangements have a high point for the heaven, a medium balance for man and generally a colorful or unique base representing earth. Makimoto builds a flower arrangement with agonizing suspense. First, he gazes contemplatively at the container, wondering what flowers will best fit its special contours. Japanese containers are also stark in their simplicity yet exotic in design. His students watch with quiet absorption [as he proceeds] … Makimoto, through an interpreter, said that he had studied flower arranging for 12 years. His father was also a famous teacher, and one of the favorite activities of his youth in his farming community was flower arranging. He is due to be sent back to Japan in 10 more months. He regrets this because his students (he also teaches in Guadalupe) are just at the stage where they are advanced enough to need more help," *SMT*, July 20, 1959, p. 3.
1960 – "Fender Bender. A collision... The drivers were Taro Makimoto, 34, Betteravia...," *SMT*, April 13, 1960, p. 2.

Mallinson, Anne (Lompoc)
Teacher of domestic science and art at Lompoc high school, 1921, 1922.
Is she Anne Lynn Mallinson b. 1898 in Calif. to Henry Martin Mallinson and Annie L. Molleson, who married Ralph Lloyd Hardman and was residing in Burlingame, Ca., in 1935 per Galleguez Family Tree (refs. ancestry.com).
See: "Lompoc, Ca., Union High School," 1921, 1922

Mamoulian, Azadia (Mrs. Reuben / Rouben / Rueben Mamoulian) (Hollywood)
Artist who exh. with "Hollywood notables" at Santa Ynez Valley Art Exhibit, 1954. Wife of motion picture director Reuben Mamoulian, who, at one time, was also married to Greta Garbo.
See: "Santa Ynez Valley Art Exhibit," 1954

Manning, Jack
Photographer who visited the Santa Ynez Valley to take photos for Saturday Evening Post, 1946.
See: "Photography, general (Santa Ynez Valley)," 1946

Manning, Russell "Russ" George (1929-1981) (Orcutt / greater Los Angeles)
Artist grad. of Santa Maria Union High School, '46. Topographic artist with the military during the Korean War. Exh. Santa Maria Art Festival, 1952. Comic book artist.

■ "Russell G. Manning, 52, died Tuesday in the Veterans Hospital in Long Beach… Mr. Manning was born in Van Nuys, Jan. 5, 1929. He was a former resident of Santa Maria. He attended local schools and was the illustrator of the comic strips, 'Tarzan' and 'Star Wars.' He was also the Chief of Majeska [Sic. Modjeska] Canyon, Orange County Fire Station. Survivors include his widow, Doris Manning of Modjeska Canyon…," *SMT*, Dec. 10, 1981, p. 8.

■ "American comic book artist who created the series *Magnus, Robot Fighter* and illustrated such newspaper comic strips as *Tarzan* and *Star Wars*. He was inducted into the Comic Book Hall of Fame in 2006," per Wikipedia. Manning, Russell (notices in Northern Santa Barbara County newspapers on microfilm and on newspapers.com)
1946 – HS art student "Manning Wins Contest. The art department of the school was thrown into a turmoil late yesterday with the announcement that Russell Manning, talented high school art student, had copped first place in an all-California contest to design a 25th century school bus. For this, the Crown Body and Coach Corp. of Los Angeles, which sponsored the contest, is awarding Russell $100. He spent about two weeks on his sketch, a pen and ink design which features a bus with atomic jet power. It is of a streamlined bullet shape, encased in a separate plastic cylinder. Russ hopes to enter the field of art and is aiming at illustration," *SMT*, May 24, 1946, p. 3; "SM High School Graduation Class," *SMT*, June 14, 1946, p. 4.
1949 – "Orcutt News… Mrs. Manning visited Russell Manning who is attending art school in Los Angeles…," *SMT*, May 13, 1949, p. 5.
1950 – "Private Chosen for Special Army Training. Pvt. Russell G. Manning, 21, recently called into federal service with Southern California's 40th Infantry Division, has been selected to receive special training in a Topographic Drafting course at the Engineer school, Ft. Belvoir, Va. He will rejoin his unit, Headquarters Battery of the 40th Division Artillery, at Camp Cooke upon completion of the course. Pvt. Manning lived with his mother, Mrs. Opal G. Manning, at 450 Union avenue, Orcutt," *LR*, Oct. 12, 1950, p. 14.
1952 – "Korean Vets coming Here… recent arrival in Seattle aboard the Navy transport *Gen. Simon Buckner*… Sgt. Russell G. Manning of Orcutt…," *SMT*, Feb. 7, 1952, p. 1.
1981 – "Dec. 1, 1981: Santa Maria Union High School graduate Russell Manning died. Manning drew the popular Tarzan comic strip from September 1967 until June 1979." per santamariatimes.com/lifestyles.
See: "Santa Maria [Valley] Art Festival," 1952

Margeson, Marion J. (Mrs. Guy L. Margeson) (Placer County / Lompoc)
Instructor in crafts at USO, Lompoc, 1942.
Margeson, Marion (misc. bibliography)
Taught bible class at Fort MacArthur in San Pedro, 1944. Taught crafts at "C Street USO' in either Marysville or Yuba City, Ca., in 1945 per *Appeal-Democrat* (Marysville, Ca.), Aug. 21, 1945, p. 2. Member of Business and Professional Women's club of Auburn, Ca., 1947. Mrs. Marion J. Margeson, housewife, resident of Bowman, registered to vote in Placer County, Ca., 1934-44 per *Voter Registers* (ref. ancestry.com).
See: "United Service Organization," 1942

Marion, Harue Kuranochi (Mrs. Donald Francis Marion) (1930-2008) (Vandenberg)
Doll maker, 1959.
■ "At Vandenberg, Mrs. Donald Marion is a doll maker. She takes slender, graceful figures and colorfully dresses them in the costumes of the Japanese of 100 years ago. Kabuki dancers, geisha ladies, and housewives, all are depicted by Harue Marion's flying fingers. Harue Kuranochi was a young girl growing up just outside Tokyo when her mother insisted that she learn the art of doll making, much as an American mother insists on music lessons for her daughter. Her tutor was Mrs. Katayana of the Sakuirae School. 'I didn't like stitching while there were so many other things to do,' she says. 'But I learned.' She also learned dressmaking and English. She met S-Sgt. Donald Marion while he was stationed in Tokyo. Two years and miles of red tape later, they were married in the American Consulate. As gifts to her husband's family, Harue made and dressed 15 dolls. They were such a hit that she began to look at doll making as a pleasure and not a chore. The Marions have been stationed in Chicago and at Travis AFB, California. At both stations Harue made Japanese dolls. She showed her dolls and her technique for making them to the Girl Scouts and other interested groups. The Marion family, the Sergeant, Harue, and their two daughters, Linda and Janice, spent two years in Japan. Harue and the children stayed with her family while the Sergeant was quartered in Kyushu. When the girls learned to talk, Harue wanted to get right back to the United States because they had, naturally, learned Japanese. ... The fabulous dolls Harue makes are real conversation pieces. She works on them while her husband has night duty with the Third Weather Detachment at VAFB. 'When Donald is away at night and the children are in bed, I have peace and quiet. Then I can work on my dolls,' she says. It takes eight hours, spread over a week for the dolls to reach the finished stage. A Hank of Hair. Harue starts with a hand of artificial hair, a face form, and some scraps of silk and brocade. She paints the face. Then she stuffs and forms the head. She dresses the hair with tiny wisps of bangs and puffs that are held in place with minute decorative hair pins. She makes the body and stuffs it with excelsior. The hands have silken fingers stitched around five tiny wires. When the doll becomes a figure. Harue begins the garments. Coral, red, persimmon, black, lavender, all the glowing colors for the kimonos. Heavy brocade shellacked with blue is used for the high-riding obi. She makes the tiny split-toed zoris and

presto a new doll joins the procession. The stitches on the clothing are precise and beautiful. On the outside garment the holding stitches form a part of the decoration. Sell my dolls? I have sold some. But mostly I make them just for the pleasure of making them,' says the petite Harue. All of her supplies come from Japan...," and port. of Harue Marion with dolls per "Japanese Dolls Hobby of Wife," *SMT*, Oct. 22, 1959, p. 6.
Marion, Harue (misc. bibliography)
Harue Marion b. Jan. 17, 1930 and d. Dec. 26, 2008, wife of Donald Francis Marion, is buried in Sacramento Valley National Cemetery per findagrave.com (ref. ancestry.com).

Marionettes
See: "Puppets"

Markevich, Louise (Santa Maria)
See: "Corollo, Louise Markevich"

Marriott, O. C. & Co. (Lompoc)
General contractor and construction company that had its own drafting department, 1927.
■ "We wish to announce to the public that we are locating in Lompoc to engage in the business of general contractors and builders. We have built the largest percentage of the better class residences and mercantile buildings in Santa Maria during the past ten years... We have our own drafting department... We prepare preliminary plans and give estimates without obligation... O. C. Marriott & Co. Office, 108 South H. Street, Lompoc, California. Telephone 47. Office, 120 West Church Street, Santa Maria, California. Telephone 124," *LR*, March 11, 1927, p. 10.

Marsalisi, Mary Margaret "Marge"
See: "Fratis (Marsalisi) (Minnick), (Mary) Margaret "Marge" (Mrs. Joseph Marsalisi) (Mrs. James Minnick)"

Marshall, Mary Lea (1925-2008) (Santa Maria)
Art editor of Santa Maria High School Review, 1942.
Commercial art major at Vassar, 1943+.
■ "Santa Maria Descendant of Daniel Boone Wins Two College Scholarships... [parents] Bert Marshall and his wife, Mary Leslie Marshall, pianist... Mary Lea will graduate from the local high school on June 9, climaxing four years of outstanding scholarship attainment which earned her membership in the Honor Scholarship Society. She has also taken a prominent part in extra-curricular activities and has been listed as outstanding in good citizenship... Miss Marshall has chosen to attend Vassar where she will major in commercial art. The local girl has studied under... **Stanley and Elizabeth Breneiser**...," *SMT*, May 25, 1943, p. 1.
Marshall, Mary (notices in Northern Santa Barbara County newspapers on microfilm and on newspapers.com)
1944 – "Vassar Student Home – Mary Lea Marshall, a student in Vassar College, Poughkeepsie, N. Y., arrived

yesterday to spend a six-week vacation with her parents, Mr. and Mrs. Bert Marshall," *SMT*, July 10, 1944, p. 3.
1946 – "Miss Marshall a Vassar Graduate… She chose art as her major field of study…," *SMT*, June 26, 1946, p. 4.
1951 – "Miss Mary Lea Marshall, who is employed in San Francisco, has returned north after being here on a vacation of two weeks with her parents…," *SMT*, June 2, 1951, p. 4.
1970s – According to the obituaries of her parents who died in the 1970s, Mary Lea was residing in Santa Maria.
Marshall, Mary (misc. bibliography)
Mary Lea Marshall, mother's maiden name Pullian, was b. Dec. 4, 1925 in Santa Barbara county per Calif. Birth Index; Mary Lea Marshall is listed in the 1940 U. S. Census as residing in Santa Maria (1935, 1940) with her parents Egbert P. Marshall (age 49) and Mary Lester Marshall (age 48) and brother Egbert (age 16); Mary Lea Marshall was residing in Foster City, Ca., in 1996 per *U. S. Phone and Address Directories, 1993-2002*; Mary Lea Marshall d. June 15, 2008 in Oakland, Ca., per Lyons Family Tree (refs. ancestry.com).
See: "Santa Maria, Ca., Union High School," 1938, 1940, 1941, 1942

Martin, Ben (c. 1911-?) (New York)
Artist of four-week Christmas cartoon titled "Heavenly Daze" run in the Santa Maria Times in 1954.

■ "Martin's experiences as news editor of a Philadelphia television station, playwright, artist, author, and syndicate editor, have sometimes taken him distressingly far from heaven. … Ben Martin is the author of three books, all illustrated by himself, '*Alfred*,' published by Simon and Shuster, tells of a dachshund… who wishes to become a trained seal; '*John Black's Body*' and '*Mr. Smith and Mr. Schmidt*' were both published by Vanguard. The versatile Mr. Martin has also written a number of plays (he gets depressed when he counts unproduced ones). Recently Philco Playhouse adapted one of them, '*Bonanza*' for TV presentation. Primarily a cartoonist… Ben Martin's panels have appeared in *Colliers, This Week, Saturday Evening Post, Mademoiselle, Vogue, Punch*, and just about every other major publication in the world. Ben was born in Oakland, California, and he is a graduate of the University of California. He flew east via Cleveland and Philadelphia. Mr. Martin lives a citified New York life. He is in no way fond of the great outdoors, finds the sun irritating. When asked if [he] had any hobbies, he thoughtfully volunteered, 'yes,'" per port. and "Angel and Imp Will Romp in Christmas Comic Strip," a four-week Christmas fable cartoon titled "Heavenly Daze" by Ben Martin of the *New York Tribune*, is taken up by several papers including *Press-Courier* (Oxnard, Ca.), so says article printed Nov. 26, 1954, p. 1.
■ "'All men are half angel, half imp,' declared Ben Martin. Adding (prodded no doubt by the angelic side of his nature) 'and I'm no exception.' Not satisfied with philosophy for philosophy's sake, Mr. Martin has translated his theory into a four-week Christmas fable, called 'Heavenly Daze.' Mr. Martin is both author and artist of this completely original comic strip, which will appear in the *Times* Monday and continue right through to Christmas. 'Heavenly Daze' … records Heavenly's (namesake and

hero of the strip) struggle to wrest the Christmas Star from the remarkably irredeemable Fielding the Fiend. Without the star, Santa Claus will have no guide for his yearly gift deliveries. Fortunately, Heavenly has the assistance of Griddlebone, the most unusual dachshund that ever flew at an angel's side. And the merry spirit of Christmas prevails. Mr. Martin's philosophy is not the result of years of uninterrupted thought on a rarified mountain-top. Nor do all his thoughts fly up … he has spent a busy career with earthmen. In fact, his experiences as News Editor of a major Philadelphia television station, playwright, artist, author, and Syndicate Editor, have sometimes taken him distressingly far from heaven," per port. and "Times New Cartoonist Says 'All [Men] Are Half Angel, Half Imp," *SMT*, Nov. 27, 1954, p. 1.
New York newspapers for 1938 carry many notices on "Ben Martin" of Cornwall, Orange County, NY, a Democrat, who opposed Hamilton Fish for the congressional seat, 1938, but they were not itemized here.
Martin, Ben (misc. bibliography)
Ben Martin is listed as a Junior, member of Hammer and Coffin (National Humorous Publications Society) in the University of California, Berkeley, yearbook, 1932; port. of Ben Martin, editor, Pelican, spring, in University of California, Berkeley, yearbook, 1933; Ben Martin is listed in the 1940 U. S. Census as age 29, b. c. 1911 in Calif., finished college 4th year, a self-employed writer, residing in Cornwall, Orange County, NY with wife Jane (age 26) and child Alice (age 2); Benjamin Martin, artist, is listed with wife Jane in the *Newburgh, NY, CD*, 1938-46 (refs. ancestry.com).

Martin, Ellen A. (Mrs. Henry Neal Martin) (Lompoc)
Exh. Tri-county Art Exhibit, 1958. Mentioned re: Open-Air Art Exhibit, 1960. Deputy City Clerk, 1956.
[Do not confuse with "Ellen Martin" of Solvang.]
Ellen A. Martin is listed in the *Lompoc, Ca., CD*, 1945, 1947, 1958 and in the *Santa Maria, Ca., CD*, 1958, 1965 (ref. ancestry.com).
See: "Alpha Club," 1962, "Open-Air Art Exhibit," 1960, "Tri-County Art Exhibit," 1958

Martin, Gilbert (1906-1987) (Lompoc)
Photographer with color slides. Filmmaker, amateur, who showed his films of Oregon and Washington at the Lompoc Film Council meeting, 1948. Elementary school principal.

■ "Gilbert Martin… born June 5, 1906 in Carpinteria to pioneers… He was raised and educated there, graduating from Carpinteria High School. He attended Santa Barbara State Teacher's College… In 1938 he received a teaching position in Lompoc, leaving in 1942 to serve with the Army Corps of Engineers during World War II. He spent three years in the South Pacific. After the war, he taught in Santa Maria and Lompoc schools, becoming principal of Lompoc and **Clarence Ruth** elementary schools…," *LR*, March 11, 1987, p. 3.

Martin, Gilbert (notices in Northern Santa Barbara County newspapers on microfilm and on newspapers.com)
1946 – "Kiwanians See Pictures of Life on Okinawa Isle... Life on Okinawa illustrated in Kodachrome pictures... The speaker was Gilbert Martin... who spent considerable time on the island during the American campaign. ... Showing and describing the slides... [the speaker told of the harsh life for the natives] ... He saw (and showed in pictures) pine trees on the island... He also found a wild lily... He also showed films of huge ferns and numerous pictures of tombs in the hillsides ...," *LR*, Feb. 14, 1946, p. 5.
1960 – "Shriners to See Alaskan Film Tonight... Gilbert Martin will show film of a recent trip to Alaska...," *LR*, July 21, 1960, p. 23.
1961 – "Mrs. Steves is PTA ... **Clarence Ruth** School PTA... Gilbert Martin presented a program on Alaska, illustrated by color slides," *LR*, Nov. 16, 1961, p. 7.
1969 – "Sea cruise topic at woman's club... a trip by sea freighter to the South Pacific ... guest speaker Gilbert Martin ... Lompoc Community Woman's Club... took a seven-week sabbatical to Tahiti, Samoa, Fiji and New Caledonia Islands. Illustrating his talk with color slides, Martin showed the native markets, tropical vegetation and miles of beautiful ocean," *LR*, Feb. 17, 1969, p. 4.
And, several additional slide lectures were not itemized here.
See: ""Lompoc Film Council," 1948

Martin, Hazel Brown (Mrs. Martin)
Home Demonstration agent, 1947-60+.
See: "Alpha Club," 1954, "Home Department of the State Farm Bureau," 1947, 1948, 1953

Martin (Anderson), Norma Catherine (Mrs. Clarence Robert Anderson) (1926-?) (Santa Maria / Lompoc)
Arts teacher at Santa Maria High School, 1948-50.
Martin, Norma (notices in Northern Santa Barbara County newspapers on microfilm and on newspapers.com)
1946 – "Norma Martin is Elected to Honorary Society... a Junior at San Jose State College, has been elected to Delta Phi Delta, national honorary art fraternity. Miss Martin, the daughter of Mr. and Mrs. John Martin, was one of 10 students in the art department of the college honored...," *LR*, Dec. 12, 1946, p. 4.
1948 – "Norma Martin Graduating from San Jose State," *LR*, June 10, 1948, p. 9; "Board Gives Contract... "Miss Norma Martin was elected to teach crafts and arts at $2,700 in place of **Miss Verla Leonard**, who resigned," *SMT*, June 16, 1948, p. 8; port. and "Norma Martin to Teach in Santa Maria... Miss Martin recently graduated from San Jose state with a Bachelor of Arts degree and a special secondary teaching credential. She is a graduate of the Lompoc high school," *LR*, July 15, 1948, p. 8.
1954 – "Norma Martin Becomes Mrs. Anderson... The new Mrs. Anderson is a graduate of Lompoc schools, Santa Maria Jr. College and of San Jose State College where she was a member of Delta Phi Delta, national art sorority. She was formerly employed at Johns-Manville... The groom... is now a chemical engineer at Johns Manville," *LR*, July 1, 1954, p. 5.

Martin, Norma (misc. bibliography)
Norma Catherine Martin, mother's maiden name Serres, was b. April 8, 1926 in Santa Barbara County per Calif. Birth Index; port. in Lompoc High School yearbook, 1944; port. in Santa Maria High School yearbook, 1951; Norma is listed with Clarence R. Anderson, custodian, Unified School District in the *Palo Alto, Ca., CD*, 1956 (refs. ancestry.com).
See: "Lompoc, Ca., Union High School," 1940, "Santa Maria, Ca., Union High School," 1948, 1949, 1950

Martin, Virginia (Mrs. Martin) (Los Alamos)
Ceramic student at Los Alamos Adult School, 1954.
Martin, Virginia (notices in Northern Santa Barbara County newspapers on microfilm and on newspapers.com)
1952 – "Student Council... Los Alamos children are enjoying a series of miniature scenes depicting states of the Union which are being arranged weekly by Mrs. Virginia Martin in the school corridor. States depicted are Maine and California. The next state scene to be presented will be that of Arizona," *SMT*, Feb. 25, 1952, p. 4.
1954 – "Off to Buffalo. Mrs. Virginia Martin and children, Robert, Martha and Rosemary, and her mother, Mrs. Florence Krause, left Los Alamos Saturday morning by bus for Buffalo, N. Y.," where they have relatives, *SYVN*, Jan. 22, 1954, p. 6; "Clever Card. The clever and beautifully done Easter greeting card that appeared in the Los Alamos post office window, was the handiwork of Mrs. Virginia Martin," *SYVN*, April 23, 1954, p. 4.
Approx. 50 notices in the *SMT* and the *SYVN* for "Virginia Martin" c. 1950-54 show that she was often put in charge of decorating for special events, that she advised on nursing, and that she supported extra-curricular activities in which her children participated.
This individual could not be fully identified.
See: "Los Alamos, Ca., Adult/Night School," 1954

Masked Arts Ball
See: "College Art Club" 1935

Mason (Collison) Elizabeth (Mrs. Thomas F. Collison) (Santa Maria)
See: "Collison, Elizabeth"

Mason, Robert Dwight (aka Dwight Fred Stewart) "Stew" (1913-1989) (Santa Maria / Los Angeles)
Student at Santa Maria High School, class of '32, and Jr. College and member College Art Club, 1932. Became an artist in Los Angeles.

■ "My father, Robert Dwight Mason, born Dwight Fred Stewart, 23 January 1913, in Verdon, Nebraska, to Fred Uriah Stewart and Edna Iva Mahannah. The family was living in the train depot at Verdon, Nebraska since Fred was a telegrapher and station master for the railroad They lived an ideal life and little Dwight was the love of his mother and father. Sometime after 1925, the Stewarts had to get out of town, because as family history has it, Fred did something that, well, called for a fast exit. The

family then moved to Santa Maria, California, where we believe Fred went to work for another railroad. Now this is where the Stewarts become the Masons, and little Dwight becomes Robert 'Bob' (named after his favorite cousin Robert Burns). So confusing because when Bob Mason went to Chouinard Art Institute in Los Angeles, everyone called him 'Stew' as in Stewart. Anyways, Bob goes to Santa Maria High School, is head cheerleader, and a lifeguard during the summer in Santa Barbara. He does a lot of riding the rails during the summers, and finally heads to Los Angeles after high school (only completed his 2nd year). Here's another weird thing, my dad is living with his folks (new stepmother LaVerne) during the 1940 census, and Bob says he's 3 years younger than he was, and his father says he's 6 years younger... somebody still running from the law? Meanwhile Bob has been skiing in the local mountains and has become very good. So good he starts teaching skiing in Minnesota, where he meets my mother, Helen Marie Skogerson. This was a very quick romance and marriage, with a ski vacation in Sun Valley, Idaho, and other strange things happening. Also, as far as I can tell she married Dwight Stewart, because she didn't legally change her name to Mason until July of 1944, nine months before my sister and I were born. As the story continues, working as an artist for Northrup Aviation at the start of WWII, dad then joins the Merchant Marines during World War II, sails around the world delivering death to every doorstep. Returns home, works for Douglas Aircraft as an artist, then heads for the mountains (Running Springs, California) to teach skiing at Snow Valley near Big Bear, California. Happy days growing up in the mountains going to a one room school house. Dad hears the call for adventure again and heads to Alaska and works at the Parson's Hotel as a desk person. He returns to the family, now living in Sherman Oaks, California (I think this is when mom and dad separate and life starts sucking.) Dad was a good man and raised another family which produced Mark, my hero and brother. Dad worked for many years for Aerospace Corporation, retired, stayed active skiing, biking, playing tennis and swimming. He eventually had a horrific bicycle accident and never really recovered. He had a wonderful friend in MaryLee, who cared for him until he died on 10 July 1989 of prostate cancer...," and photos, per trippingthroughthegenepool.blogspot.com.
Mason, Robert (notices in California newspapers on microfilm and on newspapers.com)
1931 – Port. with cast of high school play, *SMT*, June 11, 1931, p. 3.
1934 – "Visits Mother – … Robert Mason who came up from Los Angeles to spend the week-end… A former college student, he now holds a position in an art store in the southern city," *SMT*, May 16, 1934, p. 3.
1935 – "Here From Nebraska – Mrs. N. R. Rasch of Nebraska is a guest of her daughter, Mrs. Edna Mason. Robert Mason, formerly Santa Maria high school student who is now doing art work in Los Angeles, came north to visit…," *SMT*, Sept. 5, 1935, p. 2.
1946 – Author of *Why Ain'tcha Rich?*, Pasadena, Ca.: E. F. Crowell Co., 1946.
[His age does NOT match with the "Robert D. Mason" industrial designer of Los Angeles c. 1950-70.]

Mason, Robert (misc. bibliography)
Robert D. Mason is listed in the 1930 U. S. Census as b. c. 1913 in Neb., residing in Santa Maria with his parents Bert D. Mason (age 40) and Edna I. Mason (age 39); port. as cartoonist for *Review* in Santa Maria High School yearbook, 1931; Robert Dwight Mason provided the following information on his WWII Draft Card dated Oct. 16, 1940 = b. Jan. 23, 1913 in Verden, Neb., working for Douglas Aircraft Co., and residing in Manhattan Beach, Ca., and mother is Edna I. Kehrer; Robert Dwight Mason, mother's maiden name Mahannah and father's Stewart was b. Jan. 23, 1913 in Other Country [Sic?] and d. July 10, 1989 in LA County per Calif. Death Index; Robert D. Mason b. Jan. 23, 1913, last residence El Segundo, Ca., d. July 10, 1989 per Social Security Death Index; many photos relating to Dwight Fred (Robert) Stewart (Mason), b. Jan. 23, 1913 and d. July 10, 1989, including one of him sitting at his drawing board surrounded by cartoons, are contained in *Public Member Photos & Scanned Documents* (refs. ancestry.com).
See: "College Art Club," 1932, "Scholastic Art Exhibit," 1931

Mathewson, Esther (Santa Maria)
Photographer, Santa Maria, 1946.

■ "I specialize in Child and Family Group photography. To ensure natural expressions, all my work is done in the home by Appointment. For a picture of your child or your family group that you will treasure and cherish always, this kind of photography cannot be excelled. For further information, without obligation, call Esther Mathewson at 306-W. Rates are low and Satisfaction is guaranteed. No fuss – no bother – no traveling – just call me and leave your address or phone number. P. S. I like children and if your child has proven a picture taking problem, let me help you solve it. Esther Mathewson. Phone 306-W," *SMT*, June 26, 1946, p. 2.
Repro: Coronation of Santa Maria's 'king' and 'queen' at **Pythian Sisters** baby show, *SMT*, Aug. 15, 1946, p. 3.

Matsubara, Kazuo (1895-after 1932) (Hawaii / France / Guadalupe / Japan)
Japanese artist active in Guadalupe, Ca., 1930.

■ "World is Making a Path to Door of Japanese Artist at Guadalupe… Possessing the Diploma of Honor from the board of judges of the International Exposition of Fine Arts at Bordeaux in 1927 and acclaimed by E. Spencer Macky of San Francisco as a 'born artist' … He will show Morro Bay, San Luis Obispo county and Santa Maria valley scenes at his exhibition this week-end. The story of his life, which has reached only 30-odd years so far, is extremely interesting … In 1912 he came from his birthplace, the Hawaiian Islands to San Francisco where he entered the School of Fine Arts. Later he spent three years studying in France, principally in Paris and for the last six months has been living in Guadalupe… [and Mackey's extended opinion of him] … ," *SMT*, Feb. 7, 1930, p. 8.

Matsubara, Kazuo (notices in American newspapers on microfilm and on newspapers.com)
1930 – Art Exhibition to Remain Open Until Thursday… So keen has been the interest of Santa Maria valley people in the exhibition of paintings hung in the Japanese association hall at Guadalupe by Kazuo Matsubara, young Oriental painter … Over the week-end several hundred Americans and Japanese from various parts of the district viewed the exhibition. Comment in general was most favorable … sponsored by **Setsuo Aratani**, owner of the Guadalupe Produce company and president of the Japanese association there. Matsubara's technic [Sic.] is definitely divided. His portrait work of Japanese notables, both in this region and elsewhere, is primarily the product of a camera and of the brush and oils second. Reality … is stressed to the exclusion of artistic beauty. They are somewhat flat in appearance yet certainly true to the subject … It is in his handling of still lifes that Matsubara stands out as premier… Seldom will there be found a 31-year-old painter who so thoroughly expresses his own sense of what is true in beauty … Tinged lightly with the technique of the eastern, modernized by Occidental conceptions of structural values and marked by a distinctive air which hints at Old World influences, his landscapes are really notable. Yesterday, in the short space of an hour, there were more than a dozen Santa Marians who viewed the canvases … Art students in particular should make the trip to Guadalupe for Matsubara is a most willing conversationalist and has innumerable tips that will benefit any young painter. Years of study in American art schools, three years in France, including work under masters at the Louvre and at Bordeaux, and a willingness to pass on his solution of problems in oils and etching should result in an exodus of local artists to Guadalupe. Only one etching is on display. It would be a fine thing if some Santa Maria organization invited him to bring here an exhibition of his work in this line alone," *SMT*, Feb. 10, 1930, p. 5; "Young Japanese Artist Nearly Discovered Priceless Frescoes… Concarneau… In 1926 Kazuo Matsubara, young Guadalupe artist who closed his exhibit in the Japanese association halls there last week, sauntered into one of the inns near Concarneau…," and lengthy anecdote, *SMT*, Feb. 26, 1930, p. 3; "An Island-Born Artist Returns. Paintings by Kazuo Matsubara Impress visitors at YMBA… Young Men's Buddhist Association… born in Kauai, Matsubara was educated at the Japanese high school in Honolulu and later studied art on the mainland and in France…," *Honolulu Star-Bulletin*, July 12, 1930, p. 5; repro. of seated nude and repro. of etching and "Matsubara Paintings Now at Art Academy… island-born artist who has recently returned after 19 years' study on the mainland and in Europe may be seen at the Honolulu Academy of Arts … etchings, pencil sketches, and monotypes… Matsubara's departure on July 23, when he sails to show his work in the prominent galleries of Tokyo. Matsubara, who speaks Japanese, English and French fluently, has received special honors for his work, especially the nudes that were hung in the national salon in Paris in 1926 and 1927. Two striking portraits are paintings of Rabindranath Tagore, Bengali philosopher and Yoshie Fujiwara, Japanese tenor. In his oils, Matsubara proves himself to be a naturalistic painter, purely in the Occidental style, but in his prints one may see the Japanese influence, especially in the bird and flower subjects. An etching of ducks, exhibited at the Salon d'Automne in 1926, has been added to the collection at the British Museum," *Honolulu Star-Bulletin*, July 19, 1930, p. 54 (i.e., Ten); repro: "Mother and Son" oil painting and repro. of etching, "In the Autumn Water," and article, "Matsubara Exhibit at Academy of Art will be Concluded This Evening," *Honolulu Advertiser*, July 20, 1930, p. 30 (i.e., Twelve).
1931 – "Noted Japanese Artist Guest in Valley, Plans to Exhibit work in Guadalupe and Here… [**Chiura Obata**] guest in the home of **Settsuo Aratani**, Guadalupe produce dealer and patron saint of baseball teams as well as artists… It is Aratani whose protégé, Matsubara, has been so well received in art circles of the coast and who now is studying in his homeland…," *SMT*, June 24, 1931, p. 1.
1932 – Repro of Matsubara's picture of **Setsuo Aratani**, Guadalupe Japanese leader, and biography of Aratani, *SMT*, April 9, 1932, p. 3.
1940 – Repro of port. of **Setsuo Aratani**, *SMT*, April 17, 1940, p. 6.
See: "Matsubara, Kazuo," in Gordon H. Chang, et al., *Asian American Art: A History, 1850-1970*, Stanford, Ca.: Stanford University Press, 2008, p. 384+.
Matsubara, Kazuo (misc. bibliography)
Kazuo Matsubara, artist, b. Hawaii, June 1, 1895, father Umekichi Matsubara, mother Kouko Toyota had been in Calif. 8 years and was then living at 1881 Pine St., SF, per California State Library artist card dated 1920; Kazuo Matsubara, artist and Rep. is listed in the *Supplementary Index to Register [of Voters], City and County of San Francisco, Precinct 56*, 1924 (refs. ancestry.com).
See: "Aratani, Setsuo," "College Art Club," 1932, "Japanese Art"

Mattei, Charles Clayton (1886-1961) (Los Olivos / Santa Barbara)
Portrait painter. Attended Chicago Art Institute, 1916. Exh. first annual Santa Ynez Valley Art Exhibit, 1953. Brother to Clarence Mattei, below.

■ "Charles Mattei… 75, of Santa Barbara, a former Valley resident and member of one of the Valley's first families. … Mr. Mattei was born July 27, 1886 in Cayucos. His parents, Felix and Lucy Mattei opened Mattei's Tavern in Los Olivos in 1888. Mr. Mattei attended Los Olivos Elementary School, Santa Ynez High School and the Chicago Art Institute, where he studied with **Albert Herter** and Herman Herkimer. He was known for his fine portrait painting. For 40 years Mr. Mattei worked with his father at Mattei's Tavern, now operated by his brother Fred L. Mattei. For the past 14 years he operated Matteis' Cutlery Shop in Santa Barbara. Mr. Mattei married Lorraine Hannaman of Auburn Oct. 27, 1935, and they have lived in Santa Barbara most of the time since then. Mr. Mattei served in the Navy in World War I and was a member of the American Legion, the Masons, and the Society of Los Alamos…," *SYVN*, Oct. 13, 1961, p. 8.

Mattei, Charles (notices in Northern Santa Barbara County newspapers on microfilm and on newspapers.com)
1910 – "Best Trout Fishing… Charles Mattei of the Los Olivos hotel, is preparing for the opening of the Alamo

Pintado Inn at Ballard… The main hotel at Los Olivos, also, has been much improved…," *SMT*, March 19, 1910, p. 1; "Charles C. Mattei to Take Management of McKittrick Hotel. Los Olivos. … He has had a good experience with his father, Felix Mattei…," *Independent* (Santa Barbara, Ca.), Dec. 15, 1910, p. 5.

1916 – "According to the *Santa Ynez Argus* our old friend Charles Mattei of Los Olivos, leaves soon for Chicago where he will enter an art school. Mr. Mattei's brother is already a very successful artist," *LR*, Nov. 24, 1916, p. 5, col. 2; "Chas. Mattei, a son of the well-known Felix Mattei of Los Olivos, has gone to Chicago, to resume work as an artist. He is among the finest artists with a brush in the country," *SMT*, Dec. 2, 1916, p. 4.

1932 – "Bricks… Recently saw a painting of **Harry Hobbs** done by Charlie Mattei. It was so lifelike we stood there waiting for Harry to give one of his famous laughs," *SYVN*, Feb. 19, 1932, p. 4.

1935 – "Charles Mattei and Lorraine Hanneman Married October 29th… in Auburn, Ca… Mr. Mattei … is an artist… in Santa Barbara, where the Matteis will make their home…," *SYVN*, Nov. 8, 1935, p. 1.

1948 – "Many Out-of-Towners Attend Silver Tea Marking Anniversary of … Santa Ynez Valley Presbyterian Church… 50th anniversary… One of the highlights of the program was the unveiling of a portrait of the late <u>Judge Samuel Lyons</u>, pioneer resident of Ballard, and the man who directed the building operations of the church 50 years ago. The painting was done by Charles Mattei, who was present for the ceremony. The Lyons painting will be displayed at a County-wide exhibition at the Santa Barbara Museum. Following the exhibition, it will be presented to the Lyons family," *SYVN*, May 21, 1948, p. 1.

1949 – "Mattei's Salad… The recipe was presented as one of the regular series of outstanding American recipes… in the November-December issue of the *Lincoln-Mercury Times*, national bi-monthly full-color production. Accompanying the recipe… is a water-color sketch of the outside of the Tavern with an old stage-coach stopped in front of the main entrance," *SYVN*, Dec. 16, 1949, p. 2.

1953 – "Odin Buell Home… A large porch fronts the house. The large living room … A grandfather's clock is on one side of the fireplace, while hanging above the fireplace is an oil painting of <u>R. T. Buell</u>, Mr. Buell's father. The painting is the work of Charles Mattei and was taken from a photograph of R. T. Buell on the latter's 21st birthday…," *SYVN*, Nov. 13, 1953, p. 10

1954 – "Mattei Portrait of <u>Arthur Hapgood</u> Planned by Lompoc Schools Alumni… Lompoc educator for whom the school was named… Charles Mattei, noted Santa Barbara portrait artist and long-time friend of Hapgood, has agreed to paint the portrait for considerably less than his accustomed fee…," *LR*, March 11, 1954, p. 6; "Hapgood Portrait Project Receives Hearty Support," *LR*, March 18, 1954, p. 6; "Contributions for Hapgood Portrait… The third sitting for the portrait has been completed and the fourth probably will be arranged during the next week. Mattei began the work with a charcoal sketch of Hapgood and is now working with oils," *LR*, April 1, 1954, p. 6; "Hapgood Portrait Unveiling at School Dedication May 2… As the painting neared completion this week in Mattei's Santa Barbara studio, letters containing cash contributions toward

the project continued to tumble into the Lompoc post office…," *LR*, April 8, 1954, p. 3; "Distant Alumni Continue to Send Hapgood Portrait Contributions," *LR*, April 15, 1954, p. 7; "Enthusiastic Letters Still Arriving from Former Arthur Hapgood Students," *LR*, April 22, 1954, p. 5.

And, more than 30 additional references for "Charles Mattei" primarily regarding his local travels and attendance at social events were not itemized here.

<u>Exhibit</u> – *The Art of Clarence and Charles Mattei*, Santa Barbara Historical Society. [Charles C. Mattei (1886-1961) and Clarence Rudolph Mattei (1883-1945) were brothers.] Through December 31, 2004.

<u>Mattei, Charles (misc. bibliography)</u>
Charles Clayton Mattei was b. July 27, 1886 in Cayucos, Ca., to Felix Mattei and Lucy Fisher, married Inez Loraine Hannaman, was residing in Los Olivos in 1935, and d. Oct. 7, 1961 in Santa Barbara per Shoup-Newcomb Family Tree; Charles Clayton Mattei is buried in Oak Hill Cemetery, Ballard, per findagrave.com (refs. ancestry.com).

<u>See</u>: "Buell, Josephine," 1953, "Faulkner Memorial Art Gallery," 1932, "Hobbs, Harry," "Lyons, Jeannette," "Mattei, Clarence," 1918, "Presbyterian Church," 1948, "Santa Ynez Valley Art Exhibit," 1953, "Santa Ynez Valley Historical Society"

Mattei, Clarence Rudolph (1883-1945) (Huasna / Los Olivos / Santa Barbara)
Portrait Painter. Brother to Charles Mattei, above.

■ "Clarence Mattei Won Fame as Artist. … one of the best-known portrait painters in the West and a native of the Huasna in SLO county, died Monday at the Cottage hospital in Santa Barbara, at the age of 61 years. Mr. Mattei was born Nov. 13, 1883 on his father's dairy ranch on the Huasna, and in 1885 moved with his parents to Cayucos where his father owned a hotel. In 1888 the family moved to Los Olivos where his father, Felix Mattei, built **Mattei's Tavern**, one of the most famous old inns of the west. His mother was Mrs. Lucy Fisher Mattei of Troy City, N.Y. As a child he showed a gift for painting, copying old prints such as 'Washington Crossing the Delaware.' Later he used the sides of box cars at Los Olivos, which was the terminus of the old SLO Port Hartford (later Port SLO) narrow gauge railroad. The late Mr. and Mrs. Herman Duryea of New York, winter residents of Santa Barbara, saw a copy of 'Washington,' and impressed with the quality of the painting asked permission to send the 16-year-old boy to art school. Through their arrangements, he studied at the Hopkins Art Institute in San Francisco for three years, then went to New York where he was a student at the Art Students' League three years, winning a scholarship. At the age of 22 years, he went to Paris to study at the Academie Julien where one of his teachers was Jean Paul Lorenz. In 1908 he had a painting hung in the Paris salon. He continued his studies in Paris, Italy and Spain, until 1910 when he returned to New York and maintained a studio there for four years. Although successful in New York he loved the informal out-of-door atmosphere of Santa Ynez valley and Santa Barbara and returned to California. For 20 years he traveled back and forth, painting portraits in New

York then returning to the coast and painting other portraits of persons of social, civic and financial prominence. While he painted in oil, he was better known for his black and white portrait sketches. Surviving are his wife, Merle Wilhoit Mattei and his stepson RM Douglas Wilhoit, USN, three brothers, Fred Mattei, who manages the tavern, Albert C. Mattei, president of the Honolulu Oil Co., and Charles C. Mattei, Santa Barbara artist, and a niece Susanne Mattei, daughter of Charles," *SLO T-T*, April 6, 1945, p. 8. OBITS – "Funeral Rites for Noted Artist… Santa Barbara," *SMT*, April 5, 1945, p. 8; "Clarence Mattei laid to Rest in Valley Cemetery… 61… passed away Monday after a short illness in Santa Barbara…," and lengthy bio, *SYVN*, April 6, 1945, p. 1; "Rites are Held for Clarence Mattei" portrait painter of Santa Barbara, *AG*, April 13, 1945, p. 3.
<u>Mattei, Clarence (notices in Northern Santa Barbara County newspapers on microfilm and on newspapers.com)</u>

■ "The next principal [of the <u>Los Olivos school</u>] was Mr. **Frank Miller**, and Clarence Mattei and I were in the upper class under him. Mr. Miller was a very good and very popular teacher. He was quite artistic and had the ability to put on popular little shows or entertainments. These little plays were enacted entirely by the school children. The last Entertainment, which was directed by Mr. Miller, was during the year in which our class graduated. This show consisted, for the most part, of three main features entitled: 'Shadow Pictures,' 'A Drama' and 'Art Exhibitions,' the latter presented by Clarence Mattei. The unfinished second floor of the school building was, of course the 'playhouse.' The stage was a raised platform at the rear end of this large room. A curtain was so arranged that it could be raised and lowered; side enclosures were of cloth, and lighting was by kerosene lamps. The shadow pictures came through quite successfully and received many compliments from the audience. I recall one of the shadow picture scenes which was presented in two parts. The first part, entitled 'What the Little Boy did to the Teacher,' showed a teacher's desk and chair as shadows on the curtain. Then the shadow of a small boy tiptoed up and placed a tack on the seat of the chair, point up. Next, the teacher's shadow appeared, seated itself, and, of course, took off with all the expected dramatic results. The second part of the skit, which was entitled, 'What the Teacher did to the Little Boy,' depicted the teacher applying a paddle to the seat of the little boy's pants.' 'Art Exhibitions' consisted of charcoal drawings done 'on the spot' by Clarence Mattei. The drawings were made on white sheets of paper, large enough so that even people sitting on the far end of the room could clearly see him making the pictures as well as the finished work. Clarence was dressed in gay colors, with his face blacked like a negro's. He announced that he was going to make pictures 'ob de Tree Principal Characters ob Los Olibus.' The three principal characters turned out to be Emile Heyman, proprietor of the General Store, John Waugh, a former stage driver, and Tom Edgar, a constable… [description of the three characters] … Well, Clarence made three separate charcoal drawings of these unique men in a very few minutes. Just a few strokes and flourishes of the crayon and, 'presto' … It was particularly marvelous as this was before he had attended art school. It was a gift handed down from his forefathers. I had seen many drawings which were done by his father's relatives in the old country. These were kept in the Matteis' private cottage which was separate from the Hotel. Of course, Clarence became famous later [after he was sent to Paris to study by a wealthy sponsor.]" from "Tales of the Back County, The Upper Santa Ynez Valley," by an unknown author, *Noticias*, Winter, 1985, pp. 76-77.
1909 – "Returns Home with Laurels. The return home to Los Olivos of C. R. Mattei, the artist, recalls the story of how a small boy with a wonderful talent gained the attention of Mrs. Duryea, a wealthy woman, and was given all the advantages in art studies the world has to offer…. In a party who went to Los Olivos on a pleasure jaunt was Mrs. Duryea. The party stayed at the Felix Mattei hotel and became interested in the portraits of various members of the household which decorated the room they occupied. Upon inquiry they learned the artist was a young son of the house, a mere child of 12. Mrs. Duryea decided to assist the boy and he was sent to San Francisco and placed in the best art school. Six years ago, he went to Paris, where he continued his studies, spending part of the time in Italy. He has returned home to visit his family and will probably remain here until October, when he will go to New York and open a studio. 'If it had not been for the advice I gave his father,' Mr. Hankerson said, 'Clarence would probably have been caricaturist on the *Examiner*, as some of the cartoons of Mark Hanna had attracted attention and he had flattering offers. It was during the McKinley campaign. But I told his father that he ought to complete his high school education anyway, as a man must be a good historian to be a caricaturist. The artist will not be idle during his visit here and is already planning to paint the portraits of two old stage drivers – two picturesque figures who are identified with the pioneer days of this country. One of them is John Waugh and the other is Tom Cole. There are five boys in the family, all splendid fellows, who are doing well – *Santa Barbara Independent*," *SMT*, March 13, 1909, p. 1.
1914 – "The Doctor's Portrait," *SMT*, April 4, 1914, p. 8; "Lucas Portrait. Excellent Painting of the Past Grand Master on Exhibition at T. A. Jones & Sons. Two splendid paintings of <u>Dr. W. T. Lucas</u> have been on exhibition this week at T. A. Jones & Sons' furniture store, from the brush of Clarence R. Mattei. One of the pictures are [sic.] to be sent to the Grand Lodge of Free Masonry in San Francisco, where the likenesses of all living Past Grand Masters of the State are to be placed in the new lodge hall… The other picture was ordered by the Guadalupe Lodge in honor of its distinguished member and will occupy a place of honor in the handsome new hall recently completed. Clarence R. Mattei, the artist … In portraying Dr. Lucas he has brought out a very fine and true expression… It shows the doctor in a serious, contemplative mood …," *SMT*, May 2, 1914, p. 1; "An Excellent Portrait of Dr. W. T. Lucas. Two splendid paintings of Dr. W. T. Lucas have been on exhibition this week at T. A. Lucas [Sic. Jones?] & Sons furniture store, from the brush of Clarence R. Mattei….," and repeat of *SMT* article, above, *LR*, May 8, 1914, p. 3.
1918 – "Los Olivos Boy is Busy Portrait Painter. News comes of Clarence Mattei … who almost a year ago opened a studio in New York. He is doing a tremendous amount of work and has commissions to keep him busy for some time. He hopes to come home some this summer and will probably do so later in the season. Several commissions for

portraits await him in this county. One of the pictures recently finished … a portrait of Winston Churchill and is to be used as a frontispiece for the author's new book…. Clarence… has two brothers in the service, Frank and Charlie," *SMT*, July 6, 1918, p. 3; "Clarence Mattei Here from East to Register….," *Santa Barbara Daily News and the Independent*, Sept. 16, 1918, p. 10; ■ "Crossing the continent from New York to Santa Barbara to register here for the new selective draft, was how Clarence R. Mattei, artist, the eminent portrait painter, proves his loyalty. Mattei and his brother, **Charles Mattei**, reached Santa Barbara yesterday morning, and after the artist had received his registration card, the brothers left for their parents' home at Los Olivos. **Charles Mattei** was in the uniform of an American sailor. For more than a year since he enlisted, he has been stationed at the Great Lakes naval training station at Chicago. He was in Chicago, a student at the Chicago art institute, when the United States entered the war and at once volunteered for the navy. Another brother, Burt Mattei, having but just completed his studies at Stanford University when war came, was among the first national army men sent for training at Camp Lewis, later entering the officers' training school at Camp Taylor, Kentucky. He only within the last month was commissioned second lieutenant. The three brothers met at Chicago last week, Lieutenant Burt Mattei having been ordered there on duty. Clarence R. Mattei had maintained a studio in Santa Barbara until a year and a half ago, when, having received a commission to paint two portraits in New York, he went there and opened a studio, remained, having met with exceptional success in his work – *Santa Barbara Press*," *LR*, Sept. 20, 1918, p. 4; "Clarence Mattei, an artist of New York and brother Charles of the U. S. Navy arrived recently for a short visit with their parents… Lieutenant Bert Mattei, stationed at a camp in Florida, was unable to attend the family re-union which was held yesterday at Mattei's Tavern in Los Olivos," *SMT*, Sept. 21, 1918, p. 7, col. 2.

1926 – "Clarence Mattei… is exhibiting a very remarkable portrait at the Santa Barbara Art Club's annual spring exhibit at the Paseo de la Guerra club rooms," *SMT*, Feb. 23, 1926, p. 4, col. 5.

1927 – "Artists Paint Flora Wealth at Figueroa … Hundreds of people have been admiring the hillsides of flowering sage on the Salsipuedes Rancho this past week… It is stated that Clarence Mattei and three other noted artists have pitched camp on the road to Figueroa mountain and are engaged in painting the enchanting scenes and especially the flower-covered mountain sides…," *LR*, April 1, 1927, p. 8; "Santa Ynez Notes. A noteworthy exhibition of paintings and portrait drawings by Clarence R. Mattei opened yesterday in the Santa Barbara Art league for a three weeks' showing…," *SMT*, July 16, 1927, p. 4; "Clarence Mattei of Los Olivos sails for Europe at an early date in November," *SYVN*, Nov. 4, 1927, p. 4, col. 3.

1928 – Repro: "Mrs. Bernard W. Ford" of Burlingame, *SF Examiner*, Aug. 2, 1928, p. 14; "Clarence Mattei… has just completed a fine oil portrait of Mary Pickford at her home in Beverly Hills. It is said that is it such a striking likeness of the movie queen that she seems to be ready to speak right out of the canvas," *SYVN*, Oct. 19, 1928, p. 8, col. 2; "Painters of the West Exhibit… Clarence Mattei's portrait

of Mary Pickford was reproduced here last week and hanging in solitary state in the smaller gallery, is attracting scores of delighted visitors. His uncatalogued picture of a boy with a dog is very well drawn and full of happy sentiment…," *LA Times*, Nov. 4, 1928, p. 57 (i.e., pt. III, p. 19); "Bert [Sic?] Mattei's Picture of Mary Exhibit Feature," *Woodland Daily Democrat* (Woodland, Ca.), Nov. 5, 1928, p. 1.

1932 – "Friendship Between F. Mattei and Gus Told in SF 'Call'… Later [after work] Mattei and Gus [the waiter] played together in the office their usual afternoon game of pinochle. Clarence, a son of Mattei, is a portrait artist… entering into the spirit of this friendship, painted the portraits of his father and Gus. They were framed and now hang on the wall in the Tavern office. Mattei had his hung in the bad light and Gus, the waiter's, in the good light… Mattei went [died] and left Gus alone…," *SYVN*, Jan. 15, 1932, p. 10; "Noted Artist Takes Out License… approaching marriage of Mrs. Merle Gossett Wilhoit, of Montecito, and Clarence Mattei… who secured a marriage license Wednesday in Reno… They plan to be married shortly," *Ventura Weekly Post and Weekly Democrat* (Ventura, Ca.), Oct. 14, 1932, p. 8.

1933 – "Scanning Headlines… **Gavin Arthur** or Chester Alan Arthur… He is a neighbor of ours … lives at La Grande beach near Halcyon … they have started a magazine called the 'Dune Forum.'… contributors-to-be include… Clarence Mattei, painter…," *SMT*, Dec. 27, 1933, p. 6.

1935 – "A recently completed portrait of Mrs. Curtis Hutton by Mr. Clarence Mattei is being shown to her friends at her Montecito home. It is a charcoal… Mr. Mattei has also done some studies of the young children of Mr. and Mrs. Pardee Erdman and Mr. Lewis Nixon. …," *SF Examiner*, Dec. 13, 1935, p. 21.

1937 – Gus "Well Known Man is Called by Death… Gustav Berg, 92, who for 46 years was identified with **Mattei's Tavern**…Many friends will recall the painting made about 10 years ago by Clarence Mattei… Felix Mattei and Gus playing pinochle, which has become famed as a character sketch and reproduced in colors for gift card purposes…," *SYVN*, Feb. 5, 1937, p. 1.

1939 – "Clarence Mattei… has just completed a portrait of Dr. W. L. Lucas of Santa Maria for the gallery of California past grand masters of the Masonic order in the new Masonic temple in San Francisco. He is finishing a second portrait of Dr. Lucas which probably will be sent to the Masonic lodge in Guadalupe," *SMT*, April 7, 1939, p. 4; Repro: "Herbert Hoover" drawing by Clarence Mattei, *SYVN*, July 14, 1939, p. 7.

1940 – "Getting Around… Clarence Mattei of Santa Barbara, pupil of the late great John Sargent, specializes in charcoal drawings and has made very fine ones of Mrs. Howard Spreckels and her late husband, Nion Tucker and numerous others of the uppity set," *SF Examiner*, Jan. 28, 1940, p. 35 (i.e., D-5), col. 1.

1942 – "Magician Visits Los Olivos School… Clarence Mattei… sleight-of-hand performance given as his Christmas treat to the youngsters… All had a gay time and the youngsters are living in anticipation of his next performance, which has been promised soon, with

drawings and color work added," *SYVN*, Dec. 25, 1942, p. 1.

Exhibit – *The Art of Clarence and Charles Mattei*, Santa Barbara Historical Society. Through December 31, 2004. Erin Graffy de Garcia, "Clarence Mattei," *Noticias* (publication of the Santa Barbara Historical Society), v. L, no. 3 (Autumn 2004).

Mattei, Clarence (misc. bibliography)
Clarence Rudolph Mattie [sic.] provided the following information on his WWI Draft Registration Card dated Sept. 12, 1918 = b. Nov. 13, 1883, artist, place of employment, 24 E. 63rd St., New York, permanent home address, Los Olivos, Ca., nearest relative Felix Mattei; Clarence R. Mattei is listed in the *Santa Barbara, Ca., CD*, 1915, 1922-43; Clarence Rudolph Mattei b. Nov. 13, 1883 and d. April 2, 1945 is buried in Oak Hill Cemetery, Ballard, Ca., per findagrave.com (refs. ancestry.com).
See: "Fisher, Leonard," 1976, "Mattei, Charles," "Mattei's Tavern," 1931, "Miller, Frank," and "Dune Forum (Oceano)," in *Arroyo Grande Art and Photography before 1960*

Mattei, Elaine S. (Mrs. Fred L. Mattei)
Collector of Lake County Indian baskets.
See: "Collectors, Art/Antiques (Santa Ynez Valley)," 1956

Mattei's Tavern (Los Olivos)
Tavern decorated with artwork. Prop. Felix Mattei.
Mattei's sons, Clarence and Charles, became artists.
■ "One of the most famous taverns in California stands by the side of the road... Every old Californian knows it – beds that are soft mountains – a great old fireplace where huge logs burn in winter evenings – A Chinese cook... dark walls lined with etchings by a famous artist – metates and old stone mortars worn thin by the calloused little hands of Indian women... petrified shells...," *SYVN*, Aug. 22, 1930, p. 4, col. 3-4.

Mattei's Tavern (notices in Northern Santa Barbara County newspapers on microfilm and on newspapers.com)
1930 – "Felix Mattei, A Valley Pioneer, Passes Suddenly... heart attack. Two of his sons, Frank who resides in Los Olivos, and Clarence, an artist residing in Santa Barbara, were with him when the end came...," and biography. Born in Switzerland, married in SLO 1879, moved to Los Olivos about 40 years ago and established Mattei's Tavern, stage stop, *SYVN*, Dec. 12, 1930, p. 1.
1931 – "Mattei's Tavern to be Operated Under Son's Management. Carrying on the name of Mattei... Fred Mattei, second son of Felix Mattei, recently deceased will operate Mattei's Tavern, near Los Olivos... placed in charge... by his two brothers, all of whom were named as owners... Gus Berg, the lifelong pal and chief assistant to the senior Mattei, will remain at the desk. He it was that **Clarence Mattei**... pictured playing cards with his father in his famous painting, 'Pinochle,' ...," *LR*, Jan. 9, 1931, p. 7.
See: "Better Homes Exhibit," 1932, 1933, "Mattei, Charles," "Mattei, Clarence," "Parker, Vernon," "Quilts," 1933, "Santa Ynez Valley Art Exhibit," 1953, "Walford, Ernest"

Matzinger, Philip Frederick, Rev. (1861-1942) (Chicago / Solvang / Orosi)
A portrait he painted in 1921 was lent to the Art Loan Exhibit, 1935. Pastor of the Presbyterian church.
■ "Matzinger – Rev. Philip Frederick Matzinger, 2889 San Pasqual Street, passed away June 19, 1942. He was a native of Tiffin, O., but had lived in Pasadena seven years. He is survived by his wife, Irene Parkes Matzinger...," *Pasadena Star-News* (Pasadena, Ca.), June 20, 1942, p. 12; "... studied at the AIC [Art Institute of Chicago] under John Vanderpoel]" per Edan Hughes, *Artists in California, 1786-1940*.

Matzinger, Philip (notices in American newspapers on microfilm and on newspapers.com)
1893 – "Awaits the elders' reasons... Rev. Philip Matzinger, the deposed pastor of Christ Chapel [protégé of the Fourth Presbyterian Church, Orchard and Center streets] ... Mr. Matzinger said last night that he would do nothing until the elders had given their reason for removing him...," *Chicago Tribune*, Nov. 22, 1893, p. 8.
1900 – "The Rev. Philip F. Matzinger, Campbell Park Presbyterian Church, is on his way to Japan. He will return in September," *Chicago Tribune*, July 8, 1900, p. 38.
1907 – Port. and caption reads, "The 500 members of the Campbell Park Presbyterian church are planning to welcome their pastor, the Rev. Philip Matzinger, on his return from a tour around the world. ... a few days before his departure last summer the minister was married to Miss Irene Parks. ... visited Hawaii, Japan, China, Ceylon, India, Egypt and Italy," *Chicago Tribune*, Jan. 23, 1907, p. 12.
1912 – "Art Institute Graduation Today. Closing exercises of the Art institute will be held today. The Rev. Philip F. Matzinger will give the address on 'The Adventitious Value of Art'," *Chicago Tribune*, June 14, 1912, p. 13.
1916 – "Normal Park Presbyterian Church... Evening service at 7:45, chalk talk, 'The Snake Dance of the Hopi Indians,' by Rev. Philip F. Matzinger," *Suburbanite Economist* (Chicago, Ill.), Feb. 11, 1916, p. 2.
1926 – "Big Interest Being Shown in Gallery [Carmelita Gardens] and brief rev. of groups by Philip Matzinger and **Nell Walker Warner**, *Pasadena Star News*, May 24, 1926, p. 14 (per *Publications in California Art*, vol. 8, p. 105, col. 1).
1929 – "Pupils and Teachers... Pasadena junior college dined last night at Calvary Baptist church... The main feature of the evening gathering was a chalk talk by Rev. Philip Matzinger on 'Happiness and How to Attain It'," *Pasadena Post*, March 13, 1929, p. 13; "Prepare for Art Exhibit. With more than 100 canvases to be shown... Short Memorial Home by the Fresno Art association, starting Sunday... The following artists have entered exhibits: ... Philip Matzinger...," *Fresno Morning Republican*, April 5, 1929, p. 6; "Rev. Philip Matzinger and son Phil returned Friday from several days spent in Death Valley," *Visalia Times-Delta*, April 9, 1929, p. 3; "Paintings Hung in Fresno Show by Orosi Pastor... 10 oil paintings ... at the Short Memorial home in Fresno. ... The exhibition will close December 22... The following each exhibited 10 paintings: Rev. Philip Matzinger, Orosi...," *Visalia Times-Delta* (Visalia, Ca.), Dec. 18, 1929, p. 5.
1930 – "Orosi Pastor Will Leave... To Live at Carmel... Rev. Matzinger came to Orosi in 1926 as pastor of the St.

James Presbyterian church and held that position until last October when he resigned from active duty… Rev. Matzinger may engage in insurance work at Carmel," *Visalia Times-Delta*, Feb. 24, 1930, p. 3; "Orosi News Briefs… Rev. Philip Matzinger and son, Phil Matzinger of Carmel, are spending a few days in town on business," *Visalia Times-Delta*, March 26, 1930, p. 3.

More than 100 notices on "Philip Matzinger" appear in Calif. newspapers primarily regarding his pastoral duties and were not itemized here.

Matzinger, Philip (misc. bibliography):
Rev. Philip Frederick Matzinger was b. Nov. 12, 1861 in Tiffin, Ohio, d. June 19, 1942 in Los Angeles County and is buried in Mountain View Cemetery and Mausoleum, Altadena, Ca., per findagrave.com (ref. ancestry.com).
See: "Art Loan Exhibit (Solvang)," 1935

Mau, Martha E. Davidson (Mrs. Louis C. Mau) (c. 1872-after 1947) (Santa Maria)
Exh. painting at Art Loan Exhibit, 1895.

■ "Another Wedding … Miss Martha E. Davidson and Louis C. Mau … Mr. Mau… accountant for the firm of **W. A. Haslam & Co**… Miss Martha Davidson – now Mrs. Mau – is the accomplished daughter of Col. Allan Davidson, a wealthy rancher of Ukiah, Mendocino county. She came here to visit her friend, Mrs. Matlock, and soon formed the acquaintance of Mr. Mau. The acquaintance grew into mutual affection and has added a new family to Santa Maria society," *SMT*, Oct. 13, 1894, p. 2.
1932 – MOTHER – "Pioneer Woman Dies at Willits. Mrs. Mary Davidson…," *Ukiah Dispatch Democrat*, Aug. 19, 1932, p. 1 and daughter is administratrix.
Mau, Martha (misc. bibliography)
Martha E. Mau is listed in the 1910 U. S. Census as age 38, b. c. 1872 in Calif. residing in Santa Maria with husband Louis C. Mau (age 38) and child Aleene E. (age 8); Martha Mau is listed in the 1920 U. S. Census as residing in Oakland with husband L. C. Mau and daughter Aleene; Martha E. Mau is listed in the 1930 U. S. Census as manager of an apartment house, residing in San Jose with husband Louis C. Mau (age 55); Martha, wife of Louis C. Mau, manager Mira Mar Apts., is listed in the *San Jose, Ca., CD*, 1947 (ref. ancestry.com).
See: "Art Loan Exhibit (Santa Maria)," 1895

Maxwell (Solum), Lyla Grace (Mrs. Maxwell) (Mrs. O. Larry Solum) (1895-1961) (Solvang)
Teacher of handwork. Prop. of Danish Village Gifts that sold handwork, 1946+.

■ "Gift Shop to Open… announcement by Mrs. Lyla G. Maxwell… on February 2nd… The shop will specialize in unusual greeting cards and stationery in addition to its regular stock of ceramics, glassware, yarns and embroidery materials. It will be located in the Sunny Corner Inn building, across the street from the bank, on Main Street. Mrs. Maxwell, whose home was formerly in San Diego, has been a frequent visitor to the Valley for a number of years. 'I don't know whether it was the blood I inherited from my Danish grandfather or the delightful country that kept pulling me back,' she said, 'But each time I came I

renewed my desire to live here permanently.' She finally moved here last July… The teaching of handwork will be one of the things local women will welcome about the shop. Its owner is experienced in this line… She will assist in designing knitted or crocheted sweaters, coats or dresses, and is qualified to teach knitting, crocheting, tatting, and embroidery. As soon as merchandise is available, she will carry a full line of handicraft materials… 'I have tried to stock only the things that are not available in other Solvang stores,' Mrs. Maxwell said …," *SYVN*, Jan. 18, 1946, p. 1.

■ "Lyla M. Solum… retired Solvang businesswoman who started Solvang's first gift shop in 1945 … The gift shop business started by Mrs. Solum was the forerunner of several others begun in Solvang following World War II in a period marked by the growth of the tourist industry in Solvang. Mrs. Solum was an accomplished writer and for several years authored [a] column 'Of Pussy Cats and Sealing Wax' in the *Santa Ynez Valley News*… Mrs. Solum was born Dec. 29, 1895 in Petersen, Ia. She came to California in 1914 and for the greater part of the time lived in the Southland area. During World War II she worked in Pennsylvania. Returning to the coast, she came to Solvang to begin her gift shop business…," *SYVN*, Sept. 8, 1961, p. 12.

And, more than 100 additional notices for "Lyla Maxwell" primarily regarding her club, social and civic activities were not itemized here.
Maxwell, Lyla (misc. bibliography)
Lyla G. Solum, mother's maiden name Packerin, was b. Dec. 29, 1895 and d. Sept. 2, 1961 in Santa Barbara County per Calif. Death Index; Lyla Grace Solum is buried in Oak Hill Cemetery, Ballard, Ca., per findagrave.com (refs. ancestry.com).
See: "Danish Village Gifts," 1950, "Solvang Woman's Club," 1948

Maxwell, Margaret (San Luis Obispo)
SLO art teacher who exh. at Santa Ynez Valley Art Exhibit, 1955. Exh. Allan Hancock [College] Art Gallery, 1958.
See: "Allan Hancock [College] Art Gallery," 1958, "Muro, George," 1952, "Santa Maria [Valley] Art Festival," 1952, "Santa Ynez Valley Art Exhibit," 1955, and *San Luis Obispo Art and Photography before 1960*

May, Theodore Wilson Dixon "Dick" (1917-1979) (Santa Barbara)
His tooled leather works, including saddles, were exhibited in Santa Maria, 1954 and some were given as prizes at rodeos. Prop. Dick May's Saddle Shop, Santa Barbara, 1950s and, in the 1970s, W. Dick May Stables.

■ "Worth seeing this week in Santa Maria are two hand tooled leather western saddles made by Dick May, Santa Barbara. He was a visitor here this week-end at the parade and rodeo. The saddles are on display at Prindles, together with seven silver buckles. They are to be awards in stock-horse classes at the 'Old Spanish Days Fiesta' in Santa Barbara. Design on the saddles is the Castilian rose, which appears on all articles made by May. The youthful

craftsman began leather work as a hobby a few years ago and now his finished items are in demand by the Fiesta riders… The rose of Castile, a California wild flower was chosen by May, he said, after reading a passage in a California book of early history, describing an area 'carpeted with the rose of Castile – where the antelopes fled before us,'" per "Leather Saddles Have Rose Design," *SMT,* June 7, 1954, p. 4.

Port. of W. D. "Dick" May, *SMT,* June 4, 1955, p. 4; One of his saddles from the Ruth Newman estate was sold at californiaauctioneers in Ventura, Ca.

May, Dick (misc. bibliography)
Wilson Dick May provided the following information on his WWII Draft Card dated Oct. 16, 1940 = b. Sept. 10, 1917 in Hosston, La., residing in Silverton, Tx.; Dick May Saddlery (Wilson D. and Barbara J.) is listed in the *Santa Barbara, Ca. CD*, 1954-1960; "May Dick Saddlery (Richard May) Custom Made Saddles and Bridles. Hand Carved Leather Goods. 9 W. Anapamu, Tel WOodland 6-6395," *Santa Barbara, Ca., CD*, 1960; W. Dick May Stables in Gaviota is listed in the *Santa Barbara, Ca., CD*, 1972-76; Theodore Wilson "Dick" May was b. Sept. 10, 1917 in Louisiana to James Herring May and Lillian Georgia Hicks, married Joan B. Ireton, was residing in Briscoe, Tx., in 1940, and d. June 9, 1979 in Santa Barbara County per Evans Family Tree; there is a brief bio. about army service for Wilson Dixon "Dick" May, Sept. 10, 1917 – June 9, 1979 in *Public Member Stories*; Wilson Dixon May was b. Sept. 10, 1917 in Hoston, La., and d. June 1979 per Social Security Applications and Claims Index (refs. ancestry.com).

Mayer, Edna Leslie Cooke (Mrs. Eugene D. Mayer) (1928-2017) (Santa Barbara / Lompoc / Santa Fe, N. M. / Fayetteville, Ark.)
Commercial artist c. 1949+. Easel painter, Lompoc, 1960-83. Art teacher in Lompoc adult school.

■ "Hawaii-born Leslie Mayer studied Commercial Art at Woodbury College in Los Angeles prior to joining the Woman's Army Corps where she worked in the Drafting and Training Aids Dept. A Lompoc resident since 1960, where she is the originator of the monochromatic brown-tone technique for painting area historical sites and buildings, for the past five years she has taught Lompoc Adult Education art classes in all media. Among her commissioned paintings and murals that may be viewed locally are those at Lompoc Imperial Savings and Loan Assn., and at McDonald's in Lompoc, Santa Maria and Arroyo Grande. Her large mural of the Double Arch Ranch at Santa Ynez hangs in the conference room of the ranch owned by Ray A. Kroc, founder of the McDonald's chain," and port. from a brochure in the coll. of the Lompoc Valley Historical Society.

Mayer, Leslie (notices in Northern Santa Barbara County newspapers on microfilm and on newspapers.com)
1969 – Port. at her easel painting abstracts per "Leslie Mayer experiments… Leslie's easel time produces about 30 paintings a year. Since coming to Lompoc nine years ago with husband Eugene and their three children, Jean, Leslie and Andrea, Leslie shifted to fine art. She was formerly engaged in commercial art for 11 years in Santa Barbara and other areas. Leslie likes to keep her own hours and for that reason prefers fine art to commercial art and deadlines. During the week, she teaches art classes part-time for adults and children at a studio in Lompoc…," *LR,* Feb. 3, 1969, p. 4.
1970 – Port. and "Ghosts of Mother Lode Country turned into artistic memories. Leslie Mayer sketches history, visits old graves… Big Sur and Mother Lode country… Sacramento… Coloma… Placerville…," and details of recent trip, *LR,* Oct. 26, 1970, p. 4.
1980 – Port. and "New method of teaching drawing is producing amazing results…. Leslie Mayer's class in drawing at the Parks and Recreation Department… 'Drawing on the Right Side of the Brain'…," *LR,* March 17, 1980, p. 4.
1983 – "Reflections… For a city its size, Lompoc has more than its fair share of talent. Even so, when Leslie Mayer moves to Santa Fe, N. M. she will leave a big void in the art community… A final exhibit of a collection of her work is on display now through Feb. 27 in the multipurpose room of the Lompoc Library," *LR,* Feb. 15, 1983, p. 6. And, more than 300 additional notices in the *LR* between 1960 and 1986 and more than 230 notices in New Mexico newspapers between 1980 and 1992 and in Arkansas newspapers 1997, were not itemized here.

Mayer, Leslie (misc. bibliography)
Leslie Mayer with husband Eugene was residing in Fayetteville, Ark. in 1996-2002 per *U. S. Phone and Address Directories, 1993-2002*; Edna Leslie Cooke Mayer b. March 13, 1928, d. Aug. 8, 2017 in Bowling Green, Ky. per *U. S. Obituary Collection* (refs. ancestry.com). One of her paintings is in the collection of the Lompoc Valley Historical Society.
See: "Lompoc Valley Historical Society, House"

Mayers, George (Santa Maria)
Painter of signs, houses, carriages and a decorator, 1889-90.

Mayers, Mr. (notices in Northern Santa Barbara County newspapers on microfilm and on newspapers.com)
1889 – "Fine Painting. Persons who are interested in fine painting, plain or ornamental for house, sign or carriage painting, should by all means call at Mr. Mayer's shop in Jones & Lucas building where some finely executed signs of a recent production can be seen. Among them are noticed a beautiful sign for the Rice House and a most lovely and neatly executed sign for the proprietor, Mr. Mayers. Also, in the same room we noticed the Hart House bus shining as brilliantly as the day when first brought out of the shop …," *SMT,* Dec. 14, 1889, p. 2; "Mr. Mayers the painter has turned out a plain and neat sign for the Graphic office," *SMT,* Dec. 21, 1889, p. 3, col. 2.
1890 – "Mr. Mayers, the artistic painter, talks of spending a few weeks in some of the lively cities of the north until business in this line revives in Santa Maria. He will leave his family here," *SMT,* Jan. 25, 1890, p. 3; "The Painter – Mr. Mayers, the painter, has done some excellent work in graining the post office boxes and during the past few days has been engaged in repainting the front of Mr. Kallmeyer's drug store and putting up a neat glass sign," *SMT,* Feb. 8, 1890, p. 3, col. 2; "Mrs. Mayers and children

left on Tuesday morning for Washington, where Mr. Mayers is engaged at present in the painting business," *SMT*, April 19, 1890, p. 3, col. 3.

Mayhew, Nell Danely Brooker (1876-1940) (Los Angeles)
Artist of a OMS at Andersen's, 1954. Best known for her series of color etchings of the Calif. missions.
■ "Etcher, painter, teacher, Mrs. Mayhew was a pupil of the University of Illinois under Newton A. Wells of the art Institute of Chicago and of John Johansen. She was in Los Angeles by 1908 and while here taught at the College of Fine Arts, USC, and at Chouinard Art Institute. She also conducted private classes and exhibited her work locally," per Nancy Moure, "Dictionary of Art and Artists in Southern California before 1930," (*Publications in California Art*, vol. 3).
Bibliography:
Turner, Steve and Victoria Dailey, *Nell Brooker Mayhew: Color Etchings and Paintings*. Los Angeles, Ca.: Turner Dailey Fine & Applied Arts, 1989. 16 pp.
Alissa J. Anderson, *Nell Brooker Mayhew: Paintings on Paper*, Princeton Architectural Press, 2006.
Mayhew, Nell (misc. bibliography)
Mayhew was b. Astoria, Ill., April 17, 1876, d. Highland Park, Ca., Sept. 24, 1940 and is buried in Inglewood Park Cemetery per findagrave.com (ref. ancestry.com).
See: "Andersen's Pea Soup Restaurant," 1954

McAllister (Florence) Studio (Santa Barbara)
Photographer who took photos for SYVU high school yearbook, 1946-48.
See: "Nelson, Robert," 1948, "Santa Ynez Valley Union High School," 1946, "Solvang Photo Shop," 1947

McArthur, Virginia
See: "Murray (McArthur), Virginia (Mrs. John McArthur)"

McBride, Alice (Santa Maria)
See: "Laubly (McBride), Alice"

McBride (Bollaert), Virginia Ailene (Mrs. Rene Bollaert) (1907-1991) (Santa Maria)
Santa Maria High School grad. who designed costumes for a school play, 1925. Art teacher, Los Banos, 1933-37. Became a ceramist in the Bay Area.
McBride, Virginia (notices in Santa Barbara County newspapers on newspapers.com)
1925 – "Miss Virginia McBride left last evening for San Francisco and Berkeley where she will make her home in the future. Miss McBride, who was a graduate in the June class of the high school, will enter one of the northern colleges next year," *SMT*, July 21, 1925, p. 5.
1927 – "Miss Virginia McBride is leaving this evening for Oakland to resume her duties at the College of Holy Name, after visiting at the home of her aunt and uncle," *SMT*, Jan. 7, 1927, p. 5, col. 2.

1930 – "Miss McBride Wins Honors at College... [elected] ... to Delta Epsilon, art honor society at University of California at Berkeley. Miss McBride, who graduated from the university last year and who will finish her fifth year in May to obtain her high school teacher's credentials...," *SMT*, April 10, 1930, p. 5.
1933 – "To Study Art in Mexico. Mexican art will be especially observed by Miss Virginia McBride... when she and a friend vacation in Mexico City this summer as the guests of friends living in that famous old capital. ... Since her graduation from the local high school, Miss McBride has attended the University of California, securing there credentials to teach art. She has been engaged as an instructor in that subject at Los Banos and in the fall will resume her work there," *SMT*, July 12, 1933, p. 3.
1935 – "Miss McBride Returns from Vacation Trip. Miss Virginia McBride and ... instructors in Los Gatos [Sic? Banos?] schools... They arrived Saturday, concluding an extensive trip through Wyoming and Colorado. They spent several weeks in the Rockies... Boulder dam...," *SMT*, July 15, 1935, p. 2.
1937 – FATHER – "Well-Known... E. J. McBride...," died in Sacramento per *Appeal-Democrat* (Marysville, Ca.), Feb. 19, 1937, p. 3; "Will Do Modeling – Miss Virginia McBride... who has been teaching art in Los Banos high school, has taken a year's leave of absence during which she will do clay modeling in San Francisco...," *SMT*, June 23, 1937, p. 3.
1940 – "Classes in Pottery... Oakland Evening High School... announces an afternoon class in pottery work on Tuesdays and Thursdays from 3:15 to 5:15 under Miss Virginia McBride. Miss McBride exhibited her work at the **Golden Gate International Exposition**. She is a member of the Society of Women Artists, San Francisco," *Oakland Tribune*, Feb. 25, 1940, p. 19; "Bay Region Potters in Eastern Show... Syracuse Museum National Ceramic exhibit: Namely... Virginia Ailene McBride...," *SF Examiner*, Nov. 3, 1940, p. 53.
McBride, Virginia (misc. bibliography)
Virginia McBride is pictured in Santa Maria High School yearbook, 1924; Virginia A. McBride is pictured in the UC, Berkeley, yearbook, 1929 with caption, "Transfer from College of Holy Names"; Virginia Bollaert registered to vote per *Index of Affidavits of Registration, Precinct – Oakland 328*, Nov. 7, 1944; Virginia Ailene McBride b. March 4, 1907 in San Francisco to Edward James McBride and Ailene Russell, was residing in Alameda, Ca., in 1944, married Rene Bollaert, and d. Dec. 24, 1991 in Santa Rosa, Ca. per Sauls Russell Family Tree (refs. ancestry.com).
See: "Santa Maria, Ca., Union High School," 1924, 1925

McCabe, Helen (Mrs. John McCabe) (Santa Maria)
AAUW Chairman of Creative Arts section, 1955, and of Art section, who helped arrange exhibits at Allan Hancock [College] Art Gallery, 1956.
[Do not confuse with Helen, Mrs. Roscoe E. McCabe who was active with Rainbow Girls.]
See: "Allan Hancock [College] Art Gallery," 1956, "American Association of University Women," 1955, 1956

McCabe (Beers), Olivia Rebekah (Mrs. Dr. Charles Joseph Beers) (1883-1927) (Lompoc / Sierra Madre)
Student Anna S. C. Blake Manual Training School, Santa Barbara, 1907/08. Sloyd instructor in Lompoc elementary and high schools 1908-11.

■ "Popular Couple are Married…at the home of Mr. and Mrs. J. D. McCabe… their daughter Olivia to Dr. Charles Joseph Beers of Los Angeles… Miss McCabe is a Lompoc girl and was for several years a teacher in Santa Barbara county and for the past year has had charge of the manual training and domestic science departments in both schools in Lompoc. She is active in society and a young woman of uncommon worth. Dr. Beers is a dentist of Los Angeles…," *LR*, July 21, 1911, p. 1.

■ "Native Daughter of Lompoc Valley is Laid to Rest," *LR*, Oct. 21, 1927, p. 1.

McCabe, Olivia (notices in local newspapers)
1906 – "School Opens…. Montecito public school … Miss Olivia R. McCabe is in charge of the primary department," *Independent* (Santa Barbara), Aug. 21, 1906, p. 5.
1909 – "Expects Increase in Numbers in School… districts in the vicinity of Lompoc… 'and an excellent showing is being made by the manual training department of the Lompoc grammar school under the supervision of Miss McCabe. She is a graduate of the Santa Barbara sloyd normal'," *Independent* (Santa Barbara), April 17, 1909, p. 8 and similar article in *LR*, April 23, 1909, p. 1; "Alpha Club Will Enjoy Vacation… Mrs. [Sic. Miss] Olivia McCabe, second vice-president…," *LR*, June 4, 1909, p. 1; and additional notices about her Alpha Club activities not itemized here.

McCabe, Olivia (misc. bibliography)
Olivia McCabe is listed in the 1900 U. S. Census as b. Dec. 1883 and in the 1910 U. S. Census as age 27, b. c. 1883 in Calif., a teacher in school, residing in Santa Barbara Township 5 (Lompoc City) with her parents John D. McCabe (age 59) and Margret M. McCabe (age 57); Olivia Rebekah McCabe was b. Dec. 1883 in Calif., married Charles Joseph Beers, and d. Oct. 17, 1927 in Santa Barbara county per Beers Family Tree (refs. ancestry.com).
See: "Anna S. C. Blake Manual Training School," "Barker, Frank," "Lompoc, Ca., Elementary Schools," 1909, 1910, "Lompoc, Ca., Union High School," 1910

McClive, Ruth
See: "Pierce (McClive), Ruth (Mrs. William McClive)"

McClure, Hazel
See: "Santa Maria, Ca., Elementary/Grammar School," 1934, 1940

McClure (Borg), Olive Jane (Mrs. Sven Hugo Borg) (1898-1985) (Santa Maria)
Teacher of handcraft in the home economics department at Santa Maria High School, 1934/35. Became a teacher at Beverly Hills High School.
McClure, Olive Jane (misc. bibliography)
Olive Jane McClure is listed in voter registration records in Los Angeles in 1934, 1940, 1942, 1950, 1952; Olive Jane

McClure port. appears in Beverly Hills High School yearbooks, 1936-58; Olive J. McClure married Sven H. Borg on Oct. 20, 1972 in Los Angeles per Calif. Marriage Index; Olive J. McClure Borg, mother's maiden name Emmons, father's McClure, was b. Sept. 24, 1898 in Illinois and d. Nov. 10, 1985 in Los Angeles County per Calif. Death Index (refs. ancestry.com).
See: "Santa Maria, Ca., Union High School," 1934, 1935

McCollough, Katherine Malendale? (Mrs. Rev. Alvin R. McCollough?) (1867-1936?) (Indiana / Santa Maria / Watsonville)
Exh. painted plaque and luster painting at "Santa Barbara County Fair," 1889.

■ "Kate S. McCollough is Taken by Death… Mrs. McCollough was born at Williamsport, July 28, 1867, a daughter of John H. and Minerva Schlosser, attended schools there, and was married to Dr. Alvin McCollough in 1888. After their marriage they went to California where Dr. McCollough was a minister. Meanwhile he studied medicine and then returned to Williamsport for the practice of his profession. Later she took up residence in Stockwell and 18 years ago she came to West Lafayette…," *Journal and Courier* (Lafayette, Indiana), Aug. 6, 1936, p. 19.
Is she Katherine Malendale McCollough the wife of Rev. Alvin R. McCollough?
HUSBAND – "At Nipomo (The Foothills) a little town seven miles from Santa Maria, we organized a mission church, which will be under the supervision of Santa Maria. Bro. A. R. McCollough, the preacher at Santa Maria will preach for them twice a month. Bro. McCollough is a young man who has recently come to California from Indiana and he is much loved by the church in Santa Maria," *SMT*, Jan. 26, 1889, p. 2, col. 2.
And several additional notices on Rev. McCollough in the *SMT* between 1888 and 1893 not itemized here.
See: "Santa Barbara County Fair," 1889

McCullough, Marie (Mrs. Joseph J. McCullough) (1911-1965) (Santa Maria)
Artist. Exh. with Santa Maria Art Assn. at Santa Barbara County Fair, 1952. Creative arts chairman of the local AAUW, 1956-57, who helped arrange shows and acted as judge at Allan Hancock [College] Art Gallery, 1956, 1957.
McCullough, Marie (misc. bibliography)
Marie McCullough is listed with Joe J. McCullough in the *Santa Maria, Ca., CD*, 1958; Marie L. McCullough, mother's maiden name Nagel, was b. July 27, 1911 in Ill., and d. March 27, 1965, in Santa Barbara county per Calif. Death Index (refs. ancestry.com).
See: "Allan Hancock [College] Art Gallery," 1956, 1957, "Santa Barbara County Fair," 1952, "Santa Maria Art Association," 1950, "Allan Hancock College Adult/Night School," 1958

McCollum / McCullom, W. H. (or H. W.) (Santa Maria)
President Santa Maria Camera Club, 1960.
This individual could not be identified.
See: "Santa Maria Camera Club," 1960

McCormick, Robert J. (1911-1992) (Ventura County)
Artist in National Art Week show at Minerva Club, 1940.
See: "National Art Week," 1940, "Snider, Ann," 1940, and
Central Coast Artist Visitors before 1960

McCoy, Frank (Santa Maria)
*Prop. of Santa Maria Inn. Occasionally, he housed
visiting artists and commissioned artworks of them. The
Inn was decorated with antiques.*
See: "Breneiser, Stanley," 1937, "College Art Club," 1934,
"Cooper, Colin," 1928, "Lakey, Andrew," 1929, "Poock,
Fritz," "Santa Maria Inn," "Walker, Winifred," "Waller,
Lionel," 1938, "Williams, Ernest"

**McCullough, Bertha (Mrs. Willis Evan "Tiny"
McCullough) (1915-1996) (Santa Maria / Arroyo
Grande)**
*Exh. bedroom furniture and ceramics at Santa Barbara
County Fair, 1949. Possibly a student at DeNejer Studio
and Dunham cabinetry.*
See: "Santa Barbara County Fair," 1949, "Santa Maria Art
Association," 1950

**McDonald, Minnie (Mrs. Donald McDonald) (1869-
1969) (Lompoc)**
Photographer, amateur, 1907.
■ Port. and "Oldest woman resident dies… Minnie
McDonald, 101 years old. Mrs. McDonald was born in a
log cabin in Indiana in 1868 on Washington's birthday,
Feb. 22. She was married to Donald McDonald and with
their daughter Zena, made the long trek west to Los Olivos
from Nebraska in 1889. Shortly after, the family moved to
Lompoc on a 45-acre farm on Sweeney Road. Mrs.
McDonald was then 22 years old. Following her husband's
death in 1927, she continued to operate the farm. A resident
of the Solvang Lutheran Home since 1964, she was
recently moved to the long-term care unit at the local
hospital," *LR*, March 26, 1969, p. 1.
McDonald, Minnie (notices in Northern Santa Barbara
County newspapers on microfilm and on newspapers.com)
1952 – "Lompoc Glimpses … Mrs. Minnie McDonald
displaying photographs she took when the Robison bridge
washed away in 1907," *LR*, March 2, 1952, p. 1.
1962—Port. and "Mrs. Minnie McDonald Marks 94th
Birthday," *LR*, March 1, 1962, p. 4.
McDonald, Minnie (misc. bibliography)
Minnie McDonald, 1869-1969, parents: John W. and
Amanda (Davis) Sides, is buried in Lompoc Evergreen
Cemetery per findagrave.com (refs. ancestry.com).

**McDonald (Murphy), Vina? "Vinnie" (Mrs. Henry
Cloyd Murphy) (1873-1966) (Lompoc)**
*Grad. Lompoc school, 1890? Exh. symbolic oil painting
on felt at "Santa Barbara County Fair," 1891. Teacher at
Lynden school, 1891. Participated in local public
recitations and "theater".*
McDonald, Vinnie (notices in Northern Santa Barbara
County newspapers on microfilm and on newspapers.com)
1889 – "The public library has been removed to the
schoolhouse and is now in charge of Miss Vinnie
McDonald…," *LR*, Feb. 16, 1889, p. 3. col. 1.
1890 – Author of "Movable Type – Its Effects Upon
Literature," *LR*, Jan. 18, 1890, p. 3; "Successful
Applicants… The following pupils passed the graduating
examination of their schools and received diplomas …
Lompoc – Vinnie McDonald…," *LR*, July 5, 1890, p. 3.
1891 – "Miss Vina McDonald is giving good satisfaction as
teacher of the Lynden school," *LR*, Aug. 8, 1891, p. 3, col.
1.
1892 – "Miss Vinnie McDonald has been engaged to teach
the Garey school," *LR*, July 23, 1892, p. 3, col. 2.
McDonald, Vinnie (misc. bibliography)
Vinnie A. Mcdonald married Henry Cloyd Murphy in 1892
in Santa Barbara County per Western States Marriage
Index; Vinnie A. Murphy is listed in the 1900 U. S. Census
as b. Aug. 1873 in Michigan, residing with husband Henry
in Alisal, Monterey County, Ca.; Vinnie A. Murphy,
mother's maiden name Anderson, b. Aug. 21, 1873 in
Michigan, d. March 20, 1966 in Monterey County per
Calif. Death Index (refs. ancestry.com).
See: "Santa Barbara County Fair," 1891

McDuffie, Lola
See: "Feeley (McDuffie), Lola (Mrs. Murl McDuffie)"

**McFadden / MacFadden, Ann (Mrs. McFadden) (Long
Beach, Ca.?)**
*Itinerant art education consultant for The American
Crayon Co. who was in Lompoc 1960. Artist / designer
from Long Beach, Ca.*
■ "Fun Evening to Benefit HS Band. A 'strictly for fun'
meeting is planned by Hapgood PTA on the evening of
December 12 in El Camino School cafetorium… All the
audience will participate in making Christmas decorations
with Mrs. Ann MacFadden [Sic.?] … Mrs. McFadden is an
art education consultant on the staff of The American
Crayon Co., since 1959 has an outstanding background in
many fields of art. An auction of the 'best' articles will be
held and proceeds will go to the Lompoc High School band
fund…," *LR*, Dec. 8, 1960, p. 31; "Artist Gives Program for
Local [Hapgood] PTA. Mrs. Ann McFadden, area
education consultant … demonstrated the creation of lovely
centerpieces, Christmas cards, wrappings and figures.
Following the demonstration, more than 100 parents and
children participated in a craft workshop. Also included in
Mrs. McFadden's program was a five-minute drawing
lesson during which each one present created a portrait of
the person opposite. There were hilarious results," *LR*, Dec.
22, 1960, p. 28.

McFadden, Ann (notices in California newspapers on newspapers.com)
1958 – "Art Display, Talks … Long Beach Museum of Art … Talks on Saturday … and on Sunday, 'Symbolism in Art,' by Ann McFadden… 2 p.m.," *LA Times*, Dec. 21, 1958, p. 114 (pt. VIII-L, p. 2).
1960 – "Art Educators Discuss Color in LA, May 14 … spring meeting of the Southern California Art Education Assn., May 14, in Los Angeles State College… Participating … Miss Ann McFadden, American Crayon Co., 'Manufacture of Color'," *Independent* (Long Beach, Ca., May 9, 1960, p. 5.

McGee, (James) Henry (1868-1958) (Guadalupe / Lompoc / Arroyo Grande / Los Angeles)
Photographer, artist, active 1893-1909. In the 1920s and 1930s he served as agent / manager for Packard Ranch in the Lompoc area.

■ "Rites Held Here for H. McGee… Henry McGee, 90-year-old Lompoc pioneer… who passed away Sunday in Santa Barbara. Mr. McGee was born in Santa Cruz on April 6, 1868. He was for many years manager of the Packard estate in Lompoc and was active in civic affairs. For the past several years he has resided in Santa Barbara. Mr. McGee leaves his wife, Birdie…," *LR*, Aug. 14, 1958, p. 3.

McGee, J. H. (notices in Northern Santa Barbara County newspapers on microfilm and on newspapers.com)
1890 – Is he "Henry McGee returned to his post of duty as Manager of the telegraph office at Acton …," *LR*, July 12, 1890, p. 3, col. 2.
1893 – "Photographer **Briggs** left town Thursday morning for Santa Ynez and from there will commence making a tour of the county making photographs. He will be assisted by Henry McGee. When they return the new gallery in the Sherman Building will be finished and Briggs will move in and to celebrate the event will make a specialty of cabinet photos and crayon work…," *LR*, July 22, 1893, p. 3.
1894 – "Mr. Henry McGee is home from Cayucos, San Luis Obispo county, on a Thanksgiving visit. Henry will locate in Guadalupe about the beginning of the next year," *LR*, Nov. 10, 1894, p. 3, col. 2; "Henry McGee one of Lompoc's finest young men and an artist of more than average ability, intends locating here in a few days," *SMT*, Dec. 1, 1894, p. 2.
1895 – "Guadalupe Items ... Henry McGee of Lompoc has fitted up his photograph gallery in good shape and is now ready for business. Henry is a first-class artist, a first-class boy, and having come to stay, will make a first-class citizen," *SMT*, Jan. 26, 1895, p. 3; "Mr. Henry J. McGee, Photographer at Guadalupe, is visiting his parents in Lompoc. Henry reports great activity in that section in railroad construction and says that the first train is expected next week. Then will follow soon the construction of the great steel bridge of the Santa Maria river," *LR*, Feb. 2, 1895, p. 3; "Railroad Rumblings. Guadalupe Reporter. Last Saturday morning J. H. McGee, the photographer, and ye editor 'driv' over to the scene of track laying, so that the reporter might give to its patrons more news upon this subject… they were then at the western edge of the sand hills, seven miles from the Santa Maria river – and also from Guadalupe…," and details on how tracks are laid but no further information on the photographer, *LR*, Feb. 16, 1895, p. 2; "Guadalupe Items… Henry McGee, photographer, has sold his tent to Hansard and will locate in Arroyo Grande where he will continue his business," *SMT*, April 6, 1895, p. 3; "Henry McGee, the photographer, has gone to Lompoc to spend a few days, after which time he will go to Pismo and engage in his business," *SMT*, May 18, 1895, p. 2; "James H. McGee of Lompoc has been spending several days at Pismo with his nephew, Henry McGee…," *SMT*, June 22, 1895, p. 3, col. 6.
1906 – "M'Gee Divorce. Florence Edith McGee got a divorce yesterday from James Henry McGee on the ground of desertion. They were married in this city in January 1899. McGee was a photographer and in July 1905 he left for Arizona, deserting her for all time," *LA Times*, Sept. 18, 1906, p. 18.
1909 – "Henry McGee who was connected with the Vincent Photograph Company in Los Angeles, has returned to Lompoc to remain in the future," *LR*, Oct. 29, 1909, p. 8, col. 4.
1930 – "Present Owner of the *Record* Gives a 'Who's Who' of Lompoc when he Landed 31 Years Ago [i.e., **1899**] … Henry McGee and **Blair Ray** were the photographers and McGee was considered a real artist…," *LR*, April 18, 1930, p. 2.
1945 – "Lompoc Glimpses… **Policeman Olson** – hobby collecting old photos of pioneer people and local views made by Henry McGee, **Briggs** and other early day photographers," *LR*, Nov. 9, 1945, p. 8.
McGee, J. H. (misc. bibliography)
[Do not confuse with James Henry McGee the farmer/contractor of Lompoc active c. 1889-96?]
Is he James Henry McGee listed in the *Santa Barbara County Voter Register* for 1892 – age 24, 5' 6", fair complexion, gray eyes, light hair, b. Calif., residing in Lompoc; Henry McGee, photographer, is listed at 611 Temple in the *Los Angeles, Ca., CD*, 1900; is he Harry McGee, age 35, photographer, listed in the *Index to Register of Voters, Los Angeles City Precinct no. 38*, 1910; is he Henry McGee listed in the 1910 U. S. Census as age 36, b. c. 1874 in Calif., father born Canada, a photographer, residing in Los Angeles in a rooming house?; "James Henry McGee was b. April 6, 1868 in Santa Cruz to William John McGee and Jessie Legasick, was residing in Los Angeles in 1900, and d. Aug. 10, 1958 in Lompoc, per Erma Thompson Family Tree; James Henry McGee is buried in Lompoc Evergreen Cemetery per findagrave.com (refs. ancestry.com).
See: "Briggs, E. T.," 1893, "Lompoc Valley Pioneer Society," 1930, "Olson, Idell," "Ray, Blair"

McGehee, Ramiel (Redondo Beach)
Dancer, artist who accompanied the Merle Armitage collection to Santa Maria for its viewing at the Art Festival. He lectured on the collection as well as on Oriental Art, 1935. He was in and out of Santa Maria on other occasions, 1931, 1932, etc.
1933 – "Mr. McGehee will lecture on, 'My Year in a Japanese Monastery,' at the **Chandler Weston** studio, 619 East Central avenue, this Saturday evening," *SMT*, May 10, 1933, p. 5, col. 2.

See: "Art Festival," 1935, "College Art Club," intro., 1931, 1933, 1935, "Community Club (Santa Maria)," 1935

McGray, Thelma Whitley (Mrs. Donald Herbert McGray) (Santa Maria)
Handcraft chairman, Jr. Community Club, c. 1951-54, president, 1958.
See: "Junior Community Club (Santa Maria)," 1951, 1952, 1954, 1958

McGuire, Neil Elwood (1896-1972) (Santa Maria)
Santa Marian who became an artist in Hollywood.

■ "Neil E. McGuire, son of Mr. and Mrs. M. L. McGuire. He graduated in 1909 from the local grammar school and attended the high school, where his teacher, **Miss Hile [Sic. Heil]**, caused him to realize his ability to become a great artist. He studied mathematics, Latin, etc., but disliked all these studies, as art overpowered them all. While in school, he drew pictures of his fellow students and teachers. His friends at that time predicted he would make good in art someday. After two years at the Santa Maria high school, Mr. McGuire was persuaded to attend an art school, where he could develop his natural talent …. In 1911 he entered the West Lake Art Studios in Los Angeles, where he later received his diploma. Mr. McGuire was first associated with the Ince Company, at Universal City, being with this company three years. Later he went to New York and was so successful that the Selznick Company gave him credit on the screen as 'Art Titles by Neil McGuire.' In June, 1920, he joined Mr. Martin and Mr. Newcombe in opening their own studio at 727 Seventh Avenue, New York. At present Mr. McGuire and Mr. Newcombe are the proprietors of this establishment. In order to accommodate all the picture corporations desiring their work, five extra artists have been secured to aid them. Theatregoers who know Mr. McGuire will no doubt recall seeing his name on some of the pictures shown at the local theatre. He does work for some of the largest and best corporations. The following is a list of some of his latest productions and will show his class of pictures: 'Passion' (First National) was put on at the Capital theatre, the largest in New York. 'The Inside of the Cup' (Cosmopolitan) played January 2, 1921, at Criterion, the best theatre on Broadway. 'Kismet' (Robertson-Cole) is to be played at the **Gaiety** theatre in this city soon. 'Straight is the Way,' (Cosmopolitan). 'What's a Wife Worth?' (Robertson-Cole). 'Love's Penalty' (First National), Constance Talmadge in 'Dangerous Business' (First National) and numerous other productions," per "Local Boy Gains Fame in N. Y. Art Circles," *SMT*, Feb. 12, 1921, p. 1.

■ "McGUIRE, Neil Elwood, art director; b. Santa Maria, Calif.; educ. Univ. of Calif. and Art Students League; screen career, Universal, Triangle, Thos. H. Ince, art title director, Famous Players, Selznick, recent productions: 'Passion,' 'Inside of the Cup,' 'Vendetta.' Neil Elwood McGuire was born in Santa Maria, California, on October 17, 1896. He died there on January 8, 1972. In 1942 he was employed at Fine Arts Studios, Santa Monica Boulevard, Hollywood." Federico [Magni] adds: "This is the text of McGuire's Variety obituary (*Daily Variety*, Feb 14, 1972) –

"Neil McGuire, special effects technician who started his film career during silent pix, died in Santa Maria, Calif., Jan. 8, it was learned over weekend. He had made his home there, where he was reared, since retirement in 1965. McGuire was with Universal early in career, later also active in TV. He produced a number of educational films, including 'Lincoln's Gettysburg Address.' He specialized in scenic effects and miniatures," from nzpetesmatteshot.blogspot.com.

McGuire, Neil (notices in Northern Santa Barbara County newspapers on microfilm and on newspapers.com)
1911 – "Neil McGuire, the bright local artist whose cartoons and decorative drawings have attracted considerable attention, expects to enter the Los Angeles Art school Wednesday. He expects to make a specialty of newspaper illustrating, for which he seems to have a special talent…," *SMT*, Sept. 30, 1911, p. 4.
1916 – "Neil McGuire and Miss Marguerite Coffey Married… in San Francisco… The groom is the son of Mr. and Mrs. Mortie McGuire and is well known in this city, having resided here with his parents until a few years ago. He is now employed as an artist by the Universal Film Company in Los Angeles," *SMT*, March 4, 1916, p. 1.
1920 – "Neil E. McGuire… is now in charge of the art work of the Selznick Motion Picture Corporation in New York. He is working at the old Biograph studio in the Bronx," *SMT*, March 23, 1920, p. 3, col. 3; "Former Resident Here Now Art Director… Neil McGuire, who is art director for the Selznick Company. Last evening, in 'Sealed Hearts,' a photodrama shown at the Gaiety theatre, his illustrations on the title parts of the picture was one of the pleasing features. The young artist is a son of Mr. and Mrs. Mortimore [Sic.] McGuire of this city," *SMT*, May 29, 1920, p. 2.
1923 – "Local News … L. McGuire returned Tuesday from Los Angeles where he has been visiting his son, Neil, art title specialist at the United Studios in Hollywood," *SMT*, Oct. 4, 1923, p. 5.
1927 – "Santa Maria Boy Develops New Film Plan. Neil McGuire, a former Santa Marian … new method of film-making. Mr. McGuire, as an artist, has been connected with the film industry in Hollywood for a number of years … a film, 'Mickey in Moonland,' to be shown at the **Gaiety** theatre… All the locations in the pictures are painted by Mr. McGuire. The new process calls for taking the actors… placing them before the painted scenes …," *SMT*, March 24, 1927, p. 5.
1932 – 'Leaving for New York – Mr. and Mrs. M. L. McGuire… to spend the next two months visiting with their son, Neil McGuire, who is with the National Screen service in that city," *SMT*, July 1, 1932, p. 3.
1943 – FATHER – "Valley Pioneer Dies Here… Son An Artist…. father of Neil McGuire, art director and motion picture director and producer of Hollywood, who has been here for the past two weeks. … Neil McGuire, now operating his own studios, achieved fame as the creator of the third-dimension effect in pictures and has been with Warners, Walt **Disney** and nationally known concerns in the East and in Hollywood…," *SMT*, July 7, 1943, p. 3.
1972 – "Neil E. McGuire … Mr. McGuire, born Oct. 17, 1893 in Santa Maria, died Jan. 8 in a local hospital. He attended local schools and was an artist and designer of

animated miniature sets for movies and television. Mr. McGuire had been associated with Walt **Disney** and other Hollywood movie producers. He also produced and directed his own musical and short subject films. Mr. McGuire last operated an art studio at 112 W. Church St.," *SMT*, Jan. 10, 1972, p. 2; port. in group in front of early grocery store, *SMT*, Aug. 5, 1972, p. 23 (i.e., 9-B). And additional notices regarding visits home to his family were not itemized here.

McGuire, Neil (misc. bibliography)
Neil Elwood McGuire b. Oct. 17, 1896 in Calif. to Mortimer Lafayette McGuire and Lulu Eleanore Humbert, married Marjorie Power, was residing in Los Angeles in 1938, and d. Jan. 8, 1972 in Santa Maria, per Samuel Cook Pine Family Tree as well as WWI and WWII draft cards not itemized here (refs. ancestry.com).

McIntosh, Carmen (Lompoc)
Collector of tea pots, 1960. Some local groups used the recreation room in her home for meetings.
See: "Collectors, art and antiques (Lompoc)," 1960

McKenzie, Mr. (Lompoc)
Sign painter, grainer, marbler, 1890.
■ "Messrs. McKenzie & Snell, practical painters, have located among us… They make a specialty of carriage and sign painting. A specimen of their sign work can be seen at Spanne's blacksmith shop," *LR*, March 22, 1890, p. 3; "Kalsomining. Graining. McKenzie & Snell, practical House, Sign, Ornamental and Carriage Painters. Paper Hanging and Decorating. Satisfaction Guaranteed. Charges Moderate. All orders left at the Grand Central Hotel will meet prompt attention. Marbling. Frescoing," *LR*, June 7, 1890, p. 1.

McLaughlin, Conley Raymond (1926-2004) (Lompoc)
Art teacher, Lompoc High School, 1951-56. Teacher of ceramics at Lompoc adult school and other places, 1954, 1955. Teacher at John Burroughs High school in Burbank for the remainder of his career.
■ "Eight Members Join High School Staff … Conley R. McLaughlin … instructor in arts and crafts. He holds an A. B. degree from Los Angeles State College and taught in the LeConte school in Los Angeles…," *LR*, Aug. 30, 1951, p. 8.

McLaughlin, Conley (misc. bibliography)
Port. in John Burroughs High School, Burbank, yearbook, 1958, 1963, 1965, 1972, 1986, 1987; Conley Raymond McLaughlin was b. Aug. 11, 1926 in Aurelia, Iowa, to William Conley McLaughlin and Verla Elizabeth Bruner, and d. Dec. 7, 2004 in Burbank, Ca., per Marsalis_Phillips Family Tree; Conley Raymond McLaughlin is buried in Forest Lawn Memorial Park, Glendale, per findagrave.com (refs. ancestry.com).
See: "Alpha Club," 1954, "Four-H," 1952, "Halloween Window Decorating Contest (Lompoc)," 1954, "Lompoc, Ca., Adult/Night School," 1954, 1955, "Lompoc, Ca., Union High School," 1951-56, "Wygal, Elsa"

McLaughlin, (Dolores?) Dee (Mrs. Jack McLaughlin) (1921-?) (Santa Ynez Valley)
Muralist, interior decorator, antique dealer, horsewoman, 1959-76?
McLaughlin, Dee (notices in Northern Santa Barbara County newspapers on microfilm and on newspapers.com)
1959 – "Memo Pad… Valley Views… The new seven room ranch style home of Earl Petersen in Skyline Park… open house… among its features are two bedrooms with hand painted walls executed by interior decorator, Dee McLaughlin…," *SYVN*, Nov. 6, 1959, p. 2.
1960 – "Medical Clinic Building Open House Slated… new wing… Included in one of the waiting rooms is a special area designed for children. Hand painted murals by Valley artist Dee McLaughlin depict a gay circus theme on the walls, and the room contains a large expanse of blackboards, small tables and chairs…," *SYVN*, April 22, 1960, p. 7.
1963 – "Several New Artists' Work… The Castle Art gallery is featuring the work of several new artists this month. In the main gallery can be seen … painting by Dee McLaughlin, one of the former co-owners of the Cable Car gallery in San Francisco…," *Santa Cruz Sentinel*, March 10, 1963, p. 22.
1965 – Is she – "Mrs. Dolores E. McLaughlin of Skyline Park, wife of John McLaughlin, one of the several candidates along with the three incumbents running in the Santa Ynez School district. Mrs. McLaughlin is the mother of Sandee, 13, and Kevin, 10, both students in the school. The family has lived in the Valley six years," *SYVN*, March 25, 1965, p. 6.
1974 – Ad: "In place of cards we have chosen to send a donation to Children's Home Society… Joyous Christmas … Jack and Dee McLaughlin…," *SYVN*, Dec. 12, 1974, p. 10.
1976 – "Five local antique dealers among exhibiters at Heart Assn. show… Sixth Annual Antique Show and Sale… in Santa Maria… Dee McLaughlin… in Santa Ynez…," April 22, 1976, p. 20.
McLaughlin, Dee (misc. bibliography)
Is she Dolores E. McLaughlin, b. Sept. 15, 1921, who was residing in Santa Ynez, Ca., in 1970 per *U. S. Public Records Index, 1950-1993*, vol. 1? (ref. ancestry.com). *This individual could not be more fully identified.*

McLean, Mae Anthony Broughton (Mrs. Alexander McLean) (c. 1867-1934) (Lompoc)
In charge of Fine Arts exhibit at "Santa Barbara County Fair," 1894 and in charge of needlework exhibit at Lompoc Valley Fair, 1928. Sister to Chara Broughton, above.
■ "Friends Unite in Tribute… Mrs. McLean. Father Founded the *Record*… died in a Santa Barbara Hospital… Was Community Leader. She was married to Alexander McLean on June 8, 1886 and to the union were born two sons, James B. of Fresno and George H., now deceased. Mrs. McLean was active in community affairs and was one of the charter members of the Lompoc Alpha Club. She, with others, started the Euchre Club, which later became the Social Club… She was active in the Lompoc Civic

Club and was one of those instrumental in acquiring the memorial flagpole…," *LR*, March 2, 1934, p. 6.

McLean, A., Mrs. (notices in Northern Santa Barbara County newspapers on microfilm and on newspapers.com)
1891 – "A. McLean of late years a resident of Pasadena, has sold his home on the corner of Cypress and Orange Grove avenue and is moving to Lompoc, his former residence where he is going to plant an apple orchard…," *LR*, Nov. 28, 1891, p. 2, col. 6.
1910 – FATHER – "Old and Respected Citizen Called… and Mrs. Mae McLean of Lompoc, survive the deceased. Judge [William Wallace] Broughton was one of the first publishers of the *Santa Cruz Sentinel*…," *LR*, Feb. 18, 1910, p. 1.

McLean, A., Mrs. (misc. bibliography)
Is she Mae McLean listed in the 1920 U. S. Census as age 52, b. c. 1868 in Calif., residing in Lompoc with husband Alexander McLean (age 64); is she Mae A. McLean b. c. 1867, who d. Feb. 23, 1934 in Santa Barbara County per Calif. Death Index (refs. ancestry.com).
See: "Broughton, Chara," "Lompoc Valley Fair," 1928, "Santa Barbara County Fair," 1894

McMillan, Charles (1853-1914) (Santa Maria)
Photographer with brother John, below, under the name of McMillan Bros., 1885-c. 1888.

■ "Chas. McMillan Dead. Charles McMillan, a brother of the late John McMillan of this city and who at one time conducted a photograph gallery with his brother here, passed away in Colfax on Friday of last week. Mr. McMillan was here early this summer looking after his interests and was as genial and good natured as usual and his death comes as a surprise. Regarding Mr. McMillan's departure the *Vallejo Chronicle* says: Charles McMillan, Vallejo's pioneer photographer, died this morning at Colfax… the decedent was first taken sick lst May and went south in the hope that the change would help him, but at the end of six weeks his condition became so alarming that he was removed to a hospital in San Francisco … Three weeks ago, he went to Colfax and there his condition became so alarming that his family was summoned … Chas. McMillan was born in Kingston, Canada, May 3, 1861 [Sic. 1853] and at an early age removed to Chicago, where he spent a number of years, coming to California in 1889. He spent a short time in Southern California, from whence he removed to Vallejo, buying out the Solano Photograph Gallery from James G. Smith, who retired from the business. From the start he made a success of his venture here and during the succeeding years amassed a modest fortune. His sunny disposition and dry humor made him a favorite in all circles and his integrity and sterling qualities won for him a legion of sympathy …," *SMT*, Aug. 29, 1914, p. 8.

McMillan, Charles (notices in Northern Santa Barbara County newspapers on microfilm and on newspapers.com)
1888 – "Fifty Years Ago… Charles McMillan left for La Grange, Calif. to engage in the photography business," *SMT*, May 19, 1938, p. 4.
1897 – "From Charles McMillan, a former Santa Marian, now conducting a photographic studio at Vallejo, we received this week a very nice 8 x 10 tinted photograph of

the *U. S. S. Oregon* as she lays at anchor in San Francisco Bay," and details of ship, *SMT*, Oct. 2, 1897, p. 3.

McMillan, Charles (misc. bibliography)
Charles Mcmillan is listed in the 1900 U. S. Census as age 47, b. May 1853 in Canada, naturalized, a photographer residing in Vallejo, residing with wife, Isabelle R. (age 36); Charles Mcmillan is listed in the 1910 U.S. Census in Vallejo; Charles McMillan, b. c. 1853, d. Aug. 21, 1914 in Placer County per Calif. Death Index; Charles H. McMillan b. May 3, 1853 and d. Aug. 21, 1914 has photos in *Private Member Photos* (refs. ancestry.com).
See: "McMillan, John"

McMillan, John (1838/40/41-1910) (Santa Maria)
Photographer with brother Charles, above, under the name of McMillan Bros., 1885-c. 1900. Later he seems to have focused on his musical interests.

■ "John McMillan Crosses the Great Divide… John McMillan was a native of Pennsylvania and spent his younger years in the east, taking up photography as a study. In 1870, together with his brother, Charles McMillen, he opened a photograph gallery in Chicago and after ten years of successful business and having gone through the great Chicago fire, the two came to California. After traveling over the state, the two brothers located in Santa Maria in 1885 and purchased the property where McMillan's Hall stands today. The deceased was a fine musician and especially a good violinist and for many years McMillan's Orchestra had a state wide reputation for its excellence. He married in 1884 and is survived by his loving widow, two daughters and four sons as well as two brothers…," *SMT*, Dec. 3, 1910, p. 1.
"On Nineteenth Century Photography," by Barbara Cole, *Quarterly, Santa Maria Valley Genealogical Society and Library*, Fall, 1999, p. 4.

McMillan, John (notices in Northern Santa Barbara County newspapers on microfilm and on newspapers.com)
1885 – "Ho! For the Falls. The camping excursion… for the Sisquoc Falls… the McMillan Bros. photographers and artists extraordinary to the invaders, who are expected to be always on duty and furnish each invader a photograph with the celebrated falls in the background…," *SMT*, April 18, 1885, p. 5; "A Fine Christmas Present Given Away. From Dec. 1st until New Year's Day we will give free of charge a fine large album holding cabinet and card pictures and worth $2 to every person who has one dozen Cabinet Photographs taken, and a floral card size album worth $1 to all those who have one dozen Card Photographs. Remember no increase in prices of photographs. …," *SMT*, Dec. 12, 1885, p. 5.
1887 – "James Letrora has added a beautiful frame of photographs to his attractive salon. It is the work of McMillan Bros. and is an ornament to the place and a credit to the artists," *SMT*, April 30, 1887, p. 5; "Can you beat the following record of grain cutting? Mr. Wm. Smith residing about four miles southeast of town… we saw McMillan, the artist, heading for that way on Thursday morning, and later we learned that Mr. Smith, with his entire family, consisting of ten, would have their pictures taken, all standing in the header bed, including Mr. and Mrs. M. P.

Nicholson, Isaac Miller, Jr., and Miss Annie Richardson," *SMT*, July 23, 1887, p. 3.

1890 – "A fine photograph of Mr. J. G. Prell's residence was taken this week by our photographer, John McMillan," *SMT*, April 26, 1890, p. 3, col. 2; "Mr. John McMillan kindly offered to photograph the fine floral tributes placed on the casket of our deceased constable, I. W. Southward," *SMT*, May 10, 1890, p. 3, col. 2; "Our photographer, John McMillan, photographed the double wedding party, the wedding decorations, etc., at the residence of J. F. Dana, on the day of the wedding, the 21st inst.," *SMT*, May 31, 1890, p. 3, col. 2; "Mr. John McMillan … created many smiles among the young ladies at Miller's orchard and fruit drying establishment last Wednesday noon. He took his camera along and photographed the working crew, the orchard and surroundings," *SMT*, Aug. 9, 1890, p. 3, col. 2; "John McMillan photographed the 'Red Riding Hood' party on Saturday last," *SMT*, Aug. 23, 1890, p. 3, col. 2.

1891 – "A Lovely Birthday Party. Miss Lillie Fleischer… Mr. John McMillan was called out with his camera to photograph the merry crowd," *SMT*, April 11, 1891, p. 3.

1893 – FATHER – "Obituary" for his father [Charles McMillan] in Canada, *SMT*, Oct. 7, 1893, p. 2; in a drawing… 3. Prem – One dozen Cabinet Photographs of yourself, furnished by our popular photographer, John McMillan…," *SMT*, Dec. 16, 1893, p. 1.

1894 – "The Creamery is Running… McMillan the photographer, was down yesterday, photographing the buildings and machinery. These views will be stereotyped and used by the *Times* in illustrating a Special Creamery Number which we will issue in the near future…," *SMT*, Feb. 10, 1894, p. 2, col. 2; "We Will Exhibit… at the **Midwinter Fair**… Mr. John McMillan will photograph the valley and place it on display…," *SMT*, Feb. 17, 1894, p. 2, col. 6; "Wedding Bells. A Double Wedding at the M. E. Church… O. S. Setler of Pozo and Miss Ada Stephens of this city. M. L. Stephens … and Miss Sadie Hampton… On Friday morning the bridal party together with the floral decorations were photographed by John McMillan …," *SMT*, July 7, 1894, p. 3.

1895 – "Teacher's Institute… Thursday, Aug. 22nd… After singing and roll call, the teachers repaired to the school grounds where McMillan, the photographer, took a snap shot at them…," *SMT*, Aug. 31, 1895, p. 1.

1896 – "McMillan, the photographer, has the thanks of the *Times* for views of the laying of the corner stone of the new school house at Guadalupe. Copies of the pictures may be secured of him," *SMT*, March 28, 1896, p. 3, col. 1.

1901 – "We are indebted to photographer McMillan for a fine photograph of Willis McMillan as Teddy Roosevelt," *SMT*, July 20, 1901, p. 3, col. 3.

1903 – "John McMillan is enlarging his [music] hall by tearing out the partition which formerly separated the lemonade stand from the main hall," *SMT*, May 1, 1903, p. 3, col. 3.

And, more references for "John McMillan" in the *SMT* between 1889 and 1910 not itemized here.

McMillan (misc. bibliography)
John McMillan is listed in the 1900 U. S. Census as age 61, b. July 1838 in Pennsylvania, a photographer residing in Township 7, Santa Barbara County, with wife Helen (age 36) and four sons: John, Daryl, Willis and Lindsay; listed in

the 1910 U. S. Census in Santa Maria; John A. McMillan, b. c. 1841, d. Nov. 25, 1910 in Santa Barbara County per Calif. Death Index; John A. McMillan (1840-1910) is buried in Santa Maria Cemetery District per findagrave.com (refs. ancestry.com).
See: "McMillan, Charles," "Stephens, Ada," 1894

McMillan Bros. (John and Charles) (Santa Maria)
Photographers. Exh. "Santa Barbara County Fair," 1886, 1888, 1889, 1890, 1891. Notions and photographers, 135-137-139 W. Main, Santa Maria, per Santa Barbara, Ca., City Directory, 1908.
See: "Jones, O. L.," 1888, "Koerner, Fred," "McMillan, Charles," "McMillan, John," "Santa Barbara County Fair," 1886, 1888, 1889, 1890, 1891

McMurray, Nellie (Smith?) (Mrs. S. K. McMurray) (Solvang)
Collector / lender of flower studies to Art Loan Exhibit, Solvang, 1935. Conceived the idea of the Santa Ynez Valley Fair, 1928.
See: "Art Loan Exhibit (Solvang)," 1935, "House, H. Elmer," "Santa Ynez Valley Fair," 1927, 1931

McNeill, Patricia (Anaheim)
Artist who visited Solvang, 1948, 1949.
■ "Valley Views… lovers of horses and art fans will like the two paintings now on display in the News office … they were done by Patricia McNeill of Anaheim… she is a niece of Mr. and Mrs. John Henslick of Ballard…," *SYVN*, June 18, 1948, p. 2; "Guests of Mr. and Mrs. John R. Henslick last weekend were Mr. and Mrs. Dan Day and Patricia McNeill of Anaheim. Miss McNeill, niece of Mr. and Mrs. Henslick, is an artist who specializes in paintings of horses," *SYVN*, Jan. 21, 1949, p. 4.
This artist could not be further identified.

Mead, Igor (aka Medvedev) (1931-2015) (Reseda)
Painter of abstracts who exh. at Allan Hancock [College] Art Gallery, 1957.
See: "Allan Hancock [College] Art Gallery," 1957, and *Central Coast Artist Visitors before 1960*

Medora, (Mr. and Mrs.?) (Australia)
Artist / entertainers in Santa Maria, 1911.
See: "Chalk Talks"

Medvedev, Igor
See: "Mead, Igor"

Mehlschau (Brotzman), Marian (Mrs. James Brotzman) (Nipomo / Laguna Beach)
Art prize winner. Exh. Allan Hancock [College] Art Gallery, 1957.
See: "Allan Hancock [College] Art Gallery," 1957, and *Arroyo Grande Art and Photography before 1960*

Mehlschau, Ursula Arlene / Arline
See: "Sander (Mehlschau), Ursula Arlene / Arline (Mrs. George Mehlschau)"

Melby (Hitchen), Karen Arlene (Mrs. Douglas Hitchen) (1933-?) (Santa Maria / Arroyo Grande)
Draughtsman. Exh. at Santa Barbara County Fair, 1951. Art student at UCSB, 1952.
■ Port. and "Engagement News Told at Melby's ... home of Mr. and Mrs. Arnold Melby... both Miss Melby and her fiancé are students at Santa Barbara college., University of California. Miss Melby is taking courses in art, while Mr. Hitchen [son of M/M S. L. Hitchen, Lompoc] is specializing in industrial arts...," *SMT*, Dec. 29, 1952, p. 4.
Melby, Karen (notices in Northern Santa Barbara County newspapers on microfilm and on newspapers.com)
1968 – "70 New Teachers Coming to Lucia Mar School District... Mrs. Karen Hitchen – Obtained her B. S. Degree with honors from Cal Poly during the winter quarter, 1967. She did her practice teaching at Crown Hill and was a home teacher and a substitute in our district this spring. Mrs. Hitchen will teach English at Orchard Avenue...," *Arroyo Grande Valley Herald Recorder*, Aug. 29, 1968, p. 20.
More than 150 notices on "Karen Melby" in the *SMT* between 1945-1953 and more than 65 for "Karen Hitchen" in the *Arroyo Grande Valley Herald Recorder* 1953-80, were not itemized here.
Melby, Karen (misc. bibliography)
Karen Arlene Melby, mother's maiden name Fylling, was b. Nov. 20, 1933 in Santa Barbara County per Calif. Birth Index; Karen A. Melby is listed in the 1940 U. S. Census as residing in Santa Maria with her parents; Karen Melby appears in the Santa Maria High School yearbook, 1949 (refs. ancestry.com).
See: "Santa Barbara County Fair," 1951, "Santa Maria, Ca., Union High School," 1951

Melton, Edward "Eddie" Allen (1930-2006) (Santa Maria)
Art major at Santa Maria high school, 1946. Studied with Jeanne DeNejer, 1946. Joined the Marines.
1946 – "Melton Designer. Designer and painter of the Christmas decoration at Coast Counties Warehouse on West Main street, was revealed today as Eddie Melton, 16-year-old senior in Santa Maria high school. Melton, the son of Mr. and Mrs. G. [George and Agnes] E. Melton of 310 W. Orange street, is an art major in school," *SMT*, Dec. 21, 1946, p. 7.
2006 – Port. and "Edward Allen Melton... 50-year Sacramento resident... He was a Marine in the Korean War, but some of his best days came while working with the Rio

Linda School District...," *Sacramento Bee*, Nov. 15, 2006, p. 25.
See: "DeNejer, Jeanne," 1946

Mendelowitz, Daniel Marcus (1905-1980) (Palo Alto)
Watercolorist. Professor of art at Stanford who spoke to AAUW and high school art students, 1955. Held a OMS at Allan Hancock [College] Art Gallery, 1955.
See: "Allan Hancock [College] Art Gallery," 1955, "American Association of University Women," 1955, "Junior Community Club," 1955, and *Central Coast Artist Visitors before 1960*

Menezes, Herman (Sisquoc / Santa Maria)
Collector of carvings made by German prisoners of war at Camp Cooke during WWII. Gun collector.
See: "Art, general (Camp Cooke)," WWII, "Collectors, Art/Antiques (Santa Maria)"

Menton, Mary (1848-1913) (San Francisco)
Created images of Mission Santa Inez and Mission San Miguel between 1906 and 1913.
See: *Central Coast Artist Visitors before 1960*

Meredith, Margaret, Miss (New York?)
Decorative consultant for Columbia Mills of New York, who spoke to Minerva club, 1947.
See: "Minerva Club," 1947

Merlo, Jane Winifred Hunt (Mrs. Peirino Merlo) (1921-2000) (Santa Maria)
Teacher of physical education who retired, 1949. Painter. Exh. Tri-County Art Exhibit, 1950, first annual Santa Ynez Valley Art Exhibit, 1953, and Allan Hancock [College] Art Gallery, 1956. Wife of Peirino Merlo, below.
■ Port. and dedication page courtesy 4-H and FFA exhibitors at County Fair, thankful for her support of youth, *SMT*, Aug. 13, 2000, p. 18 (i.e., B-6); port. and lengthy obit., *SMT*, June 17, 2000, p. 2.
Merlo, Jane (notices in Northern Santa Barbara County newspapers on microfilm and on newspapers.com)
1945 – "Schools Reopen...Mrs. Jane Merlo, a war wife also, will be the girls' physical education instructor...," *SMT*, Aug. 29, 1945, p. 5.
Merlo, Jane (misc. bibliography)
Jane Merlo, b. Feb. 23, 1921 to Archie M. and Bess Hunt, and d. June 13, 2000 is buried in Oak Hill Cemetery, Ballard, Ca., per findagrave.com (ref. ancestry.com).
See: "Allan Hancock [College] Art Gallery," 1956, "Merlo, Peirino," "Santa Ynez Valley Art Exhibit," 1953, "Tri-county Art Exhibit," 1950

Merlo, Peirino Charles (1918-1976) (Santa Maria)
Woodshop teacher, adult school, 1946+. Long-time chairman of the Department of Applied Technical Arts at Santa Maria High School. Husband to Jane Merlo, above.

■ "Peirino C. Merlo… Mr. Merlo died Saturday in a local hospital. He was born Jan. 20, 1918 in Canavese Rivorolo, Italy. He had been an area resident since 1946… Mr. Merlo was a physical education teacher at Allan Hancock college. He started his teaching career in 1946. At that time, he taught physical education, carpentry and woodshop at Santa Maria High School and at the Santa Maria Junior college… Mr. Merlo was a long-time chairman of the Department of Applied Technical Arts … A graduate of Santa Barbara City College, Mr. Merlo majored in physical education and industrial arts. During WWII he served in the Air Force as a physical training instructor and was stationed for one year in Calcutta, India…," *SMT*, Feb. 16, 1976, p. 2.

Merlo, Peirino (misc. bibliography)
Peirino 'Pietro' Charles Merlo was b. Jan. 20, 1918 in Italy to Pietro 'Pete' Merlo and Bernadetta (Secunda) Mautino, married Jane Winifred Hunt, and d. Feb. 14, 1976 in Santa Maria, Ca., per Morawski-Merlo Family Tree (refs. ancestry.com).
See: "Allan Hancock College," 1955, "Allan Hancock College Adult/Night School," 1955, 1960, "Santa Maria, Ca., Adult/Night School," 1946, 1948, 1949, 1950, 1951, 1953, "Santa Maria, Ca., Union High School," 1953, 1954

Merrill, Arthur Loren (1880/81-1955) (San Francisco / Santa Maria / Santa Cruz)
Woodworking teacher at Santa Maria high school, 1928-46 and at adult school c. 1928-c. 1935.

■ "MERRILL – In Santa Cruz, March 24, 1955. Arthur L. Merrill; aged 74 years, native of California. Brother of Percy Merrill and Edith Nelson of Santa Cruz… Funeral arrangements are pending at Wesendorf Mortuary," *Santa Cruz Sentinel*, March 24, 1955, p. 12.

Merrill, A. L. (misc. bibliography)
Arthur Merrill is listed in the 1930 U. S. Census as age 47, b. c. 1883 in Calif., a teacher, Hancock Foundation College of Aeronautics, residing in Santa Maria with his wife, Ada (age 46); listed in the 1940 U. S. Census in Santa Maria with wife, Ada; Arthur Loren Merrill gave the birth date of Oct. 19, 1881 on his WWII Draft Registration Card, filled out in Santa Maria in 1942; Arthur L. Merrill, mother's maiden name Cutler, father's Merrill, was b. Oct. 19, 1880 in Calif. and d. March 24, 1955 in Santa Cruz County per Calif. Death Index (refs. ancestry.com).
See: "Santa Barbara County Fair," 1930, "Santa Maria, Ca., Adult/Night School," 1928, 1930, 1935, 1936, 1944, "Santa Maria, Ca., Union High School," 1928, 1930, 1934, 1935, 1936, 1938

Merrill, King (1922-1998) (Solvang)
Photographer and author of a column, "The Memo Pad," in the Santa Ynez Valley News, 1947+. Exh. Santa Ynez Valley Art Exhibit, 1955.

■ "King Merrill, who served for eight years as a member of the editorial staff of the *Paterson Morning Call* in Paterson, N. J., was named this week to the post of news editor of the *Santa Ynez Valley News* … new post… Mr. Merrill would be in complete charge of all news gathering for *The Valley News*… Mr. Merrill, a veteran of three years' Army service, represents the third generation of newspapermen in his family. While on *The Paterson Morning Call,* he did general editorial work, which included a police 'beat,' city hall reporter and desk work, handling sport and suburban copy. He entered the Army Signal Corps in 1942 and was trained in radio work at Camp Crowder, Mo. And at the Eastern Signal Corps Schools in Fort Monmouth, N. J. He was later assigned to the 20th Armored Division and saw service in the European Theatre of Operations under the late Gen. Patton. While in Europe, Mr. Merrill served on the staff of 'The Dispatch,' the division's own paper and the only daily paper printed by combat troops in the ETO. Scheduled for redeployment to the Pacific Theatre, the 20th Armored was sent to Camp Cooke. While there, Mr. Merrill was assigned to the staff of the *Camp Cook Clarion*, official camp newspaper. Following his discharge, he returned to the East and resumed his duties on the *Morning Call* and was assigned to cover the City of Passaic, a municipality of almost 70,000 people. Mr. Merrill and his wife, the former Miss Elenita de la Cuesta, returned to California last fall. They are residing at Rancho Alamo Pintado in Ballard," per "King Merrill Named News Editor," *SYVN*, Jan. 24, 1946, p. 1.

■ Obit. "King Merrill, 76, veteran valley newsman… long period of ill health… Merrill served as managing editor of the *Santa Ynez Valley News* for some 35 years. Following his retirement from that position he became senior editor of the *Los Padres Sun* for a short period before moving, in Nov. 1989, with his wife from their long-time home on Rancho El Alamo Pintado between Solvang and Ballard to Yosemite Lakes Park in the foothills of the Sierras. A native of Onset, Mass., on Cape Cod, Merrill, whose father and grandfather were both journalists… began his journalistic career at the *Paterson Morning Call* in New Jersey … Merrill was founder and president of his own public relations firm, King Merrill Associates, which for many years was highly successful in touting the attributes of Solvang and the Santa Ynez Valley throughout the United States and Canada. He was twice president of the Solvang Business Association…," *SYVN*, Sept. 10, 1998, p. 5.

Merrill, King (notices in Northern Santa Barbara County newspapers on microfilm and on newspapers.com)
1953 – Repro: children in library, *SYVN*, March 6, 1953, p. 2; and numerous additional photos not itemized here; port. *SYVN*, Dec. 25, 1953, p. 4.
1955 – "Memo Pad" discusses his relatives in the journalism field, *SYVN*, May 27, 1955, p. 2.
1956 – "Memo Pad" discusses his photos of his new baby, *SYVN*, Feb. 24, 1956, p. 2.

1958 – Port. with family dressed in Danish costume, *SYVN*, Aug. 8, 1958, p. 1.
More than 8,450 hits appear for 'King Merrill' in the *SYVN*, between 1946 and 1998 and were not even browsed for inclusion here.
Merrill, King (misc. bibliography)
King Merrill b. June 2, 1922 and d. Sept. 6, 1998 is buried in Oak Hill Cemetery, Ballard, per findagrave.com (ref. ancestry.com).
See: "Brandt-Erichsen, Thor," "Santa Ynez Valley Art Exhibit," 1955

Merritt (Green), Dorothy (Santa Maria)
See: "Green, Dorothy Merritt"

Metal Craft Club (Santa Maria)
Club at Santa Maria High School, 1935, 1938.
See: "Santa Maria, Ca., Union High School," 1935, 1938

Mexican Market
Run by Presbyterian Ladies Aid and held in Dania Hall, Solvang, 1944. Handicrafts were exhibited and sold.
See: "Presbyterian Church / Ladies Aid," 1944

Meyers, Mr. (Santa Maria)
Photographer, 1905.
■ "Mr. Meyers, photographer, who has been viewing in and about Santa Maria for the past two months, has left all his negatives with the **Santa Maria Photo Gallery**. Any one desiring duplicate orders from same, kindly call. **E. D. Shull**, Prop.," *SMT*, Aug. 12, 1905, p. 3, col. 4.
This individual could not be further identified.

Michetti, Othello Francesco (1895-1981) (Marin County)
Artist of Marin County who exh. paintings at Santa Maria Inn, 1951.
See: "Santa Maria Inn," 1951, and *Central Coast Artists Visitors before 1960*

Mickey Mouse Club (Lompoc)
A branch of the statewide club in Lompoc, 1935.
See: "Calvert, Earl," 1935

Middlecamp, Betty (San Luis Obispo)
Artist who exh. at Santa Maria Valley Art Festival, 1953, Santa Ynez Valley Art Exhibit, 1955 and Santa Barbara County Fair, 1959, 1960.
See: "Santa Barbara County Fair," 1959, 1960, "Santa Maria Valley Art Festival," 1953, "Santa Ynez Valley Art Exhibit," 1955, and *San Luis Obispo Art and Photography before 1960*

Midland School / Midland Ranch School (Los Olivos)
Boarding school for boys which stressed the simple, outdoor life, 1951. The school had occasional brushes with art.
■ "Midland School was founded in 1932 and for nine years occupied a cattle lease on the Laguna ranch, which it finally bought in 1941. Because of its origin on leased land, the school had to experiment with classrooms and other facilities such as could be easily moved and could be built by masters and boys. Such simple quarters were found to be no detriment to school work nor to the health of the boys, thus the school has not changed its original plan of extreme simplicity, though in 1947 its life was made somewhat easier by the introduction of electric current. Midland School has an eighth grade, but most of its boys are in the high school grades… from all parts of California, except the immediate region… The graduates go to a wide variety of colleges east and west… Says Headmaster Squibb, 'We began work in the midst of the depression and with very little money, partly as a protest to the extravagant life of the 1920s… We have avoided vocational courses…," and more, *SYVN*, Sept. 14, 1951, p. 1.
Midland School (notices in Northern Santa Barbara County newspapers on microfilm and on newspapers.com)
1934 – "Midland Ranch School Notes (from the *Midland Mirror*). An exciting contest was recently held for the horse and buggy enthusiasts at Midland. Mr. Chamberlin, a neighboring rancher, agreed to award an old breaking cart to the boy or boys who made the best drawing of plans for remodeling and repairing the cart for practical use. The drawings were soon made, and on Wednesday, February 28, Mr. Chamberlin arrived to judge… 'Because of the simplicity of their design and because of the short time they specify for finishing it, I hereby award the cart to Nelly, Loomis and Payne," *SYVN*, March 9, 1934, p. 4.
1937 – "Midland Ranch School Notes… On Sunday, February seventh, **Mr. Fred G. Anderson**, the well-known Santa Barbara photographer and Mrs. Anderson had dinner at the school. In spite of the rainy weather, he succeeded in making many excellent group photographs of the school as a whole, the council, the seniors, the soccer team, the athletic committee, the club Heptagon, the honorable and mysterious society of the Yehudi Menuhin of Midland and the newly organized fire department. He also made several interesting and somewhat amusing candid shots of the school life… **Mr. Eliot O'Hara**, nationally known water color artist, visited the school on Sunday, February 14. From the porch of the main house, he painted two sketches of school scenery and then showed the boys some of the paintings he has made on a recent trip," *SYVN*, March 12, 1937, p. 8.
1939 – Photo of Midland School Students and Faculty, *SYVN*, June 2, 1939, p. 4.
1943 – "Midland School Notes. … A new system of woodcutting has been adopted by Mr. Parks… **Mrs. Wood** is instructing on Tuesday afternoon a class in sketching, drawing and cartooning…," *SYVN*, Oct. 15, 1943, p. 4.
1952 – "Paul Squibbs Announce Plans to Turn Over Management of Midland to Mr., Mrs. Rich," *SYVN*, April 4, 1952, p. 5.
See: "Chrimes, Louise," "Posters, American Legion (Poppy) (Santa Ynez Valley)," 1953, "Stonehart, Leslie J.,

Jr.," "Tri-county Art Exhibit," 1947, "Venske, Harold,"
1960, "Wilson, James," "Wood, Mildred," 1951

Midtby, Mary (Mrs. Midtby) (Santa Barbara)
Exh. first annual Santa Ynez Valley Art Exhibit, 1953.
Is this Alveda/Alvilda Midtby (Mrs. John Midtby) of Santa
Barbara? or Marvel Gabriel Midtby?
See: "Santa Ynez Valley Art Exhibit," 1953

Midwinter Fair (San Francisco)
*California Midwinter International Exposition, Golden
Gate Park, 1894. Popular tourist destination. Contained
booths that promoted California's various counties as
well as some art exhibits. Many individuals from Santa
Barbara County visited the fair. Artists were influenced
by the art they saw there.*
■ "… a little further … reveals a very unique building
alongside that of the southern counties. It is the Santa
Barbara pyramid… You are even more surprised with the
interior… [newspaper is torn in spots] In another room we
find a … of paintings of all the missions of California. It is
said to be the only complete collection, painted by one
man. They have but lately returned from Chicago where
they attracted a great deal of attention [**Henry Chapman
Ford**?] …," *SMT*, April 7, 1894, p. 6.
See: "Art Loan Exhibit (Santa Maria)," 1895, "McMillan,
John," "Smith, Minnie"

Milburn, Eddy / Eddie (Los Angeles?)
*Instructor in costume design, mask construction, puppets,
and the dance at Santa Maria School of Art, 1933.
Accompanied Ramiel McGehee from Los Angeles as
assistant, 1933.*
Is he Tony Mann (aka D. Edward Milburn) an illustrator in
the Los Angeles area who had an unique marriage
ceremony held in a cable car over Hoover Dam, *LA Times*,
Oct. 11, 1936, p. 124 (i.e., Sunday Magazine, p. 14); port.
of couple, *Pasadena Post*, Jan. 10, 1933, p. 6.
See: "Santa Maria School of Art," 1933

**Mildred I. White Ceramics Shop / Betti's (Santa Maria
and Lompoc)**
*Retailer of ceramics materials, with main shop in Santa
Maria and branch in Lompoc, 1957. Prop. Mildred White.
In Lompoc, Betti Tognetti managed the store, then bought
it (1958).*
■ "Local Manager for New Ceramic Shop. **Mrs. Philip
Tognetti** of Lompoc will be the local manager of the soon
to open branch of Mildred I. White Ceramics shop here…
A grand opening of the new shop, which is located at 218
½ North I street, has been planned for the near future.
However, classes of free instruction are now being
conducted daily from 10:00 a.m. to 4:00 p.m. Monday
through Saturday except for Thursday. Night classes are
conducted … on Mondays and Wednesdays from 7:00 to
10:00 p.m. **Mrs. Mildred White**, proprietor of the shop in
Santa Maria and the new Lompoc establishment, conducts
the advanced class held on Monday evening and remains in

town for the Tuesday morning session. The shop is
equipped with three kilns and a wide stock of ceramic
supplies, with a master kiln available in the Santa Maria
shop for large pieces….," *LR*, Oct. 10, 1957, p. 3.
Mildred White shop (notices in Northern Santa Barbara
County newspapers on microfilm and on newspapers.com)
1957 – "Ceramics Shop Window Broken" and article adds,
"City police reported today that an eight-by-12-inch
window panel had been broken out of a ceramics shop at
218 South Blosser owned by Mrs. Mildred White. Nothing
was taken, they said," *SMT*, Jan. 21, 1957, p. 3; "Hand-
made gifts. Mildred White Ceramics, 218 ½ North I
Street," *LR*, Dec. 12, 1957, p. 6.
1958 – "Ceramics Shop Has New Owner. **Betti Tognetti**
has taken over the ownership and management of the
ceramics shop formerly operated by Mildred White at 218
½ North I street. Free instruction classes will be conducted
daily except Saturday from 10:00 a.m. to 4:00 p.m. Classes
will also be offered Monday and Wednesday evenings.
Mrs. Tognetti operated a yarn shop here a few years ago,"
LR, May 1, 1958, p. 9; "**Betti's**, 218 ½ North I Street will
be closed for vacation, June 24 to July 14. Get Your
Ceramic Supplies Soon," *LR*, June 19, 1958, p. 14; "Free
Ceramic Instruction. Greenware & supplies priced
reasonably. Hobby firing done on premises. **Betti's** 218
No. I St. – Phone 8-2633. Lompoc," *LR*, Nov. 27, 1958, p.
14.
1959 – "Free Ceramic Instruction. Greenware & supplies
priced reasonably. Hobby firing done on premises.
Betti's…," *LR*, April 23, 1959, p. 14; "Ceramic Mold Sale.
One day only, Dec. 5th, 10 a.m. to 4 p.m., **Betti's**…," *LR*,
Dec. 3, 1959, p. 27.
1960 – "Club Does Ceramics… Welcome Wagon Club
members are learning ceramics in a weekly class conducted
at **Betti's** Ceramic Shop on Wednesday afternoons from 1-
4. Such items as vases, ash trays, lamp bases, coffee mugs,
religious statues, cake plates and canister sets are being
made. Members and guests of the class include: **Mrs.
Russell Balise**, WW president, **Mrs. William Presly**
publicity chairman, **Mmes Cecil Streepy, Darryl Reed,
Jay Nixon, Edward Scott**, Marion [Sic. Marian?] Hoag,
Paul Polk, Jasper Wygal, Bert Guy, and Miss **Ann
Wygal**," *LR*, March 17, 1960, p. 7.
1961 – "White Ceramics Wins K of C Display Contest.
White Ceramics, 218 S. Blosser Road, won first place
honors in the 'Keep Christ in Christmas' religious scene
display contest among Santa Maria business
establishments. … sponsored by the Santa Maria council of
the Knights of Columbus. **Mrs. Mildred White**, proprietor
of the store, will receive a madonna trophy … for a
year…," *SMT*, Dec. 23, 1961, p. 2.
And additional notices in both the *SMT* and *LR* not
itemized here.
See: "Lompoc, Ca., Recreation Department," 1961, 1963

Miles, W. F. (Lompoc)
*Prop. of Variety Store, July 1890-Jan, 1891. Sold picture
frames. His stock may have been liquidated to Morehead
& Douglass, 1891, later W. H. Douglass.*
See: "Douglass, W. H.," "Morehead & Douglass," "Variety
Store"

Miller, ? (Mrs. R. C. Miller) (Lompoc / Santa Barbara?)
Exh. china painting at "Santa Barbara County Fair,"
1894.
Is she: "Mrs. R. C. Miller, wife of the presiding elder of
Grace M. E. [Methodist Episcopal] Church, was yesterday
presented with a handsome gold watch on the occasion of
her leaving for Los Angeles," *Independent* (Santa Barbara,
Ca.), Sept. 3, 1896, p. 4.
See: "Santa Barbara County Fair," 1894

Miller, Agnete (Mrs. Anders Miller) (1882-1964) (Santa Ynez Valley)
Art student under Leo Ziegler in adult school, 1949.
See: "Santa Ynez Valley, Ca., Adult/Night School," 1949,
"Santa Ynez Valley Art Exhibit," 1958

Miller, Barney S./M., Major / Sgt. (1902-1990) (USDB, Santa Maria)
Photographer, amateur, active with Santa Maria Camera
Club, 1950s, president 1954 and color chairman 1956.
His films of flowers taken in Korea and Japan were
shown to the Minerva Club, 1954. First chairman of the
photography section of the Santa Barbara County Fair.
Husband to Lillian Miller, below.
■ "Mr. Miller was born in Leeds, England and moved to
the United States in 1907 (?). He settled in Los Angeles in
1920 and moved to Santa Maria in 1949 where he served as
a quartermaster officer at Camp Cooke He joined the
National Guard in 1928 and entered the U. S. Army in
1941, serving in Alaska, Europe and Korea. He retired as a
major in 1960 (?). He was active in many civic projects and
was the first chairman of the photography section of the
Santa Barbara County Fair... [and club memberships
named] Survivors include his wife of over 65 years, **Lillian
F. Miller**...," *SMT*, July 26, 1990, p. 6.
Miller, Barney (notices in Northern Santa Barbara County
newspapers on microfilm and on newspapers.com)
1954 – "Major Miller on Home Leave. Maj. Barney Miller
is at home on leave after 17 months of duty in Korea with
the Quartermaster Corps. He has been reassigned to duty at
USDB, Lompoc, and meanwhile will reside here at his
family home 544 DeArmond. Mrs. Miller drove to Seattle
to meet her husband... on August 13. The Millers spent a
week or so traveling home, routing their way through
scenic spots where it was possible to take color
photographs. While overseas, Major Miller filmed movies
to add to a 'memory' collection that includes many scenes
from earlier European travel as well as American gardens
and flowers. Both camera fans, the Millers were successful
on their recent homeward trip in getting reflection pictures
at Crater Lake, logging and river scenes in the Rogue River
area," *SMT*, Aug. 27, 1954, p. 4.
1957 – "'Round the Town. After a week's vacation in
Death Valley and Kingston, where they visited gold and
tungsten mines, Maj. and Mrs. Barney Miller went to
Monrovia and visited Mrs. Alice M. Ruedy, mother of Mrs.
Miller...," *SMT*, Jan. 5, 1957, p. 4.
1958 – "Barney Millers Home After Trip... 18-day
vacation trip with their trailer, traveling to their ranch in
Death Valley and to Zion and Bryce National Parks and

Grand Canyon. On the trip the Millers had luck with
photography in beautiful scenic country and in changing
weather. On one occasion their trailer and camp was
covered with snow and on another they tried photography
in a cloudburst on the desert. Both have been active in the
Santa Maria Camera Club," *SMT*, Nov. 6, 1958, p. 5.
1963 – Supervisor of photo division at Santa Barbara
County Fair, *SMT*, July 13, 1963, p. 8, photo caption.
Miller, Barney (misc. bibliography)
Barney Miller, mother's maiden name Appleston, was b.
Aug. 8, 1902 in Other Country and d. July 23, 1990 in
Santa Barbara County per Calif. Death Index (refs.
ancestry.com).
See: "Miller, Lillian," "Minerva Club," 1954, "Minerva
Club, Art and Hobby Show," 1957, 1958, "Santa Maria
Camera Club," 1954, 1955, 1957, 1959

Miller, Barse (1904-1973) (Southern California)
Painter, nationally known. Some of his paintings were
lent by a Los Angeles art gallery (Cowie or Dalzell
Hatfield) to the Santa Maria Art Festival, 1953.
■ "Painter in oils and watercolors. Miller studied at the
National Academy of Design, New York, at the
Pennsylvania Academy of the Fine Arts, and in Paris. He
moved to California in 1924 where he remained until
World War II. Locally he taught drawing and painting at
the Chouinard Art Institute and elsewhere and painted
murals. Miller served in World War II in the Pacific and
afterwards settled in New York where he taught for a
number of years at Queens College before devoting full
time to his painting in Maine," and extensive bibliography,
Nancy Moure, "Dictionary of Art and Artists in Southern
California Before 1930," (*Publications in California Art*,
vol. 3).
See: "Santa Maria Valley Art Festival," 1953

Miller, Evylena Nunn (1888-1966) (Santa Ana)
Painter who with three other members of the Women
Painters of the West, spoke to the Minerva Club on head
dresses, 1936. Painted a canvas of the Santa Maria Inn.
■ "Painter, teacher, Evylena Miller moved to Santa Ana
with her family when she was high school age. She studied
art at Occidental and Pomona Colleges and at the Los
Angeles Normal School. She further studied at the Art
Students League of New York and at the Berkshire School
of Art. From 1911 to 1918 she taught art in Claremont High
School and in Riverside Girls High School. Later she
taught at Santa Ana High School and from 1920 to 1922
taught two years in a boy's school in Japan. She returned to
Los Angeles via China and Egypt, and the paintings made
on that trip were published in Evylena Nunn Miller's
Travel Tree (Santa Ana: Fine Arts Press, 1933)," and
extensive bibliography in Nancy Moure, "Dictionary of Art
and Artists in Southern California Before 1930"
(*Publications in California Art,* vol. 3).
1928 – "Business Men Back Chamber of Commerce... One
of the more recent projects -- booklet of 12 pages ... The
front and back cover portrays 'The **Santa Maria Inn**,
redolent with Old World Charm' and is taken from a
painting by E (?) N. Miller. The back page is a pastoral

scene of cattle browsing under a spreading oak …
Bountifully filled with pictures …," *SMT*, Nov. 16, 1928, p. 1.
1936 – "Women Painters Visit Minerva Club to Talk on Head Dress … Miss Hill was accompanied on her visit to Santa Maria by Evalina [sic. Evylena] Nunn Miller whose painting of **Santa Maria Inn** is reproduced in color on Chamber of Commerce bulletins. She is junior past president of Women Painters of the West. Miss Miller is especially interested this time in sketching picturesque spots in this part of the state and in seeing the native flowers, which are dotting the hillsides," *SMT*, March 21, 1936, p. 2 (?).
Indexed in Nancy Moure, *Publications in California Art Indexes*, vols. 10, 12.
See: "Hill, K. Ethel," "Minerva Club," 1936

Miller, Frank John (1874/75-1941) (Lompoc)
Painter. Exh. "Santa Barbara County Fair," 1891, 1892, 1894. Teacher, Los Olivos school, 1897+. Prop. Miller's in Lompoc, 1911.

■ "Funeral Services for Frank Miller… for many years a resident of Lompoc… Mr. Miller was the son of the late Andrew Miller who came to Lompoc with his family in the '70s. The deceased was an instructor in the local school previous to embarking upon his business career as owner of the Elite café [bakery and soda fountain]. For the past several months he has been in ill health…," *LR*, Oct. 31, 1941, p. 8.
Miller, Frank (notices in Northern Santa Barbara County newspapers on microfilm and on newspapers.com)
1890 – "Graduating Exercises… first public graduating exercise given by our public schools… The boys and girls who have just received their diplomas may now enter the Normal School of San Jose or Los Angeles without further examination… The graduating class consisted of … Mr. Frank Miller of the Maple school…," *LR*, Sept. 20, 1890, p. 3.
1892 – "Union High School. Following is the list of students in the High School with their classification: Middle Class – Scientific Course – … Frank Miller…," *LR*, Jan. 23, 1892, p. 3.
1897 – "A private letter from Los Olivos announces that the Board of Trustees has elected Frank J. Miller of Lompoc as teacher in Los Olivos school district for the ensuing year," *SMT*, Aug. 14, 1897, p. 4, col. 3. [See: "Mattei, Clarence" for an anecdote of this era.]
1920 – WIFE – "Mrs. Miller's Death Occurs at Altadena… Mrs. Sadie Miller… She was united in marriage with Frank J. Miller on December 21, 1903. Mr. Miller was engaged in the merchandise business in this city until last year when he sold out and they moved to Santa Ana, Cal. where he again engaged in business and where they made their home until a few weeks ago when they sold out the store and moved to Altadena, in the hope that the climate at that place would benefit Mrs. Miller," *LR*, May 28, 1920, p. 1.
1922 – "Eight Named in Race for City Council… Frank J. Miller, bank cashier, president of the library board and member of the grammar school board," *LR*, March 24, 1922, p. 1.

1924 – "Miss Lothele Miller, who is attending the teachers' college at Santa Barbara, came up and spent the weekend at the home of her father, Frank Miller of the Pacific Southwest Bank…," *LR*, Nov. 11, 1924, p. 5.
1930 – "3 Councilmen End Terms of Service… The terms of the other members… Frank J. Miller, will expire within the near future," *LR*, March 7, 1930, p. 1.
1933 – "1932, Year of Marches… Bicyclists for Repeal of Law… They even staged races… Then next year, Frank Miller, who lived at Floradale Farm and kept himself in the pink of condition by pedaling to his teaching duties at Purisima school, won the race over a circular track located across H street from the grammar school…," *LR*, Jan. 6, 1933, p. 2.
1940 – "Ramblings… Frank Miller, Local businessman, taught Purisima and won recognition that landed him the job as vice-principal of the Lompoc elementary school…," *LR*, Aug. 9, 1940, p. 8.
And several notices in the *LR* in the 1890s detailing Miller's grammar and high school education were not itemized here.
Miller, Frank (misc. bibliography)
Frank J. Miller is listed in the 1880 U. S. Census as age 5, b. c. 1875 in Calif., residing in Santa Barbara County with parents Andrew J. Miller (age 38) and Elisa J. Miller (age 38) and three siblings: Henry, Ida, and Ella; Frank John Miller, teacher, age 23, 5' 5 ½", fair complexion, blue eyes, brown hair, registered to vote April 27, 1898 in Los Olivos per *Santa Barbara County – Ballard Precinct*; Frank John Miller gave the following information on his WWI Draft Registration Card dated Sept. 12, 1918 = b. Aug. 19, 1875 [Sic?], a merchant, residing in Lompoc, Ca., with wife Sadie; Frank J. Miller, 1874-1941, is buried in Lompoc Evergreen Cemetery per findagrave.com (refs. ancestry.com).
See: "Lompoc, Ca., Union High School," 1891, "Mattei, Clarence," "Miller's," "Santa Barbara County Fair," 1891, 1892, 1894, "Teacher Training," 1895, and *San Luis Obispo Art and Photography before 1960*

Miller, Lillian Florence Myers (1901-1996) (Mrs. Barney S./M. Miller) (Santa Maria)
Photographer who specialized in color slides of vacation trips and flowers / gardens. Color photo chairman of the Santa Maria Camera club, 1954. Often projected her slides or films to Santa Maria clubs. Very active with Minerva Club Garden Section, 1950s. Photo contest judge, 1960. Collector of plates, 1958. Wife of Barney Miller, above.

■ "Lillian Florence Miller… Mrs. Miller was born June 30, 1901 in Kansas City, Kan. She was a resident of Santa Maria for more than 45 years and a homemaker for more than 65 years. Mrs. Miller was a member of the Order of Eastern Star Mizpah Chapter #100…," *SMT*, Feb. 12, 1996, p. 5.
Miller, Lillian (notices in Northern Santa Barbara County newspapers on microfilm and on newspapers.com)
1952 – "British Cousin, Guest at Tea" and cousin visited with her aunt, Mrs. Alice M. Ruedy in Compton and with Capt. and Mrs. Barney Miller, 544 DeArmond, Santa Maria, *SMT*, Jan. 9, 1952, p. 4.

1953 – "Garden Section to Hear… Minerva Club…
Another feature of the program will be the exceptionally
beautiful colored slides taken by Mrs. Barney Miller during
her travels in Germany, Holland and Switzerland. In
addition, Mrs. Miller will show scenes from the flower
division of the 1952 Santa Barbara County Fair which were
photographed by **Mr. J. Miles Boothe**," *SMT*, Jan. 6, 1953,
p. 4; port. as Minerva Club Flower Show chairman, *SMT*,
Oct. 20, 1953, p. 4.
1954 – "Flowers are Topic…," at Minerva Club Garden
Section meeting, "Outstanding photography in color films
of gardens and flowers about the world were viewed
yesterday… Mrs. Barney Miller showed films with
comment [and several films were loaned by others] **Maj.
Barney Miller**, Korea and Japan, and Mrs. Miller's
pictures photographed of many beautiful formal gardens
and scenic spots in several countries of Europe.
Exceptional in color photography were pictures of tree
peonies and Korean park scenes by Major Miller… There
was special interest in the ones Mrs. Miller had made at the
1953 Spring Flower show of the Minerva club," *SMT*, Jan.
16, 1954, p. 4.
1955 – "Films of Mexico are Shown Garden Section. Color
slides that illustrated a travel talk on Mexico and the San
Blas Islands by Mrs. Barney Miller… The films showed
many out-of-the-way places not usually seen by tourists…
Most of the roads appeared in good condition for travel, but
at least one of the films showed a road where it was
necessary to drive through a stream, with young boys,
working as guides who offered to sit on the radiator and
point the way… Mrs. Miller showed one picture of a
deserted hacienda which was a large and beautiful home of
a land owner. … The films also included a study of
Maximillian's palace, which is now a museum. The
audience enjoyed many interesting studies of cactus and
flowers and something unusual but common in Mexico,
cactus hedgerows. As an added feature, there were several
displays of flower arrangements…," *SMT*, Nov. 12, 1955,
p. 4.
1957 – "'Round Town. Maj. and Mrs. Barney Miller have
returned from a vacation of two weeks at their ranch in
Kinston Valley. They called at Monrovia for Mrs. A. M.
Ruedy, Mrs. Miller's mother," *SMT*, Dec. 5, 1957, p. 2.
1958 – Port. with plates she collected to be shown at
Minerva Club's Hobby & Arts Show, *SMT*, April 10, 1958,
p. 3; "Barney Millers Home… M-Sgt and Mrs. Barney
Miller have returned from an 18-day vacation trip with
their trailer, traveling to their ranch in Death Valley and to
Zion and Bryce National Parks and Grand Canyon. On the
trip the Millers had luck with photography in beautiful
scenic country and in changing weather. On one occasion
their trailer and camp was covered with snow, and on
another they tried photography in a cloudburst on the
desert. Both have been active in the Santa Maria Camera
Club," *SMT*, Nov. 6, 1958, p. 5.
And, additional notices for "Mrs. Barney Miller" in the
SMT, 1950s, cover her activities with the Santa Maria
Camera Club, the Minerva Club Garden Section and
Flower Show, and her illustrated lectures to various clubs,
some of which were not itemized here.

Miller, Barney, Mrs. (misc. bibliography)
Lillian F. Myers is listed in the 1910 U. S. Census as b. c.
1902 in Kansas, living in Los Angeles with her parents
John W. Myers (age 31) and Alice M. Myers (age 31);
Lillian F. Miller is listed with Barney Miller in the *Santa
Maria, Ca., CD*, 1959-83; Lillian Florence Miller, mother's
maiden name Moss, father's Myers, was b. June 30, 1901
in Kansas and d. Feb. 10, 1996 in Santa Barbara County per
Calif. Death Index (ref. ancestry.com).
See: "Community Club (Santa Maria)," 1954, "Miller,
Barney," "Minerva Club," 1954, 1960, "Minerva Club, Art
and Hobby Show," 1957, 1958, "Santa Maria Camera
Club," 1952, 1954, 1955, 1957, 1959

**Miller (Barrett), Minna "Minnie" (Mrs. Thomas C.
Barrett) (1873-1933) (Santa Maria)**
*Child artist. Exh. painting of deer at Art Loan Exhibit,
1895.*
More than 45 notices for "Miss Minnie Miller" in the *SMT*
between 1880 and 1895 show she attended Central School
(1883), turned 12 (c. Oct. 24, 1885), had brothers named
George, Willie, James, and Herschel, was a member of
Eastern Star, was active socially, and participated in
amateur theatricals, but they were not itemized here.
Miller, Minnie (misc. bibliography)
Minna Miller is listed in the 1880 U. S. Census as age 6, b.
c. 1874 in Calif., residing in Santa Maria with her parents
Isaac Miller (age 52) and Annie Miller (age 41) and
siblings: Isaac, James, George and William; Minna Miller
was b. Oct. 21, 1873 in Calif., married Thomas C. Barrett,
and d. Jan. 14, 1933 in SLO per 1Davis/Cloud Family Tree
(ref. ancestry.com).
See: "Art Loan Exhibit (Santa Maria)," 1895

**Miller, Ralph Davison / Davidson (1858-1945) (Los
Angeles)**
*Artist. One of his paintings was owned by M/M Harry
Nuss, 1926.*
■ "Ralph D. Miller, Painter, 87 … of 2035 Laughlin Park
Drive … The artist broke his hip in a fall a month ago…
Miller was born Sept. 7, 1858 at Cincinnati and came to
Los Angeles in 1890 to live here hereafter except for a six-
year period when he resided in the art colony at Carmel. He
painted actively until a year and a half ago when arthritis
compelled him to put aside his brushes. Miller began
painting seriously in 1880 in Kansas City. His works,
which presented largely characteristic California scenery,
the mountains, deserts and the sea in its varying moods,
were exhibited in galleries all over the country. One honor
in which he took pride came to him in 1919 when the
Gardena High School students, beginning their custom of
selecting the best work by a California painter each year,
chose one of Miller's paintings…," *LA Times*, Dec. 17,
1945, p. 12.
See: "Collectors, Art/Antiques," 1926, and *Central Coast
Artist Visitors before 1960*

Miller's (Lompoc)
Retailer of artists' materials and frames, 1911-17+. Prop.
Frank John Miller.
Miller's (notices in Northern Santa Barbara County
newspapers on microfilm and on newspapers.com)
1910 – "F. G. [sic.?] Miller has returned from a business
trip to San Francisco and is now engaged in arranging to
open his new store in the Rudolph block," *LR*, Sept. 30,
1910, p. 5, col. 1; "The Graham Drug Company have
disposed of their magazine and newspaper agency to **F. J.
Miller**, who will carry on the business in the Graham Drug
store until his new store on H street is opened up," *LR*, Oct.
7, 1910, p. 5, col. 2; "F. J. Miller's new store on H street is
nearing completion and promises to be one of the neatest
and most attractive in town. The fixtures are all of mission
design. Spot cash prices will make Miller's the Mecca of
discerning shoppers," *LR*, Oct. 21, 1910, p. 5, col. 2;
"Don't forget Miller's when doing your Christmas
shopping. Look over their line of well-made, durable toys,
dolls, games and books," *LR*, Dec. 2, 1910, p. 1.
1911 – "Artists oil and water colors, drawing paper, water
color paper, mat boards, brushes and other art material may
be had at Miller's," *LR*, Jan. 27, 1911, p. 5, col. 3; "Oil and
water colors, drawing paper, canvas and other artist's
material at Miller's. A new line of picture mouldings just
arrived," *LR*, May 19, 1911, p. 5, col. 3; "Business and
social stationery of all kinds at Miller's. Artist material,
pictures, and picture framing at right prices," *LR*, July 7,
1911, p. 5; "Plaques, frames, boxes and many other articles
for pyrography work just in at Miller's," *LR*, Dec. 4, 1911,
p. 5, col. 5.
1912 – Ad: "You are safe at Miller's. Fine China, English
semi-porcelain and the best of American Crockery are
found on our shelves. A most complete line of thin blown,
cut and pressed glassware is carried... Our line of kitchen
and household ware is as complete as we can make it...
latest magazines... popular books... stationery... Your
Pictures Framed at Miller's," *LR*, July 26, 1912, p. 17; "Do
you want a beautiful picture Free? You can have your
choice of ten different subjects by inserting a classified ad
in the *Record*. Call and see them. Miller will frame the
picture at a special rate," *LR*, Aug. 2, 1912, p. 4; ad: "Have
Your Pictures Framed at Miller's. F. J. Miller, Prop'r. New
Mouldings in Stock," *LR*, Oct. 18, 1912, p. 4; "Beautiful
hand painted copies of old French China at Miller's," *LR*,
Nov. 22, 1912, p. 3, col. 4; "Beautiful hand painted hangers
at Miller's...," *LR*, Dec. 13, 1912, p. 4.
1915 – "Framed pictures, marble busts and statues and
picture frames on display at Miller's. A new and attractive
line," *LR*, Dec. 10, 1915, p. 7, col. 1.
And additional ads for "new line of picture frames," 1913,
1917, not itemized here.
See: "Miller, Frank J."

Millier, Arthur (Los Angeles)
Los Angeles Times art critic and artist who frequently
traveled to the Central Coast for subject matter for his
water colors and etchings. He praised Lompoc for its
artistic beauty, 1957. His prints were shown at the Alpha
Club, 1935.
■ "Arthur Millier was a British-born American painter,
etcher, printmaker, and art critic. He was the art critic for
The *Los Angeles Times* from 1926 to 1958," per Wikipedia.
See: "Alpha Club," 1935, "Hibbits, Forrest," 1957,
"National Art Week," 1935, "Scholastic Art Exhibit,"
1932, "Seldis, Henry," and *Central Coast Artist Visitors*
before 1960

Mills, Elizabeth
Artist who exh. at Santa Ynez Valley Art Exhibit, 1954.
Two artists named "Elizabeth Mills" (Elizabeth Ann
McCandless Mills, 1915-1993, and Elizabeth Lucille Mills,
1913-2002) are listed in Edan Hughes, *Artists in California*
1786-1940, but whether one of them is this artist is
unknown.
See: "Santa Ynez Valley Art Exhibit," 1954

**Mills, Jody Rich (Mrs. Abbot L. Mills) (1928-?) (Santa
Barbara / Connecticut)**
Weaver who won an award for her stole at the Santa
Maria Valley Art Festival, 1952.
Mills, Jody (notices in California newspapers on microfilm
and on newspapers.com)
1950 – "Magazine Pictures Life at Scripps. Claremont. Life
at Scripps college is pictured on four pages in the current
issue of *Life*... Other local personalities... are Abbott
Mills, his wife, Jody Rich Mills, and their son, born four
weeks before she was graduated from Scripps...," *Pomona*
Progress Bulletin, June 23, 1950, p. 8.
1953 – Winner at a fair for her wool and raw silk suiting
material, *LA Times*, Oct. 25, 1953, p. 277 (i.e., magazine?,
p. 33).
1955 – "28 Weavers Exhibit ... Scripps College National
Weaving Show at the Florence Rand Lang Art Building...
Directing it is Mrs. Marion Stewart, lecturer in weaving at
Scripps... Former students of Mrs. Stewart exhibiting
include... Jody Rich Mills, Santa Barbara," *Pomona*
Progress Bulletin, Feb. 23, 1955, p. 15 (i.e., p. 3, sec. 2).
Mills, Jody (misc. bibliography)
Jody R. Mills is listed with husband Abbot L. Mills,
reporter for the Santa Barbara News Press in the *Santa*
Barbara, Ca., CD, 1951, 1953; Jody R. Mills is listed with
husband in *Darien, Ct., CD*, 1956-67; Jody R. Mills b.
March 3, 1928, is listed in Guilford, Ct., in 1996 per *U. S.*
Public Records Index, 1950-1993, vol. 1 (refs.
ancestry.com).
See: "Santa Maria [Valley] Art Festival," 1952

Minerva Club (Santa Maria)

Organized as Literary Society, 1894. Name changed to Minerva Club, 1906. The Minerva Clubhouse, designed by Julia Morgan, opened 1928. Handicraft Section was started 1934. The Club held art programs, and a flower show that contained a competition for floral design. It held Art Loan exhibits in 1895 and 1920, a National Art Week exhibit of Santa Barbara artists in 1940, and an Art and Hobby Show, 1957, 1958, 1959.

■ "Minerva Club. Something was missing in Mollie Smith's life. So, one Friday in October 1894 she … invited 24 women over to her Santa Maria home. These friends came thirsty for tea, coffee – and intellectual discussions. That day the **Ladies Literary Society** was born, and in the 103 years since, Santa Maria women have expanded their minds… and helped their city develop. … the LLS attracted more and more members, and became the Minerva Club, a group that continues to shape Santa Maria history. [The ladies] … wanted to get out of the house now and then, meet other women, and find out about other ways of life. They wanted to learn about health issues and practical concerns, and they wanted to enjoy the arts. So the LLS held frequent get-togethers that began with readings of poems, articles, and books, which sparked heated conversations. … The club, which changed its name in 1906 to honor founding member Minerva Thornburg, was a driving force behind Santa Maria's first public library. In their first year, the LLS had raised $79.09 to start a library. Committees were formed: a bookcase bought; and by summer of 1896, Santa Marians had 90 books to choose from. T. A. Jones' store gave the fledgling library a corner in which to set up. There it grew to 268 books by 1899, and the society hired a librarian, who raked in the wage of $1 a month. But the books, as their number grew, needed a permanent place to be, as did the multiplying group of women. So, the Minervans wrote to library benefactor Andrew Carnegie, and to the State Federation of Women's Clubs, asking for financial help – but didn't wait around for it. The women held suppers, lunches, teas, and lavish balls … Through all the fund-raising and planning, the club's members kept up their meetings and discussions. … 'We do not discuss religion or politics. We don't care what church you go to or how you vote,' said Klein. Explorations of art and peeks into other worlds are still the main courses at Minerva get-togethers. … Santa Maria's public library, funded in part by the Minerva Club, opened in May 1909 [Sic.] … Dinner dances, flower shows, cake sales … brought in a few hundred dollars at a time to the clubhouse building fund. And plenty of Minerva money also poured into other groups' bank accounts, including the one that paid for The Plunge, Santa Maria's public swimming pool in 1925. … One member's mother happened to have a formidable architect friend. **Julia Morgan**, who designed Hearst Castle, stepped in to design the Minerva clubhouse. The building at Lincoln and Boone in Santa Maria is on the National Register of Historic Places. Besides educating themselves the Minervans – who now number 475 – have shown a commitment to spreading educational opportunity around in their community. … scholarship fund was begun in 1952…. Other Santa Maria charity groups get much-needed Minerva boosts …," by

Diane D. Urbani, "Minerva Club," *SMT*, March 27, 1997, B-1, B-5.

■ "History of Santa Maria's Pioneer Literary Club," including comments on the art loan exhibit, *SMT*, Oct. 11, 1919, p. 6.
Minerva Club (notices in Northern Santa Barbara County newspapers on microfilm and on newspapers.com)

1895 – See: "Art Loan Exhibit (Santa Maria)," 1895.

1899-1906 – Study groups on the works of various authors and on various countries, public lectures of a general appeal, entertainments, concerts and dances.

1906 – "Meeting of Minerva Library Club… Paper on life of [Washington] Irving… History of the Alhambra, illustrated by pictures…," *SMT*, Sept. 8, 1906, p. 6.

1919 – "Russia and her Music. … The fascinating subject of Russia has been studied by the club for several months. Russian art, literature and geography have been reviewed in papers and informal talks by the members…," *SMT*, Nov. 22, 1919, p. 8;

1920 – "Art Exhibit is Minerva Club Plan… plans for March 19 in the Masonic hall… [reprises] art exhibit given by the club many years ago in McMillan's hall. Santa Maria is rich in historic interest and background… keepsakes and heirlooms… Examples of the best in modern art will form a large part in the display. Notable examples of the paintings of California artists and others are owned by private individuals here… The committee is at work now…," *SMT*, Feb. 21, 1920, p. 5; "Minerva Club Exhibit Brings Out Heirlooms," *SMT*, March 1, 1920, p. 2; "Famous Old Relics to be Shown at Minerva Exhibit," *SMT*, March 20, 1920, p. 1; "**Art Loan Exhibit** … of the Minerva Club, which will be held in the store building next door to Northman's, Thursday afternoon and evening, April 8. The exhibit, judging from the valuable collections of works of art, relics and curios, which have been listed, will be one of the greatest achievements in Santa Barbara county… [and description of two rare items] Two of the best paintings of the late William Keith … will be shown … All the exhibits will have the owner's name and a description," *SMT*, April 6, 1920, p. 2.

1921 – "Noted Artist Will Address Minerva Club Members," i.e., **Fernand Lungren** to discuss Santa Barbara School of Arts, *SMT*, Feb. 17, 1921, p. 5; "Minerva Club Holds Interesting Program… **Fernald [Sic.] Lungren**, artist of Santa Barbara, was unable to be present at the Minerva club meeting yesterday afternoon in the Guild hall, on account of illness…," *SMT*, Feb. 19, 1921, p. 8.

1922 – "Minerva Club Members Enjoy Program on Art" – Artists of the Nineteenth Century by Mrs. K. R. Holeman and others discuss Corot, Millet and Inness, *SMT*, Jan. 21, 1922, p. 5; "Art Exhibit Open to Public Friday March 10," i.e., Minerva Club sponsors exhibit of **Print Makers Association of California** at Red Cross rest room, *SMT*, March 8, 1922, p. 5; "Prints to be Exhibited Tonight at Red Cross Bldg" and lecture by Mr. **S. G. Breneiser**, director of art in the high school, *SMT*, March 13, 1922, p. 3; "Minerva Club Holds Enthusiastic Meet" and intends this

year to study "California" including government, art, grammar, history and music, *SMT,* Sept. 15, 1922, p. 5.

1923 – "Minerva Club Members Enjoy Special Program" lecture on 'True Values in Costume Development' by **S. Breneiser**, followed by actual costumes modeled by living models, *SMT,* Nov. 17, 1923, p. 5.

1924 – "Minerva Club Enjoys Art Lecture at School. Yesterday afternoon in the high school auditorium, the **Blue Mask** club… presented… a lecture on the modern interpretation of paintings by **Stanley G. Breneiser**…," and extended description of program by **Blue Mask Club** which consisted of nine living pictures (posed by members), representing various schools of painting – Italian, Spanish, French, English, American, *SMT,* Nov. 8, 1924, p. 5.

1928 – "New Minerva Club Home is Dedicated with Reception and Ceremonies… on Lincoln and Boone streets… 34-year-old organization… The organization held its meetings every week at homes of the various members and its first settled home was **Mrs. Stearns'** studio…," *SMT,* Oct. 27, 1928, p. 5.

1929 – "Charity Work… Minerva Club… **Miss Ruth Blanchard**… gave an interesting demonstration on wrapping and tying Christmas packages…," *SMT,* Dec. 13, 1929, p. 12.

1930 – "Minerva Club will Have Speaker… Miss **Mary Wesselhoeft**, artist from Santa Barbara… Miss Wesselhoeft will give a demonstration lesson in flower arrangement. She is a well-known artist who studied color and design with Denman Ross at Harvard and has made two stained glass windows in Santa Barbara – one in the Natural History museum and the other in the Unitarian church… Members of the Garden Section will have arrangements of flowers for Miss Wesselhoeft to criticize," *SMT,* Oct. 15, 1930, p. 5.

1931 – "'Flower Arrangement' Provides Theme… Minerva Garden club… Monday afternoon at 2:30 o'clock when **Miss Mary Wesselhoeft** of Santa Barbara will lecture on Flower arrangement… Miss Wesselhoeft, who has studied this subject under the best instructors including Dale Robbins of Yale university, will… show… how to arrange them, as to color schemes and balance…," *SMT,* Feb. 27, 1931, p. 5.

1934 – "Garden Groups of Three Clubs Meet Here… Mrs. **P. H. Benson** [of the Alpha Club, Lompoc]… explained the work of their home handcraft section and declared the purpose… is to create interest and knowledge of what can be done in the home by means of handcraft at very little expense…," *SMT,* Feb. 7, 1934, p. 3; "New Handicraft Club Section Will Meet… at the clubhouse… with **Mrs. D. D. Smalley**, chairman… **Mrs. Lucy Benson** of Lompoc, county federation chairman of handicraft will… assist in outlining a program. Products… by members of the Alpha club of Lompoc under the guidance of Mrs. Benson, were… displayed… at a recent meeting of the Garden section…," *SMT,* March 6, 1934, p. 2; "Twenty-six Join New Club Unit… of the newly organized Handicraft section… with **Mrs. D. D. Smalley** as chairman…," *SMT,*

March 8, 1934, p. 2; "Minerva Club to Form Handicraft Section," and article says, "Holding its first meeting, the newly organized handicraft department of the Minerva club, outlined plans … under the direction of **Mrs. D. D. Smalley**, chairman… Helping with the program was **Mrs. Lucy Benson** of Lompoc, county federation chairman of handicraft. At a recent meeting of the garden section here, specimens of the handiwork of members of the Alpha club in Lompoc, which were made under the guidance of Mrs. Benson, were displayed," *SMFA,* March 9, 1934, n. p.; "Garden, Handcraft Units Meet… The Handcraft section will be presided over by **Mrs. D. D. Smalley**, chairman," *SMT,* March 31, 1934, p. 2; "**Miss [Ruth] Blanchard** Talks on Handicraft… An exhibit of work done in her classes [at the high school] offered splendid suggestions," *SMT,* May 11, 1934, p. 3.

1935 – "Handicraft Group… this section will continue throughout the summer. Since the section started last fall members have finished a great many hand-made articles. Knitting was the most popular type of handiwork done," *SMT,* April 25, 1935, p. 2; "Minerva Club Hears Huntington Library Expert Talk on Museum… During the business meeting… **Mrs. C. B. Ferguson**, chairman of the handcraft section, announced that the objective of the group for the year would be the creation of a wall hanging for the clubhouse done in crewel work," *SMT,* Sept. 7, 1935, p. 2.

1936 – "Heirlooms and Lecture Brings Colonial Atmosphere to Club," i.e., exhibit of heirlooms and talk on restoration of Colonial Williamsburg, *SMT,* Feb. 8, 1936, p. 2; "Japan Draws Inspiration from World" speaker at Minerva Club, and display of flower arrangements, screens, wall hangings, vase, statuary, *SMT,* March 7, 1936, p. 2; "Hairdresses is Theme for Minerva Talk. Hairdresses of women since 1350 B. C. to the present day will be discussed and illustrated by **K. Ethel Hill** in her lecture 'Crowning Vanities'… Friday afternoon at 2:30 o'clock. She will show 75 colored slides taken from paintings by **Blanche Collet Wagner**…," *SMT,* March 17, 1936, p. 3; "Women Painters Visit Minerva Club to Talk on Head Dress" i.e., lecture by **K. Ethel Hill**, member of the Women Painters of the West and student of costume, illustrated with 75 colored slides painted by **Blanche Collet Wagner**, and accompanied by **Evylena Nunn Miller**, *SMT,* March 21, 1936, p. 2.

1937 – "Minerva Club Hears Artist and Author … **Anthony Euwer**, artist and author, illustrated to members of the Minerva Library club yesterday afternoon, his ability to picture both the commonplace and the unusual in scenes and happenings, both with his pen and with water colors. Quoting poems inspired by the beauties of nature, and others suggested by children and persons of his acquaintance, he added much by his colorful manner of expression. These selections were taken from a collection entitled, 'By Scarlet Torch and Blade.' Known as a 'master of humorous jingles and limericks,' he recounted a number taken from his 'Clinic Limerique,' on the human anatomy. Euwer also exhibited a collection of landscapes in water color, some humorous paintings and original book plate designs, as well as copies of his volumes of poems. An exhibition of water colors is being shown in Los Angeles at

the present time by the artist and poet," *SMT,* Feb. 6, 1937, p. 2; **Stanley** "**Breneiser** to Talk to Minerva Club" on modern print making, and an exhibit of original prints from the collection of his son **John Breneiser** will be shown, *SMT,* March 16, 1937, p. 3; ■ "'Vision is the most important part in appreciating art and must come through intellect and emotion, instead of being purely physical,' said **Stanley G. Breneiser**, art instructor in the Santa Maria high school, who spoke on art prints at the regular semi-monthly meeting of the Minerva Library club yesterday afternoon. Mr. Breneiser's speech pointed out that the four types of vision are the practical, curious, imaginative, and pure. Very few people have the most important type of vision, the pure, which is the dissociation of a common thing from what it really is, he said. A widespread interest is taken today in the different print methods, he pointed out, asserting that prints are most easily understood and appreciated than other forms of art, and one need not be a connoisseur of art to be able to enjoy them. The speaker also gave the history of wood cuts… He showed the club his collection of etchings, lithographs, aquatints, woodcuts and wood engravings, to illustrate his talk," per "S. Breneiser is Minerva Club Speaker," *SMT,* March 20, 1937, p. 2; "Minerva Club Elects" and hears talk on architecture by Andrew Hill, Jr., principal of the HS, *SMT,* April 3, 1937, p. 2.

1938 – "Color Pictures of Flowers Shown" by Pasadena photographer, **Ernest Williams**, to Minerva club, *SMT,* March 26, 1938, p. 2; "Landscaping is Subject of Club Talk" by **George F. Verhelle**, landscape artist from Santa Barbara. "Verhelle, who is one of the owners of the Santa Barbara City Nursery, gave pointers on types of plants to use and how to plant them. He had with him a type of palm grown in Jerusalem during Christ's time and told his listeners that this could be grown here. He also displayed a thorn, mentioning that it, and not the kind generally accepted, was the type with which Christ's head had been bound. This plant had thorns six to eight inches long. … the average person uses three times as many plants as he needs … all foundation planting should be entirely in before the lawn is put in…," *SMT,* April 15, 1938, p. 3; Henry E. Huntington Library "Art Treasures to be Club Topic" lecture by **Catherine Price Nelson**, a researcher at the library, *SMT,* Nov. 29, 1938, p. 3.

1939 – "Fourteen Past Presidents of Minerva Club" honored, and talk by **Elizabeth Breneiser** on SF **Golden Gate Expo** and its art, *SMT,* April 22, 1939, p. 3.

1940 – "Many Artists Show at SM Exhibition" – Minerva Club/ **National Art Week** show, *Santa Barbara News Press* (clipping, hand dated Nov. 29, 1940, p. 22:1 in SMVHS).

1941 – "Art Objects to be Shown by Owner for Club," **George Porter** to Minerva Library club, *SMT,* Jan. 2, 1941, p. 3; "Collector's Items Shown to Club by Local Man" **George Porter** and article lists some of his antiques, begun when he inherited some from his grandmother, and stories about their acquisition, *SMT,* Jan. 4, 1941, p. 3; **Merrell Gage** – "Sculptor to Present Program on Lincoln for Minerva Club" – Lincoln as the Sculptor Sees Him. Gage is an instructor at USC, *SMT,* Jan. 15, 1941, p. 3; "Sculptor

Performs for Minerva Club … Donning a smock, the sculptor went to work on a mass of clay to fashion the bust of Lincoln… He worked from a life mask of Lincoln made just after his nomination for the presidency by Leonard W. Volk…" and recap of his demonstration/talk, *SMT,* Jan. 18, 1941, p. 3.

1943 – "Pre-War Scenes Shown Minerva … half film-lecture presented by **Francis R. Line**, color photographer, whose pictures of the Pacific area were taken shortly before the outbreak of war… Shanghai… Singapore … Guam, Wake… Midway… Dutch East Indies… Hawaii," *SMT,* Feb. 6, 1943, p. 3.

1945 – **Miss Louise Wood** – "Decorator to Address Club Women" at Minerva Club, *SMT,* Nov. 14, 1945, p. 3; **Louise Wood** – "Santa Barbara Decorator Addresses Minerva Club," *SMT,* Nov. 17, 1945, p. 3.

1947 – "**W. Gilbert** Speaks on Landscape" architecture to Minerva Club. "The trend for improved architecture… has stimulated a similar trend for better gardens… Gilbert illustrated his talk with brief sketches, emphasizing the desirability of unsystematical lines, large open spaces and the planting of slow growing shrubs and trees…," *SMT,* March 29, 1947, p. 3; "Designs for Windows to be Minerva Topic" by **Miss Margaret Meredith**, decorative consultant for Columbia Mills of NY, *SMT,* Nov. 19, 1947, p. 3.

1948 – "Orchid Floral Industry… garden certificates awards of the month… **Mrs. Irene Ferini**, 501 North Miller…," *SMT,* Feb. 28, 1948, p. 3; port. with camera and announcement that **Dorothy Dean Sheldon** will speak and show films of 'intimate views' of California birds, flowers and animals," *SMT,* March 2, 1948, p. 3; "Minerva Club Hears of New Trends in Furniture" from **Edgar Harrison Wileman** from Barker Brothers in LA, *SMT,* April 17, 1948, p. 5.

1949 – "Slides of European Scenic Spots… Belgium Lace-making Centers… colored slides are to illustrate an informal talk by **Marie J. Hibbets [Sic. Hibbits]**. Her husband, **Forrest Hibbets [Sic. Hibbits]** will have an exhibit of paintings," *SMT,* Jan. 5, 1949, p. 3; "Arranging Flowers is Demonstrated for Audience… before Minerva club yesterday of **Margaret Carrick**, authority… principles of contrast, repetition, interweaving, balance and opposition…," *SMT,* April 2, 1949, p. 5; "Minerva Club's History … An oil painting, study of flowers, purchased as a memorial to Mrs. Goodwin, was dedicated at the close of the program," *SMT,* Oct. 22, 1949, p. 5; "Antiques to be Subject… History of early pressed and molded glass… **Ruth L. Koonce** art collector and owner of the Seven Gables studio, Santa Barbara, is to be the speaker … She will also speak on travel in Europe and from the standpoint not only of a collector but an artist, since she had a number of fine paintings, her own work," etc., *SMT,* Nov. 29, 1949, p. 6.

1950 – "America May Become Art Center Artist Says… **Milford Zornes** … [to] an audience at Minerva club yesterday… Zornes, who began his education in Santa Maria public schools…," and newspaper describes his lecture, *SMT,* Feb. 18, 1950, p. 6; "Will Give Talk on Art at Public Showing of Paintings" at Minerva Club re: paintings

by 56 artists of North Santa Barbara County and Nipomo which are on view at the club, **Tri-County show**, by **Joseph Knowles**, *SMT*, May 10, 1950, p. 6.

1951 – "**Patricia Sailors** [of Sloan's Beverly Hills] to Tell Minervans of Home Décor," *SMT*, Jan. 3, 1951, p. 5; "New Color Schemes for Home Please Clubwomen," *SMT*, Jan. 6, 1951, p. 5; "Minervans Will Hear Speaker on 'Antiques. **Harry L. Kaplun** [Sic **Kaplan**] of Santa Barbara whose business is antiques… He will bring items from his Santa Barbara collection… and has invited members of the club to bring articles on which they would like opinions as to authenticity of value…," *SMT*, April 17, 1951, p. 4; **Harry L. Kaplan** of Santa Barbara "Speaker Tells Club the Story of Collecting" i.e., Minerva Club, *SMT*, April 21, 1951, p. 4.

1952 – "Story of Pottery Told [Minerva Club] by S M Artist," **Jean DeNejer**, who speaks of general world-wide development and "Among work shown was a stoneware bell, made by Rick Patterson, a bowl, made by **Ward Youry** of Santa Maria High school faculty, and other pieces by **Mrs. Wildenhain**, **Miss Laura Andresen**, UCLA art department teacher, and Antonio Prieto of Mills college teaching staff and others by Mrs. **DeNejer**," *SMT*, Feb. 9, 1952, p. 4; "**Richard Gump** Will Tell Jade Story," *SMT*, Dec. 30, 1952, p. 4.

1953 – "To Hear **Richard Gump**" of Gump's in SF, port, speak on Jade, Jewels and Junk, *SMT*, Jan. 3, 1953, p. 4; "Jade Story is Told by **Richard Gump**," *SMT*, Jan. 7, 1953, p. 4; "Table Settings to Highlight [Autumn Flower] Show. First autumn flower show in many years will be sponsored November 7 and 8… Minerva club members have been busy for a week making posters… are done in fall shades of green, brown, orange and yellow. Striking and original in design, they are to be on display in all of the smaller towns in the valley," *SMT*, Oct. 27, 1953, p. 4; "Winter Wonderland… Christmas meeting… demonstration of making Christmas candles by Mrs. A. T. Garey… blocks of paraffin were sealed together with a hot iron, melted and poured into a container for size. Next, a mixture, using poster paint for color, was whipped up and applied in the manner of cake frosting and sprinkled with gilt powder… Another feature was the making of a Danish Christmas tree composed of tinsel balls and red ribbon in streamers and rosettes…," *SMT*, Dec. 12, 1953, p. 4.

1954 – "Flowers are Topic at Garden Meeting… Outstanding photography in color films of gardens and flowers about the world were viewed yesterday… **Mrs. Barney Miller** showed films with comment. Included were those loaned by **Mrs. A. B. Hanson**, taken in Japan and Hawaii, of Switzerland and France from **Mrs. Burns Rick**'s collection, of India and Siam, from films owned by Col. Harry L. Mayfield, British Columbia and Mexico, taken by **Dr. and Mrs. W. Leland Smith**, **Maj. Barney Miller**, Korea and Japan, and **Mrs. Miller**'s pictures… of many beautiful formal gardens and scenic spots in several countries of Europe. Exceptional in color photography were pictures of tree peonies and Korean park scenes by **Major Miller**… There was special interest in the ones **Mrs. Miller** had made at the 1953 Spring Flower show of the Minerva club…," *SMT*, Jan. 16, 1954, p. 4; "Ybarra

Painting is Gift to Club. A water color seascape by **Alfred Ybarra** has been presented by his sister, **Mrs. Raymond Stearns**, to the Minerva club. The same donor presented two other paintings, all of them being accepted for the club yesterday… hung on the south wall of the new tearoom. Mrs. Stearns, who was present, passed an art magazine published in Mexico, that contained an illustrated article with a number of reproductions of her brother's paintings," *SMT*, Jan. 20, 1954, p. 4; "Minerva Club Entertains… The club received from **Mrs. Raymond Stearns** the third in a gift group of pictures for the club building. Suitably framed, the one accepted yesterday, pencil sketch by the late **Mrs. Minnie Stearns**, is valued as work of a charter member of the Minerva club," *SMT*, Feb. 3, 1954, p. 4; "Club Hears Speaker on 1954 Home Décor" **Edgar Harrison Wileman** of Barker Bros. in LA, *SMT*, March 3, 1954, p. 4; "Fall Parade of Fashions… Posters made by the **Rev. Leonard Wood**, have been distributed to local stores," *SMT*, Sept. 9, 1954, p. 6.

1955 – **Lynn Basse**, public relations representative with Cannell & Chaffin in LA "To Speak at Minerva Club" and "The speaker will not dictate a style… His firm subscribes to the idea that any period or style can be in good taste, the ultimate aim being to help with realization that a home in which one feels comfortable… The audience will be shown how to begin a decorating plan… the trend in decorating style today," *SMT*, Feb. 10, 1955, p. 7.

1956 – **Walter J. Knecht** of Ventura, "Landscape Artist to Speak Friday… The speaker, who owns several acres of growing plants, glass houses and lath houses has had experience working with decorative plants and flowers of every description… he is well versed on landscaping and recently has completed a refresher course on tropical and potted plants in a Los Angeles school," *SMT*, Nov. 6, 1956, p. 4.

1957 – "Puppet Theater to be Minerva Program" in comedy, opera and circus acts, by **Daniel Llords**, *SMT*, Dec. 5, 1957, p. 2; **Daniel Llords** … "Puppets! Colossal Show," *SMT*, Dec. 14, 1957, p. 3; photo of **Daniel Llords** with eight of his puppets," *SMT*, Dec. 16, 1957, p. 8; port of **Mrs. James Hosn** pictured with silver-sprayed dried grasses and seed pods she made for Christmas decoration, *SMT*, Dec. 17, 1957, pp. 2 and 3.

1959 – Photo of women checking posters for Minerva Club Fashion show, *SMT*, Aug. 24, 1959, p. 11.

1960 – Port. of **George Stuart** of Ojai and "Minerva Club Will Present George Stuart Artist, Sculptor… [his talk titled] 'Crown Versus Commonwealth' …," *SMT*, Feb. 1, 1960, p. 3.

Bibliography:
Vada F. Carlson, *This is Our Valley* (compiled by the Santa Maria Valley Historical Society), Santa Maria, 1959, Chapt. XVI "Cultural Development" p. 176+, includes the Minerva Club.
The Santa Maria Public Library owns the *Minerva Club Yearbooks* 1906-1947 and they can be browsed on the library website.
See: "Art Loan Exhibit (Santa Maria)," 1895, 1920, "DeNejer, Jeanne," 1952, "Floats," 1949, 1951, 1954,

"Jagla, Margarette," "Jones, Gaylord," "Minerva Club, Art and Hobby Show," 1957-59, "Minerva Club, Flower Show," "National Art Week," 1940, "Orcutt Women's Club," 1927, "Santa Barbara County Fair," 1941, 1952, "Santa Barbara County Library (Santa Maria)," intro., "Santa Maria Camera Club," 1952, "Santa Maria, Ca., Union High School," 1935, 1953, "Taylor, Elizabeth," "Westmont, Oscar," 1960, "Winter Arts Program"

Minerva Club, Art and Hobby Show (Santa Maria)
Show sponsored by the Garden section and held at Minerva clubhouse 1957, 1958, 1959.
Minerva Club (notices in Northern Santa Barbara County newspapers on microfilm and on newspapers.com)
1957 - First Annual: "Art and Hobby Show to be Sponsored April 12," *SMT,* March 8, 1957, p. 3, and article adds it will be held in the clubhouse with members and their families entering hobby collections; "Minervans Will Have Hobby Show" but article makes no mention of the art portion, *SMT,* April 9, 1957, p. 3; photo of **Mrs. George Rand** with 3 paintings, a dairy and silo south of Arroyo Grande… the Battles Plant… [and] "Market Scene in Mexico," and article says, "Art Exhibits for Hobby Show Friday" which states entries are limited to Minerva members, and "Added to exhibits by **Mrs. Donald H. Taylor, Mrs. Fred Beerbohm, Mrs. James Hosn, Miss Elizabeth Scott** and **Mrs. T. A. Twitchell** is to be a collection loaned by Mrs. Mabel Bright," of works by her father," [**Werner Lehman**], and 12 members have promised flower arrangements, *SMT,* April 11, 1957, p. 5; repro. of art section of show with Mrs. Melville Bright, organizer, holding **Werner Lehman**'s painting "Chinese Junk" and **Mrs. George Rand** looking on at some other paintings, and "Public Praises Hobby & Arts Show," and article adds, "Flowers, paintings and hobby collections combined to draw interest and praise yesterday at Minerva Club's first annual Hobby & Art Show. Response by the public may encourage the club to make it an annual affair… The stage in the main room was filled with an excellent collection of paintings, many of them picturing nearby subjects and landscapes, entered by the adult AHC College art class. Several paintings loaned by **Werner Lehman** were entered by Mrs. Melville Bright, a new member of Minerva club. Flower Exhibits… Tea Table … Hobby Collections. Hobby and travel collections filled the north room. These were Mrs. William V. Black, fine antique china and glass, Mrs. George M. Scott, ship's clock and collection of rare time-pieces, Mrs. A. B. Hanson, Japanese paintings and crafts, Mrs. John Murray, china tea-cup collection, Mrs. A. T. Garey, Elizabethan tapestry, Mrs. August Moliath, imported brasses, including warming pan, charcoal braziers, keys and candlesticks, Mrs. W. E. Coughlin, miniature pianos. Jewelry Imports. **Mrs. Burns Rick,** jewelry from Guatemala, Peru, Mexico, Alaska and India, **Mrs. Barney Miller**, porcelain snuff and trinket boxes, Mrs. Lloyd M. Clemons, two collections, of antique steins, and silver spoons, Mrs. William Forbes, early American glass. Mrs. Lloyd A. Pearson, carved ivories, George Radke, pipes and stamp collection, Mrs. Ray Andrews, wood salt and pepper shakers, **Fred Beerbohm,** carved wood canes, Mrs. A. A. Verdugo, hand knit stoles

and dresses, **Dr. and Mrs. W. Leland Smith,** jewelry, china, brass, copper, silver, wood and textiles from Mexico, **Mrs. James Hosn,** decorative hand-made ceramics, **Mrs. Ray Stearns,** book and plaques, Mrs. W. H. Summer, china clocks and ceramics, Mrs. J. Miles Boothe and Mrs. Scott Sinclair, books and china," *SMT,* April 13, 1957, p. 3.

1958 - Second Annual: "Hobby & Art Show at Minerva Club," but newspaper refers to it as the third annual, that it will be held April 11 at 1 p.m., that it is sponsored by the Garden section, and that it will contain hobbies and art, *SMT,* April 8, 1958, p. 3; "Art & Hobby Show Draws Exhibitors" to flowers, art, collections / hobbies categories including, in painting, three men: **Robert Wygle, Merton Likes** and **Fred Beerbohm** plus approx. 12 women artists will show paintings, *SMT,* April 9, 1958, p. 3; "Art, Hobby Show Attracts Visitors" and photo of **Mrs. Don Taylor,** with painting exhibited by Jacqueline Moffett, and article adds, "Praised as an excellent show combining art, flowers and hobby collections, visitors to Minerva clubhouse Friday said the Art & Hobby show should by all means be continued as an annual attraction. The show, open to the public, drew a gratifying attendance. The section displaying oil paintings was of interest for entries, desert cactus and fruit still life by **Werner Lehmann** [Sic. Lehman] and for still life and landscapes by **Robert Wygle. Mrs. Arnold Knudsen** entered her painting, 'Fishermen's Paradise,' and **Mrs. T. A. Twitchell** had two landscapes, one of them, 'Superstition Mountain.' 'View from Hancock College Campus,' was **Myrton Likes** entry, and visitors liked to look at 'Magnolia Blossom' by **Mrs. Betty Hosn.** Exceptional was the **Joey Wilson** pastel of Bryan Sheehy, and quality appealing to parents of boys was appreciated in **Mrs. George Rand**'s painting of boy with fishing catch. 'Minerva Clubhouse,' by Jacqueline Moffett was given a place of honor at the main entrance. It featured the red flowering eucalyptus that is now in bloom in the clubhouse garden. One picture in needlework was **Miss Elizabeth Scott**'s entry in art. Many valuable items were seen in the tables of collections. Mrs. Gladys Forbes and Mrs. Fred May, whose hobbies are antique furniture and silver, both had heirloom items, Mrs. May showing her grandmother's wedding silver. Antique vase, desk, file and ink stand with family album were Mrs. Frank Johnson's exhibit. **Barney Miller's** small ceramic saki bottles brought from Korea and Mrs. Miller's large collection of plates were admired by all show visitors. Haviland china and early American glass was entered by Mrs. Elsie Dorsey. Mrs. Milo Ferini's table was filled with Meissen ware in blue onion pattern. Kitchen appliances no longer in use, such as a sad-iron, waffle iron and apple-peeler, as well as carnival glass, was Mrs. Tonascia's exhibit. Mrs. William Summer showed a collection of ceramic originals, including a clock patterned after the Dresden china time pieces. Others were Mrs. Fred Luther, complete bedroom [sic?] set of Spode china in floral pattern; Victorian dolls, Mrs. Holmes Tabb; glass, Mrs. C. B. Ferguson and Mrs. Edgar Craig; Chinese antique china, Mrs. F. F. Pimentel; souvenir travel plate collection, Mrs. Manuel Bello; election campaign documents, buttons, posters, coins, and insignia, Mrs. Alfred Perlman. George Radke's Indian artifacts, all of them found in this area by the owner, included bowls and pestles, scrapers, axes, pipe bowls, drills, spearheads and

bird points of flint, the latter picked up near Betteravia Lake. Many exceptionally lovely flower arrangements…," *SMT*, April 14, 1958, p. 3.

1959 - Third Annual: "The Minerva Club Garden Section will present their third annual 'Arts and Hobby Show' Friday, March 13, in the Minerva clubhouse… There are to be 30 exhibitors in all with such countries as England, Persia, Mexico, France, Portugal, West Indies, Germany, Iran, and Morocco being represented. Colored glass will be on display as will a collection of campaign posters, antiques, 20 floral exhibits, 10 art exhibits featuring 2 pictures of each exhibitor, a table featuring named camellias grown in this area, and antique furniture," per "Public Invited to Arts & Hobby Show," *SMT*, March 10, 1959, p. 3; "Public Invited to Hobby-Art Show," *SMT*, March 12, 1959, p. 5; "Visitors to the Minerva Club's Hobby & Art Show yesterday praised it for one packed with interesting items… Large tables were set up in the tea room to hold collections of china, glass, textiles, leather and art from Denmark, Persia, Russia, Switzerland, Portugal, Germany, Holland, Mexico and other countries. One collection, mainly of silver, came from Ecuador and Peru. In the main room, the stage was set with a group of paintings that included a pair of exquisite pastels of a house in the country and weathered barn by Mrs. **Winifred Dixon**. Mrs. **Valerie Rand** entered a group, one a water color of the home of Mr. and Mrs. A. B. Hanson in Santa Maria. **Byron Openshaw**'s new painting of the old church at Sisquoc; a painting of Santa Barbara Mission, portraits by **JoAnn Smith Wilson**, a seascape by Robert Barror [b. c. 1950], and others were shown. Collections of dolls, antique silver and china, Sevres bowls, display from Iran and Morocco, furniture and brass, and campaign buttons, posters, and old periodicals, one carrying news of President McKinley's death…," per "Art & Hobby Show is Praised," *SMT*, March 14, 1959, p. 7 (i.e., p. 5); "Many valuable collections of art and crafts from foreign countries, no duplications of what had been shown before, marked the Minerva Club's Art & Hobby Show held the past week-end as the finest to date. … Mrs. Melville Bright was in charge of the art exhibit of paintings either original or loaned, by **Mrs. George Rand, Mrs. Donald Wilson, Mrs. M. S. Openshaw**, Mrs. Robert F. Barror, **Miss Olga Tognazzini [Sic. Tognazzi]**, Mrs. [Melville] Bright, **Mrs. James Hosn, Mrs. Arnold Knudsen, Mrs. Don Taylor** and Mrs. **H. W. Dixon**," and the article names flower arrangers and those contributing hobbies (but not the items they exhibited), per "Minerva Club Art Show Best to Date," *SMT*, March 18, 1959, p. 7.
See: "Breneiser, Stanley"

Minerva Club, Flower Show (Santa Maria)
Show usually held annually in spring. Floral displays of both specimens and arrangements. Some years the show sponsored a poster contest for school children. At other dates the show included a display of flower photos, often arranged by the Santa Maria Camera Club.
For Autumn flower show, see "Minerva Club," 1953.
Minerva Club, Flower Show (notices in Northern Santa Barbara County newspapers on microfilm and on newspapers.com)
1933 – "Flower Show… there has been splendid cooperation from the art departments of the grade and high schools whose posters … now decorate many of the downtown windows. Under the supervision of **Mrs. Stanley Breneiser**… Viola Bisho, **Carol Rushforth** and **Elaine Dudy** have executed conventional designs on black background. **Mrs. Dorothy Merritt Green**, art director in the grades… work of these pupils will be on exhibit at the flower show," *SMT*, April 28, 1933, p. 1; "Ribbon Prizes Awarded… An interesting feature in connection with the show was the spring flower poster contest conducted in the art departments of the local schools. After being used to announce the show in the business windows, they were hung in the lobby of the clubhouse during the flower exhibit. First prize was won by Irene Abajian and second by **Joffre Bragg**, both pupils of **Mrs. Dorothy Merritt Green** in the upper classes of El Camino street school. Other grade pupils who participated in the contest were …," *SMT*, May 3, 1933, p. 3.
1936 – "SM Pupils Win Floral Art Award" for their posters advertising Minerva Club annual spring flower show, "**Margaret Chester [Breneiser]** won first prize… Miss Chester's poster featured the red amaryllis. She received a prize of $2. Her poster will be displayed in the public library. **Masuo Ueki** took second place… First honorable mention went to Ruth Morishita for her tiger lily poster, **Elva Allen**, second honorable mention, morning glory theme, and Bert Sharwood, third honorable mention, modernistic interpretation of vines. Posters were made in the art classes of **Elizabeth Breneiser**…," *SMT*, April 23, 1936, p. 2.
1942 – "Oceanic Theme in Flower Show Exhibit," *SLO Telegram-Tribune*, April 23, 1942, p. 8.
1948 – "Poster Contest Winners Named" for Minerva Club Spring Flower Show, and include third prize to **Charmian Turner**, *SMT*, March 29, 1948, p. 1; "Mrs. Kenneth Trefts … As chairman of public relations for the flower show, Mrs. Harry C. Dorsey gave a report… She credited four local photographers, Joe Bell, **Kenneth Moore, Albert Taylor** and her son, **Harry Dorsey**, with a share of the publicizing the show with photographs of arrangements of flowers reproduced in *Sunset Magazine*," *SMT*, April 3, 1948, p. 5; repro: entry for Minerva Club flower show by **Mrs. Leon Vaughn**, *SMT*, April 5, 1948, p. 5 (date erroneously says April 7); repro: entry for Minerva Club flower show by Mrs. Ralph Bardin, and "Posters Are Given Honorable Mention… 5th, 6th, 7th, and 8th grades… Cook Street School …Miller Street School… Main Street School … El Camino… the honorable mention posters are on display in downtown stores," *SMT*, April 7, 1948, p. 4; repro: flower arrangement entry for Minerva Club flower show by Mrs. Robert E. Ferguson, *SMT*, April 8, 1948, p.

11; repro: <u>Mrs. Allen Fesler</u> and her flower arrangement destined for Minerva Club flower show, *SMT,* April 9, 1948, p. 1; repro: bonsai tree by **Mrs. George Rand**, *SMT,* April 8 [sic. 9], 1948, p. 5; repro: <u>Mrs. Fred O. [Elizabeth] Sherrill</u> with her flower arrangement for the Minerva Club flower show, *SMT,* April 10, 1948, p. 1; "<u>Mrs. Ferguson, Palmquist</u> Take Top Honors at Flower Show," *SMT,* April 12, 1948, p. 1.
1950 – "Flower Show <u>Posters</u> Judged … drawn by students in Santa Maria elementary schools … **Miss Edna Davidson**… announced winners [and children's names given including **Jesse Lopez**, seventh grade, son of Mr. and Mrs. S. V. Lopez]," *SMT,* April 28, 1950, p. 6.
1954 – "Club to Work on Flower Show <u>Posters</u>…," *SMT,* March 24, 1954, p. 4; "<u>Posters</u> are Designed for Flower Show," *SMT,* March 30, 1954, p. 4.
And numerous additional entries in the *SMT* on the Flower Show were not itemized here. Individual entries were NOT created for the makers of flower arrangements.
<u>See</u>: "Floral Design (Flower arranging)," "Minerva Club," "Santa Maria Camera Club"

Minerva Library Club
<u>See</u>: "Minerva Club"

Minetti, Henry (Santa Ynez / Cambria)
Teacher of woodwork in Cambria, 1926+, who grew up in the Santa Ynez area.
<u>Minetti, Henry (notices in Northern Santa Barbara County newspapers on microfilm and on newspapers.com)</u>
1926 – "To Teach at Cambria. Mr. Minetti has accepted a position at the Cambria high school where he will teach Woodwork, Physical Education and Mechanical Drawing," *SYVN,* Aug. 6, 1926, p. 1; "Solvang and Vicinity. … Henry Minetti, who received his B. A. degree from the state college at Santa Barbara this year, has accepted a position… Cambria high school…," *SMT,* Aug. 10, 1926, p. 6; "About People… visits his parents … of Santa Ynez," *SYVN,* Oct. 15, 1926; "Henry Minetti, who is teaching at Cambria, drove up to see the football game at Berkeley…," *SYVN,* Nov. 26, 1926; and many additional notices describing his returns to visit his parents in Santa Ynez not itemized here.
<u>See</u>: *Cambria Art and Photography before 1960*

Minetti, Italo (Guadalupe)
Photographer, Army Air Force, 1943. President of Guadalupe Rotary Club before WWII.
■ "Italo Minetti, former Guadalupe constable and president of the Guadalupe Rotary club when he joined the Army Air Force, is at home on a brief furlough from Victorville, where he is training in aerial photography. He gained 20 pounds in eight weeks after joining the Army. He hopes to be detailed for photographer instruction in Hollywood with a view to taking part in the making of battle pictures with the Army. His present work is photographing bomb-hits from planes," *SMT,* June 19, 1943, p. 3; "Italo Minetti who volunteered for the Air Service more than a year ago and has been stationed on Victorville Air Field, has been discharged as past the age for flying," *SMT,* April 7, 1944, p. 3.

Minetti, Umberto (1865-1936) (Santa Ynez)
Owner of a painting of Santa Ines Mission used as a backdrop for a booth at the Santa Maria fair, 1935.
<u>See</u>: "Collectors, Art / Antique (Santa Ynez)" 1935

Minnich (Miller), Mabel / Mable (Mrs. Francis Everett Miller) (1914-2011) (Kingsburg, Ca. / Fresno)
Painter of wildflowers who held an exhibit at the Santa Maria High School, 1938.
<u>See</u>: "Santa Maria, Ca., Union High School," 1938, and *Central Coast Artist Visitors before 1960*

Minnick, Mary Margaret "Marge"
<u>See</u>: "Fratis (Marsalisi) (Minnick), (Mary) Margaret "Marge" (Mrs. Joseph Marsalisi) (Mrs. James Minnick)"

Mintz, Harry (1907-2002) (Chicago / Los Angeles)
Artwork shown at first Santa Maria Valley Art Festival, 1952, courtesy Cowie or Dalzell Hatfield Gallery in LA.
■ "Harry Mintz (1907–2002) … was born in Ostrowiec, Poland ... he immigrated to the United States, where he spent the majority of his professional years painting in the Chicago and Los Angeles areas," per Wikipedia
<u>See</u>: "Santa Maria [Valley] Art Festival," 1952

Miranda, Ira Ernest (1905-1968) (Santa Maria)
Sign painter, 1935.
<u>Miranda, Ira (notices in Northern Santa Barbara County newspapers on microfilm and on newspapers.com)</u>
1930 – MOTHER – "Obituary. Leontine Salgado, 44… pioneer resident of this valley…," *SMT,* July 16, 1930, p. 5.
1935 – "Painter Fined. Ira Miranda, 30, Santa Maria sign painter, arrested yesterday for painting a sign at 114 South Broadway without a city license, received a $25 suspended fine in the city court … this morning after he purchased a license," *SMT,* Aug. 20, 1935, p. 4; "I Spied – … Ira Miranda, Spanish, painting a Chinese sign in a south Broadway window," *SMT,* Sept. 20, 1935, p. 1.
And, more than 30 additional notices for "Ira Miranda" in various Calif. newspapers 1920-1940 revealing he was also an auto salesman, were not itemized here.
<u>Miranda, Ira (misc. bibliography)</u>
Ira Ernest Miranda was b. April 13, 1905 in Santa Maria to James J. Miranda and Leontina Valenzuela, married Celia Medina, and d. Feb. 13, 1968 in Santa Maria per Hansen Family Tree (refs. ancestry.com).

Mission La Purisima (Lompoc)
Eleventh mission of 21. Founded 1787. <u>Owned by the</u>
<u>*State of California, not the Catholic Church.*</u> *The mission*
was restored by the National Park Service with CCC help
as a federal project during the Depression. The original
mission contained artworks such as wall paintings as well
as easel paintings hung on the walls, and "art," much of
it created by local Native Americans working at the
mission, was also seen in decorative wood carvings and
ironwork. The restored mission was dedicated as a state
historical monument, 1941. Over the years the mission
has been the subject of many photographs, paintings and
other artworks. Art and artisan festivals have been held
on its grounds.

■ "Mission La Purisima Concepción, the eleventh
mission in the chain, was founded by Father Lasuén on
December 8th, 1787; ... The structure of Mission La
Purisima has been rebuilt several times. The first mission
complex, originally built at the Indian village of Algascupi,
collapsed and was rebuilt of adobe in 1802, but an
earthquake in 1812 brought the mission down again. In the
spring of 1813, the mission was rebuilt about three miles
[north] from its original site in the Valley of Watercress,"
californiamissionsfoundation.org.
Mission La Purisima (notices in Northern Santa Barbara
County newspapers on microfilm and on newspapers.com)
1935 – "Mission Tract Becomes State Park This Week…
507 Acres," *LR*, Jan. 11, 1935, p. 1; "Architects Need
Pictures of Old Purisima Mission. Incidental to,"
restoration, *LR*, Jan. 18, 1935, p. 1; **"Pioneers** to Sponsor
Mission Restoration," *LR*, Feb. 1, 1935, p. 1; "Pictures of
Mission. A person from Los Angeles who makes a hobby
of collecting pictures of California's old missions was a
visitor at La Purisima last week end and the U. S. Park
Service officials will probably receive many valuable
pictures from him. In the days when the mission was still in
its glory, not many individuals had cameras – picture taking
was confined to professional photographers – and pictures
of the mission are scarce. … Already the Park Service has
received a fine picture of the chapel room in the main
buildings, which shows everything more or less complete
except that the altar has been removed," *LR*, Feb. 22, 1935,
p. 1; "Colored Walls. That Indians practiced their art of
painting on the walls of old Mission La Purisima is
evidenced by many bits of plaster that have been removed,
and now the **CCC** youths have found that many of the
rooms in the mission were bordered with colored plaster.
Bits of plaster have been found in green, blue, burnt orange
and yellow …. Apparently, the walls were painted with a
strip about two feet high running about just above the
floors. The rest of the walls were white. We also saw pieces
of hardware that the CCC youths have been making this
week, duplicating the old rusty hinges and door bolts found
about the ruins," *LR*, April 26, 1935, p. 1.
"A Fine Exhibit. Through the courtesy of the National Park
service staff at the mission park, a fine exhibit of
photographs and sketches is on display this week at *The
Record* office, along with a replica of the main mission
building. Photographs of the replica are difficult to
distinguish from pictures of the mission as it stood back in
1887 – it is correct in every detail and proportion and color.
It is made of plaster of Paris. … many of the pictures

shown disclose many details of the mission long forgotten
… Several pen and ink sketches, drawn by **Fred Hageman**,
are to be used in a booklet on the mission being published
by the local Chamber of Commerce along with a colored
scene painted by **Richard [Sic. Richmond] Kelsey**, Santa
Barbara artist," *LR*, Aug. 30, 1935, p. 1; "Start Burning
<u>Brick</u> for Mission Columns. Under the supervision of Mr.
W. I. Keerl, Ceramics engineer for the park service, four
Purisima camp enrollees set the kiln, at the Johns-Manville
plant, with 750 tiles for the mission columns, last
Wednesday. One day will be required for drying and three
days are needed for the necessary temperature in the tunnel
kiln," *LR*, Nov. 15, 1935, p. 9; "Palaver… Mission to be
Example. News reports from Washington last weekend
revealed that old Mission La Purisima is one of two
missions selected by the National Park service as examples
of their work in restoring historical sites. A photographer is
to take both still and <u>moving pictures</u> of Purisima and also
the mission in Goliad, Tex. Pictures have been taken from
time to time by the local park service staff, which, with the
new ones to be taken, will be used in a campaign to bring
about restoration of other historical sites. The pictures will
be made available for educational uses and will be part of a
campaign to let the nation know about La Purisima…," *LR*,
Nov. 15, 1935, p. 1.
1936 – "Mission Publicized… *National Motorist* magazine
for February … Illustrated with photographs of the mission
in the '90s, as it appears in present stages of restoration,
and pictures of the padres' soap works and of the nursery
for the mission gardens…," *LR*, Feb. 21, 1936, pp. 1, 8;
repro: three drawings of proposed restoration of mission,
LR, Sept. 4, 1936, p. 10; "State Park Board Asks **CCC**
Project… remaining restoration… [lesser buildings] I can
picture these buildings as the center of mission study…
Here can be gathered all of the relics pertaining to
missions… One of the rooms can be devoted entirely to
photographs and reproductions of views of Purisima
mission. Another room might contain the finest obtainable
views of each of the California missions. Another room
could be devoted to a library of books and papers relating
to the missions and, particularly, the data and drawings
used in the restoration of this mission…," *LR*, Nov. 20,
1936, p. 3.
1937 – "Plans Ready for Next Mission Unit. Brick Making
to be Resumed … Most of the **CCC** enrollees have been
occupied this week with project of laying out the gardens…
Artists have been at work during the last few weeks
decorating the chapel room in the residence building. The
pulpit has been completed and was being decorated this
week [**Everett Wurz**] as were the choir loft and
communion rails. The artists are painting parts of the rails
and pulpit so they appear like marble, similar to the artistry
of the mission founders. A group of enrollees have been
restoring the fountains that add to the attractiveness of the
gardens. A WPA project artist in Santa Barbara has
partially completed sculptor [sic.] work on the two Indian
heads that were part of the largest fountain …," *LR*, April
16, 1937, p. 1; "Tile and Missions… **Harry Hobbs**… The
'hard pan' that he has uncovered in his back yard is tile
flooring, once part of the original La Purisima mission…
And this is not ordinary tile – it is thinner than usually used
in California missions, and only one other mission has the

tile layed diagonally as in the 8 x 15 room Hobbs has uncovered…. Many of the tiles have the imprints of children's, dogs' and turkeys' feet. And now along comes Emmet O'Neill, pioneer resident… with a copy of an old painting … It is a painting discovered in San Francisco that is supposed to be the original La Purisima mission founded December 8, 1787. The painting shows a combination small church and monastery building, with walled garden in the foreground. … located between the present Catholic church and the mouth of Miguelito canyon. O'Neill opines that this picture is of the first mission founded here, which lasted only ten years before it was destroyed and then the padres built a larger mission establishment farther east, which was destroyed in 1812 by earthquake. He believes that the mission, now being restored in Mission canyon, was the third structure… rather than the second…," *LR*, May 7, 1937, pp. 1, 8.

"Chamber Commerce Publishes… a new edition of the booklet telling the history and restoration of 'Historic Mission La Purisima Concepcion' has been published… This booklet includes photographs and information on the many attractions and industries in The Valley Beautiful," *LR*, June 4, 1937, p. 3; "Palaver… articles on the history and restoration of old mission La Purisima appeared in the monthly magazine published by the Union Oil company. The cover and a dozen pages, complete with fine photographs…," *LR*, Nov. 19, 1937, p. 1; repro: artist's conception of mission, *LR*, Dec. 3, 1937, p. 4.

1938 – "An ancient bronze crucifix believed to be nearly 200 years old, has been uncovered by Ray Casses, one of the CCC youths working on restoration of La Purisima mission in Lompoc. The crucifix was buried seven feet deep in sand that had been washed about the old church since it began to go to ruin," *SYVN*, March 18, 1938, p. 8, col. 5; "Purisima Mission Gets Valuable Publicity… *LA Times*, rotogravure section…," *LR*, Oct. 7, 1938, p. 5.

1939 – "Excavation Shows 500-foot Indian Residence… It had been planned to take photographs of the foundations of what was believed to be the infirmary building, CCC enrollees were put to work clearing away dirt so that good pictures could be obtained; but the farther they dug, the larger the building appeared…," *LR*, March 31, 1939, p. 1; "Schoolmen… **Edward Rowe**, landscape artist of La Purisima Mission, gave an interesting campfire talk on 'Native Flora and its Influence on Early California Life'," *LR*, May 12, 1939, p. 2; This mission, restoration finished c. Aug. 1939, the town celebrated with "Mission Day" festival, *LR*, Sept. 1, 1939, p. 1 and following pages contain articles about Lompoc's history; "Drawings of La Purisima Are Finished. Two vivid water color drawings of scenes of La Purisima mission have just been completed by **Harvey Harwood**, National Park Service architect at Purisima camp. Harwood has painted many pictures of the colorful mission. One of the two pictures is a striking view of a portico of the administration building seen through the early California gardens. Drawn from the esplanade facing the gleaming white building, the central motif of the picture is the great drinking fountain of the old padres. The other painting depicts the drinking fountain and domestic storage fountain on the mission grounds," *LR*, Dec. 29, 1939, p. 3.

1940 – "Chamber Commerce Publishes Folder. Six-page folder showing several views of mission La Purisima and including short articles on the history and restoration of the old landmark was published this week… The attractive cover was photographed by **Paul S. Curie**, senior clerk in the NPS office at the CCC camp. Other photographs were taken by **Ernest Brooks**… and **E. D. Rowe**, landscape architect on the mission project," *LR*, March 29, 1940, p. 1; "Mission Units to be Rebuilt," *LR*, Nov. 8, 1940, p. 1;

■ "Mission La Purisima Concepcion: A Glance Through its History and The Story of Its Restoration. by H. V. Smith," *LR*, Dec. 13, 1940, pp. 1, 8; and Part VI. Reconstruction of First Unit Begun…," and full page article describing in detail how old photos were used to determine original construction, etc., *LR*, Dec. 27, 1940, p. 7. [And additional parts of article not itemized here.]

1941 – "Mission Fiesta Plans Completed… annual festival… October 5… a basket picnic, music and dancing on the mission grounds and demonstrations of artifacts of the old mission days. The latter will include exhibits of basket weaving, leather working, tile and adobe brick making and iron work…," *LR*, Sept. 26, 1941, p. 1; "Oil Painting to be Hung…," *LR*, Oct. 31, 1941, p. 2; "Ancient Picture as Mission Gift… [**Michael Cobera**, Sic. **Miguel Cabrera**] An oil painting of La Purisima mission will be hung in the mission as a gift from John R. Southworth of Santa Barbara and marks the first of gifts to be offered to La Purisima. The painting, entitled 'La Virgin Purisima'…," *SMT*, Nov. 1, 1941, p. 3; "County-wide Festival to End Sunday…. Famed Painting to be Unveiled at Ceremony… Part of the religious service will be the unveiling entitled 'La Virgin Purisima' by **Michel [Sic. Miguel] Cabrera**, 18th century Mexican painter who is known as 'The Murillo of Mexico.' The painting is signed and dated 1771. The painting is 7 feet by 5 two inches. It was purchased in the City of Puebla, Mexico, in 1903 by John Southworth and was taken to London in 1911 during the Mexican revolution. The painting was subsequently brought to Santa Barbara by Southworth in 1920. It was given by Southworth and accepted by the State Park Commission to hang in the reconstructed church at La Purisima…," *LR*, Dec. 5, 1941, pp. 1, 10.

1949 – "Move to Make Purisima Living Monument… Purisima Park program discussed by the state group at its first meeting since reorganization several weeks ago… The question of the kind and type of handicrafts to be developed at the mission was reviewed. The plan is to have people living at the mission and following the handicrafts which were undertaken there during the days of the Padres. … The possibility of… obtaining artifacts and exhibitions from the museums in Santa Barbara and Los Angeles was also discussed," *LR*, July 28, 1949, p. 1; "Ramblings… This week we unearthed some really fine photos – made by a Padua Hills artist at the time the reconstruction of La Purisima Mission was getting underway. Bess Garner brought the Padua Hills players here and put on a fine little fiesta at the Old Mission…," *LR*, Dec. 1, 1949, p. 14.

1953 – "Members of Pioneer Spanish Family … Frank Gutierrez, curator of the museum at La Purisima Mission, was made very happy this week by addition to its art treasures of an old oil painting of 'San Miguel Archangel.' The painting was a gift from Miss Eva Rodriguez of Ventura, a niece of Senora Josefa Malo de Janssens, who was born at the Mission in 1855. Background of the gift is

the secularization of the Missions... Jose Ramon Malo bought La Purisima from John Temple for $1600... This was in 1845 and it was one of the first three Missions sold at auction.... When the Malo family moved from the Mission, some of the original articles were taken with them for safe keeping. They now are being returned to La Purisima to their original places...," *LR*, July 9, 1953, p. 5.
1955 – "Mission Development Plan Outlined by State... The largest of the projects planned is the restoration of the mission water system... [others]... completion of the pottery kiln and acquisition of pottery accessories... construction or acquisition of furnishings and fixtures for the shops and quarters... acquisition of Stations of the Cross paintings for the church ... Eventually the plan calls for the location of families at the mission who will follow trades which prevailed in the mission era. Products such as pottery and weaving produced by them will be sold to make the project self-supporting," *LR*, March 10, 1955, p. 1; photo of oil portrait of Father Fermin Lasuen, founder of Mission La Purisima, *LR*, Aug. 11, 1955, p. 1.
1957 – Repro. and caption reads, "Gift for La Purisima. The California Division of Beaches and Parks has selected La Purisima mission as the repository for the above painting. The picture was given the State by the R. W. Bates (left) of Carpinteria. It has been identified by the Rev. Maynard Geiger, OFM of Santa Barbara Mission, as a painting of St. Anthony of Padua... Fr. Geiger believes the work, which was discovered in Italy, is based on the legend of the apparition of the Christ-child to St Anthony. The surrounding figures are angels. St. Anthony wears the Franciscan habit. The picture has been hung in the main church building at La Purisima," *LR*, Dec. 19, 1957, p. 22.
1958 – "Sill Makes Report on Mission Restoration... Several acquisitions in the way of furnishings and equipment were made... three 18th century statues, including La Purisima, St. Anthony, and St. Joseph. They were obtained from Mexico through Alfred Stendahl, Hollywood importer. The statues have been placed in the small chapel where the mission staff also built and installed an altar. A large painting of La Purisima and one called the Virgin of Hope were procured and hung in the chapel...," *LR*, Jan. 23, 1958, p. 1.
The *Lompoc Record* was filled with articles on the restoration of the Mission, Jan, 1935+, but this book has not the space to itemize all of them here.
Bibliography:
Fr. Zephyrin Engelhardt, *Mission La Concepcion Purisima*, Santa Barbara: McNally & Loftin, 1986, pp. 42+. "It seems the Fathers trusted this fancy work to the girls of the *monjerio*, that is to say all girls over eleven and unmarried women who dwelt together in a house set apart for them and by the people called the *monjerio* or nunnery... At some Missions, when they had found good tutors, the girls proved apt pupils so that there was little need to look to Mexico for anything but the material. In this year [1817] a fine cope was added to the sacristy wardrobe. It had golden galloons [ed. a narrow ornamental strip of fabric, typically a silk braid or piece of lace] and was intended to be worn by the priest for the first time on the feast of the Resurrection or Easter Sunday. Damask curtains, linen altar cloths, three surplices, five cassocks of blue material for the altar boys and three gilded chandeliers for the presbytery

are mentioned among the articles secured... 1818 ... articles procured for the church were ... In 1823 the church was enriched with an alb of the finest linen and an aice [Sic?] of the same material, both perhaps the offering and handiwork of some pious Senora or Senorita. Furthermore... six oil paintings of various saints were secured...," but some items were purchased from merchant ships. "The adobe church erected in 1818 and intended to be but a temporary edifice ... [became permanent] In 1825 its main altar was adorned with two statues, one of St. Bonaventure, the Seraphic ... and the other St. Anthony... The statue of the Immaculate Queen also received a new throne... but the church soon went broke supporting Spanish soldiers and their families...," and the new mission was being constructed on the opposite side of the river where the restored mission now stands.
"Mission La Purisima; The **Civilian Conservation Corps** Story," *Noticias*, v. 50, no. 2, Summer 2004.
See: "Civilian Conservation Corps," "Davies, John," "Ford, Henry Chapman," "Lompoc, Ca., Elementary Schools," 1935, "Mayhew, Nell Brooker," "Missions, in photography, art, silverware," "Motion Pictures (Lompoc)," 1946, 1948, 1959, "Olivera, Bob," "Photography, general (Lompoc)," 1937, "Ramirez, Jose," "Seegert, Helen," "Signs, general," 1947, 1950, "Works Progress Administration," "Young, Carl," and *Central Coast Artist Visitors before 1960*

Mission Santa Ines (Solvang)
Franciscan mission founded 1804 and restored c. 1947-55. Owned by the Catholic Church. Restored and expanded by art-oriented priests (Casimir, Kerwick, Cyprian, and O'Sullivan) at various times, over the years, primarily funded by private donations. Currently contains wall paintings and a large collection of other artwork (including painting, carvings, vestments, etc.). Held several celebrations in which there were exhibits of contemporary artists.

■ "Mission Santa Inés, in spite of being one of the last Missions to be founded, today possesses a remarkably large collection of paintings from the Mission period, as well as a number of statues. One of the most important paintings is The Archangel Raphael (pictured at right), currently on display in the Mission Museum. It is the only Mission-period painting on canvas by a native convert, other than a set of Stations of the Cross housed at another Mission (San Gabriel). The decorations in the church were done under the direction of skilled artisans who had access to old pattern books of neoclassical design. The skillfully executed architectural and floral decorations include the particularly fine floral and Greek key pattern in the sacristy. Designs outside the altar rail appear to have been done by neophyte artists. All the original designs (1818-1820) had survived untouched until they were restored and repainted in the 1970s." (from http://www.missionsantaines.org)
Mission Santa Ines (notices in Northern Santa Barbara County newspapers on microfilm and on newspapers.com)
1926 – "Preservation of Old Mission Under Way... members of Reina del Mar Parlor of Native Daughters... planting...," *SYVN*, Feb. 5, 1926, p. 1; "Santa Ynez Mission Will be Improved... restoration... At present time

Father Casimir is directing work in the Sacred Garden, just west of the Mission proper. A fountain and fish pond are now nearing completion...," *SYVN*, May 21, 1926, p. 1.

1927 – "Many Famous Paintings Displayed in Old Mission. Twenty-nine paintings...," and list of saints represented, *SYVN*, Feb. 25, 1927, p. 5; "Improvements being Made at Old Mission...," and gift of etchings by **Edward Borein**, *SYVN*, Nov. 4, 1927, p. 1; "Arts Displayed at Old Mission... **Edward Borein**, noted cowboy artist, is completing a commission for Mrs. Mary Perkins of Boston, calling for etchings of all the old Missions of California, which Mrs. Perkins is donating as a nucleus of an art gallery, to be one of the outstanding details in the development plans for the ancient structure. Ten of these etchings have been completed and the eleventh, which will be of the Santa Ynez Mission, is now being started. In addition, the ancient oil paintings which have hung in main chapel at the Old Mission for more than 100 years are to be transferred to the room set aside for the art gallery, and to supplement these pictures and etchings the room will also display costly robes of the padres...," *SYVN*, Nov. 11, 1927, p. 1.

1928 – "Visits Ancient Mission at St. Ynez, by J. A. Bosse...," *AGH*, May 24, 1928, p. 3; "Santa Ines Mission Founded in 1804...," and details on interior painting, murals, *SYVN*, July 27, 1928, p. 16.

1930 – "An old Spanish painting recently received as a gift... 'This was painted by **Miguel de Santiago** for Doctor Manuel de Dios Perez y Molia unto the greater glory of God – the year 1623...," and mission art is overseen by **Father Kerwick**, *SYVN*, Aug. 22, 1930, p. 4.

1931 – "New Book Just Published... '*The Mission of The Passes*' Old Mission Santa Ines by Miss Marie Walsh... [contains] a map indicating routes to the Mission... illustrated with rare old photographs, documents and charts," *SYVN*, April 17, 1931, p. 1.

1933 – "Norwegian Artist Renews Old Canvas... **Al Sonndag**, Norwegian artist of... Oakland, and who has been engaged to paint the murals of the new War Memorial building in San Francisco, displayed some recent sketches and gave a most interesting talk to about twenty ladies at the Mission Santa Ines on Monday afternoon. Mr. Sonndag talked on the restoring of a canvas found by Father Jarlath of the Mission several months ago in an obscure corner... was shown to the artist on a previous visit of his to the Mission... Mr. Sonndag most generously offered to restore the canvas for the mere cost of materials... represents the Nativity and is about 8 feet by 9 feet in size... early Peruvian and about three hundred years old, being painted on hand woven canvas made in strips and sewed together...," and details, *SYVN*, July 28, 1933, p. 1.

1941 – "Mission Santa Ynez Has Fine paintings... *SLO T-T*, March 24, 1941, p. 30 [Sic. p. 14].

1947 – "Repair Work to Start Soon on Buildings at Old Mission," *SYVN*, April 4, 1947, p. 4; "Restoration... Shows Part of Building Once Had Second Level," *SYVN*, Oct. 10, 1947, p. 1.

1949 – "Valuable Carved Tablet Returned to Old Mission... hand carved wooden tablet depicting what is believed to be St. Anthony ... brought to the Mission this week by **Mrs. Lockwood de Forest**... who said it had been sent to her by Mrs. Anna Gilman Hill of Palisades,

Rockland County, N. Y. In a letter to Mrs. de Forest, Mrs. Hill wrote, 'this ancient carved Spanish saint was purchased by Mrs. Winthrop Gilman from the priest in charge of the Santa Ines Mission in 1886 when we were camping near by ... The mission was neglected and in terrible disrepair and the poor priest was selling the vestments and carvings to pay for his food, etc....," *SYVN*, April 22, 1949, p. 2; "New Phase of Restoration Work Starts at Old Mission... rebuilding of a part of the Mission in the rear southwest corner, the extension of archways in the same area, repairing of the plastered exterior walls, the building of a parapet along the second story balconies, and the tearing down of the present bell tower and the erection of a new one which will more closely conform to the Old Mission architectural lines and the original design ... Architecture for the restoration work is being done under the direction of **Lawrence [Sic. Laurence] D. Viole** of North Hollywood, who specializes in Mission architecture," *SYVN*, Aug. 19, 1949, pp. 1, 3.

1950 – "Campaign to Raise Funds for Old Mission [restoration] Slated... $4,000... completion of the rooms on the south end of the Mission...," *SYVN*, May 5, 1950, p. 1.

1951 – "**Father Cyprian** Ends Work, Leaving Mission... After successfully directing a program of restoration at Old Mission Santa Ines the past five years... Father Cyprian came to the Mission in October of 1946. His assignment was for a three-year period and it was during this time that the first stages of the restoration program began... The restoration project grew in magnitude and Father Cyprian's stay at the Old Mission was extended another two years to enable him to 'see the project through.' Among the work completed... was the re-creation of a second story and living accommodations, rebuilding of a portion of the Mission building in the rear, the extension of archways in the same area, repairing of the plastered walls, the building of a parapet along the second story, and the replacing of the bell tower with one which conformed more closely to the one which fell in 1911...," *SYVN*, Nov. 9, 1951, p. 1.

1953 – Photo and "One of Old Mission Santa Ines Original Bells Enroute to Holland for Recasting," *SYVN*, May 22, 1953, p. 1; "Mission Men's Club Members Paint Chapel at Santa Ynez... **Paul Kuelgen** and **Jack Griesbauer** headed the committee... Mr. Kuelgen directed the activities of the volunteers working out the color schemes... The interior was painted a beige color with white trim and cocoa brown base. A sky blue color was applied over the altar and Mr. Kuelgen will complete mural work behind the chapel this week...," *SYVN*, Oct. 2, 1953, p. 2.

1954 – Photo and "Recast Mission Bell to Herald New Year...," *SYVN*, Jan. 1, 1954, p. 1, and photo of bells, p. 5; "Carnival Proceeds to Aid Old Mission Restoration," *SYVN*, Jan. 8, 1954, p. 1; photo of **Dr. Kurt Baer** and Bob Cary, both of Santa Barbara, repainting virgin and "Restored Statue of Santa Ines will be Unveiled, Rededicated in Ceremony ... The restoration of the wood carved statue was done by Dr. Kurt Baer, professor of art of Santa Barbara College, University of California, and Bob Cary, Santa Barbara artist whose paintings of the patrons of the Missions and the Madonnas of the Americas are well known...," *SYVN*, Jan. 22, 1954, p. 1; photo of hand-carved statue of Junipero Serra and "Saint Agnes Gift Shop Open," *SYVN*, June 11, 1954, p. 4; "**Dr. Baer** at Old Mission

Directing Arrangements of Priceless Articles. Preparations for the 150th anniversary of Old Mission Santa Ines, begun last February with the $11,000 museum restoration, are now reaching an artistic climax. Dr. Kurt Baer … is spending three weeks at the Mission to supervise the arrangement of the priceless old paintings and artifacts in the museum and the sculptures in the church. Each piece will be numbered and its history described in a special folder now in preparation. Visitors may then take a complete tour of the Mission without a guide… Material for the self-guide folder is taken from the manuscript of Dr. Baer's forthcoming book, 'The Treasures of Santa Ines,' to be published in the fall. It will be a complete catalogue of the artwork…," SYVN, July 16, 1954, p. 8; "150th Birthday Today," SYVN, Sept. 17, 1954, p. 1 and newspaper has a giant 58 page issue with many feature stories; "**Father Tim O'Sullivan** Pastor Here Since '51" and summary of restoration of mission that he oversaw, SYVN, Sept. 17, 1954, p. 5; John "Gebhard Builds Grotto Replica for Garden of Old Mission… voluntary… replica of the famed Lourdes Grotto of the Pyrenees in Southern France… hand carved statues… from Oberammergau…," SYVN, Dec. 24, 1954, p. 6.

1955 – "Old Mission Santa Ines Anniversary… due to restoration programs of recent years, it is now emerging from a period of neglect… The restoration program became accelerated in 1947 with general repair and reconstruction, new roofs on the church and convento, reconstruction of the original convento and rebuilding of the campanario according to its original lines. From 1953 through 1954 … extensive work in the museum area, creation of a Chapel of the Madonnas and improvements to the church itself… During the past year… Funds for the new heating system were given the Mission by the Santa Barbara Foundation. Installation of the plant to provide heat for the museum was deemed necessary for the preservation of priceless paintings, sculpture, vestments and artifacts… A new addition to the museum during the past year is a 12 by eight-foot colored map drawn in vivid colors by Santa Barbara artist **Robert Cary**, which notes the Spanish Colonial Empire from 1492 to 1898… In front of the map on a glass enclosed table is a large-scale model of Mission Santa Ines in 1820… the work of **Ralph Preston**, Altadena ceramics designer. Preston spent three months engaged in research work before starting on the model, which took him a year to complete…," SYVN, Sept. 16, 1955, pp. 1, 4 and repro. of map; "Grotto Replica at Mission to be Dedicated after Mass… Gebhard [the creator] earns his living in the Valley by caring for the gardens of many of the large ranches … In addition, … he spends several hours and sometimes days, working at the Mission garden," SYVN, Oct. 7, 1955, p. 1; "36-Page Booklet Describes History of Old Mission… founding Sept. 17, 1804… photographs," SYVN, Nov. 11, 1955, p. 5.

1956 – "Visitor Here: Suggests Fund be Established for Museum Area at Old Mission. Charles Brady… with an armful of artifacts he had discovered in touring Old Mission Santa Ines property south of the Mission… suggesting that a fund be started for establishment of a closed sector in this area of the Mission property as a means of preserving Mission relics of the past," and text of his letter of appeal, SYVN, Nov. 9, 1956, p. 8.

1957 – The mission continues its annual fund raiser but the newspaper articles were not itemized here; "**Dr. Baer**'s book on Mission Reviewed… 'The Treasures of Mission Santa Ines' … history and catalogue of the paintings, sculpture and craft works at Mission Santa Ines…," SYVN, March 22, 1957, p. 2; "Early Day Mission Records Transcribed, Translated … from 1804-1904… Mrs. Louise Peck of Santa Barbara has presented a 200-page transcribed and translated volume of records to the Mission here. Working diligently for 50 weeks, Mrs. Peck has translated the first books of baptisms, marriages and deaths as recorded in Spanish… a cross file card index…," SYVN, Sept. 20, 1957, p. 1.

Bibliography:
Fr. Zephyrin Englehardt, *Mission Santa Ines*, Santa Barbara, Ca.: Mission Santa Barbara, 1932 (and illustrations include: an etching by **Edward Borein**, "Earliest Illustration of Mission Santa Ines," p. 5, and "First Authentic Etching," by **Henry Chapman Ford**, 1883, p. 9, and photo of interior of restored mission p. 165).
Baer, Kurt, *The Treasures of Mission Santa Inez*, Fresno, Ca.: Academy of California Church History, 1956.
See: "Donahue, Katherine," "Ford, Henry Chapman," "House, Elmer," "Lindsley, Holt," "Mayhew, Nell Brooker," "Missions, in photography, art, silverware," "Motion Pictures (Santa Ynez Valley)," 1940, 1946, "Murals," 1947, "Rowe, Edwin," "Vasquez, Rafael," and *Central Coast Artist Visitors before 1960*

Missions, in photography, art, silverware
California's missions supplied a popular theme to the state's artists, active from the mid-18th century to the present.

■ "San Francisco, Cal. The old missions of California have been pictured by many well-known photographers … for they are the Mecca for tourists and local residents. Everyone possessing a Kodak … feel that their collection is not complete unless they have one or more of the old missions… Many of the artists have the same mania; they must paint the missions for they are a departure from the rugged landscape and pastoral scenes. The jewelers took the old missions for their souvenir spoons and … 'made a hit.' They were ideal gifts, not only for residents of the Golden State, but to send to friends far and near. … [and a local? SF? artist is making for her daughter a series of silver teaspoons, each one having one of the old missions engraved on it] … Each one has the picture of the mission and the date engraved in the bowl of the spoon and on the handle is her name and the date of the birthday and the year 1900," SMT, July 7, 1900, p. 1.
See: "Abbott, Ronnie," 1956, "Borein, Edward," "Ford, Henry Chapman," "Lauritzen, Dillon," "Minetti, Umberto," "Mission La Purisima," "Mission Santa Ines," "Moore, F. J., Rev.," "Sandham, Henry," "Santa Barbara County Fair," 1953, "Santa Ynez Valley, Ca., Adult / Night School," 1949, 1954, 1955, and *Central Coast Artist Vistors before 1960*

Mockford, Frances Rose Alford (Mrs. Rev. Arthur Julian Mockford) (Lompoc)
Member of Art Section of Alpha Club, 1928, 1929. By the 1930s she and her husband were residing in Sacramento.
See: "Alpha Club," 1928, 1929

Modern Art
General opinions on "modern" art. Lectures to explain "modern art" to the lay person were popular.
Modern Art (notices in Northern Santa Barbara County newspapers on microfilm and on newspapers.com)
1931 -- "Moronic Art. A good many persons, puzzled by some of the so-called modernistic art, have a warm fellow feeling for the California preacher who achieved peculiarly artistic revenge on a bunch of harsh art critics. His wife had painted a few pictures that didn't make a hit with the critics. He thought they didn't know their business and decided to show them up. He took some canvases and, as he explains it, 'just slopped on a lot of paint.' Among the resulting works was a crude picture of a stout colored woman scrubbing clothes in a wash tub while gazing upward at a nondescript bird sitting on a modernistic clothes pole. 'Aspiration, by Pavel Jerdanowich, founder and supreme master of the disumbrationist school of painting,' was the description in the catalog compiled by this genius. He added the explanatory words: 'To those who realize that art depicts not what we see, but what we feel, hear and smell, these soul-revealing creations will be sources of ecstatic, moronic rapture.' They were. The pictures got a showing in several cities and were given serious study by various critics," *LR*, May 1, 1931, p. 2.
See: "Alpha Club," 1932, 1936, 1948, 1954, "American Association of University Women," 1957, "Business and Professional Women's Club," 1937, "College Art Club," 1927, "Delphian Society," 1934, "Federation of Women's Club," 1949, "Santa Ynez Valley Art Exhibit," 1954, "Santa Ynez Valley Union High School," 1946, "University of California, Extension," 1964

Modern Neon Sign Co. (Santa Barbara)
Sign company. Headquartered in Santa Barbara but was active in Lompoc and Santa Maria, 1959. Prop. Gene Wilkinson.
Modern Neon Sign Co. (notices in Northern Santa Barbara County newspapers on microfilm and on newspapers.com)
1958 – Ad: "Modern Neon Sign Co. Free estimates and Designing. **Gene Wilkinson**, Lompoc... Santa Maria... Santa Barbara...," *SMT*, Dec. 13, 1958, p. 2.
1959 – Ad. "Start the Year Out Right! Increase Your Business by Proper Identification with a Neon Sign, designed and built by Modern Neon Sign Co., 136 E. Haley St. – Santa Barbara. Phone: WO 2-1182. Lompoc: 213 ½ Ocean Ave., Phone 8-2891, Santa Maria, 311 No. Lincoln. Ph: WA 5-3725. Free Estimates & Designing. We Specialize in Provincial Type Electric Signs," *SYVN*, Jan. 9, 1959, p. 6.
And more than 70 notices in various Central Coast newspapers, primarily requests for variances to erect neon signs, were not itemized here.

Monakee, Fred William "Monte" (aka Mahneke) (1885/6-1964) (California)
Photographer with Santa Barbara Associates (a PR firm), who shot views of various parts of the Santa Maria Valley, 1935.
■ "News Photographer Tells Troubles of Cameramen... reminiscences of Fred M. [Sic. W.] Monakee given before the Argonauts' breakfast... Monakee, now a San Bernardino photographer, related some of his experiences with gangsters, aviators... while attached to the picture staffs of the *Chicago Tribune, New York Mirror* and other papers ...," *San Bernardino County Sun*, Feb. 12, 1937, p. 6.
Photos bearing the "Monakee" signature are contained in the photo negatives removed from the files of *The San Francisco Call* (1937-39) per cdlib.org.
Monakee, Fred (misc. bibliography)
Fred William Monakee provided the following information on his WWII draft registration card dated 1942 = b. May 1, 1886 in Hilbert Jct., Wisc., employed by Straud Arms Apt. at 500 S. Westlake Ave., LA; Fred W. Maneke was b. May 1, 1885 in Wisc., married Grace Trammel, and d. March 22, 1964 per ARKimmel Family Tree; Fred W. Mahneke (1885-1964) is buried in Cana Cemetery, Creal Springs, Ill. per findagrave.com (ref. ancestry.com).
See: "Photography, general (Santa Maria)," 1935

Monroe Hollywood Marionettes
See: "Puppets (Santa Maria)," 1932

Monson, Winnie (San Luis Obispo)
Artist who exh. at Santa Maria Art Festival, 1953.
See: "Santa Maria Valley Art Festival," 1953, and *San Luis Obispo Art and Photography before 1960*

Montgomery, Alfred (1857-1922) (Los Angeles)
"Farmer / painter" who spoke in Santa Maria, 1918.
■ "Painter, teacher. Montgomery never attended school and was bound out as a farmhand as a child. He later studied under a minister and earned a teacher's certificate at age sixteen. He rose to be principal of the drawing department in the public schools of Topeka, Kansas. On his own he painted corn, sheep and chickens becoming known as the farmer-painter. He lived in Los Angeles for sixteen years before his death," Nancy Moure, "Dictionary of Art and Artists in Southern California before 1960," (*Publications in California Art*, vol. 3).
1918 – "The farmer-painter, A. Montgomery, who has been lecturing in Santa Barbara for several weeks, will speak in Santa Maria at the Presbyterian church on March 10 on Religion in Art. He has had paintings on exhibition at the Paris exposition. It is a rare opportunity for the people of Santa Maria to hear a real artist. He is passing through town on his way east … Mr. Montgomery is to establish a boys' school in the northern part of this state where he has purchased several thousand acres for that purpose. The lads attending the school will be given a chance to work for their tuition," *SLO DT*, March 6, 1918, p. 3.

Montgomery, George (1916-2000) (Hollywood)
Actor / sculptor. Exh. with "Hollywood notables" at the annual Santa Ynez Valley Art Exhibit, 1953, 1954.

■ "George Montgomery (born George Montgomery Letz, August 29, 1916 – December 12, 2000) was an American actor, painter, director, producer, writer, sculptor, furniture craftsman, and stuntman who is best remembered as an actor in Western film and television," per Wikipedia.
See: "Santa Ynez Valley Art Exhibit," 1953, 1954

Moody, Louise G., Miss (1919-2013) (Lompoc)
Fine Art grad. from Radcliffe. USO "YWCA employee," Oct. 1943-April 1945. Teacher of a craft class for wives of servicemen at the USO, 1944.
1943 – "New Worker... Miss Louise G. Moody has recently joined the staff of the Walnut street USO... employed by the National Board of the YWCA... A native of Old Town, Maine, Miss Moody holds a B. A. degree in Fine Arts from Radcliffe college ... and was also a student at the University of Maine...," *LR*, Oct. 22, 1943, p. 4.
1944 – Port. and caption reads, "associate director for the YWCA at the Walnut Street USO Club," *LR*, Aug. 4, 1944, p. 4.
1945 – "To Santa Monica – Louise Moody, YWCA staff assistant for over a year and a half, who will now go to a USO center in Santa Monica," *LR*, April 6, 1945, p. 4.
Moody, Louise (misc. bibliography)
Louise Gray Moody was b. Old Town, Maine, Jan. 22, 1919 per Maine Birth Records; Miss Louise G. Moody, USO Staff Asst, Rep. is listed in *Lompoc Precinct No. 1* per *Santa Barbara County Voter Register*, 1942-44; Louise Gray Moody b. Jan. 22, 1919, d. Oct. 11, 2013 in Bangor, Maine and is buried in Lawndale Cemetery, Old Town, Maine per findagrave.com (ref. ancestry.com).
See: "United Service Organization," 1944

Moore, Anna Fatima (Mrs. Frank Bines Moore) (1868/70-1952) (Lompoc)
Charter member of Alpha Club (active c. 1909-1912). Her "Red Cactus" was exh. with art by other "pioneers" at the Alpha Club, 1954. Her son, Ernest Moore, excelled at drawing (per "Lompoc, Ca., Union High School," 1912) and her granddaughter Lothelle Moore Grossini, above, showed artistic talent.

■ "Funeral Conducted Here Tuesday for Mrs. Anna Moore... Mrs. Moore was born in Goleta on November 8, 1868. She attended Los Angeles Normal School, now UCLA, and upon her graduation came to Lompoc where she taught one year in the Miguelito school. Thereafter, she was married to the late Frank Moore, pioneer Lompoc merchant... A charter member of the Alpha club, Mrs. Moore took a leading part in civic affairs...," *LR*, March 27, 1952, p. 1.
Moore, Anna (misc. bibliography)
Anna F. Moore is listed in the 1900 U. S. Census as age 29, b. Nov. 1870 in Calif., married 1894, residing in Lompoc with husband Frank M. [Sic. B.] Moore (age 31, a merchant) and children Howard J. (age 5) and Earnest [Sic. Ernest] F. (age 4); Anna F. Moore (1868-1952) is buried in

Lompoc Evergreen Cemetery per findagrave.com (ref. ancestry.com).
See: "Alpha Club," 1954, "Moore Mercantile"

Moore, Barbara (Santa Maria)
Student at Santa Maria JC who exh. at several venues in Santa Maria 1951-53.
See: "Posters, general (Santa Maria)," 1951, "Santa Barbara County Fair," 1951, "Santa Barbara County Library (Santa Maria)," 1951, "Santa Maria, Ca., Union High School," 1951, 1953, "Santa Maria Valley Art Festival," 1953

Moore, Brett Frederick (1904-1950) (Santa Barbara)
Artist in National Art Week show at Minerva Club, 1940.

■ "Artist Sings 'Home on the Range' ... Cowboy, the range, art schools and painting – that has been the regular pattern in rotation of Brett Moore's life since his 13th [Sic. 15th?] year when in Denver he got a job with a cow outfit. Just now he is in the range pattern, patrolling Los Padres national forest. He put away his paint and brushes the day war was declared. ... Limns forest work. 'Every free minute I get, I use it to etch. I am doing a series of etchings of the forestry activity. The painting and landscapes will have to wait.' At 15, Brett Moore left the Denver High school and joined a cow outfit, following the stock with seasoned cowpunchers in Colorado, Wyoming, Nebraska and Washington. The cold winters in those states, he recalls, are no relation to California's milder winters. Upon occasion, the Santa Barbaran, in his pre-Santa Barbara days, went into action in small rodeos. Later he painted and drew the cow country and put figures of cowhands into them. Studied between times. Brett Moore always had the urge to paint, and between times of his work on the range he attended the Chicago Art Institute. He studied there for three years, working with Forsburg and J. de Forest Schook, among others. The last year he was there he was on the staff as instructor in drawing. Wanting more work in landscape, the young artist came to Santa Barbara in 1930 to study with **Belmore Browne** at the Santa Barbara School of the Arts, then in existence... The artist met his future wife and married her his first year here. She was Miss Beulah Smith, also a student at the art ... Lungren Influence. Mr. Moore's meeting with another Santa Barbaran played a momentous part in his life. He was the beloved artist, **Fernand Lungren**. Mr. Moore, on the staff of the Santa Barbara Museum of Art [Sic. Natural History?], was there when Mr. Lungren was painting the background for the bighorn sheep group of the Fleischmann mammal wing. The two became fast friends. Both loved the mountains and the desert and made many painting trips there. They saw the desert and its beauty eye to eye. The paintings and portraits of the artist were shown often at the **Faulkner Memorial Art gallery** in the public library ... Mr. Moore is just one more resident who came out for a short stay, succumbed to the charm of the place, and remained. They live in Mission canyon. Now his whole family is here. His parents... came out from Chicago several years ago and bought Dr. Horace Pierce's home here. They have been joined recently by their daughter...

Mrs. Waters, the former Miss Jesse Moore, was at the Chicago Institute of Art while her brother was and studied designing and interior decorating. Fred Moore [Brett's father] has a famous collection of Oriental rugs and is an authority on the subject. He also collects paintings. He retired recently as president of the Wall Paper and Paint company of Chicago," unidentified newspaper clipping on *Public Member Photos & Scanned Documents* on ancestry.com.

Moore, Brett (misc. bibliography)
Brett F. Moore, "artist," and Rep. is listed at 679 Mission Canyon Road with wife in *California Voter Register, Mission Precinct,* 1930-32, and as "artist" with wife at 215 E. Canon Perdido St., *Santa Barbara No. 12* precinct, 1934-36, and as "artist" with wife at 24 Maple Ave., *Santa Barbara Precinct No. 28,* 1938-40, and at the same address without wife, 1942-44; Brett F. Moore is listed as "instr. S.B. Sch. of Arts" in the *Santa Barbara, Ca., CD,* 1933 and as director, 1936 and at other times, consistently, as "artist"; Brett Moore provided the following information on his WWII Draft Registration Card = employed by U. S. Forest Service at the Los Prietos Ranger Station; Brett Frederick Moore was b. Jan. 23, 1904 in Iowa to George Frederick Moore and Sadie Ursula Brubaker, married Beulah May Smith, was residing in Omaha, Neb. in 1920 and d. Feb. 9, 1950 in Santa Barbara, Ca., per Waters Coalescent Family Tree; Brett Frederick Moore is buried in Santa Barbara Cemetery per findagrave.com; photos of Moore, including one at his easel, are contained in *Public Member Photos & Scanned Documents* (refs. ancestry.com).
See: "National Art Week," 1940

Moore, Kenneth Slocum (1906-1986) (Santa Maria / Arroyo Grande)
Photographer, amateur, specializing in color, late 1930s+. Founder Santa Maria Camera Club, 1938. Organized photography classes at Santa Maria High School, 1947/48. Taught crafts and photography at Arroyo Grande High School 1947/48.

■ "Obituaries... Mr. Moore was born in Sterling City, Okla. and had been a resident of Santa Maria since 1937. He graduated from Chico State University in 1931. And received his administration credentials from there in 1934. He did postgraduate work at USC and UCSB. Mr. Moore had been a principal of Rancho School in San Luis Obispo County and retired from San Luis Obispo School District in 1969, ending 37 years in the educational field. He is listed in the golfers Hall of Fame being credited with eleven holes-in-one. He was also very active in many service and educational organizations...," *SMT*, June 8, 1986, p. 26.
Moore, Kenneth (notices in Northern Santa Barbara County newspapers on microfilm and on newspapers.com)
1940 – "Guadalupe Rotarians... Kenneth S. Moore, member of the faculty of Cook street school in Santa Maria, entertained with a showing of color photography from portraits to clouds, snow scenes and forest fires," *SMT*, Dec. 21, 1940, p. 3.
1941 – "On Photo Tour – Kenneth S. Moore, instructor in Santa Maria elementary schools and an expert in color photography, is leaving tomorrow for Shasta dam and

Grass Valley to execute some orders for his work," *SMT*, June 11, 1941, p. 3.
1943 – "I Spied... A picture of 'rainbow mixture' chrysanthemums in color from a photograph by Kenneth Moore of Santa Maria, on the front cover of Vaughn's seed catalog, ten other color pictures by him throughout the catalog," *SMT*, April 19, 1943, p. 1.
1947 – "Resume Publication. Arroyo Grande Union High School has resumed publication of its bi-weekly newspaper, suspended during the war years. The school's journalism teacher, Kenneth Moore, is supervising. Moore lives in Santa Maria, where he taught for a number of years in the elementary school then he taught in Orcutt until this year. He is also well known for his commercial photography work," *SMT*, Oct. 13, 1947, p. 8.
1948 –"Moore Gets Contract as Principal. Kenneth S. Moore of Santa Maria has been elected teaching-principal of Nipomo Union elementary school. Moore was on the staff of Arroyo Grande Union high school the past year where he taught shop, crafts, photography, journalism and … tennis… The new principal served as principal of Eagleville school in Modoc county for four years and was also a teacher in Terra Bella school system in Tulare county for one year. He was a teacher, shop instructor and physical education teacher in the Santa Maria elementary schools for seven years and spent three years as teacher and physical education instructor in Orcutt Union school … Moore organized photography classes at Arroyo Grande high school last year, a new department. Moore's hobby has been photographic work and some of his work has been published nationally… as well as in the *Santa Maria Times*… He is a tennis enthusiast … The new principal is a graduate of Chico State Teachers' college, graduating in 1931. He holds a B. A. degree in education, General Elementary credential and was a member of Alpha Psi Omega, national honor society, in dramatics while in college. Married, Moore is the father of two children, Carol and Steve Moore," *SMT*, June 18, 1948, p. 5; "Moore Will Head School at Nipomo… a member of the faculty of AGUHS last school term… Moore taught shop, crafts, photography, journalism and tennis at the high school… A graduate of Chico State Teachers' college in 1931, Moore has a B. A. degree in education, general elementary credential…," *AGH*, June 18, 1948, p. 3;
1949 – "Nipomo School Class Visits Santa Barbara … taken by Principal Ken Moore… and Principal Moore, whose hobby is photography, took the students also to visit three photographic studios in the city where developing and printing of colored and black and white film were explained and photographic techniques demonstrated. Among studios visited was the **Brooks Institute** of Photography…," and more on demonstrations, *SMT*, Feb. 16, 1949, p. 8; "B.P.W. Members … At Tuesday's meeting… an educational program with Kenneth Moore as speaker on 'Photography.' The speaker told of the development of his hobby with the camera and spoke of the use of pictures, films and slides in public school classrooms… **Ted Bianchi** assisted…," *SMT*, April 21, 1949, p. 5.
More than 250 notices for "Kenneth Moore" and another 250 for "Ken Moore" appear in the *SMT* between 1930 and 1960 but were not even browsed for itemization here.

Moore, Kenneth (misc. bibliography)
Kenneth Slocum Moore b. Feb. 26, 1906 in Calif. and d.
June 6, 1986 in Santa Barbara County is buried in Adin
Cemetery, Modoc County, Ca., per findagrave.com (refs.
ancestry.com).
See: "Minerva Club Flower Show," 1948, "Santa Maria
Camera Club," intro., 1938-44, 1946, 1955, "Summer
School," 1947, "Teacher Training," 1940

Moore Mercantile Company (Lompoc)
*Occasional retailer of art supplies. Prop. Frank Bines
Moore, 1926. Wife was Anna Moore, above.*

■ "Moore Mercantile Celebrates 54th Anniversary …
Fifty-four years ago – in 1885 – G. W. Moore traded a six-
horse team for a two-thirds interest in the small grocery
business of Dickerson Brothers … Frank Calhoun was a
partner and when his health caused his retirement from the
business in 1890, G. W. Moore and his son, Frank B.
Moore, became owners… On September 18, 1903, the firm
was incorporated under the firm name of Mercantile
Union… [later] became the Moore Mercantile… Since the
death of Frank B. Moore in May 1927, the store has been
operated by his widow, Mrs. **Anna Moore** and her two
sons, Ernest and Howard Moore. A fine new building was
erected by the firm in November 1937…," *LR*, Aug. 25,
1939, pp. 1, 2.
Moore Mercantile (notices in local newspapers)
1925 – "Get your Christmas Cards at Moore's. California
Greeting Cards. A real photograph of a California scene
pasted on the front of a card… Moore Mercantile…," *LR*,
Dec. 11, 1925, p. 4.
1926 – "There's Fun and Joy Aplenty at Our TOY FAIR –
Here's what Santa left at our store: paint and drawing
outfits, children's art sets, modeling clay outfits, desk
blackboards … tinker toys… boy's building sets…," *SYVN*,
Dec. 17, 1926, p. 4.
More than 1800 ads for "Moore Mercantile" appear in the
LR between 1916 and 1960 but most advertised non-art
items and were not itemized here.
See: "Moore, Anna"

**Moran (Spires), Muriel Frances (Mrs. Harry Edward
Spires) (1909-1976) (Lompoc)**
*Member Alpha Club Art Section, 1933. Art teacher
Lompoc high school, 1932/34. Later in life, as Muriel
Spires in northern California, she expended her artistic
talents on flower arranging and sand casting.*

■ "Muriel M. Spires… 66, who was active in many
organizations in Sacramento. Mrs. Spires … was born in
Jackson and moved to Sacramento 20 years ago. She was a
member of the Woodlake Garden Club, Tuesday Club,
Women's Forum, Kingsley Art Club, California Alumni
Association, YWCA, and the American Association of
Retired Persons…," *Sacramento Bee*, Oct. 16, 1976, p. 4.
Moran, Muriel (notices in California newspapers on
microfilm and on newspapers.com)
1925 – Attended Richmond Union High School,
"Richmond," *Oakland Tribune*, Oct. 9, 1925, p. 27 (i.e., p.
28).

1932 – "Newcomers to High School Faculty… Miss Muriel
Moran…," *LR*, Sept. 9, 1932, p. 10.
1933 – "Teachers Visit Homes at Easter … Miss Muriel
Moran… in Berkeley…," *LR*, April 14, 1933, p. 5; "School
Board… As the result the faculty will be paid during the
school year to begin Tuesday … Miss Muriel Moran, art,
$1800…," *LR*, Sept. 1, 1933, p. 1; "Hi Enrollment… Miss
Muriel Moran spent the summer in Oakland, also visiting
Russian River, Yosemite and other points of interest," *LR*,
Sept. 8, 1933, p. 7.
1934 – "Nuptials Announced… An envelope carried the
announcement of the marriage of Miss Muriel Frances
Moran to Harry Edward Stires [Sic. Spires] of Yuma,
Arizona, December 20, last. Following her resignation from
the faculty of the high school recently, Miss Moran's many
friends were expecting an announcement of her
engagement, but the wedding announcement came as a
complete surprise…," *LR*, May 18, 1934, p. 9.
1954 – Port. at Redwoods Presbyterian Church Talent Fair,
Daily Independent Journal (San Rafael, Ca.), March 10,
1954, p. 17.
1955 – "Spend Week at Alumni Camp at Pinecrest. Back…
are Mr. and Mrs. Harry E. Spires and their children,
Priscilla and Scott of Belveron gardens. It was the seventh
year they had spent the first week of August at the
University of California Alumni camp. Both Mr. and Mrs.
Spires are Cal graduates…," *Daily Independent Journal*
(San Rafael, Ca.), Aug. 19, 1955, p. 17; "With Little Time
and Work Tract Home Can Have Garden… In the
neighboring community of Belveron gardens [Tiburon],
Mr. and Mrs. Harry E. Spires have a combination flower
and vegetable garden, orchard and outdoor living room…,"
Daily Independent Journal, Sept. 17, 1955, p. 59 (i.e., H-
40).
1957 – "Mrs. Harry Spires" won several awards for flower
arranging at the Marin Fair per *Daily Independent Journal*
(San Rafael, Ca.), July 5, 1957, p. 18.
1958 – "Subject Matter… shows at Sacramento State
College… students of SSC's Robert Else in the art building
gallery … Muriel Spires, sand cast plaque…," *Sacramento
Bee*, April 19, 1958, p. 69.
1963 – "Woodlake Club Plans Demonstration Talk…
Woodlake Garden Club… Mrs. Harry E. Spires will present
the program on Sandcasting and Mosaics for the Garden
and Patio. She will present a demonstration and display
some of her completed works," *Sacramento Bee*, Feb. 3,
1963, p. 113 (i.e., CL 15); "Pioneer Club will Hear Casting
Talk… Mrs. Harry Spires of Sacramento … will discuss
Sand Casting…," *Sacramento Bee*, Oct. 20, 1963, p. 132
(i.e., CL 14).
1964 – "Sand Casting Will be Garden Club Topic… Azeala
[Sic.?] Garden Club… in the Sacramento Garden and Art
Center… Mrs. Muriel Spires, a member of the Woodlake
Garden Club, will speak on Sand Casting…," *Sacramento
Bee*, Jan. 19, 1964, p. 111 (i.e., CLI 1?).
And additional notices for "Muriel M. Spires" reveal that
she worked at polling places in San Rafael in the late 1950s
and that she was interested in folk dancing.
Moran, Muriel (misc. bibliography)
Muriel F. Maran [Sic. Moran] is listed in the 1920 U. S.
Census as age 10, b. c. 1910 in Calif. residing in Richmond,
Ca. with her parents Alexander Moran (age 36) and Eva

Moran (age 35) and siblings; Muriel Moran is listed in the 1930 U. S. Census as residing in Oakland, Ca., with her parents and siblings; Muriel F. Moran port. appears in the UC, Berkeley, yearbook, 1931, and as a member (grad) of the Guild of Applied Arts, UC, Berkeley, yearbook, 1932; Muriel F. Moran, b. c. 1909, married Harry E. Spires on Dec. 20, 1933 in Yuma, Arizona per Arizona County Marriage Records; Muriel F. Moran was b. Nov. 14, 1909 in Amador County and d. Oct. 10, 1976 per Moran Family Tree (refs. ancestry.com).
See: "Alpha Club," 1933, "Lompoc, Ca., Union High School," 1933

More, Susan Elizabeth Patton Miller (Mrs. "Capt." Elliott / Elliot More) (1848-1922) (Orange Vale / Santa Maria)
Exh. as "Mrs. Capt. More" a pencil drawing at "Santa Barbara County Fair," 1889.
More, (notices in Northern Santa Barbara County newspapers on microfilm and on newspapers.com)
1885 – "Capt. E. More and Mrs. Susan E. Miller were united in matrimony last Sunday… The Capt. is quite military in appearance and is well known as a thrifty farmer of the Santa Maria valley and a man of temperate habits. The bride and her sprightly, intelligent children will be missed from the public and social gatherings and yet we hope to see them frequently," *SMT*, Jan. 10, 1885, p. 5.
1891 – "Capt. More's Ranch & Home" description, *SMT*, Aug. 15, 1891, p. 2.
More, (misc. bibliography)
Susan E. Miller married Capt. E. More in 1885 in Santa Barbara County per Western States Marriage Index; Susan E. More is listed in the 1900 U. S. Census as b. Sept. 1848 in Missouri, residing in San Francisco; Susan E. Patton is cited as wife of Elliot Moore (1822-1898) per Loscutoff & Shane/Shain – Tree; S. E. Morse [sic. More] [aka Susan Elizabeth Patton, Susan Elizabeth Miller, Susan E. More] is listed in the 1920 U. S. Census as age 71, b. c. 1849 in Missouri, widowed, residing in San Francisco; Susan Elizabeth Patton was b. Sept. 25, 1848 in Missouri to Thomas Scott Patton and Susanah White, married James Sproul "Uncle Doc" Miller, and d. Jan. 26, 1922 in San Francisco per Davis Family Tree (refs. ancestry.com).
See: "Santa Barbara County Fair," 1889

Morehead, Minnie (Lompoc?)
Exh. "Santa Barbara County Fair," 1891.
May be the same as Nina Morehead, below.
See: "Santa Barbara County Fair," 1891

Morehead (Rudolph), Nina Durand (Mrs. John Casper Rudolph) (1874-1916) (Lompoc / Alameda)
In 1891 exh. watercolor and in 1892 won Best crayon drawing at "Santa Barbara County Fair," Lompoc. Sister (?) to William Morehead of Morehead and Douglas, below.
■ "Death of Mrs. Rudolph Occurs at Alameda… relict of the late John C. Rudolph… friends in Lompoc, having spent the greater part of her life here, leaving about a dozen years ago to make her home in Alameda," *LR*, June 30, 1916, p. 8.
Morehead, Nina (notices in Northern Santa Barbara County newspapers on microfilm and on newspapers.com)
1892 – "Teachers' Examinations… by the County Board of Education, the following named persons received certificates: Primary Grade: … Nina D. Morehead…," *The Independent* (Santa Barbara, Ca.), June 22, 1892, p. 4, and also reported in *LR*, June 25, 1892, p. 3.
1893 – "Married. Rudolph – Morehead – In Lompoc, at the residence of the bride's parents, Wednesday forenoon, April 5th, 1893, by the Rev. Silas Sprowls, John C. Rudolph and Miss Nina Morehead," *LR*, April 8, 1893, p. 3.
1910 – HUSBAND – "Dies at Alameda. Died, March 24, 1910, in Alameda, John C. Rudolph, husband of Nina D. Rudolph and father of George, Olivia, Philip, Durand and Ralph Rudolph," *Independent* (Santa Barbara, Ca.), March 29, 1910, p. 2.
1916 – MOTHER – "Funeral of Mrs. Morehead… Olivia Morehead…," *LR*, Jan. 28, 1916, p. 8.
Morehead, Nina (misc. bibliography)
Nina D. Morehead is listed in the 1880 U. S. Census; Nina D. Morehead is listed in the 1900 U. S. Census as age 25, b. Nov. 1874 in Calif. residing in Township 5, Santa Barbara County, Ca., with her parents Samuel F. Morehead (age 67) and Olivia Morehead (age 52) and siblings William, Harry, and Ernest; Nina D. Morehead married John C. Rudolph in 1893 in Santa Barbara per Western States Marriage Index, 1809-2011; Nina D. Rudolph is listed in the 1900 U. S. Census as residing in Lompoc with her husband and two children; Nina D. Rudolph is listed in the 1910 U. S. Census in Alameda, Ca.; Nina Durand Rudolph b. Nov. 1874 in Calif. d. June 28, 1916 in San Francisco County and is buried in Mountain View Cemetery, Oakland, per findagrave.com (refs. ancestry.com).
See: "Santa Barbara County Fair," 1891, 1892, and *San Luis Obispo Art and Photography before 1960*

Morehead & Douglass / W. H. Douglass / Cash Store (Lompoc)
Grocer who sold picture frames, engravings, oil paintings, artists' materials, 1891-92. Ocean Ave. Wm. A. Morehead sold out to (?) W. H. Douglass c. March 1892. Their picture frames may have come from the inventory of the Variety Store.
Morehead & Douglass (notices in Northern Santa Barbara County newspapers on microfilm and on newspapers.com)
1891 – "The long looked for stock of stationery, school supplies, pictures, and novelties for W. A. Morehead has arrived and he invites inspection…," *LR*, Feb. 7, 1891, p. 3, col. 1; "Preferred Locals… A s'endid lot of Mouldings for Picture Frames, just received by W. A. Morehead," *LR*, Feb. 14, 1891, p. 3; ad: "Wm. A. Morehead. W. H. Douglass. Morehead and Douglas. Proprietors of the Cash Store. This new establishment will keep a full line of general merchandise consisting of groceries and provisions together with a full line of stationery, books, pictures, picture frames and moulding…," *LR*, May 16, 1891, p. 3: "Oh! Say! Have you seen those Beautiful Steel Engravings and Pastels at Morehead and Douglass'," *LR*, Oct. 17, 1891, p. 3, col. 4.

1892 – "Staple and Fancy Groceries, Stationery, Bibles, School Supplies, etc. We have in Stock the Latest Styles in Picture Frames, Moldings and Railing, also Engravings, Oil Paintings and Artists' Material," *LR*, Feb. 27, 1892, p. 1; "As will be seen by the advertisement, Mr. Morehead has withdrawn from the firm and Mr. W. H. Douglas will continue in business at the old stand," *LR*, March 12, 1892, p. 3, col. 1.
1893 – "Preferred Locals. Go to W. H. Douglass' store on Ocean Avenue for groceries, provisions, picture frames, etc.," *LR*, May 27, 1893, p. 3. The store became Douglass brothers in mid-1893 and by early fall W. H. Douglass was continuing his grocery business separately from his brother, who opened a jewelry business.
1894 – "W. H. Douglass. H Street, Lompoc. Dealer in Gen'l Merchandise, Groceries, Provisions, Stationery, Etc. Ladies and Gents Underwear. Boots and Shoes, Gloves, Etc. Pictures Framed with the Best of Mouldings and in the Latest Styles. Eggs and Butter taken in exchange for goods. Agent for all San Francisco papers and Eastern Periodicals," *LR*, April 14, 1894, p. 2.
See: "Morehead, Nina"

Morgan, Julia (1872-1957) (Bay Area / San Simeon)
Architect who designed the Minerva Clubhouse, Santa Maria, opened 1928.

■ "Julia Morgan (January 20, 1872 – February 2, 1957) was an American architect and engineer. She designed more than 700 buildings in California during a long and prolific career. She is best known for her work on Hearst Castle in San Simeon, California," per Wikipedia.
See: "Minerva Club," intro., and *Cambria Art and Photography before 1960*

Morris, Mr.
Cartoonist and baritone with itinerant California All-Star Quartet, 1923.
See: "Chalk Talks," 1923

Morris, Ed (Santa Maria)
Photography teacher for after-school classes for fifth and sixth graders at Main St. school, 1960.
Writer/photographer with Santa Maria Times, 1957+.
See: "Santa Maria, Ca., Elementary school," 1960

Morris, Lillie B. McCarley (Mrs. Joseph Edward "Ed" Morris) (1859-1932) (Santa Maria)
Painter. Under the name, "Mrs. J. E. Morris," she exh. flower pieces, roses, flags, and a landscape in oil at the "Santa Barbara County Fair," 1891, and as "Mrs. J. Morris," she exh. 1893. Teacher of painting, 1894. Under the name, "Mrs. E. Morris," she exh. a painting at the Art Loan Exhibit, 1895.

■ "Lillie B. Morris... passed away at her home on west Church street... The deceased was born in Illinois, February 29, 1860 and with her parents, Mr. and Mrs. J. H. McCarley, crossed the plains in 1862 in a covered wagon, settling in San Jose. She lived in San Jose until her marriage to Joseph Edward Morris on October 1, 1879. With her husband she moved to Santa Maria valley where she lived ever since. Two daughters were born to this union, Bessie Morris Kendrick, who died November 23, 1931 and Henrietta, who passed away in infancy," *SMT*, Sept. 26, 1932, p. 5.
Morris, Lillie (notices in local newspapers)
1894 – "The young people composing the painting class of Mrs. Morris' had an entertainment at the Professor's last Tuesday night and an enjoyable time is reported," *SMT*, March 31, 1894, p. 2, col. 3.
There are several notices for "Mrs. J. E. Morris" in the *SMT* in the early 1890s whose HUSBAND, J. E. Morris, was a teamster. "Joseph Edward Morris... succumbed at the family residence, 209 West Church street, last evening. He was a native of Nebraska and had been a resident of Santa Maria valley for more than half a century. Surviving him are his widow, Lillie B., a daughter, Bessie Kendrick...," *SMT*, Apr. 27, 1931, p. 3.
A few additional notices for a "Mrs. Morris" in the *SMT* between 1893 and 1897 show she was active at her church, was involved with various decoration projects (Christmas), and resided on Church St., but were not itemized here.
Morris, Lillie (misc. bibliography)
In the 1890, 1892 and 1896 *Santa Barbara County Voter Registers*, there is a Mr. Joseph E. Morris, age 36, b. Nebraska, a merchant, listed in Santa Maria; The will of Joseph Edward Morris leaves one dollar to his daughter Bessie Kendricks and the residue of his estate to a trust for his wife, Lillie B. Morris, per *California Wills and Probate Records*, Santa Barbara, vol. 27-29, 1930-1932; Lillie B. McCarley b. Feb. 1859 in Iowa, married Joseph Edward Morris, gave birth to a daughter, Bessie, and d. Sept. 25, 1932 in Santa Barbara per Lola's Family Tree (refs. ancestry.com).
See: "Art Loan Exhibit (Santa Maria)," 1895, "Santa Barbara County Fair," 1891, 1893

Morrison, L. J. (Santa Maria?)
Photographer. Active with Santa Maria Camera Club, 1950.
1951 – Port. playing a trumpet as part of Veterans of Foreign Wars band, *SMT*, Sept. 27, 1951, p. 6.
See: "Santa Maria Camera Club," 1950

Morse, Edna C.
See: "Rich (Morse), Edna C. (Mrs. Louis Kennedy Morse)"

Morse, James (Guadalupe / San Francisco)
Exh. best architectural drawing at "Santa Barbara County Fair," 1883, and 1886. Father of Angie Morse Ayres, above. "Mrs. Jas. Morse" exh. oil painted panel at the "Santa Barbara County Fair," 1889.
Morse, James (notices in Northern Santa Barbara County newspapers on microfilm and on newspapers.com)
1883 – Is he James Morse, Carpenter & Contractor, Cabinet Maker and Paper Hanger who advertised in the *SMT*, Aug. 18, 1883, p. 5 (and in 1886).

1886 – "The Los Angeles Marble works sell grave stones and monuments cheaper than any other house on the coast. James Morse, Agent," *SMT*, Sept. 4, 1886, p. 5, col. 1; "Additional Premiums and Corrections… James Morse awarded premium on family blackboard and Hookut rug," at Santa Barbara County Fair, *SMT*, Nov. 6, 1886, p. 4.
1889 – "For Sale Cheap. Second hand buggy… household furniture. Also, mare and colt and a three-year-old horse. Sawing machine, band saw, turning lathe, mortise machine, patent miter machine, etc. etc. James Morse," *SMT*, Aug. 10, 1889, p. 3.
1890 – "Elsewhere in our columns will be found an excellent communication from our old friend and former Santa Marian, Mr. James Morse. Mr. and Mrs. Morse continued their journey from Santa Maria south to the Mexican line and returned to San Francisco by the interior route," *SMT*, Oct. 25, 1890, p. 2.
1894 – It is reported that Billy Ayres and family and James Morse and family will return to Guadalupe to reside and go into business at once. Mr. Morse will work at his trade, contracting and building…," *SMT*, Nov. 10, 1894, p. 3, col. 1.
And hundreds of additional notices, primarily ads for his contracting, were not itemized here.
See: "Ayres, Angie," "Los Angeles Marble Works," "Santa Barbara County Fair," 1883, 1886

Morton, Billy Joe (1928-2010) (Santa Maria)
Santa Maria High School student who won a Certificate of Merit in the Latham Foundation poster contest, 1944. Member of DeNejer's art class, 1946. Graduated high school, 1945, and JC, 1947.
Morton, Billie (misc. bibliography)
Billie Joe Morton was b. Aug. 15 (or 17), 1928 in Texarkana, Tx., to Joseph Jefferson Morton and Cora Bee White, married Loretta M. Marsh, and d. March 13, 2010 in Milpitas, Ca., per Ward Family Tree (ancestry.com).
See: "DeNejer, Jeanne," 1946, "Posters, Latham Foundation (Santa Maria)," 1944

Morton (Brotherton), Margaret Opal (Mrs. Gurdon Saltonstall Brotherton) (1915-1982) (Lompoc)
Art teacher at Lompoc High School, 1938/40.
■ "Miss Margaret Morton to Become Bride of G. Brotherton in Fresno… Miss Morton is the daughter of Mr. and Mrs. Charles Morton of Fresno… the bride-elect is a graduate of Fresno High school and Fresno State college. She has been engaged as art instructor at the local high school … The couple will make their home in Lompoc…," *LR*, June 7, 1940, p. 7; "Margaret Brotherton… for a number of years she worked for the Rex Petroleum Co. and was a publicity director for the Milford Preparatory Academy and an office manager for the H. L. Green retail store, all of Milford, Conn. Mrs. Brotherton was also an art teacher in Lompoc, Calif. and a supervisor of the Stop and Shop retail store in Jerome, Iowa," *Rutland Daily Herald* (Rutland, Vt.), July 29, 1982, p. 10.

Morton, Margaret (notices in Northern Santa Barbara County newspapers on microfilm and on newspapers.com)
1940 – "Schools Employ… Resigning from the high school staff were… Miss Margaret Morton…," *LR*, May 17, 1940, p. 1.
And, more than 40 additional social and travel notices for "Margaret Morton" in the *LR* between 1937-1940 were not itemized here.
Morton, Margaret (misc. bibliography)
Margaret Morton is listed in the 1940 U. S. Census as age 24, b. c. 1916 in Calif., finished college 4th year, a school teacher, residing in Fresno, Ca. (1935) and lodging in Lompoc, Ca. (1940); Margaret Brotherton is listed with Gurdon in the *Lompoc, Ca., CD*, 1945, 1947 and in the *Santa Maria, Ca., CD*, 1948; Margaret Opal Brotherton b. Sept. 16, 1915 in Calif. d. July 27, 1982 in Randolph, Vt., per Vermont Death Records (refs. ancestry.com).
See: "Lompoc, Ca., Union High School," 1938, 1939, 1940, "Posters, American Legion (Poppy) (Lompoc)," 1939

Moselle's Gifts at the Inn (Lompoc)
Gift shop located at the La Purisima Inn, 1959-61.
Featured local artists. Prop. Moselle R. Forward.
■ "Mrs. Forward Sole Owner of Inn Shop. Mrs. Moselle Forward announced today that she has purchased the interest of her partner [Mrs. Robert Sudden] in the firm Gifts at the Inn and has changed the name of the shop to Moselle's Gifts at the Inn. … She will change the policy of the shop to feature work of local artists," *LR*, Sept. 29, 1960, p. 2.
Moselle's Gifts at the Inn (notices in Northern Santa Barbara County newspapers on microfilm and on newspapers.com)
1959 – "Garden Section … of the Lompoc Community Women's Club met … Mrs. Moselle Forward of the Inn's Gift Shop displayed a variety of unusual gifts… The usual desire of the shop's customer was to 'find something to make somebody happy' …," *LR*, April 16, 1959, p. 4.
1960 – "Wanted: Paintings, Gem Work, Art and Handicraft Work of All Types – by Lompoc and Vandenberg Residents Only – to be offered for sale at Moselle's Gift Shop at the Inn. Phone for appointment with Mrs. Moselle Forward RE 6-8018," *LR*, Oct. 20, 1960, p. 23.
1961 – "Certificate of Abandonment… the undersigned does hereby certify that she is no longer transacting business at 205 North H Street, Lompoc, California under… Moselle's Gifts at the Inn Shop…," *LR*, June 1, 1961, p. 20 (i.e., page following 3c).
See: "Forward, Moselle"

Moser, Julon Modjeska (1900-1997) (Ventura)
Artist. A painting by her was won by the Jr. Community Club, 1952.
■ Port. at easel and "Ventura's Julon Moser… Mr. and Mrs. Moser have converted their garage down from their hillside home on Artemesia drive, into a garage-and-studio. Above the cars' space, they've added a spacious room for painting… 'When I went to school, water color was taught

first and then students went into oils… Works Out Idea. The beginnings of a Julon Moser water color painting come when she first gets an idea for a picture … She quickly sketches the idea on anything at hand… Then she usually does a black-and-white study, to get her design, line and values … Last, before starting the painting itself, she does a 'little quickie,' a rapidly done study to test her color ideas… Served as Judge. Mrs. Moser has had experience in seeing flaws in other painters' work… She served a year on the jury of the Women Painters of the West… In addition to her activities in the Women Painters … the Ventura artist is a member of California Water Color Society… 'I'm one of those perennial students,' Mrs. Moser says of herself. She studied first in Binghamton, N.Y., with Frank Taylor Bowers, a student of William Chase. Since… she has frequently enrolled in other courses, working at Chouinard's and taking private lessons from a number [of] noted artists. One summer, at Scripps college, she took a course in modern design… Mrs. Moser likes both modern and conservative approaches… As for the usefulness of studying with other artists, 'once you've had the fundamentals, it's up to you to work out your own salvation, your own style … The artist expresses equal liking for still lifes, florals, portraits and landscapes although she smiles, 'I've only won prizes in still life…,' On the easel in the new studio is a partly-finished landscape picturing a scene in the Ojai valley… Already the cabinets along one wall of the new studio are almost filled with paintings. They line the walls of the Moser home…," *Ventura County Star-Free Press*, March 18, 1950, p. 5. Bio. in Phil Kovinick and Marian Yoshiki-Kovinick, *An Encyclopedia of Women Artists of the American West*. And, nearly 250 additional notices for "Julon Moser" in California newspapers, 1940-1997, on newspapers.com not itemized here.
See: "Junior Community Club (Santa Maria)," 1952

Motion Pictures (Guadalupe)
Motion pictures filmed in Guadalupe up to 1960.
Motion Pictures (Guadalupe) (notices in California newspapers on microfilm and on newspapers.com)
1923 – "Picture People to Use 2000 People in Film to be Made Near Here," i.e., Ten Commandments, *SMT*, April 21, 1923, p. 1; "Movie to be Made in Santa Maria" – a Biblical epic by Famous Players-**Lasky**, *AN*, May 4, 1923, p. 3; "Entire City Built for Big Photoplay," *AN*, June 22, 1923, p. 2; "DeMille Representative Tells Rotarians of Motion Picture Industry," *SMT*, June 5, 1923, p. 1; **Lasky** Players Ready to Film" Kipling's 'Light that Failed,' on sand dunes, *SMT*, Aug. 25, 1923, p. 1.
"DeMille's Mystery City in the Dunes," [Guadalupe dunes], in *Sagas of the Central Coast: History from the Pages of Central Coast: The Magazine of Pleasures and Pursuits*, by Bob Nelson, Santa Maria, Ca.: RJ Nelson Enterprises, Inc., 1994, pp. 83-85.
1926 – "Picture Co. Will Make 'Men of the Dunes' on Sands at Guadalupe… **First National Pictures**… starring Milton Sills… Since the filming of the 'Ten Commandments' three years ago, many motion picture scenes have been taken on Guadalupe sand dunes," *SYVN*, July 30, 1926, p. 1; "Resume Work on Filming on

Guadalupe Sand Dunes…," halted earlier by fog, *SYVN*, Sept. 3, 1926, p. 1.
Bibliography: Peter Brosnan, *Co-Starring the Guadalupe Dunes: 85 Years of Hollywood Movies in the Guadalupe Dunes*, Self-published, 2006.

Motion Pictures (Lompoc)
Motion pictures filmed in Lompoc up to 1960.
Motion Pictures (Lompoc) (notices in Northern Santa Barbara County newspapers on microfilm and on newspapers.com)
1933 – "News Cameramen Film Many Scenes at Big Celebration [San Julian highway opening, i.e., a scenic cut-off between Highway 101 at Las Cruces, north of Santa Barbara, and Lompoc] … the process of barbecuing meat underground in covered pits was recorded on film when Robert V. Phelan and W. H. Waddell, Warner Brothers newsreel photographers took 'shots' of the operation here Sunday when 17 beeves were barbecued and served to a crowd of over 6000 people… In addition, … the photographers took 500 'stills' both at the barbecue and at the official opening of the highway near the San Julian ranch house. The film cameras also were used at the highway opening ceremonies and during the parade in the downtown section. The pictures will be shown at the Lompoc Theater within a few days…," *LR*, June 2, 1933, p. 3.
1946 – "Technicolor Lenses… next few weeks while a group of technicians and actors from the Universal Pictures studios are on location here. The troupe is to be quartered at Camp Cooke. … they will photograph La Purisima mission, Miguelito canyon, parts of the Army reservation, the San Julian, and other areas in this vicinity which can be used as background for motion pictures. It was reported that approximately 300 persons are in the location party," *LR*, April 25, 1946, p. 2.
1948 – "'Pirates' Movie Filmed Here to Open Monday. 'Pirates of Monterey,' a motion picture filmed in the Lompoc vicinity, has been booked for the Lompoc theatre starting January 5. Much of the Technicolor movie was filmed here last spring at La Purisima Mission and in the Santa Rosa and San Julian districts where the colorful mustard-covered hills formed the background… While in Lompoc, the company of several score players lived at Camp Cooke and in the sequences filmed at the mission, many Lompoc children were used as extras. The picture stars Maria Montez and Rod Cameron and is a romantic drama of early California…," *LR*, Jan. 1, 1948, p. 10.
1959 – "La Purisima Mission… The month of August brought to Purisima **Mr. Ted Peshak**, photographer for Coronet Films, who set up and filmed scenes for an educational movie depicting Spanish colonial life in the Southwest. The mission grounds and buildings provided much of the background and even Residence Number 2, an adobe building occupied by the Gutierrez's, served as the home of the Ranchero in the picture. A number of local people were given parts in the picture," *LR*, Feb. 19, 1959, p. 9.
See: "Mission La Purisima"

Motion Pictures (Santa Barbara County)
Motion pictures featuring scenes from several different places in Santa Barbara county up to 1960.
Motion Pictures (Santa Barbara County) (notices in Northern Santa Barbara County newspapers on microfilm and on newspapers.com)
1913 – "Outline Moving Picture … 'A year in Santa Barbara county,' will be the title of the moving picture display that will constitute Santa Barbara's chief exhibit at the **Panama-Pacific** fair in 1915… American Film Company… Scenes of Santa Barbara county's big ranches, views of various cities and places of historic interest, scenes of the mountains and the beaches…," *SMT*, Sept. 13, 1913, p. 3.
1914 – "Moving Picture Exhibit Men are in Lompoc. The 'Movie' men are here from Santa Barbara to make pictures for county's exhibit at the **Panama-Pacific Exposition**… They came up yesterday afternoon… Yesterday they took pictures of the mustard thresher in operation. This machine was constructed by Chas. Arkley of this place and is distinctly a Lompoc product as it is the only machine of the kind known of in the world," *LR*, July 31, 1914, p. 1, col. 2.
1952 – "Plan to Film County Story… Santa Barbara City Council… The film will take about a year to produce and will include shots of the County's events such as the Fiesta, Semana Nautica, Danish Days, and the Santa Maria Elk's rodeo as well as the flower fields in Lompoc," *SYVN*, April 4, 1952, p. 1; "Film Contract is Awarded… Rocket Pictures of Hollywood… Rocket Pictures has made films for a number of big industries… it would take a year and a half…," *SYVN*, June 20, 1952, p. 1; "County Film Completed… The film is to be cut from more than three hours to some 27 minutes of running time… budget of $24,000," *SYVN*, Nov. 21, 1952, p. 3.

Motion Pictures (Santa Maria)
Motion pictures filmed in the Santa Maria area up to 1960.
Motion Pictures (Santa Maria) (notices in Northern Santa Barbara County newspapers on microfilm and on newspapers.com)
1914 – "Film Artists Invade Santa Maria Oil Fields… from the 'Flying A' studio of Santa Barbara, reproduced a live gusher and wove around the crude oil scenery a thrilling story of love, sentiment and daring bravery. … title of the movie is to be 'The Widow's Investment,' written by Jere Calef… poor old widow striking oil on her ten acres of sand just as the mortgage fell due and all hope was lost. Following are the members of the company…," *SMT*, Feb. 14, 1914, p. 1; "C. H. Gray, of the Diamond Film Co., in Santa Barbara, was here this week with a troop of artists taking pictures in and around Santa Maria valley," *SMT*, Aug. 1, 1914, p. 5, col. 3.
1925 – "Picture Company to Film Scenes," *SMT*, March 7, 1925, p. 1; "Film Company to Make Picture in Local Valley," First National Picture, *SMT*, April 17, 1925, p. 1; "Movie Company Cancels Plans for Local Scenes," *SMT*, April 23, 1925, p. 5.
1926 – "'Sheik' Picture Scenes to be Taken in Valley" by United Artists making "Son of the Sheik," *SMT*, May 22, 1926, p. 1; "Movie Company May Film Desert Scenes in

Valley," for "Winning of Barbara Worth," *SMT*, May 28, 1926, p. 1.
1936 – "Race Scene [at county fair] to Be Shot for a Movie. Louis Shapiro, location manager for RKO studios… long distance 'shots' and closeups of the races and the crowds in the stands tomorrow…," *SMT*, July 24, 1936, p. 2.
1955 – "Movie Crews Begin Arriving for Filming 'Lindbergh Story'," *SMT*, Nov. 7, 1955, p. 1; "Rain Continues at Hancock as Lindbergh Filming Begins," *SMT*, Nov. 15, 1955, p. 1; "Clear Sky Changes 'Lindy' Schedule," *SMT*, Nov. 22, 1955, p. 1; "First U S Woman Flyer Visits Lindy Location," *SMT*, Nov. 23, 1955, p. 1.
See: "Motion Pictures (Guadalupe)"

Motion Pictures (Santa Ynez Valley)
Motion pictures filmed in the Santa Ynez Valley to 1960.
Motion Pictures (Santa Ynez) (notices in Northern Santa Barbara County newspapers on microfilm and on newspapers.com)
1926 – "Buster Keaton Filming Picture… 'Battling Butler'," *SYVN*, Jan. 1, 1926, p. 1; "Film Company Now on Location," *SYVN*, Jan. 22, 1926, p. 1; "Local Items… The Buster Keaton Motion Picture Company… concluded their work here last Tuesday and returned to the studio in Hollywood," and "College School of Santa Ynez dispensed with lessons from books last Monday morning, giving the children an opportunity to see motion pictures in the making. The school marched in a body to the College Hotel where scenes from 'Mr. Battling Butler' were being filmed…," *SYVN*, Jan. 29, 1926, p. 4; "'Boot Jack' from Santa Ynez Valley Kept by William Hart… 'I made [it] one summer while I was filming a picture in the Santa Ynez Valley'," *SYVN*, Feb. 5, 1926, p. 1; "Taking Movies Here. Mr. Jackson of Hollywood, accompanied by seven others, was at the Minetti hotel in Santa Ynez Monday, Tuesday and Wednesday. They were taking pictures on the Armour ranch for one of Hoot Gibson's pictures," *SYVN*, Dec. 17, 1926.
1928 – "Looking Backward. 30 Years Ago. Richard Barthelmess and his troupe of 60 members of the First National Company's motion picture people of Hollywood, were in Los Olivos Tuesday. The Pacific Coast engine used in the film on a logging train, burning wood in the engine, was dressed up as an old timer, and the company took scenes depicting the early days in California. They were making pictures for 'The Little Shepherd of Kingdom Come,' a story by John Fox, Jr. Mr. Barthelmess had Miss Molly O'Day with him as his leading lady, the filming being taken under the direction of Alfred Fantell," *SYVN*, Feb. 21, 1958, p. 2.
1940 – "Scenes for New Picture Made at Old Mission… Fox studios… the new picture 'California' starring Tyrone Power… The artists stopped at Mattei's tavern in Los Olivos and Andersen's Valley Inn at Buellton," *SYVN*, Aug. 9, 1940, p. 1; "Looking Backward… 20 Years Ago. Solvang was all a stir Wednesday and Thursday owing to the Fox Studios here taking shots for the new picture, 'California,' starring Tyrone Power. The setting was made around Old **Mission Santa Ines**, which was all decked up for the occasion. The Fox studio had a cast of about 50 here

for the taking, and operations started Wednesday morning and finished up Thursday afternoon," *SYVN*, Aug. 19, 1960, p. 2.

1946 – "Film Company on Location Here. La Vega Park and country along the Santa Rosa road to Lompoc, have been used during the past week for portions of the coming Universal picture, 'The Pirate of Monterey.' On the location for these scenes were the two stars, Rod Cameron and Maria Montez, plus the supporting cast and production personnel," *SYVN*, May 3, 1946, p. 1; "Rin Tin Tin Picture Being Filmed Here. Rin Tin Tin III... Romay pictures came here to film the first of a series of pictures starring the grandson of Rin Tin Tin... The picture is being filmed on the **Channing Peake** Ranch and at the Old **Mission Santa Ines**. The final shots are to be made on Hope Ranch. The picture, a refugee boy-dog story, is being filmed in Technicolor," *SYVN*, Sept. 6, 1946, p. 1.

1947 – "Valley Ranch Shots Appearing in Film. Sequences shot on Sam de la Cuesta's Rancho El Alamo Pintado near Ballard, depicting sheep grazing on a hillside, are scheduled to appear in the prologue of a forthcoming Roddy McDowall picture tentatively entitled 'Rocky.'... Lindsley Parsons Productions, Inc., of Hollywood and also connected with Monogram Pictures Corporation. Mr. Parsons took the pictures... about a month ago...," *SYVN*, Nov. 7, 1947, p. 5.

1949 – "Mission, Valley Featured in Film... the Vitacolor motion picture, 'The Return of Rin Tin Tin,' which was filmed here... two years ago when actors and actresses, camera crews, director and producers were here for the filming... Two complete color camera crews were used...," *SYVN*, April 29, 1949, p. 7.

1954 – "Peake in Horse Film in Solvang over Weekend... 'Stormy' ... **Walt Disney**...," *SYVN*, Aug. 20, 1954, p. 5.

1955 – "**Danish Days** Film... Solvang Danish Days filmed last August, is a feature of Fredric Christian's new color travelogue, 'California,' which he will show and narrate in person at the Wilshire Ebell Theatre... Los Angeles, Saturday night, Feb. 5 at 8:30 on the annual World Adventure Series," *SYVN*, Jan. 28, 1955, p. 8.

1956 – "**Disney**'s 'Cow Dog,' filmed in Valley... on the **Channing Peake** Ranch last Spring and which featured Peake in one of the leading roles...," *SYVN*, Nov. 9, 1956, p. 6.

1957 – "**Danish Days** Color Film Wins Applause... filmed and produced by Robert B. Neubacher of Neubacher Productions of Los Angeles...," *SYVN*, Jan. 11, 1957, p. 6.

1958 – "Part of Folk Dance Group Performs for Film Maker... L. Haynes Speer who is making a color film of various groups in California of different ethnic background...," *SYVN*, April 25, 1958, p. 1.

1960 – Photo showing principals of movie 'Homicidal' on location last Friday in Solvang...," *SYVN*, Nov. 11, 1960, p. 1; photo of filming "Homicidal," *SYVN*, Nov. 11, 1960, p. 7 and article on it.

See: "Calvert, Earl," 1939, "Peake, Channing"

Mott, Martha (Solvang)
See: "Brandt-Erichsen, Martha"

Motzko (Reiner), Helen Sanford (Mrs. John J. Motzko) (Mrs. Ralph O. Reiner) (c. 1897-after 1972) (Santa Barbara)
Painter. Exh. at Andersen's restaurant, 1954, at opening of Allan Hancock College Art Gallery, 1954, and at Santa Maria Inn, 1954, 1955. Member Santa Barbara Art Association.

■ "Tribute to the Motzkos... now that they have sold the *Hayward Journal* ...," *Daily Review* (Hayward, Ca.), Dec. 14, 1945, p. 4.

Motzko, Helen (notices in Northern Santa Barbara County newspapers on microfilm and on newspapers.com)

1930 – "Teachers are Selected... Hayward... Bret Harte school – ... Helen Motzko...," *Oakland Tribune*, July 28, 1930, p. 5.

1954 – "Andersen's [Restaurant in Buellton] shows Motzko Paintings. Over a dozen colorful oil paintings done by Santa Barbara artist Helen Motzko, went on display... in a move by the restaurant ownership to encourage and promote the work of California artists... Mrs. Motzko is the first artist to exhibit...," *SYVN*, July 16, 1954, p. 6; Ad for Oil Paintings at **Santa Maria Inn** until Sept. 10, *SMT*, Aug. 23, 1954, p. 4.

1955 – "Art Events This Week ... Helen S. Motzko paintings, **Santa Maria Inn**, Santa Maria, current through Sept. 30," *LA Times*, Sept. 11, 1955, p. 109 (i.e., IV-7). And, more than 70 additional notices in Bay Area newspapers reveal she was a school teacher, active with the Hayward Business and Professional Women's Club, and at one time state publicity chairman for BPWC, but they were not itemized here.

Motzko, Helen (misc. bibliography)
Helen S. Motzko is listed in the 1940 U. S. Census as age 43, b. c. 1897 in Massachusetts, married to John J. Motzko, and living, since 1935, in Hayward, Ca.; Helen S. Motzko is listed with husband John in the *Santa Barbara, Ca., CD*, 1948-60; [John Motzko who died in 1956 – obit in *LA Times*, March 25, 1956 – was a retired newspaper publisher of the *Vallejo Times-Herald* and the *Hayward Journal* – married to Helen Sanford]; is she Helen S. Motzko (wid. John J.) listed at h 533 Alameda Padre Serra, in the *Santa Barbara, Ca., CD*, 1960; OR, is she Helen A. Sargent/Motzko, b. c. 1897, who married Ralph O. Reiner on Nov. 10, 1962 in Santa Barbara County per Calif. Marriage Index; Ralph O. Reiner, retd. h. 3021 Samarkand Dr. with no wife, is listed in the *Santa Barbara, Ca., CD*, 1966; [Ralph O. Reiner d. 1967]; Helen S. Reiner (wid. Ralph O.) retd, h. 3021 Samarkand Dr., is listed in the *Santa Barbara, Ca., CD*, 1968-72 (refs. ancestry.com).
See: "Allan Hancock [College] Art Gallery," 1954, "Andersen's," 1954

Mounts, Billy, Dr. (Pismo Beach)
Photographer who won first place for a black and white photo at Santa Barbara County Fair, 1960.
See: "Santa Barbara County Fair," 1960, and *Arroyo Grande Art and Photography before 1960*

Mud Mill Pottery Studio (Solvang)
Prop. Kirsten and Frank Pedersen. Opened, 1959. Moved location, 1961. Sold to Dwight and Claire Watts, 1968.

■ "Mud Mill Pottery Studio Opens Sunday in Solvang… Kirsten and Frank Pedersen… The Mud Mill Pottery Shop is equipped with a potter's wheel which Pedersen made for his wife, and a large gas-fired kiln which was once owned by the Santa Barbara Boy's Club. The clay which Mrs. Pedersen uses comes from San Francisco ready 'for throwing a pot' … Master potters, she pointed out, are capable to creating 60 pots an hour… Mrs. Pedersen plans to create a wide variety of pottery items for her shop, including lamp bases, tea pots, vases, bowls, pitchers, tiles, flower bowls and ash trays. Her husband, whom she married in 1952 in Santa Barbara, will be in the shop on weekends and will continue his work of creating by what is known as a slab process highly colorful replicas of native African, Alaskan and American Indian masks, which the Pedersens say make excellent decorative pieces for redwood and grape stake fences. The shop will also feature an exhibit of water colors and pastels by <u>Gary Chafe</u>, young Santa Barbara artist. The Pedersens moved to Solvang last January from Santa Barbara. … They will celebrate the opening of their pottery shop with an open house Saturday Nov. 7 from 2 to 5 p.m.…," *SYVN*, Oct. 30, 1959, pp. 1, 10.
<u>Mud Mill Pottery Studio (notices in Northern Santa Barbara County newspapers on microfilm and on newspapers.com)</u>
1965 – "Mrs. Pedersen will Address … Santa Ynez Valley Woman's club… talk and demonstration of autumn and holiday decorations by Mrs. Frank Pedersen who is better known to her many local friends as Kirsten as she signs her name on the bottom of each piece of pottery she makes in her Mud Mill shop," *SYVN*, Nov. 4, 1965, p. 15 (i.e., 7B).
1961 – Axel Nielsen is creating a three-level commercial structure on the property behind Rasmussen's Store… there will be three shops in the basement, three on the ground floor and studio shop with balcony overlooking the Dannebrog beer garden… The Mud Mill Pottery Studio will occupy one of the shops…," *SYVN*, Aug. 11, 1961, p. 4.
1966 – "Cubs Tour Mud Mill… Den 5 of Buellton… and watched Kirsten Pedersen make a bowl and vase … The boys were taken thru the pottery work shop by Mrs. Pedersen and viewed the kilns and molds and were shown how Mud Mill pottery and figures are made," *SYVN*, May 5, 1966, p. 8.
1967 – "Brownies See Mrs. Pedersen Make Pottery," *SYVN*, Nov. 23, 1967, p. 13 (i.e., 5B).
1968 – "Notice to Creditors of Bulk Transfer… Mud Mill … transferees… Dwight Watts and Claire Watts, 1880 Old Mill Road, Solvang…," *SYVN*, May 9, 1968, p. 7.
1969 – "Art Gallery Adds Rumadums… fanciful creation of Esther Anderson of Anderson's Arts… hand made of clay and fired at The Mud Mill in Los Olivos…," *SYVN*, Oct. 23, 1969, p. 13 (i.e., 13A).
And, many additional notices on the Mud Mull not itemized here.
<u>See</u>: "Pedersen, Kirsten"

Muench, (Adam) Emil (1902-1989) (Santa Barbara)
Photographer of national repute who occasionally judged camera contests on California's central coast, 1953, 1955.

■ "Top notch photographers have been secured for judges… Emil Muench of Santa Barbara will be the judge for the color show. Muench has been the first man to win the 3-star award of the photographic society of America. He has also received the highest honors that can be awarded by PSA. Muench has a brother, Josef, who is widely known for his outstanding color work in the magazine, *Arizona Highways*…," per "**Camera Council** Staging Big Show in Santa Maria,' *SLO T-T,* April 23, 1953, p. 16.
<u>Muench, Adam (misc. bibliography)</u>
Adam Emil Muench was b. Schweinfurt, Germany on July 31, 1902 to Georg Josef Muench and Rosalie Ullrich, married Lilian Norah Muench, was residing in Montecito, Ca., in 1957 and d. January 24, 1989 in Santa Barbara per Harris Family Tree on ancestry.com.
<u>See</u>: "Santa Maria Camera Club," 1955, and *San Luis Obispo Art and Photography before 1960*

Mullins, William (Santa Maria)
Photographer. Member Santa Maria Camera Club, 1938-39.
<u>See</u>: "Santa Maria Camera Club," 1938, 1939

Muradian, Thaddeus "Ted" G. (1930-1993) (Solvang)
SYVU High School photo club sponsor, 1954+. Music teacher.

■ "Thaddeus G. Muradian has been at the high school since 1954 after receiving his education at Pasadena City College and the University of Southern California. He teaches chorus, band, English, coaches tennis, sponsors the music and photography clubs and is co-sponsor of the freshman class. He lives with his wife, Sylvia, on Refugio Road, Solvang," *SYVN*, April 27, 1956, p. 1, col. 1.
<u>Muradian, Thaddeus (misc. bibliography)</u>
Thaddus G. Muradian was b. 1930 in NY and d. Sept. 2, 1993 per Roy Family Tree (refs. ancestry.com).
<u>See</u>: "Santa Ynez Valley Union High School," 1956

Murals (Northern Santa Barbara County)
Herein are placed general references to murals. Often the artist is unknown or little known or from outside Santa Barbara county. Other murals are listed under the name of the artist. Native American artists painted and chipped images on the walls of caves or rock faces (see Central Coast Artist Visitors before 1960). Elementary school students created "murals" often as aids to the study of history, etc. Local social clubs scheduled lectures on murals. In the years <u>after</u> 1960 Lompoc was the recipient of many public murals.
<u>Murals (notices in Northern Santa Barbara County newspapers on microfilm and on newspapers.com)</u>
<u>Santa Maria</u>
1918 – "The <u>Bank of Santa Maria</u> is almost ready for the interior decorators to begin their work… The building is a massive one with huge white columns in Pantheon style

and with the interior walls in fresco work, which was done by an artist from the east," *SLO DT*, June 27, 1918, p. 2.

1928 – Santa Maria Theater. "The decorating of the new Santa Maria theatre was executed by the Robert E. Power Studios, one of the largest interior decorating firms in the United States… Spanish [style] … richly colored auditorium sidewalls with the all-over stencil design gives a tapestry feeling… The proscenium arch affords a 40-foot opening bordered with carved staff work with five art head paintings of dramatic masters above…," from several articles on the theater in *SMT*, April 4, 1928, p. 12.

1934 – "Santa Maria's New City Hall Near Ready… The main lobby [described] … Above the main door and each window is a carving, lightly done, depicting some scene in the history of California. This lobby or rotunda is to be known as the Pioneer lobby and in glass cases set in the wall will be displayed relics of early days and trophies of community interest. Over the entrance leading down the long hall is a mural in Spanish design in bright colors … The city council chamber, … is high ceilinged with exposed beams, the wall stencilings of Mosaic design…," *SMT*, Sept. 14, 1934, p. 1.

1935 – "Murals Planned in Postoffice in Santa Maria," *SMT*, Aug. 27, 1935, p. 4.

1936 – "Mural for Postoffice is Assured… The new Santa Maria post office building will have a mural painting for its lobby according to present plans for the Treasury's Section of Painting and Sculpture….," *SMT*, Oct. 28, 1936, p. 1.

1941 – "Junior Chamber [of Commerce] to Furnish City Library Mural," *SMT*, Jan. 30, 1941, p. 1; "Mural Outline for Library Displayed… proposed for the new city library… considered for hanging at the east end of the main reading room… was done by **Joseph Knowles** of Santa Barbara. The miniature of the final painting displays a panorama of valley industries with sugar, vegetable, cattle, oil, flowers and other valley enterprises prominently in evidence. The mural itself will be 22 feet long by eight feet wide …," *SMT*, June 4, 1941, p. 8.

1945 – "Miss Hall Entertains… Marjorie Hall was hostess at a 'open house.' The studio has just been redecorated, featuring a mural designed by **Mrs. M. V. Hall**…," dance teacher, *SMT*, June 26, 1945, p. 3.

1947 – "Malt Shop … Solvang's Malt Shop has been completely redecorated; a new sign has been inscribed on the store window… One of the chief attractions… will be a huge mural depicting a scene of the Valley, Old **Mission Santa Ines** and Solvang. The mural was done by **Vern Parker** and is 22 feet long and six and a half feet wide," *SYVN*, May 30, 1947, p. 4.

1952 – "Town House Has Buffet Sundays… Cocktails at the Town House are served at the bar which is decorated with a can-can girls' chorus mural," *LR*, May 22, 1952, p. 8.

1956 – Repro: interior of coffee shop showing murals by **Kay Patton**, *SMT*, Aug. 1, 1956, p. 6; repro: murals on walls of **Santa Maria Inn** coffee shop and banquet room, painted by **Kay Patton**, *SMT*, Aug. 2, 1956, p. 12.

1957 – "Announcing Re-Opening of the Famous El Mar Club (The Fun Spot on the Beach) – Under New Management – (Open Daily) Dancing to Popular Bands. Every Friday – Saturday. See Our Lovely Murals," *SMT*, July 2, 1957, p. 11.

1958 – "One look at Lompoc Brings Pat and Diana Glavin Here… The Lompoc Lady, a beauty center … Mural painting around the walls tell the story of hair styles down through the ages to the present time. The murals were done by a young art student from Los Angeles, **Miss Linda Harrod**, an 18-year old who is interested in commercial art and fashion designing. … sign painting by **Juan Flores**…," and repro of murals, *LR*, July 3, 1958, p. 4.

1959 – "Full Color Photo Murals. 45 x 65 in. $1.99 ea. … Sears Roebuck and Co.," *SMT*, April 29, 1959, p. 3; "Just Arrived from Canada. Breathlessly Different… 1959 Wallpapers! ... 3 new scenic wall murals with matching backgrounds. Monterey Pines. Virginia Colony. Spring Time. Pre-trimmed, pre-pasted, plastic coated, washable. Per set. $22.95 to $26.95. … Fuller Paint & Glass Stores," *SMT*, Nov. 14, 1958, p. 3.

See: "Andersen's Pea Soup Restaurant," 1959, "Art, general (Camp Cooke)," 1942, 1943, 1945, "Berger, Fred," "Blakely, June," "Blauer, Joyce," "Bodrero, James," "Capitani, Lorenzo," "Carman, David," "Cherry, Herman," "Civil Works Administration," "Ewing, Louie," "Garnsey, Elmer," "Grant, Campbell," "Haemer, Alan," "Harcoff, Lyla," 1937, "Harris, Richard," "Helmle, Henry," "Herter, Albert," "Hesthal, William," "Hoyer, Fred," "Hutchinson, Amory," "Knowles, Joseph," 1955, "Lindberg, Oscar," 1960, "Linsenmayer, Alice," "Lompoc, Ca., Elementary Schools," 1934, "Mayer, Leslie," intro., "McLaughlin, Dee," "Mission La Purisima," "Mission Santa Ines," "Native American," "Panama-Pacific Exposition," 1915, "Parker, Vernon," "Parshall, Douglass," 1938, "Peake, Channing," intro., "Public Works of Art Project," "Santa Barbara County Fair," 1940, 1954, 1958, "Santa Maria, Ca., Elementary School," 1943, 1947, 1955, 1956, 1957, 1958, "Sykes, John," "Tashiro, Yukio," 1950, "Treasury Department, Section of Painting and Sculpture," 'United States Disciplinary Barracks," 1955, "Works Progress Administration," "Young, Carl"

Murayama, Frank Sadamu (1921-1992) (Lompoc)
Architect / draftsman, 1958.

■ Port. and Local building designer Frank Murayama dies… Mr. Murayama was born Aug. 3, 1921 in Lahaina, Maui, Hawaii. He served with the United States Army from 1945 to 1952 during which he was awarded numerous medals for his marksmanship. His skills led hm to the final qualifying round for the 1948 Olympics before he was eliminated. He came to Lompoc with the army in 1951 from Ft. Ord and began his career in building design in 1958. He received his architectural license in 1986 …. His countless building designs stand as a monument to his memory. Among his designs are the Lompoc Valley Boys and Girls Club, Lompoc Elks Lodge, Nazarene Church, Jetty and Magellan restaurants, Avenue and Valley Florists, Starbuck-Lind Mortuary and hundreds of other apartment buildings and houses. He also designed the Spy Glass and Trader Nick's Restaurants in Pismo Beach …," *LR*, Feb. 11, 1992, pp. A-1, 5.

Murayama, Frank (notices in Northern Santa Barbara County newspapers on microfilm and on newspapers.com)
1958 – "A request for a home use permit by Frank Murayama who plans to conduct a designing and drafting

office in his home on North A street was approved...," *LR*, Nov. 6, 1958, p. 13, col. 4.

1959 – Repro of drawing of church and "Trinity Nazarene Church Proposes Modern Bldg... Frank Murayama, architectural draftsman for the building," *LR*, Jan. 22, 1959, p. 20 (i.e., 8c); port. with J. A. Peterson and group breaking ground for a new motel at 528 North H street, *LR*, Feb. 26, 1959, p. 3; ad: designer of Hinode Market owned by Mr. Inouye, *LR*, Sept. 10, 1959, p. 19 (i.e., 3-c).

1961 – Ad: designer of Rooster Drive-in, *LR*, Sept. 28, 1961, p. 22 (i.e., 6c).

And, numerous additional notices not itemized here.

<u>Murayama, Frank (misc. bibliography)</u>

Frank Sadamu Murayama was b. Aug. 3, 1921, d. Feb. 9, 1992 and is buried in Lompoc Evergreen Cemetery, per findagrave.com (refs. ancestry.com).

Muro, George Peter (1925-2005) (Santa Maria)
Artist / teacher Santa Maria High School, 1951+, at Allan Hancock College, 1954+, head of college art gallery, 1954+, and president of Santa Maria Art Association. Exh. Santa Ynez Valley Art Exhibit, 1955, 1956. Exh. painting at Santa Barbara County Fair, 1952. Chairman of art division at Santa Barbara County Fair, 1958+.

■ "George Peter Muro, 1925-2005 ... retired Hancock College Art instructor, died Wednesday, August 10 in Prescott, Arizona, at the Margaret Morris Alzheimer Center. George Lived in Santa Maria for 50 years. He taught art at Hancock College for 38 years and was head of the Art Department... George was born January 4, 1925 in Los Angeles, Ca., and served 4 years in the navy during World War II and was stationed in Alaska. After leaving the navy, he attended San Jose State University where he received his B. A. degree in Art and then went on to receive his M.A. degree in Art from Stanford University. He was quoted as saying he was most proud of his students who had taken his classes and rewarded him by becoming award winning artists who achieved prominent positions in the field of art. His passion for the arts was demonstrated through his philosophy, 'If I can give people just one thing, I hope it will be awareness of their surroundings and the impact on their community.' Among George's other accomplishments include his planning the design of the Humanities Building at Hancock College, The Growth and Development of The Arts Department under his direction, and his artistic expression that was recognized not only in Santa Maria but also through exhibits at The DeYoung Museum in San Francisco, The Pasadena Museum (Norton Simon Museum) and The Springfield Museum of Art in Mo. He was celebrated as man of the year on April 8, 1995 as a leader facilitating The Communities Cultural Identity with his art and design experience," per "George Peter Muro 1925-2005," *SMT*, Aug. 14, 2005, p. 11.

■ "'If I had to do it again, I'd be exactly what I became,' George Muro said without hesitation. He always knew he wanted to be an artist. 'I was born with a brush in my hand,' he quipped. The Santa Maria Museum Art Center Fantasy Gala honored Muro recently for a lifetime of artistic achievement and leadership. 'They said so many nice things about me that I was ready to weep,' he said.

'Growing up, I sometimes felt I was the least likely to succeed.' As a child in Los Angeles during the Great Depression, Muro, 70, remembers being inventive with very little. 'Paper was precious,' so he drew on wrapping paper. He built tree houses and caves from whatever was available. 'Having less made me appreciate more,' he said. A native Californian, 'born into the Golden State when it truly was golden,' Muro loved the natural beauty that surrounded him, especially the wide expanses of beaches. 'I know I was lucky to live in L.A. then,' he said. Before it was destroyed by 'too much money and greed.' Los Angeles 'was a second Athens – it had all the vitality and beauty.' Muro radiates energy and vitality – two words he uses frequently as he recalls his accomplishments in the arts and education. He describes himself as 'an individual who doesn't compromise principles,' and someone with 'a searching energy, a craving to learn.' He always 'wanted to know what was going on everywhere.' In the sunny pristine studio of the Orcutt home he designed three years ago, Muro doesn't simply discuss his achievements or ideas. Taking portfolios from the nearby shelves or digging into files from his desk, he illuminates his points with paintings, clippings or course material. He whips out a map of 'the best designed community in the United States' to show alternatives to the unnatural grid-pattern used for most city streets. He loves 'the excitement of something new.' He 'wants to be contemporary and discover things.' His artist approach is 'always changing.' He's experimenting these days with new techniques for pouring paint. He's 'playing with abstract things, looking for patterns.' In part, his search involves the Fibonacci sequence, mathematical ratios found in nature. Described by 13th century Italian mathematician Leonardo Fibonacci, sequence is evident everywhere – the patterns of pine cones, the proportions of the human body, the center of sunflowers, the branches of trees and the way rivulets merge into rivers. 'The system could be used for anything,' Muro said enthusiastically, opening a book on the subject. 'We should teach it to kids. We should be looking at it for design elements of furniture, buildings, the flow of traffic.' He thinks 'we're in dire need' of a system that creates a more organic environment. 'We're human beings not boxes. I suffer when I see ugliness being built,' he said. 'We bulldoze things until they are flat. We build ugly things and we're destroying the environment.' Muro likes the 'instinctive qualities, the delicacy and transparency' of watercolors. The medium's lightness also attracted him – not just the paint's artistic properties, but the actual weight. 'I could take it with me without it being cumbersome.' A distinct advantage for someone who has traveled extensively, forever seeking beauty and ideas that 'ignite' something within him. His art has been exhibited at the De Young Museum of Art in San Francisco, the Santa Barbara Museum of Art, the Springfield Museum of Art in Missouri, and at Guadalajara University in Mexico, plus many one-man shows. Muro joined the Navy at 18 where 'they trained me to be a neat-nik,' he said jokingly. After the war he earned his bachelor's degree at San Jose State University and his master's degree at Stanford. He came to Santa Maria to teach art at Santa Maria High School and the newly established college. 'When I started teaching there was a vitality that was exciting,' he recalled. The post-World War

II period in California was one of 'the best times – people in education were creating something. The arts were being revitalized.' At Hancock College from 1951 until his retirement in 1989, he served as chairman of the Fine Arts Department for 36 years. He developed the department, established three design courses, and was 'very much involved in the physical growth of the campus' as an architectural adviser for many of the buildings, including the Learning Resource Center, Child Development Center and the new Humanities Complex, which he likes the best. 'What pleases me most was the energy I got out of the students,' he said of his career at Hancock. By his estimate, he has taught more than 8,000 students. Teaching is a 'privilege,' he said. He's preparing a three-day workshop in watercolors, to be held this September at the San Luis Obispo Art Center. 'I'm a helluva competitor. I love competition,' Muro said, laughing. His dynamism and intensity galvanized students to incredible levels of accomplishment. Santa Maria High School students in the 1950s won many Gold Key awards in state-wide competitions. His Hancock student's art work awards in 12 out of 13 categories at the California State Fair. In 1970 the only non-professionals in a field of 800 entries, the Hancock students won first prize in the Pasadena Museum of Art 'California Design Eleven' competition. The 'ARTiculating Forms' that Muro developed with his students still intrigue him. These simple geometrically shaped units can be combined horizontally, vertically and at different angles to create a variety of environments. 'I'll be ticked off if I don't do something with them before I die,' he said. Scanning a notebook of clippings and photographs of these forms, he read one of his statements about them aloud: 'Human involvement in art is long overdue. The art forms of tomorrow must come out of the museums and become an active part of the environment.' For a moment Muro was still, 'Now, that's profound, isn't it? I want that on my tombstone,' he said smiling. As he works on his July show at Corbett Canyon Winery, Muro is planning 'something different' to display the paintings. They won't just hang on walls. He first tried this when he opened the Hancock College's first art gallery in the barracks – art hung from screens made of old army cot bed springs. The success of the experiment fostered his belief that paintings can be effectively exhibited in new and interesting ways. Muro has served the community as Santa Barbara County Arts commissioner; chairman for the '1 percent for the arts committee'; art director of the Santa Barbara County Fair; and as exhibition judge for various competitions. Though active on the Santa Maria Arts Council, MAC board of directors, the Central Coast Watercolor Society and Lompoc Mural Society, he said he's cutting back on meetings. 'I want quietness in this part of my life,' he said. 'You have to be able to sit and meditate about what you're doing and about nature and beauty. Beauty is an essential need of mankind. It gives us an environment that provides the stimulation man needs – without it you get people killing each other…" per Cheryl Weiss, "Art Center Honors Artist for Lifetime Contributions: A Man with 'Searching Energy,'" *Santa Maria Times*, April 28, 1995, pp. B-1, B-6+.

Muro, George (notices in Northern Santa Barbara County newspapers on microfilm and on newspapers.com)
1951 – "Creative Crafts," i.e., copper, leather, block printing, and design in various mediums, to be taught in adult school by Muro, *SMT,* Sept. 10, 1951, p. 4.
1952 – He was very active as president of **Santa Maria Art Assn** in 1952; teacher of art at Santa Maria HS, "Muro Exhibit is at **Forden** Gallery," *T-T,* Sept. 8, 1952, p. 2; bio. and titles of "Pictures by Muro Displayed at **Forden** Hardware," *T-T,* Sept. 10, 1952, p. 5; "George Muro's Paintings are Reviewed," by **Margaret Maxwell**, *T-T,* Sept. 19, 1952, p. 2; "Panhellenics to see Muro Paintings" at private home and hear his lecture on modern art, illustrated primarily with a showing of his own water colors principally of Santa Maria Valley subjects, *SMT,* Nov. 4, 1952, p. 4.
1953 – Art teacher at Santa Maria HS and president of **Santa Maria Art Assn**, "George Muro is Speaker on Art for Women's' [i.e., Community] Club," *SMT,* Feb. 11, 1953, p. 4; "Painting is Hung in Museum" i.e., watercolor at DeYoung in SF, *SMT,* April 7, 1953, p. 4.
1954 – Port. at easel and "Water Colors by Muro on Exhibition… in the Broadway windows of Ames and Harris… All of the scenes are those that may be seen on a summer vacation trip through California… The artist, who teaches in Santa Maria High school art department, says that his own favorite… 'Westlake Park' … In contrast are the San Francisco paintings. Here, the artist has finished only one modern study showing buildings in a metropolitan skyline… It is plainly evident his own preference is for the scenes of old San Francisco, one of them a block of the ancient frame houses on a steep hillside street… 'I would like to spend more time in San Francisco, and I am certain if I did, then I would have to do more of the older houses – and perhaps the waterfront.' Fisherman's Wharf is the subject of one of the sea front studies… fishing boats rocking at anchor was done while at Monterey and Big Sur on an Easter vacation sketching trip… This week he sent a painting titled 'The Plaza,' to show at a Monterey Fair exhibition… Los Angeles subject. There is one local scene… The old schoolhouse at Betteravia… painting is his favorite hobby as well as vocation, the artist is beginning work on a portrait of his daughter, Renee, age eight-and-a-half months. And… drawing of plans for a new home, to include a studio …," *SMT,* June 30, 1954, p. 4.
1955 – "Jr. Community [Club] Hears George Muro on Art," and also sees show of jewelry made by Mrs. Fern Shipley, *SMT,* Nov. 3, 1955, p. 4.
1956 – "Muro Water Colors to be Exhibited" at Hancock Art Gallery in February sponsored by **Beta Sigma Phi** sorority, *SMT,* Feb. 1, 1956, p. 4; "Lends Paintings for Club Bridge" i.e., Minerva Club's dessert bridge party, *SMT,* April 8, 1956, p. 5; "'Magnolias' Water Color Won as Prize," from art exhibit hung at Santa Barbara County Fair arranged by AAUW, *SMT,* July 31, 1956, p. 4; a class in producing the college yearbook was added to his classes at Hancock College, *SMT,* Sept. 6, 1956, p. 8; "Muro Paintings New Exhibit at [Hancock] Gallery," and article explains, ■ "A one-man show of 20 or more paintings… Outstanding are his three studies in water color of turkeys, Rhode Island hens and roosters and guinea fowl. The barnyard pictures were made of live subjects at a local

valley farm. By request, he is again showing the 'Possum' painting made at Waller Park Menagerie that was first exhibited last summer at the County Fair. Of interest to students of local history is his new water color of an ancient frame house, said to have once been the home of Mrs. Minerva Thornburg, after whom the Minerva club is named. It is next to an aged frame store building, both structures now located at the rear and almost hidden in the 300 block West Church. Mrs. Madeline Sykes is loaning two Muro paintings, 'Morro Rock,' and 'Red Car on Santa Maria Valley Railroad.' **Mrs. Emma Brians** is loaning her commissioned Muro water color of 'Matilija Poppies.' Two sea coast paints [sic. paintings] both being shown for the first time are 'Beach Home at Morro Bay,' and 'Sand Dunes at Oso Flaco,' where sand, sea, sky and beach and wildflowers native to the dunes blend their colors. Others of the artist's favorite subjects, the sea, are a San Diego beach scene and boats at anchor and beached for repair," *SMT,* Nov. 2, 1956, p. 4.

1957 – "Muro's Paintings at Padua Hills Exhibit," i.e., 18 paintings made possible through **Milford Zornes**, and "Muro previously had paintings displayed at the **Faulkner** Gallery in Santa Barbara and a one-man exhibit at the art gallery in San Luis Obispo," *SMT,* Feb. 19, 1957, p. 3; port. at easel and "Poor Man's Picasso" and repro. of drawing p. 1-B and 1-C, and article states: ■ "George Muro is the poor man's Picasso. Along with being the art instructor at Allan Hancock College, George Muro has also done many works of art himself which have been displayed from the **Santa Maria Inn** to the de Young Museum in San Francisco. Muro designed the front pages for the retail and brochure sections of this 75th anniversary edition of the *Times.* He tried to incorporate the many phases of living found in the Santa Maria Valley. His work was displayed at this year's County Fair, where he was in charge of the decorations in the exhibit building. The theme of 'Circus Time' was used by Muro and assistant **Nat Fast**, high school art instructor, who designed a large carousel as a theme center piece. He also designed the *Times* display booth in the big tent. Muro was born and raised in Los Angeles where he attended city schools. However, when he attained college age, he decided to get out of the smog. He went to San Jose State where he received his bachelor degree. He attended Stanford for his master's degree, and returned to Los Angeles for art work at the Chouinard Art School. He also spent two and a half years with the Navy as an aviation mechanic. He has been teaching in Santa Maria schools for the past seven years. For the first part of the time, he worked a dual position with the high school, but during the past two years he has been teaching only at the college. Recently the *Times* did a story in its Home section on the Muro home, which he designed. It is in the Pabst Tract off the Orcutt road. Last year's college year book, the *MASCOT,* was also among the specialties designed by Muro. Using strong opposing verticals and horizontals, Muro made a book of [Sic.?] rare approach to creative design. A binding panel of textured material added change of design to the outward appearance of the book. Muro delights in the challenging possibilities of using mechanical and hand designed art in a panel. This was shown quite graphically in his use of hand drawn advertisements in the back of the book. Sparking the cartooning possibilities of

many of his students, Muro was able to use this combination of designs in his year book. For his own work, however, he has stayed mainly with water colors and has had many one-man shows of his paintings. He explains that water color paints are easier to carry than oils and they are somewhat easier to manipulate. However, he has done many fine paintings in oil and other media, and feels that an artist should try all forms of art rather than dwindle down to only one or two forms. Many of his works have been in art galleries in Los Angeles, San Luis Obispo and Santa Barbara in addition to Santa Maria and San Francisco," *SMT,* Oct. 11, 1957, p. 10 [i.e., newspapers.com has this as p. 6]; "Speaker at [Miller Street school] Mothers Club," on topic of "Art and Your Child," *SMT,* Oct. 25, 1957, p. 3.

1958 – Port. with one of his wc's advertising his exhibit at Rick's restaurant, with "paintings hung in the lounge, dining room and Dutch room include San Francisco scenes, waterfront studies, the San Simeon lighthouse tower, Morro Dock with fishing boats and a Yosemite forest stream… he has framed all of the paintings in this exhibit" per *SMT,* Dec. 20, 1958, p. 3.

1960 – "Artistic Point of View… Women's Division of the Chamber of Commerce… [art] is an important element missing in the planning of communities… message brought by George Muro…," *LR,* March 7, 1960, p. 8.

Muro, George (misc. bibliography)
George P. Muro was b. Jan. 4, 1925 in Los Angeles to Thomas Muro and Mary Brichta, married Carole M. Dawson, and d. Aug. 10, 2005 in Prescott, Ariz., per Brady Family Tree; George P. Muro is buried in Santa Maria Cemetery District per findagrave.com (refs. ancestry.com).
See: "Allan Hancock College," 1955, 1956, 1959, "Allan Hancock College Adult/Night School," 1956, 1957, 1958, 1959, 1960, "Allan Hancock College, Art Department," intro., 1955, "Allan Hancock [College] Art Gallery," intro., 1954-58, "Amador, Trinidad," 1956, 1990, "American Association of University Women," 1958, "Dipple, Gordon," 1953, "Elk's Club," 1960, "Fairey, Mildred," "Fast, Nat," intro., "Forward, Moselle," 1960, "Fujioka, Henry," 1959, "Halloween Window Decorating Contest (Santa Maria)," 1953, "Heller, Hazel," 1953, "Junior Community Club," 1955, "Mendelowitz, Daniel," "Oback, N. Eric," "Posters, American Legion (Poppy) (Santa Maria)," 1953, 1956, "Prater, Barbara," 1959, "Rembrandt Club," "San Luis Obispo County Art Show (San Luis Obispo)," 1957, "Santa Barbara County Fair," 1952, 1953, 1958, 1959, 1960, 1961, "Santa Barbara County Library (Santa Maria)," 1951, 1953, "Santa Maria Art Association," 1952, 1953, "Santa Maria, Ca., Adult/Night School," 1951, 1953, 1954, 1955, "Santa Maria, Ca., Union High School," 1952, 1953, 1954, 1955, 1956, "Santa Maria [Valley] Art Festival," 1952, 1953, "Santa Ynez Valley Art Exhibit," 1955, 1956, "Veglia, Mario," "Wilson, JoAnn Smith," intro., "Winter Arts Program," intro, 1952

Murphy, Palmyra (Mrs. Thomas Murphy) (Santa Ynez)
Member of Santa Maria Valley Adult School painting class under Leo Ziegler, 1947, 1949.
Palmyra Murphy is listed in the 1940 U. S. Census as age 48, b. c. 1892 in Calif., finished elementary school, 8th grade, residing in Santa Ynez (1935, 1940) with husband Thomas Murphy (age 68) and daughter Genivive (age 26) (ref. ancestry.com).
See: "Santa Ynez Valley, Ca., Adult/Night School," 1947, 1949

Murphy, William "Bill" (W. J.) (1914-1976?) (Santa Maria)
Photographer. Member Santa Maria Camera Club, 1944-49.
Murphy, William (notices in Northern Santa Barbara County newspapers on microfilm and on newspapers.com)
1942 – "Notice. I have sold the business known as Terry Service, located at 401 South Broadway, City of Santa Maria… to W. J. Murphy, Santa Maria, California… H. R. Terry…," *SMT*, May 15, 1942, p. 3.
1945 – "Notice. I will not be responsible for any debts contracted for Murphy service except by myself after this date, W. J. Murphy," *SMT*, June 4, 1945, p. 3.
Murphy, William (misc. bibliography)
Is he William J. Murphy listed in the 1940 U. S. Census as age 26, b. c. 1914, finished high school 4th year, service station attendant, residing in Brookings, S. D. (1935) and Santa Maria, Ca. (1940) with Edythe M. Murphy (age 26); is he Wm. J. Murphy, pres. Mission Auto Sup., who is listed with wife, Edythe M. at 108 S. Bonita St., per *Santa Maria, Ca., CD*, 1970; is he William J. Murphy b. Jan. 31, 1914 in South Dakota, d. Aug. 13, 1976 in Santa Barbara County per Calif. Death Index (refs. ancestry.com).
See: "Santa Maria Camera Club," 1944, 1946, 1947, 1949

Murray, Robert "Bob" Ernest (1924-2004) (Lompoc)
Photographer. Member La Purisima Camera Club, 1948. Credited with photos repro. in the LR, 1960, 1961.
■ "Robert Ernest Murray… passed away on June 10, 2004 in Crescent City… He was a resident of Curry County, Oregon, for the past 13 years, and prior to that was a 37-year resident of Lompoc, California. His family owned a ranch in Miguelito Canyon. Robert spent three years in the Army in the Pacific… He enjoyed photography both as an amateur and as a professional his whole life…," *LR*, June 16, 2004, p. 3.
Murray, Robert (notices in Northern Santa Barbara County newspapers on microfilm and on newspapers.com)
1941 – "High School Relay Meet Scheduled… Ticket Prices Listed … Other officials will include… Robert Murray, photographer…," *LR*, April 18, 1941, p. 1.
1942 – Port., with Lompoc high school Class of '42, *LR*, May 29, 1942, p. 6.
1946 – "Carol Ford Bride of … Robert Ernest Murray, son of Mrs. L. R. [Lottie Rose Whipple] Murray… On December 23rd Murray received his discharge from the service. Following their marriage, the couple have made their home with his mother, Mrs. Walter [Ernest] Murray, in Miguelito Canyon," *LR*, Jan. 24, 1946, p. 3.

1950 – Port. of Robert Ernest Murray with bride, Shirley Ann Maase, *LR*, Sept. 14, 1950, p. 4.
1960 – Repro: "Honored Couple… Holmdahl," *LR*, Feb. 4, 1960, p. 6; repro: "Men's Camp," *LR*, Feb. 11, 1960, p. 4; repro: "Ribbon Cutting" Lompoc Valley Bowl, *LR*, Feb. 15, 1960, p. 3; repro: "Mr. and Mrs. Walter Ploch, Jr.," *LR*, Feb. 18, 1960, p. 4.
1961 – Repro: "New Officers" of Federal Electric Corporation wives Club, *LR*, May 11, 1961, p. 6.
And, a few additional notices reveal he was taking flying lessons (1946), was skipper of the Sea Scout Ship (1948), and was Grange chairman (1951) but they were not itemized here.
Murray, Robert (misc. bibliography)
Robert Ernest Murray provided the following information on his WWII Draft Card dated June 30, 1942 = age 18, b. Jan. 13, 1924 in Los Angeles, residing in Lompoc, employer is Lottie Murray (refs. ancestry.com).
See: "La Purisima Camera Club," 1948

Murray (McArthur), Virginia (Mrs. John McArthur) (Lompoc)
Art teacher, Lompoc Union High School, fall 1945.
■ "Virginia Murray Married. … Miss Virginia Murray was married on January 9 to John McArthur at her parents' home in Wadena, Minnesota. While in Lompoc Mrs. McArthur was art instructor at the Lompoc High School," *LR*, Jan. 10, 1946, p. 8.
See: "Lompoc, Ca., Union High School," 1945, 1946

Museums (Northern Santa Barbara County)
Institutions or organizations that collected and displayed art prior to 1960.
■ "Suggests Staging Danish Days, funds to Aid Proposed Museum…. It would be best if this museum could be a community project. We have promises from the Carlsberg Brewing Co. of Denmark that if we show them that we have good intentions of building this museum that they will assist us in getting articles and buildings for same. Here is my proposition: Let's hold **Danish Days** this year, but a trifle later, say the last weekend in September or the first weekend in October. Let's have our breakfast on the street, our Danish exhibits, folk dancing, gym team, etc. Perhaps a dance on Saturday night. No program in the bowl, unless it can be simple, and turn in the proceeds toward the Danish museum. Another thing, too, let us have everything on a volunteer basis… **Ray Paaske**," *SYVN*, April 24, 1959, p. 10.
Many additional sites served as temporary art exhibition venues including rooms in the various public schools and libraries, rooms in civic buildings such as community centers, and at special events, not itemized here.
See: "Alpha Club," "Allan Hancock [College] Art Gallery," "Art, general (Santa Maria)," 1932, "College Art Club," 1932, "Danish Days," "Elverhoj Museum," "Lompoc Valley Historical Society," "Minerva Club," "Minerva Club, Art and Hobby Show," "Mission Santa Ines," "Santa Barbara County Library" in Lompoc, Santa Maria, and Solvang, "Santa Maria Valley Historical Society," "Santa Ynez Valley Historical Society"

Mussell, Elwin Elbert (1905-1980) (Santa Maria)
Charter member, College Art Club, 1926. Carver of gunstocks. Owner of a print shop. Mayor of Santa Maria. His son Allen Mussell also showed artistic talent but is not listed here.

■ Port. and "Elwin Mussell killed in accident… former mayor dies in canyon roll-over… Willy's jeep pick-up … rolled off Santa Maria Mesa road…," *SMT*, May 12, 1980, p. 1.
Mussell, Elwin (misc. bibliography)
Elwin Elbert Mussell was b. March 16, 1905 in Wahpeton, ND, to William Levi Mussell and Susie Lillian Hansen, married Barbara Eleanor Higgins, and d. May 12, 1980 in Santa Maria, Ca., per Mussell 2013 Family Tree (refs. ancestry.com).
See: "College Art Club," intro, 1927, "Community Club," 1952

Mussell, Ruth Agnes
See: "Bettersworth (Mussell), Ruth Agnes (Mrs. Loren H. Mussell)"

Musselman, Darwin B. (1916-2001) (Fresno)
Painter / art teacher in Fresno. Judge of art exh. at Santa Barbara County Fair, 1960.

■ "Darwin B Musselman (1916-2001), was born in Selma, California, and lived in Fresno during most of his childhood, graduating from Fresno High School, and Fresno State College. After completing his post graduate studies and early career opportunities, he returned to Fresno, and lived there from 1953 to 1987, Los Osos, Ca. from 1987 to 1995, and Lancaster, Pa. from 1995 to his death on June 28, 2001," from darwinmusselman.com and also see darwinmusselmanpaintings.com.
See: "Santa Barbara County Fair," 1960

Myers, Edna Maude (Mrs. True E. Myers) (1896-1973) (Santa Maria)
Painter. Exh. Tri-County Art Show, 1950, and "Home Talent" art show at Allan Hancock [College] Art Gallery, 1955.

■ "Edna M. Myers… 76, a long-time resident of Santa Maria [funeral] … held Tuesday at Menlo Park with burial following at Alta Mesa Memorial Park, Palo Alto. Mrs. Myers, widow of True E. Myers, a 35-year employee of Pacific Gas and Electric Co. in Santa Maria, died Feb. 16 in Atherton where she had lived with a daughter since her husband's death in 1964. She was an active clubwoman in Santa Maria and was a 25-year member of Mizpah chapter of Eastern Star and a member of the Minerva club, Emera Club and the Presbyterian Church. Mrs. Myers was born July 25, 1896 in Norwalk, Iowa. She moved to California in 1927, living in Porterville and San Luis Obispo before moving to Santa Maria. They moved from Santa Maria to Redwood City in 1960 on Mr. Myers' retirement…," *SMT*, Feb. 24, 1973, p. 4.
And, articles in the *SMT* show she was active with the Red Cross.

See: "Allan Hancock [College] Art Gallery," 1955, "Rembrandt Club," 1955, "Tri-County Art Show," 1950

Myers, T. A.
Photographer employed by [Fred] Hartsook Photograph Co. He looked over Santa Maria as a possible site for business, 1918. According to California newspaper ads, the Hartsook Photograph Company was active in Bakersfield, Oakland, Pomona, Santa Cruz, Sebastopol, Stockton, Visalia and other smaller central California towns roughly between 1912 and 1931.
1918 – "T. A. Myers, representing the Hartsook Photograph Co. was in town looking over possibilities for setting up a business here," per "Twenty-five Years Ago," *SMT*, April 30, 1943, p. 6.

N

Nadeau (pseud?) (Rogers), Evelyn Hunt (nee Evelyn Dilly Hunt) (Mrs. Dale Bush Rogers) (1898-1976) (Santa Barbara / Los Angeles / Tepesquet)
Painter. Resident with her parents at Ventura (1900), at Pasadena (1910) and probably later in LA, since she cites studying under LA artist Ricardo de Artega Espino for eight years. By April 1936 she was probably married to Dale Rogers and was working for the WPA as an artist at the Southwest Museum. During WWII she did cartographic work for the U.S. Navy (in Washington, D.C.?) In 1947 she returned to LA but by 1948 was in Watsonville, Ca., where she taught art and worked freelance. Listed as an artist in Fresno c. 1955-60. Listed as an artist in Santa Barbara, c. 1966-67. Retired to the family ranch in Tepesquet canyon, northern Santa Barbara county, where she died, 1976.

■ "Watercolors by WPA Artist Evelyn H. Nadeau on view at the Southwest Museum …From April 1936 through June 1937 Evelyn H. Nadeau was commissioned by the WPA to document the Southwest Museum's collection of Southwestern basketry and selected pieces of Navajo, Mojave, Pima and Maricopa pottery. Twenty-five of her exceptional watercolors will be on view in the Lower Lobby Gallery through October 5, 1997. … The National Park Service established a unit within the Federal Art Project to, among other things, provide for the preservation of antiquities of national significance. From April 1936 until July 1937 the Southwest Museum, under the leadership of Curator Mark R. Harrington, participated in this part of the Project, utilizing as many as 32 artists and crafts people. The rate of pay ranged from $84 to $94 per month, and 'street-car tokens could be issued for those living at a distance.' … Evelyn Hunt Nadeau was among the artists who worked in the Art Project during its 16 months at the Museum. She produced nearly 40 watercolors, mostly of pottery, with some paintings of baskets, robes and hides. A comment about her work found among the records of the Project states, 'For reference purposes, sets of watercolors were made, the best of which is an excellent series illustrating the typical pottery of the

various tribes of Southwest Indians..., a series worthy of exhibit or reproduction.' A letter dated June 11, 1937, from the Museum to a WPA official calls Evelyn 'one of our best and most versatile workers.' When the WPA ended its tenure at the Southwest Museum in 1937, Evelyn was hired directly by the Museum to continue cataloging its collections and provide illustrations for *The Masterkey.* During World War II Evelyn lived in Washington, D.C. and worked for the armed forces in cartography and aerial mosaics. In 1947 she returned to California, where she became an art teacher and free-lance artist. Eventually she retired to the family ranch just outside Santa Maria, where she died in 1976 at the age of 77" (from a PR release of the SW Museum appearing on http://www.tfaoi.com/newsmu/nmus47.htm).

Nadeau, Evelyn (notices in Northern Santa Barbara County newspapers on microfilm and on newspapers.com)
1940 – "Nadeau Paintings Will Be Exhibited. Water color studies of exotic plants and wild flowers of California… at the Southwest Museum, Tuesday… The water colors also will include illustrations of American Indian pottery. Miss Nadeau, a great-grand-daughter of Remi Nadeau, studied for eight years under Ricardo de Artega Espino [b. Mexico but resident of LA, c. 1916-54]," *LA Times*, March 3, 1940, p. 13 (i.e., pt. II, p. 1); "Laguna Beach Art Association has sent paintings by some of its members to the Art Commission's galleries, third floor and Tower Room, City Hall, where they will be shown to Aug. 6… [including] Flower paintings by Evelyn Nadeau…," *LA Times*, Aug. 11, 1940, p. 53 (pt. III, p. 9, col. 2).
1941 – "New Exhibits This Week … Arroyo Seco Library – Evelyn Nadeau water colors, to Nov. 30," *LA Times*, Nov. 16, 1941, p. 61 (pt. III, p. 7).
1956 – FATHER – obit. "Herbert F. Hunt, pioneer rancher in the Tepesquet Canyon for the past 40 years… He is survived by his wife… daughters… Mrs. Evelyn Nadeau, Fresno…," *SMT*, Sept. 28, 1956, p. 3.
1973 – "Art Show Held at Tepesquet. Art works by Evelyn Nadeau were presented in a one-day exhibit Sunday, June 10, at the Brogoitti Ranch in Tepusquet. The event is believed to be the first art show ever held in the rural canyon area. Some 40 oils and a variety of watercolors… Mrs. Nadeau is a free-lance artist and is a member of the Hunt family of Santa Barbara. She now makes her home in the Tepusquet area. For a number of years, she was associated with the Southwest Museum of Los Angeles, illustrating museum publications. During war years she did cartographic drafting for the U. S. Navy and aerial mosaic work for both the U. S. Army and Navy. She is represented in many California and Washington, D. C. exhibits. Mrs. Nadeau taught private art classes for 10 years. Along with art affiliations, she is a member of the Archaeological Survey Association," *SMT*, June 16, 1973, p. 21.
Bibliography: *PSCA*, vol. **4/5/6**, p. V-294.
Nadeau, Evelyn Hunt (misc. bibliography)
GRANDMOTHER – Evelyn's mother, Lydia Bell Hunt, had a mother named Mary Rose Nadeau (1857-1935) per Steven Philip Bell Family Tree (?); "Mary S. [Sic. R.] Nadeau" married James H. Bell on April 8, 1874 in LA City per Calif. County Birth Marriage and Death Records, and per the 1880 Census of LA James and wife Mary R. begat children Alexander, Lydia and Minnie.

Evelyn D. Hunt was born Aug. 27, 1898 in San Bernardino, Ca. per 2RehobothANC Family Tree; Evelyn D. Hunt is listed in the 1900 U. S. Census as age 1, b. Aug. 1898 in Calif., to Herbert F. Hunt and Lydia Hunt [1876-1904], residing in Hueneme, Ventura County, Ca., with her parents at the home of her grandparents Jane [Sic. James] Bell and Mary Bell; Evelyn D. Hunt is listed in the 1910 U. S. Census as residing in Pasadena with her father: Herbert F. Hunt (age 33) and step-mother Edith B. Hunt (age 33) and siblings: Jesse/Jessie H. Hunt (age 9), and Alice M. Hunt (age 7); in the 1930 U. S. Census Dale Rogers is married to "Gene" who was b. c. 1898 but in "Illinois" with no children – is this Evelyn?; Evelyn Rogers is listed in the 1940 U. S. Census as age 41, b. Calif., highest grade completed is High School, 3rd year, an illustrator in a Museum working six hours a week but only having worked 2 weeks in 1939, residing in Los Angeles City, Ward 54 (604 Frontinac Avenue) (1935, 1940) with husband Dale Rogers (age 37, an auto body repairman); Evelyn Rogers at 604 Frontenac Ave., LA, is listed as "Person who will always know your address" on WWII Draft Card "Change of Address" for Dale Bush Rogers, who was then residing in the Overland Hotel, Winnemucca, Nevada (card dated 1942?); Evelyn D. Nadeau is listed in the *Watsonville, Ca., CD, Rural Routes*, 1948; Mrs. Evelyn D. Nadeau is listed as "artist" in the *Fresno, Ca., CD*, 1955, 1958, 1960; Mrs. Evelyn D. Nadeau is listed in the *Santa Barbara, Ca., CD*, 1966, 1967; Evelyn Dilly Hunt was b. Aug. 28, 1898 in Escondido, Ca. [Sic. San Bernardino?], to Herbert Fred Hunt and Lydia Bell, married Dale Bush Rogers, and d. July 18, 1976 in Santa Barbara County per Rogers Family Tree; port. appears in Public Member Photos & Scanned Documents (ref. ancestry.com).

Nahl, Perham (1869-1935) (Northern California)
Teacher of drawing for University of California Extension, 1921.

■ "Perham Wilhelm Nahl also known as Perham Nahl was an American printmaker, painter, illustrator and an arts educator active in Northern California," per Wikipedia.
See: "Japanese Art," "University of California, Extension," 1921

Narjot, Ernest Etienne (1826-1898) (California)
One of his paintings was lent to the Art Loan Exhibit, Solvang, 1935.

■ "Ernest Étienne Narjot was an American artist of the 19th century. He produced many fine paintings of California landscape, in particular of life in the Gold Country," per Wikipedia.
See: "Art Loan Exhibit (Solvang)," 1935

National Art Week / American Art Week (Northern Santa Barbara County)

National Art Week was first mentioned in an American newspaper (Birmingham, Ala.) in 1920 with the implication it was a movement of the National Federation of Women's Clubs. It is assumed that each member club was encouraged to hold art exhibitions of its choice during the first week of November. The idea appears to have been taken up by the Federal Art Project (and according to some authors was hatched by the Project) in the mid-1930s to cultivate a greater cultural and consumer awareness of the arts across America. The celebration appears to have been held frequently c. 1935-41. However, the idea (and the name) seem to have been carried over by some cities, sometimes interchangeable with American Art Week, until at least 1960 and possibly later. Occasionally an art exhibit was mounted in northern Santa Barbara county that was associated with "National Art Week."

Bibliography: History of the WPA version of the event is detailed in a pamphlet, *National Art Week, November 25th - December 1st: A work of American art in every American home*, Chicago: Illinois WPA Art Project, bet. 1936 and 1941. **November 25-December 1, 1940** - *"National Art Week" is sponsored by the Section and WPA/FAP,* per wpamurals.com/history.

National Art Week (notices in Northern Santa Barbara County newspapers on microfilm and on newspapers.com)
1935 – "S. M. Artists to Exhibit Works here During National Art Week," *SMT*, Oct. 30, 1935, p. 3; "Western Artists Exhibit Works in High School. Celebration of National Art Week … artists of the West and Southwest… displayed in the upper corridors of the high school and in the art department. It was hung under the direction of **Stanley G. Breneiser**. The oil paintings, ten in all, depict scenes in New Mexico. They are the interpretations by the three **Breneisers – Stanley, Barbara [Sic. Elizabeth?]** and **John Day** – of the vividly colored, picturesque country of Southwestern United States, which the three artists visited this summer. They spent several months in Santa Fe, studying, teaching and exchanging ideas with other artists… Most of the oils … are bright with the blues, greens, purples and reds of the desert lands. Typical of the group is 'Rounding Forms' by **John Breneiser**… As one progresses down the corridor, the reviewer sees 'On the Way to Frijoles, N. Mex.' by **Elizabeth Breneiser**, and 'Near San Ildefonso, N. Mex.' 'Pecos Mission Ruins' and 'Storm at Sunset Near Tesuqui, N. Mex.,' by **Stanley Breneiser**. The rest of the oils are the younger **Breneiser**'s and include 'In the Pueblo,' which depicts two Indians; 'Otowi, N. Mex.', 'Near the Rio Grande – San Ildefonso,' which shows a cross over the grave of one Juan Valdez … 'Cienega, N. Mex.,' and 'New Mexico Mesa.' His one pastel crayon is 'Pastel Amarillas.' Artistic Reaction to Hollywood. Subject matter of the prints varies from a lithograph by Peter Krasnow, showing one of his reactions to Hollywood, to an etching, 'Malibu Meadows,' by **Arthur Millier**… Mrs. **Breneiser**'s work is represented by a woodblock, 'Spiders,' while **John Breneiser** has several woodblocks and lithographs. One lithograph which creates much comment is 'Water Lilies.' 'Morro Bay,' a woodblock, which was reproduced in *Western Artist*, is also

in the collection done by **Mr. Breneiser. Mildred Bryant Brooks** has submitted 'In Chapman Woods,' an etching. … Private Collection Shown. Thirteen lithographs, one aquatint, six block prints and one etching have been taken from **John Breneiser**'s private collection for the exhibit. **Marian Hebert, Helen Ferne Slump [Sic. Slimp], Tom Barr, Mildred Bryant Brooks, Gerald Cassidy, Henrietta Shore,** Zane [?]**, Stanley Breneiser, Maxine Albro,** Bea Brooks [?] and **Richard Day**… are represented. One of Mr. Breneiser's favorites is the **Albro** lithograph of 'Indian Madonna' which shows an Indian mother and her child… on display during the rest of the week during the day. Tomorrow evening, from 7 to 9 o'clock…," *SMT*, Nov. 6, 1935, p. 3.
1940 – "To See Exhibits in Santa Maria," Nov. 25 - Dec. 1, purpose is to make talent of American artists known to public and encourage purchase. **Stanley Breneiser** is local chairman. Work of local artists to be hung at Minerva Club library, and in upper hall of HS will be a national traveling exhibit of autographed miniature palettes, four of which were made by the Breneisers, *SMT*, Nov. 7, 1940, p. 3; "Art Exhibits on Display Next Week" and at HS will be exhibit of original silk screen paintings, copies of old Navajo rugs, lent by Museum of Anthropology of Santa Fe, and at **Minerva club** will be a "Santa Barbara" display plus four works by the late **Joffre Bragg**, several by **Nicholas Firfires**, some by **Byron Openshaw** of Orcutt and several by **John, Margaret, Elizabeth and Stanley Breneiser**, *SMT*, Nov. 23, 1940, p. 1; "Santa Maria Artists Featured in Exhibit for Art Week," including **Breneisers, Nicholas Firfires, Byron Openshaw** of Orcutt, **Marian Volk** of Nipomo, and the late **Joffre Bragg**. "Many of the pictures are for sale…. Among those not for sale are the elder **Breneiser**'s 'Pecos Mission Ruins,' his landscape, 'Near Sacramento,' and 'Storm Near Tesuque' (New Mexico). The younger **[John Day] Breneiser** has a still life which is marked with a certificate of exhibition in the **Golden Gate Exposition**… and another still life. A Point Sal scene… Two Western pictures by young **Firfires** have been hung … They are 'Lone Rider' and 'Sun Up.' He also has two landscapes in the show. One of the pictures which has been sold already is **Byron Openshaw**'s 'Cuyama.' He also has 'Decorative Flowers' and 'Foxen Memorial Church'… the latter complete to the cross awry on top…," and many Santa Barbara artists included. "In addition to the show in the clubhouse, there is also an exhibition in the high school, second floor hall, adjacent to the Art department where may be seen a collection of 24 autographed miniature palettes loaned by Duncan, Vail Co. In the collection are those of **Stanley, John Day** and **Margaret Breneiser**…," and at HS are silk screen prints of old Navajo rugs made by **Louie Ewing**, former Santa Marian and now an art teacher in New Mexico, *SMT*, Nov. 26, 1940, p. 3; "The art exhibition in the **Minerva club** has been arranged by **Stanley Breneiser** in observance of National Art Week… Oils, watercolors and prints are being shown. The artists include **Nicholas Firfires** of Santa Maria and **Allan G. Cram, John B. Hamilton, Margaret E. Webb, Brett F. Moore, Lily [Sic. Lilly] P. Bitterly, Alice Bigler, A. Harold Knott, James Bodrero, Martin A. D'Andrea, Trin F. Bonn, Robert J. McCormick, Blossom Owen, Barton Hopkins, Mary S. [Sic. F.] Wesselhoeft, Virgil**

Ravenscroft, Standish Backus, Jr., Dora Bromfield, Thomas Stetson, Charlotte S. Stuart, Henry S. Ford, Evelyn K. Richmond, Campbell Grant, Joseph Knowles, DeWitt Parshall, N. A., Grace Vollmer, Mary Hughitt Halliday, Charlotte Berend and **Clarence Hinkle** of Santa Barbara," per "Many Artists Show at SM Exhibition," *Santa Barbara News Press* (clipping, hand dated Nov. 29, 1940, p. 22: 1 in SMVHS).

1954 – "American Art Week is Marked with Exhibitions" such as SLO artist **Thornton Snider**'s exhibit at the Santa Maria Public Library, "**Mrs. Thurman Fairey**, art chairman for the [**Junior Community**] club, arranged for the artist to speak at Tuesday's meeting and show some of his paintings," and the paintings represent the artist's "memory of characters and scenes in France and Bavaria, where he was stationed while in the Armed Services. A few are of subjects in the Central Coast district, including landscapes and ranch scenes. On appearing at the Junior Community club's meeting, Snider demonstrated painting with a palette knife instead of brush. The 'bowl of fruit' study, made before the club, was presented to the membership as a gift," *SMT*, Nov. 4, 1954, p. 7.

See: "Breneiser, Stanley," 1936, "College Art Club," 1935, "Community Club (Santa Maria)," 1950, "Flower Show," 1948, "Junior Community Club (Santa Maria)," 1951, 1955, "Minerva Club," 1940, "Owen, Blossom," 1952, "Santa Barbara County Library (Santa Maria)," 1950, 1951, 1952, "Santa Maria, Ca., Union High School," 1935, 1952, "Santa Maria Camera Club," 1940

National Scholastic Art Exhibit / Contest/ Awards
See: "Scholastic Art Exhibit"

National Society of Illustrators (New York)
See: "Art, general (Lompoc)," 1960

Native American
The main tribe in Santa Barbara County was the Chumash.
See: "Collectors, Art/Antiques," "Harcoff, Lyla," "Jones, S. J.," "Likes, Myrton," "Lompoc Historical Museum," "Mission La Purisima," "Mission Santa Inex," "Murals," "Ruth, Clarence," "Sanja Cota Indian Reservation," "Santa Barbara County Library," 1948, "Weldon, John," and *Central Coast Artist Visitors before 1960*

Naval Missile Facility (Point Arguello)
Employer of draftsmen, 1959.
■ "Federal Electric Corp.... Operator and Maintenance Contractor of the Naval Missile Facility... Pt. Arguello, has immediate openings for... Junior Draftsman. Young man or lady to perform drafting duties in Engr. Dept. Duties include detailed drawings and sketches, retouching work, preparation of calibration curves, layout and some art work. Applicant should be High School Graduate with one-year exper. in drafting capacity. Photo-Optics Trainees. Excellent opportunity for young men, preferably high school graduates, to undergo training course for Photo

Optics positions on expanding Naval Missile Facilities Project. Motion picture or commercial photography experience and knowledge of optical equipment highly desirable," *LR*, Oct. 29, 1959, p. 28.
See: "Drafting," "Spallino, Robert"

Needlecraft Club / Needle Craft Club / Los Olivos Needle Craft (Los Olivos)
Sewing club organized 1913. Frequent contributor to the Santa Ynez Valley Fair, 1930s.
■ "Needle Craft Gives Party... The Needle Craft Club of Los Olivos honored Mrs. Dallas Davis... Mrs. Davis is one of the charter members of the club, which was organized sixteen years ago this coming March...," *SYVN*, Aug. 30, 1929, p. 1.

Needlecraft Club (notices in Northern Santa Barbara County newspapers on microfilm and on newspapers.com)
1926 – "Needlecraft Celebrates 13 [th] Anniversary... with chicken supper and social...," *SYVN*, March 26, 1926, p. 1; "... met at the home of Mrs. Harvey Stonebarger on Thursday...," *SYVN*, Sept. 3, 1926, p. 1; will hold a cooked food sale at Henning's Hall, *SYVN*, Nov. 19, 1926, p. 4.
1933 – "The Needlecraft Club met at the home of Mrs. D. D. Davis in Santa Maria... The afternoon was spent in sewing on a quilt. Those present were ...," *SYVN*, June 23, 1933, p. 4.
1934 – "The February meeting of the Needlecraft society was held Thursday at the home of Mrs. Bernard Davis. Bert Carner of the Santa Ynez High School called during the afternoon and discussed the **EEP program**. It was decided to spend one afternoon a week on an arts crafts course if a teacher could be procured," *LR*, March 9, 1934, p. 6.
1938 – "Needlecraft Club to Celebrate 25th Birthday," *SYVN*, March 11, 1938, p. 1.
1954 – "Looking Backward... 20 Years Ago... annual election of officers," *SYVN*, Dec. 17, 1954, p. 6.
And, more than 75 hits for "Needle Craft" and nearly 50 for "Needlecraft Club" in the *SYVN*, 1920-1960 and several hits for "Needlecraft" and "Needle Craft" in the *LR*, were not itemized here.
See: "Better Homes," 1932, "Briggs, Dorothy," "Santa Ynez Valley Fair," 1932, 1936, 1938, 1941

Needlecraft Club (Santa Maria)
Club at Santa Maria High School, 1935. Referred to as "Knitting and Needlecraft" in 1938.
See: "Santa Maria, Ca., Union High School," 1935, 1938

Needlework
See: "Handwork / Handiwork," "Needlecraft"

Needlework Guild
Section of the Junior Community Club.
See: "Community Club," 1953, 1954, "Junior Community Club (Santa Maria)," 1951, 1955, 1957

Neff, Adele
Itinerant entertainer / delineator (chalk-talk artist) who gave a program before the Lompoc Community Women's Club, 1956.
See: "Lompoc Community Woman's Club," 1956

Negus (Lindegaard) (Johns) (Allen), Annette Irene (Mrs. Svend Lindegaard) (Mrs. Roger M. Johns) (Mrs. James Allen) (1937-1991) (Lompoc / Solvang)
Santa Ynez High School grad., 1955. Winner of Poppy poster contest, 1955. Art major at UC, Santa Barbara. When married to Lindegaard, she maintained an art studio on the Lompoc-Buellton road, 1966. Daughter of Martha Negus, below.

■ "Annette Negus Allen, 54, of Hamilton, died of cancer Tuesday at her residence. She was born March 13, 1937 in Lompoc, Calif. the daughter of Edward and Marth Negus. She received her education from U. C. Santa Barbara and Allen Hancock Community College and then received a B. A. in education and an M. A. in special education at Chico State University. She taught in the Glenn County School district for 20 years and was scheduled for retirement in June. Upon retirement she had planned to join her husband in Hamilton. On Nov. 27, 1984 she married James Allen at Lompoc, Calif. She was an energetic, giving person who enhanced the lives of those she taught and nurtured. She was enthusiastic about the arts and life in general. She enjoyed the outdoors and all that nature had to offer...," *Ravalli Republic* (Hamilton, Mont.), Nov. 8, 1991, p. 8.
Negus, Annette (notices in Northern Santa Barbara County newspapers on microfilm and on newspapers.com)
1955 – "Annette Negus Awarded Art Scholarship by St. Mark's. ... a graduating senior at Santa Ynez Valley Union High School, has been awarded a $250 scholarship by the Art Scholarship Committee of St. Mark's-in-the-Valley Episcopal Church... the first to be made by the committee... from proceeds from the 1954 art exhibit... It is understood that Miss Negus will continue the study of art at the School of Arts and Crafts in Oakland...," *SYVN*, June 3, 1955, p. 1.
1956 – Port. and "Annette Negus Engagement told...," *LR*, Feb. 9, 1956, p. 13; port. and "Miss Negus, Mr. Lindegaard are Engaged. Mr. and Mrs. Edward Negus of 619 W. Cypress Avenue, Lompoc, have announced the engagement of their daughter Annette to Svend Lindegaard, son of Mr. and Mrs. K. P. Lindegaard of Solvang. Both Miss Negus and her fiance received their diplomas from Santa Ynez Valley Union High School. The future bride, attending the University of California, Santa Barbara College as an art major is a resident of Manzanita Hall. Lindegaard served four years in the United States Air Force and is now employed at the Union Oil Company Nipomo Refinery. An early fall wedding is planned," *SYVN*, Feb. 17, 1956, p. 3; Port. with new husband and "Annette Negus, Svend Lindegaard Married in Lompoc Church Rite," *SYVN*, Sept. 21, 1956, p. 3.
1964 – "Mrs. Lindegaard Art Displayed... Solvang Branch Library... A colorful exhibit of eight oils including abstract and stylized landscapes... will be on view for a month ...," *SYVN*, March 6, 1964, p. 15 (i.e., 7-B); "Buellton Library... A group of extraordinary paintings by Annette Lindegaard

are on display," *SYVN*, July 9, 1964, p. 10 (i.e., 2B); chairman of Christmas parade, *SYVN*, Dec. 24, 1964, p. 8.
1965 – Port. with son on departure for Denmark where she will teach briefly at a school there, *SYVN*, June 3, 1965, p. 15 (i.e., 7B).
1966 –"Annette Lindegaard's New Art Studio Opening Noted by Party. An April Fool's champagne party in celebration of the opening of Annette Lindegaard's new art studio was given in her honor by her husband, Svend Lindegaard on All Fools' Day. Highlight of the festive occasion was the combining of everyone's talent in oils on one large canvas. The art studio is located behind the Lindegaard house on the Lompoc-Buellton road. Mrs. Lindegaard recently received honors for two of her paintings entered in the Mission Hills Art Show," *SYVN*, April 7, 1966, p. 15.
1970 – "Chico State Midyear Exercises... Will Confer 739 Degrees... Chico – ... Annette I. Johns...," *Sacramento Bee*, Jan. 26, 1970, p. 13 (i.e., B-3).
1971 – Author of a letter-to-editor regarding "immorality" of present school system, *LR*, May 19, 1971, p. 9.
Negus, Annette (misc. bibliography)
Annette Irene Negus, mother's maiden name Erickson, was b. March 13, 1937 in Santa Barbara County per Calif. Birth Index; Annette Negus is listed in the 1940 U. S. Census as age 3, b. c. 1937, residing in Lompoc with her parents Edward Negus (age 34) and Martha Negus (age 30) and brother Carl (age 1); Annette Irene Negus, married Svend Lindegaard on Sept. 8, 1956 in Santa Barbara County per Calif. Marriage Index; Annette I. Negus / Lindegaard, b. c. 1937, married Roger M. Johns on April 14, 1968 in Santa Barbara County per Calif. Marriage Index; Annette Negus Allen b. March 13, 1937 in Lompoc, Ca., d. Nov. 5, 1991 in Hamilton, Mont., per Montana State Deaths (refs. ancestry.com).
See: "Four-H," 1952, "Hibbits, Forrest," 1964, "Negus, Martha," "Posters, American Legion (Poppy) (Santa Ynez Valley)," 1955, "Santa Ynez Valley Art Exhibit," 1958,

Negus, Marjorie (Mrs. Richard William Negus) (Lompoc)
Artist, 1957. Member Junior Alphas, 1953-54.

■ "Mr. and Mrs. Richard Negus, formerly of Lompoc, now residents of Pacific Beach, San Diego, for the past two years, spent the Fourth of July weekend with his mother, Mrs. William Negus at her Santa Rita Ranch. Ted and Tim, the Negus children, accompanied their parents... Mrs. Richard Negus was recently honored with a first place award for one of her watercolor paintings exhibited at the Art Display held in Balboa Park. She is now **Penny Arts** chairman of the CFW, Junior Membership, Women's club of San Diego," *LR*, July 18, 1957, p. 16.
A few notices in Calif. newspapers concern only her club work and were not itemized here.

Negus, Martha Helena Erickson (Mrs. Edward Louis Negus) (Lompoc)
Art Section chairman of Alpha Club, 1948. Flower arranger, 1950s. Mother to Annette Negus, above.
1957 – Author of "Fun With Flower Arrangements," a several-column article of instructions, *LR*, June 20, 1957, p. 20.
1962 – "Boeing Wives to Meet… Featured on the program will be a flower arrangement demonstration by Mrs. Ed Negus," *LR*, Feb. 1, 1962, p. 6.
More than 150 notices for "Mrs. Ed Negus" in the *LR* show that she was advisor to Blue Birds and Boy Scouts and PTA when her children were active, and that she volunteered with charitable organizations, but they were not itemized here.
See: "Alpha Club," 1948, "Community Center," 1947, "Negus, Annette," "United Service Organization (Lompoc)," 1945

Neil, Milt (1914-1997) (Buellton)
Former Disney artist and, in 1947, advertising manager for Andersen's pea soup. Originated the cartoon pea-splitters Hap-pea and Pea-wee.
■ "Milt Neil (May 30, 1914 – October 18, 1997), sometimes known as 'the Duck Man', was an American animator, toy designer and comics artist. He was born in New Jersey in 1914. He worked for **Disney** Studios from 1935 to 1944. He worked on *Fantasia, Dumbo, Saludos Amigos,* and *The Three Caballeros.* After leaving Disney he briefly worked for <u>Walter Lantz</u>. He was also active in advertising and redesigned the two mascots of Pea Soup Andersen's. They received their permanent names Hap-Pea and Pea-Wee through a contest. Neil became involved with the children's show *Howdy Doody*, for whom he designed puppets and various other merchandising objects. Together with Chad Grothkopf he adapted the TV show into a newspaper comic between 1950 and 1953, though he only worked on it for the first three months, after which Grothkopf took over. Neil ran the character animation program at the Joe Kubert School of Cartoon and Graphic Design. He passed away in 1997," per Wikipedia.com.
<u>Neil, Milt (notices in Northern Santa Barbara County newspapers on microfilm and on newspapers.com)</u>
1947 – "Ad, Sales Manager Named by Andersen. Milt Neil, former vice-president of Mabelim Associates Advertising Agency, with offices in Hollywood, Chicago and New York, has recently been appointed advertising and sales manager for **Andersen's Frozen Green Split Pea Soup**. Mr. Neil, a former **Walt Disney** artist and director, originated Hap-pea and Pea-wee, the comical Andersen pea splitters who adorn the highways and packages of frozen split pea soup. The new member of the Andersen organization is married and has two children, a boy and a girl. He is going to settle in or around Buellton but said today he was about to embark on a house-hunting expedition," *SYVN*, June 6, 1947, p. 1; "Provincial Art Work Presented … Milt Neil, formerly with the **Walt Disney** studios in Hollywood and also former advertising manager for Andersen's in Buellton, completed the art work this week on a series of pictures which are principally provincial in character. Many of the pictures depict

attractive little Danish girls attired in bright costumes, while others tend to present the atmosphere of the Valley. The pictures go on sale today at the office of the *Valley News*," *SYVN*, Sept. 19, 1947, p. 1; "Mr. and Mrs. Milt Neil and family, who have been living at Little Creek Ranch the past three months, moved from the Valley Saturday for their home in New Jersey. Mr. Neil was former advertising manager for Andersen's in Buellton," *SYVN*, Oct. 24, 1947, p. 4, col. 3.
1954 – Re-drew the Andersen's pea soup chefs, Hap-Pea and Pea-Wee to their present form, *SYVN*, Sept. 17, 1954, p. 42 (i.e., 16).
See: "Andersen's," 1954

Nelson, Catherine Price (Los Angeles)
Researcher at the Huntington Library, San Marino, who lectured on the Library to the Minerva Club, 1938.
See: "Minerva Club," 1938

Nelson, Dorothea D. (Mrs. Paul L. Nelson) (1903-1994) (Santa Maria)
Librarian who curated art and other exhibits at the Santa Maria Library, 1939+.
■ "Dorothea D. Nelson… died Nov. 17, 1994 at the home of her daughter in Fort Worth, Texas. Mrs. Nelson was born in Colorado Springs, Colo. She came to California in the early 1920s. Mrs. Nelson graduated from Library School at Berkeley and took a position as head librarian in January of 1934 for the City of Santa Maria. She remained in that position until her retirement in 1968…," *SMT*, Dec. 14, 1994, p. 6.
See: "Santa Barbara County Library (Santa Maria)"

Nelson, Harry Gustaf (1905-1986) (Lompoc / Shell Beach)
Teacher of mechanical drawing and industrial arts (woodshop) at Lompoc High School, 1926-46. Photographer. Prop. Nelson Fuchsia Garden in Shell Beach.
■ "Harry Nelson… 83… Mr. Nelson was born Feb. 20, 1902 in Firth, Idaho. He taught at Lompoc Union High School for 20 years. When he retired in 1946, he and his wife Esther moved to Shell Beach where they owned the Nelson Fushia [Sic. Fuchsia] Gardens for 18 years…," *LR*, Jan. 22, 1986, p. 3.
See: "Lompoc, Ca., Junior High School," 1938, "Lompoc, Ca., Union High School," 1926, 1927, 1928, 1931, 1932, 1933, 1934, 1937, 1946, "Santa Barbara County Fair," 1950, "Santa Barbara County Library (Lompoc)," 1937, "Swaney, James"

Nelson, Lucy
See: "DeGasparis (Nelson), Lucy Elaine (Mrs. Dr. Harold Olaf Nelson)"

Nelson, Milton Eugene (1911-1994) (Lompoc)
Model maker, who had a college degree in architectural drafting, 1955.

■ "A Model Minded Family… with all of his business and civic activities it is something of a minor miracle that Milton Nelson can find the extra hours needed to engage in a hobby, especially such a time-consuming one. … Model building is 'Milt's' hobby and his interesting collection of beautifully assembled ship, plane and automobile models are ample proof of the skill … Using the regular packaged model kits found in hobby shops… Milton has created numerous miniature replicas of old-fashioned cars, modern airplanes, impressive Navy battleships and aircraft carriers and romantic old sailing vessels. Milt has been at his model building for seven or eight years now… [works together with his son Stephen on a card table set up in the living room] … Milt has always liked to work with his hands and while in high school he took special elective courses in lathe work… Working with both wood and plastic models, Milton has some times spent as much as thirty-two hours on putting together just one model… The Nelsons, who live at 420 East Hickory Ave…. came to Lompoc from Santa Maria in 1940. Milt was born in Modesto, California, and was educated in San Jose at the high school and state college… In college he majored in architectural drafting but upon graduation in the middle of the depression years… went into his father's profession ... the vegetable business… He first came to Lompoc with the California Pine Box Distributors and then in 1942 when the California-Vegetable Growers company started operations in the valley, he was their first employee. He has remained with Cal-Veg and will still handle sales for them in this area though he has recently accepted a position as general manager and sales manager for Phelan and Taylor Produce Company Inc. in Oceano. … Active in almost all major local organizations, Milt was the original organizer of the 20-30 Club, a Past Master of the Lompoc Masonic Lodge No. 262, a Past President of the Shrine Club, a Cub Scout commissioner… In addition to his model building and stamp collecting hobbies, Milt is a chess enthusiast… In addition to son Steven… the Nelsons have a married daughter, Mrs. Loma Lee Huseman… the Nelsons… will soon be moving to Fair Oaks or Arroyo Grande to be nearer Milt's new job….," *LR*, Feb. 3, 1955, p. 5.
Nelson, Milton (misc. bibliography)
Milton Eugene Nelson provided the following information on his WWII Draft Card dated Oct. 16, 1940 = b. April 7, 1911 in Modesto, Ca., employee of California Pine Box Distributers, residing in Lompoc with wife, Margie Nadine; Milton Eugene Nelson b. April 7, 1911 in Calif., d. Jan. 10, 1994 in San Luis Obispo County per Calif. Death Index (refs. ancestry.com).

Nelson, Robert Carrol (1912-1991) (Solvang)
Commercial photographer. Prop. of Solvang Photo Shop, 1947-51.

■ "Robert C. Nelson, manager of the Mission Theatre, is leaving the Valley today for Fresno where he will assume a position with the Fresno City and County Housing Authority. … A resident of the Valley since he was six years of age, Mr. Nelson is a veteran of World War II and

served in the Navy. He entered the service in 1942 and was aboard the aircraft carrier *USS Copahee* in the Pacific during the war. He left the service with the rating electrician's mate first class. After leaving the service in 1945, he worked for Axel Nielsen, owner of the theatre, and in 1947 leased the theatre from him. In 1948 Nelson established the **Solvang Photo Shop** on Main Street and a year later took over the appliance business in the same store from H. B. Foss. In 1951 he sold out his appliance business to the Linden Electric Co. During the last year Mr. Nelson has devoted his time to the theatre and worked for Harland Bennett of the Valley Electric Service. Mr. Nelson is the son of Mrs. Carolyn Nelson of Ballard…," *SYVN*, Aug. 29, 1952, p. 7.
Nelson, Robert (notices in Northern Santa Barbara County newspapers on microfilm and on newspapers.com)
1947 – "**Solvang Photo Shop**. Opening for business Saturday – October 25… Copenhagen Square – north end of barracks building behind brick building. Soon handling a nationally known line of Film and Photo Supplies…," *SYVN*, Oct. 24, 1947, p. 4; "Flying Club… Develop New Landing Strip… Since the club was organized, eight members have learned to fly and have obtained their flying licenses. They are … Robert C. Nelson…," *SYVN*, Dec. 5, 1947, p. 1.
1948 – Repro: photo of cast of play, 'Growing Pains' at the high school (p. 1), and "Nelson to Handle Annual Photo Work… for this year's annual of the senior class of the Santa Ynez Valley Union High School. This work was previously done out of the Valley. The individual pictures of each class member will be taken by the **Florence McAllister Studio**," *SYVN*, March 5, 1948, p. 6; "Sorensen-Nelson Nuptials Held Saturday at Ceremony in Fresno… Mr. Nelson is a graduate of the Santa Ynez Valley Union High School and during the war served in the Navy for three and a half years," *SYVN*, June 11, 1948, p. 4; "Bring your film to the **Solvang Photo Studio**. Developing and printing. 24-hour service. Robert C. Nelson, proprietor…," *SYVN*, Nov. 19, 1948, p. 9.
1949 – Repro: awards ceremony at high school for Junior Livestock Show, *SMT*, May 14, 1949, p. 8; ad: "Announcement. From July 1st, Mr. Robert C. Nelson has taken over management and ownership of the appliance business. We are continuing the store as usual … the store has been enlarged… H. B. Foss Electric Shop," *SYVN*, July 8, 1949, p. 4.
1950 – Repro: ceremonies at dedication of Davison flag pole at Oak Hill Cemetery, *SYVN*, April 21, 1950, p. 1; repro: new clubrooms of **Solvang Woman's Club**, *SYVN*, May 19, 1950, p. 5; "Michele Mayet Assumes Management of Theatre… from Robert C. Nelson, who has managed it since February of 1947," *SYVN*, June 2, 1950, p. 5; "Portrait Work Offered Here by Griesbauer. Robert C. Nelson of the **Solvang Photo Shop** announced today that **Jack Griesbauer**, portrait photographer and commercial illustrator, will now be affiliated with the shop…," *SYVN*, Sept. 15, 1950, p. 1; repro: nativity scene by **M/M Viggo Brandt-Erichsen**, *SYVN*, Dec. 22, 1950, p. 1.
1951 – "*Ford Times* Gives Story on Solvang… the attractive, colored photo was taken by Robert C. Nelson of the **Solvang Photo Shop**… The photo showed **Ferdinand Sorensen**'s windmill, with four youngsters in Danish

costumes appearing in the foreground …," *SYVN*, Jan. 5, 1951, p. 4; "Notice of Intended Sale and Transfer… Michele Mayet of Solvang… intends to sell, transfer and assign to Robert C. Nelson of Solvang, California, all of the stock in trade of a popcorn and candy stand and the fixtures and equipment used therein and all of the supplies of a motion picture theatre business known as 'Danish Village Theatre'…," *SYVN*, April 6, 1951, p. 7; Classified ad: "Still on Hand – Ansco Clipper and Shur Shot Cameras. Kodak chemicals, Weston meter and large selection View Master Reels. All bargains at 15% off. Robert Nelson, 5891," *SYVN*, April 27, 1951, p. 7.

1952 – "Valleyites Aid at Cooke. Many residents of the Valley are giving of their time and knowledge to make life more interesting for the ambulatory patients, a majority of them Korea war veterans at the Army Hospital at Camp Cooke… Robert C. Nelson, manager of the Mission Theatre, has spent several hours … teaching the soldier patients the principles of sound projection," *SYVN*, Aug. 15, 1952, p. 8; "Bob Nelson Taking Post in Fresno… he will assume a position with the Fresno City and County Housing Authority," and article recaps his history in Solvang, *SYVN*, Aug. 29, 1952, p. 7; "New Pharmacist Buys Nelson Home," *SYVN*, Nov. 7, 1952, p. 6.

Nelson, Robert (misc. bibliography)
Robert Carrol Nelson provided the following information on his WWII Draft Card = age 28, b. June 12, 1912 in Fair View, Montana, residing in Santa Ynez, nearest relative Caroline M. Nelson, mother; Robert Carrol Nelson b. June 12, 1912, d. Aug. 8, 1991 and is buried in Oak Hill Cemetery, Ballard, per findagrave.com (refs. ancestry.com).

Nerheim, Betty Van Stone (Mrs. Leif Nerheim) (Long Island)
Painter. Visiting daughter of Mrs. H. S. (Elva) Van Stone and member of Santa Maria Art Assn. who exh. painting at Santa Barbara County Fair, 1952.
See: "Santa Barbara County Fair," 1952, "Van Stone, Elva"

New Deal
"… series of programs, public work projects, financial reforms, and regulations enacted by President Franklin D. Roosevelt in the United States between 1933 and 1939. It responded to needs for relief, reform, and recovery from the Great Depression," Wikipedia
Various New Deal projects were active in northern Santa Barbara County in the 1930s.
See: "Federal Art Projects," "Seegert, Helen," "Works Progress Administration," and *Central Coast Artist Visitors before 1960*

Newcomb (Huntoon), Alice Winston Adams (Mrs. Harry "Hal" Howard Newcomb) (Mrs. John Wesly Huntoon) (1869-1962) (Pasadena)
Artist of novelties made of butterfly wings and flowers that were displayed at Valley Variety Store, 1922.
See: *Central Coast Artist Visitors before 1960*

Newhall, Elbridge Gerry, Jr. (1898-1967) (Santa Barbara)
Photographer who exh. at Santa Ynez Valley Art Exhibit, 1954, 1955. Also acted as a photography judge throughout Southern and Central California.
Newhall, Elbridge (notices in American newspapers on microfilm and on newspapers.com)
1944 – "Photographic Guild… New officers of the Photographic Guild of Detroit are … Elbridge G. Newhall, Jr., secretary…," *Detroit Free Press*, June 18, 1944, p. 36 (i.e., pt. 4, p. 6).
1945 – "Birmingham Couple… Mr. and Mrs. Elbridge Newhall who with their family are moving to Los Angeles, Calif. are being feted at a round of farewell parties…," *Detroit Free Press*, Nov. 25, 1945, p. 22 (pt. 3, p. 2).
1949 – DAUGHTER – "New Yorker Honored… Newhalls Tell Troth. Mr. and Mrs. Elbridge Gerry Newhall of the Channel City have announced the engagement of their daughter Elaine to John Richard McCarty …," *LA Times*, Dec. 18, 1949, p. 91 (i.e., pt. III, p. 7).
And, more than 20 references in Calif. newspapers to his acting as a photography judge that describe him as "a top Southern California pictorialist and a frequent salon contributor," as a "nationally known salon and magazine contributor," and as "an associate of the Photographic Society of America," but they were not itemized here.
Newhall, Elbridge (misc. bibliography)
Elbridge Newhall is listed in the *Santa Barbara, Ca., CD*, 1949-67; Elbridge Newhall was b. July 2, 1898 in Detroit, Mi., to Elbridge Gerry Newhall and Mary N. Lyon, married Florence S. Lemont, and d. March 6, 1967 in Santa Barbara per Gideon and Zillah Merrill Ellis Descendants Family Tree (refs. ancestry.com).
See: "Santa Ynez Valley Art Exhibit," 1954, 1955

Newlove, Bertha Annette
See: "Kleine (Newlove), Bertha Annette (Mrs. Ernest Alford Newlove)"

Newman, Helen (Santa Maria)
Child, age 10, who exh. a crayon drawing at "Santa Barbara County Fair," 1893.
See: "Santa Barbara County Fair," 1893

Nichols, Adda / Addie Reading (Mrs. Almon H. Nichols) (Santa Maria)
Active with College Art Club, 1934. Wife of Almon H. Nichols of the Santa Maria Bulb Gardens. Active with garden section of Minerva Club and frequent speaker on flowers (and on Mexico where she traveled, 1934) to local clubs. Moved, with her husband, to Oceanside, c. 1939.
See: "College Art Club," 1934

Nichols (Barton), Alice "Allie" Jane Morton (Mrs. Andrew Jackson "Jack" Nichols) (Mrs. Eugene Martin Barton of Manila and Los Gatos) (1852/53-1920) (Lompoc)
Painter. Art teacher. Exh. best portrait in oil and superintended the arts department at "Santa Barbara County Fair," Lompoc, 1892; and exh. a portrait and a marine, 1894. Taught art to Mrs. J. D. Black. Wife of Andrew Nichols, above.

■ "Death at Los Gatos of Former Resident. Mrs. Alice Burton [Sic.] (nee Mrs. Jack Nicols [Sic.]) died of double pneumonia in Los Gatos... Mrs. Barton formerly resided in Lompoc and will be remembered by all the early settlers...," *LR*, July 16, 1920, p. 1.
Nichols, A. J., Mrs. (notices in Northern Santa Barbara County newspapers on microfilm and on newspapers.com)
1892 – "Yesteryears. 64 Years Ago... Mrs. A. J. Nichols had presented the Grammar Department a fine oil painting, her own work, to aid the teachers and pupils in beautifying the rooms," *LR*, Nov. 13, 1952, p. 12.
1895 – "Mrs. Alice Nichols of Lompoc, wife of A. J. Nichols who was accidentally killed last week, is in the city on business connected with the estate," *Independent* (Santa Barbara, Ca.), May 18, 1895, p. 4, col. 2.
1909 – FATHER – "Lovett Himson [Sic. Stimson] Morton Passes Away in Siskiyou County ... Two daughters, Mrs. E. M. Barton of Manila and Mrs. J. D. Bacon of Alameda ...," *LR*, Oct. 22, 1909, p. 1.
Nichols, A. J., Mrs. (misc. bibliography)
Alice J. Nichols [Alice J. Morton] is listed in the 1880 U. S. Census as age 26, b. c. 1854 in Ohio, father's name Louett [Sic. Lovett] S. [Stimson] Morton (age 51) and mother's Emma A. [Ann Ford] Morton (age 46), residing in Carlinville, Ill., with husband Andrew J. Nichols (age 32, watchmaker and jeweler) and son Souett M. [Sic. Lovett M., age 4] and daughter Emma L. (age 3 months); Mrs. Eugene Barton, Wife Ex. Capt. Vols. Infantry, arrived from Manila by ship, *Serbia*, at SF Dec. 15, 1903 per Calif. Passenger and Crew Lists; Eugene M. Barton, hotel keeper in Manila applied for a passport on Sept. 16, 1913 for himself and "wife" to return to the U. S. for two years, per *U. S. Passport Applications, 1795-1925*; "Allie" J. Barton, age 64, b. Cleveland, Ohio, April 20, 1853, address in US = 1535 Benton St., Alameda, Ca., sailed with husband Eugene M. [Martin] Barton, age 60, b. Walpole, Mass, July 5th, 1857, from Manila, P. I. on Feb. 23, 1918, on the *S. S. Ecuador*, arriving at San Francisco March 31, 1918 per Calif. Passenger and Crew Lists; Alice J. Barton is listed in the 1920 U. S. Census as age 63, b. c. 1857 in Ohio, residing in Redwood, Santa Clara County, Ca., with husband Eugene M. Barton, a rancher; Alice J. Barton, b. c. 1852, d. July 6, 1920 in Santa Clara County per Calif. Death Index; Alice Jane Barton b. 1852 and d. 1920 is buried in Cypress Lawn Memorial Park, Colma, San Mateo County, Ca., per findagrave.com (refs. ancestry.com).
See: "Santa Barbara County Fair," 1892, 1894, and *San Luis Obispo Art and Photography before 1960*

Nichols, Andrew Jackson "Jack" (1849/50-1895) (Lompoc)
Jeweler. Exh. jewelry at "Santa Barbara County Fair," 1892, 1894. Husband of Alice Nichols, below.

■ "A. J. Nichols. Dealer in ... watches... jewelry... Seth Thomas Clocks, Quadruple Silver Plated Ware, Violins, Guitars... Spy and Field Glasses ... Johnston's Interchangeable Spectacles and Eye Glasses... All Goods Bought of Me Engraved Free. Having had twenty years practical experience as watchmaker and jeweler I am prepared to Repair the Most Complicated and Finest Watches. Sole Agent for the celebrated White Sewing Machine," *LR*, May 14, 1892, p. 1.
1931 – SON – "Morton Nichols Revisits Boyhood Home... many changes... The *Record* office, for instance: Back in the early days the present location of *The Record* office was occupied by Jack Nichols ... who conducted a jeweler's shop here... Morton Nichols is now a warrant officer in the Army being attached to Fort Mason, San Francisco... One couple upon whom the Nichols' called were Mr. and **Mrs. J. D. Black**. Mrs. Black recalled that she took painting lessons from **Mrs. Jack Nichols** many years ago...," *LR*, July 31, 1931, p. 4
Nichols, A. J. (misc. bibliography)
Is he A. J. Nichols b. 1850, d. May 5, 1895 and buried at Lompoc Evergreen Cemetery per findagrave.com (refs. ancestry.com).
See: "Nichols, Alice," "Santa Barbara County Fair," 1892, 1894

Nichols, Charles T. (Santa Ynez Valley)
Collector of early California antiques; owner of Las Cruces Inn, 1955.
See: "Collectors, Art/Antiques (Santa Ynez Valley)," 1955

Nichols, Estelle N. (1877-1960) (Lompoc)
Artist of a painting in the collection of the Lompoc Valley Historical Society.

■ "Services Held for Pioneer... She was born in Lompoc on March 4, 1877 to Merrit S. Nichols and Pastoria Dakan Nichols, pioneer settlers... in 1916 [her widowed mother married H. S. Rudolph, pioneer Lompoc merchant] ... On her graduation from Lompoc High School, she went to college and began her teaching career in 1900...," *LR*, July 4, 1960, pp. 1, 3.
See: "Lompoc Valley Historical Society, House"

Nichols, Maye / Mae Christine (Mrs. Charles Herbert "Herb" Nichols) (1901-1980) (Santa Maria)
Painter. Exh. artwork at several venues, 1949-53+. Exh. Allan Hancock [College] Art Gallery, 1955, 1957. Original member Santa Maria Art Association.

■ Port. with husband, C. H. Nichols, and "Golden Anniversary Marked... residents of Santa Maria for 35 years... The former Miss Maye Nichols, born in Melrose, Wis. and her future husband of Creston, Iowa, met at College in Dickinson, N. D. They were married December 10, 1923 in Wibaux, N.D. in the parsonage of the

Methodist Church. They moved from N. Dakota to Santa Maria in 1938. Nichols has been employed in general contracting here since that time," *SMT*, Dec. 28, 1973, p. 7; "Maye C. Nichols…," obituary, *SMT*, March 25, 1980, p. 7.

Nichols, Maye (notices in Northern Santa Barbara County newspapers on microfilm and on newspapers.com)
1949 – "Notice of Intended Sale… C. H. Nichols and C. Maye Nichols, his wife, doing business as Nichols' Cottage Grocery at 323 East Mill Street in the City of Santa Maria… will sell to Robert E. Brass said business…," *SMT*, July 14, 1949, p. 11.

Nichols, Maye (misc. bibliography)
Maye Christine Nichols was b. July 23, 1901 in Wisconsin, mother's maiden name Russell, and d. March 23, 1980 in Santa Barbara County per Calif. Death Index (refs. ancestry.com).
See: "Allan Hancock [College] Art Gallery," 1955, 1957, "Community Club (Santa Maria)," 1950, "Halloween Window Decorating Contest (Santa Maria)," 1951, "Junior Community Club," 1953, "Rembrandt Club," 1955, "Santa Barbara County Fair," 1949, 1951, 1952, 1953, "Santa Maria Art Association," 1949, 1951, 1953, "Santa Maria Valley Art Festival," 1952, "Tri-County Art Exhibit," 1949, 1950

Nicholson, John Leonard (1879-1940) (Santa Maria)
Photographer, carriage painter, c. 1910-40.

■ "Resident Here for 30 Years is Called. James [Sic. John] Leonard Nicholson, aged 50, a native of San Francisco and a resident of Santa Maria for the past 30 years, died early today… after an illness of three months. Deceased was a photographer and a painter and even though a very young man when he arrived here, he had been engaged in coach painting, then a very fine art. For a number of years, he was part owner in a West Main street rooming house. … Deceased was a member of the local aerie of Eagles," *SMT*, Feb. 24, 1940, p. 1.

Nicholson, John (misc. bibliography)
John Leonard Nicholson, mother's maiden name Hyland, was b. Oct. 5, 1879 in Calif. and d. Feb. 24, 1940 in Santa Barbara County per Calif. Death Index; John Leonard Nicholson is buried in Santa Maria Cemetery District per findagrave.com (refs. ancestry.com).

Nicholson, Juanita E. (1883-1967) (Lompoc / Bay Area)
Teacher of drawing at Lompoc High School, 1911-14.

■ "Rites Held for Juanita Nicholson… art teacher in the Oakland School district for 32 years before her retirement in 1949 …. She was 83. Miss Nicholson who died at her home at 119 Monte Cresta Ave., began her career [in Oakland] in 1917 at Garfield Elementary School and at the time of her retirement was an art teacher and student counselor at Roosevelt Junior High School. She was a member of the State and National Retired Teachers Associations and Esperanza Chapter, Daughters of the American Revolution…," *Oakland Tribune*, Jan. 30, 1967, p. 18.

Nicholson, E. Juanita (notices in Northern Santa Barbara County newspapers on microfilm and on newspapers.com)
1908 – "School of Design Exhibits Art Work… first annual exhibition since the fire of the California School of Design… Among the exhibitors last night, the following were given honorable mention in their respective departments: Life class – Juanita Nicholson… Decorative design – Juanita Nicholson …," *SF Call*, May 16, 1908, p. 5, col. 2; "Wins Scholarship for Second Time. Miss Juanita Nicholson, formerly of Orange, for the second time has been awarded a scholarship in the John Hopkins Institute of Art… Miss Nicholson's home at present is at St. Helena to which place her parents recently moved from Berkeley," *Santa Ana Register* (Santa Ana, Ca.), July 17, 1908, p. 3, col. 1; "Give Scholarship for Best Drawing… Julian Medal… [from students at] school of design of the San Francisco Institute of Art… Thirty drawings were sent to Paris and a jury, composed of Jules Lefebvre, Tony Robert Fleury and Jules Pages… awarded the medal… Those students whose work was favorably criticized are: … Juanita Nicholson…," *SF Call*, Aug. 21, 1908, p. 3.
1909 – Port. and "Woman for the Second Time Wins Blue and Gold Contest… for a suitable design to be used as a frontispiece in the annual class book of the university, the Blue and Gold, has been won by a woman student of the California School of Design in San Francisco. Miss Juanita Nicholson, a scholarship student… A Clever Design. The work, which is done in clay modeling, represents the figure of a graceful girl, with bowed head, holding a volume opened in her hands. It is done in relief work… The prize awarded is a summer vacation trip to the mountains," *Oakland Tribune*, March 7, 1909, p. 22.
1913 – "High School Teachers on Summer Vacations… U. C…. Miss Nicholsen [Sic. Nicholson] will be an instructor in drawing at the same institution …," *LR*, June 13, 1913, p. 1; "News of Art and artists… One of the most important features of the summer school at the University of California this year will be … [and teachers named] … Miss Juanita Nicholson completes the teaching force of the department," *SF Call*, June 8, 1913, p. 32.
1914 – "High School Seniors Pleasantly Entertained… [at home of] Miss Vivian Saunders… Miss Juanita Nicholson, … contributed a unique novelty… in the way of place cards. These consisted of figures drawn by her on the cards to depict the character represented by each in the senior class play given at the opera house last Friday evening," *LR*, May 22, 1914, p. 1.
1915 – "Miss Juanita Nicholson returned to her home at Livermore Monday. Miss Nicholson spent Thanksgiving vacation with friends here," *LR*, Dec. 3, 1915, p. 5, col. 2.
1921 – "Twenty-one Nations… The May Festival of the Arts showing the Oakland Public Schools at work will open in the Municipal Auditorium tomorrow… [demonstrations?] May 4… 4 to 4:30 p.m. – Demonstration of useful ornaments made of permodello or modeling clay, Miss Juanita Nicholson, Longfellow School, in charge…," *Oakland Tribune*, May 1, 1921, p. 1.
1924 – "Festival Staged … students of the Roosevelt High school … Settings and posters were drawn and hundreds of yards of cloth for the costumes … were dyed by members of the applied arts and stagecraft groups under the direction

of Miss Juanita Nicholson…," *Oakland Tribune*, Dec. 12, 1924, p. 33, col. 2.
1928 – "Registration Opens… Sierra summer school of the Fresno State College at Huntington lake… four new instructors… Juanita Nicholson…," *Fresno Morning Republican*, June 25, 1928, p. 10.
1931 – "Sierra Summer School… Juanita Nicholson, art instructor at the Roosevelt high school in Oakland since 1923 and instructor in the University of California summer session, will be the new addition to the art department…," *Fresno Morning Republican*, April 12, 1931, p. 10.
And more than 60 additional notices, primarily in the *Oakland Tribune*, regarding her teaching, were not itemized here.

Nicholson, E. Juanita (misc. bibliography)
Juanita E. Nicholson is listed in the 1900 U. S. Census as residing in Orange, Ca., with her family; Juanita E. Nicholson was b. April 2, 1883 in Mexico to William H. Drake Nicholson and Abigail D. Cochrane, was residing in St. Helena, Ca., in 1910, and d. Jan. 15, 1967 in Oakland, Ca., per Southwick Family Tree (refs. ancestry.com).
See: "Lompoc, Ca., Union High School," 1911, 1912, 1914

Nickson, Herbert William (1881-1961), Ivy Mizpah Pettit Nickson (1892-1985) (Santa Maria)
Proprietors of Darling Ceramics, Santa Maria, 1945-48. Their daughter, Nellie Nickson (Wiley) also showed artistic talent as a Santa Maria High School student, 1930/31.

■ "'Work is what you make it – and we make it fun,' Mr. and Mrs. H. W. Nickson, of 812 South Pine street, say, in speaking of their hobby-business, 'Darling Ceramics.' The Nicksons started the making of ceramics … as a hobby, over a year ago. Soon the possibilities of the hobby as a business became evident to them, and before long, as it grew by leaps and bounds, the Nicksons found themselves with a full-fledged economic asset. … In a neat little workshop in the rear of their home, the Nicksons have some of the finest equipment used in ceramics. Their designs are original, and both Mr. and Mrs. Nickson have to be fully satisfied with all designs before they cast them into the mold through which they can make countless reproductions. 'We work back and forth,' Nickson says, 'until we agree on all points, and then we start. Sometimes we stay in the workshop until 1 o'clock or 2 in the morning,' they say…. Nickson had been associated with an oil company here for 30 years, until last September 1, when he was retired. 'I decided the 'shelf' was not the place for me,' he says … From Clay. The step-by-step process of ceramic art has a basic beginning in earth and clay, but even here, its leaning toward art rather than utility, as in simple pottery, is evident. 'Our clay,' Mrs. Nickson pointed out, 'is not just clay. It is a combination of several kinds, from different parts of the country, and blended in a formula the secret of which we guard closely.' Each type of clay is chosen for a different quality. One provides elasticity, one porousness, and another some other essential sought by the ceramic master. The clay is molded into the design – an urn, a figurine, vase, or plate – and is then baked or fired, in the potters' kiln. The Nicksons have a huge gas kiln, thermostatically controlled, in their workshop, in which they fire their work. When the article is removed from the first firing, it is decorated with colored glaze, usually by hand, and then over this is sprayed the clear outer glaze. The article is then fired again, and emerges as the finished product. Between these basic steps however, is a world of pitfalls, described ruefully by the Nicksons, as they point to what they call their 'disappointment shelf.' Here they have placed, in their workshop, articles which turned out not as they expected. 'Over-firing, under-firing, the wrong type of glaze, or a misjudgment in design, are responsible for the various failures, which were made when the Nicksons were learning their art and were experimenting. Now the failures are few and far between, and the Nicksons keep the 'disappointment shelf' just as a reminder to themselves of hurdles they met and overcame. Duplicate Designs. After the making of the first design by hand it is duplicated through means of a plaster cast. From this is made a 'master mold,' which is tabulated and stored away as a precaution against breakage of the original. The cast is then used for 'pouring' other models from clay, and the process of firing and glazing begins over again, but this time on a mass scale. Not only skilled, after a year of work at their hobby, in the technical end of it. The Nicksons are both artists, as their designs show. The fact that both are enthusiastic gardeners is evident too, for in their work, they follow nature closely. 'We aim for perfection,' Mrs. Nickson said, 'and where better could one find perfection than in nature.' One of the articles designed by her is topped with a ceramic rose, the petals of which are so delicately indented and veined as to appear real. Mrs. Nickson actually made a plaster cast of a rose petal, and from this formed her decorative rose design. Another design is a faithful copy of a geranium leaf; in still another, is a delicate replica of the ivy vine. This one was done by the Nicksons' daughter, Mrs. Dean Wiley [Nellie Nickson], who shares her parents' enthusiasm for their hobby, as does their son, Arnold. Operation of Kiln. The operation of the kiln is perhaps one of the most interesting steps in the production of ceramics, and a careful recording of each firing is maintained. There are apertures in the heavy door, and near these in the line of vision, are placed two small cone shaped objects, called pyrometric cones. As their name implies, they are measures of heat. When the first one melts, after some four hours of heat, it is a warning that the firing time is almost completed. When the second one melts over on its side, it is an indication that the firing is completed and the heat should be turned off. Then some 12 to 14 hours later, the length of time necessary for the kiln to cool, the finished articles are removed. The Nicksons' equipment includes an electric compressor, with which the glaze is sprayed on. Ceramic experts have declared their glaze to be among the finest. As they show visitors their fine equipment and their little display room incorporated with their extensive begonia-filled lath house, this couple whose hobby has turned into a business, say happily, 'We don't know what time is any more. We just want to be out here in our workshop all the time.' Orders are coming in constantly and as they daily increase, the Nicksons will have to spend more and more time to fill them. So far, in their dealings, mostly with wholesalers, several businesses have contracted for their products. And art lovers in Santa

Maria are stopping more and more frequently at the South Pine street home, to bring away a 'Ceramic of Santa Maria'," *SMT,* Oct. 23, 1946, p. 7.

■ "Herbert Nickson. Masonic funeral services for Herbert William Nickson, 79, who died Saturday in his home at 812 S. Pine St. ...Mr. Nickson, a retired Union Oil Co., employee, had been a resident of the Santa Maria area for 54 years. He was born in England Aug. 5, 1881, and came to California in 1907. He sought employment with the Pinal Dome Oil Co. at Orcutt, which later became the Union Oil Co. He was made a Mason in Hesperian Lodge, 264, in 1910... Mr. Nickson leaves his widow, Mrs. Ivy Nickson ...," *SMT*, July 3, 1961, p. 2.

Nickson, Herbert (notices in Northern Santa Barbara County newspapers on microfilm and on newspapers.com)
1946 – On view at Santa Barbara County Fair, Santa Maria "Fair Chatter," *SMT,* July 27, 1946, p. 1.
1947 – "Mrs. H. Nickson, Speaker, Tells of Ceramics" to **Phi Epsilon Phi** Sorority, *SMT*, March 27, 1947, p. 3; "Y's Men Hear Talk on Making Ceramics," *SMT*, April 1, 1947, p. 5; "Ceramic Art Subject of Masonic Club Talk," *SMT,* June 3, 1947, p. 8.
1948 – "Presbyterians Hear Talk on Ceramics," *SMT,* March 19, 1948, p. 3; "Orcutt Cub Scouts Visit Ceramic Studio," *SMT,* July 6, 1948, p. 4.
And, additional notices not itemized here.
Nickson, Herbert (misc. bibliography)
Herbert William Nickson was b. Aug. 5, 1881 in Newmarket, England, to James Nickson and Betsey "Bessie" Richards, married Ivy Mizpah Pettit, gave birth to Nellie Mizpah, was residing in Santa Maria in 1948, and d. July 1, 1961 in Santa Maria, Ca., per Retallick/Saundry/Cleife Family Tree;
Ivy Mizpah Pettit Nickson, b. Oct. 1, 1892 in Higham, Suffolk, England to Charles William Pettit and Jane Augusta Pettit, d. July 17, 1985 in Santa Maria and is buried in Santa Maria Cemetery District per findagrave.com (refs. ancestry.com).
See: "Lompoc, Ca., Adult/Night School," 1948, "Santa Barbara County Fair," 1946, "Santa Ynez Valley, Ca., Elementary / Grammar Schools," 1948

Niederhauser, William "Bill" (Santa Maria)
Photographer of color slides. Active with Santa Maria Camera Club, 1958.
Various articles in the *SMT* reveal Niederhauser was a school trustee and was head clerk at the Union Oil, Santa Maria, Refinery, etc. but they were not itemized here.
See: "Santa Maria Camera Club," 1958

Nielsen, Anna
See: "Larsen (Nielsen), Anna (Mrs. Paul Nielsen)"

Nielsen, Lois (Santa Ynez Valley)
Chalk talk artist, 1943.
See: "Chalk Talks," 1943

Nielsen, Oscar Carl (1881-1966) (Alaska / Solvang)
Metal worker, numerologist, 1953.

■ Port. and "Oscar Nielsen is a veteran of life in Alaska. He first arrived in Anchorage in 1919. There was hardly anyone there at that time … Mr. Nielsen worked on the railroads in Alaska for years. He went out of retirement during World War II to make parts for airplanes. It was during this period of time that Mr. Nielsen constructed and created the unique metal plaque which is now on display in the window of the *Valley News*... The Oscar Nielsen family moved to Solvang from Alaska about three years ago (purchasing a home on the Skytract from Mrs. Lila Harris.) His wife, Kitty and five-year-old daughter, Inga Marie, are now in Alaska, where Mrs. Nielsen is engaged in a business…," per "Oscar Nielsen Displays Unique Hand-Tooled Object of Metal… [i.e.] oval-shaped, brass rimmed… with deer head and antlers and a horseshoe in the top center. A star hangs above…," that contains a matrix of dates and ages that, combined in various sequences, predicts famous dates, such as the end of WWII, *SYVN,* Dec. 4, 1953, p. 3.
Nielsen, Oscar (notices in Northern Santa Barbara County newspapers on microfilm and on newspapers.com)
1958 – Port. of Nielsen and "Does it Again: Oscar Nielsen Two-Time Winner of Ice Classic… Over the years Nielsen has developed an elaborate theory for predicting the break-up time [of ice] ... Nielsens have divided their time between here and Alaska where Mrs. Nielsen is engaged in the real estate business… The fourth member of the Nielsen pool, Claveau… and Nielsen went to Alaska about 54 years ago and both prospected for gold and trapped for a number of years," *SYVN*, May 16, 1958, p. 5.
Nielsen, Oscar (misc. bibliography)
Oscar Carl Nielsen was b. May 15, 1881 in Denmark and d. Dec. 19, 1966 and is buried in Oak Hill Cemetery, Ballard per findagrave.com (refs. ancestry.com).

Nielsen, Ronald (Solvang)
SYVUHS student whose painting was purchased by S. R. Rasmussen, 1946. Attended a field trip to view Santa Barbara art. Continued his study of art after his move to Tucson, 1947. Studied dentistry. Lieutenant in the military, 1959.
Nielsen, Ronald (notices in Northern Santa Barbara County newspapers on microfilm and on newspapers.com)
1947 – "Art Members Go Sketching. Members of the National Art Honor society at Tucson high school with Miss Eva B. Culley, art director, went on a sketching trip Monday afternoon in the Catalina foothills... Honorable mention was given... and Ronald Nielsen...," *Tucson Daily Citizen,* May 21, 1947, p. 6.
1952 – "At Manzanita. Ronald Nielsen, son of Mr. and Mrs. Walter Nielsen of Tucson, Ariz., formerly of Las Cruces, is spending the summer at Manzanita Lake near Mt. Lassen. He is a student at the University of Arizona at Tucson," *SYVN,* June 13, 1952, p. 5.
See: "Santa Ynez Valley Union High School," 1946

Nippert, Glenn Jay (d. 2000) (Solvang)
Attended the College of Arts & Crafts, Oakland.

■ "Glenn Nippert, Irma Bortolazzo Engagement Told… Glenn Jay Nippert, son of Mrs. Madge Nippert of Solvang… born in San Luis Obispo, attended schools in Salinas and is a graduate of Salinas High School. He also attended arts and crafts schools in Oakland and is now employed at Lunde and Chester Chevron Service in Solvang. The couple will marry in November at the El Monte Catholic church and will make their home at 410 North F street, Lompoc," *LR*, Sept. 4, 1958, p. 13 and *SYVN*, Sept. 12, 1958, p. 3; "Glenn Jay Nippert… 72 of Goleta, died of cancer May 14 in Santa Barbara… lived in Goleta for 22 years. He was employed with General Research International for 18 years. He graduated from Salinas High School in 1945," and served in the Navy, *Californian* (Salinas, Ca.), May 24, 2000, p. 20 (i.e., 2-C).

Nirodi, Hira (India / Pond Farm / Santa Maria)
Fulbright scholar in ceramics, who roomed with Jeanne DeNejer in NY in the spring, studied at Pond Farm in the summer, and visited Santa Maria in the fall of 1953.

■ Port. and bio. of **Hira Nirodi** and "Scholar from India in Ceramics Study" is a guest at the Santa Maria home of M/M John Simko [ed. Mrs. Simko is a member of the Santa Maria Art Assn., and Nirodi learned about Santa Maria from **Jeanne DeNejer**, a fellow student at Alfred university, NY] and after having spent time at Pond Farm [ceramics workshop of **Marguerite Wildenhain**] is touring the state before going on to Mills College for a year on a fellowship grant, *SMT*, Sept. 11, 1953, p. 4.
See: "DeNejer, Jeanne," 1953

Norcross, Lorin Durkee (1910-1978) (Santa Barbara)
Photographer associated with Norcross Photography at 3011 De La Vina (c. 1948-76) who attended a meeting of the Santa Maria Camera Club, 1949.
See: "Santa Maria Camera Club," 1949

Norris, Clarence Oscar (1905-1984) (Orcutt / Santa Maria)
Santa Maria High School student who won a contest to design the masthead for the Santa Maria Times, 1924. Sign painter and prop. of Norris Sign Shop, c. 1932+.

■ "Clarence O. Norris… lengthy illness. Mr. Norris was born in Orcutt and had been a lifelong resident of the area. He attended Orcutt elementary schools and graduated from Santa Maria High School in 1925. He had worked as a sign painter in the Santa Maria area for more than 45 years. He was a veteran of the U. S. Army Air Corps during World War II," *SMT*, July 30, 1984, p. 11.
Norris, Clarence (notices in Northern Santa Barbara County newspapers on microfilm and on newspapers.com)
1924 – Santa Maria "High Athlete Wins Times Prize in Art Contest," i.e., his design wins prize for new masthead for Santa Maria Daily Times, *SMT*, May 2, 1924, p. 5.

1927 – "Norris Family Holds First Reunion Since 1906… The Norris family is one of the oldest in Santa Maria valley…," *SMT*, Dec. 29, 1927, p. 5.
1930 – "Wedding of Miss Hockett, Clarence Norris, Planned Today in San Luis Obispo," *SMT*, Dec. 24, 1930, p. 5.
1945 – "I Spied… A letter from Clarence Norris saying he's still at his trade of sign painting, though now with the Army in England," *SMT*, March 9, 1945, p. 1.
1949 – "Hearing Set on Guadalupe Business License Case. Charges of violating the Guadalupe city business license ordinance have been filed against two Santa Marians, Clarence O. Norris and **Roy Potter**, sign painters, in Guadalupe city court. The two are alleged to have painted a sign on the new Prindle's store in Guadalupe without taking out a business license in that city…," *SMT*, Aug. 17, 1949, p. 4.
1950 – "Home-Built Scoreboard to be Installed at Elks … field… To the extreme right of the balls, strikes and outs is an Elks lodge emblem, painted in blue and white by sign painter Clarence Norris. Painted on the side of the scoreboard which will face Miller street is 'Elks Field, Home of the Santa Maria Indians'… yellow block letters…," *SMT*, April 18, 1950, p. 2.
1951 – "National Publicity for Rossini Electric… sign installation at Leo's Drive-in restaurant. The giant electrical sign was designed by Clarence O. Norris, who sketched it and did all of the art work. Following approval of the design, the sign was built completely in the Rossini shop here. It measures 22 feet high with a lion, five by six feet in size, atop it…," *SMT*, Sept. 8, 1951, p. 8.
1953 – Photo of float he designed for Orcutt parade, *SMT*, June 13, 1953, p. 5.
1955 – "Tattlin' Tongue… tale behind the *Daily Times* insignia on the front window of this newspaper… Orcutt's Clarence Norris designed the insignia in 1923 [Sic.] while still a student in Santa Maria high, and the decorative name plate was painted onto the window glass [of the building] a few years later. *The Times* held a school contest at that time to select an insignia for the paper. Norris, a mechanical drawing student, entered, although most of the entries were turned out by the art classes…. good ship Santa Maria… Like other relics in *The Times* office, though, it will go by the wayside when the move to new premises takes place this fall," *SMT*, June 11, 1955, p. 6.
And, more than 100 additional high school track notices and social notices for "Clarence Norris" in the *SMT*, 1926-1960, were not itemized here.
Norris, Clarence (misc. bibliography)
Clarence Oscar Norris was b. Aug. 3, 1905 in Orcutt to Robert Brent Norris and Anna Bertha Pfitzner, was residing in Orcutt in 1920, married Ruth Hilda Hockett, and d. July 28, 1984 in Santa Maria per Brickey Family Tree (ref. ancestry.com).
See: "Norris Sign Shop," "Santa Maria, Ca., Union High School," 1924, 1925

Norris Sign Shop (Santa Maria)
221 E. Church St. Old mirrors re-silvered. Prop. Clarence
Norris, c. 1930+?
1932 – Ad: "Removal Notice. New Location – 208 W.
Church. Phone 936. We Make All Kinds of Signs,
Showcards, Etc. Prices Reasonable. Norris Sign Shop,"
SMT, May 14, 1932, p. 3.
Seven ads appear in the *SMT*, 1932-1939, but were not
itemized here.
See: "Holcomb, Tobe," "Norris, Clarence"

North H Ceramics Shop / King's Ceramics (Lompoc)
See: "King, Angie"

Novelty Studio (Santa Barbara / Santa Maria)
Itinerant or chain studio of photography, J. R. Collins,
prop. Active in Santa Barbara and Santa Maria, 1915-16.
Novelty Studio (notices in Northern Santa Barbara County
newspapers on microfilm and on newspapers.com)
1915 – "Special Offer – 18 Postal cards $1. 12 photos
mounted in folders $1. Special prices on all photographs.
Will make these prices for a short time only. Novelty
Studio. 5th W. Haley St., J. R. Collins, Prop.," *Santa
Barbara Daily News and the Independent*, Sept. 9, 1915, p.
5.
1916 – "Don't Fail to See the New Photographer at the
Novelty Studio. All work guaranteed at reasonable prices.
All kinds of novelty costumes furnished free. Expert Kodak
developing. 125 So. Broadway over Jones' store," *SMT*,
Sept. 16, 1916, p. 1; "Novelty Studio… is making some
special prices on photos this week. Kodak finishing and
commercial work a specialty. Reasonable prices on all
photos. Open Sunday…. Over T. A. Jones & Son's store,
125 So. Broadway, Santa Maria," *SMT*, Oct. 7, 1916, p. 13,
col. 2.
And, more than 1000 hits for "Novelty Studio" in
California newspapers, 1910-1940 show that it was active
in San Francisco (1905), LA (1911), Long Beach (1914),
Fresno (1925), Napa (1927), Oakland (c. 1926-35), Santa
Ana (1927) and other California towns, but those articles
were not itemized here.

Nu-Art Photos (Lompoc)
Photography studio. Prop. John W. Wozny, 1946.
■ "Certificate of Doing Business under Fictitious Name.
I, the undersigned, do hereby certify that I am transacting
the business of photo finishing, consisting of developing,
printing and enlarging of camera film and photographs at
124 North "K" Street, City of Lompoc, County of Santa
Barbara, State of California, under a designation …: **Nu-
Art Photos**. Dated, this 3rd day of July 1946. John W.
Wozny, Residence: 124 North K Street, Lompoc,
California…," *LR*, Aug. 8, 1946, p. 4.
Nu-Art Photos (notices in Northern Santa Barbara County
newspapers on microfilm and on newspapers.com)
1946 – Repro: **Clarence "Ruth**'s Indian Museum," *LR*,
Aug. 29, 1946, p. 1; "For Sale – Aerial views of Federal
Prison on Camp Cooke reservation. Nu-Art Photos…," *LR*,
Sept. 5, 1946, p. 8, col. 1; "Are You Having a Party at

Home? Pictures are your most precious remembrances of
such a party. Call 4915 for an expert photographer who will
come and take action shots of your party. There is no
charge for taking the picture. You pay only for the prints
you order, Nu-Art Photos," and "Photo Finishing: bring us
your roll of film any size and we'll develop and print it for
you in less than 24 hours. Rolls brought in before 6 p.m.
can be had by noon the next day. … two prints on each
negative for 50c…," *LR*, Oct. 3, 1946, p. 11.
See: "Wozny, John W."

Nursery Schools (Northern Santa Barbara County)
Day care and nursery schools included arts and crafts in
their programs.
Nursery Schools (notices in Northern Santa Barbara
County newspapers on microfilm and on newspapers.com)
1943 – Extended "Day Care School… Mrs. Grace H. Smith
in charge … school operating in Main street school [Main
Street Child Care Center] for children of busy mothers… A
typical afternoon's program for students in the various
classes… Grades 3 and 4 … Wednesday, arts and crafts…
Friday, arts and crafts… Grades 5 and 6 … Monday, arts
and crafts… Friday, arts and crafts… Students who have
joined the arts and crafts classes are now making and
painting first-aid kits … Attendance is not required every
day…," *SMT*, April 13, 1943, p. 2; "Craft Work of
Children Shown… in the Main street school Child Care
Center … exhibit of the handcraft they have been doing this
summer with the work divided into grade groups. The
younger children under the direction of Fernie Gleason and
Mrs. Louise Whitteker, showed work in painting, cutout
paper work and clay modeling while the craft of the older
group, under Miss Katherine Mulloy, included jigsaw
work, such as basketry, book ends and wooden book covers
as well as painting on cloth and wood…," *SMT*, July 23,
1943, p. 3.
See: "Allan Hancock Nursery School," "Happytime,"
"Lompoc Nursery School," "Santa Maria, Ca., Elementary
/ Grammar School," 1943, "Santa Ynez Valley Child
Workshop Project"

Nuttall, M. P., Miss (Santa Maria)
Artist. Exh. best water colors at "Santa Barbara County
Fair," 1888.
Possibly related to Reginald W. Nuttall (1836-1931) land
agent in Santa Maria and Arroyo Grande and his wife
Sophia Frances Chute Nuttall (d. 1930)?
Nuttall, M. P. (miscellaneous)
Is she Miss P. Nuttall, member of the Western Addition
Club, per *SF Examiner*, March 17, 1887, p. 3; There are
two notices about travels (to SLO and to Oakland) of "Miss
Nuttall" in the *SMT* in 1889 not itemized here.
FATHER? – Reginald W. Nuttall, b. England, was
naturalized 12-8-1887, registered in vol. 95, p. 2711 per
*Naturalization Index of the Superior Court for Los Angeles
County, California*; Reginald William Nuttall, age 50, b.
England, a real estate agent in Santa Maria, is listed in *The
Great Register, Santa Barbara County California*, 1890;
"The Death of R. W. Nuttall Aged Pioneer... Their two
children preceded them – a son [Reginald Chute Nuttall]

died in 1888 [obit, *SMT*, Oct. 24, 1888, p. 3] and their daughter [Miss M. P.?] died in 1915 [?]. A grandson, their daughter's child, was killed in the World War...," *Pismo Times* (Pismo Beach, Ca.), Dec. 11, 1931, p. 1 and a longer obit in the *Arroyo Grande Valley Herald Recorder*, Dec. 11, 1931, p. 1.
See: "Santa Barbara County Fair," 1888

Nygren, Holmes, Rev. (Santa Ynez Valley)
Chalk talk artist, 1959.
See: "Chalk Talks (Northern Santa Barbara County)," 1959

O

Oakes, Mortimer Leon (1860-1949) (Lompoc / Atascadero)
Photographer of Atascadero who ran Oakes Art Studio in Lompoc c. 1929-30.
Oakes, Mortimer Leon (notices in Northern Santa Barbara County newspapers on microfilm and on newspapers.com)
1929 – Ad: "M. L. Oakes has purchased the **Van's Studio** and is prepared to do all kinds photographic work – Portraits – Scenic – Color Work. Kodak Finishing of the Better Kind. 24 Hour Service. Make this studio your photographic headquarters," *LR*, March 29, 1929, p. 3; "Bring Your Kodak Work to Oakes Art Studio, 122 South H Street. In today – out tomorrow," *LR*, April 19, 1929, p. 4.
1930 – "Photograph of Joaquin Miller Found Here Among Odds and Ends; Colored and Displayed in Photographer's Shop... Discovery of a colored photograph of a bearded patriarch in the window of the M. L. Oakes photo studio a week ago prompted inquiries... Photographer Oakes did not know, at first, the name of the subject, but had picked up the negative when he moved into the studio several months ago and had made a print from it, later applying the coloring matter effectively. ... he asked **Charles Baechler**, another local photographer... "No, I do not,' the pioneer photographer replied, 'but he was a writer who came down here from San Francisco for a few days twenty-five or thirty years ago, and lived in the hills back of Oakland...' Some predecessor of Mr. Oakes in the studio had taken the picture during the poet's visit here and had left it ...," *LR*, April 4, 1930, p. 1; "Pots Pictures... 1930 Edition of [high] School Annual... Class photographs were taken at the high school yesterday by M. L. Oakes... and cuts will be made from the pictures selected by Principal ... and the student editors ... will be printed in the commercial printing department of the Lompoc Record...," *LR*, April 11, 1930, p. 3.
See: *Atascadero Art and Photography before 1960*

Oakes Art Studio (Lompoc)
See: "Oakes, Mortimer," "Van"

Oback, N. Eric (1920-1979) (San Jose)
Artist. Exh. watercolors at Hancock Gallery, 1958. Judge at Santa Barbara County Fair, 1959.
■ "N. Eric Oback (1920-1979) Born: Sweden; Studied: California College of Arts and Crafts (Oakland); Member: American Watercolor Society, Society of Western Artists. N. Eric Oback's family emigrated from Sweden to Chicago in 1927. He was awarded US citizenship in 1946, after serving honorably in the US Army during World War II. After being discharged, he moved to Oakland, California and began to professionally exhibit his watercolor paintings in the late 1940s. In 1950, he accepted a teaching professorship at San Jose State University's School of Art. In 1971-72, N. Eric Oback suffered heart failure. As a result, he received one of the earliest heart transplants performed at Stanford University Medical Center. He continued to teach art at San Jose State University until his untimely passing in 1979. He is survived by his wife, Ruth, 10 children, and numerous grandchildren." Biographical information: Interview with son John Oback, 2009, from www.californiawatercolor.com
Oback, N. Eric (notices in Northern Santa Barbara County newspapers on microfilm and on newspapers.com)
1958 – "23 water colors by Eric Oback, instructor in San Jose State College Art department [are on view at **Allan Hancock College Art Gallery**]. ... Some of the paintings are done by rather interesting techniques, such as the still-life done with an eye-dropper, and three others done with a piece of cardboard in substitution of a brush... **George Muro**, in charge at the gallery... comments: 'Oback's work reveals an individual direct interpretation of the subject. His work is fresh and is proficiently adapted to the medium.' The artist received his education at California College of Arts and Crafts, where he won his degrees in fine arts. Oback was a commercial artist for Swift & Company before World War II and was artist with the Continental Air Force Finance office, Washington, D. C. He is a member of the Society of Western Artists, East Bay Art Association, a professional group. He was born in Aryika, Sweden... Oback's paintings have been on exhibit in New York at the National Academy Gallery, at the San Francisco Museum of Art and DeYoung Museum, at the Swedish American Exchange in Chicago and at other galleries in Oakland and on the East Coast," per "Paintings by Oback at Hancock Gallery," *SMT*, Jan. 10, 1958, p. 2.
See: "Allan Hancock [College] Art Gallery," 1958, "Santa Barbara County Fair," 1959

Obata, Chiura (1885-1975) (Bay Area)
Bay Area artist who was invited to northern Santa Barbara County by art patron, Setsuo Aratani. He held an exhibit of his work in Guadalupe as well as at the Little Theater in Santa Maria, the latter under the auspices of the College Art Club, 1931.
See: "Aratani, Setsuo," "College Art Club," 1931, "Gorham, John," "Japanese Art," "Little Theatre," "Matsubara, Kazuo," and *Central Coast Artist Visitors before 1960*

Oberon, Merle (1911-1979) (Hollywood)
Actress / artist who exh. with Hollywood notables in Santa Ynez Valley Art Exhibit, 1955.

■ "Merle Oberon (born Estelle Merle O'Brien Thompson; 19 February 1911 – 23 November 1979) was a Eurasian actress who began her film career in British films as Anne Boleyn in *The Private Life of Henry VIII* (1933). After her success in *The Scarlet Pimpernel* (1934), she travelled to the United States to make films for Samuel Goldwyn. She was nominated for an Academy Award for Best Actress for her performance in *The Dark Angel* (1935)," and further extended biography on Wikipedia.
See: "Santa Ynez Valley Art Exhibit," 1955

Ocean Avenue Ceramics (Lompoc)
109 E. Ocean Ave., 1956-57. Prop. Elva Beattie / Bernice Woodall and later Nina Hitchen. Shared quarters with the shoe shop of Bill Hitchen, father-in-law to Nina.
Ocean Avenue (notices in Northern Santa Barbara County newspapers on microfilm and on newspapers.com)
1956 – "Lompoc Glimpses. Mrs. Bill Hitchen taking over from **Bernice Woodall** and **Elva Beattie** as the operator of a ceramics shop," *LR*, Aug. 9, 1956, p. 1; ad: "Ceramic Hobbyists. We now have ceramic supplies – greenware, paints, brushes, glazes, etc. Will do firing. Come in and look around. If we do not have what you want, we will order it. Ceramic Shop Open 10:00 a.m. to 4:00 p.m. – closed Mondays. **Nina Hitchen**. Ocean Avenue Shoe Shop – 105 E. Ocean Ave.," *LR*, Aug. 16, 1956, p. 9; "Firms to move to new building… formerly located at 105 East Ocean avenue, will open Monday in the new building constructed at 109 East Ocean avenue, it was announced by Bill Hitchen, proprietor. The firm's ceramics shop will also move to the new location," *LR*, Nov. 22, 1956, p. 2; Christmas Greetings, *LR*, Dec. 20, 1956, p. 13.
1957 – "Sale. Start your Christmas Gifts now. ½ off on greenware, underglazes and glazes. Ocean Avenue Ceramics, 109 East Ocean Avenue," *LR*, Oct. 10, 1957, p. 7.

Ocean Avenue Shoe Repair and Upholstery Shop / Ocean Shoe Service & Ceramics Shop (Lompoc)
See: "Ocean Avenue Ceramics"

Ocean Park, Ca.
See: "Anderson, Dick," "Baechler, Charles," "Signs"

Oester, Ethel June (Mrs. Vernon W. Oester) (1931-2005) (USAF, Lompoc)
Exhibited mosaics at Lompoc Gem and Mineral Club Hobby Show, 1960.
See: "Lompoc Gem and Mineral Club," 1960, 1962

Oishi, Yoshisuke (1918-2017) (Guadalupe)
Santa Maria high school student who exh. at Faulkner Memorial Art Gallery, Santa Barbara, 1933. Won a Latham poster prize, 1935. Received honorable mention in Procter & Gamble soap sculpting contest, 1936. After 1946 he listed himself as laborer / vegetable worker in Guadalupe.
Oishi, Yoshisuke (misc. bibliography)
Yoshisuke Oishi provided the following information on his WWII Draft Card dated Oct. 16, 1940 = age 22, b. Jan. 3, 1918 in Guadalupe, employed by Santa Maria Produce Co., next of kin is his mother, Kito Oishi; Yoshisuke Oishi b. Jan. 3, 1918 in Guadalupe, d. May 17, 2017 and is buried in Guadalupe Cemetery per findagrve.com (ref. ancestry.com).
See: "Faulkner Memorial Art Gallery," 1933, "Posters, Latham Foundation (Santa Maria)," 1935, "Santa Maria, Ca., Union High School," 1934, 1937, "Tashiro, Yukio," 1938

Okamoto, Ada (Guadalupe)
Santa Maria high school grad. '34 who exh. at Faulkner Memorial Art Gallery, Santa Barbara, 1933. Won a certificate of merit in the Latham poster contest, 1934. Art major at UC, Berkeley, 1934.
1934 – "To Berkeley – K. Matsura left today to drive his son… [and] Ada Okamoto… to Berkeley where they will enroll in the University of California… Miss Okamoto majors in art…," *SMT*, Aug. 13, 1934, p. 2.
1936 – "Spinsters' Dance ... Among the students who have arrived for the vacation are ... Ada Okamoto of Guadalupe... attending UCLA," *SMT*, Dec. 24, 1938, p. 3.
See: "Faulkner Memorial Art Gallery," 1933, "Posters, Latham Foundation (Santa Maria)," 1934

Old World Metal Craft / Old World Metalcraft (Solvang)
Fabricator of artistic metal products, 1950-75. Prop. Walter Kristensen.
Old World Metal Craft (notices in Northern Santa Barbara County newspapers on microfilm and on newspapers.com)
1950 – Ad: "The Contest is Over. We have a New Name. It's 'Old World Metal Craft' **Walter Kristensen**, Prop. Mission Drive – Solvang. Iron, Copper and Brass Work. We also do repairing …," *SYVN*, Oct. 6, 1950, p. 4.
1975 – "Notice of Dissolution of Partnership… Old World Metalcraft… **F. Walter Kristensen**… has withdrawn from and has ceased to be associated in the carrying on of the business…," *SYVN*, May 1, 1975, p. 18; photo of owners after Kristensen, and history of Old World Metal Craft, *SYVN*, Nov. 27, 1975, p. 61 (i.e., IV-1).
And, many additional articles in the *SYVN* not itemized here.
See: "Scandinavian Arts and Crafts"

Olivera, Bob (La Purisima)
Plaster artist of CCC at La Purisima Mission, 1936.

■ "An Artist. One of the CCC enrollees working on the restoration project at **La Purisima** mission stands out… for the fine plastering he is doing and for the fine reproductions of the fluted columns. Bob Olivera is a member of an early California Spanish family, and he takes his adobe work and plastering seriously. A few of the several fluted columns peculiar to this mission remained when the restoration program was started …[but others needed to be re-created] This week we watched Olivera plastering one of the columns, first with a cement mixture of natural color and then applying the reddish colored plaster in trimming …," *LR*, Oct. 23, 1936, p. 1, col. 1.

Olivera, James B., III (Lompoc)
Photographer with USAF in Far East, 1956.

■ Port. and "Descendent of Early California Family Selects Portland Girl as Bride-Elect… son of Mr. and Mrs. James B. Olivera, Jr. of Lompoc… The groom elect, a native of Lompoc, is a descendent of one of California's oldest original families. He is the grandson of the late Jim Olivera, Sr. … He is a graduate of Lompoc High School and of Santa Maria Junior College and has recently been honorably discharged from the U. S. Air Force after serving a four year tour of duty. As Airman First Class, James B. Olivera III recently returned from the Far East. He enlisted in October of 1952, took his basic training at Parks Air Force Base, was later stationed at Mather Air Force Base near Sacramento and for the past two years was stationed in Tokyo, Japan as a photographer in headquarters FEAF. His assignment in Japan took him on flights to all major cities in that country and in Korea as well as the Philippines. He was with the group of airmen who flew CARE packages to the Korean Orphanage last Christmas, thus taking part in providing the first real Christmas experienced by hundreds of Korean orphans. On the same trip, he also had occasion to photograph Cardinal Spellman of New York who was in Korea at the time for the purpose of giving Christmas Mass to servicemen in the Far East. After visiting his family here in Lompoc, Mr. Olivera II journeyed to Portland where he is now visiting his fiancée and her family…," *LR*, Oct. 25, 1956, p. 5.

And, more than 40 notices in the *LR* between 1938 and 1960 on either he or his father were not itemized here.

Ollis, Donald Glenn (1918-1996) (Santa Barbara)
Photographer, free-lance, 1950, and for Beaudette Foundation for Biological Research near Santa Ynez, 1959.

Ollis, Don (notices in Northern Santa Barbara County newspapers on microfilm and on newspapers.com)
1950 – "Valley Dentist… A feature article 'Boy Meets Dentist,' appears in the current issue of the *Woman's Home Companion*… The youngster shown is the doctor's nephew, three-year-old Donnie Ollis. The photos were taken by the youngster's father, Don Ollis, who is a free lance photographer," *SYVN*, Oct. 27, 1950, p. 1.
1959 – "… study of marine plant life … The research Foundation has been incorporated one year… At this time… Don Ollis, a photographer, is associated with the group…," *LR*, July 9, 1959, p. 11; "Dr. Dawson to Present Science Lecture… Beaudette Foundation for Biological Research … The motion picture, filmed by naturalist photographer, <u>Don Ollis</u> of Santa Barbara, demonstrates the varied biological activities of the foundation both in the Santa Ynez Valley laboratory and in the coastal waters of Latin America… The foundation has undertaken studies both of the marine vegetation and of the invertebrate animal life of Pacific Latin America, and the film shows some of the underwater diving operations by which specimens are observed, photographed and collected…," *SYVN*, Dec. 4, 1959, p. 5; "Lecture Set on Findings in Research… The lecture with the filmed colored motion pictures which were made by Santa Barbara photographer, Don Ollis, promises to be both entertaining and educational… Marine plant specimens … will be shown … College School Auditorium…," *LR*, Dec. 10, 1959, p. 20.
Ollis, Don (misc. bibliography)
Donald G. Ollis, photographer / writer and later, president Osborne's Book Store, is listed with wife Barbara in the *Santa Barbara, Ca., CD*, c. 1949-1978; Donald Glenn Ollis was b. Nov. 24, 1918 in Mo., to William Herbert Ollis and Lelah F. Hulse, was residing in Goleta, Ca., in 1977 and d. July 15, 1996 in Goleta, Ca., per Johnson Family Tree (refs. ancestry.com).

Olson, Idell Estair "Bud" (1909-1981) (Lompoc)
Photographer, amateur. Developer, and amasser of historic photographs as well as contemporary photos of historic buildings, 1945.

■ "Bud Olson… Mr. Olson was born in Bijou Hills, S. D. on Oct. 19, 1909 and died at his home Tuesday. He had lived in Lompoc since 1915 and served on the Lompoc Police and Santa Barbara County Sheriff's departments for 29 ½ years [1948-69]. He was Lompoc's first motorcycle police officer…," *LR*, Dec. 10, 1981, p. 2.
Olson, Idell (notices in Northern Santa Barbara County newspapers on microfilm and on newspapers.com)
1945 – "Lompoc Glimpses… Policeman Olson – hobby collecting old photos of pioneer people and local views made by **Henry McGee, Briggs** and other early day photographers," *LR*, Nov. 9, 1945, p. 8.
1968 – "Historical Society gives life membership to 'Bud' Olson… [for] donating his time and talents over many years in photographing, developing and printing pictures of Lompoc Valley, its historical homes, landmarks and families. Through his work, the society has been able to compile many photo albums showing almost every aspect of historical Lompoc…," and fact-filled bio., *LR*, June 13, 1968, p. 6.
1969 – Port and "Testimonial Set for Olson Tonight… retires officially from the Sheriff's department… 21 years…," and long bio, *LR*, Oct. 11, 1969, p. 1.
And, hundreds of notices on "Bud Olson" in Santa Barbara County newspapers were not even browsed for potential inclusion here.
Lompoc Valley Historical Society, *Legacy Newsletter*, 1981.
See: "Jones, Gaylord," 1966, "Lompoc Valley Historical Society, House"

Olvera Puppeteers
See: "Puppets (Santa Maria)," 1933

O'Neal, Merilyn Mason (Mrs. Major John F. O'Neal) (1900-?) (Santa Maria)
Collector of Japanese art and practitioner of Japanese flower arranging, 1960.
■ "Community Club Seniors Hear of Travel in Japan… Mrs. John F. O'Neal … Dressed in an authentic Japanese Kimono, she illustrated her talk with colored slides which were taken during the three years that she resided in Tokyo with her family, while her husband, Major O'Neal, was serving with the USAF at Headquarters in that city. She also showed an attractive display of Japanese art treasures, paintings, pottery and embroidered linens which she has collected. Having studied with a teacher of the 'Koryu' school of flower arranging, she exhibited three of her own arrangements. Until she moved to Santa Maria last summer, she was a member of the Ikebana International in Macon, Ga.," *SMT*, July 6, 1960, p. 3.
O'Neal, Merilyn (misc. bibliography)
Merilyn B. O'Neal b. Dec. 17, 1900 was residing in Moreno Valley, Ca., at an unknown date per *U. S. Public Records Index, 1950-1993*, vol. 2 (ref. ancestry.com).

Ontivera/as, A., Miss (Santa Maria)
Exh. "Santa Barbara County Fair," 1886.
1886 – "Social Parties… On Friday evening of last week, the residence of Mr. Chas. Bradley was the scene of a merry assemblage … Among those present… Miss Ontivera…," *SMT*, March 27, 1886, p. 5.
This individual could not be further identified unless she is actually Mrs. A. Ontiveras/os, below.
See: "Santa Barbara County Fair," 1886

Ontiveras/os, (Maria) Doraliza/ Dorolisa Vidal (Mrs. Abraham / Abram Ontiveras/os) (1861-1900) (Santa Maria)
Exh. embroidered works at "Santa Barbara County Fair," 1888 and a transfer picture on glass, 1889. A family portrait was painted from a photograph, by O. L. Jones, 1886.
Ontiveros, Abraham, Mrs. (misc. bibliography)
Is she Maria D. A. Vidal who married Abraham Ontiveros in 1879 per Western States Marriage Index; Doraliza Ontiveros is listed in the 1880 U. S. Census as residing in Sisquoi [Sic. Sisquoc], Santa Barbara County with husband Abraham Ontiveros and child Blandina (1 month old); Dorolisa Ontiveros is listed in the 1900 U. S. Census as age 39, b. Sept. 1860 in Calif., residing in township 8, Santa Barbara County, with husband Abram Ontiveros (b. April 1852, Sic. 1848-1926) and six children ranging in age from 19 to 14; Maria D. A. Vidal was b. 1861 in Calif. to Francisco Vidal and Ana Maria Munoz, married Abraham Ontiveros, and d. Sept. 28, 1900 in Santa Maria, Ca., per Christa's Family Tree (refs. ancestry.com).
See: "Art, general (Santa Maria)," 1907, "Art Loan Exhibit (Santa Maria)," 1895, "Jones, Oliver," "Santa Barbara County Fair," 1889

Open-Air Art Exhibit / Open-Air Art Show / Festival Art Exhibit / Flower Festival Art Show / Exhibit (Lompoc)
Sponsored by the Lompoc Community Woman's Club and held in conjunction with the Alpha Club's annual, late spring Flower Festival, 1957+. The inspiration of Mary Brughelli. Originally for adults, in 1959 it was opened also to children.
Open-air Art Exhibit (notices in Northern Santa Barbara County newspapers on microfilm and on newspapers.com)
1957 – "Park Use for Art Exhibit Okayed… during the Flower Festival June 22 and 23…," *LR*, May 9, 1957, p. 2; "Art Show to Lend Beauty and Interest to Lompoc's Annual Flower Festival… **Mrs. Mary Brughelli**, chairman… announced that all types of art pieces in all media are being sought… **Mrs. Elsa Schuyler**, who likes to take a realistic approach to her paintings and who prefers working with watercolors … **Mrs. Ethel Bailey**, who likes impressionistic effects which are frequently achieved by 'moving a barn exactly where I want it,' will exhibit watercolor paintings. **Mrs. Nora Wiedmann**, who likes to capture the lines of industrial plants and who has an eye on the Great Lakes Carbon Corporation's smoke stacks, which she can see from her front window, will exhibit… Mrs. **Marian Lewis**, who likes to paint with watercolor, in fine detail, naturalistically… **Mrs. Mary Brughelli**, who likes to paint fantasies unrestricted by prescribed forms… Other local artists which include all those who paint for pleasure… are the **Mmes.** Mary Sandell, **Rosie Cox, Bert Romano, Helen Lilley, Marie Huyck, Paul Highfilll, Grace Anderson** and **Uka Carlson**…," and photo of **Elsa Schuyler, Mrs. Mary Brughelli, Mrs. Marian Lewis, Mrs. Nora Wiedmann** and **Mrs. Ethel Bailey**, *LR*, June 6, 1957, p. 11; "Art Exhibitors Respond to Call… Artists … bring their pictures to Ryon Park between 12:30 and 1:00 p.m. on each afternoon of the show… Paintings, drawings, watercolors or sketches entered by children or by persons who have not framed their pictures, may be taken to the City Library basement between the hours of 1:00 and 5:00 p.m. on Saturday, June 15," *LR*, June 13, 1957, p. 7; "Festival Art Exhibit in Park Attracts Viewers and Praise… first open-air art exhibit… local artists… Community Woman's Club arrangements under the general chairmanship of **Mrs. Mary Brughelli**, who as an artist, also exhibited her paintings. Other pictures viewed were done by Lee Ray, Jeanette Alexander, **Euka Carlson,** Valerie Forward, **Grace Anderson, Nora Wiedmann, Ernest J. Wiedmann,** Janet Hauenstein, Virgie Sanborn, Webb Herrier, Mary Sandell, **Mrs. Bert Romano, Marie Huyck, Patti Highfill, Helen Lilley, Mrs. Robert Cox, Mrs. James Lewis, E. T. Andersen, June Blakely** [Mrs. Capt. Hugh Blakely], **Judy Collier, Elsa Schuyler, Oma Perry, Ethel Bailey** and **Leila Maimann**. Assisting Mrs. Brughelli with the successful event were the Community Woman's club president…," *LR*, June 27, 1957, p. 4.
1958 – "Art Exhibit Plans Made. **Mrs. Erick Andersen**, chairman of the Art Exhibit to be held in conjunction with the Annual Flower Festival on June 21 and 22, announced this week that Mrs. Kermit Hover would be available by telephone to provide information on exhibit arrangements. The number to dial is 4223," *LR*, April 17, 1958, p. 15; "Art Exhibit Plans Ready… Artists and art students who

wish to exhibit paintings in the Festival Art Exhibit being sponsored by the Community Woman's club are invited to contact the chairman, Mrs. Erick Anderson … Entries may be left in her care all next week or may be brought to the exhibit point, Ryon Park, on the day of the exhibit, Saturday, June 21 from 11:30 a.m. until the event starts at 1:00 p.m.," *LR*, June 12, 1958, p. 13; photo of paintings in the park, *LR*, June 26, 1958, p. 4.

1959 – "Art Exhibit Planned for Festival," *LR*, March 12, 1959, p. 13; "Art Exhibit Plans Being Formulated," *LR*, April 30, 1959, p. 29; "Children's Section Added to Exhibit. A special children's section will be added to the adult display in the Festival Art Exhibit this year… limited to pictures submitted by boys and girls under 12 years of age… The show… will take place Saturday June 20 from 1 to 4 p.m. and is sponsored by the Community Women's Club …," *LR*, May 28, 1959, p. 7; "Children, Adults to Exhibit Art… non-competitive art exhibit June 20 from 1 p.m. to 4 p.m. in Ryon Park… Boys and girls under 12… are eligible for collages (paper mosaics) will be accepted as well as oil, water color, ink, pencil, pastel and other mediums except crayon…," *LR*, June 8, 1959, p. 4; photo of children and their art and caption reads, "Budding Artists – Exhibiting their work under supervision of their art teacher **Mrs. Arnold Brughelli** …," *LR*, June 11, 1959, p. 3; "New Highlight Adds Children to Art Show … special section … children under 12 years old… suggested by **Mrs. Arnold Brughelli**… who feels that 'a chance to exhibit their art gives children the encouragement and incentive to produce more and better art.' For the past four years she has been teaching art to private students, and she is hoping that all nine of her students will enter the exhibition. The big pepper tree at Ryon Park creates a most inviting open air setting for the Art Exhibit, which was begun three years ago at the suggestion and under the guidance of **Mrs. Brughelli**. It is non-competitive and open to all the residents of Lompoc, the USDB, and Vandenberg. In the children's section paper mosaic as well as oil, pastel, water color, ink, pencil and other mediums will be accepted. Because of the limited space, no crayon entries will be accepted. The show is open to the public and will take place between 1 and 4 p.m. next Saturday. Members of Lompoc Community Women's Club, the sponsors of the exhibit, will be on hand to serve as hostesses. Entry blanks and instruction sheets are now available at the *Lompoc Record* office…," *LR*, June 15, 1959, pp. 4, 6; "Aquacade to Open Gala 2-Day Event… [parade, art shows, flower shows, folk dancing, little league game, etc.] … Art Exhibit. Also on on Saturday, the outdoor art exhibit will be staged in Ryon Park beginning at 1 p.m. and lasting until 4 p.m. Amateur and professional artists …," *LR*, June 18, 1959, p. 1; "188 Visitors View Paintings… From as far away as Winnipeg, Canada and Honolulu, Hawaii… came last weekend… viewed 88 pictures exhibited in the Festival Art Show sponsored by Lompoc's Community Women's Club…," *LR*, June 25, 1959, p. 4.

1960 – "Artists are Asked to Exhibit Works … Exhibits will be in two sections, children's' for those under 12 years, and adults for all those over 12," *LR*, May 5, 1960, p. 6; "Artists Ready Entries… This year's exhibits will be on display from 1-5 p.m., Sunday, June 26, in a lovely outdoor setting under the trees. Huge portable frames made of 2 x

4's and wire netting will hold up to 100 entries… Lompoc area artists…," *LR*, June 2, 1960, p. 6; "Art Show Grows… Flower Festival feature… Ryon Park… 1-5 p.m., Sunday, June 26. Sponsoring the show is Lompoc Community Woman's Club with **Mrs. Erick Anderson** [Sic. **Andersen**] as chairman… open to all artists… Among the local artists preparing pictures for exhibit are: **Mrs. Mary Bondietti, Mrs. Marion Lewis, Mrs. Elsa Schuyler, Mrs. Ethel Bailey**, Miss Virgie Sanborn, **Mrs. Arnold Brughelli**. Students of Mrs. Brughelli and **Mrs. Neal Martin** are also considering entering displays. Entries will be solicited from all Lompoc Valley, Vandenberg and other military installations … The annual park Art Show was started about five years ago with 25 entries shown. **Mrs. Arnold Brughelli** was in charge for the first two years. She was assisted by Mrs. Anderson who assumed charge in 1958. The show has continued to grow… Last year… there were 86 entries…," *LR*, June 23, 1960, p. 38; "Local Artists Exhibit… The quality of entries… is improving each year according to **Mrs. Erick T. Anderson**, art chairman from the Community Woman's Club… We can see the development of talent … Entries numbered 103 this year, 87 of these in the adult division, 16 in the children. Mrs. Anderson reports many comments on the two water colors, 'Sunday Morning' and 'Cosmopolitan Character,' painted by Mrs. Jan Mullen [i.e., Mrs. Robert R. Mullen, Convair wife]; two entries by **Jan Westrope**, a floral watercolor of an orchid and a water fowl scene; a still life oil by **Marion Lewis** and entries in oil by **Mrs. R. J. Bork**, an arrangement of roses, a tree stump with background in browns and ambers and an African tribal mother and child. Mosaics. Also attracting much attention were three mosaics entered by Mrs. Joy Oliver, one of which was a scene from the Wori Ranch on North H street, an oil titled 'Lazy River' by Ellen M. Shervais [i.e., Mrs. Major Stephen Shervais] (a first painting), two moderns by Pat O'Keefe [d. 1960, founder O'Keefe Furniture], and a white pencil drawing on black paper done by Dean Norlund. The latter was called 'A Moment of Privacy.' The first attempts of Mrs. H. L. Mundell [i.e., Mildred, Mrs. Henry Leroy Mundell], a water color landscape, and the pencil sketch of her small son by Mrs. Eleanore Lloyd … Entries in the children's division were of good quality… Among the entries were those which had won first place ribbons this spring at the school art exhibit sponsored by the Community Woman's club. These included exhibits by Paul Martin Silver and Mary Lynn Silver, Macy Jeffers, Duncan Kohler and Kathy Schuknecht…," *LR*, June 30, 1960, p. 6 and more info. on p. 10 under "It Reminds Me".

See: "Flower Festival (Lompoc)," 1957+, "Lompoc Community Woman's Club," 1957

Openshaw, (Joseph) Byron (1914-1978) (Orcutt)
Commercial artist. Printmaker, painter. Santa Maria high school grad., 1935, who exh. at Faulkner Memorial Art Gallery, Santa Barbara, 1933. Appears to have studied art in Los Angeles. Was teaching art to children for the WPA in Santa Maria, 1937. Listed as an artist in the Santa Maria CD, 1938. Worked as an artist in Santa Barbara by 1940. Back in Santa Maria by 1947. As a painter, exh. Minerva Club Art and Hobby Show, 1959.

■ "J. Byron Openshaw… died Wednesday in a local convalescent hospital. A resident of Santa Maria since 1922 … was last employed at G&O Production Services. A former member of the Orcutt Lions Club…," *SMT*, Sept. 14, 1978, p. 19.

Openshaw, Joseph Byron (notices in Northern Santa Barbara County newspapers on microfilm and on newspapers.com)
1939 – "Local Artist's Painting Hung for Fair," i.e., **Golden Gate Expo** in SF, "… dry-point etching of several nude figures … last year's art editor of '*Mascot*,' J. C. annual…," *SMT,* March 10, 1939, p. 3.
1947 – "I Spied … A color cartoon poster depicting action between the 'Revenuers' and the 'Lonesome Polecats,' executed by Byron (Bones) Openshaw, hanging above the golf team scores at the Country Club," *SMT*, April 29, 1947, p. 1.
1967 – "TV Network Formed in West. Salt Lake City. The Western Education Network (WEN) of television stations to serve 14 states… Byron J. Openshaw, program director for the University of Utah's KUED television and organization spokesman, said the WEN will strengthen the bargaining position of educational television in the west… headquartered in Sacramento…," *LA Times*, March 3, 1967, p. 78 (i.e., pt. IV, p. 18).

Openshaw, Joseph Byron (misc. bibliography)
Byron Openshaw is listed in the 1930 U. S. Census as residing in Careaga, Santa Barbara County, with his mother, Jennie (age 35) and siblings Reuel (age 17), twin? Myron (age 15), Dale (age 14) and twins? Jay and Joyce (age 9); Byron Joseph Openshaw, student and Dem., is listed in *Index to Register of Voters, LA City Precinct, No. 1327*, 1936; Byron Openshaw is listed as artist in the *Santa Maria, Ca., CD*, 1938; Byron Openshaw is listed in the 1940 U. S. Census as age 25, b. c. 1915 in Idaho, finished high school 4th year, single, an artist, residing in Santa Barbara (1935, 1940) with his brother Reuel Openshaw (age 27); Byron Openshaw, office manager of Peak Oil Tool Serv., is listed in the *Santa Maria, Ca., CD*, 1947, 1948; Joseph Byron Openshaw was b. Nov. 13, 1914 in Oakley, Id., to Alan Ingham Openshaw and Jennie Mae Poulton, and d. Sept. 13, 1978 in Santa Barbara per Severe Family Tree (ancestry.com).
See: "Blue Mask Club," intro., "Faulkner Memorial Art Gallery," 1933, "Minerva Club, Art and Hobby Show," 1959, "National Art Week," 1940, "Santa Maria School of Art," 1933, "Scholastic Art Exhibit," 1933, "Splash," 1935, "Works Progress Administration," 1937

Orcutt, Ca., art
See: "Art, general (Orcutt)"

Orcutt, Ca., Elementary School
School classes included art and handicraft programs, some to develop manual dexterity and some to enhance children's study of academic subjects such as history, geography, etc. Posters and puppet making were frequent projects. Part of the Santa Maria school system.
Orcutt, Ca., Elementary School (notices in Northern Santa Barbara County newspapers on microfilm and on newspapers.com)
1947 – "Exhibit Posters – Orcutt school children entered a total of thirty-one posters in the county art exhibit conducted by **Joe Knowles** … students from the kindergarten through the eighth grade. … done with wax crayon… water color. All classroom teachers in the Orcutt school teach their own art," *SMT*, April 19, 1947, p. 3.
1953 – "Visual Education at Orcutt School," where students are taught history by allowing them to make models and other art, which gives them a lively interest in the subject of early California people, and photo of children, *SMT,* April 25, 1953, p. 1.
1957 – Photo of children painting puppet heads with teacher Mrs. Anne Morganti, and "Teaching [is] Hard Work But Still Enjoyable, Veteran Orcutt School Instructor Says…," *SMT*, April 26, 1957, p. 1.
See: "Orcutt Community Church," 1947, "Santa Maria, Ca., Elementary Schools"

Orcutt Community Church
Conducted a Junior Art Class, 1947-49? probably the special project of Alice Linsenmayer, artist and wife of the pastor during those four years. [Church building is now an antique store.]
Orcutt Community Church (notices in Northern Santa Barbara County newspapers on microfilm and on newspapers.com)
1947 – "Grade Pupils Decorate Orcutt Church Windows," *SMT,* March 27, 1947, p. 3; "Class Work Exhibit Planned Thursday," *SMT*, Aug. 27, 1947, p. 3; "Orcutt Parents View Work by Children," *SMT*, Sept. 2, 1947, p. 3; "Orcutt News… An unusual Christmas creche … is attracting considerable attention. Fluorescing paints were used by the artist **Mrs. Alice Linsenmayer**. Ultra violet lights activate the pigments and produce an illusion of self-luminosity," *SMT*, Dec. 30, 1947, p. 3.
1948 – "Art Exhibit Held by …" youth art students of church, *SMT,* May 7, 1948, p. 8.
1949 – "Orcutt Church… Worshippers attending Easter services… received an unusually colorful bulletin… The design on the cover, showing the women coming to the empty tomb, was drawn by Mrs. **Alice Linsenmayer**. The covers were hand-painted in colored India inks by children of the Junior Art class of the church" and children named, *SMT,* April 18, 1949, p. 5; "Junior Art Class Concludes Course," and article says, "Junior children in the art classes taught by Mrs. **Alice Linsenmayer** for children connected with the program of the Orcutt Community church are busy completing all work which was not finished at the end of the school year," *SMT,* June 11, 1949, p. 5; "Orcutt Church School Children to Hold Exhibit," *SMT,* Aug. 11, 1949, p. 5; "Orcutt Church School Program Attracts Crowd" and it includes marionettes/puppets, *SMT,* Aug. 15, 1949, p. 5;

"Choirs to Combine at Orcutt, Los Alamos... The chancel of each church has been decorated with the Christmas star and Bahbino [Sic?] painted by **Alice Linsenmayer** in the style popularized in the fifteenth century by Italian artists," *SMT*, Dec. 17, 1949, p. 3.
1950 – "Antiques are **Hobby Show** Items ... show given by the Friendly Aid society of the Orcutt community church at the youth cabin...," and paintings are mentioned but with no details, *SMT*, June 22, 1950, p. 6.
1957 – "Circle Hears Talk on Church and Art," by **Mrs. Alice Linsenmayer**, wife of a former pastor, on "Religion and Art" through history, and article adds, "She illustrated the subject with a display of pictures and books collected during her many years of interest in the subject," *SMT*, April 4, 1957, p. 4.
See: "Boy Scouts," 1947, "Home Department," 1930

Orcutt Woman's Club / Orcutt Women's Club / Woman's Improvement Club of Orcutt (Orcutt)
Woman's club in Orcutt, a satellite town to Santa Maria, that was active c. 1919-47. Members held regular meetings with programs (lectures or entertainments of music, drama), played cards, raised monies for charitable purposes, gave entertainments, and interfaced with other local women's clubs.
Orcutt Women's Club (notices in Northern Santa Barbara County newspapers on microfilm and on newspapers.com)
1919 – "Community Tree Planned for Orcutt... Woman's Improvement Club of Orcutt...," and they studied Japan, *SMT*, Dec. 4, 1919, p. 2.
1920 – "Woman's Improvement Club of Orcutt Elects Officers...held its annual business meeting Tuesday afternoon at the club rooms," *SMT*, Jan. 8, 1920, p. 1.
1927 – "Orcutt Club has Picture Exhibit... oils, water colors, etchings... 13 pictures now being exhibited at the Orcutt Grammar school under the auspices of the Orcutt Women's club... Next week, after the club holds an art meeting at which the history and details of the painting of many of the pictures will be reviewed, they will be sent to Santa Maria to be exhibited by the **Minerva club** of this city... artists... who make their homes in Santa Barbara include... **Colin Campbell Cooper, Fernand Lungren, Albert Herter, H. [Sic. A.] G. Cram** and etchings by **Edward Borein**... the artists have consented to their being exhibited by various clubs and throughout the county for the benefit of the citizens ... Orcutt club secured the pictures through **Mrs. E. T. Croswell**, county art chairman...," *SMT*, Nov. 2, 1927, p. 5.
1932 – "Fine Arts Stressed at Meet... regular bi-monthly conference of the Santa Barbara County **Federation of Women's clubs** to be held at Buellton on Tuesday, November 29, with the Orcutt Woman's club... as hostess. Review of the current situation in art, drama, literature and music will be given...," *SMT*, Nov. 25, 1932, p. 5.
1934 – "Local Club Women Attend Orcutt Meet... Mrs. **Leila Maimann**, art chairman for the Santa Barbara County Federation of Women's clubs, gave a talk on art programs for clubs. Mrs. Maimann also displayed an exhibit of oil paintings done by her sister, Miss **Oma Perry**, one of whose paintings was a gift to the Alpha club, presented by the art section. ...," *LR*, June 15, 1934, p. 14.

And, more than 30 additional entries in the SMT, 1931-1941, not itemized here.

Orendorff (Arnold), Martha Angela (Mrs. Lowell J. Arnold) (1930-1976) (Santa Barbara)
Watercolorist. Exh. Santa Ynez Valley Art Exhibit, 1956. Photography teacher at Redwood High School, San Rafael, Ca., 1964-65.
Orendorff, Martha (notices in Northern Santa Barbara County newspapers on microfilm and on newspapers.com)
1959 – STEPFATHER – "Abel Maldonado, Magician, Dies," in Santa Barbara, *Progress-Bulletin* (Pomona, Ca.), Dec. 9, 1959, p. 5.
1965 – Photo of two of her photography students from Redwood High School, *Daily Independent Journal* (San Rafael, Ca.), March 27, 1965, p. 40 (i.e., M-12).
Orendorff, Martha (misc. bibliography)
Martha A. Orendorff, b. c. 1931, married Lowell J. Arnold on Jan. 28, 1955 in Santa Barbara County per Calif. marriage Index; Martha Angela Orendorff was b. Oct. 27, 1930 in San Francisco to Pvt. James Raymond Orendorff and Madelaine Tait, was residing in Santa Barbara in 1946, and d. March 23, 1976 in Marin, Ca., per Penn / Hall Family Tree (refs. ancestry.com).
See: "Santa Barbara County Fair," 1958, "Santa Ynez Valley Art Exhibit," 1956

Organ, William Hugh Johnston, Rear Admiral (1903-1992) (Lompoc)
Painter and collector, 1960. Head of Federal Electric Corp. at Pacific Missile Range, 1959+
■ "William Organ Home on Christmas Tour... eight room home of Mr. and Mrs. William Organ, 501 East Fir Avenue... Furnishings are contemporary with touches of other culture added through pieces bought in foreign countries in which the family lived during the years of Mr. Organ's US Navy service. The lovely paintings which lend so much to the various rooms include a number done by the master of the house. Two of these grace the dining room, one a scene of ballerinas, the other a still life of colorful fruit. The latter is especially effective in its frame of primitive Puerto Rican wood. A Puerto Rican scene in the living room was also done by Mr. Organ as was the large oil which strikingly sets off the teakwood wall of the entrance hall... living room... Tones of beige ... The fireplace wall is dominated by a mosaic wall plaque executed in bright color tones... A heavily carved chow bench from Shanghai off-balances the lovely Baby Grand... Twin beds in the third bedroom are covered with striped spreads. Furniture is mahogany and rattan. Here hangs the pastel portrait of Mr. Organ as a young naval officer, painted by famed Bostonian artist de Madame Receimeir [Sic.?] ... dining furniture ... From China are the beautiful Oriental rugs here and in the front entrance hall... The Organs moved to Lompoc about 18 months ago and Mr. Organ is project manager for Federal Electric Corporation at Point Arguello. They have two sons, Bob, a student at USC, and Lt. James Organ, on submarine duty in Japan; also a daughter, Perry, employed by a publishing firm in London," *LR*, Nov. 28, 1960, p. 4.

Orin, Aldo Bishop (1917-2010) (Santa Maria / Nipomo / Atascadero / Riverside County / Grants Pass, Ore.)
Lapidary teacher at Allan Hancock College adult school, 1960, 1961. Brother to Charley Orin who d. Santa Maria, 1993.
See: "Allan Hancock College Adult/Night School," 1960

Orr (Ames), Lucille Eagler (Mrs. Edward F. Orr) (Mrs. Oliver Ames) (Santa Maria)
Photographer, amateur. Active Santa Maria Camera Club, 1939.
See: "Santa Maria Camera Club," 1939

Ortega & Sammons (Solvang)
Art & Drafting Design, 1957-58.
■ "Around the Valley… R. M. Ortega and William Sammon of Santa Barbara opened an architectural art and drafting service in the studio in the rear of Arden T. Jensen's law offices, 1623 Mission Drive, Solvang. The firm will offer a building plan and rendering service," *SYVN*, Aug. 23, 1957, p. 8.
Ortega & Sammons (notices in Northern Santa Barbara County newspapers on microfilm and on newspapers.com)
1957 – Ad: "Ortega & Sammons. Art & Drafting, Design. Rear – 1623 Mission Drive, Solvang," *SYVN*, Sept. 6, 1957, p. 5.
1958 – "R. M. Ortega… Wm. Sammons. Art. Design. Building plans. R. M. Ortega, General building contractor, Conventional and Adobe Construction. Santa Barbara Office: 1212 Chapala street, Call WO 5-5425 collect. Solvang Office S Y 6031," *SYVN*, April 4, 1958, p. 8.
See: "Santa Ynez Valley Industrial Center," 1960

Orton (Calandri), Xandra "Sanny" (Mrs. Raymond E. Calandri) (1935 -?) (Santa Ynez Valley)
Exh. annual Santa Ynez Valley Art Exhibit, 1953, 1955. Daughter of Margaret Orton Gardner, above.
■ "… Sanny Orton, aged 17, is a junior in high school and said, 'Ever since I was old enough to hold a crayon I drew and sketched. I used to sit for hours when I was little and paint. It has always been my first love. Now the art work I do in school is a class in design, painting and drawing. If I go on to college I will major in art'…," *SYVN*, Jan. 30, 1953, p. 3; "Miss Orton… Mr. and Mrs. John Gardner of the G-K Ranch, Buellton, have announced the engagement of their daughter, Miss Xandra Orton to Ray Calandri, son of Mr. and Mrs. Mike Calandri. … Miss Orton was graduated from Santa Ynez Valley Union High School in 1954. She later attended Colorado College at Colorado Springs. She recently returned home after spending the summer in Europe [;] touring the continent with her were her aunt and uncle… Joining them for a month on the tour was her brother, Mark de Forrest Orton, who is stationed with the US Army near Paris…," *SYVN*, Sept. 30, 1955, p. 5.

Orton, Sanny (notices in Northern Santa Barbara County newspapers on microfilm and on newspapers.com)
1954 – "HS Achievement Award Winners… Bank of America Achievement award winners… at Santa Ynez Union High School… arts and music, Sanny Orton, and vocation arts Buddy Sechler. Each will receive an engraved certificate …," SYV, March 19, 1954, p. 8.
1955 – "Xandra Orton Welcomed Home. Mrs. John Gardener gave a luncheon party at her ranch home recently honoring her daughter, Miss Xandra Orton on her return home from a three-months trip to Europe," *SYVN*, Sept. 2, 1955, p. 3.
1956 – Port. and "Xandra Orton, Raymond E. Calandri Wed in Ceremony at Old Mission… Following the wedding ceremony… a wedding trip to Lake Tahoe, Yosemite, Reno, Virginia City and Las Vegas… After April 23 they will be at home on Central Avenue in Buellton…," *SYVN*, April 13, 1956, p. 3.
1965 – "Mrs. Calandri will Receive PHT Degree… Mrs. Xandra Calandri will be among 125 wives receiving their PHT, Pushing Hubby Through degrees at California State Polytechnic College on Sunday, June 13 in San Luis Obispo. … Her husband, Raymond E. Calandri, will receive his degree in Business Administration June 19… After graduating … the family will move to Sacramento where Calandri will be employed by the Wells Fargo Bank," *SYVN*, May 20, 1965, p. 11 (i.e., 3-B).
2003 – Port. with sculpture, "Good Looks. Show and Tell. Wooden sculpture. … Name: Xandra Calandri. Neighborhood: Cathedral City. I inherited from my mother a wooden sculpture of a cowboy roping a calf. It is painted to be realistic. When it came to me it was broken in several pieces. I took it to a master sculptor who repaired it. He told me the horse and saddle were both carved from one piece of wood. The sculpture is signed by Mary Crouch [of Sacramento]. It is only about eight inches high but very intricately carved and detailed. It sits on its own stand in my living room, under glass. My mother had it made for my stepfather who was a rodeo cowboy and roper. He spent time in with other ropers at Deep Well Ranch in Palm Springs," *Desert Sun* (Palm Springs, Ca.), Dec. 20, 2003, p. 69 (i.e., F).
2006 – Port. and "50th Anniversary. Ray and Xandra Calandri… were married at the Santa Ynez [Sic.] Mission on April 7, 1956… Ray and Xandra have lived in the Coachella Valley since 1992," *Desert Sun* (Palm Springs, Ca.), June 25, 2006, p. 50 (i.e., E-4).
Orton, Sanny (misc. bibliography)
Xandra Orton port. appears in the Santa Ynez Valley, Ca., High School yearbook, 1954; Xandra Orton flew on TWA from NY to Paris on June 24, 1955 per Passenger Manifest, TWA; Xandra Orton married Raymond E. Calandri on April 7, 1956, in Santa Barbara county per Calif. Marriage Index; Xandra O. Calandri, b. April 21, 1939, was residing in Palm Springs, Ca., in 1993 per *U. S. Public Records Index, 1950-1993*, vol. 1 (refs. ancestry.com).
See: "Gardner, Margaret," "Santa Ynez Valley Art Exhibit," 1953, 1955, "Santa Ynez Valley Union High School," 1951, 1953

Osbourne (Strong) (Field), Isobel "Belle" (Mrs. Joseph Dwight Strong) (Mrs. Edward Salisbury Field) (1858-1953) (Monterey / Los Olivos)
Painter, author, contributor to Dune Forum, 1934. Built a studio on the Field property in Los Olivos after 1926. At the Field home she entertained many actors and writers.

■ "Belle was born in Indianapolis to Samuel and Fanny Van de Grift Osbourne and married the artist Joseph Dwight Strong (1853–1899) in 1879, giving birth soon after to a son, Austin Strong (1881–1952) who later became a successful playwright. Joe Strong had a drinking problem and Belle divorced him in 1892. Belle moved to Vailima, Samoa, in May 1891 with her mother and step-father. There she was Robert Louis Stevenson's literary assistant transcribing his words when he was too ill to write. In 1914, she married her mother's secretary (and possibly lover), the younger journalist Edward Salisbury Field, six months after her mother died. Field was only three years older than her son Austin. When oil was discovered on property owned by Field, they became wealthy. In 1926 Field purchased Zaca Lake and surrounding land in the Figueroa Mountains near Los Olivos, California [300 acres]. Isobel built an artists' studio there and the Field home became a popular meeting place for writers and actors. Isobel and her brother Lloyd wrote about Robert Louis Stevenson and their experiences in Samoa in *Memories of Vailima* (1902). Later Isobel wrote her memoirs in two books *This Life I've Loved* (1937) and *A Bit of My Life* (1951)," from Wikipedia.

■ "Isobel Field is one of the great ladies of the West. Her childhood, when she was known as Belle Osbourne, was spent in mining camps of the Sierra Nevada and both sides of San Francisco bay. Her stepfather, Robert Louis Stevenson, immortalized her in his 'Vailima Letters.' In Samoa the natives affectionately named her *Teuila* (White Duck), a name which all who love her (an innumerable host) call her to this day. In San Francisco with her artist husband, Joe Strong (their son Austin is the author of 'Seventh Heaven'), she was in the thick of everything creative in the then undisputed metropolis of the West. Now that her present husband, Salisbury Field, author of 'Zander the Great,' co-author of 'Twin Beds,' is writing for the movies in Hollywood, she takes as alive a part in the life of the newer metropolis as she did once in the older. But her real home is romantic old Serena, on the shore between Santa Barbara and Carpinteria, which [her mother] Mrs. Stevenson bought for her old age, and where she died. [Sic.] There is a rumor that, at the request of her son, Mrs. Field is writing her memoirs, and that Scribner's has spoken for them without even seeing them… So rich a life promises enthralling reading, full of anecdotes, humor, pathos, and deep understanding," *Dune Forum*, March 15, 1934, p. 69; "Apologies are Due Isobel Field… we did not make a single mistake in our introductory note concerning her, but five!... *Teuila*, for instance, does not mean 'White Duck,' but 'Decorator.' The nickname was given her by the Samoans because of her love of decorating their women with trinkets, and their love of her in consequence. She was not 'immortalized' by her stepfather, Robert Louis Stevenson, in the 'Vailima Letters,' but acted as his amanuensis in the writing of them. Mrs. Stevenson, furthermore, did not buy Serena for her old age, nor did she

die there. It was a combination of her love for fishing and a wharf out to the kelp beds that was the reason for her choice," *Dune Forum*, April 15, 1934, p. 112.
And, photos and biography for "Isobel Field" on findagrave.com and in many newspapers.
See: "Dune Forum"

Ostini, Natalie M. (Mrs. Frank B. Ostini) (Santa Maria)
Art chairman, Jr. Community Club, 1953-54.
See: "Junior Community Club (Santa Maria)," 1953, 1954

O'Sullivan, Tim, OFM (Mission Santa Ines)
Art minded priest who oversaw some restoration work on Mission Santa Ines, 1951+. Lent artwork to and cooperated with Solvang art exhibits.

■ "Father Tim O'Sullivan, Pastor Here Since '51," and summary of his mission restoration work, *SYVN*, Sept. 17, 1954, p. 5.
1953 – Port., *SYVN*, Feb. 13, 1953, p. 1.
And, many additional ports. and articles in the *SYVN* not itemized here.
See: "Danish Days," 1957, "Mission Santa Ines," 1954, "Rowe, Edwin D.," "Santa Ynez Valley Art Association," 1953

Otis, Helen (Santa Maria)
Art editor of Santa Maria High School Review. Pianist. Singer. High school student body president, 1915/16, and grad., 1916. Student at California School of Arts and Crafts, Berkeley, 1916.
Otis, Helen (notices in Northern Santa Barbara County newspapers on microfilm and on newspapers.com)
1916 – "3 Days' Celebration… Santa Maria… The High School *Review* is out … a splendid line of original compositions… Helen Otis as art editor and Darrell Froom as assistant contributed illustrations of unusual merit…," *Santa Barbara Daily News and the Independent* (Santa Barbara, Ca.), May 26, 1916, p. 6; "Frank [Russell] Otis [a barber, b. c. 1870, 1860?] and his daughter, Miss Helen, left for Richmond Wednesday night to visit Mr. Otis' brother, Harry Otis and his wife. Miss Otis will remain in Richmond until she enters the **California School of Arts and Crafts** in Berkeley," *SLO DT*, June 10, 1916, p. 3. [In 1916 Frank Otis moved to Richmond, California, to help his brother, who became seriously ill. Is he Frank R. Otis, barber, listed in the 1940 U. S. Census as age 80, b. Ind., residing with his daughter and son-in-law, Helen G. and Charles Macintosh, in Richmond, Ca.?]

Otte, William Louis (1871-1957) (Santa Barbara)
Artist who worked with pastels and oils. Sketched in Santa Maria, 1929. Curator of an exhibition of Santa Barbara artists held at Santa Maria city hall, 1935.

■ "The Invaders by Fred Hogue… wall space in the … Biltmore Salon is filled with canvases of the members of the Santa Barbara Art League… the canvases of one member… William L. Otte, to fame and artistic fortune yet unknown, awaken in me a livelier emotion… than those of

the national academicians. Otte spent his youth in Wall street, a successful broker. Ill health drove him an exile to the Far West. He located on the flowering foothills overlooking Santa Barbara and the Pacific. … The creative desire to reproduce on canvas the masterpieces which nature has strewn… about the inlet of Santa Barbara would not be denied. He began with pastel, then turned to oil … Nature was his school…," *LA Times*, June 13, 1927, p. 20 (i.e., pt. II, p. 4).

1929 – "Mr. and Mrs. William Louis Otte have returned to their home in Santa Barbara after a sojourn in this city. They have been here resting, and on a sketching tour," *SMT*, Sept. 24, 1929, p. 5, col. 3.

1938 – "Back Home. Mr. and Mrs. William Louis Otte of Santa Barbara have returned home from a six weeks motor tour of Mexico," *LA Times*, March 9, 1938, p. 28 (i.e., pt. II, p. 8).

And, approx. 20 notices of his work in group shows, usually consisting of "Santa Barbara" artists, held in California in the 1920s and 1930s, appearing in California newspapers on newspapers.com, were not itemized here. Listed in Nancy Moure, "Dictionary of Art and Artists in Southern California before 1930," *Publications in California Art*, vol. 3 and other volumes in the set.

Otte, William (misc. bibliography)
[Do not confuse with William Otte of northern California, associated with the post office.]
William Louis Otte b. Dec. 5, 1871 in Wisc., and d. Feb. 15, 1957 in Santa Barbara county, is buried in Oak Hill Cemetery, Ballard, per findagrave.com (refs. ancestry.com).
See: "College Art Club," 1935

Outwater, Florence DeGaston / Gaston (Mrs. James A. Outwater) (1886-1966) (Lompoc)
Photographer, amateur, of flower subjects, who sojourned in Lompoc, 1951-52.

Outwater, Florence notices in Northern Santa Barbara County newspapers on microfilm and on newspapers.com)
1951 – "Two Lompocans See Laguna Art Masters Pageant. Mrs. Margaret Buckman and Mrs. Florence Outwater returned this week from a two and one half weeks trip through the Southland. They visited with friends at Long Beach, La Jolla, National City, Bell, Alhambra and Whittier. While in Laguna Beach they attended the Festival of Arts 'Pageant of the Masters' …," *LR*, Aug. 2, 1951, p. 3; "Deputy Grand Matron OES… Florence Outwater. Mrs. Outwater showed pictures of Lompoc and the flower fields, desert country, Golden Gate Park, San Diego Zoo and closed her series with reflection studies," *LR*, Aug. 16, 1951, p. 3.
1952 – "Community Club Garden Section has Program… Mrs. Florence Outwater… used her hobby of color photography to give the members an entertaining program. She showed color slides of the Pasadena Flower Show, of the Mission Fiesta and others in which a floral display was center of interest," *LR*, Feb. 28, 1952, p. 4.
1959 – BROTHER – Albert H. DeGaston, a native of Trenton, N. J., died in Sacramento, *Sacramento Bee*, May 15, 1959, p. 33 (i.e., C3).

Outwater, Florence (misc. bibliography)
Florence G. Outwater wife of James A. Outwater is listed in the *Rochester, NY, CD*, 1929, 1931; Florence G. Outwater is listed in the 1940 U. S. Census as age 53, b. c. 1887 in New Jersey, widowed, a saleslady, lodging in Trenton, N.J.; Florence G. Outwater, milliner, is listed without husband in the *San Diego, Ca., CD*, 1945, 1947; Florence G. Outwater is listed without occupation or husband in *La Jolla, Ca., CD*, 1950; Florence G. Outwater is listed without occupation or husband in the *Santa Barbara, Ca., CD*, 1953; Florence Outwater, mother's maiden name Cresder, was b. Aug. 23, 1886 and d. Jan. 15, 1966 in Alameda County per Calif. Death Index (refs. ancestry.com).

Ovington, Earl Kester "Kes" (Santa Maria)
Photographer, amateur. Showed his slides to Lions Club, 1945, and to Santa Maria Camera Club, 1946.

Ovington, Kes (notices in Northern Santa Barbara County newspapers on microfilm and on newspapers.com)
1945 – "Trip Shown Lions. Kess Ovington was guest speaker last night during the meeting of Lions' club in Rusconi's Café. Last summer he and Lion Clint Kramer went fishing near Bishop and Ovington showed colored slides he took at the time," *SMT*, Dec. 7, 1945, p. 3.
1946 – "I spied – … Kes Ovington rigged out as a field and stream philosopher and equipped with camera and appropriate supplies, accompanying the game warden on a fish planting expedition," *SMT*, April 26, 1946, p. 1.
1947 – "Billy Kramer Celebrates Third Birthday… Mrs. Kramer was assisted by Mrs. Kes Ovington whose husband took color pictures of the party," *SMT*, Feb. 26, 1947, p. 3; "Sportsmen Ask Zaca Purchase… Kes Ovington, Sportsman's president, showed colored slides of the lake… covering an area of 17 acres, if made a public park the place will become popular …," *SMT*, Aug. 6, 1947, p. 1; "Leaving for Bishop – Mr. and Mrs. Kes Ovington and daughter, Ardis, will leave this week end for Bishop, where Ovington is transferring to the Interstate Telephone Company after being employed with the Santa Maria Branch of the Associated Telephone Co. the past 10 years. Ovington has been active in the Santa Maria Sportsman's Association and has served as president of that organization the past year," *SMT*, Oct. 16, 1947, p. 5.

Ovington, Kes (misc. bibliography)
Kester Earl Ovington is listed in the 1940 U. S. Census as age 28, b. c. 1912 in Mass., married, switchman, residing in Santa Barbara (1935, 1940); Earl K. Ovington, switchman, is listed with wife Nora in the *Santa Maria, Ca., CD*, 1945, 1948; Earle Kester Ovington was b. March 30, 1912 in Newton, Mass., to Earle Lewis Ovington and Adelaide Alexander, and d. Oct. 16, 2006 in Lancaster, LA County, Ca., per story Family Tree (refs. ancestry.com).
See: "Santa Maria Camera Club," 1946, 1947

Ow (Kochsmeir), Alberta Agnes (Mrs. S. W. Kochsmeir) (1915-2004) (Santa Maria)
Student at Santa Maria School of Art, 1933. Vice-president of College Art Club, 1935. Art editor of JC annual, 1935. Teacher of handcraft at Camp Drake, 1937. Active in Christian Endeavor.
1939 – "Miss Alberta Ow to Receive degree... Wheaton College, Illinois... candidate for the degree of bachelor of philosophy with a major in Christian education. She transferred from Santa Maria junior college in 1937...," *SMT*, July 31, 1939, p. 3.
See: "Camp Fire Girls," 1937, "College Art Club," 1935, "Santa Maria, Ca., Union High School," 1935, "Santa Maria School of Art," 1933

Owen (Hollister), Elizabeth "Blossom" (Mrs. Stanley Hollister) (1913-1980) (Santa Barbara / Nevada)
Artist in National Art Week show at Minerva Club, 1940.
■ "Elizabeth O. Hollister. ... Elizabeth 'Blossom' Owen Hollister, 67, of Genoa died Sunday... She was born Jan. 7, 1913 in Santa Barbara, Calif., moving to Genoa in 1952 where she and her husband, Stanley, ranched until they moved to Gardnerville in 1956. The couple returned to Genoa 10 years later. Mrs. Hollister was an artist and a longtime member of the Nevada Artists Association," *Reno Gazette-Journal* (Reno, Nev.), Feb. 19, 1980, p. 23.
Owen, Blossom (notices in US Newspapers on newspapers.com).
1938 – "Flower Ball Personnel Appointed... of the Santa Barbara Spinsters... at the home of Miss Blossom Owen in Montecito...," *LA Times*, Aug. 3, 1938, p. 26 (i.e., pt. II, p. 8).
1948 – BROTHER – "Dr. Owen ... death of Dr. Donald Owen, youngest son of the late Dr. Frank S. Owen... mother, Mrs. F. S. Owen, Montecito, Cal... a brother, Hubert... and another sister, the former Blossom Owen, who lives on a ranch near Santa Barbara," *Sandusky Register*, Oct. 16, 1948, p. 10.
1952 – "**National Art Week** Observed... exhibit at the Leisure Hour hall, Carson... Oil paintings shown included works by ... Blossom Owen... The same pictures exhibited in Carson will be shown at the Nevada Art Gallery in Reno, Nov. 9 to 16...," *Reno Gazette-Journal* (Reno. Nev.) Nov. 5, 1952, p. 13.
1953 – "Nevada Artists Open Display... in the Fable room of the Mapes Hotel is the Nevada Artists Association annual exhibit... first to be held in Reno... Other exhibitors include ... Blossom Owen...," *Reno Gazette-Journal*, March 20, 1953, p. 7.
Owen, Blossom (misc. bibliography)
Elizabeth Owen is listed in the 1930 U. S. Census as age 17, b. c. 1913 in Calif., residing in Santa Barbara with her parents Frank S. Owen (age 73) and Elizabeth A. Owen (age 60); Eliz. Owen, artist, is listed at the same address as Frank S. and Eliz. A. Owen, 44 El Bosque Rd., in the *Santa Barbara, Ca., CD*, 1939; Frank Styles Owen's last will and testament of 1939 leaves money to his wife, Elizabeth A., and ... ¼ each of the residue of his estate to his four children: "Hubert K. Owen... Donald R. Owen... Gertrude Thomas... [and a trust set up for] Elizabeth Owen ...," *California Wills and Probate Records, Santa Barbara*, vol.

34-39, 1936-40; Elizabeth Owen, artist and Rep., is listed in *California Voter Registrations, Santa Barbara County, Montecito No. 1* precinct, 1938-1940; Elizabeth Owen Hollister b. Jan. 7, 1913 in Santa Barbara to Frank Stiles Owen and Elizabeth A. Keys, married Stanley Hollister, and d. Feb. 17, 1980 in Genoa, Nev., per McDonald, Thomas Owen primary 1_AutoBackup Family Tree (ref. ancestry.com).
See: "National Art Week," 1940, "Peake, Channing," 1941

Oxx, William Gardener, III (1923-1991) (Twin Camps)
Draughtsman with CCC camp, 1941. Continued to pursue art during his WWII stint in the Navy and afterwards at Long Beach State College. His main career was as a teacher of government and history in Los Angeles.
■ "Navy Pays Tribute to Former Lompoc CCC Enrollee for Drawings. 'He even made the North Points on his maps look like battleships.' That was the report Soil Conservation Service men at the La Purisima CCC camp gave on William G. Oxx, 19-year-old ex-enrollee who has gained recognition since enlisting in the Navy for his drawing of Uncle Sam's battle wagons... his drawings and models were responsible for 80 [Sic?] CCC men from Lompoc enlisting in the Navy. While at the La Purisima camp, Oxx spent much of his time as a draftsman for the SCS. Occasionally his preference for drawing cruisers and destroyers interfered with his assignments of drawing topographical maps and sketches of storm drains. On these occasions he was given 'vacations' from the drafting room during which he handled the business end of a shovel. Oxx's interest in ships and the Navy spread to other enrollees at the local camp and when he left Lompoc last June, 30 of the boys went with him to enlist in the Navy. One of his sketches has been hung in the library of the naval training station at San Diego. Last spring, an exhibit of Oxx's model ships was placed in the Lind building window on East Ocean avenue," *LR*, Feb. 6, 1942, p. 1.
Oxx, William (notices in California newspapers on newspapers.com and genealogybank.com)
1946 – "City College Ad Club... Reorganization of the Long Beach City College Advertising club, which was inactive during the war, was announced yesterday by William Oxx, former marine artist and draftsman with naval intelligence. Aims of the club will be to promote better advertising and acquaint students with advertising techniques, said Oxx," *Long Beach Independent*, May 26, 1946, p. 42.
1948 – "Student Elected. William Oxx, son of Mrs. May Jelenic, 4346 East LaCara, was elected president of California hall, men's dormitory at the University of Redlands, recently. Oxx graduated from Lompoc high school and attended Long Beach city college before going to Redlands," *Long Beach Independent*, Oct. 1, 1948, p. 3.
1969 – Port. and "...is a candidate for Board of Education Office No. 2. Oxx teaches government and history at William Howard Taft High School, Woodland Hills and serves as faculty chairman of the Los Angeles District Attorney's Youth Crime Commission. He served in the Office of Naval Intelligence in the Navy Department, Washington, D. C., from 1941 to 1945 (?). Oxx was graduated from the University of Redlands, where he

received his Bachelor's degree in history in 1949 and his Master's degree in social science in 1951. Oxx has been teaching in the Los Angeles city schools since 1954. He is the author of several chapters published in five books on history, government, Navy and military affairs. These appeared in a Simon and Schuster publication, *Encyclopedia Britannica* and a publication of the Navy League of the United States. He also was a graduate fellow and instructor in the history department at University of Redlands. Oxx is 46 years old and resides in Northridge with his wife and three children," *Van Nuys News*, March 21, 1969, pp. 1, 16.

1971 – Port. and is running for school board "Oxx, a teacher at William H. Taft High School in Woodland Hills, stands in opposition to 'forced busing', would encourage more vocational education, a roll back and 'freezing' of the small property owners' educational tax assessment, and expulsion of all known drug carriers and peddlers from the schools. ... He also holds six California teaching and administrative credentials. He has been an educator for the schools for 16 years. Oxx is a member of Professional Educators of Los Angeles. He is married and has three children, all attending schools in the Valley...," *Valley News* (Van Nuys, Ca.), March 26, 1971, p. 14.

Oxx, William (misc. bibliography)
William Gardener Oxx was residing in Long Beach, Ca., in 1945 per his WWII Draft Card; William Gardener Oxx was b. Jan. 19, 1923 to William Gardener Oxx and Mary Estelle Bjorkman in Newport, R. I., was residing in Newport, R. I. in 1928, and d. Nov. 27, 1991 in Ventura County, Calif., per Simle Family Tree; William Gardner Oxx, III, 1923-1991, is buried in Pierce Brothers Valley Oaks Memorial Park, Westlake Village, Ca., per findagrave.com (refs. ancestry.com).

Oyama, Ann Kazue
See: "Konishi (Oyama) (Aihara), Ann Kazue (Mrs. Fred Y. Oyama) (Mrs. Henry K. Aihara)"

P

Paaske, Raymond Marcus (1916-1983) (Solvang)
Photographer? Tried to organize a Camera Club in Solvang, 1950. Developer / owner of Copenhagen Square, built in Danish style according to his father's dream of making Solvang a town of Danish provincial architecture. In charge of Danish Days for several years in the late 1950s. Civically active.

■ "Raymond was a B-17 pilot and prisoner of war in WWII. Raymond's father, Termann Paaske, had come to Solvang, California in 1918 and opened a furniture store and mortuary. Though his father had died in 1942, Paaske continued the older man's dream of redesigning Solvang in Danish architecture. With Sorensen's help, Paaske and his brother Erwin, known as 'Youngie,' started building the Danish provincial style Copenhagen Square on Alisal Road at the end of Main Street. In 1947 Paaske dedicated the building to his late father and a friend, John Frame, with

whom Termann Paaske had discussed the idea," per *Santa Ynez Valley News* 30 June 2011 as repro. on findagrave.com.
Paaske, Raymond (notices in newspapers from California's central coast on microfilm and the Internet)
1952 – "Paaskes Buy Mission Land... contains the land upon which the Copenhagen Square buildings are located...," *SYVN*, March 7, 1952, p. 1; "Ray Paaskes Wed 12 Years," *SYVN*, June 13, 1952, p. 4.
1954 – Photos and "Ray Paaske Home on Second Floor of Danish Style Building," *SYVN*, Jan. 29, 1954, p. 10; "Paaske Plans New Building," *SYVN*, March 19, 1954, p. 8.
1958 – Port. departing for Copenhagen, *SYVN*, Sept. 26, 1958, p. 3.
Thousands of notices on "Raymond Paaske" and "Ray Paaske" in the *SYVN*, were not even browsed for potential inclusion here.
Paaske, Raymond (misc. bibliography)
Raymond Paaske was b. March 10, 1916 in Pasadena, Ca., to Termann Paaske and Karen M. Nielsen, was residing in Solvang in 1930 and d. Sept. 22, 1983 in Santa Barbara per Jensen Family Tree; Raymond Paaske is buried in Oak Hill Cemetery, Ballard, per findagrave.com (refs. ancestry.com).
See: "Architecture (Solvang)," "Camera Club (Solvang)," "Danish Days," 1954, 1955, 1956

Pace, E. J., Dr.
Traveling entertainer – Christian cartoonist, 1939.
See: "Chalk Talks," 1939

Pach-Winther, Carl von (1878-1954) (Los Angeles / Montecito)
Danish-born photographer, magazine writer, active in Los Angeles, who took photos in the Solvang area for three days in the fall of 1933.
See: *Central Coast Artist Visitors before 1960*

Packard, Alton
Cartoonist with Chautauqua, 1925.
See: "Chalk Talks," 1925

Padrick, Walter R., Captain / Major (Lompoc / USDB)
Photographer, amateur, and collector of Japanese art acquired during a tour of duty in Japan, 1948. Gave several presentations of his colored slides to local clubs in 1948.
Padrick, W. R. (notices in Northern Santa Barbara County newspapers on microfilm and on newspapers.com)
1948 – "3-F Club Meets at Alpha Clubhouse... Captain and Mrs. W. R. Padrick entertained the members with colored films taken during their stay with the occupational forces in Japan. Also displayed was a large collection of silks and Japanese handiwork," *LR*, Jan. 22, 1948, p. 8; "Party Honors Ralph Davidson... During the evening, the group was entertained by Capt. W. R. Padrick who showed colored photos he had taken while recently stationed in Japan," *LR*, July 1, 1948, p. 9; "Club to Furnish Oxygen

Tent… Lompoc Rotary club… guest speaker at last night's meeting at the Valley Club was Capt. Walter Padrick of the USDB who gave a talk on his experiences in Japan illustrated with colored slides of photographs which he took while in the country. Capt. Padrick, who is in the Training and Industry section at the USDB spent a year in Japan…," *LR*, July 15, 1948, p. 1; "Brothers' Night is Observed by Eastern Star… Following the business meeting, Capt. Walter Padrick of the U.S.D.B. showed colored slides of Japan taken by him when he was stationed there," *LR*, July 29, 1948, p. 1.
1952 – "Col. Kirbys Compliment Visitor… Major and Mrs. Padrick have just returned from a tour of duty in Alaska and are on their way to his new assignment at Camp Roberts," *LR*, Aug. 21, 1952, p. 5.

Palmer, "Bunny" (Mrs. Victor Palmer) (Solvang)
Attended a picnic with the adult school art or art appreciation class, 1953. Puppeteer, 1960. Wrote letters about the family's trip in Europe that were published in the SYVN, 1958.
See: "Puppets (Santa Ynez Valley)," 1960, "Santa Ynez Valley, Ca., Adult/Night School," 1953

Palmer, David, Sgt. (Lompoc)
Ceramist, painter, 1957.
■ "People and Places: 'Trouble with our two Siamese, 'Tweetie' and 'Puddie' is that they don't know they're cats,' said Sgt. David Palmer of 210 South B street. 'My wife, Barbara, and my 5-year-old daughter, Barbara Ann… Sgt. Palmer putters around with ceramics. Makes ashtrays and ceramic heads – 'Abstracts,' he calls them. Knows something about painting, too. Started out in Korea with numbered paint kits and went on from there," *LR*, Feb. 21, 1957, p. 10.

Palmer, Eva M. Poling Palmer
See: "Venske, Eva M. Poling Palmer (Mrs. Garrett D. Palmer)"

Panama-Pacific Exposition (San Francisco)
World's Fair, SF, 1915. It celebrated the completion of the Panama Canal. It contained a high proportion of art – numerous murals and sculpture on the grounds as well as many different art exhibits of both European and American art, indoors. Influential on California artists.
See: "Denman, J.," "Motion Pictures (Santa Barbara County," "Sculpture, general (Northern Santa Barbara County)"

Parades
See: "Floats"

Paradise, Phil (Claremont / Cambria)
Artist who exh. at first Santa Maria Valley Art Festival, 1952, courtesy Cowie or Dalzell Hatfield Gallery in LA. Featured artist at SLO County Art Show, 1959. Art teacher to some Northern Santa Barbara County artists.
See: "Bailey, Ethel," "Lawhorne, Roy," and *Cambria Art and Photography before 1960* and *San Luis Obispo Art and Photography before 1960*

Parent Teachers Association (PTA)
See: "Lompoc, Ca., Elementary Schools," "Santa Maria, Ca., Elementary Schools," "Santa Ynez, Ca., Elementary Schools"

Paris, Peter, Sgt. (1912-2001) (Camp Cooke / Wisconsin)
Teacher of a sketching class at the USO, 1945.
■ "Well-known Milwaukee artist Peter Paris of Shorewood died Nov. 5. He was 89. The Milwaukee native grew up on the city's northside and graduated from the old Wisconsin State Teachers College, now the University of Wisconsin-Milwaukee. Pursuing his studies during the Depression, he worked as a sign painter to pay his tuition. He continued his education in Chicago, where he worked as an advertising artist for the *Chicago Tribune*. He returned to Milwaukee and launched a long career as an art teacher [at various schools] …. He also did scenery for the Perhift Players, Milwaukee's former Yiddish theater. … Known for donning an artist's cap, the black beret, he specialized in caricature sketching. …The couple met at the Jewish Community Center's Art Club. She was a fashion illustrator. They married and spent the following summer in California, where Paris worked as an artist for Universal Studios. Among his favorites of the caricatures he did there were W. C. Fields and Mae West. But the couple missed their families and returned to Milwaukee when Paris began his teaching career. He was stationed in California during World War II, serving in the U.S. Army Corps of Engineers, where he helped produce maps and sketches. In his spare time, he drew portraits of officers and several generals. In addition to teaching, he maintained a commercial art studio," in Milwaukee, per *Wisconsin Jewish Chronicle*, March 31, 2008, repro. on the Internet.
Paris, Peter (misc. bibliography)
Peter Paris b. April 27, 1912 in Milwaukee, Wisc., d. Nov. 5, 2001 and is buried in Anshai Lebowitz Cemetery in Milwaukee per findagave.com (ref. ancestry.com).
See: "United Service Organization (Lompoc)," 1945

Park, Kenneth Leroy (1937-2016) (Santa Maria)
Photographer of color slides who exh. at Santa Barbara County Fair, 1959. Part time photographer for Santa Maria Times, 1958-59. Hancock College journalism student, 1958.
■ "Pvt. Ken Park Now in Germany… Army Pvt. Kenneth L. Park, son of Mr. and Mrs. Roy C. Park, 1353 S. Thornburg, recently was assigned to the 18th Artillery in Germany. A cannoneer in the artillery's Battery A in Darmstadt, Park entered the Army last June and completed

basic training at Fort Ord. The 22-year-old soldier is a 1956 graduate of Santa Maria Union High School and a 1959 graduate of Allan Hancock College. Before entering the Army, he was a part-time photographer for the *Santa Maria Times*," *SMT*, Jan. 11, 1961, p. 9.

Park, Ken (notices in Northern Santa Barbara County newspapers on microfilm and on newspapers.com)
1958 – Repro: Bob Phillips receiving scholarship from Hancock College, *SMT*, Feb. 19, 1958, p. 3; repro: "First Touchdown," *SMT*, Oct. 4, 1958, p. 4; repro: "Biddy Tipoff" basketball, *SMT*, Dec. 10, 1958, p. 10; repro: "Final Tipoff," *SMT*, Dec. 13, 1958, p. 5; repro: "Stepping Out," *SMT*, Dec. 19, 1958, p. 5; repro: "Who Will Reign?," *SMT*, Dec. 24, 1958, p. 3.
1959 – Repro: "Ballet or Basketball?," *SMT*, Jan. 24, 1959, p. 5; repro: "Lawson Leaps," *SMT*, Feb. 14, 1959, p. 4.
1965 – Port. of Ken Park who won the Red Triangle Award for service to the YMCA, *SMT*, Jan. 29, 1965, p. 12.
Park, Ken (misc. bibliography)
Kenneth Leroy Park was b. Oct. 8, 1937 in Santa Rosa, Ca., to Roy Cleo Park and Dorothy Kathryn Jones and d. Dec. 25, 2016 in Santa Maria per Coll – Schmanski Family Tree (refs. ancestry.com).
See: "Santa Barbara County Fair," 1959

Parker, Mary Lucile / Lucille Dutcher (1923-1995) (Goleta)
Watercolor winner at Santa Barbara County Fair, 1958, 1959, 1960. Exh. California State Fair, Sacramento, 1956. Member of and exh. with the California Water Color Society.
Parker, Mary (notices in California newspapers on microfilm and on newspapers.com)
1959 – "New Exhibitions… Santa Barbara Museum of Art: Mary Parker paintings, Jan. 13-Feb. 8…," *LA Times*, Jan. 11, 1959, p. 104 (i.e., pt. V, p. 6).
1961 – "Three Valley Artists Win … In addition to the artists who have been listed, the following had paintings selected for the James D. Phelan Art Exhibition: Mary Parker of Goleta…," *Valley News*, April 7, 1961, p. 14; won a $50 award at the California Water Color Society exhibit, 41[st] annual at the Pasadena Art Museum, *LA Times*, Nov. 26, 1961, p. 475 (i.e., magazine, p. 18).
1973 – "For Professionals. Winners in the San Fernando Valley Art Club spring show were: … Portrait… second, Mary Parker…," *Van Nuys News*, June 10, 1973, p. 97.
1975 – MOTHER – "Clara L. Dutcher, 77… Mrs. Dutcher was born in Scott's Valley and lived in Lake County all her life…. She is survived by her husband, Oscar Dutcher, Upper Lake… daughter, Mary Parker, Goleta…," *Press Democrat* (Santa Rosa, Ca.), Nov. 24, 1975, p. 29 (i.e., 20). And entries for "Mary Parker" in the *SMT* 1961+ show that she continued to win prizes for her watercolors at the Santa Barbara County Fair in 1961, 1962, 1965, 1971, 1972 but they were not itemized here. Exh. with California National Water Color Society, 1961.
Bibliography:
Exh. Laguna Beach Art Association, 1967, 1971 per "Index to California Art Exhibited at the Laguna Beach Art Association, 1918-1972," *Publications in California Art*, v. 11.

Parker, Mary (misc. bibliography)
Mary Lucile Parker was b. Feb. 16, 1923, mother's maiden name Wray, father's Dutcher, and d. March 27, 1995 in Shasta, Ca., per Calif. Death Index (ref. ancestry.com).
See: "California State Fair, Sacramento," 1956, "Santa Barbara County Fair," 1958, 1959, 1960

Parker, Robert J., T-Sgt (Camp Cooke)
Photographer associated with Base Photographic Laboratory who won a Camp Cooke photography contest, 1959. Active Lompoc c. 1957-61. Developed a unique technique for creating abstract paintings.

■ Port. with "worm" painting, and "Sgt Has New Angle on Art, Lets Worms Do Painting. TSgt. Robert J. Parker has been a hobby enthusiast for many years but his latest hobby 'really has me bug-eyed,' he admits. ... 'Everybody is painting these days,' says Parker. 'Some artists place art board on the front bumper of their automobiles, speed down the highway and use smashed insects to achieve that modern approach.... Me, I'm not too different. It is just that I use worms.' To date, Parker has accomplished only one painting via his worm technique. 'It's certainly no masterpiece,' he says, but those who have viewed it like it. 'I think it's my style and method that excites their interests.' Sgt. Parker's wife is among his most enthusiastic supporters... One thing that the artist sergeant likes best about his new hobby is that it is inexpensive. All that is required is a little art board, some paint and some worms... 'and no talent on the part of the artist,' he says. ... 'all you do is spread your paints on paper, work in several worms, and then allow them to crawl around on the art board'," *LR*, Feb. 16, 1961, p. 17 (i.e., C-1?).
Parker, Robert J. (misc. bibliography)
Robert J. Parker, USAF, is listed with wife, Patricia, in Lompoc in the *Santa Maria, Ca., CD*, 1958, 1959 (refs. ancestry.com).
See: "Photography, general (Camp Cooke)," 1959, 1960

Parker, Ruby (Lompoc)
Lompoc High School grad. 1931. Student at Santa Barbara State Teachers College. Domestic Science teacher at Lompoc High School who also taught handicrafts such as weaving, embroidery, hemstitching, fine sewing, 1935-38. Costumer for various school theater productions, 1937, 1938.
Parker, Ruby (notices in Northern Santa Barbara County newspapers on microfilm and on newspapers.com)
1934 – "Ocean Park News… Sunday visitors … Mrs. J. P. Holland and daughter, Ruby Parker…," *LR*, July 13, 1934, p. 12; "Students Home – Miss Marjorie Meyers and Miss Ruby Parker are among the students from the Santa Barbara State Teachers College spending the Thanksgiving holiday here with their families," *LR*, Nov. 30, 1934, p. 5;
1936 – Port. with Lompoc high school faculty, *LR*, June 12, 1936, p. 4.
See: "Lompoc, Ca., Union High School," 1935, 1936, 1937, 1938, "Lompoc Valley Fair," 1930

Parker, Vernon "Vern" Orn / Oren (1899-1978) (Visalia / Hollywood / Los Olivos / Florida)
Muralist for Solvang's Malt Shop, 1947. Woodcarver. Sign carver, 1940s, 1950s. Donated an altar he carved to the Los Olivos grange, 1950.

■ Port. and "Vern Parker was born in May, 1889 [Sic. 1899], to James Madison Parker, wagon master and blacksmith, and Anna Bills, in Hanford, California. He and his twin sister were the last of seven children. Little is known of his early years. He became best-known as a painter and woodcarver in the 40s and 50s when he carved gates and signs for the wealthy ranchers and landowners in Santa Ynez, California. His carvings remain on display at the Santa Ynez Historical Museum, and a stagecoach carving can still be seen above the entrance to **Mattei's Tavern**, former stagecoach stop, now a popular restaurant in Los Olivos, California. He then moved to Benson, Arizona where he had a studio and gift shop with his wife and stepson ...," per askart.com

■ Posed in his shop and "Renown as Wooden Horse Carver … Hanford native and former resident of Lindsay brings horses and riders, cattle and other animals vividly to life out of solid blocks of shapeless wood… His father, J. M. Parker, was one of Lindsay's first blacksmiths. Vern Parker was born in Hanford in 1899 and moved with his parents to Lindsay. After the death of his father, Vern Parker went to Hollywood where he started his career as an artist and sculptor of wood. In addition to his wood carvings, he has won recognition for his pencil sketches, water colors and oils. He has done many murals – more than 30,000 square feet of them on public buildings from California to Florida. One of his most favored undertakings is the sculpturing in wood of replicas of famous teams of horses… Another project was that of an eight-horse team of beautiful Belgian horses owned by Tom Parks, of Santa Ynez. Each horse is made from a solid block of sugar pine… He does all his sculpturing without the aid of mechanical devices – using only a few simple tools. In recent years he has been living at Santa Ynez," *Visalia Times-Delta* (Visalia, Ca.), Nov. 7, 1950, p. 14.
1946 – "Social and Personal. Mr. and Mrs. Vern Parker, former residents of the Valley, are expected to arrive here this week. They have been living in Florida but expect to make their home in the Ed Smith cottage in Los Olivos," *SYVN*, April 12, 1946, p. 5.
1950 – "Grange Hall is Dedicated… Los Olivos… A hand-carved altar, made by Vern Parker, was presented to the organization…," *SYVN*, April 21, 1950, p. 1.
And, additional articles on him in the *Hanford Sentinel* not itemized here.
Parker, Vern (misc. bibliography)
Vernon O. Parker is listed in the 1900 U. S. Census in Hanford, Ca.; Vernon Parker is listed in the 1920 U. S. Census as residing in Lindsay, Ca., with his parents and twin sister, Vera, with no occupation; Vernon Orn Parker filled out a WWI Draft Registration Card; Vernon Parker is listed in the 1940 U. S. Census as age 40, highest grade completed – elementary school 8th grade, divorced, a free-lance artist, lodging in Los Angeles, Ca.; Vern Oren Parker gave the following information on his WWII Draft Card = age 43, b. July 29, 1899 in Hanford, Ca., residing at 512 Town Ave., LA, where his next of kin, Mrs. Annie Parker,

was living, but he was working as a mural painter in Los Olivos; Vernon Orn Parker b. July 29, 1899 in Hanford, Ca., d. July 4, 1978 in Tucson, Ariz., and is buried in Hillside Cemetery, Silverton, Colo., per findagrave.com; copies of census and other records are contained in *Public Member Stories* and photos appear in *Public Member Photos & Scanned Documents* (refs. ancestry.com).
See: "Murals," 1947

Parshall, Dewitt Henry (1864-1956) (Santa Barbara)
Artist. Exh. in an exhibit for National Art Week held in Santa Maria, 1940. He was in charge of the WPA art work at the Veterans' Memorial in Lompoc, 1936. He sometimes traveled to northern Santa Barbara county to hunt. Father of Douglass Parshall, below.

■ "Prominent Artist Dies in Channel City," *SMT*, July 8, 1956, p. 4.
Parshall, Dewitt (notices in Northern Santa Barbara County newspapers on microfilm and on newspapers.com)
1919 – "Noted Artist at Guadalupe Gun Club. **Dewitt Parshall** a noted artist from New York and his son Douglas [Sic. Douglass], also a successful artist, are among the distinguished members enjoying the opening of the duck season at the Guadalupe Gun club. Parshall, the elder, has many paintings hung in the leading salons and galleries of the United States. His son has the unusual distinction of having [had] his pictures exhibited when he was but sixteen years of age. Mr. Parshall and his son pass a good deal of their time in Santa Barbara, where they have a winter home," *SMT*, Oct. 17, 1919, p. 2.
See: "National Art Week," 1940, "Parshall, Douglass," "Works Progress Administration," 1936, and *Morro Bay Art and Photography before 1960*

Parshall, Douglass Ewell (1899-1990) (Santa Barbara)
Santa Barbara artist who was active in Morro Bay in 1928, 1933, 1934, 1938 and probably on other occasions, and who is known to have also painted in San Simeon and other places on the Central Coast at various times. Active in Santa Maria late 1930s. Taught an art class at De Nejer Studios, 1952. Judge at Santa Maria Art Festival, 1953. Judge at Santa Ynez Valley Art Exhibit, 1954, and exh. 1955. Member Santa Barbara Art Association, who exh. at opening exh. of Allan Hancock College Art Gallery, 1954, and in 1956. Held a one-man show at Hancock Gallery, 1957. Exh. painting at Santa Barbara County Fair, 1952, 1961, 1962, 1964. Son of DeWitt Parshall, above.
Parshall, Douglass (notices in California newspapers on newspapers.com and genealogybank.com)
1918 – "Douglass Parshall is Poster Prize Winner… national service section of the U. S. Shipping board… 17-year-old art student in the Thatcher School at Nordhoff… school children's division. The subject of his poster was 'Help to Build the Kaiser a Coffin'," *Santa Barbara Daily News and the Independent*, Aug. 14, 1918, p. 3.
1928 – "Artist Returns – Douglass Parshall, Santa Barbara landscape artist, returned home Tuesday after a stay in this section the past two weeks…. since early boyhood has engaged in painting. Since completing his education, he has

devoted his time exclusively to art," *SLO DT,* Aug. 8, 1928, p. 8; "Morro Bay... Douglas [Sic.] Parshall ... has returned to Morro Bay for a week," *SLO DT,* Aug. 29, 1928, p. 5; "Douglas [Sic.] Parshall, artist of Santa Barbara, who received honorable mention at the San Francisco exhibition, is expected in Morro Bay. This is his third trip here this summer," *SLO DT,* Sept. 13, 1928, p. 9; "Douglass Parshall, an artist of note from Santa Barbara, is in Morro Bay again to paint landscapes of Morro Bay," *SLO DT,* Oct. 2, 1928, p. 5.

1930 – "Douglass Parshall, an artist of Santa Barbara, is spending a few days in Morro Bay and Cambria," *SLO DT,* Feb. 7, 1930, p. 7, col. 2.

1931 – "Douglass Parshall, artist, and his friend **Channing Peake**, also a well-known artist, have returned to their home at Santa Barbara after a pleasant week at Morro Bay," *SLO DT,* Jan. 22, 1931, p. 5, col. 5; "Douglass Parshall... arrived at Morro Bay Saturday for a few days' stay," *SLO DT,* Jan. 29, 1931, p. 12; "Douglass Parshall... is spending a week in Morro Bay," *SLO DT,* Feb. 11, 1931, p. 8, col. 7; "Douglass Parshall, a Santa Barbara artist who has been making frequent visits to Morro Bay, returned home Friday," *SLO DT,* March 4, 1931, p. 6, col. 2.

1938 – "Mr. and Mrs. Douglass Parshall who were married this week in Santa Barbara will occupy the recently completed home of Mrs. Mary Osborne Craig. Mr. Parshall will do some murals for the J. J. Mitchell home on Juan y Lolita rancho," *SYVN,* Jan. 14, 1938, p. 5.

1939 – Port. painting "California Here we Come from 47 States for Ham and Eggs," *SMT,* Oct. 26, 1939, p. 2-A (newspapers.com, p. 7); photo showing him painting a poster "California Here we Come, from 47 States for Ham and Eggs" showing invasion of transients for free food, *T-T,* Nov. 1, 1939, p. 6.

1946 – "Mr. and Mrs. Douglass Parshall of Santa Barbara were Solvang visitors Wednesday," *SYVN,* May 31, 1946, p. 5, col. 4.

1952 – "Douglas Parshall to Teach Class... in oil and water color painting beginning March 24 at **DeNejer studio**. ... The noted artist... will be one of a panel of three distinguished artists who will speak on 'Art and You' at the Santa Maria Arts festival May 24 and 25 in Veterans' Memorial building. To date, nine local students are enrolled for his class...," *SMT,* March 18, 1952, p. 4; ad for portrait classes at **De Nejer** Studio on Mondays from 1-4 p.m., *SMT,* June 28, 1952, p. 4.

1957 – Repro: "Winter Scene," *SMT,* March 9, 1957, p. 3; "Santa Barbaran Exhibits at [Hancock] Art Gallery," i.e., 17 paintings for a March exhibit, and "While most of Parshall's much talked of paintings are now in **Cowie Galleries** at the Biltmore, Los Angeles, where he exhibits permanently, he reserved some of his paintings of people and of trees to show in Santa Maria. One, 'The Lesson' had the element of humor well defined as it depicts a group taking a lesson in dancing. Parshall likes to interpret the human figure... Experimenting lately in abstracts, Parshall has sent one of these...," *SMT,* March 11, 1957, p. 3.

1961 – "Gallery 8 Offers Parshall Exhibit... located at 19 West Anapamu Street, Santa Barbara... an exhibition of painting and watercolors ... figure and landscape compositions completed within the past two years," *SYVN,* March 10, 1961, p. 10.

1962 – "Actor James Stewart Buys Palacio del Rio Property... Stewart and his wife plan to redecorate the mansion to meet their own needs and those of their four teenaged children. The one-story white masonry building with red tiled roof and walled courtyard was built by the Mitchells in 1928...[and interior described] The two-story southern addition contains the ground-floor garage, which can be used as a ballroom. The walls are decorated in western scenes done by artist Douglass Parshall...," *SYVN,* Nov. 9, 1962, p. 3.

And numerous additional references under both "Douglass Parshall" and "Douglas Parshall," most announcing his exhibits at Gallery De Silva, Montecito in the 1970s and 1980s, were not itemized here.

Parshall, Douglass (misc. bibliography)

Douglass Ewell Parshall was b. Nov. 19, 1899 in New York City to DeWitt Henry Parshall and Caroline Elizabeth "Carrie" Ewell, was residing in Southampton, NY, in 1900, married Alice Barbara Cowles, and d. Aug. 29, 1990 in Montecito, Ca., per Budge Family Tree / Kansas / USA (refs. ancestry.com).

See: "Allan Hancock [College] Art Gallery," 1954, 1956, 1957, "Bowen, William," 1941, "Bromfield, Dora," 1953, "California State Fair," 1951, 1956, 1957, "Castagnola, Gladys," intro., 1955, "Civil Works Administration," 1934, "DeNejer, Jeanne," intro., 1952, "Liecty, Ruth," "Parshall, DeWitt," "Public Works of Art Project (PWAP)," 1934, "Santa Barbara County Fair," 1952, 1961, "Santa Maria Art Association," 1952, "Santa Maria [Valley] Art Festival," 1952, 1953, "Santa Ynez Valley Art Exhibit," 1954, 1955, "Signorelli, Guido," 1964, "Taylor, Donald," "Tri-County Art Exhibit," 1947, 1950, 1957, "Vollmer, Grace," "Wilson, JoAnn," "Works Progress Administration," 1936, and *Morro Bay Art and Photography before 1960* and *Cambria Art and Photography before 1960*

Parsons, Ivy (SLO)
Exh. Santa Maria Art Festival, 1953, and Santa Barbara County Fair, 1960.
See: "Santa Barbara County Fair," 1960, "Santa Maria Valley Art Festival," 1953, and *San Luis Obispo Art and Photography before 1960*

Parsons, Wayman Francis (1903-1981) (Bakersfield / Santa Maria)
Watercolor painter, active at least 1932-36. Photographer. Architect who designed the Santa Maria City and Town Halls, 1934.

■ "Wayman Francis Parsons – As an architect he co-designed the Santa Maria, Ca., City and Town Halls dedicated in 1934; he designed 'The Fort' patterned after Sutter's Fort in Sacramento, in Bakersfield, for the WPA in 1938; he also designed the Hart Park, Bakersfield, adobe, for the WPA in 1939," see livingnewdeal.org; listed *American Architects Directory*, 1956, 1962, 1970; with the firm Wright, Metcalf and Parsons in Bakersfield in 1962; d. March 21, 1981.

Parsons, W. Francis (notices in Northern Santa Barbara County newspapers on microfilm and on newspapers.com)
1932 – "Local Architect Back from European Tour. A vivid description of Mediterranean countries is brought to this city in words and water colors by Wayman Francis Parsons, local architect.... Parsons returned to Santa Maria two weeks ago … On his trip he studied the various types of architecture… His paintings are to be exhibited in Tacoma, Wash. and in Los Angeles in the near future… Parsons left Santa Maria on November 7, just after he was notified that he had successfully passed the state examination for architects. He sailed through the Panama Canal, touched at the Canary Islands and landed in Marseilles. From this French seaport his itinerary included stops in Sicily, the principal cities of Italy, where he spent three months, Kairouan, Africa, a lengthy stay in Spain and France before driving across the continent, ending his trip with an automobile tour of the northwest. The Santa Marian found the southern countries of Europe rich in material for artists and architects … The depression seems not to have affected France apparently, according to Parsons. Italy shows more distressing signs, while Spain is the hardest hit of the three…," and other non-art impressions, *SMT*, Aug. 3, 1932, pp. 1, 6; "Local Artist's Work Exhibited in City Tonight… at the Little Theatre… exhibit sponsored by the Santa Maria Rotary. Sailing from the United States last fall, Parsons traveled through Italy, Sicily, Spain, France and northern Africa in a tour devoted to studying old European architecture as well as painting and sketching various scenes on the two continents. The exhibit will be held this evening only, when nearly 100 pictures selected from Parson's works will be shown. … water colors and ink drawings… Parsons studied water color work and sketching after his graduation from the University of Southern California… He … now is associated with **Louis N. Crawford** of this city," *SMT*, Sept. 7, 1932, p. 1.

■ "European Trip Produces Many Fine Sketches. … water colors and pen sketches of rare beauty and technique were inspected by several hundred Santa Marians at the **Little Theatre** last night, where selected paintings of Wayman Francis Parsons were hung in an exhibit sponsored by the Rotary club of this city. Although he is an architect, the works displayed… showed none of the precise, cold influence that one might expect because of architectural training … A total of 53 water colors were on view, as well as a score of pen sketches done in both India and sepia inks. All of the pictures were made during an eight-month tour of the Mediterranean countries last winter and spring. On his trip Parsons made more than 150 water colors. The Santa Marian had reproduced on paper scenes from Italy, Sardinia, Sicily, Tunisia, Africa, Spain and France. The only American subject was an admirable water color of New York city's famous skyline that the artist made on his return to this country. Parsons' treatment of cathedrals is especially impressive. He had on view water colors of Toledo, Seville, Segovia and Salamanca cathedrals of Spain and the familiar Notre Dame of Paris, Rheims, Amiens and Beauvais cathedrals in France. Four aspects of the Seville cathedral were shown, including an interior made at Easter, when the walls were hung with great crimson drapes. Other allied subjects included an old church in Perugia, Italy, Church of the Templars, Segovia

and the St. Germain du Pres of Paris. The artist's work is characterized by an excellent use of color, a specific study he made in his tour. … Scenes of mosques and shops in Tunis and Kairouan, northern Africa, were extremely interesting, while ancient doorways and arches, fountains, streets, gardens, bridges, housetops, waterfronts and landscapes presented a variety of attractive subjects… The Santa Marian will exhibit in Los Angeles and in Seattle in the near future. He is a graduate of the University of Southern California and at the present time a licensed architect associated with **Louis N. Crawford**. Crawford, with Ross McCabe and D. D. Smalley, formed the Rotary committee in charge of last night's exhibit," *SMT*, Sept. 8, 1932, p. 1; "College Women [Panhellenic] in Luncheon… The guest speaker of the afternoon was Francis Parsons, who gave an interesting exhibit of his water color paintings of European cathedrals and landscapes made during his recent tour abroad," *SMT*, Nov. 7, 1932, p. 3.

1935 – "I Spied. Francis Parsons and Al Bruner discussing enlargements of miniature photographs Parsons snapped in Italy two years ago," *SMT*, May 17, 1935, p. 1.

1936 – "To Tell BPW's About Art" with title of his lecture being, "What is in Back of the Picture" at Christian church bungalow, *SMT*, April 2, 1936, p. 2; ■ "Local Water-Colorist Finds Similarity in Life and Art … Francis Parsons revealed a philosophical turn of mind last night as he discussed painting technique and compared it to various aspects of life… Parsons, who specializes in water-colors, paints constantly during his spare time and has a sizeable collection of sketches of the picturesque nearby country-side. One of his most recent works is that of a group of eucalypti and pines at the Golf club. 'One can think in terms of patterns of life as one draws,' he remarked. 'The uneventful life resembles a blank page – there are no highlights or shadows. As in life, it takes spots of light and darkness to make a picture interesting.' Pictures Illustrate Talk. The young artist illustrated this point of contrasts by his painting of a familiar gnarled oak tree, located about a quarter of a mile south of Pismo Beach. The painting also brought out another idea of his that both in pictures and in life the brightest lights are next to the deepest shadows. Sketches of Oceano sand-dunes, flowered sea coast near Casmalia, a field of poppies and other wild flowers on the Berros-Oceano road and the colorful bank of Santa Maria river illustrated his points. 'Just as in our lives, there must be balance in pictures,' Parsons continued, showing his interpretation of a Colorado desert scene to define balance and also the need for a 'point of entry' into a picture. The Sunday motorist may encounter Parsons in any of a dozen interesting places about this part of the county or in San Luis Obispo county pursuing his art. … The Santa Marian displayed his depictions of Notre Dame, Mont St. Michele, Avila in Spain, Tunis, Seville and other picturesque spots in France and along the Mediterranean coast," i.e., lengthy report on his talk to Business and Professional Women, *SMT*, April 8, 1936, pp. 3, 6.

1955 – ■ Port. at easel and helping raise funds for Cunningham Memorial Gallery in Bakersfield – "W. Francis Parsons, architect, is typical of business and professional men who are supporting the fund drive. Like his fellow dabblers in Men's Painters' Club, he feels that 'art is for everyone; the Cunningham Gallery will be an

epicenter for those of us who enjoy the personal pleasure and relaxation pursuit our hobby brings, as well as provide facilities for really fine artwork.' Parsons is a long-time member of the Art Association, has several times acted as commentator-in-chief at informal member exhibitions. He prefers to sketch from nature, in watercolor or oil, and later completes his picture in his home studio," per *Bakersfield Californian*, March 29, 1955, p. 17.
1974 – As president of the Bakersfield Art Commission he requests funds from Board of Supervisors to expand the Cunningham Memorial Gallery, per *Bakersfield Californian*, Feb. 21, 1974, p. 27.
Parsons, W. Francis (misc. bibliography)
Wayman Francis Parsons, mother's maiden name Knable, was b. Feb. 6, 1903 in Kansas and d. March 21, 1981 in Kern County per Calif. Death Index (refs. ancestry.com).
See: "College Art Club," 1932

Pate, Bea (Lompoc)
Photographer. Woman's Page editor at Lompoc Record, fall, 1958. Moved to the Oxnard Press Courier, 1959+.

■ "Buzzin' with Bea. Bea Pate… newcomer… Just hailing from the 'high desert' with temperatures averaging 100 degrees … Replacing **Moselle Forward** as Woman's Editor and photographer, plus many other miscellaneous jobs, leads me to believe these will be footsteps hard to follow … I have been spending days in the *Record* office… reading the history of this community… Rentals are extremely scarce, but with the help of many individuals an apartment was awaiting me when I arrived last weekend…," *LR*, Sept. 4, 1958, p. 6.
Pate, Bea (notices in California newspapers on microfilm and on newspapers.com)
1955 – "Two Section Staffers Win Press Club Awards… Bea Pate of the *Garden Grove News* won the three places for society writing and also second and third place for society photography and second place for 'puff' photography…," *LA Times*, Nov. 27, 1955, p. 185 (i.e., pt. VIII, p. 2).
Nine notices for "Bea Pate" appear in Ventura County newspapers, 1959-60 on newspapers.com but were not itemized here.
Pate, Bea (misc. bibliography)
Bea Pate is listed at the Garden Grove News in the *Santa Ana, Ca., CD*, 1952, 1954; Bea Pate is listed in the *Santa Maria, Ca., CD*, 1958; Bea Pate is listed at the Oxnard Press-Courier in *Oxnard and Ventura, Ca., CD*, 1959, 1960, 1963 (refs. ancestry.com).
See: "Forward, Moselle," 1958

Patin, Ray Maurice (1906-1976) (Los Angeles area)
Cartoonist, Santa Ynez Valley News, 1949. Probably did not reside in Santa Barbara County.

■ "'Milford Muddle' [by] Ray Patin. **Ray Patin** began his cartoon career on a Los Angeles High school paper. He went to Otis Art Institute in Los Angeles and worked for **Walt Disney's** Studio for 6 ½ years. Ray has done a considerable amount of story work both for the studio and cartoon books. During the war he headed the poster group at Douglas Aircraft Corp," *SYVN*, July 29, 1949, p. 4.

■ "Patin, Ray Maurice passed away January 17, 1976 in Panorama City… A resident of Los Angeles since 1919 and was a well-respected pioneer in the animation industry…," *LA Times*, Jan. 18, 1976, p. 32 (i.e., pt. II, p. 2).
Patin, Ray (misc. bibliography)
Ray Maurice Patin was b. Oct. 14, 1906 in Breaux Bridge, La., to Maurice Patin and Therese Marie Durand, married Maxine Jane Riley, and d. Jan. 17, 1976 in Burbank, Ca., per Gonzales Family Tree; buried in Westwood Memorial Park, LA, per findagrave.com (refs. ancestry.com).
See: "Comic Strip (*Santa Ynez Valley News*)"

Patishall, Marguerite Leah Olive Hoppes (Mrs. Rev. Ira Euther Patishall) (Santa Maria)
Demonstrated the making of wood fiber flowers at Jr. Community Club, 1953, 1957. Prop. Patishall's, below.
See: "Community Club," 1953, "Junior Community Club (Santa Maria)," 1953, 1957

Patishall's (Santa Maria)
Book store and flower shop at 116 N. Broadway. Sold pictures, frames, wood fibre flowers and makings, 1954.
Patishall's (notices in Northern Santa Barbara County newspapers on microfilm and on newspapers.com)
1954 – "The keynote of spring fashions … Patishall's beautiful Fibre Flowers make the ideal ornaments for the ear, lapel and hair. See these 'Fibre Flower Fixtures' at Patishall's or better still, learn to make them. Call 5-7511 for Class Schedules. Instructions are Free. … 116 N. Broadway…," *SMT*, March 15, 1954, p. 10, col. 2; "Pictures – Frames. Picture Framing. Happy to announce Picture and Picture Framing Department added to our book Store. **Mr. A. E. Hoppes**, formerly of Dallas, Texas, and Culver City, Calif., will be in charge. Selection of Framed Pictures. Choice Picture Prints Framed to Order. Your own Prints or Paintings Framed to Order. A general line of Pictures PLUS Sallman's famous Religious paintings in FOURTEEN titles. NOW, an appropriate Picture to add charm and character to any setting. For Home, Church, School or Office. Also featuring the Artistic Rustic ARTWOOD Plaques. A reminder: Why not make your Easter Gift a Bible, Book, Corsage or Picture. Patishall's Bible – Book – Flower Shop. 116 N. Broadway – Telephone 5-7511 – Santa Maria," *SMT*, April 13, 1954, p. 6.
See: "Patishall, Marguerite"

Patterson, Clayton and Walter (Northern California?)
Photographers. Exh. first annual Santa Ynez Valley Art Exhibit, 1953.
Is she Clayton Patterson listed in the 1920 U. S. Census as age 23, b. c. 1897 in Colo., residing in Berkeley with husband Walter C. Patterson (age 25, a shipping clerk) (refs. ancestry.com).
See: "Santa Ynez Valley Art Exhibit," 1953

Patterson, Esther Adeline Eaton (Mrs. John A. Patterson) (1813-1896) (Ohio / Kansas / Los Alamos)
Artist of portraits exh. at "Santa Barbara County Fair," 1892. Age 79.
Patterson, Mrs. (misc. bibliography)
"Esther Adeline Eaton" married John A. Patterson on Oct. 22/29 (?), 1833 in Huron, Ohio, per Public Member Stories; "Ester" Patterson is listed in the 1850 U. S. Census as b. c. 1813 in NY and residing in Peru, Ohio with husband, John, and children: Austin, Eliza, Edward, Irene, George, and Charles; Esther Patterson is listed in the 1860 U. S. Census as age 46, b. c. 1814 in NY, residing in Peru, Ohio, with husband Jno A. Patterson, a farmer, and children Sarah, Hannah, George, and Charles, as well as three laborers; Esther A. Patterson is listed in the 1870 and 1880 U. S. Census as b. c. 1812/14 in NY, residing in Oskaloosa, Ks., with husband, John A. Patterson; Esther A. Patterson b. 1813 and d. Oct. 22, 1896 is buried in Los Alamos Cemetery per findagrave.com; obit. for "Esther Patterson" is contained in Ohio, Rutherford B. Hayes Presidential Center, Obituary Index that cites *Norwalk Daily Reflector* (Norwalk, Ohio), Oct. 29, 1896, p. 3, col. 2 (refs. ancestry.com).
See: "Santa Barbara County Fair," 1892, 1893?

Patterson, Vivian Maude (1918-1994) (Santa Maria)
Photographer – hobbyist, teacher, traveler, collector, 1950s.
■ "After three years of travel in two continents away from home, Europe and Asia, Miss Vivian Patterson has returned here to spend the summer with her mother, Mrs. J. C. Patterson, at 309 E. Chapel. For the past year, Miss Paterson has taught in an American school at Zweibruchen, Germany, on the Saar border. Previously she had taught in Japan for two years. The two teaching assignments offered many opportunities to travel and to indulge in her hobby of photography. She has a good collection of slides. In Japan, it was possible to travel and also to purchase goods made in native crafts and industries. In Germany on the same pay scale, it was not possible to indulge both in travel and shopping. Price tags on German-made products were higher. So the majority of American teachers settled for sight-seeing and travel on their free time in Europe. During the time spent in Japan, 1952 to 1954, Miss Patterson taught in the U. S. Army Dependents' school, known as Yoyogi school. It is located on Washington Heights, residential section occupied by U. S. Armed Forces personnel and their families. ... In Germany the Santa Maria teacher was happy to find that a number of faculty friends, met while in Japan, also were transferred to teaching in Europe. Often the teachers made up week-end travel parties. During her year in Europe, Miss Patterson made tours in all of the major European countries and the British Isles. She spent last Christmas vacation on a tour of Spain and Portugal. Purchases in Japan included many nice pieces of porcelain and some carvings and figurines. A pair of ceramic white barnyard fowl, sent to her mother from Japan are family favorites at the Chapel Street home. One of the bronzes is a figure of the Japanese 'Abraham Lincoln.' ... 'I am waiting for my belongings to come home from Germany,' Miss Patterson said. A pair of handsome silver filigree earrings in crescent shape, purchased in Frankfurt, were the only pieces of German-made jewelry she had in the luggage permitted in traveling home by air, on which a limit in weight is placed. ... She will teach for a change in California this year, either in Santa Maria or in some other community not too far away from home," per port. and "Traveler Returns to Spend Summer in S.M.," *SMT*, July 30, 1955, p. 4.
Patterson, Vivian (notices in Northern Santa Barbara County newspapers on microfilm and on newspapers.com)
1951 – "Travel Talk on Panama... Mrs. Dart's guest at the luncheon was her niece, Vivian Patterson who has taught school in the Canal Zone and whom she traveled with on a sightseeing tour and return to the United States," *SMT*, July 25, 1951, p. 4.
1952 – Port. and "Miss Patterson Leaves for Work Oversea... Japan...," *SMT*, Aug. 13, 1952, p. 4.
1953 – "Miss Patterson Leaves for Teaching Overseas... leaving for Japan to teach for the second term in an American school... Miss Patterson spoke of her surprise and pleasure on discovering that Japan is a country of great scenic and natural beauty, especially so since she has taken up photography as a hobby...," *SMT*, Aug. 14, 1953, p. 4. And more than 70 notices on "Vivian Patterson" in the *SMT* between 1940 and 1965 show that she was active with the USO during WWII and that she was an elementary school teacher in Santa Maria both before and after her assignments abroad, but they were not itemized here.
Patterson, Vivian (misc. bibliography)
Vivian Maude Patterson was b. Sept. 10, 1918 in Santa Barbara to John Claude Patterson and Grace Pearl Fields, was residing in Santa Barbara in 1939 and d. Oct. 3, 1994 in Alameda. Ca., per Orr Family Tree; Vivian Maude Patterson is buried in Santa Maria Cemetery District per findagrave.com (refs. ancestry.com).
See: "Camp Fire Girls," 1941, 1942

Patterson, Walter
Photographer. Exh. first annual Santa Ynez Valley Art Exhibit, 1953.
See: "Patterson, Clayton"

Patton, Kay (Los Angeles?)
Painted murals at Santa Maria Inn, 1956.
Patton, Kay (notices in California newspapers on microfilm and on newspapers.com)
1954 – Repro: mural in the home of Edgar Cheesewright, AID, *LA Times*, May 16, 1954, p. 238 (magazine?, p. 14).
1956 – Repro of a mural in the home of Mrs. Courtland Van Horn," *LA Times*, April 15, 1956, p. 337 (magazine?, p. 17); repro. of murals at **Santa Maria Inn** that she painted, *SMT,* Aug. 2, 1956, p. 12.
This individual could not be further identified.
See: "Murals," 1956

Paul, ?? (Mrs. Dixon Paul) (Lompoc)
Water color painter, 1948.

■ "Mrs. Dixon Paul Exhibits Paintings. … water color paintings … now on display at the Lompoc Furniture company. Mrs. Paul's pictures are of Lompoc subjects. She previously has exhibited her work in Chicago and New York galleries and was on the staff specializing in art of both the University of Chicago and [at] Colorado university," *LR*, Dec. 9, 1948, p. 12.
This individual could not be further identified.

Payne, Euland Roy (1904-1996) (Orcutt? / Santa Maria)
Teacher in industrial arts at El Camino Jr. Hi, 1931-69. Judge of Boy Scout handicraft, woodcarving, metalwork, painting and carpentry, 1933.

■ Port. and "Mr. Payne was born Feb. 9, 1904 in Provolt., Ore. In 1909 he moved to California by covered wagon with his family, settling in Cedarville. In 1912 they returned to Provolt, Ore., and he attended a one room schoolhouse. The family moved to Medford, Ore., in 1917 where he spent his freshman and sophomore years at Medford High School and drove a horse-drawn bus. They moved to Chico in 1919 and Mr. Payne completed high school, lettering in football, boxing, basketball and baseball, and was captain of the football team at Chico High School. He worked for the Chico Fire Department before entering college at Chico State where, in 1925 as a senior, he played football and was considered the star on the team and was featured on the sport page of the *San Francisco Chronicle*. In 1923 he was nominated to the U. S. Naval Academy at Annapolis but was nine days too old to meet age requirements. Following college graduation Mr. Payne taught junior high school in Chico for 3 years, marrying Claudia Notley in 1926. They moved to Santa Maria in 1931 where he helped put El Camino Junior High School into commission, teaching there until he retired in 1969. Mr. Payne was a veteran of the U. S. Navy from 1941-1946 and retired from the U.S. Naval Reserve in 1964 after 21 years as chief petty officer. He was the recipient of a special commendation and received many medals…," and other memberships and honors cited, *SMT*, June 25, 1996, p. 5.
And, more than 420 hits for "Euland Payne" in the *SMT* between 1931 and 1960 were not even browsed for inclusion here.
Payne, Euland (misc. bibliography)
Roy Euland Payne was b. Feb. 9, 1904 in Oregon to John Theodore Payne and Emma Gertrude Bostwick, married Claudia Aleen, was residing in Santa Maria in 1935 and d. June 23, 1996 in Santa Barbara County per Brissenden / Hale Family Tree (refs. ancestry.com).
See: "Boy Scouts," 1933, "Santa Barbara County Fair," 1941, "Santa Maria, Ca., Elementary Schools," 1931, 1932, 1941, 1950, 1952, 1953

Peake, Channing Devine (1910-1989) (Buellton / Santa Barbara)
Painter of abstractions. Owner of rancho Jabali near Buellton where he raised horses, 1941+. Husband of Katherine Peake, above.

■ "Channing Peake, 1910-1989, a well-known Santa Barbara County artist, lived for many years in the Santa Ynez Valley, where he raised Quarter Horses and created spectacular paintings and drawings of the world around him. During his career Peake worked with **Edward Borein**, Diego Rivera and **Rico Lebrun**. He spent several years living and working in New York, San Francisco, France and Mexico, but most of his adult life he lived in Santa Barbara County. He is considered one of the finest California painters ever to chronicle the West.
Born in Marshall, Colorado, in 1910, Channing Peake moved with his family to California, settling in the San Fernando Valley. His artistic talent was evident from a young age and with the assistance of his high school art teacher, the photographer <u>Barbara Morgan</u>, Peake won a scholarship to the **California School of Arts and Crafts** in 1928. Three years later Peake came to Santa Barbara to attend the Santa Barbara School of Fine Arts. During this time he also assisted Western artist **Edward Borein** on a painting for El Paseo, where Peake would later paint his own mural in the 1980s. Captivated by the medium of the fresco mural, Peake next traveled to Mexico where he spent a year traveling and documenting many aspects of Mexican life. As an apprentice to Diego Rivera, he worked on the murals at the National Palace in Mexico City. Returning to the U.S. Peake moved to New York City where he continued his studies at the Art Students League. Commissions for murals during this period included two major projects for the WPA. Peake executed many other important murals, assisting **Rico Lebrun** on a mural for the Pennsylvania Station in New York City and Lewis Rubenstein on a mural in the Germanic Museum at Harvard University. In our area, Peake painted the Don Quixote mural for the Santa Barbara Public Library (1959), the Santa Barbara Biltmore mural (1978-79), and the Santa Barbara El Paseo mural (1984-85). In the 1940s, Peake came back to Santa Barbara to paint and for the next two decades he maintained a studio on a working ranch in the Santa Ynez Valley. He later traveled and painted extensively in Europe, then returned once more to Santa Barbara, where he continued to play a vital role in shaping the cultural life of the city. He was a founding member of the Santa Barbara Museum of Art, and a gallery named in his honor is located in the lobby of the Santa Barbara County Administration Building (from *The Santa Ynez Valley Magazine*, Nov. 24, 2009, on the Internet).
The County Art Commission's Channing Peake Gallery, is on the 1st floor of the Santa Barbara County Administration Building, at 105 E. Anapamu St., Santa Barbara.

■ "In January 2011, The Santa Barbara County Arts Commission, with the City of Santa Barbara at the City Hall Gallery, recognizes Channing Peake's impressive art history legacy, and presents the exhibition *Channing Peake: Mural Studies*. The work in this exhibition will be seen at City Hall in conjunction with the unveiling of the restored Peake Fiesta Mural at the new Santa Barbara

Airport in April 2011. In storage more than a decade after it was removed from the section of the downtown El Paseo Restaurant (that is now the Wine Cask).… In Santa Barbara, he painted the Don Quixote Mural with **Howard Warshaw**, now inside the Santa Barbara Library, a mural for the Santa Barbara Biltmore in 1978-79 (that was removed), and the last mural for the El Paseo Restaurant from 1984-85" (from the Internet).

■ "Buellton rancher and artist Channing Peake … was born in Boulder, Colorado, and his family moved to California's Inyo Valley in 1915. He attended both the California College of Arts and Crafts in Oakland and the Santa Barbara School of the Arts as a scholarship student. In 1934, he journeyed to Mexico with the intention of studying mural painting under Diego Rivera, but he was disappointed in Rivera's work which 'looked like blown-up poster painting to me,' so he spent his time traveling around the country, sketching and painting the people. Upon his return from Mexico, he married **Katy Schott**, an accomplished artist herself, and they set off for New York, where Channing enrolled at the Art Students' League.' There was a course listed which said 'Mural Painting by **Rico Lebrun**.' I'd never heard of Rico, but I took this course and my association with him became an important part of my development as an artist.' After working with Lebrun on the WPA mural at the Pennsylvania Station, Peake returned to Santa Barbara in 1938 and settled down at Rancho Jabali, a 1300-acre ranch near Buellton, where he raised quarter horses," per "Santa Barbara Art & Artists 1940 to 1960," *Noticias* (Quarterly magazine of the Santa Barbara Historical Society), v. XLIII, No. 1, Spring, 1997, p. 14.

Peake, Channing (notices in Northern Santa Barbara County newspapers on microfilm and on newspapers.com)
1941 – "**Owen Hollister** Place Sold for Horse Ranch… 600 acres … transform the dairy ranch into a thoroughbred horse ranch…," *SMT*, May 2, 1941, p. 1.
1948 – "Group Visits Peake Studio… Peake … was host at his studio on the Jalama [Sic. Jabali] ranch to a group of Lompoc women Saturday afternoon. The artist discussed his own work and modern art in informal remarks. Attending were …," *LR*, May 20, 1948, p. 14.
1953 – "Peake Displays Art in Exhibit at S.B. Museum. Buellton rancher-artist… is represented in a group exhibition of four painters which opened Tuesday at the Santa Barbara Museum of Art… Mr. Peake, who received his training at the Old School of Arts in Santa Barbara, has long been regarded as one of the leading artists of this area. Two years ago, he had his first one-man show at the Art Museum, and he is represented in its permanent collection. After his early training here, the Denver-born artist studied at the School of Fine Arts and Crafts at Oakland and at New York's Art Students League. Here in the Valley, Mr. Peake is perhaps better known as a rancher and expert roper than artist, while his paintings have won wide recognition in Western art circles…," *SYVN*, Jan. 9, 1953, p. 1; "Local Artist's Work in U. of Illinois Art Exhibition. Channing Peake of Lompoc … in the 1953 University of Illinois, Exhibition of Contemporary American Painting and Sculpture opening March 1 on the Urbana campus. Title … 'Santa Ynez Valley'," *LR*, Feb. 26, 1953, p. 9.

1954 – "Demos Plan 'Day at Ranch'," i.e., at Rancho Jalabi [Sic. Jabali] owned by Mr. and Mrs. Channing Peake, *SYVN*, May 14, 1954, p. 10; port. of Jackie Peake and her drawing of a horse, next to her father, Channing Peake, and "Democrats to Gather for 'Day at Ranch' Sunday," *SYVN*, May 21, 1954, p. 1; "Peake in Horse Film in Solvang over Weekend… 'Stormy,' … **Walt Disney**…," *SYVN*, Aug. 20, 1954, p. 5.
1955 – "Channing Peake… Rancho Jabali, is listed among the 129 painters and 16 sculptors included in the 1955 Illinois Exhibition of Contemporary American Paintings and Sculpture opening at the University of Illinois Feb. 27. A committee of faculty members from the University's department of art traveled from coast to coast to select the work to be exhibited…," *LR*, Feb. 24, 1955, p. 9; "Roping Sunday at Peake's," *SYVN*, April 8, 1955, p. 5; "Channing Peakes Return from East… flew to New York to attend the funeral of her father, the late Max Schott," *SYVN*, Nov. 25, 1955, p. 8.
1956 – "Actor Gregory Peck, French Writer, Wed in Ceremony at Peake Ranch… Channing Peake was best man and Mrs. Peake matron of honor…," *SYVN*, Jan. 6, 1956, p. 3; "Rodeo Season Opens Sunday" on Peake ranch, *SYVN*, Feb. 24, 1956, p. 5.
1957 – "Paintings Included in [SLO County] Art Show Gallery," *T-T*, Feb. 9, 1957, p. 2; "Ranch Featured in Movie" **Disney**'s Cow Dog, *T-T*, Feb. 15, 1957, p. 2; "Memo Pad… Paintings of artists Channing Peake of the Valley and **Howard Warshaw**… will be exhibited from Monday to March 16 at the Jacques Seligman Gallery in New York," *SYVN*, Feb. 22, 1957, p. 2; port and "Peake Puts Ranch Life on Canvas," at SLO County Art Show, *T-T*, March 11, 1957, p. 1.

Peake, Channing (misc. bibliography)
Channing Devine Peake, b. Oct. 24, 1910 in Marshall, Colo., married Harriet S. Thurtle [and was also married to **Katherine Schott** and Gloria P. Haines], and d. May 15, 1989 in Solvang, Ca., per Eberhart / Fleming Family Tree (refs. ancestry.com).
See: "Alpha Club," 1948, "Carpenter, Dudley," 1945, "Castagnola, Gladys," 1955, "Community Center (Lompoc)," 1948, "Lompoc Community Woman's Club," 1948, "Motion Pictures (Santa Ynez Valley)," 1946, 1956, "Parshall, Douglass," 1931, "Peake, Katherine," "Santa Barbara Museum of Art," 1955

Peake, Katherine "Katy" Anne Schott (Mrs. Channing Peake) (1917-1995) (Santa Barbara County)
Decoupage artist who exh. at Santa Ynez Valley Art Exhibit, 1953. Co-owner of Kit-n-Kate – producers of broomstick horse toys, 1955. First wife of Channing Peake, below.
Peake, Channing, Mrs. (notices in Northern Santa Barbara County newspapers on microfilm and on newspapers.com)
1942 – "Public Invited… AWVS headquarters… Foss building… An example of the uses of these special talents [of volunteers] is shown by the attractive poster in the window of headquarters. This was made by Mrs. Channing Peake, who volunteered this service on her enrollment card," *SYVN*, Feb. 6, 1942, p. 1.

1957 – Author of an article opposing the improvement of six miles of the Santa Rosa Road past the Channing Peake ranch, *SYVN*, Sept. 13, 1957, p. 5.
And, more than 100 hits for "Katherine Peake" and for "Mrs. Channing Peake," 1935-1960, primarily concerned her activities with horses and were not itemized here.

Peake, Channing, Mrs. (misc. bibliography)
[Do not confuse with her daughter "Catherine Anne Peake."]
Catherine [Sic. Katherine] Peake is listed in the 1940 U. S. Census as age 22, b. c. 1918 in Colo., finished high school, 4th year, residing in Santa Barbara (1935, 1940) with husband Channing Peake (age 29) and child Catherine (age 1); Katherine A. Peake was b. Dec. 26, 1917 and d. Dec. 10, 1995 per Social Security Death Index (refs. ancestry.com).
See: "Collectors, Art/Antiques (Santa Ynez Valley)," 1956, "Santa Ynez Valley Art Exhibit," 1953, "Kit-n-Kate," "Peake, Channing"

Peck, (Sara) Virginia Schwartz (Mrs. Sidney / Sydney Chilton Peck) (1888-1952) (San Francisco / Santa Maria)
Wood carver. Examiner in woodcarving for Boy Scouts, 1933. Charter member, College Art Club, 1926. Husband Sidney was a violinist and head of the music department at Santa Maria High School c. 1926-40? Sister of Davis Schwartz, below.

Peck, Virginia (notices in Northern Santa Barbara County newspapers on microfilm and on newspapers.com)
1927 – "Santa Maria School of Art Faculty Dinner Party… entertained at dinner last evening by Mr. and Mrs. Sydney Peck in a charming and artistic manner. The guests were served a Spanish dinner in a truly Bohemian style at small tables which were candle-lighted…," *SMT*, July 26, 1927, p. 5.
1932 – "Studies Wood Carving – Mrs. Sydney Peck has just returned from Los Angeles where she had been studying wood carving at the Florence Walker Studio of Carving in Hollywood," *SMT*, Sept. 21, 1932, p. 3; "Sir Syd [an article on her husband] …For seven years he has been a resident of Santa Maria… visit his studio at 123 East Cook street… In one corner is a miniature art gallery. There you'll find the autographed photos of famous men and women… In another corner are fiddles and bows… paintings… wood carvings (these from the hands of Virginia Peck and her talented family of brothers) … and behind the piano a library of music and books…," *SMT*, Dec. 15, 1932, p. 6.
1933 – "Pecks Arrive Home From Kentucky…," i.e., from tour of many states and visits to relatives, *SMT*, July 13, 1933, p. 3.
1935 – "Three memorials for St. Peter's to be Dedicated. A new hand-carved name sign for **St. Peter's Episcopal church**, the donation of Mr. and Mrs. Sydney Peck, is being erected in front of the attractive little church at Lincoln and Cook streets… when Bishop R. B. Gooden comes here to dedicate the two **stained glass** windows…," *SMT*, Sept., 12, 1935, p. 7; "Church Unveils Two Windows" and a carved wood sign, *SMT*, Sept. 16, 1935, p. 4; "Pickups… Besides being the wife of Sydney and a member of the county grand jury, Virginia Peck has an

even greater claim to fame. She is a wood carver of real ability, and a large cabinet in the Peck home on Cook street attests her skill and craftsmanship…," *SMT*, March 15, 1935, p. 1.
1937 – "Pickups… The carved sign Virginia Peck donated to **St. Peter's** church has been refinished after its winter wear – and several mischievous attacks by boys…," *SMT*, March 9, 1937, p. 1.
1941 – "Processional Cross for **St. Peter's**… Tomorrow morning, in connection with morning prayer, the vicar will dedicate a processional cross, handwrought from brass by Mrs. Sydney Peck, whose husband made the staff for it…," *SMT*, March 22, 1941, p. 3.
1945 – "Studio-Home Sold by Sydney Pecks… on south McClelland street…," *SMT*, Aug. 21, 1945, p. 3.
1947 – "Sydney Peck Found Dead at Home…. Since shortly after deceased resigned from Santa Maria high school and sold his residence in the 800 block of south McClelland, Mrs. Sara Virginia Peck, the wife, had lived either in the Southland or here. Presently she is a resident of Rosegate Lodge on South Speed street…," *SMT*, Oct. 20, 1947, p. 5.
1952 – "Mrs. Virginia Peck Dies in Los Angeles… 64, a former resident of Santa Maria… Services were held December 8 and interment took place in the cemetery of the Church of Our Savior in San Gabriel. Mrs. Peck died following a long illness," *SMT*, Dec. 13, 1952, p. 1.
And, more than 300 additional references in the *SMT* to either "Virginia Peck" or "Mrs. Sydney Peck" primarily about her volunteer work with the church or in presenting pageants or socializing or local travels, were not itemized here.

Peck, Virginia (misc. bibliography)
Sara Virginia Peck was b. Aug. 16, 1888 in Ohio and d. Dec. 5, 1952 in Los Angeles County per Calif. Death Index; Sara Virginia Peck was buried in San Gabriel Cemetery, Altadena, father's full name: Charles Wilhelm Schwartz, mother's Mary Elizabeth Davis, Spouse: Sydney Chilton Peck, Children: Malcolm Treat Messer, per findagrave.com (refs. ancestry.com).
See: "Boy Scouts," 1933, "College Art Club," intro., "Schwartz, Davis"

Pedersen, Ernst Rudolf (1911-1969) (Solvang)
Metalwork partner for a brief time with Walther Kristensen, 1949, and then sole prop. of Iron Art.

■ "Iron Works Development Underway. Mr. and Mrs. Ernst Pedersen and Walther Kristensen, who came to the Valley a few months ago from Denmark to start an ornamental iron works plant, are going ahead with their plans and expect to have their shop completed within a few months. The plant will be located on the Jacob Roth property south of the high school. The Pedersen's and Mr. Kristensen plan to make wrought iron clocks, ranch signs, door knockers, gates, lamps and lanterns. Models for many of the items they plan to manufacture are original copies brought from Denmark. Several designs are worked out for prospective customers on paper. The customer chooses the design he likes best and then work is started… At the present time the Pedersens and Kristensen are kept busy making over their building which will house a

manufacturing and designing room, a display room and office. They anticipate a grand opening sometime in the middle of March," *SYVN*, Jan. 28, 1949, p. 4.

■ "Funeral Services Conducted for Ernst R. Pedersen, 57… Mr. Pedersen was born in Denmark April 27, 1911 and was educated there. He married his wife, Lili Ruth, July 7, 1940 in Denmark. They came to the United States in 1948. Beginning with a work shop at the site of the former Homer Roth ranch on Refugio Rd., Mr. Pedersen's business flourished, and in 1950 he founded the **Iron Art** Gift Shop which was located in Copenhagen Square. The shop was expanded to double the original floor space and Mr. and Mrs. Pedersen made numerous buying trips to Denmark. In 1965, Mr. Pedersen purchased the Mercantile Grocery Building on the south side of Copenhagen Drive, remodeled it to an attractive Danish style building and moved the Iron Art Gift Shop to its present location. … Interment was at Oak Hill Cemetery in Ballard," *SYVN*, Jan. 16, 1969, p. 8.

Pedersen, Ernst (notices in Northern Santa Barbara County newspapers on microfilm and on newspapers.com)
1948 – "Pedersen Offers Antiques for Sale… Einst [Sic.] Pedersen, who arrived in this country six months ago with his wife from Denmark is planning to start an ornamental iron works in the Valley. Mr. Pedersen brought with him antiques in copper, including kettles, tea pots, ornamental plaques and several hand paintings. He is offering these items for sale and may be contacted at his home on the Jacob Roth ranch south of the high school," *SYVN*, Dec. 10, 1948, p. 5.
1949 – Solvang Men Turn Out Fancy Metal Articles" candelabra, weather vanes, clocks, light fixtures, *SMT*, July 7, 1949, p. 5.
1953 – "Mrs. Pedersen, Son Going Abroad," *SYVN*, Jan. 9, 1953, p. 7.
1954 – "Memo Pad… Ask Ernst Pedersen of the Iron Art Gift shop if he doesn't think people are honest…," *SYVN*, June 25, 1954, p. 2.
1956 – "Pedersen's Given Housewarming," *SYVN*, May 11, 1956, p. 9.
More than 170 hits for "Ernst Pedersen" appear in the *SYVN*, 1948-69 but were not even browsed for inclusion here.
See: "Collectors, Art/Antiques (Santa Ynez Valley)," 1954, "Iron Art," "Old World Metal Craft," 1949, "Signs, general, " 1952, 1953, "Solvang Woman's Club," 1949

Pedersen, Kirsten (Mrs. O. Frank Pedersen) (1930-2010) (Solvang / Los Olivos)
Ceramist. Prop. of Mud Mill Pottery Studio, 1959-68.

■ "Joining the host of artisans who have given the Danish American community for the old world [sic.?] creations are Kirsten and Frank Pedersen who are opening their Mud Mill Pottery Studio Sunday in the new Danish provincial styled Bruhn building on Copenhagen Drive. Mrs. Pedersen, a native of Jylland, Aalborg, Denmark, is the potter of the family. She first became exposed to the art as a child when she often visited a pottery factory located across the street from her home. Later, her family moved to Copenhagen where she studied dressmaking and design. Mrs. Pedersen came to the United States and to Santa

Barbara in 1950 where she made her home with an aunt and uncle. A day after her arrival in Santa Barbara, she enrolled as an English language student in an adult education class at Santa Barbara High School. It was at this time, too, that Mrs. Pedersen learned that a course in pottery making was offered under the adult education program. … Mrs. Pedersen signed up for the evening class taught by William Neely three years ago. Working as a dressmaker by day, she … attended classes eight hours a week for three semesters. Mrs. Pedersen said Neely studied pottery-making in Denmark, among other places, and she regards him as one of the top men in his field. Known for his casserole and dinnerware pieces, she plans to stock a group of his creations in her shop," *SYVN*, Oct. 30, 1959, pp. 1, 10.

■ "Kirsten Pedersen… died Thursday December 9, 2010 in Santa Barbara Cottage Hospital… she lived 52 years here in Solvang, starting her pottery studio, 'The Mud Mill' then moving it to Los Olivos. After retiring from pottery, she began catering, feeding the many, plenty, for over 30 years here in the Valley…," *SYVN*, Dec. 23, 2010, p. A6.

Pedersen, Kirsten (notices in Northern Santa Barbara County newspapers on microfilm and on newspapers.com)
1960 – Port. with Crown Princess Margrethe, *SYVN*, June 10, 1960, p. 7.
And, additional notices in the *SYVN* not itemized here.
Pedersen, Kirsten (misc. bibliography)
Kirsten Pedersen b. Jan. 11, 1930, d. Dec. 9, 2010 per Social Security Death Index (refs. ancestry.com).
See: "Mud Mill Pottery Studio," "Santa Ynez Valley Union High School," 1960

Penfield, Phyllis M. (Mrs. Thomas P. Penfield)
Artist. Member of Santa Maria Art Association, 1953, and exh. at Santa Barbara County Fair, 1952.
See: "Santa Barbara County Fair," 1952, "Santa Maria Art Association," 1953

Penney, Mae Agnes (1887-1975) (Solvang)
Proprietor Creative Arts and Woman's Exchange in 1949 with her sister Sadie Forsyth. Member of board of Santa Ynez Valley Art Association, 1953.

■ "Services held… Miss Mae Agnes Penney, 88, of the Solvang Lutheran Home … A retired legal secretary, she has been a resident of the Santa Ynez Valley for the past 28 years…[and list of memberships] … She is survived by one sister, Mrs. Sadie Forsyth of Solvang…," *SYVN*, Jan. 1, 1976, p. 14.

Penney, Mae (misc. bibliography)
Mae Agnes Penney, b. Jan. 18, 1887 and d. Dec. 24, 1975, appears in photos with her sisters on *Public Member Photos & Scanned Documents* (ref. ancestry.com).
See: "Creative Arts and Woman's Exchange," "Forsyth, Joseph," "Forsyth, Sadie," "Red Cottage," "Santa Ynez Valley Art Association," 1953

Penny, Laura (SLO)
Teacher of handcraft at Camp Talaki, 1934.
See: Camp Fire Girls," 1934, and *San Luis Obispo Art and Photography before 1960*

Penny Art Fund / Penny Arts Program
Project of the Federation of Women's Clubs. First mentioned in Santa Barbara area newspapers in regard to the Community Club, Santa Maria, 1938 and the Alpha Club, Lompoc, 1939. The program appears to have originated in New Jersey, c. 1917 (?) but was only first mentioned in national newspapers, c. 1923.

■ "Book and Needle Club's Meeting… [NJ]… Mrs. Alvoni Allen [Mrs. Nellie Wright Allen, Federation Chairman of Art, New Jersey, 1923] … she explained the penny art fund of which she was the instigator and told how much had been done by each person giving a penny toward the art fund to purchase a beautiful picture…," *Record* (Hackensack, N.J.), Oct. 27, 1924, p. 10.
1951 – "Penny Art Fund is Explained by **Mrs. Huebner** … started in 1917 [Sic.?] whereby pennies are collected from individual members to … purchase canvases by American artists … in California, Santa Maria **Junior Community Club** stands in first place in its educational program in art conducted at all meetings. If the club maintains this lead … the membership will receive one of the paintings purchased out of proceeds of the Penny Art fund as a prize…," *SMT,* March 15, 1951, p. 4.
1952 – Calif. Federation of Women's Clubs "Art Chairman Speaks at Community Club Program … She spoke on the Federated clubs' 'Penny Art Fund' in which clubwomen have raised $100,000.00 to promote and further the cause of fine art in America," *SMT,* Feb. 13, 1952, p. 4.
See: "Alpha Club," 1946, 1951, 1954-58, "Art Corner," "Chilson, Velma," "Community Club (Santa Maria)," 1951, 1952, 1957, "Cox, Rose," "Horowitz, Leonard," "Junior Community Club," 1957, "Locke, Vance," "Lompoc Community Woman's Club," 1952, "Negus, Marjorie," "Scheidt, Isabel"

Percival, Florence Helen
See: "Sollman (Percival), Florence Helen (Mrs. Arthur Percival)"

Perry, Annette (Mrs. Fred Eugene Perry) (1872-1965) (Los Angeles)
Los Angeles artist who sketched around Pismo Beach and Shell Beach with her art student, Jack Rinehart, 1922.
See: "Rinehart, Jack," 1922, and *Central Coast Artist Visitors before 1960*

Perry, Charles (Santa Barbara)
Photographer. Teacher, Brooks Institute. Author of books on photography. Judge and lecturer at Santa Maria Camera Club on numerous occasions, c.1946-50.
See: "Santa Maria Camera Club," 1946, 1948, 1949, 1950

Perry, Oma (1880-1961) (Carmel / Los Gatos)
Artist from Los Gatos who exh. paintings at Santa Maria Inn, and spoke to Alpha Club, 1939. Was frequently in and out of SB County visiting her sister, Mrs. Maimann of Lompoc, above.
See: "Alpha Club," 1933, 1939, "Maimann, Leila," "Open-Air Art Exhibit," 1957, "Orcutt Women's Club," 1934, "Tri-County Art Exhibit," 1948, and *Central Coast Artist Visitors before 1960*

Peshak, Theodore "Ted" Joseph (1917-2005) (Midwest)
Photographer for Coronet Films who filmed La Purisima mission, 1959.

■ "Educational-Film Director Ted Peshak Dies … Theodore Joseph Peshak was born Dec. 22, 1917, in Plymouth, Iowa, and worked on his family's farm as a young man. Active in the Boy Scouts, he was singled out by a scoutmaster for his short skits, writing that led him to study journalism at the University of Iowa. After graduation in 1940, he worked in advertising and editing at two Iowa newspapers. He served in the Army Signal Corps during World War II as a photographic officer, first in Puerto Rico and then at Fort Monmouth, N.J. He attended an Army motion-picture college and made various training films. At Coronet, he started with 'Shy Guy' (1947), about adjustment to a new town. ... In the late 1950s, he started ... Peshak Films and began finding clients throughout the Midwest. ...," by Adam Bernstein, Oct. 15, 2005, on washingtonpost.com.
See: "Motion Pictures (Lompoc)," 1959

Petersen, Earl Calvin (1930-2014) (Solvang)
Draftsman, designer, builder, 1959.

■ Port. and caption reads "Drafting Design – Earl C. Petersen is pictured in his drafting-design studio which he opened recently in the Duff building, Alisal Road, Solvang. Petersen, who teaches at Santa Ynez Valley Union High School, will devote full time to his studio after school dismisses in June. A graduate of the University of Minnesota, he also attended law school at the University of California. Petersen and his wife, Delores, who is a third grade teacher at the Solvang Elementary school, live at 1526 Oak Street. They have an 18-month old daughter, Stephanie. Petersen's studio offers a new service in the Valley of drafting and building design, including residential and commercial structures," *SYVN,* April 10, 1959, p. 8.

■ "Earl C. Petersen… born in Grantsberg, Wisc. on Jan. 15, 1930, the son of the late Rev. Roy Petersen and Loetta Caldwell Petersen. Soon after high school Earl joined the army and was a member of the 82nd Airborne for four years. After the military he attended Western Washington University in Bellingham, Washington. He also attended the original UCSB in Santa Barbara, where he met his wife to be, Dolores Demelik… They were married in 1956. Earl finished his degrees in Political Science and History at the University of Minnesota… The Petersen family moved to Solvang in 1958 and Earl taught U. S. Government and History at the Santa Ynez Union High School… That same year Earl began designing homes throughout the Santa

Ynez Valley, eventually quitting teaching for a full-time career in drafting and building homes. Earl's projects included Brookhaven farms in Santa Ynez, the second phase of Alisal Glen in Solvang, Walnut Grove in Los Olivos and various individual homes throughout the valley. In Santa Barbara he designed and built Hope Terrace for which he won the Governor's Award for 'Best Architecture Spanish Homes in Santa Barbara since 1920'. Earl also designed many commercial buildings throughout Solvang, including The Royal Copenhagen Motel, the Hamlet Motel, The Little Mermaid Building, The Mole Hole building, The Petersen Village Annex, Hamlet Square, The Greenhouse Building, Chimney Sweep Inn, the Petersen Village Inn and Square. He also redesigned the Mortensen's Bakery Building and Denmarket Square. One of his most notable achievements was the design of the Solvang Theaterfest…," and the development of Leavenworth, Washington into a Bavarian Tourist Village, patterned after Solvang. "For the past 28 years he and his wife Dolores have owned and operated The Petersen Village Inn and Mortensen's Danish Bakery," *SYVN*, Oct. 23, 2014, p. A6.
Petersen, Earl C. (misc. bibliography)
Earl C. Petersen is listed in many *Santa Barbara County CDs* c. 1955-2000; Earl Calvin Petersen, b. Jan. 15, 1930 and d. Oct. 10, 2014 has a port. in *Public Member Photos & Scanned Documents* (refs. ancestry.com).
See: "Santa Ynez Valley Union High School," 1960

Petersen, Holger August (1886-1972) (New York / Solvang / Carmel)
Landscape painter active in Solvang, 1958-59, who later settled in Carmel.
■ "Petersens Making Home in Solvang. Mr. and Mrs. Holger Petersen of Rockville Center, L. I., have been making their home in Solvang since November. Mr. Petersen is an artist specializing in Danish paintings. Mrs. Petersen is a sister of Kai Mortensen who operates the Copenhagen Inn," *SYVN*, April 4, 1958, p. 3.
Petersen, Holger (notices in Northern Santa Barbara County newspapers on microfilm and on newspapers.com)
1959 – "Brotherhood Lodge… A painting by Holger A. Petersen of Solvang depicting a California countryside scene, was awarded to Bernhard Poulsen of Solvang," *SYVN*, Feb. 27, 1959, p. 5.
Petersen, Holger (misc. bibliography)
Holger A. Petersen, with no occupation or wife, living at 101 Pine, is listed in *Rockville Center, NY, CD*, 1939; Holger August Petersen provided the following information on his *U. S. of America Declaration of Intention*, State of New York, No. 91651 – aged 38, b. Dec. 16, 1886, at Helsinge, Denmark, a painter. "I emigrated to the United States of America from Copenhagen, Denmark on the vessel *Hellig Olav*… I arrived at the port of NY on or about the 18 day of March, 1925…," *NY State and Federal Naturalization Records*, 1925; Holger Petersen is listed in the 1940 U. S. Census as age 54, b. c. 1886 in [Helsinge] Denmark, finished elementary school 8th grade, an alien, a self-employed painter of homes, residing in Rockville Centre, N.Y. (1935, 1940) with wife Anna (age 53) and children B. Theodore Petersen (age 24) and Lydia Petersen (age 16); Holger Petersen b. Dec. 16, 1886, d. May 1972 in

Carmel, Ca. per Social Security Death Index; d. May 6, 1972 per Calif. Death Index (refs. ancestry.com).
See: "Santa Barbara County Library (Solvang)," 1959

Petersen, Peter A. [?] (1866-1940) (Solvang)
Landscape painter, c. 1926-40?
■ "Peter Petersen Passes Away at Santa Barbara Hospital… painter and landscape artist, age 74 … long illness. Mr. Petersen has resided in Solvang for over 20 years and was known for his paintings of local scenery. He was married and leaves a wife living in Chicago and two nieces living in Los Angeles… Interment will be made in the Solvang cemetery," *SYVN*, Oct. 18, 1940, p. 1.
Petersen, P. A. (notices in Northern Santa Barbara County newspapers on microfilm and on newspapers.com)
1926 – "Mr. P. A. Petersen of Solvang is the artist whose initials appear on a large oil painting of Gaviota Pass, which is now on exhibition in Andersen and Mathiesen's pool hall. The painting is done in colors that blend to a perfect likeness of the subject and is a real piece of artistic work," *SYVN*, April 16, 1926, p. 1, col. 3; "A large oil painting of Gaviota Pass done by a local artist, Mr. P. A. Petersen is attracting much attention at the pool hall of Andersen and Mathiesen, where it is on exhibition," *SMT*, April 20, 1926, p. 4, col. 2.
1933 – "Dania Society purchased three paintings this week from P. R. [Sic.?] Petersen, local artist. The paintings, one of the Danish Lutheran church and one of Old Mission Santa Ines and the third a valley scene will be hung in Dania hall," *SYVN*, Dec. 22, 1933, p. 4, col. 5.
Petersen, P. A. (misc. bibliography)
Is he Peter R. [Sic.?] Petersen listed in the 1930 U. S. Census as age 63, b. c. 1867 in Denmark, immigrated 1880, naturalized, single, a painter working on his own account, residing in Solvang; Peter Petersen is listed in the 1940 U. S. Census as age 73, b. c. 1867 in Denmark, finished elementary school, 8th grade, naturalized, retired, married residing in Solvang (1935, 1940) in his own home by himself; Peter Petersen b. May 7, 1866 in Other County, mother's maiden name Jorgenson, father's Hansen, d. Oct. 16, 1940 in Santa Barbara County per Calif. Death Index (refs. ancestry.com).

Peterson, Nellie (Atascadero)
Artist who exh. at Santa Ynez Valley Art Exhibit, 1954.
See: "Santa Ynez Valley Art Exhibit," 1954, and *Atascadero Art and Photography before 1960* and *San Luis Obispo Art and Photography before 1960*

Pezzoni (Righetti), Lily / Lillie (Mrs. E. Righetti) (Guadalupe)
Child who exh. at "Santa Barbara County Fair," 1891.
"Miss Lillie Pezzoni, daughter of Mr. and Mrs. B. Pezzoni of Guadalupe, returned home from San Luis Convent on Tuesday to spend a short vacation with her parents," *SMT*, May 3, 1890, p. 3, col. 3.
See: "Santa Barbara County Fair," 1891

Phi Epsilon Phi (Santa Maria)
Social sorority, national. The Santa Maria chapter held several "art" events, c. 1940-60.
Phi Epsilon Phi (notices in Northern Santa Barbara County newspapers on microfilm and on newspapers.com)
1940 – "Santa Maria Host to Sorority on Week-end … Phi Epsilon Phi educational sorority's Southern District council… Trips to the flower fields… and a typical 'Santa Maria barbecue' entertained the visitors… The barbecue followed in the Elks' club. In keeping with the Western attire… the committee arranged a display of Western paintings, loaned by **Nicholas Firfires**… and Mexican and early California curios as well as silver mounted riding equipment typical of California. There was also an exhibit of woodcarvings of Western subjects by the **Hoback** family of Orcutt…," *SMT,* July 15, 1940, p. 3.
1946 – Phi Epsilon Phi "See Pictures" of Switzerland by **Mario De Bernardi**, *SMT,* Nov. 21, 1946, p. 3.
1952 – "Mrs. Forbes is Chapter Speaker" on history and techniques of glass, *SMT,* Feb. 28, 1952, p. 4.
1955 – Photo of members of Phi Chapter of Phi Epsilon Phi making jewelry, and "Do It Yourself Series Started by Phi Chapter," and "instruction was given on making sequined earrings and other costume jewelry sets. Mrs. Frank Bobo, here from Cle Elum, Wash. to visit her brother-in-law and sister, Mr. and Mrs. Pierce Samuelson, was teacher for the session. Mrs. Samuelson, a member of the chapter, attended with her… class. Others will be on the program of homemaking arts," *SMT,* Jan. 28, 1955, p. 4.
1960 – "'Phi Chapter Members Study Photography… visit to the studio of **Norman Brown** of Arroyo Grande… Brown showed pictures for more than an hour… [and] explained that this is termed a Creative Hobby …," *SMT,* Aug. 29, 1960, p. 3.
And, many additional non-art references to the sorority were not itemized here.
See: "Bianchi, Theodore," 1949, "DeNejer, Jeanne," 1950, "Hoback, Gene," 1939, "Nickson, William," 1947, "Reiner, Donald," 1957, "Rick, Maxine," 1953, "Stonehart, Elsie," 1948, "Weir, Rickie," 1954

Photo-Craft Studios (Lompoc)
Photography studio run by John Charles Wallace and Richard A. Bodwin, 1960-61.
■ "New Photo Studio Set Up in Lompoc… at 117 North G Street, called the Photo-Craft Studios. The new business is owned by **John Charles Wallace** and **Richard A. Bodwin**. The photo studio will specialize in portraiture, wedding coverage and general commercial photography," *LR,* Nov. 17, 1960, p. 29.
Photo-Craft Studios (notices in Northern Santa Barbara County newspapers on microfilm and on newspapers.com)
1961 – Repro: "Mrs. David Gaitan," *LR,* Feb. 2, 1961, p. 10; repro: "Sets Date," *LR,* Feb. 27, 1961, p. 18; repro: "Miss Sharon Marie Huyck," *LR,* May 4, 1961, p. 6; repro: "Eldon Stevens," *LR,* June 22, 1961, p. 6; repro: "Mrs. Fred C. P. Perry," *LR,* June 26, 1961, p. 4.

Photographers (commercial, military, and amateur / still and moving) (Northern Santa Barbara County)
Photographers exhibited at the Santa Barbara County Fair and other fairs, created clubs for self improvement, and taught photography at various times in the area high schools and JC's. Camp Cooke/Vandenberg AFB had many photographers involved in taking PR photos, documenting military matters, etc. Police photographers dealt with mug shots, photos of traffic accidents, fingerprints, etc. Films of vacations were taken by many locals and sometimes shown to local clubs.
See: "Abbott, Mary," "Abel, L. E.," "Adam, Kenneth," "Adams, Ralph," "Affleck, Roy," "Almanzo, Robert," "Ames, Joseph," "Anderson, John," "B&B Studio," "Baechler, Charles," "Bailey, Vic," "Barmack, Manasseh," "Beane, Frank," "Bell, Dorothy," "Bianchi, John," "Bianchi, Ted," "Bixby, Barbara," "Bixby, Dwight," "Booth, Stanley," "Borst, George," "Bowersox, Lee," "Boyd, Gardner," "Bradford Studio," "Braflaadt, Chester," "Brians, Emma," "Briggs, Egbert," "Bright, Jack," "Brooks, Ernest," "Brouhard, Jess," "Brown, Norman," "Bullock, Percy," "Burke, Ed," "Calvert, Earl," "Campbell, Linda," "Carey, E. T.," "Carlin, David," "Colgrave, David," "Conn, Jesse," "Cooper, Frank," "Dahlgren, John," "Day, Willard," "Deaderick, Moreland," "DeBernardi, Mario," "Dinnes, Bert," "Dinnes, Gladys," "Dobro, Boris," "Domingos, Albert," "Donoho, David," "Dorsey, Harry," "Dowe, Oscar," "Dunlap, William," "Dupuis, Robert," "Dupuis, Shirley," "Edwards, Ernest," "Elliott, William," "Elsasser, M.," "Emerson, Herbert," "Feeley, John," "Fitzgerald (Karleskint), Mary," "Forbes, Andrew," "Forsyth, Joseph," "Forward, Moselle," "Frame, John," "Gardner, Loris," "Gardner, Margaret," "Gibbs, Frederick," "Gibbs, Kittye," "Gleason, Ellen," "Greene, Robert," "Griesbauer, John," "Guerrero, Mike," "Hardy, Wilfred," "Hart, David," "Hart, Merrill," "Haslam, William," "Hawkins, Rudy," "Heath, George," "Hendricks, Bob," "Herold, Betty," "Herold Roland," "Hertz, Louis," "Hodges, Virgil," "Holman, Richard," "Holmes, Paul," "Houghton, James," "Houston, Rolla," "Hudson, Robert," "Huntington, Harold," "Hutchinson, Barbara," "Ikeda, Victor," "Jellum, Herbert," "Jensen, Chris," "Johnson, James," "Jones, Gaylord," "Jorgensen, Karl," "Judkins, David," "Judkins, Edgar," "Judkins (Weaver), Etta," "Judkins (Chitolis), Hila," "Kaiser, Art," "Karleskint, Bernard," "Karleskint, John," "Kaukonen, Dave," "Keller, Fred," "Kent, Dexter," "Keys, Wesley," "Kinney, Harold," "Knechtel, Lloyd," "Koerner, Fred," "Lantis, Jack," "Lawhorne, Roy," "LeBlanc, E.," "Lemere, Bosworth," "Lew, Elmer," "Leyva, Belvin," "Likes, Myrton," "Lyons, Jeannette," "Magdaleno, Lupe," "Martin, Gilbert," "Mathewson, Esther," "McDonald, Minnie," "McGee, James Henry," "McMillan, Charles," "McMillan, John," "Merrill, King," "Meyers, Mr.," "Miller, Barney," "Miller, Lilllian," "Minetti, Italo," "Moore, Kenneth," "Morrison, L. J.," "Muench, Emil," "Mullins, William," "Murphy, William," "Murray, Robert," "Myers, T. A.," "Nelson, Harry," "Nelson, Robert," "Newhall, Elbridge," "Nicholson, John," "Niederhauser, William," "Oakes, Mortimer," "Olivera, James," "Ollis, Donald," "Olson, Idell," "Orr (Ames), Lucille," "Outwater, Florence," "Ovington, Earl," "Paaske, Raymond," "Padrick, Walter,"

Photography, general (Camp Cooke / Vandenberg AFB)

The military had many uses for photography – identification, PR, illustrations for military-produced publications, documentation of its activities (war, base activities, missile launches), spying (aerial photography), etc. Among base social activities for amateur military photographers were base photo clubs and base photo exhibits.

Photography, general (Camp Cooke / Vandenberg) (notices in Northern Santa Barbara County newspapers on microfilm and on newspapers.com)

1946 – "Photo Contest to be Held… sponsored by 37th Hq. Special Troops VII Corps is open to all military personnel stationed at Camp Cooke. Thirty-six dollars in cash prizes will be divided among the winners, with prizes of five, three, two, and two prizes of one dollar each being rewarded for the five best pictures in each class. The committee of judges will include Capt. Adrian W. Krier, post I and E officer, **Sgt. Marty Shien [Sic. Shein]**, post signal photographer and **Wynee [Sic.? Wynn?] Bullock**," *LR*, Jan. 24, 1946, p. 1.

1957 – Armed Force Day to be Observed… guided tours… Photographs can be taken of any activities other than the confinement facilities or inmates…," *LR*, May 9, 1957, p. 1.

1958 – "Photography Unit 'Pics' Vandenberg… at Vandenberg AFB, California, a crew of some 30 airmen are in the process of setting up facilities to photograph missile activities of SAC's missile training center, when the base reaches full operational stages. Major Daniel A. McGovern is the commander of this unit which has been assigned the clip name of 'Operating Location No. 1.' In Major McGovern's words, the mission of the squadron is: 'To provide on-site accomplishment of photographic support for the 1st Missile Division (SAC), and the Air Force Ballistic Missile Division, Inglewood, involving operational and training photography.' … For 'Photo journalism and documentation of key air events,' APCA recently received the Arts and Letters Award from the Air Force Association. Thus, the APCS became the first military unit in the 10-year history of the AFA to receive the award," *SMT*, Oct. 22, 1958, p. 12.

1959 – "Photography Contest Winners Announced. Base Photography Contest… top winners will be sent to SAC Headquarters for SAC-wide competition… scenic category [**T-Sgt Robert J. Parker** and other winner's names listed] … color transparencies Lt. Colonel Charles H. Paradise… **Sgt. Parker**… color sports in action… A-1c George A. Mecum… military life category, color slides Airman **Robert F. Spallino** …**T-Sgt. Robert J. Parker**… **M-Sgt M. M. Barmack** of the 1352d Motion Picture Squadron at Vandenberg, and Mrs. James M. Callan [Jayne], acted as judges. The finals of the contest were held in the Mesa Service Club…," *SMT*, April 14, 1959, p. 3.

1960 – "Lab Situation Frustrating to Base Sergeant... **TSgt. Robert Parker**, NCOIC of the Base Photographic Laboratory, this week broke precedence and conceded that '... my section is in a stinking mess.' The sergeant complains that conditions at the Photo Lab have placed a social stigma upon him and have even caused him certain hardships in the domestic area. ... Jones' advice ... 'Hang your clothes out in the sun for several days and in the future keep all doors to the lab tightly shut so that skunks can't get in'," *LR*, Oct. 24, 1960, p. 9.

■ "Cameras Snap 'Birdies' of Rare Breed at VAFB. In the era of modern missilery and space vehicles, photography has gained a prominence never before dreamed of. Much of the demand for quality documentation and news coverage is generated here where many of America's missile and space ventures unfold. …

responsibility… of the Air Photographic and Charting Service subcommand. At Vandenberg, APCS's mission is carried out by members of Detachment 1 of the 1352nd photographic Squadron commanded by Maj. Daniel A. McGovern. In this detachment, 150 photographic technicians carry out the many and varied demands... APCS photography, from historic documentation through motion picture feature films to aerial photo-mapping and complex engineering photography, is making important contributions to the nation's defense. Precise surveys of the earth made by APCS flying and ground crews over distances spanning oceans and continents are vital to accurate missilery and charting. Commanded by Brig. Gen. Clifford H. Rees, the 4,500 military and civilian personnel of APCS, are [at] 24 permanent locations and currently operating from dozens of temporary sites. Two large squadrons – one at Orlando Air Force Base, Fla., serving the eastern United States and Europe, another at Los Angeles, handling the western half of the nation and the Pacific area … Detachments of these units document the missile activities at Cape Canaveral and Vandenberg AFB…," *LR*, Nov. 14, 1960, p. 3.

■ "San Nicolas Island Important Part of PMR…. 55 miles southwest of Pt. Mugu… several hundred personnel who operate the 'eagle eye' of the Pacific Missile Range… Navy and civilian technicians… maintain and operate a huge 60-foot radar antenna and National Space and Aeronautics Administration instrumentation equipment… Function of the antenna is to track aircraft, missiles and satellites… Using a 35 mm camera, photographs are made of the video-scope at 30-second intervals. The 35 mm negatives are rushed to the Naval Missile Center photographic laboratory for processing, where they are developed by Navy photographer's mates. Minutes later the finished negatives and prints are delivered to a special analysis team at the PMR…," and additional details, *LR*, Dec. 1, 1960, p. 14; "Navy Has Important Role in Discoverer Launching. Important down-range functions were performed by the U. S. Navy during the firing and flight of Discoverer II accomplished here Monday. Some of the jobs carried out by the Navy were: … high accuracy metric photographs… radar and optical tracking… The Range Ships *USNS Private Joe E. Marin* and *USS King County* were alerted enough in advance to take up suitable positions down range. The Navy is responsible for the establishment of range safety precautions for all missiles or vehicles launched into the Pacific Missile Range… Metric Photographs. As the missile leaves the launch complex, the Navy's PMR takes high accuracy metric photographs of the vehicle during the launch phase by means of photo-optical tracking equipment which is located at several sites around the launch pad. These photographs are rushed to Point Magu where they are reduced to significant data which is then used by AFMD and its contractor for initial trajectory analysis. The early stage of the missile is optically tracked by the Navy from VAFB and Point Arguello and radar tracked by FPS-16 and the VAFB auxiliary station at Point Magu…," *LR*, April 16, 1959, p. 31; "Mugu Personnel Tested for Radiation Exposure," using radar equipment, *LR*, Dec. 26, 1960, p. 11.
See: "Abel, L. E.," "Art, general (Camp Cooke / Vandenberg)," "Brown, Marian," "Bruckner, Pete," "Camp

Cooke," "Carey, E. T.," "Conover, Roy, Pfc.," "Dupuis, Robert," "Dupuis, Shirley," "Guerrero, Mike," "Knechtel, Lloyd," "LeSuer, John," "Redshaw, Ward," "Smith, Tom," "Spallino, Robert," "Stover, Dalton," "Vandenberg AFB"

Photography, general (Guadalupe)
Photography, general (Guadalupe) (notices in Northern Santa Barbara County newspapers on microfilm and on newspapers.com)
1897 – "Guadalupe… An artist notified the teachers and children that he would be on hand to take their pictures in a group on Friday. Of course all will wear their most beautiful smile," *SMT*, Sept. 4, 1897, p. 2.
1949 – "Guadalupe got in the news all the way to London last week – *Life* sent a photographer and newspapers sent representatives—to check up on the broadcast that 'Guadalupe has 9,000 dogs' three times as many as there are humans," *LR*, March 31, 1949, p. 14.
See: "Art, general (Guadalupe," "Motion Pictures (Guadalupe)"

Photography, general (Lompoc)
Lompoc had many permanent photographers and studios, although some were short-lived. It also was a stop for itinerant photographers. Photographers made special trips to northern Santa Barbara County from outside the county to photograph the eclipse of the sun (1923, 1926), the flower fields, and the condors. Photos were frequently taken to illustrate new tourist publications and for publicity, as well as to illustrate the local newspaper. Amateur photographers formed self-help clubs and sometimes had their photos reproduced in the newspaper. Photography was taught intermittently at Lompoc High School. Lompoc inventor Charles Baechler, developed an easy and inexpensive method to make photo engravings.
Photography, general (Lompoc) (notices in Northern Santa Barbara County newspapers on microfilm and on newspapers.com)

1882 – "A photographer has been holding forth here for the last week, and I see his sign is still out, so I suppose he is kept busy," *LR*, April 22, 1882, p. 2.

1929 – "Wrecked Lumber Schooner's Cargo Salvage… coasting steam schooner *Anne Hannify* which went ashore three miles south of Surf on the night of July 2… Hundreds of Lompoc people made pilgrimages to the bluffs where the salvage crew now is hoisting lumber… The sight called forth the efforts of many local photographers, amateur and otherwise, and an airplane picture of the wreck appeared in a recent issue of the *Lompoc Review*," *LR*, Aug. 23, 1929, p. 7.

1936 – "Old-Time Portraits Recall Early Scenes to Returning Pioneers. A large collection of old-time scenes and portraits is on display in the window of **Ernest Brooks**… They were brought in by members of pioneer families… [and include] Charter members of Foresters… early school houses… 'saloon busters,' … [families]…, old Hotel Arthur… 'Lompoc' band… old fashioned bicycle… town's first butcher shop… Santa Ynez mission… First

threshing machine in the valley with the crew… Capt. Frederick Hugo Bose's portrait…," *LR*, Sept. 4, 1936, p. 7.

1937 – "County Joins in Purchase of New Aerial Maps," produced with aid of aerial photography, *LR*, Sept. 17, 1937, pp. 1, 3.

1938 – "New Aerial Survey of River Necessary After Winter Flood… both the Santa Ynez river and Santa Maria river will be made via airplane … heavy winter floods changing the course of the rivers…," *LR*, July 29, 1938, p. 1.

1946 – "United Nations Atmosphere… Burpee Seed farm… Photographers representing the *Saturday Evening Post* were at the farm this week taking colored pictures for a forthcoming article on the flower seed industry," *LR*, July 4, 1946, p. 8; "Photography Fans Get Chance to Compete in C of C Contest… for scenic views that tell the story of Lompoc…," *LR*, July 18, 1946, p. 1; "Two Weeks Remain in Chamber of Commerce Photography Contest… The theme of the contest is 'Lompoc, The Valley Beautiful' and photos which show the scenic beauties of the valley and city will be given preference in the judging. Particular emphasis will be placed on photos of the flower fields, community buildings, parks, **Mission La Purisima**, and other spots of interest in the valley… The photos will be used by the Chamber of Commerce in publicizing the city and valley… Chamber is planning to build a backlog of suitable photographs through the contest… The contest will close on August 10. Committee of judges…," *LR*, Aug. 1, 1946, p. 8; "Lompocan Chosen 'Poster Girl' by Garden Bureau. A photo of Miss Virginia Grossini displaying some of Lompoc's choice vegetables and flowers has been chosen by the Garden Bureau as its poster for the year. The color photo was made early this summer in Lompoc by a staff photographer for the National bureau. The posters are distributed throughout the United States to publicize and stimulate interest in home gardens…," *LR*, Sept. 12, 1946, p. 3; "C of C Planning 'Morgue' for Publicity Photos. Acquisition of a backlog of photographs to be used in publicizing Lompoc Valley was authorized Thursday night at a meeting of the Chamber of Commerce … The photographs will be provided by the **Camera Shop**'s photographic studio, and will be made available to magazines and other publications as well as being used in publicity material prepared by the Chamber of Commerce," *LR*, Nov. 14, 1946, p. 11.

1948 – "Free Photograph, size 5 x 7 inches, of your child, age 2 months to 6 years. October 7-8-9, Thursday-Friday and Saturday… Must be Accompanied by Parent. Selection of Proofs. No Appointment Necessary. No Obligation to Buy. To all mothers, Lompoc and vicinity. This offer of a free photograph of your child – taken by a specialist in child photographs – is made in appreciation of your patronage. No trouble… just bring your child during any regular store hours, October 7-8-9 and sitting will be made right in our store. Store hours 9:30 to 6:00 p.m. Ray R. Cooper, Western Stores, 115 W. Ocean Ave., Lompoc, Calif.," *LR*, Oct. 7, 1948, p. 2.

1954 – "May Furniture Contest. Residents of Lompoc and vicinity will have an opportunity to enter their children in a photo contest… held at May furniture Company, 205 West Ocean avenue, Lompoc, on January 20. A photographer who specializes in children's portraits will be in Lompoc to take pictures next Wednesday, January 20, at the May store. The hours will be from 10 a.m. to 5 p.m. Children up to the age of 12 years may enter… photos will be judged on personality and expression only…," *LR*, Jan. 14, 1954, p. 11; "Colored Photos of 4th of July Parade Sought… by the Chamber of Commerce for inclusion in a new brochure publicizing Lompoc Valley… ," *LR*, Oct. 7, 1954, p. 1.

1955 – "Portraits Belong in the Home. Decorators are dreaming up unique ideas proving that portrait photographs belong in the home. You'll see them mounted on beautiful leather mats in high fashion colors, matted on coarse linen and burlaps and fishnets, on tortoise shell paper. And, in some cases, they're even mounted directly on wallpaper whose motifs lend themselves well to such treatment – like wallpapers with square or rectangular patterns. Framed portrait photographs are being hung on interesting textured backgrounds, such as perforated wallboard and expanded metal lath. Portrait photographs are now seen in practically every room of the house – not only in the living room, but in the dining room, the dinette, the bed room the rumpus room, the foyer and a display of portraits is an excellent way to make a monotonous spare wall interesting," *LR*, April 28, 1955, p. 10.

1957 – "Lompoc Glimpses… Eastman Kodak photographers taking pictures of the Denholm flower fields on the Cooper ranch for use as a panel 30 feet long in Grand Central Station, New York," *LR*, July 4, 1957, p. 1; "State Provides City with Aerial Photos… of the City of Lompoc … The prints… are 36 inches by 36 inches in size and show the entire incorporated area plus some surrounding territory at the scale of 2000 feet to the inch. The prints are enlargements of the original photographs taken by aerial survey contractors in connection with Statewide studies of California's street, road and highway systems. The studies are intended to provide inventory of what is needed to bring the State's transportation arteries up to the standards adequate to serve present and future traffic…," *LR*, Aug. 22, 1957, p. 12.

1960 – "Perforated hardboard is a fine backdrop for hanging portrait photographs because new photographs can be added quickly and easily. For a decorator effect, try mixing frame sizes and shapes. Mats can range from wallpaper to drapery fabric, rich red velvet or matboard to pastel silk shantung," *LR*, Aug. 11, 1960, p. 13, col. 1; "Full-Length Portrait Photographs in direct color are the most recent decorator-treatment for paneled screens. The photographs are covered with a protective spray for easy cleaning," *LR*, Aug. 15, 1960, p. 2, col. 3; "A Bright Idea for decorating over a desk is to have your neighborhood professional photograph [printed Sic.?] on diamond shaped paper. Mat it in red checked gingham. Frame in white wood and hang," *LR*, Aug. 18, 1960, p. 17; "For a Dramatic Effect, portrait photographs can be printed on chalk red- blue- or gold-toned paper. For example, a portrait photograph of a girl in evening dress has a misty-by-moonlight look when printed on blue-toned paper," *LR*, Aug. 29, 1960, p. 4, col. 6; "Life Size Photograph of your

Child, Monday-Tuesday, Oct. 3-4, 1960, In Co-operation with Nationally Famous Child Photographers. We offer you one 16 x 20" life-size photograph of your child for only $1.89. Limit one per family within 6-month period (Parents must accompany child) ...," *LR*, Sept. 29, 1960, p. 11.
See: "Lompoc, Ca., Police Department," "Lompoc Valley Historical Society," "Lompoc Valley Pioneer Society," "Photographers (Northern Santa Barbara County)," "Photography, general (Camp Cooke)"

Photography, general (Santa Maria)
Santa Maria had many permanent photographers and studios, although some were short-lived. It also was a stop for itinerant photographers. Photographers made special trips to northern Santa Barbara County from outside the county to photograph the eclipse of the sun, and the condors. Aerial photographers often used Hancock Field for their airport to take photos for surveys and maps. Photos were frequently taken to illustrate new tourist publications and for publicity, as well as to illustrate the local newspaper. Amateur photographers formed self-help clubs and sometimes, along with journalism majors at Santa Maria JC, had their photos reproduced in the newspaper. Photography was taught intermittently at Santa Maria High School and Junior College. The Benthograph was a submarine invented at Allan Hancock Foundation to carry cameras into ocean depths. Richard Scalf invented a process that allowed the firing of photographs into ceramic tile, 1947. Joe Wilson invented a device to synchronize sound with home films, 1949.
Photography, general (Santa Maria) (notices in Northern Santa Barbara County newspapers on microfilm and on newspapers.com)

1884 – Photographer "For you pretty folks, now is the time to test your beauty by calling on the artist who will gladly take your impression at the gallery situated next to Jones, Smith & Co's brick building. From what we learn and can see from his samples, he is the best we have ever had visit our town and seems to understand his business perfectly," *SMT*, May 10, 1884, p. 5, col. 1.

1897 – "A traveling photographer was up and took a picture of the school in a group by the door and also one of the building. Both pictures show good work, which pleases the pupils who show their appreciation by buying the same," *SMT*, Sept. 11, 1897, p. 3, col. 4.

1899 – "Things Wise and Otherwise by **A. P. B.** ... It was in 1899 that Southern Pacific railroad built that portion of its coast road connecting Santa Barbara with Surf ... There were three great construction camps ... This writer was detailed by a Los Angeles newspaper to go to the scene of operations and write a story... and securing photographs of interesting features ...," *SMT*, Feb. 5, 1932, p. 4; "The stamp-photo man is here and quarters are flowing his way almost in a steady stream... Rogers, the stamp-photo fiend, will be in Santa Maria until Tuesday next to accommodate the crowds now awaiting on him... Make up your mind not to laugh when you call on **Rogers, the Stamp Photographer** and he will do the rest – 20 for 25 cents... Rogers, the Stamp Photographer will

have a nice selection of broaches and pins to put your Stamp Photos in. Be in time and get one as they are very pretty," *SMT*, Aug. 26, 1899, p. 3, col. 2-4.

1900 – Ad: "P. W. Jones' Popular Drug Store... Cameras, Plates, Films, Photographic Supplies...," *SMT*, March 17, 1900, p. 2; "Los Angeles artists are with us taking pictures and giving stereopticon entertainments at the hall. They took the pictures of the school children last Wednesday but as the proofs are not out yet we cannot say whether any mischievous boy spoiled his phiz or not...," *SMT*, May 5, 1900, p. 3.

1922 – Santa Barbara Chamber of Commerce "Seek Photos of Buellton Picnic," to celebrate completion of Coast Highway to be used for publicity, *SMT*, Sept. 12, 1922, p. 1.

1923 – "Announcement! *The News*, in connection with the **Gaiety** Theatre, has just completed arrangements with a motion picture producer to make a limited number of screen tests of people in Santa Maria... Twenty-five feet of film will be devoted to each individual subject. These films will be combined and shown at the **Gaiety** Theatre. It will then be taken to Hollywood, where it will be reviewed by James Livingston of the Associated Photo-Plays Corporation. After the pictures have been shown and reviewed, the film will be cut and turned over to the subject as his individual property.... Expert Camera Man Will Make Film Tests. **N. C. Travis**, who will direct The News screen tests, is a man of vast experience with motion pictures. Since he started with Pathe in 1909, he has been in close touch with all branches of the industry. As a camera man, he made the pictures of Paul J. Rainey's African Hunt and served as official photographer for the American Red Cross in Russia during the World War. He has been connected with the William H. Fox Company and Universal Film Company and more recently with the Paramount Picture Corporation, making Thomas Meighan pictures. Mr. Travis invented the ultra-rapid camera that photographs what is commonly known as slow-motion pictures. Mr. Travis will make his headquarters at *The News* office for the next two weeks and will personally supervise the making of the tests...," *SMT*, Sept. 24, 1923, p. 3.

1924 – Eclipse of the sun – "The eclipse of last September in California was a sad blow to the numerous astronomers who had taken expensive apparatus and traveled long distances in order to make observations ...," *SMT*, Nov. 25, 1924, p. 6; and numerous other notices on photographers and the eclipse were not itemized here.

1925 – "Power Company Advertises Santa Maria Valley... this month's issue of '*The San Joaquin Power*,' ... profusely illustrated with city and valley scenes, prominent public and private buildings being shown in large numbers... The story of the development of the entire valley...," *SMT*, July 23, 1925, p. 1.

1927 – "Samuel W. Harwick of Hollywood, supervisor of construction of the new theatre, was here the past few days... It is planned to take photographs every week, or at every lift, to illustrate the progress of construction," *SMT*, Oct. 31, 1927, p. 5.

1928 – "Pamphlet Tells About Property. ... Real estate at Bella Casa Addition number 2 is moving rapidly according to C. W. Johnson, owner and subdivider, who has just issued an interesting little pamphlet … The pamphlet contains sepia photographs of Santa Maria's new theatre, the high school and a birds-eye view of the town," *SMT*, April 26, 1928, p. 5; "Pictorial Story of Valley… The most comprehensive collection of photographs of the Santa Maria valley and its various industries ever gathered between two covers has been included in a richly bound album presented to the Chamber of Commerce by Captain G. Allan Hancock, Los Angeles financier and owner of Rosemary Farms… more than 50 views, the work of **George Stone**, special photographer for Capt. Hancock…," and description of types of views, *SMT*, Aug. 30, 1928, p. 1; "Santa Maria Air Survey… Aerial Mapper Has Instruments and Ship Here. Santa Maria's new airport has been the base for the past week of one of the newest developments of aviation—aerial mapping. **Harold C. Rycher** of New York, representing the **Fairchild Aerial Surveys**, landed here September 17, when some minor detail of his plane went wrong, and … decided to make Santa Maria the base of his operations ... Previous to this he had been flying from Carpinteria…. Aerial photography was used extensively during the war, but in recent years it has been turned to commercial uses, such as real estate and highways study… The work which Rycher is doing at present is on contract with the government and necessarily confidential … However, the method of taking the photographs was explained this morning… 'We work at an altitude of 15,000 feet,' he said. 'At that height it is possible to take a picture of five square miles in one exposure. The camera used in this case is a Fairchild, capable of taking 110 shots with one loading, on a film 75 feet long. … The plane flies in one direction without varying from the course even a fraction. Then a quick turn is made and a parallel course is traced back over another bit of territory. When the completed film is made, the pictures fit together like a set of shingles, making a perfect reproduction of all the details of the region covered. Rycher and his pilot fly six hours a day, usually, depending upon weather conditions, and make approximately 400 square miles of snap on each trip," *SMT*, Sept. 22, 1928, p. 1.

1929 – "Magazine for Filipinos… The June issue of the *Filipino Nation*, published by the Filipino Federation of America… contains photographs of a number of [Santa Maria valley residents from the islands]…," *SMT*, June 26, 1929, p. 6; and generally there were notices on x-ray photos, on photos used to document automobile accidents, on photos of fingerprints, on photos of the faces of "wanted men," on photos of the eclipse of the sun, on submarine photos, on aerial photography for surveying and documentation of geography and vegetation, and on photos transmitted long distance via wire.

1932 – "Santa Marians Flock to Avila for Glimpse at Wandering Vessel… derelict fishing skiff '*Novi*' of Seattle and its skipper, B. A. Riggs of Dutch Harbor, Alaska, who was adrift for 115 days on the Pacific ocean. They took numerous photographs of the little craft … without rudder or jib boom…," *SMT*, Aug. 22, 1932, p. 1.

1934 – "Local Group Obtains Photographs of Big Condors in Cuyama … Robert E. Easton, president of the Santa Maria Gas company, who… headed an expedition Saturday and Sunday which obtained photographs… **E. I. Dyer** of Piedmont, member of the Ornithological Society of California… The party hid in a blind prepared three days earlier… For hours at a time, members of the party watched the huge birds feast on the carcass of a dead horse. … Motion Pictures Taken. With the latest equipment for taking colored motion pictures, **Dyer** is believed to have taken some valuable films of the birds while **Miss [Kathleen] Dougan** [of Berkeley] took many still shots…," *SMT*, July 5, 1934, p. 1; "City Hall Photos Tell Story of Long Ago… placed in the glass cabinets in the Pioneer lobby of the new city hall. The collection even includes a few pictures snapped in the '70s when Santa Maria was known as Central City…," and article cites some individual photos, *SMT*, Oct. 2, 1934, p. 1.

1935 – "Pictures of Santa Maria Flowers… broadcast to the newspapers and magazines of the country. Earl O'Day of Santa Barbara Associates, accompanied by Photographer **Monte Monakee**, is making the pictures… Today they are in Cuyama valley. Yesterday they did pictures of flowers along the Point Sal coast… Tomorrow, pictures will be made in Tepusquet canyon…," *SMT*, March 20, 1935, p. 1; "Condors Photographed. A number of fine photographs of the scenery about Sisquoc falls retreat of a colony of condors, have been made by Chester Cox and Dudley Brady who went into the back country on a camping trip last week… R. E. Easton has many photos of the region and of the condors," *SMT*, June 4, 1935, p. 3.

1937 – Itinerant "Photo Racket Brings Kicks," *SMT*, April 7, 1937, p. 3.

1938 – "Fliers Making Base Here for Aerial Mapping. Santa Maria airport… headquarters for an army photographic plane which is making an aerial photographic map of San Joaquin valley to be used in connection with the Central Valley's water conservation project…," *SMT*, July 27, 1938, p. 1.

1941 – "Fire Blazes in Mutau Creek. Army Photographs Burton Mesa Fire … With an aerial camera from Hancock College…," *SMT*, Sept. 23, 1941, p. 6.

1944 – **Dorothy Dean Sheldon**, Berkeley photographer "Naturalist Here, Visiting G. M. Scotts" and will show photos to local students, *SMT*, March 22, 1944, p. 3.

1946 – "Lines of Type… We had occasion the other day to go through some of *The Times* files and we ran across a whole stack of photographs that give a good picture of Santa Maria and its people over the last 30 or 40 years…," and discussion of certain specific photos, *SMT*, Nov. 14, 1946, p. 8.

1947 – "What are you buying? … Photograph? … it always pays to deal with your 'neighbor' … Santa Maria's four established studios can fill your every need… **Adams Studio**, 117 West Main, **Arrow Portrait Studio**, 120 East Church St., **Santa Maria Camera Shop**, 118 South Broadway, **Stonehart Studio**, 110 West Church," *SMT*, Feb. 25, 1947, p. 6; "Hood Announces Photography

School… FBI…April 1 and 2… held from 9 a.m. to 5 p.m. each day in the Fire Department recreation room in the City Hall. Special Agent **Gilbert Stuckey** of the Los Angeles FBI office will conduct the classes, and Special Agent William B. Nolan, Jr., FBI agent stationed at Santa Maria will make the arrangements. The purpose… is to [train] in practical photography as applied to police work. Actual practice will be given both in taking and developing photographs… all local enforcement officers in Santa Barbara County are eligible to attend…," *SMT*, March 20, 1947, p. 4; Two-day "Photography School Concludes Today" for local peace officers conducted by **Gilbert Stuckey** of LA's FBI, *SMT,* April 2, 1947, p. 4.

1950 – "Times Adds New Photo Service" i.e., new photo-engraving process that will allow more photos in the newspaper, *SMT,* Oct. 26, 1950, p. 1; "Snap Christmas Fun in a Flash With Tower Flash Camera Kits… smartly designed, easy-to-use, Tower Flash Camera; photographs inside, outside, day or night. Takes 8 pictures on 120 roll film. Handsome black fiber carry case holds 4 flash bulbs, 2 penlight batteries, 2 rolls 120 film, flash holder and instructions [and artists' renderings of Tower Camera Case, Camera with Flash, Tower Camera Outfit] … Sears, *SMT*, Dec. 12, 1950, p. 8; and other articles discuss photography of flying saucers, photographs seized from "spies," photographs taken of the universe through telescopes and of the ocean depths, and x-ray photos taken for health, but were not itemized here.

1951 – "Quality Sought in Photography" says **Billo Smith** of San Antonio, Tx. to Soroptimists, *SMT,* Aug. 8, 1951, p. 4 and note on his visit, col. 2.

1952 – "Al Stewart to Speak on Color Photography" (possibly with Winter Arts Program), *SMT,* Nov. 22, 1952, p. 4.

1954 – "Photo Contest Sponsored by The *Times* for New Directory," *SMT,* May 18, 1954, p. 1; "*Times* Photos Readied Here. … For the first time in this publication's history, pictures are made, converted into engravings and used – all in the same day. Two weeks ago, a new darkroom facility was completed on *The Times*' second floor. Monday a Fairchild Corporation Scan-A-Graver was installed. This means that subscribers to *The Times* now will see today's local pictures today. It also means that *The Times* will augment more news stories with photography," *SMT*, Oct. 16, 1954, p. 1.

1955 – "Pacific Railroad Society Films Rail Tour of Santa Maria Valley … special excursion over the Southern Pacific and Santa Maria Valley railroad lines for nearly 200 members…," *SMT*, Aug. 1, 1955, p. 1.

1956 – "House-to-House Selling… An ordinance which would prohibit city-wide soliciting in residential areas for photography work and magazine sales is now being drafted by City Attorney… **Les Stonehart** led a delegation of local photography studios in requesting City Council action to limit itinerant photographers from making house to house calls. … He explained that since license fees charged are so small and overhead at minimum, the outsiders … are able to undersell local firms…. He asked that the $5 business license fee be raised substantially, possibly to $50 a day…

solicitations of the kind mentioned would be considered a misdemeanor," *SMT*, April 3, 1956, p. 1.

1957 – "*Times* to Observe 75th Anniversary of Founding…. *The Times* will initiate a search for old photographs to illustrate the past in relation to the present…," *SMT*, July 1, 1957, p. 1; "Aerial Maps Given to SM. Prints of up-to-date aerial photographs of the City…," *SMT*, Aug. 21, 1957, p. 14.

1958 – Photo and caption reads "… local Department of Motor Vehicles office… camera that will be used to photograph all applicants for a California driver license…," *SMT*, Oct. 28, 1958, p. 2.

1959 – *SMT* has first "anniversary salute" issue with many articles (not on art) in which Santa Maria calls itself "Missile Capital of the Free World" and continued articles on missile launches, many of which fail in attempt to surpass Russians in space race, *SMT,* Oct. 2, 1959, entire issue.

1960 – Advances in photography – all through the 1950s photography as a spying device with photos taken either by Russians or Americans, on foot or, in the later 1960s, by airplane or satellite, is news; cameras in stores are used to catch shoplifters; astronomy is advanced through photography, Polaroid Camera comes on the market. At Vandenberg, photos document missile launches, and in other cases document atom bomb detonations, phony checks, car crashes, murder victims, fugitives from the law, etc.
See: "Elk's Rodeo," "Photographers (Northern Santa Barbara County)"

Photography, general (Santa Ynez Valley)
Photography, general (Santa Ynez Valley) (notices in Northern Santa Barbara County newspapers on microfilm and on newspapers.com)

1925 – Ad. – "Gift suggestions. A Kodak is an entirely appropriate gift for anyone … They can be had in a wide range of prices to suit your wish…," *SYVN*, Dec. 18, 1925, p. 1.

1928 – "Taking Pictures. W. LeRoy Broun, executive secretary of the Santa Barbara county publicity bureau, was at Solvang with his photographer taking a number of pictures of Solvang and the Santa Ynez Mission for the new county publicity booklet which will be off the press some time before the first of the year," *LR*, Sept. 21, 1928, p. 5.

1931 – "Photographs taken every week at Einer Johnsen's Jewelry store by a representative of the Santa Barbara **Bradford studio**. Watch windows for display of pictures every week," *SYVN*, Aug. 14, 1931, p. 1, col. 5.

1938 – "**Dr. G. Annabelle** of Stanford University, gave the last of a series of lectures on photography Thursday at the Solvang school, before a group of the teachers of the valley," *SYVN*, June 3, 1938, p. 4.

1939 – "Travel Editor Here. **S. N. Van Wormer**, travel editor of the *Los Angeles Herald-Express*, was a visitor in

Solvang this week, securing data and photographs of the Old Mission. A special edition to be published of the **Golden Gate exposition** will show a tour of the Missions of the coast," *SYVN*, Feb. 10, 1939, p. 1.

1940 – "Aerial Maps will be Made of County. The U. S. department of agriculture has announced that aerial photographs will be taken of 603 square miles of the Santa Ynez and Cuyama valley lands this summer. Maps have already been made of Lompoc and Santa Maria valleys, and this summer's aerial work will conclude the photographing in the county's major agricultural areas. The maps are important… for measurements in connection with the agricultural conservation program. The maps are used in checking on farm compliance with the program for benefits," *LR*, May 3, 1940, p. 7.

1946 – "To Take Pictures of the Valley. **Jack Manning** will be in the Valley this week to take pictures of the Santa Ynez Valley for an article that is to appear in the *Saturday Evening Post*. The article was written by Emil Jennings," *SYVN*, Aug. 2, 1946, p. 1, col. 1; "Picturesque Valley Provides Photogenic Poses for All Year Club Photographer… where they secured photos for their annual advertising campaign…," and details of the trip, *SYVN*, Aug. 23, 1946, p. 1.

1947 – "Pictures Needed for New Booklet… descriptive booklet on the Santa Ynez Valley," prepared by the Solvang Businessmen's Association," *SYVN*, May 2, 1947, p. 7.

1949 – "Woman's Club Program Tonight at Memorial Hall. Slides taken by residents of the Valley while in Denmark during the past year or so will be shown…," *SYVN*, Jan. 28, 1949, p. 1; "Alisal Assumes Hollywood Atmosphere. The Alisal Guest Ranch was a miniature Hollywood location last weekend when a quartet of movie stars, accompanied by studio executives, magazine editors and photographers arrived to do a picture story for *Photoplay* magazine…," and stars and principals named including cameraman **Sterling Smith**, *SYVN*, Nov. 25, 1949, p. 1.

1953 – "Photographers Hear Plans for West Coast Meet… met last night in Valley Inn, Buellton, to hear J. Edmund Watson, Los Angeles president of the California Photographers' Assn. who outlined plans for the western states convention to be held at Long Beach July 25-28…," *SMT*, Jan. 9, 1953, p. 4.

1954 – "Council Plans … Los Alamos… community get-together… Aug. 7… school auditorium. Henry Gewe was appointed chairman to collect pictures of interest taken in the community or school during the period between 1922-37. These will be shown on the screen as an entertainment feature…," *SYVN*, July 23, 1954, p. 6.

1955 – "Agriculture Department Films Seeding of Burned Watershed… Refugio Fire area… color motion pictures…," *SYVN*, Oct. 14, 1955, p. 4.

1958 – "Memo Pad. … Solvang was filled with two bus-loads of camera fans last Saturday when 70 members of the **Los Angeles Bureau of Power and Light Camera Club**

visited here. … they were seen taking pictures throughout the general area and thanks to Mrs. Al Weisbrod, had a field day shooting away at performing, costumed folk dancers in front of Copenhagen Square…," *SYVN*, May 23, 1958, p. 2.

1959 – Photo and caption reads, "Flower Time… field of midget marigolds and asters planted for seed and in full bloom along Buell Flat between Solvang and Buellton. Large numbers of camera toting tourists stop along highway to photograph…," *SYVN*, Aug. 28, 1959, p. 1; "Mail Delay Results in Omission of Photos… Due to the inability of the U. S. Postal Department to deliver a package of engravings mailed early Tuesday afternoon in North Hollywood to the *Valley News* in Solvang in time for publication yesterday… today's issue of the newspaper is printed without the usual array of photographs…," *SYVN*, Dec. 11, 1959, p. 1.

1960 – Photographers descended en masse on Solvang when the town was visited by Crown Princess Margrethe, "Danish Quarter," *SYVN*, June 10, 1960, p. 2.
See: "Jorgensen …," "Photographers (Northern Santa Barbara County)," "Rexall Drug Store," "Santa Ynez Valley News," "Solvang Drug Company"

Photography, general (Vandenberg AFB)
See: "Photography, general (Camp Cooke/ Vandenberg AFB)"

Picture Frames (northern Santa Barbara County)
Purveyors of… Picture moulding was sold by lumber yards. Picture frames were also made in manual training classes at various schools and sometimes carved by the artists themselves. Photography studios sold frames.
1957 – "Make your own picture frame. Artistic Picture Mouldings. Four Different Styles and Sizes. Pacific Coast Lumber Co. of California. San Luis Obispo, Santa Barbara, Santa Maria. 300 E. Jones," *SMT*, Jan. 3, 1957, p. 5.
See: "Fuller's," 1954, "Gardner, Loris," intro., "Hibbits, Forrest," 1953, "Home Department," 1954, "Jones, T.A. & Son," 1882, "La Petite Galerie," 1953+, "Leslie's," 1883, "Lompoc, Ca., Union High School," 1914, "Miller's," 1911, 1915, "Morehead & Douglass," 1891-94, "Patishal's," 1954, "Pictures in the Home," "Santa Maria Studio of Photography," 1957, "Stonehart Studio," 1947, "Summer School (Lompoc)," 1949, "Variety Store," 1888+

Pictures in the Home
Syndicated column by Alma Zaiss (WNU Service) that ran in the Lompoc Record, 1927.
"Pictures and Proper Frames," *LR*, April 22, 1927, p. 7.

Pierce, Minerva Lockwood (Mrs. Charles William Pierce) (1883-1972) (San Francisco / Reno)
Painter who showed her works at the home of friends in Santa Maria, 1936.
See: *Central Coast Artist Visitors before 1960*

Pierce (McClive), Ruth (Mrs. William McClive) (Santa Maria)
Her sketches were displayed at the Jr. Community Club, 1951.

■ "Wedding Takes Place. Mrs. William McClive, a recent bride, is making her home here with her sister and husband, **Mr. and Mrs. Jack Burck**, while her husband is continuing his training in the army at Officers Candidate school, Fort Belvoir, Va. … Mrs. McClive is the former Miss Ruth Pierce, daughter of Mr. and Mrs. A. W. Pierce of Stanford, Texas. She is employed locally while in Santa Maria. After her husband's term of duty in the Armed Service, they will locate in California…," *SMT*, June 4, 1952, p. 6.
See: "Junior Community Club (Santa Maria)," 1951

Pioda, Marie T., Miss (1870-1912) (Santa Maria / Santa Cruz)
Teacher of drawing and manual training at Santa Maria High School, 1909. Primarily a music teacher. Most of her life seems to have been spent in Santa Cruz.

■ "Died. Pioda—At Adler's sanatorium, San Francisco, November 9, Miss Marie Pioda, a native of California," *Santa Cruz Evening News*, Nov. 11, 1912, p. 5 [newspapers.com dates this as 1913 but the paper itself states 1912]; "Miss Pioda Passes After Long Illness… Miss Marie T. Pioda… The remains were shipped to Santa Cruz, the place of her birth…," *Californian* (Salinas, Ca.), Nov. 11, 1912, p. 5.
Nearly 200 notices appear on "Marie Pioda" primarily in the *Santa Cruz Sentinel* on newspapers.com but were not itemized here.
Pioda, Miss (misc. bibliography)
Marie / Maria T. Pioda, teacher, is listed in the *San Jose, Ca., CD*, 1890, 1892; Marie T. Pioda is listed in the 1900 U. S. Census as age 30, b. April 1870 in Calif., a school teacher, residing in Santa Cruz, Ca., with her mother Mary E. Pioda and brothers Louis W. (age 24) and Albert W. (age 21); Maria (M. E.) Pioda, teacher, is listed in the *Santa Cruz, Ca., CD*, 1905, 1907, 1913; Marie Pioda is listed in the 1910 U. S. Census with no birth date, a teacher in high school, b. USA, boarding in Santa Maria, Ca.; and she is also listed a second time as Marie T. Pioda, age 30 (?), b. c. 1880 in Calif., a teacher, residing in Santa Cruz with her mother, Mary C. Pioda (age 66) and brother Albert W. Pioda (age 28) (refs. ancestry.com).
See: "Santa Maria, Ca., Union High School," 1909

Pioneer Society (Lompoc Valley)
See: "Lompoc Valley Pioneer Society"

Pittman, Hobson Lafayette (1899-1972) (North Carolina)
Artist whose work was supplied to the Santa Maria Valley Art Festival, 1952, by his Los Angeles gallery.

■ "Hobson Pittman, NC Artist, Dies…. 'poet-painter of the empty room' … The Tarboro native lived much of his life in Pennsylvania, teaching at the State University of Pennsylvania for 33 years and 25 years at the Academy of Fine Arts in Philadelphia. Pittman was noted for his haunting paintings of interiors, evocative of the turn-of-the-century south and for his flower paintings…," *News and Observer* (Raleigh, NC), May 7, 1972, p. 22.
See: "Santa Maria [Valley] Art Festival," 1952

Plaskett, Theda
See: "Ferini (Plaskett), Theda (Mrs. Archibald Lealand Plaskett)"

Plumm, Howard Allen (1923-2007) (Santa Maria / San Jose / Sacramento)
Santa Maria High School grad. 1942. After service in WWII, grad. as art major from San Jose State College, 1949. Continued to produce art as an adult and teacher.

■ "Howard Plumm, son of Mr. and Mrs. Clyde E. Plumm of Santa Maria, is having a one man showing of portraits in oils this week at San Jose State college, where he formerly was a student. Presently residing with his wife in Sacramento, Plumm has taught school in the northern community, and has now completed study to receive a master's degree in art. He has taught school in the art department at Del Paso Heights district of Sacramento. Interest in painting began while he attended Santa Maria high school and when he was encouraged to study with **Mrs. Ray DeNejer** as head of the department. He subsequently was a student in the local Junior college classes, and majored in art while attending San Jose State college," per "Is Having Exhibit at State College," *SMT*, Aug. 10, 1951, p. 4.
Plumm, Howard (notices in Northern Santa Barbara County newspapers on microfilm and on newspapers.com)
1945 – "Plumm Discharged," *SMT*, Dec. 8, 1945, p. 3.
1949 – "Howard A. Plumm, former Santa Marian now of Sunnyvale, and son of Mr. and Mrs. Clyde E. Plumm of Santa Maria, is one of 200 students graduated from San Jose State college at the end of the fall quarter. He was to receive an A. B. degree with a secondary teaching credential in art," *SMT*, Dec. 23, 1949, p. 6.
1957 – Helps make the art exhibit at the Lodi Grape Festival a success, per *Lodi News Sentinel*, Sept. 14, 1957, p. 1.
Plumm, Howard (misc. bibliography)
Listed in 1940 U. S. Census as Howard A. Plumm, age 16, b. c. 1924, living in Santa Maria, Ca., with his parents Clyde and Edith Plumm; port. in Santa Maria High School yearbook, 1942; port. in *La Torre Yearbook* (San Jose State College), Class of 1949, p. 50, next to port. of Marjorie Plumm; teacher of arts and crafts, per *Del Pasado Yearbook* (Sacramento), Grant Union High School, class of 1951, port. p. 53; Howard Allen Plumm b. Dec 17, 1923 to Clyde Elmer Plumm and Edith May Westcott, married Marjorie Ruth Whearty, d. July 17, 2007 in Sacramento, Ca., per Chris Clough Family Tree (refs. ancestry.com).

Podchernikoff, Alexis Matthew (1885-1933) (Santa Barbara)
Artist who painted in Santa Maria, c. 1928.

■ "Born in Vladimir, Russia in 1886 [Sic. 1885] into a family of artists, Podchernikoff first studied art with his grandfather, Dmitri Zolotarieff and later with Illya Repin and Verestchagin. In Moscow he was awarded a gold medal and his work 'My Beloved Russian Woods' was purchased by the Royal Art Commission. After the Russo-Japanese War, he immigrated to the United States and settled in San Francisco. In 1913 an art dealer from Santa Barbara convinced Podchernikoff to move there. A painting of his Santa Barbara studio appeared on the front cover of *Literary Digest*, March 10, 1928. Although he spent the last 20 years of his life in Southern California, he returned often to San Francisco to paint scenes of Marin County and the northern coast. He is well known for his landscapes done in the manner of Corot. His last years were spent in Pasadena where he died on October 31, 1933 of tuberculosis," biography courtesy of DeRu's Fine Arts, www.antiquesandfineart.com/derus and reproduced on findagrave.com.

Podchernikoff, Alexis (notices in Northern Santa Barbara County newspapers on microfilm and on newspapers.com)
1919 – "Mr. Junior [art dealer in the Belvedere gallery] Exhibits Santa Barbara Artists in East… This past exhibit was sent by Mr. Linnard from the several beautiful galleries in the Belvedere, the Alexander and in the Maryland [ed. exclusive hotels], with the main idea of showing eastern people what California looks like. And of California, Santa Barbara remains the most advertised of any place for the artist, whose pictures made the greatest hit is none other than A. M. Podchernikoff, a Russian, who has settled in Santa Barbara and lives on Chapala across from the big Belvedere sign… He paints in the old master style… rich coloring… golden browns… The special exhibit of Podchernikoff in the Carson-Pirie-Scott Gallery in Chicago brings the following comment in the *Chicago Evening Post* … The painter has taken his subject in the gentler spirit of William Keith, rather than in the dramatic significance of **William Wendt**… translator of color of sunset, midsummer and spring… twenty-eight landscapes, a few relating to the fine old Spanish architecture at San Juan Capistrano and San Gabriel. … moods. … It is gratifying to meet this finished landscapist from the west coast. The major number of canvases are large and important. Montecito, Miramar, Santa Barbara, San Diego, Ojai Valley, the Golden Gate …," *Santa Barbara Daily News and the Independent*, Nov. 1, 1919, p. 6.
1928 – "Santa Maria is to Share Advertising… next year's All Year Club advertising campaign…. The [Santa Barbara] County Publicity bureau secured the front cover of the March 10 issue of *Literary Digest* for a fine color reproduction of an oil painting of 'A Persian Garden… Santa Barbara, California,' by Alexis A. Podchernikoff… It is planned to have the All Year Club commission Podchernikoff to paint a picture of the flowers in Cat Canyon. The artist has already promised to do such a painting, when the flowers are in bloom… The cost of putting Santa Barbara on the front cover of the *Literary Digest* was only $15.00, just enough to cover the cost of

shipping the painting to New York…," *SMT*, March 3, 1928, p. 1.
1933 – "Artist Selects Reno for Second Divorce. ... Alexis M. Podchernikoff, internationally known artist whose paintings once hung in the Russian czar's palace, has filed suit for divorce here against Myrtle Rosaleugh [Sic?] Podchernikoff of Hollywood. Podchernikoff was divorced from a former wife, his first, here three years ago," *Sacramento Bee*, July 17, 1933, p. 9; Obituary – "Landscape Artist Answers Summons… Rites Thursday in Glendale," *Pasadena Star News*, Nov. 1, 1933, p. 13.
Auctioned – "Morning Light, Santa Inez Mountains," o/c, at Butterfield's, 6/24/92, lot 6449 (F&J 2001); "Morning, Santa Maria," 28 x 36 in., o/c, at Bonhams & Butterfields, SF, 6/15/1995.
References to him appear in various volumes of Nancy Moure, *Publications in California Art*. See Index in v. 10.
Podchernikoff, Alexis (misc. bibliography)
Alexis Podchernikoff provided the following information on his WWI Draft Registration Card dated Sept. 12, 1918 = b. March 17, 1885, in Russia, a declarant alien, a self-employed artist residing at 577 Third Ave., San Francisco, wife Ida, physical description = tall, slender, blue eyes, brown hair; Alexis Podchernikoff is listed in the 1930 U. S. Census as naturalized, a self-employed artist, residing in Los Angeles with wife Myrtle (age 32) and step-son, Jerry Lamb (age 7); Alexis Matthew Podchernikoff was b. March 17, 1885 in Vladimir, Russia, was residing in Santa Barbara in 1929, and d. Oct. 31, 1933 in Pasadena per Working Through Our Family Tree; Alexis Mathew Podchernikoff (1885-1933) is buried in Forest Lawn Memorial Park, Glendale per findagrave.com (refs. ancestry.com).

Pointer, G. R. (Santa Maria)
Sign painter, Oct. / Nov. 1902.

■ "Messrs. G. R. Pointer and **P. B. Johnston** have leased a portion of Lucas Hall and are prepared to do all kinds of sign and carriage painting as well as general sign advertising. Both gentlemen come well recommended and judging from what work they have already done about town they are certainly up to date. Orders… can be left at Lucas Hall…," *SMT*, Oct. 11, 1902, p. 3; "G. R. Pointer, P. B. Johnston, Lucas Hall. Sign and Carriage Painters, Advertisers," *SMT*, Oct. 25, 1902, p. 2.

Police
Police departments of the various towns as well as the California Highway Patrol utilized photography in many ways and some had their own darkrooms.
1942 – "I Spied… Sgt. Jack Beach of the Highway Patrol, building a 'dark room' for photography work in the squad room of the police department," *SMT*, Dec. 1, 1942, p. 1.
See: "Beach, Clyde," "Dupuis, Bob," "Holman, Richard," "Johnson, James," "Olson, Idell," "Lompoc, Ca., Police Department," "Photography, general (Santa Maria)," "Reynolds, James," "Santa Maria Camera Club," "Smith, Richard Olney," "Stonehart, Elsie," "Stuckey, Gilbert"

Pollard, Esther F. (Mrs. Forrest K. "Ken" Pollard) (Lompoc)
Member La Purisima Camera Club, 1948. Wife of Forrest Pollard, below.
See: "La Purisima Camera Club," 1948, "Pollard, Forrest"

Pollard, Forrest Kimball "Ken" (Lompoc)
Photographer, amateur. Fire Chief. Assisted at Camera Shop, 1948. Member and president of La Purisima Camera Club, 1947, 1948. Husband of Esther Pollard, above.
1952 – Repro: "Surprised," *LR*, Dec. 25, 1952, p. 19.
See: "Camera Shop," 1948, "Community Center," 1947, "La Purisima Camera Club," intro, 1947, 1948, "Pollard, Esther"

Polley, Frances (Mrs. Rudolph A. Polley) (SLO)
Exh. weaving at Santa Barbara County Fair, 1937. Artist who exh. at Santa Ynez Valley Art Exhibit, 1954. Flower arranger who competed in, organized, and judged competitions, 1938-41. Husband was an architect. Moved to Fresno before 1945.
See: "Santa Barbara County Fair," 1937, "Santa Ynez Valley Art Exhibit," 1954, and *San Luis Obispo Art and Photography before 1960*

Pomeroy, Mark (Lompoc)
Exh. Second best crayon drawing at "Santa Barbara County Fair," Lompoc, 1892.
Various newspaper references to "Mark Pomeroy" show he was a member of "Real Estate Agency of Pomeroy & Shoults," 1893, and was Town Clerk of Lompoc, 1894, among other things.
See: *San Luis Obispo Art and Photography before 1960*

Poock, Fritz (Carl Rudolph Frederick) (1877-1945) (Germany / Mexico / Highland Park section of Los Angeles)
Artist / engineer who was active in northern Santa Barbara County, 1934.
See: "Art Loan Exhibit (Solvang)," 1935, "College Art Club," 1934, "Santa Maria, Ca., Union High School," 1934, and *Central Coast Artist Visitors before 1960*

Poole, Harvey Enos (1881-1954) (Santa Maria)
Wood carver, 1950. Mail carrier.
1950 – "I Spied… Harvey E. Poole, mail carrier on the Santa Maria-Gaviota run, displaying wood carvings of deer, squirrels and other animals and birds turned out in his hobby shop," *SMT*, Oct. 27, 1950, p. 1.

Pope, Ethel (Santa Maria)
Member College Art Club, 1930. Teacher of drama / puppeteer at Santa Maria High School, 1934-36.
See: "College Art Club," 1930, "Santa Maria, Ca., Union High School," 1934, 1935, 1936, "Waugh, Mabel Odin"

Porter, Asa (Sr. or Jr.?) (Huasna)
Painter, amateur, who exh. in local exhibits, 1952.
See: "Santa Barbara County Fair," 1952, "Santa Maria Valley Art Festival," 1952

Porter, George (Santa Maria)
Collector of art objects shown to Minerva Club, 1941.
See: "Minerva Club," 1941

Posters, American Legion (Poppy) (Cuyama)
Annual poster competition. The poppy was the American Legion's memorial flower chosen following WWI. Disabled vets in hospitals made artificial poppies which were sold to raise funds to help support them, and the special sale occurred annually in May. Contest sponsored annually by local Legion Auxiliary. Entrants limited to school children. Occasionally a local student won in the greater 16th district and his/her poster was sent to state competition.
[Elementary school children were NOT given individual entries.]
Posters (notices in Northern Santa Barbara County newspapers on microfilm and on newspapers.com)
1947 – "500 Legion Poppies Sold… Children of Cuyama City helped by making a number of posters which will be on exhibit in the post office, stores and restaurants until after Memorial Day," *SMT*, May 26, 1947, p. 1.
1949 – "Cuyama Legion… 40 poppy posters had been made by children in the Apache, Maricopa and Cuyama schools to aid the poppy sales in May. The posters were displayed at the meeting," *SMT*, April 7, 1949, p. 5.

Posters, American Legion (Poppy) (Guadalupe)
Contest sponsored annually by local Legion Auxiliary. Entrants limited to school children.
[Elementary school children were NOT given individual entries.]
Posters, American Legion (notices in Northern Santa Barbara County newspapers on microfilm and on newspapers.com)
1933 – "Guadalupe… best Poppy poster, … made by Kinaka Nakano won the dollar prize," *SMT*, March 23, 1933, p. 3.
1934 – "A poppy poster contest is also underway… A prize of $1 will be given for the best poster…," *SMT*, Feb. 19, 1934, p. 2, col. 1.
1936 – "Guadalupe Notes… The Poppy poster contest … resulted in 27 posters… The cash award was given Shigeji Nakano and second and third awards went to Sadie Hashimoto and Mary Murata…," *SMT*, April 8, 1936, p. 5.
1937 – "Guadalupe Notes… Oscar Antunes received first award and Ellen Costa second for poppy posters done in the art class of Guadalupe school under the supervision of Miss Mary Beatrice, acting for the American Legion auxiliary," *SMT*, June 1, 1937, p. 6.
1939 – "Guadalupe Notes… Poppy posters were judged and the prize was awarded to Belen Antunez, a seventh grade pupil," *SMT*, May 13, 1939, p. 3.
1942 – "Guadalupe Notes… At the last meeting of the American Legion auxiliary… Hazel Moffitt presented the poppy citation and defense stamps for the poppy poster

contest to Kiyoko Matsuura, first prize, and Tom Sakamoto, second. In the second group, John Zarate won first prize and Josephine Rodriguez, second. Kiyoko Matsuura, seventh-grade student and John Zarate, sixth-grade, won third place in the poppy poster contest in the sixteenth district…," *SMT*, June 6, 1942, p. 3.

1953 – "Guadalupe Unit Judges Legion Poppy Posters," *SMT*, May 1, 1953, p. 4.

1954 – "Guadalupe News… results of the annual… poppy poster contest in the local grammar school… announced… Winners…," are named, *SMT*, May 15, 1954, p. 4.

1955 – "Guadalupe News … American Legion Auxiliary… poppy chairman announced the winners in the poppy poster contest," and names given, *SMT*, May 31, 1955, p. 9.

1956 – "Two Guadalupe Contest Winners… poppy poster… 35 posters submitted… Winners are …," *SMT*, May 3, 1956, p. 5.

1958 – "Poppy Poster Winners Named at Guadalupe," *SMT,* May 3, 1958, p. 2.

1960 – "Poster Contest Winners Told," *SMT*, May 6, 1960, p. 12; "Legion Auxiliary Meets… Antoinette Oliveira, daughter of Mr. and Mrs. Toney Oliveira who won first place in the local poppy poster contest had won first place in the 16th district…," *SMT*, July 4, 1960, p. 3.

Posters, American Legion (Poppy) (Lompoc)
Contest sponsored annually by local Legion Auxiliary.
Entrants were limited to school children.
[Elementary school children who made posters were NOT given individual entries.]
Posters, American Legion (notices in Northern Santa Barbara County newspapers on microfilm and on newspapers.com)

1928 – "Annual Poppy Sale Planned by Auxiliary… will sponsor a poster contest…," *LR*, April 6, 1928, p. 1.

1930 – "Auxiliary will Sponsor Sale of Poppies… Plans for Big Memorial Day Program… The high school is cooperating in awakening interest in the poppy sales by writing essays on the subject and in making posters at the arts department of the high school…," *LR*, May 23, 1930, p. 10.

1931 – "Auxiliary Prepares for Poppy Sale…**Mrs. Lloyd Huyck** and **Mrs. William Hoag**, with others, will make posters advertising the poppy sale," *LR*, April 24, 1931, p. 7.

1933 – "Auxiliary Aids Veterans… **Mrs. Ruth Anderson** was appointed chairman of the poppy sale committee and announced that the high school art class would co-operate by making the posters to publicize the sale, which is scheduled for a date late in May," *LR*, April 7, 1933, p. 8.

1935 – "Legion Auxiliary Plans Poster Contest and Sale … with **Mrs. Ruth Andersen** as the chairman, a poppy poster contest will be staged with pupils of the local schools…," *LR*, March 15, 1935, p. 9; "Legion Auxiliary Names Judges, Plans Sale. Judges for the Poppy Day poster contest sponsored by the American Legion auxiliary were appointed on Tuesday evening… **Mrs. Eric Anderson** [Sic. Andersen] has been in charge of the contest conducted among pupils of the Lompoc schools. Judges of the posters will be Mrs. William Proud, Mrs. Ray Swartz and Mrs. T. M. Parks…," *LR*, April 19, 1935, p. 6; "Posters on Poppy

Day Get Prizes…," and children named, *LR*, May 3, 1935, p. 10; "Legion Auxiliary… Report on plans for a Memorial Day program… **Mrs. Eric Anderson** reported awarding of silk flags to winners in the student Poppy day poster contest, announcing that the 20 posters entered would be displayed in store windows…," *LR*, May 10, 1935, p. 7.

1936 -- "Women's Auxiliary… Poppy posters made in the art class of the high school were judged by Mrs. William Davis, Mrs. Malcolm Williams, Mrs. Chester Grant and Mrs. Joe Holland…," *LR*, April 10, 1936, p. 4; "Auxiliary Announces Poster Contest Winner… Takeo Kasamatsu…," *LR*, April 17, 1936, p. 5.

1938 – "Auxiliary Names Poster Contest Winner… Miss Virginia Pirtle, a junior at Lompoc high school… The work was done in the art classes of the high school under the direction of **Miss Mary Elisabeth Bucher**. Judges making the selection included Mrs. L. C. Huseman, **Mrs. H. U. Gaggs** and Mrs. Howard Moore. Miss Pirtle's poster will be sent in to compete with other selections from high schools in the 16th Legion Auxiliary district…," *LR*, April 8, 1938, p. 3.

1939 – "Legion Auxiliary… The annual poppy poster contest has been begun in the local high school… The best local poster will compete with both district and state divisions for a cash award. Junior Auxiliary members, whether in high school or not, may enter. Closing date for contest is May 1…," *LR*, Feb. 24, 1939, p. 5; "Poppy Poster Prizes Awarded… by Mrs. A. J. Jensen, for the high school… First prize of two dollars will go to John Domingos, freshman and second prize of one dollar to Doris Kalin, junior. The two posters were selected from the eight turned in. They were made under the supervision of Miss **Margaret Morton**, art instructor," *LR*, May 19, 1939, p. 7.

1940 – "American Legion Auxiliary to Have Poppy Day… May 25… Alice Machado, freshman, was first prize winner in the recent poppy poster contest… Tsukiko Tanouye was seond prize winner," *LR*, April 12, 1940, p. 7.

1941 – "Mary Sousa Wins Poster Contest… high school student. Second prize went to Grace Bay, junior high school pupil…," *LR*, May 2, 1941, p. 3; "Winners Named… Mary Sousa, senior high school student, won the Poppy Poster contest in the high school and also won first prize in the 16th district. …," *LR*, May 9, 1941, p. 7.

1944 – "Legion, Aux. Hold District Meeting… Final plans for the poppy sale and poster contests in the schools were culminated… observed May 27…," *LR*, March 31, 1944, p. 1.

1948 – "Poster Awards… In Class I, first, second and third prizes were awarded to Eleanor Gutierrez, Frances Beattie and Frank Valesquez, respectively. In class II, first prize was awarded Helen Perry and second prize, Phyllis Eckert. Class III awards went to **Wallace Grider**, first, Jean Ann Martin, second, and Lela Selby, third. Honorable mention was accorded Earlane Newby…," *LR*, April 8, 1948, p. 3.

1950 – "Legion Auxiliary to Sponsor Poppy Poster Contest in Local Schools… cash awards," *LR*, Oct. 5, 1950, p. 4.

1951 – "R. J. Pacheco in First Place in Poster Contest… Each poster, with a fitting slogan and picturing the Flanders Poppy in correct color, had to be entered not later than May 1. The judging was divided into two classes, that of the 4th, 5th and 6th grades. Winners were First place: R. J. Pacheco,

Second place: Victor Armento, Third place: Marshall Williams. All of the Class I winners are students at the Maple school. In the second division, Cecilliam Wuest won first place, Jane Hibbits second place and Frank Trejo third place. All second division entries were from the Lompoc junior high school… posters are sent to Santa Paula where … judge them in district competition," *LR*, May 10, 1951, p. 8.

1952 – "Lompoc Schools to Take Part in Aux. Annual National Poppy Poster Contest," *LR*, April 3, 1952, p. 4; "Poppy Poster Awards … Announced & List of Nominees Named… They were students in the fourth, fifth and sixth grades in the Maple school … The first place poster has been sent to the 16th District to compete with other winning posters in the District…," *LR*, May 8, 1952, p. 2; "Gold Star Mothers… Mrs. John McCarthy, Poppy chairman, announced that Joe Bendele, a student of Maple School, had won first place in Sixteenth District Poppy Poster contest and his poster was being sent to the Department of California to compete with winning posters from other districts …," *LR*, May 22, 1952, p. 2; photo "Youthful Prize Winners," *LR*, May 29, 1952, p. 1; "Mrs. Hazel Carlton… At the Tuesday meeting of the Auxiliary… awarded a gold medal to Master Joe Bendele, a son of Mr. and Mrs. G. Ebaniz of Lompoc. The medal, inscribed 'For Excellence in Poppies,' was awarded to Joe for having entered the adjudged best poster in the 16th District Poppy Poster contest," *LR*, June 5, 1952, p. 2.

1953 – "Poppy Poster Winners Announced… First prize went to Frank Garcia, fourth grade, and second prize to Tony Centeno, fourth grade, both of the Maple school. Sylvia Rice, a fifth grader from Lompoc elementary school won the third prize…," *LR*, May 7, 1953, p. 2.

1954 – "Legion Auxiliary Honors Gold Star Members at Dinner… Judging of the poppy posters created by school children was the next order of business; **Mrs. Arnold Brughelli** and **Mrs. [Juka?] Carlson**, judges, awarded prizes as follows… [and children named]," *LR*, May 6, 1954, p. 5; "Lompoc Girl Wins Medal… Excellence of the Poppy Day poster she submitted in a contest covering the counties of Ventura, Santa Barbara and San Luis Obispo won a First Place gold medal this week for **Amelia Alvarez**, 12, a sixth grade student at Hapgood school. The contest was sponsored by the American Legion Auxiliary… The poster has now been entered in the all-state contest… Amelia, daughter of Mrs. Pauline Alvarez of 511 North I street, is an outstanding art student, according to her teacher, Carl Hardin of the Hapgood faculty. In the Lompoc poster contest, she took second place but tri-county judges disagreed with the local decision. First place winner here was Gary DeBernardi, a student at Maple school. Third place in the local competition was won by Joe Quinonez, also a student at Hapgood school. Little **Miss Alvarez** said today that she hopes to attend 'a big art school' when she gets older. Her aim is to be a fashion designer. Her school art work is only part of Amelia's efforts – she admits that her home is full of paintings she creates in her spare time. None of them are framed, however, 'because the frames are so expensive….' Carl Hardin, her teacher… declares Amelia is one of the best art students he has ever had. He entered one of her water color paintings in the recent Solvang art exhibit.

Amelia won second prize in the elementary school class during last year's Hallowe'en window painting here. Her Poppy Day poster depicted a crippled soldier saying 'Thanks, little soldiers!' to a trio of youngsters uniformed as a sailor, soldier and nurse, respectively, who are engaged in selling Memorial poppies. The work was done in water color," *LR*, June 3, 1954, p. 4.

1956 – "Legion Aux Names Poster Winners… The best of the Poppy Posters … were declared to be those submitted by Eddie Escobar, Richard Gomez, Linda Aguilar, in that order, and an honorable mention award given to the poster entered by Tommy Garcia…" *LR*, May 17, 1956, p. 4; "Maple School Graduates Six… Special recognition was awarded Edward Escobar, a graduate, who was awarded the 16th District medal for his outstanding Poppy Poster in Class One. The medal and citation award now qualifies him for the State competition which is to be held at Patriotic Hall in Los Angeles…," *LR*, June 14, 1956, p. 5.

1958 – "Legion Auxiliary Names Winners in Local Poppy Poster Contest… Sheri Highfill won first place in the Class I group of 4th, 5th and 6th graders. Merle Manfrina was second and Maria Venegaz was third. In the class II group composed of 7th, 8th and 9th graders, Jerry Agnelli, and Richard Gomez tied for first place honors. Poppy posters were judged by **Marie Huyck, Elsa Schuyler** and **Mary Brughelli**," *LR*, May 8, 1958, p. 13; "Legion Auxiliary… presented a medal to Sheri Highfill whose Poppy Poster won first place in local and district competition. **Mrs. Paul Highfill** pinned the medal on her daughter," *LR*, June 26, 1958, p. 4.

1959 – "Poppy Poster Wins… Those who won were Gary Evans, first prize, Sheri Highfill, second prize, Diane Brooks, third prize and Sue Ellen Morlan… honorable mention. Judges were **Elsa Schuyler, Marion Lewis** and **Mary Brughelli**," *LR*, May 14, 1959, p. 2; photo of Gary Evans and caption reads "is presented with a first-place medal… This prize represented Gary's first in the 16th district and above 336 other posters…," *LR*, June 11, 1959, p. 16.

1960 – Photo of "Poppy Poster Winners," *LR*, May 19, 1960, p. 20.

Posters, American Legion (Poppy) (Santa Maria)
Contest sponsored annually by local Legion Auxiliary.
Entrants limited to school children.
[Elementary school children were NOT given individual entries.]
Posters, American Legion (notices in *Santa Maria Times*)

1932 – "Preparing for President's Visit… American Legion Auxiliary… report of Mrs. Mary Jane Hanson, chairman of the poppy poster committee … four were chosen to be sent to area headquarters to compete for the national prize… Mary Jane Hanson, **Francis Gregory**, Archie Case and Clyde Small. The other posters… will be used in the windows of local business places…," *SMT*, March 19, 1932, p. 3.

1933 – "Winners for Posters Named…," *SMT*, March 6, 1933, p. 2; "Best Poppy Day Poster Will Be Sent to Judges… contest among seventh, eighth and ninth grade school pupils… **Archie Case**, ninth grade member of **Stanley G. Breneiser**'s art classes and winner of the first award in the local contest…," *SMT*, March 21, 1933, p. 6;

"Poppy Posters Herald Date for Sales… World war dead will be honored by Americans in wearing of Flanders poppies. Many of the posters were made by pupils in El Camino school and high school freshmen…," *SMT*, May 15, 1933, p. 3.

1934 – "Poster Contest Winners… Irene Sutter, grade 7-A… first place and Gwendolyn Shrull, grade 7-B, second…," *SMT*, March 17, 1934, p. 2.

1935 – "LeNora Bragg Wins Art Contest… eighth grade student…," *SMT*, May 4, 1935, p. 2; "S. M. Girl Wins Poster Award. LeNora Bragg won first place … in the 16th district comprised of Santa Barbara, San Luis Obispo and Ventura counties…," *SMT*, June 26, 1935, p. 3.

1936 – Sueko Watanabe, "Local Student Wins in Art Contest" American Legion Poppy Day poster contest, *SMT*, April 14, 1936, p. 3.

1937 – "Judges Named in Poster Contest" for American Legion poppy, *SMT*, April 1, 1937, p. 1; Legion "Auxiliary will Give Poster Awards," *SMT*, April 3, 1937, p. 2.

1938 – "Poppy Posters Will Be Judged Today," *SMT*, March 29, 1938, p. 3; Veteran's "Auxiliary Poppy Day Posters Judged," with winner **Yukio Tashiro** and others named, *SMT*, March 30, 1938, p. 3.

1939 – "Poppy Posters to be Judged Friday," *SMT*, April 12, 1939, p. 3; "Local Students Win in Poster Competition" with first prize to **Yukio Tashiro**, *SMT*, May 1, 1939, p. 4.

1940 – "Poppy Sale Posters Judged Here … made by students from the fourth to the twelfth grades… Posters were made here under the direction of **Miss Edna Davidson** in El Camino school, and **Stanley G. Breneiser** of the high school," *SMT*, April 20, 1940, p. 2.

1941 – "Winners Announced … Sam Morishita, first, Mary Stornetta, second, and Peggy Giles, third. All are from the seventh grade in El Camino school," *SMT*, April 22, 1941, p. 3; "Poppy Day Set With Awards… several who also won poster awards. Eileen Polley, winner of first place medal for Americanism also was a winner in the poster contest and will be remembered as taking honors in previous contests …," *SMT*, May 21, 1941, p. 7.

1942 – "Poppy Posters Judged … first place to Kazuo Inouye in the seventh grade in El Camino school and second place to Lorraine Piercey of the same grade. Honorable mention went to …," *SMT*, April 18, 1942, p. 3.

1947 – "To Judge Poppy Sale Posters Wednesday … Judges will be **Mrs. Paul Nelson**, city librarian, **Mrs. Ray de Nejer** and **Mrs. John Foster**…," *SMT*, April 1, 1947, p. 2 (on microfilm after April 2, p. 6); Poppy "Posters on Display" in library, *SMT*, April 7, 1947, p. 3; "Poppy Poster Contest Winners Named Here," *SMT*, April 8, 1947, p. 3.

1949 – "Poppy Posters are Judged by Auxiliary Unit … The posters, displayed last night at the home of the poppy chairman… were those drawn by elementary school students of the sixth, seventh and eighth grades in Cook street, Alvin Avenue and El Camino schools…," *SMT*, April 14, 1949, p. 5; "Auxiliary… poppy poster contest… winners…," and children named, *SMT*, April 16, 1949, p. 5.

1950 – "3,500 … Poppies Arrive… The only prize awarded in a poppy poster contest was presented to… Jack Cunningham, grade school student…," *SMT*, May 8, 1950, p. 6.

1952 – "Poppy Poster Winners Announced at Fluff Party," *SMT*, May 3, 1952, p. 4; "Winning Poppy Poster… Pat Gregory, winning first place in Santa Maria judging, has won third place in the district contest…," *SMT*, May 22, 1952, p. 4.

1953 – "Auxiliary Poppy Posters Judged, Winners Named… contest in both the elementary school, for which **Miss Edna Davidson** was art instructor… and in the high school, not yet judged… under supervision of **George Muro** …," *SMT*, May 12, 1953, p. 4.

1954 – "Winners Named in Poppy Posters," *SMT*, May 24, 1954, p. 4.

1956 – "Call Out… a vote of thanks to Santa Maria elementary school administration for help in permitting students to make poppy posters… the poster by James Zepeda placed first, Tony Vartanian, second and Robert Bourbon, honorable mention. Judges… **George Muro**… **Miss Edna Davidson** was the art teacher in charge of the posters. They will be placed in Santa Maria stores and buildings to help publicize the sale," *SMT*, May 21, 1956, p. 4.

See: "Posters, American Legion (Cuyama)," "Posters, American Legion (Guadalupe)"

Posters, American Legion (Poppy) (Santa Ynez Valley)
Contest sponsored annually by local Legion Auxiliary. Entrants limited to school children.
[Elementary school children were NOT given individual entries.]
Posters, American Legion (notices in Northern Santa Barbara County newspapers on microfilm and on newspapers.com)

1932 – "Legion Auxiliary Busy on Poppy Contest… conducted in the seventh, eighth and ninth grades of all schools in the valley… contest is state-wide… winning poster will be used as the official poster for American Legion Auxiliary Poppy Day throughout California…," *SYVN*, Feb. 19, 1932, p. 8; "Prizes Awarded in Legion Poster Contest. Miss Evelyn Kalouner, a first-year student in the Santa Ynez high school, was the lucky winner in the Poppy Poster contest conducted in the Valley schools by the American Legion Auxiliary … There were eighteen posters entered… Miss Kalouner will be presented with a book, a life of Washington, by the American Legion at the annual Poppy dance in May," *SYVN*, March 25, 1932, p. 1.

1934 – "Elna Roth is Awarded Prize in Poppy Contest. First prize… of Solvang with special mention to Jean Payne of Ballard…," *SYVN*, March 23, 1934, p. 5.

1935 – "Legion Auxiliary Met… The local auxiliary with Mrs. Barbara Phelps are sponsoring a poppy poster contest again this year in which all schools of this valley have been asked to participate. The contest will close on April 31 and to date the only poster sent in was by the Ballard school," *SYVN*, April 19, 1935, p. 1.

1938 – "Legion Discuss Important Questions… The auxiliary… voted to participate in the nation-wide Poppy Poster contest by sponsoring a local contest with the best entry to be sent to the chairman of the 16th district for entry in the state and nationwide contest…," *SYVN*, March 11, 1938, p. 1.

1941 – "Winners of Poppy Poster Contest Announced… Los Olivos and Solvang schools did not take part.

513

Following are the winners for 4, 5, and 6 graders…
Winners in the 7 and 8 grade classes … Winners… will be
awarded their prizes at a special gathering in the near
future," *SYVN*, April 25, 1941, p. 1.
1943 – "Poppy Day Posters Judged Here Tuesday… 1st
Class Students (4th, 5th and 6th grades) … 2nd Class Students
(7th and 8th grades) … [and names of winners and judges]
…," *SYVN*, May 7, 1943, p. 1.
1951 – "Poppy Day Sale… Poppy Day posters have been
placed in most stores throughout the Valley… The
auxiliary conducted a poster contest with Bobby Hixon and
Sue Marchbanks tied for first prize…," *SYVN*, May 25,
1951, p. 1.
1952 – "Roberta Appel Wins Poppy Poster Contest. The
first prize of $5 offered by the Ladies Auxiliary to
American Legion Post No. 160, was won by Mrs. Roberta
Appel of the Santa Ynez Valley Union High School… The
winning poster has been sent to the 16th District poppy
contest… to compete for the Department of California
prizes… The department winner will then compete for a
national prize…," *SYVN*, May 2, 1952, p. 8; "Mrs. Appel
Poppy Poster Wins Prize… second place" in 16th district,
SYVN, May 23, 1952, p. 3.
1953 – "Poppy Day Poster Event Winners Told… Winners
in the high school group were Marilyn Madsen, first, and
Muriel Weathers, second…," *SYVN*, May 8, 1953, p. 8;
"Nan Bryant Poster Wins More Laurels. The Poppy Day
poster of Miss **Nan Bryant**, a ninth-grade student at Santa
Ynez Valley Union High School, took first prize in
American Legion auxiliary competition… also placed
second in its class – junior high group – in State-wide
competition. Miss Bryant, who resides at **Midland
School**…," *SYVN*, July 3, 1953, p. 8.
1954 – "Legion Aux. Poppy Poster Winners Told… 12
posters completed in the design class at the high school
under the direction of **Mrs. Jack Anderson**, were entered.
The winners in class three were: Thora Mae Nielsen, 12th
grader, first prize, and **Ruth Lindegaard**, 11th grader,
second prize. Lori Gordon, a ninth grader, won first prize in
class two… Last year, the first-place poster entry of **Nan
Bryant** won statewide honors. The poppy posters will be
on display here the week before Poppy Day, which is May
29," *SYVN*, May 7, 1954, p. 1.
1955 – "Poppy Poster Winners Told… In the Valley, first
place award went to **Miss Annette Negus** of Lompoc, a
student at the Santa Ynez Valley Union High School. Other
winners were Evangeline Neitzert, second place, Merle
Steele, third place, and **Ruth Lindegaard**, fourth. **Mrs.
Lenora Andersen** [Sic. **Anderson**] instructed the group. In
the 16th district competition, the entry of **Miss Negus**
placed third," *SYVN*, May 27, 1955, p. 4.
1956 – "Annual Poppy Days… As part of the Poppy Days
sale here, the Legion Auxiliary conducts a poppy poster
contest for school children of the Valley. This year two
students of the Los Olivos School won first and second
prizes… first … to Oliver Harris and second to Robert
Ramirez," *SYVN*, May 25, 1956, p. 1.
1957 – "Poppy Poster Winners Told… Rudy Camarillo,
first, and Randie Roddie, second. Both are eighth graders of
Los Olivos… The two winning posters are on display at
Nielsen and Rasmussen's," *SYVN*, May 24, 1957, p. 10.

Posters, general (Lompoc)
*Before 1910, posters consisted of bills printed by the local
newspaper printing office and of pre-printed posters
brought to Lompoc to advertise traveling entertainments,
etc. The posters cited under this heading are posters hand
made by residents of Lompoc for miscellaneous events.*
Posters, general (Lompoc) (notices in Northern Santa
Barbara County newspapers on microfilm and on
newspapers.com)
1919 – "Quoirda Pomeroy and Irene Whipple of this place
won honorable mention in the Victory Loan poster
contest," *LR*, April 11, 1919, p. 5.
1921 – "Prize Essays and Posters. … Bond Essays and
Posters… for new school," *LR*, April 8, 1921, p. 2.
1925 – "Gossip Heard at Rehearsal of Minstrels … Posters
are now being painted to advertise the show and all the
local artists have been drafted into the work of putting out
something jazzy…," *LR*, April 10, 1925, p. 2.
1928 – "Prizes Awarded for Posters on Clean-Up Week…
judged Tuesday by … **Mrs. J. P. Truax, Mrs. Bradford
Kelley** and Mrs. Lee Sims… three sets of prizes…
Grammar, the Junior High and the High school… [and
winner's names given] The posters were numbered so that
the judges had no idea whose work they were judging. The
posters are in the store windows, where they will remain
until after Clean-Up week, which is all of next week. The
posters depict clean yards, yards that need cleaning up and
are in various ways suggestive of Clean Up week…," *LR*,
March 16, 1928, p. 1.
1929 – "'Clean-Up' Week by Civic Bodies Starts on
Monday… The Junior High and Senior High School pupils
will make posters for the drive and the latter will be
distributed by the Boy Scouts throughout the city…," *LR*,
April 12, 1929, p. 1; "Be Kind to Animals… every public
and private school is asked to observe the day [Friday] with
humane subjects in the various classes… in the art classes
with posters depicting same…," *LR*, April 12, 1929, p. 6.
1935 – "To Enter Poster. **Miss Pauline Cronholm** is
working on a poster to be entered in the World Peace
contest sponsored by the Epworth league during May and
June. Miss Cronholm's poster is to be entered in the
alliance contest May 19. Winners will be rewarded with
paid fees for any summer institute sessions they choose to
attend or with a 12-day attendance at the Whittier Institute
with all expenses paid," *LR*, April 26, 1935, p. 8.
1952 – "Concert Membership Drive… Community Concert
Association of Lompoc… two special assemblies were held
at the Grade School for the purpose of awarding prizes to
the winners of the Concert Poster Contest… [and winners'
names listed] … Local artists, **Mrs. J. Kennedy [Sic.
Kenney]**, **Mrs. M. Schuyler**, and **Mrs. Wm. Bailey**,
judged the posters," *LR*, Oct. 9, 1952, p. 2.
1953 – "Poster Party… Lompoc Teen Age club…
preparing advertising posters for their forthcoming 'Okie
Stomp'… ," *LR*, Feb. 12, 1953, p. 5; "Nearly 100 Volunteer
Workers Rally for Concert Association Drive… Winners of
the School Poster Contest will be announced. First prize for
posters designed and executed by students in the 4th, 5th and
6th elementary grades will be a student membership in the
concert association plus a one-week pass to the Lompoc
Theatre. Second prize…," *LR*, Nov. 5, 1953, p. 5; "Annual
Bazaar and Ham Dinner… St. Mary's Auxiliary… The

display posters which have been used in downtown advertising were designed by **Roy Potter** of the USDB civilian complement…," *LR*, Nov. 26, 1953, p. 20.

1959 – "Lompoc Players to Stage 'Curious Savage' comedy… the brush and stage settings of the **Brughellis, Arnold and Mary**, and the fine poster designs of Roy Wheeler…," *LR*, Feb. 5, 1959, p. 4; "Student Posters Tell School Need" – of failures in Lompoc School System, *SMT*, April 30, 1959, p. 8; photo of poster artists "More Winners" in Fire Prevention poster contest, *LR*, Oct. 15, 1959, p. 15.

1960 – "Shari Smith Wins Poster Contest… a senior… in observance of Library Week," *LR*, April 7, 1960, p, 21. And additional notices on hand-made posters made to advertise rummage sales, card parties, church events, student elections, Fire Prevention Week, **Public Schools Week**, Rebecca events, and polio benefits, etc., several of which were designed by **Mrs. Arnold Brughelli**, were not itemized here.

See: "Flower Show," "Halloween Window…," "Lompoc, Ca., Union High School," "Posters, American Legion (Poppy) (Lompoc)"

Posters, general (Los Olivos)
See: "Posters, general (Santa Ynez Valley)

Posters, general (Orcutt)
See: "Posters, general (Santa Maria)

Posters, general (Santa Maria)
Hand-made posters, usually by school children and often for competitions, 1910+.
[Many parties held by women's clubs to make posters for their various events were not itemized here.]
Posters, general (Santa Maria) (notices in Northern Santa Barbara County newspapers on microfilm and on newspapers.com)

1911 – "Katzenjammer Picnic… Don't forget the date of the Picnic in the first week of December. The posters which will announce the date are all hand painted and were executed by Mrs. Payne," *SMT*, Nov. 25, 1911, p. 1.

1919 – "Local Girl Wins Helmet N Poster. To Mildred Oliver of 305 North Vine street, Santa Maria, falls the honor of winning the German officer's helmet in the Great Victory Loan poster contest carried on by the *Daily News* under the auspices of Victory Loan Publicity committee at Washington, D. C.," *SMT*, April 12, 1919, p. 4.

1921 – "Art Pupils [of state high schools] Invited to Draw [poster] Designs for Orange Show" in San Bernardino, *SMT*, Oct. 24, 1921, p. 1.

1933 – "Pets Entered… Posters made by the seventh and eighth grade students of El Camino school under the direction of **Dorothy Merritt Green**, advertising the pet circus and parade, which have been displayed in the Dorsey building next to the post office the past several days, were placed in business windows throughout the valley today…," *SMT*, May 20, 1933, p. 6.

1934 – "LeNora Bragg is Winner of Pet Poster Contest… grade 7B student at El Camino elementary school… Many

other posters were made under the supervision of **Dorothy Green**, elementary school art instructor …," *SMT*, April 30, 1934, p. 1.

1936 – "Pupils Enter Clean-Up Contest," for posters, *SMT*, April 30, 1936, p. 2; "Poster Contest Winners Named," in 20-30 club clean-up campaign, *SMT*, May 6, 1936, p. 3; Repro of poster by unnamed artist, *SMT*, May 22, 1936, p. 1.

1939 – "Poster Contest Opens Monday" for HS on tuberculosis prevention, *SMT*, Jan. 19, 1939, p. 3; HS "Poster Judging," *SMT*, Feb. 11, 1939, p. 2; **Yukio Tashiro** is Contest Winner … in the tuberculin testing poster contest… **Frances Sutherland**, 12A, won second prize…," *SMT*, Feb. 17, 1939, p. 3; "Model Plane Meet Gets 48 Posters" to advertise its meet run by Lions' club, *SMT*, March 18, 1939, p. 3; "Awards are Made by Lions on Posters for Plane Meet," *SMT*, March 25, 1939, p. 2 with first place going to **Elva Allen**, Santa Maria junior college and second to **Yukio Tashiro** judged by **Breneiser**.

1941 – "Winners Announced in Poster Contest," *SMT*, April 22, 1941, p. 3; "Dance to Aid… Posters calling attention to the Community Recreation Center donation dance Saturday night… were designed by **Mina Rushforth** and **Ruth Dowty**, local girls studying art in San Jose State College…," *SMT*, Aug. 14, 1941, p. 9.

1945 – "Mary Lou Coleman Wins in Contest" – i.e., certificate of merit for Victory poster, student in Santa Maria High School, *SMT*, May 4, 1945, p. 3.

1946 – Community "Concert Poster Contest is Outlined by Miss Willman," *SMT*, Sept. 25, 1946, p. 3; "Winners in Concert Poster Contest Announced Today," *SMT*, Oct. 8, 1946, p. 3.

1947 – High school student "**Kenneth Brown** Wins Prizes for Best Poster" in Community Concert Assn. contest, *SMT*, April 24, 1947, p. 5.

1948 – "Mother's Day Poster Winners Announced by Retail Merchants … Top honors went to **Gloria Stevens**… [her poster] shows a child bearing a gift for her mother, 'the nation's first lady.' The second prize went to **Lenore Peterson**, ninth grade and third prize to Lola Clark, ninth grade. Lorna Lee, Patricia Palmer and Shirley Bagdons were given honorable mention," *SMT*, May 4, 1948, p. 1.

1949 – "Hobby Posters by Eighth Graders on Exhibit," *SMT*, Nov. 15, 1949, p. 6.

1950 – "Name Winners of Safety Poster Contest," *SMT*, Feb. 23, 1950, pp. 1, 6; "Edward Savarese Winner of Soroptimist Sign Contest… 34-year-old unemployed sheet metal worker, Santa Maria air base… designing of the best poster in connection with the club's highway sign project. Savarese, who took up art as a hobby to fill in his idle hours, received a $50 first prize… the winning poster has Santa Maria in large gold letters with smaller black lettering underneath stating, 'Valley of the Gardens'…," *SMT*, April 3, 1950, p. 1; "Hobby Show Posters Made," *SMT*, Aug. 31, 1950, p. 4.

1951 – "Poster Winners on Fr. Hubbard Film Announced … on 'Bering Sea Patrol' … Winner of the high school competition… was Jean Clark, with Bernard Silveira taking second place… In the Junior college competition, Gil Silva won first prize, **Paul Veglia**, second and Sally Wygle, third with honorable mention to **Elva Van Stone**," *SMT*, March 2, 1951, p. 4; "Posters to be Distributed for Merchants

Show," *SMT*, Aug. 29, 1951, p. 4; port of **Virginia Johansen** with her poster and her teacher **Ward Youry** and "Poster Test Laurels to **Virginia Johansen**" artist of poster USO-Youth Fund drive, and "Second place … were tied between Dale Aldridge and **Elva Van Stone**. Third place also was tied between **Barbara Moore** and Carmen Manning. And honorable mention poster winners named, *SMT*, Nov. 1, 1951, p. 1.

1952 – "Conservation Poster Test Now Under Way," *SMT*, March 6, 1952, p. 1; poster "Conservation Contest Closes," *SMT*, March 20, 1952, p. 1; "Name Winners in SM Region Poster Contest… Conservation…," *SMT*, March 28, 1952, p. 1; photos of children and posters in Conservation contest, *SMT*, March 29, 1952, p. 4.

1953 – "Conservation Week… Posters a Feature," i.e., a contest for children from third through eighth grades, *SMT*, Feb. 17, 1953, p. 1; "Los Alamos [School] Students Enter Poster Contest… Conservation...," *SMT*, March 16, 1953, p. 5; photo of Conservation poster winners, *SMT*, April 3, 1953, p. 1; "William Massey and Annette Sutton were today chosen as prize winners in the Get-Out-the-Vote art poster contest held for Santa Maria Union high school art students in downtown Santa Maria yesterday. First prize of $10 went to Massey for his painting in the north window of Patterson Ford… 'Vote yes on school bonds – Our schools are bulging now.' A bulging school house depicted his plea. Miss Sutton received $5 for her efforts in the window at Simas Smart Shoes… She painted the picture of a war baby pleading, 'Vote yes on school bonds and make room for us.' Judges in the art contest were Mrs. **Edna Davidson**, elementary art teacher, and Robert M. Seavers, Santa Maria Chamber of Commerce manager," per "Poster Contest Winners Named," *SMT*, May 14, 1953, pp. 1, 6; "Charlie Flores Wins Safety Poster Award," *SMT*, Dec. 31, 1953, p. 1.

1954 – "Anela Eisert Wins Poster Contest Cash" in American Cancer Society contest, she is Nipomo seventh grader, *SMT*, Feb. 15, 1954, p. 5; photo of winners and "Soil Conservation Poster Winners Cited," and include Certificates of Merit, including **Barbara Prater**, *SMT*, April 8, 1954, p. 1; "Pupils Win Poster Awards. Hoberly Nicholson, son of Mr. and Mrs. Frank Nicholson of Los Alamos and fifth grade pupil… was one of the 15 students who received a certificate of merit and cash award prize… in the annual poster contest sponsored by the Santa Maria Valley Soil Conservation District. Patricia Phipps, also a 6th grade Los Alamos pupil, the daughter of Mr. and Mrs. Harry Nott, was among the fifteen second highest rated contestants who received a certificate of honorable mention," *SYVN*, April 16, 1954, p. 15.

1955 – Photo of Santa Maria school district officials planning conservation poster competition, *SMT*, Jan. 28, 1955, p. 1; Soil Conservation Report… sponsored a conservation poster contest among the twelve Elementary Schools of the district during California Conservation Week. Fifteen prizes of $2 each were provided by Azcarate Concrete Products Company… judged by the Staff of the Santa Maria Library. The winning entries were displayed in… show window of Ames & Harris store. Over 500 posters were submitted for competition," *SMT*, March 18, 1955, p. 10; photo of student artists and "Name Conservation Poster Winners," twenty students and names

listed, *SMT*, March 26, 1955, pp. 1, 8; "Los Alamos Valley… Hoberly Nicholson, 7th grade Los Alamos Elementary School pupil, won a cash award and certificate of merit for the second consecutive year during the recent annual California Conservation Week Poster contest sponsored by the Santa Maria Soil Conservation District. Also winning a cash award and certificate was Marcella Lewis, 6th grade, whose drawing was entitled 'Keep Your Camp Clean for the Next Person.' An honorable mention certificate was presented Gloria Tiboni of the 7th grade…," *SYVN*, April 8, 1955, p. 6; "Poster Contest Announced" for Santa Maria's Golden Anniversary celebration, *SMT*, Aug. 27, 1955, p. 1.

1957 – Photo of students and posters and "BPW [Business and Professional Women's Club] Announces Winners in Safety Poster Contest," and all winners are elementary school students, *SMT*, Feb. 23, 1957, p. 1; photo of Soroptimists working on posters for an enchilada supper, *SMT*, March 13, 1957, p. 3.

1959 – "Three Santa Maria high school art students have earned honorable mention awards in a poster contest sponsored by the National Humane Association. Clifford Quijada, Catherine Arreguy, and Lavada Cook entered posters illustrating the 'Be Kind to Animals' theme. The 42nd annual contest drew 1741 entries to Denver from 31 states and Canada including ten from Santa Maria high school. Quijada earlier was awarded a $25 dollar prize when his poster won top regional honors in Santa Barbara," per "High School Artists Honored in [Humane Society Poster] Contest," *SMT*, April 6, 1959, p. 8.

1960 – Photo of women making posters for the Welcome Wagon Club dinner dance…," *SMT*, May 18, 1960, p. 3. [Posters made by school art departments for school plays, etc., were itemized under the school.]
See: "Minerva Club, Flower Show," "Santa Maria, Ca., Union High School"

Posters, general (Santa Ynez Valley)
Hand-made posters, usually by school children and often for competitions, 1920+.
[Posters made by school art departments for school plays, etc., were itemized under the school.]
Posters (notices in Northern Santa Barbara County newspapers on microfilm and on newspapers.com)

1925 – "Solvang and Vicinity. The Girls' League of the Valley High School is to present the moving picture, 'Peter Pan' at the high school auditorium… the Girls' League has offered prizes of a free ticket to the performance to the boy or girl in each room of every school in the valley for the best posters, the girls' to be a poster for 'better books,' and the boys' posters appropriate for Armistice Day. The posters are to be displayed at the high school," *SMT*, Nov. 6, 1925, p. 7.

1926 – "Students to See 'Abraham Lincoln' … film version. A contest is being held in the school… best composition or poster suitable for Lincoln's Birthday," *SYVN*, Jan. 29, 1926, p. 1.

1927 – "Prizes Given for Best Advertising Posters… advertising the coming of Miss Frieda Peycke next Monday evening have been made by the children in the different grade schools of the valley…," and list of winners at each

school who received free tickets to the performance, *SYVN*, Sept. 23, 1927, p. 1.

1958 – "Humane Society Sponsoring Poster Contest for Students. The Santa Barbara Humane Society with animal shelters in Lompoc, Santa Maria and Santa Barbara…designed to focus attention on the need for consideration of the rights and welfare of animals… 22 inches by 28 inches…, crayon, pencil, pen, ink, paint, or water colors… entry blanks … have been mailed to **Leo Ziegler**, art instructor at Santa Ynez Valley Union High…," *SYVN*, Jan. 3, 1958, p. 4; "LO [Los Olivos] Students Win Carnival Poster Prizes. The seventh and eighth grades…," *SYVN*, Sept. 19, 1958, p. 4; "Los Olivos Carnival … As a means of advertising the events, a poster contest was staged among seventh and eighth grade boys and girls. Winners of first prizes were Janice Montanaro, Garry Roddie and Charlotte Gott. Receiving honorable mention awards were Bob Holzer, Jeanette Olsen and Gilbert Alvarez," *SYVN*, Sept. 26, 1958, p. 1.

1959 – Photo of five youngsters of the Solvang Grammar School who won honors in a poster contest sponsored by the Santa Barbara County Humane Society, *SYVN*, March 13, 1959, p. 8.

1960 – Photo with caption "Carnival Sunday – The Los Olivos School Mother's Club… 12th annual carnival… Here Principal Gates B. Foss… with a trio of youngsters who captured the first three prizes in a poster making contest. They are Monya Gravett, left, Gerald Cheatwood, and Lynda Roddie…," *SYVN*, Nov. 4, 1960, p. 1.

See: "Santa Ynez Valley, Ca., Elementary / Grammar Schools," "Santa Ynez Valley Union High School"

Posters, general (Solvang)
See: "Posters, general (Santa Ynez Valley)"

Posters, Latham Foundation (Santa Maria)
The Latham Foundation of Oakland fostered kindness to animals. Posters were made by school children for competition.
Posters, Latham Foundation (notices in Northern Santa Barbara County newspapers on microfilm and on newspapers.com)

1933 – "College Student Wins State Prize… **Rex Hall**, junior collegian… Latham Foundation for the Promotion of Humane Education … second prize… **Leonard Fisher**… honorable mention…," *SMT*, May 23, 1933, p. 1.

1934 – "Local Art Students Win Poster Awards. Five Santa Maria high school junior college students… Latham Foundation … **Leonard Fisher, Louie Ewing, Marie [Sic. Marrie] Breneiser, Joffre Bragg** and **Ada Okamoto**… made under the direction of **Stanley G. Breneiser**…," *SMT*, May 19, 1934, p. 1 [and repeated p. 5].

1935 – "Two Pupils Win Art Prizes… Tenth Annual International Humane Poster contest… for Promotion of Humane Education… **Yoshisake** [Sic. **Yoshisuke**] **Oish** [Sic. **Oishi**] and … **Joffre Bragg**…," *SMT*, May 6, 1935, p. 2.

1937 – "Receive Honor – **Elva Allen, Nick Firfires** and **Joffre Bragg**, students in Santa Maria high school, have been awarded Certificates of Merit for their outstanding

work in the 1937 poster contest held in Oakland and sponsored by the Latham Foundation…," *SMT*, May 14, 1937, p. 3.

1938 – "Local Lad Wins Prize for Poster. **Yukio Tashiro**" – second prize in National Latham Foundation for the Promotion of Humane Education, and article adds, "A nest of baby birds with the plea, 'Don't Orphan Us,' was the subject of Yukio's poster. **Mina's [Rushforth]** contribution pictured a chained dog and lettering asking, 'A Free Country for Me!' A painting of a bear and the slogan, 'Help Protect Wild Life,' was Gloria's [Hart] poster," *SMT*, May 18, 1938, p. 3.

1939 – "Local Students Win in Poster Competition… **Yukio Tashiro** won first prize in Group IV. Certificates of merit were awarded to Eleanore Needham, **Leslie Stonehart** and **Frances Sutherland**. All winning posters will be on exhibition in the Women's City Club auditorium…," *SMT*, May 1, 1939, p. 4.

1943 – "Broadcasting Class… of **Stanley G. Breneiser**… Students are now working on posters for the Latham Foundation… The Latham foundation, founded by those who advocate kindness to animals, has changed its poster contest to tie in with the war and the winning posters will be exhibited throughout the country for the furtherance of the 'win the war' effort," *SMT*, Nov. 12, 1943, p. 5.

1944 – "Poster Contest … Students in the art department of the high school have entered…," *SMT*, Feb. 5, 1944, p. 3; "Local Students Win Poster Awards … A second prize in Group 3 was won by **Jo Ann Smith**, and Certificates of Merit awarded to Bob Beall, **Billy Morton,** Dolores Simas, Louis Spruill, Jr., Gertrude Thornburgh and Richard Van Dyke," *SMT*, May 3, 1944, p. 3.

1949 – "**Kenneth Brown** Wins College Poster Contest," *SMT*, May 19, 1949, p. 5.

1959 – "Diane Wolf, a student at Santa Maria High School, won second prize, Group Three, in the 37th Annual International Poster Contest sponsored by the Latham Foundation for the Promotion of Human[e] Education. The following Santa Maria High School students were awarded certificates of merit: Joanne Knight, Sandra Wright, Patricia Casey, Gloria Bogavda [Sic.?], Juanita Almaquer, Deborah Daymon, Eddie Miller, Lyle Farmer, Susan Chadband, Peggi [Sic. Peggy, Margaret?] Bricker, Frances Manning, Tina Gamble, Melba Moroff, Barbie Maas, Ronnie Andrews, Jerry Mann, Cliff Quijada, Maria Silva, Jim Way, Frederica Filipponi, Isabel Juarez, Sherry Curnutt, Pat Way [Mrs. Charles Frank Kline], Bill Lister, Nancy Freitas, Don Morris, Willa Preast, Ponce Avelino, **Carol Schilder**, Lauri Kreiss, Peter Rodriguez, Barbara Piatt, Dorothy Uyeshima, Leslie Groves, Betty Kimmenau, Chuck Buchert, Richard Palato, Edward Villegas, Craig Smothermon, Sandra Paulson," per "Local Students Win in Contest" in Latham Foundation, *SMT,* May 18, 1959, p. 12 (i.e., p. 6).

1961 – "S. M. Student 4th in Poster Competition. John Mortenson, sophomore… won fourth prize in the senior high school division … Certificates of merit were awarded to the following Santa Maria High School students… Barbara Nunes…," *SMT*, May 20, 1961, p. 14.

See: "Santa Maria, Ca., Union High School," 1937, 1958, "Tashiro, Yukio"

Posters, Latham Foundation (Santa Ynez Valley)
The Latham Foundation of Oakland was founded by those who advocate kindness to animals. Posters were made by school children for competition.
Posters, Latham Foundation (notices in Northern Santa Barbara County newspapers on microfilm and on newspapers.com)
 "Solvang Pupils Win Awards. Five students of the Solvang Grammar School… were recently awarded certificates of merit in the 31st annual international poster contest sponsored by the Latham Foundation… The posters… portray kindness and world friendship through humane education…," *SYVN*, May 25, 1956, p. 2.

Posters, Minerva Club Flower Show
See: "Minerva Club, Flower Show"

Potter, Roy Whittier (1917-1978) (Santa Maria / Lompoc)
Commercial artist, 1946+. Sign painter with Clarence Norris, 1949. Designed cover of Santa Barbara County Fair premium book, 1950. Member of USDB civilian complement who designed posters for St. Mary's Auxiliary annual Bazaar, 1953.
Potter, Roy (notices in newspapers on newspapers.com)
1946 – Ad: "Fair Time is Here. Signs… Show Cards, Posters, Muslin Signs for Fair Booths, Stands, Displays. Roy Potter 'Dr. of Signs' (Painting, that is). 419 E. Church St. Phone 405-W. Residence Phone 952-R," *SMT*, July 20, 1946, p. 3.
1950 – "just offhand … *The Times* has been printing these annual fair premium books for more than a quarter of a century (26 years to be exact). But this year something new was added. Larry asked Roy Potter to design a suitable cover, and Roy did. 'It's the best looking fair book yet,' announced Bob Baker …," *SMT*, May 20, 1950, p. 4.
Potter, Roy (misc. bibliography)
Roy W. Potter, sign painter, is listed in the *Santa Maria, Ca., CD*, 1959, 1962, 1965; Roy Whittier Potter was b. May 27, 1917 in Colorado to Clyde A. Potter and Glennola Kathryn Whittier, married Flora Linda Monighetti, and d. April 28, 1978, in Pacific Grove, Ca., per Elmore Family Tree (ref. ancestry.com).
See: "Norris, Clarence Oscar," 1949, "Posters, general (Lompoc)," 1953

Potvin, Moise (Canadian)
French Canadian wood carver whose miniature carvings, owned by Delrae of Atlantic City, toured the nation and were exh. at Santa Barbara County Fair, 1952.
See: "Santa Barbara County Fair," 1952

Powers, Clifford James (1923-2000) (Lompoc)
Santa Ynez High School grad., 1940. Teacher of drafting at Lompoc high school, 1954/57.
■ Port. and "… joined the Lompoc High school faculty after a year in the Pasadena school system [i.e., McKinley Junior High]. He is a teacher of mathematics, drafting, shop

math and junior high general shop. Powers is a SantaYnez native and attended Compton college, Santa Barbara college, Long Beach State, Los Angeles State, and Auburn University. He is a member of Alpha Pi, honorary service organization and served in the Army Air Force. He resides with his wife, a son and a daughter, at 506 North J street," *LR*, Oct. 14, 1954, p. 7.
Powers, Clifford (notices in Northern Santa Barbara County newspapers on microfilm and on newspapers.com)
1945 – "Clifford Powers Given Three Oak Leaf Clusters," as a B-17 gunner in WWII, *SYVN*, Sept. 7, 1945, p. 1.
1947 – "Norma Gleason, Clifford Powers Engaged… Mr. Powers, who is a student at University of California, Santa Barbara College, graduated from the Santa Ynez Union Valley High School with the class of 1940 and attended Compton Junior College for two years before entering the Army Air Forces. Eleven months of his three years in uniform were spent overseas in Italy," *SYVN*, May 23, 1947, p. 6.
1952 – "Clifford Powers… son of Mr. and Mrs. James Powers of Santa Ynez, was graduated from Long Beach State Teachers college on June 13 and has accepted a teaching position in Pasadena," *SYVN*, June 27, 1952, p. 7.
Powers, Clifford (misc. bibliography)
Clifford James Powers was b. April 18, 1923 in Los Angeles to James Francis Powers and Erma Vivian McClain, married Norma Ann "Nonie" Gleeson, was residing in Orange, Ca., in 1964, and d. Dec. 28, 2000 in Encinitas, Ca., per Doug Powers Family Tree (refs. ancestry.com).
See: "Lompoc, Ca., Union High School," 1955

Powers, Sehon Wadsworth (San Luis Obispo)
Photographer. Showed his colored slides of flowers to Santa Maria Camera Club, 1952. Judged the flower photo competition at the Santa Barbara County Fair, 1953.
See: "Santa Barbara County Fair," 1952, "Santa Maria Camera Club," 1952, and *San Luis Obispo Art and Photography before 1960*

Prater (Foster), Barbara Lee (Mrs. Richard Foster) (1939-?) (Santa Maria)
Student at Santa Maria High School who exh. Allan Hancock [College] Art Gallery, 1957 and who won a prize in the Scholastic Art Exhibit, 1958. Art student at Hancock College, 1958/59.
■ Port. and "Mr. and Mrs. R. Foster Will Reside in Louisiana… Miss Prater is the daughter of Mrs. Alice Prater of 1030 W. Cypress and the late Fred Prater… The new Mrs. Foster attended local schools and was graduated from Santa Maria high school in 1958. She attended Allan Hancock College one year and has been employed at Spencer's Jewelry Store…," *SMT*, Sept. 26, 1961, p. 3.
Prater, Barbara (notices in Northern Santa Barbara County newspapers on microfilm and on newspapers.com)
1958 – "Students Win in National Art Show," i.e., National **Scholastic Art Awards** – and article adds, "Barbara Prater received an honorable mention for her wood sculpture of a Madonna and child. She plans to continue her study of art … at Allan Hancock College after graduating from the

local high school… Winning works are included in the national high school art exhibition in New York to be shown starting June 5," *SMT,* May 13, 1958, p. 3; "Awards Given at SMUHS Assembly … a $37.50 art award from the Junior Community Club to Barbara Prater…," *SMT,* June 6, 1958, p. 8; "SRO Audience Acclaims Hall Studio Dance Recital… **Forrest Hibbits**… and Barbara Prater, student of art in Allan Hancock College supervised by **George Muro**, painted sets…," *SMT,* June 17, 1959, p. 3.

Prater, Barbara (misc. bibliography)
Barbara Lee Prater, mother's maiden name Vierra, was b. April 19, 1939, in Santa Barbara county per Calif. Birth Index (refs. ancestry.com).
See: "Allan Hancock [College] Art Gallery," 1957, "Halloween Window Decorating Contest (Santa Maria)," 1953, "Posters, general (Santa Maria)," 1954, "Santa Maria, Ca., Union High School," 1955, 1958, 1959, "Scholastic Art Exhibit," 1958

Presbyterian Church / Presbyterian Ladies Aid (Santa Ynez Valley)
Group involved in several "artistic" activities – an Art Loan exhibit, 1935, a Mexican Market, 1944, the Santa Ynez Valley Fair (annual), 1927+, etc.
Presbyterian (notices in Northern Santa Barbara County newspapers on microfilm and on newspapers.com)
1935 – "The Presbyterian Ladies Aid are sponsoring an Art Loan exhibit which will be held at Legion Hall in Solvang next Saturday afternoon. Pictures of valley points or those painted by valley artists will be on display," *LR,* March 8, 1935, p. 5.
1944 – Presbyterian Ladies "Aid to Hold Sale… Mexican Market on Saturday Sept. 16 in Dania Hall… There will be an exhibit of paintings from member's homes, and **Mr. Leo Zeigler** [Sic. Ziegler] has donated two of his paintings to be auctioned off… **Sadie Forsyth**, art chairman … There will be an exhibition of Mexican arts and crafts," *SYVN,* Sept. 8, 1944, p. 1; "Presbyterian Women Hold Food Sale and Mexican Market. Two lovely water colors, one a scene on the Alisal Ranch and the other which the artist calls 'Sunset' have been given to the women of Santa Ynez Valley Presbyterian church to sell at auction at their Mexican Market on Saturday at 4 p.m. **Leo Ziegler**, the artist, has framed these pictures ready for hanging. They will be on exhibit all day Saturday. There will be an exhibit of Mexican things, but no other art exhibit as previously announced," *SYVN,* Sept. 15, 1944, p. 1.
1945 – "Presbyterian Ladies Aid… A lovely painting by **Leo Ziegler** of the Alisal hills was presented to the retiring president, **Mrs. Grace Davison**…," *SYVN,* March 9, 1945, p. 1.
1948 – "Silver Tea … This will celebrate the Golden Anniversary of the building of the church in Ballard. An oil painting of the late Judge Samuel Lyons, recently completed by **Charles Mattei** of Santa Barbara, will be shown for the first time. Judge Lyons was the head carpenter in construction of the building. There will be several other paintings on exhibit, some old photographs and some interesting keepsakes. A program has been planned and **Mr. and Mrs. Uno Sandvik** will sing," *SYVN,* May 14, 1948, p. 6.

1949 – "Presbyterian Church Ladies Aid… Arts and Crafts will be the theme of the August meeting with **Mrs. James Simerly** in charge…," *SYVN,* Feb. 11, 1949, p. 5.
And, nearly 450 hits for "Presbyterian Ladies Aid" in Santa Barbara County newspapers between 1930 and 1960 detailing teas, pot lucks, various fund raisers, etc. were not even browsed for possible inclusion here.
See: "Mexican Market," 1944, "Santa Ynez Valley Fair," "Ziegler, Leo"

Presbyterian Ladies Aid
See: "Presbyterian Church"

Preston, Ralph (Altadena)
Ceramics designer who made a large-scale model of Mission Santa Ines as it was in 1820 (Coll. Mission Santa Ines).
See: "Mission Santa Ines," 1955

Price, Ellis D. (1903-1983) (Lompoc)
Photographer, chemistry teacher and Audio Visual supervisor at Lompoc High, 1952/58.
■ Port. and "Ellis D. Price… has combined a chemical engineering degree and a teaching credential to become a chemistry teacher at Lompoc High. Price studied at Cal., Long Beach State, and San Diego State. At the latter school he played football, was a track athlete and a member of the annual staff. For seven years Price was engaged in foreign travel making photos and travelogues for steamship companies in the Far East and South America. His work has appeared in *National Geographic* and other magazines. Price was in other branches of the commercial photography field for 10 additional years and for six years was an industrial chemist. He is in his third year of teaching here. Price and his wife reside at 516 West Laurel avenue," *LR,* Oct. 21, 1954, p. 8.
Price, Ellis (notices in Northern Santa Barbara County newspapers on microfilm and on newspapers.com)
1952 – "Price Talks on Plastics. Ellis Price of Lompoc last night told Lompoc Rotarians about many of the new uses of plastics in science, commerce and industry. He discussed the composition and manufacture of plastics and illustrated his talk with samples of plastic material which were passed around among the members. Price… was formerly associated with a plastics firm in Los Angeles and still maintains a lively interest in the subject as a hobby," *LR,* July 24, 1952, p. 4.
Price, Ellis (misc. bibliography)
Ellis D. Price port. and caption "Central High School, Worden, Montana. Junior College," appears in San Diego High School yearbook, 1921; Ellis D. Price port. appears in University of California, Berkeley, yearbook, 1928; Ellis D. Price is listed in the 1930 U. S. Census as age 26, b.c. 1904 in Ill., single, working as a chemist in a food cannery in Long Beach, Ca.; Ellis D. Price, photographer, is listed on ship arrivals and departures from either NY or California, 1932, 1935 (age 31); Ellis Price (Audio Visual, Life Sciences, Chemistry) is pictured in the Lompoc High School yearbook, 1956; Ellis D. and Florence E. Price are

listed in the *Lompoc, Ca., CD*, 1958-76; Ellis D. Price, b. Sept. 11, 1903 in Ill., mother's maiden name Brooks, d. Aug.1, 1983 in Fresno, Ca., per Calif. Death Index (refs. ancestry.com).

Price (Clifton), Pauline Atkins (c. 1922-?) (Mrs. Clifford Franklin Clifton) (Santa Maria)
Exh. still life at Santa Barbara County Fair, 1949.
Recording secretary of Santa Maria Art Assn., 1949.
Five-year employee of Pacific Gas & Electric, 1951.
■ "Wedding Bells… Clifford Franklin Clifton, 37, 627 East Church and Pauline Atkins Price, 30, 121-A East Cypress," *SMT*, May 10, 1952, p. 4.
See: "Santa Barbara County Fair," 1949, "Santa Maria Art Association," 1949

Price, Vincent Leonard (1911-1993) (Hollywood)
Actor / artist / collector invited to be guest speaker at Santa Maria Art Festival, 1952.
■ "Vincent Leonard Price Jr. (May 27, 1911 – October 25, 1993) was an American actor best known for his performances in horror films, although his career spanned other genres, including film noir, drama, mystery, thriller, and comedy. He appeared on stage, television, and radio, and in more than 100 films," per Wikipedia.
He had a special interest in art. He was donor of the Vincent Price Art Museum at East Los Angeles College.
See: "Santa Maria [Valley] Art Festival," 1952

Prindle, Frances H. (Mrs. Kenneth Prindle) (Santa Maria)
Exh. tooled leather goods at Santa Barbara County Fair, 1937. First wife of Kenneth Prindle, below.
See: "Prindle, Kenneth," 1962, "Santa Barbara County Fair," 1937

Prindle, Kenneth Everett (1909-1962) (Santa Maria)
Amateur photographer. Member Santa Maria Camera Club c. 1948+ who lectured to the Woman's Club of Arroyo Grande, 1950. Exh. Santa Barbara County Fair, 1959. Husband to Frances Prindle, above.
■ "Funeral services for Kenneth E. Prindle, Santa Maria businessman who died Thursday morning… Mr. Prindle, 52, was born March 7, 1909, near Pecos, Tex. He came to Hanford, Calif., in 1918 with his parents and then in 1926 to Santa Maria. He was graduated from Santa Maria High School. He worked as an auto mechanic until he purchased a local shoe store, expanding it eventually to the present clothing store for men and boys. He served as president of the Santa Maria Retail Merchants Assn. in 1961. He also was a past president of the Santa Maria Camera Club and was a member of the Chamber of Commerce, Kiwanis Club, Elks Lodge, Santa Maria Shrine Club and Santa Maria Club. Surviving him are his wife, Elizabeth…," and port. and "Ken Prindle Final Rites on Saturday," *SMT* March 2, 1962, p. 2; "Ken Prindle, Merchant, Dies at 52," *SMT*, March 1, 1962, p. 1.

Prindle, Kenneth (notices in Northern Santa Barbara County newspapers on microfilm and on newspapers.com)
1949 – "Mr. and Mrs. Kenneth Prindle and family will leave tomorrow to spend ten days at Yuba river. Traveling with their trailer house, the Prindles are carrying equipment for the family to fish and also to photograph scenic spots en route," *SMT*, July 1, 1949, p. 5.
1955 – "Prindle Wins Print of '54 Camera Prize" from Santa Maria Camera Club, and other prize winners listed, *SMT*, Jan. 17, 1955, p. 4.
1956 – Port of **Norman Brown**, winner of a prize, and "Kenneth Prindle Wins [5-C] Photography Contest," *SMT*, Nov. 21, 1956, p. 4 and Arroyo Valley Camera Club won "B" prize, and other prize winners listed.
1962 – "Mrs. Elizabeth Prindle (right) widow of former Santa Maria Camera Club President Ken Prindle, presents County Fair theme girl Sue Sjoquist with the Ken Prindle Memorial Trophy which will be awarded for the best black and white print in the photography division of the Fair… The trophy will become the permanent possession of the first photographer to win it three times…," *LR*, July 19, 1962, p. 31 (i.e., 1-D); "Trophy Set to Honor K. Prindle… 'the man who was never too busy to help other photography amateurs.' Mrs. Elizabeth Prindle is donating a perpetual trophy for the best of show black and white print at the 1962 County Fair… Photography fans in the past have seen many of the late Kenneth Prindle's fine prints. They have won ribbons at County Fairs of recent years and have been hung in the monthly print exhibits judged for Santa Maria Club in which he was an active member and past president …," *LR*, July 19, 1962, p. 33 (i.e., 3-D).
Approx. 220 hits for "Kenneth Prindle" and more than 100 for "Ken Prindle" in the *SMT* between 1935 and 1962, many of which refer to his activities with the Santa Maria Camera Club, were too numerous to be browsed for potential inclusion here.
Prindle, Kenneth (misc. bibliography)
Kenneth E. Prindle, mother's maiden name Hoyt, was b. March 7, 1909 and d. March 1, 1962 in Santa Barbara County per Calif. Death Index; Kenneth Everett Prindle (1909-1962) is buried in Santa Maria Cemetery District per findagrave.com (refs. ancestry.com).
See: "Arroyo Grande Valley Camera Club," "Boy Scouts," 1949, "Deaderick, Moreland," 1955, "Prindle, Frances," "Santa Barbara County Fair," 1959, "Santa Maria Camera Club," 1948, 1949, 1950, 1952, 1954, 1955, 1957, 1960

Print Makers Association of California [Sic. Printmakers Society of California, formerly Printmakers of Los Angeles]
Exh. at the Minerva Club, 1922.
See: "Minerva Club," 1922

Pritchard, George Thompson (1878-1962) (Australia / California)
Painter from Australia who held an exh. at Santa Maria High School sponsored by Junior Art Club of the College Art Club, 1933, and a second exh., 1934.

■ "Pritchard was born in Havelock, New Zealand on April 11, 1878. He studied in Auckland at the Academy of Art, at the Elam School of Art and at the Melbourne Academy of Fine Arts. He first came to the US (San Francisco) in 1906 following the earthquake and remained for three years painting many landscapes. Then he moved on to Milwaukee and finally to Paris and to Amsterdam where he took further art study. During WWI he lived in Canada, New York and Richmond, Va. In 1935 he settled in southern California where he both taught art and exhibited his works," per *National Cyclopedia of American Biography.*
Exh. at Francis Webb Galleries, LA, 1935, 1940 per Nancy Moure, *Publications in California Art*, v. 6.
Pritchard, George (misc. bibliography)
George T. Pritchard was b. April 11, 1878 in Other Country and d. Feb. 26, 1962 in Los Angeles County per Calif. Death Index; many photos relating to Pritchard are in *Private Member Photos* (refs. ancestry.com).
See: "College Art Club," 1933, "Santa Maria, Ca., Union High School," 1934

Procter, Burt (1901-1980) (Pasadena / Corona del Mar / Palm Springs)
Artist who exh. at Santa Maria Valley Art Festival courtesy Cowie or Dalzell Hatfield Gallery in LA, 1952, 1953.

■ Painter of western landscapes and of "cowboys and Indians" while working at his main career – that of mining engineer and later commercial illustrator, per askart.com.
See: "Santa Maria [Valley] Art Festival," 1952, 1953

Professional Photographers (Santa Maria)
Photography business run by Robert Dupuis, 1960.
See: "Dupuis, Robert C."

Public Schools Week (Northern Santa Barbara County)
Annual event instituted by the Masons c. 1919. Parents were invited to visit the school, meet the teachers, and view displays of student work.
[Sometimes referred to by the newspapers as "Parent's Night" or "Education Week."]
See: "Allan Hancock College Art Gallery," 1956, "Dipple, Gordon," "Guadalupe, Ca., Elementary School," 1934, 1939, 1957, "Lompoc, Ca., Adult/Night School," 1952, "Lompoc, Ca., Elementary Schools," 1932, 1936, "Lompoc, Ca., Union High School," 1936, "Posters, general (Lompoc)," 1960, "Santa Maria, Ca., Elementary Schools," 1934, 1945, 1947, 1950, 1954, 1956, 1958, "Santa Maria, Ca., Union High School," 1934+, "Santa Ynez Valley, Ca., Elementary / Grammar Schools," 1949, 1951, 1954, "Santa Ynez Valley Union High School," 1961

Public Works of Art Project (PWAP)
New Deal Art Project, 1934. Short-lived relief project. Art by some of its artists was distributed to public buildings in northern Santa Barbara County.

■ "The Public Works of Art Project (PWAP) was a program to employ artists, as part of the New Deal, during the Great Depression. It was the first such program, running from December 1933 to June 1934. It was headed by Edward Bruce, under the United States Treasury Department and paid for by the Civil Works Administration... The purpose of the PWAP was 'to give work to artists by arranging to have competent representatives of the profession embellish public buildings.' Artists were told that the subject matter had to be related to the 'American scene'. Artworks from the project were shown or incorporated into a variety of locations … Artists participating in the project were paid wages of $38 – $46.50/week," per Wikipedia.
PWAP (notices in Northern Santa Barbara County newspapers on microfilm and on newspapers.com)
1934 – "Art Works Hung in Santa Maria Public Buildings… An allotment of several hundred studies in [oils, water colors and etchings] … was given to Mrs. [Muriel] Edwards [County Superintendent for schools] for distribution in Santa Barbara county schools and [Douglass] Parshall, as representative of the PWAP, was in charge of distribution of more pictures in Ventura and San Luis Obispo counties. Oils were given to Santa Maria Union high school and the county office building. Others were earmarked to be hung later in the city hall when it is completed. A massive oil, using technique similar to that employed in murals, was hung in the superior court room in the county office building, centered behind the judge's bench. Lincoln is Depicted. Entitled 'Leaders of American Democracy,' this oil depicts Abraham Lincoln holding a bust of Washington with the spires of a city and rural fields as background… Lyla Harcoff's painting, 'Carnations,' was given to the county health department headquarters… An etching, 'Boulder Dam,' portraying the sweating labor of man and machine… was set aside for the city hall. Also for the city building is an oil, 'Sagebrush and High Sierra,' by Ernest Browning Smith. 'Relic of the Gay Nineties,' an oil by Gile Steele, was hung in the county building. Three Oils for School. Santa Maria high school received three oils, 'Minute Man,' Lorser Feitelson, 'Premier in Westwood,' Dedrick B. Stuber, and 'Bolero,' John Coolidge. The latter composition was suggested by the musical number… by Maurice Ravel. Two water colors and an etching also were presented to the high school. 'Antique Figure,' J. C. Wright; 'Road Mark,' Milford Zornes, and 'Trespassers,' by Mildred Bryant Brooks… 'Scripps Institute Pier at La Jolla,' by Milford Zornes and 'Yacht Harbor at San Pedro,' Robert Lockwood, were hung at El Camino, and 'Santa Barbara Mountains,' Everett L. Bryant and 'Baby Street,' Mildred Bryant Brooks, were left at Guadalupe. The pictures all were painted under the auspices and with funds of the PWAP … Mrs. Edwards and Parshall were on a tour of the schools of the county and left pictures at Carpenteria, Santa Barbara, Lompoc, Goleta, Vista del Mar, Orcutt, Santa Ynez, and in this valley …," *SMT*, June 7, 1934, p. 1.

"Art Works Hung in Santa Maria," and article says, "Two water color scenes, 'Road Mark' and 'Scripps Institute Pier at La Jolla,' both by **Milford Zornes**, a Santa Maria High school and College student, now hang in Santa Maria schools, the former at the High school and the latter at El Camino elementary school. They were only two of a dozen or more brought to this part of the county Wednesday by Mrs. Muriel Edwards, county superintendent of schools, and **Douglass Parshall** … Under the ruling of the Public Works of Art Project, the oil paintings can only be hung in public buildings and high schools; water colors and original colored **Millard Sheets** [sic.] to elementary schools; 'Declaration of Independence' to all schools, and lithographs for all elementary schools. Other creations and their locations are: …" *SMFA*, June 8, 1934, n. p.

Puppets (including marionettes) (Lompoc)
Puppets were frequently created in public schools and in recreation programs beginning in the 1930s. Itinerant and locally produced puppet shows were performed.
Puppets (Lompoc) (notices in Northern Santa Barbara County newspapers on microfilm and on newspapers.com)
1932 – "Marionette Show Scheduled at Hi School… **Hollywood Marionette Theater**…," *LR*, Sept. 9, 1932, p. 8.
1947 – "More Than 900 Entertained at … Johns-Manville [Christmas Party] at the Veterans Memorial building… A high light of the afternoon was a puppet show presented by the **Geddis and Martin Puppet Theater** of Santa Barbara. The three puppet plays were 'Punch and Judy,' 'Rabbit Ballet,' and a trained seal act. Earl Weaver entertained the children with his cartoons…," *LR*, Dec. 18, 1947, p. 26 (actual date on paper reads Dec. 25, 1947, p. 2).
See: "Alpha Club," 1953, "Stover, Dalton," "Summer School (Lompoc)," 1953, 1958, 1959, 1960, "Wolo"

Puppets (including marionettes) (Santa Maria)
Puppets were frequently created in public schools and in recreation programs beginning in the 1930s. Itinerant puppet shows were performed in town.
Puppets (Santa Maria) (notices in Northern Santa Barbara County newspapers on microfilm and on newspapers.com)
1932 – "High School Students Sponsor Show Tonight of **Monro Marionettes**… 50 marionettes, many of them real portrait puppets of famous movie stars," and history of Monro Marionettes in Hollywood, *LR*, Sept. 16, 1932, p. 8; "Puppet Show for Lunch Fund… PTA is sponsoring… shown… at the high school auditorium… **Monroe Hollywood Marionettes**…," *SMT*, Oct. 18, 1932, p. 3.
1933 – "Famous Puppeteers to be in Santa Maria," and article adds, "Fairyland and Hollywood combined will be introduced to Santa Marians on October 9 when that delightful and bizarre troupe, 'The Famous **Olvera Puppeteers**,' present their 'Puppet Gaieties of '33,' at the Main street school auditorium… Exact puppet replicas of Greta Garbo, Marie Dressler, Clark Gable and Joan Crawford are troupers in this famous show which is on tour from their Olvera St., Los Angeles, theatre," *SMFA*, Sept. 22, 1933, n. p.; "Puppeteers of Hollywood on Stage Here… benefit performance for the school hot lunch fund… Santa

Maria Parent-Teacher council… three performances at the Main Street school auditorium…," *SMT*, Oct. 6, 1933, p. 3.
1935 – "Marionette Artists Entertain Hi School Students," and article adds, "**Robert** and **Edith Williams**… show, 'The Birds, the Beasts, and the Carpenter,' at the [Santa Maria] high school auditorium. The story is an adaptation of Richard Burton's translation of the Arabian Nights. All marionettes used by the performers are personally constructed. The two artists first started their noteworthy career as a strolling company on the Pacific coast seven years ago. Their itinerary includes a year in Spain and France and the distinction of being the first American marionette artists to have played in Paris. Since returning from the continent they have played in New England, New York and southern California. Old favorites, such as 'Alice in Wonderland,' 'Romeo and Juliet,' 'Calarency Among the Indians,' 'Hansel and Gretel,' and 'Peer Gynt' are included in their stock of productions," *SMFA*, March 1, 1935, n. p.; "Audience Sees a Puppet Show. 'The Worm Turns,' a two-act … Methodist church social hall…," *SMT*, March 8, 1935, p. 3; "St. Peter's … The **Saints' Puppeteers** entertained with a puppet performance of 'The Worm Turns.' Those taking part in the operation of the puppets were: …," *SMT*, May 9, 1935, p. 4; "Puppets to be Exhibited Here…," i.e., Christmas program by unnamed itinerant troupe sponsored by Shell Oil," *SMT*, Dec. 4, 1935, p. 2; Shell's "Puppets Entertain Children" and photo, *SMT*, Dec. 11, 1935, p. 6.
1938 – Shell Shows Puppet Playlet in **S. M. Fair**," *SMT*, July 20, 1938, p. 6; "Santa Claus and Joey the Clown who will arrive soon with the Shell Christmas Show bringing a novel puppet performance," *SMT*, Dec. 8, 1938, p. 10; "Puppet Show in H.S. Jan. 6" by **Dr. E. L. Barbour**, ventriloquist, *SMT*, Dec. 17, 1938, p. 2.
1941 – Shell Oil's "Santa and Joey Here Soon," *SMT*, Dec. 11, 1941, p. 8.
1945 – "Puppet Show Here Next Wednesday" put on by Helen Gardner of Santa Barbara's City Recreation Department and her students, *SMT*, March 22, 1945, p. 3; "Puppet Show to be Indoors" in public library, "The Golden Cockerel," *SMT*, March 27, 1945, p. 3; "Puppet Show has Large Audience," *SMT*, March 28, 1945, p. 3.
1954 – Photo and "**Gilmore Puppets** to Show" sponsored by AAUW and shown at Santa Maria high school, *SMT*, Feb. 18, 1954, p. 4; "Standing Room Only Audiences See Marionettes," *SMT*, Dec. 6, 1954, p. 4; photo of women and crafts and "Girls Friendly Society to Stage Puppet Shows … at Christmas Fair at the Episcopal Parish hall… ," *SMT*, Dec. 3, 1954, p. 4.
See: "Arts and Crafts Guild," 1954, "Boy Scouts," 1951, 1955, 1958, "Camp Fire Girls," 1955, 1956, 1958, "Chalk Talks," 1951, 1952, "Dal Porto, Gertrude," "DeNejer, Jeanne," 1945, "Girl Scouts," 1952, 1954, 1956, 1959, "Guadalupe, Ca., Elementary," 1957, "Lompoc, Ca., Elementary Schools," 1934+, "Milburn, Eddy," "Minerva Club," 1957, "Neil, Milt," "Orcutt, Ca., Elementary School," 1949, 1957, "Orcutt Community Church," 1949, "Santa Barbara County Fair," 1938, "Santa Barbara County Library (Lompoc)," 1960, "Santa Maria, Ca., Elementary Schools," 1934+, "Santa Maria, Ca., Union High School," 1934+, "Santa Maria School of Art," 1933, "Santa Maria Valley Art Festival," 1952, 1953, "United Service

Organization," 1945, 1946, "University of California, Extension," 1955, "Zendejas, Rene"

Puppets (including marionettes) (Santa Ynez Valley)
Puppets were frequently created in public schools and in recreation programs beginning in the 1930s. Itinerant puppet shows were performed in town.
Puppets (Santa Ynez Valley) (notices in Northern Santa Barbara County newspapers on microfilm and on newspapers.com)
1955 – "Thursday, Aug. 25, Santa Ynez Valley Community Arts Music Assn., garden party and puppet show, at home of Mrs. Sarah A. Kirkpatrick, 3 p.m.," *SYVN*, Aug. 19, 1955, p. 1, col. 1.
1960 – "Solvang Youngsters Join for Puppet Theatre Fun… the four youngsters of **Mrs. Mitchell Hoenig** and **Mrs. Victor Palmer [Bunny]** and another foursome of … friends… It all began two weeks ago when Mrs. Hoenig, who lives at 1637 Copenhagen Drive, created two hand puppets for her daughter, Susan, 6, and son, Peter 4… Twin children of Mrs. Palmer, Teresa and Claude, 8, were attracted to the colorful puppets… as were the Hoenig's next-door neighbors… Mrs. Hoenig… With the aid of the children, she made another 10 puppets. Jon Moore obtained a large cardboard carton and painstakingly went about cutting out a theatre and stage. Complete with curtains, the name Mission Theatre… was inscribed across the front… writing two plays… 'Electing a King,' a one-act production, the second was the three-act mystery, 'The Case of the Missing Pastries.' The youngsters are now involved in rehearsal… Mrs. Hoenig, who moved to Solvang with her children and husband, an engineer at Vandenberg Air Force Base, last September from Massachusetts, is on temporary leave of absence from the puppet theatre. She became the mother of an eight-pound, nine ounce baby girl last Saturday in Santa Barbara," *SYVN*, June 24, 1960, p. 3; "Puppet Show Set Tomorrow… **Bob Bromley** and his Personality Puppets will be the featured attraction at the 1 p.m. matinee tomorrow at the Mission Theatre. Bromley has appeared many times on TV… Each puppet is a separate personality, or, rather, a satire on a famous personality… Bromley, formerly with the technical department at MGM… recently finished a series of puppet cartoons in Hollywood…," *SYVN*, Oct. 21, 1960, p. 3 and ad. on p. 6.
See: "Hibbits, Forrest," "Hibbits, Marie," "Santa Ynez Valley, Ca., Elementary Schools," 1933+, "Solvang Woman's Club," 1951

Purcella, Ida Mae
See: "Chester (Huffman) (Purcella?), Ida Mae (Mrs. Fred Huffman) (Mrs. Purcella?)"

Purisima Camera Club (Lompoc)
See: "La Purisima Camera Club"

Purkiss, Myrton N. (1912-1978) (Fullerton)
Potter. Exh. in Santa Maria Valley Art Festival, 1952, 1953. Distantly related to the Glines family of Santa Maria.
■ "**Zornes** Paintings to be in Art Show" along with "Myrton Purkiss will be represented in the pottery division of the professional section… He is also represented in many of the museums and private collections in the United States. He is winner of many awards …. Mr. Purkiss is a resident of Fullerton," *SMT*, May 20, 1952, p. 4.
Purkiss, Myrton (misc. bibliography)
Myrton Purkiss b. March 10, 1912 in Canada, d. Sept. 15, 1978 in Fullerton, Ca., and is buried in Loma Vista Memorial Park, Fullerton, per findagrave.com that also includes ports. of him and the statement "Myrton Purkis was a painter of fine ceramic art pottery. Based in Fullerton, California, his innovative mid-century designs are highly collectible today and are even displayed in museums" (refs. ancestry.com).
See: "Santa Maria [Valley] Art Festival," 1952, 1953

Pursel, Ruberna Ruth
See: "Downs (Pursel) , Ruberna Ruth (Mrs. Harry Wellman Pursel)"

Puttering Micks (Lompoc)
Group of female Lompoc ceramists, 1958.
"The guests included the Mesdames **Eddie Houk, Robert Hendy**, Kenneth [Norma] Stillman, **Joe Grossini, Ken Skeate, Phillip Tognetti**, Pearline, [Mrs. Dwight] Babcock and **Cecil Thompson**, members of the Puttering Micks Ceramics group," per "Birthday Party Honors Pioneer," i.e., Mrs. Nellie Ayala, *LR*, June 5, 1958, p. 13.

Putz, Siegfried Georg (1893-1975) (Pennsylvania / Ohio)
Artist / writer for Burpee Seeds, who sketched in Lompoc, 1936.
■ "Seed Catalog Artist Concludes Work at Burpee Farm Here. Siegfried Putz, artist and descriptive writer, returned this week to Pennsylvania after spending a month at the Floradale farms of the Burpee Seed company going over the fields, making color sketches and writing descriptions for catalogs for the seed company…," *LR*, June 19, 1936, p. 8.
Putz, Siegfried (misc. bibliography)
Siegfried Putz is listed in the 1930 U. S. Census as age 37, b. c. 1893 in Germany, working as a seed man, residing in Doylestown, Pa., with wife, Gertrud (age 27); Siegfried Putz b. March 7, 1893 and d. Aug. 29, 1975 in Maumee, Ohio, is buried in Ottawa Hills Memorial Park, Ottawa Hills, Ohio, per findagrave.com (refs. ancestry.com).

Pythian Needlecraft Society / Pythian Sisters Thimble Bee / Pythian Sisters
Needlecraft sub-group of the Pythian Sisters, a fraternal organization for women aged 16 and older that provides opportunities for them to help themselves and others grow through the principles of Purity, Love, Equality and Fidelity," per pythiansisters.org.
See: "Girl Scouts," 1952, "Haslam, Lucy," "Heiges, Margaret," 1942, 1963, "Mathewson, Esther," 1946, "Quilts," 1928, "Santa Barbara County Fair," 1939, "Thimble Bee"

Q

Queisser (West), Vina Virginia (Mrs. Franklyn / Franklin E. West) (1905-1976) (Lompoc / Santa Barbara / Palo Alto)
Teacher of art and drawing at Lompoc high school, 1927/31.
"Returns Home – Mrs. Franklyn West returned to her home in Santa Barbara Wednesday night after spending several days visiting Mrs. Floyd J. McCabe. Mrs. West will be remember[ed] as Miss Vina Quiesser [Sic. Queisser], a former teacher in the local high school…," *LR*, Sept. 25, 1931, p. 5.
Queisser, Vina (misc. bibliography)
Vina Virginia West, father's name Queisser, was b. June 2, 1905 in Calif. and d. Sept. 8, 1983 in Santa Clara County per Calif. Death Index; Vina Virginia West (1905-1983), father's name Alexander Queisser and mother's Theresa Louise Queisser, husband's name Franklin E. West, is buried in Alta Mesa Memorial Park, Palo Alto, Ca., per findagrave.com (ref. ancestry.com).
See: "Lompoc, Ca., Union High School," 1927, 1928, "Lompoc Valley Fair," 1930

Quick, Jonah "Bud" (Jonah Quick, Jr.) (1920-2011) (Orcutt)
Photographer, amateur. Active with Santa Maria Camera Club, 1950s, and president, 1953. Exhibited and won prizes at Santa Barbara County Fair, 1958+. Photo contest judge, 1960.
■ "Jonah 'Bud' Quick (1920-2011) … He was born on Feb. 4, 1920 to Jonah and Florence Quick in Deepwater, Mo. Bud has lived in Santa Maria since his childhood and attended local schools in Orcutt and Santa Maria. He is a graduate from Santa Maria Union High School. He served his country in the U. S. Navy during WWII. After being discharged, he returned to Santa Maria and worked for Union Oil Co. until his retirement after 38 years…," *SMT*, Dec. 9, 2011, p. A4.
More than 110 notices for "Bud Quick" appear in the *SMT*, 1950-1970, and primarily detail his photography, but they were too numerous to itemize here.
See: "Community Club (Santa Maria)," 1960, "Santa Barbara County Fair," 1958, 1959, 1960, "Santa Maria Camera Club," 1953, 1954, 1955

Quilting Club (Gaviota)
See: "Quilts," 1930

Quilts (Northern Santa Barbara County)
Quilts were made by individuals and at "sewing bees," and many antique and/or newly made quilts were displayed at the County and other local fairs.
Quilts (notices in Northern Santa Barbara County newspapers on microfilm and on newspapers.com)
1888 – "Perhaps the most notable piece of handiwork exhibited in the state at any of the fairs, is the white knitted cotton quilt by Mrs. D. C. Henning of Lompoc, which took the premium at the late Santa Barbara Fair and is now on exhibition at the Santa Maria Fair. It took one hundred days of faithful work…," *LR*, Sept. 15, 1888, p. 3.
1890 – "Miss Addie Jackson, the 13-year-old daughter of Major Jackson of Lompoc, has put in all her leisure time during the past year in constructing a beautiful 'crazy work' silk quilt, and last week … sent it to the fair at Santa Maria where it received the first premium for work of that class…," *LR*, Sept. 20, 1890, p. 3.
1910 – "Santa Rita Items. The Ladies' Aid is to meet at the home of Mrs. Mary Randells… Cutting quilt blocks will be the order of the day," *LR*, Jan. 28, 1910, p. 1; "Santa Rita Items. Last week… the Ladies' Aid met … and quilted a very nice friendship quilt for Mrs. Eunice Brown…," *LR*, Jan. 21, 1910, p. 5.
1911 – "Honey Crop … The Ladies' Aid met at the church Thursday and Friday of this week for the purpose of quilting a quilt for one of its members," *LR*, July 21, 1911, p. 1.
1927 – "The Embroidery Club met last Friday… The afternoon was spent in working on a quilt for the Associated Charities…," *LR*, Dec. 9, 1927, p. 1.
1928 – "The **Pythian Sisters** enjoyed a social afternoon Wednesday when several members tied quilts at the home of Mrs. Dan Douglass," *LR*, Feb. 17, 1928, p. 4.
1929 – "Quilt Made for Fair – The Catholic ladies met yesterday at the Parish House to make a beautiful star pattern quilt which will be disposed of at the fair to be held by the Altar Society in November," *LR*, Oct. 4, 1929, p. 7; "Gavotan Notes. A group of ladies held a 'quilting bee' in the school auditorium this week. The blocks … were pieced by the boys and girls of the four upper grades. The quilt is a gift by them to Mrs. Cecil R. Scott, director of the school orchestra," *SYVN*, Nov. 8, 1929, p. 6.
1930 – "Gaviota news… The ladies of the **Quilting Club** are now busy quilting their fourth quilt in the school auditorium," *SYVN*, Feb. 7, 1930, p. 5; "Baptist Women Meet – The Women's Union of the Baptist church met for an all-day session… typing a quilt…," *LR*, April 4, 1930, p. 8; "'Friendship Quilt'… composed of more than 950 pieces of cloth donated by pioneers…," per "Five Years Ago – 1930," *LR*, Sept. 20, 1935, p. 2.
1933 – "Santa Maria to Hold Quilt Show," *SLO T-T*, March 22, 1933, p. 5; "Lompoc Women Join **Better Homes** Tour… **Mattei's Tavern**… exhibition of 19 hand-made quilts. Outstanding among them was one made of sateen in the 'Dresden Plate' pattern," *LR*, April 28, 1933, p. 2.
1934 – "Mexican Women Encouraged to Raise Standard of Living by Instruction in Needlework Given by Local

Women… Last Saturday some 20 women and girls were busily engaged in making quilts and garments…," *LR*, Feb. 16, 1934, p. 2; "Treasured Quilts are Displayed in Los Olivos Exhibit… Ladies Missionary Society entertainment and quilt exhibit in the Los Olivos School auditorium…," and some quilts described, *SYVN*, June 1, 1934, p. 1.
1935 – "Patchwork Quilt, 48 Years Old, is Displayed…," *LR*, Aug. 9, 1935, p. 6; "Quilting Bee Held at Beattie Home…," *LR*, Aug. 9, 1935, p. 9; "La Purisima Club Quilt Drawing. Spider Web Pattern Quilt. Holder of this lucky ticket gets this pretty quilt to be drawn at this store Saturday, October 19th, 3 p.m. Moore's Grocery," *LR*, Oct. 18, 1935, p. 3; "Patch-Work Quilt Pageant" will be Presented by Church… exhibits old quilts," *LR*, Oct. 18, 1935, p. 5; "103-year-old Quilt Wins Prize at Methodist Pageant," *LR*, Nov. 8, 1935, p. 3.
1936 – "Pieced Quilt Prize at Mission … Pieced and quilted by Mission bridge club members… 'Fan' pattern… main prize…," at public card party, *LR*, May 8, 1936, p. 10; "Guild Members Work on Quilts. Presbyterian Guild… 'fan' pattern," *LR*, Aug. 21, 1936, p. 9; "Mrs. Spanne Wins 'Memory' Quilt… [made by] Senior American Legion Auxiliary…," *LR*, Dec. 18, 1936, p. 7.
1937 – "Sewing Bee Enjoyed by Miguelito Circle. Sewing on their quilt formed the main order of business when Miguelito Circle of Eastern Start met Thursday afternoon…," *LR*, July 30, 1937, p. 4.
1943 – "Red Cross… A great deal of credit is due Mrs. Soren Petersen who has made over a dozen baby quilts and 50 pairs of wool slippers…," *SYVN*, April 16, 1943, p. 4.
1945 – "Finish Quilt – The members of the Women's Society of Christian Service of the Methodist Church finished sewing on the quilt which they will send to one of the veterans' homes…," *LR*, Oct. 12, 1945, p. 2.
1951 – Presbyterian "Guild Circles… Work on Quilt. Members will continue working on the quilt they are making when Circle Four meets…," *LR*, May 31, 1951, p. 4.
1959 – Photo of a woman with a "Centennial Quilt" made 100 years ago in Nebraska, on a loom, *LR*, Feb. 26, 1959, p. 4.
Many additional notices on quilts made by individuals, needlework groups, Home Department, Red Cross, **AWVS**, Ladies Aid, etc., for donation to the poor or to be raffled or given as prizes were too many to be itemized here. How-to articles on quilt making, whose popularity revived in the 1930s along with other handwork, were not itemized here.
See: "Better Homes," 1932, 1933, "Callis, Martha," "Handwork," "Santa Barbara County Fair," "Thimble Bee"

R

Radford (Simas), Dorothy Laura (Mrs. Vernon Lawrence Simas) (1921-2007) (Santa Maria)
Art student at Santa Maria high school. Her design for a child's nursery design won a prize in a contest conducted by Pacific Mills, 1937.

■ Port. and "Dorothy L. Simas … Her parents, Charles and Loretta Radford brought her to Casmalia when she was

two months old. Soon after, they moved to Orcutt, where Dorothy was raised. She attended Orcutt School, then Santa Maria High School… Dorothy also was a top athlete in high school and won an award for designing material. Later in her life she was a secretary for Joe Nightingale at Orcutt School. She also worked for Union Oil during WWII…," *SMT*, July 27, 2007, p. 11.
Radford, Dorothy (notices in Northern Santa Barbara County newspapers on microfilm and on newspapers.com)
1937 – "Student Wins Prize for Design," and article states, "A picture of Dorothy Radford, junior student of the Santa Maria high school, will appear in the fashion section of the September issue of the *Woman's Home Companion*, it was learned this week, when a letter was received announcing Miss Radford as a winner of a $5 prize for a nursery design submitted in the contest conducted by the Pacific Mills, a large textile company. Along with Miss Radford's picture will run a picture of her winning design which will be used in fabrics for children's garments. She is a student in Miss **Elizabeth Breneiser**'s design class…," *SMT*, May 22, 1937, p. 2; "Miss Radford Wins Prize … for a textile design in a contest sponsored by the Pacific Mills Co. and conducted by the *Woman's Home Companion* magazine. As a prize, Miss Radford has received five yards of curtain material printed with her own design, which is suitable for curtains in a child's nursery or bedroom. Winning designs will be published in a fall issue of the magazine," *SMT*, Sept. 9, 1937, p. 2.
Radford, Dorothy (misc. bibliography)
HUSBAND - married Vernon Lawrence Simas, April 13, 1938, per her husband's obituary on santamariatimes.com, Dec. 1, 2004 and it adds, "Mr. Simas is survived by his wife of 66 years, Dorothy; his daughters, Sandy Knotts of Santa Maria and Patricia Lister of Orcutt; his sons, Tim Simas and wife Christy of Park City, Utah, and Scott Simas and his wife Mary of San Francisco. Dorothy Laura Radford was b. Jan. 31, 1921 in Holtville, Ca., to Charles William Radford and Loretta Looney, married Vernon Lawrence Simas, and d. July 25, 2007 in Santa Maria, Ca., per Simas Family Tree (refs. ancestry.com).
See: "Santa Maria, Ca., Union High School," 1937

Ragland (Goodman), Peggy Lynne (Mrs. David Goodman) (1941-?) (Santa Maria)
Art major at Santa Maria High School, 1959.

■ Port. and "Peggy Ragland is VAFB Elks Queen Candidate… one of the eight candidates to be queen of the Elks Rodeo… senior at Santa Maria Union High School where she is taking a college preparatory course with a major in art. The one problem Peggy has about her future career is the field of art she should pursue. 'I paint in oils and I sculpture [Sic.] in soap and clay,' she said, 'but I don't know which I want to do. I think I'll study different kinds and find out what I like and can do best.' Peggy … would like to continue her art training at a school in Los Angeles. One difficulty here is that her parents, Lt. Col. and Mrs. Richard Ragland, are at Vandenberg Air Force Base and Col. Ragland could be transferred to another assignment…. Peggy's other interests are also on the creative side. She enjoys writing stories and participating in dramatics. She was in the all school play this year… She

has even had a fling at radio broadcasting as a disc jockey. She was 'Miss Moon Miss' and had a nightly program for a radio station at Topeka, Kan. Peggy teaches Sunday School… The Raglands are natives of Texas… This is the first time Peggy has lived in California, although her father's career as an Air Force officer has taken the family to many places, including Germany, France, the Netherlands and Puerto Rico, along with many different states in the Union. Peggy is sponsored by Vandenberg Air Force Base…," *LR*, May 28, 1959, p. 24.
Ragland, Peggy (misc. bibliography)
Peggy Lynne Ragland was b. June 7, 1941 in Fort Riley, Kansas, to Richard M. Ragland and Reba Ragland, and was confirmed June 23, 1957 in Forbes Air Force Base, Kansas per *U.S. Evangelical Lutheran Church in America Church Records* (refs. ancestry.com).

Rahbar, Ethel (Mrs. Christian William Rahbar) (Santa Maria)
Painter. Member John Breneiser's adult school art class, 1936. Exh. painting at Community Club, 1938. Collector of antiques. Clubwoman.
See: "Community Club (Santa Maria)," 1938, "Santa Barbara County Fair," 1936, "Santa Maria, Ca., Adult/Night School," 1936

Rahbek, Frida Nielsen (Mrs. Ludwigsen) (1895-?) (Denmark)
Danish Artist / painter, book illustrator, who visited Solvang, 1951.
■ "Danish Artist Gives Solvang Oil Painting. Danish artist Frida Rahbek who has been visiting in the Valley the past few weeks… has given the Solvang community one of her oil paintings… Mrs. Rahbek, who has been visiting in the United States the past two years … It is a scene of the training ship 'Danmark,' on its way from Denmark to New York in 1939 prior to the outbreak of World War II. … her son was one of the 120 cadets aboard… Mrs. Rahbek, a modest person who served in the Danish underground during the German occupation of Denmark… The painting, which measures 36 inches in width and 31 inches in depth, exclusive of the beautiful wood frame, is now on display in the window of the *Valley News*. It was to be turned over to the Solvang Businessmen's Association, which will accept it in behalf of the community. Plans call for its placement in the Veterans' Memorial Building… Mrs. Rahbek said war broke out in Europe while the ship was visiting American ports. It remained in American waters during the war. Mrs. Rahbek's son was a member of the American Merchant Marine during the war and was aboard two ships which were torpedoed. At the present time he is living in Jacksonville, Fla, with his wife… [She comments on WWII in Denmark] The Danish artist plans to remain here for another week or so … She says she would like to remain in America but said it was difficult to live here 'without money.' She added, 'All of my money is in Denmark, and so I may have to return there soon'," *SYVN*, Oct. 5, 1951, pp. 1, 5.
1988 – SON – "Hans B. [Borge] Ludwigsen, 70, of Bartow… He is survived by … his mother, Frida Rahbek of

Silkeborg, Denmark…," *Tampa Tribune* (Florida), Oct. 19, 1988, p. 71 (i.e., 3-Polk).
Rahbek, Frida (misc. bibliography)
Frida Rahbek Nielsen, b. Nov. 8, 1895 in Denmark; Frida Nielsen b. Nov. 8, 1895 flew from Copenhagen to NY on *Loftleidir* on Dec. 7, 1961, destination Florida (240 E Hookor St., Bartow, Fla) per NY State Passenger and Crew Lists (ref. ancestry.com); Frida Rahbek Nielsen, b. Nov. 8, 1895 in Hoverdal, daughter of Christen Nielsen and Maren Tarp, wife of Niels Borge Ludwigsen, kunstmaler, per geni.com.

Ramirez, Jose Antonio (La Purisima)
Carpenter and stone mason at La Purisima Concepcion, 1811.
■ In 1811 Jose Antonio Ramirez, carpenter and stone mason, was hired to work at **Mission La Purisima** for $200 in silver per year plus room and board and two pounds of chocolate a month. The mission was destroyed by an earthquake c. 1813. Items were salvaged and used to build a new (the current) mission. (summarized from Lapurisimamission.org/1787-1812).

Rand, Valerie D. (Mrs. George Rand) (1891-1965) (Santa Maria)
Painter. Exh. at local venues mid 1950s+. Flower arranger. Judge for some poster contests.
Rand, Valerie (notices in Northern Santa Barbara County newspapers on microfilm and on newspapers.com)
1950 – "Mr. and Mrs. George Rand left today to spend a vacation of two weeks in Mexico. They will go direct to Mexico city and from there will travel to Juanto [Sic. Guanajuato?] , former mining town and art colony…," *SMT*, Jan. 10, 1950, p. 6; "Tourists Get Glimpse Into Mexico of Past Centuries… San Miguel de Allende… art center…," *SMT*, Jan. 30, 1950, p. 6.
Rand, Valerie (misc. bibliography)
Valerie D. Rand, mother's maiden name Dawdall, was b. Nov. 9, 1891 in Calif. and d. Jan. 16, 1965 in Santa Barbara County per Calif. Death Index; Valerie D. Rand is buried in Santa Maria Cemetery District per findagrave.com (refs. ancestry.com).
See: "Allan Hancock [College] Art Gallery," 1955, "Minerva Club, Art and Hobby Show," 1957, 1958, 1959, "Minerva Club, Flower Show," 1948, "Santa Barbara, Ca., Public Library (Santa Maria)," 1948, "Santa Maria Valley Art Festival," 1952

Randall, Eleanor (Morro Bay / SLO)
Painter. Exh. Santa Maria Art Festival, 1953.
See: "Santa Maria Valley Art Festival," 1953, and *Morro Bay Art and Photography before 1960* and *San Luis Obispo Art and Photography before 1960*

Rasmussen, (Rasmus) Thorvald (1894-1977) (Solvang)
Artist who exh. at Santa Ynez Valley Art Exhibit, 1954,
1957. Owner of a ranch with his brother Carl on which
the Old Grist Mill was located. Active civically.

■ "R. Rasmussen services… He was a farmer and came to
the Santa Ynez Valley in 1911, farming until his death. He
was a 50-year member of the Danish Brotherhood and
belonged to the Bethania Lutheran Church of Solvang. He
is survived by a brother, Carl Rasmussen…," *SYVN*, May
12, 1977, p. 15.
Rasmussen, Thorvald (notices in Northern Santa Barbara
County newspapers on microfilm and on newspapers.com)
1947 – Appointed caretaker of Atterdag College when
Viggo Tarnow decided not to restart the college after
WWII, *SMT*, April 14, 1947, p. 8.
1954 – "The Old Grist Mill: It's A Tourist Attraction…,"
SYVN, June 25, 1954, p. 1.
Rasmussen, Thorvald (misc. bibliography)
Rasmus Thorvald Rasmussen provided the following
information on his WWI Draft Registration Card = b. May
12, 1894 in Alden, Minnesota, working as a farmer;
Thorvald Rasmussen b. May 1894, to Christian Rasmussen
and Kirsten Pedersen, was residing in Carlston, Minn. in
1910, and d. May 8, 1977 in Santa Barbara County per
Saiser Family Tree (refs. ancestry.com).
See: "Danish Days," 1957, "Santa Ynez Valley Art
Association," 1953, "Santa Ynez Valley Art Exhibit,"
1954, 1957, 1958, "Santa Ynez Valley, Ca., Adult/Night
School," 1949, 1953

Ravenscroft (Burno), Virgil Alice Totten (Mrs. Gordon
B. Ravenscroft) (Mrs. Edward Stanley Burno) (1915-
1994) (Santa Barbara)
Artist who exh. in National Art Week show at Minerva
Club, 1940. Her marriage to Gordon B. Ravenscroft
appears to have lasted only c. 1937-44.
Ravenscroft, Virgil (misc. bibliography)
Virgil Alice Totten, 21, married Gordon Bartow
Ravenscroft, 29 in Long Beach per *Santa Ana Register*,
Feb. 6, 1937, p. 1; Mrs. Virgil Ravenscroft, housewife and
Dem. is listed with Gordon B. Ravenscroft, bookkeeper and
Rep. at 1322 Anacapa St. in the California Voter
Registrations index, *Santa Barbara Precinct, No. 20*, 1938-
40, 1942-44; Virgil A. Ravenscroft is listed with Gordon B.
in the *Santa Barbara, Ca., CD*, 1939, 1940, 1941 and in the
Long Beach, Ca., CD, 1941; Mrs. Virgil T. Burno is listed
as cosmetologist and Rep. in *Index of Affidavits of*
Registration, Precinct – Livermore 6, 1944; Virgil Alice
Totten b. March 17, 1915 in Washington, Ks. to Edgar
Willis Totten and Lillian M. Taylor, married Edward
Stanley Burno and d. April 28, 1994 per
Kennedy_Gallagher Family Tree (refs. ancestry.com).
See: "National Art Week," 1940

Ray, Blair (Lompoc)
Photographer active in Lompoc, 1900.
"Pioneer Days of Lompoc… 1900. … Photographers are
Henry McGee and Blair Ray…," *LR*, Sept, 1, 1955, p. 12.

Ray, Blair (notices in newspapers)
1930 – "Present Owner of the *Record* Gives a 'Who's
Who' of Lompoc when he Landed 31 Years Ago [i.e.,
1899] … **Henry McGee** and **Blair Ray** were the
photographers and McGee was considered a real artist…,"
LR, April 18, 1930, p. 2.
This individual could not be positively identified (although
there was a farmer named William Blair Gray active in
Lompoc and who d. 1898).

Rayo Auto Paint Shop (Santa Maria)
Sign painter, 1918.
"Rayo Auto Paint Shop. **R. Fernandez**, Prop., Auto and
Sign Painting. 305 East Main Street, Santa Maria," *SMT*,
Aug. 22, 1918, p. 2.

Rec Ramblin's
Column in the SMT authored by Paul Nelson (Santa
Maria City Recreation Director), 1949.
See: "Santa Maria, Ca., Recreation Department," 1949

Recreation Programs
Most of Santa Barbara County's major towns had
recreation programs sponsored either by the school
system or by a city recreation department. Classes
included the teaching of sports, crafts, puppets, etc.
See: "Atterdag College," "Emergency Educational
Program," "Lompoc, Ca., Recreation Department,"
"Puppets," "Santa Maria, Ca., Recreation Department,"
"Santa Ynez Valley, Ca., Recreation Program," "Summer
School …," "United Service Organization," "Works
Progress Administration"

Recreation Week
A special week set aside by the WPA and held mid June
1937. Included exhibits of handicrafts.
See: "Works Progress Administration," 1937

Red Cottage (aka Creative Arts and Woman's
Exchange) (Solvang)
Retailer of "Handcrafts, Antiques, Giftwares," c. 1949-55
Red Cottage (notices in Northern Santa Barbara County
newspapers on microfilm and on newspapers.com)
1949 – "The Red Cottage Woman's Exchange. Mission
Drive. Phone 4692. Gifts for those seeking the unusual…
large selection of ceramics, needlework, wood turning,
antiques…," *SYVN*, Nov. 25, 1949, p. 5.
1950 – "Mrs. **DeNejer**… Pottery made by Mrs. DeNejer is
being sold by … the Red Cottage Gift shop in Solvang…,"
SMT, July 15, 1950, p. 5.
1951 – "Come In – Browse Around Awhile. Featuring –
Handblocked printed place mat sets – designed and made
by Valley artist. Mission Dr., corner Nygaard, Solvang.
Phone 4692," *SYVN*, Aug. 10, 1951, p. 8.
1952 – "The Red Cottage. Handicrafts, Antiques,
Giftwares, Highway 150 – Solvang," *SMT*, March 1, 1952,
p. 8.

1955 – "Red Cottage Property Sold. Miss **Mae Penney** has announced… on Mission Drive in Solvang to Mr. and Mrs. Ted Lau. Miss Penney has conducted a gift and antique shop at the location the past seven years as well as offering guest accommodations. She plans to go out of the gift shop and antique business and will hold a disposal sale beginning next Monday. The Laus plan a motel operation…," *SYVN*, Oct. 7, 1955, p. 6.

And, more than 100 classified ads for individual items sold by the shop were not itemized here.

See: "Creative Arts and Woman's Exchange"

Red Cross
Organization most visibly active during WWI and WWII. Sponsored handicraft and other activities, such as photography, for rehabilitating soldiers.
1942 – "Red Cross Photo Contest in Progress… national photographic contest… with awards in War Savings bonds… pictures which portray Red Cross activities…," *SYVN*, Oct. 16, 1942, p. 1.
See: "Art, general (Camp Cooke)," 1943, "Daniels, Charles," 1940, "Hau, Charlotte," "LaVaut, Mary," "Lompoc, Ca., Adult/Night School," 1952, "Lompoc, Ca., Union High School," 1938, "Minerva Club," 1922, "Quilts," 1943, "Santa Barbara County Library (Lompoc)," 1922, "Santa Maria, Ca., Union High School," 1918, 1925, 1944, "Santa Ynez Valley Union High School," 1942, "Shelly, Constantine S.," "Solvang Woman's Club," 1942, "Tuckerman, Lilia," 1943, "Wiedmann, Nora"

Redshaw, Ward Fuller, Lt. (1923-2009) (Camp Cooke)
Photographic officer, Camp Cooke, 1950+.
■ Port. and "Know Your Neighbor from Cooke… One of the few Americans to have witnessed an atomic bomb dropped… Second Lieutenant Ward F. Redshaw… A prisoner of the Japanese, Lt. Redshaw was being held in a stockade near Nagasaki when the city was destroyed… A veteran of 10 and a half years of active duty in the Army, Lt. Redshaw was commissioned a second lieutenant in August 1950 and sent to Camp Cooke. He has been the Post's photographic officer ever since. Included among the many duties his staff performs is the taking of all photographs released from the camp to the newspapers," *SMT*, Sept. 17, 1951, p. 1.
Redshaw, Ward (misc. bibliography)
Ward Fuller Redshaw was b. March 31, 1923 in Great Falls, Mont., to Thomas Alfred Redshaw and Elvina Annie Fuller, married Margaret Dewar MacPherson, and d. March 28, 2009 in La Cruces, NM per Rosenthal/Konojacki Family Tree (refs. ancestry.com).

Reed, Leonard Howard "Bud" (1923-2017) (Lompoc)
Lompoc High School grad, 1941. Photographer's mate 2/c, US Navy, 1944, who photographed the atomic tests at Bikini atoll. Later a photographer and scientist.
■ Port. and "Leonard Howard Reed… son of Judge Horace T. Reed… passed away … in Buffalo, NY… A traveler, Leonard nevertheless often lived in Lompoc over the long course of his life… he graduated from Lompoc High School in 1941. He joined the Navy that December and was proud to serve through the end of the war, primarily as a photographer. Among his most memorable moments was capturing the first two atomic tests at Bikini Atoll. Leonard returned to Lompoc in 1947 and worked with the family business, Reedson's Dairy… After 1956, Leonard returned to photography as a livelihood and found another life-long interest, aeronautics and rocketry. He worked for Rocketdyne, Triad, and Benson Lehner at various times as both a photographer and a salesman. Leonard was a licensed pilot… He was a pioneer of Central Coast scuba diving… a member of … the Society of Photographic Scientists and Engineers…," *LR*, Dec. 27, 2017, p. A6.
Reed, Leonard (notices in Northern Santa Barbara County newspapers on microfilm and on newspapers.com)
1944 – "In Which They Serve … Photographer's mate 2/c Leonard 'Bud' Reed is spending a 30 day leave here with his parents… Bud recently returned from New Caledonia where he has been with the Navy for over the past year," *LR*, Feb. 4, 1944, p. 4; "Leonard Reed, photographer's mate 1/c in the Navy, visited his parents, Mayor and [Mrs] Horace Reed, here this week, enroute to Pensacola, Florida, where he will be stationed," *LR*, April 7, 1944, p. 5.
1946 – "Reed Arrives in U.S. From Bikini… Leonard Reed… his ship having arrived in San Diego on the week end. Reed is a photographer's mate 1/c and was one of the Navy personnel assigned to photographing the tests. He recently appeared in a Pathe newsreel made of the photographers at Bikini," *LR*, Aug. 22, 1946, p. 10; "Photographer Describes Atom Bomb Test… Kiwanians Hear Leonard Reed… A graphic account of the organization which went into 'Operations Crossroads' was given the Kiwanis club Tuesday night by Leonard Reed, PhoM 1/c who arrived back in the United States last week from Bikini Atoll. Reed was one of 300 photographers detailed by the Navy to cover the atom bomb tests, and he was in charge of cameras placed on the towers constructed on one of the islands. The young Navy man reported that while many of the casual observers of the test were disappointed by the size of the explosion … [and detailed description of process]," *LR*, Aug. 29, 1946, p. 3.
1957 – "Leonard 'Bud' Reed recently moved from Lompoc to Canoga Park where he is in the photography department of a guided missile test plant. The youngest Reed, Horace Oscar, is living with Bud and Jane and their three children and working at the same plant," per "The Horace Reed Family Story," *LR*, Aug. 29, 1957, p. 13.
Reed, Leonard (misc. bibliography)
Leonard Howard Reed was b. July 21, 1923 in Santa Barbara to Horace Truitt Reed and Hilda Mary Rose, married Jane Ann Read and d. Dec. 8, 2017 in Buffalo, NY (refs. ancestry.com).

Reep, Edward Arnold (1918-2013) (Bakersfield / LA)
Painter. Exhibited watercolors of world airfields at Hancock College, 1957. Exh. Allan Hancock [College] Art Gallery, 1956.

■ "Edward Arnold Reep (1918-2013) was a major 20th Century American artist who has brought water media painting into the ranks of significant academic and professional discussion with a body of mixed media work stretching from the 1930s to the present, and through his seminal book *The Content of Watercolor*, first published in 1969. Born in Brooklyn, NY, Edward Reep was a combat artist / captain in World War II and was awarded a Guggenheim Fellowship in 1956-7. Reep taught for more than 40 years in art schools and universities, exhibited widely, received numerous awards and distinctions, and his works are in major museums and private collections," from edwardreep.com.

Reep, Edward (notices in Northern Santa Barbara County newspapers on microfilm and on newspapers.com)
1957 – "Edward Reep Water Colors at [Hancock] Gallery … The result of his arduous but fascinating trip to paint airport scenes around the world, this collection has been the subject of a ten-page illustrated article in the 'Jet Airage' issue of *Life* magazine, published last June. The paintings have been exhibited in most major cities in the East and Mid-west, before being brought to California, which is now the artist's home state. Material on which the artist worked, highly colorful and varied, includes such subjects as air passengers in typical native dress of many countries. Most picturesque to western viewers are those portraying the people of India and its provinces; Istanbul, Turkey, Lebanon, Greece and Switzerland. Scenes about the airports of Germany, England, Shannon, Ireland, and France and what the artist saw from Lisbon and Dankar to South American cities are the subject of paintings filled with romance… Summing up his painting air excursions for *Life* magazine, Reep says, 'It was a most punishing schedule with very little time to cogitate. I was plagued by assorted illness, changes of weather, food, language, customs and weather conditions. I've no excuses though, and probably did more of what they wanted traveling this way. And believe me, after this trip, the United States looks good.' … Edward Reep had a notable career in the U. S. Armed Services that took him on earlier world travels to places re-visited on his painting assignment tour by air. He has taught since 1947 in art schools of Southern California and is currently on the staff of Chouinard Art Institute, Los Angeles. … The artist has sent some of his small matted pen and ink drawings that will be available to those interested, and there will be price tags on some of the larger water colors also…," *SMT,* Feb. 11, 1957, p. 4.
See: "Allan Hancock [College] Art Gallery," 1956, 1957, and *Atascadero Art and Photography before 1960*

Reid, Helen G.
See: "Rose (Reid), Helen G. (Mrs. Morley Clayton Reid)"

Reid, Margaret E. Miss (Santa Maria)
Teacher of newly introduced handwork in the Santa Maria elementary schools, 1919, 1920.
1918 – MOTHER – "Died at Pinal Lease. Margaret Dundas…," *SMT,* Feb. 2, 1918, p. 1.
1920 – "Miss Margaret Reid, domestic science teacher at the local grammar school, has returned home from Berkeley, where she attended the University of California summer school," *SMT,* Aug. 7, 1920, p. 5.
See: "Santa Maria, Ca., Elementary schools," 1919, 1920

Reiner, Donald Eugene, Dr. (1913-1998) (Santa Maria)
Photographer, amateur, post WWII. Physician. He showed his colored slides to various local organizations. Wife, Mary Elizabeth, collected Japanese Art and showed films of Japanese flower gardens.

■ Port. and "Donald Reiner, Leading Doctor," *SMT,* Jan. 30, 1998, p. 9.
Reiner, Donald (notices in SLO *Daily Telegram* and *Telegram-Tribune* on genealogybank.com)
1955 – "Panhellenic to Hear Talk, See Orient Films. Mrs. Donald Eugene Reiner will speak… The topic will be 'Japan' … accompanied by slides and music … as well as a display of native arts and crafts," *SMT,* March 29, 1955, p. 4.
1956 – "Horizon Club… Theme of decorating and of the program of slides on Japan shown by Mrs. Donald Reiner… The films… showed the farm, home and cultural life of the Japanese," *SMT,* March 14, 1956, p. 4; "Mariners Hear Talk, See Slides of Japan," and article adds, "Dr. Reiner showed color picture slides taken while he and his family were living in Japan after the war. He related many interesting facts about Japan, its people, their customs and industries," *AG,* June 1, 1956, p. 10.
1957 – "Dr. Reiner is Speaker… **Phi Epsilon Phi** … gave members an informative first-hand account of Army and civilian life in Japan… color slides…," *SMT,* Feb. 1, 1957, p. 4; "Christ Methodist… The Nisei WSCS will sponsor a family night next Friday with Dr. Donald Reiner to show slides and speak on his stay in Japan," *SMT,* Feb. 9, 1957, p. 6; "**Beta Sigma Phi**… Dr. D. E. Reiner who showed films taken while he served in Japan with the United States Army. Dr. Reiner, who was accompanied by Mrs. Reiner, spoke on his impression of Japan and its people," *SMT,* April 6, 1957, p. 3; "Guild Meeting – St. Monica's Guild… Speaker of the evening will be Mrs. Donald Reiner … on Japan," *SMT,* April 22, 1957, p. 3.
See: "Japanese Art," 1954, 1958

Reitzel, Marques E., Dr. (1896-1963) (San Jose / Pescadero)
Artist. Founder and director of the Pescadero Summer School of Art. Exh. at Santa Maria High School, 1946. Artist-in-Residence at Allan Hancock College, 1959.
See: "Allan Hancock [College] Art Gallery," 1959, "Brackenridge, Marian," 1960, "Santa Maria Art Association," intro., and *Central Coast Artist Visitors before 1960*

Relief Projects of the 1930s
See: "CWA Project," "Civilian Conservation Corps,"
"Emergency Educational Program," "Federal and State
Relief Projects" "Public Works of Art Project," "Treasury
Department," "Works Progress Administration"

Rembrandt Club, Allan Hancock College (Santa Maria)
*Art club at Hancock College made up of students of G.
Muro, 1955.*
■ "Has Coffee Party," to celebrate end of semester and to
discuss class artworks, and class members present were:
"**Betty Scott, Florence Foster, Marian Wise, Ann
Konishi,** Dorothy Branker, Barbara Chrisman, Lee LaRue,
Alexis Merkuris, Mildred Hale, Wanda Hermann [second
grade teacher], **Maye Nichols, Edna Myers** and Colleen
Negrich," *SMT,* June 3, 1955, p. 4.

**Remick, Merrill Blanchard (1924-2002) (Santa
Barbara)**
*Member Santa Barbara Art Association, who exh. at
opening exh. of Allan Hancock College Art Gallery, 1954.
Art teacher at Santa Barbara High School, late 1950s,
and at San Marcos High School in Santa Barbara, c.
1960-85.*
Remick, Merrill (misc. bibliography)
Port. of Merrill Remick as member of Delta Sigma Phi in
the Santa Barbara College of the University of California,
yearbook, 1949; port. of Merrill Remick, B.A. UCSB, art
teacher, in Santa Barbara High School yearbook, 1956-58,
and in San Marcos High School yearbook, 1960-85; Merrill
Blanchard Remick was b. Nov. 4, 1924 in Seattle, Wa., to
Homer George Remick and Emma B. Blanchard, and d.
June 1, 2002 in Santa Barbara, Ca., per Byrd/Musselman
Family Tree (refs. ancestry.com).
See: "Allan Hancock [College] Art Gallery," 1954

**Renoult, Japhet Francis (SLO / Santa Maria /
Riverside)**
*House painter, decorator, portrait painter, art teacher,
active in several towns in California, including Santa
Maria, 1883.*
Renoult, J. F. (notices in Northern Santa Barbara County
newspapers on microfilm and on newspapers.com)
1883 – "Mr. Frank Renoult is sojourning in this place, and
a number of our young folks wishing to take lessons in
drawing are making up a class. Those wishing to join it will
please leave their names with Mrs. Vincent, at the candy
factory," *SMT,* Feb. 24, 1883, p. 5; "J. F. Renoult, the artist,
has gone to Los Alamos to remain a week or so, when he
will return to Santa Maria. His artistic work has made a
remarkable change in our town," *SMT,* March 3, 1883, p. 5,
col. 1; "J. F. Renoult, Practical Sign, Pictorial and Fresco
Painter, San Luis Obispo, California," *SMT,* May 26, 1883,
p. 4; "Renoult and Bradley will open a paint shop in this
place on Wednesday next. Mr. Renoult's well-known
ability as an artist is sufficient to secure to the firm the full
confidence of the community. They will be prepared to do
kalsomining, graining, house painting, frescoing, sign
painting, etc.," *SMT,* July 14, 1883, p. 5, col. 1; "We have

received the first number of *Poor Richard*, a monthly
publication issued by J. K. Tuley at San Luis Obispo… The
coming number will consist of eight pages and will be
illustrated by J. F. Renoult…," *SMT*, Sept. 15, 1883, p. 4,
col. 1; "*Poor Richard* comes to us this month with a new
head artistically ornamented by Renoult. It is as full as a
plum pudding with good reading matter – the paper, not the
head," *SMT*, Sept. 29, 1883, p. 4, col. 2.
And many additional notices for "Renoult" in the *SMT*
through 1883 were not itemized here.
See: *San Luis Obispo Art and Photography before 1960*

Ret, Etienne (1900-1996) (France / Hollywood)
Artist. Exh. Santa Maria Valley Art Festival, 1953.
■ "Etienne Ret, 96, painter known internationally for his
portraits and lithography. A native of Bourbonnais, France,
he studied at the Ecole des Arts Decortifs in Paris and
immigrated to Southern California in 1924 [Sic. 1934]. He
did portraits of the wealthy literati who passed through
Santa Monica, including Ernest Hemingway, Aldous
Huxley and Jean Renoir. Ret exhibited at the Dalzell
Hatfield Galleries in the Los Angeles area and has
paintings in the permanent collections of museums in Santa
Barbara, Pasadena and San Diego, as well as museums
elsewhere in the United States and in France. A *Times* critic
noted of a 1943 exhibit, 'Ret is a poet and his pictures are
poetic paintings.' In 1950, he published a prizewinning
book, 'Advice to a Young Artist.' Ret later taught and
worked in mixed media in San Antonio. He had returned to
France more than a decade ago," *LA Times*, June 29, 1996,
p. 422 (i.e., A22).
And, more than 150 "hits" occur for "Etienne Ret" in
California newspapers (particularly the *LA Times*), 1930-
1996, but they were not even browsed for inclusion here.
See: "Santa Maria [Valley] Art Festival," 1953, "Stark,
Jack Gage," 1944

Revetagat, Eugene (SLO / Santa Maria)
House painter, decorator, active in Santa Maria, 1890s.
Revetagat, Mr. (notices in Northern Santa Barbara County
newspapers on microfilm and on newspapers.com)
1892 – "E. J. L. Revetagat, a professional painter from San
Luis has recently located in town. He has purchased lots,
built a house and shop. He is a full-fledged resident, ready
to do anything that comes along in his line," *SMT*, March
26, 1892, p. 3; "E. L. Revetagat was initiated into the
mysteries of the Forresters at their regular meeting on
Friday evening of last week," *SMT*, Aug. 13, 1892, p. 3,
col. 1; ad: "E. J. L. Revetagat. Graining. Painting. Sign
painting, Calsomining. In the highest style of the art," *SMT*,
Oct. 1, 1892, p. 2; "Mr. Revetagat, the painter, has his
hands full now days. Aside from driving his paint brush, he
is employed to look after the heavy work at **W. A. Haslam
& Co's** warehouse," *SMT*, Dec. 3, 1892, p. 3, col. 1.
1894 – "The new Blochman residence on south Broadway
looks quite nobby since Revetagat the painter gave it the
finishing touches," *SMT*, April 28, 1894, p. 3, col. 3.
1896 – "Revetaget, the painter, has been engaged this week
in decorating the interior and front of the Edwards building
on Main street," *SMT*, Feb. 22, 1896, p. 3, col. 1.

And, 9 additional notices on "Revetegat" and 23 for "Revetagat" and 1 for "Revetaget" in Santa Barbara County newspapers, 1885-1905, not itemized here.
See: *San Luis Obispo Art and Photography before 1960*

Review
Yearbook of the Santa Maria Union High School. Some issues contained student artwork.
See: "Santa Maria, Ca., Union High School," various years

Rexall Drug Store (Solvang)
Retailer of photographic equipment. On rare occasions, the store provided space for art displays.
1952 – "Merry Gifting One and All… Wide Variety of Toys… Cameras, Projectors, Photo Supplies … Rexall Cut Rate **Solvang Drug**," *SYVN*, Nov. 28, 1952, p. 5.
1957 – "1c Sale. April 29, 30, May 1, 2, 3, 4 … Camera Projector Reduction Sale. While they last! Everything in Camera Equipment & Cameras," and list of cameras, projectors, accessories and prices," *SYVN*, April 19, 1957, p. 6.

Reynolds, A. G. (Santa Maria)
Photographer, with Clendenon Studio, 1909.
See: "Clendenon Studio"

Reynolds, (James) Elmer (Santa Maria)
Photographer, amateur. Active with Santa Maria Camera Club, 1941. Cameraman for the police department, 1942.
"Pay Raises for City Employees… Deferment of James Elmer Reynolds, fingerprint and cameraman for the police department … is not allowable…," *SMT*, Sept. 22, 1942, p. 1.
See: "Santa Maria Camera Club," 1941

Rhead, Loiz
See: "Lord, Loiz Whitcomb"

Rhodes, Alvin E. (San Luis Obispo)
Examiner in woodcarving for Boy Scouts, 1933. President, San Luis Obispo Camera Addicts, and demonstrator of motion picture sound equipment to Santa Maria Camera Club, 1940. County school superintendent in SLO, 1950.
See: "Boy Scouts," 1933, "Santa Maria Camera Club," 1940, and *San Luis Obispo Art and Photography before 1960*

Ricca, Theresa (Santa Ynez Valley?)
Teacher of leathercraft at Santa Ynez Valley Adult/Night School, 1946 and at Union High School, 1947.
Ricca, Theresa (notices in Northern Santa Barbara County newspapers on microfilm and on newspapers.com)
1947 – "Miss Theresa Ricca Honored at Party… instructor in leather craft … was tendered a farewell party by members of her class Monday at the school…," *SYVN*, June 6, 1947, p. 1; "5 Teachers to Quit HS… Teachers who will not return… Miss Theresa Ricca, instructor in general science, biology and leathercraft… Mr. Hamm said that Miss Ricca is returning to Michigan for the Summer but expects to come back to California in the Fall for other school work…," *SYVN*, June 13, 1947, p. 1.
Ricca, Theresa (misc. bibliography)
Is she Theresa Ricca, advisor for Girls' League per Lawndale High School, Lawndale, Ca., yearbook, 1969 (refs. ancestry.com).
See: "Santa Ynez Valley, Ca., Adult/Night School," 1946, "Santa Ynez Valley Union High School," intro.

Rich (Morse), Edna C. (Mrs. Louis Kennedy Morse) (Santa Barbara)
President of the new Santa Barbara State Normal School of Manual Arts and Home Economics [formerly? Anna S. C. Blake Manual Training School], who lectured on the value of manual training at Santa Maria High School, 1912.
1910 – "Carpinteria Will Have Sloyd School… It remained for Miss Edna Rich to present a plan," to the Carpinteria Woman's club," *Independent* (Santa Barbara, Ca.), Oct. 26, 1910, p. 5.
And numerous additional notices in Santa Barbara newspapers on her travels in relation to her school.
See: "Anna S. C. Blake Manual Training School," "Boyer, Mary Ann," "Santa Maria, Ca., Union High School," 1912

Rich, Frances (nee Irene Frances Lither Deffenbaugh) (1910-2007) (Santa Barbara)
Sculptor. Member of Santa Barbara Art Assn. who exh. a pair of bronzes at opening exh. of Allan Hancock [College] Art Gallery, 1954.
■ "Talented Sculptor… Frances Rich… now resides in the suburb of Hope Ranch Park… In the rambling studio of the now defunct Santa Barbara Girls' School… Frances Rich was exposed as a child to modeling – as many of the students were – a small boy's head by Desiderio da Settignano. 'I worked hard and long copying the little white plaster head. I lost track of the hours. 'Ha,' I thought to myself, 'I like this sense of timeless being. When I grow up, I'm going to be a sculptor.' So, it was always sculpture, with the exception of an interlude or two. There were school plays, with roles taken by Frances Rich (whose mother is Irene Rich, the actress) and a classmate, Katherine De Mille (daughter of Cecil B. DeMille of Hollywood). Then came the college stint at Smith. She also had a fling at the theater, as well as motion pictures. 'It was the movies that finally got me down. Imagine being offered a $100 a week on a seven-year contract! … I'd be 28 at the end of the contract, so instead I set off to study sculpture

seriously.' Her current work, a bust of Lotte Lehmann, a Hope Ranch neighbor … Throughout the rambling country garden, ungroomed yet lovely in its natural state, there are statues, heads, busts, figures created by the artist. In the front patio, just before you enter the studio is a magnificent bust from her Army-Navy Nurse Memorial at Arlington National Cemetery. Her master's – Malvina Hoffman, Alexandre Jacovleff, Carl Milles – would be proud of their pupil could they see the 50 pieces assembled for this month's show at the Santa Barbara Museum of Art. Fountains… Free-style small sculptures cast in bronze and silver – pieces that would fit into the small contemporary houses… Portraits such as the one of Mme. Lehmann… Her fourth project, though, is religious sculpture – and that for someone who is not by nature an intensely religious individual in the orthodox sense. A magnificent St. Francis of Assisi – full sized – which Frances Rich has settled by the edge of her property overlooking the water… There is a markedly Californian attitude in Frances Rich's work, for it is free and easy as our mode of living…," *LA Times*, Oct. 14, 1952, p. 56 (i.e., pt. III, pp. 1, 4).

■ "Frances Rich (born Irene Frances Lither Deffenbaugh, January 8, 1910 – October 14, 2007) was an American actress, artist and sculptor. She was the daughter of actress Irene Rich," Wikipedia.

Rich, Frances (notices in Northern Santa Barbara County newspapers on microfilm and on newspapers.com)
1955 – "Stokowski … Pacific Coast Festival… 'Sculptor at Home' event in the gardens of artist, Frances Rich, here, Sept. 10, 11, 17 and 18. Miss Rich has arranged a special exhibit of her works as a benefit for the student ticket fund of the Music Festival," *SMT*, Aug. 31, 1955, p. 9.
And, more than 280 notices in various California newspapers for "Frances Rich" in the 1950s and 1960s not itemized here.
See: "Allan Hancock [College] Art Gallery," 1954

Richardson, Leighton Loris (1911/12-2009) and Marion Louise Deck Richardson (1917-after 1993) (Santa Maria)
Photographer, amateur. Active with Santa Maria Camera Club, 1940s.
More than 80 hits for "Leighton Richardson" (including "Mrs. Leighton Richardson") and 5 for "Marion Richardson," in the *SMT* between 1935 and 1960, reveal the couple married in 1939, that he served as a corporal during WWII at which time he motorized a bicycle for transportation (1944), that he was a licensed "radio ham" who was the first in the Santa Maria Valley to get TV reception (1949), and that she was art chairman of the Community Club, 1951/52, but they were not itemized here.
Marion L. Deck was b. Sept. 15, 1917 in San Bernardino County, mother's maiden name Dyson, per Calif. Birth Index; Marion L. Richardson b. Sept. 15, 1917 was residing in Bakersfield, Ca., in 1993 per *U.S. Public Records Index, 1950-1993*, vol. 1 (refs. ancestry.com).
See: "Santa Maria Camera Club," 1941, 1942, 1947

Richardson, Mary / May / Mae L. (1860/62/63-1933) (Lompoc)
Received a diploma in "Fine Arts" for her flowers and a drawing exh. at "Santa Barbara County Fair," Lompoc, 1892.
Richardson, Mary (notices in Northern Santa Barbara County newspapers on microfilm and on newspapers.com)
1910 – "At the Court House… Deed – May L. Richardson to Ellen M. Scott, 30 acres in farm lot 71, Lompoc rancho… Deed – Ellen M. Scott and husband to May L. Richardson, Lots 35 and 36 of block 63, Lompoc…," *Independent* (Santa Barbara, Ca.), March 12, 1910, p. 4.
1918 – MOTHER – "Pioneer Woman Goes to her Reward… Catherine Richardson… settled first in … San Jose. They afterwards moved to Lompoc valley, coming here in 1888. James Richardson died March 16, 1905. Eight children were born… four boys and four girls, seven of whom survive their mother… They are: Mrs. Thomas G. Clark, of Berkeley, Calif., James W. Richardson of Lompoc, Miss Mary L. Richardson, who made her home with her mother here in Lompoc, Mrs. Walter A. Calvert of Lompoc, Mrs. Frank Rudolph of Lompoc, Thomas A. Richardson of Van Nuys and Ben A. Richardson of Lompoc…," *LR*, March 22, 1918, p. 6; "Card of Thanks. We wish to extend our heartfelt appreciation to the many dear friends in our time of sorrow… May L. Richardson…," *LR*, March 29, 1918, p. 3; "Miss May Richardson left Lompoc with her sister, Mrs. Clark, for the latter's home in Berkeley where she expects to remain for several weeks," *Santa Barbara Daily News and the Independent*, May 4, 1918, p. 3, col. 2.
1923 – Her brother-in-law, Thomas G. Clark, dies in Berkeley, *LR*, Jan. 12, 1923, p. 1.
1933 – "In Critical Condition – Miss Mae Richardson, who has been confined to her bed for the past three months, is reported to be in a critical condition at her home," *LR*, March 17, 1933, p. 9; "Court Summary… Deed: Mary L. Richardson to Clara C. Clark… Lots 33, 34, 35 and 36, Block 90, Lompoc," *LR*, April 7, 1933, p. 11.
Richardson, Mary (misc. bibliography)
Mary L. Richardson is listed in the 1870 U. S. Census as age 8, b. c. 1862 in Calif., residing in San Jose with her parents James and Catherine and four siblings: Clara, James, Nellie B. and Katy; May L. Richardson is listed in the 1880 U. S. Census as age 18, b. c. 1862 in Calif. residing in San Jose with her parents and siblings; Mary L. Richardson is listed in the 1900 U. S. Census as age 40, b. Feb. 1860 in Calif., residing in Lompoc with her parents, James Richardson (age 69, a farmer) and Catherine Richardson (age 61); May Richardson is listed in the 1920 U. S. Census as age 57, b. c. 1863, a dressmaker, residing in Lompoc; Mary L. Richardson was b. Feb. 1860 to James Richardson and Catherine Woodiwiss per Mantel / Stevens Family Tree; is she May T [Sic.] Richarson b. c. 1862 and d. March 24, 1933 in Santa Barbara County per Calif. Death Index; is she Mae L. Richardson, 1863-1933 buried in Lompoc Evergreen Cemetery per findagrave.com (refs. ancestry.com).
One of her paintings is in the collection of the Lompoc Valley Historical Society.

See: "Lompoc Valley Historical Society, House," "Santa Barbara County Fair," 1892, and *San Luis Obispo Art and Photography before 1960*

Richmond, Evelyn Louisa Kimball (Mrs. Harold Anthony Richmond) (1872-1961) (Santa Barbara)
Santa Barbara artist who exh. in a group show of Santa Barbara artists sponsored by the College Art Club at city hall, Santa Maria, 1935. Exh. National Art Week show at Minerva Club, 1940.
[Do NOT confuse with Evelyn Richmond, Manhattan Beach, competitive photographer.]
Richmond, Evelyn (notices in California newspapers on microfilm and on newspapers.com)
1896 – In the Unitarian church, Jamaica Plain, Friday night, Miss Evelyn Kimball was married to Mr. Harold Anthony Richmond… A reception was held at the Kimballs' home… will reside on Edge Hill road, Brookline," *Boston Globe*, April 26, 1896, p. 29, col. 3.
1932 – "Noted Artists Exhibit Water Colors in Oxnard… Art Club of Oxnard… in the Community Center building … Evelyn K. Richmond is another strongly individual colorist, but achieves her effects through an entirely different medium. Her color is strong and vivid, but broken up by variations of intensity, shade, in something almost like stippling to denote the presence of light. She succeeds in making her pattern, which is always definite and fairly detailed, as pronounced as her color that might otherwise be glaring. Viewed closely, her work resembles a conglomeration of tiny, variegated flames," *Ventura County Star*, April 14, 1932, p. 2.
1936 – COUSIN – "Artist Buried in Lot He Chose. Santa Barbara… Robert Keith Snow, arts patron and long resident of the city…," *LA Times*, July 19, 1936, p. 29 (i.e., pt. II, p. 15).
1939 – DAUGHTER – "Mrs. Hugh Miller, 41, daughter of Mrs. Evelyn Kimball Richmond… was found dead of asphyxiation in her Brentwood Heights home by her husband, a professor in the University of California at Los Angeles," *SMT*, July 5, 1939, p. 4; "Women Painters Exhibit… Four women painters who recently exhibited at the **Faulkner Memorial Art Gallery** in Santa Barbara, have opened an exhibition of portraits, landscapes, flowers, etc. in the Palos Verdes Art Gallery. They are … Mrs. Evelyn Richmond… and a tea in their honor was held last Sunday afternoon in the art gallery. … until November 17…," *Redondo Reflex* (Redondo Beach, Ca.), Nov. 3, 1939, p. 4.
1940 – "New Gallery Opens Tomorrow at Artists' Barn… the Pepper Tree Gallery, Mr. and Mrs. Lawrence Hinckley will be hosts … Fillmore… Paintings, ceramics and sculpture by the 'best artists in the west'… Included …Evelyn K. Richmond…," *Ventura County Star-Free Press*, March 2, 1940, p. 5; "Work of Ventura Artists … Artists' Barn in Fillmore… in the Pepper Tree Gallery… Others whose work will be on view … Evelyn K. Richmond…," *Ventura County Star-Free Press*, Sept. 26, 1940, p. 11; "Barbareno Here. Mrs. Evelyn K. Richmond of the Santa Barbara art colony is in Westwood at the home of her son-in-law, Dr. Hugh Miller of the UCLA faculty, for a

visit with her three young grand-daughters," *LA Times*, Nov. 26, 1940, p. 27.
1941 – "**Jessie Arms Botke**… 49th annual exhibition of the National Association of Women Painters and Sculptors in the American Fine Arts galleries in New York City. Other well-known Southern California names on paintings in the exhibition are … Evelyn K. Richmond…," *Ventura County Star-Free Press*, Jan. 21, 1941, p. 5.
See: *Publications in California Art*, vols. 1-12.
Richmond, Evelyn K. (misc. bibliography)
Evelyn Louisa Kimball b. Jan. 29, 1872 to Herbert Wood Kimball and Abby Rice Brown, married Harold Anthony Richmond on April 24, 1896 in Boston, Mass., per *North America, Family Histories*; Evelyn Kimball Richmond d. Nov. 7, 1961 in Santa Barbara and is buried in Santa Barbara Cemetery per findagrave.com (refs. ancestry.com).
See: "College Art Club," 1935, "National Art Week," 1940, "Wright, James C.," 1933

Rick, Maxine F. (Mrs. Myron Burns Rick) (1915-1999) (Santa Maria / Nipomo)
Photographer, 1950s. Collector of items from world travels.
■ "Maxine Rick, 84… died Feb. 16, 1999 in a local Santa Maria hospital… Mrs. Rick was born… in Phoenix, Ariz. She was a graduate of UCLA and taught school in Los Angeles prior to moving to Santa Maria in 1945. She taught for the Santa Maria Elementary School District for one year. She and her husband, Burns Rick, opened, owned and operated Rick's Drive-in Restaurant in Santa Maria (the first drive-in restaurant in Santa Maria). She was a member and past president of Minerva club. Along with her husband, she was an avid world traveler…," *SMT*, Feb. 23, 1999, p. 5.
Rick, Mrs. (notices in Northern Santa Barbara County newspapers on microfilm and on newspapers.com)
1950 – "Club Women Hear of Travel in Guatemala… Minerva clubhouse at the monthly luncheon… Mrs. Burns Rick as speaker. Mrs. Rick wore a Guatemala native costume and in vivacious manner told informally of a vacation visit south of the border and in Guatemala last fall. Her topic was illustrated with color slides…," *SMT*, Feb. 11, 1950, p. 6.
1952 – "Jamaica Pictures – Mrs. Burns Rick will show colored slides of Jamaica for the Christian Church Women's Fellowship at 8 o'clock Thursday evening in the church building," *SMT*, Jan. 15, 1952, p. 4; "Travelogue by Santa Marian for Off. Wives' Club… Mrs. Rick told of a tour of the Caribbean made by herself and Mr. Rick, which she illustrated with color slides… of places of interest in the Caribbean Islands…," *LR*, April 17, 1952, p. 8.
1953 – "Color Slides of Europe Resorts Shown to Chapter… resorts in France, Germany, Belgium, Holland, Italy and Switzerland, filmed … on a tour last year were shown last night with travel talk for … **Phi Epsilon Phi** sorority…," and some information on trip, *SMT*, Feb. 26, 1953, p. 4.
1955 – "Ricks Show Slides on South America. First organization to view exceptional color slides taken by Mr. and Mrs. J. Burns Rick on travels in South America was the Minerva club…," and lengthy description of trip, *SMT*, Jan.

19, 1955, p. 4; "Mrs. Rick is Guest Speaker at Jr. Community Club… illustrated her talk on travel in South America with colored slides and an exhibit of handcraft items from several countries in which she traveled recently with her husband…," *SMT*, March 16, 1955, p. 3.
1956 – "Pacific Films to be Shown by Mrs. Rick. Color slides … scenes in Tahiti, Fiji and the Hawaiian Islands and others in Australia and parts of New Zealand … shown at Minerva club…," *SMT*, Feb. 23, 1956, p. 6; "Islands of Pacific Shown in Color Film… slides of the islands of Fiji and Tahiti and of Australia and New Zealand… Minerva club Book section," and description of some of her travels, *SMT*, Feb. 29, 1956, p. 4; "Community Club Juniors Hear Mrs. Burns Rick… recent trip through Australia…," *SMT*, May 3, 1956, p. 5; "Betteravia Club Meets at Dinner… at Rick's Rancho Santa Maria in the Dutch Room… Mr. and Mrs. Burns Rick tell about a wonderful trip which… [they] took last year… Fiji Islands, Tahiti, New Zealand and the Australia… Mrs. Rick is an artist with a camera, and the colored films, together with the very interesting comments which she laced through the program made the evening one to dream about…," *SMT*, Nov. 27, 1956, p. 4.
1958 – "Audience Enjoys Armchair Travel… Mrs. Burns Rick reviewed round the world travel with her husband for the Minerva Club Travel section Thursday evening in the clubhouse. Exceptional subjects, good photography and witty, descriptive comment… Mrs. Rick wore a gorgeous royal blue and gold sari… The tour, traced on a map on the screen to introduce the pictures, followed a route west to Hawaii, the Orient, to Burma, India, Africa, Egypt and home by the way of Bermuda and New York. There were numerous side trips… The films of Japan pictured native artistry in flowers… Life on junks and sampans off the coast at Hong Kong… Burma's temples … Hard travel into the back country… Angkor… Scenes in the major cities of India… The travelers photographed many wild animals in their native habitat in Africa on safari … visiting pygmies… In Egypt the films showed beautifully preserved wall paintings in the kings' tombs … The pictures ended with a 'home again' shot of two tired and happy travelers as they were greeted after many weeks absence from their Nipomo home," *SMT*, March 1, 1958, p. 2; "CSF Students are Minerva club Guests… enjoyed films taken on a 'round the world' trip and narrated by Mrs. Burns Rick who is showing the films by popular demand to many Santa Maria organizations," *SMT*, March 21, 1958, p. 3.
1959 – "House on Hill Has Scenic View… Mr. and Mrs. Burns Rick…," and is full of items they collected on their world travels, *SMT*, Aug. 31, 1959, p. 20, 21 (i.e., 10-11-S?).
And more articles on other slide lectures were not itemized here.
Rick, Mrs. (misc. bibliography)
Maxine F. Rick was b. Jan. 11, 1915 in Phoenix, Ar., and d. Feb. 16, 1999 in Santa Maria per obit (refs. ancestry.com).
See: "Junior Community Club (Santa Maria)," 1955, "Minerva Club," 1954, "Minerva Club, Art and Hobby Show," 1957, "Santa Maria Camera Club," 1956

Righetti, Lily/Lillie
See: "Pezzoni (Righetti), Lily/Lillie (Mrs. E. Righetti)"

Rinehardt, Everett Albert (1896-1940) (Santa Maria)
Filmmaker, amateur, 1937-40.
1937 – "Lions See Deep Sea Motion Pictures. Motion pictures of deep sea fishing in the South Seas were shown to members of the Lions' club by Everett Rinehardt when they held their weekly dinner meeting in Santa Maria club last night," *SMT*, July 17, 1937, p. 2.
1938 – "I Spied… Everett Rinehardt returning from Yosemite with about 300 feet of colored film he had taken," *SMT*, July 30, 1938, p. 1; "Sons of [American] Legion Install at Party… Following the program, movies in color of the Pacific Northwest were shown by Everett Rinehardt," *SMT*, Oct. 14, 1938, p. 3.
1939 – "Ladies Night Entertains Lodge. Odd Fellows were hosts to Rebekahs… Monday night in the lodge hall… Everett Rinehardt showing motion pictures which he has made of local vegetable fields, Yosemite, Crater Lake, the Pasadena Rose Parade, and the Bakersfield Model Plane meet, in color," *SMT*, May 31, 1939, p. 3; "Shark Fishing… weekly dinner in the Santa Maria club for the local Lions' club… Everett Rinehardt showed colored motion pictures of the County Fair parade here," *SMT*, Aug. 12, 1939, p. 2; "Camp Fire Leader Visits Today… A meeting of the Camp Fire council will follow at 7:30. Colored motion pictures of Camp Talaki … will be shown by Everett Rinehardt," *SMT*, Sept. 22, 1939, p. 3; "Rinehardts Finish Extended Tour…," of South, etc., *SMT*, Oct. 16, 1939, p. 3; "Sub-District Head… Twenty-Thirty club… Everett Rinehardt was a guest of the club at dinner last night to show motion pictures of his recent trip to the 'old South'," *SMT*, Dec. 13, 1939, p. 3.
1940 – "Clarence Ward is Club Speaker… Twenty-Thirty club dinner … Everett Rinehardt showed motion pictures of the European war," *SMT*, July 3, 1940, p. 3; "Rinehardt Rites Set for Two Tomorrow… Everett Rinehardt who died suddenly yesterday in his house…," *SMT*, Sept. 4, 1940, p. 3; And a few additional notices on his films were not itemized here.
See: "Santa Maria Camera Club," 1939

Rinehart, Jack (Santa Maria / Hollywood)
Painter, dancer. Held an exh. of paintings at Haslam's Art Shop, 1922. Visited several times in Northern Santa Barbara County with his art teacher, Annette Perry.
See: "Perry, Annette," and *Central Coast Artist Visitors before 1960*

Risor, Lettie B. (Mrs. Risor) (1863-1955) (Lompoc)
Painter, first half 20th century.
■ "Mrs. Lettie Riser is Honored on Her 89th Birthday… hospitalized for 2 ½ months with a broken hip… Born and raised in Trinity County, Pennsylvania, Lettie Risor was left an orphan early in life. However, she was fortunate in being reared in a happy foster home. She came to California some 40 years ago and met her husband and was married in the northern part of the state. In 1916, while residing up north, the Risors met the Elmer Fields, former Lompocans, who described the town to them and interested them in coming here to live. The couple moved here that year … Mr. Risor was a well-known carpenter until his

retirement. He passed away several years ago. The couple had one son, Roland, who is married and now lives in Goleta. Despite her advanced years and the fact that she is almost totally blind, Mrs. Risor has insisted on living independently in her own little apartment at 426 North H street, taking care of her needs and even preparing her own meals alone. Kindly neighbors have kept a friendly watch over the little elderly widow… Mrs. Risor was an unusually gifted artist. Her son has quite a number of her paintings in his Goleta home," *LR*, Dec. 23, 1954, p. 5.

Risor, Lettie (notices in Northern Santa Barbara County newspapers on microfilm and on newspapers.com)

1943 – "Mrs. Lettie Risor Leaves for South. Mrs. Lettie Risor, who, for the past 27 years has made her home in Lompoc, left this week for Hawthorne, where she plans to reside. She was accompanied south by her son and daughter-in-law, Mr. and Mrs. Roland Risor of Hawthorne," *LR*, Sept. 3, 1943, p. 2.

1950 – "From Southland. Mr. and Mrs. Roland Risor were here from the southland over the weekend visiting Mr. Risor's mother, Mrs. Lettie Risor, who is recuperating from an illness in the Lompoc Community hospital," *LR*, Sept. 7, 1950, p. 5.

1955 – "Risor Rites Held Here Yesterday… Lettie B. Risor… Mrs. Risor was born in Pennsylvania on December 16, 1863. She became a resident of Lompoc in 1916 and was a member of the Rebekah Lodge here…," *LR*, Dec. 29, 1955, p. 1.

Rivol, Lala Eve (San Francisco)
Painter of Indian pictographs in California for the Federal Art Project, 1936.
See: *Central Coast Artist Visitors before 1960*

Roberts, Mabel May (Mrs. George Lewis Roberts) (1886-1951) (Hermosa Beach / Santa Cruz County)
Painter of Lompoc flower fields, 1947.
See: *Central Coast Artist Visitors before 1960*

Roberts, Stanley (Santa Barbara)
Photographer from Brooks Institute who attended a meeting of the Santa Maria Camera club, 1949.
See: "Santa Maria Camera Club," 1949

Robinson, Edgar G. (1893-1973) (Hollywood)
Actor / artist / art collector who exh. his own paintings with a group of Hollywood notables at Santa Ynez Valley Art Exhibit, 1954. Husband of Gladys Lloyd Robinson, below.
■ "Edward G. Robinson (born Emanuel Goldenberg) December 12, 1893 – January 26, 1973) was a Romanian American actor of stage and screen during Hollywood's Golden Age," per Wikipedia.
See: "Robinson, Gladys," "Santa Ynez Valley Art Exhibit," 1954

Robinson, Gladys Lloyd (1895-1971) (Hollywood)
Actress / artist who exh. with a group of Hollywood notables at Santa Ynez Valley Art Exhibit, 1954. Wife of Edgar G. Robinson, above.
See: "Robinson, Edgar," "Santa Ynez Valley Art Exhibit," 1954, and *Atascadero Art and Photography before 1960*

Robinson, Mary E. (Los Angeles / Santa Maria)
Photographer. Prop. Robinson Studio, 1936.
Robinson, Mary E. (misc. bibliography)
Mrs. Mary E. Robinson, photographer, and Rep. is listed in *Index to Register of Voters, Los Angeles City Precinct No. 765*, 1936 and as "Miss" in *Index to Register of Voters, Los Angeles City Precinct No. 424*, 1940, 1942 (refs. ancestry.com).
See: "Robinson Studio"

Robinson Studio (Santa Maria)
Photography studio at 217 South Broadway, 1936.
■ "New Photo Studio is Opened in S. M. **Mary E. Robinson**, who comes to Santa Maria from Los Angeles, has opened a photographic studio at 217 South Broadway. She was engaged in photography in Los Angeles for 15 years before coming here. Julia Rehlbach, of Santa Maria, a cousin of the studio owner, will be employed in its operation. It is announced that the studio is equipped with the latest mechanical paraphernalia for taking, developing and finishing photographs," *SMT*, Aug. 10, 1936, p. 5.
Robinson Studio (notices in Northern Santa Barbara County newspapers on microfilm and on newspapers.com)
1936 – "At Robinson Studio… A child's portrait. You'll want to remember your children as they appeared at important stages of their lives. When is there a more important time than first starting to school. An 8 x 10 platinum finish photograph is offered as a three-day Special for Children or Adults, at \$1.00," *SMT*, Aug. 28, 1936, p. 2; "Beautiful Portraits, oil tinted on our popular bronze finish can be had for 85c each until November 26 ONLY. Take advantage of the regular \$3 value now… a Pre-Christmas Saving! Order one or as many as you wish. Proofs shown. No appointment is necessary. Bring this Advertisement. Personalize your Greeting Cards with your photograph this year. A beautiful selection starting at \$1.50 per doz. Robinson Studio. 217 S. Broadway. Phone 1016," *SMT*, Nov. 16, 1936, p. 2.
See: "Robinson, Mary E."

Rodgers, Luella (Mrs. Melvin C. "Ray" Rodgers) (Santa Maria)
Member College Art Club who designed stage scenery for a play at the Santa Maria High School, 1934. Campfire Girls guardian, 1935. The Rodgers family occupied the Breneiser house, the Ark, while the Breneisers were in Santa Fe, 1935. Mother of Melva Bell Rodgers, student at Santa Maria School of Art, 1933.
See: "Santa Barbara County Fair," 1935, "Santa Maria, Ca., Union High School," 1934

Rodriguez (Taggart), Margaret (Mrs. Stanley Taggart) (Santa Maria / Carpinteria)
Art chairman of BPW who arranged a hobby show and exh. hammered silver and a silk quilt, 1941. Teacher in Cook Street school? 1938.
See: "Business and Professional Women," 1941

Roebuck, Miss (Chicago / Santa Maria / Montana)
Photographer. Prop. of Fitzhugh Studio, 1904-05.
■ "Resident Photographer. Miss Roebuck of Chicago has purchased the **Fitzhugh Studio** on Broadway, and the gallery will now be open six days in the week. Characteristic Poses a Specialty. Good Work at Reasonable Prices. Films or Plates Developed and Printed. Instruction and Help Given to Beginners. Houses, Groups, Out-door Pictures Taken," *SMT*, Dec. 31, 1904, p. 2.
Roebuck, Miss (notices in Northern Santa Barbara County newspapers on microfilm and on newspapers.com)
1905 – "Miss Roebuck's Photograph Studio next to Post Office is open every week day," *SMT*, Jan. 14, 1905, p. 2; "Have you seen the new exhibit at Miss Roebuck's new Studio? Just take a look at it," *SMT*, Feb. 4, 1905, p. 3, col. 1; "From ten to three is the best time to visit Miss Roebuck's Photograph Studio," *SMT*, March 11, 1905, p. 3, col. 1; "Are you proud of the seniors and juniors at high school? If so, take a look at them in Miss Roebuck's show case, and be prouder still…," *SMT*, May 27, 1905, p. 3, col. 2; "Take one more look at that much admired showcase rearranged for the last time. Miss Roebuck is soon to leave for a large gallery north, and those desiring work finished by her are requested to attend to it at their convenience," *SMT*, June 17, 1905, p. 3, col. 3 or 4.
Roebuck, Miss (misc. bibliography)
Is she Edith A. Roebuck, photographer, listed in the *Kalispell, Mont., CD*, 1905, 1907, 1909? (refs. ancestry.com).

Roemer, Mary Karleskint (Mrs. Frank L. Roemer) (Santa Maria)
Joint proprietor with her brother, Bernard Karleskint, of the Santa Maria Camera Shop, mid 1940s. Sister to John Karleskint, above.
[Do not confuse with Mary Fitzgerald Karleskint (Mrs. John Karleskint).]
See: "Fitzgerald (Karleskint), Mary," "Karleskint, Bernard," "Karleskint, John," "Santa Maria Camera Shop"

Rogers, Alma Lavonne (1935-2014) (Mrs. M. Sgt. Harry Rogers) (Vandenberg AFB)
Artist. Wife of Vandenberg serviceman and active as an artist in Lompoc, 1958+.
■ "One of the nicest things about service families is the way they give of themselves. An example of this is M. Sgt Harry Rogers and his wife Lavonne. … The Rogers twosome have been married only a year; they met on a blind date in Texas and both agree that it was love at first sight. … Lavonne was completing college at Baylor and was majoring in Art. She had spent time in Mexico City College and was planning a vagabonding art trip to

England. … Lavonne designed her wedding gown and plans were all made when Uncle Sam stepped in ... Harry was being transferred to Vandenberg in April. … They lived in Lompoc until the houses on base were opened … They brought with them their two dogs, Gus and Queenie. … Their home on Oceanview reflects the artistic talents of the couple. Using the same furniture each family can draw from the government, Lavonne and Harry Rogers have created a distinctively pleasant home. Lavonne's collection of artifacts from Mexico, her paintings, shells and driftwood mementos of trips are used to accent the beauties of the pleasant rooms. … Lavonne … A school teacher's work is really never done. She is concerned for the 36 children in her class room in the hospital ward. … It's a full day every day for the Rogers. But, in the quiet of the evening their new piano can be heard accompanying that baritone voice as Harry sings to Lavonne 'To Each his Own,' or songs from musicals he dreams of doing with the Starlite players. …," and port. at easel and piano, and "Active Rogers Couple are Average Family at Vandenberg AF Base," *SMT,* March 21, 1959, p. 4.
■ Port. and "Alma Lavonne ROGERS – 1935 - 2014 … Alma Lavonne Rogers … passed away April 2, 2014 after a long struggle with Alzheimer's disease. Lavonne was born October 10, 1935 … in Marlin, Texas. A graduate of Marlin High School Class of 1954, Lavonne studied for 2 years at the University of Mexico City before graduating from Baylor University in May 1958 with a Bachelor of Fine Arts. On Thanksgiving 1957 her high school classmate, Fran Burke, introduced her to Harry Foster Rogers her future husband. They married on Easter Day, April 6, 1958 in her Marlin home. Lavonne and Harry soon moved to Lompoc, California where daughters Roshay and Rosanne were born at Vandenberg Air Force Base. Their third daughter, Rosemary was born in Marlin before Lavonne joined Harry at his duty station in Wiesbaden, Germany. For the next few years Lavonne, Harry and their 3 daughters were stationed in Europe and North Africa. During this time Lavonne taught elementary school, supported Harry in his theater endeavors by painting stage sets for his local productions and continued to raise her three young children. They settled in Austin, Texas after retiring from the Air Force in 1967. … Lavonne was a prolific artist. Her paintings were in shows in Austin and the Hill Country." - See more at: http://www.legacy.com/obituaries/statesman/obituary.aspx?pid=170487439#sthash.SXaFjYas.dpuf

Rogers, Clarence Mortimer (1886-1973) (Mountain View / Santa Maria)
Teacher of manual arts and drawing at Santa Maria High School, 1916-19.
■ Clarence Mortimer Rogers provided the following information on his WWI Draft Registration Card = b. Aug. 31, 1886 in Knoxville, Tenn., working as a teacher in Santa Maria; Clarence Mortimer Rogers was b. Aug. 31, 1886 in Knoxville, Tenn., to William Marion Rogers and Tryphena 'Triffie' Kennedy, was residing in Tenn. in 1900, and d. Aug. 23, 1973 in Santa Barbara County per Moore Family Tree (ref. ancestry.com).
See: "Santa Maria, Ca., Union High School," 1916-19

Rogers, Jo Ruth (Mrs. Julian Rogers) (Santa Maria)
Art chairman of Lompoc Community Woman's Club,
1948. Student in crafts at Lompoc Adult School, 1946.
See: "Alpha Club," 1948, "Lompoc, Ca., Adult/Night
School," 1946, "Lompoc Community Woman's Club,"
1948

Rogers, The Stamp Photographer
See: "Photography, general (Santa Maria)"

**Rohlfsen, Margaret Ercie (May) Clark (Mrs. Arbor
Glen Rohlfsen) (1895-1981) (Lompoc)**
Studied flower arranging in Santa Barbara, 1930.
Chairman Arts and Crafts Section, Lompoc Community
Woman's Club, 1956.
■ "Margaret Rohlfsen... Born in Protem, Mo.... Mrs.
Rohlfsen came to Lompoc in 1927 where she maintained
permanent residency until 1960. During that time, she was
a charter member of the Alpha club and active in the
Community Women's Club, Eastern Star, the Presbyterian
church and the Lompoc Unified School District. She was
the widow of A. G. Rohlfsen who, until retirement, was
chief electrical engineer with Johns-Manville...," *LR*, Jan.
6, 1981, p. 2.
See: "Lompoc Community Woman's Club," 1956,
"Wesselhoeft, Mary," 1930

Rohrbach, William (1925-2017) (Santa Barbara)
Art teacher UC Santa Barbara, beginning late 1940s.
Speaker at Winter Arts Program, 1953. Judge of Santa
Ynez Valley Art Exhibit, 1956. Invited to exhibit at Santa
Barbara County Fair, 1961.
■ "Rohrbach Exhibit Slated Thursday... Santa Barbara
Museum of Art... Currently an Associate Professor of Art,
Rohrbach has been an instructor at the University of
California, Santa Barbara, for the past nine years.
Originally from Stanford, Connecticut, he studied at the
University of Michigan and later the University of
California at Berkeley, where he received his master's
degree in art. Rohrbach was awarded the Ann Bremer Prize
in 1951. He is a frequent participant in regional and
competitive exhibitions, such as Pacific Coast Biennial and
the San Francisco Museum Annuals. This is his fourth one-
man show at the Santa Barbara Art Museum," *LR*, Dec. 19,
1960, p. 18 (i.e., 6b).
And, c. 40 additional notices for "William Rohrbach" in
California newspapers 1935-2000 not itemized here.
See: "Santa Barbara County Fair," 1961, "Santa Ynez
Valley Art Exhibit," 1956, "Winter Arts Program," 1953

**Rolle, Frederick / Fredrick John (1872-1954) (Santa
Barbara / Santa Maria)**
Painter / decorator, relocated to Santa Maria, 1924.
Rolle, F. J. (notices in Northern Santa Barbara County
newspapers on microfilm and on newspapers.com)
1915 – "F. J. Rolle, Corydon Drive, has the contract for
$850 for the painting on the 2-story residence now being
built in Beverly Hills for W. D. Foote, C. F. Skilling, arch.,

Garland Bldg." per *Southwest Contractor and
Manufacturer*, March 13, 1915, p. 16, col. 3.
1916 – Classified ad: "Professional Cards. F. J. Rolle,
painting, decorator, silk, tapestry, wood and marble
imitation, frescoing and everything in the painting line, Box
1776," per *Bisbee (Arizona) Daily Review*, Nov. 3 (and
Nov. 10), 1916, p. 7.
1924 – "New Painting Decorator Locates in Santa Maria"
from Santa Barbara, and has done churches and theaters in
SF, LA and SB, *SMT,* April 9, 1924, p. 6.
There are more than 800 ads, etc. for "F. J. Rolle" in Santa
Barbara County newspapers but they were not even
browsed for potential inclusion here.
Rolle, F. J. (misc. bibliography)
Fredrick J. Rolle was listed in the 1920 U. S. Census in
Santa Barbara; Frederick J. Rolle is listed in the 1930 U. S.
Census as b. c. 1873 in Germany, naturalized, a painter /
decorator, residing in Santa Maria with wife Marie C. (age
45) and daughter Ruth M. (age 18); Frederick John Rolle
was b. July 25, 1872 in Other Country and d. June 11, 1954
in San Luis Obispo County per Calif. Death Index (refs.
ancestry.com).

Romano, Lucille "Lou" (Mrs. Bert Romano) (Lompoc)
Exh. painting at Open-Air Art Exhibit, 1957. Teacher of
flower arranging, 1962.
1962 – "Council of Catholic Women Learn Flower
Arrangement. Mrs. Bert Romano was the instructor for a
floral arrangement workshop Tuesday night following a
meeting of the La Purisima Council of Catholic Women...,"
LR, Sept. 27, 1962, p. 6.
See: "Open-Air Art Exhibit," 1957

Rome, Richardson "Dick" (1902-1981) (Boulder, Colo.)
Artist visitor who made sketches for planned Christmas
cards depicting Solvang, 1947. Prop. Rome Creations,
Denver, a producer of stationery bearing artistic etched
scenes.
See: *Central Coast Artist Visitors before 1960*

Romer, Christian C. (1877-1949) (Los Prietos)
Teacher of carpentry and woodcraft at Los Prietos CCC
camp, 1937.
Romer, C. C. (misc. bibliography)
Christian C. Romer is listed in the 1930 U. S. Census, and
in the 1940 U. S. Census as age 62, b. c. 1878 in Denmark,
finished high school 4th year, naturalized, a carpentry
instructor residing in Santa Barbara (1935, 1940) with wife
Mary R. (age 55) and five children; Christian C. Romer b.
1877 and d. 1949 is buried in Goleta Cemetery per
findagrave.com (ref. ancestry.com).
See: "Santa Ynez Valley Union High School," 1937

Rose, Blanche (Shell Beach)
Artist who exh. at the Santa Ynez Valley Art Exhibit,
1954. Exh. Santa Barbara County Fair, 1959, 1960.
See: "Santa Barbara County Fair," 1959, 1960, "Santa
Ynez Valley Art Exhibit," 1954, and *San Luis Obispo Art*

and Photography before 1960 and *Arroyo Grande (and Environs) Art and Photography before 1960*

Rose (Reid), Helen Grace (Mrs. Morley Clayton Reid) (1894-1970) (Lompoc)
Teacher of commercial subjects and of drawing at Lompoc High School, 1919, but she was soon assigned only to commercial subjects.
Rose, Helen (notices in Northern Santa Barbara County newspapers on microfilm and on newspapers.com)
1922 – "Sail from New York on European Tour… Miss Helen Rose… are now on their way east and will sail from New York July 1st on the *S. S. Homeric* of the White Star Line for a three months' tour of Europe…," *LR*, June 23, 1922, p. 6; "Italy in Turmoil According to … principal of the Lompoc high school who, with Miss Helen Rose … has been touring Europe during the summer… 'Went from France to Germany, Germany to Austria, Austria to Italy and no one in the party had any trouble passing the customs. Italy is in pretty much of a turmoil politically… railroads, street cars and cabs to strike. For two days we walked – walked miles and miles… We leave for Naples tomorrow…," *LR*, Aug. 25, 1922, p. 1.
Rose, Helen (misc. bibliography)
Helen Rose is listed in the 1900 U. S. Census residing with her family in Colorado Springs, Colo.; Helen Rose is listed in the 1920 U. S. Census as age 25, b. c. 1895 in Colorado, a teacher, rooming in Lompoc; Helen G. Rose, teacher and Rep. is listed in Voter Index*, Lompoc Precinct No. 4*, 1920-28; Helen Grace Rose applied for a passport in LA to visit Japan, China, Hongkong, 1924; Helen Rose sailed from San Francisco on the *S. S. Manoa* on March 26, 1924, arriving at Honolulu, April 2, 1924 per *Honolulu, Hawaii, Passenger and Crew Lists*; Helen Rose b. April 5, 1894 in Grand Junction, Colo, departed Shanghai, China, on the *S. S. President Taft* on Oct. 28, 1927 and arrived in Los Angeles on Nov. 20, 1927 per Calif. Passenger and Crew Lists; Helen Grace Rose married Morley Clayton Reid in Shanghai, China, on June 17, 1930 per *U. S. Consular Reports of Marriages, 1910-1949*; Helen R. Reid b. April 5, 1894 in Colo., d. Dec. 21, 1970 in San Francisco County per Calif. Death Index (refs. ancestry.com).
See: "Lompoc, Ca., Union High School," 1919

Rose, Iver (1899-1972) (New York / Rockport, Ma.)
Artwork shown at first Santa Maria Valley Art Festival, 1952, courtesy Cowie or Dalzell Hatfield Gallery in LA.
■ "Born in Chicago, Illinois, Iver Rose attended the Art Institute of Chicago and the Cincinnati Art Academy. He began his career as a commercial artist in New York City and turned to painting in the 1930s. He had nine one-man shows in New York galleries, among them Kraushaar Galleries, where he exhibited paintings and lithographs of his primary subjects, which included clowns, children, musicians, and old Jewish patriarchs. He held studios in both New York City and in Rockport, Massachusetts, where he was a member of the Rockport Art Association," per fineart.ha.com (Heritage Auctions).
See: "Santa Maria [Valley] Art Festival," 1952

Ross, Gene (Mrs. Ross) (Santa Barbara)
Silhouette artist who cut images at the Santa Ynez Valley Art Exhibit, 1957, 1958.
Ross, Gene (notices in Northern Santa Barbara County newspapers on microfilm and on newspapers.com)
1956 – "Memo Pad… Valley Views… An attraction which should be popular with youngsters and their parents at the [St. Mark's-in-the-Valley] Art Show this weekend is the appearance of Jene [Sic. Gene] Ross of Santa Barbara, silhouette artist… she will do cutout silhouettes of youngsters each afternoon of the show beginning at 3 p. m….," *SYVN*, May 25, 1956, p. 2.
1957 – "Christy Fox… Mrs. Gene Ross, who used to cut silhouettes of the Grove merrymakers…," *LA Times*, April 15, 1957, p. 37 (i.e., pt. II, p. 5).
1958 – "Valentine Fete… Santa Barbara… Souvenir silhouettes will be fashioned by Gene Ross…," *LA Times*, Feb. 9, 1958, p. 81 (i.e., pt. IV, p. 9).
Ross, Gene (misc. bibliography)
Gene Ross, artist, with no husband cited, residing at 865 Ashley Rd., Montecito, is listed in the *Santa Barbara, Ca., CD*, 1959, 1964, and then in an apartment, 1966 (refs. ancestry.com).
See: "Santa Ynez Valley Art Exhibit," 1957, 1958

Ross, Royala L. (Mrs. William G. Ross) (Bell)
State Handcraft Chairman, California Federation of Women's Clubs, who spoke to Alpha Club, 1938.
See: "Alpha Club," 1938

Rossini (Winter), Hazel (Mrs. Aldo E. Rossini) (Mrs. Bill Winter) (Valley of Gardens)
Student of oil painting, DeNejer studio?, who exh. at Santa Barbara County Fair, 1949. Member Santa Maria Art Association, 1949. Exh. Tri-county Art Exhibit, 1949.
■ "Bill Winter and Bride… Mrs. Winter, the former Hazel Rossini, has made her home since childhood with her uncle and aunt, Mayor and **Mrs. A. E. Gracia**. She is the daughter of H. G. Silveria of Hollister. … both Mr. and Mrs. Winter have attended public schools of Santa Maria. The bride has been employed locally with the PG and E company… They will make their home in Santa Maria," *SMT*, Nov. 6, 1950, p. 4.
See: "Santa Barbara County Fair," 1949, "Santa Maria Art Association," 1949, "Tri-County Art Exhibit (Santa Barbara)," 1949

Rowe, Barbara F. (Lompoc)
Teacher, art hobbyist, 1954. Often served on decoration committees for special events.
■ Port. and "Introducing… Barbara F. Rowe… has been with the elementary school faculty for the past 10 years and for three prior years taught in a Santa Barbara private school. She has an A. B. degree from the University of California Santa Barbara College with a general elementary credential. She is the daughter of the late E. D. Rowe who was closely connected with the restoration of Purisima mission and has been active in Mission Association work. Miss Rowe is a member of the Catholic Daughters of

America and her special interest is working with children in almost any capacity. Weaving, leather carving and painting are her favorite hobbies," *LR*, Oct. 7, 1954, p. 7.
See: "Christmas Decorating Contest (Lompoc)," 1955

Rowe, Edwin / Edward Denys (1881-1954) (La Purisima / Solvang)
Landscape designer employed by the National Park Service who planted the grounds of Mission La Purisima (mid 1930s) and Santa Ines (1954).
■ Port with Father **Tim O'Sullivan** designing gardens for Santa Ines mission, and "E. D. Rowe Last Rites… E. D. Rowe, chairman of the Santa Barbara County Park Commission and veteran Santa Barbara County horticulturist who died in his sleep at his home in Lompoc early last Thursday morning. Mr. Rowe, who was 73, was a native of England and had studied horticultural methods in Europe before coming to America and California in 1903. He had lived in this state ever since. During the depression he worked for eight years with the National Park Service when CCC boys were brought to Lompoc to restore **La Purisima Mission**. Mr. Rowe experimented with native plants and their need for water until the mesa above the Mission has become a 'forest' of between 800 and 900 trees. These trees, which today tower 20 to 50 feet in the air, were surplus trees, left over from the Mission project. During recent years, too, Mr. Rowe acted as landscape consultant at Old **Mission Santa Ines** in Solvang. At the time of his death, he was engaged in a landscape project at the Mission having to do with the old cemetery area… During the war years, Mr. Rowe worked as a farm labor replacement official in the Lompoc and Santa Ynez Valley areas. For a time, he worked on county parks, such as Santa Rosa and Nojoqui…," *SYVN*, March 26, 1954, p. 1, 5; "E. D. Rowe, Civic Leader, Passes Here," *LR*, March 18, 1954, p. 1.
Rowe, E. D. (notices in Northern Santa Barbara County newspapers on microfilm and on newspapers.com)
1950 – "A total of 253 varieties of native California shrubs, trees and flowers are now being cultivated at **La Purisima Mission**, says E. D. Rowe, landscape artist for the National Park Service," *LR*, Feb. 23, 1950, p. 10.
Rowe, E. D. (misc. bibliography)
Edward D. Rowe, horticulturist, is listed in the *Santa Barbara, Ca., CD*, 1937, 1940; Edwin Denys Rowe was b. Jan. 18, 1881 in Finchley, England, to Charles Frederick Rowe and Amelia Skidmore Dennis, married Frances W. Welch, and d. March 18, 1954 in California per Penny DNA Tree (refs. ancestry.com).
See: "Alpha Club," 1935, "Community Center (Lompoc)," intro, "Mission La Purisima," 1939, 1940

Rubey, Ervin Burdett, Ens. (1926-2013) (Solvang)
Photographer with U. S. Navy, 1950.
■ "Capt. Ervin Burdett Rubey, Jr., U. S. Navy (Ret)… He attended Buellton Grammar school and graduated with the class of 1943 from the Santa Ynez Valley Union High School. 'Rube' joined the U. S. Navy in 1943 and retired in 1977… 'Rube' flew a wide variety of aircraft from carrier decks as well as from air bases. His main interest was in

Naval Intelligence… He was a graduate of The Naval War College at Newport, R. I.," *SYVN*, Sept. 5, 2013, p. A-6.
Rubey, Ervin Burdett (notices in newspapers on newspapers.com).
1950 – "Ensign Rubey in Photo Unit. Ens. Ervin B. Rubey, USN, son of Mr. and Mrs. E. B. Rubey, Sr., of Laguna Ranch, Solvang, is attached to the Navy's only combined multi-engine and single engine (fighter type) photographic squadron. He is presently stationed at San Diego with Composite Squadron 61. The squadron is composed of veteran pilots, aerial photographers and crewmen who carried out hazardous photo missions during the past war. It specializes in precise aerial photography for mapping purposes, in photographic interpretation, and in all phases of Naval photography in the air, aboard aircraft and on the ground. One of its biggest tasks has been to map over 70,000 square miles of terrain in Alaska," *SYVN*, March 31, 1950, p. 3.
Rubey, Ervin (misc. bibliography)
Ervin Burdett Rubey was b. Dec. 14, 1926 in Santa Barbara to Ervin Burdett Rubey and Mabel Claire Testerman, married Mary Rose Jorgensen and d. Aug. 20, 2013 in Coronado, Ca., per Daniel Family Tree (refs. ancestry.com).

Rudolph, Dorothy Louise Riggs (Mrs. Richard F. Rudolph) (1911-1963) (Lompoc)
Ceramist, 1950s. She and two friends made ceramic table favors for the annual footballers' awards dinner. Real estate sales person.
1955 – "Grid Dinner… Special table favors which will be given to the football players at the dinner are on display this week in the window of Penney's store. They were made by a group including Dorothy Rudolph …," *LR*, Nov. 10, 1955, p. 8; "Gridders Get Awards at Club Dinner … Favors consisting of clever ceramic football shoes were presented to each of the varsity players… designed by Dorothy Rudolph and made by a group of players' mothers," *LR*, Nov. 17, 1955, p. 12.
See: "Ceramics," 1956, "Wygal, Elsa," 1958

Rudolph, Helen Aliene (Mrs. Kenneth Rudolph) (1894-1978) (Lompoc)
Member, Art Group and Handicraft group and Arts & Crafts group of Alpha Club, 1938, 1939, 1940. Taught crafts at USO, 1945, 1946.
■ "Helen Rudolph… former longtime Lompoc resident. At the time of her death, she lived in Long Beach. While living in Lompoc, Mrs. Rudolph was an active member of the business community … a past president of the Alpha Club and active in the Pioneer Society…," *LR*, May 15, 1978, p. 2.
Rudolph, Helen (notices in newspapers on newspapers.com).
1938 – "Mrs. Kenneth Rudolph is President of Alpha Club," *LR*, June 24, 1938, p. 1.
Rudolph, Helen (misc. bibliography)
Helen Rudolph is listed in the 1920, 1930 and 1940 U. S. Census as b. c. 1895 in Colorado residing with husband Kenneth in Lompoc; Helen Aliene Rudolph, 1894-1978, is

buried in Lompoc Evergreen Cemetery per findagrave.com (ref. ancestry.com).
See: "Alpha Club," 1938, 1939, 1940, "Lompoc, Ca., Adult/Night School," 1940, "United Service Organization (Lompoc)," 1945, 1946

Rudolph, Nina (Mrs. John C. Rudolph) (Lompoc)
See: "Morehead, Nina"

Rule, Alex Sherman (1926-2012) (Lompoc)
Teacher of Arts and Crafts, Lompoc Elementary School, 1955/56, transferred to Lompoc High School c. 1956 where he taught to 1958, and taught Lompoc Adult School, 1957/58. He also served as a coach at Lompoc High. He moved on to teach for many years in Los Angeles County and after c. 1970 in Alaska.
Rule, Alex (notices in newspapers on newspapers.com).
1955 – "66 Will Receive Degrees at CSCE … Colorado State College of Education… Bachelor of Arts (with teaching certificate) … Alex Rule, Grand Junction…," *Greeley Daily Tribune* (Greeley, Colo.), March 9, 1955, p. 8.
1957 – "Master's Degree Conferred… Greeley, Colo. The degree of master of arts in fine arts was conferred upon Alex Sherman Rule of 209 ½ South G. street, Lompoc, at the summer commencement of Colorado State College of Education here Thursday, August 15," *LR*, Aug. 22, 1957, p. 9.
He was first hired as a 7th grade teacher in the Hapgood School, 1955/56.
Rule, Alex (misc. bibliography)
Alex Sherman Rule's WWII Draft Registration Card, dated May 20, 1944, reveals he was a patient in the Vets Hospital, Walla Walla, Wa.; Alex S. Rule appears in the Lompoc High School yearbook, 1958; Alex Rule appears in the Centennial High School, Compton, Ca., yearbook, 1962, 1963, 1964, 1965, 1966; Alex S. Rule, teacher of Crafts I, II, appears in the Dominguez High School, Compton, Ca., yearbook 1967, 1968; Alex Rule, teacher of Fine Arts, is pictured in the Seward High School yearbook (Seward, Alaska), 1971, 1972, 1973; Alex Rule, Sr., was residing in Seward, Alaska, 1996-2001 (and also Ocala, Fla.?) per *U. S. Phone and Address Directories*; Alex Sherman Rule was b. March 8, 1926 in Santa Barbara to Arthur Sherman Rule and Alice E. Penny, married Helen Marie Lake, and d. Nov. 24, 2012 in Seward, Alaska per Rule Family Tree (refs. ancestry.com).
See: "Hapgood School," "Lompoc, Ca., Adult/Night School," 1957, 1958, "Lompoc, Ca., Union High School," 1956, 1957

Rushforth, Carol Ruth (Santa Maria)
Advanced art student of Elizabeth Breneiser at Santa Maria High School, and art editor of high school annual, 1935 and of JC Mascot, 1937. Often produced posters, costumes and stage settings for high school theatricals. Actress in amateur theater, singer, and interested in music. Older sister of Mina L. Rushforth, below.

See: "Minerva Club Flower Show," 1933, "Rushforth, Mina," "Santa Maria, Ca., Union High School," 1935, 1937, "Santa Maria School of Art," 1933, "Scholastic Art Exhibit," 1933

Rushforth, Mina L. (Santa Maria)
Santa Maria high school student who won a prize for best inked drawing, 1935, was art editor of the yearbook, 1939, and the subject of a poster. Winner in Latham poster contest, 1938. Often produced posters, costumes and stage settings for high school theatricals. Actress in amateur theater, singer. Younger sister of Carol Rushforth, above.
Rushforth, Mina (notices in Northern Santa Barbara County newspapers on microfilm and on newspapers.com)
1940 – "In College Chorus – Mina Rushforth, student in San Jose State college, has been accepted as a member of the school's acapella chorus. Daughter of Mr. and Mrs. E. F. Rushforth of Santa Maria, she is a graduate of the local high school and of the junior college (class of last June)," *SMT*, Oct. 5, 1940, p. 3.
See: "Posters, general (Santa Maria)," 1941, "Posters, Latham Foundation (Santa Maria)," 1938, "Rushforth, Carol," "Santa Maria, Ca., Elementary / Grammar School," 1933, "Santa Maria, Ca., Union High School," 1935, 1939, "Santa Maria School of Art," 1933, "Splash," 1938

Russell, George C., Prof. (1844-?) (Santa Maria)
Principal Santa Maria High School, 1896-99, who also taught photography, 1899.
1896-99 – "History of the Santa Maria Union High School, by Miss Mamie Nance… In 1896 Geo. C. Russell was elected principal and Mrs. Blochman assistant. The following year the work was satisfactory in the required number of subjects to admit the school to the accredited list of the State University. Mr. Russell served as principal for three years…," *SMT*, June 24, 1904, p. 1.
Russell, George (misc. bibliography)
George C. Russell is listed in the 1900 U. S. Census as age 46, b. March 1844 in Ohio, principal of school, residing in Los Gatos with wife Ella A. Russell (age 43) and child Hattie M. Russell (age 13) (refs. ancestry.com).
See: "Santa Maria, Ca., Union High School," 1899

Ruth, Clarence Emory (1890-1975) (Lompoc)
Collector of Native American material, 1939. Exh. at County Fair, 1930, and other places. Model maker. His collection of Chumash and other Native American materials are contained in the Lompoc Museum. Brother to Hazel Ruth Berger, above. Brother-in-law to Fred Berger, above.
■ Port. with part of his collection and "Local Indian Museum Tells Story of Chumash Indians in Lompoc… The Indian Museum, owned and established by Clarence Ruth at 230 North G Street, has within its walls an elaborate collection of weapons and tools used by the Chumash Indians… Thousands of arrowheads and other items… have taken archeologist Ruth 33 years of hunting, research and excavating to recover and identify. The former school principal has discovered over 50 Chumash village sites

since… 1926… The archeologist indicated the Indians had lived on shell fish prior to the arrival of the Spaniards… As far as the present sources of information can determine … the Chumash Indians inhabited the area from Malibu beach to the south to Morro bay to the north… Ruth has uncovered cave paintings, skulls and skeletons, bowls, beads, arrowheads, spear heads, knife blades… All of his collection is on display at the museum on North G Street … Ruth has designed and painted a map which… indicates the location of every Chumash village he has discovered … Clarence Ruth graduated from Chico State college in 1922 and later earned his master's degree in archeology from the University of Southern California. He wrote his thesis for the masters on the Indians in this area," *LR*, Aug. 13, 1959, p. 28.

Ruth, Clarence (notices in Northern Santa Barbara County newspapers on microfilm and on newspapers.com)
1939 – "Clarence Ruth Tells Santa Maria Pupils of Indian Life… principal of the local elementary school… He took with him parts of his large collection of Indian artifacts to show the children…," *LR*, Feb. 24, 1939, p. 2.
1957 – "Justice Court Flag… Santa Maria Valley Historical Society… W. W. Stokes reported that a thesis by Clarence Ruth… on Indian lore of this area is being copied for records of the society by **Miss Betty Scott** and **Mrs. Hosn**. It was requested that pictures accompanying the thesis be reproduced…," *SMT*, Feb. 20, 1957, p. 7.
And, more than 2,860 hits for "Clarence Ruth" including more than 450 for "Clarence Ruth" plus "Indian" in Santa Barbara newspapers between 1920 and 1975, were not even browsed for potential inclusion here.
See: "Berger, Fred," "Berger, Hazel," "Lompoc, Ca., Elementary Schools," 1932, 1934, 1935, "Lompoc Historical Museum," "Lompoc Valley Fair," 1928, 1930, "Martin, Gilbert," "Santa Barbara County Fair," 1930, "United Service Organization," 1944

Ryan, Margaret Russe
See: "Sutter (Ryan), Margaret Russe (Mrs. John A. Ryan)"

Rycher, Harold C. (New York)
Photographer with Fairchild Aerial Surveys who mapped the Santa Maria valley with aerial photos, 1928.
See: "Photography, general (Santa Maria)," 1928

Ryon Park (Lompoc)
Site of art exhibits, festivals, summer recreation classes, and some adult education classes.
See: "Christmas Decorations (Lompoc)," "Flower Festival," "Lompoc, Ca., Union High School," 1939, "Open-Air Art Exhibit," "Summer School (Lompoc)," 1946+

S

Sabin, Charles Lester (1907-2005) (Lompoc)
Teacher of wood working and drafting at Lompoc high school, 1952+. His students repaired broken toys for Christmas gifts, 1954, and built stage sets for school plays.
■ Port. and "C. Lester Sabin is a graduate of Kent State University and Ohio State, having a Master's degree in education. He is in his third year on the Lompoc High school faculty and is a teacher of wood working and drafting. As an undergraduate his activities included track and drama. Sabin was in the teaching profession for 15 years before coming to Lompoc. He is a member of the Methodist church and names cabinet making as his favorite hobby. Mr. and Mrs. Sabin and their three children reside at 130 South M street," *LR*, Oct. 21, 1954, p. 8.
Sabin, C. Lester (notices in Northern Santa Barbara County newspapers on microfilm and on newspapers.com)
1952 – "New Faculty Members … Instructor in General Shop for the Junior High will be C. Lester Sabin who formerly taught at Randolph High in Randolph, Ohio, and the Nelson Township High School in New Garretsville, Ohio. Mr. Sabin has a B. S. and M. S. from Kent State University, Kent, Ohio," *LR*, Aug. 28, 1952, p. 1, 10 (i.e., pp. 1, 8).
Sabin, C. Lester (misc. bibliography)
Lester Charles Sabin was b. Oct. 19, 1907 in Randolph, Ohio, to Charles Carl Sabin and Harriet "Hattie" May Brumbaugh, married Luella Florence King and d. Feb. 3, 2005 in Lompoc, Ca., per Swartz Family Tree (refs. ancestry.com).
See: "Lompoc, Ca., Union High School," 1952, 1955, 1960

Saddle Shop (Solvang)
Leatherworker. Opened in Copenhagen Square, April 1948-51.
■ "Two Ex-GI's Start Valley Saddle Shop… Jake Copass and Travis Bohannon… The two men will make their own saddles, will repair saddles, and will do practically every kind of leather work. They plan an extensive stock of hand tooled leather items, including bridles, belts and other leather goods…," *SYVN*, April 23, 1948, p. 1.
Saddle Shop (notices in Northern Santa Barbara County newspapers on microfilm and on newspapers.com)
1949 – "Saddle Shop Moves… to the opposite end of the Army barracks type building at the rear of Copenhagen Square in Solvang. Copass and Bohannon also announced the shop is handling a line of Western boots," *SYVN*, Aug. 5, 1949, p. 6.
1950 – "Saddle Shop. Everything you need in the leather line," *SYVN*, March 31, 1950, p. 5.
1951 – Sponsored a trophy in a horse show, *SYVN*, March 23, 1951, p. 1, col. 6.
1952 – "Travis Bohannons Have Baby Girl…," and move to Santa Maria, *SYVN*, June 27, 1952, p. 3.
1953 – Article on Copass – "Shoe'n Horses Nearly Lost Art, Says Copass. Valley Man Serves Wide County Area…

Solvang Saddle Shop. This business is no longer in operation …," *SYVN*, Sept. 11, 1953, p. 7, 8.

Sailors, Patricia (Beverly Hills)
Interior decorator of Sloan's, Beverly Hills, who spoke to Minerva Club, Jan. 1951.
See: "Interior Decoration," "Minerva Club," 1951

Saint
See also "St."

Saint Mark's-in-the-Valley, Episcopal Church (Solvang)
Sponsor of an art exhibit to raise funds, Feb. 1953. In the following years the show was officially titled "Santa Ynez Valley Art Exhibit" and ran 1954-58. Excess money raised at the exhibit went toward an art scholarship. The church contained a stained glass window made by Judson Studios of Los Angeles.
Various of its rooms were used as classrooms for adult and children's art classes, including Santa Ynez Valley Child Workshop Project, 1955.
1953 – For the Saint Mark's-in-the-Valley Art Exhibit, see "Santa Ynez Valley Art Exhibit," 1953.
1954 – "St. Mark's Art Scholarship Award Now Available Here… Eligible for the scholarship is any graduate or senior of the **Santa Ynez Valley Union High School** or to any resident of the Valley who desires further training… The scholarship provides funds for study in an accredited school or private instruction in the fields of art, including oil painting, water colors, ceramics, commercial arts, photography and sculpture… The award will be made on the basis of financial need, present achievement and intention of study in field of art," *SYVN*, June 4, 1954, p. 4.
1958 – Photo of Memorial Window which depicts Christ calling St. Andrew to discipleship that was designed and made by the **Judson Studios** of Los Angeles… given by friends in memory of Rev. Father Alfred C. Bussingham, *SYVN*, Nov. 7, 1958, p. 1.
See: "Abbott, Ronnie," 1953, 1956, "Barbera, Helen," "Danish Days," 1957, 1958, "Joughin, Helen," "Kuelgen, Paul," "Negus, Annette," "Ross, Gene," "Santa Ynez Valley Art Association," "Santa Ynez Valley Art Exhibit," "Santa Ynez Valley, Ca., Elementary / Grammar Schools," 1955, "Santa Ynez Valley Child Workshop Project"

Saint Mary's …
See: "St. Mary's"

Saint Peter's Episcopal Church (Santa Maria)
See: "St. Peter's Episcopal Church"

Saints' Puppeteers
See: "Puppets (Santa Maria)," 1935

Saladin, Theodore F. "Bardy" (1913-2004) (Santa Maria)
Photographer. Briefly a member of Santa Maria Camera Club, 1943. Furniture store owner.
[Do not confuse with his son, Bard Saladin, b. 1944.]
See: "Heath, George," "Hoback, Gene," 1953, "Santa Maria Camera Club," 1943, "Souza, J."

Sample, Alice / Alyce (Mrs. Lynn Sample) (1888-1971) (Santa Maria)
Craftswoman / painter / crafts shop owner? Taught ceramics at DeNejer Studio, 1949. Exh. paintings at Tri-county Art Exhibit, 1950 and Santa Barbara County Fair, 1952.
■ "Miniatures and Stones are Sisters' Hobbies. Mrs. Alyce Sample of Lynn Samples' craft shop [Sic.?] of Santa Maria, exhibited a hand-made church model made from stone, glass and beads at the Santa Barbara County Fair. This church is patterned after the architecture of the St. Mary's Church in Santa Maria. Mrs. Sample, who is the sister of Mrs. H. E. Johnston of Grover City, and **Mrs. Peggy Clark**, Oceano, excels in almost every part of the art and craft field. She built her church after working with Mrs. Clark on a miniature stone castle. Mrs. Clark is a lapidarist and has utilized polished stones in the decoration of her home with the help of Mrs. Sample, who drew the designs and plans. Mrs. Clark's home is on 1090 13th Street in Oceano. Mrs. Sample is the mother of Lee Johnson, formerly linotype operator for the *Herald-Recorder* and now with the California Highway Patrol," *AG*, Aug. 15, 1958, p. 1.
■ "Obituaries. Arroyo Grande… Mrs. Alice Sample… born Dec. 15, 1888 in Missouri, died Tuesday in a Santa Maria hospital. She had been a resident of California since 1922 and a resident of Santa Barbara County for 36 years," *SMT*, Nov. 10, 1971, p. 8.
Sample, Alice (misc. bibliography)
Alice Sample is listed in the 1940 U. S. Census as age 51, b. c. 1889 in Missouri, finished high school 4th year, working as a masseuse, residing in rural SLO county (1935) and Santa Maria (1940) with her husband, Lynn J. Sample (age 55) and her own son and daughter by the last name of Johnson; Alice Sample, b. Dec. 15, 1888 in Missouri, d. Nov. 9, 1971 in Santa Barbara County per Calif. Death Index (refs. ancestry.com).
See: "DeNejer, Jeanne," 1949, "Santa Barbara County Fair," 1949, 1952, "Tri-county Art Exhibit," 1950

San Luis Obispo County Art Show (San Luis Obispo)
Annual art exhibit sponsored by the American Association of University Women, 1947+, that attracted artists from northern Santa Barbara County.
San Luis Obispo County Art Show (notices in Northern Santa Barbara County newspapers on microfilm and on newspapers.com)
1948 – "SLO County Art Show Sets Entry Deadline" and submission guidelines, *SMT*, Feb. 5, 1948, p. 3.
1950 – "Deadline for Entries in Art Exhibit Nears… extended to Feb. 10… Entry blanks are also available locally by contacting *The Record*," *LR*, Jan. 26, 1950, p. 7.

1952 – "SLO Art Show is Scheduled" and invites entries, *SMT*, Feb. 2, 1952, p. 5.
1953 – "Artists Invited to Show Paintings," *SMT*, Jan. 22, 1953, p. 4.
1957 – "SM Artists Invited to Enter SLO Show," *SMT*, Feb. 5, 1957, p. 4; "AAUW at San Luis to Sponsor Art," and entering show will be **Richard York** and **George Muro** of Santa Maria, *SMT*, March 9, 1957, p. 3.
See: "Glasgow, Charles," "Johnson, Don," "Joughin, Helen Eloise," 1956, "Paradise, Phil," "Peake, Channing," 1957, and *San Luis Obispo Art and Photography before 1960*

San Luis Obispo County Fair (San Luis Obispo / Paso Robles)
Fair, held annually to display local products. Some years included an exhibit of art and handiwork. After WWII its exhibits of artwork expanded. Residents of Santa Barbara County were invited to enter.
San Luis Obispo County Fair (notices in Northern Santa Barbara County newspapers on microfilm and on newspapers.com)
1887 – "SLO Items… The San Luis Obispo County Agricultural Fair will be held in this city [SLO] … October 12, 13, 14 and 15…," *SMT*, Sept. 17, 1887, p. 3, col. 5.
1890 – "We are in receipt of San Luis Obispo Fair catalogue announcing the 16th District Agricultural Fair from the 2nd to the 6th of September inclusive. The catalogue is neatly printed and quite artistic… It is the work of the *Tribune*'s job department…," *SMT*, Aug. 9, 1890, p. 2, col. 1.
1899 – "Sept. 26, 27, 28, 29 and 30," *SMT*, Aug. 12, 1899, p. 2.
See: *San Luis Obispo Art and Photography before 1960*

Sander (Mehlschau), Ursula Arlene / Arline (Mrs. George Mehlschau) (1930-2007) (Santa Maria)
Painter, hobbyist, 1957.
■ "The only queen to appear in the parade on a horse rode down Broadway in 1948. She was Ursula Sander then, but is now Mrs. George Mehlschau of Gustine, California. And that is not her only contribution to the rodeo. Her husband ropes at the fair each year. They have a four-year-old son who is learning the western skill himself. Besides horseback riding, Ursula has painting as a hobby. She has done a bulldogging scene which she hopes to display here during the rodeo. In time she hopes to become a professional artist…," per "Past Queens… Elk's Rodeo," *SMT*, May 29, 1957, p. 12.
Sander, Ursula (notices in Northern Santa Barbara County newspapers on microfilm and on newspapers.com)
1950 – Port of Mr. and Mrs. George Mehlschau cutting their wedding cake, *SMT*, June 17, 1950, p. 5.
And, several articles on "Ursula Sander" regarding her queen contest and her wedding were not itemized here.
Sander, Ursula (misc. bibliography)
Ursula Arlene Sander b. Jan. 16, 1930 in Santa Maria, d. Jan. 17, 2007 per Social Security Applications and Claims Index (refs. ancestry.com).

Sanders, Ellen Carpenter (Mrs. Lt. Col. Allen W. Sanders) (c. 1920-1996) (Lompoc)
Portrait painter, draftswoman, 1958-1959. Husband, Al, had an interest in photography. Swimmer.
■ "Meet Your New Neighbors! [by] Mary Jane Clemmer. (News of Cooke AFB Officers and their families who have bought homes in Lompoc.) An avid interest in art is the keynote throughout the new home of Lt. Col. and Mrs. Allen Sanders, at 222 North N street. Ellen Sanders is a native of Greenville, South Carolina, and has many claims to fame. She was the first girl to attend Clamson college in Clamson, S. C. and studied architecture. Ellen is a very talented portrait artist and seems to find time for bridge and swimming and also the many involuntary things for which she is often volunteered by her two children, Nancy, 12, and Allen, Jr., 9… '**Sandy' Sanders** is the Army Area Engineer here, also a graduate of Clemson, and he received his Master's Degree from the University of Illinois. He is very interested in photography and when that sunny dry weather arrives you will be able to see the Sanders out in force turning their garage into a dark room. Colonel and Mrs. Sanders, Nancy and Al, attend St. Mary's Episcopal church," *LR*, April 3, 1958, p. 7.
■ "Ellen C. Sanders, Greenville. Ellen Carpenter Sanders, 76… died Aug. 6, 1996. Born in Greenville, she was a daughter of the late John Lewis and Myrtle Pemberton Carpenter and was the wife of the late retired Col. Allen W. Sanders, Jr. She was a homemaker and at one time was employed as a bookkeeper and architect. She was a member of … the class of 1937 of Greenville High School. She attended Clemson College, now Clemson University…," *Greenville News* (Greenville, S.C.), Aug. 8, 1996, p. 27 (i.e., 5D).
Sanders, Ellen (notices in Northern Santa Barbara County newspapers on microfilm and on newspapers.com)
1959 – "Lompocans Devote Time … [to produce Lompoc Aquatic Club's fourth Annual Aquacade] … The Allen W. Sanders family proves that the Aquatic Club can provide every member of a family an important role to perform at show time. In charge of costuming is Mrs. Sanders… she is presently doing drafting for a local architect. Her artistic background together with her joy in sewing qualifies her admirably for the task. Lt. Col. Sanders, her husband and Area Engineer at Vandenberg, will help with scenery while daughter Nancy swims…," *LR*, June 8, 1959, p. 6.
Sanders, Ellen (misc. bibliography)
Ellen C. Sanders is listed with husband Allen W. Sanders in Lompoc in the *Santa Maria, Ca., CD*, 1958, 1959 (refs. ancestry.com).

Sandham, Henry (1842-1910) (New York)
Illustrator who made an etching of Mission Santa Ines, 1883.
See: *Central Coast Artist Visitors before 1960*

Sandvik, Uno and Florence Bland, Mr. and Mrs. (Ballard)
Active in the Solvang cultural world as donors, volunteers, etc. Main interest was music.
Sandvik (notices in Northern Santa Barbara County newspapers on microfilm and on newspapers.com)
1949 – "Ziegler Heard in Goethe Talk. Mr. and Mrs. Uno Sandvik were hosts at a buffet supper at their home last Sunday evening… and the group heard a talk on Goethe by **Leo Ziegler**…," *SYVN*, Sept. 2, 1949, p. 5.
1968 – "Uno Sandvik… born in Larsmo, Finland, came to the United States as a boy … naturalized… concert singer… He resided in Washington, D. C. and San Francisco before coming to the Valley in 1947…," *SYVN*, July 25, 1968, p. 3.
1969 – "Florence Bland Sandvik Rites… 22-year resident of the valley… attended Pasadena area schools including Throop Polytechnic Institute… A voice teacher…," *SYVN*, June 12, 1969, p. 2.
And, more than 500 additional notices for "Sandvik" between 1945 and 1968 were not even browsed for inclusion here.
See: "College Art Club," intro., "Presbyterian Church," 1948, "Santa Ynez Valley Art Association," 1953, "Santa Ynez Valley Art Exhibit," 1956, "Santa Ynez Valley, Ca., Adult/Night School," 1953, "Santa Ynez Valley Union High School," 1951, "Solvang Woman's Club," 1949, 1951, "Ziegler, Leo," 1951

Sanja Cota Indian Reservation (Santa Ynez Valley)
Chumash reservation. 99 acres. Expanded in 2010 with the purchase of an additional 1400 acres.
See: "Native American"

Santa Barbara Art Association (Santa Barbara)
Art club for painters of Santa Barbara, founded under the name Santa Barbara Artists Group, 1952. Most members lived in the town of Santa Barbara.
[Only notices on northern Santa Barbara County artists' activities with the Association are itemized here.]
Santa Barbara Art Association (notices in Northern Santa Barbara County newspapers on microfilm and on newspapers.com)
1960 – "Valley Artists Exhibiting Work… The current exhibit of the Santa Barbara Art Association now on view at the **Faulkner Gallery** in the Santa Barbara Public Library includes work by three Valley artists. Represented are: **Charles Glasgow** with an oil, 'Seascape at Point Lobos,' **Marie Jaans** with 'Autumn,' a watercolor on rice paper, and **Forrest Hibbits** with a watercolor, 'Woman with Orange.' The current exhibit will continue on view through February," *SYVN*, Jan. 22, 1960, p. 10; "Valley Artists Display Work. The new exhibit of the Santa Barbara Art Assn. will be at the former Town House on State St. instead of at its usual place in the **Faulkner Gallery** of the Santa Barbara Public Library. Three artists from the Valley are exhibiting paintings. They are **Marie Jaans [Hibbits]** and **Forrest Hibbits**, water colors on rice paper and **Charles Glasgow** of Los Olivos, the oil landscape of Carmel on exhibit. **Mrs. Elsa Schuyler** of Lompoc, a pupil

of Mrs. Hibbits, is also exhibiting a painting…," *SYVN*, Dec. 23, 1960, p. 5.
See: "Allan Hancock College Art Gallery," 1954, "Art, general (Santa Barbara)," "Backus, Standish," "Bailey, Ethel," "Curlee, Wallace," "Dole, William," "Faulkner Memorial Art Gallery," "Glasgow, Charles," "Gorham, John A.," "Hibbits, Forrest," "Hibbits, Marie," "Kiler, Elza," "Knowles, Joseph," "Liecty, Ruth R.," "Motzko, Helen," "Parshall, Douglass," "Remick, Merrill," "Rich, Frances," "Santa Ynez Valley Art Exhibit (third)," 1955, "Ussher, Neville T.," "Vollmer, Grace"

Santa Barbara, Ca.
See: "Art, general (Santa Barbara)"

Santa Barbara, Ca., Public Library
Library branches held some art exhibits.
See: "Santa Barbara County Library (Lompoc)," "Santa Barbara County Library (Santa Maria)," "Santa Barbara County Library (Solvang)"

Santa Barbara County Fair / Lompoc Valley Fair / Santa Maria Agricultural Fair of the Santa Maria Valley Agricultural and Stock Association / Santa Maria Valley Fair (Santa Barbara / Lompoc / Santa Maria)
Fair that, over the years was sponsored by various organizations, went under several names, and was held at a number of different sites. Before 1886 fairs were held only in the town of Santa Barbara. Between 1886 and 1894, at certain times fairs were held either in the town of Santa Barbara or as a separate fair in Santa Maria alternating with Lompoc. In 1891 Santa Maria applied for its own Agricultural District (37th) and sometimes called its fair "Santa Maria Valley Fair." (Almost all of the county's agriculture took place north of the Santa Ynez mountains and a fair in that area was logical.) These fairs had needlework and fine arts sections. No important fair was held in either Santa Barbara or Santa Maria from c. 1895-1927 [except 1900 in Santa Maria]. In 1902 there was an attempt in the state legislature to combine Santa Barbara County's two agricultural districts or to limit it to one. After a long period of no fairs, in the 1920s Santa Barbara town made several attempts to put on a fair but failed. In 1927, perhaps out of frustration, Lompoc put on a Lompoc Valley Fair. In 1928 Santa Maria revived the "Santa Maria Valley Fair" [and some histories trace the beginning of the first official "Santa Barbara County Fair" in Santa Maria to this date] and Santa Ynez put on a Santa Ynez Valley Fair. These may have been attempts by each town to claim itself as the site for an official Santa Barbara County Fair, if one should come to fruition. The Santa Maria Valley Fair "sagged" at the depths of the Depression (early 1930s) but then revived in 1934 and ran to 1940 during which time it was held in various rented sites. Needlework, art, and schoolchildren's exhibits were included. Floral arrangements in competition became annual, possibly starting in 1935. In 1941 Santa Maria purchased a

permanent fairground site and held a fair, but then immediately "went dark" during WWII. Revived in 1946, Fair "artistic" mainstays remained flower displays and Domestic Arts (cooking, table arrangements, and needlework). 1946 also witnessed a small ceramic display by the Nicksons in the floral booth. Post WWII "fine art" seems to have received its first presence in 1948 with a small display arranged by Jeanne DeNejer (who included some of her pupils as well as persons from the newly formed Santa Maria Art Association) in a corner of the floral booth in the main tent. Art demonstrations were given. Small displays by DeNejer and the Association continued. "Art" exhibits were: 1950 – Domestic Arts/needlework, DeNejer pottery, leatherwork by Joseph Knowles. 1951- Flower paintings by the Santa Maria Art Association, high school art. 1952 – Santa Maria Art Association exhibit with Art-in-Action, floral photographic prints by Santa Maria Camera Club hung in a corner of the floral booth. 1953 – a display of miniature missions, photographs in the floral booth, Domestic Art/Handicraft. In 1954 and 1955, there were competitions for "Clothing and Textiles," for table settings, and for floral displays. In 1956 – a ceramics exhibit was added. In 1957 – first full-scale art show, County Fair Camera Day, a new division called "Arts and Crafts" that offered cash prizes for ceramics and crafts. 1958 – trade mark of "Casey Jr" was adopted, art show was curated by George Muro with cash prizes offered, ceramics, re-design of certain fair buildings for "a new look," photo exhibit. In 1959 – enlarged arts and crafts display, addition of leather and metalwork divisions, art exhibit, photography exhibit, ceramics and China exhibit. Following years saw increased and higher quality entries in all these areas and further décor changes to the Fair grounds to spice them up. In 1960 two art purchase awards were instituted, to acquire works for a permanent collection.

■ "First [Santa Maria Agricultural] Fair in '86, [Reldon] Dunlap Reveals,' Contrary to popular misconception, Santa Maria had its first fair back in 1886 and a fair was held here each year until 1890 ... Between 1890 and 1900 the fairs were alternated between Santa Maria and Lompoc … But from 1900 until the fair was revived in 1928, there were none held. Jesse Chambers, former fair manager who retired June 1, told Rotarians how the fair was revived after a joint meeting of the Rotary and Kiwanis clubs in January of 1928 … [anecdotes about early fairs] … Chambers told how fairs of one kind or another had been held since the beginning of history and there were references to them in the Bible, 'and as long as we stay with our country-type fair we'll get along all right,' Chambers said. 'We have spent a half million dollars for improvements on the fairgrounds, including five permanent buildings, a utility system, grandstand and fencing, and it hasn't cost taxpayers a dime.' He explained that all money came from pari-mutuel racing revenues at race tracks over the state. … Dunlap… The new manager told how 5,890,000 had attended California's 79 county fairs last year …. Dunlap … explained that during the last year the fair paid out $63,000 in the community as an operating budget, making it a large business for Santa Maria," per "First Fair in '86," *SMT*, July 23, 1952, p. 1.

■ "Products of Pioneers… Three 'unofficial' county fairs of record were conducted in the Santa Maria valley prior to the establishment of the 37th district Agricultural Association in 1891. … These early fairs were operated under the banner of the Santa Maria Agricultural and Stock association. … The city of Santa Barbara beat Santa Maria 'to the bat' in 1890 when an agricultural district was sanctioned there by the governor and a fair held in the autumn following… Not content to be outdone by the county seat city … exhibits were placed in the cannery building near the Pacific Coast tracks west of the city and it was the first annual official fair to be held here supported by appropriations from the state treasury. Fairs were held at alternating years in Lompoc and Santa Maria until … legislature refused to grant the agricultural district appropriations… The Santa Maria valley remained barren of fall exhibits for 28 years. Not until early in 1928 did local residents gather sufficient momentum … four days were given over to the event which started Tuesday, August 7 … booth exhibits… Kiddies' day… no horse show… some livestock and dairy cattle… a fair poultry show and a mediocre agricultural exhibit… showed a profit…," *SMT*, Aug. 9, 1930, p. 9.

Santa Barbara County Fair (notices in Northern Santa Barbara County newspapers on microfilm and on newspapers.com)

1880 – Santa Barbara. "The County Fair … From all accounts our County Fair was a great credit… A full report occupies over four columns of the Santa Barbara papers… The exhibits comprised fruits, flowers, grain in the greatest variety, other horticultural and agricultural and some dairy and kitchen products; fancy, artistic, historical and curious articles… Lompoc, Los Alamos and Jonata sent some fine specimens and we are sorry Guadalupe and Santa Maria did not… From a long list, we cull the following mention of articles shown there from this section… Mrs. Phil Tucker has credit for beautiful silk and wool embroidery and silk quilt; Mrs. R. Carr, one set of pillow and sheet shams. With a little longer notice, Mrs. Geo. Roberts would have contributed fine lace curtains of her own make. Mrs. Legrand Friel, wax flowers …," *LR*, Nov. 6, 1880, p. 3.

1882 – Santa Barbara? "According to the Press, this county is to have a fair this season, probably about the first of August. The directors of the Agricultural Society have received such pecuniary aid from the citizens of Santa Barbara as to justify a very liberal premium list," *SMT*, July 1, 1882, p. 5, col. 1.

1883 – Santa Barbara – at the theatre and adjoining grounds. "The County Fair. … The Third Annual Exhibit of the Santa Barbara County Agricultural Association… Inside the main building… Other Displays. … men's boots… harness… floral and herbal… dried or evaporated fruits and vegetables… J. E. Goux had a very interesting exhibit of artificial flowers made from silk cocoons, also raw silk and cocoons… saddle made by Alvino Meza… beautifully embroidered in silk, gold and silver thread… I noticed 4 or 5 loaves of brown and white bread… while there was much fancy painting, embroidery and other ornamental and fancy work displayed as the handicraft of young women, there was no really practically useful article

made by such on exhibition… Art Room. Which was 'just lovely' with its rich display of paintings on canvas, on china, on glass, on plaques, embroidery work of all kinds, shell work, wax work, fancy needlework, photographic views and portraits, and scores of other things most attractive to the eye. Among these the wax roses and pond lilies made by Mrs. Kent… A. M. Stringfield, the popular photographer, exhibited in one corner some magnificent views and plain and plaque portraits. These latter were in two styles, convex and concave, and were beautiful specimens of the art… Stringfield is a perfect enthusiast in his profession and is always studying out some novelty. Judd also had a fine photographic display on exhibition… the embroidery work by the pupils of St. Vincent School… The sea-moss wreaths and designs, and pictures … Upstairs there were some very fine home-made bed-quilts and spreads…," *SMT*, Oct. 20, 1883, pp. 1, 8.

1884 – Santa Barbara. Oct. "The Fair. What is Going on at Lobero's Theatre…," *Independent* (Santa Barbara), Oct. 21, 1884, p. 4.

1886 – Santa Maria. Oct. 27-29. "New Agricultural District… The people of our town and valley are a progressive people… In 1886 several of our enterprising citizens got together and organized a Fair Association with the view of holding Annual Fairs at Santa Maria… Our first Fair was held on the 27th, 28th and 29th of October 1886. A neat catalogue of thirty-six pages with full premium list, race programme and daily and evening programme for the pavilion was issued," *SMT*, March 21, 1891, p. 2; "Entries at the Pavilion… Fine Arts. **Mrs. W. H. Walker**, collection of five oil paintings of Santa Barbara scenery; **Jas W. King**, oil painting of Point Sal, Sisquoc Falls, Cave Landing and other scenery; **O. L. Jones**, fine collection of portraits, oil paintings representing Silver Dell and Mt. Shasta; **McMillan Bros**, large display of photographs. Very fine. **Miss Ballenger**, pencil drawing of dapple horse and saddle. Very fine work for an amateur. **Miss A. Arellanes**, water color flowers, horse on Java canvas, silk needlework deer; **Miss A. Ontiveras**, worsted flower wreath; **C. H. Gilnes/Glines**, specimen ornamental pen work; **Mrs. M. Fleisher**, plaque painting, life size portraits; **J. Cavallier**, pencil drawings of Zaca lake, scene on Carisa plains, sculptured head, drawing of school on a thigh bone; **G. W. Jenkins**, specimen of business and ornamental penmanship; **L. Hertz**, photographs of the great fires in Santa Maria; **Mrs. T. A. Jones** exhibits plate hand painted by **Miss Mary Hathaway** [Sic? Hathway], **McMillan** sisters, hand painted plate and motto; **Miss Vidal**, beautiful wreath of hair work in globe; **Miss Annie Strube**, oil painted plaque. Fancy Work [long list of crochet, quilts, etc.] **Mrs. J. H. Frazier**, Florentine plaque… **S. J. Jones**, cross in wood and abalone… **Mrs. J. F. Goodwin**, Kensington banner… **Mrs. Fleisher**, Kensington painting… … Fine Arts. Best oil painting, **J. W. King**, Best water color, **McMillan Bros.**, Best India ink drawing, **O. L. Jones**, Best pencil drawing, **Miss Margaret Ballenger**, Best crayon drawing **O. L. Jones**, Best landscape painting, **Mrs. W. H. Walker**; Best portrait painting, **O. L. Jones**, Best plaque painting **Mrs. Frazer**, Best panel painting **O. L. Jones**, Best exhibit photographs **McMillan Bros**, Best Architectural drawing, **Jas Morse**,

Best penmanship G. W. Jenkins. Ladies' Department [and list of winners]," *SMT*, Oct. 30, 1886, p. 5.
"First Fair in '86," *SMT*, July 23, 1952, p. 1.

1887 – Santa Barbara. Sept. "Next Tuesday our County Fair will open for its annual exhibition and will be … attended from all portions of the county and State as well. The new railroad facilities make it easy for the people from the outside counties to reach Santa Barbara and the great novelty of seeing a railroad into the town will draw…," *LR*, Sept. 24, 1887, p. 3; "The County Fair [opens] … Pavilion presents a scene of bustling energy… Even before the city became an attraction to foreigners, we had held Rose Fairs and Floral Carnivals…," *Independent* (Santa Barbara, Ca.), Sept. 28, 1887, p. 2, col. 1.

1888 – Santa Maria Agricultural Fair. McMillan Bros. hall. September 13-15. "The articles of incorporation of the Lompoc Agricultural Association are prepared … The object of the Association as stated in the articles is to buy, sell and improve land for fair and stock purposes… In a very few years Lompoc and vicinity could arrange a most interesting fair… It will be the special province of this society to promote the general good by arranging for an annual fair in our valley," *LR*, April 21, 1888, p. 4; "Copy has been furnished this office by the Fair Committee for the pamphlets to be printed for the Santa Maria Agricultural fair to be held in Santa Maria commencing Oct. 4th…," *SMT*, July 4, 1888, p. 3, col. 2; "The Premium List for the Coming Fair … 32 pages… to be held on the 13th, 14th and 15th of next month…," *SMT*, Aug. 29, 1888, p. 3; "It is Proper for Ladies to Serve Refreshments at a Fair… Santa Maria Agricultural Fair to be held on the 13th, 14th and 15th of this month… This society has no Fair grounds of its own, consequently had to hire the hall of **McMillan Bros**… and also leased the race course…," but should not serve at the race track, *SMT*, Sept. 8, 1888, p. 3; "List of Entries at Pavilion. Ladies' Department… **Mrs. J. McMillan**, 1 case fancy work, Kensington banner, **Mrs. Judge Thornburg**, 2 banners, 2 painted panels… **Jesse Hobson**, sofa pillow, table scarf in Kensington… **Crow**, 4 pieces Kensington work… Mrs. Geo. Smith, banner, table scarf, Kensington embroidery… **Mrs. Angie Ayers**, 3 panel paintings in oil … **Miss Anna Strube**, barbatine placque, scenery painting, plaque, crystal oil portrait painting, photograph case, velvet painting, hand painted china plates, easel Kensington painting… **Miss M. P. Nuttall**, 4 pen and ink drawings, 9 sketches in water colors; **Miss E. Ballengee** [Sic. Ballenger] 4 pencil drawings. Gentlemen's Department. **O. L. Jones**, oil paintings, 2 pairs panels, 1 single panel, 7 landscapes, portraits in India ink… **McMillan Bros**, photographs… **J. Dunlap**, carving in Pt. Sal gypsum… The Premium List… Ladies Department. Best exhibit **Mrs. K. A. Crow**, $2… Fine Arts. Best panel painting, **Mrs. Angie Ayres**, $2, second, **Miss A. Strube**, $1; Best pencil drawings, **Miss E. Ballengee** [Sic. Ballenger], $2, second **Miss Ada Stephens**, $1, third, **Miss E. Ballengee** [Sic **Ballenger**], Sp. Men.; Best water colors, **Miss M. P. Nuttall**, $2; Best India ink, **O. L. Jones**, $2; Best landscape painting, **O. L. Jones**, $2, second **Miss Anna Strube**, $1; Best pen and ink drawing, **Miss M. P. Nuttall**, $2; Best photographs, **McMillan Bros.**, $2, Best penmanship, Prof. Juan

Murrarios, $2… General List of Judges at Pavilion…
Painting and Photographs: Prof. Mrs. Kallmeyer and Miss
Reynolds…," *SMT*, Sept. 19, 1888, p. 3.

**1889 – "Santa Barbara County Fair (Nineteenth District
Agricultural Association) to be held at the Pavilion,
Santa Barbara, October 1st to 4th**, 1889, inclusive, grand
stock parade… baby show… ladies tournament… bicycle
races," *LR*, Sept. 14, 1889, p. 3.

Santa Maria. September."Our Coming Fair… [categories
for competition] … Class 3 – Painting & Drawing…
[categories listed]… Class 6-Juvenile… drawing…," *SMT*,
Aug. 3, 1889, p. 2; "Our Grand Exhibit. The Fair a
Complete Success… Entries at the Pavilion… Fine Arts,
etc. **Mrs. Capt. More**, pencil drawing; Johnny Jones,
painted ship, one box turtle eggs; **S. T. Jones**, pencil
drawing, crayon drawing; **Mrs. Emma Ables**, flower
painting; **J. D. Cavallier**, photograph; **Mrs. Abraham
Ontiveros**, transfer picture on glass; **Bob Hudson**, pencil
drawing; **Mrs. Ketcham**, Nipomo, Kensington painted
banners, flower painting, painted panel, water colors,
landscape painting, flower painting in water colors, fruit
picture, flower pencil drawing; **S. J. Jones**, landscape in oil
painting; **Mrs. McCollough**, painted plaque; **Mrs. Lucy
Haslam**, one set hand painted China plates; **Miss Hattie
Hart**, hand painted plate; **T. A. Jones**, oil painting; **L. T.
Jeter**, fruit painting and other paintings in oil colors; **Mrs.
Emma Ables**, painted panel; **Mrs. Ketcham**, Nipomo,
flower panel; **Mrs. McCollough**, luster painting; **S. J. Ban**
[?] luster paintings; **Mrs. Lucy Haslam**, luster painting
panel; **Mrs. Jas. Morse**, oil painted panel; Warden S.
Jones, penmanship; **Miss Ada Stephens**, pen drawing;
McMillan Bros., general display of photographs … [and
list of handicrafts, i.e., domestic arts] … The art gallery on
the second floor was tastefully arranged and contains some
beautiful oil painting, crayon drawings, pencil drawing,
etc.… Premium list… Juvenile Work [maps/ industrial/
ornamental drawings]… Fine Arts… Best painting on
bolting cloth, **Mrs. Wm. Haslam**; Landscape painting in
oil, **Mrs. Ketchum**, second, Johnny Jones; Plaque painting
in oil, **Mrs. McCollough**; flower painting in oil, **Mrs.
Ketchum**, second **Mrs. Emma Ables**; Fruit painting in oil,
L. T. Jeter; Water color – flower painting, **Mrs. Ketchum**;
Pencil drawings, **Bob Hudson**, second **Mrs. Ketchum**,
third **S. J. Jones**; Photographs, **McMillan Bros.**;
Penmanship, Warden Jones; Crayon drawing, **Miss Ada
Stephens**; Luster painting, **Mrs. McCollough**; Kensington
painting, **Mrs. Ketchum**; Transfer pictures, **Mrs. A.
Ontiveros**; Painting on China, **Mrs. Haslam**, second **Miss
Hattie Hart**; Panel painting, **Mrs. Haslam**, second **Mrs.
Emma Ables**; … Fancy cabinet work in natural woods, **S.
J. Jones** … Industrial drawing, **Daisy Trott**, second, **Mrs.
Ketchum**…," *SMT*, Sept. 28, 1889, pp. 1, 2, 3; "Santa
Maria at the County Fair. A List of Premiums Captured by
Our Valley, Etc. The County Fair held in the Channel City
has come and gone… **O. L. Jones**, India ink portraits,
Medal…," *SMT*, Oct. 12, 1889, p. 3.

1890 – Santa Barbara. Agricultural Park. September.
"Our County Fair… On the 23rd the County Fair will open
– at Agricultural Park, in Santa Barbara…," *SMT*, Sept. 13,
1890, p. 1;

**Santa Maria. Fourth. Santa Maria Valley Agricultural
and Stock Association. Mid September.** "Our Coming
Fair… In October we are to hold our Fourth Annual fair…
Now is the time to begin preparations… Outside papers
have given us the credit heretofore of producing an exhibit
fully equal to the county fair display – either San Luis
Obispo or Santa Barbara counties…," *SMT*, May 31, 1890,
p. 3; "Magnificent Display… Third Department… Fine
Arts, Etc. Class 3 – Painting and Drawing. **Miss Belle
Fugler**, four paintings in oil, plaque painting, two paintings
on Ivorine; **Bert Hudson** two crayon drawings; **Miss Sallie
Lucas**, ten oil paintings, crayon drawing; **Chas Curryer**,
pencil cartoon; **Mrs. J. Denton**, six oil paintings; **A.
Bianchi**, transfer pictures; **Grant Battles**, three colored
photographs. Class 4, **Miss Bell Fugler**, panel painting.
Class 5 – Needlework… Class 17. **McMillan Bros.**
General display of photographs and crayon drawings…,"
SMT, Sept. 13, 1890, p. 3 [this entry does not come up with
digital searching and must be found by browsing and also
some material repeated in *SMT*, Sept. 20, 1890, p. 1]; "The
Premium List of the Fourth Annual Exhibition of the
SMVA&SA…Class 3 & 4 – Painting and Drawing. Best
plaque painting **Belle Fugler** D; Best panel painting **Miss
Belle Fugler** $2; Best painting on china, **Belle Fugler** 1.00;
Best Pencil drawing, **B. H. Hudson** 2.00; General display,
Mrs. Denton, Hon M. class 5 – Needle Work…," *SMT*,
Sept. 20, 1890, p. 3; "General Fair Notes… **Miss Belle
Fugler**'s paintings, drawings, etc., composed quite an art
gallery within themselves. They were neat, artistic and
finely executed. **Mrs. J. Denton** displayed a fine collection
of paintings, drawing, etc. of her own execution and **Miss
Sallie Lucas**, teacher of the art, recently from Oroville, did
likewise. The ladies art gallery was a perfect beauty,
displaying some of the finest needle work, paintings, etc.,
ever placed on exhibition in any of our Southern California
Fairs," *SMT*, Sept. 20, 1890, p. 3.

**1891 – Santa Maria. First. 37th District Agricultural
Association. September.** "New Agricultural District…
The people of our town and valley are a progressive
people… In 1886 several of our enterprising citizens got
together and organized a Fair Association with the view of
holding Annual Fairs at Santa Maria… Our first Fair was
held on the 27th, 28th and 29th of October 1886. …. Last fall
[1890] after our Fair was over, some of the directors … at a
meeting of the board, said it was perfectly proper that we
should have state aid… Consequently, a bill was prepared
for formation of a new Agricultural District, No. 37… At
the meeting of the Legislature in January 1891 the bill was
presented [and passed] … Santa Maria, March 13th, 1891.
A general meeting was called… for the directorate of an
Agricultural Association for Agricultural District No.
37…," and full quote of resolution, *SMT*, March 21, 1891,
p. 2; "List of Premiums of the First Annual Fair of the 37th
District Agricultural Association to be held at Santa Maria,
Cal. Commencing Tuesday September 1st and Lasting Four
Days from 1st to 4th Inclusive… at the Pavilion… Ladies
Department – Entries Free … [and list of handiwork
categories including rugs, bedspreads, embroidery, etc.]
Children's Department – Entries Free (Age 15 years and
under) [and list of artworks, handiwork, sewing,
penmanship, maps, etc.] … Fine Arts – Entries Free. **Miss
Sally Lucas**, Superintendent [and list of categories of oil

paintings, watercolor paintings, pencil drawings, etchings, photographs, etc.] Class 2 – for Amateurs [and approx. same list of items repeated] … Manufactures of this county… [buggies, mantels & decorative work in wood, stamped leather work, articles manufactured from copper… jewelry, stone cutting, etc.] …," *SMT*, Aug. 22, 1891, pp. 1, 2; "Excellent Display. A Very Fine Exhibit for the New Agricultural Association… Exhibits at Pavilion… Fine Arts. **Miss Sallie Lucas**, Supt. Mrs. Holman, floral piece, fruit, art for competition, in oil; **Mrs. Johny Adams**, roses from nature, floral piece, poppies, gladiolus and two landscapes in oil; **Mrs. K. A. Crow**, marine scene, 1 fruit piece in oil; **Mrs. J. E. Morris**, flower piece, roses, flags, landscape in oil; **Mrs. H. E. Snow**, landscape and floral piece; **Mrs. A. E. Lutnesky**, marine view; **Mrs. G. W. Curryer**, landscape, flowers; **Mrs. G. C. Smith**, landscape, marine view, painted scarf; **Mrs. [Sic.?] Robt. Hudson**, figure piece crayon; **Mrs. Snow**, portrait crayon; … **Miss Minnie Smith**, painted scarf on satin, painted rose sachet; **Miss Sallie Lucas**, landscapes, marine scenes, fruit piece, horses' heads, portraits; **McMillan Bros.**, Crayon portrait of a child and 2 of an infant… Ladies Department [listing of handiwork] … Children's Department. A Most Excellent Exhibit of Drawing, Penmanship, etc. … there never was, in Santa Barbara County, an exhibit of children's work superior in execution or larger in quantity than the present display at the pavilion. Santa Maria District has a full display from every department. The kindergarten work – paper folding, weaving, etc., from Miss Lawrence's room… Another banner that must be mentioned was a symbolic oil painting done on felt by **Miss Vinnie McDonald**. The design was made by **Nina Morehead** a class-mate… It is impossible, in our limited space, to enumerate all the banners and pictures sent by the Lompoc school – it must suffice to say that they are all excellent; an etching on glass executed by **Frank Miller** called forth universal admiration. The Casmalia school has a fine display of kindergarten work and some of the best maps in the whole exhibit… The Laguna school made a fine display of penmanship and general drawing. Two large pictures, one of the Santa Ynez Mission by **Bertha Kleine** and one of the Santa Barbara Mission by **Agnes Kleine**, are very praise worthy… The young ladies have never received any instruction in drawing and drew their pictures from very small text book cuts. **Lily Pezzoni** also entered a pretty little landscape. There are exhibits of drawing from Olive and Pine Grove Districts that are excellent… Los Olivos school made a display of map drawing… The art, cooking, sewing and fancy work departments of children's work were not so well represented… In the art department three water color floral pieces painted respectively by **Hattie Shoults, Nina Morehead** and **Clara Ellis** were conspicuous for their excellence. An oil painting and a crayon portrait from **Robt. Hudson** were executed in that young gentleman's best style. A painted draping scarf by **Lena Tognini** added much…," *SMT*, Sept. 5, 1891, p. 3; "Notes on the Fair… We notice that **Robert Hudson** had his drawings on exhibition again and his pictures were better than last year although they were very good then, which goes to show that he is bound to be a good artist in a few years… **Mrs. Coblentz** exhibited a very unique floral design; it was a miniature boat modeled after the steamer

'*Santa Maria*' and filled with cut flowers from her own dooryard…," *SMT*, Sept. 12, 1891, p. 2; "The List of Premiums Ladies Department … [list of rugs, lace, hairwork, etc.]… Children's Department. Best oil painting, **Mina [Sic. Nina] Morehead** and **W. McDonald**, 2.00, Next best **R. Hudson** 1.00, Best water colors, **Minnie [Sic. Nina?] Morehead** 2.00, next best **Hattie Shoults** 1.00 … Fine Arts. The best display of paintings **Miss Sallie Lucas** Dip. Amateurs. The best landscape painting, **Mrs. Snow** 2.50, The best marine painting, **Mrs. K. A. Crow** 2.50, The best fruit painting, **Mrs. K. A. Crow** 2.50, The best flower painting, **Mrs. J. Adams** 2.50, The best paint scarf, **Minnie Smith** 2.50, The best crayon drawing, **R. Hudson**, 2.50 … The best wood work, **J. S. Denton**, Dip., The best stamped leather, A. Ward, Dip., The best stone work, **J. Dunlap**, Dip.," *SMT*, Sept. 12, 1891, p. 3.

1892 – Lompoc. 37th Agricultural District. Opera House. End of September. "Our Fair. Our first fair… Directors of the 37th Agricultural District… The fine arts exhibited was most extensive, having been contributed to by many local amateur painters, many pieces showing a high order of talent. The school department was filled with much interest… Among the rare things of the Fair were the numerous choice pieces of needlework, embracing [sic.] quilts, rugs, … mats, scarfs, knitted quilts and handsomely designed crochet work. This department was most numerously stocked and constituted one of the chief attractions of the Fair. The flower department… Among the exhibits were numerous collections of ancient and modern coins, postage stamps, Indian relics and a rare collection of bird's eggs…," *LR*, Sept. 24, 1892, p. 2; "The Display at the Pavilion… The large Opera House was barely sufficient to hold the multitudes of people from all over this district who are here in attendance at the Pavilion and race track… Next is the Fine Arts Department, superintended by **Mrs. A. J. Nichols**. This booth is somewhat larger and the three walls are just simply crowded with paintings in oil and water colors, crayons, photographs, drawings in pen and pencil, etc. The paintings consist of views of animal, marine, figure, landscape, fruit and flowers, and on the wall also is three paintings painted by a lady 79 years old, **Mrs. Patterson** of Los Alamos, who never took a lesson in her life, and the portraits are something marvelous to look at. The balance of the paintings have been by ladies in our own town most notably **Mesdames Nichols, Sloan, Sudden, Hendrickson** and **Miss May Richardson**. The booth looks home-like, there being chairs comfortably arranged for the benefit of visitors … while easels are numerous on which rest large portrait crayons. On a little stand is a number of placques and various small paintings, besides an exhibit of crepe flowers … The next department visited was the Public School children's department… varied assortment of school work… two large crayon portraits made by Mable Gruwell and Lottie Bouton. Also, a large crayon of the La Purisima mission … This was done by **Hattie Shoults**… The school children had a number of collections… We next looked at a case of photographs made by **E. T. Briggs**, the Photographer, and they are works of art, showing clear and sharp … The Ladie's [sic.] Department then caught the reporter's eye… The booth was draped with lace curtains, festooned with lavender ribbons… crazy quilts, afghans … crochet work… fine

Spanish drawn work… pillow shams… Passing on we arrived at the children's department… In this booth there is fancy work, minerals, wood-carving, wool work, two large crayons… The next display looked at was that of **A. J. Nichols**, the jeweler… We next stepped into the relic and curiosity room where we found large collections of coins, minerals, stamps, bird egg collections, stuffed birds, Indian relics… besides a large quantity of knick knacks picked up from all over the world…," *LR*, Sept. 24, 1892, p. 2; "Premium List… Awarded at the Fair… Ladie's [sic.] Department… [embroidery, rugs, quilts, etc.] … School Children's Department [penmanship, maps] … Fine Arts. **Chas LaSalle**, Landscape diploma, **Miss Vivian**, animal, diploma, **Mary Richardson**, flowers, diploma, **Mary Richardson**, special drawing, diploma, **E. T. Briggs**, photographs, diploma. Fine Arts – Amateurs. **Mrs. A. J. Nichols**, portrait in oil 2.50, **Mrs. Jas Sloan**, landscape 2.50, **Mrs. A. J. Nichols**, marine, 2.50, **Mrs. W. H. Sudden**, fruit, 2.50, **Mrs. J. D. Black**, flowers, 2.50, **Mrs. Dr. Hendrickson**, flowers, 2.50, **Frank Miller**, animal 2.50, **Nina Morehead**, crayon drawing 2.50, **Frank Miller**, pencil drawing 2.50, **Annie McGee**, painting on satin 2.50, **C. B. Hughston**, photographs, 2.50, Mark Pomeroy, 2nd best crayon 1.50, **Mrs. Patterson**, Los Alamos, special mention," *LR*, Oct. 1, 1892, p. 2.

1893 – Santa Maria. 37th District Agricultural Association. End of September. "The Successful List. Premiums Awarded by the 37th District Agricultural Association… Ladies Department [long list of handiwork including **Mrs. Alma Thornburgh**, paper flowers… **Mrs. A. Farrington**, purse] … Children's Class, Under 15 Years… **Miss Alma Thornburgh**, oil painting, 1st pr. 2.00… **Wesley Ward**, wood carving, 1st pr 2.00… Public School Department … [penmanship and maps] … Fine Art Department. **Augusta Stone**, Landscape in oil D., **Augusta Stone**, Marine in oil, D., **Augusta Stone**, Animals in oil, D., **Augusta Stone**, Flowers in oil, D., **Mrs. Dr. Snow**, oil painting, Special D. Department 2nd – Amateurs. **Miss O. Kelsey**, lanscp oil 1st pr. 2.50, **Miss O. Kelsey**, Marine in oil, 1st pr 2.50, **Mrs. Farrington**, animal in oil, 1st pr. 2.50, **John Adams** flowers in oil, 1st pr. 2.50, **Mrs. A. Patterson**, flowers in oil, 2nd pr. 1.50, **Minnie Smith**, crayon drawing, 1st pr. 2.50, **Mrs. J. Morris**, crayon drawing … pr. 1.50, **Mrs. Lutnesky**, velvet plush painting, 1st pr 2.50, **Mrs. B. Laughlin**, silk or satin painting, 1st pr 2.50, Mrs. C. Mathison, penmanship, 1st pr. 2.50, **Helen Newman**, crayon drawing, child 10 years, spec D.," *SMT*, Sept. 30, 1893, p. 4.

1894 – Lompoc. Fourth Annual. 37th District Agricultural Association. "The Fourth Annual Fair of the Thirty-Seventh Agricultural Association at Lompoc… The Pavilion… The beauty of the place grows upon one as the fine arts exhibit is visited. This booth is conspicuous in location, size, and tasteful arrangement as well as for the character of the display. A delicate shade of green with white is used in the drapery of this booth and forms a quiet and harmonious setting for the fine collections of paintings on exhibition. In a show case at the front are shown many beautiful things in china painting, painted satin cushions, and bottles painted, celluloids sets, etc. Here also is exhibited an heir-loom 150 years old, a medallion,

Corriggio [Sic.] Madonna, painted on mother of pearl. **Mrs. A. McLean** has charge of the booth and she has had a fine field for the display of her taste and skill in effective arrangement. The elegant rugs, easels and other furnishings were kindly loaned by Mr. A. F. McPhail. … The school department … Some excellent work is shown, drawing in physiology from the Purisima school… and some fine drawings from Maple school… A corner to the right of the stage is occupied by a curio booth, the work of Mr. Eugene Schyler… to the left of the stage is a glass case containing an interesting collection of curios exhibited by **Mrs. Murray**… **Mr. A. J. Nichols** has an interesting display of jewelry and articles in his line … ," *LR*, Oct. 6, 1894, p. 3; "Fourth Annual Fair of the Thirty-Seventh Agricultural Association at Lompoc… [Living Pictures] Each evening one or more tableaux were presented on the stage [and names of pictures posed]… Ladies' Department [knitting, rugs, quilts, crochet, embroidery]… Children's Department [list of some artwork by children]… Fine Arts – Class 2 – Amateurs – Portrait painting in oil, **Mrs. A. J. Nichols**, $2, landscape painting in oil, **Miss Ida Simpson**, $2, Marine painting in oil, **Mrs. A. J. Nichols**, $2, animal painting in oil, **Frank Miller**, $2, fruit painting in oil, **Mrs. L. L. Colvin**, $2, flower painting in oil, **Mrs. L. L. Colvin**, $2, fruit, water colors, **Frank Miller**, $2, flowers, water colors, **Mrs. E. Burtch**, $2, crayon drawing, **Mrs. W. C. Ball**, $2, pencil drawing, **Frank Miller**, $2, painting silk or satin, **Mrs. B. E. Laughlin**, $2, special Kensington plaque, **Miss C. Broughton**, special china hand painting, **Mrs. R. C. Miller**," *LR*, Oct. 13, 1894, p. 2.

1895-1899 – No fairs?

1900 – Santa Maria. Fifth Annual. 37th Agricultural District. "Magnificent Display… Premium List and Exhibits… Fifth annual fair… Ladies Department [list of quilts, knitted items, etc. including some embroidery by **Mrs. A. Farrington**], Kensington painting, **A. Lutneskay** [Sic. Lutneskey]… **Mrs. J. Adams**… Children's Department [list of map drawings, etc.]… Fine Arts. Portrait painting **Miss M. Smith** 2.00, Landscape painting **Mrs. H. E. Cox** 2.00, Marine painting **Mrs. Jno Adams**, 2.00, Fruit painting, **Mrs. L. L. Colvin**, 2.00, Flower painting, **Mrs. Jno Adams**, 2.00, Crayon drawing, **Mrs. H. E. Cox**, 2.00, Pencil drawing, **Elsie Thornburgh**, 2.00. Amateur photos. Landscape **W. A. Haslam** 2.00, Landscape A. F. Fugler, [Arthur Francis Fugler (1871-1944)] 1.00, Marine **Mrs. L. T. Wade**, 2.00, Comic **W. A. Haslam**, 2.00, Ex. six or more **Hattie Hart**, 1.00…," *SMT*, Oct. 13, 1900, p. 3; "The committee who had the Ladies Department to charge at the fair wish to extend **Grandma McCorkle** special mention for her handwork in outline embroidery and crazy patch work. Grandma has passed the 72-mile stone in life and the display she had on exhibit at the fair just past would do credit to one much younger," *SMT*, Oct. 20, 1900, p. 3.

1901- 1925 – The only "county fair" listed in the *LR* 1895-1920, was Ventura (1914, 1915, 1916, 1918, 1919, 1923, 1924, etc.), Sonoma, Riverside, Colusa, San Diego, SLO (1921, 1924).

1902 – Santa Barbara. "County Fair… The directors of the agricultural district association met yesterday afternoon and decided to hold the district fair in this city on four days beginning August 12th…," *SMT*, April 26, 1902, p. 4; "Editor Broughton … Will the Santa Barbara county fair set for August 12th be the success… August is entirely too early for a proper exhibit of deciduous fruits and cereals and many kinds of vegetables … There will be an effort made in the next legislature to have the two agricultural districts of Santa Barbara county combined with the understanding that every other year the fair should be held in, and the entire appropriation go to the northern portion of the county," *SMT*, May 24, 1902, p. 4; "Evidently the managers of the Santa Barbara fair had little faith in the people of this section of the county taking any part in the same. Not a dollar was expended in advertising this county fair in either Lompoc, Santa Ynez, Guadalupe or Santa Maria," *SMT*, Aug. 16, 1902, p. 2.

Post WWI.

1919 – "Bill Encourages County Fairs in Calif… Sacramento … Appropriations aggregating $800,000 for the encouragement of state and county fairs," etc., *SMT*, Feb. 15, 1919, p. 4.

1920 – "County Fair is Favored by the Lompoc Growers… A county fair in 1921 is favored…," *LR*, Oct. 22, 1920, p. 1.

1921 – Santa Barbara. "The County Fair Project… This Plan Divides the Fair into a Number of Departments… such as Educational, Agricultural, Live Stock, Woman's Department, Amusements (such as racing, horse show, music, free features, etc.), Automobile Department, Machinery Department, Industrial Department (such as merchandise and advertising displays, etc.). … This Fair Will Belong to Santa Barbara County…," *LR*, April 15, 1921, p. 8; "Subscriptions Start for County Fair Stock…," *LR*, March 18, 1921, p. 1; "County Fair to Purchase Forty Acre Tract… Rutherford tract…," *SMT*, June 24, 1921, p. 1; Santa Barbara "County Fair Board Plans Model Buildings… [possibly] improvements for Exposition Park, the Santa Barbara County Fair Association property on Hollister avenue just within the city limits…," *SMT*, June 29, 1921, p. 8; "Fair Plans Off for Time Being," *LR*, July 15, 1921, p. 1; "Lack of Support Causes County Fair to be Deferred," *SMT*, July 15, 1921, p. 1; "Would Join with Ventura for Annual County Fair," *LR*, Oct. 14, 1921, p. 4.

1923 – Santa Barbara. "County May Hold Fair Next Year…," decided at meeting of the directors of the Santa Barbara county Farm Bureau, *SMT*, Sept. 20, 1923, p. 1; "County Fair Project Dropped for Next Year," *LR*, Dec. 7, 1923, p. 1.

1924 – Santa Barbara. "Fair For Central Coast Counties to be Planned. Directors of the Santa Barbara farm bureau and the board of supervisors will be invited to join with San Luis Obispo and Monterey counties early next month in forming a Central Coast Counties Fair association. As none of the three counties has permanent fair grounds…," *SMT*, March 17, 1924, p. 5; "Lompoc Sugar Beets Placed on Display at Ventura County Fair," *LR*, Oct. 3, 1924, p. 1.

1927 – See: "**Lompoc Valley Fair**," 1927-35, "**Santa Ynez Valley Fair**," and "**San Luis Obispo County Fair**"

1928 – Santa Maria Valley Fair. **August**. "Only Nine Weeks Before Exposition… scheduled for August 7-11… Photograph albums containing pictures of booths from other fairs are to be obtained at the Chamber of Commerce offices by local exhibitors who desire to get ideas …," *SMT*, June 6, 1928, p. 1; "Santa Maria Valley Fair Will Have Many Fine Exhibits," *SYVN*, June 22, 1928, p. 1; "Santa Maria Exhibitors Busy Today. Many Booths are Nearly Ready … **Leon Vaughn**, already noted as a scenic artist, has produced a remarkably fine piece of work in the painting of Filipponi's service station, which forms a background for their exhibit…," *SMT*, Aug. 4, 1928, p. 1; "Times Topics… Santa Maria Valley Fair… Library Park… Fair Grounds… The Valley Fair project has been developing for the last four months … Chamber of Commerce… The long train of the carnival company pulled in yesterday… The inside of the big main tent was like a three-ring circus… From bare sheets of wallboard and scaffolding has appeared a great avenue of gaily colored booths… In one corner, the Guadalupe Japanese Association has constructed a marvelous miniature garden… In another, an inviting little house proves to be the Blochman school exhibit. The high school art department has a 50-foot wall covered with brilliant posters and … other work…," *SMT*, Aug. 6, 1928, p. 6.

1929 – Santa Barbara. **August**. "Not Represented… Santa Barbara County Fair… empty booth near the entrance to the exposition… booth had been reserved for entries from Lompoc but that advantage had not been taken of this gratuitous offer… Why?," *LR*, Aug. 9, 1929, p. 2.

Santa Maria. **August**. "Santa Maria to be Scene of County Fair Next Month … attracting Lompoc and Santa Ynez valley entries… Other departments of the fair include the Women's Department … where needlework and art craft will be on exhibition. This department will be under Mrs. D. Acquistapace," *LR*, July 5, 1929, p. 5; "Model Airplane Contest at the Santa Maria Fair… It is the desire of the contest committee to have the boys and girls demonstrate their own skill at building model planes, so one of the first rules is that no entry may be made with a commercial 'knock down' airplane… A special booth will be provided for showing the exhibition models, all of which must be accompanied by scale drawings…," *AGH*, July 18, 1929, p. 6; "Women Plan Great Fair Exhibition… The Women's department is divided into three classes, the needlework, culinary, and antique groups," and details regarding various categories. "Miscellaneous: hand painted handkerchief, hand painted scarf, hand painted china, bead work, hooked rug, lamp shades both fabric and painted, fabric painting, weaving… *SMT*, July 29, 1929, pp. 1, 6; "Great Floral Display … Arrangements have been made for 100 five-gallon oil tins which have been transformed into mammoth vases…," *SMT*, July 31, 1929, p. 9; "Floral Booth Important Center… The floral headquarters in our county fair is one of the Doo-Dads manager Chambers brought along from the district fair of last year. No other county in California can stage an August flower display at a fair because they haven't flowers enough to even contribute one

smell to a main tent… The Valley of Gardens does it because among the many sponsors of this fair we number the Nichols 'glad' gardens, the Walker-Warren-Smith-McCoy dahlias, the W. S. Edwards oldest planting of ornamental shrubbery in this end of the county, and a thousand acres of burgeoning plants at the Waller-Franklin Seed Farm… Not only will this booth display flowers, but it is the distributing point from which flowers will be spread the full length of the 336 foot main tent…," but no mention of flower arrangements, *SMT*, Aug. 2, 1929, p. 6; photo showing "part of the department devoted to education… Specimens of school children's work from painting to basket weaving and penmanship…," and "Commercial and Civic Exhibitors are Praised… One of the most unique booths in the entire county fair is that of the Bank of Italy. … a miniature art gallery with a dozen splendid paintings by western artists Attracting fully its share of admirers is the Guadalupe City display. One, made by **S. Fukuto**, a Guadalupe farmer, is a remarkable creation. This was an exhibit of 'gold' fish, other fish, a white stork, butterflies, water lilies, a rabbit, mouse, chrysanthemums and other things displayed in a pool of water, 'simply to show' as one bystander said, 'that vegetables may be used for something other than eating.' A fish net here was made from a single carrot. **Leon Vaughn**'s miniature setting of the filming of 'Beau Geste' on the desert of Guadalupe, done for the city of Guadalupe, was truly a realistic accomplishment…," *SMT*, Aug. 7, 1929, pp. 1, 4; "Guadalupe Show at Fair Brings many Admirers… **S. Fukuto**…," *SMT*, Aug. 8, 1929, p. 2; "Pioneers of Valley Have Fine Display … **Pioneer Association of Santa Maria Valley**… old photographs… Indian relics… Firearms… posters, dolls … the model made by **S. J. Jones** of the first windmill and water lift in the Santa Maria valley made and used by the late John Thornburgh in 1874…," *SMT*, Aug. 10, 1929, p. 5; "Educational Exhibits in County Fair Draw Praise… almost every article displayed is the handiwork of pupils… brilliant posters, paintings and drawings, cut paper projects, crayon and watercolor sketches… Mill Street school has a circular table divided into four sections with each containing a miniature model… such as Holland, the North Pole or a Japanese scene… Blochman School has an unusual display of wooden toys made and painted by the pupils… Santa Maria Union high school … containing work of the night school classes as well as the day students… woodshop and mechanical drawing …," *SMT*, Aug. 10, 1929, p. 6; "Officials of Association Enthusiastic… More Prizes Awarded… Further blue ribbon awards in the Fair were assigned late Saturday… Guadalupe school: Three blue ribbons for freehand painting on oil cloth, for first grade freehand paper cutouts, and for language teaching telephones," *SMT*, Aug. 12, 1929, p. 1, 4; "Guadalupe Exhibit… The central item consisted of a movie set from 'Beau Geste' one of the many movies which have found their location near this community… The other part of the booth and quite the most wonderful… was the display of cut vegetables made by **S. Fukuto**, a Japanese. A farmer, birds, fish and flowers were included in the many exquisite items shown around a tiny pool of water. Every bit of the work was made from locally grown

vegetables, but at first glance the tiny gold fish and other things appeared to be alive," *LR*, Aug. 16, 1929, p. 6.

1930 – Santa Maria. August 12-16. "Help the County Fair. Lompoc will participate in the Santa Barbara County Fair to be held at Santa Maria, August 12 to 16. Two large local organizations, the Farm Bureau and the Lompoc Valley Chamber of Commerce will stage exhibits… not enough. … Individual growers and business men should participate…," *LR*, July 25, 1930, p. 2; "Flowers to be Present Again at Exposition," *SMT*, Aug. 9, 1930, p. 17; "Junior Fair Tent… Devoted to Education… Upon first entering… one sees displays of work accomplished in the primary grades of both Santa Maria city and outlying district schools. Charts … miniature of the Fairlawn school… Art work in water and primary colors, crayon, are featured by the elementary grades including all Santa Maria schools and Blochman, Doheny, Guadalupe, Rice, Betteravia, Pleasant Valley, Tepusquet, Orcutt, Los Alamos and Suey… high school. Shop classes conducted by **A. L. Merrill**, mechanical drawing classes directed by **Harry Snell**, as well as art classes of **Mr. and Mrs. S. G. Breneiser** have unusually fine exhibits… **Clarence Ruth** has on display a booth filled with an interesting collection of Indian relics… The newest step in educational institutions in this valley, the Hancock Foundation College of Aeronautics… booths filled with airplane motors… Other displays here typical of the college include miniature airplanes, photographs… Boy Scout and **Camp Fire Girls**… Designs Booths. Three exhibits designed and made by **Leon Vaughn** are attracting much attention. The unusual booths which were created for the Broadway Bootery. 'The Woman in the Shoe,' a clever display for Shamhart's, and an unusually interesting exhibit for G. M. Scott," *SMT*, Aug. 14, 1930, p. 4; "Close Glimpses Caught at the Fair Grounds… Jim's Studio. The sign-painting art is practically demonstrated by **Jim Wheeler** in his booth at the fair… Photographs of numerous Santa Maria schools and homes designed by **L. N. Crawford**, local architect, are nicely displayed in one of the most interesting booths in the main tent…," *SMT*, Aug. 14, 1930, p. 7; "County Fair Breaks Record… The booth entered by the Lompoc Center of the County Farm Bureau… has been awarded a blue ribbon and cup… The booth, a corner one in the main exhibit tent, near the entrance … Contribution to the successful display… Lompoc Center of Farm Group has Excellent Booth… The Chamber of Commerce booth is a representation of a flower field in the Lompoc valley, delicate sweet peas in the foreground merging into a background painted by **Mr. A. S. Bloom**, local artist … **Clarence Ruth** constructed the miniature house… **Clarence Ruth** has an exhibit of Indian arrowheads and other Indian artifacts which could not be duplicated outside of a museum and which represented many years of effort and industry in collecting. This exhibit, part of which as been on display in Santa Barbara, has occasioned great admiration," *LR*, Aug. 15, 1930, pp. 1, 10; "County Fairs Get Funds. The Santa Barbara County Fair association is to get $468 from the state…," *SMT*, Sept. 27, 1930, p. 2.

1931 – <u>Santa Maria. 37th District Agricultural Assocation.</u> <u>Mid August</u>. "Plans Nearly Complete for Annual Show… <u>Flower Display</u> Great… floral displays in the big tent…," *SMT*, Aug. 5, 1931, p. 1; "'Valley of Gardens' to be Center of County Fair Beginning August 11… Santa Maria… 37th District Agricultural association… huge tents … horse show…," *LR*, Aug. 7, 1931, p. 3; "Whispers from the 'Big Top'… Because of his knowledge of decoration and applied art, **Leon Vaughn** again was chosen this year to prepare several booths in the 'big top.' Dressed in a carpenter's outfit and wearing an old slouch hat, Leon looked every bit the part of a 'nailer' …," *SMT*, Aug, 8, 1931, p. 3.

■ "Show Opening Tuesday… inception of the first 'big show' which was held in 1928. This occurred before the advent of a county exhibition and was known as the <u>Santa Maria Valley fair</u>. Sponsored by local merchants… While the venture proved successful in all its phases, the fair committee did not definitely decide to stage another exposition for quite some time… Then <u>in 1929 the entire county was included in the exhibits and this paved the way toward a beginning of the Santa Barbara County Fair</u>…. An added feature was the horse show… With the close of the 1929 fair, Santa Maria was assured of another show in 1930… bigger and better… Exhibits were enlarged and included [livestock]… Pioneers Win Honors. Perhaps one of the most outstanding displays… was… the <u>Santa Maria Pioneers</u>. Historical pictures of Santa Maria in its infancy and photographs of residents who lived here … proved an attraction… a parade… Now the gates are to be opened to the residents of not only Santa Barbara county but all other adjoining counties… It's true that business conditions are not the very best at the present… [prizes given for livestock] … As in the past, there will be a carnival. Foley and Burke's Combined shows… A record-breaking attendance is expected," *SMT*, Aug. 8, 1931, p. 2; "Whispers from the 'Big Top' … Moving pictures for a talking newsreel to be run in the local theatre if possible … will be taken Saturday when <u>Bob Phelan</u> of Santa Barbara brings his Warner Brothers-Daily News camera to the fair…," and "Commercial Booths Hold Great Interest in Main Tent … Lompoc boys' and girls' **4-H clubs** featured the Santa Barbara county display… The girls' <u>needlework</u> projects representing a half year's work are fine examples… Photographs of many beautiful scenes at the county seat are arranged in the Santa Barbara Chamber of Commerce display … **Tobe Holcomb**, sign painter, has conveniently located a branch work shop in the main tent," *SMT*, Aug. 12, 1931, p. 4; "Many Booths Draw Notice… replica of the Guadalupe adobe which was built by **Leon Vaughn** for the Guadalupe Chamber of Commerce. Correct in every detail, this miniature building is the counterpart of its big brother which stands near the business section of the town of Guadalupe," *SMT*, Aug. 13, 1931, p. 1; "Whispers from the Big Top **Mrs. Frances Meade Jensen**'s booth of paintings still is drawing interest and no little comment… A strong favorite … is the Gaviota pass painting which Mrs. Jensen has named, 'The Sentinel of Gaviota Pass'," *SMT*, Aug. 14, 1931, p. 1; "Local Exhibits Outstanding… Valley Beautiful Leads in Agricultural Division… two Lompoc booths, one sponsored by the Farm Center and the other by the Chamber of Commerce… A combination of farm produce and handiwork is displayed in the booth exhibited by the local 4-H Club boys and girls … Judging of the girls' exhibits in the 4-H Club booth was delayed when the rain, which fell Wednesday night, got the handiwork wet. It was necessary to send almost the entire display to the laundry…," and prize winners in agriculture were listed but apparently there was no art or crafts for women, *LR*, Aug. 14, 1931, p. 8.

1932 – Only a horse show was staged.

1933 – [County Fair to be held in Solvang?, *LR*, July 14, 1933, p. 11, col. 1 and next year to be held in Buellton, *LR*, Oct. 6, 1933, p. 5.] Only a horse show was staged.

1934 – <u>Santa Maria</u>. <u>August 10-12</u>. "City Building Permit… Improvements at Santa Barbara County Fair association grounds in Santa Maria totaling $7200…," *SMT*, May 14, 1934, p. 1; "Fair Decorations… The fair this year marks the first step toward economic recovery since the depression… <u>The past two years only the horse show has been staged</u> at county fair time. This year the usual exposition features will be offered," *SMT*, July 27, 1934, p. 4, col. 1; "<u>Handicraft</u> to be Judged at Fair…," and rules for judging, *SMT*, Aug. 1, 1934, p. 2; "It is Your County Fair … Revival of the complete fair program… Housewives and girls will find many displays catering to their interest and talents. Needlework and food contests…," *SMT*, Aug. 2, 1934, p. 1; "<u>County Fair Slated in Santa Maria August 10, 11, 12</u> … many new features… Harness and Running Races on the new measured half-mile track… Horse Show…," *LR*, Aug. 3, 1934, p. 4; "**4-H** Club Notes… We decided to have each member of our group send some of her clothing projects to the County Fair…," *LR*, Aug. 10, 1934, p. 10; "<u>Japanese Association</u>. Santa Maria Valley Japanese association ordered the painting of Mount Fujiyama on the background of their booth. Vegetables will crowd shelves of this exhibit," *SMT*, Aug. 10, 1934, p. 2; "Directors of Fair Decide on Show for Coming Year," *SMT*, Oct. 2, 1934, p. 1.

1935 – <u>Santa Maria</u>. <u>Late July</u> – "Santa Ynez Planning for Display at Fair. A huge painting of Santa Ynez mission is to be used as a background for the Santa Ynez Valley Farm bureau display at the … fair next month," *SMT*, June 22, 1935, p. 1; "Women's Entries for Santa Maria Fair. <u>Domestic Arts</u> Department…," categories and potential prizes, including handicraft, *SMT*, June 26, 1935, p. 2; "Painting Exhibit is Planned for Fair. Headed by **Mrs. J. E. Burton**, a committee of local home department members plan a <u>painting and wood finishing demonstration</u> as their exhibit in the home department booth at the county fair to be held in Santa Maria July 24 to 28," *LR*, July 5, 1935, p. 7; "Many New Features to Make Annual County Fair in S.M. Outstanding… space in the main tent was exhausted a week ago… Participation of the world-famous Gilmore Circus with its mile-long parade of spectacular, inflated-rubber animals and freaks… addition of two tents…. Horse show… Three days of horse racing… One full day of auto races… Foley and Burk shows …," *LR*, July 12, 1935, p. 4; "<u>Domestic Arts</u> Department <u>Premium List</u> for County Fair in S.M.," and article includes general rules, list of needlework classes, foods, antiques, rugs, needlework tapestry, patchwork and applique bedspreads, embroidery,

crochet and knitting, wearing apparel, *LR*, July 19, 1935, p. 3; "County's Best to be Seen … Flower Exhibits to be a Feature … Flowers… The large Community club floral booth … Women's clubs from Ventura to San Luis Obispo have been asked by the Community club of Santa Maria to participate in a competition for best flower arrangements …," *SMT*, July 20, 1935, p. 1; "Antiques, Foods and Fancy Work Attract Notice at County Fair... One of the outstanding exhibits of handwork is Mrs. Lawrence Jensen's of Betteravia... Each year Mrs. Jensen brings to the fair an entirely new set of fancywork... Mary Mendoza at 1108 West Church street, is another exhibitor who has a great many examples... including .. handmade laces...," *SMT*, July 24, 1935, p. 3; "Many Win Prizes in Flower Contest. Unusual arrangement…," *SMT*, July 25, 1935, p. 3; "Fair-Goers Throng Domestic Arts Section… antiques, culinary, needlework…," *SMT*, July 25, 1935, pp. 3, 5; "Many First Places Won by Local Entries in Biggest County Fair. Local Women Excel in Exhibition… Antiques … Class four needlework … [and names given] Although the Lompoc Farm center entry, a miniature of the town and valley, did not receive a prize," continued on p. 6 [not there], *LR*, July 26, 1935, p. 1; "Blue Ribbon Entries Selected in Domestic Arts Division of Fair…," and detailed listing of needlework and culinary and antiques winners' names, *SMT*, July 26, 1935, pp. 3, 6; "Display Shows What [**Camp Fire Girls**] Club Teaches… seen in the organization's booth in the Farm Center tent of the County fair this year. Decorated boxes of wood were made by Gloria Hart, Mary Ellen Germain, Eileen Germain and Helen Wasson. Imogene Dunlap, Patsy McGregor, Mary Linman and Louise Schionnemann designed and painted the plaques. A Campfire map of the United States was drawn with crayolas on cloth by Doris Cole, Helen Wasson, Mary Ellen Germain and Gloria Hart under the direction of Else Leblanc. Examples of basketry have been submitted by Gloria Hart, Esther Taylor and Campfire girls from **Mrs. Ray Rodgers**' group. Ceremonial gowns, book covers of hand-tooled leather and candle holders of wood are also displayed," *SMT*, July 26, 1935, p. 3.

1936 – Santa Maria. July 22+. "Premiums for Handicraft Announced," *SMT,* July 8, 1936, p. 3; "Big Parade to Open Santa Maria's Fair Tomorrow," *SMT*, July 21, 1936, p. 1; "Artistic Work of Needle Seen," *SMT*, July 22, 1936, p. 6, and article adds, "Many attractive and difficult types of needlework are on display in the women's handicraft section of the fair. … A drawn-work linen table cloth more than three yards long and an American flag made by placing silk rayon rosettes as stars on a background of silk, both done by Mrs. P. D. Solminihae of Santa Maria… Mrs. Ralph Williams from the coast near Goleta has contributed several hangings and samplers in petit point and needlepoint… **J. H. Strong** has contributed a hand-woven basket and Mrs. J. J. Kinyon has brought in her collection of seaweed and seashells gathered near Santa Maria. Mrs. Kinyon also has a pine needle basket on display. One fine article is a small chest made by Oscar J. Reel with a small handsaw and a pocket knife. This box consists of 3087 pieces of eight different kinds of wood"; "Large Show of Antiques Seen in Fair Booth," *SMT*, July 22, 1936, p. 6; "Large Domestic Arts Displays," and "Awards are Made in Handicraft and Needlecraft" and names listed, and some of

the names associated with the more artistic creations are: "In the rug division … Hooked wool or silk, Mrs. Josephine Terhune, first, Mrs. Frank M. Johnson, second and Mrs. A. O. Soares, third [and] Woven, Mrs. A. C. Soares, first… In the needlepoint class… Wall hangings, Mrs. Ralph Williams, Goleta, first and Mrs. Rutherford, second [not transcribed here were quilts, pillow slips, bedspreads, table cloths] woven purses. Mrs. Hall received a first and **Mrs. Ralph Lidbom**, second [skipped were doilies, booties, embroidery division (including pillows, dresser scarfs, doilies, table runners, aprons, luncheon sets, centerpieces)] *SMT*, July 23, 1936, p. 2; "Antique List Augmented at Fair," and article states, "The display of antiques in the fair was augmented yesterday by a variety of interesting objects including a wooden chest brought to America from England in 1714 and an old New York newspaper of 1783 containing Washington's farewell address. The chest was contributed by H. J. Notta/s of Los Alamos, while S. J. (Jeff) Jones is the owner of the newspaper. Mrs. Howard Corbett has contributed a dish dating from 1785. Another interesting article is a large clock, over 100 years old, with which the parents of **Mrs. C. W. Rahbar** set up housekeeping. This clock is still running. Other contributors to the antique division are: Ralph Tuthill, miner's candle holder, skates, quilt blocks, lantern, newspapers; Mrs. Isaac Porter, daguerreotype, baptismal clothes, baby's high chair and rocker; Mrs. J. M. Boothe, old dress; Mrs. Joe Gracia, apron; Mrs. C. E. Boardman, Table; Mrs. L. L. Chew, Spanish comb; **Mrs. Rahbar**, stool; Mrs. Corbett, plates, Confederate money; **Mrs. Ralph Lidbom**, plates, vases; Mrs. W. G. Sharwood, jewelry; Mrs. Pauline Doyle, napkin rings; Mrs. Ethel Cleaver, woven coverlet; Fred Shaeffer, old documents, books; Mrs. Mae Peterson, tooled leather cushion; Mrs. H. P. Krelle, child's dress, skirt flounce and daguerreotypes; Mrs. Gene Catteel, framed picture, fruit bowl, pitcher; Mrs. C. B. Taylor, books; Mrs. Nellie Warren, pictures, vases, doily sets, fruit dish; Edward Myers (?), typewriter" and gives list of awards, *SMT*, July 23, 1936, p. 2; "Fair Awards on Arrangement of Flowers Given," *SMT*, July 24, 1936, p. 2.

1937 – Santa Maria. Late July. "Fine Handicraft to be Shown at Fair," *SMT,* July 15, 1937, p. 3; "Fine Handwork Displayed at Fair … Among the outstanding exhibits is an embroidered wall hanging and an embroidered bedspread by L. Beronio of Arroyo Grande, a piece of tapestry done in crayon, a carved wood chain by John Carr of Los Alamos, a tooled leather book cover, an afghan made by both knitting and cross-stitch, a crocheted rag rug…," *SMT*, July 21, 1937, p. 3; "Awards are Made in Handicraft Needlework Section of Fair," and categories include "Rugs – hooked wool or silk rugs, Mrs. C. B. Fagerbourg, first… Needlepoint… Patchwork and appliqué [curtains, quilts]… Crochet and Knitting … Wearing apparel… Embroidery or hemstitching… Infants' Wear… Miscellaneous – Best weaving, **Mrs. R. A. Polley**, first, **Mrs. J. H. Strong**, second, **Val Breneiser**, third. Best tooled leather goods, **Mrs. Elizabeth Breneiser**, first, **Mrs. Kenneth Prindle**, second, Mrs. E. B. Volk, third. … Best carved wood, **Manuel Valente**, first, John Carr, second, **J. H. Hoback**, third…" *SMT,* July 23, 1937, p. 3: "Many Exhibits Entered

in <u>Flower Arrangements</u> Contest at Fair," *SMT*, July 24, 1937, p. 3.

1938 – <u>Santa Maria</u>. <u>Late July</u>. "Judges Selected for <u>Handcraft Section</u>," *SMT*, July 19, 1938, p. 3; "Judging Set for Household Arts" which includes many water colors, *SMT*, July 20, 1938, p. 3; "Main Tent of Fair … North of the flower show is the exhibit of Los Padres National Forest showing a typical camp scene… and a large painting of a forest scene with stream is the background. … Turning west and going up the north side of the tent in a westerly direction, the first stop is at the Shell Oil Co. puppet show… glass blowers … Oriental Bazaar… The women's department is the last booth on the east in the center section…," and contains cooked items, needlework…," *SMT*, July 21, 1938, p. 2; "Nine First to Woman Winner … **Mrs. Lawrence Jensen** of Betteravia" in handicrafts, but no mention of wc, *SMT*, July 22, 1938, p. 2.

1939 – <u>Santa Maria</u>. <u>Late July</u>. "Awards are Made for <u>Needlework</u>, Knitting and Candy on Women's Fair Displays," *SMT*, July 27, 1939, p. 3, and in town there are two societies for needlecraft, i.e., **Pythian Needlecraft Society** and the sewing club of the Woman's Benefit association.

1940 – <u>Santa Maria</u>. <u>Late July</u>. "Camera Fans! Parade Committee Wants Pictures and Will Pay for Them," *SMT*, July 23, 1940, Fair Edition, p. 1; "Clubrooms Opened at Fairgrounds… 'Whiskerino hideout' … serves as a meeting place for the sponsors during Fair season. To carry out the Western spirit, in keeping with 'Whiskerino' garb, the 'hideout' has been decorated with <u>murals</u> painted by **Nicholas Firfires**…," *SMT*, July 23, 1940, p. 3; "Wide Range Seen in <u>Handiwork</u> Displayed by Women in Fair," *SMT*, July 24, 1940, p. 3, winners.

1941 – <u>Santa Maria</u>. <u>14th Annual</u>. <u>New Permanent Fair Grounds</u>. <u>Late July</u>. "Purchase of Site for Fair… on West Stowell road… 40 acres… from the estate of the late James Adam…," *SMT*, Jan. 16, 1941, p. 1; "More Buildings to be Erected by Air College" as soon as old Fair ground's fences and barns are removed…," *SMT*, Feb. 4, 1941, p. 1; "President Approves $50,000 Work Project for Santa Maria Fair Grounds… WPA project…," *SMT*, May 26, 1941, p. 1; "Women's Section… more nearly approximate home settings than in the past," *SMT*, June 25, 1941, p. 3; "County Fair Ready in <u>New Home</u>" Santa Maria's Big Show Began in a Small Way… the first Fair held in 1928. 'Our Fair grounds then were the <u>old Santa Maria baseball park</u>, about two blocks beyond the Main Street school. We held it there for two years and then required more room, so we knocked out the left field fence and annexed part of Judge Armstrong's property. … Santa Maria had long before staged a Fair on an old race track on the Nance property but that was long before the first Fair in 1928 … After holding the Fair on East Main street for three years… moved to grounds just south of the railroad tracks, across Miller street from the Southern Pacific Milling Co. … one year… and then in 1932 the Adam property was rented and it was staged on that property until this year…," *SMT*, July 22, 1941, p. 1; "<u>Women's Section</u> of County Fair Being Readied… [managed by **Community Club** and **Minerva Club**] there will be the regular classifications for [foods] …

and in the needlework and handcraft section there will be rugs, needlepoint, patchwork and applique, crochet, knitting, wearing apparel, infants' apparel and embroidery or hem stitching," *SMT*, July 15, 1941, p. 3; "Displays Galore Seen in Main Tent… Across the end of the tent … and the Forest Service display. The Forest Service shows a model camp in a forest with a painted background… Then comes … **John Weldon**'s display of Navajo Indian pottery, basketry and other tribal products. This booth also contains a large collection of Indian arrowheads. Ship Models, Carving. Another booth is filled with ship models made by **Euland Payne** and carving done by **J. H. and Erma Hoback** of Orcutt. Outstanding in the Hoback collection is a blacksmith shop with carved figures at work, operated by a clock. … A Mexican weaver, <u>S. Castanado</u>, is operating a loom, weaving rugs, in the next booth… Down the opposite side of the main tent from the flower section… The **Santa Maria Valley Pioneer Assn.** has a cabin, built of logs and boards…," *SMT*, July 24, 1941, pp. 1, 2; "Entries Varied in Needlework Display," *SMT*, July 24, 1941, p. 3.

1942 – "Fair Called Off for This Year," *SMT*, March 27, 1942, p. 1.

1944 – "Sound Films Shown to … Community Club… **Ted Bianchi**, and were of the County Fair in Santa Maria," *SMT*, Nov. 29, 1944, p. 3; "County Fairs Discuss Dates… Approximately 40 county fairs will operate next year… The date for the Santa Barbara County Fair has not yet been scheduled…," *SMT*, Dec. 2, 1944, p. 3.

1945 – "Fair Premiums Increased… decided to conduct a two-day Junior Fair for the benefit of Future Farmers and 4-H Club members…," *SMT*, Jan. 26, 1945, p. 2.

1946 – <u>Santa Maria</u>. <u>15th Annual</u>. <u>July 24-28</u>. "Pictures of Fair Beauties… Sixteen attractive young Santa Maria girls will assemble at the city library tomorrow afternoon at 1:30 for test pictures which will be used to select eight lucky misses who will be used as models for 'The Californian' in a picture feature story of the Santa Maria County Fair… Donald A. Carlson, managing editor of 'The Californian,' and an art director and photographer of the publication will be on hand to take the photographs," *SMT*, July 1, 1946, p. 2; "Women Asked to Show Work," – <u>handiwork</u> in the domestic science and domestic arts divisions, *AG*, July 19, 1946, p. 1; "<u>Domestic Arts</u> and Sciences Prize Classes," and premiums announced, *SMT*, July 17, 1946, p. 2; "Variety of Commercial Exhibits Attracting Attention at Fair … main tent … *Flower Show*. Across the west end of the main tent is the flower show in which one of the novelties is a display of ceramics manufactured by **Mr. and Mrs. H. W. Nickson**, 312 South Pine street… U. S. Forest Service… forest service booth has a painted background… On the North Side… A booth featuring women's needlework for sale is next… Beside the south end of the stage, inside the big tent, is a photo booth …," *SMT*, July 25, 1946, pp. 1, 2; "Mrs. Calvin Funk Takes Honors in Fair <u>Domestic Arts</u> Exhibits," and list of winners names, *SMT*, July 25, 1946, p. 4.

1947 – Santa Maria. "Domestic Arts Department of Fair Lists Sections, Premiums," including Class 97 household arts and crafts, textile painting, *SMT,* July 16, 1947, p. 6; "Big Tent Booths… Santa Maria Fair … Take it from the east entrance, which is nearest the gate. If you go straight ahead, down the south side of the tent, you first encounter… then a place where you can have your portrait sketched in crayon… Next is a booth with shell jewelry, the shells with sketches on them in oil… George Fuller's book store… In the background is a painting of a pair of caballeros on horseback done by **Nicholas Firfires**… Across the west end of the tent is the flower show… Turning down the north side… Next is a food booth of the SPRSI lodge and then the Exchange Club's booth… Paintings of an old-time bar scene, done by **Nicholas Firfires**, form the background and what purports to be an enlarged copy of 'Stella,' who was a sensation at the 1915 San Francisco Exposition, sprawls across the front. This is also by Firfires. His Stella has some diaphanous covering in places where the original didn't wear anything. … Scouts and health… Then comes a display of accoutrements, hobbies and the work of boys in Cub packs 2 and 5… In the Center. Booths down the center of the main tent include the home economics and the home culinary department; a booth where you can get funny pictures of yourself or friends made… In this central section, the Santa Maria Union High school shows a miniature house under construction… samples of school art…," *SMT,* July 24, 1947, pp. 1, 4; "Prizes in Domestic Arts," *SMT,* July 25, 1947, pp. 1, 8.

1948 – Santa Maria. "Fair in Full Swing. Main Tent… [and booths described] … Santa Maria Union high school and junior college shows some… work from its journalism, art and home-making departments… 'Art Action' labels a booth displaying paintings, china, sculpture, figurines and other objects of art from the **De Nejer** studio… A girl student sits amidst the display modeling a statuette in clay… The **Americana Shop** of 208 West Church street… features antiques and gifts including some very old family pictures in equally old frames… Glass blowers and the Aycock handmade kitchen knives have adjoining booths…," *SMT,* July 22, 1948, p. 8; "Work was progressing rapidly today on the first permanent exhibition building now going up on the grounds. The structure is the first unit in a planned long-range construction program…," *SMT,* July 26, 1948, p. 1.

1949 – Santa Maria. "Fair Flower Show Section Nearly Complete… Inside the Flower Show the Santa Maria Public Library, the Artists Barn of Fillmore and the **Brooks School of Photography** of Santa Barbara have asked for space. Flowers will be arranged as usual on tables through the center, with the north wall featuring a large landscape painting by **Leon Vaughn**…," *SMT,* June 14, 1949, p. 1; "Art in Action Will be Attraction at County Fair" … The show comprises work of many members of **Santa Maria Artists' Assn.** which has headquarters in **DeNejer studios** on Black road. The studio has joined forces this year with the **Dunham Cabinet** shop to bring an outstanding educational feature… Assisting **Mrs. Jeanne DeNejer** are artists **Alice Linsenmayer** of Orcutt and **Forrest Hibbits** of Lompoc, plus all of the student artists in the association.

Hibbits has been teaching a painting class for men during the past term at the studio. Work by three of his students that has been shown at Santa Barbara will be on exhibit. Students of oil painting and their work exhibited will be **Melba Bryant**'s 'Phantasy' and landscape, 'Cat Canyon'; **Florence Foster**'s 'Calendulas,' and abstract painting, 'The Swan'; **Ida Gracia**, spring bouquet, 'Daffodils'; **Maye Nichols**, landscape, 'Blossoms'; **Hazel Rossini**, 'San Juan Bautista Mission,' and 'Blossoms'; **Pauline Price**, still life study of 'Vegetables'; **Vera Sears**, 'Treasures' and 'Fruit'; **Elaine Smith**, 'vegetables,' still life study. Sculpturing students will have from one to four items each of their best work in the exhibit. Students and their entries will be as follows: **Elinor Chambers**, 'Child at the Beach,' and 'Child With a Lamb'; **Ida Gracia**, 'St. Francis,' and 'Mask of a Clown'; **Lesli Hopkins**, 'Girl,' and 'St. Francis'; Kathryn Kerwood, 'Siamese Cat'; **Maye Nichols**, 'Chinese Girl' and 'Mask of a Clown'; **Hazel Rossini**, 'Chinese Girl'; Inez Roemer, 'Two Chinese,' and 'Angels'; **Alice Sample**, 'Quarter Horse,' 'Girl' and 'Mask of Balinese'; **Vera Sears**, 'Eighteenth Century Girl,' and 'Angels' and 'Swedish Girl.' Bedroom furniture in the display was designed and built by **Kenneth Dunham** and decorated by **Mrs. DeNejer**… **Vern Dixon** is entering a decorated chest, bowls and tinware and **Rose Dunham** a hand decorated desk and chair re-built from a discarded radio cabinet; **Bertha McCullough**'s work includes a chest, hamper and decorated tinware, and Inez Roemer a decorated chest and basket. Ceramics items too numerous to be listed are vases, bowls, trays, tableware, kitchen utensils and lamp bases. They are being entered by Lela Brians, **Mary Ellen Conrad, Elinor Chambers, Vern Dixon, Rose Dee Dunham, Ina [Sic. Ida] Mae Epperly, Irene Ferini, Edwina Freitas, Lesli Hopkins,** Louise Johnson, Kathryn Kerwood, Maud Loomis, **Christine Loomis, Peg Loomis, Bertha McCullough, Hazel Rossini,** Inez Roemer, **Vera Sears** and **Alice Sample**. **Jeanne DeNejer** is exhibiting decorated furniture, three air brush paintings of Chinese characters, ceramics including three clowns, old peasant woman, a cupid and a ballerina. Bowls on display are principally those turned on a potters' wheel with glazes developed by the studio owner. After the fair closes, **Mrs. DeNejer** will study painting with Frederic Taubes, who is coming to Carmel from New York for the summer session. She will also take additional ceramic work for two weeks in Los Angeles. Classes next year will offer instruction in oil painting, water color, commercial art, ceramics, sculpturing and modeling, decorating, drawing and China painting. To these has been added French conversation lessons and jewelry design and making,"*SMT,* July 19, 1949, p. 5; "Economics Department At Fair… A hooked rug by Mrs. E. Sprague… braided rugs… crochet… quilt… sweaters… Braided leather riata and harness, framed cross stitch pictures and wood carving…," *SMT,* July 21, 1949, p. 5; "Ceramic Figurines Capture Interest. In the County fair flower mart… one of the exhibits is a ceramics display in which **Mrs. Audrey Chappell** is exhibiting items from her studio on Orcutt road… many original figurines, one of them a 'buttons and bows girl.' There are many unusual designs for wall vases, trinket boxes, and decorative pieces for a living room table or shelf. The studio is equipped to complete all of its own work, and holds classes. One of the

groups of interest… is a miniature band, the members formed of wire with wrapped chenille in different colors. This group is complete with toy piano, also made by Mrs. Chappell," *SMT,* July 23, 1949, p. 5; "Mrs. Paul Sword Winner of Textile Sweepstakes," and list of exhibitors and quilts, fancy work, etc., *SMT,* July 25, 1949, p. 6,

1950 – Santa Maria. July 14. "Art Assn. Plans Exhibit at Fair. Plans for an exhibit in the 1950 County Fair occupied members at a recent meeting of the **Santa Maria Art Assn.**," but show does not seem to have come to fruition, *SMT,* May 3, 1950, p. 6; "Santa Barbara County Fair Opens in Santa Maria on Wednesday," *SYVN,* July 14, 1950, p. 1; "County Fair Swings Into Its Second Day… main tent … **Nelson Fuchsia [Sic. Fuschia] Gardens** of Shell Beach have a large display of their finest specimens. It is in this division that the **DeNejer pottery** manufacturing is operating… The Home Economics department headed by Mrs. Walter Word has by far the largest number of entries in the history of the fair…," *SMT,* July 20, 1950, pp. 1, 3; "Leather Work of **Knowles** Displayed" in Home Ec department of County Fair, and article adds, "Tooled leather, that is remarkable for its workmanship and artistic design, is one of the valuable entries in the home economics department at the county far. … A leather photo album cover by **Joe Knowles** is decorated with a blue ribbon. Mrs. Knowles has entered a zipper-topped knitting bag and a bill fold. The Knowles entries also include a tooled photo frame… Many have the same design of leaves and birds, an exception being a desert scene with tall cactus on one of the items," *SMT,* July 21, 1950, p. 6; "Home Beautiful Ideas Put into Practice," in the booth of the Sisquoc Farm-Home Department, and "Cross-Stitch Picture Gets Blue Ribbon," in the home economics room and other needlework winners named, *SMT,* July 22, 1950, p. 5.

1951 – Santa Maria. "County Fair Crochet Contest Offers Awards," and list of needlework categories at Fair, *SMT,* June 4, 1951, p. 4; "Souvenir Edition," "Flower Paintings Should Not be Missed by Visitors to the Fair. Floral studies in casein … comprise the exhibit of **Santa Maria Art Assn.** The canvases shown are the work of three Santa Maria residents: **Mrs. Florence Foster, Mrs. Melba Bryant,** and **Mrs. Maye Nichols.** The three artists all are gardening fans… This year, the three gardens were a riot of color… and in between gardening, their owners 'rested' while transferring to canvas their very best blooms. Visitors to the fair may see the prints displayed in the floriculture department… they plan to do some painting as an educational feature… canvases which may be changed for the latter part of the fair, will note studies by two of the artists of the same arrangement of bird of paradise flowers in a driftwood container… all are pupils of **Mrs. Ray DeNejer**… There are several pairs of smaller and medium-sized floral prints as well as larger-scale framed studies that are well worth seeing…," *SMT,* July 24, 1951, p. 4; "Flower Mart is Beauty Spot … The **Maurice Blum** interior decorating shop has arranged a room display in a modern theme using textile and other furnishings from their store," *SMT,* July 25, 1951, p. 4; "High School Art Students have Work Display in Main Tent at Fair" SB County Fair, and article adds, "The school's contribution also shows examples of work from the commercial and machine shop

departments and equipment used by students in these courses. The collection of paintings, well worth seeing, include 'Western Scene,' **Elva Van Stone**; 'House,' by Elizabertha Saenz; 'Hacienda,' by Joyce Gifford; study of boy in class, **Glenn Carroll**. **Virginia Johansen** has titled her drawing, 'Just Weeds,' and a similar drawing is that shown by **Karen Melby**. Other paintings are 'Ranch House With Palms,' Henry Oda; 'The High School,' (unsigned); 'Girl Winding Yarn,' Kathleen Tobin; 'Cock-fight,' Claudia Nettle [high school student]; 'Wild Horses,' **Barbara Moore**; 'Baseball Game,' **Glenn Carroll**; 'Ancient Farm House,' **Virginia Johansen**, and 'House at Night,' Susan Jensen…," *SMT,* July 27, 1951, p. 4. aerial photo of Fairground dominated by race track, *SMT,* July 30, 1951, p. 1; "Jeanne De Nejer to Show at State Fair and Others… She had a ceramics demonstration booth at the Santa Barbara county fair in Santa Maria for the past three years but, being out of instruction now, did not take a booth space this year…," *SMT,* July 31, 1951, p. 5.

1952 – Santa Maria. "Artists to Take Part in Fair," *SMT,* June 27, 1952, p. 4; "Santa Maria Artists … A call for artists of the community to exhibit their work in the county fair was made [at the Santa Maria Art Assn. meeting]," *SMT,* July 8, 1952, p. 4; "Artists Will Display… Members of **Santa Maria Art Assn.** are busily preparing entries for the art exhibition [County Fair] … Two exhibits are planned, one of floral paintings in the floral division… the other a general exhibit in the big tent. … Artists from Santa Barbara and Santa Maria to exhibit are **Gladys Castagnola [SB], George Keen, Marjorie Weighman [Sic. Weigman], Ruth Liecty, Lollis de Toreto, Grace Vollmer [SB], Douglass Parshall [SB], Katharine Holmes, Jaffrey Harris, Ava Turner, Margart Haideman [Sic. Weigman?], Mrs. Ward Youry, Lena Boradori, Jeanne DeNejer, Asa Porter, Betty Nerheim, Vern Dixon, Irene Ferini, Marie McCullough, Elinor Chambers,** Carol Muro, **George Muro, Elizabeth Taylor, Betty Scott, Maye Nichols, Melba Bryant, Alice Sample, Ida Gracia, Florence Foster, Helen Hollister, Mrs. Raymond Stearns, Elva Van Stone, Kathryn Grainger, Guido Signorelli, Phyllis Penfield, Ward Youry** and **Ynez Lukeman.** Lompoc artists and those of other communities who would like to exhibit are invited… To further the kiln fund for the Juvenile Home for delinquents in Santa Barbara, prizes will be given away. **Melba Bryant** is offering an oil painting and **Mrs. DeNejer** one of her ceramics for this cause. Art in action will be a feature… This is the fifth year that **Santa Maria Art Assn.** has taken an active part in the Santa Barbara County fair. Each year it has become apparent that their exhibits have gained in popularity," and **Mrs. DeNejer** goes to Lake County Fair to demonstrate pottery, *SMT,* July 18, 1952, p. 4; "Floral [photographic] Prints are Feature at Fair" sponsored by **Santa Maria Camera Club,** "For the first time in history of Santa Barbara County Fair, a contest has been held in floral print photography. … fourteen flower arrangements made by members of the **Minerva club** garden section… The prints form a feature display in the floral division…," Judged by **Sehon Powers,** San Luis Obispo photographer and member of the council of Central California Camera clubs, the prints were hung under the supervision of **Luther Thurman,** print chairman of the **Santa Maria Camera**

Club…," *SMT,* July 23, 1952, p. 4; "Famed Exhibit of Miniatures at County Fair" hand carved with nothing but a pocket knife by **Moise Potvin**, French Canadian violin maker, but exhibit is owned by Delrae of Atlantic City who is touring it around the world, *SMT,* July 24, 1952, p. 3;

■ "Fair Visitors See Art Exhibitions," and article adds, "**Santa Maria Art Assn.** is sponsoring two exhibits at the County Fair, in the floral exhibit building and in the main tent. In the two collections are being shown the work of artists of Santa Barbara, Lompoc, Orcutt, Los Alamos and Santa Maria. **Lena Boradori**'s 'Barn,' is a charming study and worthy of notice by all fair-goers. Her 'White Roses,' to be seen in the floral division is an equally lovely study… The artist is a resident of Los Alamos and has shown paintings in **Santa Maria Art Festival** …. **Elizabeth Kenny** [Sic. Kenney] is showing 'La Purisima,' and **Ethel Bailey**'s entry is 'Orchard in Spring.' Mrs. **Milton Schuyler** is showing a still life. The three artists are residents of Lompoc, and their work is typical of that section of the central coast that is coming into its own thru new and growing interest. From Santa Barbara comes the older, most professional expression in painting, ten artists representing that city… This group and their paintings are: **Gladys Castagnola**, 'Carnival,' **George Keen**, 'Steer Head,' **Margaret [Sic. Marjorie?] Weigman**, 'Cabbage,' **Ruth Liecty**, 'Iris,' **Lollis de Laret**, 'Clown,' **Grace Vollmer**, 'Girl and Flowers.' **Douglass Parshall** is exhibiting a seascape with boats in which his easy style is evident. 'Portrait of a Girl,' by **Katherine Holmes**, has an alive quality… 'High and Dry,' a boat study by **Jofrey [Sic. Jaffrey] Harris**, is one [that] men especially appreciate. 'Chinatown,' by **Ava Turner**, is a colorful 'do' on a street in San Francisco…. Local amateur artists and their exhibits are **Alice Sample**, with colorful oil of 'Bryce Canyon'… **Maye Nichols**' 'Portrait of Husbanl,'[sic?] so fresh the paint is barely dry; **Elva Van Stone**, 'Yellow' shown for the first time, **Ida Gracia**'s 'Hydrangeas,' outstanding for their color and realism… 'Roses,' a pair of water colors many would like to own. **Mrs. Van Stone**'s daughter **Betty Nerheim**, of Long Island, N. Y. has a pair of quaint flower studies in which real flowers are prepared and framed. **Betty Scott**'s 'Night,' an abstraction is stimulating to the imagination. Patty Soule [Mrs. Don G. Soule] is showing a water color, 'Abandoned,' while **Jeanne DeNejer** has a whimsical study called 'Land's End,' that has an atmosphere of romance. **Melba Bryant**'s 'Barn,' is a sunny sparkling picture that gives the onlooker a lift. The same artist's painting, 'Lilies,' with deep blue background, is pleasing as a result of a theatrical lighting arrangement used over the subject. **Florence Foster**'s 'Flying Saucers,' a semi-abstraction, is mystic in color and design, that draws comment, amusing and always favorable. Her 'Zinnias' in the flower department picture show are up to her high standard of painting. **George Muro**'s watercolors, one of them, '**Santa Maria Inn**,' have color and line, with quality best described as dynamic. Ceramics of **Ward Youry**'s and **Jeanne DeNejer**'s are to be seen placed artistically among the pictures. An art-in-action group is a feature at the fair, a large canvas set up on which several of the artists are painting their impression of the floral displays. To raise money for the purchase of a ceramics kiln for the Juvenile Delinquent home in Santa Barbara, a table is set up with a peanut guessing game as the attraction. Prizes to be given to the two guessing nearest the number are an oil painting by **Melba Bryant** and a ceramic piece by Mrs. **DeNejer**…," *SMT,* July 24, 1952, p. 4.

1953 – Santa Maria. July 22. "Mission Miniatures Scheduled for Fair," and repro. of "La Purisima Conception," but artist's name not mentioned, *SMT,* July 14, 1953, p. 1; "Floral Dept. Head Busy… Commercial displays and a food booth… the west wall adjacent to the organ enclosure will have a special display of photographs made possible by individuals of the area," *SMT,* July 14, 1953, p. 3; repro: miniature of Santa Ines Mission "Another of the series of 21 California missions to be on display at the " fair, *SMT,* July 15, 1953, p. 1; "Fair Invites Homemakers Enter in Home Ec. Dept.," *SMT,* July 17, 1953, p. 4; "Bring Flowers to Fair is Plea by Management… **Mrs. Melby Bryant** of Santa Maria Art Assn. is to be in charge of a floral painting entry. Another group is endeavoring to have installed a mechanical device which will show flower slides in color of the entries of 1952. The **Camera club** is getting ready its collection of floral prints…," *SMT,* July 18, 1953, p. 4; "Artists Plan Two Exhibits at Fair," i.e., **Santa Maria Art Assn.** will have one exhibit devoted to florals in the main exhibit building and another will be in the main tent, and "Included in the list of prospective exhibitors are: **Florence Foster, Elva Van Stone, George Muro, Maye Nichols, William Lentz, Elizabeth Taylor, George Larson** and Mrs. **Bryant**" as well as artists from Santa Barbara, *SMT,* July 20, 1953, p. 1; "Home Economics is Top Attraction at Fair," and exhibits briefly discussed, *SMT,* July 23, 1953, p. 4.

1954 – Santa Maria. July 22. "C of C to Sponsor Fair Booth… Santa Maria Chamber of Commerce… located in the fairgrounds pavilion… The rear of the booth, … will consist of the front of a house with a thatched roof composed of bundled valley grains. Murals on either side of the house will depict valley oil, cattle and dairy industries. A flagstone effect will be obtained on the pathway leading to the house through the use of dried grains…," *SMT,* June 30, 1954, p. 1; Port of **Reldon Dunlap** and caption tells of new fair construction," *SYVN,* July 16, 1954, p. 1; "Home Economics Award Winners," *SMT,* July 24, 1954, pp. 3, 4; "Senior Floriculture Arrangements Awards," *SMT,* July 27, 1954, p. 8.

1955 – Santa Maria. July 25. Photo of Mrs. Floyd Cheadle surrounded with examples of her crocheting, *SMT,* July 22, 1955, p. 7; port. photo, "Table Arranger," *SMT,* July 26, 1955, p. 7; port. with floral arrangement, "Mrs. Charles Jensen Floral Champ," *SMT,* July 28, 1955, p. 1; ports. and "Three Local Women Win Sweepstakes at County Fair… Canned and Preserved Foods … clothing and textiles … baked goods and confections…," *SMT,* July 28, 1955, p. 14; port. and "**Mrs. Charles Laubly** Floral Arrangement Winner," *SMT,* July 30, 1955, p. 1 and other winners named; "Jesse H. Chambers, 74, Founder of Fair, Dies,"– fair started in Santa Maria in 1928, which was underwritten by the Santa Maria merchants, *AG,* Dec. 30, 1955, p. 2.

1956 – Santa Maria. July 25. Photo and "Ceramics Entries. Something new is added this year at the County Fair with a new department for display of the ceramics art… Jeanette Word," *SMT*, July 24, 1956, p. 4; "Fair Home Economics Sweepstakes Winners: Mrs. George Farnum Tops Clothing, Textile Entries," *SMT*, July 25, 1956, p. 1; photo of part of crochet entries, *SMT*, July 25, 1956, p. 4; "Fair Clothing, Textile Prize Winners," lists "Arts and Crafts. Leather purse – Alice Goodman, first. Earrings – Vick Mohr, first. Ceramics. Simple items – Gloria Acosta, Janet Bradley, Marilyn Stanley, Irene Ray, Betty Pilkington, first; Lee Leal, Connie Romero, Irene Corral, Pauline Novo, second; Veda Dalessi, Hilda Bisho, Carrie Serpa, Gloria Bognuda, third. Elaborate items – Gloria Acosta, Lee Leal, Hilda Bisho, Connie Romero, Carrie Serpa, first; Irene Ray, Betty Pilkington, second; Sophie Corral, Marilyn Stanley, Janey Smith, third," *SMT*, July 26, 1956, p. 5; "Mrs. Lloyd Pearson Wins Floral Arrangement Trophy," and other winners named, *SMT*, July 29, 1956, p. 12.

1957 – Santa Maria. July 24. Three repros. and "Flower Arranging Can be Easy," general instructions written by Gerry Anderson and mention of competition at Santa Barbara County Fair, *SMT*, June 28, 1957, p. 4; "Art Show at County Fair Set," with repro of **Milford Zornes** demonstrating with two of his paintings, and article adds,

■ "The first full-scale art show to be presented with the Santa Barbara County Fair will be held in the Main Tent at the Santa Maria fairgrounds. **Milford Zornes** of Claremont, art director of Padua Hills, and **Forest Hibbits**, free-lance artist from Solvang, will present 'Artists in Action' demonstrations. Hibbits will show oil painting techniques on Saturday afternoon and evening, while Zornes will demonstrate water color painting from 3 to 5 p.m. on Sunday. Paintings submitted by local artists will be on display all during the fair. Some 40 paintings from the Santa Barbara area alone have been entered. Artists from Morro Bay, San Luis Obispo, Pismo Beach, and other northern points will exhibit their work," *SMT*, July 23, 1957, p. 2; "County Fair Camera Day, Experts Aid Amateurs," *SMT*, July 24, 1957, p. 7 and members of the **Santa Maria Camera Club** will be on hand at the club booth to assist amateur picture takers, models available, and a contest for pictures that tell the story of the fair, and entrants must be members of 37th agricultural district, and works will be in black and white and winners will become property of the fair; "New Division Created at Fair," and port. of **Mrs. Joe White**, article reads, "Growing interest in ceramics and other crafts hobbies will be given further encouragement with announcement by **Reldon Dunlap**, secretary-manager of the Fair Association, that cash prizes are to be offered in two sections for the first time in the 1957 County Fair in July. Cash premiums of $1 first, .75 second, and .50 third are offered winning exhibitors of ceramics who are under 14 years. The prizes for those over 14 will be $3, $2, and $1… **Mrs. Joe White** is named director of the new Arts and Crafts division. She states that to be eligible for premium awards in this division, all entries must have been made by the exhibitor within one year of the opening date of the Fair and must not have been shown at any previous Fair. All of the work must be by

amateurs, defined as 'one who engages in arts and crafts as a hobby, or for the love of his work without thought of remuneration.' Suggested as entries by exhibitors under 14 years are animals, boxes, figurine, vase, dish or other items not listed. Exhibitors over 14 may enter figurine, box, dish, vase, place setting (five piece), colored glazes, plates, planter or any other item not listed. Handmade pottery may be entered either coil, slab or wheel by exhibitors over 14. The Arts and Crafts division also invites entries in hand-painted china, which may be cups and saucers, plates, teapots or cream and sugar bowl. There will be space for entry of non-competitive displays of ceramics by professionals for exhibit only. Leather Goods. Entries by adults are invited in leather goods, handwork and hobbies, such as belts, billfolds, key cases, purses, earrings, copper work, both elaborate and simple in design. Three cash premiums of $3, $2, and $1 are offered. Ribbons only will be given entries of work in adult education, such as an upholstered chair," *SMT*, May 1, 1957, p. 3; "Santa Maria Fair Draws Valley Entries," including **Milford Zornes** and **Forest Hibbits** of Solvang demonstrating how to paint, *AG*, July 26, 1957, p. 1; "Women Win Fair Awards" *AG*, Aug. 9, 1957, p. 3 for embroidery, weaving, crochet.

1958 – Santa Maria. July 23-27. "Fairmark Chosen for County Fair. **'Casey Jr.'** is now the official 'Fairmark' of the Santa Barbara County Fair … 'Casey Jr.' has been sent to an artist to be drawn up as a caricature for use in advertising and publicity… and within the next few months a little boy will be picked to impersonate 'Casey Jr.' during fair time …," *LR*, April 10, 1958, p. 8; "Art Show at Fair Invites Entries" curated by **George Muro**, and article adds, "A feature at the County Fair that has grown in importance and favor from year to year is the Art Department. **George Muro** …who will again be in charge at the County Fair July 23 to 27 says by way of encouragement to exhibitors: 'If all expectations are achieved in the next few years, the Art Exhibition at Santa Barbara County Fair will be a display unique of this area and recognized the country over. Although premiums are small, they are expected to increase as time progresses. The success, however, depends on the quality of the work admitted and the effectiveness with which it is displayed.' In the professional division there will be a first-place award of $75 in oil paintings, and ribbons in second and third, $25 for water color, ribbons second and third. In an amateur section, the cash awards will be $5, $3 and $2 for oils, water color or graphic, the same offered for sculpture. A ceramic premium list may be obtained on application at the County Fair office. Serving on a committee of selection and awards will be **William Hesthal**, curator at Santa Barbara Museum of Art, **William Dole**, art instructor, University of California, **Joseph Knowles**, County art coordinator, and **George Muro**, fair art director. Entry blanks may be obtained and should be secured immediately at the County fair office, the Public Library or **Santa Maria Camera Shop**. Rules for entering are: Exhibitors must be of Santa Barbara or San Luis Obispo County and all work must be original, no copies accepted. All prints, drawings or other graphics, and water colors also, must be framed in glass. Entries must be delivered to the Fair Grounds, or to the Mission Paint Store, 1424 N. State St., Santa Barbara and must be picked up from place of delivery July 28 to Aug. 1. Name and address

should be plainly marked on the back of entry," *SMT,* June 24, 1958, p. 2; port. of **Trinidad Amador** erecting "Dancing Flowers" display, designed by **George Muro**, at the County Fair, *SMT,* June 19, 1958, p. 1; "Santa Barbara Artists Win Fair Ribbons… in professional oils… Judging the show… were **William Dole, William Hesthal** and **Joseph Knowles**… **Clarence Hinkle**'s 'Rincon Vista' was judged the best in professional oils. Second place winner with 'Whistle Boy' was taken by Montanes. And **Bertha Y. Girvetz** took third place honors with 'Rear View.' Winners in professional water colors were **Mary Parker**, Goleta, **John Gorham** of Santa Barbara and **Leslie Kilar** [Sic. **Kiler**] also of Santa Barbara. Honorable mention … went to **Martha Orentorff** [Sic. **Orendorff**] of Santa Barbara. In amateur oils first place was won by **Elsa Schuyler** of Lompoc with 'Melon No. 2', second spot went to **Richard Lyle York**, Santa Maria, for his entry 'Spring at my Window,' and third place went to **Lano Trussler** of Paso Robles with 'Three Guitars.' … [Watercolors?] were won by **Cornelia Chapman** of Santa Barbara, first place, **Ethel Bailey** of Lompoc, second, and **Lynn Bush**, Santa Maria, third place. Sculpture winners were **Robert Gronendyke** and **Trinidad Amador** of Santa Maria, first and second spot and Emta Evans of Santa Barbara, third place," *SMT,* June 21, 1958, p. 1; "'New Look' Takes Shape at Fairgrounds… Heading up the new look is **George Muro**, Art Director and his Assistant, **Trinidad Amador**…," *SMT,* June 30, 1958, p. 1; "County Fair Grounds Being Given New Look… Heading up this new look is **George Muro**, art director and his assistant **Trinidad Amador**… they have designed a new front for the Floriculture department based on the theme 'Dance of the Flowers' … Different display layouts in the Home Show Building and the tent also promise new views for fairgoers… Adding to the new look… will be competitive prizes and awards in the photography show, headed up by **Mr. Merle Slauson** [Sic. **Mervin Slawson**]…," *LR,* July 3, 1958, p. 2; photo of fair's "new look" and "Closing Date for Photography Division of Fair is July 15 … **Merv Slawson**, division head. Slawson said that cash prizes will be sponsored by the **Santa Maria Camera Club** and open only to amateur photographers. **Gaylord Jones**, head of the black and white section reported … prints to be on 16 x 20 mounts… Color slides must be 2 x 2 mounts… **Robert Dupuis**, color section head… A public judging will be held at the recreation building at Elks Field July 20 with all winners being shown at the fairgrounds July 23-27," *SMT,* July 7, 1958, p. 1; "Exhibits at Fair Expanded… The effects of **George Muro** and his art department will be clearly seen in the colorful designs and murals to be seen along with a newly designed front for the Floriculture department based on the theme of 'Dance of the Flowers'," *LR,* July 10, 1958, p. 12; ■ "Art Show Draws Many Visitors. Long-term efforts of **George Muro**, head of the art department at Allan Hancock College to develop public interest in art is getting results as may be seen on a visit to the art exhibit at the County Fair. The large space allotted in the main exhibit hall was enough to hold but half of the items offered in response to mailed invitations this year, and many paintings that arrived cannot be shown, which, said attendants at the show, is an encouraging sign. The exhibits consisting of oil paintings, water colors, drawings,

prints, sculpture and ceramics are well displayed. **Muro**, art director at the Fair and designer of many picturesque effects seen about the grounds, said that placing them any closer than they are would lose effectiveness for the many fine pieces that range from the abstract to representative type works. Judges have awarded first place to an oil painting of a coastal scene by the Santa Barbara artist, **Clarence Hinkle**. An artist who signs himself only 'Montones,' is winner of second place award with his painting of a boy. Muro, commenting on this said the painting is interesting for the use of color, freely handled, and for the plain white subtle but simple framing. **C. M. Glasgow**'s oil landscape of horses in a grove of trees in strong dramatic color and line is the third-place winner. The scene may have been of cottages at Mattie's in the artist's home town of Los Olivos. Attention is drawn to sculptures of welded metal by **Robert Gronendyke**, teacher in Santa Maria High school art department as something not to overlook while visiting the art department, which has a fine representative display both in professional and amateur classes," and photo of **Muro** next to artwork by unnamed artist, *SMT,* July 24, 1958, p. 3; "Lompoc Artists Win Awards in Fair Art Show… **Elsa Schuyler** and **Ethel Bailey** have prize-winning entries in the Santa Barbara County Fair. **Mrs. Schuyler**'s entry 'Melon No. 2,' won first place in the amateur division for oils. **Mrs. Bailey**'s entry was the second-place winner in the amateur division for water colors," *LR,* July 24, 1958, p. 12; "Final Entry Date is Set in Fair Photo Contest. Closing date for the newly formed Photograph Division of the Arts and Crafts Department, of the Santa Barbara County Fair will be July 15… cash prizes will be awarded in this division sponsored by the **Santa Maria Camera Club** and open only to amateur photographers," per *AG,* July 11, 1958, p. 6; "**Bud Quick** of Orcutt Sweeps Fair Photography Judging… made a near clean sweep of the black and white photography division… Other winners were **Fred Gibbs**… **Barbara Bixby**… **Vernon Houghton**… **Neil Huddleson**… **Ernest Smith**… George S. [Sic. F.] Scamahorn [electrician]… In color landscapes Scamahorn again took first, **Carl L. Morgan**… **Buddy Hinkle** … First prize in architectural color slides was won by **Morgan**… **Lillian Miller**… **Gaylord Jones**… In animal life and nature slides, **Ernest Smith**… In color slide still lifes, Scamahorn won first place, **Jones** second and **Robert C. Dupuis** … **Lillian Miller**. … The show was judged by professional photographer **William Rowland** of Bakersfield…," *SMT,* July 21, 1958, p. 1.

1959 – Santa Maria. July 22-26. "Arts, Crafts Aimed at Hobbyists," and article reads, ■ "An enlarged arts and crafts display will enable more amateur hobbyists to participate in the Santa Barbara County Fair here July 22-26. Chairman **George Muro** today announced the addition of metal and leather work divisions to the art, photography and ceramics of past years. Leatherwork entries may include belts, purses, billfolds, key cases and other leather objects. Metalwork sections include copper tooled pictures other copper-tooled items and metal jewelry. The art division is offering a $75 premium to the best professional oil painting entered and $25 for the best professional watercolor painting. Amateurs may also compete in oil and

water paintings, with an added $10 premium for the best amateur entry. There is also a sculpture and mosaics division. The best single prints in black and white and color slides will receive best print trophies in the photography division in addition to premiums offered in a variety of sections. All photographic work must be later than July 30, 1959. The ceramics and China division, open to amateurs only, includes wheel thrown and painted creations of figurines and animals," *SMT,* June 24, 1959, p. 3; "Enlarged Displays at Santa Barbara Fair… crafts… [added] metal and leatherwork divisions to the art, photography and ceramics of past years," *LR,* June 25, 1959, p. 3; ■ "Professional Painters Repeat as County Fair Art Winners," and article explains, "Santa Barbara's **Clarence Hinkle**, 415 Hillcrest Road, and **Mary Parker**, 119 Mallard, Goleta, repeated as first place winners in the professional art competition at the Santa Barbara County Fair. Hinkle took the $75 first place award in professional oil paintings with his exhibit entitled 'Green Bananas.' Mrs. Parker won the $25 water color award with an exhibit entitled, 'Concert.' Professional and amateur paintings will be displayed at the County Fair which opens a five-day run at the Santa Maria Fairgrounds Wednesday. **Joanne Gidford** [Sic. Gibford] of San Luis Obispo captured best amateur water color honors with her painting of 'Winter.' **Rena Towle**, 817 South Miller, Santa Maria, took top honors in amateur oil painting with an exhibit entitled 'Tureen with Fruit.' The paintings were judged by **N. E. Oback** of San Jose College and **John V. DeVincenzi**, also of San Jose. Art judging results: Oil, Professional: **Hinkle**, Santa Barbara, first; **Forrest Hibbits**, Buellton, second; **Richard York**, Santa Maria, third; **Berta Wise Giruetz** [Sic. Girvetz], Santa Barbara, honorable mention; **Olga Higgins**, Santa Barbara, honorable mention. Water Color, Professional: **Parker**, Goleta, first; **Forrest Hibbits**, Buellton, second, **Elli Heimann**, Santa Barbara, third; **Olga Higgins**, Santa Barbara, honorable mention; **Janet Ketron**, Santa Barbara, honorable mention. Oil, Amateur: **Towle**, 817 S. Miller, Santa Maria, first, and second; **Blanche Rose**, Shell Beach, third; Barbara Maas, 411 W. Agnes, Santa Maria, honorable mention; **Carolyn Jean Milton**,717 E. Cook, Santa Maria, honorable mention. Water Color, Amateur: **Gidford** [Sic. Gibford], San Luis Obispo, first; **Betty Middlecamp**, San Luis Obispo, second; **Viola Soe**, Shell Beach, third. Graphic, Amateur: **Anne Gronendyke**, 213 W. Morrison, Santa Maria, first and second; **Richard York**, Santa Maria, third. Sculpture, Best Presented: **Robert Gronendyke**, 213 W. Morrison, Santa Maria, first and second," *SMT,* July 20, 1959, p. 10; "Art Exhibits Total 88. Eighty-eight art exhibits will be displayed at the Santa Barbara County Fair, according to arts and crafts chairman **George Muro**. Muro reported 52 exhibitors have entered art work… In addition, … there will be 54 photographic entries and 25 entries featuring ceramics, leatherwork and metal work," *SMT,* July 21, 1959, p. 17; "Professors go to Fairgrounds… Santa Barbara County Fair…**George Muro**, Hancock art instructor, is the ideal man for the fair. He's been the brain behind the Fair's new look for the past three years, creating new and interesting designs and displays for fair goers," *SMT,* July 21, 1959, p. 13; **Ken** "**Prindle** Print Best Photo in County Fair," and article adds "Prindle's 'Mr. Dunn' was selected

the best black and white print. [**Vernon**] **Houghton**'s still life slide entitled 'Woodpatterns' took 2 x 2 slide honors, and [**Ken**] **Park**'s slide entitled 'Wood Texture' copped 2 ¼ x 2 ¼ slide honors" and the article goes on to list other photographic winners for Black and White (various sub groups) **Ken Prindle, Bud Quick, Barbara Bixby, Vern Houghton**, and Color Slides (various sub groups) **Bob Dupuis, Bud Quick, Vern Houghton, C. Dean, Clark Willett, Ken Park, Bernice Kalland**, *SMT,* July 22, 1959, p. 9; ■ "County Fair Crowds Praise Art Exhibit," and article reads, "Even before the County Fair opened, there were many visitors seeing the art exhibit in the main agriculture and home economics building. Praise for its arrangement is due to **George Muro**, head of the art department in Allan Hancock College, who also did space theme decorations about the fair grounds. 'If I had to comment on it,' said Muro, 'I would say the art exhibit represents a good cross section of art with items that should appeal to many tastes. I think it is better displayed than ever before owing to the space given to it. There are varied mediums, in oils, water colors, ceramics, carving and sculpture in both amateur and professional work.' There is much interest in voting by fair goers to select the best amateur painting. Many are taking the time to mark their choice in the ballot provided, and therein will help the winner receive a prize of painting materials. Contemporary art in watercolor and mosaic effects are in the collection. Overheard by one who was looking at **Mary Parker**'s water color, 'Concert,' blue ribbon winner was the comment, 'I do not understand it but I like the lines that give a feeling of motion and sound and the colors in greys, black and gold with stage and musicians to be imagined in the outlines.' For those who like realism in painting there is 'Winter' a still like [sic?] watercolor by **Joann Gibford**, and 'Channel Islands' a scene by **Forrest Hibbits** of Buellton. **Blanche M. Rose** has captured a beautiful California scene in springtime in her oil painting, 'Lupines Near the Mesa.' Striking colors that are beautifully blended attract the fair visitor to the blue-ribbon oil painting, 'Tureen with Fruit' by **Rena S. Towle**," *SMT,* July 24, 1959, p. 3; "Valley Entries… Eighty-eight art exhibits will be displayed at the Fair according to arts and crafts chairman **George Muro**. He reported 52 exhibitors have entered art work in the Fair. In addition to the art entries, there will be 54 photographic entries and 25 entries featuring ceramics, leatherwork and metal work…," *SYVN,* July 24, 1959, pp. 1, 8.

1960 – Santa Maria. July 20-24. "Top Artists to Judge Fair Art Show. **Darwin Musselman**, one of the nation's top artists and **Howard Warshaw**, University of California at Santa Barbara art instructor will judge art entries in the Santa Barbara County Fair to be held July 20-24 at Santa Maria Fairgrounds. **Musselman**, who has had numerous one-man exhibits on the West Coast and has been listed in *Who's Who in American Art* since 1952, is Associate Professor of Art at Fresno State College. Among his top awards were first prizes in the San Joaquin Valley art contest, Fresno Art League annual, Fresno District Fair and Northern California Art exhibit at Sacramento. Musselman is currently working in a variety of styles ranging from the most realistic to complete non-objective. Art department

chairman **George Muro**… also announced that two professional art purchase awards will be offered this year. The County Fair will purchase the winning oil painting for $150 and the *Santa Barbara News-Press* will buy the winning water color exhibit for $50. Both paintings will be turned over to the fair to start a permanent art collection. Fairgoers will again ballot on the most popular amateur painting, with the winner to receive a paint kit from the **Santa Maria Camera Shop**…," *SMT*, June 20, 1960, p. 6; "Art, Photography Winners Selected in Fair Preview…,"

and "Top Art Entries Selected… **Richard York**… and **Mary Parker** of Goleta won the top cash awards in art competition … York's oil painting, entitled, 'Knight Resting,' won first prize in the professional art purchase category and will be bought by the County Fair for $150. **Mrs. Parker**'s water color 'Winter of '59' copped honors in the professional art purchase section and will be bought by the *Santa Barbara News Press* for $50. 'High Dunes,' a water color by **Harold Forgostein** of Halcyon was judged the best professional entry, and a water color by **Donald Johnson**, 334 Linda Dr., entitled 'Hills of Home' won a best amateur award of $10. 'Cactus Blossom' by Gertrude Hinkle, 1415 Hillcrest, Rd., Santa Barbara, won the best professional oil painting blue ribbon, and a Shell Beach view in water color by **Blanche Rose**, Shell Beach, won professional water color honors. Sculpture – **Violet Campbell**, no second or third. Mosaic – **Bette Grace**, mosaic lamp, **Miss Melba Boroff**, 35 Clark St., Orcutt, abstract," *SMT*, July 18, 1960, p. 1; ■ "Ronald [Sic. Roland] Herold, Bill Mounts Win Fair Photo Competition. Roland Herold, 211 S. Airport, and **Billy Mounts**, Pismo Beach, copped top honors … **Herold** won best color slide honors with 'Bath Night,' showing his 18-month-old daughter, Nancy, bathing in a bucket. Mounts took the best black and white print trophy with a closeup of a youngster entitled, 'Just Bill.' **Barbara Bixby**, Santa Maria, gave Mounts a close race for black and white honors, winning firsts in three of the five categories. **Mrs. Bixby** won first in industry and architecture with 'Modern Architecture,' first in animal life and nature studies with 'The Kid' and first in still life with 'Net and Float.' **Mounts**, in addition to his best print award, took first place in people with 'Just Bill,' and in landscapes and seascapes with 'End of the Line.' **Herold** took a pair of firsts in color slides, winning the people category with 'Bath Night' and still life with 'High Noon Rose.' **Bud Quick**, 510 Mariposa Way, also won a pair of firsts in color slides. **Quick** took honors in landscapes and seascapes with 'Crescent Lake' and repeated as winner of industry and architecture with 'Going Up.' **Bud Bixby**'s 'Cactus Blossoms' won first place in animal and nature study competition in the color slides. Winning prints and the top 10 color slides in each category will be on display at the County Fair which opens Wednesday. **Richard Smith** of the *Santa Barbara News Press* was judge of the photo competition. Photo Results: Black and White. People – **Billy Mounts**, 'Just Bill,' Pismo Beach; **Mounts**, 'Sabu,' **Bud Quick**, 'Surgical Nurse,' honorable mentions: **Barbara Bixby**, Santa Maria, 'Summer Silhouette' and **Stan Byrd**, Pismo Beach, 'Portrait of Farmer.' Landscapes, seascapes – **Mounts**, 'End of Line,' **Barbara Bixby**, 'Harbor Scene,' **Quick**, 'Sparkling Water,' honorable mentions: **Vern Houghton**,

816 E. Orange, 'Clouds Over Lake' and 'Two Windmills." Industry, architecture – **Barbara Bixby**, 'Modern Architecture,' **Quick**, 'Gauger,' **Houghton**, 'Fishermen at Evening,' honorable mention: **Houghton**, 'Sunday at Morro Bay.' Animal life, nature study – **Barbara Bixby**, 'The Kid,' **Bixby**, 'Nature Study,' **Quick**, 'Zip,' honorable mention, **Bixby**, 'The Lookout.' Still life – **Barbara Bixby**, 'Net and Float,' **Quick**, 'Table Top,' **Stan Byrd**, 'Knot Eyes.' Color slides. People – **Roland Herold**, 'Bath Night,' **George Scamshorn**, 312 Sharry Lane, 'To the Unknown,' **Bud Bixby**, 'Summer Fun,' honorable mention: **Bud Bixby**, 'Fishing.' Landscapes, seascapes – **Quick**, 'Crescent Lake,' **Bud Bixby**, 'Desert View,' **Freddie Weaver**, 'Old Barn,' honorable mentions: Stan Brager, San Luis Obispo, 'Trees' and **Betty Herold**, 221 S. Airport, 'Redwood Trees.' Industry, architecture – **Quick**, 'Going Up,' **Doris Houghton**, 816 E. Orange, 'Ceiling Beams,' **Bud Bixby**, 'Tabernacle,' honorable mention: **Roland Herold**, 'Fishing Boat.' Animals and nature study – **Bud Bixby**, 'Cactus Blossoms,' **Gaylord Jones**, 212 Palm Court Drive, 'Amole,' **Bud Bixby**, 'Sego Lilies,' honorable mention: **Freddie Weaver**, 'Big Thirst.' Still Life – **Roland Herold**, 'High Noon Rose,' **Vernon Houghton**, 'Pussy Willow,' **Houghton**, 'Wings,' Honorable mentions: **Bud Quick**, 'Sand Dollar' and **Freddie Weaver**,' Old Watch'," *SMT*, July 18, 1960, p. 2.

■ "Art Winners Named at Santa Maria… The following winners have been announced and will have their work on display during the fair, scheduled to run July 20 to 24 at Santa Maria. Dr. **Billy Mounts** of Pismo Beach took a first and second in the 'people section' with pictures titled 'Just Bill' and 'Sabu.' He also took first in landscape with 'End of the Line.' **Stan Byrd**, also of Pismo Beach took a third place in still life with 'Knot Eyes,' and honorable mention in the people class with 'Portrait of a Farmer.' Stan Brager of SLO was awarded an honorable mention in the color slide landscape section. In the art division, **Harold Forgostein** of Halcyon took a first in professional water colors with 'High Noon.' The same painting was judged best professional painting, oil or water. In the amateur oil painting, **Blanche Rose** of Shell Beach took first place with 'Shell Beach View.' In professional oil painting category, **Ivy Parsons** of SLO was awarded third place with 'Old Rancho.' Third place in the professional water colors went to **Betty Middlecamp** of SLO for her painting of 'Holister Peak.' **Kathryn Schofield** [Sic. Scofield] of SLO took a third place in amateur watercolors with 'Mission Trails'," *SLO T-T*, July 19, 1960, p. 5; "Talented Crew Does Decorating… **Henry Fujioka**… Peter Loschan, an art companion of Fujioka's in San Francisco, assisted. Also helping out in the art and painting department was **Trinidad Amador**…," *SMT*, July 20, 1960, p. 36 (i.e., 20-B); port. of **Henry Fujioka** who designed parts of fair and "Artist Expresses Fair's Magnitude… He was born in Santa Ana 25 years ago and came with his family to live here when he was in the fourth grade. Henry Fujioka has produced pagoda-style ticket booths… gold-colored roof structure spreading across the main entrance. Beneath this gracefully curved cornice are three panels. On the left is one of several ancient Japanese gods of fortune. This one symbolizes the farmer and the fruits of agriculture. On the opposite side is portrayal of …deity of war… Between… is

a white bird… Designed intricately, the figures nevertheless stand out from a distance. They are painted in rough technique for projection rather than for detail… Another example of his work is seen within the floral exhibit … a large circular painting, with soft blues dominant. The subject here is a valley farm … His work at the fair emphasizes the largeness of Santa Barbara county, the productivity of its soil and its people and the charm of living here as expressed in his treatment of the entrance design. Capping the portico, in a large gold circle, is a figure that resembles a 'stick man' on the run. This is a Japanese word sign, the artist said, symbolizing largeness. And that's the essence of this year's fair," *SMT*, July 20, 1960, p. 40 (i.e., 24-B); "Oriental Theme Authentical" 7 Departments Included in Fair … home economics… floral… **George Muro** set up the art exhibits and **Bob Dupuis** handled photographic entries… agriculture… livestock… horse shows…," *SMT*, July 20, 1960, p. 39;

■ "Local Artists Place at S.B. County Fair… prize winning oil paintings of **Miss Barbara Kern**, 635 Korina Street, VAFB, and **Mrs. Eldon Baird**, 508 North Poppy Street. Barbara, the 17-year-old daughter of Major and Mrs. Russell Kern, won second place with the first still life oil she had ever painted, a picture called 'Rusty Shears.' She has been taking lessons for a few months from **Col. Allen Haemer** at the base. Previous to that she had dabbled in water colors and done some sketching. Barbara is interested in other forms of art, including dancing, singing and piano. She has been an assistant teacher at the Marjorie Hall School of Dancing and this summer is teaching Vandenberg pupils while Mrs. Hall is in Europe. A June graduate of Lompoc High School, she will attend Santa Barbara City College this fall, majoring in art. She will also teach dancing at Gunsett Academy of the Dance. Barbara's mother is also a painting enthusiast and takes lessons at the base. Her sister Lillian took art while attending Allan Hancock College. Another sister, Judy, 13, does pen and ink and pencil sketches of her favorite subject – horses. **Mrs. Baird**, whose painting, 'Only a Few Treasured Years' won third prize in the amateur oil painting division, was inspired by thoughts of her son, Billy, who died in 1957. The picture was a form of recording his interests as a memorial to the boy. Pictured are the autographed baseball which Mrs. Duke Snyder presented to Billy when he and his father attended a World Series game; his saxophone, his Bible, a model airplane, Boy Scout symbols, and a copy of the newspaper for which he was a carrier boy. Mrs. Baird has been interested in painting for some years. From the age of 10 until her high school graduation, she took lessons in pastels and pencil sketches. After that she took up oil painting on her own. She has painted many pictures for her home and as gifts to friends. In her home she presently displays one called 'Stormy Day,' a snow scene and one of a mountain and lake. Her own favorite, besides the memorial picture, is the snow scene. This is her first entry in competition, although she displayed a number of pictures in Ryon Park this June at the Flower Festival Art Show… Other hobbies of Mrs. Baird include ceramics, artificial flower making, gardening and sewing. The Bairds have two daughters, Kathy and Mrs. Harry Keller, and a son, Mark," and port. of **Barbara Kern** at her easel and port of **Mrs. Eldon Baird** with several of her paintings, *LR*, July 25,

1960, p. 6; photo and caption reads, "Receives Photo Trophies. First place trophies are presented to left, **Billy Mounts**, 690 Hanford St., Pismo Beach for his black and white photo, 'Just Bill,' and to **Roland Herold**, 211 S. Airport, right, for the best color slide, 'Bath Nite.' Presenting the trophies was **Bob Dupuis**, center, photography director for the … Fair," *SMT*, July 27, 1960, p. 10.

1961 – Santa Maria. "Professional Artists' Invitational Showing Scheduled for County Fair. Some 30 known professional artists from the Santa Barbara and San Luis Obispo County areas are taking part this year in an experimental limited professional invitational show headed by Art Director **George Muro**… On the invitational list from Santa Barbara are **William Dole**, **William Rohrbach**, **Howard Fenton**, William Ptaszynski, Thomas Cornell, John Bernhardt, Jorgen Hansen, **William Hesthal**, **Olga Higgins**, James McMenamin, Aage Pedersen, Jens Pedersen, Arthur Secunda, **Joe Knowles**, **Forrest Hibbits**, Vern Swanson, **Standish Backus, Jr.**, **Douglass Parshall**, **Gladys Castagola** and **Howard Warshaw**… San Luis Obispo area: **Phil Paradise, Gladys Gray, Harold Forgostein, Jane Gault, Everett Jensen, Lano Trussler, Arne Nyback, Charles Ross, Robert Pyle** and **Norman Griffin**…," *SMT*, July 5, 1961, p. 10.

1962 – Santa Maria. "Morro, S. B. Artists Cop Fair Award … professional prints and drawings… 'Head,' by **Olga Higgins**, third," *SMT*, July 23, 1962, p. 9; " and "Oceano Man Wins Top Photography Trophy," *SMT*, July 23, 1962, p. 9.

1965 – Santa Maria. Port. of **Paul Winslow** with students applying the paint to decorate the County Fair and "Art Teacher Designed 'Wonderland,' … art figures and displays at this year's … fair… **Paul Winslow**, 33, art director at Santa Maria High School… Winslow started thinking and designing for the forthcoming annual Fair in March, as soon as the Fair theme was selected… But, it was not until July 1, some 20 days short before the fair… that he and his crew actually were able to move into the buildings and onto the grounds to start work…," *SMT*, July 19, 1965, p. 4.

See: "American Association of University Women," 1958, "Art, general (Santa Barbara)," "Home Department of the State Farm Bureau," 1935, "Lompoc Valley Fair," 1927-35, "Santa Maria Art Association," "Santa Maria, Ca., Union High School," 1951, "Santa Maria Camera Club," "Santa Ynez Valley Country Fair," "Darling Ceramics"

Santa Barbara County Library (Lompoc)
Library constructed with funds provided by Andrew Carnegie and opened in 1911. It contained books (on art, crafts, hobbies) and sometimes was the site of exhibits. Meetings of various organizations were held in library meeting rooms. In 1969 a new library was constructed further north in the town, and the "Carnegie" library became the Lompoc Historical Museum.
[Only exhibits of art objects and/or photos were noted here.]

Santa Barbara County Library (Lompoc) (notices in Northern Santa Barbara County newspapers on microfilm and the Internet)

1922 – "Special Artist's Exhibit at Library … charcoal drawings and color sketches by Miss Anna Milo Upjohn will be shown at the Public Library in Lompoc the week of December 18. The pictures, which have been secured from the Pacific Division headquarters of the American Red Cross, …," and show was extensively exhibited in California and consists of sketches of children in war torn Europe, by Upjohn who was born in New Jersey and specializes in portraiture and illustrative drawings, *LR*, Dec. 15, 1922, p. 3.

1933 – "Paintings and Books Constitute Display at Lompoc Library. Arranged in honor of the return voyage of the *U. S. S. Constitution* along the coast on its way back to the Atlantic… A large framed picture depicts 'Old Ironsides' in full sail and another shows the ship as it is now. Among the books included in the display…," *LR*, Oct. 6, 1933, p. 10.

1935 – "Outstanding Exhibit… sixty photographs…," *LR*, Sept. 13, 1935, p. 1; "Historic Photos… the **H. P. Webb** collection of photographs of California missions, now on display in the library clubrooms. The exhibit was secured through efforts of **Fred Hageman**, national park service architect… pictorial panorama of all the remaining buildings… details of doorways, sacred objects… and handmade utensils …," *LR*, Sept. 20, 1935, p. 1.

1937 – "Wood Work Display. **Harry Nelson**, high school applied arts instructor, brought in an exhibit yesterday which may be seen in the window of *The Record*, of wood work turned out this year by high school students. This is a bit of advertising for a big exhibition, slated April 26 at the library of work from the applied arts classes, the domestic science department and the art department….," *LR*, April 2, 1937, p. 1.

1960 – Photo of women making finger puppets and "Story Hour Draws Big Attendance… Innovations… This week's program drew an attendance of 57. It included the appearance of Pat Sterling's marionettes… Planned for next week's session is the use of finger puppets to illustrate the story of Henny Penny…," *LR*, Aug. 11, 1960, p. 22.
See: "Lompoc Historical Museum"

Santa Barbara County Library (Santa Maria)
Library that contained books on art, crafts, hobbies and sometimes was a site for exhibits curated by librarian Dorothea Nelson and guests (1941-55). Carnegie Library, active 1909-1941, was replaced with a Spanish-Mission style building at 420 South Broadway. It received two expansions – in 1963 and 1969. In 2008 the library moved to its current location at 421 South McClelland Street.

■ "The history of the city library goes back to October 1894, when 25 women met in the home of Mollie Smith to discuss the possibilities of organizing a ladies society. With the town consisting of mostly farm families and a few shop keepers, the social life of that time was centered on church gatherings and school activities. These women wanted something more. Thus, the **Ladies Literary Society** of Santa Maria was formed. As more women became interested, the club/s membership grew, and before three months had passed, the membership had more than

doubled. … they also felt that the town should have a community library. They deposited all profits earned through their various activities into their newly opened Library Fund. By the end of the first year, the Library Fund contained a grand total of $79.09. However, this was only the beginning. On April 3, 1896, the motto Higher Knowledge and Better Morals was adopted. The sweet alyssum became its flower and the women voted on purple and gold as its colors. **Mrs. Stearns** designed a seal of a lighted torch over an open book. The following July, a bookcase was purchased, stocked with 90 books, and placed in a corner of **T.A. Jones** store. Library cards were sold to the community and the revenue was used toward the purchase of more books. … In April 1899, when the library had 268 books to lend, the women hired a librarian (**Minnie Stearns**), paying her $1 per month. In 1903 the club raised her wages to $2 per month. In 1900 the circulating library was moved to the Post Office, a more convenient location for the general public. The women had great expectations, as well as many projects to follow through on. … Most of all, though, they wanted a library for Santa Maria. In March 1901, the women wrote their first of many letters to Andrew Carnegie, asking him to consider Santa Maria as a site for one of his Carnegie Libraries. In November 1902, the women began to meet in the studio of the artist **Minnie Stearns**. To thank Mrs. Stearns for her generosity, they would periodically present her with a half a cord of wood. The group met in Mrs. Stearns/ studio until 1907. In 1906, the club/s name was changed to the **Minerva Library Club** of Santa Maria. …m When the ladies discovered that they could not buy real estate unless their group was incorporated, they began compiling a constitution and by-laws with the help of a local attorney. The documents were then sent to the Secretary of State for the State Seal and ratification. On July 9, 1906, when the seal was affixed, the Minerva Library Club had taken another step in its progress. In September 1906, the women felt they needed a permanent place in which to house their books. After a committee was appointed to find a library lot, a 57-by-75-foot lot was offered by a member at the corner of Cook Street and Broadway … and the ladies made a down payment of $ 50. On Sept. 6, 1907, the women made the second payment of $200 on the lot designated as the future site of the hoped-for Carnegie Library. In January the following year, the women borrowed $200 from the bank in order to pay off the outstanding balance on their lot. Five months later the loan was repaid." (The story of the building of Santa Maria/s Carnegie Library will continue in future columns. Shirley Contreras lives in Orcutt and writes for the Santa Maria [Valley] Historical Society. Contact her at 934-3514 or at shirley2@pronet.net. Her book 'The Good Years,' a selection of stories she/s written for *The Times* since 1991, is on sale at the Santa Maria Valley Historical Society on South Broadway," per santamariatimes.com/lifestyles.

■ "Until 1907, the only resource for books in Santa Maria was the **Minerva Library Club** which dispensed approximately 600 volumes in the lobby of the Post Office, then on the west side of Broadway between Main and Church Streets in the Jones Building. Soon after the incorporation of the City of Santa Maria in 1905, people began talking about the possibility of a library and in 1907

the City appointed a Board to make plans to that goal. Because the Carnegie Library Foundation was then giving money for buildings ..., the Board applied for a grant in the amount of $10,000. ... The women of the **Minerva Club** got their wish for a new library after cityhood. After consideration of various locations, Mr. Paul O. Tietzen generously donated a plot of land, with 210 feet fronted on Broadway and Cook Street ... A beautiful Carnegie Library opened in May 1909, initially with 600 volumes. Mrs. **Minnie Stearns**, local painter and former schoolteacher, was named as Librarian at the salary of $70 per month (including janitorial service). She served for over 25 years until retiring in 1934. ... As the population grew, the need for a new library building gathered momentum. At the total cost of $36,700 Mr. H. E. Small built the library. It was dedicated on July 15, 1941, one of the last library buildings to be constructed on the West Coast before World War II. The book collection numbered about 10,000 volumes. The old Library at 420 S. Broadway (State Highway 135) had three additions since construction of the original structure in 1941. A mezzanine and storage area was added in 1958, bringing the total square footage to 7,800. ... Meanwhile, the original Carnegie Library served as a USO center and then a youth center under the Parks and Recreation Department but it was ultimately condemned. Costs of rehabilitation were too high and so it was razed in 1966 amid deep feelings of nostalgia." from www.cityofsantamaria.org/home.

Santa Barbara County Library, Santa Maria, (notices in Northern Santa Barbara County newspapers on microfilm and the Internet)

[Only exhibits of art objects and/or photos were noted here.]

1934 – "**Mrs. Stearns** ... Custodian of Books Retires After 25 Years," *SMT*, Jan. 2, 1934, p. 1.

1939 – "Library Features Microscopes, Adds List of New Magazines... As often as time and available facilities permit, **Mrs. Nelson** places on exhibit anything that she believes will be of interest to those taking advantage of the library service... The library also boasts a number of magazines heretofore unavailable. These include *American Photography... Recreation*, a monthly publication devoted to the wise use of leisure time and to hobbies and games...," *SMT*, Feb. 9, 1939, p. 9.

1941 – "Santa Maria's New Public Library Building to be Dedicated Tonight at 7:30," and old library became recreation center, *SMT*, July 15, 1941, p. 4; **Santa Maria Camera Club** "Flower Prints on Display in New Library," *SMT*, Aug. 1, 1941, p. 3; "Indian Craft in Library Display ... part of the large collection of **John Weldon** and will be left on display for the next three weeks... pottery bowl, woven sandal, and a stone axe-head recovered by Weldon from Indian ruins in Arizona. Also to be seen, are a pueblo Indian painting by Po-Povi...," and other items described are all from Arizona/New Mexico, *SMT*, Oct. 14, 1941, p. 2; "Mosaic to be [**Community**] **Club**'s Gift to Library" but no artist mentioned, *SMT*, Nov. 8, 1941, p. 3.

1942 – "Library Shows Burmese Display... loaned by A. B. Stephens who spent several years in Burma and India...," *SMT*, Jan. 7, 1942, p. 3.

1943 – "Heirlooms are Displayed... in honor of the **Santa Maria Valley Pioneer association**... by the librarian, **Mrs. Dorothea Nelson**. All of the articles were loaned by

members of early families... two weeks, and others to be added during the display...," and items included mantilla, quilts, photographs, lantern, etc., *SMT*, May 1, 1943, p. 3; "Local Groups Present Gift to Library... [books, world globe] ... there is also an Alaskan display consisting of photographs made by **Dr. Carrie Thwaites** of this city on a trip through the territory in the early 1900s. Among the photographs is one of the entire population of Attu at that time," *SMT*, June 30, 1943, p. 3; "Photos of Indian Chiefs Shown... Ten enlarged and colored photographs of leading Indian tribal chiefs west of the Mississippi ... loaned by **Sgt. W. S. Hardy**, photographer stationed in the Santa Maria Air Base. The pictures, all 20 x 24 inches in size, were taken by Sgt. Hardy in 1936-37. They were colored by Mrs. Hardy, now employed in a local studio following ten years of similar work in studios in Hollywood and Middle Western cities. The exhibit first was shown in the Ambassador hotel, Los Angeles, and subsequently toured other leading cities. It will be shown... for the next two or three weeks. Outstanding among the photos are several of Chief Thunder Bird...," and other sitters named, *SMT*, July 28, 1943, p. 3; "Timely Exhibit Shown... back-to-school theme... Schoolbooks varying from 50 to 100 years old... photograph," of a schoolhouse, *SMT*, Sept. 10, 1943, p. 3; "Art Craft Exhibit in Library. **Miss Myrtle F. Lange**, who has recently joined the high school faculty to replace Mrs. Stanley Breneiser as arts teacher, has arranged a display of craft work in the public library window. An illustration of the work taught in the Monday and Thursday night school sessions under her direction, the exhibit includes articles made by Miss Lange in many mediums. Shown are hand-blocked linens, wooden carved plaques, examples of stenciling, jesso [sic. gesso] craft, plastics and metal articles," *SMT*, Sept. 28, 1943, p. 4; "Handcraft by Soldiers on Display... soldiers of Camp Cooke Station Hospital...," under **Mrs. Fred Hau**, *SMT*, Nov. 8, 1943, p. 3.

1944 – "Collection of Toby Jugs in Library," *SMT*, May 18, 1944, p. 2; "Collection of Dolls Shown in Library," *SMT*, Nov. 15, 1944, p. 3; "Philippines Display in Library" handicrafts: metal, paper from pineapple fiber, doll, rebozo, *SMT*, Dec. 29, 1944, p. 3.

1947 – **Catherine Jackson** – "Ensemble Harpist Shows Paintings in City Library," *SMT*, April 15, 1947, p. 3; "Hansen Silhouettes Exhibit at Library," belonging to Mrs. Clelia Hansen, a result of many years of collecting, *SMT*, June 13, 1947, p. 3; "City Playday... In connection with the playday program, an exhibit has been arranged by **Mrs. Paul Nelson** at the Public Library of handcraft by children attending the **summer school** classes. ... carved wooden napkin rings, plastic placemats, braided leather bracelets, belts, and other items. Younger children have made coaster sets of cork with hand drawn and painted designs," *SMT*, July 29, 1947, p. 3; "Library Has Display on Mexico," *SMT*, Aug. 9, 1947, p. 3; "Exhibit by Local Artist at Library," i.e., **Mrs. Ross Linsenmayer**, *SMT*, Oct. 16, 1947, p. 3.

1948 – "Visual Education Exhibit at Library" comprises miniature models of California Native American and Spanish/Mexican era scenes borrowed from Santa Barbara city schools, *SMT*, March 12, 1948, p. 10; "Amateur Artists Have Water Color Exhibit," and article says, "They have been arranged through the interest of **Leo Ziegler**, resident

of Santa Ynez valley, who has a studio on Ballard Road. The paintings include scenes from Avila, Santa Maria, Los Alamos valley and El Capitan beach. Ziegler, commenting, said the work shows a deep feeling of beauty and an appreciation of many excellent subjects in the nearby communities. The exhibitor's group includes **Lena Boradori, Esther Jones, Ida Kriegel, Mrs. George Rand, Mrs. Don Taylor,** and **Olga Tognazzini [Tognazzi]**, and there are also studies by **Ziegler**, who has taught in Atterdag college at Solvang," and also an article antique "Teacups on Display at Library" *SMT*, May 12, 1948, p. 5 [Not May 11 as recorded in newspapers.com].

■ "Creative work in various mediums by **Mario Veglia**, Casmalia artist, forms an exhibit at the public library this week. … Chosen for the local display are several of the artist's favorite serigraphs done on silk screening. Still experimenting with this form of painting, one of the best examples in the lot is that of a Monterey pine. There are pastels, block prints, and pen and ink sketches in the exhibit. Worth seeing are water colors of Casmalia landscapes, flowers and ranch scenes. The display at the library has been arranged at the request of Santa Marians who have viewed his work" per "Shows Paintings at Library," *SMT*, Jan. 18, 1949, p. 5; "Concert Window Display is Library Exhibit… autographed photographs of concert artists… A set of valuable porcelain plates with reproduction of paintings of the great composers as the design from the collection of **Dr. Clifford Case**…," *SMT*, May 5, 1949, p. 5; "Buttons are Timely Exhibit at Library," *SMT*, Oct. 18, 1949, p. 6.
1950 – "Art Exhibit Opens in City Library Today," by **Andre Durenceau** and **Anton Kurka**, pictures are on loan from the owners, Travelers Insurance Co., Hartford, Conn., local agent C. Wes Hatch announced. Hatch said the paintings have been displayed in galleries in many cities and have been used to illustrate a natural history series in *National Geographic*," *SMT*, Sept. 11, 1950, p. 6; "Paintings are Library Exhibit," – 20 paintings mostly of animals and plant life on the theme of self-preservation in the world of nature, **A. J. Kurka** and **Andre Durenceau** are artists, *SMT*, Sept. 12, 1950, p. 4; "Local Art Work on Display" – 28 paintings by HS and Jr college art classes for **National Art Week, Ward Youry**, teacher, and article adds, "The local display will include works representing each of four different techniques. Seven were shown [Sic.] the work being done in the class in creative design, seven are pencil sketches, seven are plates designed to show creative line and pattern designs for plates, and seven are colored pencil sketches made by high school students," *SMT*, Nov. 3, 1950, p. 1.
1951 – "Local Artists Show Paintings" at Library sponsored by **Junior Community Club** and hung by its art chairman **Mrs. James Hosn**, and article adds, "The paintings comprise water colors of flowers, fruit, scenes and landscapes. Five contemporary paintings made with tempera paints by the design class [of **Santa Maria JC**], taught by **Ward Youry**, will be in the collection. Students who have paintings in the exhibit are: Dolores Brosche, Gil Silva, **Doree Bond**, Louise Foltz, **Paul Veglia**, **Virginia Johansen**, Pat Knight, Kathleen Tobin, **Barbara Moore**, Daniel Warshaw, **Lowell Evans**, and Bernice Fairchild," *SMT*, March 5, 1951, p. 4; "Library Art Show" of eight wc

landscapes etc. an arrangement of the **Junior Community Club** and **George Muro**, for **National Art Week**, *SMT*, Nov. 3, 1951, p. 4.
1952 – "Club to Give Art Book," i.e., Calif. Fed of Women's Clubs give book on Washington, D. C. architecture, *SMT*, Jan. 8, 1952, p. 4; "Water Colors on Display at Library," and article adds, "In observance of **National Art Week**… Paintings shown are by **Glenn Carroll, Betty Eya**, Horace Martinez and **Henry Fujioka**, students in Santa Maria High school art department," *SMT*, Nov. 4, 1952, p. 4.
1953 – "Paintings by Santa Maria Artists Shown," at Library, curated by **G. Muro**, and article adds, "First spring showing of paintings done in recent months by members of **Santa Maria Art Assn.**," *SMT*, March 20, 1953, p. 4.
1954 – "Currier & Ives Original Prints to be Exhibited," *SMT*, April 27, 1954, p. 4; "Adults and Students See American Prints," *SMT*, May 4, 1954, p. 4.
1955 – "Prize Painting [by **Ida Deakin** won by **Junior Community Club**] to be Exhibited at Library," *SMT*, May 24, 1955, p. 4.
See: "Jackson, Catherine," "Kriegel, Ida," "Murals," "Nelson, Dorothea," "Santa Maria, Ca., Recreation Department," 1947

Santa Barbara County Library (Santa Ynez Valley)
See: "Santa Barbara County Library (Solvang)"

Santa Barbara County Library (Solvang)
Founded 1912? Library that contained books on art, crafts, and hobbies. Located in Veteran's Memorial Building. Beginning 1959, after moving into larger and temporary quarters, and after the Solvang Woman's Club began taking an interest in it, artist Oscar Lindberg began serving as chairman of a revolving art exhibit, 1959+, succeeded by other curators.

■ "Santa Ynez Branch Library First Organized in State – the modest little frame house, 12 x 14 feet, built in Santa Ynez in 1912 from the proceeds of a dinner dance… The Buellton Branch was established on April 26, 1923. It was housed in the Buellton Garage for a time… Solvang library service was established on June 1, 1912 in the postoffice. It was moved to Zink's Clothing store and from there to the present quarters at the Veterans Memorial Building in 1940… branch library was established in Los Olivos [c. 1920]," *SYVN*, Sept. 17, 1954, p. 3.
Santa Barbara County Library (Solvang) (notices in Northern Santa Barbara County newspapers on microfilm and the Internet)
1943 – "Library News. Dr. McKenzie Brown, librarian of the Santa Barbara Free Public Library, announces the addition of two compartments of shelves, a large reading table, a heating stove, and three hundred volumes of new and recent books to the Solvang Branch Library located in the Veterans Memorial building… Books and magazines may be borrowed for a period of one or two weeks with renewal… Monthly art exhibits are being planned for the coming year, dates to be announced later," *SYVN*, Oct. 8, 1943, p. 1.

1959 – "State, County Library Officials Attend … Open House at Branch in Solvang… The Solvang Branch Library, which moved to its larger but temporary quarters just a month ago… Red spring flowers were used throughout the library room … display of antique Valentines loaned by the county library. An exhibit of paintings by local artists and students was much admired… Exhibit of local art work will become a permanent adjunct to the library. Currently on display are oil paintings by **Amory Hare Hutchinson, Mrs. Andrew Joughin, Charles Glasgow, Forrest Hibbits, Holger Petersen** and **Oscar Lindberg. Mrs. Viggo Brandt-Erichsen** is showing drawings by two of her students, Pamela Van Valln and Robert Lybarger. Lindberg made arrangements for the art display," *SYVN*, Feb. 20, 1959, p. 5; "Glasgow Paintings in Library Exhibit. … for the next six weeks at the Solvang Branch of the Santa Barbara Public Library," *SYVN*, March 13, 1959, p. 1; "Solvang Library Exhibiting Art... through Aug. 1 are six oil paintings by **Amory Hare Hutchinson**. In the children's department Kathy Krogh is showing a water color painting and Mark Sanchez a chalk and crayon painting. Recent additions to the children's library are two Danish dolls and a Danish mobile purchased with the children's contributions to the Marie Brons Memorial Fund…," *SYVN*, June 19, 1959, p. 1; port. and "Friends Tender Mrs. Franks Surprise Farewell Luncheon," *SYVN*, Aug. 28, 1959, p. 3; "Mrs. Markgraf New Librarian," *SYVN*, Aug. 28, 1959, p. 8; "… Valley Woman's Club… Among the accomplishments she listed were: the moving of the Solvang Branch Library to larger quarters… change in name of the club. A word of thanks was extended to **Oscar Lindberg** for the display of paintings by Valley artists in Solvang Branch Library which has a new artist on view every six weeks," *SYVN*, Sept. 18. 1959, p. 3; "Lindberg Paintings in Library Showing. Six oil paintings by **Oscar Lindberg** of Janin Acres are currently on display until Nov. 15 at Solvang Branch Library. Any resident of the Valley, especially newcomers, whose work in the field of fine arts are ready for exhibit, are invited to participate in this display of Valley talent. They may make inquiries with Mr. Lindberg, phone 7933, who is chairman of this continuous library exhibit," *SYVN*, Oct. 9, 1959, p. 2; "Solvang Branch Offers Display. … A colorful poster by Mrs. Lorna E. Pinassi, Sunny Hill, Solvang, depicts the theme of the October exhibit in the Solvang Branch of the Santa Barbara County Public Library, 'Exploration, 1492-1960.' … Mrs. Karl Markgraf, librarian, said hobby groups and organizations are invited to display their materials at the library. Mrs. Clyde Knight, secretary of the **Valley Rock Club**, reported that an exhibit of rocks and minerals will soon be available for the library branch. Mrs. L. W. Grubgeld, a teacher at the Valley school, is sponsoring an exhibit in natural history which will be shown later in the year," *SYVN*, Oct. 16, 1959, p. 1; "Library Exhibits **Sloane** Paintings… and will be on display for the next six weeks. The exhibit includes five oils and one pastel," *SYVN*, Nov. 20, 1959, p. 8.

1960 – "Art Display. Paintings by **Mrs. Margaret Sutter** make up the art display hung last weekend in the Solvang Branch Library. This exhibit will be on view for about six weeks," *SYVN*, Jan. 15, 1960, p. 7; "Valley Regional Library in Solvang Recommended," *SYVN*, Jan. 29, 1960,

p. 1; "Solvang Library Corner… **Santa Ynez Valley Rock Club** described the rocks in a display case, which is a permanent exhibit at the Solvang…," *SYVN*, Feb. 12, 1960, p. 7; "Valley Rock Club Donates Display Case to Library … The case is illuminated and glass covered … Against the black velvet lining are labeled rocks and polished stones as well as some mounted jewelry. Books on geology and rock collecting…," *SYVN*, Feb. 12, 1960, p. 8; "Painting Exhibit at Solvang Library. Exhibitions of paintings by well-known Valley artists have been on display at the Solvang Branch Library in the Veterans Memorial Building for the past months, and this month Lloyde [Sic.] **Upton** is exhibiting six oil paintings. This display… will remain… until April 15. **Oscar Lindberg**, another well-known Valley artist who had an exhibition last year, is in charge of arranging these exhibitions, and all artists in the Valley wishing to show their work are asked to contact him at his Janin Acres home in Solvang," *LR*, March 10, 1960, p. 13; "Library Shows Art by Upton. Unusual birds and wildlife are the subjects of a new art exhibit at the Solvang Branch Library. The paintings are by Valley artist, **Lloyd Upton** of Rural Rt. 1 on Highway 150. The paintings are done in oil color and will be on display until April 15 …," *SYVN*, March 18, 1960, p. 10; photo of library display for **Valley Rock Club**, *SYVN*, March 25, 1960, p. 3; "'Friends of Library' Group in Valley Formed to Support Branches in Area," *SYVN*, April 29, 1960, p. 3; "Solvang Branch Showing Pastels. Colorful portraits in pastels by Valley artist **Mrs. Viggo Brandt-Erichsen** are now on display at the Solvang Library. This exhibit will continue until June 1. Also being shown are selected paintings in watercolor and pastels by the young artists of the Valley who are students of Mrs. Brandt-Erichsen," *SYVN*, April 29, 1960, p. 6; "**Mrs. Viggo Brandt-Erichsen** has a very colorful exhibition of her paintings on display at the Solvang Library in the Veterans Memorial Building. The exhibition will be continued through May," *LR*, May 12, 1960, p. 20; "Art Exhibit Change… the new exhibit features six paintings by **Mrs. Robert R. Elliott**. There are four in oils and two portraits in pastels," *SYVN*, June 10, 1960, p. 3; "Solvang Library Corner… Exhibiting artist for the next six weeks is **Charles Glasgow**. Four of his paintings are of colorful flowers. Above the librarian's desk is 'House in Carmel,' and 'Seascape at Pt. Lobos.' This last is one of his more outstanding, a blend of land and sea reduced to an abstraction of essential forms, painted in warm post-impressionistic colors. **Oscar Lindberg**, who is in charge of art exhibits, would like to have 12 rotating artists. He said that either professionals or amateurs are welcome to exhibit – there is no attempt to 'jury' – the paintings simply will demonstrate the skill of the individual artist," *SYVN*, July 22, 1960, p. 7; "Solvang Library Corner… Artist's Exhibit. The two artists exhibiting at the Library for the next six weeks are **Forrest Hibbits** and **Marie Jaans**. Mr. Hibbits' three paintings demonstrate his unusual versatility and craftsmanship. He is at home in any media or style or subject matter. 'Pumpkin and Bottle' is a still life water color, 'Medieval City' a jewel-like collage; 'Figure' a drawing in ink and charcoal. **Marie Jaans**, who is Mrs. Hibbits in private life, shows her proficiency in an unusual technique: water color on rice paper. These delicate outlines with their running, blended colors, lend a

Japanese-like quality to 'Pink Sails,' 'Spires,' and 'Cachuma Lake'," *SYVN*, Sept. 23, 1960, p. 8; "Solvang Library Corner… The colorful flower oil paintings that have been on the Library walls are those of **Mrs. Andrew Joughin** who is well known in the Valley for her love of flowers and her arrangements," *SYVN*, Nov. 4, 1960, p. 11; "Library Features display… **Mrs. Amory Hare Hutchinson** is exhibiting her oil paintings at the Solvang Library for the next five weeks. Among them are several picturesque harbor scenes painted at Martha's Vineyard, Mass.," *SYVN*, Dec. 16, 1960, p. 9.

[Only a few exhibits were listed here after 1960.]

1961 – "Art in Library. Paintings of **Gertrude Evelyn Joughin** are now on exhibit… until the first of March. There are four oil paintings and two silk screen," *SYVN*, Jan. 27, 1961, p. 3; "Painting Display… Oil paintings by **Lloyd Upton** were put on display this week in the Solvang Branch Library… continue… through Aug. 15," *SYVN*, July 7, 1961, p. 7; "Library Features New Art Display… **Mrs. Robert Elliott** … who lives in Happy Canyon, did the five paintings and one pastel now hanging in the Library room. Three of the five oils are done with palate knife technique. The pictures include still life, landscapes and one portrait of the artist's husband," *SYVN*, Nov. 24, 1961, p. 5.

1962 – "Hutchinson Art Hung at Library… newly hung paintings by **Amory Hare Hutchinson**… seven oils, landscapes, boats and three of horses will be in the library until May 15. Also on display… are two pictures by elementary school students of **Mrs. Viggo Brandt-Erichsen**, 'Spring' by Bobette McClelland and 'Easter' by Cindy Appel," *SYVN*, April 6, 1962, p. 7; "**Miss [Evelyn] Joughin's** Art displayed… Six oils… of varied subject matter will be on exhibit until July 1. Miss Joughin has studied at Otis Art Institute, Art Center and Chouinard Art Institute, all in Los Angeles," *SYVN*, May 18, 1962, p. 3; "Art Displayed… Six oils of floral subjects painted by **Eloise Joughin** will be on view for six weeks," *SYVN*, July 6, 1962, p. 10.

1963 – "Art Exhibition. Local artist, **Lloyd Upton** has six oil paintings now on display in the Solvang Branch Library room. They will be hung until Feb. 15. Mr. Upton chooses as his subjects out-door scenes and nature settings," *SYVN*, Jan. 11, 1963, p. 1; "Larson Oils… **Oscar Lindberg**, who has represented the Friends of the Library in making arrangements for a new display of Valley art work each six weeks since Feb. 1959, will be moving from the Valley with his wife Ann next week and will take up residence in Hemet. **Lloyd Upton** has agreed to carry on the work. Lindberg, thru the *Valley News*, wishes to thank the 13 local artists on his list who have cooperated with him in seeing that a continuous display of art has been hanging in the Solvang library…," *SYVN*, Feb. 7, 1964, p. 3; "**Mrs. Elliott's** Art Displayed… six paintings … The oils include a portrait of her son, a still life, two seascapes and two landscapes which will continue to hang through May," *SYVN*, May 3, 1963, p. 18; "**Evelyn Joughin** Art Displayed," *SYVN*, Oct. 25, 1963, p. 1.

1964 – "Art Display. Oil paintings or nature subjects, **Lloyd Upton**, artist, six in all, are hanging during the month of June in Solvang Branch Library," *SYVN*, June 11, 1964, p. 15.

1965 – "**Evelyn Joughin** Art Displayed. Eleven pictures painted by Miss Evelyn Joughin are now hanging… All are in oil with the exception of one watercolor. The pictures include one of chickens, a recent prize winner, landscapes and architectural patterns. The pictures will be on display for a month," *SYVN*, March 18, 1965, p. 14; "**Upton** Art on display… five oil paintings… is now on view at Solvang Branch library and will remain through the first of the year. Upton has two figures, a field, a bridge at sunset, and an old oil refinery in his picture collection," *SYVN*, Dec. 9, 1965, p. 17.

1966 – "**Mrs. Elliott** Art Displayed … nine… painted by **Mrs. Robert Elliott** of Happy Canyon are now hanging during March… The group includes three portraits in pastel and the others oils of still lifes and landscapes," *SYVN*, March 10, 1966, p. 13; "**Evelyn Joughin's** Art Style Change Noted… Solvang Branch Library… Newly hung are nine pictures… with contrasts in styles evident … The flowers and still lifes in 5 paintings are characteristic of Miss Joughin's former colorful work. But in contrast, the sparkle of the four pictures on the divider wall … indicates … she is using her still life models as colorful designs … The painting of fruit and vegetables is outstanding in its beauty," *SYVN*, Aug. 11, 1966, p. 14.

1967 – "Late Artist **Brandt-Erichsen** Work Displayed… Viggo… include two bronze figures, one of a bull and one of a horse, two carved wooden plaques, and five framed black and white prints, two of them woodcuts, dating from 1934. This is the last exhibit to be arranged by **Lloyd Upton** for the Friends of the Library. For several years he has provided change of display for Valley artists every six weeks. Taking his place in arranging will be **Miss Evelyn Joughin** who invites local artists, either beginners or professionals to use the library displays as a means of art communication with local residents," *SYVN*, Jan. 19, 1967, p. 8; "Art Display… oil and watercolors of florals and still lifes by **Miss Evelyn Joughin** of Palos Verde Ranch," *SYVN*, May 25, 1967, p. 8.

Santa Barbara County School News

■ "… first issue… published twice monthly by teachers and pupils… under the direction of superintendent Arthur S. Pope…," *SYVN*, Feb. 5, 1926, p. 1.

Santa Barbara Museum of Art (Santa Barbara)
Art Museum founded 1941 in the repurposed Post Office.
Main art museum for Santa Barbara County.
[Although many of the museum's art exhibits were announced in northern Santa Barbara County newspapers, only shows that included northern Santa Barbara County artists were itemized here.]
Santa Barbara Museum of Art (notices in Northern Santa Barbara County newspapers on microfilm and the Internet)
1951 – "Art Museum to Hold Reception" to celebrate 10th anniversary of founding, *SMT,* Aug. 1, 1951, p. 4.
1955 – "Art for Rent Exhibit has Lompoc Artists. The Women's Board … will re-open the Museum's Art Rental Gallery at a preview showing of Art for Rent … The exhibit will be on view to the general public beginning April 13, for one month in the Hammer Gallery II… All works are … for sale at prices ranging from $25 to $300 and rental fees range from $1.00 to $3.00 per month plus a 50-cent handling charge… Among the contributing artists are **Forrest Hibbits** and **Channing Peake** of Lompoc," *LR,* April 7, 1955, p. 7; "Valley Artists Among Contributors… Santa Barbara Museum of Art… Art Rental Gallery… Among the contributing artists are **Forrest Hibbits** and **Channing Peake** of the Valley," *SYVN,* April 8, 1955, p. 1.
1956 – "Fashion Show July 26 Aids Santa Barbara Art Museum… sponsored by Santa Ynez Valley members of the Santa Barbara Museum of Art…," *SYVN,* July 13, 1956, p. 3.
1958 – Following a month of renovation, "Art Museum to Open Aug. 12," *SMT,* Aug. 11, 1958, p. 3.
1959 – "Museum … to Have New Wing" gift of Mrs. Morton… The present structure, originally the Federal Post Office, is the property of the County and is leased by the Santa Barbara Museum of Art, Inc.," *SMT,* Oct. 9, 1959, p. 4.

Santa Ines
See: "Mission Santa Ines," "Santa Ynez"

Santa Maria Agricultural Fair
See: "Santa Barbara County Fair"

Santa Maria Art Association (Santa Maria)
Art association, located in Santa Maria, founded 1945 at the instigation of Jeanne de Nejer. For several years its headquarters were at the DeNejer Studios. It appears to have lost its impetus when DeNejer moved to the East Coast at the end of 1952. George Muro served as president but the last newspaper notice for the group appeared in 1955 at which time George Muro lectured to the group.
■ "**Jeanne de Nejer** to Form City Art Club," and a sketching club and has already made sketching excursions with **Florence Foster** and **Marcelle Bair** [Sic. **Bear**] as well as **Myrton Likes** and **Elizabeth Huff**, and as HS instructor she intends to bring a series of art exhs. to be on view at HS including next one of work by Dr. **Marques E.**

Reitzel coming from the Santa Barbara Museum, *SMT,* Dec. 5, 1945, p. 3.
Santa Maria Art Association (notices in Northern Santa Barbara County newspapers on microfilm and the Internet)
1949 – "Elects [**Mrs**] **Vern Dixon**," as president, and "The staff for 1949 will include **Florence Foster**, first vice president, **Irene Ferini**, second vice president, **Hazel Rossini**, corresponding secretary, **Pauline Price** recording secretary, Kathryn Curwood, treasurer. Named to serve on committees… are Mrs. Lou Johnson, decorating, **Mrs. Eileen Terrell**, programs, **Mrs. Jeanne DeNejer**, exhibits, and **Mrs. Alice Linsenmayer**, publicity. Mrs. Mary Bianchi is serving as historian and **Mrs. Rose Dunham** as sergeant-at-arms," *SMT,* Jan. 13, 1949, p. 10; "Will Discuss Berlin Exhibit" in LA, *SMT,* Feb. 3, 1949, p. 14; "Berlin Group is Art Study Topic," *SMT,* Feb. 18, 1949, p. 5; "To Meet Monday" for pot luck dinner, *SMT,* March 3, 1949, p. 5; "**Leslie Hopkins** Designs Card for Art Club… meeting in DeNejer studio… now 26 members… Designs for the membership card were handed in and judged with that made by Leslie Hopkins being selected as the winning entry. **Mrs. Maye Nichols** gave a talk on the life and works of Franz Hals, illustrated by the showing of several prints of his work. Mr. and Mrs. **Forrest Hibbits** of Lompoc showed colored slides of views in Belgium and Luxembourg taken during their five months visit in Belgium…," *SMT,* March 11, 1949, p. 5; "Van Gogh to be Subject of Book Review," *SMT,* March 31, 1949, p. 5; Van Gogh "Artists Work is Reviewed for Group," *SMT,* April 7, 1949, p. 5; "Will Meet Monday" at **De Nejer** studio to discuss history of art from Romantic period, *SMT,* April 28, 1949, p. 10; "Art History is Reviewed for Group. Developments in art from 1725 to 1825 in Europe and America presented by **Mrs. Jean DeNejer** and **Mrs. Alice Linsenmayer** for Santa Maria Art assn., Monday. The group met in DeNejer studios… Prints of the works or representative artists, including a group from England, were used to illustrate…," *SMT,* May 4, 1949, p. 5; "Ceramics Explained for Art Clubbers," *SMT,* June 11, 1949, p. 5. [DeNejer and Association exhibited in the floral booth at the **Santa Barbara County Fair**.]
1950 – "Art Assn. Plans Exhibit at Fair. Plans for an exhibit in the 1950 County Fair occupied members at a recent meeting of the Santa Maria Art Assn. held in the home of **Mrs. Eleanor Chambers**, 112 South Airport. **Mrs. Verne Dixon** presided. Other members at the meeting were Mrs. Kathryn Kerwood, Mrs. Lou Thompson, **Mrs. Florence Foster, Mrs. Irene Ferini, Mrs. Marie McCullough, Mrs. Bertha McCullough, Mrs. Jeanne DeNejer** and **Mrs. Alice Linsenmayer**…," *SMT,* May 3, 1950, p. 6; "S M Art Assn to Have Stage at Hobby & Art Show" sponsored by Jr. Community Club – Assn has 20 active members and **Mrs. Elinor Chambers** president and **Mrs. DeNejer** who founded the assn. will exhibit ceramics, and article adds, "it will be the second annual show to be sponsored co-operatively by the Community club and Junior Community club, and will be held in Veterans' Memorial building. The Art Assn.'s collections will occupy the stage of the large auditorium…," *SMT,* Sept. 8, 1950, p. 4.

1951 – "Art Club Meets at **Mrs. [John] Foster**'s Home" new president, recent paintings by Mrs. Foster and Mrs. **Maye Nichols** were shown, and reports given, *SMT,* Nov. 6, 1951, p. 4; "Art Group Joins Museum of Art" in Santa Barbara, and meeting at home of **Mrs. John Foster**, and art books reviewed and "Mrs. Foster exhibited her recent paintings," *SMT,* Dec. 13, 1951, p. 4.

1952 – "**George Muro** is Chosen Art Association President," *SMT,* June 11, 1952, p. 4; "Artists to Take Part in [**Santa Barbara County] Fair**, Plan Artists Ball," i.e., some of many activities planned for coming year, and club plans show of flower paintings in the floral section of the County Fair, and other exhibits through year include a clothes line sale in December at the Public Library, a Founders day dinner, an artists and models ball in January, and a Christmas play, as well as sketching trips and visits to art exhibits, *SMT,* June 27, 1952, p. 4; "Santa Maria Artists Give Money for Kiln Project" at Juvenile Delinquent Home in Santa Barbara and other minutes of meeting, *SMT,* July 8, 1952, p. 4; musical play "Prince Swineherd" by traveling troupe "To Be Sponsored by Artist Group," whose goal is to make available cultural advantages to locals, *SMT,* July 25, 1952, p. 4; "Artists Raise Funds for Gifts to School" i.e., kiln to Juvenile Detention school, and flower painting by **Mrs. Melva [Sic. Melba] Bryant** awarded to Lompoc woman, *SMT,* July 28, 1952, p. 4; "Art Group to Present Kiln Check at Picnic," *SMT,* July 30, 1952, p. 4; "Check for Kiln is Given by Artists," and history and mission of juvenile hall, "teachers give instruction in ceramics, leather work, native stone-cutting and polishing sewing, embroidery, textile painting and photography ... Funds to finance the hobby shop are necessarily limited by the county and the money donated for the kiln...," *SMT,* Aug. 4, 1952, p. 4; "To Meet Tomorrow Evening" at De Nejer home to discuss year's art program under **Mrs. De Nejer**, *SMT,* Sept. 29, 1952, p. 4; "Art Assn to Meet Tuesday Night" at home of **Mrs. Irene Ferini**, *SMT,* Oct. 13, 1952, p. 4; "Art Assn to Meet" to view **Winter Art Program** on modern dance and to hold meeting, *SMT,* Nov. 17, 1952, p. 4.

1953 – "Paintings by Santa Maria Artists Shown," at [Santa Barbara County] **Library [Santa Maria]**, curated by **G. Muro**, and article adds, "First spring showing of paintings done in recent months by members of Santa Maria Art Assn. were viewed by visitors to the library... as a contribution to local ... National Library week. Among those on exhibit were: 'Sugar Factory,' by **Florence Foster**, who also showed a fruit still life and 'The Urn,' also a still life study. Mrs. **Lena Boradori** of Los Alamos brought two pictures, 'Silos,' and 'Flowers in Blue Vase.' Miss **Betty Scott** showed 'Oil Fields.' **Mrs. Thomas Penfield** sent two flower pictures... **Melba Bryant** was represented with two oils, 'The Bob,' and 'Night Scene.' **Maye Nichols**' 'Old Barn,' and an abstraction, 'Broken Hearts,' were in the showing. Mrs. **Elva Stone** had four flower pictures in water colors," *SMT,* March 20, 1953, p. 4.

No notices for "Santa Maria Art Association" appear in the *SMT* 1954-60.

See: "Allan Hancock College Art Gallery," 1955, "Community Club (Santa Maria)," 1949, 1950, "DeNejer, Jeanne," "Muro, George," 1952, 1953, "Santa Barbara County Fair," 1949-53, "Santa Barbara County Library (Santa Maria)," 1953, "Winter Arts Program"

Santa Maria Art Festival
See: "Santa Maria Valley Art Festival"

Santa Maria Art Gallery
See: "Allan Hancock [College] Art Gallery"

Santa Maria, Ca., Adult/Night School
1918-54. Most classes were held at the Santa Maria High School and taught by high school teachers. Cabinetry, mechanical drawing and drafting were mainstays. But, in 1922, Stanley Breneiser offered a class in art. His 1920s classes were on a college level consisting of art history and principles of design. In 1932, at the depth of the Depression, adult school was curtailed for two years. But in 1934 it resumed with highly attended and long-lasting woodworking classes taught by A. L. Merrill and metal work classes taught by W. D. Harkness. Sporadic arts and crafts classes in the 1930s were taught by members in the Breneiser circle. Interior decoration was offered mid-decade. Beginning 1939 for two years H. O. Schorling taught an art metals class. During WWII, although woodwork and metal work classes continued, art appears to have been dropped. New classes in support of the War included airplane drafting. In 1943 a photography class admitted both civilians and service personnel and appears to have been offered consistently, although with undersized enrollment, through 1960 by J. M. Boothe. During WWII it is probable that servicemen added to class numbers in all subjects. Arts and Crafts was offered in the 1950s, with several classes taught by George Muro. 1954+ -- Adult school seems to have been moved to Allan Hancock College, although some classes (such as ceramics and woodshop that demanded special equipment) continued to be held at the high school.
[Do not confuse with Allan Hancock College Adult/Night School that started c. 1955.]

Santa Maria, Ca., Adult/Night School (notices in Northern Santa Barbara County newspapers on microfilm and the Internet)

1918 – 'Night Classes at the High School. At a meeting of the Santa Maria Union High School Board, it was decided to open a night school... Practically every department of the high school will be thrown open for classes to meet two or three times a week from 7 to 9 o'clock in the evening... It is planned to start classes in the following subjects: ... penmanship... manual training, and drawing... The night school will be open to people of all ages no matter what their previous school training...," *SMT,* Sept. 12, 1918, p. 3.

1919 – "Night School will Open Next Tuesday... at the ... High School building... Classes may be organized in Home Economics, Mechanical and Architectural Drawing...," *SMT,* Sept. 25, 1919, p. 6.

1920 – "Household Arts and Science in Night School... courses of the high school open September 21 ... A course

in millinery will be given on Tuesdays from seven until nine p.m. …," and other courses include sewing, *SMT*, Sept. 16, 1920, p. 1.

1921 – "Classes Promised in <u>Mechanical Drawing</u> – Woodwork … Drafting, including architectural drawing of floor plans and elevations, tracing blue printing, and building specifications as desired, is especially suitable for building men. … Mechanical drawing, including machine and gear drawing, cam and machine design, structural steel or topographical drawing will be offered if desired along with tracing and blue printing for mechanics and technical men… Further details may be obtained from **B. E. Cannon** at the high school…," *SMT,* Sept. 21, 1921, p. 3; classes listed and include <u>furniture making</u> and <u>drafting</u>, *SMT,* Oct. 3, 1921, p. 3; "Night School Sessions Tues. and Thursdays… <u>Drafting and mechanical drawing</u>, 7-9 p.m., any periods. <u>Furniture and cabinet making</u>, 7-9 p.m., any periods. …," *SMT*, Oct. 10, 1921, p. 5.

1922 – ■ "New <u>Art Classes</u> for Night Session at High School," and article reads, "This course is to be a practical course in art – arranged mostly for beginners and will cover two one-hour periods. The first period is to be devoted to lectures and note book work on the principles of art and design and the theory and practice of color. The second period will be spent on actual elementary drawing including drawing from objects, natural study, lettering, etc. with individual help given to those advanced far enough to progress rapidly with the work. The work will be in charge of Mr. **Breneiser**, …," *SMT*, Feb. 1, 1922, p. 3.

■ "Interest Shown in <u>Art Class</u>," and article reads, "The enrollment in the new class at the high school in Art and Appreciation will continue Thursday evening at seven. Keen interest in this course has developed, and it is hoped that others will avail themselves of this opportunity to broaden their viewpoint and find out the real value of art from the practical as well as from the cultural outlook of life. Art is the silent worker in a school, a community, and in an in …ishing much good of which we are almost unawares. Art is one of the highest forms of education for it includes relationship with every other study and is a partner with music and drama. Mr. **Breneiser** is pleased with the response to art which the Santa Maria folks are making and feels certain that all who engage in this study will never regret the step they made in taking it up," *SMT*, Feb. 9, 1922, p. 2; ■ "<u>Lecture Course in Art</u> Feature of Night School," given by **Stanley Breneiser** in 22 sessions covering art principles and history of art in Europe and America from Renaissance to modern times, and full list of classes and dates, *SMT,* Sept. 20, 1922, p. 1.

1923 – "Night School at Union High," <u>will be held in newly completed H.S. building</u> and there will be classes in Manual Arts and Art Appreciation among other subjects, *SMT*, Jan. 24, 1923, p. 1; "Predict Record Enrollment at Night School… <u>Art Courses</u>. The plans for art instruction… short unit courses – taking up in each unit course some phase of practical art instruction in one hour and in the other hour, lecture work on the same general subject… The short unit courses will include … freehand elementary drawing, color theory and practice, clay modeling, decorative design and lettering… The lecture

work will include such subjects as historic costume, period decoration, art in the home, practical color sense development, etc. A longer course in the History and Appreciation of Painting into colored illustrations may be arranged," *SMT*, Sept. 11, 1923, p. 1; "Night School Opens Tonight" with courses in <u>mechanical drawing, woodwork,</u> and <u>art</u> among other subjects, *SMT,* Sept. 18, 1923, p. 1; "Special <u>Mechanical Drawing</u> Course at Night School … will include the use of instruments, making and reading blue prints, training in the theory and practice of mechanical and architectural drawing… Individual instruction…," *SMT,* Sept. 22, 1923, p. 5.

1924 – "Night School to Re-Open for Second Semester… Classes … <u>Dressmaking and Millinery</u> – Miss Gaw, room 105. <u>Woodwork</u> and <u>Mechanical Drafting</u> – **Mr. Snell**, room 203…," *SMT*, Jan. 7, 1924, p. 3; "New Courses in Art Offered at High School. Two new courses… The first hour course will be one devoted to a comprehensive study, in lectures, of the history of painting from earliest to modern times. The lectures will be illustrated by the splendid colored reproductions of the works of famous masters in art that belong to the school through a gift of the **Blue Mask** club. This course has never been offered in the night school before. The second hour will be devoted to a course in practical home applied design. A study of the laws and principles of design as applied to articles for use in the home will be taken up and the making of articles by those students who desire to do so," *SMT*, Sept. 18, 1924, p. 5.

1925 – "Night School Begins Here Next Tuesday… There will be classes … Other subjects… art, shop, domestic art… Shop classes will include <u>mechanical and free-hand drawing</u>… Domestic art will include dressmaking and millinery…," *SMT*, Sept. 11, 1925, p. 1; "Night School… An interesting branch… is the correlated <u>art course</u>, 'Design and Its Application,' under … **S. G. Breneiser**… either one or two periods may be taken in this course. The work taken up during the first period will be in lecture form and will be illustrated by drawings made by Mr. Breneiser. During the second period work will be done by stenciling, block printing, jesso [sic. gesso], plastic (a new colored art clay), and oil paints in various finishes. The classes in shop will be under the direction of **H. M. Snell** and **Wm. [Sic. Wilbur] Harkness**. They will include instruction in mechanical and free-hand drawing…," *SMT*, Sept. 14, 1925, p. 1.

1926 – "Night School classes will be of Varied Type… in the Industrial department of the high school … In the drafting room <u>architectural and mechanical drawing</u> will be taught…," *SMT*, Sept. 16, 1926, p. 3.

1928 – "Night School Starts Anew January 10… The industrial department will have courses in … forging and <u>mechanical drawing</u>… Special work in wood turning and cabinet work will be offered…," *SMT*, Jan. 5, 1928, p. 1; "Night School Classes … The art classes under **Mr. and Mrs. Stanley G. Breneiser**, will not start for another month, while the former prepares his lectures and gathers his material concerning his recent trip to the art centers of Europe," *SMT,* Sept. 12, 1928, p. 1; "Night School to Open Here Monday Night… An opportunity to learn cabinet making and lathe work… **Arthur L. Merrill** of San

Francisco who is considered a leader in the making of fine cabinet work has been brought to Santa Maria especially … **Harold Foster** will have charge of the classes in architectural and mechanical drawing…," *SMT*, Sept. 15, 1928, p. 1.

1929 – "Evening High School Opens Monday… Following are the subjects… Art: design and crafts, drawing, commercial art and illustration… Industrial arts: architectural drawing, mechanical drawing, cabinet making and furniture design… Household arts: dressmaking, millinery… Two one-hour classes will be offered in art this year with **John A. Breneiser** as instructor. First hour will be for those interested in freehand drawing, commercial art and illustration. Its scope is wide and will offer the fundamentals of industrial art through experience in freehand drawing, representation and color. The second hour will be in design and crafts, beginning with elementary problems," *SMT*, Sept. 14, 1929, p. 1.

1930 – "Night School… Practically any subject for which there is a demand will be taught… Following are the subjects… Cabinet-making, furniture design, room 302, 7-9, **A. S. Merrill**. Metal shop, room 303, 7-9, **W. D. Harkness**… Mechanical Drawing, room 301, 7-9, **H. M. Snell**…," *SMT*, Sept. 18, 1930, p. 1.

1931 – "Drawing Classes will be Offered… Mechanical drawing and architectural drafting classes offered with college credit will be taught at evening high school commencing next Monday at 7 o'clock by **Harry Snell**…," *SMT*, Jan. 24, 1931, p. 3.

1932 – "Night School is Abandoned Here… In order further to reduce school expenditures, no night school classes will be held at Santa Maria union high school this year…," *SMT*, Aug. 10, 1932, p. 8.

1934 – "Arts and Crafts Class Opens… this evening under the direction of **Louie Ewing**. The classes will meet Monday, Wednesday and Friday evenings, 7:30 to 9:30 each week. Subjects include leather work, etching, batique [Sic.] making, wood carving, posters, lettering and commercial art…," *SMT*, Oct. 22, 1934, p. 2.

1935 – "Night School Courses Start Next Monday," and article adds, "The new work offered will be chosen from the following list and will be held on Mondays and Thursdays from 7 to 9 p. m…. Metal Shop, Woodshop…In addition to these, it is possible to enroll in classes which started last fall. These will continue three days a week as heretofore and include: … Arts and Crafts…," *SMFA*, Jan. 4, 1935, n. p.; "Night School Classes Will Open Monday," and article says, "One of the new additions to the curriculum is a class in interior decorating conducted by **Gaylord Jones**. Mr. Jones, who has built quite a reputation for himself in his exquisite hand-carved work, has been deemed by the school board the most suited person for the job. The class will be open for both men and women. Other classes will be … woodshop, **A. S. Merrill**, metal shop, **W. D. Harkness**? … design and crafts, **John Day Breneiser**… Classes are held Monday and Wednesday evenings from 7 to 9 o'clock…," *SMFA*, Sept. 20, 1935, n. p.; "Night School Class Gets a New Room… **Gaylord Jones** … his classes in upholstering and interior decorating has been

provided in the high school in George H. Chester's department. The classes on the theory of interior decorating will meet hereafter, he said, from 8:15 p.m. to 9 p.m. Mondays and Thursdays. There is additional room in his class in mechanical drawing, he said. Wood carving is also taught in this class…," *SMT*, Oct. 9, 1935, p. 6.

1936 – "Shops of Night School Draw Many Adults … woodshops and the metal shops of Santa Maria high school… supervised by **A. L. Merrill**… Mrs. S. J. Stevens Jr. … has turned out… footstools, cobbler's bench and end table. Tom Bickett … [carving and re-creating historic furniture] … Women Do Metal Work … classes of **W. D. Harkness** … pewter porringers…," and other students and their work described, *SMT*, May 21, 1936, p. 1; "Women Find Night Art Classes Yield Many Attractive Results … Leather work has been the most popular… Mrs. Neil Meagher has finished a deep brown, tooled handbag… Mrs. Pearl Smith is also working on a purse. **Mrs. Stanley Breneiser** is making a large bag in which she has planned compartments… Miss Ariel Ashton has completed a red suede bag on which her initials have been painted. She has also designed a monogram and picture in a block print to be used on her stationery. Mrs. Lloyd Hitchcock has made a suede purse and a tooled leather belt. Mrs. Elaine Lory has made several tooled leather bookmarks and a large music container. Mrs. Cora Volk has finished a photograph album, key container and bill fold. **Mrs. C. W. Rahbar** has added to her household furnishings a wall hanging made by drawing desert scenes and Indian designs on unbleached muslin and a hand-painted lamp shade of parchment paper. Other articles made in the art classes are block prints and stencils for luncheon cloths and bridge table covers, batik wall hangings, Christmas and other greeting cards and book covers," *SMT*, June 5, 1936, p. 3; "Night School's Work Outline… Art Classes… instruction will be decided by… each student. **John Breneiser**, instructor, said that last year greatest activity was in leather work. Tonight he will show the class an extensive exhibit of hand-tooled leather articles illustrating the great variety of useful things that can be made. This year, for the first time, the art classes will be able to study Mexican tin work. Lettering and designing work will be taught also… drawing, block printing, stenciling and gesso work… Furniture Making… **Arthur Merrill** instructor…," *SMT*, Sept. 21, 1936, p. 6.

1937 – "Night School Semester Opens Tonight… Night school art classes offer instruction in drawing, lettering and commercial art as well as craft work. Members of the class at present are working at wall hangings done in oil paints or crayons and tin work, also tooled leather applied modeled and batik for silk fabrics," *SMT*, Jan. 25, 1937, p. 6; "Ma and Pa Go Back to School … [with Petroleum Production being the highest attended class] 19 separate courses… cabinet making taught by **A. L. Merrill**… metal work … ceaseless pounding. Copper and tin plates, bowls and dishes… **W. D. Harkness** … art crafts course where leather work and linoleum block cutting is taught … Leather purses, billfolds, sandals, key-tainers and art pieces … linoleum block cutting … for printing Christmas cards …," *SMT*, Dec. 3, 1937, p. 4.

1938 – "Large Classes in Night School" include <u>art and craft</u>, etc., *SMT,* Feb. 3, 1938, p. 3; "New High for Night School" with high attendance at classes, and article adds, "<u>Cabinet making</u> ranked as one of the strongest courses, principally among commercials who found the instruction advantageous for their jobs. <u>Art and craft</u>, which has ranked among the leaders for the past three years, continued good, reaching a high mark just before Christmas," *SMT,* June 7, 1938, p. 6.

1939 – "Night School to Open Monday … seventeen classes … Art, **John Breneiser**, room 101… Woodshop (cabinet and furniture) **A. L. Merrill**, high school wood shop … Machine shop work, **W. D. Harkness**, high school auto shop," *SMT,* Sept. 13, 1939, p. 2; "New Courses in Night School… new course in ornamental metal work, including work in copper, brass and pewter, would be offered… by **Horace Schorling** of the high school faculty. A display of his work is on exhibit in the vice principal's office," *SMT,* Sept. 19, 1939, p. 3; "<u>Art Metal Class</u> in Evening High … **H. O. Schorling** is in charge. He plans to give instructions in work in copper, brass and pewter and possibly in silver. The classes are held between 7 and 9 on Monday and Thursday evenings," *SMT,* Sept. 23, 1939, p. 3.

1940 – "Night School to Open Monday… Monday and Thursday Evenings… Classes to be offered… wood shop, **A. L. Merrill** … art metal work, **Horace Schorling**… airplane drafting, <u>W. R. McConnell</u> … art, **Stanley Breneiser**…," *SMT,* Sept. 14, 1940, p. 5.

1941 – "New Courses in Night School … drafting by <u>Ed Werner</u> who came to the school from the Lockheed plant. He is said to have been responsible for perfection of the famous Hudson bomber in use by the British and U. S. air forces… Full list of night school courses… Woodwork – **A. L. Merrill**… Art Metal Work – **H. O. Schorling**…," *SMT,* March 6, 1941, p. 10; "Defense Features Night School … National defense will be stressed … welding … airplane engine mechanics … drafting … regular classes … woodshop, **A. L. Merrill**, art metal shop, **Harold H. Wetzler** …," *SMT,* Sept. 3, 1941, p. 8.

1942 – "Night School to Aid War Work … meet all the needs of those desiring to enter war industries or the Air Service… special classes in physics, mathematics and chemistry … airplane drafting … woodshop, **A. L. Merrill**. Airplane drafting, **J. W. Reynolds** … First aid…," *SMT,* Sept. 18, 1942, p. 2; "Plane Drafting Class has New Instructor. <u>W. L. Bach</u> … Bach replaces **James Reynolds** who has departed for Pasadena to teach in California Institute of Technology… meets on Monday and Wednesday at the airport," *SMT,* Oct. 10, 1942, p. 3.

1943 – "<u>Photography</u> Class… will be started in night school… opening tonight at seven o'clock in room 50 under the supervision of **J. Miles Boothe**. Servicemen as well as civilians may enroll," *SMT,* April 15, 1943, p. 2; "Airplane Studies, <u>Handcraft</u> Open… classes in crafts taught by **Myrtle Lange** in room 102 of the high school… leather tooling, plastics, wood carving, Prang stencils for cloth and paper, and box designing," *SMT,* Sept. 18, 1943, p. 6; "Housewives… Sufficient enrollment was made last night for the opening of an arts and crafts class by Miss **Myrtle Lange** on Monday night at seven o'clock in room 102…," *SMT,* Oct. 1, 1943, p. 3.

1944 – "Night School to Begin… <u>Woodwork</u>, **A. L. Merrill**, wood shop… <u>Arts and Crafts</u>, **Myrtle Lange**, room 102 …," *SMT,* Sept. 2, 1944, p. 4; "Night class in <u>Blue-Print Reading</u> … and sketching for oil field workers… offered by the Junior college under the Adult Education Division… Monday and Thursday evenings for 12 weeks… Instruction will be given in the theory of mechanical drawing… sketchings, pipe drawings, structural steel drawings, pipe-line drawings, graphs, charts and layout work for welders… intensive nature of the course…," *SMT,* Oct. 12, 1944, p. 8.

1945 – "Adult Classes" include <u>woodshop, crafts, jewelry making, painting, and welding</u>, *SMT,* Aug. 29, 1945, p. 3.

1946 – "Night School for Adults Resumes Here Monday" with classes on <u>photography</u> by **J. Miles Boothe**, <u>woodshop</u> by **Peirino Merlo**, <u>welding</u> by **Thomas Lindekugel**, *SMT,* Sept. 14, 1946, p. 3; "High School Night School Classes Open… The subjects, instructors, and the number reenrolled… Photography, **J. M. Boothe**, 10… Welding, **H. H. Lindekugel**, 14… Woodworking, **Peirino Merlo**, 34…," *SMT,* Oct. 16, 1946, p. 4.

1947 – "<u>Photography Class</u>" started in night school, **J. Miles Boothe** will be the instructor, *SMT,* Oct. 6, 1947, p. 2.

1948 – "Free Course Offered in <u>Arts and Crafts</u>" and article adds, "arts and crafts, leather and copper work, and in oils and water colors… One class is filled but there are openings for all who would like to make up additional classes… **Mrs. Esther Jones**, member of the Santa Maria High School faculty, whose husband is connected with USC College of Aeronautics administration, is to be the instructor in the new course," *SMT,* March 8, 1948, p. 5; "Sewing Course Opens… **Mrs. Esther Jones**… who has had experience with design and pattern-cutting on a large manufacturing staff will be the teacher," *SMT,* March 9, 1948, p. 5; "Night School Begins Fall Term" and includes <u>photography, woodshop</u> and "<u>Crafts</u>, including work in leather and metal will be taught by **Attilio De Gasparis**," *SMT,* Sept. 11, 1948, p. 5; "Add Two New Night School Classes… [welding and PE] … Other teachers… photography, **J. M. Boothe**… woodshop, **Peirino Merlo**… crafts, **Attilio DeGasparis**…," *SMT,* Sept. 23, 1948, p. 1.

1949 – "<u>Woodshop</u> Most Popular Adult School Class," *SMT,* May 19, 1949, p. 12; "Night School Classes Open Monday" and include "<u>photography</u> taught by **J. M. Boothe** will be held Mondays only from 7-10 p.m. Courses offered and their instructors are: … crafts, **Attilio De Gasparis**, woodshop, **Peirino Merio [Sic. Merlo]** … drafting, blueprint reading, slide rule and descriptive geometry, **William Hyland**," *SMT,* Sept. 8, 1949, p. 1.

1950 – "Attendance Figure … For the last month of the night school, April 17-May 12, 515 adults were enrolled… <u>Wood-shop</u> had an enrollment of 41… <u>crafts</u> 17 … <u>welding</u>… 15… <u>mechanical drawing</u>… eight… <u>photography</u>… four," *SMT,* June 22, 1950, p. 1; "Night

School Classes to Open Monday" with <u>crafts</u> taught by **Atillio De Gasparis** on Mondays and Thursdays 7 to 9 p.m. Subjects will be metal tooling, leathercraft, metal crafts, plastics, shell work and textile painting." and "A <u>photography workshop</u>, Mondays only, will be taught by **J. Miles Boothe**. … Awaiting arrival of new equipment, a woodshop course with **Peirino Merlo** and **Albert Fleischauer** as teachers will begin September 14," *SMT*, Sept. 9, 1950, p. 1; "Offer Blueprint Course… blueprint reading and related subjects… beginning Monday. The course will include arithmetic as used in carpentry, elementary <u>mechanical drawing</u>, elementary to advanced blueprint reading … **William H. Hyland** of the city engineer's department is to give the instructions," *SMT*, Sept. 29, 1950, p. 8.

1951 – "Adult Education Classes and Extension School Open Monday… at Santa Maria high school… A new course … <u>interior decorating</u> with **Maurice Blum** teacher… Color usage and both period and contemporary design in the home will be taught. Scale models to visualize plans may be made. Field trips to Los Angeles fabric shows may also be arranged … Teachers and courses… include… <u>creative work shop</u>, **George Muro**, <u>woodshop</u>, **Perino Merlo** and **Albert Fleischauer**… <u>photography</u>, **J. Miles Boothe**, <u>art</u>, **Ward Youry** …," *SMT*, Sept. 8, 1951, p. 1; "Adult Classes Get Approval of Trustees" and include art taught by **Ward Youry**, at 7 p.m. Wednesday, to learn sketching and drawing and make field trips on weekends, *SMT*, Sept. 12, 1951, p. 3.

1952 – "Night School Classes Open… a <u>photography</u> class is to be added Thursday with **J. Miles Boothe** as instructor. The class will begin at 7 p.m. The school reports room in <u>crafts</u>…," *SMT*, Sept. 16, 1952, p. 3; "Night School Fee Set Up… A small registration fee will be charged adults attending night school classes with start of the next semester in January… Registrar Leon Furrow's monthly report on attendance … October 27 to November 21 showed three classes lagging in average attendance… <u>photography</u>… drop the classes if registration for the next semester in January failed to increase…," *SMT*, Dec. 11, 1952, p. 1.

1953 – "Night School Classes Set for Monday… Enrollment Fee of $1 to be Charged… Enrollment in each class must be 15 or more… **Miles Boothe**'s <u>photography</u> class ended the last semester with only seven students in regular attendance… and appears to be the lone class in jeopardy…," *SMT*, Jan. 15, 1953, p. 1; "Adult Classes will Open Monday Night… in Santa Maria High School … <u>crafts</u>, **George Muro**, <u>photography</u>, **J. Miles Boothe**… <u>woodwork</u>, **Peirino Merlo**…," *SMT*, Sept. 12, 1953, p. 5.

1954 – "<u>Adult Photo Class</u> Open… **J. M. Boothe**… The only charge is a one dollar laboratory fee. … each individual follows his own calendar of studies…," *SMT*, Jan. 4, 1954, p. 1; "Night School Classes to Open Soon" with <u>photography</u> under **J. M. Boothe**, which will be held Tuesday night only, <u>crafts</u> taught by **G. Muro** in room 102, *SMT*, Sept. 10, 1954, p. 1.

1955 – "Night School Classes Monday" include <u>photography, welding, woodshop, crafts</u>, and "All classes

are held Monday and Thursday nights from 7 to 9 p.m. except photography, which is taught Tuesday night… in the high school," *SMT*, Jan. 21, 1955, p. 1; "Adult Education Classes Open Tomorrow" with <u>art classes</u> taught by **George Muro** in old cafeteria and woodshop, and <u>photography</u> taught by **J. Miles Boothe** will be held in the Science building at the high school, Mondays and Thursdays. *SMT*, Sept. 14, 1955, p. 1; "<u>Photography</u> class Still Has Vacancies… The class includes developing of negatives and printing of pictures… instructed by **J. M. Boothe**," *SMT*, Oct. 10, 1955, p. 1.

1956 – "Night School Opens Tonight… Classes are conducted Monday and Thursday in stenotyping, <u>crafts</u>, typing and office machines, English and citizenship and welding. Tuesday and Thursday classes are upholstering and Spanish. <u>Photography</u> class is offered Monday night… Classes are held from 7 to 9 p.m.," *SMT*, Jan. 9, 1956, p. 1; "Add Developmental Reading to Adult Education Classes… Other Thursday night courses include… <u>functional home furnishing</u>, high school woodshop. <u>crafts</u>, room 36… <u>photography</u>, room 129 at high school… <u>woodshop</u>, room 31 at 6:30. <u>welding and ornamental iron</u>, room 30 at 6 p.m. <u>machine shop and art metals</u>, room 27 at 6…," *SMT*, Sept. 20, 1956, p. 5.
<u>See:</u> "Allan Hancock College Adult/Night School," 1955+

Santa Maria, Ca., art, general
<u>See:</u> "Art, general (Santa Maria)"

Santa Maria, Ca., Elementary / Grammar school/s (including PTA news)
Starting 1919, grade school students were given erratic classes in sloyd, drawing, and handicrafts. Later came clay modeling, etc. Through the 1920s the purpose of art was to cultivate good taste, cultivate the powers of observation, and to foster appreciation of beauty in life. Art was taught in a basement at Main Street School. In 1931 El Camino School was constructed as a grammar school but to also serve as a "Junior High" where woodshop and specialized classes in art were taught. Art was taught in a second story room. Main Street school was repainted in 1934 with SERA labor. Elementary school projects included puppets and posters. Art teachers were Dorothy Green and Edna Davidson. "Jr. High" enjoyed art classes in many subjects and media. By 1936 Blochman School was receiving national publicity for its teach-by-doing method. In 1936 the WPA paid for handicraft recreation classes. After WWII school- and city-sponsored summer recreation programs offered handicrafts. Art was used to teach academic subjects, as in the making of maps to learn geography or the making of miniature models of California missions when teaching history. Mr. and Mrs. Sluchak were unique in using their hobby of filmmaking to teach (1947). The best children's products were displayed at open houses during Public Schools Week each spring. Occasionally school children's artwork was exhibited at county fairs. Elementary school children also participated in contests to design posters for various events and to paint windows of retail stores in celebration of Thanksgiving. Artwork in classes varied

depending on the talents of individual teachers and whether the school system had a manual training specialist or art specialist on its payroll. Special art teachers included Margaret Reid, 1919/21, Holland Spurgin, 1921?/26, Hal Caywood, 1926/28, Dorothy Merritt Green, c. 1930/34, Edna Davidson, 1937-57, and Joseph Knowles from Santa Barbara, c. 1948+. Blochman school stood out for its creation of Blochman City. El Camino elementary school (that morphed into a Jr. High between 1947 and c. 1953) gave specialized classes in shop by long-timer Euland Payne, and art by long-timer, Edna Davidson, and had its own ceramic kiln by 1950.

■ "Santa Maria Grammar School… District was organized in 1881 under the name of Central School District, the town at that time being known as Central City… the school was conducted for about six years in a two-story wooden building in the southwest corner of the present school grounds. In 1888 the brick building in use at present [1904] was erected… [teachers named] … From 1891 to 1904 inclusive, there have been about 225 pupils graduated…," *SMT*, Dec. 17, 1904, p. 8.

■ "Santa Maria is First School in Union District. Schools in the Santa Maria Union high school district vary in their founding from the earliest in 1869 to the latest, Wasioja in 1932. The history of these schools starts with the first school in the Santa Maria valley, which came into existence in November, 1869… In '72 the first library was established… district of Agricola was formed in 1875. At this time the town of Central City (now Santa Maria) was laid out… by 1881 the school was crowded. A new district was then formed, the division being called Central district. … Guadalupe district, formed in the early seventies… A fine two-story building was erected in 1871 which took care of the attendance until 1930 when the districts of Laguna and Oso Flaco in San Luis Obispo county consolidated with the Guadalupe district when the fine, modern building was built. The Tepusquet school, founded in 1883… a building was erected … Other early schools established were Olive in 1870 and Los Alamos in 1877. The Bonita grammar school was established… in 1895… Garey district… present building was erected in 1889. Another of the schools to start… was the Rice school, founded in 1893… Four of the Santa Maria Union District schools have been established in this century. Bicknell… and Betteravia in 1905, Cuyama … Laguna…," *SMT*, March 8, 1933, p. 2.
Santa Maria, Ca., Elementary (notices in Northern Santa Barbara County newspapers on microfilm and the Internet)

1914 – "Notice to Architects. … Board of Trustees of Santa Maria School District… invite the submission of …plans and specifications for one primary school building and for one grammar school building to be erected … within said Santa Maria School District" and specifications listed, *SMT*, May 16, 1914, p. 2.

1918 – "Kindergarten Notes for Month of February… Hand work: drawing and painting flags, valentines. Cutting and pasting badges of red, white and blue. Folding, cutting and pasting letters and valentines. Building with gift blocks: forts, camps. Light houses, post office and other public buildings," *SMT*, Feb. 16, 1918, p. 4; "Kindergarten Notes for the Month of March… Drawing – Windmills, weather vanes, vehicles. Painting – Pussy willow twig. Folding: furniture, boxes, kites, pin wheels…," *SMT*, March 30, 1918, p. 3.

1919 – "Grammar Schools Will Open… teaching staff … **Miss Margaret Reid** of Los Angeles, sloyd and home economics…," *SMT*, Aug. 6, 1919, p. 3; "Improvements at Grammar School… A new feature of the grammar school is the introduction of handwork in the primary grades. The special teacher in this work, **Miss Margaret Reid**, devotes half a day each week to each grade. The children are taught basketry, raffia work, weaving, folding, cutting and clay modeling…," *SMT*, Sept. 6, 1919, p. 5.

1920 – "Departmental System Teaching in Schools Beginning Monday… grammar school… The Departmental work in the grammar school will be taught in the sixth, seventh and eighth grades… Each teacher has a miscellaneous group of subjects in her roll call class such as spelling, penmanship and drawing. **Miss Reid**, manual training teacher, will devote all Fridays to hand work in the primary schools," *SMT*, Jan. 17, 1920, p. 5; "Art Exhibition Coming Here Next Week. An art exhibit of unusual merit is to be held in our Main street school building on Tuesday, February 17. The exhibit will be put on by Green's Art Store of Los Angeles. The collection will comprise 300 selections and will embrace some beautiful specimens of pictures and paintings. Rev. Nelson will attend the exhibit and will speak on some of the paintings. The exhibition will be shown between 3 and 5 in the afternoon and 7 to 10 in the evening, during which a musical program will be rendered. The object of the exhibit is to raise funds in order to buy some pictures to embellish the school rooms," *SMT*, Feb. 11, 1920, p. 2; "Picture Show at the School on Tuesday… P-T Association… east Main street school … Reverend W. F. S. Nelson will explain the pictures and tell of his personal recollections of the many he has seen in the famous galleries of Europe. It will be recalled that on another occasion of a picture exhibit held here several years ago, the Reverend Mr. Nelson gave some delightful talks…," *SMT*, Feb. 14, 1920, p. 1; "Picture Exhibit Financial and Art Success … The pictures were shown in four rooms of the school and in the halls. The sepia reproductions… Some of the etchings of the notable specimens of architecture were among the best things shown. … pictures of sculpture… work of the great Holland masters… California's great landscape painter, Keith, was represented by his 'Oaks.' The teachers of the different rooms selected pictures from the exhibit to be hung in the class rooms…," *SMT*, Feb. 18, 1920, p. 1; "Exhibit of School Work Scheduled for Next Wednesday," *SMT*, March 19, 1920, p. 5; "PTA to Inspect Children's handwork… business meeting… After this session there will an interesting exhibit of handwork done by the children of the Cook and Mill street schools… arranged now by the class teachers … [and] the showing of the pictures bought for the class rooms here by the fund of the picture exhibit staged last month. The pictures are being hung in the hall of the Cook street school for exhibition," *SMT*, March 23, 1920, p. 2; "Honors Awarded Cook St. School for Hand Work. An exceptional school exhibit of

hand work, done by the Mill and Cook street schools, was viewed yesterday by over 100 … members of the Parent-Teacher Association. This was the first exhibit of this kind in the primary schools and it proved a great success. The exhibition covered a broad field … clay modeling, rag doll, weaving and cut-out work … [ed. A line of type appears to be missing here.] liminary examination before a U. [another line of type appears to be missing] conceded to go to the fourth grade in the Cook street school, taught by Miss Gladys Froom. The cunning little rag dolls, and splendid example of freehand drawing and cut-out work attracted much attention. Perhaps the most original piece of the exhibition was done in Mrs. Wickline's first grade by a young sculptor, Dempster Glines. Out of modeling clay, the clever youngster has fashioned a work of art in miniature, showing a jockey alert on a racing pony. A fine example of basket weaving was done by Loretta Escabosa of the fifth grade, taught by Mrs. Erkens at the Mill street school. … in the second grade of the Cook street school… was the clever little stick vegetable markers and cotton chicken Easter favors. The babies of the exhibition, Miss Hollaway's kindergarten pupils, proved to be handy with colored pencils and scissors … **Miss Mabel Blosser**'s third grade had an interesting showing in hammock weaving, clay modeling and Easter favors. Little Katherine Youngling's clay model of a teapot and sugar bowl was unique and clever…," *SMT*, March 25, 1920, p. 2; "New Pictures Adorn Walls of Local School. The pictures which were bought with the picture fund of the Parent-Teacher Association for the classrooms of the grammar and high schools were hung in the Cook street school… Some of the pictures are duplicates of the world's masterpieces in paintings…. One of the finest pictures shown at the picture exhibit of last month, was bought by the high school. It is an unusually lovely etching of the Rheims cathedral … Some of the other pictures which will add charm to the classrooms are: Raphael's 'Sistine Madonna,' Van Dyck's 'Baby Stuart,' Millet's 'Feeding her Birds,' Reynold's 'Age of Innocence,' Corot's 'Goat Herders,' Landseer's 'Dog,' and Bonheur's 'Horse Fair,'" *SMT*, March 26, 1920, p. 3; "S. M. Elementary School Announces Instructors… **Margaret E. Reid**, Manual Training and Home Economics… Main Street School … Grace Horner, Penmanship, Spelling, Drawing, Music… new teachers… Miss Horner is a graduate of the Los Angeles State Normal. For one and a half years she taught all grades of a rural school. For the past three years, Miss Horner has been a teacher in the Ventura city schools…," *SMT*, Aug. 5, 1920, p. 8.

1921 – "Grade School Students Arrange Interesting Exhibit" of sloyd, drawing, and hand work, *SMT*, May 25, 1921, p. 4; "School Children's Exhibit Shows Excellent Training" in drawing, blanket weaving, clay modeling (particularly a clay model of two Indians riding horses, carrying bows and arrows and wearing feathers near a tent by [James] Dempster Glines), sewing, manual training (furniture construction), held at Main Street School, *SMT*, May 31, 1921, p. 7.

1922 – "Elementary Schools… **Holland A. Spurgin**, Manual Training, grade work and physical education…," *SMT*, Aug. 18, 1922, p. 1.

1923 – "School Work Exhibit to be Held Friday" … in the Main street school auditorium… weaving, basketry, clay, plasteline modeling, paper cutting… pencil, crayon, water color and stick printing, etc., *SMT*, May 23, 1923, p. 2; "School Exhibit Shows High Grade Work of Pupils" and article gives extensive details on items (posters, freehand drawing, paper cutting, costume designing, fancy work) from various teachers' classes and schools are named, held in Main Street School auditorium on Friday afternoon, *SMT*, May 29, 1923, p. 2.

1924 – "Grade Schools Will Open… teachers … Main Street School … **Holland Spurgin** – Manual Training and Physical Education…," *SMT*, July 5, 1924, p. 1.

1925 – "Art Exhibit at Main Street School Auditorium" by **Elson Art Publication** company consists of reproductions of famous art pieces made in carbon photographs, photogravures and prints in full colors, 200 in number, with lectures by Rev. Nelson and **S. Breneiser**, *SMT*, Feb. 23, 1925, p. 5; "Art Exhibit Attraction at Main Street School," and money derived from admission will be used toward purchase of some of the reproductions, *SMT*, Feb. 26, 1925, p. 5; "Thirty-Four Graduate from Eighth Grade … teachers … for the coming year… Main Street School. **Holland Spurgin**, acting principal. Manual training and physical education…," *SMT*, June 12, 1925, p. 1.

1927 – "Eight New Teachers … Grammar School … General Departments – **Hal Caywood**, Physical Education and Manual training …," *SMT*, Aug. 2, 1927, p. 1.

1928 – "School and Home Weeks Open Today… **Public School Week**… The exhibits at the various schools will be open every day from 1 to 5 o'clock. Wednesday evening from 7 to 9 o'clock… Main Street School. Drawing of various things, seasonal drawings and construction work, Miss Jessie F. Tilley, 6A… Crayola drawing, stick printing, clay models, cut paper work, paper construction, raffia weaving, **Mrs. Muscio**, 2. Water color work, Miss Agnes Moore, 7A … Free hand drawing, cutting and handwork, **Mrs. Nell Hamaker**, A-B. Manual Training and Mechanical Drawing, **H. D. Caywood**… Mill Street… First Grade … Paper Hats … 3-A and 2-B… Easter drawings… May baskets… Egg shell and nut shell novelties… 4-B… coping saw work … embroidery. Cook Street. 3-A and 4-B… Doll dresses… Woven book bags… Paper construction work… Drawing… Weaving paper mats… Posters … 5-B… Weaving… Drawings… Posters… Embroidery… Woodwork. 3-A and 3-B… Free hand cutting. Braided jump ropes. Woven bags. Painted coat hangers. Painted boxes… Mrs. Hazel Bidamon… Weaving – rugs, hammocks, caps. Free-hand tearing. Free-hand cutting… Mrs. Maud Wickline 1-B and 1-A… Free-hand paper tearing. Weaving. Free-hand drawing. Mrs. Gertrude Boyd – 5-A… Basket weaving. Poster work. Mrs. K. Cook – 1-2-3-4, Agricola. Clay modeling. Poster work," *SMT*, April 23, 1928, pp. 1, 8.

1930 – "Stress Industrial Arts in Efficient School Systems… strong movement towards vocational education… In the Santa Maria schools this course is introduced in the sixth grade. The introduction includes a workable understanding of simple mechanical drawing, the

names of tools, their uses and the correct way to use them. Completed, the pupil starts to work on the actual project. … as the pupil advances, so does the difficulty of the project. Some of the articles made by the boys are bill files, bread boards, broom holders, necktie holders, candle holders, book ends, book racks, magazine racks, taborets, etc…," *SMT*, Oct. 25, 1930, p. 1.

■ "Children Strive to Develop Artistic Tastes in Gloomy, Dark Basements by **Dorothy K. Merritt**. In the elementary schools of Santa Maria, art education is taught as a special subject. … The purpose of art education in our elementary schools is not to produce artists but to … cultivate good taste in any other practical problems of life… cultivate the powers of observation, to create a desire to know and appreciate beauty in life… Art instruction in Mill Street, Fairlawn, Cook Street and Miller Street schools is conducted in the different class rooms. In the sixth grade at the Miller Street school, the regulation school desk is used, and it is too small to hold supplies and give enough room for working. … The art work in the Main Street school is conducted in a basement room. The children work at serving tables, six children to a table. The children are seated too closely together and it is difficult to maintain discipline. Seated in this manner, one-third of the children are forced to have their back to the teacher and the instruction board. There is a great need, especially for the seventh and eighth grades, to have a better equipped art room and a variety of art courses. At present … all in one grade having the same type of work. It is desirable to have the art education adapted to the different abilities of the children, giving handcrafts for those that are not adapted to or interested in drawing…. The children that are not interested in art work, as it is given at present, are a great handicap to the teacher as well as the other children. The teacher has to offer work that they are able to do, thus lowering the type of work that could be obtained from the children that are interested and also, hindering their development in art education. There should be separate art courses for the different types of pupils. The present supplies and art equipment are inadequate for proper art instruction. There are no books for children or teacher's reference. No articles for cultivating appreciation such as pottery pictures, books and so forth. Each child should have a desk and most important, the art department should be equipped for handcrafts such as weaving, basketry, tie-dying, etc. This would necessitate handcraft materials and room equipment such as a sink and lockers. … There is a great future in the field of art such as architecture, advertising, interior decoration, stagecraft, costume design, etc. There is no doubt but what some Santa Maria children may get their first ideas in the elementary art studies which will cause them to take up as their life work professions, trades or business which will require such training," *SMT*, Oct. 27, 1930, p. 1.

1931 – "El Camino School Contract Bids… will take in all of the seventh and eighth grade pupils in the entire city and also the pupils of the first six grades of the district. It will be a departmental school doing the same work as a junior high… state school law these grades are required to take the following subjects: … art… Electives… manual training… basketry… advanced art… woodwork…," *SMT*,

Feb. 23, 1931, p. 2; "New School Given City… El Camino street school… largest and most modern elementary school in the city… **Louis N. Crawford** of Santa Maria is supervising architect… reinforced concrete… two wings… all academic classes are to be held in the main building… The only second-story room of the school is located in the center of the main section and will house the art classes…," *SMT*, Aug. 8, 1931, p. 8; "Toy Workshop… students as well as adults to repair and renovate old toys at El Camino school… **Euland Payne** will supervise the toy-making and repairing, **Miss Lola Feeley**, head of the domestic arts department, will be in charge of the doll repairing and dress repairs, while **Miss Dorothy Merritt**, art teacher, will oversee the decorating and painting of toys and dolls," *SMT*, Nov. 6, 1931, p. 1; "One of Finest Grammar Schools in State… Open House… most modern and best equipped… El Camino Street school… novel departure … both as to the building itself and the methods of study and classes maintained… designed to serve somewhat the same purpose as a junior high school but at a much lower cost of administration. In addition to the regular academic courses, pupils in the high or grammar school grades at the El Camino school are offered a much richer curriculum, including instruction in woodshop, electric and sheet metal shops, art craft, basketry, elective art and music, French and Spanish… Already the students at El Camino school have produced some excellent exhibits of work done in the shops, including baskets … The woodshop has now been named the 'Santa Claus Toy and Workshop' where toys are repaired for Christmas by the children… **Euland Payne** is in charge of the shops at the institution, **Miss Lola Feely [Sic. Feeley]** directs cooking and sewing, and **Miss Dorothy Merritt** is instructor in painting and designing. Miss Hazel Brown is in charge of basketry classes…," *SMT*, Nov. 23, 1931, p. 1.

1932 – "Art Work of Students to be Shown… **Public School Week**, elementary schools of the city will arrange an exhibit in the auditorium of the Main Street school… Miss **Dorothy Merritt**, head of the art department, is general chairman of the exhibit…," *SMT*, April 19, 1932, p. 3; "School Exhibits for Education Week… **Public School Week**… art and handcraft in the auditorium of Main Street school today… completely fill the large auditorium… Worthy of special mention is the clay modeling. An exact duplicate is shown of the Santa Barbara mission… Various types of transportation vehicles have also been shaped… Maps and art work on paper … wide range of creative work in colorful wall paper designs, book covers and posters, making use of both cut work and crayon. Outstanding features, however, are the sheet metal, woodcraft, weaving… exhibits… wooden candlesticks, book racks, magazine holders, benches… Beautiful baskets woven from reed and paper… Tables of needlework… Special position in the room is given to a good-sized miniature airplane built by Joe Ontiveros, a seventh-grade student… Another… a beautifully constructed ship… by **Euland Payne**, instructor of manual arts, who devoted more than 400 hours to the work…," *SMT*, April 25, 1932, p. 3; "School Toyshop Looks Like Santa Claus Land… repairing and remodeling of more than 700 toys… El Camino school…," *SMT*, Dec. 10, 1932, p. 3.

1933 – "Posters are Made Up by Students. Participating in **Better Homes** campaign… **Dorothy Merritt Green**'s pupils … El Camino school have designed noteworthy posters," *SMT*, April 26, 1933, p. 3; "Posters Show School Work. Dogs, cats, birds, burros and sheep are some of the subjects illustrated on 45 posters made by seventh and eighth grade students of El Camino schools in a contest sponsored by the Twenty-Thirty club in connection with the pet circus… exhibited in the windows of H. C. Dorsey's building… and tomorrow are claimed by **Dorothy Merritt Green**, instructor of art in El Camino school…," *SMT*, May 17, 1933, p. 5; "Kiddies Parade Pets… Poster Prizes Given. **Mina Rushforth** and Tsukiko Fukuto were winners of first prizes… contest held under the supervision of **Dorothy Merritt Green**…," *SMT*, May 27, 1933, p. 4.

1934 – "Pupils' Work Displayed… Main Street school… **Public Schools week**… Indian life is the theme illustrated in sand table work in the second grade… Art work exhibits by pupils in third to sixth grades was worked out along a progressive plan by Instructor **Dorothy Green** and were correlated with social studies when possible… Miss **Svensrud**'s classes also have studied special handicraft work and exhibit tapestries, scrapbooks, reed upholstering …," *SMT*, April 23, 1934, p. 1; ■ "Stencils and Paint Make Over Main Street School… **SERA** labor… Formerly the walls were plain white… Separating the two colors [of tan and cream]… workers have stenciled a border in soft contrasting shades. … The greatest transformation has been wrought, however in the auditorium. Formerly a dull gray… [now tan and cream] and in addition to the stenciled border between the lower and upper colors, the walls and ceiling have been decorated in other appropriate stenciled designs. The side walls… have been broken by the painting of imitation columns in darker colors… at intervals, with tall, flaming torches in the panels between the columns. On either side of the stage, above the curving ends of the proscenium, stenciled designs have also been placed to break the monotony… The treatment of the ceiling has been carried out by grouping stenciled designs about the lighting ornaments and in corners of square and diamond-shaped designs. The stencils were cut and the decorating work supervised by **Louis Turek**…," *SMT*, Dec. 5, 1934, pp. 1, 4; "Students Will Give Show… Main street auditorium at 2 o'clock when the fifth grade of Miller Street school under the direction of **Hazel McClure** will present a puppet show, 'The Life of the Pilgrims.' Every member of the class of 36 students has had a part in the creation of the puppets and the presentation… Six different scenes, each eight and one-half feet long and three feet wide, have been painted by the students … wrote the play…," *SMT*, Dec. 11, 1934, p. 3.

1935 – "Children Make Puppets for Playlet… second grade students of Main street school… 'Jack and Jane on the Farm,' … written by the pupils who also designed and drew the invitations…," *SMT*, April 9, 1935, p. 3.

1936 – "School Project Gets National Prominence. *Woman's Home Companion* for November contains an illustrated article on Blochman school community project, written by **Mrs. Bina L. Fuller**, school principal, and illustrated with 12 photographs by the author…," *SMT*,

Oct. 21, 1936, p. 1; "Boy and Girl Program Opens… Federal Recreation Work to Be Inaugurated at Main Street School… daily between 3 and 5 and on Saturdays from 10 to 12 and 1 to 5. The work is to be under the … **WPA** recreation program, and **J. V. Woodside** will be in charge of handcraft work… conducted in Main street school…," *SMT*, Nov. 10, 1936, p. 1; "New Gym Class for Guadalupe… **WPA**… average attendance of 900 to 1100 children weekly on the [**WPA**] recreation project … at Main street school… These classes meet daily except Saturdays and Sundays from 3 to 5 and embrace games in the open and handcraft work in the wood shop…," *SMT*, Dec. 2, 1936, p. 8.

1938 – "School Pageant… 'The Mystery of the Nativity,' in pantomime and music… **Miss Edna Davidson** is art director. On the student art staff are **Mary Lee Marshall**, who made the block print for the program cover …," *SMT*, Dec. 7, 1938, p. 3.

1939 – "El Camino News… **Miss Edna Davidson**'s art classes of the third grade have been making several pictures on the subject of Indians. The fourth grade has based its art work on designs. Her fifth-grade pupils are making a frieze, starting from the Vikings and following the Westward movement up to the early explorers of America. The sixth grade has based its subject on the Greeks. Lately they have been drawing Greek figures. **Glendon Lawson**'s low seventh grade classes have been drawing landscape scenes, animals and faces. **Mrs. Davidson**'s high seventh grade pupils are making friezes. Some of the class are drawing friezes having to do with the Westward movement. The others have placed their theme on music and libraries. The low eighth grades are also making friezes on libraries, music and travel," *SMT*, Jan. 20, 1939, p. 3; "Fine Pictures to be Shown by Schools," i.e., reproductions traveling exhibit at Main St. school, *SMT*, March 15, 1939, p. 3; "Bonita School Shows Pupils' Handcraft" made during study of Indian lore, *SMT*, Nov. 7, 1939, p. 3.

1940 – Miller Street school 6th graders taught by Mrs. **Hazel McClure** – "Puppet Show Amuses Young Guests of O.E.S. Chapter," *SMT*, March 15, 1940, p. 3; "Blochman School is Given New Boost in Magazine," i.e., March issue of *Reader's Digest* reprints John Lodge's article in *Popular Science*, *SMT*, March 22, 1940, p. 3.

1941 – "Exhibits Mark 'Book Week' … teacher **Edna Davidson** has directed the work of El Camino school pupils in making dioramas to illustrate popular books. These are on display in El Camino library … Most imposing of the dioramas is that made by [children named] … Measuring over three feet in height and over two feet in width, in a gilt frame, it is a three-dimensional picture of a scene from '*Far Away Desert*' by Grace Moon. Other dioramas illustrate '*The Arabian Nights*'… '*Jungle River*' by Howard Pease, such old favorites as '*The Three Bears*' (a large display in the main hall complete with log cabin and hand modeled bears made by Cliff Bruce's eighth-grade boys under the direction of **Euland Payne** in the wood shop, and many more," *SMT*, Nov. 4, 1941, p. 3.

1942 – "School Art Show Remains Open for Week… in college social hall…," *SMT*, Feb. 25, 1942, p. 3; "Visual Needs – Posters from various countries are sent by request to Main street school, headquarters for elementary school libraries. Mrs. Edna Lockwood, visual education supervisor, frames and mounts pictures for the Santa Maria schools. She orders all the stereograph sets, moving pictures, which are all educational, and kits showing products and raw materials from different manufacturers. There are various colored slides on Santa Maria industries and still films on nature study. The teachers may check out these supplies at intervals…," *SMT*, April 9, 1942, p. 8; "News of Elementary Schools… Art News…Santa Maria children from the fourth grade up, enjoy school art once a week under the direction of **Miss Edna Davidson**, present instructor, who has taught there for five years. The lower grades have 50 minutes and the upper grades 80 minutes of art each week. These children, on the average, prefer drawing landscapes and realistic drawings. At the present, the fourth graders are drawing missions with colored chalk. The fifth-grade children are working on stencil designs. Castles out of colored chalk are being made by the sixth grade. In the seventh grade, the pupils are making slogans, then printing and painting them on heavy paper. Maps are also being made by this class. Miss Davidson says that on the whole they are better than last year. Eighth-grade students are making designs of all kinds. These are modernistic drawings…," *SMT*, April 23, 1942, p. 10.

1943 – "School Pupils… The school Day Extension program is operating this week… in Main street school where games, story-telling and handcraft work is being done under faculty supervision…," *SMT*, April 19, 1943, p. 3; "Care Center to Open Earlier… operated by Main Street school… During the Easter week the students are fixing up the bicycle room of Main Street school to be used for an arts and crafts room. This week they are white washing the walls and later, will paint murals on the walls as a project of the arts and crafts class," *SMT*, April 21, 1943, p. 3; "Child Handcraft Exhibit Planned… by the 70 children participating in the Main Street Child Care Center, has been arranged, according to **Mrs. Louise Whitaker [Sic. Whitteker]**, teacher in the center… all day Thursday in the school cafeteria. The work shown … by children of kindergarten age through the sixth grade," *SMT*, July 20, 1943, p. 3; "Craft Work of Children Shown… Main street school Child Care Center…," *SMT*, July 23, 1943, p. 3; "I Spied… Exhibits of handcraft and art from the Child Care Center of Main street school, in a store window in the 100 block on West Main Street," *SMT*, July 26, 1943, p. 1.

1944 – "Recreation School in Session… conducted in Main street elementary school… average daily attendance of 125… Reading classes… orchestra and wood shop… Rosalie Menghetti teaches intermediate handcraft and … **Mrs. [Louise] Whitteker** and **Miss [Fernie] Gleason** teach primary handcraft…," *SMT*, June 19, 1944, p. 3.

1945 – "Miller Street School Pupils Present Outstanding Program… during… **Public Schools Week**… orchestra … violin solo… glee club… Youngsters who made and presented their own puppets in a show were … folk dance…," *SMT*, April 28, 1949, p. 7.

1946 – "Post Article Lauds Blochman Village… the model village built and operated by pupils of Blochman school… two-page spread … in the Sept. 28 issue of *Saturday Evening Post*… illustrated with a series of photographs by **Gene Lester** of the village…," *SMT*, Sept. 24, 1946, p. 1.

1947 – "Schools Plan Exhibits for Annual [**Public Schools**] 'Week'," including art, *SMT*, April 10, 1947, p. 2; "School Art Classes Develop Children's Creative Powers… says **Miss Edna Davidson**, art supervisor of the elementary schools… All children have creative abilities… [and they must be developed by teachers' projects] In the field of illustration… many mediums may be used including paints, crayons and clay. Art may be directed towards teaching other subjects, such as a mural by the students depicting early life in California or industries of the country. Smaller children are directed in making figures of animals… In the field of design … painting of decorative maps can lead to a better understanding of geography or history… The making of leather wallets leads… to development of a useful technique and acquaintanceship with a useful industry. Arrangement of flowers in classrooms, making posters for safety drives and notebooks with illustrated covers … A love of beauty seems to be inherent in man… primitive peoples decorate their faces… The love of attractive homes, the development of flower gardens … 'In classroom activities the children soon learn that no amount of room decoration can be effective unless the room is first orderly….' Art training can be defined as adding to the enjoyment and enrichment of a child's life through creative experience…," *SMT*, Aug. 22, 1947, p. 2; "Magazine Tells of SM Fifth Grader's Movie… October issue of *Sierra Educational News*… **Mrs. Marie Sluchak**, fifth grade teacher in the Main Street Elementary School. The course [in American history] was taught by making an eight-millimeter movie in color with the class of 1946 as the actors and actresses, technical staff and assistant directors. Since photography is the hobby of both Mrs. Sluchak and her husband, John, who filmed most of the scenes, both adapted their knowledge of lighting … so that it was not necessary to have studio lights. Taking about eight minutes to show [covers the history of America and some scenes were filmed at Avila and Pismo Beach] … Costumes were made by the children's mothers…," *SMT*, Oct. 14, 1947, p. 3.

1948 – "El Camino PTA… An attendance banner displayed at the board meeting was designed and made by **Phil Bostwick**, a local high school student… In blue and gold, the official colors of El Camino school …," *SMT*, Jan. 8, 1948, p. 5.

1949 – "Blochman Group Inspects Art Work of School Pupils," *SMT*, Oct. 13, 1949, p. 12.

1950 – "Miller Street Mothers Hear Talk on Art… **Mrs. Edna Davidson**… talk on art. Defining it as 'an expression of personal experience in a medium,' the speaker also told of art as a help in the development of thinking and understanding in fields not necessarily artistic. Mrs. Davidson presented a demonstration …," and names of children who aided her, *SMT*, March 2, 1950, p. 5; "Alvin… Avenue and Air Base schools will be hosts to the public Wednesday in observance of **Public School week**…

The kindergarten program: Miss Mary Jane Reed's class, Room 2, 9:30 to 10 a.m. children at crayon work, painting at easels, modeling in clay, working in block building and with scissors and paste...," *SMT*, April 24, 1950, p. 1; "Parents See Handicraft," at El Camino school during **Public Schools Week**, and "In the sewing room, mothers saw clothes and home conveniences made by their daughters. They saw a wardrobe closet constructed of orange crates. Orange crates were also worked into bedside stands and even into a dresser. Maria Duran, Josephine Cardenas, Sally Aguilar, Nesaye Maeno and Donna Hanson constructed the dresser at a cost of $2.05 for the materials... Dads were interested in the shops where **Euland Payne**'s boys are making almost anything that can be made of wood or sheet metal. Aluminum ash trays, copper flower containers, card receivers and many other articles, all hammered, were shown. More practical things such as flour or sugar scoops made from old tin cans are also be to seen. Porch chairs and lawn seats are being made by some... Along the wall of the entrance hall is a series of tempera paintings made by students depicting Latin-American birds and animals and early American figures," *SMT*, April 28, 1950, p. 5; "Ceramics are Favorite Hobby Class at El Camino," and article explains, "Johnny Patino's ceramic cowboy is back at its accustomed place in El Camino school after causing consternation on an overnight disappearance. ... it was learned that Johnny, unable to wait for the final baking and glazing process, had taken the cowboy home for the night in its partially completed state to show to his family. The class, taught by **Miss Edna Davidson**, was happy to learn of the safety to John's cowboy, that one classmate described as: 'Special, because the cowboy's hat, arms and legs all repeated the same curve, and showed fine rhythm.' There was also great excitement around El Camino when the students watched opening of the kiln to see their original and finished designs. Duane McCall took home a handsome blue-green cylinder box he designed. Kenneth Heath made a blue bowl with colored stripes... Chuck Hebard and Bob Brown made amusing gorillas... Particularly well made were the square boxes worked by Marjorie Mors and Nadine Rodriguez. The class decided that Billy Phillips' blue and white plaque reminded them of an early medieval design. Rayma Williams added to her shoe collection by making an old fashioned high-button blue shoe. Other outstanding pieces listed were: Rush Guerra, a heart-shaped bank; Mary Lopez, an old-fashioned girl; Newman Whitmire, cowboy playing guitar, James Buchert, a tray with fantastic bird design. Worth having for the front room is an ash tray with fluted edges made by Gloria Kaukonen. ... Martha Mouguette modeled a very small black puppy... Alvin Bognuda made a glossy black horse... Gene Smith went for a rocket design on his ash tray, and Gregory Bond designed a prehistoric animal. Stage coaches appealed to Manuel Dias and Peter Flores. These are drawn by mules... Arthur Hernandez turned to sports and designed a football player about to throw a forward pass. **Miss Davidson** said there were many more original ceramics she would like to mention. She added that she is afraid so many will be on the Christmas trees as gifts that there will not be many left by education week next spring," *SMT,* Nov. 25, 1950, p. 4.

1951 – "Miller [Street School] Mothers are Presenting Planter to School... A redwood planter is being obtained for temporary use until the copper one being made by **Darrell Froom** is completed...," *SMT*, Oct. 12, 1951, p. 4.

1952 – "Children Make Ceramics" at Benjamin Foxen school under Jessie Crum, i.e., first grade children are making bowls, trays, snowmen, heads, *SMT,* March 17, 1952, p. 4; "Mizpah Chapter Sees Work by Public Schools... OES... Chapter members were invited to inspect displays of school work, one of the exhibits being a model of a medieval castle and moat, made by history students of Miss Hazel Valentine in El Camino school... One exhibit consisted of ceramics made by students under direction of **Miss Edna Davidson**... Crayon drawings and posters made by children of the first, second and third grades of Alvin Avenue school... Examples of woodwork and basket-making from shop classes at El Camino school, taught by **Euland Payne**... Girls of the upper grades home economics classes displayed aprons they had made...," *SMT*, April 25, 1952, p. 4.

1953 – Port. of **Edna Davidson** art teacher at El Camino school ... El Camino school, Santa Maria Elementary School district's only junior high... located on about eight acres of land at El Camino and Pine streets, across from the Veterans memorial building, was constructed in 1931... gradual change... school being almost entirely a Junior high (seventh and eighth grades) for the past six years... Several classes are taught at El Camino which won't be found at other elementary institutions... such as wood and sheet metal shop, cooking and sewing... Teachers are ... wood and sheet metal shops, **Roy E. Payne**, cooking and sewing Miss Betty Foster, art, **Miss Edna Davidson**...," *SMT*, March 19, 1953, p. 1.

1954 – "Benj. Foxen to Observe PSW [**Public Schools Week**] ... A display of art work, with emphasis on printing and poster making will be shown, together with ... showing of the work of a talented sixth grade boy, Ralph Ybarra. Ralph entered the Blochman school last fall and ... one of the most talented in this field in the entire school," *SMT*, April 23, 1954, p. 7; Casmalia school – photos of children at easels and setting up finger painting, *SMT,* June 3, 1954, p. 16; "**Joseph Knowles** in Art Talk ... featured speaker at the Blochman Union District PTA tonight in the multipurpose room of Benjamin Foxen school. Knowles will talk on 'Understanding Children's Art Work in School.' He will also show two films, 'Art Belongs to All Children,' and 'Understanding Children's Drawings.' Demonstration of typical art work of children in grades one through eight will be provided by the Foxen school ...," *SMT*, Nov. 10, 1954, p. 7.

1955 – Photo of children – Ellen Swanson, Mike Sheen and John Patterson – painting a mural related to their study of California Indians, *SMT*, April 13, 1955, p. 1; "School... In the sixth-grade room of Mrs. Lavada Peterson the subject will be art. The instruction will feature the making of a design from a single line, learning color harmonies, learning to balance a design. This type of lesson, Mrs. Peterson reports, gives encouragement to those children who think they cannot succeed in art, because no certain shape or form is prescribed," *SMT*, April 25, 1955, p. 3;

"Marvin school held open house Saturday morning… Parents and other visitors were invited to see… crayon drawings… all of which were in a county fair theme. Near the entrance was a large mural on which several of the children had worked to depict a farm and countryside scene. The young artists had pictured farm animals to be seen in a county fair … One table held a home economics display… and fine hand embroidery…," *SMT*, May 31, 1955, p. 4; "Marvin [School] Children Give Christmas Tableaux… fifth annual… making their own stage sets … Classwork of the children in posters and large Christmas greeting cards decorated the walls…," *SMT*, Dec. 17, 1955, p. 4.

1956 – "Robert Bruce PTA Marks Founders Day…," and information on the puppet show, *SMT*, Feb. 17, 1956, p. 4; photo of Puppet Show at Robert Bruce School that tells Founders Day tale, *SMT*, Feb. 19, 1956, p. 11; "Casmalia Holds Open House… Public Schools week… display of a mural showing early stages in American history, which was made by the third, fourth and fifth grade classes under the direction of… Mrs. Doris Nugent," *SMT*, April 27, 1956, p. 1; photos of art made by elementary school children, *SMT*, Oct. 27, 1956, p. 7; photo of a child and Halloween art, *SMT*, Oct. 31, 1956, p. 1; photo of wire sculptures of animals made by students, *SMT*, Nov. 23, 1956, p. 1; repros. of children's art, *SMT*, Nov. 24, 1956, p. 7; **Joseph Knowles**, Santa Barbara elementary school art consultant "To Speak on Art," i.e., the basic principles of art and design as it is applied to home-making, explained to Blochman Union School PTA, *SMT*, Nov. 12, 1956, p. 4; "**Joseph Knowles** to Speak on Art…," *SMT*, Nov. 12, 1956, p. 4; "John [sic. **Joseph**] **Knowles** Gives School Art Talk," on creative activities that parents and children can do together, and article adds, "The artist brought with him framed examples of children's paintings, which although childlike, when dramatized by being matted and framed, were colorful and interesting and not unsuitable for being given a place on the walls in the children's own homes… The strongest bond exists between a parent and child who are good friends,' he said, 'Children need to feel that they have status by being allowed to participate as members of the family group.' … in such ways as sewing, cooking, finger painting and many other kinds of useful work," *SMT*, Dec. 3, 1956, p. 4; repros. of children's art, *SMT*, Dec. 22, 1956, p. 7 and Dec. 24, 1956, p. 1; "Art Consultant at Foxen School. **Joseph Knowles**" in Sisquoc, gives art advice to local teachers, "He stressed functional arrangement of room furnishings as well as pleasing and effective bulletin board displays. Too much material crowded together is one of the most common faults to be found with school bulletin boards," *SMT*, Dec. 4, 1956, p. 4.

1957 – Repros. of children's art, *SMT*, Jan. 26, 1957, p. 7; repro. of children's art produced in 1st grade class taught by **Aline Gronendyke**, *SMT*, Feb. 11, 1957, p. 10; repros. of children's art from Cook Street School, *SMT*, Feb. 23, 1957, p. 4; photo: and caption reads, "Eighth graders from El Camino school are sketching houses that are in the 200 block of West Chapel as part of their art course… Students in the nine different classes will make larger paintings from their rough sketches under the direction of **Miss Edna**

Davidson…," *SMT*, March 6, 1957, p. 1; "El Camino [junior high] School Page" has repros. of children in wood and metal shop classes and "Art Classes Offer Variety," which says, "This year we have made a variety of things. **Miss Davidson** our art teacher helped us. At the first of the year we made art envelopes that we kept some of our work in. We decorated them so they were very attractive. Next, we made some pictures of early cave men. We made them in colored chalk. Next, we made some designs with paints. Then we made some crayon etchings. Just before Christmas we made linoleum block printings with designs for Christmas cards. Some made cloth or stencil printings. Right after Christmas we made paper bowls (counter change) [Sic?]. Right now we are working with clay pieces. We have glazed and painted them. We finger painted and now are drawing figures," *SMT*, March 30, 1957, p. 7; repros. of art by students at Alvin Avenue School, *SMT*, April 27, 1957, p. 8; photo of elementary students in front of paper mural, *SMT*, May 1, 1957, p. 1; photo of child at easel at Hancock school, *SMT*, Oct. 10, 1957, p. 9; repros. of art by children of Fairlawn School, *SMT*, Oct. 30, 1957, p. 4; Marvin School Children Make Progress… handicapped… pass time happily on constructive projects… Their next drawing and poster work on the Thanksgiving theme … The children's most ambitious work … is a model house with 8 x 12-foot floor space… The rooms will be complete with furniture, pictures and curtains, all to be made by the children…," *SMT*, Nov. 12, 1957, p. 2; repro of art by student at Main Street school, and "Class Plans Own Mission… fourth grade… build a mission of clay…," and "I Like Art by Wally Hoffmann. I am in art, and I like it. I like to draw. We do lots of art. We got to paint posters for our carnival. We drew a sky-scraper," *SMT*, Nov. 27, 1957, p. 10 [newspapers.com cite it as p. 22]; 2 repros. of children's' art from Robert Bruce school, *SMT*, Dec. 18, 1957, p. 4.

1958 – "Art Talk for El Camino PTA," *SMT*, Jan. 15, 1958, p. 3; "El Camino PTA Hears Art Talk… 'Objectives in Art' by **Miss Edna Davidson**…," *SMT*, Jan. 17, 1958, p. 3; three repros. of art by children of Miller School, *SMT*, March 3, 1958, p. 4; repro: mural painted by students at Robert Bruce School during **Public Schools Week**, *SMT*, April 21, 1958, p. 5; repro. of paper mural at Air Base school, *SMT*, April 22, 1958, p. 2; repros. of 2 drawings by children of Cook St. school, *SMT*, April 23, 1958, p. 5; photo of student at art work and "Special Classes Pay Off" says Miller St. school principal Jack Patton, *SMT*, June 4, 1958, p. 6 [Newspapers.com incorrectly gives this as p. 12.]; photo of children in art class of **Edna Davidson**, *SMT*, Nov. 1, 1958, p. 6.

1959 – Repro of poster for Robert Bruce School PTA Fall Festival, *SMT*, Nov. 18, 1960, p. 4.

1960 – "Special Classes Beginning Soon at Main Street School. Forty-one fifth and sixth grade students… will participate in special classes, after school hours, in a program designed to broaden their knowledge of various fields of science… The classes, which will start next week, include… photography… Instructors will be **Ed Morris**, *Santa Maria Times*, photography…," *SMT*, Jan. 6, 1960, p. 17;

"Alvin PTA Membership Drive Starts… Posters are on display in the rooms… Posters were made by the following [and children named] …," *SMT,* Oct. 8, 1960, p. 3.
See: "Blochman City," "Blochman School," "Fuller, Bina L.," "Guadalupe, Ca., Elementary School," "Nursery Schools," "Orcutt, Ca., Elementary School," "Posters," "Works Progress Administration," 1937

Santa Maria, Ca., High School
See: "Santa Maria, Ca., Union High School"

Santa Maria, Ca., Junior College
Founded in 1920 by the Santa Maria High School District. Earliest classes consisted of advanced classes in all subjects offered by the high school, taught by high school teachers and in high school buildings. During WWII the Junior College "ground aviation school" was housed next to Hancock College of Aeronautics at Hancock Field. In 1954 the Junior College became a stand-alone, moved to Hancock airfield buildings, and the name was changed to Allan Hancock College.
See: "Allan Hancock College," "Hancock College of Aeronautics," "Santa Maria, Ca., Union High School"

Santa Maria, Ca., Junior High School
El Camino School was built as an elementary school, 1931 and morphed into a stand-alone Junior High c. 1947+.
See: El Camino School in "Santa Maria, Ca., Elementary Schools," 1947+, 1953

Santa Maria, Ca., Public Library
See: "Santa Barbara County Library (Santa Maria)"

Santa Maria, Ca., Recreation Department / City Recreation Department
The old city library (Carnegie) was turned into a recreation center, 1941. In 1942 a Recreation Commission was formed and a Recreation Director hired. The Center was used as a USO 1942-46. Post WWII the department sponsored summer schools and special classes that included arts and crafts programs. During the Korean war in the early 1950s the Carnegie building was returned briefly for USO use to the military. Santa Maria built a new recreation building in 1964, and there were also smaller centers in satellite towns.
Santa Maria, Ca., Recreation Department (notices in Northern Santa Barbara County newspapers on microfilm and the Internet)
1935 – "Social Agencies Urge a City Recreation Board… Last year more than 185 children used the facilities offered by the local playground. They were taught handcraft, games that could be played in the home, and outdoor sports. Pyle … proposed plans for a permanent center on the site of the old Mill Street school… **EEP** educational and recreational directors from Suey transient camp told of

the work being done in the camp… **SRA** work…," *SMT,* May 22, 1935, p. 1.
1941 – "Santa Maria's New Public Library Building to be Dedicated Tonight at 7:30," and old library to become a recreation center, *SMT,* July 15, 1941, p. 4; "Steps Taken Toward Recreation Set-Up for the City" … "The city council has no plans, but will listen to a citizens' committee with a plan," and local groups presented statistics on local recreation and listed existing facilities at Camp Cooke and in Santa Maria, *SMT,* Nov. 27, 1941, p. 3; "City-Sponsored Recreation Plan Urged on Council. Recommendation for a comprehensive city-sponsored recreation program in Santa Maria and the construction and installation of required equipment to complete it was made to the city council by Councilman L. M. Clemons… submitted a survey of the existing facilities and the suggested improvements… [supported by a] citizens' committee …" of various local civic and school groups, and five-year plan submitted, *SMT,* Dec. 2, 1941, pp. 1, 6.
1942 – "City Recreation Commission Organizes," established by an ordinance recently passed by the council, *SMT,* July 13, 1942, p. 1; "Director Named for Recreation. Gustavus Schneider… during an informal meeting of the Recreation commission and the city council … A general discussion of the needs and aims of a recreation program was held and the new director was instructed to present an outline of his program…," *SMT,* Nov. 19, 1942, p. 1.
1947 – "Atkinson Asks Council… Plans for a $58,000 civic recreation center to be erected on the city's McClelland street property were submitted by Recreation Chairman Art Atkinson… frame and stucco… 86 x 156 feet and contain a basketball court, washrooms… three group clubrooms, woodworking room, printing room, and handicraft room, library…," *SMT,* April 8, 1947, p. 1.
1948 – "Craft Classes Offered by City," woodwork, metal, leather, *SMT,* Jan. 16, 1948, p. 3.
1949 – "City Recreation Department Issues Annual Activity Report" that includes classes for crafts, *SMT,* March 4, 1949, p. 6; **Rec Ramblin's** by Paul Nelson (City Recreation Director… Fall and winter months are ideal for the craftsman to haul out materials for handicraft… With tools and instruction furnished free, the recreation center welcomes everyone… Norvie Clift [who worked with youths at Nazarine church] instructs … on his leather craft shop at the center. Now is an excellent time to make that Christmas leather wallet for your friend," *SMT,* Oct. 25, 1949, p. 2.
1950 – "Recreation Building Petition Short of Goal by 131 Signatures…," *SMT,* Sept. 27, 1950, p. 1.
1955 – "Seeking Female Recreation Leader… the full-time city employ[ee] would have charge of organizing and administering a recreational program for girls of all age groups. Activities would include sports, clubs, arts and crafts and dancing. Applicants must be high school graduates with supplemental college or recreation training and must be between the ages of 21 and 40. Beginning salary is $250 per month," *SMT,* June 17, 1955, p. 2; "Historical Society Receives Showcase… a glass showcase… preparation of the city recreation building basement as historical headquarters. The city will officially turn the site over to the society September 10…," *SMT,* Aug. 16, 1955, p. 4.

1959 – Classified ad: "Women's' Rec. Director. City of Santa Maria. Position Open. Apply Immediately. Must be able to work with children and adults in varied recreation programs including Swimming, Arts and Crafts… Assist in planning programs of specialized activities. Instruct and lead adults and children in group activities. Apply – City Administrator's Office, 116 East Cook Street…," *SMT*, April 2, 1959, p. 8; "Christmas Craft Workshop Planned," and article reads, "The adult Christmas craft workshop, sponsored by the Recreation department, will have its first meeting, Monday, Nov. 2 at 10 a.m. at the Recreation Center…. The Jr. Girls Club, which is open to all girls in the 6th through 8th grades, will start their Christmas craft workshop on Monday, Nov. 9, also held at the Recreation Center. This craft workshop for the girls will be held on Mondays and Wednesdays, after school … Our craft workshop will be geared toward making simple but attractive decorations for your home, for the holidays. Simple gift items, may also be made…," *SMT*, Oct. 31, 1959, p. 3; "Kids' Art Program Scheduled. City Recreation Department with the assistance of the **AAUW**… art class for six to nine year old boys and girls. The instructor will be **Nat Fast**. The classes will be held in the kindergarten class room at Robert Bruce School. The classes will begin at 10:30 a.m. and run until noon. Children must wear old clothes or smocks. All material will be furnished, and there will be a $2.50 registration charge to pay for the materials and the instructor. The class will be limited to thirty… Classes will be held on the below dates with the type of art work to be done listed after the date. December 5 – paper sculpture, December 19 – printing (posters), January 9 – collage, January 22 – drawing (Conte Crayon) and February 6 – painting," *SMT*, Nov. 28, 1959, p. 4; "Rec Center to Have Yule Craft Open House," *SMT*, Dec. 16, 1959, p. 5; photo and "Christmas Craft Class Shows Fine Handwork," and article reads, "A Christmas craft 'Open House' held Friday at the Recreation Center, exhibited some truly fine center pieces and artistic arrangements for use in the home for the holiday season. In the children's division as well as in the women's class a very fine display of do-it-yourself decorations for the Yuletide that showed imagination, unusual beauty and of course lots of patience but little expense, were shown. Just what scissors, a little gold paint and paste, aluminum foil, ribbons, net and glitter can do to form arrangements that surprise and delight cannot be told in simple words. Ordinary pine cones sprayed with golden gilt paint, dried artichoke blooms, large and small manzanita branches and twigs, some polished in the natural wood and some painted or gilded, with regular tree ornaments hanging in a profusion of color from the limbs, dried thistle or teasel spikes colored or bronzed stuck in styrene foam bases, all this was taught in the classes of Pat Givens, in her craft workshop in the old Recreation Center on S. Broadway. Magnolia leaves add so much to an arrangement but when told of the time and patience it takes to prepare the leaves before they even can be worked with makes one realize their true value. The leaves must be seasoned and dried and allowed to soak in glycerin water for three weeks before anything more can be done to them. The woody stems must be crushed also but after all this preparation the leaves will last for years, they say. A tinsel tree was shown made with commercial

material that was lovely to look at but one could see that Mrs. Givens favored the things made from mother nature's abundant supply. Moss, cat tails, Queen Anne's lace blooms, all these are nature's own, but certain symbols are traditional and must be clearly recognizable so put the familiar ageless angel, stars, wreaths, or baubles in color with the arrangement and that makes it 'Christmasy.' Candles were also hand made in the classes, some tall and square, some short and round, some were tall and thinly tapered with glitter on most of them. The candles displayed were unique, unusual and beautiful. One should share the Yule tide cheer with their neighbors by using outdoor decorations or on the windows to give out a warm friendly feeling to passers-by," *SMT*, Dec. 21, 1959, p. 4.

1960 – "Art Class to Begin... Tuesday at 10:30 a.m. with **Nat Fast** instructor. The class will be held every Tuesday and Thursday morning until Sept. 1, from 10:30 to 12 noon at the McClelland Park Recreation Building, and it is limited to the 25 students who registered during registration week last June," *SMT*, Aug. 13, 1960, p. 3.

1964 – "Atkinson Park Building Dedication… Construction of the new recreation building will be completed this month… Planning for a community center on 38 acres of land at Allan Hancock College was set …," *SMT*, Sept. 11, 1964, p. 3.

See: "Summer School (Santa Maria)"

Santa Maria, Ca., schools
See: "Allan Hancock College," "Allan Hancock Nursery School," "Blochman School," "El Camino Junior High School," "Guadalupe, Ca., Elementary Schools," "Orcutt, Ca., Elementary School," "Santa Maria, Ca., Adult/Night School," "Santa Maria, Ca., Elementary School," "Santa Maria, Ca., Union High School," "Santa Maria Junior College," "Schools"

Santa Maria, Ca., Union High School (including Santa Maria Junior College up to 1954)
Organized 1891 and held in various sites until a building was constructed in 1894. Freehand and mechanical drawing, as well as handicrafts as part of the Domestic Arts program, were considered important classes from the early twentieth century. In 1920 a Junior College section was started consisting of advanced classes in various subjects taught by high school teachers in high school rooms. Through the years art programs advanced in sophistication and adhered to "university requirements" established by the state school system. Students produced "practical" projects, such as posters to advertise various events, designed stage settings and costumes for locally-produced plays, designed and produced high school publications, such as Splash and the yearbook, etc.
Specific teachers – Photography was taught, 1899, by George Russell. Art was first taught by local artist, Minnie Stearns (1903-09), followed by Miss Pioda (1909/10), Francis Heil (1910-12), Miss Kriegel (1919-22), Stanley Breneiser, art (1922-45), Elizabeth Breneiser, arts and crafts (1929?-43), Myrtle Lange, arts and crafts (1943/45), Jean DeNejer (1945/46), Ann Duggan (1945/46), Verla Leonard (1946+), Helen Bury (1946/47),

Delia Davis/Sudbury (1947/50), Norma Martin (1948-50), Ward Youry (1950-52), George Muro (1951-54?), Gordon Dipple (1953-), Attilio DeGasparis (drawing / industrial arts, c. 1948-57), Nathaniel Fast (arts & crafts, ceramics, 1955-), Robert Gronendyke (art, drawing, painting, 1956-?). Manual Training / Industrial Arts teachers (including some who taught mechanical drawing) include George Young (1912-16), C. M. Rogers (1916-19), Louis Crawford (1919), Perino Merlo (1953-). Mechanical Drawing teachers include Harry Snell (1922-34), John W. Stout (1934-46+), Attilio DeGasparis (1955). Photography unit under J. Miles Boothe (1945, 1952-), Mervin Slawson (1958-78). During WWII the Junior College taught "ground-based aeronautical" classes adjacent to Hancock College of Aeronautics.

■ "History of the Santa Maria Union High School, by Miss Mamie Nance… organized in August 1891 … Prof. Denton as teacher… In 1893 the classes were removed to Lucas Hall awaiting the completion of the building, which took place in June 1894. H. C. Faber was then principal. The same year the Commercial course was added … In 1896 **Geo. C. Russell** was elected principal and **Mrs. Blochman** assistant. The following year the work was satisfactory in the required number of subjects to admit the school to the accredited list of the State University. Mr. Russell served as principal for three years. During the year of '97-'98 a special Latin teacher was added… For the years '98-'01 L. L. Evans was principal, **Mrs. Blochman** first assistant and Miss Ruth Henry second asst. and teacher of Latin and later also of Spanish. In 1902 Mr. H. F. Pinnell was elected principal. In August 1902 Mrs. Gibbs, the fourth teacher was added. In July 1903 … Mr. E. L. Mitchel was appointed principal, Miss Marshall was retained as Latin instructress, and **Mrs. Stearns** as drawing and singing teacher. **Mrs. Blochman** who has conducted the English department since 1896, was also retained…," and lengthy article and photo of school, *SMT*, June 24, 1904, p. 1.

Santa Maria, Ca., Union High School (notices in Northern Santa Barbara County newspapers on microfilm and the Internet)

1899 – "High School Notes… Photographing is becoming quite the rage; **Prof. Russell** has taken the various classes in their entirety and in detail and the clearness and finish which he succeeds in giving his pictures, make his rank as a photographer several degrees above an amateur. Not only this, but he has imparted his knowledge to some of the pupils, and the sunny windows are now full of mysterious plates and slides and films and what-not …," *SMT*, Feb. 25, 1899, p. 3.

1903 – "At the Meeting of the high school board of trustees on Saturday last, **Mrs. Stearns** was appointed teacher of drawing. Mrs. Stearns is a fine artist and will unquestionably keep the study up to the standard required," *SMT*, Aug. 14, 1903, p. 3.

1904 – "New Course of Studies Adopted… for several "majors" i.e., Literary, Latin, Latin-German, Scientific, Commercial… [Scientific majors are given Freehand Drawing in their first and second year and Geometrical Drawing in their fourth year]," *SMT*, July 22, 1904, p. 3;

"The Faculty of the Santa Maria Union High School… In July 1903… **Mrs. Stearns** was also added to the faculty to teach music and drawing…," *SMT*, Dec. 17, 1904, p. 8.

1906 – "This week the *Times* was awarded the contract in a competitive bid for printing the *High School Review*, the annual publication issued by that institution at commencement time… the *Review* is to consist of between fifty and sixty pages…," *SMT*, April 14, 1906, p. 2; "Creditable Work… Santa Maria High School *Review* … An artistic green and gold cover is used, designed by **Mac Langlois**, '06, who has also contributed some very humorous and clever illustrations…" and "One of the Best… A feature of the edition are the splendidly executed cartoons, which are suggestive of events in school life… the genius of **Mac Langlois**, who, aside from his skill with the pen is an athlete …," *SMT*, June 30, 1906, p. 6; "High Compliment. We are in receipt of a copy of the High School *Review*, the annual of the Santa Maria high school… The pen and ink work of **Mac [Sic. Max] Langlois** is far above the average high school artist. The many beautiful illustrations magazinize [Sic.?] the brochure… The *Arroyo Grande Recorder*," *SMT*, July 7, 1906, p. 8; "Our New High School… **Mrs. Minnie Stearns**, drawing and music… new section of the building… the rooms are now occupied by various classes… On entering the building, the new room to the left is given over to the drawing classes and most appropriately so, for the light here is splendid…," *SMT*, Aug. 18, 1906, p. 4.

1907 – "New High School Term. The Union High School begins August 12th… **Mrs. Minnie Stearns** drawing and music…," *SMT*, July 20, 1907, p. 1.

1908 – High School Elects Teachers… **Mrs. Minnie Stearns**, free-hand and mechanical drawing and music…," *SMT*, June 20, 1908, p. 1.

1909 – "High School Teachers Selected… The Trustees of the Santa Maria Union high School have chosen three teachers to fill the vacancies caused by the resignation of Mr. Blochman, **Mrs. Stearns** and Mr. Boston. The work of the departments has been slightly rearranged… **Miss Pioda** of the Santa Cruz city schools and a graduate of the **Anna S. Blake Manual Training school** of Santa Barbara, comes to take charge of drawing and manual training…," *SMT*, May 22, 1909, p. 1 and p. 3; "High School Bazaar… November 20th in Hart's Hall… a program… fancy work, school pennants and sloyd articles made at the school on exhibition and for sale. …," *SMT*, Nov. 13, 1909, p. 1.

1910 – "Our High School… Faculty this year consists of seven members… **Francis J. Heil**, drawing and manual training: Graduate of State Normal, Los Angeles; special teacher of music and drawing in Santa Ana schools, 1896-08; Student of Pratt Institute, New York City 1908-10; Graduated 1910," *SMT*, Sept. 17, 1910, p. 4.

1911 – "Commencement of Union High School… seventeen members of the graduating class… There will be an exhibit of all the school work next Thursday and Friday at the school. The special exhibit will be of the drawing and manual training work. **Miss Heil** and her classes have spent

some time arranging the paintings and drawings to their best advantage…," *SMT*, May 20, 1911, p. 1.

1912 – "Fine <u>Art Exhibit</u> will be Here Shortly. This Exhibition of Pictures… carbon photographs and engravings, loaned by **A. W. Elson & Co.**, of Boston, Mass. … reproductions of the masterpieces of art of different countries and periods…. Two hundred subjects representing all the principal schools of art and including many reproductions of sculpture, architecture and important views from nature… catalog has been prepared giving important facts bearing on the artists and their masterpieces. The catalog will be on sale… ten cents… wholesome and refining influence of pictures of the right sort on the school walls… The funds for purchasing such pictures, as well as an opportunity to make a selection from a very large number, is secured by means of the exhibition. The larger the attendance, the greater the number of pictures that can be secured for the High School … The Exhibition will be held in the Park Pavilion from March 27th to March 30th, four afternoons, 2:30 to 5:30 and four evenings, 7 to 10. The admission will be only ten cents. … On Saturday evening, March 30… an address will be delivered by **Miss Edna C. Rich**, President of the new Santa Barbara State Normal School of Manual Arts and Home Economics… she will address … 'The Value of Manual Training for our Boys and Girls'," *SMT*, March 23, 1912, p. 1; "Art Exhibit is a Big Success. The **Elson Art** Exhibit, which is being held at the Park Pavilion under the auspices of the Santa Maria Union High School …," *SMT*, March 30, 1912, p. 1; "High School Begins… three new members in the faculty… and **Mr. Young**, the <u>manual training, drawing</u> and gymnasium teacher…," *SMT*, Aug. 17, 1912, p. 1.

1913 – "High School opens for the fall term Monday morning, August 11th. The faculty is as follows… **George D. Young** <u>Manual Arts, Drawing</u> and Athletics…," *SMT*, Aug. 9, 1913, p. 4.

1915 – "High School Notes. On Friday afternoon, April 23rd, the High School gave its annual exhibition of the work done in the domestic science and <u>drawing and the manual training</u> departments… The members of the class in drawing hung their work for the year on the boards in the art room. These drawings, water colors, charcoal sketches, and pen and ink drawings were very excellent – the water colors being especially interesting…," *SMT*, April 24, 1915, p. 1.

1916 – "High School Notes. From three thirty to five o'clock on Friday afternoon, April 28th, the high school entertained the people of the town at an exhibit of the Domestic Science, <u>Manual Training</u> and <u>Drawing</u> departments. The exhibition which was in the nature of a reception, took place in the manual training building of our high school… exhibited the drawings, in order, showing the advance in the progress of the first-year drawing students. There were sketches in pencil and in pen and ink of jugs and jars and single flowers. The second class in drawing had on exhibition some very creditable water color and charcoal sketches. In this room was also displayed the work of the mechanical drawing class, the shop problems of the beginners in manual training and the finished products,

such as library tables, chairs and settees shown by the advanced class in <u>wood working</u>," *SMT*, April 29, 1916, p. 1; "There will be two changes in the high school faculty the coming year… **C. M. Rogers** of Mountain View will be the instructor in <u>manual arts</u>, athletics and <u>drawing</u>, succeeding **Prof. Young** – Santa Maria Notes," *LR*, July 14, 1916, p. 8, col. 4.

1917 – "The High School Exhibit. Last Friday afternoon the <u>Manual Arts</u> and Domestic Science departments gave an exhibition of their completed work…. The drawings, model maps … writing sets, sewing and manual training pieces were exhibited in the manual arts building. Perhaps the most interesting of the exhibits was the model bungalow which was built by the boys in manual arts department under the direction and supervision of **C. M. Rogers**. The little home was six and one-half feet by eight feet and was three feet high. It was the exact duplicate of a modern bungalow. It had a breakfast alcove, sleeping porch and other modern conveniences. Eva Keiner, Margaret McKenzie and Helen Oakley with the assistance of Miss Arms, furnished the bungalow … The <u>drawing</u> exhibit was very good and it showed the work from start to finish and the various advancements…," *SMT*, May 19, 1917, p. 1.

1918 – '<u>Night Classes</u> at the High School. At a meeting of the Santa Maria Union High School Board, it was decided to open a night school… Practically every department of the high school will be thrown open for classes to meet two or three times a week from 7 to 9 o'clock in the evening… It is planned to start classes in the following subjects: … penmanship… manual training, and drawing… The night school will be open to people of all ages no matter what their previous school training…," *SMT*, Sept. 12, 1918, p. 3; [for details, <u>see</u> "Santa Maria, Ca., Adult/Night School"]; "How Local High School … Mr. **C. M. Rogers** the Manual Training teacher of the High School has supervised all the manual training projects of the Junior Red Cross of this Chapter," *SMT*, Dec. 23, 1918, p. 6.

1919 – "**C. M. Rogers**, manual training and physical director of the local high school has resigned his position and will move with his family to Berkeley at the close of school," *SMT*, May 15, 1919, p. 5; "Few Changes in Teaching Staff… **Louis N. Crawford** who fills the vacancy in the manual training department made by **C. M. Rogers**. Mr. Crawford has been on the Lompoc high school faculty…," *Santa Barbara Daily News and the Independent*, Aug. 8, 1919, p. 3, col. 3; "An Important Meeting of P-T… At the conclusion of the program in the auditorium, a sewing and <u>drawing exhibition</u> will be held in the domestic science bungalow adjoining the main building. Miss Miranda Arms, instructor of that department will have on display a sewing exhibit, Miss Kdiegel's [Sic. **Kriegel's**] classes in drawing will exhibit their work," *SMT*, Nov. 18, 1919, p. 5; "PTA Meeting Well Attended… at high school… After the talks the people went to the domestic science bungalow… The guests enjoyed an interesting sewing and art exhibit by **Miss Kreigel's** class in drawing," *SMT*, Nov. 22, 1919, p. 8.

1920 – "Parent-Teacher Ass'n… lecture… **Miss Irene Struthers**, formerly of the Carnegie Institute and now of the Santa Barbara normal, who spoke on 'Art in the Home.'

… 'Art,' said Miss Struthers, 'is for life's sake and not for art's sake'… Art, according to the speaker, is the doing of a thing in the finest possible way… The elements the speaker discussed to be dealt with in the study of art were line, form, dark and light color. Color was treated as to its psychological and physical effect upon human things [Sic.?]. **Miss Struthers** analyzed each color of the spectrum, stating its helpful and harmful influence. … Miss Struthers told of the importance of choosing and making each object for the home. … meet the purpose for which it was intended… In order to develop this knowledge, the art training in the public schools is no longer a representation of flowers and other objects but the actual production of things for the home and the individual…. A demand for good things will be met by the production of good things. Miss Struthers showed some of the work of her classes in the normal. In the display there were textiles woven by the students from materials of their own dyeing and designing. Needlework, Batiks and paintings were shown," *SMT*, Jan. 31, 1920, p. 1;

■ "**Junior College** Assured for Santa Maria… for the year 1920-21… necessary… in view of the fact that the better collegiate institutions of California are filled to capacity… [eliminates cost of boarding in a university town] … gives two years of university work at home… While the Junior College is vitally interested in preparing students for the university, it also aims to offer advanced work for those who wish to extend their education beyond the high school… Any graduate of an accredited California high school… who contemplates entering the Santa Maria Junior College, should communicate with the principal of the Santa Maria Union High School, in order that he may have some idea of the number entering as well as the courses that must be given…," *SMT*, June 29, 1920, p. 1.

1921 – "High School *Breeze*" published weekly, on Saturday, in the *Santa Maria Daily Times*, beginning Feb. 12, 1921, per *SMT*, Feb. 19, 1921, p. 2; art sketches invited for "*Review*" and to be sent to Bernie Ontiveros, art editor. "The Art Department has been working for the past week on Japanese posters for 'The Mikado.' **Miss Kriegel** plans to hold an exhibition of the posters just before Easter. All Japanese pictures and designs are being kept in one corner of the drawing room. The Art Department will be very grateful for any contributions to this corner. Don't forget this is Kodak Week. The *Review* needs 'snaps' to make it snappy… JUNIOR NEWS. The Juniors are to have their individual photographs taken this week for the *Review*. At a recent class meeting, it was decided to have the pictures taken with dark backgrounds and without hats," *SMT*, Feb. 26, 1921, p. 3; "Better Ventilation Project. The charts for the ventilation of the various rooms in the school building… have been drawn by the Junior boys of the Mechanical Drawing class …," *SMT*, March 12, 1921, p. 3; "High School Advertises 'Mikado' with Display," done by Art Department of HS and consists of posters made under direction of **Miss Kriegel**, *SMT*, March 29, 1921, p. 5; "The Poster Exhibit," *SMT*, April 2, 1921, p. 4; "Junior College. New courses are now being considered for next year's Junior College…," *SMT*, March 19, 1921, p. 6; "Editorial" Jr. College is a reality for second year and offers local students cheap living costs and more personal

attention than larger, out of town colleges and universities, such as at Berkeley, *SMT*, April 2, 1921, p. 4; "Mikado Drop Curtain" painted by art class, *SMT*, April 9, 1921, p. 6; "Talk on Victorian Age. **Mrs. Hall** gave the Senior English class a short talk Tuesday, May 10, on the painters and artists of the Victorian age. … illustrated by pictures of the different artists and painters …," *SMT*, May 14, 1921, p. 6; "Plans for Next Year" – **Miss Kriegel** will have the art classes, library and algebra, and "Requirements for Entrance to U. C. and J. C." include geometrical drawing and freehand drawing, *SMT*, May 28, 1921, p. 2; "'A College Town' Posters. The Art classes worked for more than a month on posters for the Senior comedy, 'A College Town' … showing typical college scenes and characters and a great deal of color and action…," *SMT*, May 21, 1921, p. 4; "Junior College-High School to Open August 22," per *SMT*, Aug. 17, 1921, p. 1; "Santa Maria Union High School Opens [and extensive list of classes] … Faculty… **B. E. Cannon**, Mechanical Drawing, Manual Training. … **Ida M. Kriegel**, Art, Algebra, Library…," and slate of classes, *SMT*, Aug. 10, 1921, p. 2.
1922 – "Value of Art Education," brief paragraph in High School *Breeze* section, and "Art Exhibit" of students in the lower hall that **Breneiser** plans to change every week or two, *SMT*, May 8, 1922, p. 2; "New Stunt from the Art Department. The Art classes have been wondering for some time how they could contribute something to THE *REVIEW* and at last have been given the chance … A large oil painting of the Santa Ynez Mission by Mr. Breneiser [Sic. **Breneiser**] is to be sold for the benefit of THE *REVIEW*. The committee in charge has decided to hold a 'raffle,' and tickets at the low price of twenty-five cents will soon be for sale," *SMT*, May 16, 1922, p. 4; "No 471 Wins Picture of Old Santa Ynez Mission" by **Breneiser**, and drawing took place at dance, *SMT*, May 29, 1922, p. 1;

"Art Exhibit to be Held… The **Blue Mask** and the Spanish club have joined forces in bringing to the school an exhibit of 300 colored pictures, reproductions of the canvases of great masters of paintings, both old and modern. The pictures will be exhibited in the art room and will be on view two days and evenings, December 13 and 14… These reproductions will be grouped according to the school in which they belong, such as Italian school, Spanish schools, French school, etc., and different members of the faculty have consented to give talks on the paintings and the artists of the different schools… The proceeds will be used in purchasing the entire collection of pictures for the new school, to provide for the pleasure and education in good art…," *SMT*, Nov. 24, 1922, p. 6; "Old Art Room to See Last Big Affair… December 13 and 14 when the **Blue Mask** and Spanish clubs will display a splendid collection of the world's greatest paintings in colored reproductions. Three hundred pictures… Lecturers from the high school faculty will… help interpret the pictures. **Mrs. Hall** will discuss the Spanish paintings; Mrs. Allen, the French; Miss Mohney, the English and American, and **Mr. Breneiser** will be on hand to point out the distinguishing characteristics of the Italian, Flemish, Dutch, German and Scandinavian schools. One thousand tickets at twenty-five cents are on sale… [the collection] may be purchased for a permanent exhibit in the new building," *SMT*, Dec. 8, 1922, p. 8.

1923 – "Postpone Exhibition of Paintings," i.e., traveling exh. of reproductions of famous paintings is not yet arrived so will be shown in early 1923, *SMT*, Dec. 12, 1922, p. 5; "Move into **New Building**" and "The art room that has been used in the past has been very inconvenient for both teacher and students. This fault will be remedied in the conveniently fitted art room," *SMT*, Feb. 3, 1923, p. 4; "Art Students Make Posters for Better Speech Week," taught by **Breneiser**, new supplies arrive, and special instruction for students who intend to go to art school, and making drawings for *The Review*, *SMT*, Feb. 10, 1923, p. 6; "Art Students Work Out Historic Costume Designs," designing costumes on paper and then designing contemporary fashions from the ideas, *SMT*, Feb. 23, 1923, p. 2; "Santa Maria *Breeze*… Better Speech Week… We wish to thank the art department who so willingly and ably made the clever posters distributed throughout the school," *SMT*, Feb. 26, 1923, p. 2; "Entertainment and Art Exhibit H.S. March 21, 22," i.e., **Blue Mask Club** to exhibit reproductions of paintings from early Italian to modern European, *SMT*, March 13, 1923, p. 5; "Art Exhibit and Jubilee Planned for Next Week," and "**Blue Mask** Decides on Art Exhibit and Play," *SMT*, March 17, 1923, p. 2; "Mr. **Breneiser** Opens Hang-Out and Rest Room," i.e., art room is popular as a social space, *SMT*, March 19, 1923, p. 4; "Art Exhibit to be Held at New High School" i.e., 200 reproductions of old and modern masters, *SMT*, March 20, 1923, p. 5; "Music, Singing, Art Exhibit at Hi School Tonight," *SMT*, March 21, 1923, p. 5; "The Jay Sees" have their own annual named "*The Jay See*," *SMT*, April 16, 1923, p. 4; "**Blue Mask** Finances Sound, Club Pays for Pictures," and repays **Miss Kriegel** $60 for her loan, *SMT*, May 7, 1923, p. 3; "**Blue Mask** Club Receives Timely Gifts" to help reimburse them for pictures they purchased for art exhibit, *SMT*, May 25, 1923, p. 3; "The '*Splash*' Makes its First Splash Monday," i.e., art magazine, 40 pps. under direction of **Breneiser**, *SMT*, Sept. 28, 1923, p. 6 and hope to put out five numbers a year; "Art Staff Added to *Breeze*" the newspaper published each week by the news writing class and reproduced in the HS section of the *Times* newspaper, with the result that cartoons are now included *SMT*, Sept. 29, 1923, p. 2; "*Review* Staff Ready" with editor-in-chief being **John Breneiser**, "… art editor, **Margaret Fortune**, assistant art editor, **Mabel Burwick**…," *SMT*, Sept. 29, 1923, p. 3; "Art Class Works on Posters to Advertise the Orange Show," *SMT*, Oct. 19, 1923, p. 6; "Scrap Book of Games and Poses to be Made" by art dept. for PE dept., *SMT*, Nov. 24, 1923, p. 2; "New '*Splash*' December 3" will have 2 short stories in addition to art, *SMT*, Nov. 26, 1923, p. 2; "Art Students Decorate Xmas Gifts," *SMT*, Dec. 7, 1923, p. 3; "The *Splash* Even Better in its Second Issue," *SMT*, Dec. 8, 1923, p. 4; *Breeze* "Front Page Next Week to be Thing of Beauty," i.e., designed by art department, *SMT*, Dec. 14, 1923, p. 6; "Over Eighty Xmas Gifts Produced in Art Dept.," such as candlesticks, pin holders, boxes, paper knives, pendants, *SMT*, Dec. 22, 1923, p. 6.

1924 – "Art Class Growing. Mr. Breneiser announces the largest enrollment of art students he has had in this school. This is his third year here. **Mabel Burwick, Virginia McBride, Clarence Norris** and **Allen Dart** represent the *Breeze* Art Staff," *SMT*, Jan. 21, 1924, p. 6, col. 4; "*Splash*

Staff Selected… for second semester… **Mable Burwick** and **Jack Oates**, art editors, Margaret Graham, "We Grow Serious" and Art History columns…," *SMT*, Jan. 26, 1924, p. 2; "Class to Study Paintings" taught by **Breneiser** and "The course is much enhanced by a wonderful set of replicas of famous paintings presented to the school by the **Blue Mask** and Spanish Club," *SMT*, Jan. 26, 1924, p. 2; art class makes "Posters to Advertise the Operetta" *SMT*, Feb. 29, 1924, p. 3; "Many Interested in [Haig] Arklin Art Symposium" on famous paintings of the past, *SMT*, March 17, 1924, p. 5; "*Breeze* Extends Thanks to Art Department" for supplying cartoons, heads and art covers, *SMT*, April 11, 1924, p. 2; "Post Cards to be Sold For *Splash* Benefit. The members of the art department have beautifully painted about forty post cards which will be sold at 15 cents each for the benefit of the *Splash*. **Mr. Breneiser** bought the blank post cards on which the students painted decorative scenes of the school…," *SMT*, April 11, 1924, p. 2; "High 'Vodvil' … presentation of the High School… in the auditorium this evening… program … Chalk Chuckles [by] **Mabel Burwick**…," *SMT*, April 25, 1924, p. 1; "Stanford Awards Prizes to *High Breeze-Review*" [first prize in California awarded to *Breeze*, among mimeographed HS journals, and merit prize given to *Review*, the HS annual] and award to **John Breneiser** editor, at journalism convention at Stanford, *SMT*, May 5, 1924, p. 5; "Art Students to Give Exhibit" of year's work, which will also be shown at teachers' convention in SF, *SMT*, May 12, 1924, p. 2; "'*Review*' for 1924 is Credit to High School… printed on 124 pound sepia silkote paper, profusely illustrated … **John Breneiser** is the editor… Honors for the prize drawing were awarded to **Miss Mable Burwick**. **Clarence Norris**, also of the art department, was awarded the prize for the best cartoons. … **Stanley Breneiser** the 'art' supervisor. … The photographs were made by **L. J. Stonehart**… and Kodak pictures were made by Pleno [Sic. Plenio] Tomassini [sic. Tomasini] …," *SMT*, May 22, 1924, p. 1; "The **Blue Mask** and Spanish clubs … entertained… in the art room at the school yesterday afternoon with an exhibit of bird, animal and flower paintings and a program of musical numbers," *SMT*, May 23, 1924, p. 5; "Exhibition of School Art Class Given Praise … Included… are many fine examples of original adaption of plants and flowers to cretonne and textile designs. Conventionalized designs and covers are also seen as well as some fine paintings of animals. A number of pages of the *Splash* are shown… Two plaques, one of Paderewski and a colored one representing the ship, 'Santa Maria,' the work of **Leon Vaughn**, created much comment. Other work of this student could not be shown since it was taken to San Francisco last week by **Mr. Breneiser** to be shown at the California School of Fine Arts, where young Vaughn is trying for a scholarship to study sculpture," and also not shown was work by **John Breneiser** who is hoping to get into Otis Art Institute. "Caricatures and cartoons drawn by **Mable Burwick** and the art work of **Clarence Norris**, were importantly used in the *Splash* pages. These two students have much of their work in the annual *Review* and… in many school publications, illustrations and advertisements. **Clarence Norris** was winner of the prize offered by *The Times* for a head, which is now being used... Most of the work shown

has just been returned from San Francisco where it has been on exhibition…," *SMT,* May 24, 1924, p. 5; "High School, Junior College, Open August 18… Faculty… **Stanley G. Breneiser**, art… **Winifred K. Crawford**, domestic art and English… **W. D. Harkness**, wood shop, metal shop… **Elizabeth Smith**, domestic science, domestic art. **H. M. Snell**, mechanical drawing, wood shop…," *SMT,* Aug. 7, 1924, p. 1; "Art Instructor at High Gives Practical Training… **Breneiser**… His articles appear in the art and commercial magazines and papers throughout the United States… In the '*American Art Students*' magazine for the month of September is a lengthy article on 'High School Art that Functions'… using our local school's art department as an example… illustrated with two full page reproductions from '*The Splash*' … and several smaller cuts from the '*Breeze*'… It says, in substance: 'Experience with art editors of newspapers and magazines shows that they feel a prejudice toward the beginning artist, feeling that his viewpoint and ideas are limited to the rather narrow line of work had in high school where the student does no thinking for himself… The art department in the Santa Maria high school gives practical experience. The commercial art and illustration class puts out a monthly magazine called '*The Splash*,' entirely made by hand, four copies only being made, and rented from the library. It contains 20 to 40 pages of interest… illustrated by original drawings in pen and ink and wash and blue prints. These are made from negative drawing, on transparent paper. Cartoons are reproduced by the aid of the mimcoscope and the mimeograph. There are art history, current art and news departments illustrated in color drawings or water colors; a California department illustrated by decorative landscapes in tempera. The cover designs offer a field for real endeavor. In the school newspaper, '*The Breeze*,' there are cartoons from life and a front-page cartoon and illustration. … The student who does unusually good work has still another opportunity, that of illustrating the articles written by the instructor… Each illustration must contain all the efforts and ideas in drawing from objects or still life, perspective and foreshortening, color, proportion, principles of design, development of technic as well as additional study in print methods, color and engraving process and extra reading and research study in all arts and crafts' …," *SMT,* Sept. 13, 1924, p. 5.

1925 – "School's Junior Red Cross… [preparing a portfolio for an exchange of school ideas with Latvia and Italy] … *The Breeze*, the official organ of the newswriting class… The mechanical arts, drafting, shop work and electricity… One of the most interesting sections of the portfolio is that devoted to the art department and its work. This department illustrated the portfolio itself with pictures in color, black and white and with photographs of the school, our local scenery, winter and summer garb, the coast at Casmalia, and other drawings of interest including a very clever page of 'Funnies'," *SMT,* Jan. 2, 1925, p. 6; "Marionettes to be Attraction" handled by M/M **Paul Clemens**, *SMT,* Jan. 14, 1925, p. 5; "New Art Course at High School" combines a lecture on art periods with hands-on design, *SMT,* Jan. 15, 1925, p. 5; "Rehearsals of 'Giant's Heart' … **Virginia McBride** designed all the costumes… and work is underway in the art department to draw and paint the

designs on the different costumes. Great interest has also been shown by the students in making posters…," *SMT,* Feb. 16, 1925, p. 5; "High and Jay-See… Junior Red Cross… called upon to render services for the Junior Red Cross in any line of work… This school, especially the art department, has been carrying on services for this society by sending portfolios containing pictures, stories and other interesting information about our school to foreign schools and by painting 500 Christmas menu cards for the United States Veterans at Tacoma, Washington. The expense of this work has to be met by the school itself. In order to further this great work, the **Blue Mask** club is sponsoring a play… 'The Giant's Heart'…," *SMT,* Feb. 18, 1925, p. 5; "Work In Art Made Practical in Local School," i.e., making Norwegian style costumes for the play, "The Giant's Heart" and "The costumes themselves are also original in design, most of them being planned by **Virginia McBride**…," and costumes described. "The Page, **Mabel Burwick**, who also made her charming costume, will introduce each character…," *SMT,* Feb. 20, 1925, p. 3; "Elaborate Stage Settings for Giant's Heart" play being made by student **Leon Vaughn** and his instructor **S. Breneiser** based on illustrations by Kay Nielsen, a Danish born artist who worked for **Disney**, *SMT,* Feb. 23, 1925, p. 5; *Breeze* not repro. in newspaper Jan 1925-?; "Marionettes Attraction in High Course," by M/M **Paul Clemens** in High School Review, *SMT,* March 28, 1925, p. 5; "Marionettes Will Be High School Series Attraction," M/M **Paul Clemens** of New York booked by Redpath Bureau, and he is also a musician and actor, *SMT,* March 30, 1925, p. 3; "Pinafore To be Presented by Students" with stage scenery painted by **Leon Vaughn**, *SMT,* March 31, 1925, p. 3; "Marionettes Come to Santa Maria Friday, April 3," M/M **Paul Clemens**, *SMT,* March 31, 1925, p. 1; "Marionettes Please in Review Series," **Clemens**, *SMT,* April 4, 1925, p. 5; "Public Invited to Attend the Kiwanis Karnival … Scenes and signs for the side-show attractions were painted by **Mable Burwick**, **Virginia McBride**, **Leon Vaughn** and **Clarence Norris**, art students at the high school," *SMT,* May 13, 1925, p. 1; "Art Exhibit to be Held at H. S. Friday," i.e., newspaper discusses this year's *Splash* and some of the projects displayed by the students, *SMT,* May 21, 1925, p. 5; "Art Exhibit Attracts Notice at High School," and prizes given, *SMT,* May 23, 1925, p. 5; "More Prominence Gained for High Art Department… September number of the *School Arts Magazine*… an article entitled 'Art in High School Periodicals' written by **Stanley G. Breneiser** and illustrated with a full-page illustration by **Mabel Burwick**, one of last June graduates, who specialized in art. The article… gives a brief description of the founding of the *Splash*, the art department's bi-monthly magazine and also tells something of the art department's part in the work of the *Breeze*. The art work put out by the students in our high school has become deservedly well-known and praised and accounts of various phases of the school's activities have appeared from time to time in the *Christian Science Monitor*, the *American Art Student Magazine* and the *School Arts Magazine* from the pen of the art instructor, **Mr. Breneiser**," *SMT,* Sept. 4, 1925, p. 5; "Work of Art Student Praised by Magazine… 'Giant's Heart' … The scenery was designed and made in the art department by **Leon Vaughn**

under the direction of **Mr. Breneiser**. The unusual color effects, the decorative settings and exceptional originality of this production… In the October issue of *The School Arts Magazine* appears an article written by Mr. Breneiser giving an account of this production. Several naïve illustrations drawn by **John Breneiser** show the spirit of the play … The **Blue Mask** club, which is the art and drama club of the school, has been under the direction of **Mr. Breneiser** for three years and a half, but has now been turned over to Miss Edith Mohney, the capable drama teacher in the high school. Mr. Breneiser continues an interest, however, as he is instructing the drama class in the principles of art as related to the stage …," *SMT*, Sept. 26, 1925, p. 1; "Senior Fair Enjoyed at High School. 'Ye Olde Englyshe Faire,' the annual senior event… program in the auditorium… A feature of the play which deserved mention was the backdrop, painted by **Leon Vaughn**. On the drop was pictured a green meadow surrounded by a stone wall. Beyond the wall were a number of the typical Irish white washed cottages…," *SMT*, Nov. 2, 1925, p. 5; "Christmas Program… Colored slides depicting the Holy Family were thrown on the screen… The exercises closed with a living picture of the Holy Family… The paintings for the living picture were made by Margaret Graham, Barbara Lamb, Barbara Poole and Inez Itria…," *SMT*, Dec. 12, 1925, p. 5.

1926 – No *Breeze* was reproduced in the *SMT* spring 1926; "Unusual Drawings to be Displayed at Art Exhibit" along with works by **M/M Breneiser**, and awards to be given, and "Junior College Art Classes to Display Work," and **Breneiser** has been striving for the experimental and individualistic, *SMT*, May 20, 1926, p. 5; "Art Exhibit at High School Wins Praise … May 21… The very odd and unusual design for a mantle over-hanging, by Lillian Harvey, a Junior … was awarded the first prize for the best painting… by the judges: **Miss Ida M. Kreigel [Sic. Kriegel]**, Dr. S. B. Hepburn, and **Mrs. L. N. Crawford**. First honorable mention was awarded to Juliet Thorner in the special art division on a water color painting of a copper object and on charcoal cast drawings. In the general art department, the student who had made the most progress and was awarded first prize was Frieda Goedinghaus, and honorable mention went to Barbara Lamb. One of the odd types of patterns on display was examples of horrible and grotesque painted masks, based on geometrical figures. The lettering and applied designs made by the students of the general art section were especially commendable. In the Junior College section, the first prize for the best painting or drawing was given to Barbara Higgins, whose design derived from two paroquets… **John Breneiser** received honorable mention. For the student who had made the most progress the prize went to Frances Worden and honorable mention went to Barbara Poole," *SMT,* May 22, 1926, p. 1; "Union High School and Junior College Schedule… Faculty… High School… **H. M. Snell**, vocational advisor, mechanical drawing… **Stanley G. Breneiser**, art. **Winifred K. Crawford**, domestic art, English… **Myrton D. Likes**, biology, chemistry … **Lewis C. Sanders**, wood shop … **Elizabeth Smith**, domestic science, domestic art… Junior College… **Stanley G. Breneiser**, art… **H. M. Snell**, descriptive geometry, machine drawing… Junior College … **H. M. Snell**, descriptive geometry, machine

drawing…," *SMT*, Aug. 14, 1926, p. 1; "Art Department of School Wins Recognition … September issue… *School Arts* magazine….the making of 'Stencil Process Posters' by **Stanley G. Breneiser**…. Two full page illustrations… [of H.S. posters]," *SMT*, Sept. 7, 1926, p. 1; "Students Attend Inter-Scholastic Press Parley… Barbara Lamb for the *Splash*…," *SMT*, Nov. 5, 1926, p. 5.

1927 – "Pictures Will Feature 1927 '*Review*'… Large senior pictures, with 12 on a page… Individual pictures of the faculty… a campaign for snapshots and Kodak days at the high school will bring forth the necessary number of snapshots. Athletics… Photographs of all school plays… Title pages will be linoleum prints of the school made by **Mr. Breneiser**'s classes…," *SMT*, Feb. 4, 1927, p. 5; "Annual Art Exhibition at HS Thursday. The sixth annual exhibition of students' art work… will be held on Thursday, May 19, from 9 a.m. to 4 p.m. … In the display will be found… drawings from objects, from various forms of nature, and from various parts of the building, of designs for scarfs, lamp shades, chests, batiks, and many other practical things. There are also decorative designs, expressionistic art examples, figure drawing, head construction and problems in color balance. A variety of problems in commercial art and poster work… The exhibit covers all the available wall space in the art room… only represents a small portion of the students' accomplishments … for much of the … work leaves the department in the form of posters of all kinds, signs, stage scenery and equipment, and lots of other problems in service to other school departments and organizations… hand made art magazine, 'The Splash.' … Two scholarships for full tuition in the **Santa Maria School of Art** will be awarded today to two high school students… One will also be granted to the student of art in the Junior College who has made the greatest progress during the year…," *SMT*, May 18, 1927, p. 1; "Many Local People Visit Art Exhibition…," *SMT*, May 20, 1927, p. 5; "Senior Class Will Present Play. The art and sewing departments of the local high school have been very busy during the last five weeks in designing and making costumes and settings for the three one-act plays to be presented by the senior class on Friday night…. [costumes] … 'Turtle Dove,' a Chinese play… The designing was done by **Barbara Higgins** of the Junior College Art class… The art class has been especially busy on … the settings… 'Turtle Dove' includes panels twelve feet high and four feet wide which will be painted with typical Chinese figures, fish, dragons, etc. These panels were designed by **Florence Cook** of the Junior College Art class," and more, *SMT*, May 25, 1927, p. 5; "Senior Class Plays… The sets for all three … were designed and executed by **Mr. Breneiser** of the Art Department, **Florence Cook** and certain of the Art students…," *SMT*, May 27, 1927, p. 1; "Six Teachers at High Resign, Four Replaced… **Ruth Blanchard**," *SMT*, June 8, 1927, p. 1; "Photos of Hi School. **George Stone** who is doing some camera work for the G. Allan Hancock interests, took photographs at the high school yesterday… primarily of the school but … several of the students to pose in the pictures. The pictures will be placed in an album that Hancock is getting out for Santa Maria valley…," *SMT*, Sept. 29, 1927, p. 6; "Art Students Draw Posters… [for] Harmony Series… work of **S. G.**

Breneiser's advanced art students... Norman Williams as Peachum in the 'Beggar's Opera' is cleverly illustrated... by Barbara Lamb... humorous... is Frieda Goedinghaus' poster of three jolly colonial men. Softer pastel shades were employed by **Ninalee Waiters** and Lela Strong... to advertise the Marmein Dancers. Three outstanding posters made by Junior College students are those of **Florence Cook** and **Ruth Bettersworth** for the Kniesel Quartette and Mrs. Dorothea Hoover's illustration of Polly Peachum, one of the leading characters in the 'Beggar's Opera' ...," *SMT*, Dec. 2, 1927, p. 5.

1928 – "Staff for 1928 School Annual Chosen... **Lucy DeGasparis**...," *SMT*, Jan. 27, 1928, p. 8; "No. 1... There will be eight new teachers this year... **Arthur L. Merrill**, woodshop instructor from Cogswell Polytechnic school, San Francisco... **Harold Foster**, practical electricity instructor, night school instructor for two years and lately with the Santa Barbara Telephone company...," *SMT*, Aug. 18, 1928, p. 5; "Posters Will Be Drawn Up For Contest... With the play 'Icebound' ... for the Players Club of Santa Maria.... 20 students working on the posters which will be displayed in downtown store windows," *SMT*, Oct. 9, 1928, p. 6; "Girl Artist Wins Poster Contest... **Lucy DeGasparis**, junior college art student, won the first prize in the Players Club poster contest... Miss DeGasparis, who had had several years art training in the schools of Santa Maria under ... Breneiser, used 'Icebound,' three-act drama... Miss Mary Freitas, also of the junior college art class took the second prize ... Barbara Lamb, Adella Knotts and **Margaret Sutter** ... third place," *SMT*, Oct. 25, 1928, p. 1; "Junior Colleges Increase Rapidly. There were 8 junior colleges in Southern California last year. There are 16 this year. The attendance has doubled in some... There is an increasing tendency to offer such courses as accounting, business law, shorthand, typing journalism, agriculture, commerce, public school music, home economics, drafting and machine shop...," *SYVN*, Nov. 23, 1928, p. 5.

1929 – "Dance Revue... **Blue Mask** Club... presents its annual offering at the school auditorium... Costumes and setting are the work of the sewing, art and woodshop departments of the high school... **Elizabeth** and **Stanley G. Breneiser**... making the posters and stage sets ... [theme] glorification of Nature ... [several different numbers] spirit of the future with grotesque and beautiful masks the work of the art department and brilliant costumes in a geometric setting...," *SMT*, April 6, 1929, p. 1; "School Gives Art Exhibit... Seventh Annual Art exhibition of students' work... class room of ... art department... It is divided into three groups: designs for stencils, batik, tiles, block prints and other craft design made by students under **Mrs. Elizabeth D. Breneiser**. The illustration class is also taught by her. The second division consists of the work of **Stanley G. Breneiser**'s students in general art and includes poster design, lettering, still life and nature drawing, figure work and general design principles. The third group is the work of junior college students who are studying art. These are working under both instructors, and their work includes Graphic Expression, Technique and Methods, Cast and Still Life drawing, Illustration and principles and method for prospective teachers of elementary art ... Craft work is not

included, since a recent exhibition was held in Santa Barbara of this work as well as in the local high school during **Better Homes Week**... the gold medal won by the '*Splash*' art magazine at the Columbia Press Association competition arrived today...," *SMT*, May 14, 1929, p. 5; High School and Junior College Students Given Acclaim... through an article published in the *Christian Science Monitor* for May 28 written by **Stanley G. Breneiser**... It describes the Dance Revue given here recently by the **Blue Mask** club... and is headed 'One Test of a School Project – the Correlation it Effects.' ... **Blue Mask** club, which is devoted to art, drama and music. This club not only seeks to increase interest and understanding of the arts in the student body, but each year tries to be of service to the school by presenting it with something along artistic lines. This year the **Blue Mask** club purchased a set of dolls in historic costumes of English periods from the fourteenth to the nineteenth centuries. These will be of use to students of costume design, history... and to the art department. In order to pay for the dolls, it was necessary to raise a large sum of money. The idea of giving a dance revue was conceived... One of the most interesting of all the scenes enacted was the modernistic processional. The setting was worked out by boys in the mechanical drawing classes. They were studying geometric drawing at that time... They made large models out of light wood and iron tag paper. These 'solids' were painted in brilliant colors, in fantastic triangles, diamonds and the like... In all over 125 girls took active part in the dancing; at least 50 or 60 worked on the making of the costumes... nearly every member of the art department was helpful in designing and making scenery masks and 50 posters executed by the silk screen stencil process; several boys in the wood working department constructed sets and members of the mechanical drawing classes made working drawings...," *SMT*, June 7, 1929, p. 7; "Stage Settings are Unusual in Musical Comedy... 'Old Vienna' staged by the music department ... next Friday... **Stanley G. Breneiser** and his art classes... An old European tavern... A back drop of village houses, streets and trees has been designed by an art student, Benjamin Hechanova. This work, in vivid coloring most pleasing to the eye, is exceedingly well done... The courtyard wall... made in the woodshop... painted by the art classes... All over town one sees the work of Mrs. **Elizabeth Breneiser**, high school art teacher, in arresting posters ... It was her clever hand that designed and made the linoleum block print from which these posters were created," *SMT*, Dec. 10, 1929, p. 1.

1930 – "High School Plans Vodvil... in the school auditorium on Saturday evening, March 1... The art department is busy with the posters... the sewing department with the costumes, the shops with the scenery...," *SMT*, Feb. 20, 1930, p. 5; "High School Notes... *Mascot*... **Virginia Alletson**, photography... **Anita Jones**, art editor, **Margaret Sutter**, assistant art editor...," *SMT*, Feb. 25, 1930, p. 7; "Soap Carvings Attract Many. High School Classes Exhibit Work. The carvings done in soap by students of **Elizabeth Breneiser**'s craft classes in the high school displayed in the windows of the Santa Maria Guarantee Building-Loan association... Especially... two rhinos, one by Mike Caudillo, the other by Henry Shimizu, two or three of the bas-reliefs, a

mermaid by <u>Nellie Nickson</u>, three seated figures by <u>Lucille Muscio</u> and a nude figure by <u>Ian [Sic. Ina] Van Noy</u>. Rabbits and elephants are present in great numbers... 'The basic difficulty of this work,' **Mrs. Breneiser** says, 'lies in the fact that the students must begin to think in an entirely new way for their only models are photographs or sketches and all the views – top, front, back, etc. – not depicted for them must be mentally visualized... The cream of the work will be sent east to the Nation Soap Sculpture committee for entrance in a competition ... The beautiful batik forming the background for this exhibit is the work of **Margaret Sutter**, junior college student...," *SMT*, March 3, 1930, p. 5; "Learning Useful Trades. A busy place is the <u>woodworking department</u> at the high school where students under **A. L. Merrill** are learning to fashion all kinds of furniture and wooden utensils. The students built the scenery for the third act of the recent play... Principal... took this writer through the department... There were several beautiful walnut chests, cedar-lined and hand carved... These youthful woodworkers have saved the school district many dollars by the construction of necessary appliances and equipment ... such as teachers' desks, library shelves, bulletin boards... T-squares for mechanical drawing room, <u>four drawing tables for the art department</u> ... <u>This department is crowded for space and its importance would seem to warrant the construction of additional room</u>," *SMT*, April 30, 1930, p. 2; "Learn to Work <u>Metals</u>... instructor **W. D. Harkness**..." and besides sheet metal and auto mechanics and machine shop "... During the fourth semester instructor Harkness teaches... <u>ornamental iron work</u>...," *SMT*, May 3, 1930, p. 8; "<u>Nutcracker</u> to be Presented by High School. Under the general direction of **Stanley G. Breneiser**... New scenery for all three acts have been keeping art classes considerably busy," *SMT*, May 15, 1930, p. 5; "<u>Eighth Annual Art Exhibit</u> of High School Departments Opens Today... **Little Theatre** at 8 o'clock... The subjects around which the exhibition centers are batiks, stencil designs, figure and nature drawing, cartooning, mural decorations, general designs, illustration, commercial art work, historic decoration and pen designs in colored inks. The art work, which was sent to Pittsburgh, Pa., for exhibition and for which **Ninalee Waiters** and <u>Merville Johnson</u> won prizes, has now arrived and will be shown....," *SMT*, May 20, 1930, p. 5.

1931 – "High School Offers Display of Art Work by New York Students... the New York School of Fine and Applied Art... The **College Art club**, cooperating with the **Blue Mask** club... secured the exhibit through its association with the American Federation of Arts in Washington. There are 42 large mounts... illustrating several branches of artistic study: graphic advertising and illustration, costume design and illustration, interior decoration and design ... open to the public...," *SMT*, Jan. 13, 1931, p. 5; "Enrollment High... **Gaylord Jones**, <u>mechanical drawing</u> teacher... have additional periods... **Stanley Breneiser** teaches the <u>new arts</u> course...," *SMT*, Feb. 6, 1931, p. 1; "County-Wide <u>Display of Students' Art Work</u>... Each spring for several years the Art department of the local high school has held an exhibit of work done during the current school year. Various places of exhibition and methods of presentation have been tried. Some years windows of Santa

Maria stores were loaned to display... again it was held in the Art room of the school, while last year the display was shown in the **Little theatre**. This year ... the art exhibit of the high school will be a unit in a general exhibit of work done in schools throughout Santa Barbara county. ... at the new **Faulkner** gallery, next to the library in Santa Barbara ... Santa Maria pupils will display problems in commercial art, illustration, design, sketching from life, casts and nature, block printing, color work in different mediums, batik and stenciling. Cases will contain examples of work in soap carving, leather and silver. Work by students of the junior college will have its own space...," *SMT*, May 5, 1931, p. 3; "Annual High School ***Review***... advisership of Miss **Ida Kriegel** of the faculty, the 116-page ***Review***... Singularly interesting and well done are insert pages for which cuts were made and designed by <u>Erma Whitener</u> and <u>Nellie Nickson</u> with each one hand painted ... They constitute a departure from the usual high school annual. Each portrays a different department of the book in purple, pink, orange and green colors...," *SMT*, June 10, 1931, p. 1; "Junior College Annual... '*The Mascot Pictorial*' ... The book contains more than 40 pages of photographs, write-ups, and snapshots concerning junior college activities for the last two semesters. ... Notable... are the insert pages, photographs of buildings on the campus from various angles and printed in green... **Lucy de Gasparis**, art editor, **Muriel Metzler**, assistant art editor...," *SMT*, June 11, 1931, p. 1; "<u>Stage Setting</u> for Iolanthe is Elaborate... to be presented by the music department of the local high school December 18... Both scenes were designed by **Lucy de Gasparis** and all of the painting was done either by her or under her able direction by students from the art department... first act depicts a rustic Arcadian vale with a stream... The second act represents the front of Westminster hall in England...," *SMT*, Dec. 12, 1931, p. 6.

1932 – "<u>Art Course</u> at School Here is Given Mention... [in] *Christian Science Monitor*. The article outlines the course covering the seven fine arts – architecture, sculpture, painting, literature, music, drama and dancing and points out that its purpose is not only to instruct but to entertain. It covers one year of study in two parts of 20 weeks each," and how one discipline relates to the others and how the students learned to appreciate new forms of each kind of art, *SMT*, Dec. 13, 1932, p. 5.

1933 – "<u>Photography</u>... Photography work for this year's issue of the ***Review***, a high school annual, was begun this week... **Pauline Quick**, art editor, <u>Virginia Hanson</u>, assistant art editor, <u>Erle Fulghum</u>, cartoonist...," *SMT*, Feb. 18, 1933, p. 3; "<u>Breeze</u>... in word and photograph ... this week consists of eight pages of facts about Santa Barbara county schools and the elementary grades... actual writing was done by the *Breeze* staff...," *SMT*, March 7, 1933, p. 1; "Work on making <u>masks</u> to be used in the presentation of the play 'Seven Gods of the Mountain' by Lord Dunsany, which will be staged jointly by members of the **College Art club** and the **Blue Mask club**... next March, has already been begun, and several members of the cast have theirs already completed. ... Art students and members of the **Blue Mask club** will construct the masks... the scenery will be designed and made by the art classes of the high school ... at last meeting... **Mr. Breneiser** also gave a

short talk on the appreciation of modern art, declaring that art should not be an imitation but an interpretation of what the artist sees," *SMT*, Oct. 31, 1933, p. 2; "Operetta Near Complete... Scenery for ... 'South in Sonora' which will be presented by the combined Glee Clubs of Santa Maria High school Dec. 7 is being designed and planned by Henrietta Ontiveros, a senior student. Most of the scenery will exemplify a Spanish garden... There will be one scene which will represent one room of the interior of a small shack ... Miss Onitveros is being assisted by **Theda Ferini** and advanced high school art students... under the direction of **Stanley Breneiser** ...," *SMT*, Dec. 2, 1933, p. 2.

1934 – "Dunsany Play to be Given... 'The Gods of the Mountains' ... by the **College Art** and **Blue Mask** clubs under the direction of **Stanley G. Breneiser**. Mr. Breneiser is president of the art club and faculty advisor of the **Blue Mask** organization. He has directed many plays, both in Santa Maria and in the east, the last one 'The Bad Man' for the Players club here several years ago... The 'Gods of the Mountain' will be unusual... Every member of the cast is to be masked, each mask being a character study and a work of art. They have been made by students in the high school art department. Each costume ... likewise has been designed and created for the particular symbolic character it represents. The costumes have been made by and under the supervision of **Mrs. Ray Rodgers** of the College Art club. Scenery, which will be modern ... relies upon simplicity and studied lighting effects to produce fantastic results needed as atmosphere ...," *SMT*, Feb. 5, 1934, p. 2; "Parents in Class Tonight ... Outstanding exhibit in the shops is a Swedish loom, one of two or three in this country, just finished by **Yoshisuki Oishi** and Masao Minamide under direction of **Arthur L. Merrill** in the high school woodshop. It will be operated tonight by **Anna Adele Black**...," *SMT*, April 24, 1934, p. 1; "Parents See How Local High School Conducts Classes... **Public Schools Week**... An inspection tour of dozens of exhibits made by junior college and high school students preceded the speaking program. All departments of the school contributed... woodwork, art, ... mechanical drawing, handcraft...," *SMT*, April 25, 1934, p. 1; "Local Art Students Win National Praise... *The Splash*... high school art magazine, received a special award at the recent scholastic press competition sponsored by the Columbia Press association in New York. The art work in the magazine was described as 'excellent' and the report further stated: 'The creative painting of your classes is easily the best we have seen from any school this year. The color and form of your entry is far above the normal for high school students, and your entire class is to be congratulated.' Special mention was given to **Guido Signorelli** for his work," *SMT*, April 25, 1934, p. 1; "Public to Attend Program Tonite at High School... Miss **Marian Svensrud** was to address the group there on work done by her special artcraft department, and many examples will be shown and explained," *SMT*, April 26, 1934, p. 8; "New Courses Added to H. S. Curriculum... Handcraft, a one-semester course for girls ... also will be introduced next fall," *SMT*, June 11, 1934, p. 1; "New Courses Will Be Available... **John Stout**... will fill the place left vacant by the late **H. M. Snell** as mechanical drawing instructor... **Miss Helen Sutphen**, graduate of Mills college, who has

attended the Wolf School of Costume and Chouinard School of Art in Los Angeles and was formerly a teacher at Burbank high school, will teach in the home economics department, taking the place of **Miss Ruth Blanchard**.... Other new courses are ... A new shop course: 'Industrial Arts,' which includes five weeks each in metal shop, electrics, wood shop and mechanical drawing. ... No teacher has as yet been chosen for a new course in handicraft...," *SMT*, Aug. 15, 1934, p. 1; "High School... New Instructor... caused by the resignation of Miss Mildred Daniels in the home economics department. ... Miss **Olive Jane McClure**, graduate of the University of Illinois with experience in Denver public schools and recently at Girls Collegiate school in Glendora, Cal., will succeed Miss Daniels...," *SMT*, Aug. 23, 1934, p. 1; "Magazine Staff Selected. **Nicholas Firfires** will act as art editor of '*The Splash*,' ... He will be assisted by **Joffre C. Bragg**...," *SMT*, Sept. 8, 1934, p. 2; "4 New Teachers... Miss **Helen Sutphen**, sewing teacher appointed to fill the vacancy left by **Miss Ruth Blanchard**, has received her master's degree at the University of California at Los Angeles. Miss Sutphen has formerly taught in Glendale, Burbank, San Mateo and Fremont high schools... **John Stout**, who replaces the late **H. M. Snell** as mechanical drawing teacher, has attended the University of Oregon, University of California at Berkeley and the Massachusetts Institute of Technology," *SMT*, Sept. 11, 1934, p. 5; "Art Exhibits in High School ... **G. Thompson Pritchard**, Australian who displayed his work here last year, has hung 25 oils, some of them works he showed before, as well as new paintings with California subjects. Interesting is the exhibit of **Fritz Poock**... Poock has 80 water colors hung in the second-floor hall of the building and in the art classroom. Old Spanish missions in California, the Arroyo Seco and other canyons in the southland, mountain landscapes, Death Valley sketches and miscellaneous landscapes and city scenes in Los Angeles make up his work done in Southern California. Poock also is showing reproductions of some pen-and-ink work done in Germany, including one of Halberstadt cathedral in the Harz mountains. Poock believes America is beginning to appreciate the values in water colors for landscapes. First of all a mechanical engineer, Poock gave up engineering and turned to art when he was approaching middle age. 'An artist has no age limit, but there comes a time in the life of an engineer when he becomes the anvil instead of the hammer,' he said. The transition from draughtsmanship to art is shown in a group of industrial water colors included in the collection. **Poock** lived eight years in Mexico as an engineer," *SMT*, Oct. 5, 1934, p. 5; "Students Enter BPW Contest... annual national poster contest... *Business Women's Week*...," *SMT*, Oct. 10, 1934, p. 2; "Designing Unusual Play Scenery. Under the direction of **Eleanor Kelsey**, members in the junior college section of the Art department ... unusual sets for ... 'The Importance of Being Earnest'...," *SMT*, Oct. 29, 1934, p. 2; "High School Shop Courses to be Switched by the Students. ... end of the second five weeks of school... Students now taking Woodshop will change to electric... Electrics students will go to mechanical drawing where they will learn... the use of drawing instruments under the direction of **John Stout**. They also learn how to draw simple objects such as tools

and small machine parts besides learning to read blueprints… Metal shop is the next step of mechanical drawing where **Dale Harkness** instructs… making of such articles as hasps, paring knives, candle-sticks and ash-stands. The metal workers will change to woodshop… under the direction of **Arthur Merrill**…," *SMT*, Nov. 6, 1934, p. 2; "Students Give Puppet Show Today. High school drama students under **Miss Ethel Pope** … 'The Three Bears'… Eight more plays are in preparation… Five students are making their own puppets under the direction of **Mrs. Elizabeth Breneiser**…," *SMT*, Nov. 16, 1934, p. 3.

1935 – "**Joffre Bragg** is *Splash* Editor… appointed by **Elizabeth Breneiser**, adviser… art editor, Marie Goodchild, 2A, assistant art editor **Nicholas Firfires**, 2A. Other art students working are **Francis Gregory**, James Lackey, **Arthur Pimentel**, and **Joaquin Mendez**. Working on the art year-book are two of Mrs. Breneiser's advanced students, **Carol Rushforth** and Donna Drumm. Carol is making the outer cover and Donna is making a pongee batak [Sic. batik] for cover lining," *SMT*, Feb. 1, 1935, p. 3; "Aileen Footman is Editor of H. S. Annual… **Carol Rushforth** is the new art editor and **Nicholas Firfires** will be the cartoonist…," *SMT*, Feb. 9, 1935, p. 2; "Mexican Mart… Review carnival in Santa Maria high school tomorrow night… What is believed to be the first puppet show ever presented locally will be given by high school drama students of **Miss Ethel Pope** who made the puppets, the theatre and curtain and wrote the play…," *SMT*, Feb. 14, 1935, p. 2; "**Minerva Club** … Two dramatic productions will entertain members of the Minerva … **Miss Ethel Pope**, instructor in the local high school and junior college, bring several of her students to perform. The first will be a one-act play … The second will be a puppet show, 'The Worm Turns,' also directed by Miss Pope. Students… made the puppets, the stage and wrote the play," *SMT*, Feb. 27, 1935, p. 3; "Breneiser Art Course Given Recognition. The high school introduction to the arts class under **Stanley G. Breneiser** has been described in a circular sent out by the State Department of Education to all faculties of secondary schools in California. In this pamphlet are brief descriptions of projects and classes recommended for the improvement of the high school curriculum. Breneiser says of his class: 'The idea of the course specifically is to give students an elementary understanding and appreciation of the arts, especially painting, music, sculpture, architecture, the dance, literature, and drama.' Informal lectures and the use of photographs are used… Mr. Breneiser feels that the values gained are many and valuable. Much appreciation is developed in the higher things of life, prejudices against classical music is lifted, and a new and different attitude toward literature is established," *SMT*, March 2, 1935, p. 2; "Pupils Design Settings of J. C. Play… Richard B. Sheridan's 'The Rivals'… **Eleanor Kelsey**, Henrietta Ontiveros, **Theda Ferini** and **Rowena Lowell**… under the direction of **Stanley G. Breneiser**. Miss Kelsey is designing the backdrop of the 'North Parade' using an 18th century print of a typical street scene… as a model. Miss Ontiveros will sketch the men's lounge, while Miss Ferini has charge of … Mrs. Malaprop's boudoir. The king's mead fields where the duel between Bob Acres and Captain Absolute takes place, will be done by Miss Covell …,"

SMT, March 22, 1935, p. 3; "Students Asked to Exhibit in Fair… **California Pacific International exposition** in San Diego … Miss **Olive McClure**'s handcraft class will be represented by pictures taken of students at work. … Two issues of the *Breeze* … will be found in the Palace of Education," *SMT*, May 15, 1935, p. 3; "Pupils Win Prizes – In a recent contest conducted among freshmen art students in the high school, Teruto Ito won a prize for the best penciled drawing, Helen Miller, best painting, and **Mina Rushforth**, best inked drawing," *SMT*, March 29, 1935, p. 3, col. 2; "Collegians Prepare 1935 Annual… The *Mascot*… **Alberta Ow**, art editor…," *SMT*, May 8, 1935, p. 3; "Pupils Collect Everything from Feathers to Jewelry by Eva Freitas. Feathers, stamps, coins, bottles, and jewelry collecting are only a few of the many hobbies picked by Santa Maria high school students. The enthusiasts who collect feathers are **Mina Rushforth** and Josephine Verdin. Mina has quite a collection which consists of blackbird, cedar wax wing, bluebird, love bird, canary, parrot, linnet and humming bird feathers. She says she gets them on hikes. Those who collect bottles… Quite a few students collect coins… Marina Starfas and Constance Purkiss collect china figures… Caroline Serpa and **Elva Allen** are scrapbook enthusiasts… A few students have started jewelry collecting … Hugh Radke has the largest collection of Indian relics, among them being 25 arrows which were mostly found here in Santa Maria valley, such as near Betteravia lake, Casmalia, Cuyama and some at Point Sal. He also boasts the only pipe bowl in Santa Maria. It is made of a stone free from cracking. He also has spear-heads, bowls used for grinding corn, chip flint used for axes, beads, sinkers used for fishing and basket mortars," *SMT*, June 3, 1935, p. 5; "School Board … Three vacancies in the teaching staff… **Miss Olive Jane McClure**… signed contracts with Beverly Hills high school… Miss McClure has been teaching home making, boys' cooking and handcraft…," *SMT*, July 18, 1935, p. 3; "Rush is Asked… New Instructor Signed… **Mrs. Elizabeth Taff Dennison** of Palo Alto as an instructor in home-making, sewing and handicraft. Mrs. Dennison is a graduate of Stanford University and of Santa Barbara State college…," *SMT*, Aug. 15, 1935, p. 1; "Students Make Batiks – in the high school art classes of **Mrs. Elizabeth Breneiser** by Patty Boyd, Gloria Hart and **Bernice White**," *SMT*, Oct. 12, 1935, p. 2; "Teaches Handcraft. **Mrs. Elizabeth Dinneson** [Sic. Dennison], handcraft teacher, is teaching girls in her class how to weave purses and other articles on hand-looms, also how to knit sweaters and do other types of handcraft," *SMT*, Oct. 12, 1935, p. 2; "High School Students … Twenty-three organizations… have been formed by students of Santa Maria high school as part of their extra-curricular activities… **Needlecraft club**… with 60 members… supplies for the **Metal Craft club** under **W. D. Harkness** have also been ordered. Other clubs that will operate are **Blue Mask** club, **Stanley Breneiser**… **Commercial Art Service, Mrs. Elizabeth Breneiser**, Woodcraft, **Arthur M. Merrill**…," *SMT*, Oct. 22, 1935, p. 3; "H. S. Clubs Pick Leaders for Semester… **Blue Mask club**… **Metal Craft club**… Kodak club… Teddy Ito, vice president… **Needle Craft club**… Woodcraft…," *SMT*, Oct. 23, 1935, p. 3; "Western Artists Exhibit Works in

High School. Celebration of **National Art Week**," *SMT*, Nov. 6, 1935, p. 3.

1936 – "Students Work on Art Yearbook" – school yearbook has theme of "creative expression," *SMT*, Feb. 1, 1936, p. 2; "Pupils to Rehearse Two Spring Plays," one, 'Tomboy,' to be directed by [**Stanley**] **Breneiser**, *SMT*, Feb. 22, 1936, p. 2; "**Breneiser** Paints for J. C. Play" a life size portrait of Lavinnie Johnson as Abby, *SMT*, March 28, 1936, p. 2; "Schools to be Hosts Tonight to the Public… Homecoming… Exhibits Laid Out… **Public Schools Week**… Handicraft Work. The handicraft section will show two looms for weaving, hand-made baskets, trays and mats, hooked rugs, quilts in the process of being made, refinished furniture and examples of upholstering… One room will be turned over to the woodshop display in which there will be examples of Colonial, Dutch and Spanish furniture, desks, lamps, benches, tables, chests and chairs made by students… exhibits of classwork in commercial classes, art work and metal craft work will be shown…. Mechanical drawing… In addition to displays in the library and study hall, there will be exhibits in the Art and Homemaking departments on the second floor … The shops will also be open," *SMT*, April 28, 1936, p. 2; "School Musical Slated… 'The Golden Trail' … operetta… Scenery, designed by **Stanley Breneiser**… will be realistic. The idea for the scene, which consists of a street in a mining town, complete with a hotel and trees, was taken from old photographs made… in Weaverville… **Arthur Merrill**, woodshop adviser, has charge of the boys who are constructing the set. The stage craft club under **Miss Ethel Pope**, is making a trick rose bush…," *SMT*, May 12, 1936, p. 3; **CONTINUATION SCHOOL** – "Little Red School Was Never Like This. Part-time students in Santa Maria high school not only have a home of their own, but they are constantly making it more charming… The girls are housed and taught in the old bungalow at the south end of south Pine street, on school property, where Miss **Marian Svensrud** is their instructor and guide. Some of the boys also receive training from her, too… Most of the boys go in for shop work, however, and work under the direction of Geo. H. Chester… in another building. Miss Svensrud and her girls took over the old bungalow when it needed many things, and the school board allowed them little for supplying it. But they have, by diligent effort… and with the help of Chester and the boys, converted it into a very attractive homey place… **Miss Svensrud** and Chester accomplish the double purpose of fitting out the building and teaching the children useful work for future service in the home, in making the furnishings for the place. For example, the rugs made of old stockings …screen [of] spare lumber… paneled with heavy cardboard… painted in bright colors… curtains [decorated with] ordinary crayons. The crayon seems to be a mightily factor in the transformation of the ordinary into the attractive… girls have done some imitation leather for binding scrapbooks… the edging for the leaves has been rendered artistic simply by burning the sheets irregularly along the edges… Can they cook? Oh Boy… And they find time for gardening as well as for study, housework, sewing, music, painting and whatnot…," *SMT*, May 15, 1936, pp. 1, 2; "Seniors Present School with Camera," *SMT*, June 11, 1936, p. 2; "High School's Staff… **Elizabeth** and **Stanley**

Breneiser, art… **W. D. Harkness**, metal shop… **Arthur L. Merrill**, woodshop… **John W. Stout**, mechanical drawing…," *SMT*, Aug. 20, 1936, p. 2; "Bus Shed Bids… Possibility of asking for an additional **PWA** [Sic. WPA?] grant amounting to approximately $700 for construction of the junior college building was discussed. **E. Keith Lockard**, architect… Principal Hill presented requests from **WPA** organizers that artists be allowed to make a painting for the new junior college building and to carve an ornamentation for an arched doorway in one of the rooms. Cost to the district would be for materials only. It was decided to enter an agreement for a painting for the history department. The other request was denied. Cost of the painting would be about $15 for materials…," *SMT*, Nov. 19, 1936, pp. 1, 6.

1937 – "Miss Escobar will Edit *Review*… Florence Doyle, 4A, art editor, Ted Ito, 4B, assistant art editor…," *SMT*, Feb. 6, 1937, p. 2; "Etchings, Woodcuts, Drawings to be Shown Here During Week" at Santa Maria Union H. S. arranged by **S. Breneiser**. "For the first time in nearly a century Americans of average means are offered an opportunity to view the most significant art being created and to own it, for copies will be on sale. For years, by destroying the original image on a copper plate, lithographic stone, or wood block, an arbitrary scarcity has been created of artworks of this type. This has kept up the prices. The **American Artists Group** considers this practice, which originated in Europe during the Nineteenth century, essentially un-American and undemocratic… The artists whose works are to be shown here include **Rockwell Kent**, John Marin, Allen Lewis, J. J. Lankes, Adolf Dehn, Mabel Dwight, Ernest Fiene, Wanda Gag, Howard Cook, Emil Ganso, William Gropper, Yasuo Kuiyoshi, George Biddle, Reginald Marsh, Kenneth Hayes Miller, Miguel Covarrubias, Conrad Buff, **Paul Landacre**, Arnold Ronneback, Waldo Pierce and 29 others of the foremost etchers, woodcutters, and lithographers living in America today," *SMT*, Feb. 13, 1937, p. 2; "Miss Marriott is Editor… junior college annual, the '*Mascot*.' … **Carol Rushforth** and **Edna Davidson** art departments…," *SMT*, Feb. 13, 1937, p. 2; "School Receives Art Prints. … 'And Now Where?' by **Rockwell Kent**, and 'Forest Girl,' by **Paul Landacre** have been purchased by the **Blue Mask** club to add to the collection of the high school. The club has given numerous similar gifts for use in the art department including 300 colored reproductions of famous paintings …," *SMT*, April 3, 1937, p. 7; "Art Exhibit to be Shown Next Week" comprised of reproductions of works by world famous artists, along with block prints from 30 HS across the U. S., and a selection from Santa Maria H. S., arranged by **S. Breneiser**, *SMT*, April 7, 1937, p. 3; "PTA Will See School Films… type of work done with visual education in the Santa Maria high school… films were taken by **Merton D. Likes** of the faculty… [afterwards] an exhibition of high school students' art work and reproductions of famous paintings to be placed on display in the junior college during the week. **Stanley G. Breneiser** will lecture on the exhibit," *SMT*, April 9, 1937, p. 3; "Teachers in High School Get Contracts… **John W. Stout**, mechanical drawing… **Elizabeth Dennison**, foods and handicraft…," *SMT*, April 15, 1937, p. 1; during Parents' night, "Classes will Exhibit to Parents … The

sewing classes under the direction of Mrs. Ruth Crakes and Mrs. Rita Keller, will have girls demonstrating in room 105… There will also be a needle craft exhibit… Shop students will have exhibits arranged in the shops and will be working on their various projects… Handwork in the form of quilts, crochet rugs, doilies, luncheon sets, purses, etc. and a demonstration of weaving on three looms will be shown by the handicrafts class taught by Mrs. **Elizabeth Dennison** in room 102… **John W. Stout** will keep the mechanical drawing room open and Mr. and Mrs. **Stanley Breneiser** will exhibit block prints and other student art work in the upper hall. Students will be working in the design and crafts department and in the art room," *SMT,* April 28, 1937, p. 3; "Art Student Wins National Prize," and article explains, "**Yukio Tashiro**, art student of Stanley G. Breneiser, in the high school, yesterday received word that he had won a cash award in the **National Scholastic Art** contest sponsored by the Scholastic High School magazine of Pittsburgh, Pa. The Santa Maria boy's entry was a wood carving of a lion. Certificates of merit were won by **Joffre Bragg**, for a block print of a mission scene, and by **Masuo Ueki** for a cretonne design. The local students' entries were among 746 accepted for exhibition out of 12,000 entries from schools throughout the country. This marks the fourth consecutive year in which Santa Maria has placed in the national contest. Among the annual prizes are 20 scholarships and $10,000 in prizes," *SMT,* April 30, 1937, p. 3; "Antiques are Loaned for J. C. Play… 'Night Over Taos' … 1847 setting… A large papier-mâché crucifix … made on a clay foundation by a high school art student under direction of **Stanley G. Breneiser**. Other members of one art class worked together in painting a large map of the fictionary [Sic.] region of Taos. … To heighten the Mexican atmosphere of the room, a complete set of Monterey furniture constructed by George Chester's vocational class will be used. Cut tin candlesticks, loaned by the Breneisers, will adorn the mantlepiece. Early Mexican glassware, brass and copper implements lent by the **Santa Maria Inn**, pottery and wicker baskets borrowed from **Miss Ida Kriegel** and **Miss Elizabeth Smith**… Armaments for the soldiers will be furnished by Fred L. May, high school board member, who has a large collection of old guns… Since 'Night Over Taos' takes place in New Mexico during the period corresponding to early California days, the May collection is especially valuable as most of the guns in it were used in California during the past 200 years," *SMT,* May 4, 1937, p. 3; "Student Wins Prize for Design. A picture of **Dorothy Radford**, junior student of the Santa Maria high school, will appear in the fashion section of the September issue of the *Woman's Home Companion*, it was learned this week, when a letter was received announcing Miss Radford as a winner of a $5 prize for a nursery design submitted in the contest conducted by the Pacific Mills, a large textile company. Along with Miss Radford's picture will run a picture of her winning design which will be used in fabrics for children's garments. She is a student in … **Elizabeth Breneiser's** design class. This is the third national award received this year by the high school and junior college art department. The first recognition was honorable mention given to **Yukio Tashiri, Joffre Bragg** and **Masuo Ueki** in a **National Scholastic Awards** contest, and the other the

certificates of merit award to **Elva Allen?, Nick Firfires,** and **Joffre Bragg** from the **Latham Foundation** for the Promotion of Humane Education. In 1935 **Yoshisuke Oishi** won a $5 prize for achievement in this contest," *SMT,* May 22, 1937, p. 2; "Three Hundred see 'Kind Lady' … junior college play… high school auditorium… Pictures for the play were done locally. They are 'Indian Dance,' by **Louie Ewing**, former J. C. student; 'Chopin Prelude,' a decorative painting by **Stanley Breneiser**, and 'Portrait,' by **Marie Breneiser Ewing**. Students in the art department also did several paintings in pastel, water color, and poster paints for the play. The Troubetzkoi figure was made by **Mrs. Stanley Breneiser**…," *SMT,* Nov. 19, 1937, p. 3; "H. S. Art Department Plans Exhibits" beginning with 200 plates of historic costumes (coll. **Breneisers**), second exh. is new set of colored reproductions of famous modern paintings, then a show of 50 original watercolors, a traveling exhibit of foremost American artists from NYC, and 20 original photographs from Paris exhibitions sent out by the Art Center School of Los Angeles, *SMT,* Dec. 2, 1937, p. 3; "H. S. Freshmen Publish New Magazine. '*The Zephyr*' little sister to the high school newspaper, '*The Breeze*'… temporary [staff] … Juan Ramoz, art editor… Donald Allen, cover design… a more permanent staff was chosen… art, Hideo Nishimura… A core class… published a magazine, '*The Roundabout*' in October … Sueko Watanabe, art editor…," *SMT,* Dec. 7, 1937, p. 3; "Blue Mask Club Presents Play Tomorrow… 'Don't Ever Grow Up'… The **Blue Mask club** is one of the oldest and most active in the high school. It was first organized in January 1922, to promote an interest in drama, music and art. **Stanley G. Breneiser**, head of the high school art department, has since been the club's adviser and director of plays. In recent years, drama has been the club's main interest… For student assemblies it has presented 'Tomboy,' 'The White Phantom,' 'The Red Lamp' and, last semester, 'Aunt Cindy Cleans Up'," *SMT,* Dec. 9, 1937, p. 3.

1938 – "Water Colors Exhibited in Santa Maria" – traveling exhibit of American paintings circulated by Grumbacher and hung in the upper hall at Santa Maria high school. "Twenty-five water color paintings, a section of traveling exhibits sponsored by M. Grumbacher of New York City, have arrived here from Oregon State college where they were last exhibited… Included… are three paintings by Santa Maria artists. One, 'Flower Market in Rome,' was painted by **Stanley G. Breneiser**… 'Spring, California Coast' was painted near Point Sal by **John Day Breneiser**, and the third, an interesting composition called 'Succulents' was made by **Margaret Chester Breneiser**. It was painted in the garden of the **Santa Maria Inn**. The exhibit opens today and will remain until February 18," *SMT,* Feb. 7, 1938, p. 3; "Aeronautics Course… projected addition of an industrial aeronautics course… Courses intended… are aircraft engine maintenance and manufacture, aircraft design, and drafting. Classroom facilities and instructors will be furnished by the flying school, while students' equipment and materials … will be furnished by the junior college…," *LR,* Feb. 11, 1938, p. 7; "Many Assist in H. S. Vodvil… tomorrow in the school auditorium … Students and faculty members not taking part in the actual performance are serving as a stage crew,

sewing costumes, and painting scenery. For once the Art department is not overloaded with work… they have little to do… outside of a 'Big Apple,' a stage drop and a few signs…," *SMT*, Feb. 24, 1938, p. 3; "Clubs in High School… three groups, Tennis, Aero, and **Metal Craft**, have definitely decided to discontinue their operations… The **Blue Mask** and its auxiliary have merged and will call meetings only at such times as it seems necessary. The **Junior Blue Mask** has agreed to meet during noon period… Other clubs that voted to continue are … **Knitting and Needlecraft**… **Leather Craft**… ," *SMT*, March 14, 1938, p. 3; "Painting Exhibited. A collection of wild flower paintings by **Mrs. Mabel Miller Minnich [Sic. Mable Minnich Miller]**, is being exhibited in the upper hall of the main building of the local high school," *SMT*, March 25, 1938, p. 3; "Mystery Motif Featured in J. C. Play… 'The Eyes of Tlaloc' … presented by junior college on April 7 in the high school auditorium… the production department of the play, headed by **Stanley G. Breneiser**… and Otto Schewe, Jaycee student, has created Aztec paintings, objects and designs with help from **Mrs. Elizabeth Breneiser**… The room in which the play takes place will be decorated with a border design of grotesque pictures done in the Aztec style. As wall-hangings, a replica of the Aztec calendar and the painting of the god, Tlaloc, will be used… A statue of Tlaloc, with a protruding tongue, ugly teeth, horns, and a huge bonnet, will also be used… Its legs are crossed and its hands raised as if in supplication," *SMT*, April 1, 1938, p. 3; "Cook and Orcutt Schools… **Public School week**… The high school and junior college open house… The art department on the upper floor will exhibit works of illustration, water color, fashion design, commercial art, tooled leather, tooled metals, tiles, wood-carving, and batik. Parents may see students at work on various projects as they appear during the day… In the home economics department … weaving, upholstering and other hand work will be shown… In the Library… original drawings… Shop classes… A Welsh dresser, cabinets, desks, vanity cases, tables, stools, book cases and other woodwork will be seen in the woodshop. Ornamental metal work in copper, brass, pewter and iron … will be displayed in the machine and metal shops…," *SMT*, April 27, 1938, p. 3; "Two Teachers… High School Takes on Aeronautics Course… marking an extension of the vocational training offerings … Sign a contract with the Santa Maria School of Flying… **Capt. Roy Jones** would handle aeronautical drawing…," *SMT*, May 12, 1938, p. 12; "Shop Training is Increased. … Expansion of the trade-training and vocational education offerings of the Santa Maria high school and junior college… Principal Hill pointed out that three years ago the only shop work taught was of the manual arts type, none of it directed toward trade training… a little more than half of the teaching time… or four clock hours per day… will be devoted to trade-training work under the Smith-Hughes bill… new course to be offered in aeronautics… will require purchase of new shop equipment…," and list of many new non-art courses, *SMT*, June 3, 1938, p. 8; "Flying School is Near Ready… classrooms at Airport Prepared… course in aeronautics… of the Santa Maria junior college … the school will occupy three rooms, two shops and a mechanical drawing room. Benches, drafting tables and pupil lockers are now under

construction… Manning the school… three instructors… **Capt. Roy L. Jones** will instruct in meteorology, mechanical drawing… W. L. Bach, formerly associated with the Northrup division of Douglass Aircraft Corp., will teach airplane construction, drafting and lofting," *SMT*, Aug. 20, 1938, p. 3; "High School's Faculty… Instructors of technical courses will include… **W. D. Harkness**, metals shop, **Arthur Merrill** wood shop, **John Stout**, mechanical drawing… **Capt. Roy L. Jones**, aerodraughting, etc.,… **Elizabeth Breneiser** will teach arts, crafts and design while **Stanley Breneiser** will be instructor in art… Head Librarian will be **Ida Kriegel**… ," *SMT*, Sept. 3, 1938, p. 3; HS art magazine "*Splash* Out, First Since 1935" – organized by Breneiser in 1923, and there have been 11 annual issues to date, and repros. of student art plus a stencil spray picture by **Harold C. Stadtmiller** of Exeter who taught in the Santa Maria Summer Art School, *SMT,* Nov. 29, 1938, p. 3.

1939 – "Poster Judging… tuberculin testing project… conducted by **Stanley Breneiser**'s art class…," *SMT*, Feb. 11, 1939, p. 2; "Shakespeare Play Scenes Built by JC Students… 'Twelfth Night'… six separate sets. … designed by **Archie Case**… Paul Twyford is in charge of painting the stage sets and is assisted by **Archie Case**…," *SMT*, March 10, 1939, p. 3; *Splash*, "S.M. Art Magazine First in National Competition," i.e., 15th annual Columbia Scholastic Press Assn., 20 copies total handmade, *SMT,* April 21, 1939, p. 3; "High School to Show its Work… **Public School** night… mechanical drawing will also be exhibited… General art problems including decorative landscaping, costume and fashion design, watercolor, block prints, the art magazine *Splash*, and commercial art will be shown in one section of the Art department and batik, leather tooling, metal etching and other design and crafts in another…," *SMT*, April 26, 1939, pp. 1, 5; "Mystery Play is Given by Students," directed by **S. Breneiser**, *SMT,* April 26, 1939, p. 2; "New Instructors in High School… Instructional Staff… **Elizabeth Breneiser**, art crafts, **Stanley Breneiser**, art… **Elizabeth Dennison**, handicraft… **W. D. Harkness** metal shop… **John W. Stout**, mechanical drawing, general shop…," *SMT*, Aug. 30, 1939, p. 2; "Varied Program Due Tonight… The 'American Frontier,' depicted in a series of five tableaux will be presented by members of the high school Theatre Arts class… **Mrs. Elizabeth Breneiser**… are in charge… Students who are working on the committees are: Betty Brees and Betty Ruth Friday, costumes, **Leslie Stonehart, Frances Sutherland** and **Warren Doane**, stage sketches…," *SMT*, Oct. 12, 1939, p. 3; "Staff Named for Annual '*Review*' … photography editor, Joe Olivera, assistant photography editor, Ken Tanaka, art editor, **Leslie Stonehart** …," *SMT*, Oct. 18, 1939, p. 3; "Miss Myers Named *Mascot* Editor… junior college annual… Others on the staff are Jack Wells, photography editor, **Mina Rushforth**, art editor…," *SMT*, Nov. 1, 1939, p. 3; "Christmas Music and Plays Planned… by the high school … A tableau, 'Holy Night,' inspired by the famous painting by Correggio, will be presented under the direction of **Mrs. Elizabeth Breneiser**… The back drop is being painted by **Miss Mina Rushforth** assisted by Betty Brees and other students of the Art department…," *SMT*, Dec. 11, 1939, p. 3.

1940 – "Two-Day Exhibit of Art Here," i.e., Rocky Mountain Artists Assn. at Social hall at Jr. college, arranged by **S. Breneiser**, *SMT,* Feb. 17, 1940, p. 1; "*Splash* Wins First in a National Competition," sponsored by Columbia Scholastic Press, *SMT,* March 18, 1940, p. 3; "Founders' Day Observed … by the high school and junior college PTA… [after the program] … The group adjourned from the social hall… to a darkened room for a motion picture shown by **Myrton D. Likes** and called 'The Lost World.' Later … an exhibit of paintings by Artist J. Warren Calvin, Western landscapes predominating …," *SMT,* Feb. 22, 1940, p. 2; "Jaysee Play Draws Large Audience… 'Seven Sisters'… in the high school auditorium … Hungarian atmosphere… Painting designs on dishes used as decorations for the living room of the Hungarian home… were in charge of **Ruth Dowty**…," *SMT,* April 19, 1940, p. 5; "Play, Music and Exhibits Planned for Parents" night at school, *SMT,* April 24, 1940, p. 3; "*Splash* Postponed" until summer, *SMT,* June 6, 1940, p. 2; "School Decorates for Christmas Program. Transformed to represent **stained glass** windows, the two big windows over the front stairway at the high school are to be lighted when the public attends the school's Christmas program. … The windows have been planned to represent medieval glass, the many parts being colored by the Art department as a group project under **Elizabeth D. Breneiser**. **Mary Lea Marshall** made the design, and the same design is being repeated on the front door to the main building, *SMT,* Dec. 17, 1940, p. 3.

1941 – "Drama Groups Busy… 'The Turtle Dove' a Chinese play… The costumes are being made by the girls of the Theatre Arts class… The designs are being painted by **Francis Sutherland** and Gordon Jenkins assisted by **Mary Lea Marshall**. Francis reproduced the scenery from a willow plate…," *SMT,* Feb. 19, 1941, p. 3; "Theatre Arts Presentation… high school Theatre Arts class… The class was begun by **Stanley Breneiser** in 1938 as an outgrowth of the old **Blue Mask** club organized in 1922," *SMT,* April 29, 1941, p. 3; "School Parades Student Life for Parents" on annual parents' night [**Public Schools Week**], *SMT,* May 3, 1941, p. 3; "Art Exhibit to Open in Junior College," 40 exhibits by Jr. College students of **Stanley Breneiser**, and "Students showing their art are **Frances Sutherland**, Donald Buck, Lois Mansfield**, George Utsunomiya**, Satoko Murakami, **Eliot Breneiser**, Eleanore Vaughan, Maxine Hannam, Wayne Chambers, Esther Snow and Shirley Burton," *SMT,* May 21, 1941, p. 3; "Pre-Registration Conferences [for Santa Maria Junior College]… Work will be given in Airplane Factory Mechanics… those interested in design may take the Airplane Drafting course…," *LR,* Aug. 15, 1941, p. 7.

1942 – "*Review* Staff Announced… **Mary Lea Marshall**, art editor…," *SMT,* Oct. 28, 1942, p. 5.

1943 – "Aeronautics Department Toured… Junior College Aeronautics department … The engine, airplane, welding, lofting and drafting departments were all included…," *SMT,* Feb. 25, 1943, p. 3; "180 Enrolled in **Summer School** … junior college… **Mrs. Fred Hau** also gives instruction in handcraft," *SMT,* July 28, 1943, p. 6; "School Plans… Teacher Resigns. Resignation of **Mrs. Elizabeth**

D. Breneiser as a member of the teaching staff was accepted… Supt. Tyler recommended **Miss Myrtle F. Lange** of San Francisco, a graduate of the California College of Arts and Crafts and former instructor in art in the Hanford High School, to replace Mrs. Breneiser…," *SMT,* Sept. 16, 1943, p. 1.

1944 – "Naturalist Here, Visiting G. M. Scotts" and will show photos to local students, *SMT,* March 22, 1944, p. 3; "Local Students Win Poster Awards," *SMT,* May 3, 1944, p. 3; "Pioneer Days of Santa Maria High School Related," at dedication of a memorial court to pioneers, *SMT,* May 8, 1944, pp. 1, 6; "High School's '*Review*' Staff Selected… Photography editor, John Peterson… art editor, **Elizabeth Dennison**, assistant, **Jo Ann Smith**…," *SMT,* Nov. 3, 1944, p. 3; Stanley "**Breneiser**'s 25th Production Tonight" of HS play 'Ghost Wanted'," *SMT,* Dec. 8, 1944, p. 3.

1945 – "**Schools Week** Activities in High School… Wednesday evening… The Photography unit directed by **J. M. Boothe** will conduct a photography contest, with the visitors as judges," *SMT,* April 19, 1945, p. 3; "Schools Reopen Sept. 10," and **Jean DeNejer** will teach art in place of **Stanley Breneiser**, who is in New Mexico on a year's leave of absence … **Mrs. Ann Duggan**, a service man's wife, will teach arts and crafts, taught last year by **Myrtle Lange**…, *SMT,* Aug. 29, 1945, p. 5; "Art Class Works on Settings for Jaysee Play," *SMT,* Dec. 4, 1945, p. 3.

1946 – "**Public Schools** Observance… April 11… committee… **Mrs. Jean DeNejer**, Harold Sharp and three students Mary Lou Coleman, Caroline Perry and Jack Dyer. Competent members of the art department are now at work making posters…," *SMT,* March 26, 1946, p. 4; "Some Teachers … Those who did not return high school contracts yesterday were **Mrs. Jeanne DeNejer**, art department director; **Mrs. Ann Duggan**, crafts instructor…," *SMT,* May 21, 1946, p. 1; "Student Art Show… display of oil paintings opening in the art room today. As beginners they have worked faithfully for the past month on these oils which range from wild poppies in a field to illustration of the quotation about a jug of wine, a crust of bread and so on," and names of students: **Elizabeth Dennison**, Myrna Wood, Barbara Simas, Leo Davis, **Joyce Blauer**, Caroline Perry, Nellie Abenido, Gilbert Cota and Shirley McAree," *SMT,* June 4, 1946, p. 4; "17 New High School Teachers … **Miss Helen Bury**, the new crafts teacher, is a graduate of the University of California at Los Angeles and taught in the Sturges Junior High School in San Bernardino. Her home is in San Gabriel [Sic.? Alhambra] … New Art Teacher. Miss **Verla Leonard** comes from Corey, Pa., and will teach art in the high school and junior college. She is a graduate of Pennsylvania State Teachers' College and has a master's degree from Pennsylvania State College, She has been art supervisor in the elementary and high schools of Pennsylvania," *SMT,* Aug. 28, 1946, pp. 1, 4; "New Welding Shop for School," *SMT,* Oct. 26, 1946, p. 1.

1947 – "17 New Teachers … Santa Maria High School and Junior College … **Delia Davis**, Lompoc, Crafts …," *SMT,* Aug. 23, 1947, p. 1.

1948 – "Radio Workshop... of the Santa Maria High School and Junior College... new schedule... The art department,

with **Miss Verla Leonard**, art instructor, supervising, presented a program last night over station KSMA on 'The Meaning of Art.' ... advanced students of the junior college art classes appeared...," *SMT*, Jan. 22, 1948, p. 3; "Gold Senior Sweaters... the class of 1949 in Santa Maria High School has voted to have yellow senior sweaters. Jeannine Bostwick has designed a diamond-shaped emblem, drawn by **Phil Bostwick** with 'SM '49ers' in script across a gold miner's pick and shovel," *SMT*, Feb. 19, 1948, p. 5; "High School teachers' Contracts Approved... Probationary teachers rehired... **Delia Davis** ...," *SMT*, March 17, 1948, p. 2; "Students Have Displays... **Public Schools Week**... a number of downtown stores will feature window displays of articles made by students in various departments of the local high school ... mechanical drawing at Arrow Studio...," *SMT*, April 23, 1948, p. 5; "High School Faculty Adds 16 Members... **Norma C. Martin**, Lompoc, A. B., San Jose State, Crafts...," *SMT*, Aug. 28, 1948, p. 1; "College Men... **Myrton Likes**, dean of Santa Maria junior college... greatly expanding its curricula this year. For the first time a two-year college course in agriculture is being offered... [comprised of] twenty separate courses... a three-period course in auto shop... a new course in elementary photography...," *SMT*, Sept. 2, 1948, p. 1.

1949 – "Cultural Topics to be Explained for Hi ... **Mrs. Delia Sudbury**, teacher in the art department, will tell how new types of art are introduced to the classes. **Norma Martin** will speak on creative work in crafts... and the audience will be invited to view an exhibit of work by the art students...," *SMT*, Jan. 14, 1949, p. 5; PTA "Camellia Show... Soroptimist club... Two dozen attractive posters... have been made in the Santa Maria High school art department...," *SMT*, Jan. 26, 1949, p. 5; "Enlarged Program to be Offered... This year the college offers 110 courses in 14 departments including an expanded program in agriculture, photography added to the trade and industrial department... and interior decoration for girls... added to the homemaking course...," *LR*, Sept. 8, 1949, p. 13; "Hobbyists... Junior and Senior Community clubs... Posters to help publicize the show, submitted by 20 students in Santa Maria high school taught by **Miss Delia Sudbury** have been judged. Winners in first, second and third place are **Margaret Giorgi, Paul Veglia** and T. Inouye. Honorable mention... **Virginia Johansen**, Phyllis Berry and **Vic Parker** ...," and names of judges, *SMT*, Nov. 9, 1949, p. 6.

1950 – "Five Teachers... High School ... Elected to serve their third year were ... **Norma Martin**... The board accepted the resignation of **Mrs. Delia Sunbury** [Sic. **Sudbury**] who said she is leaving Santa Maria after the end of the present school year," *SMT*, March 22, 1950, p. 1; port. in group and "High School Breeze Staff Edits S. M. Times... **Roland Youtz** was photographer...," *SMT*, March 31, 1950, p. 1; "SM Wins... Playday ... Prizes in the form of large decorated clam shells... [by] the school art department... lettering and stencils used in events were supplied by the mechanical drawing students, and **Attilio DeGasparis. Mrs. Delia Sudbury** and **Miss Norma Martin** and students helped make posters...," *SMT*, May 16, 1950, p. 9.

1951 – "JayCee Hi-Lites... February 9 will be the last day to enroll in new classes... there are openings in the photography class... Organization pictures are now being taken... for '51 College Annual *Mascot*... ," *SMT*, Feb. 2, 1951, p. 10; "Father Hubbard... Knights of Columbus... [sponsoring] illustrated lecture, 'Bering Sea Patrol,' A poster contest [for it] is being held in... art classes with **Ward Youry** instructor. Prizes are to be awarded ... for three best ... Entries... judged by **Mrs. Jean DeNejer**, former art class instructor in the local high school and now head of DeNejer Art studio...," *SMT*, Feb. 24, 1951, p. 4; "'Belvedere' to be Presented by JayCee Players... high school auditorium stage... The art department is in charge of making posters with Gil Silva in charge...," *SMT*, May 3, 1951, p. 5; "Mills Resigns ... **George Muro**, a San Jose graduate with a Master's degree in fine arts, was hired for the art department at a salary of $3,500 plus the $300 cost of living adjustment," *SMT*, June 20, 1951, p. 1; "High School Art Students have Work Display in Main Tent at Fair" **SB County Fair**, and article adds, "The schools' contribution also shows examples of work from the commercial and machine shop departments and equipment used by students in these courses. The collection of paintings, well worth seeing, include 'Western Scene,' **Elva Van Stone**; 'House,' by Elizabertha Saenz; 'Hacienda,' by Joyce Gifford; study of boy in class, **Glenn Carroll**. **Virginia Johansen** has titled her drawing, 'Just Weeds,' and a similar drawing is that shown by **Karen Melby**. Other paintings are 'Ranch House With Palms,' Henry Oda; 'The High School,' (unsigned); 'Girl Winding Yarn,' Kathleen Tobin; 'Cock-fight,' Claudia Nettle; 'Wild Horses,' **Barbara Moore**; 'Baseball Game,' **Glenn Carroll**; 'Ancient Farm House,' **Virginia Johansen**, and 'House at Night,' Susan Jensen," *SMT*, July 27, 1951, p. 4; "Story Book Lane Bazaar... Church of Jesus Christ of Latter Day Saints... Most of the paintings and all of the sketches for decorating were done by art students of Santa Maria High school, taught by **George Muro**. Clever and original, they apply [Sic.] on the various booths, as the pictures of 'Mary, Mary Quite Contrary' on the booth where flower plants and cuttings are sold," *SMT*, Nov. 30, 1951, p. 4.

1952 – "11 Students Win Awards from Bank [of America] ... Achievement awards... Certificate Winners – **Virginia Johansen**, Art...," *SMT*, March 26, 1952, p. 1; "Praise is Given '52 *Review* Staff... **Luther E. Thurman** has served as faculty adviser and along with **J. Miles Boothe** is responsible for much of the photography that has been praised by the school as excellent... **Charmian Turner**, art editor...," *SMT*, June 10, 1952, p. 4; "13 Awards Go to Local Graduates... during commencement... M. B. O'Brien Memorial cash award to **Virginia Johansen**, outstanding art student...," *SMT*, June 13, 1952, p. 1; "H. S. Groups Set Exhibits in S. M. Stores" for **Public Schools Week** and **Ward Youry** and **George Muro** set up art, consisting of paintings, designs, leather work, and ceramics, in Ames and Harris, *SMT*, April 26, 1952, p. 8; "Exhibit of Art Students Opens" i.e., art from Muro classes displayed in Karl's Shoe Store, sponsored by Senior Community Club in honor of **National Art Week**. "Students whose work is shown include: **H. Fujioka, Earl**

Leitner, David Kennedy, Betty Cuckler and Ann Holbak," *SMT,* Nov. 1, 1952, p. 4.

1953 – "Models Are Chosen for Fashion Show… **Minerva Club**… Art students … making posters… are **Barbara Moore,** Jim Jeffers, Cathy Tobin and **Glen Carroll**. … taught by **George Muro**. The posters are in a new mobile motif, contemporary design, using color, and the effect of motion to suggest a parade of models wearing styles for spring and summer," *SMT,* Feb. 25, 1953, p. 4; "High School and Junior College Plan Observance… **Public Schools Week**… Other features of the Wednesday night open house will include… industrial art classes demonstrating under the direction of **Peirino Merlo,** art exhibits by instructors **George Muro** and **Gordon C. Dipple**. Also photographic displays by **Boothe**'s classes… fluorescent materials displayed by **Merton D. Likes** geology classes…," *SMT,* April 22, 1953, p. 1; photo of Industrial Arts students building model houses, *SMT,* April 28, 1953, p. 1; photo of HS student painting a shop window urging people to get out and vote, *SMT,* May 14, 1953, p. 1; "Open House for New Science Unit… provides facilities for a complete modern science course with chemistry, biology, physics and photography laboratories conducted under … and **J. Miles Boothe,** biology and photography…," *SMT,* Oct. 26, 1953, p. 1.

1954 – "Achievement Award Winners are Announced… Bank of America Achievement awards… Engraved cup… Alyce Ann McKenzie, Guadalupe, in fine arts [Newspaper notices suggest she was primarily interested in singing, dancing, and animal husbandry.] … Certificate award winners… **Henry Fujioka,** 505 South Railroad avenue, art…," *SMT,* March 17, 1954, p. 1; "**Public Schools Week** Prompts Student Writers. Eight booths, each containing projects from the various Industrial Arts classes … will be arranged for Public Schools Week on April 28 at the boys' gym… The woodworking classes under [Peirino] Merlo will exhibit a scale home… a chair made by James Edgar in the furniture class, a desk made by Jim DeBoi [etc.] … Raymond Netherton's machine shop classes are going to exhibit projects of metal… Candle stick holders… In **Attilio DeGasparis**' drawing classes, where the projects are on drawing paper, the class will show how essential drawing is in the industrial field…," *SMT,* April 19, 1954, p. 7; "**Public Schools Week**… by **Jesse Joe Lopez**… Arts and Crafts. Work by Gold Key and Certificate of Merit award winners of this year's **scholastic arts award** contest will be on exhibit… new boys' gym… Exhibits of art and crafts work completed throughout the year will be arranged by **Gordon Dipple** and **George Muro** of the art and crafts departments. Basic and advanced problems in painting, color and design will be shown. In crafts a display of contemporary ideas in handling of wood, metal, enamels and leather will be of special interest. Moving sculpture, or mobiles, will also be hanging in the display room. Notable work being displayed will be **Henry Fujioka**'s watercolors, **Betty Eya**'s designs, Alfred Tabisola's [Sic. Saenz] metal work, and two mobiles by **Jesse Joe Lopez**…," *SMT,* April 20, 1954, p. 3; "**Public Schools Week**… Photography. A contact printing demonstration will be done by photography students in the science building on April 28… under the supervision of **J. M.**

Boothe," with Q&A, *SMT,* April 23, 1954, p. 5; group photo of June 1954 graduating class, *SMT,* May 26, 1954, p. 9; "18 Students Receive Special Awards at Graduation… Double award recipients were Catherine Neiggemann, **Henry Fukioka [Sic. Fujioka]** and Mary Kay Sykes. **Fukioka [Sic. Fujioka]** received the Bank of America top art department student cup and a $400 scholarship to the College of Arts and Crafts… **Betty Eya** the $200 Nisei scholarship from the local Japanese-American Association to study art at the College of Arts and Crafts … Bank of America engraved cups went to… and Alice McKenzie, fine arts…," *SMT,* June 11, 1954, p. 1. Fall -- JUNIOR COLLEGE MOVED TO HANCOCK FIELD BUILDINGS

1955 – "Five High School Students Win [28th Annual **Scholastic] Art Contest** Gold Key Honors," and photo of **Ben Amido,** Allen Dart and Allen Mussell, *SMT,* Feb. 15, 1955, p. 1; "High School Open House Set April 27… **Public Schools Week**… After the program, individual classrooms will be open with special exhibits… Interesting and unusual projects will be on display in the art department. Pictures which won **Scholastic [Art Exhibit]** Gold Key Awards will be shown. The winners from **Gordon Dipple**'s art classes are … Myron Battles… **Barbara Prater**… The winners from **George Muro**'s classes are Allen Dart, **Ben Amido** and Allan Mussell … Mechanical drawing classes under **Attilio DeGasparis** will display sample drawings and projects made by the 10th, 11th and 12th year mechanical drawing and applied drawing classes. The industrial arts department will also exhibit projects made by students. Boys will be working in different shops…," *SMT,* April 19, 1955, p. 5; photo of boy and girl at easels but caption describes trumpeters, *SMT,* April 20, 1955, p. 7; "High School Photo Class to Exhibit … [at] open house on Wednesday. One display, under glass, appears in the covered ramp near room 129, where photography is taught. A second exhibit of salon size prints has been arranged in a display case in the south wing of the main building… just outside the vocal music classroom, room 17. The making and mounting of a salon size print is a regular second semester assignment for students of photography. Some of these pictures have been snapped on the campus and by 'shooting' through archways, or selecting interesting angles… A recent display of student work was shown in the public library, and **Santa Maria camera club** has assisted in judging work and has offered constructive criticism… **J. Miles Boothe** teaches high school and evening school photography and will have the laboratory open for inspection… during the evening of April 17," *SMT,* April 21, 1955, p. 20; "14 Teachers New to High School… **Nathaniel Fast,** Arts and Crafts, **Robert Bruchs,** business …," *SMT,* Sept. 2, 1955, p. 1.

1956 – Port. of **Trinidad Amador,** student, and **George Muro,** art teacher and "Student Paints Vaquero Backdrop," i.e., 5-panel view of Vaquero dam, *SMT,* Jan. 20, 1956, p. 1.

1957 – "Industrial Arts Courses Explained to School Board … Industrial arts courses are not vocational training classes, but preliminary training in the study of occupations, **Attilio DeGasparis,** department head at Santa Maria high school, told trustees last night. DeGasparis was

making the second in a series of monthly reports to the school board on high school curriculum. The industrial arts courses show students the opportunities in the various fields and has a lot of hobby value because of the present do-it-yourself trend, DeGasparis reported. He outlined six classes in his department – basic shop, woodwork, electricity, metal shop, auto shop, and mechanical drawing. All of the shop classes stress proper use of tools, safety and the care of tools. Basic shop includes 10 weeks each of drawing, woodwork, metal and electric work. … Metal shop includes work with sheet metal, soldering, rivet work, metal spinning and use of lathes. … The language of the industry is taught in mechanical drawing, he said, where all types of drawing and blue prints are produced by pupils," *SMT*, Feb. 13, 1957, p. 6; photo of student artists: Dennis Allen, Jeanette Brickey, Eleanor Powell, Cookie Hughes, Dorene Stowell, Pauline Minjares, Ron Andrews, Bill Furrow and Duke Rojas, and paper mosaic mural, *SMT*, March 30, 1957, p. 1; "Special Exhibits to Highlight School Open House… **Public Schools Week**… The homecrafts classes of **Mrs. Elizabeth Dennison** … two rooms of Homecraft exhibits… woven rugs and chairs stools and tables that have been recovered by homecrafts students… The industrial arts department under the direction of **Attilio DeGasparis** will present exhibits of … wood, metal, plastic and electricity…," *SMT*, April 25, 1957, p. 1; "Faculty Wives Meet… in the art building of Santa Maria High School… **Nat Fast**… demonstrated exhibits of ceramics and clay modeling…," *SMT*, April 26, 1957, p. 3; "The Tattlin' Tongue… Where's the Birdie? Money expended for photographic equipment in the Errett Allen science building is not being utilized. Enrollment in the high school photography class is less than it should be for 1400 students. It would also seem logical that students in the photography class should handle picture assignments for the school newspaper (*Breeze*) and the annual (*Review*). It's a good chance for on-the-job education," *SMT*, Nov. 16, 1957, p. 4.

1958 – "High School Open House will Include Music, Art Exhibits" – **Public Schools Week** … Latin Classes will have… posters and pictures showing Roman life and customs… Some of the students have also made models of wood and soap… sculptured busts. There will also be implements of war used by Caesar… a Roman house which is complete with furnishings… Dolls dressed in authentic Roman dress… Diagrams and maps showing the city of Rome… Art Department… broken down into two sections," i.e., Art (drawing, painting, papier mâché, etc.) under **Mr. Robert Gronendyke** and Crafts (wood, leather, and jewelry) under **Nat Fast**. "The theme of the art section will be 'With These Hands'. The more advanced art class will exhibit life size figures of the human body. The figures are made of papier mâché with a wire frame. Art 9 and 10 will also have several exhibits including wood cuts, papier mace, wire sculpture, and water colors. The crafts section of the department will exhibit wood work, wood sculpture, leather work, such as purses, wallets, jewelry, and ceramics," *SMT*, April 21, 1958, p. 5; "HS Science Display Set for Tonight… 7:30 to 10:00 p.m. on Wednesday, April 23… In the photography department, under the direction of **Mr. Boothe**, the class will demonstrate the enlargement of photographs…," *SMT*, April 23, 1958, p. 5; "Students Win

in National Art Show," i.e., **National Scholastic Art** Awards. "Mary Cordero, student taught by **Nathaniel Fast**, and **Barbara Prater**, senior in the class taught by **Robert K. Gronendyke**. Mary Cordero won a medal award in crafts on a teakwood bowl. **Barbara Prater** received an honorable mention for her wood sculpture of a Madonna and child. She plans to continue her study of art … at Allan Hancock College after graduating from the local high school… Forty-four cash awards and honorable mentions for Southland art students were made from a regional entry of 100 paintings and art works… Winning works are included in the national high school art exhibition in New York to be shown starting June 5," *SMT*, May 13, 1958, p. 3; "Two Art Students Place in World-Wide Contest [Protect Wildlife contest at Stanford University]… Don Coulon, a senior, won fourth in the same competition. … Coulon's certificate of merit was accompanied by a check for $5. Both posters were praised as outstanding inasmuch as this was the 23rd annual contest, international in scope, with 26,000 entries representing students in 22 countries. Sixty posters were sent in by Santa Maria High School, certificates being won by the following: Carlos Haro, Mieko Oku, Rosie Furuya, Rodney Truman, Phyllis Brosche, Irving Jensen, Herschel Cobb, Linda Fletcher, Marty Rodriguez, Lois Brooks, Robert McGonigal, Autry Smith, Patricia Morrell, Curt Reid, Jim Staples, Jean Heritage, **Roy Imamura**, Floyd Ault, Betty [Elizabeth] Burger, Manuel Palato, Ernie Fimbres, Helen Hammond, Lawrence Varela, Lydia Hernandez, Mary Rodriguez, Donna Talaugon, Margaret Donaldson and Tillie Robles," *SMT*, May 21, 1958, p. 2 [A 2020 search for this on newspapers.com revealed the company missed digitizing the whole month of May and did August twice.]; photo of students at work on annual window design for **Elk's rodeo**, *SMT*, May 23, 1958, p. 1; "30 Academic Awards Given at SMUHS Assembly. Scholarships… Bank of America Achievement Awards … **Trinidad Amador**, art, **Richard York**, English… Other awards… the $100 Heritage Foundation award to **Richard York**, a $250 scholarship to the California College of Arts and Crafts to **Trinidad Amador**… a $37.50 art award from the Junior Community Club to **Barbara Prater**…," *SMT*, June 6, 1958, p. 8; "Trustees Choose… Two Santa Maria residents were also employed… and **Mervin Slawson** … to instruct photography at the high school and junior college," *SMT*, June 25, 1958, p. 1.

1959 – "Several Santa Maria high school students are sending art work to the **Scholastic Art Exhibit** in Los Angeles, **Robert K. Gronendyke** of the school's art department announced today. An exhibit displaying the more than 7000 entries will be featured at Bullock's Downtown from Feb. 28 through March 14. Judges will select approximately 300 (?) winners. … Gronendyke will accompany several participating students to the exhibit. 'This year's entries have an excellent chance,' Gronendyke said. Last year the school had nine regional winners. Of these, two went on to win national honors in New York City. Students submitting entries in this year's contest are: **Carol Schilder**, Debroah [sic.?] Daymon, Lyle Farmer, Janet Hand, Darrel Mollica, Charleen Wray, Catherine Arreguy, Lauri Kreiss, Kara Warner, Ronald Andrews, **Melba Boroff**, Juanita Alamaguer [Sic. Almaquer], Susan

Chadband, Dan Creasey, Carolyn Milton, Pat Morrell, Dorene Stowell and Linda Fletcher. Students who last year won awards in national competition were **Barbara Prater**, certificate of merit, and Mary Cordero, gold medal," per "High School Art Work in Exhibit" at **Scholastic Art Exhibit** in LA, *SMT,* Feb. 3, 1959, p. 2.

1960 – "Revisions… Curriculum Success Reported. Of 10 curriculum revisions put into operation at Santa Maria High School this past year, seven worked out completely satisfactorily… The 1960-61 revisions proposed… A second-year photography course … for students interested in advanced work. About 12 are tentatively signed up …," *SMT,* June 29, 1960, p. 9; "Arts, Crafts Being Displayed. Some of the better work of the beginning art and crafts classes is being displayed at Santa Maria high school, advised **Nat D. Fast**, instructor. The crafts classes will present copper jewelry such as cuff links, rings, bracelets, pins and clips. Work by Marie Minetti, Hal Zubriate, Willa Preast, Sandie Harris, Anna Maria Almaguer and Albert Ruiz is featured in the display, which also includes some drawings from the art classes," *SMT,* Nov. 19, 1960, p. 12. See: "College Art Club," "Halloween Contest," "Posters," "Public Works of Art Project," 1934, "Santa Barbara County Library (Santa Maria)," 1951, "Scholastic Art Exhibit," "Splash"

Santa Maria Camera Club (Santa Maria)
Camera club organized 1938. Composed of photographers interested in learning more about their craft and who held monthly meetings centered around learning of techniques and aesthetics through guest lecturers or self-criticism. Meetings were held at various temporary venues (Elk's field recreation building, high school, city recreation center, USC College of Aeronautics). Held monthly and yearly competitions for black and white photos and for color slides. Some members took motion pictures. 35 mm color slides and color films were "new" media for amateur photographers beginning in the mid 1930s. Occasionally members held public exhibits of their work. Club members exhibited at several Santa Barbara County Fairs and competed and exhibited with camera clubs in neighboring towns.

■ "Camera Club Organized. First meeting of the Camera club will be held Thursday night in the basement of Main Street school. The club is being organized by a group which includes **Ted Bianchi, Bernard Karleskint, Karl Bell, Ernest Edwards, Kenneth Moore** and **Earle Conrad**. Membership will be composed of those wishing to study camera technique and to improve their skill," *SMT,* Oct. 17, 1938, p. 3.
Santa Maria Camera Club (notices in Northern Santa Barbara County newspapers on microfilm and on newspapers.com)

1938 – "Airport Work Subject… Toastmasters club… **J. Miles Boothe** discussed 'Miracles of Photography'," *SMT,* Oct. 20, 1938, p. 3; **Bernard "Karleskint to Head Camera Club**," *SMT,* Oct. 21, 1938, p. 3; "Camera Club Tonight," *SMT,* Nov. 17, 1938, p. 3; "**Wm. Mullins** Wins Camera Contest" for architecture, doorways and animals. **Bernard Karleskint** took second … Third… **Harry Bell Jr**. …

Preceding the judging, **John Karleskint**, program chairman, presented color slides and **Irving Truitt** ran a movie reel…," *SMT,* Nov. 18, 1938, p. 3; "Camera Club to Plan Film Study," *SMT,* Nov. 26, 1938, p. 3; "Camera Club Enters Second Month," *SMT,* Nov. 30, 1938, p. 3; "Club Judges Print Contest Tonight," *SMT,* Dec. 15, 1938, p. 3; "Contest Winners Told," *SMT,* Dec. 17, 1938, p. 2; "Camera Fans Meet Tomorrow Night," *SMT,* Dec. 28, 1938, p. 3; "Aids to Good Color Film Told Fans," by **Kenneth Moore**. "In explaining the process of making and developing color film, Moore gave some of the history… 'Though the general public has not until recently become color conscious, it may not be long until natural color photographs will lead over those in black and white' … In a discussion of the next print contest to be judged Jan. 12, the club appointed **Ernest Brooks** of Lompoc to serve with **Leslie Stonehart** as critic. **Myrton Likes** of the high school faculty will criticize the motion pictures," *SMT,* Dec. 30, 1938, p. 3.

1939 – "Camera Club Judges Prints Tonight," *SMT,* Jan. 12, 1939, p. 3; "Camera Club Shows Pictures Tonight … exhibit of enlarged photographs, prizewinners from Chicago Camera clubs, has been arranged for the public tonight in Main street school… **Harry Bell**, print contest director, is in charge. In addition, **John Bianchi** will give an Eastman Kodak lecture, 'How to See Pictures.' **Myrton Likes**… will show a motion picture which he has made," *SMT,* Jan. 26, 1939, p. 2; "Composition of Pictures is Club Topic" of speaker **John Bianchi**. "Lantern slides, run by **John Karleskint**… **Myrton Likes**… ran two of his motion picture reels, 'Expedition of the Western Navajo Indian Reservation in Arizona,' and 'Yellowstone National Park.' An exhibit of prizewinning photographs from the Chicago Camera clubs was displayed… **Frank Beane**, president of the Lompoc Camera club, extended an invitation to Santa Maria members to attend a Lompoc meeting Feb. 16," *SMT,* Jan. 27, 1939, p. 3; **Patricia Auman** – "Girl to Pose for Camera Club," *SMT,* Feb. 9, 1939, p. 3; "Small Girl is Camera Study Subject … The team with the best photographs of Patsy [Auman] will be awarded a prize at the next meeting, Feb. 23, according to Harry Bell, Jr., print director. First place in the print contest on 'railroading' was won by **William Mullins**, second by **Kenneth Moore**, third by **John Karlskint** with honorable mention going to **Dorothy Bell**… Edward [Sic. Ernest] Brooks of Lompoc … gave criticism on each print. 'Entitled to Success,' a movie reel showing how to title film, was run … An exhibit of prize-winning prints from the Sierra Camera club, Sacramento, was displayed," *SMT,* Feb. 10, 1939, p. 3; "Camera Fans will Hear Essentials" of picture making from **Bernard Karleskint**, *SMT,* Feb. 23, 1939, p. 3; "Camera Club Photo Contest Judged … candid camera shots of Patsy Auman, with **Bernard Karleskint**'s team winning… taken by **Kenneth Moore**. April 20 is the date set for 'movie fan night' at which time reels are to be run and prizes awarded … A colored motion picture reel showing the Boy Scouts on an educational tour in San Francisco and in camp at Santa Barbara and at Camp Drake was run by **Basil Hanson**… 'Child Portraiture' is the topic for the next print contest…," *SMT,* Feb. 24, 1939, p. 3; "Camera Club will Judge Prints," *SMT,* March 9, 1939, p. 3; "**John Karleskint** Wins in Camera Contest" for child portraiture,

"**William Mullens**, second, Karl Hellberg, third, [**Harry**] **Bell** fourth and honorable mention going to Mr. and Mrs. **B. Karleskint, Dorothy Bell** and **Irving Truitt**," *SMT*, March 10, 1939, p. 3; "Scavenger Hunt with Cameras," *SMT*, March 15, 1939, p. 3; "Camera Club has Unique Party," *SMT*, March 16, 1939, p. 3; "Hunt Results to be Displayed … i.e., scavenger hunt… **Kenneth Moore** is giving a lecture on 'Color Photography.' 'Composition of Pictures' is the topic to be discussed by **William Mullens**. The manager of the Ward theater in Pismo is to show a film for the club…," *SMT*, March 23, 1939, p. 3; "**Kenneth Moores** Win Camera Contest. … scavenger hunt… Judging of the prints was done by **William Mullin, Ernest Brooks** and **Verne ???y** [Sic. **Verne Laney?**]. **Ernest Edwards** was appointed acting secretary-treasurer by **Bernard Karleskint**, president. The club secretary-treasurer, **Harry Takke**, is leaving for a vacation in South America. 'Personal opinion plays a large part in composing a picture but there are some fundamental principles'… Mullin told members… correct division of space … express a mood… an angle shot gets vertical lines and points to the main motive… Straight on shots of a building give a flatness. A slanting line shows motion and a curved line gives a feeling of continuity of motion. Zig-zag lines show violent motion. In a delicate subject, tones should be soft and in a heavy subject, contrasts in black and white.' … 'Photography in Color' was presented by **Moore**. … **Takken** ran one of his motion picture reels…," *SMT*, March 24, 1939, p. 3; "Grand Prize in Local Camera Contests Won by **William Mullin** … Second prize… **Bernard Karleskint**… **Irving Truitt** … third… **Kenneth Moore** fourth…," *SMT*, April 7, 1939, p. 3; "Night Pictures Explained for Camera Club" by **Mrs. Harry Bell, Jr.**, *SMT*, April 21, 1939, p. 3; "Flower Print Contest won by **Irving Truitt** … **Mrs. Harry Bell, Jr.** was second… **Kenneth Moore** placed third… **John Karleskint**, fourth… **Truitt** gave a talk on print control. **Everett Rinehardt** showed motion pictures of Yosemite and of the Bakersfield Model Plane meet made by himself. … city librarian has arranged for members of the Camera club to photograph the interior of the library with all prints to be submitted for judging…," *SMT*, May 5, 1939, p. 3; "Traveling Exhibit Planned by Local Camera Club," to be sent on exchange to clubs in other cities, *SMT*, May 19, 1939, p. 3; "Nine Have Prints in Traveling Exhibit," *SMT*, May 26, 1939, p. 3; "Seascape by **Kenneth Moore** is Winner in Contest," *SMT*, June 2, 1939, p. 3; "Pictorialism is Camera Club Topic," *SMT*, June 16, 1939, p. 3; port. of **John Karleskint**, *SMT*, June 26, 1939, p. 3; "Print Competition" for sand dune prints, *SMT*, June 29, 1939, p. 3; "Cameras to Record Wonders of Nature in Club Contest," *SMT*, June 30, 1939, p. 3; "Many Entries in Camera Club Contest" on whiskerino subjects, *SMT*, July 13, 1939, p. 3; "Snapshot Entries are Open to Anyone" in whiskerino contest, *SMT*, July 18, 1939, p. 3; "Whisker Judging at [Exchange] Club Ball Tonight," *SMT*, July 29, 1939, p. 3; "Pop Black Photo is Prize Winner … Whiskerino contest… **Irving Truitt**… second… **Lucille Orr**…," *SMT*, Aug. 1, 1939, p. 3; "Attention All Camera Fans. Meeting of Santa Maria Camera Club. Thursday Evening. September 7. 8:00 p.m. Main Street School. Lecture and Pictures by Eastman Kodak Co. All those interested in Photography are

cordially invited to attend," *SMT*, Sept. 6, 1939, p. 1; "Popularity of Camera Hobby Continues" says **E. F. Edwards**, and next contest is architecture subjects, *SMT*, Sept. 22, 1939, p. 3; "Cameras and Crime to be Discussed," *SMT*, Oct. 5, 1939, p. 3; "**Kenneth Moore** Wins Camera Competition," *SMT*, Oct. 6, 1939, p. 2; "Camera Club Darkroom Planned," *SMT*, Oct. 20, 1939, p. 3; "Moore Heads Local Camera Club. **Kenneth Moore**… **J. C. Conn** and **Capt. James L. Tobin** were given honorable mention… print competition," *SMT*, Nov. 4, 1939, p. 4; "Special Contest of Camera Club Due," i.e., shots of Port San Luis Lighthouse, *SMT*, Nov. 14, 1939, p. 3; "**J. Souza** First in Photography Competition … prints developed from 'shots' of Port San Luis lighthouse and surroundings taken on a field trip Sunday. **Bert Dinnes** of Orcutt won second prize," *SMT*, Nov. 17, 1939, p. 3; "Aerial Photos Discussed for Camera Club… by Andrew R. Burke, flying instructor of the Santa Maria detachment of the army flying school… In this month's print competition, 'Still Life,' first place was awarded to **Bert Dinnes**… Second… **Mrs. Ernest Brooks**… Third… **John Karleskint**… Honorable mention… **Irving Truitt**," *SMT*, Dec. 1, 1939, p. 3; "Camera Club Meeting," *SMT*, Dec. 14, 1939, p. 3; "Shark Fishing Described for Camera Club," *SMT*, Dec. 15, 1939, p. 3; "Feminine Portraits" to be subject for next photo contest, *SMT*, Dec. 28, 1939, p. 3; "**Kenneth Moore** Wins Camera Competition," *SMT*, Dec. 29, 1939, p. 3.

1940 – **Irvin Truitt** – "One-Man Show Set for Camera Club," and demonstration by **Alvin Rhodes**, president of San Luis Obispo Camera Addicts, *SMT*, Jan. 11, 1940, p. 3; **John Feely** [Sic. **Feeley**], night school "Photography Class Asked by Club … Those interested were asked by President **Kenneth Moore**, to contact … Three methods for producing talking motion pictures at home were demonstrated by **Mitchell Allen** and **Alvin Rhodes** of San Luis Obispo… With his first film Allen ran recordings sent through a loud speaker … In the second reel, Rhodes ran music on the turntable and spoke through a 'mike.' …synchronized with the film … The one-man show of **Irvin Truitt** was criticized by Rhodes. A joint camera scavenger hunt with San Luis Obispo Camera Addicts is set for Jan. 18, " *SMT*, Jan. 12, 1940, p. 3; "Camera Club Party" scavenger hunt, *SMT*, Jan. 17, 1940, p. 3; "Camera Fans Pursue Hobby at Party" where they met and were given list of subjects to photograph, *SMT*, Jan. 19, 1940, p. 3; monthly "Print Competition" is on subject of hands, *SMT*, Jan. 25, 1940, p. 3; **John** and **Mrs. Bernard "Karleskints** Win Camera Contest," *SMT*, Jan. 26, 1940, p. 3; "Camera Fans Visit SLO Club," *SMT*, Feb. 1, 1940, p. 2; "Model to Pose for Camera Fans … 'Photographic Makeup' will be the topic for a discussion … by **Bernard Karleskint**," and other events for evening listed, *SMT*, Feb. 8, 1940, p. 3; "Miss [Norma] Dolan Sits as Photographers' Model … Those entered in the competition were divided into teams, one captained by **Irvine Truitt** and made up of **Bert Dinnes, Capt. James L. Tobin, Dave Kawtonen** [Sic. **Kaukonen**], **Mrs. Gertrude Collins**, Francella Joy and **Harry Bell, Jr.**, and the other captained by **Kenneth Moore** and comprising **Victor Ikeda, Al Taylor, John Bianchi, Mary Fitzgerald, Ken Swonger** and **Joe Souza**," *SMT*, Feb. 9, 1940, p. 3; "Capt. Tobin has 'Aviation' Movie. **Capt. James L. Tobin** of Hancock College of

Aeronautics will show motion pictures of aviation at a meeting of Camera club tonight in Main street school. Aviation is also the topic for print competition, to be judged tonight. A color demonstration of **Kenneth Moore** is slated, and **Bert Dinnes** will relate current events…," *SMT*, Feb. 22, 1940, p. 2; **Harry Bell Jr's** "Fogbound, is Judged Best Picture … **J. C. Conn** was in second place… **Kenneth Moore** received honorable mention… coming competition for landscapes. ... **Moore** demonstrated Dufay color process. **Bert Dinnes** sat for photographs by club members and technical tests followed. At the next meeting there will be a one-man show of prints by **Conn**…," *SMT*, Feb. 23, 1940, p. 3; **J. C. Conn** "One-Man Show for Camera Club. There will be a color print demonstration by **Bernard Karleskint**… and color transparency will be demonstrated by **Kenneth Moore**, club president," *SMT*, March 7, 1940, p. 3; **Kenneth "Moore** Wins Camera Club Contest," *SMT*, March 9, 1940, p. 2; **Dr. Harold Case** "X-Ray to be Shown for Camera Club… Prints will be judged in landscape competition…," *SMT*, March 21, 1940, p. 3; "Dangers of X-Ray Told to Club … by **Dr. Harold Case**… During the evening the Camera club judged prints in the competition for landscapes, awarding **Joe Souza** first and fourth places with **Kenneth Moore** in second place and **Irvine Truitt**, third. **John Bianchi** received honorable mention. **Moore** showed colored slides of Santa Maria valley scenes. **Al Taylor** reported current events…," *SMT*, March 22, 1940, p. 3; "Photographic Demonstration" by **Irvine Truitt**, "**Bernard Karleskint** will show motion pictures of national parks and **Kenneth Moore** will show colored slides…," *SMT*, April 3, 1940, p. 3; "Flash Pictures Demonstrated" by **Truitt**, *SMT*, April 5, 1940, p. 3; "Old Fashioned Cameras Used in Contest," and winners included **Irvine Truitt, J. C. Conn**, *SMT*, May 3, 1940, p. 3; "Pets Subjects for Camera Studies," *SMT*, May 15, 1940, p. 2; **Bob Stewart** "New Member Wins Over Veterans," and other activities of meeting listed, *SMT*, May 17, 1940, p. 3; "Camera Club Gives Demonstration. … **Kenneth Moore** and **Harry Bell, Jr.** were guests of Schooner club last night to demonstrate and explain amateur photography…," *SMT*, May 22, 1940, p. 3; "Picture-Taking for Market to be Described" by **Ernest Brooks**, commercial photographer, and brief summary of his South American trip, *SMT*, May 28, 1940, p. 3; "Large Crowd at **Brooks**' Lecture," *SMT*, May 31, 1940, p. 3; whiskers "Camera Contest to Precede Fair … Prizes awarded in the monthly print competition last night on the subject of Missions went to **Kenneth Moore**, first, **Joe Souza**, second and fourth and **Dave Kaukonen** third. … **Kenneth Moore** showed colored slides of valley flowers. **J. R. Hess**, who has been making aerial photographs of the valley was a guest… **Harold Huntington**, student photographer for the high school for the coming year, was also a guest…," *SMT*, June 14, 1940, p. 3; "Milt Nelson Begins Term… Twenty-Thirty Club… Last night **Harry Bell, Jr.** and **Kenneth Moore** of Santa Maria Camera club explained the rudiments of photography developing several pictures and demonstrating the use of the enlarger," *SMT*, June 26, 1940, p. 3; "Photography Contest Planned at Dinner … Whiskerino and Western costume…," *SMT*, July 12, 1940, p. 3; "Western Picture Contest Rules Announced," *SMT*, July 18, 1940, p. 3; "Camera Fans to Get Vantage Point" for SB Co. Fair

parade, *SMT*, July 23, 1940, p. 3; "Prizewinning Pictures on Exhibit" in whiskeroo contest, *SMT*, Aug. 1, 1940, p. 3; "Camera Club Contest Won by **J. C. Conn**," on subject of fences, *SMT*, Sept. 27, 1940, p. 3; Stanley "**Breneiser** Speaker for Camera Club" on "Composition," *SMT*, Oct. 12, 1940, p. 3; "Photography Topic for **Police** Chief. … Forbes Barrett… 'Criminal Photography' … Main street school… public has been invited… Also on tomorrow night's program will be colored motion pictures of San Luis Obispo county… [by] **Mitchell Allen**. … there will be print competition on the subject of sand dunes…," *SMT*, Oct. 23, 1940, p. 3; "**Police** Chief Lauds Photographers' Aid … As an added feature… a colored motion picture of San Luis Obispo county made for the **Golden Gate Exposition** was shown by **Mitchell Allen**, the photographer who acted as commentator… In print competition… **Joe Souza**… took both first and second… Third … went to **Dave Kaukonen**. Pictures were of sand dunes. Further plans were made for an exhibition for the public of best prints by club members, which is tentatively set for Thanksgiving week. **Harry Bell, Jr., Irvine Truitt** and **Al Taylor** are in charge," *SMT*, Oct. 25, 1940, p. 3; "**Harry Bell, Jr.** Heads Camera Club," *SMT*, Nov. 8, 1940, p. 3; "Camera Club's Show Opens Tomorrow" at old Lederman store building, coinciding with **National Art Week**, and includes prints, slides, motion pictures, *SMT*, Nov. 19, 1940, p. 3; "Camera Art Seen in Exhibit by Santa Marians," *SMT*, Nov. 25, 1940, p. 3.

1941 – "Camera Club Starts Year with New Officers," *SMT*, Jan. 9, 1941, p. 3; "Flyer to Speak for Camera Club" on piloting for famous photographers, *SMT*, Jan. 23, 1941, p. 3; "Camera Contest Won by **Al Taylor**," *SMT*, Feb. 7, 1941, p. 4; "Self Portraits in Camera Contest," *SMT*, Feb. 19, 1941, p. 2; "**Bell, Houston** Win Portrait Contest and **Rolla Houston** was awarded a first place for the most unique self-portrait. **Capt. James L. Tobin** was winner in a camera quiz… **Stanley G. Breneiser** gave a talk, illustrated by sketches, of 'Composition in Photography'," *SMT*, Feb. 21, 1941, p. 3; "Camera Club Sets 'Model' Contest," *SMT*, March 6, 1941, p. 3; "**Al Taylor** Winner in Camera Contest," *SMT*, March 7, 1941, p. 3; "Camera Fans to Have Surprise Program," *SMT*, March 20, 1941, p. 3; "**Al Taylor** Gets Three of Four Camera Awards," *SMT*, April 4, 1941, p. 3; "Camera Fans Plan Swapout," *SMT*, April 17, 1941, p. 2; "Photography Contest Entries Increase … 35 pictures… In the advanced group, **Kenneth Moore** took first place, **Joe Souza**, second and **Rollo [Sic. Rolla] Houston**, third and fourth. In the beginners' group, Glenn Wilson was first, **Jimmy Johnson** was second and **Jack Bright** took third and fourth. Subject was trees… In the next monthly competition, favorite pictures of any subject are to be entered…," *SMT*, May 2, 1941, p. 3; "Camera Club Meeting – **George Heath** will show and discuss his work in amateur photography… in Main street school and **Barney Karleskint** will conduct a camera quiz," *SMT*, May 15, 1941, p. 3; "Camera Contest Winners … **Rollo [Sic. Rolla] Houston**, first and second, and **Kenneth Moore**, third and fourth… **Jim Johnson**… **George Heath**… **Dorothy Bell**… June's contest… has seascapes as the subject…," *SMT*, June 2, 1941, p. 3; "Free. Free. Photographic Lecture and Demonstration on Natural Color and Black and White Photographs by Coleman Schwartz.

Auspices Santa Maria Camera Club. Public Invited. Thursday June 12, 8 p.m. Main Street School Auditorium," *SMT*, June 11, 1941, p. 1; "Film Demonstration Open to Public," *SMT*, June 12, 1941, p. 2; "Camera Contest Prize Winners… seascapes… **Al Taylor** as first place… **Rollo [Sic. Rolla] Houston** in second place and **Joe Souza**, third and fourth; **Dave Walton**, first, second and third in the amateur division and **Earl Stubblefield**, fourth. … The meeting was taken up with discussion of technical problems encountered by the members… Kodachrome competition was planned for the next meeting July 10 and black and white flower print competition for July 24. Several members are attending a Camera club conclave in Oakland, among them **Al Taylor, Mr. and Mrs. Bert Dinnes** and **Irvine Truitt**," *SMT*, June 27, 1941, p. 3; "Camera Club Adopts New Judging Plan … outside judges… Seascapes will be the subject for the contest. The club is also starting a competition for Kodachrome or colored slides first set for July 24, when general scenes may be submitted. Last night the club had Coleman Schwartz of the Defender Photo Supply Co. of Los Angeles to give a demonstration of chromatone, [Sic.] color photography and also of black and white. He had a display of color prints which was moved to the Camera shop today for two days," *SMT*, June 13, 1941, p. 3; "Camera Contest Prize Winners Announced," *SMT*, June 27, 1941, p. 3; "Field Trip for Camera Fans July 20," to Figueroa Mountain, "Feature of the evening was judging of Kodachrome slides… **Bert Dinnes**, for first and second place, by **Kenneth Moore** for third, and by **Bob Stewart** for fourth…," *SMT*, July 11, 1941, p. 3; "**Jack Bright** Wins Camera Contest… **Joe Souza** took second and third and **George Heath** fourth. **Mr. and Mrs. Leighton Richardson**…," *SMT*, Aug. 30, 1941, p. 3; "Barbecue for Camera Club… in the home of the **Joe Souzas**… print contest … animals, **Al Taylor** took first prize. **Leighton Richardson, Rollo [Sic. Rolla] Houston** and **Joe Souza** took second, third and fourth prizes respectively. **Irvine Truitt** spoke briefly on work he has been doing in Army photography," *SMT*, Sept. 27, 1941, p. 3; "Camera Club has Barbecue," *SMT*, Oct. 11, 1941, p. 3; "Camera Club Meeting" has barns as subject, *SMT*, Oct. 23, 1941, p. 3; "'Cops' Cop Prizes for Photography … prizes were awarded… by the local Camera club… **Chester Braflaadt** of the Highway Patrol took first prize and **Elmer Reynolds** of the **Police** department, second in the beginners' division. **Kenneth Moore** and **Mrs. Leighton Richardson** tied for first … in the advanced division. Mrs. **Richardson**'s husband took second prize and **Rollo [Sic. Rolla] Houston**, third. George L. Meder, representative of Defender Photo Supply Co. was speaker… **Ted Bianchi** showed colored motion pictures of the **Santa Barbara County Fair** parade," *SMT*, Oct. 24, 1941, p. 3; "**Al Taylor** Heads Camera Club," *SMT*, Dec. 5, 1941, p. 3.

1942 – "**Al Taylor** Names Camera Club Committees… **Leighton L. Richardson, James Johnson** and **John Bianchi,** program committee; **Bert Dinnes** and **Chet Braflaadt**, field trip committee; **Ken Moore**, guest chairman; **Rollo [Sic. Rolla] Houston, Jack Bright** and **George Heath**, print competition committee; **Harry Bell, Jr.** and **Ken Moore**, Kodachrome competition committee; **Marion Richardson** and **Helen Braflaadt**, publicity

committee … In the yearly print competition… **Al Taylor** was winner with **Rollo [Sic. Rolla] Houston** and **Joe Souza** in second and third places … In the monthly competition for black and white prints, winners were **Al Taylor** again and **John Bianchi** and **J. C. Conn**. At the next meeting there will be Kodachrome competition and for the next black and white print competition, 'Your Yard' was announced as the subject," *SMT*, Jan. 10, 1942, p. 3; "Camera Club Judges Two Contests… one a black and white print competition with 'Back Yards' as the subject and the other color photography of any subject. In the former, winners were **Joe Souza**, first, **Rollo [Sic. Rolla] Houston**, second and fourth, and **George Heath**, third. In the color competition, winners were **Kenneth Moore**, first and fourth, **Bert Dinnes**, second and **Jack Bright**, third and fifth. **Kenneth Moore** gave a demonstration on the use of make-up for better portraits. At the next meeting, competition will be by teams… Subject for the competition is 'feet'," *SMT*, Feb. 13, 1942, p. 3; "Army Restrictions on Photography… were discussed… last night … by Capt. Alvin J. Williams of Camp Cooke… winners in the black and white print competition on the subject of 'Children' were **James Johnson** and **Kenneth Moore**, tied for first place, **Leighton Richardson**, second, **Rollo [Sic. Rolla] Houston**, third and **Bert Dinnes**, fourth. 'Streams' was given as the subject for the next competition," *SMT*, April 10, 1942, p. 3; "Alaskan Films Shown… **Marian Brown** who is employed in Camp Cooke, showed… motion pictures in color made during several months which she spent in Alaska. Miss Brown combines a love of adventure with skill in photography … Next meeting of the Camera club… monthly print competition on July 2…," *SMT*, June 19, 1942, p. 3.

1943 – "Camera Club Resumes Its Meetings. **Joe Souza** was host… last night… **John Bianchi** succeeded **Al Taylor** as president… **Rollo [Sic. Rolla] Houston**, vice president, **Bert Dennis [Sic. Dinnes?]**, secretary … **Ken Moore**… program chairman. **George Heath**, print and publicity and Taylor, field trips and parties. Each member brought a mounted print … for general criticism and **Jim Johnson** gave an illustration of making photographs of finger prints for police records. Two new members welcomed were **Bardy Saladin** and Joe Perry," *SMT*, Jan. 29, 1943, p. 3; "Camera Club Judges… meeting… held last night in the **Al Taylor** home on East Camino Colegio. Among those present were **Mr. and Mrs. Bert Dennis [Sic. Dinnes], Mr. and Mrs. Rolla Houston, Mr. and Mrs. Jack Bright, Mr. and Mrs. George Heath, Joe Souza, John Bianchi** and **Ken Moore**. The evening was devoted to the study and criticism of the oil tinted prints, mounted on 16 x 20-inch mounting boards. The group voted the best print 'Calla Lilies' by **Heath**, second, 'Oso Flaco Lake' by **Rolla Houston** who also took third place with 'Sunset,' and fourth, a tie between **Joe Souza** for 'Cuyama Landscape' and **Bert Dennis** [Sic. **Dinnes**?] for 'La Purisima Mission.' Dr. Leland Smith was guest … illustrated dental photography in Kodachrome…," *SMT*, March 26, 1943, p. 3; "Camera Club… in the home of Mr. and Mrs. **Rollo [Sic. Rolla] Houston**. Plans were made for a picnic-meeting Aug. 29. The subject of prints to be shown at this time will be pets. President **John Bianchi** said that

non-members interested… in the club, may call him…," *SMT*, July 30, 1943, p. 3.

1944 – "Camera Club's New Officers Preside," *SMT,* Jan. 29, 1944, p. 3; "Camera Club – Red Cross Program … making pictures of various Red Cross activities here will comprise the 1944 project of the Santa Maria Camera club. **John Bianchi**… will serve as photography chairman … the club will also furnish all materials and equipment…," *SMT,* Feb. 11, 1944, p. 3; "Awards Given Camera Club Members," *SMT,* Feb. 25, 1944, p. 3; "Camera Club Takes New Members," *SMT,* March 31, 1944, p. 3; "Monthly Session of Camera Club," *SMT,* April 28, 1944, p. 3; "Stage Photography Awards Given" at **Breneiser** home, and "… prizes contributed by **Mrs. Breneiser** went to **Joe Souza, Ken Moore, George Heath** and **William Murphy**…," *SMT,* May 18, 1944, p. 2; "Camera Club Award to New Member," *SMT,* May 26, 1944, p 3; "Camera Club Shown War Films," *SMT,* June 30, 1944, p. 3; "Camera Club Plans Picnic for August," *SMT,* July 28, 1944, p. 3; "Color Process Demonstrated by Camera Club," *SMT,* Aug. 30, 1944, p, 3; "Interest Shown in Color Process" by Ansco, *SMT,* Sept. 2, 1944, p. 3; moving pictures "New Department Added to Club," *SMT,* Sept. 29, 1944, p. 3; "Camera Club to Discuss Technique … print competition judging will be on 'Animals.' There will be a lecture-discussion on 'Time Magnification,' and as the lecture goes along, films and slides provided by Eastman Kodak Co. will be shown. … often referred to as high speed photography…," *SMT,* Oct. 25, 1944, p. 3.

1945 – "**Houston** Named to Head Camera Club," *SMT,* Jan. 26, 1945, p. 3; **Al "Taylor** First for Camera Study," *SMT,* Jan. 27, 1945, p. 3; "Camera Club Program … Color movies of Sequoia Park will be shown by **Dave Kaukonen** and there will be a lecture on landscape photography by **Bert Dinnes**," *SMT,* March 7, 1945, p. 3; "Awards in Print Contest Made," *SMT,* March 23, 1945, p. 3; "Print Contest," *SMT,* April 20, 1945, p. 3; "**Vic Bailey** First in Print Contest," *SMT,* July 13, 1945, p. 3; "Camera Club Resumes" after summer vacation, its twice-monthly meetings with view of photos by **Wynn Bullock**. "Bullock attended Los Angeles Art Center School of Photography … The meeting will be at 8 o'clock in room 50 in the high school," *SMT,* Oct. 11, 1945, p. 3; **Bert "Dinnes** Given Two Print Awards … Lieut. C. Beall showed colored slides taken by him in Germany. Technically they were of interest to club members who studied the German processing for color … Bill Motta and Mr. and Mrs. **Earl Stubblefield** became new members. Stubblefield has just been discharged from the Navy. In service he was a photographer," *SMT,* Oct 26, 1945, p. 3.

1946 – "**Ken Moore** Heads Camera Club," *SMT,* Jan. 11, 1946, p. 3; "Camera Club Group Hears SB Speakers" i.e., **Ernest Brooks** of the Brooks Photographic Store in Santa Barbara and four instructors, including **Charles Perry**, and they spoke on correct development and exposure of negatives and the use of the Weston Exposure Meter, *SMT,* Jan. 31, 1946, p. 3 (on microfilm after Feb. 28); **Kes "Ovington** Shows Colored Slides of Fishing Trip … into Bishop County. He made the slides with a Leica camera…," *SMT,* Feb. 8, 1946, p. 3; "Camera Club Plans to

Have Models. Four local school girls… for portraits to be made at the next meeting… The purpose of the meeting is to learn portrait lighting. At last night's meeting… **Vic Bailey** gave a demonstration of correct use of color filters and the color temperature meter for color photography," *SMT,* March 29, 1946, p. 4; "Camera Club Plans Annual Barbecue," *SMT,* May 14, 1946, p. 3; "Annual Outing," *SMT,* May 24, 1946, p. 3; "Judging on Prints at Camera Meet," *SMT,* June 7, 1946, p. 5; "**Joe Souza** First in Camera Club Competition," *SMT,* July 19, 1946, p. 3; "Camera Club has Full Program," *SMT,* Sept. 13, 1946, p. 4; **Al "Taylor** Takes Honors in Print Show," *SMT,* Sept. 27, 1946, p 3; "Camera Club Meeting" at Rec Center with talk by **William Murphy** and slides by **Mario DeBernardi**, and next print competition is on doorways, *SMT,* Oct. 11, 1946, p. 3; "Camera Club Members Choose Winners" in monthly print contest, *SMT,* Oct. 25, 1946, p. 3; "Slides to be Shown" by Miss Ovington of Santa Barbara [this could be Audrey, sister of **Kes Ovington**, below]… landscapes, portraits and subjects of all kinds… Some of Miss Ovington's pictures have been shown in various magazines, such as '*Coronet*'," *SMT,* Nov. 7, 1946, p. 3; "Prizes Awarded at Camera Club … subject was 'Shoes.' … prizes were won by **Al Taylor**, first, **Bob Stratton**, second, **Dave Kaukonen**, third and **Norman Brown** won the fourth and fifth prizes. Two new members were taken into the club. They were **Roland Youtz** and [Pvt.] Joe Carlon. Next subjects of the club will be 'Roofs'… On Dec. 5 a program will be given and **Mr. Brooks** of the Brooks School of Photography in Santa Barbara will give a lecture… 'Print Quality' and 'Negatives'," *SMT,* Nov. 22, 1946, p. 3; "Special Meeting" – dinner at Swiss Chalet followed by lecture by **Mr. Brooks**, *SMT,* Dec. 5, 1946, p. 3; "Mr. Brooks and Staff Guest of Camera Club… dinner in the Swiss Chalet Thursday evening with a group of Santa Barbara instructors as guests. They were **Ernest Brooks** … and his staff, **Mary Abbott, David Donoho**, an artist and photographer, **R. Lawhorned** [Sic. **Lawhorne**] and **M. M. Deaderick**. Each member brought two prints which the guests criticized and discussed. **Brooks** will be here in Santa Maria in the latter part of January to start a series of lectures. Next meeting will be Dec. 19. The prints and subject will be on 'roofs.' … This meeting will be in the City Recreation Center," *SMT,* Dec. 7, 1946, p. 3.

1947 – "Camera Club has Judging of Prints … night scene out of doors… **Mervin Slawson** took top honors… **Brown** and **Al Taylor** tied for third. **Bob Stratton** was fourth … In Group B, **Bill Murphy** won first place. Peter Carlotti and **Harold Kinny** [Sic. **Kinney**] tied for second … **Vernon Houghton** and **Rev.** [Sic.] **Roland Youtz**, tied for fifth. This event was followed by the women judging the best prints of the year…1946. **Bert Dinnes**… took first place and **Norman Brown** took second… **Taylor** and **Rollo** [Sic. **Rolla**] **Huston** tied for third…," *SMT,* Jan. 17, 1947, p. 3; "Winners of Print Competition Named Thursday," *SMT,* Feb. 14, 1947, p. 8; "Camera Club to See Demonstrations" by **Ernest Brooks**, "meet this evening in Hancock College, class room four at 7:30 p. m… Next… meeting will be held March 13 in the city Recreation Center which will be a print competition on 'Farm Landscapes'," *SMT,* Feb. 27, 1947, p. 3; "Camera Club to Meet with Erwin [sic **Ernest**]

Brooks," *SMT,* March 26, 1947, p 3; "Special Competition Held by Camera Club" judged by **Ernest Brooks** and two instructors, **Rex Flemming**, a noted photographer, and **Dave Donahoe**, a famed artist and photographer, *SMT,* March 28, 1947, p. 3; "Reflections Subject for Camera Club," *SMT,* April 11, 1947, p. 5; "**N Brown** Takes First Place in Print Judging … 50 prints, a 'traveling exhibit' which are original prize winners from the magazine, '*The Camera*' were displayed. … [contest] **Norman Brown**, first, **W. J. Murphy** second, **Al Taylor**, third, and honorable mentions, **Mervin Slawson** and **Bob Stratton** … It was voted for the group to sponsor a project of photographing gardens, yards and points of interest in Santa Maria," *SMT,* April 26, 1947, p. 3; "Final Judging on Camera Club Prints … by the **Brooks School of Photography**… In the A group **Mervin Slawson** won first and third place, **Norman Brown**, second, **Al Taylor** fourth and **Rolla Houston**, fifth. In the B group **Bert Dinnes** won first and **Joe Sousa [Sic. Souza]**, second. Third place was a tie between Dinnes, Sousa and **Bert Domingos**… exchange of negatives between the members with each owner and receiver making a print from the negative… annual barbecue… with the Brooks staff as honored guests," *SMT,* May 23, 1947, p. 5; "Camera Club Displays Prints" on the subject of 'The Oil Industry'," and winners named, *SMT,* June 20, 1947, p. 5; "Plans Trip to Avila … with the object of photographing marine subjects for an exhibit… [current] competition on 'curves'… A color slide show… under the direction of **Kes Ovington**. Subjects included scenic, portraiture, reflections, children, industry and animals. Contributors to the color show included **Bert Dinnes, Ovington, Bert Domingos, Rollo [Sic. Rolla] Houston, William Murphy, Mervin Slawson, Vernon Houghton** and Pete Carlotti… a special competition of hand-colored prints will be arranged for the meeting of Thursday, Aug. 7… [and] a print competition on the subject of 'architecture'," *SMT,* July 11, 1947, p. 5; **Norman "Brown** Enters Winning Print in Competition … subject of curves… Other awards in class A were **Mervin Slausson [Sic. Slawson]**, second, **Joe Sousa [Sic. Souza]**, fourth and **Bert Dinnes**, fifth. Class B winners were **Leighton Richardson**, first, **Bert Domingos**, second and honorable mention and **Roland Youtz**, third and fifth … At the next meeting there will be a special showing of 8 by 10 hand tinted color prints to be submitted by all members…. [and one print on 'architecture'] to be judged by the Brooks School of Photography," *SMT,* July 26, 1947, p. 3; "Camera Club Has Print Salon Scheduled … to be held at Arroyo Grande … meeting held in City Recreation Center… getting together a traveling collection of prints… A print competition on marine subjects is slated …," *SMT,* Aug. 22, 1947, p. 5; "Camera Club Addressed by Experts" i.e., **Ernest Brooks**, *SMT,* Sept. 19, 1947, p. 5; "**Bert Dinnes** Given Party by Camera Club. 'Negative Analysis' and use of a densitometer to measure the density of films were subjects discussed and demonstrated at last night's meeting… Prints on the subject of 'Texture' were submitted and will be forwarded for judging at the **Brooks Institute** in Santa Barbara. They will be returned, each accompanied with written criticism… 'Sand Dunes' was the print topic assigned for the following competition. After the meeting, the 35 members present adjourned to the home

of Mr. and Mrs. **Al Taylor** where a surprise birthday party was given for **Bert Dinnes**… 11 years as the club's secretary," *SMT,* Oct. 3, 1947, p. 3; "Camera Club Invites Public to [Its] Exhibit" at City Recreation Center, *SMT,* Nov. 5, 1947, p. 3; "**Joe "Sousa** [Sic. **Souza**] Wins in Camera Print Contest," *SMT,* Nov. 22, 1947, p. 3; **Mervin "Slawson** Named Prexy of Camera Club," *SMT,* Dec. 19, 1947, p. 3.

1948 – "SM Camera Club Prints to be Exhibited in North" at county meeting of Women's Federated Clubs of San Luis Obispo in Arroyo Grande, *SMT,* Jan. 7, 1948, p. 3; "Brown Submits Print of 1937… **Mervin Slawson** was installed president at last night's dinner meeting… held in the Orcutt Recreation Building. Clem Inskeep of Pasadena… an authority on pictorial photography… judged the prints…," *SMT,* Jan. 15, 1948, p. 5; "European Techniques Told to Camera Fans," by **G. [Sic. B.?] Dobro** and **M. Deaderick** of Brooks. "**O. M. George**… first place… subject was 'Vegetables' **Norman Brown**… **Bert Dinnes** … **John O'Neal** and **Al Taylor**… Dramatic highlights and shadows will be the subject for the next competition March 4…," *SMT,* Feb. 20, 1948, p. 3; "Camera Club Fetes President, Gets Award," *SMT,* May 8, 1948, p. 5; "Camera Club Gives Awards in Print Contest. Flowers was the subject… **Kenneth Prindle**'s prints won first and second place in class B. **Miles Boothe** placed third… **Roland Youtz**… honorable mention… [upcoming] barbecue… At the meeting there was an exhibit comprising 50 prints of the 1946 traveling Graflex salon," *SMT,* May 21, 1948, p. 3; "Camera Club Holds Barbecue at Rice Cabin … more than 80 were present… Members of the **Brooks Photography Institute** … guests… judged this month's print competition on the subject, 'One Light Portrait.' … The next meeting… will be held at USC College of Aeronautics June 10. A demonstration will be given by a representative of the Defender Co. on projection printing… ," *SMT,* June 7, 1948, p. 5; "Camera Club Given Pointers by Photo Expert" on "How to Make a Good Projection Print," by **Brooks** Inst. staff, and "**Deadrick** [Sic. **Deaderick**] gave a talk on the Photographic Society of America with which the Santa Maria Camera club is an affiliate…," *SMT,* July 9, 1948, p. 5; "Camera Clubs Plan Joint Print Display… in Arroyo Grande," *SMT,* Sept. 13, 1948, p. 3; "Camera Fans Slate Dinner Meeting and Competition … Santa Maria Camera club will meet at Arroyo Grande with the Camera clubs of Lompoc and San Luis Obispo at dinner and afterwards will have a tri-club competitive print exhibit… Thursday… met … at the home of Mr. and Mrs. **Kenneth Prindle**… print competition… judged by Brooks staff… **Al Taylor** … **Joe Sousa [Sic. Souza]** … **Mervyn Slawson**… **Norman Brown**…," *SMT,* Sept. 18, 1948, p. 5; "S M Camera Club Rates First in Print Contest" as judged by Brooks school staff members **Brooks, Boris Dobro** and **Charles Perry**, against SLO and Lompoc camera clubs, *SMT,* Sept. 20, 1948, p. 5.

1949 – "Best Amateur Print to be Chosen for 1948," *SMT,* Jan. 7, 1949, p. 5; "**Norman Brown** Places Winning Print of 1948 … [judged] by Jack Powell of Pasadena… **Norman Brown** … president for 1949. Other officers… **Kenneth Prindle**, vice president, **Bert Dinnes**, secretary and treasurer, **Vernon Houghton** and **Ollie Hudson**, print

chairmen, **Dave Carlin**, program chairman, **Al Taylor**, membership, **Mervin Slawson**, inter-club activities and **Bill Murphy**, publicity…," and present were a group from **Brooks Institute**, who have provided professional judging including **Ernest Brooks, Boris Dobro, Charles Perry** and Rex Fleming [of Rex Fleming Productions, motion picture producer, Santa Barbara]," *SMT,* Jan. 17, 1949, p. 5; "Inventor Holds Demonstration of Synchro-Meter… **Joe Wilson**…," a device to synchronize sound with home-made movies, *SMT,* Feb. 24, 1949, p. 5; "Views Print Exhibit" by **Jimmie Johnson** of Santa Barbara, formerly of Santa Maria, at home of **Prindles,** *SMT,* April 1, 1949, p. 5; "Local Camera Club to Host **Brooks Institute** … for a lecture and demonstration on 'high key lighting'… Included in the Santa Barbara group… will be **Boris Dobro**… **Lorin Norcross, Stanley Roberts** and **Ernie Brooks**…," *SMT,* Aug. 17, 1949, p. 5.

1950 – "Best Print [of 1949] by *Amateur Photographer* to be Named," at dinner at Shaw's, judged by **Morland Deitrich [Sic. Deaderick]** and present will be **Brooks** staff, and next print competition will be montage, *SMT,* Jan. 13, 1950, p. 5; "**Norman Brown** Wins Award for Best Print of 1949," and other awards given to **Harold Kinney, William Bush** (of Shell Beach) and **Ernest Brooks** gave a talk on "What is New in Photography," and officers named and installed, *SMT,* Jan. 16, 1950, p. 6; "Photography is Topic for Woman's Club Meeting at Arroyo" Grande by **Norman R. Brown**, T-T, Jan. 17, 1950, p. 2; "Camera Club Opens Contest" series of OMS at Camera Shop starting with **Bob Leyva**, *SMT,* Feb. 15, 1950, p. 6; "Camera Clubbers Exhibit Wares to Rotarians… **Norman Brown**… and **Kenneth Prindle**… for Guadalupe rotary club last night in the Commercial hotel… described enlarged photographs and Prindle, present president, placed the pictures under the light in a shadow box. **David Carlin**, also amateur photographer, was chairman of the program and assisted … Commenting on the pictures, Brown said California hills are difficult to photograph because of lack of contrast – they are either all brown or all green at the same time. He said pictures of waves off the coast are very difficult to make. Of some shots of desert, mountain and sand dunes, he described how a rather large figure in a foreground gives 'a feeling of depth'…," *SMT,* March 25, 1950, p. 8; "Camera Club to Hear Film Expert" **Charles Perry** of Brooks, "He will speak on 'Densitometry and Sensitometry,' while explaining mechanics of devices to gauge quality of negatives. The speaker is co-author of a book on this subject. He is author also of a correspondence course, and a former technician with Eastman Kodak Co. and instructor in a color course," *SMT,* April 5, 1950, p. 6; Central Coast "Camera Club Plans Contests" in IDES hall, SM Camera Club forced to move from recreation center which was turned over to servicemen, *SMT,* Oct. 27, 1950, p. 5; "Camera Fans from Mid-Coast to Exhibit" in exh. at DES hall sponsored by Santa Maria Camera club, and judges of competition named, **Fred Archer, Boris Dobro,** and **Morland Deadrick [Sic. Deaderick]**, magazine photographer, also of Santa Barbara… *SMT,* Nov. 2, 1950, p. 4; ad – "Santa Maria Camera Club presents Central Coast Counties Camera Club Competition. Saturday, November 4, DES Hall – 8 p.m. Admission Free …," *SMT,* Nov. 3, 1950, p. 10; "Group Prints by S.M. Win in Camera

Club Show … [i.e.] Coast Counties Camera Clubs' print show held in DES hall… Santa Maria won in a group showing… ," and judges and winners named. **Archer** gave an informal talk, and "judging of prints entered by eight central coast clubs, by **Fred Archer** of the Archer School of Photography, Los Angeles, **Boris Dobro**, Brooks School of Photography, Santa Barbara and by **Max Deaderick**, Carpinteria, citrus grower and amateur photographer. [winners and titles named] … Announcement was made of a special showing of 60 prints in Santa Maria by **Boris Dobro**, the evening of November 23… This noted artist and judge… gave an informative and humorous talk on creating your own scene, illustrated with a print of sunflowers. **Deaderick** talked on the unusual and close-at-hand subjects often overlooked illustrating his talk with striking examples of his own work on Carpinteria valley scenes," *SMT,* Nov. 6, 1950, p. 5; repro of "Open Big" by **L. J. Morrison**, *SMT,* Nov. 11, 1950, p. 8; "Brooks to Speak Here. **Ernest H. Brooks**… will speak on 'Pictorial Photography' at a special meeting of Santa Maria Camera club tonight at 8 in DES hall… Brooks will illustrate his talk with the latest photographic works of **Boris Dobro** and will exhibit 60 photographs in black and white and color… Brooks has assisted the local camera club for the past two years, serving as judge in many of its print competitions. Several local residents have attended his school," *SMT,* Nov. 30, 1950, p. 1.

1951 – "Local Man Wins Photo Award," *SMT,* March 2, 1951, p. 1; "To Give Free Course in Photography… beginning May 3… in the photo laboratory at USC College of Aeronautics and will meet thereafter for five consecutive Thursdays … under leadership of **William E. Bush**…," *SMT,* May 1, 1951, p. 4; "Photo Prints are on Floral Theme" at **Santa Barbara County Fair**, *SMT,* July 27, 1951, p. 4.

1952 – "**Mervyn Slawson**'s Sand Dunes Wins… first award at annual print contest… **Ernest Brooks**… was judge… **Vernon Houghton**'s print won second and **Kenneth Prindle**'s was fourth… officers were installed… Prints on a subject of the photographer's choice … at the club's next meeting the evening of February 7 in the photo laboratory, USC College of Aeronautics" and inception of Desk Trophy, *SMT,* Jan. 29, 1952, p. 4; "To See Expert Prints" and hear talk by **James T. Johnson** of Santa Barbara, Director of portfolios for the Photographic Society of America, *SMT,* Feb. 19, 1952, p. 4; "To Take Photos of Flowers for Fair. The first of two 'shoot-em' nights… will be at 7:30 tomorrow in the photo laboratory at USC College of Aeronautics when all local amateur photographers are invited to photograph flowers… spring flower arrangements made by members of the **Minerva club** … The photo prints are to be displayed at the [**Santa Barbara**] **county fair** in the floral division rooms…," *SMT,* March 5, 1952, p. 5; "Camera Club to Meet … at Hancock Field photo laboratory at 8 p.m. Wednesday. Anyone interested in color photography is cordially invited to attend," *SMT,* June 21, 1952, p. 4; "Floral Prints are Feature at Fair" sponsored by Santa Maria Camera Club, *SMT,* July 23, 1952, p. 4; "Color Group of Camera Club Sees Flower Slides … 100 slides by **Sehon Powers** featuring wild flowers of San Luis Obispo county… judged

the competition slides entered by members… flower studies. First award went to **Mervin Slawson**, second, **J. Miles Boothe**, third, **Mrs. Lillian Miller**, and two honorable mentions to **Mrs. Barbara Bixby** and **Vernon Houghton**…," *SMT*, Aug. 30, 1952, p. 4.

1953 – "Annual Award Dinner is Saturday," **Bud Quick**, president and **Fred Gibbs**, vice president, *SMT*, Jan. 9, 1953, p. 4; "Camera Print Exhibits Attended by Over 200 – … **Central California Camera club council** with Santa Maria Camera club as host…," and exhibit held in IOOF hall, and extensive list of winners, *SMT*, April 27, 1953, p. 4; "To Meet Tonight … in classroom No. 4, USC College of Aeronautics… **Bud Quick**, president… A talk will be given on photography, lenses and filters by E. Leiscion, representative of the Graflex …," *SMT*, May 21, 1953, p. 4.

1954 – Al "Taylor to Guide SM Camera Club… installed… at a dinner meeting at 3 p.m. today at the Ranch House," *SMT*, Jan. 16, 1954, p. 7; "Prindle Wins 1953 Top Award… **Kenneth Prindle**… seascape print and also was awarded second, third, and honorable mention in the black and white division. … **Boris Dobro**… **Barbara Bixby**… Slide of the year, entitled 'Ducky,' was … entered by **Fred Gibbs**… **Bud Bixby** won the award for highest number of points in color photography for the year… The club extended thanks to **Bert Dinnes** on retirement as secretary since 1940. **Joe Souza** was chairman of the barbecue committee … A birthday cake was cut for Mrs. Kay Kent and Elmer Rice…," *SMT*, Jan. 18, 1954, p. 4; "Camera Club to Hear Tape on Color Judging" for competitions in Dec. and Jan. "Awards… December … first, **Dave Colgrove [Sic. Colgrave]**, second and third, **Bud Bixby**, honorable mention, **Fred Gibbs** and **Vernon Houghton**. **Vernon Houghton**, with color photographs taken on a trip to the Canadian Rockies in the Lake Louise district carried first, second and third prizes in the January show. Honorable mention was received by entries of **Gibbs** and **Bixby**…," *SMT*, Feb. 11, 1954, p. 4; "Camera Club to Exhibit Famed Prints… the celebrated set of black and white prints of John R. Hogan FPSA, FRPS… in the Elks Field recreation building. … **Mrs. Lillian Miller**, chairman of the color division, announced the next meeting of her group is scheduled for one week from Friday…," *SMT*, Feb. 24, 1954, p. 1; "Camera Club to See Color Prints. The color division … will meet at 7:30 p.m. Friday in the Elks Field Recreation building, **Mrs. Barney Miller**, color chairman…," *SMT*, March 4, 1954, p. 6; "Camera Club Prints Judged … **Fred Gibbs**, first … **Al Taylor**, second, **Ken Prindle** and **Barbara Bixby** honorable mention. Class B, **Lillian Miller**, first, **Luther Thurman**, second and third…," *SMT*, March 12, 1954, p. 4; "Live Models for Camera Club Tonight … at Elks Field recreation building at 7:30 p.m. … **Mrs. Barbara Bixby**, program chairman… Two complete studios will be set up… The club's color group meets April 2, same place and hour… **Mrs. Barney Miller**, color group chairman. The program will feature the viewing and judging of this month's 'texture' slides…," *SMT*, March 25, 1954, p. 1; "Camera Club to see Sand Dune Pictures" of Death Valley by **Deadrick [Sic. Deaderick]**, *SMT*, April 22, 1954, p. 6; "Prize Winning Prints Viewed by Camera Club … invited to a week-end camera field day at Arroyo Grande, to be sponsored Sunday

by the Five C council of Camera clubs… **M. M. Deadrick [Sic. Deaderick]**, photographer from Carpinteria, spoke last night on a display of his prize-winning prints taken along California highways… potluck supper preceding the meeting in Elks Field Recreation building," *SMT*, April 23, 1954, p. 4; "Santa Maria Photographers Win at Arroyo … 5C competitions… at Arroyo Grande elementary school… Lynn Fayman, APSA, judged color slides… Honorable mention winners were **Albert Taylor**, president of Santa Maria Camera club… black and white prints were judged Saturday evening by **Boris [Dobro?]** …," *SMT*, April 26, 1954, p. 1; "Tony Kent [prop. record shop and a radio personality] Wins in Color Photos," *SMT*, May 8, 1954, p. 4; "Camera Club Views Exhibits at Meet … winners… black and white… **Al Taylor**… **Fred Gibbs**… **Bud Quick**… **Barbara Bixby**… **Mrs. Lillian Miller** … members viewed two traveling exhibits. Thirty prints that included unusual portraiture, was that of **Elmer Lew**, Fresno Camera club. The traveling salon of John Hogan, ARPS, APSA…," *SMT*, May 14, 1954, p. 4; "Field Trip Planned" to Morro Bay State Park, and "Camera Club to Enter *Times* Photo Contest," *SMT*, May 22, 1954, p. 1; "To Name Four Best," *SMT*, Aug. 31, 1954, p. 4; "Camera Club – Pictures in color, taken by **Maj. Barney Miller** on a 17-month tour of duty overseas with the United States Army, will be shown for the Camera club… at 7 p.m. Thursday in Elks Recreation building. **Mrs. Miller**, wife of the photographer, is club chairman of the color division and has helped arrange for the showing, to contain many human interest and scenic photographic studies…," *SMT*, Oct. 20, 1954, p. 4.

1955 – "Camera Club Sets Events for January," and extended article on installation of officers, **Norman Brown** print demonstration, **Lillian Miller**, *SMT*, Jan. 3, 1955, p. 4; "Camera Club Award Night at Ranch House Saturday … On January 20, members are to meet at 7:30 p.m. in the … High school laboratory… **Norman Brown** of Arroyo Grande will give a talk and demonstration on toning… January 26 will be 'color night'… Six assignments are being given for the year as follows: February, back lighted, March, portraits, May, humorous, July, speed, September, song titles, and November, love… **Fred Gibbs**… **Kitty [Sic. Kittye] Gibbs**," *SMT*, Jan. 12, 1955, p. 4; repro of **Ken Prindle's** photo of an elderly farmer, *SMT*, Jan. 17, 1955, p. 1; "**Prindle** Wins Print of '54 Camera Prize … judged by **Max Deadrick [Sic. Deaderick]**… **Fred Gibbs**, incoming president… Honorable mention … **Bud Quick, Barbara Bixby, Fred Gibbs** and **Ken Prindle**…," and other names mentioned are **Bud Bixby, Mrs. Kitty [Sic. Kittye] Gibbs, Bert Dinnes, Lillian Miller, Gaylord Jones, Bosworthy Lamere [Sic. Bosworth Lemere], Jimmie Johnson**, *SMT*, Jan. 17, 1955, p. 4; "Camera Club Hears of Print Toning" from **Norm Brown** of Arroyo Grande, *SMT*, Jan. 21, 1955, p. 1; repro of **Mervin Slawson's** photo 'Susan,' winner of Print of the Month, *SMT*, Feb. 11, 1955, p. 6; "Camera Club to Entertain" Spring show for Council Five camera clubs, "Recreation building at Elks field… **Elmer Lew**, Fresno, … will speak and give a demonstration on portrait photography… judged… by **Emil Muench**…," *SMT*, March 4, 1955, p. 4; "Photo Contest Honors Won by Santa Marians… at the Five-C show… judged by **Elmer Lew**… [winners]

Kenneth Prindle... Bud Quick... Barbara Bixby ... Educational feature of the day was a portrait photography demonstration by **Elmer Lew** using a living model," *SMT,* March 7, 1955, p. 1; "Camera Club Print Night Set Thursday," *SMT,* April 5, 1955, p. 5; "Camera Club Studies Color Photography ... Developing color films in the home studio was demonstrated... by **Vern Houghton**... prints were on display in the Elks Field Recreation building... assignment given in July... theme 'Speed' [and winners] **Kitty Gibbs** ... **Gaylord Jones**... **David Colgrave**... **Gladys Dinnes**... second group... marine scenes, **Mrs. Lillian Miller**... **Barney Miller**... **Bert Dinnes**... Vacation pictures taken by **Mr. and Mrs. Vern Houghton** on their recent trip to Mammoth Lake and San Francisco were shown ... New type color films put out by Ansco, had been used by three members of the club, **Major and Mrs. Miller** and **Vern Houghton** on different type subjects in day and night photography. These were developed and printed in the demonstration ...," *SMT,* Aug. 25, 1955, p. 6; "... Will Bring International to Area... founded in 1938 by **Ken Moore, Harry Bell, Jr.** and **Basil Hanson**... **Fred Gibbs**, president ... officers... **Barney Miller**... **Mrs. Vernon Houghton**... **Joe Sousa** [Sic, Souza], **Bert Dinnes, Al Taylor** and **Moore** 'held the club together during the war, meeting in each other's homes and helping the members get film and paper...' Among the current projects, the club is bringing to Santa Maria on July 23, the fourth international nature salon, an 'outstanding showing of color slides from all over the world.' Membership at this time totals 22 active members, all of them 'amateur' photographers, with a pronounced yen to portray the unusual in excellent prints. A monthly competition for 'Print of the Month,' is held for black and white photographs by members, and the club's meetings on the first and third Thursdays (color meetings fourth Wednesday) of each month are customarily augmented by speakers ...," *SMT,* April 30, 1955, p. 12; **Santa Barbara "County Fair" Floral Show Previewed ... Mrs. Barney S. Miller**, assistant superintendent for the show... For added entertainment, Santa Maria Camera club will have continuous showing of color slides of past shows, selected from prize winning slides ... entered in Camera club judging in the past year. There is also to be a display of black and white photography of flowers...," *SMT,* July 9, 1955, p. 1; "Camera Club to Sponsor Salon... Fourth annual International Salon of Nature Photography set for July 23 at 8:15 p.m. in the Gas Company auditorium... a color show and color slides on nature subjects from all over the world... Color night will be July 27 with slides from both May and June competitions... Assignments for July are: Advance pictorial, speed, record shots and marine," *SMT,* July 11, 1955, p. 4; "Camera Club Hears Speaker on 'Color'," *SMT,* Sept. 16, 1955, p. 4; "Camera Club to Meet Tuesday," *SMT,* Oct. 24, 1955, p. 4.

1956 – "Camera Club to Have Board Meet" to plan for annual award meeting and dinner to be held the evening of Jan. 14 at the residence of **Mr. and Mrs. Burns Rick** in Nipomo, *SMT,* Jan. 4, 1956, p. 4; port. of **Al Taylor** and another group port. showing **Gaylord Jones, Mrs. Jones, Mrs. Kittye Gibbs, George [Sic. Fred] Gibbs** and "**Taylor, Dinnes Gibbs** Win in Photography, *SMT,* Jan. 16, 1956, p. 4; "Camera Club Results of Month Posted," *SMT,*

Feb. 23, 1956, p. 6; "Begins New Series on Camera," i.e., How to Get Your Money's Worth Out of Your Camera, *SMT,* March 12, 1956, p. 4; "Nature Color Slides to be Shown... tomorrow at 8 p.m. in the Gas Company's auditorium. Some 379 slides from all parts of the world... sponsored by the ... and Camera Club... **Gaylord Jones**, president, has extended an invitation to the general public," *SMT,* July 20, 1956, p. 6; "Black & White Judging Tonight," *SMT,* August 2, 1956, p. 4; "Camera Club to Plan Installation," *SMT,* Dec. 6, 1956, p. 7.

1957 – "**Dave Colgrave** Scores Camera Club 'Sweep'... of the advanced pictorial color slide exhibition contest... **Ken Prindle** received the big trophy for the print of the year... **Fred Gibbs** was another member who put on a one-man show. In the 35 mm black & white class with a maximum print enlargement size of 8 x 10, Gibbs placed first... **Vern Houghton** placed first in the color slide record shots with a picture of Chinese lanterns in San Francisco. **Barney Miller** received first place on points... Other winners were... Advanced pictorial color slides, **Bob Hendricks**...," *SMT,* Jan. 14, 1957, p. 1; "Still in a Fog by **Gardner Boyd**. ... Since Saturday night I have become a one-man recruiting committee to try to locate some more members for the Santa Maria Camera club. And especially some color artists to compete with **David Colgrave**, our present top winner... Since Dave was elected color chairman for the coming year it seems that we can't bounce him from the club... [and details of recent judging] ... All this time **Lillian Miller**, last year's color chairman's secretary (**Barney Miller** was chairman) kept chuckling to herself, for she knew whose slides they were... Dave has had a big advantage on many of the local color fans in that he has had an opportunity to travel around a bit from coast to coast. This has placed him at the right place at the right time with his camera in his hand. His first-place prize winner was of a Chicago hotel all lighted up on a rainy night... His second was of a transcontinental airliner at dusk with the plane silhouetted against the setting sun. The third place was a row boat tied to a small pier ... dusk. His two honorable mentioned slides were of a single streetlight reflected in the rainy evening's walk and a Minnesota snow scene. Dave has been making a study of the technique of night, evening and dusk color photography, Mrs. Miller told me... The whole show seemed to be lopsided for **Ken Prindle** won the black and white award for the picture of the year... **Fred Gibbs** took most of the places in the 35 mm division... **Joe Souza** is the president for 1957... So get out your box Brownie and come around to the recreation building at Elks field next Thursday," *SMT,* Jan. 14, 1957, p. 6; "Camera Club Holds Educational Program ... held the first of a series of educational programs on photography Friday at the Elks Field Recreational House. **Ken Prindle** and **Vern Houghton** held a round table discussion on new films and methods of handling. **Fred Gibbs** showed a PSA Portfolio of 35 mm prints," *SMT,* Feb. 25, 1957, p. 8; German "Film on Cameras Free to Public," *SMT,* June 20, 1957, p. 4; "PSA Portfolio to Show. Santa Maria Camera Club color section will show a 50-slide portfolio of the 1956 Photographic Society of America winning slides in a national competition at 8 o'clock Wednesday in Elk's Field Recreation building. ... open to the public ... mainly scenics from all sections of

the United States," *SMT*, Sept. 24, 1957, p. 3; "To Hear Lecturer," i.e., first of a series of recorded lectures provided by Photographic Society of America in Recreation Building at Elks Field, and June Nelson, APSA will lecture on "Lighting Glass for Photography." Forty color slides will accompany the lecture, *SMT*, Dec. 5, 1957, p. 3.

1958 – Port of presidents **Joe Sousa [Sic. Souza?]** and **Ray Webb**, and "Camera Club Awards Trophies," and "Arabia Films to be Shown Camera Club," *SMT*, Jan. 15, 1958, p. 3; "To See Chinese Photography" via PSA recorded lecture program entitled 'Pictorial Photography from the Chinese Viewpoint'… 52 slides… themes, '<u>Fresh</u>' for April, '<u>Music</u>' for September and '<u>Portraits</u>' for November. Entries will be received in both black and white and color slides… The next competition meeting… Feb. 20. Another 'Through the Lens' travelogue slide show … on South America will be shown for the club on March 6. **Ray Webb** is president… with **Gardner Boyd**, vice president, **Bob Dupuis**, secretary, **Doris Houghton**, Treasurer, **Dave Colegrave** and **Bill Niederhauser**, color slides, **Gaylord Jones**, black and white chairman," *SMT*, Jan. 30, 1958, p. 2; "To Name Winners" in Jan. competition, *SMT*, Feb. 20, 1958, p. 2; "Composition to be Topic for Camera Club. The 'Story of Composition' will be told Thursday evening… by Mrs. Vella Finne, an internationally known photographic salon exhibitor from Southern California. More than 80 color slides will be shown in this recorded lecture which will cover all phases of both color and black and white photography. The club meets at the McClellan Park field house at 7:30 p.m. the first and third Thursdays of the month…," *SMT*, April 8, 1958, p. 3; "Trophies [won at **Santa Barbara County Fair**] to be Awarded… Aug. 7 in the Recreation Building at Elks Field… **Gardner Boyd**…," *SMT*, July 31, 1958, p. 3.

1959 – "Colored Slides – by **Sgt. and Mrs. Barney Miller** on a recent tour… Bryce and Zion National Parks and trailer-toured in the deserts of Southern California in the Palm Springs area…," *SMT*, Jan. 14, 1959, p. 5; "Lecture [i.e., Portraiture in Color] Planned for Camera Club … Black and white monthly competition is being reactivated, President **Bob Dupuis** said …," *SMT*, Feb. 4, 1959, p. 11; "Camera Club Show Firmed," i.e., color slide competition, *SMT*, Sept. 15, 1959, p. 6; "Camera Club Holds Slide Competition," *SMT*, Sept. 18, 1959, p. 8; "Camera Fans Slate Meeting Thursday" for pot luck and Photographic Society of America lecture on modern art and modern photography at clubhouse at McClelland Park, *SMT*, Sept. 30, 1959, p. 2; "Camera Club Plans Color Slide Event," *SMT*, Oct. 14, 1959, p. 9; "**Shirley Dupuis** Captures Color Slide Honors," *SMT*, Oct. 16, 1959, p. 2; "To Meet Thursday" for pot luck and slides of Eastern trip, *SMT*, Nov. 4, 1959, p. 2; "Judging Slated at Camera Meet," *SMT*, Nov. 17, 1959, p. 2; "Plans Monthly Showing," *SMT*, Dec. 15, 1959, p. 2.

1960 – "To Hear Lecture. A tape-recorder lecture, 'Table Top Tricks,' combined with more than 80 color slide illustrations will be given at tonight's meeting… at 8 p.m. in the Recreation Building at McClelland Park… **W. H. McCollum [Sic? McCullom]**, president…," *SMT*, Feb. 4, 1960, p. 9; "Photography Club Meets Thursday. Open competition in slides and black and white prints … 8 p.m. Thursday in the recreation building at McClelland Park. **Mervin Slawson**… will judge…," *SMT*, Feb. 17, 1960, p. 2; "**Freddie Weaver** Tops Camera Club Contest… in color slide competition… **Pete Bruckner** of Vandenberg… Honorable mentions went to **L. E. Abel**, Vandenberg, and **Vern Houghton** … **Ken Prindle** was judge… The club will meet again on Aug. 4 when members are asked to bring up to 40 slides on any one subject for showing…," *SMT*, July 23, 1960, p. 2.

1961 – "SM Camera Club Names President… The annual dinner will be held January 20 at the Santa Maria Club. **Max Deaderick** FPSCA will be the guest judge and will choose the print and slide of the year…," *SMT*, Dec. 7, 1961, p. 13.

1962 – Photo of Camera Club winners: **Peter Bruckner, Barbara Bixby, Max Deaderick** (judge), <u>Dave Weaver</u>, **Vernon Houghton**," *SMT*, Jan. 24, 1962, p. 23.

1964 – "Photo Contest Winners. <u>Jack McKnight</u> and **Freddi Weaver**… **Max Deaderick** of Oxnard judged… Weaver Photo…," *SMT*, Jan. 22, 1964, p. 14.

And many, many additional notices on the Camera Club in Santa Maria newspapers not itemized here.

<u>Santa Maria Camera Club (articles from *Arroyo Grande Herald Recorder*)</u>

1948 – "Woman's Club, PTA to Have Photographic Salon" in Arroyo Grande, *AG*, Jan. 9, 1948, p. 1; "Over 700 Persons See Photo Display," *AG*, Jan. 16, 1948, p. 1; "Prize Winning Photos are Now Being Displayed," *AG*, Feb. 20, 1948, p. 10; "Prize Winning Photos are Now Being Displayed," *AG*, Feb. 20, 1948, p. 10.

1950 – "Winners Revealed by Camera Club," *AG*, March 24, 1950, p. 8.
See: "Community Club (Santa Maria)," 1949, "La Purisima Camera Club," 1947, "Minerva Club, Flower Show," 1948, "Photographers," "Santa Barbara County Fair," 1952, 1957, 1958, "Santa Barbara County Library (Santa Maria)," 1941, "Santa Maria, Ca., Union High School," 1955, "Thurman, Luther," 1952

Santa Maria Camera Shop (Santa Maria)
Retailer of photographic supplies and some art supplies, 108 West Main, 1939+. Prop. Bernard Karleskint and his sister, Mary Roemer.

■ "Opening the New Santa Maria Camera Shop, 108 West Main Street. Saturday, April 15, 1939. By **Mary Roemer**. Exclusive agent for: Carl Zeiss, Inc., World's Finest Cameras and Lens. Bell and Howell, Precision Made Home Movie Equipment. Keystone Home Movie Equipment. Rolleiflex and Rolleicord Cameras. World Famous Schneider Lens. Featuring: Agfa Ansco Film, Paper and Supplies and Eastman Kodak, Film and Supplies. Double Sized Prints at no Extra Cost. Portraits by **Ernest Brooks**. City's Finest Equipped Studio. Passports and Glossy Prints for Reproduction. Commercial Photography," *SMT*, April 14, 1939, p. 3.

Santa Maria Camera Shop (notices in Northern Santa Barbara County newspapers on microfilm and on newspapers.com)

1939 – "Photography – S. M. Camera Shop. Tel. 630-R. Photography a Year Around Hobby. Our endeavor is to have as complete a stock of the finest photographic merchandise available. Films, Supplies, Developing and Printing. S.M. Camera Shop – **Mary Roemer** – 108 West Main," *SMT*, April 24, 1939, p. 6.

1942 – "What to Give For Christmas! How About Yourself? Santa's found the word for it! The most precious gift you can give those you love – is a photograph. Naturally posed, artistically developed, handsomely framed – a picture of yourself conveys your Yuletide wishes through the years. We will mail to any point in the United States in time for Christmas delivery. Santa Maria Camera Shop. 118 So. Broadway. Phone 370-W," *SMT*, Nov. 13, 1942, p. 3.

1944 – "Quality Portraits that will be cherished for a lifetime. A photograph can express your sentiments. Santa Maria Camera Shop. **Mary Roemer. Bernard Karleskint.** 118 South Broadway. Phone 370-W," *SMT*, Nov. 28, 1944, p. 2.

1951 – "Everything for the amateur and professional photographer… the finest equipment … Eastman Kodak, Bell & Howell, Graflex, Sawyers View Master, Rolleiflex and others… Mother's Day, May 13th. Suggestions for mother. Art supplies: Cameras & Equipment, Ceramic Paint, Textile Painting Sets. Photograph Albums, Santa Maria Camera Shop. Printing and Developing. 118 So. Broadway. Phone 5-4654," *SMT*, May 5, 1951, p. 5.

1952 – "Artists Supplies. A Complete Stock in Pictograph Oil Colors – Casein and Water Colors and Paint Books at Santa Maria Camera Shop. 118 S. Broadway. Phone 5-4654," *SMT*, Sept. 16, 1952, p. 7; "Gifts that will keep precious moments alive forever… Photographic Equipment… Artists' Supplys [sic] Complete stock of Canvas, Paints, Brushes, also Textile Painting Sets, Pictograph Sets …," *SMT*, Nov. 28, 1952, p. 19.

1958 – "$15,000 Camera Shop Break-In," and list of missing items, *SMT*, May 15, 1958, p. 1; "Polaroid Land Camera. That's all there is to it! … pictures in 60 seconds… No messing with chemicals. All ready for you in a minute… Beautiful, lasting, black-and-white pictures… Santa Maria Camera Shop, *SMT*, Nov. 25, 1958, p. 9.
More than 1370 notices for "Santa Maria Camera Shop" in the *SMT* between 1939 and 1960, many of them ads, were not even browsed for itemization here.
See: "Karleskint, Bernard," "Roemer, Mary"

Santa Maria County Fair
See: "Santa Barbara County Fair (Santa Maria)"

Santa Maria Fair
See: "Santa Barbara County Fair (Santa Maria)"

Santa Maria High School
See: "Santa Maria, Ca., Union High School"

Santa Maria Historical Society
See: "Santa Maria Valley Historical Society"

Santa Maria Hospital
See: "Community Club," 1941, "Elk's Rodeo," 1953, "Junior Community Club," 1950, 1953, 1956

Santa Maria Inn
Hotel opened 1917. Proprietor Frank J. McCoy commissioned artworks of some artists and decorated certain rooms with antiques. The Inn was also site of some art exhibits.

■ "Santa Maria Inn Opened Today… May 19th … The plans for the building were drawn up early last fall… The painting has been in the hands of B. R. McBride… There are 30 bedrooms…," *SMT*, May 19, 1917, p. 1.
Santa Maria Inn (notices in Northern Santa Barbara County newspapers on microfilm and on newspapers.com)
1931 – "Bruner's Browsings… **Frank J. McCoy**, proprietor… The dining room…. On side-boards around the walls – antique pots and old fashioned pewter and brass utensils create an atmosphere of the old world. Throughout the entire building one can find antique articles of furniture and relics … The lobby likewise maintains a cheery atmosphere… Here again we find the antique furniture, old chests, Indian corn grinding bowls, and other forms of Indian utensils too numerous to mention. The lounge… wide, comfortable divans… second floor… tiny patio… The star-studded sky forms the roof…," *SMT*, May 28, 1931, p. 3.
1932 – "Antiques of Inn… 'A Trip to California's Flower Kingdom'… February issue of *California Arts and Architecture*…," *SMT*, March 28, 1932, p. 1; F. J. Dennis, "Trip to California's Flower Kingdom: Collection of Frank McCoy at Santa Maria Inn,' *California Arts & Architecture*, v. 41, Feb. 1932, pp. 20-21+.
1951 – "**Michetti** Paintings on Exhibit at Inn" sponsored by Marin Art Assn. "Principally of California or Mexico subjects, one of the latter, 'Indian Canoe on Lake Patzquaro' has been purchased by Mrs. E. B. Bettis of San Francisco, who was a guest at the Inn on her way home from Palm Springs," *SMT*, Feb. 9, 1951, p. 4.
See: "Art Festival," 1935, "Breneiser, Stanley G.," 1933, 1937, "Cadorin, Ettore," 1935, "Capitani, Lorenzo," intro., "College Art Club," 1934, "Cooper, Colin," 1929, "Herter, Albert," 1920, "McCoy, Frank," "Miller, Evylena," 1928, 1936, "Motzko, Helen," 1954, 1955, "Murals," 1956, "Muro, George," 1957, "Patton, Kay," 1956, 'Perry, Oma," "Poock, Fritz," "Santa Barbara County Fair," 1952, "Santa Maria, Ca., Union High School," 1937, 1938, "Santa Maria Valley Art Festival," 1952, "Santa Maria Valley Historical Society," intro., "Sheldon, Dorothy," 1943, "Stonehart, Les," 1944, "Taylor, Elizabeth," 1952, "Veglia, Mario," 1954, 1956, "Walker, Winifred," "Waller, Lionel," 1938, "Warner, Nell Walker," 1939, 1940, "Williams, Ernest"

Santa Maria Junior College

Santa Maria's "Junior College" was held on the campus of Santa Maria High School up to c. 1954 and afterwards at Allan Hancock College.

See: "Allan Hancock College," "Santa Maria, Ca., Union High School"

Santa Maria Library

See: "Santa Barbara County Library (Santa Maria)"

Santa Maria Photo Gallery / Santa Maria Photography Gallery (Santa Maria)
Photo Gallery, 1909.

■ "Have your baby's, wife's or sweetheart's photo put on a pillow top. Any portrait or scene from a stamp to an oil painting can be put on them and guaranteed to wash and iron just like a piece of goods. Call and see them. Santa Maria Photo Studio, one door west of St. James Stables," *SMT*, Feb. 6, 1909, p. 1, col. 3.
See: "Judkins, D. R.," "Judkins, Etta Hazle," "Meyers, Mr.," "Santa Maria Studio," "Shull, E. D."

Santa Maria School of Art
Summer art school run by Mr. and Mrs. Stanley G. Breneiser in 1927, 1933.

■ "The Santa Maria School of Art which held its first session during the summer of 1927, will again conduct classes this year from early July through the first week of August. … The school will be conducted by the local high school and junior college art instructors, **Mr. and Mrs. Stanley G. Breneiser**. … some of the classes will be held in the art room of the high school building, while others will be given in the studio of the Breneiser home on the Lower Orcutt Road. … about twenty students will be assisted with tuition fees or given free instruction entirely. … The school will offer courses in outdoor sketching and painting, in design, crafts, commercial art and in public school art for teachers. The instructors will include, beside Mr. and Mrs. Breneiser, **John Day Breneiser** and two instructors from out of town. Catalogues will be issued in a short time," per "Art Instructors Plan Summer School," *SMFA*, May 12, 1933, n. p.
Santa Maria School of Art (notices in Northern Santa Barbara County newspapers on microfilm and on newspapers.com)
1927 – "Art Scholarships Won by Students. Two scholarships for full tuition … were awarded yesterday to the two high school students who made the greatest general progress in art this year. The winners were **Cora Culp** and **Ruth Bettersworth**. **Walter Cleaver** of the Junior college was awarded a like scholarship and Barbara Higgins given honorable mention…. The tuition fee is $50 and this summer's session will be the most prosperous in the history of the school," *SMT*, May 19, 1927, p. 5; "School of Art Announces Lecture Courses. The Santa Maria School of Art, which opens on June 27, in the high school building, announces three lecture courses to be offered …this summer. One… general study on the Appreciation of Art in which the basic principles of architecture, sculpture and

painting will be explained; the study of concrete historic examples of past and present ages through photographs and personal experience of the instructors on European fields will be given; discussions of the principles of esthetics and how to apply them… 10 a.m. on Monday, Wednesday and Friday of each week. The second course will be one on the art of the Italian Renaissance. It will include a study of architecture, sculpture, painting, minor arts and of the artists of this period in Italy. This course will be given on Tuesdays, Thursdays and Saturdays at 10 o'clock in the morning. The third course will be … the technical and practical side of art in order to gain a better understanding of art in general. It is a course on Form, Color and Design. This will be given in the afternoons on the days best suited to the greatest number… The lectures will be so arranged that each of the four instructors in the school will share in the work. Anyone can enroll in one or all of these courses without having had any previous art training. The courses can be taken for credit or … as an auditor…," *SMT*, June 9, 1927, p. 5; ■ "School of Art Exhibit Ready. The work of students who have been attending the summer session of the Santa Maria School of Art will be exhibited on Thursday and Friday in the windows of Bryant & Trott's hardware store on East Main street. The work includes drawings, clay modeling, designs and imaginative expressions of children from the age of 4 ½ to 10. **John A. Breneiser** is teacher of this class. Drawings from flowers, designs, tooled leather, clay craft work and general art problems of students of high school age will be included in the exhibit. This class has been taught by **Mrs. Elizabeth D. Breneiser**. Pencil sketches, pastel drawings and oil paintings by more advanced students will also be shown. These classes have been taught by LeComte [Sic. LeConte] Stewart of Kaysville, Utah. Stewart is considered Utah's greatest artist. The classes in Pictorial Composition and in Methods for teachers have been taught by **Harold C. Stadtmiller** of Exeter, Calif. … Some of the work of the class in Decorative Design, taught by **Breneiser**, the director of the school, will also be on view. The session covered five weeks' instruction, six days a week and it has proven to be a very successful first year… Twenty-five pupils were enrolled," *SMT*, July 26, 1927, p. 6.
1933 – "**Breneiser**s Prepare for Summer Art School … In order to help finance this work, the Breneisers, who have sponsored the art school, are conducting an extensive sales campaign of a set of three block prints by three Pacific coast artists, who are skilled in this art. These original block prints have been donated to the cause by the artists. Two of the artists will teach in the school. Classes for children, high school students and adults will be conducted in the art room of the high school and in the studio of 'The Ark' on the Lower Orcutt road," *SMFA*, May 19, 1933, n.p.; "Santa Maria Art School for Summer … July 3 to August 5 … Conducting a similar school here in 1927 proved for Instructor Breneiser, that there is a definite need for such an institution in California… Assisting him this year will be **Harold C. Stadtmiller**, affiliated with the school in 1927, **Elizabeth D. Breneiser**, local high school and junior college teacher, **John Day Breneiser**, young Santa Maria artist, **Lucy De Gasparis**, design and drawing, and **Eddy Milburn**, Los Angeles, instructor in costume

design and the dance. Five major courses will be offered: painting and composition, form and graphic analysis, design and crafts, school art and methods of teaching, and costume design and dance. **Miss De Gasparis** will conduct a class for students of pre-high school age in drawing, design, color and modeling, while other courses to be offered are outdoor pencil sketching, abstract, interpretative design, pictorial linoleum block printing. Director **Breneiser** will have charge of form and graphic analysis classes, while **Mrs. Breneiser** is in charge of design and crafts courses. **John Day Breneiser** will teach painting and composition and **Harold Stadtmiller** school art and methods of teaching. Classes will be conducted in the high school building… They also will be held in part at 'The Ark'… Registration will begin July 1 with classes commencing July 3 …," *SMT*, May 20, 1933, p. 1; repro: wood block print by N. B. Zane and "Summer School of Art Given Eastern Note… a three-column reproduction of a wood-block print … *Christian Science Monitor*," mentions block prints by three artists of note on the Pacific coast will be sold to finance upcoming summer art school," *SMT*, June 8, 1933, p. 6.

■ "**Breneisers** Open Summer Art School in this City … Breneiser family in instigating this five-week summer School of Art at the local high school building is doing a creditable service to the community – putting the best of art instruction within the reach of those who may find much pleasure and satisfaction in the work… The Breneisers established a summer art school once a few years ago, but the appreciation of arts had not been developed in Santa Maria to any extent and the school met with failure," *SMFA*, June 16, 1933, n. p.; "Practical Side of Art is Worked Out in Summer Schools Conducted by Breneisers," and lengthy details of art techniques taught, and visit to classes, *SMT*, July 25, 1933, pp. 1, 6.

■ "Exhibit on August 4 Will Culminate Summer Art School Work in S. M. … **Stanley G. Breneiser** feels that the Santa Maria School of Art, held under his direction this summer, and which will soon hold an exhibit at the **Little Theater**, has been a success. The success was not a financial one, however, Mr. Breneiser adds, although he admits that it has not been a financial failure. Most of the incidental expenses and supplies have been paid for, and a couple of the instructors have received a small remuneration – a very small one, if the truth were known, but the entire faculty has enjoyed the opportunity of giving of their knowledge to deserving pupils in the school. … Thirty-two pupils were enrolled… including children and adults from 7 years to 50. The enrollment fee paid by each student was 50 cents, which covered the incidental expenses, and the tuition fee was correspondingly low. Due to the fact that many of the students who were anxious to attend, were unable financially to do so, three original block prints by well-known Pacific coast artists were being purchased at a nominal fee by interested individuals and friends who wished to help… The prints are still on sale at $2 apiece and $5 for three. The school will close on August 4 with an exhibit of students' and instructors' work at the **Little Theatre**, which is open to the public… **Harold C. Stadtmiller** completed an exceptional amount of work including 70 problems finished by his class during the short term of the school. **John Breneiser**'s class in oil paintings

have also completed an extensive program. But perhaps the most responsive group was the children's classes under **Lucy De Gasparis**. … many of those attending both as instructors and pupils made their home with the Breneisers during the five weeks' session. This arrangement afforded an added interest in the school. Each morning, early, **Eddie Milburn**, instructor in costume and mask construction, conducted a dancing class for the assembled guests… Mr. Milburn has studied dance under Ruth St. Dennis and Ted Shawn, and it was through this beginning that he took up the study of costume and mask design and construction, applicable to the stage, in which he has had ample training on stages and motion picture lots…. Four courses equivalent to lower division college credit courses, were offered. No. 1 – Painting and composition. A thoroughly modern, interpretative class in landscape, portrait, and elements of composition. Mediums, oil and water colors. Class meets three half days each week. Individual criticisms and class discussions. Instructor – **John Day Breneiser**. No. 2 – Form and graphic analysis. A progressive course in the study of abstract form, emotional expression and intellectual analysis of fundamental forms and principles. There will be an elementary and an advanced section in this class. Work in commercial art is carried out as well. The instructor is **Stanley G. Breneiser**. No. 3 – Design and Crafts. Color study, design principles and the modern aspect applied to the crafts. Instructor – **Elizabeth Day Breneiser**…. courses for teacher, both elementary and high school. Instructor – **Harold C. Stadtmiller**. Other courses – Children's class. A class for students of pre-high school age. Work in drawing, design, color and modeling. Instructor **Lucy de Gasparis**. If there is a sufficient demand, the following courses will be added to the list next year: Outdoor pencil sketching, **Stanley G. Breneiser**. Abstract, interpretative design, **Lucy de Gasparis**. Pictorial linoleum block printing, **H. C. Stadtmiller**. Mr. Breneiser says: 'The Santa Maria School of Art does not aim to compete in any way with the summer sessions of accredited California colleges or art schools. It provides a place to study, for those who wish it, among the relatively small group of serious students in a pleasant, convenient location under instructors well qualified to interpret the standard, as well as the modern, progressive movements in art'," *SMFA*, July 28, 1933, n. p.; "Art School's Exhibit at Theatre… tomorrow afternoon and evening… 32 students enrolled during the five weeks' summer session. … Decorative original masks made in **Eddie Milburn**'s class in mask construction, craft work and designs done under **Mrs. Elizabeth Breneiser** and oil paintings, life drawings and compositions produced by students in the class taught by **John Day Breneiser** will be included … examples of art work… by children instructed by **Miss Lucy de Gasparis**, studies in graphic form and analysis as created by students of **Stanley Breneiser** … and problems in school art worked out under the guidance of **H. C. Stadtmiller**. In addition to the students' work, a group of water color paintings by **Mr. Stadtmiller**, masks and puppets by **Mr. Milburn** and an original lithograph by **John Breneiser** may be seen…," *SMT*, Aug. 3, 1933, p. 3; "Art School's Exhibit is Lauded. Original masks, puppets, wall hangings, portfolios, luncheon cloth designs, drawings, jewelry, painting and sculpture on display in the

Little Theatre last week…," and 32 students and teachers named, "Isaac Gingrich, **Eliot Breneiser, Valentine Breneiser**, Anna Lou Rencher, Jacqueline Drake, **Mina Rushforth**, Paul Mallory, Melva Bell Rodgers, Jimmie Hoag, Harry Rodgers, Amy Hiratzka, Madeline Dotson, Betty Ann Booth, Lloyd Johnston, **Margret Sutter**, Elizabeth Cheadle, Pauline McCoy, **Carol Rushforth, Alberta Ow, Guido Signorelli,** Lucy DeGasparis, **E. D. Breneiser, Byron Openshaw**, Alice Brees, Geneva Grimsley, **Rowena Lowell, Mrs. Elizabeth Taylor, Anna Adele Black, Louis Ewing, Marrie Breneiser**, Rosalind Cooper, Marian Deck, **H. C. Stadtmiller** and Homer Hawkins," *SMT*, Aug. 7, 1933, p. 3.
See: "Santa Maria, Ca., Union High School," 1927

"Santa Maria Sketches"
Single frame cartoons run in the Santa Maria Times, 1940-41, by unknown cartoonist whose name seems to read "Carrie Carroll" aka "Will Danch"?
Santa Maria Sketches (notices in Northern Santa Barbara County newspapers on microfilm and on newspapers.com)
1940+ – Repro: "I can't understand why Mayor Marion Rice …," *SMT,* June 10; "I think Mrs. Dorothea Nelson…," *SMT,* June 19, 1940, p. 1; "That's Why Cap Twitchell …," *SMT,* June 20, 1940, p. 1; "Better Tell Dad …," *SMT,* June 21, 1940, p. 1; "They're going to get …," *SMT,* June 22, 1940, p. 1; "They're Copies of the Times …," *SMT,* June 24, 1940, p. 1; "That's What I Like About Paul Nelson…," *SMT,* June 25, 1940, p. 1; "He's Getting Artistic…," *SMT,* June 26, 1940, p. 1; "Can You Direct Me…," *SMT,* June 27, 1940, p. 1; "Never Mind that War News…," *SMT,* June 28, 1940, p. 1; "Kenneth Trefts is on one end…," *SMT,* June 29, 1940, p. 1; "Better Not Chew Up the Society Section…," *SMT,* July 1, 1940, p. 1; and sketches continue daily on p. 1 through Dec. 31, 1940 and through the first couple weeks of 1941.
1940 – "Artist Sketches Real Monrovians in New Series. Interesting facts about real Monrovians will be portrayed in 'Monrovia Sketches,' clever drawings prepared by Artist Will Danch for the *Monrovia News-Post*," *Monrovia News-Post* (Monrovia, Ca.), Aug. 19, 1940, p. 1; "Monrovia Sketches" by Will Danch, but cartoon signed "Carrie Carroll," *Monrovia News-Post* (Monrovia, Ca.), Sept. 4, 1940, p. 3; and others in the same newspaper 1940-41; "Petaluma Sketches" by Will Danch but cartoon signed "Carrie Carroll," *Petaluma Argus-Courier* (Petaluma, Ca), Sept. 12, 1940, p. 11; "Roseville Sketches" by Will Danch, but cartoon signed "Carrie Carroll," *Roseville Press* (Roseville, Ca.), Dec. 24, 1940, p. 2.
1941 – "San Pedro Sketches" cartoon signed "Carrie Carroll" but heading contains the name "Will Danch," per *News-Pilot* (San Pedro, Ca.), Feb. 26, 1941, p. 3: "Salinas Sketches" by Will Danch, *Salinas Morning Post* (Salinas, Ca.), Dec. 2, 1941, p. 4.
See: "Danch, Will"

Santa Maria Studio (Santa Maria)
See: "Judkins, David," "Santa Maria Photo Gallery"

Santa Maria Studio of Photography (Santa Maria)
Photography studio, 123 W. Cypress, 1955-76. Prop. Robert "Bob" and Elizabeth Hendricks. In 1960 moved to 121 W. Jones. Specialized in baby photography.
■ "A Business Biography… Santa Maria Studio of Photography," and history of the business, *SMT*, Feb. 27, 1974, p. 30.
Santa Maria Studio …(notices in Northern Santa Barbara County newspapers on microfilm and on newspapers.com)
1955 – "Only one day left! To get your complimentary photograph from the Santa Maria Studio of Photography, 123 W. Cypress, Santa Maria, During our Grand Opening. We specialize in the type and quality of work you like. Portraits, Wedding, Commercial, Copies, Color. Stop in today and get acquainted with our friendly service. Just opposite the Post Office," *SMT*, Sept. 30, 1955, p. 9; "Santa Maria Studio of Photography. Portraits – Weddings Color. Restorations of Old Photos…," *SMT*, Oct. 7, 1955, p. 8; "The Perfect Gift – Your Photograph! Call for your Appointment Now! WA 5-7430. Santa Maria Studio of Photography. Across from post office. Bob Hendricks. Watch today for our complete price list. 3 5 x 7 photos $12.50," *SMT*, Nov. 29, 1955, p. 5.
1956 – "2 Weeks Only. Photos of your baby (3 mos. thru 5 yrs.) at a saving of 29%. 1 large 8 x 10, 2 medium 5 x 7, 6 small, 3 ½ x 5. All for $20. This offer, good only Oct. 1st. through Oct. 13th," *SMT*, Sept. 28, 1956, p. 2; "Make it a perfect day. Give your portrait. …," *SMT*, Nov. 24, 1956, p. 8.
1957 – "Baby Photography. Weddings. Portraits. **Bob Hendricks**… Closed Mondays," *SMT*, Feb. 25, 1957, p. 3; "Mother's Day Special. 3 – 5 x 7 Silk finish Portrait for less than half price $3.95 plus regular sitting charge…," *SMT*, April 26, 1957, p. 10; "Prizes to be presented to the 'Mom for a Day,' Winner… Santa Maria Studio of Photography – Framed picture of actual crowning ceremony…," *SMT*, May 6, 1957, p. 10; "Photography is an art! Let an Expert Photograph You! Portraits. Weddings. Santa Maria Studio of Photography… Custom made picture frames," *SMT*, Oct. 17, 1957, p. 11; "We'll Photograph Your Wedding for only 14.95…," *SMT*, Nov. 29, 1957, p. 11; "In all the world no gift like it… Your Portrait…," *SMT*, Dec. 11, 1957, p. 9.
1958 – Repro: "Mrs. Derry Ames," *SMT*, Sept. 4, 1958, p. 3; "We Will Photograph Your Wedding for only $14.95 … 110 S. Lincoln. WA. 5-7430," *SMT*, Sept. 6, 1958, p. 13; "Uncle Bob's Diaper Club of baby pictures at baby prices! **Bob Hendrick**'s Santa Maria Studio…," *SMT*, Sept. 12, 1958, p. 3; "Pre-Xmas Special. One 8 x 10 in. Living Oil Color. Three 5 x 7 Charcoal Grey. 19.95. Reg. 25.50. Special Ends Oct. 31. **Bob Hendricks**…," *SMT*, Oct. 3, 1958, p. 2; repro: "Betrothed – Miss Evelyn Dias…," *SMT*, Nov. 13, 1958, p. 5; repro: "Wedding Reception," *SMT*, Nov. 21, 1958, p. 5.
1959 – Repro: "Mr. and Mrs. Laurence C. Seaman," *SMT*, Jan. 13, 1959, p. 3; "Enroll Your Baby in Uncle Bob's Diaper Club for only $6.95 entitling you to one 8 x 10 portrait at no further cost. And one 8 x 10 thereafter for only $2.95 – on each birthday to kindergarten age. Nothing else to buy!," *SMT*, Jan. 26, 1959, p. 5; "6-pose panel of your Tiny Tot. 5-years & under. All for $10.95. Limited Offer – Reg. $22.50…," *SMT*, March 20, 1959, p. 17; "We

Will Photograph Your Wedding for only $19.95 …," *SMT*, Sept. 7, 1959, p. 4; "Enroll your year-or-less baby in our Tiny Tots Photo Club. Enrollment is $4. Then you get seven 8 x 10 portraits at ages 3 mos., 6 mos., 1 yr., 2 yr., 3 yr., 4 yr. & 5 yr. for only $2.95 each...," *SMT*, Oct. 12, 1959, p. 3.

1960 – Photo of façade and "New Photo Studio. The Santa Maria Studio of Photography will open at its new location, 121 W. Jones St., Tuesday… Photographs of children, adults and large groups are accomplished by owner Bob Hendricks and his wife, Elizabeth ... A feature of the grand opening will be a 20 per cent discount on all photographic sittings. The new concrete block building features a light-cream exterior with soft fluorescent lighting. The 17 by 28 foot sitting room will have two areas, one for photographing children and the other for adults and groups, including large wedding parties. A combined-dressing room and lavatory is provided… Other parts of the building contain a film developing room, finishing room and retouching area. The reception area in the front of the building will be devoted to a display of photographs and frames," *SMT*, July 25, 1960, p. 4; "Congratulations … Stacie Smith, Baby Girl Bi-County. We are Very Pleased That Stacie's Parents Selected Our Studio for Her Photograph. We Specialize in Baby Photography. Have your Baby's Photograph taken at regular intervals. You'll treasure them in later years," *SMT*, July 7, 1960, p. 27; "Hurry!!! Time Limited for Xmas Portrait… New Location. 121 W. Jones. Closed Mondays," *SMT*, Nov. 18, 1960, p. 14.

And, more than 100 ads in the *SMT* between 1955 and 1965 were not itemized here.

See: "Hendricks, Robert L. 'Bob' and Elizabeth"

Santa Maria Valley Amateur Art Show (aka "Home Talent Art Show," 1955, "Art Talent Show" 1957)
See: "Allan Hancock [College] Art Gallery" 1955, 1956, 1957

Santa Maria Valley Art Festival / Santa Maria Art Festival / Valley Art Festival (Santa Maria)
Festival sponsored by the Santa Maria chapter of the American Association of University Women, 1952, 1953. Goals – 1) to create an opportunity for adult and junior artists to show their work and 2) to provide an interesting exhibition for the public. Mrs. De Nejer was advisor.
Santa Maria Valley Art Festival (articles from Northern Santa Barbara County newspapers on microfilm and the Internet)
1952 - First annual: "S M Art Festival Moved to May 24," and will be held in the Veterans' Memorial Building, and has two goals 1) create opportunities for adult and junior artists to enter their work and 2) provide an interesting exhibition for the public, and **Mrs. De Nejer** advises, *SMT*, Jan. 17, 1952, p. 4; "Art Festival Plans to Advance at March 4 Meet" ■ "Objectives are to awaken and promote interest in the creative arts in Santa Maria, to stimulate expression by individuals, and to enable the public to see examples of fine contemporary art and craft. The festival is expected to stimulate interest in a program of free classes in

art as an aid to personality development. These will be offered by the Santa Maria branch AAUW. Finally, the plan is to build a fund for a future museum in Santa Maria. A pre-opening program for teachers, AAUW members and leaders will be addressed on both days by **Natalie Cole**, noted art educator and author. Workshops with children under guidance of participants of the morning session will open at 1:30, when the exhibits will open… **Ward Youry** will supervise the afternoon 'Art in Action' demonstration of work on the pottery wheel, making of jewelry, weaving, sculpture and painting. There will be a show of professional artists, school exhibits, and work by amateurs in three exhibitions. **Natalie Cole** will speak in the afternoon, and the festival management has invited **Vincent Price**, collector and lecturer, to be a guest speaker also," *SMT*, March 1, 1952, p. 5; "Art Festival Support Offered by Volunteers" with William Pike as business manager, and headed by **Mrs. DeNejer**, and other artists involved include **Mrs. Florence Foster, Ward Youry**, and **George Muro**, *SMT*, March 5, 1952, p. 5; "Plans Moving Along for AAUW Art Festival on April 24-25," and objective is to awaken and promote interest in fine arts, and list of volunteers, *SMT*, April 4, 1952, p. 5; "Art Festival Plans are Told to Soroptimists" by **Mrs. DeNejer**, who says there will be a large exhibit of paintings by well-known West Coast artists, *SMT*, April 16, 1952, p. 4; ■ "Art Festival's Program is Set for May 24, 25…" and list of objectives including starting a fund for an art museum, "Program: Saturday, May 24 – 9 to 12 a.m. – Creative art workshops under… **Natalie Cole**… rest period from 12 to 1 … From 1 to 1:45 p.m., workshop with children under guidance of participants of the morning session, Mrs. Cole supervising. At 2 p.m. the formal opening of the festival… Exhibits of professional, amateur and school art will be open from 2 until 11 p.m. Saturday and from 12 noon to 5:30 p.m. Sunday, May 25. Paintings marked with blue stars will be contributed by **Cowie Galleries** of the Biltmore hotel, and paintings and sculpture and ceramics marked with red stars are contributions of the **Dalzell Hatfield Galleries** of the Ambassador hotel. Over half of the artists represented in these two shows have been featured in *Life* magazine…. [and there will be programs on music and dance] … From 4:15 to 5:30 p.m. 'Art in Action' will be featured. **Ward Youry** and **George Muro** will present pottery making, jewelry and enameling, **Mrs. Youry** weaving, **Forrest Hibbits** painting, **Mrs. Melba Bryant** painting and **Renzo Fenci** sculpture. … [8-8:30 music] … The 'Art in Action' demonstration will be repeated from 9:30 to 11 p.m. and doors will close at 11:30 p.m. … Sunday [1:30 to 2 p.m. music] A panel discussion on the subject 'Art and You' will be held from 2 to 3 p.m. Members are **Henry Seldis** [newspaper art critic], **Vincent Price**, actor, lecturer and art collector, **Mrs. Ruth Lockwood**, state art chairman of the AAUW, **Douglass Parshall**, ANA, **Howard Fenton**, art department of the University of California, D. D. Chern of Santa Maria and **Emil Kosa**, moderator… [3-4 p.m. theater presentation] … Another 'art in action' demonstration from 4 to 5:30 p.m. will conclude the show. Tickets are 50 cents for adults and 25 cents for children, good for one day only," *SMT*, April 25, 1952, pp. 1, 6; "Child Art to Have Spot in Festival," *SMT*, April 26, 1952, p. 4; "**Vincent Price** Taking Part in SM Art Soiree" as member of a panel

discussion with **Howard Fenton** (of the art dept. of UCLA), **Douglass Parshall, Ruth Lockwood** (state chairman of the AAUW art section) and D. D. Chern with moderators **Emil Kosa** and **Henry Seldis**, *SMT,* May 1, 1952, p. 1; "Residents Post Art Cash Awards … The Ray Holzer award of $25 is offered for jewelry and metal craft … pottery … In the weaving section, first place will win $25 to be paid by Mr. and Mrs. A. J. Diani. Sculpture top prize of $50 is being offered by **Dr. Clifford Case** … Awards in the amateur section will be $25 from **Santa Maria Inn** for the oil painting winning the largest number of votes … Mrs. Lillian Burrow is giving the $10 first prize for a water color, chosen by the public … Mr. and Mrs. Dan Chern will present the $10 prize offered for… crafts…," *SMT,* May 8, 1952, p. 4; "Art Teacher [**Natalie Robinson Cole**] to Hold Children's Class" at Santa Maria Valley Art Festival – she is an LA elementary school teacher and author of '*Arts in the Classroom,*' *SMT,* May 16, 1952, p. 4; "**Zornes** Paintings to be in Art Show" along with those of **Myrton Purkiss**, potter, and bios., *SMT,* May 20, 1952, p. 4; "Public to Vote on Festival Exhibits," and article repeats awards available, and "Among exhibitors in the amateur section are **Mrs. Maye Nichols, Mrs. Melba Bryant, Mrs. Ida Gracia, Mrs. Helen Hollister, Asa Porter, Mrs. Don Taylor, Miss Elizabeth Scott, Mrs. Valerie Rand, Guido Signorelli, Mrs. A. F. Knudsen, Mrs. Elinor Chambers**, and many others," *SMT,* May 21, 1952, p. 4; photo of **Emil Kosa**'s "Clown" that will be on view at festival, *SMT,* May 22, 1952, p. 1; "Santa Maria Valley Art Festival Under Way in Memorial Hall Here," *SMT,* May 24, 1952, p. 1; "Festival Wins High Praise: 1,500 Attend in Two Days," and "Santa Maria award of $150 to the best oil painting in the professional section, **Josephine Spaulding**'s 'Juan Romero,' the Mr. and Mrs. A. B. Hanson $75 award for best water color, **Milford Zornes**' 'Petersburg, Alaska.' Also, in the professional section, the **Dr. Clifford Case** $50 award for sculpture, to **Renzo Fenzi**'s [Sic. **Fenci**] 'Jill'. Ray Holser's $25 award to jewelry, necklace, made by Nita Reis. Pottery awards in the professional exhibits were for groups of five pieces, $50 offered by Mr. and Mrs. Kenneth Sheehy, won by **Myrton Purkiss**, the same pottery winning the prize of $25 offered by Mr. and Mrs. F. H. Anderson, for the best single piece of pottery. **Jody Mills** won the $25 award [donated] by Mr. and Mrs. A. J. Diani for a hand-woven stole. A sweepstakes prize given by Orcutt Lions club was awarded to **Elizabeth S. Taylor** in the amateur section for her painting entitled 'Leslie,' as single entry receiving most votes. The same artist and painting was chosen to win the $25 award for best oil painting in the amateur exhibit. A second prize in the same section, the **Florence Foster** $10 award, was presented to **Russ Manning** for his painting, 'Twilight.' Amateur section prizes also were: **Helen Hollister** whose watercolor, 'Odette,' received the Lillian Burrow $10 award. **Elizabeth S. Taylor**'s 'Waller Park,' placing second to win the $5 Mrs. Reginald Rust award. A prize of $10 placed by Mr. and Mrs. Dan Chern was awarded to the sixth grade of Orcutt for their exhibit of puppets. Mrs. **Catherine Grainger**'s entry in graphic arts won for her the Mr. and Mrs. Jose Rowan's award of $25… The festival was sponsored by the Santa Maria chapter of the American Association of University Women. **Mrs. Jean DeNejer**

was general chairman. Professional paintings at the show were provided by the galleries of Los Angeles. Such artists as **Emil Kosa, Jr., James Cowie** and **Dalzell Hatfield, Art [sic. James] Swinnerton, Anna Sten,** and **Hobson Pittman** were represented," *SMT,* May 26, 1952, pp. 1, 3; "Art Teachers Hear Mrs. **Natalie Cole**… noted teacher of art, spoke on 'Personality Development Thru Creative Arts,' at Saturday's program at the art festival… teaching techniques for parents and teachers were demonstrated," *SMT,* May 26, 1952, p. 4; "Audience Hears Panel Speakers on 'Art and You.' … Moderator [**Jacob] Hanson** commented on children's art in the main auditorium … saying 'it is simple, beautiful and expressive of the child's feeling.' He spoke of some of the best paintings in the state being in the Santa Maria exhibition. **Douglass Parshall**, A.N.A., a guest speaker, told of good pictures not giving up their secrets too easily. Parshall said a fine painting is not and need not be an exact reproduction. Dan Chern on 'The Layman Looks at Art,' spoke of Santa Maria's lack of opportunity or facility to view art and sculpture and of the need for a building in which traveling and local exhibits could be seen. **Mrs. Ruth Lockwood**, state art chairman for the sponsoring AAUW, who described herself as a dabbler in many forms of art… **Henry Seldis**, art editor of *Santa Barbara News Press*, commented that an art critic would rather see a good painting… **Professor Howard Fenton** of U of C Santa Barbara college spoke of national history and cultural backgrounds as learned thru art. The Santa Maria exhibit, he said, serves to tell the story of this age in America's history, perhaps to future generations," *SMT,* May 26, 1952, p. 4; "Children's Art is held Open Extra Time. Hundreds of children of Santa Maria elementary schools… visited the children's art exhibit in the Veterans Memorial building…," *SMT*, May 26, 1952, p. 4; California Federation of Arts "State Chairman of Art Praises S. M. Festival. **Mrs. Mary Jane Thornburgh**," *SMT,* May 26, 1952, p. 4 and half page devoted to other articles on Festival; "Children's Art is Appreciated" and will be given spot in next year's Festival says **Mrs. De Nejer**, *SMT,* May 28, 1952, p. 4; "Mrs. Taylor Wins **S.M. Inn** Prize… **Mrs. Don H. Taylor**… with her portrait in oils of **Mrs. Lesli Hopkins**," *SMT,* May 28, 1952, p. 4; "Acknowledgements are Given Festival workers… The acknowledgements were followed with one of the several half-hour art in action demonstrations. Taking part… were **George Muro**, jewelry and enameling, **Ward Youry**, pottery, **Forrest Hibbits** and **Mrs. Melba Bryant**, painting, and **Mrs. Ward Youry**, weaving…," *SMT,* May 26, 1952, p. 4.

Santa Maria Valley Art Festival (articles from SLO *Telegram-Tribune*)
1952 – Sponsored by Santa Maria AAUW. An "Arts Festival" consisting of workshops for children and art exhibits provided by **Cowie** and **Dalzell Hatfield** galleries of LA, *T-T,* May 24, 1952, p. 5; "Obispans Participate in First Annual Santa Maria Valley Art Festival … Members of the San Luis Obispo Art association who were invited to participate in the first annual Santa Maria Valley Art Festival held last weekend in Santa Maria were **Miss Margaret Maxwell, Mrs. Elaine Stranahan, Mrs. Lena Boradori, Mrs. Stanton Gray** and **Harold Forgostein**. Although dancing, music, crafts and drama formed a part of

the festival, paintings were the highlight of the affair with the **Cowie Galleries** of the Biltmore hotel and the **Dalzell Hatfield** galleries of the Ambassador hotel in Los Angeles sending work by such well-known names as Louis Boss, **Phil Dike, Richard Haines, Dan Lutz, Douglass Parshall, Phil Paradise, Hobson Pittman, Bert Proctor [Sic. Burt Procter], Iver Rose, Sueo Serisawa, James Swinnerton, [Oscar] Van Young, Millard Sheets, Harry Mintz** and **Emil Kosa.** Other top ranking artists sending pictures were **Rex Brandt, Francis de Erdely, Joseph Knowles, Ejnar Hansen, Armin Hansen** and **Anna Sten. Milford Zornes's** watercolor, 'Petersburg, Alaska,' was voted the most popular picture. 'This is the first time that paintings of this caliber have been viewed so close to home,' **Mrs. Gray** said today. 'We of San Luis Obispo feel that Santa Maria has made a 'milestone' toward the day when 'big name' as well as amateur art may be brought to our own community.' Art in action was thoroughly incorporated throughout the entire program of two day's duration. In the attractive patio, artists wove cloth, made jewelry and ceramics or viewed painting in the process. Demonstrations and doing exhibitions followed one after the other… A well filled auditorium composed chiefly of people who paint, listened to a panel discussion on 'Art and You' as handled by the moderator, **Jacob Hanson** [Sic. Lindberg-**Hansen**], instructor [in the art dept. at UC Santa Barbara] *SLO T-T,* May 28, 1952, p. 4.

1953 – Santa Maria Valley Art Festival (notices in Northern Santa Barbara County newspapers on microfilm and the Internet)

1953 - Second annual: "May Date Set for '53 Art Festival … will be held on May 29, 30, and 31 at Veteran's Memorial Building," chairmen being **Mrs. Leslie Hopkins, Miss Betty Scott** and Mrs. Marsha Riley. "… festival, founded by **Mrs. Jean DeNejer,** who is now studying in New York… the local management is planning to have the **Cowie Galleries** of Los Angeles Biltmore hotel select the outstanding painting… There will be lectures on how puppets are made as well as puppet shows… Invitational blanks are being mailed to individual artists…," *SMT,* Feb. 21, 1953, p. 4; "Valley Art Festival Plans Second Annual May Showing," to raise money for an art museum, *SMT,* April 25, 1953, pp. 1, 6; "Deadline for Art Festival Entries Set… ," and awards cited, *SMT,* May 21, 1953, p. 1; "Community Art Festival to Open Second Annual Showing May 29," and port. of Miss **Edna Davidson,** and ■ "Santa Maria Valley school children and their teachers are this week busy with plans for participation in the second annual community Art Festival which will open at the Veterans Memorial, May 29, for a three-day run, **Miss Edna Davidson,** art supervisor of the local elementary schools and chairman of this section of the festival program, stated today… The children's work, Miss Davidson said, will as far as possible be hung by grades rather than by schools with emphasis on individual creative expression. There will be no awards as the children's exhibit is non-competitive. Kindergarten through eighth grade… High school and adult sections, both professional and amateur, will be separate festival features. 'We feel particularly fortunate in securing an art educator of Miss Davidson's experience and professional background to head this section,' **Mrs. Leslie Hopkins,** general chairman of the festival [said]… 'Miss

Davidson, who has been art supervisor in the local elementary schools for some years, received her bachelor of arts degree from the California College of Arts and Crafts and has added to that graduate work at the University of California, Los Angeles, at Claremont and San Jose State college. 'As the number of entries last year was too large for the hanging space, this year's exhibit will be smaller, she said. Miss **Natalie Cole,** author of '*The Arts in the Classroom*,' will again visit the Festival, Miss Davidson said, adding that she would give a talk and demonstration with children on Saturday morning," and article follows with list of donors and potential awards, *SMT,* May 14, 1953, pp. 1, 6; ■ "'Art in Action' to Feature Annual SM Art Festival … 'Art in Action,' the popular feature whereby artist and artisan demonstrate their arts and crafts to the public, will again be a star attraction of the Santa Maria Annual Art Festival to be sponsored by the **American Association of University Women**… Festival is to be held in the Veterans' Memorial building, where the patio will be the center of various art demonstration projects. The dates decided upon are May 29-30-31. According to those in charge, 'Art in Action' serves a four-fold purpose: 1) makes art more dynamic and meaningful to those acquainted only with the end product…; 2) emphasizes the 'doing' or activity aspect as well as the finished work in art; 3) instructs in the various technical methods and procedures of the art or craft; and 4) provides delightful entertainment, as was proved by the enthusiastic reception of last year's demonstrations by large audiences. Those participating in this year's 'Art in Action' program will be **George Muro,** … **Mrs. Elisabeth Dennison** of the Santa Maria Union High School department of home economics; and **Gordon Dipple** of the Santa Maria Union High School art department. It is also hoped that in the field of ceramics **Harold Huntington** will demonstrate various processes involved in the creation of objects from clay on his potter's wheel. Water color, an art form far removed from the child's paint box and actually one of the most difficult of art media, will be demonstrated by **Muro.** He is well qualified to deal with the difficult technique. … Muro will actually complete a water color in about an hour's time each day for the Festival. His work will also be on exhibition. **Dipple** will show the production of metal crafts in three classifications: jewelry, hammer work in copper and silver, and enamelware. There will be a keen interest in his work because of the public comment caused by the outstanding exhibit of enamelware shown in a local store window during **Public Schools Week,** all the work of his high school students. He is a graduate of the California College of Arts and Crafts, where he also was a member of Delta Phi Delta. His work has been shown in national magazines. Although **Mrs. Dennison** is of the home economics department of SMUHS, she believes that art should be woven like a thread through all the fields of home making. Art has been so interwoven into her own training and experience. A graduate of Stanford, she spent her first two years at that institution concentrating on art before decided to major in [home?] economics. It was after her fifth year at Stanford, from which she also received her General Secondary credential, that she spent two years at Santa Barbara College specializing in home economics. For her part in 'Art in Action,' **Mrs. Dennison** will

demonstrate weaving on a loom belonging to the art department of SMUHS. She plans to weave place mats of a soft apricot hue intermingled with bright metallic thread. … [She] spent two years at the Swedish School of Applied Arts, a weaving center in San Francisco. She also teaches it to her home making students at the high school," *SMT,* May 18, 1953, p. 3; ■ "31 Professionals Entered in Art Festival to Date … Santa Marians… **Winnie Monson** and **George Muro**. The others are artists representing most areas of Southern California and a few from the north section. The Monson painting is entitled 'Rose of Sharon,' Muro's 'Three of a Kind' and 'Train.' … Tomorrow night a truck will arrive in Santa Maria bearing a 20-painting exhibit from the **Cowie Galleries**… Among… such noted works as **Douglass Parshall**'s 'The Rodeo,' **Armin Hansen**'s 'Hugging the Sea,' **Burt Proctor**'s [Sic. **Procter**] 'Restin' and **Mentor Huebner**'s 'The Lonely One.' All are in oil …," *SMT,* May 26, 1953, p. 1; photo of **Natalie Cole** demonstrating finger painting, *SMT,* May 27, 1953, p. 1; "All in Readiness for Opening" – judges of artworks – **Douglass Parshall, Forrest Hibbits** and Francois Martin [of Geddis-Martin Studios in Santa Barbara]. Lecture by **Henry Seldis** on "Value of the Art Critic in the Community," and **Lesselli Marionettes** will put on a show, and there will be a lecture on flower arranging, *SMT,* May 28, 1953, p. 1, and photo of arriving canvases; "AAUW Sponsoring Three-Day Annual Art Festival Over Week-end in SM," *LR,* May 28, 1953, p. 3; "AAUW Sponsoring Three-Day Annual Art Festival… the jury, **Forrest Hibbits**, Jacques Martin and **Douglass Parshall**…," and lengthy article on attractions, *LR,* May 28, 1953, p. 3; "Art Festival Opens Three Day Showing" and list of prizes and donors, *SMT,* May 29, 1953, p. 1; "Santa Maria Art Festival This Weekend," *SYVN,* May 29, 1953, p. 4; "1,200 Visit Second Annual Santa Maria Art Festival … 'The paintings in the professional class this year were far superior to those of last year,' Mrs. Hopkins said. She declared the 'high school work is unbelievable. **George Muro** and **Gordon Dipple** are doing a wonderful job…' The festival awards also announced by Mrs. Hopkins: Professional Class. Watercolor – ($100) – Howard Clapp's 'Hill Section.' **Rex Brandt**'s 'Harris Ranch' received first honorable mention; **Dan Lutz**, 'Life Guard,' second. Oil – (100) – **Richard Haines**' 'Sail Pattern,' **Etienne Ret**'s 'Still Life with White Pitcher,' received first honorable mention; **Sueo Serisawa**'s 'Father and Child,' second. Sculpture – ($25) – John L. Walker's 'Bird Form.' Pottery – ($50) – **M. Purkiss**' ceramic bowls ($25) – **Margaret M. Hart's** 'Funeral Urn.' Weaving – ($25) – Florine M. Sondergaard, skirt. Jewelry – ($25) – Patricia I. Rowland. Amateur Class. Watercolor – ($25) – **Lucile Bartholomew**'s 'Black Lillies.' Oil – ($25) – Florence Richardson's 'Shocking Wheat.' Most outstanding amateur paintings ($20) – **Barbara Moore**'s. Crafts: C. Swieger's copper pin, first honorable mention; R. Boll's calfskin purse, second. High School. Painting: Shirley Lentz' oil, $10; **Betty Eya**'s watercolor, $5, and Louie Almaguer's tempera, $5. Crafts: Tom Brice's jewelry, $7.50; Mary Long's enamel, $7.50; Hermenia Parades' leatherwork, $5; Dario Fraire's woodwork, $5, and Roy Shinomi's [Shimomi?] drawing, $5," *SMT,* June 1, 1953, pp. 1, 8; **Lesselli** "**Marionette** Show Pleases

Audience at Festival," *SMT,* June 1, 1953, p. 4; "**Natalie Cole** Gives Talk on Children's' Art," *SMT,* June 1, 1953, p. 4.

Santa Maria Valley Art Festival (articles from SLO *Telegram-Tribune*)

1953 – "It will feature such varied attractions as lectures and workshops by noted authorities, art-in-action, demonstrations by skilled artists and craftsmen, and a marionette show, as well as comprehensive exhibits of both professional and amateur work in various classifications of fine arts and crafts… Among artists from the San Luis Obispo art association whose work will be represented in the professional exhibit are **Gladys Gray, Carroll E. Gulley, Betty Middlecamp** and **Ivy Parsons**. Morro Bay will be represented by **Aaron Kilpatrick, Eleanor Randall** and **Charlotte B. Skinner. Cora Wright** will represent Arroyo Grande, and **Harold Forgostein**, Halcyon. About 30 Santa Barbara artists have been invited to send their work, and Santa Maria will be represented by **Winnie Monson** and **George Muro**. Expected to attract the attention of art connoisseurs throughout the surrounding valleys are the entries of such well-known artists as **Cornelis** and **Jessie Arms Botke, Rex Brandt, Phil Dike, Emil Kosa, Jr., Dan Lutz, Barse Miller. Douglass Parshall** and **Sueo Serisawa**, all among the foremost Southern California painters and representing the **Cowie** and **Dalzell Hatfield** galleries in Los Angeles. … **Henry Seldis**, art reviewer of the *Santa Barbara News Press* will lecture from 3:30 to 4 p.m. on 'The Art Critic in the Community.' In the evening from 7 to 8:30 p.m. the famed **Lesselli Marionettes**, professional puppeteers and specialists in children's art theater, will present their first show, 'Hansel and Gretel.' **Lesselli** represents the combined names and talents of Leslie and Eleanor Heath, the only marionette artists listed in '*Who's Who on the American Platform*'," per "Valley Art Festival Opens in Santa Maria on Friday," *SLO T-T,* May 28, 1953, p. 5; "S M Art Show Blanks Available," *T-T,* May 8, 1953, p. 3.

Santa Maria Valley Fair / Santa Maria Agricultural Fair (37th Agricultural District)
Northern Santa Barbara county's annual fairs, between 1886 and 1894, were sometimes termed the Lompoc Valllley Fair and at other times the Santa Maria Valley Fair and held alternately in Lompoc and Santa Maria. In 1928 Northern Santa Barbara county towns, perhaps frustrated with Santa Barbara's inability to put on an agricultural fair, took matters into their own hands and held their own fairs (Santa Maria Valley Fair, Lompoc Valley Fair, Santa Ynez Valley Fair). Santa Maria "won out" and from the 1930s onward became the site of the official Santa Barbara County Fair.
[Newspaper notices on precursors of the official Santa Barbara County Fair were lumped under the County Fair heading.]
See: "Santa Barbara County Fair," 1886, 1888, 1889, 1890, 1891, 1893, 1894, 1900, 1928, 1929, 1930, 1931

Santa Maria Valley Historical Society
Society organized 1955.

■ "Historical Society to Form at S M Inn Dinner … More than 1000 persons have been invited to attend the charter dinner of the Santa Maria Historical Society August 17 in the **Santa Maria Inn**. Francis Price, president of the Santa Barbara Historical Society, is scheduled to be guest speaker… Members of the Historical Society arrangement committee are seeking glass showcases, a typewriter and receptionist desk to be used in the society's display in the basement of the recreation building" *SMT,* Aug. 8, 1955, p. 4.

Santa Maria Valley Historical Society (notices in Northern Santa Barbara County newspapers on microfilm and on newspapers.com)

1955 – "Extend Deadline… for reservations for the Santa Maria Historical Society charter dinner… A charter scroll, designed by **Mr. and Mrs. Don Taylor**, will be signed by those attending…," *SMT,* Aug. 13, 1955, p. 1; "History Society Charter Dinner Scheduled for Tomorrow Night," *SMT,* Aug. 16, 1955, p. 1; photo of woman signing the illuminated parchment scroll along with ports. of **Mr. and Mrs. Don Taylor**, "Santa Maria Historical Society Formed. Value of Preserving Valley's Past History…," *SMT,* Aug. 18, 1955, p. 1; "History of City Cited by Mrs. Dorsey … temporary chairman… 'It is of utmost importance to save documents of yesterday and today for future historians. Without documentation, the writers of tomorrow's history can not write authentically," *SMT,* Aug. 19, 1955, p. 6; "Historical Scroll to be Preserved… **Mr. and Mrs. Donald Taylor**, donors of the scroll, had arranged to have a photostatic copy of the document made and that this copy would be among the historical items to be buried in the time capsule," *SMT,* Aug. 20, 1955, p. 1; "Mrs. [Irene D.] Julien Appointed Museum Curator" in basement of city recreation building open Wednesday afternoons, *SMT,* Sept. 15, 1955, p. 6; "Historical Society Opens Museum Today," *SMT,* Oct. 6, 1955, p. 4 and exhibit will be open Thursday, Friday and Saturday afternoons.

1956 – "Letter Head Seal Contest Open to Artists," *SMT,* Sept. 4, 1956, p. 4; "Historical Society to Open in New Quarters" at Lincoln and Main with Native Daughters of the Golden West presiding, *SMT,* Sept. 5, 1956, p. 4; "Museum to Open Sunday," *SLO T-T,* Sept. 7, 1956, p. 4; seal designed by Mrs. **Jo Ann Wilson**, *SMT,* Sept. 20, 1956, p. 4, col. 6; repros of official letterhead and seal by **Mrs. Jo Ann Wilson**, 548 Mariposa Way, and Mrs. Wilson is a member of the pioneer Smith family, *SMT,* Sept. 24, 1956, p. 1.

See: "Santa Maria Valley Pioneer Association"

Santa Maria Valley Pioneer Association
Association of pioneer residents formed 1923. Held annual get-togethers and collected historic photos and other items. Known for its annual barbecues. Still active in 2020, and see its website smvpioneerassociation.com.

■ "Santa Maria Valley Pioneers' Assn. was organized 26 years ago by 13 men at a meeting in the Bradley hotel, Fred L. May told the annual Pioneer meeting of the Santa Maria

Kiwanis club yesterday in Santa Maria club. … Martin read stories of early Santa Maria taken from *The Santa Maria Times* files…. May said the formation of the Pioneer Assn. came out of a picnic held on the banks of Alamo creek in 1923, when Oakley Bros. & Stowell gave a picnic to celebrate completion of a bridge over Huasna creek on the road to Cuyama valley. 'Most of those attending were early settlers here,' he said, 'and they decided it would be nice to form an organization of pioneers. 'In the early days of the city, Fourth of July celebrations had always been held in Buena Vista park on South Pine, but these had not been held for some time, so with the picnic held in 1923, it was decided to do something about continuing annual celebrations. 'A meeting was held in the Bradley hotel, attended by 13 men, as I recall, and Fremont Twitchell, father of the present supervisor, T. A. Twitchell, was elected president. 'In 1924 the hoof and mouth disease was prevalent, and it was decided inadvisable to have people visiting the cattle areas, and no celebration was held, but in 1925, the organization held a celebration on the banks of the Alamo creek. W. C. Rice was elected president that year. 'In 1926, a lease was arranged with the Newhall land & Farming Co. for use of a plot of land and a platform for dancing, and pits for barbecuing were erected, and the association held its first meeting in Pioneer park. 'These meetings continued there for about 15 years. We had an old-time orchestra and danced the old-time dances. … The late Samuel Jefferson Jones always registered everyone attending the reunions. We danced all afternoon and then we came to town and danced again that night in Princess hall, now an automobile paint shop on Pine, just off Main.' He referred to the Smith family as always being prominent in the celebrations. Judge Marion Smith was chairman of the day yesterday. 'Both Marion and his brother, Douglas, have been speakers at annual celebrations,' said May, 'and their brother, Dr. Leland Smith, has been a president of our association. Bill Saladin always furnished a piano for the music.'… In recent years, May said, the lease on Pioneer park had been allowed to lapse and the celebrations have been held in Waller county park, closer to town and handier for older members of the organization. The annual dances are now held in the high school gymnasium," per history, *SMT,* May 6, 1949, p. 1.

See: "Santa Barbara County Fair," 1941, "Santa Barbara County Library (Santa Maria)," 1943

Santa Rosa Club (Santa Ynez?)
Needlework club?, 1925-39.

■ "The club voted to hold their regular meetings hereafter on the first and third Thursdays of each month [at private homes] … All members are requested to bring their sewing and fancy work," *SYVN,* Dec. 18, 1925.

Notices on the "Santa Rosa Club" appear sporadically in the *SYVN,* c. 1925-39.

Santa Ynez *Argus*
Santa Ynez Valley's first newspaper, 1887. NOT indexed in this publication.

Photo of front page, *SYVN,* Sept. 17, 1954, p. A-1.

Santa Ynez High School
<u>See</u>: "Santa Ynez Valley Union High School"

Santa Ynez Library
<u>See</u>: "Santa Barbara County Library (Solvang)"

Santa Ynez Mission (Solvang)
<u>See</u>: "Mission Santa Ines"

Santa Ynez Sewing Circle
Circle organized, 1913. Met at members' homes.
More than 170 notices on the Circle appeared in northern
Santa Barbara county newspapers on newspapers.com
between 1940 and 1960 but were not itemized here.

Santa Ynez Valley Art Association
*Association of four churches, formed late 1953, that put
on the Santa Ynez Valley Art Exhibit, 1954+.*

■ "Churches Form Valley Art Association Here. The
Santa Ynez Valley Art Association came into being last
Monday night. At a dinner meeting at the home of Mrs.
Ruth Gordon, 25 representatives of the four Valley
churches, agreed to form the association because of the
great interest throughout the community in art, and voted to
stage a four-day art festival in Solvang next April. The
forming of the association is an outgrowth of the successful
St. Mark's-in-the-Valley art exhibit held here last
February. The four churches of the Valley will participate
in the festival and it was unanimously agreed by those
attending that St. Mark's should again sponsor the event....
Proceeds from the festival will be channeled for three
specific purposes: 1. Part of the proceeds will revert back to
the association for future festivals. 2. Another portion will
be earmarked for the establishment of an art student
scholarship fund. This fund will be controlled by a board of
directors composed of a representative of the Santa Ynez
Valley Presbyterian Church, Bethania Lutheran Church,
Old Mission Santa Ines, and St. Mark's-in-the-Valley. 3.
and a final portion will go to St. Mark's Church. The
festival is being held later in the season this year because it
was felt by those attending Monday's meeting that the
event will have a strong tourist attraction. The art show this
year is being extended to a four-day affair in order to
enable a greater attendance and permit more people to view
the exhibition. Nationally known artists from all parts of
the country will again participate in the show. Several
innovations are planned for this year, including a 'Living
Picture,' a famous painting that will come to life; cash
awards for a first hanging; competitive class for all children
of Santa Barbara county, and showing of a wide variety of
handcrafts. Elected to the executive <u>board of directors</u> for
two year terms at the meeting Monday were **Mrs. Ruth
Gordon**, president, **Mrs. Andrew Joughin**, vice-president,
<u>John Adams</u>, treasurer, <u>Mrs. G. G. Davidge</u>, recording
secretary, <u>Mrs. Perle Whitford</u>, corresponding secretary,
<u>Mrs. John Adams</u>, public relations, **Mrs. Palmer
Beaudette**, publicity, <u>Mrs. Harold Imbach</u>, St. Mark's
Guild representative, **Paul Kuelgen, Viggo Brandt-**

Erichsen, Ferdinand Sorensen, Harold Imback [Sic.
Imbach], and technical advisors; Mrs. Paul Kuelgen, **Mrs.
Viggo Brandt-Erichsen**, Mrs. A. G. Ruge, **Miss Mae
Penney**, Mr. and Mrs. Sigvard Hansen, Mrs. Ferdinand
Sorensen, **Mr. and Mrs. Uno Sandvik, Thorvald
Rasmussen**, Fr. Tim O'Sullivan, OFM, Cap., Rev. and
<u>Mrs. L. Lynn Parker</u>, and <u>Mr. and Mrs. Leonard Parsons</u>,
who are also members of the board," *SYVN*, Oct. 30, 1953,
pp. 1, 8.
<u>Santa Ynez Valley Art Association (notices in Northern
Santa Barbara County newspapers on microfilm and on
newspapers.com)</u>
1954 – "Art Show Feature Here Each Year. The annual **St.
Mark's-in-the-Valley Art Show and Exhibit** is one of the
highlights of the year in the Valley. Now operated under an
Art Association formed in the fall of last year, the show
provides an art scholarship …," *SYVN*, Sept. 17, 1954, p.
47 (i.e., 5)
<u>See</u>: "Santa Ynez Valley Art Exhibit"

**Santa Ynez Valley Art Exhibit / aka Santa Ynez Valley
Art Festival (Solvang)**
*Annual art exhibit inspired by the successful Art Exhibit
held by Saint Mark's-in-the-Valley Episcopal Church at
the Veteran's Memorial Building, Solvang, 1953. In 1954
the organization of the show was in the hands of a
consortium, named the Santa Ynez Valley Art
Association, was renamed the Santa Ynez Valley Art
Exhibit and ran 1954-58. It included art exhibits
(including photography) and an art auction and other
related events. In 1954 a mini show of Hollywood artists
provided a draw. The two years it was under the direction
of Mrs. Joughin, 1955, 1956, the show included artists
from outside northern Santa Barbara County. In 1957 the
exhibit returned to being limited to Santa Ynez Valley
artists, moved to the church parish hall, and was held in
conjunction with Danish Days. In 1958 it was also part of
Danish Days. The 1959 Danish Days was cancelled, also
cancelling the 1959 art exhibit.*

■ "Art Exhibit Auction Due Here Feb. 25. As a means of
aiding **St. Mark's-in-the-Valley** Episcopal Church
building fund, a Valley **Art Exhibit and Art Auction** will
be staged in Solvang on Wednesday evening Feb. 25 at the
Veterans' Memorial Building. The affair will feature the
collections from the paintings of Valley artists and it will
also be a show of art treasures from the private collections
of Valley residents. Doors to the exhibit and auction will
open at 7:30 p.m. The auction of paintings and antiques
will come at 9 p.m. A group of the Valley's outstanding
artists have agreed to participate in the event by showing
their work. They will also give one of their paintings or a
piece of sculpture for the auction. Taking part will be such
artists as **Martha Mott (Mrs. Viggo Brandt-Erichsen),
Charles Glasgow, Viggo Brandt-Erichsen, Forrest
Hibbits, Amory Hare Hutchinson, Juanita Abbott,
Eloise Joughin**, and **Leo Ziegler** and a group of his
students…," *SYVN*, Dec. 19, 1952, p. 7.
<u>Santa Ynez Valley Art Exhibit (notices in Northern Santa
Barbara County newspapers on microfilm and the Internet).</u>
1953 – **"First annual"** <u>St. Marks-in-the-Valley Art
Exhibit</u> – "Name Committees for Coming Valley Art

Exhibit, auction… Among the art which will be exhibited will be five paintings from the noted collection of **John Gamble** of Santa Barbara, a collection of paintings of Santa Barbara artist **Mary Midtby**, sculptor work by **Francis M. Sedgwick** of Los Olivos, and a showing of original etchings and water colors by the late western artist, **Ed Borein**. Also included among the showings will be a memorial exhibit of the work of the late **Michael Barnes** of Ballard who was a student of **Leo Ziegler**. There will also be a section devoted to photographic art and will feature the work of Mrs. **Alice Whittenberg**, Mrs. **Ellen Gleason**, **Jack Griesbauer**, and the late **Mrs. Clayton Patterson**, regarded as one of the country's outstanding photographic artists. A group of student artists of the Valley will also show their work… The exhibit will also feature the showing of a wide collection of art gathered from the homes of the Valley. Among the Valley artists who will show their work, in addition to those already mentioned are… **Juanquina Abbott, Lena Boradori** of Los Alamos, **Roseanne Hill, Jane Merlo, Leo Ziegler** and **Eloise Joughin**," *SYVN*, Jan. 9, 1953, p. 1; "Valley Artists Showing Here for First Time… three Valley artists who will show their work here for the first time. The artists are **Charles Glasgow**, Los Olivos painter, **Paul Kuelgen**, a new resident of the Valley and RKO Studio illustrator, and **F. M. Sedgwick**, Los Olivos sculptor. All three artists are outstanding in their respective fields…," *SYVN*, Jan. 16, 1953, p. 2; **Kuelgen** "… The names of other artists who show their work… include **Frank Armitage**, an Australian whose specialty is murals. Married to the former Joan Drake of the Valley, Armitage recently returned from Jamaica where he had a one-man show. Also scheduled to display her work is **Lila Tuckerman** of Carpinteria, mother of Mrs. Sigvard Hansen of the Valley. Mrs. Tuckerman is well-known for her work in oils. Both **Mrs. Tuckerman** and Mr. Armitage have donated a picture to the auction. **Jeannette Davison** of Solvang will display some water colors while **Cpl. Dexter Kent** of the U.S. Air Force will show some of the photographs he has taken in the Far East with his Air Rescue Squadron. Kent is stationed in Japan and is the son of Mr. and Mrs. Hewell Kent of Solvang," and news about two auction items, per "**Paul Kuelgen**, Former RKO Artist…," *SYVN*, Jan. 23, 1953, p. 6; ■ "Youth Will Be Represented, Too, in Coming Art Exhibit, Auction… Among the youthful participants are **Sgt. Lee Bowersox**, in Japan with the U.S. Air Force, **Jean Abbott, Sanny Orton,** Nancy Imbach, **Wendt Plumb, Helen Holman** and **Tony Bell**. With the exception of Sgt. Bowersox, all are 17 or younger. Seventeen-year-old **Tony Bell** will display a photo snapped on a sunny afternoon and taken clearly for effect. Born in Copenhagen, Denmark, Tony said he 'was not a bit interested in photography until five years ago when I immigrated to the United States with my family. I was clicking away with a box camera then.' Now living in Solvang, Tony, who wanted to let people know he was 'looking for a darkroom' now does his picture taking with a Rolleicord No. 3, and the photo he is displaying was taken on Plus X film, using a yellow filter. The photos being shown by **Sgt. Bowersox** were sent home from Japan especially for the exhibit. They were taken in Japan. **Sanny Orton**, aged 17, is a junior in high school and said, 'Ever

since I was old enough to hold a crayon I drew and sketched. I used to sit for hours when I was little and paint. It has always been my first love. Now the art work I do in school is a class in design, painting and drawing. If I go on to college I will major in art.' **Helen Holman**, also 17 and a junior in high school, has always had a desire to draw. She says, 'I have been taking art for three years from a very good instructor who has taught me many techniques about drawing.' **Miss Holman** plans to go to college and major in art. The picture Nancy Imbach is showing was done when she was nine years old and it is of Lee Taft's playhouse. The water color of Wendy Plumb [thirteen-year-old daughter of Preston Plumb] was also done about two years ago. Youthful **Jean Abbott** will show her work in water colors. She was taught to paint by her mother, **Jouquina**, who is also exhibiting in the St. Mark's show. … there is a possibility of the showing of a collection of Miss Lee Taft's pictures… Valley and out-of-Valley artists have already contributed more than 25 items of art to be auctioned…," *SYVN*, Jan. 30, 1953, p. 3; ■ "Work of Valley Artists to Lend Distinction to Exhibit Sponsored by Solvang St. Marks-in-the-Valley Church. The exhibit is to be held in the Veterans' Memorial building in Solvang the evening of Wednesday, February 25… On view will be work of such well-known valley artists as **Forrest Hibbits** of Lompoc and Buellton, **Mr. and Mrs. Viggo Brandt-Erickson (Martha Mott)**, **Leo Ziegler**, **Charles Glasgow**, **Amory Hare Hutchinson (Amory Hare)**, **Mrs. Andrew Joughin**, and **Paul Kuelgens**. Santa Barbara artists who will exhibit their work are **John M. Gamble, Mary Midtay, Charles C. Mattei, Francis Sedgwick**, and **Lilia Tuckerman**. Also exhibiting will be **Mrs. Lena Boradori**, of Los Alamos, **Mrs. Joaquina Abbott, Mrs. Rose Anne Hill, Mrs. Jeannette Davison**, student artists of the valley from Santa Ynez Valley high school. [and later there will be a silent auction of pictures and rare antiques] … Both professional art photographers and those who follow the art as a hobby will have exhibits, among them **Jack Griesbauer, Hans Sorensen, Ellen Gleason, Mrs. Alice Whittenberg**, and a collection of the late **Mrs. Clayton Patterson** who did outstanding work … In addition will be a collection of photographs taken by **Cpl. Dexter Kent** of Solvang who is with the 39th Air Rescue Squadron, 3rd Air Rescue Group, in Japan. Cpl. Kent is official photographer for his outfit. … Additional works of art are arriving daily," *LR*, Feb. 5, 1953, p. 14; ■ "Interest Increases as Date for Exhibit, Auction Nears… Much of the art work will carry the flavor of the Valley. The painting donated by **Joaquina Abbott** is a water color of historic **Mattei's tavern**, old-time stage stop in Los Olivos. A painting given by **F. M. Sedgwick** is of his Corral de Quati Ranch, while **Forrest Hibbits'** donation will be a water color entitled 'Oak Tree in Summer,' and **Leo Ziegler**'s donation is entitled 'Alisal.' **Walter Krell**, well-known Santa Barbara resident, has joined the exhibit and has donated a painting called 'Mountain Road.' **Jeannette Davison** of Solvang is giving a water color, 'River Scene.' In the young people's category, there will be a display of ceramic work created by the students of the high school under the tutelage of Mrs. **Lenora Anderson**. Joining the under-17-years-of-age group who will display their work are four of the Sedgwick children, Edith, F. M. Sedgwick, Jr., Alice Sedgwick and

H. de F. M. Sedgwick. Among the art treasures to be shown in the small room at the Memorial Building are two 14th Century St. George and the Dragon medals strung on platinum and pearls from the Order of the Knights of the Garter. … two lace mantillas… some of the art treasures from the collection of Phoebe Apperson Hearst… **Mr. and Mrs. Beaudette** will show from their collection a table made by movie star **George Montgomery**, a reproduced oil painting of William May Wright by Prince Troubetskoy, another painting, 'Ducks in Flight' by Peter Scott, and an etching by Paul Whitman, which the Beaudettes are donating to the auction. Among the many Valley exhibitors will be Dan Britton… display… 14th Century gold brocaded Buddhist ceremonial robe … ancient Buddhas…," and photo of **Leo Ziegler** at his easel taken by **Hans Sorensen**, *SYVN*, Feb. 6, 1953, p. 1; "Art Exhibit in Solvang Feb. 25 … ," and upcoming details and names of artists, *SMT*, Feb. 7, 1953, p. 4; ■ "Artists from San Luis Obispo to Ojai are cooperating in making the art exhibit to be held in the Veterans Memorial hall here at 7:30 p.m., February 25, an outstanding success-to-be … In connection with the exhibition, a silent auction of pictures donated by participating artists will be in progress. ... Also offered for auction will be rare antiques… Proceeds from the exhibit and auction will benefit St. Marks' building fund… Photographic Art will also have a place in the exhibit …," per "Art Exhibit in Solvang Feb. 25 Will Aid Church" and will be held in Veteran's Hall, *SMT*, Feb. 7, 1953, p. 4; ■ "Photography – from New World and Old, Join Art Exhibit. Valley's First Showing Creates High Interest. … local lens talent… the two Valley professional photographers: **Jack Griesbauer**, a group of studies, portraits and scenic shots, and **Hans Sorensen**, with a collection from Denmark and later ones from America. Mrs. **Alice Whittenberg** will show a selection of her animal portraits and landscapes. Mrs. **Ellen Gleason**, a 1952 award winner from the **Channel City Camera Club**, will show a group of her Hawaiian prints. Also, **Walter and Clayton Patterson**, who have won awards in the southland, will exhibit a selection of their works. The Patterson's interest in photography grew out of their love for flying and the subsequent visual aid that photography gave flying. From the Far East will come interesting and unusual prints from two Valley servicemen stationed in Japan: **Dexter Kent** and **Lee Bowersox**," *SYVN*, Feb. 13, 1953, p. 1; "An Apology… joke between two fellows boomeranged into an embarrassing situation… [Japanese artifacts displayed at St. Mark's-in-the-Valley Auction] given to me as going away presents by friends in Japan [not stolen as reported earlier in newspaper]," *SYVN*, Feb. 13, 1953, p. 4; ■ "Art Entries Continue Momentum… **Jeanne de Nejar** of Santa Maria, famous for her pottery and ceramics, has donated two pieces to be auctioned off. On exhibition too, will be other pieces of her work from the collections of Mrs. Archie Hunt and **Mrs. Jane Merlo**. At the present time she is exhibiting a one-woman show at the Pottery Barn in New York. **George Heth**, who 'discovered' Solvang while stationed at Camp Cooke, will exhibit several of his latest canvases. Heth is experimenting with a new method of painting in which he uses unmixed colors. In viewing the finished work from the distance, the eye

does the actual blending. His specialty is in missions. In the etching and watercolor section, the ever-famous western art of **Edward Borein** will surely prove a favorite with all. Exhibitors of his art will be: Mr. and Mrs. Glen Cornelius, Mr. and Mrs. E. L. Janeway, Mrs. Maxine Michaelis and Mr. and Mrs. Raymond Cornelius," *SYVN*, Feb. 13, 1953, p. 1; "Mounting Interest Forecast Success for Solvang Art Exhibit… Among arrivals last week was a group of ceramics from **Jeanne DeNejer** of Santa Maria, just now in New York conducting a one-man showing of her work. … Others were 10 oils, mostly coastline scenes, by **Mario Veglia** of Casmalia… Among the artists from San Luis Obispo to Ojai … who will have their work on view are **Forrest Hibbits** of Lompoc and Buellton, **Mr. and Mrs. Viggo Brandt-Erickson (Martha Mott), Leo Ziegler, Charles Glasgow, Amory Hare Hutchinson (Amory Hare), Mrs. Andrew Joughin,** and **Paul Kuelgens**. Santa Barbara artists who will exhibit their work are **John M. Gamble, Mary Midtay, Charles C. Mattei, Francis Sedgwick** and **Lilia Tuckerman**. Also exhibiting will be **Mrs. Joaquina Abbott, Mrs. Rose Anne Hill, Mrs. Jeannette Davidson [Sic.? Davison?]**, student artists of the valley and a group of student artists from Santa Ynez Valley high school… Both professional art photographers and those who follow the art as a hobby, will have exhibits, among them **Jack Griesbauer, Hans Sorensen, Ellen Gleason, Mrs. Alice Whittenberg**, and a collection of the late Mrs. **Clayton Patterson** who did outstanding work…In addition will be a collection of photographs taken by **Cpl. Dexter Kent** of Solvang…," *LR*, Feb. 19, 1953, p. 2; ■ "Some of Country's Leading Artists Displaying Work in Show Wednesday: Proceeds Going to St. Mark's Building Fund… Among the artists who will display are included **Mary Mitby [sic. Midtby], Charles Mattei,** and **John Gamble**, Santa Barbara, **Amory Hare, Leo Ziegler, Paul Kuelgen, Martha Mott, Charles Glasgow, Forrest Hibbits**, all of Santa Ynez Valley, **Lena Boradori** of Los Alamos, **Gladys Gray** of San Luis Obispo, **Charlotte Kubon** of Alaska, **Red Skelton, Clifton Webb, Dinah Shore** and **George Montgomery** of Hollywood, **Harold Forgostein** of San Luis Obispo, **Mario Veglia** of Casmalia and **Lila Tuckerman** of Carpinteria. There will also be a large exhibit of **Ed Borein** originals in water colors and etchings of the far West. Sculptors who will show are **Viggo Brandt-Erichsen** of Solvang and **F. M. Sedgwick** of Los Olivos. Showing ceramics will be **Jeanne De Nejer** and **Ellen Gleason**. All of the foregoing have donated one or more pieces of art to the auction… There will also be a display of photographic art, featuring the work of professionals **Jack Griesbauer** and **Hans Sorensen** of Solvang and **Ellen Gleason**… Also showing in the photo class will be Mrs. **Alice Whittenberg**… and **Walter and Clayton Patterson**…," and listing of other treasures shown, "The treasure room will also feature the showing of rare jewelry, lace and old fans… All of these will be shown by **Mrs. Channing Peake**… who will also show her decoupage pictures of animals and a necklace of Mexican royal reals… an ivory covered prayer book set with rose diamonds…," *SYVN*, Feb. 20, 1953, pp. 1, 5.

■ "Art Show Big Success… More than 600 people converged upon the Veterans' Memorial Building Wednesday night… auction of 46 pieces of art. With Fred

621

Brown as auctioneer, the auction netted over $700… the affair realized more than $1000 …," *SYVN*, Feb. 27, 1953, p. 1; "Valley Hoo… The Art Festival was a big success too… **Paul Kuelgen** was talking to one of the artists. 'Do you think you could paint a good portrait of my wife?' Paul asked him. 'Listen my friend,' the artist said, 'I can make it so lifelike that every time you look at it you will jump.' Otto Battles was admiring one of the pictures. 'Is this one of the old masters?' Otto asked the artist. 'No,' the artist said, 'it's my missus.' A lot of people go to the art show like they go to the opera. The Warden out at our house went… She was admiring one of the paintings. 'Ah,' she said, 'what soul, what expression, what superb feeling. This is the work of the world's greatest artist.' 'Yeah,' **Amory Hare Hutchinson** said, 'that's where I clean my brushes.' Someone asked **Viggo Brandt-Erichsen** to what he attributed his success as a futuristic painter. 'I use a model with hiccups,' he said," *SYVN*, Feb. 27, 1953, p. 2; photo of people at art exhibit and "People Still Talking About St. Mark's Art Show, Exhibit… A crowd estimated at between 600 and 700 people jammed the Veterans' Memorial Building… The show proved that the people of the Valley have appreciation for art… should have been spread over a longer period of time [so that people could have time to view all the exhibits] … The affair also resulted in the birth of a community-wide choral group of 40 voices…," *SYVN*, March 6, 1953, p. 6; "Valleyhoo by Dan Britton… Art Treasure collections. Every exhibit was a museum piece – including the items from Tiburcio Vasquez' collection. **Mrs. Joughin** and Mrs. Kirkpatrick's collection of Chinese cloisonné was perhaps the most fabulous collection ever shown in the United States… well over 200 years old. **Edna George**'s collection of Noh masks, porcelains and Japanese scrolls was the finest that will ever be seen in the United States. **Mrs. Tallant**'s two porcelain pre-Ming dynasty dogs – from a collector's standpoint – were worth more than the entire show was insured for… I liked 'Swede' Larsen's music box and Mrs. Davidge's fabulous collection of treasures," *SYVN*, March 13, 1953, p. 6; "Art Show Donors Luncheon Sunday," *SYVN*, May 22, 1953, p. 1; "St. Mark's-in-the-Valley Luncheon Honors Fund Donors," *SYVN*, May 29, 1953, p. 6.

1954 – Second annual [renamed to **Santa Ynez Valley Art Exhibit**] - "Revise Art Show Plans, Dates Set… This year the art exhibit will be held April 1-4 and will be divided into four classes: student, professional and amateur, and photographic. There will also be a display of arts crafts and sculpture…," *SYVN*, Feb. 5, 1954, p. 1; "Festival Theme to Mark Art Show… April 2nd – 4th. Cash awards and ribbons… No more than three pictures for each artist will be hung, with each artist donating one of the three paintings for auctioning… In the sculpture class, entries are limited to four pieces with one of the four to be donated for auction. In photography there will be two classes, one for professionals, exhibit only, and amateur, with cash prizes… In ceramics, not more than four entries may be submitted with one of the four to be donated for auction. Under lithographs, drawings, mobiles and etchings, not more than two pieces may be submitted. Any donation in these classes for auction will be gratefully accepted… deadline… March 20… there will be a living picture to be presented each evening…," *SYVN*, March 5, 1954, pp. 1, 8; "Art Exhibit

Entries Now Being Received… scheduled for April 2, 3, and 4 in the Veterans Memorial building… The theme for this year's festival will be 'Modern Art.' …," *SMT*, March 8, 1954, p. 9; "Solvang to Open Charity Art Exhibit in April," *SLO T-T*, March 6, 1954, p. 2; "Art Exhibit in Solvang Scheduled… second annual Santa Ynez Valley art exhibit and auction to be held April 2, 3, 4, in Solvang … student art work from the schools of SLO county… living pictures…," *LR*, March 11, 1954, p. 9; photo of **Viggo Brandt-Erichsen** and **Paul Kuelgen** with their sculptures and "Art Show Entries Close March 20…," *SYVN*, March 12, 1954, p. 1; "Annual Art Exhibit, Auction Opens Here Next Friday… three-day affair… Friday, Saturday and Sunday… 10 a.m. to 10 p.m.…. **Viggo Brandt-Erichsen** will exhibit a set of ceramic chessmen, while Los Olivos sculptor **Francis Sedgwick** will display portrait busts of **Standish Backus** and Mrs. Joseph Bradley… The exhibit, which will follow the theme of modern art, country style, will also feature a 'Painting with Materials' exhibit, a display of 20 hooked rugs created by the class of women directed by Mrs. Jens Rasmussen. Youthful artists from Santa Barbara County schools… Among those showing in the water color class this year is **Mrs. Grace L. Davison** of Ballard, a student of **Leo Ziegler**. She will display three water colors, one of Old Mission Santa Ines and another of a Santa Ynez river scene and the third, a side view of the Old Mission. The latter she is donating to the auction. Much in the way of photographic art will also be shown both in amateur and professional classes. **Jack Griesbauer** heads the photographic art committee, and judges will be Jim Johnson, Dave Hart and **Joseph Knowles**. Another feature of the exhibit will be the living picture display, one a Norman Rockwell creation by **Paul Kuelgen** and the other a Danish painter's work by Paul Palmer. … William Sarandria heads the auctioneer's committee…. Judges in the amateur art class are **Dr. Elliot Evans, Douglass Parshall** and **Ala Story**," and photo of artworks by **Amory Hare Hutchinson** and **Cora Wright** and photo of **Cora Wright**, *SYVN*, March 26, 1954, p. 1; photo of **Mrs. Odin Buell** of Buellton, Father Lynn Parker and **Mrs. Cora Wright** of SLO and "Art Show Nears," *SLO T-T*, March 27, 1954, p. 8; "Santa Ynez Show Promises Variety of Art Exhibits … Each teacher in Lompoc elementary and Hapgood schools was allowed to enter one student painting and one piece of ceramics. Those entered include: [and list follows by grade]," *LR*, April 1, 1954, p. 5; photo of children applying paint to clay masks which will be displayed at the Art Show, *SYVN*, April 2, 1954, p. 1; "Artists, Guests From Here Attend Solvang Art Show," *SLO T-T*, April 2, 1954, p. 6; "Art Show Opens Today. Memorial Hall Setting for Event… 'Modern Art – Rural Style' will provide the theme… The amateur photography class was judged Monday, with the following results: first, 'The Glory of Harlech,' **Elbridge Newhall**, Santa Barbara; second, 'The Open Road,' **Peggy Gardner**, Buellton and third, 'Fish Nets or Floats,' **Ed Campbell**, Santa Barbara; first honorable mention, 'Crater Lake,' **Elbridge Newhall**, second honorable mention, 'Fish Basket,' **Ed Campbell**, and third honorable mention, 'Desert Bloom,' **Merrill C. Hart**, Santa Barbara… One of the attractions at the show this year will be the courtesy exhibit featuring art work of Hollywood notables including amateurs **Dinah Shore, Red**

Skelton, George Montgomery, Edgar G. Robinson, Gladys Robinson, John Lindsay, Tony Longinotti, Adriana Edna Simeone and professionals Tony Duquette, Mrs. Reuben Mamoulian, Wallace Seawell, Boris Lovet-Lorsky [Sic. Lorski] and Nicholas Tregor… Artists whose work will be displayed… Leo Ziegler, Joaquina Abbott, Martha Mott, Betty Corbett, Juka Carlson, Florence Clippinger, Grace Davison, Dorothy de Araujo, Joan Dougherty, Edwin E. Engleman, Jr., Jean Baird, Stanton Gray, Carroll E. Grulley [sic. Gulley] Vern Greenelsh, Charles H. Glasgow, John Helms, Florence B. Hendrickson, Forrest Hibbets [Sic. Hibbits] Elli Heimann, Joyce V. Hedin, Donald Harrah, Amory Hare Hutchison [Sic. Hutchinson] Isabel Kershaw, Katherine Lauck, Elizabeth Milis [Sic. Mills], Frances Polley, Nellie Peterson, Thorvald Rasmussen, Blanche M. Rose, Grace Smith, Gertrude Smith, Lila Tuckerman, Mrs. Harold Vensure [Sic. Venske ?], Faye Vonsild, Emma Hernhuler Wilson, Ernest G. Walford, Margaret Ely Webb, Cora A. Wright, Matte Willis Beard, Ruth Leicty [Sic. Liecty], Gladys Castagnola, Lee Dabney, Harold Forgostein, and Helen Eloise Joughin. Sculptors, Viggo Brandt-Erichsen and Matte Willis Beard. Photographers, Joe Ames, Anthony Bell, Edward Campbell, Edwin E. Engleman, Jr., Ellen Gleason, Beverly Buell Kay, Elbridge Newhall, Hans Sorensen, Maurice Shook, and George Tallant. Ceramics, Viggo Brandt-Erichsen, Helen Barbera, Grace Lainhart, and Mrs. Charles Sloan [Sic. Erna Marie Sloane]. Drawings, Rhio O'Connor. Mobiles, Lee Dabney. Rugs: Verne Regaha, Connie Rasmussen, Mrs. Chris Roth, Nettie Turner, Mrs. George Boverson, Mrs. Kenneth FitzGerald, Elizabeth Howell, Mrs. George Burtness and Mrs. Paul Kuelgen. Ink and ink pastels, Peter Wolf. Lithographs, Rockwell Carey. Tempera, Margaret Hart," SYVN, April 2, 1954, pp. 1, 5; "'Professional' Touch Reflected in Art Show… [events described] …Not all of the exhibits were good, of course… not to have a jury… One of the most interesting displays was contributed by school children, from five to 16 years old… The photographs shown were also excellent. … Hans Sorensen's fine print of an antenna and the vapor trail of a jet… a dramatic battlemented castle by Elbridge G. Newhall and Peggy Gardner's charming 'Boy with a Gun,' among others, were much enjoyed. There were some stunning handwoven rugs. And, of the many ceramics shown, Viggo Brandt-Erichsen's enchanting chessmen, displayed on a chess table of inlaid wood, was much admired. Nettie Turner showed some quaint embroidery pictures and Rockwell Carey had a portfolio full of his strong lithographs. The crowd seemed to enjoy the canvases loaned the exhibit by a group of Hollywood personalities… Red Skelton's weird clown, Mrs. Edward G. Robinson's landscape, and Mrs. Rueben Mamoulian's sympathetic portrait. Here and there through the hall mobiles twisted and turned. And, there were several fine bronze heads by Francis Sedgwick of the Valley… Quite a number of pictures were sold during the three days of the exhibit… first prize to Leslie Kiler and honorable mention to Gladys Castagnola and John Lindsay," SYVN, April 9, 1954, p. 2, and photo of interior display of paintings, p. 3.

1955 – Third annual – group photo of Exhibit chairpersons including Mrs. Andrew Joughin and exhibit will be staged at Veterans' Memorial Building in Solvang April 29 through May 1," SYVN, March 18, 1955, p. 1; photo of Festival chairpersons and "Art Festival Scheduled" and invites exhibitors, SMT, March 21, 1955, p. 3; "Solvang Prepares for Art Festival," LR, March 24, 1955, p. 13; port of planners and "Mrs. Joughin Heads Solvang Art Exhibit Slated for April," SLO T-T, March 29, 1955, p. 4; "Lompoc Artists are Invited to Enter Solvang Art Exhibit," and details of entry rules, LR, April 7, 1955, p. 5; "Annual Art Show Due…," and listing of awards and submission guidelines," SYVN, April 15, 1955, p. 1; "Third Annual Art Exhibit Heads Named," SYVN, April 16, 1954, p. 5; photo of sign advertising art show, and standing to left is Paul Kuelgen, SYVN, April 22, 1955, p. 1; "Artists Invited to Send Pictures for Auction," SLO T-T, April 22, 1955, p. 8; "Artists Reception at Solvang," SLO T-T, April 23, 1955, p. 2; "Curtain to Rise on Annual Art Exhibit at Memorial Hall … auction… added feature… special display of rare religious arts at St. Mark's Parish Hall… group of rare woodcuts – the work of the late Viggo Brandt-Erichsen…," SYVN, April 29, 1955, p. 1; photo of Forrest Hibbits studying some of the religious art to be shown, and "Art Show Opens Here… An important exhibit at this year's show will be a group of rare woodcuts - the work of the late Viggo Brandt-Erichsen… The pictures are varied in subject. Some were made from drawings done during the 10 years Brandt-Erichsen camped in the wilderness of Scandinavia and Prussia. Others were made in the warmth of tropic Bermuda and others in Paris in art school days with a background of Mont Martre. One American subject from the Indians, 'Buffalo Hunt,' is an exception. … in the Scandinavian wilderness includes 'Woodcock,' 'Squirrel,' and 'Ducks,' from Bermuda 'Fruit Vendor,' 'Native,' from Paris, 'Mermaid,' 'Dance of Spring,' and 'Composition,' and from America, 'Hunting Buffalo' … Valley artists showing their work will include Helen F. Barbera, ceramics, Martha Mott Brandt-Erichsen, water colors, Betty Corbett, oils and water color, Grace L. Davison, water colors, Charles M. Glasgow, oils, Forrest Hibbits, oils and water color, Amory Hare Hutchinson, oils, Helen Eloise Joughin, oils, Catherine de W. Mackenzie, oils and pastel, Xandra Orton, collage, C. A. Sloane, water colors, Mrs. Harold Venske, oils and water color, Ernest Wolford [Sic. Walford], oils and Paul Kuelgen, water colors and oils. There are also a large number of photography entries. Among the Valley exhibitors are Mrs. John Gardner, Ellen Gleason, King Merrill, Catherine A. Peake [daughter of Channing Peake], and Else Vett. Other photographers displaying will be Joe Ames, of Lompoc and Elbridge Newhall of Santa Barbara. Among the Santa Barbara Art Association members who will exhibit are Douglass Parshall, Gladys Castagnola, Jeffrey [Sic. Jaffrey] Harris, Leslie Kiler, Ruth Liecty, Dr. Neville T. Ussher, Margaret Ely Webb and Charles Glasgow and Forrest Hibbits. San Luis Obispo Art Association members showing include Margaret Maxwell, Betty Middlecamp, Elaine Stranahan Badgley, John Badgley, Edwin E. Engleman, Jr., Harold Forgostein, Gladys and Stanton Gray, Dorothy de Araujo, and Joan Dougherty.

Exhibiting from Santa Maria is **George Muro**. Another exhibitor will be **Merle Oberon**, movie star of Hollywood…," *SYVN*, April 29, 1955, pp. 1, 4; "Winners Named," *SLO T-T*, April 30, 1955, p. 2; "Tri-County Art Lovers Assemble for Show at Solvang," *SLO T-T*, May 4, 1955, p. 8; "St. Mark's Art Show Success… A special children's exhibit drew much attention. An innovation this year and a feature which drew a large number of people was the … display of religious art at St. Mark's Parish Hall… Prize winners in the photography class were: **Joe Ames**, Lompoc, 'Jeffrey Pine,' first; **Peggy Gardner**, Buellton, second, 'Baby Sitter,' and **Bud Quick**, Santa Maria, 'Uncle Tom,' third. Results of judging in the other classes were not available at press time yesterday," *SYVN*, May 6, 1955, pp. 1, 4.

1956 – Fourth annual – Photo of Robert Herdman holding a still life by **Gladys Castagnola** and showing it to **Mrs. Andrew Joughin**, art show chairman, and "Plans Underway for Fourth Annual SY Valley Art Show," and artists as far afield as Laguna Beach may submit, *SYVN*, Feb. 24, 1956, p. 3; "Various Committees Named for Coming Art Festival… to be held in the Veterans Memorial Building in Solvang on May 25, 26, and 27… **Mrs. Uno Sandvik** is in charge of a new feature of the show which will be called 'Artists at Work.' Well-known artists will demonstrate techniques in oil and water color painting, ceramics and weaving. Mrs. Sandvik will be assisted by **Forrest Hibbits**, portrait artist. **Mrs. Joughin** will have charge of the hanging of the art work. She will be assisted by several Santa Ynez Valley artists… Mrs. Joughin announced that through the gracious cooperation of **Mrs. Ala Story**, director of the Santa Barbara Museum of Art, prize winning pictures will be hung in the Santa Barbara Art Museum for one week following the local show… this year's show coincides with the annual horse show to be held at the Alisal Guest Ranch…," *SYVN*, March 16, 1956, p. 3; photo of **Mrs. Andrew Joughin** and Rev. Carl Markgraff announcing upcoming festival May 25, 26, 27, *SLO T-T*, April 12, 1956, p. 8; "Exhibitors Invited to Take Part in St. Mark's Art Show," and list of rules and regulations, *SYVN*, May 4, 1956, p. 2; "County Artists Enter Exhibits in Solvang Show," *SLO T-T*, May 10, 1956, p. 6; "Art Show Entry Deadline Monday. **Charles M. Glasgow**, nationally famous artist, will be one of the exhibitors… Thus far, entries have been received from as far north as Carmel and from [as] far south as Laguna Beach. Santa Maria High School and Junior College have indicated they will exhibit this year. Lompoc High School has already submitted its formal application…," *SYVN*, May 11, 1956, p. 6; "Southland Exhibitors in Coming Art Exhibit… Among the Santa Ynez Valley artists who will participate are **Helen Barbera**, nationally known ceramist, **Forrest Hibbits**, **Charles Glasgow**, and others. … A preview of [the] exhibit is slated for next Thursday night for the participating artists," *SYVN*, May 18, 1956, p. 7; "Opens Today" and photo of **Mrs. Stanton Gray** and **Harold Forgostein**, *SLO T-T*, May 25, 1956, p. 4; port. of **Forrest Hibbits** holding a portrait and "Art, Horse Shows Here. St. Mark's Art Exhibit Opens This Afternoon… 'Artists at Work.' **George Muro**, instructor in art at the Santa Maria High School and Hancock Junior College, will demonstrate techniques in art tomorrow from 11 a.m. to 3

p.m. **Forrest Hibbits**… will show his particular techniques tomorrow from 3 to 5 p.m. On Sunday from 1 to 3, **Gladys Gray**, SLO artist, will demonstrate techniques in oils and water colors and **Jeffery [Jaffrey] Harris**, Santa Barbara artist, will paint from 3 until 5 p. m… **Martha Brandt-Erichsen** is decorations chairman… **Mrs. Odin Buell** and Mrs. Charles Glasgow were heard on another radio show… **Mrs. Joughin** was seen on a Santa Barbara television program… Among the local artists exhibiting this year will be **Charles Sloane** of Solvang. Sloan is a Valley poultry rancher who didn't believe he had any real artistic talent until he became ill and was told that he could no longer do any heavy work. When his morale had slipped to the point where he thought that the world had ended for him, **Paul Kuelgen**, his neighbor and former RKO Studio staff artist, put a brush in Sloane's hand, gave him an easel, some paints, a canvas and told him to start painting. Last year, Sloane won several prizes at the show. He has been studying under **Forrest Hibbits** and **Leo Ziegler**… this will be Sloane's third year of exhibition in the show…," *SYVN*, May 25, 1956, pp. 1, 12; photo of Santa Ynez High School students **Lief Nielsen** and **Crystal Rett** working on crafts for the upcoming art show, overseen by Mrs. **Lenora Anderson**, *SYVN*, May 25, 1956, p. 4; "High Quality of Art Noted at Show Here… judges, **William Rohrbach**, art department, University of California at Santa Barbara College, **William Hesthal**, educational assistant at the Santa Barbara Museum of Art, and **Harold Forgostein**, artist-teacher of San Luis Obispo… They gave awards to: oils, **Ruth Liecty**, Santa Barbara, painting, 'Park Lane,' first; **M. Eli Webb**, Santa Barbara, still life, second; **Gladys Castagnola**, Santa Barbara, fruit still life, third and **Charles Glasgow**, Los Olivos, still life, honorable mention. Water colors, **Elaine Stranahan Badgley**, SLO, 'Cross Roads,' first; **James Evans**, San Simeon, 'Span No. 2,' second, **Martha Odrendorff [sic. Orendorff]**, Santa Barbara, 'Buildings,' honorable mention. Ceramics **Jerrold Friedman**, Santa Barbara, 'Bowl Planter,' first and honorable mention to **Helen Barbera**, Solvang, **Elva Beattie** and **Bernice Woodall**, Lompoc. Attracting much attention Friday, Saturday and Sunday afternoons were the 'Artists at work.' **George Muro**… **Forrest Hibbits**… **Gladys Gray**… **Jeffrey [Sic. Jaffrey] Harris** of Santa Barbara… provide an art student scholarship. **Miss Jean Abbott**… Supervising the hanging of the painting was **Rudolph Gilbert**, curator of the **Faulkner Gallery**, Santa Barbara. The prize-winning work… will be placed on exhibit at the Hammett Gallery of the Santa Barbara Museum of Art beginning next Tuesday through June 17," *SYVN*, June 1, 1956, p. 7.

1957 – Fifth annual – "Valley Art Exhibit Slated During **Danish Days** Weekend … Aug. 17 and 18… the bishop's committee of the church 'have concluded that artists of the Valley have a distinctive contribution of make. With this in mind, it has been decided to limit the entries this year to Santa Ynez Valley artists and to hold the exhibit in the church parish hall during Danish Days as a contribution to the festival'… The parking area of the church will be transformed into a 'sidewalk café' where refreshments will be served during the exhibit… Up until this year, the St. Mark's Art Exhibit was staged over a weekend each Spring in the Veterans Memorial Building with artists from all

parts of southern California invited to participate," *SYVN*, June 7, 1957, p. 8; "**Danish Days**: Art Exhibit of St. Mark's New Feature of Celebration … limited to Valley artists only… Among the first-time exhibitors who have indicated their intention of showing… are **Oscar W. Lindberg, Harold N. Young, Philip Leighton, Ellen Gleason, Ida Belle Tallant,** Lee Taft, Venetia Gleason, Daniel Adams, and **Mrs. Al Constans**. Included among the artists who have previously exhibited and intend to do so again are **Forrest** and **Marie Hibbits, Martha Brandt-Erichsen, Leo Ziegler, Amory Hare Hutchinson, Charles Glasgow, Walter Swackhamer, Charles Sloane, Marie Venske, Grace Davison, Jeannette Davison, Joaquina Abott, Eloise Joughin, Natalie Elliott,** and **Thorvald Rasmussen**…," and photo of three Valley artists who will show their work for the first time, along with their artworks, Mrs. **Monica Kramer**, Miss **Ursula Wolf** and Mrs. Dennis FitzGerald, all students of **Mrs. Viggo Brandt-Erichsen**," *SYVN*, July 19, 1957, p. 1; "Valley Art Exhibit Slated During **Danish Days** Weekend … Aug. 17 and 18… the bishop's committee of the church 'have concluded that artists of the Valley have a distinctive contribution to make. With this in mind, it has been decided to limit the entries this year to Santa Ynez Valley artists and to hold the exhibit in the church parish hall during Danish Days as a contribution to the festival'… The parking area of the church will be transformed into a 'sidewalk café'; where refreshments will be served during the exhibit… Up until this year, the St. Mark's Art Exhibit was staged over a weekend each Spring in the Veterans Memorial Building with artists from all parts of southern California invited to participate," *SYVN*, June 7, 1957, p. 8; "Dansk Dage… Art Festival, Sidewalk Café Slated… There is no admission fee… The exhibit will be planned around a worship center at one end of the parish house. The paintings and works of art are being loaned for the worship center by a number of Valley residents, including **Father Tim O'Sulivan** … and **Mrs. Amory Hare Hutchinson**… Among the Valley artists who will exhibit are **Francis Sedgwick,** Mrs. Albert Weisbrod, **Paul Kuelgen, Oscar Lindberg, Forrest** and **Marie Hibbits, Martha Brandt-Erichsen, Leo Ziegler, Amory Hare Hutchinson, Charles Glasgow, Walter Swackhamer, Charles Sloane, Marie Venske, Grace L. Davison, Jeannette Davison, Joaquina Abbott, Eloise Joughin, Natalie Elliott, Thorvald Rasmussen,** Harold M. Young, **Ellen Gleason, Ida Belle Tallant,** Lee Taft, Venetia Gleason and **Mrs. Al Constans**… One of the features of the art festival will be the appearance of Santa Barbara silhouette artist **Gene Ross**. Another attraction will be a large Danish costumed pair, painted by **Mrs. Brandt-Erichsen**. It is expected that upon the wooden shoulders of the artist-created couple will rest the heads of many a visitor and local resident anxious to take home a 'picture' of himself in Danish costume. A Polaroid camera for this feature is being loaned the art show committee by **Mrs. Palmer Beaudette**," *SYVN*, Aug. 16, 1957, pp. 1, 5; "Arts, Crafts Exhibit… Danish arts and crafts scheduled for the Veterans Memorial Building…," *SYVN*, Aug. 16, 1957, p. 3; "Area Returns to 'Normal' … The St. Mark's-in-the-Valley Art Exhibit and sidewalk Café, staged at the parish house… A crowd estimated at 2,000 viewed the exhibit… Art exhibit award winners

were: first, water color, **Leo Ziegler**'s 'Figueroa Canyon,' second, **Forrest Hibbits**, 'Still Life With Lantern,' third, **Marie Jaans (Hibbits)**, 'Cachuma Lake,' drawing, first, **Forrest Hibbits**, 'Cat,' second, **Catherine Mackenzie**, 'Potted Plant,' third, **H. N. Young**, 'The Aloha,' oils, first **Francis Sedgwick**, 'Corral de Quati,' second, **Ernest Wolford [Sic. Walford]**, 'Los Olivos Barn,' third, **H. N. Young**, 'The Road Runner,' oil still life, first, **Oscar Lindberg**, 'Magnolias,' second, **Charles Glasgow**, 'Sun Flowers,' third, **Charles Sloane**, 'Tea Towels and Jug'," *SYVN*, Aug. 23, 1957, pp. 1, 5.

1958 – Sixth Annual – Photo of **Forrest Hibbits** and a still life by **Susan Markgraf** and caption reads, "Art Show Coming – As one of the added attractions during the **Danish Days** weekend in Solvang, the sixth annual St. Mark's-in-the-Valley Art Exhibit," *SYVN*, July 18, 1958, p. 1; "Coming Art Exhibit Danish Days Feature… Among the Valley artists who have entered thus far and the work they will exhibit includes **Mrs. Viggo Brandt-Erichsen**, portraits of Judy and Michael Wipf; **Mrs. Emma Constance**, 'Ballard School House'; **Charles Glasgow**, landscape, still life; **Forrest Hibbits**, 'Santa Barbara Harbor' watercolor; **Marie Jaans**, 'Blue Jug,' oil; Mrs. **Eloise Joughin**, 'Flowers'; **Charles Sloane**, 'Out Through My Bedroom Window'; **Leo Ziegler**, 'Sun Life, Santa Ynez Valley'; **Francis Sedgwick**, 'Admiral Sir George Monro,' 'Dive Bombers'; **Amory Hare Hutchinson**, 'The White Foal' and 'James Fitzsimmons,' trainer of Nashua and Bold Ruler and a leading horse trainer for 50 years; and **Ernest Walford**, 'Alamo Pintado Bridge,' 'Los Olivos Church.' Other artists from the Valley who will exhibit are **Mrs. Joaquina Abbott, Mrs. Grace L. Davison, Mrs. Ellen Gleason, Mrs. Monica Kramer, Mrs. Agnete Miller, Oscar Lindberg, H. A. Petersen, Dr. Walter Swackhamer, Mrs. Marie Venske, H. N. Young, Mrs. Jean Schley,** and **Mrs. Betty Corbett**. Also, **Lena Boradori,** Mrs. Katherine FitzGerald, **Mrs. Inger Kelsen, Miss Evelyn Joughin, Miss Catherine MacKenzie, Mrs. Margaret Nielsen, Mrs. Ida Belle Tallant, Thorvald Rasmussen, Miss Ursula Wolf, Mrs. Robert Elliott, Mrs. Florence Wynn,** and **Mrs. Clyde Weston**," *SYVN*, Aug. 1, 1958, p. 1; "**Danish Days** in Solvang…" and "Old World Exhibit Set for Festival. A display of Danish Arts and crafts… One of the attractions this year will be a display of Danish publications," and "Art Show, Sidewalk Café Scheduled at St. Marks… The work of approximately 50 Santa Ynez Valley artists… It was also announced that **Gene Ross**, silhouette artist and well-known to Santa Barbara patrons of El Paseo, will be at St. Mark's during the art exhibit… to make silhouettes of those attending," and other articles in *SYVN*, Aug. 8, 1958, pp. 1+; "Annual Solvang Festival Draws 10,000 People," *SYVN*, Aug. 15, 1958, p. 1; "St. Mark's Annual Art Show Winning Entries Announced… paintings included, first award, 'Pears with Bottle,' **Charles Glasgow**; 'Church, Los Olivos,' **Forrest Hibbits**; 'Waiting,' **Russell Thomas**, and 'Los Olivos Church,' **Ernest Walford**. Also, second award, 'Turquoise Jug,' **Marie Jaans**; 'Autumn at Alisal,' **Walter B. Swackhamer**; 'Harvest Time,' **Evelyn Joughin**, and 'Winter in New England,' **H. A. Petersen**, and third award, 'View from the School,' **Borge Andresen**; 'Mr. Fitz,' **Amory Hare Hutchinson**; 'Tom Cat,' **Ellen Gleason**, and

'Young Woman,' **Ursula Wolf**. … Among the exhibitors who sold their paintings were: **Martha Mott**, portrait; **Forrest Hibbits**, 'Los Olivos Church'; **Marie Jaans**, 'Turquoise Jug'; **H. A. Petersen**, 'Dybbol Molle'; **Annette Negus**, 'Seascape,' and **Howard Young**, 'Santa Ynez Valley'…," *SYVN*, Aug. 15, 1958, p. 3; "Buellton Briefs… According to a report from Robert Herdman, chairman of the sixth annual St. Mark's-in-the-Valley Art Exhibit, 1640 people attended… during the three days of Danish Days celebration. [repeat of awards per above article] … Six artists sold their paintings during the exhibition. **Forrest Hibbits** sold his painting of the Los Olivos church, **Martha Mott** sold a portrait, **Marie Jaans**, Turquoise Jar, **Annette Negus**, a Seascape, **H. A. Petersen**, Dybbol Molle, and **Howard Young**, a scene of the Santa Ynez valley," *LR*, Aug. 21, 1958, p. 9.
1959 – "**Danish Days** Celebration Cancelled by Businessmen," *SYVN*, April 3, 1959, p. 1.
See: "Danish Days," "St. Mark's in the Valley, Episcopal Church, Solvang," "Santa Ynez Valley Art Association"

Santa Ynez Valley, Ca., Adult / Night School
An "adult school" in the Santa Ynez Valley was taught in 1934 under the Emergency Education Program. In 1940 a professor visiting from the State College in Santa Barbara taught commercial law and English to adults at night at the Solvang grammar school. Commercial courses (typing, etc.) were offered in 1942. Typing and machinery repair were offered in 1943. Art (still life and landscape painting) was taught by Leo Ziegler, 1946-1957, sometimes using Santa Ynez High School facilities and at other times working at scenic landscape spots. Arts and crafts were taught by Mrs. John Simerly (1948), Mary La Vaut (1949), Lenora, Mrs. Jack Anderson, 1950-54+, and Fillmore Condit (1958).
Santa Ynez Valley, Ca., Adult/Night School (notices in Northern Santa Barbara County newspapers on microfilm and the Internet)

1946 – "Still Life Painting Class Offered. An evening class in still life painting will be offered at the High School if a sufficient number of persons are interested. The class will be taught by **Leo Ziegler**…," *SYVN*, July 12, 1946, p. 1; "Meeting to be Held on Adult Art Classes. Several adults have expressed an interest in the adult evening classes in art which will be offered by Mr. **Leo Ziegler** at the Santa Ynez Valley Union High School. … Mr. Ziegler will again offer instruction in landscape and still life painting to interested students as part of the regular high school program… The art classes for students will be scheduled soon after the opening of the fall term," *SYVN*, Aug. 23, 1946, p. 1; "Adult Art Class to Meet at High School. The first meeting… Library on Wednesday, September 4, at 8 o'clock. … A class in landscape painting may also be organized if enough are interested. There is no charge…," *SYVN*, Aug. 30, 1946, p. 1; "Several Evening Classes Offered at High School… **Miss Teressa Ricca** will offer Leather tooling on Tuesday and Thursday evenings at 7:30 in room 4. **Leo Ziegler** will offer instruction in landscape and still life painting on Tuesday and Thursday. Those interested in landscape painting will meet on Tuesday afternoon at 4 o'clock and those interested in still life work

will meet on Thursday evenings at 7:30…," *SYVN*, Sept. 13, 1946, p. 1.

1947 – "Personal Notes… The Adult Art Class surprised **Leo Ziegler**, instructor, with a gift and a party at the Santa Ynez Valley Union High School Tuesday evening in appreciation of his help to the class," *SYVN*, May 30, 1947, p. 9?; "Adult Art Class Meeting Tonight. An adult training class in art, including landscape and still life drawing and painting will be offered at the Santa Ynez Valley Union High School again this year. **Leo Ziegler** will be the instructor… A meeting will be held tonight (Friday) at 8 o'clock at the high school library to arrange the program and days and hours of the class…," *SYVN*, Sept. 12, 1947, p. 1; "Adult Art Classes to Start Tomorrow," *SYVN*, Sept. 19, 1947, p. 1; 'High School Offers Classes in Crafts… The class will include leather craft, sewing, textile painting, picture making, copper tooling, crepe paper work and many other crafts. Classes will meet in the homemaking building on Tuesday and possibly Thursdays from 7 to 10 p.m. The first meeting will be held Tuesday evening Oct. 7 at 8 p.m. for the purpose of discussing the program and activities for the year… The class will be under the direction of **Miss Isabelle MacPherson**," *SYVN*, Sept. 26, 1947, p. 1; "Art Class Paints at Gaviota Beach. Members of the adult landscape painting class… went to Gaviota Beach last Saturday where they painted the ocean and cliffs and later joined in an improvised picnic. Those attending were **Mrs. Boradori** and daughter, **Mrs. Grace L. Davison, Mrs. Jeanette Davison, Miss Jeannette Lyons, Mrs. Talmyra [Sic. Palmyra] Murphy, Miss Olga Tognarri [Sic. Tognazzi],** V. E. Wicks and **Leo Ziegler**, instructor," *SYVN*, Oct. 24, 1947, p. 9; "Ziegler Arranging Art Museum Tour. **Leo Ziegler**, instructor of the Adult Art Class, has announced… visit the Santa Barbara Art Museum tomorrow…," *SYVN*, Nov. 14, 1947, p. 1; "Night School… More than 20 men turned out for the welding class … **Miss McPherson's [Sic. MacPherson]** arts and crafts… and **Mr. Ziegler**'s art class are proving very popular…," *SYVN*, Nov. 21, 1947, p. 6.

1948 – "High School Again Offering Evening Classes for Adults… The courses in landscape and still life painting will be held by **Leo Ziegler** and will be open to anyone who is interested … Both beginners and advanced students… There is no tuition charge and all art materials will be furnished without charge… The still life class is scheduled for each Tuesday evening from 7:30 to 9:30 p.m. The first meeting will be held next Tuesday in room No. 4 of the high school. The landscape class will be held out of doors each Saturday from 10 a.m. to 12 noon and will meet for the first time on Saturday, Sept. 25, at the entrance of the Veterans' Memorial Building in Solvang. The arts and crafts class will include copper work, textile painting and home crafts, and will meet on Thursday evening at 7:30 p.m. with the first meeting scheduled for Thursday, Sept. 23. **Mrs. Simerly** will conduct the class…," *SYVN*, Sept. 17, 1948, p. 1; "**Mrs. Viola Dykes** Teaching Night Class… leather tooling, ceramics, upholstering and lamp shade making at the Thursday evening adult classes at the Santa Ynez Valley High School. **Mrs. John Simerly** will teach copper work and textile work…," *SYVN*, Oct. 1, 1948, p. 1; "Class will Study Jewelry Making… shell jewelry will be

626

demonstrated by **Mrs. John Simerly** at the adult home crafts class at the Valley Union High School next Thursday. Materials will be available… The classes in copper tooling and textile painting will be continued…," *SYVN*, Dec. 3, 1948, p. 1.

1949 – "Adult Art Class Resumes Program. **Leo Ziegler**, instructor of the adult art class of the Valley Union High School… The still life class will meet on Tuesday evenings from 7:30 to 9:30 p.m. in room 4 of the high school… The landscape course will be held on Saturday mornings from 10 to 12 noon… during the winter the members of this class will meet every Saturday morning at 10 o'clock at room 4 of the high school. If the weather is favorable, the class will be held outdoors at a nearby location. If the weather is inclement, screen demonstrations of colored slides of old and modern masters will be shown and the principles of art and pictorial composition will be discussed… The courses are offered through the high school as a community service. They are free to the public and materials are furnished without charge…," *SYVN*, Jan. 7, 1949, p. 8; "Mrs. Dykes Cancels… **Mrs. Viola Dykes**, adult class teacher of ceramics, upholstery and leather tooling at the high school, is canceling her classes here due to ill health. Students with uncompleted upholstery projects will be aided by Mrs. Dykes at a regular afternoon class in Lompoc," *SYVN*, May 20, 1949, p. 2; "Art Class Ends Work for Year. The Adult Art Class… held its final session for the year last Saturday at El Capitan Beach. A full day of painting was enjoyed. Class members present were **Mrs. Lena Boradori, Mrs. Grace L. Davison**, Mrs. Christina Larsen, **Mrs. Agnete Miller, Mrs. Palmyra Murphy**, Mrs. Charlotte Ruge, Miss Olga Tagnazzi [Sic. Tognazzi], Mrs. Ritte Wissing [Mrs. Soren J. Wissing], **Dr. C. W. Borland, Thorvald Rasmussen**, and **Leo Ziegler**, instructor. Guests included Mrs. Borland and Miss Bowersox," *SYVN*, June 10, 1949, p. 3; "Adult Art Class Resumes… **Leo Ziegler**, instructor … A landscape course in water color and eventually oil will be held on Saturday mornings from 10 to 12 noon. If a sufficient number of persons are interested, Mr. Ziegler said, a still life and flower painting evening course in water color and eventually oil and pastel, will also be offered. A preliminary meeting of both groups will be held next Tuesday night at 7:30 o'clock in the high school library to choose the evening and hour agreeable to the majority… the courses are offered through the high school as a community service. They are free…," *SYVN*, Sept. 2, 1949, p. 6; "Homemaking Class… A meeting of all those interested in attending the Adult Education Crafts class will be held next Thursday evening at 7 p.m. at the Santa Ynez Valley Union High School auditorium… The instructor will be **Mrs. Mary March LaVaut**, who is teaching crafts and homemaking at the high school," *SYVN*, Sept. 23, 1949, p. 4; "Variety of Adult Classes Offered at High School… **Mrs. Mary La Vaut** conducts a class in arts and crafts, ceramics, leather work and copper tooling each Monday evening from 7 to 10 p.m. Every Tuesday night from 7:30 to 9:30 **Leo Ziegler** is in charge of an art training class… during the past few weeks has met each Saturday morning for a class in front of Old Mission Santa Ines," *SYVN*, Oct. 14, 1949, p. 6; "Voters May Go… Board … voted to buy a kiln for the firing of materials made in the adult ceramics class and the arts and craft class…," *SYVN*, Oct. 21, 1949, p. 1.

1950 – "Valley Adult Art Classes Will Resume… **Leo Ziegler**, art instructor… The landscape class will be held on Saturday mornings from 12 to 1 noon. The class meets tomorrow in Solvang on Laurel Avenue, next to St. Mark's-in-the-Valley Episcopal Church. The still life class will be held on Tuesday evenings room 7 to 9:30 p.m. in the new art room of the high school, next to the library. The first meeting of this class is scheduled for next Tuesday. … beginners… advanced…," *SYVN*, Sept. 8, 1950, p. 4; "Adult Art Time Class Corrected… The landscape class will be held on Saturday mornings from 10 a.m. to 12 noon… The class in still life painting is held each Tuesday evening from 7 to 9:30 o'clock in the art room of the high school," *SYVN*, Sept. 15, 1950, p. 3; "Adult Arts, Crafts Class to be Formed… during the early part of October… supervision of **Mrs. Jack Anderson**," *SYVN*, Sept. 15, 1950, p. 5; "Adult Crafts Class to Start at High School… leather tooling, copper work, jewelry making and other crafts will begin at the high school next Monday at 7 p.m. **Mrs. Jack Anderson**, formerly at College School and now on the high school faculty, will be the instructor… adults only," *SYVN*, Oct. 20, 1950, p. 1; class cancelled because of serious illness of teacher's father, *SYVN*, Nov. 10, 1950, p. 10; "Crafts Class Meets Monday," *SYVN*, Nov. 17, 1950, p. 1; "Adult Classes Being Offered at High School. Ten classes… More than 180 adults…," crafts, **Mrs. Jack Anderson**… art, still life painting and drawing by Leo **Ziegler** … Saturday – landscape painting and drawing, **Leo Ziegler** …, *SYVN*, Dec. 22, 1950, p. 3.

1951 – "Crafts Class Meets Tuesday… instead of next Monday as originally scheduled… **Mrs. Jack Anderson**, instructor … class will offer … ceramic work… copper and leather work…," *SYVN*, Jan. 19, 1951, p. 3; "Crafts Class Meet Postponed … **Mrs. Jack Anderson**, instructor," for spring vacation, *SYVN*, March 16, 1951, p. 3; "Crafts Class Comes to Close … for the current term… resumed in the Fall…," *SYVN*, May 4, 1951, p. 3; "Adult Art Classes Resume… The landscape course will be held on Saturday mornings from 10 to 12 noon. The class will meet for the first time tomorrow on the Solvang-Los Olivos road next to the Petersen Dairy. The still life class is scheduled for each Tuesday evening from 7 to 9:30 in the high school library…," **Leo Ziegler**, *SYVN*, Sept. 7, 1951, p. 6; "More than 100 Enroll in Six Adult Education Classes Here… The art class in still life painting and drawing meets on Tuesday evenings from 7 to 9:30 p.m. It is taught by **Leo Ziegler**. Mr. Ziegler also teaches a class in landscape painting and drawing on Saturday mornings from 10 to 12 noon… The crafts class offered by **Mrs. Lenora Anderson** will be organized within a few weeks…," *SYVN*, Oct. 12, 1951, p. 8; "Crafts Class Starts at H.S. on Tuesday… with **Mrs. Jack Anderson** as instructor… Instruction in textile painting, ceramics and leathercraft will be offered … three meetings before the Yule holiday will make it possible for those interested in textile painting to complete two or three items. All those interested in textile work are asked to bring material and a board to which the material can be tacked… there are ready cut stencils and paints available which are suitable for dish towels, guest towels, luncheon sets and

other small items which would make attractive Christmas gifts…," *SYVN*, Nov. 30, 1951, p. 1.

1952 – "Adult Art Classes Underway, Art Appreciation Offered… **Leo Ziegler**. … An innovation this year will be the introduction of a course in art appreciation, if a sufficient number of people are interested… The landscape course will be held on Saturday morning from 10 to 12 noon. The class will meet for the first time tomorrow at the parking place of the Veterans' Memorial Building in Solvang. The still life class is scheduled for each Tuesday evening from 7 to 9:30 o'clock in the high school library… art appreciation… Tuesday evening at 7:30 p.m. at the high school library…," *SYVN*, Sept. 12, 1952, p. 1; "Many Attending New Art Class… art appreciation…," by **Leo Ziegler**, and class members named, *SYVN*, Oct. 3, 1952, p. 4; "Adult Craft Class Begins Tuesday… Mrs. **Lenora Anderson** will again teach the class which will include work in copper tooling, leathercraft and ceramics…," *SYVN*, Oct. 3, 1952, p. 5.

1953 – "Crafts Class Resumes Tuesday… **Mrs. Lenora Anderson**… Leather craft and ceramics…," *SYVN*, Jan. 9, 1953, p. 1; "Adult Art Appreciation Class Closes. The first year of the Santa Ynez Valley Union High School art appreciation class has drawn to a close. Looking at hundreds of paintings on the screen, the group analyzed and discussed the art of the ages… At the closing meetings, **Mrs. Odin Buell** presented a report on the art treasures of the Louvre, Paris, and Mrs. Barbara Houghwout gave a report on the work and life of Toulouse-Lautrec. The class was conducted by **Leo Ziegler**," *SYVN*, May 22, 1953, p. 5; "Art Group Enjoys Picnic… pot luck luncheon last Saturday at Nojoqui Falls Park. Attending were Mrs. Endoxia Bathey, Herbert T. Bathey, **Mrs. Nena [Sic. Lena] Boradori, Mrs. Josephine Buell, Mrs. Grace L. Davison,** Mrs. Barbara Haughwout, **Mrs. Rose Ann Hill, Mrs. Bunny Palmer, Thorvald Rasmussen, Mrs.** Verna Regalia, **Mrs. Florence Sandvik, Uno Sandvik, Dr. H. [Sic. W.] B. Swackhamer, Miss Olga Tognazzi, Mrs. Martha Williams,** Miss Gene [Sic. Jean] Boradori, Dr. Earl M. Hill, **Mrs. H. [Sic. W.] B. Swackhamer,** Bobby Haughwout, Charla Ann Hill, Judy Veino, and **Mr. and Mrs. Leo Ziegler**," *SYVN*, June 12, 1953, p. 3; "Adult Art Classes to Resume. With the beginning of the Fall term… **Leo Ziegler** instructor… The landscape course will be held on Saturday mornings from 10 to 12 noon… The still life class is scheduled for each Tuesday evening from 7 to 9:30 o'clock in the high school library…," *SYVN*, Oct. 2, 1953, p. 1; "Crafts Class Starts Tuesday… room 4 of the Santa Ynez Valley Union High School. Mrs. **Lenora Anderson** will be instructor…," *SYVN*, Oct. 9, 1953, p. 1; "Crafts Class Meets Tuesday… 7 o'clock at the Santa Ynez Valley Union High School. **Mrs. Lenora Anderson** … lessons will be given in copper tooling, ceramics and leather craft…," *SYVN*, Oct. 16, 1953, p. 1.

1954 – "Six Adult Classes at H.S.… Mrs. **Lenora Anderson** is teaching a class in crafts, including ceramics, leatherwork, copper tooling and related crafts on Tuesday evenings from 7 to 10. Also, on Tuesday evenings from 7 to 9 a class in still life painting and drawing is offered by **Leo Ziegler**. Mr. Ziegler also gives a class in landscape

painting and drawing, which meets from 10 to 12 on Saturday mornings…," *SYVN*, Jan. 22, 1954, p. 8; "Adult Art Class Will Resume Here… The landscape course will be held on Saturday mornings from 10 to 12 noon. The class will meet for the first time tomorrow in Solvang in front of Old Mission Santa Ines. The still life class is scheduled for each Tuesday evening from 7 to 9:30 o'clock in the high school library…," *SYVN*, Sept. 10, 1954, p. 1; "Craft Class to Start… Tuesday evening at 7 o'clock… Mrs. **Lenora Anderson**…," *SYVN*, Oct. 22, 1954, p. 2.

1955 – "Adult Art Class Enjoys Potluck… had 30 members during the school year enjoyed its annual farewell party last Saturday at the **Leo Ziegler** ranch, Sunny Hill. Seventeen persons enjoyed a potluck luncheon including the honorary and oldest members, **Mrs. Grace L. Davison** and **Mrs. Martha Williams**, formerly of the Valley and now of Santa Barbara," *SYVN*, June 3, 1955, p. 2; "Valley Adult Art Classes Will Resume. **Leo Ziegler**… The still life class is scheduled for each Tuesday evening from 7 to 9:30 o'clock in the high school library… The landscape course will be held on Saturday mornings from 10 to 12 noon. The class will meet for the first time Saturday, Sept. 24, in Solvang just back of Copenhagen Square on the road to Old Mission Santa Ines…," *SYVN*, Sept. 16, 1955, p. 2; "Los Alamos – **Leo Ziegler**, art instructor in the local elementary school, today announced the formation of an adult art class conducted by the Santa Ynez Valley Union High School, to meet every Saturday, 10 a.m. to 12 noon. The next class will be at Los Olivos, one block west of the flagpole, he said, in inviting all residents of the Los Alamos community to join. Share-the-ride arrangements can be made, he said. Meeting places will be announced in advance of each Saturday, Ziegler said. Mrs. **Lena Boradori** and **Miss Olga Tognazzini [Sic. Tognazzi]**, members of the painting group and regular attendants for several years, and Miss Joan Scolari have joined again for this fall, he said. The class practices mostly in landscape painting, Ziegler said. The group assembles in the Santa Ynez High School library on rainy days for still life painting, practice in perspective, composition and color arrangement. All materials are furnished without charge by the school. A small enrollment fee is the only cash outlay, Ziegler pointed out, adding that beginners as well as more advanced students will be welcomed into the group. Further information may be had from Ziegler at the Los Alamos school Friday or at his home after 8 p.m., phone: Santa Ynez 3642," per "Adult Art Class Formed" *SMT,* Oct. 12, 1955, p. 8; "Los Alamos Valley… Mr. **Leo Ziegler**… extended a cordial invitation to all residents in the Los Alamos Community to join his Adult Art Class…," *SYVN*, Oct. 14, 1955, p. 6.

1956 – "Adult Classes Offered Here… Class in landscape and still life painting and drawing is taught by **Leo Ziegler** on Saturday mornings from 9 to 12…," *SYVN*, Jan. 6, 1956, p. 6.

1957 – "Valley Adult Art Class to Resume… With the beginning of the new year… according to **Leo Ziegler**, instructor of the Santa Ynez Valley Union High School. The class will be held every Saturday from 10 a.m. to 12 noon. The group will meet regularly outdoors to take full

advantage of the beauty of the Valley's landscape. Only on days of unfavorable weather will the class meet indoors to study, among other subjects, still life, principles of pictorial composition and perspective. ... the first meeting to be held Saturday, Jan. 4, at 10 a.m. to 12 noon in the high school auditorium...," *SYVN*, Dec. 27, 1957, p. 2.

1958 – "Adult <u>Shop</u> Class Due. An adult evening workshop in woodwork, crafts, and ceramics will be offered at the Santa Ynez Valley Union High School during the current school term, if there is sufficient interest. ... **Fillmore Condit** will teach the class in the school's new industrial building... meeting on Tuesday evening, Sept. 16 at 8 o'clock...," *SYVN*, Sept. 5, 1958, p. 8; "Buellton Briefs... Woodwork, ceramics and other <u>crafts</u> will be taught at the Santa Ynez Valley Union High School this term by **Fillmore Condit**, and all adults who are interested are asked to contact him at SY 3811 or SY 5895. Condit will teach this adult class in the new industrial building starting Sept. 16 at 8:00 p.m.," *LR*, Sept. 11, 1958, p. 16; "Workshop Class. The initial meeting of a prospective evening adult education workshop class... **Fillmore Condit**...," *SYVN*, Sept. 12, 1958, p. 2.

Santa Ynez Valley, Ca., Elementary / Grammar Schools
"The 'Valley' Schools, even today, consists of one High School District (Santa Ynez Valley Union) and six elementary districts (Ballard, Buellton, College, Los Olivos, Solvang, and Vista Del Mar)," per Vista-vdm-ca.schoolloop.com. "Art" was an integral part of the curriculum as it was thought to help hand-eye coordination, and often it was used to enhance the teaching of certain academic courses, such as history. Early art teaching depended on the personal proclivities of the teachers. By the early 1930s, children were making puppets and posters and miniature models (of things like missions), in addition to drawing and crayon work. By the 1940s, circulating art instructors, such as Joseph Knowles from Santa Barbara gave special instruction in art. In 1947 Leo Ziegler's name is first mentioned as teaching art to elementary school students. In 1949 students began firing ceramics with a kiln.

■ "Early Day History of Valley Schools... a subscription school was held in the old <u>Ballard</u> Stage station, built in 1860... A public school was formed and the Lewis granary was used as a school room. Mrs. Marilla Marshall ... was the first teacher. That was in the year 1881. In the following year the school was moved to a vacated building. In the Spring of 1883, the new building in Ballard was ready... The first teacher in the new school house was Miss Nellie Gallagher of San Francisco... From 1885 to 1889 a Miss Lee Hosmer of Massachusetts was the teacher. She is still living in her ancestral home in the East. ... She instilled in them a love for good music, an appreciation of good literature, a love for art and beauty... It was several years after the <u>Ballard School</u> District was established that the <u>Santa Ynez District was formed</u>. Miss Abbie Halls, a member of one of Santa Barbara's most prominent families was the first teacher.... The Town of Santa Ynez was founded in the Spring of 1882 and the fast-growing community demanded its own school. The name College

District was given... about the same time the <u>Santa Ynez District</u> near the Old Mission was formed... The present <u>College School</u> got its name from a grant of land given by Gov. Micheltorena of California to Mission Santa Ines on which to establish and support a seminary. ... In 1844 the first ecclesiastical seminary in California was dedicated... one-room school house in Santa Ynez was built near the center of town. This was afterward replaced as the town grew and a two-story building was erected on the site of the present school. ... The upper room of this building housed the first high school established in 1896. ... In 1898 the school building burned to the ground and the College Hotel served as a school... <u>Los Olivos School</u>. The third public school to be formed was Los Olivos. The coming of the railway in 1887 and a number of families arriving from the mid-west, attributed to the need of the community having its own school. A subscription school was held in a cottage belonging to Felix Mattei, and later the first public school was held there in 1888... Next school to be established here was the <u>Jonata (Buellton) district</u>. For a number of years a school was maintained on the Buell Ranch, San Carlos de Jonata. When Mr. Buell sold 12,000 of his 37,000 acres to the Santa Ynez Land and Development Co... population increased. A school was in demand. Rufus T. Buell ... loaned the use of his harness shop... Henry Evans was teacher. This arrangement lasted until a new school was built in the early '90's. ... the present school building in Buellton was erected in the Fall of 1924... Prior to, or about the same time ... the Ynez district came into being... <u>Mrs. Muriel Edwards</u> was one of the first teachers in this new district at a time when the school house and the Old Mission ... were the only two buildings in the area [that later became Solvang] The present <u>Solvang school</u> building was completed in 1940. It is now a four-teacher school..." *SYVN*, April 21, 1950, p. 4; "<u>San Marcos School</u> Has Interesting History," *SYVN*, Oct. 23, 1953, p. 6.
<u>Santa Ynez Valley, Ca., elementary schools (notices in Northern Santa Barbara County newspapers on microfilm and the Internet)</u>

1925 – "School Buys Picture – <u>Santa Ynez Grammar</u> school is displaying a beautiful new picture which was purchased with the proceeds of the entertainment recently given by the school children," *SYVN*, Dec. 11, 1925.

1926 – "PTA... Afternoon Session. The afternoon session was opened by a 'Punch and Judy Show,' given by Master Robert Anderson of <u>Buellton School</u>, one of the four Demonstration Schools of the County in Creative Education taught by Miss Jeanette Lyons... **Miss Jeanette Lyons** next spoke on Creative Education ... appealing to the rightness in the child and bringing the child by this means to a sense of his responsibilities... **Mrs. Croswell**, State Chairman of Art, and Art teacher of the Santa Barbara Teacher's College, spoke on art expression as a creative education. Mrs. Croswell says that are (art?) not only teaches us appreciation of things in general, especially of beauty and our surroundings, but it teaches us to select the beautiful and fine thereby making life itself beautiful. She states that there is a great lack of art in all of the schools and practical life of today. If we had more, we would have greater civic improvement, beauty as well as be able to appreciate the finer and more beautiful things of life... Mrs.

Croswell is hoping to obtain a special teacher not only for art in drawing but in music as well to send throughout the schools of the county as instructors in these two subjects. She is strongly backed by our Supt. of Schools… The PTA of this district also voted their hearty approval of this plan…," *SYVN*, Oct. 15, 1926, p. 10.

1927 – "Art Exhibit at Gaviota School… A forthcoming event… Elson Art Exhibit to be on display at the Vista Del Mar school on the afternoon and evenings of Thursday, Friday and Saturday, January 27, 28, and 29. Recognizing the educational advantages to be derived from opportunities to see good art, the principal of this school has arranged with the **Elson Art Publication Co.** of Belmont, Mass. for this art exhibition. It consists of two hundred carbon photographs, photogravures, prints in full colors … of the masterpieces of art of the different countries and periods. This is the first exhibit of these pictures in Santa Barbara county … A small admission fee will be charged, the entire proceeds of which, after deducting the expense of the exhibit, will be used in the purchase of pictures for the new Alcatraz school… During each of the evening exhibits there will be Living Picture Tableaux. The pupils … will represent… several of the best-known pictures…," *SYVN*, Jan. 21, 1927, p. 1.

1931 – "Last Monday night, June 8, the Los Alamos school gave an exhibit of the year's work … Mrs. Wade, who had charge of the art work, had arranged a very delightful display of drawing, painting, weaving, manual training projects and general class room work… ," *SYVN*, June 12, 1931, p. 4.

1932 – "College grammar school in Santa Ynez … teachers had emphasized 'Better Homes' in their respective rooms by poster, pictures, and projects. The pupils in Miss Cross' room had demonstrated how a house might be modestly furnished with little expense. A miniature five-room house had been constructed and fitted out by the children, having in it home-made furniture, rag rugs, and curtains and drapes made from dyed flour sacks," *SYVN*, May 6, 1932, p. 1, col. 2.

1933 – "College Grammar… assembly… program… A puppet show illustrating an early Thanksgiving in the Colonies, was rendered by pupils of the fourth and fifth grades…," *SYVN*, Dec. 1, 1933, p. 1.

1935 – "Solvang School Notes… A bright new November Calendar now decorates the blackboard. The artists were Gerda Svendsen and Mary Nelson…," *SYVN*, Nov. 8, 1935, p. 5.

1936 – "Los Olivos School… The primary grades are making a Conservation poster in Art…," *SYVN*, March 6, 1936, p. 4; "Solvang School Notes… A new April calendar now decorates the front board. The artist … was Helga Roth," *SYVN*, April 3, 1936, p. 4.

1937 – "Solvang School… The children in **Miss Ibsen**'s room are working on Japan… They are showing a Japanese puppet show… The boys are making a large papier mâché map of Japan… Others… are making a movie showing different industries of Japan and are having a fashion show to show costumes," *SYVN*, April 16, 1937, p. 5.

1938 – "Ballard School Notes. We are now studying Switzerland… Two of the girls are making a Swiss mountain scene on a shelf … Some of us are doing wood carving as the Swiss do during their long winter months… we are each making a notebook about Switzerland. We made our own cover designs…," *SYVN*, May 13, 1938, p. 4; "Buellton School… diplomas. Hansina Hansen, Ruth Bodine, Lynnette Campbell and Mary Clinton have made a puppet theatre and will present, 'The Life of an Indian Family.' They wrote their play and made and costumed their puppets…," *SYVN*, May 27, 1938, p. 1; "Solvang School… **Miss Ibsen** is going to start a new puppet class. There will be two classes, the beginners and last year's class…," *SYVN*, Oct. 14, 1938, p. 5; "Solvang School… The puppet class have made their puppets and also a theatre," *SYVN*, Oct. 21, 1938, p. 8.

1939 – "Solvang School… The puppet class gave a play called 'Station URA2T. It was very funny," *SYVN*, March 3, 1939, p. 8; "Solvang School… This is Conservation Week and … The upper grades are drawing pictures and giving reports about birds and trees…," *SYVN*, March 10, 1939, p. 8.

1940 – "Solvang School… The sixth graders made booklets about Washington. They drew pictures and wrote stories in their booklets… Our pictures from the photographers finally arrived… Everyone has been busy exchanging pictures with each other… The primary room is making plans for their miniature town of Solvang. They have already drawn pictures about it and are drawing plans now…," *SYVN*, Feb. 23, 1940, p. 4.

1942 – "Solvang School… **Mr. Knowles** of the Santa Barbara Museum of Art, gave three hours' assistance in art to the various grades of the school on Thursday morning," *SYVN*, Feb. 20, 1942, p. 5.

1944 – "Buellton School… The upper grades of the Buellton Union School spent a busy week on the study of the United States Constitution for their government unit… A lesson on lettering was found necessary for the many banners and posters needed in the activities," *SYVN*, May 5, 1944, p. 8.

1946 – "Los Olivos. … On January 8, 1946, the pupils of the Los Olivos Grammar School had their pictures taken by a lady from the 'School Photography Service' of Santa Barbara…," *SYVN*, Jan. 18, 1946, p. 5; "Solvang School… During vacation several drawings disappeared from the walls in the Upper Grades' room. These were charcoal drawings done under the teaching of Mrs. Toll. … Mrs. Ross said they disappeared shortly after school was out … The four pupils whose pictures were missing are very disappointed and unhappy as they were justly proud of their work… An expert photographer with modern equipment took pictures of each student on Monday," *SYVN*, Jan. 18, 1946, p. 5; "Los Olivos Mothers Club… met Wednesday, April 10. Drawings, paintings, and other school work were on display…," *SYVN*, April 19, 1946, p. 7; Solvang "Grammar School… will have a program and exhibit at Atterdag Gymnasium on Friday, June 7, at 8 p.m. … and there will be an exhibit of art work and school papers from Mrs. Roland's and Mrs. Toll's rooms…," *SYVN*, June 7,

1946, p. 1; "Mother's Club [of the Solvang Grammar School] President Reports on Club's History..," *SYVN*, Sept. 13, 1946, p. 8; College School Notes… Grades 5th and 6th … **Mr. Knowles**, art supervisor, visited our room last week, and showed us how to make some pictures for our transportation unit… Seventh Grade … **Mr. Knowles**… gave us an art lesson on our unit: Our Personal Appearance… **Joseph Knowles** also visited the 3rd and 4th grades and gave a demonstration of water color technique and a lesson in the right use of color," *SYVN*, Dec. 13, 1946, p. 8.

1947 – Photo of old College Grammar School, *SYVN*, April 25, 1947, p. [4]?; "College School Notes. 5th and 6th Grades… **Mr. Knowles**, art instructor, visited our room recently. He took two of Ralph Ross' paintings to the school exhibit which is being held at the Museum of Art this week… 3rd and 4th Grades. **Mr. Knowles** selected several pictures of the third and fourth grade children for exhibition at the school arts exhibit…," *SYVN*, May 2, 1947, p. 7; "Elementary Schools Notes. College… **Mr. Knowles**, art supervisor, visited our school Wednesday. After giving us some new ideas to try out in our painting, he selected art work in each room to use in an art exhibit in Santa Barbara…," *SYVN*, Oct. 17, 1947, p. 3; "Elementary Schools Notes. College… Kindergarten… We find it is great fun to paint and we have to learn to take turns with the brushes just as we do for other things… 7th and 8th Grades. On Wednesday, **Mr. Knowles**, art supervisor, visited College School. In the upper grade room, he made helpful suggestions about our drawings. He also demonstrated the use of water color and chalk as a new media. The chalk is used on the wet paper to accent the water color picture. **Mr. Knowles** took pictures from each room to be used in the art exhibit at the Santa Barbara Museum of Art. From our room he took a pastel of a Spanish galleon by Ralph Ross and a country scene by Denny Treloar and Douglas Campbell…," *SYVN*, Oct. 24, 1947, p. 8; "Elementary Schools Notes. College. Kindergarten… Painting is such fun! Robbie Andersen's mother and daddy are on their way home from the East and he painted a picture of the train, Santa Barbara, and even Solvang and Buellton. Claire FitzGerald got hungry so she put some candy in her picture… Solvang… Upper Grades. Several girls made posters for the Mothers' Club Bake Sale tomorrow…," *SYVN*, Oct. 31, 1947, p. 9; "Solvang School. **Mr. Knowles**, art supervisor, visited the school last Thursday… Primary Room… We are making beautiful models in clay…," *SYVN*, Nov. 14, 1947, p. 4; "Elementary Schools… Solvang School… Thompson Photographers were with us last Thursday to take individual and group pictures…," *SYVN*, Nov. 28, 1947, p. 3; "Elementary Schools… Buellton… Boy Scouts… The powdered paint was in many colors and the enamel was in very small cans and only one can each of red, white and blue. Each room also has a bottle of silver and a bottle of gold paint… Ballard… routine classwork has been disrupted this week with preparations for the Christmas program… The upper grade children have been busy painting scenery. The primary grades are working on Christmas cards and Christmas tree decorations. All the children are now starting to make presents for their parents… Solvang… All the rooms are actively engaged in making Christmas

preparations… tree decorations… Christmas cards for the Veterans in our hospitals…," *SYVN*, Dec. 5, 1947, p. 3; "Elementary Schools… Los Olivos… **J. E. Knowles**, art supervisor, visited both rooms of our school on Tuesday. He looked over the work we had done and showed us ways of making it more interesting…," *SYVN*, Dec. 12, 1947, p. 7; "Los Olivos… annual Christmas program… scene painting, **Leo Ziegler**…," *SYVN*, Dec. 19, 1947, p. 5.

1948 – "Elementary Schools… College School. **Joseph Knowles**… visited our school last week. He appointed Miss Margaret Downs and **Miss Lenora Anderson** to serve on a county committee which will arrange an exhibit of children's art work in Santa Barbara during April… 3rd and 4th Grades. **Joseph Knowles**… visited our room last Thursday. The class has been painting pictures and writing stories about the Chinese rice growers. These pictures are to be made into a book. Mr. Knowles helped the children by suggesting some improvements on their pictures. He also gave a talk on Chinese art and music… 5th and 6th Grades. … **Mr. Knowles** gave us a lesson in design on his last visit. The children have been working on some designs for cloth … March of Dimes… seventh and eighth grade… For the language period in Mrs. Anderson's room the class has decided to publish a newspaper… art editors, Lawrence Brown, **Vernal Gillum** and Leonard Breck…," *SYVN*, Jan. 30, 1948, p. 4; "Elementary Schools Notes… Santa Ynez… The third and fourth graders are still studying about China. They are working on their plays… they must make their costumes and stage furniture. Patricia Kessler, Floyd Ross and David Brown are the artists who are painting the murals for the stage scenery…," *SYVN*, Feb. 27, 1948, p. 3; "Elementary School Notes… Santa Ynez… 7th and 8th Grades… Kate Houx visited… with **Mrs. Anderson's** class and introduced some very interesting… books. These books are beautifully illustrated. As the upper grades have been doing some nice work in painting and drawing, they were interested in the different types of illustrations …," *SYVN*, March 5, 1948, p. 3; [ed. several articles were bypassed although they spoke of the children doing drawings or charts or graphs in association with social and historical studies]; "Elementary Schools… Santa Ynez… 5th and 6th grades… conservation week… posters and pictures we made ourselves. Some of us carved animals and birds from soap…," *SYVN*, March 26, 1948, p. 8; "Elementary Schools… Santa Ynez. General. **Joseph Knowles**, art supervisor, visited school on March 18. He selected pictures from each room to use in the April art exhibit at Santa Barbara…," *SYVN*, April 2, 1948, p. 4; "School Notes. Buellton. Intermediate. We are having lots of fun studying about Alaska. **Mr. Noyes** [Sic. **Knowles**?] took **Ruth Lindegaard**'s and Frances Downey's paintings of Alaska to display in the art museum… We carved totem poles out of balsa wood, also kayaks, which we painted bright colors…," *SYVN*, April 2, 1948, p. 10; "Elementary Schools… Santa Ynez… 5th and 6th Grades… **Joseph Knowles**… visited our room Tuesday. He talked to us about paintings, books, and music and told us interesting things as to why some compositions are great and are remembered throughout the years while others are forgotten in a short time…," *SYVN*, April 30, 1948, p. 9; "Elementary Schools… Buellton. Primary Grades… on Tuesday and **Mr. Knowles** looked in for a minute. He

found some of us busily painting and told us he liked our things. David Contreras had a picture in the All County exhibit at the Santa Barbara Art Museum in April and it may also be shown at an all schools exhibit in Sacramento…," *SYVN*, May 14, 1948, p. 9; "Elementary Schools… Solvang… Intermediate Room… unit on Health… Later, posters and displays will be made to illustrate the work. We all like Friday because **Mr. Ziegler** teaches art on that day… Buellton… We are studying about water… We are making large maps of California showing the rivers, and we have drawn pictures of rivers, lakes and waterfalls… Ballard… working on models of a stage coach and a covered wagon in connection with their study of the Westward Movement… Lower grades are … construction of their farm. Some children are making their animals and trees from clay and then baking them in the sun…," *SYVN*, Oct. 1, 1948, p. 3; "Elementary Schools… Buellton… We are having a lot of fun writing and illustrating chart stories [and details] … College … Kindergarten… We need rags for painting and we would also appreciate the help of any daddy who will offer to make a paint box or two. The dimensions are as follows: length, 11 inches, width six inches, depth three inches, handle five inches high. … Solvang… Primary Room… Our Indian drawings are very nice and we have them on display… We like art even tho' we can't take it on Friday from **Mr. Ziegler** with the 'big folks.' … Vista del Mar… Intermediate Room… We have made Indian bowls out of clay this week. **Mr. Knowles** came today and helped us with our study of primitive designs and symbols. When we have each made an original design, we will decorate our bowls and shellac them…," *SYVN*, Oct. 8, 1948, p. 3; "Elementary Schools… College … 2nd and 3rd Grades … We enjoyed our paper pulp. We painted it to resemble oranges, lemons and tomatoes… Solvang… Primary Room… The little folks observed Columbus Day by drawing the three ships that he sailed in … Vista del Mar… Intermediate. We have finished making our Indian bowls. Some of us found clay near our homes and used it to make bowls that are of lighter weight than the ones made of the clay furnished by the school. All the bowls are attractive with colorful and original designs…," *SYVN*, Oct. 15, 1948, p. 3; "Elementary Schools … Vista del Mar. Primary… making mud molds for making papier mâché masks…," *SYVN*, Oct. 22, 1948, p. 3; "Elementary Schools… Solvang. The teachers of the Valley and several supervisors from the county office met at school yesterday afternoon for an art workshop. Robert J. Shelley, a member of the Art Committee, was in charge of room arrangement, while **Mr. Knowles**, the art supervisor, and **Mr. Ziegler**, art instructor in the Valley directed the activity itself," *SYVN*, Oct. 29, 1948, p. 12; "Valley Teachers at Art Workshop Held in Solvang… Grammar School. The meeting was planned by the art committee of the County department of education with Miss Kate Houx, area supervisor and **Joseph Knowles**, art consultant. During the Workshop, there was a discussion of the general philosophy of art for elementary school children, a practical demonstration in the use of tempera paints, colored chalk, transparent water color, charcoal, and clay. A work period followed this at which time teachers selected various art media and produced several pieces of work using techniques themselves which they will later use with children in the classrooms. … The members of the art committee assisting were **Mrs. Lenora Anderson**, College School, Mrs. Ada Hall, Ellwood School, Mrs. Dorothy Schneller, San Marcos School, Robert Shelley, Solvang School, and Mrs. Irene Moss, Los Alamos School. Teachers attending and taking part in this workshop were from the following schools … **Leo Ziegler**, art teacher in the Valley, was a visitor… **Mr. Knowles** was the leader for the two-hour period, assisted throughout by the several members of the art committee," *SYVN*, Nov. 5, 1948, p. 1; "Elementary Schools… Buellton First Grade … American Education Week… For our exhibit we painted a mural [and list of student artists] … College … Kindergarten… Our paintings are showing a great deal of improvement from those which we made at the beginning of the year. Cows, houses, snakes, Christmas trees, pretty colors and many other things adorn our walls. It is lots of fun and we are happy when it comes our day to paint… Vista del Mar. .. Intermediate. We have been making large pictures of Indians at work for our room…," *SYVN*, Nov. 12, 1948, p. 3; "Elementary Schools… College… 2nd & 3rd Grade… We've modeled many figures and dishes which we wish to have fired for permanent use," *SYVN*, Nov. 26, 1948, p. 3; "Elementary Schools… Solvang… Next Monday, Thompson Photo Service of Los Angeles will be at the school to take pictures. This photographer has served the local school for three successive years and does satisfactory work…," *SYVN*, Dec. 3, 1948, p. 3; "Elementary Schools… Los Olivos… **Mr. Ziegler** is preparing for the annual art exhibit which will be held in Los Angeles. Art work of pupils of the valley schools will be entered… Solvang… Primary Room. We have been making Christmas decorations for the room. We did spatter paint and are very proud of our work," *SYVN*, Dec. 10, 1948, p. 7; "Elementary schools… College… Kindergarten. On Tuesday morning the *News Press* photographer from Santa Barbara visited the Old Shoe and took a number of pictures… Solvang… Primary Room… We are very anxious for Christmas now that we have been singing carols, painting and drawing Christmas scenes. We all enjoyed spatter-painting and are very proud of the pine trees that we made in this manner… We took a trip to **Mrs. Nickson's pottery shop** in Santa Maria last Wednesday. She gave us a treat and a ceramic …," *SYVN*, Dec. 17, 1948, pp. 3, 6; "Los Alamos School Presents Yule Program… in the School auditorium… A marionette show called 'What No Christmas,' was given with Nancy Hutchinson… operating the marionettes and saying their parts. The marionettes were made by the children of Mrs. Hayden's room…," *SYVN*, Dec. 24, 1948, p. 5.

1949 – "Elementary Schools… Los Olivos. The Pupils of the school are working on a scrapbook to be sent to France. The pupils are drawing pictures, taking photographs of our school, the teams, our pets and other things around our community…," *SYVN*, Jan. 21, 1949, p. 7; "Elementary Schools… The seventh grade had two movies … **Mrs. John Gardner** loaned the reels which were in color and showed activities at rodeos…," *SYVN*, Jan. 28, 1949, p. 3; "Elementary Schools… Los Olivos… Returns to School… Jimmy Plunkett brought his camera to school to take pictures last week. He took two rolls and some of the pictures included shots of both rooms, seven or eight class

pictures of each room… We plan to send these to France in our scrapbook. … Vista del Mar … Upper… We have recently enjoyed using the new electric kiln which belongs to the County office. We made vases, figurines, ash trays and other things of clay; then they were fired in the kiln. We have particularly enjoyed being able to decorate the things… with different colors of clay slip and then covering them with a transparent glaze…," *SYVN*, Feb. 4, 1949, p. 3; "Elementary Schools. Buellton. Grade 1… garden… We are studying seed catalogues and painting luscious vegetables and flowers. … On squared paper we made a plan of our garden before we planted it," *SYVN*, Feb. 25, 1949, p. 3; "Elementary Schools… College… 2nd-3rd Grades. We drew pictures of our father's work and wrote stories ourselves of what they do. We've been doing finger painting. We like to make designs and pictures… 7th-8th Grades. … preparing to do ceramics. Fifty pounds of plaster of Paris have been made into bats and 50 pounds of clay has been mixed. The first problem will be the making of tile. The kiln will be here April 4, some vases and figurines should be completed by that time…," *SYVN*, March 4, 1949, p. 3; "Elementary Schools… College… Second and Third… We are enjoying finger paints in our free time … Vista del Mar… Upper grades. Last week we began our new unit about conservation… One committee has been working on making large pictures of wild flower…," *SYVN*, March 11, 1949, p. 3; "Elementary Schools… Buellton. Grades 7-8. Last Tuesday was a banner day for us… **Mr. Knowles** … present to help us… College… Second and Third… We finger paint every day… Seventh and Eighth… In the afternoon Joseph Knowles, Santa Barbara County School Art Consultant met the class at the art museum. He had arranged for one of the Navy artists, **Standish Backus** to talk about the exhibit. the U. S. Navy was showing 'Operation Palette'…," *SYVN*, March 18, 1949, p. 3; "Elementary Schools… College… Upper Grades. The pupils in the upper grade room have each completed two articles in ceramics: a tile and a figurine or vase. **Mr. Knowles**… visited the class Tuesday. He complimented the class on its clay work and explained the firing process. His talk included the decorating and history of Ceramics in china and Egypt… Solvang. Primary Room… We are making Easter posters for our room," *SYVN*, April 1, 1949, p. 3; "Elementary Schools. Buellton… 2nd and 3rd Grades. **Mr. Knowles** visited us and showed us lots of new strokes for Crayolas. Then we made an elephant and a rabbit and flower using the new strokes… 7th and 8th Grades. **Mr. Knowles** visited our class for a few minutes and demonstrated the use of tempera color and the interesting effects obtainable by using a brush in different ways… College… Second & Third Grade … Soon we will make gifts of clay for Mothers' Day and fire them in the County schools' kiln, which we now have… Seventh & Eighth Grade. **Mr. Knowles** was here on Tuesday and helped us stack the kiln with our pottery and gave us instructions on how to fire it…," *SYVN*, April 29, 1949, p. 3; "Elementary Schools… College… Second and Third Grades. We are making figurines, dishes and ash trays to fire in the kiln this week… Seventh and Eighth Grades. The bisque firing of the ceramics in the upper grade room was very successful. May 3 was **Mr. Knowles**' day at College School, so he helped the class with their first glazing. This

was to be fired Wednesday…," *SYVN*, May 6, 1949, p. 3; "**Public Schools Week** Ends with Program in Solvang. All the elementary schools and the Valley Union High School cooperated last Friday evening in giving an exhibition of school work in a program presented at the Veterans' Memorial Building… [PSW was] Instituted by the Masonic order some 30 years ago in the interest of public education, schools have endeavored to observe this week, each in their own individual schools in the Valley. This year, however, under the sponsorship of Valley Masons, they gave a combined exhibition and program at the Memorial Building. The social studies of elementary schools was visualized in art work hand craft… The main hall of the Memorial Building was filled with exhibitions from the lowest grade to and including the High School and adult art classes…," *SYVN*, May 6, 1949, p. 4;"New Teacher Joins Solvang School Staff… the three present faculty members will return next Fall… John L. Rinn has been retained to teach music as has **Leo Ziegler**, art instructor," *SYVN*, June 3, 1949, p. 8; "Community Club Meeting… **Mrs. Jack Anderson**, upper grade teacher at the College Grammar School, will speak on the ceramic work of her students at a meeting of the Santa Ynez Community Club next Tuesday afternoon at 2 o'clock at the College School. A display of the work done in pottery by the younger children of the school will be shown…," *SYVN*, June 3, 1949, p. 3; new teacher bios, *SYVN*, Sept. 2, 1949, p. 8; "College… Second and Third Grades… We are … painting some pictures to put on our walls," *SYVN*, Sept. 16, 1949, p. 3; "Buellton… 2nd and 3rd Grades… We found something different when we came back. We had a new ceiling and hardwood floor and wonderful corner for painting," *SYVN*, Sept. 23, 1949, p. 3; "Elementary Schools… College… First Grade… We made some big pumpkins with our Crayolas and pencils. We are going to paint some too…," *SYVN*, Oct. 7, 1949, p. 3; "Elementary Schools… College… Fourth and Fifth Grades… In connection with our study of Mexico, we are working with clay and making leather belts and other things to show the arts and crafts developed in the home… Los Olivos… Everyone in the room is now making a picture about Venezuela. They are drawing the details first, then painting them…," *SYVN*, Oct. 14, 1949, p. 3; Elementary Schools Notes. College… Second and Third Grades. We have made many pictures about the wildlife in our room… Miss Houx asked for three of our easel paintings to put up in the county office in Santa Barbara …," *SYVN*, Oct. 21, 1949, p. 13; "Elementary Schools… College … Second and Third… We are all going to be spic and span Wednesday when the photographer comes to take our pictures…," *SYVN*, Oct. 28, 1949, p. 3; "Elementary Schools… Buellton. Grades 1 and 2… Across one wall of our room is a painting of a freight train… College. … First Grade. Frank Espinosa is in the hospital… He wants us to send him some pictures and we are going to make a book from our own drawings… Fourth and Fifth Grades… We are still working on the industries of Mexico… We have made many interesting belts in connection with the arts and crafts of Mexico. We will soon bake the pottery we have made…," *SYVN*, Nov. 18, 1949, p. 7; "College School's New Kiln Arrives. For firing the various clay articles made by the children. It arrived last Thursday and has a capacity of little more than a cubic foot. … It was purchased and

given to the school by the Community Club. There is already much completed clay work ready for firing," *SYVN*, Nov. 18, 1949, p. 10; "Elementary Schools… College… Fourth and Fifth Grades. We are still working on the industrial phase of the Mexican unit. We are working on our reports and illustrating them with maps and pictures. Bob Hutchinson is weaving a rug using sisal and colored rags as materials. We now have a loom strung up and are about ready to start weaving. We will probably make a small rug. We are planning to make pottery for Christmas gifts…," *SYVN*, Nov. 25, 1949, p. 8; "Elementary Schools… Solvang… 5th and 6th Grades. Be sure to see the Mission that we have made that is on display in the window of the *Valley News* office…," *SYVN*, Dec. 9, 1949, p. 3; "Solvang Students' Mission on Display in *News* Office… The model, made from miniature adobe bricks and covered with a corrugated cardboard roof painted to resemble the red tile roof of the Mission… done as part of the activities of the social studies unit 'Our Community'," *SYVN*, Dec. 9, 1949, p. 7; "Elementary Schools… College… Sixth and Seventh Grades… We are unable to complete our pottery before Christmas because the kiln is out of order," *SYVN*, Dec. 16, 1949, p. 4.

1950 – "Elementary Schools … Buellton. 2nd and 3rd Grades. This week **Joseph Knowles**, county art consultant visited us. He helped us paint with our hands and fingers… College… Kindergarten… We have drawn many pictures of Zoo animals…," *SYVN*, Jan. 13, 1950, p. 3; "Elementary Schools… Solvang… 3-4th Grades. We have been studying famous paintings. Then we paint our own landscape pictures…," *SYVN*, Jan. 20, 1950, p. 3; "Elementary Schools… Buellton. Grades 1 and 2… Our papier mâché fruits, vegetables and meats are finished and we painted them… College. Kindergarten… We painted many pictures of zoo animals which Mrs. Roland put up so our mothers could see them…," and reports of watching **Merrell Gage**'s presentation on Lincoln, *SYVN*, Feb. 3, 1950, p. 3; "Elementary Schools… College… Second and Third. We have been using clay which can be fired. We experimented with the plasticine before we used it…," *SYVN*, Feb. 10, 1950, p. 3; "Elementary Schools… Solvang… 7th and 8th Grades… We are studying the Pacific Islands… and several girls are painting Hawaiian scenes for the classroom…," *SYVN*, March 24, 1950, p. 3; "Totem Poles are Raised by Pupils" at Los Alamos elementary who are studying Alaska, *SMT*, April 4, 1950, p. 6 and comment that totems were made of redwood, carved by the children and painted in bright colors, and the totems were placed in the corner of the school yard; "Elementary Schools… College … Second and third… We enjoyed drawing pictures and painting some about things we did during vacation…," *SYVN*, April 14, 1950, p. 3; "Elementary Schools … Buellton Grades 1 and 2… We have our puppet stage nearly completed and are using stockings to make our puppets… painted a woods scene for our play… [circus in town] … College… Second and Third… We had a good time finger painting on the front porch… Solvang… 3-4th Grade… We are drawing pictures, making booklets… about Mexico…," *SYVN*, April 28, 1950, p. 3; "Elementary Schools… Buellton. Grades 1 and 2. **Joseph Knowles** came to our school Tuesday and borrowed some of our circus paintings for the exhibit at the Santa Barbara Museum of Art… College… Fourth and

fifth. Bud Engles and Harvey Duryea are making a relief map …," *SYVN*, May 19, 1950, p. 3; "Solvang School Staff Complete… **Leo Ziegler** will again instruct art…," *SYVN*, July 14, 1950, p. 1; "Elementary Schools… College… First Grade… Each day we have written a story about something we saw on the trip. Then we draw a picture about the story…. Fourth and Fifth Grades… we can have a play about early California. We are also planning to paint the background scene for our play… Seventh and Eighth Grades… We had a water color lesson stressing shading and contrast of colors. Some very good pictures resulted… Los Olivos. Primary Room… Last Monday we did finger painting… Upper Room… Last week we painted some pictures. After they were painted, we voted on which was best. Rhonda Stonebarger's landscape scene was first. Julia Meisgeier's tree on the horizon was second and Peter FitzGerald's hunter in a field and Joe Brace's deer feeding were tied for third…," *SYVN*, Sept. 22, 1950, p. 3; "Elementary Schools … Buellton… General News… On Wednesday afternoon we have art… Some of us draw and paint and some of us model with clay. Those who aren't interested in art are taking science… Solvang… Art. About 50 students take art on Friday from Mr. **Leo Zeigler [Sic. Ziegler]** …," *SYVN*, Sept. 29, 1950, p. 3; *The Elementary School column was discontinued in the newspaper at this point.* "Miss Downs at State Meeting… principal of the College Grammar School… state conference … in San Diego… she described the work going on at the College School … Selected paintings by the children… were used to supplement the presentation," *SYVN*, Nov. 3, 1950, p. 6.

1951 – "Valley Residents Invited to Take Part in Observance of **Public Schools Week**… College School… Penmanship… will be the third grader's contribution to the program…," *SYVN*, April 20, 1951, p. 1; "New Teacher Joins Staff at Buellton… **Ruth Ward**…," *SYVN*, Aug. 24, 1951, p. 3; "Consultants Visit – Miss Kate Houx, general educational consultant and Ray Barron, consultant in audio-visual aids, spent Wednesday at Los Alamos school observing classes at work. Several photographs were made of the varied activities. These pictures will be preserved…," *SMT*, Nov. 16, 1951, p. 4.

1953 – "Community Club… College School… **Joseph Knowles**… showed two films of children at work under the current art program in the schools today," *SYVN*, April 10, 1953, p. 1; "Primary Youngsters of Los Olivos School in New Room… One of the features of the room is a 30 foot area designed especially for water color painting… The floor… is covered with linoleum…," *SYVN*, Sept. 11, 1953, p. 1; "Buellton School Ceramics displayed… now on exhibit in the window of the *Valley News* in Solvang," *SYVN*, Dec. 4, 1953, p. 8; College school – photo of June Strom giving advice to child artist, *SYVN*, Dec. 15, 1953, p. 23; photo of child at easel at College School, *SYVN*, Dec. 25, 1953, p. 23.

1954 – "Teachers Workshop… in ceramics next Wednesday afternoon at the College Grammar School from 2:45 to 5 p.m. The workshop is being held by the county school office at the request of the teachers. Attending from the county office will be **Joseph Knowles**, consultant in art education and Miss Kate House [Houx?], consultant in

general elementary education…," *SYVN*, Jan. 8, 1954, p. 5; "Community Club to Hear … **Joseph Knowles**… guest speaker at a meeting of the College School Community Club next Tuesday at 1:45 p.m. at the school. His subject will be 'Art in Every Day Living'," *SYVN*, Jan. 29, 1954, p. 1; "College School Club… The meeting closed with members visiting Mrs. Louise Holt's third grade room where they were shown an exhibit of Indian craft. The bowls, paintings, dolls, weaving, gardening, building models and ceramics were made by the children in their social studies of the Pueblo Indians…," *SYVN*, March 5, 1954, p. 4; "Education Week… Buellton School observed **Public Schools Week**… There was a night program in each room… Mrs. Barbara Haughwout's class demonstrated how social studies were learned through the medium of a puppet show," *SYVN*, May 7, 1954, p. 11; Jonata School photo taken in 1896, *SYVN*, Sept. 17, 1954, p. A-1; photo of façade of College School, *SYVN*, Sept. 17, 1954, p. 5; "Present College School Building Constructed in 1908…," *SYVN*, Sept. 17, 1954, p. C-5; "Present-Day Buellton Grammar School Came About Following One-Room Jonata School," *SYVN*, Sept. 17, 1954, p. C-12; "Solvang Grammar School Shows Growth Through Years," *SYVN*, Sept. 17, 1954, p. C-9.

1955 – "Panel Discussion… Buellton School PTF Meeting… The group discussed the possibility of forming a ceramics class with **Joseph Knowles** as instructor…," *SYVN*, Jan. 28, 1955, p. 5; "**Paul Kuelgen** Visits School… third and fourth grade at the Buellton School Wednesday, Jan. 26. The class is studying ways of transportation. Mr. Kuelgen drew many ways of transportation both old and new such as two wheeled cart, velocipede, car, train, covered wagon, airplane and many other things. After filling the blackboard with sketches, the drawings were erased and the class drew at least two of the ways of transportation," *SYVN*, Feb. 11, 1955, p. 2; "Los Alamos School Hosts [Santa Ynez Valley] Principal's Association… Achievements of the previous year were reviewed… The association members previewed the colored photographs of all the art prints which are available in their schools from the Educational Service Center…," *SMT*, Sept. 24, 1955, p. 8; "Buellton Kindergarteners Stage Annual 'Graduation'… First, they gave a puppet show for the first and second grades… The puppet show was later repeated for all the mothers. Each puppet was a story book character and each child had a hand in making them of papier mâché and creating lines for each character. Characters portrayed were Raffie Giraffe…," *SYVN*, June 17, 1955, p. 6.

1958 – "Architecture Firm Selected by Buellton School Trustees… **John Badgley** and Associates of SLO…," *SYVN*, Sept. 26, 1958, p. 4.

1959 – "Buellton Carnival – Buellton Parent-Teachers Assn… first annual carnival … food booths… toy rummage… potted plants… darts… [and other games] … ponies for the rides… One of the attractions will be the offering of a prize of an oil painting by **Forrest Hibbits**… given to the carnival. The art work event is under the chairmanship of Mrs. Updike… Proceeds … will aid the PTA…," *SYVN*, May 1, 1959, p. 5; "Youngsters of Solvang School Plan Annual Halloween Parade… It was also reported that Roy Maple [itinerant?] will entertain the school children by painting with sand on a black velvet canvas at the first in a series of national school assembly programs next Monday…," *SYVN*, Oct. 23, 1959, p. 8.

1960 – "Mosaic Work Shown… A demonstration of mosaic work by **J. R. Billet** of Santa Barbara, emphasized gift articles of jewelry, trays and checkerboards as well as hobby items such as pictures at a meeting of the College School Community Club last Thursday afternoon…," *SYVN*, Nov. 18, 1960, p. 8.

And numerous additional notices were too numerous to be itemized here.
See: "Ballard School," "Posters," "Public Schools Week," "Santa Ynez Valley Child Workshop," "Scholastic Art Exhibit," "Valley Nursery School"

Santa Ynez Valley, Ca., High School
See: "Santa Ynez Valley Union High School"

Santa Ynez Valley, Ca., Recreation Program
Recreation program that focused on sports rather than crafts, launched 1950.
■ "Youth Recreation Program Launched Here… The Valley Coordinating Council is giving its wholehearted support to the program… The executive board of the Coordinating Council met Wednesday night at the high school to discuss the recreation program… ," *SYVN*, April 21, 1950, p. 4.
Santa Ynez Valley, Ca., recreation programs (notices in Northern Santa Barbara County newspapers on microfilm and on newspapers.com)
1950 – "Council Planning to Widen Scope of Recreation Program. The Santa Ynez Valley Coordinating Council meeting… laid plans for extending the Valley recreation program to include a greater variety of activities and to include all of the various age groups. In addition to the weekly beach parties, playground program… the council hopes to enlist the aid of Valley organizations and individuals in sponsoring work in arts and crafts, music and handicrafts activities during the summer. Other activities which were suggested include … a photography club…," *SYVN*, May 26, 1950, p. 1; "Elementary Schools Recreation Program Scheduled to Start Nov. 4… The Valley Recreation Program…," is all sports, *SYVN*, Oct. 27, 1950, p. 6
See: "Summer School (Santa Ynez Valley)"

Santa Ynez Valley, Ca., Union High School
See: "Santa Ynez Valley Union High School"

Santa Ynez Valley Child Workshop Project
Nursery school combined with teaching of parents, 1955.
1955 – "Work Shop Hears Talk by … **Joseph Knowles**… at the regular class of the Santa Ynez Valley Parent-Child Workshop Monday evening at **St. Mark's** Parish Hall… mothers attending. They indulged in finger painting and

other forms of art work used by their children at the nursery school laboratory…," *SYVN*, Dec. 16, 1955, p. 10; "The Santa Ynez Valley Child Workshop Project, an experiment in education for both youngster and parent, has been in operation here since the end of September… The workshop, sanctioned by the trustees of the Santa Ynez Valley Union High School, is a two-fold program: it encompasses a three-mornings-a-week nursery on the grounds of the **St. Mark's-in-the-Valley** Parish Hall and discussion sessions at which parents and sometimes guest speakers delve into the inner workings of the project as a whole. Thus far between 20 and 25 little boys and girls between the ages of 2 ½ and 5 attend … A few minutes after 9, youngsters are given the opportunity of choosing their sectors of recreation. There are the playhouse, swing, paint, and sidewalks areas. As the morning progresses, youngsters move from one area to another… some become deeply involved with paint brush and water colors at easels on small stands…," and photo of children at easels, *SYVN*, Dec. 23, 1955, p. 1, and photo of children washing their hands after painting, p. 6 (or C-1, or 17).
See: "Santa Ynez Valley, Ca., Elementary …"

Santa Ynez Valley Community Arts and Music Association / Santa Ynez Valley Community Arts-Music Association / Santa Ynez Valley Arts-Music Association
Branch/es of the Santa Barbara Music and Art Association? Music seems to be its main interest, 1952+.

Santa Ynez Valley Fair / Santa Ynez Valley Community Fair / Santa Ynez Valley Country Fair / Valley Fair (Los Olivos)
After years of no county fair put on by people in Santa Barbara, the various valleys in north county appear to have taken things into their own hands and each put on a fair. The first was the Lompoc Valley Fair in 1927, followed by the Santa Ynez Country Fair, sponsored by the Presbyterian Ladies Aid of the Valley Community church and a Santa Maria Valley Fair, both first held 1928.
Santa Ynez Valley Community Fair (notices in Northern Santa Barbara County newspapers on microfilm and on newspapers.com)
1927? – "Valley Fair to be Held Sept. 12 … The first fair for the valley, which was sponsored by the Ladies' Aid and which was the thought of **Mrs. S. K. McMurray**, was held in Santa Ynez at Minetti's hall in 1927 [Sic. 1928?] …," *SYVN*, Aug. 7, 1931, p. 1.
1928 – "Valley Country Fair Draws Much Interest" to be held at Minetti's hall in Santa Ynez, and list of exhibit categories, *SYVN*, Sept. 21, 1928, p. 1; "Valley Fair Had Many Exhibits, Every Booth Filled to Capacity," and antique booth extensively described, *SYVN*, Oct. 5, 1928, pp. 1, 8.
1929 – **Second Annual**? "Big Valley Fair Sept. 7th… Plans… are nearly completed… Woman's Fancy Work Department. 1. All exhibitors must be residents of Santa Ynez Valley. 2. All entries must be actual work of exhibitor. 3. All entries must be turned in to Mrs. Browning of Los Olivos or Mrs. James Westcott of Santa Ynez by

Friday evening, Sept. 6. 4. No exhibitor may make more than one entry under one of lot number. 5. Where there is but one entry in a class, judges will award first premium only, except that should the article be not worthy of a premium, none shall be awarded. CLASS 1 – White Embroidery… Class 2 – Colored… Class 3 – Crochet… Class 4 – Bedspread and Quilts… Class 5 – Miscellaneous. Lot 1. Hand painted handkerchief, 2. Hand painted scarf, 3. Hand painted china, 4. Bead work, 5. Hooked rug, 6. Lamp shade (fabric), 7. Lamp shade (painted), 8. Fabric painting, 9. Weaving, 10. Knitting, 11. Needlepoint, 12. Cut work. Antiques – Articles to be 25 or more years old. Each article must be accompanied by a card giving age, by whom made and any interesting historical information. All articles to be left with Mrs. Fish, Mrs. Stark or Mrs. Frame or brought to L. O. Anderson not later than 8 a.m. Sat., Sept. 7…," coverlets, bibles, newspapers, coins, laces, Indian relics, Daguerreotypes, dishes, *SYVN*, Aug. 23, 1929, p. 1; "Extraordinary Displays Seen at Our Country Fair. Second annual… between 600 and 700 people attended… [and extensive list of entries] … The valley schools contributed many interesting and attractive things made by the pupils… [fruits, vegetables, flowers, livestock] … The fancy work booth had a collection of beautiful work, exquisite lace and embroidery, patch work, drawings and hand painted china… The antique booth occupied the whole north side of the hall and was the most interesting exhibit… People were especially kind to loan these many valuable and priceless old heirlooms … Outstanding was a Stradivarius dated 1713 belonging to the Kelly boys… A Bible dated 1589… 'Horse pistol'… Springfield… hand-made silk dress… long baby dresses… brocaded velvet waistcoat… old Spanish chest. Two spinning wheels… pipes of old German make… cyclopedia of 1838… Spanish prayer book dated 1856… brass candlesticks… old dishes… silver… Spanish shawl… patch work quilts… head of an African buffalo… rocks…," *SYVN*, Sept. 13, 1929, p. 1.
1930 – Third Annual – "Santa Ynez Valley Fair at Solvang…. [Sept. 13] in the College Gym…," *SYVN*, Sept. 12, 1930, p. 1; "Valley Fair Huge Success… antiques [described] …," and judges named, including **Grace Garey** of the valley, for needlework, *SYVN*, Sept. 19, 1930, p. 1, and fancywork described, p. 8.
1931 – Fourth Annual – "Valley Fair to be Held Sept. 12… Owing to the fact that the Craig Pavilion in Santa Ynez will not be available on that date it was thought best to hold the fair in the Los Olivos school hall… The first fair for the valley, which was sponsored by the Ladies' Aid and which was the thought of **Mrs. S. K. McMurray**, was held in Santa Ynez at Minetti's hall in 1927 [Sic.?] … This year, being a semi-dry year, it is somewhat difficult to make as good a showing as in former years… The following organizations will have booths… **Los Olivos Needle Craft**… The fair committees are as follows: fancy work, Mrs. Mattie Edie… fancy work, Mrs. Frances Frame… antiques, **Mrs. Emma Weston**… school exhibits, **Miss Jeannette Lyons**… This year we are desirous of making the antique booth well worthwhile. Your treasures will be carefully guarded… Another feature to be added to this booth is that of old photos to form a picture gallery. Bring out photographs of early residents or early valley scenes …," *SYVN*, Aug. 7, 1931, p. 1; "Wonderful Exhibits on

Display… [and list of awards in agricultural products, floral exhibits] … Fancy Work… [including rugs, hobbies, crocheting, cutwork… quilts] … **Rubena Downs**, first on collection of crayon drawings…," *SYVN*, Sept. 18, 1931, p. 4.

1932 – Fifth Annual – "Country Fair is Deserving of High Mention… This year, special attention will be paid to an exhibit of quilts, both old and modern. There is a revival of quilt making in the valley… Also, a choice collection of quilts of intricate design made in the days of our grandmothers may be seen…," *SYVN*, June 24, 1932, p. 6; "Country Fair Exhibits… [agricultural, floral] **Captain William McKittrick**'s fine collection of Indian relics, which he also displayed at the valley fair last year, was given much praise. … The Antique booth had a much smaller display than usual, but as usual, very interesting. Of especial interest were a few tools, a jack plane, a smoothing plane and a sausage mill belonging to A. L. Nosser. They had been the property of his grandfather and of his father and were 140 years old. Mrs. Linus Buell displayed a Haviland china plate that had been Mr. Buell's mother's and brought into the valley 64 years ago. Several curios added to the interest, buffalo horns from Yellowstone park, relics connected with the early history of the state and valley, including a cap and ball pistol… Several dolls with interesting histories… Three schools of the valley, Los Olivos, Solvang and Ballard, put on a fine display of school work. The industrial project work of Ballard, the Art work of Solvang and the cut work frieze of Los Olivos won special praise… [prizes] Art group – 1. Animal wall hanging, Solvang, 2. Sea panel, Solvang. In this connection the tapestry drawings by Ellen Johnson showed marked talent. Art – Individual to Schools… Other booths were the **Los Olivos Needle craft**, very artistic with palm leaf decorations and with bright plumaged real birds for color…," *SYVN*, Sept. 16, 1932, p. 1.

1933 – "Valley Fair Awards… Fancy Work… 16 quilts and other pieces of fine needle work… Quilts: appliqué [and winners named] … Antique Booth… shawls … quilts… costumes… pottery… old books, *SYVN*, Sept. 22, 1933, pp. 1, 4.

1934 – "Buellton in Bid for 1934 [Santa Ynez Valley Fair] Valley Fair. Lompoc's Co-Operation in Staging Exhibition Would be Asked" in return for Buellton cooperating in the Lompoc Valley Fair of 1935, *LR*, Sept. 22, 1933, p. 8; "SY Valley Fair Awards… Mrs. James Main, Mrs. Louis Erwin and Miss Evelyn Vaughn judged the handiwork display. Awards were given as follows …," and long list of names and articles, *SYVN*, Sept. 14, 1934, p. 4.

1935 – Seventh Annual [Sic?] -- "New Ideas are Planned for Valley Fair… September 14… This year, in place of separate entries, the center floor space will be divided into four sections, representing the four districts of the valley, Santa Ynez, Los Olivos and Ballard, Solvang, and Buellton…," *SYVN*, May 31, 1935, p. 1; "Seventh Annual… Attracts 600 …," *LR*, Sept. 13, 1935, p. 4.

1936 – Eighth annual [Sic?]– "Valley Fair Plans Progress… September 12… Ballard and Los Olivos are working together and have an excellent prospect for a fine display. Mrs. Harvey Stonebarger is the chairman backed by the **Needlecraft Club**… A room in the Los Olivos school, where the fair will be held, will be used as a picture gallery where old photographs, art pictures and objects of art will be shown. Mrs. William Maloney will have charge assisted by **Mrs. J. H. Forsyth**. One room will be used as a display room for fancy work, quilts, etc. A school exhibit will be staged in still another room…," *SYVN*, Aug. 28, 1936, p. 1.

1937 – Tenth Annual – "Valley Fair Displays… at Los Olivos school… Home arts prizes were awarded to Mrs. B. Davis, largest display of quilts and to Mrs. Edgar Davison for a shirred rug … Ribbons in the Home Arts department … [and winners named] … Quilt awards… [and winners named]," *SYVN*, Sept. 17, 1937, p. 1.

1938 – Eleventh Annual – "Numerous Awards Given at Successful 1938 Valley Fair… excellent display of agricultural and floral products… Farm organizations represented… the home department of the Farm Bureau showing hand-work of the women of that department… **Needlecraft club** with a Swiss chalet and the Matterhorn seen through the back window, representing Switzerland… school display… ladies in costume attending the various booths… [and long list of awards given in all the categories]… Mrs. Fred Mattei and Miss Eleanor Martin judged the fancy work display. The following awards were made …," and long list of awards for quilts, cut work, embroidery, etc., *SYVN*, Sept. 23, 1938, pp. 1, 8.

1939 – "Valley Fair Pronounced Hugh Success… Many lovely pieces of hand embroidery, hand-made lace bedspreads… Awards were as follows [and names given]," *SYVN*, Sept. 22, 1939, pp. 1, 10, cols. 5, 6.

1941 – Thirteenth Annual – "Valley Fair Opens Sat. at Los Olivos… Grand Display of Grain, Fruits, Vegetables… Sponsored by the Presbyterian Ladies Aid… The display booths include the agricultural and flower booth, the hand-work display… No stock show… commercial booths … American Legion Auxiliary where articles made by disabled veterans will be sold… **Los Olivos Needlecraft**… **Santa Ynez Sewing Circle**…," *SYVN*, Sept. 12, 1941, p. 1.

1943 – "Valley Fair Plans Cancelled for this Year… unforeseen circumstances… past 17 years has featured the valley's agricultural products, handcraft, etc. … conducted each year entirely by the women of the valley…," *SYVN*, Aug. 13, 1943, p. 1.

Santa Ynez Valley Historical Society (Santa Ynez)
Launched by Santa Ynez Valley Woman's Club, 1960.
The Historical Society currently has its own suite of
buildings in Santa Ynez. See: SantaYnezMuseum.org.

■ "Historical Society Formation Discussed … ," *SYVN*, Oct. 2, 1959, p. 3; "Woman's Club to Launch Historical Society Here. Plans developed during the past year by the Santa Ynez Valley Woman's Club…," *SYVN*, Sept. 30, 1960, p. 1.

■ "S. Y. Valley Historical Society Gallery Opening … The gallery is located in the McKillop building in Santa Ynez and the use of the large gallery room and patio have been made available to the society through the generosity of William McKillop. Items of historical interest pertaining to the Valley… A large oil portrait of Judge Samuel Lyons painted by **Charles Mattei**, framed photographs of Roman [de la Cuesta] and **Micaela de la Cuesta**, and photographs of his parents, loaned by Odin Buell, all dominated one

wall… The evening was enlivened by the arrival of Mr. and Mrs. John Bacon in their fringed surrey drawn by a team of horses. … Special displays… valuable collection of muzzle-loading guns, one dating back to 1600, owned by Richard Lawton; a table devoted to papers and artifacts relating to a veteran of the Civil War, including the battle flag; items of cowboy lore; many photographs and articles donated by Grace Davison, including the old Ballard post office; and an amusing item, the Edison phonograph bought in 1903 by Marcus Nielsen … the board hopes to open the museum each Sunday afternoon from 11 to 5…," *SYVN*, July 7, 1961, p. 12.
See: "Santa Ynez Valley Woman's Club"

Santa Ynez Valley Industrial Center (Solvang)
1230 Mission Drive – 11 firms were in place at the opening in 1960, some of which were craftsmen.
■ "… open house Saturday afternoon, Oct. 8 from 2 to 5 p.m. … hosting the affair to which the public has been invited are the 11 firms of the center … Delbert Jepson Painting… **Walter Kristensen** hand crafted metal work… Thenn and Associates, civil engineers, and **R. M. Ortega**, designer…," *SYVN*, Sept. 30, 1960, p. 2.

Santa Ynez Valley Museum of Natural History (Santa Ynez)
A public service unit of the Beaudette Foundation for Biological Research, 1960+.
Santa Ynez Valley Museum of Natural History (notices in Northern Santa Barbara County newspapers on microfilm and on newspapers.com)
1960 – "Museum Plan Aired at Foundation Meet," i.e., second annual meeting of the board of directors of the Beaudette Foundation for Biological Research last week at Palacio del Rio… proposal to establish a Valley Natural History Museum in Solvang or vicinity as an educational facility…," *SYVN*, June 24, 1960, p. 1; "Foundation Establishes Natural History Museum… a public service unit of the Beaudette Foundation for Biological Research… south room of the Solvang Elementary School where the museum will have its inception and location for the next year… The staff of the Beaudette Foundation will supervise the preparation of exhibits… need for display cases," *SYVN*, Aug. 19, 1960, p. 1; photo of new quarters and caption reads 'Home of New Museum… in this 10-room, two story dwelling on Calzada Avenue, Santa Ynez… the [Beaudette] foundation is now readying display cases for exhibits and the museum is scheduled to open late in November. For the beginning four rooms on the second floor will provide additional laboratory space…," *SYVN*, Sept. 30, 1960, p. 10; "Natural History Museum Open Tomorrow… The museum will be open regularly on each Saturday and Sunday afternoon from 1 to 5… operated as a public service by the [Beaudette] foundation… memberships in the museum have been made available… The museum features displays of mammals, birds, insects and marine life and plans to provide varied exhibits of the Santa Ynez Valley region…," *SYVN*, Dec. 2, 1960, p. 1. [Earlier articles on the Beaudette Foundation 1959, 1960, were not itemized here.]

Santa Ynez Valley News (Solvang)
Newspaper, first published Dec. 11, 1925.
■ "30 Years Ago. Walter L. Hanson, a printer on the *News* for a short time, bought the *Santa Ynez Valley News* last week and has gone to Solvang to take possession… Mr. Hanson is a recent arrival in California, coming from Montana, where he published a newspaper…," *SYVN*, Dec. 6, 1957, p. 2.
Santa Ynez Valley News (notices in Northern Santa Barbara County newspapers on microfilm and on newspapers.com)
1954 – Staff photos and history, *SYVN*, Sept. 17, 1954, p. C-14.
1957 – "Valley News Wins Three Top National Newspaper Awards: Best Feature Story, Job Printing, Photography… National Editorial Association… the paper captured an honorable mention or fourth place for the best use of photographs for papers under 2,000 circulation… In judging the entries, consideration was given to reader interest of illustrations, presswork excellence, quality of photograph and half-tones, use of newspaper make-up, relevancy to news stories and number of photo engravings …," *SYVN*, June 21, 1957, p. 1.

Santa Ynez Valley Rock Club
Club that maintained an exhibit in the Solvang Library, 1960+. Some members made jewelry.
Santa Ynez Valley Rock Club (notices in Northern Santa Barbara County newspapers on microfilm and on newspapers.com)
1959 – "Meet Slated for Tuesday," and plan to enter a hobby show in Lompoc, *SYVN*, Nov. 6, 1959, p. 5.
See: "Santa Barbara County Library (Solvang)," 1959, 1960, "Tenney, Ed"

Santa Ynez Valley Union High School (Santa Ynez)
High School opened 1896. By 1921 the school offered freehand drawing and mechanical drawing and, by the mid-1920s, in the homemaking department, drawing and art as related to the home. Beginning March 1926, news of the school appears as a regular column in the SYVN penned by teachers and students. Evening classes for adults were started 1929 [Sic.?]. In the 1930s any "art" classes, such as freehand drawing, appear to have been taught by the Domestic arts teacher (Grace Garey, 1929-32, Mary Gladys Johnson, 1932-35, Margaret Conneau, 1935-38, Elner Martin, 1938-39, Theodora Corey, 1939-43). New school buildings were constructed 1935-36, and two rooms were allotted pieces of WPA art (by Harcoff and Swanson) for decoration. A special Civilian Conservation Corps satellite high school was established 1936 in Los Prietos and ran for five years. After WWII domestic arts (including arts and crafts) was assumed by Mrs. Isabelle MacPherson Simerly, 1947, followed by Mrs. LaVaut, 1949/50, Lenora Anderson, 1950/56. Crafts were then taught by Chester Brownlee, 1956 and by Fillmore Condit, 1957, 1958. Mechanical Drawing was taught by L. L. Jones in 1942, 1943, followed by Harold Venske, 1945/49, 1952, 1953, who also oversaw the production of the school annual and took photos. In 1944

professional artist <u>Leo Ziegler</u> began teaching landscape art part time and may have continued almost to his death in 1961. The small faculty often took on a variety of subjects and each teacher's slate changed from year to year. In 1957 a new building for shop and photography, including a ceramic kiln, was constructed. <u>Industrial Arts</u> was taught by Wilfred Stensland, 1959+. In 1959 the school offered its first summer classes. In 1960 an arts building was designed to be added to the Industrial Arts building. From c. 1944 graduating art students donated artwork to the school which was hung in classrooms.

■ "History of Valley Union High School Marked by Rapid Growth … It was 51 years ago that a group of men attended a meeting in the old College Grammar School to lay plans for the establishment of the Santa Ynez Valley Union High School… Originally slated for Los Olivos, the town of Santa Ynez was selected as the site… During the first few years … students were required to take all of the courses offered. There were no electives… opening… must have been in the late Fall of 1896… By 1904 the school had grown from a dozen to more than 20 students and an attic room in the grammar school was renovated to house the added students… In 1908 the people voted a bond issue to raise funds for the erection of a high school building. Meanwhile… classes were held in the College Hotel in Santa Ynez… <u>The first evening classes for adults was established in 1929 [Sic?]</u> … In 1934 the federal government approved an application for financial aid in the building of a new school… It was from 1935 to 1936 that classes in the school were held under the tents… <u>construction of the new school. The shop was completed in the Spring of 1935 and work began on the homemaking and administration buildings</u>… The **Civilian Conservation Corps** was established at Los Prietos in 1936. It continued for five years and offered opportunities for a high school education to nearly 1,000 boys. More than 200 graduated from the high school… The present school buildings were … used by the students for the first time [in September 1936]. … In June of 1941 Hans C. D. Skytt was awarded a contract for the construction of a new gymnasium. In the last few years further improvements have been made in the school plant. An orchard was planted, a turf athletic field sown, tennis courts are now being built… driveway has been resurfaced… Cafeteria service has been established… and additional classes and instruction in several important subjects, including vocations, highway safety, marriage and family relations have been added to the curriculum…. A total of 186 graduates served in World War II… The present principal of the school is Hal Hamm, who came to the Valley in the Summer of 1944 from the Surprise Valley Union High School in Modoc County… Other members of the faculty include… Miss **Theresa Ricca**, life science and leather crafts, Miss Estelle Koth, homemaking… **Leo Ziegler**, art…," *SYVN*, April 25, 1947, pp. 1, 8.

■ "Valley High School Opened in Fall of '96, First Classes Held in Old Grammar School," *SYVN*, Sept. 17, 1954, p. C-13.

■ "School News… The Old High School. The first high school in this valley was located in the place where the college grammar school now stands. It was a wooden building two stories high. The lower floor was occupied by the grammar grades, while the upper floor housed the high school classes. In a small alcove up near the bell tower were situated several typewriters… [school] burnt many years ago… the stairway was very steep, narrow and winding… The old school bell still lies in the grammar school grounds… There was often an enrollment of at least fifty students in the high school. These pupils came from all over the surrounding country, some even driving by horse and buggy from Los Alamos…," *SYVN*, April 9, 1926; "High School Anniversary Plans Near Complete Stage … <u>60th birthday</u>… assembling of brief autobiographies of school's 1,100 graduates. The autobiographies will be printed in booklet form…," *SYVN*, April 13, 1956, p. 10; "60 Years of Progress … History Highlights School's Growth … By 1921… <u>Freehand Drawing</u>… <u>Mechanical Drawing</u>… Several New Classes… in the late '20's including <u>Art Appreciation, Color in Home and Dress</u>, Penmanship…," *SYVN*, April 27, 1956, pp. 1, 2, 3.

<u>Santa Ynez Valley Union High School (notices in Northern Santa Barbara County newspapers on microfilm and on newspapers.com)</u>

1925 – "James A. Westcott, principal … recently instituted a <u>poster contest</u> in the valley schools whereby the boy and girl in each room making the best posters for Armistice Day and Better Book Week, respectively, should receive a free ticket to the motion picture, 'Peter Pan' shown at the High School this week…," *SMT*, Nov. 13, 1925, p. 3.

1926 – "School News… In <u>Home Making</u> II, **Mrs. Fields** has had the girls do some very interesting work, such as making rugs, plaques, candlesticks, making scrap books, drawing house plans and furnishing them… They also visited the Solvang Furniture Store so as to study… furniture… At present they are painting vases, baskets, jars, trays, and different things…," *SYVN*, March 5, 1926, p. 5; "School News… <u>Drawing Class</u> which has been doing some excellent work this year has decided not to gain honor and renown by designing gowns, but instead has taken to drawing cartoons. Beware! Students and faculty of SYHi. You are the subject of their artistic efforts. Prepare yourselves for a shock," *SYVN*, March 12, 1926, p. 5; "School News… <u>Homemaking</u> II. The girls… are making some very interesting things, among which are lamp shades, candle holders, candle sticks, novelty boxes and various other things… tie dying…," *SYVN*, April 23, 1926, p. 1; "High School Night. Friday evening, June 4th the high school is to have an <u>exhibition</u> of the work of the various classes during the year. The Home-making classes will have their sewing, plans, house furnishings … Freehand and mechanical drawings will also be shown. The work of the Farm Mechanics and Manual Training classes will be exhibited…," *SYVN*, May 14, 1926, p. 2; "High School News… High School Night June 4… <u>exhibition</u> of student accomplishments. Freehand and mechanical drawing, domestic science…," *SYVN*, May 28, 1926, p. 4; "School News… Books of Authorship. Last Monday night the English classes exhibited the books they have written this term. The books were artistically illustrated… the work was enjoyable and those who liked to write and draw had a chance to show their talents…," authored by <u>Ruth Wolford</u>, *SYVN*, June 11, 1926, p. 4; "Solvang and Vicinity.

Commencement week at the Santa Ynez high school … High School Night on Monday, June 7… After the program … the various types of work done by the high school students… were displayed in the various class rooms. Exhibits included very artistically illustrated note books done by the English class, free hand and mechanical drawing. Sewing, home craft of all kinds…," *SMT*, June 17, 1926, p. 6; "High School to Open Monday… faculty… Principal, … English and Music, … Spanish and Latin, **Iva M. Fields**, Homemaking and Physical Training…," and various courses listed, *SYVN*, Aug. 20, 1926, p. 1; "Valley High School Receives Set of Books… three volume set … '*The Birds of California*' … [by] William Leon Dawson of Santa Barbara… 1100 half-tone cuts of birds life, nests, eggs and favorite haunts from photographs. There are 44 drawings and 15 full-page color plates…," *SYVN*, Dec. 23, 1927, p. 1.

1927 – "The Esyhi… Homemaking II. The second year homemaking class… are now taking up sewing and painting. … Very soon there is to be an exhibit at the High school…," *SYVN*, May 20, 1927, p. 4; "Prizes Awarded High School Students in Drawing Contest. The Misses Leatha Riley, **Ruberna Downs** and Ruth Wolford, high school students, were awarded prizes this week in a drawing contest instituted by the Solvang Business Men's association to secure suggestive data for use in advertising literature. Miss Riley's drawing was awarded first place with a cash prize of $3 and Miss Downs and Miss Wolford were awarded $2 each for their splendid efforts," *SYVN*, June 3, 1927, p. 1.

1929 – "ESYHI Section… a high school must have at least 200 students in order that it may offer a program of studies that has variety and meets the demands of the majority of students, keeping the cost within a reasonable amount. When this article is written, the enrollment in our high school is … Total 86… A teacher must give a certain amount of time to each subject taught no matter how many pupils there are in the class… periods of 45 minutes length… Of subjects taught here, that means Homemaking, Farm mechanics, bookkeeping, Mechanical Drawing, General Science, Biology, Physics, Chemistry and Freehand Drawing… [necessitate double periods] … Some schools, however, use 30-minute periods … Such procedure fits a small high school better and enables the school to make a better program. It also balances the work better among the teachers. The SYVUHS uses this latter plan. Such a plan allows us to have five full hour periods, one 30-minute period and one 45-minute period. The 30-minute period is used for chorus, glee club, orchestra and assembly. The 45-minute period is used for physical training… There are four different grades, 9, 10, 11 and 12. A student in any grade carries four subjects as regular work. Then there is some variety of subjects to choose in the different years… To sum up, 6 teachers, 4 classes, 5 periods, and 26 subjects must fit together… (To be continued)," *SYVN*, Feb. 1, 1929, pp. 1, 7; "High School Overcrowded, State to Make Dist. Survey… The [High School] Board ordered a census taken for the purpose of securing information relative to starting a night school… inadequate room for the students at the high school owing to the fast growth here…," *SYVN*, Nov. 29, 1929, p. 1.

1931 – "ESYHI Section… This week the second-year homemaking class have [sic.] been completing their projects… and are making a quilt for the rest room in the homemaking building. Every girl in the class brought two large blocks, each containing six smaller blocks, four inches square. We have been putting them together," *SYVN*, Jan. 23, 1931, p. 8; "ESYHI Section… The second year homemaking class is working on the selection of famous paintings suitable for the living room. They are also making reports on the best-known artists to see what their favorite paintings are," *SYVN*, March 6, 1931, p. 4; "Selection of Pictures. The following was taken from a pamphlet of Miss Garey's. It was used as a reference for the classes that have been studying pictures in homemaking…," and follows an extended discussion of appropriate artworks for homes, *SYVN*, March 27, 1931, p. 6; "ESYHI Section… Class Notes… The mechanical drawing class is now drawing cones and collapsible boxes…," *SYVN*, April 10, 1931, p. 10; "Records are Broken… A corps of eight teachers has been engaged… **Miss Grace Garey** will have charge of 1st, 2nd and 3rd year classes in home economics and free hand drawing. G. L. Erwin, Smith-Hughes instructor, will instruct in crops and soils, animal husbandry, 1st and 2nd year shop, and mechanical drawing…," *SYVN*, Aug. 28, 1931, p. 1; "High School Report Explains Survey… [of current facilities] … Special Classrooms… The household arts quarters are cramped. Drawing and crafts are taught here in very crowded quarters. New laboratories with modern equipment are the only final solution. The shop has the virtue of floor space only. The light is very poor. A new, light, modern shop of fireproof materials with adequate equipment is desirable…," *SYVN*, Sept. 25, 1931, p. 10; "Two high school girls, members of Miss **Grace Garey**'s art classes, have become sign painters. A new state law requires the words 'School Bus' to appear on the front and rear of all school busses. These girls have lettered the school busses in accordance with the law," *SYVN*, Oct. 23, 1931, p. 4, col. 2; "Valley High School Survey Report… six-year organization would be of advantage to the students … would permit of greater specialization on the part of teachers and also permit of the introduction of such vocational fields as … and such avocational or appreciation subjects as music and art… The curriculum of the small high school must fulfill the needs… of three types of students. 1. Those who are preparing to enter an institution of higher learning. 2. … vocational training… 3. Those who seek… cultural enrichment which will result in more complete living… [subjects proposed]. Mechanical Drawing (11th and 12th) … Art (five years beginning in 7th, required in grades 7th and 8th and an elective art major in three upper grades) … It is recommended that Latin be dropped. … Nine full-time teachers will be required… Specialists could be provided in the fields of … music and art…," *SYVN*, Nov. 6, 1931, p. 8; "Class Notes… Some of the girls in the Art Class are making Christmas cards as part of the class work. Several members… are to make posters for the … coming basketball games," *SYVN*, Nov. 13, 1931, p. 5; "**Miss Garey**'s art classes have agreed to make the posters for … the high school athletic contests. The art classes have also arranged to do the decorations for the scrap-book being made," *SYVN*, Dec. 11, 1931, p. 4.

1932 – "High School Notes… The Free hand Drawing class, under the direction of **Miss Garey**, is working on original drawings. Previously the class worked from studies," *SYVN*, Feb. 12, 1932, p. 4; "$2500 to be Saved … **Mrs. Mary G. Johnson** is to teach home economics and freehand drawing and other work. She is a graduate of Santa Barbara State Teachers' College and of U.C., and holds secondary and Smith-Hughes credentials and has had several years' teaching experience. She has been for the last three years on the Berkeley high school teaching staff. She has had broad experience in home economics and was county supervisor in Alameda county a few years ago. Mrs. Johnson has a small 6 year old daughter and will move to this district sometime during the summer," *SYVN*, July 8, 1932, p. 1; "High School… faculty… **Mrs. M. Gladys Johnson**, Home Economics, Drawing, Applied Arts…," *SYVN*, Aug. 12, 1932, p. 1; "High School… faculty… **Mrs. J. [Sic. Mae] Gladys Johnson**, Home Economics, Drawing, Applied Arts," *SYVN*, Aug. 12, 1932, p. 1; "The Farm shop class has partitioned off a part of the shop building for the use of the mechanical drawing class," *SYVN*, Nov. 11, 1932, p. 3.

1933 – "High School Notes… The advent of a mouse to the Domestic Science building during fifth period one day last week gave the girls in Freehand Drawing an excellent opportunity to display their bravery…," *SYVN*, Feb. 10, 1933, p. 2; "The Freehand Drawing class attempted applied art in the field of batik work this past week. Some encouraging articles were made, and the girls plan to continue with more difficult projects," *SYVN*, March 17, 1933, p. 2, col. 4; "School Notes… Girls in the art classes found interesting employment in the making of quilt blocks. Patterns were taken from authentic early-American design…," *SYVN*, April 28, 1933, p. 2; "High School Notes… The Student Body Scrap Book for the school year 1932-1933 is being compiled. It is assembled by the news reporter. The drawings in it were made by Mildred Jones and Boyd Davis," *SYVN*, June 9, 1933, p. 3; "Home Economics Work Begins" and summary of class work by **Mrs. Johnson**, *SYVN*, Sept. 1, 1933, p. 3; "School Notes… Luncheon Series… The Art classes have each contributed a Thanksgiving poster to the Girls' League for Thanksgiving," *SYVN*, Nov. 24, 1933, p. 3.

1934 – "School Notes… New Posters. All the art students are working on posters. Some of them are being used to advertise the basketball games. Others in the class hope to attain skill enough to work on the posters for the basketball games and the Senior Class Play," *SYVN*, Jan. 26, 1934, p. 2; "High School Opens… All shop work, home economics, art and physical education will be given at the old site and all the other work will be given in the tents on the new site. The shop building on the new site will not be completed for four or five weeks yet… **G. L. Erwin**, who will instruct in Smith-Hughes work, will also teach vocational agriculture and mechanical drawing… **M. Gladys Johnson**, home economics and drawing instructor… Practically all the desks, furniture, etc. has been moved and arranged in the tents," *SYVN*, Sept. 21, 1934, p. 1; "Midwinter Festival… The menu for the dinner, on a large poster hand printed by **Mr. Erwin**, is in the new office window, and several other posters announcing the event were made by the high school

art class under the direction of **Mrs. Gladys Johnson**. They have been placed at the post offices in Buellton, Santa Ynez, Los Olivos and Solvang," *SYVN*, Dec. 14, 1934, p. 1.

1935 – "School Notes… Miss Elizabeth Van Loben-Sels… left… Girls League… At the same meeting, 'Miss Van's' successor, Miss Beryl O. Schreiber, was inaugurated, and **Mr. Carle** of Hollywood gave an interesting talk on trick photography in motion picture production," *SYVN*, March 1, 1935, p. 5; "High School Faculty has Been Chosen… Miss **Margaret Conneau** of Berkeley, a graduate of the University of California and the State College at San Jose will be the instructor in homemaking, vocational education and in home economics. Home making courses under the Federal vocational act will be introduced when school opens… Those who will attend summer school session are **Miss Conneau**…," *SYVN*, June 14, 1935, p. 1.

1936 – "High School Opens Aug. 31 in New Modern Buildings… Santa Ynez Valley Union High School… There is probably a no more artistically and beautiful room within Santa Barbara county than the Library and study room. Here are located the three beautiful murals painted by the celebrated artist **Miss Harcourt [Sic. Harcoff?]**. These portray three stages in the historical development of Santa Ynez Valley. The first is that of earliest settlement and the work of the first Franciscans; the next portrays the romantic life on the ranches and shows a strikingly beautiful palomino horse of the Dwight Murphy ranch. The third drawing pictures the later or machine age within this valley. Recently these three pictures were exhibited in Santa Barbara, and the artist and her work were most favorably criticized … Besides these three drawings there is a wood carving by **Mr. Swanson**, who also is very favorably known in the world of art … The Homemaking work which last year was organized according to the Smith-Hughes plan, is under the direction of **Miss Margaret Conneau**. She will also direct the Glee club and a course in fine arts," *SYVN*, Aug. 21, 1936, p. 1.

1937 – "An Art Exhibit from the **Colonial Art Company** will be displayed at the High School from May 3rd to 7th… A small fee will be charged, and the money taken in will be spent to buy pictures for our High School," *SYVN*, April 30, 1937, p. 5; "Fine Exhibit of Art at High School Auditorium… assortment of paintings … The paintings will be on display until Wednesday and all proceeds from the door will be used for buying pictures for the school…," *SYVN*, May 7, 1937, p. 1; "High School Notes… Reproductions of works of artists of many generations will be on display at the Santa Ynez Valley High School from May 6th to May 11th. This collection consists of 150 Masterpieces representing the French, Italian, Flemish, Dutch, Spanish, German and American Schools of Art. In addition to your enjoyment in this collection you will assist up in raising a fund for the purchase of pictures for our school," *SYVN*, May 7, 1937, p. 4; "Girls' League Give Tea… the hall where the guests were entertained was attractively decorated… flowers… An exhibit of paintings through the courtesy of the **Colonial Art Co.** and of garments made by the home economics girls were on display…," *SYVN*, May 14, 1937, p. 1; "H. S. Students Resume Classes… **Los Prietos CCC** Instructors. These

instructors are under the direction of the local high school principal and the CCC students are instructed at the camp by the following: **C. C. Romer**, carpentry, woodcraft… **Richard Waterman**, art, mechanical drawing…," *SYVN*, Aug. 27, 1937, p. 1.

1938 – First issue of school newspaper, *Solvang Sunshine*, (or *Sunshine News*, was mimeographed) published, *SYVN*, Feb. 4, 1938, p. 4; "High School Notes. Our school paper, produced by the third-year English class members, is getting bigger and better every week. Its production is made possible by a cooperative effort of the Art, Typing and Language classes…," *SYVN*, Feb. 4, 1938, p. 4; "New Teacher Here. **Miss Elner Martin** of Oakland, filling the position made vacant by the resignation of Miss **Margaret Conneau**," *SYVN*, Aug. 26, 1938, p. 1.

1939 – "**Miss Elner Martin** who resigned as home economics teacher, has gone to Oakland," *SYVN*, June 16, 1939, p. 1; "High School Notes. **Edwin M. Dill**, Master Potter, presented a demonstration on the making of pottery at the school Friday afternoon at 2:45. He started with the history of pottery-making … and told of his own seven years' apprenticeship, where the clay was found, and how it is prepared; then he kneaded a lump of it to the right consistency, placed it on the wheel, and fashioned a jug and two vases during his 45-minute visit. All during the process of making the jug and two vases, he explained the different details and related interesting happenings which took place while he demonstrated the methods of making pottery at the San Diego and Chicago World's Fairs…," *SYVN*, Nov. 3, 1939, p. 1; "Captain Art Hook, world-famous deep-sea diver, will appear at the high school at 8:40 Monday morning, December 11th…. With him he brings a large number of oil paintings, each about four feet square, to show the kinds of plant and animal life abounding in Davy Jones' Locker…," *SYVN*, Dec. 8, 1939, p. 3.

1942 – "High School Faculty Listed… **Miss Theodora Corey** – Home Economics and Art… **L. L. Jones** – Mechanical Drawing and Administration," *SYVN*, July 31, 1942, p. 1; "All Valley Schools Will Open Monday… Four new courses have been added… Aeronautics, Art, Mechanical Drawing, and a general Home Economics course for girls who are not specializing in this field…," *SYVN*, Sept. 11, 1942, p. 1; "Red Cross, **AWVS** to Bring Cheer to Soldiers… Art students of the high school are making posters to advertise the program…," *SYVN*, Oct. 30, 1942, p. 8; "**AWVS**… Attractive posters made under the direction of **Miss Theodora Corey** at the high school will be placed this week near the cartons where Christmas gifts for service men are being collected," *SYVN*, Nov. 6, 1942, p. 8.

1943 – "Home Economics Teacher… left on Tuesday to spend the summer vacation in Berkeley and other points. **Miss Corey** reports a very successful class year… The latest project under her supervision has been leather work, successfully undertaken in the Art and Craft class," *SYVN*, June 11, 1943, p. 1; "Valley High School to Open… faculty… **Mr. [L. L.] Jones**, principal and mechanical drawing," *SYVN*, Aug. 27, 1943, p. 1; "School Supplies. There were plenty of smiles on the Mechanical Drawing students' faces Friday morning when they saw that

everyone had a stool to sit on. Before these stools arrived, a few unlucky students had to use chairs while drawing which were not very comfortable…," *SYVN*, Nov. 19, 1943, p. 1.

1944 – "Miscellaneous Notes. The high school has received on approval a considerable number of strip films in the field of science, mathematics and mechanical drawing," *SYVN*, March 3, 1944, p. 8; "High School… Art: Seven girls are studying landscape painting and drawing with **Leo Ziegler**, who has been employed on a part time basis to teach art at Santa Ynez Valley high school. Mr. Ziegler is a graduate of the university of Vienna and has studied with some of the great masters of Europe," *SYVN*, Dec. 8, 1944, p. 4.

1945 – "Registration of Students… The program of classes is as follows: 1st period: Home economics III… mechanical drawing… 3rd period: Home economics II… 4th period: … 5th period: … arts and crafts… 6th period: Home economics I … 7th period: Related art …," *SYVN*, Aug. 17, 1945, p. 1; "SYVU Hi School News… New elective classes offered at Santa Ynez this year are mechanical drawing taught by **Mr. Venske**…," *SYVN*, Sept. 21, 1945, p. 4.

1946 – "High School… The Freshmen of **Mr. Ziegler**'s Art Class were painting a romantically located house in Solvang. Out came the owner – S. R. Rasmussen who looked at the pictures and said he would buy one. He chose the painting made by **Ronald Nielsen** and paid $5.00 in cash…," *SYVN*, Jan. 25, 1946, p. 5; "High School Notes… Seven students of the Art Class made an excursion with **Mr. Ziegler** to the Santa Barbara Museum of Art, Thursday night, January 24. They were: Else Jensen, Dolores Judge, Patty Flynn, Mary Beth Woodill, Jane Best, **Ronald Nielsen** and Alvin Jorgensen. They studied interesting water colors of **Emil Kosa** and **Phil Dike**, two well-known California landscape painters and the wildlife paintings of Glade B. Kennedy. They also attended a lecture, 'What is Modern Art?' by **Donald Baer [Sic. Bear]**, Director of the Museum. His lecture was illustrated by colored slides from the collection of the Museum of Modern Art of New York…," *SYVN*, Feb. 1, 1946, p. 4; "High School Notes … **Mr. Venske** took pictures for our school annual, '*The Pirate Revue*,' Wednesday and Thursday of last week. Pictures of the FFA boys, student council members, basketball and football players were taken Wednesday. On Thursday the chorus, band, faculty, girl's PE, school reporter, school employees and the four classes had their pictures taken. Three pictures were taken of each class – one of the boys and one of the girls. The other was of the class officers," *SYVN*, Feb. 22, 1946, p. 4; "The Senior Class, accompanied by Mr. Hamm and Mr. Silva, were in Santa Barbara last Saturday to have their photographs taken at **McAllister's Studio**. Mr. Hamm drove the school bus," *SYVN*, Feb. 22, 1946, p. 4; "**Mrs. Florence MacAllister [Sic.]** was here to take photograph orders from the Senior class members, Tuesday," *SYVN*, March 15, 1946, p. 4; "High School Notes… Seniors who had their photographs taken at **MacAllisters Studios [Sic.]**, received their finished photographs last Wednesday," *SYVN*, April 5, 1946, p. 8; "High School Notes… Easter Vacation… **Mr. Ziegler** spent the week at home…," *SYVN*,

April 26, 1946, p. 8; "High School… Mr. Hamm took **Mr. Ziegler**, Patty Flynn, Mary Beth Woodill, and **Chiyoko Ochi** to El Capitan Beach to paint last Sunday, May 19. They also had a picnic… Annuals Received… **Mr. Venske** and the student council are responsible for the making and assembling of this annual. We hope to make this a regular school project…," *SYVN*, May 24, 1946, p. 7.

1947 – "High School Teaching Staff… program of classes: … Second period … mechanical drawing … Third period … art… Fourth period … art …," *SYVN*, Aug. 22, 1947, p. 1. [ed. - **Leo Ziegler** is also teaching art in night school.]

1948 – "Valley Schools… **Leo Ziegler** will again offer instruction in art…," *SYVN*, Aug. 27, 1948, p. 10; "H.S. Offers Handbook… contains… a history of the school… complete list of faculty members and their educational background… activities…," *SYVN*, Sept. 10, 1948, p. 3; "Hamm Analyzes Problems of Small High Schools… 'Many of the problems of finance stem from the high per student cost of operating small high schools.' Mr. Hamm wrote, 'Small schools must have facilities for shop work, homemaking, crafts… in addition to college preparatory classes… One of the avowed and oft stated purposes of Amendment 3 was to provide financial assistance to schools in rural areas in order that students in those areas might receive equal educational opportunity…," *SYVN*, Dec. 3, 1948, p. 4.

1949 – "Art Students Enter Exhibit at Los Angeles. Students in the art class of **Leo Ziegler** at the Santa Ynez Valley Union High School have entered paintings in the third **scholastic art** regional exhibition at Bullock's Downtown Store in Los Angeles..." and student names cited, *SYVN*, Feb. 18, 1949, p. 1; "High School… Every year about this time **Mr. Venske** gets out his trusty camera and starts taking pictures for the annual… Many of the students got their share of exercise, running over to the gym, having their picture taken, then going back to the main building. Maybe the next period they would have to go back over to the gym and have their picture with another group…," *SYVN*, Feb. 25, 1949, p. 3; port of homemaking II class under the direction of **Mrs. James Simerly** and article on homemaking and the study of interior decoration, crafts class redecorating of school sick room, *SYVN*, March 11, 1949, p. 1; "Art Students Take Field Trip… Students of the Valley Union High School art class and members of the Adult Art Class took a field trip recently to the Santa Barbara Museum of Art to study the first exhibition of the leading American watercolorist John Marin and to view the students exhibit of commercial art work of the Art Center School of Los Angeles. Participating in the tour were …," and participants named, *SYVN*, April 22, 1949, p. 7; "H.S. Teacher Plan for Summer… **Leo Ziegler** plan to remain in the Valley for the Summer… Mr. and **Mrs. John Simerly** will go on a week's vacation and will return to start building operations on their new home. **Harold Venske** plans to spend some time visiting his sister in Monterey. All members of the faculty will return to their positions at the high school next Fall with the exception of … Mrs. Simerly… **Mrs. Simerly** [will devote] her full time to housewife duties," *SYVN*, June 24, 1949, p. 3; "H.S. Teaching Staff Complete… replace the vacancies created

by the resignations of … **Mrs. James Simerly**. Mrs. **La Vaut** will teach homemaking, arts and crafts…," *SYVN*, July 1, 1949, p. 1; "H.S. Registration Next Week, Class Schedule Announced… First period… commercial art… Fourth period… mechanical drawing… Sixth period… home crafts… The art classes in landscape and still life painting will meet during the third and fourth periods on Tuesdays and Wednesdays. Students who wish to take art will be excused from regular class one day each week. Mr. Hamm said most students should register for five classes, one study hall and physical education," *SYVN*, Aug. 26, 1949, p. 1; "High School Notes… The students from **Mr. Ziegler**'s art class, most of them freshmen, have an exhibit of this year's first work in the hall of the main building. They show landscapes of Solvang and Santa Ynez and are excellently painted in water colors … The name of the students whose work are shown are … Barbara Vallance… **Michael Barnes**, Jack Love, Alton Turk …," *SYVN*, Oct. 14, 1949, p. 6.

1950 – "**Mrs. Anderson** to Join H.S. Faculty… the high school board has accepted the resignations of … Mrs. Mary La Vaut, home economics teacher… **Mrs. La Vaut** has taught at the high school the past year. She will teach near Fresno next term. Her husband will attend school in that area…," *SYVN*, May 12, 1950, p. 1; "H.S. Registration Starts Next Week… schedule of classes… Fourth period… farm mechanics and shop… commercial art… Seventh period: crafts. … **Leo Ziegler** will teach art classes in landscape and still life painting on Tuesday and Wednesdays during the third and fourth periods. Students who wish to take art will be excused from regular classes one day each week…," *SYVN*, Aug. 25, 1950, p. 1; "Philosophy of Education Developed During Past Six Years at High School," by Hal W. Hamm, principal, *SYVN*, Nov. 24, 1950, p. 1; "HS Senior Gay Nineties Play Dec. 7… French comedy about the trials of a country maiden back in grandpa's day. Art instructor **Leo Ziegler**'s painting will add beauty and color to the stage set," *SYVN*, Nov. 24, 1950, p. 6.

1951 – "… H.S. Building Program… gave praise to those who had played a part in the construction of the new building. Included … **Mr. and Mrs. Uno Sandvik** who contributed a painting of Beethoven for the new building…," *SYVN*, March 23, 1951, p. 3; "Art Class visits Museum… under the guidance of **Leo Ziegler**, visited the Santa Barbara Museum of Art on Tuesday to view several exhibitions which were just opened. Among these were the California Water Color Society and the exhibitions of Jean Varda and Howard Cook, and last but not least the showing of the Santa Barbara county High school art, arranged by **Joseph Knowles**. The Santa Ynez Valley Union High School show. Participating in the excursion to the museum were Pat Pogue, **Lanny [Sic. Xanny?] Orton, Helen Holman**, Gloria Lynch, **Judy Clark, Shirley Crandall**, Joanne Karman, **Ruth Lindegaard**, Vicki Smith, **Michael Barnes, Tony Bell**, Pedro Contreras, Marvin Jensen, **Glen Harris**, Alton Turk, and Aage Block," *SYVN*, Dec. 14, 1951, p. 10.

1952 – "Horse Show… Second Annual Santa Ynez Valley Horse Show… Colorful posters made by the students of

Mrs. Jack Anderson's class at the high school are being circulated throughout the county. Programs for the show are being printed at the high school," *SYVN*, March 7, 1952, p. 1; "Art Class Visits Museum… Santa Barbara Museum of Art where paintings of Lovis Corinth, a memorial exhibition of unusual interest, are on show. The visit was a kind of memorial for the late Director **Donald Bear**, who was always very helpful to all art students. Months ago he had extended an invitation to the art class to view his show of the great German painter's work… Those on the trip from the high school were Ardis Naur, Pat Pogue, **Helen Holman, Tony Bell**, Georgia [Sic. Gloria] Lynch, **Judith Clark, Ruth Lindegaard, Shirley Crandel**, Joan Karman, Lee Smith, **Glen Harris** and **Leo Ziegler**, instructor," *SYVN*, March 28, 1952, p. 5; "Four Students From High School Capture Bank of America Awards… Santa Ynez Valley Union High School… Ardis Naur, fine arts… [given] to high school seniors for achievement in scholarship, leadership, and promise of future success and service to society…," *SYVN*, March 28, 1952, p. 3; "High School Registration Begins Monday… First Period: Crafts… Seventh Period: Design… Mechanical Drawing…," *SYVN*, Aug. 22, 1952, p. 1; "Several New Classes Offered Students at High School… Two classes in general shop will be offered with Robert M. Stockton and Robert Wooldridge each having a class. These classes are designed to help boys learn to use hand tools and will provide instruction in woodworking, elementary electricity, metal work … A class in mechanical drawing will again be offered this year. It will be open only to 11th and 12th grade students and will be taught by **Harold Venske**… The class in design and crafts, which was offered as a combination class last year, will be divided into two classes. The crafts class will include work in leather tooling, ceramics, textile paintings, etc., and the class in design will center around a more careful study of design and various art forms. These classes will again be taught by **Mrs. Jack Anderson**… **Leo Ziegler** will again teach classes in landscape and still life painting and drawing and will also teach a class in art appreciation. The class in art appreciation will offer an opportunity for students to study the history and view and discuss the work of the great artists. The classes in art will meet only one day a week, and students may register for art in addition to a regular program of classes…," *SYVN*, Aug. 22, 1952, p. 5; "Senior Play Due Nov. 21… 'January Thaw'… **Leo Ziegler** will lend his painting touch in designing the scenery," *SYVN*, Nov. 14, 1952, p. 1.

1953 – "Art Students Visit Exhibit – **Scholastic Art Award**s at Bullock's and the art collections of the County Museum. Those taking part were **Thor Brandt-Erichsen**, Judy Clark, Patty Emery, **Glen Harris, Ruth Lindegaard**, Mary Lona, Evangeline Neitzert, Vicki Smith, Annette Stuart and **Sanny Orton**…," *SYVN*, March 6, 1953, p. 2; "H. S. Annual Distributed to Students… **Helen Holman**, associate art editor, Judy Clark, associate art editor… **Tony Bell**, photographer… Mrs. **Lenora Anderson**, annual advisor," *SYVN*, June 5, 1953, p. 8; "Thirty-Five Different Subjects… Art … Craft… Design… The Art class taught by **Mr. Ziegler** will be offered as a regular class and will meet during the third period four days a week. On one of these days the class will continue through the fourth period in order to make it possible for students to have a double

period for landscape painting. Students who take Art should schedule a study hall the fourth period if possible, otherwise they will need to arrange to be excused from their fourth period class one day a week on the day that Art meets a double period…," *SYVN*, Aug. 21, 1953, p. 5; "Valley School Children Return to Classrooms… high school… **Harold Venske**, Algebra I and II, geometry, mechanical drawing and physics…," *SYVN*, Aug. 28, 1953, p. 1; "S.Y. High School Agriculture Students Learn by Doing, Classroom, Shop… Among the projects in metal work, the students have made trailers, repaired farm machinery, repaired and reconstructed automobiles, while, in woodwork they have made silage bunks, hay racks, calf pens, hog troughs, self-feeders, cabinet work, including gun racks, coffee tables and they are now working on their first TV table…," *SYVN*, Dec. 25, 1953, p. 9.

1954 – "Mother of Senior… impressions of the recent high school class educational trip … On Monday we checked out of the hotel at 8 a.m. for a guided tour of the **Walt Disney Studio** … Disney's studio guide explains the drawing animation and complete cycle necessary to project their cartoons on the screen. They explain the mixing of paints and ink used and the many drawings necessary to be able to flash one second of an animated character on the screen …," *SYVN*, June 18, 1954, p. 4; "HS Preps for Opening… schedule of classes… 1st Period… 7th Period: crafts… mechanical drawing, general shop. The art class will also meet the fourth period one day a week. Students who take art should schedule a study hall fourth period, if possible…," *SYVN*, Aug. 27, 1954, p. 8.

1955 – "HS Students Sign Up Time… the schedule follows: … Third Period: … art (Monday, Tuesday, Wednesday and Thursday). … Sixth Period: design… Seventh Period: crafts… general shop," *SYVN*, Aug. 26, 1955, pp. 1, 8; "Homemaking Building Plans Ok'd… Construction is expected to begin in November with completion in early summer…," *SYVN*, Sept. 16, 1955, p. 8.

1956 – "HS Seeking Information on Former Faculty Members" and list of former teachers, *SYVN*, April 6, 1956, p. 3; "SB College Aiding in Plans for Industrial Arts Building. The industrial arts class of Santa Barbara College, University of California, is aiding the Santa Ynez Valley Union High School in developing preliminary plans for the construction of a new industrial arts building at the high school. The new addition… will probably be constructed within the next year… The general shop classes are at present housed in the vocational agriculture building and share the facilities with classes in farm mechanics. With the increase in enrollment… it is necessary to offer additional classes in both vocational agriculture and industrial arts. In the past, the industrial arts program has been largely a general shop program with emphasis upon carpentry and with some work in mechanics and welding…," *SYVN*, April 13, 1956, p. 1; "60 Years of Progress… Here are Thumbnail Sketches of Personnel Connected in Operation of Valley High School… **Thaddeus G. Muradian** has been at the high school since 1954 after receiving his education at Pasadena City College and the University of Southern California. He teaches

chorus, band, English, coaches tennis, sponsors the music and photography clubs… He lives with his wife, Sylvia on Refugio Road, Solvang… Miss Muriel E. Verrill teaches homemaking… **Harold Venske**… Robert C. Wooldridge came to the high school in 1951 after teaching at Los Olivos elementary School. At the high school, he teaches general shop… **Leo Ziegler**, a doctor of law, received his education at the University of Vienna and Claremont Graduate School. He has been teaching art at the high school since 1944 and also instructs an adult art class. Ziegler and his wife, Esther, came to the Valley in 1940 and live at their Refugio Road Ranch, 'Sunny Hill.' Mrs. **Lenora K. Anderson** teaches sophomore English, crafts and designs and serves as co-sponsor of the sophomore class and advisor to the Yearbook staff. Mrs. Anderson came to the Valley in 1938 and has been teaching at the high school since 1950. She previously taught in the elementary schools in the Valley. She and her husband, Jack, live in Santa Ynez. Mrs. Anderson received her education at the University of California at Santa Barbara, the University of Southern California, the University of California at Los Angeles and Claremont College…," *SYVN*, April 27, 1956, p. 1; "School Staff Members… faculty… **Mrs. Lenora K. Anderson**, English, Design and Crafts… Miss Muriel Verrill, Café Supervisor and Homemaking… **Mr. Leo Ziegler**, Art. The faculty at Los Prietos High School is … **Mr. Chester E. Brownlee**, Principal, English, Math, Science, Crafts and Typing; **Mr. Kenneth M. Engle**, Physical Education, Sports Direction, Algebra, Shop, Drafting and Driver Education…," *SYVN*, April 27, 1956, p. 8; "Fall Registration at HS Underway… work in general shop is being extended to include broader training in the field of industrial arts… A number of elective classes are offered in the fields of … and art… The schedule follows: First Period… homemaking I… Second Period… general shop… homemaking III and IV and art (Monday only). Third Period… art (Monday, Tuesday, Wednesday and Thursday). Fourth Period… general shop… Fifth Period… mechanical drawing… homemaking I. Sixth Period… homemaking II… Seventh Period: Crafts…," *SYVN*, Aug. 24, 1956, p. 5.

1957 – "Memo Pad. Valley Views… Approximately 15 drafting students at Santa Ynez Valley Union High School accompanied by instructor **Phil Condit**, took part in a field trip to the Douglas Aircraft plant yesterday…," *SYVN*, April 5, 1957, p. 2; photo and "HS Shop Students Building Outboard Boats…general interest in boating … since the development of … Lake Cachuma as a recreational area…," *SYVN*, May 24, 1957, p. 5; "Construction Underway on HS Industrial Arts Building…," *SYVN*, June 28, 1957, p. 1; "Buellton By-Lines… Another building on the Santa Ynez Valley High School grounds is under construction. It will house equipment for photography, metal work, woodwork, plastics, radio and various other crafts. This will give the students an opportunity to learn good workmanship and develop skill in a number of trades …," *LR*, July 4, 1957, p. 5; "Advance Registration for High School Set… First period, general shop, homemaking II… Second period… homemaking I, and art. Third period, crafts… homemaking I… Fifth period… homemaking III-IV… Sixth period, general shop…," *SYVN*, Aug. 23, 1957, pp. 1, 4; "Career Talks Due at PTA… A representative of

the University of California at Santa Barbara College will speak on drafting as a career," *SYVN*, Nov. 29, 1957, p. 2; "Post HS Opportunities Told at PTA Meet… section sessions… drafting, Dr. Kermin Seefeld, UCSBC, **Phil Condit**…," *SYVN*, Dec. 6, 1957, p. 5.

1958 – Photo of students in crafts class, a part of the industrial arts program, making copper enameling, and "New Industrial Arts Building Completed … headed by **Fillmore Condit**, who has been a member of the faculty since 1956 and who was graduated in 1955 from the University of California at Santa Barbara… Condit said of the seven girls enrolled in industrial arts, five are studying crafts and two are enrolled in drafting class… The lowest level provides space for a photographic darkroom, ceramic shop kiln, lumber storage and printing equipment. The general shop and finishing room occupy the main floor, while students enrolled in drafting study are in a classroom on the uppermost level… The new building is equipped with tools and machinery to teach woodworking, metal work, plastics… photography, crafts and the graphic arts. The classroom is fitted as a drafting room and contains all of the necessary equipment for basic drafting as well as mechanical drawing, house planning, design, rendering, and some free hand drawing… eight main objective… appreciation of good workmanship and design… etc., " *SYVN*, Jan. 31, 1958, p. 1; "Four Valley HS Senior Win Awards… Bank of America's statewide achievement award program… **Alex Valles**, fine arts…," *SYVN*, March 21, 1958, p. 1; photo of Award Winners for Bank of America program including **Alex Valles** for fine arts, *SYVN*, March 28, 1958, p. 5; photo of students in shop, p. 4, and photo of students in drafting class, p. 5; "High School to conduct Advance Registration… Schedule… First period: General Shop… Homemaking II, Second period: Crafts… Homemaking I, and Art. Third period: … General Shop… Art. Fourth period: … Homemaking III-IV. Fifth period: … Drafting… Homemaking II-IV. Seventh period: … General Shop I…," *SYVN*, Aug. 22, 1958, p. 1; "H.S. Students Publish Paper, 'Pirate Log' … The paper's staff includes … Pat Marshall, artist…," *SYVN*, Oct. 17, 1958, p. 1; "Pirate Revue Sale Remains Under 200… new annual featuring color and individual pictures of all students… Miss Marshall recently designed the cover for the '59 yearbook: a Pirate caricature and a Pirate ship in white on a screen background," *SYVN*, Dec. 19, 1958, p. 4.

1959 – "Fine Arts Night Set for May 15 … Dramatics Club… will sponsor a Fine Arts Night at the Veterans Memorial Building in Solvang… as a means of raising funds for school productions… The main attraction… one-act drama, 'The Wall.' … war time tragedy… Pat Marshall and Lee Adams are designing the set…," *SYVN*, May 8, 1959, p. 7; "Summer Classes Start Monday at High School… first summer school offered in the history of Santa Ynez Valley Union High School… classes in English… mathematics…," *SYVN*, June 26, 1959, p. 1; "Nine New Teachers… Valley High… two of the 22-member faculty will work on a part-time basis. They are … librarian and **Leo Ziegler**, art instructor… **Earl Petersen** who is in the drafting and design business in Solvang… **Wilfred Stensland** [biography] … he will teach classes in industrial arts …," *SYVN*, Aug. 21, 1959, p. 1; "Advance

Registration Set for High School… First period… crafts… homemaking II… Second period: … crafts…homemaking II, art… Third period: homemaking I, art… Fourth period: homemaking III and IV. Fifth period… general shop I… home making I. Sixth period: … drafting… advanced general shop… homemaking I. Seventh period: drafting… advanced general shop…," *SYVN*, Aug. 28, 1959, p. 1; "Valley High's June Class… Other local people enrolled in college for the first time are … Joyce Faulkner, Art Center, Chicago…," *SYVN*, Sept. 18, 1959, p. 5.

1960 – "PTA International Night… Featuring a dinner with foreign dishes, displays of arts and crafts of lands around the world… The International Night program will also feature an exhibition of Danish lace making by **Miss Elna Larsen** and pottery making by **Mrs. Kirsten Pedersen**. There will also be displays of wood carving, art objects and paintings from countries around the world," *SYVN*, April 1, 1960, p. 1; "Registration Next Week… Schedule… first period… crafts… homemaking III-IV, art… Second period… crafts… art… Third period… general shop I… drafting II … homemaking I and art. Fourth period… drafting I… homemaking I… Fifth period… general shop I, homemaking I… Sixth period… general shop II… homemaking II… Seventh period… crafts IIA…," *SYVN*, Aug. 26, 1960, p. 5; "High School Arts Building Addition Set. The board of trustees of the Santa Ynez Valley Union High School Wednesday authorized preparation by architects for an addition to the industrial art building… ," *SYVN*, Sept. 16, 1960, p. 1.

1961 – "**Ziegler** Art Pupils Open H. S. Exhibit. Paintings recently completed by students of the late Leo Ziegler … member of the faculty of the Santa Ynez Valley Union High School for 17 years, have been framed and placed on exhibit in the school auditorium … arranged by Mrs. Ziegler and Julio Contreras, will continue through April, which includes **Public Schools Week**… Hal W. Hamm, high school principal, said 'several years ago we asked Mr. Ziegler to arrange with seniors in art to leave one of their paintings to the school upon graduation. This tradition has been followed for 12 or 13 years and there are a number of students' paintings hanging in the classrooms. Mrs. Ziegler is arranging with the senior students in art to leave pictures with us again this year to hang in our new classrooms,' Hamm added," *SYVN*, March 31, 1961, p. 2.
See: "Posters," "Santa Ynez Valley, Ca., Adult/Nigh School," "Scholastic Art Exhibit," "Works Progress Administration," 1936

Santa Ynez Valley Woman's Club (Solvang)
Woman's Club originally founded 1927, renamed to Solvang Woman's Club, and renamed again in 1959.

■ "Woman's Club in Election, Approves Change of Name… Known since 1928 as the Solvang Woman's Club and with a membership of 95 throughout the Valley and in Santa Barbara… The Valley Woman's Club has its own building on Atterdag road and has staged meetings there the past nine years. In the coming year, the club will have three sections: book review, music study and writers. An historical society project is in the planning stage…," *SYVN*, June 19, 1959, p. 3.

Santa Ynez Valley Woman's Club (notices in Northern Santa Barbara County newspapers on microfilm and on newspapers.com)
1959 – "Coming Fair, Forming of Historical Group [i.e., **Santa Ynez Valley Historical Society**] Chosen as Major Projects by Woman's club… the fair is to raise money for the long-range project of tree planting for the Valley, beginning with Solvang…," *SYVN*, Oct. 16, 1959, p. 3.
1960 – Photo of **Oscar Lindberg** and sign he painted for the Santa Ynez Valley Woman's Club, *SYVN*, June 17, 1960, p. 6; "Various Reports Given... children's concert here in the Spring. The art committee, under the leadership of **Mrs. Alfred Constans**, is planning special events…," *SYVN*, Oct. 21, 1960, p. 8; **Edwin "Gledhill** Tells Club Women Historical Society Import," *SYVN*, Dec. 16, 1960, p. 3.
See: "Mud Mill Pottery," 1965, "Joughin, Helen Eloise," intro., 1973, "Lindberg, Oscar," 1960, "Santa Ynez Valley Historical Society," "Solvang Woman's Club"

Scalf, Richard (Santa Maria)
Inventor of the process that allowed the firing of photographs into ceramic tile, 1947.

■ "The ancient age-old art of ceramics and the modern miracle of photography have finally been brought together in a new, highly complicated process in which photos may be fired into tile plates at high temperatures. The amazing story of tile photography was told here today by Richard Scalf, inventor of the process, who is now a local resident. The Scalf-light photo process took more than eight years to develop, he revealed, and was brought to perfection just as the war broke. No work was done during the war years, however, due to lack of necessary, high priority photo equipment, he said. Although the process is an innovation in the photographic industry, Scalf is not planning to 'go commercial' with his discovery, he said, as he has other plans for the new development which he did not reveal. The process of printing photos on tile, and of then firing the tile at temperatures of 2000 degrees Fahrenheit, will give the photos an enduring quality that is almost unbelievable. They are practically indestructible, are impervious to heat (a blow torch will not obliterate the image), an iron nail cannot scratch the image, and immersion in water for centuries would not alter the image… Details of the process are confidential, Scalf says, but some of its general principles were disclosed. Under a photographic safe light, an unbaked tile is coated on one side with a photographic emulsion, which strangely enough, contains no silver nitrate, a 'must' in other photographic development. The emulsion may contain any ceramic coloring or pigment. As a matter of fact, Scalf says, photo toning is accomplished even before the 'print' is made. An ordinary film negative containing the desired image is placed over the tile emulsion and exposed to a powerful light for a brief period of time. When the negative is removed, the first traces of the process may be seen, as the reproduced image has begun to appear in a foggy state upon the surface of the tile. The tile is then set aside in the dark and allowed to dry, after which it may be placed under any kind of light without damage to the image. Later, the tile is fired for four hours and cooled for six hours. During the firing process,

the foggy image becomes clear and distinct. The image now is as impervious to wear and tear as any well-glazed pottery. ... The tile may be ground down for mounting in a picture frame if desired... The process may become of great value in preserving permanently historical records, as paper prints and celluloid films are hardly enduring in terms of millenniums," per "Local Man Develops Process to Photograph on Tile Surface," *SMT*, Feb. 8, 1947, p. 1. *This individual could not be more fully identified.*

Scandinavian Arts and Crafts (Solvang)
Shop in the Old World Metalcraft Building that sold metalcraft made by Walter Kristensen as well as imported objects, 1956+. Proprietors were Bendt and Marie Fischer.

■ "Rare Art Display to Mark Opening of shop tomorrow... The Fischers will host an open house... at their new shop which features a line of imported wares from [the company] Danish Art, exporters, and including ceramics, silver, applied art, electrical fixtures, interior decorations and home furnishings. ... Solvang's newest arts and crafts shop will also feature the hand-made metal craft of **Walter Kristensen**," *SYVN*, May 4, 1956, p. 3.

Scantlebury, Elizabeth Ellis Loan/e (Mrs. Spurgeon Charles Scantlebury) (c. 1858-after 1933) (Sierra Madre)
Maker of costumed dolls purchased by the Blue Mask Club for Santa Maria High School, 1928. Visited Santa Maria, 1927.
See: "Blue Mask Club," 1928, and *Central Coast Artist Visitors before 1960*

Scheidt, Isabel (Mrs. Louis Andrew Scheidt) (1892-1972) (Hollywood)
Her painting, purchased by the Penny Art Fund, was won by the Alpha Club, 1946.
See: "Alpha Club," 1946, and *Central Coast Artist Visitors before 1960*

Schilder, Carol Ann (Santa Maria)
Student, Santa Maria High School, who submitted art to Scholastic Art Exhibit, 1959. Won a certificate of merit in the Latham Foundation poster contest, 1959. Won top honors in Elks Rodeo window decoration contest, 1962. Helped design props/sets for Hancock College play, 1962.
See: "Allan Hancock College, Art Department," 1962, "Elk's Club – Rodeo," 1962, "Posters, Latham Foundation (Santa Maria)," 1959, "Santa Maria, Ca., Union High School," 1959

Schmidt, D. K., Rev.? (West Denmark, Wisconsin and Walla Walla, Washington?)
Hand carver of pulpit and altar at Bethania Lutheran Church, Solvang, 1953. "A shoemaker of West Denmark, Wis."
1953 – Hand carver of pulpit and altar at Bethania Lutheran Church, Solvang, *SYVN*, July 31, 1953, p. 5.
This individual could not be further identified.

Schmidt, Janet E. (Mrs. George J. Schmidt) (Santa Maria)
Fine Arts and Philanthropy committee chairman of Junior Community Club, 1953/54.
See: "Junior Community Club," 1950, 1953

Schneider, Esther Wood (Mrs. Gustavus / Gustave Schneider) (1879-1943) (Oakland / Santa Maria)
Painter whose artworks were shown at a party given in Santa Maria in her memory by her husband, 1943. For many years, while in northern California, she was an artist and a Camp Fire Girls executive.

■ "Mrs. Schneider ... Mrs. Esther Wood Schneider, 64, wife of City Recreation director Gustavus Schneider, died Saturday afternoon ... She had been in failing health for some time. Deceased was a native of Ione, Amador county. In addition to the husband, she is survived by a sister, Mrs. Alice Wood Nicklin of Los Angeles... Entombment... in Mountain View Mausoleum, Oakland," *SMT*, July 19, 1943, p. 1.
Schneider, (notices in California newspapers on microfilm and on newspapers.com)
1924 – Port. as Campfire Leader, *Oakland Tribune*, Feb. 1, 1924, p. 26 (i.e., *Daily Magazine*, p. 1?)
1925 – "Will Speak ... Mrs. Esther Wood Schneider, Camp Fire executive of Oakland will make an address at the High school auditorium ... Mrs. Schneider talks over the radio KGO on every Friday to the girls from 5:30 to 6 p.m.," i.e., "'Girls' Half Hour," *Petaluma Argus-Courier*, Jan. 6, 1925, p. 7; MOTHER – "Last Rites Held for Mrs. Woods... came to California in 1875, the wife of a Baptist minister...," *Oakland Tribune*, Aug. 27, 1925, p. 2.
1937 – "Art Exhibit at Mission Inn... by the newly-organized Artists and Craftsmen's Association of Sonoma County... oils by Esther Wood Schneider...," *Santa Rosa Republican*, Aug. 25, 1937, p. 5; "Art Exhibit ... second exhibition of work of Sonoma county artists will be held at Chappelle's, 412 Mendocino avenue... Oils of Esther Wood Schneider, who recently came here from southern California, will be featured. The exhibit is being arranged by Artists and Craftsmen of Sonoma county ...," *Santa Rosa Republican*, Sept. 17, 1937, pp. 1, 2; "Exhibit of Oils to Supplant Watercolors... Chappelle's studio in Mendocino avenue ... Next week's exhibit will be of some of the oils of Mrs. Esther Wood Schneider, the collection to include landscapes, seascapes and flower studies. One oil in particular should interest everybody who has ever driven around San Rafael and Sausalito looking at the old shacks on stilts in the water. ... This poetic expression of mood is something especially noted by critics in her works and, combined with a rare clarity of color, characterizes her

work. Mrs. Schneider has had exhibits at Gumplo and Barker Brothers galleries in Los Angeles, in the Hotel Laguna at Laguna Beach and at Riverside Mission Inn in Riverside and at the present time has some of her work on display at the Sonoma Mission Inn in another Artists and Craftsmen's exhibit…," *Santa Rosa Republican*, Sept. 18, 1937, p. 8; and another announcement in *Petaluma Argus-Courier*, Sept. 17, 1937, p. 4.

1938 – "Craftsmen to Exhibit at Fair Here… Artists and Craftsmen of the Redwood Empire… will have an outstanding exhibit at the Fourth District Agricultural Fair (Sonoma-Marin) in Petaluma… Included in the exhibits will be … oils, Esther Wood Schneider, Santa Rosa…," *Petaluma Argus-Courier*, Aug. 5, 1938, p. 8.

1939 – "Artists and Craftsmen… of the Redwood Empire entered an exhibit in the Citrus Fair … Esther Wood Schneider exhibited several small oils, a landscape, a seascape and a still life. Mrs. Schneider is formerly of Laguna Beach and well-known in southern art circles. She is a charter member of the Artists and Craftsmen…," *Cloverdale Reveille* (Cloverdale, Ca.), Feb. 23, 1939, p. 4.

1943 – "Course Ends… party for members of the class in the home of Gustavus Schneider, director of recreation… a showing of the oil paintings of the late Mrs. Schneider …," *SMT*, Nov. 24, 1943, p. 3.

And, more than 330 California newspaper articles for "Esther Wood Schneider" primarily concerning Camp Fire work, were not itemized here.

Schneider, (misc. bibliography)
Esther Schneider is listed in the 1910 U. S. Census in Oakland, and in the 1920 U. S. Census in Berkeley, and in the 1930 U. S. Census in Riverside, and in the 1940 U. S. Census in San Jose; Esther Wood Schneider was b. April 17, 1879 in Calif., mother's maiden name Harbour, father's Wood, and d. July 17, 1943 in Santa Barbara county per Calif. Death Index (refs. ancestry.com).

Scholarship, art
Bank of America annually gave art scholarship / awards to the most outstanding high school graduating senior. Scholarships were also given out by the Santa Ynez Valley Art Exhibit, and various civic clubs. The College of Art and Crafts in Oakland gave scholarships to attend their college to graduating high school students whose art merited it.
See: "Alpha Club," (?) "Lompoc, Ca., Union High School," "Saint Mark's-in-the-Valley," "Santa Maria, Ca., Union High School," "Santa Ynez Valley Art Association," "Santa Ynez Valley Art Exhibit," "Santa Ynez Valley Union High School," "Sedgwick, Francis Minturn"

Scholastic – Ansco Photography Awards competition.
Photographic competition, annual, for students.
"Scholastic-Ansco Contest Offers numerous Prizes. This is the 32nd year for the … competition which is designed to stimulate and reward talent in photography and is the largest and oldest photographic contest run expressly for youth. … encourages participation in photography as a hobby and, among junior and senior high school students, possibly as a career… classifications include both the

amateur and advanced photographer…," *SMT*, Dec. 13, 1958, p. 13.

Scholastic Art Exhibit / Scholastic Art Awards
National art competition held annually among junior and senior high school students, sponsored by Scholastic Art magazine. Local winners' works were exhibited at the Regional *exhibit (the "Southern California Scholastic Art Exhibit" held in Los Angeles at Bullocks-Wilshire Department Store), and winners there had their work exhibited at the* National *Scholastic Art Exhibit held in Pennsylvania. Lompoc High School does not seem to have participated in this contest. Santa Maria High School students appear to have first entered competition in 1930 under Stanley Breneiser. At Santa Ynez Valley Union High School students under Leo Ziegler first placed in a Scholastic exhibit in 1947.*

■ "Local High Pupils Plan Participation in National Contest. Like students of thousands of other junior and senior high schools throughout the United States… seventh annual National Scholastic Awards for creative work in literature and art in which last year two Santa Marians received creditable mention. The event is sponsored and conducted by the scholastic national high school magazine… The art division of the scholastic awards includes prizes for pictorial art, sculpture, soap sculpture, decorative design, textile design, etchings, lithographs, engravings, pottery, jewelry, metal work and special prizes [for] work done with pen, pencil and colored drawing inks. In each of these classifications a group of prizes is awarded… Thirty students in the high school art department … have decided to enter this year's contests," *SMT*, Nov. 25, 1930, p. 5.

Scholastic Art Exhibit (notices in central California Coast newspapers on microfilm and the Internet)
1930 – "Local Students Win National… Two Santa Maria Union High school students, Merville Johnson, 20 and **Ninalee Waiters**, 18, have… their work included in the Third National high school art exhibit of the Scholastic Awards… The two drawings submitted… were a semi-decorative landscape, made with colored pencils by Johnson, and a decorative illustration in black, white and grey tempera paint by Miss Waiters… **Stanley G. Breneiser**, head of the art department … 'This is the first year that our work has been sent from the local high school,' …," *SMT*, April 26, 1930, p. 1.

1931 – "High School Art Department Students Seek Many Prizes… It will be the third successive year that local students have entered their work in national competition…," *SMT*, Nov. 16, 1931, p. 6; "National Prize Won by Student… Competing against more than 40,000 high school students from every state… **Robert Mason**, a senior B student at Santa Maria union high school, won honorable mention and a prize in the Charles M. Higgins' award class of the National Scholastic contest… This is the second year that students of **Mr. and Mrs. Stanley G. Breneiser**… have captured outstanding recognition …. Last year, two students had examples kept for exhibition in the Carnegie Institute and this year two more gained the same honor. One was an oil painting of a still life group made by Merville Johnson who graduated in the mid-year

class. The other is an unusual colored ink drawing of a portion of the high school and its surrounding made into a lettering pen by **Mason** who won the prize consisting of a set of drawing inks. His photograph and a record of his honorable mention are published in the current issue of *The Scholastic…*," *SMT*, May 6, 1931, p. 5.

1932 – "Art Work of Local Youth Wins in N. Y. Henry Evans, high school student and son of Mr. and Mrs. R. S. Evans … Young Evans, student in the art classes of **Stanley G. Breneiser**… entered a tempera painting made from Schubert's 'Impromptu,' a musical selection from which he drew an artist's conception on paper. … Writing in the *Los Angeles Times* about student art work, **Arthur Millier** says: 'Is there an American Art Renaissance? On the Pacific coast emphatically yes!'…," *SMT*, April 12, 1932, p. 4; "Art Work… For the third successive year the art work of Santa Maria high school students has placed in the annual art competition conducted by *The Scholastic* … Pencil sketches made from nature by **Rex Hall** and Carl Barbettini, both graduates of the local high school last January, received honors at the exhibit in Carnegie Museum, Pittsburgh, Penn., as did a block print by Curtis Saunders, senior in the Santa Maria school. A sketch by Henry Evans was one out of 100 that placed in a group of 15,000 exhibits entered in a special contest sponsored by the American Crayon company…," *SMT*, May 2, 1932, p. 1.

1933 – "Local Girl is National Art Winner. Elizabeth Cheadle, 18-year-old Santa Maria Union high school senior and daughter of Mr. and Mrs. H. T. Cheadle… third prize… for leather design… Her entry consisted of a leather purse, made, tooled and colored by herself as part of her high school art department work under… **Elizabeth Day Breneiser**… Miss Cheadle's cash award will be $15. Other local students who also entered the arts competition included Viola Bisho, **Carol Rushforth**, Ruth Litzenberg, **Elaine Dudy, Guida Signorelli**, Lloyd Johnston, Ruby Marston and **Byron Openshaw**. The contest, inaugurated in 1928 after a widespread response to the magazine's contest for the best cover designs, has two major classifications, the literary and art divisions, and several subdivisions," *SMT*, April 26, 1933, p. 1; "Santa Maria Girl Wins Art Prize. Pittsburgh, Pa. … Winners of scholarships and cash prizes totaling $10,000 awarded in the annual national competition in literature, crafts and visual arts, were announced today by *Scholastic* national high school magazine. Winners in the four major art divisions included Elizabeth Cheadle, 18, Santa Maria, Calif., third prize leather design," *SLO DT*, April 26, 1933, p. 2.

1935 – "**Elaine Dudy** Wins Art prize… pupil of **Elizabeth Day Breneiser**… honorable mention. The piece of work was a telephone screen with a modern design done in gesso and metallic colors. The screen, made and designed in the school Art department was sent to the Applied Art division of the National Scholastic awards…," *SMT*, April 22, 1935, p. 3.

1937 – "Art Student Wins National Prize … **Yukio Tashiro**, art student of **Stanley G. Breneiser**, in the high school, yesterday received word that he had won a cash award in the National Scholastic Art contest sponsored by the *Scholastic* High School magazine of Pittsburgh, Pa. The

Santa Maria boy's entry was a wood carving of a lion," *SMT*, April 30, 1937, p. 3.

1939 – "**Yukio Tashiro** is Again National Contest Winner … Scholastic … Last night his work hung with that of other prize-winning students, at the opening of an exhibition in the Fine Arts section of Carnegie Institute in Pittsburgh, Pa…. A piece of sculpture won the scholarship. He sent several pieces, all of which were placed in the exhibit." The scholarship was to California College of Arts and Crafts, Oakland, *SMT*, May 2, 1939, p. 3.

1947 – "Local Students Art… Miss Barbara Leonard and Miss Patty Flynn, students at the Santa Ynez Valley Union High School and both members of the art class conducted by **Leo Ziegler**, have received recognition in the Regional Scholastic Art Exhibit at Bullocks in Los Angeles…," *SYVN*, March 14, 1947, p. 6.

1948 – "Valley Youngsters Given Art Awards… A group of the Santa Ynez Valley Union High School – art class of **Leo Ziegler** – and youngsters of his art classes at Los Olivos and Los Alamos Schools, left last Saturday for Los Angeles to attend the presentation ceremony of Gold Achievement Keys and certificates of merit at the 1948 Southern California Regional Exhibit Scholastic Art Award… Among the 115 winners of Gold Achievement Keys selected by a 14-member expert-jury were Jimmie Jo Howell of the Santa Ynez Valley Union High School, Louise Rich of Los Olivos School, and Joan Moss of Los Alamos School. Their pictures will be forwarded to the Carnegie Fine Art Galleries, Pittsburgh, to compete there for a place in the national exhibit. Certificates of Merit for Achievement in Art were won by Frances Field, Lucy Rosales and Ruth Warner [Daughter of Mrs. K. C. Dumont, former owner of Rancho Santa Ynez] of the High School and by Nancy Hutchinson of Los Alamos school… In the afternoon the group went to Exposition Park to visit the galleries of the County Museum…," *SYVN*, March 12, 1948, p. 1.

1949 – "Art Students Enter Exhibit at Los Angeles. Students in the art class of **Leo Ziegler** at the Santa Ynez Valley Union High School … Dorcas Aldrich, Darell [Sic. Darrel] Anderson, **Michael Barnes**, Alice Flynn, Lawrence Hernandez, Jimmy Jo Howell, **Terry Hubbard, Dexter Kent**, Rose Squier, Etelvina Telles, **Barbara Vallance** and Ruth Warner," *SYVN*, Feb. 18, 1949, p. 1; "2 from Solvang School… Certificates of Merit have been awarded to Sylvia Casberg and Phyllis Toll, students of the Solvang Grammar school, for their outstanding art work… in the 1949 Southern California Scholastic Art Exhibition at Bullock's downtown. This exhibition of junior and senior high school art work, co-sponsored by *Scholastic Magazine* and Bullocks…," *SYVN*, March 11, 1949, p. 4; "Five Students Win Art Prizes… from three schools in this area… in the 1949 Southern California Scholastic Art Award Exhibition in Los Angeles… All are students of **Leo Ziegler**'s art classes… Darrell [Sic. Darrel] Anderson and Alice Flynn are the students from the Santa Ynez Valley Union High School…," *SYVN*, March 18, 1949, p. 1.

1950 – "An annual scholastic Art Awards exhibit will be held at Bullock's, Los Angeles, from February 25 thru March for the fourth consecutive year. Those entering from Los Alamos school art class are Laura Abeloe, Derrald Alexander, **Esther Benson**, Jeannette Cipollo, Lee

Contreros, Nancy Hutchinson, Curtis Munoz and Pat Parson," *SMT*, Feb. 4, 1950, p. 6; "Elementary Schools … Solvang … 1-2nd Grades. Our silhouettes are very lifelike and we enjoyed posing for them. We like our new paints and crayons and shall try our best to paint spring scenery. The following Solvang students have paintings entered in the fourth annual Southern California Scholastic Art Exhibit at Bullocks in Los Angeles: Vernon Madsen, Nancy Imbach, Karen Strandskov and Barbara Tanis. Last year two of our students earned awards in this display. They were Phyllis Toll and Sylvia Casberg," *SYVN*, March 3, 1950, p. 3; "Art Students from [Santa Ynez] Valley Win Top Prizes in LA. … For the fourth consecutive year, students of **Leo Ziegler**'s art classes took top honors. Certificates of merit for their outstanding art work were awarded to **Michael Barnes** of the high school… Attending the Scholastic Art exhibit and taking part in a trip to the Exposition Park County Museum were…," and student names listed, *SYVN*, March 3, 1950, p. 6; Los Alamos school students will enter, *SMT*, Feb. 8, 1949, p. 5, col. 3; "Students Win Art Awards. Certificates of merit were awarded Laura Abeloe and Lee Contreras for outstanding art work… **Leo Ziegler**, art teacher, took the winners to Los Angeles," *SMT*, March 11, 1950, p. 6; "Students Receive Art Certificates," *SMT*, March 31, 1950, p. 6.

1951 – "Valley Students Win Art Awards. In the fifth annual Southern California Scholastic Art Exhibit… **Michael Barnes** has been awarded a gold achievement key and one of his winning entries, a watercolor painting of Old Mission Santa Ines, will be sent to Pittsburgh, Pa. to compete there in the National Exhibition in the Fine Arts Galleries of Carnegie Institute… Marvin Jensen of Buellton, a freshman, whose two pictures were hung at the exhibit, was awarded a certificate of merit… The prize winners are students of **Leo Ziegler**'s…," *SYVN*, March 2, 1951, p. 5.

1952 – "**Virginia Johansen** Wins Regional Art Contest" with wc 'Village Scene', and she is 17-year-old senior at SMHS, daughter of Mrs. Gerda Johansen, *SMT*, Feb. 23, 1952, p. 5; "Local Student Wins Art Test at Los Angeles… "Students Win Art Awards… **Virginia Johansen**… gold achievement key… Art work done by the 200 winners… will be on exhibit in the fourth-floor lounge at Bullocks thru March 8. Then the winning entries will be shipped to the national exhibition at Carnegie Institute in Pittsburgh to compete for art scholarships," *SMT*, Feb. 25, 1952, p. 1; "Students Win Art Awards… 'Certificates of Merit for Achievement in Art' from the Valley high school are **Michael Barnes**, a senior, and Pat Pogue, a junior, both students of **Leo Ziegler**'s art class. Young Barnes is honored the third consecutive year in this annual contest, having been awarded two gold keys in prior years. After graduation he intends to continue his study in the fields of fine or commercial art…," *SYVN*, Feb. 29, 1952, p. 3; "Vern Heaney Wins School Art Contest," and he is from Los Alamos Elementary School and an art student of **Leo Ziegler**, and his art is one of 200 chosen from out of 7000 entries, *SMT*, March 4, 1952, p. 4.

1953 – "3 SM Students Get Art Awards… Gerald Teiseira [Sic. Teixeira], Melvin Hanson and **Betty Eya** …," *SMT*, Feb. 14, 1953, p. 1; "H. S. Student Wins Bullock's Art

Award. **Glen Harris**, sophomore student of **Leo Ziegler**'s art class, has won a certificate of merit… His picture of the Santa Ynez Valley Presbyterian Church in Ballard is on display in the exhibition at Bullock's in Los Angeles…," *SYVN*, Feb. 20, 1953, p. 1; "Hanson, Teiseira [Sic. Teixeira], Win Art Awards. Melvin Hanson and Gerald Teiseira [Sic. Teixeira], Santa Maria Union high school students, have won $25 awards in the 1953 National Scholastic art judging at Carnegie Institute in Pittsburgh. Melvin's award was based on a transparent water color; Gerald's on leathercraft. The two were among 40 Southern California young people to win either scholarships or awards. **Betty Eya**, also a student at the high school, won a place for her greeting card design in the Institute's art exhibition, which begins today and runs throughout the month…," *SMT*, May 2, 1953, p. 1.

1954 – "Three High School Students to Receive Arts Key Awards… Santa Maria Union high school… Mary Kay Sykes, **Henry Fujioka** and Dario Fraire… Accompanying the students to Los Angeles Saturday will be art instructors **Gordon Dipple** and **George Muro**," *SMT*, Feb. 19, 1954, p. 1; "Sydney Hopper… Wins Gold Achievement Key… In the eighth annual Southern California Scholastic Art Exhibit… Sydney Hopper, a freshman in **Leo Ziegler**'s art class has been awarded a Gold-Achievement Key. … Miss Hopper and her mother, Mrs. Joseph Hopper are invited by Bullock's as co-sponsor to the award ceremony… for the eighth consecutive year the students of **Leo Ziegler**'s art class have won honors in this contest," *SYVN*, Feb. 19, 1954, p. 1; port. of Dario Fraire, Mary Kay Sykes and **Henry Fujioka** from Santa Maria who won prizes, *SMT*, Feb. 20, 1954, p. 1; "Farm School Pupil Wins Art Award. Katy Tremaine, of Scottsdale, Ariz., an eighth-grade student of Mr. and Mrs. Percy Hodge's **Valley Farm School**, has been awarded a certificate of merit for achievement in art… Her water color, 'Junk,' depicting car wreckage in the background of a Los Olivos garage, is hung in the exhibit now held at Bullock's. … **Leo Ziegler** is art instructor of the Farm School's upper grades, while **Mrs. Viggo Brandt-Erichsen** teaches art and crafts to the smaller children," *SYVN*, Feb. 26, 1954, p. 4; port. of **Henry Fujioka** and Mary Kay Sykes – "Two SMUHS Students are Cited… **Henry Fujioka** … has won one of the 102 art scholarships offered in the 1954 National Scholastic Art awards event at the Carnegie Institute at Pittsburgh… The scholarship will pay part of the talented youngster's tuition to the California College of Arts and Crafts… [George] Muro reported that three art students at the local high school had submitted entries… Two of the three received awards… and Dario Faire… Miss **Sykes** won a $25 award for her leathercraft entry of a large woman's handbag made of combined cowhide and unborn calf. **Fraire**'s entry was a free shape carved teakwood bowl… **Fujioka**'s winning entry was a portfolio containing 19 different art objects ranging from oil and water paintings to textile designs. Chosen as an exhibition piece by the judges was one of Henry's transparent water colors …," *SMT*, May 8, 1954, p. 1.

1955 – "HS Students Win Four Art Awards… For the ninth consecutive year, students of **Leo Ziegler**'s art class have won honors in the annual Scholastic Art Award Contest… **Alex Valles**, freshman, Arne Christiansen and **Phil**

Leighton, sophomores, and Sarah Pardee, senior. Their paintings are hung in the exhibit now held at Bullock's in Los Angeles through March 5," *SYVN*, Feb. 25, 1955, p. 1; Photo of Sarah Pardee, **Phil Leighton**, Arne Christiansen, and **Alex Valles**, along with **Leo Ziegler** and the students' paintings and caption reads "Art Winners – For the ninth consecutive year students of Leo Ziegler's art class won honors… certificates of achievement …," *SYVN*, April 8, 1955, p. 5.

1956 – "Art Awards Deadline Saturday… for submitting entries in the 1956 Scholastic Art Awards… National prize winners are eligible for 75 art school scholarships and cash prizes… Art works will be screened and judged Feb. 8-10. Students may submit as many entries as desired," and article gives a LONG list of media, *SMT*, Jan. 17, 1956, p. 6; "Arthur Hibbits receives Award for Watercolor. A Certificate of Merit for Achievement in creative art has been recently awarded to Arthur Hibbits, a sophomore at the Santa Ynez Valley Union High School. This high honor also marks the tenth consecutive year that instructor **Leo Ziegler**'s art class, of which Hibbits is a member, has won honors in the annual southern California Regional Scholastic Art Contest. Hibbits' watercolor, selected from over 7500 entries of 14 counties is among 500 other works of art now on display at Bullock's Downtown Los Angeles through March 10…," *SYVN*, March 2, 1956, p. 8.

1958 – Port. of Mary Cordero, **Barbara Prater, Trinidad Amador**, and Tina Gamble, SM High winners in the Scholastic Art Regional Show held in LA. "Artists from Santa Maria High School took four of the top 100 places in a competition involving more than 7000 pieces of art from schools throughout southern California in Los Angeles… The winning pieces of art will be entered in a national competition, instructors **Nat Fast** and **Bob Gronendyke**, said. The art works are on display at Bullock's Department store in los Angeles. The winners will go to the city on Feb. 22 to receive their awards…," *SMT*, Feb. 12, 1958, p. 1; "Students Win in National Art Show," i.e., National Scholastic Art Awards – Mary Cordero and **Barbara Prater**, *SMT,* May 13, 1958, p. 3.

1959 – "Four Win Merit Awards for Art. Four Santa Maria High School art students have won certificates of merit in the art contest sponsored by Bullock's and the *Scholastic* magazine… Kara Warner, Carolyn Milton, Pat Morrell and Juanita Almaguer [Sig. Almaquer]. The winners traveled to Los Angeles with **Gronendyke** to view the exhibit at Bullock's… Kara Warner's entry was a giraffe made of chicken wire. A knight on horseback made of wire and brass was submitted by Carolyn Milton. A chicken-wire rooster by Pat Morrell and an old-style lettering exercise by Juanita Almaguer were also honored," *SMT*, March 11, 1959, p. 8.

1960 – "Local Students Enter Art Show. Thirteen students at Santa Maria High School have entered projects in the 14th annual Scholastic Art Awards program in Los Angeles, **Paul Winslow**, art instructor announced today. Keith Berry and **William Lister** both entered craft projects. **Nat Fast** is the craft instructor at the high school. Students entering pencil drawings… are Rose Furuya, Myron Ives, Sandra Haria, Ed Deslaurier (3), Keith Guenther, Janet Hand (2), Charlyn DeVoss, Yoko Unno, Rick Mclain, Linda Caldwell and Pam Taylor. Entries are expected from 702 junior and

senior high schools in Southern California. Fifteen hundred selections … will be chosen by a professional art jury for exhibition and 300 will be awarded the traditional Gold Keys of excellence and will be sent on to the national program in New York," *SMT*, Jan. 16, 1960, p. 2; "Student Earns Art Certificate. Bill Lister, a Santa Maria high school senior, earned a 'Certificate of Merit' in the annual Scholastic Art Show… Lister's entry, a carved wooden bowl, won the equivalent of a third-place rating in the crafts division…," *SMT*, March 12, 1960, p. 2.

See: "Amador, Trinidad," "Amido, Benjamin," "Bragg, Joffre," "Fujioka, Henry," "Galbraith, Joann," "Hopper, Sydney," "Johansen, Virginia," "Santa Maria, Ca., Union High School," 1937, 1954, 1955, 1958, 1959, "Santa Ynez Valley, Ca., Elementary / Grammar Schools," "Santa Ynez Valley Union High School," 1949, 1950, "Ueki, Masuo"

School of Creative Education (Buellton)
See: "Buellton School"

Schools (Northern Santa Barbara County)
This column contains general information regarding the Santa Barbara school system and its attitude toward "art."
Schools (notices in Northern Santa Barbara County newspapers on microfilm and on newspapers.com)

1880 – "Change of School Books… each County Board makes its own selection, and families moving to different counties… may have to buy new books each time. Our Co. Board have made the following selections: … Bartholemew's Drawing Series…," *LR*, July 10, 1880, p. 2.

1894 – "The Course of Study Revised…. Board of Education… A proviso has been made for those schools that are able to complete the essentials at the end of the eighth year. They may with the consent of the trustees and teachers of their respective districts, pursue the first year's work of the adjoining high school (in lieu of the regular ninth year's work). The Prang drawing models have been recommended for use in the schools. … Teachers' Examinations. The following subjects will be required for teachers' certificates: Primary Grade … music, drawing, composition, penmanship… [and required in Grammar Grade and High School]," *LR*, July 7, 1894, p. 2.

1905 – "Board of Education… papers prepared by applicants for teachers' certificates… The following were successful: Special in drawing – **Mrs. Josephine M. George**…," *SMT*, Dec. 23, 1905, p. 3.

1909 – "County Examinations… Miss Eva Dickover was granted a special certificate to teach drawing and carving in the county schools…," *SMT*, Jan. 9, 1909, p. 1; "Board of Education to Meet Once a Month… At last night's session official action was taken on the appointment of Miss Ellen Hughes, who is performing the duties of supervisor of music and drawing in the schools, in place of Miss Elenor Bush, resigned. Miss Bush is now supervisor of singing in the Pasadena schools… *Santa Barbara Independent*," *SMT*, Jan. 9, 1909, p. 7.

1910 – "Our County Educators and Their Schools – Lompoc… **A. G. Balaam**, supervising principal…Sloyd and Sewing – 8th, 7th, 6th, 5th, 4th grades. Paper Sloyd – 3rd

and 2nd grades. Mechanical Drawing 7th and 8th grades. Marguerite Rennie, 7th and 6th grade, free-hand drawing … **Lillian Dodge**, 5th Grade, free-hand drawing… Lompoc Union High … **Marie Simon**, Commercial branches, botany and drawing; **Olivia McCabe**, manual training… Santa Maria Union High school – … **Frances J. Heil**, drawing, manual training…," *SMT*, Sept. 17, 1910, p. 8.

1911 – "Teachers Get Life Certificates… [Santa Barbara] Florence L. Hassinger and Minnie Stevens, special teachers of drawing," *SMT*, Jan. 7, 1911, p. 1; "Teachers Granted Life Certificates. Five teachers well-known in this county have been granted life certificates by the state board of education… Emily O. Lamb, instructor of drawing, at present teaching in the San Diego school…," *LR*, April 14, 1911, p. 1; "Full Program of the Teachers County Institute… Lecturers and Instructors… [at Santa Barbara] Lucia Lowe, supervisor of drawing, Chicago… Upgraded School Section, room 6, 9:30 'Model Lessons in Drawing and the Interpretation of the Prang Drawing Books'," Mrs. Lucia Prang [sic.?], *SMT*, Dec. 16, 1911, p. 8.

1916 – "Examination Report of the Santa Maria District Schools, June 1916," and chart gives name of student (?) and his/her grade anent various subjects including "Drawing," *SMT*, Aug. 5, 1916, p. 5.

1920 – "Law Requires Equipment… Section 1620 reads as follows: 'Writing and drawing paper, pens, inks, blackboards, blackboard rubbers, crayons, and lead and slate pencils and the other necessary supplies for the use of schools, must be furnished under the direction of the city boards of education…'," *SMT*, Dec. 13, 1920, p. 1.

1927 – "State's Secondary Education Program… course of study… 6. The major units of a complete plant include… music rooms, art rooms… home economics laboratories and vocational shops… Objectives for Secondary Education… 2. Applying Fundamental Processes to Scientific and Social Phenomena. An increased command of the fundamental processes extended to include English, foreign languages, mathematics and the languages symbols of the fine arts with an appreciation of their importance … 3. Discovering Interests and Aptitudes…. 4. Using Native Capacities to the Maximum… 5. Preparing for Economic Independence or Advanced Training. Proficiency evidenced by acquiring vocational skills or by meeting entrance requirements for technical or academic schools of higher rank. …," *LR*, March 25, 1927, p. 5.

1948 – "The Parents' Corner by Richard Barbour… Why are your western schools so 'arty?' my visitor asked. 'Every hall has art displays. Every classroom I have seen has a 'creative corner,' with paints, clay, crayons or charcoal for the youngsters to use. 'Wouldn't the pupils be better off studying the Three R's?'…," and answer, *SMT*, June 9, 1948, p. 4.

See: "Allan Hancock Nursery School," "Atterdag Folk School," "Ballard School," "Buellton, Ca., Adult/Night School," "Chautauqua," "Croswell, Mary," "ESYHI Section," "Guadalupe, Ca., Elementary School," "Knowles, Joseph," "Lompoc, Ca., Adult/Night School," "Lompoc, Ca., Elementary School," "Lompoc, Ca., Union High School," "Lompoc, Ca., Junior High," "Los Alamos, Ca., Adult/Night School," "Midland School (Los Olivos)," "Orcutt, Ca., Elementary School," "Public Schools Week," "Santa Barbara County School News," "Santa Maria, Ca.,

Adult/Night School," "Santa Maria, Ca., Elementary school," "Santa Maria, Ca., Schools," "Santa Maria, Ca., Union High School," "Santa Maria School of Art," "Santa Ynez Valley, Ca., Adult/Night School," "Santa Ynez Valley, Ca., Elementary Schools," "Santa Ynez Valley Union High School," "Summer School…," "Teacher Training," "Valley Farm School"

Schorling, Horace O. (Santa Maria)
Teacher of art metal work in Santa Maria Adult School, and Santa Maria High School, 1939/41.

■ "Schorling-Frisbie Wedding Rites … The bridegroom attended the Fresno State College where he was a member of the Sigma Delta Upsilon Fraternity. He was graduated from the San Jose State College…," *Fresno Bee*, March 29, 1940, p. 6.
Schorling, Horace (notices in Northern Santa Barbara County newspapers on microfilm and on newspapers.com)
1939 – "Teachers Certified – Certificates were awarded 50 Santa Barbara county teachers … Horace O. Schorling, special secondary…," *SMT*, Oct. 24, 1939, p. 3.
1940 – "High School Teacher Takes Bride … Their romance beginning when both were students in Fresno State college … He joined the teaching staff this year as shop instructor. His bride has been employed in the business offices of an Oakland wholesale house. The Schorlings are making their home at 123-A East Cypress…," *SMT*, March 25, 1940, p. 3.
1941 – "Instructor Leaves. Resignation of Horace O. Schorling, general shop instructor, was accepted by the board. Schorling is leaving to take a post with Fresno State College," *SMT*, June 19, 1941, p. 1.
See: "Santa Maria, Ca., Adult/Night School," 1939, 1940, 1941

Schuich, Mr. and Mrs. (Santa Maria / Oakland)
Photographers of the Columbian Art Gallery, 1894.
1894 – "Mr. and Mrs. Schuich of the Columbian Art Gallery, who have been doing a prosperous photo business at Lucas' Hall the past few weeks, will soon leave for their home in Oakland," *SMT*, June 16, 1894, p. 3, col. 1.

Schuyler, Elsa May Hatlestad (Mrs. Dowse) (Mrs. Milton Schuyler) (1887-1964) (Lompoc)
Painter. Student of Forrest Hibbits. Exh. at many venues from c. 1948+. Active with Alpha Club. Wife of Milton Scuyler, below.

■ "Mrs. Schuyler Rites… resident of the community for the past 40 years … Mrs. Schuyler was a member of the Lompoc Grange, Alpha Club and Rebekahs…," *LR*, Sept. 29, 1964, p. 3.
Schuyler, Elsa (notices in Northern Santa Barbara County newspapers on microfilm and on newspapers.com)
1949 – "Neighbors of Woodcraft Meet… Mrs. Milton Schuyler displayed her paintings …," *LR*, Sept. 15, 1949, p. 11.
1959 – "Lompocans Join SB Art Assoc…. **Ethel Bailey** and Elsa Schuyler… Membership was granted as a result of

the paintings which they submitted…," *LR*, July 13, 1959, p. 4.

1962 – "Mrs. Schuyler to Exhibit Paintings. Mrs. Elsa Schuyler, a resident of Lompoc for 39 years, is exhibiting a number of her oil paintings this month in the adult reading room of the Lompoc Public Library… Mrs. Schuyler obtained her training in art from **Forrest Hibbits** of Buellton. Her favorite medium is water color, but this offers problems for her as the brushes and tools need more meticulous care. The oils will be on exhibit for the rest of August," *LR*, Aug. 23, 1962, p. 18 (i.e., 6-B?).

1964 – "**Hibbits**' Art Pupils Show Work… at their studio Saturday and Sunday… Among the artists exhibiting were … Elsa Schuyler… of Lompoc…," *SYVN*, June 18, 1964, p. 11.

Schuyler, Elsa (misc. bibliography)
Elsa May Hatlestad Schuyler was b. July 15, 1887 in Decorah, Iowa, and d. Sept. 28, 1964 in Lompoc, Ca., and is buried in Lompoc Evergreen Cemetery per findagrave.com (refs. ancestry.com).
See: "Allan Hancock [College] Art Gallery," 1955, 1956, "Alpha Club," 1948, 1950, 1952-53, 1955, 1957, 1960, 1961, 1962, 1964, "Art general (Lompoc)," 1961, 1962, "Bailey, Ethel," 1959, "Community Club (Lompoc)," 1948, "Federation of Women's Clubs," 1960, "Flower Festival," 1957, "Flower Show," 1948, 1949, 1958, "Hibbits, Forrest," 1964, "La Petite Galerie (Buellton / Solvang)," 1950, "Lompoc Community Woman's Club," 1952, 1957, 1958, 1959, "Lompoc Gem and Mineral Club," 1960, "Lompoc Hospital, Women's Auxiliary," 1949, 1952, 1956, "Open-Air Art Exhibit," 1957, 1960, "Posters, American Legion (Poppy) (Lompoc)," 1958, 1959, "Posters, general (Lompoc)," 1952, "Santa Barbara Art Association," 1960, "Santa Barbara County Fair," 1952, 1958, "Schuyler, Milton," "Thornburgh, Mary," 1952, "Tri-County Art Exhibit," 1948, 1950, 1958, 1959

Schuyler, Marian (Mrs. Vernon Schuyler) (Santa Maria)
Exh. oil painting at Amateur Art show at Allan Hancock [College] Art Gallery, 1956. One of several Alpha Club artists, 1964.
See: "Allan Hancock [College] Art Gallery," 1956, "Alpha Club," 1964

Schuyler, Milton (1875-1956) (Lompoc)
Photographer, amateur, c. 1890. Husband of Elsa Schuyler, above.
■ "Milton Schuyler, Lompoc Pioneer… coming to Lompoc in 1876… On May 27, 1908, Mr. Schuyler married Blanch Lorraine McClure who passed away on Thanksgiving Day, 1924. … In May of 1939, he was married to Elsa May Dowse," and further bio. of his career, *SMT*, June 24, 1956, p. 4.

Schuyler, Milton (notices in Northern Santa Barbara County newspapers on microfilm and on newspapers.com)
1955 – Repro: "Old Bardoa Bridge" showing Rambler belonging to Milt and Gene Schuyler, *LR*, Sept. 8. 1955, p. 9; repro: "Early Town Scene," c. 1890, "courtesy of Milton

Schuyler who was one of the first photography enthusiasts in Lompoc," *LR*, Sept. 8, 1955, p. 14.
See: "Schuyler, Elsa"

Schwartz, David / Davis (1879-1969) (San Francisco / San Gabriel)
Artist who painted landscapes in northern Santa Barbara County, 1943. Frequent visitor to his sister, Virginia Peck, above.
See: "Peck, Virginia," and *Central Coast Artist Visitors before 1960*

Scofield, Kathryn (Pismo Beach)
Exh. "Mission Trails" water color, at Santa Barbara County Fair, 1960.
See: "Santa Barbara County Fair," 1960, and *Atascadero Art and Photography before 1960* and *Arroyo Grand (and Environs) Art and Photography before 1960*

Scofield, Ronald (Santa Barbara)
Art and music critic of the Santa Barbara News Press, who spoke to Alpha Club, 1950.
See: "Tri-County Art Exhibit," 1950, 1958

Scolari, Robert "Bob" (1928-?) (Lompoc)
Lompoc High School grad., 1946, who worked as a commercial artist in the Bay Area for ten years and then returned to Lompoc where he was active as a commercial artist, 1958+.
Scolari, Bob (notices in Northern Santa Barbara County newspapers on microfilm and on newspapers.com)
1949 – "From Oakland – Mr. and Mrs. Robert Scolari and son, Steven, returned to Lompoc. Bob is a student in the California College of Arts and Crafts in Oakland and has just completed his first year," *LR*, June 30, 1949, p. 8; "Grange Fair Booth… which displayed an old-fashioned farm implement … Background for the booth was a cartoon drawn by Bob Scolari depicting the early temperance colony in Lompoc," *LR*, July 28, 1949, p. 2.
1958 – Ad: "Exclusive! For Lompoc Business Firms. Advertising and Commercial Art. Lettering – Signs – Showcards. Silk Screen Processing. Christmas Decorations. Store Window Displays and Interiors. Advertising Consulting Service. Brochure Art. Ten-Years experience in San Francisco and Bay Area. Bob Scolari. Advertising Art Service. 516 North First Street – Lompoc," *LR*, Nov. 6, 1958, p. 19 (i.e., 7a).
1959 – "Merchants Assn. Meets… Bob Scolari local art draftsman, displayed to the group the letterhead he had designed …," *LR*, March 12, 1959, p. 24 (i.e., 8a).
1960 – Port. with competitors in wish bone decoration contest held by A and B Market, *LR*, Dec. 5, 1960, p. 3.
1962 – Port. with City Beautification committee, *LR*, Oct. 4, 1962, p. 4; "Deadline Nears for Publishing New Lompoc Valley Map… now in preparation by Bob Scolari Art Service. A full 17 x 22 inches in size … made on an up-to-date aerial photograph… produced in cooperation with the Lompoc Valley Chamber of Commerce…," *LR*, Nov. 5,

1962, p. 10; ad: "Bob Scolari Art Service. 209 E. Ocean Ave., Lompoc. RE6-4060," *LR*, Dec. 24, 1962, p. 13.
1964 – "Dodge-McCracken Engagement… James Wilson McCracken… is an LHS graduate of Allan Hancock Jr. College and is presently a commercial artist for Bob Scolari's Graphic Arts," *LR*, May 6, 1964, p. 10; port. painting sign for Kiwanis Club auction, *LR*, Oct. 23, 1964, p. 1.
1965 – "Glimpses. Earl Calvert showing off a well-executed drawing by Bob Scolari of a proposed Lompoc Valley Historical Society Museum," *LR*, March 27, 1965, p. 1.
Scolari, Bob (misc. bibliography)
Port. and credits read "Navy 4, Art" in the Lompoc High School yearbook, 1946; Bob Scolari b. March 19, 1928 was residing in Lompoc, Ca., in 1993 per *U. S. Public Records Index, 1950-1993* (refs. ancestry.com).
See: "Lompoc, Ca., Union High School," 1943, 1960

Scott, Dorothy Dean
See: "Sheldon (Scott), Dorothy Dean (Mrs. Sheldon) (Mrs. Scott)"

Scott, Elizabeth "Betty," Hart, Miss (1917-2006) (Santa Maria)
Painter. Exh. at Santa Barbara County Fair, 1952, at Allan Hancock [College] Art Gallery, 1955, at Minerva Club Art and Hobby Show, 1957, 1958. Helped organize the Santa Maria Art Festival, 1952, 1953. Member Historical Society and Santa Maria Art Association.

■ "Elizabeth Hart Scott, 1917-2006. Elizabeth was born November 10, 1917 in Santa Maria to George and Hattie (Hart) Scott. She was a member of the pioneer Scott and Hart families. Elizabeth graduated from Santa Maria High School and later University of California at Berkeley. During World War II she was employed with the American Red Cross as a social worker at the Oaknoll Navy Hospital in Oakland, California. Elizabeth was active in Santa Maria organizations including the Minerva club, Santa Maria Historical Society, University Women and the Santa Maria Library Board…," *SMT*, June 7, 2006, p. 11.
Scott, Betty (notices in Northern Santa Barbara County newspapers on microfilm and on newspapers.com)
1955 – Port. of Betty Scott at easel preparing for an exhibit of local artists at Hancock college art gallery, and she is possibly a member of Muro's adult class, *SMT*, March 15, 1955, p. 1.
Scott, Betty (misc. bibliography)
Elizabeth H. Scott is listed in the 1920 U. S. Census as age 2, b. c. 1918 to George M. Scott (age 40) and Hattie H. Scott (age 38) (ref. ancestry.com).
See: "Allan Hancock [College] Art Gallery," 1955, "Minerva Club, Art and Hobby Show," 1957, 1958, "Rembrandt Club," 1955, "Ruth, Clarence," 1957, "Santa Barbara County Fair," 1952, "Santa Maria Art Association," 1953, "Santa Maria Art Festival," 1952, 1953

Sculptors and carvers (northern Santa Barbara County)
See: "Anderson, Frederick," "Beerbohm, Frederich," "Brackenridge, Marian," "Brandt-Erichsen, Viggo," "Cadorin, Ettore," "Carpenter, Dudley," "Case, Clifford," "Dipple, Gordon," "Duncan, Raymond," "Dunlap, Joe," "Fenci, Renzo," "Fratis, Margaret," "Gage, Merrell," "Gronendyke, Robert," "Hart, Margaret," "Hoback, Eugene," "Hoback, Joseph Herrick," "Hoback, Joseph Quimby," "Hosier, Roy," "Jones, Gaylord," "Lakey, Andrew," "Lebrun, Rico," "Lord (Huyck), Loiz," "Lovet-Lorski, Boris," "Montgomery, George," "Mussell, Elwin," "Parker, Vernon," "Peck, Virginia," "Poole, Harvey," "Potvin, Moise," "Rich, Frances," "Schmidt, D. K.," "Sedgwick, Francis M.," "Seegert, Helen," "Sorensen, Soren," "Stuart, George," "Swanson, David," "Tashiro, Yukio," "Tregor, Nicholas," "Wilkinson, Gene," "Wulff, Jeppe"

Sculpture, general (Camp Cooke/ Vandenberg AFB)
Sculpture (including statuary, monuments and woodcarving) was created both by American soldiers as well as by German prisoners of war at Camp Cooke during WWII.
See: "Art, general (Camp Cooke / Vandenberg AFB)," WWII, "World War II and art"

Sculpture, general (Northern Santa Barbara County)
The earliest sculpture in Northern Santa Barbara County was created by the Native Americans (See: Central Coast Artist Visitors before 1960). Religious sculptures were carved for the area's two missions. Early settlers of European background created some sculpture in the form of tombstones and monuments. The many settlers from northern Europe brought with them the tradition of wood carving, and some carved interiors for their churches. At the turn of the twentieth century America's "city beautiful" movement encouraged cities to add parks and sculpture, but the medium did not impact California significantly until the Panama-Pacific Exposition in San Francisco, 1915, that contained many sculptures. A few sculptors utilized the area's soft stone (diatomaceous earth – brand name, Celite). Lectures on sculpture and sculptors were given at various times at clubs and organizations. The Works Progress Administration paid for a couple of sculptures for the northern part of Santa Barbara County in the 1930s and their recreation programs fostered sculpture in soap and clay. Elementary schools taught clay modeling and model making. Sculpture was exhibited at various fairs and festivals, principally after WWII.
Sculpture, general (notices in Northern Santa Barbara County newspapers on microfilm and on newspapers.com)
1915 – On or about this date the newspapers carried many articles on the sculpture/statuary on display at the **Panama-Pacific** Exposition in San Francisco, but they were not itemized here.
1929 – "Memorial at S. [Santa] M. [Maria] Unveiled" to Fremont and Foxen, *SLO T-T*, Sept. 9, 1929, p. 8; "Splendid Collection of Photographed Sculptury… 175

photographs taken of the exhibit of the American Sculptors' association now being held at the Palace [of the] Legion of Honor in San Francisco is on display at the **Little Theatre** by courtesy of Captain G. Allen Hancock. The exhibit of photographs was brought here by **George E. Stone**, director of visual education service with offices in Carmel, Calif.," and description of some of the sculpture, *SMT*, Dec. 3, 1929, p. 5.
1937 – "Plaque is Set in Gaviota Honoring Trio of Pioneers ... [91 years ago] when Benjamin Foxen and his son William warned Gen. John C. Fremont and his battalion against traveling through the pass where a band of native Californians were awaiting them... Christmas day, 1846... bronze plaque ... [at the dedication] Near the spot stood original paintings of the pass, one by **H. C. Ford**, done in 1879 and another by **Frances Mead Jensen**. A painting of Gen. Fremont also had been placed in a conspicuous spot...," *SMT*, May 17, 1937, p. 6.
1958 – "Solvang Marker Discussion... monument in memory of the three founders of the Solvang community...," *SYVN*, July 11, 1958, p. 2.
1960 – "Hunter's Lounge to Open... Hunter's Inn coffee shop... Brass sculpture of a cougar and a deer and a hunting scene will be part of the Hunt Room's decorations. The artist is **Gene Wilkinson** of Santa Barbara," *SMT*, Sept. 22, 1960, p. 7.
See: "Anderson, Frederick," "Los Angeles Marble Works," "Menezes, Herman," "Mission La Purisima," "Mission Santa Ines," "Sculptors," "Sculpture, general (Camp Cooke/ Vandenberg AFB)," "Turek, Charles," "Works Progress Administration"

Sears, Vera (Mrs. William E. Sears) (Santa Maria)
Artist who exhibited at the Santa Barbara County Fair, 1949 and at the Tri-County Art Exhibit, 1949, 1950.
[Do not confuse with her daughter Vera Ann Sears, b. c. 1939.]
See: "Santa Barbara County Fair," 1949, "Tri-County Art Exhibit," 1949, 1950

Sears, Roebuck and Co. (Lompoc)
Retailer of children's paint sets, 1953.
1953 – "Merry Christmas... Chalk, Slate Sets, Packed with Creative Fun. 51 Pieces at only 88c. Complete thrifty gift set including drawing board, 16 pieces of chalk, 8 crayons, 10 stencils, eraser, 15 pictures. Hapi-Time paint Sets, reg. .98, Now. 88. ... Crayon Book Sets 77c," *LR*, Nov. 26, 1953, p. 22.
1959 – "Full Color Photo Murals. 45 x 65 in. $1.99 ea. ... Sears Roebuck and Co.," *SMT*, April 29, 1959, p. 3.

Seawell, Wallace (1916-2007) (Hollywood)
Photographer who exh. with Hollywood notables at Santa Ynez Valley Art Exhibit, 1954.
■ Seawell was an "American photographer best known for his portraits of Hollywood stars...," Wikipedia.
See: "Santa Ynez Valley Art Exhibit," 1954

Secour, Martha Jane Brayton (Mrs. George Edwin Secour) (Santa Maria)
Art chairman, Community Club, Art Festival, 1935. Active with other art events. Wife of publisher of Bulls Eye, a monthly paper in Santa Maria. Clubwoman.
See: "Art Festival," 1935, "Breneiser, Marrie," 1939, "Community Club (Santa Maria)," 1935, 1937, 1938, "Delphian Society," 1934, "Jensen, Frances Mead"

Sedgwick, Francis Minturn "Duke" (1904-1967) (Rancho Corral de Quati and Rancho Laguna)
Sculptor. Exh. annual Santa Ynez Valley Art Exhibit, 1953, bronze heads, 1954, 1957. Collector.
■ "Francis Minturn Sedgwick was born in New York on March 13, 1904. He was the son of the noted historian and author, Henry Dwight Sedgwick, and Sarah May Minturn. ... Sedgwick came to Santa Barbara in early infancy ... attended Groton School in Massachusetts and Cate School in Carpinteria. He graduated in three years from Harvard University in 1926. During his collegiate years he acquired the nickname of 'Duke'... His talents in the fields of painting and sculpture were first revealed during his Harvard years. After postgraduate work at Trinity College, Cambridge, in England and the Harvard Business School, Sedgwick embarked on what he supposed would be a lifelong career in banking... After three years of banking, he returned to New York in 1932 to study painting under DeWitt Lochmann... [and to] Long Island to study sculpturing for five years in the studios of Hermon MacNeil ... Just prior to World War II, Sedgwick purchased a 25-acre lemon ranch on Cathedral Oaks road near Tucker's Grove in the Goleta Valley as a wartime home for his wife and children, who eventually numbered eight. He also bought the historic Corral de Quati ranch at the south end of Foxen Canyon ... one of the original land grants dating from Mexican times.... In July, 1952, the Sedgwicks purchased the 6,000-acre Rancho La Laguna from Evan S. Pillsbury III. It was Sedgwick's home until the time of his death... He and his wife left their La Laguna property to the University of California, Santa Barbara, the largest single private gift the university had ever received," from beta.medallicartcollector.com who sourced it from Francis Sedgwick's obituary.
Sedgwick, Francis (notices in Northern Santa Barbara County newspapers on microfilm and on newspapers.com)
1952 – "Pillsbury Sells 6000 Acre La Laguna Ranch to Sedgwick... F. M. Sedgwick, owner of the Rancho Corral de Quati on Foxen Canyon Road... tentative plans call for the formation of a corporation to operate the property with H. H. Davis continuing to run cattle on the ranch... The property, located about six miles north of Santa Ynez, covers about 6000 acres adjoining Los Padres National Forest... Mr. Sedgwick, an artist of note, is an avid rancher and raises commercial cattle on his Corral de Quati Ranch with Dick Degan as foreman... Mr. Davis, a director of the Santa Ynez Valley Bank, owned the Corral de Quati at one time and sold it a few years ago to Mr. Sedgwick," *SYVN*, Aug. 1, 1952, p. 6.
1957 – "2,100 Acre Ranch Sold. Mr. and Mrs. Francis M. Sedgwick have sold a 2,100-acre cattle ranch in the Zaca area of Foxen Canyon ... Since 1952, the Sedgwicks have

been living on another cattle ranch, La Laguna in the Valley," *SYVN*, March 1, 1957, p. 4.

1960 – "Rare Art to be Shown… The 15th to 17th century masterpieces making up the Sedgwick Collection at the University of California at Santa Barbara will go on public view beginning Tuesday, Oct. 18 in the campus Art Gallery. … 20 paintings … This beautifully preserved group of masterpieces include Italian, Dutch, Flemish and German artists. In subject matter they deal with portraiture, religious subjects, landscapes and still life with emphasis on portraiture. The collection represents the choicest examples from the collection of the late Robert S. Mintern, augmented by six additional paintings acquired by Francis Mintern Sedgwick … The paintings are on permanent loan to the University with the 'hope and expectation' of the donor that the collection will eventually become the property of UCSB," *LR*, Oct. 17, 1960, p. 9.

1967 – "2 Prime Ministers at UCSB… will be honored by the University of California at Santa Barbara during the observance of the 99th birthday of the university on April 3… Rancher-sculptor Francis M. Sedgwick will receive the doctor of arts degree," *SMT*, March 29, 1967, p. 19; "Cabrillo Students Set Memorial **Scholarship**… High School have established an art scholarship to honor the memory of Francis M. Sedgwick who died in Santa Barbara Tuesday. Sedgwick, an internationally famous writer, poet and sculptor is known locally for his sculpture of the school's large rendition of a conquistador. Scholarship funds will be used to aid needy and worthy art majors completing their education beginning next year… The students decided to establish the scholarship last June in gratitude for Sedgwick's contribution… his bas-relief sculpture of a conquistador and cast it in bronze-looking plaster. It had taken him almost a year from the early design stage. The art work is eight feet tall and about five feet wide. School officials plan to install it in the lobby of the school gym, probably by October of 1968. The students hope to build the scholarship fund from proceeds of their annual art show and with donations… Sedgwick spent almost his entire life in the county. As a young man he started out in the world of banking but switched to the art interests that were to occupy the rest of his life," *LR*, Oct. 27, 1967, p. 3; "Cobbs Offer Ranch Land for College… following the example set by the late Francis Sedgwick and his wife, who recently presented the University of California at Santa Barbara with several thousand acres of land on La Laguna Ranch in the Valley…," *SYVN*, Nov. 9, 1967, p. 1.

1914 – The collection of Old Masters donated by Alice and Francis Sedgwick were exhibited at UC, Santa Barbara's Art, Design & Architecture Museum – "Based in the Santa Ynez Valley… Born to wealthy East coast families, both were part of a cultural milieu that celebrated and supported the arts. Duke not only spearheaded the couple's collecting but was also a noted sculptor and novelist and served on cultural and educational boards. During his lifetime Duke witnessed the rise of Modernist Art. This was, in his estimation, a deplorable situation producing terrible works of art such as 'junkyard sculpture.' He attributed this decline to the development of photography…" (see Internet).

Sedgwick, Francis (misc. bibliography)
Francis Minturn "Duke" Sedgwick was b. March 13, 1904 in New York City to Henry Dwight Sedgwick and Sarah May Minturn, married Alice Delano DeForest, was residing in Cambridge, Mass. in 1930, and d. Oct. 24, 1967 in Santa Barbara per Beaudette Family Tree (refs. ancestry.com).
See: "Danish Days," 1957, "Lompoc Hospital, Women's Auxiliary," 1952, 1956, "Santa Ynez Valley Art Exhibit," 1953, 1954, 1957, 1958, "Tri-County Art Exhibit," 1947

Seegert (Jansen), Helen / Helena May Gould (Mrs. Frederich Seegert) (Mrs. William Jansen) (1907-1975) (Santa Barbara)
Sculptor for the Works Progress Administration who created two artworks allotted to Lompoc sites, 1936.

■ "Helen Seegert, born in 1907, was one of a number of color woodcut artists working in Santa Barbara in the early 20th century. She was listed as a sculptor in the New Deal Registry and did a bas relief sculpture at the La Purisima Mission in Lompoc, CA. She probably studied in Santa Barbara with **Frank Morley Fletcher** and did woodcuts for the California WPA in 1936…" (from www.annexgalleries.com).
"Sculptor. Created a decorative concrete fountain at La Purisima Concepcion Mission, WPA-FAP, 1936. Created "Building the Mission" a painted cement bas relief plaque 7 x 12 feet in 1936 in the foyer of the Veterans' Memorial Building, Lompoc, WPA-FAP per (www.newdealartregistry.org).
Port. in Spanish dress with burro, *LA Times*, Aug. 7, 1936, p. 20; port. in Spanish dress astride a donkey, *LA Times*, Aug. 10, 1938, p. 19 (pt. II, p. 1).
Seegert, Helen (misc. bibliography)
Helen M. Seegert is listed in the 1930 U. S. Census as age 23, b. c. 1907 in Calif., working as a teacher in a School of Art, married to Frederich A. Seegert (age 26) and both living with her in-laws (Frederich G. and Minne E. Seegert) in Santa Barbara; Helena G. Jansen was b. Jan. 12, 1907 in Calif. and d. Sept. 26, 1975 in Santa Barbara County per Calif. Death Index (refs. ancestry.com).
See: "Works Progress Administration," 1936, 1937, Internet

Seffens, Charles (Lompoc)
Science teacher at Lompoc high school who spoke to La Purisima Camera Club on the use of film, 1947.

■ "Charles Seffens Resigns from H. S. Faculty. Charles Seffens, instructor at the high school for the past 22 years, has turned in his resignation effective November 1. He plans to move from Lompoc to his home in Fortuna, in Humboldt county. Seffens has been a science teacher – physics and chemistry – and has been the supervisor of audio-visual education at the local school. After his many years of service in the local school, Seffens entered the Army. Upon his release following the war, he returned here to resume teaching…," *LR*, Oct. 16, 1947, p. 17.
See: "La Purisima Camera Club," intro

Seldis, Henry (1925-1978) (Santa Barbara / Los Angeles)
Santa Barbara art critic who was active in Northern SB County to 1958. Art critic of the LA Times, 1958-78.

■ "Henry Seldis, 53, Times Art Critic Found Dead at Home … In 1958, upon the retirement of art editor **Arthur Millier**, Seldis came to *The Times* from the *Santa Barbara News Press*, where he was art critic and feature editor…," *LA Times*, Feb. 24, 1978, pp. 3, 32.
See: "Allan Hancock [College] Art Gallery," 1954, "American Association of University Women," 1956, "Glasgow, Charles," 1956, "Santa Maria [Valley] Art Festival," 1952, 1953

Sellers, Ada Calista
See: "Stephens (Sellers), Ada Calista (Mrs. Oliver Sheridan Sellers)"

Sellers, Lois M. (Mrs. Robert "Bob" Sellers) (Santa Maria)
Artist. Handcraft chair, Jr. Community Club, 1954-55.
See: "Junior Community Club (Santa Maria)," 1954, 1955

SERA
See: "State Emergency Relief Administration"

Serisawa, Sueo (1910-2004) (Los Angeles)
Artist whose art was exh. at first Santa Maria Valley Art Festival, 1952, courtesy Cowie or Dalzell Hatfield Gallery in LA.

■ "Sueo Serisawa (April 10, 1910-September 7, 2004) was a Japanese American who became a modernist of the Los Angeles school," Wikipedia.
See: "Santa Maria [Valley] Art Festival," 1952, 1953

Set Decoration / Stage Design / Set Design / Set Painters / Stage Scenery / Theater Sets (Northern Santa Barbara County)
Sets were designed for Little Theater groups and for High School productions in both Lompoc and Santa Maria. Some designers came from outside the area and were associated with the theater groups, but most of the sets were designed, constructed and painted by local high school art and industrial arts classes. Children designed and built theaters for puppets.
Set Decoration (notices in Northern Santa Barbara County newspapers on microfilm and on newspapers.com)
1934 – "Lompoc's new Players Club… 'Ghost Parade' was produced… in the high school auditorium on Friday and Saturday evening… sponsored by the Alpha Club… Special mention is also due to the construction crew who made the set and to the artists who painted and finished it. **Charles L. Batkin** was in charge of this work, assisted by **Miss Edna Davidson, Walter A. Snyder** and others…," *LR*, April 20, 1934, p. 12.
1951 – "The charming backdrop which adorned my little ballet recital was painted by one of our Valley artists Jay

Sayre of Solvang, who so generously donated his time and effort… Bessie Holt," *SYVN*, March 2, 1951, p. 2; "Rural Farce Here Next Week… at the Veterans' Memorial Building in Solvang… The production management… and Jay Sayre scenery…," *SYVN*, April 20, 1951, p. 1.
See: "Blue Mask Club," "Crosby, Edward," "Doane, Warren," "Fashion Design / Costume Design," "Gaiety Theater," "Laney, Vern," "Lompoc, Ca., Union High School," "Rolle, F. J.," "Santa Maria, Ca., Union High School," "Santa Ynez Valley Union High School," "Smith, Tom," "Theater," "Vaughn, Leon"

Seward, Coy Avon (1884-1939) (Kansas)
Printmaker whose exh., circulated by the Smithsonian Institution, was presented at Santa Maria High School, sponsored by the College Art Club, 1932.

■ "Free Exhibition. Lithographs – Wood-block prints and Etchings by the nationally known artist, C. A. Seward of Wichita, Kansas. Santa Maria Union High School Art Room. Daily – 9 a.m. to 4 p.m. – May 9 to 13th and Monday and Thursday evening, 7-9. Sponsored by the **College Art Club**," *SMT*, May 9, 1932, p. 1.
See: "College Art Club," 1932

Shaug, Helen
See: "Kelleway (Shaug), Helen (Mrs. James Jerome Shaug)"

Shaw, Richard "Dick" Blake (1916-1976) (Los Angeles)
Cartoonist whose cartoons ran in Santa Ynez Valley News, 1949+. Yachtsman out of Newport Beach. Resided Balboa, Ca., 1953. Buried at sea.

■ "'Sidetrack' … **Dick Shaw** started magazine cartooning in 1935 when he sold his first cartoon to *Collier's* magazine. Attended the Art Institute of Chicago for four years and drew cartoons for *Post, Collier's* and *Aviation* magazines until 1939. Started working for **Walt Disney**'s Studio in 1940 and worked as Story and Gag man until 1946. At Walt Disney's studio he worked on the famous story of Casey Jones, which was an inspiration for the series of cartoons called 'Sidetrack.' Dick's hobby is trying to pay off the phone bill," *SYVN*, July 29, 1949, p. 4; single frame cartoons repro. in *SYVN* from 1949; in mid-1952 he drew a series of single frame cartoons on car safety titled "Lucky You," concerning those who broke driving laws but still remained alive, an example being *SYVN*, Sept. 12, 1952, p. 2.
1976 – "Burial at Sea Planned for 'Mr. Magoo' Writer … Newport Beach … A resident here for 25 years, Shaw was founder and periodically the leader of Balboa Island Punting and Sculling society … ," *Santa Ana Register*, Aug. 27, 1976, p. 11.
Shaw, Dick (Internet)
Biographical information on his student years appears in Donald S. Vogel, *The Boardinghouse: The Artist Community House, Chicago*, 1936-37 (a Google ebook), in which is described Vogel's first year at the Chicago Art Institute and his art colleagues, pp. 12-18; many sites on the Internet offer his cartoons for sale.

Shaw, Dick (misc. bibliography)
Richard B. Shaw was b. Feb. 15, 1916 in Washington and d. Aug. 22, 1976 in Los Angeles County per Calif. Death Index (refs. ancestry.com).
See: "Comic Strip (*Santa Ynez Valley News*)"

Shaw, Ruth Faison (1889-1969) (New York)
Inventor of finger painting who demonstrated the technique to Santa Barbara County teachers at Main Street School, Santa Maria, 1937.
"… credited with introducing finger painting into the USA as an art education medium. She developed her techniques while working in Rome, Italy, patenting a safe, non-toxic paint in 1931," Wikipedia.
See: "Teacher Training," 1937

Sheets, Millard (Los Angeles)
Artist whose art was exh. at first Santa Maria Valley Art Festival, 1952, courtesy Cowie or Dalzell Hatfield Gallery in LA. One of his paintings was distributed to a public building in northern Santa Barbara County by the PWAP, 1934.
See: "Allan Hancock College Art Gallery," 1956, "Alpha Club," 1937, "Gray, Gladys," 1957, "Public Works of Art Project," 1934, "Santa Maria [Valley] Art Festival," 1952, and *Atascadero Art and Photography before 1960* and *San Luis Obispo Art and Photography before 1960* and *Arroyo Grande Art and Photography before 1960*

Shein / Shien, Marty, Sgt. (Camp Cooke)
Post signal photographer, 1946.
1946 – Repro: "It's a New Paint Job for 67 Camp Cooke Vehicles," *LR*, March 14, 1946, p. 1.
This photographer could not be further identified.
See: "Photography, general (Camp Cooke)," 1946

Sheldon (Scott), Dorothy Dean (Mrs. Sheldon) (Mrs. Scott) (1891-1981) (Berkeley / Oakland)
Photographer, naturalist, who showed bird films that she made to Santa Maria students, 1943, 1944.
1943 – "Bird Films in Color Shown Here. Mrs. Dorothy Dean Sheldon of Oakland, showed California bird films in color before an audience in El Camino school this morning. Tomorrow evening, she will show them in Camp Cooke… She is a member of the National Audubon Society and one of the best-known naturalists in the country… she is a guest of **Santa Maria Inn**," *SMT*, Sept. 25, 1943, p. 4.
And, more than 60 additional notices on her showing her bird films to various groups throughout California during WWII and stating she attended Boston University, was associated with Mills College, was a trustee for several Eastern girls' colleges, was active with Girl Scouts, and was a world traveler, but they were not itemized here.
Sheldon, Dorothy (misc. bibliography)
Dorothy Dean Scott was b. Aug. 29, 1891 in Mass., mother's maiden name Schadt and father's Dean, and d. June 19, 1981 in Monterey County per Calif. Death Index (ref. ancestry.com).

See: "Minerva Club," 1948, "Photography, general (Santa Maria)," 1944

Shelly, Constantine Ivanovitch Shelokov / Schelokov (1911-1989) (Lompoc)
Head of Lompoc Recreation Department, 1947-48. Majored in arts and crafts in college. Husband to Helen Shelly, below.
■ "Shelly Appointed Recreation Head for Lompoc … C. S. Shelly, former recreation director for the City of Santa Clara and now on terminal leave from the Red Cross, has been appointed superintendent of the recreation for the City of Lompoc. Shelly will take over his duties on July 1 and will plan and organize the city's summer recreation program… Shelly is a graduate of San Francisco State College and has a special secondary teaching credential. He majored in arts and crafts with a minor in physical education. … His experience in recreational work began while he was in college at which time he worked part-time as a playground director in San Francisco. Upon graduation he became a full-time director. He was supervisor of WPA recreation in Santa Clara county for one and one-half years and was the assistant supervisor of the recreation exhibit for the San Francisco World's Fair in 1940. Following two years' service as superintendent of recreation in Santa Clara, he resigned to join the field service of the American Red Cross in which he held the position of field director. He is coming to Lompoc from Camp Stoneman at Concord, California, after more than four years with the ARC… he will live temporarily in the USO building," *LR*, June 19, 1947, p. 4.
Shelly, C. S. (notices in Northern Santa Barbara County newspapers on microfilm and on newspapers.com)
1948 – "Commission to Study… The resignation of C. S. Shelly as superintendent of recreation was accepted by the city council…," as he was unhappy with the commission actually running things and he not allowed to, *LR*, April 8, 1948, p. 8.
And, more articles on him appear under both "Shelly" and "Shelley" but were not itemized here.
Shelly, C. S. (misc. bibliography)
Constantine S. Shelly is listed in the 1940 U. S. Census as ae 28, b. c. 1912 in Manchukuo (i.e., Manchuria, China) Harbor (?), finished college 4th year, naturalized, working as a playground director, residing in San Francisco (1935, 1940) with wife Helen O. Shelly (age 20); C. S. Shelly with wife Helen O. Shelly is listed in the *Lompoc, Ca., CD,* 1947; Constantine Shelokov Shelly was b. 1911 in Harbin, Heilongjiang, China to Ivan Shelokov and Marya Zolotov, and d. 1989 in Santa Rosa, Ca., per Shelly Family Tree; Constantine Schelokov Shelly b. Aug. 29, 1911 in China, d. March 26, 1989 in Sonoma County per Calif. Death Index (refs. ancestry.com).
See: "Alpha Club," 1947, 1948, "Community Center (Lompoc)," 1947, "Lompoc, Ca., Recreation Department," 1947, "Shelly, Helen"

Shelly, Helen Olson (Mrs. Constantine S. Shelly) (b. c. 1920-?) (Lompoc)
Teacher of block printing at Community Center, 1947.
Wife of C. S. Shelly, above.
Shelly, C. S., Mrs. (misc. bibliography)
Helen O. Shelly is listed in the 1940 U. S. Census as age 20, b. c. 1920 in Denmark, finished college 3rd year, naturalized, working as a doctor's assistant, residing in San Francisco (1935, 1940) with husband Constantine S. Shelly (refs. ancestry.com).
See: "Alpha Club," 1947, 1948, "Community Center (Lompoc)," 1947, "Lompoc, Ca., Recreation Department," intro., 1947, "Shelly, C. S."

Shepherd, Olive C.
See: "Kelsey (Shepherd), Olive C. (Mrs. Francis A. Shepherd)"

Shields, Glenda
See: "Burke (Shields), Glenda (Mrs. Charles Shields)"

Shinn, William "Bill" Curtis (1932-2011) (Santa Maria)
Ceramics instructor at Hancock College, 1962-88.

■ "Local renowned artist dies… The Central Coast lost an internationally renowned artist last week when Santa Maria resident William "Bill" Shinn died April 25 at the age of 78. As a ceramics instructor at Hancock College from 1962 to 1988, Shinn generously shared his art techniques, years of experience and many works with students and professional audiences, becoming known worldwide for his work in ceramics upon retirement from the college. Shinn, who had more than 40 years of art experience, beginning in the late '50s, still was teaching ceramics out of his Santa Maria studio. He also was continuing to show his work as recently as a March exhibition at the San Luis Obispo Museum of Art that featured some of his award-winning watercolors and clay pieces. His vases, teapots and other works were displayed for years in the Judith Hale Gallery in Los Olivos before it closed a year ago, with his work still represented today on her gallery website. What struck Hale most about Shinn, she said, was his intense love of art and his desire to show his artistic process to anyone who wanted to observe. 'He loved to demonstrate,' Hale said. 'He loved to show them how he created. I think the thrill of it was watching his enthusiasm toward his work and his product. He was enjoying his life and doing what he loved to do.' As one of Shinn's former students at Hancock, Marti Fast can attest to his contagious enthusiasm in the classroom. Fast, who now is a fine arts instructor at the college, said she has taken classes out to Shinn's studio as recently as last spring for students to observe his craft. 'He would get so excited in the process,' Fast said. 'His mind worked differently because he wasn't worried about a specific outcome. He's just made a really profound impact on lots and lots of people…' A short list of shows in which Shinn won awards includes Feats of Clay National, Lincoln, Sculpture in Clay, Portland, Maine; Strictly Functional, New Cumberland, Pa., and Contours VI & VII National, Sonora. International show awards include the 48th international Ceramic Competition in Faenza, Italy, the Fletcher Challenge Ceramic Award Competition in Auckland, New Zealand, and the World Ceramic Exposition 2001 in Korea. Shinn earned both his bachelor-of-arts degree and master's in ceramics design at UCLA and was schooled in art at the famous Sorbonne and Academie Julian in Paris…," *SMT,* May 1, 2011, p. B1.

■ "William Shinn taught ceramics at Hancock College for 23 years, simultaneously earning a national reputation for his unique creations in clay. Eight years ago, Shinn retired from teaching. Then he went back to Hancock – as an art student. A lifelong experimenter, Shinn wanted to paint – tackling watercolor, a delicate and difficult medium. He won his first national award in painting. 'I was bowled over, ecstatic,' the bubbling Shinn said of the Texas Watercolor Society Memorial Award for Members and Friends for his painting, 'Les Enfants D'Avignon.' This unusual work will now join the society's travel show for 1996. Shinn, who has won countless awards for ceramics was excited as a beginning artist about his recent painting successes. His latest collection of honors began in November 1995, when his entry 'Batalah' took first prize in the Senior Art Tournament Water Color category at the Episcopal Diocese of Los Angeles. The latter contest was sponsored by the Commission on Affirmative Aging. No artistic stick-in-the-mud, Shinn continues his lifelong creative experimentation, illustrated again by his two winning watercolors, so different it's hard to realize they were done by the same artist. 'Les Enfants' is painted on tracing paper attached to a textural backing which makes it a kind of collage. Shinn's friends considered this depiction of a group of children 'weird.' Their forms are distorted because Shinn took his image from a slide, slanting the projector to achieve an admittedly odd perspective. The pudgy figures appear whimsical and oddly poignant at the same time. Shinn himself was surprised. 'I reluctantly entered this semi-abstract painting. Winning was a big surprise!' he chortled, then added, 'Look at this ball. I was framing the piece and spilled a drop of coffee right here. That's the ball!' It is the sense of whimsy which enlivens much of Shinn's work. Unlike the suffering artist of literature, Shinn is a happy man, unashamed to laugh, cry, or be gentle. This is a man who can find joy in hiking the Sierras, create a hybrid musical instrument he called a 'ceramicin,' and then capture serenity on canvas or paper, as he did in 'Batalah.' Here, in an image inspired from a travel slide taken in Portugal, is a scene aglow in golds and greens, a moment of tranquility glimpsed through an archway, drawing the viewer into a more peaceful place. In another piece, 'Naxos Octopi,' Shinn has endowed these normally pure white dead sea creatures with rosy hues, yet capturing their true 'octopiety' in form. 'They have such beautiful shapes, but I had to give them color,' he explained. 'Painting takes so much more discipline. It was hard to get started and it's hard to stop,' said Shinn, who returned to this medium after a twenty-year absence. He credits his renewed confidence to Bob Burridge, his Hancock art teacher. 'He should teach a class on how to teach art,' Shinn emphasized. He is particularly receptive to Burridge's encouragement to experiment. In what he calls a clay painting, Shinn took the oxides he uses to color ceramics, worked some acrylic admixture into them, and

applied the mix to standard water color paper. Texture still appeals to him, perhaps as a result of his continuing career in ceramics. So Shinn plans more work in the painting / collage technique he used for 'Les Enfants.' And, he'll keep on entering competitions. 'People who don't enter competitions, I think their paintings reflect a fear. You have to break through that fear of risking failure,' he said. 'When I started to paint again, it was very depressing. Everything I did, I hated and thought I just couldn't do it. It took me a while to work into it. I had to start over, do representational work (much of ceramics are abstract) and to use and mix color again. 'When you are trying to get acceptance for a show, you always have doubts. That is what kills people who want to enter shows. They can't stand rejection. Shinn won't let this happen to him. He also encourages former students and other young artist to compete. 'You can have a piece you really like rejected from a couple of shows, then it will be accepted and win an award.'… He keeps his own 'rejections' in a portfolio, out in his spacious home studio. 'I dig them and 'recycle' them,' he said. 'I like to experiment. Then, you discover something new. It's the most exciting thing to me. the destination isn't that important. It's discovering all these things.' These days, Shinn is using the extruder to create new and different ceramics. These pieces and others are sold in nine galleries throughout Southern California, including Gallery 912 ½ in Santa Maria and the Cody Gallery in Los Olivos. 'The paintings are for my own enjoyment,' Shinn said. Others will have the opportunity to enjoy them also as award-winning art on exhibit in The Watercolor Society Exhibit in Los Angeles in the Commission on Affirmative Aging art show. Continuously learning to make art in new ways and have fun while doing so, Bill Shinn is definitely more 'affirmative' than 'aging'," per "Santa Maria Artist Bill Shinn Finds When a Teacher Becomes a Student the Success in the Art World Continues," *SMT*, March 8, 1996, p. 9 (i.e., B-1 and B-5).
And, many additional notices in the *SMT* after 1960 not itemized here.
Shinn, William (misc. bibliography)
William C. Shinn b. Nov. 17, 1932, was residing in Santa Maria at an unknown date per *U. S. Public Records Index, 1950-1993*; a port. photo and a photo working on a ceramic are held in *Public Member Photos & Scanned Documents* (refs. ancestry.com).

Shook, Maurice (Santa Maria)
Photographer who exh. at Santa Ynez Valley Art Exhibit, 1954. Co-owner of Camera and Hobby Shop, 1960. Shook's Van & Storage.
See: "Camera and Hobby Shop," "Santa Ynez Valley Art Exhibit," 1954

Shore, Dinah (1916-1994) (Hollywood)
Singer / actress, television personality, artist. Exh. with Hollywood notables at annual Santa Ynez Valley Art Exhibit, 1953, 1954. Wife of George Montgomery, above.
■ "Dinah Shore (born Fannye Rose Shore; February 29, 1916 – February 24, 1994) was an American singer, actress, and television personality, and the top-charting

female vocalist of the 1940s. She rose to prominence as a recording artist during the Big Band era," Wikipedia.
See: "Santa Ynez Valley Art Exhibit," 1953, 1954

Shore, Henrietta (1880-1963) (Los Angeles / Carmel)
Printmaker, one of whose works was owned by John Breneiser and exhibited at National Art Week, 1935.
■ "Henrietta Mary Shore (January 22, 1880 – 1963) was a Canadian-born artist who lived a large part of her life in the United States, most notably California," per Wikipedia.
See: "Art Festival (Santa Maria)," 1935, "National Art Week," 1935

Shore, Merle Morris Scholnek (1919-2006) (Los Angeles / Santa Barbara)
Painter from Los Angeles who made an image of Ballard School for Westways magazine, Sept. 1959.
See: *Central Coast Artist Visitors before 1960*

Shostrom, Nell Walker Warner
See: "Warner (Shostrom), Nell Walker (Mrs. Emil Shostrom)"

Shoults (Lawrence), Hattie Belle (Mrs. Howard C. Lawrence) (1873-1962) (Lompoc)
Exh. artwork at "Santa Barbara County Fair," 1891, 1892.
Shoults, Hattie (notices in Northern Santa Barbara County newspapers on microfilm and on newspapers.com)
1891 – "A large audience filled the Opera House on last Friday evening to listen to the exercises by the graduates of our Grammar School… Those graduating from grammar grade were … Miss Hattie Shoults…," *LR*, Sept. 5, 1891, p. 3, col. 3; "High School Opened. The Union High School opened Monday last with the following named pupils: Junior Class – … Hattie Shoults, Lompoc…," *LR*, Nov. 7, 1891, p. 2.
1892 – "Teachers' Examinations… held by the County Board of Education the following named persons received certificates: Primary Grade: … Hattie Shoults…," *Independent* (Santa Barbara, Ca.), June 22, 1892, p. 4, col. 3, and similar announcement in *LR*, June 25, 1892, p. 3, col. 4; "Premiums Awarded at the Fair… Culinary… Hattie Shoults, brown bread $1.00…," *LR*, Oct. 1, 1892, p. 2.
1893 – "Brief Items… The Purisima school opened last Monday with Miss Hattie Shoults as teacher," *LR*, Feb. 18, 1893, p. 3, col. 1.
1895 – "List of Active Teachers … The following teachers have been engaged to teach in the schools of this county – the new school year commencing June 30th, 1895 … Lompoc – Grammar … Hattie Shoults…," *SMT*, Aug. 24, 1895, p. 1.
1896 – "A Revised List of the Teachers of Santa Barbara County… second term… District… Lompoc grammar… Hattie Shoults, Lompoc…," *SMT*, Feb. 22, 1896, p. 3.
1897 – "Clerks and Teachers of the Several School Districts of Santa Barbara County for 1897-'98… Lompoc

Grammar… $50. Hattie Shoults…," *SMT*, July 31, 1897, p. 4.

Shoults, Hattie (misc. bibliography)
Hattie Belle Shoults, b. c. 1873 in Calif., married Howard C. Lawrence on Jan. 12, 1898 in Los Angeles per Calif. County Birth, Marriage and Death Records; Hattie Scholts [sic.] was b. May 18, 1873 in Calif., married Howard C. Lawrence, was residing in Los Angeles in 1930, and d. June 1, 1962 in Tulare per Clark Family Tree (refs. ancestry.com).
See: "Santa Barbara County Fair," 1891, 1892

Shull, Edmond / Edward Dillon (c. 1858-after 1908) (Santa Maria / Santa Ynez)
"The Tent Photographer," 1904. In business with D. R. Judkins as Santa Maria Photography, 1906-07. Hazel / Hazle Judkins worked as an assistant.

■ Port. and "Mr. E. D. Shull has earned for himself the title of 'The Tent Photographer' but judging from his grade of work, which is the finest and latest finish ever brought to Santa Maria this term, hardly does him justice. For several years, Mr. Shull has been with one of the largest portrait houses in San Francisco, where the finest work was under his personal supervision. After making a thorough tour of California, Mr. Shull has decided to permanently remain in Santa Maria and being unable to secure a suitable location were [sic.] obliged to make a large and convenient tent answer the purpose for the time being. At the earliest possible moment, a more desirable place will be fitted with everything to be found in a well-appointed city gallery. New and artistic screens will be put in and special attention will be paid to posing subjects. This branch of the business is considered of utmost importance by the true artist and Mr. Shull has made a special study of it… Another very important factor … is the retouching, and in this line Mr. Shull has no superior… Last … is the finishing of photographs. … as much, if not more progress, has been made in the various styles of finishing than any other branch of the work… A lady attendant will constantly be at the gallery … After getting settled in a more desirable quarter, Mr. Shull will use tents in making periodical trips throughout the valley from Los Olivos to Arroyo Grande… 'If you have beauty, we will take it. If you have none, we will make it'," *SMT*, Dec.17, 1904, p. 9.
Shull, E. D. (notices in Northern Santa Barbara County newspapers on microfilm and on newspapers.com)
1904 – "The tent photographer E. D. Shull will leave shortly; therefore come at once if you want your picture taken," *SMT*, Oct. 29, 1904, p. 3, col. 2.
1907 – "E. D. Shull, our well-known photographer, returned from a business trip to Lompoc," *SMT*, March 23, 1907, p. 5, col. 3.
1908 – "E. D. Shull, the photographer of this city, is in Santa Ynez conducting a temporary branch of his establishment," *SMT*, May 23, 1908, p. 5.
Shull, Edmond (misc. bibliography)
Edward D. Shull, photographer, is listed in the *San Francisco, Ca., CD*, 1901; Edmond D. Shull, photographer, is listed in *Voter Registrations in Crocket Precinct in Contra Costa County* sometime between 1900 and 1916, and in the *Voter Registrations in Santa Maria Precinct, No.*

1, sometime between 1900 and 1918; E. D. Shull working for Shull and Judkins is listed in the *Santa Maria CD*, 1908 (refs. ancestry.com).
See: "Art, general (Santa Maria)," 1907, "Judkins, D. R.," "Judkins, Etta Hazle," "Meyers, Mr.," 1905

Sicard, Pierre (1900-1980/81) (France / United States)
Artist who painted a view of an Atlas missile launching at Vandenberg AFB, 1960.
See: "Art, general (Lompoc)," 1960, and *Central Coast Artist Visitors before 1960*

Signorelli, Guido Elmer (1915-2004) (Guadalupe)
Santa Maria high school student who exh. at Faulkner Memorial Art Gallery, Santa Barbara, 1933. Farmer who painted in retirement.

■ "Guido was born on Nov. 28, 1915, in Guadalupe, to Rosa and Celestino Signorelli. He attended local schools and graduated from Santa Maria High School in 1934. It was during this time that he met and fell in love with … Bernice. They married on April 15, 1939. He worked for Texaco and then for Security First National Bank. Guido left banking for the farming business as a partner in the Grisingher-Signorelli Ranch and as a co-owner of Bonita Packing. He retired for the first time at the age of 40. He went back to work for Souza Packing as a General Manager. He retired the second time at the age of 70. During that span of time, he revisited his passion for the arts and particularly painting. He dabbled in a variety of mediums and most recently discovered a talent for Chinese brush art. He has been the subject of several local art shows, and his paintings grace the walls of many buildings. His daughter and grandchildren are especially proud to display and show off the works of 'Grandpa Sig'. Guido was a charter member of the Rotary Club of Guadalupe and an avid lawn bowler for many years. He also extensively traveled the world with family and friends. Guido could be counted on for a joke or anecdote to lighten the mood of any room," findagrave.com.
Signorelli, Guido (notices in Northern Santa Barbara County newspapers on microfilm and on newspapers.com)
1956 – Port. of Guido and Celestino Signorelli and their success with growing sugar beets, "6600 Pounds Per Acre," *SMT*, Oct. 20, 1956, p. 7.
1962 – Port. at easel, and "Santa Maria Artist Displays Paintings at Gas Co. Office… The paintings, many of them inspired by Signorelli's 1960 Europe trip… San Luis Obispo Art Association … arranging displays for the gas company office. Signorelli, who now devotes most of his time to oil and palette knife works, is a life-long resident of the Santa Maria area. He has studied under Arnie Nybak at Cambria and completed Norman Rockwell's Famous Artist Course. The current display, which is to continue through the end of January, portrays a variety of European scenes including 'Tranquility' in a Belgian picture-book village, 'Fisherman's Landing' at a Holland seaport and 'Laiguella' on the Italian Riviera," *SMT*, Nov. 19, 1962, p. 9.
1964 – "Exhibit in SLO. Art works by Guido Signorelli, 201 S. Western Ave., are now being featured in a one-man show in the Mezzanine Art Gallery at Riley's in San Luis

Obispo … for about five weeks. Featured are works created first as sketches of the various places Signorelli visited on a 1960 European tour. Aside from a limited number of lessons from such outstanding artists as **Forrest Hibbits, Douglass Parshall,** Arne Nybak, and the late **Stanley G. Breneiser**, Signorelli is largely self-taught. While in Europe, Signorelli visited many of the outstanding art galleries of the world," *SMT*, Aug. 21, 1964, p. 10.

Signorelli, Guido (misc. bibliography)
Guido Elmer Signorelli was b. Nov. 28, 1915 in Guadalupe, Ca., to Celestino Signorelli and Rosa Delfina Taminelli, married Bernice Mary Souza, and d. May 21, 2004 in Santa Maria per Silveira/Souza/Machado and Then Some Family Tree; Guido Elmer Signorelli is buried in Santa Maria Cemetery District, per findagrave.com (refs. ancestry.com).

See: "Faulkner Memorial Art Gallery," 1933, "Santa Barbara County Fair," 1952, "Santa Maria Art Association," 1952, "Santa Maria, Ca., Union High School," 1934, "Santa Maria School of Art," 1933, "Santa Maria Valley Art Festival," 1952, "Scholastic Art Exhibit," 1933

Signs, general (Northern Santa Barbara County)
Various types of signs – ranch, business, street, highway, billboard, neon, etc. – were designed or made by Northern Santa Barbara County artists. Earliest signs were painted by general purpose painters (house/sign/carriage). Once automobile roads were constructed – primarily 1913+ – road signs and billboards appeared. In the late 1920s opinion that billboards and extraneous other advertising signs along highways prevented tourists from seeing California's natural beauty led to laws restricting signage. Several local artists were known for their hand-carved ranch signs. Neon became a medium in the 1950s.

Signs (notices in Northern Santa Barbara County newspapers on microfilm and on newspapers.com)
1925 – "Electric Sign Would Include Three Towns… proposed electric sign as outlined by the committee from the Lompoc Chamber of Commerce… a rough sketch… by the Lompoc Chamber of Commerce's engineer… would include Buellton, to occupy an arch over the center of the sign, Lompoc to occupy the west half of the sign and Solvang to have the east half… The proposed sign will be erected on steel posts and will span the highway… clearance of 22 feet… on top of the Solvang side the words 'Santa Ynez Mission,' and on the Lompoc side 'La Purisima Mission'," *SYVN*, Dec. 18, 1925.
1928 – "Which Kind Attracts Tourists … Will California scenery soon be entirely obliterated by billboards and shacks…," *SYVN*, Sept. 7, 1928, p. 5.
1929 – "Telephone Man Talks to Club… Solvang Businessmen's Association… **John Frame** and Alfred Fauerso were appointed to act as a committee on road signs. It was suggested that a large sign be placed at the intersection of San Marcos pass road and the coast highway near Goleta directing motorists over the San Marcos into the Santa Ynez Valley. Several other similar signs will be placed on the state highways in the valley," *SYVN*, Nov. 29, 1929, p. 1.

1947 – "Price on Sign for Las Cruces… [Lompoc] Chamber of Commerce has been authorized to negotiate further for the purchase of a directional sign to be located at the Las Cruces turn-off… It is a reflector-type sign 20 feet in length and will display a drawing of **La Purisima mission**," *LR*, Aug. 7, 1947, p. 4.
1950 – "Chamber of Commerce … For the first time the city government is joining in the Chamber's program for publicizing the valley through financial assistance in erecting handsome new directional signs at the Santa Maria and Gaviota cut-offs. An artist's sketch of the sign, which depicts the valley's flower fields and **La Purisima mission**, was displayed by Miller…," *LR*, May 18, 1950, p. 15; "Mr. Merchant. Have you too noticed the effective new sign over Linda's Dress Shop at 127 south I Street! This is the new Plastic Sign that really 'Packs a Punch,' is economical and has many other advantages. For information, call or write – City Neon Service, Manufacturers of Quality Neon and Plastic Signs, 286 Higuera St., San Luis Obispo," *LR*, Sept. 14, 1950, p. 14; "Few Billboards Publicize S.B. County Business," and article says only 1/3 of the 389 signs along public highways in Santa Barbara county publicize businesses within the county – the rest publicize things outside the county, and SB County Planning commission is considering outlawing the billboards, *SMT*, Sept. 22, 1950, p. 3.
1952 – "Ad Firm Tells Businessmen No More Billboards Here" unless approved by local businessman's association, and a competing billboard company "suggested to the businessmen that letters be written to other outdoor advertising companies informing them of the anti-billboard feeling in the Valley area," *SYVN*, Feb. 29, 1952, p. 7; "Lompoc Views… The little settlement of Ocean Park… many of the homes are freshly painted. The tiny homes there are neat looking. Some artist has painted a nifty sign at the entrance… It's done in various colors, with a fish as the central theme, and designates the place as a Santa Barbara County Park," *LR*, Nov. 13, 1952, p. 12; "Better Signs… Aired by Retailers… Solvang Businessmen's association… **Ernest Pedersen** of Iron Art introduced the subject of better road signs on the highway directing motorists to Solvang. He volunteered to make the signs and suggested they be bedecked with the traditional stork…," *SYVN*, Nov. 21, 1952, p. 1.
1953 – "Retailers Again Talk About Signs," *SYVN*, Jan. 16, 1953, p. 5; "Suburban Signs Coming Down," *SYVN*, May 29, 1953, p. 3; "Solvang Retailers … signs designating Solvang… Borge Andresen and **Ernst Pedersen** to work out the details of designing these signs…," *SYVN*, July 24, 1953, p. 1; "The Memo Pad" discusses news release from Calif. Highway Patrol, discussing 6000 yearly accidents resulting from disregarded signs, and article segues into commercial signs, *SYVN*, Aug. 14, 1953, p. 2; "Ranch Directory Sign Project Idea Might be Applied Here," *SYVN*, Sept. 18, 1953, p. 11; "Suburban Gas Signs Coming Down," *SYVN*, Oct. 23, 1953, p. 4.
1954 – Photo of sign advertising Old Mission Carnival, *SYVN*, Jan. 29, 1954, p. 1; "Businessmen Briefed on Plan to Advertise Town with Signs," *SYVN*, Feb. 26, 1954, p. 6; "Highway Signs Value Noted… designed and erected by **Paul Kuelgen** and **Holt Lindsley**…," *SYVN*, Sept. 24, 1954, p. 10.

1956 – Photo of Danish style school signs and "Danish Fashioned Markers Placed at Solvang School" to slow down speeders, *SYVN*, Feb. 3, 1956, p. 1; photo of sign to raise money for swimming pool, *SYVN*, May 18, 1956, p. 1.
1957 – "Billboard Control Law is Pushed… Ordinance Calling for Strict Ban Held as Discriminatory," *LR*, Feb. 7, 1957, p. 1.
1958 – "Group Hits Loud Signs. Solvang Retail Merchants… voiced disapproval… neon or flamboyant painted signs… encourage conformity with European type lettering and signs which blend in with the Danish provincial type architecture of Solvang," *SYVN*, May 16, 1958, p. 6.
1960 – "Valley Signboards Slated for Scrutiny by Planners," *SYVN*, March 25, 1960, p. 1; "Planners Approve Permit for Single Church Sign," *SYVN*, May 20, 1960, p. 5; "Propose Road Sign Plan… new freeway sign program … State Division of Highways which has a rigid policy against 'commercial' directional signs along the new freeways… the county is seeking to eliminate large signboards from alongside freeways. Some stretches of freeway have become known as 'signboard alleys' … promote scenic beauty…," *LR*, Dec. 8, 1960, p. 5; letter-to-editor opposing neon signs, *SYVN*, Dec. 9, 1960, p. 8.
1990 – "Historic sign will mark new amphitheater... A sign that marked the original Atterdag bowl ... in the 1940s has been donated to the city to use at its new amphitheater... the sign most closely resembles the work of the late **Walter F. Kristensen**, a business associate of Kris Klibo, a local blacksmith... Klibo said that if Kristensen didn't actually do the work himself, it came out of his shop…," *SMT*, Oct. 24, 1990, p. 5.
See: "Art, general (Lompoc)," 1940, "Austin, W. H.," "Beard, Ed," "Bowen, William," "Brezee, Frank," "Brigham, B. L.," "Brughelli, Mary," "Churchman, Reece," "Crosby, Ed," "Denman, John," "Fabing, Henry," "Forsyth, Joseph," "Hart, John," "Henning, Dewitt," "Holcomb, Tobe," "Hosier, Roy," "Howell, Charley," "Iron Art," "Jeter, Lawrence," "Jones, Oliver," "Kuelgen, Paul" "Learned, George," "Leitner, Earle," "Lompoc Community Woman's Club," 1960, "Lompoc Valley Fair," 1930, "Mayers, George," "McKenzie, Mr.," "Miranda, Ira," "Modern Neon Sign Co.," "Murals," 1947, 1958, "Norris, Clarence," "Parker, Vernon," "Peck, Virginia," "Pedersen, Ernst," "Pointer, G. R.," "Potter, Roy," "Rayo Auto Paint Shop," "Renoult, Japhet," "Revetagat, Eugene," "Santa Barbara County Fair," 1930, "Scolari, Robert," "Sookikian, C. J.," "Star Auto and Sign Painting Shop," "Stover, George," "Stuart Sign Service," "Thielman, Paul," "Utsunomiya, George," 1952, "Ziegler, Leo," 1947

Silva, William Posey (1859-1948) (Carmel)
Carmel artist who exh. in Santa Maria, 1929.
See: "College Art Club," intro., 1929, and *Atascadero Art and Photography before 1960* and *Central Coast Artist Visitors before 1960*

Silver Jubilee (Solvang)
See: "Art, general (Solvang)"

Simas, Dorothy L.
See: "Radford (Simas), Dorothy L. (Mrs. Vernon Lawrence Simas)"

Simeone, Adriana Edna (Hollywood)
Actor / artist who exh. with Hollywood notables at Santa Ynez Valley Art Exhibit, 1954.
This individual could not be identified.
See: "Santa Ynez Valley Art Exhibit," 1954

Simerly, (Lillian) Isabelle MacPherson (Mrs. James Bell Simerly) (1921-?) (Solvang)
Crafts teacher at Santa Ynez Valley adult school, 1947/48 (as MacPherson) and at Santa Ynez Union High School (as Simerly), 1948/49. Left the SY Valley 1955.
■ "Miss MacPherson, James Simerly United in Marriage at Glendale… both teachers at the Santa Ynez Valley Union High School. Miss MacPherson is the daughter of Mr. and Mrs. R. C. MacPherson of Hemet, and Mr. Simerly [b. 1916] is the son of Mr. and Mrs. C. [Clarence] G. [Gordon] Simerly of Laton [Ca.] … Mrs. Simerly taught home economics at the high school last year… Mrs. Simerly is a graduate of Belmont High School in Los Angeles and the University of California at Los Angeles…," *SYVN*, July 2, 1948, p. 4.
Simerly, Isabelle (notices in Northern Santa Barbara County newspapers on microfilm and on newspapers.com)
1947 – "High School Teaching Staff Now Complete… Miss Isabelle MacPherson … who comes to the Valley from Laton Union High School, will teach in homemaking…," *SYVN*, Aug. 22, 1947, p. 1.
1950 – "Mrs. John Simerly, former home economics instructor at the Santa Ynez Valley Union High School, spoke on 'Making the Home Attractive' at a meeting of the Ladies of the Santa Ynez Valley Presbyterian Church Wednesday afternoon…," *SYVN*, April 28, 1950, p. 4; "Simerlys Feted at Housewarming…," *SYVN*, June 23, 1950, p. 3.
1955 – Port. and "J. B. Simerly is Leaving H. S. Post" because of asthma condition," *SYVN*, Oct. 7, 1955, p. 7.
Several notices in the *SYVN* indicate "Isabelle Simerly" handled makeup for the amateur dramatic productions overseen by her husband, but they were not itemized here.
Simerly, Isabelle (misc. bibliography)
Isabelle MacPherson was b. March 2, 1921 in Butte, Mont., per Montana Birth Records; Isabelle MacPherson is pictured in the Belmont High School yearbook, 1939; Isabelle MacPherson is listed in the 1940 U. S. Census as age 19, b. c. 1921 in Montana, finished college 1st year, residing in Los Angeles (1935, 1940) with her parents Richard MacPherson (age 62) and Catherine MacPherson (age 55) and siblings: Alice and Dorothy; Isabelle MacPherson is pictured in the UCLA yearbook, 1943; Lillian I. MacPherson married James B. Simerly June 29, 1948 at an unknown place per California, County Birth, Marriage and Death Records; Isbelle Simerly and husband James are listed in the *Porterville, Ca., CD*, 1952-65; Isabelle Simerly is pictured in McLane High School, Fresno, yearbook, 1986 (refs. ancestry.com).

See: "MacPherson (Simerly), Isabelle," "Presbyterian Church / Presbyterian Ladies Aid," 1949, "Santa Ynez Valley Adult/Night School," 1947, 1948, "Santa Ynez Valley Union High School," 1949, "Solvang Woman's Club," 1948

Simon, Marie (Lompoc / SLO)
Teacher of drawing at Lompoc high school, 1910/11. Went on to teach in San Luis Obispo.
1910 – "Miss Simon, teacher of the High school, is stopping at Mrs. Mary Harmon's," *LR*, Aug. 19, 1910, p. 3.
1911 – "A Visit to the High School … After the luncheon… a brief visit … was made to the rooms used for the different divisions… Marie Simon, Science … Drawing and Engraving…," *LR*, May 12, 1911, p. 1.
See: "Lompoc, Ca., Union High School," 1910, and *San Luis Obispo Art and Photography before 1960*

Simpson (Sloan), Ida (Mrs. James Sloan) (1869-1953) (Lompoc)
Exh. landscape painting in oil at the "Santa Barbara County Fair," 1894. Active with Alpha Club 1939+.
Simpson, Ida (notices in Northern Santa Barbara County newspapers on microfilm and on newspapers.com)
1895 – "List of Active Teachers … Lompoc – Grammar … Ida Simpson…," *SMT*, Aug. 24, 1895, p. 1.
1897 – "Clerks and Teachers… Lompoc Grammar… $60 Ida Simpson…," *SMT*, July 31, 1897, p. 4.
Simpson, Ida (misc. bibliography)
Is she Ida Louella Simpson b. May 24, 1869 in Paris, Ill., to Henry Lowery Simpson and Laura Katherine Bruner, who married James Sloan, who was residing in Lompoc in 1930, and who d. April 27, 1953 in Santa Barbara per Robert G. Mack Family Tree; port. in *Public Member Photos & Scanned Documents* (refs. ancestry.com).
See: "Alpha Club," 1939, 1940, 1941, 1954, "Santa Barbara County Fair," 1894, and *San Luis Obispo Art and Photography before 1960*

Sims, Lee Thomas (Lompoc)
Teacher of mechanical drawing at Lompoc high school, and coach, 1925/29. In 1929 he became principal of Clarksburg school, Yolo County, Ca.
1929 – "To Clarksburg – Mr. and Mrs. Lee Sims left today for Berkeley where they will attend Summer School before going on to Clarksburg, where Mr. Sims will be the principal of the High School recently formed there. Mrs. Sims, who holds a California elementary certificate will complete her requirements for a high school certificate during the summer…," *LR*, June 7, 1929, p. 5.
Lee T. Sims port. appears in Lompoc High School yearbook, 1936 [Sic. 1926], but not in the order listed in the caption (refs. ancestry.com).
See: "Lompoc, Ca., Union High School," 1925, 1928

Sinclair's Drug Store (Santa Maria)
Retailer of photograph equipment and goods, 1925, 1927, 1928, 1930, 1931, 1932, 1934.
1925 – "119 West Main St. Kodaks, Brownies, Films, and All Eastman Photographic Goods," *SMT*, May 29, 1925, p. 5.
1939 – Photo of several different Kodak cameras and descriptions, for sale, Sinclair Drug Store, *SMT*, May 24, 1939, p. 5.
And additional notices not itemized here.

Singer, Margaret / Margarete (1921-2019) (Santa Barbara)
Santa Barbara artist who exh. paintings at Hancock College, 1959.
■ "The Nazi invasion of Frankfurt forced Singer's family on a constant move throughout Germany. Eventually, her father obtained visas and the family left for America when Singer was 17. 'I never thanked my father,' said Singer. 'Although we loved him and were grateful, I don't remember saying 'thank you' for saving our lives.' Art has helped both women heal and thrive. 'There is one thing we learned from this horrible time ... Every human being is valuable,' said Singer," from writeup for "The Art of Survivors," Bronfman Family Jewish Community Center, Santa Barbara, Jan. 2015.
Bio. "After arriving in the U.S., I worked in a factory in New York. A friend introduced me to the American People School, where I studied art with my teacher Carl Nelson. After moving to Santa Barbara, I worked at different jobs, attended City College and then UCSB, where I received a BA in art and MA in educational psychology. After graduating, I became a teacher at City College Adult Education and taught portrait, figure, and landscape painting for 20 years," from jewishsantabarbara.org/portraits.
■ "The present exhibit [at Art Gallery at Allan Hancock College] by Margaret Singer displays talent in various media such as water color and pencil, pen and ink, and mixed media. The subject matter ranges from nude figures to intricate landscapes, each with a modern flavor. Mrs. Singer was born in Germany in 1923 and after receiving a primary education there, arrived in New York to study art in 1938. Mrs. Singer's most celebrated instructor, Carl Nelson, left a most lasting creative impression which has impelled this artist to continue her career. The paintings being shown here have been exhibited in a one-man show at Santa Barbara Museum of Art and at other noteworthy art centers of the west coast, such as Carmel," and port with 2 paintings, per "Singer Paintings at Hancock Art Gallery," *SMT*, Jan. 16, 1959, p. 7.
Singer, Margaret (misc. bibliography)
Margaret Singer b. June 11, 1921 was residing in Carpinteria, Ca., in 1987 per *U. S. Public Records Index, 1950-1993*, vol. 1; Margarete Singer b. June 11, 1921 in Friedrichsthal, Ger., to Leo Leon Leibisch Singer and Gitla Kolber, d. May 14, 2019 in Santa Barbara per Jewish Saar Family Tree (refs. ancestry.com).

Sissons, Ronald "Ron" (1919-2010) (England / Lompoc / Southern California)
Creative individual with creative children, 1959. Horticulturist.

■ "English Housewife Tells of Decision to Come to Cal… Veronica and Ron Sissons and their two children Angela and Tony are making Lompoc their home… They didn't know about Lompoc until W. Atlee Burpee Co. accepted his job application and sponsored him over here… Ron is quiet and thoughtful, with a twinkle in his eye. He works beautifully with his hands, whether it be tending his little green plants in the greenhouse or painting or drawing pictures or writing stories or letters. Angela is 11 years old, in the 7th grade and lives horses, horses, horses. She had a horse in England and she draws horses, makes up stories about horses, and illustrates them and collects miniature horses. Tony, 14 and a freshman, loves to work with mechanical drawing problems, science and electricity. '… the commercial horticultural industry was gradually showing diminishing prospects. The post-war years carried with them a depression that left my husband despondent about our future. People were emigrating to Canada, Australia and New Zealand by the thousands… suddenly swallowed his convictions and proceeded to write to the horticultural industry in the U. S. requesting a post. … we couldn't raise enough money to pay our passages… Then, like a bolt from the blue came a letter from Burpees… offer of a 3 months trial with the option to return to England on its completion… We decided that whatever the outcome of the trial period my husband would stay in America. So… we sold our home … And so, here we are, with even less in the bank than we had in England, with a home to buy and accumulated debts to repay our sponsor, but how nice it is to know that in a few years we will be on our feet…," *LR*, Jan. 22, 1959, p. 9.
Sissons, Ron (misc. bibliography)
Ronald Sissons b. July 14, 1919 Petition for Naturalization (No. 254828) stated he entered the US at New York on 9/11/58 and that his lawful admission for permanent residence in the US was at Los Angeles, Calif., via TWA on 5/26/58; Ronald Sissons is listed in the *Santa Maria, Ca., CD*, 1959-65; Ronald Sissons was b. July 14, 1919 in East Retford, England, to George William Sissons and Florence May Littlewood, married Veronica Emily Young, and d. Dec. 23, 2010 in Chula Vista, Ca., per Sissons Family Tree (refs. ancestry.com).

Skeate, Gladys (Mrs. Kenneth Leroy Skeate) (Lompoc)
See: "Puttering Micks Ceramics"

Skelton, Richard Bernard "Red" (1913-1997) (Hollywood)
Comedian / painter. Exh. with Hollywood notables at Santa Ynez Valley Art Exhibit, 1953, 1954. Best known theme was clowns.

■ "Richard Bernard 'Red' Skelton (July 18, 1913 – September 17, 1997) was an American comedy entertainer. He was best known for his national radio and television shows between 1937 and 1971, especially as host of the television program The *Red Skelton* Show," per Wikipedia.

See: "Santa Ynez Valley Art Exhibit," 1953, 1954

Skinner, Charlotte B. (Morro Bay)
Exh. Santa Maria Art Festival, 1953.
See: "Santa Maria Valley Art Festival," 1953, and *Morro Bay Art and Photography before 1960*

Skytt, Clara, Miss (Santa Ynez Valley)
Collector / lender of flower studies to Art Loan Exhibit, Solvang, 1935. Miss Santa Ynez, 1931. Musician.
See: "Art Loan Exhibit (Solvang)," 1935

Slawson, Mervin Z. (1913-2005) (Santa Maria)
Photographer who was given a OMS at Allan Hancock [College] Art Gallery, 1956. Headed up the photography exh. at Santa Barbara County Fair, 1958. Active with Santa Maria Camera Club. Photography instructor at Santa Maria High School, 1958-78.

■ Port. and b. May 6, 1913, Kansas and d. April 9, 2005 in Santa Maria, Ca. "Mervin was born in Kansas in 1913. He served in the US Army from 1942-1945. May 10 of 1942 he married Dorothy Walline. After attending art school in Los Angeles, and at the request of Captain Allan Hancock, Mervin moved to Santa Maria in 1946 to work for the USC College of Aeronautics as a Link Trainer instructor, mechanic, and photographer. From 1958-1978, Mervin was a photography instructor at Santa Maria High School, producing 18 yearbooks during that time. He was a member of Hesperian Lodge #264 since 1956. Throughout his years, Mervin had a deep love and interest in photography, raising Orchids, collecting stamps, and fishing in Colorado. … Mervin is survived by his wife of 62 years, Dorothy Slawson, a daughter Sharee Fromholtz from Colorado…," per www.findagrave.com, and SantaMariaTimes.com/lifestyles obituaries posted April 14, 2005, and also "Mervin Z. Slawson 1913-2005," *SMT*, April 13, 2005, p. 9.

■ "Farm scenes, landscape, people, industry and animals are all portrayed in the display … Seventy-five per cent of the pictures on exhibit, Mr. Muro states, have won prizes and two of the portraits – a little girl and the captivating picture of a small boy – have been hung in Huntington Library. Also, among the thirty-one black and white prints are scenes from Waller park, Shell Beach, Avila, Laguna Beach, Union Oil refinery and the Santa Maria valley. Slawson developed an interest in photography in 1938 and then attended Los Angeles Institute of Photography in 1946. He also was graduated from Santa Maria junior college and completed a 15-week course in color photography at **Brooks Institute**. He is currently employed with La Brea Securities Company," per "Slawson Photography Shown at [Hancock] Art Gallery," *SMT*, Oct. 6, 1956, p. 5.
Slawson, Mervin (notices in Northern Santa Barbara County newspapers on microfilm and on newspapers.com)
1946 – "Visiting Mother – Mrs. Mervin Slawson… is in Arcadia… Slawson, a link-trainer instructor in University of Southern California Aeronautics College on Hancock Field, is devoting his spare time to his hobby of amateur

photography while Mrs. Slawson is away," *SMT*, Sept. 17, 1946, p. 4.

1959 – "Given History Book. Los Alamos – Two local boys, **Ronald** and **Dean Dunson**, have been presented copies of '*This is Our Valley*,' area history book, in recognition of photography work accomplished for the book. The two worked under the supervision of Mervin Slawson …," *SMT*, Nov. 19, 1959, p. 26.

See: "Allan Hancock College Adult/Night School," 1958, 1959, "Allan Hancock [College] Art Gallery," 1956, "Santa Barbara County Fair," 1958, "Santa Maria, Ca., Union High School," 1958, "Santa Maria Camera Club," 1947, 1948, 1949, 1952, 1955, 1960

Slimp, Helen Ferne (1890-1995) (Texas)
Printmaker, one of whose works was owned by John Breneiser and exhibited at National Art Week, 1935.

■ "1931 Castle Hills namesake house… nearby Olmos Creek… constructed in 1931… Slimp was a lifelong artist who worked in oils, lithography, **stained glass** and china painting…," and more on *San Antonio Express-News*, May 26, 2016, on the Internet.

See: "National Art Week," 1935

Sloan, Ida Simpson (Mrs. James Sloan) (Lompoc)
See: "Simpson, Ida"

Sloane, Charles Albert (1892-1975) (Santa Ynez Valley)
Rancher / artist / collector. Exh. Santa Ynez Valley Art Exhibit, 1955-58. OMS Solvang Library, 1959.

■ "Sloane Seeking Information on Portrayal of Spanish Armada. Charles Sloane, long-time resident of the Santa Ynez Valley, poultry rancher and artist hobbyist, is in the process of determining the value of an early-day English painting which portrays the Spanish Armada. The painting has been loaned to Sloane by his brother-in-law, Don McKinzie of Robles del Rio… The Santa Ynez Valley rancher-artist is enjoying the job of studying the history of the painting because of his love of art since boyhood days. A native of Santa Barbara – he was born 64 years ago in what was known as the old Spanish fort at the corner of Canon Perdido and Santa Barbara Streets – he became interested in art and cartooning when a student at Santa Barbara High School. He took a number of correspondence courses in art and for a time studied at night by attending classes in Los Angeles. Sloane left the art interest shortly after that period and 45 years went by before he resumed his work in this field. He was encouraged to return to his easel and water colors and oil by his next-door ranch neighbor, **Paul Kuelgen**… Sloane transformed a small wooden structure behind his home into a studio and today Sloane spends his time, when not caring for his chickens, at his easel. Sloane is studying today under **Ziegler** and **Forrest Hibbits** and he considers his two most notable achievements in the field of art two water colors – a still life and an outdoor scene which portrays Sycamores at Nojoqui Park. He displayed both of these paintings at last year's **St. Mark's-in-the-Valley Art Show** and is considering now displaying some of his more recent work

at the St. Mark's Show the latter part of May. Sloane operates his 20-acre ranch on Chalk Hill road with his stepson, Howard Jensen. They produce eggs from 3,000 White Leghorn laying hens with another 1,000 birds in the week-old chick to the laying stage age. Sloane's late father, Albert M. Sloane, acquired the ranch property in 1928. Sloane has been operating the place since 1932," *SYVN*, March 23, 1956, p. 4.

Sloane, C. (notices in Northern Santa Barbara County newspapers on microfilm and on newspapers.com)

1938 – "Old Pictures. In line with the many old-time pictures on display all over Santa Barbara during La Fiesta, Chas. Sloane brought in several old photographs recently which are now on display in the *News* office window. One is a very old tintype. Several pictures are of Sloane's father, who kept horses for Dixie Thompson in Santa Barbara in 1893," *SYVN*, Aug. 12, 1938, p. 4.

1957 – "Memo Pad… Valley Views … Charlie Sloane … is a collector of memorabilia… among the latter is a receipt for the State poll tax for the year 1886; it was issued to A. M. Sloan on April 26, 1886 in the County of San Luis Obispo for $2…," *SYVN*, May 31, 1957, p. 2; "Memo Pad… Charles Sloane of Solvang has returned home after a two-week vacation stay at Carmel Valley and White Rock Mountain. … he spent a great deal of the time enjoying his hobby of painting… Charlie will be among the exhibitors in the forthcoming **St. Mark's-in-the-Valley Art** exhibit…," *SYVN*, Aug. 2, 1957, p. 2.

1959 – "Memo Pad… Valley Views –- Charles Sloane of Solvang, former Santa Ynez Valley poultryman who is spending his years of retirement as an artist, was among a class of 61 painters and sculptors who attended a five-week course at Sedona, Ariz., conducted by Dr. Harry Wood of the University of Ariz. … Sloane who turned to water colors and oils at a later age, has exhibited each year at the St. Mark's-in-the-Valley Art Show and at various shows in Santa Barbara…," *SYVN*, Aug. 21, 1959, p. 2; "**Library** Exhibits Sloane Paintings… and will be on display for the next six weeks. The exhibit includes five oils and one pastel," *SYVN*, Nov. 20, 1959, p. 8; "Buellton Briefs… Six paintings by Charles Sloane are on exhibition at the library in Solvang…," *LR*, Nov. 26, 1959, p. 9.

1960 – "Memo Pad. Valley Views… Charles Sloane of Carmel Valley, former long-time resident of the Valley, spent the day here Saturday visiting friends… now retired, he keeps busy daily painting… before moving north he exhibited his oils at several shows here and in Santa Barbara…," *SYVN*, Oct. 7, 1960, p. 2.

1975 – "Charles A. Sloane… of the Solvang Lutheran Home… Mr. Sloane was a retired farmer. He was born March 3, 1892 in the old Spanish fort at the corner of Canon Perdido and Santa Barbara Streets in Santa Barbara. He served with the National Naval Volunteers during World War I and was past commander of American Legion Post No. 160. He moved to the Valley in 1932, retired in 1957 after many years in chicken ranching, and took up painting. He was a lifelong resident of California and had lived in the Carmel Valley for three years," *SYVN*, Jan. 30, 1975, p. 18.

And additional newspaper notices not itemized here.

Sloane, C. (misc. bibliography)
Charles Albert Sloane was b. March 31, 1892 and d. Jan. 27, 1975 and is buried in Oak Hill Cemetery, Ballard per findagrave.com (refs. ancestry.com).
See: "Danish Days," 1957, "Santa Barbara County Library (Solvang)," 1959, "Santa Ynez Valley Art Exhibit," 1955-58

Sluchak, John Martin and Marie Myers (Santa Maria)
School teachers whose hobby was photography, and who used filmmaking in their teaching, 1947.
Sluchak, John (notices in Northern Santa Barbara County newspapers on microfilm and on newspapers.com)
1945 – "Our Men in Service. Capt. John Martin Sluchak…," and information on his service, *SMT*, April 27, 1945, p. 3.
1947 – "Sluchaks Return … from Huntington Lake where they have completed a six-week summer course given by Fresno State College. Mrs. Sluchak took the course in ornithology and her husband's studies consisted of photography and the Constitution. They also enjoyed fishing at Florence Lake…," *SMT*, Aug. 25, 1947, p. 5; "Magazine Tells of SM Fifth Grader's Movie. Recognition has been given in the October issue of *Sierra Education News*, a state publication, … to the original teaching method in American history by Mrs. Marie Sluchak, fifth grade teacher in the Main Street Elementary School. The course was taught by making an eight-millimeter movie, in color, with the class of 1946 as the actors and actresses, technical staff and assistant directors. Since photography is the hobby of both Mrs. Sluchak and her husband, John, who filmed most of the scenes, both adapted their knowledge of lighting while making the picture, so that it was not necessary to have studio lights. Taking about eight minutes to show, the picture covers the exploration, colonization and pioneer periods of American history. In its making, the children learned by doing what took place in the daily lives of the early colonists. The landing of Columbus and later the Pilgrim fathers called for beach scenes, and these were enacted at Avila and Pismo Beach. … With the limited facilities at hand, ingenuity sometimes had to be practiced, as in the case where 'trick photography' was the solution, using a model Columbus flagship against a miniature background with sand table… To make the schoolroom sequence, benches were moved into a class room. Both students and teacher wore costumes … letters coming in to Mrs. Sluchak, not a few of them from her former classmates at San Jose State College, where she received her education, graduating three years ago," *SMT*, Oct. 14, 1947, p. 3; "Special Events at Presbyterian Church… following the evening worship of the church, John Sluchak will show his movies of the national parks, narrating same … Sluchak took the pictures while on recent trips with his wife…," *SMT*, Dec. 4, 1947, p. 3.
1951 – "Mrs. and Mrs. True E. Myers of 913 Haslam left Friday for Sun Valley where they will meet their son-in-law and daughter, Mr. and Mrs. John Sluchak and go on to Big Bear to spend next week. Sluchak has one more year in University of Southern California's Dental college," *SMT*, June 15, 1951, p. 5.

And approx. 100 additional references regarding the couple's teaching were not itemized here.
See: "Camp Fire Girls," 1945, "Santa Maria, Ca., Elementary School," 1947

Small, Clyda (1919-1934) (Santa Maria)
Artistically inclined teen who died of a baffling disease before achieving her potential, 1934.
■ "Baffling Malady Claims 15-Year-Old S. M. Girl… daughter of Mr. and Mrs. H. E. Small … died… after suffering for more than four years… Despite her affliction, she enrolled as a freshman in high school, but was unable to continue her studies. As an elementary school girl, she showed considerable artistic talent, painting many posters displayed in downtown shop windows…," *SMT*, Dec. 21, 1934, p. 1.
Small, Clyda (misc. bibliography)
Clyda Small was b. Sept. 15, 1919 in Monticello, Utah, to Harry Emil Small and Ablenda Caroline Young, and d. Dec. 19, 1934, in Santa Barbara per Stanley Family Tree (refs. ancestry.com).

Smalley, Evelyn (Mrs. David D. Smalley) (Santa Maria)
Chairman Handicraft Section, Minerva Club, 1934.
See: "Minerva Club," 1934

Smiley, Francis W. (Lompoc)
See: "Smiley's Ceramic Supplies"

Smiley's Ceramic Supplies (Lompoc)
Ceramic shop that opened 1950. Sold supplies, fired greenware. Prop. Francis W. Smiley. Located in (?) Smiley's Feed Store.
■ "Ceramics Shop Opened Here. … newest business enterprise started operations this week at 126 ½ South H street, with Francis W. Smiley as proprietor. The new shop specializes in ceramics supplies of every description, possessing a very complete stock in this line. Slip paint, color glazes, Tru-Fyre ceramics colors and China paint are four of the featured stocks. Smiley has been a Lompoc resident since 1919. For the past seven years he has been employed with the local Railway Express Agency office. Other lines carried by Smiley's… include… clays for molding, slip for casting, plaster of Paris for molds, greenware of all kinds, ceramics and sculpture books, and a full line of tools, paints and miscellaneous supplies. The shop also has kilns for sale and does firing," *LR*, Jan. 19, 1950, p. 8.
Smiley's Ceramic Supplies (notices in Northern Santa Barbara County newspapers on microfilm and on newspapers.com)
1950 – "Ceramics Class is Inaugurated. Classes in China Painting will begin at Smiley's Ceramics Shop on Thursday, February 2. … A number of persons have already registered for the course… taught by **Mrs. Marynett Duffy**. Mrs. Duffy was an instructor for several years at the Willoughby Studios, famous ceramics institution in Los Angeles. Mrs. Duffy is now a resident of

Lompoc. The classes will start on Thursdays at 7 p.m.," *LR*, Jan. 26, 1950, p. 5; ad: "Smiley's Ceramics Shop... China Painting Lessons begin here Today, 7:00 p.m. Mrs. **Marynett Duffy**, Instructor," *LR*, Feb. 2, 1950, p. 24; "126 ½ So. H., Bill Smiley, Mgr. ... Also, ceramics and Supplies, kiln firing, .05 to .25 per piece. Ceramics taught Wed. nite, 7:30. Also china painting by one of the best, **Mrs. Marynett Duffey**, a licensed teacher,' *LR*, Sept. 14, 1950, p. 15; ads continued to run in the *LR* July-Dec. 1950, Jan.-Feb., 1951.

Smith, Billo (San Antonio, Tx)
Photographer of national repute who ran Billo Smith Photography (for portraits) 1956+, in San Antonio, Texas, and who spoke to the Santa Maria Soroptimists, 1951. His wife's (Beverly Silveira) parents, Mr. and Mrs. John Ruffoni, resided in Guadalupe, leading to his visiting California on several occasions.
See: "Photography, general (Santa Maria)," 1951

Smith, Charles Alexander (Chicago)
Draughtsman with California Portrait Co. active in Santa Maria, 1905.
■ "Chas. Alexander Smith of Chicago, an artist of exceptional ability, has just completed a fine portrait of Mrs. S. A. Johnson. Mr. Smith is a brother of Jas. Smith, a prominent driller in the oil field. Samples of his work are on display in Jones & Sons' furniture store, and parties contemplating having work done in this line should bear Mr. Smith in mind," *SMT*, June 3, 1905, p. 3, col. 4.
Smith, Charles Alexander (notices in United States newspapers on microfilm and on newspapers.com)
[Is he Charles Alexander Smith (1864-1915), painter of Ontario, Canada? Or is he Charles L. A. Smith (1871-1937) of Chicago who retired to Calif. c. 1920s?]
1893 – "Canadian Building at the World's Fair ... The number of exhibiters whose works fill the two rooms of the Art Palace allotted to Canadian artists is not large, but among them there are several whose painting is of a high order of merit... Charles Alexander Smith has two French scenes of which the most pleasing is 'Gathering Plums.' It shows a young peasant girl seated on a wheelbarrow under a plum tree in a garden...," *Chicago Tribune*, Aug. 14, 1893, p. 12.
1905 – Ad: "Portraits of all kinds enlarged in Crayon and Water Colors – from photographs only. We Make Our Own Frames. Prices reasonable and within the reach of all. All work guaranteed. Beware of traveling agents. We are here permanently and do our own work. **California Portrait Co.** Santa Maria, Cal.," *SMT*, Aug. 26, 1905, p. 4, and other ads in June and July.
See: "California Portrait Co."

Smith, Dick (Santa Barbara)
Art editor, Santa Barbara News Press, who lectured in conjunction with the Tri-County Art Exhibit, 1959.
See: "Tri-County Art Exhibit," 1959

Smith, Elaine (Santa Maria)
Student artist of Santa Maria Art Association at DeNejer Studio who exhibited at the Santa Barbara County Fair, 1949 and the Tri-County Art Exhibit, 1949, 1950.
See: "Santa Barbara County Fair," 1949, "Tri-County Art Exhibit," 1949, 1950

Smith, Elizabeth L. (1883-1970) (Santa Maria)
Teacher of domestic science and domestic art at Santa Maria High School, 1924-47?
■ "Elizabeth Smith... She was born March 12, 1883 in California and was a retired home economics teacher for the Santa Maria High School. The Home Economics building is named in her honor. She was a past president of the AAUW...," *SMT*, May 27, 1970, p. 4.
Smith, Elizabeth (misc. bibliography)
Elizabeth L. Smith, teacher at 615 S. Lincoln is listed in the *Voter Register, Santa Maria Precinct, No. 4*, sometime between 1920 and 1928; port. in group photo of faculty and caption reads, "Elizabeth Smith, A. B., Mills College, Santa Barbara Normal, Instructor in Domestic Science, Domestic Art, Home Management," Santa Maria High School yearbook, 1924; Elizabeth L. Smith is listed in the 1930 U. S. Census as age 40, b. c. 1888 in Calif, a teacher, lodging in Santa Maria; port. as Domestic Arts teacher in Santa Maria High School yearbook, 1930; port as head of Dept. Homemaking, Cafeteria Manager, Santa Maria High School yearbook, 1947; Elizabeth L. Smith was b. March 12, 1883 and d. May 15, 1970 per Social Security Death Index (refs. ancestry.com).
See: "Santa Maria, Ca., Union High School," 1924, 1926, 1937

Smith, Ernest Browning (1866-1951) (Los Angeles)
Painter, one of whose paintings was distributed by the PWAP to a public building in northern Santa Barbara County, 1934.
Musician (of Los Angeles) who also painted landscapes between c. 1903 until his death, per Nancy Moure, "Dictionary of Art and Artists in Southern California Before 1930," *Publications in California Art*, vol. 3.
See: "Public Works of Art Project," 1934

Smith, Gertrude (Nipomo?/Chico?)
Artist who exh. at Santa Ynez Valley Art Exhibit, 1954.
She may be Mrs. Gertrude Smith of Chico, mother of Mrs. George Knotts of Nipomo, who made extended visits to the Central Coast in the 1950s.
See: "Santa Ynez Valley Art Exhibit," 1954

Smith, Grace (SLO)
Artist who exh. at Santa Ynez Valley Art Exhibit, 1954.
See: "Santa Ynez Valley Art Exhibit," 1954, and *San Luis Obispo Art and Photography before 1960*

Smith, Hattie Rennie (Mrs. James M. Smith) (1890-1971) (Lompoc)
Chairman of the Alpha Club Handicraft Section, 1934 and active with the club 1940-54. Collector of China.
See: "Alpha Club," 1934, 1938-42, 1947, 1948, 1953, 1954, "United Service Organization," 1944

Smith (Wilson), JoAnn (Mrs. Donald Wilson) (Santa Maria)
See: "Wilson, JoAnn Smith"

Smith, Julia Anne Beeson (Mrs. Dr. William Leland Smith) (Santa Maria)
Photographer who filmed gardens in British Columbia and Mexico which she projected for the Minerva Club, 1954.
See: "Junior Community Club," 1955, "Minerva Club," 1954, "Minerva Club, Art and Hobby Show," 1957

Smith, Lucretia Hazel (Mrs. George Clinton Smith) (1874-1936) (Santa Maria)
Exh. landscape, marine view at "Santa Barbara County Fair," 1891. Painting associate of Minnie Stearns, 1892. Member of the Art Loan committee, 1895. Grandmother of Marilyn Smith, below.
■ "Funeral Held for Mrs. Geo. Smith… Mrs. Lucretia Hazel Smith, 61, who died in the family residence, 107 West Park avenue, early yesterday morning. She was the wife of George C. Smith, pioneer realtor and insurance man here. … Mrs. Smith, in her earlier years in Santa Maria, was connected with *The Santa Maria Times* as a writer," *SMT*, Dec. 16, 1936, p. 6.
And, hundreds of notices on her club and volunteer activities as well as her travels were not itemized here.
Smith, G. C. (misc. bibliography)
Lucretia Hazel Smith (1874-1936) is buried in Santa Maria Cemetery District per findagrave.com (refs. ancestry.com).
See: "Art Loan Exhibit (Santa Maria)," 1895, "Santa Barbara County Fair," 1891, "Smith, Marilyn," "Stearns, Minnie," 1892

Smith, M., Miss
Exh. portrait painting at "Santa Barbara County Fair," 1900.
This individual may be the same as "Minnie Smith," below.
See: "Smith, Minnie," "Santa Barbara County Fair," 1900

Smith, Margaret Edith / Edith Margaret
See: "Fortune (Smith), Margaret Edith (Mrs. Herman A. Smith)"

Smith (Anderson), Marilyn Gayle (Mrs. John E. Anderson) (1935-?) (Santa Maria)
Santa Maria High School grad. '54, who studied art at Mills College, 1955. Grand-daughter of Lucretia Smith, above.
■ "Mills College Sophomore Marilyn Smith of Santa Maria is among the art students represented in the annual exhibition of student work in arts and crafts currently on public display in the Art Gallery of the Oakland college. … Among Marilyn's works now on exhibit are examples of mobile sculpture. She has been studying this year under William Gaw, noted California painter and chairman of the Art Department at Mills. Marilyn is the daughter of Mr. and Mrs. George Clinton Smith [Jr.] of 623 East Central. Before entering Mills College, she was graduated from Santa Maria High school," per "Sculpture Shown," *SMT*, May 31, 1955, p. 4.
Smith, Marilyn (notices in Northern Santa Barbara County newspapers on microfilm and on newspapers.com)
1957 – "Marilyn Smith, Honor Graduate… of Psychology," *SMT*, June 15, 1957, p. 3.
Smith, Marilyn (misc. bibliography)
Marilyn Gayle Smith, mother's maiden name Adair, was b. Dec. 9, 1935 in Santa Barbara County per Calif. Birth Index; Marilyn G. Smith is listed in the 1940 U. S. Census as age 4, b. c. 1936, living in Santa Maria, Ca. with her parents George and Nathalie and baby sister Nathalie; port. appears in Santa Maria High School yearbook, 1952; Marilyn G. Smith, b. c. 1936, married John E. Anderson on July 8, 1967 in Santa Clara County per Calif. Marriage Index (refs. ancestry.com).
See: "Camp Fire Girls," 1950, "Smith, Lucretia"

Smith, Mary B. (Mrs. Smith) (Lompoc)
Teacher, who entertained the Alpha Club with cartooning, 1919.
Smith, Mrs. (notices in Northern Santa Barbara County newspapers on microfilm and on newspapers.com)
1919 – "Fire Consumes Odd Fellows Mortgage… The program was as follows: … Recitation with cartoon illustrations, Mrs. Mary B. Smith…," *LR*, May 2, 1919, p. 1; "Purissima School Closes for Summer… Mrs. Mary B. Smith, teacher…," *LR*, June 6, 1919, p. 3.
Smith, Mary (misc. bibliography)
She may be the Mary B. Smith, b. Kansas, c. 1881, teacher, listed in the 1920 U. S. Census as being active in Ontario, Ca., and later also teaching in Oakland, Ca., 1923 (refs. ancestry.com).
See: "Alpha Club," 1919

Smith, Minnie F. (1872-1953) (Santa Maria)
Exh. painted scarf, sachet, at "Santa Barbara County Fair," 1891, and crayon drawing, 1893.
[She may also be the Miss M. Smith, above.]
■ "Miss Minnie F. Smith Dies at San Diego… a resident here [San Diego] since 1913 and formerly of Santa Maria, died August 27 in a local sanitarium," *SMT*, Sept. 10, 1953, p. 6.

Smith, Minnie (notices in Northern Santa Barbara County newspapers on microfilm and on newspapers.com)
1887-1904 – "Monday evening another party took possession of the house of Mr. Wm. Smith three miles from town. This time the surprise was for Minnie Smith…," *SMT*, Jan. 22, 1887, p. 5, col. 1; "Central School Report… Grammar Room… B. class – Minnie Smith, 97…," *SMT*, Oct. 27, 1888, p. 3; "Committees Appointed… Presbyterian church… Minnie Smith…," *SMT*, Dec. 20, 1890, p. 3; attended the Midwinter Fair in SF and returned "home" on the *City of Mexico* steamer, *SMT*, July 14, 1894, p. 3, col. 3; "A birthday surprise party was tendered Miss Minnie Smith at the residence of her brother Frank in town last Wednesday evening," *SMT*, Sept. 8, 1894, p. 3, col. 4; "Chas., Fred and Minnie Smith … returned the first of the week from the Cuyama where they had been putting in a few days on a couple of claims owned by Miss Minnie and Fred," *SMT*, Oct. 16, 1897, p. 3, col. 6; "Worthy of Emulation. Mrs. L. L. Colvin has opened her new store in the Ables' building… millinery… dress-making… Miss Dollie Gray is in charge of the hat trimming department with Miss Minnie Smith as assistant," *SMT*, Dec. 17, 1904, p. 3.
And, additional notices detailing her schooling, her social, church and club activities, including those with the Magnolia Temple, Rathbone Sisters, were not itemized here.
Smith, Minnie (misc. bibliography)
Minnie Smith is listed in the 1900 U. S. Census as age 28, b. Sept. 1871 [Sic.?], residing in township 7 of Santa Barbara County, with her parents William and Sarah J. Smith and two brothers: Walter L. and Robert D. and a sister Mary J.; Minnie F. Smith is listed in the 1920 U. S. Census as residing in San Diego with the family of her brother, Fred, and in the 1930 U. S. Census as residing in San Diego with her mother; Minnie F. Smith is listed in the 1940 U. S. Census, finished high school 3rd year, no occupation, residing alone in San Diego (1935, 1940); Minnie F. Smith was b. Sept. 5, 1872 in Calif. to William Smith and Sarah Jane Dayment, and d. Aug. 27, 1953 in San Diego per Benjamin Franklin Sharp Family Tree (refs. ancestry.com).
See: "Santa Barbara County Fair," 1891, 1893, "Smith, M."

Smith, Pearl / Pearle "Pearlie" (Guadalupe)
See: "Gleason (Smith), Pearl / Pearle "Pearlie" (Mrs. Smith)"

Smith, Richard "Dick" Olney (1906-1947) (Lompoc)
Photographer with the Highway Patrol and the Lompoc Police Department, 1942.
■ "City Employees… Plans are now underway for the 'mugging' and fingerprinting of all city employees and key men in the civilian defense council. Officer R. O. Smith of the police department is the photographer in charge. The photographing is being done as part of the local civilian defense program, and the photos will later be placed on identification cards," *LR*, March 27, 1942, p. 1.

Smith, R. O. (notices in Northern Santa Barbara County newspapers on microfilm and on newspapers.com)
1935 – "R. O. Smith Take Over Traffic Work… of the California Highway patrol, transferred to Santa Maria from the Santa Barbara office…," *SMT*, May 20, 1935, p. 4.
1947 – "Former Lompoc Police Officer Ends Life in S.M. Richard (Dick) Smith, former member of the Lompoc Police department … Smith was a member of the Highway Patrol before joining the Lompoc police force. He was a traffic officer here," *LR*, Feb. 27, 1947, p. 3, and similar report in *SMT*, Feb. 24, 1947, p. 1.
See: "Lompoc, Ca., Police Department"

Smith, Sterling (Hollywood)
Photographer who visited Alisal Guest Ranch to take photos for an article in Photoplay magazine, 1949.
1948 – "Palm Desert Setting for Photoplay Magazine Tale … ace photographer Sterling Smith and H. Fink," *Desert Sun* (Palm Springs, Ca.), Nov. 26, 1948, p. 10
This individual could not be further identified.
See: "Photography, general (Santa Ynez Valley)," 1949

Smith, Tom Phillip (1918-2010) (Lompoc)
Photographic coordinator for Lockheed Missiles at Vandenberg AFB, 1959. Photographer and director of Lompoc Players, a theater group, 1959.
■ "Mr. and Mrs. Team Spark Lompoc Players' Production… Tom Smith, director for the Lompoc Players, utilizes his many talents as a professional photographer, teacher and motion picture director in bringing out the best in the cast… Though Mr. Smith's principal interest is motion pictures, he finds that stage direction of amateur productions affords him the chance to work with people and create moods… In turn, his background as a teacher of color and cinematography at Davidson Institute of Photography in Burbank, director and writer for commercial films, and his knowledge of camera angles as a still photographer serve him well in achieving a more polished production. As photographic coordinator for Lockheed Missiles System Davidson at Vandenberg Air Force Base, Tom and his family moved here in September. While newcomers to the community, one of the 'firsts' on their social calendar was to become part of the local theatre group. Having directed 'The Curious Savage' previously in Georgia, Tom has an understanding of the play which enables him to develop the characterizations of the actors… Mrs. Tom Smith, … is acting as assistant for her husband … Her experience dates back to her days at RKO Studios where she worked in publicity and answered fan mail for Jane Russell and other stars… and at night acted in the studio's little theatre group. … The Smiths live at North L Street, Lompoc, with their two sons, Tom, 13, and Bryn, 3…," *LR*, March 5, 1959, p. 19.
■ "Tom was the eldest son of Dr. Tom Nelson Smith and Hazel Marguerite Prom. He was preceded in death by his parents and one brother, Prof. David R. Smith. His younger brother, Rev. Dana Prom Smith is the sole survivor of their family. In 1935 Tom graduated from Herbert Hoover High School in Glendale, California and upon entering UCLA he pledged Kappa Sigma Fraternity, Delta Nu chapter and was

a pre-med student planning to join his father's dental practice. After his father's death in 1937, Tom left college, electing to take up photography. He graduated from Los Angeles Art Center in 1940, where he perfected his technique in portrait photography and later, employed by Lockheed Aircraft in Burbank. During World War II, Tom, still working for Lockheed, photographed Top Secret material that was used in design of the P-38 Lighting. In 1954, Lockheed transferred Tom and his Family to Marietta, Georgia where he was in charge of producing and directing films to promote the huge C-130 cargo plane. While in Georgia, Tom and Wife Meg helped to form the Marietta Theater Guild. In 1958, Tom was transferred back to California and assigned to Vandenberg Air Force Base as Photo-Coordinator for Lockheed's Missile Systems and Space Division, where he was in charge of photographing the first rocket launched from the West Coast facility. Tom is survived by his wife Meg, son Tom O. Smith," from findagrave.com.

Smith, Tom (notices in Northern Santa Barbara County newspapers on microfilm and on newspapers.com)
1960 – "Meg, Tom Smith Get Present from [Lompoc] Players… crystal and silver paperweight table lighter… They now reside in Santa Maria…," *LR*, Aug. 27, 1959, p. 5.

Smith, Tom (misc. bibliography)
Tom P. Smith, motion picture co-ord Lockheed, and wife Omega "Meg" A., are listed in the *Santa Maria, Ca., CD*, 1959, 1961, 1967, 1970, 1977; Tom Phillip Smith b. Feb. 22, 1918 in Langdon, ND, d. Aug. 7, 2010 in Santa Maria and is buried in Santa Maria Cemetery District per findagrave.com (refs. ancestry.com).

Smith, Zet (Santa Maria/ Pismo)
Cartoonist / electrician, 1906.
1906 – "Zet Smith, the popular cartoonist of Santa Maria is now an electrician at Pizmo; he can be easily found as his tent in Tent City is covered with his clever cartoons," *SLO DT*, June 20, 1906, p. 5.
This individual could not be further identified.

Snapshot Guild
Nationally syndicated column by John Van Guilder run in the Santa Maria Times, 1952-1958. How-to lessons in photography directed to the many photo buffs seeking instruction.
Snapshot Guild (notices in Northern Santa Barbara County newspapers on microfilm and on newspapers.com)
1952 – "Plan for Thanksgiving Pictures Now," *SMT*, Nov. 24, 1952, p. 10; "Take Your Christmas Pictures in Color," *SMT*, Dec. 22, 1952, p. 5.
1953 – "Put Your Christmas Pictures to Work," *SMT*, Jan. 8, 1953, p. 12; "Prize Money for Teenagers," *SMT*, Jan. 22, 1953, p. 7; "Birthday Pictures Are A Must," *SMT*, Jan. 30, 1953, p. 5; "Here's How Everyone Can Get Into the Picture," *SMT*, Feb. 18, 1953, p. 8; "Your Camera Can Help You Be Original," *SMT*, Feb. 23, 1953, p. 8; "Put Your Pets in the Family Album," *SMT*, Feb. 25, 1953, p. 8; "Picture 'A Day at Home'," *SMT*, March 6, 1953, p. 3; "Mirror Mirror on the Wall," *SMT*, March 17, 1953, p. 8;

"Pictures for Spring," *SMT*, March 21, 1953, p. 5; "Camera Movement, Arch Enemy of Pictures," *SMT*, April 11, 1953, p. 8; "Picture Taking in the Night," *SMT*, May 7, 1953, p. 6; "Your Camera at a Wedding Reception," *SMT*, June 5, 1953, p. 8; "If You Only Knew the People," *SMT*, June 17, 1953, p. 7; "Use Your Camera in Your Own Back Yard," *SMT*, Dec. 28, 1953, p. 6; "Not Too Near, Not Too Far," *SMT*, Dec. 29, 1953, p. 12.
1954 – "A Camera, a Table and Your Imagination," *SMT*, Jan. 30, 1954, p. 7; "Go Fly a Kite but Take Your Camera," *SMT*, May 3, 1954, p. 9; "Plan a Special Picture-a-Year Album," *SMT*, Sept. 9, 1954, p. 16; "Come to the Fair," *SMT*, Sept. 23, 1954, p. 12; "Some to Keep, Some to Throw Away," *SMT*, Sept. 23, 1954, p. 20; "Hints on Goblin Shooting," *SMT*, Oct. 13, 1954, p. 9; "Eating is So Much Fun," *SMT*, Oct. 18, 1954, p. 13; "Take Your Camera When You Go For a Swim," *SMT*, Oct. 19, 1954, p. 12; "Snap an Illustrated Secretary's Report," *SMT*, Oct. 28, 1954, p. 10; "Prizes for Teen Photographers," *SMT*, Nov. 11, 1954, p. 10; "Pictures Make it a Small World," *SMT*, Nov. 22, 1954, p. 15; "Whose Point of View – the Bird's or the Ant's," *SMT*, Nov. 30, 1954, p. 5; "Pictures in a Series Tell a Story," *SMT*, Dec. 1, 1954, p. 4; "Flash Pictures at Night," *SMT*, Dec. 15, 1954, p. 5; "Color is a Must at Christmastime," *SMT*, Dec. 20, 1954, p. 7; "Make a Christmas Album," *SMT*, Dec. 21, 1954, p. 14; "Fireworks Take Their Own Picture," *SMT*, Dec. 27, 1954, p. 5; "Everyday Snapshots Have Their Place in the Family Album," *SMT*, Dec. 28, 1954, p. 13; "Group Pictures Needn't Be Dull," *SMT*, Dec. 29, 1954, p. 7; "Movies for Christmas," *SMT*, Dec. 30, 1954, p. 7; "Don't Put Family Snapshots Off Until Tomorrow," *SMT*, Dec. 31, 1954, p. 11.
1955 – "Sunlight and Snow Make Dramatic Pictures Easy," *SMT*, Jan. 3, 1955, p. 9; "Cameras Respond to Good Treatment," *SMT*, Jan. 4, 1955, p. 7; "School Days are For Remembering," *SMT*, Jan. 11, 1955, p. 7; "Use Simple Props to Make Story-Telling Snapshots," *SMT*, Feb. 3, 1955, p. 12; "Valentine's Day is for Pictures," *SMT*, Feb. 8, 1955, p. 6; "A Special Day for Children Calls for Pictures," *SMT*, May 23, 1955, p. 5; "Snapshot Silhouettes," *SMT*, May 25, 1955, p. 6; "Snapshots 'Illustrate' Your Letters," *SMT*, May 26, 1955, p. 9; "Show Professionally Made Movies at Home," *SMT*, May 27, 1955, p. 8; "Stereo – the Newest Thing in Photography," *SMT*, June 1, 1955, p. 6; "It's Fun to Make Mistakes on Purpose," *SMT*, June 3, 1955, p. 8; "Collect with Your Camera," *SMT*, July 14, 1955, p. 12; "Picture High Point Views at Night," *SMT*, Aug. 1, 1955, p. 10; "Shooting in the Rain," *SMT*, Aug. 4, 1955, p. 12; "Pretty Pictures in the Sunset," *SMT*, Aug. 4, 1955, p. 14.
1956 – "Flash! And You've a Picture for Remembering," *SMT*, Feb. 16, 1956, p. 18; "Silhouettes – Interesting Outdoors or In," *SMT*, Feb. 27, 1956, p. 6; "Not All Movie Stars are in Hollywood," *SMT*, Feb. 28, 1956, p. 3; "Night Life for Your Camera," *SMT*, Aug. 6, 1956, p. 3; "Turn Your Camera on Flowers," *SMT*, Sept. 5, 1956, p. 3; "Pictures and Prizes," *SMT*, Sept. 6, 1956, p. 5; "Be a Landscape Artist with Your Camera," *SMT*, Sept. 8, 1956, p. 3; "Picture the Return to School," *SMT*, Sept. 10, 1956, p. 3; "Back Up Your Fish Story," *SMT*, Sept. 13, 1956, p. 9; "A Camera Goes to Camp," *SMT*, Sept. 18, 1956, p. 9;

"Background," *SMT,* Sept. 19, 1956, p. 7; "Do Your Christmas Shooting Early," *SMT,* Oct. 1, 1956, p. 8; "Youngsters Should Have Their Own Cameras," *SMT,* Oct. 3, 1956, p. 5; "A Boy and His Dog," *SMT,* Oct. 15, 1956, p. 5; "Take Your Family Portraits Out of Hiding," *SMT,* Oct. 20, 1956, p. 4; "Films Give Variety to Club Programs," *SMT,* Nov. 5, 1956, p. 10; "The Brownie Book of Picture Taking," *SMT,* Nov. 7, 1956, p. 9; "Wallet Prints From Your Portrait," *SMT,* Nov. 7, 1954, p. 12; "Thanksgiving with Movies of Home," *SMT,* Nov. 21, 1956, p. 5; "The Christmas Card that No One Else Can Send," *SMT,* Nov. 26, 1956, p. 6; "The Movie Camera Wrappings," *SMT,* Nov. 29, 1956, p. 14; "Color Doesn't Have to be Bright," *SMT,* Dec. 13, 1956, p. 18; "Here's a Rainbow Path to Pot of Gold for Teen Cameraman," *SMT,* Dec. 20, 1956, p. 19; "Up in the Air with Your Camera," *SMT,* Dec. 24, 1956, p. 7.

1957 – "Still-Life Snapshooting," *SMT,* Jan. 11, 1957, p. 10; "Family Album – Modern Style," *SMT,* Jan. 19, 1957, p. 3; "Make it a Good Show," *SMT,* Feb. 14, 1957, p. 10; "Picture Your Favorite Room," *SMT,* March 20, 1957, p. 2; "Memories in Motion," *SMT,* March 21, 1957, p. 7; "Picture for Your Valentine," *SMT,* March 28, 1957, p. 7; "Silhouette Snapshots," *SMT,* April 1, 1957, p. 2; "Doing What Comes Naturally," *SMT,* April 8, 1957, p. 4; "Find a Picture to Keep," *SMT,* April 8, 1957, p. 10; "Capture Easter Joys on Color Film," *SMT,* April 18, 1957, p. 9; "Spring Activities Call for Camera Action," *SMT,* April 25, 1957, p. 8; "Be Sure you Have Beginner's Luck," *SMT,* May 2, 1957, p. 8; "Night Life for your Camera," *SMT,* May 9, 1957, p. 8; "Make Movies of History in the Making," *SMT,* May 16, 1957, p. 8; "Remember Mama – In and With Pictures," *SMT,* May 23, 1957, p. 9; "Take Notes with Your Camera," *SMT,* May 28, 1957, p. 8; "Choose Background with Care," *SMT,* Oct. 3, 1957, p. 5; "Plane Talk for Picture Takers," *SMT,* Oct. 24, 1957, p. 5; "Recording Becomes Fourth 'R' f: School Days," *SMT,* Oct. 31, 1957, p. 4; "Plan to Shoot a Christmas Story," *SMT,* Dec. 26, 1957, p. 4; "Camera Tips for 'Sidewalk Superintendents'," *SMT,* Dec. 27, 1957, p. 7.

1958 – "Cameras Turn to the Dogs - and Cats" *SMT,* Jan. 2, 1958, p. 5; "Teen-agers Click Camera in Contest," *SMT,* Jan. 27, 1958, p. 2; "Picture the Family," *SMT,* Jan. 30, 1958, p. 5; "Make Your Own Picture Book," *SMT,* Feb. 1, 1958, p. 4; "Play Ball," *SMT,* April 8, 1958, p. 8; "The Picture of Spring," *SMT,* April 24, 1958, p. 4; "Graduation – Truly a Picture Occasion," *SMT,* May 31, 1958, p. 7; "Baby Picture Taking Tips," *SMT,* June 5, 1958, p. 4; "Picture Your Easter in Color," *SMT,* June 14, 1958, p. 8; "The Bride's Always a Picture," *SMT,* Oct. 13, 1958, p. 12; "Maytime is Picture Time," *SMT,* Oct. 14, 1958, p. 8; "Holidays Offer Chance for 'Once a Year' Photographs," *SMT,* Dec. 20, 1958, p. 8.

Snell, Harry Merton (1874-1934) (Sacramento / Santa Maria)
Mechanical Drawing instructor at Santa Maria High School, and at Adult School, 1922-34.

■ "Heart Attack Fatal… Harry M. Snell, instructor in mechanical drawing and head of the industrial department of the Santa Maria High School, died suddenly at his home in the neighboring city on Tuesday following a heart attack. Mr. Snell is survived by his wife, three daughters and one son. He was a native of England and a graduate of Birbeck College in London and Naas Seminarium of Sweden," *LR,* July 6, 1934, p. 8.

Snell, Harry M. (notices in Northern Santa Barbara County newspapers on microfilm and on newspapers.com)
1922 – "William [Sic. Harry M] Snell of Sacramento was in Santa Maria today conferring with A. A. Bowhay, Jr., principal of schools, in regard to the vacancy created by **B. E. Cannon** who recently resigned his position as mechanical drawing and manual training teacher in the local school," *SMT,* Oct. 3, 1922, p. 5.
1923 – "Real Estate Transactions. March 19, 1923 – Deed: Santa Maria Realty Co. to Harry M. Snell & wf Eunice, $3000, lot 2, blk 4, Thornburg's Add., Santa Maria," *SMT,* March 29, 1923, p. 5.
1934 – "Sudden Heart Attack Fatal…," *SMT,* June 26, 1934, p. 1.
And, almost 300 hits for "Harry Snell" covering his teaching as well as his social, sports and civic club activities were not itemized here.

Snell, Harry M. (misc. bibliography)
Harry Merton Snell provided the following information on his Passport application = emigrated to the United States from Winnipeg, Canada, about December 1907, that he resided eight years uninterruptedly at Sacramento, that he was naturalized as a citizen of the US before the Superior Court of Sacramento, Cal., 1913, that his permanent residence was Sacramento where his occupation was supervisor of manual training, that he was about to go abroad temporarily and return within three months with the purpose of settling the estate of his brother who had just died and that he intended to leave the United States from the port of New York sailing on board the *Philadelphia* on Sat. 15th July, 1916; Harry Merton Snell provided the following information on his WWI Draft Registration Card, dated 1918 = b. Sept. 18, 1874, working as school master for the City of Sacramento; Harry Merton Snell was b. Sept. 18, 1874 in Battersea, England, to William Snell and Frances Louisa Wilkins, married Eunice Mellor, and d. June 26, 1934 in Santa Barbara per Davison Family Tree; Henry Merton Snell is buried in Santa Maria Cemetery District per findagrave.com (refs. ancestry.com).
See: "Boy Scouts," 1933, "Santa Barbara County Fair," 1930, "Santa Maria, Ca., Adult/Night School," 1924, 1925, 1930, 1931, "Santa Maria, Ca., Union High School," 1924, 1926, 1934

Snell, Phyllis
Assistant home demonstration agent, 1949.
See: "Home Department of the State Farm Bureau," 1949

Snider, Ann Louise (1899-1973) (Santa Barbara)
Artist who held a one-man-show at Andersen's 'Pea Soup' Restaurant in Buellton, 1954. Exh. Allan Hancock [College] Art Gallery, 1958.

■ "Buellton Restaurant has New Art Exhibit… 18 oils and water colors by Ann Louise Snider … Miss Snider has had numerous showings of her work along the Pacific Coast during the 20 years she has been in Santa Barbara. Her paintings have been exhibited at the **Golden Gate Exposition** in San Francisco, at Balboa Park in San Diego, and in special exhibits in Oakland, Sacramento and Los Angeles in addition to many in Santa Barbara," *LR*, Nov. 18, 1954, p. 9.

Snider, Ann (notices in Northern Santa Barbara County newspapers on microfilm and on newspapers.com)
1938 – "Artist to Show Paintings Here… for PTA Benefit … invitation to become a member of… National Society of Women Painters, will present a display of portraits, landscapes and still life for the benefit of Franklin PTA, Tuesday afternoon, November 15 from 3 to 5 o'clock at the school… Color is Miss Snider's long suit, although she does not lose sight of form and structure. Her work at Chicago Art Institute was praised for her understanding of color. She has studied with Louis Rittman, George Oberteuffer and others… her prize-winning 'The Boulevardier' being particularly endowed with life, clarity and insight," *Bakersfield Californian*, Nov. 10, 1938, p. 7.
1940 – "**Robert McCormick**… Paintings for the coming exhibit at the Fillmore Artists' Barn will be provided by … Miss Ann Louise Snider of Santa Barbara … Miss Snider, with oil as her medium, specializes in portraiture, although she also does still life and landscape. She has studied at the Tri-City Art league in Davenport, Iowa and the Art Institute of Chicago. Since coming to Santa Barbara, Miss Snider has been affiliated with the School of the Arts, teaching portrait classes, and is now teaching privately … permanently represented in the new Pepper Tree gallery of the Barn…," *Ventura County Star-Free Press*, March 27, 1940, p. 4.
1941 – Repro: "The Art Lesson," *Sacramento Bee*, Sept. 6, 1941, p. 15.
1946 – "Santa Barbara Artist… Miss Ann Louise Snider… who is exhibiting oils and water colors in Ojai Community Art center, was guest of honor at a tea…," *Ventura County Star-Free Press*, Sept. 30, 1946, p. 5.
1954 – "Snider Paintings on Exhibition… Andersen's 'Pea Soup' Restaurant in Buellton… 18 oils and water colors… month of November and through Dec. 7, *SYVN*, Nov. 19, 1954, p. 6.
1959 – "One-Man Show On. Ann Louise Snider of Santa Barbara has a one-man show in the Art Center at Ojai through this month," *LA Times*, Oct. 18, 1959, p. 83 (i.e., pt. IV, p. 3).
And, some notices on her work in group shows were not itemized here.

Snider, Ann (misc. bibliography)
Ann Louise Snider is listed in the 1940 U. S. Census as age 40, b. c. 1900 in Ill., single, finished college 3rd year, working as a teacher & artist-painter in a private studio, residing in Santa Barbara (1935, 1940) with her parents William C. Snider (age 76) and Patty Snider (age 73); Ann Louise Snider was b. Jan. 2, 1899 in Ill., to William Clinton

Snyder (Sic.) and Pattie Sue Sims, and d. May 23, 1973 in Santa Barbara per Murphy Family Tree_2012-04-18 (refs. ancestry.com).
See: "Allan Hancock [College] Art Gallery," 1958, "Andersen's Pea Soup Restaurant," 1954

Snider, Thornton (San Luis Obispo)
Artist. Exh. in Santa Maria in conjunction with American / National Art Week, 1954. Spoke to Junior Community Club on art, 1954.
See: "National Art Week," 1954, "Junior Community Club," 1954, and *San Luis Obispo Art and Photography before 1960*

Snow, Della May Donahoo Ralph (?) (Mrs. Dr. Harry Edgar Snow) (1867-after 1935) (Iowa / Santa Maria / New Jersey)
In 1891 Mrs. H. E. Snow exhibited Best landscape painting at Santa Barbara County Fair. And exh. 1893.
Snow, H. E., Mrs. (notices in Northern Santa Barbara County newspapers on microfilm and on newspapers.com)
1890 – "Wedding Bells. The Marriage of Dr. Harry E. Snow and Della Ralph… [at Fresno at] the residence of Mrs. Donahoo… they will reside in Santa Maria where the Dr. has established a practice …," *SMT*, July 19, 1890, p. 3.
1895 – "Following is the list of letters remaining in the post office at Sant Maria, Nov. 2, 1895… Mrs. H. E. Snow…," *SMT*, Nov. 2, 1895, p. 3.
1935 – "Deeds and Mortgages… Mirror Holding corp. to Della M. Snow, West Milford, Lots No. 1226-1229 on map of Island section," *The News* (Patterson, NJ), Dec. 26, 1935, p. 29.
Snow, H. E., Mrs. (misc. bibliography)
Della Snow is listed in the 1900 U. S. Census as age 33, b. Jan. 1867 in Iowa, residing in Spring Lake, N. J. with her husband Harry E. Snow and a daughter Goldie Snow (age 15) and information that Della was married 16 years [Sic.?]; Della Snow is listed in the New Jersey State Census of 1905 as b. Jan. 1867 in Iowa and residing in Belmar, N. J.; Della M. Snow is listed in the 1910 U. S. Census as age 42, b. c. 1868 in Iowa, residing in Belmar, N.J. with husband Harry E. Snow (a physician, age 51) and two boarders (teachers in public school) and a servant; Della M. Snow is listed in the 1920 U. S. Census as age 50, b. c. 1870 in Calif. [Sic.], widowed, residing in Nutley Ward, N. J., with her daughter Goldie M. Collins and her son-in-law Hamlet P. Collins (age 39); Dien [Sic. Della / Dilla] Snow, is listed in the 1930 U. S. Census as b. c. 1867 in Iowa, residing with her daughter and son-in-law in Trenton, N. J. (refs. ancestry.com).
See: "Santa Barbara County Fair," 1891, 1893, and *San Luis Obispo Art and Photography before 1960*

Soe, Viola (Shell Beach)
Exh. Santa Barbara County Fair, 1959.
See: "Santa Barbara County Fair," 1959, and *San Luis Obispo Art and Photography before 1960* and *Arroyo Grande (and Environs) Art and Photography before 1960*

Sollman (Percival), Florence Helen (Mrs. Arthur Percival) (1879-1952) (Lompoc)
Teacher of history, drawing and Spanish at Lompoc high school, 1903/06?
Sollman, Florence (notices in Northern Santa Barbara County newspapers on microfilm and on newspapers.com)
1902 – "Transport Thomas in Port… thirty-one days from Manila… cabin passengers were … Miss Florence Sollman …," *SF Call*, April 16, 1902, p. 13; "Asks School Board … Teachers' certificates were granted to … Florence Sollman …," *SF Call*, Dec. 25, 1902, p. 5.
1903 – "Graduates Given Positions as Teachers … graduates of the University of California … High School … Florence Sollman, Lompoc …," *SF Examiner*, July 27, 1903, p. 5; "University Graduates Who Will Teach … Florence Sollman, Lompoc: History, Spanish, Drawing…," *Berkeley Gazette*, July 27, 1903, p. 5.
1907 – "Advertised Letters… Women… Miss Florence H. Sollman…," *Independent* (Santa Barbara, Ca.), June 26, 1907, p. 7.
1908 – "Women of Brains Don Fine Feathers. Collegiate Alumnae From All the State of the Union Assemble Here … met at the Fairmont hotel… gathered for a week or papers, reports and essays … Florence Sollman …," *SF Call*, Sept. 1, 1908, p. 16.
1910 – "Declared Regular Teachers… Miss Florence Sollman of the Commercial School, were declared regular teachers, having completed the required two years' probationary period," *SF Examiner*, June 16, 1910, p. 12; "Regular Teachers Named by Board… Florence Sollman, Newton J. Tharp Commercial…," *SF Call*, June 16, 1910, p. 17; "Clubs Squabble… Requests for a year's leave of absence from … and Florence Sollman Percival, were denied," *SF Call*, Sept. 1, 1910, p. 7.
Sollman, Florence
"She was from San Francisco, graduated 1896 San Francisco High School, graduated UC Berkeley 1900, and a teacher's certificate in 1902. Was shown in a Berkeley publication in 1903 as in Lompoc teaching History, Spanish and drawing. 1908 working at Commercial High School in SF. In *city directories for S.F.* in 1910-1912 as a teacher," per Lompoc Valley Historical Society.
Sollman, Florence H. (misc. bibliography)
Port. appears in the UC, Berkeley, yearbook, 1899; Florence H. Sollman is listed in the 1900 U. S. Census as age 19, b. Nov. 1880, at school, residing in San Francisco with her parents and siblings; Florence H. Sollman, teacher, is listed in the *SF, Ca., CD*, 1904; Florence H. Sollman is listed in the 1910 U. S. Census as age 31, b. c. 1879 in Calif., a teacher in public school, residing in San Francisco with her parents William Sollman (age 56) and Mary C. Sollman (age 46) and brothers William and Paul; Florence Percival is listed in the 1920 U. S. Census as married to Arthur Percival and residing in Alameda and is listed in the 1930 U. S. Census as widowed and residing with her son in Vallejo, Ca., and is listed in the 1940 U. S. Census as finished college 4th year, widowed, teaching privately, and residing alone in San Francisco (1935) and Oakland (1940); Florence H. Percival, b. Nov. 11, 1879 in Iowa, mother's maiden name Robeck, father's Sallmann [Sic. Sollman], d. April 14, 1952 in Alameda County per Calif. Death Index (refs. ancestry.com).

See: "Barker, Frank," "Lompoc, Ca., Union High School," 1905, "Teacher Training," 1903

Solum, Lyla Grace Maxwell (Mrs. O. Larry Solum) (Solvang)
Prop. of Danish Village Gifts, c. 1946.
See: "Danish Village Gifts," "Maxwell, Lyla"

Solvang Art Show
See: "Santa Ynez Valley Art Exhibit"

Solvang, Ca., architecture
See: "Architecture (Solvang)"

Solvang, Ca., art
See: "Art, general (Solvang)"

Solvang, Ca., elementary school
See: "Santa Ynez Valley, Ca., Elementary Schools"

Solvang Drug Co. / Solvang Pharmacy (Solvang)
Retailer of photography equipment and film developing, 1949.
Solvang Drug Co. (notices in Northern Santa Barbara County newspapers on microfilm and on newspapers.com)
1941 – "Something New in Color Photography – Kodak Minicolor Prints. Full Colored Prints. Done by Eastman Agents Only. Solvang Drug Company," *SYVN*, Sept. 5, 1941, p. 8.
1949 – "See Us for your Cameras and Photographic Equipment. We have them in stock at minimum prices. Eastman Movie Cameras and projectors – 8 and 1- mm. Keystone Movie Cameras and projectors. All types of still cameras. Printing and developing One Day Service, Main Street…," *SYVN*, Feb. 11, 1949, p. 5; ad: "At Last a Camera so Tiny you can wear it on your wrist. It's the Whittaker Micro16 Pixie Camera. Makes Big Pictures in Color and Black & White. … 14 Wallet size B&W Prints and film all for only $1.29. Color Prints 3 for $1.00. Buy your Pixie today. $4.95," *SYVN*, May 6, 1949, p. 3; ad: "Camera Specials. Snaps at Night are easy with the Brownie Flash six-20 Camera. Formerly $12.10. Now 11.75, Kodak Flash Bantam F 4.5. Formerly $57.75. Now – 49.50. Kodascope Eight 33 Projector. F2 Lens – 500 W. Lamp. Formerly $85.00. Now - $75. 8 MM Movie Camera F27 Lens. Formerly $71.75. Now - $63. 8 MM Movie Camera F 1.9 Lens. Formerly $103. Now - $93.," *SYVN*, May 20, 1949, p. 5.
1950 – New building opened, *SYVN*, Dec. 1, 1950, pp. 1, 3.
1953 – "Photo Supplies at Big Savings. Stereo Viewers, Iloca Stereo Cameras, All Types Movie & Still Cameras, Light Meters, Tripods, Darkroom Outfits & Supplies, Flash Units, Flash Bulbs, Photo Albums, Film …," *SYVN*, July 10, 1953, p. 3.

1957 – "We Now are Agents for Polaroid and carry a full line of Polaroid Cameras and Film. 'See Your Picture One Minute After Taking'," *SYVN*, Oct. 18, 1957, p. 8.
1958 – "Down Go Prices. Camera Clearance," and ad lists seven types of movie cameras priced between $24.95 and $98.95, a projector at $93.45, *SYVN*, Aug. 22, 1958, p. 4; "See Our New Line of Foreign Made Cameras... Yashica ... Voigtlander... Taron... Eastman's Cameras, Bell & Howell Cameras... Christmas Gifts Galore," *SYVN*, Dec. 19, 1958, p. 5.
1959 – "Give a Camera. 10% off on all cameras and projectors (except those fair-traded). Eastman, Bell & Howell, Argus, Voigtlander, Polaroid, accessories. For your Christmas gifts shop at the Solvang Pharmacy," *SYVN*, Dec. 11, 1959, p. 7.

Solvang High School
<u>See</u>: "Santa Ynez Valley Union High School"

Solvang Library
<u>See</u>: "Santa Barbara County Library (Solvang)"

Solvang Photo Shop / Solvang Photo Center (Solvang)
Proprietor Robert C. Nelson, 1947+, and Jack Griesbauer, 1950s.
■ "New Photo Shop Opens tomorrow. The Solvang Photo Shop, owned and operated by **Robert C. Nelson** and located in the north end of the army-type building located in Copenhagen Square, will be open for business starting tomorrow. Associated with Mr. Nelson... will be the **Florence McAllister Studio** of Santa Barbara... Mr. Nelson will devote most of his time to the developing and printing of roll film... Nelson also said that he soon expects to handle a nationally known line of film and photo supplies. The McAllister Studio, which has been in Santa Barbara for many years and which is operated by H. E. and Florence McAllister, will operate every Thursday starting Oct. 30, from 10 a.m. to 6 p.m. in the Photo Shop. Appointments for studio work may be made by contacting Mr. Nelson or calling Santa Ynez 222. The McAllister firm will also feature for sale a line of photo frames and albums," *SYVN*, Oct. 24, 1947, p. 1.
<u>Solvang Photo Shop (notices in Northern Santa Barbara County newspapers on microfilm and on newspapers.com)</u>
1948 – Ad: "Now in stock – 8 mm Kodachrome Film, 25 ft. Spools. Kodacolor Special. All popular sizes – at cost plus tax," *SYVN*, Oct. 15, 1948, p. 6.
1949 – "Photo Shop Moves July 1. **Robert C. Nelson**, owner of the Solvang Photo shop, announced this week that beginning on July 1, the photo shop will be located in the Frame-Jensen building in Solvang. The shop is moving from the rear of the Copenhagen Square Building... Mr. Nelson also announced that beginning July 1, all photo developing and finishing work will be done by Bogue's Photo service in Santa Barbara. The photo shop owner said he would then be able to devote his time to commercial photography, specializing in weddings. Mr. Nelson also said he hoped to gradually build up a complete line of cameras, film and other photographic supplies after the

shop is situated in its new location," *SYVN*, June 24, 1949, p. 3; ad: "24-Hour Photo Service. Photo Finishing by Bogue's... Commercial Photography. Weddings a Specialty," *SYVN*, June 24, 1949, p. 3; Ad: "Solvang Photo & Electric Shop," *SYVN*, Aug. 5, 1949, p. 5.
1950 – "Photo Shop Host Tomorrow. **Bob Nelson** of the Solvang Photo Shop... open house... introducing **Jack Griesbauer**, portrait photographer... Examples of Mr. Griesbauer's work will also be on display," *SYVN*, Oct. 13, 1950, p. 1; "Photographic Christmas Cards. Beautiful, Personalized Cards from Your Own Negatives... Large Selection of Natural Color Christmas Cards by Mike Roberts...," *SYVN*, Dec. 1, 1950, p. 1; ad for Bolex movie cameras and lenses, *SYVN*, Dec. 8, 1950, p. 5.
1952 – "Certificate of Individual Transacting Business under Fictitious Name... I, the undersigned, do hereby certify that I am transacting the business of a photography studio, sale of photographic supplies and equipment, film, cameras and the development and printing of photographs at Copenhagen Square... Solvang Photo Center. **J. Griesbauer**," *SYVN*, Aug. 1, 1952, p. 7; ad: "Solvang Photo Center, Copenhagen Square...," *SYVN*, Nov. 21, 1952, p. 3; "Pay Water Bills at Photo Center," *SYVN*, Dec. 5, 1952, p. 1.

Solvang schools
<u>See</u>: "Santa Ynez Valley, Ca., Elementary / Grammar Schools," "Santa Ynez Valley Union High School" ■

Solvang Spirits Shop
Retailer of camera film, 1952.
Solvang Spirits Shop sells films, *SYVN*, Dec. 12, 1952, p. 6.

Solvang Studio / Solvang Studio of Photography (Solvang)
Photographic studio run by Loris Gardner, 1959-62. Sold out to George Ives, 1963?
Gardner appears to have stopped using the name "Solvang Studio" in early 1962, using instead **Loris Gardner Photos.** George Ives started his career in Solvang using the business name "Solvang Studio" but appears to have altered the name in 1966 to "Ives Studio" when he moved to the newly completed "Ives Building."
<u>Solvang Studio (notices in Northern Santa Barbara County newspapers on microfilm and on newspapers.com)</u>
1963 – "Certificate of Fictitious name. This is to certify that George T. Ives is engaged in the business of operating a photography studio and photo frame shop under the fictitious name and style of 'Solvang Studio' ... 271 Alisal road...," *SYVN*, Oct. 18, 1963, p. 8; photo and caption reads "The new Danish provincial styled structure built by **Hans Sorensen** at 271 Alisal Road. Occupants... George Ives Solvang Studio of Photography...," *SYVN*, Nov. 8, 1963, p. 13.

Solvang Woman's Club (Solvang)
Woman's Club that began 1927, only occasionally sponsored lectures on art. Its first meeting in its new clubhouse, a private home donated to the club, was April 1950. Renamed in 1959 to the Santa Ynez Valley Woman's club.

■ "... afternoon was spent in recalling the various activities of the club since its beginning in 1927 when it was known as The Friday Afternoon Club. The constitution states the purpose of the club is first, to further and provide meetings and social activities for the members, and second, to further and assist any community enterprise which in the judgment of the members is worthy and needful of assistance. ...Twelve women have been members for over 25 years. As early as 1929 a building fund was started. The project became a reality three years ago when a very attractive club house was built on Spring Street. A partial list of what the Solvang Woman's Club has contributed to the Valley includes a series of card parties to raise money to furnish a room in the Solvang Grammar School... contributions to the Solvang Light Fund and regular contributions to organizations such as the Red Cross, Cancer Fund, etc. The club donated chairs to the Presbyterian Church, a piano to the USO and $100 to a needy family. During the war the members sold $6,000 in War Bonds in one day, donated money to furnish a day room for the hospital staff at Camp Cooke, sent concentrated food for 1000 meals to Europe, furnished gifts and cookies for Camp Cooke and **AWVS**. The club has sponsored very successful flower shows and plans to continue them; it has entered floats in the fourth of July parades, and members have been hostesses for Ranch and Mission Pilgrimage Tours...," per "Woman's Club Members Recall Events," *SYVN*, May 15, 1953, p. 10.

Solvang Woman's Club (notices in Northern Santa Barbara County newspapers on microfilm and on newspapers.com)

1933 – "Interesting Meeting... Another interesting feature... was the demonstration of Square Knotting [macramé?] by Leo Rutters. This handicraft is very popular among the sailors, and handbags, belts and many other articles are made during their spare time while at sea...," *SYVN*, Sept. 1, 1933, p. 1.

1934 – "Danish Weaving Shown... at the Seventh Annual Convention held Tuesday in the Rockwood Clubhouse in Santa Barbara... The local club contributed a display of Danish weaving and yarn pictures to a handicraft exhibit which was held under the direction of **Mrs. Lucie Benson**, county handicraft chairman of Lompoc," *SYVN*, March 23, 1934, p. 2.

1936 – "Womans' Club Meeting Feb. 28th to Feature Landscape Gardener... **Lockwood DeForrest** [sic. **Forest**] will talk on home gardening. He will also show a sketch of a 50-foot garden plot using plants and shrubs suitable to local climatic conditions...," *SYVN*, Feb. 21, 1936, p. 1.

1938 – "There will be a talk on flower arrangements ...," *SYVN*, March 25, 1938, p. 1; "Woman's Club Will Honor Mothers Today. A display of old quilts and needlework will be featured at the regular meeting... at Memorial hall ...," *SYVN*, May 6, 1938, p. 1.

1939 – "Woman's Club Program... In charge of the program at the next meeting, March 10th, will be Miss Esther Ibsen. Finger painting will be shown," *SYVN*, March 3, 1939, p. 1.

1940 – "Woman's Club Meeting To-Day... An interesting handcraft exhibit has been arranged...," *SYVN*, Feb. 23, 1940, p. 1.

1942 – "Woman's Club... Red Cross work... Mrs. Arden Jensen and Mrs. Robert MacDonald are in charge of the program, which will be on Handicraft," *SYVN*, Jan. 9, 1942, p. 1.

1945 – "Flower Show and Art Exhibit sponsored by Solvang Woman's Club, Friday, April 13, Veterans Memorial Hall, 3 to 5 p.m., Admission and Refreshments 35 c," *SYVN*, April 6, 1945, p. 1; "Flower Show Great Success... the art exhibit created a great deal of interest. Also, the exhibit of articles sent home by service men was most interesting," *SYVN*, April 20, 1945, p. 1.

1946 – "... To Hold Flower Show – Hobby Exhibits... Because of the great interest shown in the Flower show last year, the Solvang woman's club will hold a second Flower Show on Thursday April 11, in the Veteran's Memorial Building... In connection with the Flower Show, Hobby exhibits will be displayed. The committee is trying to unearth all types of hobbies, but they ask everyone not to wait to be asked for their hobbies, but to contact the committee and offer their exhibits. Suggestions are model railroads, leather work, wood craft, plastics, airplane models, needlecraft, paintings, collections of butterflies, arrowheads, dolls, rocks, stamps, coins, old glass, guns, copper, brass, silver, miniatures, and veteran souvenirs...," *SYVN*, March 29, 1946, p. 1.

1947 – "'Tour of Homes' Conducted ... Last Friday," and homes discussed, *SYVN*, Jan. 17, 1947, p. 8.

1948 – "Woman's Club... next Friday afternoon, March 12, at the Solvang Grammar School. Included will be a display of arts and crafts, hooked and braided rugs, paintings, copper and aluminum work, leather and other handiwork. A unique collection of pitchers, plates and lamps owned by the members will be on exhibition...," *SYVN*, March 5, 1948, p. 12; "School Director Will Speak... Last month's meeting was attended by 40 people... Mrs. Jens Rasmussen displayed hooked rugs and a large room size braided rug. She also showed aluminum and leather made articles. **Miss Isabelle McPherson** [Sic. **MacPherson**] of the high school faculty presented an exhibit of metal crafts and fabrics. Paintings done by her art class students were also shown. Other items on exhibition included a collection of lamps by **Mrs. Lyla Maxwell**, a collection of hand carved articles made by displaced persons in Europe and shown through the courtesy of Raleigh Roland, 20 water color paintings done by the students of **Leo Ziegler**'s adult art class, and Hans Brons displayed an inlaid wood table which represented the eclipse of the sun done in dark and light-colored woods...," *SYVN*, April 2, 1948, p. 1.

1949 – "All Danish Program Given... A trip through Denmark by word and picture and the exhibition of Danish antique copper paintings and other pieces of valuable art brought here from the old country... last Friday evening at the Veterans' Memorial Building... these were shown by **Ernst Pedersen** and **Walther Kristensen** who recently arrived in the Valley," *SYVN*, Feb. 4, 1949, p. 4; "Women Sponsor Luncheon for Clubhouse Fund... [some of the

foods provided by **Mrs. Uno Sandvik**] … The oil painting donated by the **Sandviks** as another means of raising money for the new clubhouse, was presented to Mrs. Percy Hodges of the **Valley Farm School**," *SYVN*, Nov. 18, 1949, p. 5.

1950 – Photo of members hanging a painting and "Solvang Woman's Club Headquarters Being Readied," i.e., redecorated, *SYVN*, March 3, 1950, p. 1; photo of interior of woman's club, *SYVN*, May 19, 1950, p. 5; "Woman's Club… Fashion Show…," *SYVN*, Nov. 10, 1950, p. 5; and sponsored several events in other artistic media such as music and theater as well as lectures illustrated by colored slides.

1951 – "**Brandt-Erichsen** Talk Set Jan. 12… Solvang Woman's Club…," but no title of talk provided, *SYVN*, Jan. 5, 1951, p. 7; "Solvang Women Hear Sculptor… [**Brandt-Erichsen**] narrative of his life, describing it in the third person until near the close of his talk when he reverted to the first person, thus giving himself away," *SYVN*, Jan. 19, 1951, p. 2; "Solvang Women to Hear Talk on Glassware. **LeRoy Hunt** of Hunt's China Shop, Santa Barbara, will be the guest speaker… Mr. Hunt's subject will be 'Antique China and Glass.' He will have a display of such pieces with him from his collection," *SYVN*, April 6, 1951, p. 1; "Woman's Club… Guest speaker will be **Mrs. Mary J. Coulter**, Santa Barbara artist, who will speak on the topic, 'Art and its Relations to Life.' … Prior to the meeting, Mrs. Coulter will be the guest of the club at a luncheon at Orchard House…," *SYVN*, May 4, 1951, p. 1; "Sally Nielsen President of Woman's Club… **Mrs. Coulter**, artist of Santa Barbara, was introduced… she spoke of 'Art and its Relations to Life.' She brought with her many beautiful things, etchings, paintings, jewelry, a woven coverlet, books and silver, some very old and hand made to show how man can express his innermost longings for beauty and perfection in these objects, most of which are utilitarian in purpose. There is always a slight imperfection in things hand-made, which makes them particularly endearing, Mrs. Coulter said…," *SYVN*, May 18, 1951, p. 8; Valley Rug "…met Tuesday afternoon at the Solvang Woman's Club with Mrs. Frank [Verna] Regalia and Mrs. Charles Day as hostesses. Mrs. Axel Nielsen was welcomed as a new member. The group meets the third Tuesday of each month," *SYVN*, Sept. 14, 1951, p. 9; "Christmas Party, Puppet Show… **Forrest** and **Marie Hibbits** of La Petite Galerie of Buellton presented their puppets in 'Hansel and Gretel.' Immediately after the show, a puppet selected the name of **Mrs. Sandvik** as the winner of the water color painting donated by Mr. Hibbits for the **AWVS** overseas package fund. Mr. and Mrs. Hibbits also gave the Woman's club a painting for the clubrooms…," *SYVN*, Dec. 21, 1951, p. 4; "**Mrs. Sandvik** Given Water Painting. Mrs. Uno Sandvik was awarded the water color painting donated by artist **Forrest Hibbits** of Buellton at the Christmas party of the Solvang Woman's Club last Friday in Friendship Hall in Ballard. Funds derived from the painting event were turned over to the **AWVS** overseas package fund," *SYVN*, Dec. 21, 1951, p. 6.

1952 – Donald "Bear to Talk … director of the Santa Barbara Museum of Art… Friday afternoon, Jan. 11 at 2:30 o'clock at the club rooms… During the afternoon musical selections will be played by Mrs. **Marie Hibbits**," *SYVN*,

Jan. 4, 1952, p. 1; "Woman's Club… Guest speaker for the afternoon will be Miss **Louise Chrimes** who will talk on Early Tin Painting…," *SYVN*, May 9, 1952, p. 1; "Woman's Club Hears Museum Director… **Mr. Bear** accompanied his talk with colored slides of art treasures of the museum…," *SYVN*, Jan. 18, 1952, p. 4; "Woman's Club [1952-53] Year Book Lists Events… Feb. 13. Speaker, Walter Kong on Chinese art… April 10. Speaker, **Mr. Frederickson [Sic. Fredrickson]** of 'Frederickson and Tower,' interior decoration…," *SYVN*, Nov. 21, 1952, p. 7.

1952-59 – The club sponsored various theater and music programs, travel programs with slides and/or films, had a Book Section, and gave Christmas entertainments, pot lucks, rummage sales, and card parties.

1953 – "100 Attend Home, Garden Tour Sponsored by Woman's Club," *SYVN*, Oct. 23, 1953, p. 3.

1955 – "Woman's Club Says Thank You… recent play, 'Icebound'… **Pat Brandt-Erichsen**. She attended every practice with her son, David, and acted as prompter during rehearsals and the two nights of the performances. She was also responsible for the attractive posters which helped to advertise our play…," *SYVN*, March 11, 1955, p. 2; photo of exterior, *SYVN*, May 20, 1955, p. 4.

1957 – "Woman's Club Starts Club Year … The Solvang Woman's Club was organized in 1927 and at present has a membership of approximately one hundred … Programs for the year will include a travelogue, musicale, and lectures of an informative and educational nature," *SYVN*, Sept. 20, 1957, p. 5.

1958 – "Yule Decorations Talk… A demonstration and talk on Christmas decorations will be given by Mrs. Vernon La Mois of Solvang… Friday afternoon, Dec. 12 at 2:30 at the clubhouse…," *SYVN*, Dec. 5, 1958, p. 7.

1959 – "Woman's Club to View Display of Chinese Coats. A display by **Miss Jeannette Lyons** of Ballard of hand-crafted materials and coats from pre-Communist China…," *SYVN*, May 1, 1959, p. 3; Changed its name to the Santa Ynez Valley Woman's Club, obtained enlarged quarters for the local library and held a fashion show; "Historical Society Formation Discussed," *SYVN*, Oct. 2, 1959, p. 3. See: "Santa Ynez Valley Woman's Club"

Somerville, Marietta Breckenridge (Mrs. Ernest Lincoln Somerville) (1875-1958) (Los Angeles)
A painting by her was won by the Jr. Community Club, Santa Maria, 1953.

■ "Marietta Somerville… former Waterloo resident who died Thursday of a heart condition at Sunland, Calif. Mrs. Somerville was born in Waterloo, Aug. 23, 1875. She attended the Waterloo schools, graduating from East High. She was a member of Christ Episcopal church and the Elklets and Pythian Sisters. She had resided in Los Angeles since her marriage to Ernest Somerville several years ago. He, her parents, two brothers and a sister preceded her in death. Survivors include a daughter, Mrs. Chester Brewer, Sunland, Calif…," *The Courier* (Waterloo, Iowa), March 2, 1958, p. 2.

Somerville, Mariett (notices in California newspapers on microfilm and on newspapers.com)
1950 – "Artists to Appear on Highland Park Ebell's Program… Marietta B. Somerville, art and handicraft curator will introduce …," *LA Times*, March 21, 1950, p. 39 (i.e., pt. III, p. 3).
1958 – "Somerville, Marietta B., loving mother of Mary Julia Brewer …," *LA Times*, Feb. 28, 1958, p. 46, col. 4 (i.e., pt. III, p. 10).
Somerville, Marietta (misc. bibliography)
Marietta Somerville is listed in the 1920 U. S. Census as age 41, b. c. 1879 in Iowa, residing in Los Angeles with husband Ernest L. Somerville (age 43) and daughter Mary J. (age 8); Marietta Someville is listed in the 1930 U. S. Census as residing in Los Angeles with her husband Ernest; Marietta B. Somerville was b. Aug. 22, 1875 in Iowa, mother's maiden name Wheelock, father's Breckenridge, and d. Feb. 27, 1958 in Los Angeles County per Calif. Death Index (refs. ancestry.com).
See: "Junior Community Club (Santa Maria)," 1953

Sonndag, Al (Oakland)
Restorer of a painting at Mission Santa Ines, 1933.
See: "Mission Santa Ines," 1933

Sookikian, Charles John (1933-2011) (Lompoc)
Commercial artist, Lompoc, 1957+.

■ Port. and "Mr. Sookikian was born July 21, 1933 in Brooklyn, NY and passed away on Saturday, March 12, 2011. He was a son of the late Hagop Sookikian and Rose der Casberian Sookikian. Mr. Sookikian was a member of Our Lady of the Hills Catholic Church and a member of Knights of Columbus. He was a 20-year veteran of the US Air Force. He worked for SC Parks and Recreation and Midlands Tech as a graphic artist. He also ran his own design studio for many years. Mr. Sookikian was a die-hard LA Dodgers Fan (Brooklyn). Mr. Sookikian is survived by his wife of 54 years, Marguerite 'Peggy' Sookikian of Columbia…," findagrave.com.
Sookikian, C. J. (notices in Northern Santa Barbara County newspapers on microfilm and on newspapers.com)
1956 – "Engagement of Miss Marguerite ['Peggy'] Anne Perry to S. Sgt. Charles J. Sookikian, son of Mrs. Lucy Sookikian of Dorchester, has been announced," *Boston Globe* (Boston, Mass.), Oct. 16, 1956, p. 28.
1957 – "Artists' Service. Sign Painting. Illustrations. Window Displays. Murals. Reasonable Prices. Contact after 5:00 p.m. C. J. Sookikian. 126 North E Street, Lompoc," *LR*, Dec. 26, 1957, p. 7.
1991 – MOTHER – "Sookikian – of Belmont… Lucy… Beloved wife of the late Jack Sookikian. Devoted mother of Charles Sookikian of Columbia, S. C….," *Boston Globe*, Oct. 18, 1991, p. 86.
Sookikian, Charles J. (misc. bibliography)
Charles John Sookikian b. July 21, 1933 in NYC to Hagop/Jack Sookikian and Lucy Casbarian, d. March 12, 2011, in Columbia, S. C. per Kevin Charles Perry (1) Family Tree; Charles John Sookikian is buried in Bush River Memorial Gardens, S. C., per findagrave.com (refs. ancestry.com).

Sorensen, Ferdinand (1900-1987) (Solvang)
Designer of a home and windmill in Danish style as well as many other public constructions in Solvang.

■ "Ferdinand Sorensen's legacy will remain… died early June 29 at his Danish-style Mollebaken, 'Mill on the Hill,' home. … he and his late wife, Gundrun, a native of Copenhagen, first arrived in Solvang in 1933 from Chicago… Ferd… started life in Solvang as a plumber… It was Ferd who built the first of four provincial styled windmills which grace the Solvang horizon today… A multitude of other signs of Ferd Sorensen's creative talent appear throughout the town – simulated storks on the rooftops, unique weather vanes, hand-carved benches, bright red royal guard boxes which serve as telephone booths, thatched roofs, bindingsvaerk walls, weathered copper and wood towers and on ad infinitum. The Solvang Park … Sorensen designed gazebo or band stand, the bust of Hans Christian Andersen which he arranged to have placed in the park and the Viking grave marker or barrow … a Nebraska farm boy who grew up in later years to become a Knight of the Queen of Denmark… He played a major role in Danish Days… was a past president and longtime member of the Solvang Business Association / Chamber of Commerce and the Danish lodges… knighted upon receiving the Order of the Dannebrog Medal… honorary mayor of Aalborg, Denmark, Solvang's sister city…," *SYVN*, July 9, 1987, p. 4; and hundreds of additional notices not itemized here.
See: "Architecture (Solvang)," "Lauritzen, Dillon," 1948, "Nelson, Robert," 1951, "Santa Ynez Valley Art Association," 1953

Sorensen, Hans (1922-1994) (Solvang)
Photographer, 1953+ Exh. Santa Ynez Valley Art Exhibit, 1954. Prop. of Atterdag Studio, 1953-59.

■ Port. on staff of *Valley News*, "Hans Sorensen, printer and chief compositor on the *News* staff the past year, can extend greetings for the holiday in either Danish or English with ease. A native of Copenhagen, Hans learned the printing trade in the old country and is an efficient worker. He first came to America and Solvang as a member of the Danish gym team and has been in the United States the past three years. Possessing photographic ability, he plans to devote his full time to that endeavor after the first of the year," *SYVN*, Dec. 26, 1952, p. 2.

■ "Hans Sorensen, 71, of Ashland, Ore. Died Feb. 2, 1994 at Providence Hospital and Medical Center, Medford. He was born May 20, 1922 in Copenhagen, Denmark… On March 6, 1948 in Copenhagen, he married the former Alice Ransdal, who survives him. They moved to Rogue Valley four years ago from Solvang. He was a real estate broker in Shady Cove, Ore.," *SYVN*, Feb. 10, 1994, p. 9.
Sorensen, Hans (notices in Northern Santa Barbara County newspapers on microfilm and on newspapers.com)
1952 – Repro: various photos of little theater, *SYVN*, March 14, 1952, p. 1.
1953 – Repro: photo of **Leo Ziegler** at his easel, *SYVN*, Feb. 6, 1953, p. 1; repro: photo of **Charles Glasgow** at his easel, *SYVN*, Feb. 20, 1953, p. 1; and many repros in *Santa Ynez Valley News* in succeeding newspapers because he is

paper's "official" photographer; photo of he and wife airing their costumes for Danish Days, *SYVN*, July 24, 1953, p. 1; "Hans and Alice Sorensen Launch Dance Classes Here. Boys and girls… age from six through the teens… ballroom dancing," *SYVN*, July 24, 1953, p. 5.
1954 – Ad offering to take wedding photos, *SYVN*, April 9, 1954, p. 3.
1958 – Ad wishing clients Season's Greetings, *SYVN*, Dec. 26, 1958, p. 4.
1959 – Repro: "Wed in Solvang… Capelli," *SYVN*, Jan. 9, 1959, p. 3; repro: "New Masonic Officers," *SYVN*, Jan. 16, 1959, p. 6; repro: "Exchange Vows – Mr. and Mrs. Arden Darrell Petersen," *SYVN*, July 24, 1959, p. 3; "**Gardner** Opens Photographic Studio Here… purchased the photographic studio of Hans Sorensen…," *SYVN*, Oct. 9, 1959, p. 1.
1966 – Port. with his family as honorary parade marshal, *SYVN*, Sept. 22, 1966, p. 5.
1968 – Ad: "Promotional Advertising. For Business. Product. Service. Photography. Art. Design. Hans Sorensen. 688-5101," *SYVN*, June 6, 1968, p. 6.
1989 – Port. and "Return to Valley … Hans Sorensen and his wife, Alice, have returned to the Santa Ynez Valley from Roseburg, Oregon, where they have lived for 15 years… now associated with Solvang Realty…," *SYVN*, March 2, 1989, p. 7.
And additional photos repro. in the *SYVN* not itemized here.
See: "Atterdag Studio," "Carlson, Juka," intro., "Gardner, Loris," "Knudsen, Robert," intro., "Santa Ynez Valley Art Exhibit," 1953, 1954, "Solvang Studio," 1963, "Ziegler, Leo," 1953

Sorensen, Soren C. "Rock" (1894-1974) (Solvang)
Stone mason, sculptor / carver of a rune stone, Atterdag Bowl, 1951. Creator of "Folk Art Environment" at his home, 1933+.
■ "Soren Sorensen Gives Wall, Runesten to Atterdag Bowl… Mr. Sorensen, who resides on Highway 150 east of Solvang, and who is an expert at working with bricks, rocks and mortar, has given his time and material to construct a rock wall at Atterdag bowl. In addition to erecting the 125 foot-long wall at the rear of the stage in the bowl, Mr. Sorensen has completed a runesten (Rune Stone) which was the 'writing tablet' used by the Vikings centuries ago… is a replica of an original Viking stone with the message carved out… On a rock below the stone are carved the rune letters with corresponding letters in English… The runesten is about 18 inches wide and 30 inches high. The stone has been placed in the rock wall… Rocks for the wall are of every shape and color and were gathered by Mr. Sorensen. … Also recommended as Good Samaritans are **Kris Klibo** and **Walter Kristensen**. … the two men were in the process of installing an iron railing for the top of the wall…," *SYVN*, July 27, 1951, p. 3.
Sorensen, Soren (notices in Northern Santa Barbara County newspapers on microfilm and on newspapers.com)
1954 – "Soren Sorensen's Rock-Built Residence East of Solvang, Unique … A native of Denmark, Mr. Sorensen came to the United States in 1916. In 1928 he built the Solvang Hotel, now known as the Solvang Inn. He also

built and operated the service station now owned by Elmer Lunde next to the Inn… Five years later he bought the 'Bakkely' property… 1933 …," and several photos, *SYVN*, April 23, 1954, p. 10.
1974 – "Soren 'Rock' Sorensen, 80, Dies… born in Denmark Jan. 1, 1894 and came to the United States in 1918 [Sic.?] … traveled in the western United States before coming to Solvang in the 1920's. … He was at one time owner and operator of Solvang Inn… In the 1930s he began building the rockwork on his hillside property on Old Mission drive and practically singlehanded raised the rock walls, built the steps, castles, arches and garden niches that won him the name of Rock. In the 1940's and 50's his profusion of flowers, trees and shrubs became a show place of the town … He was written up in a number of national magazines and newspapers … The materials for his structures came from old buildings, Tecolote tunnel and the sugar mill at Goleta… Among his many projects was the building of the rock foundation for the stage in former Atterdag Bowl… During the depression he built his own house of rocks … In his earlier years he was one of the Solvang folk dancers and sometimes played the fiddle for the dancing…," *SYVN*, Oct. 24, 1974, p. 17.
And, many additional notices in local newspapers not itemized here.
Sorensen, Soren (misc. bibliography)
Soren C. Sorensen was b. Other Country Jan. 1, 1894 and d. Oct. 21, 1974 in Santa Barbara County per Calif. Death Index (refs. ancestry.com).

Sortomme, Richard
See: "United Service Organization (Lompoc)," 1945, "United Service Organization (Santa Maria), 1945, and *Atascadero Art and Photography before 1960*

Soul, Alan (1918-1964) (Los Angeles / La Purisima)
Staff artist for CCC, 1936.
He may be Alan Wayne Soul b. July 13, 1918 in Los Angeles to Harold Maurice Joseph Soul and Marie Johnson, who was residing in Los Angeles in the 1940s, and who d. April 4, 1964 in Ohio per Wood Family Tree (refs. ancestry.com).
See: "Civilian Conservation Corps," 1936

Southern California Scholastic Art Exhibition (Los Angeles)
See: "Scholastic Art Exhibit"

Souza / Sousa, Joseph Luis (1901-1977) (Santa Maria)
Photographer, amateur. Member Santa Maria Camera Club, 1939-58+.
■ "Joe L. Souza," *SMT*, April 14, 1977, p. 16.
Souza, J. (notices in Northern Santa Barbara County newspapers on microfilm and on newspapers.com)
1948 -- "Congratulations to Joe Sousa…. Wish you … success in your new business venture – the Sousa Radio & Appliance Service. Your eighteen years with the Saladin Store proved your worth and dependability while manager

of our service department… With sincere best wishes… W. H. Saladin … **Bardy Saladin**, John L. Corins, **George C. Heath**, Bill Harkness, Joan De La Guerra," *SMT*, March 1, 1948, p. 3.

<u>Souza, J. (misc. bibliography)</u>
Joseph "Joe" Luis Souza was b. Sept. 18, 1901 in Pedro Miguel, Azores, Portugal, married Lydia Dias, was residing in Santa Maria in 1942, and d. April 11, 1977 in Santa Maria, Ca., per Tangled Vines Family Tree (refs. ancestry.com).
<u>See</u>: "Santa Maria Camera Club," 1939-44, 1946-48, 1954, 1955, 1957, 1958

Spallino, Robert F. (Vandenberg)
Airman, Naval Missile Facility, Point Arguello, and winner in the color slide competition in a Vandenberg photography contest, 1959.
<u>See</u>: "Photography, general (Camp Cooke)," 1959

Spangler, Lafayette "Fay" Robinson (1885-1970) (Santa Maria)
Architect, Santa Maria, 1919-20.
■ "Fay R. Spangler, local architect, has moved this week into his new office suite in the Jones building. This suite was formerly occupied by a photographer. The room was subdivided into four rooms, reception room, secretary's office, drafting room and private office. The interior finishings are quite out of the ordinary. The private office is finished in a sage green and gold. The woodwork in the other rooms is a very artistic old ivory with the gold. O. C. Marriott & Company was in charge of the remodeling. The decorating was done by the **B. R. McBride Paint store** and the hangings by the Bonynge Furniture company," *SMT*, Sept. 8, 1919, p. 4.

Spaulding (Anderson), Florence (Mrs. Sydney A. Anderson) (Santa Barbara County)
Santa Barbara Co. Home Demonstration Agent, 1942-47
■ "Miss Spaulding Quits County Post… and early in August will be married to Sydney A. Anderson, county farm advisor, her 'boss' for the four years she has been on duty in the county. The wedding will take place in Los Angeles… The bride is a graduate of the University of California with a degree in home economics…," *SMT*, June 30, 1947, p. 2.
<u>Spaulding, Florence (misc. bibliography)</u>
Florence Spaulding is listed as County Home Demonstration Agent in the *Santa Barbara, Ca., CD*, 1944, 1945, 1946; Sydney and Florence Anderson are listed in the *Santa Barbara, Ca., CD*, 1948 (refs. ancestry.com).
<u>See</u>: "Fagin, Irene," 1942, "Home Department of the State Farm Bureau," 1942, 1947

Spaulding, Josephine (Santa Maria)
Painter who won the audience vote for "best oil in the professional section," at the Santa Maria Valley Art Festival, 1952.
Is she Josephine Marie McManus (Mrs. Albert Quincy Spaulding) of Montecito, Ca., 1897-1954?
<u>See</u>: "Santa Maria [Valley] Art Festival," 1952

Spindler, Cliff, Jr. (1925-1969?) (20th Armored Division, Camp Cooke)
Sketched portraits in conjunction with a traveling art exhibit at the USO, 1945.
<u>Spindler, Cliff (misc. bibliography)</u>
Is he Clifford Clarence Spindler, Jr., who provided the following information on his WWII Draft Card (1943), age 18, b. March 21, 1925 in Duluth, Minn., student at Maine High School, and his parents live in Park Ridge, Ill.; port. of Cliff Spindler, art editor of Oberlin college yearbook, 1948; is he Clifford C. Spindler, Jr., 1925-1969, buried in North Lawn Cemetery, Canton, Ohio, per findagrave.com? (refs. ancestry.com).
<u>See</u>: "United Service Organization," 1945

Spires, Muriel F.
<u>See</u>: "Moran (Spires), Muriel F. (Mrs. Harry E. Spires)"

Splash
Art magazine (hand-made) published by the art students at Santa Maria Union High School, 1923+. Contained stories and original art. Won national prizes.
<u>Splash (notices in Santa Barbara County newspapers on newspapers.com and on microfilm)</u>
1923 – "The '*Splash*' Makes its First Splash Monday," art magazine, 40 pps. under direction of **Stanley Breneiser**, *SMT*, Sept. 28, 1923, p. 6, and students hope to put out five numbers a year.
1927 – "Art Magazine is Acclaimed… The '*Splash*,' a handmade magazine published … about twice a month, [Sic ?], appeared this week in the high school library for the first time this semester. This issue is the 'Travel' number and deals largely with scenes and stories from foreign countries. Four issues of the '*Splash*' have been put out. One is kept on file, and the other three placed in the library. The magazine was made by sewing heavy paper together and pasting the designs and stories on the sheets of paper. This copy has 56 pages. There are four stories and one poem – the other pages are devoted to drawings, block prints, blue prints of tracings and designs. **Lucy DeGasparis** is the editor… **Mario Veglia** is the art editor, **Stanley G. Breneiser**, instructor, is the advisor … Drawings for the '*Splash*' were made by **Mario Veglia**, <u>Paul Yarnell</u>, <u>Emma McMillan</u>, **Ninalee Waiters**, <u>Charles Taylor</u>, <u>Charles Howard</u>, **Ruth Bettersworth**, <u>Mary Mendoza</u>, <u>Lela Strong</u>, <u>Rosa Mendoza</u>, <u>Herbert Tognazzini</u>, **Ralph Adams**, <u>Charles Merrifield</u>. <u>Mary Lindner</u>, <u>Jennie Sorhondo</u>, <u>Kathleen Bettersworth</u> and **Cora Culp** … There are seven blue prints of tracings made by **Ruth Bettersworth** and <u>Maggie Downs</u>," *SMT*, Dec. 1, 1927, p. 8.

1928 – "Anniversary Number of '*The Splash*' Published…
main theme of this issue was the making of illustrations in
many mediums for passages from selected works of the
greatest writers and poets… 60 pages and represents the
work of 26 students under the teaching of **Mrs. Elizabeth
D. Breneiser** and supervision of **Stanley G. Breneiser**.
The outstanding illustrations that show unusual talent and
splendid technique were made by Kathleen Bettersworth,
Margaret Sutter, Margaret Scaroni and **Paul Yarnell** of
the high school students and of the junior college art
department. Very beautiful specimens of the work of **Ruth
Bettersworth**, **Milford Zornes** and Barbara Lamb are
found. … Many of the illustrations are linoleum block
prints. Others are pen and ink drawings, while still others
are worked out in either water color, tempera or
modomestic poster painting. The covers are perhaps the
most beautiful … being made of hand tooled leather. The
design was made by **Cora Culp** and the four covers were
tooled by her assisted by Mabel Wasson and Leila Strong
[Mrs. Lewis R. Frye] …," *SMT*, June 5, 1928, p. 5.
1933 – "School Magazine Winner… for the fourth
consecutive year, '*The Splash*' … has captured highest
honors in its class in competition at Columbia University in
New York… a 'special medalist' award has been won by
'*The Splash*,' edited this year by Henrietta Ontiveros with
the assistance of a selected staff of student artists… Only
45 copies of '*The Splash*' were published, but every one
was done by hand with the assistance of specially
developed processes in the art department," *SMT*, April 21,
1933, p. 1.
1934 – "Magazine Staff Selected. **Nicholas Firfires** will
act as art editor of '*The Splash*,' official organ of Santa
Maria high school and junior college art department, during
the coming semester… He will be assisted by **Joffre C.
Bragg**… **Mrs. Elizabeth Breneiser**, faculty adviser…,"
SMT, Sept. 8, 1934, p. 2.
1935 – "Antiques to be on Display… Coincidentally with
the opening of the [Santa Maria Art] festival, '*The Splash*,'
art magazine… will make its initial appearance this year.
The theme of this edition… is 'Adventure,' and the
magazine is devoted to **Rockwell Kent**, many of whose
original works will be exhibited here during the festival.
Short stories contributed by Herbert Grundell and Yvonne
Patten are illustrated with block prints and etchings. Poems
and biographies also are illustrated, and most of the pages
are decorated, all of the work being done by students under
the supervision of Mrs. **Elizabeth Breneiser**. The staff is
composed of Pauline McCoy, editor, **Nicholas Firfires**, art
editor, **Joffre Bragg**, assistant editor, **Francis Gregory**,
business manager, and Mrs. Breneiser, adviser. Only eight
copies have been made. Four of these will be distributed to
Rockwell Kent, Columbia Press association, National
Scholastic Press association, and the school library. The
remaining four have been sold," *SMT*, Jan. 5, 1935, p. 3;
"*The Splash* is Given High Rating. … won the 'All
American rating' (highest given) from the National
Scholastic Press association, Minneapolis. The advisor…
Mrs. Elizabeth D. Breneiser. The judges… wrote that 'the
magazine is a clever and unique review, far above the
average.' Special mention was made of the work of **Byron
Openshaw**, **Rowena Lowell** and **David Breneiser**. The
director of the association also wrote that '*The Splash*' is a

superior and decidedly original publication… I look
forward to seeing '*The Splash*' each year, and I hope it will
be published for many years to come.' The second issue of
'*The Splash*' for this school year, is scheduled to appear
early in June …," *SMT*, May 13, 1935, p. 2; "**Rockwell
Kent** Gives Prints to Pupils…," in exchange for their
present to him of one of the hand-made copies of the
Splash," *SMT*, Nov. 13, 1935, p. 3.
1938 – HS art magazine "*Splash* Out, First Since 1935," –
organized by **Breneiser** in 1923, and 11 annual issues to
date. "The magazine is made entirely by hand. Only 24
copies were made and these sold in advance, except the
copy that will be kept in the high school library… The
cover design by the editor, **Elva Allen**, carries an
impression of the phoenix bird and the title, done in the silk
screen method. Backing is done in a reproduction of a
block print by Fred McVicar. The first section of the
magazine is given over to a description of four different
mediums of art with illustrations of each, by students.
These include the offset press method in oil paint, the
cliché verre, the block print and the hectograph method;
students represented are Harriet Bright, Eleanore Needham,
Mina Rushforth, **Ruth Dowty**, **Leslie Stonehart**, Juro
Shintani, Imiko Matsumoto and **Yukio Tashiro**.
Outstanding among the pictorial pages is the block print by
Yukio Tashiro, sculpture student of a bust of the
instructor, **Stanley Breneiser**. There is also a humor
section, with cartooning by Juro Shintani and Robert Foxen
and a fashion section with designs created from the
inspiration of the phoenix bird, including hats and dresses
and representing the work of Betty Friday and Tokiye
Tamaki. Only picture by other than students is the stencil
spray by **Harold C. Stadtmiller** of Exeter who has taught
in the Santa Maria Summer Art school," *SMT*, Nov. 29,
1938, p. 3.
1939 – "**Ruth Dowty** Named *Splash* Editor. 'California'
will be the theme …," *SMT*, Sept. 22, 1939, p. 3.
And, additional notices not itemized here.
See: "Breneiser, Stanley," 1924, "DeGasparis, Lucy,"
1928, "Santa Maria, Ca., Union High School," 1923-27,
1929, 1934, 1935, 1938-40

Sprouse-Reitz Dime Store (Lompoc)
Retailer of hobby materials, 1949.
"Hobby Shop Artists – Take notice. Shop at Sprouse-Reitz
Dime Store for those tools and doo-dads so necessary for
the home shop… 104 E. Ocean," *LR*, July 21, 1949, p. 6.

Spurgin, Holland (Santa Maria)
*Teacher of manual training in the Santa Maria
Elementary Schools, 1921/26.*
1924 – "A wedding … Miss Pearl Morrison… Holland
Spurgin… Mr. Spurgin is a member of the faculty of the
elementary schools, the coming term making his third year
here as instructor in manual training and physical
education…," *SMT*, Aug. 11, 1924, p. 5, col. 6.
1926 – "Holland Spurgin, instructor in the Santa Maria
elementary schools for the past few years and principal of
the Main street school the past year, has accepted a position

in the Compton schools and is moving his family to that city…," *SMT*, June 16, 1926, p. 5.
See: "Santa Maria, Ca., Elementary Schools," 1922, 1924, 1925

Squier, Crystal Lund
See: "Lund (Squier), Crystal"

Squire, Carrrie Strube (Mrs. Arthur M. Squire)
See: "Strube, Carrie"

SRA
See: "California State Relief Administration," "Summer School (Santa Maria)," 1935

St.
See also: "Saint"

St. John, ? (Mrs. ? St. John) (Solvang)
She and her daughter exh. flower studies at Art Loan Exhibit, Solvang, 1935. "Mrs. St. John resided here many years ago, her husband having been supervisor from this district at one time."
This individual could not be further identified. Remarried?
See: "Art Loan Exhibit (Solvang)," 1935

St. Mark's in the Valley Episcopal Church (Solvang)
See: "Saint Mark's in the Valley"

St. Mary's Catholic Church (Santa Maria)
See: "Japanese Art," 1958, "Sample, Alice," "Summer School (Santa Maria)," 1930

St. Mary's Episcopal Church (Lompoc)
Included a puppet show by Forrest and Marie Hibbits in its annual Bazaars.
See: "Ceramics," 1958, "Hibbits, Forrest," 1951, 1952, 1956, "Maimann, Leila," "Posters, general (Lompoc)," 1953, "Potter, Roy"

St. Peter's Episcopal Church (Santa Maria)
Episcopal church that contained stained glass windows and sponsored various fundraisers, such as that by its Arts and Crafts Guild.
See: "Arts and Crafts Guild," "Howard, Leonard," "Judson Studios," 1959, "Peck, Virginia," 1935, 1937, 1941, "Puppets, general (Santa Maria)," 1935, "Stained Glass," 1949, "Waller, Lionel"

Stackpole, Peter (1913-1997) (NY / California)
Photographer for Life magazine who took photos in Solvang, 1940.
■ "'Life's Cameraman in Solvang 'Shooting' for special Denmark Section… He took pictures of typical Danish scenes, as seen in Denmark. *Life* is planning a special section in its magazine featuring Denmark and the Danes in this country… The gymnastics class of the Solvang grammar school … and a group of local folk dancers in Danish costumes were assembled at Atterdag college for a few shots… He also took pictures of the school and the church, air views of Solvang, the Burchardi and Alfred Jacobsen dairies, 'Pop' Bruhn in his shop, Rasmus Rasmussen and his team of horses working in a field, Eric Thomsen and children in their home, Alfred Petersen and family, and Alfred Jorgensen in his home… Hubert Voight, county publicity director… was here earlier in the week with a writer for the *New York Times* who was preparing a story on this locality for her … paper," *SYVN*, April 12, 1940, p. 1.
■ "Peter Stackpole was an American photographer. … he was one of *Life Magazine*'s first staff photographers and remained with the publication until 1960. He won a George Polk Award in 1954 for a photograph taken 100 feet underwater, and taught photography at the Academy of Art University. He also wrote a column in *U.S. Camera* for fifteen years. He was the son of sculptor Ralph Stackpole," Wikipedia.

Stadtmiller, Harold Cardwell (1895-1953) (Exeter)
Artist. Taught at Santa Maria School of Art, summer, 1927, 1933. School principal and artist at Exeter, Ca., for 46 years.
See: "Breneiser, Stanley," 1950, "Santa Maria, Ca., Union High School," 1938, "Santa Maria School of Art," 1927, 1933, "*Splash*," 1938, and *Central Coast Artist Visitors before 1960*

Stage Design (Northern Santa Barbara County)
See: "Set Decoration"

Stained Glass (Northern Santa Barbara County)
Windows were created for various buildings, usually churches. Most often these were made by artists residing outside Santa Barbara County.
Stained glass (notices in Northern Santa Barbara County newspapers on microfilm and on newspapers.com)
1935 – St. Peters – "Church Unveils Two Windows … The windows, placed over the altar, portray figures of St. Peter and St. Paul. The St. Peter window is the gift of **Lionel D. Waller** in memory of John Henry Franklin, M. D., his former business associate. The St. Paul window, in memory of the Rev. George Francis Weld of Santa Barbara, was presented by his widow, Mrs. Dorothy Appleton Weld. … **Leonard Howard** designed and executed the new windows in his studios in Kent, Conn.," *SMT*, Sept. 16, 1935, p. 4.
1945 – "Remodeling of Ballard Church… Santa Ynez Valley Presbyterian Church… The one small stained-glass

window in the back wall of the chancel remains intact. It was the handiwork of **Mr. D. B. W. Alexander**, pioneer of the valley, who presented it to the original church built in 1898…," *SYVN*, Feb. 9, 1945, p. 8.

1949 – "… three stained glass windows given by Mrs. Marian Ellis and Mrs. A. T. Ericson. The window presented by Mrs. Ericson in memory of her parents has the central figure of St. Elizabeth in Hungary. Dedicated to the Christian pioneers of Santa Maria valley are the pair of windows given by Mrs. Ellis and installed in the South wall near the main entrance. A figure of Christ is pictured in one window and in the other that of St. Francis, with figures of animals and birds he loved in the border design," but no artist named, per "Stained Glass in **St. Peter's** Honors Pioneers," *SMT*, April 11, 1949, p. 5.

See: "Brandt-Erichsen, Viggo," 1953, "Brigham, B. L.," 1899, "College Art Club," 1932, "Ewing, Louie," "Gray, Gladys," "Jeter, L. T.," 1892, "Judson Studios" "Linsenmeyer, Alice," "Los Alamos Community Church," "Meadows, Helen," "Orcutt Community Church," "Peck, Virginia," 1935, "St. Mark's-in-the-Valley," "Santa Maria, Ca., Union High School," 1940, "Slimp, Helen," "St. Peter's Episcopal," 1949, "Wesselhoeft, Mary," "Wright, James Couper"

Stanley, Alexander Luce / Alexis Luce, "Lex," Deacon (1858-1919) (Santa Maria / Sisquoc)
Art student of Minnie Stearns, 1893. Exh. painting of deer at Art Loan Exhibit, 1895. Farmer. Prop. Pioneer Trucking and Express, 1893.

1891 – "Lex Stanley, the new drayman, although rushed with business, is giving good satisfaction," *SMT*, Oct. 24, 1891, p. 3.

1893 – "'They say,' that Lex Stantley's [sic. Stanley] pups attract more attention at Mrs. Stearns' Art Studio than any other study on the easel. No one suspected 'Lex' posing as an artist, but talent will find expression sooner or later," *SMT*, Dec. 16, 1893, p. 3.

1894 – "Deacon Stanley was in town Thursday. He brought down the monument for the late Henry Dolcini's grave. Mr. Clark of Santa Cruz came down with him. Mr. C. will superintend the setting up of the monument," *SMT*, June 9, 1894, p. 3.

And, many notices under "A. L. Stanley" (?) between 1885 and 1900 not itemized here.

Stanley, A. L. (misc. bibliography)
Alexis Luce Stanley was b. Jan. 1858 in Monmouth, Ill., to Orlando B. Stanley and Eliza Jane McNeil, married Effie Grace Orr, and d. July 6, 1919 in Santa Maria, Ca., per hcgriff1009 Family Tree (refs. ancestry.com).

See: "Art Loan Exhibit (Santa Maria)," 1895, "Stearns, Minnie," 1893

Stanwood, Carolyn K. (Mrs. Samuel J. Stanwood) (Mission Canyon, Santa Barbara)
Chairman of Art, Santa Barbara County Federation of Women's Clubs, and collector of art by Santa Barbara artists, 1940.

See: "Alpha Club," 1940, "College Art Club," 1935

Star Auto and Sign Painting Shop (Santa Maria)
W. J. Osborn Prop., 1920.

"W. J. Osborn of the Star Auto and Sign Painting Shop has engaged an expert sign painter. Prompt attention given to all kinds of sign work. Call Phone 490," *SMT*, May 25, 1920, p. 4.

Stark, Jack Gage (1882-1950) (Los Angeles / Santa Barbara)
Santa Barbara artist who exhibited at Hancock Gallery, 1958.

■ "Painter. Stark went to Paris in 1900 to study art and worked under Van Horne Millet. His paintings were first exhibited there in 1905. Between 1909 and 1915 he was centered in New Mexico but was in and out of LA exhibiting. During WWI he served with the fortieth engineers. He resided in Santa Barbara for many years before his death," and extensive bibliography in Nancy Moure, "Dictionary of Art and Artists in Southern California Before 1930" (*Publications in California Art*, vol. 3); a collection of his paintings are held by the Santa Barbara Museum of Art.

■

Stark, Jack (notices in newspapers on microfilm and on newspapers.com)

1905 – Ad: "Jack Gage Stark – His Etchings, Monotypes, Oil Paintings and Water Colors, for one week at Swan's, 1018 Grand, Kansas City," *Kansas City Star* (Mo.), June 4, 1905, p. 20 (i.e., Second Section, p. ?).

1908 – "Gossip of Society. Mrs. A. B. Walton of Altoona, Pa., announces the engagement of her daughter, Elizabeth Bell to Mr. Jack Gage Stark of Silver City, N. M… Mr. Stark is a son of the late Dr. John K. Stark of Kansas City and brother of Dr. Will T. Stark and of Mrs. J. E. Guinotte," *Kansas City Times* (Kansas City, Mo.), Aug. 21, 1908, p. 6; "Jack Stark's Paints Here… Sixteen interesting paintings by Jack Gage Stark of this city are on free public view in the gallery of the Findlay Art company, 929 Walnut street. Mr. Stark has studied in several schools of art both at home and abroad and has roamed at his pleasure through the byways of France and Spain. He has camped several seasons in New Mexico and other parts of the American southwest. All of his sixteen pictures, with one exception, an example in still life, speak for his love of outdoor life, sunlight and of that freedom which comes with broad sweeps of free landscape. A disciple of the impressionistic school… Mr. Stark paints in strong colors, almost roughly used, and trusts to the general effects to convey his ideas. One of the most attractive of the sixteen pictures is a bit of hilly ground near Silver City, N. M. Among the lesser paintings the best is a sketch showing little red-tiled houses of Chesy (?) grouped about an irregular court or village square," *Kansas City Star* (Mo.), Sept. 23, 1908, p. 3; "Territorial News Notes… Mrs. Adessa B. Walton has announced the marriage of her daughter, Miss Elizabeth Bell Walton to Mr. Jack Gage Stark Wednesday, September 23, 1908 at Kansas City, Missouri. The bride and groom are well-known and popular in Silver City where they have resided for some time past. … The groom is an artist having been a student in Paris for a number of years and has occupied himself in following

his art while in Silver City…," *Santa Fe New Mexican*, Oct. 8, 1908, p. 2.

1909 – "Art Notes… Jack Gage Stark will formally open his one-man exhibit in Assembly Art hall … Mr. Stark comes direct from Paris with his paintings of the impressionist school…," *LA Herald*, Nov. 15, 1909, p. 7; review of exh. at Blanchard in "Art Notes," *LA Herald*, Nov. 25, 1909, p. 6; "Jack Gage Stark, who recently held an exhibition of his impressionistic paintings in the Blanchard gallery, is now painting in and about San Diego and expects to exhibit his paintings at Vickrey's [Sic. Vickery] at San Francisco, in the near future," *LA Evening Express*, Dec. 30, 1909, p. 8.

1910 – "Art Notes… Jack Gage Stark was in the city recently en route to Taos, N. M. where he and E. A. Burbank will occupy the studio of F. P. Sauerwein for a year or more during the absence of Mr. Sauerwein in the east," *LA Herald*, April 24, 1910, p. 38 (i.e., pt. III, p. 10).

1911 – "Art Notes. An exhibition of nineteen paintings from the brush of Jack Gage Stark was held in Portland, Or., from January 19 to January 28. Many of the pictures shown last year in Los Angeles were exhibited," *LA Times*, Jan. 29, 1911, p. 42 (i.e., pt. III, p. 14); "Art Notes… Jack Gage Stark is still sketching in the neighborhood of Silver City, N. M. Later in the year he will travel eastward, showing his pictures in Minneapolis, Chicago and New York," *LA Times*, Dec. 17, 1911, p. 51 (i.e., pt. III, p. 21).

1912 – "Joseph Greenbaum… spent all of last September and October in 'The Big Country'… on a ranch with Jack Gage Stark near Silver City, N. M. and he describes the surroundings as 'wonderful, wild and rugged.' Moreover, they are full of color of the kind that appeals to painters, and they have never been painted before," *LA Times*, Feb. 25, 1912, p. 47 (i.e., pt. III, p. 21, col. 1); "Will Sail for Tahiti Islands… Dec. 20…," *LA Evening Express*, Dec. 7, 1912, p. 16; "Art Notes… Jack Gage Stark… came to this city from his New Mexico home last week and made a short stop en route to the South Sea Islands," *LA Evening Express*, Dec. 14, 1912, p. 5.

1914 – "Artists Coming and Going… 'Jack Gage Stark, the landscape painter,' says the same paper [*LA Times*] 'has been in Los Angeles for a week.' He returned to his ranch studio in Silver City, N.M. on Thursday. He is working hard and next year Los Angeles May expect an exhibition of impressions from his able brush," *Albuquerque Morning Journal* (NM), Oct. 4, 1914, p. 10.

1936 – "New Englanders… Mr. and Mrs. Mahonri Young of Ridgefield, Ct., have arrived in Santa Barbara for an extended visit with Mr. and Mrs. Jack Gage Stark…," *LA Times*, April 14, 1936, p. 25 (i.e., pt. II, p. 5).

1937 – "Brush Strokes … **Faulkner Memorial Gallery**, Santa Barbara: Jack Gage Stark paintings, drawings, January 20-31," *LA Times*, Jan. 17, 1937, p. 47 (i.e., pt. III, p. 5).

1941 – "Starks Return from New Mexico. Mr. and Mrs. Jack Gage Stark of 1709 Eucalyptus Hill Road, Santa Barbara, have returned from a visit to their estate near Silver city, N.M. where they passed several weeks," *LA Times*, Dec. 12, 1941, p. 40 (i.e., pt. II, p. 10).

1942 – "France Forever Chapter Formed in Channel City," and among the members is Jack Gage Stark, *LA Times*, Aug. 2, 1942, p. 58 (i.e., pt. IV, p. 4).

1944 – "Stark's Work Praised. A large exhibition of paintings and drawings by Jack Gage Stark… shown at the Santa Barbara Museum of Art through March 12, drew lyrical praise from Museum Director-Critic **Donald Bear**," *LA Times*, Feb. 27, 1944, p. 30 (i.e., pt. III, p. 6); "At De Young Museum… Paintings and Drawings by Jack Gage Stark, opening September 6… Special Lectures… 'A Discussion of the Works of **Etienne Ret** and Jack Gage Stark' by Miriam Sweeney, September 28, 11 a.m.," *Oakland Tribune*, Sept. 3, 1944, p. 18 (i.e., 2C); "Seabees Work… new exhibit at the de Young Museum. The same museum has put up paintings by Jack Gage Stark of southern California…," *SF Examiner*, Sept. 10, 1944, p. 73.

1945 – "Art Institute Calendar… Tomorrow is the last day of the Jack Gage Stark show, and on Feb. 4 two new exhibitions will be presented…," *Pasadena Star News*, Jan. 27, 1945, p. 5.

1948 – "Encyclopaedia Britannica's Collection… Now Being Displayed at Pasadena Institute… 129 paintings by 20th century artists… Ten artists who live in California are represented… Jack Gage Stark…," *LA Times*, Jan. 25, 1948, p. 49 (i.e., pt. III, p. 5); "In Santa Barbara… One of the country's foremost artists, Jack Gage Stark, has returned to his home city with a one-man exhibit of his paintings in the Santa Barbara Museum of Art…," *LA Times*, Feb. 15, 1948, p. 57 (pt. IV, p. 7); "New Exhibits… Jack Gage Stark drawings. Mid-20th Century Gallery. Through Dec. 31," *LA Times*, Dec. 5, 1948, p. 110 (i.e., pt. IV, p. 10).

1949 – "In the Galleries. … Each painting in the exhibition of Jack Gage Stark at the James Vigeveno Galleries, 160 Bronwood Ave., Westwood Hills, to May 18, seems to be an attempt to sum up in a broad manner and with extreme simplicity the essence of a moment of sensation experienced by the painter. 'Three Women by the Sea' and 'Flowers in a Blue Jar' are especially successful, combining bare structure with delicate color changes. The flashing 'Evening in Cuba,' and 'Circus Girls,' 'Miss May Performing' and the ultra-simple 'Old Pernod,' are other good pictures. A few canvases seem restrained to the point of emptiness," *LA Times*, May 1, 1949, p. 106 (i.e., pt. IV, p. 8).

1951 – "A valuable exhibit of oil paintings by the noted California artist, the late Jack Gage Stark, has been loaned by the Santa Barbara Museum of Art from its private collections to show this month in Allan Hancock College Art Gallery… The nineteen paintings by this artist, who was born in 1882 and died in 1951 [sic?] … Some of the still life titles are 'Library Table,' 'Table with Decanter,' 'Hot Country,' and 'Bathers.' There are other interesting still-life studies and a few nudes that drew attention and a measure of fame to this artist," and repro of painting and "Stark Oil Paintings in [Hancock] Gallery Exhibit," *SMT*, Dec. 11, 1958, p. 5.

And, numerous notices about his works appearing in group shows were not itemized here.

Stark, Jack (misc. bibliography)

Jack Gage Stark provided the following information on his WWII Draft Registration Card – residence Overlook Lane, Santa Barbara… artist / painter; Jack Gage Stark was b. March 24, 1882 in Missouri, married Elizabeth Bell Walton, and d. Dec. 2, 1950 in Santa Barbara per Koch-

Duncan-Rosenberg-Good Family Tree; Jack Gage Stark is buried in Santa Barbara Cemetery per findagrave.com (refs. ancestry.com).
See: "Allan Hancock [College] Art Gallery," 1958

State Emergency Relief Administration (SERA)
"The State Emergency Relief Administration (SERA), created in 1933 … responsible for distributing state and federal funds to improve conditions in California during the Great Depression, and administered unemployment relief," from Wikipedia. SERA superseded the CWA, which ended March 30, 1934. Paid for the re-painting and decorating of Main Street School, Santa Maria.

■ "The first of the month all unemployed relief work will be taken out of the hands of the county welfare department and administered by the SERA. A SERA office is being established in the old commissary building at Church and Lincoln streets. This office will be manned by a force of five… The State Emergency Relief Administration's work program, now estimated to be providing sustenance for approximately 250,000 Californians, is restoring men and women to work in lines of industry for which they are trained or adapted… Classified as professional, technical, and women's work, so called 'white collar' jobs range from sewing and canning – fields occupied by women almost exclusively – through nursing, nutritional, health, safety, and recreational vocations, to education, research, clerical and similar activities as well as music, art, and literature. … Recent compilations indicated that approximately 58 per cent of employment in Los Angeles county is upon construction…," per "SERA Office to be Opened in Santa Maria," *SMFA*, July 20, 1934, n. p.
State Emergency Relief Association (notices in Northern Santa Barbara County newspapers on microfilm and on newspapers.com)
1934 – Photo of men modeling a relief map and caption reads, "Fifty men are employed daily on this SERA project to make relief maps of all of the state's national forest territories. Piecing together topographic maps and giving the relief maps a life-like appearance is the work of expert map-makers and artists… The maps will give the public a graphic picture of California's forests at a moment's glance," *SYVN*, Nov. 2, 1934, p. 2.
1935 – "The SERA is planning a summer recreation program which is expected to include community recreational projects, athletics, music projects, drama groups, art and handicraft programs, social programs and a long list of educational projects. Surveys are being made of recreational projects which were successful last summer…," *SYVN*, June 14, 1935, p. 2; "SERA Program Ordered Closed," *LR*, Aug. 23, 1935, p. 1.
See: "Santa Maria, Ca., Elementary Schools," 1934

Staudigel, Arthur, Dr. (Solvang)
Optometrist who was also a photography enthusiast, 1958.
■ "Dr. Staudigel: Both Optometrist, Wife Accomplished Musicians," and lengthy bio., *SYVN*, Dec. 19, 1958, pp. 1, 6.

Stearns, Clara Y. (Mrs. Raymond S. Stearns) (Santa Maria)
Maker of plaster paints, 1953. Sister to Alfred Ybarra, below. Daughter-in-law to Minnie Stearns, below. Donated paintings to the Minerva club.
See: "Junior Community Club (Santa Maria)," 1951, 1952, 1953, "Minerva Club," 1954, "Minerva Club, Art and Hobby Show," 1957, "Santa Barbara County Fair," 1952, "Stearns, Minnie," "Ybarra, Alfred," 1958

Stearns, Minna "Minnie" Allott (Mrs. Charles W. Stearns) (1862-1948) (Santa Maria)
Painter. Teacher of private art classes, 1892+. Teacher of drawing at the Santa Maria High School, 1903-09. Librarian for Minerva Club and then for the public library, 1908-34. Mother-in-law of Clara Stearns, above.

■ "Mrs. Stearns … Custodian of Books Retires After 25 Years … Resignation of Mrs. Minnie Stearns, city librarian, who has been head of Santa Maria's Carnegie library since it was built 25 years ago, became effective yesterday, January 1, 1934… Stearns was the first and only librarian… having been appointed when the library building on South Broadway was completed in the winter of 1908," and article continues with some history of the library itself, *SMT*, Jan. 2, 1934, p. 1.
Stearns, Minnie (notices in Northern Santa Barbara County newspapers on microfilm and on newspapers.com)
1892 – "Fifty Years Ago. Minnie Allott Stearns, daughter of James Allott, was to open a class in oil and china painting in Fleisher's hall," *SMT*, Sept. 2, 1942, p. 4; "Minnie Allott Stearns the artist who has been visiting relatives here for some time past, left last week for Fort Yuma where her husband is engaged as telegraph operator. **Mrs. G. C. Smith** accompanied her as far as the Nojoqui Falls where Mrs. Stearns did some sketching, and the scenes will be painted by Mrs. Smith," *SMT*, Oct. 15, 1892, p. 2; "Last Sunday **Mrs. G. C. Smith** and Mrs. Minnie Stearns, guests of Mr. and Mrs. J. S. Curryer, spent the day at Nojoqui Falls. Mrs. Stearns sketched the falls and will complete the picture when she arrives home…," *SMT*, Oct. 15, 1892, p. 3.
1893 – "'They say,' that **Lex Stantley**'s [Sic. **Stanley**] pups attract more attention at Mrs. Stearns' Art Studio than any other study on the easel. No one suspected 'Lex' posing as an artist, but talent will find expression sooner or later," *SMT*, Dec. 16, 1893, p. 3.
1894 – "Mrs. Jos Allott paid the *Times* a business call… She says… [her daughter] Mrs. Stearns will remain all winter. This last item will be joyful news to many of our readers who are interested in painting and anxious to have a chance to take lessons…," *SMT*, Jan. 6, 1894, p. 3; "Class in Oil Painting. Lessons given in oil painting by Mrs. Stearns, at Lucas' Hall on Tuesday and Wednesday and Friday and Saturday of each week. You can join the class at any time. Mrs. Stearns, teacher," *SMT*, Jan. 20, 1894, p. 2; "Mrs. Stearns the artist has placed on sale at Wright Gardner's drug store a fine line of paintings and other art work for the holiday trade. …," *SMT*, Dec. 15, 1894, p. 2.
1897 – "Classes in painting every Monday, Thursday and Saturday afternoons from 2 to 4:30 o'clock at Lucas Hall. Mrs. Stearns," *SMT*, Oct. 9, 1897, p. 3, col. 2.

1901 – "Mrs. M. Stearns has organized a class in painting and drawing. Lessons Tuesday and Saturday afternoons from 2 to 5 at Lucas' hall, down stairs. Fifty cents a lesson. Painting and drawing is a nice art, and parents should avail themselves of the opportunity to educate their children in something that is useful as well as ornamental," *SMT*, Nov. 30, 1901, p. 4; and other "ads" through the fall of 1901 were not itemized here.

1902 – "Mrs. M. Stearns has organized a class in painting and drawing. Lessons Tuesday and Saturday afternoons from 2 to 5 at Lucas' Hall, down stairs. Fifty cents a lesson ...," *SMT*, Jan. 11, 1902, p. 3, col. 4.

1903 – "An elegant painting, one of Mrs. Stearns' masterpieces, is to be raffled off for the benefit of Mrs. Stearns, who is now critically ill in a San Francisco hospital. The tickets are 50 cents and can be had at Jones & Son's store," *SMT*, March 27, 1903, p. 3, col. 3; "Studio Re-opened. Mrs. Stearns will give lessons in painting and drawing every Monday and Saturday afternoon from 2 until 5 o'clock, at the Studio next to the Methodist Parsonage," *SMT*, July 3, 1903, p. 3; "At the meeting of the high school board of trustees on Saturday last, Mrs. Stearns was appointed teacher of drawing. Mrs. Stearns is a fine artist...," *SMT*, Aug. 14, 1903, p. 3, col. 4.

1904 – "The New High School Board... appointment of teachers... Mrs. M. Stearns, Drawing and Music...," *SMT*, July 15, 1904, p. 3.

1906 – "China Painting. Mrs. Stearns has resumed her classes in drawing, water color and oil painting. China Painting has been added. Classes Tuesday and Thursday from 3 to 5," *SMT*, Dec. 29, 1906, p. 5.

1908 – "Juvenile Actors Make Big Hit... play entitled 'The Noble Outcast,' given by the High School, assisted by Mrs. Stearns... To Mrs. Stearns is due credit for the excellent presentation of the play in regards to its scenic aspect. The special scenery was of her own designing and painting as were also the artistic stage-settings, all being harmonious, true to detail and a delight to the eye," *SMT*, May 30, 1908, p. 5.

1911 – "Painting Lessons. Mrs. Stearns announces that she has started a class in painting. Lessons Tuesday and Thursday mornings from 9 until 12 at 609 South Lincoln street. Tuition 75 cents and $1," *SMT*, April 1, 1911, p. 5.

1945 – "Mrs. Stearns Observes 83rd Anniversary... at an 'open house' in her home at 615 south Lincoln... for many years librarian here and well-known for her painting and other art work... Mrs. Stearns' son and daughter-in-law, Mr. and **Mrs. Raymond Stearns** were host and hostess," *SMT*, July 23, 1945, p. 3.

1951 – "Gift of Painting" i.e., by Minnie Stearns, donated by Mrs. M. B. O'Brien, showing a Cuyama landscape, to SM Public Library, with the picture hung in the main room *SMT*, Oct. 29, 1951, p. 4.

Stearns, Minnie (misc. bibliography)
Minnie Allott married Charles W. Stearns on July 10, 1888 in Los Angeles county per Calif. Select Marriages; Minnie Stearns is listed in the 1910 U. S. Census as age 47, b. c. 1863 in England, widowed, working as a librarian in a public library, residing in Santa Maria with her parents Joseph Allott (age 71) and Tamar E. Allott (age 69) and her brother Harry Allott (age 45) and her son James B. Stearns (age 17); Minnie Stearns is listed in the 1940 U. S. Census

as age 77, b. c. 1863 in England, finished high school 4th year, widowed, residing in Santa Maria (1935, 1940) with a lodger; Minnie Allott Stearns, mother's maiden name Sharp, was b. July 22, 1862 in Other Country and d. Oct. 12, 1948 in San Luis Obispo County per Calif. Death Index; the residue of her estate went to her son Raymond S. Stearns, executor per California Wills and Probate Records, Santa Barbara, vol. 51-56, 1946-1949 (refs. ancestry.com).
See: "Art Loan Exhibit (Santa Maria)," 1895, "Collectors, Art/Antiques (Santa Maria)," 1945, "Junior Community Club (Santa Maria)," 1951, "Minerva Club," 1928, 1954, "Santa Barbara County Library (Santa Maria)," intro., 1934, "Santa Maria, Ca., Union High School," 1903, 1904, 1906, 1907, 1908, 1909

Steele, Gile McLaury (1908-1952) (Los Angeles)
One of his paintings was distributed to a county building in northern Santa Barbara County by the PWAP, 1934. Costume designer for the motion picture studios who painted at his leisure.
See: "Public Works of Art Project," 1934, and *Central Coast Artist Visitors before 1960*

Stelzer, Glenn, M/M (Buellton)
Proprietors of Abbet's County Store, a retailer of antiques and gifts, 1957? Prop. Valley Income Tax Service of Van Nuys and Los Angeles as well as Country Lane Motel.
Stelzer, Glen (notices in Northern Santa Barbara County newspapers on microfilm and on newspapers.com)
1956 – "New Residents Readying Business. Mr. and Mrs. Glenn Stelzer and children of Van Nuys are now in process of remodeling Mac's Auto Court in Buellton which they recently purchased. They plan the opening of Abbet's County Store and will deal in antiques and gifts. They formerly operated a similar business under the same name in North Hollywood for 10 years," *SYVN*, March 16, 1956, p. 1.
1957 – "At Antique Show. Mr. and Mrs. Glenn Stelzer of Buellton left Monday for Los Angeles where they plan to attend the antique and decorator show at the Pan Pacific Auditorium. The Stelzers are planning to open their antique shop in connection with their Country Lane Motel in Buellton in the near future," *SYVN*, Oct. 18, 1957, p. 5; "Glenn Stelzers Home from East... six-week tour to the east coast and Canada... the Stelzers made a point ... to gather antiques," *SYVN*, July 27, 1962, p. 3.

Sten, Anna (1908-1993) (Los Angeles)
Actress / artist, one of whose paintings was lent by a L. A. gallery to the Santa Maria Valley Art Festival, 1952.
■ Ukrainian-born American actress, per Wikipedia. Her obituary in the *LA Times* (Nov. 16, 1993) states that after her Hollywood acting career she focused on her painting.
See: "Santa Maria [Valley] Art Festival," 1952

Stenner, Muriel Violet / Violette Jenkins (Mrs. Percival Cleon Stenner) (c. 1904-1999) (Santa Maria)
Photographer. Portrait painter. Employee of a photography studio, early 1930s. Half-sister of Nicholas Firfires, above.

Stenner, Violette (notices in Northern Santa Barbara County newspapers on microfilm and on newspapers.com)
1931 – "Mrs. Violette Stenner returned early this morning from Los Angeles where she spent the week taking a special course in portrait painting," *SMT*, Oct. 3, 1931, p. 5.
1932 – "Changes Position – According to word received by Mr. and Mrs. M. Firfires, their daughter, Miss [Sic?] Violet Stenner, who has heretofore been employed in a photograph studio in Santa Barbara, has changed positions, being now employed in the Robert Bordeaux studio in that city," *SMT*, March 24, 1932, p. 5.
Stenner, Violette (misc. bibliography)
Viloet [Sic. Violet] M. Jenkins is listed in the 1920 U. S. Census as age 16, b. c. 1904 in Calif., residing in Santa Maria with her stepfather Michael N. Firfires (age 33) and her mother Ethel M. Firfires (age 33) and siblings: Angeliki and Nickolas; Violet Stenner is listed in the 1930 U. S. Census as b. c. 1904, working as a re-toucher of photographs, residing in Santa Maria with husband Percy Stenner (age 30); port. of Violet Stenner b. c. 1904-Jan. 14, 1999 is contained in Public Member Photos & Scanned Documents (refs. ancestry.com).
See: "Firfires, Nicholas"

Stensland, Wilfred T. (1931-?) (Buellton)
Teacher of industrial arts and general mathematics at Santa Ynez Valley Union High School, 1959+.

■ "Wilfred Stensland – attended Monterey Peninsula College and UCSB. He was a member of the California Scholarship Federation in high school and attended college on a Hal Youngman scholarship. He was active in student government in high school and college and was a varsity letterman in football at UCSB. He served a year and a half in the Marine Corps and during the past three years has been teaching industrial arts at Westmoor High School in Daly City. Married and the father of a two-year-old daughter, he will teach classes in industrial arts and general mathematics and will assist in sports," per "Nine New Teachers," *SYVN*, Aug. 21, 1959, p. 1.
Stensland, Wilfred (misc. bibliography)
Wilfred Stensland appears in the Santa Ynez Valley Union High School, yearbook, 1968; Wilfred Stensland, b. Aug. 27, 1931, was residing in Buellton, Ca., at an unspecified date per *U. S. Public Records Index, 1950-1993*, vol. 2 (refs. ancestry.com).
See: "Santa Ynez Valley Union High School," 1959

Stephens (Sellers), Ada Calista (Mrs. Oliver Sheridan Sellers) (1866-1957) (Santa Maria / SLO / Santa Cruz)
Exh. pencil drawing at "Santa Barbara County Fair," 1888, and a crayon drawing, 1889.

Stephens, Ada (notices in Northern Santa Barbara County newspapers on microfilm and on newspapers.com)
1888 – "Miss Ada Stephens who has been spending the past few months in Santa Barbara attending school, returned home recently for a few weeks' vacation," *SMT*, Jan. 7, 1888, p. 3.
1892 – "Away at School. How Santa Maria Girls Manage to Spend Their Time. Stockton, Cal., April 14, 1892. … As you know, my sister Mamie and I are attending the Stockton Business College…," and further details, Ada Stephens, *SMT*, April 23, 1892, p. 2.
1894 – "Wedding Bells. A Double Wedding at the M. E. Church… O. S. Seller [sic. Sellers] of Pozo and Miss Ada Stephens of this city. M. L. Stephens … and Miss Sadie Hampton… On Friday morning the bridal party together with the floral decorations were photographed by **John McMillan** …," *SMT*, July 7, 1894, p. 3.
And, approx.. 50 additional social, travel and school notices for "Ada Stephens" not itemized here.
Stephens, Ada (misc. bibliography)
Ada C. Sellers is listed in the 1910 U. S. Census as residing in Santa Margarita, SLO County, with husband, Oliver S. Sellers (age 44) and children Lelia E., Martie E. and Marigold G.; Ada C. Sellers is listed in the 1930 U. S. Census as b. c. 1867 and residing in SLO with her brother Martin H. Stephens (age 61); Ada C. Sellers is listed in the 1940 U. S. Census as age 73, b. c. 1867 in Calif., finished high school 4th year, widowed, residing in Santa Cruz by herself; Ada Calista Stephens b. 1866 in Calif. to Martin Henry Stephens and Mary E. Martin, married Oliver Sheridan Sellers, in 1894, and d. June 20, 1957 per Fishback / Avery Family Tree (refs. ancestry.com).
See: "Santa Barbara County Fair," 1888, 1889

Stephens, Sallie
See: "Lucas (Stephens), Sallie (Mrs. Joseph Josiah Stephens)"

Stetson, Thomas Carne (1914-1946) (La Verne / Ojai?)
Artist of Ojai / Montecito who exh. in National Art Week show at Minerva Club, 1940.

■ "Here and There… wedding of Mrs. Melville T. Curtis and Thomas Carne Stetson in the Chapman Park chapel in Los Angeles… The bridegroom, member of Ventura and Santa Barbara county pioneer families, is the son of Mr. and Mrs. Guy T. Stetson of Montecito. Mr. Stetson attended schools in the Ojai valley and prepared for Stanford university at Andover. He later studied at the Los Angeles Art Center under Barse Miller and has exhibited his water colors in the **Faulkner** memorial gallery in Santa Barbara and at the San Francisco and Pomona fairs. He is now studying citrus culture at the Vorhees unit, branch of the California Institute of Technology. He is the grandson of the late Mr. and Mrs. John Carne, Ojai valley pioneers and owners of one of the first ranches there, still operated by the family," *Ventura County Star-Free Press*, Sept. 17, 1940, p. 5.
Stetson, Thomas (notices in California newspapers on newspapers.com).
1941 – "Water Colors Exhibition Opens at Art Center Today. … Thomas C. Stetson of La Verne, formerly of Ojai, will be shown at Ojai Art Center for a week beginning today. Mrs. Stetson, bride of the artist, was guest of honor at a tea given by Mrs. Guy Stetson of Montecito…

yesterday afternoon at the Art Center...," *Ventura County Star-Free Press*, Jan. 4, 1941, p. 3; "Ojai Masonic Lodge... The exhibition of water colors by Thomas Stetson of La Verne at Ojai Art Center will be continued for another week as inclement weather kept many away from the gallery. The pictures are for sale. The artist, son of Mr. and Mrs. Guy Stetson, was born and educated in the valley," *Ventura County Star-Free Press* (Ventura, Ca.), Jan. 14, 1941, p. 3.

1942 – Classified ads – Miscellaneous – "Watercolor Sale by Thomas Stetson, April 3. Rock bottom prices. Has volunteered in the army. Art and Frame Shop, 135 E. Carrillo, Santa Barbara," *Ventura County Star-Free Press*, April 9, 1942, p. 15.

Stetson, Thomas (misc. bibliography)
Thomas C. Stetson is listed in the 1920 U. S. Census as age 5, b. c. 1915 in Calif., residing in Nordhoff, Ventura County, Ca., with his parents Guy T. Stetson (age 35) and Lucey R. Stetson (age 31); Thomas Carne Stetson is listed in Voter Registers in Santa Barbara County in the 1930s; Thomas C. Stetson enlisted in the Army May 22, 1942 in LA per WWII Army Enlistment Records; Thomas Carne Stetson, mother's maiden name Carne, father's Stetson was b. Jan. 12, 1914 in Ventura, Calif., and d. June 23, 1946 in Los Angeles per Calif. Death Index; died in LA but is buried in Springdale Cemetery and Mausoleum, Peoria, Ill., per findagrave.com (refs. ancestry.com).
See: "National Art Week," 1940

Steves, Grace Marion (Mrs. Hamilton?) (1907-1979) (Topeka, Kansas)
Photographer from Topeka who took pictures of Santa Maria Valley flowers, 1956.
See: *Central Coast Artist Visitors before 1960*

Stewart, Al (Santa Barbara?)
Photographer. President of Channel City Camera Club, Santa Barbara, who spoke in Santa Maria, 1952.
1952 – "Al Stewart to Speak on Color Photography ... evening of November 26... 'Flower Portraiture Under Artificial Light' ... The speaker is one of America's foremost color photographers and has written many articles for magazines on color photography. This presentation is the same as given recently by Stewart at San Diego Town Meeting, Photographic Society of America. ... at Hancock Field," *SMT,* Nov. 22, 1952, p. 4.
See: "Photography, general (Santa Maria)," 1952

Stewart, Dwight Fred
See: "Mason, Robert Dwight"

Stewart, Frank and Miss (his sister?) (Illinois / Santa Maria / San Jose)
Crayon artists / art teachers in Santa Maria and Arroyo Grande, winter 1892-93.
■ "The Stewart Art Studio. Mr. Frank Stewart and his sister, both noted artists, have opened an art studio at the Holloway residence, where they are now engaged, giving

instructions in crayon work. ... They make crayon work so simple and easy that anyone can learn it in a very few lessons ... Both landscape and portrait work made plain and easy by their new advanced method. Call at the studio and see the portrait work they are doing for some of our citizens. Samples of students' work can be seen at the Hart House and T. A. Jones & Son's. Visitors always welcome," *SMT*, Oct. 1, 1892, p. 3.

Stewart, Mr. and Miss (notices in Northern Santa Barbara County newspapers on microfilm and on newspapers.com)
1892 – Is this "Miss Stewart" – "The District Fair... The Art Department ... Notes ... Miss Kathryn Stewart of Riverside, an artist of rare merit, has a stand in the Riverside department where she is giving exhibitions of her work with an air brush. This class of work is a novelty on the coast. Both India ink and watercolors may be used. Miss Stewart has a number of excellent portraits on exhibition," *Daily Courier* (San Bernardino, Ca.), Feb. 24, 1892, p. 3, col. 5; "Colton Column... Fair... Awards made ... Air-Brush Painting – First premium $2, Miss Kathryn Stewart, Riverside," *Daily Courier* (San Bernardino, Ca.), Feb. 28, 1892, p. 3, col. 4; "Riverside... A crowd of interested spectators gathered about Miss Kathryn Stewart to observe her work with the air brush," *LA Times*, Feb. 28, 1892, p. 7, col. 3; "Miss Kathryn Stewart, whose crayon work with the air brush attracted so much attention at the Colton fair, has established a studio in this city," i.e., Redlands, *LA Times*, May 12, 1892, p. 7, col. 3.
1892 – "The town is full of artists. The work done by the pupils of Mr. and Miss Stewart at the Holloway residence is the admiration of all who have seen it. Quite a number of new pupils will be added to their class next week. Samples of student's work can be seen in the show window at T. A. Jones & Sons and at the Hart House," *SMT*, Oct. 1, 1892, p. 3; "Mr. Stewart the crayon artist will go to Arroyo Grande to see what are the prospects for a class. His sister will remain here a few days yet," *SMT*, Nov. 12, 1892, p. 3; "Mr. Frank Stewart and sister, artists, have gone to Arroyo Grande. They are well pleased with their success in Santa Maria. While here they had a good class and quite a number of attentive students. They think of returning here sometime in the near future as there are several who desire to take lessons who did not avail themselves of the opportunity this time," *SMT*, Nov. 19, 1892, p. 3; "Frank Stewart and his sister will return to Santa Maria during vacation and teach another class in crayon work and free hand drawing," *SMT*, Dec. 3, 1892, p. 3, col. 2; "Frank Stewart and sister, the artists, have returned to Santa Maria and will open a class in crayon work and free hand drawing at Lucas Hall on Monday next. They were here before and gave good satisfaction," *SMT*, Dec. 10, 1892, p. 3.
1893 – "Miss Stewart the crayon artist, accompanied by Miss Grace Holloway, started for San Francisco on Thursday last where they will visit for some weeks and may take a trip east before returning. Miss Stewart's brother Frank remains in Santa Maria," *SMT*, Jan. 21, 1893, p. 3; "Frank Stewart, who has spent the winter in Santa Maria, being of late interested with E. J. Morris in butchering veal, left on Tuesday for San Jose where he will visit his sister, the crayon artist, a few days before starting for his home in Illinois. He lives within 100 miles of

Chicago and thinks he cannot afford to stay away from home this year," *SMT*, April 8, 1893, p. 3.
These individuals could not be identified.

Stewart, LeConte (1891-1990) (Kaysville, Utah)
Teacher at Santa Maria School of Art, 1927.

■ "LeConte Stewart (April 15, 1891 – June 6, 1990) was a Mormon artist primarily known for his landscapes of rural Utah. His media included oils, watercolors, pastel and charcoal, as well as etchings, linocuts, and lithographs. His home / studio in Kaysville, Utah is on the National Register of Historic Places," Wikipedia.
See: "Santa Maria School of Art," 1927

Stewart, Robert Ralph "Bob" (1924-2015) (Santa Maria / Guadalupe)
Photographer, amateur. New member Santa Maria Camera Club, 1940. Served in USN Air Force in South Pacific. Became an artist in San Diego associated with Village School of Art in Ocean Beach, 1945. Entrepreneur in Guadalupe; retired to Santa Barbara.

■ "(2/1/1924 - 4/9/2015) Robert Ralph Stewart was born February 1, 1924 to Raymond and Mary Stewart (nee, Corazza) in Santa Maria California. On April 9, 2015, at the age of 91, he passed from this life at Serenity House in Santa Barbara … Robert was a lifelong resident of Santa Barbara County. He was a varsity swimmer and graduated from Santa Maria High School in 1942. While attending the Southern California School of Aeronautics in 1943, he left the program to join the U.S. Navy, serving in San Diego and the South Pacific. While stationed in San Diego, Robert met the artist Orren Louden, who mentored Bob in the fine points of painting in oils. In 1945 they opened the Village School of Art in Ocean Beach. Bob's paintings now grace the homes of many family members and friends. Robert met and dated the love of his life, Annette Kathleen Mahoney while they were students at Santa Maria High School. … Robert opened Stewart's Body and Paint Shop in Guadalupe when he was a young man and continued the entrepreneurial spirit with his ownership and operation of the Guadalupe Milk Company, until passing the baton in 1973. In 1953 he was appointed Judge of the Guadalupe Justice Court, and at that time was the youngest judge in the state of California. He was reelected by the residents of Guadalupe every six years and was the last non-attorney judge in the state at the time of his retirement in 1978. …. In 1973, the Stewart family moved to Santa Barbara, where Bob and Annette have resided ever since. In retirement they traveled extensively," and more bio. per www.newspress.com (Santa Barbara) listed on line April 14, 2015 (and also "Robert Ralph 'Bob' Stewart'" a clipping, probably the *Santa Barbara News Press*, hand dated 4-16-15, in the SMVHS Scrapbook).
Stewart, Robert Ralph (notices in Northern Santa Barbara County newspapers on microfilm and on newspapers.com)
1941 – "Besides being ace sprinter for the high school, Bob Stewart is developing into an ace photographer. Many of his camera studies seen about town have caused much favorable comment," *SMT*, Feb. 14, 1941, p. 2, col. 1.

1945 – "Bob Stewart Instructing in Art. Robert Ralph Stewart, son of Mr. and Mrs. Ray A. Stewart of Santa Maria, who has run up an enviable record in the U. S. Naval Air Forces in the South Pacific, has joined the staff of instructors of the Village School of Art in San Diego. He has already attracted attention among critics in Southern California for his paintings of the California Scene. Stewart's instructing work is done during the day time, in and about Ocean Beach and La Jolla. In the evenings he continues his Navy work," *SMT*, May 28, 1945, p. 3.
Stewart, Robert Ralph (misc. bibliography)
Robert Ralph Stewart was b. Feb. 1, 1924 in Santa Barbara to Ray A. Stewart and Mary Elsilia Corazza, and d. April 9, 2015 per Menicucci Family Tree (refs. ancestry.com).
See: "Santa Maria Camera Club," 1940, 1941

Stewart, Theodore Walter (1874-1939) (Santa Maria)
Photographer, 1920.

■ "New Studio. We have opened a new Photograph Studio fitted with a modern outfit and have had 23 years' experience in the photograph business. We are prepared to give our customers good pictures at reasonable prices. We solicit your patronage. Grand Theatre Bldg. T. W. Stewart, Photographer," *SMT*, Feb. 18, 1920, p. 2.
Stewart, T. W. (misc. bibliography)
Thodore [Sic.] W. Stewart is listed in the 1900 U. S. Census as age 24, b. Dec. 1875, single, working as a photographer and boarding in Raccoon, Ohio, with the Lewis Wood family; Theodore W. Stewart is listed in the 1920 U. S. Census as age 45, b. c. 1875 in Ohio, working as a photographer in his own studio, residing in Santa Maria with wife Hettie Stewart (age 44) and daughter Helen (age 11); Theodore W. Stewart, photographer, is listed in *Daytona Beach, Fla., CD*, 1922, and in *Anaheim, Ca., CD*, 1925; Theodore Walter Stewart was b. Dec. 23, 1874 in Harrison, Ohio, to James Doliver Stewart and Elizabeth Jane Frownfelter, married Hettie Weidman, had a child named Helen, and d. March 23, 1939 in Blue Ridge, NC per Reaser Family Tree (refs. ancestry.com).

Stewart, Walter Arthur, Jr. (1908-1999) (Lompoc)
Woodwork teacher in shop department of Lompoc high school, 1932/34.

■ "Mr. and Mrs. Walter Stewart, Jr., are expected to return to Lompoc Saturday from Los Angeles where Mr. Stewart has been attending summer session at the University of California at Los Angeles. Mr. Stewart is a teacher at the local high school and was married early in the summer," *LR*, Aug. 11, 1933, p. 5, col. 1.
Stewart, Walter (misc. bibliography)
Walter Arthur Stewart, Jr., was b. July 18, 1908 in Lompoc to Walter Arthur Stewart and Minnie May Shutts, and d. Feb. 16, 1999 in San Diego per Drollinger/Stone Family Tree (ref. ancestry.com).
See: "Lompoc, Ca., Union High School," 1934

Stillman, Clinton Edward (1920-2005) (Lompoc)
Artistically inclined Lompoc high school student, 1936-39. Prop. Valley Flower Shop, 1949+. Became a building inspector.
[Do not confuse with his father Clinton Adelbert Stillman who attended Lompoc High School, 1915 and excelled at carpentry and drawing.]
1945 – "S/Sgt. Clinton Stillman has received his discharge from the Army at Fort MacArthur and arrived in Lompoc. He is the son of Mr. and Mrs. E. F. Stillman.... Stillman enlisted with the 144th Field Artillery in 1940 and went overseas... He was in the European theatre of war for 18 months...," *LR*, Oct. 26, 1945, p. 2.
1949 – "Clinton Stillman to Open New Florist Shop... Associated with him... will be **Wesley Keys**, former head floral designer for Flower Haven in Denver, Col.," *LR*, Nov. 17, 1949, p. 10.
See: "Keys, Wesley," 1949, "Lompoc, Ca., Union High School," 1936, 1937, 1939

Stilwell, [Naomi] Elsie
See: "Thornburg (Stilwell), [Naomi] Elsie (Mrs. Benjamin Franklin Stilwell)"

Stine, Mary F. (Mrs. Jake E. Stein) (Solvang)
Maker of wood fiber flowers. Co-owner of Trading Post, liquor store and gift center, 1952-59, and of Red Barn restaurant and cocktail lounge in Santa Ynez, 1958.
■ "... The Trading Post, situated in the former location of the Solvang Bakery west of first Street, is a package liquor store... It is also a gift center and will include among its stock Indian Jewelry and gifts, Pa-Poo, Shus-dolls, imported lamps, which are reproductions of colonial and Victorian originals, beautiful and colorful Navajo rugs, imported brass ware from India, hand-made wood fibre flowers, corsages and center pieces for all occasions. Mrs. Stine takes great pride in the beauty and attractiveness of her wood fibre flowers and recounts interesting information concerning their origin and manufacture. She said, 'The story of wood fibre dates back thousands of years to the land of China, where it was first known... they succeeded in keeping their secret until 1859 when the Aralia Papyrifera plant was discovered in Formosa from which source the Chinese obtained wood fibre... The pith is cured and cut into short lengths. It is then set in small mandrels and shaved off in a continuous ribbon with a sharp knife... These sheets are then pressed, cut to size, tied into small bundles and shipped to America... here in factories it is dyed in colors.... 'So real are flowers made from wood fiber that it amazes people," *SYVN*, Feb. 27, 1953, p. 8.
See: "Trading Post"

Stitch and Chatter Club (Santa Ynez and Lompoc)
1.Needlework club, active in Santa Ynez in 1938-39 and 2. an unrelated club with the same name associated with 4-H (or with the Lompoc High School chapter of Future Homemakers of America) active, 1947-49. May be the same as the Stitcher's Club, below.
The few notices in local newspapers were not itemized here.

Stitchers' Club (Lompoc)
Four-H needlework club, Lompoc, 1937-42. May be the same as the Stitch and Chatter Club, above. May be the same as "Quick Stitchers," a 4-H group, active 1959.
The few notices on this club that appeared in the *LR* were not itemized here.

Stock, Melvin Moses (1913-1944) (Lompoc / Minnesota)
Photographer. Employee of Camera Shop, 1941-42.
■ "Melvin Stock to be Married in Mid-West State. Melvin Stock, who has been employed at the Camera Shop since last November, leaves this week-end for Minnesota, where he will be married to Miss Mary Silverman. Following a honeymoon, Stock will enlist as a photographer in the Navy," *LR*, March 6, 1942, p. 8.
Stock, Melvin (notices in Northern Santa Barbara County newspapers on microfilm and on newspapers.com)
1943 – "Soldier Wins Promotion. Corporal Melvin M. Stock, formerly employed at The **Camera Shop**... has been promoted from technician fifth grade to technician fourth grade in the Supply Detachment, Supply Division, Section 1, Signal Corps... stationed at Fort Benning, is a photographer with the Signal Corps Photographic Laboratory," *LR*, May 21, 1943, p. 2.
Stock, Melvin (misc. bibliography)
Melvin Moses Stock provides the following information on his WWII Draft Card dated Oct. 16, 1940 = age 27, b. Jan. 11, 1913 in Minneapolis, self employed as a photographer, mother's name Rose Stock; Melvin M. Stock married Mary Silverman on March 14, 1942 in Hennepin, Minn., per *Minnesota, Marriages from the Minnesota Official Marriage System*; Melvin M. Stock b. Jan. 11, 1913, d. April 20, 1944 and is buried at Ft. Snelling National Cemetery, Minnesota, per findagrave.com (refs. ancestry.com).

Stone (Maggini) (de Angeles), Augusta J. (Mrs. Charles Maggini) (Mrs. de Angeles) (c. 1869/71-1939) (Los Alamos / Santa Maria)
Exh. oil paintings (landscape, marine, animals, still life), at "Santa Barbara County Fair," 1893.
■ "Miss Augusta Stone. Formerly of Santa Maria Marries Mrs. Joel H. Cooper, received a letter a few days ago from her daughter, Miss Augusta Stone ... who has been employed as chief clerk in the office of the American Consul at Guatemala, South America for the past year or more. Miss Augusta accepted a position from the Consul as governess of his children and also to occupy an unimportant clerical position in his office. When the consul and family left San Francisco for his post of duty nearly

two years ago, Miss Stone accompanied them. She was not in the consul's Office long before it was discovered that she was the most competent clerk in his employ and, in consequence, she was rapidly promoted until she occupied the first position in the office. The letter received by Mrs. Cooper stated that on the 23rd of last month, Miss Augusta was united in marriage to Senor de Angeles, a wealthy and prominent army officer. The wedding took place at the Consul's home … Shortly after their marriage Mr. and Mrs. de Angeles took passage for their future home, Bogota, United States of Colombia," *SMT*, Nov. 2, 1895, p. 2.
Stone, Augusta (notices in Northern Santa Barbara County newspapers on microfilm and on newspapers.com)
1886 – "The Maggini – Stone Wedding… The wedding of Miss Augusta Stone and Mr. Chas. Maggini was solemnized on Wednesday evening last at the residence of Mr. and Mrs. Frederick Wickenden …," and extensive description of the wedding, *SMT*, May 8, 1886, p. 5.
1930 – "Stone-Benefield. Dr. Augusta Stone, Mrs. George H. Stone and Mrs. Walter D. Benefield, sisters, descendants of William Benjamin Foxen, were here visiting in this section this week. They are returning to their home in Los Angeles…," *SMT*, Sept. 18, 1930, p. 5.
Stone, Augusta (misc. bibliography)
Augusta J. Stone is listed in the 1880 U. S. Census as age 11, b. c. 1869 in Calif., residing in Santa Maria, with her parents John R. Stone (age 46) and Maria A. Stone (age 33) and 5 siblings; Augusta Stone, without occupation and with no husband, is listed in the *Los Angeles, Ca., CD*, 1916, 1917, 1918, 1920; Augusta De Angeles Stone, M. D., had her license revoked for illegal operation, violation of medical act, Feb. 20, 1924, per *California Occupational Licenses, Registers and Directories, 1876-1969*; is she Augusta J. Stone, b. c. 1871, who d. March 22, 1939 in Los Angeles County per Calif. Death Index (refs. ancestry.com).
See: "Santa Barbara County Fair," 1893

Stone, George Eathl (1889-1964) (Carmel / San Francisco)
Special photographer for Capt. Hancock. Took views of the Santa Maria High School, 1927, and the Santa Maria valley, and presented them to the Chamber of Commerce, 1928. Director of Visual Education Service, Inc., that educated through still photography, lantern slides, and film. Professor emeritus of photography at San Jose State college, 1959.
See: "Photography, general (Santa Maria)," 1928, "Santa Maria, Ca., Union High School," 1927, and *Central Coast Artist Visitors before 1960*

Stone, James B. (Santa Maria)
Photographer, amateur, with the U. S. Navy, c. 1910-c. 1928.
■ "Stone Outlines Naval Action to Lions. Taking as his topic 'The Navy in Action,' James B. Stone, chief of maintenance at Hancock College of Aeronautics outlined the various types of vessels in the U. S. Navy and their uses… before Lions club weekly meeting... He illustrated his talk with photographs taken during his 20 years in

service. He joined the Navy in 1908 and in 1916 became connected with the air service in which he stayed until he left the Navy in 1928," *SMT*, Feb. 1, 1941, p. 5.

Stonehart, Beatrice Marie Ascarate (Mrs. Leslie "Les" Jean Stonehart, Jr.) (1925-2008) (Solvang / Santa Maria)
Photo tinter with Solvang Photo Studio, 1947+. Wife of Leslie J. Stonehart, Jr.
■ "Beatrice M. Stonehart, 1925-2008. Beatrice loved gardening and cooking…," *SMT*, July 31, 2008, p. A9.
Stonehart, Beatrice (notices in Northern Santa Barbara County newspapers on microfilm and on newspapers.com)
1949 – Port. with Soroptimist club women, *SMT*, Dec. 3, 1949, p. 6.
1957 – "'Round Town. Mrs. Les Stonehart Jr. has completed a course in re-touching at the Brooks Studio of Photography in Santa Barbara. She is employed here in photography with her husband," *SMT*, Sept. 11, 1957, p. 2.
Stonehart, Beatrice (misc. bibliography)
Beatrice M. Stonehart b. April 10, 1925 and d. July 14, 2008, is buried in Santa Maria Cemetery District per findagrave.com (refs. ancestry.com).
See: "Stonehart, Leslie J., Jr.," intro.

Stonehart, Elsie Rosamond Sims (Mrs. Leslie Jean Fingado Stonehart, Sr.) (1898-1983) (Santa Maria)
Photographer. Specialty babies. Wife of Leslie Stonehart, Sr., below.
■ "'How I make babies cry for me and how they smile for me' was the interesting topic on which Mrs. Elsie Stonehart, professional photographer and member, spoke yesterday before the Soroptimist club at their first meeting of the year. … Mrs. Stonehart, who illustrated her talk with a collection of her finest camera studies of babies, told the audience that with tiny babies, there is no trouble to have them act naturally for a picture. Good results are more often obtained with older children without their parents in the room. Often good pictures are made after the child's confidence is gained by an appeal to cooperate with the photographer in a surprise for the parents. The second part of her talk was an outline history of her career as a photographer, in which she mentioned experience as an aerial photographer and **police** photography. 'My favorite work,' said Mrs. Stonehart, 'is in photographing babies, and I have photographed those of many nationalities …," per "Photography of Babies Speaker's Topic" at Soroptimist Club, *SMT*, Jan. 4, 1956, p. 4.
Stonehart, Elsie (notices in Northern Santa Barbara County newspapers on microfilm and on newspapers.com)
1937 – Photographic portrait by Mrs. L. J. Stonehart of Breneiser's daughter, Catherine, wins Associated Photographers of California award, *SMT*, April 28, 1937, p. 5.
1938 – "To Laguna – Mrs. Leslie Stonehart left yesterday for a several weeks' stay at Laguna Beach, where she will take a course in art photography," *SMT*, Aug. 15, 1938, p. 3.
1942 – "Jack Sims stopped over in Santa Maria today for a visit with friends and his sister, Mrs. L. J. Stonehart, on his

way to Santa Barbara to take over the photography shop of his brother, 'Dink,' for the duration, so the latter can leave for the Army," *SMT*, June 11, 1942, p. 3.

1946 – "Russell Warns… Soroptimist Club… Elsie Stonehart wore the 'exemption hat,' (a stovepipe style, decorated with flowers on foot-long stems), and was therefore entitled to unlimited advertising of her business. She gave fellow members as gifts, small leather photograph folders and also distributed 1947 business calendars," *SMT*, Nov. 7, 1946, p. 3.

1948 – "Color Film of Indian Country… taken while on a vacation at Fort Apache Indian reservation… were shown by Mrs. Elsie Stonehart … for … **Phi Epsilon Phi**… Wearing native Indian dress, a gift of one of the women on the reservation, Mrs. Stonehart accompanied the pictures with instructive commentary and explained that she had resided on the reservation and taught school in one of the Indian villages some years ago. She was successful in meeting with families she had known previously and had persuaded several of the leading residents to pose for the original pictures," *SMT*, Aug. 27, 1948, p. 5.

1949 – Port with camera and "Passing Parade is Halted by Infant Photos" in front window of Stonehart shop, and Elsie gives tips 'know your camera… [parents of children under 4 must Not be in the room] … finishing and processing are important … Speed is a must….' Earlier in her career Mrs. Stonehart was an aerial photographer, then after developing a talent for child photography went to Laguna Beach to study with the Mortensen school. She won the coveted Wynona award… Both Mrs. Stonehart and her husband are members of the National Association of Photographers…," *SMT*, May 31, 1949, p. 5.

1955 – "Officer Vic… Soroptimist club… luncheon program… Wearing the exemption hat for the day, Mrs. Elsie Stonehart gave a talk on her profession, 'Photography,' and arranged an exhibit…," *SMT*, Feb. 16, 1955, p. 4.

1983 – "Elsie Stonehart Dead at 84… with her husband Les operated **Stonehart Studio**s here for more than 50 years… A native of Lemoore, Mrs. Stonehart moved here in 1919. She and her husband owned Stonehart Studios from 1919 until their retirement in 1962. 'She was primarily involved with taking portraits of children while her husband was a studio photographer,' said John Demeter… Demeter said the Stoneharts sold their business to Gabor Batay in 1962 and that he purchased the studio in 1974. … A life member of the Santa Maria Soroptimist club, Mrs. Stonehart was also a member of the Professional Business Association and a past president of the American Legion Auxiliary," *SMT*, April 12, 1983, p. 5.

And, more than 400 hits for "Elsie Stonehart" in Santa Barbara county newspapers on newspapers.com that were too numerous to even be browsed for potential inclusion here.

Stonehart, Elsie (misc. bibliography)
Elsie Rosamond Sims Stonehart, b. Oct. 4, 1898 in Lemoore, Ca., to William Sims and Rose Hale, married Leslie Jean Fingado Stonehart, and d. April 9, 1983 in Santa Maria, Ca., per Kimzey & Whitfield Family Trees; Elsie Rosamond Stonehart is buried in Santa Maria Cemetery District per findagrave.com (refs. ancestry.com).

See: "Stonehart, Leslie, Jr.," 1955, "Stonehart, Leslie, Sr.," 1969, "Stonehart Studio," 1947, 1959, 1960

Stonehart, Leslie J., Jr. (1920-1974) (Solvang / Santa Maria)
Winner in Latham poster contest, 1939. Cartoonist with Warner Brothers and Disney Studios, Hollywood. Opened Solvang Photo Studio, 1947. Exh. drawings at Jr. Community Club, 1952. Wife is Beatrice Stonehart, above. Mother is Elsie Stonehart, above. Father is Leslie Stonehart, Sr., below.

■ "Leslie J. Stonehart Jr. of Santa Maria, a veteran of more than two and a half years' service with the Navy, will open a photo studio and film processing business in Solvang this Summer. Mr. Stonehart will rent space in the Paaske brothers furniture warehouse in Copenhagen Square. At the present time he is affiliated with his father, **Leslie J. Stonehart, Sr.**, in photo studio work in Santa Maria. The younger Mr. Stonehart will do portrait and commercial photography, and his wife, Mrs. **Beatrice Stonehart**, will handle the retouching and tinting part of the business. Mr. Stonehart's uncle, Jack Sims, will be in charge of the roll film processing. Mr. Stonehart said the studio would offer a 24-hour service on the developing and printing of roll films. … Mr. Stonehart has been connected with the photography business since childhood. He attended **Midland School**, Woodbury College, and the Chouinard's School of Art in Los Angeles. During the war he served as a pharmacist's mate in the Navy, attached to the Third Marine Division. Mr. Stonehart saw service on Guadalcanal and Bouganville. He contracted malaria while on the South Pacific Islands. He was returned to the States and later released from the service. After the war he was employed for a time as a cartoonist with Warner Brothers in Hollywood and worked on several of the Warner animated cartoons, including 'Bugs Bunny.' Mr. Stonehart will move his wife and two-and-a-half-year-old son 'Jigger' to the Valley to make their home," *SYVN*, May 16 1947, p. 1.

Stonehart, Leslie, Jr. (notices in Northern Santa Barbara County newspapers on microfilm and on newspapers.com)
1935 – "Les Stonehart Given Dinner Party… Leslie is leaving to enroll in the Midland School for boys, located in the mountains back of Los Olivos," *SMT*, Feb. 2, 1935, p. 2.

1941 – "Stonehart Studies Cartooning – Leslie Stonehart, Jr., who has just completed a commercial art course in Woodbury college, has begun a course at Hollywood Art Center in cartoon animation being taught by Lester Novros, who directed 'Snow White,' 'Pinocchio' and 'Fantasia'," *SMT*, Feb. 25, 1941, p. 3; "Art Student Employed – While continuing his studies in Hollywood Art Center, Leslie Stonehart, Jr. … has summer employment making papier mâché stage properties," *SMT*, June 9, 1941, p. 3.

1944 – "Les Stonehart to Marry in South… Miss **Beatrice Ascarate** to Leslie Stonehart, Jr., pharmacist's mate second-class, now stationed with the Navy in Long Beach…," *SMT*, Feb. 10, 1944, p. 4.

1947 – "Son to Arrive… Leslie Stonehart Jr. … will arrive here this afternoon from Hollywood where he is employed with the Warner Brothers Studios, to join his parents in

photography work. His wife and son will arrive later," *SMT*, Feb. 21, 1947, p. 3; repro: baby pictures of Leslie Stonehart Sr. and Jr., *SMT*, March 6, 1947, p. 3; "Les Stonehart, Navy Veteran, to Open Solvang Photo Studio," *SYVN*, May 16, 1947, p. 1; "Plans New Business – Leslie J. Stonehart, Jr., son of Mr. and Mrs. Leslie J. Stonehart of Santa Maria and now connected with their photographic business, is planning to open a business of his own in Solvang as soon as the Paaske Bros. furniture store is completed on Copenhagen Square. He will do portrait work and commercial photography and his wife will do retouching and tinting. His uncle, Jack Sims, will be in charge of the film printing and developing department," *SMT*, May 19, 1947, p. 6; "Lions Hear Dr. Nelles… A. B. Stephens had as his guest Leslie Stonehart, Jr., who had completed for the club a two-page drawing in color of Santa Maria valley, depicting its industries of oil, flower seeds and agriculture, to place in the Lions' traveling history book," *SMT*, Aug. 20, 1947, p. 5; "Officers Named… The Supper Forum of First Presbyterian Church… introduced Leslie Stonehart, Jr., who gave a talk on animated cartooning and his work at the Walt **Disney** studios," *SMT*, Nov. 25, 1947, p. 8.

1949 – "Winners Lose at Soroptimist Dinner. … Original posters for the tables, with pictures of Bugs Bunny and other **Disney** characters, were by Leslie Stonehart, Jr., formerly of the Walt Disney studio," *SMT*, Jan. 28, 1949, p. 5; "Passing Parade… enthusiasm for work with the camera is shared by their son, Leslie Stonehart, Jr., who gave up his career as a cartoonist with the Walt Disney Studios to be associated with their work in his home city," *SMT*, May 31, 1949, p. 5.

1951 – "I Spied… Les Stonehart Jr. pursuing his favorite hobby in drawing an attractive poster publicizing the Alvin school PTA cake sale tomorrow," *SMT*, Nov. 9, 1951, p. 1.

1952 – "Mr. and Mrs. L. J. Stonehart and Leslie J. Stonehart, Jr., their son, … are in San Francisco to attend the state convention of California Photographers Assn. …," *SMT*, Aug. 9, 1952, p. 4.

1955 – "'Round Town. **Leslie J. Stonehart, Jr.** and **Mrs. Elsie Stonehart** are leaving today to attend the Western States Photographers' convention at the Statler hotel, Los Angeles, to be in session for several days," *SMT*, July 8, 1955, p. 3.

Repro of Leslie Stonehart, Jr.? poster for 4th annual poster contest, 1939-40 on www.swarthmore.edu/library/peace.

Stonehart, Leslie, Jr. (misc. bibliography)
Leslie Stonehart was b. Dec. 12, 1920 in Santa Maria, Ca., to Leslie Jean Stonehart and Elsie Rosamond Sims, married Beatrice Marie Ascarate, and d. July 9, 1974 in Phoenix, Ariz. per Jeannette Logan Family Tree (refs. ancestry.com).
See: "Junior Community Club (Santa Maria)," 1952, "Posters, Latham Foundation (Santa Maria)," 1939, "Santa Maria, Ca., Union High School," 1939, "Splash," 1938, "Stonehart, Beatrice," "Stonehart, Elsie," "Stonehart, Leslie, Sr.," "Stonehart Studio," 1947, 1960

Stonehart, Leslie "Les" Jean, Sr? (1890-1981) (Santa Maria)
Photographer. Prop. of Electric Art Studio / Stonehart Studio. Father of Leslie Stonehart, Jr., above. Husband of Elsie Stonehart, above.

■ "Pioneer Photographer Stonehart dies… Mr. Stonehart was born Sept. 15, 1890 in Poplar Bluff, Mo. He was the owner of Stonehart Photography Studio for many years. He was a Veteran of the U. S. Army, having served in World War I. … He was a resident of Santa Maria since 1919. He is survived by his widow, **Elsie R. Stonehart** of Santa Maria… He was preceded in death by a son, **Leslie Jean Stonehart, Jr.**, who died July 9, 1974…," *SMT*, Oct. 27, 1981, p. 2.

Stonehart, Leslie, Sr. (notices in Northern Santa Barbara County newspapers on microfilm and on newspapers.com)
1924 – "Stoneharts Attend Eastman School of Photography," June 2, 1924, p. 5.
1938 – "Photographers Win Awards for Work," M/M Leslie Stonehart won awards of merit at state photographers' convention in Sacramento. "A pictorial photo of a banana blossom won an award and will be put in an exhibit which will tour the entire country. Portrait awards were won by photographs of …," *SMT*, April 28, 1938, p. 3.
1958 – "Round Town. Les J. Stonehart has returned from Kansas City, Mo., his former home state, where he attended a five-day workshop seminar on color portrait photography. The course, put on by U. S. Camo Corporation, was attended by 50 photographers from several states, *SMT*, April 26, 1958, p. 5; "Photographer Brings Back Big Fish … Les Stonehart has returned from a fishing trip vacation at Mackay, Idaho, and brought back big trout packed in ice to prove his good luck while fishing in Big Lost river and Lake Mackay. Running into extra heavy business at home with more than the usual number of weddings scheduled in August, it was decided he should not forego his annual fishing trip this time, and his son and wife volunteered to share extra duties to allow him to fish and camp. He enjoyed fine fishing, beautiful scenery that tempted him to shoot a few pictures, good weather and at least some of the comforts of home in his house trailer," *SMT*, Aug. 12, 1958, p. 2.
1969 – Port. of Les and Elsie in 1919 shortly after their marriage and another taken in 1969 on their 50th wedding anniversary and "Leslie, **Elsie Stonehart** Have Recorded Central Coast Growth… On a Sunday in May, 1919, a young soldier, recently discharged following the end of World War I, was wandering around Santa Maria looking the town over, 'broke like all soldiers' and wondering what to do with himself since the town seemed to be deserted. Later Leslie Stonehart was to learn the Sunday was Pioneer Day and Santa Maria had turned out for the big picnic. A young lady, named Miss Elsie Sims, with a life-long dream of becoming a nurse, had arrived in Santa Maria some three months previously to make her home with her sister while raising funds to attend nursing school in Los Angeles. Stonehart liked the town, more so once the picnic was over and Santa Maria had become repopulated, opened a photography studio in the old McMillan building, which stood on the present site of Wayne's Tires and looked for an assistant. Miss Sims, who was not working, applied for

the job to finance her trip to Los Angeles. Together they started the Stonehart Studio which was to serve the Santa Maria Valley under their ownership until 1963. The assistant and her boss fell in love and were married October 18, 1919. … She said, 'I tried to learn the business but I couldn't stand photography. It was like washing dishes.' The couple lived in an apartment in the rear of the studio until shortly before their son, Leslie Jr., was born … when fire destroyed their business, home and belongings. Undaunted, with the help of friends, the young couple opened the '**Electric Art Studio**' in the old Heller building, the present site of Mae Moore's on W. Main St. The studio was so-called because, as Stonehart said, 'we were just learning to take pictures with electricity instead of daylight.' One branch of the business in which Stonehart did not excel, was photographing babies. He 'didn't understand them and couldn't get pictures.' To help out, his wife tried her hand with the youngsters and said, 'I soon became wrapped up in photographing babies and wouldn't trade it for nursing.' She became famous for her baby portraits which have appeared in magazines and on magazine covers. For some years, Stonehart was the official photographer for the late Capt. G. Allan Hancock. He recalls flying along side the late captain's plane snapping pictures of the Captain's first solo flight. He also mentioned an accident, which today sends the shivers up their spines, when a barnstorming pilot flew into town and Stonehart decided to go up and photograph Santa Maria from the air. In order to get a clear view, he strapped himself to a wing with a piece of wire. While he was flying merrily over the city, his wife heard the plane, ran out to see what was going on and nearly collapsed when she saw her husband. Stonehart said, though it didn't bother him at the time, he doesn't like to think about it today. During the earlier years of their business, before restraining walls were built, heavy rains would cause the Cuyama and Sisquoc rivers to flood down Cook St., which was referred to locally as 'Cook River.' He snapped many pictures of floods in the city. Two incidents which stand out in the minds of both and which they recorded were the disastrous wreck of seven navy destroyers in the fog off Pt. Hondo in 1923 and the earthquake which leveled Santa Barbara in 1925. To photograph the former, they traveled to a small town near Pt. Arguello and then trudged over the dunes for miles loaded with heavy camera equipment. Permission had to be granted by a string of officials for the Stoneharts to photograph the earthquake ruins and they became the official photographers of the cataclysm. Their son, **Leslie Jr.**, … joined his parents to learn the photography business and was with the studio for 16 years before moving on to other fields. In 1963, after photographing three genrations of babies and recording the growth of the Santa Maria scene, the Stoneharts decided to retire. They sold the new studio at 110 W. Church St. into which they had moved some years before, to Gabor Patay who, with his wife, Maria, continues to operate it today. The Stoneharts, who live at 200 E. Hermosa St. in a home they built many years ago when the surrounding lands were planted to beans, are happy to have played a large part in the history of Santa Maria… Stonehart now finds time to pursue his interests in hunting and fishing. The lady who 'couldn't stand photography' says her hobby still is photographing

children, which she sometimes does today – with an Instamatic," *SMT*, Dec. 6, 1969, p. 8.
And, more than 100 additional notices not even browsed for inclusion here.
Stonehart, Leslie, Sr. (misc. bibliography)
Leslie Jean Stonehart, mother's maiden name Campbell, was b. Sept. 15, 1890 in Missouri and d. Oct. 24, 1981 in Santa Barbara County per Calif. Death Index; Leslie Jean Stonehart, Sr., is buried in Santa Maria Cemetery District per findagrave.com (refs. ancestry.com).
See: "Allan Hancock College," 1959, "Boy Scouts," 1933, "Electric Art Studio," "Photography, general (Santa Maria)," 1956, "Santa Maria, Ca., Union High School," 1924, "Santa Maria Camera Club," 1938, "Stonehart, Elsie," "Stonehart, Leslie, Jr.," "Stonehart Studio"

Stonehart Studio / Electric Art Studio (Santa Maria)
Photography studio, known as Electric Art Studio. 1919-24 and then as Stonehart Studio to 1962. Prop. Leslie Stonehart, Sr. Photographer of babies was Elsie Stonehart. In 1947 son Leslie Stonehart, Jr., joined the business as a photographer.

■ "Photographs Live Forever … That's the motto used by the Stoneheart Studio. 'Les' Stoneheart, as he is known by a legion of friends, may be seen up on the job with his trusty camera at every fair, race, or holiday celebration that comes to this city. Years ago, Les kept his studio out on west Main street, remembered as the **Electric Art Studio**, but when the new theatre building was built, he immediately picked out one of the fine modern offices there and moved. Since that time, he has been adding to his equipment and arrangement until it is one of the finest on the coast. He deals in motion picture equipment, copying, Kodak finishing, enlarging, oil tinting, and has had the pleasure of making portraits of most of the people here. He does his work reasonably and in a very pleasing manner. His interest does not cease with the mere taking of a picture but with the desire to create for his patrons and friends a photograph that will be treasured to eternity," *SMFA*, 10/30/31, n. p.

■ "Stonehart's Modern Studio" - photo of interior of studio and article says, "The above photograph is of the camera room of the Stonehart Studio. Built to have the appearance of a home – no old-fashioned backgrounds and collateral usually found in most studios. They use artificial light for all their sittings because it is always uniform and easily controlled. ... The Stonehart Studio has been located in Santa Maria for 14 years under the same ownership… This Christmas… twelve photographs will solve a dozen gift problems…," *SMFA*, hand-dated Nov. 20, 1931, n.p. (at Santa Maria Valley Historical Society).
Stonehart Studio (notices in Northern Santa Barbara County newspapers on microfilm and on newspapers.com)
1919-24 – See: "Electric Art Studio"
1925 – "Many Babies Entered in PTA clinic…
Announcement of the winners of the baby contest was to have been made at the closing sessions… In addition to the prizes that have been offered… awards will be made by the Stonehart Studios. To the girl attaining the highest percentage, an 8 x 10 photograph encased in a Collins Photo mount. To the boy attaining the highest percentage,

an 8 x 10 photograph, also encased in a Collins Photo mount," *SMT*, Sept. 30, 1925, p. 1; "Photos of Prize Winning Babies are on Display… in the windows of the Stonehart studios. A photograph was awarded to each of the prize-winning babies by the Stonehart Studios," *SMT*, Oct. 7, 1925, p. 5.

1926 –"A fine display of photographs of the big Chief Eagle Gray are on exhibition in the window of Stonehart's studio," *SMT*, April 30, 1926, p. 5, col. 2; ad for studio in *SYVN*, July 2, 1926, last page; line drawing of man admiring photo of woman, captioned, "Yes Sir, That's My Baby. That's the Gift he'll appreciate – your Photograph… Make your appointment now and avoid the December rush. Stonehart Studio," *SMT*, Nov. 1, 1926, p. 5.

1927 – "Someone somewhere wants your photograph. Graduation Portraits a specialty. Stonehart Studio," *SMT*, May 28, 1927, p. 5; repro: photo of two ancient Reo automobiles, *SMT*, Sept. 14, 1927, p. 5; "Send Your Picture as a Christmas Gift. Give photographs this Xmas. A Dozen Photographs Solves 12 Xmas Problems. Make Your Appointments Today. Stonehart Studio…," *SMT*, Nov. 23, 1927, p. 5.

1928 – "Stonehart Studio is the Official Photographer for the Fair. See Stonehart for rates on booth photographs. New Theatre Bldg. Phone 330-W," *SMT*, Aug. 6, 1928, p. 1; "Advance Xmas Specials. Prices Reduced on all Photographs until November 1…," *SMT*, Oct. 16, 1928, p. 1; "The cast of 'Icebound,' the play to be presented by the Players' club, November 2, faced the lights last night at Stonehart's Studio when they were snapped in character poses with costumes, makeup and all the trimmings. The photographs will be displayed on miniature lobby boards designed by **Gaylord Jones** and will be shown in downtown store windows," *SMT*, Oct. 27, 1928, p. 6, col. 3; "Give Photographs this year for Christmas. A dozen Photographs will solve a dozen Christmas problems. Prices from $5.00 per dozen up. Come in and see our Christmas Specials," *SYVN*, Nov. 30, 1928, p. 4.

1929 – "Hundreds View Marchetti Ship… Air photographs of the plane were 'shot' by L. J. Stonehart… in a Stearman biplane from the Santa Maria Airlines, Inc. The Marchetti ship was piloted by Bert Lane," *SMT*, Aug. 21, 1929, p. 5; "Santa's Mail Box… Old St. Nicholas has arranged with 12 downtown stores to give prizes for the best letters he receives… For Girls… Second prize, one-half dozen four by six inch photographs attractively mounted, at Stonehart's studio," *SMT*, Dec. 11, 1929, p. 1.

1930 – "All Your Life You'll Remember Graduation … photograph as a priceless possession. Stonehart Studio," *SMT*, May 15, 1930, p. 5; "Special One Week. One-half Dozen 3 x 5 Photographs, including One 6 x 8 Enlargement, $3.00. Stonehart Studio," *SMT*, Aug. 6, 1930, p. 1.

1931 – "For the FIRST Baby Born in Santa Maria in 1931. We will give a photograph FREE … Size 7 x 9 – Novelty Picture – In one of our latest model mountings. The lucky baby's parents will call at our Studio to obtain order. The picture of the baby will be taken at the age of three months. Stonehart Studio. 110 W. Church. Phone 330-W," *SMT*, Jan. 6, 1931, p. 8.

1934 – "Stonehart's Studio… It's Time to Think About Christmas and the Friends on Your Gift List…," *SMT*, Oct.

18, 1934, p. 10; "Special Offer on Christmas Gift Photos. … As a Special Inducement to Place Orders Early and Avoid the Holiday Rush, a 20% Discount is Offered on All Pictures Taken Between Now and Thanksgiving. Make Your Appointments Now! Stonehart Studio. Theatre Building Phone 330-W," *SMT*, Nov. 16, 1934, p. 6.

1935 – "Give Photographs. The Most Personal and Lasting of Gifts. Portraits for Christmas Delivery Must be Taken at Once. Make Your Appointment Today! Stonehart Studio," *SMT*, Dec. 6, 1935, p. 6; "Stonehart Studio Will give Handsome Photograph of the First New Year's Baby Born in 1936…," *SMT*, Dec. 30, 1935, p. 7.

1936 – "Send your photograph. Christmas photos. Special rates for November. Make an appointment Now… Stonehart Studio," *SMT*, Nov. 5, 1936, p. 4; and *SMT*, Dec. 10, 1936, p. 10.

1937 – "For Mother's Day May 9th. You Are Her Greatest Treasure. Give Her the Gift She Will Appreciate Most. Your Photograph. Stonehart Studio," *SMT*, April 20, 1937, p. 3; "Stonehart Studio. Photographs Live Forever…," *SMT*, Sept. 3, 1937, p. 6; "Picture of New Well – A photograph of Gallison Well No. 1 taken by Les Stonehart, submitted with permission of Frank Jones, head of the California Lands Inc., will appear in a forthcoming issue of *Petroleum World*…," *SMT*, Dec. 23, 1937, p. 3, col. 1; "Valuable Gifts to First Baby Born Here in 1938… Stonehart Studio, photograph of baby," *SMT*, Dec. 29, 1937, p. 1.

1938 – "Before Mother's Day, arrange for Photographs. Gifts for every member of the family. How they will appreciate them. Stonehart Studio," *SMT*, April 4, 1938, p. 5; "Give a Portrait Photo. Remember the Folks with something they cannot buy … Your Photograph. Special Reduced Rates… Stonehart Studio," *SMT*, Dec. 2, 1938, p. 6; "First Baby of Year in S. M. Will Be Lucky… Stonehart Studio, photograph of baby," *SMT*, Dec. 31, 1938, p. 1.

1939 – "Until Dec. 1st Only. Special Rates on Your Christmas Photographs. Evening Sittings by Appointment (except children). Stonehart Studio," *SMT*, Nov. 24, 1939, p. 1.

1940 – "Give Photographs This Xmas. Remember everyone on your Christmas list with a photograph of you … A sitting this week will deliver the finished pictures to you in ample time for Christmas giving. A small deposit will hold your order until delivery. Stonehart Studio," *SMT*, Nov. 27, 1940, p. 3.

1941 – "Who Will Be the First New Year Baby in Santa Maria. Stonehart Studio Will Give The First 1942 Baby One 8 x 10 Photograph and Keepsake Baby Book. A Gift to Cherish in the Years to Come. Stonehart Studio," *SMT*, Dec. 31, 1941, p. 6.

1942 – "To the First 1943 Baby. One 8 x 10 Studio Photograph and Keepsake Baby Book. A Gift to Cherish in the Years to Come. Stonehart Studio," *SMT*, Dec. 31, 1942, p. 6.

1943 – "To the First 1944 Baby. One 8 x 10 Photograph and Keepsake Baby Folder. A gift to cherish in the years to come. Stonehart Studio," *SMT*, Dec. 31, 1943, p. 6.

1944 – "Dry Cleaners… Gather in S.M. **Santa Maria Inn**… Tomorrow… the visitors will pose in the Inn Gardens for a photograph by Les Stonehart," *SMT*, Jan. 22, 1944, p. 1; "Wanted – Girl with experience, any branch of

photography, also receptionist. Stonehart Studio," *SMT*, Feb. 17, 1944, p. 5.

1945 – "Sportsman's Group... steelhead contest... Les Stonehart offered to present to any member, with his compliments, a photograph of that member with his steelhead, providing the fish weighs ten pounds or more," *SMT*, Dec. 13, 1945, p. 6.

1946 – "I Spied... Les Stonehart experiencing difficulty as he tried to arrange a staircase photograph setting of high school senior girls, the girls coming in groups of two and three and gradually overflowing the selected area," *SMT*, May 22, 1946, p. 1.

1947 – Repro: **Leslie Stonehart, Jr**. Taken 1923... His son 'Jigger' Taken 1947. Photographs of Children Never Grow Up. Keep Them as they are Today with a Photograph by Stonehart," *SMT*, March 6, 1947, p. 3; "Mother's Day. May 11th. Give her the gift she'll treasure most. Your Photograph. The Only Gift that Only You Can Give. See our complete line of distinctive frames. Sizes for all photographs – from miniatures to 14 x 11 in. wood, metal and Lucite... Les Stonehart, Photographer. Child Photography by **Elsie Stonehart**... Stonehart...," *SMT*, April 3, 1947, p. 2; Classified ad – "We have the right frame for your photograph. Complete stock from tiny gold medallion miniatures to size 11 x 14. Also antique frames with engraved gold plate mats especially made to meet today's demand for re-framing of old-fashioned photographs. Stonehart Studio," *SMT*, Dec. 19, 1947, p. 5.

1948 – "Picture Your Memories with a First Communion Portrait ... Stonehart," *SMT*, March 1, 1948, p. 3.

1949 – "Give Copies of Those Treasured Old Photographs for Christmas ... Bring in your treasured old pictures to be restored by excellent copies. Also, we have the right frame to complete the gift... Stonehart Studio," *SMT*, Sept. 16, 1949, p. 6.

1950 – "School Days Ahead! Your boys and girls will soon start back to school. Don't neglect to have a new Photograph made now before the busy school term starts. Today's Photograph – Tomorrow's Treasure.... Stonehart Studio," *SMT*, Aug. 17, 1950, p. 4.

1951 – "Mother's Day – Sunday – May 13th... Who Loves You Most of All? Mother! Her children are her greatest treasures. If she can't have you, send her the Mother's Day gift she will appreciate most... your Photograph. Stonehart Studio," *SMT*, April 13, 1951, p. 7.

1957 – "Father's Day – June 16. What could be better for Dad than Your Photograph...," *SMT*, May 22, 1957, p. 2.

1959 – "From Stonehart Studio to the First Mother. A Beautiful White Baby Album plus 6 – 5 x 7 photographs of your choice. All Photography of Children by **Elsie R. Stonehart** ...," *SMT*, Dec. 31, 1959, p. 4.

1960 – "Time is So Fleeting, 'Why Not Keep Them as They Are Today'? with a living natural portrait by **Elsie Stonehart**, who photographs babies and children exclusively. With Time and Patience to Make Every Picture a Perfect Reproduction! **L. J. Stonehart – Les Stonehart, Jr.**, Photographers – **Elsie R. Stonehart**, Child Photography... Portraits – Weddings – Commercial Photography," *SMT*, July 7, 1960, p. 17.

See: "Electric Art Studio," "Froom, Darrell," 1928, "Photography, general (Santa Maria)," 1947, "Stonehart,

Elsie," "Stonehart, Leslie, Jr.," "Stonehart, Leslie, Sr.," "Stubblefield, Earl," 1950

Storey, Richard (Lompoc)
Teacher of arts and crafts in Lompoc Jr. High, 1954.

■ Port. and "Richard Storey is teacher of arts and crafts at Hapgood school and is in his first year in the teaching profession. He attended [the] Art Institute of Chicago, Wright Junior College and Roosevelt College, and holds a B. A. degree in education. Storey was for three years in the Armed Forces serving in France, Germany and the Philippine Islands. He is a member of the Catholic church, and his hobbies include photography and sports. Storey is married and resides at 109 North E street," *LR*, Oct. 28, 1954, p. 4.

Storey, Richard (notices in Northern Santa Barbara County newspapers on microfilm and on newspapers.com)
1954 – Photo with group of teachers, *LR*, Aug. 26, 1954, p. 1.

See: "Hapgood School," "Lompoc, Ca., Junior High School," 1954

Story, Ala (1907-1972) (Santa Barbara)
Director, Santa Barbara Museum of Art, 1952+. Judge at Santa Ynez Valley Art Exhibit, 1954.

See: "Hibbits, Forrest," 1952, "Santa Ynez Valley Art Exhibit," 1954, 1956

Stotts, Lucy Evelyn Bello (Mrs. Bert Emmett Stotts) (1915-2010) (Santa Maria)
Ceramist. Active with child recreation programs and with Nipomo PTA, late 1940s. Prop. Stotts Potts ceramic studio, 1951+. Painter.

■ Port. and "Lucy Evelyn Stotts born March 24, 1915 on a farm near Betteravia, Ca. ... She passed away in Bend, Or., a resident of High Desert Assistant Living Center... A life-long resident of the Santa Maria Valley, Lucy had a love of crafts and creating and taught ceramics [at] her and Bert's 'Stott's Potts'. An accomplished painter, she belonged to the Los Padres Art Guild and sold over 320 oil paintings. She retired from Santa Maria High School where she had graduated in 1933. ...," *SMT*, June 19, 2010, p. B2.

Stotts, Lucy (notices in California newspapers on newspapers.com).
1949 – "Lodge Observes 25th Anniversary... Nipomo Pythian Sisters... Charter members present were escorted to the altar and presented with corsages of silvered magnolia and eucalyptus leaves... Lucy Stotts designed them ...," *AGH*, Aug. 19, 1949, p. 4.

1950 – "PTA at Nipomo Holds Hobby Show... under the direction of Mrs. Bert Stotts... Mr. and Mrs. Stotts displayed ceramics and copper and wood work...," *AGH*, Jan. 20, 1950, p. 8.

Stotts, Lucy (misc. bibliography)
Port. as attendance clerk in the Santa Maria High School yearbook, 1973, 1977; Lucy Evelyn Stotts was b. March 24, 1915, d. June 13, 2010 and is buried in Santa Maria Cemetery District per findagrave.com (refs. ancestry.com).
See: "Stotts Potts"

Stotts Potts (Nipomo Mesa / Santa Maria)
Ceramic studio, c. 1951+. Prop. Lucy and Bert Stotts.
Stotts Potts (notices in Northern Santa Barbara County
newspapers on microfilm and on newspapers.com)
1951 – "**Camp Fire Girls** Visit Hobby Shop. 'Stott's Potts'
ceramic hobby shop of Mr. and Mrs. Bert Stotts of Nipomo
Mesa… Mrs. Stotts explained how the clay is mixed to
pour into the molds and then how it is dried and cleaned to
make ready for the two firing steps before the glaze and
trim are put on. They saw the large and small kilns and a
demonstration of free-hand decoration," *SMT*, Nov. 19,
1951, p. 4.
1954 – Ad: "You're Invited to a… Open House. Thursday,
Oct. 14. 11 a.m. to 4 p. m. 7 p. m. to 9 p. m. at Stotts Potts
Ceramics. (Lucy & Bert Stotts) Ceramic & China Supplies.
Custom Firing. Stotts Potts Ceramics. 708 West Alvin.
Phone 5-3283. Open for business Friday, October 15,"
SMT, Oct. 13, 1954, p. 9; ad: "The Gift for Christmas and
after. Special 'Get Acquainted' Offer on greenware. Good
selection to make your Christmas gifts. Figurines, vases,
cigarette boxes, ash trays and a lot more. All for 10, 15 &
25c. A few at 50c. Stotts Potts Ceramics. 798 W. Alvin.
Santa Maria," *SMT*, Nov. 2, 1954, p. 4.
1956 – "Ceramics Demonstrations – **George [Sic. Charles]
West**, Los Angeles artist in ceramics, will give a
demonstration at the Stotts Potts ceramics studio, 708 W.
Alvin, at 2 p.m. Friday. Sent by Mayco, he will show
painting and will have an exhibit of his own finished work.
Mrs. Bert Stotts will be in charge," *SMT*, Jan. 19, 1956, p.
6; ad: "Stotts Potts Ceramics, 708 West Alvin St. Will be
Closed for Vacation. June 4 to July 2," *SMT*, May 31, 1956,
p. 4.
See: "Stotts, Lucy," "West, Charles"

**Stout, John W. (1884-1980) (SLO / Santa Maria /
Buellton)**
*Mechanical Drawing teacher at Santa Maria High
School, 1934-46.*
■ "John W. Stout… Mr. Stout died at home Feb. 10 after
a long illness. He was born July 4, 1884 in Texas and lived
in the Santa Ynez Valley from 1941 to 1960 when he
moved to Ventura… cremation and burial at sea," *SYVN*,
Feb. 14, 1980, p. 9.
Stout, John (notices in Northern Santa Barbara County
newspapers on microfilm and on newspapers.com)
1934 – "New Courses Will Be Available… John Stout,
graduate of Oregon State college, post-graduate of
University of California and Massachusetts Institute of
Technology and formerly a teacher at the California
Polytechnic school in San Luis Obispo will fill the place
left vacant by the late **H. M. Snell** as mechanical drawing
instructor," *SMT*, Aug. 15, 1934, p. 1.
1941 – "Stouts Buy Place. Mr. and Mrs. John Stout of
Santa Maria have purchased the Erwin Lewis place,
comprising 22 acres, west of Buellton. Stout is a drafting
instructor in the high school," *SMT*, June 26, 1941, p. 3 and
June 28, 1941, p. 9; "Dr. Stout Here. Dr. Willard Stout,
son… daughter, Mrs. John Ransom…," in Santa Maria for
the holidays, *SMT*, Dec. 24, 1941, p. 3.
1945 – "School Personnel Attend Class. … four instructors
of Santa Maria High School have been invited to attend the

Army Air Forces' educational demonstration unit program
in California Polytechnic College in San Luis Obispo
Wednesday. … John W. Stout… to familiarize civilian
educators with Army Air Forces teaching methods and
techniques… traveling mobile unit…," *SMT*, July 16, 1945,
p. 3; "USC Aviation Classes Open Today on Hancock
Field… Co-operating with the Trojan air school, the Santa
Maria Union High School and Junior College has assigned
as part-time instructors: John W. Stout, engineering
drawing…," *SMT*, Nov. 1, 1945, p. 1.
1946 – "17 New Teachers for High School … So far the
high school authorities have been unable to find a successor
to … John W. Stout who expects to retire soon…," *SMT*,
Aug. 28, 1946, p. 4.
Several articles about his son, "John Stout, Jr.," excelling at
Chemistry studies were not itemized here, nor were the
many articles for "Mrs. John Stout" an active clubwoman.
See: "Boy Scouts," 1941, "Santa Maria, Ca., Union High
School" 1934, 1936, 1937, 1938, 1939, and *San Luis
Obispo Art and Photography before 1960*

**Stover, Dalton Brevort, II, MSgt. (1910-1990) and wife
Adelia Emma "Delia" "Dee" Jenkins Stover
(Vandenberg AFB)**
*Photographer, amateur, 1960. Wife, Adelia, made
puppets.*
■ Ports. and "Wife Extraordinaire… the couple was
headed for Camp Roberts, Calif., where Dalton took basic
training… in Paso Robles where she and her husband lived
in a converted chicken coop in the early days of World War
II. … Dalton who is calm, logical, dignified and reserved.
He is 6 feet 3 inches tall, likes his home, loves his family
and admires his wife's abilities tremendously. Out of the
army after the war he worked four years for Trans World
Airlines in Kansas City as a statistician. Then he enlisted in
the Air Force, and the couple plans to stay in, 'as long as
the Air Force will have us.' A hobby the Stovers enjoy is
baking. … Dalton favors gardening, baking and
photography. Both enjoy German oompah band music and
reading. Their Hummel collection numbers 60 at present,
including the beautiful nativity scene of which only 200
sets are made each year. Members of the NCO Wives club
will see the collection on display at the club Oct. 18. At
Vandenberg only a short time, having come from San
Bernardino in July …," *LR*, Sept. 8, 1960, p. 9 (i.e., 1c) and
p. 11 (i.e., 3c).
Stover, Dalton (notices in Northern Santa Barbara County
newspapers on microfilm and on newspapers.com)
1987 – "Dee Stover's good life includes service… Sitting
amidst a mine field of brightly-colored, handmade puppets
… Stover makes about 140 puppets a month for the Marian
Medical Center Auxiliary and about 200 a year for Valley
Community Hospital. The felt creatures range from Daffy
Duck and Santa Claus to Garfield and Dumbo the elephant
… Eight years ago… Stover opted for puppet-making….
However, after an accident in which her hip had to be
replaced, Stover quit working professionally and began
making puppets a full-time commitment…. [after studying
law] Stover married in 1942 and followed her husband,
Dalton, to U. S. Army Camp Roberts, near Paso Robles. …
None of us [military wives] had ever been more than 10

miles from home unprotected… The following year, the couple moved to Georgia where Dee Stover joined the judge advocate's office… After her husband was sent to Europe, Stover returned to Kansas City… After the war, Dalton Stover flew for TWA before he decided to go back into the service. Dee and Dalton's next stop was Alaska, where the couple adopted two boys… at that point Dee Stover stopped working professionally… In 1957, after a brief 1 ½ year stint in New Mexico, the couple traveled to Remstein, Germany… The family remained in Germany four years… While her husband worked at Vandenberg AFB in the early 1960s, Stover wrote for the *Santa Barbara News Press*… Upon Dalton Stover's retirement in 1966, the family moved to Santa Maria – where Dee Stover has been busy ever since…," *SMT*, June 7, 1987, p. 40 (i.e., 4-B).

Stover, Dalton (misc. bibliography)
Dalton Brevort Stover, II, was b. Feb. 3, 1910 in Nova Scotia, Canada, to William Alexander Stover and Elinora Stover, married Adelia Emma 'Delia' Jenkins, was residing in Santa Maria in 1970, and d. Nov. 24, 1990 in Santa Maria per Crane Family Tree (refs. ancestry.com).

Stover, George H. (1886-1954) (Los Angeles / Lompoc / Ontario, Ca.?)
Sign painter, 1909.
Stover, George H. (notices in Northern Santa Barbara County newspapers on microfilm and on newspapers.com)
1909 – "Geo. H. Stover, of Los Angeles, has been doing some very neat sign work in town this week. Mr. Stover is an artist in his line and has been kept busy," *LR*, May 21, 1909, p. 8; "George Stover left yesterday morning for Chicago over the Salt Lake railroad," *Independent* (Santa Barbara), June 15, 1909, p. 5, col. 3.
Stover, George H. (misc. bibliography)
George H. Stover is listed in the 1910 U. S. Census as age 22, b. c. 1888 in Michigan, a house and sign painter, residing in Ontario, Ca., with his parents Charles W. Stover (age 57) and Louada Stover (age 47) and 4 siblings; George H. Stover, Sr., b. 1886 and d. 1954 is buried in Bellevue Memorial Park, Ontario, Ca., per findagrave.com (refs. ancestry.com).

Straight, Margaret J. (1908-2001) (Santa Barbara)
Santa Barbara High School art teacher (c. 1951-71) who exh. non-objective art at Allan Hancock [College] Art Gallery, 1958.
1977 – "A look at the professional woman workshop … Montecito… Presenting community and volunteer service opportunities for women in retirement will be Margaret Straight, retired art teacher, Santa Barbara High School…," *SMT*, Nov. 4, 1977, p. 10.
Straight, Margaret (misc. bibliography)
Miss Margaret J. Straight is listed in Fresno, Ca. (in either the Voter Registrations or the *CD*) 1932, 1934; port. of Margaret Straight appears as "art teacher" in the Santa Barbara High School yearbook, 1951, 1952, 1954, 1958, 1960, 1962, 1965, 1966, 1967, 1970, 1971; Margaret J. Straight was b. March 14, 1908 in Washington, D. C., to Leonard Joseph Straight and Madge Hawthorne Smith and

d. July 9, 2001 in Santa Barbara county per Ward v. 2 Family Tree (refs. ancestry.com).
See: "Allan Hancock [College] Art Gallery," 1958

Stranahan (Badgley), Elaine (Mrs. John Badgley) (San Luis Obispo)
SLO artist who exhibited in Santa Barbara County.
See: "Badgley, Elaine," "Santa Maria [Valley] Art Festival," 1952, "Santa Ynez [Valley] Art Exhibit," 1955, 1956, and *San Luis Obispo Art and Photography before 1960*

Stratton, Robert "Bob" (Santa Maria / Tucson)
Prop. Arrow Photo Finishers, 1945-1952. Sold out to Henry Datter. Active with Santa Maria Camera Club late 1940s.
Stratton, Robert (notices in Northern Santa Barbara County newspapers on microfilm and on newspapers.com)
1949 – "I Spied… Students in Vice Principal W. J. Wilson's office in the high school admiring Bob Stratton's color pictures of the May Queen festivities," *SMT*, June 9, 1949, p. 1.
1952 – "Bob Strattons Leave for Tucson… where he will enter a partnership with a relative in the real estate business. Their new home address will be 2127 East Grant road, Tucson. The Strattons sold the Arrow Photo Finishers to Henry Datter, formerly of Arcadia. Their home, 411 East Camino Colegio, has been purchased," *SMT*, Nov. 21, 1952, p. 4.
See: "Arrow Photo Finishers," "Santa Maria Camera Club," 1946, 1947

Streeter, Josefa (c. 1828-after 1895) (Mrs. A. W. [W. A.?] Streeter) (Santa Barbara)
Exh. painting of carnations and needlework at Art Loan Exhibit, Santa Maria, 1895.
1893 – "The Art Rooms of Mrs. A. W. Streeter will be closed from July 15th to August 15th," *Independent* (Santa Barbara, Ca.), July 12, 1893, p. 4, col. 3.
1894 – "Mrs. Streeter, 1005 State street, has a new lot of decorative art materials. Stamping. Lessons given. Terms, cash," *Independent* (Santa Barbara, Ca.), July 6, 1894, p. 4, col 2/3.
Mother of Minerva Lucinda Streeter (Mrs. William Bradbury Hosmer) of Santa Maria, who she visited from Santa Barbara in the 1890s per *SMT*.
Streeter, A. W., Mrs. (misc. bibliography)
Josefa Streeter is listed in the 1850 U. S. Census as residing in Santa Barbara, new wife of W. A. Streeter; Josefa Streeter is listed in the 1870 U. S. Census as age 43, wife of Wm. A. Streeter, Dentist, who appears to have born her husband six children including Minerva (age 6); Josefa Streeter is listed in the 1860 and 1880 U. S. Census as b. c. 1828 in Calif. residing in Santa Barbara with her husband and children; is her husband – ad: "W. A. Streeter, All Kinds of Repairing, Trunks, Furniture, etc. State Street. Above County Bank Building," *Santa Barbara, Ca., CD*, 1886, p. lvii (ref. ancestry.com).
See: "Art Loan Exhibit (Santa Maria)," 1895

Streib, Arthur C. (1894-1945) (Los Angeles)
Photographer of Keystone Photo Company who took photos of sweet pea fields belonging to John Bodger & Sons, Lompoc, 1922.
See: *Central Coast Artist Visitors before 1960*

Strong, Grace Margaret Clark (Mrs. John Henry Strong) (1873-1960) (Santa Maria)
Exh. a basket and a weaving at Santa Barbara County Fair, 1936, 1937. Pioneer. Wrote several historical articles for the Santa Maria Times.
Hundreds of notices on her club work as well as historic articles and reminiscences she authored in the *SMT* were not itemized here.
Strong, J. H., Mrs. (misc. bibliography)
Grace Margaret Strong b. March 23, 1873 and d. Oct. 4, 1960 in Los Angeles County is buried in Santa Maria Cemetery District per findagrave.com (refs. ancestry.com).
See: "Art, general (Santa Maria)," 1886, "Santa Barbara County Fair," 1936, 1937

Strong, Isobel "Belle"
See: "Osbourne (Strong) (Field), Isobel "Belle" (Mrs. Joseph Dwight Strong) (Mrs. Edward Salisbury Field)"

Strube, Misses (Anna and Carrie) (Santa Maria / Visalia)
Painters. Teachers of Kensington painting, 1887. Milliners.
1886 – Ad: "Ladies. You are respectfully invited to visit the stylish Dressmaking Parlors on Main St. in Nance's Building Recently opened by the Misses Strube of San Jose," *SMT*, Nov. 27, 1886, p. 5.
1887 – "All ladies desirous of receiving instructions in Kensington painting will take notice that the Misses Strube are ready to give lessons at their place of business in the Nance building on Main street," *SMT*, Jan. 15, 1887, p. 5, col. 1; [Kensington painting = fast and easy alternative to needle work... oil paints... stippled to simulate stitches, per wikisource.] "Ladies, if you want a neat fitting dress made to order, don't fail to visit the dress making parlors of Misses Strube on Main St. Nancy building," *SMT*, Feb. 26, 1887, p. 5; "Jubilee at the Opening... The Misses Strubes have issued invitation cards to attend the opening of their new millinery store in Santa Maria on the 10th, 12th and 13th... see the latest styles and the magnificent stock of millinery ... west of McMillan's hall," *SMT*, Sept. 10, 1887, p. 3.
1889 – "Hats almost for nothing at Miss Strubes' all next week," *SMT*, April 6, 1889, p. 3, col. 1.
See: "Strube, Anna," "Strube, Carrie"

Strube (Lutnesky), Annie / Anna (Mrs. A. E. Lutnesky) (Santa Maria)
Sister to Carrie Strube, below.
See: "Lutnesky, Anna Strube," "Strube, Misses"

Strube (Squire), Carrrie (Mrs. Arthur M. Squire) (Santa Maria / Hanford)
Sister to Anna Strube, above.
1893 – "A marriage license has been issued to Arthur M. Squire of Hanford and Carrie Strube of Santa Maria," *Daily Independent* (Santa Barbara), Nov. 27, 1893, p. 4.
See: "Strube, Misses"

Struthers, Irene, Miss (Santa Barbara)
Teacher in the "household art" department at Santa Barbara Normal School who lectured on "Art in the Home" at Santa Maria High School, 1920.
1917 – "Normal School to Give Emergency Courses... The faculty of the summer session department of household art is ... Irene Struthers, director fine arts ...," *Santa Barbara Daily News and the Independent*, May 28, 1917, p. 10.
See: "Santa Maria, Ca., Union High School," 1920

Stuart, Charlotte S. (Mrs. Robert D. Stuart?) (Santa Barbara)
Artist who exh. in National Art Week show at Minerva Club, 1940.
Is she Charlotte S. Stuart listed in the 1930 U. S. Census as age 45, b. c. 1885 in New Jersey, residing in Santa Barbara with husband Robert D. Stuart (age 45) and children: Robert O. and Florence C.? (ref. ancestry.com).
See: "National Art Week," 1940

Stuart, George S. (1929-?) (Ojai)
Sculptor who spoke to Minerva Club, 1960. The George Stuart Historical figures (originally created as stage props for his monologs on world history) are in the permanent collection of the Museum of Ventura County (per galleryhistoricalfigures.com).
See: "Minerva Club," 1960, and *Central Coast Artist Visitors before 1960*

Stuart Sign Service (Santa Maria)
Everything in Signs, 1925-28. Prop. Ryan W. Stuart (nee William Huston Hannon, 1893-1943).
■ "Pictorial Sign Painter Opens Business Here. Mr. and Mrs. R. W. Stuart arrived this week from Los Angeles and will make this city their permanent home. Mr. Stuart has opened the Stuart Sign Service at 111 West Chapel street, where he will conduct a general sign painting business, but featuring more particularly pictorial signs. He will submit ideas or work out the experssions [sic.] of others on any pictorial subject," *SMT*, Aug. 22, 1925, p. 5; "Stuart Sign Service Adds New Equipment... located at 111-113 West Chapel St.... now equipped to turn out any of the many branches of Sign and Pictorial Art, from attractive air-brushed show cards to mammoth all-metal bulletin boards for highway display ads. Electric Signs are also handled. Mr. R. W. Stuart, the owner and manager... has been previously engaged as Pictorial Artist for the Thos. Cusak Co., of Chicago (a nationally known out-door advertising company), and also the Foster & Kleiser Co. of Los Angeles. Mr. Stuart reports that while his shop and studio

has only been open for business since September 1ˢᵗ, he is more than satisfied with the amount of business that has been taken care of in that time… In regard to the Bulletin Advertising, a plan has been devised which enables the company to construct an all-metal Bulletin, such as are now on the highways and, contrary to the usual custom of ad companies in just renting the space thereon, in this case they can be purchased outright – complete in all details for about 1-3 of the cost of rental, on a 3-year contract. They can also be rented at a minimum rate… In addition to this feature, lettering, designs and pictorial can be selected by the purchaser…," *SMT*, Oct. 29, 1925, p. 3.

Stuart Sign Service (notices in Northern Santa Barbara County newspapers on microfilm and on newspapers.com)
1925 – "Stuart Sign Service… One of the most attractive signs to be painted and displayed in this community, declared by many to be a real work of art, has been completed by the Stuart Sign Service for Gibson & Drekler, owners of the Paramount dairy, just north of the city limits… The sign displays one of the pur bred Holstein cows … which was drawn from life by the artist. Dairy and vegetable products of the valley are featured in full colors… with the Holstein as the central figure. … Mr. Stuart declares that the cow was of a modest disposition and at first objected to posing for the drawing," *SMT*, Nov. 7, 1925, p. 5.
1926 – "New Paint and Wall Paper Store… Owing to the many requests for a paint that equals that quality which is used in the Sign and Pictorial advertising, the Stuart Sign Service of the city have now annexed a sales department, having taken over the entire building at 111-113 West Chapel street … The annex is stocked with a full line of Paints and Painting materials, supplies, etc. … The Paints and Varnishes are made by the well-known Tibbets-Oldfield Co. and the Dupont Co., makers of the famous Duco system. Mr. Stuart will continue to personally conduct the Sign Advertising work and the purchasing for the new annex; the estimating and contracting end is in the hands of the Nelson Painting and Decorating Co., a new concern of well-known local men, who have had over 23 years of painting experience in Santa Maria. Their offices are located in the annex. Stuart's Paint and Wall Paper Store (Annex to Stuart Sign Service) …," *SMT*, Feb. 27, 1926, p. 6; "Mrs. R. W. Stuart, who was formerly in the office of the Sanitary Laundry, is now in charge of the office of the Stuart Sign Service, paint and wall paper store," *SMT*, Aug. 19, 1926, p. 5.
1928 – "Owing to illness of R. W. Stuart … the doors of the concern have been closed since Tuesday, January 24. Mr. Stuart has been confined to his bed with influenza [sic.]," *SMT*, Jan. 28, 1928, p. 7; "Notice to Creditors. All creditors having accounts against Stuart Sign Service are requested to mail itemized bills before April 1, 1928. Stuart Sign Service. R. W. Stuart," *SMT*, March 7, 1928, p. 5. And, c. 40 ads not itemized here.

Stuart, Ryan W. (misc. bibliography)
Ryan W. Stuart is listed in the 1930 U. S. Census as age 36, b. c. 1894 in Ohio, married, a self-employed sign painter, residing in Santa Maria with his children: Wallace H. and William D.; Ryan W. Stuart, artist and Dem. residing at 1528 11ᵗʰ Ave., registered to vote in San Francisco County, 1936; Ryan William Stuart [aka William Huston Hannon]

b. Sept. 26, 1893 in Xenia Ohio, to William H. Hannon and Lavinia Kildow – in June 1937 called himself Ryan William Stuart and in Aug. 1942 his name was listed as William Huston Hannon per Social Security Applications and Claims Index; William Huston Hannon b. Sept. 26, 1893 in Xenia, Ohio, to William H. Hannon and Sevine [Sic.] Kildow, married Florence Clare Jackson Carnes and d. Nov. 12, 1943, in San Francisco, per Matson Family Tree; William Huston Hannon (Jr.) is buried in Golden Gate National Cemetery, San Bruno, per findagrave.com (refs. ancestry.com).
See: "Holcomb, Tobe," 1926

Stubblefield, Earl Edward "Stubby" (1918-1990) (Santa Maria / Arroyo Grande)
Photographer, amateur. Member Santa Maria Camera Club, 1941, 1945. Photographer in the Navy in WWII. Prop. Stubby's Sporting Goods and Camera Supply store, 1946-c. 1950.

■ "Earl E. Stubblefield… Mr. Stubblefield was born in Avant, Okla., and had lived in the Arroyo Grande area for the past five years, moving from Homeland. He worked as a district manager in the insurance business for 20 years. Following World War II, he owned and operated Stubby's Sporting Goods and Camera Supply Store and manufactured fishing rods in Santa Maria… he was a former member of the Santa Maria Camera Club…," *SMT*, Dec. 19, 1990, p. 16.
Stubblefield, Earl notices in Northern Santa Barbara County newspapers on microfilm and on newspapers.com)
1946 – "Sport Goods, Camera… Carrying as complete a line of camera supplies and sporting goods as post-war conditions permit … Stubby's Sporting Goods and Camera Supply store will hold its grand opening tomorrow morning. The store, located at 308 South Broadway has on hand… a wide variety of equipment for the camera enthusiast… Owner and manager of the new store is Earl E. Stubblefield who received his honorable discharge from the Navy last Oct. 19 after four years of service. A native of Guthrie, Okla., Stubby came to Santa Maria nine years ago and was employed by a construction firm. He later was associated with the Woolworth store there and was transferred to the company's store in Porterville as assistant manager. Just before entering the service he was in charge of the sporting goods department of the Visalia Montgomery, Ward & Co. store. An ardent camera enthusiast and free-lance photographer, he was assigned to a photographic unit in the Navy and served as head of such a unit on the carrier *U. S. S. Cape Gloucester*. He is a survivor of the *U. S. S. Hornet,* and three weeks prior to the A-bomb attack on Hiroshima did aerial reconnaissance over that enemy city. His service decorations include the American Defense ribbon and the Asiatic-Pacific ribbon with five battle stars. Stubby, his wife, Betty Lee Stubblefield and two-year-old daughter, Linda Jean, recently moved here from Arroyo Grande," *SMT*, Feb. 14, 1946, p. 2.
1950 – "Farmer's Hardware… for the sportsman there's a complete line of goods … handled by Earl Stubblefield who had previously operated Stubby's Sporting Goods store…," *SMT*, Nov. 24, 1950, p. 11, and port. in sporting

goods department and photo by **Stonehart Studio**, *SMT*, Nov. 24, 1950, p. 13.

Stubblefield, Earl (misc. bibliography):
Earl Edward Stubblefield was b. Sept. 8, 1918 and d. Dec. 16, 1990 and is buried in Santa Maria Cemetery District per findagrave.com (ref. ancestry.com).
See: "Santa Maria Camera Club," 1941, 1945

Stubbs, C. S. (Santa Maria)
Photographer, with short-lived Clendenon Studio, 1909.
See: "Clendenon Studio"

Stubby's Sporting Goods and Camera Supply Store (Santa Maria)
See: "Stubblefield, Earl"

Stuber, Dedrick B. (1878-1954) (Los Angeles)
Los Angeles artist, one of whose paintings was distributed to a public building in northern Santa Barbara County by the PWAP, 1934.

■ Landscape painter who studied at the Art Students League in NYC and arrived in Los Angeles in 1920. Active painting moody and idealized Southern California landscapes through 1940, per Nancy Moure, *Publications in California Art*, vols. 1-13.
See: "Public Works of Art Project," 1934

Stuckey, Gilbert (Los Angeles)
Los Angeles based FBI photographer who taught a class in police photography in Santa Maria, 1947.
See: "Photography, general (Santa Maria)," 1947

Studio Workshop (Solvang)
Private art classes for children and adults taught by Martha Brandt-Erichsen, 1956+.
See: "Brandt-Erichsen, Martha"

Sudbury, Delia "Dee" L. Davis (Mrs. Jay Royal Sudbury) (1924-?) (Lompoc)
Crafts teacher Santa Maria High School, 1947-50. Painter of landscapes, particularly flower fields, and other subjects, 1960s+.

■ "Mrs. Jay (Dee) Sudbury was born and raised in the Lompoc area, the daughter of Grace Davis of Rucker road and the late Charles Davis, one of Lompoc's pioneer families. She attended local schools and graduated from the University of California at Santa Barbara with a bachelor's degree in art. She also holds a teaching credential from UCSB. Dee says she started painting in a very conservative style. She learned about abstract painting from **Forrest Hibbits** whose classes she attended in the 1960's. Hibbits now teaches at Brooks Institute of Fine Arts in Santa Barbara and Dee feels he has had a great impact on her painting. Her favorite painters are the Impressionists. Their style and philosophy have influenced much of her work. Painting nearly every day keeps Dee busy. Her primary

subjects are landscapes and still life. She does like to try a variety of methods, including abstract mixed media of hard-edge design. Dee paints with acrylics now, although she started with oils. The palette knife is her favorite tool, and she prefers to paint inside, out of the wind. Wild colors used to fill her canvases. She describes her palette as mellowing, however, with emphasis on the warm tones of browns, yellows, reds and oranges. According to Dee, sketching is an important practice for artists. She encourages her students to sketch as much as possible. During the school year, Dee teaches oil and watercolor technique and mixed media in daytime adult education classes at the Lompoc veterans Memorial building... She is scheduled to hold a one-woman show of her work in the multi-use room of the Lompoc Library from August 1-22," *Lompoc Record – Vistas*, July 31, 1971, p. 4 (clipping from the Lompoc Valley Historical Society); "Specializing in acrylics … Her abstract paintings of local landscapes and flower fields, well-known in the Lompoc Valley and surrounding areas… A judge of numerous Art Shows, she also has created magazine covers, and her Christmas cards designed for Duncan McIntosh are sold throughout the United States" and port. (brochure in coll. Lompoc Valley Historical Society).

Sudbury, Dee Davis (notices in Northern Santa Barbara County newspapers on microfilm and on newspapers.com)
1947 – "Engagement of Miss Delia Davis … to Francis Eugene Payne of Santa Maria… Mr. and Mrs. Charles Davis of Lompoc… Miss Davis' engagement was announced Sunday morning at the Delta Sigma Epsilon sorority house in Santa Barbara. She graduated from Santa Barbara College last week and will teach arts and crafts at Santa Maria Junior College starting in the Fall. Payne is a student at the University of California in Berkeley…," *LR*, June 26, 1947, p. 3; "17 New Teachers… Santa Maria High School and Junior College… Delia Davis, Lompoc, crafts…," *SMT*, Aug. 23, 1947, p. 1.
1948 – "High School Teachers' Contracts… Probationary teachers rehired were … Delia Davis…," *SMT*, March 17, 1948, p. 2; "Legal Recordings – Marriage licenses issued… Jay Royal Sudbury, Felloes, and Delie Lord Davis, Lompoc …," *SMT*, Aug. 5, 1948, p. 6; "Couple Honeymoon in Santa Cruz… Mr. and Mrs. Jay Royal Sudbury … The bride, the former Delia Davis, is the daughter of Mr. and Mrs. Charles Davis and the bride groom is the son of Mr. and Mrs. B. L. Sudbury of Fellows, Calif… Mrs. Sudbury is a graduate of the University of California and was an art instructor at the Santa Maria high school and Junior College. Mr. Sudbury is a junior at California Polytechnic. On their return the couple will reside at San Luis Obispo," *LR*, Aug. 19, 1948, p. 3.
1983 – "Both men and women winners of the [Lompoc Valley of the Flowers] marathon (26.2 miles) and the half marathon (13.1 miles) will receive a painting of a flower field by Dee Sudbury, a native of Lompoc Valley. 'What's better than to have something of the flower fields?' asked race director Norman Yiskis. Yiskis met Sudbury through a mutual acquaintance and when he became race director in 1980 decided to give the winners 'something unique to the valley.' Sudbury received her degree in art from the University of California at Santa Barbara in 1947, then spent three years teaching at Santa Maria High School and

Santa Maria Junior College, now called Allan Hancock College. She also taught adult education for the Lompoc Unified School District before retiring last year. Her husband, Jay, retired from Lockheed as a mechanical engineer after 20 years. 'He's quite a critique artist,' Sudbury said, explaining that she likes another opinion. 'Another person can see its problems. If he's wrong, I leave it alone, but usually he's right.' She said she thinks Lompoc is an ideal place for painters. 'I just think there's a lot to be said for what we have going in our valley,' Sudbury said from her painting room on Purisima Road. The room, crammed with canvases, frames, paint and palette knives, looks out over a walnut orchard and a flower field. 'I'm proud of what our little valley has to offer painters. We're kind of an artistic valley and that's neat,' Sudbury said as she dabbed one of her latest creations with acrylic paint. 'For a town that isn't known as an art community, I think Lompoc is really way ahead of the average community in art,' she said. Much of the credit for this, she said, goes to the local schools. 'I think we've had good teachers. Not only our adult education teachers, but our high school teachers have been really good ones, and it can't help but make a difference. Although she probably would never admit it, Sudbury's paintings grace more walls in Lompoc than any other artist. Sudbury prefers using acrylics, but sometimes paints with water colors. Her paintings are usually landscapes, especially flower fields, but she has also done seascapes, still lifes and abstracts. Her subjects are taken from photographs she has taken or sketches she's made, and occasionally she paints in her car on location. She'll spend about eight hours a day preparing for this year's Flower Festival June 23 to 26, when she will gather together about 80 of her works to sell in a booth. In addition to the winners' prizes, everyone entering the race will receive a color certificate Sudbury painted of two joggers running through a flower field. Director Yiskis said he had over 1,000 of the certificates printed for the June 19 event" *LR [Mission Valley Review and Santa Ynez Valley Review]*, June 9, 1983, p. 18 [i.e., p. 2].
And, there are more than 710 hits for "Dee Sudbury" in newspapers, 1960-2020 but there were too many to be browsed for potential inclusion here.

Sudbury, Dee Davis (misc. bibliography)
Delia Sudbury, "Art, Art Apprec.," port. appears in Santa Maria High School yearbook, 1949; Delia L. Sudbury, teacher, public school, Lompoc, is listed in the *Santa Maria, Ca., CD*, 1961; Dee Sudbury, spouse J. R. Sudbury, is listed in Lompoc in the *Telephone Directory, 1994-2002*; Delia L. Sudbury, b. Oct. 26, 1924, was residing in Lompoc, Ca., at an unspecified date per *U. S. Public Records Index, 1950-1993*, vol. 2 (refs. ancestry.com).
See: "Alpha Club," 1960, "Art, general (Lompoc)," 1961, 1962, "Davis (Sudbury), Delia," "Hibbits, Forrest," 1964, "Lompoc Gem and Mineral Club," 1960, "Santa Maria, Ca., Union High School," 1947, 1948, 1949, 1950

Sudden, Maria / Marie Antoinette Hernster (Mrs. William Henry Sudden) (1866-1914) (Lompoc)
Painter. In 1892 exhibited Best fruit, in oil at "Santa Barbara County Fair," Lompoc. Exh. needlework, 1894.

■ "Death of Mrs. Sudden. Word has been received in this city of the death of Mrs. N. [Sic.] A. Sudden in Oakland last week. The remains were taken to Lompoc for interment. The deceased was the widow of the late W. H. Sudden who met a violent death near the Rinconada a few years ago when his automobile was overturned," *SMT*, July 18, 1914, p. 1.
And more than 100 social notices for "Mrs. W. H. Sudden" not itemized here.

Sudden, Mrs. W. H. (misc. bibliography)
Antoinette Hernster is listed in the 1870 U. S. Census as age 5, b. c. 1865 in Calif., residing in Township 2 of Santa Barbara County with her mother Elizabeth Hernster (age 33) and father? George Hernster (age 44, a liquor merchant, b. Bavaria) and her siblings: Barbara and George; Maria A. Hernster married William H. Sudden in 1886 in Santa Barbara per Western States Marriage Index; Maria R [Sic. A] Sudden is listed in the 1900 U. S. Census as age 33, b. Aug. 1866 in Calif. residing in Lompoc with her husband William S. [Sic.] Sudden (age 36) and daughter Lita H. (age 13); Antoinette Hernster was b. Aug. 1866 in Calif., was married to William Henry Sudden, was residing in Santa Barbara in 1910 and d. 1914 per Williams and Irwin Family Tree (refs. ancestry.com).
See: "Santa Barbara County Fair," 1892, and *San Luis Obispo Art and Photography before 1960*

Summer School (Lompoc) (aka Summer Playground and Recreation program / Summer Recreation Program)
First held, 1940. Directed by Lompoc schools in conjunction with the city of Lompoc, and by 1946, completely by the city Recreation Commission. Consisted of sports and handicraft. Held at the grammar school, at Ryon Park, and in 1949 at the Community Center. Long term teacher of crafts was Mary Brughelli (c. 1952-59).
Summer School (notices in Northern Santa Barbara County newspapers on microfilm and on newspapers.com)
1940 – "170 boys and Girls Participate in Playground… at the grammar school … being financed by the two school districts and the city … conducted for the first time in Lompoc… Tentative Schedule Monday, Wednesday and Friday – morning programs: Grammar school… and handicraft… Tuesday and Thursday morning program: Grammar school playground… hobbies, handicraft, nature study hikes… The afternoon program is incomplete at present …," *LR*, June 21, 1940, p. 5; "Large Attendance… Twenty children are doing simple handicraft…," *LR*, June 28, 1940, p. 7.

1941 – "Activities of Playground… Lompoc Summer Playground and Recreation program carried on at the local grammar school… August 15 will mark the close of the program. On the morning schedule… Tuesdays and Thursdays 9-11:30, orchestra and rhythm band and handicraft and hobby club…," *LR*, July 4, 1941, p. 7.

1943 – "Playground Program … A schedule of activities at the public playground during the summer months sponsored jointly by the city and schools was announced… at 2 o'clock, a story hour and handcraft period will be open to children 10 to 14 years old…," *LR*, July 2, 1943, p. 8; "Playground Notes. The week of July 5-10 was marked by increasing attendance at the Lompoc Grammar school playground. In handcraft children concentrated on making bird houses. Boys and girls who bring in scrap wood may make many interesting and attractive articles," *LR*, July 16, 1943, p. 5.

1944 – "Summer Session of Recreation Starts Monday… The summer school will be staffed by … Fred Crawford [high school science teacher] who will be in charge of boys' work and the craft program… The session will be … financed by the high school and elementary school, the city of Lompoc, the Legion and Kiwanis and Rotary clubs. A well-rounded program has been planned… include handwork such as toy building, weaving, craft work and the making and playing of traditional games…," *LR*, June 23, 1944, p. 1.

1946 – "Recreation for Summer Season is Planned… facilities at the grammar school playgrounds and **Ryon Park** after July 4th. Activities for the summer will include: games, folk dances, singing, simple handcraft, story telling, hobby shows, contests, swimming and other special events … Cooperating in the program are: Grammar school and high school boards, the City Recreation commission, Kiwanis, Rotary, **Junior Alpha club**, **Alpha club** and the **AWVS**," *LR*, June 20, 1946, p. 2.

1949 – "Summertime Fun for All is Theme of Recreation Program for Summer… Something to do for every member of the family… Two city play areas will be the center of activity when the Ryon park and grammar school playgrounds open on July 5th… [and list of children's programs] … **Adult education** classes will be held at the Community Center Monday through Thursday, 9:30 p.m. [sic.] to 3:30 p.m. and Tuesday and Wednesday nights, 7:00 to 9:30 p.m. Classes are held in ceramics, leather carving, upholstering, silk lamp shades, draperies, picture framing and interior decorating. Special events are planned and arranged by the Recreation department…," *LR*, June 23, 1949, p. 7; "190 Children on Hand… Arts and crafts classes for children are also to be conducted … under the supervision of **Miss Joanne Galbraith**. The classes will be held twice weekly, the first being scheduled for Wednesday at the Elementary school. On the following day the class will be conducted at Ryon park. Miss Galbraith … has specialized in arts and crafts at Pasadena college and Santa Maria junior college," *LR*, July 7, 1949, p. 5.

1952 – "Playgrounds Attract More than 300 Children… playgrounds directed by the City Recreation department… The Arts and crafts class far exceeded opening day expectations of **Mary Brughelli**, instructor, as more than 52 children crowded around the three picnic tables to do crayon coloring, finger painting, cutouts and other crafts. …," *LR*, June 26, 1952, p. 9; "Summer Playgrounds Draw Crowds… Recreation Department's daily special activities… After two weeks of water coloring, finger painting, crayon coloring and splatter painting, the Arts and

Crafts classes held at the two city playgrounds will progress to sculpturing. **Mary Brughelli**, instructor of the class, announced that starting next Monday at Ryon Park and Tuesday at the Elementary School, she will teach the children how to model with clay…," *LR*, July 3, 1952, p. 7; "Children Enjoy Arts, Crafts… Modeling clay made a big hit with the children at Ryon Park and the elementary school playgrounds… **Mrs. Brughelli** announced that next week she will concentrate on finger painting…," *LR*, July 10, 1952, p. 8; "Arts and Crafts Classes Continued. The City Recreation department's Arts and Crafts class is continuing with a varied program at Ryon park and the elementary school playgrounds under the direction of **Mary K. Brughelli**. During the past seven weeks the children have done finger painting, water coloring, splatter painting, clay modeling, crayon coloring and paper cut outs of circus animals. They have also made letter wall holders out of soap boxes and are now making wooden plaques. Projects for the coming week will include making dolls out of wool for the girls and miniature furniture making, bottle decorating and the polishing of fancy pieces of driftwood found at the beaches for the boys. Boys are asked to bring their own fancy bottles and driftwood for their projects," *LR*, Aug. 7, 1952, p. 8; "Playground Jamboree Ends Recreation Dept. Schedule… at Ryon Park… During the Children's show, Mrs. Mary Brughelli, playground arts and crafts instructor, was introduced and several children from her class exhibited some of the things they made made during the summer months," *LR*, Sept. 4, 1952, p. 16.

1953 – "Children to Learn Art of Puppetry. As part of the Arts and crafts classes to be conducted by the City Recreation department on the two playgrounds this summer, **Mrs. Arnold Brughelli**, who will instruct the class, announced that she will devote one two-hour session on Wednesday of each week at Ryon Park to the making of puppets and puppet shows. In addition, … Mrs. Brughelli will also teach finger painting, water and crayon coloring, paper cutouts, modeling in clay, the making of clothes pin furniture and many other items. Mrs. Brughelli has spent the greater part of her art career in and around San Francisco. She attended the Art Institute of Chicago and the California Art School of San Francisco through which she became a member of the San Francisco Art association. Mrs. Brughelli was also a designer, creating new designs for some of the leading interior decorators around the bay area. Prior to coming to Lompoc she had won several one-man shows of her art work at the Western Women's building and the William McCann galleries in San Francisco. The craft classes will be held on Monday and Wednesday at Ryon Park and on Tuesdays at the elementary school playground from 1:30 to 3:30 p.m. starting June 22," *LR*, June 11, 1953, p. 13; "Puppet Class Popular… Wednesday afternoon arts and crafts classes conducted by **Mrs. Arnold Brughelli** at Ryon Park… 35 attending. … In the first class… the children made the hand type using crepe paper for the head and clothes. In the second class the children learned to make marionettes using spools for the head and body. This type can also be made to move by manipulating strings attached to the hands and feet…. Future classes… concentrate on teaching the children how to make the real marionettes out of wood. Upon completion of the marionettes, the children will …

present a program at the Ryon park playground," *LR*, July 16, 1953, p. 10.

1954 – "Craft Classes are Offered at Three City Playgrounds… under the direction of **Mrs. Arnold Brughelli**… [and bio. of Mrs. Brughelli] … The classes are open to all children and are held at Ryon park on Mondays, the H street school on Tuesdays, and the Ocean Avenue park on Wednesdays at 1:30 p.m.," *LR*, June 24, 1954, p. 6; "Craft Classes to be Resumed Monday… discontinued because of the illness of the instructor… The project for the coming week will be clay modeling," *LR*, July 8, 1954, p. 15.

1955 – "Summer Rec Program is Outlined… 'Summer Fun for All' … two summer playgrounds conducted at Ryon and Floresa parks, the arts and crafts classes … copies of the 1953 program of summer activities can be picked up in the office of the City Recreation department located in the Community Center," *LR*, June 2, 1955, p. 16; photo captioned, "Popular Playground Activity," showing handcraft class at Ryon park taught by **Mrs. Mary Brughelli**," *LR*, July 14, 1955, p. 5.

1956 – "Well-known Artist Instructs at Park. With the opening of the two playgrounds this week, the summer Arts & Crafts classes under the direction of **Mrs. Arnold Brughelli** were conducted by the City Recreation Department at Ryon and Floresta Parks … During the first two sessions of the Arts & Crafts Class, conducted at both playgrounds, Mrs. Brughelli had the children working with clay. Next week she will concentrate on modeling with sawdust. The Arts and Crafts classes, open to all children, are held at Ryon Park on Mondays and Floresta Park Tuesdays, every week starting at 1:30 p.m.," *LR*, June 28, 1956, p. 5; photo and caption reads, "Outdoor Workshop for participants in the Arts and Crafts classes held in Ryon Park on Mondays… **Mrs. Arnold Brughelli** is shown here in a group of youngsters…," *LR*, July 26, 1956, p. 13.

1957 – "**Mary Brughelli** Lends Art Talent for Park Program… Mrs. Brughelli, who recently was in charge of the very successful 'Outdoor Art Exhibit' held at Ryon Park during the Flower Festival has conducted arts and crafts classes … During the first two sessions of the arts and crafts classes, Mrs. Brughelli had approximately 25 children in each class, tracing, cutting, assembling and painting animals of all kinds. For next week's project the children will concentrate on painting on plaster, known as Jeso [sic. gesso] work. The arts and crafts classes, open to all children, are held at Ryon Park on Mondays and [at] Floresta Park Tuesdays every week starting at 1:30 p.m.," *LR*, June 27, 1957, p. 5; photo of children sitting at a table working on crafts, *LR*, July 11, 1957, p. 13.

1958 – "Playground Open Here on Monday… Lompoc's summer recreation program… two supervised playgrounds operated by the City Recreation department open at Ryon and Floresta parks… Special daily programs … will include… Arts and Crafts classes to be held Monday, Ryon park, and Tuesday, Floresta park from 1:30 to 3:30 p. m….," *LR*, June 19, 1958, p. 7; "Playgrounds Open … More than 250 Lompoc children… The baton twirling and arts and crafts classes conducted at both playgrounds again

proved to be popular activities…," *LR*, June 26, 1958, p. 5; "Arts and Crafts Attract Youngsters… **Mrs. Arnold Brughelli**… During the first two sessions of the Arts and Crafts class, Mrs. Brughelli had about 25 children in each class making egg-head puppets. For next week's project the children will do clay modeling… open to all children … held weekly at Ryon Park on Mondays and Floresta Park on Tuesdays, starting at 1:30," *LR*, June 26, 1958, p. 4, col. 4-5.

1959 – "Art Classes to Start Tomorrow. Special art and craft classes will be conducted every Tuesday starting June 23 from 2 to 4 p.m. in the Community Center annex, 119 West Walnut Avenue as part of the summer recreation activities… These classes will be taught by **Mrs. Arnold Brughelli** … The instruction will cover leather thonging, working with plaster molds, clay modeling, metal picture tooling, puppet making, painting and other areas of art and crafts. All children of eight years of age and up are invited to attend these classes which are given free of charge for both instruction and materials, under the sponsorship of the Recreation Department," *LR*, June 22, 1959, p. 9; photo of children at work on crafts at Lompoc Community Center annex, *LR*, June 29, 1959, p. 7; "94 Children Attend Arts, Crafts Class… painted plaster figures … in the annex of the Community Center. **Mrs. Mary Brughelli** … has her hands full… Helping… were Mrs. Florina Glidden and Mrs. Betty McCarthy. This class meets every Tuesday from 2 to 4 p.m. and is open to all children eight years old and over. There is no charge …," *LR*, July 2, 1959, p. 12.

1960 – "PTA Guest Speaker at Hapgood. Summer recreation... will be explained by Jack Anderson, recreation director…," *LR*, May 5, 1960, p. 6; "Full Schedule of Summer Activities Planned… Arts and Crafts classes… will be held at the Recreation Center at 2 p.m. Crafts will be held on Mondays starting July 11; Puppetry will be on Tuesdays starting June 28 – all students must be in the sixth grade or over with a real interest in making puppets for a show, building a stage and writing their own playlet for their puppets; Mask Making will be on Thursdays starting June 30 – pupils must be eight years of age and older, the masks will be used in the Circus Day parade…," *LR*, June 2, 1960, p. 19; photo of children watching a puppet show at Ryon Park, *LR*, Aug. 1, 1960, p. 4.

See: "Lompoc, Ca., Recreation Department"

Summer School (Santa Maria)
Summer programs that included crafts were run by church schools, by the SRA (1935) and by the Santa Maria, Ca., Recreation Department, 1947+, to keep children learning and active during public school summer breaks.
[Do not confuse with the private Santa Maria School of Art, held during the summer, for adults.]
Summer School (notices in Northern Santa Barbara County newspapers on microfilm and on newspapers.com)
1930 – "Children of Catholic Summer School… Exhibit Handicraft, Art Work… first Catholic summer vacation school conducted here during June and July were exhibited together with … a program at high school auditorium last night. The display of the handiwork of students ranging in age from 6 to 14 years… placque designs, dolls made of

paper sacks and fancy paper napkins… miniature of St. Mary's Catholic church…," *SMT*, Aug. 30, 1930, p. 5.

1935 – "Hundred Children Enjoy Playground… East Main Street school… Six instructors employed by **SRA** which is sponsoring the program… [instructors named] Story telling, dramatics and athletic games … A woodshop was opened yesterday… Handcraft and other divisions will be added later if more interest develops…," *SMT*, July 9, 1935, p. 2.

1947 – "City Playday… children up to 12 years old… first annual community playday…in Buena Vista park … a well-rounded program of games and entertainment… picnic lunch… **Kenneth Moore** will be on hand to take action shot pictures… and the pictures will be placed in a scrap book … In connection with the playday program, an exhibit has been arranged by **Mrs. Paul Nelson** at the **Public Library** of handcraft by children attending the **summer school** classes. … carved wooden napkin rings, plastic placemats, braided leather bracelets, belts, and other items. Younger children have made coaster sets of cork with hand drawn and painted designs," *SMT*, July 29, 1947, p. 3.

1950 – "Extensive Summer Recreational Program Announced… The program will go into full swing June 19 at Main Street school … at Fairlawn School … at McClelland Street playground… and at the recreation center under **Miss Evelyn Willits'** direction… Other places where portions of the activities will be staged are the municipal plunge, the public library and the Veterans Memorial building… At the two schools … From … 10:30 – 11 a.m., arts and crafts…," *SMT*, June 10, 1950, p. 1; "Plans Recreation Program of four weeks' duration will open Monday in Los Alamos school and on its playgrounds… arts and crafts from 11 until noon…," *SMT*, June 17, 1950, p. 1.

1954 – "Buena Vista Summer Playground… for youth under 12 years of age will open July 1… A handicraft class… will be conducted from 9 a.m. to noon Monday through Friday at the city recreation center," *SMT*, June 26, 1954, p. 2; "City Has Varied Rec Program… A five-day-a-week handicraft class for youths 6 to 8 under direction of Miss Betty Jo Kauffman from 9 a.m. to noon in the city rec. center. Classes are to be held next month for youngsters 9 to 12 years of age," and photo of her with students, *SMT*, July 10, 1954, p. 8; "Handicraft Class Signup Tomorrow. Registration of youths 9 to 12 years of age who wish to participate in a summer handicraft class … Miss Betty Jo Kauffman, in charge of the class, reported a second handicraft class will be conducted if enough youngsters enroll," *SMT*, Aug. 3, 1954, p. 2.

1955 – "Air Rifle, Archery, Handicraft Summer Recreation Starts Soon… Miss Jane Stornetta will have charge of the handicraft and playground activities. Handicraft signup will be Monday at the Elks field recreation building …," *SMT*, June 18, 1955, p. 2; photo of children at arts and crafts class, *SMT*, July 25, 1955, p. 1.

1959 – "Junior Art Course Will Open Saturday," and article adds, "Art classes, sponsored by the City Recreation Department and the **American Association of University Women**, for which many Santa Maria children registered earlier in the summer, will begin Saturday, 10 a.m. to 12 noon in the Recreation Building at McClelland Park. Children ages 8, 9, and 10 through 11 will be welcomed.

Nat Fast, a member of Santa Maria High School faculty art department will instruct in crayon, drawing and painting. Materials will be furnished for the summer class in art for juniors, according to Gordon Gill, City director of recreation. It will be a four weeks course," *SMT*, July 30, 1959, p. 5.

1960 – "City's Summer Rec Program is Varied… Special Events… scheduled during the June 13 - Sept. 1 period include … father photo contest, June 18… craft exhibit and play demonstration, Aug. 13… Special instructors are… **Nat Fast**, art…," *SMT*, May 19, 1960, p. 9; "Recreation Exhibit Set. Orcutt – Summer recreational activities will be featured at an open house at the Joe Nightingale School… Art and craft work will be displayed … Orcutt Recreation Assn… **Mrs. Barbara Wiedmeier** supervised arts and crafts," *SMT*, Aug. 10, 1960, p. 2; "Art Class to Begin. The Santa Maria Recreation Department art class will begin Tuesday at 10:30 a.m. with **Nat Fast** instructor. The class will be held every Tuesday and Thursday morning until Sept. 1, from 10:30 to 12 noon at the McClelland Park Recreation Building, and it is limited to the 25 students who registered during registration week last June," *SMT*, Aug. 13, 1960, p. 3.

Many additional references to summer programs for children appearing in the *SMT* were not itemized here. See: "Hau, Charlotte," "Santa Barbara County Library (Santa Maria)," 1947, "Santa Maria, Ca., Recreation Department," "Santa Maria School of Art"

Summer School (Santa Ynez Valley)
The Valley's summer recreation program focused on sports but in 1958 Fillmore Condit taught a craft class. Summer classes of academic subjects overseen by Santa Ynez High School began 1959.
Summer School (notices in Northern Santa Barbara County newspapers on microfilm and on newspapers.com)

1957 – "Valley Pool Proposal … Civic Center Acts passed by the Legislature in 1913 and 1917 which provides for the use of school plants for civic purposes, and of the recreation acts passed in 1939 and 1951 which enables schools to conduct community recreation programs just as cities and larger communities do. Trustees of the Valley have followed a policy of making school buildings and facilities available for community use…," *SYVN*, April 19, 1957, p. 5.

1958 – "Crafts Class Slated Here. As part of the Santa Ynez Valley Summer recreation program, a course in crafts will be offered boys and girls between the ages of 10 and 14, at the industrial arts building of the Valley high school starting on Monday, June 30. **Fillmore Condit**, high school industrial arts instructor, will teach the class. He said older students willing to help and work on their own projects are welcome to attend. The class will meet each Monday and Wednesday evening from 6 to 8 p.m., beginning June 30 and continuing until Wednesday, Aug. 20. The program will include projects in leather tooling, hand wood work, metal work, clay modeling and casting, model making, copper enameling, tooling and basic printing," *SYVN*, June 20, 1958, p. 1; "Buellton Briefs," *LR*, June 26, 1958, p. 7; "Crafts Class Starts…," *SYVN*, July 4, 1958, p. 8; "Summer Recreation Program Closes… Under the direction of

Fillmore Condit, the weekly craft classes were especially enjoyed… Plans are now being made for the fall Recreation program…," *SYVN*, Aug. 29, 1958, p. 8.
1960 – "Summer Recreation Program Offers Variety of Activities… [mostly sports] Expanded classes in music are offered every Monday starting at 10 a.m. and continuing through the evening in the music room of the Valley high school…," but NO mention of arts or crafts, *SYVN*, Aug. 5, 1960, p. 1, 8.
See: "Atterdag College (Solvang)," "Atterdag Folk School," "Santa Ynez Valley, Ca., Recreation Program," "Santa Ynez Valley Union High School," 1959

Sutherland, Frances May / Francis (Santa Maria)
Santa Maria High School student who produced notable art. Horsewoman.
See: "Posters, general (Santa Maria)," 1939, "Posters, Latham Foundation (Santa Maria)," 1939, "Santa Maria, Ca., Union High School," 1939, 1941

Sutphen (Word), Helen S. (Mrs. William F. Word)
(1901-1982) (Santa Maria)
Artist, costume designer, who took the place of Ruth Blanchard teaching home economics at Santa Maria High School, 1934/35 and, under the name Helen Word, in 1935/36. She designed and sewed costumes for several of the high school plays.
■ "New Instructor to Teach at H. S. Miss Helen Sutphen of Los Angeles… Miss Sutphen is now receiving her master's degree at University of Southern California. A graduate of Mills College, she has also taken special courses at Chouinard School of Art and Wolfe School of Costume in Los Angeles. She has heretofore taught at Burbank, San Mateo and Los Angeles Fremont high schools and has conducted a shop of her own in Hollywood for three years," *SMT*, June 9, 1934, p. 2.
Sutphen, Helen (notices in Northern Santa Barbara County newspapers on microfilm and on newspapers.com)
1935 – "Engagements and Weddings… Miss Helen S. Sutphen… and W. F. Word, Jr., Santa Barbara, have filed with the county clerk in Santa Barbara notice of their intention to wed… Her fiancé is associated with the International Harvester Co…," *SMT*, June 19, 1935, p. 3.
Sutphen, Helen (misc. bibliography)
Helen Sutphen is listed in the 1920 U. S. Census as residing in Los Angeles with her mother and sister and aunt; Helen S. Sutphen is listed in the 1930 U. S. Census as age 29, b. c. 1901 in Montana, proprietor of a ladies' apparel shop, residing in Los Angeles with her aunt, Cora Sanders (age 57) and her mother Ella H. Sutphen (age 55) and others; Helen S. Sutphen married William F. Word on July 30, 1935 in Los Angeles County per Calif. County Birth, Marriage and Death Records; Helen Word, mother's maiden name Sanders and father's Sutphen, b. Dec. 18, 1901 in Montana and d. Nov. 20, 1982 in Orange County per Calif. Death Index (refs. ancestry.com).
See: "Santa Maria, Ca., Union High School," 1934

Sutter, Margaret Louise Ball (Mrs. Charles W. Sutter)
(1901-1962) (Solvang)
Painter who exh. at the Solvang Library, 1960, 1961.
■ "Mrs. C. W. Sutter… a resident of Solvang the past five years… The former Miss Margaret Louise Ball, she was born in Salem, O., Sept. 30, 1901. Mrs. Sutter and her husband, an engineer, were married May 10, 1921 in Salem. They came to California from Ohio in 1935 and moved to Solvang from Long Beach…," *SYVN*, March 9, 1962, p. 8.
Sutter, Margaret (notices in Northern Santa Barbara County newspapers on microfilm and on newspapers.com)
1960 – "Art Display. Paintings by Mrs. Margaret Sutter make up the art display hung last weekend in the Solvang Branch Library. This exhibit will be on view for about six weeks," *SYVN*, Jan. 15, 1960, p. 7.
1961 – "Margaret Sutter Art on Display… oil paintings at the Solvang Library until the end of May. Among them is a large abstract painting of a flight of seagulls against a dark background and one of a stylized colorful cluster of hillside houses seen through the foreground branches of a tree," *SYVN*, April 21, 1961, p. 10.
Sutter, Margaret (misc. bibliography)
Margaret Louise Sutter b. Sept. 30, 1901, d. March 4, 1962 and is buried in Oak Hill Cemetery, Ballard, Ca., per findagrave.com (refs. ancestry.com).
See: "Santa Barbara County Library (Solvang)," 1960

Sutter (Ryan), Margaret Russe (Mrs. John A. Ryan)
(1907-1985) (Santa Maria)
Student and asst. to art teacher, Santa Maria Union High School/JC, early 1930s.
■ "Miss Sutter Married… John A. Ryan of Orcutt… both the newlyweds were graduates of the local high school. Since her graduation, Miss Sutter has been acting as assistant to **Stanley Breneiser**, head instructor in the art department of the local high school…," *SMT*, April 4, 1934, p. 3.
Sutter, Margaret (misc. bibliography)
Margaret Sutter, teacher and Dem. is listed at 512 E. Main St., Santa Maria, the same address as Mrs. Beryl, J. George and John H. Sutter, in *Calif. Voter Registrations*, *Santa Maria Precinct No. 15*, 1930-32; Margaret Russe Sutter was b. Sept. 2, 1907 in West Virginia, to John George Sutter and Louise Beryl Sellers, married John A. Ryan, was residing in Santa Maria in 1940, and d. Feb. 10, 1985 in Santa Barbara County per Eckman-Warren Family Tree (refs. ancestry.com).
See: "Art, general (Santa Maria)," 1929, "Kelsey, Eleanor," 1934, "Santa Maria, Ca., Union High School," 1928, 1930, "Santa Maria School of Art," 1933, "Splash," 1928

Sutton, Arthur R. (Santa Maria)
Twelve-year old who exhibited paintings at Tri-county art show, Santa Barbara, 1949.
■ "Arthur Sutton, 12-year-old son of Mr. and Mrs. Ralph A. Sutton, 201 East Park, is among exhibitors at the Tri-counties art show in Santa Barbara. One of the oil paintings he entered, a still life entitled 'Rose in the Window,' has

received favorable comment. The youthful artist, who is also a *Times* carrier, will return home today or tomorrow from Cambria Pines, where he has been at 'Y' camp this week. While there, his artistic talent found other outlets in making a butterfly pin, a pair of earrings fashioned of tiny shells, two scatter pins and a copper cigarette box. His parents visited the camp yesterday and were shown the one-man craft display, result of a week's work… His fondness for drawing, developed without assistance while he was ill with rheumatic fever two years ago, influenced his parents to arrange lessons. He has been a pupil only since February at **deNejer** Studios with **Forrest Hibbits** as his instructor," per "Has Painting in Tri-County Show," *SMT*, June 20, 1949, p. 6.

Sutton, Arthur (notices in Northern Santa Barbara County newspapers on microfilm and on newspapers.com)
Nearly 100 notices on "Arthur Sutton" in local newspapers reveal he was the son of Mr. and Mrs. Ralph Sutton, active in Boy Scouts and DeMolay, played the saxophone, was a paperboy, and by 1957 was studying for the ministry at Westminster Presbyterian College at Salt Lake City, but they were not itemized here.
See: "Tri-County Art Exhibit," 1949

Svensrud (Acquistapace), Marian (Mrs. Leo Elmo Acquistapace) (Santa Maria)
Examiner in Leathercraft for Boy Scouts, 1933. Teacher of elementary school, 1934, and of "continuation" class in home economics in Santa Maria High School that taught handcraft, artcraft, interior decorating, 1936.
See: "Boy Scouts," 1933, "Santa Maria, Ca., Elementary / Grammar School/s," 1934, "Santa Maria, Ca., Union High School," 1934, 1936

Swackhamer, Walter Byrd, Dr. (1879-1971) and Edith (Santa Ynez Valley)
Painter. Exh. Santa Ynez Valley Art Exhibit, 1957, 1958.
■ "Dr. Walter B. Swackhamer Memorial Services … retired physician who served many years in the one-time Veterans' Bureau Service and later Veterans Administration medical facilities… Dr. Swackhamer and the former Miss Edith Odell were married July 5, 1904. Mrs. Swackhamer died last year… Following Dr. Swackhamer's retirement, he and his wife moved to the Santa Ynez Valley in 1940. They had resided on a small ranch on Refugio Road directly north of Baseline Avenue," *SYVN*, March 11, 1971, p. 3.
Swackhamer, Walter (misc. bibliography)
Dr. Walter V. Swackhamer is listed as retired and with wife Edith F. in Santa Ynez in the *Santa Maria, Ca., CD*, 1948; Walter B. Swackhamer was b. July 4, 1879 and d. March 15, 1971 per Social Security Death Index (refs. ancestry.com).
See: "Danish Days," 1957, "Santa Ynez Valley Art Exhibit," 1957, 1958, "Santa Ynez Valley, Ca., Adult/Night School," 1953

Swaney, James E. (Santa Maria)
Flower shop manager, interior decorator, photographer, 1954.
Swaney, James (notices in Northern Santa Barbara County newspapers on microfilm and on newspapers.com)
1954 – "Fuchsia Society Will See Slides … color slides of flower gardens … promised by **Harry Nelson** and James Swaney …," *SMT*, April 16, 1954, p. 4; "James Swaney, local flower shop manager and interior decorator, entertained at the [Fuchsia] society's recent meeting with many scenic photographs taken in and around Seoul, Korea. Religious shrines, palace gardens, industrial and … nome (?) buildings… colorful slides …," *SMT*, Oct. 2, 1954, p. 4.
1955 – 'Round Town. James E. Swaney, veteran who served in Korea, is a patient in Sawtelle hospital. He had made his home here with his mother, Mrs. H. P. Gudgel, and had been employed at Stanley's," *SMT*, Aug. 11, 1955, p. 7.
1965 – MOTHER – "Blanche Gudgel… She had lived here for the past 13 years… at 1690 N. McClelland St., coming from Indianapolis, Ind., Survivors include… James E. Swaney, Jr. of Salinas…," *SMT*, Sept. 15, 1965, p. 8.

Swanson, David Cornelius (aka David Kornelyus Svennsson or David K. Svenson) (1898-1994) (Santa Barbara / Lompoc)
Sculptor. Created "Indians and Father Lasuen" a wood carving, 3.5 x 9 feet, in 1936 installed in the second floor club room above the fireplace in the Veterans' Memorial Building, Lompoc, WPA-FAP.
■ "Wood Sculpture by David Swanson to be Exhibited… Claremont … until November 1 at the David H. Howell studio, 116 Harvard avenue. Swanson, who has a studio in Pasadena, is a member of the Pasadena Society of Artists and his wife, the former Nadine Speer, was graduated from Pomona college with the class of 1932. Born and educated in Stockholm, Sweden, Swanson came to the United States as a young man and spent much time during his first years here roaming New Mexico on horseback. His first sculpture was done while he was living in Santa Barbara and was exhibited in the **Faulkner** Art gallery there. His work also has been exhibited at the Vose galleries in Boston and in the Gallerie Moderne in Stockholm during one of his trips to his homeland. He spent one year as a Fellow at the Research Studio in Maitland, Fla., where he worked in green concrete as a medium for direct carving. It was after World War II that he began to do wood engravings and woodcuts and some of these have been hung in the Joseph Pennell show in Washington, D. C., at the Brooklyn Museum, the Northwest museum in Seattle, the Pasadena Art Institute and in the yearly invitational exhibition at the Los Angeles Ebell club where 'Penitente Land' was given honorable mention this year," *Pomona Progress Bulletin*, Oct. 16, 1950, p. 9.
■ Swanson exhibited at the Laguna Beach Art Association, 1953-57 per Nancy Moure, "Index to California Art Exhibited at the Laguna Beach Art Association, 1918-1972," *Publications in California Art*, vol. 11 (2015).

Swanson, David (notices in Northern Santa Barbara County newspapers on microfilm and on newspapers.com)

1935 – "Annual Sculpture Display at Palos Verdes… in the Library Art Gallery at Palos Verdes Estates. This is the fourth annual exhibit of sculpture presented by the Community Arts Association… David Swanson in his Chinese head, 'Inscrutable,' 'Maya Priest,' and 'Rain Maker,' gets simple shapes, but no depth behind them…," *LA Times*, March 24, 1935, p. 39 (pt. II, p. 9).

1936 – "Plans Wood Carving – A mahogany wood carving featuring the celite industry, size five feet by three feet, is under construction by David Swanson, Santa Barbara artist, to be placed in the foyer of the high school auditorium in Lompoc. Swanson is also doing a wood carving for the new Veterans' Memorial building," *LR*, Nov. 13, 1936, p. 3.

1949 – "Hand-wrought silver by Harry Osaki, color woodblocks by Anders Aldrin, wood sculpture by David Swanson, Pasadena Public Library, through October 15," *Pasadena Independent*, Oct. 2, 1949, p. 27, col. 1.

1951 – "Showing in Pasadena Conservative, Not Dull… Pasadena Society of Artists … annual exhibition (the 28th) … at the Pasadena Art Institute through Jan. 20… and David Swanson with a sculptured 'St. Francis.' Are among others who acquit themselves well… [and] National Exhibition. The Print Makers Society of California has a national exhibition in Pasadena Public Library's lecture hall to Thursday. … the block print, 'Steam Whalers' by David Swanson … stood out for me …," *LA Times*, Dec. 23, 1951, p. 63 (pt. III, p. 12).

1952 – Port. with giraffe carving announcing planning of the 8th annual Art Fair, *Pasadena Independent*, Aug. 31, 1952, p. 36.

1954 – "In the Galleries… One of the best annual exhibits the Pasadena Society of Artists have ever staged, their 30th, is at the Pasadena Art Institute through June 5. We were immediately struck by the excellence of … and the fine 'Torso' carved in walnut by David Swanson…," *LA Times*, May 23, 1954, p. 107 (i.e., pt. IV, p. 7).

1955 – "Sierra Madre Art Show Due Friday… 21 prominent California artists… Wood Carvings … A feature of the show will be a display of a number of the woodcarvings by sculptor, David Swanson…," *LA Times*, Oct. 30, 1955, p. 175 (i.e., pt. VII, p. 15).

1956 – Port. with artworks and "Pasadenan to Exhibit Masks … [with the] Pasadena Society of Artists … in the Greek Theater at Los Angeles' Griffith Park…," *LA Times*, Nov. 4, 1956, p. 191 (i.e., pt. VIII, p. 5).

And, additional more minor notices in LA and Pasadena newspapers not itemized here.

Swanson, David (misc. bibliography)

David K. Svenson data, including his arrival in NY, appears in *Sweden, Emigration Registers*; David Cornelious [Sic.] Swanson provided the following information on his WWI Draft Registration Card = residence Ida, Iowa, relative Gustaf Swanson (refs. ancestry.com).

See: "Santa Ynez Valley Union High School," 1936, "Works Progress Administration," 1936, 1937

Swanson, Walter A. (1884-1962) (Solvang)
Artist resident of the Solvang Lutheran Home, 1960.

■ Port. with paintings and "Trio of Residents Enjoy Painting … A trio of Solvang Lutheran Home residents, two men and a woman … are providing daily pleasure for themselves as well as for fellow home inhabitants by the creation of oil and water paintings covering a variety of subjects. The elderly artists are **Miss Astrid Blystad**, 74, a retired masseuse, who received art training in her native Norway as a girl and later when she lived in Los Angeles, Walter A. Swanson, 76, and **Peter Jacobsen, Sr.**, 86, both of whom taught themselves to wield an artist's brush. … Swanson, who is 76, and his wife, Anna, moved to the home last April after residing in Solvang for a year and a half. They came to Solvang from Pasadena. Swanson said, 'I took up painting as a hobby at the age of 60 and have never had instruction from anyone. Prior to 1910 he was engaged in surveying in Iowa, Kansas, Oklahoma and Idaho, and later served for 26 years as business manager of an Iowa institution. He limits his painting to working in oils, and like Miss Blystad, sets up his easel on a non-routine basis and generally paints only when 'I'm in the mood or when an idea strikes me.' Swanson is a native of Orion, Ill. … B. P. Christensen, home manager, said plans are now under way to show the work of the three artists at an outdoor exhibit which will be staged at the home during Solvang's golden jubilee celebration next August," *SYVN*, Dec. 9, 1960, p. 6.

Swanson, Walter (misc. bibliography)

Walter A. Swanson, mother's maiden name Anderson, was b. Oct. 29, 1884 in Ill., and d. Nov. 20, 1962 in Santa Barbara County per Calif. Death Index (refs. ancestry.com).

Swartz (Christensen), Jean (Mrs. Fred Christensen) (Lompoc)
Studied art at San Jose State College, c. 1944.

■ "Jean Swartz and Fred Christensen Wed in Nevada… On Nov. 2 he and Miss Jean Swartz, daughter of Dr. and Mrs. Ray Swartz, drove to Reno, Nevada, and were married in a civil ceremony… They returned to Lompoc on Nov. 3 … The young couple will make their home in Lompoc where the groom will be associated with his father in the operation of the Christensen's Paint Store. Mrs. Christensen, who is a graduate of the Lompoc Union High School, has been attending San Jose State College where she was studying art. She was in her second year…," *LR*, Nov. 9, 1945, p. 2.

Swartz, Jean (notices in Northern Santa Barbara County newspapers on microfilm and on newspapers.com)

1941 – "Major Hudson… Mrs. Hudson, accompanied by her daughter, Jean Swartz, made the trip east by boat. Jean is a student at the Thomas Jefferson Junior high school in Arlington," *LR*, Feb. 28, 1941, p. 5.

1945 – HUSBAND discharged from Navy and the couple plans to settle in Lompoc, *SYVN*, Nov. 16, 1945, p. 1, col. 1.

Sweetland, C. M. (?) (California)
Photographer, itinerant, 1894. Woods & Sweetland.

■
Sweetland, (notices in Northern Santa Barbara County
newspapers on microfilm and on newspapers.com)
1894 – "Sweetland & Woods photographers were doing the
town and valley the past week," *SMT*, May 5, 1894, p. 3,
col. 4; "We acknowledge receipt of a fine photograph of
our public school building taken by the traveling
photographers **Woods & Sweetland**," *SMT*, May 12, 1894,
p. 3, col. 3; "A photographer from San Jose is taking views
of the dwellings in our village. He does good work and was
well patronized here. He expects to locate at Nipomo next,"
SMT, June 9, 1894, p. 3, col. 8; "Photographer Sweetland
had rather a narrow escape on his return home the other day
from Santa Barbara. He and his horse tumbled over an
embankment when near the summit of the mountain. When
they got through tumbling Mr. S. says that he picked
himself up and then helped his horse out of the scrape. Both
returned home on Tuesday last feeling a little or somewhat
sore," *SMT*, July 7, 1894, p. 3.
1895 – Is he – "Filed His Transcript. H. W. Woods has
filed in the superior Court his transcript on appeal from the
judgment of Justice Henry in the case of C. M. Sweetland
vs. H. W. Woods and H. Mallet. Sweetland sued for the
recovery of a valise and contents, alleged to be left by him
last February as security for a bill of $2, or else for $40. He
got judgment for $30 and costs and Woods now appeals the
case," *Record-Union* (Sacramento), Sept. 13, 1895, p. 4.
This individual could not be identified.
See: "Woods, H. W. (?)"

**Swinnerton, James (San Francisco / New York /
Riverside / San Simeon)**
*Cartoonist for Hearst papers. Painter of Southwest desert
landscapes. One of his paintings was lent by a Los
Angeles gallery to the Santa Maria Valley Art Festival,
1952.*
See: "Santa Maria [Valley] Art Festival" 1952, and
Cambria Art and Photography before 1960

Swonger, Claude Kenneth "Ken" (1920-2011) (SLO)
*Photographer, amateur, whose mother, Hattie Swonger,
lived in Santa Maria. Attendee at a Santa Maria Camera
Club meeting, 1940.*
See: "Santa Maria Camera Club," 1940

Sykes, John (1859-1934) (Santa Barbara)
Landscape painter, c. 1890-1934.

■ "Old-Time Artist of S. B. Found Dead. Death has
closed the career of one of Santa Barbara's best-known
characters, John Sykes, who in the heyday of his half
century of residence there was widely known as an artist.
Discovery of his lifeless body in the modest candle-lit
quarters in the rear of 116 East Gutierrez street, which had
been his home for years, was made by police Saturday
night. It was evident that he had died of natural causes and
police expressed opinion he had been dead about three
days. Many Santa Barbarans have works of Sykes in their
homes, and he painted a number of murals in that city,"
SMT, Dec. 10, 1934, p. 4.

■ "Colorful Character Succumbs. Santa Barbara's …
eccentric Englishman who became in fifty years' residence
here one of Santa Barbara's best-known characters… Sykes
was known as Santa Barbara's first 'remittance man,'
having come here when 25 years of age after trouble with
his father. When remittances ceased, he depended on the
modest return from the sale of his oil paintings and from
singing engagements. He painted some of the murals that
decorate the Lobero Theater and did similar work at the
Old Mission. Many of his oils are hung in homes of
wealthy Montecito residents. As a singer, he was much in
demand in his younger days. He was a familiar figure on
State street, always dressed in grey and carrying a cane. He
refused to substitute electricity for candles in his modest
home and subsisted on vegetables, being a strict vegetarian.
He had no known relatives in this country. Friends will
arrange his burial," *LA Times*, Dec. 10, 1934, p. 4.
Sykes, John (notices in Northern Santa Barbara County
newspapers on microfilm and on newspapers.com)
1891 – "John Sykes, the artist, was up before Judge Swank
on Monday morning on a charge of kissing little girls. He
was found guilty and given thirty days in the county jail,"
Santa Cruz Sentinel, July 3, 1891, p. 2, col. 2.
1893 – "Santa Barbara Brevities… Marriage Licenses have
been issued to John Sykes and Flora Harsh… by Cupid
Hunt in the County Clerk's office," *LA Times*, May 31,
1893, p. 7; "Santa Barbara County … Marry in Haste,
Repent, Etc. In Friday morning's *Press* there appeared a
card signed by John Sykes, in which he announces that he
will no longer be responsible for his wife's debts…," *LA
Times*, June 3, 1893, p. 7.
1894 – "Sykes Vs. Sykes – Divorce… John Sykes is a well-
known resident of Santa Barbara. He is a scenic artist of
more than ordinary ability, and the product of his brush can
be seen on the Opera House stage and on numerous
buildings around town. He is also a musician and has on
one or more occasions appeared before Santa Barbara
audiences who were delighted with his singing. He was on
the high road to wealth and happiness when one year ago
he married. Miss Flora Harsh was the lady … One day of
the honey-moon passed, but not another. They decided to
separate almost before the ink on the marriage agreement
was dried. Since then, they have lived distant and apart; and
now he wants the bonds of matrimony severed for once and
all," *Independent*, June 7, 1894, p. 4; "A divorce was
granted today to John Sykes from his wife of three days, on
account of desertion. The woman said she did not love Mr.
Sykes, hence she deserted him," *Independent*, June 13,
1894, p. 4, col. 2; "The Pyke Company…. Opera House…
'H. M. S. Pinafore'… The special scenery for the opera,
painted on short notice by Mr. John Sykes the scenic artist
at the Opera House, was very well executed and reflects
credit on the artist," *Independent*, Aug. 16, 1894, p. 4.
1895 – "Professor John Sykes, the artist, arrived from
Watsonville Wednesday to paint several pictures of the
Carmel mission. He was here about four years ago doing
the same kind of work," *Monterey Cypress*, March 30,
1895, p. 3; "Mr. John Sykes, the artist, arrived yesterday
from San Francisco, having walked the entire distance to
enjoy the scenery and also for the exercise. He painted

pictures in every town on the way and had a good time generally," *Independent*, April 16, 1895, p. 4.

1898 – "Local Brevities… John Sykes, the artist, arrived in Monterey last Monday after several years' absence," *Monterey Cypress*, Feb. 19, 1898, p. 2; "Santa Barbara Items… John Sykes the painter has returned to Santa Barbara after a few months' absence," *LA Herald*, July 3, 1898, p. 6.

1906 – "Sykes Failed to Show Up. W. H. Thomas, an employee at the Peerless saloon, was arrested late yesterday afternoon upon complaint of John Sykes who divides his time between doing certain lines of art work and doing the best he can at selling Navajo blankets. He appeared before Justice of the Peace Overman in answer to a charge of assault and battery … [but Sykes never showed up in court. The purported assault was a result of] report made to Thomas by his wife to the effect that Sykes, while negotiating for the sale of a set of blankets, made improper proposals to her…," *Independent*, Sept. 28, 1906, p. 5.

1907 – "In Brief…. John Sykes, artist, will appear in opera at the old opera house tonight in songs from 'La Cigale' and other operas," *Independent* (Santa Barbara, Ca.), Nov. 27, 1907, p. 5.

1910 – "John Sykes Released… a house painter and amateur musician, was convicted of disturbing the peace by a jury in police court this morning… sentenced… to 30 days in the county jail and then suspended sentence pending good behavior," *Independent*, April 7, 1910, p. 5; "John Sykes to Sing. Local Operatic Tenor to be Heard at Riggslee Friday night…," *Independent*, Sept. 15, 1910, p. 8.

1913 – Ad: "La Petite Theatre. … Tonight – Amateur Night, featuring John Sykes in Grand Opera Selections of 'Pagliacci.'…," *Santa Barbara Daily News and the Independent*, Nov. 17, 1913, p. 2.

And, numerous additional notices on his singing (sometimes in amateur contests for cash prizes) were not itemized here.

<u>See</u>: *Morro Bay Art and Photography before 1960*

Szeptycki, Jerzy George (1915-2004) (Santa Barbara)
Ceramist, worker in wrought iron, who visited the Santa Ynez Valley, 1950.

■ "Artist, Wife Visit Sorensens. Guests of Mr. and Mrs. Arne Sorensen Saturday afternoon were Mr. and Mrs. George Szeptycki of Santa Barbara. Mr. Szeptycki is an artist and architect while Mrs. Szeptycki is a pianist. Mr. Szeptycki, who works in ceramics and recently exhibited wrought iron work at the Santa Barbara Museum of Art, has been translator the past year of Polish letters for Valley people who have been sending food and clothing to Poland through God-Parents, Plan, Commission for Children's Relief. It was the Szeptyckis first visit to the Valley," *SYVN*, Oct. 13, 1950, p. 5

Szeptycki, George (notices in Northern Santa Barbara County newspapers on microfilm and on newspapers.com)

1959 – "Former War Prisoners Adopt Polish Orphan… by Warsaw-born parents who met in a wartime German slave labor camp… at Kassel Mattenberg, Germany, after their arrest as members of the Polish uprising of 1942. Under auspices of UNRRA, Szeptycki became chief architect of the camp and Inka became his secretary. He designed and built the camp church in which they were married in 1945. They came here in 1948. Szeptycki got a master of arts degree in architecture at SC in 1952 and began his career of church and school design. The Szeptyckis live at 4428 ½ Price St., but are building a home in the Hollywood Hills," *LA Times*, Sept. 17, 1959, p. 22.

And, many additional notices on his architecture after 1960.

Szeptycki, George (misc. bibliography)

Jerzy George Szeptycki was b. Oct. 6, 1915 in Poland to Witalis Shyptycki and Jadwiga Skup, married Inka Sabina Szeptycka [Sic?], was residing in Los Angeles in 1993, and d. 2004 per Johnson/Shyptycki/Znack/Niziankiewicz Family Tree (refs. ancestry.com).

T

Taft (Gleason), Ellen Cargill Hanchette (Mrs. Oren Byron Taft III) (Mrs. Robert P. Gleason) (Solvang)
See: "Gleason, Ellen"

Takken, Harry Bruce (1883-1969) (Santa Maria)
Filmmaker, amateur. Projected one of his films for Santa Maria Camera Club, 1939. Cobbler.

Takken, Harry B. (notices in Northern Santa Barbara County newspapers on microfilm and on newspapers.com)

1936 – "Foreign Travels Told by Takken. Mr. and Mrs. Claire Dailey entertained in their home on West Park street to welcome home Mr. and Mrs. H. B. Takken on their return from a five months' tour of the Orient and Europe. The evening was spent in viewing pictures taken on the trip and hearing Mr. Takken's resume of interesting places they had seen," *SMT*, Dec. 23, 1936, p. 2.

1939 – "Harry Takkens Show Moving Pictures to Forensic. Picturesque scenes in the South Seas and the pyramids near Mexico City… were shown in moving pictures to the Forensic club, meeting last night in the home of Mr. and Mrs. O. F. Glenn, by Mr. and Mrs. Harry Takken who spent three months touring the world. Before the pictures were shown, Mrs. Takken gave a resume of the trip as a foundation for the film. The two began their pictures in New Orleans and continued while in Alabama, where they boarded the boat for Tahiti. Upon returning to the United States, they visited Sun Valley, Yellowstone Park, Bryce and Zion canyons and the Carlsbad caverns…," *SMT*, July 18, 1939, p. 3; "Cruise Pictured for [Lions] Clubmen by Harry Takken. Colored motion pictures of a summer cruise…," *SMT*, Aug. 5, 1939, p. 2; "Kiwanians See Films of Tour by Takken… winter vacation route of Mr. and Mrs. Harry Takken through Central and South America… three-month vacation tour…," *SMT*, Aug. 17, 1939, p. 4.

1940 – "Films Scheduled for Club Friday… Caribbean cruise movies will be shown for Minerva Library club Friday afternoon in the clubhouse… The Takkens also visited Mexico … Mr. Takken went to San Luis Obispo last night to show the picture for a service club…," *SMT*, Feb. 27, 1940, p. 3.

1944 – "Takken Shows Pictures to Lions … through Mexico, South America and the United States …," *SMT,* April 28, 1944, p. 3.

And, nearly 400 notices for "Takken," 1935-1965, some relating to films of his travels, were not itemized here.

Takken, Harry B. (misc. bibliography)
[Do not confuse with his son Harry Woods Takken of SLO.]
Harry Bruce Takken (1883-1969) is buried with wife Selma Virginia Brown Takken in the Santa Maria Cemetery District, per findagrave.com (refs. ancestry.com).
See: "Boy Scouts," 1941, "Santa Maria Camera Club," 1939

Tallant, George Payne (Los Olivos)
Photographer who exh. at Santa Ynez Valley Art Exhibit, 1954. He and his wife, Ida Belle, below, were active in Valley cultural events, particularly music.

■ "G. P. Tallant dies at 61…. Moved to Los Olivos after retiring from the shipping business in San Francisco 10 years ago…," *SYVN,* July 22, 1960, p. 7.
See: "Santa Ynez Valley Art Exhibit," 1954, "Tallant, Ida Belle"

Tallant (Mailliard), Ida Belle Wheaton (Mrs. George Payne Tallant) (Mrs. Thomas Page Mailliard) (Santa Ynez Valley)
Exh. an artwork at Santa Ynez Valley Art Exhibit, 1957. Wife of George Tallant, above.
See: "Danish Days," 1957, "Santa Ynez Valley Art Exhibit," 1953, 1957, 1958, "Tallant, George"

Tank House Studio (Ballard)
See: "Chrimes, Louise"

Tarnow, Viggo (1892-1977) (Solvang)
Teacher of physical education, gymnastics, folk dancing, crafts. Prop. Atterdag College.
See: "Atterdag Folk School," "Rasmussen, Thorvald," 1947

Tashiro, Yukio (1918-1982) (Santa Maria)
Santa Maria high school art student, 1937+ and grad. 1939. Winner in Latham poster contest, 1938, 1939. Became an artist in New Mexico and with the U. S. Army.
Tashiro, Yukio (notices in Northern Santa Barbara County newspapers on microfilm and on newspapers.com)
1937 – "Art Student Wins National Prize," and article explains, "Yukio Tashiro, art student of **Stanley G. Breneiser**, in the high school, yesterday received word that he had won a cash award in the National **Scholastic Art contest** sponsored by the Scholastic High School magazine of Pittsburgh, Pa. The Santa Maria boy's entry was a wood carving of a lion. … The local students' entries were among 746 accepted for exhibition out of 12,000 entries from schools throughout the country. This marks the fourth consecutive year in which Santa Maria has placed in the national contest. Among the annual prizes are 20

scholarships and $10,000 in prizes," *SMT,* April 30, 1937, p. 3; "Wins Art Contest – Yukio Tashiro, high school art student, was notified today that he had won $10 in a national contest in soap sculpture sponsored by a nationally-known soap company. His art work was of a Japanese dancer," *SMT,* Sept. 14, 1937, p. 3.
1938 – "Local Lad Wins Prize for Poster. Yukio Tashiro" – second prize in National **Latham Foundation** for the Promotion of Humane Education, and article adds, "A nest of baby birds with the plea, 'Don't Orphan Us,' was the subject of Yukio's poster. … Tashiro has received many prizes for his high school art work. He won an honorable mention and $10 in a national soap sculpture contest last year and in a plastic wood sculpture contest conducted by *Scholastic Magazine,* he received third prize. Yukio also won an honorable mention rating in a former Latham Foundation contest," *SMT,* May 18, 1938, p. 3; "Yukio Tashiro Wins Sculptor Prize… art student in Santa Maria high school… second-place winner in the annual competition for small sculptures in White Soap sponsored by the Procter & Gamble Co. He will receive a cash prize of $75 for … 'Hare and Tortoise' carved last spring. It will be displayed with other entries in the national contest on Sept. 19 to Sept. 24 in New York City. Last year young Tashiro received fourth-place prize in the same divison. **Yoshisuke Oishi** received an honorable mention two years ago in a similar contest," *SMT,* Sept. 16, 1938, p. 3.
1939 – "Wins Art Certificate" for honorable mention from American Youth Art Forum, "Young Tashiro, who graduated with honors from the local high school in June, has received numerous awards for his outstanding soap carvings and has been a winner of the American Legion poster contests," *SMT,* July 17, 1939, p. 3; "Local Boy Scores as Sculptor. Yukio Tashiro… has been awarded $10 as honorable mention in the senior class in the fifteenth annual competition for small sculptures in white soap by a national soap manufacturer. Tashiro's prize winning entry, entitled 'End of Toil,' is part of an exhibition in the Franklin Institute, Philadelphia, from Oct. 20 through Nov. 30," *SMT,* Oct. 18, 1939, p. 2.
1941 – "Yukio Tashiro Wins More Honors. In the October *Art Digest*… an account of the Santa Fe (New Mexico) Fiesta exhibition… mentions especially two water colors by Yukio Tashiro… He is to be honored this month with a one-man exhibition of paintings and sculpture in the Museum and Art Gallery in Santa Fe, Oct. 15 to 30. Out of the 249 entries in the Fiesta, 50 of the best were chosen by the judges for a traveling exhibit, one of which is a portrait, 'Maria' by Tashiro. At present, Tashiro is living on the **Breneiser** ranch in New Mexico, looking after the ranch and keeping up with his painting and sculpture," *SMT,* Oct. 10, 1941, p. 3.
1947 – "Gerry Kunkel… The Hill and Canyon School of the Arts is having its first exhibition… presents work of … Yukio Tashiro…," *The Herald* (Jasper, Ind.), April 28, 1947, p. 3.
1948 – "Art in the News… new exhibitions at the Art gallery of the Museum of New Mexico… Yukio Tashiro's work in water color painted on silk, in oil painting and in wood sculpture shows his usual sense of delicacy, restrained strength, and often well realized plastic form. This artist possesses taste, and he knows when to pause

upon the brink of an overdramatic pictorial statement. Tashiro's future should be a fulfillment of his present promise. He has tried several techniques and in each his own personality has asserted itself, a good sign in a young artist who, like Tashiro, approaches art with the utmost sincerity," *Espanola Valley News* (Espanola, NM), Jan. 8, 1948, p. 2.

1949 – "Yukio Tashiro, sculptor and painter who taught in the Hill and Canyon school, is doing art work in the army at Fort Bliss, El Paso, in connection with recruiting. He has received two promotions since he went there a few months ago," *Santa New Mexican*, Feb. 27, 1949, p. 13; "Fine Arts Exhibit Opens in EP Tech… Sgt. Yukio Tashiro, El Paso: 'Franklin Range'," *El Paso Times*, Dec. 29, 1949, p. 10.

1950 – "Among Artists in Northern New Mexico … Yukio Tashiro, former student at the Hill and Canyon School of the Arts and adopted son of the **Stanley Breneisers**, is the head of the special services department at Fort Bliss. His work is largely art, including painting murals at the base," *Santa Fe New Mexican*, April 2, 1950, p. 13; repro: "1951 Women's Army Corps Fashions – Poster depicting the 1951 fashion creations for the Women's Army Corps… was painted by Sgt. Yukio Tashiro, staff artist with military personnel procurement, Headquarters Fourth army, Fort Sam Houston, Tex. Live models were used by Sgt. Tashiro and were selected from WAC personnel of Fort Sam Houston…," *Dunkirk Evening Observer* (Dunkirk, NY), Aug. 28, 1950, p. 8.

1953 – Port. receiving commendation ribbon – "Commendation Ribbon for meritorious service in Korea. Sgt. 1C Tashiro is a member of the 1st Radio and Broadcasting Group, which is a part of the U. S. Army's Far Eastern Psychological Welfare [Sic. Warfare?] Section…," *News-Pilot* (San Pedro, Ca.), Oct. 14, 1953, p. 20.

1956 – Port at easel and "SFC Yukio Tashiro, foster son of Mrs. Stanley Breneiser, Santa Fe, Visual Section, FE Psychological Warfare Detachment, 8239th AU, puts the finishing touches on his portrait of Gen. I. D. White, commanding general, Eighth U. S. Army. This is one among many portraits of high-ranking military officials that Tashiro has drawn. Tashiro, who was wounded during the Korean conflict, is now stationed with the Psychological Warfare Detachment in Japan (U.S. Army Photo)," *Santa Fe New Mexican*, Feb. 17, 1956, p. 9.

1958 – "Literary Guild…," illustrator for Magic and Magicians by Bill Severn, *Berkshire Eagle* (Pittsfield, Mass.), Sept. 16, 1958, p. 8.

1959 – Artist of decorations in the novel *The Crystal Horse* by Catherine Fowler Magee, per *Chicago Tribune*, Nov. 1, 1959, p. 222 (i.e., in a one-page ad for Longmans' books).

1960 – "Newsman to Speak… during the presentation of an oil painting to the parents of a deceased Reardan soldier… The painting is of Pfc. Joe E. Mann, who died heroically at Best, Holland, during World War II… The portrait… was completed by Sgt. 1/c Yukio Tashiro of the army pictorial center in Washington, D. C….," *Spokane Chronicle* (Spokane, Wash.), Feb. 24, 1960, p. 5; "People and Parties… Mrs. Bailey's new book, *The Hawaiian Box Mystery*, with decorations by Yukio Tashiro, is just off the press…," *Honolulu Star-Bulletin*, Feb. 23, 1960, p. 28 (i.e.,

26); illustrator for *Rope Roundup* by Bill Severn, *Chicago Tribune*, Nov. 6, 1960, p. 209 (i.e., Sect. 2, pt. 4, p. 55).

1965 – Illustrator for *Let's Find Out About the Moon* by Martha and Charles Shapp, *Boston Globe*, Nov. 7, 1965, p. 130 (i.e., Books, 38-A).

1966 – "Children. *The Alchemists*… by Richard Cummings, illustrated by Yukio Tashiro…," *Argus-Leader* (Sioux Falls, SD), Oct. 9, 1966, p. 39 (Sect. C, p. 15).

<u>Tashiro, Yukio (misc. bibliography)</u>

Yukio Tashiro provided the following information in the New Mexico World War II Records, b. April 4, 1918 in Los Angeles, enlisted Jan. 27, 1942 at Fort Bliss, Texas, served briefly in India, military occupational specialty was "Artist 296", expert carbine sharpshooter rifle M-1, participated in Central Burma campaign, discharged Nov. 17, 1945 at Fort Oso G. Meade, Maryland, rank Pfc but raised to Tec 4; Yukio Tashiro was b. April 4, 1918 in California, to Koichi Tashiro and Mumeno Nakagawa, married Masaye Kato, and d. New York per Hunt Family Tree; Yukio Tashiro b. April 4, 1918 and d. Nov. 9, 1982 is buried in Calverton National Cemetery, New York, per findagrave.com (refs. ancestry.com).

<u>See</u>: "Business and Professional Women," 1937, "Posters, American Legion (Poppy) (Santa Maria)," 1938, 1939, "Posters, general (Santa Maria)," 1939, "Posters, Latham Foundation (Santa Maria)," 1938, 1939, "Santa Maria, Ca., Union High School," 1937, "Scholastic Art Exhibit," 1937, 1939, "Splash," 1938

Taylor, Albert "Al" Jackson (1906/7-1989) (Santa Maria)
Photographer. Member and once president of Santa Maria Camera Club, c. 1940-1956.

■ "Albert J. Taylor… Mr. Taylor was born in San Luis Obispo and attended schools in Santa Maria. After graduation he started work at the **W. A. Haslam** Store. He later managed the family drug store, Gardner-Wheaton, from 1938 to 1960, when the store was sold. He then went to work at Rowan's and Kauffman's mens' clothing stores until 1980. In the early '30s he played in dance bands throughout the valley. He was an active member in the Kiwanis Club and the Elks Lodge No. 1538…," *SMT*, March 19, 1989, p. 19.

<u>Taylor, Al (notices in Northern Santa Barbara County newspapers on microfilm and on newspapers.com)</u>

1946 – Repro: photos of women's shoes, *SMT*, April 3, 1946, p. 6.

1948 – "Mrs. Kenneth Trefts… As chairman of public relations for the flower show…. She credited four local photographers… Albert Taylor… with a share of the publicizing the show with photographs of arrangements of flowers reproduced in *Sunset Magazine*…," *SMT*, April 3, 1948, p. 5.

1949 – "Dr. Clifford Case returned by plane… He was met at the airport by a group of close friends, showered with rice and presented with a bouquet of vegetables in a mock reception. Al Taylor made photographs…," *SMT*, June 10, 1949, p. 5.

1963 – "Leslie Sutherland… chosen as 'Miss Photography of 1953' … Judging… Albert Taylor, photography expert…," *SMT*, Jan. 17, 1963, p. 9.

And, more than 20 notices for "Albert Taylor" plus "Camera" were not itemized here.

Taylor, Al (misc. bibliography)
Albert Jackson Taylor, mother's maiden name Ruiz, was b. May 19, 1906 in Calif. and d. March 16, 1989 in Santa Barbara County per Calif. Death Index (refs. ancestry.com).
See: "Minerva Club Flower Show," 1948, "Santa Maria Camera Club," 1940-43, 1945-49, 1954-56, "Thurman, Luther," 1954

Taylor, Cameron Rob (1914-1972) (Isle of Guernsey / Santa Maria)
Architect, photographer, 1956+.
■ Ports. and "Traveling Channel Island Family Finds Home in Santa Maria… Cameron R. Taylor, his wife, Trixie, and their children, Robert, 17, Tony, 16, and Wendy, 14… [came from] what the Romans termed Sarnia, known now as the 'Channel Islands' of Guernsey and Jersey… The Taylors left Guernsey during World War II when the Nazis occupied the Channel Isles and they have been on the move ever since. Taylor, an architect by profession, was an architectural engineer in civil service for the Guernsey States… At the outbreak of World War II, Taylor was assigned to the Royal Engineers… In 1944, Taylor was employed by the British Government as a Technical Planning Adviser with plans for the rebuilding of London. In 1946, Taylor resigned this post to go to British Columbia, where he worked for the Canadian government in Town Planning… Taylor, also a professional photographer, did magazine and publicity work for several advertising firms as well as the Canadian Travel Bureau and National Film Board… Taylor said the family decided then to get rid of their 'web feet' and move to California. … Taylor took a post with the Beneficial Standard Life Insurance Company. He was just recently appointed Santa Maria Valley district manager. The two sons are now enrolled in Santa Maria high… [mother and daughter] have appeared on calendars and magazine covers – the result of his using them as models…. Son Bob's interest also lies with photography, while Tony is an amateur entomologist…," *SMT*, Feb. 26, 1956, p. 9.
Taylor, Cameron (misc. bibliography)
Cameron Rob Taylor, spouse's name Trixie, was b. April 1914 and d. April 28, 1972 in Lane County per Oregon Death Index (ref. ancestry.com)

Taylor, Elizabeth Soares (Mrs. Donald H. Taylor) (1905-1996) (Santa Maria)
Painter. Exh. several sites in the 1950s. Clubwoman.
■ "Mrs. Taylor Wins S.M. Inn Prize… Mrs. Don H. Taylor… with her portrait in oils of Mrs. **Lesli Hopkins** … was also winner of the **Santa Maria Inn** award for best oil painting in the amateur section of the show. The sweepstakes prize was offered by Orcutt Lions club to the single entry receiving highest number of votes in the show. Mrs. Taylor, who studied at the University of California and at the California School of Fine Arts and who is now attending classes by **Douglass Parshall** at **DeNejer studio**, also was winner of a third award, for second place in

amateur water colors with her 'Waller Park' painting," *SMT*, May 28, 1952, p. 4.
■ "Elizabeth S. Taylor… Mrs. Taylor was born July 22, 1905, near Santa Maria in the home of her parents… preceded in death by her husband, Donald H. Taylor, her parents Manuel and Anna Soares…," *SMT*, Feb. 14, 1996, p. 7.
Taylor, Donald, Mrs. (notices in Northern Santa Barbara County newspapers on microfilm and on newspapers.com)
1950 – "'Resthaven' Play… Santa Maria High School… cast of local women, members of the sponsoring Minerva club… Publicity… Mrs. [Don H. Taylor] drew the design for the program cover," *SMT*, March 7, 1950, p. 6.
1951 – "Cook Book… The new Minerva club cook book, '*Company's a Comin'*… The cover and design was drawn by Mrs. Don Taylor and it illustrates cooking and hospitality in the valley…," *SMT*, Nov. 30, 1951, p. 4.
1955 – "Fashions Modeled… Minerva club… On the stage, a mannequin, in the dress of an artist, appeared to be putting finishing touches on a painting by Mrs. Don Taylor. The easel was placed near a white sprayed tree on which hung a large, decorative Easter hat…," *SMT*, March 18, 1955, p. 4.
1958 – Port. of Mrs. Don Taylor, chairman of art entries for Minerva Club Art and Hobby Show, inspecting a painting of the Minerva clubhouse which was entered by Jacqueline Moffett," *SMT*, April 14, 1958, p. 3.
And, more than 130 additional notices for "Mrs. Don H. Taylor" "Mrs. Donald H. Taylor," "Elizabeth S. Taylor" and other variations primarily detailing her club work, sometimes working on a decorating committee, were not itemized here.
Taylor, Donald, Mrs. (misc. bibliography)
Elizabeth Taylor is listed in the 1940 U. S. Census as age 34, b. c. 1906 in Calif., finished college 2nd year, residing in Santa Maria with husband Donald Taylor (age 34) and two children (refs. ancestry.com).
See: "Allan Hancock [College] Art Gallery," 1955, "Judson Studios," 1959, "Minerva Club, Art and Hobby Show," 1957-59, "Santa Barbara County Fair," 1952, 1953, "Santa Barbara County Library (Santa Maria)," 1948, *"Santa Maria Art Association," 1952, "Santa Maria School of Art," 1933, "Santa Maria [Valley] Art Festival," 1952, "Santa Maria Valley Historical Society," 1955, "Tri-County Art Exhibit (Santa Barbara)," 1947

Taylor, James "Jim" R. (1936-2013) (Santa Maria)
Photographer. Allan Hancock College student who provided photographs for various college publications, 1955, and had many of his photos reproduced in the Santa Maria Times, 1954-56.
■ "James R. Taylor, son of Donald Holland and Elizabeth Soares Taylor, passed in Redding, Ca. on August 13. Jim was born on January 29, 1936 in Santa Maria. As a youth he attended local schools. He graduated from Santa Maria High School in 1953 and later attended Allan Hancock College… enthusiasm for model railroading, a lifelong pursuit of family genealogy and avid interest in historical subjects…," *SMT*, Oct. 23, 2013, p. A4.

Taylor, James (notices in Northern Santa Barbara County newspapers on microfilm and on newspapers.com)
1954 – Repro: Hancock College Homecoming Court, *SMT*, Nov. 13, 1954, p. 2.
1955 – Repro: "Bulldog's Thomas," *SMT*, Jan. 14, 1955, p. 2; repro: "Dick Rife," *SMT*, Jan. 21, 1955, p. 2; repro: "… best dancers …," *SMT*, March 26, 1955, p. 4; "Jim Taylor Captures News Photo Award at USC Newspaper Day… Taylor, photographer for the college paper, 'Bulldog's Bark' not only snapped the winning picture but also developed and printed it in the Hancock darkroom," *SMT*, March 28, 1955, p. 1; repro: basketball game of Hancock College, "… college photographer Jim Taylor to win first place honors in the news photo division at the annual USC newspaper day," *SMT*, March 28, 1955, p. 2; repro: candidates for Floralia queen, *SMT*, May 12, 1955, p. 1; port. as photo editor for Hancock college yearbook, *SMT*, May 25, 1955, p. 5; "College '*Mascot*' … first annual to be compiled on the new Allan Hancock college campus… Jim Taylor and … are responsible for group and activity pictures and **Bill Currens** supplied the cartoons spotted throughout the pages…," *SMT*, May 28, 1955, p. 7.
1956 – Repro: group of men in Navy garb, *SMT*, May 11, 1956, p. 1.
Taylor, Jim (misc. bibliography)
Jim Taylor is pictured several times in the Santa Maria High School yearbook, 1953 (ref. ancestry.com).
See: "Allan Hancock College," 1955

Teacher Training (Northern Santa Barbara County)
General articles on art training for teachers, often provided at the Santa Barbara County annual Teacher's Institute. In the mid-20th century art training was given elementary school teachers and lectures were given to parents and PTAs by Edna Davidson and later by Joseph Knowles, Consultant in Art Education for the Santa Barbara County schools. Teachers also often took summer school art classes at out-of-town universities. Art techniques were also taught in one-day or weekend seminars by itinerant representatives of commercial companies that sold art materials, such as Grumbacher, etc.
Teacher Training (notices in Northern Santa Barbara County newspapers on microfilm and on newspapers.com)
1886 – "Teacher's Association. Programme… Saturday, Sept. 11th… Map drawing Agnes Longworthy…," *SMT*, Sept. 4, 1886, p. 5; "Teachers' Association… list of teachers in attendance… Minutes… Map drawing by Miss Agnes Longworthy; after remarks on the gradual development of map drawing in connection with the earlier training in freehand drawing, the diagram of South America was dictated to three of the teachers and was drawn by them without the use of a ruler…," *SMT*, Sept. 18, 1886, p. 5.
1888 – "Teacher's Institute… county… Thursday Afternoon… 3 o'clock – How to Teach Drawing J. W. Young. Discussion on School exhibits….," *SMT*, Sept. 12, 1888, p. 3.
1890 – "The following named topics will be discussed at the next meeting of the Teacher's Association on May 17th, viz: … Drawing, **Idella Rudolph**, Clay Modeling, Nellie

Gray," *LR*, May 10, 1890, p. 3; "The Teachers' Association… teachers of Santa Maria and vicinity… Miss Richards spoke on the subject of 'Geography.' … She makes great use of map drawing and recommended modeling maps from sand or clay… Miss Virginia Fauntleroy next briefly called the attention of teachers to the kindergarten drawing paper which she has used very successfully in her work. She showed some of the paper and also some designs made on it suitable for oil cloth. She has found this attractive and profitable buswork [Sic. busywork] and has noticed that the regular drawing book work has been better since she has used this …," *SMT*, Nov. 15, 1890, p. 2.
1891 – "Minutes of Oct. 9th. Institute… Miss Morgan then gave her report of the exhibit of school work… First year's work, especially Drawing, Los Alamos; Penmanship, Den, … Drawing, Pine Grove, History Maps, Santa Maria, … Greatest variety, Drawing and Neatness, Purisima… Drawing, Lompoc, Largest display, fine drawings, Montecito, … very small exhibit Drawing from Misses Winchester and Varner's room …," *LR*, Oct. 10, 1891, p. 3.
1895 – "Teacher's Institute … General session … Prof. Barnes lecture on 'Johnny Looking in the Air' … showing … how uniformly the minds of children of a given age run in the drawing of pictures… Primary Section. Miss Ada Lakey … teaching of geography and history in the primary grades… drawing of imaginary pictures… E. J. Peet discussed the subject of Memory… advocated drawing as one of the aids… Thursday, Aug. 22nd… **F. J. Miller** gave an excellent talk on drawing. He would have the child go to nature to find objects to draw from… Primary Section. Miss Darrah recommended as a help in sand modeling, Frye's book, 'The Child and Nature'," *SMT*, Aug. 31, 1895, p. 1; "Teacher's Institute… The Last Day… Chalk Talks by **F. J. Miller** was an interesting and laughable series of comic sketches which was much enjoyed by the audience…," *SMT*, Aug. 31, 1895, p. 1.
1897 – "Teachers' Institute. Will Open in Santa Barbara on September 27th … Miss Ball, San Francisco's Noted Drawing Teacher, Will be Present," *SMT*, Aug. 21, 1897, p. 1; "Teachers' Institute. Complete Program for the Week… in the high school building, Santa Barbara, September 27th … Miss Ball will give four class exercises in Prang's System of Drawing in which all the teachers will take part. Each teacher must provide the necessary material, which can be had at the high school building for forty cents…," *SMT*, Sept. 25, 1897, p. 4; "The Institute… annual session… The afternoon session… Professor W. P. Schull discussed the topic, 'What Proportion of Time in Each Grade should be Devoted to Each of the Five Groups of Studies: Language, Mathematics, History, Natural Science and Manual Training and Art… **Professor J. S. Denton** of Lompoc talked on Industrial Art in Education and… paid a left-handed compliment to the art display in the stage end of Channel City Hall …," *SMT*, Oct. 2, 1897, p. 4; "Our Sloyd School. Ranks First on the Pacific Coast… The October number of *The Western Journal of Education* speaks in flattering terms … sloyd school founded by Anna S. C. Blake [in Santa Barbara] … The building, which includes a department of cooking, a department of sewing and a department of drawing and tool work…," *SMT*, Nov. 6, 1897, p. 1.

1898 – "Santa Barbara County Teachers' Institute will be held at Santa Barbara October 3d… The forenoons will be devoted to Section work… Miss Adams will give special instruction in drawing…," *SMT*, Sept. 17, 1898, p. 4.

1903 – "Closing Features of Teachers' Institute… The Closing Session … number of papers on various themes … by … Misses … **Sollman**…," *Independent* (Santa Barbara, Ca.), Oct. 8, 1903, p. 5.

1909 – "Teachers of County in Session… Prof. A. G. Balaam, principal of the grammar school … Teachers attending from here were … **Olivia McCabe** …," *LR*, Oct. 22, 1909, p. 1.

1937 – "Teachers are Shown New Art Work… demonstration on new art mediums last night by **Ruth Faison Shaw** in the Main street school auditorium. The artist is the originator of 'finger painting' for which she has developed a special product and paper. The new mode of expression is deemed suitable and of interest to students in elementary grades. It is among the studies offered by Miss Shaw in her school of art in New York. The artist was presented through the courtesy of the Zellerbach Paper Co…," *SMT*, April 6, 1937, p. 3.

1940 – "Teachers to Hold Discussions… for teachers of visual education and art in Santa Barbara county public schools… **Miss Edna Davidson**, art teacher for El Camino school, will be … of the art meeting, which is to be devoted to 'Art as Integrated with Units of Study.' This meeting is limited to teachers of the fourth, fifth and sixth grades," *SMT*, Oct. 9, 1940, p. 3; "Value of Hobbies Extolled… 'Hobbies for Teachers' was the theme of a Teachers' Institute here in Main street school last night … Miss Esther Poulsen, principal of Montecito union school was guest speaker explaining the value of hobbies for teachers and pointing out the diversity of hobbies which may be chosen. She also showed a number of examples from her own hobby collection, weaving, photography, flower arranging and others. Several local teachers followed with brief remarks on their hobbies. ... **Kenneth Moore**, Cook street school, gave highlights of three different hobbies: leather stamping, for which he makes his own tools, and his collection of Indian baskets and his latest hobby of photography. Chairman [**Ernest F.**] **Edwards** concluded with a short talk on cutting, branding and polishing of rock, illustrating the use of the black lamp in fluorescing …," *SMT*, Dec. 6, 1940, p. 3.

1953 – "Teachers workshop Ends at Betteravia… A two-day workshop in the use of construction tools for teachers … **Joseph Knowles**… conducted the workshop before 26 teachers and administrators from Orcutt, Betteravia, Bonita, Casmalia and Blochman school…," *SMT*, Oct. 23, 1953, p. 10.

1955 – "Offer Extension Courses" at Allan Hancock College, "'Measurement in Education,' part of six University of California extension courses, will be offered Wednesday at 7 p. m. … in room 12 at Allan Hancock college… 'Integrated Craft Activities for Elementary Schools,' opened Saturday in room 12 at **Hancock college**. The course will be given alternate Saturdays from 9 a.m. to noon and 1 to 3:30… The Wednesday night class [concerns tests to evaluate students' progress] … The Saturday classes, taught by **Edward A. Kincaid** of Santa Barbara college, will offer three units of upper division credit. The class will take up the processes of such crafts as puppets, paper sculpture, ceramics, leather tooling, weaving, metal tooling, wood construction displays and audio-visual aids… Other extension courses… include 'Curriculum Construction,' … 'Psychology of Exceptional Children,' … 'Natural Science for Education,' … 'Introduction to Remedial Speech'," *SMT*, Sept. 26, 1955, p. 1.

1957 – "Teachers Take Part in Art Workshop… Teachers of the Santa Ynez Valley and Lompoc schools participated in a special Art Workshop at the College Elementary school yesterday afternoon and evening. According to **Joseph Knowles**, Consultant in Art Education for the Santa Barbara county schools, the group participated in art experiences centered around the social studies program. For the drawing session from 4:00 to 6:00 o'clock, 11 different media were used. During the painting session, from 7:00 to 8:30, six different kinds of painting were employed," *LR*, Feb. 28, 1957, p. 3.

1958 – "Some Thoughts on Creativity… by **Nora Wiedmann**. In connection with my job as an Art Education consultant it has been my privilege to attend regional and national meetings of those associations specifically concerned with the advancement of cultural activities in our society. A striking novelty appeared at these meetings in the past two years: the main speakers … were scientists… Some of the topics these philosophers, psychologists, physicists, chemists and anthropologists had been given were – 'A Place for Art Action,' 'The Role of Art in Our Schools,' 'The Art Teacher in a Changing World,' 'Art in the Space Age,' 'Raw Materials for Creative Action.' You know, of course, what had happened. With the powerful impact of recent scientific advance… the artists had got cold feet! Were their jobs threatened?... 'maybe Johnny could read – if so much time weren't wasted on fringe activities such as art.' To the artists, this was a bomb-shell! … invite top scientists to the art meetings and have them state their platforms. To everyone's great surprise not a single scientist-speaker advocated the elimination of Art from our schools. On the contrary, Dr. Margaret Mead … reported that at this year's National Science Educators Association meeting in Washington, the continuous battle-cry on curriculum improvement had been: 'Let's have more Art!.' Why? … Because Art is the only subject we teach in which the child not only has the freedom to be creative but is expected to be creative… according to our scientists, the 'creative process' is exactly the same in science as it is in art.' … It has also been discovered that while potential creativity is an inherent trait, it atrophies when left unstimulated. Anyone who has taught Art to children knows how spontaneous and uninhibited their work is on primary level and how much of it is lost in the intermediate grades… In our American picture, Art had for a time a feminine context… Today, however, American Industry has become the great patron of Art – 'Good Design' is a household word… there isn't a man-made object … that didn't start on a drawing board. The talented lad is no longer the 'odd ball.' He may earn an excellent living as a designer in any field. … Creativity is an integral part of human life… Only 50 years ago there was no place in our schools specifically devoted to the development of this precious aspect in our children… Then came a great change. The United States, the first to take this step on a

national scale, adopted 'Creative Art' as a part of the required public school course. Away from copying Julius Caesar off a plaster bust or filling in mimeographed outlines with colored pencils, a few educators dared venture into the field of self-expression… Imagination in everyone is recognized and given equal chance to develop. In our schools we call it 'Integrated Art,' and what we mean is: Art is an attitude rather than a limited activity for a talented few. We sponsor Art as an active part of every subject through the school day … scientists… say that while good, reliable statistic-type scientists are always essential, in the end it is the creative scientists who mark progress. … And, as one scientist put it: 'If the creative ability of each person could be raised by only a small percentage, the social consequences would be enormous'," *LR*, June 19, 1958, p. 27 (i.e., 7d).
See: "Heller, Clio," "Homecraft Institute," "Ketchum, Helen," "Knowles, Joseph," "Lovely, Anna," "McFadden, Ann"

Teall (Fairley), Margaret (Mrs. William Fairley) (Buellton)
Teacher of interior decorating and landscape gardening, EEP, 1934.
1934 – "Miss Margaret Teall who substituted for Mrs. Johnson during her enforced absence, left for Yosemite last Thursday. She has a regular position there," *SYVN*, May 11, 1934, p. 3; "Marriage Licenses… Fairley-Teall – in Reno, Nev., July 21, 1934, to William Fairley, 26, and Margaret Teall, 22, both of Yosemite National Park, Mariposa County, Calif.," *Sacramento Bee*, July 23, 1934, p. 7.
See: "Emergency Educational Program," 1934

Tenney, Ed (Cecelia Edna?) (1914-1992?) (Santa Ynez Valley?)
Exhibited novelty concreations (gems and feathers) at Lompoc Gem and Mineral Club Hobby Show, 1960. Also made enameled bead jewelry, 1971?
Is this Cecelia Edna Ludanyi Tenney (Mrs. Robert Tenney of San Marcos Pass Road) a member of the Santa Ynez Valley Rock Club or a relation?, *SYVN*, Aug. 12, 1965, p. 11?
See: "Lompoc Gem and Mineral Club," 1960

Teubner, Richard Charles (b. 1925) (Santa Maria)
Teacher of mechanical drawing at Santa Maria Union High School, 1953. Most of his teaching career seems to have been spent in Salinas, Ca.
■ Port. and caption reads, "… instructor in auto mechanics and mechanical drawing. Single, Teubner is living at 505 East Orange. He previously taught industrial arts in San Leandro high school. He received his BA at the University of California in Santa Barbara," *SMT*, Oct. 12, 1953, p. 1.

Theater
Many artists also expended their abilities on theater "art" such as acting, costume design, stage makeup, set design, set painting, singing and dancing.
See: "Blue Mask Club," "Chalk Talks," "Crosby, Edward," "Dorsey, Harry," "Fashion Design / Costume Design," "Gaiety Theater," "Kiddie Kartune Club," "Little Theatre," "Lompoc Civic Theatre," "Lompoc Theater," "Murals," 1928, "Set Decoration," and see student theater activities mentioned under the headings of various high schools

Thielman, Paul Henry Louis (c. 1866-after 1920) (Santa Maria)
Itinerant sign artist, 1896-1919+.
Thielman, Paul (notices in Northern Santa Barbara County newspapers on microfilm and on newspapers.com)
1913 – "Paul Thielman is engaged in decorating the windows of the *Times* office with artistic signs. The work is being put on in a manner quite up to the usual high standard of this well-known artist. Paul is a sign writer with a professional facility equaled by few," *SMT*, Dec. 20, 1913, p. 6.
1916 – "Paul Thielman, the well-known sign painter and gold leaf artist has returned to Santa Maria and is at present spreading the gold on the plate glass windows for the Gardner Wheaton Co.," *SMT*, Sept. 2, 1916, p. 5, col. 3.
1917 – "Paul Thielman has been busy during the past week embellishing the windows of B. R. McBride, Black Bros. and the Chocolate Shop," *SMT*, March 10, 1917, p. 5.
1919 – "Dr. Lay Fined … administered drugs… Paul Theilman [Sic. Thielman] a painter, swore to one of the complaints against Dr. Lay. Theilman was sentenced to thirty days in the county jail for using the drug," *SMT*, April 19, 1919, p. 1.
Thielman, Paul (misc. bibliography)
Paul Henry Louis Thielman, age 29, a painter, b. NJ, is listed in register of voters *Santa Barbara County – Lompoc Precinct, No. 2*, 1896; Paul Thirlman [Sic. Thielman] is listed in the 1920 U. S. Census as age 54, b. c. 1866 in New Jersey, a painter, lodging in Santa Maria (refs. ancestry.com).

Thielst, Gruenhild / Grunhild / Gunthild (Copenhagen / Santa Barbara)
Photography student who took photos of Buell ranch, 1937.
"Miss Gruenhild Thielst of Copenhagen, who is visiting her brother and wife, Mr. and Mrs. Gunnar Thielst in Santa Barbara, came to the Walter Buell ranch Sunday and took some interesting pictures. Miss Thielst will leave soon for Laguna Beach where she will take further study in the art of photography before returning to her home next spring," *SYVN*, Dec. 17, 1937, p. 7; "Miss Grunhild Thielst of Santa Barbara called on friends in the valley recently," *SYVN*, March 18, 1938, p. 8.

Thimble Bee of Pythian Sisters (Santa Ynez)
Needlework club, 1926+.
Thimble Bee (notices in Northern Santa Barbara County newspapers on microfilm and on newspapers.com)
1926 – "Santa Ynez Valley Temple of Pythian Sisters announce a Thimble Bee for next Wednesday afternoon, March 24th in the local lodge rooms. A small admission will be charged and the general public is invited to attend," *SYVN*, March 19, 1926, p. 1; "Santa Ynez Notes … The Santa Ynez Valley Temple of Pythian Sisters were hostesses at a thimble bee last Friday which brought together the members and their friends for a pleasant afternoon," *SMT*, April 20, 1926, p. 6; "Mrs. Nels Jensen will entertain the Thimble Bee at her home at Refugio crossing this afternoon…," *SYVN*, Oct. 1, 1926, p. 1; sewing for bazaar which will be held the first week in December, *SYVN*, Nov. 19, 1926, p. 1.
1933 – "Sixteen Sisters were present at the afternoon meeting of the **Pythian Sisters** held at Dania hall… Plans were made to start another quilt at the next meeting of the Thimble Bee…," *SYVN*, March 3, 1933, p. 1; "The Thimble Bee will meet at the C. R. Weston home Wednesday afternoon, March 15th. A new quilt will be started," *SYVN*, March 10, 1933, p. 4.
1938 – "Met at Mrs. **Clyde Weston**'s home. The afternoon was spent piecing quilt blocks…," *SYVN*, Feb. 25, 1938, p. 1.
1942 – "Meeting Dates of Valley Organizations… Thimble Bee… Every 3rd Wednesday," *SYVN*, April 17, 1942, p. 8; "The Pythian… The Thimble Bee meetings are discontinued for the summer," *SYVN*, June 26, 1942, p. 8.
1952 – "Thimble Bee is [Re?] Organized… **Pythian Sisters**…," *SYVN*, Aug. 29, 1952, p. 7.
1953 – "Thimble Bee Bazaar Coming," *SYVN*, Oct. 23, 1953, p. 3.
1958 – Photo showing some handiwork to be sold at the Bee's annual bazaar, *SYVN*, Oct. 3, 1958, p. 3.

Thimble Club (of the Neighbors of Woodcraft) (La Purisima)
Needlework club active 1926 and through the 1930s.
Hundreds of newspaper notices in the *LR* for this club were not itemized here.

Thomas, Myrtle Fredericka
See: "Lange (Thomas), Myrtle Fredericka (Mrs. Mervin A. Thomas)"

Thompson, Frank Wildes, Capt. (1838-1905) (Santa Barbara)
Painter of marine views, one of whose works hung in the Santa Maria City Clerk's office, 1897. Captain of the schooner, Santa Rosa.

■ "Art and Artists… VIII. Capt. Frank W. Thompson. I regret my inability to personally interview this gentleman… Mr. Thompson is a sailor and was, I am informed, born on the ocean. His experience as a deep-water sailor has been varied and thrilling. He has been connected with sixteen different clipper ships…. In these vessels Capt. Thompson visited nearly every part of the world… Capt. Thompson is a self-taught man and if he has many crudities let us not wonder… I got a chance to see several of his pictures. They are all marine views, and the artist's perfect knowledge of his subject is apparent. No man could paint the ocean, as does our artist, save he were a close student of it in its changing moods, its calms, its storms. In depicting the ever-moving water of ocean, its white capped waves … few men of great name equal Frank W. Thompson… Before me, as I write, is a picture of the new cruiser '*Charleston*' which lately made its trial trip down this coast… [and elaborate description of painting] The great ship is under full headway… A moonlight scene with several fisher boats whose crews are running out a seine… In my opinion Capt. Thompson paints the ocean … better than any artist here. His great fault is extreme diffidence and unwillingness to show his talent…," *Independent*, Aug. 22, 1889, p. 4.
Thompson, Capt. (notices in Northern Santa Barbara County newspapers on microfilm and on newspapers.com)
1885 – "The schooner *Angel Dolly*, Capt. Frank Thompson leaves to-day for San Miguel Island on an otter expedition. It is possible before he returns he will take in the Southern Coast and make an extensive hunting trip," *Independent*, Jan. 16, 1885, p. 4.
1888 – "The schooner *Star of Freedom* left for the islands yesterday with thirty-nine sheep-shearers on board. The schooner will hereafter be commanded by Capt. Frank Thompson," *Independent*, March 27, 1888, p. 4.
1890 – "A Clipper Ship. Panoramic View in San Francisco Harbor. Capt. Frank W. Thompson's Latest Marine Picture… In the window of the Great Wardrobe appears a panoramic view of San Francisco harbor… from Meigg's wharf and is made up from a model of one of these clipper ships and a background painted in oil. Of course, the most prominent object is the clipper ship which is perhaps of 2,000 tons and carrying a crew of 32 men before the mast. The ship is loaded with wheat, the Custom House officer has just departed and the small row boat astern is bringing the Captain… On the left appears Alcatraz island… A barkentine, '*The Tropic Bird*,' one of Spreckels' sugar carrying vessels, is being towed out towards the Golden Gate by a wheezy steam tug. At the right appears a Government steam tender… In the distance and at the left we see an Australian steamer…," *Independent*, Feb. 7, 1890, p. 4; "Prize List… of Great Wardrobe… Edgar Leach of this city is to be congratulated on receiving the first prize, the famous clipper ship model and painting by Capt. Frank Thompson. It is valued at $150… Walter Hardy took the second and E. S. George took the third. Both these latter prizes were marine paintings by Capt. Thompson…," *Independent*, July 1, 1890, p. 1.
1891 – "Capt. Frank Thompson, as usual, will spend the winter months on shore and is succeeded in command of the schooner *Santa Rosa* by Capt. Burtis. We trust Capt. Thompson will devote his time to painting some of the charming marine views which all admire so much and for which he has so much talent. It takes a thorough sailor to paint truthful marine pictures … Capt. Thompson succeeds admirably," *Independent* (Santa Barbara, Ca.), Sept. 30, 1891, p. 4.

1897 – "Captain Davis has disposed of the fine oil painting that has graced the walls of the City Clerk's office during the past few months, to Judge R. B. Canfield at a good figure. The painting, called 'Near the Coast,' is one of Capt. Thompson's best and represents a lagoon and meadow scene on 'Dixie' Thompson's ranch in Ventura county …," *SMT*, Dec. 4, 1897, p. 4.

1900 – "All May Study Art. Many Fine Paintings to be Displayed… Educational Association… Art Loan Exhibit… Our own artists will be represented… Capt. Frank Thompson by a marine view…," *Independent*, Nov. 10, 1900, p. 1.

1905 – "Suicides in City Prison. Capt. Frank Thompson of Sant Barbara, a cousin to the late Dixie Thompson, committed suicide in the Santa Barbara city prison on Sunday by shooting himself in the head with a revolver … charge against him was only that of drunkenness…," *SMT*, July 29, 1905, p. 1.

Thompson, Capt. (misc. bibliography)
Frank Wildes Thompson was b. in Topsham, Maine in 1838 and d. in Santa Barbara in 1905 and is buried in Santa Barbara Cemetery per findagrave.com (refs. ancestry.com).

Thompson, Henrietta A. "Katie" (Mrs. Cecil Morris Thompson) (1908-1993) (Lompoc)
Ceramist. Member Puttering Micks, 1958. Hairstylist.

■ Port. watering her African violets and "Hair Spray, Shampoo Are Hobby Setting. Mrs. Cecil Thompson's hobby flourishes in the middle of hair spray, bobby pins, curlers and shampoos. Her 250 African violets sit placidly on four shelves and grow while she cuts washes and sets hair for customers in her beauty shop on south E. Street… Another hobby stemming from her plant collection is that of making the pots in which to put the flowers. She has a kiln and molds and every now and then decides to add another flower pot to the shelf. She buys what is called slip (a mixture of clay) in a 200-pound batch and agitates it in a washing machine two hours every day for seven days. Then it is left to sit for three weeks. When she wishes to make a pot, she pours the slip into a mold, lets it stay for about 15 to 20 minutes and pours the slip back into a large bottle. A quantity of the slip will have remained in the mold and will congeal in three or four hours. After this has taken place, the form is taken out of the mold and looks like a gray flower pot. She then bakes it in the kiln for ten or twelve hours at 1800-1900 Fahrenheit, after which it is painted. Another baking occurs for approximately six and a half hours and she has her flower pot…," *LR*, Jun 25, 1959, p. 5.

1964 – "Henrietta Thompson for a home use permit to establish a beauty shop in her residence, 118 S. E. St., zoned R-2 limited multiple residence," *LR*, Jan. 27, 1964, p. 1, col. 5.

Thompson, Cecil, Mrs. (misc. bibliography)
Henrietta A. Thompson was b. June 26, 1908 in Lompoc, to John Valla and Teresa Valla, and d. July 13, 1993 in Lompoc and is buried in Lompoc Evergreen Cemetery per findagrave.com (ref. ancestry.com).
See: "Puttering Micks Ceramics"

Thompson & West (San Francisco)
Publishing firm that commissioned artists to make drawings of significant towns, buildings and farms in Santa Barbara County to illustrate its <u>History of Santa Barbara & Ventura Counties, California</u> 1883 (reprinted Berkeley, Ca.: Howell-North, 1961). Santa Maria scenes illustrated by Kistenmacher.

■ "Messrs. Thompson & West, who issued the illustrated history of Los Angeles county, are about to engage in a similar work in Santa Barbara county. Mr. Thompson and two of his assistants – Mr. Craft and Mr. Champion – are already in Santa Barbara, taking the preliminary steps," *Los Angeles Evening Express*, May 21, 1881, p. 3, col. 7; "J. M. Howard, who visited Santa Barbara in the interest of Thompson & West, of the County History… is now day clerk at the Horton House, San Diego, Cal.," *Independent* (Santa Barbara, Ca.), July 26, 1883, p. 4, col. 2; The *Los Gatos Mail*, a handsome weekly paper… editor is J. D. Mason, well-known in Santa Barbara as the writer of Thompson and West's history of Santa Barbara county," *Independent*, April 23, 1884, p. 2, col. 1.

1882 – "For the Illustrated History. Santa Maria is to be well represented in the *Illustrated History of Santa Barbara* county. **Mr. Kistmacher** [Sic. **Kistenmacher**] the artist, was in town last week sketching for the book. He took views of Crosby Brothers new hotel, Blosser's hotel and McElhaney's new building and the *Times* office. He has gone to Nipomo to sketch the residences of J. F. Dana and Wm. Dana," *SMT*, July 1, 1882, p. 1.

Illustrations in the sequence they appear in the book:
Santa Maria Hotel, Santa Maria, S.M. Blosser, prop., opp. p. 48.
Residences of T. A. Jones & S. J. Jones with Store, Central City (Santa Maria), opp. p. 52.
Residence & Business Place of Robert Braun, Central City, opp. p. 52.
Ranch "Santa Rosa" of J. W. Cooper, opp. p. 56.
Livery Feed & Sale Stable & Store, C. D. Patterson, prop., Los Alamos, opp. p. 68.
Union Hotel, J. D. Snyder, owner & prop., Los Alamos, opp. p. 72.
Residence & Ranch of John S. Bell, Los Alamos, opp. p. 128.
La Patera Ranch, Residence of W. N. Roberts, Santa Barbara Co., Cal., opp. p. 224.
Residence & Ranch of Samuel Conner, Santa Maria, opp. p. 224.
J. F. Dinwiddie's Store & Hall, Lompoc, opp. p. 228.
Residence & Ranch of J. R. Stone, Tinaquaic Rancho, opp. p. 228.
Residence, Business Place & Crushing Mills of Reuben Hart, Central City, Sta. Maria Valley, opp. p. 232.
Ranch & Residence of Jesse I. Hobson, Santa Maria Valley, opp. p. 285.
Residence & Ranch of John G. Prell, Santa Maria, opp. p. 285.
Stock Ranch of Jesse Hill & Mission La Purisima, near Lompoc, opp. p. 288.
Canada Honda, Stock Ranch & Residence of Geo. H. Long, Point Tranquillon, opp. p. 293.
Residence & Ranch of Juan B. Careaga, near Los Alamos, opp. p. 296.

Store and Post Office at Los Alamos, A. Leslie Prop., opp. p. 297.
Residence of A. Leslie, Los Alamos, opp. p. 297.
Central City Hotel, Crosby Bros. props., Central City, opp. p. 300.
Residence and Ranch of C. H. Clark, Point Sal, opp. p. 300.
View of the Town of Ballard, with Residence of Mr. G. W. Lewis, opp. p. 301.
Residence & Ranch of W. T. Morris, Central City, Sta. Maria Valley, opp. p. 302.
San Carlos de Jonata Rancho & Residence of R. T. Buell, Childs Station, opp. p. 302.
Ranch, Residence and Store of William L. Adam, Santa Maria, opp. p. 307.
Ranch and Residence of J. H. Rice, near Guadalupe, opp. p. 308.
Residence of Thos Hart at Guadalupe, opp. p. 311.
Stores & Blacksmith shop, Thos Hart prop., at Guadalupe, opp. p. 311.
Point Sal Creamery, Battista Pezzoni, prop., Point Sal, opp. p. 312.
Residence & Ranch of Thos. Saulsburry, near Guadalupe, opp. p. 313.
Residence & Ranch of Thomas Wilson, Santa Maria, opp. p. 314.
Residence & Ranch of Isaac Miller with partial view of the town of Central City, opp. p. 316.
Residence & Ranch of H. Stowell, Santa Maria Valley, opp. p. 317.
Ranch & Residence of George J. Trott, Santa Maria Valley, opp. p. 316.
General Merchandise Store & Post Office of Goodwin & Bryant, Santa Maria, opp. p. 318.
Residence, Feed & Livery Stable of R. D. Cook, Central City, opp. p. 318.
Fashion Stable J. W. Hudson, prop., Guadalupe, opp. p. 319.
Store & Agency of Wells Fargo & Cos. Express, Kreidel & Fleisher, Central City, Sta. Maria Valley, opp. p. 319.
Residence and Ranch of Charles Bradley, Santa Maria (with inset of Sheep Shearing Barn), opp. p. 320.
Residence & Ranch of Guillermo J. Foxen, Tinaquaic Rancho, opp. p. 321.
Residence & Ranch of Thomas Foxen, Tinaquaic Rancho, opp. p. 322.
Residence, Ranch and Store of Fred Wickenden, Tinaquaic Rancho, opp. p. 323.
Residence & Ranch of Frederic R. Foxen, Tinaquaic Rancho, opp. p. 324.
Residence & Ranch of John C. Foxen, Tinaquaic Rancho, opp. p. 325.
Residence & Ranch of James Tyler, 8 miles from Guadalupe, opp. p. 332.
Antonio Tognazzini's Dairy, near Guadalupe, opp. p. 332.
McElhany's Hall & Stores, J. M. McElhany, prop., Santa Maria, opp. p. 340.
And various portraits of notables not itemized here.

Thornburg, [Cora] Alma (1880/81-1901) (Santa Maria)
Exh. oil painting in Children's class, "Under 15 years," "Santa Barbara County Fair," 1893. Sister to Elsie Thornburg, below.

■ "Death of Alma Thornburg. Miss Cora Alma Thornburg, eldest daughter of Mrs. Q. [Quinie] Thornburg, died on Sunday morning last after a lingering illness of several months from consumption, aged 20 years, 1 month and 13 days. She was born and reared in our valley and educated in our schools being a member of the graduating class of the Santa Maria Union High School in June last…," *SMT*, Nov. 23, 1901, p. 3.
Thornburg, Alma (misc. bibliography)
Cora Alma Thornburg (1880-1901) is buried in Santa Maria Cemetery District per findagrave.com (ref. ancestry.com).
See: "Santa Barbara County Fair," 1893, "Thornburg, Elsie"

Thornburg (Stilwell), [Naomi] Elsie (Mrs. Benjamin Franklin Stilwell) (1884/5-1979) (Santa Maria)
Exh. pencil drawing at "Santa Barbara County Fair," 1900. Sister to Alma Thornburg, above.
Thornburg, Elsie (misc. bibliography)
Elsie Thornburg is listed in the 1900 U. S. Census as age 15, b. Jan. 1885, in Calif., at school, residing in Township 7 of Santa Barbara County with her mother Quinnie Thornburg and siblings: Alma C. (b. Oct. 1881), L. Edith, Ralph L., Harry M., Henry J., John E. and Ellen E.; Naomi Elsie Thornburg was b. Jan. 23, 1884 in Calif. to Larkin Thornburgh and Quintilla F. Whaley, married Benjamin Franklin Stilwell and d. Dec. 20, 1979 in Post Falls, Ida., per Gillis/Horton Family Tree (ref. ancestry.com).
See: "Santa Barbara County Fair," 1900, "Thornburg, Alma"

Thornburg/h, ? (Mrs. Judge Thornburgh) (Santa Maria)
Exh. 2 banners at "Santa Barbara County Fair," 1888.
This individual could not be further identified.
See: "Santa Barbara County Fair," 1888

Thornburg/h, Mary Jane Warner (Mrs. Wayne Wright Thornburg/h) (1896-1963) (Santa Monica / Pasadena)
State Art Chairman, Federation of Women's Clubs, 1952.

■ Port. and her body found in her Pasadena home, "had been active in the South Pasadena Republican Club… awaiting the arrival of her daughter, Mrs. Jane Rogers, from Carson City, Nev," *South Pasadena Review*, April 10, 1963, p. 1.
Thornburg, Mary Jane (notices in *Lompoc Record* on newspapers.com).
1952 – "Lompoc Clubs to Host Monthly Meeting of County Federation… in the Alpha clubhouse… January 15… At the afternoon session in Grange Hall the guest speaker will be Mrs. Mary Jane Thornburgh [Sic. Thornburg], State Art chairman. Members may take ceramic work done by the club, also oil and water color paintings, one exhibit per person," *LR*, Jan. 3, 1952, p. 2;

"County CFWC Meeting in Alpha Club … Highlight of the afternoon will be an exhibit of paintings and ceramics done by members with Mrs. Mary Jane Thornburgh [Sic. Thornburg] of Santa Monica, State Art chairman, as speaker. She will illustrate her talk with a number of her own paintings. **Mrs. Milton Schuyler**, County Art chairman, will be in charge of the exhibit, which will be followed by a brief discussion of new trends in flower arrangement…," *LR*, Feb. 7, 1952, p. 8.

Thornburgh, Mary Jane (misc. bibliography)
DAUGHTER – "Mary Jane Thornburg was b. Nov. 14, 1920 in Yavapai, Arizona, to Mary Jane Warner and Wayne Wright Thornburg; Mrs. Mary Jane Thornburgh is listed in *voter registrations in Los Angeles County* as a "Teacher," 1938-1962; Mary Jane Thornburgh b. Aug. 4, 1896 in Iowa and d. April 9, 1963 in Los Angeles County is buried in Forest Lawn Memorial Park, Glendale, per findagrave.com (refs. ancestry.com).

See: "Community Club (Santa Maria)," 1952, "Federation of Women's Club," 1949, 1952, "Lompoc Community Woman's Club," 1952, "Santa Maria [Valley] Art Festival," 1952, "Tri-County Art Exhibit," 1950

Thurman, Luther Edward (1901-1982) (Santa Maria)
Photographer, amateur. Print chairman Santa Maria Camera Club, 1952. Many of his photos were reproduced in the Santa Maria Times, 1953-56. Journalism Instructor, Santa Maria High School.

■ "Journalism Teacher Arrives at School. Luther E. Thurman… graduate of Kansas State Teachers college, having completed undergraduate and post graduate study at the same college in Pittsburg, Kan., and with further summer courses at Kansas University and at Stout Institute, Menomonie, Wis. In 1940, Thurman spent a summer at work in Carnegie Institute at Pittsburgh, Pa.," *SMT*, Aug. 28, 1948, p. 5.

Thurman, Luther (notices in Northern Santa Barbara County newspapers on microfilm and on newspapers.com)
1952 – "Luther Thurman Addresses Santa Maria Junior Club … former printer with the *Herald-Recorder*, now journalism instructor at the Santa Maria Union High School, was guest speaker at a recent meeting in Santa Maria for the Community Club Juniors. He spoke on his hobby, photography, and told of the activities of the **Santa Maria Camera Club**. He said that everyone should have a hobby. Thurman displayed a number of pictures taken by members of the camera club," *AG*, March 28, 1952, p. 3; "I Spied… Photographer Luther Thurman getting blocked out while attempting to take pictures during last night's Arroyo Grande Santa Maria football game," *SMT*, Nov. 8, 1952, p. 1; repro: "Final Score," *SMT*, Nov. 21, 1952, p. 2.
1953 – Repro: "Nifty Nightingale," *SMT*, Jan. 17, 1953, p. 2; repro: "Hot Hook," *SMT*, Jan. 19, 1953, p. 2; repro: "Santa Maria high's baseballers," *SMT*, May 2, 1953, p. 2; repro: "Santa Claus," *SMT*, Dec. 24, 1953, p. 12.
1954 – Repro: basketball picture, *SMT*, Jan. 2, 1954, p. 2; repro: "Don Waiters (No. 15) of Arroyo Grande," *SMT*, Feb. 5, 1954, p. 2; repro: "Santa Maria high's Ralph Heskitt," *SMT*, Feb. 17, 1954, p. 2; repro: "Pastor Given Recognition," *SMT*, Feb. 27, 1954, p. 4; "Saints to Crash Movies… Movies will be taken of tonight's intrasquad

clash at Dave Boyd field… Movies will also be taken of all other home games… by **Al Taylor** and Luther Thurman. The films will be shown to the Saint footballers during Monday chalk talks…," *SMT*, Sept. 17, 1954, p. 2.
1955 – Repro: "Santa Maria Automobile Dealers," *SMT*, March 17, 1955, p. 9; repro: "Queen Claire," *SMT*, May 7, 1955, p. 1.
1956 – Repro: "Danish Student," *SMT*, Dec. 1, 1956, p. 4.

Thurman, Luther (misc. bibliography)
Luther Edward Thurman was b. Aug. 27, 1901 in Iowa to Edward Thurman and Elizabeth Orth, married Ada Jane Thurman, and d. Aug. 14, 1982 in San Diego, Ca., per Thurman Family Tree (refs. ancestry.com).

See: "Junior Community Club (Santa Maria)," 1952, "Santa Barbara County Fair," 1952, "Santa Maria, Ca., Union High School," 1952, "Santa Maria Camera Club," 1954

Thwaites, Carrie Frances Warn, Dr. (Mrs. John E. Thwaites) (1866-1959) (Santa Maria)
Photographer of Alaska in the early 1900s who exh. at Santa Maria Library, 1943.

■ "Dr. Carrie Thwaites… osteopathic physician for many years in Santa Maria… born on Oct. 28, 1866 in Michigan and had resided here for 40 years. One of her hobbies was horticulture, which she practiced in a large orchard she owned which was planted to fruit trees of uncommon varieties in the Paso Robles district…," *SMT*, Jan. 13, 1959, p. 2.

Thwaites, Carrie (misc. bibliography)
Carrie Frances Thwaites was b. Oct. 28, 1866 in Michigan, mother's maiden name Brown and father's Warn, and d. Jan. 12, 1959 in Santa Barbara County per Calif. Death Index (ref. ancestry.com).

See: "Santa Barbara County Library (Santa Maria)," 1943

Tinsley, Thomas Shirley (1928-1991) (Santa Barbara / Santa Maria)
Painter. Exh. Allan Hancock [College] Art Gallery, 1955.

■ "Thomas S. Tinsley… Mr. Tinsley was born and reared in Santa Barbara. He served in the U. S. Navy during the Korean Conflict from 1950 to 1952. He then attended and graduated from the California College of Mortuary Science in Los Angeles and worked for Haider Mortuary in Santa Barbara from 1953 to 1955. He moved to Santa Maria in 1955. From then until his retirement in 1990 he worked for Home Motors Chevrolet in many capacities… He enjoyed gardening, gourmet cooking and oil painting," *SMT*, May 29, 1991, p. 16.

Tinsley, Thomas (misc. bibliography)
Thos Tinsley, USN, with no wife cited, is listed on Foothill rd in the *Santa Barbara, Ca., CD*, 1951; Thomas Shirley Tinsley was b. Nov. 28, 1928 in Santa Barbara to Thomas S. Tinsley and Lily B. Sangster, married Ida Mae Harris, and d. May 27, 1991 in Santa Barbara County per Rutherford Family Tree (refs. ancestry.com).

See: "Allan Hancock [College] Art Gallery," 1955

Tobe (Santa Maria)
Sign painter, 1927.
See: "Holcomb, Matthew Winfield 'Tobe'"

Tobin, James L., Capt. (Santa Maria)
Photographer, amateur. Member Santa Maria Camera Club, 1939-41.
1939 – "Funds Provided for Air Schools… Capt. James L. Tobin, formerly stationed at Hamilton Field, San Rafael, arrived today at the local airport to begin his assignment as flight surgeon for the Santa Maria School of Flying…," *SMT*, June 22, 1939, p. 1; "Air School in Rotogravure… yesterday's *Los Angeles Times* was devoted to the training of young army fliers at Santa Maria School of Flying. One picture… showed Capt. James L. Tobin, flight surgeon, giving Cadet C. A. Morgan, Jr., a visual test…," and other pictures described, *SMT*, July 31, 1939, p. 6.
And, more than 20 additional notices in the *SMT* not itemized here.
See: "Santa Maria Camera Club," 1939, 1940, 1941

Tognazzi [sometimes Tognazzini], Olga Lessie, Miss (1893-1981) (Los Alamos)
Painter. Lent paintings to Minerva Club Art and Hobby Show, 1959. Student under Leo Ziegler at Los Alamos Adult School, 1947-55.
■ "Olga L. Tognazzi… Los Alamos… Miss Tognazzi was born Sept. 4, 1893 in Morro Bay. She had been a resident of Los Alamos since 1895. She was a member of the pioneer Tognazzi family…," *SMT*, July 25, 1981, p. 4.
Tognazzi, Olga (notices in Northern Santa Barbara County newspapers on microfilm and on newspapers.com)
More than 300 "hits" (primarily social and club notices) for "Olga Tognazzi" in local newspapers were not itemized here.
Tognazzi, Olga (misc. bibliography)
Olga L. Tognazzi is listed in the 1940 U. S. Census as age 44, b. c. 1896 in Calif., finished high school 2nd year, manager of a private ranch, residing in Los Alamos, with her father Victor Tognazzi (age 79); Olga Lessie Tognazzi was b. Sept. 4, 1893 in Calif. to Victor or Velos Tognazzi and Jennie Locarnini and d. July 23, 1981 in Los Alamos per Tognazzi Family Tree (refs. ancestry.com).
See: "Minerva Club, Art and Hobby Show," 1959, "Santa Barbara County Library (Santa Maria)," 1948, "Santa Ynez Valley, Ca., Adult/Night School," 1947, 1949, 1953, 1955

Tognetti, Betti / Betty Weber (Mrs. Phillip Tognetti) (1926-?) (Lompoc)
Teacher of yarncraft at Recreation Dept., 1948, and of hand work and of ceramics in the first half of the 1960s. Managed Mildred I. White Ceramics Shop in Lompoc, 1957, renamed it Betti's Ceramics, prop., 1958-60.
1964 – Port. serving tea at Medical Missions Tea, *LR*, Aug. 21, 1964, p. 4.
Tognetti, Betty (misc. bibliography)
Betty Tognetti is listed with husband Philip / Phillip in the *Santa Maria, Ca., CD*, 1958-1961, and as "Betti" in 1965; Betty J. Tognetti b. Oct. 9, 1926 was residing in San Juan

Capistrano in 1996 per *U. S. Public Records Index, 1950-1993*, vol. 1 (ref. ancestry.com).
See: "Lompoc, Ca., Recreation Department," 1948, 1961, 1963, "Lompoc Gem and Mineral Club," 1960, "Mildred I. White Ceramic Shop," "Puttering Micks Ceramics"

Tognini (Knight), Lena (Mrs. Charles Fredrick Knight) (1876-1950) (Guadalupe / San Francisco)
Exh. painted scarf at "Santa Barbara County Fair," 1891.
See: "Santa Barbara County Fair," 1891

Tournament of Roses, Pasadena
Parade held annually on New Year's Day to which various northern Santa Barbara county entities provided floats.
See: "Auman, Patricia," "Floats," 1930s

Towle, Rena Evelyn (Mrs. Arnold George Towle) (1916-2001) (Santa Maria)
Student, Allan Hancock College, 1959. Resident while her husband was stationed at Point Arguello. Exh. Santa Barbara County Fair, 1959.
Towle, Rena (misc. bibliography)
Rena E. Towle is listed with husband Arnold G. Towle in the *Santa Maria, Ca., CD*, 1958-1961; Rena E. Towle is buried in Tahoma National Cemetery, Kent, Wa., per U. S. Veterans' Gravesites (refs. ancestry.com).
See: "Allan Hancock [College] Art Gallery," 1959, "Santa Barbara County Fair," 1959

Toy (Cook), Zelia Anna (Mrs. George Crist Cook) (1878/9-1979) (Santa Maria)
Artist, 1895. Exh. drawings at the "Santa Barbara County Fair," 1893. Grad. of Santa Maria Union High School, 1897.
■ "Zelia A. Cook, 101… Mrs. Cook was born March 7, 1878 in Storm Lake, Iowa, and was a resident of Santa Maria since 1888. She was a member of the pioneer Toy family, a graduate of Santa Maria high in 1897 and San Diego Normal School. She taught school in Tepesquet and Garey for many years. From 1968-1977 she lived in Morro Bay, then returned to Santa Maria," *SMT*, April 7, 1979, p. 3.
Toy, Zelia (notices in Northern Santa Barbara County newspapers on microfilm and on newspapers.com)
1893 – "Public School Department … Zelia Toy, map drawing… 2nd pr 1.00, Zelia Toy, general drawing. 1st. pr 2.00," at the Santa Barbara County Fair, *SMT*, Sept. 30, 1893, p. 4, col. 2.
1895 – "Zelia Toy has suddenly sprung into prominence as a skillful artist. Specimens of her ingenious handiwork may be seen any day upon application at her studio. She has made numerous sketches of the teachers and school mates in various postures and expressions of countenance," *SMT*, Nov. 9, 1895, p. 3.

1898 – "Dan Toy and family left this Friday a.m. for Santa Barbara where Miss Zelia Toy will take the examination for teachers' certificate," *SMT*, June 4, 1898, p. 5.

1899 – "Miss Zelia Toy closes the fall term of the Tepesquet school today," *SMT*, Dec. 2, 1899, p. 3, col. 2.

1901 – "Misses Susie and Zelia Toy, who have been attending the Normal school at San Diego, returning Wednesday morning to spend their vacation with their parents," *SMT*, July 6, 1901, p. 3 [and she graduated June 1902].

Toy, Zelia (misc. bibliography)
Zelia A. Toy is listed in the 1900 U. S. Census in township 7, Santa Barbara County; Zelia Anna Toy was b. March 7, 1878 in Storm Lake, Iowa, to Hugh Daniel Toy and Laura Ada Mudgett, married George Crist Cook, was residing in Oakland, Ca. in 1910 and d. April 5, 1979 in Santa Maria, Ca., per Walters/Roderick Family Tree (refs. ancestry.com).

Toyland (Lompoc)
Located at Roberson's Variety Store. It sold children's craft sets, 1943.
"Dolls… Handicraft Games! Clay Craft Sets, Wood Cutting Sets. Sewing – Embroidery Sets… Roberson's Variety Store," *LR*, Dec. 10, 1943, p. 5.

Trading Post (Solvang)
Seller of Navajo rugs, Indian jewelry and gifts, along with liquor, 1953.
■ "Trading Post Open House Slated… The Trading Post, situated in the former location of the Solvang Bakery… is a package liquor store… It is also a gift center and will include among its stock Indian jewelry and gifts, Pa-Poo, Shus-dolls… beautiful and colorful Navajo rugs, imported brass ware from India, hand-made wood fibre flowers, corsages and center pieces… Mrs. Stine takes great pride in the beauty and attractiveness of her wood fibre flowers," *SYVN*, Feb. 27, 1953, p. 8.

Trading Post (notices in Northern Santa Barbara County newspapers on microfilm and on newspapers.com)
1953 – Ad: photo of interior and "You are cordially invited to attend our opening Saturday February 28, 10 a.m. to 5 p.m. Package Liquor Store Beer-Wines-Liquors-Soft Drinks, Canape spreads, Indian Jewelry and Gift Pa-Poo-Shus-Dolls, Imported Lamps, Reproductions of Colonial and Victorian, Navajo Rugs, Hand-Made Wood Fibre Flowers, Corsages – Center Pieces of all Occasions. 'The Story of Wood Fiber Flowers.' Be sure to register for door Prize. Free refreshments. Main Street, Solvang, Trading Post, Phone 6041, Mary and Jake Stine," *SYVN*, Feb. 27, 1953, p. 6.

Travis, N. C. (Hollywood?)
Photographer, formerly with Pathe Studios, who took "screen tests" in Lompoc, Sept. 1923. He also took "screen tests" in San Bernardino, Jan. 1923 (per San Bernardino County Sun).
See: "Photography, general (Santa Maria)," 1923

Treasury Department, Section of Painting and Sculpture (Washington, D. C.)
Depression-era Federal funding source, nicknamed "Section," for a potential mural in the new Santa Maria Post Office, 1936. The project never saw fruition.
■ "Mural for Postoffice is Assured. The new Santa Maria post office building will have a mural painting for its lobby according to present plans… [section] officials said they would confer with officials of the Treasury's procurement division to see if money can be secured from the total amount of $86,504 set aside as the entire cost of the Santa Maria building project. At least one percent of the total allotment for a new federal building is supposed to be available to a mural… officials stated they thought the subject for the mural would come from… historical life and incidents of the Santa Maria region, [or] general postal activities, and [or] the present day industrial or agricultural life of the Santa Maria section. The artist selected… will be allowed to choose his subject from one of the three fields, although his design must be approved by members of the Section…," *SMT*, Oct. 28, 1936, pp. 1, 2.
See: "Young, Carl Vinton"

Tregor, Nicholas (Hollywood / New York / Chile)
Sculptor who exh. with a group of Hollywood notables at Santa Ynez Valley Art Exhibit, 1954.
1950 – "The Commodore's Marriage… Chic Chat… cocktail party … Serge Obolensky… for famed sculptor Nicholas Tregor who has just completed – and unveiled – a head of his host… Tregor, a White Russian who became a United States Army captain in World War II, has reaped enormous gratitude from many a severely wounded service man for his work in aiding plastic surgeons to restore faces and features at Walter Reed hospital… Tregor and his South American wife live in the southern part of Chile in a mountain region…," *Journal Herald* (Dayton, Ohio), July 25, 1950, p. 19.
1952 – "Nicholas Tregor, Sculptor, Chosen for Memorial Job. … appointed director of art for the Hollywood Memorial Cemetery yesterday. He is recognized for his busts of President Truman, Gen. Eisenhower and the late Eva Peron. He has been commissioned to sculpture [sic] a bust of Prime Minister Churchill and execute a frieze for the Hollywood Cemetery depicting the 23rd Psalm…," *LA Times*, Nov. 14, 1952, p. 2.
1965 – "Noted Sculptor Nicholas Tregor is sculpting a bust of Salvador Dali. It's an exchange deal. Dali is painting Tregor's portrait in return," *The Gazette* (Cedar Rapids, Iowa), June 29, 1965, p. 10, col. 2.
See: "Santa Ynez Valley Art Exhibit," 1954

Trend (Santa Maria)
Santa Maria high school / JC bi-monthly, fashion magazine, 1935.
See: "College Art Club," 1935

Tri-County Art Exhibit (Santa Barbara)
Annual art exhibit open to artists of the counties of San Luis Obispo, Santa Barbara and Ventura, held at Santa Barbara Museum of Art beginning 1947 and later at the Santa Barbara Museum of Natural History. Some years, at the end of the show, selected items from the exhibit were cobbled into a smaller exhibit and sent on tour. This smaller show exh. at the Vets Memorial Building (Lompoc), and the Minerva Club (Santa Maria), 1950, and exh. at Alpha Club (Lompoc), and Allan Hancock [College] Art Gallery, 1958, and at Vandenberg AFB and Alpha Club house (Lompoc), as well as Allan Hancock [College] Art Gallery, 1959.

■ "Tri-County Art Exhibit Planned for February in Santa Barbara... Museum of Art... open the weekend of Feb. 9... jury members as **Clarence Hinkle, Douglass E. Parshall** and **Joseph Knowles**. One entry from each artist will be hung provided it is not a copy, nor copied from a photograph. 'This is a new experiment designed for the local artist,' Mr. Bear said. 'We would like to have two, but not more, entries from everyone, although only one will be hung... both painting and sculpture. 'Work should be delivered not later than Friday, Jan. 31. All oils must be framed, and water colors, drawings and prints must at least be matted...," *SYVN*, Jan. 3, 1947, p. 1.
Tri-County Art Exhibit (notices in Northern Santa Barbara County newspapers on microfilm and on newspapers.com)
1947 – "Local Artists' Exhibits in Show at Santa Barbara," – first Tri-County exh., and list of local artists with titles of pictures: "**Elizabeth S. Taylor** of Santa Maria, with a painting, 'Conversation,' **Florence F. Foster** of Santa Maria, a painting, 'Studio Corner,' **Mario Veglia** of Casmalia, a painting, 'Mattei's Tavern.' Also to be seen are 'Café of the Red Piano,' a painting by **Jeanne de Nejer** of Santa Maria, 'Hibiscus,' a painting by **Lucille L. Bartholomew** of Los Alamos, and 'The Little White Church,' a painting by **L. Boradori** of Los Alamos," *SMT*, Feb. 7, 1947, p. 3; "Sedgwick, Wood Art Showing... Two Valley residents have contributions showing at the Tri-County Exhibition... One of the two sculptures on exhibit is a bronze piece, 'Howdy' Russell, by **Francis M. Sedgwick** of Los Olivos. In the painting exhibition is included 'Valley Home' which was done by **Mildred C. Wood**, of the Midland School," *SYVN*, Feb. 14, 1947, p. 7.
1948 – "Lompocans Exhibit... The art sections of the Alpha club and **Lompoc Community Woman**'s club attended the Tri-county Art Exhibit ... at the Santa Barbara Museum of Art. ... second annual... **Forrest Hibbits** exhibited an oil painting and other exhibitors from Lompoc included **Mrs. Ruth LaRue, Mrs. Joan Bienieck**, Mrs. Noel Kingsbury [Mrs. First Lt. Kenneth Adair Kingsbury], **Mrs. Elizabeth Kenny** [Sic. **Kenney**], **Mrs. Elsa Schuyler, Mrs. Lila Maimann** and **Oma Perry**. In the afternoon following the exhibit, the group visited the **Joseph Knowles** Studio in Santa Barbara. Those attending from Lompoc were...," *LR*, June 17, 1948, p. 2.
1949 – "S M Artists Enter Canvases ... **Mrs. Fred Gracia**, wife of Santa Maria's mayor, has a painting in oils entitled, 'Spring Bouquet,' and 'Blossoms' is the appropriate title for another Valley of Gardens entry by **Hazel Rossini**. **Florence Boster**'s [Sic. **Foster**] 'Pink Hibiscus,' and still life studies by **Maye Nichols, Elaine Smith** and **Vera**

Sears are other paintings in the exhibit. **Mrs. Ray DeNejer** has entered a piece of sculpture, 'The Clown,' and there are others by **Forrest Hibbits**, Lompoc artist and teacher in the DeNejer Studios, and also his youthful pupil, twelve-year-old **Arthur Sutton**... Twelve artists from Santa Maria were in the group [that visited the show at Santa Barbara] ... and also **Mario Veglia** Casmalia artist and his son," *SMT*, June 23, 1949, p. 5.
1950 – "Touring Art Exhibition ... to Stop Here Wed... the show contains paintings from Lompoc artists as well as other artists in the Santa Barbara, San Luis Obispo and Ventura counties area... Included in the paintings now being shown at the annual exhibit in the Santa Barbara Museum of Art are works by Lompoc artists **Mrs. W. H. Bailey, Mrs. Anthony** [Sic. **Arnold**] **Brughelli, Mrs. Claire Callis, Forrest Hibbits, Mrs. R. G. LaRue, Mrs. Charles Maimann** and **Mrs. Milton Schuyler**," and repro of Portrait by **Douglass Parshall** in the show, *LR*, April 27, 1950, p. 1; "Tri-County Art Show Women to Aid... Several committees have been named to take charge of activities for the local showing of the Fourth Annual Tri-County Art Show scheduled to take place here Wednesday afternoon and evening. ... **Mrs. William Bailey** will have charge of the exhibit and will be assisted by Mmes. Walter Anderson, John Counts, **James Kenney** and **Milton Schuyler**...," *LR*, April 27, 1950, p. 3; repro of 'Portrait of a Lady' by unnamed artist and "Tri-County Art Show Travels to Santa Maria May 11 at Minerva Club ... 56 paintings will be sent to Santa Maria... **Mrs. Ray DeNejer** of Santa Maria, who is exhibiting in the show for the second year, is showing a landscape with figures, titled 'Land's End.' Canvases from other Santa Maria students and artists, all of them in oils, are 'Fairytale,' by **Elaine Smith**, 'Gall Bouquet,' **Florence Foster**, 'Phantasy,' **Edna Myers**, 'Still Life,' **Vera Sears**, and "Bowl of Fruit,' **Jane Merlo**... Special mention was made by Mrs. DeNejer... of the unusually fine painting by David Hall Julian, judged best of the show, and also that by **Milford Zornes**, former resident of Nipomo," from Santa Barbara Museum of Art, *SMT*, April 28, 1950, p. 6; ■ "Tri-County Art Show Draws Responsive Crowd Yesterday... Lompocans greeted the showing of 50 representative pieces of art work being exhibited from the Fourth Annual Tri-County Art Show... at the Veterans Memorial building. The paintings, ... by both amateur and professional artists in the tri-county area, were exhibited here as the first stop in a traveling tour. Sponsored locally by the Alpha club, the art show was held in conjunction with a flower exhibit. Highlight of the afternoon was an address by **Ronald Scofield**, art and music critic of the *News Press*... who stressed the need for each community to provide incentive and encouragement to its potential artists... Out-of-town guests present were ... **Mrs. Mary Jane Thornburgh**, Santa Monica, district federation of women's clubs chairman of art and Mrs. Little, district welfare chairman. Mrs. Little gave a talk on art to sixth grade youngsters who visited the art show early in the afternoon...," *LR*, May 4, 1950, p. 3.

■ "Encouragement of self-expression thru painting by means of such organizations as the Tri-county art show may someday bring about discovery of one even greater than Rembrandt, **Joseph Knowles**, Santa Barbara artist told an audience yesterday in Minerva clubhouse. ... the local

exhibit sponsored by the *News Press* Publishing Co. …Knowles praised the show as a means of encouraging artists in this area. He said, if the quality of exhibits continues improvement at the pace set in its four years of existence, that the 24th annual show should be one in which great strides in development of native talent will have been made. Value of the exhibit, said Knowles, is the comparison of work as it appears with that of others. … 'Very young and a conglomerate culturally,' was Knowles' expressed thought about art in America. But he believed it possible, thru greater emphasis on education in art that a definitely American form, one that reflects hopes and aims of its people, may grow. More than 50 paintings were shown in the local exhibit including one by Knowles, purchased by Santa Barbara Museum for its collection. A panoramic water color of San Fernando valley painted from a high hillside vantage point, the artist said he had utilized smog to blot out details that would have detracted from the valley scene of farms and homes. A revelation to visitors at the show were several canvases by Santa Maria artists. In oils, 'Autumn Bouquet,' by **Alyce Sample**, was distinguished for its color contrast and form. An excellent still life by **Maye Nichols** featuring glass, was titled, 'Green Bottle.' **Jane Merlo**, former teacher in Santa Maria high school, exhibited her remarkable fine still life study named 'Fruit.' Her third effort at painting, the work is exceptional for its good color and detail. **Florence Foster**'s versatile talent is seen in two different type paints, one a flower and vase delicate study, the other a portrait in pastels titled 'Odette.' The portrait in tragic theme depicts a young French woman against postwar ruins of a city. Sisquoc Foxen memorial chapel is a praiseworthy first canvas of a beginner, Laura L. Taylor [Mrs. William Steck Litzenberg]. Dream quality is seen in 'Lands' End,' phantasy study by **Jeanne DeNejer**. This work has good perspective, scale, and treatment of light and shadow beneath trees. The artist is also a teacher in Santa Maria. **Douglass Parshall**'s handsome portrait, unofficially chosen best of the show this year, occupied a prominent place in the local exhibit. Near the portrait was seen an extreme modern titled 'Anywhere the Wind Blows,' by **Mildred C. Wood** of Los Olivos. Despite its modern style, this canvas was noticeable for its painstaking detail. 'Sophistication' might have been the title of **Mrs. W. E. Sears** still life, with open fan and ornamental vase against textiles in handsome color contrast. **Edna Myers**' 'In the Woods,' on a fairy story theme drew favorable comment for excellent work by a virtual beginner. Graceful line and delicate color reflected work of one who loves flowers in the canvas entered by **Lena Boradori** of Los Alamos – R. B.," per "Speaker Tells of Exhibit as Aid to Culture Growth," *SMT,* May 12, 1950, p. 6.

1951 – 0

1952 – "Valley Artists Show in S.B. Seven Santa Ynez Valley artists are among the 250 represented in the Tri-County Exhibition at the Santa Barbara Museum of Art… through Tuesday, April 29. … **Mrs. Grace L. Davison, Mrs. Don Davison, Mrs. Ronald Abbott, Lyman Emerson, Mrs. Martha Williams, Forrest Hibbits and C. M. Glasgow**…," *SYVN,* April 11, 1952, p. 1.

1953-56 – 0

1957 – "Tri-County Art Exhibit Slated… Over 300 paintings, ceramics and art pieces… Tenth Annual… Santa Barbara Museum of Art, May 7-26… Artists from the counties of Santa Barbara, Ventura and San Luis Obispo… artists such as **Douglass Parshall** and **William Hesthal**…," *LR,* May 9, 1957, p. 12; "Tri-County Art Exhibit is Open," in Santa Barbara Museum, *SMT,* May 11, 1957, p. 3.

1958 – "Buellton Briefs… Mary Steel, assistant art director, asks all who wish to exhibit their painting or sculpture work in the 11th Annual Tri-County Exhibition to bring their entries to the Santa Barbara Museum of Art April 22 and 23. The exhibition … will be open from April 28 until May 18," *LR,* April 17, 1958, p. 8; "**Jr. Alphas**. … will sponsor a local exhibit of the Eleventh Tri-County Exhibition following the Santa Barbara Museum of Art event which opens Monday, April 28 and continues until May 18 … The Junior Alphas are urging all local artists and art students to enter the Santa Barbara Exhibit so that their paintings will be included in the local art show to be held May 27-28 in the **Alpha club**," *LR,* April 17, 1958, p. 13; "Public Invited to Art Exhibit at Alpha Club … paintings on exhibit under the auspices of the Lompoc Junior Alpha club in cooperation with the *Santa Barbara News-Press* … no admission charge… On Wednesday evening, May 28, at 8:00 o'clock, there will be a speech given by **Mr. Ronald Scofield** of Santa Barbara on 'The Value of Expression in Any Medium Today.' The exhibit will include approximately 25 paintings selected from the 267 which were shown in the Tri-Counties Art Exhibit … **Mrs. Ethel Bailey**'s award-winning 'Wild Geese' which was declared one of the outstanding semi-abstractions in the showing, will be among the paintings… 'Hibiscus' by **Mrs. Joe Grossini**, 'Austrian Swamp' by **Mrs. James Lewis**, and 'Iris' by **Mrs. Paul Highfill** will also be on exhibit. Other paintings by the **Mmes. Grace Anderson, Neal Martin, Robert W. Chilson, Arnold Brughelli** and **Elsa Schuyler** and by the Messrs. Harold Cutting [foreman of the machine shop at Johns-Manville], Charles B. Henning, and Jerry S. Luckett, will also be on display. **Forrest Hibbits**, well-known in art circles will have a painting in the exhibit as will artists from Buellton, Los Olivos, Santa Maria, Solvang, San Luis Obispo, Atascadero, Halcyon, Paso Robles, Morro Bay and Santa Ynez," and port. of **Mrs. James Lewis, Mrs. Joe Grossini** and **Mrs. Paul Highfill** with **Mrs. Lewis**' painting 'La Purisima Mission,' *LR,* May 22, 1958, p. 4.

1959 – "Art Exhibit to Open Today," *LR,* June 29, 1959, p. 4; "Oils, Pastels, Sculpture Shown… among the 28 paintings shown last Monday and Tuesday in the Alpha Club House. Part of the tri-county art show at Santa Barbara Museum of Natural History earlier this year, the traveling section came to Lompoc from a showing at Vandenberg Air Force Base. Several paintings were displayed on a lattice screen and many were placed on Alpha Club house walls… Among the paintings were those done by two Lompoc artists, **Ethel Bailey** and **Elsa Schuyler** who are both students of **Forrest Hibbits**, Buellton artist. Mrs. Bailey exhibited a water color scene of summertime vacationers while Elsa Schuyler's oil painting was a bold still life entitled, 'Still Life with Green Bottle.' The two have placed in several art shows. … 'Plate Glass'

by **Gladys Gray**, a watercolor of orange and yellow shades … 'Round House' by **Harold Forgostein**, a watercolor, and 'Family of Birds' by **Marie Jaans**, wife of Forrest Hibbits. Mosaic style was seen in 'Nefretite' by <u>Lloyd W. Kingsley</u> [resident of Santa Barbara and Lompoc where he ran Kingsley Upholstering in the 1970s] and 'Summer Mosaic' by **Woody Yost**. A silver tea took place Tuesday evening following a talk by **Dick Smith**, art editor of the *Santa Barbara News Press* on 'Origins of Taste in Art'," and repro: of "Still Life with Green Bottle" by **Elsa Schuyler**, a student of Forrest Hibbits, *LR*, July 2, 1959, p. 5.

1960 – "Annual Tri-County Art Exhibit Set. The Santa Barbara Museum of Art announces that its 13th annual Tri-County art exhibition will take place this year from March 31 through April 10," and invites participation, *LR*, Feb. 29, 1960, p. 5.

<u>See</u>: "Allan Hancock [College] Art Gallery," 1958, 1959, "Alpha Club," 1948, 1958, "Guadalupe, Ca., Elementary School," 1949, "Hibbits, Forrest," 1952, 1957, "Liecty, Ruth," 1956, "Minerva Club," 1950, and *San Luis Obispo Art and Photography before 1960*

Trott (Herron), Irma Daisy (Mrs. James Herron) (1875-1954) (Santa Maria)
Juvenile. Exh. industrial drawing at "Santa Barbara County Fair," 1889.

■ "Mrs. Irma Herron, Pioneers' Daughter… Mrs. Herron was born in Santa Maria Dec. 16, 1875. She graduated from the Santa Maria Union High School in 1895 and was later married to the late James Herron, who died in 1942…," *SMT*, April 26, 1954, p. 1.

<u>Trott, Daisy (notices in Northern Santa Barbara County newspapers on microfilm and on newspapers.com)</u>
More than 30 notices for "Daisy Trott" in *SMT* between 1880 and 1900 show that she was 14 years old in 1889, that she took her teacher's examinations in 1894, that she graduated from Santa Maria Union High School in 1895, that she taught at the Casmalia school in 1899, and after no newspaper notices between 1900 and 1914, she reappears in Santa Maria as Mrs. Irma Trott Herron, a judge in a voting precinct, 1915.

<u>Trott, Daisy (misc. bibliography)</u>
Erma [sic. Irma] D. Trott listed in the 1880 U. S. Census as age 4, b. c. 1876 in Calif., residing in Sisquoc with her parents George J. Trott (age 27) and Mary E. Trott (age 22) and siblings; Irma Trott Herron, b. Dec. 16, 1875, mother's maiden name Oakley, d. April 25, 1954 in Santa Barbara County per Calif. Death Index (refs. ancestry.com).
<u>See</u>: "Santa Barbara County Fair," 1889

Truax, Emma Frances / Frances Ferguson (Mrs. Dr. Jesse P. Truax) (1871-1958) (Lompoc / San Francisco)
Member of Alpha Club Art Section 1929+ and head, 1937/41 and 1942/44.

■ "Truax Rites Held Here… Frances Ferguson Truax, a resident of Lompoc for the past 38 years…. Wife of Dr. J. P. Truax… She was born in North San Juan, Calif. on June 17, 1871. She came here with her husband and children when Dr. Truax became the company physician for the

Celite company. She was a member of the Alpha club and an active member of the Presbyterian church. …," *LR*, July 10, 1958, p. 2.
Many references to her in local newspapers were not itemized here.
<u>Truax, Frances (misc. bibliography)</u>
Emma Frances Truax was b. June 17, 1871 in Calif., d. July 7, 1958 in Santa Barbara County and is buried in Lompoc Evergreen Cemetery per findagrave.com (refs. ancestry.com).
<u>See</u>: "Alpha Club," 1929, 1932-44, "Flower Festival / Show," 1932, "Posters, general (Lompoc)," 1928

Trudeau, Harold Charles (1915-1955) (USA)
Photographer from Holiday magazine who photographed Solvang, 1947.

■ "Harold C. Trudeau, 39, of 728 Buckingham Pl, a photographer in *The Tribune*'s color studio for two years, died yesterday in Lake Forest hospital as a result of a heart attack he suffered July 10 on the Deerpath golf course, Lake Forest. He leaves his widow Mildred…," *Chicago Tribune*, July 23, 1955, p. 37.

■ "'Miniature' Danish Days Here Sunday… when some of the town's residents don native costumes and go through all the motions of the festival for the benefit of *Holiday* magazine which plans to feature an article on the town. Two of the magazine's staff members, Bill Graffis, writer, and Harold Trudeau, photographer, have been busy all week… 'Unfortunately,' Graffis said, 'we arrived a few months too late to record for *Holiday* a picture of Solvang as it is during a native celebration. So, we're going to attempt to do the next best thing and that is to get the people of the town to help us in preparing the article.'…," *SYVN*, Oct. 10, 1947, p. 1.
Numerous reproductions of his photos appear in the *Chicago Tribune* 1953-1955, but were not itemized here.

Truitt, Irvine "Irving" Hamilton (1911-1994) (Santa Maria)
Photographer. Member Santa Maria Camera Club, 1938-41. Spoke on his activities as an Army photographer, 1941.
<u>Truitt, Irving (notices in Northern Santa Barbara County newspapers on microfilm and on newspapers.com)</u>
1942 – "Move to Long Beach … Mr. and Mrs. Irvine Truitt… also have gone to Long Beach as defense workers," *SMT*, April 7, 1942, p. 3.
1954 – Port with members of the Ridgecrest Gun Club, *Bakersfield Californian*, Jan. 20, 1954, p. 18.
<u>Truitt, Irving (misc. bibliography)</u>
Irvine Hamilton Truitt was b. Nov. 4, 1911 in Los Angeles to Jonathan D. "Jadie" Truitt and Hazel G. Smith, was residing in Santa Maria in 1930 and 1940, and d. June 21, 1994 in Seal Beach, Ca., per kgrubaugh2008 Family Tree (refs. ancestry.com).
<u>See</u>: "Santa Maria Camera Club," 1938, 1939, 1940, 1941

Tucker, Charles W. (c. 1862-1913) (Lompoc / Seattle)
Draughtsman, photographer, etc., 1880s.

■ "Passes Away at Seattle… Charles W. Tucker… He was born in Santa Cruz, Cal., came to Lompoc when a boy. After leaving school was deputy postmaster for several years, then was agent for W. F. & Co. and Western Union Tel. Co. In 1887 went to City of Mexico for W. F. & Co. Not being able to stand the climate there … in 1889 went to Seattle and bought out a business but was burned out in the great Seattle fire a few days after purchasing the business. Mr. Tucker then went into the post office as letter carrier, which position he held until his death… 24 years," *LR*, May 23, 1913, p. 1.

Tucker, Charles (notices in Northern Santa Barbara County newspapers on microfilm and on newspapers.com)
1882 – "Chas. Tucker has shown us some very fine specimens of pen drawing executed by himself. They are very neatly and artistically done and would reflect credit upon a person of far more practice and experience than our young artist," *LR*, May 20, 1882, p. 3.
1889 – "Mr. C. W. Tucker left Lompoc Friday for Seattle, where he intends going into business in company with photographer **Briggs** who left Lompoc some weeks since," *LR*, May 25, 1889, p. 3.
Possibly 100 hits for variations on his name in Lompoc papers detailing his several jobs before moving to Seattle, 1889, were not itemized here.

Tucker, Charles (misc. bibliography)
Charles W. Tucker is listed in the 1880 U. S. Census as age 18, b. c. 1862 in Calif., a printer, residing in Lompoc with his parents Benjamin F. Tucker (age 50) and Emily R. Tucker (age 66, sic. 46) and brother; Charles W. Tucker b. c. 1862, d. May 21, 1913 in Seattle per Washington Death Records (refs. ancestry.com).

Tuckerman, Lilia McCauley (Mrs. Wolcott Tuckerman) (1882-1969) (Santa Barbara / Carpenteria)
Painter. Exh. annual Santa Ynez Valley Art Exhibit, 1953, 1954. Exh. Allan Hancock [College] Art Gallery, 1956.

Tuckerman, Lilia (notices in Northern Santa Barbara County newspapers on microfilm and on newspapers.com)
1926 – "Invitations Received… to a tea and reception by Mrs. Wolcott Tuckerman of Santa Barbara at the Santa Barbara Art club, 15 East de la Guerra street, Wednesday, April 28, from 3 to 6 o'clock. After tomorrow the public will be permitted to view the paintings that will be hung for the reception," *Press-Courier* (Oxnard, Ca.), April 27, 1926, p. 2; repro: "El Camino Nuevo," exh. in the 17th annual exh. of the California Art Club at Exposition Park, *LA Times*, Oct. 17, 1926, p. 136 (pt. ?, p. 4).
1927 – Repro: "The Leaning Tree," *LA Times*, May 22, 1927, p. 141 (i.e., pt. ?, p. 5).
1934 – "Santa Barbara Exhibition of Art Scheduled… artists division of the Santa Barbara Associates… fourth monthly exhibition of Santa Barbara county paintings… in the unique gallery which the Chamber of Commerce has established in its East Cabrillo street building… exhibits by… Lilia Tuckerman…," *LA Times*, Dec. 11, 1934, p. 26 (i.e., pt. II, p. 8).

1937 – "Santa Barbara Artist Opens Exhibit with Tea… Little Gallery of Carrillo street… On the walls were twenty-nine paintings by the artist-hostess, mostly regional landscapes. The painting 'Ilex' had just returned from exhibitions at the National Academy of Design, the National Association of Women Painters and the National Arts Club exhibits in New York City, at Washington, D. C., Stockbridge, Mass., Sacramento, Santa Cruz and Oakland. Mrs. Tuckerman is a member of the artists' division of Santa Barbara Associates, the Washington Society of Artists, the Boston Art Club, the California Art Club of Los Angeles and the Fine Arts Society of San Diego," *LA Times*, Feb. 7, 1937, p. 54 (pt. IV, p. 2).
1940 – DAUGHTER – "Clara Tuckerman will Wed **Campbell Grant**… the bride-elect, the daughter of Mr. and Mrs. Wolcott Tuckerman of Carpinteria, who has won considerable success in the stage design field… She attended the Santa Barbara Girls School and was graduated from Smith College. Her fiancé is a prominent young California artist and the brother of the late Gordon Kenneth Grant, Santa Barbara artist," *SF Examiner*, April 23, 1940, p. 17.
1943 – "Artist's Show will Aid Red Cross. Mrs. Wolcott Tuckerman of Foothill Road, Carpinteria (Lilia Tuckerman…), will open a two-week exhibition of her paintings at the Coral Casino of the Santa Barbara Biltmore tomorrow, proceeds of the sale going to the American Red Cross War fund. This will be the artist's second annual show and sale for the Red Cross," *LA Times*, April 16, 1943, p. 39 (i.e., pt. II, p. 5).
1947 – "Lilia Tuckerman Exhibit… is being held in the Gallery, 135 E. Carrillo St., Santa Barbara …," *LA Times*, Dec. 7, 1947, p. 43 (i.e., pt. IV, p. 1).
1953 – "Tuckermans Mark Golden Anniversary… Yesterday their children, five daughters, journeyed to their parents' home for luncheon…," *LA Times*, Nov. 26, 1953, p. 73 (pt. III, p. 1?).
1961 – "Carpinteria Artist to Hold Benefit Sale. Artist Lilia… Tuckerman of Carpinteria Valley is having an exhibition and sale of paintings at the Little Gallery in Santa Barbara to benefit Santa Barbara Society for Crippled Children and Adults, through Saturday," *LA Times*, April 9, 1961, p. 106 (i.e., Sect. I, p. 2).
And, a few additional articles in California newspapers not itemized here, and more than 60 on "Mrs. Wolcott Tuckerman" not itemized here.

Tuckerman, Lilia (misc. bibliography)
Lilia Tuckerman was b. July 15, 1882 in Minneapolis, Minn., to Edward and Frances McCauley, d. Aug. 7, 1969 in Santa Barbara County and is buried in Santa Barbara Cemetery per findagrave.com (refs. ancestry.com).
See: "Allan Hancock [College] Art Gallery," 1956, "College Art Club," 1935, "Santa Ynez Valley Art Exhibit," 1953, 1954

Turek, Charles Alois "Karl" (1858-1925) (Santa Maria)
Monument dealer 1910+. Sold out to F. A. Anderson, 1922 and took back the business, 1924. Father of Louis Turek, below.

■ "Chas. A. Turek, Local Business Man Passes. Charles Alois Turek, resident of Santa Maria for the past 14 years, passed away… Mr. Turek was a native of Austria, aged 77 years, and came to the United States 51 years ago. He was engaged for many years in the monumental business in Chicago… With his family, he removed from there to Texas where he followed his occupation until 1901 [Sic. 1910?} when he came to California, the family locating in this city, with an establishment on West Main street. Mr. Turek was industrious and efficient… He leaves to mourn his loss, the widow, Mrs. Katherine Turek…," *SMT*, Oct. 28, 1925, p. 1.

Turek, Charles A. (notices in Northern Santa Barbara County newspapers on microfilm and on newspapers.com)
1910 – "Chas Turek of Wichita Falls arrived here last week with his family and will open up in business here with a fine line of monuments and copings. Mr. Turek has been a prominent business man in Wichita and having decided to locate here, will bring in several car-loads of fine marble and granite stones," *SMT*, Oct. 29, 1910, p. 5, col. 2.
1911 – "Tombstone Dealer After Big Project. C. A Turek the monument dealer contemplates removing from Santa Maria and locating in San Francisco …," *SMT*, Aug. 12, 1911, p. 1.
1924 – Ad. "C. A. Turek. Open again, monument business in his old place, 219 West Main Street. First class work and reasonable prices; 25 per cent off any monument bought before March 1, 1925," *SMT*, Dec. 23, 1924, p. 4.
More than 200 additional notices (primarily ads) in the *SMT* for "Turek" were not itemized here.
Turek, Charles A. (misc. bibliography)
Charles Alois "Karl" Turek was b. April 7, 1858 in Prague, Czech Republic, to Mrs. Ludmila Turek, married Katerina Stastny Dvorak, and d. Oct. 28, 1925, in Santa Maria per Huffman Family Tree (refs. ancestry.com).
See: "Anderson, Frederick A.," "Turek, Louis"

Turek, Louis (Santa Maria)
SERA artist who supervised the stenciled decoration on the ceiling of the auditorium in the Main Street School, 1934. Son of C. A. Turek, above.
See: "Santa Maria, Ca., Elementary Schools," 1934, "Turek, Charles"

Turner, Ava E. (Mrs. Frederick W. Turner) (Santa Barbara)
Exh. painting at Santa Barbara County Fair, 1952.
Turner, Ava (misc. bibliography)
Ava Turner is listed with Frederick W. Turner, in the *Santa Barbara, Ca., CD*, 1956-58 (refs. ancestry.com).
See: "Santa Barbara County Fair," 1952

Turner (Graham), Charmian Anne (Mrs. Dwain W. Graham) (1934-2019) (Santa Maria)
Won a prize for her poster advertising the Minerva Club Flower Show, 1948. Art major at Santa Maria high school, 1952. Vocalist.

■ "Charmian Turner will Marry Dwain Graham of USAF… [daughter of] Mr. and Mrs. Harold Turner… The bride-elect is a senior in Santa Maria Union high school where she is active in organizations and campus affairs. She is majoring in art, and two years ago was one of the winners of the Southern California Regional **Scholastic Art** awards with a colored crayon landscape, displayed with other winning student work in Los Angeles. She is this year's art editor of the high school annual," *SMT*, May 8, 1952, p. 4.
Turner, Charmian (notices in Northern Santa Barbara County newspapers on microfilm and on newspapers.com)
1952 – Port. and "Charmian Turner Takes Lead … Elks rodeo queen contest. … Charm is art editor of this year's high school annual, *The Review*… A singer Miss Turner has often entertained ward patients at Camp Cooke Army hospital," *SMT*, May 26, 1952, p. 8.
And, more than 80 additional notices for "Charmian Turner" show that she competed in floral arrangements, appeared many times as a singer, etc., but were not itemized here.
Turner, Charmian (misc. bibliography)
Charmian A. Turner married Dwain W. Graham on Jan. 25, 1953 in Santa Barbara County per Calif. Marriage Index; Charmian Anne Turner was b. Oct. 2, 1934 in Santa Maria to Harold Turner and Laurie Shepard / Sheppard, and d. Feb. 4, 2019 in Smethport, Pa., per Graham Family of Angelica, NY, Family Tree (ref. ancestry.com).
See: "Minerva Club, Flower Show," 1948, "Santa Maria, Ca., Union High School," 1952

Twenty-Thirty Club (Santa Maria)
Club that proffered its members some programs on art.
The Twenty-thirty Club is/was a national club with local chapters composed of individuals between the ages of 20 and 39.
Twenty-Thirty Club (notices in Northern Santa Barbara County newspapers on microfilm and on newspapers.com)
1937 – **Rev. Marius Krog** of Solvang, "Minister Talks of Art to Club. … 'We Americans have been accused of not being cultural. But whatever Americans may lack in culture, they make up in other ways. There is a spontaneity in Americans that is entirely wholesome.' This was the assertion of the Rev. Marius Krog of Solvang, in a talk before the Twenty-Thirty club meeting last night in Santa Maria club. His address was titled, 'A Key to the Understanding of Art.' 'Your ability to respond to the better things in life means that your circle of response has been widened,' said the speaker. 'Unless you learn to respond to art, it is a closed circle. Many of us have failed to get in touch with culture because we have failed to open our minds to it. Explains Art. The speaker explained that art is not a matter of combining a group of colors, or the ability of a person to play musical notes rapidly and dexterously, but declared: 'Art is the portrayal of an inspiration, and the conveying of that inspiration to others. As we get older, life

seems to close in on us. But if we open our minds to art and culture, we have something age cannot take from us. The time to learn art is when a person is young. It is hard to learn when we get older.' In explaining some of the aspects of art, the speaker said, 'the most artistic thing in the world is the human face.' He stressed the use of lines in the portrayal of art. Strong upward lines, portray strength and the striving for something, he said. Curved lines portray the sensual, while horizontal lines signify rest, repose, death or laziness. Appreciation of Art. To gain an appreciation for art, and to increase the scope of appreciation of the better things in life, the speaker advised the group to look for the most subdued colorings in paintings, rather than the glaring, cheap things, and also to look for the more subdued, rather than the glaring in music. 'The things of culture are not of the moment,' concluded the speaker. 'They live on, so that generation after generation come to enjoy them'," *SMT,* March 24, 1937, p. 3.

Twin Camps
CCC camps near La Purisima.
See: "California Conservation Corps"

Twitchell, Edwina Josephine Zanetti (Mrs. Theodore Andow "Cap" Twitchell) (1901-1989) (Santa Maria)
Exh. landscape paintings at Minerva Club Art and Hobby Show, 1957, 1958, 1959. Musician.

■ "SM pioneer family member Edwina Twitchell dead at 87… She worked as a bookkeeper for J. M. Davis of Santa Maria until she married in 1926, after which she devoted her time to raising her children. Edwina was a 55-year member of the Minerva Club, a member of the A-Z Club, Catholic Daughters and was interested in the Santa Maria Historical Society… Edwina's parents were Anita Tonini Zanetti who was born on the Tonini Ranch in the Los Osos area and Maurice Zanetti from Switzerland…," *SMT,* Nov. 8, 1989, p. 2.
Twitchell, T. A., Mrs. (notices in Northern Santa Barbara County newspapers on microfilm and on newspapers.com)
And, more than 30 additional notices for "Edwina Twitchell" and more than 40 for "Mrs. T. A. Twitchell" in local newspapers between 1955 and 1965 reveal her husband, a supervisor, died in 1955, but they were not itemized here.
Twitchell, T. A., Mrs. (misc. bibliography)
Edwina Josephine Twitchell was b. Dec. 16, 1901, d. Nov. 8, 1989 and is buried in Santa Maria Cemetery District per findagrave.com (refs. ancestry.com).
See: "Delphian Society," 1934, "Minerva Club, Art and Hobby Show," 1957, 1958, 1959

Tyler (Gaddis), Marilyn Jean (Mrs. Lucius Wesley Gaddis) (b. 1928?) (Santa Maria)
Santa Maria High School grad. 1946, who became an art teacher at Poly elementary school in Pasadena, 1950.

■ "Marilyn Tyler to be Among June Brides, will Wed L. Wesley Gaddis, … daughter of Mr. and Mrs. Harry E. Tyler… Miss Tyler was graduated from Santa Maria high school and Pomona college and in the past year she has

taught part time in the art department at Pasadena Polytechnic elementary school…," *SMT,* June 5, 1951, p. 4.
Tyler, Marilyn (notices in Northern Santa Barbara County newspapers on microfilm and on newspapers.com)
1950 – Daughter of local couple and recent graduate of Pomona College, Claremont, "To Teach Art" at Poly elementary and jr. high in Pasadena, "a private school, and meanwhile will study for her master's degree…," and list of activities including "was awarded the Drew art prize in 1949…," *SMT,* June 15, 1950, p. 6.
And, more than 90 additional notices reveal she led an active social life, worked summers at Yosemite National Park, played first bass in orchestra, excelled scholastically, won speaking contests, and held class office, but they were not itemized here.
Tyler, Marilyn (misc. bibliography)
Maryln [Sic.] J. Tyler, is listed in the 1930 U. S. Census as residing in Sacramento with her parents; Marilyn Jean Tyler is listed in the 1940 U. S. Census as age 11, b. c. 1929 in Nebraska, residing in Sacramento with her parents Harry E. Tyler (age 41) and Jennie L. Tyler (age 42) and siblings; port. in Santa Maria High School yearbook, 1946; port. in Pomona College, *Metate Yearbook,* class of 1950; Mrs. Marilyn T. Gaddis is listed in Los Angeles County Voter Registrations, 1952-60; Mrs. Marilyn Gaddis is listed in the *Whittier, Ca., CD,* 1952, 1954 and in the *Pomona, Ca., CD,* 1956; HUSBAND – d. 1974; is she Dr. Marilyn T. Gaddis b. June 27, 1928, residing in San Marcos, Tx., per *U. S. Public Records Index, 1950-1993,* vol. 2 (refs. ancestry.com).

U

Ueki, Masuo (Guadalupe)
Santa Maria High School artist who won a prize for his poster for the Minerva Club Flower Show, 1936. Won a prize in the Scholastic Art Awards, 1937. Prop. with George Y. Sahara of Home Food Basket in Guadalupe, 1947+.
See: "Minerva Club Flower Show," 1936, "Santa Maria, Ca., Union High School," 1937

United Service Organization (USO) (Lompoc and Surf)
WWII recreation organization for servicemen founded Feb. 4, 1941. In mid-July 1942 the local Foresters Hall was dedicated as a soldier recreation center. Main center was located on Walnut Street, Lompoc, 1942+, [with another on H Street – run by NCCS – National Catholic Community Service?] and a branch at Surf, 1944+. Among its activities were classes on painting, crafts and photography. Used by servicemen (as well as service wives.) [Crafts also were taught on base at Service Clubs.] Walnut St. site closed mid-1946.

■ "With America's military growing rapidly in response to the increasing threat preceding America's entry into World War II, President Franklin Delano Roosevelt challenged six private organizations – the YMCA, YWCA, National Catholic Community Service, the National Jewish

Welfare Board, the Traveler's Aid Association and the Salvation Army – to handle the on-leave recreation needs of members of the armed forces. These organizations pooled their resources and the United Service Organizations – which quickly became known as the USO – was incorporated in New York State," from www.uso.org.

United Service Organization (notices in Northern Santa Barbara County newspapers on microfilm and on newspapers.com)

1942 – "Hundreds Attend Opening of Foresters Hall as USO Soldier Recreation Center… Dinwiddie… hall…," LR, July 17, 1942, p. 1; "Federal Trailer Project News Notes… USO. Starting September 21, we will have handcraft classes. We are already stenciling articles for Christmas gifts. There are many other gifts to be made and facilities to make them with, such as burnt wood trays, cigarette boxes and so forth. Make the USO your Headquarters…," LR, Sept. 11, 1942, p. 2; "Arts and Crafts Class to be Started Sept. 21… **Mrs. Marion Margeson** will be the instructor… Articles of leather, paint, stencil, luncheon sets, purses and costume jewelry can be made. … no charge for instruction and the material may be purchased at cost prices. Craft Shop hours will be… Tuesday, Thursday and Saturday evenings from 7 to 10 p.m. and every afternoon from 2 to 4:30 o'clock," LR, Sept. 11, 1942, p. 4 and repeat on LR, Sept. 18, 1942, p. 3; cartoon by Tech. John L. Galitello and Tech. John C. Divon, soldier artists, re: U. S. O. fund raising, LR, Oct. 9, 1942, p. 1; "Federal Trailer Project News Notes… Everyone is cheering over the return from her vacation of **Mrs. Bayonne Glenn**, the director of the Penthouse in the Walnut street USO. The arts and crafts classes are getting a good response…," LR, Oct. 16, 1942, p. 6; "Wives to Meet – The Army and Cadet wives will meet in the USO building on Wednesday at 8 o'clock. The handicraft class will specialize in Christmas cards and Christmas place cards," SMT, Nov. 23, 1942, p. 3; "Mrs. Margeson Resumes Duties… **Mrs. Guy L. Margeson** returned to Lompoc… and resumed her duties as instructor for the arts and crafts classes at the Walnut street USO club. New ideas which she received in the east on pom-pom rugs and other types of rugs will be introduced at the craft class meetings which are held daily from two to four thirty o'clock," LR, Dec. 18, 1942, p. 5.

1943 – "USO Walnut Street… Tuesday, January 19th, the **USO Camera Club** will start the new year with the first in a series of illustrated lectures by a noted photographer. … the Camera Club is extending the invitation to all servicemen and their families or friends… The series will consist of illustrated talks and demonstrations in the art and technique of not only taking good pictures but developing, printing and enlarging them. One of the highlights will be a demonstration of the use of lighting in portrait photography," LR, Jan. 15, 1943, p. 6; "USO Reporting. Tuesday evenings at the Walnut Street USO brings an interesting and unusual opportunity for this time is set aside for the new series of illustrated talks on the art of Photography. These demonstrations will be conducted by a professional photographer and will include such fascinating information as How to Take Pictures Correctly, How To Develop, Print and Enlarge Your Pictures and to cap the

climax there will be a lecture on the use of lights, in which lighting for portraits will be featured and by a living model. Realizing that many people outside the **Camera Club** are vitally interested in photography, the Club cordially invites everyone to attend the series," LR, Jan. 22, 1943, p. 6; "USO Reporting… The first in a series of illustrated talks on photography by … **Ernest Brooks** … Pictures of a tour through South America were shown and their photographic techniques explained. Not only was it an evening of interest to Camera Fans but an evening of enjoyment for everyone. Following the pictures, the boys were enabled to clear up many technical problems on photography that had been confronting them through an open question period. At the next lecture, Mr. Brooks will demonstrate the methods and techniques of developing films and printing pictures. These meetings are now open to all servicemen and their friends. Remember the time – Tuesday, at 8:00 p.m.," LR, Jan. 29, 1943, p. 6; "Public Invited to Attend Service Club Event. … Walnut Street club… The purpose of USO Open House is to enable the American people at first hand to observe a USO club and to become acquainted with the services rendered… From 1 to 6 p.m. the public is invited to … see USO in action… Examples of art and craft work, photographs and other products of hobby groups executed by service men will be on view…," LR, March 26, 1943, pp. 1, 8; "USO. Walnut Street… From 2 to 4 Monday through Friday, Army wives have found fun creating useful articles in the USO handcraft room. Belts, billfolds, scrapbooks, trays and stencil work have proved popular projects…," LR, May 21, 1943, p. 3; "USO Reporting… Vibratin' through the room in the Penthouse at the Walnut Street USO are such remarks as 'Where are the designs' – 'Give me the leather tools' – 'Where's the red paint?' Nope, it's not a meeting of the Builders' Association but an Arts and Crafts Class. This class meets every day from 2 until 4. Under the supervision of Mrs. Madge Gomilla, many a maid has learned to create masterpieces … This class is a haven for soldiers' wives… Here they are able to spend 2 hours making useful items such as wallets, belts, trays, etc. The class is open to all Service wives…," LR, Aug. 13, 1943, p. 4.

1944 – ■ "'Picturecords' Popular at H street USO … is now an added service made possible by the experimentation of Chester Hennessy, Albert Henning, Sgt. Wm. Kerstner and Director Ed Trainor. These pictures and recordings are made at the same time and can be mailed at once and give promise of being popular. Photographers, skilled and amateur, among the local citizens and servicemen, will celebrate next Sunday night the 105th anniversary of the science of photography (daguerreotype). … The evening's program will feature camera, Technicolor and other photographic talks as well [as] music, luncheon and informal dancing," LR, Jan. 14, 1944, p. 2; "Activities Varied at Two USO's … Recreation Program Expanded… The year 1943 saw a deepening and intensification of the USO program. Last year was organized inter-agency training courses in arts and crafts, social recreation, sports and dramatics…," LR, Feb. 4, 1944, p. 2; "Surf USO Club Separate Soon Due to Growth… 'The work of the Surf extension of the Walnut street USO has grown to such large proportions we have decided to make it a separate operation. Beginning March 1, the club will be activated on

a two-worker basis with an entirely separate program.' … The Surf extension which was opened in August serves men up and down the coast as well as soldiers waiting for train transportation. … An art exhibit based on colored photographic studies in this and allied nations will be on display all week," *LR*, Feb. 25, 1944, p. 1; "Walnut St. USO Invites Public to Sun. Exhibit…. July 9th… a display of water colors by **M/Sgt. Harold L. Zachman**, and a band concert… Sgt. Zachman has studied at American Academy of Art in Chicago and was production manager of Tempo, Inc., prior to induction. Some of his paintings have been forwarded from Chicago and others were completed here," *LR*, July 7, 1944, p. 2; ■ "Hobbies Featured Sunday … exhibit of arts, crafts and many other leisure time activities to be displayed at the Walnut street USO Sunday, March 12, from two to four in observance of National Hobby Week… Community people as well as servicemen who have interesting hobbies are invited to take part… Some of the collections to be exhibited include relics of old California such as **Mrs. Charles Laubly's** bells and Al Lazarus' costume jewelry made from California stones, as well as **Clarence Ruth**'s Indian lore. Antique lovers will enjoy **Mrs. James Smith**'s collection of pitchers and trays as well as the fine Haviland saucers displayed by **Mrs. O. B. Chamberlain** and the vases shown by **Mrs. Will Hall**. Those who search diligently for Humel [Sic. Hummel] greeting cards will be envious of Mrs. J. J. Garner's large assortment. Miss Ruth Mary Green will share her miniature horses, and Dr. Philip Bryson, his elephants. Dale Wood's collection of eggs will please ornithologists, and philatelists may pore over the stamps of Charles Davis and Ernest Smale. Other exhibits will be shown by **Crystal Lund** and Harriet Charnholm and by Al and Bill Schuyler. The Walnut street USO now has a craft class for wives of servicemen every week-day between 2 and 4 p.m. under the direction of **Miss Louise Moody**. This week marks the beginning of another new craft program for the convenience of servicemen particularly. … Tuesday night at 7:30 under the direction of **Miss Crystal Lund**, art teacher at the high school," *LR*, March 10, 1944, p. 3; photo of craft classes at work, *LR*, Aug. 4, 1944, p. 4 and also a port. of **Louise Moody**.

1945 – "H St. USO Sends Lorrayne Hansen as Craft Worker… **Lorrayne Hansen**, graduate of Mundelein College in Chicago and wife of Major Alton Hansen of Camp Cooke, has started afternoon Craft classes in the Reconditioning Shop at the Camp Cooke Station Hospital under the sponsorship of the H St. (NCCS) USO. … Working directly under Captain R. J. McNulty, Chief of Reconditioning at Camp Cooke, Mrs. Hansen is assisted by **Patricia Dayton** of the H St. Club staff," *LR*, May 11, 1945, p. 2; ■ "Ceramics Kiln Being Sent USO … a kiln has been shipped and is expected to arrive soon at the Walnut Street, USO, which will make it possible for ceramics to be added to the list of crafts offered the servicemen. Another new craft, plastics, will also be added, as equipment was received this week from National USO which will make it possible for work with Lucite. At a meeting of the Junior Hostess cabinet on Monday, plans were made for the making of a craft room upstairs, where the equipment for the different crafts will be accessible to all servicemen… Besides the two new ones added, they

have facilities on hand for leathercraft and shell craft …," *LR*, June 15, 1945, p. 2; "Walnut Street USO Evenings are Enjoyed… concentrating on evening activities for women… For those who like to work with their hands, leather craft and other forms of handiwork are available…," *LR*, Aug. 18, 1944, p. 3; "Busy Schedule Planned Next Week… Tuesday, 8 p.m., arts and crafts group meets in Recreation Hall," *LR*, Oct. 12, 1945, p. 2; "Another Busy Week in USO … Thursday at 7:30 p.m., a weekly class in sketching was slated to begin under direction of **Sgt. Peter Paris**, open to all interested in the community. Sgt. Paris, an experienced portrait and sketch artist, formerly was an instructor in art in Milwaukee … Other weekly events… Arts and Crafts group, Tuesday night… Weekly meetings of the **Camera Club** are held Wednesday afternoons at 3 o'clock," *LR*, Oct. 26, 1945, p. 2; "Interest Grows… The **Camera Club** is adding members who enjoy many weekly hours experimenting and developing prized film in the well-equipped dark room. Corp. **Tom Yeager [Sic. Yager]**, president presented **Ernie Brooks** of the **Camera Shop** in a demonstration at the club's weekly meeting Wednesday…," *LR*, Nov. 9, 1945, p. 3; "Thanksgiving Day to be Open House… **Sgt. Robert S. Avery**, baritone… Sgt. Avery, a native Ohioan attached to the 13th Armored Headquarters Division, has many friends in Lompoc … through his participation in USO and community activities. He has been an enthusiastic member of the Tuesday night USO Arts and Crafts group and was given special assistance by **Mrs. Helen K. Rudolph**, a volunteer Crafts sponsor. Nov. 13th, Sgt. Avery was awarded a first prize, a GI [War Bond?] … in Camp Cooke Army Crafts Contest conducted by Lt. Frank Showalter of Post Special Services department and Pfc. Clayton Hotzell of Service Club No. 1. His entry was a matched cowhide hand bag, coin purse and billfold, suede lined, hand tooled and laced, displayed most attractively in box and interior he designed…," *LR*, Nov. 16, 1945, p. 1; "**Alpha Club** and USO Will Have Art Exhibit," *LR*, Nov. 23, 1945, p. 3; "Traveling Art Exhibit to be on Display at USO," *LR*, Nov. 30, 1945, p. 2; "Problems Facing USO Discussed… in the penthouse of the Lompoc USO… [and list of directors of Surf and Lompoc USOs] … The problem of volunteers in the Hobby shop at the Camp Cooke Station Hospital was discussed by Mr. Trainor, who explained the NCCS work there under the Army Chief of Reconditioning. Mr. Trainor invited the other USO agencies to send professional craft workers to the NCCS Craft office as professional instructions [sic? instructors] to the hospitalized soldiers is most desirable… Janet Grant of Santa Maria expressed a desire that the Art Exhibit, now currently shown in the Lompoc USO, be sent to Santa Maria," *LR*, Dec. 7, 1945, p. 2; ■ "**Alpha Club** Tea Opens Art Exhibit… A tea served in the USO auditorium… December 2 … marked the official opening of the Art Exhibit on display there this week… This traveling exhibit was prepared for the USO Division National Board, YWCA, by the Museum of Modern Art, New York City, and comes to Lompoc through the courtesy of the local USO and the Lompoc Alpha Club… Included in the display are the following groups: Sortomme-Ten original paintings in water color by **Richard Sortomme**. Latin American Art – Colored prints of paintings by Latin American artists. Four American

Artists – Colored prints of paintings by Fienne-Pascin-Hart-Wood – with brief biographical sketch of each artist. Attractive flower placements illustrating art principles of line and color harmony were planned by **Mrs. Ed Negus** and her committee… The portrait sketching by **Cliff Spindler, Jr.**, 20th Armored Division, Camp Cooke, was a popular feature… Artist Spindler will continue sketching evenings from 7-9 for the duration of the exhibit which will close Saturday, Dec. 8th," *LR*, Dec. 7, 1945, p. 3; ■ "Art Exhibit at Local USO Opens Sunday… the walls and tables in the spacious auditorium are adorned with color and beauty – the handiwork of artists of several countries – their varied backgrounds, experiences, transmitted to us with paint brush, weaving skills, and adeptness with metals … The local **Alpha Club** members formally opened the Art Exhibit with a tea… Also, opportunity was opened with chance slip drawings, to individuals for 'sketch sittings' before **Pfc. C. C. Spindler**, young portrait sketcher. The further 'works of art' were provided by **Mrs. Ed Negus**, in her artistic flower arrangements… The exhibit continues through December 10 provided through the courtesy of the New York Museum of Modern Art and the National Board, YWCA-USO Division. Pictures of the exhibit were made Sunday by **B. B. [Sic. Fred C.?] Keller** of the local **B & B Studio** (courtesy services) and color photographs are being made by **Pfc. Roy Conover** of Camp Cooke … extended invitations to High School and elementary grade students… At the Sunday afternoon Fellowship-Vesper Hour in USO Club Lounge, Post Chaplain Gary W. Roush augmented the … event with his subject 'Art in Life.' He took his hearers on a veritable tour of the many countries in which he has served, confining his observations to the many historical art 'citadels' and indigenous artcrafts of several races from whom he gained first-hand knowledge …," *LR*, Dec. 7, 1945, p. 5; "Xmas Garlands Bring Yule Spirit to Walnut USO… Posters in gay Christmas colors heralding holiday events in the Club were done by Mrs. Alice Harig, a recently recruited skilled volunteer … Xmas Garlands Bring Yule Spirit to Walnut USO… An added colorful holiday contribution by an Arizona serviceman is a display of his own and his brother's craftwork (Hopi Indian). **Corporal Wallace Honawain**? sent for and arranged four distinctive hand-woven plaques, a hand carved wooden Indian character doll, and two bows and arrows painted Indian colors, and with real eagle feathers. Mrs. **Helen A. Rudolph**, Crafts sponsor, is arranging a craft display in leather for the Saturday December 22nd," *LR*, Dec. 21, 1945, p. 3.

1946 – "Program Plans of USO for New Year Under Way… All events on the USO weekly calendar continue as scheduled. The Tuesday night Arts and Crafts group… are growing in popularity…," *LR*, Jan. 10, 1946, p. 2; "Local USO Area Staff Heads Meet… Lompoc USO club is continuing with its newly adopted policy of serving the civilian population of Lompoc as well as the military… The Tuesday night program consists chiefly of leathercraft and shell craft, sponsored by **Mrs. Helen A. Rudolph**…," *LR*, March 28, 1946, p. 6; photo of USO officials and "USO Program for Community This Week-end Last Activities…. The H street club closed in 1944, the Surf club, the first of this month. With the closing of the Walnut

avenue branch… the work will be brought to an end," *LR*, May 23, 1946, p. 1.

<u>Korean War:</u>
The Walnut Street USO Building was sold in 1947 to the City of Lompoc for a city Community Center. Recreational services for Korean-era servicemen were administered by the City of Lompoc Recreation Department.
See: "Alpha Club," 1945, "Art, general (Camp Cooke/Vandenberg)," "Community Center (Lompoc)," "Lompoc, Ca., Adult/Night School," "Lompoc, Ca., Recreation Department"

United Service Organization (Santa Maria)
Recreational organization used by military personnel from Santa Maria Army Air Field, WWII. (Hancock College of Aeronautics taught Army pilots.) USO met at the former Carnegie Library at Broadway and Cook, 1942-46. The building was later used for youth recreation and then razed in 1969. The Santa Maria USO emphasized reading and sports rather than arts and photography.
United Service Organization (notices in Northern Santa Barbara County newspapers on microfilm and on newspapers.com)
1941 – "Santa Maria Drive for Funds for Recreation of Men in Armed Services Planned," *SMT*, July 10, 1941, p. 1; "USO Coming in Here Dec. 10. No [Federal] Funds Now for Building…," *SMT*, Nov. 26, 1941, p. 1.
1942 – "CRC 'Breaks In' USO Clubhouse … new USO clubhouse… Because of the central location, at Broadway and Cook streets … lights and music… dancing on the main floor, ping pong and other games in the basement game room, and the card room open upstairs," *SMT*, Feb. 26, 1942, p. 3; "USO Bulletin Announces Full Schedule… club at 410 South Broadway is open from 9 a.m. to 11 p.m. every day … Facilities listed are showers, lounging room, library, current magazines, games, a radio and a piano. It also announces that the city is making the Municipal plunge available to service men at reduced rates … Plans are disclosed for another trip to Camp Cooke by Santa Maria girls to dance …," *SMT*, March 25, 1942, p. 3. [Soft ball and recreation field were located on the Fair grounds]
1945 – "Art Exhibition Scheduled to Open Jan. 1. An exhibit of modern painting will open… at 8 p.m. Tuesday, New Year's Day and will remain on view until Jan. 10. It contains original paintings by **Richard Sortomme**, a sailor artist, colored prints of paintings by Latin American artists, as well as samples of hand-made tapestry and jewelry and examples of modern and ancient Latin American crafts. Also included… are colored prints of four American artists: Fiene, Pascin, Hart and Grant Wood. The exhibit will be sponsored by **Mrs. Jeanne DeNejer** of the art department of Santa Maria High School and Junior College and the Santa Maria Art Association. An introductory talk will be made at the opening … by **Miss Joyce Blauer**… **Marcelle Bear** will give a demonstration of pastel painting at the USO at 8 p.m. Thursday, Jan. 3, and a demonstration of finger painting will be given by **Mrs. DeNejer**, Saturday at 8 p.m. Puppets made by students of Mrs. DeNejer will be added to the display as well as original paintings by **Mrs. DeNejer**…," *SMT*, Dec. 28, 1945, p. 3.

1946 – "Two Art Shows Now Hanging in the City … in the USO… group of puppets also from San Jose. Tonight at 8 o'clock **Mrs. Marcelle Bair** [Sic. **Bear**] will give a demonstration of wash and watercolor technique … open to civilian residents as well…," *SMT*, Jan. 3, 1946, p. 3; "Art Exhibit Opens" of reproductions of pictures portraying Jewish orthodox life, at USO building, arranged by **Jeanne DeNejer**, *SMT*, Feb. 2, 1946, p. 3; "USO to Continue Indefinitely with Reduction in Personnel… voted to continue their use of the USO owned dormitory in the second floor of the Houk building [at Hancock College of Aeronautics] on a month to month basis… The USO Setup… Santa Maria was operated under the auspices of the YMCA with a Jewish Welfare Board representative as assistant… Henceforward, until additional troops in Camp Cooke or Santa Maria Army Air Field should warrant an increase in staff, Parminter, the YMCA representative will handle all activities but they will be under the USO as in the past…," *SMT*, Feb. 15, 1946, p. 1; "Santa Maria USO Closes March 31. Will Surrender Building April 15 … confer … on plans for use of the USO building in future as a recreational center for the community … the old city library," *SMT*, March 15, 1946, pp. 1, 2.

Korean War

1951 – "City 'Donates' Recreation Bldg. for USO's Use … rent free, with ownership and overall supervision of the structure remaining with the city…," *SMT*, Feb. 20, 1951, p. 1; "G. I. Guide… USO 410 South Broadway… Santa Maria Airbase Transportation furnished from USO," *SMT*, Aug. 17, 1951, p. 1.

1952 – "USO-GSO to Enter Float… in Elks Rodeo parade…," *SMT*, May 28, 1952, p. 1; "USO **Closes**… Operations at Santa Maria USO were halted today with packing up work the main order of business… He said the USO entertained approximately 40,000 GIs this year, or about 3,000 per month. He had high praise for the GSO organization … that organized dances, informal parties and other activities…," *SMT*, Dec. 30, 1952, p. 1.

More than a thousand entries for "USO" in the *SMT*, 1945-1955, most not reporting art or photography programs, were not even browsed for potential inclusion here.
See: "DeNejer, Jeanne," 1945

United States Disciplinary Barracks - USDB / Federal Correctional Institution – FCI / United States Penitentiary (Lompoc / Surf)
Military prison under the U. S. Army, activated Dec. 1946, that segued into a medium-security prison run by the Federal Bureau of Prisons (Aug. 1959). As the USDB it contained murals and as the FCI it offered, among its educational programs, mechanical drawing and vocational crafts such as painting and woodwork, 1960. Some USDB employees (and their wives) and teachers were artistic.

■ "Extensive Plans for Armed Forces Day are Mapped… The observance will mark the first time that the training systems, rehabilitation program and prison life in general at the USDB have been presented to the general public… through a big display to be staged at the Community Center and through a recently completed Armed Forces motion picture which was filmed at Camp Cooke… Major Hoch,

troop commander at the USDB said the display from the military installation will consist of examples of the arts and crafts which are taught inmates… in the Army's rehabilitation program. The extensive academic and vocational training programs will also be indicated through samples of work and photographs. The officer revealed that the motion picture of life in the USDB is the first of the kind produced by the Armed Forces. With members of the guard contingent appearing in the film in the place of actual prisoners, the motion picture shows what happens to the typical prisoner upon his arrival at Surf until his release after serving a sentence…," *LR*, May 4, 1950, p. 7.
United States Disciplinary Barracks (notices in Northern Santa Barbara County newspapers on microfilm and on newspapers.com)
1946 – "Disciplinary Barracks to be Activated December First," *LR*, Nov. 7, 1946, p. 1.
1955 – "International Nite at Officers' Club… USDB Officers' club… A mural done by [**June**] **Mrs. Hugh Blakely** and Mrs. Walter May depicted South Sea island scenes. The club bar represented an English pub and the dining area resembled a small French café…," *LR*, June 23, 1955, p. 4.
1959 – "Disciplinary Barracks Near Lompoc to Close. 400 Prisoners Move to Kansas," *SMT*, May 27, 1959, p. 1; "USDB Processed 20,608 Prisoners in 12 Years," and history of base, *LR*, May 28, 1959, p. 1; "Memos… USDB… [described]… A striking shadow figure on horseback beside a Yucca cactus watching a red sunset overlooks the mess hall and to a degree seems out of place – a quiet and peaceful scene in the midst of the clatter and clammer of dishes. Other murals were hanging in the mess – each and every one executed by prisoners of artistic bent," *LR*, June 18, 1959, p. 10; "Confinement Facilities of DB Shift… Official acceptance of the confinement facility of the Branch United States Disciplinary Barracks by the Federal Bureau of Prisons was announced…," *LR*, Aug. 3, 1959, p. 1.
See: "Federal Correctional Institution," "Horowitz, Leonard," "Miller, Barney," "Padrick, Walter," "Potter, Roy," "Utsunomiya, George"

United States Variety Store (Santa Maria)
Retailer of paintings, pens, pencils, 1892.
[Do not confuse with the "Variety Store" in Lompoc.]
"Sam Jones has opened a United States Variety Store, one door east of Farrington's Market, and if there is a variety of jewelry, stationery, shell goods, paintings, pen, pencils or notions of any kind that he has not got in already, he has it coming straight from Chicago, and there is no place in the United States where they sell such things any cheaper than he does," *SMT*, Jan. 2, 1892, p. 2, col. 6.
See: "Variety Store"

University of California, Extension
Extension courses in art were offered by UC, Berkeley, at first by mail, as early as 1920, and later by Santa Barbara-based educators at various sites in Santa Barbara County. In the 1950s extension courses were part of the curriculum of UC, Santa Barbara. Popular "art" classes consisted of workshops for teachers of art in elementary schools taught by various instructors, 1955+. Extension provided teachers the benefit of University credit. A special "Winter Arts Program" sponsored jointly by art organizations in Santa Maria was held in Santa Maria, 1952/53.

[Only those art classes held in Northern Santa Barbara county were itemized here. Many others were available in the city of Santa Barbara.]

University of California (notices in Northern Santa Barbara County newspapers on microfilm and on newspapers.com)

1920 – "Largest School Room in World in California… Extension Division of the University of California. In this great school room the teacher's desk is located in Berkeley in Room 301, California Hall, on the University campus, and the students' desks are scattered all over the State… students are varied… A youth threatened with a serious ailment is studying architectural drawing, for he knows that he will have to find light work to protect his health… Three thousand answer to the roll call… more than 100 different subjects…," *SMT*, March 1, 1920, p. 2.

1921 – "University Has Many Art Students Throughout State" with its correspondence drawing class offered through Extension, with **Perham Nahl** teaching freehand drawing, and **Prof. Hermann Koker** teaching mechanical drawing, *SMT,* Feb. 8, 1921, p. 1.

1949 – "Varied Courses Offered Here… one in art and one in public speaking, and the other in mental hygiene – will be presented in Lompoc beginning next week. The art class will be taught by **Forrest Hibbits**, local artist, and will cover freehand drawing. … The art and speech classes will enroll February 15 at the high school and thereafter the former will meet on Monday nights … Hibbits' class will deal with the principles of perspective, form, and pencil technique. … University credit of two and three units respectively will be offered for the Art and Psychology courses. The classes will meet at 7 p.m. once a week for 15 weeks," *LR*, Feb. 10, 1949, p. 9; "Adult Classes Show Gains in Enrollment… While the high school's adult education classes appeared to be flourishing, … courses offered by the Extension Service of the University of California were running into difficulty. Classes in free-hand drawing and mental hygiene drew such small enrollments that it is probable that they will not be conducted this year…," *LR*, March 3, 1949, p. 5.

1952 – "UC Extension Announces Wide Range of Courses for Spring… In Santa Maria [Sic. Santa Barbara?] … 'Development of Art in the United States,' taught by Dr. **Elliot A. P. Evans**, chairman of the Art department at Santa Barbara college, meeting in room 27, Santa Barbara high school, starting February 18. 'Art Education for Elementary Schools,' **Joseph E. Knowles**… Santa Barbara high, room 30, February 20. Also, simultaneously, 'Problems in Art Education'…," *SMT*, Feb. 5, 1952, p. 6.

1952/53 – "**Winter Arts Program**" (see below).

1955 – "Offer Extension Courses" at Allan Hancock College, "'Integrated Craft Activities for Elementary Schools,' opened Saturday in room 12 at Hancock college. The course will be given alternate Saturdays from 9 a.m. to noon and 1 to 3:30… The Saturday classes, taught by **Edward A. Kincaid** of Santa Barbara college, will offer three units of upper division credit. The class will take up the processes of such crafts as puppets, paper sculpture, ceramics, leather tooling, weaving, metal tooling, wood construction displays and audio-visual aids," per *SMT,* Sept. 26, 1955, p. 1.

1960 – "Nine Credit Courses to be Offered by Extension… 'Art in the Elementary School' begins Thursday, February 11, Room 8, Solvang Elementary School, 565 Atterdag Road. Hours given are from 7-9:30…," *LR*, Feb. 1, 1960, p. 5.

1961 – "Three Extension Courses Offered… Lompoc Union High School … 'Painting for the Elementary Grades' is a daytime class that meets on Saturdays 9:30 a.m. to noon, and 1-3:30 p.m. held every two weeks with the first meeting in the Art Room of Lompoc Union High School on Saturday February 18 at 9 a.m. **Joseph Knowles**, MFA… will be the instructor," *LR*, Jan. 19, 1961, p. 12 (i.e., 4b).

1962 – "Extension Courses Offered… At Santa Ynez, 'Art in Elementary schools' will be taught by **Joseph Knowles**. The course will be offered for Saturdays beginning February 10," *LR*, Jan. 8, 1962, p. 11; "Art in Schools Course Starts Here Feb. 10…," **Joseph Knowles**, *SYVN*, Jan. 26, 1962, p. 9.

1963 – "Nine Courses Offered Here in Spring by University of California Faculty… at Lompoc and Vandenberg Air Force Base… 'Art in Elementary Schools' is planned on an intensive six-week basis and meets on Saturdays from 9 a.m. to noon and from 1:00 to 3:00 p.m. The first class is on Feb. 2 in the Art Building. … **Joseph Knowles**, MFA, will teach 'Child Growth and Development'…[Sic.?]" *LR*, Jan. 21, 1963, p. 8.

1964 – "UCSB Slates … Classes… An analysis of modern art, under the instruction of …. **Joseph E. Knowles**… three-unit course will meet every Wednesday beginning Feb. 19 in the Administration Building at Allan Hancock College from 7 to 10 p.m… lecture-slide recognition format aided by field trips to museums and to see private collections… artists of various periods…," *LR*, Feb. 7, 1964, p. 8; "Teachers Art Course Offered… **Joseph E. Knowles**… held at the Righetti High School, Room 206E Building on alternative Saturdays, 9 a.m. to noon and 1 to 3 p.m. beginning Saturday," *SMT*, Sept. 24, 1964, p. 6.

See: "Winter Arts Program," 1952, 1953

Upton, Dean (Lompoc)
Wood shop instructor at Lompoc High School, grad. of UC, Santa Barbara, 1946.
See: "Lompoc, Ca., Union High School," 1946

Upton, Lloyd Goodnough (1889-1978) (Santa Ynez Valley)
Painter of birds and wildlife who held several OMS at the Solvang Library, 1960-67. Curated art exhibits for the Solvang Library, 1964-67.

■ "Lloyd C. Upton dies at his home… cremation… Born in Oberlin, Ohio on April 8, 1889, he died March 2 at his home here. He had been a resident of the Valley since 1957. He was a charter member of friends of the Library, served as host of the Beaudette Foundation, and was a long-time member of the Audubon Society… a retired furrier, was an artist, who, along with other local artists, furnished his paintings to hang in the local Solvang Library," *SYVN*, March 9, 1978, p. 18.

■ "Library Shows Art by Upton. Unusual birds and wildlife are the subjects of a new art exhibit at the Solvang Branch Library. The paintings are by Valley artist, Lloyd Upton of Rural Rt. 1 on Highway 150. The paintings are done in oil color and will be on display until April 15. Upton has lived in the Valley for three years. Since he retired from being a furrier, he has been able to devote full time to his hobby of painting and sketching landscapes and wildlife. His paintings have also been exhibited in Los Angeles and Long Beach," *SYVN*, March 18, 1960, p. 10.

Upton, Lloyd (misc. bibliography)
Lloyd Goodnough Upton was b. April 8, 1889 in Oberlin, Ohio, to Lucius W. Upton and Lila Aminta Bostwick, married Christine E. Taylor, and d. March 2, 1978 in Solvang, per Craigen Family Tree (refs. ancestry.com).
See: "Lindberg, Oscar," 1964, "Santa Barbara County Library (Solvang)," 1960, 1961, 1963, 1964, 1965, 1967

Ussher, Neville Thompson, Dr. (1901-1963) (Santa Barbara)
Member Santa Barbara Art Association, who exh. at opening exh. of Allan Hancock College Art Gallery, 1954. Exh. Santa Ynez Valley Art Exhibit, 1955.
See: "Allan Hancock [College] Art Gallery," 1954, "Santa Ynez Valley Art Exhibit," 1955

Utsunomiya, George (1917-2006) (Santa Maria)
Returned from study in Japan, 1936. Active in art at Santa Maria High School, 1941. During WWII was at Gila, Arizona, relocation camp. Attended art school in Los Angeles to 1948. Vocational instructor at Federal Correctional Institute who also designed the queen's float for the Flower Festival for many years.

■ Port. and "Mr. George T. Utsunomiya 1917-2006. Age 89, passed away December 14, 2006 at Marian Medical Center in Santa Maria, Ca. George was born September 21, 1917 in Santa Maria and at the age of 2 ½ till age 19 was raised and educated in Japan, returning to Santa Maria in 1936. During WWII he was interned in Gila, Arizona. In 1945 George was transferred to the Santa Barbara Tuberculosis Sanitarium … for treatment, and it was there that he met his future wife, Fumiko, who was also a patient. After the war George attended art school in Los Angeles until 1948 when he returned to Santa Maria and married Fumiko. He taught every Saturday at the Santa Maria Japanese Language School for 26 years and at the same time worked as a vocational instructor at the Federal Correctional Institute for over 26 years retiring in 1976. Following retirement, he then worked for Tandam Frozen Foods for a number of years… [active in Christ United Methodist Church in Santa Maria] George was also active in the local chapter of the JACL (Japanese-American Citizens League) as well as the Central Coast Japanese Community Center. For most of his life, George had an interest in and enjoyed art and in the last several years took art classes at Allan Hancock College. He was also a Master Teacher in SHIGIN, a form of Japanese Poetry Recitation," *SMT*, Dec. 19, 2006, p. 4.

Utsunomiya, George (notices in Northern Santa Barbara County newspapers on microfilm and on newspapers.com)
1941 – "Elaborate Sets Designed for Opera Scenes" by George Utsunomiya of the Theater Arts class at the high school, and opera is presented by Minerva Club, *SMT*, May 9, 1941, p. 3.
1952 – Port. with sign he painted welcoming 44th Infantry Division to Camp Cooke, *SMT*, Feb. 18, 1952, p. 1.
1954 – "Signs, Show-cards, Commercial Art Works, advertising design, spot illustration, silk screen, posters, Geo. T. Utsunomiya, 106 N. Western Ave., Dial 5-3267," *SMT*, Feb. 18, 1954, p. 2.
1970 – Float designer for "Spirit of '76," Queen's float, 1970 Flower Festival, and repro. of float, *LR*, June 26, 1970, p. 20.
1971 – Port with float, *LR*, June 12, 1971, p. 12 and *LR*, June 22, 1971, p. 1.
1974 – "The FCI float, a festival tradition… brainchild of one man: George Utsunomiya. George has been working at the FCI since 1959, and every year since then he has come up with the idea and design that makes the float the traditional eye catcher during flower time… Then inmates, who are part of mechanical services at FCI, start constructing the float … The designer… says he's very interested in art. In fact, he once attended the Kann Art Institute in Los Angeles. And George's artistic talent has shown through in each of the FCI's floats. It got to be so one-sided in the competition that the Flower Festival committee politely asked the FCI to withdraw from competition and concentrate on constructing the queen's float," *LR*, June 28, 1974, p. 2; port. of Utsunomiya holding photos of float and caption reads, "FCI paint shop foreman who designed and supervised the float construction [for annual Flower Festival] For several years, the FCI [Federal Correctional Institution] has contributed its efforts to the design and building of the queen's float," *LR*, Oct. 10, 1974, p. 1.
1998 – Repro. of drawing of internment camp in Arizona and "Former internees recall what it was like to be of Japanese descent during WWII," *SMT*, Nov. 1, 1998, p. 25 (i.e., LIFE, p. 1).
2004 – Port. and "Led to a place he believes saved his life [from death by tuberculosis]. Methodist parishioners share stories of joining the 'beacon of hope for Japanese immigrants'," *SMT*, Nov. 8, 2004, p. 1.
Utsunomiya, George
Port: Dawn Kamiya, "Friends with Japanese American Display at Santa Maria [Valley] Historical Society

Museum," *The Re/Collecting Project*,
http://reco.calpoly.edu/items/show/2307.
Actor in the 1950 movie *Three Came Home*, 1950?
Utsunomiya, George (misc. bibliography)
George Utsunomiya was b. Sept. 21, 1917 in Santa Barbara
to Fujitaro Utsunomiya and Toyo Nakamura, and d. Dec.
14, 2006 per Sueoka Family Tree (refs. ancestry.com).
See: "Federal Correctional Institution," "Santa Maria, Ca.,
Union High School," 1941, "United States Disciplinary
Barracks"

V

**Vadney (Williamson), Addie Marie (Mrs. Lewis A.
Williamson) (1886-1965) (Chico / Lompoc)**
*Teacher of Domestic Art, Drawing, at Lompoc Union
High School, 1914/16.*

■ "New Teachers Chosen… Miss Addie M. Vadney will
teach domestic science, domestic art and home
management as well as some classes in drawing. Miss
Vadney is a graduate of the University of California as well
as the Chico Normal school…," *LR*, June 12, 1914, p. 1.
Vadney, Addie M. (misc. bibliography)
Addie Marie Vadney was b. Oct. 18, 1886 in Chico, Ca., to
George Edward Vadney and Georgie Etta Roberts, married
Lewis A. Williamson and d. March 30, 1965 in Chico, Ca.,
per Geleney/Richards Family Tree (refs. ancestry.com).
See: "Lompoc, Ca., Union High School," 1914, 1915

Valente, Manuel
*Exh. carved wood at Santa Barbara County Fair, 1937.
Prop. Santa Maria Glass and Mirror Co., 1949+.*
See: "Santa Barbara County Fair," 1937

Valles, Alex (Santa Ynez Valley)
*Santa Ynez Valley High School grad., 1958, who won a
Bank of America achievement award for fine arts, 1958.
Won a certificate of merit at the Scholastic Art Exhibit,
Bullocks, LA, 1955.*
See: "Santa Ynez Valley Union High School," 1958,
"Scholastic Art Exhibit," 1955

Valley Art Festival (Santa Maria)
See: "Santa Maria Valley Art Festival"

Valley Beautiful
Term used to denote the Lompoc Valley in the 1930s and
the Santa Maria Valley, c. 1978.

Valley Ceramic Shop (Solvang)
Ceramic Shop. Prop. Helen Barbera, 1954-57.

■ Photo of interior of ceramic shop and "The shop is
located at 436 Second Street a half block off Copenhagen
Drive. Here under the largest oak tree in Solvang is the
historic old Danish house called 'Braedehytten' to which
Helen Barbera has added a studio and shop and painted
yellow," *SYVN*, Sept. 17, 1954, p. B-11.
Valley Ceramic Shop (notices in Northern Santa Barbara
County newspapers on microfilm and on newspapers.com)
1954 – "Ceramic Shop Open House Due… Saturday, Oct.
23 from 3:30 to 7 p.m." and named "Valley Ceramic
Shop," *SYVN*, Oct. 15, 1954, p. 8.
1955 – "Perfect for M'Lady. New Line of Pretty Social
Stationary. $1 Box. Helen Barbera's – Valley Ceramic
Shop," *SYVN*, April 8, 1955, p. 3.
1956 – Port. of Helen Barbera with some of her ceramic
art, *SYVN*, May 18, 1956, p. 3.
1957 – Classified – "Household Furnishings – Also closing
out ceramic gift shop, Helen Barbera, Valley Ceramic
Shop, 436 Second St., Solvang," *SYVN*, Sept. 13, 1957, p.
7, col. 2.
See: "Barbera, Helen"

Valley Fair (Los Olivos)
See: "Santa Ynez Valley Fair"

Valley Farm School (east of Los Olivos)
*Private school located on San Marcos Pass Road. Run by
Mr. and Mrs. Percy Hodges, c. 1949+. Leo Ziegler taught
art there some years, beginning c. 1951 and Mrs. Brandt-
Erichsen c. 1953+.*

■ Photo of exterior and "Valley Farm School Shows
Growth Since Start in '49 … co-educational day and
boarding school for grades one through eight, located on a
ranch… Mr. and Mrs. Percy Hodges… wanted country life,
a healthful environment… and to be near enough to some
city to have the cultural advantage of museums, art and
music … Originally Mr. Hodges did all the teaching. Then
Mrs. Hodges took the primary group. Each year a new part-
time teacher has been added. The first was **Leo Ziegler**,
who has successfully taught art… this past year **Mrs.
Viggo Brandt-Erichsen** has taught art to the primary
group…," *SYVN*, Sept. 17, 1954, p. 20 (i.e., p. 10).
Valley Farm School (notices in Northern Santa Barbara
County newspapers on microfilm and on newspapers.com)
1953 – "Farm School Starts Term… fifth year… **Leo
Ziegler** for the third year will teach the art classes with
Mrs. Brandt-Erichsen teaching arts and crafts to the
smaller children…," *SYVN*, Sept. 25, 1953, p. 3.
1954 – "**Leo Ziegler** is art instructor of the Farm School's
upper grades, while **Mrs. Viggo Brandt-Erichsen** teaches
art and crafts to the smaller children," *SYVN*, Feb. 26, 1954,
p. 4.
1957 – "Anthony Dunn Appointed New Headmaster of
Farm School… Plans for expanding the facilities of the
school were outlined by Dunn last week… establishing of a
kindergarten at one end of the curriculum and a ninth grade
at the other, the taking in of a limited number of boy
boarding students and the offering of college preparatory

course. Dunn has also recommended that a crafts shop be added to the curriculum…," *SYVN*, June 14, 1957, p. 12.
1958 – Photo of boys in woodshop, *SYVN*, Jan. 17, 1958, p. 4 and part 1 of lengthy two-part history of school; photo of tots painting at easels and part 2 of two-part history, "Pre-Primary Youngsters Take Delight Participating in Varied Class Program … All of the youngsters have an opportunity each morning to take part in art activities, including application of water colors to easel mounted sheets of paper. Others color with primary chalk…," *SYVN*, Jan. 24, 1958, p. 4.
1959 – "Memo Pad… In last week's *Valley News* a story appeared regarding the start of the new term at the Valley School near Los Olivos… unfortunately the name of Valley artist **Leo Ziegler** was omitted as a member of the faculty… **Mr. Ziegler** will once again teach art at the school…," *SYVN*, Sept. 18, 1959, p. 2.
See: "Scholastic Art Exhibit," 1954

Valley Nursery School (Solvang)
Private school for children ages 3 to 5 located at 1665 Mission Drive that offered art within its curriculum, 1952-59. Prop. Katherine Franks.
Valley Nursery School (notices in Northern Santa Barbara County newspapers on microfilm and on newspapers.com)
1952 – known as "Katherine Frank's Nursery School."
1953 – "Nursery School Registration Set," *SYVN*, Aug. 28, 1953, p. 5.
1954 – "Valley Nursery School Opens… Outdoor play equipment. Toys, and tools for creative enjoyment of music, painting and other activities… Mrs. Katherine Franks, director … plan to follow the flexible routine found successful in previous years … [including] painting with brush and fingers… from 9 to 12, four mornings a week," *SYVN*, Aug. 27, 1954, p. 5.
1955 – Photo of children at easels, *SYVN*, June 3, 1955, p. 6; photo of Valley Nursery School children engaged in water color painting aided by Connie Serritslev of the work education program of Santa Ynez High School, *SYVN*, Dec. 30, 1955, p. 17.
1958 – "Valley Nursery School Sets Reopening in Solvang Oct. 1… Mrs. Katherine Franks… at her home, 1665 Mission Drive… the school will offer a balanced program of pre-kindergarten activity… 9 until 11:45… many forms of enjoyment in creative activities are explored, including music, dancing, rhythms, painting and clay-play, carpentry, imaginative play of all kinds…," *SYVN*, Sept. 19, 1958, p. 8.
1959 – "Valley Nursery School going out of business. Equipment and play materials for sale. No reasonable offer refused," *SYVN*, Aug. 21, 1959, p. 7, col. 1.

Valley Rock Club (Santa Ynez Valley)
See: "Santa Ynez Valley Rock Club"

Valley Rug Class (Solvang)
See: "Solvang Woman's Club"

Valley School (Los Olivos)
See: "Valley Farm School"

Van (Lompoc)
Photographer, 1927-29. Studio purchased by M. L. Oakes of Atascadero, 1929.
Van (notices in Northern Santa Barbara County newspapers on microfilm and on newspapers.com)
1927 – "Rotary Party is Jolly Event Wednesday Eve… enjoyed a 'children's party' in the Odd Fellow's hall… guests in children's costumes … Considerable amusement was furnished by the showing of early pictures of the Rotarians and Rotaryanns on a screen in the lodge room after the dinner. Many were surprised to see what handsome infants some of the members had been, and the old-fashioned clothes made the pictures amusing. A group picture was taken of the guests by Van, local photographer," *LR*, Oct. 14, 1927, p. 5.
1928 – Ad: "Who? Is the official photographer for 'Suicide Slim's' Airplane Stunt. Why – Van the Picture Man. Photos made night or day," *LR*, June 15, 1928, p. 3; "Holiday Sales… Van photographer – Christmas business with me was much better this year than last," *LR*, Dec. 28, 1928, p. 5.
See: "Lompoc Valley Historical Society, House," "Oakes, Mortimer"

Van Dyke (pseud?) (Lompoc)
Itinerant artist who visited Lompoc, 1891.
Van Dyke (notices in Northern Santa Barbara County newspapers on microfilm and on newspapers.com)
1891 – "Van Dyke, the most celebrated and rapid all-round worker in the art of painting that ever visited this coast, has just placed in the post office a mammoth card containing advertisements of all the principal business houses in town, most beautifully lettered and embellished with rare sketches. The central design is a thing of beauty. Van Dyke is surely an artist of rare merit," *LR*, April 25, 1891, p. 3; "Mr. Van Dyke, the celebrated painter, has been importuned by many of our people to take a class and teach them his rapid method of painting, lettering, etc. No one who has seen Mr. Van Dyke's work, in both lettering and landscape painting, doubts his consummate ability to teach the art in its highest style. … He is not a high-priced teacher, but will make his charges come within range of all. If there are sufficient to warrant his starting in he will open the school at once. Mr. Van Dyke can be found at the Nichols House parlors …," *LR*, May 16, 1891, p. 3, col. 1.

Van Guilder, John
Photographer and author of a nationally syndicated "how-to" column on photography, "Snapshot Guild," that appeared sporadically in the Santa Maria Times, 1952-58.
See: "Snapshot Guild"

Van Sant (Buntz), Florence V. (Mrs. Lloyd Buntz) (1895/96-1980?) (Berkeley / Lompoc)
Teacher of drawing at Lompoc High School, 1919, 1920.
Van Sant, Florence (notices in California newspapers on newspapers.com).
1926 – "Palo Verde Valley Teachers Elected… for Term of 1926-1927… Arrowhead—Florence V. Buntz…," *Riverside Daily Press*, Aug. 31, 1926, p. 3 (on genealogybank.com)
1927 – "Life Diplomas… approved by the state board of education… Florence V. Buntz, special secondary," *Hemet News*, Aug. 12, 1927, p. 9.
1955 – "Cretors – Miss Maude Cretors of Temple City… survived by four nieces, Mrs. Lloyd Buntz of Casa Grande, Ariz. …," *Pasadena Independent*, Aug. 23, 1955, p. 27.
Van Sant, Florence (misc. bibliography)
Florence Van Sant is listed in the 1900 U. S. Census as age 4, b. Nov. 1896 in Illinois, residing with her parents Ed and Ella Van Sant and brother James; Florence Van Sant is listed in the 1910 U. S. Census as age 14, b. c. 1896 in Chicago, residing in San Diego with her parents Edwin S. Van Sant (age 49) and Elle Van Sant (age 49) and brother James A. (age 22); Florence V. Van Sant, student, is listed in the *San Diego Ca., CD*, 1913, 1916, 1917; Florence Van Sant, teacher, Longfellow School, is listed in the *Riverside, Ca., CD*, 1923; Florence V. Van Sant married Lloyd Buntz c. 1922 per *California, County Birth Marriage and Death Records*; Mrs. Florence V. Buntz, teacher and Dem. is listed as residing in Blythe, Ca., along with Lloyd Buntz, Farmer, in the California voter index, *Solano Precinct* (1922-26); Florence Van Sant b. Nov. 11, 1895 in Chicago to Edwin Stanley Van Sant and Ella Cretors, who was residing in San Diego in 1910 and who married Lloyd Buntz, per McCrary Family Tree; supposedly there is an obituary for Florence Buntz, 1616 W. Glendale Ave., in the San Fernando (?) Valley newspaper, b. c. 1896 and who d. Nov. 8, 1980 but this cannot be located (refs. ancestry.com).
See: "Lompoc, Ca., Union High School," 1919, 1920

Van Stone, Elva (Mrs. Harold S. Van Stone)
Santa Maria JC? student who exh. painting at Santa Barbara County Fair, 1951, 1952. Exh. Allan Hancock [College] Art Gallery, 1955. Mother to Betty Nerheim, above.
See: "Allan Hancock [College] Art Gallery," 1955, "Nerheim, Betty Van Stone," "Posters, general (Santa Maria)," 1951, "Santa Barbara County Fair," 1951, 1952, "Santa Maria Art Association," 1952, 1953, "Santa Maria, Ca., Union High School," 1951

Van Tassel, Robert "Bobby" Enus (1944-?) (Solvang)
Photographer, film maker, child prodigy, 1959.
■ "Bobby Van Tassel, 15 years old, has never seen a missile fired. But because of his talent in photography, he can fool most people into believing that he has. Using only his imagination and ideas from magazine photographs, Bobby has duplicated the atmosphere of missile launching, using the playground at Orcutt School as a 'test site.' Using model missiles put together by his younger brother, a puff of cotton and natural terrain, Bobby has duplicated on film scenes that normally could only be photographed at one of the nation's missile facilities. His work is so good that a local professional has termed him a 'crackerjack' photographer. Bobby, who lives at 400 Clark Ave., has only been taking pictures for about six months. But he has been thinking about photographing toy missiles to achieve a realistic firing effect for about two years. Throttling the old theory that it takes a high-priced camera to make a good picture, Bobby shot his simulated missile shots with a Brownie Starflex. He braced the camera firmly on a low box, so it would give a realistic viewpoint. The missile was perched on a hunk of clay with a pencil running up through it to give support against the wind whipping across the school play yard. He carefully composed so that trees in the background would appear in proportion to the small missile. Bobby also has a collection of photographs of miniature soldiers, aircraft and military equipment. His 'locations' for these photographs were construction sites in and around Orcutt, where he could use the chewed-up terrain to lend authenticity to the photographs. He recently purchased a more expensive 35-millimeter camera, but finds that the lens is too sharp to give him the realism he desires for black and white work. It's working out well in color though. Bobby hasn't decided what he wants to become, although he is considering photography as a career. He's taking this subject in high school this year, and hopes to become a member of the local camera club. But in the meantime, he would like to hear from other youngsters who are interested in photography. He wants to continue experimenting and feels that talking to others who are interested in the same things will help him," and port. and repro of photo and "Teenager's Missile Photos Duplicate 'Real Thing'," *SMT*, Oct. 2, 1959, p. 1.
Van Tassel, Bobby (notices in Northern Santa Barbara County newspapers on microfilm and on newspapers.com)
1977 – "High Cost Feared if Airport Closes Down … Hollywood-Burbank Airport… Robert E. Van Tassel, manager of technical services for Henningson, Durhan & Richardson, the planning firm retained for such an analysis …," *Valley News* (Van Nuys, Ca.), Feb. 8, 1977, p. 1.
Van Tassel, Bobby (misc. bibliography)
Robert Van Tassel is pictured in the Santa Maria High School yearbook, 1962; Robert E. Vantassel, b. c. 1944, married Sharon H. Matsuoka on Jan. 19, 1963 in Santa Barbara County per Calif. Marriage Index; Robert E. Van Tassel with no wife cited is listed in the *Santa Maria, Ca., CD*, 1968; Robert E. Vantassel, b. Jan. 15, 1944, was residing in Solvang, Ca., in 1993 per *U. S. Public Records Index, 1950-1993*, vol. 1 (refs. ancestry.com).

Van Wormer, S. N. (Los Angeles)
Travel Editor of LA Herald-Express who visited Solvang with a photographer, 1939.
See: "Photography, general (Santa Ynez Valley)," 1939

Van Young, Oscar (1906-1991) (Los Angeles / Laguna Beach?)
Painter. His artwork was shown at the first Santa Maria Valley Art Festival, 1952, courtesy Cowie or Dalzell Hatfield Gallery in LA.

■ Austrian / Russian immigrant who arrived in Chicago in the mid-1920s where he began experiencing art to which he would turn as a vocation. Supported by his wife who worked as a journal editor in Los Angeles, to which the couple moved in 1940, Van Young developed his painting and eventually became prominent in the town's art world and enjoyed many exhibits of his works, per oscarvanyoung.com.
See: "Santa Maria [Valley] Art Festival," 1952

Van Zandt, Warren (1906-1931) (Lompoc)
Draftsman with Celite Corp., 1931.

■ "Warren Van Zandt Passes Suddenly at Redwood City... 25, son of Mr. and Mrs. Reuben Van Zandt ... at the home of his brother, Allan... Warren Van Zandt came here from San Francisco with his parents 15 years ago and attended the elementary and high schools here. He followed mechanical drafting, being employed in this work at the Celite Corporation plant for some time after graduation from school. Later he went to Pennsylvania, where he resided with relatives and about a year ago he returned to Lompoc. Recently he had been residing in Redwood City with his brother, Allan ...," *LR*, Nov. 20, 1931, p. 5.
Van Zandt, Warren (misc. bibliography)
Warren Van Zandt (1906-1931) is buried in Lompoc Evergreen Cemetery per findagrave.com (refs. ancestry.com).

Vandenberg Air Force Base (originally named Camp Cooke, 1941-58) (Lompoc, Ca.)
Military base where some art occurred, particularly during WWII when the base was known as Camp Cooke. After renaming of the base in 1958 and the onset of the missile program, "art" and photography was produced by military personnel in the post's public relations office and missile tracking areas, by women in officers' wives clubs, by military personnel at recreation clubs on the post, and by talented individual military men in their off-hours.
See: "Art, general (Camp Cooke / Vandenberg AFB)," "Guerrero, Mike," "Naval Missile Facility (Pt. Arguello)," "Photography, general (Camp Cooke / Vandenberg AFB)"

Vandenberg AFB Junior High School
See: "Hampton, Tommy"

Variety Store (Lompoc)
Seller of picture frames, 1888-89. Prop. A. Hoopes (1888-July?, 1890). Store taken over by W. F. Miles (c. July 26, 1890-Jan. 1891). Stock may have been absorbed into the store of Morehead & Douglass.
1888 – "Mr. A. Hoopes has just received direct from Cincinnati, a large invoice of choice picture frames of various shades and sizes which he is selling too cheap. Mr.

Hoopes occupies the room in the Dimock block formerly used by Dr. Bolton as a dental office," *LR*, Feb. 25, 1888, p. 3, col. 2.
1889 – "Mr. A. Hoopes has opened at the old Lansdell jewelry store on H street, a diversified business. He keeps books, Bibles, pictures, picture frames, stove pipe shelves, patent mops, picture cards... Mr. Hoopes takes orders for enlarging pictures and the samples of work exhibited are most perfect," *LR*, Jan. 26, 1889, p. 3; ad: "Variety Store (At Lansdell's Old Stand) Lompoc.... Constantly on hand. Pictures and Picture Frames... Bibles and other books, albums, Patent Mops, Stove Pipe Brackets, Notions... Photographs Enlarged...," *LR*, May 18, 1889, p. 2.
1890 – Ad: "Variety Store. At Lansdell's Old Stand. A. Hoopes... Proprietor. Constantly on hand. Pictures and Picture frames, Bibles and other books, Albums, Stationery of all kinds. Picture frames of all styles furnished to order. Photographs Enlarged. In the highest style of the art," *LR*, Oct. 18, 1890, p. 1; [and yet an ad in the *LR* on July 26, 1890 says that **W. F. Miles** is proprietor]; ad: "For Sale. Owing to failing health, the undersigned will dispose of his stock of stationery, books, Picture Frames, Etc. A Bargain for somebody. Call and get price. W. F. Miles, Rudolph building, H. Street," *LR*, Nov. 1, 1890, p. 3.
1891 – Ad: "Variety Store. At Lansdell's Old Stand. ... W. F. Miles, Proprietor," *LR*, Jan. 3, 1891, p. 1.
See: "Miles, W. F.," "Morehead & Douglass," "United States Variety Store"?

Vasile, Doree Nan
See: "Bond (Wilkie) (Vasile), Doree Nan (Mrs. Herbert Marston Wilkie) (Mrs. Alfred Vasile)"

Vasquez, Rafael (? - c. 1905?) (Santa Ynez)
Painter of "San Raphael" owned by Mission Santa Inez.
"Santa Ines has the finest collection of old vestments to be found in California... We are indebted to a devoted Spaniard, Rafael Vasquez for the preservation... During the long years of abandonment, he kept them at his own home... and later returned them to the Mission," *SYVN*, Feb. 7, 1930, p. 8.
San Jose Pioneer, March 5, 1877, pt. 2, p. 5 is cited by Edan Hughes, *Artists in California, 1786-1940*, but this newspaper has not yet been digitized on the Internet. Ancestry.com has NO information on a Rafael Vasquez dying in California c. 1905.

Vaudeville
Live stage show consisting of variety acts. Popular form of entertainment. One "act" that involved art, was chalk talks.
See: "Chalk Talks"

Vaughan, (Samuel) Edson (1901-1999) (Santa Barbara)
Santa Barbara artist who exh. in a show of Santa Barbara artists sponsored by the College Art Club at city hall, Santa Maria, 1935.

■ "Miss Lucia Kittle is Bride of Mr. Samuel E. Vaughan… The young couple, following a honeymoon trip, will make their home at 3511 West Sixth street in Los Angeles. … Mr. Vaughan was graduated from Stanford as a mechanical engineer. For two years following his graduation he was associated with the Pacific Steel Company as inspector. His interest in art led him to forsake his engineering career and to study painting. He was a student at the Santa Barbara School of the Arts for two years, then went abroad to study. For over four years he studied portrait painting, mostly in Rome. At the winter exhibition of the work of Santa Barbara artists at the **Faulkner** gallery, his portrait was one of the outstanding ones. Recently he removed to Los Angeles where he has a studio," *SF Examiner*, July 23, 1933, p. 37 (i.e., S 7).

Vaughan, S. Edson (notices in California newspapers on microfilm and on newspapers.com)
1935 – "Western Foundation… Father and Son. R. [Reginald] W. Vaughan of Santa Barbara has always loved etchings. A few years ago, he began making some himself. Now a good group of them hangs in the Galleria at Ebell Club together with water colors by his son, S. Edson Vaughan. Vaughan pere's subjects are from Europe, the Southwest, New England, craftsmanly done and printed. Vaughan fils painted the architecture of old Italy with a pearly-toned wash that recalls Walcot in its quality…," *LA Times*, Jan. 13, 1935, p. 38 (pt. II, p. 6).
1936 – "New Exhibits… **Faulkner Memorial Art Gallery**, Santa Barbara: **John M. Gamble**, S. Edson Vaughan, April 5 to 30," *LA Times*, April 5, 1936, p. 55 (pt. III, p. 11).
1941 – "Barbarenos Visit Son. Mr. and Mrs. Reginald Vaughan of 316 E. Los Olivos St., Santa Barbara, cut short their visit to Ft. Lewis, Washington, when orders came transferring their son, Maj. Samuel Edson Vaughan to Ft. Warren, Wyoming," *LA Times*, Aug. 20, 1941, p. 34 (pt. II, p. 6).
1949 – "Vaughans on Visit. Lt. Col. and Mrs. Samuel Edson Vaughan are visiting Col. Vaughan's parents… The visitors, with their daughter Mary, are en route to Stanford, where the Colonel will act as assistant professor of military science and tactics …," *LA Times*, May 1, 1949, p. 97 (i.e., pt. III, p. 17).
1964 – "Santa Barbara Homes on Tour Route… under the sponsorship of the Women's Projects Board of the Santa Barbara Historical Society… the Italian villa owned by Guido Ferrando that was built for Samuel Edson Vaughan by architect Russel C. Ray…," *LA Times*, Aug. 2, 1964, p. 71 (Sec. E, p. 13).
S. Edson Vaughan exhibited canvases at the Statewide Art Exhibit of the Santa Cruz art League, 1933-38 per "Index to the State-Wide Art Exhibits," *Publications in California Art*, vol. 12.
Vaughan, S. Edson (misc. bibliography)
Samuel Edson Vaughan was b. March 24, 1901 in San Diego to Reginald Wilmer Vaughan and Miriam Rippey, married Lucia Kittle Pierson and d. Jan. 30, 1999 in Portola

Valley, San Mateo County, Ca., per Vaughan Family Tree (refs. ancestry.com).
See: "College Art Club," 1935

Vaughn, Leon Wylie (1904-1985) (Santa Maria)
Set designer and scenic painter, 1927. Aspired to a sculpture scholarship at art school in SF. Designed and constructed theater sets while still in high school, designed and constructed parade floats for the Chamber of Commerce, and designed and constructed booths in the County Fair, c. 1928-31. Photographer / filmmaker, 1935. Landscape painter, 1975+. Husband of Virginia Vaughn below.

■ "Leon W. Vaughn. … Mr. Vaughn was born in Los Angeles and moved with his family to the Santa Maria valley in 1918. He attended local schools and graduated in 1925 from Santa Maria High School, where he was involved with drama productions in stage and set designs. He was a violinist with the Santa Maria orchestra in the late 1920s and 1930s. Following graduation, he worked as a jeweler with his father, L. E. Vaughn, until becoming involved in the radio repair business in 1935. He owned and operated a television and radio repair business until his retirement in 1975, and served the Santa Maria area with commercial sound for the Santa Barbara County Fair and the Santa Maria Elks Rodeo and Parade for most of the past 50 years. During World War II, he taught radio at the Cal Poly adult education classes. After his retirement, he and his wife, his sons and their families moved to a 20-acre Christmas tree farm in Nipomo. He again took up painting, specializing in landscapes, and in November was honored as the feature artist at a showing in May Hoyt's senior art classes at Hancock College…," *SMT*, Dec. 10, 1985, p. 6.

Vaughn, Leon (notices in Northern Santa Barbara County newspapers on microfilm and on newspapers.com)
1927 – "'Hansel and Gretel' Plays to Appreciative Audience in Fine Local Amateur Production… Special mention must go to Leon Vaughn whose work in designing and painting the scenes for the second and third acts was so pleasing …," *SMT*, Dec. 17, 1927, p. 2.
1928 – "New Settings are Built for Pirate Comedy… presented by the Players club of Santa Maria… through the efforts of Leon Vaughn, scenic artist of this city and the March Studios of Los Angeles. Every bit of scenery used in the second act has been arranged and built by Vaughn whose work in the opera 'Hansel and Gretel' is well remembered… high school stage…," *SMT*, March 27, 1928, p. 1.
1934 – "Santa Maria Will Send 'Santa Maria' to Fiesta Parade… The ship will ride on a float which carries sparkling ocean waves as background. Complete rigging, sails, equipment… Leon Vaughn, local radio expert and craftsman is building the model…," *SMT*, Aug. 20, 1934, p. 1.
1935 – "SRA Authority… Last night, L. E. and Leon Vaughn showed motion pictures which they had taken of Yellowstone park, the landing of the Southern Cross [airplane] in Santa Maria, boating at Avila and motorcycle and motor races. Leon Vaughn is planning to film pictures of life at Suey camp," *SMT*, July 16, 1935, p. 3.
1952 – Port., *SMT*, Nov. 12, 1952, p. 8.

And, hundreds of additional notices on his helping with theater sets at the High School both for the Players' Club and for high school productions, building floats for the Chamber of Commerce, and building booths at the County Fair, were not itemized here.

Vaughn, Leon (misc. bibliography)
Leon Wylie Vaughn, mother's maiden name Barcia, was b. Nov. 15, 1904 in Calif. and d. Dec. 8, 1985 in Santa Barbara County per Calif. Death Index (refs. ancestry.com).
See: "Kaiser, A.," "Santa Barbara County Fair," 1928, 1929, 1930, 1931, 1949, "Santa Maria, Ca., Union High School," 1924, 1925, "Vaughn, Virginia"

Vaughn, Lucille (Mrs. William M. Vaughn) (Santa Maria)
Chairman of handicrafts, Junior Community Club, 1945. Her husband taught leathercraft to club members, 1945. She exhibited handicraft at the Santa Barbara County Fair, 1947 and other years.
See: "Junior Community Club," 1945

Vaughn, Virginia Nye (Mrs. Leon W. Vaughn) (Santa Maria)
Flower arranger who competed in many shows, 1940+. Wife of Leon W. Vaughn, above.

■ "**Leon Vaughn** Will wed in Summer… Miss Virginia Nye… Miss Nye has lived in Burbank since early childhood and is a graduate of Burbank high school, later attending business college in Glendale and a school of costume design in Los Angeles. The couple will make their home here where the prospective bride groom is engaged in the radio business and engages in several forms of art work….," *SMT*, Dec. 7, 1939, p. 3.
See: "Floral Design," "Minerva Club Flower Show," 1948, "Vaughn, Leon"

Veglia, Mario Moses (1908-1988) (Casmalia)
Artist, restauranteur, lapidarist. Exh. Santa Ynez Valley Art Exhibit, 1953. Exh. Allan Hancock [College] Art Gallery, 1955, 1956. Father to Paul Veglia, below.
[He is NOT the Hollywood artist who was key makeup artist in two films in 2010 and 2011]

■ "Mario M. Veglia, 80, who died Monday in a San Luis Obispo hospital … Mr. Veglia was born in Betteravia and had been a life-long resident of Santa Maria. He attended local schools and graduated from Santa Maria High School. From 1945 until the Ostini family took over, he was part owner of Hitching Post in Casmalia. He was active in lapidary work in the area and taught lapidary courses at Hancock College," *SMT*, Sept. 13, 1988, p. 12.
Veglia, Mario (notices in Northern Santa Barbara County newspapers on microfilm and on newspapers.com)
1952 – "Mario Veglia and Family See Son in Alaska," and details of trip on which he made some paintings, *SMT*, Oct. 1, 1952, p. 4.
1953 – "New Look at Solvang Inn. … Boyd and Jean Wyse's Solvang Inn… cocktail lounge… dance floor… modernistic look… Redwood planters will also adorn the

room as will a number of original oil paintings by Mario Vegilia of Casmalia, who was Mr. Wyse's partner when the latter operated the Hitching Post…," *SYVN*, Feb. 27, 1953, p. 4; "Some of the visitors to the Hitching Post were new. They had never seen the decidedly professional paintings by Mario Veglia (owner of the building and former partner of the establishment) which practically line the walls of the suburban steak house…," *SMT*, March 30, 1953, p. 6.
1954 – "Veglia Paintings Exhibited at … **Santa Maria Inn**… His Son, **Paul Veglia**, home on a 30-day leave from duty with the Armed Forces Radio service in Alaska, who is also an artist and student of art, is spending the week-end at the Inn while the paintings are being exhibited. In all, there are 47 canvases including valley and coastal scenes… Santa Barbara Mission… mountain scenes, ranch and canyon pictures… There is much interest in miniatures in which the local artist has developed scenes that are typical of California. Beginning his study of art in Santa Maria High school when the late **Stanley Breneiser** taught, Mario Veglia continued without instruction after school… his paintings have been displayed in Santa Barbara, Los Angeles and San Francisco art museums. One dozen of the paintings he made while in Alaska were hung in a Fairbanks exhibit arranged by his son while the latter was stationed last year in Alaska….," *SMT*, July 3, 1954, p. 4.
1955 – Photo of Mrs. Veglia viewing painting by her husband in local art show, and "Home Talent Art Show is Drawing Large Number," *SMT,* April 2, 1955, p. 4; photo of painting – a study of trees and lake at sunset – and "Painting is Group Gift to Recent Bride," *SMT,* Nov. 18, 1955, p. 4.

1956 – ■ Port. with paintings "Mario Veglia's Paintings on Exhibit," and "Santa Maria Valley's own artist, Mario Veglia, is exhibiting oil paintings, all of them studies of Central coast scenes, opened yesterday at **Allan Hancock [College] Art Gallery**. The collection includes subjects about the hills of Casmalia, which is the artist's home, and interesting studies along the seacoast of this section. The exhibit has some fine work in paintings of wooded areas and close-ups of trees. The artist apparently is one who would count Joyce Kilmer's poem on 'Trees' one of his favorites. He has painted the California live oaks and trees in general as they appear in different seasons of the year. One, in tones of gold and brown, he has named 'Golden Autumn.' More modern than others in style is his 'Monterey Cypress.' In this study is seen a single gnarled cypress such as grow along this wind-swept section of coast … His paintings have been described as dramatic in their use of color and romantic in style rather than modern. There is one, made from a description only, of Sisquoc Falls near where a colony of condors, almost extinct, were discovered a few year ago in this almost inaccessible section of northern Santa Barbara county. The scene shows a ribbon of a waterfall spilling over a rocky ledge into the pool below. It was so described to Veglia by an old timer who camped near the spot. No California collection would be complete without at least one lupine field. The one entered here is in lustrous blues shading to purple. It is a valley scene reminiscent of California in the wildflower season in early spring. A point of interest in the show is Veglia's painting within a painting. This is a small reproduction of 'Golden Autumn' in the framed picture that

completes a still life study of an old-fashioned teapot and geraniums in a bowl on a corner table. There are some good marine paintings for those interested and one group of miniatures that are well worth seeing. The artist has made his own frames to fit each individual canvas. Mario Veglia has resided here since childhood in Guadalupe and Casmalia. He attended Santa Maria High school and received a part of his training with the late **Stanley Breneiser**. He said of being partly self-taught: 'I read everything that I could find that would be of help, and I have attended art gallery exhibits whenever it has been possible to do so.' He had one exhibit last year in **Santa Maria Inn** that drew much favorable comment by Inn guests from out of state who said his painting is typically of California. Veglia said much credit is due **George Muro** of the High school and College art departments, and to **American Assn. University Women** for interest in the promotion of art, for which there is a definite need in Santa Maria," *SMT,* Jan. 9, 1956, p. 4.

1965 – Port. with lapidary students, *SMT*, Oct. 9, 1965, p. 19 (i.e., 7-B); port. and "Paintings of Casmalia Artist Displayed at AHC... Allan Hancock College Art Gallery... Veglia has been painting over a period of 30 years and offers 20 of his most recent oils... Most of Veglia's paintings represent a California theme of the mountains the sea and the desert and would make a colorful contribution to the décor of any home...," *SMT*, Nov. 4, 1965, p. 8.

1972 – "130 Displays Set for ... Santa Maria Gem and Mineral Society's 'Santa Maria Gemboree' Sept. 9-10 in the Fairgrounds Convention Center... Among the many attractions will be a display of work by students of the Allan Hancock College lapidary class. Instructor is Mario Veglia," *SMT*, Sept. 2, 1972, p. 18 (i.e., 2-B).

Veglia, Mario (misc. bibliography)
Mario Moses Veglia was b. June 13, 1908 in Calif. to Paul "Paolo" F. Veglia and Maria Esperanza Oliva Ferrero, married Stella Margaret Tognetti, and d. Sept. 12, 1988 in San Luis Obispo, Ca., per Veglia Family Tree (refs. ancestry.com).
See: "Allan Hancock [College] Art Gallery," 1955, 1956, "Community Club (Santa Maria)," 1950, 1951, "Santa Barbara County Library (Santa Maria)," 1949, "Santa Ynez Valley Art Exhibit," 1953, "Splash," 1927, "Tri-County Art Exhibit," 1947, "Veglia, Paul"

Veglia, Paul (Santa Maria)
Student at Santa Maria JC who exh. art in Library, 1951. Primarily a vocalist. Son of Mario Veglia, above.
See: "Posters, general (Santa Maria)," 1951, "Santa Barbara County Library (Santa Maria)," 1951, "Santa Maria, Ca., Union High School," 1949, "Veglia, Mario"

Venske, Eva Marie Poling Palmer (Mrs. Garrett D. Palmer) (Mrs. Harold Venske) (1899-1992) (Santa Ynez Valley)
Exh. Santa Ynez Valley Art Exhibit, 1954, 1955, 1957, 1958. Second wife of Harold Venske, above. She appears to have gone her separate way after Venske's retirement, c. 1959.

Venske, Eva (notices in Northern Santa Barbara County newspapers on microfilm and on newspapers.com)
1952 – "Harold Venskes Return to Valley.... From San Jose on Saturday. The Venskes were married earlier in July in San Jose.... Mrs. Venske was also in the teaching profession and taught in Mill Valley the past two years and prior to that in Northern California and Michigan," *SYVN*, Aug. 8, 1952, p. 8.

Venske, Eva (misc. bibliography)
Mrs. Eva M. Palmer, teacher, is listed in the *San Rafael, Ca., CD*, 1955; Eva M. Poling / Palmer, b. c. 1898, married Harold H. Venske on July 22, 1952 in Monterey County per Calif. Marriage Index; Eva Marie Venske, teacher Arth Hapgood School, Solvang, is listed in the *Santa Maria, Ca., CD*, 1961 and teacher in PS, 1965; Eva M. Venske, retired, is listed without husband in the *San Jose, Ca., CD*, 1969, 1977; Eva Marie Venske is listed in San Jose in 1992 per *U. S. Public Records Index, 1950-1993*, vol. 1; Eva M. Poling was b. Dec. 31, 1899 in Union, Ohio, to Daniel E. Poling and Daisy Dougal, married Garrett D. Palmer [and later Harold Venske], and d. Oct. 17, 1992, in Dowagiac, Mich., per Ibach Family Tree (refs. ancestry.com).
See: "Danish Days," 1957, "Santa Ynez Valley Art Exhibit," 1954, 1955, 1957, 1958, "Venske, Harold"

Venske, Harold Henry (1898-1973) (Santa Ynez Valley)
Photographer, amateur. Teacher at Santa Ynez Valley Union High School (1931+) who for several years, c. 1945, 1952 and 1953, taught mechanical drawing. Husband of Eva Marie Venske, c. 1952-58, below.

■ "Here are Thumbnail Sketches... Valley High School... Harold Venske ... joined the staff in 1931 and teaches mathematics and science. He completed his education at Stanford University, the University of Oregon and Oregon State College. Venske and his [second] wife, Eva Marie, make their home in Solvang," *SYVN*, April 27, 1956, p. 1.

Venske, Harold (notices in Northern Santa Barbara County newspapers on microfilm and on newspapers.com)
1958 – "Harold Venske: Teacher Given PTA Life Membership," *SYVN*, Feb. 7, 1958, p. 1.

1960 – "Memo Pad... The current issue of the *Midland Mirror*, Midland School newspaper, reveals that Harold Venske, retired mathematics and science instructor at Santa Ynez Valley Union High School, has been appointed a member of the Midland faculty... Mr. Venske will tutor in math and physics and direct the sophomore half-unit algebra II class," *SYVN*, Dec. 16, 1960, p. 2.

Venske, Harold (misc. bibliography)
Harold Henry Venske, b. June 22, 1898 in Wausau, Wisc., to Herman Venske and Marie T. Reinhart, married Ada Marie Jenkins [first wife] and d. July 19, 1973 in Victoria, BC, per Tuthill Family Tree 2.0 (refs. ancestry.com).
See: "Santa Ynez Valley Union High School," 1945, 1949, 1952, 1953, 1956, "Venske, Eva"

Verhelle, George F. (Santa Barbara)
Landscape designer, nurseryman, who spoke to Minerva Club, 1938.
See: "Minerva Club," 1938

Veterans Memorial Building (Lompoc)
Recipient of artwork by WPA artists, 1937. Venue for occasional art exhibits and lectures.
See: "Art, general (Lompoc)," 1960, "Boy Scouts," 1950, "Brackenridge, Marian," "Flower Festival," "Lompoc Gem and Mineral Club," 1959, 1960, "Puppets (Lompoc)," 1947, "Tri-County Art Exhibit," 1950, "Works Progress Administration"

Veterans Memorial Building (Santa Maria)
Site of various civic events.
See: "Community Club," 1950, "Santa Maria Valley Art Festival,"

Veterans Memorial Building (Solvang)
Site of the Solvang Library, and site of various civic events, including prom dances.
See: "Danish Days," 1948, 1952, 1955, "Santa Barbara County Library (Solvang)," "Santa Ynez Valley Art Exhibit," "Solvang Woman's Club," 1945

Vett, Else (Santa Ynez Valley)
Photographer who exh. at Santa Ynez Valley Art Exhibit, 1955.
Vett, Else (misc. bibliography)
Else Vett (Danish passport 708276) sailed from England, Nov. 6, 1956 on the Norwegian M/V *Bolinas* and arrived at Los Angeles, Nov. 28th, 1956 per Calif. Passenger and Crew Lists (refs. ancestry.com).
See: "Santa Ynez Valley Art Exhibit," 1955

Viole, Laurence Deleval (1896-1952) (North Hollywood)
Architect / engineer in charge of architectural restoration of Mission Santa Ines, 1949. Designer of more than 150 Catholic schools and churches, primarily in the Los Angeles area.
Laurence Deleval Viole was b. Sept. 24, 1896 in Calif. and d. Dec. 31, 1952 in Los Angeles and is buried in Calvary Cemetery, LA per findagrave.com (ref. ancestry.com).
See: "Mission Santa Ines," 1949

Vista del Mar school (Gaviota)
Part of the Santa Ynez Valley school system.
See: "Public Works of Art Project," 1934, "Santa Ynez Valley, Ca., Elementary Schools"

Vivian, Clara, Miss (Lompoc / Oakland)
Awarded a diploma for her landscape painting at "Santa Barbara County Fair," 1892.
Vivian, Miss (notices in Northern Santa Barbara County newspapers on microfilm and on newspapers.com)
1892 – "Miss Clara Vivian of Oakland, a Normal graduate, takes the Honda school which opens Monday next," *LR*, July 23, 1892, p. 3, col. 2.
Vivian, Miss (misc. bibliography)
Is she Clara Vivian listed in the 1900 U. S. Census as age 29?, b. April 1872 in Michigan, a school teacher, residing in San Leandro Precinct No. 1, Alameda county, with her mother, E. Clara Vivian and sister, Kate, also a school teacher; is she Clara A. Vivian who married Thomas F. Maher in San Leandro, Dec. 18, 1909 per Calif. Marriage Records from Select Counties (refs. ancestry.com).
See: "Santa Barbara County Fair," 1892, and *San Luis Obispo Art and Photography before 1960*

Volk, Marian Alice (Mrs. Ralph P. Volk) (Green Bay, Wisc. / Nipomo)
Exh. National Art Week exhibit in Minerva Library, 1940.
See: "National Art Week" 1940, and *Arroyo Grande (and Environs) Art and Photography before 1960*

Vollmer, Grace Libby (Mrs. Ralston Vollmer) (1884-1977) (Santa Barbara)
Member Santa Barbara Art Association, who exh. at opening exh. of Allan Hancock College Art Gallery, 1954, and at several additional venues in northern Santa Barbara County, 1950s.
■ "Painter. Grace Vollmer was a pupil of Martinez, E. Vysekal and Roscoe Shrader. She exhibited locally as early as 1926 and was listed as an artist in Laguna to 1940," per Nancy Moure, "Dictionary of Art and Artists in Southern California before 1930," *Publications in California Art*, vol. 3,
Exhibited in Pasadena per Nancy Moure, "Index to Articles on California Art and Artists found in Newspapers Published in … Pasadena (c. 1900-1940)," *Publications in California Art*, vol. 8.
Exhibited with Laguna Beach Art Association per Nancy Dustin Wall Moure, "Index to California Art Exhibited at the Laguna Beach Art Association 1918-1972," *Publications in California Art*, vol. 11.
Vollmer, Grace (notices in California newspapers on microfilm and on newspapers.com)
1952 – "Channel City… Mrs. Ralston Vollmer's paintings are being exhibited in a one-man show at the Santa Barbara Museum of Art. She paints regularly with **Douglass E. Parshall**'s group in Montecito," *LA Times*, Nov. 16, 1952, p. 98 (pt. III, p. 6).
And approx. 40 additional notices of her work exh. in group shows in Calif. were not itemized here.
Vollmer, Grace (misc. bibliography)
Grace Libby Vollmer b. Sept. 12, 1884 to Edgar Howard Libby and Annie Laurie Libby, married Ralston Vollmer, d. Nov. 24, 1977 and is buried in Santa Barbara Cemetery per findagrave.com (refs. ancestry.com).

See: "Allan Hancock [College] Art Gallery," 1954, "California State Fair," 1951, "National Art Week," 1940, "Santa Barbara County Fair," 1952

Vonsild, Faye (Mrs. Fred Vonsild) (Pismo Beach)
Artist who exh. at Santa Ynez Valley Art Exhibit, 1954.
See: "Santa Ynez Valley Art Exhibit," 1954, and *Arroyo Grande Art and Photography before 1960*

W

Wade, Lillie Clark? (Mrs. Dr. Lyman Trevitt Wade?) (Santa Maria / San Luis Obispo)
Photographer, amateur, who exh. a marine photo at "Santa Barbara County Fair," 1900.
"Mrs. L. T. Wade" is probably "Mrs. Lyman Trevit Wade." According to newspaper references Dr. Wade was active in Santa Maria c. 1900-1906/9.
Wade, L. T., Mrs. (misc. bibliography)
Lillie C. Wade is listed in the 1900 U. S. Census as age 32, b. Oct. 1867 in Scotland, came to America in 1872, married in 1893, and was residing in Township 9, Santa Barbara County (Guadalupe?), with husband Lyman T. Wade, a physician and surgeon, and two children; Lillie C. Wade is listed in the 1930 U. S. Census as residing in San Luis Obispo; Lillie C. Wade is listed in the *Paso Robles, Ca., CD*, 1942, 1950, 1953, 1956 (ref. ancestry.com).
See: "Santa Barbara County Fair," 1900

Wagner, Blanche Collet (Mrs. Dr. Henry Raup Wagner) (1873-1957) (Pasadena)
Painter who visited Santa Maria and had her paintings discussed at the Minerva Club by K. Ethel Hill, 1936.
See: "Hill, K. Ethel," "Minerva Club," 1936, and *Central Coast Artist Visitors before 1960*

Waiters (Holland), Ninalee (Mrs. Leland Holland) (Santa Maria)
Santa Maria High School student who made a poster for a play, 1927 and won a prize for her drawing at the Scholastic Art Exhibit, 1930. Drawing repro. in Splash, 1927. Active in high school theater.
See: "Santa Maria, Ca., Union High School," 1927, 1930, "Scholastic Art Exhibit," 1930, "Splash," 1927

Waldron, Ralph E. "Wally," TSgt (Vandenberg)
Crafts hobbyist in ceramics, leather, 1960.
■ Port. and "Helped Fire Dozen Thors ... member of the 392nd MI's Standardization team... His first assignment, after entering the army in 1942 was with the 1st Cavalry Remount Division at Monterey, California. Soon, however, he shifted to the aircraft field and became an engineer gunner with the 95th Bomb Group of the 8th Air Force in England ... On his 16th mission he was shot down over Germany and spent the remainder of the war as a POW.

After WWII he took part in the Berlin Airlift and later in the U. S. worked on the development test phase of the B-45.... Waldron's off-duty activities and interests are as variegated as his military career. ... If he's not doing any of these things, he can be found at home working on his leathercraft and ceramics hobbies. He has made many personalized coffee cups and ash trays for the men he works with at Control Center No. 2. Sergeant Waldron resides at 302 Oceanview with his wife Betty and their three daughters," *LR*, Dec. 8, 1960, p. 22.

Walford, Ernest George (1883-1975) (Los Olivos)
Self-taught landscapist who exh. at Santa Ynez Valley Art Exhibit, 1954, 1955, 1957, 1958.
■ Port. and "Ernie Walford Honored at 90th Birthday Party. Ernie Walford of Los Olivos celebrated his 90th birthday... Walford came to the Santa Ynez Valley in 1910 and is a native of Bristol, England. He has traveled over most of the world, more than once shouldering his pack and walking across Australia. He can recount endless tales of exciting adventure experienced during trips to Australia, Canada and in the United States. He worked at **Mattei's Tavern** for 34 years, several years for Mrs. Charles Glasgow in Los Olivos, and has made his home behind the Los Olivos Post Office for over 15 years. He is a self-taught artist, paints charming pictures of Los Olivos and rural scenes, speaks Spanish, also self-taught, and in addition to keeping a thriving garden, lists other pastimes as knitting and crocheting...," *SYVN*, May 24, 1973, p. 6.
Walford, Ernest (notices in Northern Santa Barbara County newspapers on microfilm and on newspapers.com)
1964 – "Wide Variety of Entries Highlight 4-H Hobby Show...money raising event... Among the entrants... oil paintings, Ernest Walford...," *SYVN*, Nov. 5, 1964, p. 10A.
Walford, Ernest (misc. bibliography)
Ernest G. Walford was b. May 10, 1883 in Other County [England] and d. Jan. 2, 1975 in Santa Barbara County per Calif. Death Index; Walford is buried in Oak Hill Cemetery, Ballard, Ca., per findagrave.com (refs. ancestry.com).
See: "Santa Ynez Valley Art Exhibit," 1954, 1955, 1957, 1958

Walker, Addison, Pfc. (1923-2018) (Camp Cooke)
Painted a mural at Camp Cooke, 1945.
■ Port. and "Addison Morton Walker (September 3, 1923 – January 27, 2018) was an American comic strip writer, best known for creating the newspaper comic strips *Beetle Bailey* in 1950 and *Hi and Lois* in 1954," per Wikipedia
See: "Art, general (Camp Cooke)," 1945

Walker, (Lizzie Lucille Owen?) (Mrs. W. H. Walker) (Los Alamos?)
Exh. five oil paintings of Santa Barbara scenery at "Santa Barbara County Fair," 1886.
Is she the wife of W. H. Walker of Ayres & Walker, dealers in Drugs and Medicines, Los Alamos, Cal.," *LR*, Aug. 19, 1882, p. 3.
Walker, W. H., Mrs. (misc. bibliography)
Is her HUSBAND William H. Walker listed in the 1880 U. S. Census as age 21, b. c. 1859, residing in Guadalupe with his father Benjamin O. Walker and siblings; is she Lizzie L. Owen who married Wm. H. Walker, Nov. 29, 1884, in Santa Barbara per *Calif. County Birth, Marriage and Death Records* (refs. ancestry.com).
See: "Santa Barbara County Fair," 1886

Walker, Theodore Roderick, Sergeant (1885/86-1920?) (Los Angeles)
Chalk talk artist who illustrated a lecture about a cross-country trek, 1914.
1920 – "At Santa Barbara… Marriage licenses issued … to Los Angeles people: Theodore Roderick Walker, 35, Belle Townsend, 30, both of Sawtelle…," *LA Times*, June 19, 1920, p. 25 (i.e., pt. II, p. 11); is he Theodore R. Walker, Deputy City Assessor, mentioned in Sawtelle Taxes, valuations, *LA Times*, March 24, 1922, p. 22.
Walker, T. R. (misc. bibliography)
Theodore R. Walker, b. June 16, 1885 in Ill., to Zachary T. Walker and Harriett I. Beasley, resident of Chrisney, Ind., married Leah F. Kinney on Jan. 4, 1913 per Indiana Marriages; Theodore Roderic Walker, Commercial Artist, 122 9th St., member of the Progressive Party, is listed in *Index to Register of Voters, Los Angeles County, Sawtelle City Precinct, No. 4*, 1914; Theodore R. Walker, bookkeeper, is listed in the *Santa Monica., Ca., CD*, 1914; Theodore R. Walker, b. c. 1886 in Illinois, was discharged from the military in 1919, and admitted to the military hospital at Sawtelle, in Los Angeles County 1920, per *U. S. National Homes for Disabled Volunteer Soldiers*; Theodore R. Walker is listed in the 1920 U. S. Census as age 35, b. c. 1886 in Illinois, residing in National Military Home, Malibu; Theodore R. Walker is listed a second time in the 1920 U. S. Census as age 34, b. c. 1886 in Illinois, widowed, working in editorial work in a newspaper, residing with his parents, Zachary and Harriet, in Los Angeles; Theodore R. Walker, waiter, is listed in *Index to Register of Voters, Sawtelle City Precinct No. 4*, 1922; Theodore R. Walker was b. June 16, 1886 in Illinois to Zachary T. Walker and Harriet Harris, married Leah Frances Kinney, and d. 1920? per Oakes Family Tree (ref. ancestry.com).
See: "Chalk Talks," 1914

Walker (Fryett), Winifred (Mrs. Col. Fryett) (1882-1966) (England)
English artist who painted flowers in Lompoc and Santa Maria intermittently 1928, 1935, 1940, 1943, 1945.
See: *Central Coast Artist Visitors before 1960*

Wallace, John Charles (Lompoc)
Co-Prop. of Photo-Craft Studios, 1960-61.
■ "New Photo Studio Set Up in Lompoc… at 117 North G Street, called the Photo-Craft Studios. The new business is owned by John Charles Wallace and **Richard A. Bodwin**. The photo studio will specialize in portraiture, wedding coverage and general commercial photography," *LR*, Nov. 17, 1960, p. 29.
No additional information on this individual could be found.

Waller, Lionel Duncuff (1882-1940) (Santa Maria)
Photographer of gardens; owner of flower seed company. Donated a stained-glass window to St. Peter's, 1935. Waller Park, named in his honor, was the subject of paintings by several artists over the years.
■ "Born April 5, 1882, in London, England, son of John and Katherine, Grandson of Lionel Askim Bedingfield Waller. Had one sister, Viola. Educated in English public schools. Emigrated, November 1908 to Canada, then to US. Moved in 1909, to Arroyo Grande, California, to grow Sweet Peas, initially worked for Reverend Louis Routzhan. Founded in 1912, LD Waller Seed Company, which became Waller Franklin Seed Company which became Waller Flowerseed Company. Married May 10, 1916, Elsie May Tillson of San Francisco … Built, in 1924 his home in Santa Maria, CA. Lionel Waller died on February 15, 1940 from a stroke; he had been largely paralyzed for two years prior. After his death, the park he had designed was named for him … Waller Park, in Santa Maria" per wanderingthewest.com/idbio/
"Death Calls L. D. Waller, Pioneer Flower Seed Grower…," *SMT*, Feb. 13, 1940, pp. 1,6.
Waller, Lionel (notices in Northern Santa Barbara County newspapers on microfilm and on newspapers.com)
1938 – "Rotarians See Color Pictures in Photography," of local gardens and flowers, "at **Santa Maria Inn**. The color pictures, made and shown by L. D. Waller, were of **Frank J. McCoy's** garden, Waller's home garden, the Waller-Franklin seed farm, and shots in Santa Ynez canyon and San Marcos pass and at Catalina Island," *SMT*, Feb. 1, 1938, p. 2.
1940 – "County Gives Name of L. D. Waller to Pleasure Park. Washington County park is now Waller park. The new name is in honor of the late L. D. Waller, who selected the site and developed the park while chairman of the county Forestry board," *SMT*, Aug. 13, 1940, p. 1.
See: "Ingram, J. S.," "Stained Glass," 1935

Walton, David "Dave" A. (Santa Maria)
Photographer, amateur. Active with the Santa Maria Camera Club, 1941.
■ "Sea Scouts… trip this week-end… new second mate, David Walton, a new resident who was formerly in the Navy and now is connected with Hancock College of Aeronautics…," *SMT*, Aug. 28, 1941, p. 4; "Many From Here Join the Navy… enlistment of David A. Walton here for aviation machinist's mate, first class, Naval Reserve…," *SMT*, Oct. 29, 1941, p. 6.

See: "Santa Maria Camera Club," 1941

Wammack, Ritchie (Lompoc)
Child with cerebral palsy who painted modern paintings, 1959.

■ "Lompoc's Tuesday Visitor… from Santa Barbara… Mrs. Betty K. Germain… on each side of the station wagon there is an Elks emblem and the words, 'California Elks Association, Major Project, Aiding Physically Handicapped Children.' This is the Cerebral Palsy Mobile unit… Ritchie, who is watching out of the window for her has been receiving treatment since 1950… started in Eureka, Calif., where he was living until 1956… If it isn't raining, Ritchie may run out to help Mrs. Germain carry in bubble blowing liquid, a workshop kit, surrogate dolls, a mirror and other colorful, attractive games and articles into his home. … provide stimulation and motivation for speech … Blond, blue-eyed Richie has difficulty pronouncing a clear 'r' sound, maintaining the proper lip closure and is working to strengthen the muscles of his right arm and hand… Blowing Bubbles. While blowing bubbles to strengthen his muscles for proper lip closure… Ritchie talks of his many interests – swimming, Cub Scouts, arithmetic and science. He wants to be an engineer. He is taking art lessons – likes to create modern looking paintings. He plays the piano and is taking lessons. He is on the honor roll in the fifth grade at Hapgood School and is excited about attending camp in Santa Cruz County during August. He attends the Presbyterian Sunday School…," *LR*, July 13, 1959, p. 5. And, many additional notices not itemized here.

Ward, Margery (Southern California)
A painting by her was shown at the Jr. Community Club, 1953.
1946 – Is she – "New Teacher at Elementary School. … The Encino Elementary school welcomes this term Mrs. Marjorie Ward… kindergarten… Mrs. Ward resumes her work after a short leave of absence when her husband, Lt. Robert Ward, MM returned from overseas. She is a resident of the Valley, a graduate of the Valley schools and of UCLA where she received her teacher training and BA degree," *Van Nuys Valley Times and North Hollywood Sun-Record*, Feb. 11, 1946, p. 7.
1963 – Is she the artist named Marjorie Ward who exhibited a mosaic of a Madonna at the Christmas Art and Music Festival at Eureka Inn per "Exhibits and Artists," *Eureka Humboldt Standard*, Nov. 30, 1963, p. 8.
This individual could not be identified.
See: "Junior Community Club (Santa Maria)," 1953

Ward, Ruth (Buellton)
Teacher at Buellton School who had a special interest in art and ceramics, 1951+.

■ "New Teacher Joins Staff at Buellton… to succeed Mrs. Marguerite G. Wilson… Miss Ward is a graduate of Ventura Junior College and has her B. A. Degree from Colorado State College, Greeley, Colo. She taught in Colorado following her graduation from Greeley and has taught the past four years in Ventura. She specializes in art

activities and is especially interested in ceramics…," *SYVN*, Aug. 24, 1951, p. 3.
Ward, Ruth (notices in Northern Santa Barbara County newspapers on microfilm and on newspapers.com)
1957 – "Something New for Students at All Three Lompoc Schools… Hapgood… faculty include… Miss Ruth Ward…," and port. in group, *LR*, Aug. 22, 1957, p. 16 (pt. II, p. 8).
And more than 25 additional references about her teaching (NOT art teaching) were not itemized here.
Ward, Ruth (misc. bibliography)
Ruth Ward, teacher, Pub Sch, residing in Lompoc, is listed in the *Santa Mara, Ca., CD*, 1958, 1959 (refs. ancestry.com).
See: "Santa Ynez Valley, Ca., Elementary / Grammar Schools," 1951

Warner (Shostrom), Nell Walker (Mrs. Emil Shostrom) (1891-1970) (La Canada / Carmel)
Painter of floral still lifes. Guest of Santa Maria Inn, 1938, 1939, where she painted and exhibited her paintings of local blooms, 1940.
Warner, Nell (notices in Northern Santa Barbara County newspapers on microfilm and on newspapers.com)
1938 – "Painting on Display" in **Mrs. Hall**'s shop window on Church St. shows water lilies, *SMT*, May 19, 1938, p. 3.
1939 – "Southland Artists Visit Here … Mrs. Nell Walker Warner, who will remain for three weeks as Frank J. McCoy's guest in **Santa Maria Inn**, while she paints flowers in the valley…," *SMT*, Sept. 21, 1939, p. 3.
1940 – "Special Showing of Flower Paintings" at **Santa Maria Inn** where Warner has been residing and painting local blooms. "The paintings include two of pelargonium blossoms, one of Matilija poppies and irises, one of Cherokee roses and larkspur, one of an iris group, one of red geraniums and one of lilacs and yellow roses. Mrs. Warner has used some of the Inn's ancient copper pieces to good effect in her groupings," *SMT*, May 20, 1940, p. 3.
See: "Matzinger, Philip," 1926, and *Central Coast Artist Visitors before 1960*

Warren, John (Santa Barbara)
Artist and director for the WPA who spoke to the Alpha Club about what the government is doing for unemployed artists, 1936.
See: "Alpha Club," 1936, "Works Progress Administration," intro.

Warshaw, Howard (1920-1977) (Santa Barbara)
Artist of national repute. Judge at Santa Barbara County Fair, 1960, exh. 1961. Art teacher at UC, Santa Barbara, 1957+.

■ Warshaw was born and educated in New York City – in art at the Art Students League and the National Academy of Design. Shortly afterwards he moved to Southern California where he taught at the Jepson Art Institute in Los Angeles. Befriending fellow artists **Rico Lebrun** and Eugene Berman, he benefitted from their art advice, and in 1957 became an art professor at the University of

California, Santa Barbara – excerpted from bio. on sullivangoss.com.
Several monographs on him and his art have been published.
See: "Peake, Channing," intro., 1957, "Santa Barbara County Fair," 1960, 1961

Waterman, Richard Alan (1914-1971) (Los Prietos / Santa Barbara)
Teacher of art and mechanical drawing at Los Prietos CCC camp, 1937-40.
Waterman, Richard (misc. bibliography)
Richard A. Waterman, mother's maiden name Cooper, was b. July 10, 1914 in Santa Barbara County per Calif. Birth Index; Richard A. Waterman is listed in the 1940 U. S. Census as age 26, b. c. 1914 in Calif., finished college 5th or subsequent year, wage or salary worker in Government work, instructor CCC Camp F-118, residing in Los Prietos; Richard Alan Waterman d. Nov. 8, 1971 in Tampa, Fla., per Waterman Family Tree (refs. ancestry.com).
See: "Santa Ynez Valley Union High School," 1937

Wathey Studio (Lompoc)
Is he Thomas E. Wathey (1896-1957), photographer, listed in the Santa Barbara CD, 1931-45? His business appears to have been taken over by his daughter, Ruth, 1948+.
Wathey Studio (notices in Northern Santa Barbara County newspapers on microfilm and on newspapers.com)
1932 – "Baby Show Contest Scheduled Soon by Theater and Studio… five babies of Lompoc or vicinity are the best looking will take place at a baby beauty contest to be held at the Lompoc Theater February 17, 18, and 19.
Attractively posed photographs of the babies will be shown on the screen, and the audience will vote to decide … No names will be used, each slide carrying a number instead… Parents are urged by the studio to enter their babies… All children under the age of six years are eligible, and to enter the contest each baby must have its picture taken at the Wathey Studio on any of the following dates: February 4, 5, 6, 8, 9, or 10. If desired, the photographer will take the pictures at the home instead… As all expenses are paid by the theater the parents assume no obligation…," *LR*, Jan. 29, 1932, p. 6; ad: "Baby Show pictures now being taken at Wathey Photo Studio, 419 East Ocean Avenue … Contest Open to all children under 6 years… The pictures will be shown on the Lompoc Theater screen on the evenings of February 17, 18, 19. No names will be used and the audiences will vote on the most popular babies… Pictures for entry in the contest must be taken at Wathey studio between today and Wednesday, February 10…," *LR*, Feb. 5, 1932, p. 7; photo of Raymond Bishop, winner, *LR*, Feb. 26, 1932. p. 1.
[Baby show contests in general were popular (some with live babies and others with photos of babies shown in conjunction with motion picture theater promotions). In 1932 alone there were baby contests (unrelated to each other) in San Francisco, Salinas (by William Carde, cameraman for Scenegraph film company), Woodland, Pomona, Hanford, etc. Various photographers may have

recognized a potential sales opportunity in the midst of the Depression and tried their hand at it.]
Wathey Studio (misc. bibliography)
Thomas E. Wathey is listed in the 1940 U. S. Census as age 43, b. c. 1897 in Arizona, finished elementary school, 8th grade, working as a photographer and residing in Santa Barbara (1935, 1940) with wife Grace O. (age 40) and children Ruth E. (age 17) and Lawrence L. (age 12); Thomas Earle Wathey b. Oct. 16, 1896 in Cochise County, Ariz., d. Aug. 1, 1957 in Santa Barbara County and is buried in Santa Barbara Cemetery per findagrave.com (ref. ancestry.com).

Watkins, Suzanne
See: "Grossini (Watkins), Suzanne / Suzann / Suzzann (Mrs. Frank O. Watkins)"

Watson, Mrs. (Santa Maria)
Member of the Art Loan committee, 1895. By process of elimination, she is probably Kate Alida Sedgwick Crow Watson (Mrs. John Nathaniel Watson).
1894 – "The programme for the **Ladies' Literary Society**… Mrs. John Watson…," *SMT*, Oct. 20, 1894, p. 3.
Watson, Mrs. (misc. bibliography)
SON? – Duncan Sedgwick Watson was born to John N. Watson and Kate Alida Sedgwick on Aug. 12, 1894 in Santa Maria; HUSBAND? – John N. Watson, age 34, b. Illinois c. 1862, laborer, is listed in California Voter Registers, *Santa Barbara County – Santa Maria Precinct No. 2*, 1896 (and he is also listed 1892 and as "John Nathaniel Watson" foreman in 1898), and he was associated with the Sisquoc mines in the late 1890s (refs. ancestry.com).
See: "Art Loan Exhibit (Santa Maria)," 1895, "Creative Arts and Woman's Exchange," "Crow (Watson), Kate"

Waugh, Mabel Glazier "Grace" Burwick (Mrs. Coulton Waugh) (aka Odin Burvik) (1904-1998) (Santa Maria / New York)
Art major at Santa Maria High School, grad. 1925. Artist and collaborator with her cartoonist husband, Coulton Waugh, on the syndicated comic strip, "Dickie Dare," 1940s.
■ "Mabel Odin Waugh, who was graduated from Santa Maria Union High School and received her first artistic training there, and her husband, Coulton Waugh, today celebrate the publication of his book, 'The Comics,' by The MacMillan Company. In her Santa Maria days, Mrs. Waugh, who was then Mabel Odin Burwick, distinguished herself as a writer and also began what was later to become an important artistic career. In high school she studied writing with Miss **Ethel Pope** and won a prize for the best study of the year. She studied art under **Stanley G. Breneiser** … In the field of art, the future Mrs. Waugh also won a prize for the best work of the year. Since then, she has been associated with various leading advertising agencies in Minneapolis, St. Paul, and Chicago, and more recently took over the comic strip, 'Dickie Dare,' which was previously drawn by her husband, Colton Waugh. The

Waughs now have a three-month-old daughter, Phyllis Elizabeth, and live in Newburgh, New York," per "New Book by Husband of Local Woman," *SMT,* Nov. 17, 1947, p. 3.

Waugh, Mabel (notices in Northern Santa Barbara County newspapers on microfilm and on newspapers.com)
1925 – "Friends in this city have received word of the entrance of Miss Mabel Burwick into the state university of Colorado…," *SMT,* Sept. 17, 1925, p. 5.
1945 – "Former Orcutt Teacher Visits. Mrs. Della Burwick… Her daughter, Mrs. Colton Waugh, the former Mabel Burwick, and her son, Robert Burwick, are producers of a well-known syndicated comic strip called 'Dickie Dare.' Mrs. Waugh does the drawing and Burwick the script," *SMT,* Oct. 27, 1945, p. 3.
And, more than 20 additional references to "Mabel Burwick" discussing her acting in high school theater and taking part in high school athletics were not itemized here.
Waugh, Mabel (Internet)
"Several of her artworks have been sold at Heritage Auctions, i.e., historical.ha.com….
Waugh, Mabel (misc. bibliography)
Mabel Burwick port. appears in Santa Maria High School yearbook, 1924; "Ink-Slinger Profiles" by Allan Holtz. Odin Burvik was the pseudonym of Mabel Glazier 'Grace' Burwick, who was born in Colorado Springs, Colorado, on September 17, 1904…" Her parents, Odin and Della Burwick are listed in the *Colorado Springs CD,* 1905, 1907, 1910. The 1920 U. S. Census has Mabel, her mother and brother Robert Olesen, in Los Angeles. "According to the *Kingston Daily Freeman* (NY), April 13, 1968, she 'decided at the age of 12 to become a professional artist. … Mrs. Waugh studied at Minneapolis and Chicago Art Institutes and with Harvey Dunn at Grand Central Galleries in New York…" Under the first name of "Grace" she is listed in the 1930 U. S. Census in Minneapolis, Minn., with her parents, where she was working as a self-employed commercial artist. She visited Europe in 1933 per ship passenger lists. She was employed as an artist with the L. S. Donaldson Co. in Minneapolis, 1934. She is referenced in *The Federal Illustrator,* Spring Number, 1938. She is listed in the 1940 U. S. Census in New York City where she was a free-lance artist claiming two years of college. Worked as an assistant (using the pseudonym Odin Burvik) to Coulton Waugh (son of marine painter Frederick Judd Waugh) who had been producing the *Dickie Dare* comic strip for many years. Waugh wished to give up the strip. In the Spring of 1944, a competition mounted by the Associated Press to find a successor, was won by Burwick. Ironically, Waugh married Mabel Burwick on January 17, 1945. Mabel's brother, Robert, began working on the strip by lettering and later, when Coulton and Mabel wished to retire so that they could paint, Robert Burwick took over the strip entirely. Burwick's painting was cited in "Success Stories," *Parade* magazine, January 12, 1958. Later newspapers revealed she studied painting with her husband. During the mid-1960s and 1970s the couple produced the panel *Junior Editors Quiz.* After Coulton Waugh's death in 1973, she married Hubert A. Buchanan, 1981. She illustrated Buchanan's book, *Winnowing Winds* (1984). She died June 17, 1998 – all this is paraphrased from Holtz's research in Public Member Stores (refs. ancestry.com).

See: "Santa Maria, Ca., Union High School," 1923, 1924, 1925

Weaver, Dave
See: "Weaver, Freddie"

Weaver, Freddie Keith (1922-2005) and Dave R. Weaver (19??-19??) (Santa Cruz / Santa Maria)
Photographer. Freddie – prop. with husband, Dave R. of Weaver's Camera Shop, 1957+. Active with Santa Maria Camera Club, 1959+.
■ Port. and Freddie K. Weaver… a long-time resident of Santa Maria… Freddie was born on March 29, 1922 in Cleburne, Texas, the daughter of Fred Lee Keith and Mary Louise Skaggs. After the birth of Freddie's brother, Bob, the family moved to Childress, Texas, where Freddie graduated high school in 1940. During the Great Depression the small family made the long trek to California in 1935, settling in the San Bernardino area. In 1947, Freddie married Dave Weaver, owner and operator of Weaver Photo Service, leading Freddie into the world of photography. The couple moved to Santa Cruz in 1949 where Dave signed on as a photographer for the *Santa Cruz Sentinel.* In 1957 the Weavers moved to Santa Maria and opened Weaver's Camera Shop on the corner of Main and Broadway … Freddie not only became an expert on cameras, she also joined the Santa Maria Camera Club and became well-known as a photographer in her own right. She specialized in portraits of cats, a number of them were Blue Ribbon winners at the Santa Barbara County Fair. In 1964, Meg Smith encouraged Freddie to join the Santa Maria Civic Theatre … became the paramount activity in her life. Freddie was a talented actress…," and under "survived by" there is no mention of husband, Dave, *SMT,* Dec. 23, 2005, p. 11 (i.e., B-3).
1957 – "Business News… Dave and Freddie Weaver of Santa Cruz have opened a new camera shop at 102 S. Broadway. Weaver was born in Santa Maria but moved north with his family when he was 10 months old," *SMT,* Dec. 2, 1957, p. 8.
Weaver, Freddie (misc. bibliography)
Freddie Weaver is listed with husband, Dave, in the *Santa Maria, Ca., CD,* 1960-1970 and then singly until her death in 2005; Dave R. Weaver is last listed in Santa Maria in 1988 per *U. S. Public Records Index, 1950-1993,* and possibly in 1994 (ref. ancestry.com).
See: "Santa Barbara County Fair," 1960, "Santa Maria Camera Club," 1960

Weaver, Mary Elizabeth Brown (Mrs. Rev. George T. Weaver) (c. 1850-1899) (Santa Maria)
"Mrs. Weaver," a member of the Literary Society, exh. a portrait at the Art Loan Exhibit, 1895. Ed. – She may have lent a painting from her collection, not painted it. A rarity for Santa Maria, she traveled to Europe at least twice.
■ "Death of Mrs. Weaver. The Wife of the Pastor of the Local Unitarian Congregation. … after an illness of but a week. She had caught a severe cold… Mrs. Weaver was

born in Ohio forty-nine years ago. She came to Redlands from her home at Santa Maria shortly after Mr. Weaver had been asked to fill the pulpit of Unity Church and entered energetically into the work of the church and outside literary and charitable work. She was a woman of much force of character and possessed great executive ability… As an organizer she has been prominent, starting several woman's clubs within a few years past and instituting and delivering lectures upon the literature of art. … Mr. and Mrs. Weaver were united in marriage seven years ago…," *San Bernardino County Sun*, Feb. 12, 1899, p. 8.
Weaver, Mary (notices in newspapers on newspapers.com).
1892 – "Rev. George T. Weaver, a Methodist clergyman of Santa Maria, Cal., was married on the 10th inst. to Mrs. Mary E. Brown at San Jose," *SF Chronicle*, March 20, 1892, p. 9; author of "A Bird's Eye View of Rome, as Seen by a Santa Maria Lady Who has Been There…," *SMT*, Nov. 19, 1892, p. 1.
1893 – "A Santa Maria Lady Pens a Picture of the Buried City and Burning Mountain [Pompeii]… It was my dream from childhood to visit Southern Europe… But one day a friend said to me, 'come along with our party to Europe'," *SMT*, Feb. 11, 1893, p. 1.
Articles by HUSBAND, Rev. G. T. Wheeler, on his (and his wife's) trip abroad in 1893 – "The Columbian Exposition," *SMT*, June 3, 1893, p. 2; "Jottings from Abroad. They Arrived in London…," *SMT*, Sept. 2, 1893, p. 1; "A Look at London," part II, *SMT*, Sept. 16, 1893, p. 1; "A Look at London," part III, *SMT*, Sept. 23, 1893, p. 1. Several social and travel notices for "Mrs. G. T. Weaver" appear in the *SMT* in the early 1890s but were not itemized here.
Weaver, Mrs. (misc. bibliography)
Mary L. Weaver b. c. 1850 in Ohio, d. Feb. 10, 1899 in San Bernardino County per Calif. County Birth Marriage and Death Records (ref. ancestry.com).
See: "Art Loan Exhibit (Santa Maria)," 1895

Weaver's Camera Shop (Santa Maria)
Prop. Dave and Freddie Weaver, 1957-1988. Sold to James and Nancy L. Boster, 1988.
More than 1000 notices for "Weaver's Camera" appeared in the *SMT*, 1959-1988, but primarily consisted of advertising and thus were not itemized here.
See: "Weaver, Freddie"

Webb, Clifton (1889-1966) (Hollywood)
Actor / painter. One of several Hollywood notables who exh. art at first annual Santa Ynez Valley Art Exhibit, 1953.
■ "Webb Parmelee Hollenbeck, known professionally as Clifton Webb, was an American actor, dancer, and singer remembered for his roles in such films as *Laura*, *The Razor's Edge*, and *Sitting Pretty*. Webb was Oscar-nominated for all three," per Wikipedia.
See: "Santa Ynez Valley Art Exhibit," 1953

Webb, Holton Erastus David (1853-1913) (Lompoc)
Teacher Lompoc High School, 1888/92. His students excelled at pen drawing.
1888 – Recommended as a teacher by *Modesto Daily Evening News*, *LR*, July 7, 1888, p. 3, col. 2.
1891 – Visited by his brother Rev. J. C. Webb," *LR*, June 27, 1891, p. 3, col. 2.
Webb, Holton (misc. bibliography)
Holton Webb is listed in the 1900 U.S. Census as a teacher, residing in Lompoc with his wife and three children; Holton Webb is listed in the *Riverside, Ca., CD*, 1906, 1907 as a teacher; Holton Erastus David Webb was b. April 13, 1853 in Wisconsin to Elbridge Gerry Webb and Anna Sarepta Boughton, married **Idella Rudolph** [in Lompoc on June 7, 1890], and d. Sept. 22, 1913 in Riverside, Ca., per Webb Family Tree (ref. ancestry.com).
See: "Lompoc, Ca., Union High School," 1889

Webb, Hugh Pascal (Monrovia)
Photographer. His photos of California Missions were shown at the Santa Barbara County Library, Lompoc, 1935. Husband of painter/historian, Edith Buckland Webb.
See: "Santa Barbara County Library (Lompoc)," 1935 and *Central Coast Artist Visitors before 1960*

Webb, Margaret Ely (1877-1965) (Santa Barbara)
Illustrator. Designer of bookplates. Artist who exh. at Santa Ynez Valley Art Exhibit, 1954, 1955, 1956. Exh. at Allan Hancock [College] Art Gallery, 1954.
■ Port. and repros and "Margaret Ely Webb (1877–1965) was an American illustrator, printmaker, and bookplate artist. She was part of the Arts and Crafts movement of the early 1900s," per Wikipedia.
Webb, M. E. (notices in California newspapers on microfilm and on newspapers.com)
1934 – "For the children is 'Old-Fashioned Fairy Tales,' by Marion Foster Washburne… illustrated by Margaret Ely Webb," *Pomona Progress Bulletin*, Jan. 3, 1934, p. 7, col. 2.
1937 – MOTHER – "Southern Visitor Dies Suddenly… at Ben Lomond, Mrs. Mary Gregory Storke, Santa Barbara vacationist… A daughter, Miss Margaret Ely Webb also of Santa Barbara, survives," *Santa Cruz Evening News*, Aug. 16, 1937, p. 3.
1945 – "Sundials – A charming gift book… is '*The Sundial in Our Garden*' by Violet and Hal W. Trovillion … End papers done by Margaret Ely Webb, the book plate artist of Santa Barbara," *LA Times*, Dec. 2, 1945, p. 30 (pt. III, p. 6). And more than 20 additional "hits" for "Margaret Ely Webb" in California newspapers, 1920-1965, mainly concern her exhibits in group shows and were not itemized here.
Webb, M. E.
Bio. in Nancy Moure, "Dictionary of Art and Artists in Southern California before 1930," in *Publications in California Art*, vol. 3.
See: "Allan Hancock [College] Art Gallery," 1954, "National Art Week," 1940, "Santa Ynez Valley Art Exhibit," 1954, 1955, 1956

Webb, Ray E. (Santa Maria)
Photographer, amateur. President Santa Maria Camera Club, 1958.

■ Port. and "Webb Buys Lusitania … Ray Webb, owner of Webb's Paint, expanded his business interests this week by purchasing the Lusitania Travel Service … Webb first came to this area as an Army officer assigned to Camp Cooke [public relations office] in 1950 following five years in Europe. In 1953 he was sent to the Orient, returning in 1955. Upon retirement from the army as a captain in 1956 he settled in Santa Maria and opened Webb's Paint at 205 E. Main," *SMT*, May 22, 1961, p. 13.
And, c. 1965 he opened a Realty office.
See: "Santa Maria Camera Club," 1958

Weeks, Waldo (c. 1912-1936) (Lompoc)
Lompoc High School student, 1929. Sketcher, 1928.
Weeks, Waldo (notices in Northern Santa Barbara County newspapers on microfilm and on newspapers.com)
1928– "Kiwanis Komments… Visitors were… and Waldo Weeks of Lompoc. The latter entertained with sketches of various members that caused a lot of merriment. Waldo is a very promising young artist and his work was very good," *LR*, April 6, 1928, p. 1.
Weeks, Waldo (misc. bibliography)
Waldo Weeks appears in a group picture in the Lompoc High School yearbook, 1929; Waldo Weeks is listed in the 1930 U. S. Census as age 18, b. c. 1912 in Calif., working as a dairy truck driver, residing in Lompoc with his parents Joe Weeks (age 58) and Hattie A. Weeks (age 42) and 6 siblings; Waldo Weeks, b. c. 1912, d. Aug. 3, 1936 in San Joaquin County per Calif. Death Index (refs. ancestry.com).

Wegner, Helen A. Arnold (Mrs. Glen / Glendon Wegner)
Artist who exh. a painting and two mosaics at the Lompoc Gem and Mineral Club Hobby Show, 1960.
See: "Lompoc Gem and Mineral Club," 1960

Weidmann, Nora (Lompoc)
See: "Wiedmann, Nora"

Weigman / Weighman, Marjorie / Margret (Mrs. Frederick Christian Weigman) (Santa Barbara)
Artist who exh. a painting at Santa Barbara County Fair, 1952.
Weigman, Marjorie (misc. bibliography)
Marjoria [Sic.] Weigman is listed in the 1940 U. S. Census as age 31, b. c. 1909 in Canada, finished high school 4th year, submitted first papers for naturalization, residing in Santa Barbara (1935, 1940) with husband Frederick Weigman (age 37) and child Fred (age 2); Marjorie M. Weigman is listed in the *Santa Barbara, Ca., CD*, 1934-1949 (refs. ancestry.com).
See: "Santa Barbara County Fair," 1952

Weill, Isadore (c. 1845-1895) (Lompoc)
Donor of "paintings" to Lompoc School, 1889. Prop. of I. Weill & Co. general merchandise store, 1890. Vice-President and Manager of Lompoc Bank, 1894.

■ "Death of Isadore Weill… Mr. Weill had been a resident of Lompoc for the past seventeen years and had accumulated a fortune and also gained most enviable reputation for probity and integrity… He was a native of France and was born at Mommenheim, Alsace but emigrated to America many years ago…," *SMT*, Oct. 5, 1895, p. 3.
See: "Lompoc, Ca., Elementary School," 1889

Weir, Barbara
See: "Lamb (Weir), Barbara (Mrs. Lan M. Weir)"

Weir, Ricky? (Mrs. Bert / Burt Weir) (Santa Maria)
Art Chairman, Junior Community Club, 1954. Maker of a mobile shown at the Jr. Community Club, 1954. Landscape paintings by her husband / son (?) were shown at the Jr. Community Club, 1954.
1953 – Port. Mrs. Rickie Weir from San Francisco, former cosmetic specialist for Milkmaid and Coty toilet lines," *SMT*, Oct. 16, 1953, p. 4.
1954 – "Cosmetics Use Demonstrated… **Phi Epsilon Phi** sorority… given by Mrs. Burt Weir, who gave the history of cosmetics and illustrated various products while giving one of the chapter members a facial," *SMT*, March 11, 1954, p. 6; "Ricky Weir, cosmetologist with Bellis drug store, has returned from a two-day stay at the Biltmore, Los Angeles, where she attended a course on skin analysis," *SMT*, May 19, 1954, p. 4.
Weir, Burt, Mrs. (misc. bibliography)
Is she Margaret Weir, wife of Burt W. Weir listed in the *San Francisco, Ca., CD*, 1948? (ref. ancestry.com).
See: "Junior Community Club (Santa Maria)," 1954

Weldon, John Anthony (1903-1990) (Santa Maria)
Collector of Southwestern Native American artifacts that he exh. at the Santa Maria library, 1941. Elk's parade announcer.
Weldon, John (notices in Northern Santa Barbara County newspapers on microfilm and on newspapers.com)
1935 – "Prehistoric Indian Relics Shown Here… in Fryer's café…," *SMT*, March 5, 1935, p. 3.
1939 – "Apache Indians are Guests Here of John Weldon… Weldon became acquainted… while he was connected with a CCC camp composed of Apache Indians on the San Carlos reservation," *SMT*, July 5, 1939, p. 3; "Weldon to Give Relics to Museum. Several Indian relics, estimated around 2000 years old, which he secured on the San Carlos Indian reservation in Arizona, will be presented to the museum of Mission San Miguel by John Weldon … earthen water jug, fire sticks, vases and candles, while employed as director of a CCC camp on the reservation in 1933-34. The materials, the work of old Apache Indian tribes, were unearthed from caves …," *SMT*, July 29, 1939, p. 1.

1940 – "Booths Fill Big Tent in Fair... Next is a booth in which John Weldon's Indian collection of ollas, mortars, pestles, moccasins, Navajo blankets and baskets are shown....," *SMT*, July 25, 1940, p. 3.
1941 – "Weldon's Return from Trip to Southwest. John Weldon and his mother, Mrs. Mary [Sic. Elizabeth?] Weldon have returned from a two weeks' vacation spent visiting the Indian pueblos of New Mexico....," *SMT*, Aug. 21, 1941, p. 3.
And, hundreds of additional references in local newspapers not itemized here.
Weldon, John (misc. bibliography)
The 1940 U. S. Census states he was b. c. 1905 in Utah and that his mother was named, Elizabeth; John Anthony Weldon was b. June 25, 1903 in Eureka, Utah, to James Weldon and Elizabeth "Lizzie" Hannifin, and d. April 7, 1990 in Santa Barbara per Hannifin Family Tree (ref. ancestry.com).
See: "Santa Barbara County Fair," 1941, "Santa Barbara County Library (Santa Maria)," 1941

Wendt, William (Los Angeles / Laguna Beach)
Landscape painter of national repute who sketched in the Santa Ynez Valley, summer 1914. Also sketched at other sites on the Central Coast, including Morro Bay and San Luis Obispo. His art was studied by the Alpha Club, 1933.
See: "Alpha Club," 1933, "Podchernikoff, Alexis," and *Morro Bay Art and Photography before 1960* and *Central Coast Artist Visitors before 1960*

Wesselhoeft, Mary Fraser (1873-1971) (Santa Barbara)
Artist who taught flower arranging to Minerva Club members, 1930, 1931 and who exh. in National Art Week show at Minerva Club, 1940. Judged a flower show.
■ "Mary Fraser Wesselhoeft (February 15, 1873 – March 23, 1971) was an American graphic artist, watercolorist, and stained-glass artist," per Wikipedia.
Wesselhoeft, Mary (notices in Northern Santa Barbara County newspapers on microfilm and on newspapers.com)
1924 – "The Glass Workshop ... In the baptismal chapel of Grace Church, Kansas City, is an exquisite window that Mary Wesselhoeft spent six months in making. She has some lovely little panels for a boudoir or nursery, dainty flowers and figures that give an expected flow and warmth to a room. Some of these have a delicate bit of painting on the glass ... given an opportunity for a filmy network of lines...," *Selma Enterprise / Irrigator* (Selma, Ca.), April 19, 1924, p. 7 (i.e., "Magazine Page").
1928 – "Tells Plans for Art Expression. In a very inspiring talk given at the Community Center yesterday, Miss Mary Wesselhoeft, Santa Barbara artist, told what her ideas are for the continuation of art classes, begun here last year under the auspices of the Oxnard Art Club... Miss Wesselhoeft will come to Oxnard to 'guide' her classes, the year's work to open next Saturday morning, October 6 from 10 to 12 o'clock ... Miss Wesselhoeft says she does not like to 'teach,' but rather to guide the pupil in expression of ideas through the medium of the brush, pencil, or color. She is much interested in the art of eurythmics, the art of rhythmic expression that lies back of

all art... In the work here she would like to develop skill, rather than the technic stressed by the large art schools – something more in the oriental manner – a skill and facility in the use of the hands. Painting, Miss Wesselhoeft said, is essentially color, and she desires to stress color more than form ... as a means of expression. Each color has its region, and she plans to give her pupils problems in color, tending to the production and understanding of harmony... The speaker touched on the technical perfection of the machine and reminded that we are machines ourselves and can attain our expression through the development of skill. Pattern, which is in all action, is another element... Miss Wesselhoeft indulged a fascinating little rhapsody about the light and color in our marvelous climate and scenery, this glory of light here that effects [Sic. affects] the people who come from severer climes and makes them feel exalted. We need to relate ourselves harmoniously to it, to realize and build on it... training the eye to see and the hand to express the inner emotions and ideas. She concluded with a sketch of the work Mr. and Mrs. Jack Burton are doing in Santa Barbara ... Those present also enjoyed looking at a little exhibition of the work done here last year, including scenes, flower pictures and sketches from still life," *Press-Courier* (Oxnard, Ca.), Sept. 29, 1928, p. 2.
1930 – "Mrs. A. G. Rohlfsen ... in Santa Barbara this week at a class being conducted by Mrs. [Sic.] May [Sic. Mary] F. Wesselhoeft on the arrangements of flowers," *LR*, March 21, 1930, p. 7, col. 1.
1935 – "Mary Wesselhoeft. The right picture for your gay breakfast-room may be among the water colors of fruits, flowers and vegetables with nicely chosen bowls and vases, which Mary Wesselhoeft ... painted for her exhibit at the Stendahl Galleries. These are slowly organized pictures, making counter-point of the simplest things. Color, pattern, atmosphere are all consciously employed with intelligence and that extra bit of taste that makes real painting," *LA Times*, Jan. 27, 1935, p. 40 (i.e., pt. II, p. 8).
And, more than 150 additional notices for "Wesselhoeft," primarily about her art teaching in Oxnard (c. 1925+), as instructor in color theory at the School of the Arts in Santa Barbara (1927), and her group and one-man exhibits in Los Angeles and the Bay Area, in California newspapers on newspapers.com that were too numerous to itemize.
Mary Wesselhoeft bio. and some bibliography appears in Nancy Moure, "Dictionary of Art and Artists in Southern California before 1930," in *Publications in California Art*, vol. 3, and other information on her appers in vol. 4/5/6, and in vol. 8.
Wesselhoeft, Mary (misc. bibliography)
Mary "Polly" Fraser Wesselhoeft was b. Feb. 15, 1873 in Boston, Mass. to Dr. Walter W. Wesselhoeft and Mary Sara Silver Fraser, was residing in Cambridge, Mass., in 1910 and d. March 23, 1971 in Santa Barbara per Cameron Wesselhoft Family Tree (refs. ancestry.com).
See: "Minerva Club," 1930, 1931, "National Art Week," 1940

West, Charles (Los Angeles)
Ceramist. Demonstrated glazes at Stotts Potts ceramics studio, 1956, one of his many stops on a national tour demonstrating the products of Mayco Colors of North Hollywood, Ca., in 1956.
See: "Stotts Potts," 1956, and *Central Coast Artist Visitors before 1960*

West, Katherine (Santa Maria)
Interior decorator. Prop. House of Charm, 1949.
■ "Will Open Interior Decoration Shop Here. Mrs. Katherine West of the 'House of Charm' in San Luis Obispo, will soon establish an interior decorating shop in the 600 block of East Main … The shop, which will feature custom-made furniture and upholstering of all types will be operated by Mrs. West and her son. … The Wests will sell drapery material and different types of yardage. Chrome and wooden furniture will be featured," *SMT,* Aug. 25, 1949, p. 4.
See: "House of Charm"

Westmont, Marjorie W. Fraser (Mrs. Oscar B. Westmont) (1899-1966) (Lompoc)
Member of Art Section of Alpha Club, 1933-43. Active also with Music Section of Alpha Club and a practicing cellist. Avid volunteer. Wife of manager of the Lompoc Plant of the Johns-Manville Corp. below.
See: "Alpha Club," 1933, 1939-43, 1946, "Westmont, Oscar"

Westmont, Oscar B. (1898-1995) (Lompoc)
Photographer, amateur. Gave several "lectures" on his travels that he illustrated with his 35 mm-colored slides. Husband of Marjorie Westmont, above.
■ "Oscar Westmont… was a World War I veteran. He came to Lompoc in 1926 as a chemical engineer with the Celite Corp. He later became supervisor of various plant operations and in 1938 was appointed plant manager, remaining in that position until his retirement in 1964. He was actively engaged in local civic affairs and organizations…," *LR,* Nov. 15, 1995, p. 3.
Westmont, O. B. (notices in Northern Santa Barbara County newspapers on microfilm and on newspapers.com)
1953 – "Rotarians … Hawaiian Night… Westmonts spent three and a half weeks in Hawaii… O. B. Westmont then presented a group of colored slides which he and Mrs. Westmont had taken…," and subjects named and commentary given, *LR,* July 2, 1953, p. 5; "Kiwanians View Films… Colored slides of a trip taken to Hawaii last spring were shown to the Kiwanis club Tuesday evening… The photographs were taken by Westmont and graphically displayed the natural beauty of the several islands making up the Hawaii group and included shots from the air as well as from the ground," *LR,* July 30, 1953, p. 5.
1958 – Vacationists Tour Nat'l Parks. Mr. and Mrs. O. B. Westmont of 701 West Ocean avenue, returned Sunday from a three-week trip which included visits to 12 national parks and monuments. Mr. Westmont, who was bitten several years ago by the colored picture bug and who has since been called upon by fellow Rotarians and other groups to show his pictures from other trips, had a field day of photography on this trip. He took some 500 pictures … The couple left here July 3 with the Grand Canyon as their first designated tour site. The Petrified Forest and the Canyon deChelly in Arizona were duly appreciated and photographed before going to Mesa Verde National Park in Colorado. … Black Canyon of Gunnison National Monument … and the State Park in Colorado…. Colorado Springs. … Denver… Pike's Peak … Rocky Mountain National Park… Central City, a restored mining town… wild flowers… Continental Divide… Aspen, Colorado… Grand Junction National Monument in Colorado, Arches National Monument in Utah and then on to the Capitol Reef in Utah… Cedar Breaks… Zion National Park… Apple Valley," *LR,* July 31, 1958, p. 4.
1960 – "Club Travel Section to Feature Alaska. The **Minerva Club**… colored slides of Alaska… The major portion of the state will be presented by Mr. and Mrs. O. B. Westmont of Lompoc. Their slides include scenes of Eskimo life, McKinley Park, Alaskan trees, plants and flowers, the Trail of 1898 taken by train, the inland passage and cities as far north as Nome. Westmont has been plant manager for Johns-Manville since 1937 and photography, specializing in colored slides, has been his favorite hobby for many years…," *SMT,* March 23, 1960, p. 3.
And, Westmont showed his slides to other organizations not itemized here.
Westmont, O. B. (misc. bibliography)
Oscar B. Westmont was b. Dec. 28, 1898 in Solon Mills, Ill., to Charles Westmont and Margaret Louise Skillicorn, was residing in Niagara Falls, NY in 1925, and d. Nov. 12, 1995 in Beverly Hills, Ca., per Westmont Family Tree (refs. ancestry.com).

Weston, Brett (1911-1993) (Santa Maria / Santa Barbara)
Photographer who resided and exh. in Santa Maria, 1931. Shared a studio with his brother, Chandler, at Cook and McClelland streets. Son of Edward Weston, below.
■ "Brett Weston (originally *Theodore Brett Weston*; December 16, 1911, Los Angeles–January 22, 1993, Hawaii) was an American photographer. … He was the second of the four sons of photographer Edward Weston and Flora Chandler. Weston began taking photographs in 1925, while living in Mexico with Tina Modotti and his father. He began showing his photographs with Edward Weston in 1927, was featured at the international exhibition at Film und Foto in Germany at age 17, and mounted his first one-man museum retrospective at age 21 at the De Young Museum in San Francisco in January, 1932. Weston's earliest images from the 1920s reflect his intuitive sophisticated sense of abstraction. … He began photographing the dunes at Oceano, California, in the early 1930s. This eventually became a favorite location of his father Edward and later shared with Brett's third wife Dody Weston Thompson. Brett preferred the high gloss papers and ensuing sharp clarity of the gelatin silver photographic materials of the f64 Group rather than the platinum matte photographic papers common in the 1920s," from Wikipedia.

Weston, Brett (notices in Northern Santa Barbara County newspapers on microfilm and on newspapers.com)
1931 – "Exhibition of Camera Work Starts Friday. Santa Maria's **Little Theatre** next Friday will be the site for an exhibition of photographic art the like of which those interested in 2 x 4 cameras to giant studio machines never before witnessed. It will be offered by **Chandler** and Brett Weston, formerly of Carmel-by-the-Sea and sons of **Edward Weston**, internationally considered the most famous artist with the lens and print. The two young Westons have moved to Santa Maria and have established their studio at East Cook and McClelland streets. Their exhibition opening Friday is to continue for one week. … 10 in the morning to 10 at night, every day until October 30. More than 100 prints will be on display… including numerous portraits of prominent Santa Marians and a large number of studies in industrial and natural scenes… In coming to Santa Maria, their avowed purpose is to start out in a small city, just as their father did in Tropico, now a part of Glendale. They refuse to coast along on their father's reputation and hope to show … that their own work will stand by itself. They were offered openings in Santa Barbara and in San Jose but selected this city in preference. They have remodeled the house in which they are living and with the two Mrs. Westons expect to make Santa Maria their home in the future. An insight into the type of work they do is offered by **Merle Armitage**, manager for Mary Garden, who wrote in a Los Angeles newspaper recently about Brett Weston: 'He is a fascinating example of the man with sharp artistic understanding and true mechanical sympathy. His feeling for form, for character, for design and for the basic qualities of art developed hand in hand with his expertness in achieving with his instrument, the camera'," *SMT*, Oct. 21, 1931, p. 1; and a couple of additional articles on this exhibit not itemized here.
1932 – "Weston Photographs Exhibited in S.B.… two-week period in the shop of Mrs. Chester Parker, 819 Anacapa street… Weston, associated here with his brother, Chandler, now is located in his studio in the city hall plaza at the county seat," *SMT*, April 6, 1932, p. 3.
1933 – "Former Local Artist's Work Draws Praise. Brett Weston… now lives in Santa Barbara… exhibits in the M. H. de Young Memorial Museum…," *SMT*, Jan. 28, 1933, p. 6; "Weston Exhibition held at Ojai… Ojai valley school. They recently were on display at the **Faulkner Memorial Art gallery** and include studies of Henry Eicheim, Roland Hayes, Harald Kreutzberg, S. M. Eisenstein and Mme. Archipenkia," *SMT*, Dec. 12, 1933, p. 3.
1934 – "Former Resident Shows Photos. Striking photographs of Oceano sand dunes, taken by Brett Weston, former Santa Maria photographer, have been on exhibit this week in Weston's studio at the Coast Highway and Eucalyptus Lane in Montecito. The display will be exhibited next month in the Julian Levy gallery, New York city. It will be Weston's first New York showing," *SMT*, Aug. 22, 1934, p. 3.
See: "Weston, Chandler," "Weston, Edward," and *Arroyo Grande Art and Photography before 1960*

Weston, (Edward) Chandler (1910-1993) (Santa Maria)
Photographer who resided and exh. in Santa Maria, 1931-33. Had a home / studio at Cook and McClelland streets, Santa Maria, c. 1931-33. Active with College Art Club, 1930-31. Brother to Brett Weston, above, and son of Edward Weston, below.

■ "Edward Chandler Weston … known as Chandler, was born on April 26, 1910. Named Edward Chandler, after Weston and his wife, he later became an excellent photographer on his own. He clearly learned much by being an assistant to his father in the bungalow studio. In 1923 he bid farewell to his mother and sibling brothers and sailed off to Mexico with his father and Tina Modotti. He gave up any aspirations in pursuing photography as a career after his adventures in Mexico. The lifestyle of fame and its fortune affected him greatly. His later photographs, as a hobbyist, albeit rare, certainly reflect an innate talent for the form," from Wikipedia.

Weston, Chandler (notices in Northern Santa Barbara County newspapers on microfilm and on newspapers.com)
1931 – "Photographic Prints Being Shown in Santa Maria Now… at the **Little Theater** … Chandler and Brett Weston …," *SYVN*, Oct. 23, 1931, p. 1; "Photograph Print Exhibition Opens. Santa Maria. … at the **Little Theater** … commencing today and continuing for a week when Chandler and Grett [Sic. **Brett**] Weston, formerly of Carmel-by-the-Sea present an exhibition of photographic prints. Included in the Exhibit will be portraits of local people as well as industrial and natural subjects…," *LR*, Oct. 23, 1931, p. 8; "Photograph Print Exhibition Opens," *LR*, Oct. 23, 1931, p. 8; ■ "Weston Exhibition at **Little Theatre**… photographic portraits, industrial studies and nature themes in black and white presented by Chandler and **Brett Weston** … The exhibition will remain until Friday of next week, opening at 10 o'clock… Studies of Santa Marians whose faces are familiar to everyone here attracted a great deal of interest… faculty of reproducing a person mentally as well as physically… total absence of an affected pose… industrial shots… Line, shadows and texture only are employed to interpret what the artist sees … Simple subjects, such as kelp, sand, water, trees and other facts in nature are turned into living representations… The two brothers have been trained in their art by their father, Ed Weston of Carmel… It is a case of 'like father, like son' in the matter of observation of details, but not of interpretation. The younger Westons have… a certain vigor and freshness … The portraits hanging now will be changed in midweek for new ones, giving those who already have seen the exhibition opportunity to enjoy other of the Westons' creations," *SMT*, Oct. 24, 1931, p. 6; ad: "Compliments of the Season. Brett and Chandler Weston. Photographs. Cook and McClelland Sts.," *SMT*, Dec. 24, 1931, p. 2.
See: "College Art Club," intro., 1930, 1931, 'McGehee, Ramiel," 1933, "Weston, Brett," "Weston, Edward," and *Arroyo Grande Art and Photography before 1960*

Weston, Edward (Los Angeles / Carmel / Oceano)
Photographer of international fame. Father of Brett and Chandler Weston, above.
Weston, Edward (notices in Northern Santa Barbara County newspapers on microfilm and on newspapers.com)
1932 – 'Noted Photographer Here – Edward Weston… resident of Carmel, is a guest here this week of his son and daughter-in-law and grandson, Mr. and Mrs. Chandler Weston and son Teddy at their home on East Cook and McClelland streets," *SMT*, May 4, 1932, p. 3.
See: "College Art Club" intro., 1931, "Weston, Brett," "Weston, Chandler," and *Arroyo Grande (and Environs) Art and Photography before 1960*

Weston, Elsie (Lompoc / Santa Barbara)
Manager of the Camera Shop, WWII.
Elsie Weston is listed in the *Lompoc, Ca., CD*, 1945 (ref. ancestry.com).
See: "Camera Shop"

Weston, Emma Browning (Mrs. Clyde Roy Weston) (Buellton)
Collector / lender to Art Loan Exhibit, Solvang, 1935. Author of Buellton By-Lines in the Lompoc Record, c. 1956. According to the obituary of her husband in the SYVN, 1961, the couple arrived in Buellton in 1924. Two sons: Edward (not the famous photographer) and Kenneth.
More than 700 notices (primarily social and club) appeared for "Mrs. Clyde Weston" and more than 280 for "Emma Weston" in northern Santa Barbara county newspapers but they were not even browsed for potential inclusion here.
See: "Art Loan Exhibit (Solvang)," 1935, "Santa Ynez Valley Art Exhibit," 1958, "Santa Ynez Valley Fair," 1931, "Thimble Bee of Pythian Sisters," 1938

Westrope (Cucchetti), Janice "Jan" Marie (Mrs. 1ˢᵗ Lt. Robert P. Cucchetti) (1944-?) (Lompoc)
Exh. Open-Air Art Exhibit, 1960. Grad. of Lompoc High School, class of '62. PE / art major in college.
■ Port. with one of her paintings and "Flowers are Favorite Subject of Girl Artist. One of the strongest contenders for a blue ribbon in the Flower Festival Art Show is Jan Westrope, a native of Lompoc and junior in high school. Jan has proven herself a budding artist since she won an art contest in the seventh grade. Her favorite subject is flowers, because, she says, they are more challenging. Her favorite flowers are roses. She prefers to paint sprays of flowers without vases. Jan outlines the steps in painting a water color picture: 1 – pick a favorite subject, 2 – sketch it lightly in pencil, 3 – draw in the details darker, 4 – cover with a light coat of water color, 5 – erase pencil lines, 6 – apply final two coats of paint," *LR*, June 23, 1960, p. 42 (i.e., 2cc); port. with her family, *LR*, Sept. 1, 1960, p. 5 (sect. B, p. 1?).
1961 – "Art Exhibit Slated at Church Hall… First Presbyterian Church, Saturday afternoon from 2-4 p.m. Exhibitors will be members and friends of the church… Currently planning to enter their original paintings are …

[and list of adult professionals] … Young people who will enter paintings… include Jan Westrope…," *LR*, Nov. 30, 1961, p. 4.
1962 – "Jan Westrope Leaves Sept. 9 for College of Idaho," *LR*, Aug. 30, 1962, p. 20 (i.e., 8-B), col. 1.
1967 – "Degree Earned… Janice M. Westrope received a bachelor of arts degree with a double major in physical education and art from the College of Idaho…," *LR*, June 16, 1967, p. 2.
1970 – Port. and "Summer Bride. Mr. and Mrs. Neal Westrope… announce the engagement of their daughter Jan. to 1ˢᵗ Lt. Robert P. Cucchetti … The bride-elect teaches [physical education] at the Lompoc High School and is a graduate of the College of Idaho. She was born and raised in Lompoc, as were her father and her paternal grandmother, Mrs. Clara Westrope. She is a past worthy advisor of Lompoc Assembly of the International Order of Rainbow for Girls…," *LR*, Feb. 12, 1970, p. 4.
Many notices for "Jan Westrope" and "Janice Westrope" in the *LR*, c. 1955-1970 were primarily for Rainbow Girls and were not itemized here.
See: "Open-Air Art Exhibit," 1960

Whitaker, Rosemary (Mrs. Robert "Bob" Whitaker) (Santa Maria)
Handicraft chairman, Jr. Community Club, 1956/57.
See: "Junior Community Club (Santa Maria)," 1956

Whitaker, Sara Joyce
See: "Blauer (Whitaker), (Sara) Joyce (Mrs. Leslie Arthur Whitaker)"

White, Annie Rose Sumner (Mrs. Charles Benjamin White) (1881-1967) (Santa Maria)
Teacher (private) of painting and crafts, 1925-27. Founder of White's Doll Hospital on W. Fesler, 1958. Collector of dolls.
■ "Annie R. White, 85, 207 W. Fesler St., died on Wednesday in her home. She was born in Seymour, Texas on Oct. 26, 1881 and came to California in 1912," *SMT*, Sept. 7, 1967, p. 2.
White, (notices in Northern Santa Barbara County newspapers on microfilm and on newspapers.com)
1925 – "I will open my classes of basket weaving, clay craft and veltex lamp shade work Tuesdays, Wednesdays and Thursdays from 2 to 5 p.m. All lessons will be free this month. While attending the University at Berkeley this summer, I learned many things that will be of great help to those who could not attend. … Mrs. C. B. White, 207 West Fesler," *SMT*, July 20, 1925, p. 3.
1926 – Ad: "Art Classes are Now Open. Wednesday and Thursday Afternoon and Evening. Fabric Painting. Leather Tooling. Reed Basket Work. Clay plaque and Lamp Shades. Visitors welcome ... Lessons are Free. Mrs. A. R. White, 207 West Fesler," *SMT*, Oct. 27, 1926, p. 1.
1927 – "Spring is almost here, when we will need new pictures and lamp shades to beautify our homes. Also nice baskets and ferneries. Come join our Art Classes, Wednesdays and Thursdays, afternoon and evening. You

will be surprised at the many beautiful things you can make for your home. Mrs. C. B. White, 207 West Fesler," *SMT*, Feb. 23, 1927, p. 4.

1958 – Ad: "Now Open. White Doll Hospital. Complete Dolls & Parts. Or Dress Them Yourself. Repairing. 207 West Fesler," *SMT*, July 9, 1958, p. 5.

1961 – "Camp Fire Girls. Visit Doll House... 100-year-old German made dolls and dolls from all parts of the world," *SMT*, Feb. 2, 1961, p. 4; "Camp Fire Girls... visited Mrs. A. R. White's Doll Hospital... Mrs. White showed her display of dolls, the tiniest of which rested in a cradle fashioned from an egg shell. There were large and small dolls and dolls in native costume from many lands and some over a hundred years old...," *SMT*, Dec. 1, 1961, p. 4.

White, (misc. bibliography)
Annie Rose White was b. Oct. 26, 1881 in Paris, Tx., d. Sept. 6, 1967, and is buried in Santa Maria Cemetery District, and port. per findagrave.com (refs. ancestry.com).

White, Arthur I. (Santa Maria)
Photographer, U. S. Army, 1960.

■ "Security Assignment for Youth... son of Mr. and Mrs. Allen K. White, 1006 Rosiland Drive, has enlisted in the U. S. Army Security Agency ... He was born in and attended school here, graduating from Santa Maria High School this year. His hobby is photography, and many of his pictures appeared in school publications and several were entered in national competition. Upon completion of eight weeks basic combat training at Fort Ord, he is expected home for a short leave prior to reporting for advanced training with the Security Agency," *SMT*, July 15, 1960, p. 7.

White, Fern G. (Mrs. Joseph R. White) (Santa Maria)
Director of the new Arts and Crafts division Santa Barbara County Fair, 1957.
See: "Santa Barbara County Fair," 1957

White (Houghton), Mildred Irene Smith? (Mrs. Warren White) (Mrs. Solon "Jerry" Houghton) (1902-1975) (Santa Maria)
Ceramist. Prop. Mildred I. White Ceramics in Santa Maria and Lompoc, c. 1957+.

■ "Mildred I. Houghton... Mrs. Houghton was born July 28, 1902 in Rawleigh [Sic?], Mo. and died Friday at her home, 218 S. Blosser Rd. Mrs. Houghton, a Santa Maria area resident for 50 years, was a founding member and secretary-treasurer of the Culinary Alliance Union Local 703. She owned and operated White's Ceramic Shop on south Blosser Road for 20 years ... Survivors are her husband Solon (Jerry) Houghton, V. R. 'Sandy' Smith of Nipomo...," *SMT*, Feb. 15, 1975, p. 2.

White, Mildred (notices in Northern Santa Barbara County newspapers on microfilm and on newspapers.com)
1951 – Author of letter to editor about post office sending mail to boys on Korean front, *SMT*, Oct. 17, 1951, p. 8.
1957 – HUSBAND? – "Warren White... 68, who died of carbon monoxide poisoning Thursday.... Mr. White had lived in Santa Maria since 1942. He was a general building

contractor. Survivors include his widow, Mrs. Mildred White...," *SMT*, June 1, 1957, p. 2.

1962 – "Art & Madonna Show to be Held at Rick's Rancho. A collection of Madonnas from many countries and of various ages... Mrs. Mildred White is showing several ceramics, each different and beautiful and made in our own City...," *SMT*, April 13, 1962, p. 3.

1964 – "Theta Upsilons... guest speaker, Mildred White. Mrs. White owns a shop and teaches the art of ceramics," *SMT*, April 8, 1964, p. 3.

White, Mildred (misc. bibliography)
"White, Mildred Ceramics" 218 S. Blosser Rd. is listed under "Ceramic Products" in the *Santa Maria, Ca., CD*, 1966-67; "White, Mildred Ceramics (Mrs. Mildred I. Houghton) sales & instruction, 218 S. Blosser Rd." is listed in the *Santa Maria, Ca., CD*, 1958-70; Mildred I. Houghton was b. Missouri on July 28, 1902 and d. Feb. 14, 1975 in Santa Barbara County per Calif. Death Index; Mildred Irene Houghton, is buried in Santa Maria Cemetery District per findagrave.com (refs. ancestry.com).
See: "Mildred I. White Ceramics Shop"

White, Stella Glidden (Mrs. Raymond Morton White) (Lompoc)
Member of Art Section of Alpha Club, 1939, 1946. Librarian.
See: "Alpha Club," 1939, 1946

White Oak Flats
Summer camp used by various groups.
See: "Four-H Camp"

White's Doll Hospital (Santa Maria)
See: "White, Annie"

Whitteker, Louise S. (Mrs. Alfred T. Whitteker) (Santa Maria)
School principal who taught handicrafts to tots in summer school, 1943, 1944.
See: "Nursery Schools," 1943, "Santa Maria, Ca., Elementary Schools," 1943, 1944

Whittemore, B. F., Rev. (Lompoc)
Principal of the private (?) Collegiate Institute, 1890-92, whose curriculum apparently included drawing. In 1892 became principal of Lompoc High School.
See: "Collegiate Institute"

Whittenberg, Alice (Mrs. ? Whittenberg) (Santa Barbara)
Photographer. Exh. animal studies and landscapes at first annual Santa Ynez Valley Art Exhibit, 1953.
Whittenberg, Alice (misc. bibliography)
Mrs. Alcie [sic. Alice] Whittenberg, without occupation or husband, is listed in the *Santa Barbara, Ca., CD*, 1954 (refs. ancestry.com).

See: "Santa Ynez Valley Art Exhibit," 1953

Wiedmann, Ernest J. (Lompoc)
Exh. Open-Air Art Exhibit, 1957. Husband of Nora Wiedmann, below.
See: "Open-Air Art Exhibit," 1957, "Wiedmann, Nora"

Wiedmann, Nora Prochaska Zweybruck (Mrs. Ernest J. Wiedmann) (1921-?) (Lompoc)
Painter. Art consultant, 1957. Taught "Arts and Crafts Made Simple" in 1959 to Alpha Club mothers and their children. Wife to Ernest Wiedmann, above.

■ "Lompoc Attracts Art Consultant and Family from Los Angeles. Her husband is a ski enthusiast, her 19-month-old son dances to Mozart's music, and she likes to paint factory scenes, railroad yards or busy harbors… The Weidmanns [Sic. Wiedmann], formerly of Los Angeles, now live at 516 East Locust and although young Christopher hasn't begun to put words into sentences yet, his parents are quite articulate in expressing their fondness for Lompoc. 'When I heard there was going to be an assignment here,' said Ernest Wiedmann, who works for the Federal Agriculture Research Department, 'I started in trying to get it…' … 'It's wonderful – fresh, clean and quiet,' his wife agreed. 'I feel at home already.' Nora Weidmann [Sic. Wiedmann], is a well-known artist and art consultant. Born and raised in Vienna, Austria, she attended Professor Franz Cizek's Children's Art Classes for eight years; later she studied music and painting and attended afternoon art classes at her mother's academy of Fine and Industrial Arts. She received Baccalaureate degree at seventeen, majoring in English and Psychology. Summers were spent traveling in Austria, Germany, Italy, Yugoslavia and Czechoslovakia to see galleries and study art museums, music, etc. She came to the United States to attend college, choosing Oberlin, Ohio, for its musical atmosphere but majoring in Art History. Summer classes at the California College of Arts and Crafts and Columbia University in New York, ample traveling in the United States accompanying her mother, Professor Emmy Zweybruck, on lecture tours and one year of training at the Art Center School in Los Angeles, rounded out her formal education. Finishing college in 1943, she has done further postgraduate work in Art and Art History at Columbia University, the Institute of Fine Arts Graduate School of New York University, the University of Oregon Summer School, and the Cornish School in Seattle, Washington. She has studied water color painting under Alexander Nepote of San Francisco, James Edward Peck of Seattle, Dong Kingman of San Francisco and New York, and Hardy Gramatky of Connecticut, has been awarded several first prizes and had a one-man show of water colors in New York City. Her first job was that of assistant to the Art Director of Shulton, Inc., in New York City which first kindled an interest in packaging design, wrapping paper design, etc., which she has done on a free-lance basis ever since. In 1944 Mrs. Wiedmann, then Miss Zweybruck, joined the staff of the New York Prang Textile Studio of The American Crayon company, her activities consisting of assisting the Art Director, Professor Emmy Zweybruck, in designing, executing layouts, writing articles, preparing instructional leaflets on various art techniques, printing fabrics and teaching the adult evening classes in stenciling and silk screening. She has had charge of these classes for eight years and has had considerable experience in leading professional instruction in all art media to teachers, educators, designers, professional printers, hobbyists, housewives, Girl Scout leaders, occupational therapists, Red Cross workers and art students. She has given many demonstrations in the public school system, [to] teachers, colleges, professional art schools and to special groups. In 1946 she joined the faculty of the Newark School of Fine and Industrial Art, where she functioned as head of the Textile Department up to January, 1953, when she moved to the west coast. She has also taught silk screening in the In-Training Division in the Art Department of the Newark Board of Education and landscape water color classes for In-Service Training of the Board of Education in Los Angeles. Nora Wiedmann has written many articles on children's and adult's work with different art media and on-screen printing methods for magazines such as *Everyday Art, Design Magazine, McCall's Needlework, Screenings*, and *Signs of the Times*, the latter being a professional printers' magazine. She has frequently worked with special teachers' groups to solve special art work problems. She taught silk screening and textile design to teachers' summer classes sponsored by the Cornish School in Seattle, Washington, and the University of Oregon, Klamath Falls, Oregon, Summer Art Classes. Since early spring 1953 Mrs. Wiedmann has been giving special classes in Media Experience and the proper use of various art media to public school teachers for the aid of their art programs in the classroom, covering art problems from preschool children's' classes through high school and on to teachers' college students. This is a service offered by The American Crayon company and also encompasses many accredited In-Service Training classes for teachers. She is continuing her designing, painting and writing activities at the same time. With Lompoc as home base now, Mrs. Wiedmann is now scheduling consultations and classes up and down the west coast. This week she is in Los Angeles. Next week she plans a two-week jaunt into Oregon. But, she'll be around here most of the time," and port with husband, child and painting, *LR*, Feb. 21, 1957, pp. 5, 7.
Wiedmann, Nora (notices in Northern Santa Barbara County newspapers on microfilm and on newspapers.com)
1958 – "Artist to Share 'Know-How' Skills. Mrs. Nora Weidmann [Sic. Wiedmann], Educational Art Consultant for the American Crayon company of New York, will give two classes of instruction on fabric design, printing and tinting of materials and silk screening techniques for beginners, to the ladies of the Relief Society in the recreation hall of the Church of Jesus Christ of L.D.S. on Wednesday, February 5 and again on the first Wednesday in March…," *LR*, Jan. 30, 1958, p. 5; "Art Class Slated… An open invitation has been extended … to attend the April 23rd class on Textile Painting and Silk Screen Painting to be held in the recreation room of the Latter Day Saints church on East Fir street. Mrs. Nora Wiedmann, Art Education Consultant for the American Crayon company will conduct the class, the third in a series, starting at 7:30 p.m.," *LR*, April 17, 1958, p. 13.

1959 – "Memos by Marilee Milroy," is a two-column article on Mrs. Weidmann's [Sic. Wiedmann] opinions on teaching art to children, *LR*, March 26, 1959, p. 10.
1960 – "Art Talk Scheduled at Hapgood. 'Your Child is an Artist' will be the subject of Mrs. Ernest Wiedmann Monday night … for <u>Hapgood PTA</u> in the school auditorium. She will also show slides of art pictures she has made… Mrs. Wiedmann is an artist of long standing … [and discussion of her art background] … She is a member of the Lompoc Alpha Club where she has given a series of workshops. She has also worked with various church groups and given lectures for civic groups. She has just returned from a tour of San Francisco," *LR*, Oct. 10, 1960, p. 10.
<u>Wiedmann, Nora (misc. bibliography)</u>
Nora Zweybruck is listed in the *Manhattan, N. Y., CD*, 1945-53; Ernest J. Wiedmann married Nora Zweybruck Prochaska (b. 1921) on July 4, 1953 in Los Angeles County per Calif. Marriage Index; Ernest J. Wiedmann divorced Nora P. Zweybruck in Nov. 1973 in Santa Barbara County per Calif. Divorce Index (refs. ancestry.com).
<u>See</u>: "Alpha Club," 1957, 1959, 1961, "Camp Fire Girls," 1958, "Girl Scouts," 1960, "Lompoc Community Woman's Club," 1957, "Open Air Art Exhibit," 1957, "Teacher Training," 1958, "Wiedmann, Ernest"

Wildenhain, Marguerite (1896-1985) (Pond Farm artist colony near Guerneville, Ca.)
Potter / ceramist. Demonstrated ceramics at DeNejer studio, 1949, and taught a course at DeNejer studio, 1951.
<u>See</u>: "DeNejer, Jeanne," intro., 1949, 1950, "Minerva Club," 1952, "Nirodi, Hira," and *Central Coast Artist Visitors before 1960*

Wileman, Edgar Harrison (1888-1989) (Los Angeles)
Interior decorator for Barker Brothers, LA, who spoke to Minerva Club, 1948, 1954, and to Lompoc Community Woman's Club, 1948, 1950.
<u>Wileman, Edgar (notices in Northern Santa Barbara County newspapers on microfilm and on newspapers.com)</u>
1948 – Community "Woman's Club… **Edgar H. Wileman**, manager of the Home Advisory Bureau at Barker Bros., in Los Angeles, will be the guest speaker at next Wednesday's meeting… Wileman will bring samples of floor coverings and drapery fabrics to illustrate his talk on home furnishings. After graduating from the University of London, England, he received training in several British studios and then traveled to South America where he started in his travels all over the world. He has been with Barker Bros. since 1923 as lecturer and consulting decorator. He is instructor of Interior Decoration with the Extension Division of the University of California and conducts a daily radio program over KNX. …," *LR*, May 6, 1948, p. 4.
1950 – "Los Angeles Interior Decorator Set as Community Club Speaker. Edgar Harrison Wileman, noted lecturer and consulting decorator… guest speaker for Wednesday afternoon's November meeting… At the present, manager of Barker Bros. decoration studio … Los Angeles… Wileman is also a contributor to national and local magazines, newspapers and trade journals. Born in London, he was educated at Roan schools in Greenwich, Eng., and at Goldsmith Institute at the University of London. To Buenos Aires. His early training also included work at Goodyear studios on Regent street in London. From London he went to Buenos Aires with Messrs. Thompson Muebles as designer and occupied the position as decorator and buyer of antiques for the firm. He represented them in Chile. Wileman has traveled extensively in Europe, South America and the United States, visiting factories, museums and art centers. On Television. A radio and television commentator, he has been with Barker Bros. since 1923 as lecturer and consulting decorator and has been with the **University of California extension** division since 1926 as instructor of interior decoration. Home furnishings will be the speaker's subject when he addresses the gathering at the Community Center…," *LR*, Nov. 2, 1950, p. 3; "Home Decorator Talks on Color, Design to Community Women's Club," and details, *LR*, Nov. 9, 1950, p. 3.
1954 – "Home Decorating to be Minerva Topic. 'The California Home and its furnishing' is to be the topic for **Minerva club** at a 2 o'clock meeting on Tuesday afternoon with Edgar Harrison Wileman…," *SMT*, Feb. 27, 1954, p. 4.
<u>See</u>: "Lompoc Community Woman's Club," 1948, 1950, "Minerva Club," 1948, 1954

Wilkie, Doree Nan
<u>See</u>: "Bond (Wilkie) (Vasile), Doree Nan (Mrs. Herbert Marston Wilkie) (Mrs. Alfred Vasile)"

Wilkinson, Gene (Santa Barbara?)
Prop. of Modern Neon Sign Co., 1958+. Sculptor of a brass cougar displayed in Hunter's Lounge, 1960.
<u>See</u>: "Modern Neon Sign Co.," "Sculpture, general (Northern Santa Barbara County)," 1960

Willett, Cambridge Graham (1848-1917) (Santa Maria)
Photographer. Prop. Judkins Studio, 1917.
■ "Cambridge Graham Willett, aged 69 years, 7 months and 5 days and a native of Pennsylvania, passed away on Friday of last week. The deceased was a photographer and bought the **Judkins Studio** last spring. … The funeral took place from A. A. Dudley's funeral chapel … He is survived by a daughter, Miss Gertrude L. and a son William B. Willett of San Francisco. His demise was due to metal poisoning, contracted in handling photo solutions, which contained poisonous mineral substances," *SMT*, Dec. 15, 1917, p. 1.
■ "Cambridge G. Willett, photographer, was born in Fulton County, Pa., May 2, 1848. Resided in Pennsylvania until he came to Kansas in 1866. Located at Lawrence, where he was engaged two years in the hotel business, and in other enterprises until 1872, when he began business as a photographer at Garnett. After a residence of two years at that place he returned to Lawrence, where he continued the same business until the fall of 1881, when he removed to Emporia. He has a fine suite of rooms, in a central location, and does a prosperous business and good work. He is a

member of the First Methodist Episcopal Church of Emporia, and a member of the I. O. O. F. Married Miss Kate E. Scouten, a daughter of Richard Scouten, of Douglas County, April 21, 1870, by which marriage he has one child, Gertrude Louisa, born May 4, 1874," from William G. Cutler, *History of the State of Kansas*, 1883 and quoted on findagrave.com.

Willett, C. G, (misc. bibliography)
Cambridge G. Willett is listed in the 1910 U. S. Census as an "artist" working "all around" and residing in Township 13, Kern County, Ca., with his wife "Kate" at the home of his son, William B. Willett; Cambridge Graham Willett was b. May 20 [sic], 1848 in Wells, Pa., to Allan Willett and Sarah Ann Green, married Catherine [Sic. Katherine] E. Scouten, was residing in Topeka, Ka., in 1900 per Walker Family Tree; Cambridge Graham Willett b. May 2, 1848 in Fulton County, Pa., d. Dec. 7, 1917 in Santa Maria and is buried in Santa Maria Cemetery District per findagrave.com (refs. ancestry.com).

Williams, ? (Mrs. L. L. Williams) (Los Angeles)
State Federation of Women's Clubs chairman for crafts, who lectured to the Alpha Club, 1951. Speaker on art to Lompoc Community Woman's Club, 1954.
See: "Alpha Club," 1951, "Lompoc Community Woman's Club," 1954

Williams, Ernest (1872-1961) (Pasadena)
Photographer of flowers and gardens / itinerant lecturer to Minerva club, 1938. Frank McCoy invitee.
See: "Minerva Club," 1938, and *Central Coast Artist Visitors before 1960*

Williams, Josephine
Assistant Home Department Agent, 1947.
See: "Home Department of the State Farm Bureau," 1947

Williams, Martha C. / Cole? (Mrs. Arthur H.? Williams) (1876-1967) (Santa Ynez / Santa Barbara)
Art student of Leo Ziegler's adult class, 1953, 1955. Exh. Tri-county Art Exhibit, 1952. Teacher in Ballard for five years who retired, 1946. Ran Hill-Top Nursery School?, 1947-52.
Is she Martha C. Williams, mother's maiden name Stults, who was b. Jan. 28, 1876 in Calif. and d. March 28, 1967 in Santa Barbara per Calif. Death Index (ref. ancestry.com).
See: "Santa Ynez Valley, Ca., Adult/Night School," 1953, 1955, "Tri-County Art Exhibit," 1952

Williams, Robert and Edith
Marionette artists, itinerant, who presented a show at the Santa Maria High School auditorium, 1935.
See: "Puppets (Santa Maria)," 1935

Williams, Vivian (Mrs. William "Bill" Williams) (Santa Maria)
Created art items and taught handcraft to Camp Fire Girls as well as to her fellow Guardians of Camp Fire Girls, 1950. Active in the art and handicraft programs at the Jr. Community Club, 1950-52.
Vivian Williams is listed with husband, William / Bill, in the *Santa Maria, Ca., CD*, 1945, 1947, 1948 (refs. ancestry.com).
See: "Camp Fire Girls," 1950, 1951, "Junior Community Club," 1950, 1951, 1952

Willinger, Laszlo (1909-1989) (Hollywood / Lompoc)
Photographed female models against the backdrop of Lompoc flower fields, 1946.
■ "László Josef Willinger (April 16, 1909 – August 8, 1989) was a Jewish-German photographer, most noted for his portrait photography of movie stars and celebrities starting in 1937," and more on Wikipedia.

Willinger, Laszlo (notices in newspapers on newspapers.com)
1946 – "Photographer 'Shoots' Flower Fields… Lazlo [Sic. Laszlo] Willinger, outstanding Southern California photographer, was in Lompoc today taking pictures of the flower fields. Willinger was formerly the chief portrait photographer for Metro-Goldwyn-Mayer studios, and now has a photographic studio of his own in Hollywood. He brought three models from the film center…," *LR*, June 27, 1946, p. 1.

Wilson, Emma Hernhuler (Santa Barbara?)
Artist who exh. at Santa Ynez Valley Art Exhibit, 1954.
This individual could not be identified.
See: "Santa Ynez Valley Art Exhibit," 1954

Wilson, JoAnn "Joey" Smith (Mrs. Donald Wilson) (1929-?) (Santa Maria)
Santa Maria High School grad. 1947. Winner in Latham poster contest, 1944. Art major at Whittier college, 1949. Teacher, painter. Exh. Allan Hancock [College] Art Gallery, 1955, 1956. Exh. paintings at Minerva Club Art and Hobby Show (under her married name, Mrs. Donald Wilson), 1959. Designer of letterhead and seal for Santa Maria Valley Historical Society, 1956. Secretary of Faculty Wives Club at Santa Maria High School, 1956.
■ "'I have always loved to draw faces,' was the modest comment of Mrs. JoAnn Wilson, attractive wife of Coach Don Wilson, and mother of two young sons whose really remarkable talent for portrait painting is winning recognition and praise from all who see examples … Mrs. Wilson's first painting without supervision, a lifelike study of her five-year-old son Billy, made when he was three, gave her encouragement for further effort, and she has completed several portraits since… Most striking… is one in oils, done in a class in which she was instructed and supervised by **Douglass Parshall** of Santa Barbara. The professional model, a very beautiful young woman, member of a California Spanish family, is painted with dark background against which her dark hair, expressive

eyes, and handsome features are highlighted and contrasted with the deep warm color of a scarlet shawl. … One of her unfinished portraits interrupted by illness is that of her grandmother, Mrs. Myrtle Smith, who sometimes helps her with the children while she is painting. She has yet to finish the background and [the] dress the model wears … 'Someday I will certainly finish it,' Mrs. Wilson said… Her two newest pastels are those of her father, Dr. W. Leland Smith, and a commissioned painting of the five-year-old daughter, Constance Marie, of Mr. and Mrs. Robert Garcin of Santa Maria, and granddaughter of Mr. and Mrs. H. O. Bell. Members of the little girl's family spoke of the painting as 'fabulous' and of the study of Dr. Smith as an almost startling likeness. Mrs. Wilson said, when comment was made on the lifelike expression of eyes and skin texture, that she strives for realism and has never tried impressionist painting. 'And I feel that I have a great deal to learn about color in my painting,' was Mrs. Wilson's comment when she was complimented on the good framing of her portraits. Many artists agree that… [it is the] permissible and the accepted thing to paint children's portraits from a good photograph since good photographers are also artists and children usually are too active to be good models. Mrs. Wilson works by that plan and prefers pastel as the medium rather than oil. And she cannot give all of her time to the hobby, which is obviously fast becoming a profession. There are her two sons and husband, and a well-cared for home to show what happens to time in the Wilson household, and she is also a substitute teacher in Santa Maria elementary schools. Her studio is the den, which has a north light. Early talent for drawing, noticed by her mother when she was a small child, was encouraged in grade school by **Miss Edna Davidson**. She liked to copy faces and often sketched magazine cover pictures for amusement. While in Santa Maria high school, Mrs. Wilson studied painting under **Stanley G. Breneiser**, … She was designer of the Saint mascot, worn on baseball uniforms of the teams coached by her husband. Her design for a permanent seal used by the …**Santa Maria [Valley] Historical Society** was accepted only last November, the best of those entered. The local artist said she considers help from the late **Stanley Breneiser** to have been valuable, and especially enjoyed classes when she spent a summer at the Breneiser school in Santa Fe, New Mexico. Her college education at Whittier, where she majored in elementary education, did not allow much time to draw or paint, but now the outlook is for more painting than teaching, which was to have been her life work. Santa Maria is fortunate, she said, in having **George Muro** as the present high school and college art teacher. Mrs. Wilson visits all of the exhibits brought to Allan Hancock Gallery by Muro, and she mentioned that appreciation could be shown by a large attendance for the several good shows planned this year," and port. with her drawings in "Home Portraits Gaining Recognition," *SMT*, Jan. 5, 1957, p. 4.

Wilson, JoAnn (notices in Northern Santa Barbara County newspapers on microfilm and on newspapers.com)
1946 – Port. as editor of Santa Maria High School yearbook, *SMT*, May 24, 1946, p. 4;
1949 – "Miss JoAnn Smith, daughter of Dr. and Mrs. [W.] Leland Smith, spent the week-end here visiting her parents. JoAnn, who is a sophomore at Whittier college, majoring in

art, and is the art editor of the college annual. She has been elected assistant editor of the annual for next year," *SMT*, May 9, 1949, p. 5.
1950 – "Smith-Wilson Engagement Announced… Miss Smith is a junior at Broadoaks Kindergarten school at Whittier college. She is a member of the Athenian society and is a member of 'The Sponsors,' a group of ten chosen students. As a sophomore she was a member of the Soseco group of 20, chosen as top students by her class. She was assistant art editor of the college annual, the *Acropolis*, as a freshman, and served as art editor last year before becoming associate editor of the school publication this term. While in Santa Maria high school, the bride-elect was editor of the *Review*. As a junior, she spent two months at Mills college with Junior Statesmen… she spent two summers at Hill and Canyon art schools, Santa Fe, N. M. in art study. Last summer she was a playground teacher here for the local public schools and City Recreation department…," *SMT*, Jan. 23, 1950, p. 6; port as bride-to-be, soon to be married to Donald Wilson of Norwalk, Ca., a Whittier college student, *SMT*, Jan. 28, 1950, p. 6; port. as bride, *SMT*, Sept. 9, 1950, p. 8.
1956 – "History Research… **Santa Maria Valley Historical Society**… The secretary was requested to write a letter of appreciation to Mrs. Don Wilson for her designs for a letter head and seal for the Society," *SMT*, Nov. 12, 1956, p. 1.
1957 – "Nursery School Opens. Mrs. Don Wilson is the director and teacher this term at **Allan Hancock Nursery School**… Mrs. Wilson, who received nursery school education training in college, will direct the evening classes for mothers…," *SMT*, Sept. 10, 1957, p. 3.
1958 – Port. with **Minerva Club** sisters, *SMT*, June 30, 1958, p. 2.
Wilson, JoAnn (misc. bibliography)
JoAnn Smith is listed in the 1930 U. S. Census as age 0, b. c. 1930 in Calif., residing in Santa Maria with her parents W. [William] Leland Smith (age 28, a dentist) and Julia [Anne Beeson] Smith (age 27); Joann S. Wilson b. Oct. 2, 1929 was residing in Santa Maria in 1979 per *U. S. Public Records Index, 1950-1993*, vol. 1 (refs. ancestry.com).
See: "Allan Hancock [College] Art Gallery," 1955, 1956, "Allan Hancock College Nursery School," "Art, General (Camp Cooke)," 1942, "Camp Fire Cottage," intro., "Junior Community Club," 1953, "Minerva Club, Art and Hobby Show," 1958, 1959, "Posters, Latham Foundation (Santa Maria)," 1944, "Santa Maria, Ca., Union High School," 1944, "Santa Maria Valley Historical Society," 1956

Wilson, Joseph John "Joe" (1900-1953) (Santa Maria)
Photographer. Photo store owner. Santa Maria HS grad. Inventor of device to synchronize home films and sound, 1949. Wilson-Garlock Syncro-Meter.

■ "Joe Wilson Dies… Born April 26, 1900 in Kansas City, Kan., he was the son of Mrs. Nellie C. Wilson, 512 South Lincoln, with whom he had made his home for a number of years. Mr. Wilson came to Santa Maria from Mountain View in 1908, attended school here, and in 1920 moved to Santa Ana where he owned and operated the De Luxe Photo Finishers. He was seriously injured in an automobile accident in March of 1937 and had since lived

here with his mother. He was an active radio ham and operated short wave station W6-PQS here. He was a member of the ... Projectionist's Union," *SMT*, May 11, 1953, p. 8.

■ "Santa Marian Invents Machine for Home Talkies… known as the Wilson Synchrometer… neat looking box about the size of a table-model radio… channels sound … Wilson will give a demonstration of the equipment at 8 p.m. Wednesday in **Stonehearts**. The handicap Wilson suffered in sustaining a broken back in an auto accident about 15 years ago has been turned to account in spending days and often nights at work on radio and projector equipment. He has invented several other gadgets but this is his most important piece of work. His interest in photography began while he attended high school in Santa Maria. As early as 1914 he had become a free-lance cameraman, working on industrial, promotion and agricultural films. His most spine-chilling recollection, as related to a *Santa Maria Times* reporter was, at the age of 17, climbing to the top of the city water tower, then a brand new structure, to get a panoramic view for a real estate concern. He carried the heavy, bulky movie camera and tripod to the tip-top of the tank, set it up on a ledge, and turned the two cranks, one for the movie and the other to get the panoramic view. The window of Wilson's room on South Lincoln looks out on the tower… Wilson began to think about the synchronization of sound and films when he was a projectionist in 1922, showing agriculture films in various high schools. He frequently watched rehearsal of high school plays and believed here was good material. 'I wanted to make a school movie with sound badly enough, and worked out a home device of synchronization,' he recalled. Asked if he feared the invention might be copied, Wilson said the set is so terrifically complicated this would not be easy. Due to his handicap and the amount of work involved, he found it necessary to take in a partner… Wilson read an article in a magazine in April 1947 by an amateur photographer who was attempting to synchronize home movies with recordings. Wilson wrote him, 'I have what you need,' and the result was a meeting in Santa Maria at which, after several days' work on drawings, the two formed a partnership. From the drawings, a working model was built. By a process of elimination, a market model set was produced and with considerably fewer gears than the original. The items will probably be manufactured in Hollywood, he said. The Syncro-meter will mean sound for all silent 8 mm and 16 mm films. While working on the theory, sound was transferred from recordings to tape and wire. The machine will handle the three mediums with home-made movies. Looking ahead, Wilson predicts families will stay at home more than they do now for entertainment due to television, and he thinks that many families will have home film and recording libraries and also exchange services. Dealers and distributors in Germany…[etc.] have applied to be dealers for the appliance in response to a '*Home Movies*' magazine advertisement. Wilson whiles away long hours at night, talking by code over his amateur radio station W6PQS…. The Santa Maria inventor has attached an electric motor to a wheel chair and so takes daily constitutionals and gets away from home occasionally," *SMT*, Feb. 7, 1949, p. 5.
See: "Santa Maria Camera Club," 1949

Wilson, Marie (?)
Teacher of Interior Decoration at Winter Arts Program, 1953.
See: "Winter Arts Program," 1953

Window Decorating and Window Displays (Northern Santa Barbara County)
Decoration of central business district windows by school students was done for special events such as the Elk's Club Rodeo, and for Halloween and Christmas. Sometimes the Boy Scouts or school students displayed their artwork in a business front window. Posters advertising events and made by students were often placed in business front windows. Photographers sometimes displayed examples of their photos in their front windows. Some stores, such as T. A. Jones in Lompoc, received notice for their well-designed window displays.
See: "Boy Scouts," "Christmas," "Elk's Club – Rodeo and Race Meet," "Halloween," "Public Schools Week"

Winslow, Paul G. (1931-1998) (Arroyo Grande / Santa Maria)
Artist. Ceramics instructor in Santa Maria Adult School, 1959. Art teacher Santa Maria High School, c. 1960-62. Instructor of Art at Hancock College, 1964. Art director of the Santa Barbara County Fair, 1965. Prop. of Winslow Design, 1981+.
■ "Paul G. Winslow. Artist and Teacher… 66… Mr. Winslow was born Aug. 23, 1931 in Gunnison, Colo. He lived in Santa Maria for 40 years. He was a teacher and artist at San Maria High School and Hancock College before opening Winslow Design in 1981. He was the art and exhibit design director for the Santa Barbara County Fair in Santa Maria throughout the 1960s and 1970s. He earned two bachelor's degrees and two master's degrees…," *SMT*, Jan. 31, 1998, p. 7.
And many notices on him in Santa Maria newspapers between 1960 and 1998 were not itemized here.
Winslow, Paul (misc. bibliography)
Paul Winslow is listed as teacher, public school, r. Arroyo Grande, in the *Santa Maria, Ca., CD*, 1961; Paul G. Winslow was b. Aug. 23, 1931 and d. Jan. 28, 1998 per Social Security Death Index (refs. ancestry.com).
See: "Santa Barbara County Fair," 1965, "Santa Maria, Ca., Adult/Night School," 1959, "Scholastic Art Exhibit" 1960

Winter, Hazel
See: "Rossini (Winter), Hazel (Mrs. Aldo E. Rossini) (Mrs. Bill Winter)"

Winter, Ralph Courtney / Eugene?, Pfc. (1919-1984) (Sacramento / Camp Cooke)
Painted murals of a Snowman and Yule Log for Christmas at Camp Cooke, 1945.
■ Port. with other students helping plan the annual Sacramento Junior College Art Students League Ball, *Sacramento Bee*, Nov. 6, 1943, p. 13; "College Art Student … California State Chamber of Commerce [art competition]

... Other entries receiving mention were those of ... Ralph E. Winter...," *Sacramento Bee*, Jan. 24, 1947, p. 16; "Exhibit is Planned. Ralph Winter of 2218 ½ Eleventh Street, a student at the Chicago Academy of Fine Arts, will display his work in commercial illustration in a four day exhibit in the school starting June 3rd," *Sacramento Bee*, May 28, 1948, p. 5; "Pictures Will Be Shown – Ralph Eugene Winter, son of C. E. Winter, 2218 ½ Eleventh Street, will have a number of illustrations shown next week in the forty seventh annual exhibit of the Chicago Academy of Fine Arts, where he is a student," *Sacramento Bee*, May 27, 1949, p. 5.

Winter, Ralph (misc. bibliography)
Ralph Courtney Winter, b. June 16, 1919 in Minnesota and d. May 31, 1984 in Sacramento, Ca., per My Hinton Family Tree (ref. ancestry.com).
See: "Art, general (Camp Cooke)," 1945

Winter Arts Program (Santa Maria)
Sponsored winter 1952 / 53 by Santa Maria Arts Association, AAUW and Minerva Club under the aegis of the University of California (Santa Barbara?) extension. Held at Santa Maria Junior College. Organized by Jeanne DeNejer.

■ "Winter Art Program Series to Begin on November 11," includes 15 classes to be held on Tuesdays organized by **Mrs. DeNejer** "in cooperation with the Extension Service of the University of California, and under the general direction of **Dr. Elliott Evans**, chairman of the department of art, Santa Barbara college, University of California. Included in the series will be a circle theater drama, an evening of choral speech, lectures and demonstrations of the dance, demonstrated lectures on music, painting, sculpture, architecture, ceramics, textiles and metals," and tickets will be overseen by **George Muro**. "Seven welcomed as new members [to **Santa Maria Art Association**] ... **Mr. and Mrs. William Bailey**, Mr. and Mrs. Jack Oliver, **Gordon Dipple** instructor in art for the high school and junior college and Mr. and Mrs. Alvin Hall...," *SMT*, Oct. 3, 1952, p. 4.
Winter Arts Program (notices in Northern Santa Barbara County newspapers on microfilm and on newspapers.com)
1952 – "Art Program to be Offered the Public," i.e., a series of lectures, theater, music and fine art demonstrations culminating in hands-on experience, *SMT*, Sept. 27, 1952, p. 4; "Tickets are On Sale for Winter Series of Art," *SMT*, Oct. 16, 1952, p. 4; "Tickets Sell for Winter Art Series ... **George Muro**, president of Santa Maria Art Assn., reports tickets are in demand for the winter art series. Santa Maria Art Assn., Minerva club and AAUW members are selling tickets as well as three local stores, **Santa Maria Camera shop**, Associated Drug and Broadway Bootery. Tickets for adults are $4.80 and students, $2.40 including tax. Many teachers are availing themselves of the opportunity to secure college credit from the course. The opening class in the course on November 11, 7 to 9 p.m. in Junior college social hall will feature **Dr. Elliot A. P. Evans**, PhD, Santa Barbara college art department. This speaker will introduce the art course which will be geared for the layman's appreciation. He will cover the scope of the course 'What and Why of Arts.' On November 18, Miss Jean Bellinger,

M.A., will bring a group of her dance class to demonstrate her presentation of 'The Dance.'...The following Tuesday, November 25, the class will hear Rollin W. Quimby, Ph.D., with an evening devoted to 'Speech.'... On December 2, literature will be the topic. The professor who will give this lecture will be named at a later date, as well as who takes charge of the evening on music, December 9. Architecture, and the arts in California, textiles, sculpture, pottery, and minor arts including interior decoration will fill following evenings of the series. All money received in excess of the cost of the series will be channeled into the Santa Maria Museum building fund," *SMT*, Oct. 23, 1952, p. 4; "Art Lectures Covering Many Fields Set for City in Fall," *SMT*, Oct. 28, 1952, p. 5; "Ticket Sale for Winter Art Series is in Progress," *SMT*, Nov. 3, 1952, p. 4; "Secret Desires to be Featured in Coming Art Lectures," i.e., 15 demonstrated art lectures in dance, drama, etc. *SMT*, Nov. 8, 1952, p. 5; "Art Course to Begin" with "Art in Our Lives" by **Elliott A. P. Evans**, *SMT*, Nov. 10, 1952, p. 4; "**Dr. Elliot Evans** Opens Art Series" to packed audience and gist of his speech and consideration of moving events to larger quarters, such as the high school auditorium, *SMT*, Nov. 12, 1952, p. 4; "The Theater to be Art Series Topic Tomorrow," *SMT*, Nov. 24, 1952, p. 4; "Art Course Group Hears Talk on Novel and Poetry" by W. Hugh Kenner, *SMT*, Dec. 3, 1952, p. 4.
1953 – "Winter Arts Program to Resume Soon" with "Arts and Architecture in California" given by **Dr. Elliot A. P. Evans**, chairman of the Department of Art at Santa Barbara College of the University of California, *SMT*, Jan. 2, 1953, p. 6; "**Dr. Evans** Speaks on Architecture at Junior College. The university extension course, offered with **Santa Maria Art Assn.** sponsorship cooperatively with AAUW and Minerva club, has resumed Tuesday night classes in the Junior college social hall... **Elliott A. P. Evans**... on 'Architecture and Arts in California'... showed slides of California missions ... spoke of early artists and craftsmen ... showing slides of their work and included photographs ... of California collections of Mrs. Phoebe Hearst and the San Francisco Flood family...," *SMT*, Jan. 8, 1953, p. 4; "Winter Art Program... 'Costumes and Furnishings'... next lecture... at the Santa Maria Junior college. Presenting the lecture jointly will be two members of the art department of Santa Barbara College of the University of California – **Catherine C. Campbell**, assistant professor of art, and **Dr. Elliot A. P. Evans**, chairman of the department... Next week, Jan. 20, two prominent Santa Barbara artists will present a program on sculpture. They are **William Dole**, painter and assistant professor of art, and **Renzo Fenci**, sculptor and instructor in art, both on the Santa Barbara College faculty," *SMT*, Jan. 12, 1953, p. 3; "Story of Pottery Told by Hansen," i.e., **Jacob Lindberg Hansen**, assistant professor at Santa Barbara College, UC, *SMT*, Jan. 28, 1953, p. 4; "**J. Lindberg Hansen** to Speak Tuesday. 'Painting Through the Ages'... at the Junior college social hall... The audience heard an interesting talk on 'The Home Inside and Out' at last Tuesday's class with **Marie Wilson** as speaker... How to select colors, fabric and furniture for the home... and the new 'Pacifica' idea in home décor were subjects covered... Subjects for the four remaining classes... will be on prints and drawings, art and the photographer, and the artist in action. **Dr. Evans** will give the final lecture, 'Art Comes from You,' on March

10," *SMT*, Feb. 9, 1953, p. 4; "Art of Painting is Speaker's Topic," i.e., **Hansen**'s exact topic was "Painting Through the Ages," *SMT*, Feb. 11, 1953, p. 4; weekly classes on Tuesday evenings at Junior College – "Two Speakers are Heard by Class on Study of Arts" – next speaker being **Dr. Elliot Evans** on "Art Comes from You" and February programs were on prints and drawing and on "Art and the Photographer." A past lecture by **Wm. Dole** and **Wm. Rohrbach** was on "The Artist in Action," *SMT*, March 5, 1953, p. 4.

Winter Arts Program (notices in other newspapers)
1952 – "Santa Maria Plans Art Program" series of lectures sponsored by **Santa Maria Art association** and Santa Maria chapter of AAUW, *SLO T-T*, Nov. 8, 1952, p. 2; "Art Lectures Due at Santa Maria J. C. Nov. 11," *PRP*, Nov. 10, 1952, p. 8, by U of C, Extension.
1953 – Winter "Arts Program Opens Tonight" with lecture by **Dr. Elliot A. P. Evans**, chairman of the dept of art at Santa Barbara College, *SLO T-T*, Jan. 6, 1953, p. 3; "Sculpture, Art on Winter Program," taught by **William E. Dole** and **Renzo G. Fenci**, both of Santa Barbara, and **Jacob Lindberg-Hansen** and **Jeanne DeNejer**, *PRP*, Jan. 26, 1953, p. 4.
See: "University of California, Extension"

Wise, Marian J. (Mrs. David Wise) (Santa Maria)
Hancock College student who exh. Allan Hancock [College] Art Gallery, 1955, 1956. Member Rembrandt Club, 1955. Aided Bluebirds with crafts, 1954.
Marian Wise, with husband, David, is listed in the *Santa Maria, Ca., CD*, 1958-65 (refs. ancestry.com).
See: "Allan Hancock [College] Art Gallery," 1955, 1956, "Rembrandt Club, Allan Hancock College," 1955

Wisser, Judith "Judy" Amelia
See: "Collier (Wisser), Judith "Judy" Amelia (Mrs. Robert Chester Wisser)"

Woggon, William H., Jr. (1911-2003) (Santa Barbara)
Comic strip artist of "Katie Keen" and "Debby," who visited Santa Ynez Valley, 1950.
■ "William Woggon (January 1, 1911 – March 2, 2003) was an American cartoonist who created the comic book *Katy Keene*. Woggon was born the fourth of six children in Toledo, Ohio, and he grew up there. Fascinated by an art correspondence course that his older brother Elmer Woggon was taking, he became interested in drawing...," Wikipedia
1950 – "Sunday Visitors. Mr. and Mrs. William Woggon and son and daughter of Santa Barbara, visited at the home of Mr. and Mrs. Dan Britton on Sunday. Mr. Woggon is a syndicated comic strip artist and authors Katie Keen, Debby and other strips," *SYVN*, Sept. 15, 1950, p. 3.
Woggin, William (misc. bibliography)
William H. Woggon, cartoonist, and wife, Jane, are listed in the *Santa Barbara, Ca., CD*, 1954-85 (ref. ancestry.com).

Wolf, (Charles) Peter (1929-1977) (Santa Barbara)
Exh. pen and ink and pastels at Santa Ynez Valley Art Exhibit, 1954.
Wolf, Peter (misc. bibliography)
Peter Wolf, artist, with no wife, is listed in the *Santa Barbara, Ca., CD*, 1948, and at the same address of 1534 De la Vina is listed Charles P. Wolf, artist with Regent Advertising Studios as well as Charles T. Wolf, steward, University Club; Peter Wolf, artist, with wife Kathleen, is listed in *Santa Barbara, Ca., CD*, 1959; Charles Peter Wolf, b. Jan. 16, 1929 to Charles Wolf and Lottie Mueller, married Katheleen [Sic.?] Yvonne Murphy, and d. Sept. 12, 1977 in Santa Barbara per Wolf Family Tree (refs. ancestry.com).
See: "Santa Ynez Valley Art Exhibit," 1954

Wolf, Ursula, Miss (Santa Ynez Valley)
Dress designer and student of Mrs. Viggo Brandt-Erichsen who intended to exh. at Santa Ynez Valley Art Exhibit, 1957, 1958. Resided with Leo Ziegler family.
■ "Miss Ursula Wolf Designs 'Best Seller' for S.F. Apparel Firm... she is assistant to the head designer, has recently announced that a simple black dress designed by Miss Wolf is currently a best seller. 'Uschi' as she is known here, has been employed for the last eleven months by Jane Andre Dresses of 16 Minna St., San Francisco, and their creations, including her designs, are sold in large stores throughout the country... Miss Wolf, who is the daughter of Mrs. Gunnar Thielst of Santa Barbara, came to the Valley with her mother three years ago directly from her home in Germany. Before she left a year ago to work in San Francisco, she made her home with Mr. and Mrs. **Leo Ziegler** on Refugio road. She made many friends here and designed and made dresses for many women of the Valley...," *SYVN*, July 31, 1959, p. 3.
Wolf, Ursula (notices in Northern Santa Barbara County newspapers on microfilm and on newspapers.com)
1957 – Port. with artists who will exhibit at Santa Ynez Valley Art Exhibit, 1957, *SYVN*, July 19, 1957, p. 1.
1958 – "Surprise Party... Miss Wolf, who participated in the Danish Days celebration as a member of the Solvang Folk Dance group, is leaving today to make her home in San Francisco. She has been employed at the Copenhagen Inn," *SYVN*, Aug. 15, 1958, p. 3.
Wolf, Ursula (misc. bibliography)
Is she Ursula Wolf, age 28, who married Bruno Parola, 44, in San Francisco per *SF Examiner*, Aug. 14, 1964, p. 56, col. 4 (i.e., 5C2H) (refs. ancestry.com).
See: "Santa Ynez Valley Art Exhibit," 1957, 1958

Wolhaupter (Kelly), Helen Phillips (Mrs. Maurice Kelly) (1897-1978) (Santa Monica / Arizona)
Santa Monica artist who visited Lompoc where she painted local scenes, 1932.
See: *Central Coast Artist Visitors before 1960*

Wolo (aka Wolo von Trutzschler aka Baron Wolff Erhardt Anton Georg Trutzschler von Falkenstein) (1902-1989) (Switzerland)
Artist, actor, puppeteer, author, singer who performed in Lompoc 1957.
See: *Central Coast Artist Visitors before 1960*

Woman's Club of Arroyo Grande
See: "Prindle, Kenneth," and *Arroyo Grande (and Environs) Art and Photography before 1960*

Women's clubs (Northern Santa Barbara County)
See: "Alpha Club," "Community Club (Santa Maria)," "Guadalupe Welfare Club," "Junior Community Club (Santa Maria)," "Lompoc Community Woman's Club," "Minerva Club," "Orcutt Women's Club," "Santa Ynez Valley Woman's Club," "Solvang Woman's Club"

Wood, Adrian L. (Santa Ynez Valley)
Draftsman, 1958.
Wood, Adrian (notices in Northern Santa Barbara County newspapers on microfilm and on Internet sites)
1958 – "Drafting Service. Residential Design & Interiors. A. L. Wood. Phone S.Y. 7923," *SYVN*, Jan. 31, 1958, p. 6; photo of men discussing plans drawn by Adrian Wood for the conversion of Nielsen's Market into a Danish provincial style building, *SYVN*, May 2, 1958, p. 1.

Wood, Louise, Miss (Santa Barbara)
Interior decorator from Santa Barbara who spoke to the Minerva Club, 1945. Several ads for her business were run in the SMT 1945, 1946 but were not itemized here.
See: "Minerva Club," 1945

Wood, Mildred C. (Cuthbert?) (Mrs. Alexander H. Wood) (Los Olivos / Van Nuys)
Painter. Taught art at the Midland School, 1943. Exh. in Tri-County Art Exhibit, 1947, 1950. OMS water color landscapes at the Santa Barbara Museum of Art, 1951.
Wood, Mildred (notices in Northern Santa Barbara County newspapers on microfilm and on Internet sites)
1951 – "Mrs. Wood's Paintings in S.B. Exhibit. Beginning today and continuing through Thursday, Oct. 25, an exhibit of water colors depicting scenes of the Santa Ynez Valley will be displayed by Mildred C. Wood of Van Nuys, formerly of the Valley, at the Santa Barbara Museum of Art. The exhibit by Mrs. Wood has been entitled the 'Santa Ynez Valley Series.' On display will be landscapes and compositions… semiabstract interpretations of nature. Mrs. Wood is the wife of Alex Wood, formerly of the faculty of the **Midland School**," *SYVN*, Oct. 5, 1951, p. 2.
1962 – "Midland School Stages 30th Annual Graduation… Among other visitors recognized was Mrs. Alexander Wood of Santa Barbara whose late husband taught at Midland for 10 years. Her two sons, Robert and Guy Wood were both graduated in the class of 1948…," *SYVN*, June 15, 1962, p. 10.

Wood, Mildred (misc. bibliography)
Is she Mildred Cuthbert who married Alexander H. Wood on April 12, 1930 in Manhattan, NY per *NY Extracted Marriage Index*; Mildred Wood is listed with husband Alexander H. Wood, teacher at the Midland School, in the *Los Olivos, Ca., CD*, 1945; Mildred C. Wood, homemaker and Rep. is listed at Midland School in California voter registrations, *Ballard Precinct*, 1942-44 (refs. ancestry.com).
See: "Midland School," 1943, "Tri-County Art Exhibit," 1947, 1950

Woodall, Bernice E. (Mrs. Monroe D. Woodall) (Lompoc)
Ceramist who exh. at Santa Ynez Valley Art Exhibit, 1956. Prop. Ocean Avenue Ceramics, 1956. By 1962 she was residing in Salinas, Ca.
See: "Ocean Avenue Ceramics," "Santa Ynez Valley Art Exhibit," 1956

Woodcraft (Santa Maria)
Club at Santa Maria High School, 1935.
See: "Santa Maria, Ca., Union High School," 1935

Woods, ? (Mrs. Woods) (Mildred Wood?) (Lompoc)
Art teacher at Lompoc High School, 1960.
See: "Lompoc, Ca., Union High School," 1960

Woods, H. W.?, Mr. (Santa Maria)
Photographer, itinerant, 1894. Woods & Sweetland.
Woods, H. W. (notices in Northern Santa Barbara County newspapers on microfilm and on Internet sites)
1894 – "D. Rossi and Mr. Woods the photographer went to Oso Flaco last Tuesday on a business run," *SMT*, June 2, 1894, p. 3, col. 1; "Photographer Woods returned from an up-country trip Thursday evening," *SMT*, July 28, 1894, p. 3, col. 1.
See: "Sweetland, C. M.?" 1895

Woods & Sweetland (Santa Maria)
See: "Sweetland, C. M.?," "Woods, H. W.?"

Woodside, Joseph V.
Teacher of handicraft / director, WPA, 1936, 1937.
See: "Santa Maria, Ca., Elementary Schools," 1936, "Works Progress Administration," 1936, 1937

Word, Helen S.
See: "Sutphen (Word), Helen S. (Mrs. William F. Word)"

Works Progress Administration / Work Projects Administration (WPA) (Northern Santa Barbara County)

Funds appropriated 1935. The WPA was the largest of the New Deal programs and funds were expended from 1936 to 1942. In its most famous project, Federal Project Number One, the WPA employed musicians, artists, writers, actors and directors in arts, drama, media, and literacy projects. The five projects dedicated to these were: the Federal Writers' Project (FWP), the Historical Records Survey (HRS), the Federal Theatre Project (FTP), the Federal Music Project (FMP), and the Federal Art Project (FAP). The Art Project that covered northern Santa Barbara County was administered out of the town of Santa Barbara. Artists funded by the project resided outside north county and their art was distributed to north county. Biggest benefactors were in Lompoc – the Veteran's Memorial building, the Lompoc High School, and Mission La Purisima. The Santa Ynez Valley Union High School also received art. The WPA also sponsored recreational programs that led, post WWII, to individual cities starting their own recreation programs. A subsection of the Federal Art Project was the Index of American Design.

■ "Warren Explains WPA Plans for Unemployed Artists… [at] Alpha club meeting … **John Warren**, Santa Barbara artist and director for the WPA. The country is divided into sections, each with a director and sub-directors. In Santa Barbara **Douglass E. Parshall** is chief of the group which is composed of 20 persons, 18 artists and two directors. Sculptors, painters and commercial artists are included in the unit. The local [Veterans] Memorial building will receive examples of art created by this group, in compliance with the requirements of the federal government. In each case, a cooperating sponsor, public or quasi-public institution, works together with the artists. Artists spend 96 hours a month working… Work, when completed, is passed on by directors. An innovation by the Works Project Administration is the American <u>Index of Design</u>. Consisting of the accumulation and filing of every phase in the history of American art, the Index will present a complete folio of early American art. All types of craftsmanship will be represented…," *LR*, Nov. 13, 1936, p. 4.

Works Progress Administration (notices in Northern Santa Barbara County newspapers on microfilm and on newspapers.com)

1936 – "Atterdag College Notes… **Herman Cherry**, artist from Santa Barbara is staying at the college for a couple of weeks. Mr. Cherry is employed by the PWA [Sic? WPA] and is painting sketches of the Santa Ynez valley…," *SYVN*, April 3, 1936, p. 8; "Artists to Add to Beauty of Local Memorial. Lompoc's <u>Veterans Memorial</u> and Civic Center building… as result of a new WPA project… **DeWitt Parshall**, Santa Barbara artist, will be in charge … Sketches are now being made of the proposed frescoes, murals and other types of artistry. First being planned includes frescos at the main entrance … which unit of the memorial is now nearing completion…," *LR*, July 10, 1936, p. 1; "Artists to Aid Lompoc on its New Memorial … Construction work on <u>Lompoc's Veterans' Memorial</u> and County Offices' building is progressing rapidly. First coat

of plaster on the outside was completed yesterday and work began on the interior of the large auditorium. … The building will be given added touches of architectural distinctiveness as result of a new WPA project which will call for considerable sculpture and other art work. **DeWitt Parshall**, Santa Barbara artist, will be in charge of the project, on which Santa Barbara artists will be employed," *SMT*, July 11, 1936, p. 4; "High School Opens Aug. 31 in New Modern Buildings… **Santa Ynez Valley Union High School**… There is probably a no more artistically and beautiful room within Santa Barbara county than the Library and study room. Here are located the three beautiful <u>murals</u> painted by the celebrated artist **Miss Harcourt [Sic. Harcoff?]**. These portray three stages in the historical development of Santa Ynez Valley. The first is that of earliest settlement and the work of the first Franciscans; the next portrays the romantic life on the ranches and shows a strikingly beautiful palomino horse of the Dwight Murphy ranch. The third drawing pictures the later or machine age within this valley. Recently these three pictures were exhibited in Santa Barbara and the artist and her work were most favorably criticized … Besides these three drawings there is a wood carving by **Mr. Swanson**, who also is very favorably known in the world of art," *SYVN*, Aug. 21, 1936, p. 1; "Fed. Art Director Visits [Lompoc] **High School**. **Douglass E. Parshall**, director of Federal Arts project in Santa Barbara, visited Lompoc high school Tuesday. He discussed the advisability of painting a mural, but decided against it. Instead, **J. [Sic. D.] Swanson**, who accompanied Parshall, will make a wood-carving of the celite industry," *LR*, Oct. 23, 1936, p. 12; "New Deal Using P. O. Lobby for Its Advertising. A <u>poster</u> two feet wide and five and a half feet tall extolling the New Deal's WPA work, has been set up in the Santa Maria post office lobby," *SMT*, Oct. 27, 1936, p. 1; "Boy and Girl Program Opens… Federal <u>Recreation</u> Work to Be Inaugurated at <u>Main Street School</u>… daily between 3 and 5 and on Saturdays from 10 to 12 and 1 to 5. The work is to be under the … **WPA** recreation program, and **J. V. Woodside** will be in charge of <u>handcraft</u> work… conducted in Main street school…," *SMT*, Nov. 10, 1936, p. 1; "WPA Plaque to be Installed… <u>Veterans Memorial</u> … by **Mrs. Helen Seegert**… will be ready for installation on November 16… **Douglass E. Parshall**… was a Lompoc visitor yesterday morning to make arrangements for transportation of the plaque. Weighing a ton, the sculpture is ten by eight feet and will be placed between the two archways leading into the auditorium," *LR*, Nov. 13, 1936, p. 1; "New Gym Class for Guadalupe… WPA… average attendance of 900 to 1100 children weekly on the [WPA] recreation project … at <u>Main street school</u>… These classes meet daily except Saturdays and Sundays from 3 to 5 and embrace games in the open and handcraft work in the wood shop…," *SMT*, Dec. 2, 1936, p. 8.

1937 – "<u>Vet Memorial</u> Described… Tomorrow will be the grand opening… at night… Above the structure appears the lighted cross overlooking the site of the original La Purisima mission… Walking into the main entry… colorfully tiled floor and walls of the foyer created an authentic Old Spanish atmosphere… Through a graceful archway opposite the entrance, we saw the inner lobby… a mural of the Indian neophytes busily engaged in the

construction of a mission while the Mission padre blesses them. A Federal Art project, this huge <u>mural</u> done by **Helen Seegert** of Santa Barbara… To either side of the mural is a doorway leading to the largest room in the building, the auditorium. Wine colored velour drapes and the stage hangings, planned by <u>Mrs. Evelyn Phipps</u> of Oakland, interior decorator… In the west wing we discovered, are the kitchen, banquet room. ... Here in the veterans' wing… Auxiliary meeting place. This is well equipped for sewing and handicraft projects with an ironing board… Ascending the stairs again we went to the second floor where the veterans' clubroom is… Attractive quarters are provided for the vets here… Above the fireplace hangs a large wood-carved <u>mural</u> made by **David Swanson**, Santa Barbara artist…," *LR*, Feb. 5, 1937, p. 6; "Seven Direct Playing… WPA Projects to be Enlarged… Twenty centers of WPA <u>recreational activity</u> are operating in ten communities employing 50 workers in Santa Barbara county. Santa Maria has seven of these workers. There are two centers of activity… the <u>high school</u>, <u>Main Street school</u> and <u>Cook Street school</u>. On the Main Street school playground, Joe Young and **Joe Woodtide** [Sic. **Woodside**] are in charge of the playground work and handicraft classes respectively. Woodcarving, art, painting and weaving are the subjects…," *SMT*, April 19, 1937, p. 6; Elementary grade pupils "School Work Shown in Window" of Woolworth store, part of <u>WPA recreation project</u> directed by **Joseph Woodside** and **Byron Openshaw**, and includes objects made by weaving, water coloring, wood working, etc., *SMT*, May 11, 1937, p. 3; "<u>Mural</u> is Given to [**Lompoc**] **High School**. A mural, carved in wood and portraying a phase of the Celite industry titled 'The Celite Plant' has been presented to the Lompoc high school by the WPA art project at Santa Barbara. This picture will be hung in the lobby of the high school auditorium. This carving is made of Spanish cedar and is 60 inches long and 30 inches wide. The artist was **David Swanson**. An art exhibit selected from the WPA projects, is being sent to Washington, D. C. and on a tour of the United States, after which four or five will be given to the high school to hang in the different rooms," *LR*, May 14, 1937, p. 1; "<u>Hobby Display</u> for Next Week… Gov. F. F. Merriam has proclaimed the week beginning Monday as "<u>Public **Recreation Week**</u>.' A display of handicraft and hobbies, supervised by **Byron Openshaw**, will be open to the public…," *SMT*, June 19, 1937, p. 4; "<u>Appraisal of WPA's Venture in the Arts</u>. About two years ago, the United States government, through WPA, instituted a regime of relief projects designed to provide a living for white-collar workers interested in four branches of the arts – theatre, music, painting and sculpture, and writing. As the products of these workers began to filter out of the workshops and strike the public consciousness, they stirred up countless little storms of protest…," etc., *SMT*, July 28, 1937, p. 4. **1938** – "<u>Water-Colors</u> to Adorn High School … Thirteen water-color paintings dealing with subjects familiar to Santa Barbara county were presented to **Lompoc high school** … Cost to the school was the price of materials… The selections were made by Principal W. R. Hull, Miss **Mary Elisabeth Bucher**, art instructor, and a group of art students," *LR*, March 4, 1938, p. 6.

1939 --"More Millions for What?," *SMT*, May 27, 1939, p. 4.
<u>Works Progress Administration from the Internet</u>
A fountain at **La Purisima Mission** State Historic Park was created by sculptor **Helen Seegert**, WPA artist, in 1936, also the CCC restored the entire Mission in 1934-41, and there is a painted ceramic plaque titled "Building the Mission," 7 x 12 feet, sculpted by **Helen Seegert**, WPA artist, in the foyer of the auditorium of the Veterans' Memorial Building, Lompoc, per www.newdealartregistry.org.
<u>See</u>: "Alpha Club," 1953, "Civilian Conservation Corps," 1937, "Grant, Campbell," "Federal Art Projects," "Lompoc Nursery School," "Mission La Purisima," 1937, "Nadeau, Evelyn," "National Art Week," "Openshaw, Byron," "Parshall, Dewitt," "Parsons, Wayman," "Peake, Channing," intro., "Recreation Week," "Santa Barbara County Fair," 1941, "Santa Maria, Ca., Elementary Schools," 1936, "Santa Maria, Ca., Union High School," 1936, "Santa Ynez Valley Union High School," "Seegert, Helen," "Swanson, David," "Warren, John," "Woodside, Joseph"

World War I (WWI) and art
Artists in the form of topographical engineers and photographers had been used by the military since the media were invented. WWI saw the formation of the Signal Corps that, among other things, developed photos and films taken by the air forces.
<u>World War I and art (notices in Northern Santa Barbara County newspapers on microfilm and on newspapers.com)</u>
1917 – "<u>Signal Corps</u> Seeks Expert Camera Men. Washington – An appeal was this week sent out for expert photographers to enlist in the signal corps now being formed. After brief training the men who enlist will proceed to France. They will be responsible for the immediate development and printing of all photos taken by the air forces," *SMT*, Oct. 27, 1917, p. 3.
1918 – "Opportunity Given in Limited Service. Men in the draft classified for special or limited service or in deferred classification because of dependents can be inducted into the 472nd engineers, according to Sergeant S. A. Wayman of the army recruiting station at Santa Barbara. Men experienced along the following lines are desired: Typographical and lithographic <u>draftsman</u>, negative cutter, surveyors, typographical assistant, <u>photographers,</u> computer, surveyors, typographical expert, photo transferers, process printers, transfers (lithographers) and pressmen," *SMT*, Aug. 24, 1918, p. 7.
1919 – "War Lectures Noted Painter at the Grand… <u>Miss Brenda Francklyn</u>, a miniature portrait painter of international note and an English war worker who since 1914 has devoted her time to lectures in Canada and the United States on the war, will speak tonight at 8 o'clock at the Grand Theatre for the benefit of the Fatherless Children of France," and extended article, *SMT*, May 20, 1919, p. 6.
1928 – "War Relics on Display … Memories of the days of 1917 and 1918 … exhibit of relics… in the windows of **W. A. Haslam and Co**'s store. They were loaned by the Marshall N. Braden post of the American Legion… Legion banners… rifles… a machine gun… The most interesting

feature of the whole exhibit is a large collection of war photographs showing marching troops, work in the munition factories, and above all, the scenes of devastation left by the fighting…," *SMT*, Nov. 9, 1928, p. 1.
See: "Santa Barbara County Library (Lompoc)," 1922

World War II (WWII) and art
"Art and War" experts identify important European monuments in the path of the Allies advance so they will not be bombed, *SMT*, May 16, 1944, p. 4.
See: "Art, general (Camp Cooke / Vandenberg AFB)," "Photography, general (Camp Cooke / Vandenberg AFB)," "United Service Organization" and *Atascadero Art and Photography before 1960* and *San Luis Obispo Art and Photography before 1960*

Worthington, James, Prof. (Los Angeles)
Scientist / photographer whose expedition took photos of the solar eclipse as seen from Lompoc, 1923, and had them developed by Charles Baechler.
See: "Baechler, Charles," 1923

Wozny, John W. (Lompoc / Chicago)
Photo finisher. Prop. of Nu-Art Photos, 1946.
■ "John Wozny Joins Staff of *Record*. John Wozny, until last Saturday attached to the Army medical corps at Camp Cooke, has joined the staff of the *Lompoc Record* as reporter and advertising man. Wozny was separated from the services Saturday. Before entering the Army, Wozny was a student at DePaul University in Illinois. He was editor of the university paper, the *DePaulia*, and was also employed on the night desk of the *Chicago City News Service*. Other experience in newspaper and allied fields was gained by Wozny in his family's commercial printing plant in Chicago. Mr. and Mrs. Wozny will reside at 124 North K street," *LR*, March 28, 1946, p. 10.
Wozny, John W. (notices in Northern Santa Barbara County newspapers on microfilm and on newspapers.com)
1946 – "Depart From Lompoc – Mr. and Mrs. John W. Wozny left Lompoc Monday… by plane to Chicago where they will reside…," *LR*, Dec. 26, 1946, p. 10.
See: "Nu-Art Photos"

Wright, Cora (Arroyo Grande)
Artist. Exh. Santa Maria Art Festival, 1953. Exh. Santa Ynez Valley Art Exhibit, 1954.
See: "Santa Maria Valley Art Festival," 1953, "Santa Ynez Valley Art Exhibit" 1954, and *San Luis Obispo Art and Photography before 1960* and *Arroyo Grande (and Environs) Art and Photography before 1960*

Wright, James Couper (1906-1969) (Santa Barbara / Los Angeles)
Artist who painted a view of Morro Rock. Lectured to College Art Club on Stained Glass, 1932. One of his paintings was distributed to a public building in northern Santa Barbara County by the PWAP, 1934.
■ "Stained Glass Lecture to be Given Club. A lecture on 'Stained Glass' by James Couper Wright, illustrated with examples of his own work, will be given … Mr. Wright came to California two years ago from Scotland. He was born in Kirkwall in the Orkney islands. … He is interested in teaching and has been conducting successful art classes in Santa Barbara where he resides. The artist attended school and college in Edinburgh, Scotland, where he was graduated in design from Edinburgh College of Art, taking first place for his year. He has also studied in London, Paris, Germany, Austria, Belgium and Switzerland. In 1930 he designed for the League of Nations section at the International exhibition of hygiene at Dresden. His work has been exhibited by the Society of Scottish Artists, Edinburgh, Royal Society of Arts, London, Courvoisier Gallery, San Francisco, **Faulkner Gallery**, Santa Barbara (by invitation), Garden Studio, Santa Barbara, State Fair, Sacramento, De Young Museum and California Palace of the Legion of Honor, San Francisco, Los Angeles Museum, Fine Arts Gallery, San Diego, Los Angeles Artists Fiesta and Los Angeles State [Sic.] Fair. Many awards have been bestowed upon him. These include a London scholarship, maintenance and traveling scholarship for study in Europe from Edinburgh College of Art, second prize by the California Water Color society, 1931, first honorable mention from the Southern California artists, San Diego, 1931," *SMT*, Oct. 1, 1932, p. 6.
Wright, James (notices in Northern Santa Barbara County newspapers on microfilm and on Internet sites)
1933 – "Tea to Open Art Exhibit… water color paintings… by James Couper Wright… at the balcony gallery in De La Guerra studios in Santa Barbara … Assisting… Mrs. **Evelyn K. Richmond**…," *Ventura County Star*, April 17, 1933, p. 2.
1935 – "Morro Bay … Mr. Wright, artist of Santa Barbara, arrived Thursday, where he will spend a few days painting," *SLO DT*, Sept. 16, 1935, p. 7.
And more than 100 notices for "James Couper Wright" in Ventura County newspapers on newspapers.com not itemized here.
Bibliography: various references to him can be found in Nancy Moure, *Publications in California Art*, vols. 1-13.
Exh. "Morro Rock," in *Oils by **Clarence Hinkle**, Watercolors by James Couper Wright*, **Faulkner** Memorial Art Gallery, Free Public Library, Santa Barbara, Dec. 16 – 30, 1937.
See: "College Art Club," 1932, "Public Works of Art Project," 1934, and *Morro Bay Art and Photography before 1960*

Wright, Stanton MacDonald (Los Angeles)
Modernist artist of national repute who made a pencil drawing of Gaviota Pass, 1927, that was exh. in *Works of Art Selected from Collections of Alumni of The University of Michigan,* Museum of Art, Oct. 1-29, 1967, no. 130.
See: *Central Coast Artist Visitors before 1960*

Wulff, Jeppe Christian Charles (1885-1936) (Solvang)
Sculptor. Geologist. Collector.
■ "Wulff Laid to Rest in Oakhill Cemetery… Jeppe Christian Charles Wulff… [resident of Solvang since 1911] … engaged in farming… a charter member of the Geological Society of Santa Barbara and a member of the Santa Barbara Museum of Natural History society, and had attained distinction as an amateur geologist and archaeologist. He had the largest private collection of minerals, ores and archaeological specimens in the United States. These specimens were collected from all parts of the world, and many distinguished people have visited the Wulff ranch to see the collection. In addition, Mr. Wulff had collected a large assortment of antique vases, pictures, wood-carvings, etc. Several carved wood articles carved by himself are included in the collection. Mr. Wulff, who had charge of the construction work for the pageants for the Solvang Silver Anniversary celebration June 5-6-7 at the time he received the injuries from which he later died, made several wood carvings for that purpose as well as carvings in stone…," *SYVN*, June 12, 1936, p. 1.
Wulff, Jeppe (misc. bibliography)
Jesse [Sic. Jeppe] Charles Christian Wulff gave the following information on his WWI Draft Registration Card = b. March 30, 1885 in Denmark, a farmer residing in Solvang, nearest relative Ane Margrethe Wulff; Jeppe C. Wulff was b. c. 1885 and d. June 4, 1936 in Santa Barbara County per Calif. Death Index; buried Oak Hill Cemetery, Ballard per findagrave.com (ref. ancestry.com).

Wygal, Elsa Marian Horn (Mrs. Jasper Kennedy Wygal) (1914-1999) (Lompoc)
Ceramist, c. 1948+. Creator of ceramic souvenirs for high school football Booster Club dinner, 1950s.
■ Port. with plaques (**Tom Yager** photo) and "Meet Your Neighbor… Mrs. Jasper Wygal, a native daughter of Lompoc, is a housewife with a hobby … For many years Mrs. Wygal was interested in ceramics and had a steadfast desire to learn the craft. However, the demands of raising a family of three robust youngsters left her little free time… So, she waited until six years ago when the youngest of her brood trooped off to school … Mrs. Wygal first took up the craft under… Mrs. **Viola Dykes** … in the Adult Education program… After Mrs. Dykes moved away, Mr. **Conley McLaughlin**, art instructor at the local high school, held a night class in ceramics for adults, and Mrs. Wygal studied under him. In discussing the art of creating ceramics Mrs. Wygal explained that she used mostly ready-made molds which she found less expensive and time consuming than trying to make her own models, or else she worked with 'greenware' which are the unpainted, unfired pieces. In working a piece of greenware into a finished product, said Mrs. Wygal, one must paint the article then give it a bisque

firing in a kiln for six hours, then apply clear or colored glaze and fire it for another six hours. Another six hours firing period is necessary if a china finish is desired. The kiln must be allowed to cool down between each firing and this takes 24 hours… Mrs. Wygal owns her own Dickinson electric kiln and finds that this is quite an expense saver. Ready-made molds, greenware and paints are not very costly, she explained, but that the price of having pieces fired is … She and her friends engaged in the same hobby often share their equipment. … Mrs. Wygal has turned out hundreds of beautiful pieces ranging from lamps, cookie jars, figurines and knick knacks to dishes and decorative plates and wall plaques. This Christmas alone she made thirty-three of the attractive holiday plates … to give as Christmas gifts. That is one of the nice things about such a hobby, she explained, one always has a supply of unique and charming gifts on hand… Last May she started … making eighty miniature ceramic footballs as favors for the annual dinner given by the Boosters club for the high school Varsity and JV football teams. She made the mold for the favors herself, and each little football featured the year, name and team number of the player. She worked on the project on and off for five months. The year before last she and a number of friends finished little greenware figurines of football players as favors for the dinner. Ceramics, said Mrs. Wygal, is a hobby which most anyone can adopt … Once you begin the craft it becomes a 'real bug,' laughingly commented Mrs. Wygal, 'you dream it, live it, practically eat it.' After six years she is still as enthusiastic about the hobby as when she began. In addition to managing her cozy little home at 222 South I st., raising her three children, Kenneth 17, Anne 13 and Marian 11, sharing family life with her husband, Jasper, who is a café owner, and engaging in her hobby, Mrs. Wygal still manages to find time to help with community youth activities," *LR*, Dec. 16, 1954, p. 3.
Wygal, Elsa (notices in Northern Santa Barbara County newspapers on microfilm and on newspapers.com)
1954 – "Hi-Fi Recordings… The Booster Club held their annual 'football banquet' last night at which both varsity and junior varsity received their own personalized football. Made by Mrs. Jasper Wygal, the balls are little ceramic replicas of the pigskin and were on display in Penny's window…," *LR*, Nov. 25, 1954, p. 9.
1957 – Port. and "Mrs. Jasper Wygal Honored by PTA with Life Membership Award… Mrs. Wygal's interest and participation in 4-H, Cub Scouts, Bluebird and Girl Scout groups as well as the help and assistance given to PTA activities, was noted and tribute given for the ceramic football awards she has made for the Letterman Club for the past four years. 'Her summers are spent at Gaviota beach,' Mrs. Chilson said, 'where her three children and from ten to fifteen others of Lompoc, realize the thrills of camping and learning to share all chores that go with the outdoors," *LR*, Feb. 21, 1957, p. 4.
1958 – Photo of three women with figurines and caption reads "Something for the Football Boys. Plans for the annual Booster club's dinner are never quite complete until the ceramic favors are all ready for presentation to Varsity and Junior Varsity players… Now **Mrs. Clarence Carlson**, Mrs. Jasper Wygal and **Mrs. Richard Rudolph**, who have made the ceramic figurines for the past several years with

the assistance of others in the Tuesday night Ceramic group, put the finishing touches on colorful football statuettes to be presented at the Jan. 27 Booster Club Dinner. In past years, helmets, footballs and shoes have been presented to players," *LR*, Jan. 23, 1958, p. 4; "Hein Talks to Lompoc Boosters… Miniature football players dressed in the Lompoc blue and white uniforms with the name and number of the individual players on them designated the place setting for the honored guests. The small players were created and made by Mrs. Elsa Wygal and her ceramics class," *SMT*, Jan 30, 1958, p. 6.

Wygal, Else (misc. bibliography)
Elsa M. Wygal was b. Nov. 17, 1914, d. Sept. 29, 1999 and is buried in Lompoc Evergreen Cemetery per findagrave.com (refs. ancestry.com).
See: "Ceramics," 1956, "Mildred I. White Ceramics Shop," 1960

Wygle, Robert Howard (1896-1961) (Santa Maria)
Painter. Exh. still life and landscape paintings at Minerva Club Art and Hobby Show, 1958. Organist. His wife competed in flower arrangement contests. The Wygle family were Japanese prisoners during WWII.
1961 – "Obituaries…," *SMT*, April 24, 1961, p. 2; "Santa Maria Fuchsia Society Sponsors Hobby Night Show… Elks Recreation Hall… oil paintings by Robert H. Wygle were shown by Mrs. Wygle…," *SMT*, July 3, 1961, p. 3.
Wygle, Robert (misc. bibliography)
Robert Howard Wygle was b. Aug. 15, 1896 in Clarksville, Ia., to Robert Isaiah Wygle and Luella Maria Mather, married Margaret Swartz Wygle, and d. April 20, 1961 in Santa Barbara per Wygle Family Tree (refs. ancestry.com).
See: "Hobby Night," 1961, "Minerva Club, Art and Hobby Show," 1958

Y

Yager, Thomas "Tommy" (1922-2005) (Lompoc)
Photographer who worked for (1947-54) and was later prop. of (1954-89) the Camera Shop. Author of "Camera Tips" in the Lompoc Record, 1954. Many of his photos were reproduced in the Lompoc Record, 1950s and other years.
■ "Tommy Yager… Tommy was born in St. Joseph, Mo., on Nov. 7, 1922 to Louis and Iowa Lamb Yager. He served with the U. S. Army during World War II and was stationed for a time at Camp Cooke in 1945. He settled in Lompoc in 1947, moving here from St. Joseph, Mo. His love of photography led him to begin working with **Ernie Brooks** at his camera shop. Tommy was a member of the first graduating class of **Brooks Institute** and assumed ownership [of the **Camera Shop**] 1955. Besides photography, Tommy also enjoyed hunting and fishing. He was a member of Lompoc Elks Lodge 2274. He died … Nov. 9, 2005 at the Convalescent Care Center. Survivors include his wife of 27 years, Irene…," *LR*, Nov. 13, 2005, p. 3.

Yager, Thomas (notices in Northern Santa Barbara County newspapers on microfilm and on newspapers.com)
1947 – "Announcing the Association of Mr. Thomas Yager (Graduate of **Brooks Institute** of Photography) as Portrait Photographer, **Camera Shop** and Sporting Goods, 106 East Ocean Avenue," *LR*, Jan. 16, 1947, p. 4; "Former 20th Division Soldier Moves to Lompoc. Mr. and Mrs. Thomas Yager are now… residing at 115 South E street. Yager was formerly with the 20th Armored Division which was stationed at Camp Cooke and lived heretofore in St. Joseph, Mo. He is now associated with the **Camera Shop** as photographer," *LR*, Jan. 16, 1947, p. 5.
1954 – Repro: "Fashion's Pet," *LR*, March 25, 1954, p. 5.
1955 – "Fish Rodeo Committee… Third Annual Fishing rodeo… for boys and girls is being arranged by the City Recreation department… committee chairmen …Tommy Yager, photography…," *LR*, July 14, 1955, p. 3; "Great Lakes Carbon Corp… R. L. Douglas, Advertising Manager of the Los Angeles office. Mr. Douglas f.rnished much of the technical information used in today's special edition of the *Record*. Some of the photographs used in this issue were taken by Tommy Yager of Lompoc and some were furnished by Mr. Douglas," *LR*, July 21, 1955, p. 24.
1956 – Repro: "Well, Say Now!," *LR*, Sept. 6, 1956, p. 5.
1960 – Repro: "Mr. and Mrs. John Marcus Coughran, Jr.," *LR*, Feb. 11, 1960, p. 6; "Thoughts While Shaving. Lots of photographers grateful to Tom Yager last Friday night. It seems the local photog possesses an electrical hand warmer. Hanging on to that chrome of the camera on a cold night can be mighty uncomfortable…," *LR*, Oct. 20, 1960, p. 6.
And, many photos by him were reproduced in the *LR* in the 1950s and an article, "Mobile CB Units Foster Friendship," *LR*, Sept. 2, 1976, p. 1, reveal he was a Citizen's Band radio ham, but they were not itemized here.
Yager, Thomas (misc. bibliography)
Thomas F. Yager, b. Nov. 7, 1922 and d. Nov. 9, 2005 is buried in Lompoc Evergreen Cemetery per findagrave.com (refs. ancestry.com).
See: "Benhart, Fred," intro., "Brooks, Barbara," "Camera Shop," "Camera Tips," "Flower Festival / Show," 1955, "Forward, Moselle," 1955, "Grady, Elmer," intro., "La Purisima Camera Club," 1947, "Lewis, Marion," intro., "United Service Organization," 1945, "Wygal, Elsa," intro.

YMCA, Fun Club (Santa Maria)
See: "Young Men's Christian Association Fun Club"

York, Richard Lyle (1940-1994) (Santa Maria)
Santa Maria High School art major and grad., 1958. Exh. in amateur art show at Allan Hancock [College] Art Gallery, 1956, 1957. Photographer of his "UN" trip who, on his return, used the photos to illustrate lectures to local groups. Exh. Santa Barbara County Fair, 1959. Student at California School of Fine Arts, SF, 1960. [ed. Probably the clergyman of the Berkeley Free Church who was involved in the Berkeley riots of 1969 re: the planned development of People's Park.]
■ "Richard York to Hold Summer Show and Sale. On Sept. 3, 4 and 5, Richard L. York, son of Mr. and Mrs. C.

P. York, will hold a summer show and sale of his art work. The show will include oil paintings, water colors, drawings, lithographs, woodcuts and collages … The show will be held at his home, 1107 So. Broadway… York was a graduate of SMHS in 1958 and is now attending California School of Fine Arts in San Francisco. He will return to San Francisco for the fall semester on Sept. 9. He was the winner of the first purchase prize in the professional oil painting division of the Santa Barbara County fair this year. York plans on teaching art after completing his education," *SMT*, Sept. 3, 1960, p. 3.

York, Richard (notices in Northern Santa Barbara County newspapers on microfilm and on newspapers.com)
1956 – "UN Trip was Great Says Richard York," *SMT*, July 10, 1956, p. 4.
1957 – Port. and "Richard York Present at Freedom Forum … Among the 150 conferees attending Harding College's Freedom Forum XVIII is a 17-year-old high school junior from Santa Maria. Richard Lyle York… represents the strain of American youth who today pose the important question, 'Have I arrived too late to enjoy the American heritage.' The Santa Maria junior won an all-expense paid air-trip to the forum after writing a winning essay, 'My American Heritage,' based upon content of the 'American Adventure Series' of 13 TV films produced by the National Education Program. Capt. Allan Hancock, owner of Santa Maria Valley railroad, bought the series and telecast it over local television station KEYT. Hancock, who has sent representatives to previous Freedom Forums, then sponsored a three-county contest among high school students based upon the series… York is an art major in high school, but has long maintained a deep interest in the American way of life. 'My essay is actually a condensed synopsis of the 'American Adventure Series,' the youth confessed, 'but in arranging and organizing the ideas in my mind I discovered the true meaning and value of my American heritage.' The California youth attends all the forums with his fellow conferees and takes a camera along to record his experiences. 'I'll be expected to speak a dozen times once I get back to California, and, with the camera I hope to get some good shots for color slides,' he said. During this week York has rubbed shoulders with industrialists and educators from all over the United States who have come to the forum to learn of the threats to the American free enterprise system and what they can do to combat these threats…" *SMT,* April 22, 1957, p. 7.
1960 – "Young Artists Planning Show Here Thursday… work of students of Richard L. York, will be held Thursday from 7:30 to 9:30 p.m. at the First Methodist Church, Broadway and Cook Street. The students range from 9 to 12 years of age. They have been attending classes two mornings a week during the summer. The students will comment on their own work by tape recordings… York, a Santa Maria resident, was winner of the first purchase prize in the oil painting division of this year's Santa Barbara County Fair. He is having a show and sale of his own work on Sept. 3-4-5 at his home 1107 S. Broadway," *SMT*, Aug. 24, 1960, p. 5.
1961 – "Bride Shower… Joy Nesmith… Mr. and Mrs. York were married in San Francisco in January. He is continuing studies at the San Francisco Art Institute,

formerly California School of Fine Arts," *SMT*, April 27, 1961, p. 4.
York, Richard (misc. bibliography)
Richard Lyle York was b. March 16, 1940 in Los Angeles to Clifford Park York and Florence Anna Zellers, married Joy Elaine Nesmith, and d. Dec. 26, 1994 in Alameda County per Rosemary Leaves Family Tree (refs. ancestry.com).
See: "Exh. Allan Hancock [College] Art Gallery," 1956, 1957, "San Luis Obispo County Art Show (San Luis Obispo)," 1957, "Santa Barbara County Fair," 1959, 1960, "Santa Maria, Ca., Union High School," 1958, and *San Luis Obispo Art and Photography before 1960*

Yost, Woody (Paso Robles)
Artist who had a one-man show at the Allan Hancock College Art Gallery, 1958.
See: "Allan Hancock College, Art Gallery," 1958, "Tri-County Art Exhibit," 1959, and *Atascadero Art and Photography before 1960*

Young, Carl Vinton, Sr. (1898/1900/1901-1980) (La Purisima)
Painter. U. S. Treasury Dept.-paid artist assigned to Co. 2519, Civilian Conservation Corps, 1935, 1936, where he taught art and painted "before and after" pictures of missions as well as murals in the CCC recreation hall. Art instructor at San Bernardino Valley Junior College, 1944+.
■ "Carl Young, Yucaipa. Carl V. Young Sr., 79, a 14-year resident of Yucaipa, died Wednesday in San Bernardino. He was born in Bakersfield and was a retired Lancaster Unified School District teacher. He was a member of AARP of Yucaipa and was an Army veteran of World War II. He had worked with the DASH program at the Jerry L. Pettis Memorial Veterans Hospital…," *San Bernardino County Sun*, Jan. 27, 1980, p. 32.
Young, Carl (notices in Northern Santa Barbara County newspapers on microfilm and on newspapers.com)
1935 – "Artist at Mission. Oil paintings of La Purisima mission as it stood before restoration work began and as it now is are to be exhibited in the *Record* window this weekend. Carl Vinton Young, artist commissioned by the United States Treasury department to paint scenes at La Purisima and other nearby state parks, has sent a number of canvases to Washington, D. C., since beginning work here early this year. A view of the north buttresses and the tumbling columns of the mission, one of the main buildings as it is being constructed, and local landscapes are among the recently completed paintings by Young, which will be displayed before they are sent to the national capital. They are to be hung in various public buildings," *LR*, Sept. 6, 1935, p. 1.
1936 – "Giggles and Gasp. Three local CCC boys: Young, official artist, and … broke into Lompoc society last Sunday night via the Methodist church …," *LR*, Jan. 31, 1936, p. 7, col. 5; "Enrollee Carl Young, talented artist attached to Purisima is spending the week in San Francisco on leave. He is expected to return Saturday, after which he will be transferred to the Model CCC Camp at the

California International Exposition at San Diego where he will do modeling. He will be greatly missed from this camp where he has completed a set of murals in the recreation hall and served as instructor in various art classes," *LR*, May 29, 1936, p. 7, col. 6.

1944 – "College Staff… Art will be taught this year at the college by Carl V. Young, who joins the faculty after graduate work for the past year at the University of California at Los Angeles. Mr. Young has also studied drawing, painting and sculpturing at the Chouinard School of Art and at the Academie de la Grande Chaumiere in Paris," *San Bernardino County Sun*, Sept. 22, 1944, p. 7.

1945 – "Junior College Ceramic Exhibit… at the library gallery of the San Bernardino Valley Junior college… Carl Vinton Young, instructor in art at the San Bernardino Valley Junior college, will exhibit some of his work in ceramics and sculpture…," *San Bernardino County Sun*, April 15, 1945, p. 10.

1946 – "Artists will Present Exhibit at JC Tuesday… [i.e., a print show circulated by Associated American Artists] … Carl Vinton Young… made arrangements for the show… while in New York last summer. Mr. Young will speak on 'A Century in Photography.' … The after-lecture discussion will be on the question, 'Is Photography Art?'," *San Bernardino County Sun*, Jan. 6, 1946, p. 11.

1947 – "Carl Young Named… Carl V. Young, chairman of the art department at the San Bernardino Valley college, has been elected president of the San Bernardino Art association," *San Bernardino County Sun*, June 7, 1947, p. 6; And, many additional notices on him in San Bernardino County newspapers not itemized here.

Young, Carl (misc. bibliography)
Carl Vinton Young, b. Dec. 1, 1898, and wife Lenore (2 years older than him), of San Francisco, sailed from Bremen, Germany, on Sept. 19, 1929 on the *S. S. München* arriving at New York on Sept. 29, 1929 per NY Passenger and Crew Lists; Carl Vinton Young's WWII Draft Card states he was born Dec. 1900 in Bakersfield, that he was working for Vega Aircraft Corp. in Burbank, Ca., that he was married to Lenore, and a penciled note at the top states that on 4/12/45 he was at San Bernardino Jr. College; Carl Vinton Young was b. Dec. 1, 1901 in Calif. to Charles Elmer Young and Etta Lavena Steele, and d. Jan. 23, 1980 in San Bernardino, Ca., per Genealogy Family Tree (refs. ancestry.com).
See: "Alpha Club," 1936, "Civilian Conservation Corps," 1935, 1936

Young, George Demming (1889-1972) (Santa Maria)
Drawing and manual training teacher at Santa Maria Union High School, 1912/16. Baritone. Active in church. In retirement turned to painting landscapes.

■ "Memorial for George D. Young… longtime Oakland schoolteacher and, in retirement, an artist… died after a lengthy illness. A homesteader in the Oakland Hills in 1913, he taught high school woodshop classes in Oakland for 32 years and pioneered in vocational education for exceptional boys. After he retired, Mr. Young studied painting and was a member of the Santa Cruz and Carmel Art Leagues. His work has been honored by both organizations…," *SF Examiner*, Aug. 18, 1972, p. 59;

"George D. Young Dies in Hospital… He was on the board of the Santa Cruz Art League and was named Artist of the year in 1967…," *Santa Cruz Sentinel*, Aug. 13, 1972, p. 34; "George D. Young Rite Tomorrow. Santa Cruz… After retiring from teaching, he worked for *The Tribune* for five years as a paper route manager. He also studied painting, becoming a landscape and seascape artist, and was an honored member of the Carmel and Santa Cruz Art leagues …," *Oakland Tribune*, Aug. 18, 1972, p. 28F.

Young, George (notices in Northern Santa Barbara County newspapers on microfilm and on newspapers.com)
1913 – "Will be Married in June… The engagement of Miss Olivia Rudolph and George D. Young… Miss Rudolph is a member of the Congregational church choir … Mr. Young is a baritone singer who has sung in several quartettes and church choirs in the bay cities and is a former Alameda businessman. He is now instructor in manual training and drawing in the Santa Maria High School – *San Francisco Chronicle*," *LR*, Jan. 10, 1913, p. 6; "Geo. D. Young, the Manual Training and Drawing teacher of the high school is still confined to his bed," *SMT*, April 26, 1913, p. 5; "George D. Young … left Tuesday for the Mojave Desert, where he will have improvements made on his government claim of 320 acres," *SMT*, June 7, 1913, p. 7; "High School Teacher Married. George D. Young, the drawing and manual training teacher in our high school was married Wednesday, June 25th in the first Congregational Church in Alameda, to Miss Olivia Rudolph of that city. They expect to visit the Yosemite Valley and other interesting points in Southern California before returning here to Santa Maria where they will reside," *SMT*, June 28, 1913, p. 1.

1963 – Port. of George and Olivia Young standing near various of his paintings and "Prize-Winning Poet and Her Artist Husband Wed 50 Years… Young, who taught advanced shop courses in Santa Rosa and Oakland high schools for 32 years, began painting just five years ago under the tutelage of the late Abel Warshawsky of Monterey. Now he's studying with Marshall Merritt and starting to teach pupils of his own. His paintings have been exhibited locally as well as [at] the Little Picture gallery in Carmel, Gamble's in Monterey, Placer college in Auburn, the Sacramento Art fair and the DeSaisset gallery at University of Santa Clara. After his retirement he and his wife lived in Auburn and in Pacific Grove and Carmel, moving to Santa Cruz last fall," *Santa Cruz Sentinel*, June 23, 1963, p. 22.

And, many additional notices on his art in the *Santa Cruz Sentinel* were not itemized here.

Young, George (misc. bibliography)
George Demming Young b. Oct. 7, 1889 in Alameda to James Henry Young and Elizabeth Sarah Neal, married Olivia Rudolph, and d. Aug. 1972 in Santa Cruz, Ca., per Veliquette Family Tree (refs. ancestry.com).
See: "Santa Maria, Ca., Union High School," 1912, 1913, 1916

Young Men's Christian Association / Young Women's Christian Association (YMCA / YWCA)
Sponsor of craft classes at the Fun Club and at Camp Ocean Pines in Cambria.

■ "... founded on 6 June 1844 by Sir George Williams in London, originally as the Young Men's Christian Association, and aims to put Christian principles into practice by developing a healthy 'body, mind, and spirit'. From its inception, it grew rapidly and ultimately became a worldwide movement ...," Wikipedia.

Young Men's Christian Association (notices in Northern Santa Barbara County newspapers on microfilm and on newspapers.com)
1948 – "'Y' Boys Camp Opening June 19… Camp Ocean Pines … June 19 to June 26… Cambria… Girls' camp will be held June 16 to July 3… The staff includes Marjorie P. King, Morro Bay, craft instructor…," *SYVN*, May 21, 1948, p. 3.
1950 – "Girls' 'Y' Camp Opens Session… Bob Weatherill of Paso Robles instructs handicraft…," *SMT*, June 21, 1950, p. 3.
See: "Fun Club," "United Service Organization," intro., and see "Camp Ocean Pines" in *Cambria Art and Photography before 1960*

Young Women's Christian Association (Northern Santa Barbara County)
See: "Young Men's Christian Association"

Your Home of the Week (Lompoc)
Weekly feature article appearing in Lompoc Record launched Sept. 13, 1951.

■ "'Home of Week' Series Launched in Today's *Record*. A new feature, 'Your Home of the Week' … consists of a series of floor plans and front elevations of new homes and is being published to promote interest in home construction in Lompoc. The plans and architectural drawings are by **Guy Koepp**, Los Angeles architect," *LR*, Sept. 13, 1951, p. 1; And, additional articles ran in the *LR* on Oct. 4, 1951, Oct. 18, 1951, and possibly additional days.

Youry, Marguerite Henrietta Schultz (Mrs. Leon Ward Youry) (1913-2001) (Santa Maria)
Weaver. Demonstrated weaving as part of "Art in Action" at the Santa Maria Valley Art Festival, 1952. Wife of L. Ward Youry, below. Member of Faculty Wives Club, 1951.
Marguerite H. Youry was b. 1913 in Owosso, Mi., d. Dec. 11, 2001, and is buried in Forest Lawn Memorial Park, Cypress, Ca., per findagrave.com (ref. ancestry.com).
See: "Santa Barbara County Fair," 1952, "Santa Maria [Valley] Art Festival," 1952, "Youry, L. Ward"

Youry, (Leon) Ward (1916-1994) (Santa Maria)
Ceramicist. Teacher at Santa Maria High School / JC, 1950-52. Exh. ceramics at Santa Barbara County Fair, 1952. Art teacher at Long Beach State College, c. 1953+. Husband of Marguerite Youry, above.

■ Port. at potter's wheel, and "Ward Youry, assistant professor of fine arts at Long Beach State College and instructor in ceramics, will demonstrate 'throwing' techniques on the potter's wheel at the Long Beach Art Association meeting at 8 p.m. Tuesday in the Art Center… Youry has exhibited in the Art Center here and at the Los Angeles County fair. For the past two years he has been invited to exhibit at the annual ceramics show at Scripps College at Claremont, and he has exhibited at the annual spring exhibition in the Rotunda Gallery at the City of Paris in San Francisco. In 1950 he won a first prize at the state fair in Sacramento," *Independent Press-Telegram* (Long Beach, Ca.), Oct. 18, 1953, p. 156 (i.e., Southland Magazine, p. 6?).

Youry, Ward (notices in California newspapers on microfilm and on newspapers.com)
1950 – "J C Instructor Gets $100 Ceramics Prize" at Calif. State Fair, Sacramento, "Youry, who joined junior college at the opening of the present semester, received his Master of Fine Arts degree from Claremont college graduate school last June," *SMT*, Sept. 21, 1950, p. 12.
1951 – "S. M. Artists Work Shown at Scripps" in first all-alumni art exhibit, 65 young professional artists, holders of the degree of master of fine arts from Claremont Graduate school, at Florence Rand Lang art gallery, *SMT*, Oct. 23, 1951, p. 4.
1952 – "Speaks to AAUW Art Group" on "Line as a Basic Element of Design" at **DeNejer** home, *SMT*, Feb. 12, 1952, p. 4; "Youry to Exhibit at Scripps Show," i.e., in group show titled "California Ceramics for Contemporary Living," the ninth annual invitational ceramics exhibit, *SMT*, March 8, 1952, p. 8; **Beta Sigma Phi** "Sorority Hears Program on Art," at home of Mrs. Virginia Young, *SMT*, May 10, 1952, p. 4.
And, more than 100 additional notices on "Ward Youry," primarily about his teaching and his ceramics appear in Los Angeles area newspapers between c. 1953 and c. 1979, but were not itemized here.

Youry, Ward (misc. bibliography)
Port. of Ward Youry appears in Santa Maria High School yearbook, 1951, 1952; L. Ward Youry, prof. Long Beach State College is listed with wife, Marguerite H., teacher at Helen Keller Elementary School in the *Long Beach, Ca., CD*, 1955, 1963, 1965, 1969; Leon Ward Youry was b. Aug. 6, 1916 in Brekenridge, Mi., to Frank John Youry and Eula Aravine Harris, married Marguerite Henrietta Schultz, and d. March 13, 1994 in Long Beach per Youry Family Tree (refs. ancestry.com).
See: "Minerva Club," 1952, "Posters, general (Santa Maria)," 1951, "Santa Barbara County Fair," 1952, "Santa Barbara County Library (Santa Maria)," 1950, 1951, "Santa Maria, Ca., Adult/Night School," 1951, "Santa Maria, Ca., Union High School," 1951, 1952, "Santa Maria [Valley] Art Festival," 1952, "Youry, Marguerite"

Youtz, Roland Garvin (1930-2008) (Santa Maria)
Photographer. Member Santa Maria Camera Club,
1946+. Student at Brooks School of Photography, 1950.
Photographer for the Santa Maria High School edition of
the Santa Maria Times, 1950.

■ "Caroline Fickle Becomes Bride of Roland [Garvin]
Youtz… Following their honeymoon, they will make their
home in Santa Barbara where the bridegroom is a student in
Brooks School of Photography and where Mrs. Youtz
plans to continue her education in Santa Barbara high
school," *SMT*, Nov. 6, 1950, p. 4.
Youtz, Roland (notices in Northern Santa Barbara County
newspapers on microfilm and on newspapers.com)
1949 – Repro: "Having Fun at 91," *SMT*, Dec. 10, 1949, p.
6.
1950 – "Roland Youtz, younger son of the Rev. and Mrs.
Roy O. Youtz, is at home for a week's vacation after
completing the first quarter of a course of study at **Brooks
school** of photography in Santa Barbara. He will return
south Monday to resume classes in the sixteen-week
course," *SMT*, Aug. 23, 1950, p. 4.
1951 – "Mr. and Mrs. Roland Youtz have returned south
after a recent visit… He is presently stationed at Camp
Pendleton and is listed for overseas duty after a six-week
training period," *SMT*, Sept. 5, 1951, p. 4.
1952 – 'Round Town. Pfc. Roland Youtz has received his
discharge from the Marine Corps and with his wife and
their four-month-old daughter, Ann, plans to reside here.
During his term of duty he has been stationed at Camp
Pendleton and in North Carolina…," *SMT*, Sept. 23, 1952,
p. 6.
1953 – Repro: "County Officials Enjoy Barbecue," *LR*,
May 21, 1953, p. 4.
1964 – "Youtz Named Robinayre Head… principal of the
Robinayre Junior Academy, a private school for boys in
Thousand Oaks. Before his appointment he was a fourth-
grade teacher for four years in the Pleasant Valley School
District, Camarillo. Youtz graduated from Ventura College
and attended University of California at Santa Barbara,
Brooks Institute of Photography and the California
Lutheran College," *Ventura County Star-Free Press*, June
17, 1964, p. 4.
And, numerous additional notices on his photography in
local newspapers c. 1948-52 were not itemized here.
Youtz, Roland (misc. bibliography)
Roland Youtz is pictured in the Santa Maria High School
yearbook, 1948, 1949; Roland Garvin Youtz was b. Nov. 6,
1930 in Los Angeles to Roy Orville Youtz and Lenell E.
Garvin, married Sandra Lorraine Schulz, and d. Sept. 8,
2008 in Twain Harte, Ca., per Omer/Steer/Callahan/Calvert
Family Tree (refs. ancestry.com).
See: "Santa Maria Camera Club," 1946, 1947, 1948, "Santa
Maria, Ca., Union High School," 1950

Z

**Zachman, Harold LeRoy, M/Sgt. (1913-1992) (Camp
Cooke)**
Artist. Exh. water colors at the USO, 1944.

■ Zachman "… attended Youngs Art School in Chicago
where he was production manager with Tempo Studio. He
studied at the Chicago Academy of Arts and was later
employed as a commercial artist. He retired as an art buyer
for the Leo Burnett Advertising Agency in Chicago. Upon
retirement, Harold and Clara moved to Appleton, WI,"
from Public Member Stories for Harold LeRoy Zachman,
b. Oct. 17, 1913 and d. Oct. 30, 1992 (ref. ancestry.com).
Zachman, Harold (misc. bibliography)
Harold Zachman is listed in the 1940 U. S. Census as age
26, b. c. 1914 in Ohio, finished second year of college, an
artist with his own studio, residing in Chicago (1935, 1940)
with his brother Arthur Zachman and Arthur's wife and son
(ref. ancestry.com).
See: "United Service Organization," 1944

**Zendejas, Rene Gerardo / Gary (1927-2014) (Burbank /
Orange County)**
Puppeteer who performed at the Santa Barbara County
Fair, 1960. Performed on many TV shows.
Zendejas, Rene (notices in Northern Santa Barbara County
newspapers on microfilm and on newspapers.com)
1960 – Photo and "Top Name Talent Scheduled [at County
Fair] … **Rene** is a superb puppet-master whose puppets
give unique and startling life like impressions of tap
dancers, pianists, tight rope walkers and opera singers …
he has been featured at the Mapes Hotel in Reno where he
has returned to play many repeat engagements," *SMT*, July
14, 1960, p. 6; "Puppeteer Features. Rene Zendajas [Sic.
Zendejas] …," *SMT*, July 20, 1960, p. 40.
And, more than 30 hits for "Rene Zendejas" in California
newspapers on newspapers.com were not itemized here.
Rene Gerardo Zendejas was b. Sept. 24, 1927 in San
Salvador, El Salvador, and d. Oct. 8, 2014 in Burbank, Ca.,
per *U. S. Obituary Collection* (ref. ancestry.com).

Ziegler, Leo (1879-1961) (Santa Ynez Valley)
[Name was often misspelled by the newspapers as Zeigler.]
Artist. Collector. Conducted private adult landscape
painting classes at Santa Ynez, 1941+. Art instructor at
the Santa Ynez Valley Union High school, 1944+.
Conducted Adult School classes in art, 1946-57. Taught
at Santa Ynez Elementary 1947+ and at Valley Farm
School, c. 1951+. Exh. Santa Ynez Valley Art Exhibit,
1954, 1956, 1957.

■ "Graveside Services… Santa Ynez Valley artist… Oak
Hill Cemetery, Ballard… Mr. Ziegler died suddenly at 7
a.m. last Friday at his ranch home on Refugio Road… He
was born April 15, 1879 in Vienna, Austria, grew up in
Vienna and attended its schools. He was a graduate of the
University of Vienna where he received degrees in law and
philosophy. He also attended the Vienna Academy of Fine
Arts and studied art under Vienna's famed masters. Mr.

Ziegler fought with the Austrian Army during World War I. He practiced law in Vienna for 30 years and at the same time continued his art as a hobby. He and Mrs. Ziegler were married April 6, 1918 in Vienna. Mr. and Mrs. Ziegler came to the United States and to Chicago in 1938. Two years later they moved to the Santa Ynez Valley where they purchased their 10-acre ranch, Sunny Hill, on Refugio Road. Both Mr. and Mrs. Ziegler pioneered in developing the property into a walnut ranch. After coming to the Valley, Mr. Ziegler turned to art as full-time vocation. He began conducting classes for both children and adults and gave instruction in all the of the Valley's public and private schools, including the Los Alamos Elementary School. Mr. Ziegler had been a member of the faculty of the Santa Ynez Valley Union High School the past 17 years and had the distinction of being the oldest teacher in terms of age and length of service. Widely known as an artist throughout Santa Barbara County, his work was exhibited regularly at Valley art shows as well as in Santa Barbara. Mr. Ziegler was a linguist and for a time taught German language classes under the high school adult education program…," *SYVN*, March 24, 1961, p. 8.

Ziegler, Leo (notices in Northern Santa Barbara County newspapers on microfilm and on newspapers.com)

1941 – "Those who enjoyed the hospitality of Mr. and Mrs. Leo Ziegler at their ranch home Wednesday afternoon were …. The Zieglers, who recently came to the Valley, lived at the Wulff apartments until their new home was built. They own ten acres north of the high school. Walnut trees have been planted … and a fine home has been made out of the old house on the place. The Zieglers have many old and interesting vases as well as antique furniture. They also have a real art gallery with a collection of lovely paintings," *SYVN*, June 6, 1941, p. 1, col. 1; "Artist to Teach Landscaping [i.e., landscape painting]. Some people interested in drawing and painting may be pleased to hear that Mr. Leo Ziegler, artist of the modern school, who received his art training in Vienna by the famous Danish master, Prof. C. Robin Andersen, by Prof. Josef Dobrowsky and Prof. Franz Windhager, opens a private class in landscaping. A personal inspiring instruction for beginners as well as for advanced people will be given at the studio of Mr. Ziegler and there out of doors in the middle of this beautiful valley. The opening of a class makes it possible to moderate the rates. The studio is located on Grand Avenue, just half a mile north of the Santa Ynez Valley High School, second house at left…," *SYVN*, June 6, 1941, p. 4; "Art. Drawing and Painting. Landscaping out of doors. Personal Inspiring Instruction of Beginners and Advanced Students by Leo Ziegler. Grand Ave., half mile North of the Santa Ynez Valley High School at left, 'Sunny Hill,' Phone 3768, where all information is obtainable," *SYVN*, Aug. 22, 1941, p. 1.

1946 –FATHER – "Marcus Ziegler Honored on Eightieth Birthday," *SYVN*, Sept. 20, 1946, p. 5.

1947 – "… Valley Lions Club… Leo Zeigler [Sic. Ziegler], Valley artist, was given an expression of thanks for the art work he did on the book accompanying the Lions Traveling Cup. The club also expressed thanks to **Grace L. Davison** for her contributions to the book," *SYVN*, March 14, 1947, p. 8; "School Safety Sign… silhouette type… The painting of the sign was done by Leo Ziegler," *SYVN*, May 16,

1947, p. 1; "Artist Offers Landscape Course… Leo Ziegler, artist and art instructor at the Santa Ynez Valley Union High school who has conducted adult landscape painting classes at Santa Ynez, plans to offer a private out-of-door adult landscape course in Santa Maria, if a sufficient number of persons are interested. The course, to be held in sessions once each week, will be open both to beginners and advanced students," per "Artist Offers Landscape Course," *SMT*, Oct. 24, 1947, p. 3; ad for classes, *SMT*, Nov. 13, 1947, p. 7, col. 2.

1949 – "Personals… Mr. and Mrs. Frank Nordhoff had as guests at a fireside tea on Sunday afternoon, Mr. and Mrs. Leo Ziegler…," *SYVN*, Oct. 28, 1949, p. 5.

1950 – "Solvang Mothers Meeting… at the Veterans Memorial Building… with Leo Ziegler, artist, speaking on art education for grammar school children…," *SYVN*, March 17, 1950, p. 5.

1951 – "Solvang Mother's to Hear Ziegler… An exhibition of art work of the students of Leo Ziegler, Santa Ynez Valley Union High School art instructor, will be the highlight of a meeting this afternoon of the Solvang Mother's Club. Mr. Ziegler will present the work of his students and will describe each painting…," *SYVN*, May 18, 1951, p. 1; "**Sandviks** Hosts at Goethe Supper… Present were Mr. and Mrs. Leo Ziegler… During the evening Mr. Ziegler gave a talk on Goethe's philosophy…," *SYVN*, Aug. 31, 1951, p. 8.

1952 – "**Girl Scouts** Pay Teacher Surprise Visit at Home. Los Alamos Girl Scouts… visit to their art teacher, Leo Ziegler… The girls presented Mr. Ziegler with a box of candy and a five-dollar credit slip from an artists' supply store …," *SMT*, April 26, 1952, p. 4; "The other day at school, Dixie Hall, eight-year-old daughter of the Harwood Halls, was painting in Mr. Ziegler's art class. She was drawing a beautiful picture of a bride. 'But where is her husband?' Mr. Ziegler asked Dixie. 'Oh, you see, they are on their honeymoon,' Dixie said, 'and he's gone off fishing'," *SYVN*, Nov. 7, 1952, p. 2; "L.A. Visitor… Mrs. Helen Leinkauf of Los Angeles as a house guest over Christmas…," *SYVN*, Dec. 26, 1952, p. 4.

1953 – Photo of Leo Ziegler at his easel by **Hans Sorensen**, *SYVN*, Feb. 6, 1953, p. 1.

1954 – Photo of Ziegler at his easel, *SYVN*, Jan. 1, 1954, p. 6.

1958 – Fall - one-line notices explain Ziegler continues to teach art at Valley School and at Santa Ynez Valley Union High School, but citations were not listed here.

1960 – "Leo Ziegler Announces Plans to Instruct Course in German. Leo Ziegler, art instructor at Santa Ynez Valley Union High School… offering a private course in his native language of German. Ziegler said 'more and more people are traveling to Germany, Austria and Switzerland… Many… may want guidance in correct pronunciation… understanding, speaking and reading simple German. Correct language and pronunciation will be practiced in the course through simple conversation… open to adults and high school students…," *SYVN*, April 1, 1960, p. 8; "German Class Meets Monday. Beginning next Monday night, a German language class will meet every Monday night at 7:30 in room 8 at the Santa Ynez Valley High School, Leo Ziegler, instructor announced today. The class

organized last Monday night with 20 members," *SYVN*, April 22, 1960, p. 5.

1961 – "Leo Ziegler Memorial Art Fund Founded… [Santa Ynez Valley Union High School] … Proceeds… will be used for an art department scholarship or for the purchase of extra-curricular materials for the school's art department…," *SYVN*, April 7, 1961, p. 1.
And, many additional newspaper notices not itemized here.
Ziegler, Leo (misc. bibliography)
Leo Ziegler is pictured in the Santa Ynez Valley Union High School yearbook, 1954; Leo Ziegler, mother's maiden name Beran, was b. April 15, 1879 and d. March 17, 1961 in Santa Barbara County per Calif. Death Index (refs. ancestry.com).
See: "Alpha Club," 1946, "Art, general (Solvang)," 1946, "Ballard School," 1951, "Danish Days," 1957, "La Petite Galerie," 1950, "Posters, general (Santa Ynez Valley)," 1958, "Presbyterian Church," 1944, 1945, "Sandvik, Uno," 1949, "Santa Barbara County Library (Santa Maria)," 1948, "Santa Ynez Valley Art Exhibit," 1952-54, 1956-58, "Santa Ynez Valley, Ca., Adult/Night School," 1946-57, "Santa Ynez Valley, Ca., Elementary/Grammar Schools," 1947-50, "Santa Ynez Valley Union High School," 1944-59, 1961, "Scholastic Art Exhibit," 1947-56, "Solvang Woman's Club," 1948, "Sorensen, Hans," 1953, "Valley Farm School," intro., 1953, 1954, 1959

Ziesche, Walter (1887-1989) (Lompoc)
Watchmaker & Jeweler, 1921. Purveyor of art goods. Photographer who took colored slides, 1954.

■ Port. and "Ziesche still keeps tabs on Lompoc… left Germany in 1914 to avoid military service under Kaiser Wilhelm… On Jan. 5, 1989, Ziesche celebrates his 102nd birthday… Ziesche brought his skills as a watchmaker to Los Angeles. After two years… Ziesche was offered a job in Lompoc… [arriving 1916] …expanded his watchmaking business into a jewelry store and built quite a reputation before retiring in 1950," *LR*, Jan. 4, 1989, p. 6.
Ziesche, Walter (notices in Northern Santa Barbara County newspapers on microfilm and on newspapers.com)
1921 – "I am showing an assortment of Copenhagen Art Fayence the most exclusive Art Pottery in the world. Each piece is decorated by hand in exquisite color embracing almost the scale of the artist's pallet… The coloring is preserved indefinitely by a splendid lustrous glaze," *LR*, July 22, 1921, p. 1.
1954 – "Pre-Veterans' Day Celebration… American Legion… An interesting program of entertainment was provided by Mr. Walter Ziesche who showed a series of beautiful colored slides taken last year when he and his wife visited Italy, Germany, France and Belgium," *LR*, Nov. 11, 1954, p. 5.
More than 700 notices on "Walter Ziesche" appear in local newspapers but were not even browsed for inclusion here.

Zimmer, Sandy / Sandi (Lompoc)
Assistant to art editor for Lompoc High School yearbook, 1960. Voted "most artistic girl" at the high school, 1961. Attended Western State College, Colo., 1963.
See: "Lompoc, Ca., Union High School," 1960

Zornes, J. Milford (Nipomo)
Watercolorist who studied at Santa Maria Junior College. Exh. Allan Hancock [College] Art Gallery, 1956.
See: "Allan Hancock [College] Art Gallery," 1956, 1957, "Breneiser, Stanley," 1951, 1953, "Minerva Club," 1950, "Muro, George," 1957, "Public Works of Art Project (PWAP)," 1934, "Purkiss, Myrton," "Santa Barbara County Fair," 1957, "Santa Maria [Valley] Art Festival" 1952, "Splash," 1928, "Tri-County Art Exhibit," 1950, and *San Luis Obispo and Photography before 1960* and *Arroyo Grande (and Environs) Art and Photography before 1960*

Zwall, Jerry
Traveling evangelistic chalk talk artist who appeared in Buellton, 1957, 1959.
See: "Chalk Talks," 1957, 1959

SOURCES BROWSED or SEARCHED DIGITALLY
for this publication

ANCESTRY.COM
Digitally searched pertinent genealogical records: Vital statistics, Census records, City Directories, etc.

CAMP COOKE CLARION
Browsed – 1942-1946 (microfilm at Lompoc Library)
Browsed – 1950s – (scattered issues available in hard copy at Lompoc Valley Historical Society)

***LOMPOC RECORD*, Lompoc, Ca.**
Browsed and searched digitally – 1875-1960 (on newspapers.com)

GENEALOGYBANK.COM
Digitally searched San Luis Opispo County as well as Californian and American newspapers.

NEWSPAPERS.COM
Browsed and digitally Searched pertinent Santa Barbara County newspapers including the *Lompoc Record*, the *Santa Maria Times*, and the *Santa Ynez Valley News*. Occasionally searched newspapers published outside Santa Barbara County.
(Page numbers cited in this tome were those given by Newspapers.com – which were not always the same as the page number printed on the actual newspaper.)

SANTA MARIA FREE ADVERTISER
Browsed – 1931-Nov. 1, 1935. (Hard copy at the Santa Maria Valley Historical Society)

SANTA MARIA ARMY AIRBASE
None of these publications were browsed for this tome.
- ***The Bombsighter,*** v. 1 (April 7, 1943) – v. 2, no. 2 (April 26, 1944)
- ***The Fighter Pilot,*** v. 2, no. 3 (May 10, 1944) – v. 3, no. 1 (Aug. 10, 1945)
- ***Santa Maria Army Air Field Fighter Pilot,*** v. 3, no. 2 (Aug. 15, 1945) – v. 3, no. 27 (Dec. 19, 1945)

SANTA MARIA TIMES
Browsed – 1921-1959 (microfilm owned by Calif. State Library, Sacramento)
Digitally searched – c. 1880-1960+ (on newspapers.com)

***SANTA YNEZ VALLEY NEWS*, Solvang, Ca.**
Browsed – 1925-1960 (microfilm in the Coll. of University of California, Riverside)
Digitally searched – 1925+ (on newspapers.com)

Some data was carried over from previous *Publications in [Southern] California Art*, vol. 13, nos. 1-4, including from newspapers published in San Luis Obispo County.